CONTEMPORARY
PHOTOGRAPHERS

CONTEMPORARY ARTS SERIES

Contemporary Artists
Contemporary Architects
Contemporary Photographers
Contemporary Designers (forthcoming)

CONTEMPORARY
PHOTOGRAPHERS

Editors:
George Walsh, Colin Naylor
Michael Held

Advisers:
Ryszard Bobrowski, Cornell Capa
James L. Enyeart, Helmut Gernsheim
Rune Hassner, Mark Haworth-Booth
Mark Holborn, Sir Tom Hopkinson
Takao Kajiwara, Laurence Le Guay
Jean-Claude Lemagny, Pedro Meyer
Weston J. Naef, Beaumont Newhall
Daniela Palazzoli, Aaron Scharf

ST. MARTIN'S PRESS NEW YORK

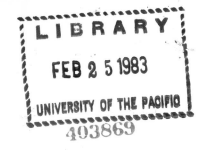
ST. MARTIN'S PRESS, INC.
175 Fifth Avenue
New York, NY 10010, USA

Library of Congress Cataloging in Publication Data

Main entry under title:

Contemporary photographers.

 Includes index.
 1. Photographers—Biography. 2. Photography,
Artistic. I. Walsh, George. II. Held, Michael.
III. Naylor, Colin.
TR139.C66 770'.92'2 (B) 82-3337
ISBN 0-312-16791-1 AACR2

Printed in Hong Kong

CONTENTS

The selection of entrants in *Contemporary Photographers* is based on the recommendations of the Advisers whose names are listed on page ix. In certain instances they have deferred to the judgment of contributors in particular countries, but, overall, there has been a remarkable consensus. The choice of 650 entrants is intended to reflect the best and most prominent of contemporary photographers (those who are living and those who have died in the recent past); photographers from earlier generations whose reputations are essentially contemporary; and photographers from the inter-war years and after who continue to be important influences. There are many kinds of photography: the Advisers have tried to suggest diversity as well as continuity within the medium. As with the other volumes in the "Contemporary Arts" series, *Contemporary Photographers* will hereafter be revised every five years. Photography is dynamic, constantly changing: we expect the consensus to change as well.

Entries consist of: biography; individual exhibitions (we list two-and three-man shows in this category); a selection of up to 10 group exhibitions; a listing of those public galleries and museums that have the work of the entrant in their collection (again, up to a limit of 10); and a bibliography of books and articles by and about the entrant (in the interests of space, we have not listed magazine publication of portfolios and picture stories). As well, living entrants have been invited to make a statement on their work or on contemporary photography in general and to choose a representative photo. The entry ends with a signed critical essay by one of 155 contributors.

Our research was carried out mainly in the libraries of the Art Institute of Chicago and The Photographers' Gallery, London: we are grateful to the staff at both institutions as well as to members of staff at the Museum of Modern Art and the International Center of Photography in New York; the Center for Creative Photography, Tucson; the Friends of Photography, Carmel; and the Galerie Wilde, Cologne.

This book has its faults. Most of them probably can be traced to the editors. Others have to do with photography itself. Photography is now more than a century old, but its having been taken seriously as an art form is a recent development, and that very newness creates problems for the compilers of a reference book. A "scholarly apparatus" does not yet exist, and errors introduced in one source—say, an exhibition catalogue—have a way of being perpetuated for years. To correct these errors (and often to find any source of accurate information at all), we had to start at the beginning; we had to rely on the entrants. When the entrants were dead, we had to appeal to the essayists, as well as to families and friends of the entrants—and to curators, scholars, critics and former associates not otherwise connected with this book who were experts on a particular photographer. The response was overwhelmingly co-operative, and one of the disappointments of this book must be that we cannot individually thank the many hundreds of people who helped to create the entries that follow.

—The Editors

ADVISERS / CONTRIBUTORS

Advisers

Ryszard Bobrowski, Cornell Capa, James L. Enyeart, Helmut Gernsheim
Rune Hassner, Mark Haworth-Booth, Mark Holborn, Sir Tom Hopkinson
Takao Kajiwara, Laurence Le Guay, Jean-Claude Lemagny, Pedro Meyer
Weston J. Naef, Beaumont Newhall, Daniela Palazzoli, Aaron Scharf

Contributors

Hans Christian Adam, James Alinder, Pamela Allara
Karyn Allen, Dana Asbury

Roger Baldwin, Lewis Baltz, Thomas F. Barrow
Derek Bennett, Erika Billeter, Ulrich Bischoff, M. Teresa Blanch
Lázaro Blanco, Ginette Bléry, Ryszard Bobrowski, Georges Bogardi
Inge Bondi, Elmer Borklund, John E. Bowlt, Bonnie Boxer
Theodore M. Brown, Doris Bry

Alison Carroll, Jean Caslin, Christian Caujolle
Jean-Francois Chevrier, Monica R. Cipnic, Stu Cohen, A.D. Coleman
Attilio Colombo, Robert W. Cooke, David Corey

Judy Dater, Sue Davies, A. de Jongh-Vermeulen, Robert J. Doherty

James L. Enyeart, Ute Eskildsen, John Esten, Tom Evans

David Featherstone, Joan Fontcuberta, Tina Freeman, Marianne Fulton

Arnold Gassan, Helmut Gernsheim, Norman A. Geske
G.M. Gidley, Vicki Goldberg, Arthur Goldsmith
Bradford G. Gorman, Nada Grcevic, Judith Mara Gutman

Nancy Hall-Duncan, Margaret Harker, Carole Harmel
David Harris, Akira Hasegawa, Rune Hassner
Ralph Hattersley, Mark Haworth-Booth, Ted Hedgpeth
Marvin Heiferman, Michael Held, H.K. Henisch
Mark Holborn, Klaus Honnef, Sir Tom Hopkinson
Graham Howe, F. Jack Hurley

Chris Johnson, William Johnson, Rune Jonsson

Takao Kajiwara, Bruce Kellner, Fritz Kempe
Hardwicke Knight, Kineo Kuwabara

Martha Langford, Laurence Le Guay, Jorge Lewinski
Jerome Liebling, Bernd Lohse

Guy Mandery, Katya Mandoki, Victor Margolin
Jacqueline Markham, Norihiko Matsumoto, Arthur McIntyre
William Messer, Arno Rafael Minkkinen, Francesc Miralles
Marco Misani, Margaretta K. Mitchell, David Moore
Anita V. Mozley, Daniela Mrázková, Andreas Müller-Pohle, Joan Murray

Colin Naylor, Barbara Norfleet, Claude Nori, Michel Nuridsany

Maria Crístina Orive

Daniela Palazzoli, Deba P. Patnaik, Marcuse Pfeifer
Christopher Phillips, Kenneth Poli, Ralph Pomeroy
Allan Porter, Edo Prando, H.Y. Sharada Prasad
Derrick Price, Sarah Putnam

Vladimír Remeš, Grant B. Romer, Naomi Rosenblum, Mike Rowell

Peter Sager, Catharine Sanders, Aaron Scharf, Jack Schofield
Giuliana Scimé, Julia Scully, James L. Sheldon, Abigail Solomon-Godeau
Ruth Spencer, Heinz Spielmann, Maren Stange, Philip Stokes
Brian Stokoe, William Stott, Maia-Mari Sutnik

Petr Tausk, Roger Therond, Peeter Tooming
Anne W. Tucker, Roland Turner

Marina Vaizey, Karel van Deuren, David Vestal, Larry A. Viskochil

Rolf Wedewer, Evelyn Weiss, Leif Wigh, Jürgen Wilde
Jonathan Williams, Sheldon Williams, Anna Winand
Ken Winokur, Kelly Wise

Italo Zannier, Colette Ziwes

Translators

Diana Blackstock, Iris Combes-Bijker, Teresa Czaplinska-Archer
Chris Fawcett, John George, Laura Harris, Marie-Madeleine Moore
Brenda Ohlmann, Chris Shimojima, Rogelio Vallejo-Lozano
Kirsten Williams, Hugh Young

CONTEMPORARY PHOTOGRAPHERS

James Abbe
Berenice Abbott
Yuri V. Abramochkin
Ansel Adams
Robert Adams
Lucien Aigner
James Alinder
Paul Almasy
Max Alpert
Manuel Alvarez Bravo
Emmy Andriesse
Diane Arbus
Eve Arnold
Barbara Astman
Eugène Atget
Erich Auerbach
Paul Ausloos
Richard Avedon

Gerry Badger
David Bailey
Oscar Bailey
John Baldessari
Richard Baltauss
Dmitri Baltermans
Lewis Baltz
Micha Bar-Am
Thomas F. Barrow
Claude Batho
John Batho
Yngve Baum
Horst H. Baumann
Herbert Bayer
Peter Beard
Cecil Beaton
Bernhard and Hilla Becher
Mitter Bedi
Hans Bellmer
E. J. Bellocq
Linda Benedict-Jones
Derek Bennett
John Benton-Harris
Roloff Beny
Gianni Berengo-Gardin
Ferenc Berko
Ruth Bernhard
Ian Berry
Henri A. Berssenbrugge
Aenne Biermann
Gunar Binde
Werner Bischof
Michael Bishop
John Blakemore
Lázaro Blanco
Carel Blazer
Ernest Bloch
Barbara Blondeau
Karl Blossfeldt
Donald Blumberg
Erwin Blumenfeld
Christian Boltanski
Pierre Boogaerts
Walter Bosshard
Enrique Bostelmann
Édouard Boubat
Pierre Boucher
Robert Bourdeau
Margaret Bourke-White
Brian Brake
Bill Brandt
Brassaï
Werner Braun
Denis Brihat
Alexey Brodovitch
Dean Brown
Anton Bruehl
Francis J. Bruguière
Jan Bulhak
Wynn Bullock
Jerry Burchard
Victor Burgin
René Burri
Larry Burrows
Vitaly Butyrin

Romano Cagnoni
Harry Callahan
Jo Ann Callis
Bryn Campbell
Cornell Capa
Robert Capa
Paul Caponigro
Lisetta Carmi
Henri Cartier-Bresson
Toni Catany
Giuseppe Cavalli
Harold Cazneaux
Martin Chambi
Walter Chappell
Jean-Philippe Charbonnier
Chargesheimer
Chim
Václav Chochola
Paul Citroen
Arnaud Claass
John Claridge
Larry Clark
Lucien Clergue
William Clift
Alvin Langdon Coburn
Lynne Cohen
Mark Cohen
Van Deren Coke
John Collier
Linda Connor
Thomas Joshua Cooper
Pierre Cordier
Carlotta M. Corpron
Raúl Corrales
Marie Cosindas
Gerry Cranham
Robert Cumming
Imogen Cunningham

Tošo Dabac
Louise Dahl-Wolfe
Robert D'Alessandro
Alicia D'Amico
Jacques Darche
Judy Dater
Bruce Davidson
Bevan Davies
Bob Davis
Joe Deal
Roy DeCarava
Liliane DeCock
Ger Dekkers
Jack Delano
Toni Del Tin
Robert Demachy
Paul Den Hollander
Paul de Nooijer
Raymond Depardon
Bernard Descamps
Pavel Dias
Jan Dibbets
Jean Dieuzaide
Michael Disfarmer
Miodrag Djordjević
Zbnigniew Dlubak
Robert Doisneau
John Dominis
Ken Domon
Benedykt Jerzy Dorys
Ed Douglas
Tom Drahos
Antoon Dries
Frantisek Drtikol
David Douglas Duncan
Max Dupain
Allen A. Dutton

Harold E. Edgerton
Mark Edwards
William Eggleston
Josef Ehm
Alfred Eisenstaedt
Sandra Eleta
Eliot Elisofon

Rennie Ellis
Hugo Erfurth
Elliott Erwitt
Walker Evans

Sara Facio
Bernard Faucon
Andreas Feininger
Robert W. Fichter
Erwin Fieger
Gabriel Figueroa Flores
Larry Fink
Hans Finsler
Steve Fitch
Franco Fontana
Joan Fontcuberta
Martine Franck
Robert Frank
Leonard Freed
Jill Freedman
Ferran Friexa
Gisèle Freund
Lee Friedlander
Benno Friedman
Toni Frissell
Hideki Fujii
Masahisa Fukase
Hamish Fulton
Jaromír Funke

Oliver Gagliani
Charles Gagnon
Avi Ganor
Anatoli Garanin
William A. Garnett
Charles Gatewood
Jean-Claude Gautrand
André Gelpke
Arnold Genthe
Helmut Gernsheim
Georg Gerster
Luigi Ghirri
Mario Giacomelli
Victor Gianella
Ralph Gibson
Tim N. Gidal
Laura Gilpin
Paolo Gioli
Douglas Glass
Burt Glinn
Hervé Gloaguen
Igor Gnevashev
Mikola Gnisyuk
Fay Godwin
Frank Gohlke
Judith Golden
Henry B. Goodwin
Fritz Goro
John R. Gossage
Emmet Gowin
Mladen Grčević
Brian Griffin
Franco Grignani
René Groebli
Jan Groover
Sid Grossman

Ernst Haas
Betty Hahn
Heinz Hajek-Halke
Gary Hallman
Philippe Halsman
Hiroshi Hamaya
David Hamilton
Hans Hammarskiöld
Charles Harbutt
Bert Hardy
Erich Hartmann
Edward Hartwig
Sam Haskins
Rune Hassner
Raoul Hausmann
Robert Häusser
John Heartfield

David Heath
Nick Hedges
Robert Heinecken
Jürgen Heinemann
Keld Helmer-Petersen
Nigel Henderson
Fritz Henle
Florence Henri
Fernando Herraez Gomez
François Hers
Abigail Heyman
Paul Hill
John Hilliard
Lewis W. Hine
Hiro
Thomas Höpker
Thurston Hopkins
E. O. Hoppé
William Horeis
Horst
Frank Horvat
Eric Hosking
Eikoh Hosoe
Graham Howe
George Hoyningen-Huene
Hanns Hubmann
Peter Hujar
David Hurn
Kurt Hutton
Scott Hyde

Tetsuya Ichimura
Boris Ignatovich
Irèna Ionesco
Yasuhiro Ishimoto
Graciela Iturbide
Izis

Joseph D. Jachna
Lotte Jacobi
Arno Jansen
James Jarché
Miroslav Jodas
Yale Joel
Tore Johnson
Harold Jones
Pirkle Jones
Philip Jones-Griffiths
Sune Jonsson
Kenneth Josephson
Paul Joyce
Bishin Jumonji

Simpson Kalisher
Karol Kalláy
Jonas Kalvelis
Art Kane
Yousuf Karsh
Kikuji Kawada
Alexander Keighley
Fritz Kempe
Gyorgy Kepes
Victor Keppler
Andre Kertesz
Dmitri Kessel
Erika Kiffl
Chris Killip
Ihei Kimura
Richard Kirstel
Aart Klein
William Klein
Berenice Kolko
Gennadi Koposov
Josef Koudelka
George Krause
Les Krims
Vilem Kriz
Germaine Krull
Heinrich Kühn
Kipton Kumler
Seiji Kurata
Taras Kuščynskyj
Kineo Kuwabara

Syl Labrot
Daniel Laizerovitz
Suzy Lake
Michel Lambeth
Dorothea Lange
William Larson
Jacques-Henri Lartigue
Clarence John Laughlin
Robert Lebeck
Russell Lee
Arthur Leipzig
Branko Lenart
Erica Lennard
Joanne Leonard
Cesare Leonardi
Robert Leverant
Helen Levitt
Jerzy Lewczyński
Alexander Liberman
Rudolf Lichtsteiner
Jerome Liebling
Herbert List
Stephen Livick
Eugeniusz Lokajski
Eli Lotar
Giorgio Lotti
Risto Lounema
Markéta Luskačová
George Platt Lynes
Danny Lyon
Joan Lyons

Greg MacGregor
Aleksandras Macijauskas
Arnaud Maggs
René Magritte
Peter Magubane
Mari Mahr
Alexandr Makarov
Hans Malmberg
Vasili Malyshev
Felix H. Man
Constantine Manos
Man Ray
Harald Mante
Werner Mantz
Robert Mapplethorpe
Richard Margolis
Mary Ellen Mark
Martin Martincek
Daniel Masclet
Max Mathys
Herbert Matter
Elaine Mayes
Roger Mayne
Angus McBean
Will McBride
Leonard McCombe
Ron McCormick
Donald McCullin
Ralph Eugene Meatyard
Ashvin Mehta
Susan Meiselas
Pepi Merisio
Roger Mertin
Ray K. Metzker
Pedro Meyer
Joel Meyerowitz
Duane Michals
Yoichi Midorikawa
Wilhelm Mikhailovsky
Gjon Mili
Roger Minick
Arno Rafael Minkkinen
Richard Misrach
Michael Mitchell
Lisette Model
Tina Modotti
Lucia Moholy
Laszlo Moholy-Nagy
Sarah Moon
David Moore
Raymond Moore

Inge Morath
Barbara Morgan
Jun Morinaga
Daidoh Moriyama
Wright Morris
Grant Mudford
Ugo Mulas
Andreas Müller-Pohle
Martin Munkacsi
Nickolas Muray
Carl Mydans

T. S. Nagarajan
Masatoshi Naitoh
Masaya Nakamura
Hans Namuth
Ikko Narahara
Paul Nash
Rafael Navarro
Bea Nettles
Floris M. Neusüss
Arnold Newman
Helmut Newton
José Luis Neyra
Lennart Nilsson
Pål-Nils Nilsson
Nicholas Nixon
Sonya Noskowiak
Gabriele and Helmut Nothhelfer
Ralph Nykvist

Georg Oddner
Ken Ohara
Cas Oorthuys
Ruth Orkin
José Ortiz-Echagüe
Pablo Ortiz Monasterio
Tzachi Ostrovsky
Paul Outerbridge
Bill Owens

Hilmar Pabel
Marion Palfi
Ameris M. Paolini
Tod Papageorge
Olivia Parker
Norman Parkinson
Gordon Parks
Martin Parr
Irving Penn
Gilles Peress
Philip Perkis
Walter Peterhans
Anders Petersen
Georgii Petrusov
John Pfahl
Joaquin Pla Janini
Bernard Plossu
David Plowden
Eliot Porter
Marion Post Wolcott
Wieslaw Prazuch
Count Giuseppe Primoli
Doug Prince
Josef Prošek
Rosamond Wolff Purcell

Enzo Ragazzini
Claude Raimond-Dityvon
Jaroslav Rajzík
Romualdas Rakauskas
Tony Ray-Jones
Lilo Raymond
Albert Renger-Patzsch
Bruno Requillart
Marcia Resnick
Robert Reusens
Nancy Rexroth
Marc Riboud
Mirella Ricciardi
Leland Rice
Heinrich Riebesehl
Leni Riefenstahl
David Robinson

Alexandr Rodchenko
George Rodger
Milton Rogovin
Fulvio Roiter
Willy Ronis
Walter Rosenblum
Jaroslav Rössler
Arthur Rothstein
Meridel Rubenstein
Eva Rubinstein
Edward Ruscha
Marialba Russo

Erich Salomon
Lucas Samaras
Karl Sandels
August Sander
Jan Saudek
Naomi Savage
Hajime Sawatari
Christian Schad
Xanti Schawinsky
Michael Schmidt
Gotthard Schuh
Emil Schulthess
Wilhelm Schürmann
Tazio Secchiaroli
Michael Semak
Paul Senn
Ben Shahn
Arkadii Shaikhet
Charles Sheeler
Igael Shemtov
Kishin Shinoyama
Yoshikazu Shirikawa
Arkadii Shishkin
Stephen Shore
Jeanloup Sieff
Arthur Siegel
George Silk
Raghubir Singh
Art Sinsabaugh
Aaron Siskind
Ulf Sjostedt
Gail Skoff
Neal Slavin
Edwin Smith
Henry Holmes Smith
Keith Smith
W. Eugene Smith
Vera Smoková-Váchová
Michael Snow
Snowdon
Frederick Sommer
Eve Sonneman
Emmanuel Sougez
Humphrey Spender
Jan Splichal
Egons Spuris
Pavel Stecha
Chris Steele-Perkins
Edward Steichen
Ralph Steiner
Otto Steinert
Abram Sterenberg
Bert Stern
Louis Stettner
Alfred Stieglitz
Dennis Stock
Paul Strand
Liselotte Strelow
Roy Stryker
Issei Suda
Josef Sudek
Jean-Pierre Sudre
Wolf Suschitzky
Antanas Sutkus
Homer Sykes
Steve Szabo
Mieczyslaw Szczuka
Karin Székessy
Gabor Szilasi

Maurice Tabard
Keiichi Tahara
Filip Tas
Edmund Teske
George A. Tice
Shomei Tomatsu
Peeter Tooming
Michael Torosian
Philip Trager
Mikhail Trakhman
Charles Traub
Arthur Tress
Hiromi Tsuchida
Nicolas Tucker
Jakob Tuggener
Deborah Turbeville

Shoji Ueda
Jerry N. Uelsmann
Doris Ulmann
Umbo
Joao Aristeu Urban
Burk Uzzle

John Vachon
Ed van der Elsken
James Van Der Zee
Willard Van Dyke
Carl Van Vechten
Luigi Veronesi
David Vestal
Roman Vishniac
Christian Vogt
Verena von Gagern

Arne Wahlberg
Todd Walker
John Walsh
Andy Warhol
Cary Wasserman
Todd Webb
Weegee
William Wegman
Dan Weiner
Jack Welpott
Henry Wessel, Jr.
Brett Weston
Cole Weston
Edward Weston
Minor White
Ludwig Windstosser
Geoff Winningham
Garry Winogrand
Rolf Winquist
Kelly Wise
Witkacy
Wols
Don Worth

Georgij Zelma
Piet Zwart

James Abbe: *Bessie Love in the Photographer's Paris Studio*, 1934

A

ABBE, James (Edward).
American. Born in Alfred, Maine, 17 July 1883. Educated in public schools in Newport News, Virginia, until 1900; self-taught in photography. Married Phyllis Edwards in 1909 (separated, 1922); children: Elizabeth, Phyllis, and James Jr.; married Polly Shorrock in 1923 (separated, 1937); children: Patience, Richard and John; married Irene Caby in 1939; children: Melinda and Matilda. Worked in his father's store, Abbe's Book Store, Newport News, 1898-1910; freelance photojournalist, in Virginia, 1913-17; established own studio, working for the *Saturday Evening Post*, *Ladies Home Journal*, the *New York Times*, etc., New York, 1917-22, 1923; film stills photographer, actor and story-writer, mainly for Mack Sennett Studios, Hollywood, California, 1922, and in Italy, 1923; established studio in Paris, working for *Tatler*, *L'Illustration*, *Vu*, *Vogue*, *Berliner Illustrierte Zeitung*, *Vanity Fair*, *Harper's Bazaar*, and the *New York Herald Tribune*, in Sweden, Spain, Germany, Mexico and the U.S.S.R., 1924-32; freelance photojournalist, in Larkspur, Colorado, 1934-36, and in Spain, for *Alliance* newspaper, 1936-37; rancher in Colorado, 1937-38, and in Sheridan, Wyoming, 1938-45, and for KLX radio station, San Francisco, 1945-50; television critic, *Tribune* newspaper, Oakland, California, 1951 until his retirement, 1961. Estate: James and Kathryn Abbe, Brookville Road, Jericho, New York 11753. Agent: Washburn Gallery, 820 Madison Avenue, New York, New York 10021. *Died* (in San Francisco) *11 November 1973.*

Individual Exhibitions:

1972 *Photographs of the 20's*, Lexington Lab Gallery, New York
1975 Washburn Gallery, New York
1976 *Stars of the 20's*, Canon Photo Gallery, Amsterdam
Fashions of the 20's, Washburn Gallery, New York
1977 The Photographer's Gallery, London (with Serge Lutens)
1978 *Dictatorship in the 30's*, Washburn Gallery, New York

Selected Group Exhibitions:

1975 *Fashion 1900-1939*, Victoria and Albert Museum, London (travelled to the Royal Scottish Museum, Edinburgh)
1977 *The History of Fashion Photography*, International Museum of Photography, George Eastman House, Rochester, New York (travelled to the Brooklyn Museum, New York; San Francisco Museum of Modern Art; Cincinnati Art Institute, Ohio; and Museum of Fine Arts, St. Petersburg, Florida)
1979 *Amerika Fotografie 1920-1940*, Kunsthaus, Zurich

Fleeting Gestures: Dance Photographs, International Center of Photography, New York (travelled to The Photographers' Gallery, London)

Collections:

Washburn Gallery, New York; James and Kathryn Abbe, Jericho, New York.

Publications:

By ABBE: books—*I Photograph Russia*, New York 1934, London 1935; *James Abbe: Stars of the 20's*, with text by Mary Dawn Earley, London 1975.

On ABBE: books—*Around the World in Eleven Years* by Patience, John and Richard Abbe, London 1936; *Fashion 1900-1939*, exhibition catalogue, by Valerie Lloyd and others, London 1975; *The Magic Image* by Cecil Beaton and Gail Buckland, London and Boston 1975; *The Photography Catalog*, edited by Norman Snyder, New York 1976; *The Vogue Book of Fashion Photography* by Polly Devlin, with an introduction by Alexander Liberman, London 1979; *The History of Fashion Photography* by Nancy Hall-Duncan, New York 1979; *Amerika Fotografie 1920-1940* by Erika Billeter, Berne 1979; article—by Margaretta Mitchell in *Popular Photography* (New York), July 1975.

James Abbe was the foremost stage, screen and society photographer of the early 20th century. He photographed in New York, Hollywood and Europe, and brought before his camera virtually every luminary of the entertainment world, among them Fred and Adele Astaire, Lillian and Dorothy Gish, Rudolph and Natasha Valentino, Mary Pickford, Katherine Cornell, Helen Hayes, Charlie Chaplin, John Barrymore, Theda Bara, Noel Coward, Irving Berlin, The Dolly Sisters, Gertrude Lawrence and Anna Pavlova. Indeed, his pictures reflect the dreamed-for-glamour and urbane sophistication which America wanted in the theater of the 1920's. And through Abbe we discover in images the collective dream of our culture much as we do in the writings of Fitzgerald or Hemingway.

His New York work consists of fine large-format studio portraiture for which he used an 8 x 10 Folmer and Schwing and orthochromatic film (ASA 8). He was a master of studio lighting; in his early work he used the traditional northern skylight with mirrors as reflectors but later he used lamps. He developed a spontaneous style from experience, from working on actual theater stages and movie sets.

Opportunities lured Abbe to Europe in the 1920's where he set up a studio in Paris and made his conquest of the European stage, beginning with the song and dance queens of the Moulin Rouge. Abbe also had a byline in several magazines for which he both wrote and photographed. For the *London Magazine* he was introduced as "Our Tramp Photographer," and his career brought him back to the United States and Mexico to cover stories as diverse as the end of the revolution in Mexico, crime and prohibition in Chicago and the wealthy on the Riviera. Abbe was among the first photojournalists of the 1930's although he was never comfortable with his newly-bought Leica and preferred the Kodak folding camera.

As the dream faded into the Depression of the early 30's he moved onto the political stage, capturing on film many of the famous (or infamous) faces of power: Adolph Hitler, Josef Stalin, Benito Mussolini, Herman Goering, Franco and Franklin Roosevelt. In 1932 Abbe left the stage lights of Paris and traveled to Russia in order to "stalk the Kremlin" and come away with a portrait of Stalin for Kurt Korft, the editor of Gemany's largest weekly. His book *I Photograph Russia* told the story to an eager American audience. From Stalin he went on to capture Hitler on film, but as the scenes of German life were more and more grim to record, Abbe sent more copy and fewer pictures to his editors. His career as a photographer ended when he returned to the United States for good after a stint as a Loyalist news correspondent in the Spanish Civil War.

After more than twenty years as a photographer and journalist, he became a radio news commentator and a newspaper columnist for radio and television on the West Coast.

Abbe was by nature a mischievous elf of a man, small in stature, driven by a constant search for adventure and for daring photo conquests. He managed to live well—by his camera, his pen, his wits and his charm. He was a storyteller, a spinner of dreams. His work expressed the ideals of beauty before they were commercialized by the encroachment of a mass culture. Once that cultural transformation was complete, he no longer photographed. His vision remained with the youthful dream of a prewar culture that followed Charles Lindbergh across the Atlantic. He had to be the hero—the photograph his prize and the proof of his having been at the glamorous and dangerous center stage of the cultural and political drama for the better part of two decades.

—Margaretta K. Mitchell

ABBOTT, Berenice.
American. Born Springfield, Ohio, 17 July 1898. Educated at public schools in Columbus, until 1916; studied (general studies) at Ohio State University,

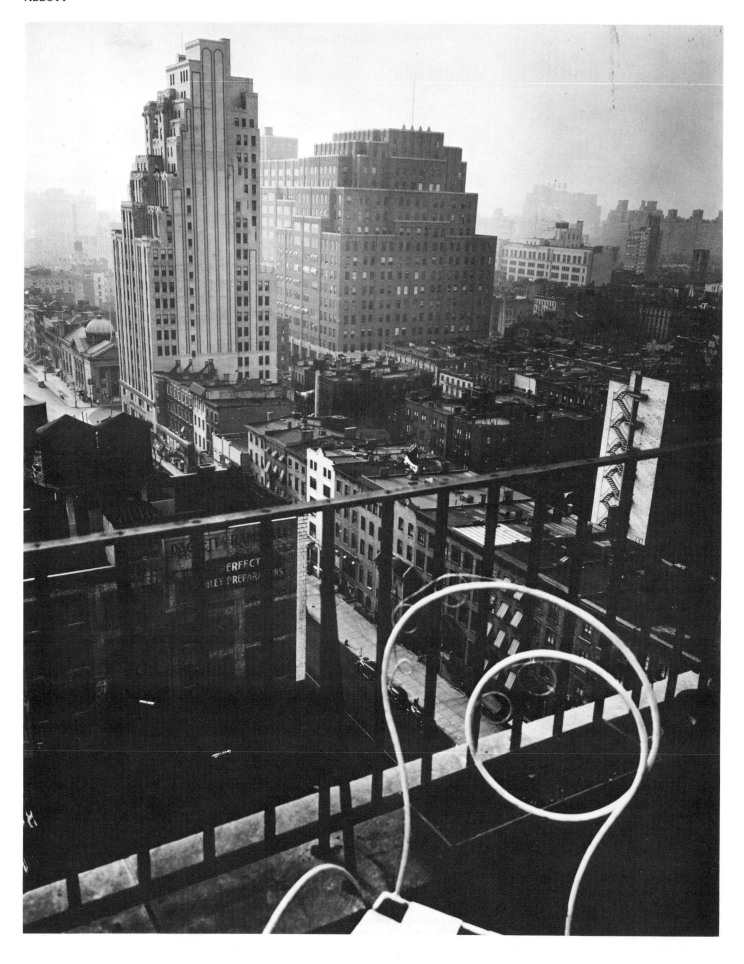

Berenice Abbott: *General View from the Penthouse at 56 Seventh Avenue*, New York, 1937 Courtesy Art Institute of Chicago

Columbus, one semester, 1917-18; studied journalism, Columbia University, New York, few weeks, 1918; did independent study of drawing and sculpture, in New York, 1918-21, and in Paris (partially under Antoine Bourdelle), 1921-23; studied at the Kunstschule, Berlin, Winter/Spring 1923. Assistant to Man Ray, Paris, 1923-25; introduced to the work of the photographer Eugène Atget, Paris, 1925: subsequently acquired the Atget archives and promoted his work; independent portrait photographer, establishing own studio, Paris, 1926-29; independent documentary and portrait photographer, New York, 1930-68: worked for *Fortune* and other magazines, and for the W.P.A. Federal Art Project, 1930-39; worked for the Physical Science Study Committee of Educational Services Inc., New York, 1958-61; settled in Abbot Village, Maine, 1968. Instructor in Photography, New School for Social Research, New York, 1935-58. Honorary doctorate: University of Maine, Orono, 1971; Smith College, Northampton, Massachusetts, 1973; New School for Social Research, 1981. Address: R.D. 1, Abbot Village, Maine 04406, U.S.A.

Individual Exhibitions:

1926 *Portraits Photographiques*, Galerie Au Sacre du Printemps, Paris
1930 Contemporary Art Club, Harvard University, Cambridge, Massachusetts
1932 Julien Levy Gallery, New York
 Museum of the City of New York
1934 New School for Social Research, New York
 Photos of New York City, Museum of the City of New York
 Oakland Art Museum, California
 Urban Vernacular of the 40's, 50's and 60's, Yale University, New Haven, Connecticut (toured the United States)
1935 Jerome Stavola Gallery, Hartford, Connecticut
 Springfield Museum of Fine Arts, Massachusetts
 Fine Arts Guild, Cambridge, Massachusetts
1937 *Changing New York*, Museum of the City of New York
1938 Hudson D. Walker Gallery, New York
1939 Federal Art Gallery, New York
1941 Massachusetts Institute of Technology, Cambridge
1947 Galerie de l'Epoque, Paris
1950 Akron Art Institute, Ohio
1951 Art Institute of Chicago
1953 San Francisco Museum of Art
 Caravan Gallery, New York
1955 Currier Gallery of Art, Manchester, New Hampshire
1956 Toronto Art Museum
1957 *Portraits of the 20's*, Limelight Gallery, New York
1959 *Science Photographs*, New School for Social Research, New York
 Science Photographs, Massachusetts Institute of Technology, Cambridge
1960 Carl Siembab Gallery, Boston
 Science Photographs, Currier Gallery of Art, Manchester, New Hampshire
 The Image of Physics, Smithsonian Institution, Washington, D.C. (toured the United States)
 Kalamazoo Art Institute, Michigan
1969 *Women, Cameras and Images III*, Smithsonian Institution, Washington, D.C.
1970 Museum of Modern Art, New York
1973 Witkin Gallery, New York
1975 Focus Gallery, San Francisco
1976 Marlborough Gallery, New York (travelled to Lunn Gallery, Washington, D.C.)
 Allan Frumkin Gallery, Chicago
1977 Vision Gallery, Boston (with Bill Brandt and Brassaï)
 Galerie Zabriskie, Paris (with Eugène Atget)

1979 Gallery for Fine Photography, New Orleans
1980 *Changing New York*, Galerie zur Stockeregg, Zurich
1981 *The 20's and the 30's*, International Center of Photography, New York

Selected Group Exhibitions:

1932 *New York by New Yorkers*, Julien Levy Gallery, New York
1966 *The Photographer's Eye*, Museum of Modern Art, New York
1967 *Photography in the 20th Century*, National Gallery of Canada, Ottawa (toured Canada and the United States, 1967-73)
1975 *Women of Photography*, San Francisco Museum of Art
1977 *Documenta 6*, Museum Fridericianum, Kassel, West Germany
1978 *Paris-Berlin 1900-1933*, Centre Georges Pompidou, Paris
1979 *Photography Rediscovered: American Photographs 1900-1930*, Whitney Museum, New York (travelled to the Art Institute of Chicago)
 Recollections: 10 Women of Photography, International Center of Photography, New York (toured the United States, 1979-82)
 Film und Foto der 20er Jahre, Würtiembergisshe Kunstverein, Stuttgart (travelled to Folkwang Museum, Essen; Werkbundarchiv, Berlin; Kunsthaus, Zurich; Kunstverein, Hamburg; and Museum des 20. Jahrhunderts, Vienna)
 Photographie als Kunst 1879-1979, Tiroler Landesmuseum Ferdinandeum, Innsbruck, Austria (travelled to Neue Galerie am Wolfgang Gurlitt Museum, Linz, Austria; Neue Galerie am Landesmuseum Joanneum, Graz, Austria; and Museum des 20. Jahrhunderts, Vienna)

Collections:

Museum of Modern Art, New York; Metropolitan Museum of Art, New York; Museum of the City of New York; International Museum of Photography, George Eastman House, Rochester, New York; Museum of Fine Arts, Boston; Smithsonian Institution, Washington, D.C.; Art Institute of Chicago; Museum of Fine Arts, Houston; San Francisco Museum of Art; Bibliothèque Nationale, Paris.

Publications:

By ABBOTT: books—*Changing New York*, with text by Elizabeth McCausland, New York 1939, as *New York in the Thirties*, New York 1973; *A Guide to Better Photography*, New York 1941, revised edition as *A New Guide to Better Photography*, New York 1953; *The View Camera Made Simple*, Chicago 1948; *Greenwich Village Today and Yesterday*, with text by Henry Wysham Lanier, New York 1949; *Eugène Atget Portfolio: 20 Photographic Prints from His Original Glass Negatives*, portfolio of 20 photos, New York 1956; *Eugène Atget*, Prague 1963; *The World of Atget*, New York 1964; *Magnet*, with text by E.G. Valens, Cleveland, Ohio 1964; *Motion*, with text by E.G. Valens, Cleveland, Ohio 1965; *A Portrait of Maine*, with text by Chenoweth Hall, New York 1968; *The Attractive Universe*, with text by E.G. Valens, Cleveland, Ohio 1969; *Berenice Abbott: Photographs*, with an introduction by David Vestal, foreword by Muriel Rukeyser, New York 1970; *Berenice Abbott: 10 Photographs*, portfolio, with an introduction by Hilton Kramer, Roslyn Heights, New York 1976; *Berenice Abbott's New York*, portfolio of 12 photos, New York 1978; *Lisette Model*, editor, New York 1980; articles—

"Photographer as Artist" in *Art Front* (New York), vol. 16, 1936; "Photography 1839-1937" in *Art Front* (New York), vol. 17, 1937; "Eugène Atget" in *Creative Art* (New York), vol. 5, 1939; "My Ideas on Camera Design" in *Popular Photography* (New York), May 1939; "My Favorite Picture" in *Popular Photography* (New York), February 1940; "Eugène Atget" in *The Complete Photographer* (New York), vol. 6, 1941; "Documenting the City" in *The Complete Photographer* (New York), vol. 22, 1942; "Nadar: Master Portraitist" in *The Complete Photographer* (New York), no. 51, 1943; "View Cameras" in *The Complete Photographer* (New York), no. 53, 1943; "From a Student's Notebook" in *Popular Photography* (New York), vol. 21, no. 6, 1947; "What the Camera and I See" in *Art News* (New York), vol. 50, no. 5, 1951; "It Has to Walk Alone" in *Infinity* (New York), vol. 7, no. 11, 1951; "Photography at the Crossroads" in *Universal Photo Almanac*, New York 1951; "The Image of Science" in *Art in America* (New York), vol. 47, no. 3, 1959.

On ABBOTT: books—*Photographers on Photography*, edited by Nathan Lyons, New York 1966; *Photography in the 20th Century* by Nathan Lyons, New York 1967; *Masters of Photography* by Beaumont and Nancy Newhall, New York 1969; *Looking at Photographs: 100 Pictures from the Collection of the Museum of Modern Art* by John Szarkowski, New York 1973; *The Woman's Eye*, edited by Anne Tucker, New York 1973; *Women of Photography: An Historical Survey*, edited by Margery Mann and Ann Noggle, San Francisco 1975; *The Magic Image* by Cecil Beaton and Gail Buckland, London and Boston 1975; *Photographs from the Julien Levy Collection, Starting with Atget*, exhibition catalogue, by David Travis, Chicago 1976; *Masters of the Camera: Stieglitz, Steichen and Their Successors* by Gene Thornton, New York 1976; *Photographs: Sheldon Memorial Art Gallery Collection, University of Nebraska*, with an introduction by Norman A. Geske, Lincoln, Nebraska 1977; *Documenta 6/Band 2*, exhibition catalogue, edited by Klaus Honnef and Evelyn Weiss, Kassel and Cologne 1977; *Helen Gee and the Limelight: A Pioneering Photography Gallery of the Fifties*, exhibition catalogue, by Peter C. Bunnell, New York, 1977; *Fotografie der 30er Jahre: Eine Anthologie*, edited by Hans-Jürgen Syberberg, Munich 1977; *Paris-Berlin 1900-1933*, exhibition catalogue, by Herbert Molderings, Werner Spies, Günter Metken and others, Paris 1978; *Amerika Fotografie 1920-40* by Erika Billeter, Berne 1979; *Photographie als Kunst 1879-1979/Kunst als Photographie 1949-1979*, exhibition catalogue, 2 vols., by Peter Weiermair, Innsbruck 1979; *Photographen der 20er Jahre* by Karl Steinorth, Munich 1979; *Film und Foto der 20er Jahre*, exhibition catalogue, by Ute Eskildsen and Jan Christopher Horak, Stuttgart 1979; *Photography Rediscovered: American Photographs 1900-1930* exhibition catalogue, by David Travis, New York 1979; *Recollections: 10 Women of Photography*, edited by Margaretta Mitchell, New York 1979; *A Ten Year Salute* by Lee D. Witkin, foreword by Carol Brown, Danbury, New Hampshire 1979; *The Photograph Collector's Guide* by Lee D. Witkin and Barbara London, Boston and London 1979; *Life: The First Decade 1936-1945*, with texts by Robert Littmann, Ralph Graves and Doris C. O'Neill, New York 1979, London 1980; *Classic Essays on Photography*, edited by Alan Trachtenberg, New Haven, Connecticut 1980.

After almost 60 years in photography, Berenice Abbott claims her rightful place as one of the greatest of American photographers. She has always been an exponent of realism, a tireless and uncompromising advocate for the documentary approach in photography. In 1951 she wrote, "We should take hold of that very quality [realism], make use of it and explore it to the fullest."

Abbott, herself, has achieved excellence in more than one kind of photography. Her earliest work consists of straightforward and penetrating portraits made during the 1920's in Paris. The largest body of work comes from the 1930's when she created an elaborate and systematic documentation of New York City during that dynamic decade of change. Her next vision led her to explore the remote realms of science in order to seek visual explanations for the layman. Her last major project was to follow Route 1 from Maine to Florida, recording the American scene in all its variety.

However, a proper assessment of Berenice Abbott's substantial contribution to the medium was delayed for almost 40 years because of her association with the French photographer, Eugène Atget. The young Berenice Abbott had met Atget while she was photo-assistant to Man Ray in Paris where she had gone to study sculpture. She rescued Atget's archives from destruction, preserved and printed it and finally published portions, allowing her own work to languish until she had achieved this remarkable contribution to the history of 19th and 20th century photography.

In Paris during the 1920's Abbott opened a portrait studio on the Left Bank and there photographed writers, artists, aristocrats and collectors such as André Gide, Marcel Duchamp, Max Ernst, Leo Stein, Princesse Marthe Bibesco, Sylvia Beach, James Joyce, Jean Cocteau and Violette Murat as well as an assortment of the now-famous expatriate Americans in Paris such as Edna St. Vincent Millay, Janet Flanner and Peggy Guggenheim. Her portraits have an unusually forthright human dignity based upon her intuitive understanding of the balance of strength in women and gentleness in men; each sitter is treated with individual respect, neither a stereotype nor a sentimental image among them.

On a return visit to New York in 1929 she decided to stay; she set herself the goal of documenting the city, a project which occupied the better part of the next decade. In 1939 her book *Changing New York* was published.

Her later scientific work took years of preparation spent in learning, building apparatus and convincing scientists to collaborate with her work. In 1958, right after the Russian spacecraft, Sputnik, was launched, Abbott was asked to work for the Physical Science Study Committee at the Massachusetts Institute of Technology in Cambridge. In her scientific "illustrations" Abbott's capacity to clarify complex ideas once again succeeded even though their photographic beauty was originally hidden by the inadequate design of the high school textbook in which they were published.

Living now in Maine, Berenice Abbott makes photographs and prints her work to meet the increased demand for prints. She defines her contribution as one of witnessing the American scene, but to thus summarize her life-work is to give this major photographer only partial praise. The value of her contribution to the medium should be based not only on the enormous concepts she herself developed and photographed but should also include her defense and advancement of the medium itself which can be summed up in her appreciation of Atget's work—which she states has "a relentless fidelity to fact, a deep love of the subject for its own sake, a profound feeling for materials and surfaces and textures, a conscious intent in permitting the subject photographed to live by virtue of its own form and life."

—Margaretta K. Mitchell

ABRAMOCHKIN, Yuri V(asilyevich).
Russian. Born in Moscow, 11 December 1936. Educated in primary and secondary schools, Moscow, 1944-54; studied photography at the Training School of Pictorial Journalism, Novosti Press Agency, Moscow, 1958-60; studied law at the All-Union Juridicial Institute, Moscow, 1963-74, Dip. Legal Science 1974. Married Svetlana Viktorovna in 1966; daughter: Tatyana. Special Photographer, Novosti Press Agency (APN), Moscow, since 1961. Member, Photo Section, U.S.S.R. Journalists' Union, Moscow, since 1963. Recipient: Diploma, Economics Category, *Interphoto*, Prague, 1962; Bronze Medal, *Interpress*, Moscow, 1966; Political Reportage Prize, U.S.S.R. Journalists' Union, 1969; Merited Worker of Culture Award, of the Russian Federation, 1977; Medal, *Interpress*, Havana, 1979; Gold Medal, *Sport as Ambassador of Peace Exhibition*, Moscow, 1980. Lives in Moscow. Address: c/o Photo Illustration Department, Novosti Press Agency, 4 Zubovsky Boulevard, Moscow 119021, U.S.S.R.

Individual Exhibitions:

1970 *Photographs from the U.S.S.R.*, City Museum, Sopron, Hungary
1974 *U.S.S.R.: Country and People*, Photo Artists' Salon, Belgrade
1976 *From the Photographer's Album*, House of Culture, Prague
 Photographs from the U.S.S.R., Exhibition Pavilion, West Berlin
1978 *Photographs from the U.S.S.R.*, Soviet Cultural Centre, Damascus
 Sowjetunion: Land und Leute im Foto, Majakowski Galerie, West Berlin
1979 *From the Photographer's Album*, Photo and Cine Club, Belgrade

Selected Group Exhibitions:

1961 *National Photo Exhibition*, Manege Exhibition Hall, Moscow
1962 *International Photo-Agency Exhibition*, Prague
1964 *World Press Photo*, Amsterdam (and 1965-69, 1975-76, 1978)

1966 *Interpress Photo '66*, Manege Exhibition Hall, Moscow
1975 *Fotos uit de Sovjet Unie*, Stedelijk Museum, Amsterdam
1976 *Photographs from the U.S.S.R.*, Trade Fair Hall, West Berlin
1979 *Interpress Photo '79*, Havana
1980 *Sport as Ambassador of Peace*, Manege Exhibition Hall, Moscow

Collections:

Novosti Press Agency, Moscow; Photo Section, U.S.S.R. Journalists ' Union, Moscow.

Publications:

By ABRAMOCHKIN: books—*Soviet Tartaria*, edited by A. Osipenko, Moscow 1975; *Kazan*, edited by N. Tkachenko, Moscow 1976; photographs in books—*Soviet Photo Artists*, edited by M. Bugayeva, Leipzig 1962; *Photointernational '63*, edited by R. Maahs and H. Bronovski, Leipzig 1963; *Interpress Photo '66*, edited by B. Burkov, Moscow 1966; *Photo '70: Works by Soviet Photographers*, Moscow 1970; *Moments of Happiness*, edited by A. Krasnovsky, Moscow 1972; *Photo Book U.S.S.R.*, Moscow 1975; *Photo Album U.S.S.R.: Country and People*, edited by Vazlav Yiru, Prague 1975; *Photo Album '76: For Life*, edited by D. Ardamatsky, Moscow 1976; *Soviet Photo Artists and Amateurs*, Moscow 1977; article—"APN Photographers" in *Hasselblad Magazine* (Goteborg, Sweden), no. 4, 1977.

On ABRAMOCHKIN: articles—"Fotos aus der Sowjetunion: Eine Ausstellung des Stedelijk-Museums in Amsterdam" in *Foto Magazine* (Munich), April 1975; "Exportausstellung der UdSSR 1976" in *Der Abend* (West Berlin), December 1976; "Sowjetunion in Bild" in *DSF Journal* (West Berlin), April 1977; "Creative Biography of Yuri Abramochkin" in *Tishrin* (Damascus), 31 January 1978; "Der Kiosk: Bildende Kunst" in *Die Welt* (Hamburg), 7 April 1978; "Mann, was lauft hier ab" by Ralph Franz and Thomas Krekelius in *Die Wahrheit* (West Berlin), May 1978; "The Soviet State in

Yuri V. Abramochkin: *Three for the Road*, 1980

Photographs" by V. Shatrov in *Sovetskaya Kultura* (Moscow), June 1978.

I have been working with a camera for 20 years, trying to be satisfied personally with my shots. I've also been doing my best to draw people's attention to something that might interest them, too. To do this, I release the shutter of my camera at just the right moment for me.

I consider photos from life the most interesting; therefore, an "immediate" moment is preferable. So my task is to "catch" such a moment. Naturally, I admit that a "man with a camera" must have his own secrets of shooting to do his job successfully. And his job is rather complicated, since he should be both in the midst of events and at the same time invisible while shooting.

Here is one of my secrets that I should like to share: a photographer is sometimes too tense during shooting, because he must fix on his subject and always try to keep it. I love to photograph people, and often manage to make each of them my partner. This doesn't mean that the subject tries to play up to me—gradually trust grows between us. Each does his own job in the process of photography. My "hero" doesn't pay any attention to me, but I'm on the alert and can take as many photos as possible, and in a way I like best. I cannot describe exactly how I manage to make contact with so many different people, but usually I succeed.

However, trust alone is not enough. The photographer has another task—for me, a social task, to convey themes of grief and joy, love and hatred, health and disease.

Photography is one of the most truthful means of mass media. It is an expressive and the most convenient language of communication between peoples of different outlooks and taste. No "distance" exists in modern photography.

Because of its emotional impact, photography helps people to understand each other at first glance, to know a lot about each other.

I'm pleased that I can perform such an honorable task.

—Yuri V. Abramochkin

Yuri Abramochkin is well known as one of the leading Soviet agency photographers (he works for APN, the Novosti press agency) and as an important correspondent of outstanding topical events and important political happenings at home and abroad. Because a traditional focus on the most closely covered official events does not offer much scope to journalists, however, Abramochkin, an inventive artist, has taken an individual stand and devised less conventional ways of presenting any given topic. Abramochkin has said of his work that he tries to bring "to contemporary photo reporting, in addition to sensations, emotional and humanistic aspects."

He successfully applied this credo and tested it in practice when, as an amateur, he took snapshots at the *World Festival of Youth and Students* in Moscow in 1957. The various faces and characters that marched past his lens, the noticeable differences in appearance and mentality, the changing situations—all of these aspects of his subjects made him seek out a common denominator in the feelings of short-term yet comradely fellowship of the young people from all parts of the world. He found it in his photo appraisal of friendship.

Abramochkin also took an unusual approach to another task he was to face later, as a professional. He was assigned to photograph the discussions at the 25th Congress of the Communist Party of the U.S.S.R. He did not so much concentrate on the speakers as on the whole atmosphere of the Congress, which always determines the political and economic conditions in the country for years to come. The backstage discussions and the lively reaction of the participants proved to be thematically worthwhile, producing more human effects. These

pictures, and his agency photographs of similar events in Soviet political life, have been published, and have made his name known, around the world.

Like most Soviet photojournalists, Yuri Abramochkin has also devoted himself to freelance photography as a kind of compensation for his work at the agency. He has been engaged in long-term projects, cycles on certain themes in Soviet domestic life ("People of My Country," "Siberian Geologists," "Kamchatka," etc.) as well as foreign topics ("Vietnam Diary," "Paris Sketches," "America As It Is," "People of Prague.") Some of these cycles are created after short visits; others, such as the cycle about the inhabitants of Prague, have been created over longer periods and are the result of systematic observation and deepening understanding formed over a number of visits.

But, such versatility, which to a certain extent is essential in work for the press agency, does have its drawbacks. Abramochkin's inventive approach to agency work loses its effect in those instances in which a mere impression is not sufficient, in which the artist cannot make do with just the fascination of first impact. Then the result can be just a pleasing effect or chance vision which, even though professional inventive and witty, seems too premeditated and facile.

—Vladimír Remeš

ADAMS, Ansel (Easton).

American. Born in San Francisco, California, 20 February 1902. Tutored privately at home; studied piano, San Francisco, 1914-27, and photography with the photofinisher Frank Dittman, San Francisco, 1916-17. Married Virginia Best in 1928; children: Michael and Anne. Began career as a photographer, 1927, and worked as a commercial photographer, 1930-60; Photography Correspondent, *Fortnightly Review*, San Francisco, 1931; Founder-Member, with Willard Van Dyke, Edward Weston, Imogen Cunningham, Sonia Noskowiak and Henry Swift, Group f/64, San Francisco, 1932; Director, Ansel Adams Photography and Art Gallery, San Francisco, 1933-34; Founder, with Beaumont Newhall and David McAlpin, Photography Department, Museum of Modern Art, New York, 1940; Photo-Muralist, United States Department of the Interior, in California, 1941-42; Photography Consultant, Office of War Information, Los Angeles, 1942-44. Consultant to the Polaroid Corporation, Cambridge, Massachusetts, since 1949. Lived and worked in the Yosemite Valley, California, 1937-62. Since 1962, has lived and worked in Carmel, California. Instructor, with Edward Weston, *U.S. Camera* photographic forum, Yosemite Valley, 1940; Instructor in Photography, Art Center School, Los Angeles, 1941, and Museum of Modern Art, New York, 1945; Founder-Instructor, Department of Photography, California School of Fine Arts, San Francisco, 1946. Since 1955, Founder-Instructor, Ansel Adams Annual Photography Workshops, Yosemite Valley. Member of the Board of Directors, 1934-71, and since 1978 Honorary Vice-President, Sierra Club, San Francisco; Founder, 1967, and now Chairman of the Board, Friends of Photography, Carmel. Recipient: Guggenheim Fellowship, 1946 (renewed, 1948), 1958; Brehm Memorial Award, Rochester Institute of Technology, New York, 1958; John Muir Award, Sierra Club, 1963; Conservation Service Award, United States Department of the Interior, 1968; Progress Medal, Photographic Society of America, 1969; Chubb Fellowship, Yale University, New Haven, Connecticut, 1970; Special Citation, American Institute of Architects, 1971; First Ansel Adams Conservation Award, The Wilderness

Society, 1980; United States Presidential Medal of Freedom, 1980. D.F.A.: University of California, Berkeley, 1961; Yale University, 1973; University of Massachusetts, Amherst, 1974; University of Arizona, Tucson, 1975; D.H.: Occidental College, Los Angeles, 1967. Fellow, American Academy of Arts and Sciences, 1966, and Society of Photographic Scientists and Engineers, 1975. Honorary Fellow, Royal Photographic Society, London, 1976. Address: Route 1, Box 181, Carmel, California 93923, U.S.A.

Individual Exhibitions:

1931 Smithsonian Institution, Washington, D.C.
1932 M.H. de Young Memorial Museum, San Francisco
1933 Delphic Studios, New York
1934 Albright Art Gallery, Buffalo, New York
 Yale University, New Haven, Connecticut
1936 An American Place, New York
 Katherine Kuh Gallery, Chicago
 Arts Club, Washington, D.C.
1938 University of California, Berkeley
1939 San Francisco Museum of Art
1944 Museum of Modern Art, New York
1946 Santa Barbara Museum, California
1950 Pasadena Art Institute, California
1951 Art Institute of Chicago
1952 International Museum of Photography, Rochester, New York
 Smithsonian Institution, Washington, D.C. (toured the United States)
1956 Photokina, Cologne
1956 Limelight Gallery, New York
1957 University of Hawaii, Honolulu
1961 American Federation of Arts, Carmel, California
1963 M.H. de Young Memorial Museum, San Francisco (retrospective)
 The Story of a Winery, Smithsonian Institution, Washington, D.C. (with Pirkle Jones; toured the United States)
1967 Boston Museum of Art
1970 Witkin Gallery, New York
1972 Philadelphia Print Club
 Witkin Gallery, New York
 Stanford University, California
 San Francisco Museum of Art
1973 Friends of Photography, Carmel, California
1974 Metropolitan Museum of Art, New York
 University of Arizona, Tucson
1976 Columbia Gallery of Photography, Missouri
 Cronin Gallery, Houston
 Center for Creative Photography, University of Arizona, Tucson
 Victoria and Albert Museum, London
1977 Fotografiska Museet, Stockholm
1979 *Ansel Adams and the West*, Museum of Modern Art, New York
1981 *Ansel Adams, Eliot Porter, William Clift*, Cronin Gallery, Houston, Texas
 Facets of the Permanent Collection: Ansel Adams, San Francisco Museum of Modern Art
 Chrysler Museum, Norfolk, Virginia
1982 *Ansel Adams at an American Place*, San Francisco Museum of Modern Art

Selected Group Exhibitions:

1932 *Group f/64*, M.H. de Young Memorial Museum, San Francisco
1937 *Photography 1839-1937*, Museum of Modern Art, New York
1944 *Art in Progress*, Museum of Modern Art, New York
1951 *Contemporary Photography*, Contemporary Arts Museum, Houston

1959 *Photography at Mid-Century*, International Museum of Photography, Rochester, New York

1963 *The Photographer and the American Landscape*, Museum of Modern Art, New York

1966 *American Photography: The Sixties*, University of Nebraska, Lincoln

1974 *Photography in America*, Whitney Museum, New York

1977 *Photographs: Sheldon Memorial Art Gallery Collection*, University of Nebraska, Lincoln

1978 *Mirrors and Windows: American Photography since 1960*, Museum of Modern Art, New York (toured the United States, 1978-80)

Collections:

Center for Creative Photography, University of Arizona, Tucson (archives); San Francisco Museum of Modern Art; M.H. de Young Memorial Museum, San Francisco; Bancroft Library, University of California, Berkeley; Museum of Modern Art, New York; Victoria and Albert Museum, London; Bibliothèque Nationale, Paris.

Publications:

By ADAMS: books of photographs—*Taos Pueblo*, with text by Mary Austin, San Francisco 1930; *Sierra Nevada: The John Muir Trail*, Berkeley, California 1938; *Illustrated Guide to Yosemite Valley*, with Virginia Adams, San Francisco 1940, 8th revised edition 1963; *A Pageant of Photography*, exhibition catalogue, San Francisco 1940; *Michael and Anne in Yosemite Valley*, with text by Virginia Adams, New York and London 1941; *Born Free and Equal: The Story of Loyal Japanese-Americans at Manzanar Relocation Center*, New York 1944; *Yosemite and the High Sierra*, with text by John Muir, edited by Charlotte Mauk, Boston 1948; *My Camera in Yosemite Valley*, Boston 1949; *My Camera in the National Parks*, Boston 1950; *The Land of Little Rain*, with text by Mary Austin and Carl Van Doren, Boston 1950; *Death Valley*, with text by Nancy Newhall, San Francisco 1954, 1963; *Mission San Xavier del Bac*, with text by Nancy Newhall, San Francisco 1954; *The Pageant of History in Northern California*, with text by Nancy Newhall, San Francisco 1954; *The Islands of Hawaii*, with text by Edward Joesting, Honolulu 1958; *Yosemite Valley*, edited by Nancy Newhall, San Francisco 1959; *This Is the American Earth*, with others, with text by Nancy Newhall, San Francisco 1960; *Death Valley and the Creek Called Furnace*, with text by Dewin Corle, Los Angeles 1962; *These We Inherit: The Parklands of America*, San Francisco 1963; *Introduction to Hawaii*, with text by Edward Joesting, Redwood City, California 1964; *Fiat Lux: The University of California*, with text by Nancy Newhall, New York 1967; *The Tetons and The Yellowstone*, with text by Nancy Newhall, Redwood City, California 1970; *Ansel Adams*, edited by Liliane DeCock, New York 1972; *Singular Images*, with text by Edwin Land and David H. McAlpin, Dobbs Ferry, New York 1974; *Ansel Adams: Images 1923-1974*, with text by Wallace Stegner, Boston 1974; *Photographs of the Southwest*, with text by Lawrence Clark Powell, Boston 1976; *The Portfolios of Ansel Adams*, with an introduction by John Szarkowski, Boston and London 1977; *Yosemite and the Range of Light*, Boston 1979; technical books—*Making a Photograph*, New York and London 1935; Basic Photo Series: 1) *Camera and Lens*, New York 1948, 1970, 2) *The Negative*, New York 1948, 3) *The Print*, New York 1950, 4) *Natural Light Photography*, New York 1952, and 5) *Artificial Light Photography*, New York 1956; *Polaroid Land Photography Manual*, New York 1963; *Polaroid Land Photography*, Boston 1979; *The Camera*, Boston 1980.

On ADAMS: books—*The Eloquent Light* by Nancy Newhall, San Francisco 1963; *Photography in America*, edited by Robert Doty, with an introduction by Minor White, New York and London 1974; *Great Photographers*, by the Time/Life editors, New York 1971; *Looking at Photographs* by John Szarkowski, New York 1973; *Masters of the Camera: Stieglitz, Steichen and Their Successors* by Gene Thornton, New York 1976; *Ansel Adams*, exhibition catalogue, by Ake Sidwall and Wallace Stegner, Stockholm 1977; *Ansel Adams: 50 Years of Portraits* by James Alinder, Carmel, California 1979; films—*Ansel Adams, Photographer*, directed by David Myers, 1957; *Yosemite, Valley of Light*, directed by Tom Thomas, 1957; *Photography: The Incisive Art*, 5 television films directed by Robert Katz, 1959.

Why has photography enjoyed such an extraordinary elevation of interest in recent years? It has always been a popular art and craft, and the appearance of the small "automatic" cameras has excited the interest of millions. We must remember that photography is, in its largest amateur applications, a visual diary system. Passing from the simple recording of interesting facts and events to more selective personal observations and interpretations encourages people to think of photography as something in which they might creatively participate. From there, the steps of appreciation, acquisition and actual production of images are obvious and ever-expanding.

In addition, the photo-journalism explosion has identified the camera image with everyday events, and the proliferation of images in magazines, newspapers and on the television screen competes with the printed word. With the camera image, one feels a strong identity with the world about him. Certainly, only a very small part of photography is "art," but that aspect has been nurtured by the general recognition of photography as a language. This surprises me only because of its vast scale. I think we were all aware of the growth of photography for decades, but the present situatiton is beyond all expectations. The rate of growth may level off in time, but I am sure photography—in all its forms and manifestations—will remain a permanent and dominant force in our lives.

When I started with photography, about 1916, I certainly had no idea of what photography was or where it was going. My early work was of the "snapshot" diarist character; I was anxious to record and retain recollections of experiences. The expressive potentials (perhaps latent in us all) gradually developed, but when I entered the field professionally around 1931 my knowledge of the techniques and my awareness of creativity were relatively small. Associations with Group f/64 opened new worlds. My experiences with Stieglitz and the Museum of Modern Art in New York confirmed my compelling devotion to the medium. With a few reservations, I feel better now about photography than ever before. I feel the young people of today will carry a brighter torch than any of us of earlier days have ignited and held aloft.

Yet, as a stabilizing comment, I must quote Charles Sheeler after he and I had seen an exhibition of photographs dating from the 1940's through the late 1950's: "Adams, isn't it remarkable how photography has advanced without improving?"

—Ansel Adams

Everyone at the dinner that evening was noisy, cheerful and a bit intoxicated. Ansel, at 78, presided over his guests at the head of the long table. He entertained us all with an endless round of jokes. His own laughter bellowed and resounded in the large, high-ceilinged room. I was seated to his right, and intermittently, in moments of particular good humor, his knarled hand would creep along the table and pounce on my arm. My startled reaction sent him into new fits of laughter. Here we all were, enjoying

a good dinner at Ansel's, after having come to ask a favor of him. It had all started over 5 o'clock cocktails, a long established tradition, Virginia and Ansel being the most generous and gracious hosts to the endless parade of visitors who come almost daily.

After dinner Ansel continued his joking and with his boundless energy and enthusiasm wanted to show his guests some new "toys," an IBM typewriter and a 4x5 view camera that Virginia had recently given him as a present. We, half his age, were already tired, Virginia had slipped off to bed, but Ansel could have gone on and on. Finally with reluctance, we thanked him, and said good night. We stepped out onto the porch covered with pots of fuschia and white cyclamen, cream colored orchids, and lush ferns. A light mist filtered through Monterey pines standing just outside the windows of the house. Hundreds of feet below the Pacific rolled and broke on the black rocky shore. The night air was cool and moist, aromatic from sea and pines. We left Carmel and drove back to San Francisco, talking of our evening with Ansel: the photographer, the legend, the leprechaun.

As photographer, Adams is an undisputed master of the natural landscape. With clarity and precision he portrays and heightens the spectacular vistas and rich native details of the western United States. Rivers, mountains, valleys, orchards, deserts and sea—all are chronicled, and fused with his poetic vision and his conservationist instincts. "My approach to photography is based on my belief in the vigor and values of the world of nature—in the aspects of grandeur and of the minutiae all about us."

As technical wizard he is possibly unsurpassed, both in his work and in his writings on the craft of photography. Because of his early training as a concert pianist he often expresses his feelings about the technical aspects of photography in musical terms. "It is futile to visualize the mechanically impossible; we cannot perform something on the violin and expect it to sound like a full orchestra." Or in speaking about the printing quality of a fellow photographer, "Jesus, what a great pianist—but the piano's not very good!" He talks of the negative as being the "score." It is important to him to perform it at the highest possible level.

Though he uses the best in equipment he is not "gadget"-oriented. Gadgets in themselves are useless and can ultimately become a distraction. He uses only what he needs to achieve superior quality. "I prefer a fine lens because it gives me the best possible optical image, a fine camera because it complements the function of the lens, fine materials because they convey the qualities of the image to the highest degree."

His career is truly legendary. He has received every honor and award in the field of photography; he was recently honored by the United States Medal of Freedom. As photographer, teacher, lecturer, conservationist and writer, he has made monumental contributions and has been an important influence. His accomplishments can be overwhelming and intimidating until one has had a chance to actually spend some time with the person. It is then that the term leprechaun, while surprising, seems apt. Webster's describes leprechaun this way: "a small fairy, thought of as a sly tricky old man who, if caught, will point out a treasure." Ansel Adams does seem to possess the characteristics of a magical mythical creature. Where he gets all of his energy is a mystery. He knows how to delight and to mystify. And indeed, if caught, he could point out a treasure.

—Judy Dater

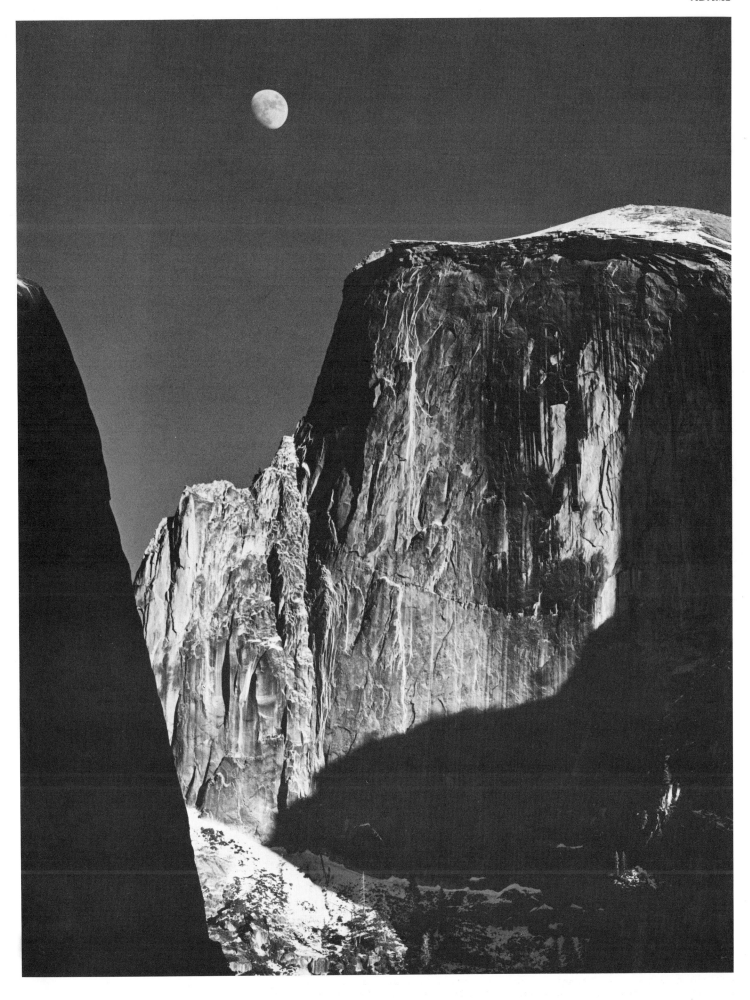

Ansel Adams: *Moon and Half Dome, Yosemite National Park, California,* 1960

ADAMS, Robert.

American. Born in Orange, New Jersey, 8 May 1937. Educated at Wheat Ridge High School, Colorado, 1952-55; University of Redlands, California, 1955-59, B.A. in English 1959; University of Southern California, Los Angeles, Ph.D. in English 1965. Married Kerstin Mornestam in 1960. Lecturer and Assistant Professor of English, Colorado College, Colorado Springs, 1962-70. Since 1967, freelance photographer and writer. Recipient: National Endowment for the Arts Fellowship, 1973, 1978; Guggenheim Fellowship, 1973, 1980; Award of Merit, American Association of State and Local History, 1975; Colorado Governor's Award for the Arts, 1979. Agent: Castelli Graphics, 4 East 77th Street, New York, New York 10021. Address: 326 Lincoln Street, Longmont, Colorado 80501, U.S.A.

Individual Exhibitions:

1971 Colorado Springs Fine Arts Center
Photographs by Robert Adams and Emmet Gowin, Museum of Modern Art, New York
1976 St. John's College, Santa Fe, New Mexico
Rice University Media Center, Houston
Salt Lake City Public Library
Castelli Graphics, New York
1977 Sheldon Memorial Art Gallery, University of Nebraska, Lincoln
Photographs by Robert Adams and Myron Wood, Colorado Springs Fine Arts Center
1978 Robert Self Gallery, London
Prairie, Denver Art Museum (travelled to the Museum of Modern Art, New York, and Baltimore Museum of Art, 1979)
1979 Werkstatt für Photographie der VHS Kreuzberg, Berlin
From the Missouri West, Castelli Graphics, New York

Selected Group Exhibitions:

1973 *Landscape/Cityscape*, Metropolitan Museum of Art, New York

1975 *14 American Photographers*, Baltimore Museum of Art (travelled to Newport Harbor Art Museum, Newport Beach, California; La Jolla Museum of Contemporary Art, California; Walker Art Center, Minneapolis; and Fort Worth Art Museum, Texas)
New Topographics: Photographs of a Man-Altered Landscape, International Museum of Photography, Rochester, New York (travelled to Otis Art Institute, Los Angeles, and Princeton University Art Museum, New Jersey)
1976 *Aspects of American Photography 1976*, University of Missouri, St. Louis
1977 *The Target Collection of American Photography*, Museum of Fine Arts, Houston (travelled to the Art Museum of South Texas, Corpus Christi, and Joslyn Art Center, Omaha)
The Great West: Real/Ideal, University of Colorado, Boulder (toured the United States)
Contemporary American Photographic Works, Museum of Fine Arts, Houston (travelled to the Museum of Contemporary Art, Chicago; La Jolla Museum of Contemporary Art, California; and Newport Harbor Art Museum, California)
1978 *Mirrors and Windows: American Photography since 1960*, Museum of Modern Art, New York (toured the United States, 1978-80)
1979 *American Images: New Work by 20 Contemporary Photographers*, Corcoran Gallery, Washington, D.C. (toured the United States, 1979-80)

Collections:

Museum of Modern Art, New York; Metropolitan Museum of Art, New York; International Museum of Photography, Rochester, New York; Princeton University Art Museum, New Jersey; Colorado State Museum, Denver; Colorado Springs Fine Arts Center; Museum of Fine Arts, Houston; Sheldon Memorial Art Gallery, University of Nebraska, Lincoln; Denver Art Museum; Australian National Gallery, Canberra.

Publications:

By ADAMS: books of photographs—*White Churches of the Plains: Examples from Colorado*, with an introduction by Thomas Hornsby Ferril, Boulder, Colorado 1970; *The Architecture and Art of Early Hispanic Colorado*, Boulder, Colorado 1974; *The New West: Landscapes Along the Colorado Front Range*, with an introduction by John Szarkowski, Boulder, Colorado 1974; *Denver: A Photographic Survey of the Metropolitan Area*, Boulder, Colorado 1977; *Prairie*, Denver 1978; *From the Missouri West*, Millerton, New York 1980; *Beauty in Photography: Essays in Defense of Traditional Values*, Millerton, New York 1981; articles—"Pictures and the Survival of Literature" in *Western Humanities Review* (Salt Lake City), Winter 1971; review of *Wisconsin Death* by Michael Lesy in *Colorado Magazine* (Denver), Fall 1974; review of *The West* by David R. Phillips in *Colorado Magazine* (Denver), Spring 1975; introduction to *A Texas Dozen: 15 Photographs* by Geoff Winningham, Houston 1976; "Good News" in *Untitled* (Camel, California), no. 14, 1979; "Inhabited Nature" in *Aperture* (Millerton, New York), no. 81, 1979; "Robert Adams," interview with Thomas Dugan, in *Photography Between Covers: Interviews with Photo Book Makers*, Rochester, New York 1979.

On ADAMS: articles—introduction by John Szarkowski to Adams' *The New West: Landscapes Along the Colorado Front Range*, Boulder, Colorado 1974; review of *The New West* by Lewis Baltz in *Art in America* (New York), March-April 1975; "Chronicling Sprawl Across the Plains" in *Photography Year 1977* by the Time-Life editors, New York 1977; "The Sublime and the Anachronistic: Robert Adams' American Landscape" by Jan Zita Grover in *Afterimage* (Rochester, New York), December 1981.

The subject of most of my pictures is a troubling mixture: buildings and roads that are often, but not always, unworthy of us; people who are, though they participate in urban chaos, admirable and deserving of our thought and care; light that sometimes still works an alchemy; a western scale that, despite our crowding, persists in long views.

If I hope the pictures show more than this, it is because I share the goal of most photographers. You may have sensed what that goal is if you have watched someone with a camera struggle for adequate results; over and over again he walks a few steps and peers, rather comically, into the camera; to the exasperation of family and friends, he inventories what seems an endless number of angles; he explains, if asked, that he is trying for effective composition, but hesitates to define it. Edward Weston, a photographer who demonstrated he knew what it was, said simply that good composition was "the strongest way of seeing." What he appears to have meant was that a photographer wants Form, an unarguably right relationship of shapes, a visual stability in which all components are equally important. The photographer hopes, in brief, to discover a tension so exact that it is peace.

Pictures that embody this calm are not synonymous, of course, with what we might see casually out a car window (they may, however, be more effective if we can be tricked into thinking so). The form the photographer records, though discovered in a split second of literal fact, is different because it implies an order beyond itself, a landscape into which all fragments, no matter how imperfect, fit perfectly.

—Robert Adams

The work of Robert Adams has, in his three major groups of landscape photographs to date, balanced

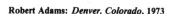

Robert Adams: *Denver, Colorado*, 1973

two seemingly contradictory concerns: the inquiry into photography's ability to describe natural beauty and the documentation and acknowledgment of man's worldly presence and intervention in the landscape.

Adams's first major published series, *The New West: Landscapes Along the Colorado Front Range*, presents a vision of grandeur tempered with modesty. The small images present natural land formations, the type generally presented (in landscape photography) on an operatic, heroic scale. The pictures in *The New West* document mountains, prairies and foothills but, with equal gravity and respect, show the tract houses, mobile homes, cities and suburbs that nestle in them. The images do not encourage judgements but suggest an uneasy coexistence. Photographed in the harsh light of the American West, the classical simplicity of the images illustrate Adams's sense of fairness. The starkness of the confrontation between cultural remembrances of the ideal landscape and the realities of recent American expansion create beautiful, troublesome photographs.

The photographs in *Denver: A Photographic Survey of the Metropolitan Area* continue Adams's earlier interests. The images in this group are more severe and unrelenting in the attempt to balance the search for form and beauty with the goal of documenting Denver, a city plagued with urban problems. Adams's goal is to "discover a tension so exact that it is peace," and these images of land that undergoes extensive development juggle a wealth of unpleasant detail, at almost direct odds against the intricate beauty of formal composition. These are extremely difficult photographs. Disturbing information abounds—motels, shopping malls and highways are carefully described—but Adams's striving for visual order is of equal importance to his goal in reportage.

From the Missouri West is Adams's most overtly lyrical work to date. The series documents natural land forms, seen by earlier inhabitants as idyllic or awesome landscape. Adams allows, in these images, for a lushness that has come to be expected from landscape imagery, but has tempered these scenes with carefully selected visual reminders of human presence (bits of litter, tire tracks, buildings and roads seen in the distance, the opacity of polluted air). These overtly seductive photographs are no less incisive than Adams's earlier, more didactic works. But what is communicated, more clearly than ever, is Adams's quest for beauty, and his affirmation of faith in the possibility of its presence.

John Szarkowski has written eloquently of Adams's work: "Adams's pictures are so civilized, temperate, and exact...that some viewers might find them dull.... But other viewers, for whom the shrill rodomontade of conventional...dialect has lost its persuasive power, may find in these pictures nourishment, surprise, instruction, clarification, challenge and perhaps hope."

—Marvin Heiferman

AIGNER, Lucien.

American. Born in Ersekujvar, Hungary, now Nove Zamky, Czechoslovakia, 14 September 1901; emigrated to the United States, 1939: naturalized, 1945. Studied at Prague University, 1920; theatre and acting at Freidrich Wilhelm University and Reichersche Dram. Hochschule, Berlin, 1921-22; law at the University of Budapest, 1922-24, LL.B. 1924; writing, Columbia University, New York, 1942; and filmmaking, New York University, 1967-68; studied photography at the Winona School of Professional Photography, Winona Lake, Indiana, 1957, 1958 and New England School of Professional Photography, University of New Hampshire, Durham, 1963; also attended photography workshops, under John Freni, Poughkeepsie, New York, 1964. Married Anne Lenard in 1932 (divorced, 1953); children: John and Steven, Anne and Kati; married Mildred A. Allen in 1955. Worked as assistant film cameraman to Stefan Lorant, Berlin, 1921-22; Reporter, then Photojournalist, 1924-27, and then assistant to their Paris Correspondent, later Paris Bureau Chief, 1927-39, *Az Est* newspaper group, Budapest; photographic assistant to James Abbe, Paris, 1926-28; Editor-in-Chief, Aral Press, Paris, 1931-39; Photo-Columnist, *L'Intransigeant* newspaper, Paris, 1932; Art Director, *Petit Journal* newspaper, Paris, 1933; Paris Correspondent, London General Press, 1935-39; Contract Photographer, *Life* magazine, in Paris, 1936-37; also, freelance photojournalist in Paris, contributing to *Vu, L'illustration, Miroir du Monde*, Paris, *Weekly Illustrated, Lilliput, Picture Post*, London, and *Berliner Illustrierte Zeitung* and *Münchner Illustrierte*, Germany, 1928-39; freelance photojournalist, based in New York, working for the *Christian Science Monitor, New York Times, Look, Click, Coronet, Pageant*, etc., 1939-48; Announcer, Scriptwriter and Producer/Director, Voice of America radio broadcasts, New York 1947-53. Owner, the Lucien Aigner Studios, Great Barrington, Massachusetts, also freelance writer-photographer for *Popular Photography, Yankee Magazine, Rotarian, Rangefinder*, etc., since 1954. Recipient: Leica Award, 1936; Art Directors Award, New York, 1941; Good Citizens Award, Freedom Inc., 1958; National Endowment for the Arts Grant, 1975, 1977. Master of Photography, 1971, and Life Member, 1973, Professional Photographers of America. Agents: The Photographers' Gallery, 8 Great Newport Street, London WC2, England; Galerie Viviane Esders, 12 rue Saint Merri, 75004 Paris, France; Anna Obolensky, 29 rue Bressolette, 14110 Arcueil, France; Pacific Press Agency, Tokyo CPO Box 2051, Japan. Address: 15 Dresser Avenue, Great Barrington, Massachusetts 01230, U.S.A.

Lucien Aigner: *Albert Einstein*

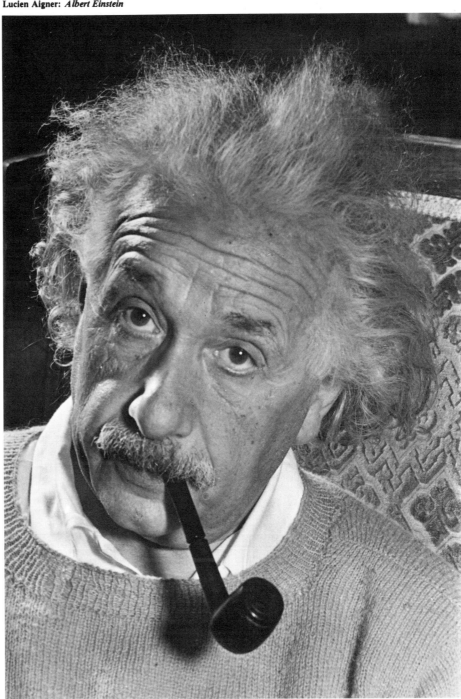

Individual Exhibitions:

1972 *Glimpses of History*, Brandeis University, Waltham, Massachusetts
1973 *Photographs by Lucien Aigner*, International Museum of Photography, George Eastman House, Rochester, New York (travelled to New York University, Focus II Gallery, New York, and Bard College, Annandale-on-Hudson, New York)
40 Years of Candid Photography, at the *Professional Photographers of America Convention*, Denver
Einstein and Others, YMHA, Highland Park, New Jersey
1975 *Faces from History*, Amerika Haus, Hamburg (travelled to Amerika Haus, Cologne)
From Marlene to Churchill, Galerie FNAC-Montparnasse, Paris
40 Years of Instant History, European Center of Photography, Chalon-sur-Saône, France
Aigner Laszlo fotómüvész, Hungarian Cultural Center, Budapest
Lucien Aigner, Photographer, National Museum of Photography, Helsinki
1976 *Picture Stories of France*, French Institute/Alliance Francaise, New York
Personal Glimpses of History, Shade Gallery, Lenox, Massachusetts
Profiles of History, Sindin Gallery, New York
Glimpses of History, Welles Gallery, Lenox, Massachusetts
1978 *Young Yehudi Menuhin*, The Photographers' Gallery, London
40 Years of Candid Photography, Temple Emanu-El, Westfield, New Jersey
1979 *Glimpses of History*, International Center of Photography, New York (travelled to Photo-Graphics, New Canaan, Connecticut, and Plymouth College, New Hampshire)
1980 *Around Quatorze Juillet*, French Cultural Center, New York (travelled to the Fine Arts Center, Key West, Florida)
Lucien Aigner, FNAC-Forum, Paris, and Galleria Il Diaframma, Milan
Einstein at Work, Waldorf Astoria Hotel, New York, and New York University Medical School
1981 *Lucien Aigner*, FNAC Gallery, Lyons
Galerie Viviane Esders, Paris

Selected Group Exhibitions:

1979 *Fleeting Gestures: Dance Photographs*, International Center of Photography, New York (travelled to The Photographers' Gallery, London)
1980 *The Statues of Paris*, Musée Bourdelle, Paris
Albert Einstein, Smithsonian Institution, Washington, D.C.

Collections:

Metropolitan Museum of Art, New York; International Museum of Photography, George Eastman House, Rochester, New York; Library of Congress, Washington, D.C.; Smithsonian Institution, Washington, D.C.; Musée Nicéphore Niepce, Chalon-sur-Saône, France; Bibliothèque Nationale, Paris; Staatliche Landesbildstelle, Hamburg.

Publications:

By AIGNER: books—*Are We to Disarm*, Geneva 1931; *What Prayer Can Do*, with preface by Norman Vincent Peale, New York 1953; *Windows of Heaven*, with text by Glenn Clark, New York 1954; *As We See Them*, with text by Florence Brumbaugh, New York 1956; *Pictures with Purpose*, Pikesville, Maryland 1956; *Between Two Worlds*, Sarcelles, France 1975; *ICP Library of Photographers: Lucien Aigner*, with an introduction by A.D. Coleman, preface by Cornell Capa, New York 1979; articles—approximately 100 articles in the European press, 1927-29; "Sixth Graders on War" in *PM* (New York), 23 June 1940; "Peace and War" in the *Christian Science Monitor* (Boston), 31 July 1940; "Einstein Interview" in the *Christian Science Monitor* (Boston), 14 December 1940; "L'Art d'Etre Grandmere" in *Vu* (Paris), no. 595, 1941; "Einstein Admits" in *Click* (Philadelphia), January 1941; "Boy with a Baton" in *Who Magazine* (New York), August 1941; "Hyde Park Spells Roosevelt" in *Click* (Philadelphia), October 1941; "French with Fun" in *Christian Science Monitor* (Boston), 20 June 1942; "Never Say in Public..." in *Christian Science Monitor* (Boston), 1 August 1942; "How to Make Planes" in *Christian Science Monitor* (Boston), 22 August 1942; "Air-Conditioned Youth" in the *Christian Science Monitor* (Boston), 12 September 1942; "One High from North" in the *Christian Science Monitor* (Boston), 17 October 1942; "Victory Corps" in the *Christian Science Monitor* (Boston), 2 January 1943; "The War of Machines" in the *Christian Science Monitor* (Boston), 27 February 1943; "A Child's Day with Music" in the *Christian Science Monitor* (Boston), 1 May 1943; "Old Skills—New Jobs" in the *New York Times* (New York), 8 May 1943; "Famous People Don't Pose" in the *Christian Science Monitor* (Boston), 24 July 1943; "Celebrity Hunting" in *Popular Photography* (New York), November 1943; "A Movie for Democracy" in *Popular Photography* (New York), May 1944; "Camera at the San Francisco Conference" in *Popular Photography* (New York), August 1945; "Photography in Education" in *Popular Photography* (New York), November 1945; "I Am a Small Town Photographer" in *National Photographer* (Chicago), March 1959; "Hawaii" in the *Berkshire Eagle* (Pittsfield, Massachusetts), 5 September 1959; "Children" in *Professional Photographer* (Chicago), October 1959; "The Face of Hawaii" in the *Christian Science Monitor* (Boston), 10 November 1959; "Children in a Minute" in *Professional Photographer* (Chicago), August 1960; "Visit with an Experimenter" in the *Christian Science Monitor* (Boston), 6 August 1960; "America Sings" in the *Christian Science Monitor* (Boston), 22 August 1960; "International Living" in the *Christian Science Monitor* (Boston), 20 October 1960; "Stage Photography" in *The Rangefinder* (Santa Monica, California), June 1962; "Steps to Acceptance" in *Professional Photographer* (Chicago), September 1965; "Laubach" in *Boys' Life* (North Brunswick, New Jersey), September 1966; "William Stanley" in *Boys' Life* (North Brunswick, New Jersey), November 1966; "Candid Photo History" in *Professional Photographer* (Chicago), July 1973; etc.

On AIGNER: articles—"Lucien Aigner in Retrospect" by Warren Fowler in the *Berkshire Eagle* (Pittsfield, Massachusetts), 11 July 1971; "Aigner's 100,000 Photos" by C.R. Wasserman in the *Boston Sunday Globe*, 16 April 1972; "Master of the Picture Story" by A.D. Coleman in the *New York Times*, 25 March 1973; "Who's Been Hiding" in *Yankee* (Dublin, New Hampshire), September 1975; "Lucien Aigner, Pionnier" by Michel Nuridsany in *Le Figaro* (Paris), 22 December 1975; "Stolen Glories" by Atticus in *The Times* (London), 7 March 1976; "Journalism—A Free Pass" by Julie Michaels in *The Sampler* (Pittsfield, Massachusetts), 11 July 1976; "Lucien Aigner, Eyewitness to History" by A.D. Coleman in *35mm Photography* (New York), Winter 1978; "Master of the Picture Story" by P. Lehmbeck in *River Valley Chronicle* (Hudson, New York), January 1979; "Lucien Aigner, un Salomon Francais" by J.J. Naudet in *Photo* (Paris), November 1980; "A Life Behind the Lens" in *The Rotarian* (Chicago), January 1981.

For fifty years photography has been my profession. The camera—first a discovery, then my obsession, my enemy, my destiny—became my way of life. Early in my professional career as a newspaper correspondent I chose it as my tool to record events and people around me. I tried to capture life as it happened in all its fleeting moments—uninterrupted, spontaneous, un-selfconscious.

At first, photography appeared an easy way out of my dilemma of recording my observations about human beings faithfully, but without the burden of recreating them in the laborious process of graphic art. I used photography to illustrate my written stories. As I lacked the skill of a painter or illustrator, I welcomed the magic tool that reproduced without effort what I saw, just by pressing a button. These pictorial notes appeared welcome shortcuts not only to graphic art but also to verbal description. Little did I realize (what I had to find out later, to my chagrin) that my tool, so wonderful when the subject *did* appear before it, was totally worthless when access to the subject was denied or when not all the essential details appeared simultaneously in time. The creative telescoping process of the graphic artist, who can summarize in one picture all the scattered details that appear at different moments, is not available to the photographer. He can take only what appears in that split second in time when he releases his shutter.

I was of the first generation of pioneers of the miniature camera, later called "candid." We enjoyed for a while the privilege of being the few who dared to trust their professional fate to an untried instrument they considered a magic tool.

As a foreign correspondent I was admitted to places from which photographers with their big cameras and obnoxious flashbulbs were barred. This gave me a privileged position at first. But as time progressed and others awakened to the advantages of the miniature camera, it became recognized as a vicious little instrument, dreaded by public figures. Worried about their "image," they tried to avoid it. Authorities and celebrities became sensitized to the danger which the candid camera represented to their pompous self-image. They started their defensive campaign against camera indiscretion. At the same time, competition became keener and keener, and life with the miniature camera became an ordeal.

To make bad things worse, the tolerant attitude of editors toward the poor technical quality of this new kind of photography gradually changed. The novelty of obtaining pictures with this new technique—using available light mostly—gradually changed. The magic that we could get pictures where usually no pictures were allowed or possible, wore thin. Editors, especially in the United States, wanted technically good pictures—not just unique documents. The need for additional equipment, over and above a miniature camera hidden in one's hip pocket, became imperative. Lights, tripods, lenses (tele and wide-angle) had to be added to the easy-to-carry small camera. The ordeal of being a photographer became more and more gruesome. I began to hate my being a photographer.

There was another reason why I resisted being a photographer—just a photographer: I had been a writer-reporter before I took up camera work. Expressing myself through images alone never satisfied me fully. I realized that while pictures had impact far beyond the written word, they were at times ambiguous. To clarify this ambiguity, words had to be added to the photograph. I have always tried to combine words with pictures in my work. I found this effort a tremendous challenge, not always easy to meet. Expression in words requires entirely different gifts from those required for pictorial expression. To practice both simultaneously is extremely difficult, and consequently practitioners

who attempt to combine writing with photography are rare. All my life long I had to face editors who wanted me to be either a photographer OR a writer—but not both. And yet, as hundreds of published illustrated articles and photo-features as well as several books for which I supplied both text and illustrations testify, I have never given up my efforts to combine words with images as a professional.

After a long life spent in photojournalism—and a short period in radio with the Voice of America as a writer-announcer and later as a production director—I settled down during the 1950's in a small New England town, Great Barrington (Massachusetts), to become a "small town photographer." My subjects became my clients instead of my victims, and *they* paid me for the privilege of appearing in front of my camera to be immortalized at their best, instead of my *editors* for capturing them at their off-guard moments—at their worst. This brought about the need for pictures that reveal character, beauty, humanity, without unmasking weaknesses—a much more loving approach than I had practiced in my earlier years. Thus my collection of both kinds of photographs grew when, after the War, my (miraculously-preserved) European collection was brought to the U.S., and I became the lucky possessor of a depository of rare historic documents. They eventually earned the reputation of uniqueness, and were sought after by museums, private collectors and publishers.

Today, approaching my 80th birthday, at the end of a photographic career of more than half a century, I have made peace with photography. I enjoy sharing with my contemporaries the episodes of my professional life. They seem to interest young and old. The latter know my subjects: the gloriously famous such as Einstein, Churchill, Sara Delano Roosevelt, Emperor Haile Selassie, Mayor La Guardia—and the infamous such as Hitler, Mussolini and their kind. The former—the young, to whom these names mean little—are eager to know about them. Reviewing the harvest of a lifetime, though obtained at the price of struggles and suffering, gives me joy which compensates for the adversities of the past.

—Lucien Aigner

Lucien Aigner's major contribution to the medium was made in the field of photojournalism between 1925 and 1947. A true photojournalist in the original sense of the word (one who integrates photographs and journalism, words and images), Aigner came to photography as a writer who began photographing because it was easier than collaborating with photographers on assignments.

Aigner's career in the field can be said to have begun in Berlin, where he worked as assistant to Stefan Lorant, whose influence on the emerging genre of photographically-illustrated journals was seminal. Aigner's professional photography, however, began after he moved to Paris, working first as manager for James Abbe and as a correspondent for newspapers in his native Hungary. Using the byline "Aral," he perfected his skills at the craft of the small-camera "picture story" or photo-essay, which to him remains the central form of photojournalism.

Aigner's articulacy as a photographer was matched by his adeptness as a writer; his ability to combine the two media effectively was one of his hallmarks. It also resulted in his being able to control the printed presentation of his work to a much greater extent than those photographers who left the contextualizing of their images entirely to their editors.

"While I have great respect for the photographic medium, I feel that pictures are not enough to say what needs saying," he has stated. "I have always been suspicious of the cliché about one picture being worth a thousand words. I think both pictures and words are important: pictures for impact, words for meaning. Pictures are sometimes ambiguous, and words are needed."

Much of Aigner's work from that period addresses the European political scene in the years leading up to World War Two. He covered such events as the 1936 Winter Olympics in Berlin and the 1932 Geneva Conference on Disarmament, photographing Hitler, Mussolini, Churchill, Gandhi, the Roosevelts, Haile Selassie, Anthony Eden and many other major figures of the time.

His approach during this phase of his work exemplifies the now-classic small-camera style which he developed in the company of such other practitioners as Salomon, Eisenstaedt and Kertész. Humanist in its inclinations, with a consistent sense of humor (often sardonically edged), Aigner's imagery—much of it made under low-light conditions—has a distinctive gestural quality which compensates in energy for what is lost in detail.

Upon moving to the United States in 1939, Aigner changed the direction of his work. Prohibited from working on most war-related subjects (due to his technical status as an "enemy alien"), he turned his attention elsewhere: pre-war life in Harlem, the Riker's Island prison, Paderewski in exile, Einstein at Princeton. Adopting the then-prevalent style of American magazine photography, Aigner developed a more formal approach, indicative of a more consciously transactional relationship between the photographer and his subjects and a more directorial attitude.

By 1947 Aigner had virtually ended his career as a full-time photojournalist. In 1954 he opened a professional portrait studio. Not until the late 1960's did he begin to reinvestigate his file of some 100,000 35mm. negatives and re-present this body of work to the public—a process which has included the reassessment of much imagery which he did not publish at the time it was made. The exhibitions, portfolios, monographs and articles he has published over the

past decade demonstrate that his is an important visual archive, valuable as both a significant resource for 20th-century history and a fine example of the classic style of European photojournalism.

—A.D. Coleman

ALINDER, James.
American. Born in Glendale, California, 31 March 1941. Educated at Roosevelt High School, Minneapolis, 1956-59; Macalester College, St. Paul, Minnesota, under Jerry Rudquist, 1959-62, B.A. 1962; University of Minnesota, Minneapolis, under Jerome Liebling, 1962-64; University of New Mexico, Albuquerque (graduate fellow; graduate teaching assistant; museum assistant), under Van Deren Coke, Richard Rudisill, and Rod Lazorik, 1966-68, M.F.A. 1968. Married Mary Street in 1965. Freelance photographer, 1956-64; Peace Corps Volunteer, Somali Republic, East Africa, 1964-66; Professor of Art, University of Nebraska, Lincoln, 1968-77. Since 1977, Director of The Friends of Photography, Carmel, California; also, Editor of *Untitled* (journal of The Friends of Photography). Member, Board of

James Alinder: *On the Road, Lancaster County, Pennsylvania*, from *Picture America*, 1982

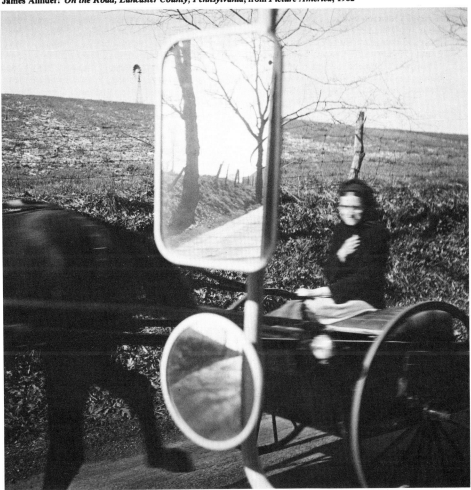

Directors, 1973-79, Editor of *Exposure* (the journal of the Society), 1973-77, and Chairman of the Board, 1977-79, Society for Photographic Education. Recipient: Photographers' Fellowship, National Endowment for the Arts, 1973, 1980; Woods Foundation Fellowship, 1974. Agent: The Weston Gallery, Post Office Box 655, Carmel, California 93921. Address: c/o The Friends of Photography, Post Office Box 500, Sunset Center, Carmel, California 93921, U.S.A.

Individual Exhibitions:

1968	*The Somali*, University of Nebraska, Omaha
	Panoramic Pictures, University of Maine, Orono
1969	Sheldon Gallery, University of Nebraska, Lincoln
1970	Focus Gallery, San Francisco
	Blanden Art Museum, Fort Dodge, Iowa
1971	Madison Art Center, Wisconsin
	831 Gallery, Birmingham, Michigan
1972	Center of the Eye, Aspen, Colorado
	Alfred University, Alfred, New York
1973	Sheldon Gallery, University of Nebraska, Lincoln
	East Street Gallery, Grinnell, Iowa
1974	*New Panoramics*, The Once Gallery, New York
	Museum of Art, University of Oregon, Eugene
1975	Gallery f/22, Santa Fe, New Mexico
	Elkhorn Gallery, Sun Valley, Idaho
	University of South Dakota Gallery, Vermillion
1976	University of Colorado, Boulder
1977	St. Michael's College Gallery, Winooski, Vermont
1979	*Instamatic and Diana Pictures*, Camerawork Gallery, San Francisco
1980	*Instamatic America*, Spiva Art Center, Joplin, Missouri

Selected Group Exhibitions:

1968	*Light⁷*, Hayden Gallery, Massachusetts Institute of Technology, Cambridge
1969	*Vision and Expression*, International Museum of Photography, George Eastman House, Rochester, New York (toured the United States, 1969-71)
1970	*Be-Ing Without Clothes*, Hayden Art Gallery, Massachusetts Institute of Technology, Cambridge
1971	*New Photographics*, CSW Art Gallery, Ellensburg, Washington
1972	*The Wider View*, International Museum of Photography, George Eastman House, Rochester, New York
1973	*Light and Lens: Methods of Photography*, Hudson River Museum, Yonkers, New York
1977	*The Great West: Real/Ideal*, University of Colorado Art Museum, Boulder (toured the United States)
	The Extended Frame, Visual Studies Workshop, Rochester, New York
	20th Century Photography, Centre Pompidou, Paris
1980	*The Diana Show*, Wynn Bullock Gallery, Carmel, California

Collections:

Museum of Modern Art, New York; International Museum of Photography, George Eastman House, Rochester, New York; Smithsonian Institution, Washington, D.C.; Art Institute of Chicago; Sheldon Memorial Art Gallery, University of Nebraska, Lincoln; Center for Creative Photography, University of Arizona, Tucson; Museum of Art, Stanford University, California; San Francisco Museum of Modern Art; National Gallery of Canada, Ottawa; Victoria and Albert Museum, London; Bibliothèque Nationale, Paris.

Publications:

By ALINDER: books of his photographs—*Consequences: Panoramic Photographs by James Alinder*, Lincoln, Nebraska 1974; *Kansas Album*, with others, edited by James Enyeart, Lawrence, Kansas 1977; *Picture America*, with text by Wright Morris, Boston 1982; other books—*Wright Morris: Structures and Artifacts*, editor, Lincoln, Nebraska 1975; *Crying for a Vision*, co-editor, Dobbs Ferry, New York 1976; *12 Mid-American Photographers*, Kansas City 1977; *Jerome Liebling: Retrospective*, exhibition catalogue, editor, Carmel, California 1978; *Ansel Adams: 50 Years of Portraits*, Carmel, California 1978; *Self-Portrayal*, editor, Carmel, California 1978; *Photographs of the Columbia River and Oregon*, editor, Carmel, California 1979; *Collecting Light: Photographs of Ruth Bernhard*, Carmel, California 1979; *Robert Cumming: Photographs*, Carmel, California 1979; *9 Critics/9 Photographers*, editor, Carmel, California 1980; *Ansel Adams: Photographs of the American West*, Washington, D.C. 1980; *Discovery and Recognition*, editor, Carmel, California 1981; *Roy DeCarava: Photographs*, editor, Carmel, California 1982.

On ALINDER: books—*Young Photographers*, exhibition catalogue, with text by Van Deren Coke, Albuquerque, New Mexico 1968; *Light⁷*, edited by Minor White, Millerton, New York and Cambridge, Massachusetts 1968; *Vision and Expression*, edited by Nathan Lyons, Rochester, New York 1969; *Be-Ing Without Clothes*, edited by Minor White, Millerton, New York and Cambridge, Massachusetts 1970; *60's Continuum*, exhibition catalogue, with text by Van Deren Coke, Rochester, New York 1972; *Light and Lens: Methods of Photography* by Donald L. Werner and Dennis Longwell, New York 1973; *The Great West: Real/Ideal*, edited by Sandy Hume and others, Boulder, Colorado 1977; *Photographs: Sheldon Memorial Art Gallery Collection, University of Nebraska*, with an introduction by Norman A. Geske, Lincoln, Nebraska 1977; *70's Wide-View*, exhibition catalogue, by Elaine A. King, Evanston, Illinois 1978; *SX-70 Art*, edited by Ralph Gibson, New York 1979; *The Photograph Collector's Guide* by Lee D. Witkin and Barbara London, Boston and London 1979; *Photography for Collectors: Volume 1: The West*, San Francisco 1979; *The Diana Show*, exhibition catalogue, by David Featherstone, Carmel, California 1980; articles—"Spirit Documents" in *Creative Camera* (London), July 1970: review in *Artforum* (New York), March 1975; "Shows We've Seen" by Kirschbrown in *Popular Photography* (New York), May 1975.

Although the images of James Alinder may seem to fall within the limits of the snapshot tradition, they have nothing in them of the mindless automatism that so frequently characterizes that way of seeing. He is primarily interested in making pictures of people, seen in the setting of their everyday concerns, at home, abroad or, by implication, in their artifacts.

In his early work he gave us a portrait of suburbia: the developer's architecture, the time payment decor, the symbolic culture of the framed reproduction of the Mona Lisa, the comfort, good health and prim perfection of the American dream home. Later there were the panoramic prints which recorded the typical sights of a vacation trip and established him as a distinctive and wryly humorous observer of the American scene in the company of Erwitt, Friedlander and Winogrand but with an accent all his own. Later still, the series entitled "Instamatic America" and a series made with the Diana camera provided the opportunity to expand his exploration of the commonplace with the equipment used by millions. In all this work, so assiduously unexceptional, he has been trying to find, it would seem, an imagery which achieves a kind of quintessential purity but avoids the bland anonymity of the snapshot, the bias of the critic or the dogged factualism of the documentarian. The repeated presence of his wife and children in the well-known prints of the 1970's is some indication of his sense of belonging to the experience he records. The wonders of Mount Rushmore or of a Hinky-Dinky market at Christmas time are, after all, genuine wonders, enveloping us all.

His enthusiasm for his subject, which is his own daily experience, shows. Often enthusiasm shades into amusement. Some of his images are "seriously" funny (witness his family posed between the legs of Michelangelo's David at the Palace of Living Art!). But, with all his sense of humor, Alinder still manages to suggest that these images carry more meaning than is obvious in their subject matter. Possibly popular culture has another side which combines, unaccountably, the real and the surreal.

—Norman A. Geske

ALMASY, Paul.

French. Born in Budapest, Hungary, 29 May 1906; emigrated to France, 1934: naturalized, 1956. Educated in Budapest until 1924; studied political science at the University of Vienna and the University of Heidelberg, 1924-28: trained for a diplomatic career. Married Sophie Elina Engelsen in 1953; children: Marietta and Isabelle. Freelance journalist, working for Swiss and German magazines (*Schweizer Illustrierte Zeitung, L'Illustré, Schweizer Allgemeine Volkszeitung, Berliner Illustrierte*, etc.) in Europe and North Africa, 1930-36; Photojournalist for Ringier and Company, publishers, Zofingen, Switzerland, 1936-76; also worked as a photographer for Unesco, Paris, 1957-77, World Health Organization, Geneva and Washington, D.C., 1958-73, and the International Labour Office, Geneva, 1960-70. Freelance photographer, Paris, since 1977. Teacher at the Centre de Perfectionnement des Journalistes, Paris, since 1970, International Institute of Journalism, Budapest, since 1975, Ecole de Photographie (ETPA), Toulouse, since 1976, and Université de Paris IV (Sorbonne-Celsa), since 1978. Vice-President, Media Forum, Paris, since 1978; Member of the Board of Directors: Musée Français de Photographie, Bièvres; Europhot, Antwerp; Association des Photojournalistes Français; and Fédération des Associations des Photographes Créateurs, Paris. Recipient: Master of Photography Award, Council of Professional Photographers of Europe, 1978. Address: 2 Villa des Peupliers, 92200 Neuilly-sur-Seine, France.

Individual Exhibitions:

1964	*La Condition Humaine*, Musée du Havre
	So sehe ich die Welt, Stadttheater, Viersen, Germany
1967	*La Main*, Nouvelles Galeries d'Orléans
1973	*SOS: The Cry of Three Continents*, International Gallery, Budapest
1974	*Appeal for a Better World*, French Chamber of Commerce, London
1975	*Livsvilkad*, Kunstindustrimuseet, Oslo
1977	*Askpetti humani*, Galleria dell'Immagine, Milan
	Les Humains, Musée de la Photographie, Bièvres, Paris

1978 *La main et son language*, Musée Nicéphore
Niepce, Chalon-sur-Saône, France (trav-
elled to the Galleria Libreria-Pan, Rome)
La Photo: Moyen d'Information, Galerie
FNAC, Paris (travelled to Galerie FNAC,
Lyons)
Larmes et sourires du Monde, Galerie Feuil-
lade, Chartres, France
1979 *Souvenirs d'Italie*, Institut Culturel Italien,
Paris
Les Rureaux, Galerie Feuillade, Chartres,
France
1980 *La language de la main*, Galerie Canon,
Paris
Le tour du monde en 80 photos, Galerie
Neptune, Nantes, France

Selected Group Exhibitions:

1952 *Weltausstellung der Photographie*, Lucerne
1955 *Biennale de la Photo*, Paris
1965 *Weltausstellung der Photographie*, Ham-
burg
1966 *Interpress Foto*, Moscow
Mostra-Concorso du Fotografie, Ascoli
Piceno, Italy
1967 *The Camera as Witness*, Toronto (travelled
to New York, Tokyo, and London)
Vom Gluck des Menschen, Berlin
1968 *Weltausstellung der Photographie*,
Hamburg
1971 *Liebe, Freundschaft, Solidaritat*, Berlin
1975 *Golden Eye '75: World Exhibition of Pho-
tography*, Novi Sad, Yugoslavia

Collections:

Bibliothèque Nationale, Paris; Musée Francais de la
Photographie, Bièvres, Paris; Musée Nicéphore
Niepce, Chalon-sur-Saône, France; Hungarian
Photographic Archives, Budapest; Kunstindustri-
museet, Oslo.

Publications:

By ALMASY: books—*Eves de Paris*, Verviers, Bel-
gium 1964; *Le Mont Saint Michel*, Verviers, Bel-
gium 1965; *Trésors du Val de Loire*, Verviers, Bel-
gium 1967; *La photographie, moyen d'information*,
Paris 1975; *Informer par la photo*, Paris 1978;
Képiras—sajtofoto, Budapest 1979; *La photo à la
une*, Paris 1980; articles—"Children of the Ameri-
cas" in *Photography* (London), March 1962; "La
photographie—art anonyme" in *Camera* (Lucerne),
March 1965; "La photographie à l'Expo 70" in
Photo Revue (Paris), September 1970; "La lecture
des photos d'information" in *Communication et
Langage* (Paris), May 1974; "La visualisation des
notions abstraites" in *Communication et Langage*
(Paris), October 1976; "Am Anfang war das Bild" in
Filter (Mainaschaff, Germany), April-October 1979;
"L'utilisation des photos de presse" in *Le Photo-
graphe* (Paris), October 1979; "Les fonctions ma-
giques de la photo" in *Le Photographe* (Paris), Jan-
uary 1980.

On ALMASY: articles—"Almasy" by Norman Hall
in *Photography* (London), July 1956; "Almasy" by
Yves Lorelle in *Le Photographe* (Paris), October
1966; "Almasy" by Roger Doloy in *Arte Fotogra-
fico* (Madrid), January 1972; "Paul Almasy, photo-
journaliste" by Yves Tessier in *Le Soleil* (Quebec),
24 July 1976; "Almasy, photojournaliste" by André
Laude in *Contact* (Paris), August 1976; "Belle ou
Bonne Photo" by B.C. in *Le Photographe* (Paris),
May 1977; "Visages Humaines d'Almasy" by Edo
Prando in *Fotografia Italiana* (Milan), August
1977; "Almasy, photojournaliste" by Olivier Vroo-

land in *Foto* (Amsterdam), February 1979; "Paul
Almasy" by Christian Imbert in *Le Photographe*
(Paris), October 1979.

I was simply a journalist and really began taking
photographs in order to illustrate some of the prob-
lems with which I was dealing in my articles. This led
me on to study the functional role of photography as
a means of information and communication.

I do not agree with those who define photography
as a "language," but think of it as a script. If you
look at the etymological derivation of the word,
photos means light and *graphein* means writing, so
that photography, therefore, must be "writing in
light!"

Don't say "photography *is* a language" but speak
about the "language *of* photography." The biggest
nonsense is to say "photography is a universal lan-
guage." There are billions of photographs in the
world, but there is no one of them which would say
the same thing to an 18 year old boy in the African
bush, to a French girl of 20, to a Chinese farmer, or
to an American professor. Of all the media, photog-
raphy is the one that is most restricted in its efficacy:
only persons of the same age, same sex, same cul-
ture, same social category, etc. can interpret a pho-
tograph *more or less* in the same way.

Similarly, I have decided views on the distinction
between the two main branches of photography—
the pictorial or artistic and the functional (as used by
the press, in advertising, in illustration, etc.) The
rules of the one are not at all applicable to the other,
and one must never speak of "photography" in an
overall sense, but must always specify the branch
one is alluding to. For myself, I have nothing to do
with pictorial photography, and I do not consider
myself an artist. My profession is that of photo-
journalist, and I try to produce photographs that are
good, not *beautiful.*

I have been studying the rules of photographic
writing (in the functional sense) for the past ten
years, and I have also considered the "reading" of
photographs. In fact, my theory concerning the rela-
tive importance of the component parts of a picture
was the basis of a survey involving 1720 interviewees
(50% men, 50% women), a survey that confirmed
that the theory was 91% correct. In this theory I

distinguish three composition materials, namely:
living beings—humans and animals; moving ob-
jects—smoke, flames, etc.; and fixed objects—moun-
tains, houses, etc. What happens, in reading, is that
the living elements take precedence over both the
moving and the still, and the moving elements take
precedence over the still. When a photograph con-
tains a living subject, whatever the area or position it
occupies within the whole, the "reading" of the pho-
tograph begins with the living subject, and any mov-
ing object comes second in order of priority. We are
talking here of a phenomenon which is part optical,
part intellectual, and part psychological, and even if
the living component is very small, it is still the
component that immediately attracts the attention
of the "reader." (One must not, of course, confuse
"reading" with perception. A fixed object, because
of its size, shape or light value, can strike the eye
within the first tenth of a second. But if one is talking
of actual reading, then it will begin with the living
object if one exists within the picture.)

If we compare a piece of writing and a photograph
(the two media we use to transmit information and
messages), the most important difference between
them is that the reading of a written text functions
on one level only—that of description; whereas the
reading of a photograph can always be said to func-
tion on two levels—description and suggestion.
Over and above that which is actually represented,
there is the suggestion of the abstract—ideas, emo-
tions. In reading a text, one's psychological reac-
tions are triggered only indirectly, because the
meaning of the words and sentences has to be fil-
tered by the imagination in order to be translated
into mental images.

As a photographer my main interest is in people
and the "human condition," which I try to portray
without any concessions. Whatever happens, I remain
firmly committed to reality; I do not sacrifice the
truth for the sake of technical quality. If the lighting
conditions are inadequate, I do not supplement
them with any kind of artificial lighting because this
would interfere with the authenticity of the subject.
As a photo-journalist, I am vehemently against the
use of flash: I have taken 325,000 black and white
exposures and 110,000 colour transparencies, and
not one has involved the use of flash. I prefer to push
film sensitivity to the limit; I expose film from 400

Paul Almasy: *Peon in the Tax-Collector's Office, Paraguay,* 1974

Max Alpert: *The Horse-Rider Girl*, 1936

pictures as well as for information...."

Amid this confusion of intentions it is agreeable to converse with Almasy, to listen to him, to learn from his pictures. They are pictures that result from sound preparation, good professionalism, seasoned with a pinch of irony. It may be a commonplace, but it is a question of that quality which the French—and he *is* French—call *esprit*. A quality very hard to find.

—Edo Prando

ALPERT, Max.

Russian. Born in Simferopol, near Odessa, Ukraine, 18 March 1899. Educated at the Jewish School, Simferopol, 1906-10; self-taught in photography. Served in the Red Army, in Odessa, 1919-21. Married Glafira Belits-Gaiman in 1947. Freelance photographer, Odessa, 1914-19; Agent, Help the Children Commission, Moscow, 1921-24; Photo Reporter, *Rabochaya Gaseta* (*Workers' Newspaper*), Moscow, 1924-29; Photo Correspondent, *Pravda* newspaper, Moscow, 1929-31, and *SSSR na Stroike* magazine, Moscow, 1931-41; War Correspondent and Photographer, for the TASS Agency, Moscow, at the Russian front, 1941-45; Photo Correspondent for the Sovinformburo, Moscow, 1945-48, for the *Soviet Union* magazine, Moscow, 1948-51, for Isogis publishing house, Moscow, 1951-58, again for Sovinformburo, 1958-61, and for the APN Press Agency, Moscow, 1961 until his death, 1980. Recipient: Silver Medal, *International Photography Exhibition*, Zagreb, 1940; Silver Medal, *International Photography Exhibition*, Boston, 1941; Diploma of the GDR 1958, First Prize, 1959, Gold Medal, 1965, and Grand Prize and Gold Medal, 1974, *Bifoto*, East Berlin; Silver Medal, *Interpressphoto '66*, Moscow, 1966; First Prize, *Socialist Fotoart Exhibition*, Dresden, 1968; Diploma and Artist Award, Fédération Internationale de l'Art Photographique (FIAP), 1973; Gold Medal for an Individual Exhibition, Czechoslovakia/U.S.S.R. Friendship Association, Prague, 1973; Grand Prix du Président de la République, France, 1976. *Died* (in Moscow) *1 December 1980.*

Individual Exhibitions:

1931 *24 Hours in the Life of the Filippov Family*, Vienna and other European cities (with Shaikhet and Tulesa)
1967 *50 Years with a Camera*, Friendship House, Sofia, Bulgaria (retrospective; toured Eastern Europe, Cuba, Finland, Denmark and France, 1972-80)

Selected Group Exhibitions:

1940 *International Photography Exhibition*, Zagreb
1941 *International Photography Exhibition*, Boston
1958 *Bifoto*, East Berlin (and 1959, 1965)
1966 *Interpressphoto '66*, Moscow
1968 *Socialist Fotoart Exhibition*, Dresden
1974 *Bifoto*, East Berlin
 Fotos uit de Sovjet Unie, Stedelijk Museum, Amsterdam

Collections:

Museum of Photographic Art, Moscow (archives).

ASA to 1600 or 3200 or at times even 6400 ASA, if necessary.

A photojournalist is something of an historian, and an historian must never lie.

—Paul Almasy

A tireless traveller, Paul Almasy, in the course of a long career, has visited every country in the world but two—as he tends to stress with a certain archness. He has always tried to be a careful and exact witness of conditions different from those of his own, and our, everyday life. His archives are enormous, more than 300 thousand shots in black and white and 50 thousand in colour. "The sum total of my work is a kind of great record of our age," he declares. And it is a record, let us add, that reveals a great desire to show that people—black and white, poor and rich—are indissolubly bound by a thread: all belong to the human race. Almasy's attention is always concentrated on man, on the endless adventure in which he is the protagonist, under every sky, under every regime and within every social structure. It is not anthropological research that he aims at, but something different, something wider—a testimony full of optimism even when it records unacceptable facts. A testimony that shows how he has

understood many things. His is a classical, composed reportage. He does not fling his truth in people's faces as other reporters do, but presents it with firmness and a great respect for the dignity of man.

Fashions come and go, but the name of Almasy is destined to remain in the histories of photography. A journalist with lens and with pen, he has understood that his profession is to communicate. He has understood that, to be comprehended, it is necessary to communicate in the simplest possible way, so simple as to reveal nothing of the trouble and study that lie behind the pressing of the camera button. The photographic critic of the French daily *Le Monde* has written about Almasy's pictures: "...the more we look at pictures of this quality, the more we want to look at them. This is reportage of great quality...." Many of his pictures, it is true, are no more than sketches, with something of the flavour of Bresson. And this is a limitation—if only there were more sketches like Almasy's! In any case, not all his pictures are in this manner. And none of his photographs is an end in itself. "...I am convinced," he says, 'that photography as an aesthetic art and photography for information must be clearly separated. In the latter there must be more room for the semantic aspect, the points that serve to communicate. But of course I do look for a pleasant aesthetic in my

Publications:

By ALPERT: books—*Troublesome Profession*, Moscow 1962; *Max Alpert*, edited by Roman Karmen, Moscow 1974.

On ALPERT: books—*Liberation*, edited by Mikhail Trakhman, Boris Polevoi and Konstantin Simonov, Moscow 1974; *Fotos uit de Sovjet Unie*, exhibition catalogue, Amsterdam 1974; *Photography Yearbook 1975*, edited by John Sanders, London 1974; *Fotografovali Valku*, edited by Daniela Mrázková and Vladimír Remeš, Prague 1975, as *The Russian War 1941-45*, with an introduction by A.J.P. Taylor, London 1978; *Sowjetische Fotografie 1928-32* by Rosalind Sartori and Henning Rogge, Munich 1975; *Geschichte der Fotografie im 20. Jahrhundert/Photography in the 20th Century* by Petr Tausk, Cologne 1977, London 1980; articles—"Great Joy is Work" (80th birthday tribute) by Grigori Chudakov in *Sovetskoye Foto* (Moscow), March 1979.

Born in 1899, Max Alpert belonged to the young generation of Soviet photojournalists in the 1920's. From the beginning of his career he showed a sensitivity and skill in the depiction of the building of industry. He was interested not only in the significant event—for instance, the celebration of the first car from a new factory—but also in the modest successes that characterized an improved standard of living.

Max Alpert's gift for choosing the representative from within typical situations predestined him to take part in one of the most interesting events in Soviet photography between the two world wars—the picture story, "24 Hours in the Life of the Filippov Family." Together with Shaikhet and Tulesa, Alpert photographed the life of the members of a family of an unknown metalworker in Moscow. From their results, the photographers selected a wonderful collection of 78 photographs which offered unusually complex information about the everyday life of a typical Soviet family in 1931. The whole series was exhibited in Vienna and in other European cities, and a large part of it was published in the journals *USSR in Construction* and *Arbeiter Illustrierte Zeitung*. The creative approach in taking the single images, then combining them in a mutually reflective series, was quite new; it was, in fact, a very important contribution to the evolution of the modern use of photographic information.

In the first half of the 1940's Alpert became a war correspondent for the agency TASS. His extensive experience in live photography in peacetime helped him in his depiction of the dramatic moments in the fight against the Nazi invaders. The eloquence of his images of the period is unique, and they continue to the present day to be examples of great photographic art. Alpert's concern in these works is humanistic, a humanism conveyed by his vision of the particular: for example, the details in the picture of Soviet soldiers, details that, as it were, "speak" of the men's desire to win; the compassion of his pictures of unknown women and children escaping before the onslaught of Fascist troops.

After the war Alpert again returned to his earliest theme, producing magnificent reports on the reconstruction of Soviet industry. Again, in this newest part of his oeuvre, he devoted his attention to people, to their enthusiasm for quick reconstruction after the devastation of wartime.

Later in life Alpert occasionally photographed abroad, and he confirmed in all of these cases his ability to isolate the typical situation, the telling image that would characterize for his audience the style of life in other countries.

Alpert died quite recently, in 1980, and the great and important work of a modern pioneer of photojournalism came to a close.

—Petr Tausk

ALVAREZ BRAVO, Manuel.

Mexican. Born in Mexico City, 4 February 1902. Educated at the Catholic Brothers School, Mexico City, 1908-14; studied painting and music at the Academia Nacional de Bellas Artes, Mexico City, 1918; self-taught in photography. Married 3 times, to Dolores Martínez; Doris Heyden; and Colette Urbajtel; children: Manuel, Laurencia, Miguel, Aurelia, and Genoveva. Worked as a copy clerk, Mexico City, 1915-16, and for the Mexican Treasury Department, Mexico City, 1916-31. Freelance photographer, Mexico City, since 1931. Instructor in Photography, Escuela Nacional de Bellas Artes San Carlos, Mexico City, 1928-29, 1938-40; proprietor of a commercial photography shop, Mexico City, 1939-42; Photographer/Cameraman and Instructor in Photography, Sindicato de Tecnicos y Manuales de la Industria Cinematografica, Mexico City, 1945-58; Instructor in Photography, Centro Universitario de Estudios Cinematográficos, Mexico City, 1966-68. Since 1959, Founder/Director and Chief Photographer, El Fondo Editorial de la Plástica Mexicana, Mexico City. Recipient: Sourasky Art Prize, 1974; National Art Prize, Mexico, 1975. Honorary Member, Academia de Artes, Mexico. Address: Espíritu Santo 83, Coyoacán, Mexico 21, D.F., Mexico.

Individual Exhibitions:

1932 Galeria Posada, Mexico City
1934 Palacio de Bellas Artes, Mexico City (with Henri Cartier-Bresson)
1935 *Documentary and Anti-Graphic*, Julien Levy Gallery, New York (with Walker Evans and Henri Cartier-Bresson)
1936 Hull House, Chicago
 Almer Coe Optical Company, Chicago
1939 Universidad Nacional de Mexico, Mexico City
1942 Photo League, New York
1943 Art Institute of Chicago
1945 Sociedad de Arte Moderno, Mexico City
1954 Centro de Relaciones Culturales Anglo-Mexicano, Mexico City
1957 Salon de la Plástica Mexicana, Mexico City
1966 Galeria de Arte Mexicano (Galeria Ines Amor), Mexico City
1968 *Manuel Alvarez Bravo: Fotografias 1928-1968*, Palacio Nacional de Bellas Artes, Mexico City
1971 Pasadena Art Museum, California
 Museum of Modern Art, New York
 International Museum of Photography, Rochester, New York
1972 *Manuel Alvarez Bravo: 400 Photographs*, Palacio Nacional de Bellas Artes, Mexico City
1973 Casa de la Cultura, Hucjitan, Oaxaca, Mexico
1974 Art Institute of Chicago
 Galeria Arvil, Mexico City
 Casa del Lago Universidad, Mexico City
 University of Massachusetts, Boston
1975 Alhondiga de Grananitas, Guanajuato, Mexico
 Witkin Gallery, New York
 Museo de Arte Moderno, Caracas
 Galeria Juan Martín, Mexico City
1976 Museo de Arte Moderno, Mexico City (opening of permanent exhibit)
 Photogalerie, Paris
 Musée Nicéphore Niepce, Chalon-sur-Saône, France
 Galerie Municipale du Chateau d'Eau, Toulouse
 Alvarez Bravo/Pedro Meyer/Lázaro Blanco, Galleria Il Diaframma, Milan
1978 Photographers Gallery, London
 Corcoran Gallery, Washington, D.C.
1979 *Rencontres Internationale de la Photographie*, Arles, France

1980 Museo de San Carlos, Mexico City
1981 Witkin Gallery, New York
 Photo Art, Basle

Selected Group Exhibitions:

1939 *Souvenir du Mexique*, Galerie Renou et Colle, Paris
1943 *Mexican Art Today*, Philadelphia Museum of Art
1955 *The Family of Man*, Museum of Modern Art, New York (and world tour)
1956 *Alvarez Bravo/Walker Evans/August Sander/Paul Strand*, Museum of Modern Art, New York
1961 *Coloquio Latinoamericano de Fotografia*, Museo de Arte Moderno, Mexico City
1977 *Concerning Photography*, The Photographers' Gallery, London (travelled to the Spectro Workshop, Newcastle upon Tyne)
1978 *Contemporary Photography in Mexico*, University of Arizona, Tucson
 Dada and Surrealism Reviewed, Hayward Gallery, London

Collections:

Instituto Nacional de Bellas Artes, Mexico City; Museum of Modern Art, New York; Brooklyn Museum, New York; International Museum of Photography, George Eastman House, Rochester, New York; Art Institute of Chicago; Pasadena Art Museum, California; Victoria and Albert Museum, London; Bibliothèque Nationale, Paris; Musée Nicéphore Niepce, Chalon-sur-Saône, France; Museum of Modern Art, Moscow.

Publications:

By ALVAREZ BRAVO: books—*Manuel Alvarez Bravo*, with text by Luiz Cardoz y Aragon, Mexico City 1935; *Manuel Alvarez Bravo: Fotografias*, Mexico City 1945; *La Pintura Mural de la Revolución Mexicana*, Mexico City 1960; *The Painted Walls of Mexico: From Prehistoric Times until Today*, with texts by Jean Charlot and Emily Edwards, Austin, Texas 1966; *15 Photographs by Manuel Alvarez Bravo*, portfolio, New York 1974; *Manuel Alvarez Bravo*, with text by Denis Roche, Paris 1976; *Photographs by Manuel Alvarez Bravo*, portfolio, Geneva 1977.

Alvarez Bravo has also edited all and designed most of the publications of the Fondo Editorial de la Plástica Mexicana, Mexico City, since 1959.

On ALVAREZ BRAVO: books—*Manuel Alvarez Bravo: Fotografias 1928-1968*, exhibition catalogue, by Juan Garcia Ponce, Mexico City 1968; *Manuel Alvarez Bravo*, exhibition catalogue, by Fred Parker, Pasadena, California 1971; *Manuel Alvarez Bravo*, exhibition catalogue, by Jane Livingstone, Boston 1978; articles—"Souvenir du Mexique" by André Breton in *Minotaure* (Paris), May 1939; "Manuel Alvarez Bravo" in *Album* (London), October 1970; Manuel Alvarez Bravo" in *Camera* (Lucerne), January 1972; "Manuel Alvarez Bravo" in *The Magic Image* by Cecil Beaton and Gail Buckland, Boston and London 1975; "The Indigenous Vision of Manuel Alvarez Bravo" by A.D. Coleman in *Artforum* (New York), April 1976, reprinted in Coleman's *Light Readings: A Photography Critic's Writings 1968-1978*, New York 1979; "Manuel Alvarez Bravo" in *Photographs: Sheldon Memorial Art Gallery Collection, University of Nebraska* by Norman A. Geske, Lincoln, Nebraska 1977; "Manuel Alvarez Bravo" in *Concerning Photography*, exhibition catalogue, by Jonathan Bayer, Peter Turner, Ian

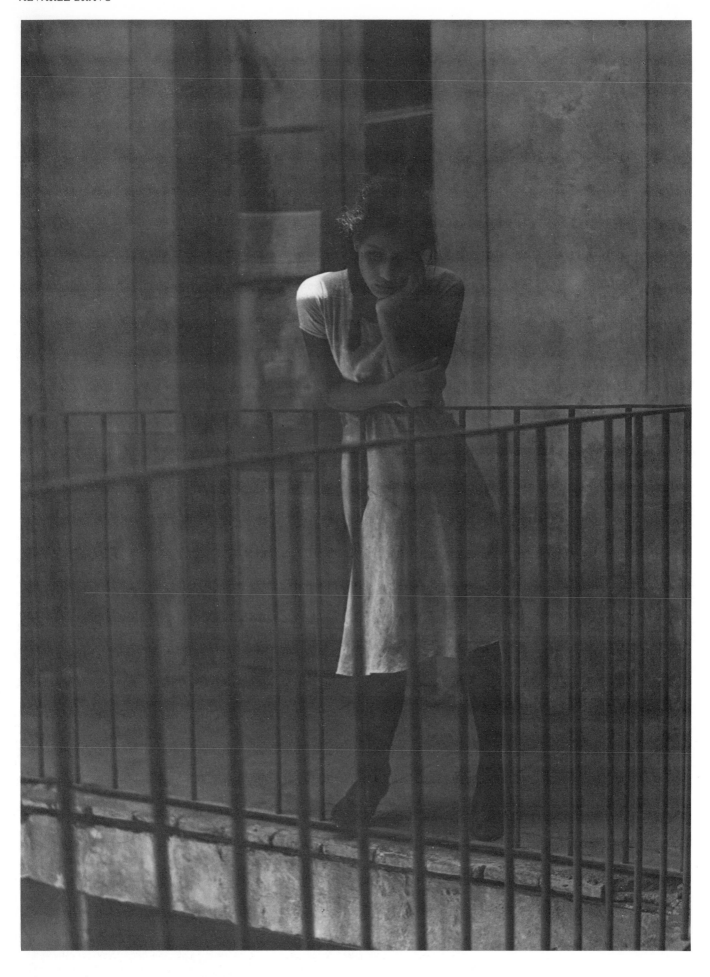

Manuel Alvarez Bravo: *El Ensueño* (Daydreaming), 1931

Jeffrey, and Ainslie Ellis, London 1977; "Manuel Alvarez Bravo" in *Contemporary Photography in Mexico*, exhibition catalogue, by Rene Verdugo and Terence Pitts, Tucson, Arizona 1978; "Manuel Alvarez Bravo," interview, in *Dialogue with Photography* by Paul Hill and Thomas Cooper, London 1979

When *A Vision of Paris*, recently reissued, was first published in 1963, it demonstrated that the juxtaposition of literature (Proust) and photography (Atget) could create a remarkable synthesis without violating the integrity of either. It is, therefore, equally remarkable that no publisher has thought to combine the words of Malcolm Lowry's *Under the Volcano* with the photographs of Manuel Alvarez Bravo. Alvarez Bravo's pictures provide the perfect counterpoint to Lowry's prose. It was, after all, Mexico which killed Firmin. The terrors and shadows that propelled Malcolm Lowry's protagonist toward his end can be found in Alvarez Bravo's vision of his native land.

Manuel Alvarez Bravo has long been judged "a photographer's photographer," which is a gentle way of saying that, until recently (although he began making photographs in the 1920's), few people, outside of a small group of artists and writers, knew of his achievements. Little wonder; apart from Peter Magubane, how many African photographers, or Brazilian, or Chilean, or—even—Japanese photographers are household names in the West? Precious few. Thus, despite the length of his professional career, and the quality and quantity of his photographs, Manuel Alvarez Bravo's first major U.S. exhibit (at the Pasadena Art Museum) was not mounted until 1971. The catalogue of that exhibit, which was, until 1978, the only collection of his photographs available, has long been out of print.

Despite this long-standing ignorance of his work, Alvarez Bravo was by no means ignorant of what was happening in the world of photography. Yet, there is little outside influence to which one may readily point. "His work," wrote Paul Strand, "is rooted firmly in his love and compassionate understanding of his own country, its people, their problems, and their needs. These he has never ceased to explore and to know intimately."

The typical Alvarez Bravo photograph (as true in the 1920's and 30's as today) is a direct, unmanipulated "straight" print. It succeeds because of his allegiance to and mastery of the formal elements of light, tone, and composition. But one might as easily describe the works of hundreds, thousands, of other photographers in such terms. The salient difference is that Alvarez Bravo's photographs exist on a powerfully symbolic plane as well. In "The Obstacles" (a 1939 image containing four carousel horses), for example, the horses are an obstacle to the viewer, filling the frame so that surrounding buildings are obscured. And that frame is but one of the obstacles preventing the horses' escape. The figures might be waiting impatiently for the Four Horseman of the Apocalypse. In this photographer's world, such conjecture is not far-fetched.

Born in 1902, Alvarez Bravo's world was that of revolutionary Mexico. The street battles of 1910 disturbed his classes; corpses, and a climate of pervasive violence, have remained vivid memories for him. Thus, the tension born of implicit violence recurs in his photographs and is one of the "themes" in his oeuvre. In Alvarez Bravo's world, violence may, as in "The Obstacles," be implied or it may, as with "Striking Worker, Assassinated" (1934), be as explicit as death. In this particularly famous example of his work, a corpse is viewed from pelvis to head. The blood-spattered shirt lies partially open and the head lies in a pool of blood. An outstretched arm and the stained sand form a triangle with the lower edge of the frame. That triangle leads directly back to the head; the geometry is as inexorable as death itself.

Death has many symbols for this master: a cemetery wall, animal bones, the grave. But there is lyricism in Alvarez Bravo's world, too. Thus, the reverie of a young woman is caught by the photographer as she is "Day Dreaming" (1931; the accompanying photograph). That particular picture, and a 1974 reprinting, are instructive, too, in revealing changes in the photographer's style.

The older print is, by and large, darker (this is true of others reprinted in the 1974 portfolio). The tonalities which sparkle in the recent print are lost in the style of the older one. "Day Dreaming" (1974) is, therefore, lyrical not only in subject, but in tonality as well. Patches of light on the young woman's shoulder and dress provide points of reference without dominating. In the 1931 print (in which the negative had been cropped considerably), those references become beacons in a dark field—the woman is virtually lost. Thus, the nightmare qualities implied even in reverie (1931) are softened (1974) and rendered less visceral.

Mystery, in the earlier works, was created, in part, by technical artifice: dark prints, heavy contrasts. In the fine, full-toned recent prints, the mystery inherent in Manuel Alvarez Bravo's vision stands on its own. The comparison is not meant invidiously. Manuel Alvarez Bravo may have selected different methods (including colour) with which to communicate his vision over the past several decades; the power of that vision, however, has never been in question.

—Stu Cohen

ANDRIESSE, Emmy (Eugenie).
Dutch. Born in The Hague, 14 January 1914. Studied under Gerrit Kiljan and Paul Schuitema, at Koninklijke Academie voor Beeldende Kunsten, The Hague, 1932-37. Married Dick Elffers in 1941. Freelance photographer, Amsterdam, 1937 until her death, 1953. Member Arfots; Vereeniging voor Ambachts-en Nijverheidskunst; Ondergedoken Camera; Gebonden Kunstenfederatie (photo section). *Died* (in Amsterdam) *21 February 1953*.

Individual Exhibitions:

1952 Stedelijk Museum, Amsterdam
1975 Galerie Fiolet, Amsterdam
 Van Gogh Museum, Amsterdam

Selected Group Exhibitions:

1937 *Foto '37*, Stedelijk Museum, Amsterdam
1945 *Ondergedoken Camera*, Meijboom Studio
 (Atelier Meijboom), Amsterdam
1952 *Welt-Ausstellung der Photographen*,
 Lucerne
1979 *Fotografie in Nederland 1920-1940*, Haags
 Gemeentemuseum, The Hague

Collections:

Print Room, University of Leiden.

Publications:

By ANDRIESSE: books—*Beeldroman*, with J.B. Charles, The Hague 1956; *The Wereld van Van Gogh/Le Monde de Van Gogh/The World of Van Gogh*, with Jos de Gruyter, The Hague 1957.

Emmy Andriesse: *Germaine Richier*, **1948** Courtesy Art Institute of Chicago

Diane Arbus: *A House on a Hill*, Hollywood, 1963 Courtesy Diane Arbus Estate

On ANDRIESSE: books—*Nederlandse Fotografie: De Eerste 100 Jaar* by Claude Magelhaes, Utrecht and Antwerp 1969; *Emmy Andriesse: Fotos 1941-52*, exhibition catalogue, with an introduction by Louise van Santen, Amsterdam 1975; *Fotografie in Nederland 1920-1940*, exhibition catalogue, by Flip Bool and Kees Broos, The Hague 1979; articles—in *Het Vaderland* (Amsterdam), 31 July 1937; "The World of Emmy Andriesse: A Report in Photographs" by W. Jos de Gruyter in *Delta IV* (Amsterdam), vol. 4, no. 19, 1948; "The Work of Emmy Andriesse" by Piet Piryns in *V.N.-bijlage* (Amsterdam), 22 December 1973; "The Second Generation" by Ursula den Tex in *V.N.-bijlage* (Amsterdam) 15 May 1976.

When Emmy Andriesse died in 1953, still very young, she left an important photographic oeuvre as her legacy. Her subjects varied from photography of a social tendency in the period during and just after the war to fashion photography, photographs of artists and travel impressions. She attended the Academie voor Beeldende Kunsten in The Hague, and was exposed to the experiments in photography of the 1930's. Her teachers, Gerrit Kiljan and Paul Schuitema, themselves important proponents of the "new photography," taught their pupil to experiment with photography, both technically and visually, at the same time paying careful attention to aesthetics, composition and exposure. Thereafter, though she moved from subjects characteristic of the 1930's—for example, commercial objects—to mainly photographing people, Andriesse continued always to attempt to achieve perfect technical and aesthetic compositions in which exposure played a great part.

At the exhibition *Foto '37* in Amsterdam, her report on people living in the populous neighborhood of the Jordan created great interest. In vivid pictures she could direct the observer's attention to one person, who seemed to be at one with his surroundings. Sometimes that person is caught engaged in some activity; at other times her subject will stop and pose in a creative relationship with the photographer.

Andriesse's approach was, indeed, always intuitive; she felt, and conveyed, an affinity with her subject. And she used her camera to express what was of importance to her. During the last year of the war—1944-45—she made a series of photographs which far surpass ordinary documentary photography. The photographs became very well known—the little boy standing soulfully, an empty saucepan in his hands, his bony legs in far too large shoes; the undertaker, himself starving, sitting on his "carrier" bicycle. Even under the most difficult circumstances, she managed to achieve a balanced composition.

After the war Andriesse was one of the first generation of Dutch professional photographers. W.J.H.B. Sandberg, at that time director of the Stedelijk Museum in Amsterdam, commissioned her, in 1951, to photograph famous Parisian and Belgian sculptors in their studios: Arp, Giacometti, Zadkine, Germaine Richier, Permeke and others. Again, in these pictures, her personal approach is obvious: the ability to capture the particular characteristics of her subject, the balance between artist and subject.

Another artist she admired was Van Gogh. Her book, *The World of Van Gogh*, was published just after her death. In it she tried to convey the environment that had inspired Van Gogh during the last years of his life, the people and landscape of the French countryside where he lived.

Because her pictures possessed technical perfection and a vivid personal touch, Emmy Andriesse has acquired her own unique place in the world of Dutch photography.

—A. de Jonge-Vermeulen

ARBUS, Diane.
American. Born Diane Nemerov in New York City, 14 March 1923. Educated at Ethical Culture School, and Feldston School, New York, until 1940; studied photography, with Lisette Model, New York, 1955-57. Married the photographer Allan Arbus in 1941 (separated, 1959); daughters: Doon and Amy. Independent photographer, New York, working first as an assistant to her husband, then as a photographer for *Harper's Bazaar, Show, Esquire, Glamour,* the *New York Times,* etc., 1941 until her death, 1971. Instructor, Parsons School of Design, New York, 1965-66; Cooper Union, New York, 1968-69; Rhode Island School of Design, Providence, 1970-71. Recipient: Guggenheim Fellowship, 1963, 1966; Robert Leavitt Award, New York 1970. *Died* (by suicide; in New York) *26 July 1971.*

Individual Exhibitions:

1967 *New Documents*, Museum of Modern Art, New York (with Garry Winogrand and Lee Friedlander; toured the United States, 1967-75)
1972 Museum of Modern Art, New York (retrospective; toured the United States, 1972-75)
 Seibu Museum of Art, Tokyo (retrospective; toured Europe and Australia and New Zealand, 1972-79)
1973 *10 Photos*, Martin Gallery, Minneapolis
1977 Galerie Zabriskie, Paris (with Lisette Model and Rosalind Solomon)
 Helios Gallery, New York
 Lunn Gallery, Washington, D.C.
 Arbus/Krims/Michals, Galerie Schellmann und Kluser, Munich
1978 Allan Frumkin Gallery, Chicago
1980 Robert Miller Gallery, New York
 Fraenkel Gallery, San Francisco
 Centre Georges Pompidou, Paris (toured France)

Selected Group Exhibitions:

1967 *Photography in the 20th Century*, National Gallery of Canada, Ottawa (toured Canada and the United States, 1967-73)
1971 *New Photography U.S.A.*, Museum of Modern Art, New York (touted the United States and Canada)
 Biennale di Venezia
1974 *Photography in America*, Whitney Museum, New York
1975 *Women of Photography*, San Francisco Museum of Art (toured the United States, 1975-77)
1977 *Documenta 6*, Museum Fridericianum, Kassel, West Germany
 Fashion Photography, International Museum of Photography, Rochester, New York (travelled to Brooklyn Museum, New York; San Francisco Museum of Modern Art; Cincinnati Art Institute, Ohio; and Museum of Fine Arts, St. Petersburg, Florida)
1978 *Mirrors and Windows: American Photography since 1960*, Museum of Modern Art, New York (toured the United States, 1978-80)
1979 *Photographie als Kunst 1879-1979*, Tiroler Landesmuseum Ferdinandeum, Innsbruck, Austria (travelled to Neue Galerie am Wolfgang Gurlitt Museum, Linz, Austria; Neue Galerie am Landesmuseum Joanneum, Graz, Austria; and Museum des 20. Jahrhunderts, Vienna)
1980 *The Magical Eye: Definitions of Photography*, National Gallery of Canada, Ottawa (toured Canada)

Collections:

Museum of Modern Art, New York; International Museum of Photography, George Eastman House, Rochester, New York; Museum of Fine Arts, Boston; Library of Congress, Washington, D.C.; Minneapolis Institute of Art; New Orleans Museum of Art; Museum of Fine Arts, Houston; Center for Creative Photography, University of Arizona, Tucson; National Gallery of Canada, Ottawa; Bibliothèque Nationale, Paris.

Publications:

By ARBUS: book—*Diane Arbus: Portfolio*, portfolio of 10 photos, New York 1971; articles—"The Vertical Journey: Six Movements of a Moment Within the Heart of the City" in *Esquire* (New York), July 1960; "The Full Circle" in *Infinity* (New York), February 1962; "Tokyo Rose Is Home" in *Esquire* (New York), May 1969.

On ARBUS: books—*Photography in the 20th Century* by Nathan Lyons, New York 1967; *Quality: Its Image in the Arts*, edited by Louis Kronenburger, New York 1969; *Diane Arbus*, edited by Doon Arbus and Marvin Israel, Millerton, New York 1972; *The Women's Eye* by Anne Tucker, New York 1973; *Women of Photography: An Historical Survey*, exhibition catalogue, by Margery Mann, San Francisco 1975; *Geschichte der Fotografie im 20. Jahrhundert / Photography in the 20th Century* by Petr Tausk, Cologne 1977, London 1980; *Mirrors and Windows: American Photography since 1960* by John Szarkowski, New York 1978; *Light Readings: A Photography Critic's Writings 1968-78* by A.D. Coleman, New York 1979; *The History of Fashion Photography* by Nancy Hall-Duncan, New York 1979; *The Photograph Collector's Guide* by Lee D. Witkin and Barbara London, Boston and London 1979; *Diane Arbus*, exhibition brochure, by Hervé Guibert, Paris 1980; articles—"Diane Arbus" in *Infinity* (New York), September 1970; "5 Photographs by Diane Arbus" in *Artforum* (New York), May 1971; "To D...., Dead by Her Own Hand" by Howard Nemerov in *Poetry* (Chicago), July 1972; "Diane Arbus: Photographer" by Doon Arbus in *Ms.* (New York), October 1972; "Diane Arbus" by Marvin Israel in *Infinity* (New York), November 1972; "Diane Arbus" by Allan Porter in *Camera* (Lucerne), November 1972; "Diane Arbus: The Art of Extreme Situations" by Barbara Rose in *New York* (New York), 27 November 1972; "Contemporary American Photographers: Diane Arbus" by Shoji Yamagishi in *Camera Mainichi* (Tokyo), December 1972; "Freakout" by Richard Roud in *The Guardian* (London), 29 December 1972; "Diane Arbus" by Peter C. Bunnell in *Print Collector's Newsletter* (New York), January/February 1973; "Diane Arbus: Playing with Conventions" by Amy Goldin in *Art in America* (New York), March/April 1973; "Diane Arbus: Early Work" in *Camera Mainichi* (Tokyo), April 1973; "The Uncanny Portrait: Sander, Arbus, Samaras" by Max Kozloff in *Artforum* (New York), June 1973; "Working with Diane Arbus: A Many Splendored Experience" by Alan Levy in *Art News* (New York), Summer 1973; "Diane Arbus," with texts by Doon Arbus and Marvin Israel, in *Camera Mainichi* (Tokyo), August 1973; "Freak Show" by Susan Sontag in *The New York Review of Books*, 15 November 1973; "Diane Arbus: Positive Images" by William Packer in *Art and Artists* (London), April 1974; bibliography—"The Diane Arbus Bibliography" by Robert B. Stevens in *Exposure* (New York), September 1977; film—*Camera Three*, CBS television film, 1972.

Towards the end of a short but intense career, Diane Arbus was regarded as a legend and her images, mainly of people, appeared to many as metaphors

for the uneasy dislocations of a society at war with itself and others. Working intuitively, Arbus was drawn to the bizarre aspects of human existence usually considered too strange and unappetizing for "family" consumption. Psychologically and physically deformed individuals exerted a particular fascination, impelling the photographer to seek out the truths behind the trauma of their lives.

In 1963, after twenty years of success as a fashion photographer, Arbus began to make vividly personal images, encouraged in this direction by her teacher, Lisette Model. At this time, she photographed in nudist camps, an experience so at odds with the demands of fashion photography that it can only be regarded as a purgative. In the same period she made "House on a Hill," an image of an elegant studio false front, set in a tangle of weeds, which seems emblematic of her profound sense of the discord between appearances and substance. Arbus regarded the camera as a "license" that permitted her to discover the real truths which facades of clothing or behavior hid from view.

At the same time, she conceded that her images were at times "mean." While she did not consider herself a satirist, she had an uncanny ability to ferret out expressions of ridiculous smugness, especially among so-called normal middle-class folk. Her photographs of bedecked and bejeweled bourgeoise women, showing them as grossly vulgar and intimidating, are particularly devastating, as is "Mother Holding Her Child," a corrosive visual indictment of the sacred concept of motherhood.

Arbus preferred to approach her sitters frontally, allowing them to come to terms with the camera and her own person. She was exceptionally sensitive to nuances of expression and gesture, but her images also are revelations of the relationship between photographer and subject. That so many of her sitters, whether distraught, dreamy or coquettish, seem so oblivious of the camera is an indication of the degree to which she could efface the apparatus and convince the sitter of a very real compassion. It was Arbus' conviction that "the subject of the picture is more important than the picture," but though she denigrated rules of composition and was uninterested in the aesthetics of printing, her sense of framing and scale are integral factors in the expressive tenor of the images.

Hers is a limited and perverse, yet compelling view of modern life. Those who are generally considered malformed in mind and body are invested with dignity, grace and poise, while ordinary people are seen as terrifying and alienated. As a documentary photographer of the inner being, the psychological truths that Arbus sought to reveal often are reflections of her own deep distrust of conformity and of a need to come to terms with her own turmoil.

—Naomi Rosenblum

ARNOLD, Eve.

American. Born in 1913. Initially studied medicine, then studied photography, under Alexey Brodovitch, New School for Social Research, New York, 1947-48. Married. Freelance photographer, London. Member, Magnum Photos co-operative agency, New York and Paris, since 1951. Agent: Magnum Photos, 251 Park Avenue South, New York, New York 10010, U.S.A. Address: 26 Mount Street, Flat 3, London W1, England.

Individual Exhibitions:

1980 *In China: Photographs by Eve Arnold*, Brooklyn Museum, New York (toured the United States, 1980-82)

Publications:

By ARNOLD: books—*The Unretouched Woman*, London 1976; *Flashback!: The 50's*, New York 1978; *In China*, New York 1980; articles—"L'Image aux J.O." in *Le Nouveau Photocinema* (Paris), November 1972; interview, with Casey Allen, in *Camera 35* (New York), November 1980; film—*Behind the Veil*, 1973.

On ARNOLD: book—*America in Crisis: Photographs for Magnum*, edited by Charles Harbutt and Lee Jones, with an essay by Mitchel Levitas, New York 1969; article—"Eve Arnold" by Pauline Peters in *You and Your Camera* (London), 10 May 1979.

Eve Arnold is petite, white haired and a grandmother, and someone lulled into complacency by those facts could overlook the fact that she has a mind like a razor. She has an acute sense of what is patronizing; she has tireless persistence and enormous compassion. It is these qualities that have formed and guided her work through three decades as a photojournalist. They would have made her a good doctor, too, had a boyfriend not given her a Rolleicord while she was studying medicine. As with many great photographers, her first assignment prefigured her future work. She had enrolled in Alexey Brodovitch's class at the New School in New York. He was Art Director of *Harper's Bazaar*, and the class—mainly professionals—included Richard Avedon. The class assignment was to do a fashion shot, and that led her to ask her baby's nursemaid if there were any fashion shows in Harlem. There were—almost daily. Eve Arnold went with her husband to do the shots, and Brodovitch liked the results. He sent her back, and she followed up the assignment for a year and a half. Later, her husband mailed some pictures to London to *Picture Post*, which published them as a major article, and then in 1951 she became the first woman to join the great Magnum agency. During the 1950's she was sometimes sent as the "token woman" to do stories about women and other minority groups—or at least, less *important* groups—old people, the poor, and blacks. There was nothing deliberately clever or showy about the pictures she brought back. Many of them were "candids," but her aim was to capture the spontaneity and easy flow of life, not to catch her subjects in compromising positions. Hers was a compassionate camera.

She also photographed political stories including past and future presidents, but even these she seems to have treated kindly.

Many of her most interesting pictures from the 50's are of famous people including Marilyn Monroe (still a memorable set of pictures), Joan Crawford, James Cagney, Paul Newman, Clark Gable and many others. She even made Andy Warhol look quite reasonable in a photograph—and he was sitting on a toilet lifting weights at the time.

In the 1960's and 70's she produced pictures with a harder edge, documenting the black civil rights movement in America, and documenting the position of women in society with a more liberated eye. Among her most memorable reportages was one on the Brides of Christ in Surrey, England (1965), and her extensive work on veiled women. She made a film, *Behind the Veil* (1973) about the harems of Arabia.

Many of her pictures show women doing menial tasks with great dignity. She also picks out some of the humorous incongruities of everyday life, which lightens her work, so she is able to make her points without starting a fight. Also many of these pictures have a stunning formal beauty, which is easily overlooked: her pictures are about the people she photographs, not about how good a photographer she is.

Her most recent major work is an all-colour book *In China*, which took five months to photograph. In some ways it is a retreat from her more feminist book *The Unretouched Woman*. She seems to stand further back, and to make herself even more transparent. She succeeds in her aim of showing what the Chinese look like, and she captures their dignity, but the pictures are so quietly composed that they generate little excitement. Only in the last section of the book, where she photographs people with a little more individuality—wrestlers, the militia, religious types—do the pictures start to leap off the page. The long and very readable text she has included in the book throws a more personal light on the pictures which helps to complete the work.

—Jack Schofield

ASTMAN, Barbara.

American. Born in Rochester, New York, 12 July 1950; moved to Canada in 1970. Educated at Irondequoit High School, Rochester, 1964-68; studied design and silversmithing, under Albert Paley, Rochester Institute of Technology, 1968-70; sculpture, under John Chandler, Ontario College of Art, Toronto, 1970-73, Associate 1973; mainly self-taught in photography. Married Noel Robert Harding in 1979. Independent photographer, Toronto, since 1973. Photographic Technician, 1973-74, and since 1976 Instructor, Nontechnical Faculty, Ontario College of Art. Instructor, York University, Toronto, 1978-80. Coordinator and Consultant, Color Xerox Artists' Programme, Visual Arts Ontario, Toronto, since 1977. Recipient: Ontario Council for the Arts grant, 1974-80; Canada Council Arts Grant, 1976, 1977, 1980, 1981. Agent: Sable-Castelli Gallery, 33 Hazleton Avenue, Toronto, Ontario M5R 2E3. Address: 2154 Dundas Street West, Toronto, Ontario M6R 1X3, Canada.

Individual Exhibitions:

1973 Baldwin Street Gallery of Photography, Toronto
1974 Ryerson Photo Gallery, Toronto
1975 National Film Board of Canada, Ottawa
1976 Saw Gallery, Ottawa
3 Photographers, Deja Vu Gallery, Toronto (with Jerry Uelsmann and Michael Semak)
1977 Sable-Castelli Gallery, Toronto
1979 *Visual Narrative Series*, Sable-Castelli Gallery, Toronto (travelled to the Jean Marie Antone Gallery, Annapolis, Maryland)
Talking Photos, Artspace, Peterborough, Ontario (with Suzy Lake; travelled to the Whitewater Gallery, North Bay, Ontario, and Brush Art Gallery, Canton, New York, 1980).

1980 *Untitled, I Was Thinking about You*, Sable-Castelli Gallery, Toronto (travelled to the Agnes Etherington Art Centre, Kingston, Ontario; McIntosh Gallery, University of Western Ontario, London; and Galerie Optica, Montreal, 1980; Laurentian University Museum and Art Centre, Sudbury, Ontario, and University of Delaware, Newark, 1981)

1981 *Red*, Sable-Castelli Gallery, Toronto (travelled to the Mendel Art Gallery, Saskatoon, Saskatchewan; University of Alberta, Edmonton; and Southern Alberta Art Gallery, Lethbridge, 1981; and the Centre Culturel Canadien, Paris, 1982)

Selected Group Exhibitions:

1975 *Chairs*, Art Gallery of Ontario, Toronto
1976 *Woman Photographs Man*, Rockefeller Center, New York
 Xerography, Art Gallery of Ontario, Toronto
1978 *The Canadian Connection*, Neikrug Galleries, New York
1979 *The Winnipeg Perspective 1979*, Winnipeg Art Gallery, Manitoba
 Alternative Imaging Systems, Everson Museum, Syracuse, New York
 20 x 20 Italia/Canada, Studio Luca Palazzoli, Milan
 Translations: Photographic Images with New Forms, Cornell University, Ithaca, New York
 Electroworks, International Museum of Photography, George Eastman House, Rochester, New York

Collections:

Ontario Arts Council, Toronto; Art Gallery of Ontario, Toronto; Stratford Art Gallery, Ontario; Agnes Etherington Art Centre, Kingston, Ontario; Art Bank, Ottawa, Ontario; Department of External Affairs, Ottawa; National Film Board of Canada, Ottawa; Winnipeg Art Gallery, Manitoba; Victoria and Albert Museum, London; Bibliothèque Nationale, Paris.

Publications:

On ASTMAN: books—*Exposure: Canadian Contemporary Photographers*, with an introduction by Glenda Milrod, Toronto 1975; *Women Photograph Men*, with an introduction by Molly Haskell, edited by Dannielle B. Hayes, New York 1977; *Alternative Photographic Processes* by Kent Wade, New York 1978; *Copy Art* by Patrick Firpo, Lester Alexander, Claudia Katayanagi and Steve Ditlea, New York 1978; *The Winnipeg Perspective 1979: Photo-Extended Dimensions*, with texts by Roger L. Selby and Karyn Allen, Winnipeg 1979; *Barbara Astman: I Was Thinking about You*, exhibition catalogue, with foreword by Joyan Sanders, London, Ontario, 1980; *Barbara Astman: Red*, exhibition catalogue, with text by Adele Freedman, Toronto 1981; articles—"The Impure Narratives of Barbara Astman" by Gary Michael Dault in *Saturday Night Leisure* (Toronto), June 1978; "Gallery Reviews" by Adele Freedman in *Globe and Mail* (Toronto), January 1980; "Barbara's Blow-Up" by Gary Michael Dault in *Toronto Star* (Toronto), 12 January 1980; "Barbara Astman" by Lydia Pawlenko in *Artscanada* (Toronto), April/May 1980; "Art in a Snap" by John Reeves in *Toronto Life* (Toronto), June 1980; "Barbara Astman: I Was Thinking About You" in *Photo Communique* (Toronto), Fall 1980: "Barbara Astman" in *City Woman* (Toronto), Fall 1980; "Barbara Astman: Peut-Etre un 'Body Art' Photographique" in *Parachute* (Montreal), Spring 1981; "Art Is Red, Black and Fine: Photographer Mixed Self Portrait with Kitchen Tools" by Lisa Balfour Bowen in *Sunday Star* (Toronto), 5 April 1981.

My work crosses over the areas of fact and fiction. My ideas stem from "real" life experiences, situations, involvements, etc.... I am not interested in documenting the real world, but rather in fabricating a world of my own within my studio.

In the newest series, titled "Red," I deal with objects that are familiar to most people. I think about breaking that sense of familiarity. I think of the implications of red, the hidden meanings of red, and what happens to these familiar home and studio objects once they are transformed to red.

The magic begins to happen once the objects are painted red: they become mysterious and lush through the transformation. Slowly, then, the decision is made to use myself as the facilitator, the presenter of these objects—the objects have, to a certain extent, been liberated from their traditional roles.

I deal with scale, and imitate a life-size scale. All of my recent bodies of work have been enlarged to "real" life scale, averaging four feet (122 cm) by four feet (122 cm). I am not interested in the sense of intimacy that small prints afford.

It is the conceptualizing, problem-solving, inventing, that excites me. The camera is used merely as a means of recording this tableau in the cleanest possible way.

—Barbara Astman

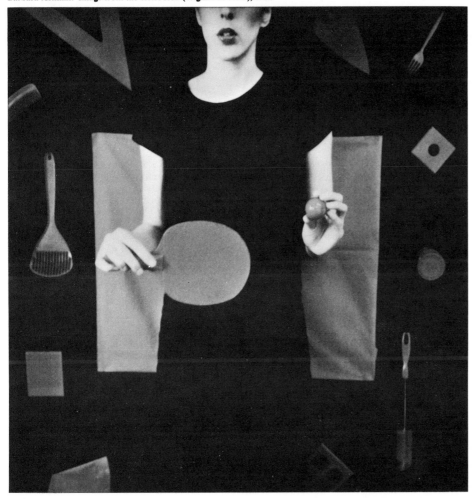

Barbara Astman: Image from the series *Red* (original in color), 1980

In her art, Barbara Astman strips away and discards elements in pursuit of the most essential aesthetic and psychological statement. It is this de-layering which gives Astman's work its unique power. The artist has referred to the process as "private performance art." Her camera works are an intriguing mixture of various traditional art forms—drawing, painting, photography, sculpture—elements which are redefined by a contemporary sensibility and the impact of which is heightened by the use of experimental technology. This fascination with current technological developments has enabled Astman to realize images of remarkable colour, texture and scale.

Her experimentation with colour xerography led to a series of large-scale murals (1976) organized in the format of a storyboard, composed of 30 8½" x 11" colour xerox images. The narrative aspect of this series was purely visual; the thematic structure was based on travelogue exotica—postcards and other found images from countries such as Italy, Russia and China—the transformation of photographic images created by new contexts which emerge from the images. Often the images were complemented by a hint of specific time and place, through the use of expanded, handwritten, journalistic notes. The resulting images presented a fictional truth, which becomes even more critical in the later work.

"The Visual Narrative Series" of 1978 represented a honing down of both format and image. This series of photographic, hand-tinted ektacolour murals consisted of 6 SX-70 images in 2 horizontal rows, accompanied by a typewritten narrative. The images are hand-coloured, stark in format and intensely personal. Despite the private/specific connotations of the text, the frontal format and its associations with traditional portraiture, there is a kind of timeless universality, not endemic to a specific point in time or in history.

Astman's work is linked to a classical, painterly tradition. The "I Was Thinking About You" series

27

Eugène Atget: *Montmartre: 2 rue de Calvaire*, **no. 6258** Courtesy Art Institute of Chicago

of 1979 is self-portraiture—the artist, perceived frontally, is posed against a fabric backdrop. These images are a kind of confessional in the format of letter writing. The words and images have become fused, the type literally blending *into* the visual field. This layering results in a consciously ambiguous dissolution of boundaries. Astman has cut the image off beneath the eyes, resulting in a kind of depersonalization. The colour of the backdrop is consistently rich, alluding to sensuous velvet typical of classical portraiture. The mouth is open, the hands poised, at a moment of revelation. It is a rich reduction of elements; the effect of the cut off eyes is to force the issue of abstraction—the result of this compositional strategy is depersonalizing. The blending of the type into the image suggests a kind of marking in time, emotional scarring. The resulting images are poignant yet severe.

The "Red" series of 1980 represents a breakthrough on several levels—symbology, content, and format. The use of words/text has been eliminated completely from these 4' x 4' ektacolour murals. The artist is posed in a frontal position amidst a carefully balanced composition of objects, which have been spray-painted red. The artist is dressed in black, her face cropped beneath the eyes; there is a tenuous balance in these works. The background objects seem to float in space, assuming something "other" than their typical function. Astman appears as a kind of prophet in this context. She is also something of a magician, using a kind of sensual constructivism, suggestive of El Lissitzky. The words have been replaced as signposts by objects which encourage a conceptual leap on the viewer's part. Recognizable objects assume new connotations related to the various implications of "red," implications that are at once playful and vaguely threatening. Astman has composed a poem-cum-new-wave-lyric to carry these radical (associative) powers of the colour:

> Red feels like a crime
> it relates to that lady
> refers to a diversion
> gets me excited
> tells me I'm new
> red causes me anger
> and can make me a communist.

The hand and the mouth become the agents of prophecy and celebration. These works are indeed a kind of discreet celebration.

It is the immediacy inherent in the implicit properties of the camera which gives the work a power that is almost gothic. There is also an implied relationship with science—objects as tools for discovery and as barometers of change and precision.

Astman is currently exploring the intimacy of private rooms and spaces. This series eliminates altogether the human figure with the result that the objects take on an added symbolic power. It is yet another step in the stripping away of layers, of taking risks, and of exploring the complex realm of memory and dream.

Barbara Astman's work is not only technically and aesthetically exquisite, but it also probes the deepest myteries of the self. The symbolic language is a constant and subtle element in this process of exploration—it offers discreet intimations that hint at voluptuous relevations. It is Astman's own mythological order.

—Karyn Allen

ATGET, (Jean)-Eugène-(Auguste).

French. Born in Libourne, near Bordeaux, 12 February 1857. Educated in Bordeaux; studied at the Conservatoire d'Art Dramatique, Paris, 1879-81; mainly self-taught in photography, Paris, from 1898. Lived with actress Valentine Delafosse, from 1885 (died, 1927). Worked as a cabin-boy, French merchant navy, 1875-77; stage actor and comedian, Bordeaux and Paris, 1881-97; independent painter, Paris, 1897-98; commercial and topographic photographer, Paris, 1898-1925. Photographic work "discovered" by Berenice Abbott, *q.v.*, Paris, 1926; subsequently acquired by Abbott with help of Julien Levy and André Calmette. *Died* (in Paris) *4 August 1927*.

Individual Exhibitions:

1930 Weyhe Gallery, New York
1931 Julien Levy Gallery, New York (with Nadar)
1939 Photo League, New York
1948 Addison Gallery, Andover, Massachusetts
1951 New School for Social Research, New York
1952 *The Paris of Atget*, Metropolitan Museum of Art, New York
1955 Boylston Street Print Gallery, Boston
1956 Limelight Gallery, New York
1960 Cincinnati Art Museum, Ohio
1965 Museo de Bellas Artes, Caracas, Venezuela
1967 *Photographs by Atget from the Berenice Abbott Collection*, University of Texas at Austin
1969 *Paris Photographs*, Witkin Gallery, New York
 Robert Schoelkopf Gallery, New York
 San Francisco Museum of Art
 Photography Place, Berwyn, Pennsylvania (with Lee Friedlander)
 Museum of Modern Art, New York
1972 Institute of Contemporary Arts, London
 Atget's Trees, Museum of Modern Art, New York
 Witkin Gallery, New York
1975 Highland Gallery, New York
 3 French Photographers, Allan Frumkin Gallery, Chicago (with Brassaï and Henri Cartier-Bresson)
1976 Stedelijk Van Abbemuseum, Eindhoven, Netherlands
 David Mirvish Gallery, Toronto
 Marlborough Gallery, New York
1977 Helios Gallery, New York
 Galerie Zabriskie, Paris (with Berenice Abbott)
1978 Kunsthaus, Zurich
 Le Paris d'Atget, at *Festival of Carthage*, Tunisia
 Bard College, Annandale-on-Hudson, New York
 Vision of Paris, Yarlow/Salzman Gallery, Toronto
1979 *Atget's Gardens*, Royal Institute of British Architects, London (toured the United States)
 University of Missouri, St. Louis
1980 Galerie Rudolf Kicken, Cologne
 International Center of Photography, New York
 Atget in Perspective, Part 1, Prakapas Gallery, New York
 Atget in Perspective, Part 2, Prakapas Gallery, New York
1981 Landerbank/Fotografis, Vienna
 The Work of Atget: Old France, Museum of Modern Art, New York
 Works from the Julien Levy Collection, Marcuse Pfeifer Gallery, New York

Selected Group Exhibitions:

1928 *1st Independent Salon of Photography*, Paris
1932 *Exposition Internationale de la Photographie*, Palais des Beaux-Arts, Brussels (travelled to Lakenhal, Leiden, Netherlands; and Kunstzaal Van Hasselt, Rotterdam, Netherlands)
1959 *Hundert Jahre Photographie 1839-1939*, Museum Folkwang, Essen, West Germany (travelled to Cologne and Frankfurt)
1965 *Un Siècle de Photographie*, Musée des Arts Décoratifs, Paris
1976 *Photographs from the Julien Levy Collection, Starting with Atget*, Art Institute of Chicago
1978 *Histoire de la Photographie Française à 1920*, Musée Française de la Photographie, Bièvres, France
 Vintage and Abbott/Atget, Pallas Photographic Gallery, Chicago
1979 *Selection 1900-1930 d'Atget à Man Ray*, Galerie Octant, Paris
 Photographie als Kunst 1879-1979, Tiroler Landesmuseum Ferdinandeum, Innsbruck, Austria (travelled to Neue Galerie am Wolfgang Gurlitt Museum, Linz; Neue Galerie am Landesmuseum Joanneum, Graz; and Museum des 20. Jahrhunderts, Vienna)
1981 *Photography in France 1843-1920*, National Gallery of Canada, Ottawa (toured Canada)

Collections:

Bibliothèque Historique de la Ville, Paris; Bibliothèque Nationale, Paris; Musée des Arts Decoratifs, Paris; Archives des Monuments Historiques, Paris; Caisse Nationale des Monuments Historiques et des Sites, Paris; Victoria and Albert Museum, London; Museum of Modern Art, New York (Berenice Abbott/Julien Levy collection of negatives and prints); Berenice Abbott Collection, New York; International Museum of Photography, George Eastman House, Rochester, New York; Gernsheim Collection, University of Texas at Austin.

Publications:

By ATGET: books—*Atget: Photographe de Paris*, with preface by Pierre Mac-Orlan, Paris 1930; *Eugène Atget: Lichtbilder*, edited by Camille Recht, Paris and Leipzig 1930, revised edition, with texts by Walter Benjamin, Berenice Abbott, Man Ray and others, Munich 1975; *Saint Germaine des Près 1900: Vu par Atget*, edited by Yvan Christ, with introductions by Charles Lochman and Pierre Descaves, Paris 1951; *20 Photographs by Eugène Atget*, portfolio, with an introduction by Berenice Abbott, New York 1956; *A Vision of Paris: The Photographs of Eugène Atget; The Words of Marcel Proust*, edited by Arthur D. Trottenberg, New York 1963, as *Paris du Temps Perdu*, Lausanne 1963; *Les Metamorphoses de Paris*, edited by Yvan Christ, Paris 1967; *Eugène Atget: Das Alte Paris*, with texts by K. Honnef, C.B. Ruger, R.E. Martinez, and G. Freund, Cologne 1978; *Atget: Voyages en Ville*, with an introduction by Pierre Gassmann, texts by Romeo Martinez and Alain Pougetoux, Tokyo and Paris 1979; *The Work of Atget: Old France* (volume 1 of projected 4 volume series), edited by John Szarkowski and Maria Morris Hambourg, Boston 1981.

On ATGET: books—*Masters of Photography* by Beaumont and Nancy Newhall, New York 1958; *Hundert Jahre Photographie 1839-1939 aus der Sammlung Gernsheim*, exhibition catalogue, Cologne 1959; *Eugène Atget* by Berenice Abbottova [i.e., Abbott] Prague 1963; *The World of Atget* by Berenice Abbott, New York 1964; *Photographs by Eugène Atget from the Collection of Berenice Abbott*, exhibition catalogue, with a foreward by Marian B. Davis, Austin 1967; *Les Metamorphoses*

de la Banlieue Parisienne, photos by Atget and others, Paris 1969; *Homage à Eugène Atget 1856-1927*, with a foreward by Jean-Claude Lemagny, Paris 1972; *Atget: Magicien du Vieux Paris en son Epoque* by Jean Leroy, edited by Pierre Jean Balbo, Paris 1975; *Photographs from the Julien Levy Collection, Starting with Atget*, exhibition catalogue, by David Travis, Chicago 1976; *The First Century of Photography: Niepce to Atget: From the Collection of André Jammes*, exhibition catalogue, by Marie-Thérèse and André Jammes, with an introduction by David Travis, Chicago 1978; *Atget's Gardens*, exhibition catalogue, by William Howard Adams, with an introduction by Jacqueline Onassis, New York and London 1979; *Eugène Atget*, exhibition catalogue, by George Puttnies, Cologne 1980; articles—"Eugène Atget 1856-1927" by Albert Valentine in *Variétés* (Paris), 15 December 1928; "Eugène Atget" by Berenice Abbot in *Creative Art* (New York), no. 5, 1929; "Eugène Atget" by B.J. Kospoth in *Transition* (Paris), February 1929; "Eugène Atget" by Berenice Abbott in *U.S. Camera* (New York), November 1940; "Eugène Atget 1856-1927" by Minor White in *Image* (Rochester, New York), April 1956; "Eugène Atget" by Piero Racanicchi in *Popular Photography Italiano* (Milan), October 1961; "Who Was Eugène Atget" by Jean Leroy in *Camera* (Lucerne), December 1962; "Eugène Atget" in *Fotografia* (Warsaw), May 1963; "Atget et son Temps" by Jean Leroy in *Terre d'Images* (Paris), May/June 1964; "Unpublished Atget" in *Infinity* (New York), January 1965; "My Memories of E. Atget, P.H. Emerson and Alfred Stieglitz" by Brassaï in *Camera* (Lucerne), January 1969; "Atget: The Little Man Who Influenced a Generation of Photographers" by David Vestal in *Popular Photography* (New York), February 1969; "Eugène Atget, Parisian and Photographer" by Guy Brett in *The Times* (London), 21 December 1971; "Not Seeing Atget for the Trees" by A.D. Coleman in the *Village Voice* (New York), 27 July 1972; "Eugène Atget: The Simplicity of Genius" in *Modern Photography* (New York), January 1973; "Atget and Man Ray in the Context of Surrealism" by John Fuller in *Art Journal* (New York), Winter 1976/77; "Eugène Atget: A Chronological Bibliography" by William Johnson in *Exposure* (New York), May 1977; "Eugène Atget: Portals, Passages and Portraits," special issue of *Camera* (Lucerne), March 1978; "The Truth about Atget" by Jean Leroy in *Camera* (Lucerne), November 1979.

Eugène Atget was first a sailor as a young man, then a bit player in a provincial theater, before he became a photographer in his middle age during the 1890's. For about 30 years he photographed mainly in Paris—the city itself was his subject—making what the sign on his door called "Documents for Artists."

His modesty shows there. His idea was simply to provide well-chosen, clearly depicted raw material from which others could make art. In keeping with this concept of his role, he sold prints for modest prices. The equivalent of 3 American dollars was one of the higher prices he is known to have charged. A cheap print would go for about 25 cents. Those who buy them now pay more.

Yet I think he knew he was an artist. When Berenice Abbott, then working as Man Ray's assistant, met Atget in 1927, she asked if he ever worked on assignment. Atget said, "No. People don't know what to photograph." By this he implied that he did know what to photograph; and that was true.

I've seen a great many Atget photographs, but I don't remember seeing any that showed doubt or hesitation. He chose what he wanted to photograph with absolute certainty each time. There are many poor pictures among them, but I don't recall any tentative or indecisive ones. He wasn't in the masterpiece business: that wasn't his idea at all. His concern was to record interesting aspects of Paris appropriately and clearly. What's remarkable is how many of his pictures go so far beyond this that

they are wonderful. On their lowest level, they give a great deal of specific information. Beyond that there is vitality, a graphic bite that is often arresting, a warmth of feeling and an extraordinary visual beauty, rare in photography.

And all of this is presented casually, offhand. No effort shows. It isn't even slick. There is no trace here of the virtuoso, and there are no mannerisms, nothing of what usually passes for style. These photographs are entirely unselfconscious. Atget never thought of having people look at his pictures and say "Wow." Instead, he wanted them to see and feel the street he had photographed as he had seen and felt it: to get the exact experience of early morning air, the slant of sunlight or the dreariness of the rain. He was evoking felt experience, not chasing after applause.

This has led even sensitive people to miss the point of Atget's work. Thus Edward Weston, a gifted artist but a self-conscious one, who kept thinking of art as something exalted that he wanted to have show in his work, thought of Atget as an overrated artisan, a fairly capable but insensitive recorder of facts. Weston was wrong. What Atget's photographs lacked was not art but artiness: a lack which did his work nothing but good. Nothing in Atget's work is phony or overdone. Plenty of others have made Weston's mistake, and the joke is on them. It's they who miss something important, not Atget.

I can't think of anything more interesting to do with a time machine than to go back and visit Paris over the Atget years. Think how many other now famous photographers, full of their own importance, must have crossed his path, seen this shabby street photographer at work, and had no idea who he was or what he was doing. And how few of their Parisian pictures can stand up beside his.

Man Ray did know him, and through him, so did Berenice Abbott. Among those who almost certainly did not were Stieglitz, Steichen, Kertész, Brassaï, and a very young Cartier-Bresson.

And there were the painters. Some Atgets that were sold to them as documents surfaced later as paintings. I've seen the same view of the Place du Tertre in a book of Atget's photographs and a book of Utrillo's paintings (neither book mentioned the other picture-maker). So that's one of Atget's customers. Braque was another. There were many.

Atget was an anachronism, old-fashioned from start to finish. At the dawn of the 35mm age, he still made his negatives on glass plates and contact-printed them on printing-out paper—the kind that is placed behind the negative in the sunlight where it slowly darkens until the print is "done." There is no chemical development.

He was right not to keep up with technical progress, since the special tonal behavior of printing-out paper (P.O.P.) is peculiarly right for his pictures.

Briefly, the contrast of a P.O.P. print is controlled by how long the paper is exposed to the sunlight. As the print's dark tones are exposed through the more transparent parts of the negative, they soon start to darken, cutting off the light from the sensitive silver salts behind the surface. After that, the dark tones darken less and less in the last stages of the print exposure, while the light tones darken with almost undiminished speed, until the photographer opens the frame, lifts a corner of the paper off the plate, looks at it, and decides that the light tones are now dark enough. He then takes the printing frame out of the sun.

Because of this self-masking property, P.O.P. printing allows negatives of extreme tonal range, from very bright highlights to very deep shadows, to print with every tone distinct over the entire range. Modern developing-out papers cannot equal P.O.P.'s ability to stretch the tonal range of a print without becoming flat and gray.

Atget was not a technician, not obsessed with craftsmanship. He did not treat his pictures as precious. But very early, he found a technical routine that gave him the results he wanted simply and without fuss.

He was a direct man with a plain approach that

fitted his subjects and the needs of his pictures exactly. And so, a rare sensitivity came through intact in beautiful, powerful, convincing photographs. A curiosity: when they were made, his pictures were old-fashioned; but now they are more modern than the avant-garde work of his time—less dated.

I think of Atget's photography as a sustained miracle. No amount of informed effort, skill, and concentration could have achieved it. But his alert sensitivity, his gentle and receptive spirit, and his deep attunement to Paris and to his very ordinary equipment and materials did achieve it. Everything had to fit together in an almost impossible way—and it did.

And almost no one noticed until he had been dead for forty years.

—David Vestal

AUERBACH, Erich.

British. Born in Falknov, Bohemia, now Czechoslovakia, 12 December 1911; emigrated to England, 1939: naturalized, 1947. Educated at grammar school in Karlsbad, Czechoslovakia, 1922-30; studied music, musical history and philosophy, at Charles University, Prague, 1930-33; self-taught in photography. Married Lizzy Tauber in 1946; daughter: Monica. Worked as a music reviewer and photo-reporter, *Prager Tagblatt* newspaper, Prague, 1930-39; official photographer to Dr. Benes' Czech Government in Exile, London, 1940-45; freelance photographer, 1944-45, then Staff Photographer, under editor Len Spooner, 1945-58, *Illustrated* magazine, London; freelance photographer, working for the *Daily Herald, Sunday Times, The Observer, Sunday Telegraph, Illustrated London News*, and for Imperial Chemical Industries (ICI), and EMI Record Company, London, 1958 until his death, 1977. Fellow, Royal Photographic Society. Estate: Lizzy Auerbach, Flat 161, 29 Abercorn Place, St. John's Wood, London NW8 9DU, England. *Died (in London) 11 August 1977.*

Individual Exhibitions:

1943 *Path to Victory*, The Royal Academy, London
1950 *People of Czechoslovakia*, Ilford Gallery, High Holborn, London
1971 *Musicians*, Ceremonial Foyer, Royal Festival Hall, London
1973 *Musicians*, Kodak Gallery, London

Selected Group Exhibitions:

1968 *World Exhibition of Photography*, Pressehaus Stern, Hamburg (and world tour)

Collections:

Royal College of Music, London (eventual archives).

Publications:

By AUERBACH: books—*Vier Unter Suchungen zur Geschichte der Franzosischen Bildung*, Berne 1951; *An Eye for Music*, London 1971.

On AUERBACH: books—*The Face of Life: Photographers Chosen by "The Observer,"* edited by Cliff Hopkinson, London 1959; *World Exhibition of Photography*, exhibition catalogue, edited by

Erich Auerbach: *Sir Georg Solti Conducting the Ring Cycle*, 1963

the other hand, so clearly shows the author's relation to the world of music that background information serves only to fill out the detail in a pattern already visible in lively outline.

Music preceded photography in Auerbach's life by many years, and his professional ambitions were towards music criticism. It was only when these were largely frustrated that he turned to photojournalism, an occupation which stood him in good stead when he was forced to flee his native Czechoslovakia for England, in 1939. For some years, until his association with *Illustrated* terminated at its closure in 1958, Auerbach was producing high quality general feature work, with a bias, despite the initial scepticism and discouragement of colleagues, towards musical subject matter.

Auerbach's subsequent specialisation in this area bore out the promise of his earlier attainments, and the viewer at once recognizes him as a man equally at home with the musical activities he was depicting and the photography through which they were being depicted. Careful study of a body of Auerbach's work leads a viewer to understand the basis of that recognition.

Most immediately evident is his photojournalist's instinct for the combination of viewpoint and moment; his balance of the inclination to take notice of the peaks with the need to say something of the atmosphere of a complete occasion, and the ability to know in advance where he must be, and what he must do, to accomplish his intentions.

Subtler, but once seen always present, is a sharp taste specific to the musical experience being referred to in each image; whether directly, as in the photographs of a performance, or by association, as in the photographs of composers. One comes in time to know that Auerbach achieved a visual form equivalent in its dynamic to the musical forms associated with his subjects. The sinuosities, the angularities, the discreteness or homogeneity of the different musics are translated to his photographs. This sensibility is the rare gift which distinguished Erich Auerbach in his chosen profession, and could only belong to a man who lived music as naturally as a bird flies through air.

—Philip Stokes

AUSLOOS, Paul.
Belgian. Born in Antwerp, 6 January 1927. Studied painting at the Academie voor Schone Kunsten, Antwerp, 1945-50, and monumental art at the National Hoger Instituut, Antwerp, 1950-55, Dip. 1955. Served in the Belgian Army, 1950. Married Mia Wuyts in 1973; son: David. Painter since 1945; Founder, G58 group, 1958. Photographer, in Antwerp, since 1968. Professor of Publicity Studies, Academie Sint-Niklaas, Belgium, since 1950; Professor of Photography, Academie of Antwerp, since 1970. Recipient: Rome Prize, for painting, 1950. Agent: Galerij Paule Pia, Kammenstraat 57, 2000 Antwerp. Address: Kasteelstraat 33, 2000 Antwerp, Belgium.

Individual Exhibitions:

1969 Galerie Venetia, St. Niklaas, Belgium
 Foto-Film Academie, Breda, Netherlands
1970 Foto-Kamer Celis, Merksen, Belgium
1971 Academie of Antwerp
 Galerie de Zwarte Panter, Antwerp
1976 Bank Brussel-Lambert, St. Niklaas, Belgium
 Galerij Paule Pia, Antwerp
1977 Galerie Vecu, Antwerp
1978 Cultureel Centrum, Heusden, Belgium

Karl Pawek, Hamburg 1968; articles—"The Art of Observation: Some Light on the Work of Erich Auerbach" by Ainslie Ellis in *British Journal of Photography Annual 1969*, London 1968; "Ein Auge für Musick: Aufnahmen Erich Auerbach" by P. Mieg in *Du* (Zurich), June 1972; "Erich Auerbach" in *Creative Camera* (London), July 1973; "Erich Auerbach: An Appreciation" by Ruth Spencer in the *British Journal of Photography* (London), September 1977; "The Visual Imagery of Musical History" by Walter Nurnberg in the *British Journal of Photography* (London), June 1978.

The co-existence of musical with photographic affinities, in certain gifted individuals, has had various manifestations. Some, as for instance in the cases of Alfred Stieglitz or Ansel Adams, require biographical and theoretical knowledge for their understanding. Erich Auerbach's photography, on

Selected Group Exhibitions:

1975 *G58 Hessenhuis*, Museum voor Schone Kunsten, Antwerp
1976 *15 Photographen aus Flandern*, Kunstlerhaus, Vienna (travelled to the Musée Nicéphore Niepce, Chalon-sur-Saône, France, 1976, and the Het Sterckshof Museum, Deurne, Belgium, and the Palais des Beaux-Arts, Brussels, 1977)
Fotografen uit Ulaanderen, Galerie de Beierd, Breda, Netherlands (travelled to the Cultureel Centrum, Ghent, 1977)
1978 *Europhot Congress*, Belgrade
1980 *Camera Belgica*, Galerie Aslk, Brussels

Collections:

Het Sterckshof Museum, Deurne, Belgium; Musée d'Art et d'Histoire, Fribourg, Switzerland.

Publications:

On AUSLOOS: book—*De Fotografie in Belgie 1940-1980*, exhibition catalogue, by Roger Coenen and Karel van Deuren, Antwerp 1980; article—"Paul Ausloos" by Karl van Deuren in *Foto* (Amersfoort), July 1977.

It is rather refreshing for me to come to a certain poetical expression without any personal handiwork, drawing, painting or photographic manipulation.

Everything has been done *before* I press the button.

There is simply nothing left for handwork.

I work in a room 5 by 5 metres, with a few lamps, a camera and a case full of objects.

—Paul Ausloos

Paul Ausloos is an artist in photography. Although he has been a successful painter, his photographs do not have a pictorial character, as was the case with the pictorialists of the last century or the abstract

photographers of the Bauhaus. His work is purely photographic; it is composed of nothing other than simple photographic shots.

Except for a limited series of mannered portraits of artists, Ausloos photographs still-lifes of humble objects such as a box with spots of rust, mould at the edges, a loose label—*objets trouvés*. He also uses old photos from his family album and picture postcards. These humble articles, through his strange virtuosity, become redolent of nostalgia and poetry and can be read as the reconstruction of a personal history. Souvenirs of souvenirs.

Then, suddenly, in this series, there is a new subject: fascism. Still-lifes (*nature mortes*) of badges of honour; a portrait of a tomb; postcards of the "Mighty of the Earth" and of "The Beloved" and of "The War Hero." War and patriotism.

This kind of photography continually makes an inventory of what life has to offer through the comforting means of art. *L'Art consolateur.*

After the theme of nostalgia, Paul Ausloos's recent color work is a happy glimpse at newly arranged still-lifes. They are attractive in a strictly intimate and incomparable way.

—Karel van Deuren

AVEDON, Richard.

American. Born in New York City, 15 May 1923. Educated at Public School No. 6, New York, 1929-37; DeWitt Clinton High School, New York, 1937-41; studied philosophy at Columbia University, New York, 1941-42; photography, with Alexey Brodovitch, at the New School for Social Research, New York, 1944-50. Served in the photo section of the United States Merchant Marine, 1942-44. Married Dorcas Norwell in 1944 (divorced, 1950); married Evelyn Franklin in 1951; son: John. Established Richard Avedon Studio, New York, 1946; freelance contributing photographer, *Life*, *Look*, *Graphis*, etc., since 1950. Staff Photographer, *Junior Bazaar*, New York, 1945-47, and *Harper's Bazaar*, under

Carmel Snow and Alexey Brodovitch, 1945-65; Staff Editor and Photographer, *Theatre Arts*, New York, 1952. Staff Photographer, under Diana Vreeland and Alexander Liberman, *Vogue*, New York, since 1966. Visual Consultant on the Stanley Donen film *Funny Face*, 1957. Recipient: Highest Achievement Medal, *Arts Directors' Show*, New York, 1950; World's 10 Greatest Photographers Award, *Popular Photography*, New York, 1958; National Magazine Visual Excellence Award, 1976; Dedication to Fashion Photography Citation, Pratt Institute, New York, 1976; Chancellor's Citation, University of California, Berkeley, 1980; Certificate of Excellence, American Institute for Graphic Arts, 1980. President's Fellow, Rhode Island School of Design, Providence, 1978. Agent: Norma Stevens, 1075 Park Avenue, New York, New York 10028. Address: 407 East 75th Street, New York, New York 10021, U.S.A.

Individual Exhibitions:

1962 Smithsonian Institution, Washington, D.C.
1970 Minneapolis Institute of Arts (retrospective)
1974 *Jacob Israel Avedon*, Museum of Modern Art, New York
1975 Marlborough Gallery, New York (travelled to the Seibu Museum of Art, Tokyo)
1978 *Photographs 1947-1977*, Metropolitan Museum of Art, New York (travelled to the Dallas Museum of Fine Arts; High Museum of Art, Atlanta; and Isetan, Tokyo)
Portraits Geants, PPS Galerie, Hamburg
1980 *Retrospective 1946-1980*, University of California, Berkeley
1981 Neikrug Photographica, New York

Selected Group Exhibitions:

1955 *The Family of Man*, Museum of Modern Art, New York (and world tour)
1959 *Photography in the Fine Arts*, Metropolitan Museum of Art, New York (and 1960, 1961, 1963, and 1967)
1964 *The Photographer's Eye*, Museum of Modern Art, New York
1965 *Glamour Portraits*, Museum of Modern Art, New York
1969 *Portrait Photography*, Museum of Modern Art, New York
1974 *The History of Photography in America*, Whitney Museum, New York
1977 *Fashion Photography*, International Museum of Photography, George Eastman House, Rochester, New York (travelled to the Brooklyn Museum, New York; San Francisco Museum of Modern Art; Cincinnati Art Institute, Ohio; and Museum of Fine Arts, St. Petersburg, Florida)
1979 *Photographie als Kunst 1879-1979*, Tiroler Landesmuseum Ferdinandeum, Innsbruck, Austria (travelled to the Neue Galerie am Wolfgang Gurlitt Museum, Linz, Austria; Neue Galerie am Landesmuseum Joanneum, Graz, Austria; and Museum des 20. Jahrhunderts, Vienna)
1980 *The Portrait Extended*, Museum of Contemporary Art, Chicago

Collections:

Museum of Modern Art, New York; Metropolitan Museum of Art, New York; International Museum of Photography, George Eastman House, Rochester, New York; Philadelphia Museum of Art; Museum of Fine Arts, Houston; San Francisco Museum of Modern Art; Haags Gemeentemuseum, The Hague; Rhodes National Gallery, Salisbury, Zimbabwe.

Paul Ausloos: *Untitled* (original in color), 1980

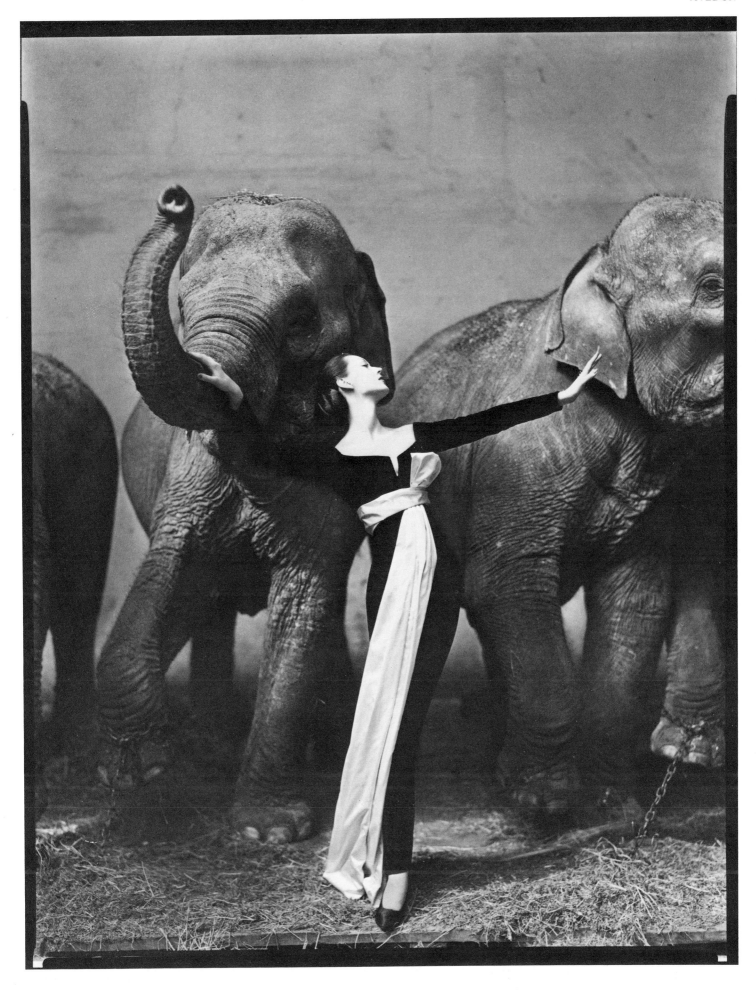

Richard Avedon: *Dovima with Elephants/Evening Dress by Dior*, 1955

Publications:

By AVEDON: books—*Observations*, with text by Truman Capote, New York and London 1959; *Nothing Personal*, with text by James Baldwin, New York 1964; *Diary of a Century: Photographs by Jacques-Henri Lartigue*, editor, New York 1970; *Alice in Wonderland: The Forming of a Company, The Making of a Play*, with text by Doon Arbus, New York 1973; *Richard Avedon: Portraits*, with an introduction by Harold Rosenberg, New York and London 1976; *Avedon: Photographs 1947-1977*, with an essay by Harold Brodkey, New York 1978; articles—"Martin Munkacsi" in *Harper's Bazaar* (New York), June 1964; "Richard Avedon" in *Camera* (Lucerne), November 1974; "The Family" in *Rolling Stone* (San Francisco), 21 October 1976.

On AVEDON: books—*The Photographer's Eye* by John Szarkowski, New York 1965; *Avedon*, exhibition catalogue, with an introduction by Anthony M. Clark and Carroll T. Hartwell, Minneapolis 1970; *Looking at Photographs: 100 Pictures from the Collection of the Museum of Modern Art* by John Szarkowski, New York 1973; *Avedon*, exhibition catalogue, New York 1975; *The Magic Image* by Cecil Beaton and Gail Buckland, London and Boston 1975; *On Photography* by Susan Sontag, New York 1977; *Geschichte der Photographie im 20. Jahrhundert/Photography in the 20th Century* by Petr Tausk, Cologne 1977, London 1980; *Avedon: Photographs 1947-1977*, exhibition catalogue, with text by Rosamond Bernier, New York 1978; *The History of Fashion Photography* by Nancy Hall-Duncan, New York 1979; *Photographie als Kunst 1879-1979/Kunst als Photographie 1949-1979*, exhibition catalogue, 2 volumes, by Peter Weiermair, Innsbruck, Austria 1979; *Avedon: Retrospective 1946-1980*, exhibition catalogue, with text by David Ross, Berkeley, California 1980; *Camera Lucida: Reflections on Photography* by Roland Barthes, New York 1981; articles—"Richard Avedon, Minneapolis Institute of Arts" in *Arts Magazine* (New York), Summer 1970; "The Mature Portraitist: Richard Avedon" by Dore Ashton in *Studio International* (London), October 1974; "Richard Avedon's Hidden Photographs" by Thomas Hess in *Vogue* (New York), September 1975; "Richard Avedon Will Sell You This Picture" by Owen Edwards in the *Village Voice* (New York), 15 September 1975; "Avedon Rising" by Douglas Davis in *Newsweek* (New York), 22 September 1975; "Avedon's Faces of Power" by Susan Cheever Cowley in *Newsweek* (New York), 11 October 1976; "Avedon" by Roland Barthes in *Photo* (Paris), January 1977; "Looking with Avedon" by Susan Sontag in *Vogue* (New York), September 1978; "The Avedon Look" by Charles Michener in *Newsweek* (New York), 16 October 1978; "Triumph der Modephotographie" by Fritz Neugass in *Du* (Zurich), December 1978; "Photographs by Avedon: A Retrospective, 1947-1980" by Aaron Walden in the *Sentinel* (San Francisco), 21 March 1980.

A photographic portrait is a picture of someone who knows he's being photographed, and what he does with this knowledge is as much a part of the photograph as what he's wearing or how he looks. He's implicated in what's happened, and he has a certain real power over the result. We all perform. It's what we do for each other all the time, deliberately or unintentionally. It's a way of telling about ourselves in the hope of being recognized as what we'd like to be. I trust performances. Stripping them away doesn't necessarily get you closer to anything. The way someone who's being photographed presents himself to the camera, and the effect of the photographer's response on that presence, is what the making of a portrait is about.

—Richard Avedon

Richard Avedon's photography touches the nerve of our identity: who we are, what we are and what we long to be. Through his two types of photography, fashion and portraiture, he has investigated the faces and fashions of our society, its dreams and desires, and told us something of ourselves.

Avedon, only 21 when he did his first work for *Harper's Bazaar* and became a protégé of the legendary art director Alexey Brodovitch, became the boy wonder of fashion photography with an appealing style born of the exuberance and versatility of youth. His stylistic innovation, an improvised and almost accidental quality achieved through blurred motion, was equalled by the fresh new look of his models, who were filled with a carefree joy and love of life. "She laughed, danced...ran breathlessly down the Champs-Elysées, smiled and sipped cognac at café tables, and otherwise gave evidence of being human" (Winthrop Sargeant, "Profiles: Richard Avedon," *The New Yorker*, 8 November 1958).

Yet despite their charm, these pictures had a fascinating emotional complexity. Avedon has throughout his career been an unparalled dramatist, able to transform occasions for wearing clothes into moments of high dramatic action. Sargeant again: "It is this power to induce the conviction that one is witnessing a crucial instant in the emotional life of the subject and to stimulate curiosity as to what brought it about and what will ensue, that give the Avedon photograph its peculiar distinction."

Throughout the 50's Avedon's work changed, maturing, gaining in sophistication and skill and moving progressively away from the straight-forward simplicity he so admired in the work of the Hungarian fashion photographer of the 1930's, Martin Munkacsi. Gradually Avedon gave up not only the outdoor locations in which he had produced his wonderful images of Parisian gambols but also the softly beautiful natural light which had illuminated his early work. He now regarded daylight, which he had loved to use, as a very romantic light. "It's like loving something from long ago that I can't really believe in anymore," he said. "It would be a lie for me to photograph the daylight in a world of Hilton's, airports, supermarkets and television. Daylight is something I rarely see—something I must give up—like childhood" (Cecil Beaton and Gail Buckland, *The Magic Image*).

Avedon moved his fashion into the studio, which he preferred because "it isolates people from their environment...they become in a sense symbolic of themselves" (Janel Malcom, "Photography: Men Without Props," *The New Yorker*, 22 September 1975). Though he retained the vitality and movement of the earlier work, he replaced romantic illumination with the harsh, raking light of the strobe. He developed the studio format which became his "signature": the model was seen running, jumping, airborne and giggling across a plain white background. Avedon became the first to combine the static studio tradition of the 20's with the exuberance of Munkacsi's outdoor realism. The Paris jaunt of the early 50's was transformed into a "locationless" shot, a change that reflected Avedon's perception of his own New York environment, which is basically confined to the interior of his studio.

In many ways the development of Avedon's portraiture has paralleled that of his fashion. In the *New Yorker* article on Avedon, Janet Malcolm traced the progression of his portraiture from the earliest portraits—"animated by an innovator's spirit of experiment and risk-taking, and by a young man's wish to please and dazzle"—through the fiercely shocking portraits from the period of his book *Nothing Personal* to the current mercurial and analytical work. We find the same progression, if not exactly the same degree of inquiry, informing both portraiture and fashion.

The most obvious characteristic of Avedon's portraits is their searing emotional impact, despite—or perhaps, more rightly, because of—their supposed lack of intervention by the photographer. Taken in the studio against white and starkly empty backgrounds, the subjects *confront* the viewer with tight-lipped, vacant expressions and frontal, "informational" poses. When set before this white field Avedon's portrait subjects, who tend to be superstar culturati and political power-dealers, also become "symbolic of themselves" and of the cultural and political values of our society.

The disquiet of Avedon's portraits is heightened by the printing, in which partial borders of the negative become black frames, by the close-up figure-to-frame relationship, and by the size, which ranges from large to vast, encompassing and involving the viewer in their expanse. The 8' high murals shown at the Metropolitan Museum of Art Avedon retrospective—the length of one of them stretched to 35'—put the viewer in an entirely new relationship to the photographic image: he was both encompassed by the field and perceived the photographed subject in a one-to-one relationship to his body size. This, in effect, transformed the image from *seen* to *felt*.

Richard Avedon is a stunningly original photographer. He has been able to express the social, material and sexual values of our society in the quicksilver and so-called "ephemeral" medium of fashion photography and to bring new meanings and emotional impact to the field of portraiture. But it is his continued ability to take creative risks, "never to bring the same mental attitude to the same problem twice," which is the key not only to his past work in this medium but also to his future.

—Nancy Hall-Duncan

B

BADGER, Gerry (Gerald David Badger).

British. Born in Northampton, 13 June 1948. Studied architecture at the Duncan of Jordanstone College of Art, Dundee, Scotland, 1964-69, Dip.Arch. 1969; studied photography under Joseph McKenzie, Dundee, 1966-69. Married Joyce Masterton in 1964; children: Jane and Emma. Architect with the Greater London Council Department of Architecture and Civic Design, 1969-73, and with Peter Wood and Partners, London, 1973-76. Architect in private practice, London, since 1976. Lecturer in Photography, Stanhope Institute, London, since 1976. Member of the Editorial Board, *Creative Camera*, London, since 1980. Recipient: Arts Council Grant for Creative Photography, 1977; Visual Arts Major Award, Greater London Arts Association, 1979. Address: 24 Clarence Road, Croydon, Surrey, England.

Individual Exhibitions:

1974 Creative Camera Gallery, London
1975 The Photographers' Gallery, London
1978 Brewery Arts Centre, Kendal, Cumbria
1979 Sir John Cass School of Art, London
1980 University of Dundee, Scotland
 Glenrothes Gallery, Scotland
 Open Eye Gallery, Liverpool

Selected Group Exhibitions:

1972 *Young Contemporaries II*, Creative Camera
 Gallery, London (toured the U.K.)
1973 *Serpentine Photography '73*, Serpentine
 Gallery, London
1976 *New Photographers*, Boxroom Gallery,
 London
1978 *Midland Group Photography '78*, Midland
 Group Gallery, Nottingham (travelled to
 the Serpentine Gallery, London)
 Stanhope Photographers, Stanhope Gallery,
 London
1980 *British Art 1940-1980*, Hayward Gallery,
 London
 Perspectives on Landscape, Arts Council,
 London (toured the United States)
1981 *Stanhope Photographers*, Stanhope Gallery,
 London
 Summer Show, B2 Gallery, London

Collections:

Arts Council of Great Britain, London; Department of the Environment, London; London Borough of Hounslow; Royal Photographic Society, Bath, England; Bibliothèque Nationale, Paris; Museum of Modern Art, New York.

Publications:

By BADGER: books—*New American Still Photography*, exhibition catalogue, Edinburgh 1976; *Singular Realities*, exhibition catalogue, Newcastle upon Tyne 1977; *John Blakemore: British Image III*, London 1977; *Mid-19th Century French Photography*, exhibition catalogue, Edinburgh 1979; *Eugene Atget, Photographer*, London 1981; articles—"Wynn Bullock" in *Photographic Journal* (London), May 1975; "Lee Friedlander" in *British Journal of Photography* (London), March 1976; "Manuel Alvarez Bravo" in *British Journal of Photography* (London), May 1976; "Dr. Thomas Keith" in *British Journal of Photography* (London), May 1977; "Walker Evans" in *Creative Camera* (London), September 1977; "William Klein" in *British Journal of Photography* (London), February 1978; "Garry Winogrand" in *British Journal of Photography* (London), March 1978; "Mark Cohen" in *British Journal of Photography* (London), March 1978; "Thomas J. Cooper" in *Artscribe* (London), July 1978; "E.J. Bellocq" in *British Journal of Photography* (London), August 1978; "Mid-19th Century French Photography" in *British Journal of Photography* (London), October 1979; "Early Photography in Egypt" in *Creative Camera* (London), December 1979.

On BADGER: books—*British Journal of Photography Annual*, edited by Geoffrey Crawley, London 1975; *British Journal of Photography Annual*, edited by Geoffrey Crawley, London 1978; *Untitled No. 14*, edited by James Enyeart and James Alinder, Carmel, California 1979; *Perspectives of Landscape*, *British Image V*, edited by Bill Gaskins, London 1979; article—by William Messer in *U.S. Camera Annual*, New York 1977.

Photography, perhaps more than any other graphic art form, is an intensely physical, as well as metaphysical, activity. The relationship between photographer and photographed is a physical one—essentially a purely physical one. The photograph merely transcribes that physical relationship. Photography might be described almost as a performing art. The photographer creates or describes a dance with space and time.

My work is concerned with the photographic art, or the process of photography—on several levels. The physical, the hunting or collecting aspect, is one of the most important. At root—one might say at the first and at the last level—there is the impulse simply to hunt, and capture that which strikes a visual chord, a subjective response. And then to stalk that thing in order to place the camera in an exact physical relationship to it. A relationship whereby the machine may not simply record the subject, but express it, give full expression to the initial chord.

But always this process must begin with the visual. Many things move me in many ways, but not necessarily to make a photograph.

Gerry Badger: *River Braan, Perthshire*, 1979

The material in the world that strikes this chord is various, but relates usually to the urban environment. I am concerned not so much with the literal documentation of social fact—a worthy yet near impossible task in terms of the medium anyway—but with a more formal and allusive exploration of the interaction between people and the environment, the interface between natural and built environment. Sometimes this material may seen unprepossessing, the detritus of a profligate society. Sometimes, on the other hand, it might be inspiring, as when one encounters the attempts of individuals to improve their own environments, light years away from the stultifying hands of professional environmentalists. So I am drawn to such things as the spaces between buildings, to cleared sites, modern middens, neglected corners, and particularly to gardens.

Formally, by natural inclination and also as a reaction against the minimalist programmes of so many contemporary photographers, I tend to make texturally and formally dense images. For that purpose, and also because of my great love for early photographic imagery, I use what is basically the same equipment used in the 19th century—a large view camera, complete with black cloth and associated paraphernalia. This is not merely an exercise in nostalgia. I am fascinated by the sheer amount of information that can drop off in a photograph made by such a process. Also, the process slows one down, forcing one to think hard, and making a perhaps protracted yet strangely pleasurable rite out of the whole act of photographing. It tends to produce images that are characterised by a sense of stillness, complexity, and intensity.

For me the delights of photography are its availability as a medium to all and its living continuities with the past, as are evident in the fact that its basic precepts remain as they were at the beginning. They are the same for the ambitious artist as for the most untutored snapshooter. We may experience the same—exactly the same—aesthetic frisson from a Timothy O'Sullivan desert landscape of the 1870's as from a NASA Martian landscape of the 1970's. Both may describe desert, light, space, and a feeling of emptiness to the same degree of perfection.

The root precepts of the medium might be overlaid—as I hope in my own case—with many layers of meaning. But however abstruse these layers of meaning may become, the whole, for me, should be transparent. The simple, mechanical fusion of light, time, space and object.

—Gerry Badger

Gerry Badger's interest in photography is both academic and practical. He has always been fascinated by the topographical and has made several studies of 19th century photographers; as well, he is currently involved in the exploration of different print methods which will be brought together for an Arts Council Exhibition shortly. In his own work he has taken this topographical interest to small areas which he explores intensely over a long period.

Badger is currently working on a back garden in London, which is revealing under the close scrutiny of his large format camera, facets which the eye would never see at first glance. This kind of intensity is something which can best be expressed by photography—no other medium can make one so aware of the tiny details and the potential for fascination in a seemingly derelict or ordinary environment. In a previous series Badger explored a section of stream and the pool from which it comes. With long exposures and great clarity he produced a group of photographs which conveyed the entire atmosphere and magical quality of the place together with an abstraction of the subject, which makes it a universal symbol for all the secret places of our childhood. These pictures really need to be seen in groups and series. It is not that they follow a conventional line around a place, or indeed a number of seasons; it is because they come and go closer and further away

from a specific point of view. In changing that point of view, they create the complete picture that one would see and carry in the memory: a particular space which has become generalised by the close attention to detail.

Gerry Badger's contribution to photography has not been entirely through his own work; to a great extent it has taken the form of teaching, lecturing and writing on photography. While it is to be hoped that his pictures will reach a wider audience as time passes, it is equally important that his knowledge and study of photography and photographic history can be given clearly and enthusiastically to the public whose appreciation and understanding of the process and potential of the medium can be greatly helped by such an informed and enthusiastic practitioner of what he preaches.

—Sue Davies

BAILEY, David (Royston).

British. Born in London, 2 January 1938. Educated at schools in London, 1948-53; self-taught in photography. Served in the Royal Air Force, Malaysia, 1957-58. Married Rosemary Bramble in 1960 (divorced); Catherine Deneuve in 1967 (divorced); Marie Helvin in 1975. Photographic assistant, John French Studio, London, 1959; contract fashion photographer, *Vogue* magazine, London, from 1960; also freelance photographer, working for *Daily Express, Sunday Times, Daily Telegraph, Elle, Glamour*, etc., London, since 1960. Director of television commercials, since 1966, and television documentary films, 1968-72. Proprietor and Co-Editor, with Patrick Lichfield, *Ritz* newspaper, London, since 1976. Fellow, Royal Photographic Society, London, 1972; Fellow, Society of Industrial Artists and Designers, London, 1975. Lives in London. Address: c/o The Photographers' Gallery, 8 Great Newport Street, London WC2, England.

Individual Exhibitions:

1971 National Portrait Gallery, London
1972 Nikon Galerie, Paris
1973 The Photographers' Gallery, London

Collections:

National Portrait Gallery, London; The Photographers' Gallery, London; Condé Nast Publications, London.

Publications:

By BAILEY: books—*The Truth About Modelling*, with text by Jean Shrimpton, London 1963; *Box of Pin-Ups*, London 1964; *Goodbye Baby and Amen*, with text by Peter Evans, London 1969; *Andy Warhol*, London 1974; *Beady Minces*, with foreword by Terence Donovan, London 1974; *Another Image: Papua New Guinea*, London 1975; *Mixed Moments*, London 1976; *Masterpieces of Erotic Photography*, with others, London 1977; *David Bailey's Trouble and Strife*, with preface by Jacques-Henri Lartigue, introduction by Brian Clarke, London 1980; article—"David Bailey," interview, in *Zoom* (Paris), November/December 1972; films—*Beaton by Bailey*, 1971; *Andy Warhol*, television film, 1973.

On BAILEY: books—*The Magic Image* by Cecil Beaton and Gail Buckland, London 1975; *Geschichte der Fotografie im 20. Jahrhundert/Photography in the 20th Century* by Peter Tausk, Cologne 1977, London 1980; *The Vogue Book of Fashion Photography* by Polly Devlin, with an introduction by Alexander Liberman, London 1979; articles—"Goodbye Bailey and Hello!" by Hugh McIlvanney in the *Observer Magazine* (London), 16 November 1969; "Great Photographers of the World: David Bailey" by S. Patterson in *Réalités* (Paris), March 1971; "David Bailey" in *The Image* (London), no. 11, 1973; "Bailey: Not Just a Photographer of Pretty Faces" by G. Hughes in *Amateur Photographer* (London), 3 April 1974; "David Bailey Photographs Faces to Watch" in the *Observer Magazine* (London), 1 March 1981.

If I have to explain my pictures in words, it means that my images have not worked.

—David Bailey

David Bailey

David Bailey emerged as a fashion photographer to be reckoned with at the beginning of the 1960's, and he has continued to be one of the most popular and famous figures in that seemingly ephemeral scene. This is because he has both enjoyed his work and taken it seriously, because he is interested in the possibilities of photography in a far wider context than any assigned work he may be given, and probably also because he has always seemed to prefer the women to the clothes, something that his predecessors—with their static and stylised forms of fashion photography—certainly did not.

Keith Waterhouse dubbed them the "Terrible Trio"—Duffy, Donovan and Bailey; but David Bailey is the one who has continued longest in the public eye, partly because his particular style of fashion photography was so revolutionary that his pictures were and are instantly recognisable, and also because his general interest in still photography has continued, and he has published several books of his personal pictures. *Goodbye Baby and Amen*, his hymn to the 1960's, is full of portraits and the dashing spirit of that time, and he has more recently used reportage and other forms to express his ideas.

The freedom that Bailey brought to the previously very stylised forms of fashion photography came from his early realization that it is the girls who wear the clothes that make them work. Both he and Duffy have said that it was the inspiration of the working girls in dance halls, who managed to create style from almost nothing, that led thim to the freer expression in their photography, an expression that was so appropriate to the relaxed atmosphere and the breaking down of class barriers that was felt throughout the 60's. This trend has continued and grown, with designers picking up ideas from The Punks and now The Posers, inventing and changing their personna as fast as ever the old designers did.

For me, the best of Bailey is to be found in those portraits made in the intimacy of the studio of his friends or of the models he knew best—the fact that they may have been showing off certain clothes at the same time is immaterial. It has been said of Marilyn Monroe that she had a love affair with the camera. From the other side of the lens, the same could be said of David Bailey. With his camera he can express that freedom from cant and exaggeration that he clearly admires both in photography and in life style, and the best of his pictures will certainly not only show the spirit of their age but also outlive it as portraits in their own right.

—Sue Davies

Oscar Bailey: *Statue*, Ohio, 1978

BAILEY, Oscar.

American. Born in Barnesville, Ohio, 23 July 1925. Educated at Wilmington College, Ohio, 1948-51, B.A. 1951; Ohio University, Athens, 1956-58, M.F.A. 1958. Married Sara Besco in 1945; children: Susan and Daniel. Printer and Designer, Cooperative Recreation Service, Delaware, Ohio, 1951-56. Photographer since 1956. Professor of Photography, State University of New York at Buffalo, 1958-69. Since 1969, Professor of Art, University of South Florida, Tampa. Artist-in-Residence, Artpark, Lewiston, New York, 1977. Founding Member, Society for Photographic Education, 1962. Recipient: Faculty Research Fellowship, State University of New York, 1967; Release-Time Grant, University of South Florida, 1974; Photographers Fellowship Grant, National Endowment for the Arts, 1976. Address: 2004 Clement Road, Lutz, Florida 33549, U.S.A.

Individual Exhibitions:

1958 Ohio University, Athens
1959 New York State University College at Buffalo
1960 Indiana University, Bloomington
1962 New York State University College at Buffalo
1963 Kalamazoo Institute of Arts, Michigan
1964 Ohio Wesleyan University, Delaware
 International Museum of Photography, George Eastman House, Rochester, New York
1965 University of Tampa
1967 University of New Hampshire, Durham
1969 University of Oregon, Eugene
1970 University of South Florida, Tampa
1971 Penland School of Crafts, North Carolina
1972 Valencia Community College, Orlando, Florida
 University of South Florida, Tampa
1973 Hillsborough Community College, Tampa
1974 University of South Florida, Tampa
1975 Ridge Art Association, Winter Haven, Florida
1976 University of Colorado, Boulder
1977 Southern Illinois University, Carbondale
1978 University of North Florida, Jacksonville

Selected Group Exhibitions:

1960 *The Sense of Abstraction in Contemporary Photography*, Museum of Modern Art, New York
1971 *New Photographics*, Washington State College, Ellensburg
1972 *Wider View*, International Museum of Photography, George Eastman House, Rochester, New York
1973 *Photo-Phantasists*, Florida State University, Tallahassee
 Light and Lens, Hudson River Museum, Yonkers, New York
1974 *New Images in Photography*, University of Miami
1976 *Photo/synthesis*, Cornell University, Ithaca, New York
1977 *The Contemporary American South*, United States Information Agency Exhibition, toured Europe and Southeast Asia
1978 *Extended Frame*, Visual Studies Workshop, Rochester, New York (toured the United States)
1979 *Florida Light*, Loch Haven Art Center, Orlando, Florida

Collections:

Museum of Modern Art, New York; International Museum of Photography, George Eastman House,

Rochester, New York; Boston Museum of Fine Arts; Smithsonian Institution, Washington, D.C.; Library of Congress, Washington, D.C.; Ringling Museum of Art, Sarasota, Florida; Florida Center for the Arts, Tampa; Museum of Fine Arts, St. Petersburg, Florida; New Orleans Museum of Art.

Publications:

By BAILEY: book—*Found Objects*, with Charles Swedlund, Buffalo, New York 1965.

On BAILEY: books—*Light and Lens*, edited by Donald L. Werner, New York 1973; *Photo/Synthesis*, edited by Jason D. Wong, New York 1976; *Modern Portraits: The Self and Others*, edited by J. Kirk and T. Varnedoe, New York 1976; articles—"Whence Does Wisdom Come?" by Minor White in *Aperture* (Millerton, New York), no. 1, 1959; "Presentation: Oscar Bailey" by Knut Forsund in *Fotografi* (Oslo), September 1978.

Whether working with conventional format cameras, 35 mm., 6 x 7 cm., 4 x 5 in., or with my Cirkut 8 (an antique, rotating, panoramic camera, producing negatives 8 by 48 inches in size), I generally deal with the human element. Whether people are in the actual photograph or not, the picture is about mankind—man has done this, has been here.

I enjoy and appreciate all facets of photographic image-making. I do some mixed-media work, constructions, photo-manipulations, but for the most part my work is "straight"—or, in the case of work with the Cirkut camera, "curved."

My aim is to present images—images equivalent to my ideas and feelings—with enough vitality to evoke an exchange of understanding. This is, for me, more important than reporting an obvious truth of the external world.

—Oscar Bailey

Oscar Bailey's work is of both a narrative and a compositional nature, but his strongest work is based on the narrative. The juxtaposition of images in a single frame and the relationship of the individual images to each other reveal Bailey's sense of humor, sometimes very subtle and often interjecting very strong opinions by the use of the parts involved. Bailey has made such comments on a range of topics from the vanity of country-western to the unreality of Florida palm trees. His work has transcended the flat plain to the dimensional; the works in gum bicromate fully utilize the visual pun. Bailey has also explored the dot pattern used in the printed image enlarged to the extent of becoming an entity unto itself, thus informing, in these large works, an image of its own structure and abstracting the original reason for its being.

His best known work has been done with his "cirkut" camera. In these long horizontals he has explored many of his earlier themes, yet, because of the camera's time lag of 10 to 20 seconds, Bailey has been able to completely throw off reality in his "backyard happenings," creating abstracted forms with a background of undistorted reality, a feat few other mechanically visual media can perform. His backyard experiences also incorporate the narrative by the selection of information in the extreme horizontal format. Because the camera moves from left to right and conceptualization then is from left to right, the natural tendency of "reading" the image is strengthened; in "Old 88 and Friends," for instance, there is a very strong sense of narrative. The cirkut images require a great deal of "pre-visualization" and precise planning, including a feeling for movement in a frozen frame. What emerges is Bailey's feeling for his surroundings and his narrative within them.

—Tina Freeman

BALDESSARI, John.

American. Born in National City, California, 17 June 1931. Educated at Sweetwater High School, National City, 1945-49; studied painting at San Diego State College, California, 1949-53, 1954-57, B.A. 1953, M.A. 1957. Married Carol Wixom in 1962; children: Anna Marie and Antonio. Professional artist since 1957. Instructor, Fine Arts Gallery, San Diego, 1953-54, San Diego city schools, 1956-57, San Diego State College, 1956, 1959-61, and Southwestern College, Chula Vista, California, 1962-68; Assistant Professor of Art, University of California at San Diego, 1968-70; also Instructor, La Jolla Museum of Art, California, 1966-70. Professor, California Institute of Arts, Los Angeles, since 1970. Visiting Instructor, Hunter College, New York, 1971. Recipient: National Endowment for the Arts Grant, 1973, 1974-75. Agents: Sonnabend Gallery, New York; and James Corcoran Gallery, 8223 Santa Monica Boulevard, Los Angeles, California 90046. Lives and works in Santa Monica, California. Address: c/o Sonnabend Gallery, 420 West Broadway, New York, New York 10012, U.S.A.

Individual Exhibitions:

1960	La Jolla Museum of Art, California
1962	Southwestern College, Chula Vista, California (and 1964)
1966	La Jolla Museum of Art, California
1968	Molly Barnes Gallery, Los Angeles
1970	Richard Feigen Gallery, New York
	Eugenia Butler Gallery, Los Angeles
1971	Galerie Konrad Fischer, Dusseldorf
	Art & Project, Amsterdam
	Nova Scotia College of Art and Design, Halifax
1972	Galerie MTL, Brussels
	Art & Project, Amsterdam
	Galleria Franco Toselli, Milan
	Jack Wendler Gallery, London
1973	Sonnabend Gallery, New York
	Galerie Sonnabend, Paris
	Galleria Schema, Florence
	Galerie Konrad Fischer, Dusseldorf
1974	Galerie Folker Skulima, West Berlin
	Jack Wendler Gallery, London
	Galleria Franco Toselli, Milan
	Art & Project/Galerie MTL, Antwerp
1975	Galerie Felix Handschin, Basle
	Galerie MTL, Brussels
	Saman Gallery, Genoa
	Sonnabend Gallery, New York
	Stedelijk Museum, Amsterdam
	Modern Art Agency, Naples
	Galerie Sonnabend, Paris
	Southwestern College, Chula Vista, California
	The Kitchen, New York
	University of California at Irvine
1976	Ewing Gallery, University of Melbourne, Australia
	Auckland Art Gallery, New Zealand
	University of Akron, Ohio
	Ohio State University, Columbus
	Cirrus Editions Gallery, Los Angeles
	James Corcoran Gallery, Los Angeles
1977	Galleria Massimo Valsecchi, Milan
	Matrix, Hartford Atheneum, Connecticut

John Baldessari: *Baudelaire Meets Poe* (2 black/white photos; 1 color photo), 1980

John Baldessari: Films, Fox Venice Theatre, Venice, California
Robert Self Gallery, London
Julian Pretto Gallery, New York
1978 Portland Center for the Visual Arts, Oregon
Sonnabend Gallery, New York
Recent Films, Theatre Vanguard, Los Angeles
Films by Baldessari, Artists' Space, New York
Three Films, Pacific Film Archives, Berkeley, California
Baldessari: New Films, Whitney Museum, New York
1979 *New York*, Halle für Internationale Neue Kunst, Zurich
1980 *Fugitive Essays*, Sonnabend Gallery, New York
1981 *Werken 1966-1981*, Stedelijk Van Abbemuseum, Eindhoven, Netherlands
John Baldessari: Deborah Turbeville, Sonnabend Gallery, New York
Wright State University, Dayton, Ohio

Selected Group Exhibitions:

1971 *Prospect '71: Projection*, Kunsthalle, Dusseldorf
1974 *Demonstrative Fotografie*, Kunstverein, Heidelberg
1975 *The Extended Document*, International Museum of Photography, George Eastman House, Rochester, New York
(Photo)/(photo)²....(photo)n, University of Maryland, Baltimore
1976 *Serial Photography*, Broxton Gallery, Los Angeles
1977 *Contemporary American Photographic Works*, Museum of Fine Arts, Houston
1978 *Kirklands International Photographic Exhibition*, Walker Art Gallery, Liverpool
1979 *American Photography in the 70's*, Art Institute of Chicago
Text-Foto-Geschichten, Kunstverein, Bonn
1980 *The Photograph Transformed*, Touchstone Gallery, New York

Collections:

Museum of Modern Art, New York; Los Angeles County Museum of Art; La Jolla Museum of Art, California; Wallraf-Richartz Museum, Cologne; Stedelijk Museum, Amsterdam; Kunstmuseum, Basle.

Publications:

By BALDESSARI: books—*Ingres and Other Parables*, London 1972; *Choosing: Green Beans*, Milan 1972; *Throwing Three Balls in the Air to Get a Straight Line (Best of Thirty-Six Attempts)*, Milan 1973; *Throwing a Ball Once to Get Three Melodies and Fifteen Chords*, Irvine, California 1975; *Four Events and Reactions*, Amsterdam 1975; *Artists and Photographers*, portfolio, with others, New York 1975; *Raw Prints*, portfolio, Los Angeles 1976; *Brutus Killed Caesar*, Akron, Ohio 1976; *A Sentence of Thirteen Parts (with Twelve Alternate Verbs) Ending in Fable*, Hamburg 1977; articles—"Photography and Language," interview, in *John Baldessari*, exhibition catalogue, Los Angeles 1976; "John Baldessari: Interview," with Diane Spodarek, in *Detroit Artists' Monthly*, June 1976.

On BALDESSARI: books—*Pop Art Redefined* by John Russell and Suzi Gablik, London and New York 1969; *Conceptual Art* by Ursula Meyers, New York 1971; *Video Visions: A Medium Discovers Itself* by Jonathan Price, New York 1972; *Art History of Photography* by Volker Kahmen, New York 1973; *Video Art* by Ira Schneider and Beryl Korot,

New York 1976; *John Baldessari*, exhibition catalogue, with texts by Marcia Tucker and Robert Pincus-Witten, and an interview by Nancy Drew, Dayton, Ohio 1981; articles—"Baldessari" by Caroline Tisdall in *The Guardian* (London), 15 April 1971; "Pointing, Hybrids and Romanticism: John Baldessari" by James Collins in *Artforum* (New York), October 1973; "Sequential Photographs" by Mark Power in the *Washington Post*, 7 March 1975; "What Develops When Painters Pick Up Cameras" by David Bourdon in the *Village Voice* (New York), 20 October 1975; "The Anti-Photographers" by Nancy Foote in *Artforum* (New York), September 1976; "New Color Photography Is a Blurry Form of Art" by Gene Thornton in the *New York Times*, 10 July 1977; "John Baldessari's 'Blasted Allegories' " by Hal Foster in *Artforum* (New York), October 1979.

The accompanying piece is a visual equivalent of how I believe Baudelaire must have felt at the moment of reading Poe for the first time.

First the snake. Groveling, sneaking along the ground, lowly, slow moving, inertia, held down by gravity. A flat point of view, like Flatland. Maybe how one feels having a writer's block? Not much happening until he encounters Poe. But also redolent of indolent voluptuousness, of poetry chained to the earth. Suggestive of the darker regions of the mind, an atmosphere that is infernal. A sign of the demands of the unconscious. I recall that Baudelaire spoke of his mistress as a "dancing serpent." I could have used a snail, I suppose. But a snake just seems better, nearer to the ground, more endless and richer with poetic overtones. Also, this image is in photogravure, but more about that later.

Which gets to the second image. The snake jumps up, curls around, embraces a more specific symbol—a jewel—wraps around it. And a baby snake, a kind of rebirth. Ready to grow. A collision of images, deliberately mixed. High and low. Chosen as Baudelaire says from "...forest of images." Juxtaposing such elements seems very much like Baudelaire. Beauty out of evil Baudelaire would say, though I think my point of view is more indefinite, thus back to Poe. At any rate, it stirs the unconscious and the pre-logical. Repressed ideas and associations begin to awaken.

The frog stands for an explosion made at the moment of impact of the two minds meeting. In color, larger than the other two images, the bursting out of, travelling out of the plane of the wall. A metamorphosis as well, changing from snake to a frog. Repelling but somehow beautiful, standing for magic. Transubstantiation. The idea reified, made flesh but in a sinister non-social fashion.

About the photogravure. It refers to print vs. the color, where the frog is no longer a sign. The frog is the artist freed.

—John Baldessari

John Baldessari's presence in an encyclopedia of contemporary photography is somewhat problematic if one accepts the distinction between artists who use photography (and in Baldessari's case, photography is just one of several media he routinely employs) and art photographers. For the former, photography is often a means to a particular end in which the notion of the photograph-as-work-of-art plays little or no role. On the contrary, many of the contemporary artists who have extensively used photography in their work—artists as disparate as Andy Warhol, Robert Rauschenburg, Joseph Kosuth, Edward Ruscha, Bill Beckly, et alia—use, make, or appropriate photographs that have little to do with the art photography tradition. Often as not, the photographs that they utilize in their works are news photos, snapshots, magazine and advertising images; in short, that photography which comprises the bulk of our image environment. Many of the photographs that these artists make are themselves literally documents, straightforward transcriptions

of events, actions, or objects that have been orchestrated, constructed, or arranged to be constituted anew (and preserved) in the camera image.

For artists like Baldessari, the salient aspects of photography are its mechanical reproducibility, its ubiquity, its legibility, and its instrumentality in both the creation and purveying of mass culture. These are of course precisely the aspects of photography that art photographers have traditionally worked in opposition to. The fine print, the limited edition, the manipulated negative are all strategies designed to separate art photography from an infinitude of mass-produced images. In the work of Baldessari, photography is employed as an efficient image-making technology which functions variously as documentation of conceptual work or as a way to present problems of narrative, representation, perception, epistomology, or aesthetic theory. Baldessari has said "the real reason I got deeply interested in photography was my sense of dissatisfaction with what I was seeing. I wanted to break down the rules of photography—the conventions.... Photography allowed me to register my ideas more rapidly than painting them. They grew out of a sense of urgency. If you're stranded on a desert island and a plane flew over, you wouldn't write HELP in Old English script." Baldessari thus employs photography as a visual sign system whose individual units may be composed of poloroid snapshots, Type C prints, movie stills, photographs shot from television, as well as conventional black-and-white photographs.

Whether working with language (a blank canvas on which a sign painter has lettered the words PURE BEAUTY), video (a 15 minute videotape in which Baldessari moves different parts of his body while intoning "I am making art"), painting (the commissioning of 14 amateur painters to copy a chosen 35mm slide on a delineated area of standard canvas to which a sign painter has appended the words "A painting by..") or photography (a horizontal series of color photographs of the sides of cars Baldessari passed en route to his studio ordered in relation to the color wheel)—Baldessari consistently uses humor to provoke complicated questions about art. Such a strategy has a distinguished ancestry (most notably in the work of Marcel Duchamp) and has further enabled Baldessari to produce a body of work which, while difficult and complex in its ideas, is witty and engaging in its presentation.

Baldessari's work is of particular importance for a new generation of artists recently termed "postmodernist". Indeed many of the intellectual influences that have profoundly informed Baldessari's art—Ferdinand de Saussure, Ludwig Wittgenstein, Claude Levi-Strauss, and Roland Barthes—have been those most important in contemporary critical thought. Viewed overall, Baldessari's production is both didactic (and it might be noted in this context that Baldessari has been an influential teacher for many years) and radical. By consistently calling into question conventional notions of authorship, narration, composition, and meaning, be it of text, image, or art in general, Baldessari has confronted and given expression to the significant problems and issues of contemporary art practice.

—Abigail Solomon-Godeau

BALTAUSS, Richard.

French. Born in Chelles-sur-Marne, 18 November 1946. Studied at the School of Fine Arts, Marseilles, 1963-65; Ecole de Choreographie, Athens, 1965-67; Ecole d'Art, Marseilles, 1967-69; Ecole des Beaux-Arts, Paris, 1969-71. Served in the French Army. Freelance photographer, Paris, since 1969. Recipient: Prix de la Ville de Paris, 1980. Agent: Galerie Delpire, 13 rue de l'Abbaye, 75006 Paris, France. Address: 100 rue d'Amsterdam, 75009 Paris, France.

Individual Exhibitions:

1979 Galerie Delpire, Paris

Selected Group Exhibitions:

1976 *From the Face to the Mental Model*, Galerie FIAP, Paris
1978 *Portraits*, French Institute, Naples
1980 *Creatis*, Galerie FNAC, Strasbourg, France
 The Month of Photography in Paris, 16th District Hall, Paris
1981 *Faces of Photography; Photography of Faces*, Centre Culturel de Yonnes, Auxerre, France

Collections:

Bibliotèque Nationale, Paris; Centre Audiovisuel, Paris; Museum of Modern Art, New York.

Publications:

By BALTAUSS: books—*Hotel d'Amérique*, Paris 1976; *Interior Portraits*, Paris 1979; article—"Photographic Experience" in *Education 2000* (Paris), October 1980.

On BALTAUSS: articles—"Portraits by Richard Baltauss" by Christian Caujolle in *Liberation* (Paris), 15 May 1979; "Richard Baltauss: Interiors" by Michel Nuridsany in *Le Figaro* (Paris), May 1979; "Inventory by Richard Baltauss" by Hervé Guibert in *Le Monde* (Paris), June 1979; "Hotel of America by Richard Baltauss" by Sophie Ristelhueber in *Le Matin* (Paris), June 1979; "We Have Seen..." in *Le Photographe* (Paris), June 1979; "Hotel of America" by O.H. in *L'Express* (Paris), June 1979; "Photographic Experience" by J.M. Dunoyer in *Le Monde* (Paris), February 1981.

The consumer instinct nurtured by our society gives birth to individualism and the cult of personality. This, in its turn, brings about a fresh approach to the environment and a new consciousness of control and yet isolation from which comes the success of the created image: a need to mythicize daily life.

Photography, therefore, becomes a means of immediate expression, a way of reappropriating the environment.

In the depths of the individual we find the universal; that which is the most intimate becomes public; subjectivity is transformed into a product, necessitating an advertising "image" of that which is most private.

It is the creation of another dimension which interests me, the formation of a link between that which is photographed and that which appears in the final result. There is a time lapse between the two that is put into a concrete form by the photograph.

It is to live the present of an experience as the past of a future; for example, I look at a door knob and imagine it at a later time. The act of projecting into the future allows me to grasp that forms have an emotional, sensitive power, resulting from a conjunction of energies and forces which indicate their epoch, and it is this experience, this emotion, which interests me as an image-maker.

—Richard Baltauss

Perhaps Richard Baltauss' first one-man exhibition should have been entitled *Night and Day*.

It began with wide-angle portraits of the tenants of the Hôtel d'Amérique where for many years Baltauss worked as night watchman. Those people who joined in the game posed one by one in front of a littered table in the lobby. In a hotel where people return only to sleep, everything happens at night: people pass by and meet the photographer loyally at his job. The tenants have no home; they come from an anonymous night, like apparitions. The images are dynamic, worth studying carefully so that their accumulated power can be slowly revealed: Baltauss is heir to the great portraitists of the 19th century who knew how to obtain the collaboration of their models. As if to acknowledge this heritage, he chooses a tinted and faded paper—an image of time past, the ephemeral, the intensity retained in the flow of things.

The solitary faces bring into focus the depth of space and time; the sameness of the decor helps to reveal them. The place begins to move, slowly transformed but always the same. The photograph is transcience at a standstill: a standstill framed in the anonymous movement of a body without fixed identity, without name, without social function. The photographs show without describing.

But this exhibition was also a montage, for it proceeded to a newer series, portraits again, but now with a background. Baltauss had photographed his friends in their daily lives, in their homes. The images lose in intensity, they no longer focus on the figure/face; the people begin to fade; the scene pla-ces them, describes them; the images set up a silent sociology. Now everything happens by day. Couples, children—solitude too, but sustained by communal life. In a hotel people live by night, at home by day. There are no couples in the hotel lobby. Above, as it were, in rooms, people form into couples, families, groups, with their furniture, their objects.

Except as they might meet at the exhibition itself, the people from above have probably never met the people from below—but the observer travels through a total space connecting the anonymity of the hotel with the domestic interiors. Private-public, high-low, black-white, full-empty, day-night: Baltauss has found an effective syntax.

Now, Baltauss works differently: models come to pose for the photographer, always within the same framework, with the same lighting, the same setting. It is no longer a question of a stop in a hotel lobby or of a portrait, somewhere, anywhere, "out of this world," everywhere and nowhere, in black-and-white, like an accelerated journey from the other side of the mirror, as if one was both photographer and model, moving in the image.

In the gallery Baltauss told a great story, enigmatic and secret, without literary intent. He strolled through his memory between the hotel and his friends' apartments, night watchman and chronicler of space.

—Jean-François Chevrier

Richard Baltauss: *Brigitte Legars*, 1980

BALTERMANS, Dmitri.

Russian. Born in Moscow in July 1912. Studied mathematics at the University of Moscow, 1928-33; self-taught in photography. Worked as a mathematician in Moscow, 1934-38. Photographer from 1936. Photo-Reporter, with the Red Army, for *Izvestia* and *Na Razgrom varaga* newspapers, 1940-45. Chief Press Photographer, *Ogonjok* magazine, Moscow, since 1945. Recipient: Second Prize, *World Exhibition of Photography*, Hamburg, 1965. Merited Worker in Culture of the U.S.S.R., 1970. Address: Bolshaia Dorogomilovskaia nr. 4, Flat 81, 121059 Moscow, U.S.S.R.

Individual Exhibitions:

1972 *Unsteady Reporter*, Foma Gallery, Prague
 Galerie Profil, Bratislava, Czechoslovakia
1973 House of Art, Brno, Czeckoslovakia
1975 Valokuvamuseon, Helsinki (toured Finland, 1976)

Selected Group Exhibitions:

1965 *World Exhibition of Photography: What Is Man?*, Pressehaus Stern, Hamburg (and world tour)
1974 *Sowjetische Kriegsreportage*, Galerie Profil, Bratislava, Czeckoslovakia
1975 *Soviet War Reportage 1941-45*, House of Soviet Science and Culture, Prague
1977 *The Russian War*, International Center of Photography, New York
1978 *The Russian War*, Side Gallery, Newcastle upon Tyne, England

Collections:

Fotografische Kammergalerie Profil, Bratislava, Czechoslovakia.

Publications:

By BALTERMANS: books—*Meeting with Tschikotka*, Moscow 1971; *Dmitri Baltermans: Selected Photographs*, with an introduction by Vasilij Peskov, Moscow 1977.

Dmitri Baltermans: *The Trail of War*, 1941

On BALTERMANS: books—*World Exhibition of Photography*, exhibition catalogue, edited by Karl Pawek, Hamburg 1965; *Liberation*, edited by Mikhail Trakhman, Boris Polevoi and Konstantin Simonov, Moscow 1974; *Fotografovali Valku*, edited by Daniela Mrázková and Vladimír Remeš, Prague 1975, as *The Russian War*, with introduction by Harrison Salisbury, New York 1977, as *The Russian War 1941-45*, with an introduction by A.J.P. Taylor, London 1978; *Geschichte der Fotografie im 20. Jahrhundert/Photography in the 20th Century* by Petr Tausk, Cologne 1977, London 1980; *The Camera at War* by Jorge Lewinski, London 1979; *Von Moskau nach Berlin* by Danièla Mrázková and Vladimír Remeš, with an introduction by Heinrich Böll, Munich 1979; articles—"Dmitry Baltermans: Photographs from World War II" in *Creative Camera* (London), March 1975; "A Cry of Anguish from Wartime Russia" in *Photography Year 1976*, by the Time-Life editors, New York 1976; "Il Soldato Fotografo" in *Fotografia Italiana* (Milan), April 1976.

For all of the centuries that art has been in existence as the creative impulse of humanity, no artist, medium, or movement—just as no politician, religion, or law—has been Herculean enough to curb the savage impulse of the world for war. One can imagine that many would have anticipated such a task for photography, especially when the medium was first discovered in 1839. Gettysburg, Dachau, or Hiroshima, however, the dumb machine, of course, could only bring back the report. Talbot's "pencil of nature" was ultimately no mightier, no more efficacious in such matters than the pen of a poet. It's no wonder that after a century and a half of photographs of mangled bodies, bombed-out churches, and point-blank assassinations, critics have begun to suspect the medium entirely, charging that counteractive influences are far more operative. By inundating our emotional thresholds with repetitive terror, so the accusation goes, the outrage violent images once provoked becomes desensitized and diminished. "Photographs shock insofar as they show something novel," writes Susan Sontag. "Unfortunately, the ante keeps getting raised—partly through the very proliferation of such images of horror." Notwithstanding the legitimacy of such

scoldings, one must consider the hypothetical disaster inherent in the opposing argument. What if photography had not been discovered or perfected? What if the grim reality of war—of clean-sweeping nuclear devastation—lacked the unequivocal confirmation of the photographic record? One shudders at the vision of world-wide destruction civilization might already have inflicted upon itself.

Certainly history must credit those front-line photographers, like the internationally-renowned Russian photojournalist Dmitri Baltermans, for having understood the dilemma before the fact. Balterman's World War II trench reportage on the Russian front restrains the enervating impact of physiological voyeurism by incorporating a psychological involvement for the viewer. His photographs, at their very best, are dramas in human exigency. In the bitter aftermath scene titled "Grief" (1942), one cannot look and expect to leave unaffected. To induce our emotional participation, Baltermans photographs a mud-field full of fresh corpses through the grief and shock of the survivors who have come to measure the loss. The survivors are the people left alive, like us, to deal with the consequences. In another photograph, titled "Tchaikovsky, Germany, 1945," one half of a living room, perhaps a German household, has been blown to pieces. The massive opening, through which a smoky war-zone landscape can be seen, admits bursts of daylight into what normally might have been a windowless room. Along the one unbroken wall, where a picture-plate still hangs and a vase of flowers sits fresh at attention, a group of war-weary Russian soldiers are gathered about a piano. One of them, having just wiped the plaster dust off the keys, begins to play. No one particularly gives a damn.

Still another persuasive indictment of war was made by Baltermans straight out of the trenches in 1941. Baltermans has focused his camera on several soldiers firing off at an unseen enemy; the soldiers are at the bottom of the picture. Above them, racing at blinding speed, in fragments of coats, boots, and unfurlled bayonets, soldiers leap across the ditch. It is an irrevocable "charge" (as the image is titled)—for some of the troops, the final ballet of the battle.

Action or aftermath, it really doesn't matter whose side you're on. For Dmitri Baltermans—a die-hard pacifist before, during and after the war—such an understanding must become an international, world-wide prerequisite. Otherwise, the ultimate—the man-made destruction of mankind—may become the inevitable.

—Arno Rafael Minkkinen

BALTZ, Lewis.

American. Born in Newport Beach, California, 12 September 1945. Educated at the San Francisco Art Institute, 1967-69, B.F.A. 1969; Claremont Graduate School, California, 1969-71, M.F.A. 1971. Married Mary Ann Rayner in 1974; daughter: Monica. Freelance photographer, in California, since 1970. Part-time Instructor, Pomona College, Claremont, 1970-72, and California Institute of the Arts, Valencia, 1972. Member of the Visiting Committee, International Museum of Photography, George Eastman House, Rochester, New York, 1978-81. Recipient: National Endowment for the Arts Fellowship in Photography, 1973, 1976; Guggenheim Fellowship, 1976; U.S./U.K. Bicentennial Exchange Fellowship, 1980. Agent: Castelli Graphics, 4 East 77th Street, New York, New York 10021. Address: Post Office Box 366, Sausalito, California 94966, U.S.A.

Individual Exhibitions:

1970 Pomona College, Claremont, California
1971 Castelli Graphics, New York
1972 International Museum of Photography, at
 George Eastman House, Rochester, New
 York
1973 Castelli Graphics, New York
1974 Corcoran Gallery of Art, Washington, D.C.
 Jefferson Place Gallery, Washington, D.C.
1975 Leo Castelli Gallery, New York
 Philadelphia College of Art
 Jack Glenn Gallery, Corona del Mar,
 California
 University of New Mexico, Albuquerque
1976 Galerie December, Dusseldorf
 Corcoran Gallery of Art, Washington, D.C.
 Lunn Gallery/Graphics International,
 Washington, D.C.
 Baltimore Museum of Art
 La Jolla Museum of Art, California
 Museum of Fine Arts, Houston
1977 Grapestake Gallery, San Francisco
 University of Nebraska, Lincoln
 Ohio University, Athens (with De Lappa and
 Syl Labrot)
1978 Yarlow-Salzman Gallery, Toronto
 Grapestake Gallery, San Francisco
 University of Nevada, Reno
 Susan Spiritus Gallery, Newport Beach,
 California
 College of Marin, Kentfield, California
1979 University of Manitoba, Winnipeg
 Nova Scotia College of Art and Design,
 Halifax
 3 Americans, Moderna Museet, Stockholm
 (with Mark Cohen and Eve Sonneman;
 travelled to Alborg Kunstmuseum, Den-
 mark; Kunstpavillionen, Esbjerg, Denmark;
 Tranegarden, Gentofte, Copenhagen; and
 Henie-Onstad Museum, Oslo, 1980)
1980 MoMing Center for the Arts, Chicago
 Galerie Fiolet, Amsterdam
 Werkstatt für Photographie, Berlin
1981 Castelli Graphics, New York
 San Francisco Museum of Modern Art
 Otis-Parsons Art Institute, Los Angeles
 Light, Los Angeles

Selected Group Exhibitions:

1975 14 American Photographers, Baltimore Mu-

seum of Art (travelled to the Newport
Harbor Art Museum, Newport Beach,
California, and La Jolla Museum of Con-
temporary Art, California, 1975; Walker
Art Center, Minneapolis, and Fort Worth
Art Museum, Texas, 1976)
New Topographics, International Museum
of Photography, at George Eastman House,
Rochester, New York (travelled to the Otis
Art Institute, Los Angeles, and Princeton
University Art Museum, New Jersey, 1976)
IX Biennale de Paris, Musée d'Art Moderne,
Paris
1977 Whitney Biennial, Whitney Museum of
American Art, New York
1978 Mirrors and Windows: American Photog-
raphy since 1960, Museum of Modern
Art, New York (toured the United States,
1978-80)
Court House: A Photographic Document,
Art Institute of Chicago (toured the Uni-
ted States, 1978-79)
1979 American Images, Corcoran Gallery of Art,
Washington, D.C. (travelled to the Inter-
national Center of Photography, New
York; Museum of Fine Arts, Houston;
Minneapolis Institute of Arts; and India-
napolis Museum of Art, 1980; American
Academy, Rome, 1981)
Industrial Sights, Whitney Museum of Amer-
ican Art, Downtown Branch, New York
1980 Photographie als Kunst/Kunst als Photo-
graphie, Museum Moderner Kunst,
Vienna

Collections:

Museum of Modern Art, New York; International
Museum of Photography, George Eastman House,
Rochester, New York; Museum of Fine Arts, Bos-
ton; Philadelphia Museum of Art; Corcoran Gallery
of Art, Washington, D.C.; Art Institute of Chicago;
Museum of Fine Arts, Houston; San Francisco
Museum of Modern Art; Bibliothèque Nationale,
Paris; National Gallery of Australia, Canberra.

Publications:

By BALTZ: books of photographs—The New Indus-
trial Parks Near Irvine, California, New York 1975;

15 Photographs by Lewis Baltz, edited by Jane Liv-
ingston, Washington, D.C. 1976; Nevada, New
York 1977; Park City, with text by Gus Blaisdell,
New York 1980; other books—Contemporary
American Photographic Works, editor, with intro-
duction by John Upton, Houston 1977; articles—
"Notes on Recent Industrial Developments in
Southern California," with William Jenkins, in
Image (Rochester, New York), no. 4, 1974; "The
New West" in Art in America (New York), March/
April 1975.

On BALTZ: articles—"Los Angeles" by Peter Pla-
gens in Artforum (New York), October 1971; "La-
tent Image" by A.D. Coleman in the Village Voice
(New York), 18 January 1972; "Route 66 Revisited:
New Landscape Photography" by Carter Ratcliff in
Art in America (New York), January/February
1976; "The Anti-Photographers" by Nancy Foote in
Artforum (New York), September 1976; "Contem-
porary American Photography" by Leo Rubenfein
in Creative Camera (London), 1976; "Lewis Baltz's
Formalism" by Joan Murray in Artweek (Oakland,
California), 27 August 1977; "San Francisco" by
Hal Fischer in Artforum (New York), December
1978; "Nevada" by Sally Eauclaire in Afterimage
(Rochester, New York), April 1980; "Full Photo-
graphs of Barren U.S. Scenes" by David Elliott in
the Sun-Times (Chicago), 25 May 1980; "Lewis
Baltz: Irvine, Nevada, Park City Portfolios" by
Deborah Bright in New Art Examiner (Chicago),
June 1980.

In five major series of photographs published and
exhibited since 1972—"The Tract Houses" (1972),
The New Industrial Parks near Irvine, California
(1975), "Maryland" (1976), Nevada (1978) and Park
City (1980)—Lewis Baltz has examined difficult
issues and developed a unique style, thereby creating
one of the most impressive bodies of work in con-
temporary photography.

With a certain constancy Baltz records images of
public spaces, homes, business establishments, con-
struction cites and the landscapes that surround
them. Human activity is often implied in the photo-
graphs, but human figures are seldom visible. The
images, which are so dense with visual information,
so descriptive, have often been discussed as being
topographic in intent, alluding to a supposed neu-
trality and objectivity in the selection of subject
matter and the mode of presentation. But the stylis-
tic elements of the photographs—their brightness,
clarity and exquisite formal beauty—belies this
approach. Baltz does not aim for a moral neutrality,
and the numerous choices involved in making a
photograph diminish the possibility of objectivity.
His photographs present contradictory informa-
tion, and the tension created gives the work its visual
and intellectual strength.

By working in extended series, Baltz acknow-
ledges that individual photographs can only des-
cribe a limited truth and only have a limited power.
By concentrating on construction as fact (and possi-
bly metaphor) in his work, Baltz transforms the
American landscape into "skeptical landscapes," as
suggested by Gus Blaisdell. The viewer sees the
result of the American dream and of economic
expansionism at work. Landscape becomes real es-
tate, and art and life seem to be on a collision course.
The beauty of the images and the harshness of the
subject matter depicted are tempered by a subtle
humor that makes the photographs a springboard
for further thought. Perhaps, when seen in over-
view, Baltz's work can be seen as "concerned photog-
raphy" stripped of its melodrama.

Rich in pictorial and informational nuance, and
acknowledging ideas from contemporary art, poli-
tics, economics and history as well as recent photo-

Lewis Baltz: *Prospector Park, Subdivision Phase II, Lot 123, Looking North,* from *Park City,* 1980

graphic thought, Baltz's work to date has a sophistication and power that are unique.

—Marvin Heiferman

BAR-AM, Micha.

Israeli. Born in Berlin, Germany, 26 August 1930; emigrated to Israel, and grew up in Haifa. Educated in Israeli public schools until age 14. Married Orna Zmirin in 1961; children: Barak and Nimrod. Active in the Haganah, the pre-state underground, 1945-48; served in the Palmach Unit of the Infantry during the Israeli War of Independence, 1948-49. Worked as a locksmith, mounted guard and youth instructor, Kibbutz Gesher-Haziv, Western Galilee, 1949-57; Photojournalist, *Bamahane* magazine, Israel, 1957-66; freelance photojournalist, Israeli newspapers, 1966-67. Photo-Correspondent in the Middle East for the *New York Times*, since 1968; Associate Member, Magnum Photos, Paris and New York, since 1968. Advisor on Photography to the Museum of Art, Tel Aviv, since 1977. Agent: G. Ray Hawkins Gallery, 9002 Melrose Avenue, Los Angeles, California 90069. Address: Post Office Box 923, Ramat Gan 52109, Israel.

Individual Exhibitions:

1958 *First Harvest*, Journalists House, Tel Aviv

1960 *West African Diary*, Journalists House, Tel Aviv
1962 *At the Foothills of the Himalayas*, Journalists House, Tel Aviv
1974 Israel Museum, Jerusalem
 The October War, The Little Gallery, Jerusalem
1978 Neikrug Gallery, New York
1979 *Jews in Egypt, Spring '79*, Museum of the Jewish Diaspora, Tel Aviv
1981 *La Nacion: Spanish and Portugese Jews in the Caribbean*, Museum of the Jewish Diaspora, Tel Aviv
 Safescapes, White Gallery, Tel Aviv
 G. Ray Hawkins Gallery, Los Angeles

Selected Group Exhibitions:

1967 *Photographs from the June War*, Tel Aviv Museum
1968 *Israel: The Reality*, Jewish Museum, New York (toured the United States and Canada)
1973 *Jerusalem: City of Mankind*, Israel Museum, Jerusalem (travelled to the Jewish Museum, New York, then toured the United States)
1978 *Egypt: First Encounter*, Tel Aviv Museum
1981 *10 Photographers at the White Gallery*, White Gallery, Tel Aviv

Collections:

Israel Museum, Jerusalem; Tel Aviv Museum; Museum of the Jewish Diaspora, Tel Aviv; Bibliothèque Nationale, Paris; The Photographers' Gallery, London; International Center of Photography, New York.

Publications:

By BAR-AM: books—*Across Sinai*, Tel Aviv 1957; *Castle of Shells and Sand*, Tel Aviv 1958; *I.D.F. at Eighteen*, as photo editor, Tel Aviv 1966; *Portrait of Israel*, with text by Moshe Brilliant, New York 1970; *The Israel Air Force*, Tel Aviv 1971; *Bat-Chen: The Story of the Women's Corps of the Israeli Army*, Haifa 1971; *When God Judged: A Yom Kippur War Battle Report*, with text by Arnold Sherman, New York 1973; *Jerusalem: City of Mankind*, co-editor with Cornell Capa, New York 1974; *On Beauties, Men, and All the Rest*, with text by Tammar Avidar-Ettinger, Ramat Gan, Israel 1976; *Israel: Face of a People*, Ramat Gan, Israel 1978; *Sinai: The Great and Terrible Wilderness*, with text by Burton Bernstein, New York 1979; *Yoram and the Puppy*, with text by Michal Snunit, Vibatayyim, Israel 1981; *The Jordan*, also author, Giatayyim, Israel 1981.

On BAR-AM: books—*Israel: The Reality*, edited by Cornell Capa, New York 1969; *Jerusalem: City of Mankind*, edited by Cornell Capa (with Bar-Am as co-editor), New York 1974; articles—"Contact" by Yvette Benedek in *American Photographer* (New York), August 1981; "Images of War and Peace" by Suzanne Muchnic in the *Los Angeles Times*, August 1981; "Micha Bar-Am" by David Fahey in *Photo Bulletin* (Los Angeles), October 1981.

"Micha Bar-Am has played a very large part in

Micha Bar-Am: *Artillery Barrage near the Suez Canal*, October 1973

putting Israel on the map in world photography and putting photography on the map in Israel," says one of his fellow-photographers. "His photographs are more than just historical archives, though they are very important as such. They represent the spirit of his generation, the generation that established the State of Israel," says one of his co-workers at the Tel Aviv Museum.

Inherent to the spirit of that generation was the mating of an almost anarchic individual freedom to an overriding collective mission. It's a fair definition of the man himself. But it is also an attitude that lends itself well to photography where, as in the most memorable of Bar-Am's photographs, a complex political situation can be distilled into its reflection in one person's concentrated response—the emotions that pour through a woman as she greets a loved one who has returned from a heroic and dangerous mission when it too easily could have been otherwise; one man who looks to see if death is approaching when all others hide their heads from the shelling (all others except the photographer, of course, who keeps his sanity by continuously giving the world order and meaning through his camera. "The clicking of the shutter becomes a kind of heartbeat," he has said).

Bar-Am's professional life is full of contradictions: How to be an objective photojournalist when you are a partisan in the struggle? How to be a museum curator when you are a working photo-journalist and a photographer interested in your own aesthetic explorations? How to live with what fate has handed you—a reputation as a war photographer—when you consider that an accident of history that doesn't enter into your self-definition?

Micha Bar-Am is an intensely private person who is intensely committed to the state he has helped build. As it is not in his nature to be a politician, he has used photography to keep himself involved with events in Israel, politically as a photojournalist and culturally as one of the godfathers of photography-as-art.

—Bonnie Boxer

BARROW, Thomas F(rancis).

American. Born in Kansas City, Missouri, 24 September 1938. Studied graphic design at the Kansas City Art Institute, 1959-63, B.F.A. 1963; filmmaking, under Jack Ellis, at Northwestern University, Evanston, Illinois, 1964; and photography, under Aaron Siskind, at the Institute of Design, Illinois Institute of Technology, Chicago, 1965-67, M.S. Photog. 1967. Freelance photographer, New York, 1967-73, and New Mexico, since 1973. Assistant Curator of Exhibitions and Associate Curator of the Research Center, 1965-71, Assistant Director, 1971-72, and Editor of *Image*, 1972, George Eastman House, Rochester, New York; Lecturer in the History and Aesthetics of Photography, Rochester Institute of Technology and State University of New York at Buffalo, 1968-71; Lecturer in Photography, Center of the Eye, Aspen, Colorado, 1969-70. Associate Director of the Art Museum, 1973-76, and since 1976 Associate Professor, Department of Art, University of New Mexico, Albuquerque. Director, Summer Photography Workshop, University of California at Riverside, 1976. Also works as an exhibition organizer and graphic designer. Recipient: National Endowment for the Arts Fellowship, 1973, 1978. Agent: Light Gallery, 724 Fifth Avenue, New York, New York 10019. Address: Department of Art, University of New Mexico, Albuquerque, New Mexico 87131, U.S.A.

Individual Exhibitions:

1969 University of California at Davis
1972 Light Gallery, New York
1974 Light Gallery, New York
1975 Deja Vu Gallery, Toronto
1976 Light Gallery, New York
1978 *2 from Albuquerque*, Susan Spiritus Gallery, Newport Beach, California (with Betty Hahn)
1979 Light Gallery, New York
1982 *Thomas Barrow/Esther Parada/John Wood*, Northlight Gallery, Arizona State University, Tempe

Selected Group Exhibitions:

1967 *Four Photographers*, Riverside Gallery, Rochester, New York
1969 *Vision and Expression*, International Museum of Photography, at George Eastman House, Rochester, New York

1970 *The Photograph as Object*, National Gallery of Canada, Ottawa
1975 *The Extended Document*, International Museum of Photography, at George Eastman House, Rochester, New York
 Photo[1]...Photo[2]...Photo n, University of Maryland Art Gallery, College Park
1976 *Aspects of American Photography 1976*, University of Missouri, St. Louis
1977 *Contemporary American Photographic Works*, Museum of Fine Arts, Houston
1979 *Translations: Photographic Images with New Forms*, Cornell University, Ithaca, New York
 The Altered Photograph, Project Studio 1, New York
 Cultural Artifacts, Florida School of the Arts, Palatka

Collections:

International Museum of Photography, George Eastman House, Rochester, New York; Philadelphia Museum of Fine Arts; University of Kansas, Lawrence; Museum of Fine Arts, Houston; University of New Mexico, Albuquerque; San Francisco Museum of Modern Art; Seattle Art Museum; National Gallery of Canada, Ottawa; National Gallery of Australia, Canberra.

Publications:

By BARROW: books—designer of numerous books, including *Light and Substance*, Albuquerque, New Mexico 1974; *The New Industrial Parks Near Irvine, California* by Lewis Baltz, New York 1975; *Frederick Hammersley: A Retrospective Exhibition*, catalogue, Albuquerque, New Mexico 1975; *Peculiar to Photography*, exhibition catalogue, Albuquerque, New Mexico 1976; articles—"A Letter with Some Thoughts on Photography's Future" in *Album 6* (London), July 1970; "600 Faces by Beaton" in *Aperture* (Millerton, New York), Summer 1970; "The Camera Fiend" in *Image* (Rochester, New York), September 1971; "Talent" in *Image* (Rochester, New York), December 1971; introduction to the *Lewis Hine Portfolio*, Rochester, New York 1971; "Looking Down" in *Image* (Rochester, New York), July 1972; "Notes on the Photoglyphic Process" in *University of New Mexico Bulletin* (Albuquerque, New Mexico), 1973; "Three Photographers and Their Books" in *A Hundred Years of Photographic History*, Albuquerque, New Mexico 1975; "Footnotes," with Peter Walch, in *New Mexico Studies in the Fine Arts* (Albuquerque), vol. II, 1977; "Some Thoughts on the Criticism of Photography" in *Northlight 8* (Tempe, Arizona), November 1978; "Learning from the Past" in *9 Critics/9 Photographers*, Carmel, California 1980.

On BARROW: books—*The Art of Photography*, by the Time-Life editors, New York 1971; *Light and Lens*, edited by Donald L. Werner, New York 1973; *The Extended Document*, exhibition catalogue, Rochester, New York 1975; *The Photographer's Choice*, Danbury, New Hampshire 1976; *Contemporary American Photographic Works*, exhibition catalogue, Houston 1977; *Self-Portrayal*, edited by James Alinder, Carmel, California 1979; *The Photograph Collector's Guide* by Lee D. Witkin and Barbara London, Boston and London 1979; articles—"Thomas Barrow" by Henri Man Barendse in *Artspace* (Albuquerque, New Mexico), Summer 1977; "Thomas Barrow's Cancellations" by Henri Man Barendse in *Afterimage* (Rochester, New York), October 1977; "Artists and Their Art: Photographers" by Stephen Sinclair in *The Cultural Post* (Washington, D.C.), July/August 1978; "Currents: American Photography Today" by Andy Grundberg and Julia Scully in *Modern Photography* (New York), April 1980.

Thomas F. Barrow: *H₂0 East*, from the series *Cancellations*, 1976

The anomalies of photography have fascinated me for some time now: a physical presence that is ignored while a literal content is described *ad nauseam*; practitioners (especially in the United States) who are determinedly and rather proudly uninformed of the history of art or culture; the almost total absence of a critical literature. The list might be extended to a tedious length. And yet, even at a primitive level of accomplishment, the medium is capable of stimulating questions of significance with regard to truth, virtue, and the areas we label as "serious thoughts." Photography has in common with almost all visual media an inability to provide direct answers to these queries, but the immediacy with which it provokes inquiry is unique. Within these contradictions lay the expressive challenges of the medium. The artist must be able to discern the questions asked by photographs and give form to them; in essence, creating form with the medium's own intrinsic characteristics.

At just this point, one can place the observed questions in opposition to each other creating an argument (dialogue is too passive a word for what occurs at this juncture). Simultaneous with the theoretical are practical aspects, "straight vs. manipulated," "color vs. black and white," that also may be set in opposition for additional clues to evolving ideas and how the images might utilize these ideas. Since the camera and its products are so ubiquitous and seductive, one can easily become the servant of a mindless device. This is, in part, why the preceding "oppositions" are so useful; they allow one to assume an adversary position for the making of art.

Although the preceding has a great deal to do with the way my own work is created, ideas are not always of primary import. I feel a certain sympathy for the following statement by Francis Ponge:

> Given such inclinations (distaste for ideas, taste for definitions), it may perhaps be natural that I devote myself first to cataloguing and defining objects in the external world, and among them, the ones that constitute the familiar universe of our culture, our time. (From *The Voice of Things*)

Or even more germane might be John Asbery's words on Raymond Roussel:

> The result in the case of each of his books is a gigantic dose of minutiae: to describe one is like trying to summarize the Manhattan telephone book. Moreover, the force of his writing is felt only gradually; it proceeds from the accumulated weight of this mad wealth of particulars. A page or even a chapter of Roussel, fascinating as it may be, gives no idea of the final effect which is a question of density: the whole is more than the sum of its parts. (From *How I Wrote Certain of My Books*)

It is beyond practicality or hope that all of my pieces might be seen at one time, and yet I have made them as a virtually unbroken series. Certainly not Arthur O. Lovejoy's *Great Chain of Being*, but a definite progression of carefully calculated, occasionally arcane linkages that connect the encyclopedia aspect of photography with the overwhelming materialism of our time.

—Thomas F. Barrow

The photographs of Thomas F. Barrow are intellectual and cerebral; they have often been referred to as conceptual. Yet to connect this artist with the Conceptual Art movement of the last decade is radically to misinterpret him. All of contemporary art photography has, in fact, a peculiar and problematic relationship with Conceptual Art; in a movement that rejected the traditional art product as bourgeois, the photograph often served as the only document of a temporal art event and the only record of the idea.

Often with little visual interest of their own, these photographs bear scant philosophical relation to contemporary idea-oriented photography. However conceptual the work of Barrow is, it is also emphatically pictorial. The idea is paramount, but so is the finished print. The work has covered a remarkably varied range of techniques and approaches, yet the underlying thread of continuity is Barrow's investigation of the nature of photography itself, and how, as a system of notation, photographs render information.

"Cancellation" (1975-77) is one of Barrow's most provocative and enigmatic series to date. If it seems at first glance a contemptuous assault on contemporary photography, it yields multiple meanings on closer examination. The "X" suggests the cancellation of printer's plates to limit an edition. If Barrow has thus destroyed his negative to limit the number of prints, he has done so before any edition has been made. These photographs have meaning only if they are cancelled; the casual, deadpan shots of urban debris are enlivened by the compositional tightness lent them by the X; the X itself takes on unique characteristics within the different qualities of the freehand drawing and the variations on how the scratching instrument scraped off emulsion or actually pierced through the acetate film base. As in all of Barrow's work, it is these visual elements that defuse the didacticism that often characterizes Conceptual Art.

The subject matter of this series, the bleak urban landscape, is itself a loaded issue; if Barrow first appears to vandalize his subject by cancelling it, in fact the X can be read as a counteraction against the waste and plunder that mark the landscape and simultaneously as an indication of a photographic trend at mid-decade. An approach to the landscape that has been labelled "New Topographics" incorporated a dispassionate view of the union of nature and city at its most banal. Barrow skillfully raises this issue of a contemporary direction, as if quoting it, and enlarges upon it, paradoxically, by abrogation. This fact, I believe, is the source of the series' dynamism and wit: Barrow is not negating but pointing us toward some of the stickiest questions in contemporary photography—the issue of editions and their limitability, the fashion of recording the defaced urban landscape, and the nature of photographic rendition. The cancellation does not actually affect the facticity of the photograph but draws into question the photographic rendition of information and what we can deduce from it.

Thomas Barrow comes to photography with the background of a painter and a keen interest in design, both of which have served him in his investigation of the properties of the photograph. Yet, it is mostly Barrow's use of the traditional syntax of photographs, their unmatched ability to record and catalogue information, and his ability to organize it visually that makes his work a skillful transformation of idea into object.

—Dana Asbury

BATHO, Claude.

French. Born Claude Bodier in Chamalières, 1 June 1935. Studied photography at the Ecole des Arts Appliqués, Paris, under Janet le Caisne and Jacques Couturat, 1950-56, Dip. Photog 1956; studied painting at the Ecole des Beaux-Arts, Paris, under Raymond Legueult, 1955-57. Married the photographer John Batho, *q.v.*, in 1963; children: Marie Angèle and Delphine. Professional photographer, working for the Archives Nationales, Paris, from 1957. Member, Groupe 30 x 40, Paris, from 1972. Recipient: First Prize, Images of Women Competition, *F* magazine, Paris, 1980. Chevalier, Ordre des Arts et

Lettres, France, 1977. Agents: Helene Faggionato, 42 Avenue de Save, 75007 Paris; and Galerie Agathe Gaillard, 3 rue des Pont Louis-Philippe, 75004 Paris. *Died* (in Paris) *in September 1981.*

Individual Exhibitions:

1964 *Photographies et Peinture*, Galerie Quai aux Fleurs, Paris
1977 *Le Moment des Choses*, Galerie Agathe Gaillard, Paris (travelled to Galerie 31, Vevey, Switzerland, and Canon Gallery, Amsterdam, 1978; Galerie Contemporaine, Bologna, Galleria Il Diaframma, Milan, Musée d'Angoulème, France, and Fotomania, Barcelona, 1979)
1980 Musée Nicéphore Niepce, Chalon-sur-Saône, France (retrospective; travelled to the Canon Gallery, Geneva)
 Photographies, Galerie du Château d'Eau, Toulouse
1981 Galerie de l'Arpa, Bordeaux
 Photogalerie Portfolio, Lausanne, Switzerland

Selected Group Exhibitions:

1978 *La Photographie Actuelle en France 1978*, Galerie Contrejour, Paris (and world tour, 1978-81)
 20 Photographies, Ecole des Beaux-Arts, Avignon
1980 *Natures Mortes*, Galerie Viviane Esders, Paris
 Transparence, Galerie Viviane Esders, Paris

Collections:

Bibliothèque Nationale, Paris; Editions des Femmes, Paris; Musée d'Angoulème, France; Musée Nicéphore Niepce, Chalon-sur-Saône, France.

Publications:

By BATHO: books—*Portraits d'Enfants*, portfolio, with a preface by Jean-Claude Lemagny, Paris 1975; *Le Moment des Choses*, with preface by Irène Schavelzon, Paris 1977, Milan 1978; article—"L'Oeil au bout des doigts" in *Femmes en Mouvements* (Paris), May 1978.

On BATHO: books—*Photographie Actuelle en France*, exhibition catalogue, Paris 1978; *Des Clefs et des Serrures* by Michel Tournier, Paris 1979; articles—"Le Moment des Choses" by Hervé Guibert in *Le Monde* (Paris), 23 November 1977; "Le Moment des Choses" by Michel Nuridsany in *Le Figaro* (Paris), 28 November 1977; "La Paix de Claude Batho" by Joan Fontcuberta in *Barcelone* (Barcelona), 24 November 1979; "Un Jour, J'aurai une Femme" by Michel Tournier in *Le Monde* (Paris), 5 October 1979; "Esta Mes" in *Nueva Lente* (Madrid), no. 88, 1979.

My photographs are too close, too much a part of me, for me to be able to look at them dispassionately. They speak of the way time passes—over people, over children, over the objects that are inanimate; those special moments....

I like to draw attention to the very simplest of fleeting instances. Without breaking the silence.

I find it hard to express in words those things that I am always saying through my photography.

My camera, "the eye at my finger-ends," accompanies me everywhere. Together we search for moments to be singled out. I love the exploring glance; the capturing of the instant; the fight against absence, oblivion, calamity, fate....

But photography also provides another kind of fulfilment. Working in the laboratory is in itself a

creative activity, in which there is the fun of developing the film, exposing the negatives, seeing the image spring out of the amber fluid. I love the physical contact of the wet bromide, coming up under my fingertips. The slow materialization of the image on the paper requires a tough and drawn-out struggle to achieve the happy outcome of the successful result.

I photograph in black and white. Perhaps one day I shall turn to colour, but as far as I am concerned black and white already takes so much time and effort—and, besides, it is difficult to do several things well at a time, quite apart from the fact that my life is more than filled by all those feminine domestic duties.

How dearly I should like to have enough time at my disposal to do all the things I want to do; not only photography, but also painting and writing.

But photography—it is for me a necessity of life.

—Claude Batho

To write with light. To speak of the self, its inner being and its moods, in gradations of grey, in flashes of white, in deep blacks. To work at nearly the "degree zero" of photography—or at least near the heart of what is most genuine about it.

Like illness, photography was a part of Claude Batho's daily life. We should not be surprised, then, by these quick glances, so full of the experience of living, which characterize her work. Glances at once obvious and yet precise, of completed moments, quiet but charged with energy, with a passion for seeing. The eye of a woman, clearly, for ordinary objects—the light on the wallpaper, the reflection of a window on a family portrait. Austere yet loving glances at children, at little girls playing, at rest, alone.

The work of Claude Batho, full of austerity and tenderness: a perfect demonstration, perhaps, that the eye of the photographer, as it travels around a room, can capture the meaning of a life and recreate the world on a few squares of paper. For here there is no cheating.

—Christian Caujolle

Claude Batho: *Le Tablier Neuf*, 1967

BATHO, John.

French. Born in Beuzeville, Normandy, 4 March 1939. Studied book restoration. Married the photographer Claude Bodier (i.e., Claude Batho, *q.v.*) in 1963; children: Marie Angèle and Delphine. Photographer, since 1960. Book Conservationist, Archives Nationales, Paris, since 1961. Recipient: Kodak Photography Critics Award, Paris, 1977. Lives in Paris. Address: c/o Galerie Zabriskie, 99 rue Aubry le-Boucher, 75003 Paris, France.

Individual Exhibitions:

1978 Zabriskie Gallery, New York
Galerie Zabriskie, Paris
Madison Art Center, Wisconsin
University of North Dakota, Grand Forks
1979 Arcade Gallery, Ann Arbor, Michigan
Photographers Gallery, London
Galerie Petit Format, Les Baux, France
1980 Camera Obscura, Stockholm
Couleurs de Fête, Galerie Zabriskie, Paris
(travelled to Zabriskie Gallery, New York)
Galerie Vorlet, Lausanne
Galerie Municipale du Chateau d'Eau, Toulouse

Selected Group Exhibitions:

1977 *Tendances Actuelles*, Musée d'Art Moderne, Paris
Exposition Kodak, Galerie Kodak, Paris
1978 *European Colour Photography*, The Photographers' Gallery, London
1979 *Venezia '79*
1980 *L'Amérique aux Indépendants*, Petit Palais, Paris
Photographia: La Linea Sottile, Galleria Flaviana, Locarno, Switzerland
Triennale Internationale de la Photographie, Charleroi, Belgium

Collections:

Bibliothèque Nationale, Paris; City of Paris; Musée Nicéphore Niepce, Chalon-sur-Saône, France; Boston Museum of Fine Arts.

Publications:

On BATHO: books—*European Colour Photography*, exhibition catalogue, by Sue Davies, Michael Langford and Bryn Campbell, London 1978; *Photographia: La Linea Sottile*, exhibition catalogue, by Giuliana Scimé and Rinaldo Bianda, Locarno 1980. article—"7 Maitres du Paysage", in *Photocinema* (Paris), May 1980.

I have been photographing in color since 1963. I like that which interrogates, provokes the eye. My photographs are made to be looked at. They tell nothing; they document nothing, nor are they commercial.

I work as simply as possible because I believe in the vigor or force of simplicity as well as of immediate visual contact.

Color is an adventure; the image is built upon chromatic balance just as upon contradictions of form, materials, light and shadows. Color doesn't allow a synthesis of these elements as easily as black-and-white.

My prints are made by a craftsman, Michel Fresson, with whom I collaborate. His process, known as the carbon process, whereby the pigments of the image are as resistant to light as those in painting, is recognized as the most effective means today for preserving color or guarding against aging. At present I am experimenting with other color photo processes.

—John Batho

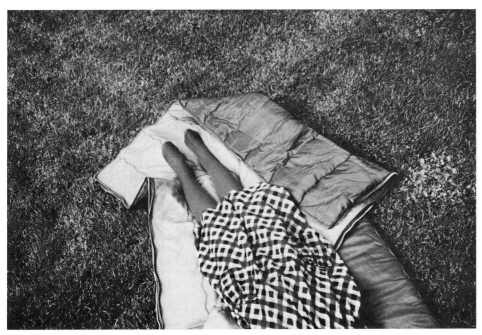

John Batho: *Collant Rouge* (original in color), 1980

The work of John Batho was shown publicly in Paris in 1977, although he had been taking photographs for many years before that. He brings to photography a new way of looking at the world by selecting from reality intensely colored pure forms. His studies are similar to those of Rothko in painting, and he has, in a sense, continued one aspect of the work of the Danish photographer Keld Helmer-Peterson, who published in 1949 a work entitled *122 Colored Photographs* in which abstraction and the study of composition with color play a determinant role. Batho took this concept of photography much further by bringing to it other parameters such as time and movement.

Batho is distinguished by his constant evolution: each exhibition marks a new stage in a quest, both true to himself and in constant transformation. A man of contained passion, Batho releases his work only when he believes that he has reached that fragile equilibrium between the idea of the picture and its realization, between the search for expression and its accomplishment in a sensitive form. The dialogue of form with color, together with a concept of the photograph as an object that must be perceived both in its materiality and sensuality, are the pivots around which his creative work evolves. He gives maximum importance to the photographic object: his carbon printings, achieved by entirely manual techniques by Michel Fresson, are produced with extreme care. This manner of completing the photographic object makes Batho very reticent when it comes to showing his photogaphs in slide form: for him, the picture at this stage is not fully completed; it remains a project which only the materiality of the paper print will perfect.

He believes that photographic space is limited to two dimensions, and he tries to use them in their totality. He has said: "The third dimension can only be hinted at, and, as the photograph itself is only an illusion, I find that even that is too much.... In the picture, color reveals, form expresses; it alone will bring out this aspect of evocation, this suggestion which generates the second stage in the reading of the picture."

At the present stage of his work, Batho seems frequently not to regard any picture as a unique object but as part of a sequence of color. A coherence is suddenly discovered in the harmonies of tone; a mysterious connection appears among the most heteroclite worlds: funeral wreaths in cemeteries correspond to fairground dolls, which find an echo in the colored rhythms of oil refinery reservoirs; the movement of children's windmills harmonize with the swirling of merry-go-rounds, which seem to spin round to the rhythm of glittering lights....

—Ginette Bléry

BAUM, Yngve.

Swedish. Born in Bjarnum, Skane in 1945. Freelance photographer, in Sweden, since 1965. Recipient: State Art Fellowship, 1967-68; City Culture Award, Stockholm 1968; SIDA Grant, 1969. Address: Mjölnargatan 1, 41104 Gothenburg, Sweden.

Selected Group Exhibitions:

1974 *Varvsarbetare*, Moderna Museet, Stockholm
1978 *Tusen och En Bild: 1001 Pictures*, Moderna Museet, Stockholm

Publications:

By BAUM: books—*Människor vid Hav: Lofoten*, Stockholm 1966; *Kiki: En Liten Man*, Stockholm 1967; *Berberby*, Stockholm 1967; *Ujama: Människor i Tanzania*, with text by Stig Holmqvist, Stockholm 1970; film—*Bilder från ett Skeppsvarv*, television film, 1974.

On BAUM: books—*Varvsarbetare*, exhibition catalogue, by Ake Sidwall and Leif Wigh, Stockholm 1974; *Tusen och En Bild*, exhibition catalogue, by Ake Sidwall, Sune Jonsson and Ulf Hard af Segerstad, Stockholm 1978.

At the end of the 1960's and the beginning of the 70's young photographers in Sweden became increasingly interested in socially committed documentary photography. Many of the students at the schools of photography preferred to turn their cameras towards the reality outside in the community, rather than to practice ingratiating product- and portrait-photography. One of the photographers who became a guiding light to the new generation was Yngve Baum. Not only was he young himself (he was born in 1945), but he had already, in spite of his youth, produced several meticulous documentary reports, which had been reproduced in books and at exhibitions. He had made himself known for sticking obstinately to a self-imposed task until he was himself thoroughly satisfied.

What many of his followers perhaps did not understand was, that his way of exploiting both photographic technique and idiomatic expression gave further weight to content, which was interesting in itself. They photographed work places and they travelled to foreign cultures, but the pictures they brought back often lacked the weight and significance of Baum's. Many of the older photographers were also surprised at the high technical quality of Yngve Baum's reportage. They guessed at large negatives, low sensitivity film and special, home-made developers. But the answer was much simpler. The pictures were taken with a small-format camera (sometimes on a tripod, sometimes in conjunction with a flash). The film was Tri-X and occasionally a medium sensitivity film, which was exposed and developed according to the manufacturer's directions. For—to paraphase Baum—when Kodak has a large specialist staff, who devote all their time to finding a suitable developing-time and a recommended ASA-number, then they ought to know better than the photographer. His simple advice was therefore: "read the instructions!"

But the excellent copies are not simply the result of a chemical/technical process. The prints also reflect a great depth of aesthetic thinking (and a lot of patience). And because of Yngve Baum's great insistence on quality, most of his laboriously produced pictures end up in the waste-paper basket. His aim has been to unite vivid reporting with high technical quality.

After producing various books, Baum went to work for television. In the beginning with still photographs and sound. But fairly soon also with motion pictures. In documentary work the sound-film is often superior to the still picture, as it incorporates the time factor and at the same time integrates picture and sound in a more natural manner. But occasionally he injects a sequence of still pictures into his television programmes. They frequently portray the working conditions of various occupations or describe life in small and tucked-away places in Sweden.

For, as time went on, Yngve Baum discovered that you don't have to go to the ends of the world to find what lives on your own doorstep. This is not to denigrate his books from Norway, Algeria or Tanzania. But as a foreigner one always runs the risk of picking out the exotic. At home it is easier to find what is real.

—Rune Jonsson

BAUMANN, Horst H.

German. Born in Aachen, 19 June 1934. Educated at the Volksschule, Aachen, 1940-44; Lessing Gymnasium, Dusseldorf, 1946-54; studied metallurgy, Technische Hochschule, Aachen, 1972-74; self-taught in photography. Married Ingeborg Geerz in 1971; daughter: Carolin; Regina Neumann in 1973; daughters: Nina, Alice. Freelance photojournalist and advertising photographer, working for *Form, Automobile Quarterly*, Fiat, Bayer, Aga-Gas, BMW, Sony, Daimler-Benz, McCann Erickson, etc., Dusseldorf, since 1957; also freelance graphic designer, Dusseldorf, since 1960. Founder-Director, Communication Design Baumann studio for communications, planning and design, Dusseldorf, since 1966; Founder with Walther H. Schünemann, Populäre Propaganda Presse (PPP) poster publishing

Horst H. Baumann: *Steel* **(original in color), 1961**

for their audacious blurring effects, and they met with just as much approval in the press as in exhibitions and yearbooks.

Advertising agencies and industrial firms soon offered him commissions, especially when, after 1960, he included graphic design among the services he offered. It is characteristic of Baumann that by 1963-64 he was already a Guest Lecturer in Photography and Film at the Ulm Design Academy, yet he was not afraid to again become a student himself at Aachen in 1972—this time in pedagogy, sociology and psychology. In 1974-76 he was again lecturing, this time at the Fachhochschule in Dusseldorf, on communication and design.

A reflection of his interests is the firm that he founded in 1966, Communication Design Baumann. Here, since then, he has developed an almost inconceivable versatility—always with photography at the center. It becomes somewhat more understandable when one considers that Baumann is a member not only of eight societies and professional organizations primarily devoted to photography, including design and video, but also of the Society of Futurology. For it is the futuristic phenomenon of the laser which, along with photography and design, determines Baumann's work today. Since *Expo '70* in Montreal, where he took part in the conception of the German Pavilion, he has constantly worked to develop new ideas—always on the basis of photography and visual communication. By this inclusion of inventive futuristic means and methods, Baumann is always one step (or two) ahead of the creative photographic fraternity.

—Bernd Lohse

company, Dusseldorf, 1968; has worked with laser displays, since 1968; worked with laser TV production, 1977. Director, City Laser Communications System, Kassel, 1978. Guest Professor of Visual Communications, Hochschule für Gestaltung, Ulm, 1963-64; Lecturer in Communications, Design and Audio Visual Media, Fachhochschule, Dusseldorf, 1974-76. Recipient: Young Photographers Prize, *Photokina*, Cologne, 1956, 1958, 1960; Grand Prix for Photography, *Biennale des Jeunes*, Paris, 1967. Address: Communication Design Baumann GmbH, Salierstrasse 10, 4000 Dusseldorf 11, West Germany.

Individual Exhibitions:

1966 *Fotografie/Grafik Design*, at *Knauer-Expo*, Stuttgart
1976 Deutsche Gesellschaft für Photographie, Cologne

Since 1968, Baumann has participated in numerous exhibitions throughout Europe involving his laser projects and developments.

Selected Group Exhibitions:

1956 *Photokina '56*, Cologne (and 1958, 1960, 1978)
1962 *Michael Lavelle's Color Photograph Exhibition*, London
Das Menschliche Antlitz Europas, at *Internationaler Münchener Fotosalon*, Munich
1965 *11 International Photographers*, Gallery of Modern Art, New York
1967 *Biennale des Jeunes*, Paris (and 1969)
1968 *Man in Sport*, Gallery of Modern Art, New York (toured the United States and Europe)
1970 *Architektonische Spekulationen*, Leverkusen, West Germany
1977 *Documenta 6*, Museum Fridericianum, Kassel, West Germany (laser-environment)
1979 *Holografie-Expo*, Kunstverein, West Berlin (laser-environment)
Deutsche Fotografie nach 1945, Kunstverein, Kassel, West Germany (toured West Germany)

Collections:

Kunstverein, Kassel, West Germany; Museum Ludwig, Cologne; Museum of Modern Art, New York.

Publications:

By BAUMANN: books—*Die Neuen Matadore*, with Ken Purdy, Lucerne 1965; *Fotofutura, Girls, Grand Prix*, Dusseldorf 1966.

On BAUMANN: books—*Magie der Farbenfotografie* by W. Boje, Dusseldorf 1961; *Die Welt der Photographe* by Peter Pollack, Dusseldorf 1962; *Architektonische Spekulationen* by Wedewer and Kempas, Droste, West Germany 1970; *Fotografie 1919-1979, Made in Germany: Die GDL Fotografen*, edited by Fritz Kempe, Bernd Lohse and others, Frankfurt 1979; *Deutsche Fotografie nach 1945/German Photography after 1945* by Floris Neusüss, Wolfgang Kemp and Petra Benteler, Kassel, West Germany 1979; article—"Meister der Leica: Horst Baumann" in *Leica Fotografie* (Wuerzbach, Germany), vo. 11, no. 3, 1962.

Even in the giddy world of professional photography, it is difficult to think of a professional photographer who has undertaken, and constantly still undertakes, such a variety of work with as much verve and success as Horst Baumann.

When *Photokina*—the photographic *World's Fair*—organized it first "Junior Photography Competition," Baumann, at that time a student of metallurgy in Aachen, was one of the winners—and he went on to win the Young Photographers Prize on two more occasions. His photographs indicated both a positive feeling for form and a social sympathy. It was an irresistible temptation for the creative, perceptive young man: in 1957 he gave up his studies, even though they were near to completion, in order to become a press photographer.

It was the time when the popular press in Europe had begun to produce coverage in color. Baumann immediately caused a sensation with essays in color; very quickly he became one of the leading figures of the color avant-garde. Particularly memorable was his coverage of motor racing (he produced a book of these pictures, in collaboration with Ken Purdy, in 1965). Baumann's photos were particularly striking

BAYER, Herbert.
American. Born in Haag, Austria, 5 April 1900; emigrated to the United States, 1938: naturalized, 1944. Educated at gymnasium, Linz, Austria, 1911-17; apprentice in architecture and decorative arts, under architect George Schmidthammer, Linz, 1919; graphic design and typography assistant to architect Emanuel Margold, Darmstadt, Germany, 1920; studied mural painting and design, with Vasily Kandinsky, at the Staatliche Bauhaus, in Weimar, 1921-23, and in Dessau, 1925-28. Served in Infantry Regiment 14, Austrian Army, 1917-19. Married Irene Hecht in 1925 (divorced): daughter: Julia; married Joella Haweis Levy in 1944. First photographs, with Irene Hecht, Dessau, 1924; independent photographer, since 1928, Young Master of Typography and Graphic Design, Staatliche Bauhaus, Dessau, 1925-28; Director, Dorland Studio of Design, Berlin, 1928-38; Art Director, *Vogue* magazine, Berlin 1928-30; freelance photographer, contributing to *Die Neue Linie*, etc., Berlin, 1930-36; painter, photographer, graphic designer, and exhibition architect, New York, 1938-45; Director, Dorland International design company, New York, 1945; Consultant Designer, 1945-56, and Chairman of Department of Design, 1956-65, Container Corporation of America, Chicago. Consultant and Architect, Aspen Institute of Humanistic Studies, Colorado, since 1946; Art and Design Consultant, Atlantic Richfield Company, Los Angeles, since 1966. Recipient: First Prize, *Foreign Advertising Photography* exhibition, New York, 1931; Medal, City of Salzburg, Austria, 1936; Gold Medal, Art Directors Club of Denver, Colorado, 1957; Gold Medal, Art Directors Club of Philadelphia, 1961; Trustees Award, Aspen Institute for Humanistic Studies, Colorado, 1965; Ambassador's Award for Excellence, London, 1968; Kulturpreis for Photography, Cologne, 1969; Gold Medal, American Institute of Graphic Arts, 1970; Adalbert Stifter Preis für Bildende Kunst Verliehen, Linz, Austria, 1971; Austrian Cross of Honor for Art and Science, 1978. Honorary Doctorate: Technische Hochschule, Graz, Austria, 1973; D.F.A.: Philadelphia College

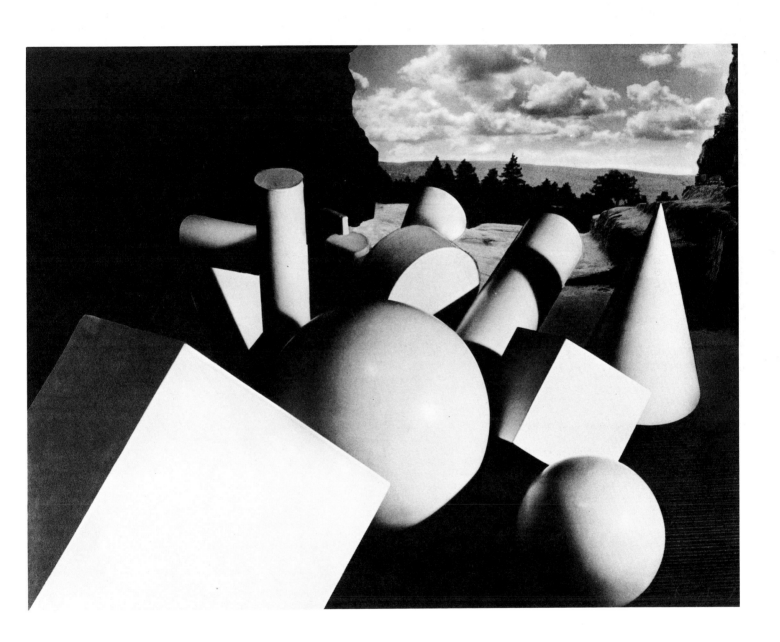

Herbert Bayer: *Metamorphosis,* 1936

of Art, 1974. Honorary Member, Alliance Graphique Internationale, 1975; Honorary Fellow, Royal Academy of Fine Art, The Hague, Netherlands, 1975. Fellow, American Academy of Arts and Sciences, 1979. Agent: Marlborough Gallery, 40 West 57th Street, New York, New York 10019. Address: 184 Middle Road, Montecito, California 93108, U.S.A.

Individual Exhibitions:

1929 Kunstverein Marz, Linz, Austria
 Galerie Povolotsky, Paris
1931 Staatliche Bauhaus, Dessau, Germany
1936 Kunstverein, Salzburg, Austria
1937 London Gallery
1939 Black Mountain College, North Carolina
 P.M. Gallery, New York
1940 Yale University, New Haven, Connecticut
1943 Willard Gallery, New York
 North Texas State Teachers College, Denton
1944 Outline Gallery, Pittsburgh
1947 *The Way Beyond Art*, Brown University, Providence, Rhode Island (retrospective; toured the United States, 1947-49)
1952 Cleveland Institute of Art
1953 Hans Schaeffer Galleries, New York
1954 Kunstkabinett Klihm, Munich
 Galleria del Milione, Milan
1955 Aspen Institute for Humanistic Studies, Colorado
1956 *33 Years of Herbert Bayer's Work*, Germanisches Nationalmuseum, Nuremberg, West Germany (retrospective; travelled to Munich, Zurich, Berlin, Braunschweig and Vienna, 1956-57)
1957 Kunstkabinett Klihm, Munich
1958 *Recent Works*, Fort Worth Art Center, Texas (travelled to Minneapolis, Minnesota and Norman, Oklahoma)
1959 Kunstkabinett Klihm, Munich
1960 Stadtische Kunsthalle, Dusseldorf
 Museum am Ostwall, Dortmund, West Germany
1961 Bauhaus Archiv, Darmstadt, West Germany
1962 Stadtisches Kunstmuseum, Duisberg, West Germany (retrospective; toured the United States, Germany and Italy)
1963 Andrew Morris Gallery, New York
 Neue Galerie, Linz, Austria
1964 Aspen Institute for Humanistic Studies, Colorado
 5207 Galleries, Oklahoma City
1965 Byron Gallery, New York
 Esther Robles Gallery, Los Angeles
 Boise Art Association, Idaho
1966 University of New Hampshire, Durham
1967 Galerie Klihm, Munich
 Galerie Conzen, Dusseldorf
 Philadelphia Art Alliance
1968 Marlborough New London Gallery
1969 University of California at Santa Barbara
 Two Visions of Space: Herbert Bayer and Ingeborg ten Haeff, Hudson River Museum, Yonkers, New York
1970 Dunkelman Gallery, Toronto
 Germanisches Nationalmuseum, Nuremberg
 Galerie Conzen, Dusseldorf
1971 Marlborough Gallery, New York
 Centre Culturel Allemand, Paris
 Goethe-Institut, Paris
 Die Neue Sammlung, Munich
 Österreichisches Museum für Angewandte Kunst, Vienna
1972 Marlborough Gallery, Montreal
 Mer-Kup Galerias, Mexico City
1973 Landesbildstelle, Hamburg (travelled to Krefeld and Leverkusen)
 Saarland Museum, Saarbrücken
 Herbert Bayer: A Total Concept, Denver Art Museum (retrospective)
1974 Marlborough Galerie, Zurich
 Galerie Klihm, Munich

Galerie Nächst St. Stephan, Vienna (travelled to Innsbruck and Graz)
 Marlborough Graphics, New York (toured the United States, 1974-75)
 Das Druckgrafische Werk bis 1971, Haus Deutscher Ring, Hamburg (retrospective; toured Germany, Switzerland, Portugal and Spain)
1975 Marlborough Gallery, Toronto
 Arte Contacto Galeria, Caracas
1976 *Beispiele aus dem Gesamtwerk 1919-1974*, Neue Galerie, Linz, Austria
 Graphics and Small Sculptures, Marlborough Gallery, New York
 Photomontages, Marlborough Gallery, New York
1977 Marian Locks Gallery, Philadelphia
 From Type to Landscape, Hopkins Center, Darmouth College, Hanover, New Hampshire (American Federation of Art show: toured the United States)
 Photographic Works, Arco Center for visual Art, Los Angeles (toured the United States)
1978 *Tapestries and Environmental Designs*, Galerie Klihm, Munich
 Museum Bochum, West Germany
1979 Marlborough Gallery, New York
 Photographic Exhibition, Galerie Breiting, West Berlin
1980 *Inaugural Exhibition of the Herbert Bayer Archive*, Denver Art Museum
 Neue Gallery, Linz, Austria
 Galerias Mer-Kup, Mexico City
1981 *A Selected Survey*, Grapestake Gallery, San Francisco

Selected Group Exhibitions:

1923 *Kunst and Technik: Eine neue Einheit*, Bauhaus und Staatliches Landesmuseum, Weimar
1929 *Film und Foto*, Stuttgart
1936 *Entartete Kunst*, Haus der Deutschen Kunst, Munich
1959 *V Bienal*, São Paulo
1966 *Les Années 25*, Musée des Art Décoratifs, Paris
1967 *50 Jahre Bauhaus*, Württembergische Kunstverein, Stuttgart (toured Europe, the United States, Canada, Argentina and Japan)
1971 *Albrecht Dürer zur Ehren*, Nuremberg
1973 *Die Zwanziger Jahre: Kontraste eines Jahrzehnts*, Zurich
1978 *Paris-Berlin 1900-1933*, Centre Georges Pompidou, Paris
1980 *Avant-Grade Photography in Germany 1919-1939*, San Francisco Museum of Modern Art (toured the United States)

Collections:

Art Museum of Modern Art, New York; Denver Art Museum, Colorado (Archives); Santa Barbara Museum of Art, California; Neue Galerie der Stadt Linz, Austria.

Publications:

By BAYER: books—*Fotomontagen*, portfolio of 11 photomontages, Berlin 1932; *Fotoplastiken*, portfolio of 10 photos, Berlin 1937; *Bauhaus 1919-1928*, with Ise and Walter Gropius, New York 1938, 1959, 1975; *Seven Convolutions*, portfolio of lithographs, Colorado Springs 1948; *World Geo-Graphic Atlas*, Aspen, Colorado 1953; *Book of Drawings*, Chicago 1961; *Eight Monochrome Suite*, portfolio of lithographs, Los Angeles 1965; *Herbert Bayer: Paintings*, portfolio of reproductions, Chicago 1965; *Herbert Bayer: Painter/Designer/Architect*, New York, Ravensburg, London and Tokyo 1967; *Herbert Bayer*, portfolio of 6 silkscreens, with introduction by Dieter Honisch, Stuttgart 1968; articles—

"Reflections from One of the Sculptors Who Contributed to the 'Route of Friendship'" in *Architecture Formes et Fonctions* (Lausanne), 1969; "Typography and Design" in *Concepts of the Bauhaus: Busch-Reisinger Museum Collection*, exhibition catalogue, Cambridge, Massachusetts 1971; "Herbert Bayer," interview, in *Dialogue with Photography*, edited by Paul Hill and Thomas Cooper, London 1979; "Many Paths from the Bauhaus," interview, in *Darkroom Photography* (San Francisco), January/February 1981.

On BAYER: books—*The Way Beyond Art: The Work of Herbert Bayer* by Alexander Dorner, New York 1947; *Fotoauge Herbert Bayer*, exhibition catalogue, edited by Jan Tschichold, Munich 1967; *Herbert Bayer*, exhibition catalogue, with text by Ludwig Grote, London 1968; *50 Jahre Bauhaus*, exhibition catalogue, by Wulf Herzongenrath, Stuttgart and London 1968; *Two Visions of Space: Herbert Bayer and Ingeborg ten Haeff*, exhibition catalogue, with introduction by Carl Black, Jr., New York 1969; *The Bauhaus* by Hans M. Wingler, Cambridge, Massachusetts 1969; *Herbert Bayer: A Total Concept*, exhibition catalogue, with introduction by Karl Otto Bach, Denver 1973; *Herbert Bayer: Das Druckgrafische Werk bis 1971*, with text by Hans M. Wingler and Peter Hahn, Berlin 1974; *Herbert Bayer*, exhibition catalogue, with introduction by Ida Rodriguez Prampolini, Zurich 1974; *Photographie als Kunstlerisches Experiment* by Willi Rotzler, Lucerne and Frankfurt 1974; *Herbert Bayer: Un Concepto Total* by Ida Rodriguez Prampolini, Mexico City 1975; *The Magic Image* by Cecil Beaton and Gail Buckland, London and Boston 1975; *Beispiele aus dem Gesamtwerk 1919-1974*, exhibition catalogue, with introduction by Peter Baum, Linz 1976; *Photomontage* by Dawn Ades, London and New York 1976; *Herbert Bayer: From Type to Landscape*, exhibition catalogue, with text by Jan van der Marck, New York 1977; *Herbert Bayer: Photographic Works*, exhibition catalogue, with text by Leland Rice and Beaumont Newhall, Los Angeles 1977; *Geschichte der Fotografie im 20. Jahrhundert/Photography in the 20th Century* by Petr Tausk, Cologne 1977, London 1980; *Fotografische Kunstlerbildnisse*, exhibition catalogue, by Dieter Ronte, Evelyn Weiss and Jeane von Oppenheim, Cologne 1977; *Kunstlerphotographie im XX. Jahrhundert*, exhibition catalogue, edited by Carl-Albrecht Haenlein, Hannover 1977; *Neue Sachlichkeit and German Realism of the Twenties*, exhibition catalogue, by Wieland Schmied and Ute Eskildsen, London 1978; *Das Experimentelle Photo in Deutschland 1918-1940* by Emilio Bertonati, Munich 1978; *Paris-Berlin 1900-1933*, exhibition catalogue, by Herbert Molderings, Werner Spies, Günter Metken and others, Paris 1978; *Photographie als Kunst 1879-1979/Kunst als Photographie 1949-1979*, exhibition catalogue, 2 vols., by Peter Weiermair, Innsbruck 1979; *Photographen der 20er Jahre* by Karl Steinorth, Munich 1979; *Film und Foto der 20er Jahre*, exhibition catalogue, by Ute Eskildsen and Jan Christopher Horak, Stuttgart 1979; *Internationale Ausstellung des Deutschen Werkbundes "Film und Foto" 1929*, facsimile reprint, edited by Karl Steinorth, Stuttgart 1979; articles— "Herbert Bayer: Photograph und Maler" by Paul Westheim in *Das Kunstblatt* (Berlin), May 1929; "Foreign Commercial Photographs Make Brilliant Showing" by Margaret Breuning in *New York Evening Post*, 7 March 1931; "Photographie" by Eberhard Holscher in *Gebrauchsgraphik* (Berlin), 1935; "From a Portfolio of Photomontages by Herbert Bayer" by Julien Levy in *Coronet* (New York), January 1940; "Die Zwischenposition von Herbert Bayer" by Franz Roh in *Die Kunst* (Munich), May 1956; "Herbert Bayer's Photographic Experiments" by Eckhard Neumann in *Typographica* (London), no. 2, 1965; "Herbert Bayer und seine Fotographischen Experimente" by Eckhard Neumann in *Foto Prisma* (Stuttgart), November 1969; "The Bayer Blitz: Two Views of a Bauhaus Veteran" by Henry J.

Seldis, Jr. in the *Los Angeles Times*, 8 May 1977; "Herbert Bayer and Photography" by Leland Rice in *Exposure* (New York), May 1977; "Masters of Photography: Herbert Bayer" by Janis Bultman in *Darkroom Photography* (San Francisco), January/February 1981; film—*Bayer: The Man and His Work* by Max Ewings, 1975.

Photography as well as photomontage has become one medium among many other mediums for the contemporary artist. It was in the depressed years after the First World War that a new optimism became evdent to the artist who began to look for the liberating forces of a new technological and scientific age. Great interest was concentrated on the newly created technologies among which was photography.

The invention of the small format camera developed in the wake of this attitude. The miniature camera became a flexible instrument on the way to new imagery. The small camera is a handy tool of creativity, and it led to the discovery of new points of view. We suddenly saw a great possibility in hitherto unexplored perspectives such as the "bird's-eye view" or the "frog's-eye view." Furthermore, new photography was inspired by photography being used for scientific aims, making it possible to look through the human body, to photograph the microcosmos as well as the macrocosmos of the universe.

From the mid-1920's, it became a preferred pictorial medium in the exploration of a new visual language. The combined use of typography and photography (typo-photo) unified these previously isolated mediums. It was seen as imparting information clearly, precisely, and when used well, aesthetically and forcefully. The discoveries of the possibilities inherent in photography made it a tool to record realism, to freeze motion and speed, to convey the invisible.

The invention of photomontage added further richness. Photomontage, collage, montage and assemblage, as used early in posters, announcements and graphics became an artistic technique at the Bauhaus and by the Dadaists of a more intimate and playful nature.

We believed that any technique is permissible when it serves the problem better than another one. Choice of a medium is therefore often suggested by the nature of the problem. Consequently, several different techniques were mixed and used simultaneously.

The one static viewpoint from which to look upon a given subject gave way to a dynamic "multipoint of view" concept to which montage lends itself naturally. Furthermore, montage not only makes images of an unreal character possible, but can also be a powerful tool to convey the invisible as well as that of a succession of complex events. It is particularly compatible with advertising psychology and the imagery of ideas.

Photography explored in many different ways is today an esteemed medium of art. Future technologies will give to the artist yet unknown concepts of exploration.

—Herbert Bayer

While considering himself primarily a painter, Herbert Bayer has distinguished himself in a variety of fields, including sculpture, typography, graphic design—and photography. His initial encounter with photography came in the 1920's, when he was a student and later teacher at the Bauhaus. Established in the aftermath of World War I, the Bauhaus urged artists to come to terms with industrial society and the machine age. Its embrace of technology and machine aesthetics furnished a particularly receptive atmosphere for experiments with the image-producing machine, the camera.

Bayer, who came to the Bauhaus in 1921 as a student and remained to teach typography and graphic design, was stimulated to take up photography by the example of László Moholy-Nagy. It was Moholy's provocative opinion (expressed in his 1925 book *Painting Photography Film*) that photographic technology had dramatically extended and intensified the visual sense, opening up a "new wealth of optical expression" available for artistic exploration.

Bayer's first investigations of what Moholy called the "new vision" shared many of Moholy's visual concerns, and the photographs that Bayer made with a small hand-held camera in the mid-1920's are strongly reminiscent of Moholy's own. In these photographs, conventional picture relations were systematically disrupted by means of a variety of then-novel devices. Everyday scenes or objects were presented from unusually high or low vantage points—the so-called "bird's-eye" and "frog's-eye" views. Extreme close-ups revealed unexpected textures and forms. Shadows were called into play as an important graphic element. The resulting images were unprecedented for their combination of graphic clarity and spatial ambiguity, and went far toward establishing the camera's potential as an instrument of abstract vision. A large group of Bayer's photographs was exhibited at the 1929 *Film und Foto* exhibition in Stuttgart, which brought together some of the most advanced work being done in Europe and America.

Bayer's very different and highly personal approach to photomontage dates from the period after 1928 when he left the Bauhaus and moved to Berlin. In "Lonely Metropolitan" (1932), a pair of eyes unexpectedly stare out of the palms of two imploring hands set before a desolate cityscape. The mingling of photographic realism and dream-like fantasy is characteristic of the surrealist art of the time, but Bayer's emphatic design and technical polish far surpass the typical surrealist production.

A related and somewhat later group of photographic images, which Bayer called *fotoplastiken*, dates from around 1936. These originated as groups of everyday objects and geometric solids which were arranged expressly to be photographed. The objects might be held in place by strings, which would later be removed by retouching. Backgrounds might be airbrushed in, serving to situate Bayer's strangely evocative collections of objects in a receding, illusionistic space.

These relatively private researches into fresh uses of photographic methods and imagery have received renewed attention in recent years. As a highly influential graphic designer, Bayer adapted many of the visual principles which inform his photomontages and *fotoplastiken* to use in posters and advertisements. By insisting on the importance of visual images in modern mass communication, he played a leading role in introducing the visual language of modern art to the public at large.

—Christopher Phillips

BEARD, Peter (Hill).
American. Born in New York City, 22 January 1938. Educated at Buckley School, New York, 1945-52; Pomfret School, Vermont, 1950-54; Felsted College, Essex, England, 1956-57; studied art, under Josef Albers, at Yale University, New Haven, Connecticut, 1958-61, B.A. 1961. Married Mary O. Cushing in 1967 (divorced, 1971); married the model Cheryl Tiegs in 1981. Photographer/diarist since 1950. First visited Africa, 1955; settled in Kenya, on "Hog Ranch," below the Ngong Hills near Nairobi, 1961; met and worked with Karen Blixen (Isak Dinesen), Denmark, 1961-62; worked in Tsavo Park, Kenya, documenting the elephant habitat crisis, 1964-65; worked with the Nuffield Unit and Wildlife Services, Dick Laws and Ian Parker in documenting elephant and hippo populations, 1966, and with Alistair Graham on a Lake Rudolf crocodile survey for Kenya Game Department, 1966-68; established second residence in Montauk, Long Island, New York, 1973. Agent: Blum-Helman Gallery, 13 East 75th Street, New York, New York 10021. Address: Post Office Box 603, Montauk, Long Island, New York 11954, U.S.A.

Individual Exhibitions:

1975 Blum-Helman Gallery, New York
1977 *The End of the Game*, International Center of Photography, New York
1979 *Last Word from Paradise*, Seibu Museum, Tokyo
 The Diary of Peter Beard, Watari Gallery, Shibuya-ku, Tokyo

Selected Group Exhibitions:

1979 *NASA: Voyager Time Capsule Exhibition*, The Photographers' Gallery, London

Peter Beard: *Hog Ranch*, 1976

Collections:

Museum of Modern Art, New York; International Center of Photography, New York; Musée Réattu, Arles, France.

Publications:

By BEARD: books—*The End of the Game*, New York 1965, revised edition as *The End of the Game: Last Word from Paradise*, with an introduction by Joseph Murumbi, epilogue by Richard M. Laws, New York and London 1977; *Eyelids of Morning*, New York 1974; *Longing for Darkness: Kamante's Tales from Out of Africa*, New York and London 1975; articles—interview in *Interview* (New York), December 1973; "Last of the Nuba" in *Natural History Magazine* (New York), December 1975; "Introduction" to *Francis Bacon*, Metropolitan Museum exhibition catalogue, New York 1976; *Interview* (New York), January 1978; interview in *Photo* (New York), January/February 1978; "Another Last Word from Paradise," interview, with Esmond Martin, in *Africana Magazine* (Nairobi), August 1978; "Introduction" to *Leni Riefenstahl*, exhibition catalogue, Tokyo 1980; films—*Hallelujah the Hills*, as actor, directed by Jonas Mekas, 1963; *Longing for Darkness*, 1975; *The Bicentennial Diary*, 1976; *Africa: The End of the Game*, ABC television film, 1979.

On BEARD: articles—"Peter Beard: The Death of a World" by Owen Edwards in the *Village Voice* (New York), 29 December 1975; "Endpaper: Four Days in the Life" by Glenn Collins in the *New York Times Magazine*, 15 February 1976; "This Is the End of the Game" by Boyce Rensberger in the *New York Times Magazine*, 6 November 1977; "Notes on the Lost Books of Peter Beard" by Jonas Mekas in *Soho Weekly News* (New York), 10 November 1977; "Epitaph on Film: Images of Ruin in Africa" by Robert Hughes in *Time* (New York), 12 December 1977; "The Collector: Photographer Peter Beard's Life and Times" by Doon Arbus in *Rolling Stone* (San Francisco), 16 November 1978; "The Last Great Herds" by Jeffery A. Davis in *Ecology* (San Diego, California), June 1979; "Peter Beard's Diary" by Carol DiGrappa in *Upper and Lower Case* (New York), June 1979.

Not to take pictures in this century is crazy. If people only knew how easy it was, everyone would be "a photographer." Photography is a great field for phony artists and frustrated technicians. All you need is enough brain to recognize good subject matter and enough money to buy a reflex camera.

I'm not much of a message bearer, but I like the idea of documentation, particularly photographic, in a sort of collage over a period of time. The thing that occurs to me, now that speeds are so accelerated, is how much we're losing in terms of values in daily life; how much quality of life we're losing, and how willingly we accept this, adapt ourselves to it, and make excuses for ourselves. Particularly in East Africa—the Paradise slum.

I mean, the capacity of human beings to fool themselves—to behave more destructively than any other animal and call it love. The human behaviorist Ronald Laing describes it perfectly in *The Politics of Experience:* "Human beings seem to have an almost unlimited capacity to deceive themselves into taking their own lies for truth.... The double action of destroying ourselves with one hand and calling this love with the other, is a sleight of hand we can marvel at.... By such mystification, we achieve and sustain our adjustment, our adaptation."

The first *End of the Game* was an amateur swan through areas I'd always read about and became interested in through Karen Blixen, and it seemed almost acceptable to carry out as a sort of corny homework assignment—I was still in school. The idea of redoing it came from a new publisher, and I was relieved to be able to fix up a half-assed project that was unmistakeably thrown together between classes. The new version encompasses 23 years of fresh observations, collections, researches, photos, documentation. It is completely rewritten, completely redone.

I keep thinking of what Faulkner said: "The ruined wood we used to know won't cry for retribution—the men who have destroyed it will accomplish its revenge." What amazes me most is that we are so willing to lose things that we can never get back—even further, we appear hell-bent on our own destruction. It's rivetting.

The End of the Game says that we have deprived the elephants of the habitat they require. It won't be long before this can be said of our own species—*they were deprived of the habitat they required.* To require means to need, to depend on. We are losing many things on earth, irreplaceable things, and we will soon find out the degree of our dependency, the extent of our need and the thoughtlessness of our expanding populations.

The End of the Game is a sort of photo album based on field studies by internationally qualified scientists who had integrity and were therefore replaced. It shows the road to hell paved with benevolence and short-term politics. Hopefully, this will give confidence and direction to the nervously emerging African citizens who do not want to denude, domesticate and ruin everything as we have—who are tired of being sucked up to and manipulated with lies: it will forever record for them a wilderness they lived in for many hundreds of years and saw mangled and over-run by our well-meaning missionaries and high-velocity heroes. As Karen Blixen says in the introduction: "The wilderness of only half a century ago, then so completely itself, has been reduced tree by tree, animal by animal, shadow by shadow, rock by rock, to its last rutted corners. The few remaining spaces have been infiltrated, divided up, domesticated, deprived of natural systems, denuded of natural processes, systematized, similarized, artificialized, sterilized, commercialized...."

The play period is over. We no longer have the luxury of living in a world where there is the time or the space for playing games in the wild-deer-ness. The speeds are too great. By tracing fossil series we know that evolution has favored size and numbers—but trends in evolution have their own limiting factors, their own built-in demise. Sheer size may do us in. We are poised at the lily pond like dinosaurs.

—Peter Beard

Peter Beard's photographs deal with only one subject and place—the natural life of the African bush—but they give such a complex and sensitive view that their meaning is universal. As a boy of seventeen Beard began to make the beautiful and melancholy photographs that appear in his three books, *Eyelids of Morning*, *Longing for Darkness*, and the classic *End of the Game*. The latter book in particular is a moving memorial to Kenya as it was in the days of its first generation of European explorers, hunters and settlers. Hoping to create "a memory of the past, a record of the present, and an image of the future," Beard photographed the extraordinary wildlife, and its human counterparts, that surrounded him on safari.

The special experience of Beard's photographs is their personal immediacy: in a sequence of shots he captures the charge of a lion—directly toward the camera. He presents the spectacular sight of an elephant herd observed from an airplane's height, but he can also find beauty in a close shot of an elephant's gigantic, decaying carcass. He shows the splendor of the impala's flight and also the moment of its death. Color photography is used for both the intricate beadwork of the African tribespeople and the bloody flesh of a flayed zebra.

Courage and humor rescue Beard's photographs from sentimentality. Certainly their beauty is melancholy; at least half of the images in *End of the Game* show death rather than life. Yet, when we see the lined and tired face of one of Africa's great old hunters sharing a spread with a tough bull rhino, mortally wounded, the humorous visual comparison helps drive home Beard's point. It is "the end of the game" in more senses than one.

Perhaps because he has arranged them in collage-like diaries that he has kept for many years, Beard's photographs work well with text and other documentary materials. His characteristically soft-focus, low contrast images convey both the urgency of his actual safari experience and the underlying preservationist concern that is the impetus of his entire project. Beard has grasped the special documentary power that is photography's. He possesses the rare ability to use the documentary aspect of the camera's power for his creative personal expression. Photographer, writer, filmmaker, sportsman, this protean artist has succeeded not only in expressing his deep and complex feelings about his beloved Africa, but also in putting the photographic medium to a use for which it is uniquely suited.

—Maren Stange

BEATON, Cecil (Walter Hardy).
British. Born in London, 14 January 1904. Educated at Heath Mount School, London; Harrow School, Middlesex; and St. Cyprian's School, Eastbourne, until 1921; studied history and architecture, St. John's College, Cambridge, 1922-25; self-taught in photogrpahy. Served as photographer with the Ministry of Information, London, 1939-45. Worked as a clerk, Schmiegelow and Company cement company, London, 1925-26. Freelance portrait and fashion photographer, 1926-30; contract fashion photographer, Condé Nast Publications, mainly for *Vogue* magazine, New York and London, 1930 until the mid-1950's, thereafter freelance photographer, until his death, 1980; also stage designer, 1925-70, and film designer, 1941-70, London and Hollywood. Recipient: Neiman Marcus Award, 1956; Antoinette Perry Award for costume, 1957; Academy Award for film sets and costumes, 1957, 1965; Honor Award, American Society of Magazine Photographer, 1963. Honorary Fellow, Royal Photographic Society, London, 1964. Chevalier, Légion d'Honneur, 1960. C.B.E. (Commander, Order of the British Empire), 1957; knighted, 1972. Agent: Sotheby's Belgravia, 19 Motcomb Street, London SW1X 8LB, England. *Died* (in Broadchalke, near Salisbury, Wiltshire) *18 January 1980.*

Individual Exhibitions:

1929 Everglades Club, Palm Beach, Florida
 Elsie de Wolfe Galleries, New York
1930 Cooling Galleries, London
1931 Delphic Galleries, New York
1936 Redfern Gallery, London
1937 Carroll Carstairs Gallery, New York
1942 Estudio do Spu, Lisbon
1951 Sagittarius Gallery, New York
1956 Sagittarius Gallery, New York
1958 Redfern Gallery, London
1960 Sagittarius Gallery, New York
1964 Redfern Gallery, London
1966 Lefevre Gallery, London
1968 Palm Beach Gallery, Miami
 Wright Hepburn Gallery, London
 Portraits 1928-1968, National Portrait Gallery, London
1969 *600 Faces by Beaton 1928-69*, Museum of the City of New York
1970 Palm Beach Gallery, Miami

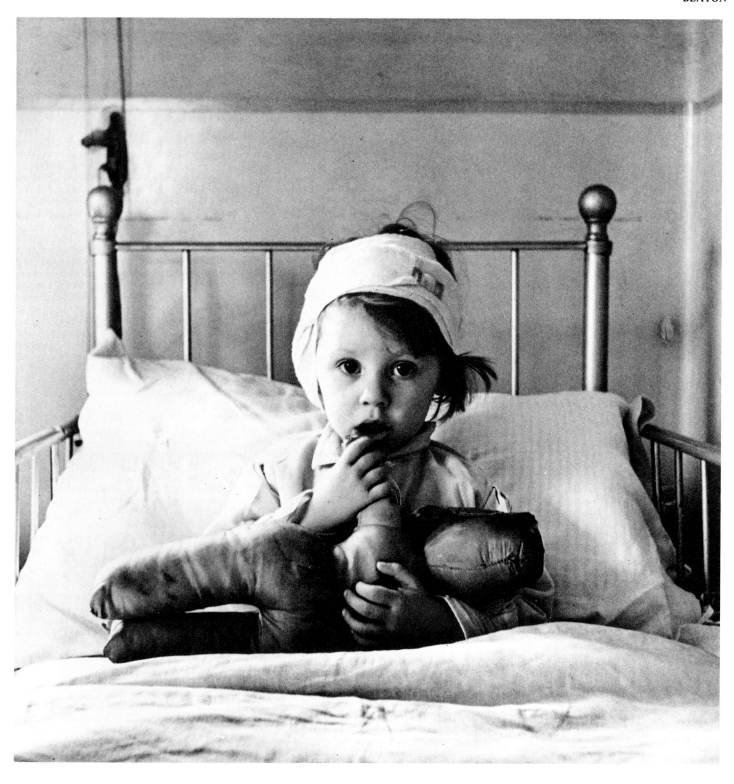

Cecil Beaton: *Eileen Dunn in the Hospital for Sick Children,* **London, 1940** Courtesy Imperial War Museum, London

1971 *Fashion: An Anthology*, Victoria and Albert Museum, London (with costumes and designs by others)
1972 Palm Beach Gallery, Miami
1973 Impressions Gallery, York
The First 10 Years, Sonnabend Gallery, New York
Record of a Period, Draytons Gallery 12, Minneapolis
1974 Kodak Gallery, London (retrospective)
1980 Galerie Zabriskie, Paris (with Joseph Cornell)
1981 *War Photographs 1939-45*, Imperial War Museum, London

Selected Group Exhibitions:

1959 *Hundert Jahre Photographie 1839-1939*, Museum Folkwang, Essen (travelled to Cologne and Frankfurt)
1964 *The Painter and the Photograph: From Delacroix to Warhol*, University of New Mexico, Albuquerque
1972 *Personal Views 1850-1970*, British Council, London (toured Europe)
1973 *Photography into Art*, Camden Arts Centre, London
1977 *Fashion Photography*, International Museum of Photography, George Eastman House, Rochester, New York (travelled to Brooklyn Museum, New York; San Francisco Museum of Modern Art; Cincinnati Art Institute, Ohio; and Museum of Fine Arts, St. Petersburg, Florida)
Happy and Glorious: 130 Years of Royal Photographs, National Portrait Gallery, London
1979 *The 30's: British Art and Design Before the War*, Hayward Gallery, London
Photographie als Kunst 1879-1979, Tiroler Landesmuseum Ferdinandeum, Innsbruck, Austria (travelled to Neue Galerie am Wolfgang Gurlitt Museum, Linz, Austria; Neue Galerie am Landesmuseum Joanneum, Graz, Austria; and the Museum des 20. Jahrhunderts, Vienna)
Film und Foto der 20er Jahre, Württembergische Kunstverein, Stuttgart (travelled to Museum Folkwang, Essen; Werkbundarchiv, Berlin; Kunsthaus, Zurich; Kunstverein, Hamburg; and Museum des 20. Jahrhunderts, Vienna)
1980 *The Queen Mother: A Celebration*, National Portrait Gallery, London

Collections:

National Portrait Gallery, London; Imperial War Museum, London; Sotheby's Belgravia, London; Life Picture Collection, New York; Boston Public Library; Yale University, New Haven, Connecticut; Rhode Island School of Design, Providence; New Orleans Museum of Art; University of Nebraska, Lincoln; Gernsheim Collection, University of Texas at Austin.

Publications:

By BEATON: books—*The Book of Beauty*, London 1930; *Cecil Beaton's Scrapbook*, London 1937; *Cecil Beaton's New York*, London 1938, 1948, as *Portrait of New York*, New York 1938; *My Royal Past, by Baroness von Bulop, as Told to Cecil Beaton (or Rather Written by Him)*, London 1939, revised edition, London and New York 1960; *Time Exposure*, with text by Peter Quennell, London 1941, 1946; *History under Fire*, with text by James Pope-Hennessy, London 1941; *Winged Squadrons*, London 1942; *Near East*, London 1943; *British Photographers*, editor, London 1944; *Face to Face with China*, with text by H.B. Rattenburg, London 1945; *Far East*, London 1945; *Air of Glory*, with text by Ministry of Information editors, London 1946; *Indian Album*, London 1946; *Chinese Album*, London 1946; *Designs for the Theatre by Rex Whistler*, editor, London 1947; *Ashcombe: The Story of a 15 Year Lease*, London 1947; *The School for Scandal*, with text by R.B. Sheridan, London 1949; *Ballet*, London and New York 1951; *Photobiography*, London 1951; *Persona Grata*, with Kenneth Tynan, London 1953; *The Glass of Fashion*, London 1954; *It Gives Me Great Pleasure*, London 1955, as *I Take Great Pleasure*, New York 1955; *The Face of the World*, London and New York 1957; *Images*, with an introduction by Christopher Isherwood, London 1959; *The Importance of Being Earnest*, with text by Oscar Wilde, London 1960; *The Wandering Years: Diaries 1922-39*, London and Boston 1961; *Quail in Aspic: The Life Story of Count Charles Korsetz*, London 1962; *Royal Portraits*, with an introduction by Peter Quennell, London 1963; *Cecil Beaton's My Fair Lady*, London 1964, as *Cecil Beaton's "Fair Lady,"* New York 1964; *The Years Between: Diaries 1939-44*, London 1965; *The Best of Beaton*, with an introduction by Truman Capote, London 1968; *Fashion: An Anthology Compiled by Cecil Beaton*, exhibition catalogue, edited by Madeleine Ginsburg, London 1971; *My Bolivian Aunt: A Memoir*, London 1971; *The Happy Years: Diaries 1944-48*, London 1972, as *Memories of the 40's*, New York 1972; *Salisbury: A New Approach to the City and Its Neighbourhood*, with text by Hugh de Shortt, London 1972; *The Strenuous Years: Diaries 1948-55*, London 1973; *The Magic Image: The Genius of Photography from 1839 to the Present Day*, with Gail Buckland, London and Boston 1975; *The Restless Years: Diaries 1955-63*, London 1976; *The Parting Years: Diaries 1963-74*, London 1978; *Self-Portrait with Friends: The Selected Diaries of Cecil Beaton 1922-1974*, edited by Richard Buckle, London and New York 1979; *Cecil Beaton: War Photographs 1939-45*, with forward by Peter Quennell, introduction by Gail Buckland, London 1981.

On BEATON: books—*Some Designs for Stage and Screen* by Orville K. Larson, East Lansing, Michigan 1961; *Beaton Portraits*, exhibition catalogue, London 1968; *The Painter and the Photograph: From Delacroix to Warhol* by Van Deren Coke, Albuquerque, New Mexico 1972; *Photography into Art*, exhibition catalogue, by Colin Osman, Ainslie Ellis and Margaret Harker, London 1973; *The Photographs of Sir Cecil Beaton*, exhibition catalogue, by Andrew Sproxton, York 1973; *American Fashion*, edited by Sarah Tomerlin Lee, New York 1975, London 1976; *Cecil Beaton: Stage and Film Designs* by Charles Spencer, London 1976; *Geschichte der Fotografie im 20. Jahrhundert/Photography in the 20th Century* by Petr Tausk, Cologne 1977, London 1980; *Happy and Glorious: 130 Years of Royal Photographs*, exhibition catalogue, edited by Colin Ford, London 1977; *Photographen der 20er Jahre* by Karl Steinorth, Munich 1979; *Film und Foto der 20er Jahre*, exhibition catalogue, by Ute Eskildsen and Jan Christopher Horak, Stuttgart 1979; *The History of Fashion Photography* by Nancy Hall-Duncan, New York and Paris 1979; *The Vogue Book of Fashion Photography* by Polly Devlin, with an introduction by Alexander Liberman, New York and London 1979; *30's: British Art and Design Before the War*, exhibition catalogue, by Ian Jeffrey, William Feaver and others, London 1979; *Dialogue with Photography*, edited by Paul Hill and Thomas Cooper, London 1979; *Life: The First Decade 1936-1945* by Robert Littman, Ralph Graves and Doris C. O'Neill, New York 1979, London 1980; *Beaton*, edited with text by James Danziger, London 1980; articles—"600 Faces by Cecil Beaton 1928-1969" by T. Barrow in *Aperture* (New York), Summer 1970; "Beaton at His Own Game" by P. Glynn in *The Times* (London), 12 October 1971; "Sir Cecil Beaton at the RPS" by Gail Buckland in *Photographic Journal* (London), July 1973; "Knight in White Satin: Cecil Beaton Talks to Penelope Tree" in *Inter/View* (New York), April 1973; "Cecil Beaton" by G. Hughes in *Amateur Photographer* (London), 10 April 1974; "Living Masters of Photography: Cecil Beaton" by Allan Porter in *Camera* (Lucerne), June 1974; "Obituary: Sir Cecil Beaton, Photographer, Writer and Stage Designer" in *The Times* (London), 19 January 1980; "Cecil Beaton: Arbiter of Elegance" by Richard Buckle in *The Observer* (London), 20 January 1980; "Cecil Beaton: Garbo Inconnue" in *Photo* (Paris), February 1980; "A Dramatic Achievement: The Life and Works of Cecil Beaton" by Ainslie Ellis in *British Journal of Photography* (London), 15 February 1980; "Sir Cecil Beaton C.B.E., 1904-1980" by Colin Osman in *Creative Camera* (London), March 1980; "Beaton: The Final Selection" by James Danziger in the *Sunday Times Magazine* (London), 5 October 1980.

Born in 1904, Cecil Beaton was educated at Harrow and Cambridge. A member of the British social elite, Beaton was and is best known as a photographer of high fashion, a portraitist of the rich and the royal, and as a designer of theatrical sets and costumes.

"I had two careers—photography and set designing. They overflowed constantly." As a young boy, Beaton was introduced to photography by his sisters' nanny, and with a Kodak 3a folding camera, began photographing his sisters, his mother, and any family friends who were willing to sit and model. Inspired by the romantic portraits by Baron de Meyer, the lavish fashion photographs by Steichen, and allegorical photographs of the Edwardian age, young Beaton's imagination and energy were unbounded.

He would go to great lengths to construct elaborate sets, using materials ranging from mirrors to cellophane, frequently painting large backdrops in strong abstract designs. He photographed his sitters posed statue-like, dressed in fanciful costumes or wrapped in silver cloth. Human subjects became elements of an entire decorative tableau. His camera did the work of a painter or a designer: the sitter became part of a preconceived schema in which the focus was not the figure or the clothes, but the creation of an entire "ambience".

In the late 1920's and 1930's, the introduction and availability of small hand-held cameras opened new possibilities in journalistic and documentary photography, leading to an interest in naturalism and depiction of "truth". Beaton did not participate in these developments. His work did not involve itself with the general social concerns of the times, but, rather, reflected Beaton's own private social interests. He continued to explore the artifice and constructed environments within the constraints of a studio. He worked as a freelance portrait photographer, patronized by members of the British upper class and old family friends like the Sitwells.

A trip to New York in 1930 began a long relationship with Condé Nast; he worked during the 30's under exclusive contract for *Vogue*. It was Condé Nast that insisted that Beaton finally abandon his beloved old Kodak 3a, and acquire an 8 x 10 view camera. Although he initially hated its cumbersomeness, the quality of his photographs improved dramatically, and Beaton was soon won over to this new camera. Throughout his photographic career he worked in large format, using a smaller Rolleiflex only on his travels and during his years as a war photographer.

From New York, Beaton went to Hollywood in 1931. This was the heyday of a new movie industry, and Beaton loved it. Here, his love of the theatrical could integrate unrestrainedly with his love of photographing. He spent days photographing movie stars in back lots and unused sets. The photographs were new, and exciting, and many had a surrealist quality to them as Beaton placed human forms amid the enormous scale and chaotic aura of back lots. On his return to London, Beaton became the official photographer for the royal family.

During World War II, the Ministry of Informa-

tion hired Beaton to take pictures of war-torn London and of Allied operations in North Africa and the Far East. The pictures were for propaganda purposes, to document the destruction of London, and to enlist American support. One image from this period, of a young victim of the bombings sitting in a hospital bed with a bandaged head, clutching a rag doll, was widely circulated and is said to be largely responsible for gaining American sympathy.

This wartime assignment presented a new challenge to Beaton, and the results are radically different from his previous work. The photographs of London are stark, simple, and straightforward, and imbued with the tense alienation of a vulnerable population. His photographs of North Africa and China do not have the drama of Capa's or Smith's, but their strength is in their grace and subtle, poetic spirit.

Following the war, Beaton returned to fashion photography, still under contract to *Vogue*. The pictures were different though, adopting the style of "new realism", in which women dressed in high fashion were photographed in everyday situations. In the 1950's, new stars in fashion photography began to emerge. The energy of Avedon and the clean grace of Penn began to make Beaton's pictures seem outdated, and his contract with *Vogue* was terminated. It had been a long and fruitful relationship.

The late 1950's and early 1960's led to his increased involvement with theater and cinema. Beaton designed the sets and costumes for both *Gigi* and *My Fair Lady*, and won Oscars for both. In 1956 he began working for *Harper's Bazaar*, photographing such personalities as Marilyn Monroe, Evelyn Waugh, Carson McCullers, and Mick Jagger. The photographs of this period are looser, more personal and engaging.

Sir Cecil Beaton was knighted in 1972. In 1974 he suffered a stroke, and was not able to photograph for several years. Sotheby's purchased his entire photographic output in 1977 (150,000 photographs, ¼ million negatives, countless color transparencies, more than a dozen scrapbooks). In 1979 he began photographing again, and continued to do so right up until the time of his death.

—Sarah Putnam

BECHER, Bernhard and Hilla.

German. Bernhard Becher born in Siegen in 1931; studied painting and lithography at the Staatlichen Kunstakademie, Stuttgart, 1953-56, and typography at the Staatlichen Kunstakademie, Dusseldorf, 1957-61; self-taught in photography. Hilla Becher born Hilla Wobeser in Potsdam in 1934; studied photography in Potsdam, and painting at the Staatlichen Kunstakademie, Dusseldorf. Bernhard and Hilla Becher married in 1961; they have worked together as freelance photographic artists, concentrating on industrial photography, Dusseldorf, since 1959. Both are instructors in photography at the Staatlichen Kunstakademie, Dusseldorf. Recipients: British Council Photo Study Grant, 1966; Fritz-Thyssen-Stiftung grant, West Germany, 1967-68. Agents: Galerie Konrad Fischer, Platanenstrasse 7, Dusseldorf, and Nigel Greenwood Inc., 41 Sloane Gardens, London SW1, England. Address: Wittlauer 4, Am Muhlenkamp 16, Dusseldorf, West Germany.

Individual Exhibitions:

1963 Galerie Ruth Nohl, Siegen, West Germany
1965 Galerie Pro, Bad Godesburg, West Germany
1966 Staatliche Kunstakademie, Dusseldorf

1967 Staatliches Museum, Munich
Technische Hochschule, Karlsruhe
Bergbau-Museum, Bochum, West Germany
Kunstakademie, Copenhagen
1968 Wachsman Institute, Los Angeles
Goethe Center, San Francisco
Stedelijk Van Abbemuseum, Eindhoven, Netherlands
Galerie Ruth Nohl, Siegen, West Germany
Städtisches Museum, Monchengladbach, West Germany
1969 Städtische Kunsthalle, Dusseldorf
1970 Städtisches Museum, Ulm, West Germany
Moderna Museet, Stockholm
Galerie Konrad Fischer, Dusseldorf
1971 Kabinett für Aktuelle Kunst, Bremerhaven, West Germany
Gegenverkehr, Aachen, West Germany
1972 Sonnabend Gallery, New York
Bennington College, Vermont
1973 Galleria Forma, Genoa
Nigel Greenwood Inc., London
Sonnabend Gallery, New York
1974 Institute of Contemporary Arts, London (toured the U.K.)
Sonnabend Gallery, New York
1975 *Fotografien 1957-1975*, Rheinisches Landesmuseum, Bonn
Galleria Castelli, Milan
Museum of Modern Art, New York
Sonnabend Gallery, New York
1976 Kunsthalle, Tubingen, West Germany
1977 Sonnabend Gallery, New York
1981 Stedelijk Van Abbemuseum, Eindhoven, Netherlands

Selected Group Exhibitions:

1969 *Prospekt '69*, Städtische Kunsthalle, Dusseldorf
1970 *Information*, Museum of Modern Art, New York
1971 *Prospekt '71: Projektion*, Kunsthalle, Dusseldorf
1974 *Idea and Image*, Art Institute of Chicago
Photokina '74, Cologne
1975 *New Topographics: Photographs of a Man-Altered Landscape*, International Museum of Photography, George Eastman House, Rochester, New York (travelled to the Otis Art Institute, Los Angeles, and Princeton University Art Museum, New Jersey)
1977 *Documenta 6*, Museum Fridericianum, Kassel, West Germany
Bienal de Sao Paulo
1979 *Photographie als Kunst 1879-1979/Kunst als Photographie 1949-1979*, Tiroler Landesmuseum Ferdinandeum, Innsbruck, Austria (travelled to the Neue Galerie am Wolfgang Gurlitt Museum, Linz, Austria; Neue Galerie am Landesmuseum Joanneum, Graz, Austria; and Museum des 20. Jahrhunderts, Vienna)
1981 *Photos der 70er Jahre*, Galerie Wilde, Cologne

Collections:

Wallraf-Richartz Museum, Cologne; Moderna Museet, Stockholm; Museum of Modern Art, New York; Allen Memorial Art Museum, Oberlin College, Ohio.

Publications:

By the BECHERS: books—*Anonyme Skulpturen: Eine Typologie Technische Bauten*, Dusseldorf 1970; *Die Architektur der Förder- und Wasser-Türme*, with text by W. Schoenberg, J. Werth and T. Aachen, Munich 1971; *Industrial Buildings*, portfolio of 14 photos, Munich 1975; *Framework Houses*

of the Siegen Industrial Region, Munich 1977; article—"Photographing Industrial Architecture," interview, with Angela Graverholz and Anne Ramsden, in *Parachute* (Montreal), Spring 1981.

On the BECHERS: books—*Visuelle Kommunikation*, edited by Hermann K. Ehmer, Cologne 1971; *Bernhard and Hilla Becher*, exhibition catalogue, edited by Lynda Morris, London 1974; *Bernhard and Hilla Becher: Fotografien 1957-1975*, exhibition catalogue, with text by Klaus Honnef, Bonn 1975; *New Topographics: Photographs of a Man-Altered Landscape*, exhibition catalogue, with text by William Jenkins, Rochester, New York 1975; *Documenta 6/Band 2*, exhibition catalogue, edited by Klauf Honnef and Evelyn Weiss, Kassel and Cologne 1977; *Geschichte der Fotografie im 20. Jahrhundert/Photography in the 20th Century* by Petr Tausk, Cologne 1977, London 1980; *Typologien Industrieller Bau 1963-1975*, exhibition catalogue, Sao Paulo 1977; *Photographie als Kunst 1879-1979/Kunst als Photographie 1949-1979*, exhibition catalogue, 2 vols., by Peter Weiermair, Innsbruck, Austria 1979; articles—"Bernhard and Hilla Becher," special monograph issue of *Kunst-Zeitung*, January 1969; "Two Books of Ultra-Topography" by Robert Sobieszek in *Image* (Rochester, New York), September 1971; "A Note on Bernhard and Hilla Becher" by Carl Andre in *Artforum* (New York), December 1972; "Bernd and Hiller Becher" by Lynda Morris in *Art Press* (Paris), May 1973; "Bernhard and Hilla Becher: Nigel Greenwood Gallery" by Georgina Oliver in *Connoisseur* (London), February 1973.

That which Hilla and Bernhard Becher depict in their photographs is exclusively an architectonic record of industrial culture. They once called their work "anonymous sculptures." Hilla, a trained photographer, and Bernhard, originally a painter, invariably represent their subjects as a composite interlocking system. They either create a formal comparison between their subjects in which so-called typologies are formed—i.e., they place mining pithead gears, gas tanks, water towers, blast furnaces, cooling towers, locomotive engine houses, grain silos, cement mixers, even standardized residences, in contrast to one another—or they execute a certain development as if it were a course of action, with the camera moving around the object so that it fixes upon a different view after each 45 degrees.

The pithead as such, in fact, is irrelevant to them, just as irrelevant as the normal residence, but the serial character of their photographic practice corresponds to the character—pre-stamped mass-manufacture—of their chosen subjects. Photographic subject and method remain in direct reciprocal relation to one another—they provide comment on and heighten each other mutually. Like the photographs of August Sander, whose photographic/artistic concepts the Bechers seized upon and consequently followed (the only German photographers to do so), their images are also documents in the truest sense of the word: visually clear proofs of the historical process of development. It is not all of social development that is portrayed, but rather only one of its aspects, that of the process of industrialization. The Ruhr District, once Germany's most important industrial area, now exists as a landscape of coal mines and steel mills only in the Bechers' photographs.

When the Bechers depict these industrial structures—which for the most part remind one of tools, of overly-enlarged objects from the realm of everyday use—they are essentially uninterested in any picturesque view of the surrounding region. They reveal their subject by means of a comparison of all available structures of a particular type and by means of a successive unfolding of different points of view—directly head on, at an angle, from the side: in this way they reveal the inner framework as well as means of production and function. Sander pro-

ceeded similarly in this presentation of the social types of the Weimar Republic. In the Bechers' photographs, the subjects continue to exist—on the strength of the methods used—with such a sense of the present that one can grasp them literally and consequently comprehend them visually. The sense of the present in the subjects results as much from a kind of plastic accuracy—the subjects in front of a neutral sky setting the language of the picture—as from the penetrating analysis of their structures.

For a long time the Bechers' work was misunderstood in photographic circles. Only with the emergence of Conceptual Art—the shift from artistic concept to reliance on pictorial result as based on artistic process—did their kind of comparative photographic interpretation begin to be understood. In it Alfred Döblin saw, with some accuracy, as he wrote in the preface to Sander's *Das Antlitz der neuen Zeit*, a scientific point of view.

—Klaus Honnef

Mitter Bedi: *Ferro Alloy Plant*, East Coast, India, 1969

BEDI, Mitter.

Indian. Born in Lahore, 26 January 1926. Educated at D.A.V. School, Lahore, 1930-40; Vidyasagar College, Calcutta, 1942-43. Married Sarla Goenka in 1956; chilren: Preeti, Jyoti, and Gayatri. Photographer since 1954; established studio, Bombay, 1956; industrial photographer, Bombay, since 1958. Visiting Professor, K.C. College of Journalism, Bombay, 1974-75, National Institute of Design, Ahmedabad, 1976, Rajendra Prasad Institute of Communication, Bombay, 1978, and SNDT Women's University, Bombay, 1978. Chairman, Leica Club of India, 1969-72. Recipient: First Prize for Applied Photography, Commercial Artists Guild, Bombay, 1968, 1969, 1970, 1974; Silver and Bronze Trophy, CAG India, 1977. Address: Mitter Bedi Industrial Photography, Behind Taj, Gateway of India, Bombay 400 039, India.

Individual Exhibitions:

1969 *Industrial Photography*, Jehangir Art Gallery, Bombay

Selected Group Exhibitions:

1970 *Commercial Artists Guild Annual Exhibition*, Jehangir Art Gallery, Bombay (and subsequent exhibitions through 1980)

Publications:

By BEDI: articles—"Those Good Old Days of Photography" in *First All-India Photographic Products Exhibition*, catalogue, Bombay 1978; "A Commitment to Industrial Photography" in *Kodak News* (Bombay), September 1978; "Photokina: The World of Photography" in *Dharamyug* (Bombay), 23 September 1979; "A Homage to Photography" in *Advertising Directory*, Bombay 1979; "High Adventure in Photography" in *Agfa Photo Gallery* (Bombay), January 1980.

On BEDI: articles—"Leading Photographers of India" by Dr. Chinwala in *Illustrated Weekly of India* (Bombay), 2 January 1959; "Mitter Bedi, Indian Photographer" by Ulf Sjöstedt in *Hasselblad Magazine* (Gothenburg, Sweden), January 1973; "Art in Industry" by Gayatri Sondhi in *Fortnight Weekly* (New Delhi), 25 July 1979; "Photographers on Models" by Mohan Deep in *Caravan* (New Delhi), August 1979; "Future Shock" in *Bombay Magazine*, 7 April 1980; "A Pioneer in Industrial Photography" in *Business India* (Bombay), 23 June 1980.

A few years ago, after Independence, India was moving towards industrialization. I started in the profession around 1954, and noticed the change that was coming in.

In 1958 I quit being a general photograper and became, exclusively, an industrial photographer. My own inexperience and the very low demand for this little-known branch of photography made the first few years very tough. It took a lot of hard work and patience to create an awareness of proper industrial photography among the business community. I did feel a bit discouraged—having given up a lucrative business. But, thank God, I did not give up. At that time the shortages of manufactured goods in India kept industrial and advertising photography next to nil, which meant very little work for me. But, with the gradual increase in production, my work caught on. I literally grew with industry, sharing its growth and prosperity. I contributed a lot of useful work towards our export promotion abroad, and I felf myself really doing a service to my country through the medium of photography. The promotion of tourism created many new challenges, and I am proud that I met them creditably.

I did a few important jobs for advertising agencies, as they too were growing rapidly, but I preferred industrial photography, which gave me much more satisfaction. I am glad that I pioneered this branch of photography in my country, and pleased that a good number of promising young people are now entering this field. Photography has still a long way to go in India, but I am sure we will "make it" sooner than is generally expected. We are already the 8th largest industrial nation in the world.

My generation of photographers in India had to meet the demand of changing times with numerous handicaps and very low fees, and I do not think we were able to evolve a philosophy of our own contemporary photography. I have, however, I hope, set standards that younger people can follow. I really did not have the kind of time available to indulge in the luxury of "Art Photography" or "Photography-for-Art's Sake."

A few of us now have international acceptance, and I have been extensively rewarded both by private institutions and by the government. I have been a teacher of photography for over five years, and I have now started my own academy, teaching both Basic and Advanced photography.

Photography in India is slowly discovering its place in society and its role as a communicator. The efforts of photographers are helping to bridge the gap created by many languages and many more dialects throughout the country, besides promoting business and industry, and aiding the growing field of education.

—Mitter Bedi

As a boy he played with a Kodak box camera, worked in his family printing press in his teens, then he moved into the movie world of India as a public relations assistant. Photography was a suppressed passion in Mitter Bedi until, at the age of 27, he finally decided to devote his life to the art. His career in photography has passed through stages—a short stint in photo-journalism, a period of unusual theatre-photography, and advertising. His huge enlarged pictures in the 1956 *International Industry Fair* in New Delhi immediately attracted national and international attention. And it was industrial photography that Bedi took up in 1958 as his life's vocation. Now, 25 years later, he is India's finest industrial photographer with a worldwide reputation. With his Hasselblads, he has not only recorded the industrial growth of a new nation, but also has made industrial photography an art-form.

For Bedi, this kind of photography does not mean just taking publicity pictures of machines and machine-hands. His firm belief is that "the subject must come alive, communicate...in the most creative manner possible." This is the unique feature of his photography—the power of communication. Lathes, pipes, cranes, bottles, and structures convey the sense of their particular materiality as well as suggest a story. This is evident even in the photographs of interiors like those of the Taj Hotel in Bombay and the Royal Palace in Muscat. The pictures of pharmaceutical bottles of all shapes and sizes carefully arranged, in the simplicity of composition and subtle manipulation of light and colour, are remarkable examples of aesthetic and communicational effectiveness. Long pipes zooming out from the bot-

tom to the top of the picture, slightly out of focus at the bottom and becoming more and more clear and shimmering in the middle of the frame, then becoming all lighted and shining at the top, while from the two sides the pipes get smaller in size, creating the illusion of convergence, is a masterful manipulation of photographic elements. His "Piston" images are a brilliant series.

Another strong feature in his industrial photography is the dimension of human value, even though no human figure is in the image. The pictures of small or giant machines, ordinary bottles, unglamourous pipes or cranes become a tribute to human ingenuity, craft and knowledge. Bedi's sense of colour, texture, and tone, and his manipulation of light and space in his better photographs are always so precise and subtle. It is this sense which gives a peculiar sensuous reality to his pictures of arrangements of forks and spoons, dead lobsters, and partytables, or those remarkable pictures of a steel tube factory in operation with all sorts of firecrackerish designs.

Mitter Bedi is an outstanding teacher; his Academy in Bombay is a major photography institution with national and international students and teachers. Despite many difficulties, Mitter Bedi continues to display his talents both as a photographer and teacher in a matchless manner.

—Deba P. Patnaik

BELLMER, Hans.

German. Born in Katowice, Silesia, Germany/Poland border (now in Poland), 13 March 1902. Studied engineering, Technische Hochschule, Berlin, 1923-24; drawing and perspective studies with artist George Grosz, Berlin, 1924; mainly self-taught in photography. Married Margarete Bellmer in 1927 (died, 1937); 2 daughters; married again in 1942 (separated, 1946); twin daughters: Doraine and Beatrice; lived with poetess Nora Mitrani, 1946, and with writer Unica Zurn, 1953-70 (died, 1970). Worked as coal-miner, Katowice, 1920-23; designer, typographer and illustrator, for Malik Publishing Company, Berlin, 1924-25; independent painter and designer, Berlin, 1926-36, in Paris, 1936-39; interned in prison camp, Aix-en-Provence, France, 1940; independent painter and designer, Toulouse, France, 1941-45, and Paris, 1946 until his death, 1975. Worked on photographs of puppet doll (Die Puppe), Berlin, 1934-36, and in Paris, 1936-39, 1946-75. Recipient: William and Noma Copley Foundation Prize, Chicago, 1958. *Died* (in Paris) *23 February 1975.*

Individual Exhibitions:

1943 Galerie Trentin, Toulouse
1945 Galerie du Luxembourg, Paris
1963 Galerie Daniel Cordier, Paris
1966 Robert Fraser Gallery, London
　　 Galerie Sydow, Frankfurt
　　 Robert Self Gallery, London
　　 Ulmer Museum, Ulm, West Germany
　　 Galerie Benador, Geneva
　　 Galerie Gmurzynska, Cologne
1967 Galerie A.F. Petit, Paris
　　 Kestner Gesellschaft, Hannover (retrospective)
　　 Galerie Wolfgang Ketterer, Munich
　　 Galleria d'Arte Moderna, Turin
　　 Galerie Thomas, Munich and Cologne
1969 Galerie A.F. Petit, Paris
1970 Stedelijk Museum, Amsterdam
　　 Galerie La Pochade, Paris

1971 Centre National d'Art Contemporain, Paris (retrospective)
　　 Von der Heydt Museum, Wuppertal, West Germany
1971 Lerner-Misrachi Gallery, New York
　　 Sidney Janis Gallery, New York
　　 Editions Graphiques, London
1974 Sidney Janis Gallery, New York
　　 Galerie Schindler, Berne
1975 Museum of Contemporary Art, Chicago
　　 Galerie A.F. Petit, Paris
1980 *Les Jeux de la Poupée*, Vision Gallery, Boston

Selected Group Exhibitions:

1935 *Exposicion Surealista*, Galeria Ateneo, Tenerife, Canary Islands
1936 *International Surrealist Exhibition*, Museum of Modern Art, New York
1947 *Exposition Internationale du Surrealisme*, Galerie Maeght, Paris
1960 *Exposition Internationale du Surrealisme*, Galerie Daniel Cordier, Paris
1977 *Künstlerphotographien im 20. Jahrhundert*, Kestner Gesellschaft, Hannover
1978 *Dada and Surrealism Reviewed*, Hayward Gallery, London
1979 *Photographic Surrealism*, New Gallery of Contemporary Art, Cleveland, Ohio (travelled to Dayton Art Institute, Ohio; and Brooklyn Museum, New York)
1980 *Masks, Mannequins and Dolls*, Prakapas Gallery, New York
　　 Avant-Garde Photography in Germany 1919-39, San Francisco Museum of Modern Art (toured the United States)
1981 *Germany: The New Vision*, Fraenkel Gallery, San Francisco

Hans Bellmer: From *Die Puppe,* **1934**　Courtesy Art Institute of Chicago

Collections:

Musée d'Art Moderne, Paris; Ulmer Museum, Ulm, West Germany; Galerie Brusberg, Hannover; Museum of Modern Art, New York; Institute for Sex Research, University of Indiana, Bloomington; Art Institute of Chicago.

Publications:

By BELLMER: books—*Die Puppe*, Karlsruhe 1934, Paris 1936, revised edition, Berlin 1962; *The Story of Eve*, with text by Georges Bataille, Paris 1944; *Les Jeux de la Poupée*, with text by Paul Eluard, Paris 1949; *L'Anatomie de l'Image*, Paris 1957; *A Sade*, Paris 1967; *Madame Edwarda*, with text by Georges Bataille, Paris 1965; *Mode d'Emploi*, Paris 1967.

On BELLMER: books—*Hans Bellmer* by Christian d'Orgeix, Paris 1950; *Hans Bellmer* by Alain Jouffroy, Chicago and London 1959; *Les Dessins de Hans Bellmer*, edited by Constantin Jelenski, Paris 1966; *Hans Bellmer: Oeuvre Gravé* by André Pieyre de Mandiargues, Paris 1969; *CNAC Archives I: Hans Bellmer*, exhibition catalogue, by Paul Eluard and others, Paris 1971; *The Drawings of Hans Bellmer*, edited by Alex Grall, London 1972, New York 1973; *Hans Bellmer* by Sarane Alexandrian, Paris 1972, New York 1973; *Photography as Art* by Volker Kahmen, London 1974; *Künstlerphotographien im XX. Jahrhundert*, exhibition catalogue, by Carl-Albrecht Haenlein, Hannover 1977; *Geschichte der Fotografie im 20. Jahrhundert/Photography in the 20th Century* by Petr Tausk, Cologne 1977, London 1980; *Dada and Surrealism Reviewed*, exhibition catalogue, by Dawn Ades, London 1978; *Le Trésor Cruel de Hans Bellmer* by André Pieyre de Mandiargues, Paris 1979; *Photographic Surrealism*, exhibition catalogue, by Nancy Hall-Duncan, Cleveland 1979; *Avant-Garde Photography in Germany 1919-39*, exhibition catalogue, by Van Deren Coke, Ute Eskildsen and Bernd Lohse, San Francisco 1980; articles—"Hans Bellmer: The Machine-Gun in a State of Grace" by John Lyle in *Art and Artists* (London), August 1970; "Balthus, Klossowski, Bellmer: Three Approaches to the Flesh" by Michael Peppiatt in *Art International* (Lugano, Switzerland), October 1973; "Le Rêve et le Désir: Au Regard de la Poupée" by J.C. Bailly in *XX Siècle* (Paris), June 1974; "Hans Bellmer: Obituary" in *Connaissance des Arts* (Paris), May 1975.

Hans Bellmer received acclaim on many levels and was internationally accorded the highest praise for the amazing delicacy of his draughtsmanship paralleled by an extraordinary facility to top pornography with a lacing of humour. As a brilliant and totally original sculptor, he turned lay-figures into doll-fetiches—in a sense, almost sophisticated toys—whose limbs, head, hands and feet could be disjointed and then reassembled differently, yet so harmoniously that somehow this new pattern of conjunctions was visually acceptable. The roundedness in Bellmer's sculpture of every ancillary part of the female human form offered a peculiarly photoattractive opportunity to the camera, so it was not surprising that Bellmer should expand his artistic range to include photography.

However, what is more to the point in this book of modern photographers is that Bellmer proved to be much more than merely adept in this medium. Sometimes the "photographs" would be an assemblage of several photos pieced together. At other times the original photo or parts of photo would be enlarged to twice or more times the size of the original object; the largest of these might enjoy dimensions of 6 ft. x 3¾ ft. and were usually laid on hard card. Working in black-and-white, he would sometimes "invent" tints to colour the finished work, drenching the image in an all-over transparency of pink or blue.

But apart from experimental subject matter and the application of personal techniques, what else had this one-time friend of and co-exhibitor with Man Ray and the other proto-surrealists to add to the history of modern creative photography?

The question is at once easy and difficult to answer. Easy, because Bellmer enjoyed his personal relationship with cameracraft. In this medium, not only could he experiment and record plans—both projected and achieved—as an aid to his work as draughtsman and sculptor, but he was also able to bring positive intentions to fruition before their official naissance. Furthermore, he could imbue the *quality* of photography (by no means lacking in the hands of others, even those favouring similar visual investigations) with a special ingredient: that of an over-powering point-of-contact with absolute carnal femininity, both shameless and shameful at the same time. Because of his obsession with puppetry (through his incredible dismemberable female lay-figures whose every segment was rich in rotundity), he could endow these dolls with an anonymity insofar as character was concerned, and yet could express through them an archetypical femininity.

Of course, there are many who would say: "What about the drawings? What about the actual sculptures? Don't they achieve ends just as 'identical?'" A summation of his work with the camera is difficult because in a sense, photography was for him almost a private activity. He created his photographic oeuvres partly for his own pleasure, partly to aid and abet the working requirements of his other artistic talents. Therefore, his photographic works were likely to languish in his studio—unless they fell by sheer chance into the hands of friends and acquaintances. If they appeared at all in exhibitions, it was to add emphasis to works in quite different media. Only later, when his world reputation as a creative genius was confirmed, were the photographs put on view to the public in their own right.

On this evidence, does Bellmer qualify as one of modern photography's giants? As in the case of the multi-faceted Picasso, he was able to disprove the traditional view, "Jack-of-all-trades; master of none!"

—Sheldon Williams

BELLOCQ, E(rnest) J(ames).

American. Born in New Orleans, Louisiana, 15 March 1873. Educated at schools in New Orleans; mainly self-taught in photography. Worked as a clerk for a wholesale shoe company, Troy Laundry Company, Crescent City Cork Works, etc., New Orleans, 1898-1908; freelance commercial photographer, New Orleans, 1908-12; established commercial portrait, topographical and industrial photography studio, New Orleans, 1912-38: worked primarily for Foundation Company Shipbuilders, New Orleans, 1918-35; retired from commercial photography, 1938. *Died* (in New Orleans) *in 1940.*

Individual Exhibitions:

1970 *Storyville Portraits*, Museum of Modern Art, New York
1971 Delgado Museum of Art, New Orleans
 Witkin Gallery, New York
1976 *Storyville Portraits*, Yajima Galerie, Montreal (travelled to The Photographers' Gallery, London, 1977).
1977 Suzette Schochet Gallery, Newport, Rhode Island

Light Gallery, New York (with Lee Friedlander)
1981 *Storyville Portraits*, Robert Freidus Gallery, New York

Selected Group Exhibitions:

1979 *Photography Rediscovered: American Photographs 1900-1930*, Whitney Museum, New York (travelled to the Art Institute of Chicago)
 Photographie als Kunst 1879-1979, Tiroler Landesmuseum Ferdinandeum, Innsbruck, Austria (travelled to Neue Galerie am Wolfgang Gurlitt Museum, Linz, Austria; Neue Galerie am Landesmuseum Joanneum, Graz, Austria; and Museum des 20. Jahrhunderts, Vienna)
1980 *Old and Modern Masters of Photography*, Victoria and Albert Museum, London
1981 *The Nude in Photography*, San Francisco Museum of Modern Art

Collections:

Museum of Modern Art, New York; New Orleans Museum of Art.

Publications:

By BELLOCQ: book—*E.J. Bellocq: Storyville Portraits*, edited by John Szarkowski, with a preface by Lee Friedlander, New York and London 1970.

On BELLOCQ: books—*Looking at Photographs: 100 Pictures from the Collection of the Museum of Modern Art* by John Szarkowski, New York 1973; *Storyville, New Orleans: Being an Authentic, Illustrated Account of the Notorious Red-Light District*, University, Alabama 1974; *Photographie als Kunst 1879-1979/Kunst als Photographie 1949-1979*, exhibition catalogue, 2 vols., by Peter Weiermair, Innsbruck, Austria 1979; *Photography Rediscovered: American Photographs 1900-1930*, exhibition catalogue, by David Travis, New York 1979; *The Photograph Collector's Guide* by Lee D. Witkin and Barbara London, Boston and London 1979; *Old and Modern Masters of Photography*, exhibition catalogue, edited by Mark Haworth-Booth, London 1980.

Every great photographer is unique in his achievement; E.J. Bellocq, however, occupies a position that is both unique and unparalleled in the history of photography. Unknown and isolated in his life, famous after his death for a single series of negatives that survived and was discovered by chance alone, the Storyville pictures, Bellocq bypasses the usual art-historical questions. He can only be approached through the photographs themselves, lovingly recreated by Lee Friedlander (who saved and printed them), with the result that we are forced to look at his work in its pure essence, undisturbed by considerations of history, influence or derivation.

The clearest pointer to the particular nature of Bellocq's greatness can be found in his relationship with his subjects, as expressed in the photographs. The Storyville pictures, nudes and portraits of girls in the brothel quarter of New Orleans, come across as collaborations in which Bellocq has persuaded his sitters to present themselves as they wish to be seen and their characters as they feel them to be. Time and again one senses that everything about the photograph—the clothes, the pose, the situation—is to the girl's choice, and that the expression on her face is a true reflection of her personality and feelings. And every girl—whether stout or slim, freshly young or past the first bloom of her youth—is shown to possess both dignity and beauty. Although the pictures, like the girls themselves, are obviously

conditioned by the dubious surroundings, they are profoundly innocent. Bellocq's vision was never prurient, never concerned with empty glamour or fake romance, but responded truthfully to the grace inherent in all humanity.

To be able to see the grace of the world in its most humble aspects, to respond so freshly to the variety of human aspirations and individuality, is in itself a form of genius. Photography, though, like every art, demands the expression of perception through form and substance. In the finest work, form and feeling are perfectly matched and fuse into an indissoluble unity. So it is with Bellocq, whose technique is as direct and honest as his human approach. His pictures are clear and sharply-focussed, without tricks or gimmicks; nothing is fudged or concealed. While none of Bellocq's own prints survive, it is clear from Friedlander's excellent re-creations that light and tone have been carefully considered. Silks and lace sparkle, skin-tones possess a luminous glow, and the overall chiaroscuro of each picture is strongly designed to direct attention to the figure and the face. There is a sure sense of formal organization to each image and a delight in strong but simple geometric constructions. Indoors, common domestic elements—doorways, bedsteads, chairs, tallboys, couches—are used to make solid spatial frameworks which compliment the soft curves of the body. Outside, a window, screen or simple rectangle of draped cloth fulfills the same function. The pictorial structure never overwhelms the figure, and frequent visual "accidents"—a row of washing on a line, a dangling flex, a crooked array of pictures on a wall—provide a casual vitality which prevents the photograph from becoming over-contrived or rigid. Bellocq was happy to return again to a successful format and his range of compositional devices was fairly limited. Within these restrictions, though, he achieved a

formal richness and a spatial harmony that matched the human and emotional interest of his subjects.

From the scanty memories that have survived, it seems that Bellocq was not a particularly cultivated man. A competent but unambitious commercial photographer in his daily work, it is unlikely that he would have considered his private pictures in any way as "art". Nevertheless, they unmistakeably combine a penetrating sensibility with a defined and powerful artistry to a degree that is rare in any medium. They are moving equally for the serene generosity, the emotional variety and warmth of the man's response to his subjects, and for their beauty as individual objects. Very simply, they are the products of a man who understood his fellow creatures, and how to tell us of them.

—Tom Evans

BENEDICT-JONES, Linda.

American. Born Linda Benedict in Beloit, Wisconsin, 21 October 1947. Educated at the University of Wisconsin at LaCrosse, 1965-69, B.S. (honors) 1969; Massachusetts Institute of Technology, Cambridge, 1980-82, M.S. in Visual Studies 1982; also studied Portuguese language and culture at the University of Lisbon, 1971-72, and French at the Alliance Francaise, Paris, 1973-75, Dip.Sup. 1975. Married Christopher Mark Jones in 1968. Freelance photographer since 1969. Instructor, American Language Institute, Lisbon, 1972-73, Technip, Rueil-Malmaison, France, 1973-75, and London College of Printing, 1977-79. Recipient: Arts Council of Great Britain grant, 1977. Agents: Galerie Fiolet, Herengracht 86, 1016 Amsterdam, Netherlands; and The Photographers' Gallery, 8 Great Newport Street, London WC2, England. Address: 43 Royal Avenue, Cambridge, Massachusetts 02138, U.S.A.

Individual Exhibitions:

1973 *Imagens de Portugal*, Centro Cultural Americano, Lisbon
 O Orfeu, Porto, Portugal
1976 Madison Art Gallery, Wisconsin
 Time Release, Galerie Fiolet, Amsterdam
 Photographs by Linda Benedict-Jones and Bruno, Photographic Gallery, University of Southhampton
1977 *Self-Portraits*, Galerie Nicéphore, Bollwiller, France
1979 *Quiet Places*, Graves Art Gallery, Sheffield
1980 Sunprint Gallery, Madison, Wisconsin
1981 Galerie Fiolet, Amsterdam

Selected Group Exhibitions:

1977 *Self-Impressions*, The Photographers Gallery, London
1978 *La Photographie Actuelle en France 1978*, Galerie Contrejour, Paris (and world tour, 1978-81)
 8 by 8, Air Gallery, San Francisco

Linda Benedict-Jones: *Lake Cormorant, Minnesota,* 1977

1979 *Landscape, Cityscape, Seascape*, London College of Printing
1980 *The Automotive Image*, Creative Photo Laboratory, Massachusetts Institute of Technology, Cambridge
Transparence, Galerie Viviane Esders, Paris
Corps/Mouvements, Galerie Viviane Esders, Paris

Collections:

Department of the Environment, London; Photographic Gallery, University of Southhampton; Graves Art Gallery, Sheffield; Bibliothèque Nationale, Paris; Musée Cantini, Marseilles; Musée d'Art et d'Histoire, Fribourg.

Publications:

By BENEDICT-JONES: books—*Time-Release*, portfolio, Amsterdam 1977; *In/Sights: Self-Portraits by Women*, with others, edited by Joyce Tenneson Cohen, Boston 1978, London 1979; *Women on Women*, with others, London 1978; articles—untitled article in *35mm Photography* (New York), Spring 1978; "Interior and Exterior Realities" in *Print Letter* (Lucerne), December 1979; "Minor White at MIT 1965-1976: Contributions and Controversy" in *Positive*, Autumn 1980.

On BENEDICT-JONES: articles—in *Diario de Lisboa*, February 1972; *Contrejour* (Paris), October 1976; *Le Nouveau Photo-Cinema* (Paris), November 1976; *Foto* (Amersfoort, Netherlands), March 1977; *British Journal of Photography* (London), April 1977; *Nueva Lente* (Madrid), October 1977; *Progresso Fotografico* (Milan), December 1978.

It was eleven years ago that I first started taking pictures. That space of time has allowed me to live in four countries and learn many new languages, both verbal and visual. In the beginning the world was a window to me, and whatever I saw through that pane of glass was fair game for my film. As time went on I began seeing my reflection in the window until it eventually became a mirror. Finding visual expression of the emotions I felt inside myself then pre-occupied me for several years. Most recently, I've been trying to integrate the two visions by retaining the strength of what I've learned from each.

The pictures from that eleven-year period reflect some of the concerns that I've dealt with personally...concerns like presence and absence...like singularity, duality or plurality...and the delicate balance that usually exists between interior and exterior realities.

—Linda Benedict-Jones

Historically men's photography of women has been almost exclusively concerned with their bodies not their minds, and this is particularly true of commercial photography. The rise of the women's movement helped identify and name ("sexist") this phenomenon without managing to change it. Instead there grew up a sort of counter-movement: women's self-portraiture. Women photographed their own less-than-perfect bodies and lifestyles in opposition to the "centrefold" culture of the mass media.

Mostly this happened in America, but in a way it was pioneered in Europe by Linda Benedict-Jones, an isolated expatriate. When The Photographers' Gallery in London mounted a group show of female self-portraiture her work was included. One of the Americans whose work was imported for the exhibition was Joyce Tenneson Cohen, who later produced the book *In Sights*. Apparently she was deluged with examples of self-portraits by women, but she found room for one print by Linda Benedict-Jones.

However, Benedict-Jones's work is not typical of the movement in general. She is neither a mystic nor a self-parodist, does not concern herself with women's role in society, and does not have much of a sense of humor (or only a very, very dry one).

In fact she seems less concerned with forming an identity than with her very existence, merely documenting her own minimal impact on the world. Rather than asserting her presence or her own, unique femininity, she tends to show herself blending in with her surroundings. In the Galerie Fiolet portfolio, for example, there is a print ("Self-Portrait," 1977) which shows her standing by a window. It includes her hands, but not her face; her white nightdress matches the tone of the window frame, with which she blends. In another print ("Ziona, Wales," 1978) you get to see the back of her head, but the main point of the picture is the similarity of tone and texture of her cardigan and the waste ground on which she is standing.

In several of her pictures she curls into a ball, her arms clasped round her legs; she coils-up foetus-like in the bath; she moves during time exposures to blur her presence. Sometimes she uses double-exposures so that when her face appears it is only as a ghost. In the more extreme cases of her self-effacement she does not appear in the pictures at all! For example, one picture in the Fiolet Portfolio shows a sofa; only through the lighting and the rumples in the sofa's cloth covering can you detect her recent presence. Another picture which has been widely published is of a blouse, backlit, on a hanger. It fills the frame. After a time you notice that the fourth button-hole below the collar is more distended than the higher and lower ones. In such minute particulars can femininity be located!

Linda Benedict-Jones's work is lyrical, sensitive and carefully observed, and its interest to women must be clear. However, this hardly explains why her pictures have been exhibited and published widely, or how she became one of the few photographers to be treated seriously by a British television arts programme. The media are still male dominated, and the modicum of nudity in Benedict-Jones's self-portraits could not account for it. Perhaps part of the reason is that viewing the pictures is slightly voyeuristic—like reading someone's secret diary. This can produce a *frisson* of excitement even if it does not include anything of major significance.

Before she became a self-portraitist, Benedict-Jones was successful, in a small way, as a portraitist and as a photographer of basketball (her husband played). She has since tried to break out of self-

portrait photography, but without generating any similar interest in the photographic magazines and galleries. She seems able to find ways of expressing her own inner realities in ways that enable other people to share them, but not able to capture the larger realities of the outer world.

—Jack Schofield

BENNETT, Derek.
American. Born in Buffalo, New York, 13 October 1944. Educated at Sir George Williams University, Montreal, 1964-69, B.A. in English 1969. Married Ruth Huber in 1973; children: Leif and Jennifer. Freelance photographer, in Switzerland, since 1971. Agent: Silver Image Gallery, 83 South Washington, Seattle, Washington 98104, U.S.A. Address: Finsterwaldstrasse 23, CH-8200 Schaffhausen, Switzerland.

Individual Exhibitions:

1974 *Fathers and Sons*, Silver Image Gallery, Tacoma, Washington
Schaffhausen Kunstverein, Switzerland
1976 Arnolfini Arts Centre, Bristol
The Swiss Photographs, Silver Image Gallery, Seattle (travelled to Gallery 38, Zurich)
Paul Caponigro/Edward Weston/Derek Bennett, Silver Image Gallery, Seattle
Gallery Tolgge, Zurich
1978 *Spaces*, Gallery Paule Pia, Antwerp (travelled to Il Diaframma, Milan, Photo Art, Basel, and Canon Gallery, Geneva, 1979)
1981 Galerie Novum, Hannover

Selected Group Exhibitions:

1976 *The Human Image in 20th Century Photography*, University of Washington Art Museum, Seattle

Derek Bennett: *Zurich*, 1978

Collections:

Bibliothèque Nationale, Paris; Polaroid Collection, Amsterdam.

Publications:

By BENNETT: articles—"Arles Meeting in Critical Phase," with Marco Misani, in *Print Letter* (Zurich), September 1976; "The Arles Book Workshop: Stalemate" in *Print Letter* (Zurich), September 1977; "Evolution and Revolution in Book Publishing" in *Print Letter* (Zurich), November 1977; "Moving Past the Mind, Past the Heart....," interview with Paul Caponigro, in *Print Letter* (Zurich), November 1977; "Jan Saudek: 'I'm Led by Instinct' " in *Print Letter* (Zurich), March 1978; "The Limited Edition Portfolio: A Special Report" in *Print Letter* (Zurich), May 1978; "European Photography and the American Sensibility" in *European Photography* (Göttingen), January 1980; "Image and Reality: Seven Aspects of Subjective Photography" in *European Photography* (Göttingen), April 1980.

On BENNETT: articles—"Derek Bennett," interview, with Marco Misani, in *Print Letter* (Zurich), July 1978; "Portfolio: Derek Bennett" in *Fotografie* (Göttingen), January 1979.

My work keeps changing, in some cases very drastically, because my personal and photographic concerns keep changing. Even so, in specific images I can see the single thread running through all the various series I have worked on. It's this thread which interests me the most. In a sense, the various series simply form a context within which I can follow the thread wherever it leads me. The first photographs I took more or less consciously were street portraits of Castro's Cuban revolutionary soldiers when I was 14 years old. About 20 years later, I suddenly found myself doing approximately the same thing, but in Germany. The "coincidence" shocked me at first, but it soon took on another kind of significance.

All art is largely a process of distillation, and photography itself has always seemed almost alchemical to me. I think probably most photographers expect to discover a kind of personal philosopher's stone within the medium, or at least within

their own work. The darkroom is obviously alchemical in nature—especially when exactly that photograph you wanted begins slowly to appear in the developer. There is an urge to jump up and shout "Eureka!" Something in the nature of the world or in the nature of simple being is clarified at that moment, and the seemingly endless process of distillation you have gone through suddenly makes itself manifest.

Photography is an eminently visual medium, more so than painting because a photograph is less tactile than a painting. Some photographs may ultimately speak to the intellect, but if they don't first attach themselves directly to the eye of the viewer, I think they ultimately fail. Personally, I have never seen a "logical" photograph, although I have seen many which attempt to express the visual world logically. But the best photographs always contain something that we cannot quite explain. I suspect that the world functions a lot differently than we think it does, and, often enough, I find that photographs bear out my suspicions.

I also suspect that photography serves an historical function having little to do with the relatively simple process of making photographs. Possibly, like the wheel, the abacus, or moveable type, photography will be seen in the future to have been the result of a kind of spontaneous combustion within the process of human "progress" or a *deus-ex-machina*. I doubt that we have even begun to understand what the camera has "done" to us, and probably it will take the death of the medium for us to find out. In the meantime, Man-the-image-maker continues to take pictures, trying to find something in his experience of the world which has the nature of a revelation.

—Derek Bennett

As Derek Bennett himself once noted, apparently the highest goal of the photographic critic is to place the photographer's work in one or another "school." Such would in any case by difficult to do with Bennett's own work: one ould be hard put to recognize if his work is of "mirrors" or of "windows" (in the Szarkowskian sense).

Bennett's early work—from the late 1960's to the mid-1970's—took its cues from what has come to be known as street photography—windows, definitely. But then his work took a sudden turn, as if photography were now a two-way mirror, to reflect and to

be looked through simultaneously. His "Spaces" series of 1976-78 consisted of easily identified, subjectively perceived and realized details of his personal environment. The "subjectivity" of these photographs arose primarily from an intellectual process influenced by personal experience, valuations, reflexes and recognitions. With time, all of these mental attitudes were transformed, and thus Bennett's approach to photography was also transformed, sometimes less, sometimes more. In the "Spaces" photographs, it is not the objects themselves—say, a nearly frame-filling white shirt on a man in a crowd—which visually please, but their suggestive aesthetic qualities, the transformation of objects, the abstractions, the intellections.

Bennett's next large series was seemingly informed solely by the tenets of straight documentary photography. It dealt with portraits of Germans—"in the footsteps of August Sander." Bennett says. That would admit of an attempt to choose subjects according to a typology, which of course invariably reflects the photographer himself. The apparent documentary nature of the attempt resulted in the subjectivity of Bennett's eye belying anything more than a superficial difference—resting, so to speak, on the surface of the photographic paper—between "Spaces" and the German portraits.

In Bennett's work as a whole, if it is not ultimately always windows or always mirrors, it is conceivably both at once.

—Hans Christian Adam

BENTON-HARRIS, John.

American. Born in New York City, 28 September 1939. Educated at St. Lukes Catholic Grammar School, New York, 1948-56; Norris High School, New York, 1956-60; City College of New York, 1960-61; Alexey Brodovitch's Design Laboratory,

John Benton-Harris: England—*The Lord Mayor's Show, Outer Temple, London*, 1974; America—*Remembering the War Dead at Grant's Tomb, New York City Armed Forces Day Parade*, 1979

Richard Avedon Studio, New York. Served in the United States Army, in San Pedro, California, and Vicenza, Italy, 1963-65. Married Jane Gaffney in 1966; children: Emma, Mark, and Jessica. Industrial Photographer, Sinclair Oil Company, New York, 1960-63; Staff Photographer, *London Life*, 1965-66. Freelance photographer, London, since 1966. Part-Time Lecturer, Wimbledon College of Art, London, 1971-80; External Assessor, 1972, and Visiting Lecturer, 1973, 1975, 1976, Trent Polytechnic, Nottingham; Visiting Lecturer, West Surrey College of Art, Farnham, 1977, 1978, 1979; Workshop Lecturer, Brewery Arts Centre, Kendal, Cumbria, 1978, 1980, and Gwent College of Further Education, Newport, Wales, 1980. Recipient: Arts Council of Great Britain grants, 1972, 1973, 1974; Merit Award (3), Art Directors Club of New York, 1978. Address: 25 Morland Avenue, Croydon, Surrey CRO 6EA, England.

Individual Exhibitions:

1962 Cafe Figaro, Greenwich Village, New York
1971 *Old Masters Were Young Once*, Serpentine Gallery, London
1972 Trent Polytechnic, Nottingham
1973 *A Walk in New York*, Impressions Gallery, York
1979 *Derby Day*, Brewery Arts Centre, Kendal, Cumbria
1981 The Photographers' Gallery, London

Selected Group Exhibitions:

1971 *Personal Views*, Arts Council travelling exhibition
1972 *2 Views*, The Photographers' Gallery, London (travelled to Poole Museum, Dorset, and Huddersfield Town Hall, Yorkshire)
11 British Photographers, Southampton Art Gallery
1974 *Midland Group Open*, Midland Group Gallery, Nottingham
1979 *Derby Day 200*, Royal Academy of Art, London
1980 *British Art 1940-1980*, Hayward Gallery, London
Eastern Arts Project, Minories Art Centre, Colchester, Essex

Collections:

Museum of Modern Art, New York; Victoria and Albert Museum, London; Arts Council of Great Britain, London.

Publications:

By BENTON-HARRIS: articles—"A Foggy Day in London Town" in *American Photographer* (New York), July 1978; "Book Review: Homecoming" in *British Journal of Photography* (London), 25 April 1980.

On BENTON-HARRIS: book—*Creative Camera Collection 5*, edited by Peter Turner and Colin Osman, London 1979; articles—"Benton-Harris on People" in *Amateur Photography* (London), August 1971; "Boot Camp" in *Creative Camera* (London), September 1971; "A Walk in New York" in *Creative Camera* (London), February 1974; "Yankee Eye—on the English" by Peter Turner in *Modern Photography* (New York), October 1977; "Benton-Harris at Home" in *Amateur Photographer* (London), August 1978; "International Year of the Child" in *British Journal of Photography* (London), August 1979; "Course Gestures" in *Amateur Photographer* (London), October 1979; "Derby Day" in *British Journal of Photography* (London), June 1980; "Street Life" in *Amateur Photographer* (London), July 1980.

My work has two primary strands, reflecting my long-term involvement with the cultures I know best: England and America.

In England, I have been drawn primarily to upper-class life as relected in such beanfeasts as Ascot, Henley, or the Derby. I have found that upper-class society, by its very nature, is secretive and wary of observation, except on those rare public occasions (one reason why I have perhaps been too obsessed in the past with prising the lid off this secrecy). I am also fascinated by the sustained belief of the English in Empire: the clinging to faded glories that is almost the only thing to cut across pervading class barriers.

My concerns in America are similar, yet different—for the Americans, obsession with the past is derived from the present, rather than from history itself. America is undeniably a new country, a culture dominated by frenzy, speed, instability, disposability, newness, adventure, innovation. Hence the collective American obsession with roots, with cultural and historical identity. There is a crying need to relate to something other than the fast buck, the hot dog, or the latest technological toy.

America is the supreme country of the individual, yet it is a country without real individual identity. So the American looks to the group, the tribe, the team, for cultural and personal fulfilment. America is an aggressively tribal society, and much more provincial than Europe. Every town, every ethnic group, club or clique, proclaims proudly and fiercely its collective identity. The barriers in American society are club rather than class.

—John Benton-Harris

An American, resident in England for many years, John Benton-Harris has still the outsider's view of the British. This leads him to explore our eccentricities with a kindly if sometimes doubtful eye: he may not always approve, but he will give us the benefit of the doubt. His visits to the Derby each year have become an annual pilgrimage, but for the most part his work is a combination of individual pictures; consideration as a series is certainly subsidiary to any one picture. He has also taken many pictures at The St. Patrick's Day Parade in New York and other annual events, but he uses these occasions as opportunities to find the pictures he wants rather than as a documentary of the event itself.

In most cases the people he photographs are aware of him, sometimes only one person in a group perhaps, but this contact is an important part of the picture; it also brings the viewer into the secret, so that we become part of what is happening and involved in the action.

John Benton-Harris brings an intensity to his work that comes through in the strong composition: each line our eyes follow adds to the sum of the subject and confirms and strengthens us in our idea of its importance. It is by no means a graphic line for its own sake, but only satisfies him when it continues to confirm our first impression and adds appreciably to the sum of the parts of the picture. These pictures never give the impression of being "snatched"; they are clearly stalked, waited for and captured at precisely that moment when everything in the frame works together. It is by no means an aggressive approach; there may be humour, but it is a smile not a guffaw, and we are always included in it ourselves. We never find that we are laughing at anyone, but rather with them at some general situation or circumstance.

There is no doubt that John Benton-Harris is extremely serious about his work. He feels it impossible to undertake assignments where instant results are required, and therefore earns his living as a teacher rather than in some other branch of photography. This concern for integrity shines through his pictures, and somehow he includes us in the concern and affection he feels for humanity in general.

—Sue Davies

BENY, Roloff.

Canadian. Born Wilfred Roy Beny in Medicine Hat, Alberta, 7 January 1924. Educated at elementary and high schools in Medicine Hat, 1931-39; Banff School of Fine Arts, Alberta, 1939-41; Trinity College, University of Toronto, 1941-45, B.F.A. 1945; Ohio State University, Columbus, 1946-47, M.F.A. 1947; Columbia University, New York, 1947; Institute of Fine Arts, New York University, 1947-48; American School of Classical Studies, Athens, 1948-49. Freelance photographer, mainly of photographic books, and working for *Vogue, Harper's Bazaar, Bunte, Sunday Times, Connaissance des Arts, Time*, etc., in Lethbridge, Alberta, and Rome; also, a painter (has had more than 25 individual exhibitions in Canada, Europe and the United States). Recipient: Guggenheim Fellowship, 1953, 1954; Centennial Medal, Canada, 1967; Visual Arts Award, Canada Council, 1968; Gold Medal, *Leipzig International Book Fair*, 1968; Silver Eagle Award, *Nice International Book Fair*, 1969. LL.D.: University of Lethbridge, 1972. Knight of Mark Twain, 1967; Life Member, Royal Canadian Academy of Arts, 1973. Member, Order of Canada, 1972. Addresses: 432 Thirteen Street South, Lethbridge, Alberta T1J 2V9, Canada; and Lungotevere Ripa 3B, 00153 Rome, Italy.

Individual Exhibitions:

1955 Institute of Contemporary Arts, London
1956 Galleria Sagittarius, Rome
1962 *A Time of Gods*, Royal Ontario Museum, Toronto
1967 *Image Canada* at *Expo '67*, Montreal
1968 *A Visual Odyssey*, Gallery of Modern Art, New York (travelled to Huntington Hartford Museum, New York, and Toronto Dominion Bank, Ontario)
1974 *In the Cloister of San Francisco*, Sorrento, Italy
1980 Palazzo dell'Esposizioni, Rome
1981 *The Churches of Rome*, Royal Institute of British Architects, Rome

Publications:

By BENY: books—*An Aegean Notebook*, Lethbridge, Alberta 1950; *The Thrones of Earth and Heaven*, with texts by Herbert Read, Freya Stark, Jean Cocteau, Bernard Berenson, Rose Macaulay and Stephen Spender, London and New York 1958; *A Time of Gods*, London and New York 1962; *Pleasure of Ruins*, with text by Rose Macaulay, London and New York 1964, 1977; *To Everything There Is a Season*, London 1967; *Japan in Colour*, with text by Anthony Thwaite, London and New York 1967; *India*, with text by Aubrey Menen, Toronto and London 1969; *Island: Ceylon*, with text by John Lindsay Opie, Toronto and London 1971; *Roloff Beny in Italy*, with texts by Anthony Thwaite, Peter Porter and Gore Vidal, London and Toronto 1974; *Persia: Bridge of Turquoise*, with text by S.H. Nasr, Toronto, London and Boston 1975; *The Churches of Rome*, with text by Peter Gunn, London 1981; *Odyssey: Mirror of the Mediterranean*, with text by Anthony Thwaite, London 1981.

On BENY: book—*The Magic Image* by Cecil Beaton and Gail Buckland, London and Boston 1975.

Roloff Beny is a seeker after grandeur. He searches for it in such places as India, Persia, Japan and the shores of the Mediterranean and Aegean seas. It is the shadow of gods and kings he tracks. He is in sympathy with the splendid, and he records splendid architecture, splendid landscapes, splendid animals, splendid ruins.

Beny is, in fact, a little in love with ruins, even seeing "majestic ruins" in the sky. Because of his

Roloff Beny: From *Odyssey: Mirror of the Mediterranean*, 1981

special response to certain situations of beauty we have another knowledge of temples and palaces, mosques and villas, the deserted, the dissolving, the magnificent, the awesome.

The gods still inhabit the world he visits—perhaps just off-stage, but *there*. Royal ghosts invisibly tread his terraces and gardens. His choice of color is as complex and beautiful as some Persian carpet; his choice of light, that certain clarity born of brightness.

—Ralph Pomeroy

BERENGO-GARDIN, Gianni.

Italian. Born in Santa Margherita Ligure, 10 October 1930. Educated at the Liceo Scientifico, Venice, until 1950. Married (separated, 1979); children: Alberto and Susanna. Did various jobs connected with the tourist industry, in Paris and Venice, 1950-60. First concentrated on photography, associating with La Gondola group of photographers, Venice,

1954; freelance photojournalist, working for *Domus*, *Epoca*, *Il Mondo*, *L'Espresso*, *Time*, *Stern*, *Harper's*, *Réalités*, *Vogue*, etc., Venice, 1960-64, and Milan, since 1964. Founder-Member, Il Ponte group of photographers, Venice, 1958. Recipient: Artist Award, International Federation of Photographic Art (FIAP), 1957. Agent: Galleria Il Diaframma, Via Brera 10, Milan. Address: Via San Michele del Carso 21, I-20144 Milan, Italy.

Individual Exhibitions:

1968 Galleria Il Diaframma, Milan
1972 Galleria Il Diaframma, Milan (retrospective)
1978 *Great Britain*, Galleria Il Diaframma, Milan

Selected Group Exhibitions:

1965 *Contemporary Photographic Expression*, International Museum of Photography, Rochester, New York
1967 *Expo '67*, Montreal
1968 *New York, a City*, Galleria Il Diaframma, Milan
1975 *The Land: 20th Century Landscape Photographs Selected by Bill Brandt*, Victoria and Albert Museum, London (travelled to the National Gallery, Edinburgh; Ulster Museum, Belfast; and National Museum of Wales, Cardiff, 1976)
1976 *Biennale*, Venice
1979 *Venezia '79*
1980 *30 Anni di Fotografia a Venezia*, Palazzo Fortuny, Venice

Collections:

Università di Pisa; Bibliothèque Nationale, Paris; Museum of Modern Art, New York; International Museum of Photography, George Eastman House, Rochester, New York.

Publications:

By BERENGO-GARDIN: books—*Venise des Saisons*, with text by Giorgio Bassani and Mario Soldati, Paris 1965; *Toscana*, 2 volumes, Milan 1966; *Viaggio in Toscana*, with an introduction by Giorgio Soavi, Venice 1967; *Morire di Classe*, edited by Franco Basaglia, Turin 1969; *L'Occhio come Mestiere*, with an introduction by Cesare Colombo, Milan 1970; *Francia*, Milan 1975; *Grecia*, Milan 1976; *Un Paese, Venti'Anni Dopo*, with Cesare Zavattini, Turin 1976; *England, Wales and Scotland*, Milan 1977; *Dentro le Case*, Milan 1977; *Dentro il Lavoro*, Milan 1978; *Case Contadine*, Milan 1979; *India*, Como 1980; *Spazi dell'Uomo*, Ivrea, Italy 1980.

On BERENGO-GARDIN: books—*Nuova Fotografia Italiana* by Giuseppe Turroni, Milan 1959; *Photography Year Book*, edited by Norman Hall, London 1961-65, 1967, 1970, 1972; *The Land*, exhibition catalogue, edited by Mark Haworth-Booth, London 1975; *The Magic Image* by Cecil Beaton and Gail Buckland, London and Boston 1975; *Geschichte der Fotografie im 20. Jahrhundert/History of Photography in the 20th Century* by Petr Tausk, Cologne 1977, London 1980; *70 Anni di Fotografia in Italia* by Italo Zannier, Modena, Italy 1978; *30 Anni di Fotografia a Venezia*, exhibition catalogue, by Italo Zannier, Venice 1980; articles—"Young Italian Photographers" by Romeo Martinez in *Camera* (Lucerne), January 1963; "Gianni Berengo-Gardin" by P. Racanicchi in *Popular Photography* (New York), October 1964; "Gianni Berengo-Gardin" by Bill Jay in *Album* (London), no. 12, 1970; "Gianni Berengo-Gardin" in *Modern Photography* (New York), December 1972; "Gianni Berengo-Gardin" by A. Natali in *Zoom* (Paris), May 1973; "Gianni Berengo-Gardin" by Gilardi in *Photo* (Milan), March 1977; "Gianni Berengo-Gardin" by Piovani in *Progresso Fotografico* (Milan), May 1979; "Gianni Berengo-Gardin" in *Zoom* (Munich), August 1980.

Gianni Berengo-Gardin has always been a freelance reporter, and he has been producing pictures for decades, investigating and revealing the weaknesses and the conventions of human life in an insistent, ironic way. Cesare Zavattini, a great Italian scriptwriter, has written of him: "This man, with a sort of absent-mindedness, has always heard the trumpets of a universal justice, a little painful perhaps in a vague sort of way but always insistently moral, hidden in the wings." Berengo-Gardin's photography takes a view that is sometimes indiscreet but is never aggressive, a view that is assimilated from reality and becomes his own, inescapably his, thanks to the effect of the acute cultural penetration and precise moral judgment that are evident in his work.

With his great skill in composing his pictures (nearly always in black and white, since color strikes him as superfluous to the true needs of "fundamental" investigation), in fitting the figure to the background, in styling the picture within the frame, Berengo-Gardin often achieves highly original results. Indeed, in Italy, and not only in Italy, he has built a reputation as an excessively "cultured" photographer—a reputation which, if it in practical terms means that he cannot work for certain magazines and periodicals, still makes him much sought after for book after book of photographs.

His photographs are, in fact, always the fruit of careful production, a period of unhurried interpretation as if to urge the beholder to look beyond that which the picture itself seems to pass over in silence.

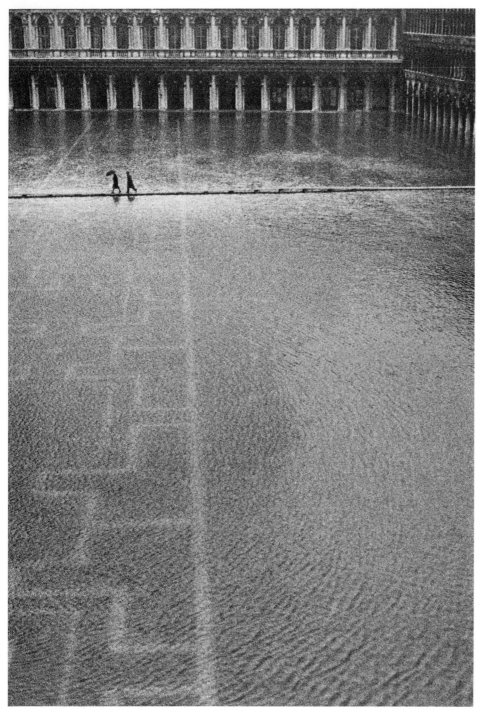

Gianni Berengo-Gardin: *Venice,* 1962

Not that Berengo-Gardin ever fails to give his subjects all the attention they require; and he will deal with a subject all the more closely the more nearly it is in line with his own convictions. The most eloquent examples of his work come from his "love affair" with Venice, from the splendid series of pictures of villages in India, or from his pictures of Luzzara, the village visited 20 years after Strand went there. Then there are his great social reportages ("High-Class Death" is the most affecting example), which he regards as his most important project—a project that is half precise, detailed documentation and half personal, literary interpretation.

Berengo-Gardin likes best to work without a set plan, so that he can move around in the most creative way. All the same, he certainly does not look upon himself as an artist; he describes himself as "an honest photographic craftsman" who learned long ago how to use his tools and employs them to tell others about the world.

—Attilio Colombo

BERKO, Ferenc.

American. Born in Nagyvarad, Hungary, 28 January 1916; emigrated to Germany, 1921, and England, 1932: naturalized, 1947; and to the United States, 1947: naturalized, 1969. Educated at primary school in Weisser Hirsch Spa, near Dresden, 1921-26; gymnasia in Dresden, 1926-27, Berlin, 1928, and Frankfurt, 1929-31, and grammar school in London, 1932; mainly self-taught in photography. Married Mirte Hahn-Beretta in 1937; daughters: Nora and Gina. Began photographing, in Dresden, 1927; freelance documentary photographer and cinematographer, Paris and London, 1936-38; Director of Photography, Bhavnani Film Productions, Bombay, 1938-39; also produced photo stories for Michael Powell and Emeric Pressburger, London Film Productions, 1938-49; established own commercial and portrait studio, in conjunction with British Advertising Agency, Bombay, 1939-44; worked as a director (Staff Captain) with the British Directorate of Kinematography, Bombay, 1944-47; Instructor in

Photography and Film, Institute of Design, Chicago, 1947-48; settled in Aspen, Colorado, 1948; worked as a photographer/filmmaker for the Container Corporation of America, Chicago, 1948-51. Independent photographer and filmmaker, Aspen, since 1952. Organizer, Photo Conference, Aspen Center for Humanistic Studies, 1951. Address: Box 360, Aspen, Colorado 81611, U.S.A.

Individual Exhibitions:

1947 *Bronzes of Southern India,* Victoria and Albert Museum, London
1967 *Berko: 75 Color Prints,* Cincinnati Museum of Art, Ohio (toured the United States)
1968 *Beauty Perceived,* Pat Moore Gallery, Aspen, Colorado
1970 *3 Color Photographers,* Neikrug Gallery, New York
1971 *Berko: Retrospective,* Institute for Humanistic Studies, Aspen, Colorado
1972 *Color Photography by Berko,* Amon Carter Museum, Fort Worth, Texas
1976 *Images of Nature,* Amon Carter Museum, Fort Worth, Texas (toured the United States)
1979 *50 Color Photographs,* Institute for Humanistic Studies, Aspen, Colorado
Berko/Fontana/Gianella, University of Texas at Austin
1980 *Berko/Bruehl,* Center for Creative Photography, University of Arizona, Tucson
1981 *Ferenc Berko,* New Gallery for Contemporary Photography, Cleveland
Ferenc Berko, 5th Avenue Gallery of Photography, Scottsdale, Arizona

Selected Group Exhibitions:

1959 *Photography at Mid-Century,* International Museum of Photography, George Eastman House, Rochester, New York
1964 *Santos of New Mexico,* Amon Carter Museum, Fort Worth, Texas
1968 *Photography U.S.A.,* De Cordova Museum, Lincoln, Massachusetts
1978 *Color Photography 30 Years Ago,* at Photokina '78, Cologne
1980 *American Portraits of the 60's and 70's,* Center for Visual Arts, Aspen, Colorado
The Carter Cabinet Portraits, National Portrait Gallery, Washington, D.C.

Collections:

Museum of Modern Art, New York; Metropolitan Museum of Art, New York; Gernsheim Collection, University of Texas at Austin; San Francisco Museum of Modern Art.

Publications:

By BERKO: books—*Nudes by Berko, Basch and Bullock,* portfolio, with text by Lou Parella, New York 1960; *The Aspen Idea,* with text by Sidney Hyman, Norman, Oklahoma 1975; *Berko: Color Photographs,* limited edition, with an introduction by Helmut Gernsheim, Los Angeles 1979; films—3 documentay films for the Epidaurus Trust, London, 1935-36; government deocumentaries on aspects of Indian Army life, Bombay 1942-43; documentary recruiting films, for the Directorate of Kinematography, Bombay, 1944-46; experimental color shorts, at the Institute of Design, Chicago, 1947-52; 2 documentary/publicity films for Container Corporation of America, Chicago, 1949-51; *Time Capsule, World's Fair,* for Westinghouse Corporation, 1950; Anne Morrow Lindbergh's "Gift from the Sea" section of the Charles Eames' film *The Sea,* for CBS-TV, 1950; film for Samsonite, Denver, 1962.

On BERKO: articles—in *Modern Photography* (New York), December 1952; in *Grossbild-Technik* (Munich), December 1955; "The Abstract Work of Ferenc Berko" by Giuseppe Turroni in *Ferrania* (Milan), April 1958; "Ferenc Berko: A Many-Sided Talent" by Jacquelyn Balish in *Modern Photography* (New York), November 1958; "3 Photo-Journalists" by Bernd Lohse in *Camera* (Lucerne), October 1976; "Ferenc Berko: Ein Meister der Stillen Farbe" by Carl Steinorth in *Format* (Karlsruhe), September 1978; "Ferenc Berko" in *Creative Camera* (London), October 1978; "Ferenc Berko" by James Enyeart in *American Photographer* (New York), July 1980.

I believe photography that endures, like any other form of art, does not need explanations.

I have no quarrel with so-called "experimental" photography, inside or outside the studio or darkroom. However, I do not feel that something is better simply because it is new, or that there is nothing left to photograph any more. The world is rich and beautiful and unendingly full of subject matter to take, be it small or large, "abstract" or "real," "documentary" or "scenic"—however we tend to compartmentalize it.

—Ferenc Berko

Shape, form and colour are Ferenc Berko's *forte*, though he is an extremely versatile photographer who it is impossible to pigeonhole. His superb colour reportages of Morocco, Mexico, Japan, India and many other countries and his striking close-ups of nature and man-made objects have strong graphic design, geometric composition and often unusual perspective in common. Long before anyone else, Berko discovered gorgeous colour designs in water reflections, sand dunes, bird feathers, lichen-covered stones, patterns of petrified wood, torn billboards. Photographs taken 30 years ago have now earned him a reputation as one of the great masters of colour photography.

Many of these fragments of nature were taken for Berko's own pleasure, others for the Container Corporation of America, which drew him in 1949 from the Chicago Institute of Design to Aspen, Colorado.

Yet not all of Berko's work is in colour. It includes many monochrome portraits of men and women famous in music, literature, painting and architecture taken in his capacity as official photographer to international music festivals and design conferences arranged by the Institute for Humanistic Studies at Aspen. They are fine character studies or photojournalistic documents of subjects taken unawares while speaking or performing.

Berko is an extremely sensitive artist, a careful observer, and an acute interpreter of nature. I have watched the overpowering impact of his striking colour shots not only on myself but also on most visitors during exhibitions.

—Helmut Gernsheim

See Color Plates

BERNHARD, Ruth.
American. Born in Berlin, Germany, 14 October 1905; emigrated to the United States, 1927: naturalized, 1935. Educated at the Akademie der Künste, Berlin, 1926-27. Served in the Women's Land Army during World War II. Freelance photographer in New York, 1927-36, in Los Angeles, 1936-53, and San Francisco, since 1953. Since 1965, Instructor at

Ferenc Berko: *Fishermen*, Mexico, 1954

Utah State University, Logan. Instructor, University of California Extension, Berkeley and San Francisco, 1967-75; Instructor, Photography Master Class, Columbia University, New York, 1971. Recipient: National Urban League Award, 1961; Dorothea Lange Award, Oakland Museum, California, 1976; City and County of San Francisco Award, 1978. Agent: Collected Visions Inc., Post Office Box 5154, Berkeley, California 94705. Address: 2982 Clay Street, San Francisco, California 94115, U.S.A.

Individual Exhibitions:

1936 Pacific Institute for Music and Art, Los Angeles
 Jake Zeitlin Gallery, Los Angeles
1938 P.M. Gallery, New York
1941 Little Gallery, San Francisco
1956 Gump's Gallery, San Francisco
1958 Institute for Cultural Relations, Mexico City
1959 City College of San Francisco
1962 San Francisco Public Library
 Carl Siembab Gallery, Boston
1963 Portland State College, Oregon
1965 Toren Gallery, San Francisco
1966 Jacksonville Art Museum, Florida
 Aardvark Gallery, San Francisco
1971 Neikrug Gallery, New York
1973 Chicago Center for Contemporary Photography
1975 Mills College, Oakland, California
1976 Halsted Gallery, Birmingham, Michigan
 Creative Eye Gallery, Sonoma, California
 Secret City Gallery, San Francisco
 Edison Steet Gallery, Salt Lake City, Utah
 Fullerton State College, California
1977 Stephen White Gallery, Los Angeles
 J. Hunt Gallery, Minneapolis
1978 Halsted Gallery, Birmingham, Michigan
 Canon Gallery, Amsterdam
1979 Image Gallery, Sarasota, Florida
 Friends of Photography, Carmel, California (restrospective)
1980 5th Avenue Gallery, Scottsdale, Arizona
 Stephen White Gallery, Los Angeles
 Photogenesis, Albuquerque, New Mexico
 Equivalents, Seattle
1981 Photography West, Carmel, California

Ruth Bernhard: *Teapot*, 1976 Courtesy Collected Visions, Berkeley

the elements which remain important to her are present in this image—the use of light, found objects, formal perfection, symbolism.

Ruth's first important commission came in 1934. The Museum of Modern Art asked her to make photographs for an exhibition and publication called *Machine Art*. It was while photographing an oversized stainless steel bowl for this assignment that the idea of her first nude emerged:

> I had a friend who loved to take off her clothes and loved to dance. I said, "Get in the bowl." She did, and I made two exposures with the 8 x 10. I wasn't aware that it was unusual to photograph nudes. I didn't even know it was unusual to be a woman photographer. I just tried very hard to be a good one.

During this period Ruth continued photographing for personal satisfaction. Despite her commercial success a fortuitous meeting in 1935 was to change the course of her life. Ruth was visiting in California. While walking along the beach at Santa Monica her companion introduced her to two of his friends, Edward and Brett Weston. Ruth accepted Edward's invitation to see his work and was profoundly affected by it.

> Although I had been a practicing photographer for more than five years, the personal power of his photographic statements made me respect my own craft for the first time. I was 30 years old and ready to make a long-term commitment to my chosen work.

> I saw Edward as often as I could over the years. I much admired his frugal lifestyle. Beans never tasted better!

Ruth's move to the West Coast was responsible for the great change in the kind of assignments she was to do. In New York she had been involved primarily with advertising, architecture and industrial design. In California, however, she began to photograph children and movie starlets. There was still ample time for personal photography, however, and she began to exhibit her work. In 1936 she exhibited at both the Zeitlin Gallery and the Pacific Institute in Los Angeles. She moved into a new studio across from the Hollywood Bowl, and after concerts there she opened her house to photographers, artist, musicians and other friends. She had become integrated into the Los Angeles art community.

During World War II, Ruth felt the need to be a part of the war effort. She became a farm hand in the Women's Land Army, taking her basic training at the Agriculture College in Farmingdale, Long Island. After this she was assigned to a large farm in Mendham, New Jersey, where she was able to become completely involved in the growing of crops and care of the animals. She remembers this period in her life with a sense of deep satisfaction. In 1947, soon after she returned to Southern California, Ruth became gravely ill. From that time until 1958 her creative efforts came to a virtual standstill while she underwent, and slowly recovered from, two major operations.

In 1952 she gave up her 8 x 10 view camera in favor of the smaller 4 x 5 Graphic View and, later, a 2¼-square negative format. A 1953 trip to Northern California excited Ruth and provided the stimulus for her move to San Francisco in April of that year. She found an ideal studio and flat on Clay Street that continues to be her home.

Ruth's studio is large enough to double as a classroom for photography students. They began arriving in the mid-1950's for informal sessions, and by 1967 she was also teaching at the University of California Extension in San Francisco. Over the past two decades she has lectured across the country and has taught many workshops and master classes.

Edwynn Houk Gallery, Chicago (with Marsha Burns)

Selected Group Exhibitions:

1965 *Contemporary Photography*, University of Illinois, Urbana
1967 *Photography in the Fine Arts*, Metropolitan Museum of Art, New York
1968 *Light 7*, Massachusetts Institute of Technology, Cambridge
 Photography USA, De Cordova Museum, Lincoln, Massachusetts
1970 *Be-Ing Without Clothes*, Massachusetts Institute of Technology, Cambridge
1972 *Photography West*, Alliance for the Visual Arts, Logan, Utah
1973 *Through One's Eyes*, Muckenthaler Cultural Center, Fullerton, California
1975 *Women of Photography*, San Francisco Museum of Modern Art
1976 *Contemporary Trends*, Chicago Center for Contemporary Photography
1979 *Recollections: 10 Women of Photography*, International Center of Photography, New York (toured the United States)

Collections:

Museum of Modern Art, New York; Metropolitan Museum of Art, New York; International Museum of Photography, George Eastman House, Rochester, New York; Massachusetts Institute of Technology, Cambridge; Museum of Fine Arts, St. Petersburg, Florida; University of Illinois, Urbana; Utah State Institute of Fine Arts, Logan; Oakland Museum, California; San Francisco Museum of Modern Art; Norton Simon Museum, Pasadena, California; Bibliothèque Nationale, Paris.

Publications:

By BERNHARD: book—*The Big Heart*, with text by Milton Van [Peebles], New York 1957; article—

"Ruth Bernhard," interview, with Morrie Camhi, in *Photoshow* (Los Angeles), no. 2, 1979.

On BERNHARD: books—*Recollections: 10 Women of Photography*, edited by Margaretta Mitchell, New York 1979; *Collecting Light* by James Alinder, Carmel, California 1979; articles—"Photographs by Ruth Bernhard" in *Creative Camera* (London), October 1971; "Ruth Bernhard" by Ben Helprin in *Photo Image* (Fullerton, California), vol. I, no. 1, 1976.

For me, photographing is a heightened experience perhaps most akin to poetry and music. The image is an attempt to express my sense of wonder at the miraculous visible world and the mysteries that lie beyond our limited human perceptions. Intensified observations lead to exciting discoveries. Looking at everything as if for the first time reveals the commonplace to be utterly incredible, if only we can be alive to the newness of it. I see a tiny seed and a mountain range as equally significant in the order of the universe, as are life and death. These are some of the concepts that have challenged me to work.

—Ruth Bernhard

Ruth Bernhard's enthusiasm not only for photography but also for life itself is infectious. The depth of her involvement is persuasive. For the past fifty years she has been doing what she has had to do as an artist. Now well into her 70's, she welcomes the growing chorus of accolades. Perhaps she wonders why it has taken us so long to discover her.

Ruth became the assistant to Ralph Steiner's assistant photographer at *The Delineator*, a popular woman's magazine. Ruth remembers the job as primarily one of darkroom scullery maid, but she did learn the basics of photography. She was fired six months later because of erratic attendance and general lack of interest; a love affair had taken priority in her life. With the $90 she received as severance pay Ruth purchased an 8 x 10 view camera along with an assortment of darkroom equipment. Her first serious photograph was of candy *Lifesavers* made in 1930. It is more than remarkable that all of

Photography for Ruth is a mystical experience. She explains:

My own creative work comes to me like a gift, pushing itself into my consciousness. A powerful feeling comes over me. It is a timeless experience, almost like being in a trance. Often I have struggled for days to get the image of the photograph to overlap the spirit I seek. It is an awesome responsibility and a lonely one.

The relatively small volume of Ruth's work can be attributed, in part, to her unproductivity during almost two decades of illness, coupled with her discarding of hundreds of negatives at a time when she felt her work was not important to others. An even greater reason lies in her uncompromising belief in the need for exquisite perfection for each exposure. Ruth truly feels a oneness with the universe which she attempts to communicate in her photographs. When all is right, there is no question in her mind as to which objects in what arrangement will complete that communication. While Ruth insists on harmony, beauty and perfection, her overriding concern is with light itself.

—James Alinder

BERRY, Ian.
British. Born in Preston, Lancashire, in 1934. Worked as a photographer assistant, press photographer for the *Daily Mail* newspaper, and as staff photographer for *Drum* Magazine—all Johannesburg, South Africa; subsequently, freelance photographer, in South Africa, then Paris, and now London. Member, Magnum Photos co-operative agency, Paris and New York, 1961-64. Recipient: Arts Council Photo Bursary, London, 1974. Address: c/o John Hillelson Agency, 145 Fleet Street, London EC4, England.

Individual Exhibitions:

1972 The Photographers' Gallery, London
This Is Whitechapel, Whitechapel Art Gallery, London
1973 *2 Views*, travelling exhibition (toured the U.K.)

Selected Group Exhibitions:

1972 *Personal Views 1850-1970*, British Council, London
1977 *Concerning Photography*, The Photographers' Gallery, London (travelled to the Spectro Workshop, Newcastle upon Tyne)

Collections:

Arts Council of Great Britain, London; British Council, London.

Publications:

By BERRY: books—*King Kong*, with text by Mona Glassner, London 1960; *The English*, London 1978.

On BERRY: books—*Personal Views 1850-1970*, exhibition catalogue, with an introduction by Bill Jay, London 1972; *British Image 2*, London 1976; *Concerning Photography*, exhibition catalogue, by Jonathan Bayer and others, London 1977; articles— "Ian Berry" in *Photo* (Paris), March 1972; "Personal Views 1895-1970" in *Creative Camera* (London) May 1972; "Portfolio: Ian Berry" in the *British Journal of Photography* (London), 23 June 1972; "This Is Whitechapel" by Peter Fuller in *Connoisseur* (London), October 1972; "What They Leave Behind Them: Photographs by Ian Berry," with text by Nicholas Tomalin, in the *Sunday Times Magazine* (London), 21 January 1973; "Bursary for Berry" in *Photographic Journal* (London), November 1974.

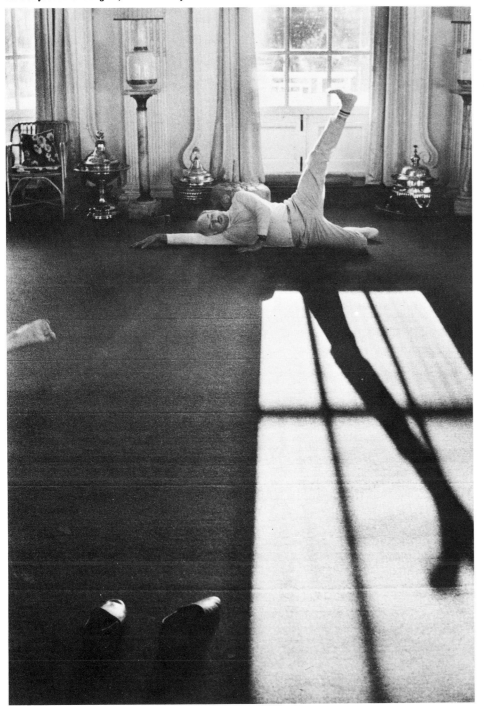

Ian Berry: From *The English*, 1978 Courtesy Arts Council of Great Britain

He arrived on the photographic scene to the sound of gunfire, which he would hear much more of over the next decade. It was March 21, 1960, and the place Sharpeville, a dusty settlement in the veldt outside Johannesburg.

"Get down, you bloody fool!" shouted his companion from the South African magazine *Drum*, as Ian Berry stood up to photograph the African crowd rushing towards him from the police firing at them from the tops of their vehicles.

"Yes, I did hear things whizzing past me," he explained in the office afterwards, "But if I hadn't been standing up, how could I have got the pictures?"

In each of the next two years the young unknown from South Africa would win the top British photographic award, which no one from outside the country had ever gained—first with a set of a witch-doctor at work, then with his coverage of the Congo uprising. Slightly-built, diffident and bearded, Berry looked more like an artist than a trouble-shooter, but he came to life with danger, like a racing man when he catches sight of the horses in the paddock. So for the next few years he ranged the troubled continent of Africa, shooting story after story for

the big picture magazines of America and Europe, and for the Magnum agency he had been invited to join.

But by the time he came to settle in Britain, Ian Berry, then in his 30's, had expanded his range of interest and vision, and could find all the stimulus he needed in the life of everyday humanity. At first on his own, and later on the first bursary ever awarded by the Arts Council, he ranged over the British scene, making pictures in Whitechapel and club-land, at Ascot and Southend; the North of England particularly seemed to give him what he was looking for. In his work a new sympathy and tenderness developed, so that he seemed to be taking pictures *with* people and not of them, he and his camera having become part of the surroundings.

Berry works out of a direct response, going to a place or occasion intuitively and shooting with little conciously-formed plan: "You're there waiting for the moment that makes the whole thing work, moving around so the shapes relate to each other and fall together". And he operates almost entirely with black-and-white: "If you're concerned with form and content, colour can be an intrusion and distraction. Also it has technical limitations—so that it becomes less easy just to walk around all day, moving in and out of situations, simply shooting."

In his early trouble-shooting days, Ian Berry let the world know what went on in places few would ever visit, recording with his camera mainly what was frightening and extraordinary. Today he photographs those scenes and events we all can see, but few of us ever notice. Drifting almost imperceptibly around to record the weakness and oddity, the callousness, humor and affection of everyday life, he tells us about ourselves and one another.

—Tom Hopkinson

Henri Berssenbrugge: *Untitled*, 1906 Courtesy University of Leiden

BERSSENBRUGGE, Henri (Bernhard Heinrich Wilhelm).

Dutch. Born in Rotterdam, 13 July 1873. Studied painting at the Akademie van Beeldende Kunste, Rotterdam, 1892-96; self-taught in photography, but influenced by Dr. Erwin Quedenfeldt, Dusseldorf. Independent painter, Rotterdam, 1896-1900; photographer in shared studio, with Pierre Paul Wulven, Tilburg, Netherlands, 1900-06; portrait and art photographer, Rotterdam, 1907-17, The Hague, 1917 until he closed his studio, 1939; lived in Goirle, near Tilburg, 1942 until his death, 1959. Photographic contributor to *Ons Eigen Tijdschrift*, The Hague, from 1922. *Died* (in Goirle), *4 May 1959.*

Individual Exhibitions:

1923 Kunstzaal Kleykamp, The Hague
1924 Arti et Industrie, The Hague
1925 Nederlandse Amateur Fotografen Vereeniging Building, Amsterdam
1926 De Lakenhal, Leiden
1934 Kunsthandel Aalderink, Amsterdam Zeestraat 65, The Hague
1935 Amateur Fotografen Vereenigning de Baronie Building, Breda, Netherlands
1950 Gemeente Archief, Rotterdam

1953 *Henri Berssenbrugge: 80th Birthday Exhibition*, Babanter Fotografen Verein, Eindhoven, Netherlands
1967 *Portrait of Man/Portrait of Rotterdam*, Gemeente Archief, Rotterdam

Selected Group Exhibitions:

1924 *AFV Salon*, Amateur Fotografen Vereeniging, Rotterdam
1928 *Nederland en Beeld*, Stedelijk Museum, Amsterdam
1929 *Film und Foto*, Deutscher Werkbund, Stuttgart
1931 *Annual Salon of Photography*, Tokyo
1937 *Foto '37*, Stedelijk Museum, Amsterdam
1939 *Collection Gregoire:100 Jaar Fotografie*, Gemeente Archief, The Hague
1941 *Salon Internationale d'Art Photographique*, Brussels
1979 *Fotografie als Kunst 1879-1979*, Tiroler Landesmuseum Ferdinandeum, Innsbruck, Austria (travelled to Neue Galerie am

Wolfgang Gurlitt Museum, Linz, Austria; Neue Galerie am Landesmuseum Joanneum, Graz, Austria; and Museum des 20. Jahrhunderts, Vienna)
Film und Foto der 20er Jahre, Württembergische Kunstverein, Stuttgart (toured Germany, Switzerland and Austria)
Fotografie in Nederland 1920-1940, Haags Gemeentemuseum, The Hague

Collections:

Print Room, Rijksuniversiteit, Leiden, Netherlands; Gemeente Archief, Tilburg, Netherlands; Gemeente Archief, Rotterdam; Gemeente Archief, The Hague; Openlucht Museum, Arnhem, Netherlands.

Publications:

On BERSSENBRUGGE: books—*Tentoonstelling Portretten, Landschappen en Grafische Foto's door Berssenbrugge*, exhibition brochure, by Peter van

den Braken, The Hague 1923; *Honderd Jaar Foto-grafie* by August Gregoire, Bloemendaal, Netherlands 1940; *Portret van een Fotograaf: Henri Berssenbrugge 1873-1959* by H.J. Scheffer, Leiden 1967; *Nederlandse Fotografie: De Erste 100 Jaar* by Claude Magelhaes, Utrecht 1969; *Straat en Landleven 1900-1930* by Kees Nieuwenhuizen, Amsterdam 1976; *Fotografie in Nederland 1839-1920*, exhibition catalogue by Ingeborg Th. Leÿersapf, The Hague 1978; *Film und Foto der 20er Jahre*, exhibition catalogue, by Ute Eskildsen and Jan Christopher Horak, Stuttgart 1979; *Photographen der 20er Jahre* by Karl Steinorth, Munich 1979; *Photographie als Kunst 1879-1979/Kunst als Photographie 1949-1979*, 2 vols., by Peter Weiermair, Innsbruck, Austria 1979; *Fotografie in Nederland 1920-1940*, exhibition catalogue, by Flip Bool and Kees Broos, The Hague 1979.

Henri Berssenbrugge was one of the first photographers at the turn of the century to work to bring more artistry to the craft of photography. He divorced portrait photography from old-fashioned clichés, and he was one of the first to take his camera to the environment of his subjects, to capture them in their own surroundings. These accomplishments, however, were still within the conceptions of the early 20th century, that photography should resemble a painting, that the way of life of the poorer segment of the population was an appropriate subject for the "artistic" photographer.

In 1901, after his education as a visual artist, Berssenbrugge started to work in photography as a new medium within which to express himself. He began by photographing farmers and gypsies in the Southern Dutch province of Brabant. From 1907, when he moved to Rotterdam, he explored the town, capturing the way of life in obscure urban alley-ways. From these somewhat romanticized "social" subjects, he made some truly beautiful photographs, in which the picturesque effect, apart from composition and exposure, was achieved by employing such processes as gum-print and oil-print. These photographs can be compared with the work of the Dutch Impressionists of the so-called "Hague School" and with the work of the painter/photographer H.P. Breitner in Amsterdam.

In Rotterdam Berssenbrugge shocked his fellow photographers with his "modern" ideas about portrait photography. He did not "position" his people; he did not falsify to create an artistic background; moreover, he did not retouch his work, wishing instead to accentuate personality in the spontaneity of exposure alone. These ideas—which were very advanced for the time—were, however, to a certain extent mitigated by his insistence that to achieve the true "artistic" picture it was essential to use certain printing techniques. His best portraits were created from the printing method he called "Fototechnick." Among the people he photographed were those of the artistic circles of the time: the actress Mien Duymaer van Twist, who looks at us with a penetrating gaze, her head rested in her hand; the violinist Odette Myrtil, holding her violin and bow in an angular way, in a kind of obvious reflection of Cubism; serious-looking writers such as B.C. Boutens, Willem Kloos, Dirk Koster; and young artists such as Cesar Domela Nieuwenhuis, painter and member of De Stijl. (Berssenbrugge's interest in the De Stijl movement was also apparent in his studio in the Zeestraat in The Hague, which was designed and built by Jan Wils and Vilmos Huszar, both members of De Stijl.) Also, his portraits of his German friend, Dr. Erwin Quedenfeldt, are interesting, not least for having been done with various printing techniques.

When at the end of the 1920's it became fashionable, Berssenbrugge started to experiment with the "New Objectivity." That he was successful is confirmed by his having been asked to submit work for the avant-garde exhibition *Film und Foto* in Stuttgart in 1929.

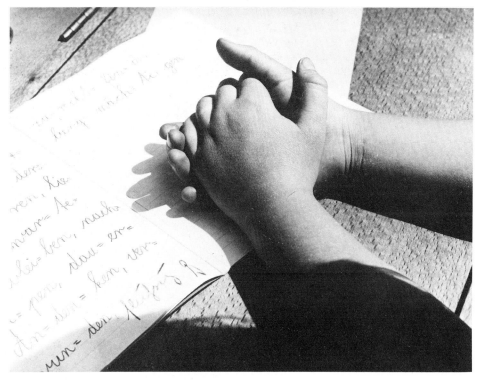

Aenne Biermann: *Hände*, **1927** Courtesy Galerie Wilde, Cologne

Nevertheless, whatever his experimentation, Berssenbrugge could not finally break away from his own idea of the "art-photograph." In 1939, when he stopped photographing and closed his studio, he had become and was to remain the most important representative of the past era of pictorial photography.

—A. de Jonge-Vermeulen

BIERMANN, Aenne.

German. Born Aenne Sternefeld in Goch, Lower Rhineland, in 1898. Educated at gymnasium in Goch, 1904-13; also studied piano; self-taught in photography. Married the businessman Herbert Biermann in 1919; children: Gerschon and Sybille. Independent photographer, associating with Franz Werfel, Theodor Litt and Franz Roh, Gera, near Leipzig, 1922-33; intensive photographic activity, contributing to magazines *Das Kunstblatt*, *Die Form*, *Das Neue Frankfurt*, *Variétés*, etc., Gera, 1927-30. Member, Deutsche Gesellschaft für Photographie (DGPh), 1932-33. *Died* (in Gera) *14 January 1933.*

Individual Exhibitions:

1928 Graphisches Kabinett, Munich

Selected Group Exhibitions:

1929 *Film und Foto*, Deutscher Werkbund, Stuttgart
1932 *Exposition Internationale de la Photogra-*

phie, Palais des Beaux-Arts, Brussels (travelled to Lakenhal, Leiden, Netherlands; and Kunstzaal Van Hasselt, Rotterdam)
1970 *Fotografinnen*, Museum Folkwang, Essen
1978 *Neue Sachlichkeit and German Realism of the '20's*, Hayward Gallery, London
1979 *Film und Foto der 20er Jahre*, Wüttembergische Kunstverein, Stuttgart (travelled to Museum Folkwang, Essen; Werkbundarchiv, Berlin; Kunsthaus, Zurich; Kunstverein, Hamburg; and Museum des 20. Jahrhunderts, Vienna)
1980 *Avant-Garde Photography in Germany 1919-1939*, San Francisco Museum of Modern Art (toured the United States)

Collections:

Museum Folkwang, Essen; Yale University Art Gallery, New Haven, Connecticut; San Francisco Museum of Modern Art.

(1000 photographs by Aenne Biermann were confiscated from Herbert Biermann's collection en route through Trieste in 1937, sent back to Germany, and presumed lost.)

Publications:

By BIERMANN: book—*Fototek 2: Aenne Biermann*, with text by Frank Roh, Berlin 1930.

On BIERMANN: books—*Fotografie der 30er Jahre: Eine Anthologie*, edited by Hans-Jürgen Syberberg, Munich 1977; *Neue Sachlichkeit and German Realism of the 20's*, exhibition catalogue, by Wieland Schmied, Ute Eskildsen and others, London 1978; *Germany: The New Photography 1927-33*, edited by David Mellor, London 1978; *Fotografie 1919-1979*; *Made in Germany: Die GDL-Fotografen*, edited by Fritz Kempe, Bernd Lohse, and others, Frankfurt 1979; *Film und Foto der 20er Jahre*, exhibition catalogue, by Ute Eskildsen and Jan Christopher Horak, Stuttgart 1979; *Photographen der 20er Jahre* by Karl Steinorth, Munich 1979; *Avant-Garde Photography in Germany 1919-1939*, exhibition catalogue,

by Van Deren Coke, Ute Eskildsen and Bernd Lohse, San Francisco 1980.

In his essay on Aenne Biermann (published in *Das Kunstblatt*, October, 1928), the art historian and author of the well-known *Foto-Auge* (1929), Franz Roh, states that there have been two great periods in the history of photography: the era of the Daguerreotype—the 20 year period following the invention of photography and the first public exhibitions in Paris—and the era of the Kalotype, or what we now call the "New Realism". Aenne Biermann, who began making her photographs in 1924, belongs to this second period.

Aenne Biermann was not one of the great figures of the period, although her photographs received some attention in a number of exhibitions (in *Fotografie der Gegenwart* and *Film und Foto*, for example, and *Das Deutsche Lichtbild*). As a friend of Franz Roh she was fortunate enough to have a show of her own, and although her work was overshadowed by such men as Moholy-Nagy and Renger-Patzsch, she nevertheless succeeded in producing some remarkable pictures. Her first photographs of plants and flowers (which were the result of a stay at a health resort) were clearly influenced by Renger-Patzsch but also reveal a strong individual style.

In an article published in *Monatsschrift für alte und neue Kultur* for May, 1929, Aenne Biermann herself writes that at first her "vagabond photography" was simply a pastime and a way of preserving moments of the past. But when she was commissioned to make photographs of rocks and minerals for a scientific publication, she began to see a purpose in photography which demanded more of her than the filling up of family albums with pictures of the children and holidays. She began to examine her medium intently, as she makes clear when she tells us "I realized more and more that the question of lighting was of crucial importance to the clarity of the representation, and I sought further experience and broader assignments. Here I must add that when I looked at the world through the camera lens, I became aware of new charms and allurements. A particular object which seems completely ordinary in its usual setting gains a life of its own on the plate of ground glass. The effect of light upon the polished surface of a metallic plate, the hithertofore unperceived play of shadows, astonishing contrasts of black and white, the problem of finding a suitable perspective—all of these things brought me endless surprises and an intense desire for a greater familiarity with objects and the possibilities of representing them.... It seems to me that the secret charm of a convincing picture lies in the sure, intuitive grasp of possible visual delights."

Then there are the impressive photos Aenne Biermann took of the piano, an instrument which she had studied. Here her familiarity with the instrument led to that "sure, intuitive grasp of possible visual delights" which also impressed Franz Roh, who placed these photographs in Paul Westheim's magazine *Das Kunstblatt*, where they attracted the attention of even those art lovers who did not necessarily regard photography as a true art form. There are three photographs in particular which have justly been compared to the movements of a formal piece of music: "First, a monumental *maestoso* of block-like simplicity; then a delicate, many-stranded movement which seems to move us off into distant spaces; and finally a third movement which blends together the geometrical force of the first movement and the thought-suffused spaces of the second."

Anyone acquainted with the relatively few photographs Aenne Biermann produced must regret the loss of this talented photographer who became terminally ill just as she was beginning to attract a great deal of attention in international publications and exhibitions.

—Jürgen Wilde

BINDE, Gunar.

Latvian. Born in the Aluksnes district of Latvia, 27 December 1933. Educated at Bejas Elementary School, Aluksnes, 1940-47; studied agriculture, Priekuli Technical and Mechanical College, Cesis, 1950-57; photography, under Povilas Karpjavicius and Genady Koposov, Moscow House of Journalists (correspondence-lecture course), 1961-63. Married Sarmite Kviesite in 1969; children: Ieva, Mara, and Elina. Worked as a theatre lighting technician, Palace of Culture, Aluksne, 1957-61, Municipal Theatre, Valmiera, 1961-62, and Youth Theatre, Riga, 1962-64; Lecturer in Photography, School of Art, Riga, 1964-75. Photographer of the Historical Museum, Dole, since 1975. Lecturer since 1978, and Head of the Youth Master Studio since 1979, Photo Club of Riga. Recipient: Artist Award, Federation Internationale de l'Art Photographique (FIAP), 1975. Member of the Photo Club of Riga, since 1964, and the Union of Journalists of the U.S.S.R., since 1967. Honorary Member, Association of Finnish Camera Clubs, 1967; Cegledi Foto Club, Hungary, 1968; Danish Camera Society, 1969; Anpas Photo Society, Sri Lanka, 1970; Osterreichische Gesellschaft der Photografie, (OGPh), Austria, 1979; Honorary Fellow, A-74 Photo Society, Poland, 1975; Honorable Worker of Art of the Latvian S.S.R., 1981. Address: Post Office Box 82, Riga 226011, Latvia, U.S.S.R.

Individual Exhibitions:

1965 Tallinn Photo Club, Estonia
1968 Photo Club, Kaunas, Lithuania
1970 School of Art, Bechin, Czechoslovakia
1971 Galerie PP, Linz, Austria
 Staatliche Landesbildstelle, Hamburg
1972 Gdansk Photo Club, Poland
1973 Society of Friendship, Sofia, Bulgaria
 Tbilisi Photo Club, Georgia
1975 Photo Gallery of Poland, Warsaw
 Krakow Photo Society, Poland
1979 Photo Society of Lithuania, Vilnius
 Photo Club of Tshelyabinsk, Russia
 Gunar Binde/Egons Spuris/Peeter Tooming, Dum Panu ż Kunstatu, Brno, Czechoslovakia (travelled to the Museum of Czeske-Budejovica, Czechoslovakia, 1979, and Kiek in de Kök, Tallinn, Estonia, 1980)
 City Academy of Science, Dubna, Russia
 Church of St. Peter, Riga, Latvia (retrospective)
1980 Riga Photo Club, Latvia

Selected Group Exhibitions:

1970 *10 Top European Photographers: East and West*, Galerie PP, Linz, Austria (toured the United States, 1971-72)
1972 *Prezentacje*, Galerie ZPAF, Warsaw
1978 *10 Weltspitzen Fotografen*, Krakow Photographic Society, Poland (travelled to the *Innsbrucker Fotoschau*, Innsbruck, Austria)

Collections:

Photo Club, Riga, Latvia.

Publications:

By BINDE: films—*Hello, Moscow*, 1966; *A Moment of the Epoch*, 1967; *With Own Hands*, 1967; *The Salute*, 1975.

On BINDE: book—*Foto '71 USSR* by the Sovetskoye Foto editors, Moscow 1971; articles—"Binde" by Pavel Bojar in *Fotografia '64*, Prague 1964; "Gunar Binde Ja Hanen Mallinsa" by P.K. Jaskari in *Kamera Lehti* (Helsinki), no. 6, 1967; "Zu Unseren Bilder" by J. Drausinger in *Osterreichisches Photo-Zeitung* (Vienna), no. 10, 1971; "Gunar Binde" by V. Robert in *Photo-Cine Revue* (Paris), no. 3, 1971; "Thinking Over the Subjects We Had Sighted" in *Sovetskoye Foto* (Moscow), no. 3, 1978; "Camera Artist Gunar Binde" in *Soviet Life* (Moscow), no. 7, 1978; "Latviesu fotografijas 'enfant terrible'" by Vilnis Folkmanis in *Maksla* (Riga, Latvia), no. 4, 1979.

Purely documentary photography is, to me, too primitive, and the subjective portrayal of one's world is incomprehensible; the real values in photo-art are somewhere between the two.

I don't pursue sensationalism, striking events or characters, nature photography, documentarism or portraiture. I am looking for a resonance between the visible world and my soul. If I perceive such a harmony, I take a picture.

When taking pictures, I influence the people who are my subject. If they submit to this influence, the result is a positive one. However, very few people actually submit to it. This influence occurs in a mysterious way; the photographer, with his sophisticated and strange apparatus, communicates his intention and feelings without words, or any sign at all....

Concerning contemporary trends in photography, I'll mention those aspects that seem to me to be negative: conceptualism, now developed to a highly personalized and individualist degree, has replaced genuine feeling in current photography; contemporary photography is short of great ideas, glutted with insignificant subjects; photographers are lazy concerning significant world events, social as well as humane.

Perhaps, however, I am not correct about this: I am coming to an age when a person must be careful about the conclusions he draws, which can prove too conservative.

—Gunar Binde

Ten or fifteen years are nothing in the cultural history of a nation, but that is exactly the time which Latvian photography needed to develop by the end of the 1960's into a quite specific expression of national culture, based on the age-old tradition of folk art. Up until that time Gunar Binde was a synonym for Latvian photography. By his own example, as well as in his teaching, he trained literally scores of contemporary photographers.

Although he is not yet 50, Gunar Binde is an historical figure, inseparably linked with the postwar development of Latvin photography—not just Latvian photography but also Soviet photography in general. At a time when a superficial, optimistic recording of outward reality prevailed, Binde presented pictures of an inward reality—psychological portraits that delved deep into the heart, mind and character of the persons depicted. And he also depicted the nude, which in Soviet photography had been taboo for a long time as something unsuitable for publication. From the outset, however, Binde's nudes were not only gentle, charming and erotically effective but also dignified. His nude women are not just attractive beings; as well, they personify the noble charm of womanhood, of motherhood, the philosophy of life of those who give life. They are filled with a strong internal tension, a promise of something that remains forever unspoken, which, for that very reason, continually attracts one's attention.

Gunar Binde was first introduced abroad in 1964 in the pages of the Czech quarterly *Revue Fotografie*. At that time he was still an amateur, working in the theatre as a lighting technician, but he was soon

Gunar Binde

to become a professional photographer. There was a growing interest in his work, especially abroad. He was included in international yearbooks, he gained recognition at exhibitions, and he began to win awards. One of the first foreign awards for this work—a Gold Medal for a portrait of the director Eduard Smilgis, which he won at an exhibition in Argentina in 1965—had a tremendous impact on many of his followers, the amateurs who followed in his footsteps: they turned their hobby into a profession, now finding in photography a suitable form for creative self-realization. This evolutionary leap, which was suddenly and almost immediately valid with regard to quality, was quite logical in a nation that for centuries had withstood the vagaries of fate and managed to preserve its own national culture. Modern photographic expression was generally fully accepted, and Gunar Binde had the lion's share in that accomplishment. It was he who in the 1960's helped to free Soviet photography in general from its pathos, who helped it to gain a direct and lively approach, full of semantic depth.

In the 1970's Binde also devoted himself to landscape photography. To a certain extent he had, in the past, already dealt with landscape: he was, for example, a pioneer in the formal placement of the female nude in landscape, which is still much imitated. But just as in those photos he made use of the symbiosis of the beauty of various shapes found in nature, in his purely landscape photos he was also above all concerned with the relationship between man and nature. This he usually expresses by a symbolic sign, which, by joining mutually incongruous elements, produces something of a surreal dramatic arrangement.

—Daniela Mrázková

BISCHOF, Werner.
Swiss. Born in Zurich, 26 April 1916. Educated at Realgymnasium, Waldshut, 1922-29; studied teaching, drawing and physical culture, Evangelische Lehranstalt, Schiers, Graubunden, 1930-32; studied photography, under Hans Finsler, Kunstgewerbeschule, Zurich, 1932-36. Served in the Swiss Army, 1939. Married Rosellina Bischof; sons: Marc Andreas and Daniel. Freelance graphic artist and photographer, Zurich, 1936-38; staff photographer and designer, Graphis Publishing House (Amstutz and Herdog), Zurich, 1938-39; editorial consultant and resident contributor, Du magazine, Zurich 1943-44; photographer, with Schweizer Spende post-war relief organization, Italy and Greece, 1946-47; free-

lance magazine photographer, mainly for *Life* magazine, Europe, 1948; contract photographer, working with *Picture Post, Illustrated* and *Observer* magazines and newspapers, Europe 1949; Member, Magnum Photos co-operative agency, New York and Paris, working for *Epoca, Paris Match, Du, Life, Fortune*, etc., in India, Italy, Indochina, Mexico, South America, and United States, 1949-54. Werner Bischof/Robert Capa/David Seymour Memorial Fund (subsequently International Fund for Concerned Photography Inc.), founded New York, 1966. *Died* (in a car accident, in the Andes Mountains, Peru), *16 May 1954.*

Individual Exhibitions:

1955 *Japan*, Art Institute of Chicago (toured the United States)
1956 Kunstgewerbeschule, Zurich (retrospective)
1957 *A Photographer's Odyssey*, Kunsthaus, Zurich (retrospective)
1960 Musée des Arts Décoratifs, Paris
1961 Smithsonian Institution, Washington, D.C. (toured the United States)
1967 Musée du Louvre, Paris
1968 IBM Gallery, New York

Selected Group Exhibitions:

1951 *Memorable Life Photographs*, Museum of Modern Art, New York
1959 *10 Years of Photography*, International Museum of Photography, George Eastman House, Rochester, New York
1960 *The World as Seen by Magnum*, Takashimaya Department Store, Tokyo (and world tour)
1967 *The Concerned Photographer*, Riverside Museum, New York
Photography in the 20th Century, National Gallery of Canada, Ottawa (toured Canada and the United States, 1967-73)
1974 *Photographes Suisses depuis 1840 à Nos Jours*, Kunsthaus, Zurich (travelled to the Villa Malpensata, Lugano, and Musée Ratch, Geneva)
1977 *Documenta 6*, Museum Fridericianum, Kassel, West Germany
1979 *Photographie als Kunst 1879-1979*, Tiroler Landesmuseum Ferdinandeum, Innsbruck, Austria (travelled to the Neue Galerie am Wolfgang Gurlitt Museum, Linz, Austria; Neue Galerie am Landesumusem Joanneum, Graz, Austria; and the Museum des 20. Jahrhunderts, Vienna)

Collections:

Kunsthaus, Zurich; Musée Réattu, Arles, France; Museum of Decorative Arts, Prague; Metropolitan Museum of Art, New York; Museum of Modern Art, New York; International Fund for Concerned Photography, New York; Rose Art Museum, Amherst, Massachusetts; Art Institute of Chicago.

Publications:

By BISCHOF: books—*24 Photos von Werner Bischof*, with text by Manuel Gasser, Berne 1946; *Japan*, with text by Robert Guillain, Zurich, Paris, Milan, London and New York 1954; *Werner Bischof: A Memorial Portfolio*, Basle 1954; *Indiens Pas Mort/Incas to Indians*, with Robert Frank and Pierre Verger, with text by Georges Arnaud, Tokyo and New York 1954, Paris 1956, Zurich 1961; *Unterwegs*, with text by Manuel Gasser, Zurich 1957; *Carnet de Route*, Paris 1957; *The World of Werner Bischof*, with text by Manuel Gasser, New York 1959; *Werner Bischof: Querschnitt*, with texts

Werner Bischof: *Shinto Priests in Snow*, **Japan** Courtesy Art Institute of Chicago

by several authors, Zurich 1961, new edition as *The Photographs of Werner Bischof*, edited by Anna Farova, Prague 1964, New York 1968.

On BISCHOF: books—*Memorable Life Photographs*, with an introduction by Edward Steichen, New York 1951; *Photography Today*, edited by Normal Hall, London 1957; *Photography in the 20th Century* by Nathan Lyons, New York 1967; *The Concerned Photographer*, edited by Cornell Capa, New York 1968; *Werner Bischof*, edited by Nikolaus Flueler, Frankfurt and Lucerne 1973, New York 1976; *Werner Bischof 1916-1954*, edited by René Burri and Rosellina Burri-Bischof, New York 1974; *Photographes Suisses depuis 1840 à Nos Jours*, exhibition catalogue, by Hugo Loetscher, Walter Binder and Rosellina Burri-Bischof, Zurich 1974; *Geschichte der Fotografie im 20. Jahrhundert / Photography in the 20 Century* by Petr Tausk, Cologne 1977, London 1980; *Documenta 6, Band 2*, exhibition catalogue, edited by Klaus Honnef and Evelyn Weiss, Kassel and Cologne 1977; *Photographie als Kunst 1879-1949 / Kunst als Photographie 1949-70*, exhibition catalogue, 2 vols., edited by Peter Weiermair, Innsbruck, Austria 1979; articles—"The Concerned Photographer," special issue of *Contemporary Photographer* (Culpeper, Virginia), vol. 6, no. 2, 1968; "Werner Bischof" in *Camera* (Lucerne), May 1969; "Werner Bischof" by Pier Paolo Preti in *Fotografia Italiana* (Milan), September 1973.

If Werner Bischof had been born before the invention of photography, Manuel Gasser has observed, "he would have realized his gifts in some other medium. It is easy to imagine him doing delicate, carefully executed silverpoints of plants and fruits on precious paper, or engraving animal images in stone in the manner of the lapidary. But instead of pencil and burin, he works with light and shadow, catching the subtlest possible shadings with his camera's crystal eye. Or, properly speaking, did so in the past.... The man who ground and polished the shell for hours in order to obtain the desired degree to translucence, who understood the means with which to render the subtlest light and shade...one day pushed aside everything he knew and had achieved, got into a jeep and drove off into the world laid waste and despoiled by war—to Germany, Holland, to Northern Italy" (and later on, of course, to India, Indo-China and Korea). Bhudpendra Karia makes much the same point: the spectacle of human suffering after the war made Bischof "transcend" his art and caused him to abandon his technical virtuosity in favor of "simple and powerful statements about the human condition."

These well-intentioned observations are helpful—but only up to a point. About Bischof's intense sympathy for human misery there can be no doubt. In 1948 he wrote "I have to make a big decision. I have the Magnum contract in hand...what is important to me is that they [Capa, Cartier-Bresson, Chim and Rodger] are all sound people and socialist-inspired." As the Korean war intensified he confessed "A lot has changed for me—I realized it when I visited an old, very beautiful chapel. Great to look at, but to battle for hours with lighting and tripod for the sake of these 'dead things' doesn't interest me any more." What did interest him, what was soon to become the driving force behind his entire work, was the need to bear witness to the human suffering he found wherever he looked in the post-war world. A few years later, during a visit to Calcutta, he asserted "I see no justification for my journey unless I am completely committed to the present and the problems of our time."

It would be a complete mistake, however, to conclude that Bischof rejected his formidable technique, simplified his style and became in any sense a polemical photojournalist. He detested sensationalism (the reporters roaming the battlefields of Korea

reminded him of "hyenas") and approached the problem of suffering by muted, indirect means. Even his most painful photographs of Indian famine victims are the work of a consummate craftsman. And yet the very notion that such subjects can be made aesthetically pleasing raises some fundamental issues. W.H. Auden, for example, claimed that it would be "wicked" to write a play about Auschwitz: "author and audience may try to pretend that they are morally horrified, but in fact they are passing an evening together, in the aesthetic enjoyment of horrors." Thus it is possible to argue that Bischof's superbly planned and executed photographs of "horrors" are morally questionable. His memorable photograph, for example, of a starving Indian, wrapped in rags and lying in front of a magnificently ornate temple door, might seem to minimize the suffering involved. But in fact it does just the opposite: the grandeur of the temple door and the abject misery of the beggar, who has been reduced to a barely perceptible, generalized human shape, make the point with a minimum of rhetoric. This is a land, the photograph quietly asserts, where such things happen as a matter of course. And there is a further point to be made in defense of Bischof's willingness to use all the formal means at his disposal to mitigate the raw pain of what is being depicted. When our sense of extreme human suffering becomes too intense, Melville once pointed out, we are not moved to sympathy. We recoil in horror, we draw back and wish to rid ourselves of an image of misery which seems completely beyond our aid. The cruelly detailed picture of the starving Biafran child, for example, is so appalling that the very idea of aid seems futile. By avoiding such extremes, by highly controlled indirection, by making his pictures into memorable aesthetic as well as human statements, Bischof produced an indelible series of photographs about human pain which have easily outlived their original occasions.

—Elmer Borklund

BISHOP, Michael.
American. Born in Palo Alto, California in 1946. Studied at Foothill College, Los Altos Hills, California, and at the San Francisco Art Institute; studied photography, under Henry Holmes Smith, San Francisco State College, B.A. 1970, M.A. 1971. Independent photographer. Instructor, San Francisco Art Institute, 1971-74; University of California at Los Angeles, 1974-75; Visual Studies Workshop, Rochester, New York, and State University of New York, Buffalo, 1975. Founder-Member, Visual Dialogue Foundation, San Francisco. Recipient: National Endowment for the Arts Grant, 1975. Agent: Light Gallery, 724 Fifth Avenue, New York, New York 10019. Address: 43 Surrey Street, San Francisco, California 94103, U.S.A.

Individual Exhibitions:

1970 Loomis Institute, Windsor, Connecticut
 Silver Image Gallery, Ohio State University, Columbus
1971 School of the Art Institute of Chicago
 Light Gallery, New York
1973 University of Rhode Island, Kingston (with Linda Connor)

1974 Imageworks, Boston
1975 Light Gallery, New York
1976 Light Gallery, New York
1979 Center for Contemporary Photography, Chicago
 Center for Creative Photography, University of Arizona, Tucson
1981 *Michael Bishop / Mark McFadden: Sleight of Eye*, Creative Photography Gallery, Cambridge, Massachusetts

Selected Group Exhibitions:

1967 *Photography for the Arts in Embassies*, Focus Gallery, San Francisco (and Oakland Museum, California)
1969 *Vision and Expression*, International Museum of Photography, George Eastman House, Rochester, New York (toured the United States, 1969-71)
 California Photographers 1970, University of California at Davis (travelled to Oakland Museum, California; and Pasadena Art Museum, California)
1971 *Photo Media: Elements and Technics of Photography Experienced as an Artistic Medium*, Museum of Contemporary Crafts, New York
1972 *60's Continuum*, International Museum of Photography, George Eastman House, Rochester, New York
1973 *Light and Lens: Methods of Photography*, Hudson River Museum, Yonkers, New York
1975 *The Extended Document: An Investigation of Information and Evidence in Photographs*, International Museum of Photography, George Eastman House, Rochester, New York
1976 *Peculiar to Photography*, University of New Mexico, Albuquerque
1978 *One of a Kind: Polaroid Color*, Corcoran Gallery, Washington, D.C. (toured the United States)
1979 *Photographic Surrealism*, New Gallery of Contemporary Art, Cleveland (travelled to Dayton Art Institute, Ohio; and the Brooklyn Museum, New York, 1980)

Collections:

Museum of Modern Art, New York; International Museum of Photography, George Eastman House, Rochester, New York; Fogg Art Museum, Harvard University, Cambridge, Massachusetts; Museum of Fine Arts, St. Petersburg, Florida; University of Tennessee, Knoxville; University of New Mexico, Albuquerque; San Francisco State University; National Gallery of Canada, Ottawa; Ryerson Polytechnical Institute, Toronto; Musée Réattu, Arles, France.

Publications:

On BISHOP: books—*Vision and Expression* by Nathan Lyons, New York 1969; *California Photographers 1970*, exhibition catalogue, by Fred R. Parker, Davis, California 1970; *Photo Media: Elements and Technics of Photography Experienced as an Artistic Medium*, exhibition catalogue, New York 1971; *60's Continuum*, exhibition catalogue, with text by Van Deren Coke, Rochester, New York 1972; *Light and Lens: Methods of Photography* by Donald L. Werner and Dennis Longwell, Dobbs Ferry, New York 1973; *The Extended Document: An Investigation of Information and Evidence in Photographs*, with text by William Jenkins, Rochester, New York 1975; *Peculiar to Photography*, exhibition catalogue, by Van Deren Coke, Thomas F.

Michael Bishop: Image from the Visual Dialogue Foundation Founders Portfolio, 1970 Courtesy Art Institute of Chicago

John Blakemore: From the series *Wind*, Shirley, Derbyshire, 1978

Barrow and others, Albuquerque, New Mexico 1976; *One of a Kind: Recent Polaroid Color Photography*, with a preface by Belinda Rathbone, and an introduction by Eugenia Parry Janis, Boston 1979; *Michael Bishop*, exhibition catalogue, with text by Charles Desmarais and Charles Hagen, Chicago 1979; articles—in *Esquire* (New York), February 1976; in *Modern Photography* (New York), July 1976.

Since Michael Bishop's banal photographic subjects present no immediately evident esthetic or other kind of value, they require special resources on the viewer's part. "Familiar, non-obtrusive objects and forms," Bishop calls his sepia-toned, overturned lawnchair in a deserted late-winter yard, his metal stepladder flashlighted in front of an open closet, his isolated traffic signs. Yet, having once agreed to yield to the photographer the extra effort that his subject matter insists upon, we become free to savor his peculiar formalism.

Bishop's universe is boxed and hedged by the junctures of such hard, non-porous, man-made surfaces as concrete, steel, and other more mysterious materials. Rarely does a fleshly being intrude, and it is these dreary intersections that seem to define and limit the world. Confining himself to the apparently trivial and mundane, eschewing, if not truth, at least beauty, the artist presents an idea of photography that has little to do with the our usual thoughts about the medium.

Bishop does not pursue the illusionistic, nor engage the topical, social or narrative concerns that preoccupy many photographers. Rather, the ever more spare and elemental subject matter that he has developed over the years actively prevents any appreciation of his work on such levels. Bishop's interest is in photographic composition—that is, in the stripped down elements of the artistic vision—and in the tonal possibilities of photography. Having found the black-and-white tonal range "visually unrewarding," he has experimented with tints and now works in color. If we are to be interested by Bishop's work, it is his ideas about, and mastery of, the formal elements of his medium that will provoke us.

Bishop's vision is, of course, surreal, trading on the unexpected, momentary juxtapositions that it is photography's special power and irony to make permanent. What gives humanity to his apparently inhuman images is his invocation of a fundamental surrealist notion. The photographs need no human subjects because, he implies, their subjects are all of us, as we endure each day of forced yet haphazard encounters with the familiar, inhuman surfaces of our own making that have increasingly become our world.

—Maren Stange

BLAKEMORE, John.

British. Born in Coventry, 15 July 1936. Educated at John Gulson School, Coventry, 1947-52; self-taught in photography. Served as a nurse in the Royal Air Force, in England and Libya, 1954-56. Married Sheila Elizabeth Reader in 1958 (divorced, 1968); children: Jay and Paul; married Penelope Anne Arkwright in 1970; children: Matthew and Gita. Worked as a farmhand in Warwickshire and Shropshire, 1952-54; freelance photographer with the

Black Star agency, London and the Midlands, 1956-58; Photographic Studio Manager, Taylor Brothers Studio, Coventry, 1958-61; Photographer, Beryl Houghton Studio, Coventry, 1961-62, Richard Sadler Studio, Coventry, 1962-63, Courtaulds Company, Coventry, 1963-68, and Hilton Studios, London, 1968-69. Freelance photographer, in Derby, since 1970. Lecturer in Photography, Derby Lonsdale College, since 1970. Recipient: Arts Council of Great Britain bursary, 1974, 1976, 1979. Agent: Contrasts Gallery, 19 Dover Street, London W1. Address: 55 Langley Street, Derby DE3 3GW, England.

Individual Exhibitions:

1964 *Area in Transition*, Coventry College of Art
1965 *Girls School*, City Architects Gallery, Coventry
1966 *West Side Story*, City Architects Gallery, Coventry
1967 *Two Photographers*, Belgrade Theatre, Coventry (with Richard Sadler)
1972 Midland Group Gallery, Nottingham
 Photographs and Paintings, Morgan Gallery, Coventry (with David Eddington)
1975 *A Vision of Landscape*, Impressions Gallery, York
 3 Photographers, Galleria Il Diaframma, Milan (with Paul Hill and Thomas Cooper)
1976 *Stand Before the World*, Arnolfini Gallery, Bristol (travelled to The Photographers' Gallery, London, then toured the U.K.)
1978 *Michael House, A Rudolph Steiner School*, Michael House School, Ilkeston, Derbyshire
1979 *Spirit of Place: Photographs in Wales 1971-78*, Photographic Gallery, Cardiff (toured the U.K.)
1980 *Lila*, The Photographers' Gallery, London (toured the U.K.)
1981 Contrasts Gallery, London
 Camera Obscura Gallery, Stockholm
 Impressions Gallery, York

Selected Group Exhibitions:

1968 *International Photography*, Midland Arts Centre, Cannon Hill, Birmingham
1971 *Those Who Can Do*, Derby College of Art and Technology
1973 *Serpentine Photography '73*, Serpentine Gallery, London
1974 *New Photography*, Midland Group Gallery, Nottingham
1975 *The Romantic Landscape*, Kodak House, London
1977 *Singular Realities*, Side Gallery, Newcastle upon Tyne
1978 *Tusen och en bild/1001 Pictures*, Fotografiska Museet, Moderna Museet, Stockholm
1979 *The Native Land*, Mostyn Gallery, Llandudno, Wales
1980 *British Art 1940-1980*, Hayward Gallery, London

Collections:

Arts Council of Great Britain, London; Department of the Environment, London; Victoria and Albert Museum, London; Royal Photographic Society, Bath, England; West Midlands Arts Association, Birmingham; National Library of Wales, Cardiff; Derby Lonsdale College, Derby; Fotografiska Museet, Moderna Museet, Stockholm; Los Angeles County Museum of Art.

Publications:

By BLAKEMORE: books—*British Image 3: John Blakemore*, with an introduction by Gerry Badger, London 1977; *Thistles*, portfolio, London 1981; article—"John Blakemore: Interview," with Helen Shield and Jan Segieda, in *Ten 8* (Birmingham), August 1979.

On BLAKEMORE: books—*British Journal of Photography Annual*, London 1976; *Creative Camera International Yearbook*, edited by Colin Osman and Peter Turner, London 1976; *Geschichte der Fotografie im 20. Jahrhundert/Photography in the 20th Century* by Petr Tausk, Cologne 1977, London 1980; *Exploring Photography* by Bryn Campbell, London 1978; *Tusen och en Bild*, exhibition catalogue, by Ake Sidwall, Sune Jonsson and Ulf Hard af Segerstad, Stockholm 1978; *British Image 5: Perspective on Landscape*, edited by Bill Gaskins, London 1978; *John Blakemore: Spirit of Place: Photographs in Wales 1971-78*, exhibition catalogue, Cardiff 1979; articles—"Reflections on John Blakemore" by Edward Martin in the *British Journal of Photography* (London), January 1976; "John Blakemore" in *Camera* (Lucerne), August 1976; "John Blakemore" in *Nye Foto* (Oslo), December 1976; "Blakemore's Moving Spirit" in *Amateur Photographer* (London), February 1980; "John Blakemore" in *Print Letter* (Zurich), January 1981; "John Blakemore: Path to Perfection" in *Amateur Photographer* (London), February 1981.

For me, photography revolves around the relationship of the photographer to his subject, upon an acceptance of the descriptive base of the medium. The photographer must express himself, his feelings, his ideas, through a discovery of the world external to himself. The work process is a refinement of one's ability to see, to respond; it is a process of recognition, the recognition of the significance of an object, an event.

Intensity of relationship, of understanding, is, to me, the core of photography. Formal and craft decisions are the means of translating experience to image, not ends in themselves.

Our civilization has lost its sense of dependence upon, connection with, nature; our relationship has become one of reckless exploitation. In a sense, I see my work in the landscape as an attempt to re-establish relationship; to become aware of, to acknowledge, myself as part of nature, not merely an observer of a process from which I am separated by consciousness.

To be alone in the landscape, to experience that aloneness with intensity, is to feel awe. It is to be made aware of one's insignificance, one's isolation—occasionally, to experience a sense of oneness, to be made aware of oneself as part of a continuum. My photography is both a response to such experience and a means of renewing it. My work is generally confined to limited areas, a stretch of river, a wooded hillside, a length of beach: places which I visit again and again, which become intensely familiar to me, allowing the possibility of understanding, of communion. What I hope to suggest through my photographs is the continuity, the spiritual and physical dynamic, the essential mystery of nature. I try to work as simply as possible—for the last five years all my photographs have been made with a 5 x 4 camera and one lens. I want my prints to suggest the qualities that fascinate me in the landscape. To have a richness of texture, of tonality, a sense of light that can evoke the richness, the fecundity of nature. I seek to make images that function both as a celebration of the landscape and as a metaphor of my response to and my connection with it. The camera provides a link, a means, both of communion and communication.

—John Blakemore

For the past two centuries a strong affinity with the landscape has been a hallmark of the English arts. John Blakemore is clearly an heir to this tradition, inasmuch as it is the forms of the countryside and natural objects that most strongly arouse his creative drive. Paradoxically, though, his work is far removed from the present dominant concerns of English photography.

In his landscapes of Wales, made between 1970 and 1978, and in his subsequent work in Derbyshire, Blakemore has adopted procedures that appear to owe more to principles of Indian philosophy than to current British artistic practice. He approaches the world neither as a collection of objects and situations to be recorded, nor as a source of internal sensations to be expressed. Instead, he seeks the elimination of subject/object duality and the attainment of an awareness of the unity of the observer and the observed within the essence of the universe. In his best work, Blakemore succeeds in combining the subjective and objective so that appearances are inseparably linked with the sensations they arouse in him.

Technically, Blakemore very properly uses the full resources of the camera and fine print (still regarded as something of a precious irrelevance by many of his fellow-countrymen) to convey his perceptions with the maximum precision. The resulting photographs are often beautiful, and their beauty provides a necessary point-of-entry for the observer—but point-of-entry only. To approach their full meaning, one must enter into the meditative spirit in which the images were created and treat them as the starting points for further meditations. If this effort is made, photographs which otherwise seem forbiddingly private can reveal a true sense of genius loci, and the ebb and flow of the forces of nature.

—Tom Evans

BLANCO, Lázaro.

Mexican. Born in Ciudad Juárez, Chihuahua, 1 April 1938. Educated at primary and secondary schools in Ciudad Juárez, and in El Paso, Texas, 1944-56; studied architecture, 1957, and experimental physics, 1958-63, Universidad Nacional Autónoma, Mexico City; science, Eastern Michigan University, Ypsilanti, and Instituto Politecnico Nacional, Mexico City, 1967; physics, New York State University at Geneseo, 1971; self-taught in photography. Worked as an actor and technician, Teátro Universitario, Mexico City, 1961; instructor in mathematics and physics at various schools, Mexico City, 1963. Photographer since 1966. Physics Instructor and I.P.S. Instructor, American School, Mexico City, since 1964; Instructor, Photography Workshop, Casa del Lago, Universidad Nacional Autonoma, Mexico City, since 1969. Contributor, *Fotozoom* magazine, Mexico City, since 1977. Founder Member, Ciné Club Ciencias, Universidad Nacional Autónoma, 1959, 35-6 x 6 Photographers Group, Mexico City, 1968, and V.O.D. Photographers Group, Mexico City, 1973; Founder Member, Head of the Exhibition Commission, Museographer, and Vice-President, Consejo Mexicano de Fotografia, since 1976; Museographer and Photography Adviser, Museo Carrillo Gil, Mexico City, since 1979. Recipient: First Prize, *National Cattle and Agriculture Exposition*, Mexico City, 1973; Acquisition Prize, *Plastic Arts National Salon*, Mexico City, 1979. Agent: Prakapas Gallery, 19 East 71st Street, New York, New York 10021, U.S.A. Address: Rep. Argentina 17-402, Mexico 1, D.F., Mexico.

Individual Exhibitions:

1967 Eastern Michigan University, Ypsilanti
 Club Fotografico, Mexico City
1971 *Fiesta del Dolor*, Galería del Bosque, Casa
 del Lago, Mexico City
 Little Gallery, Hudson Park Branch, New
 York Public Library
1975 *Las Moradas del Tiempo*, Fine Arts Insti-
 tute, Guadalajara
 Modernage Gallery, New York
 Galeria de Fotografia, Casa del Lago, Mex-
 ico City
1976 Instituto Nacional de Bellas Artes, Mexico
 City
 Modernage Gallery, New York
 Alvarez Bravo/Pedro Meyer/Lázaro Blanco,
 Galleria Il Diaframma, Milan
1977 Galleria Il Diaframma/Canon, Milan
 Azienda Autonoma Soggiorno e Turismo,
 Salerno, Italy
 Galería Pro-Arte, Mexico City
1980 Museo Carrillo Gil, Mexico City

Selected Group Exhibitions:

1968 *National Newspaper Snapshot Exhibition*,
 National Geographic Society, Washing-
 ton, D.C.
1969 *Grupo 35-6 x 6: Fotografías*, Little Gallery,
 Hudson Park Branch, New York Public
 Library
1974 *La Muerte: Expresion Mexicana de un
 Enigma*, Universidad Nacional Autónoma,
 Mexico City
1977 *Bienal de Grafica*, Palacio de Bellas Artes,
 Mexico City
1978 *Contemporary Photography in Mexico*,
 Northlight Gallery, Arizona State Uni-
 versity, Tempe (travelled to the Center for
 Creative Photography, University of Ari-
 zona, Tucson)
 Exposition of Latin American Photography,
 Museo de Arte Moderno, Mexico City
 Mexico Today, Nexus Gallery, Atlanta
 (travelled to Meridian House, Washington,
 D.C.)
1980 *7 Portfolios Mexicanos*, Casa de Mexico,
 Paris (travelled to the Picasso Museum,
 Antibes)
 El desnudo Fotográfico, Casa del Lago,
 Universidad Nacional Autónoma, Mexico
 City

Collections:

Instituto Nacional de Bellas Artes, Mexico City;
Consejo Mexicano de Fotografia, Mexico City;
Fototeca de la Casa del Lago, Mexico City; Museo
de Artes y Ciencias, Universidad Nacional Autó-
noma, Mexico City; Museo Carrillo Gil, Mexico
City; Casa de las Américas, Havana, Cuba; National
Geographic Society, Washington, D.C.; United
Nations Archives, Geneva; Hartkamp Collection,
Amsterdam.

Publications:

By BLANCO: books—*Science Experiments That
Really Work*, with others, Chicago 1970, Mexico
City 1973; *El Paisaje del Espectáculo en México*,
with others, Mexico City 1974; *El Paisaje Religioso
de México*, with others, Mexico City 1975; *Obras en
Parques Naturales*, with others, Mexico City 1975;
Caminos y Desarrollo, with others, Mexico City
1975; *Hecho en Latinoamérica*, with others, Mexico
City 1978; *America en la Mira*, with others, Mexico
City 1978; *7 Portafolios Mexicanos*, exhibition cata-
logue, with others, Mexico City 1980; *El desnudo
Fotográfico*, exhibition catalogue, with others,
Mexico City 1980; *Mexican Women in Statistics*,
Mexico City 1981; *Percepcion y Analisis*, Mexico
City 1981; *Fiesta del Dolor*, Mexico City 1981; *El
Auto*, Mexico City 1981; articles—" 'Niños' in the
Camera Eye" in the *Christian Science Monitor*
(Boston), 22 August 1967; "La Fotografía, imagen
de la realidad o una manera de ver" in *Atte Sociedad
e Ideología* (Mexico City), July 1977; "La difícil
facilidad de la fotografia" in *Artes Visuales* (Mexico
City), Spring 1977.

On BLANCO: articles—in *Revista de Bellas Artes*
(Mexico City), September/October 1975; "Lazaro
Blanco" in *Camera* (Lucerne), October 1978; "Lazaro
Blanco" in *Zoom* (Paris), April 1979; in *Printletter*
(Zurich), May/June 1980.

Those pieces of transformed reality we call photo-
graphs may awaken in the viewer latent or hidden
feelings about his world by allowing him to see,
observe, interpret, redefine, notice and become
aware of all that he has lost due to his immersion in a
deafening, numbing society. Photographs may very
well represent the outcries of those struggling to
emerge from the marsh to see the light.

The self-exploration brought about when sights
are consolidated into more or less permanent
reminders or records may help a man better under-
stand his past and look at himself with a clearer eye.
This self-exploration that photography allows is
undoubtedly due to its strong and powerful link
with reality.

People are beginning to realize that photographs
are not only tangible fragments of their own exis-
tence, but also of their illusions and dreams of events
which may never come to pass, as well as material-
ized flares of imagination and of a non-existing
world.

The ambiguity of photographs plays tricks on
even the most clever minds in an interplay estab-
lished between the photographic image and its
observer. Some observers are satisfied with im-
mediate recognition of that which is depicted while
other non-conformists search for meanings in all
they see.

The photographer must give nurtured and nutri-
tious responses to everyone. His images must con-
tain something of importance even though he may
fail to recognize it as readily as someone studying
them more closely.

He must lean on the common ordinary tactics of
the use of form and content enhanced by the inter-
action with lines, shapes, textures, etc., to direct the
observer's attention to a certain point. But then,
each photographer must be able to release the
viewer so that he uses this frozen semi-reality to fly
away on his own, to reach his own heights, and from
that viewpoint see the world, see himself.

Since the beginning of awareness, the artist, gen-
erally a painter or draftsman, has had the receptive
ability to give new meanings to that which sur-
rounds him and communicate his feelings to others.
Scientists did as well. In this sense, scientists and
artists are no different from the photographer, but
unlike the draftsman's or painter's tools, the extra
flexibility lent to the photographer by the use of
sophisticated equipment and processes enables him
to concentrate on the most difficult part of it all:
discovery and capture.

The photographer's widespread use of odd and
strange techniques as well as bizarre environments
and subjects to depict his own creations sometimes
causes the world to wonder at his audacity or even
depravity and his ability to repel and disgust yet
inform and communicate. Still, he has not forgotten
to look at the simple things around him and to
discover the magic within an ordinary subject with-
out sensationalism or unusual treatment to capture
attention.

I like simplicity—even more when I recognize the
kind that results from careful elaboration. Real
simplicity may jump out at you from a street corner,
or make its presence known when you stand staring
at a point without really knowing why and from the
blurred, out-of-focus vision, a relationship of lights
and shadows emerges that makes your heart skip a
beat with your urgency to capture it, to materialize
it.

I also enjoy seeing something that another photog-
rapher has put together, whether I discover it in a
book, a gallery, or a magazine. I always have the
same pleasurable reaction when I feel cleverness,
originality and ability blended together to produce a
photographic image that makes my heart and head
turn. I have also great respect for this type of
experience.

Conversely, I feel offended when I discover a
poorly-executed trick. I have nothing against tricks
but their purpose should always be unequivocally
defined. I, as the observer, should always recognize
the meaning and justification. I feel betrayed when a
trick is used for the sole purpose of attracting atten-
tion which otherwise would be quickly lost.

I never lean on the importance of content in my
own work, nor the emotions resulting from witness-
ing a dramatic, grotesque, comical or other kind of
attention-arresting event. I would rather use the
content as a pretext to make myself seen.

A photograph, being a visual piece, should enter
my mind through my alerted eyes.

—Lázaro Blanco

A sensitive and acute interpreter of his people and
his country, Lázaro Blanco has transformed docu-
mentary photography into a poetic narration of
facts, realities and opinions. Inheriting the concepts
of the great Mexican school of photography, which
has decisively influenced more than one famous
photographer—Cartier-Bresson, Weston, Modotti,
Strand—Blanco has created a new and personal
style in which tradition goes through a profound
process of innovation.

Certain themes that form part of the Mexican
visual heritage—socio-political declarations, religious
ritual, the influences of the cultures that preceded
Columbus, the mass of habits and customs—are all
tackled by Blanco, but allusively. This cultural net-
work, always an integral and essential part of Mexi-
can society, is actually revealed in his pictures
through minute, apparently insignificant details,
almost confused and hidden by other elements of
contemporary life.

There is also in his work a subtle contrast between
surviving symbols of the past and symbols of the
present, a truthful and faithful representation of a
society in evolution. The two ways of life and
thought in a society that lives in daily contradiction
with itself, unable to abandon the ancient myths yet
already living in a futuristic age, are depicted by
Blanco with delicate sensitivity. And he succeeds in
harmonizing within himself two approaches to real-
ity that are normally in conflict: intellectual acute-
ness in recognizing the significant subject and a
warm-hearted human sympathy. As a result, certain
asperities that come from too clear a vision of the
world and a facile tendency to sentimentalism are
resolved by Blanco in pictures of a composed and
expressive harmony.

Blanco examines the little lives, the less obvious
realities, the humdrum events, things from which
significant elements can be extracted as a means to
an overview, avoiding anything easy, obvious,
exceptional or extraordinary. He is accustomed to
reason and self-discipline and never allows himself
to be distracted by a passing emotion; with meticu-
lous care he controls every detail of a picture con-
structed from a few essential, irreplaceable ele-
ments. His graphic composition seems to be the
result of complex mathematical and geometrical
calculations, which create a perfect balance of lines,
forms, and tone. Every one of his pictures is the
result of slow deliberation; he purges anything
superfluous or redundant until he arrives more at

Lázaro Blanco: *La Comunión Primera*, **1976**

1964 *Mensen op Weg*, Stedelijk Museum, Amsterdam
1978 *Fotografie in Nederland 1940-1975*, Stedelijk Museum, Amsterdam
1979 *Fotografie in Nederland 1920-1940*, Haags Gemeentemuseum, The Hague

Collections:

Stedelijk Museum, Amsterdam; Gemeente Archief, Amsterdam; Haags Gementemuseum, The Hague, Prentenkabinet, Rijksuniversiteit, Leiden.

Publications:

On BLAZER: books—*Waar Nederland Trotsch op Is* by Paul Schuitema, Leiden 1940; *Holland and the Canadians* by Norman Phillips and J. Nikerk, Amsterdam 1946; *50 Jaar Bruijnzeel, 1897-1947*, Amsterdam 1947; *Verwoesting en Wederopbouw* by Ir. Th. P. Tromp, Amsterdam 1948; *Fotogoek over Rome*, Amsterdam 1951; *De Dijken* by Max Dendermonde, Amsterdam 1956; *Fotografie in Nederland 1940-1975*, exhibition catalogue, by Els Barents, Amsterdam 1978; *Fotografie in Nederland 1920-1940*, exhibition catalogue, by Flip Bool and Kees Broos, The Hague 1979; *Anderland: Carel Blazer Fotograaf*, with an introduction by Willem Frederick Hermans, Amsterdam 1979; articles—in *Haagse Post* (The Hague), 27 September 1958; "Carel Blazer" by Wim Alings Jr. in *De Groene Amsterdammer* (Amsterdam), 4 April 1968; Fotograaf Blazer" by Taco Swart in *Algemeen Dagblad* (Amsterdam), 9 April 1968; *Algemeen Handelsblad* (Amsterdam) 13 April 1968; "De tweede generatie" by Ursula den Tex in *Vrij Nederland-bijlage* (Amsterdam), 15 May 1976.

In 1932 Carel Blazer, while still an amateur photographer, made a photograph of a performance by an anti-fascist labour ballet group. This photograph was a surprisingly and highly successful version of the avant-garde trends of the 1930's, complete with the very characteristic dynamic diagonal accent. The reasons for so precocious a performance are these: his contacts with the Association of Worker Photographers created an incentive to choose photography as a profession; because he had trained as an electro-technician, he was already technically oriented; and, most important, he had, even at that very early age, already obtained a perfect command of the techniques of photography. That this was so soon became apparent in his photographic reports for newspapers and industry. Later on, he invested in special equipment, which allowed him to improve on his color photography—and his enlargements, for example the one he produced for the Dutch Pavilion at the *World's Fair* in Brussels in 1958. He enlarged a miniature photo into one of 100 square meters, and every photographer in Holland wanted to know how he had done it.

Blazer always went out into the world to "report." He enjoyed participating in and conveying what was happening in other people's lives. Because he was religious, he longed for a peaceful world. *May Peace Be* was the title of his exhibition at the Stedelijk Museum in Amsterdam in 1968. This title was inspired by the title of one of his photographs in the exhibition, "Viva la Pace," which both before and during the war had been the slogan in the fight against fascism. Blazer made some very moving photographs of 14 July 1936 in Paris; of the Spanish Civil War in 1937; of the "Anschluss" in Czechoslovakia in 1938; and of Amsterdam just before and after the capitulation of the Germans in 1945; but he sometimes felt frustrated that he could not do more to help fight fascism except via his photographs. He wanted at least to capture what he saw. This "capturing," which always involved ordinary people, he did continuously throughout his life, travelling all over

the suggestion than at the crude statement of an idea.

There is nothing flashy about his work, nor does he look for the "decisive moment." His approach is patient and restrained. First, he assimilates the fragments of actuality before his eyes; once his emotional response to his subject has subsided, he looks for essence in his everyday event; then, when he has reached harmony between emotional impulse and exterior image, he takes his picture. This slow intellectual and psychological process creates photographs that also take a long time to observe: the picture makes no instant, profound impact on the viewer. The totality of the message, with its myriad of minute details, is comprehended only gradually.

Lázaro Blanco "writes" with light, creating visual poems with the tempo and rhythms of an old traditional dance. And just as the dance is a metaphorical representation of life and fantasy, so we discover in his pictures how much magic is within reality.

—Giuliana Scimé

BLAZER, Carel.

Dutch. Born in Amsterdam, 16 June 1911. Educated at schools in Amsterdam, 1919-27; trained in electronics; studied photography, under Hans Finsler, at the Kunstgewerbeschule, Zurich, 1934. Worked in photographic studio of Eva Besnyö, Amsterdam,

1934; freelance photojournalist and industrial photographer, working for *De Lach, Het Leven, Wereldkroniek*, and Metz and Company, Bruijnzeel, Matex-Rotterdam, etc., Amsterdam, 1934-75: did photo-reportage in Netherlands and abroad, including the Spanish Civil War, 1937, and Anschluss in Czechoslovakia, 1938; also produced monumental photo-murals for Economische Voorlichtingsdienst, etc., Amsterdam, from 1938; Persoonbewijzencentrale, 1942-45; retired, living in Altforst, Netherlands, 1975 until his death, 1980. Instructor in Photography, under Paul Citroen, Nieuwe Kunstschool, Amsterdam, 1939-42. Recipient: Gebonden Kunstenfederatie Prize, Amsterdam, 1968. *Died* (in Altforst), *16 January 1980.*

Individual Exhibitions:

1958 Steendrukkerij De Jong, Hilversum, Netherlands
1968 *May Peace Be*, Stedelijk Museum, Amsterdam Raadhuis, Heerlen, Netherlands
1979 Gemeentemuseum, The Hague

Selected Group Exhibitions:

1937 *Foto '37*, Stedelijk Museum, Amsterdam *World's Fair*, Paris
1945 *Ondergedoken Camera*, Atelier Meijboom, Amsterdam
1948 *Foto '48*, Stedelijk Museum, Amsterdam
1957 *Fotografie als Uitdrukkingsmiddel*, Van Abbemuseum, Eindhoven, Netherlands *Bennale di Fotografia*, Venice
1958 *Gebonden Kunstenfederatie*, Rijkuniversiteit, Leiden

the world. He did it with modesty and sincerity. "When I take pictures, I take them to show to others, not so much to show the sorrow, but more to show the positive things."

For his many industrial reports Blazer still found time to improve techniques and to experiment. His reports on the Delta works in Zeeland are both dynamic and technically excellent; his series on various firms in Rotterdam are of an equally high standard. Even in these industrial pictures, he managed to achieve something special.

Another Dutch photographer once said of Blazer: "I do not think there exists any Dutch photographer who has not learned something from his work."

—A. de Jonge-Vermeulen

BLOCH, Ernest.

American. Born in Geneva, Switzerland, 24 July 1880; emigrated to the United States, 1916: naturalized, 1924. Educated at gymnasium, Geneva, Switzerland, 1885-1894; studied violin, under Louis Rey, Geneva, 1894-95; musical composition, under Emil Jaques-Dalcroze, Geneva, 1894-95; violin, under Eugène Ysaÿe and Franz Schorg, Brussels, 1896-99; under Ivan Knorr, Frankfurt, 1899-1901; under Ludwig Thuille, Munich, 1901-03; mainly self-taught in photography. Married Marguerite Schneider in 1904; children: Lucienne, Ivan and Suzanne. Independent photographer, Switzerland, France and the United States, 1898-1945. Worked as composer and music conductor, Lausanne, Neuchatel, and throughout Switzerland, 1908-10; lecturer in aesthetics, Conservatoire, Geneva, 1911-16; music conductor, New York, 1916-17; instructor in music, David Mannes School, New York, 1917; private music instructor, New York, 1918-20; Founder Director, Cleveland Institute of Music, Ohio, 1920-25; Director, San Francisco Conservatory of Music, California, 1925-30; independent composer, Ticino, Switzerland, 1930-39; lived in Agate Beach, Oregon, 1941-59; visiting lecturer in music, 1941-51, and Emeritus Professor, 1952-59, University of California at Berkeley. Recipient: Gold Medal, American Academy of Arts and Letters, 1947; New York Music Critics Circle Award, 1947, 1954; Frank L. Weil Award, National Jewish Welfare Board, 1956; Henry Hadley Medal, 1957; Special Award, Fine Arts Commission, Portland, Oregon, 1958; Brandeis University Creative Arts Award, Waltham, Massachusetts, 1959 (posthumous). D.H.L.: Hebrew Union College/Jewish Institute of Religion, 1943; Linfield College, Oregon, 1948. Honorary Member, Accademia Cecilia, Rome, 1929; Member, American Academy of Arts and Letters, 1943. Agent: Ernest Bloch Society, Star Route 2, Gualala, California 95445, U.S.A. *Died* (in Portland, Oregon) *15 July 1959.*

Individual Exhibitions:

1972 Camerawork Gallery, Portland, Oregon
1974 Teaching Gallery, University of Florida, Gainesville
 Keller Hall, University of New Mexico, Albuquerque
1975 Image Gallery, Stockbridge, Massachusetts
 Ingber Gallery, New York
1976 Museum of Art, Portland, Oregon
1979 Center for Creative Photography, University of Arizona, Tucson

1980 *Spoleto Festival*, Temple Kahal Kadosh Beth Elohim, Charleston, South Carolina

Selected Group Exhibitions:

1979 *Swiss Photographers*, Kunsthalle, Zurich

Collections:

Suzanne Bloch, New York; Center for Creative Photography, University of Arizona, Tucson; University of California, Berkeley; Lucienne Bloch Dimitroff, Gualala, California.

Publications:

On BLOCH: books—*Ernest Bloch: Creative Spirit* by Suzanne Bloch and Irene Heskes, New York 1976; *Ernest Bloch, Voice in the Wilderness* by Robert Strassburg, Los Angeles 1977; *Ernest Bloch Archive, Center for Creative Photography* by Sharon Denton and Bonnie Ford Schenkenberg, Tucson, Arizona 1979; *The Spiritual and Artisitic Odyssey of Ernest Bloch: A Centenary Retrospective*, Charleston, South Carolina 1980; articles—"A Composer's Vision: Photographs by Ernest Bloch" by Eric Johnson in *Aperture* (New York), vol. 16, no. 3, 1972; "Ernest Bloch" by Eric Johnson in *Camera* (Lucerne), February 1976; also *Ernest Bloch Society Bulletin* (annual newsletter), since 1968.

Surely there have been—and will continue to be—countless artists in every generation and of every persuasion who, failing to engender within their lifetimes a self-propelling structure of recognition for their work, slip cruelly into undeserved obscurity after their deaths. Such a fate, it would seem, has befallen the artist Ernest Bloch, a man who lived with relatively mild fanfare and who, 20-odd years after his death, is now only faintly remembered. Bloch was—as any good library card catalog will reveal—actually two people in one: foremost a composer of music, but also, as is generally less well known, a marvellously accomplished photographer.

Under-played and under-exhibited now that he is gone, Bloch may yet receive his rightful valuation. The potential for such recognition exists directly within his dual oeuvre. Those drawn to Bloch's music may someday discover his winsome, lyrical, yet penetrating photographs—of landscape, trees, and his family; there are even quite a few self-portraits. Those acquainted primarily with his photographs, on the other hand, have a joyous experience in store listening to the haunting passion and sweeping beauty of his concertos, sonatas, string quartets and Hebraic rhapsodies.

Born in the last century, but accomplishing some of his best work at the beginning of this one, Ernest Bloch stood loyal to the ideals and philosophy of a time gone by. Essentially a romantic in an age going mad with machines and modernism, Bloch composed his music from tested theories. "Art for me," he said, "is an expression, an experience of life and not a puzzle game or icy demonstration of imposed mathematical principles...the soul of art is lost in the passion for mechanical perfection." For Bloch, art "lives or dies in its ability to touch man's eternal soul." Alfred Stieglitz would undoubtedly have agreed. It was, in fact, Stieglitz who valued Bloch's opinion of his own cloud sequences. "I wanted a series of photographs," Stieglitz wrote, "which when seen by Ernest Bloch (the great composer) he would exclaim: 'Music! Music! Man, why that is music!' "

Photography and music are linked by audience more than anything else. Whether seeing or listening, the body willfully submits to restful contemplation. Composing music or making photographs, however, can be quite another matter. While Bloch's music was often subject to extremes of emotion—a pensive despair followed by a glowing sensuality—his photography assumed a steadier course. Joy and sorrow were reserved for the orchestra, charm and grace for the camera. Nevertheless, music appears to have been very much on his mind when he made his pictures. In a photograph entitled "Bach, Switzerland, 1931," two birch trees split off from center stage, each floating off to opposite ends of the frame: one is clearly the principle, the other an accompaniment. Behind them a hillside of lesser birches play to the light. In another photograph, a self-portrait taken with his three children in Geneva in 1911, father positions all four heads like ascend-

Ernest Bloch: *La Foire à Fribourg*, Switzerland, c. 1902

ing scales in a musical score. In yet another image, taken in the American Midwest in 1929, a black locomotive pulsates with steam puffs that come suddenly out of nowhere, much like a piano surprisingly introduced in the middle of a concerto.

Bloch's musical scores, while numerous, are hardly suggestive of a prolific, exceedingly original sensibility. He is best known today as a composer of Jewish music—rhapsodies such as *Schelomo*, the violin suite *Baal Shem*, or *Avodath Hakodesh*, a choral work also known as the *Sacred Service*. But then, as I say, perhaps Bloch has been denied a contemporary reconsideration and evaluaton. Many of his recorded works remain in their original, pre-stereo covers, worn out on library shelves more from aging than overuse. This paucity of re-releases is mirrored in the Bloch photographic archive reproduced to date. Bloch's photographs, derived from a collection of more than 5,000 negatives, are presented in less than half a dozen photographic journals, several books and magazines. Often the very same set of images are reproduced, suggesting that the wide stretching lake might just be shallow. Because we lack sufficient evidence, there is every reason for a re-assessment of Bloch's accomplishments. The emphasis should perhaps rest not so much on the vitality of his separate modes of expression as on their potential interplay. The sum here could be greater than its parts.

There is a wonderful image of Ernest Bloch, the man of music and photography, in Robert Strassburg's book *Ernest Bloch: Voice in the Wilderness*: "Possibly because Bloch was a hypochondriac all his life, he was a firm believer in a sane mind in a healthy body. Rarely did a day go by without his taking a long walk into the mountains or along the seashore. For company he generally took his miniature scores of Bach's *Well-Tempered Clavier*; to these he added a few apples, a bar of chocolate, and his Leica camera."

—Arno Rafael Minkkinen

BLONDEAU, Barbara.

American. Born in Detroit, Michigan, 6 May 1938. Studied painting at the School of the Art Institute of Chicago, 1957-61, B.F.A. 1961; studied photography, under Aaron Siskind and Joseph Jachna, at the Institute of Design, Illinois Institute of Technology, Chicago, 1963-68, M.S. 1968. Independent photographer, in Chicago, Notre Dame, Indiana and Philadelphia, 1966-74. Instructor, St. Mary's College, Notre Dame, 1966-68, and Moore College of Art, Philadelphia, 1968-70; Assistant Professor, 1970-71, and Chairman of the Department of Photography and Film, 1971-74, Philadelphia College of Art. *Died (in Philadelphia) 24 December 1974.*

Individual Exhibitions:

1967 St. Mary's College, Notre Dame, Indiana
1968 Northern Illinois University, DeKalb
University of Kentucky, Lexington
1975 Philadelphia College of Art
1976 Visual Studies Workshop, Rochester, New York (toured the United States)
1979 University of Georgia, Athens

Selected Group Exhibitions:

1967 *Faculty Show*, St. Mary's College, Notre Dame, Indiana
1969 *Photography Is...*, Ridgefield, Connecticut
Vision and Expression, International Museum of Photography, George Eastman House, Rochester, New York (toured the United States, 1969-71)
1970 *Contemporary Photography*, Peale House Galleries, Philadelphia
Into the 70's: Photographic Images by 16 Artists/Photographers, Akron Art Institute, Ohio
1972 *The Multiple Image*, Massachusetts Institute of Technolgoy, Cambridge (travelled to the University of Rhode Island, Kingston)
The Expanded Photograph, Civic Center Museum, Philadelphia
1974 *Visual Interface*, Tyler School of Art Gallery, Philadelphia
1975 *Ars Moriendi*, Jefferson Hospital Commons Building, Philadelphia
1976 *3 Centuries of American Art*, Philadelphia Museum of Art

Collections:

Visual Studies Workshop, Rochester, New York; Workshop Research Center, Philadelphia College of Art; National Gallery of Canada, Ottawa.

Publications:

On BLONDEAU: books—*Vision and Expression*, exhibition catalogue, by Nathan Lyons, New York 1969; *Popular Photography Annual*, New York 1969; *Into the 70's: Photographic Images by 16 Artists/Photographers*, exhibition catalogue, with text by Tom Muir Wilson, Orrel E. Thompson, and Robert M. Doty, Akron, Ohio 1970; *The Print*, by the Time-Life editors, New York 1971; *Frontiers of Photography*, by the Time-Life editors, New York 1972; *The Multiple Image*, exhibition catalogue, Cambridge, Massachusetts 1972; *Barbara Blondeau 1938-1974*, exhibition catalogue, edited by David Lebe, Joan Redmond and Ron Walker, with commentary by Charles Hagen, Rochester, New York 1976; articles—in *Camera* (Lucerne), November 1971; "Photography: Chicago, Moholy and After" by Andy Grundberg in *Art in America* (New York), September/October 1976; "Barbara Blondeau" by Charles Hagen in *Afterimage* (Rochester, New York), March 1976.

Barbara Blondeau made her lasting and considerable reputation in a photography in a mere eight years of mature work before her death from cancer at the age of 36. Although her *oeuvre* is small, it shows in every aspect an artist exploring with masterly assurance the possibilities of a medium whose limits she sought to extend.

Originally trained as a painter before studying with Aaron Siskind and Joseph Jachna at the Institute of Design, Blondeau experimented with many technical and formalistic innovations, and her work certainly belongs under the rubric "expanded photograph," the title of one of her group shows. Her technical interests included the *cliché verre* process (in which an image is hand-painted on a piece of glass which is then used as the negative for a black and white print), the half-tone screen, the photogram, and various combinations of mounted large-format transparencies and acrylic paint applied to emphasize and highlight parts of the image. Most sustained, however, was the work with strip prints for which she became widely known.

These images were made by winding an entire roll of film past the camera's open shutter, which was masked sufficiently to obtain a printable negative, and then printing each roll of film as one print. Usually taking as her subject a person posed against a black background, Blondeau created an image in which a white form, of greater or less transparency and legibility, depending on the speed at which the film was wound, extended the length of the print. Hung vertically, with the subject's face appearing clearly at certain points in the print, these images resembled totem poles and were shown as a "totem series." However, Blondeau soon adopted a horizontal presentation which emphasized the images' expanded time reference and narrative aspect, recalling the 19th-century work of Eadweard Muybridge and Etienne-Jules Marey.

Although these strange prints appear at first somewhat forbidding and starkly abstract, familiarity reveals their concern with the shapes and contours of the human body, especially the female body. In later experiments with the strip format, Blondeau used, in one instance, a strobe light and, in another, a mask in the camera to emphasize the gestures of her nude models as they moved, thus punctuating the crowded frame with familiar human elements.

This concern with our determinedly metaphorical perception of human materiality also preoccupies Blondeau in her final work. She described her "black border" series, in which a thick black border has been printed around negatives made several years earlier, as a metaphorical expression of her feelings about her approaching death. Although we can only guess at her private emotions, the energy and beauty of the images trapped within the new, heavy borders convey an unmistakable poignance.

Though Blondeau must be reckoned a formalist, she redeems the apparent starkness of the modern picturemaker's concerns with an imaginative grace and ease, and even an occasional joy, which remind us that these feelings too make up the gifted artist's sensibility.

—Maren Stange

BLOSSFELDT, Karl.

German. Born in Schielo, Harz Mountains, 13 June 1865. Educated at primary and secondary schools in Harzgerode, 1871-81; apprentice sculptor, Art Ironworks and Foundry, Mägdesprung, Germany, 1882-84; studied painting and sculpture at the Kunstgewerbeschule, Berlin, 1884-91, and, on scholarship, under Professor M. Meurer, in Italy, Greece and North Africa, 1891-96; self-taught in photography. Married Maria Plank in 1898 (separated, 1910); married Helen Wegener in 1912. Took first plant photos, with home-made plate camera, Berlin, c. 1896; independent photographer, mainly studying the forms of plants, and contributing to *Uhu, Atlantis, Photographic Correspondence, The German Photograph*, etc., Berlin, 1926-32. Instructor in the sculpture of living plants, under Ernst Ewald, 1898-99, University Teacher, 1899-1921, and Professor, 1921-32, School of the Kunstgewerbemuseums, now the Hochschule für Bildende Künste, Berlin. Agent/Estate: Galerie Wilde, Auf dem Berlich 6, 5000 Cologne 1, West Germany. *Died (in Berlin) 9 December 1932.*

Individual Exhibitions:

1929 Zwemmer Gallery, London

Karl Blossfeldt: *Aristolochia spec.*, c. 1915 Courtesy Galerie Wilde, Cologne

1975 Galerie Wilde, Cologne
1976 Rotterdam Arts Foundation
Fotografien 1900-1932, Rheinisches Landes-
museum, Bonn
1978 Museum of Modern Art, Oxford
Galerie Wilde, Cologne
Arras Gallery, New York
Städtische Galerie, Graz, Austria
Museum des 20. Jahrhunderts, Vienna
Stills Gallery, Edinburgh
1979 Galerie Haus Seel, Siegen, West Germany
Sonnabend Gallery, New York

Selected Group Exhibitions:

1929 *Film und Foto*, Deutscher Werkbund, Stutt-
gart
1977 *Documenta 6*, Museum Fridericianum, Kas-
sel, West Germany
Neue Sachlichkeit und Realismus, Museum
des 20. Jahrhunderts, Vienna
Une Fleur, Un Arbre, Une Plante...,
Yakima/Galerie, Montreal
1978 *Paris-Berlin 1900-1933*, Centre Georges
Pompidou, Paris
1979 *Photographie als Kunst 1879-1979*, Tiroler
Landesmuseum Ferdinandeum, Inns-
bruck, Austria (travelled to Neue Galerie
am Wolfgang Gurlitt Museum, Linz, Aus-
tria; Neue Galerie am Landesmuseum
Joanneum, Graz, Austria; and Museum
des 20. Jahrhunderts, Vienna)
Film und Foto der 20er Jahre, Württem-
bergische Kunstverein, Stuttgart (travelled
to Museum Folkwang, Essen; Werkbund-
archiv, Berlin; Kunsthaus, Zurich;
Kunstverein, Hamburg; and Museum des
20. Jahrhunderts, Vienna)
1980 *Experimental Photography*, Stills Gallery,
Edinburgh (toured the U.K.)
*Avant-Garde Photography in Germany
1919-39*, San Francisco Museum of Mod-
ern Art (toured the United States 1981-82)
1981 *Germany: The New Vision*, Fraenkel Gal-
lery, San Francisco

Collections:

Museum Ludwig, Cologne; Länderbank Collection,
Vienna; Bibliothèque Nationale, Paris; Metropoli-
tan Museum of Art, New York; University of New
Mexico, Albuquerque.

Publications:

By BLOSSFELDT: books—*Urformen der Kunst*,
with preface by Karl Nierendorf, Berlin 1928; *Wun-
dergarten der Natur*, Berlin, 1932, as *Art Forms in
Nature*, New York 1932; *Wunder in der Natur*, with
text by Otto Dannenburg, Leipzig 1942; *Portfolio
Karl Blossfeldt*, portfolio of 12 photos, with text by
Volker Kahmen and Jürgen Wilde, Cologne 1975;
Das Fotografische Werk, with a preface by Gert
Mattenklott, reprint of *Urformen der Kunst* and
Wundergarten der Natur, Munich 1981.

On BLOSSFELDT: books—*Karl Blossfeldt: Foto-
grafien 1900-1932*, exhibition catalogue, by Klaus
Honnef, Bonn 1976; *Documenta 6/Band 2*, exhibi-
tion catalogue, by Klaus Honnef and Evelyn Weiss,
Kassel and Cologne 1977; *Geschichte der Fotografie
im 20. Jahrhundert/Photography in the 20th Cen-
tury* by Petr Tausk, Cologne 1977, London 1980;
Neue Sachlichkeit und Realismus, exhibition cata-
logue, by Robert Schmitt, Vienna 1977; *Neue Sach-
lichkeit and German Realism of the Twenties*, exhi-
bition catalogue, by Wieland Schmied, Ute Eskildsen
and others, London 1978; *Paris-Berlin 1900-1933*,
exhibition catalogue, by H. Molderings, W. Spies,

G. Metken and others, Paris 1978; *Germany: The
New Photography 1927-33*, edited by David Mellor,
London 1978; *Photographie als Kunst 1879-1979/
Kunst als Photographie 1949-1979*, exhibition cata-
logue, 2 vols., by Peter Weiermair, Innsbruck 1979;
Photographen der 20er Jahre by Karl Steinorth,
Munich 1979; *Film und Foto der 20er Jahre*, exhibi-
tion catalogue, by Ute Eskildsen and Jan Chris-
topher Horak, Stuttgart 1979; *Experimental Pho-
tography*, exhibition catalogue, by Dawn Ades,
London 1980; *Avant-Garde Photography in Ger-
many 1919-1939*, exhibition catalogue, by Van
Deren Coke, Ute Eskildsen and Bernd Lohse, San
Francisco 1980.

Karl Blossfeldt spent his childhood and adolescence
in the unspoiled world of the Harz Mountains,
where he developed a deep attachment to nature
which was to become a major influence on his later
photographic work. During the early years of his
apprenticeship at Mägdesprung he displayed a tal-
ent for sculpture and a firm grasp of form, skills
which he went on to strengthen during his studies at
the Kunstgewerbeschule in Berlin.

In 1890, one of his professors, M. Meurer, began
the task of preparing teaching aids which would
make clear to students, by concrete examples, the
basic forms found in nature. (He also wished to
advance his own theory—now well-supported by art
history—that natural forms are carried over into
architecture and the other arts.) Along with five
other assistants, Meurer chose Blossfeldt, who was
now a competent photographer, to accompany him
on a trip to Italy, Greece, North Africa, and most
importantly, Egypt. Here the expedition collected
typical plant forms which they preserved in dried
form, in sketches, and even in plaster casts, thus
providing Blossfeldt with the basis for his photo-
graphic work between 1890 and 1932.

Nature and its inherent laws as well as his exper-
ience of Egyptian, Greek and Roman art taught
Blossfeldt directness and fidelity to what is essential.
His early photographs also reveal an interest in the
typology of plant forms which was to become a
fundamental concern of his later work. In a recent
edition of these first pictures Gert Mattenklott notes
that in one of Meurer's 1896 publications Bloss-
feldt's photographs of plant forms appear next to
architectural fragments from classical museums.

Blossfeldt used a camera which he made himself
and three different sizes of negatives (6 x 9 cm, 9 x 12
cm and 13 x 18 cm). He shot his plants in front of
neutral backgrounds, lit them with weak daylight
whenever possible, and used either a vertical or
horizontal perspective. This very simple technique
went unchanged during his 33 years of teaching and
practice. While he did not see his work as artistic
activity, he nevertheless regarded himself as a true
photographer. His main concern was to gather suit-
able plants and provide the most exact reproduc-
tions possible of them and their parts. He did not
limit himself to the separate parts of a particular
plant—to the head of a poppy, for example—but
tried rather to give a broad selection of the various
shapes and forms which appear during the growth
period and drying process.

On the basis of *Urformen der Kunst* and its influ-
ence we can now see that behind this documentary
concern was the mind of a 19th century natural
scientist and philosopher, a mind comparable to
that of a Charles Darwin, Gottfried Semper or Erich
Haeckel. Charles Darwin's *On the Origin of Species*
led Haeckel to his most important work, *General
Morphology* (prior to this, and until 1865, Haeckel
had buried himself in his work on radiolarian, on
which he published his first monograph). These pub-
lications generated a good deal of excitement at the
time and could hardly have escaped the attention of
someone like Blossfeldt, who had also devoted him-
self to the study of "nature." We may therefore
suppose that by using his plant forms Blossfeldt
wanted to demonstrate that the individual who

thinks and acts creatively is subject to the same
natural forms or inherent archetypes: that is, he
would have developed artistically without any explicit
knowledge of natural forms. In his essay, "Greek
Architecture," Robert Breuer took up this idea and
illustrated it with plant photographs by Blossfeldt
which he then compared to architecture and various
art objects. "It is not without a mysterious signifi-
cance," he writes, "that a horse willow which grows
in the north of Germany brings to mind the same
impression (allowing for differences of size) made by
a temple minaret in Delhi. That fronds just before
unfolding make us think of smithery, and that leaf
buds, with their projections to the right and left of
the middle axis remind us of modern light fixtures
(forms which have developed only because of tech-
nology and human need) also make us wonder if
there is not an unknown law which rules man and his
achievements as well as nature and its develop-
ments. It may be responsible for the growth of life in
a blade of grass, a tree trunk or blossom, and in the
brain, nerves and hands of mankind."

In his book, *Wundergarten der Natur*, Blossfeldt
makes his only comment on his photography, whose
success proved to him that "every healthy develop-
ment in art gets its fertile initiatory form from na-
ture's eternally inexhaustible 'fountain of youth.' "
At the end of his short commentary, the basis of
which can be traced back to the naturalism of the
19th century, he observes that "the plant should be
valued as a completely artistic-architectonic struc-
ture. In addition to being an ornamental, rhythmi-
cal, vibrant natural form which predominates in
nature, the plant 'builds' only useful and practical
designs. It was forced, in its struggle for existence, to
develop resistant, vital and purposeful organs. It
developed according to the same structural rules
which every architect must observe. However, the
plant never reverts to mere functionality; it is
formed and 'built' according to logic and function
and is compelled, by an elemental force, towards the
highest artistic form."

—Jürgen Wilde

BLUMBERG, Donald.
American. Born in Brooklyn, New York, 4 April
1935. Educated at Cornell University, Ithaca, New
York, 1957-59, B.S. in biology 1959; University of
Colorado, Boulder, 1959-61, M.S. in biology 1961.
Served in the United States Army, in the U.S. and
Germany, 1955-57: Corporal. Married Grace Ganz
in 1959; daughter: Rachel. Photographer since 1962.
Instructor, Brooklyn College, New York, 1962-63,
City College of New York, 1963-64, and Mobiliza-
tion for Youth (Federal anti-poverty program),
Lower East Side, New York, 1962-65. Assistant
Professor of Art, 1965-69, Associate Professor of
Art, 1969-72, and since 1972 Professor of Art and
Director of the Photography Program, State Uni-
versity of New York at Buffalo. Visiting Professor in
Creative Photography, Massachusetts Institute of
Technology, Cambridge, 1972-74; Distinguished
Visiting Professor of Art (Photography), California
State University at San Jose, 1979-80. Recipient:
SUNY at Buffalo Research Fellowship, 1966, 1967,
1969, 1972, 1973; SUNY at Buffalo Institutional
Funds Research Grant, 1967-71, 1975; Creative
Artist Public Service Grant, New York State Coun-
cil of the Arts, 1971, 1975. Agents: Visual Studies
Workshop, 31 Prince Street, Rochester, New York
14607; and Light Gallery, 800 North La Cienega
Boulevard, Los Angeles, California 90069. Address:
16918 Donna Ynex Lane, Pacific Palisades, Cali-
fornia 90272, U.S.A.

Individual Exhibitions:

1963 Camera Infinity Gallery, New York
1966 International Museum of Photography, George Eastman House, Rochester, New York
1969 University/Community Living Arts Center (Domus), Buffalo, New York
1970 State University of New York at Buffalo
1971 *Daily Photographs*, Visual Studies Workshop, Rochester, New York
 Portraits of Students, State University of New York at Buffalo
1972 International Museum of Photography, George Eastman House, Rochester, New York
1973 Harvard University, Cambridge, Massachusetts
 Massachusetts Institute of Technology, Cambridge
 Cranbrook Academy of Art, Bloomfield Hills, Michigan
 Worcester Art Museum, Massachusetts
1974 International Cultureel Centrum, Antwerp (toured Europe)
 Memorial Gallery, Rochester, New York
1976 Visual Studies Workshop, Rochester, New York
1979 *Photographs 1965-1978 by Donald Blumberg*, Cranbrook Academy of Art, Bloomfield Hills, Michigan (retrospective)
 Donald Blumberg: Recent Photographs in Series, Albright-Knox Art Gallery, Buffalo, New York
 Recent Photographs, Addison Gallery of American Art, Andover, Massachusetts
 Recent Photographs, California State University at San Jose
1980 *Photographs 1965-1980 by Donald Blumberg*, DeSaisset Museum, University of California at Sant Clara
 Photographs 1965-1980 by Donald Blumberg, Glenbow Museum, Calgary, Alberta
 Donald Blumberg: Cityscapes/Landscapes, Markham Gallery, San Jose, California
1981 *Photographs 1965-1981 by Donald Blumberg*, Los Angeles Municipal Museum at Barnsdall Park
 Glenbow Museum, Calgary, Alberta

Selected Group Exhibitions:

1966 *Current Report II*, Museum of Modern Art, New York (toured the United States, 1966-75)
1967 *The Persistence of Vision*, International Museum of Photography, George Eastman House, Rochester, New York (toured the United States, 1967-70)
 Photography in the 20th Century, National Gallery of Canada, Ottawa (toured Canada and the United States, 1967-73)
1968 *Contemporary Photographer III*, International Museum of Photography, George Eastman House, Rochester, New York (toured the United States, 1968-71)
1969 *Vision and Expression*, International Museum of Photography, George Eastman House, Rochester, New York (toured the United States, 1969-71)
1970 *New Acquisitions*, Museum of Modern Art, New York
1971 *Edward Steichen Permanent Collection*, Museum of Modern Art, New York
 The Permanent Collection, Visual Studies Workshop, Rochester, New York
1977 *Eye of the West: Camera Vision and Cultural Consensus*, Hayden Gallery, Massachusetts Institute of Technology, Cambridge
1980 *The Painterly Photograph*, Washington Project for the Arts, Washington, D.C.

Collections:

Museum of Modern Art, New York; International Museum of Photography, George Eastman House, Rochester, New York; Carpenter Center for the Visual Arts, Harvard University, Cambridge, Massachusetts; Library of Congress, Washington, D.C.; Art Institute of Chicago; Minneapolis Institute of Arts; Norton Simon Museum, Pasadena, California; Oakland Museum, California; National Gallery of Canada, Ottawa.

Publications:

BY BLUMBERG: books—*Daily Photographs*, portfolio, New York 1971; *Portraits of Students*, New York 1972; *In Front of St. Patrick's Cathedral: Photographs by Donald Blumberg*, with an introduction by Nathan Lyons, preface by Minor White, Cambridge, Massachusetts 1973; *Photographs 1965-1978 by Donald Blumberg: Recent Photographs in Series*, Buffalo, New York 1979; films—*The Art Department, State University of New York at Buffalo*, with Charles Gill, 1967; *The American Seduction*, with SUNY-Buffalo Film Club, 1967; *P.S. 32, Class 4A, 1907*, with Grace Blumberg, 1967; *Buffalo to New York, New York to Buffalo*, with Grace Blumberg, 1968; *Exorcise*, with Grace Blumberg, 1968.

On BLUMBERG: books—*Photography in the Twentieth Century* by Nathan Lyons, New York 1967; *The Persistence of Vision* by Nathan Lyons, New York 1967; *Vision and Expression* by Nathan Lyons, New York 1969; *The City: American Experience* by Alan Trachtenberg, Peter Neill, and Peter Bunnell, New York 1971; articles—"Daily Photographs" by A.D. Coleman in the *Village Voice* (New York), 28 October 1971; "In Front of St. Patrick's Cathedral" by Peter Galassi in *Afterimage* (Rochester, New York), December 1973; "From Formal to Family" by Anthony Bannon in *Afterimage* (Rochester, New York), December 1979.

My work over the past fifteen years represents a series of transitions that generally parallel my picture-making, socio-political, and family concerns. At first, my photography was dominantly concerned with expanding the photographic vernacular. *In Front of St. Patrick's Cathedral* (1965-67) dealt with extending the concepts of the photographic frame and collage concepts. The collaborative work with the painter Charles Gill (1966), involving large-format photo-linen and smaller cliche-verre, was a continuation of this phase.

In the late 1960's, during the war in Vietnam, I found egocentric production repugnant. I turned to *Daily Photographs* (transient newspaper war and domestic atrocity images transposed to large scale photographs) as a photographic political act. This was also my intention in *Portraits of Students*, which frontally records students subjected to the abuse of war-time politics.

Since 1972 and the birth of my daughter Rachel, I have been involved with images that relate to the family. They are intended (as defined by John Berger) to be "private," rather than "public" photographs. Although they are regularly shown in museums, they are made as a family document—primarily for my daughter, so that she can look back in future time and say, "This is how I was in time past and place. This is how my father chose to make the record."

—Donald Blumberg

Donald Blumberg is one of the leading practitioners of the experimental photograph. This tradition, drawn from the work of the surrealist and Dada photographers (Man Ray, László Moholy-Nagy and Herbert Bayer), was long neglected until Blumberg and a few others (e.g., John Wood, Keith Smith) began to experiment in the 1960's. Their inspiration and rationales for working came not just from these earlier photographers, but from works in many media. The making of Art was undergoing many radical approaches during the decade and these new attitudes infected and influenced the photographic community. One could do anything.

For the last 20 years, Blumberg has created an incredible amount of differing kinds of work. His images are exploratory, often irrelevant and at times political; he is one of the few photographers to have made anti-Vietnam war images. The photographs surprise, confuse, contradict. Formal concerns chiefly inform Blumberg's aesthetics. He has used collage extensively; there are photographs within photographs, gridded in various patterns, and pasted or sewn on additions of other elements such as buttons and drawings. The portrait and various approaches to it has been a continuing concern as has the relationship of color to black and white. His use

Donald Blumberg: *Rachel at the Alamo* (original in color), 1978

of cliché verre and stain photographs were revolutionary when done in 1966. However, the work always transports the viewer through the structure to discover a profound emotional and personal content. By creating a world of his own in his photographs of this world, Blumberg can reveal the issues he is concerned about. The series, "Collaboration with Rachel" (his daughter), which he has pursued for the past five years, is a powerful and evocative document of both the growth of a child and of the evolution of a father-daughter relationship in 20th century America.

Blumberg belongs to no easily described school of image-making. His work is unique because the technique of photography is not his cage; it's only one of the many tools for touching his experience to ours.

—James L. Sheldon

BLUMENFELD, Erwin.

American. Born in Berlin, Germany, 26 January 1897; emigrated to the United States, 1941: naturalized, 1946. Educated at Askanisches Gymnasium, Berlin, until 1914; self-taught in photography. Served as ambulance driver, German Army, 1916-18. Married Léna Citroen in 1921; children: Lisette, Heinz and Frank Yorick. Worked as apprentice dressdesigner, Moses and Schlochauer ladies' fashions, Berlin, 1914-16; painter and writer, associating with Dadaist artists Grosz, Mynona, Citroen, Mehring, etc., Amsterdam, 1918-23; first collages and photographs, adopting occasional pseudonym Jan Bloomfield, Amsterdam, 1919-31; proprietor, Fox and Cie Leather Goods, Amsterdam, 1922-35; professional portrait and fashion photographer, contributing mainly to *Verve*, Paris, 1936-39; Staff Photographer, *Vogue* magazine, Paris, 1938; interned in concentration camps at Montbard-Marmagne and Vernet d'Ariege, France, 1940-41; freelance photographer, working in studio of Martin Munkacsi, New York, 1941-43; opened own photo studio, New York, 1943; Art Director, Condé Nast Publications, New York, 1943; freelance photographer, working for *Vogue, Life, Harper's Bazaar, Look, Cosmopolitan*, etc., New York, 1943-65; concentrated on writing, New York 1960-69. Estate: Marina Schinz, 222 Central Park South, New York, New York 10019. *Died* (in Rome) *4 July 1969.*

Individual Exhibitions:

1932 Kunstzaal Van Lier, Amsterdam
1936 Chez Billier, Paris
1975 F.N.A.C.-Montparnasse, Paris
1977 Pentax Gallery, London
1978 Witkin Gallery, New York
 Galerie Zabriskie, Paris
1979 Musée Rath, Geneva (toured Europe)
1980 The Photographers' Gallery, London
 Sander Gallery, Washington, D.C.
1981 Canon Photo Gallery, Geneva (with Paul Citroen)
 Galerie Zannettacci, Geneva (travelled to The Jerusalem Museum, Israel)
 Prakapas Gallery, New York
1982 Centre Georges Pompidou, Paris (retrospective)

Selected Group Exhibitions:

1929 *Film und Foto*, Deutscher Werkbund, Stuttgart
1966 *Dada: Exposition Commemorative du Cinquantenaire*, Musée d'Art Modern, Paris (travelled to Zurich)
1975 *Fashion 1900-1939*, Victoria and Albert Museum, London
1977 *Tendenzen der 20er Jahre*, Neue Nationalgalerie, West Berlin
 Fashion Photography, International Museum of Photography, George Eastman House, Rochester, New York (travelled to Brooklyn Museum, New York; San Francisco Museum of Modern Art; Cincinnati Art Institute, Ohio; and Museum of Fine Arts, St. Petersburg, Florida)
1978 *Dada and Surrealism Reviewed*, Hayward Gallery, London
1979 *La Photographie Française 1925-1940*, Galerie Zabriskie, Paris (travelled to Zabriskie Gallery, New York)
 Photographie als Kunst 1879-1979/Kunst als Photographie 1949-1979, Tiroler Landesmuseum, Innsbruck, Austria (travelled to Neue Galerie am Wolfgang Gurlitt Museum, Linz, Austria; Neue Galerie am Landesmuseum Joanneum, Graz, Austria; and Museum des 20. Jahrhunderts, Vienna)
 Photographic Surrealism, New Gallery of Contemporary Art, Cleveland, Ohio (travelled to Dayton Art Institute, Ohio; and Brooklyn Museum, New York)

Collections:

Museum of Modern Art, New York; Fashion Institute of Technology, New York; New Orleans Museum of Art; Center for Creative Photography, University of Arizona, Tucson; University of New Mexico, Albuquerque; Blumenfeld Family, Grantchester, Cambridge, England; Victoria and Albert Museum, London; Prentenkabinet, Rijksuniversiteit, Leiden, Netherlands; Musée d'Art et d'Histoire, Geneva.

Publications:

By BLUMENFELD: books—*Jadis et Daguerre*, Paris 1975, as *Durch Tausendjährige Zeit*, Frauenfeld, West Germany 1976; *Blumenfeld: Meine 100 Besten Fotos*, with text by Hendel Teicher, with an introduction by Maurice Besset, Berne 1979, New York 1981; *Erwin Blumenfeld: Portfolio*, with an introduction by Inge Feltrinelli, Milan 1981; article—"Atze Lenzgedicht," poem, in *Almanach Dada*, Berlin 1920.

On BLUMENFELD: books—*Foto-Auge/l'Oeil et Photo/Photo-Eye*, edited by Franz Roh and Jan Tschichold, Stuttgart 1929; *17 American Photographers* by Ebria Feinblatt, Los Angeles 1948; *The Art and Technique of Color Photography* by Alexander Liberman, New York 1951; *Photography of the World '60*, edited by Hiromu Hara, Ihei Kimura and others, Tokyo and New York 1960; *The Painter and the Photograph, from Delacroix to Warhol* by Van Deren Coke, Albuquerque, New Mexico 1964, 1972; *Dada: Exposition Commemorative du Cinquantenaire*, exhibition catalogue, Zurich 1966; *Die Geschichte der Collage* by Herta Wescher, Cologne 1974; *Fashion 1900-1939*, exhibition catalogue, by Valerie Lloyd and others, London 1975; *Photomontage* by Dawn Ades, London 1976; *Tendenzen der Zwanziger Jahre*, exhibition catalogue, by D. Honisch, U. Prince, F. Roters and W. Schmied, Berlin 1977; *Fotografie der 30er Jahre: Eine Anthologie*, edited by Hans-Jürgen Syberberg, Munich 1977; *The Grotesque in Photography* by A. D. Coleman, New York 1977; *Das Experimentelle Photo in Deutschland 1918-1940* by Emilio Bertonati, Munich

1978; *Dada and Surrealism Reviewed*, exhibition catalogue, by Dawn Ades, London 1978; *Photographie als Kunst 1879-1979/Kunst als Photographie 1949-1979*, exhibition catalogue, 2 vols., by Peter Weiermair, Innsbruck, Austria 1979; *The History of Fashion Photography* by Nancy Hall-Duncan, New York 1979; *The Vogue Book of Fashion Photography* by Polly Devlin, with an introduction by Alexander Liberman, London 1979; *A Ten Year Salute* by Lee D. Witkin, with a foreword by Carol Brown, Danbury, New Hampshire 1979; *Fotografie in Nederland 1920-1940*, exhibition catalogue, by Flip Book and Kees Broos, The Hague 1979; *Photographic Surrealism*, exhibition catalogue, by Nancy Hall-Duncan, Cleveland 1979; *Dada Photomontagen*, exhibition catalogue, by Carl-Albrecht Haenlein and others, Hannover 1979; articles—"Erwin Blumenfeld" in *Bedrifsfotografie*, Amsterdam 1932; "Erwin Blumenfeld" in *De Groene Amsterdammer*, 4 June 1932; "Speaking of Pictures" in *Life* (New York), 26 October 1942; "Erwin Blumenfeld" by Bruce Downes in *Popular Photography* (New York), October 1944; "Erwin Blumenfeld: My Favorite Model" in *Lilliput* (London), September 1945; "Erwin Blumenfeld" by W.H. Allner in *Graphis* (Zurich), May 1946; "Great American Photographers" in *Pageant* (New York), October/November 1947; "Erwin Blumenfeld" by Bruce Downes in *Popular Photography* (New York), December 1948; "The World's Most Highly-Paid Photographer" in *The Strand* (London), April 1949; "Viewpoint: Blumenfeld" by Jacob Deschin in *Popular Photography* (New York), March 1970; "Erwin Blumenfeld" by Chenz in *Zoom* (Paris), May/June 1975; "Erwin Blumenfeld" in *L'Arche* (Paris), April 1975; "Le Retour de Blumenfeld" in *Photo* (Paris), May 1975; "Expo: Blumenfeld" in *Photo* (Paris), November 1975; "Refreshment Through Hate" by Alfred Andersch in *Times Literary Supplement* (London), 11 March 1977; "Blumenfeld: Portfolio" in *Zoom* (Paris), no. 65, 1979; "Erwin Blumenfeld: Ou la Monde Touche a l'Humain" in *Schweizerische Photorundschau* (Visp), 25 November 1979; "Les Collages de Blumenfeld" by Phillippe Mahassen in *Tribune des Arts* (Geneva), 13 June 1981.

After leading for two decades a precarious existence on the fringes of the European avant-garde, Erwin Blumenfeld in his forties leaped to sudden fame in New York's fashion and advertising circles. An indefatigable photographic experimenter and a master of darkroom manipulation, he was famous for the extraordinary lengths to which he would go to produce an utterly unique image. His methods, moreover—which included solarization, multiple exposure, optical distortion, negative/positive combinations, and selective bleaching—were but the adjuncts of a fertile imagination marked by a taste for the uncanny. His goal was always "to shake loose the unreal from the real."

Born and raised in Berlin, Blumenfeld moved to Holland after World War I and remained there for 17 years. He had already, however, formed important links with the Berlin Dada group, particularly Paul Citroen and George Grosz. In Holland, he worked at a variety of occupations—bookseller, art dealer, merchant in leather goods—while devoting his principal energies to frustrated attempts at artistic expression through writing, painting, and photography. During these years he began his photographic manipulations, and seemingly absorbed the lessons of all of the major European art movements of the day. Acutely aware of the unhappy social tendencies which flourished in Europe in the period between the wars, Blumenfeld took refuge in his imagination and in his darkroom, creating images suffused with erotic longing and the disturbing visual logic of the dream state.

In 1936, after the collapse of his leather-goods business, Blumenfeld resolved to devote his full energies to photography. He moved to Paris, and with the support of the daughter of the painter

Roualt quickly established himself in fashion, advertising, and portrait photography. More important, his highly-charged personal images were circulated in the avant-garde periodicals *Verve* and *Minotaure*, and quickly won him a wide circle of influential admirers.

Blumenfeld's erotic preoccupations never disappeared from his photography, but were sublimated, so to speak, in his fashion work. He began to work for Paris *Vogue* in 1938, at a time when surrealist-inspired images were becoming a staple of the fashion magazines. When World War II erupted in Europe, Blumenfeld survived a series of incarcerations in prison camps and finally made his way to America. He left behind his black-and-white prints and negatives, which represent the most interesting part of his creative work; these luckily survived the war.

In New York, influential magazine art directors such as Alexey Brodovitch (of *Harper's Bazaar*) and Alexander Liberman (of *Vogue*) vied for Blumenfeld's services, and within a few years he established himself as one of the most sought-after photographers of the day. The demands of American magazines and advertising led him to take up color photography, which he practiced with great success, creating bold compositions of saturated, interpenetrating colors. During the 1950's—the heyday of the mass-circulation American magazine—Blumenfeld exercised a great influence on younger photographers in the commercial field, who borrowed heavily from his seemingly inexhaustible fund of visual ingenuity. Blumenfeld took in stride his rapid ascent from a Montparnasse attic to a luxurious Manhattan studio; he was never described as less than charming.
—Christopher Phillips

Christian Boltanski: *Les Projections*, 1979

BOLTANSKI, Christian.

French. Born in Paris, 6 September 1944. Self-taught in photography. Professional photographer and artist, Paris, since 1969. Agent: Sonnabend Gallery, 420 West Broadway, New York, New York 10012, U.S.A. Address: 100 rue de Grenelle, 75007 Paris, France.

Individual Exhibitions:

1970 Galerie Templon, Paris (with Jean Le Gac)
Musée d'Art Moderne, Paris
1971 Galerie Sonnabend, Paris
1972 Galerie Folker Skulima, Berlin
1973 Galleria Lucio Amelio, Naples
Kunsthalle, Baden-Baden, West Germany
Museum of Modern Art, Oxford
Israel Museum, Jerusalem
1974 Westfalischer Kunstverein, Münster, West Germany
Louisiana Museum, Humlebaek, Denmark
Centre National d'Art Contemporain, Paris
1975 Sonnabend Gallery, New York
Kunsthalle, Kiel, West Germany
Centre d'Art Contemporain, Geneva
Württembergische Kunstverein, Stuttgart

Galerie Seriaal, Amsterdam
1976 Musée d'Art Moderne, Paris
Rheinisches Landesmuseum, Bonn
1977 Museum of Contemporary Art, La Jolla, California
Galleria Bruno Soletti, Milan
Galerie Sonnabend, Paris
1978 Badischer Kunstverein, Karlsruhe, West Germany
Galerie Jollenbeck, Cologne
Galerie Malacorda, Geneva
Galerie Foksal, Warsaw
1979 The Kitchen, New York
Maison de la Culture, Chalon-sur-Saône, France
Sonnabend Gallery, New York
1980 Musée de Peinture, Calais
Galerie Sonnabend, Paris
Carpenter Art Center, Harvard University, Cambridge, Massachusetts
1981 Musée d'Art Moderne, Paris (retrospective)

Selected Group Exhibitions:

1969 *Biennale de Paris*, Musée d'Art Moderne, Paris
1971 *Prospekt 71*, Kunsthalle, Dusseldorf
1972 *Biennale*, Venice
Documenta 5, Museum Fridericianum, Kassel, West Germany
1975 *Biennale*, Venice
1977 *Documenta 6*, Museum Fridericianum, Kassel, West Germany
1979 *Biennale*, Museum of Modern Art, Sydney
Aspectes de l'Art en France, Musée d'Art Moderne, Paris

1980 *Art in Europe*, Museum van Hedendaagse, Ghent
Biennale, Venice

Collections:

Musée d'Art Moderne, Paris; Kunsthalle, Hamburg; Kunsthalle, Kiel, West Germany; Neue Galerie, Aachen, West Germany; Louisiana Museum, Humlebaek, Denmark; Boymans-van Beuningen Museum, Rotterdam; Museum of Fine Arts, Lodz, Poland; Israel Museum, Jerusalem; Art Institute of Chicago.

Publications:

By BOLTANSKI: books—*Reconstitutions des Gestes*, Paris 1971; *10 Portraits Photographiques*, Paris 1972; *Album Photographique*, Hamburg 1972; *Inventaire*, Munster, West Germany 1973; *Quelques Interpretations*, Paris 1974; *20 Regles et Technique*, Copenhagen 1975; *Les Morts pour Rire*, Antibes, France 1975; *Modellbilder*, with others, Bonn 1976; film—*La Vie Impossible de Christian Boltanski*, 1968.

On BOLTANSKI: books—*Reconstitution* by Andreas Franke, Paris 1978; *Les Modeles* by Paull-Hervé Würz, Paris 1979; *Spurensicherung* by Günter Metken, Cologne 1979.

If I wanted to describe the images I make up, I would say that they are photographs—but that, at the same time, they are all about painting; that they show, and

Erwin Blumenfeld: *Hitler*, 1932

yet have nothing to do with, reality; that some of them are based on Japanese design, but they are all concerned with our (Western) culture only; that they are both the expression of my pessimistic viewpoint and motives for hope; that I would like them to be collective, but that they are intensely personal.

All that would be true, as would be dozens of other statements or restrictions. Words are too clear-cut to describe an image; they enclose it within limits, and I hope my photographs will be vague or fuzzy enough for each person, depending on his own background and his present mood, to "see" them each time in a different way.

—Christian Boltanski

Christian Boltanski is a painter, a painter who uses the photograph to the exclusion of every other medium. As an artist belonging to the post-1968 generation, he has rejected "great art." He uses the photograph, he says, "because it is popularized, reduced art, the art of quotation...." At the end of the Roman Empire there were poets who wrote brief plays that consisted entirely of quotations from ancient authors; collages, fragments of poetry. There is an equivalent phenomenon among the painters of today. It is as if they can create only portraits of culture, cultural quotations. As if nature can no longer be copied, only culture.

This is the impetus that makes Boltanski focus on stereotypes in his work: whether it be *Reconstitutions* of his past life or catalogues of the Western myths of today or photo albums from 1971 or Japanese gardens from 1978, Boltanski does not give us pictures but clichés. "For me," he has said, "the photograph is the equivalent of what the frame was for Lichtenstein—something that limits, which precludes, which indicates that this is not the thing itself. When Lichtenstein paints a landscape, he doesn't really paint a landscape; he paints a picture of a landscape. And this is what I want to do: these are pictures of pictures."

Pictures that have already been seen. Boltanski worked with notions of memory for a long time. The viewer, in fact, does not see nature, but recognizes a picture of this reality seen through a photograph, a scene, a movie. We know it in this way: the vision that we have of nature is a photographic vision. The green of the prairie appears beautiful only if it is Kodak green. The stereotype is a detonator of common memories.

The year 1976, with his "Composition fleuries," marked Boltanski's rupture with the "ugly" photograph in black and white, the deliberately "amateur" photograph of his early career: according to him, during this period the more ugly and "rotten" a work was, the more it was art. Boltanski now does beautiful pictures in the style of Vilmorin advertisements, "because what is 'nice' is meaningless."

Since 1976 the format of Boltanski's composition has become increasingly comprehensive. Using a background that makes everything unreal, he presented, in 1981, at the Musée d'Art Moderne, Paris, in a superb retrospective, his "Compositions heroiques," considerably enlarged photographs of little plastic soldiers placed in the dark and lighted in a very theatrical fashion: the effect was magical. Even though this work is divorced from that of the traditional artist approaching the traditional painting, and though the photographed objects are always inventories of pictures, these real objects yet possess the illusory aspect of art.

Born in 1944, Boltanski is now 38 years old. In the full effervescence of his resources he is an artist who has always refused what could lead him to stagnate. He has always been concerned with remaining in an uncomfortable position, refusing to adhere to anything established, escaping all enclosures, all ossifications. His concern to always leave form open, malleable, to pattern himself, as it were, on matter in perpetual motion, assures for the rest of us innumerably more upheavals and surprises. Boltanski

clearly exceeds the simple scope of the photograph and even of painters who use the photograph: he is, with Buren, one of the greatest French artists of today.

—Michel Nuridsany

BOOGAERTS, Pierre.

Belgian. Born in Brussels, 30 October 1964; moved to Canada, 1973. Studied at the Institut Supérieur Saint Luc, Brussels, 1963-66; Académie Royale, Brussels, 1966-67. Married Nicole Renson in 1971. Independent painter until 1972; began working with photography in 1971; based in Montreal, since 1973. Recipient: Canada Council Arts Grant, 1977, 1978, 1980. Agent: Galerie Gilles Gheerbrant, 307 Ste. Catherine West, Montreal, Quebec H2Y 2A3. Address: 500 rue de Gaspé, Apt. 309, Ile des Soeurs, Montreal, Quebec H3E 1E8, Canada.

Individual Exhibitions:

1973 *3 Plantations à Véhicle*, Véhicule Art Gallery, Montreal
1975 *Références: Plantation, Jaune-Bananier*, Galerie Optica, Montreal
 "Synthetization" of the Sky, Galerie Gilles Gheerbrant, Montreal
1977 *Arte Fiera '77*, Galerie Gilles Gheerbrant, Bologna, Italy
 New York, N.Y., Galerie Gilles Gheerbrant, and Galerie Optica, Montreal
 Palais des Beaux-Arts, Brussels
1978 International Center of Photography, New York
1979 *Une Après-Midi sur mon Balcon*, Galerie Marielle Mailhot, Montreal
 Screen Series: Street Skies, N.Y. 1978-79, Galerie Gilles Gheerbrant, Montreal (travelled to Ydessa Gallery, Toronto, 1980)
1980 *Street Corners (Pyramids) N.Y. 1978-79*, Musée d'Art Contemporain, and Galerie Gilles Gheerbrant, Montreal (travelled to the Vancouver Art Gallery, 1981)
1981 *Une Après-Midi sur mon Balcon* (second montage), Galerie Photo Vu, Quebec
 Screen Series: Street Skies, N.Y. 1978-79 (second series), National Gallery of Canada, Ottawa
 Camera Series, N.Y. 1979, Galerie Sans Nom, Moncton, New Brunswick
 Pierre Boogaerts, N.Y. 1976-79, 49th Parallel: Centre for Contemporary Canadian Art, New York

Selected Group Exhibitions:

1972 *Pour une Replantation*, Palais des Beaux-Arts Hall, Brussels
1974 *Camerart*, Galerie Optica, Montreal (travelled to Paris and London)
1975 *Conceptual*, Burpee Art Museum, Chicago
1976 *Photography as Art*, Galerija Grada Zagreba, Zagreb
 7 Photographers: Destination Europe, Galerie Optica, Montreal (travelled to Toronto, and toured Europe)

Pierre Boogaerts: *Screen Series, Street Skies, N.Y. 1978-79—Part I* (29th Street), 1979

1978 *The Winnipeg Perspective*, Winnipeg Art Gallery
1979 *Black/White and Color*, Bertha Urdang Gallery, New York
1980 *Pluralities*, National Gallery of Canada, Ottawa
 Nuages, Bibliothèque Nationale, Paris
 Art et Photographie, Caisse Générale d'Epargne et de Retraite, Brussels
1981 *Suite, Serie, Sequence*, Musée des Beaux-Arts, Nantes, France

Collections:

Collection de l'Etat, Brussels; Caisse Générale d'Epargne et de Retraite, Burssels; Bibliothèque Nationale, Paris; Art Bank, Ottawa; National Film Board of Canada, Ottawa; National Gallery of Canada, Ottawa; Musee d'Art Contemporain, Montreal.

Publications:

By BOOGAERTS: books—*3 Plantations à Véhicule*, Montreal 1974; *Bic Banana*, Montreal 1974; *New York, N.Y.*, Montreal 1977; *Pierre Boogaerts: Série Ecran—Screen Sieries—Scherm Serie*, Brussels 1977; *Coins de Rues (Pyramides)/N.Y. 1978-79/Street Corners (Pyramids)*, with an essay by Michel Denée, Montreal 1980; articles—"Pierre

Boogaerts: The 'Banana-Tree Yellow' Reference" in *Flash Art* (Milan), December 1974/January 1975; "Référence: Plantation, Jaune-Bananier" in *Parachute* (Montreal), November 1975; "Conversation entre Pierre Boogaerts et Michel Denée" in *Parachute* (Montreal), Summer 1980.

On BOOGAERTS: books—*Camerart*, exhibition catalogue, with texts by Les Levine, Chantal Pontbriand and others, Montreal 1974; *Photography as Art*, exhibition catalogue, Zagreb 1976; *The Winnipeg Perspective*, exhibition catalogue, Winnipeg 1978; *Pluralities*, exhibition catalogue, with text by Chantal Pontbriand, Ottawa 1980; *Art et Photographie*, exhibition catalogue, Brussels 1980; *Nuages*, exhibition catalogue, Paris 1980; articles—"From Object to Image" by Georges Bogardi in the *Montreal Star*, 10 May 1978; "Pierre Boogaerts" by Walter Klepac in *Artscanada* (Toronto), July-August 1976; "Référence Faite: New York; N.Y. de Pierre Boogaerts" by Thierry de Duve in *Parachute* (Montreal), Winter 1977-78; "Canada's Artists with Cameras" by William E. Ewing in *Art News* (New York), April 1978; "'Synthétisation' du Ciel" in *Le Nouvel Observateur Special Photo* (Paris), June 1978; "Erasing the Line Between Art and Photography" by Georges Bogardi in the *Montreal Star*, 28 July 1979; "Boogaerts: Les Ciels de New York" by Gilles Toupin *La Presse* (Montreal), 27 October 1979; "Pierre Boogaerts, N.Y., La Pyramide et La Photo" by René Viau in *Le Devoir* (Montreal), 20 December 1980; "Shows We've Seen" by N. Canavor in *Popular Photography* (New York), June 1981.

A few rough notes about my work, 1978-80:

What interests me most in photography are its aberrations. It seems to me that its faults, its neglects (what is eliminated) and its obstructions (that which eliminates) are strangely similar to those of the society we live in.

I know that my photographs are not durable. I like to think of their fragility as an echo of the fragility of our industrial society. I work with photography's immediacy—we don't function along the same rhythm or the same "slowness" as preceding societies. I like its democratic nature—doesn't everyone own a camera?—its waste: isn't the same landscape often photographed by thousands of people?

In a way science cannot do without it; current events, the arts and their teachings are linked to it.

Our society was born of machines and the photo-machine can only (re)produce its image.

Consumer society: a society of waste, one of form more than content (are these not the very problems of the image today?).

This is why I both love and hate photography. This may also be why my work in photography consists essentially of "shifting" or "distorting" the givens of properties of the medium. By thwarting and contradicting those properties, I emphasize them on one hand, and on the other hand, by using simple images of our environment, I draw a parallel with our society, with us, with me.

Surface:

A photograph is a surface (like a painting). It can only show us the appearance, the surface of things. When working with photography, one must therefore begin with the externals of things; one must use "photographic evidence." We are condemned to start from the superficial aspect of things, the common, the banal, what everyone sees, from democratic reality. The photographic image, with its accessibility, its waste and its reproducibility is a democratization of the world, a popularization (simplification, superficiality).

But a surface is also, by definition, the borderline between two areas. When working with photography, therefore, one must take into account, besides the external aspect of things, things outside the photograph.

Framing (Screen):

On our face, along a horizontal line, two eyes; the angle of perception is about 180°; our sight frames reality. Moreover, when we look at something, the rest fades away, becomes blurred: to regard is to re-frame.

To photograph is to frame (like a window). In a photograph, the hidden reality is greater than the visible reality; framing is an eclipse.

To photograph is to frame (like blinkers). It is, therefore, to select. Like all specializations, this specialized view demarcates a territory: photography raises walls as easily as a dog raises a leg.

Framing is the borderline between what is visible and what is not and consequently between reality and imagination, culture and myth. Framing is the border line between what we see and what we are.

To the *subtractive process* (taking a photograph, a fragment of a whole) I add an *additive process*: the group of photographs and the series.

To change the viewing angle is to modify the frontiers of looking. Chance (or aberration) and the exclusiveness of framing (or the fragility of a prejudice) modify the frontiers of vision (or the parochiality of our territory).

The logic or working with photography is the logic of framing. If one photograph refers to its borders, several photographs, as well as enlarging their respective frames of view, refer to their respective borders. The sum total of these borders will determine the shape of a piece. The sum total of these pieces will determine the shape of the work.

This multiplication of images, each of them limited but at the same time working in a larger context, reminds me of the division of cells.

A photograph is a fragment, photographs are fragments; a piece is the passage from one to several, from the individual to the group. Working with photography is therefore working at the level of connections, joints (...in any event, it's a world in pieces...).

The group of photographs—a succession of screens—opens, in the end, on the physical presence of the wall and the importance of that wall depends on whether it points out screens that are beyond photography: the screen of the wall on the landscape, of the gallery on art; of art on life; the screens of education, ideas, personality.... The piece is a knot which intertwines two visions: in one, the purpose is to see as well as we can (as much), to broaden our field of vision; in the second, the purpose is to hide, to insist on the partial aspect of vision.

The Series:

The series is the group of photographs included in a piece; it is the group of pieces included in one work.

A photograph is like a readymade, and all framings are possible. As far as I am concerned, the difference between two photographs is the difference between two stones found on a road. Anyone can find one that is more or less beautiful or one can be more or less lucky (or patient) or some may even have found a "beautiful quarry." (apparently, what makes a good photographer is 90% subject matter.) What is important to me is that these stones—these possible framings—be found on one road, that they fit into a perspective, that they indicate an *itinerary* (to photograph is also to organize, to arrange time and space). This itinerary can only be decoded through a succession of such readymades. (Repetition: endless reflection.)

By using series, I use one of the characteristics of the medium: reproducibility, *quantity*—consequently, its characteristics of being non-unique and fragmented. This is what I mean by a series.

Weightlessness:

Like light, photography has no weight. It is a "pure" image. For this reason, it cannot be "ugly." To achieve ugliness, one would have to paint it, scratch it, etc., add elements to weigh it down, make it "impure." This is why, for example, there is the aberration of war photographs or photographs of disasters which are serenely "beautiful" ("what a beautiful black, what beautiful framing, what a beautiful glossy, satin finish...").

Even if photographs stem from a certain type of perspective, they do not belong to the world of gravity. They have the lightness (and the fragility) of the image, of the simplified surface (and its thinness). The objects represented belong to the world of the sea or to the world of space (at NASA, simulated exercises in weightlessness are conducted in a liquid environment): they owe nothing to the gravity of real life but are situated in the weightlessness of the psyche.

The positioning of a photograph on the wall stems either from the logic of sight, which puts the image black right side-up (this is its figurative logic), or, from the logic of form: a photograph is a rectangle which we can position horizontally or vertically. The two types of logic usually go together. Therefore, if you follow only one type of logic at a time, what results is either a photograph which shows, for example, an upside-down New York architecture, an inversion of right and left, or else a situation in which the rectangle of the photograph will have to be placed askew on the wall, thus re-situating the image in relation to gravity.

One More Note to Avoid Conclusion:

Through individuality (framing) we rejoin a globality: man in the universe. Rediscovering space and the universe through certain aerial/aqueous qualities of the vision and of time; thus regaining along with the viewer the freedom which is also my dependency, and this at every level of my work.

—Pierre Boogaerts

Pierre Boogaerts' monumental panoramas of the Manhattan skyline are the ultimate expressions of his longstanding fascination with the edge of things, particularly the resonant edge where the urban landscape confronts and blends with nature. From the time of his first exclusively photographic works (Boogaerts was trained as a painter in his native Belgium and the earliest works he exhibited were in mixed media), Boogaerts has reached for images which would fuse and reconcile the nature-culture duality into a single entity which he has called a "synthetic image."

The New York scenes were shot from a stationary position, with Boogaerts standing on a street corner and panning his camera first upward, toward the sky, and then downward, toward the horizon. The shape of the sequence corresponds to that of the view: X-shaped sequences, for instance, resulted from a given location affording four divergent views; T-shaped and vertical columns are similarly logical configurations. In some earlier works the "synthetic image" was a fictitious one, entirely invented by the artist, but the New York shots are documentary views, faithful to the eccentricities of the urban scene even in the shape of the over-all assemblage.

With each photograph measuring 16" x 24", the sequence's scale becomes monumental, forcing the spectator to re-enact in his "reading" the panning motion of the camera: a kinesthetic experience that is almost without precedent in photography.

Boogaerts' New York photographs are slightly under-exposed so that the sky becomes a dark, unmodulated shape whose visual density is equal to that of the buildings' shapes. Through this manipulation, the usual figure-ground relationship is dispensed with: foreground and background—culture and nature—are both strained through the camera lens and made to align along a single plane. This is Boogaerts' strategy for conquering the traditional dichotomy, his way of noting that the eternal figure-ground "relationship" has always been, in effect, a schism. The "synthetic image" is thus an agent of healing, of mediation and reconciliation.

But behind this apparent fusion there is still a

struggle going on. Beyond the luminous calm of the photographic surface and the seamless perfection of the sequence, two forces oppose each other: the panning movement of the camera can be taken to represent culture in all its greed for distance and information, while the converging perspective which brings each sequence to a close is an eloquent reminder of the limits nature imposes on perception.

—Georges Bogardi

BOSSHARD, Walter.

Swiss. Born in Richterswil, Lake Zurich, 8 November 1892. Educated in Kusnacht, Maennedorf and Zurich, 1899-1910; studied pedagogy and art history, University of Zurich, 1910-14; photography, privately, with advice from Photohaus Ruedi, Lugano, Switzerland, 1927. Served in the Swiss Army, Fort Brunnen (in the Alps), Switzerland, 1914-18. Worked on plantation, and as gem-cutter's agent, travelling in Sumatra, Siam and India, 1920-27; documentary photographer and researcher, with Dr. Trinkler and Dr. H. de Terra, German Central Asia Expedition to Tibet and Turkestan, 1927-28; photographer, with agency Dephot (Deutsche Photodienst), Berlin, 1930; correspondent (writer and photographer) for Ullstein publishing house (Berlin), in East Asia, 1930-35; photographer, expedition to Arctic on *Graf Zeppelin* airship, 1931; with Black Star agency, New York, 1935-39; staff correspondent, *Neue Zurcher Zeitung*, Washington, D.C., 1942-45. Also freelance travel and documentary photographer, and journalist, 1926-56: in East Asia (especially Peking), 1936-39, in Balkans, Middle East, Greece, Turkey, and India, 1940, in Chunking, China 1940-41, in San Francisco (United Nations Assembly), 1947, in East Asia (Jenan and Peking), 1948, in Middle East (especially Cairo) and East Asia, 1952, in Korea (suffered accident and ceased photographic activity), 1953, in Geneva and East Asia, 1954: worked for *Berliner Illustrierte*, *Atlantis*, *Schweizer Illustrierte Zeitung*, *Münchner Illustrierte Presse*, *London Illustrated News*, *Daily Sketch*, *Neue Zurcher Zeitung*, etc. Retired, living in Torremolinos and Ronda, Spain, 1960 until his death, 1975. *Died (in Ronda) 18 November 1975.*

Individual Exhibitions:

1977 Kunsthaus, Zurich (retrospective)
1978 International Center of Photography, New York

Selected Group Exhibitions:

1974 *Photographes Suisses depuis 1840 à nos Jours*, Kunsthaus, Zurich
1980 *Arbeitsgemeinschaft Öffentlicher Fotosammlungen* (AÖFS), Zurich (travelled to Essen and Vienna)
1981 *Aus der Sammlung der Stiftung für die Photographie*, Kunsthaus, Zurich

Collections:

Stiftung für die Photographie, Kunsthaus, Zurich.

Publications:

By BOSSHARD: books—*Durch Tibet und Turkistan*, Stuttgart 1930; *Indien Kämpft*, Stuttgart 1931; *Results of the Botanical Findings, German Central-asian Expedition*, Zurich 1932; *Kühles Grasland Mongolei*, Berlin 1938, Zurich 1949, 1950; *Erlebte Weltgeschichte*, Zurich 1947; *Gefahrenherd der Welt: Generale-Könige-Rebellen*, Zurich 1954; *Thut*, Zurich 1960; *Im Goldenen Sand von Asswan*, Zurich 1962; film—*Mao Tse-Tung and Chou-en-Lai*, 1948.

On BOSSHARD: books—*Deutschland: Beginn des Modernen Photojournalismus/Photojournalism: Origin and Evolution 1910-1933* by Tim N. Gidal, Lucerne and Frankfurt 1972, New York 1973; *Photographes Suisses depuis 1840 à nos Jours*, exhibition catalogue, by Manuel Gasser, Hugo Loetscher, Walter Binder and Rosellina Burri-Bischof, Zurich 1974; *Walter Bosshard*, exhibition catalogue, with text by Guido Magnaguagno, Zurich 1977; articles—"Walter Bosshard Siebzigjährig" in *Neue Zürcher Zeitung*, 8 November 1962; "Walter Bosshard Achtzigjährig" in *Neue Zürcher Zeitung*, 8 November 1972; "Walter Bosshard Gestorben" in *Neue Zürcher Zeitung*, 20 November 1975.

Walter Bosshard is still a fragmented, not yet fully explored, fascinating figure. From the start, he accompanied his photographs with articles. He worked in long stretches on one subject, consolidating it into an illustrated book, before going on to the next one. What we do not know is whether he regarded himself as a photographer or as a journalist. Nor have we had the opportunity to see what is on those 15,000 captioned negatives that passed into the hands of the Stiftung für die Photographie, Zurich, after his death. What is certain is that as he became a brilliant political analyst, he disparaged and diminished his photographic efforts. Insight became more important than evidence.

The quality of the work I have seen is uneven, but from the start his best pictures turn out to be portraits of the powerful, spiritual or temporal, perhaps because he realized how power can stabilize or destroy lives. Ultimately his subject was "human rights". He was fearless: remained behind when the Japanese arrived in a Chinese village; flew on the first Japanese flight on their new Charbin-Mukden line, and when they claimed to be dropping only leaflets, showed in a moving photograph two Chinese emerging from a hole in the ground, looking up at departing aircraft.

If he was a pioneer in everything he did, he was also a person who believed in making use of every development modernity offered. Already in India in 1930 he worked with three Leicas, rarely using his little tripod, with flash only for occasional outdoor nightshots.

Whatever the final judgment, Bosshard's photographic coverages of Gandhi and Mao on the threshold of power guarantee him a place in the pantheon of history. Gandi had vowed not to pose for photographers, but allowed Bosshard to snap him asleep, eating his soup, reading reports on the troubles he had just begun to provoke with his passive resistance efforts.

Bosshard was the first European to interview Mao at Yenan in 1938. His photographs were more mature than before, but he judged rightly that his information was more far reaching. Accordingly, he published this series as articles, illustrated with a few pictures, in the important *Neue Zürcher Zeitung*, which carried them in prime space on their front page.

—Inge Bondi

BOSTELMANN, Enrique.

Mexican. Born in Guadalajara, 22 March 1939. Educated at Schools in Mexico; studied photography, under Heinz Schlicht, Alexander Von Humboldt German College, Mexico City, 1956-57; under Franz Bartel, Bayerische Staatslehranstalt der Fotographie, Munich, 1958-60, Dip. Photog. 1960. Married the photographer Yevette Noetzel del Castillo in 1966; children: Saskia and Alexis. Founder-Director, Fotografia Creativa, S.A., photography studios, Mexico City, since 1960. Secretary, Club Fotografico, Mexico City, 1961-62. Secretary, Foro de Arte Contemporaneo, Mexico City, since 1977; Treasurer, Consejo Mexicano de Fotografia, Mexico City, since 1980. Instructor in Photography, Instituto Paul Coremans, Mexico City, 1964-67. Address: (studio) Fotografia Creativa S.A., Nautla 23, Mexico 7, D.F., Mexico.

Individual Exhibitions:

1967 JWT Gallery, New York
1969 Galleria Due Mondi, Rome
1970 Casa de la Cultura, Quito, Ecuador
1971 Galleria de Arte Moderna, Perugia, Italy
1973 *Paisaje del Hombre*, Museo de Arte Moderno, Mexico City
 Universidad de Panama, Panama City (toured Mexico)
1974 *La Piel de las Aguas*, Galería José María Velasco, Mexico City (also at Unidad Xochimilco, Universidad Metropolitana, Mexico City; and travelled to Museo Guayasamin, Quito, Ecuador, and Biblioteca Municipal, Guayaquil, Ecuador, 1975)
1975 Galería Geller, Cali, Colombia
1976 *Fotomorfosis I*, Galería Jose Clemente Orozco, Instituto Nacional de Bellas Artes, Mexico City
 La Piel de las Aguas, Museo de Maracaibo, Barquisimeto, Venezuela (travelled to Valencia, Venezuela)
1977 *Proposiciones Fotográficas*, Galería Arvil 2, Mexico City
 Secretaría de Relaciones Exteriores, Mexico City
 Mexican Ceramics and Photos, World Trade Center, New York
1978 *Estructura y Biografía de un Objeto*, Galería Juan Martin, Mexico City
 Fotomorfosis II, Museo de Bellas Artes, Caracas, Venezuela (travelled to Museo de Artes Graficas, Maracaibo, Venezuela; Biblioteca Luis Angel A., Bogota, Colombia; Museo de Arte Moderno, Buenos Aires)
1979 *Suicidio y Muerte Natural*, Colegio de México, Mexico City
 Estructura y Biografía de un Objeto, Universidad Ibero Americana, Mexico City

Selected Group Exhibitions:

1958 *Photokina '58*, Cologne
1976 *10 Fotografos Mexicanos*, Salon de la Plastica Mexicana, Mexico City
1977 *Homenaje a Posada*, Academia de Artes Plasticas, San Carlos, Mexico City
1978 *La Primavera*, Galería Arvil, Mexico City
 Exposición Inaugural, Foro de Arte Contemporaneo, Mexico City
 Coloquio Latinoamericano de Fotografía, Museo de Arte Moderno, Mexico City
1980 *Retrato Contemporaneo*, Museo Carrillo Gil, Mexico City

Collections:

Secretaria de Relaciones Exteriores, Mexico City; Universidad Nacional Autónoma, Mexico City; Museo Guayasamin, Quito, Ecuador; Museo de Bellas Artes, Caracas, Venezuela.

Publications:

By BOSTELMANN: books—*American: Un Viaje a Traves de la Injusticia*, Mexico City 1970; *El Paisaje de Mexico*, Mexico City 1972; *Estructura y Biografía de un Objeto*, Mexico City 1979.

On BOSTELMANN: books—*Photokina '58*, exhibition catalogue, by L. Fritz Gruber and others, Cologne 1958; *Primer Coloquio Latinoamericano de Fotografia*, exhibition catalogue, Mexico City 1978.

Light surrounds the world. The world has so many facets that it is impossible to capture them all. That is why I feel that the responsibility of the photographer is to select those which are closest to his way of thinking, feeling and acting. To achieve this is an arduous process but one which gives great satisfaction. The quest for achievement as an end in itself should never stop because, with the help of new impulses and situations, it will regenerate itself. Ideally it will only end with the end of life itself.

—Enrique Bostelmann

Enrique Bostelmann: *Peña de Bernal*, Queretaro, Mexico, 1978

The work of Enrique Bostelmann is quite unusual in the context of Mexican photography. He is one of those rare photographers who uses color for works of personal expression; moreover, many of his photographs are a kind of objectual art: they are made up in real space of three-dimensional geometric structures. His work involves a somewhat paradoxical investigation. On the one hand he works with virtual space, the legacy of Renaissance notions of volume and perspective, as is common in photography; on the other hand, he plays with format in real space, following the experiments of the new-concretists and of the Argentinian group Madi. Both trends are found in a single work. Whereas most of his colleagues are mainly concerned with the relevance of implicit meaning in a photograph, Bostelmann places the emphasis of his search on formal innovation.

The originality of the endeavors and the photographic solutions of Bostelmann's work do not emerge without reason. The objectual and elegant geometrism with which he builds his forms is presently the dominating style in the spaces of private enterprise and of government institutions. It may be said as well that Bostelmann's color photography probably emerges from the chromatic vigor that throbs in all those places that haven't been completely soiled by smog or made drab by industrial and financial centers. A particular sense of color is found in the handicrafts, the clothing and the walls of the houses in Mexico. Bostelmann uses it to convey a harmony of man and his environment.

To search for anger, criticism, sarcasm or malice in his photographs is to view them from the wrong perspective. For him the camera is not an instrument of protest; it is a means for the magic dignification of man. In this search for the beauty that may appear in the grandiose and in the insignificant, even in poverty, there is a genuine playfulness. One could say he even has a certain childlike candor. Another characteristic of his work is his curiosity. In a search that reminds us of the experiments made by the cubists, he represents an object from different perspectives. His recent portraits and his formal exploration of a coffee pot are examples of this trend.

Unrelenting in his search for originality and inno-vation of language, Enrique Bostelmann astonishes by his unaccustomed combinations and by his technical virtuosity. He is a classicist in pursuit of balance and beauty, a photographer who has inherited the western artistic tradition and who expresses himself with reticence, subtlety and joy.

—Katya Mandoki

BOUBAT, Édouard.

French. Born in Paris, 13 September 1923. Studied printing, design, and typography at the Ecole Estienne, Paris, 1938-42. Married Bernadette Boubat in 1957; son: Bernard. Worked as a photogravure printer, Paris, 1942-45; first photos, Paris, 1946; free-lance photographer, Paris, 1946-50; Staff Photographer, *Réalités* magazine, Paris, 1951-68; freelance photojournalist and portrait photographer, Paris, since 1968. Recipient: Kodak Prize, 1947. Agent: Agence Rapho, 8 rue d'Alger, 75001 Paris. Address: 12 rue Bouchut, 75015 Paris, France.

Individual Exhibitions:

1955 Limelight Gallery, New York
1967 *Edouard Boubat: Ogonblick av Lycka*, Moderna Museet, Stockholm
1971 Galerie Rencontre, Paris
1973 Bibliothèque Nationale, Paris
1976 Witkin Gallery, New York
 Art Institute of Chicago
1978 Museo d'Arte Moderna, Mexico City
 Photographers Gallery, London
 Musée Nicéphore Niepce, Chalon-sur-Saône, France
1979 Fondation Nationale de la Photographie, Lyons
1980 Musée d'Art Moderne, Paris
1981 Camera Obscura, Stockholm

Selected Group Exhibitions:

1951 *Izis/Brassai/Doisneau/Facchetti/Boubat*, Galerie La Hune, Paris
1954 *Great Photographs*, Limelight Gallery, New York
1977 *Helen Gee & the Limelight*, Carlton Gallery, New York
1978 *Tusen och en bild*, Moderna Museet, Stockholm
1979 *Photographie als Kunst 1879-1979*, Tiroler Landesmuseum Ferdinandeum, Innsbruck, Austria (travelled to Neue Galerie am Wolfgang Gurlitt Museum, Linz, Austria; Neue Galerie am Landesmuseum Joanneum, Graz, Austria; and Museum des 20. Jahrhunderts, Vienna)
1980 *10 Photographes pour le Patrimoine*, Centre Pompidou, Paris

Collections:

Bibliothèque Nationale, Paris; Musée Nicéphore Niepce, Chalon-sur-Saône, France; Museum of Modern Art, New York; Metropolitan Museum of Art, New York; Art Institute of Chicago.

Publications:

By BOUBAT: books—*Ode Maritime*, with an introduction by Bernard George, Tokyo 1957; *Les Nouvelles Messageries de la Presse Parisienne*, with a preface by Antoine Blondin, Paris 1960; *Edouard*

Boubat: Collection Terre d'Images, with an introduction by Bernard George, Paris 1966; *Femmes/Woman*, Paris and London 1972, New York 1973; *Miroirs: Autoportraits*, Paris 1973; *Anges*, with text by Antoine Blondin, Paris 1974; *La Photographie*, Paris 1974; *La Survivance*, Paris 1976; *L'Ombre de l'Autre*, with text by Dominique Preschez, Paris 1979; *Preferées*, Paris 1980; *Au Pays du Cheval d'Orgueil*, with text by Pierre Helias, Paris 1980; *Edouard Boubat*, portfolio, with an introduction by Robert Doisneau, Paris 1981; films—*Chambre Noire*, television film, 1966; *Photos by Boubat*, television film, with Rune Hassner, 1967.

On BOUBAT: books—*Edouard Boubat: Ogonblick av Lycka*, exhibition catalogue, by Rune Hassner, Stockholm 1967; *Edouard Boubat* by Bernard George, Lucerne and Frankfurt 1972, New York 1973; *Edouard Boubat*, edited by Daniel Mauprey, Paris 1973; *La Photographie Francais des Origines à nos Jours* by Claude Nori, Paris 1978; articles—"Edouard Boubat" by Louis Stettner in *Camera* (Lucerne), May 1950; "Edouard Boubat" in *Photography of the World*, Tokyo 1956; "Boubat, un des plus poétiques parmi les photographes contemporains" by Romeo Martinez in *Camera* (Lucerne), June 1956; "Edouard Boubat, Star Photographer" in *Photography Year Book*, London 1958; "Edouard Boubat" by Tetsuo Abe in *Molders of Modern Forms*, Tokyo 1959; "Un Temoignage sur les Vraies Dimensions de l'Art Photographique: l'Univers d'Edouard Boubat" by Jean Danielou in *Réalités* (Paris), November 1962; "Edouard Boubat, photographe des instants privileges" by Bernard George in *Terre d'Images* (Paris), November/December 1964; "Edouard Boubat" by Rune Hassner in *Popular Fotografi* (Stockholm), May 1967; "Objectif sur l'Agence Vu" in *Reporter Objectif* (Paris), September/October 1971; "Edouard Boubat: Photographs of Women" in *Creative Camera* (London), June 1972; "Edouard Boubat" in *Modern Photography Annual*, New York 1974; "Les Cinq Sens en Eveil: Photos Boubat" by E. Renaudin in *Elle* (Paris), 16 December 1974; "The Humanistic Eye: Edouard Boubat" by Walter Rosenblum in *35mm Photography* (New York), Summer 1975; "Edouard Boubat" by Dominique Dubois in *Photo Cine Review* (Paris), November 1979.

I am not ashamed of being a photographer! I love music, painting, and, above all, life. Life gives me my photos. I need other people. Photography is a profession for encounters! It is in praise of life, an attempt to come close to nature and my fellow creatures.

—Édouard Boubat

It was only in the years following World War II that French photographers, after the years of restrictions and horrors, were able fully to express their originality through press and magazine photography. Whatever their mode or method, photographers participated in the moral and economic reconstruction of the country and attempted a clarification of the social and political milieu. Two kinds of photographers emerged. Photojournalists analyzed the facts, informed the public, and tried to provide a witness of the flagrant upheavals of this world: their pictures were, above all, examples of actuality, fragments of reality, and often redundant of the texts they accompanied. Another kind of photographer, difficult to categorize but which one might call humanist, expressed the poetry of daily life by conveying its simple joys and emotions—lovers, public balls, children, etc. The images of these photographers took the form of "Storytelling Pictures" in magazines, and slowly they began to be exhibited in galleries—for instance, in La Hune in 1951.

Édouard Boubat, who has much in common with the humanists, still occupies a completely unique place in French photography, a place where graphic traditions and photographic modernity meet. Always counter-current, often cut off from "actuality," creating with the passage of time his own individual space, Boubat remains a kind of living point of reference for young photographers.

His first photo, in 1946, at the age of 23, "Little Girl in the Dead Leaves," is a symbol of all of his work. (It is interesting to remember that at the same time Capa, Cartier-Bresson and Seymour had begun to lay the foundations of the Magnum Agency: Boubat's little girl seems to turn her back on them.) In this slightly blurred photo of not very impressive technique (Boubat was, after all, a beginner), a little girl drags a train of dead leaves which seem to be poised as if by magic. We cannot tell where the action takes place or at what point in time: we are confronted by a photograph which is not only a reflection of reality but which is also, above all, a photograph by Édouard Boubat. It is a photograph that refers us to other photographs—"Lella en Bretagne," 1947; "Le Jardin du Luxembourg," 1955; "Le Masque au Mexique," 1978—as a word in a sentence or a verse in a poem might suggest the whole—or as one might say of a Rembrandt—"Ah, this is a Boubat!"

Since 1952, the date of his first reportage for *Réalités*, Boubat has travelled around the world, from Spain to Africa, from India to China, going through the United States and capturing there, under the folklore and the brilliance, that which is true and unchanging. Whereas Robert Frank, like the writers of the beat generation who let themselves be carried away by their typewriters, threw in our faces a reality of chaotic emotions and spatterings, Boubat seems to organize apparent disorder to create a harmonious ensemble within which a thousand years of human history are interwoven. Consider his depiction of woman. She is strangely eternal and contemporary, not only an object for contemplation that fuses architecture and the environment, but also, and more so, the light that crystallizes vital forces and spiritual energy. She is at once Eve, Beatrice, Juliet and Angela Davis.

Today, Édouard Boubat continues to photograph with the joy and delight of a college boy on vacation. The world may have shrunk around him, but that seems only to have enlarged his creative freedom. More than ever Boubat does Boubat. The subject, the anecdote, may be passé, dissipated. What interests is the meeting of the man with forms and with light, the meeting of the photographer with the images that he carries within himself.

The photographs of Édouard Boubat are the traces of our collective past, the imprints of a paradise invented by our own social subconscious. We truly need them to lighten, to enhance, our daily lives.

—Claude Nori

BOUCHER, Pierre.

French. Born in Paris, 29 February 1908. Studied at the Ecole des Arts Appliqués a l'Industrie, Paris, 1921-25. Served as a photographer in the French Air Force, Morocco, 1928-30. Married Yvonne Prieur in 1931 (divorced, 1941); son: Jean-Louis; married Suzanne Laroche in 1950. Photographer since 1930. Founder Member, Agence Alliance-Photo photographers agency, Paris, 1933-40, and Agence de Documentation et d'Edition Photographique, Paris, 1945-72; Director of Graphic Services, Marshall Plan, Paris, 1948-52; Artistic Director, Multiphoto agency, Paris, 1952-72. Address: L'Ermitage, 7 Avenue Massoul, Faremoutiers, 77120 Coulommiers, France.

Individual Exhibitions:

1941 *L'Esprit et la Matière* mural, Convent of the Carmelites, Lyons (permanent exhibition)
1951 *Textile Industry* mural, Tweedales and Smalley, Manchester (permanent exhibition)
1961 *Petrol* mural, Northern Gas Board, Newcastle-upon-Tyne (permanent installation)
1974 *Polarisations Photo*, Galerie Camille Renault, Paris

Selected Group Exhibitions:

1937 *Affiche Photo Typo*, Maison de la Culture, Paris
1972 *Salon des Decorateurs*, Grand Palais, Paris
1974 *Art Contemporain*, Hotel de Ville, Pernes les Fontaines, France
1975 *Ecole de Paris de la Photo*, Porte de Versailles, Paris
1976 *Exposition Nationale de la Photo*, Maison de la Culture, Biot, France
1979 *La Photographie Francaise 1925-1940*, Galerie Zabriskie, Paris (and Zabriskie Gallery, New York)
 Photographic Surrealism, New Gallery of Contemporary Art, Cleveland, Ohio (travelled to the Brooklyn Museum, New York)

Collections:

Bibliotheque Nationale, Paris.

Publications:

By BOUCHER: books—*Truquages en Photographie*, Paris 1938; *Methode Francaise de Ski*, Paris 1947; articles—"La Photographie Sous-Marine" in *Photo France* (Paris), August 1950; "Photographie Sous Marine" in *Camera* (Lucerne), May 1953.

On BOUCHER: books—*Formes Nues*, Paris 1935; *Nu en Photographie* by Marcel Natkin, Paris 1935; *Photography of the World*, Tokyo 1956; *Exempla Graphica*, Zurich 1969; *Idea 93* by Noboru Sakamoto, Tokyo 1969; *Idea 150* by Noboru Sakamoto, Tokyo 1978; *La Photographie Francaise* by Claude Nori, Paris 1979; articles—"Pierre Boucher" by Remy Duval in *Arts et Metiers Graphiques* (Paris), June 1935; "Photos et Montages de Pierre Boucher" by Walter Herdeg in *Graphis* (Zurich), November 1945; "Pierre Boucher" in *Camera* (Lucerne), January 1947; "The Frieze of Pierre Boucher" in *Photography* (London), July 1950; "La Publication Instructive" in *Camera-Europhot* (Lucerne), May 1960.

More than 30,000 years ago human imagination scratched on the wall of a cave the drawing of a reindeer pierced by an arrow. The dream of food becomes palpable—the image is born, symbol of belief of success through action; the gods are not far away. Since then, in diverse forms and with an ever-increasing technical know-how, leading for the time being to photography, the image accompanies humanity in its activities and in its dreams. Graphics, painting, fresco, photography: similar procedures showing the artist's inner vision, portraying also his exterior world and communicating to others beliefs, hopes, faith and facts by means of images.

Édouard Boubat: *Hommage à Rousseau*, Jardin des Plantes, Paris, 1980

But at its birth photography had a technical impact which led to numerous protests from painters who found in photography an absolute realism towards which they themselves had tended (in their servile respect for reality) both in portraits and in landscapes. Because of its resemblance, in black and white, to their own approach to their subjects, photography frightened them, so that they distanced themselves from it, bringing about the explosion of painting into impressionism, pointillism, fauvism, cubism—all reactions to the fiendish perfection of photography, which finally so intoxicated painting as to produce, first, surrealism, and, then hyperrealism.

There is a symbiosis between photography and painting: the one is a continuation of the other, producing an amalgam: beyond the photograph other methods are appearing which will broaden our creative imagination.

My training was basically that of an artist in a school of applied arts: classical drawing studies followed by orientation towards decoration and advertising/publicity; thereafter I had photographic training in the Air Force, producing in myself the synthesis drawing/photography. The two are either interchangeable or combined or intermingled. Photo montages are not simply collages but are blended by the lens, a drawn line, then altered to arrive at richer compositions or, on the contrary, the photograph is reduced to a very graphic contour according to the needs of the composition. It is obvious that I am not purely a photographer.

The works that I produced for the agency that we created were, above all, works for use in advertising, as much images as graphics for publication in magazines or montages for exhibitions. It so happens that some of these works have now become witnesses of a past age, but that has much to do with coincidence and with current fashion.

—Pierre Boucher

The earth and the sky. Between the two the domain of light. There is where the nudes evolve, where the parts of the mural are linked together. Let water flow, and you have the elements of the work of Pierre Boucher.

This play of elements both determine and characterize his work. And Boucher is a unique case, perhaps; he did not learn photography on the ground, but in the air, on airplanes. Similarly, he learned photographic montage by working with military aerial maps, over a table, with a razor blade.

He said of himself in 1935: "I am a wanderer, a nomad. I like nature, sports, cycling, Munkacsi, simplicity and travel. Canoeing and sunbathing are a religion with me."

A religion which led him naturally to the nude. Naturist and unaffected at first, they became increasingly more elaborate, with double exposures, phantasmagorical landscapes. He also liked to photograph his friends in leaps that the shot itself makes aerial.

During the war, for the Pierre Schaeffer group, Boucher worked on a 17-meter long mural on the theme *L'Esprit et la Matière*. By virtue of his training, his experience in photography and in photomontage, he managed to create a veritable visual symphony. The mural form suited him well, and he went on to create three others. Each includes hundreds of negatives and represents several months of work. For the *Methode Francaise de Ski*, he was responsible for all aspects of production, and this book, with its very elaborate structure, can perhaps be considered his manifesto on photography.

With color, too, his creativity never diminishes. His centerfolds and publicity brochures from the 1960's combine invention with graphic expertise. And today his work has to do with large prints on which his virtuoso use of the chromatic scale make geometric subjects vibrant.

Recent publications and exhibitions try to limit Boucher to his surrealist nudes. His domain is much

Pierre Boucher: *Envol,* 1937

wider. From the first nudes to the iridescent color, from the leaping friends to the cosmic murals, from advertising montages to geometric polychromatics—his work is very rich. It is also consistent in its pursuit of plastic means to enhance images of the aerial, the immaterial, and the dream.

Pierre Boucher is nothing less than one of the outstanding creators in photography of the 20th century.

—Guy Mandery

BOURDEAU, Robert.
Canadian. Born in Kingston, Ontario, 14 November 1931. Self-taught in photography. Married Mary Eardley in 1961; sons: Robbie and Sean. Freelance photographer, Ottawa. Master Class Instructor, Banff School of Fine Arts, Alberta, 1979; Part-time Professor, University of Ottawa, 1980-81. Recipient: Canada Council Grant, 1971, 1974, 1978; Ontario Arts Council Grant, 1976, 1980. Agent: Jane Corkin Gallery, 144 Front Street West, Toronto, Ontario. Address: 1462 Chomley Crescent, Ottawa, Ontario K1G OV1, Canada.

Individual Exhibitions:

1966 National Film Board of Canada, Ottawa (toured Canada)
1969 Bibliothèque Centrale, Lucerne, Quebec
1971 Toronto Gallery of Photography
Université de Sherbrooke, Quebec
Federation des Centres Culturels de Quebec, Montreal (toured Quebec)
1973 The Photographers Gallery, Saskatoon, Saskatchewan
The Photography Gallery, Bowmanville, Ontario
1974 Photo Image 33 Limited, Kingston, Ontario
1975 Deja Vu Gallery, Toronto
1976 Owens Art Gallery, Sackville, New Brunswick
National Film Board of Canada, Moncton, New Brunswick
The Banff Centre, Alberta
Yajima Gallery, Montreal

Robert Bourdeau: *Utah, U.S.A.*, 1976

The Gallery of Photography, North Van-
couver, Ontario
Sunbury Shores Arts Centre, St. Andrews,
New Brunswick
Village Olympique, Montreal
Southern Alberta Art Gallery, Lethbridge
Vanier College, St. Laurent, Quebec
1977 Carleton University, Ottawa
Secession Gallery of Photography, Victoria,
British Columbia
Artspace, Peterborough, Ontario
1978 Moulinette Gallery, Cornwall, Ontario
Musee Regional des Mines et des Arts,
Malartic, Quebec
Memorial University Art Galley, St. John's,
Newfoundland
1979 New Brunswick Craft School, Fredericton
Mt. Allison University, Sackville, New
Brunswick
Agnes Etherington Art Center, Queen's Uni-
versity, Kingston, Ontario
Edward's Art and Books, Toronto
1981 Art Gallery of Ontario, Toronto (with Philip
Pocock)

Selected Group Exhibitions:

1967 *Photography '67*, National Film Board of
Canada, Ottawa
1968 *Light⁷*, Hayden Gallery, Massachusetts Insti-
tute of Technology, Cambridge
1970 *The Photograph as Object*, Art Gallery of
Ontario, Toronto
1972 *Canada, C'Est Quoi*, National Film Board of
Canada, Ottawa
1973 *Commonwealth Conference Exhibition*,
Canadian Government Conference
Centre, Ottawa
7 Photographers, National Film Board of
Canada, Ottawa

Collections:

National Gallery of Canada, Ottawa; National Film
Board of Canada, Ottawa; Canada Council Arts
Bank, Ottawa; Ontario Institute of Studies in Edu-
cation, Toronto; Agnes Etherington Arts Centre,
Queen's University, Kingston, Ontario; Musee d'Art
Contemporain, Montreal; The Banff Centre, Alberta;
Smithsonian Institution, Washington, D.C.

Publications:

By BOURDEAU: book—*Robert Bourdeau*, edited
by Lorraine Monk, Toronto 1979; articles—"The
Meditated Image" in *Photo Age* (Montreal), March
1965; "A Portfolio of Photographs" in *Habitat*
(Ottawa), September 1972.

On BOURDEAU: books—*Canada: A Year of the
Land*, edited by Lorraine Monk, Ottawa 1967;
Image 2: Canada, edited by Lorraine Monk, Ottawa
1967; *Light⁷*, edited and with text by Minor White,
Millerton, New York 1968; *Image 3: Other Places*,
edited by Lorraine Monk, Ottawa 1968; *Image 5:
Seeds of the Spacefields*, edited by Lorraine Monk,
Ottawa 1969; *The Photographers' Choice*, edited by
Kelly Wise, Danbury, New Hampshire 1976; *12
Canadians*, edited by Jane Corkin, Toronto 1980;
articles—"Robert Bourdeau" in *Camera* (Lucerne),
August 1969; "An Inquiry into the Aesthetics of
Photography," edited by Anne Brodzky, special
issue of *Artscanada* (Toronto), December 1974;
"Robert Bourdeau's Landforms" in *Artscanada*
(Toronto), May/June 1977; "Robert Bourdeau,
Ultimate Amateur" in *Photo Life* (Toronto), July
1978; "More Than the Eye Can See" in *Maclean's*
(Toronto), December 1979; "La Mise Entre Paren-
theses du Sublime par la Photographie et Quelques
Examples Chez Robert Bourdeau" in *Parachute*
(Montreal), Spring 1981.

I work in the landscape and, through its forces and
rhythms, have sought its inner strength and mystery.
Many things are significant and must come
together before an image is realized on the ground
glass and ultimately in the fine print. Areas of activ-
ity must function individually within the whole con-
text of the picture and have a life of their own. All
things in the image must have substance and be
revealed. Working with amorphous subjects, the

organization of the structural complexities within
the format becomes extremely important. The logic
of photographic space must be well served.
A sensitivity to nuances and an interaction between
myself and the landscape are paramount. A lucid
craftsman is central to all of these things. The
beauty, subtlety and presence of the contact print is
also central to my camerawork.
I have discovered that one of the most significant
functions of "camerawork" may be based on the
developed ability to stand aside and watch oneself
be lost in one's own photograph or object to be
photographed, or one understood, and thereby find
oneself. Others may also find rapport with their own
inner feelings while in a state of receptivity with an
intense image.
So many pictures today cry out shrilly, Stop and
look at me. And the "me" they ask you to look at is
not the photographer's gifts of vision, but the
photographer himself. The forced drama of tone
and line, the stunts, the visual shocks force the
onlooker to feel not the object or person photo-
graphed, but the author's obsessive demand for
attention and recognition. The quantity of work
today that asks instead of gives is tragic. It speaks of
the waste of human beings and their creativity. It
says that we are not strong enough to make what
contributions we can without the applause of an
audience.
It is the responsibility of the photographer who
employs "camerawork" as his medium to produce
pictures which are as free of the author's personal
contingencies as possible. His images must have a
"transparency"....
Only an image born, not made, is free. An free-
dom of the eye and heart will come to him who loves
things not for his egotistical self to exploit for per-
sonal gain or satisfaction, but who loves things and
other persons as they are—for their own unique
being.

—Robert Bourdeau

Robert Bourdeau is the most paradoxical photog-
rapher in Canada. The gelatin silver contact prints
from his view camera (11 x 14 or 8 x 10) contain
immense vistas, crackling with energy in all four
corners. When he chooses the bare landscape of the
southwestern United States like Utah and Arizona
(1973 and 1976), the images are sparse and austere.
Places like Canada's Muskoka, which he visited in
the late 1960's and early 70's, Gatineau Park (1965
onwards) or the Wordsworthian England (1975 and
1980) are rich and lush. But it's not the imagery
which matters as much as his perception, especially
of the structure of the land and its complexity.
Bourdeau met Minor White in 1958, and it meant
something to him, not so much because White's
photographs were the "equivalent of a frame of
mind" but because White told him about photogra-
phy's way of seeing.
Bourdeau wants to reveal everything, he says—as
much depth as possible (the perspective is almost
hallucinatory), the immensity of distance. But he
stresses an exquisitely subtle and continous tonal
range in black and white. Nothing is out of focus,
but the space is ambiguous. The landscape tilts into
two-dimensions. Scale is hard to determine. There's
an underlying sense of tension. In seeing everything,
the viewer notices, most of all, the passage of time.
Tombstones, though fused to and absorbed by the
landscape, are time made visible—and Bourdeau
uses the space which surrounds them positively; he
plays with almost tactile views of astonishing clarity,
stressing the interacting forces on the surface to
create a complex, overall tapestry. "I like things to
flow," he says.
There are other paradoxes. These "things as they
are" are filled with an inner luminosity and radiance,
a sense of mystery and quiet power. At first glance
cool, they have a compelling emotional and hyp-
notic life. They are riveting evidence of Bourdeau's
"new-found land."

—Joan Murray

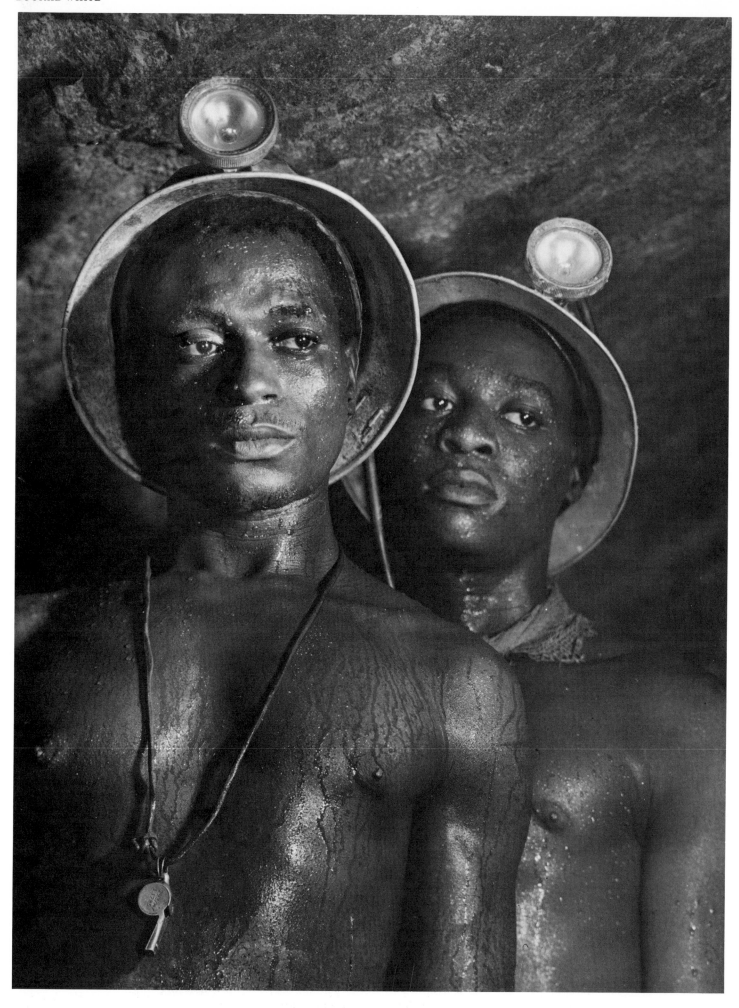

Margaret Bourke-White: *Gold Miners Nos. 1139 and 5122*, Johannesburg, South Africa, 1950

BOURKE-WHITE, Margaret.

American. Born Margaret White in New York City, 14 June 1904; adopted mother's family name "Bourke," 1927. Educated at Plainfield High School, New Jersey, 1918-21; Rutgers University, New Brunswick, New Jersey, 1922; University of Michigan, Detroit, 1923; Purdue University, Lafayette, Indiana, 1924; Western Reserve University, Cleveland, Ohio, 1925; Cornell University, Ithaca, New York, 1926-27, B.A. 1927. Married Everett Chapman in 1924 (divorced, 1926); married the author Erskine Caldwell in 1939 (divorced, 1942). Freelance photographer, Cleveland, 1928; Associate Editor and Staff Photographer, *Fortune* magazine, New York, 1929-35; also freelance photographer, working mainly for advertising agencies, New York, 1929-35; established own photo studio, Chrysler Building, New York, 1931; Staff Photographer, *Life* magazine, New York, 1936-40, 1941-42, 1945 until her death, 1971 (semi-retired, because of illness, from 1957); also, Chief Photographer, *PM* magazine, New York, 1940; Official United States Air Force Photographer, in England, North Africa, Italy and Germany, 1942-45. Recipient: Achievement Award, *U.S. Camera,* 1963; Honor Roll Award, American Society of Magazine Photographers, 1964. Agent: Time-Life Syndicate, Time and Life Building, Rockefeller Center, New York, New York 10020. *Died* (in Stamford, Connecticut), *27 August 1971.*

Individual Exhibitions:

1931 *Photographs by 3 Americans,* John Becker Gallery, New York (with Ralph Steiner and Walker Evans
 Annual Exhibition of Advertising Art, New York (with Anton Bruehl; artworks by others)
 Russian Photographs, American-Russian Institute, New York
1932 Little Carnegie Playhouse, New York
1956 Art Institute of Chicago
1966 *Bourke-White's People,* Syracuse University, New York
1971 Carl Siembab Gallery, Boston
 Witkin Gallery, New York
1972 Cornell University, Ithaca, New York
 Munson-Williams-Proctor Institute, Utica, New York
1973 Santa Barbara Museum of Art, California (with Yousuf Karsh)
1974 University of California at Santa Clara
1975 Syracuse University, New York
 Allan Frumkin Gallery, New York
 Robert Schoelkopf Gallery, New York
1976 *The Early Years,* Port Washington Public Library, New York
 2 Views of Czechoslovakia, Neikrug Galleries, New York (with Milon Novotny)
1978 *The Deco Lens,* Syracuse University, New York
 Witkin Gallery, New York

Selected Group Exhibitions:

1949 *6 Women Photographers,* Museum of Modern Art, New York
1951 *Memorable Life Photographs,* Museum of Modern Art, New York
1967 *Photography in the 20th Century,* National Gallery of Canada, Ottawa (toured Canada and the United States, 1967-73)
1975 *The Land: 20th Century Landscape Photographs Selected by Bill Brandt,* Victoria and Albert Museum, London (travelled to The National Gallery, Edinburgh; Ulster Museum, Belfast; and National Museum of Wales, Cardiff, 1976)
1977 *Documenta 6,* Kassel, West Germany
 Photographs: Sheldon Memorial Art Gallery

Collection, University of Nebraska, Lincoln
1979 *Photographie als Kunst 1879-1979,* Tiroler Landesmuseum Ferdinandeum, Innsbruck, Austria (travelled to Neue Galerie am Wolfgang Gurlitt Museum, Linz, Austria; Neue Galerie am Landesmuseum Joanneum, Graz, Austria; and Museum des 20. Jahrhunderts, Vienna)
 Photography Rediscovered: American Photographs 1900-1930, Whitney Museum, New York (travelled to the Art Institute of Chicago)
 Life: The First Decade, Grey Art Gallery, New York University
 Amerika Fotografie 1920-1940, Kunsthaus, Zurich

Collections:

The George Arents Research Library, Syracuse, New York (largest collection of prints and negatives); Life Picture Collection, New York; Brooklyn Museum, New York; Museum of Modern Art, New York; International Museum of Photography, George Eastman House, Rochester, New York; Library of Congress, Washington, D.C.; Cleveland Museum of Art, Ohio; Art Institute of Chicago; New Orleans Museum of Art; Royal Photographic Society, London.

Publications:

By BOURKE-WHITE: books—*The Story of Steel,* New York 1928; *Eyes on Russia,* New York 1931; *U.S.S.R. Photographs,* New York 1934; *You Have Seen Their Faces,* with Erskine Caldwell, New York 1937, 1975; *North of the Danube,* with Erskine Caldwell, New York 1939; *Say, Is This the U.S.A.?,* with Erskine Caldwell, New York 1941; *Shooting the Russian War,* New York 1942; *They Called It "Purple Heart Valley": A Chronicle of the War in Italy,* New York 1944: *"Dear Fatherland, Rest Quietly": A Report on the Collapse of Hitler's "Thousand Years",* New York 1946; *Halfway to Freedom: A Report on the New India,* New York 1949; *A Report on the American Jesuits,* with John La Farge, New York 1956; *Portrait of Myself,* New York 1963; articles—"Dust Changes America" in *The Nation* (New York), 22 May 1935; "Photographer in Moscow" in *Harper's Bazaar* (New York), March 1942; "Assignments for Publication" in *Encyclopaedia Britannica,* Chicago 1963; also numerous articles and photo-essays in *Fortune* (New York), 1930-55, *Vanity Fair* (New York), 1932-37, and *Life* (New York), 1936-56.

On BOURKE-WHITE: books—*Memorable Life Photographs,* with text by Edward Steichen, New York 1951; *Life Photographers: Their Careers and Favorite Pictures,* edited by Stanley Rayfield, New York 1957; *Photography in the Twentieth Century* by Nathan Lyons, New York 1967; *Life Library of Photography: Photojournalism* by Time-Life editors, New York 1971; *Margaret Bourke-White: Photojournalist* by Theodore M. Brown, New York 1972; *The Photographs of Margaret Bourke-White,* edited by Sean Callahan, New York 1972, London 1973; *The Magic Image* by Cecil Beaton and Gail Buckland, Boston and London 1975; *The Land: 20th Century Landscape Photographs Selected by Bill Brandt,* exhibition catalogue, edited by Mark Haworth-Booth, London 1975; *Concerning Photography,* edited by Jonathan Bayer, London 1977; *Documenta 6/Band 2,* exhibition catalogue, edited by Klaus Honnef and Evelyn Weiss, Kassel and Cologne 1977; *Photographs: Sheldon Memorial Art Gallery Collection, University of Nebraska,* with an introduction by Norman Geske, Lincoln, Nebraska

1977; *Fotografie der 30er Jahre: Eine Anthologie,* edited by Hans-Jürgen Syberberg, Munich 1977; *Geschichte der Fotografie im 20. Jahrhundert/Photography in the 20th Century* by Petr Tausk, Cologne 1977, London 1980; *A Ten Year Salute* by Lee D. Witkin, with a foreword by Carol Brown, Danbury, New Hampshire 1979; *Photography Rediscovered: American Photographs 1900-1930,* exhibition catalogue, by David Travis, New York 1979; *Photographie als Kunst 1879-1979/Kunst als Photographie 1949-1979,* exhibition catalogue, 2 vols., by Peter Weiermair, Innsbruck, Austria 1979; *Amerika Fotografie 1920-1940* by Erika Billeter, Berne 1979; *Life: The First Decade 1936-1945* by Robert Littman, Ralph Graves and Doris C. O'Neill, New York 1979, London 1980; *The Photograph Collector's Guide* by Lee D. Witkin and Barbara London, Boston and London 1979; articles—"Bourke-White Exhibit" in the *New York Times,* 31 December 1939; "Margaret Bourke-White" by E.M. Kelly in *Photography* (New York), August 1952; "Bourke-White's Twenty-Five Years" in *Life* (New York), 16 May 1955; "The Compleat Bourke-White" in *12 at War,* New York 1967; "Bourke-White Retrospective" in *Life* (New York), 29 January 1971; "Margaret Bourke-White Dead" by A. Whitman, in *New York Times,* 28 August 1971; "Margaret Bourke-White: A Retrospective" by N. Canavor in *Popular Photography* (New York), May 1973; "The Photographs of Margaret Bourke-White" in *Photography Year 1973,* by the Time-Life editors, New York 1973; "Margaret Bourke-White Retrospective" by Joan Murray in *Artweek* (Oakland, California), 6 April 1974.

Some professional photographers, Ansel Adams for example, work in relative isolation to produce images which are made public through exhibitions and publications. Others, such as Margaret Bourke-White, prefer to work in group efforts—indeed she flourished while working with collaborators. And her greatest photographic opportunities came through the practice of journalism, where material was assigned by editors and screened and processed by technical, design, and editorial teams before being viewed by enormous audiences in weekly and monthly publications—the picture magazine was her major medium of photographic expression.

As a crack reporter, she worked in locations throughout the world and, from the late 1920's through the early 1950's, participated in some of the most momentous events of the 20th century. An adventurer at heart, a kind of photographer-soldier-of-fortune, Bourke-White thrilled to the challenge of photographing under adverse conditions: in the stifling darkness of coal and gold mines; in the uproar of steel mills; within the mayhem of the Second World War; in droughts, floods, death camps, chain gangs, and the mass migrations of displaced populations.

Seemingly present wherever action occurred and danger abounded, Bourke-White was in Moscow during World War II when the city was first attacked by the Germans; she sailed on a ship that was torpedoed in the Mediterranean Sea; she flew with a B-17 bomber crew on a mission in North Africa; and present during the partition of India in the late 40's, she witnessed and documented the painful migration of millions of refugees. And unfailingly, she captured the facts and the aura of events in some of the most powerful images made during this century.

Toward the end of her career in the 1950's, she worked in the Korean War and also produced a brilliant coast-to-coast pictorial survey of the United States as seen from a helicopter. During that period, however, she began to suffer the symptoms of Parkinson's Disease, a degenerative illness that leaves the mind clear and alert while it progressively destroys the body's capacity to perform. No worse fate could befall such an active person.

During the last decades of her life, she accepted the most gruelling challenge of all, as she fought the disease with therapy, surgery, drugs, and sheer willpower. At the end, which came in August 1971, her lively mind was imprisoned inside a totally paralyzed body.

Good luck played a great part in Bourke-White's career, but she was skilled in arranging her life to encourage fortune to work in her favor. After drifting from college to college as a science major during the early 20's, she began doing amateur photography first at the University of Michigan then at Cornell University, where she received a bachelor's degree in 1927. Within two years she had assembled a portfolio of architectural and engineering photographs that was impressive enough to earn her an offer from Henry Luce to become the first staff photographer for *Fortune*, the second of his highly successful publishing ventures. (The first was *Time*, begun in 1923; the third was *Life*, started in 1936.) Luce recognized in her work methods and in her photographs the ingredients of a first rate photojournalist.

While on the *Fortune* staff, she also managed to maintain a freelance commercial practice; she did a photo study of the Soviet Union; and, in collaboration with the writer Erskine Caldwell—they married in 1939 and were divorced in 1942—did a pioneer study of rural poverty in the United States. *You Have Seen Their Faces* (1937), probably her most successful single work, was a leader among the large number of social documentaries published during the late 30's and early 40's, which included such well-known publications as Archibald MacLeish's *Land of the Free* (1938), Dorothea Lange's (in collaboration with P.S. Taylor) *An American Exodus* (1939), and the durable *Let Us Now Praise Famous Men* by Walker Evans and James Agee, published in 1941.

The central chapter in Bourke-White's career began in 1936, with the founding of *Life* magazine, the most accomplished of all the picture magazines of the century. Nine years out of college, with a thriving commercial practice, and a bulging portfolio of photographic production, Bourke-White and three men—Alfred Eisenstaedt among them—constituted the first of *Life's* impressive stable of photographers. Her success was underlined when her coverage of a dam construction in Montana was used on the cover and as the lead article of the new magazine. The famous cover, concrete piers under construction, sums up much of her mode of composition. The powerful forms, huge and immobile, are isolated like great pieces of sculpture; seen against them are two construction workers, tiny humans providing scale for the inhumanly-scaled technological objects. Throughout her career she tended to place people against a background of strong megaliths, establishing a partnership of man and machine.

As a woman of immense energy, compelled to work in a rapidly changing arena, Bourke-White was not inclined to engage in philosophic and aesthetic contemplation. Yet throughout her life, she spoke of "fact" and "beauty" as the basis of good pictures, and this simple affirmation offers a clue to an understanding of her views on photography. With an unshakable belief in the importance of facts, no matter how distressing, and with her assumption that fact and beauty are mutually supportive, she managed to characterize one of the salient qualities of her work.

Unsentimental and direct, her approach to photography was deceptively simple. She immersed herself in a variety of situations, extracted the essence of the experience, managed to create powerful compositions while on the fly, and communicated information about the event through extremely succinct means: isolation of cogent details, juxtaposition of mutually reinforcing components, and generally head-on views of subjects. And throughout her life she maintained a child's sense of wonder, while developing an adult's understanding of tragedy.

—Theodore M. Brown

BRAKE, (John) Brian.

New Zealander. Born in Wellington, 27 June 1927. Educated at primary school in Christchurch, and at Christchurch Boys' High School, 1941-44. Photographer since 1945: Assistant, Spencer Digby Portraiture Studio, Wellington, 1945-49; Cameraman/ Director, New Zealand National Film Unit, Wellington, 1949-53; Member of Magnum Photos, Paris and New York, 1955-66; freelance photographer, working for *Life, Paris-Match, National Geographic, Epoca, Horizon*, etc., since 1966, now based in Auckland. Recipient: British Council Bursary, 1949; Award of Merit, American Society of Magazine Photographers, 1961; Order of Merit, Government of Egypt, 1970. Associate, Royal Photographic Society, London, 1947; Honorary Fellow, New Zealand Professional Photographers Association, 1978. Agents: Photo Researchers Inc., 60 East 56th Street, New York, New York 10022, U.S.A.; Agence Rapho, 8 rue d'Alger, 75001 Paris, France; and John Hillelson Agency, 145 Fleet Street, London EC4, England. Address: Post Office Box 60 049, Titirangi, Auckland 7, New Zealand.

Individual Exhibitions:

1976 *Brian Brake: 40 Photographs*, Dowse Art Gallery, Lower Hutt, Wellington (toured New Zealand, 1976-78)
1978 *Tangata: The Maori Vision of Man*, Musée de l'Homme, Paris (and world tour, 1978-80)

Selected Group Exhibitions:

1963 *Photo Essays*, Museum of Modern Art, New York
1975 *The Land: 20th Century Landscape Photographs Selected by Bill Brandt*, Victoria and Albert Museum, London (travelled to the National Gallery, Edinburgh; Ulster Museum, Belfast; and National Museum of Wales, Cardiff, 1976)
1976 *Eye of the Beholder*, Squibb and Sons, Princeton, New Jersey
1980 *Body Electric*, Squibb and Sons, Princeton, New Jersey

Collections:

Victoria and Albert Museum, London.

Publications:

By BRAKE: books—*New Zealand: Gift of the Sea*, with text by Maurice Shadbolt, Christchurch, New Zealand 1963, 1964, 1974; *Peking: A Tale of Three Cities*, New York 1965, 1977; *The House on the Klong*, Bangkok 1968; *The Sculpture of Thailand*, New York 1972; *Form und Farbe*, Cologne 1972; *New Zealand Potters: Their Work and Words*, with text by Doreen Blumhardt, Wellington 1976; *Hong Kong*, with text by R.S. Elegant, London 1977; *Legend and Reality: Early Ceramics from South East Asia*, with text by Roxanna M. Brown and others, Kuala Lumpur 1977; *Rome and Her Empire*, with text by Barry Cunliffe, New York and London 1978; *The Sacred Image*, Cologne 1979; *The Art of the Pacific*, with text by James McNeish and David Simmons, London and New York 1980; *Sydney*, with Time-Life editors, London 1980; *Craft New Zealand*, with text by Doreen Blumhardt, Wellington 1981; films—*Ancient Egypt*, with Time-Life, 1969; documentaries on Indonesia, including *Borobudur: The Cosmic Mountain, Batik: The Magic Cloth, Ramayana, The Eternal Cycle: Festivals of Life and Death*, and *Indonesian Safari*, 1970-75.

On BRAKE: books—*Photojournalism*, by Time-Life editors, New York 1971; *Brian Brake: 40 Photographs*, exhibition catalogue, Wellington 1976.

Photography is my life and language.

—Brian Brake

Looking at some of Brian Brake's photographs, one feels that there was a series of shots leading up to the one chosen. Brake intuitively anticipates: he takes what might be called a past, present and future record of the subject or event; he then selects a frame that represents the present, which is in fact the psychological moment at which a photograph epitomises the build-up and hints at the denouement. The student with a 35mm camera would find it instructive to see the entire film strip, for the selection of the frame is part of Brake's art.

Though he has gained international fame, Brake is a born New Zealander, and it is in his home photography that he is most individual and shows the fullest interpretation of nature into photography. The work he exhibits—such as his *40 Photographs*—reveals more of his ambition than of his style. It is when he has to provide photographs for his books, such as *New Zealand: Gift of the Sea*, where he portrays subjects as varied as sheep mustering, the Rugby scrum, placid lakes, and boiling springs, that it becomes evident that he is consciously documenting. This has given him a recognizable style, a character similar to that of Cartier-Bresson. The New Zealand scene, neither human nor landscape, is not patently tense; there are no scenes of poverty, there is no majesty like Grand Canyon. It is necessary to create a photographic tenseness to arrest and interest. Brake uses black-and-white and colour. His tendency is to show human activity in terms of the tonal scale, and to use the spectral scale for portraying moods, atmosphere, and superlatives.

Brake's creativity in photography is in presenting highly informative illustrations. He is not always so successful when he is commissioned to photograph given subjects, such as the large number of ethnographic artefacts in museum collections used in *The Art of the Pacific*, where a desire to create pictures with dramatic lighting detracts from the information inherent in the items.

But the failures are few. Brake takes his place in the tradition of intensive documentary photography which New Zealand has nurtured. Though early New Zealand photographers such as J.W. Allen and D.L. Mundy are known only to photo-historians, Alfred Burton was awarded the Fellowship of the Royal Geographical Society for his ethnographic photography of the Maori people, and his work has been valued by museums throughout the world. Others followed this documentary approach. Brake's *Monsoon*, which was exhibited at the Museum of Modern Art in New York, is a most sensitive documentary in this tradition, and it has received international recognition.

Brian Brake concentrates on the more intrinsic aspects of life and avoids the trivialities of the passing scene. But though he is objective and serious in showing life as it is, he is also thrilled by his subjects and excited about his photography—and his attitude is infectious.

—Hardwicke Knight

See Color Plates

BRANDT, Bill.

British. Born in London in May 1904; raised mainly in Germany and Switzerland and attended schools there. Largely self-taught in photography; student-

Bill Brandt: From *Nudes 1945-1980*, **1980**

assistant to the photographer Man Ray, Paris, 1929-30. Freelance social documentary photographer, working for *Weekly Illustrated, Picture Post, Verve*, etc., London, 1931-39; photographer for *Lilliput* magazine, London, 1939-45; worked on photographic survey of bomb shelters for the Home Office, London, also as a documentary photographer for the National Buildings Record, London, 1940-45. Freelance photographer, London, since 1945; has spent part of each year in Provence, since 1959. Honorary doctorate: Royal College of Art, London, 1977. Member of the Faculty, Royal Designers for Industry. Honorary Fellow, Royal Photographic Society of Great Britain, 1980. Agent: Marlborough Fine Art, 6 Albemarle Street, London W1X 3HF, and Marlborough Gallery, 40 West 57th Street, New York, New York 10019. Address: 4c Airlie Gardens, London W8, England.

Individual Exhibitions:

1938 *A Night in London*, Arts et Metiers Graphiques, Paris
1948 Museum of Modern Art, New York
1969 Museum of Modern Art, New York (retrospective; travelled to the Hayward Gallery, London, 1970, then toured the U.K.)
1972 British Council Travelling Exhibition (toured European cities)
1973 Witkin Gallery, New York
1974 The Photographers' Gallery, London
 Collages, Kinsman Morrison Gallery, London
1975 *Early Photographs 1930-1942*, Hayward Gallery, London
 Musée Nicéphore Niepce, Chalon-sur-Saône
 Photogalerie, Paris
1976 Marlborough Fine Art, London
 Marlborough Gallery, New York
 Cronin Gallery, Houston
 Galerie du Chateau d'Eau, Toulouse
 Palais des Beaux-Arts, Charleroi, Belgium
1977 Vision Gallery, Boston (with Brassaï and Berenice Abbott)
 Brandt/Gibson/Klein, Vrije Universiteit, Amsterdam (with Ralph Gibson and Aart Klein)
1978 Moderna Museet, Stockholm
1979 *Perspective of Nudes*, Zeit-Foto Salon, Tokyo
 Galerij Paule Pia, Antwerp
1980 *Nudes*, Petit Trianon de Bagatelle, Paris
 Early Nudes, Galerie zur Stockerreg, Zurich
 Galerie et Fils, Brussels (with Mario Giacomelli and Aleksandras Macijauskas)
1981 Worcester Art Museum, Massachusetts
 National Centre of Photography, Bath, England
 Edwynn Houk Gallery, Chicago
 Early Photographs 1930-1942, University of Kent Library, Canterbury (toured the U.K.)
 Zeit Foto Salon, Tokyo
1982 *Photographs by Bill Brandt: 1929-1975*, Art Gallery of Ontario, Toronto

Selected Group Exhibitions:

1955 *The Family of Man*, Museum of Modern Art, New York (and world tour)
1967 *Photography in the 20th Century*, National Gallery of Canada, Ottawa (toured Canada and the United States, 1967-73)
1975 *The Land: 20th Century Landscape Photographs Selected by Bill Brandt*, Victoria and Albert Museum, London (travelled to the National Gallery, Edinburgh; Ulster Museum, Belfast; and National Museum of Wales, Cardiff, 1976)
1976 *Rencontres Internationales de la Photographie*, Arles, France
1977 *Concerning Photography*, The Photographers' Gallery, London (travelled to the Spectro Workshop, Newcastle upon Tyne)
 Fotografische Kunstlerbildnisse, Museum Ludwig, Cologne
1979 *The 30's: British Art and Design Before the War*, Hayward Gallery, London
 Photographie als Kunst 1879-1979, Tiroler Landesmuseum, Innsbruck (travelled to the Neue Galerie am Wolfgang Gurlitt Museum, Linz, Austria; Neue Galerie am Landesmuseum Joanneum, Graz, Austria; and Museum des 20. Jahrhunderts, Vienna)
1980 *Old and Modern Masters of Photography*, Victoria and Albert Museum, London (toured the U.K.)
 Modern British Photography 1919-39, Museum of Modern Art, Oxford

Collections:

Victoria and Albert Museum, London; Bibliotheque Nationale, Paris; Museum of Modern Art, New York; International Museum of Photography, George Eastman House, Rochester, New York; Art Institute of Chicago.

Publications:

By BRANDT: books— *The English at Home*, with an introduction by Raymond Mortimer, London 1936; *A Night in London*, with an introduction by James Bone, London and New York 1938, as *Londres de Nuit*, Paris 1938; *Bill Brandt: Camera in London*, edited by Andor Kraszna-Krausz, commentary by Norah Wildon, London and New York 1948; *Literary Britain*, with an introduction by John Hayward, London 1951; *Perspective of Nudes*, with texts by Lawrence Durrell and Chapman Mortimer, London and New York 1961, as *Perspectives sur le Nu*, Paris 1961; *Shadow of Light*, with an introduction by Cyril Connolly, notes by Marjorie Beckett, London and New York 1966, as *Ombre d'une Ile*, with an introduction by Michel Butor, notes by Marjorie Beckett, Paris 1967, revised edition, with introductions by Cyril Connolly and Mark Haworth-Booth, London and New York, 1977, Tokyo 1979, as *Ombre de Lumiere*, Paris 1977; *Bill Brandt: Nudes 1945-1980*, with an introduction by Michael Hiley, London and Boston 1980; articles—"Bill Brandt," interview, in *Album* (London), February and March 1970; "Bill Brandt," interview, with Ruth Spencer, in *British Journal of Photography* (London), 9 November 1973.

On BRANDT: books—*Photography in the 20th Century* by Nathan Lyons, New York 1967; *Bill Brandt: Photographs*, exhibition catalogue, by Aaron Scharf, London 1970; *The Land: 20th Century Landscape Photographs Selected by Bill Brandt*, exhibition catalogue, edited by Mark Haworth-Booth, London 1975; *Bill Brandt: Early Photographs 1930-1942*, exhibition catalogue, by Peter Turner, London 1975; *The Magic Image* by Cecil Beaton and Gail Buckland, London and Boston 1975; *Bill Brandt*, exhibition catalogue, with an essay by Norman Hall, London 1976; *Geschichte der Photographie im 20. Jahrhundert/Photography in the 20th Century* by Petr Tausk, Cologne 1977, London 1980; *The 30's: British Art and Design Before the War*, exhibition catalogue, by Ian Jeffrey, William Feaver, Brian Lacey and others, London 1979; *Photographie als Kunst 1879-1979*, exhibition catalogue, 2 vols., by Peter Weiermair, Innsbruck 1979; *Old and Modern Masters of Photography*, exhibition catalogue, by Mark Haworth-Booth, London 1980; articles—"Bill Brandt" by Ainslie Ellis in *British Journal of Photography* (London), 15 May 1970; "Bill Brandt: How Significant Is His Photography?" by John Bardsley and R. Dunkley in *Photographic Journal* (London), July 1970; "The Brandt Collection" by C. Faraldi in *The Observer* (London), 9 June 1974; "Bill Brandt: Not Resting on His Laurels" by Dave Saunders in *Hot Shoe* (London), no. 15, 1981.

The photographer must possess and preserve the receptive faculties of a child who looks at the world for the first time.... As a rule, we are all too busy, too preoccupied, too eager to be right, too obsessed by certain ideas, to find the time to stand and stare. We look at something and think that we have seen it. And yet what we see is often only what our preconceived ideas prepare us to see, or else what our past experience compels us to see, or else what our desires want us to see. Only rarely are we able to free ourselves from the burden of our thoughts and emotions and to see for the simple pleasure of seeing. And as long as we cannot do this, the essence of things remains hidden from us.

It is essential for a photographer to know his lens. The lens is his eye and is responsible for the success or failure of the work.

Composition is an important element and mainly, in my opinion, a matter of instinct. It can be developed, but I doubt that it can be learned.

To achieve the best possible work, the young photographer has to discover what moves him visually. It is up to him to discover his own personal world.

—Bill Brandt

Bill Brandt is one of the acknowledged masters of 20th century photography. Taken as a whole, his work constitutes one of the most varied and vivid social documents of a country—Britain—to be produced in our time. Not only has he documented his motherland's social contrasts and working life, but also exposed the British mentality and told of many things, from the wonders of her heritage to the human result of her war-time devastation.

It has been written that Brandt turned to photography because tuberculosis kept him from "normal" work. He intended to become a portrait photographer, but his earliest serious photography, taken in the streets of London's East End in 1928, was social documentation.

Another formative influence was exposure to the work of the American painter and photographer Man Ray, a factor which would determine the surrealist undercurrent and special tension of many of Brandt's most beautiful images. Brandt moved to Paris in 1929 as Ray's student and assistant; he became fascinated with the work of the French photographer Eugène Atget as well as with surrealist painting and film (including Luis Bunuel's *L'Age d'Or* and *Le Chien Andalou*) and tried experimental darkroom techniques, the results of which have not survived. Knowledge of the way in which these two strains—the documentary and the surreal—are used and subtly blended in Brandt's work is essential to understanding it.

Through the early 1930's documentation dominated. In 1931 Brandt joined the *Weekly Illustrated*, first as an unpaid apprentice and subsequently as a freelance photographer. He evolved the idea of publishing a book recording the dramatic social contrasts in English society, which resulted in *The English at Home*. Reading J.B. Priestley's *An English Journey* prompted Brandt to visit Northern England, where he photographed the Tyneside towns and destitute villages of East Durham. His photographs of the unemployed miners reduced to coal-searching after the hunger strike of 1937 are deeply moving, blackly moody statements of the human condition and the British predicament. In 1938, Arts et Metiers Graphiques, organizers of Brandt's first one-man show, published Brandt's second book, *A Night in London*, containing dream-like photographs with surreal overtones. One year later, the "London by Moonlight" series recorded the mystery and eerie beauty of London's buildings in the blacked-out nights of the Blitz.

At the outbreak of the war, Brandt's documentation of London continued in his work for the Home

Office and the National Buildings Record, who required photographs of important buildings to enable an accurate reconstruction record in the case of their destruction. From 1940-44 Brand made a complete photographic survey of bomb damage and produced the haunting and beautiful photographs of London's improvised air-raid shelters, which were published in *Lilliput* in 1942 opposite Henry Moore's famous shelter drawings. These images, taken for the Home Office, are perhaps the ultimate example of the social document fused with hauntingly surreal implications.

With the end of the war, Brandt's work became increasingly expressive and poetic overtones began to dominate reportage. From this time through the early 1950's Brandt used the camera to explore new spatial relationships that were rooted in his surreal beginnings of the 20's. Before this, Brandt had photographed the commonplace, charged with mystery; he now began transformations *through* the camera.

The turning point was his purchase of a second-hand box camera with an ancient wide-angle lens. The aperture of this camera was so small that there was virtually no image on the ground glass, forcing Brandt to "shoot blind" without actually seeing anything in the ground glass. This exploitation of the accidental—which the photographer characterized as changing his vision to one more like "a mouse, a fish or a fly"—was one of the primary ideas of surrealism.

With this camera, whose wide-angle lens produced acute distortion, Brandt produced a revolution in photographic vision. He became the first photographer to use perspective no longer as a delineation of space but as a tool for experiencing a new sense of form. Even more importantly, with these pictures Brandt developed an entirely new form of landscape photography, in which displaced fragments of the female form became the metamorphosized elements of *imaginary* landscapes. The female figure, enlarged and stretched with distortion, became abstract form. This use of abstraction by Brandt parallels the abstraction of such English artists as Hepworth, Moore, Nicolson and Pasmore. Brandt's subject subsequently changed from nudes to pure objects, stones and jetsam, which he photographed in color.

Bill Brandt's influence is not to be underestimated. His work has the qualities of tenderness, compassion and truth; it also has visual strength and enormous integrity. It has added the form of imaginary landscape to photography's repertoire and has extended the boundaries of both documentary and romantic imagery. It is a body of work, done over a period of more than 50 years, whose duration is equalled only by its importance.

—Nancy Hall-Duncan

BRASSAÏ.
French. Born Gyula Halász in Brasso, Transylvania, Hungary, now Rumania, 9 September 1899; emigrated to France, 1924: naturalized, 1948; adopted the name "Brassaï" (literally, "from Brasso"), Paris, 1925. Educated at schools in Brasov and Budapest, 1917; studied at the Academy of Fine Arts, Budapest, 1918-19; Akademische Hochschule, Berlin-Charlottenburg, 1921-22, B.A. 1922. Served in the

Austro-Hungarian Army, 1917-18. Married Gilberte-Mercedes Boyer in 1947. Worked as a painter, sculptor and journalist, associating with Picasso, Dali, Braque, etc., Paris, 1924-30; took up photography, Paris, 1930; freelance magazine photographer, Paris, working for *Minotaure, Verve, Harper's Bazaar*, etc., 1930-40; lived in the South of France, 1940, then returned to Paris, refused to photograph during the German occupation, but worked in Picasso's studio photographing his sculptures and designing and writing *Conversations avec Picasso*; resumed career as photographer, 1945, working for *Picture Post, Lilliput, Coronet, Labyrinthe, Réalités, Plaisirs de France*, and *Harper's Bazaar* (1936-63); also designed for ballets (creating first stage decors in photographs), Paris, 1945-50. Recipient: Emerson Medal, London, 1934; Gold Medal, *Daguerre Centennial Exhibition*, Budapest, 1937; Gold Medal, *Biennale de Fotographia*, Venice, 1957; Prize, *Cannes Film Festival*, 1956; Obelisk of Honor, *Photokina*, Cologne, 1963; American Society of Magazine Photographers Award, with Ansel Adams, 1966; Medal, City of Arles, France, 1974; Premier Grand Prix National de la Photographie, 1978. Chevalier des Arts et Lettres, 1974; Chevalier de la Légion d'Honneur, 1976. Address: L'Amandaïret, 06360 Eze-Village, France.

Individual Exhibitions:

1933 *Paris de Nuit*, Arts et Métiers Graphiques, Paris (travelled to the Batsford Gallery, London)
1946 Palais des Beaux-Arts, Brussels
1952 *Cent Photographies de Brassaï*, Musée des Beaux-Arts, Nancy, France
1954 Interclub, Toulouse
 Art Institute of Chicago
1955 Walker Art Center, Minneapolis
 International Museum of Photography, George Eastman House, Rochester, New York
 Delgado Museum, New Orleans
1956 Hansa Gallery, New York
1957 *Graffiti*, Museum of Modern Art, New York
1958 *The Language of the Wall: Parisian Graffiti Photographed by Brassaï*, Institute of Contemporary Arts, London
1959 *Eye of Paris*, Limelight Gallery, New York
1960 *Graffiti*, at the *Triennale di Milano*
1962 *Graffiti*, Galerie Daniel Cordier, Paris
 Galleria dell'Obelisco, Rome
1963 Maison de la Culture, Caen, France
 Worcester Art Museum, Massachusetts
 Brassaï: Exhibition Retrospective, Bibliothèque Nationale, Paris
 Residence du Louvre, Menton, France
1964 Staatliche Kunsthalle, Baden-Baden, West Germany
 Picasso/Brassaï, Galerie Madura, Cannes (with Pablo Picasso sculptures)
1965 Musée du Vieux-Chateau, Dieppe, France
1966 Kölnischer Kunstverein, Cologne (retrospective)
1968 Staatliche Landesbildstelle, Hamburg
 Museum of Modern Art, New York (retrospective; travelled to the City Art Museum, St. Louis, 1969; toured Australia, New Zealand, and South America, 1971-74)
1970 *L'Art Mural par Brassaï*, Galerie Rencontres, Paris
1971 Robert Schoelkopf Gallery, New York
1972 Lunn Gallery, Washington, D.C.
1973 Corcoran Gallery, Washington, D.C.
 Friends of Photography, Carmel, California
 Witkin Gallery, New York
1974 Santa Barbara Museum of Art, California
 University of Iowa Museum of Art, Iowa City
 University of California, Berkeley
 Brassaï: Hommage, Musée Réattu, Arles, France
1975 Museum of Art, Utica, New York

 Brassaï: The Eye of Paris, Baltimore Museum of Art
1976 Cornblatt Gallery, Baltimore
 David Mirvish Gallery, Toronto
 The Secret Paris of the 30's, Marlborough Gallery, New York
1977 *Paris Secret des Années 30*, Marlborough Gallery, Zurich
 Neue Galerie der Stadt Linz, Austria
 Das Geheime Paris, Galerie Levy, Hamburg
 Halsted 831 Gallery, Birmingham, Michigan
 Vision Gallery, Boston (with Berenice Abbott and Bill Brandt)
1978 *Paris Secret*, Banque Lambert, Brussels
 Le Paris Secret, Musee des Beaux-Arts, Arnhem, Netherlands
 Galerij Paule Pia, Antwerp
 Paris Secret, Camera Obscura, Stockholm
1979 *Artists and Studios*, Marlborough Gallery, New York
 The Photographers' Gallery, London

Also, exhibitions of designs, sculpture and tapestry, including: Galerie Renou et Colle, Paris, 1945; Galerie du Pont-Royal, Paris, 1960; Galerie Daniel Cordier, Paris, 1962; Galerie Les Contards, Lacoste, 1966; Galerie des Ponts des Arts, Paris, 1968; Gallery La Boétie, New York, 1968; Galerie Verrière, Paris, 1972; and Galerie Verrière, Lyons, 1973.

Selected Group Exhibitions:

1932 *Modern European Photographers*, Julien Levy Gallery, New York (as Halász)
1937 *Photography 1839-1937*, Museum of Modern Art, New York
 Daguerre Centennial Exhibition, Palais Karoly, Budapest
1939 *Maîtres Photographs Contemporains*, Palais des Beaux-Arts, Brussels
1951 *5 French Photographers*, Museum of Modern Art, New York
1953 *Post-War European Photography*, Museum of Modern Art, New York
1955 *The Family of Man*, Museum of Modern Art, New York (and world tour)
1963 *Great Photographers*, at *Photokina*, Cologne
1976 *Photographs from the Julien Levy Collection, Starting with Atget*, Art Institute of Chicago
1981 *Les Réalismes*, Centre Georges Pompidou, Paris

Collections:

Bibliothèque Nationale, Paris; Musée Réattu, Arles, France; Victoria and Albert Museum, London; Museum of Modern Art, New York; Metropolitan Museum of Art, New York; International Museum of Photography, George Eastman House, Rochester, New York; Smithsonian Institution, Washington, D.C.; Art Institute of Chicago; Walker Art Center, Minneapolis; National Gallery of Victoria, Melbourne.

Publications:

By BRASSAÏ: books—*Paris de Nuit*, with text by Paul Morand, Paris and London 1933; *Trente Dessins*, with poems by Jacques Prévert, Paris 1946; *Les Sculptures de Picasso*, with text by Daniel-Henry Kahnweiler, Paris 1948, London 1949; *Brassaï: Camera in Paris*, London and New York 1949; *Histoire de Marie*, novel (unillustrated), with an introduction by Henry Miller, Paris 1949; *Formes*, Paris 1951; *Brassaï*, with an introduction by Henry Miller, Paris 1952; *Seville en Fête*, with an introduction by Henri de Montherlant, Paris 1954, Munich 1955, as *Fiesta in Spain*, New York 1956; *Graffiti de Brassaï*,

Brassaï: *"Bijou" in a Place Pigalle Bar*, 1932

with text by Pablo Picasso, Stuttgart and Paris 1961; *Brassaï*, with text by Ludvic Souček, Prague 1962; *Conversations avec Picasso*, Paris 1964, as *Picasso and Company*, New York 1966; *Transmutations*, portfolio, Vaucluse, France 1966; *Portfolio Brassaï*, with text by A.D. Coleman, New York 1973; *Henry Miller: Grandeur Nature*, Paris 1975; *Le Paris Secret des Années 30*, Paris, London, New York and Frankfurt 1976; *Paroles en L'Air*, Paris 1978; *Henry Miller Rocher Heureux*, Paris 1978; *Revelation: Letters from Brassaï to His Parents 1920-1940*, Bucharest 1980; articles—"Du Mur des Cavernes au Mur d'Usine" in *Minotaure* (Paris), nos. 3/4, 1933; "Le Paris Insolite" in *Réalités* (Paris), December 1960; "Mon Ami André Kertész" in *Camera* (Lucerne), April 1963; introduction to *Images de Camera*, Paris, London and Lucerne 1964; "My Memories of Eugène Atget, P.H. Emerson and Alfred Stieglitz" in *Camera* (Lucerne), January 1969; "Brassaï par Brassaï: Propos Recueillis par Viviane Berger" in *Jardin des Arts* (Paris), March 1972; "Lewis Carroll: Photographe" in *Zoom* (Paris), no. 11, 1972; "Le Regard de Picasso" and "Picasso et Goethe" in *Gazette des Beaux-Arts* (Paris), October 1973; "Texte sur Man Ray (a sa Mort)" in *Nouvelles Lettres* (Paris), 23 November 1975; "Brassaï," interview, in *Dialogue with Photography*, edited by Paul Hill and Thomas Cooper, London 1979; film—*Tant qu'il y Aura des Betes*, 1955.

On BRASSAÏ books—*Art de Voir en Photographie* by Marcel Natkin, Paris 1935; *Photography 1839-1937*, exhibition catalogue, by Beaumont Newhall, New York 1937; *Histoire de la Photographie* by Raymond Lecuyer, Paris 1945; *Masters of Modern Art* by Alfred H. Barr, Jr., New York 1954; *Photography of the World*, Tokyo 1956; *The Language of the Wall: Parisian Graffiti Photographed by Brassaï*, exhibition catalogue, with an introduction by Roland Penrose, London 1958; *The Picture History of Photography* by Peter Pollack, New York 1958, 1969; *Brassaï: Exposition Retrospective*, exhibition catalogue, with a preface by Julien Cain, text by Jean Adhémar, Paris 1963; *Great Photographers of Our Century* by Fritz Gruber, Dusseldorf and Vienna 1964; *The Painter and the Photograph: From Delacroix to Warhol* by Van Deren Coke, Albuquerque, New Mexico 1965, 1972; *Photography in the 20th Century* by Nathan Lyons, New York 1967; *Brassaï*, exhibition catalogue, with a preface by John Szarkowski, and an introduction by Lawrence Durrell, New York 1968; *Looking at Photographs* by John Szarkowski, New York 1973; *The Magic Image* by Cecil Beaton and Gail Buckland, London and Boston 1975; *Photographs from the Julien Levy Collection, Starting with Atget*, exhibition catalogue, by David Travis, Chicago 1976; *The Grotesque in Photography* by A.D. Coleman, New York 1977; *Faces*, edited by Ben Maddow, Boston 1977; *Geschichte der Fotografie im 20. Jahrhundert*/*Photography in the 20th Century* by Petr Tausk, Cologne 1977, London 1980; *Histoire de la Photographie Francaise* by Claude Nori, Paris 1978; *Nudes*, edited by Constance Sullivan and Ben Maddow, New York 1980; articles—"Brassaï," special monograph issue of *La Revue Neuf* (Paris), no. 5, 1951; "Brassaï" by André Kertész, special monograph issue of *Infinity* (New York), vol. 15, no. 7, 1966.

"I invent nothing, I imagine everything." I have never looked for subjects that are exotic or sensational in themselves. Most of the time I have drawn my images from the daily life around me. I think that it is the most sincere and humble appreciation of reality, the most everyday event that leads to the extraordinary. Or, as Jean Giono said: "Reality pushed to the extreme leads to unreality/the visionary."

My subject matter, field of research: Paris by day; Paris by night; portraits of artists, writers, etc.; nudes; graffiti; abstract colors; walls; Greece, Italy, Spain, Turkey, Morocco, Sweden, Sicily, Brazil, the United States, Ireland, England, etc.; engravings; glass negatives.

—Brassaï

He was born in Transylvania at Brasso (hence his pseudonym, Brassaï) on 9-9-1899 at 9 p.m. "Nothing but 9 or multiples of 9," Brassaï remarks. He laughs. Brassaï laughs a lot. Everything amuses him. Humor is not, however, a determining factor in his work; it is, rather, a counterpoint that accompanies it, a detour, a diversion, or, more exactly, one of those glissandi by which violinists start from a low note then go up the string until they achieve perfection in the note they seek.

Curiosity—it is Brassaï's driving force. Perhaps it is what drove him to abandon drawing, in which he excelled, for the photograph—to the great dismay of Picasso. Curiosity is certainly what drove him to follow Léon Paul Fargue, the famous Paris pedestrian, on his nocturnal wanderings, far from the Dôme, far from the cosmopolitan quarter of Montparnasse which he so loves. About these peregrinations and the illicit universe that he now knows so well Brassaï has a thousand anecdotes: he adored the world of the night; he studied, judged, sized up, marvelled at, criticized, all his being on alert—yet laughter is always ready to burst out. He says today, "I nearly created sociological studies of certain milieux of this period."

Even though he belatedly discovered photography, and in Paris, Brassaï was influenced by the New Objectivity movement in Germany. If he transcends the limits of the "applied" photo where others of his era stop, it is because his reflection proceeds less from the diktats of the theorists limited by an objective combination of art and industry and much more from an in-depth analysis which finds its source in the scientific and literary thought of Goethe. The work of Goethe nourished Brassaï; he is, in fact, a disciple. It was Henry Miller who best explained Brassaï's particular philosophy: "This desire that Brassaï displays with so much force, this desire that seeks not to alter the object but to take it in its essence, *as it is*, is it not provoked by a deep humility, respect and veneration for the object itself? The more this man puts aside his vision of life and the objects and beings which compose it, plus all the interference of individual volition and of the ego, the easier it is for him to quickly assume multiple identities that usually remain foreign and closed to us. Because he was able to become depersonalized, he was able to discover his personality in everything and everywhere." And this is why, it seems to me, that his art is characterized by a kind of definitive "seizure" of things.

"I like living beings; I like life," says Brassaï, "but I like to capture it in such a way that the photo does not move. I don't really like the snapshot, the Leica with its 36 views, all of which distract attention." For Brassaï the photograph is something static. And, indeed, all of his great pictures appear immobile in their density of sculpture—yes, sculpture: his prostitutes, his low-life figures, they are *volumes* brought into light, revealed by light.

The snapshot more or less reveals nuance, psychology, detail. Brassaï seeks rather to restrict, to assemble, to contain. A mysterious power, opaque, disengages itself from these incredibly concentrated forms: it is not so much involved with the complexities of the mind or irregularities of the heart as, always, with more essential truths.

Brassaï himself does not stand still: he simply photographs the motionless. He does not capture a face when the muscles are stretching, tensed or contorted, when the mouth opens onto an interior countryside of mucous membranes and tooth decay. He waits—until the being collects itself, is contained, has ceased to disperse, to reach out from itself—when, ceasing to be an anecdote, it becomes its own story. And that is why Brassaï restricts the authority of the eye of the beholder, challenges its authority: he does not distract with detail, and he allows no escape from his own vision.

—Michel Nuridsany

BRAUN, Werner.

Israeli. Born in Nuremberg, Germany, 12 June 1918; emigrated to Israel, then Palestine, 1946: naturalized Israeli citizen, 1948. Educated at the Reform Gymnasium, Nuremberg, 1925-34; self-taught in photography. Served in the Israeli Army, 1948, 1967, and as a photo-correspondent during the Yom Kippur War, 1973. Married Yael Fleischmann in 1941 (divorced, 1976); children: Dani and Ruth; married Anat Rotem in 1977. Worked as a farmer in Sweden, 1937-39, Denmark, 1939-43, and again in Sweden, 1943-46. Owner of the Braun Photo Laboratory, Jerusalem, since 1949; freelance news, magazine and documentary photographer, Jerusalem, specializing in aerial and underwater photography, since 1950. Recipient: Third Prize, Nikon International Contest, 1979. Agent: Camera Press, Russell Court, Coram Street, London WC1, England. Address: Post Office Box 8024, 91080 Jerusalem, Israel.

Selected Group Exhibitions:

1975 *Jerusalem*, Israel Museum, Jerusalem
1976 *Jerusalem*, Stadt der Menschheit, Charlottenburg, West Berlin

Publications:

By BRAUN: books—*Olive Trees*, Teufen, Switzerland 1958; *Tel Aviv/Jaffa*, Tel Aviv 1958; *The Red Sea Is Blue*, Tel Aviv 1966; *Akko*, Tel Aviv 1967; *Israel and the Holy Land*, New York 1967; *Haifa*, Haifa 1968; *Jerusalem*, with text by G. Rosenthal, Munich 1968; *Israel, Land of Faith*, with text by Rinna Samuel, Tel Aviv 1970; *Night of the Wadi*, with text by Dvora Ben-Shaul, New York 1970; *Shalom Israel*, Tel Aviv 1972; *Sinai and the Negev*, with text by Rinna Samuel, London 1972; *Jerusalem, The Holy*, Tel Aviv 1972; *Jerusalem*, portfolio, with others, New York 1973; *Levanon*, with text by Giladi, Tel Aviv 1974; article—"Seeing the U.S.A.—the Israeli Way" in the *Chicago Tribune*, August 1965.

On BRAUN: articles—"Production Specialists: Photo Werner Braun" in *Israel Book World* (Tel Aviv), December 1973; "Leading Israeli Photographers" by Helen Davis in *Israel Scene* (Jerusalem), November 1980.

To be a photographer is more than a profession; it's a challenge that never, never ends. Since absolutely everybody can shoot pictures, you always have people glancing over your shoulder, even if they are not near you physically. This is the tension in our lives, the Darwinian survival of the fittest: every shot taken is a competition against thousands of unseen opponents. And that challenge really *does* keep you functional in body and soul. You never want to stop; you remain young. Many photographers, if they do

Werner Braun: *A Window in the Sky*, 1978

not expose themselves to too much danger, live to a very ripe old age. Doctors look at my x-rays and tell me ominously, you are 62 and your bone-structure has changed. Yes, it has; the joints do ache sometimes; so does my back. I have difficulty in carrying around 2 Hasselblads with 5 lenses, and often I switch to the easier Nikon. But would I give up flying, diving, skiing or roaming through half the world in a camper—all these activities closely and intimately related to my profession? No, I would not. Not yet; not ever, if I can help it.

It is good to specialize, because only then can you reach real perfection. I have seen the truth of that advice in the careers of many of my colleagues. But what can you do if EVERYTHING interests you, be it fashion, advertising, public relations, micro, macro, tele, animals, sports, aerials, underwater, book illustration, photo essays, calendars, posters, and the struggle of a young state called Israel? So much for *my* specialization.

Yet I do believe that photographers can be artists. The bulk of our work might not be art. But there are rare moments (you feel them in your blood) when you know that you have hit it. It can happen any time, anywhere. You can sit in an airplane and be doing routine work and suddenly you see it, and you coax the pilot to put the plane in precise position, and you get the shot in a million, the ultimate. Sometimes you have to think a lot and search and walk and wait in order to find the moment that means the difference between a shot and a photograph. When it comes, it is the most rewarding moment of your life.

—Werner Braun

Werner Braun has had a life of struggle ending in adventurous delight.

Like many other Israelis, he arrived in the country at a time of great upheaval. He had spent ten years in Scandinavia after fleeing Nazi Germany, waiting to be allowed to enter Palestine. Once there, he had the world before him, and yet nothing before him. What occupation should he follow? Upholstery?—the

family business he had been trained for? Agriculture?—he had worked as a farmer in Sweden and Denmark. But he already had hypo in his blood. In those days, however, the profession of photographer was unheard of, so he went to work as a darkroom technician in Jerusalem's only professional lab. Soon he was running it. And then, during the War of Independence (mind you, *during* the war), while he was still a soldier, he bought the place. After the war—a pioneering effort in itself—he became a photographer.

With incredible energy and stamina, Braun has helped to create the profession of photographer in Israel. Starting with the usual studio shots, he moved on to recording his country's growth, as a press photographer, as an aerial photographer, and as the creator of a series of outstanding books about his country. Many of his photos have become classics, known around the world.

Perhaps the spirit of the man is best captured by allowing him to speak for himself—his description of the photo that accompanies this entry:

This is my favorite aerial shot. I was flying over Jerusalem, and it was getting late as I had planned. The lower the sun, the better the color transparencies. But suddenly clouds were covering the sky, completely shutting out the sun. Only the far-off desert and Dead Sea to the East remained bright. I gave up; the pilot turned back in the direction of the airfield. But just then a window opened in the sky. The shaft of light fell on the Old City, but its position was changing rapidly; the luminous patch moved toward the Temple Mount. I prayed that this precious window should not close. Now, I'm not religious and I don't normally pray, but maybe because I was so near to God, He heard me. The Temple Mount and the Jewish Quarter of the Old City were bathed by the eerie sunlight. I took the shot in black-and-white because color would never stand up to this tremendous contrast. And I shouted for joy as I pressed

the shutter release. It was what we call in German *eine Sternstunde.*

—Bonnie Boxer

BRIHAT, Denis.

French. Born in Paris, 16 September 1928. Studied at the Vaugirard School, Paris, 1947; self-taught in photography. Served as a Photographer in the French Army Press Service, in Germany, 1949-50. Married Solange Robert in 1967: children: Anne and Pierre. Professional photographer, in Paris, 1947-52, Biot, 1952-56, and in Provence, since 1958: studio established, 1970. Co-Founder and Instructor, Department of Photography, Marseille-Provence University, 1975-77. Since 1969, Director, Brihat Annual Photography Workshops, Provence. Recipient: Prix Niepce, 1957. Agent: Portfolio Gallery, 21 escaliers du Marché, 1003 Lausanne, Switzerland. Address: 84480 Bonnieux, Vaucluse, France.

Individual Exhibitions:

1952 Brihat Studio, Biot, France
1957 *Prix Niepce*, Société Française de Photographie, Paris
1962 *Aventure de Matière*, Galerie Montaigne, Paris (with Jean-Pierre Sudre)
　　　Réalité Poètique, Galerie Pierre Coren, Aix-en-Provence
　　　Réalité Poètique, Galerie Michel, Carpentras, France
1963 *Réalité Poètique*, Galerie La Proue, Lyons
1965 Musée des Arts Decoratifs, Paris
　　　Galerie Les Contards, Lacoste, Vaucluse, France
1967 *Denis Brihat/ Pierre Cordier/ Jean-Pierre Sudre*, Galleri Artek, Helsinki (with Jean-Pierre Sudre and Pierre Cordier)
　　　Museum of Modern Art, New York
　　　Wooster School, Danbury, Connecticut
1968 Orly Airport Gallery, Paris
1971 Galerie La Lampe à Huile, Marseilles
1972 Galerie La Demeure, Paris
　　　Witkin Gallery, New York
　　　Art Center, Washington, Connecticut
1973 Fondation Grand Cachot de Vent, Neuchâtel, Switzerland
1974 Galleria 291, Milan
1975 Palais des Congrès, Antibes
1976 Photo-Galerie Fiolet, Amsterdam
　　　Galerie Paule Pia, Antwerp
　　　Musée d'Angoulème, France
1977 Galerie Agathe Gaillard, Paris
　　　Galerie Jean Dieuzaide, Toulouse
　　　Musée Nicéphore Niepce, Chalon-sur-Saône, France
1978 Galerie Photo-Art, Basle (with Jean Dieuzaide)
　　　Musée des Beaux-Arts, Besançon, France
1979 Galerie Portfolio, Lausanne
1980 *Denis Brihat: Photographies 1947-80*, Galerie Municipale à Chateau d'Eau, Toulouse (partial retrospective)

Selected Group Exhibitions:

1951 *Salon National de Photographie*, Bibliothèque Nationale, Paris (and 1952, 1953, 1954)
1963 *Salon Comparaisons*, Musée d'Art Moderne, Paris (and 1964)
1968 *L'Oeil Objectif*, Musée Cantini, Marseilles (with Lucien Clergue, Robert Doisneau,

Denis Brihat: *William Pear*, 1972

and Jean-Pierre Sudre)
1972 *La Photographie Française*, Moscow
1978 *European Colour Photography*, The Photographers' Gallery, London
1980 *Photographia: La Linea Sottile*, Galleria Flaviana, Locarno, Switzerland

Collections:

Bibliothèque Nationale, Paris; Musée Réattu, Arles, France; Musée Nicéphore Niepce, Chalon-sur-Saône, France; Musée d'Angoulème, France; Het Sterckshof Museum, Antwerp; Museum of Modern Art, New York; Center for Creative Photography, University of Arizona, Tucson.

Publications:

On BRIHAT: exhibition catalogues—*Denis Brihat: Photographies* by Charles Estienne, Paris 1965; *European Colour Photography* by Sue Davies, Michael Langford, and Bryn Campbell, London 1978; *Denis Brihat: Photographies 1947-80* by Jean Dieuzaide, Toulouse 1980; *Photographia: La Linea Sottile* by Rinaldo Bianda and Giuliana Scimé, Locarno, Switzerland, 1980; articles—in *Point de Vue* (Paris), December 1959; *Camera* (Lucerne), May 1964; *Techniques Graphiques* (Paris), June 1965; *Popular Fotografi* (Stockholm), April 1966; *Arte Fotografico* (Madrid), October 1971; *Photo Revue* (Paris), April 1972; *Progresso Fotografico* (Milan), October 1972.

Photography is a sum of techniques—mechanical, chemical, optical—allowing about 50 different crafts.
For fifteen years I practised many of these crafts. Through the opportunities they gave me, I learned a lot. I finally understood what must be my way in life. That is why since 1958 I have lived in Provence, growing my garden, looking after my rabbits and chickens, and making what is now called "creative photography." I work on small pieces of nature, flowers or vegetables, more a kind of portrait than still life.
Since 1968, my pictures have been mostly in colour, but from black-and-white material, using toning processes. Their purpose is to be a "poetical decoration" for the wall: the same goal as in painting, engraving, etc.
I sell my work through galleries or at home.
—Denis Brihat

From simple reportage to the most ingeniously tinted proofs, from the Niepce Prize to limited editions of prints—such is the amazing artistic journey of Brihat: the perfectly sincere journey of a reporter who deliberately retired to the countryside and tried to prove, by his own work, that photography is also a creative mode of activity, unique and remarkable in its own terms.
The precision of his work and the sophistication of his technique are well-known but are far less striking than his long attempt to create from the minimal environment of his garden a world of pure poetry. Thanks to the magic of his technique the ordinary cabbage of black-and-white photography becomes red, the tulip becomes black and airborne, the grass deeply, tenderly green. But then we all know that every true poet is something of a magician.
—Christian Caujolle

BRODOVITCH, Alexey.
American. Born in Ogolitchi, Russia, in 1898; emigrated to the United States in 1930, and subsequently naturalized. Educated at Gymnase Tenichev, St. Petersburg, 1914-15, and at the Corps des Pages Military Academy, St. Petersburg, 1915. Served in the 12th Archtirsky Hussars, in Rumania, Austria and Russia, 1916-18 (wounded in Odessa, during the Civil War, 1918): rose to rank of Captain. Married Nina Brodovitch in 1920 (died, 1959); son: Nikita. Worked at various jobs, first as housepainter, then scenery painter for Diaghilev's Ballets Russes, and as furnishings, book and poster designer, Paris, 1920-26; designer, for Maximilien Vox advertising agency, Paris, 1926-28; Art Director, Trois Quartiers department store (created 3 boutiques: Madelios, Medith and Athelia), Paris, 1928; book illustrator, for Paris and London publishers, 1928-30 (Founder, Le Cercle designers' association, Paris, 1929-30); Director, Advertising Arts Department, Philadelphia Museum School of Industrial Art, now the Philadelphia College of Art, 1930-38 (founded Design Laboratory at the School, 1936); also designer, with N.W. Ayer advertising agency, Philadelphia and New York, 1931-38 (Founder, Design Engineers designers' association, Philadelphia, 1932-34); Art Director, under editor Carmel Snow, *Harper's Bazaar* magazine, New York, 1934 until he retired, 1958; also, Art Director, Saks Fifth Avenue, New York, 1939-41; Consultant, American National Red Cross, Treasury Department, Office of Government Reports, and United Services Organization, 1941; Art Director, I. Miller and Sons, New York, 1941-43; Art Director, and Art Editor, with Frank Zachery, *Portfolio* magazine, New York, 1949-51; Consultant, *Art in America* magazine, New York, 1965. Instructor in Design, Donnelly publishers, Chicago, 1939; Visiting Lecturer in Design, Cooper Union, New York University and Pratt Institute, New York, 1940; Instructor, Brodovitch Design Laboratory, New School for Social Research, New York, 1941-49 (at the Richard Avedon Studio, 1947-49); Instructor in Design, Print Club of Philadelphia, 1946-48; Visiting Critic, Yale University School of Design and Architecture, New Haven, Connecticut, 1955; Instructor, Brodovitch Design Laboratory, American Institute of Graphic Arts (at the Avedon Studio, New York), 1964; School of Visual Arts, New York (for Young and Rubicam agency), 1964-65, and Corcoran Gallery, Washington, D.C., 1965; held design classes at the Avedon Studio, New York 1966. Retired, to Oppède-les-Vieux, France, 1967; moved to Le Thor, France, 1969. Recipient: First Prize, Bal Banal Poster Competition, Paris, 1924; 5 medals, *Exposition Internationale des Arts Décoratifs*, Paris, 1925; Book of the Year Award, American Insitute of Graphic Arts, 1945; Robert Levitt Award, American Society of Magazine Photographers, 1954; Hall of Fame Award, Art Directors Club of New York, 1972. D.F.A.: Philadelphia College of Art, 1972. *Died* (in Le Thor, France) *15 April 1971*.

Individual Exhibitions:

1928 Librairie Povolotzki, Paris (with Alexandre Alexieff)
1933 Crillon Gallery, Philadelphia
 Cosmopolitan Club, Philadelphia
1936 B. Altman Department Store, Philadelphia

Selected Group Exhibitions:

1930 Print Club, Philadelphia
1931 *Advertising Designs*, Ayer Gallery, Philadelphia
1937 *New Poster Show*, Franklin Institute, Philadelphia
 Design for the Machine, Philadelphia Museum of Art
1939 *World's Fair*, New York (Education Pavilion)
1972 *Alexey Brodovitch and His Influence*, Philadelphia College of Art (travelled to Centaur Galleries, Montreal)

Collections:

Fashion Institute of Technology, New York; Philadelphia College of Art.

Publications:

By BRODOVITCH: books—*Monsieur de Bougrelon* by Jean Lorrain, Paris 1928; *Contes Fantastiques* by Dostoievsky, Paris 1928; *A Brief History*

of Moscovia by John Milton, London 1929; *Ballet*, with text by Edwin Denby, New York 1945 (also designed); books designed—*Paris by Day* by André Kertész, New York 1945; *Paris* by Fritz Henle and Eliott Paul, New York 1947; *Sun and Shadow* by Marcel Breuer, edited by Peter Blake, New York 1956; *Observations* by Richard Avedon, with text by Truman Capote, New York and Lucerne 1959; *Saloon Society* by Bill Manville and David Attie, New York 1960; *The World of Carmel Snow* by Carmel Snow and Marie-Louise Aswell, New York 1962; *Calder* by P. Guerrero and H.H. Arnason, New York 1966; articles—"What Pleases Me" in *Commercial Art* (New York), August 1930; "Unforgettable" in *Popular Photography* (New York), June 1964.

On BRODOVITCH: books—*Alexey Brodovitch and His Influence*, exhibition catalogue, by George Bunker, Philadelphia 1972; *Alexey Brodovitch, His Work, His Influence*, thesis, by Karim H. Sednaoui, Derby, England 1974; articles—"Alexey Brodovitch: A Graphic Chemist" by R.L. Depuy in *Gebrauchsgraphic* (Zurich), January 1930; "L'Expression Graphique des Trois Quartiers" by Robert Block in *Arts et Metiers Graphiques* (Paris), no. 14, 1930; "Alexey Brodovitch" by Philippe Soupault in *The Bulletin* (Paris), August 1930; "Alexey Brodovitch" by George Herrick in *Art and Industry* (New York), November 1940; "The Remarkable Alexey Brodovitch" by Eugene Ettenberg in *American Artist* (New York), December 1961; "Alexey Brodovitch" by Charles Reynolds in *Popular Photography* (New York), December 1961; "Brodovitch on Brodovitch" by Allan Porter in *Camera* (Lucerne), February 1968; "Alexey Brodovitch 1900-1971" by Charles Reynolds in *Popular Photography* (New York), September 1971; "Hommage à Alexey Brodovitch" by M. Maingois, G. Tourdjman and J.C. Dewolf in *Zoom* (Paris), November/December 1971.

"When you look into your camera, if you see an image you have ever seen before, don't click the shutter." This was the advice given to the young photographer Hiro by Alexey Brodovitch in 1957, one year before he retired from *Harper's Bazaar*. Brodovitch had been the art director of *Harper's Bazaar* for 25 years, dominating and manipulating the form of its graphic design and establishing it in the forefront of the magazine world.

In 1934 the newly appointed *Bazaar* editor Carmel Snow, after viewing an exhibition of Brodovitch's work at the Art Directors Club in New York City, immediately offered him a provisional contract as art director of the magazine. During his years at *Bazaar* he expanded the concept of what an art director was and what a magazine could do. The magazine became a framework within which fashion photography as a distinct craft could evolve and at the same time a showcase where photographers could publish their work. Brodovitch immediately grasped the potential talent of young photographers and guided them into developing their own individual strengths, with just enough of his influence to achieve what he considered a collective visual ideal. He was one of the first art directors to conceive for a magazine a consistent graphic philosophy which expressed a point of view as effectively as the editorial content.

Alexey Brodovitch was born in 1898 in Russia in a hunting lodge near the Finnish border. His father, Cheslav, was of Polish origin, a physician and psychiatrist; his mother a talented amateur painter. The family were comfortable financially, with more than adequate means to encourage Alexey's interest in art. He studied at the best and most progressive school in St. Petersburg, and was intended for the Imperial Art Academy.

The First World War started in 1914. Alexey, at that time sixteen years of age, ran away to join the fighting. His father had him sent back, but gradually yielded to Alexey's entreaties and enrolled him in the Corps de Pages, a training school for officers of the Czarist Army. He graduated as a lieutenant and joined the Archtirsky Hussars, a regiment of the Russian Imperial Cavalry. Later he was sent to Rumania and rose to rank of Captain. When the civil war began Brodovitch served with the White Army fighting against the Bolsheviks at Odessa. In 1918 he was badly wounded and hospitalized at Kislovodsk, in the Caucasus. Late in 1918 the town was surrounded, and Brodovitch soon became one of thousands of refugees in a retreat southward that would end for him, his parents, his five brothers and sisters and Nina, his future wife, on a quay in Constantinople.

By 1920 Brodovitch and Nina were married and working in Paris. Nina worked as a seamstress, Alexey painted houses. However, within four months he had a job painting sets for Diaghilev's Ballets Russes. Working within the aura of Diaghilev's genius must have been an extraordinary inspiration for Brodovitch's somewhat uncommitted talents. During his time with the ballet he began to freelance, first fabric designs, and soon, layouts and illustration for French graphic arts magazines. He also was designing books for the Blackamore Press in London. He exhibited paintings and drawings in Paris, but the immediacy of the commercial arts was to remain his greatest concern, extending to posters, china, furniture, interiors.

Between 1925 and 1930, Brodovitch won prizes for design and now had his choice of commissions. His reputation spread to the United States, prompting John Story Jenks, Vice-President of the Philadelphia Museum of Art, to organize a department of advertising design at the Museum's School of Industrial Art (now the Philadelphia College of Art) with Brodovitch as its director.

In the Fall of 1930 Brodovitch and Nina moved from Paris to Philadelphia and he began teaching almost immediately. After 1934, he commuted between the school and *Harper's Bazaar* in New York City. In 1936 he formed the Design Laboratory at the college allowing selected advanced students to work more closely with him.

The Design Laboratory was later revived in various locations in New York City. From 1947 to 1949 it was conducted in the studio of Richard Avedon. Under the rigorous discipline of Brodovitch's guidance the fortunate few were expected to live with a kind of intense dissatisfaction with even their own successes and to see mediocrity in work they might have happily considered their best.

His familiarity, love and personal involvement with the Ballets Russes prompted Brodovitch to take photographs behind the scenes and during rehearsals of the ballet. In 1945 he designed a book containing 104 of his own photographs, published by J.J. Augustin. These revolutionary photographs, taken between 1935 and 1939, most of them, I believe, in America, convey a sense of energy, excitement and especially movement, a completely unconventional susceptibility for this time. The book is a bright afterglow of the 30-year Diaghilev epoch.

The Laboratory was dissolved in 1949 as the result of a serious accident which Brodovitch suffered while crossing a street in New York City. After a long recuperation he resumed his life with, if anything, renewed intensity. He now served as critic at the Yale School of Design; designed sets for the Ballets Russes and collaborated with Frank Zachery to produce the three extraordinary graphics art magazines called *Portfolio*. All this while continuing to serve as art director at *Harper's Bazaar*.

In 1956 a disastrous fire in his Phoenixville, Pennsylvania studio destroyed a lifetime's work, including the original negatives for *Ballet*. Also gone were his precious library and a collection of signed Picassos and Matisse lithographs. He moved to East Hampton, Long Island only to experience another fire, which forced him and Nina to move into an apartment over their garage. Then, in 1958, Brodovitch retired from *Harper's Bazaar*. Already in ill health, he was plunged into an acute state of depression on his wife's death in 1959. During the next two years he was hospitalized intermittently. However, in 1964, he again revived the Design Laboratory in the Avedon studio. At that time he was invited by the advertising agency Young and Rubicam to conduct a design workshop for art directors, based on the Design Laboratory. Despite these continued involvements, the depressions persisted, causing him to be hospitalized at the Manhattan State Hospital on Ward's Island. Then, in 1966 Brodovitch broke his hip, and for practical reasons ceased teaching. With his son Nikita he returned to France to live at Oppède-le-Vieux. However the steep hill town proved too rigorous for him and they then moved permanently to Le Thor. There on April 15, 1971 Alexey Brodovitch died.

Brodovitch was a talented designer, artist and photographer; but his greatest genius was as a teacher. One of the many lessons he taught was that a photograph could be commercial and at the same time aesthetically fine. To him there was nothing shameful about combining the two.

—John Esten

BROWN, Dean.

American. Born in Newport News, Virginia, 10 July 1936. Educated at Woodberry Forest High School, Virginia, 1950-54; studied linguistics, Cornell University, Ithaca, New York, 1954-56; music, Brooklyn College, New York, 1957-61; musicology, New York University, 1961-63; self-taught in photography. Married Carol Brown in 1960. Worked as truck-driver and delivery boy, Hampton, Virginia, 1952-54; musician, playing viola da gamba, with Waverly Consort and other music groups, New York, from 1961; music instructor, Brooklyn College, New York, 1964-67; freelance magazine and book photographer, working for *Holiday*, *Opera News*, *Fortune*, *Mademoiselle*, *New York Magazine*, *Redbook*, etc., and for Time-Life books, New York, 1967, until his death, from a climbing accident, White Mountains, New Hampshire, 1973. *Died* (in Portland, Maine) *8 July 1973*.

Individual Exhibitions:

1970 Witkin Gallery, New York (with Carol Brown)
1976 *Photographs of the American Wilderness*, Akron Art Institute, Ohio (retrospective; toured the United States)
1977 Witkin Gallery, New York (retrospective)
1980 Center for Creative Photography, University of Arizona, Tucson
1982 Center for Creative Photography, University of Arizona, Tucson

Selected Group Exhibitions:

1969 *Vision and Expression*, International Museum of Photography, George Eastman House, Rochester, New York
1975 *The Land: 20th Century Landscape Photographs Selected by Bill Brandt*, Victoria and Albert Museum, London (travelled to the National Gallery, Edinburgh; Ulster Museum, Belfast; and National Museum of Wales, Cardiff)

Alexey Brodovitch: *Choreartium*, from *Ballet*, 1945

1974 *Photography in America*, Whitney Museum, New York
1979 *10th Anniversary Show*, Witkin Gallery, New York

Collections:

Dean Brown Archive, Center for Creative Photography, University of Arizona, Tucson; International Museum of Photography, George Eastman House, Rochester, New York; Virginia Museum of Fine Arts, Richmond; University of Kansas, Lawrence; Canadian National Archives, Ottawa; National Gallery of Canada, Ottawa; Victoria and Albert Museum, London; Bucher Verlag, Lucerne.

Publications:

By BROWN: books illustrated—*Landscape Gardening* by James U. Crockett, New York 1971; *Wild Alaska* by Dale Brown, New York 1972; *Cactus Country* by Edward Abbey, New York 1973; *Wild Places: A Photographic Celebration of Unspoiled America* by Ann Sutton and Myron Sutton, New York 1973; *New England Wilds* by Ogden Tanner, New York 1974.

On BROWN: books—*Vision and Expression* by Nathan Lyons, New York 1969; *Photography in America*, edited by Robert Doty, with an introduction by Minor White, New York 1974; *The Land: 20th Century Landscape Photographs Selected by Bill Brandt*, exhibition catalogue, edited by Mark Haworth-Booth, London 1975; *Dean Brown: Photographs of the American Wilderness*, with a preface by Robert Doty, introduction by Carol Brown, New York 1976; *A Ten Year Salute* by Lee D. Witkin, with a foreword by Carol Brown, Danbury, New Hampshire 1979; *The Photograph Collector's Guide* by Lee D. Witkin and Barbara London, Boston and London 1979; articles—"Dean Brown" by Carol Brown and Weston J. Naef in *Camera* (Lucerne), January 1974; "Dean Brown Archive Established" in *Afterimage* (Rochester, New York), October 1979.

Dean Brown photographed people in such an unposed way that musicians and other people in the arts sought him out to take their publicity shots. He had a great knack of photographing celebrities with telling perception. But his pictures of the American wilderness are probably his finest achievement. He brought to them a highly personal viewpoint and a perfection of technique that resulted in a series of "artless" works of beauty.

Brown worked for clarity and detail, in color, without any trickery, to capture the transitory at large. Usually his landscapes contain no people or animals—light is his protagonist, the active element. He was a master at catching light: a shaft striking a darkening canyon wall as in a spotlight; the milky light of certain winter days; tree-screened sunshine; sunset above black hills. He photographed bare trees; long grass; water falling down rock; bright ice transforming branches and field; wild roses; chunks of ice translucent in sunlight set amid river pebbles and enlarged by the angle of viewpoint; birds made miniature in contrast to the huge face of a glacier; snow defining the shape of eroded slopes.

Brown's dye-transfer prints were printed 4" x 6" because he disliked the way the grain of film "breaks up" the image and, although he often used a wide-angle lens to get maximum information, he worked on de-emphasizing the distortions that resulted. Brown was not after panoramas but an experience of nature's complex expansiveness conveyed through the choice and depiction of the exact.

—Ralph Pomeroy

BRUEHL, Anton.

American. Born in Hawker, South Australia, 11 March 1900; emigrated to the United States, 1919: naturalized, 1940. Studied electrical engineering at Christian Brothers School, Melbourne; studied photography at the Clarence White School, New York City and New Canaan, Connecticut, 1924-25. Married Sara Barnes in 1940; children: Stevan, David and Tony. Worked as an engineer for the Western Electric Company, New York City, 1922-24; Teacher, Clarence White School of Photography, New York, 1924-26; also worked as part-time assistant to the photographer Jessie Tarbox Beals, New York, 1924. Freelance fashion and advertising photographer, working for *Vogue, Vanity Fair, House and Garden*, etc., New York, from 1926: maintained Anton Bruehl Studio, New York, 1927-66; Chief of Color Photography for Condé Nast Publications, New York, in the 1930's. Member of the Executive Committee, Pictorial Photographers of America. Recipient: Harvard Award, 1929, 1931; Illustrated Book Award, American Institute of Graphic Arts, 1933; 8 Gold Medals, Art Directors Club of New York, 1934-58. Agents: Witkin Gallery, 41 East 57th Street, New York, New York 10019; and G. Ray Hawkins Gallery, 9002 Melrose Avenue, Los Angeles, California 90069. Address: 2175 South Ocean Boulevard, Delray, Florida 33444, U.S.A.

Individual Exhibitions:

1931 Delphic Galleries, New York
 Annual Exhibition of Advertising Art, New York (with Margaret Bourke-White; art works by others)
1932 Julien Levy Gallery, New York
 Museum of Modern Art, New York
1933 *Mexican Photos*, Delphic Galleries, New York
1978 Witkin Gallery, New York
 Center for the Arts, Boca Raton, Florida
1979 G. Ray Hawkins Gallery, Los Angeles
1980 Center for Creative Photography, University of Arizona, Tucson

Selected Group Exhibitions:

1929 *Pictorial Photographers of America Annual Exhibition*, Art Center, New York
 Film und Foto, Deutscher Werkbund, Stuttgart
1932 *Murals by American Painters and Photographers*, Museum of Modern Art, New York
 New York by New Yorkers, Julien Levy Gallery, New York
1937 *Photography 1839-1937*, Museum of Modern Art, New York
1975 *Fashion 1900-1939*, Victoria and Albert Museum, London
1976 *Photographs from the Julien Levy Collection, Starting with Atget*, Art Institute of Chicago
1979 *Fleeting Gestures: Dance Photographs*, International Center of Photography, New York (travelled to The Photographers' Gallery, London)

Collections:

Museum of Modern Art, New York; Whitney Museum of American Art, New York; International Museum of Photography, George Eastman House, Rochester, New York; Art Institute of Chicago; New Orleans Museum of Art; University of New Mexico, Albuquerque; Center for Creative Photography, University of Arizona, Tucson; San Francisco Museum of Modern Art.

Publications:

By BRUEHL: books—*Mexico*, New York 1933, with text by Sally Lee Woodall, New York 1945; *Color Sells*, with text by Fernand Bourges, New York 1935; *Magic Dials: The Story of Radio and Television*, with text by Lowell Thomas, New York 1939; *Tropic Patterns*, Hollywood, Florida 1970; article—"Why I Don't Like the Photographic Press" in *Popular Photography* (New York), January 1938.

Dean Brown: *Berlin,* 1969 Courtesy Center for Creative Photography, Tucson

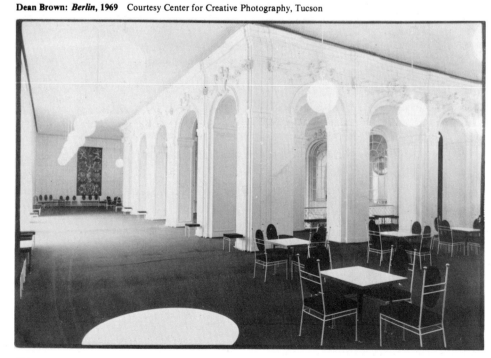

On BRUEHL: books—*Pictorial Photography in America*, annual, with a foreword by Frank Crown-inshield, New York 1929; *Form and Re-Form: A Practical Handbook of Modern Interiors* by Paul T. Frankl, New York 1930; *Fashion 1900-1939*, exhibition catalogue, by Valerie Lloyd and others, London 1975; *Photographs from the Julien Levy Collection, Starting with Atget*, exhibition catalogue, by David Travis, Chicago 1976; *The Julien Levy Collection*, edited by Lee D. Witkin, New York 1977; *The Vogue Book of Fashion Photography* by Polly Devlin, with an introduction by Alexander Liberman, London 1979; *The Photograph Collector's Guide* by Lee D. Witkin and Barbara London, Boston and London 1979; articles—"Anton Bruehl, Master of Color" by Etna M. Kelly in *Photography* (New York), November 1936; "The Brothers Bruehl" in *U.S. Camera* (New York), March/April 1939; "Anton Bruehl" in the "Camera" issue of *Vogue* (New York), June 1941; "The First of the Beautiful People" by Helen Lawrenson in *Esquire* (New York), March 1973; "Anton Bruehl" by Joe Deal in *Image* (Rochester, New York), June 1976.

Trained in electrical engineering, Anton Bruehl turned to photography in 1924; after studying under Clarence White, he took up portraiture and advertising illustration. In the 1920's, improvements in reproduction technology produced a revolution in photography for the printed page. Along with his better-known contemporaries, Edward Steichen, Paul Outerbridge, Jr., and Ralph Steiner, Bruehl emerged as a leader of photography's successful challenge to the older methods of commercial illustration.

In 1927 Bruehl and his brother Martin opened what proved to be one of New York's most durable and highly acclaimed commercial studios. However, Bruehl's reputation as a photographer of great originality extended well beyond the commercial world. His work was included in the 1929 *Film und Foto* exhibition in Stuttgart, selected for the Museum of Modern Art's 1937 survey of photography's first hundred years, and shown at the Julien Levy Gallery in New York.

Bruehl wrote, "The technical side of photography can be learned in three hours. After that, it's up to one's imagination." Working primarily in the studio, he produced images remarkable for their unusual lighting effects and angles of view; their strong, simple graphic organization; their meticulous craftsmanship; and their understated humor. Although he was best known for his stylish still life and table-top arrangements for advertising illustration, Bruehl was equally adept at the celebrity portraiture and fashion photography he contributed to *Vogue*.

In 1932 *Vogue* published the first of the color photographs Bruehl produced in collaboration with the color technician Fernand Bourges. Bourges, drawing upon his knowledge of color dyes, had devised a method of making near-perfect color transparencies to guide the Condé Nast engravers in reproduction. The Bruehl-Bourges process set the standard for color reproduction in the 1930's, and Bruehl became chief of color photography for Condé Nast Publications. His own work represents some of the most effective color photography used in advertising and editorial illustration in that decade.

Mexico, a book of twenty-five black and white photographs published in 1933, contains Bruehl's major body of work done outside the studio. His keenly-observed portraits of Mexican villagers mirror the gravity and unaffected grace of his subjects.

—Christopher Phillips

Anton Bruehl: Image from *Mexico*, 1932

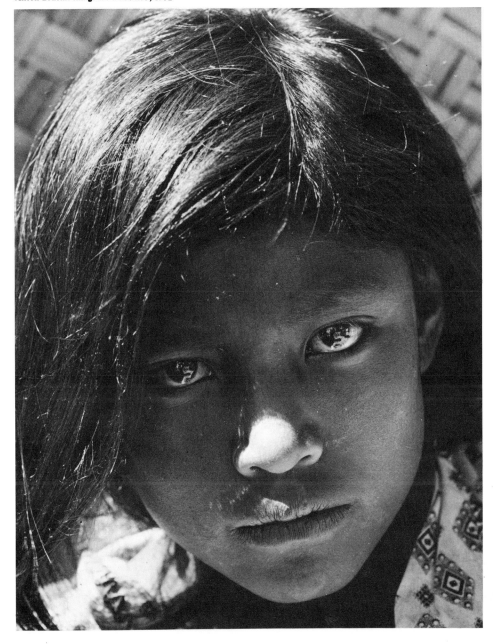

BRUGUIÈRE, Francis J(oseph).

American. Born in San Francisco, California, 16 October 1879. Educated at boarding school, Eastern United States, until 1900; studied photography, under Frank Eugene, New York, 1905. Married the actress Eliza Jones in 1901 (died, 1972); son: Francis Jr.; lived with actress Rosalinde Fuller, 1922-45. Independent painter and photographer, San Francisco, 1900-09; professional portrait photographer, establishing own studio on Franklin Street, San Francisco, 1909-19; freelance photographer, with own studio, working for *Harper's Bazaar*, *Vogue*, *Vanity Fair*, Theatre Guild, etc., New York, 1919-28, and in London, 1928-37; gradually abandoned professional photography to concentrate on painting and sculpture, London, 1937-45 (lived in Middleton Cheney, Northamptonshire, 1940-44); also, worked as set and lighting designer, with Lee Simonson and Robert Edmund Jones, New York, and advertising design, with E. McKnight Kauffer, London, 1919-32. Member, Photo-Secession, New York, 1905; Honorary Member, German Secession Group, 1928. *Died* (in London) *8 May 1945*.

Individual Exhibitions:

1927 *Photographs and Paintings by Francis J. Bruguière*, Art Center, New York
1928 Galerie der Sturm, Berlin
1929 *Photographic Designs by Francis Bruguière*, Warren Gallery, London
1930 Warren Gallery, London
1933 *Francis Bruguière in Collaboration with E. McKnight Kauffer*, Lund Humphries Gallery, London
1949 *Memorial Exhibition: Francis Bruguière*, Focal Press, London (and American Embassy, London)
Everyman Cinema Foyer, London
The Watergate Cinema, London
1959 *A Quest for Light*, International Museum of Photography, George Eastman House, Rochester, New York (retrospective)
1966 Oakland Art Museum, California (toured the United States)
1977 Witkin Gallery, New York
1978 Friends of Photography, Carmel, California (retrospective; toured the United States)
1981 Robert Miller Gallery, New York

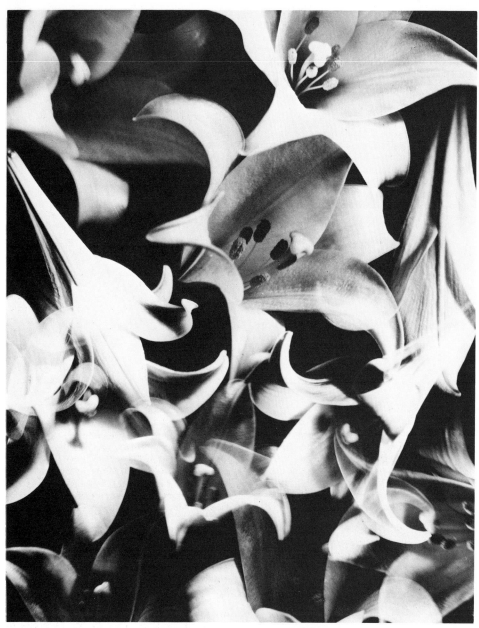

Francis J. Bruguière: *Untitled,* c. 1936-40 Printed by James Enyeart from original negative

Selected Group Exhibitions:

1910 *International Exhibition of Pictorial Photo-graphy*, Albright Art Gallery, Buffalo, New York
1929 *Film und Foto/Fifo*, Deutscher Werkbund, Stuttgart (toured Europe)
1959 *Photo-Secession*, International Museum of Photography, George Eastman House, Rochester, New York
1960 *The Sense of Abstraction*, Museum of Modern Art, New York
1967 *Photography in the 20th Century*, National Gallery of Canada, Ottawa (toured Canada and the United States, 1967-73)
1974 *Photography in America*, Whitney Museum, New York
1979 *Film und Foto der 20er Jahre*, Württembergische Kunstverein, Stuttgart (toured Europe)
 Photographie als Kunst 1879-1979, Tiroler Landesmuseum, Ferdinandeum, Innsbruck, Austria (travelled to Neue Galerie am Wolfgang Gurlitt Museum, Linz, Austria; Neue Galerie am Landesmuseum Joanneum, Graz, Austria; and Museum des 20. Jahrhunderts, Vienna)

Photography Rediscovered: American Photographs 1900-1930, Whitney Museum, New York (travelled to Art Institute of Chicago)
Fleeting Gestures: Dance Photographs, International Center of Photography, New York (travelled to The Photographers' Gallery, London)

Collections:

New York Public Library; Museum of Modern Art, New York; International Museum of Photography, George Eastman House, Rochester, New York; Library of Congress, Washington, D.C.; Art Institute of Chicago; University of Kansas, Lawrence; University of Texas at Austin; Oakland Art Museum, California; British Film Institute, London; Victoria and Albert Museum, London.

Publications:

By BRUGUIÈRE: books—*San Francisco*, San Francisco 1918; *Divine Comedy: Stage Designs*,

with Norman Bel Geddes, New York 1924; *A Project for a Theatrical Presentation of the Divine Comedy of Dante Alighiere*, with Norman Bel Geddes, New York 1924; *Photographic Designs by Francis Bruguière*, London 1929; *Beyond this Point*, with text by Lance Sieveking, London 1929; *Few Are Chosen*, with text by Oswell Blakeston, London 1931; *Francis Bruguière*, portfolio of 10 photos, with an introduction by James L. Enyeart, New York 1977; articles—"What 291 Means to Me" in *Camera Work* (New York), no. 47, 1914; "A Photograph Will and a Photograph Won't" in *Advertising Display* (London), October 1930; "Professionally Speaking" in *Close-Up* (London), April-July 1933; "Creative Photography" in *Modern Photography Annual*, New York 1935; "The Camera and the Scene" in *Theatre Arts Anthology*, edited by R. MacGregor, New York 1950; films—*The Way*, unfinished short, with Rosalinde Fuller and Sebastian Droste, 1925; *Light Rhythms*, with Oswell Blakeston, 1930.

On BRUGUIÈRE: books—*Photographs and Paintings by Francis J. Bruguière*, exhibition catalogue, with an introduction by Lee Simonson, New York 1927; *Francis Bruguière in Collaboration with E. McKnight Kauffer*, exhibition catalogue, London 1933; *Photo-Secession: Photography as a Fine Art* by Robert Doty, New York 1960; *Photographers on Photography*, edited by Nathan Lyons, New York 1966; *Photography in the Twentieth Century* by Nathan Lyons, New York 1967; *Photographie als Künstlerisches Experiment* by Willy Rotzler, Lucerne and Frankfurt 1974; *Photograpy in America*, edited by Robert Doty, with an introduction by Minor White, New York 1974; *The Magic Image* by Cecil Beaton and Gail Buckland, Boston and London 1975; *Photographs from the Julien Levy Collection, Starting with Atget*, exhibition catalogue, by David Travis, Chicago 1976; *Bruguière: His Photographs and His Life* by James Enyeart, New York 1977; *A Book of Photographs from the Collection of Sam Wagstaff*, designed by Arne Lewis, New York 1978; *Photography Rediscovered: American Photographs 1900-1930*, exhibition catalogue by David Travis, New York 1979; *Photographic Surrealism*, exhibition catalogue, by Nancy Hall-Duncan, Cleveland, Ohio 1979; *Amerika Fotografie 1920-1940* by Erika Billeter, Berne 1979; *Photographie als Kunst 1879-1979/Kunst als Photographie 1949-1979*, exhibition catalogue, 2 vols., by Peter Weiermair, Innsbruck 1979; *Photographen der 20er Jahre* by Karl Steinorth, Munich 1979; *Film und Foto der 20er Jahre*, exhibition catalogue, by Ute Eskildsen and Jan Christopher Horak, Stuttgart 1979; *Internationale Ausstellung des Deutschen Werkbundes "Film und Foto" 1929*, facsimile reprint, edited by Karl Steinorth, Stuttgart 1979; *The Photograph Collector's Guide* by Lee D. Witkin and Barbara London, Boston and London 1979; articles—"Bruguière as Artist in Lights" in *Boston Evening Transcript*, 9 April 1927; "Five Minutes with Francis Bruguière" by Oswell Blakeston in *Close-Up* (London), vol. 4, no. 4, 1929; "The Work of Francis Bruguière" by Harry A. Potamkin in *Transition* (Paris), November 1929; "New Ideas for Animations" by Harry A. Potamkin in *Movie Makers* (New York), December 1929; "Pseudomorphic Film" by Oswell Blakeston in *Close-Up* (London), vol. 10, no. 1, 1933; "The Work of Kauffer and Bruguière" in *Commercial Art and Industry* (London), February 1934; "Francis Bruguière" by Walter Chappell in *Art in America* (New York), Fall 1959; "Francis J. Bruguière" by James Enyeart in *American Photographer* (New York), July 1978.

Francis J. Bruguière was born in 1879 in San Francisco. In 1905 he made an extended visit to New York City where he met Alfred Stieglitz and Frank Eugene Smith. For the better part of a year, Bruguière and Frank Eugene (Smith) exchanged ideas which resulted in Bruguière's decision to investigate photography as an art form. He returned to San

Francisco, became a member of the Photo-Secession, and began to develop his own series of experiments in photography. By 1912 he had begun to sense the abstract possibilities for photography and was inspired by articles appearing in *Camera Work*, articles like those on the "fourth dimension" by Max Weber and on the philosophy of Japanese art by Charles Caffin. Bruguière was included in the 1910 International Photo-Secession Exhibition at the Albright Art Gallery in Buffalo, New York, and in 1916 his work was published in *Camera Work*.

He moved to New York City in 1918 and continued to refine the multiple exposure technique he had developed in 1912. He became the official photographer for the Theatre Guild, and by 1923 two forceful styles had emerged from his experiments: from the multiple exposure technique came a series of surreal images titled "The Way"; and from his growing involvement with light as the quintessence of his theatre photographs, he developed a style and method of "light abstractions" that were as unique as the photograms of Man Ray and Moholy-Nagy.

In 1922 Bruguière met Rosalinde Fuller, a young Broadway actress from England who became his lover, friend, and model, remaining with him until his death in London in 1945. Rosalinde Fuller was the only female model for the photographs of "The Way" and the predominant model for all of Bruguière's multiple exposures produced between 1922 and 1935.

In 1927, several years before surrealism made its official debut in America at the Wadsworth Atheneum in 1931 and the Julien Levy Gallery in 1932, Bruguière had exhibited the surreal photographs of "The Way" and his light abstractions at the Art Center in New York. In 1928 most of this exhibition was shown at Der Sturm Galleries in Berlin, and as a result Bruguière was made an honorary member of the German Secessionists.

In 1929 Bruguière and Rosalinde Fuller moved to London where Bruguière began a new series of experiments which resulted in the publication of two books and one of England's first abstract films. In 1929 Bruguière published *Beyond This Point* with writer Lance Sieveking. This was the first major publication of Bruguière's light abstractions. In that same year Bruguière's photographs were included in the international exhibition *Film und Foto* in Stuttgart. In 1931 Bruguière and a writer friend, Oswell Blakeston, published *Few Are Chosen*. This book was written by Blakeston and included photographs of cut-paper abstractions by Bruguière. Bruguière's film, *Light Rhythms*, was made in 1930 and utilized imagery similar to his earlier light and cut-paper abstractions; however, the cinematic quality of the film was not created by moving objects, but by the movement of light over the shapes and forms of the cut-paper abstractions, while simultaneously making multiple-exposures of various sequences.

Light Rhythms was Bruguière's last experiment with light abstractions. Between 1930 and 1940 he devoted himself to a variety of technical experiments which included solarization, composite printing, cliché-verre-like processes, relief printing, and blurred motion.

Bruguière had contracted tuberculosis in 1917, the scars of which contributed to frail health during the last ten years of his life. He continued to experiment and search vigorously for new photographic forms until about 1940. Between 1940 and 1945 he turned to writing his autobiography (never finished) and to painting, an activity which had precursed his interest in photography.

Bruguière's own words written for *Modern Photography Annual* in 1935 best summarize his contribution to the history of photography:

A photograph has been said to look "just like nature," but no one has ever agreed just how nature looks; it may, therefore, be questioned whether a photograph really looks anything like nature.... A photograph can be something in itself—it can exist independently as a photograph apart from the subject; it can take on a life of its own.

Francis Bruguière died in London the day peace was declared in Europe, 1945.

—James Enyeart

BRUNO. *See* **REQUILLART, Bruno.**

BULHAK, Jan.
Polish. Born in Ostaszyn, 6 October 1876. Studied philosophy at Jagiellonian University, Cracow, 1897-99; studied photography with Hugo Erfurth, Dresden, 1911-12, and with Ferdynand Ruszczyc, Vilnius, Lithuania, 1912-19. Married Maria Maria Hociska in 1901; son: Janusz. Photographer from 1905. Chairman of the Photo-Art Department, Universytet Stefan Batory, Vilnius, Lithuania, 1919-39. Chairman, Foto Klub Wilenski, Vilnius, 1927, Foto-Klub Polski, Warsaw, 1929, and Zwiazek Polskich Artystow Fotografikow, Warsaw, 1946. Recipient: Bronze Medal, *I Miedzynarodowy Salon Fotografii Artystycsnej*, Warsaw, 1912, 1927; and *Wystawa Satuki Polskiej*, Paris, 1923. Knight of the Order of Polonia Restituta, 1925. *Died* (in Gizycko) *4 February 1950.*

Individual Exhibitions:

1928 *Jan Bulhak*, Photographic Art Club, Warsaw
1946 *Ruiny Warszawy*, National Museum, Warsaw
1972 *Fotografika Jana Bulhaka*, ZPAF Gallery, Warsaw
1980 *Ziemie Odzyskane*, National Museum, Wroclaw, Poland
1981 *Warszawa Oskarza*, Cracow Photographic Society

Selected Group Exhibitions:

1923 *Wystawa Satuki Polskiej*, Paris
1927 *I Miedzynarodowy Salon Fotografii Artystycsnej*, Warsaw
1930 *Wystawa Fotografii*, Zacheta Gallery, Warsaw
1936 *IV Wystawa Fotografii*, Vilnius, Lithuania
1938 *I Wystawa Fotografii Ojcsystej*, Warsaw
1947 *I Ogolnopolska Wystawa Fotografiki*, Warsaw
1977 *Polska Fotografia Artystycsna do roku 1939*, National Museum, Wroclaw, Poland
1979 *Fotografia Polska 1839-1979*, International Center of Photography, New York (travelled to the Museum of Contemporary Art, Chicago; Zacheta Museum, Warsaw;

Museum of Fine Arts, Lodz, Poland; and the Whitechapel Art Gallery, London)
1981 *Photographie Polonaise 1900-1981*, Centre Georges Pompidou, Paris

Collections:

National Library, Warsaw; Warsaw University; National Museum, Warsaw; National Museum, Wroclaw, Poland; Museum of Fine Arts, Lodz, Poland; Jagiellonian Library, Cracow, Poland; Vilnius Museum, Lithuania, U.S.S.R.

Publications:

By BULHAK: books—*Wilno*, Warsaw 1924; *Moja Ziemia*, Warsaw 1924; *Dwadziescia Szesc Lat z Ferdynandem Ruszczycem*, Vilnius, Lithuania 1929; *Fotografika*, Warsaw 1931; *Wedrowki Fotografa*, 9 volumes, Vilnius, Lithuania 1931-36; *Technika Bromowa*, Vilnius, Lithuania 1933; *Bromografika*, Vilnius, Lithuania 1934; *Estetyka Swiatla*, Vilnius, Lithuania 1936; *Polska Fotografia ojczysta*, Poznan, Poland 1939; *Fotografia ojczysta*, Wroclaw, Poland 1951; also numerous articles on photography in *Polski Przeglad Fotograficzny* (Poznan), *Fotograf Warszawski* (Warsaw), *Fotograf Polski* (Warsaw), *Przeglad Fotograficzny* (Vilnius), *Swiat Fotografii* (Poznan), *Miesiecznik Fotograficzny* (Lwow/Cracow), *Leica w Polsce* (Warsaw), *Foto-Amator* (Warsaw), *Foto* (Warsaw), *Camera* (Lucerne), *Photo-Freund* (Berlin), etc.

On BULHAK: books—*Jan Bulhak* by P. Sledziewski and S. Turski, Vilnius, Lithuania, 1936; *Jan Bulhak* by Lech Grabowski, Warsaw 1961; *Fotografika Jana Bulhaka*, exhibition catalogue, by S. Turski, Warsaw 1972; *Historia Fotografii Warszawskiej* by W. Zdzarski, Warsaw 1974; *Polska Fotografia Artystycsna do roku 1939*, exhibition catalogue, by Adam Sobota, Wroclaw 1977; *Fotografia Polska 1839-1979/Polish Photography 1839-1979*, exhibition catalogue, by Ryszard Bobrowski, New York 1979; articles—"Bulhak za Granica" by Tadeusz Cyprian in *Fotograf Polski* (Warsaw), no. 9, 1932; "Tworczosc Jana Bulhaki i jez znaozenie" by T. Przypkowski in *Swiat Fotografii* (Warsaw), no. 15, 1950; "Krotkie ABC o Janie Bulhaku" by L. Sempolinski in *Fotografia* (Warsaw), no. 3, 1972; "Testament Mistrza Jana" by M. Bacciarelli in *Fotografia* (Warsaw), no. 3, 1977; "Art Photography in Poland 1900-1939" by Adam Sobota in *History of Photography* (University Park, Pennsylvania), vol. 1, no. 4, 1980.

Jan Bulhak played a leading part in the development of Polish photography, not only from his many years as a photographer and photojournalist but also as a result of his work as a writer. He has numerous articles to his credit and numerous books about photography, such as *Estetyka Swiatla* (*The Aesthetic of Light*), which profoundly influenced the Polish photographic milieu.

Bulhak viewed photography as through the prism of the fine arts—from a perspective based on painting and graphics. He did not intend that photographers should necessarily study the masters or that photography should copy particular great works of art; rather, he meant that the principles of form and colour and composition characteristic of the fine arts—what we usually call aesthetics—should be brought to photography. Bulhak's own "aesthetic," which he preached and which he followed in his own work, was very simple, based on two primary elements: the photographic motif and those light values that are characteristic of graphic art.

"We have to search," he wrote in *Estetyka Swiatla*, "in the surrounding world for such elements of reality that, thanks to their concentration and 3-dimensional lighting, will be explicit, that, apart

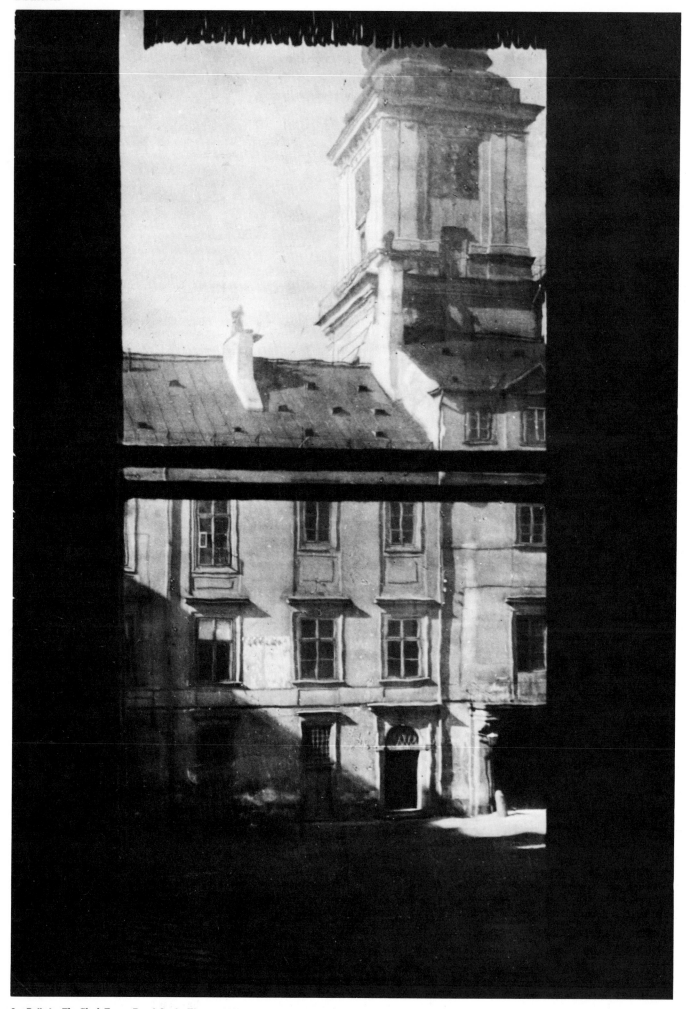

Jan Bulhak: *The Clock Tower*, Royal Castle, Warsaw, 1930

from being themselves, will also symbolize their images. In other words, we must look for motifs and, using photographic elements, create an image. Photographic motifs are everywhere and nowhere. They are a function of the artist's personality (his sensitivity and visual shrewdness) and a moment in time...."

He goes on: "The painting theme contains a domination of colored specks and surfaces in their own real tint, regardless of light—in short, it illustrates the hue itself. The drawing theme—and effectively the black and white photographic theme—is based on the play of light on the mass of objects, and illustrates the shapes in the chiaroscuro."

"The chiarscuro," he wrote in *Fotografika*, "the collection of black-and-white specks, is the way in which photography and graphics represent the lighter and darker color tones of a painting. Each color, regardless of its hue, such as blue or red, possesses a certain intensity, a certain level of light or darkness. This level is called the tone or value of that color. The final beauty of a graphic picture is determined by a full and harmonious scale of values, by which I mean a "distribution" of light and shadow the assemblage of which is pleasant to the viewer and results in his immediate appreciation of the picture's message."

In these views Bulhak shows himself to be under the distinct influence of his master and friend, the French photographer Constant Puyo, who held that "apart from the advantage of impeccable drawing, photography offers one more unique and undervalued property. It can, with a rare virtuosity, copy the most delicate modulations of tone, the most subtle changes of light on the shapes of objects."

Bulhak's belief in two essential elements in photography—the motif (the discovery of the crucial elements of a picture and their synthesis) and the graphic value (the skilful use of chiaroscuro)—induced him to proclaim in 1929 the birth of a new art form, "photo-graphics," which he contrasted with the realistic photography of the 19th century. Bulhak intended, obviously, that the very term "photographics" would suggest his particular point of view, his vision of the link with graphics (composition) and with art (high values). The term was quickly accepted and widely used, though it was later debased to mean merely any kind of "artistic" photography.

In the early years of his work as a photographer (1912-1920), inspired by his friend, the painter Ferdynand Ruszczyc, Bulhak undertook the task, as he described it, of "compiling a photographic survey of the architectural monuments of Vilnius, its region, its neighboring regions, and finally the whole of Poland." He created a very large and rich collection of architectural photographs (10,000 photographs catalogued in 158 albums), which he titled *Poland in Photographic Images by Jan Bulhak*. These little-known, startlingly composed and very high quality photographs reveal their author as a photographer extraordinarily susceptible to form, space and light, and as a subtle artist who consciously and systematically investigated each detail, the whole composition and its internal relations, an artist who, outstandingly, could express both the abstract and the poetic within the medium of photography.

After 1918, when Poland gained independence, Bulhak gradually moved away from this kind of beautiful but also static and dispassionate photography. He became an ardent patriot. "It is not enough to look within Poland for oneself," he said. "One ought to look for Poland herself. It is not enough to feel the motherland oneself; one ought to show it to others, and show it in such a way as to teach and delight." He became involved gradually with landscape photography, very soft, full of feeling, sometimes simply sentimental. Working within, then dominating, the Polish pictorial tradition, he developed a new photographic style, which later, in the 1930's, he called "native photography."

"Native photography," he wrote, "is the pictorial illustration of a country and its inhabitants in their daily lives—so true, apt and clear that the portrayal can deepen the knowledge of one's motherland and multiply the joy and pride that results from national self-recognition. In contrast with similar techniques, which confine themselves to narrower studies of landscape monuments and folklore, ancestral photography broadens the scope by including all artistically perceivable signs of human life: it records not only the relics of the past and nature's phenomena but also the whole contemporary life of man, the earth, and man's ancestral land. The aim of native photography is universal sightseeing."

Bulhak's vision of native photography therefore included not only landscape but also anthropological and human themes, all contained within the subjects of man and nature.

—Ryszard Bobrowski

BULLOCK, Wynn.

American. Born Percy Wingfield Bullock in Chicago, Illinois, 18 April 1902. Educated at elementary and secondary schools, South Pasadena, California, 1907-21; studied music, Columbia College, New York, 1925-27; University of West Virginia, Morgantown, 1931-32; in Paris, 1928, and in Milan and Berlin, 1930; studied photography, under Edward Kaminski, Art Center School, Los Angeles, 1938-40; influenced by the work of semanticist Alfred Korzybski, Los Angeles, 1940-41. Served in the United States Army, in California, 1942-44. Married Mary Elizabeth McCarty in 1925 (divorced, 1941); children: Mary Wynne (Mimi) and George (died, 1942); married Edna Jeanette Earle in 1943; daughters: Barbara Ann and Lynne Marie. Worked as singer in music revues, New York, 1921-30; managed wife's real estate business, Clarksburg, West Virginia, 1931-37; commercial and portrait photographer, producing and selling tourist postcards, Los Angeles and Santa Monica, California, 1940-42, 1944-46; commercial photographer, 1946-68, working mainly for Fort Ord military base, Monterey, California, 1946-59. Taught at the Institute of Design, Illinois Institute of Technology, Chicago, University of California at Santa Clara, and San Francisco State College. Trustee and Chairman of Exhibition Committee, Friends of Photography, Carmel, California, 1968-70. *Died* (in Monterey, California), *16 November 1975*.

Individual Exhibitions:

1941	Los Angeles County Museum of Art
1947	Santa Barbara Museum of Art, California
1954	University of California at Los Angeles
1955	Limelight Gallery, New York
1956	Cherry Foundation Art Gallery, Carmel, California
	M.H. de Young Memorial Museum, San Francisco
1957	Photographic and Cine Society, Johannesburg, South Africa
	Photographia de Assoucão dos Velhos, Pietermaritzburg, Portuguese East Africa
	Photographia de Assoucão dos Velhos, Lourenco Marques, Portuguese East Africa
	International Museum of Photography, George Eastman House, Rochester, New York
1958	Federation of Arts, Prague
1959	Gull Pacific Arts Gallery, Richmond, California
1960	Princeton University, New Jersey
	Monterey Peninsula College, California
1961	Fine Art Galerie Pierre Venderburght, Brussels
	Icon Gallery, Venice, California
	3 Photographers, Kalamazoo Institute of Arts, Michigan (with Aaron Siskind and David Vestal)
1962	Carl Siembab Gallery, Boston
	Chauncey Cowles Memorial Art Gallery, Spokane, Washington
1963	Toren Gallery, San Francisco
1964	University of Florida, Gainesville
	Heliography Gallery, New York (with Jerry Uelsmann)
1966	Foothill College, Los Altos, California
	International Museum of Photography, George Eastman House, Rochester, New York
1967	Jacksonville Art Museum, Florida
1968	Camera Work Gallery, Newport Beach, California
	Rhode Island School of Design, Providence
	University of St. Thomas Medical Center, Houston
1969	Institute of Design, Illinois Institute of Technology, Chicago
	Phoenix College, Arizona
	Reed College, Portland, Oregon
	San Francisco Museum of Art
	Skidmore College, Saratoga Springs, New York
	University of Iowa, Iowa City
	University of North Carolina, Chapel Hill
	University of the South, Sewanee, Tennessee
	Henry Gallery, University of Washington, Seattle
	Witkin Gallery, New York (with Les Krims)
1970	Amon Carter Museum, Fort Worth, Texas
	San Francisco Museum of Art
	Colorado Springs Fine Art Center, Colorado
	Minneapolis Institute of Arts, Minnesota
	Rice University, Houston
	Santa Barbara Art Museum, California
	Temple University, Philadelphia
1971	Bathhouse Gallery, Milwaukee, Wisconsin
	Columbia College, Chicago
	Halsted 831 Gallery, Birmingham, Michigan
	Friends of Photography, Carmel, California
	Maryland Institute of the Arts, Baltimore
	University of New Mexico, Santa Fe
	University of Georgia, Athens
1972	Limited Edition Gallery, Chicago
	Shado Gallery, Oregon City, Oregon
	United States Information Agency, Washington, D.C. (toured Europe and North Africa)
	University of California at Santa Clara
	Royal Photographic Society, London
1973	Light Gallery, New York
	Pasadena Art Museum, California
	Ohio University, Athens
	Bibliothèque Nationale, Paris
	3 Photographers, University of Colorado, Boulder (with Aaron Siskind and Edmund Teske)
1974	Madison Art Center, Wisconsin
1976	Metropolitan Museum of Art, New York
	Art Institute of Chicago
	San Francisco Museum of Art
1981	Focus Gallery, San Francisco (with Edna Bullock)
1982	Photography West Gallery, Carmel, California

Selected Group Exhibitions:

1955	*The Family of Man*, Museum of Modern Art, New York (and world tour)
1960	*The Sense of Abstraction*, Museum of Modern Art, New York
	Photography at Mid-Century, International Museum of Photography, George Eastman House, Rochester, New York
1974	*Photography in America*, Whitney Museum, New York

1975 *The Land: 20th Century Landscape Photographs Selected by Bill Brandt*, Victoria and Albert Museum, London (travelled to the National Gallery, Edinburgh; Ulster Museum, Belfast; and National Museum of Wales, Cardiff, 1976)

1977 *Helen Gee and the Limelight*, Carlton Gallery, New York
 Photographs: Sheldon Memorial Art Gallery Collection, University of Nebraska, Lincoln

1978 *Amerikanische Landschaftsphotographie 1860-1978*, Neue Sammlung, Munich

1980 *Photography of the 50's*, International Center of Photography, New York (travelled to the Center for Contemporary Photography, University of Arizona, Tucson; Minneapolis Institute of Arts, Minnesota; California State University at Long Beach; and Delaware Art Museum, Wilmington)

Collections:

Center for Creative Photography, University of Arizona, Tucson (prints, negatives and private papers); Museum of Modern Art, New York; Metropolitan Museum of Art, New York; International Museum of Photography, George Eastman House, Rochester, New York; Museum of Fine Arts, Boston; Smithsonian Institution, Washington, D.C.; Museum of Fine Arts, St. Petersburg, Florida; University of Nebraska, Lincoln; Oakland Art Museum, California; San Francisco Museum of Art.

Publications:

By BULLOCK: books—*The Widening Stream*, with text by Richard Mack, Carmel, California 1965; *Wynn Bullock*, with text by Barbara Bullock, San Francisco 1971; *Wynn Bullock: Photography, A Way of Life*, with text by Barbara Bullock-Wilson, edited by Liliane DeCock, Dobbs Ferry, New York 1973; *Photographs, 1951-1973*, portfolio of 12 photos, with an introduction by Ansel Adams, Monterey, California 1973; *The Photograph As Symbol*, Capitola, California 1976; articles—"Portfolio" in *Aperture* (Rochester, New York), October 1953; "Partial Reversal Line" in *The Photographic Journal* (London), April 1955; "Virtues of Large and Small Cameras Are Evaluated" in *Monterey Peninsula Herald* (California), 3 November 1956; "The Fourth Dimension" in *Photography* (London), September 1962; "Space and Time" in *Photographers on Photography*, edited by Nathan Lyons, New York, 1966; "Wynn Bullock Nudes," with George F. Pollack, in *Creative Camera* (London), June 1969; "Wynn Bullock," interview, in *Dialogue with Photography*, edited by Paul Hill and Thomas Cooper, London 1979.

On BULLOCK: books—*The Family of Man*, edited by Edward Steichen, New York 1955; *American Photography: The Sixties*, exhibition catalogue, Lincoln, Nebraska 1966; *Photography in the Twentieth Century* by Nathan Lyons, New York 1967; *Photography, USA*, exhibition catalogue, Lincoln, Massachusetts 1967; *The Land: 20th Century Landscape Photographs Selected by Bill Brandt*, exhibition catalogue, edited by Mark Haworth-Booth, London 1975; *The Photographers' Choice*, edited by Kelly Wise, Danbury, New Hampshire 1975; *Wynn Bullock* by David Fuess, Millerton, New York and London 1976; *Helen Gee and the Limelight: A Pioneering Photography Gallery of The Fifties*, exhibition catalogue, by Peter C. Bunnell, New York 1977; *Geschichte der Fotografie im 20. Jahrhundert/Photography in the 20th Century* by Petr Tausk, Cologne 1977, London 1980; *Darkroom 1*, edited by Eleanor Lewis, New York 1977; *Amerikanische Landschaftsphotographie 1860-1978*,

exhibition catalogue, with an introduction by Klaus-Jürgen Sembach, Munich 1978; *The Photograph Collector's Guide* by Lee D. Witkin and Barbara London, Boston and London 1979; *Photography of the Fifties: An American Perspective* by Helen Gee, Tucson, Arizona 1980; articles—"Photographic Horizon" by C. Weston Booth in *U.S. Camera* (New York), August 1946; "Creative Photography 1956" by Van Deren Coke in *Aperture* (Rochester, New York), January 1956; "Wynn Bullock" by Lew Parella in *U.S. Camera Annual*, New York 1956; "Thoughts on Wynn Bullock: The Landscape—An Object of Philosophy" by George Bush in *International Photo Technik* (Munich), no. 1, 1961; "The Eyes of Three Phantasists: Laughlin, Sommer, Bullock" by Jonathan Williams in *Aperture* (Rochester, New York), October 1961; "Wynn Bullock: A Critical Appreciation" by Nat Herz in *Infinity* (New York), November 1961; "Wynn Bullock: Tracing Man's Roots in Nature" by Barbara Bullock and Jerry Uelsmann in *Modern Photography* (New York), May 1970; "Wynn Bullock, a Retrospective View" by Colin Osman in *Creative Camera* (London), June 1971; "Wynn Bullock" by Gerry Badger in *The Photographic Journal* (London), May 1975; "Wynn Bullock" by Jean-Claude Gautrand in *Le Nouveau Cinema* (Paris), February 1976; "Wynn Bullock 1902-1975" in *Popular Photography* (New York), March 1976; "Wynn Bullock: Visionary and Philosopher" in *Artweek* (Oakland, California), 3 October 1981; films—*Two Photographers: Wynn Bullock and Imogen Cunningham* by Fred Padula, 1966; *Wynn Bullock: Reflections* by Tom Tyson, 1975.

Wynn Bullock was one of the most widely respected photo-artists of our time. And yet, in many ways, he was also one of the least understood. Wynn became well known for his evocative and striking photographs of trees, nudes in nature, and moving water; but in order to appreciate the scope of his creative life and work, it is important to know that in addition to being a gifted image maker, Wynn was also a deeply inspired and intellectually curious man.

Wynn Bullock's photographs have a penetrating, enigmatic and almost mystical quality that sets his work apart from that of other photographers who work with similar subjects. The best of his photography tends to catch you off guard with its combination of formal beauty and disturbingly provocative imagery. We see rocks shrouded in a luminous atmosphere that defies simple comprehension and haunting interiors with undertones of loneliness, alienation, and death. There are intimations of dynamic forces and intriguing implied narratives in many of his images, but somehow the mysteries are never explained; we are simply left to wonder in awe.

Many great works of art raise questions in the mind of the viewer without offering any obvious or immediate answers. The enigma of Mona Lisa's smile is a good example. It is this quality of mystery held in suspension that gives many of Wynn's photographs their power and depth. And yet, because Wynn's images are so visually satisfying, this is as far as most of us go in appreciating his work. To go further one needs to ask, What provided the motivating force for his creative life? Where do images like his come from?

The question is a relevant one because as well as being a skilled photographer, Wynn Bullock was also a teacher. Through his lectures and writing he wanted us to understand that our presumptions about the nature of the visual world are superficial and overly simple. Every serious artist knows this intuitively, but Wynn made the effort to formulate his ideas into a philosophical system that he demonstrated through his work and interactions with students and followers. Wynn's interest in spreading his ideas made him controversial—not everyone is comfortable with the idea of an artist lecturing on abstract philosophy. Yet he firmly believed that we can and should advance to profound conclusions

about nature by asking apparently simple and impertinent questions. In a lecture he might ask for example, "What color is this red apple?" Our first reaction might be to consider the question ridiculous. A red apple is obviously red! He would then invite us to consider the intriguing fact that the apple only appears red to our eyes because its skin is reflecting the red wavelengths of light while invisibly absorbing the others. With this idea firmly in our minds we are left with the confounding question: "What color is the apple *unto itself*?" Of course a question like this one is inherently impossible for us to answer. But then, Wynn's objective was not for us to solve the problem, but rather to begin questioning our stubborn convictions that our senses are giving us an accurate view of the world. The point that he was trying to make with exercises like this was that our proper responses to nature should be closer to wide-eyed awe than to comfortable familiarity. It was Wynn's desire to record this feeling of awe on film that motivated him to photograph the way that he did.

Wynn took this process a step further by rationalizing his awareness of nature's mystery into a number of philosophical principles that provided him with a systematic way of communicating his insights. The list of these principles includes such statements as "time is the fourth dimension," "opposites are one," and, "ordering is not the thing ordered." There were times when an experience that Wynn encountered in nature would inspire these concepts; at other times the concepts themselves would give him ideas for how to photograph more creatively. For Wynn, philosophical exploration became the natural counterpoint to this instinctive impulse to create. Consciousness and feeling merged to complete the creative process.

Wynn would happily discuss these and other subjects for hours, but of course he did more than simply think and write about these ideas; his response was to begin photographing natural subjects in a way that challenged the inherent conservatism of our senses. To this end, any photographic technique that worked was fair. Wynn loved to experiment with photography's ability to create the appearance of an altered reality, and it is for this reason that we see such a wide variety of departures from straightforward printmaking techniques in his work. Pieces of wood appear as negative images that glow where a positive print would show a shadow. Photographs of tide-pools are printed upside down so that what we know to be depressions seem to rise out of the ground. If one technique didn't satisfy or interest him he would simply try another. It was Wynn's ability to so consistently translate his ideas into persuasive images that confirms his place among the masters of creative photography. The concept "Time is the fourth dimension" became his famous study of sea palms and waves. "Opposites are one" appears as the haunting image of the naked child in the woods. We could easily dismiss these statements as being relatively unimportant when compared with the photographs themselves, but to do so would limit our understanding of Wynn's approach to life and art.

To an artist, an individual work of art is more than an isolated statement; it is also a benchmark that records his progress along the path of personal growth. When we consider the greater body of Wynn's work in this light, his progressive development as an artist/philosopher becomes easier to see. His earliest photographs show the influence of Edward Weston, but even then he experimented with the process of solarization as a way of taking his images beyond the familiar idiom. Later his work becomes strongly romantic, psychological and enigmatically sensual. He photographed nudes and children, but often in lonely and dilapidated settings that give the images a somber quality that suggests vulnerability and pathos.

Later still, Wynn formulated what was to become the central theme of his aesthetic/philosophical system. He came to believe that there is an inherent and

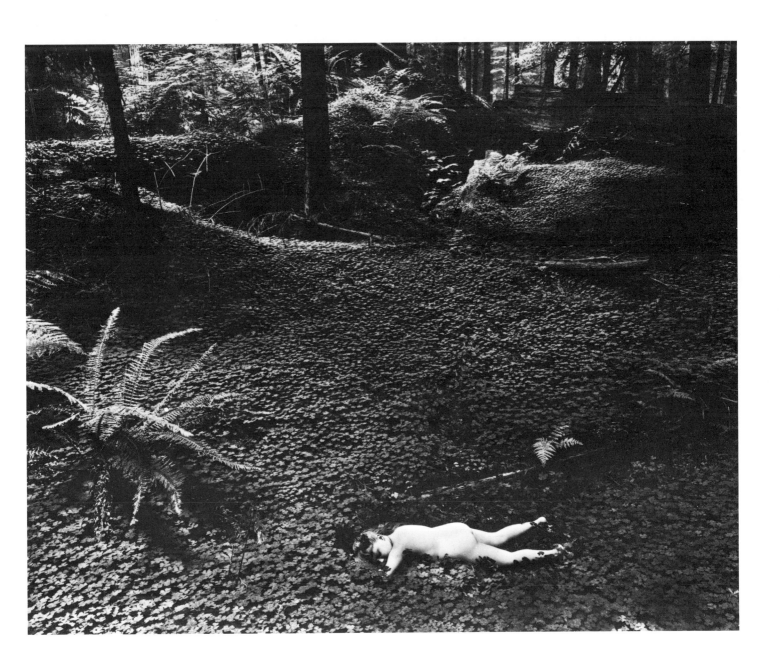

Wynn Bullock: *Child in the Forest*, **1951** Courtesy Center for Creative Photography, Tucson

profound difference between Reality, which he defined as the limited impression of the world that we derive from our senses—the redness of the apple; and Existence, those intangible and underlying qualities of the universe that are beyond the reach of our perceptions—the apple's true color. The more sensitive Wynn became to the presence of Existence in the world around him, the less content he became with strictly representational images. At this point in his career he began producing a large body of dramatically abstracted close-up studies of wood and other common objects. In these images Wynn left the world of appearances behind; the essential nature of things was all that mattered. There's a soberness that pervades this work, a dense encompassing quiet that suggests the presence of the unknown. One can feel that the attention of the artist is focussed through these photographs to sensations beyond the reach of ordinary life. In many ways these images are less accessible than his earlier descriptive work, but to many they represent the height of Wynn's accomplishment as an image maker, iconographer, and sensitive human being.

—Chris Johnson

Jerry Burchard: *Russian Hill*, San Francisco, 1970

BURCHARD, Jerry.

American. Born in Rochester, New York, 1 December 1931. Studied at the California School of Fine Arts, now the San Francisco Art Institute, 1956-60, B.F.A. 1960. Served as a photography mate, in the United States Navy, in Italy, 1952-56. Worked for the Kodak Photographic Products Company, Rochester, New York, 1950-52. Freelance photographer, now based in San Francisco, since 1960. Instructor in Photography, San Francisco Art Institute, since 1966 (Head of the Photography Department, 1968-71, 1978-79). Recipient: Photography Fellowship, 1976, 1978, and Survey Grant, 1979, National Endowment for the Arts. Agent: Jehu-Wong Galleries, 2719 Bush Street, San Francisco, California 94115. Address: 1014 Greenwich Street, San Francisco, California 94133, U.S.A.

Individual Exhibitions:

1968 *Italian Circus*, San Francisco Art Institute
1975 Texas Gallery, Houston
 A Selection of Photographs, American Gallery, San Francisco
1976 Center of the Eye, Sun Valley, Idaho
1978 Corcoran Gallery, Washington, D.C.
 Addison Gallery, Phillips Academy, Andover, Massachusetts
1979 *Color Photographs*, Jehu Gallery, San Francisco
 3 San Francisco Photographers: Jerry Burchard, Jyo Kushida, Joel Sackett, Nickle Arts Museum, University of Calgary, Alberta
 Jerry Burchard/Ingeborg Gerdes/John Spence Weir: Photographic Viewpoints, San Francisco Museum of Modern Art
1981 *New Color Landscapes*, Jehu Gallery, San Francisco

Selected Group Exhibitions:

1966 *Experience*, San Francisco Art Institute
1969 *Recent Acquisitions*, Pasadena Art Museum, California

1970 *California Photographers 1970*, University of California at Davis (travelled to the Oakland Art Museum, California, and Pasadena Art Museum, California)
 8 Photographers, Pratt Institute, Brooklyn, New York
1975 *Dimensional Light*, California State University at Fullerton
 A Kind of Beatness, Focus Gallery, San Francisco
 San Francisco Renaissance: Photographs of the 50's and 60's, Gotham Book Mart Gallery, New York
1976 *Camera in Common*, Wheelock Gallery, Boston
 Contemporary Photographs, Fogg Art Museum, Harvard University, Cambridge, Massachusetts
1979 *Burchard/Cohen/Hallman/Mertin*, Southwest Missouri State University, Springfield

Collections:

International Museum of Photography, George Eastman House, Rochester, New York; Visual Studies Workshop, Rochester, New York; Fogg Art Museum, Harvard University, Cambridge, Massachusetts; Addison Gallery, Phillips Academy, Andover, Massachusetts; Library of Congress, Washington, D.C.; Target Collection, Museum of Fine Arts, Houston; Pasadena Museum of Art, California; San Francisco Museum of Modern Art; Seattle Art Museum, Washington; Australian National Gallery, Canberra.

Publications:

On BURCHARD: books—*Recent Acquisitions*, exhibition catalogue, Pasadena, California 1969; *San Francisco Renaissance: Photographs of the 50's and 60's*, exhibition catalogue, New York 1975; *Dimensional Light*, exhibition catalogue, Fullerton, California 1975; *A Kind of Beatness*, exhibition catalogue, San Francisco 1975; *Jerry Burchard*, exhibition catalogue, Washington, D.C. 1978; *Jerry Burchard/Ingeborg Gerdes/John Spence Weir: Photographic Viewpoints*, exhibition catalogue, San Francisco 1979; *Photography for Collectors*, vol. I,

The West, Carmel, California 1980; articles—review by A.D. Coleman in the *Boston Phoenix*, 28 November 1978; "Star Streaks" by Thomas Albright in *Art News* (New York), 4 April 1979; "Photographs Are Larger Than Life" by Thomas Albright in the *San Francisco Chronicle*, 3 December 1979; "Jerry Burchard's Sensuous Color" by Ted Hedgpeth in *Artweek* (Oakland, California), 15 December 1979; "Jerry Burchard: Recent Photographs" by Robert Atkins in the *San Francisco Bay Guardian*, 15 December 1979.

There's a certain thickness in time, a re-acquaintance of a dream, an exciting match of doppelgangers from an imagined, or even quite valid, past or future sequence. I can smell the film roll through the camera. Each satisfactory depressing of the shutter leads to greater confidence. A black rainbow shimmers in the darkness. Love and lust whirl with the fingertips and sharp pain wells deep in my lungs, tiny flecks of light float across my eyes. The shutter is released and I breathe deeply, reality impinges and I am mortal again. I stand alone as sounds of the night return, a distant bicycle or buzzing of a streetlight announcing the world of others once more. Looking again at the tree, the house, the beach, I continue walking, hoping for more. Every few months, I scrape through thousands of such illusions to see if any came true. My real partner in these adventures is my camera. It sees where I am blind. My landscapes don't actually exist except on film. They certainly are not conceptual. They come from the other of the creative spectrum, the unconscious rendering of light as an advent.

Paradoxically, my work on nude still-lifes is always in brilliant sunlight, taking five and ten hours at a stretch, covering three to five hundred frames, but often hardly more deliberate, the eye more important than thought, the folds of flesh and silk and flowers flowing like a spring wine in a vision. In the end, the frequency of satisfactory images is on a par with the nightwork: sparse.

I also photograph my breakfasts, my orchids, my fish and my friends. As any artist, I record my life. My fantasies record themselves.

—Jerry Burchard

Extended night exposures have, in the last five years, become a popular and widely used technique,

especially among San Francisco Bay area photographers. Long before night photography reached its current popularity, Jerry Burchard was exploring its possibilities and continues to do so now while the faddists dwindle. As John Szarkowski noted in his exhibition *Mirrors and Windows* in 1978, photography for the last two decades has become increasingly personal and private in its imagery. In its introspection, the work of Jerry Burchard substantiates this thesis; it belongs to contemporary trends in the medium.

Burchard's best photographs seem to confound what the camera does best; rather than the sharply focused, clean, informative images one once associated with photographic vision, Burchard presents us with vague, misty, romantic compositions that depend on their titles for facts about their subjects. His technique is studiedly casual, although his results, despite skewed angles and distorted shapes, never are or even seem accidental. The approach is intuitive, but the intuition is both informal and much less naive than Burchard's statements such as "the camera sees more than I can" would indicate. Burchard's work recalls the pictorialist genre, where light and form take on a greater symbolic importance than the actual objects they represent, but there is a uniquely mystical cast to these pictures to which Burchard's own words testify:

> If you allow the camera to overexpose long enough, it starts discovering new levels of gray and new planes. Some things get so overexposed that they turn into new objects.

Despite the luxuriant drama of the places Burchard visits—Casablanca, Thailand, Chiang Rai—his photographs of the landscape are not so much pictures of a place as they are Burchard's personal reveries. The work is personal to such an extent that even the ineluctable specificity of the photograph is transcended and "Rochester at Christmastime" has the same emotional ring as "Washington Square."

What is ultimately most provocative about Jerry Burchard's works, besides the way they toy with and offer new variations on the way we expect a photograph to look, is their use of metaphor. Because of the privacy of his imagery, the meaning of these pictures remains open-ended. With the romantic associations that the lush, dense rain forest evokes, one may be assured that Burchard's photograph "Monsoon, Thailand" is not a meteorological document but a subjective response to the jungle lushness. The circumstances of these photographs may be vague, an effect heightened by the odd, nocturnal light, yet their existence is clearly, if ineffably, a personal pipe dream in which the viewer is invited to participate.

Burchard has been experimenting with color for the past several years and exploring more literally his attraction to the sensual and seductive. While he continues to make landscapes, his imagery now includes close, fragmented views of the human body which are often specifically sexual and juxtaposed against brightly patterned fabrics. In the color work, there is less use of the distortion of motion and long exposures, but the pictures retain their private and mysterious overtones.

—Dana Asbury

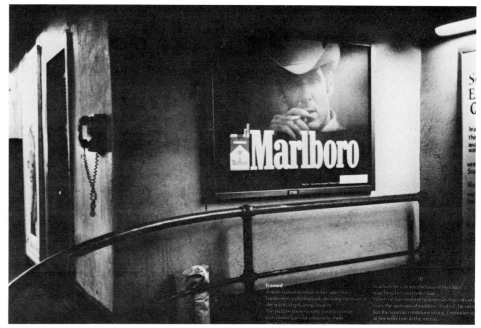

Victor Burgin: *Framed*, 1977

BURGIN, Victor.

British. Born in Sheffield, Yorkshire, 24 July 1941. Studied at the Royal College of Art, London, 1962-65, A.R.C.A. (1st class) 1965; Yale University, New Haven, Connecticut, 1965-67, M.F.A. 1967. Photographer, based in London, since 1967. Senior Lecturer in the History and Theory of the Visual Arts, School of Communication, Polytechnic of Central London, since 1973. Picker Professor of Fine Arts, Colgate University, Hamilton, New York, 1980. Recipient: U.S./U.K. Bicentennial Arts Exchange Fellowship, 1976-77; Deutscher Akademischer Austauschdienst (DAAD) Fellowship, Berlin, 1978-79. Agents: John Weber Gallery, 420 West Broadway, New York, New York 10012, U.S.A.; Liliane and Michel Durand-Dessert, 43 rue de Montmorency, 75003 Paris, France. Address: 25 St. Mary-le-Park Court, Albert Bridge Road, London SW11 4PJ, England.

Individual Exhibitions:

1976 Institute of Contemporary Arts, London
 Robert Self Gallery, London
1977 *Victor Burgin: Work*, Stedelijk van Abbemuseum, Eindhoven, Netherlands (travelled to the John Weber Gallery, New York)
1978 Museum of Modern Art, Oxford
1979 Deutscher Akademischer Austauschdienst, Berlin (travelled to the John Weber Gallery, New York; Liliane and Michel Durand-Dessert Gallery, Paris; and Max Hetzler Gallery, Stuttgart)
1980 *Victor Burgin: US 77/Zoo 78*, Picker Art Gallery, Colgate University, Hamilton, New York

Selected Group Exhibitions:

1969 *When Attitudes Become Form*, Institute of Contemporary Arts, London
1970 *Idea Structures*, Camden Arts Centre, London
 Information, Museum of Modern Art, New York
1971 *6th Guggenheim International*, Guggenheim Museum, New York
 The British Avant-Garde, New York Cultural Center
1972 *Documenta*, Kassel, West Germany
 The New Art, Hayward Gallery, London

1976 *Arte Inglese Oggi*, Palazzo Reale, Milan
1977 *Europe in the 70's*, Art Institute of Chicago
1979 *3 Perspectives on Photography*, Hayward Gallery, London
 Hayward Annual, Hayward Gallery, London

Collections:

Tate Gallery, London; Victoria and Albert Museum, London; Arts Council of Great Britain, London; British Council, London; Walker Art Gallery, Liverpool; Graves Art Gallery, Sheffield; Museum of Modern Art, Oxford; Musée d'Art Moderne, Paris; Bibliothèque Nationale, Paris; Van Abbemuseum, Eindhoven, Netherlands.

Publications:

By BURGIN: books—*Work and Commentary*, London 1973; *Two Essays on Art, Photography, and Semiotics*, London 1976; *Family*, New York 1977; *Victor Burgin: Work*, exhibition catalogue, Eindhoven, Netherlands 1977; *Thinking Photography: Essays in the Theory of Photographic Representation*, editor, London 1981; articles—"Art Society Systems" in *Control* (London), no. 4, 1968; "Situational Aesthetics" in *Studio International* (London), October 1969; "Thanks for the Memory" in *Architectural Design* (London), August 1970; "Rules of Thumb" in *Studio International* (London), May 1971; "Interview with Varsity" in *Varsity* (Cambridge), October 1971; "Margin Note" and "Interview" in *The New Art*, exhibition catalogue, edited by Anne Seymour, London 1972; "In Reply" in *Art-Language* (Leamington Spa, Warwickshire), Summer 1972; "Photographic Practice and Art Theory" in *Studio International* (London), July/August 1975; "Socialist Formalism" in *Studio International* (London), March/April 1976; "Art, Common-Sense and Photography" in *Camerawork* (London), no. 3, 1976; "Modernism in the Work of Art" in *20th Century Studies* (Canterbury, Kent), no. 15/16, 1976; "Looking at Photographs" in *Screen Education* (London), Autumn 1977; "Images of People" in *Studio International* (London), no. 2, 1978; "Seeing Sense" in *Artforum* (New York), February 1980; "Photography, Fantasy, Function" in *Screen* (London), Spring 1980.

On BURGIN: articles—"Victor Burgin: La Representation par le Text" by A. Pacquement in *Art*

Press (Paris), no. 5, 1973; "Victor Burgin" by E. Tynan in *Studio International* (London), September/October 1976; "Victor Burgin in Oxford" by D. Reed in *British Journal of Photography* (London), March 1978.

How would you describe US 77?

I'll take the question literally: there are 12 photographs, each 40 x 60 inches, with a text superimposed on each; these sections are ordered in no particular sequence—there's no linear narrative—and they're designed so that they can be viewed either together, or individually, or in groups smaller than twelve; the graphic conventions governing their appearance derive from illustrated magazines and advertising. In terms of content, the work is built around the themes of power, identity, sexuality.

It's easy to see the reference to mass-media in the way the words are put directly over the photograph, but it's not always quite so obvious what, precisely, the relationship of the text to the image is. Could you say something about this? Take, for instance, the one called "Framed."

We usually see words used to *comment* on the image in some way; for example, to give some extra information about what is shown in the image. Alternatively, we see an image used to illustrate a text—to show pictorially what has already been mentioned verbally. I tend not to do either of these things. To take the example you mention: the key word "framed" is used to relate together a number of pictured and "written" frames: the frame of the panel itself; the frame of the Marlboro poster; the frame of the photograph described in the text; and the frame of the mirror in which the woman watches herself. Secondly, the word "framed"—in the language of cowboy and gangster films—has the meaning of the misrepresentation of an individual: the good guy is "framed" by the bad guys. The cowboy in the poster helps this sort of reading. Now this idea of being framed, of having a certain "picture" of yourself imposed on you by others, against your will, can then be attached to the stereotypes which are arranged as oppositions: young girl/middle-aged woman; male hairdresser/cowboy—these are clearly distinguished cliché representations of people used in the media, and in culture in general. We can go even further with this sort of reading, although you'll probably find this a bit extreme: the cowboy in the poster is smoking a cigarette; a slang term for a cigarette, in England, is "fag," and "fag" is also a term of insult used against homosexual men. And again, under the poster there's a bag: the term "bag" is a similar sexist insult used to describe a woman "past her prime." These sorts of "literarizations" of elements in an image aren't often picked up consciously, but I think that they contribute to what we might call the "unconscious" of an image—contribute to that certain "taste" that an image has and which we find so difficult to account for.

You've always used black-and-white photos, never colour, yet your work has got an overt relationship with advertising which now predominantly appears in colour, presumably to give more pleasure. Apart from reasons of cost, why do you not use colour photographs yourself?

Colour photography *is* pleasurable, but in terms of pleasure it can also be the "cheap shot," the easy way of giving an image a rather meretricious appeal—there are very few photographers who use colour intelligently. Colour photography is also more on the side of illusion than is black-and-white; additionally, so long as black-and-white photography exists—and there may be commercial threats to its continuing existence—colour photography will tend to look anecdotal by comparison. I want to stress the image not as illusion but as *text*, to be read. Black-and-white is, of course, the combination we associate with the printed word, so again this helps my intention more than colour would. The words in

my work are formed from the same substance, the same grain-structure, as the image—they aren't added later by some other process: another way of emphasizing the indivisibility of word and image, a sort of crude analogue of the way in which the mind forms both words and images from the same "substance," on the same "surface."

Could you say something more about the more practical aspects of your work? What equipment do you use? What procedures?

Strictly standard equipment for the sort of pictures I take: HP5 in D-76; Leica M-4 with 35mm lens although I used to use the 50mm more often. But these are almost embarrassing questions for me to answer—they're the sort of questions you ask a photographer.

You don't consider yourself a photographer?

Not in the sense of the word where "photographer" means someone totally involved with the *image*. What I'm involved with is the way images and words mesh together into what we might call a "scripto-visual" discourse. The reason I'm so interested in this form of discourse is quite simply because it's the one we are most exposed to—advertising, magazines, newspapers, and so on. You see, once you're interested in photography as a discursive form, as a practice of representation, as a social *fact*, then you're bound to accept the use of writing—it's not a matter of personal choice, it just happens to be a *fact*.

It's a fact you can choose to ignore.

You can choose to ignore a fact, but if you think that makes the fact any less factural then you're in a state of delusion.

So are you saying that "art photographers" ought to take the social use of photography, this use of words, into account?

Not at all; I'm merely pointing out that my own concerns are very different from theirs.

What about the moment when you are actually taking the photograph—aren't you, at least for that moment, dealing with their concerns? Or do you only think about the text you're going to use?

I'd say that even though I may have a text in mind, and even though I may have selected the thing to photograph on the basis of that text, I'm nevertheless making an *image*, and I try to make that image as well as I can—which means dealing with "purely visual" things, but also with the *medium* as a *craft*.

So, for that moment, you're a photographer in the sense you've just objected to.

It's a very brief moment! It's what comes afterwards that's most important to the final result. Let me give you an example. You asked about technical procedures. I begin with a 35mm negative. Then I make a print on 12 x 16 paper. This print is then photographed on a 10 x 8 negative film. Another 10 x 8 negative is made of the typesetting. The two 10 x 8 negatives—one for tone, one for line—are then taped together, one superimposed on the other. Finally, a print is made from this "neg-sandwich" which, in the case of US 77 for example, is 40 x 60 inches. Now every stage of this process is accompanied by a degree of image degradation, and it's this that gives that harsh, gritty quality to the work. Now the current taste in "fine photography" is for a very low contrast, pearly effect—with very fine grain and fine detail—on a relatively small scale. They're totally different ends.

What are these ends?

They have to be very broadly defined, because, obviously, different people have different ideas about what they're trying to do. But I think there are two very broad areas of practice: the "fine photography" camp are, at base, concerned with the image as a source of *fascination*, a form of *captivation*, a sort of trap for the eye in which one's sense of being is somehow condensed into the exercise of the visual faculty—what we might call the "mesmeric" school of photography. Against this tendency there's the attempt to involve the viewer's sense of *social* existence, in addition to the more narcissistic pleasures of "just looking"—this involves much more of an

attempt to organize more particular sorts of meanings: we could call this the "discursive" tendency. There's a spectrum of concerns ranged across these two broad areas, which moves from the contemplation of one's navel, at one extreme, to the crudest sort of propaganda at the other.

—Victor Burgin (from an interview with Tony Godfrey)

In an essay written in 1975, Victor Burgin wrote: "...one thing conceptual art has done, apart from underlining the central importance of theory, is to make the photograph an important tool of practice. The consequence of such moves has been to further render the categorical distinction between art and photography ill-founded and irrelevant". Burgin's own photographic practice is itself grounded in the conceptual art pioneered in the 1960's and involves the creation of photographs with texts that demand the active participation of the viewer, as opposed to passive consumption, in order to elicit meaning.

Few contemporary photographers have been as critically preoccupied as Burgin with the ideological, social, and cultural implications of photographic practice, and Burgin's articles and essays collectively constitute one of the most thoughful and provocative bodies of photographic criticism to be produced in the past ten years. Burgin's theoretical understanding of photography and his own practice have roots in the thinking of the Frankfurt School philosophers—principally Walter Benjamin—and among contemporary theoreticians he has been most influenced by Roland Barthes. From these various sources he has distilled certain crucial insights regarding the uses of photography in mass culture, its reiteration, transmission and reinforcement of dominant bourgeois values, its simultaneous activation and frustration of the mechanisms of desire, and its functioning as a comprehensive sign system of hidden but nonetheless persuasive meaning. By thus utilizing a system of analysis derived from Marxism and semiology, Burgin attempts in his own work to subvert and deconstruct the normative ploys and strategies of the photographic image. And because the overwhelming majority of images we are exposed to are those of advertising, it is the format of the advertising image that Burgin chooses to re-present. This is a less obvious strategy than might at first appear, for Burgin perceives clearly that although "photos *appear* gratuitously provided, they are not so much objects as environment." Burgin's awareness that the proliferation of photography is not so much a plurality of discrete images as a global environment of images which are absorbed unconsciously and effortlessly dictates that the form of his own radical practice must be to compel the viewer to *conscious* apprehension of the image and to knowledge of the photograph's textuality. It is, preeminently, in order to effect this recognition that Burgin's photographs are constructed.

Burgin's photographs consist typically of rather straightforward images of mass culture, or banal and quotidian scenes of urban life often including advertising images and messages (billboards, posters, etc.). On these images Burgin superimposes texts—the form in which we see most photographs, be they in newspapers, magazines, or in advertising. The text may itself be derived from advertising or magazine copy. Sometimes it will be scrambled, as in a photograph of a Pakistani woman factory worker: superimposed is a text which begins "St. Laurent demands a whole new life style..." and ends disconcertingly with "three months ago/are a ramble through/Eastern Europe." In other cases, the text will be unambiguous and didactic. A photo of workers whose upper bodies are engulfed in the autos of their assembly line is captioned STILL IN THE DARK; this is followed by government exhortations that workers privilege the "national interest" over class, "moderate" trade unionism over more radical demands, etc., and Burgin's own analysis of the political manipulation involved. Another photograph showing a space-suited astronaut, a smiling

woman with a camera, and two children—each figure unrelated to the others—is entitled "Nuclear Power." The text concerns the fact that only 6% of American families consist of a husband, wife, and two children. A photograph of a banal surburban street scene, bisected by electrical wires, contains a flowery travel brochure text describing the California coast and is captioned TODAY IS THE TOMORROW YOU WERE PROMISED YESTERDAY.

Burgin's consistent strategy is to use the very instruments of ideological and cultural control against themselves. By juxtaposing images of the kind one sees all the time, with texts that initiate a dialectric between photograph and viewer, Burgin subverts and deconstructs the cultural myths that are so ubiquitous and internalized they have become almost invisible.

—Abigail Solomon-Godeau

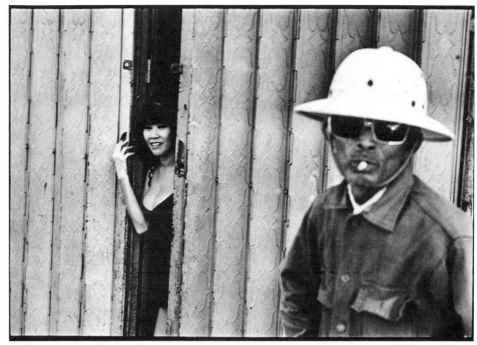

René Burri: *Korea*, 1973

BURRI, René.

Swiss. Born in Zurich, 9 April 1933. Educated in primary and secondary schools in Zurich, 1940-49; studied photography, under Hans Finsler, 1949-53, and filmmaking, 1953-54, at the Kunstgewerbeschule, Zurich; mainly self-taught as a photojournalist, but influenced by Werner Bischof. Served in the Swiss Army, 1954. Married Rosellina Bischof in 1963; children: Yasmine and Oliver. Freelance photojournalist, working for *Life, Look, Paris-Match, Stern, Fortune, Epoca, Sunday Times, Geo, Du, Twen,* etc., also a filmmaker, Zurich, since 1955. Member, Magnum Photos co-operative agency, Paris and New York, since 1959. Recipient: *International Film and Television Festival* Award, New York, 1967. Agent: Magnum Photos, 2 rue Christine, 75006 Paris; and Magnum Photos Inc., 251 Park Avenue South, New York, New York 10010. Address: Wegackerstrasse 7, 8041 Zurich, Switzerland.

Individual Exhibitions:

1965 *China*, Galerie Form, Zurich
1967 *Selected Works*, Art Institute of Chicago
1971 *Selected Works*, Galerie Rencontre, Paris
1972 *Selected Works*, Raffi Photo Gallery, New York
 Selected Works, Galleria Diaframma, Milan
1980 *Die Deutschen*, Museum Folkwang, Essen
1981 *Die Deutschen*, Galerie Kicken, Cologne

Selected Group Exhibitions:

1960 *The World as Seen by Magnum*, Takashimaya Department Store, Tokyo (and world tour)
1967 *Photography in the 20th Century*, National Gallery of Canada, Ottawa (toured Canada and the United States, 1967-73)
1968 *A Collection of Photographs*, Exchange National Bank, Chicago
1972 *Behind the Great Wall of China*, Metropolitan Museum of Art, New York (toured the United States)
1974 *Photographie Suisse depuis 1840 à nos jours*, Kunsthaus, Zurich (and world tour)
1977 *Concerning Photography*, The Photographers' Gallery, London (travelled to the Spectro Workshop, Newcastle upon Tyne)
1979 *Fleeting Gestures: Dance Photographs*, International Center of Photography, New York (travelled to *Venezia '79* and The Photographers' Gallery, London)
 Images des Hommes, at *Venezia '79*

Collections:

Stiftung für die Photographie, Kunsthaus, Zurich; Museum Folkwang, Essen; Musée Réattu, Arles, France; Bibliothèque Nationale, Paris; Palais des Beaux-Arts, Charleroi, Belgium; Museum of Modern Art, New York; Art Institute of Chicago.

Publications:

By BURRI: books—*Die Deutschen/Les Allemands*, Zurich and Paris 1962; *The Gaucho*, with text by J.L. Borges, Buenos Aires and London 1968; *In Search of the Holy Land/Im Heiligen Land*, with text by H.V. Morton, London, New York and Lucerne 1979; films—*The Two Faces of China*, BBC and German television film, 1965; *After the Six-Day War*, German television film, 1967; *Braccia si, uomini no!*, Swiss television film, 1968; also several industrial films, 1967-68.

On BURRI: books—*Photography of the World '60*, edited by Hiromu Hara, Ihei Kimura and others, Tokyo and New York 1960; *Photography in the 20th Century* by Nathan Lyons, New York 1967; *Behind the Great Wall of China*, edited by Cornell Capa, with an introduction by Weston J. Naef, New York 1972; *Concerning Photography*, exhibition catalogue, edited by Jonathan Bayer and others, London 1977; *World Photography*, edited by Bryn Campbell, London 1981; *Die Deutschen: René Burri*, exhibition catalogue, edited by Galerie Kicken, Cologne 1981; articles—by Romeo E. Martinez in *Camera* (Lucerne), no. 2, 1959; in *Leica Magazin* (Frankfurt), no. 5, 1962; in *Leica Magazin* (Frankfurt), no. 1, 1967; by Allan Porter in *Camera* (Lucerne), no. 1, 1970; in *Photo* (Paris), no. 46, 1971; in *British Journal of Photography* (London), no. 32, 1971; in *Popular Photography* (New York), no. 6, 1972; in *Fotografia Italiana* (Milan), no. 168, 1972; in *Nikon News* (Zurich), no. 4, 1976; in *Creative Camera* (London), no. 162, 1977; "René Burri" in *Glasherz* (Munich), no. 6, 1981.

René Burri's photographic career began with his interest in motion pictures. After studying filmmaking, he worked on several pictures, and was assistant cameraman on Walt Disney's *Switzerland*. He studied photography under Hans Finsler at the Kunstgewerbeschule in Zurich, and through Finsler met the photojournalist Werner Bischof. Recognizing Burri's outstanding abilities as a photographer, Bischof recommended him to the important co-operative agency Magnum. Burri became as associate photographer with Magnum in 1956, and a full member in 1959.

From the inception of his career with Magnum, Burri's progress as a photojournalist has been a full and superbly successful one. His reportages include a sensitive story on deaf-and-dumb children at Zurich's Institute of Musical and Rhythmic Education (1955), in-depth coverage of the Suez crisis from Cairo (1956), and a series of hectic magazine and industrial assignments which took him to Italy, Spain, Greece and Turkey in 1957. In 1958, he followed Nasser throughout Egypt during the country's union with Syria, trailed across Brazil and Iran (a story on the birth of an heir to the Shah) in 1960, went to Korea and Japan in 1961, then interviewed Cuba's Che Guevara for *Look*, did a colour essay on the Holy Land for *Paris-Match*, and reported on the escalation of the Vietnam war in 1963.

His best-known reportages—"Argentine Gaucho," "Japan at Work," and "Island in the Gulf of Siam"—were done for the Swiss magazine *Du*, for which he also produced the widely-seen photo-essay on the architect Le Corbusier. At the same time he created his now out-of-print book *The Germans* for publication in Switzerland and France—a little-known classic in spirit of Robert Frank's *The Americans*.

Simultaneous with his busy career as a photojournalist, however, Burii has contined to make films; he spent much of the year 1964-65 making test photos and shooting a feature movie in the Far East. His Xerox film *What's It All About?* won the New York *International Film and Television Festival* Award in 1967.

Today, René Burri's Zurich studio buzzes with film acitivity: he has concentrated on movie work almost exclusively in recent years, producing industrial films as well as programmes for the British Broadcasting Corporation and for German television.

—Colin Naylor

BURROWS, Larry.

British. Born Henry Frank Leslie Burrows, in London, 20 May 1926. Educated at a school in London, 1936-39 (left school at age 13). Did military service in Yorkshire coal mines, 1943-44. Married to Victoria Burrows; children: Russell and Deborah. Worked in the Art Department of the *Daily Express*, London, then joined the Keystone Agency, London, as photographer and darkroom technician; thereafter worked for *Life* magazine as a staff photographer, notably as a war correspondent, until his death, covering the Vietnam War, in 1971; based in Hong Kong, 1961-71. Recipient: Robert Capa Award, 1964, 1966; Magazine Photographer of the Year Award, London, 1967; British Press Picture of the Year Award, 1967. Fellow, Royal Photographic Society, 1971. *Died* (in Langvie, South Vietnam) *20 February 1971*.

Individual Exhibitions:

1971 *Work by the Late Larry Burrows*, Royal Photographic Society, London
1972 Rochester Institute of Technology, Rochester, New York (toured the United States)
 The Photographer's Gallery, London

Selected Group Exhibitions:

1967 *British Press Awards*, London

Collections:

Royal Photographic Society, London; Time and Life Inc., London; Museum of Modern Art, New York.

Publications:

On BURROWS: books—*Larry Burrows: Compassionate Photographer* by the Time-Life editors, with an introduction by Ralph Graves, London and New York 1972; *Geschichte der Fotografie im 20. Jahrhundert/Photography in the 20th Century* by Petr Tausk, Cologne 1977, London 1980; articles—"Great Photographers of the World: Larry Burrows" by Tom Hopkinson in *Daily Telegraph Magazine* (London), 1 May 1970; "Larry Burrows" by Gregory Demetrios in *Zoom* (Paris), September 1970; "Obituary: Mr. Larry Burrows, a Distinguished Trouble-Shooting Photographer" in *The Times* (London), 12 February 1971; "The Last Assignment: The Life and Work of Larry Burrows" by Ainslie Ellis in *British Journal of Photography* (London), 5 March 1971; "Les Terribles Images du Reporter Mort au Vietnam" in *Paris Match* (Paris), 6 March 1971; "De Gilles Caron à Larry Burrows: L'Indochine des Journalistes" in *Zoom* (Paris), May 1971; "Larry Burrows" by Robert L. Morse, and "Kent, Henry and Larry" by Dirck Halstead in *Infinity* (New York), May 1971; "The Compassionate Eye" in *Daily Telegraph Magazine* (London), 29 December 1972; "Larry Burrows: A la Vie à la Mort" in *Le Nouveau Photocinema* (Paris), April 1973.

No one had ever recorded war as Larry Burrows recorded the war in Vietnam, going back again and again over nine years, though his friends, colleagues, even his editors, begged him to give up. Burrows not only recorded but also took part, going on hundreds of combat missions, carrying wounded back to safety, rushing ahead to photograph the faces of men moving into battle, finally dying as a soldier when his helicopter was shot down.

Though in the thick of fighting, with four cameras round his neck and a pocketful of films, shooting whatever came his way, essentially he was a planner and achiever of spectacular effects, with the battlefield and not the stage as his arena. Cecil Beaton said of his "grand compositions": "They are *tableaux vivants*, packed with incident and details of extraordinary horror and beauty, showing us the wounded, those about to die, and those recently dead. They are the nearest we have to a demonstration that the camera could say everything that the grandiose historical paintbrush has never attempted."

How did he do it? His own explanation was "I'm an equipment man. I travel heavy. Very heavy. When I take the lot there are 26 cases. Moving around, of course, can be a problem—may mean an extra car or jeep. Each time I move on, the whole lot has to be brought down and laid out—nothing moved until I give the word. Then count it all into the car, and count it all out again the other end. But everything I take helps me to realize some effect, or achieve something I couldn't do without it."

When planning one of his "grand compositions", he visualised the whole of it in detail, and then thought out precisely how it could be done. To secure an aerial photograph of a napalm bomb exploding, framed by the pilot's helmet, took him 12 days' dangerous work. He explained what he wanted on a blackboard to the pilots taking part, and then flew with them on 32 combat missions before everything went exactly right. He particularly disliked working out of helicopters, but once flew 100 assault missions with a helicopter team in order to get a dozen shots which would be more telling and revealing than the scores that were being taken every day. "If you're not frightened," he remarked, "you're bloody silly. Everyone's frightened."

For the most spectacular of all Vietnam picture stories ("The Air War," *Life*, 9 September 1966) he worked on and off for eight months. Because of his reputation he could obtain facilities no one else would have been allowed. For a famous picture in this series—"Puff, the Magic Dragon", showing an old DC3 with guns mounted amidship enabling it to fire broadsides—he arranged for a section of the door to be removed, lashed his camera to the door frame, and fastened himself in on a long strap. "The strap round my waist made me feel like a yo-yo, but fighting against the tremendous rush of wind, I could get to my camera and shoot pictures as we circled."

In an interview not many months before his death, he summed up war as fighting men experience it, and as he had chosen to experience it with them: "At Khe Sanh I was living out in the fields for ten days. You don't get a wash. You don't go to a toilet maybe for a week. You cook on a little piece of explosive—cut it off the strip, press your cigarette into it and it flares up.... Danger to yourself? You're never out of it.... What's the hardest thing of all? It's to keep *feeling*, in an endless succession of terrible situations. Yet if you feel too much, you just couldn't go on—you'd crack.... My deepest wish? To be around to photograph Vietnam in peaceful days when all the trouble's over."

For his work in Vietnam Burrows received more awards than he could remember—ten in 1967 alone—and that was far from being the only war he covered. Suez, the U.S. landing in the Lebanon, the Mosul rising in Iraq, the Congo, the fighting between India and China, the war in Cyprus. In 20 years of trouble-shooting he was roughed up, beaten up, arrested in several continents. Attacked by a mob in the Congo, he escaped, badly battered, into the Parliament Buildings, where he spent the night piecing together a single workable camera out of four broken ones so that he could operate the next day.

A Londoner, Larry Burrows spent virtually his whole working life serving one American magazine, but he never wanted American citizenship and never wished to be anything but a staff photographer: 'I've quite enough to do thinking out how to cover an assignment, without worrying about how to make the most money out of it as well." In appearance he was tall, lean-faced, stringy—looking more like a professor than a man of action. His manner was nervous, his speech hesitant. A devoted family man, with a beautiful wife and two children, he lived in a flat in Hong Kong with a terrace 20 yards long from which he could look out on to his photographic parish, Asia, and from which haven of peace he would be drawn back again and again into scenes of violence and horror.

Looked at with hindsight, it would seem that everything in his life conspired to make him what he was. Kept out of World War II—ironically through bad eyesight—he worked in the coal mines where he learned to lift three-quarters of a ton by the use of his back, so later enabling him to hump his heavy gear around. As a photographer his private joy was copying paintings and art treasures, for which he was compelled to explore the possibilities of every kind of equipment, and often to devise his own.

"The Burrows technique," he said, "is to get the lights set. To measure everything. And then to go over everything again. You make fewer mistakes that way."

—Tom Hopkinson

BUTYRIN, Vitaly.

Russian. Born in Kaunas, Lithuania, 30 May 1947. Educated at schools in Kaunas. Married Dana Butyrin in 1977; daughter: Lina. Photographer, Vilnius, Lithuania, and Member of the Lithuanian Photography Art Society, Vilnius, since 1965. Honorary Member, Ploen Photography Society, East Germany, 1972; Honorary Member, Kaunas Photography Club, 1973; Honorary Member, NATRON Photography Club, Maglay, Yugoslavia, 1974; Honorary Salon Member, First International Salon of Photography, Landernau, France, 1976; Artist, Federation Internationale d l'Art Photographique, Berne, 1976; Honorary Member, A-74 Photography Club, Warsaw, 1977; Honorary Member, Virton Photography Society, Belgium, 1980. Address: c/o Photography Art Society of Lithuania, Pionieriu Street 8, 232600 Vilnius, Lithuania, U.S.S.R.

Individual Exhibitions:

1965 Azuolynas Movie Theatre, Kaunas, Lithuania
1969 International Friendship House, Moscow
1971 U.S.S.R. People's Ethnographical Museum, Leningrad
1973 U.S.S.R. People's Ethnographical Museum, Leningrad
1975 International Friendship House, Moscow
1977 Graphic Art Society, Moscow
1980 *Meines Fotografijos Parodos*, Vilnius, Lithuania (retrospective; toured Kaunas, Siauliai, Riga, Tallinn, Murmansk, Minsk, Lvov, Ryazan, Moscow, Alma-Ata, Chelyabinsk, Novosibirsk, and Vladivostok—all U.S.S.R.)

Selected Group Exhibitions:

1980 *Thirty Photographers*, Virton Photography Society, Belgium

Collections:

Lithuanian State Photography Museum, Siauliai; Musée Francais de la Photographie, Bièvres, France; Canon Gallery, Amsterdam; Prakapas Gallery, New York.

Publications:

By BUTYRIN: book—*Vitaly Butyrin*, Kaunas, Lithuania 1980; article—"Technology Is Our ABC" in *Fotografie* (Leipzig), 1978.

On BUTYRIN: books—*Lietuvos Fotografija*, with an introduction by Romualdas Pačésa, Vilnius, Lithuania 1978; *Vitaly Butyrin: Meines Fotografijos Parados*, exhibition catalogue, Vilnius, Lithuania 1980; *Great Soviet Encyclopedia*, volume 27, Moscow 1979; articles—in *Revue Fotografia* (Prague), no. 4, 1968; "The Sharp and Inimitable Handwriting" by Valery Kichin in *Sovetskoye Foto* (Moscow), no. 8, 1978, reprinted in *Bulgarsko Foto* (Sofia), 1979; "Photographer of Allegory and Fantasy" by Valery Kichin and M. Leontyev in *Sputnik* (Moscow), 1979.

I never talk about photography. I make it.
—Vitaly Butyrin

Vitaly Butyrin, the grand master of photo arrangement, did not begin his career with the photomontage. When he began shooting at the Kaunas Photo Club in the 1960's he was fascinated by real life, by the world around him. But even then he worked towards a laconic style. To be more exact is to put stress where perhaps it doesn't belong, but in general he began to leave out every superfluous detail (using cropping, etc.); still later, in order to stress generality, independence in existence, and to a certain extent symbolism, Butyrin completely disposed of background and replaced it with a screen. From then on, it was no great step for Butyrin to become the artist we know today, the creator of his own world.

Among the photo-montages that have been created by various artists, one can distinguish different styles and perceive different degrees of conventionality, and perhaps the artists themselves can be said to divide into two groups. The first group creates a new environment or situation on the basis of real and familiar elements, and the new reality so created is perceived as a real one. The other group creates a new world that exists only in the artist's imagination. Butyrin is of the latter group, artists whose worlds have been created by themselves and are unique.

Many observers perceive Butyrin's style as excessively aggressive and individual in a world where everything seems to reduce to the same level; whatever one's response, there is no denying that Butyrin has forged his own individuality. He doesn't hide his arrangements; he offers his world as the only possibility; we have to accept him as he is. Yet, Butyrin's photos are still conventional to the extent that there is no incentive to reduce them to some recognizable reality. Not that they immediately suggest their equivalents in reality; rather, they represent univer-

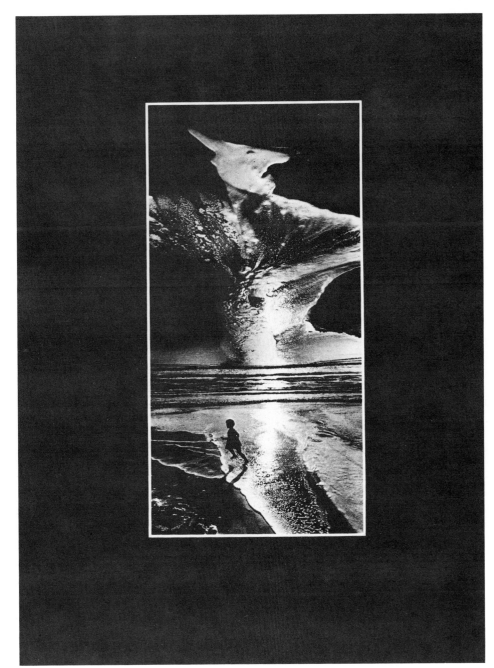

Vitaly Butyrin: *Sea Devil 5, Sea Tales,* **1976**

sal human feelings and everyday problems to which one can respond. Love and dreams, respect for the dead, pollution of the environment, youth and age—these are some of the subjects that Butyrin likes to present, with great suggestiveness and eloquence.

Is it necessary to know the nature of the elements of Butyrin's world? One has to give in to the artist's fantasy as well as his thoughts, and doing so results in a new experience: visual effectiveness is combined with philosophical import. The series "Terra Incognita" and "Sea Tales" are something more than

either thrilling or bizarre. The attentive observer notes that the sand drifts or the sea have become the sky, the clouds and stones have become the sea—and these photos allow our thoughts and fantasies their freedom; one can imagine a fairy-tale, good and beautiful world. Butyrin's photos may be mysterious, symbolic, and enigmatic, but they are never cruel. He is like the good teller of fairy tales, whose story may be mystically dark but the end of which is necessarily happy.

—Peeter Tooming

C

CAGNONI, Romano.

Italian. Born in Pietrasanta, 9 November 1935. Educated at schools in Italy; self-taught in photography. Freelance photographer and photojournalist, working for *The Observer, Paris-Match, Life, Stern, L'Espresso, Newsweek, France Soir*, etc., in London, since 1958. Recipient: Overseas Press Club Award, New York, 1970. Agent: The Photographers' Gallery, 8 Great Newport Street, London WC2. Address (studio): 81 Cadogan Square, London SW1, England.

Individual Exhibitions:

1966　*Florence Floods*, Swiss Cottage Library, London
1969　*Biafra*, Trafalgar Square Marquee, London
1975　*Romano Cagnoni, Presented by Olivetti*, Galleria Il Diaframma, Milan
1976　University Museum, Mexico City
1977　Italian Institute of Culture, London (retrospective)
1978　Museo Civico, Bologna

Selected Group Exhibitions:

1971　*Witness*, The Photographers' Gallery, London
　　　Color Supplement Photojournalists, Royal Photographic Society, London
1975　*Romano Cagnoni and the U.S.A. Avantgarde*, Museo Correr, Venice
1978　*Italian Photographers*, at *Rencontres Internationales de la Photographie*, Arles, France
1980　*African Photos*, Palazzo Isimbardi, Milan

Collections:

Bibliothèque Nationale, Paris.

Publications:

By CAGNONI: books—*Bury Me in My Boots*, with text by Sally Trench, London 1968; *The Brother's War*, with text by John de St. Jorre, Boston 1972; *Middle East War*, with text by the Sunday Times editors, London 1974; *Southern Italy: History and Technology*, Turin 1978; *Bologna*, Bologna 1979; *The South of Italy*, Turin 1980.

On CAGNONI: books—*English Painting* by R.H. Wilenski, London 1964; *The Art of Photography*, by the Time-Life editors, New York 1971; *Romano Cagnoni, Presented by Olivetti*, exhibition catalogue, with text by Bruno Segre, introduction by Renzo Zorzi, Milan 1975; *Pictures on a Page* by Harold Evans, London 1978; *The Camera at War* by Jorge Lewinski, London 1979; articles—"Romano Cagnoni" in *Life* (New York), August 1968; "Best Photographic Reporting" in *Dateline* (New York), April 1969; "Romano Cagnoni: Total Photography" by J.J. de Lucio-Meyer in the *Penrose Annual*, London 1970; "Photographic Documents by Romano Cagnoni, London" by J.J. de Lucio-Meyer in *Gebrauchsgraphik* (Munich), March 1971; "Romano Cagnoni: Biafra" in *Schweizerische Photorundschau* (Visp, Switzerland), August 1971; "Romano Cagnoni" in *Fotografia Italiana* (Milan), October 1974; "10 Years of Photographing Historical Events" in *Domenica del Corriere* (Milan), April 1975; "Sight-Insight-Foresight" by J.J. de Lucio-Meyer in *Novum* (Munich), December 1975; "Romano Cagnoni," special issue of *Progresso Fotografico* (Milan), November 1976; "Romano Cagnoni" in *You and Your Camera* (London), May/June 1980.

Many of Romano Cagnoni's photographs are beyond criticism. When a man risks his life for a picture, or gets them in almost impossible circumstances, it reduces any complaints about technical quality or composition to churlishness. Cagnoni does take risks. He was one of the first photographers into the war in Biafra (and one of the last to leave). He was the first independent photographer into North Vietnam, travelling with the writer James Cameron. He penetrated into Afghanistan shortly after the Soviet invasion, and secretly took pictures through his partly unbuttoned coat.... As well as all this, Cagnoni's black-and-white pictures show a rare gift for capturing powerful emotions. Stark, contrasty lighting and/or printing suffuse his pictures with a sense of drama, or even danger, though the source of the danger may not be shown in the frame. For example, one shot taken in Biafra and published in *Life* in 1970 seems to sum up the whole agony of that wretched war, yet all it shows is a negro's head. In theory it could have been taken anywhere, but the man's haunted expression, the fear implied by the whites of his eyes, speak volumes about that particular conflict.

Another sequence taken in Biafra the year before was so powerful it was given a whole page display in *The Times* (12 March 1969). That newspaper had so long been renowned for its failure to use pictures well, it was astonishing for them to publish a dramatic set in the *Life* manner.

Cagnoni's pictures rarely show the fighting, or tell you which side is winning. What they tell you is that people are losing. People are suffering. Often the pictures show people trying, as best they can, to help one-another. A nurse, crouching, beckons an emaciated child; doctors operate on the wounded; a man kneels before a missionary; a mother clutches at her children: the raw emotions of these pictures give them a continuing appeal long after the battles have been forgotten. In these and in more everyday newspaper pictures, Cagnoni tends to crop tightly round his figures to emphasize the points of contact between them. Unimportant parts of the picture might well be out of focus, or so grainy (due to the greatness of the enlargement) that they do not hold the eye. Everything is subordinated to the central emotion which is the point of the picture. Cagnoni's colour work is less dramatic. Colour film does not lend itself to reducing scenes to extreme contrasts of light and shade. Also, it is not built to withstand the kind of rough treatment Cagnoni gives it, and his cameras, and himself, in the pursuit of impossible pictures.

Romano Cagnoni: *Biafra*, 1969

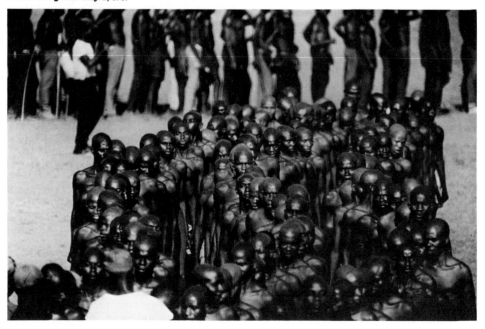

Cagnoni's limitation is that much of his best work seems likely to disappear into the mists of time, fading away like the newspapers and magazines which printed it. He was one of the first photojournalists to become deeply involved with the war he was photographing, and live with the people, while Philip Jones Griffiths was doing a similar thing in Vietnam. But where Griffiths produced an extraordinary book, *Vietnam Inc.*, Cagnoni did not make his own coverage of Biafra definitive in a similar way. Cagnoni's work is worth a major book, but so far only a slim exhibition-catalogue type collection has been published by Olivetti, and that unobtainable. The best guide to his work remains a Special Issue of *Progresso Fotographico* (November 1976) in Italian. He has certainly not secured the sort of recognition he merits in his adopted home, London, or indeed in the wider world of photography.

—Jack Schofield

CALLAHAN, Harry.

American. Born in Detroit, Michigan, 22 October 1912. Educated at public school in Royal Oak, Michigan; studied engineering at Michigan State College, East Lansing, 1931-33; self-taught in photography. Married Eleanor Knapp in 1936; daughter: Barbara. Photographer since 1938. Worked for Chrysler Motor Parts Corporation, Detroit, 1934-44; Processing Assistant, General Motors Photographic Laboratories, Detroit, 1944-45. Instructor in Photography, 1946-49, and Head of the Department of Photography, 1949-61, Institute of Design, Illnois Institute of Technology, Chicago; Associate Professor, 1961-64, Professor, 1964-77, and Chairman of the Department of Photography, 1961-73, Rhode Island School of Design, Providence. Visiting Instructor, Black Mountain College, North Carolina, 1951, University of California Extension, Berkeley, 1966, and University of Massachusetts, Boston, 1974. Recipient: Diploma and Plaque, *Photokina* exhibition, Cologne, 1951; Graham Foundation Grant, 1956; Photography Award, *Rhode Island Arts Festival*, 1963; Rhode Island Governor's Award for Excellence in the Arts, 1969; Distinguished Contribution Award, National Association of Schools, 1972; Guggenheim Fellowship, 1972; Photographer and Educator Award, Society for Photographic Education, 1976. Honored Photographer, *Rencontres Internationale de la Photographie*, Arles, France, 1977. D.F.A.: Rhode Island School of Design, 1978. Address: 153 Benefit Street, Providence, Rhode Island 02903, U.S.A.

Individual Exhibitions:

1946 750 Studio Gallery, Chicago
1951 Art Institute of Chicago
Black Mountain College, North Carolina
Museum of Modern Art, New York (toured the United States)
1956 Kansas City Art Institute
1957 *Harry Callahan/Aaron Siskind: Photographes Americains*, Centre Culturel Americain, Paris (travelled to Algiers and London)
Abstract Photography, American Federation of Arts, New York (with Aaron Siskind and Arthur Siegel; toured the United States)
3 Photographers: Harry Callahan/Walter Rosenblum/Minor White, White Museum of Art, Cornell University, Ithaca, New York
1958 International Museum of Photography,

George Eastman House, Rochester, New York (retrospective)
1960 *Aaron Siskind/Harry Callahan*, The Cliff Dwellers, Chicago
1962 Museum of Modern Art, New York (with Robert Frank)
University of Warsaw
1963 Galeria Krzysztofory, Krakow, Poland
Galeria Towarzystwo, Warsaw
1964 Heliography Gallery, New York
Hallmark Gallery, New York (toured the United States)
El Mochuelo Gallery, Santa Barbara, California
1966 Kiosk Galleries, Reed College, Portland, Oregon
1968 Massachusetts Institute of Technology, Cambridge
Museum of Modern Art, New York (toured the United States)
1969 International Museum of Photography, George Eastman House, Rochester, New York (toured the United States)
1970 Friends of Photography, Carmel, California
Witkin Gallery, New York
Siembab Gallery, Boston
1971 831 Gallery, Birmingham, Michigan
International Museum of Photography, George Eastman House, Rochester, New York
1972 Light Gallery, New York
1974 Light Gallery, New York
1975 Massachusetts Institute of Technology, Cambridge
Cronin Gallery, Houston
1976 Museum of Modern Art, New York (retrospective)
Minneapolis Institute of Arts
Picture Gallery, Zurich
Galerie Lichttropfen, Aachen, West Germany
Light Gallery, New York
Photographs by Aaron Siskind and Harry Callahan, Washington Gallery of Photography, Washington, D.C.
Aaron Siskind/Harry Callahan/Stephen Shore, Silver Image Gallery, Tacoma, Washington
1977 Galerie Zabriskie, Paris
Enjay Gallery, Boston
David Mirvish Gallery, Toronto
Rencontres Internationales de la Photographie, Arles, France
Susan Spiritus Gallery, Newport Beach, California
Grapestake Gallery, San Francisco
1978 Galerie Fiolet, Amsterdam
Light Gallery, New York
Biennal, Venice (with Richard Diebenkorn)
1980 Light Gallery, New York
Light Gallery, Los Angeles
1981 *Color Photographs 1940-1980*, Colorado Mountain College, Breckenridge

Selected Group Exhibitions:

1948 *In and Out of Focus*, Museum of Modern Art, New York
1950 *Photography at Mid-Century*, Los Angeles County Museum of Art
1954 *Subjecktive Fotografie 2*, State School of Arts, Saarbrucken
1955 *The Family of Man*, Museum of Modern Art, New York (and world tour)
1959 *Photography in the Fine Arts*, Metropolitan Museum of Art, New York
1963 *The Photographer and the American Landscape*, Museum of Modern Art, New York
1967 *Photography in the 20th Century*, National Gallery of Canada, Ottawa (toured Canada and the United States, 1967-73)
1976 *6 American Photographers*, Thomas Gibson Fine Art, London

1977 *The Photographer and the City*, Museum of Contemporary Art, Chicago
1980 *The Magical Eye*, National Gallery of Canada, Ottawa

Collections:

Center for Creative Photography, University of Arizona, Tucson (archives); Museum of Modern Art, New York; International Museum of Photography, George Eastman House, Rochester, New York; Art Institute of Chicago; Hallmark Collection, Kansas City; National Gallery of Canada, Ottawa; Bibliothèque Nationale, Paris.

Publications:

By CALLAHAN: books of photographs—*On My Eyes*, with text by Larry Eigner, Highlands, North Carolina 1960; *The Multiple Image: Photographs by Harry Callahan*, edited by Gordon Martin and Aaron Siskind, text by Jonathan Williams, Chicago 1961; *Photographs: Harry Callahan*, with text by Hugo Weber, Santa Barbara, California 1964; *Photographs by Harry Callahan*, Hallmark calendar, with text by Edward Steichen, New York 1966; *Harry Callahan*, with preface by John Szarkowski, text by Paul Sherman, New York 1967; *Callahan*, edited by John Szarkowski, Millerton, New York 1976; *Harry Callahan*, text by Peter C. Bunnell, New York 1978; *Harry Callahan: Color*, New York 1980; *Water's Edge: Photographs by Harry Callahan*, with an introductory poem by A.R. Ammons, afterword by Callahan, Lyme, Connecticut 1980; articles—"Learning Photography at the Institute of Design," with Aaron Siskind, in *Aperture* (Millerton, New York), no. 4, 1956; "Pattern" in *American Society of Magazine Photographers Annual*, New York 1957; "Harry Callahan: Conventional Subjects Become Extraordinary Photographs," with David Ebin, in *Modern Photography* (New York), February 1957; "Harry Callahan: An Interview," with A.D. Coleman in the *New York Photographer*, January 1972; "Quotes from Callahan," edited by Harvey Lloyd, in *Infinity* (New York), March 1973; "An Interview with Harry Callahan," with James Alinder, in *Exposure* (New York), May 1976; "Harry Callahan: Questions," with Jacqueline Brody, in *Print Collector's Newsletter* (New York), January/February 1977; "Callahan," edited by Melissa Shook, in *Photograph* (New York), Summer 1977.

On CALLAHAN: articles—"An Exhibition: Creative Photography" by Van Deren Coke in *Aperture* (Millerton, New York), no. 1, 1956; "The Photographs of Harry Callahan" by Minor White in *Aperture* (Millerton, New York), no. 2, 1958; "Harry Callahan in Polske" by Ursula Czartoyska in *Fotografia* (Warsaw), March 1963; "Photographs: Harry Callahan" by Margery Mann in *Artforum* (New York), September 1964; "Harry Callahan: The Multiple Image" in *Creative Camera* (London), August 1968; "Callahan Teaching Method" by Jacob Deschin in the *New York Times*, 12 January 1969; "Who Is Callahan?" by David Vestal in *Travel and Camera* (New York), May 1969; "Is His Genius Underrated?" by A.D. Coleman in the *New York Times*, 27 September 1970; "Harry Callahan" by A.D. Coleman in the *New York Times*, 31 December 1972; "Harry Callahan" by Thomas Barrow in the *Britannica Encyclopaedia of American Art*, Chicago 1975; "Harry Callahan's Detente with Experience" by Leo Rubinfen in the *Village Voice* (New York), 10 April 1978.

The person who one day writes Harry Callahan's definitive biography may not have to make a very fat book of it, unless, of course, photographs are included. Then the volume could easily bulge at the seams.

True, much is known and has been recorded

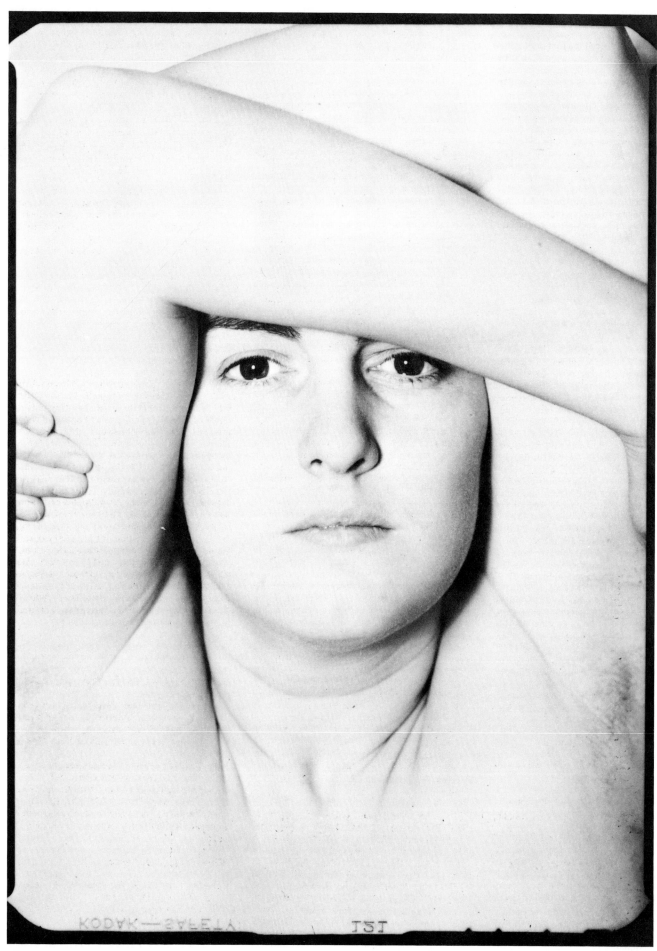

Harry Callahan: *Eleanor*, 1947

about the biographical events in Callahan's life—that his parents were farmers, that he received no formal photographic education, that he's been head over heels about Eleanor ever since the two met on a blind date in '33, or that he once worked as a clerk in the accounting department at Chrysler Motors. And Callahan himself has informed us that it was Ansel Adams who first put the bug in him, cleared away "the monkey business," and made tone and texture *a priori* conditions that liberated him for pure camera work thereafter. We know, too, of Callahan's reputation as a teacher, enduring and indisputable even after his own candid claims to the contrary—admissions that teaching for him could be murder at times. While it will never be said that Callahan made a better teacher than he is a photographer, few artist-teachers have been as influential: his great passion for photography as a way of life was eagerly adopted by generation after generation of students at both Chicago's Institute of Design and later Rhode Island School of Design. Incontrovertible as well is Callahan's reputation as an American photographer turned international artist, his work the subject of numerous exhibitions and publications, including major retrospectives at the Museum of Modern Art and the Venice *Biennale*. Yet these events, while assuredly significant and nourishing to Callahan himself, to his biographer may ultimately be non-events.

Personal attributes and accomplishments have never been easy to embellish, not without some trail of gossip or legend. Callahan's chronology contains no tales of fervent pursuit by government agents, no confiscated or destroyed negatives, no model/mistress mix-ups, no abject solitude or gross impecunity. Marked by grace and peace, the story of Harry Callahan is a triumph of self-motivation and inner volition. The details progress like inches along a yardstick—a logical and predictable chain of achievements, a checklist growing ever more prestigious with every new exhibition, publication, honor, and award. In short, Harry Callahan epitomizes the new American photographer approaching a 21st century art world, a world where artistic success with financial stability for a photographer within his or her lifetime is no longer an impossible dream.

For Alfred Stieglitz and his contemporaries, things were never that certain. For Callahan, soon to turn 70, there is now the blessed knowledge, and the confidence and satisfaction it must bring, that one's daily exercises of eye and heart are already in safe keeping, not just in the history of photography but the history of art. Callahan, along with Ansel Adams and a handful of others, is among the first living masters of the medium to witness the future Stieglitz had in mind, to benefit from the concepts he sought to reify.

"Photography is an adventure just as life is an adventure," Callahan has stated. "If man wishes to express himself photographically he must understand, surely to a certain extent, his relationship to life." Looking then at this adventure, this remarkably clear and straightforward life, the pictures, every one of them, tell the story. Harry Callahan is his work. And therein lies his legend.

The titles of Callahan's photographs—limited to place and year snapped—inform where and when, rarely what, never why, and only who if Eleanor, his wife, or Barbara, his daughter, are the subjects before his camera. While his images have been grouped into a variety of categories—geographic, chronologic, camera format used and the like—most appropriate would be to survey his life's work as he organized it himself, by some half-dozen thematic concerns. These themes—landscapes, seascapes, cityscapes, anonymous strangers, intimate loved ones, camera-confined multiple exposures (mostly combinations of his single-image subject matter), and, as it now turns out, a full-fledged career in color photography too—were all initiated in his very first years as a photographer and have preoccupied him ever since. Callahan himself was quick to recognize these first "good ones" as images

he could build on, but rarely surpass. Some of them were indeed as good as any he has ever made.

As theoretician, Callahan was an ardent disciple of the Bauhaus tradition, a staunch supporter of a discipline that treated an art form like photography as machine-made as much as it was man-made. His photographs can be viewed as a life-long challenge to the camera's eye, a series of never-ending questions on the nature of the medium itself. What do varying shutter speeds accomplish with sunlight on water? At what camera distance does the human eye stop searching for detail in a print? How contiguously can tones by rendered and still stand apart? Can a silhouette also be three-dimensional? How will the same scene overlapped upside down against itself appear on film? Or how black-and-white can a color photograph be? Callahan's answers, contained in his photographs, have never ceased to surprise with their uncanny blend of directness and subtlety.

Aesthetically, Callahan was often compelled by images that pitted perfection against imperfection, that countered visual chaos with visual order. A classic example is the 1950ish photograph of starkly bared trees set against a gray paste of Chicago sky and harbor. The branches are a mish-mash of poly-webbed obfuscation, yet the trunks are distinctively poised like impeccably mannered guests in black tuxedos. A more recent illustration of Callahan's penchant for balance with imbalance occurs in his Cape Cod series. In one of these, an imperfect horizon line, bowed slightly at center like an Ellsworth Kelly curve painting, perfectly divides a landscape into equal parts of cloudless gray sky and wind-mogulled, glittering sand. That a tiny speck of black in the distance is, in fact, the mighty Atlantic further underscores Callahan's fondness for dualities. In another photograph, a volleyball net levitates near the shoreline of a listless beach. The top cord of the net hangs in a perfect arch from pole to pole. The bottom cord, lighter in weight, catches the slight breeze and visually breaks apart.

From image to image, dichotomies reverberate in Callahan's work. When he is inside, it is the intimacy of his home life that he embraces. Sunlight filters through venetian blinds into a womb-like room where Madonna and child, Eleanor and Barbara, rest in the nude. It is a scene of tenderness only a father and husband, tip-toeing with a tripod, would catch. When Callahan is outside, it is often the anonymity of the street—two strangers and one dead lamplight—that he utilizes to symbolize the broken circuitry of human interaction.

In almost any Callahan photograph it is possible to see every Callahan photograph. There is the 1952(?) image of his friend Bob Fine standing in a shaft of city sunlight at the far end of an alleyway. Fine is so tiny, he at first appears as if seen on stage from the very last row of the top balcony. A similar scale illusion takes hold in a 1972 photograph on Cape Cod. A wind-tussled surf is about to pound a beach like a bedsheet slapped flat for a tight fit. At first, the rushing breaker threatens our toes—we think it so near—then, spying a jogger skirting the surf edge, we grasp where Callahan must be: high on the peak of a sand dune overlooking the whole ocean.

Recently, Callahan has claimed to have abandoned black-and-white photography altogether. If that turns out to be the case (and it will be verified only after many more years have passed), the switch to color signals the first true dividing line in a career notable for a paucity of turning points. With the color work fresh out of the drum—even though most of it was photographed decades ago—there is a natural inclination, almost temptation, to compare both modes of expression, especially among concurrent images. In the work with Eleanor and Barbara particularly, Callahan's choice of film seems to have made little difference. There is the black-and-white photograph of the two of them, taken in 1953, thigh and neck deep in Lake Huron. Callahan isolates and incubates his family in tranquillity and softness, out of the reach of strangers scurrying near the edges of

the frame. By comparison, there is no loss of intimacy—no compromise in compassion or beauty—in the color photograph of Eleanor leading Barbara by the hand, elephant trunklike, into a windowsill of sunlight. Here, as in the color work with Providence houses, with their spanking paint jobs and Koda-chrome blue skies vs. their black-and-white brethren, the choice is a toss up. Like two sides of a coin, the value is the same.

As any major artist approaching 70 must come to know, you rarely get any better than you already are. Callahan's great achievements may have been predicated on having accepted this knowledge right from the start. There are photographers whose lifespan outstretches their vision. Then there are photograpers like Harry Callahan who, after 40 years, still show no sign of let-up. Callahan's genius as an artist may ultimately rest as much with the purity of his vision as with this remarkable, rejuvenating continuum.

—Arno Rafael Minkkinen

CALLIS, Jo Ann.

American. Born Jo Ann Levin in Cincinnati, Ohio, 25 November 1940. Educated at Ohio State University, Columbus, 1958-60; California State University at Long Beach, 1962-65; University of California at Los Angeles (studied under Robert Heinecken), 1971-77, B.A. 1974, M.F.A. 1977. Married Gilbert Callis in 1960 (divorced, 1975); children: Stephen and Michael; married David Pann in 1980. Teaching Assistant, University of California at Los Angeles, 1967-77; Instructor, California State University at Fullerton, 1977-78. Since 1976, Instructor, California Institute of the Arts, Valencia; since 1978, Instructor, U.C.L.A. Extension. Recipient: Ferguson Award, Friends of Photography, Carmel, California, 1978; Photography Fellowship, National Endowment for the Arts, 1980. Agents: G. Ray Hawkins Gallery, 9002 Melrose Avenue, Los Angeles, California 90069; Susan Spiritus Gallery, 3336 Via Lido, Newport Beach, California 92663. Address: 2817 Glendon Avenue, Los Angeles, California 90064, U.S.A.

Individual Exhibitions:

1975 Orange Coast College, Costa Mesa, California
1977 *Callis, Kasten and Zimmerman*, University of Southern California, Los Angeles
1978 Gallery of Fine Photography, New Orleans
 Orange Coast College, Costa Mesa, California
1979 *Callis/Cumming*, Blue Sky Gallery, Portland, Oregon (with Robert Cumming)
 Color Transformations, University of California, Berkeley (with John Divola)
1980 New Image Gallery, Harrisonburg, Virginia
 G. Ray Hawkins Gallery, Los Angeles

Selected Group Exhibitions:

1976 *Emerging L.A. Photographers*, Friends of Photography, Carmel, California
1978 *The Photograph as Artifice*, California State University at Long Beach
1979 *Southern California Invitational Exhibition*, University of Southern California
 National Photography Exhibition, Women's Art Registry, Minneapolis
 Attitudes, Santa Barbara Museum of Art, California

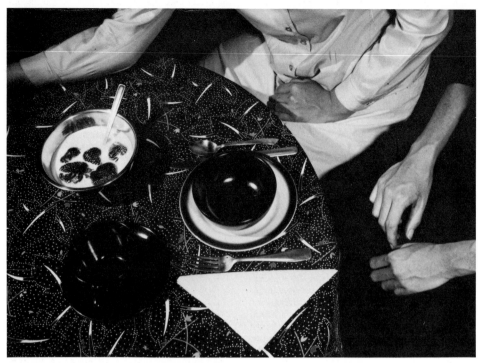

Jo Ann Callis: *Black Tablecloth* (original in color), 1979

November 1978; "Between Eroticism and Morbidity" in *LAICA Journal* (Los Angeles), no. 24, 1979; "Jo Ann Callis" in *Creative Camera* (London), October 1979; "Memorable Visions" by Joan Murray in *Artweek* (Oakland, California), 8 September 1979; "Jo Ann Callis" by Don Owens in *Photo Show Magazine* (Los Angeles), May 1980.

I make my photographs about part of my experience, and the pictures are so well related to some of my thoughts and feelings that this subject matter has continued to interest me for seven years. I find that the pictures communicate sensations and feelings to others on a level just below their consciousness, and are often narrative by nature. The dualities of attraction and repulsion, reality and unreality, exist in all my photographs. They are seductive and yet there is always a slight uneasiness about them. The pictures are about beauty and sensuality, while at the same time one senses anxiety and fear.

I use color in an emotional way, that is to say, the images are not only about color. Instead, color is used to add another suggestive element. The colors are very beautiful, yet they are also slightly sour, and at times seem to bleed through the surface of the paper.

The idea of procedure and ritual is fascinating and compelling to me. Not only is the act of making the pictures realistic, but also the subject matter elicits this connotation. All the photographs are set-up, for I fabricate an environment in which the tableau can occur.

—Jo Ann Callis

Spectrum: New Directions in Color Photography, University of Hawaii, Manoa
New Season, Witkin Gallery, New York

Collections:

Museum of Modern Art, New York; Center for Creative Photography, University of Arizona, Tucson; Museum of Modern Art, San Francisco; International Museum of Photography, George Eastman House, Rochester, New York; Denver Museum of Art; Minneapolis Institute of Art; University of Nebraska, Lincoln; New Orleans Museum of Art; Bibliothèque Nationale, Paris; Tasmanian Museum of Art, Hobart.

Publications:

On CALLIS: books—*Glass Eye* by Kikuo Mori, Los Angeles 1975, 1977; *Creative Camera Annual*, edited by Colin Osman, London 1976; *Photography Annual*, New York 1978, 1979; *Ten Year Salute* by Lee Witkin, Danbury, New Hampshire 1979; articles—"A New York Welcome" by Guy Trebay in the *Village Voice* (New York), 28 February 1977; "Jo Ann Callis" in *Popular Photography* (New York), no. 4, 1977; "Jo Ann Callis" in *Picture Magazine* (Los Angeles), no. 6, 1978; "Le Vertige des Sens" in *Photo* (Paris), no. 131, 1978; "Jo Ann Callis" by Cathy Coleman in *Artweek* (Oakland, California), 11 February 1978; "Collector's Eye" by Peter Plagens in *New West Magazine* (Los Angeles), 8

The color photographs of Jo Ann Callis are resonant with familiarity, yet one would find it difficult to describe exactly what is happening in them. Using a medium noted for its literal specificity, Callis makes photographs that slip by, like dreams, with only a trace of resemblance to the occurrences of the everyday world. She describes them as originating from pictures she sees in her mind; translated onto film, they retain a dislocated sense of unreality that defies their existence as photographs.

Callis is aware of the tensions she creates in setting up these scenes, and, like the Surrealists drawn to an Atget photograph of a headless mannequin, she understands how disturbing pristine but dislocated photographic detail can be. In order to maintain the sense that these scenes are visions, tapped from the archive of memory, Callis uses models more as objects than as recognizable persons. They are anonymous, seen either from the back or with their faces turned away, covered in shadow or masked by gesture. They are the nameless characters of dreams; their unnamed presence carries also the undertones of coercion and reluctance. Two people sit before a table, an empty red bowl in front of the woman, a bowl of strawberries and cream off to the side. Although nothing is pointedly amiss in the scene, there is a general uneasiness that is almost sinister, and a tight-lipped determination not to reveal more. In fact, in many of Callis's pictures, one has the unpleasant feeling of having walked into the scene unwelcome. A woman sits with her back to us, facing an empty chair and an illuminated lamp. Questions hover about these pictures with a foreboding that both attracts and repels us. Other of Callis's photographs, however, seem to have been arranged and performed expressly for the viewer. A nude female torso is bathed in light and surrounded with organza netting and a spray of flowers; the initial response to the loveliness is undercut by the slightly sour and acidic color that Callis has achieved with subtle effect.

Reproduction does not do justice to Callis's large-format prints. The elegance of their physical presence and their reliance on the sensual tactility of flesh and fabric are important to their ability to entice the viewer.

The set-up or directed photography has been a

Bryn Campbell: *Unemployed Miner*, 1973

vital approach to the medium ever since O.J. Rejlander's and H.P. Robinson's Victorian efforts; Jo Ann Callis distinguishes herself with a confrontation of the ritualistic nature of this act. She does not cover her tracks, and yet, as studied and dramatic as these works are, they do not ring false because they trigger the viewer's recognition. Callis has discovered in the extreme economy of a simple gesture or a certain color or form a wealth of innuendo. The photograph is, by its nature, already the record of a past confrontation; Callis amplifies this fact until we are seeing recollections of memories many times removed, and the response they evoke is as loaded, compelling, and individual as the images are simple.

—Dana Asbury

CAMPBELL, Bryn.

British. Born in Mountain Ash, Glamorgan, Wales, 20 May 1933. Educated at Mountain Ash Grammar School, 1943-51; University of Manchester, 1953-55. Served as a photographer in the Royal Air Force, 1951-53. Assistant Editor, *Practical Photography* and *Photo News Weekly*, London, 1959-60; Editor, *Cameras and Equipment*, London, 1960-61; Associate Editor, *British Journal of Photography*, London (and Picture Editor of the *British Journal of Photography Annual*), 1962-63; Picture Editor, *The Observer* newspaper, London, 1964-66. Freelance photographer, London, since 1966. Honorary Associate Lecturer in Photographic Arts, Polytechnic of Central London, 1974-77; Member of the Photography Board, Council for National Academic Awards, 1977, 1978; Member of the Photography Committee, Arts Council of Great Britain, 1978-80. Trustee, The Photographers' Gallery, London, since 1974; Member of the Art Panel, Arts Council of Great Britain, since 1980. Recipient: First Prize for News Pictures, British Press Picture Awards, 1969; Kodak Bursary, 1973; Photography Award, Arts Council of Great Britain, 1974. Fellow, Institute of Incorporated Photographers, 1969, and Royal Photographic Society, 1971. Agent: The Photographers' Gallery, 8 Great Newport Street, London WC2. Address: 11 Belsize Park Mews, London NW3 5BL, England.

Individual Exhibitions:

1973 *Reports and Rumours*, The Photographers' Gallery, London (retrospective; toured the U.K.)
1975 *Village School*, at the *Chichester 900 Festival*, Sussex
Village School, Photographic Gallery, Southampton (and regional tour)
1976 *Caring and Concern*, Kodak Gallery, London (toured the U.K.)
1977 *Sports View*, Watford Sports Centre, Hertfordshire (toured Eastern England)
1978 Salzburg College, Austria (retrospective)
1979 *Experimental Colour Work*, Salzburg College, Austria
1980 *Antarctic Expedition*, Olympus Gallery, London

Selected Group Exhibitions:

1973 *Up the Blues*, The Photographers' Gallery, London
The English by the English, Salon de Paris
1975 *The Camera and the Craftsman*, Crafts Centre, London

1976 *Photography Helps*, Kodak Gallery, London
1977 *Personal View*, British Council, London (and world tour)
1978 *European Colour Photography*, The Photographers' Gallery, London

Collections:

Arts Council of Great Britain, London; Victoria and Albert Museum, London.

Publications:

By CAMPBELL: books—*British Journal of Photography Annual*, picture editor, London 1963, 1964; *Loneliness*, with text by Jeremy Seabrook, London 1973, Stockholm 1975; *The Headless Valley*, with others, with text by Ranulph Fiennes, London 1973; *The Experience of Sport*, with text by John L. Foster, London 1975; *British Image I*, with others, London 1975; *The Camera and the Craftsman*, exhibition catalogue, with others, London 1975; *Children and Language*, London 1976; *The Facts about a Football Club*, with text by Alan Road, London 1976; *Goalkeepers Are Crazy*, with text by Brian Glanville, London 1977; *Newspaper Dragon*, with text by Alan Road, Swansea 1977; *Exploring Photography*, London 1978, New York 1979; *European Colour Photography*, exhibition catalogue, with others, London 1978; *World Photography*, editor, London and New York 1981; film—*Exploring Photography*, television series, 1978.

On CAMPBELL: books—*British Journal of Photography Annual*, London 1968, 1969, 1971, 1972, 1973, 1974; *Popular Photography Annual*, New York 1972; *The History of Photography in the 20th Century* by Petr Tausk, London 1980; articles—"Bryn Campbell: Picture Portfolio" in *Camera* (Lucerne), June 1963; "Professional Photography '71" by Ainslie Ellis in *British Journal of Photography* (London), 9 April 1971; "Death of a President" by Philippe Barraud in *Schweizerische Photorundschau* (Visp, Switzerland), October 1971; "Bryn Campbell: Portfolio" in *Photo* (Paris), July 1972; "Exploring Photography" by Ainslie Ellis in *British Journal of Photography* (London), 27 October 1978; "Bryn Campbell: Portfolio" in *You and Your Camera* (London), 1 November 1979.

I seem to have run two parallel careers, as a photographer and as an editor/critic of photography.

In my work as a photo-journalist, I have always tried to be as alert to shape as to incident and I always look for a simple, direct image. I add to the satisfaction I get from my professional activities by being constantly involved in long-term personal projects.

Most of my work has a strong documentary bias, but for the last 17 years I have also been fascinated by images that convey impressions rather than information. This curiosity has taken up much of my time in the last 4 years, and I have concentrated my experiments in the field of colour. Purely abstract compositions did not appeal to me, but I did enjoy exploring the borderline between the abstract and the representational. I wanted to see how far one could take an image before it became too vague and lost the tension of its basic shape. Then I realized that colour held the form together long after other detail had disappeared.

That is at the heart of my present preoccupation, pushing the colour image to that point beyond which its sense and structure disintegrates.

My tastes in photography are very catholic, and I am in debt to so many people for the pleasure their pictures have brought me. As an editor, I enjoy sharing this work and this enthusiasm for photography with others.

—Bryn Campbell

Bryn Campbell is best known as one of the leading British photo-journalists, but in fact his work and interests are much wider than such a categorization suggests. His work as picture editor on *The Observer* and his previous editorial work on magazines led the way to his writing and broadcasting on photography, which reflect a wide interest, appreciation and understanding of his subject.

Campbell's early black-and-white photographs, whether concerned with major news events such as Nasser's funeral or the more intimate tragedy of a child victim of leukemia, always reflect his real sense of concern for the people he photographs and his understanding of situations. They can be seen equally in his occasional sports photographs and portraits and are most often expressed in an individual picture of great strength that can sum up an event. Strong composition combined with clear and contrasting tones in the printing and a compassionate and close look at his subjects characterize his work; it shows always the emotion of his reaction as well as that of the people he photographs. His is the best kind of subjective camera work—no distance or coldness or feeling of alienation is found in these pictures. It is truly a concerned view of the world and a love of humanity that make the best of these pictures memorable.

Campbell has, over the past few years, worked more in colour in his general reportage assignments. He has also been concerned with a search for what he calls "the imprecise image": how photographs by the physical nature of the images can convey impressions rather than information has fascinated him for 20 years. About 5 years ago his casual experiments with blur, over-exposure, massive enlargement, etc., became more concentrated and involved entirely with colour. While purely abstract images did not interest him, he was fascinated by the borderline between the abstract and the representational. He wanted to see how far one could take an image before it became too vague and lost the tension of its basic shape. Because he realized that colour was sustained long after other detail had disappeared, he began a series of pictures which are now part of an ongoing project and explore the point at which colour alone can hold the sense and structure of a picture together. It is an obsession with shape and with colour in purely photographic terms, and one that is producing some very beautiful and satisfying results.

—Sue Davies

CAPA, Cornell.

American. Born Kornel Friedmann in Budapest, Hungary, 10 April 1918; emigrated to the United States, 1937: naturalized, 1943. Educated at the Imre Madacs Gymnasium, Budapest, 1928-36; studied French, Alliance Francaise, Paris, 1936-37. Served in a Photo-Intelligence unit in the United States Air Force, 1941-45: Sergeant. Married Edith Schwartz in 1940. Worked as a photo-printer, with his brother Robert Capa, *q.v.*, Paris, 1936; photographer, adopting the name "Capa," with PIX Inc. photo agency, New York, 1936-37; photo-printer with *Life* magazine, New York, 1937-41; Staff Photographer, 1946-54, and Contributing Photographer, 1955-67, *Life* magazine. Photographer with Magnum Photos co-operative agency, Paris and New York, since 1955; Executive Director, International Center of Photography, New York, since 1974. Founder, Robert Capa/David Seymour Photographic Foundation, Israel, 1958-66; Founder-Director,

Bischof/Capa/Seymour Memorial Fund, New York, 1966-74. Recipient: American Newspaper Guild Citation, 1956; Overseas Press Club Citation, 1956; Photo-Journalism Award, 1968, and Honor Award, 1975, American Society of Magazine Photographers; Mayor's Award of Honor, City of New York, 1978. Agent: Magnum Photos, 2 rue Christine, 75006 Paris, France, and 251 Park Avenue South, New York, New York 10010. Address: 275 Fifth Avenue, New York, New York 10016, U.S.A.

Individual Exhibitions:

1974 *Margin of Life*, Center for Inter-American Relations, New York (travelled to the Johnson Museum, Ithaca, New York, and Amarillo Art Center Association, Amarillo, Texas)

Selected Group Exhibitions:

1951 *Memorable Life Photographs*, Museum of Modern Art, New York
1960 *The World as Seen by Magnum*, Lever House, New York (toured Japan, the United States, and Europe)
1963 *John F. Kennedy: In Memoriam*, Library of Congress, Washington, D.C. (toured under the auspices of the United States Information Agency)
1966 *Adlai E. Stevenson*, Hallmark Gallery, New York (toured the United States)
1973 *Jerusalem: City of Mankind*, Israel Museum, Jerusalem (toured the United States and Europe)
1977 *Fotografische Kunstlerbildnisse*, Museum Ludwig, Cologne
1980 *Photography of the 50's*, Center for Creative Photography, University of Arizona, Tucson (toured the United States and Europe)

Collections:

Museum of Modern Art, New York; International Center of Photography, New York; Israel Museum, Jerusalem.

Publications:

By CAPA: books—*Retarded Children Can Be Helped*, with text by Maya Pines, New York 1957; *Through the Gates of Splendor*, with text by Elisabeth Elliot, New York 1957; *Savage My Kinsman*, with text by Elisabeth Elliot, New York 1959; *Let Us Begin*, photographic editor, New York 1961; *Farewell to Eden*, with text by Matthew Huxley, New York 1964; *The Emergent Decade of South American Painting*, with text by Thomas Messer, New York 1966; *The Andean Republics*, with Time-Life editors, New York 1966; *Adlai E. Stevenson's Public Years*, with text by Adlai E. Stevenson, New York 1966; *Swift Sword*, with others, New York 1967; *The Concerned Photographer*, editor, 2 volumes, New York 1969, 1972; *New Breed on Wall Street*, with text by Martin Mayer, New York 1969; *Israel: The Reality*, editor, New York 1959; *Behind the Great Wall of China*, editor, New York 1972; *Language and Faith*, New York 1972; *Margin of Life*, with text by J. Mayone Stycos, New York 1974; *Jerusalem: City of Mankind*, editor, New York 1974; *ICP Library of Photographers*, editor, 6 volumes, New York 1974; articles— "Cornell Capa: An Interview," with Ruth Spencer, in *British Journal of Photography* (London), 29 October 1976; "Cornell Capa" in *Interviews with Master Photographers* by James Danziger and Barnaby Conrad III, New York and London 1977.

On CAPA: books—*Memorable Life Photographs*, with text by Edward Steichen, New York 1951; *Life Photographers: Their Careers and Favorite Pictures*, edited by Stanley Rayfield, New York 1957; *America in Crisis: Photographs for Magnum*, edited by Charles Harbutt and Lee Jones, with an essay by Michael Levitas, New York 1969; *Fotografische Kunstlerbildnisse*, exhibition catalogue, by Dieter Ronte, Evelyn Weiss and Jeane von Oppenheim, Cologne, 1977; *Geschichte der Fotografie im 20. Jahrhundert/Photography in the 20th Century* by Petr Tausk, Cologne 1977, London 1980; *Great Photo Essays from Life*, edited by Maitland Edey, Boston 1978; articles—"Cornell Capa l'Universal" in *Photo* (Paris), June 1968; "ICP: Photography's Fabulous New Center" by Harvey Fondiller in *Popular Photography* (New York), April 1975; "International Center of Photography" in *Minolta Mirror* (Tokyo), 1976; "Ten Year Odyssey of Cornell Capa" by Michael Edelson in *Camera 35* (New York), March 1978; "Lighthouse of Photography" by Richard Whelan in *Art News* (New York), April 1979; "Photo Visite Venise 1979" in *Photo* (Paris), August 1979; "The Concerns of Cornell Capa" by Norman Schreiber in *Camera Arts* (New York), November/December 1980.

Single photographs are not representative of what I do best. My most effective work is groups of photographs which hang together and tell stories. My pictures are the "words" which make up "sentences" which, in turn, form the story. Just as words by themselves, removed from context, are seldom at their most meaningful, so it is with many of my photographs—singly, they do very little. I am not a maker of images which are to be enjoyed by the

Cornell Capa: *Honduras* from the *Margin of Life*, 1973

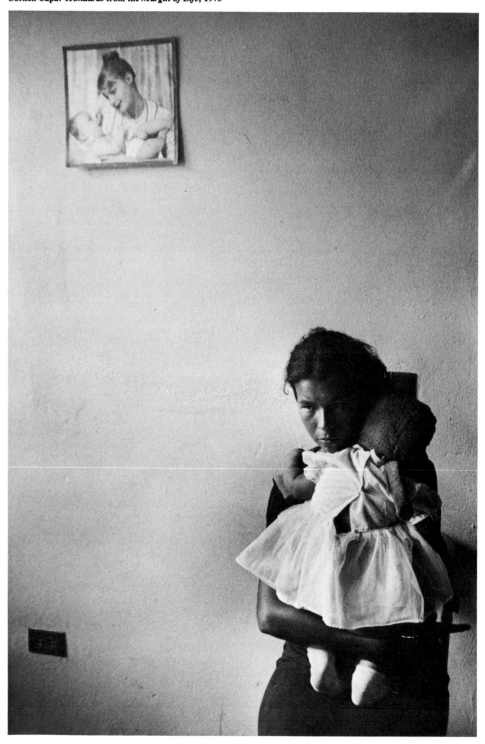

viewer for their purely aesthetic value. I hope that as often as possible my pictures have feeling, composition, and sometimes beauty—but my preoccupation is with the story and not with attaining a fine art level in the individual pictures. If I work well, my pictures mean something when they are connected in story form. And the images, by being connected, seem to gain in editorial impact and visually as well.

It took me some time to realize that the camera is a mere tool, capable of many uses, and at last I understood that—for me—its role, its power and its duty are to comment, describe, provoke discussion, awaken conscience, evoke sympathy, spotlight human misery and joy which otherwise would pass unseen, un-understood and unnoticed. I have been interested in photographing the everyday life of my fellow humans and the commonplace spectacle of the world around me, and in trying to distill out of these their beauty and whatever is of permanent interest.

The greatest joy that the camera has given me is my gained capacity to see. The next gain is that I can "be there" where things are going on and have the opportunity to partake. It also gives me a central seat in front (and, more importantly, a backstage vantage point as well) of the Greatest Spectaculars that man has created to impress others. It has given me rich opportunities to be one with fellow human beings of all varieties in their hours of trial and triumph. Thus I can live a thousand lives during my lifetime. Finally, there is the satisfaction of showing others what experiences I have gone through.

Today, so many pictures are being taken that no one is really interested in what has gone on before. Man's witness of his own times dies with him. Added to that, the technological advances in camera design have made photography seem easy. It has become so popular—so used and abused—that, because of its popularity, it is in danger of losing its own self-respect as well as the trust and confidence of viewers in its veracity and artistry.

The Fund (for Concerned Photography and *The Concerned Photographer* exhibit and book) is dedicated to the recognition of photography as a very personal means of communication, to the recognition of the photographer as an individual with his very own recognizable graphic style and human content, who translates what he sees into frozen reality. The resulting images bear the photographer's own respect for the truth. They also reveal his appreciation of the aesthetic values for light and form, and his artistic concepts of composition.

The Fund has dedicated itself to encouraging and assisting photographers of all ages and nationalities who are vitally concerned with their times. It aims not only at finding and helping new talent, but also at uncovering and preserving valuable and forgotten archives and presenting them to the public.

There are many concerned photographers all over the world whose work will provide the visual history of our century—the first century of which such a documentation will exist. In carrying out a program of documentation of "Man in His World," recovering the perishable past documents, and in capturing our rapidly changing present, the concerned photographer finds much in the present unacceptable, which he tries to alter.

—Cornell Capa

Cornell Capa photographs people. He photographs them when their empty bellies are filled with promises, with expectant wishes. He shows us leaders who parade, crowds that flood barricades, schoolrooms, demonstrators, priests, police. Usually photographing in bold black-and-white, he often uses crashing angles to emphasize a grainy black, while sections in these photographs rebound with glaring lights. Capa grabs viewers. Sometimes he enlarges the image of a foreground figure, making that figure devour a picture's frontal plane to encroach on a picture's total space—especially if the space is filled with people narrowing into a sharply angular, perspectively-reached vanishing point. He did this

when photographing Adlai Stevenson waving to a crowd from the rear of a train during the 1952 presidential campaign, the camera in back of Stevenson as Stevenson faced the crowd, his head and shoulders pre-empting the frontal space as viewers looked beyond him into the crowd converging on the horizon line with the train tracks. Twenty years later when Capa photographed a crowd marching through a Bolivian street, foreground figures cried out as they marched towards the viewers, their cries emphasized by the camera's light, all as torchlights simmered in the surrounding dark and angles faded in back of them to punctuate the figures' anguish. These 1970's figures no longer encroached on the picture's space. They took it over, their grainy black movements emphasized by light. Capa's photographs glow with the power that the living produce. Don't try to find the beauty of the human condition in Capa's photographs. Don't look for intimate personal touches. Capa's photographs are of the power the living can produce.

Sometimes that power spills with laughter, as it did in a toast that a mixed religious group of four offered in Jerusalem, the ceiling's whitened pattern swirling behind the four, they in their blackened robes as the camera, from its deep perch below them, enhanced their image against the ceiling's swirls. Sometimes that power marches across the picture's space as it does in a Jerusalem iron sculpture which mastered the picture's frontal plane with grid-like strength and revealed a lightened building set in the distance behind the sculpture's spaces. Bold blacks, set against whites, dominate so many of Capa's pictures, while foregrounds and backgrounds—each fully employed—work to focus on the living. It's not a generalized "life" Capa is after. It's the dynamic, explosive force of the living that snares him...and that he, in turn, brings to his viewers.

When he portrays people—and I am thinking of a beautiful portrait of a woman in San Salvador—he works from the same ideas and extends the same principles. A deepened silky black profile becomes the foreground. But more, it is framed by a halo of light, that delicate band outlining the profile against a darkened background, while her hand—held to her head—and the clothing which falls diagonally across her body—and the picture plane—use a slightly richer light to reveal a human texture in a grim world. That light is marginal. So is the human texture. This is just as Capa would have it. Bold visual statements need to be made about the living.

Capa's photographs contain very few grays. Gray is much too indiscriminate. Capa is looking for clear statements. Even when he took color photographs—as he did for much of his professional career as a photographer with *Life*—he reached for heightened color and stark emotional impact. Reds, especially on a rich woman's dress, dazzle his viewers, while glittering black velvets worn by cigar-smoking politicos, sharpen his viewer's perception. Avoiding middling tonalities, Capa avoids the world of middling thoughts. For not only do Capa's photographs tell us about the living, and the power the living can produce, but they also tell us about the drive the living possess once they strip indecisiveness away. Capa's photographs are clarion calls to the living as they are clear direct statements about the living.

—Judith Mara Gutman

CAPA, Robert.
American. Born André Friedmann in Budapest, Hungary, 22 October 1913; emigrated to the United States, 1939: naturalized, 1954. Educated at the Imre Madács Gymnasium, Budapest, 1923-31; studied political science at Berlin University, 1931-33; self-taught in photography. Photographer from 1930: worked as a darkroom assistant for Ullstein Enterprises, Berlin, 1931, and as a photographic assistant at Dephot (Deutsche Photodienst) co-operative press agency, Berlin, 1932-33; freelance photographer, adopting the name "Robert Capa," Paris, 1933-39, and in New York, 1939-41; War Correspondent for *Life* magazine, New York, with the United States Army in Europe, 1941-46 (awarded United States Medal of Freedom, 1947); Founder, with Henri Cartier-Bresson, David Seymour, and George Rodger, 1947, and President, 1948 until his death in 1954, Magnum Photos co-operative agency, Paris and New York; served as Temporary War Correspondent for *Life* in Indo-China, and was killed there, 1954 (awarded French Croix de Guerre with Palm, 1954). Recipient: George Polk Memorial Award, 1954; American Society of Magazine Photographers Award, 1955. Robert Capa Gold Medal Award, established by the Overseas Press Club of America and *Life* magazine, 1955, and awarded annually since then; International Fund for Concerned Photography (formerly Capa/Seymour Photographic Foundation, then Bischof/Capa/Seymour Memorial Fund), established by Julia F. Capa, Eileen Schneiderman, Rosellina Burri-Bischof, and Cornell Capa, 1958. Member, Photography Hall of Fame, Photographic Art and Science Foundation, 1976. Agent: Magnum Photos, 2 rue Christine, 75006 Paris, France, and 251 Park Avenue South, New York, New York 10010, U.S.A. *Died* (in Thai-Binh, Indo-China) *25 May 1954.*

Individual Exhibitions:

1952 *On Picasso*, Museum of Modern Art, New York (with Gjon Mili)
1960 *War Photographs*, Smithsonian Institution, Washington, D.C. (and world tour, 1960-65)
1964 *Images of War*, Smithsonian Institution, Washington, D.C.
1966 *A Magyar Fotomüvészet 125-év*, Magyar Nemzeti Galéria, Budapest

Selected Group Exhibitions:

1951 *Memorable Life Photographs*, Museum of Modern Art, New York
1955 *The Family of Man*, Museum of Modern Art, New York (and world tour)
1956 *Magnum Photographers*, at *Photokina '56*, Cologne
1960 *The World as Seen by Magnum*, Lever House, New York (toured Japan, the United States and Europe)
1967 *The Concerned Photographer*, Riverside Museum, New York (toured the United States, Europe and Japan, 1967-71)
1968 *Israel: The Reality*, Jewish Museum, New York
1972 *The Eye as a Profession*, RAI Corporation, Turin
1974 *The Classics of Documentary Photography*, International Center of Photography, New York
1978 *Tusen och en bild*, Moderna Museet, Stockholm
1981 *Spain: 1936-1939*, International Center of Photography, New York

Collections:

Metropolitan Museum of Art, New York; Museum

of Modern Art, New York; Hallmark Gallery, New York; International Center of Photography, New York; International Museum of Photography, George Eastman House, Rochester, New York; Rose Art Museum, Amherst, Massachusetts; Smithsonian Institution, Washington, D.C.; National Gallery of Art, Washington, D.C.; Bibliotheque Nationale, Paris; Museum of Decorative Arts, Prague.

Publications:

By CAPA: books—*Death in the Making*, with Gerda Taro, New York 1937; *The Battle of Waterloo Road*, with Diana Forbes-Robertson, New York 1943; *Slightly Out of Focus*, New York 1947, Tokyo 1956; *The Russian Journal*, with John Steinbeck, New York 1948; *Report on Israel*, with Irwin Shaw, New York 1950; *Images of War*, New York 1964, Milan and Dusseldorf 1965, Paris 1966; articles—"Conversation in Budapest" in *Holiday* (New York), November 1949; "The Queen and I" in *Holiday* (New York), November 1951; "No-nights in Norway" in *Holiday* (New York), September 1952.

On CAPA: books—*Memorable Life Photographs*, with text by Edward Steichen, New York 1951; *Life Photographers: Their Careers and Favorite Pictures*, edited by Stanley Rayfield, New York 1957; *Photography in the 20th Century* by Nathan Lyons, New York 1967; *Twelve at War* by Robert E. Hood, New York 1967; *Robert Capa*, edited by Anna Farova, New York 1968; *The Concerned Photographer*, edited by Cornell Capa, New York 1969; *Israel: The Reality*, edited by Cornell Capa, New York 1969; *Behind the Great Wall of China*, edited by Cornell Capa, with an introduction by Weston Naef, New York 1972; *ICP Library of Photographers: Robert Capa 1913-1954*, edited by Cornell Capa, New York 1974; *Front Populaire*, edited by Chêne/Magnum, Paris 1976; *Geschichte der Fotografie im 20. Jahrhundert/Photography in the 20th Century* by Petr Tausk, Cologne 1977, London 1980; *Tusen och en bild*, exhibition catalogue, by Ake Sidwall, Sune Jonsson and Ulf Hard af Segerstad, Stockholm 1978; *Robert Capa* by Romeo Martinez, Milan 1979; *Life: The First Decade 1936-1945* by Robert Littman, Ralph Graves and Doris C. O'Neill, New York 1979, London 1980; *Les Grandes Photos de la Guerre d'Espagne*, with text by Georges Soria, Paris 1980; articles—"Magnum Photos" by John G. Morris in *U.S. Camera Annual*, New York 1954; "Robert Capa: A Memorial Portfolio" by John Steinbeck and H.M. Kinzer in *Popular Photography* (New York), September 1954; "Magnum" by Byron Dobell in *Popular Photography* (New York), September 1957; "A Man Named Capa" in *Saga* (New York), February 1958; "A War Memorial" by Margaret R. Weiss in *Saturday Review* (New York), 6 June 1964; "The Concerned Photographer," special issue of *Contemporary Photographer* (Culpepper, Virginia), no. 2, 1968; "Bob Capa inedito" in *Fotografia Italiana* (Milan), June 1972; "Moment of Truth" by Arthur Goldsmith in *Camera Arts* (New York), March/April 1981.

Robert Capa, né Andre Friedmann, became one of the most celebrated war photographers through a chain of coincidences beginning in his native Hungary. Having been introduced to the camera by a comely daughter of a next-door neighbor in his Budapest home, he became infatuated with photography. As a young man he was already politically acute, part of a generation of European students who grew up under dictatorship and found it intolerable. When he was caught in a demonstration, at age 18, against Regent Horthy, he was summarily banished from Hungary (to his family's relief; they feared a harsher punishment).

His first photographic assignment was also a fortuitous accident. He was working as a darkroom

assistant in Berlin, all the photographers were out covering other stories, when the editor wanted someone to go to Copenhagen to photograph Trotsky giving a speech at a political rally. Press photographers were barred from the event, but young André entered the meeting hall by joining some carpenters who were carrying a ladder. His recently invented 35mm camera (a Leica) was under his leather jacket. (It was the beginning days of photo-journalism as we know it today.) Once inside the hall, he unobtrusively took a photograph of Trotsky that caught the charismatic intensity and political zeal of the man. It was used in his first published story (*Berliner Illustrierte Zeitung*, 1931) and had all the markings of Capa's life work— "superlative photography requiring exceptional courage and enterprise."

His photographic career launched, he joined the photo agency Dephot where he worked from 1932-33 while attending political science courses at Berlin University. All of this ended with Hitler's rise to power. By 1935, he was in Paris where he met Gerda Pohorylles, a German expatriate, politically sharp, spirited and charming, and Capa fell in love with her. Gerda wrote the text for his stories, and sold them to magazines as the work of a talented rich American photographer, Robert Capa. Capa's photographs were easier to sell at high prices than the photographs of André Friedmann, an impoverished Hungarian.

Gerda borrowed the name of a Japanese artist—Taro—then living in Paris, and at that time Gerda Taro and Robert Capa went to Spain where Capa took his most dramatic single photograph. This photograph of a falling Loyalist soldier brought him overnight fame.

In July 1937, Gerda was crushed by a tank in the confusion of retreat at Brunete; she was 26 years old. Capa was inconsolate, and his personal anguish turned into a lifelong commitment to her memory as well as to the documentation of wars yet to come. When *Death in the Making* was published, the dedication read, "For Gerda Taro, who spent one year at the Spanish front, and who stayed on. R.C."

From 1941-45, he photographed the Second World War in the European theater as a correspondent for *Life* and *Collier's* magazines. One of his most moving essays was entitled "The Mothers of Naples" (1943). In the faces of these women, whose sons have been killed, one sees an unbearable agony, one of the legacies of war.

In a memorial tribute (*Popular Photography*, September 1954), John Steinbeck was to write:

Capa's pictures were made in his brain— the camera only completed them. You can no more mistake his work than you can the canvas of a fine painter. Capa knew what to look for and what to do with it when he found it. He knew, for example, that you cannot photograph war because it is largely an emotion. But he did photograph that emotion by shooting beside it. He could show the horror of a whole people in the face of a child. His camera caught and held emotion.

Capa rarely took a photograph without a human figure. A few were taken during the Spanish Civil War: the demolished doorfront of the Cafe de Madrid, a bombed-out room with the focus on a photograph of a young couple, and a propeller used as a marker at a German pilot's grave site in North Africa. They underscore the human drama that is ever present in his photographs, and cannot simply be seen as pleasing shapes or forms that caught his fancy.

On D-day, Capa landed at Normandy with the first invasion, and wrote:

I would say that the war correspondent gets more drinks, more girls, better pay, and greater freedom than the soldier, but that at

this stage of the game, having the freedom to choose his spot and being allowed to be a coward and not be executed for it is his torture. The war correspondent has his stake—his life—in his own hands, and he can put it on this horse or that horse, or he can put it back in his pocket at the very last minute. I am a gambler. I decided to go in with Company E in the first wave.

Out of the 106 pictures he was able to take, only 8 were salvaged by the excited darkroom assistant who turned on too much heat and melted the emulsions on the developed film.

Looking at these photographs Capa was later to say, "If your pictures aren't good enough, you aren't close enough." They are blurred and grainy, but they have the quality of immediacy, photographs by a participant taking his chances, on the run in the midst of action. It was not easy, and he was to write very tellingly about the dilemma of the photojournalist:

The last man to leave the plane was the pilot. He seemed to be all right except for a slight gash on his forehead. I moved to get a close-up. He stopped midway and cried, "Are these the pictures you were waiting for, photographer?" I shut my camera and left for London with those successfully exposed rolls in my bag. I hated myself and my profession. This sort of photography was only for undertakers, and I didn't like being one. If I was to share the funeral, I swore, I would have to share the procession.

Next morning, after sleeping it over, I felt better. While shaving I had a conversation with myself about the incompatibility of being a reporter and hanging onto a tender soul at the same time. The pictures of the guys sitting around the airfield without the pictures of their being hurt and killed would have given the wrong impression. The pictures of the dead and wounded were the ones that would show people the real aspect of war, and I was glad I had taken that one roll before I turned soppy.

At the conclusion of the Second World War, Capa wrote: "I am very happy to become an unemployed war photographer, and I hope to stay unemployed as a war photographer till the end of my life." And for a while, he remained unemployed as a war photographer, living in Paris and spending short good times with Picasso, Hemingway, Steinbeck and other artist friends. He took intimate photographs and wrote amusing texts for *Holiday* magazine, which ran his written bylined stories with a notation "photographs by the author."

In 1947, with his prewar Paris friends, David Seymour ("Chim"), Henri Cartier-Bresson, George Rodger, and Bill Vandivert, he created a new kind of picture agency named Magnum after the two quart bottle of sparkling spirits that characterised their lives. It was a cooperative owned and operated by the photographers, and as Cartier-Bresson has said, "Everybody had full liberty. There was no doctrine, no school. But there was something which united us all very strongly—I can't define it; it may have been a certain feeling of respect for reality."

In 1954, Capa was invited to Japan where he has since become a major romantic figure. Friends from his Paris days in 1937 asked him to show an exhibit of his own work and to take on a photographic project of his won choice for the Mainichi newspaper. While there, he received a call from *Life* magazine asking him to temporarily replace another photographer who was called home due to a family illness. Capa was asked to take the assignment. At first he resisted, but then finally decided to take it on. Walking with a column of soldiers in Thai-Binh on May 25 at 2:55 p.m., Capa stepped on a land

Robert Capa: *Mothers of Naples,* **1943**

mine. The Vietnamese lieutenant said, "*Le photographe est mort.*" He was the first American correspondent to be killed in what was to become known as the "American involvement in Vietnam."

In a farewell tribute to Capa, Louis Aragon wrote: "This young man, full of courage and inexhaustible energy, was found wherever fighting was going on. War fascinated him, attracted him. He raced through the world as though he felt obliged to capture the narrow border between life and death forever on his camera."

Robert Capa created a testament against war with his photographs and with his life. He proved, in Steinbeck's words, "that the camera need not be a cold mechanical device. Like the pen, it is as good as the man who uses it. It can be the extension of mind and heart."

—Anna Winand

CAPONIGRO, Paul.

American. Born in Boston, 7 December 1932. Educated at high school in Boston, 1946-50; studied piano, College of Music, Boston University, 1950-51; studied photography, with Benjamin Chin and Alfred W. Richter, at California School of Fine Arts, San Francisco, 1956, and with Minor White, at Rochester Institute of Technology, New York, 1957-58. Served as photographer in the United States Army, 1953-55. Married Eleanor Morris in 1964; son: John Paul. Worked as apprentice in commercial photographic studio, Boston, 1952; freelance photographer since 1955, resident in Santa Fe, New Mexico, since 1973. Photo-Research Consultant, Polaroid Corporation, Cambridge, Massachusetts, from 1960. Teaching Assistant, with Minor White, Summer Photographic Workshops, San Francisco and Portland, Oregon, 1959; Visiting Instructor in Photography, at numerous colleges and workshops throughout the United States, including Boston University, 1960, St. Lawrence University, Canton, New York, 1966-71, New York University, 1967-70, and Yale University, New Haven, Connecticut, 1970-73. Founder-Member, Association of Heliographers, New York, 1963. Recipient: First Prize for Photography, *10th Boston Arts Festival*, 1961; Guggenheim Fellowship, 1966, 1975; National Endowment for the Arts Photography Fellowship, 1971, 1974; Art Directors Club of New York Award, 1974; National Endowment for the Arts Grant, 1975. Address: Route 3, Box 96D, Santa Fe, New Mexico 87501, U.S.A.

Individual Exhibitions:

1958 *In the Presence Of*, International Museum of Photography, George Eastman House, Rochester, New York
1960 Carl Siembab Gallery, Boston
Image Study, Boston University
Limelight Gallery, New York (with Minor White)
1962 Wellesley Free Library, Massachusetts
Creative Arts Center, University of New Hampshire, Durham
1963 A Photographer's Place, Philadelphia
Carl Siembab Gallery, Boston
1965 Gallery 216, New York
1968 Garik Gallery, Philadelphia
Museum of Modern Art, New York (toured the United States)
Creative Arts Center, University of New Hampshire, Durham
Phoenix College, Arizona
Carl Siembab Gallery, Boston

University of Louisville, Kentucky
1969 Focus Gallery, San Francisco
Friends of Photography, Carmel, California
Pine Manor Junior College, Chestnut Hill, Connecticut
Smith College, Northampton, Massachusetts
State College, Fitchburg, Massachusetts
1970 Princeton University, New Jersey
San Francisco Museum of Art
Bathhouse Gallery, Milwaukee
1971 Baldwin Street Gallery, Toronto
Image Gallery, Stockbridge, Massachusetts
Perspective Gallery, Poughkeepsie, New York
State University of New York at New Paltz
Wooster School, Danbury, Connecticut
1973 Art Institute of Chicago
University of Maryland, Baltimore
1974 Springfield Museum of Fine Art, Massachusetts
Lakeview Center for the Arts and Sciences, Peoria, Illinois
1975 Victoria and Albert Museum, London
Friends of Photography, Carmel, California (with Abigail Heyman)
Robbins Library Gallery, Arlington, Massachusetts
1976 Cronin Gallery, Houston
G. Ray Hawkins Gallery, Los Angeles
Albright-Knox Art Gallery, Buffalo, New York
Columbia College, Chicago
Paul Caponigro/Edward Weston/Derek Bennett, Silver Image Gallery, Tacoma, Washington
Carl Siembab Gallery, Boston
Museum of Fine Arts, Santa Fe, New Mexico
Douglas Kenyon Gallery, San Francisco
1977 David Mirvish Gallery, Toronto
1981 *Stonehenge*, Galerij Paule Pia, Antwerp
Photography Gallery, La Jolla, California

Selected Group Exhibitions:

1960 *The Sense of Abstraction in Contemporary Photography*, Museum of Modern Art, New York
1962 *10 Photographers*, Schuman Gallery, Rochester, New York
1963 *The Photographer and the American Landscape*, Museum of Modern Art, New York
1964 *The Photographer's Eye*, Museum of Modern Art, New York
1967 *Photography in the 20th Century*, National Gallery of Canada, Ottawa (toured Canada and the United States, 1967-73)
1972 *4 Directions in Modern Photography: Paul*

Paul Caponigro: *Brewster, New York,* 1963 Courtesy Art Institute of Chicago

Caponigro, John T. Hill, Jerry N. Uelsmann, Bruce Davidson, Yale University Art Gallery, New Haven, Connecticut
1974 *American Masters*, Smithsonian Institution, Washington, D.C.
Photography in America, Whitney Museum, New York
1975 *14 American Photographers*, Baltimore Museum of Art (travelled to the Newport Harbor Art Museum, California, and La Jolla Museum of Contemporary Art, California, 1975; and Walker Art Center, Minneapolis, and Fort Worth Art Museum, Texas, 1976)
1978 *Mirrors and Windows*, Museum of Modern Art, New York (toured the United States, 1978-80)

Collections:

Metropolitan Museum of Art, New York; Museum of Modern Art, New York; International Museum of Photography, George Eastman House, Rochester, New York; Fogg Art Museum, Harvard University, Cambridge, Massachusetts; Art Institute of Chicago; Target Collection of American Photography, Museum of Fine Arts, Houston; Center for Creative Photography, University of Arizona, Tucson; National Gallery of Canada, Ottawa; Victoria and Albert Museum, London; Bibliothèque Nationale, Paris.

Publications:

By CAPONIGRO: books—*Portfolio One*, portfolio of 12 photos, Redding, Connecticut 1960; *The Music of Willem Nyland*, New York 1963, 1964; *Paul Caponigro*, Millerton, New York 1967, revised edition 1972; *Portfolio Two*, portfolio of 8 photos, Redding, Connecticut 1973; *Sunflower*, New York 1974; *Landscape: Photographs by Paul Caponigro*, New York 1975; *Portfolio Three: Stonehenge*, portfolio of 12 photos, Santa Fe, New Mexico 1977.

On CAPONIGRO: books—*American Photography: The 60's*, Lincoln, Nebraska 1966; *The Photographer and the American Landscape*, exhibition catalogue, by John Szarkowski, New York 1963; *The Photographer's Eye* by John Szarkowski, New York 1966; *Photography in the 20th Century* by Nathan Lyons, New York 1967; *Photographie Nouvelle des Etats-Unis* by John Szarkowski, Paris 1969; *Photography in America*, edited by Robert Doty, with an introduction by Minor White, New York and London 1974; *The Magic Image* by Cecil Beaton and Gail Buckland, London and New York 1975; *Photographs: Sheldon Memorial Art Gallery Collection, University of Nebraska*, with an introduction by Norman A. Geske, Lincoln 1977; *Mirrors and Windows: American Photography since 1960* by John Szarkowski, New York 1978; *The Photograph Collector's Guide* by Lee D. Witkin and Barbara London, Boston and London 1979; articles—"Discovery No. 44: Paul Caponigro" by Patricia Caulfield in *Modern Photography* (New York), August 1959; "Paul Caponigro" by Herb Snitzer in *Contemporary Photographer* (Culpeper, Virginia), Spring 1963; "Paul Caponigro" by Matt Herron in *Contemporary Photographer* (Culpeper, Virginia), Summer 1963; "Camera Notes: Caponigro and Heath at Heliography" in the *New York Times*, 12 April 1964; "New York: Paul Caponigro, Museum of Modern Art" by Emily Wasserman in *Artforum* (New York), January 1969; "Paul Caponigro" in *Camera* (Lucerne), January 1973; "Paul Caponigro: Portrait of Nature" by Peter C. Bunnell in *Modern Photography* (New York), December 1973; "Caponigro and Heyman" by Joan Murray in *Artweek*

(Oakland, California), 23 August 1975; "Caponigro's Sense of Site" by Margaret R. Weiss in *Saturday Review* (New York), 15 May 1976; "Caponigro: A Respect for the Activities of Existence" by Rolf Koppel in *Santa Fe Reporter* (New Mexico), 28 October 1976.

"My concern" as a photographer, writes Paul Caponigro, is "to maintain, within the inevitable limitations of the medium, a freedom which alone could permit contact with the greater dimension—the landscape behind the landscape." He has relentlessly pursued his passion to capture in silver "the elusive image of nature's subtle realms." Caponigro's mastery and subtlety in the area of nature photography are distinctive and remarkable. There is a kind of lyrical profundity that sustains his imagery which in tone and composition display his very own style and attitude. Not so much the grandeur and majesty of nature, but the subtle harmonies and mysterious nuances are evoked in his photographs; these simultaneously being corresponded with the inner dimensions of human beinghood.

The striking element in these photographs of nature is the unromantic, un-idealized, undramatic evocation and realization that Caponigro so masterfully conveys. His images are not statements, not messages—only hints, evocations, visual notations of states of being. As one is drawn to see the specific objects in a particular image, one is instantly stirred to see into and beyond them—be they sunflower, cabbage leaf, a stone-house, running white deer, snowflakes on windowpanes, rocks, or trees. A sense of waiting—time destroyed—pervades. No foreground or background, each image presents itself with a kind of austerity and starkness nuanced by subtle rhythms.

Caponigro's photographs are not metaphors or symbols attempting to propound metaphysical concepts or ideas. They are more like epiphanic revelations of the inherent nature of things and being. The pictures of the monuments of Stonehenge as well as of the Japanese shrines among his recent work demonstrate this quality.

Caponigro is a fastidious artist. His distinctive strength lies in the tonal quality of his images. Not given to contrast or light-and-shadow play, he uses the material and medium essentially through an amazing control and subtlety of tonal values. Here again, his method and the meaning of his imagery are in perfect balance, harmony. Normally, one would get somewhat bored with such tonality. But this does not happen with Caponigro, primarily because of the element of surprise combined with the subtle evocativeness in his images. In this sense, he is innovative in the use of the photographic material and medium and in inspiring viewers in *seeing*.

—Deba P. Patnaik

CARMI, Lisetta.
Italian. Born Annalisa Carmi in Genoa, 15 February 1924. Educated at Gymnasium School, Genoa, until 1938, when, as a Jew, she was disallowed from attending public school; thereafter studied privately; studied piano at the Conservatorio di Milan, and awarded a high school diploma there, 1951; mainly self-taught in photography. Professional pianist and piano teacher, 1952-60; Music Teacher, Italsider workers' music courses, Genoa, 1961-62. Photographer since 1960. Recipient: Niepce Prize, 1966; Cultura nella Fotografia Prize, Milan, 1966; World Book Prize, Leipzig, 1978. Address: Lungoparco Gropallo 4, 16122 Genoa; or Casella 56, 72014 Cisternino (Brindisi), Italy.

Individual Exhibitions:

1964 *Genova Porto*, Società di Cultura, Genoa (travelled to the Circolo Gobetti, Turin, and Società di Cultura, Milan)
1969 *I Travestiti*, at the *Festival dei Popoli*, Florence
1970 *I Travestiti*, at the *Congress of Cultural Anthropology*, Perugia, Italy
1974 *I Travestiti*, Galleria Il Diagramma, Milan
1978 *I Travestiti*, Canon Photo Gallery, Amsterdam (travelled to the Contrejour Gallery, Paris, and to Voir Photogalerie, Toulouse)

Selected Group Exhibitions:

1967 *World Press Photo*, Amsterdam
1968 *Welt Austellung der Photographie*, Hamburg (and world tour)
1974 *Anagrafe di Genova*, at *SICOF*, Milan
1978 *Biennale*, Venice

Publications:

By CARMI: books—*Israele*, with text by Giovanni Russo, Milan 1965; *Ezra Pound*, with text by David Heymann, New York 1968, with text by Eve Hesse, Munich 1978; *I Travestiti*, with text by Elvio Facchinelli, Naples 1972, 2nd edition Milan 1980; *Il Teatro in Italia*, edited by E. Fadini, Turin 1977; *Acque di Sicilia*, with text by Leonardo Sciascia, Bergamo, Italy 1977.

On CARMI: book—*Primo Almanacco Fotografico Italiano*, edited by Lanfranco Colombo and Roberta Clerici, Milan 1969; articles—"I Travestiti" by Marcantonio Muzi Falconi in *Photo 13* (Milan), 1971; "I Travestiti" by Ando Gilardi in *Fototredici* (Milan), 1973; "I Travestiti" by Ferdinando Scianna in *L'Europeo* (Milan), 1973; "I Travestiti" by Sergio Daho in *Zoom* (Milan), 1973; "I Travestiti" by Elvio Fachinelli in *L'Erba Voglio* (Milan), 1974; "Acque di Sicilia" by Ando Gilardi in *Fototredici* (Milan), September 1978; "Acque di Sicilia" by M.C. in *Il Fotografo* (Milan), no. 17, 1978.

Work for me has always been a means of understanding myself as well as being instrumental in my search for truth.

Until the age of 35 I was a pianist. Music was then at the center of my life as an inner guide towards the attainment of a total equilibrium of man and universe.

For the following twenty years, from the age of 35 to 55, I worked as a photographer. From being totally concentrated on the inner life I plunged into the world outside: man in all his expressions and modes of being was my constant interest, taking me to all parts of the world. In this way I discovered the human soul and with it the problems that make our society so rich, fascinating and contradictory.

Today, after several travels to India, where in 1976 I encountered my spiritual master, Babaji, the avatar of the Himalayas, my search for truth continues without intermediaries, so that for the moment I have even abandoned photography. Yet I know that it has been a great help to me, a means to acquire greater knowledge and a new consciousness of life.

—Lisetta Carmi

In the years just after the Second World War Italian photographers declared their intention of using the photograph chiefly to analyze the social realities of their country, the realities that the Fascist regime had preferred to keep hidden during their "20 years," when a mediocre pictorialism was the only

alternative to photographs celebrating the Mussolinian myths—apart, that is, from the experiments of artists like Pagano, Mollino, Vernonesi and a few others within the sphere of the European avantgarde movements, whose work had been reviewed and compared in the pages of the *Fotografia* yearbook published by Domus in 1943.

The photography of the time involved what in the cinema and in literature has been called neo-realism, an ideology characterized by a kind of political imperative to practice a sociological analysis of every sector of society but most of all in the world of the peasant and the laborer, the weakest and most vulnerable. This theme of the "under-privileged" dominated Italian photography between 1948 and the 1960's, a period of excitement and revival; it affected photojournalism and the picture publishing industry, able at last to face up to international competition.

There were a few photographers who opposed this trend (one might say demand) for the sociological documentary (Cavalli, Veronesi, Vender), but they were mostly people who were involved in art photography—though even amongst these photographers there were discussions of the premise that the function of a photographer is as a cultural agent who cannot stand aloof from everyday realities, who must sometimes put considerations of form to one side, even to the point of creating a new aesthetic nourished by the photographic qualities inherent in the "ugly," the "poor," the "under-privileged."

Lisetta Carmi was not a member of the nucleus of neo-realistic photographers; she did not enter photography until the beginning of the 1960's, when the arguments between the supporters of "form" and those of "content" were coming to an end and many of the naive and pretentious ideas and aspirations were being abandoned in favor of a professionalism which, from Patellani to Roiter, Monti to Mulas, has led to a more comprehensive, profitable and functional theory and practice. Lisetta Carmi also fortunately remained outside the realm of "art" photography, even though such photography has been the fundamental—almost the only—"school" in Italy for the training of young photographers. Her visual education had external origins, not only territorially but also culturally; it was the result, too, of an eclectic reading, generally "underground," and of an apprehension that encompassed both the "pop" experiments of a William Klein or a Robert Frank and the rediscovery of the European masters, who for Carmi are Brassaï or Kertész rather than Cartier-Bresson.

Carmi's most important book, the one that made her famous, was *I Travestiti* (*The Transvestites*). The subject of transvestites (taken up later by Warhol) was, at that time (and still is), a particularly controversial one in Italy; Carmi's photography, with its communicative aggressiveness, opens up a world of "outsiders" unknown to many people; her pictures reveal, unveil, that world with great expressiveness but wholly without malice or suggestiveness. "It was all the fruit of inside investigation," she has said, "of a sincere wish to understand and to communicate." And, indeed, for Carmi social research means above all participation and adherence to a reality of which we all, in some way and to some extent, form a part.

Carmi has produced a deeply poetic, deeply affecting account, in pictures of delicacy and understanding, of a world that is normally kept out of sight, a world that many people refuse to see. Basically, and not only from the point of view of postwar European photography, *I Travestiti* is evidence of a lucid capacity to read and transcribe society visually, a capacity confirmed in Carmi's other never uninteresting works.

—Italo Zannier

CARTIER-BRESSON, Henri.

French. Born in Canteloup, Seine et Marne, France, 22 August 1908. Educated at the École Fénelon and Lycée Condorcet, and also studied painting with Cotenet, Paris, 1922-23; studied painting with André Lhote, Paris, 1927-28, and painting and literature at Cambridge University, 1928-29. Served in the French Army, 1930. Married the photographer Martine Franck, *q.v.*, in 1970. Began career as a photographer, 1931; photographer on an ethnographic expedition to Mexico, 1934; freelance photographer, studying film-making with Paul Strand, New York, 1935; Assistant Cameraman, with Jacques Becker and André Zvoboda, to filmmaker Jean Renoir, France, 1936, 1939; worked on documentary films in Spain, 1937; prisoner-of-war, Württemberg, Germany, 1940 until he escaped, 1943; active in the MNPGD (French underground photographic units), 1943-45. Since 1945, freelance photographer in Paris: worked in the United States, 1946; Founder, with Robert Capa, David Seymour ("Chim"), and George Rodger, Magnum Photos co-operative agency, New York and Paris, 1947-66 (Magnum continues to act as his agent); worked in India, Burma, Pakistan, China and Indonesia, 1948-50, in the U.S.S.R., 1954, in China, 1958-59, in Cuba, Mexico, and Canada, 1960, and in India and Japan, 1965; has concentrated on drawing since 1973 (drawings exhibited: Carlton Gallery, New York, 1975; Bischofberger Gallery, Zurich, 1976). Recipient: Overseas Press Club of America Award, 1948, 1954, 1960, 1964; American Society of Magazine Photographers Award, 1953; Prix de la Société Français de Photographie, 1959; Culture Prize, Deutsche Gesellschaft für Photographie. D.Litt.: Oxford University, 1975. Member, American Academy of Arts and Sciences, 1974. Agent: Magnum Photos, 2 rue Christine, 75006 Paris, France.

Individual Exhibitions:

1932 Gallery Julien Levy, New York
Club Atheneo, Madrid
1934 Palacio de Bellas Artes, Mexico City (with Manuel Alvarez Bravo)
1935 *Documentry and Anti-Graphic*, Gallery Julien Levy, New York (with Walker Evans and

Lisetta Carmi: *Babaji, The Avatar of the Himalayas*, 1976

1946 Museum of Modern Art, New York (retrospective)
1952 Institute of Contemporary Arts, London
1954 Art Institute of Chicago
1955 Musée des Arts Décoratifs, Paris (retrospective; toured Europe, Japan, and the United States)
1964 Phillips Collection, Washington, D.C.
1965 Asahi Gallery, Tokyo (retrospective; toured Europe and the United States)
1968 Museum of Modern Art, New York
1970 *En France*, Grand Palais, Paris (and world tour)
1974 International Center of Photography, New York
1978 Fruit Market Gallery, Edinburgh (and Side Gallery, Newcastle-upon-Tyne)
1979 International Center of Photography, New York (retrospective; toured the United States, 1979-82)
Galerie Delpire, Paris
1981 Kunsthaus, Zurich
Colorado Photographic Arts Center, Denver (with Jacques-Henri Lartique)

Selected Group Exhibitions:

1951 *Memorable Life Photographs*, Museum of Modern Art, New York
5 French Photographers: Brassaï/Cartier-Bresson/Doisneau/Izis/Ronis, Museum of Modern Art, New York
1959 *Hundert Jahre Photographie 1839-1939*, Folkwang Museum, Essen (travelled to Cologne and Frankfurt)
1964 *The Painter and the Photograph: From Delacroix to Warhol*, University of New Mexico, Albuquerque
1972 *Behind the Great Wall of China*, Metropolitan Museum of Art, New York
1975 *First International Triennale of Photography*, Fribourg
Documenta 6, Kassel, West Germany
1977 *Concerning Photography*, The Photographers' Gallery, London (travelled to the Spectro Workshop, Newcastle upon Tyne)
1979 *La Photographie Francaise 1925-1940*, Galerie Zabriskie, Paris (travelled to the Zabriskie Gallery, New York)
1980 *Looking for Picasso*, International Center of Photography, New York

Collections:

Bibliothèque Nationale, Paris; Magnum Photos, Paris; Victoria and Albert Museum, London; University of Fine Arts, Osaka, Japan; Museum of Modern Art, New York; International Museum of Photography, George Eastman House, Rochester, New York; Art Institute of Chicago; DeMenil Foundation, Houston (390 photographs).

Publications:

By CARTIER-BRESSON: books—*Images à la Sauvette/The Decisive Moment*, Paris and New York 1952; *Les Danses à Bali*, with text by Antonin Artaud, Paris 1954; *D'Une Chine à l'Autre*, with a preface by Jean-Paul Sartre, Paris 1954, as *China in Transition*, with text by Han Suyin, New York 1956; *Les Européens/The Europeans*, Paris and New York 1955; *Moscow/The People of Moscow*, Paris, London and New York 1955; *China as Photographed by Henri Cartier-Bresson*, with text by Cartier-Bresson and Barbara Brakeley-Miller, New York 1964, 1966; *The Galveston That Was*, with Ezra Stoler and Howard Barstone, New York and Houston 1966; *Photographs by Henri Cartier-Bresson*, with text by Claude Roy and Ryoichi Kojima, Paris 1963, Tokyo 1966; *Flagrants Délits/The World of Henri Cartier-Bresson*, Paris, Lucerne, Frankfurt and London 1968; *Impressions de Turquie*, booklet, with text by Alain Robbe-Grillet, Paris and Istanbul 1968; *L'Homme et la Machine/Man and Machine*, Paris and New York 1968, London 1972; *The Mandate of Heaven: Photos by Henri Cartier-Bresson*, edited by John F. Melby, London 1969; *Vive le France/Cartier-Bresson's France*, with text by Francois Nourissier, Paris, London, New York, Lucerne and Frankfurt 1970; *The Face of Asia*, with text by Robert Shapley, London and New York 1972, as *Visage d'Asie*, Paris 1972; *A Propos de l'U.R.S.S.*, Paris 1973, as *About Russia*, New York and London 1974; *Henri Cartier-Bresson, Photographer*, with a foreword by Yves Bonnefoy, Paris and Boston 1979, London 1980; articles—"The Moment of Truth" in *Camera* (Lucerne), no. 4, 1954; "The Deciding Eye" in *Lilliput* (London), no. 3, 1959; "One-Man Shows Are Best" in *Infinity* (New York), no. 10, 1959; "Henri Cartier-Bresson on the Art of Photography," interview with Yvonne Baby, in *Harper's* (New York), November 1961; interview in *Le Monde* (Paris), 5 September 1974; "Henri Cartier-Bresson," interview, in *Dialogue with Photography* by Paul Hill and Thomas Cooper, London 1979; films—*Victoire de la Vie*, 1937; *Le Retour*, with J. Lemare (for the United States Office of War Information), 1945; *Flagrants Délits*, directed by Robert Delpire, 1967; *Impressions of California*, with J. Boffety, CBS-TV film, 1970; *Southern Exposures*, with W. Dombrow, CBS-TV film, 1970.

On CARTIER-BRESSON: books—*Photographs by Henri Cartier-Bresson and an Exhibition of Anti-Graphic Photography*, exhibition catalogue, by Julien Levy, New York 1932; *The Photographs of Henri Cartier-Bresson* by Lincoln Kirstein and Beaumont Newhall, New York 1947, new edition as *Photographs of Cartier-Bresson*, New York 1963, as *Henri Cartier-Bresson: Photographs*, London 1964; *Masters of Photography* by Beaumont and Nancy Newhall, New York 1958; *Henri Cartier-Bresson* by Anna Farova, Prague 1958; *Photographers on Photography*, edited by Nathan Lyons, New York 1966; *The Magic Image* by Cecil Beaton and Gail Buckland, London and Boston 1975; *Henri Cartier-Bresson* by Claude Roy, Paris 1976; *Henri Cartier-Bresson* (Aperture monograph), Millerton, New York 1976; *Concerning Photography*, exhibition catalogue, by Jonathan Bayer, Peter Turner, Ian Jeffrey and Ainslie Ellis, London 1977; *Documenta 6*, exhibition catalogue, edited by Klaus Honnef and Evelyn Weiss, Kassel 1977; *Henri Cartier-Bresson* by Daniela Palazzoli, Milan 1978; *Henri Cartier-Bresson*, exhibition catalogue, by E.H. Gombrich, Edinburgh 1978; articles—"The Instant Vision of Henri Cartier-Bresson" by Beaumont Newhall in *Camera* (Lucerne), October 1955; "Stieglitz and Cartier-Bresson" by Dorothy Norman in *Saturday Review* (New York), no. 38, 1962; "Henri Cartier-Bresson" by P. Donzelli and P. Racanicchi in *Quaderni di Critica e Storia della Fotografia*, Milan 1963; "Henri Cartier-Bresson Today" by Bob Schwahlberg in *Popular Photography* (New York), May 1967; "Henri Cartier-Bresson: l'Immagine Riferita" by Italo Zannier in *Fotografia Italiana* (Milan), April/May 1971; "Henri Cartier-Bresson: A Lyrical View of Life" by Ernst Haas in *Modern Photography* (New York), November 1971; "Ce Cher Henri" by Claude Roy in *Photo* (Paris), November 1974; entire issue of *Camera* (Lucerne), July 1976; "50 Years of Decisive Moments" in *Photography Year 1980*, by the Time-Life editors, New York 1980; "The Sad Fate of Henri Cartier-Bresson" by Roger Clark in the *British Journal of Photography* (London), 30 May 1980; film—*Henri Cartier-Bresson, Photographer* by Gjon Mili, 1958.

An affable and unassuming man presented himself, at the time of the 1974 presidential elections, at the headquarters of the Ecologist candidate on a barge beside the Pont de l'Alma in Paris. He had given his support, and he was ready, he said, if it were necessary, to take some pictures. It was 48 hours later that the Ecologist militants noticed for the first time that the name written in the membership book was that of Henri Cartier-Bresson.

This is, of course, only an anecdote, but it is significant, for it reveals the two constants of Cartier-Bresson's personality: his deep-seated horror of all notoriety and his fidelity to an almost anarchistic/surrealistic distrust of all political ideologies.

And, how else does one speak about Cartier-Bresson except through anecdotes? He is the master theorist; he is God the father, the son and Holy Ghost; he is the *eminence grise* (or *noire*), Talleyrand or Machiavelli; he is the Caesar that no Brutus (and Brutus is legion) has succeeded in deposing. He is a guru, a high priest, a living legend.

When in Toulon in 1930 he pressed a shutter release for the first time, no one, least of all himself, realized what was to come. He was a very young man; he had been a student of André Lhote, and he dreamed only of drawing and painting; he had just returned sick from a trip to the Ivory Coast with Marc Allégret. But, little by little, he discovered the virtues of the fixed image. What followed is inscribed in the Pantheon of Photography: New York, and the friendship of Julien Levy, who gave him his first exhibition, and Helen Snow of *Harper's Bazaar* who gave him his first assignments. Paris, and it is *Vogel pour Vu* which gives him his first assignments—then the Spanish Civil War, then Germany, as a prisoner of war, where he tried to escape three times before succeeding in 1943. After the war, in 1947, the foundation of Magnum with Robert Capa, Chim and George Rodger. The discovery of China and of the U.S.S.R. Then the books—*Images à la Sauvette/The Decision Moment*, with a cover by Matisse, *Les Européens*, with one by Miro, *Vive le France*, with a text by Nourissier, *Flagrants Délits*, and finally the book published by Delpire in 1980, a superb and definitive photographic testimonial.

Everything becomes outrageous, extreme, when one speaks of Cartier-Bresson, from the hatred he provokes to the admiration and devotion that his spiritual sons accord him. Then there are his statements, his theories. The least of them, as for example his casual comments in an interview in *Le Monde* in 1974—about chance and objectives and fleeting, privileged moments—change the milieu of photography, become axioms that the rest of us continue to debate in the schools of photography. Yet the durability of Henri Cartier-Bresson in photography comes from nothing so much as from his incredible vision, his perfect sense of composition, his genius for being there at the precise moment that allows the significant image, the timelessness of his pictures.

As for everything else, his own words are best:
1) "I want to prove nothing, demonstrate nothing. Things and beings speak sufficiently."
2) "I never 'cook.' I loathe work in a laboratory or a studio."
3) "I feel a sense of solidarity with every photographer who works on the street and in the city, but absolutely none with "aestheticians" who pose 'belle jeunes filles en fleur.'"
4) "One does not learn how to become a photographer."
5) "Finally, the photograph itself does not interest me. I want only to capture a minute part of reality."
6) "The photo that succeeds is the photo that is looked at for more than a second."
7) "I really want to be a taxi driver, but I don't want to become a chauffeur."
8) "It's like having a fish on a line. You have to approach your prey carefully and strike at the right time."
9) "I love principles. I detest rules."
Growing older, Henri Cartier-Bresson has slowly turned away from photography to rediscover his

Henri Cartier-Bresson: *Family of News Vendors: Two Women Resting on the Ground*, Mexico City, **1934** Courtesy Art Institute of Chicago

first love: drawing. It seems unpardonable, even though it was he himself who warned, "Not only am I an amateur; even worse, I am a dilettante." But, of course, finally our disapproval of the way he chooses to spend his last days is unimportant. For the work of Cartier-Bresson in photography is as jealousy in *Othello*: other things will die—it, never.
—Roger Therond

CATANY, Toni.

Spanish. Born in Llucmajor, Majorca, 15 August 1942. Educated at Instituto Ramon Llull, Palma, Majorca, 1954; self-taught in photography. Freelance photographer, in Barcelona, since 1967. Agent: Cristina Zelich, Infanta Carlota 113, Barcelona 29. Address: Carrer Nou de la Rambla 34, Principal, Barcelona 1, Spain.

Individual Exhibitions:

1972 *Cantants*, Galeria Aixela, Barcelona
1975 *Ballet*, Galeria 4 Gats, Palma, Majorca (travelled to Galeria Spectrum, Barcelona, Centre Culturel, Toulouse, and Museo del Teatro, Barcelona, 1975-76)
1978 *Statues*, Fotomania, Barcelona (travelled to Galerie Voir, Toulouse, 1979)
1980 *Calotypes/Still Life*, Fotomania, Barcelona (travelled to Ca'n Duai, Majorca)
 Las Fiestas de San Juan, Bank Union, Menorca
1981 Canon Photo Gallery, Amsterdam

Selected Group Exhibitions:

1979 *4 Punts de Vista*, Galeria Lleonart, Barcelona
 Neon de Suro, Galerie Vitrine, Paris
 Expo Limite, Spanish National Tourist Office, New York
1980 *Metaphysical Presence*, at *Grupa Junij '80*, Ljubljana, Yugoslavia
 Spanish Photography, Night Gallery, London (travelled to the Photographic Gallery, Cardiff, and the Open Eye Gallery, Liverpool)

Collections:

Bibliothèque Nationale, Paris.

Publications:

By CATANY: books—*Les Illes*, edited by Abadia de Monserrat, with an introduction by Maria Antonio Oliver, Barcelona 1975; *Jorge Donn Danse Béjart*, with text by France Ferran, Paris 1977; articles—"Ballet" in *Imagen y Sonido* (Barcelona), February 1974; "Les Velles" in *Imagen y Sonido* (Barcelona), January 1975; "Els Viatjes" in *Eikonos* (Barcelona), September 1976; "Superman" in *Reflections* (Amsterdam), June 1978.

On CATANY: books—*4 Punts de Vista*, exhibition catalogue, by Francesc Miralles, Barcelona 1979; *La Novetat de la Tradició*, exhibition catalogue, by Francesc Miralles, Barcelona 1980; article—"La Calidad de la Luz" by Joan Fontcuberta in *El Correo Catalan* (Barcelona), October 1980.

Since 1976, I've been using for my personal work old cameras (13 x 8 cm; 18 x 24 cm) and using the technique of Talbot—the calotype. I try to combine this old technique with modern photographic aesthetics.

But sometimes I have new ideas that I'm not able to accomplish with these cameras and this old technique. Consequently, there is another side to my work: still-lifes done with a 6 x 6 cm camera in which I'm interested in emphasizing the composition inside a square, the light, the shadows, the reflections, transparencies, and the quality of objects (plastic, glass, flowers, etc.)
—Toni Catany

Toni Catany occupies a singular position among the younger generation of Spanish photographers. While the majority have become progressively more specialized, both conceptually and aesthetically, Toni Catany strikes one with his versatility and constant experimentation. Even more impressive is the very high level of accomplishment he attains. Outstanding in his work, to my mind, are: the reports from the Middle East and Africa; the ethnographic pictures made in Majorca; his documentation of dance; the "metaphysical" series of statues; the experiments with collage and hand-coloring; his work with "procedures" such as calotypes; and his most recent still-lifes.

Certain observations that apply to the whole of his work can be derived from an analysis of the calotypes and still-lifes.

The series of calotypes was started in 1976 when Catany had the idea of conducting a series of experiments with an old, bulky wooden camera. His next idea was to use the camera with a photographic process equally as archaic, the calotype, a system devised by Fox Talbot for obtaining prints from negatives made of paper. The project obviously presented a certain challenge—how to merge a contemporary vision with a method whose antiquity and characteristics confer an aura of primitivism or aesthetic anachronism to the resulting image. Conditions effectively enforced this appearance: a lack of clarity due to the smooth focal lens; the lack of contrast due to the irregular transparency of the paper negative; the static quality of the composition due to the slow movement of the camera.

The results demonstrate the give and take of the creative challenge, between methods that imposed certain limitations of presentation and the perseverance of the photographer, who tried to hold those limitations in check and himself direct the result. If we arrange the calotypes in chronological order, we can see a transition from a classic concept of nature as passive to one full of force and energy. Fairly unorthodox contexts and perspectives reveal themselves to an imaginative and ironic eye, which controls the situation: one is aware that a combination is being formed of contradictory methods and propositions.

This eagerness to take on a challenge, to extract the best that a particular method or style has to offer, to take it as far as it is able to go, is characteristic of Catany's creative attitude. And that is the difference between his still-lifes and those of Baron de Meyer or Josef Sudek, with whom he certainly shares similarities—in the feeling of tranquility, for example. He maintains the same kind of creative tension in his still-lifes as in his calotypes, though here the creative energy, the vitality, is conveyed in a more subtle form, given the greater control of his medium. Here, he sacrifices the irregular texture of the calotypes for precision and detail and, in turn, for the natural textures of the subjects photographed. The images acquire tactile qualities—along with a warmth and sensuality—that the calotypes lack.

It is a sensitivity to light that helps to create the vitality of these works. Much as the evocative atmosphere Sudek infuses into his images comes in great measure from the soft light of his Prague studio, so Toni Catany has a predilection for "indigenous" light, the warmer, more vigorous Mediterranean light, for a delicate but pronounced play of light and shade that is his work's principal source of inspiration. The nature of the objects photographed also contributes—at times in the style of the *objet trouvé*, but they are always the objects of his own personal world. A visit to his studio-home would reveal most of the elements which have been the protagonists of his images.
—Joan Fontcuberta

Toni Catany: *Calotip*, 1980

CAVALLI, Giuseppe.

Italian. Born in Lucera, Foggia, 29 November 1904. Studied classics at a collegio in Rome, 1914-22; studied law at the University of Rome, 1922-26; self-taught in photography. Married Costanza Cavalli in 1930; children: Daniele, Maria Anna, and Achille. Practiced as a lawyer, Rome, 1926-35; freelance photographer, Senigallia, 1935 until his death, 1961. Founder-Member, Gruppo degli Otto photography group, 1941, and La Bussola photography group, Senigallia, 1947. Recipient: Diploma, *Mostra de Arte Fotografica*, Lisbon, 1941, 1942, 1943; Gold Medal, *Concorso Internationale*, Bologna, 1949; Silver Medal, Spilimbergo, 1951; Gold Medal, *Mostra Fotografico Internazionale*, Venice, 1951; Gold Medal, *Mostra Fotografico*, Ravenna, 1951; Silver Medal, *Mostra Fotografico*, Bergamo, 1951; Award of Excellence, Federation Internationale de l'Art Photographique (FIAP), 1957. Estate: c/o Maria Anna Cavalli, Piazza Bonghi 20, 71036 Lucera, Italy. *Died* (in Senigallia) *25 October 1961*.

Individual Exhibitions:

1940	Circolo Fotografico, Rimini, Italy
	Circolo di Cultura, Ancona, Italy
	Circolo Fotografico Milanese, Milan
1948	Centro Studi Arte Contemporanea, Venice
	Galleria Vigna Nuova, Florence
1951	Galleria d'Arte Il Cavallino, Venice
1952	Circolo Fotografico, Genoa
	Circolo Fotografico, Rome
1964	Circolo di Cultua, Senigallia, Italy (retrospective)
	Associazione Pro Loco, Lucera, Italy (retrospective)
1974	Circolo Senza Testa, Osimo, Italy (retrospective)
1979	Circolo di Cultura, Senigallia, Italy (retrospective)
1980	Museo Civico, Lucera, Italy (retrospective)

Selected Group Exhibitions:

1941	*Mostra de Arte Fotografica*, Lisbon (and 1942, 1943)
1943	*Subjektive Fotografie*, Saarbrucken, Germany
1951	*Photokina*, Cologne
	Mostra Fotografico Internazionale, Galleria d'Arte Il Cavallino, Venice
1952	*Salone Internazionale Fotografico e Cinematografico*, Milan
	La Bussola Photography Group, Royal Photographic Society, London
1957	*IV Photo Biennale: FIAP*, Berne
1979	*Venezia '79*
1980	*La Metafisica*, Galleria d'Arte Moderna, Bologna
	Les Rèalismes, Centre Georges Pompidou, Paris

Collections:

All Cavalli's works are in archives maintained by his daughter, Maria Anna Cavalli, Piazza Bonghi 20, 71036 Lucera, Italy.

Publications:

By CAVALLI: books—*Immagini*, Bergamo 1940; *8 Fotografi Italiani d'Oggi*, Bergamo 1942; articles—in *Rivista Fotografica* (Milan), no. 3, 1950; in *Vita Fotografica* (Milan), no. 1, 1951; in *Revista Fotografica* (Milan), no. 2, 1951; in *Progresso Fotografico* (Milan), no. 5, 1951; in *Progresso Fotografico* (Milan), no. 7, 1951; in *Vita Fotografica* (Milan), no. 1, 1952; in *Corriere Fotografico* (Milan), no. 7, 1952; in *Rivista Fotografica* (Milan), no. 9, 1952; in *Progresso Fotografico* (Milan), no. 1, 1953; with Pietro Donzelli, in *Fotografia* (Milan), no. 1, 1953; with F. Ferroni, in *Fotografia* (Milan), no. 2, 1953; in *Rivista Fotografica* (Milan), no. 2, 1953; in *Progresso Fotografico* (Milan), no. 4, 1953; with Otto Steinert, in *Bolletino Econimista Ravenna*, no. 5, 1953; in *Corriere Fotografico* (Milan), no. 9, 1953; in *Progresso Fotografico* (Milan), no. 2, 1954; in *Fotografia* (Milan), no. 2, 1954; also, numerous articles in *Ferrania* (Milan), July 1947 to March 1961.

On CAVALLI: books—*8 Fotografi Italiani d'Oggi*, Bergamo 1942; *Nuova Fotografia Italiana* by Giuseppe Turroni, Milan 1959; *Foto-Film* by Giuseppe Turroni, Milan 1961; *70 Anni di Fotografia Italiana* by Italo Zannier, Modena, Italy 1978; *La Metafisica*, exhibition catalogue, with text by Italo Zannier, Bologna 1980.

Giuseppe Cavalli was a lawyer by profession and he came to photography late, in 1936 when he was 30, but his was a passion that burst out in enthusiasm for an "art" the existence of which he had never before suspected. Cavalli regarded the problem of "art" in photography as basic; he dedicated himself to it totally, avoiding particularly all the limitations imposed by everyday practice—the work of the commercial photographer or the press photographer—work that, to his mind, disallowed all creativity. "Photography as an art" was a slogan that accompanied Cavalli all his life, as if it were a banner.

"We believe in photography as an art...," Cavalli wrote 10 years later, in 1947, in the journal *Ferrania*, confirming yet again his basic concept (though certainly not a new concept). He declared: "A documentary record is not art," and insisted on the remoteness of the "photography which claims to be an art" from "the dead end of the documentary chronicle."

A large sector of Italian photography in the years between 1940 and 1955 was deeply influenced by these ideas, which had the attraction of stressing the creative possibilities in photography, revaluing it in relation to the other representative arts, towards which it had acquired an atavistic inferiority complex. The old dichotomy—"photography: art or record?"—was thus resuscitated by Cavalli in the 1940's; but happily the rebirth was a long way from the 19th century pictorialism that had dominated in Italy since the 1930's; and Cavalli always opposed an enquiry into the *specifics* of photography along the lines suggested by the international avant-garde, from Stieglitz to Strand and Weston in America, from Renger-Patzsch to Moholy-Nagy to Man Ray in Europe.

Cavalli published his first work as a photographer in 1940, in a travelling exhibition and in a book, *Immagini (Pictures)*, printed at Bergamo by the Italian Institute of Graphic Arts: his photography avoided the documentary and relied rather on simple, everyday subjects used as pretexts for an exquisitely "formalistic" fantasy. It was immediately successful. What Cavalli wanted was to express a "concept" in his pictures, an "artistic" idea, so that the symbols, the metaphors, of a clearly surrealist, even metaphysical, import might blossom anew—as in the accompanying photo, "La Bambola Cieca."

Giuseppe Cavalli: *La Bombola Cierca*, 1940

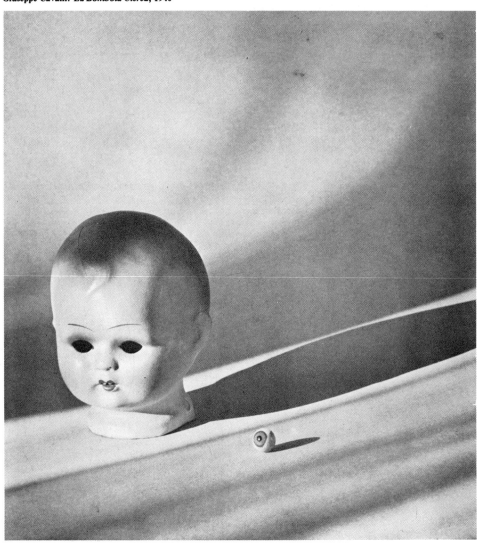

The photographs are characterized by "high key" printing, in which shining white dominates the chiaroscuro, giving an atmosphere of unreality to the subject—very different from the conventional portraiture of the "objective" photograph, achieving always a "reality that is immobile, gentle; that rejoices in its essential quality of a fragment, of a short essay, of lyric graphism" (Turroni: *Nuova Fotografia Italiana*, 1959)

Meanwhile, his ideas matured, as he met those few photographers who were keeping alive similar ideas in Italy at that time, striving to withdraw from the rhetoric of a photography that glorified the Fascist regime and to overcome the "pictorialism" that for many years had been the only possible escape in the search for an aesthetics of photography. These postulates gave rise to the "Gruppo degli Otto" ("The Group of 8:" Balocchi, Cavalli, Faccini, Finazzi, Franchini-Stappo, Leiss, Marelli, and Vender), which made its existence known at once with a book, *8 Fotografi Italiani d'Oggi* (*8 Italian Photographers of Today*), published in 1942 and notable for "high key" photography of foregrounds and details of objects and landscapes, in pictures "accurately" composed according to strictly geometric plans.

In the yearbook *Fotografia*, published in 1943 by *Domus*, this *new* photography was also propounded by the Pedrotti brothers, who in their turn made an effective contribution to the renewal of Italian photography.

But it was after the war that Cavalli won his most important battle, intervening in the discussion between "neo-realists" and "abstractionists" that had arisen in the climate of political liberty in which, with the end of Fascism, artists found themselves able to work again. Cavalli then founded La Bussola group with some of his own old comrades and with Luigi Veronesi, and wrote a "manifesto" which was published in *Ferrania* in May 1947. It had a remarkable effect, especially among amateur photographers, who were, in fact, the only ones in Italy to concern themselves with the aesthetics and language of photography.

"The philosophical inspiration of Giuseppe Cavalli," Finazzi wrote in 1962, "instilled that Crocian mastery which at that time permeated so much of Italy's artistic output"—which, in short, propounded "art for art's sake." Photography too, said Cavalli, has to be an end in itself, with no other aim than to be *photography*.

Yet Cavalli's faith in "photographic art," finally, is expressed most validly in his actual photographic work rather than in his theories, and certainly his pictures influenced the photographic taste of the 1950's in Italy more than his words, at a time when "high key" ruled through a misunderstood *climat méditerranéen* in photographic culture. Cavalli, resuming the discussion of photography as a cultural product after the war, both stressing "artisticness" and favoring the hedonism of photographic amateurs, founded a "school" of his own, the only one in Italy at the time which was dedicated in some way to re-directing photography away from its usual quality of artisan's mediocre product, and to putting forward new theories of creativity which seemed to be confirmed at the time—of pure white, high tones, deserted shores, crystalline geometrical volumes. These theories came to fruition in his own aristocratic pictures.

—Italo Zannier

CAZNEAUX, Harold (Pierce).

Australian. Born Harold Pierce Cazneau, of Australian parents, in Wellington, New Zealand, 30 March 1878; moved with his family to Australia, 1888, and settled in Adelaide, 1890; adopted name spelling "Cazneaux," 1904. Educated at public schools, Adelaide, South Australia, 1890-96; studied under H.P. Gill, Adelaide School of Art and Design, 1898-1904. Married Mabel Winifred Hodge in 1905; children: Rainbow, Jean, Beryl, Carmen, Joan and Harold. Worked as retoucher and colourist, Hammer and Company photographic studio, Adelaide (while his father, the photographer Pierce Cazneau, was manager), 1896-1904; artist and chief operator, Freeman's Studios, Sydney, 1904-18; photographic artist, then owner, Denman Chambers photo studios ("The Little Studio"), Sydney, 1918-20; photo artist and proprietor, The Studio, Roseville, New South Wales, 1919-53 (also taught photography at his studios). Correspondent, *Photograms of the Year* annual, London, 1919-52. Lecturer and Demonstrator, 1909-19, and President, 1917, Photographic Society of New South Wales, Sydney; President, Camera Circle, Sydney, 1922. Recipient: First Prize, *Kodak Photographic Competition*, Sydney, 1914; Gold Medal; *Gothenburg Exhibition*, Sweden, 1929; First Prize, *1st International Salon of Photography*, New Zealand, 1940; Award in Recognition of Photography, *Australasian Photo Review*, 1951; National Tribute, Photographic Clubs of Australia, Sydney, 1952; 2 Gold Awards, and 24 Silver Awards, *Amateur Photographer*, London, 1910 until his death, 1953. Honorary Fellow, Royal Photographic Society, London, 1937. Agents (daughters): Mrs. R. Johnson, 17 Dudley Avenue, Roseville, New South Wales 2069; Mrs. V. Field, 14 Glenview Street, Gordon, New South Wales 2072, Australia. *Died* (in Roseville, New South Wales), *19 June 1953.*

Individual Exhibitions:

1909 Photographic Society of New South Wales, Sydney
1912 Photographic Society of New South Wales, Sydney
1928 Grosvenor Galleries, Sydney
1936 *Pictorial Photographs*, Kodak Gallery, Sydney
1941 *Loan Collection*, Adelaide Camera Clubs
1966 Pymble, Sydney
1975 *Project 7*, Art Gallery of New South Wales, Sydney
1976 National Library of Australia, Canberra, A.C.T.
 State Library of South Australia, Adelaide
1978 *Cazneaux's Old Sydney*, Art Gallery of New

Harold Cazneaux: *The Wheel of Youth*, Dee Why, New South Wales, 1929

South Wales, Sydney
Cazneaux 1878-1953, National Gallery of Victoria, Melbourne (retrospective)
1980 *Loan Exhibition*, Naracoorte Art Gallery, South Australia (from Art Gallery of South Australia)
1981 *Photographs 1904-1934*, Photographers Gallery, Paddington, Sydney
Harold Cazneaux 1878-1953: Photographs, Axiom Gallery, Richmond, Victoria

Selected Group Exhibitions:

1911 *London Salon of Photography*, Royal Society of Watercolourists, London
1929 *Internationella Fotografi*, Gothenburg, Sweden
1930 *21st International London Salon of Photography*, Royal Society of Watercolourists, London
3rd International Invitational Salon, Camera Club, New York
1933 *Quarto Salone Internazionale di Fotografia*, Turin, Italy
1938 *Sydney Camera Circle*, David Jones Galleries, Sydney
Australian Commemorative Salon of Photography, Commonwealth Bank Chambers, Sydney
1940 *International Salon of Photography*, Wellington, New Zealand
1952 *1st South African Review of World Photography*, Arts Hall, Port Elizabeth, South Africa
1979 *Australian Pictorial Photography*, Ervin Art Gallery, Sydney (travelled to the Victorian College of Arts, Melbourne, and the Art Gallery of South Australia, Adelaid; then toured China)

Collections:

National Library of Australia, Canberra, A.C.T.; Australian National Gallery, Canberra, A.C.T.; National Gallery of Victoria, Melbourne; Art Gallery of New South Wales, Sydney; University of Sydney; Mitchell Library, Library of New South Wales, Sydney; State Library of South Australia, Adelaide; Art Gallery of South Australia, Adelaide; Royal Photographic Society, London.

Publications:

By CAZNEAUX: books—*Domestic Architecture in Australia*, Sydney 1919; *Sydney Harbour*, portfolio of 100 photographs, Sydney 1920; *The Abermain and Seaham Coals*, Sydney 1925; *Australia*, Sydney 1928; *Canberra A.C.T.*, Sydney 1928; *Sydney Surfing*, with text by Jean Curlewis, Sydney 1929; *The Bridge Book*, with text by Leon Gellert, Sydney 1930; *Australian Native Bear Book*, with text by Leon Gellert, Sydney 1930; *Sydney Book*, with text by Jean Curlewis, Sydney 1931; *The Frensham Book*, with text by Winifred West, Sydney 1934; *Fifty Years of Industry and Enterprise*, with text by Essington Lewis, Melbourne 1935; articles—numerous articles and photographs in *The Australasian Photo Review* (Sydney), 1906-53; *Harrington's Photo-Journal* (Sydney), 1908-26; *Photograms of the Year* annual, London 1909-52; *Amateur Photographer* (London), 1911-38; weekly column "Reflex" in *The Sydney Mail*, 1912-15; *The Home* (Sydney), 1920-40; *Art in Australia* (Sydney), 1922-37; *Australia Beautiful* (Sydney) 1927-31; *Australian Home Beautiful* (Melbourne), 1928-43; *The Home Annual*, Sydney 1932-41; *The Gallery* (London), from 1938; *Australia National Journal* (Sydney), 1940-42; *Contemporary Photography* (Sydney), 1946-50.

On CAZNEAUX: books—*The Story of the Camera*

in Australia by Jack Cato, Melbourne 1955; *Cazneaux: Photographs by Harold Cazneaux, 1878-1953*, edited by Alec Bolton, text by Max Dupain, Canberra 1978; *Australian Pictorial Photography*, exhibition catalogue, by Gael Newton, Sydney 1979; *Philip Geeves Presents Cazneaux's Sydney*, edited by Philip Geeves and Gael Newton, Sydney 1980; articles—"Harold Cazneaux" by Valdon in *Australian Photo Journal* (Sydney), October 1908; "Harold Cazneaux Exhibition" in *Australian Photo Journal* (Sydney), March 1909; "The Man and the Print" in *Amateur Photographer* (London), June 1929; "Pictures in the Making" by Mentor in *Amateur Photographer* (London), March 1938; "The Cazneaux Story" by Jack Cato in the *Australian Photo Review* (Sydney), December 1952; "Harold Cazneaux" by Charles Walton in *The Etruscan* (Sydney), December 1970.

Harold Cazneaux was probably the most influential photographer working in Australia during the "pictorial" era of the early 1900's. He was certainly the first to understand that the sombre toned approach of most European and American pictorialists was not suitable for Australia, and throughout his life he constantly sought new ways of depicting Australia as essentially a land of sunlight.

This early reaction to the "European twilight" influence eventually led to the formation of the Sydney Camera Circle in 1916, whose members shared Cazneaux's views, views he pursued for almost 50 years as a practicing photographer.

In subject matter Cazneaux clearly sought out the Australian landscape, although throughout his life he constantly explored and photographed the changing face of Sydney in plain documentary fashion, which resulted in a legacy of historic prints now in the National Library in Canberra and available in a book covering the years 1904-1934.

He developed a great critical faculty and devoted a great deal of his time to lecturing and writing in a highly articulate way about most facets of photographic art during this period. And from 1909 until 1952 he contributed reviews and photographs for the British annual of photographic art, *Photograms of the Year*. In 1937 he was made an honorary Fellow of the Royal Photographic Society, but he constantly refrained from being drawn into any form of controversy regarding photography as an art. "I do not wish to dwell on the status of photography as an art—just let us all go forward doing our work sincerely and soundly; the results will speak for themselves."

He worked patiently in a small darkroom at home to produce prints of superb quality, and quite early in his work developed an uncanny facility in relating mass to tone. He sought to eliminate extraneous detail, so much so that many of his back-lit street scenes seem spartan in their simplicity. He was naturally innovative and preferred to work in a natural environment with available light whenever possible, and his portraits of many famous people such as the dancer Anna Pavlova seem spontaneous in their simplicity.

In 1934-35 he took on a titanic industrial assignment for the Broken Hill Mining Company, which resulted in a series of memorable photographs that euologized man and the machine in prints of great strength and beauty.

But his landscapes remain as photographic testimony to his great love of space, silence and sunlight—for example, his shot of a giant eucalypt against the Flinders Ranges in South Australia entitled "Spirit of Endurance."

Perhaps part of Cazneaux's great talent lay in his personal and straightforward approach to photography at a time when it was still strongly dominated by painting. Before the days of the documentary and photojournalism, he sought to combine a clean-cut visual approach with atmosphere and information, a method he continued to pursue until his death in 1953.

—Laurence Le Guay

CHAMBI (Jiminez), Martin.

Peruvian. Born in Coaza, Carabaya district, province of Puno, in 1891. Educated at primary school, Coaza, until 1900; secondary school, Coaza, 1902-04; photographic apprentice, studio of Max T. Vargas and Brother, Arequipa, Peru, 1908. Married to Manuela Lopez Visa; children: Victor and Julia. Independent photographer, Sicuani, Peru, 1917-20; opened own studio, associating with painter and photographer Huan Manuel Figueroa Aznar, on calle Santa Teresa, Cusco, 1920-24; second studio, Banco del Peru y Londres Building, calle Heladeros, Cusco, 1924-25; established permanent studio on calle Marquez, Cusco, 1925-73. Co-Founder, Instituto Americano de Arte, Cusco, 1927-28; Founder-Patron and promoter of Professional Photography Classes, Escuela Nacional de Artes Graficas, Lima, 1971; Founder and unofficial director, Academia de Artes Plasticas, now Escuela de Artes Plasticas, Cusco, from 1971. *Died* (in Cusco) *in 1973.*

Individual Exhibitions:

1917 Centro Artistico, Arequipa, Peru
1924 Consejo Provincial, Cusco, Peru
1925 Consejo Provincial, Puno, Peru
1927 Gran Hotel Bolivar, Lima
1935 La Sal Alcedo, Lima (with painter Francisco Lazo)
Vargas Brothers Studio, Arequipa, Peru
1936 Casino de Vina del Mar, Chile
"Diario La Nacion" Exhibition Room, Santiago, Chile
1978 Sequencia Fotogaleria, Lima
1979 Museum of Modern Art, New York (toured the United States, 1979-80)
The Photographers' Gallery, London
Art Museum, University of New Mexico, Albuquerque (travelled to the Witte Memorial Museum, San Antonio, Texas, Colorado Springs Fine Arts Center, and the Heard Museum, Phoenix, Arizona, 1980)
1980 Galerie Nouvel Observateur/Delpire, Paris

Selected Group Exhibitions:

1921 *Exposicion Agropecuario-Industrial*, Arequipa, Peru
1925 *Exposicion Artistica International*, La Paz, Bolivia
1928 *Exposicion Regional de Arequipa*, Rotary Club, Arequipa, Peru
1934 *Concurso de Artes Plasticas*, Cusco, Peru
1964 *Primera Convencion de la Federacion Internacional de Arte Fotografico*, Mexico City
1969 *Fotografias del Peru*, Instituto Peruano de Cultura Hispanica, Lima, Peru

Collections:

Instituto Peruano de Cultura Hispanica, Lima, Peru; Chambi Studios, Cusco, Peru

Publications:

By CHAMBI: books illustrated—*Pintura Colonial* by Felipe Cossio del Pomar, Cusco, Peru 1928; *La Ciudad de los Incas* by J. Uriel Garcia, Cusco, Peru 1930; *Cusco Historico* by Rafael Larco Herrera, Lima 1934; *Cusco Monumental* by Luis H. Valcarcel, Lima 1934; *Pueblos y Paisajes Surperuanos* by J. Uriel Garcia, Cusco, Peru 1937; *Cusco, Capital Arqueological de America del Sur* by Luis H. Valcarcel, Buenos Aires, 1951; *Documental del Peru*, Cusco, Peru 1968.

On CHAMBI: book—*Martin Chambi*, exhibition

catalogue, edited by Sequencia Fotogaleria, Lima, Peru 1978; articles—"A Culture Caught in Time" by Jed Horne in *Quest* (New York), June 1979; "Chambi of Cuzco" by Max Kozloff in *Art in America* (New York), December 1979.

World attention was first brought to the work of Martin Chambi by the discovery of more than 14,000 glass plates in his studio several years after his death. This discovery by Ed Ranney led to his organizing a party of students to visit Cuzco and to print a range of Chambi's work for exhibition and for sale through the studio which is still run by members of the Chambi family. Although ostensibly simply the local photographer of weddings, festivals and local events, Chambi was clearly much more. He would go for miles with his big camera into the surrounding countryside and recorded many of the ruins and landscapes that were completely altered by the big earthquake in 1953. His photographs of Machu Pichu are among the finest known, but it is probably for the picture he has left us of Cuzco society between the wars that he will best be remembered.

There are marvellous group portraits of workers in haciendas and small businesses, individual pictures of local heroes, the first men with a racing motor-cycle in the village and specific traders and indians. All are alive; there is none of the static vulnerability one so often finds in pictures of this time. Everyone is involved in the making of the picture, but it is Chambi's genius that lets in the guardian at the wedding, and it is his sense of composition and love of his land and his people that gives a vibrancy to the whole series and makes one return time and again to a particular picture and almost to converse with its inhabitants. These photographs are more than just a record; they were clearly made by a man who understood the unique properties of photography at a time when many of his contemporaries were still using it as the poor relation of painting. He achieved technical brilliance without losing the dynamics of the living subjects. He must have been a strong personality but one who could use his strength to bring out the potential warmth and personality in the strong faces of his subjects.

As more archives are unearthed each year their value must begin to be weighed as photographs as well as historical artifacts. A comparison with the work of Martin Chambi could well be a worthwhile means to assess the relative importance of such discoveries.

—Sue Davies

Martin Chambi: *Indian from Ocongate*, Peru, 1934 Courtesy The Photographers' Gallery, London

with Nancy Dickinson from 1960 (separated, 1974); married Suzanne Lichau in 1977; children: Dharma, Theo, Aryan, Piki, Robin, Riversong, and Anja. Painter, poet, musician and craftsman, in Portland, San Francisco, Los Angeles, New Orleans, New York and Big Sur, California, 1942 until the early 1950's; turned to serious work in photography while hospitalized for tuberculosis in Denver, 1954-56; Curator of Exhibitions and Prints, International Museum of Photography, George Eastman House, Rochester, New York, 1957-61; Director, Association of Heliographers, New York, 1962-65; lived in Big Sur, 1965, Taos, New Mexico, 1965-70, San Francisco, 1970-74, and New Mexico, since 1974: settled on land in the Rio Grande Gorge, near Taos,

1981. Artist-in-Residence, Volcanoes National Park, Hawaii, 1977. Recipient: National Endowment for the Arts Photography Fellowship, 1977, 1980. Address (studio): Box 35, Embudo, New Mexico 87531, U.S.A.

Individual Exhibitions:

1956 Photography Workshop, Denver
 Alegro Music FM Station, Denver
 National Jewish Hospital, Denver
1957 George Wittenborn Gallery, New York
 International Museum of Photography, George Eastman House, Rochester, New

Walter Chappell: *Signature Pod, Icepond, Hilo, Hawaii*, 1976

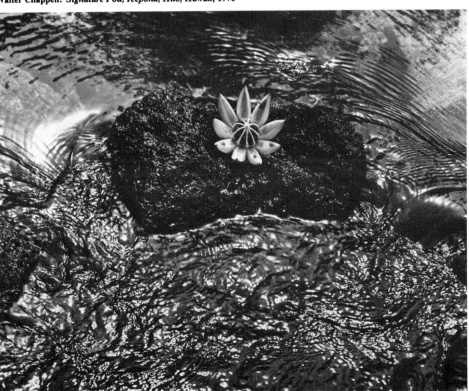

CHAPPELL, Walter.
American. Born in Portland, Oregon, 8 June 1925. Educated at the Ellison-White Conservatory of Music, Portland, majoring in piano, 1932-43, and at the Benson Polytechnical School, Portland, majoring in architectural drawing, 1939-43; studied architecture at Frank Lloyd Wright's Taliesin West, Paradise Valley, near Scottsdale, Arizona, 1953-54; apprentice photographic student with Nile Root and Winter Prather, Denver, 1954-57; studied photographic printmaking with Minor White, Rochester, New York, 1957-58. Served as a private in the 13th Airborne Division, United States Army, stationed in the Eastern United States, 1943-47. Lived with Leslie Spears from 1948 (separated, 1952); married Patricia Schmid in 1956 (died, 1959); lived

York
1959 Smithsonian Institution, Washington, D.C.
Boston University
1960 Carl Siembab Gallery, Boston
Under the Sun, Poindexter Gallery, New York (with Syl Labrot and Nathan Lyons)
1961 Polaroid Corporation, Cambridge, Massachusetts
1963 Gallery Archive of Heliography, New York
VII Photographers Gallery, Provincetown, Massachusetts
1964 Coast Gallery, Big Sur, California
San Francisco State College
El Mochuelo Gallery, Santa Barbara, California
1965 Hip Pocket Book Gallery, Santa Cruz, California
1966 Craft House, Arroyo Saco, New Mexico
Quivira Gallery, Corrales, New Mexico
Demasiado, Santa Fe, New Mexico
Levin Gallery, Santa Fe, New Mexico
1967 Atlantis Gallery, Santa Fe, New Mexico
Museum of New Mexico, Santa Fe
Antalope Press, Santa Fe, New Mexico
1968 Nirvana, Santa Fe, New Mexico
1970 Coast Gallery, Big Sur, California
Dennis Hopper Residence, Hollywood, California
1971 Sun Gallery, San Francisco
1972 Phos-Graphos Gallery, San Francisco
New Prints, Caryl Hill Residence, Carmel, California
San Francisco Art Institute (presentation)
San Francisco State College
1973 Visual Studies Workshop, Rochester, New York
Rochester Institute of Technology, New York (presentation)
Massachusetts Institute of Technology, Cambridge (presentation)
80 Prints, Light Gallery, New York
Musée d'Art Moderne de la Ville, Paris
1974 *Image Without Credential*, Camerawork Gallery, San Anselmo, California
Metaflora, Annex Gallery, Santa Rosa, California
1975 University of Iowa, Iowa City
Enjay Gallery, Boston
Creative Eye Gallery, Sonoma, California
Everett Community College, Washington
Wells College, Aurora, New York
1976 Vanderbilt University, Nashville, Tennessee
Visual Studies Workshop, Rochester, New York
Volcano Art Gallery, Volcanoes National Park, Hawaii
1977 Millersville State College, Pennsylvania
Volcano Art Center, Volcanoes National Park, Hawaii
Bank of Hawaii, Hilo
The Foundry, Honolulu
1978 Vision Gallery, Boston
Oakton Community College, Morton Grove, Illinois
Light Factory, Charlotte, North Cardina
Silver Image Gallery, Seattle
Susan Spiritus Gallery, Newport Beach, California
Philadelphia Museum of Art
Volcano Art Center, Volcanoes National Park, Hawaii
1979 Silver Image Gallery, Ohio State University, Columbus
Catskill Center for Photography, Woodstock, New York
Neuberger Museum, Purchase, New York
Santa Fe Gallery of Photography, New Mexico
1980 Nicholas Potter Gallery, Santa Fe
Colorado Photographic Art Center, Denver (retrospective)
1981 Center for Media Art, American Center, Paris

Grapestake Gallery, San Francisco

Selected Group Exhibitions:

1958 *5 Masters of Photography*, I.F.A. Galleries, Washington, D.C.
1959 *Photography at Mid-Century*, International Museum of Photography, George Eastman House, Rochester, New York
1960 *The Sense of Abstraction*, Museum of Modern Art, New York
1962 *Photography U.S.A.*, De Cordova Museum, Lincoln, Massachusetts
1963 *Heliography 1963*, Lever House, New York (and 1964)
1967 *Photography in the 20th Century*, National Gallery of Canada, Ottawa (toured Canada and the United States, 1967-73)
1968 *Light⁷*, Hayden Gallery, Massachusetts Institute of Technology, Cambridge
1974 *Photography in America*, Whitney Museum, New York
1977 *Photographs: Sheldon Memorial Art Gallery Collection*, University of Nebraska, Lincoln
1978 *Mirrors and Windows: American Photography since 1960*, Museum of Modern Art, New York (toured the United States, 1978-80)

Collections:

Museum of Modern Art, New York; Metropolitan Museum of Art, New York; International Museum of Photography, George Eastman House, Rochester, New York; Massachusetts Institute of Technology, Cambridge; Polaroid Corporation, Cambridge, Massachusetts; Fogg Art Museum, Harvard University, Cambridge, Massachusetts; Alfred Stieglitz Center, Philadelphia Museum of Art; Smithsonian Institution, Washington, D.C.; Exchange National Bank, Chicago.

Publications:

By CHAPPELL: books—*Gestures of Infinity*, New York 1957; *Logue and Glyphs*, New Orleans 1950; *Under the Sun: The Abstract Art of Camera Vision*, with Syl Labrot and Nathan Lyons, New York 1960, 1970; *Metaflora*, portfolio, Santa Fe, New Mexico 1980.

On CHAPPELL: books—*Photography in the 20th Century* by Nathan Lyons, New York 1967; *Photography in America*, edited by Robert Doty, with an introduction by Minor White, New York and London 1974; *The Photographers' Choice*, edited by Kelly Wise, Danbury, New Hampshire 1975; *Photographs: Sheldon Memorial Art Gallery Collection, University of Nebraska*, edited by Norman A. Geske, Lincoln, Nebraska 1977; *Mirrors and Windows: American Photography since 1960* by John Szarkowski, New York 1978; *The Nude*, edited by Constance Sullivan, New York 1981.

Camera vision operates as an intelligent function between the human eyes and the totality of understanding in a moment of active awareness. No camera is needed for this experience, only the keen sensibility of the human mind.

To arrest and refine this flow of impressions, creating an independent image in space, I use my camera with the same care and immediacy as I have become accustomed to practice with my eyes. The camera allows me to arrest my vision as a realization in outer space, precisely at that moment when my understanding and conscience intuitively experience a reality most important for my awareness of Life's essential presence.

This image of my "camera vision," when fully expressed in the perfected print, stands independently as a fusion, or a blending of two otherwise opposing worlds within a unified whole. By Nature invested with countless impressions, such imagery functions for me as a richly compressed emotional language, liberating ideas and gestures from the vast possibilities hidden beyond the common experience of Life.

The art of creative work in any medium is, for me personally, the struggle to unify my discovery of Nature with the growing discovery of my inner being; to find every opportunity to create a new image of understanding for my senses—these senses which can aid as well as hinder my growth of understanding. It is an extra experience in mutual communication when others experience understanding in the material results of my work.

Photography originally attracted me as a medium akin to music, both being an instantaneous vehicle for the experience of perceiving, decision, and expression; both relating precisely to the spontaneous functioning potential within our human life. All at once.

—Walter Chappell

Walter Chappell began working seriously with photography in Denver, Colorado in 1955 when he was a patient at the National Jewish Hospital, where the medical triumph of creating an effective cure for tuberculosis was celebrated. The Hospital program required each patient to be vocationally rehabilitated as part of the psychological program preceding release. Chappell had been a painter and during previous years in San Francisco had produced enormous, elegant batiks—but the fumes of the wax and of the solvents were now forbidden to him. Photography seemed a logical and productive replacement. The Hospital funded equipment and lessons with a local professional photographer who was also concerned with creative work. When Chappell left Denver, he went to Rochester, New York and continued growing as a photographic printmaker under the tutelage of Minor White, with whom he had been friends in San Francisco in the late 1940's. White introduced Chappell to Beaumont Newhall at George Eastman House and encouraged Newhall to hire Chappell as an assistant curator when White moved on from the House to R.I.T. At the same time, Chappell introduced Minor White to the ideas of G.I. Gurdjieff and P.D. Ouspensky, and together they explored the concept that the photographer ought to be responsible for the content of his work—knowledgeable about the associations and evocations implicit in the image and accepting responsibility for the general thrust and purpose of those tacit meanings—and the way to achieve knowledge of this hidden content was through careful analysis of the obvious and subtle sign language of the photograph seen as gestalt. The result of their investigation was published in a series of articles in *Aperture* in the late 1950's dealing with "reading" photographs.

Chappell's photographs were, from the first negatives, rediscoveries of images already present in his paintings. Reality is seen on more than one level, both as a transcription of what is obvious and as a revelation of what is imminent. The photograph was perceived as a "medium for the realization of inner realities." As Chappell says in his statement above, the camera is a tool which permits the artist to "arrest...vision as a realization in outer space, precisely at that moment when...understanding and conscience intuitively experience a reality...." The unfamiliar use of the word conscience in an aesthetic argument indicates the fundamentally religious structure of Chappell's relationship to photographic art.

Chappell worked with White for little more than a year before moving to downstate New York where he built a house (later destroyed by a fire which also destroyed most of his prints and negatives). In 1962,

he was a moving force in the creation of the Association of Heliographers, a cooperative photographic gallery on Madison Avenue, which sponsored a series of large exhibits in Lever House and other public spaces as well as providing exhibits for the members: Paul Caponigro, Jerry N. Uelsmann, Scott Hyde, etc. Although he initially defined the Heliographers as being "a magnetic center for Gurdjieffism," this definition was discarded by the general membership when Chappell moved West to New Mexico.

In the first days in Rochester, he became aware of the work done on resonance dowsing and adapted some of the concepts to his own photography, ideas which found parallel voicing in the writings of Castenada in the late 1960s; he also became interested in the Kirlian aura photography and since 1975 has produced a portfolio of images combining aesthetic and psycho-religious responses. The *Metaflora* portfolio invites meditation on the radiance of living forms, suggesting a spiritual documentary. Chappell's formal and spiritual needs find simultaneous statement in this work.

—Arnold Gassan

CHARBONNIER, Jean-Philippe.

French. Born in Paris, 28 August 1921. Educated at Lycée Condorcet, Paris, 1930-39, B.Phil. 1939; self-taught in photography and as assistant to movie portraitist Sam Levin. Married Gisèle Gonfreville in 1951 (divorced, 1965); married the gallery owner Agathe Gaillard in 1968; children: Marie-Christine, Prune, and Eglantine. Layout Artist, *Liberation* newspaper, Paris, 1944-49; Staff Photographer, *Réalités* magazine, Paris, 1950-74; freelance photographer, Paris, since 1974. Instructor in Photography, Ecole Superieur des Arts Graphiques, Paris, and Annual Photography Workshop, Derby Lonsdale College, England, since 1976. Agent: Galerie Agathe Gaillard, 3 rue du Pont Louis-Philippe, 75004 Paris. Address: 1 rue du Pont Louis-Philippe, 75004 Paris, France.

Individual Exhibitions:

1972 *Jean-Philippe Charbonnier: Un Photographe Français*, Maison de la Culture, Le Havre (travelled to the Centre Culturel, Brussels, and The Photographers' Gallery, London)

1974 *Jean-Philippe Charbonnier/Marc Riboud: Reporters-Photographes*, French Institute, Stockholm

1976 *I Think We Met Before*, Galerie Agathe Gaillard, Paris (travelled to Galerie Nagel, Berlin)

 Portraits and Situations, Berlin Cultural Centre

1978 *50 Photographies Nouvelles*, Galerie Agathe Gaillard, Paris (travelled to Galerie Nagel, Berlin)

Selected Group Exhibitions:

1974 *Six Great French Photographers*, touring exhibition (toured Moscow, South America, Algiers, etc., 1974-78)

1979 *Fleeting Gestures: Dance Photographs*, International Center of Photography, New York (travelled to The Photographers' Gallery, London, and *Venezia '79*)

Collections:

Bibliothèque Nationale, Paris; Musée Réattu, Arles, France.

Publications:

By CHARBONNIER: books—*Les Chemins de la Vie*, with introduction by Philippe Soupault, Paris 1957; *Un Photographe vous Parle*, Paris 1961; *107 Photographies en Noir et Blanc 1945-1971*, with an introduction by Michel Tournier, Paris 1972; other—"France," 1954, "Around the World," 1955, and "Red China," 1956, all special issues of *Réalités* (Paris); 6 photo-albums on Morocco for Royal Air Maroc, 1968-73.

On CHARBONNIER: book—*Jean-Philippe Charbonnier/Marc Riboud: Reporters-Photographes*, exhibition catalogue, Stockholm 1974; articles— "Les Tribulations de Jean-Philippe Charbonnier" by Francoise Riss in *Photo-Reporter* (Paris), March 1979; "Ile de Seine" by Hervé Le Gall in *Photo-Journal* (Paris), June 1980.

Ansel Adams said (more or less): "It's strange how photography advanced without improving." Man Ray said: "Don't ask with what camera and exposure a picture is done." Robert Capa said: "If a picture is not good, it's because you were not close enough." Henri Cartier-Bresson said: "To me, photography is the simultaneous recognition, in a fraction of a second, of the significance of an event as well as of a precise organization of forms which give that event its proper expression." (*The Decisive Moment*, 1952). Mies van der Rohe said: "Less is more, and more is too much." Also, one should read what the Bauhaus people said, and Moholy-Nagy, and Oscar Niemeyer. And Picasso said: "On ne cherche pas, on trouve."

Norman Hall was a very fine person, a marvellous friend, and he knew photography much better than anyone ever did. And he published pictures in *The Times* just for the beauty of the gesture—and said nothing, but did much. Nobody ever did it before or after.

I say: Exoticism is around the corner, but if *Geo* is out, *National Geographic Magazine* is in. One should make a movie of the life of Edward Weston. I love Halsman; Karsh is out forever. *Jamming the Blues* (Gjon Mili) and *Citizen Kane* and the Kubrick movie *Barry Lyndon* are a must for every photographer. As for *Citizen Kane*, I am sure that charming Bill Brandt agrees (he told me so recently). Larry Burrows was much greater than W. Eugene Smith. Irving Penn and Hoyningen-Huene are aristocrats;

Avedon is a good salesman; André Kertész is the ever-marching statue of modern photography.

It took me thirty years and a lot of pain to discover the truth of what H. C.-B. always said. One should use only ONE camera with one lens that coincides with your angle of vision, with the same film at its normal speed. The rest is gimmick and hardware.

—Jean-Philippe Charbonnier

A way of seeing and a commanding presence— vigor, passion, and unfailing way of catching his contemporaries, placing them among his other discoveries and desires in order to give some coherence to the life of contradictions he finds around him: this is the same man who travels all over the world for *Réalités* and submits his strong and astonishing reports, discovering the unusual in the heart of Africa and in the sumptuous nudes in a corridor of the Folies Bergères.

The great unrecognized photographer of the "French" school of reporting in the 1950's, Jean-Philippe Charbonnier is, of his generation, the man who has understood best that one does not make photographs in the same way as one works for the press or for exhibitions; he is the true professional who has made a coherent, analytic statement of his way of seeing things. To be convinced of this we need only look at his shifts in lighting, the sudden breaks in his severe style and the emergence of new intentions.

Teacher, reporter, graphic artist, typography fanatic, a colorful character, sincere, sensitive, passionate—Jean-Philippe Charbonnier is an exemplary photographer. This would be true if only because of the continuous series of photographs in which he uses the "fixed image" to question the meaning of an entire era.

—Christian Caujolle

Jean-Philippe Charbonnier: *La Piscine d'Arles*, 1975

CHARGESHEIMER.

German. Born Carl-Heinz Hargesheimer in Cologne, 19 May 1924. Studied graphics and photography at the Werkkunstschule, Cologne. Served in the German Army, 1942-45. Married Annemarie Redlin in 1970. Independent painter, graphic artist, sculptor and photographer, Cologne, from 1945. Worked as a stage- and exhibition-designer, and film director, Cologne, Kassel and Braunschweig, 1945-55; concentrated on "Meditationsmühlen" (wire sculptures with photographic elements), Cologne, 1948-51; freelance professional photographer, Cologne, 1955-71. Instructor, Schule für Fotografie und Film, Dusseldorf, 1951-53. Recipient: Kulturpreis, Deutsche Gesellschaft für Photographie (DGPh), 1968; Karl-Ernst-Osthaus Prize, Hagen, West Germany, 1970. *Died* (by suicide; in Cologne) *in January 1972.*

Individual Exhibitions:

1958 Galerie Seidee, Hannover (with D. Sommer)
1971 *Meditationsmühlen*, Kunstverein, Cologne
1972 *Hommage à Chargesheimer*, Kunstverein, Cologne
1976 Städtische Kunstsammlungen, Ludwigshafen, West Germany
1978 Sander Gallery, Washington, D.C.
1980 *Unter Krahnenbaumen*, Museum Folkwang, Essen
1981 *Chargesheimer 1924-1972: Fotografien*, Goethe-Institut, Munich (toured France, Italy, England, and the United States)

Selected Group Exhibitions:

1950 *Photokina*, Cologne (and every two years through 1980)
1951 *Mostra delle Fotografia Europea*, Palazzo di Brera, Milan
 Subjektive Fotografie, Staatliche Schule für Kunst und Handwerk, Saarbrücken
1968 *2nd World Exhibition of Photography*, Pressehaus Stern, Hamburg (and world tour)
1969 *Kunst als Spiel/Spiel als Kunst*, Kunsthalle, Recklinghausen, West Germany
1977 *Fotografische Künstlerbildnisse*, Museum Ludwig, Cologne
1979 *Deutsche Fotografie nach 1945*, Kunstverein, Kassel, West Germany (toured West Germany)

Collections:

Museum Ludwig, Cologne (archives); L. Fritz Gruber Collection, Cologne.

Publications:

By CHARGESHEIMER: books—*Cologne Intime*, with text by Schmitt-Rost, Cologne 1957; *Unter Krahnenbäumen*, with text by Heinrich Böll, Cologne 1958; *Im Ruhrgebiet*, with text by Heinrich Böll, Frankfurt and Cologne 1958; *Romanik am Rhein*, with text by H.P. Hilger, Cologne 1959; *Menschen am Rhein*, with text by Heinrich Böll, Cologne 1960; *Berlin: Bilder aus einer Grossen Stadt*, with text by Scholz, Cologne 1960; *Des Spiegels Spiegel*, with text by E. Kuby, Hamburg 1960; *Beispiele moderner Plastik aus dem Kunstbesitz der Stadt Marl*, with text by Jean Cassous, Paris 1960; *Zwischenbilanz*, with an introduction by Karl Pawek, Cologne 1961; *Theater-Theater*, with text by Martin Walser, Velben, West Germany 1967; *Hannover*, with text by G. Ramseger, Hannover 1970; *Köln 5 Uhr 30*, with text by G. Ramseger, Hannover 1970.

On CHARGESHEIMER: books—*Mostra della Fotografia Europea*, exhibition catalogue, Milan 1951; *Photography of the World '60*, edited by Hiromu Hara, Ihei Kimura and others, Tokyo and New York 1960; *Antlitz des Ruhmes* by L.F. Gruber, Cologne 1960; *2nd World Exhibition of Photography*, exhibition catalogue, edited by Karl Pawek, Hamburg 1968; *Kunst als Spiel/Spiel als Kunst*, exhibition catalogue, by Werner Schulze-Reimpell, Recklinghausen, West Germany 1969; *Deutsche Kunst der 60er Jahre*, vol. 2, by Jürgen Morschel, Munich 1972; *Chargesheimer: Aus dem fotografischen Gesamtwerk*, exhibition catalogue, Cologne 1972; *Fotografische Künstlerbildnisse*, exhibition catalogue, by Dieter Rönte, Evelyn Weiss and Jeanne von Oppenheim, Cologne 1977; *Geschichte der Fotografie im 20. Jahrhundert/Photography in the 20th Century* by Petr Tausk, Cologne 1977, London 1980; *Deutsche Fotografie nach 1945/German Photography after 1945* by Floris Neusüss, Wolfgang Kemp and Petra Benteler, Kassel, West Germany 1979; *Photokina 1980: Glanzichter der Photographie*, edited by L. Fritz Gruber, Cologne 1980; *Chargesheimer 1924-1972, Fotografien*, exhibition catalogue, by Evelyn Weiss, Munich 1981; articles—"Chargesheimer" by Daniel Masclet in *Photo-Cinéma* (Paris), October 1957; "Obituary: Chargesheimer" in *Camera* (Lucerne), April 1972.

Hardly a decade after his death, Carl-Heinz Hargesheimer (or Chargesheimer, the pen name he later adopted) has already become a legend, a mythic figure of the 1950's and 60's. He was a multi-faceted personality whose work is full of ideas and self-contradictions: during the course of his life he was a painter, a sculptor, a light-graphic artist, the inventor of kinetic machines, a stage designer, director and photographer. But it is his photographs, with their range and perfection, which remain his greatest achievement.

We can justifiably assert that Chargesheimer wrote one of the most significant chapters in the history of photography in Germany since 1945. As a typical member of the young German intellectuals of the post-war generation, he experimented first of all with the new techniques which became available once the nightmare of the Third Reich was over. Thus we have his gelatin pictures and photograms or abstract photographs. It was the era of tachism and non-objectivisim.

By the mid-50's Chargesheimer had already made a name for himself as a portrait photographer, and we are indebted to him for his many shots of actors, politicians and other prominent personalities (Josephine Baker, Jean-Paul Belmondo, Louis Armstrong, and Konrad Adenauer, among many others). He approached his subjects realistically and relentlessly, using almost without exception the close-up, in which the subject's face takes up the entire picture surface. Although he always took a series of photographs in quick succession, his pictures never suggest hastily captured emotions or random moments. They seem strongly planned and have a monumental, at times even an inexorable, power.

For the most part Chargesheimer's photographic achievements are concentrated in the period from 1957 to 1961. Like a man possessed, he produced a photographic *oeuvre* of astonishing richness and depth during these four years. He produced 8 of his well-known books in quick succession and introduced something quite new to the world of photography. After the appearance of his first volume, *Cologne Intime*, one critic wrote that we would never again be able to look at other picture books of cities. One year later, in 1958, he began his successful artistic collaboration with Heinrich Böll, who supplied the texts for 3 of his books, and set new standards for thematically organized books of photos.

Chargesheimer's subjects are the people of his native city of Cologne, the Ruhr District, and stretches along the Rhine. These people and their lives were worthy of his loving patience and amused sympathy. He knew their weaknesses as well as their strengths. He lived with them and experienced the captivating lure of "reality" and its mysteries, which the photographer better than anyone can perceive and record.

Chargesheimer: *Dr. Konrad Adenauer,* **1955** Courtesy Sander Gallery, Washington, D.C.

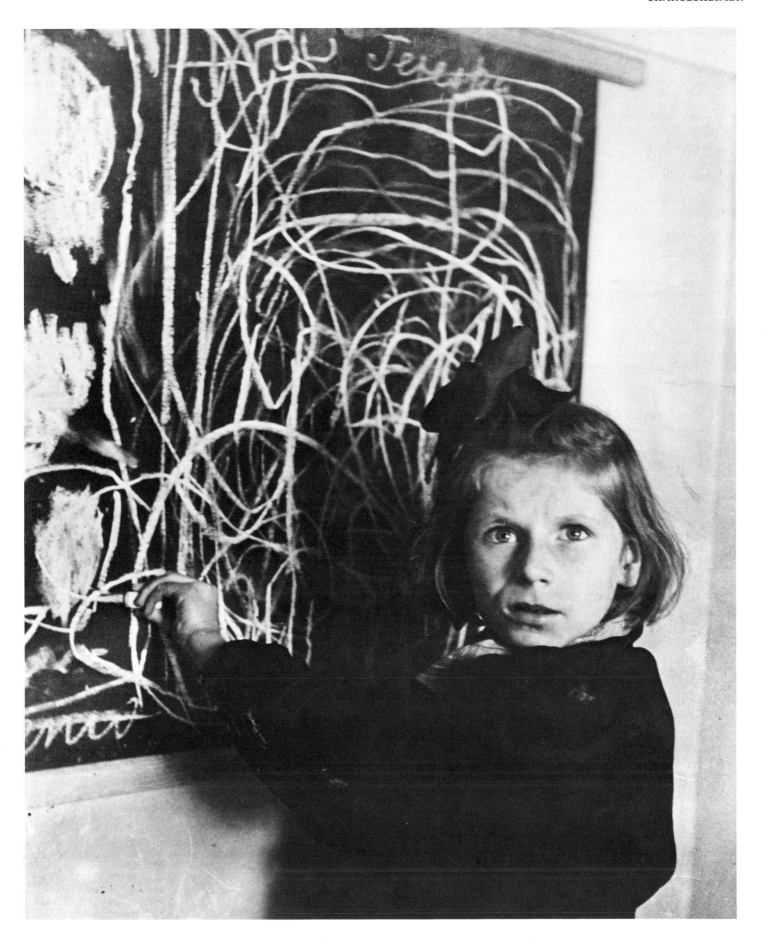

Chim (David Seymour): *Terezka, A Disturbed Child in an Orphanage: The Scrawls on the Blackboard Are Her Drawing of "Home,"* Poland, 1948

With passion, almost in a state of intoxication, he acted as both witness and interpreter, preserving the spirit of an era in hundreds of photographs. This was the famous period of the 50's, its recent past full of the ruins and memories of war, its future soon to give rise to the first meagre blooms of reconstruction. Men had achieved some stability again. The people of Cologne had rebuilt the old cathedral section of the city, the little streets were inhabited once again and had not yet been "rationalized away" to make room for bank buildings and highrise parking lots.

With these photographs Chargesheimer provided a unique documentation of Germany between the post-war years and the beginning of the "economic miracle," an era which still showed the wounds of war but also one in which people could be happy again. Chargesheimer looked at his contemporaries and loved the ways in which they settled down inside ruined walls, the ways in which they enjoyed the Rhine country in summer, the ways in which they chattered together and began to live with one another once again.

Chargesheimer had a sharp eye but was at the same time loving and indulgent, careful never to wound human dignity or invade personal privacy. It is true that many of his subjects appear comic or ludicrous—hardly ever do we see a really "noble" figure—yet he always stops short of any brutal exposures. He never gives us anything like the gallery of horrors or the shockingly brutal world of American photographers like Diane Arbus or Weegee.

Chargesheimer gives us a glimpse of an era in Germany, the golden 50's, during which people worked hard to eradicate the traces of the catastrophe and were hoping to reconstruct the world they had known before the war. And yet at the same time we can sense in these pictures a certain melancholy, an undefined sadness and hopelessness. The decade which followed was to change German history. Men reaped the benefits of the "economic miracle" and enjoyed the blessings of progress and prosperity, but at the same time they also experienced the curse of isolation, the destruction of municipal units, the reckless demolition of the old sections of many cities, and the movement of large sections of the population into new housing developments. Incomes increased, but so too did isolation, neuroses, and the failure to understand each other.

Chargesheimer must have recognized and felt deeply about all of these things in his world. He took fewer and fewer photographs and in 1961 decided to dedicate himself completely to his work as a stage designer and director of theatre and opera. He saw clearly, in the late 60's, how people in his own city grew more and more isolated, how the cities themselves became increasingly inhuman. His last book, *Köln, 5 Uhr 30*, shows only empty streets with their various signs and traffic signals. In his short text he wrote "A city without people.... The bare pictures of the world of its inhabitants...becomes a kind of x-ray for the diagnosis of an illness.... The sum and multiplicity of individual destinies touching one another, which is what, in the last analysis, must concern us most, it is this which has become invisible. Signal systems, arrows, lines, zebra crossings and so forth denote mere function, a substitution for life human. Is the opposition between man and technology and commerce all that remains to think about? Are rules and regulations, restrictions, competition and profitmaking any compensation for the loss of human brotherhood?" Chargesheimer would not, could not, say more: his camera finally became completely "silent."

—Evelyn Weiss

CHIM. (David Seymour).

American. Born David Szymin in Warsaw, Poland, 20 November 1911; emigrated to the United States, 1939: naturalized, 1942. Educated at Gymnasium Ascolah, Warsaw, 1924-29; Adademie für Graphische Künste, Leipzig, 1929-31; Sorbonne, Paris, 1931-33. Served as a reconnaissance photographer, United States Army, in Europe, 1942-45: Lieutenant. Freelance photographer, working for *Vu, Regards, La Vie Ouvriere, Ce Soir*, etc., Paris, and throughout Europe and North Africa, 1933-39; established own photo studio, New York, 1940-42, working in Europe, Israel, Egypt, 1946-56. Founder with Robert Capa, Henri Cartier-Bresson and George Rodger, 1947, and President, 1954-56, Magnum Photos co-operative photo agency, Paris and New York. Recipient: Honor Award (posthumous), Overseas Press Club, New York, 1957. International Fund for Concerned Photography (formerly Werner Bischof/Robert Capa/David Seymour Memorial Fund), New York, established 1966. Agent: Magnum Photos. *Died* (in Suez, Egypt) *10 November 1956.*

Individual Exhibitions:

1957 *Chim's Children*, Art Institute of Chicago (toured the United States)
1958 *Chim's Children*, Limelight Gallery, New York
 Chim's Children, at *Photokina '58*, Cologne
1966 Galerie Form, Zurich (retrospective)
 Chim's Times, Compo Photocolor, New York (retrospective; travelled to Jerusalem Museum, Israel; then toured Europe)
1967 School of Visual Arts, New York (retrospective)

Selected Group Exhibitions:

1949 *Quelques Images de Nongrie*, Paris
1952 *Weltausstellung der Photographie*, Lucerne
1955 *The Family of Man*, Museum of Modern Art, New York (and world tour)
1956 *Magnum Photographers*, at *Photokina '56*, Cologne
1959 *Photography in the Fine Arts*, Metropolitan Museum of Art, New York
1962 *Man's Inhumanity to Man*, at *Photokina '62*, Cologne
1965 *World's Fair*, New York
1967 *The Concerned Photographer*, Riverside Museum, New York (toured the United States, Europe and Japan, 1967-71)
1974 *The Classics of Documentary Photography*, International Center of Photography, New York
1981 *The Spanish Civil War*, International Center of Photography, New York (toured France)

Collections:

Metropolitan Museum of Art, New York; Museum of Modern Art, New York; Riverside Museum, New York; International Center of Photography, New York; Museum of Fine Arts, Boston; National Gallery of Art, Washington, D.C.; Art Institute of Chicago; Museum of Fine Arts, Houston.

Publications:

By SEYMOUR: books—*Children of Europe*, Paris 1948; *The Vatican*, with text by Ann Carnahan, New York and London 1950; *The Little Ones*, Tokyo 1957; articles—"The World of the Kibbutz" in *Holiday* (New York), January 1953; "Tales of Rome" in *House and Garden* (New York), March 1957.

On SEYMOUR: books—*The Picture History of Photography* by Peter Pollack, New York 1958; *David Seymour—"Chim": A Monograph*, edited by Anna Farova, Prague and New York 1967; *12 at War: Great Photographers under Fire*, edited by Robert E. Hood, New York 1967; *The Concerned Photographer*, edited by Cornell Capa, New York 1968; *David Seymour—"Chim" 1911-1956*, texts by Henri Cartier-Bresson, Judith Friedberg and others, New York and London 1974; *The Magic Image* by Cecil Beaton and Gail Buckland, London and Boston 1975; *Geschichte der Fotografie im 20. Jahrhundert/Photography in the 20th Century* by Petr Tausk, Cologne 1977, London 1980; articles—"Pas de No Man's Land" in *L'Express* (Paris), 16 November 1956; "A Man of Great Faith and Compassion" by William Richardson in the *New York Post*, 16 November 1956; "Tribute to Chim" in *Newsweek* (New York), 26 November 1956; "End of the Road" in *Time* (New York), 26 November 1956; "Magnum Opus" by Horace Sutton in *Saturday Review* (New York), 1 December 1956; "The World of Seymour" by John G. Morris in *Infinity* (New York), February 1957; "Snapshot of a Gentle Photographer" by Bob Considine in the *New York Journal-American*, 18 February 1957; "Masters of the Leica: On the Surge of the Tide: The Life and Death of Photographer David Seymour" by Robert d'Hooghe in *Leica Fotografie* (Würzbach, Germany), no. 2, 1957; "World's Child: The Family Album of the Late Photographer David Seymour" in *Infinity* (New York), November 1958; "Children the Theme" by Jacob Deschin in *New York Times*, 5 February 1958; "Chim: A Man of Peace" by Judith Friedberg in *Camera* (Lucerne), December 1958; "Chim—David Seymour" in *Terre d'Images* (Paris), October 1966; "Chim: Shadows of Violence" by Margaret R. Weiss in *Saturday Review* (New York), 14 January 1967; "The Concerned Photographer," special issue of *Contemporary Photographer* (Culpeper, Virginia), vol. 6, no. 2, 1968; "Chim's Way" by Inge Bondi in *Camera 35* (New York), December/January 1969/70.

The art of the reportorial photographer "Chim" addressed itself, if we can still use the phrase without flinching, to the human condition. He found that condition in the particular, and specific, and employed it in narrative.

Chim "picked up his camera the way a doctor takes his stethoscope out of his bag, applying his diagnosis to the condition of the heart; his own was vulnerable"—thus Henri Cartier-Bresson in analytic tribute to his friend and colleague, in 1966, a decade after Chim had been the victim of a tragic accident, killed by a sniper just after the cessation of hostilities in Suez.

Chim was a linguist, a world traveller, uprooted by world events from a warm, secure background. His father was a highly successful publisher of books in Yiddish and Hebrew, and the family had achieved a solid life in Warsaw, lasting until the early 1930's, in spite of the First World War and its aftermath. The nickname—Chim—came from the family surname, Szymin, which had been Americanised into Seymour by the photographer. Chim first went to Germany from Poland, to study printing in Leipzig, and art and photography, and then on to Paris which was to remain his base until 1939 and the onset of World War II.

Chim spoke seven languages, and when he became a photo-journalist he made his name internationally by photographing ordinary life, and civilian daily life in times of war, at first with the Spanish Civil War which he reported on for *Life*. It was typical that after the war he photographed children for UNICEF. Chim was a founder member of Magnum (1947) with George Rodger, Robert Capa and Henri Cartier-Bresson; he had shared a darkroom with the latter two photographers, and singly and collectively they were instrumental in the foundation of modern photo-journalism, putting into practice precepts and even theories which implicitly still

inform not only the news photograph, but, arguably, television news film as well. Chim, Capa and Cartier-Bresson really all contributed to the practice of the search in photography for the "decisive moment," as Cartier-Bresson called it.

An early interest of Chim's had been music, and at one point it was thought he would be a professional pianist. He was famous among his friends for his passionate interest in food; he was a gourmet. All his life he read dozens of newspapers, he had a vigorous intellectual life, internationally oriented, and above all, although he never married, he was profoundly concerned with the lives of the world's children, children forming the subject of a major exhibition and a book. And in his private life he was an honorary uncle to scores of children throughout the world, contributing support both material and spiritual.

This concern for children paralleled his concern for ordinary life. One of his most famous photoessays was that published in *Life* in 1938 about civilian life during the Spanish Civil War; one of his most famous photographs(accompanying this entry) was that of the young orphan girl in 1948, in Poland, standing bright-eyed, defiant, by a huge chalk scrawl she has just made which represented to her, her home. Chim on his return to Poland after the war found the family's country house an orphanage and his family dead.

In the 1930's he photographed political life in Paris, especially the gatherings of the liberal and left wing, and the Popular Front. He photographed many a leading intellectual and artist: the Curies, Romain Rolland, Picasso; after the war he photographed Toscanini, an encounter about which he wrote memorably in a letter to a friend; and summed up the look of Bernard Berenson, too. And he photographed the growth of the State of Israel, not through its leaders, and its statesmen, but through life in the settlements, in Jerusalem, on the kibbutz.

Chim's great strength was to point the obvious with subtlety, with sentiment and feeling but without sentimentality. The human event, whether it be a protest march or a very young child tentatively but with great pleasure and curiosity trying out a new pair of shoes, was paramount, the world a setting for human life in its intricate variety, at work, at play, in sorrow and in joy. His compassion and honesty won him the respect of his fellow professionals; his early pointless death was justly felt a great loss not only to the worlds of photography and photo-reporting but also to history as recorded in visual terms. It is the great news photographers whose single images—the decisive moments—bequeath the atmosphere of the recent past to the future. It is interesting that even the eulogies of Chim by his surviving sister, his fellow professionals, are very human: he was not made out to be larger than life, his foibles and eccentricities, his knowledgable passion for food, combined oddly it seems with an inseparable cigarette, were chronicled with vivid care. The photographs remain as studies in peace and war behind the enemy lines, musical and rhythmic, never artful but always authoritative, in the sense that the spectator shares the sense of "this is how it was." He kept saying, his fellow professionals have told us, "This is a great story," and the great story in its ordinary moments is what he so incisively chronicled.

—Marina Vaizey

CHOCHOLA, Václav.

Czechoslovakian. Born in Prague, 30 January 1923. Educated at secondary school in Prague, 1935-41; apprentice photographer to Otto Erban, Prague,

1941-45. Married Božena Stopkova in 1953; daughter: Blanka. Worked as a photojournalist for various newspapers and magazines in Prague, 1945-54. Freelance photographer, in Prague, since 1954. Member, Union of Czechoslovak Fine Artists, 1949. Address: Prosecká 47, CS-180 00 Prague 8, Czechoslovakia.

Individual Exhibitions:

1945 Větrník Theatre, Prague
1961 Fotokabinett Jaromir Funke, Brno, Czechoslovakia
1963 S.K. Neuman Theatre, Prague
1965 Czechoslovak Writers Gallery, Prague
1966 Czechoslovak Cultural Center, Warsaw
 Czechoslovak Cultural Center, East Berlin
 Czechoslovak Cultural Center, Budapest
1967 Czechoslovak Cultural Center, Bucharest
 Czechoslovak Cultural Center, Cairo

1968 Czechoslovak Writers Club, Prague
1969 Czechoslovak Writers Club, Prague
1974 Fotokabinett Jaromir Funke, Brno, Czechoslovakia
1980 Music Theatre, Olomouc, Czechoslovakia

Selected Group Exhibitions:

1946 *The End of the War in Prague*, Gallery ULAV, Prague
1959 *Members of the Artists Union*, Czechoslovak Writers Gallery, Prague
1963 *Vietnam Today*, Gallery Ars, Prague
1965 *Sports in the Arts*, Municipal Gallery, Prague
1966 *Surrealism and Photography*, Folkwang Museum, Essen
1967 *Exhibition 7 x 7*, Gallery Spála, Prague
1969 *Crazy Horse Saloon*, Club Metra, Blansko,

Václav Chochola: *Salvador Dali with My Portrait of Dali*, 1969

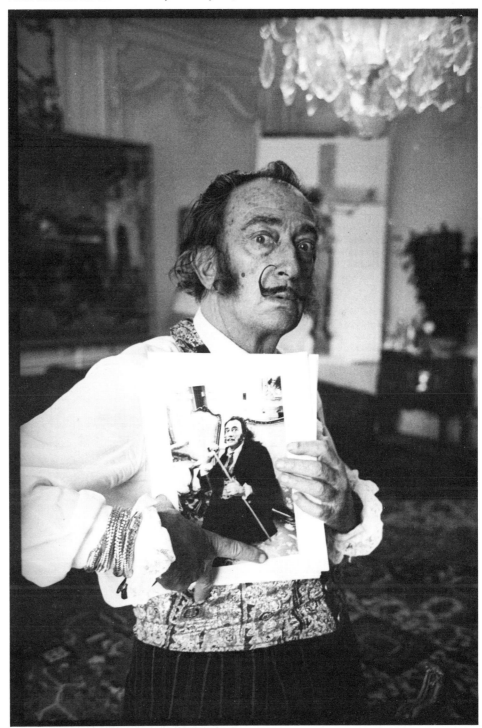

Collections:

Museum of Decorative Arts, Prague; Moravian Gallery, Brno, Czechoslovakia; District Gallery, Olomouc, Czechoslovakia; Museo Universitario de Ciencas y Arte, Mexico City.

Publications:

By CHOCHOLA: books of photographs—*Pferde/Horses*, with an introduction by Matyášová, Prague 1958, 1960; *Artists' Studios in Prague*, with others edited by J. Prošek, 1960; *Light and Shadow*, with others, Prague 1960; *Painter František Tichý*, with text by F. Dvořák, Prague 1961; *Václav Chochola 1940-1960*, edited by Jiří Kolář, Prague 1961; *Václav Chochola: Meisterfotografien*, edited by Jiří Kolář, Prague 1961; *Memory in Black and White*, edited by J. Prošek and J. Rezáč, Prague 1961; *Nudes*, with others, edited by Z. Pilař and J. Rezáč, Bratislava 1968; *Spring in Prague*, with text by Anna Fárová and Václav Holzknect, Prague 1970; *The Paintings of František Tichý*, with text by Jan Tomeš, Prague 1976; articles—"A Musical Play for Josef Sudek on His 70th Birthday" in *Ceskoslovenská Fotografie* (Prague), March 1966; "Fotografický Přehled 1967" in *Kulturni Tvorba* (Prague), no. 12, 1968.

On CHOCHOLA: book—*The Life and Work of Václav Chochola* by Blanka Chocholová, Prague 1980; articles—"Roláže V. Chocholy a Jiřiho Kolaře" by Adolf Hoffmeister in *Svět. Literatura* (Prague), no. 5, 1962; "Spiknutí krásy" by Bohumil Hrabal in *Rudé Právo* (Prague), October 1965; "Czech Points on Surrealism" by Petr Tausk in *Modern Photography* (New York), no. 9, 1969; "Jak se co dělá" by A. Sourkové in *Ceskoslovenská Fotografie* (Prague), no. 10, 1969; "Photographie Tschécoslovaque" by V. Fiala in *Photo Ciné Revue* (Paris), no. 12, 1971; "Tvar Ceskoslovenska Fotografie" by Karel Dvořák in *Ceskoslovenská Fotografie* (Prague), no. 12, 1972; "Painting and Photography" by Petr Tausk in *British Journal of Photography Annual*, London 1973.

A good photograph is a witness of the time when it was taken. The more simple the image, the better the interpretation of the spirit of the time.

The strength of photography comes from the vision of the photographer, from his abiity to discover the hidden poetry in everyday life.
—Václav Chochola

Václav Chochola once collaborated with an avant-garde theatre, and in that work he became better acquainted with Dada and the surrealistic trends of the first half of the 1940's. The dreamlike situations on stage that he had to photograph helped him to find his own way to the realm of poetry of subconscious forces. Once his creative vision and skill developed in capturing the chance meeting of subjects, he began to discover his *objets trouvés* in all parts of the world. Chochola never hunted his subjects at any price; he found them naturally, without intruding on the reality of their environments. For this reason his photographs are free from artifice, the artificiality that always conveys a certain coldness. His work is simple, direct and honest; it demonstrates the hidden richness of everyday life.

In fact, Chochola's work is more eclectic than this description suggests; he has always worked within a broad spectrum. Besides his predilection for the *objet trouvé*, he has also a sincere interest in the "live" photograph at that moment when the happening is in its most eloquent arrangement, so that he may express most clearly visual information about the event. Chochola also responds to the beauty of disciplined movement: he has been a photographer of sports, particularly in the early part of his career.

Chochola has always had close contacts with modern painters, sculptors, poets and actors, and these friendly connections have created the necessary and fertile basis for a series of psychological portraits of outstanding personalities. This theme has attracted him since practically the beginning of his creative career, and quite recently he exhibited a unique collection of famous faces from both Czechoslovakia and abroad.

—Petr Tausk

CITROEN, (Roelof) Paul.

Dutch. Born, of Dutch parents, in Berlin, Germany, 12 December 1896. Educated at the Askanisches Gymnasium, Berlin, until 1910; studied art, under Brandenburg, Studien-Ateliers für Malerei und Plastik, Berlin-Charlottenburg, 1913-14; painting and design, under Johannes Itten and Georg Muche, Staatliches Bauhaus, Weimar, 1922-25; mainly self-taught in photography. Served in the Dutch Army, at Alkmaar, Netherlands, 1915-16. Married Celine Bendien in 1929. Manager, Herwarth Walden's "Der Sturm" bookshop, Berlin, 1916-17; bookseller and art dealer, and unofficial propagandist for "Der Sturm" artists, Amsterdam, 1917-18; independent painter, associating with the Dadaists, including Richard Huelsenbeck, Georg Grosz, Walter Mehring and the Herzfelde brothers, Berlin, 1918-21; first photomontages, Berlin, 1919; freelance painter and portrait photographer, establishing photo studio with Umbo, Berlin, and travelling in Amsterdam, Paris and Basle, 1925-27; freelance portrait photographer, Amsterdam, 1928-35; painter, teacher and

Paul Citroen: *Toilet in the House of Gerrit Rietveld*, 1929 Courtesy Galerie Wilde, Cologne

occasional photographer, Amsterdam, 1935-64, in Wassenaar, from 1964. Founder Director and Professor, with Charles Roelofsz and J. Havermans, De Nieuwe Kunstschool, Amsterdam, 1933-37; Professor of Drawing and Painting, Academie voor Beeldenden Kunsten, The Hague, 1935-40, 1945-60. Address: Oostdorperweg 100, Wassenaar, Netherlands.

Individual Exhibitions:

1932 Kunstkelder, Amsterdam
1934 Toonzaal Sierkunst, Amersfoort, Netherlands
1935 Kunstkelder, Amsterdam
1956 Haagse Gemeentemuseum, The Hague
1957 Stedelijk Museum, Amsterdam
 Gemeentemuseum, Arnhem, Netherlands
1958 Stedelijk van Abbemuseum, Eindhoven, Netherlands
 Stedelijk Museum, Gouda, Netherlands
1959 De Beyerd, Breda, Netherlands (with W. Schrofer and Sierk Schroder)
 Pulchri Studio, The Hague
1960 Singer Museum, Laren, Netherlands
 Bezalel Museum, Jerusalem
1961 Pictura, Groningen, Netherlands
1962 Pulchri Studio, The Hague
1964 Zonnenhof, Amersfoort, Netherlands
1965 Stedelijk Museum, Alkmaar, Netherlands
 Dordrechts Museum, Netherlands
1966 Pulchri Studio, The Hague
1968 De portrettist Paul Citroen als Versamelaar, De Lakenhal, Leiden
1969 Haagse Gemeentemuseum, The Hague
1970 Kunsthalle, Worpswede, West Germany
1971 Rheinisches Landesmuseum, Bonn
 De Zonnewijzer, Eindhoven, Netherlands (with Sierk Schroder)
1972 Kritzraedthuis, Sittard, Netherlands
1973 Galerie M. de Boer, Amsterdam
 Kunstcentrum, Turnhout, Belgium
 Museum Leeuwarden, Netherlands
1974 Paul Citroen en het Bauhaus, Gemeentemuseum, The Hague (travelled to Hilversum, Apeldoorn, and Tilburg, Netherlands)
1975 Kulturcentrum, Ede, Netherlands
1976 Haagse Kunstkring, The Hague
 Voorchotense Kunstkring, Voorschoten, Netherlands (travelled to Gouda, Leiden, Deventer, Zurtphen, and Wassenaar, Netherlands)
1977 Pulchri Studio, The Hague
1979 Paul Citroen Fotograaf, Haagse Gemeentemuseum, The Hauge
 Galerie Rudolf Kicken, Cologne (with Umbo)
1981 Canon Photo Gallery, Geneva (with Erwin Blumenfeld)

Selected Group Exhibitions:

1923 Bauhaus-Ausstellung, Weimar
1935 School Exhibition, De Nieuwe Kunstschool, Amsterdam
1937 Foto '37, Stedelijk Museum, Amsterdam
1964 The Painter and the Photograph: From Delacroix to Warhol, University of New Mexico, Albuquerque
1969 Die Fotomontage, Stadttheater, Ingolstadt, West Germany
1973 Medium Fotografie, Städtisches Museum, Leverkusen, West Germany
1979 Fotografie in Nederland 1920-40, Haagse Gemeentemuseum, The Hague
1980 Avant-Garde Photography in Germany 1919-39, San Francisco Museum of Modern Art (toured the United States)
1981 Germany: The New Vision, Fraenkel Gallery, San Francisco

Collections:

Haagse Gemeentemuseum, The Hague; Stedelijk Museum, Amsterdam; University of New Mexico, Albuquerque; San Francisco Museum of Modern Art.

Publications:

By CITROEN: books—Palet: Een Boek Gweijd aan de Hedendaagsche Nederlandsche Schilderkunst, Amsterdam 1931; Material: Notizen eines Malers, Amsterdam 1933; Richard, The Hague 1940; Jacob Bendien 1890-1933: Ein Erinnerungsbuch, Rotterdam 1940; Licht en Groene Schaduw, The Hague 1941, 1947; Tekening en Aantekeningen, The Hague 1941; Kunsttestament, The Hague 1947, 1967; De Tekenaar Henk Hartog 1915-1942, The Hague 1947; Schets Boek voor Vrienden, The Hague 1947; Een Tekenles, Rotterdam 1954; Introvertissimo, The Hague 1956; Notities een Schilder, The Hague 1966; Wir Maler Heute und die Kunst-tradition, Zurich 1970; Paul Citroen Portretten, with text by Klass Peereboom, Apeldoorn, Netherlands 1974; Paul Citroen en het Bauhaus, with text by Kurt Lob, Utrecht and Antwerp 1974; Retrospektive Fotografie: Paul Citroen, with an introduction by Michael Pauseback, Bielefeld and Dusseldorf 1978; Paul Citroen Fotograaf, exhibition catalogue, with text by Flip Bool and Kees Broos, The Hague 1979.

On CITROEN: books—The Painter and the Photograph: From Delacroix to Warhol by Van Deren Coke, Albuquerque, New Mexico 1964, 1972; 50 Years Bauhaus, exhibition catalogue, by Wulf Herzogenrath, Stuttgart, London and Cambridge, Massachusetts 1968; Die Collage by Hertz Wescher, Cologne 1968; Die Fotomontage, exhibition catalogue, by Richard Hiepe, Ingolstadt, West Germany 1969; Nederlandse Fotografie: De Erste 100 Jaar by Claude Magelhaes, Utrecht and Antwerp 1969; Bauhaus and Bauhaus People, edited by Eckhard Neumann, Lucerne, New York and Toronto 1970; Medium Fotografie, exhibition catalogue, by Rolf Wedewer, Leverkusen, West Germany 1973; Photographie als Kunstlerisches Experiment by Willy Rotzler, Lucerne and Frankfurt 1974; Photomontage by Dawn Ades, London 1976; Geschichte der Fotografie im 20. Jahrhundert / Photography in the 20th Century by Petr Tausk, Cologne 1977, London 1980; Dada and Surrealism Reviewed, exhibition catalogue, by Dawn Ades, London 1978; Dada Photomontagen, exhibition catalogue, by Carl-Albrecht Haenlein and others, Hannover 1979; Fotografie in Nederland 1920-1940, exhibition catalogue, by Flip Bool and Kees Broos, The Hague 1979; Avant-Garde Photography in Germany 1919-1939, exhibition catalogue, by Van Deren Coke, Ute Eskildsen and Bernd Lohse, San Francisco 1980.

Paul Citroen is better known in the Netherlands as a landscape and portrait painter and draughtsman than as a photographer. That he actually did some photographic work during the years 1929-35 has only recently been rediscovered.

Citroen attended an art academy in Berlin, where in 1919 he became involved with the Dada movement. During that time he made "collages" comprised of photographs, illustrations from magazines, and postcards, of which his "Metropolis" became internationally famous. He made friends with the German photographer Otto Umbehr (Umbo) and Marianne Breslauer, who was a pupil of Man Ray in Paris. They taught him how to use the camera. When he returned to Amsterdam permanently, he began to work as a photographer because he could not earn sufficient income from his painting to survive.

Apart from experimenting in his own home, Citroen took portrait photographs of well-known Dutch artists, which were collected and published as a book, Palet, in 1931; it consisted of 53 portraits. He then began to receive more and more commissions from acquaintances and from German immigrants. In his portrait photographs—as in his portrait drawings—he tried to express the character and psyche of his subject. His portraits are far more romantic than those of his contemporaries of the New Objectivity, though they do possess the same directness and were never retouched. His portrait of Edgar and John Fernhout, sons of the artist Charley Toorop—both sensitive, nervous types, far too serious for their age—is a wonderful likeness. Of Carel Willink, the painter, he made a very sharp portrait: his face with the remarkable nose, the immaculate clothing, the brim of his hat just above his eyes—Citroen's work reminds one of Willink's own self-portrait of that time. In the portrait of Willink's wife we detect a young, confident, somewhat provoking look. The architect Rietveld looks at us maturely and seriously, photographed in his shirt, working at his drafting table. Citroen's friend Charles Roelofsz, with whom he founded De Nieuwe Kunstschool, similar in concept to the Bauhaus, comes over as a bohemian, a wine glass and bottle in front of him.

The position, situation, clothing, hair style, facial attributes—everything is used to intensify and strengthen the depiction of personality. For example, Citroen produced a series of very striking photographs of the German cabaret artist Erica Mann, who came to have her portrait drawn for her father, the German writer Thomas Mann. Citroen also photographed her. But the photographs are not models for the portrait drawings; rather, they are parallel studies in which her personality has been captured. In both media he brings her to life; tiny, restless, boyish-looking, with short cut hair, dressed in a suit and tie.

After 1932, however, Citroen began to lose interest in photography. At De Nieuwe Kunstschool he taught only drawing and delegated the teaching of photography to Eva Besnyö and Paul Guermonprez. After he was appointed to the faculty at the Academie voor Beeldenden Kunsten in The Hague, he stopped photographing altogether. Yet Citroen's psychological portraits not only have value as photography, but also they are an excellent document of the artistic life of the Netherlands in the 1930's.

—A. de Jonge-Vermeulen

CLAASS, Arnaud.

French. Born in Paris, 16 June 1949. Studied music with the composer Janine Charbonnier, Paris, 1959-67; attended Cours Hattemer, Paris, 1963-67; self-taught in photography, but influenced by work of André Kertész, Henri Cartier-Bresson and Bill Brandt. Assistant fashion photographer, Studio Camera, Montreal, 1968-69; freelance photojournalist, working for Le Nouvel Observateur, L'Express, Elle, etc., United States and France, 1970-72. Independent photographer, Paris, since 1973. Photography critic, working for La Nouvelle Critique, Zoom, etc., Paris, 1974-79. Co-Founder, Contrejour photo magazine and publishing company, Paris, 1975; visiting instructor in photography, Contrejour workshops, Ecole Nationale des Arts Décoratifs, etc., Paris, since 1975. Agent: Michelle Chomette, 240 bis Boulevard St. Germain, 75007 Paris. Address: 61 bis Avenue Ramey, 75018 Paris, France.

Individual Exhibitions:

1972 F.I.A.P. Galerie, Paris
1973 Underground Gallery, New York
1974 Galerie Le Signe, Paris

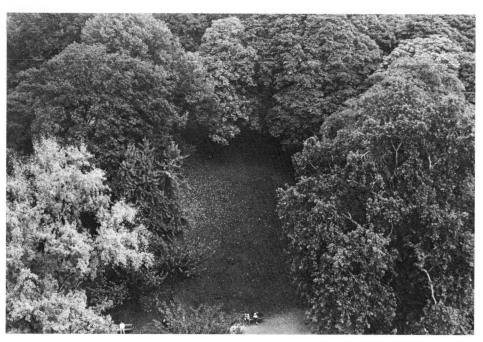

Arnaud Claass: *Parc des Buttes-Chaumont*, **Paris, 1979**

	Galerie L'Oeil 2000, Chateauroux, France
1976	Galerie Contrejour, Paris
1978	Centre Georges Pompidou, Paris
1979	Galleria Civica, Modena, Italy
1981	The Photographic Gallery, Cardiff, Wales
	Kathleen Ewing Gallery, Washington, D.C.
	Collectors' Gallery, Milwaukee
	Galerie Montesquieu, Agen, France

Selected Group Exhibitions:

1977	*Architecture*, Vinci 1840, Paris
1978	*Histoire de la Photographie Francaise*, Galerie Contrejour, Paris (toured France)
1979	*La Photographic Contemporaine en France*, at the *Festival d'Avignon*
1980	*21 Photographes Contemporains*, Vinci 1840, Paris
	Acquisitions Photographiques, Musée Cantini, Marseilles

| 1981 | *Portraits d'Arbres*, Centre Culturel de Boulogne-Billancourt, Paris |

Collections:

Centre Georges Pompidou, Paris; Bibliotheque Nationale, Paris; City of Paris Collection; Musée Cantini, Marseilles; Polaroid Collection, Amsterdam.

Publications:

By CLAASS: books—*Ellipses*, Paris 1976; *Contretemps*, Paris 1978; articles—"Vues sur la Photographie Créative" in *Photographie Nouvelle* (Paris), April 1973; "Conversacion con Arnaud Claass," with Roger Doloy, in *Arte Fotografico* (Madrid), May 1973; "Eva Rubinstein" in *La Nouvelle Critique* (Paris), September 1975; "Raoul Hausmann" in *La Nouvelle Critique* (Paris), April 1976; "Lewis

Carroll: Maître de la Chasteté" in *Contrejour* (Paris), September 1976; "Bruno" in *Zoom* (Paris), December 1976; "J.P. Charbonnier" in *Contrejour* (Paris), March 1977; "La Photographie à Beaubourg: Perspectives" in *La Nouvelle Critique* (Paris), May 1977; "Robert Frank" in *Contrejour* (Paris), October 1977; "André Kertész" in *Zoom* (Paris), January 1978; "D. Seylan" in *Zoom* (Paris), May 1978; "William Klein" in *Zoom* (Paris), April 1979; "Peter Klasen" in *Zoom* (Paris), March 1980.

On CLAASS: book—*Histoire de la Photograpie Francaise des Origine à nos Jours* by Claude Nori, Paris 1978; article—in *Fotografia* (Warsaw), May 1977.

Photography is incapable of "representing reality." Reality is fluid, sonorous and without boundaries; photography is fixed, silent, and centered. Photography is, for me, essentially an art of evocation. It allows us to fix the sensations provoked in us by that which we believe to be real. Human sight involves deciphering, a re-creation that follows physical and emotional laws. Photography is proof of the fragility of sight. It is in the recognition of this fragility that its strength, its drama, and its beauty reside.

The best way to display this strength and this beauty is by having faith in the camera. It is not necessary to seek to "express oneself" or "to be an artist." If the sight of grass in a field evokes for me the image of fur, then this evocation is already an expression of myself. The camera and the suitably used emulsion can visually fix it. That is their true objectivity.

For the series of miniature landscapes from which the accompanying photo is extracted, I chose a very small printing format for the sake of aesthetic economy (that is, the most possible with the least possible) and to compel the viewer's concentration. This choice is the result of my sustained interest in the delicacy and severity of Chinese painting.

—Arnaud Claass

The picture you are looking at in mechanical reproduction is, as an original silver print, very small in dimension, mounted within a large white mat surround and thin dark frame—a miniature landscape, perceived first in its tonalities and then its integral form. The familiarity of the natural shapes and "feel" of the foliage escorts the viewer comfortably into the picture, as the trees themselves are easily taken for small bushes or even lichen-covered rocks, as though in scale to one standing before and just above them. Just as these assumptions begin to be cast into doubt, the figures are discovered—human and dwarfed. For an instant, in realisation, as though an Alice approaching Wonderland, the viewer feels like a rapidly shrinking giant, until coming to harmonious rest somewhere on the park grounds in identifiably proper scale once again, and at peace. That is until, in exhibition, it is time to move on to the next Claass miniature.

This is a big jump from the earlier work of Arnaud Claass as seen in his self-published book *Contretemps*. The photographing is more pensive and less contemplative, more critical, less classical. Made in the USA from 1970 to 1973 and in Paris between 1976 and 1977, they are images of alienated romance and masochistic abandon, disturbing beauty and condemnative precision, a darker fascination in the revolving Doors of Perception, more like an Alice Cooper in Wonderland. Only two years elapsed between the two bodies of work, but the change is dramatic, yet equally compelling is the thread of connection; aerial perspective appeared effectively and gardens too were visited, perceptively. *Contretemps* means literally "against time". I imagine photographs, frozen in their quadrangular packages of the past, struggling like salmon, forward, against "the current," against the flowing moments, occasionally leaping into the air, showing themselves—

John Claridge: *Picmola Lake, Udaipur, India*, **1978**

glistening, future-moving fragments of time. Some succeed, reaching the spawning grounds, producing new photographs to repeat the process over again; these are the fertile and potent ones, the strong swimmers and high-jumpers, the good pictures. Only the good photographer will make them repeatedly, and Arnaud Claass is proving he can do this.

In an introductory note to *Contretemps* (a quote by Claude Simon), Arnaud Claass points us toward a way he correlates his pictures, "...as in the lush and rigourous disorder of the memory." The description also fits gardens (although perhaps more English than French, and perhaps more American than either). Is this the metaphor behind his present work, the Garden as Memory? It seems likely; it seems to work. And each time I see Claass photographs, I discover more respect for the gardener.

—William Messer

CLARIDGE, John.

British. Born in London, 15 August 1944. Educated at West Ham Technical School, London, 1955-60; self-taught in photography. Married Paula Claridge in 1972. Assistant Photographer, McCann Erickson Advertising Agency, London, 1960-62; Assistant, in London, to *American Photographer*, 1962-64. Freelance photographer, London, since 1964. Recipient: 47 Design and Art Directors' Awards, London, annually since 1974; Clio Statuette, New York, 1976, 1977, 1978. Agent: The Photographers' Gallery, 8 Great Newport Street, London WC2. Address: John Claridge Studio, 47 Frith Street, Soho, London W1V 5TE, England.

Individual Exhibitions:

1961 *East End Photographs*, McCann Erickson, London
1966 Do Not Bend Gallery, London
1968 Serpentine Gallery, London
1969 Institute of Contemporary Arts, London
1970 Kodak House, London
1972 Half Moon Gallery, London
1976 Marcus Pfeifer Gallery, New York
1978 The Photographers' Gallery, London (retrospective
 London/New York, Nikon House, New York
 Images, Image Gallery, New York
 Photography Gallery, New York
1979 *Observations*, Gallery 48, London
1980 Gallery of Photography, Dublin
 India, Pentax Gallery, London

Collections:

Arts Council of Great Britain, London; The Photographers' Gallery, London.

Publications:

By CLARIDGE: article—"John Claridge," interview, with Barry Day, in *AFAEP News* (London), November 1977.

On CLARIDGE: articles—"John Claridge" by Bill Jay in *Album* (London), November 1970; "Advertiser's Dream in Colour" in *Photo Technique* (London), February 1977; "John Claridge" by Michel Maingois in *Zoom* (Paris), March 1977; "Portfolio: John Claridge" in *Photo Technique* (London), December 1977; "Selling India's Summer" in *Zoom* (Paris), November 1978; "John Claridge" in *You and Your Camera* (London), no. 12, 1978; "The Man Who Sold India, Monsoons and All" in *Hot Shoe* (London), no. 3, 1979; "John Claridge" in *SLR Camera* (London), July 1980.

I do not believe in making verbal statements about my work. Opinions, statements, etc. must be made in my pictures.

Concerning how my time is used, I find that 50% is spent on advertising work, 25% on personal work, 25% on editorial. My advertising assignments include: U.S. Tourist Board; Fiat Cars; Bacardi; Singapore Airlines; I.C.I.; Vichy Cosmetics; Sony; Bahamas Tourist Board; BP Oil; Indian Tourist Board; Ford Cars; LLoyds Bank. Editorial work: *Harpers-Queen*; *Nova*; *Twen*; *Stern*; *Management Today*; *Travel and Leisure*; *Town*.

—John Claridge

This is a Cinderella story. John Claridge, a kid from the East End of London, started as a dogsbody in an advertising agency, and is now one of the city's leading advertising photographers. The same agency could now pay him more for a day's work than they used to pay him per annum. Nevertheless, Claridge has retained the unaffected, down-to-earth manner he began with; it is a factor in his commercial success.

His advertising pictures are far from down to earth. He shoots romantic pictures which are simple, direct, and two- rather than three-dimensional in composition. He uses a restricted colour range, generally choosing reds and purples, warm blues and rich golden browns, but the colours are always intense. As he often has to shoot in poor English light under grey, rain-laden skies, he tends to use masses of filters, and often his pictures have (as one magazine described it) "grain like rice puddin'." He often uses extreme lenses such as 16mm ultrawides and 1000mm mirror lenses to further divorce his subjects from reality. The resulting slides are grainy, moody, graphic and atmospheric. When blown up to poster size (which emphasizes the grain) and pasted up on hoardings they have enormous impact. Even as magazine spreads you can be stopped in your tracks by their raw power. The final effect is like a marriage between the styles of Sarah Moon and Jay Maisel, but as a style it is unique to Claridge.

Like many commercial photographers he also shoots reportage using Leicas loaded with Tri-X. The negatives are printed on Kodalith paper to give a slightly muddy, sepia effect and the prints—as with all his work—beautifully finished and presented. The subjects include some of the less aesthetic aspects of city life: walls and windows, cars and dustbins. The compositions are formal and, though modern, look somewhat derivative; nevertheless, many of these prints have been exhibited at prestigious galleries. However, there is in the end a coldness about them which could be put down to the photographer's having nothing to say about these subjects in the adopted style.

Claridge's most successful reportage work was accomplished on a trip to India, where he was shooting impossibly exotic scenes (elephants, banquets, palaces) for the Indian Tourist Board. Unasked, he also recorded in black and white something of the plight of the ordinary people. These pictures show a humanistic and committed concern which suggests the photographer was for once moved to passion, and this passion is communicated to the viewer.

Also, these black-and-white prints convey a sense of depth which is not found in Claridge's other work. The limbs of his subjects, in particular, have a roundness about them, a sculptural quality to the tonality, which enhances the impression of realism and somehow encapsulates the human dignity that these Indians have retained in spite of their impoverishment.

Unfortunately these prints have not been widely exhibited or published, but that remains a possibility for the future.

—Jack Schofield

CLARK, Larry.

American. Born in Tulsa, Oklahoma, 19 January 1943. Educated at schools in Tulsa, 1956-61; studied photography, under Walter Sheffer, Layton School of Art, Milwaukee, Wisconsin, 1961-63. Served in the United States Army, in Vietnam, 1964-66. Worked in family commercial portrait photo business, Tulsa, 1956-61. Freelance photographer, New York, 1964, 1966-70, and in Tulsa and New York, since 1970. Recipient: National Endowment for the Arts Photographers' Fellowship, 1973; Creative Arts Public Service Photographers' Grant, 1980. Agent: Robert Freidus Gallery Inc., 158 Lafayette Street, New York, New York 10013. Address: 225 Hudson Street, Apartment 6, New York, New York 10013, U.S.A.

Individual Exhibitions:

1971 San Francisco Art Institute
1973 University of North Dakota, Grand Folks
1973 State University of New York at Buffalo
1974 Oakton College, Morton Grove, Illinois
1975 International Museum of Photography, George Eastman House, Rochester, New York (toured the United States, 1975-78)
1976 New England School of Photography, Boston
1977 Photography Gallery Society, Saskatoon, Saskatchewan
1979 Robert Freidus Gallery, New York
 Vision Gallery, Boston
1980 The Photographers' Gallery, South Yarra, Victoria, Australia
 James Madison University, Harrisonburg, Virginia
 Glyph Gallery, Amherst, Massachusetts
1981 G. Ray Hawkins Gallery, Los Angeles
 Simon Lowinsky Gallery, San Francisco
 Zenith Gallery, Pittsburgh
 Galerie Agathe Gaillard, Paris
1982 Rhode Island School of Design, Providence
 3 New Yorker Fotografen: Peter Hujar/Larry Clark/Robert Mapplethorpe, Kunsthalle, Basel

Selected Group Exhibitions:

1978 *Photos from the Sam Wagstaff Collection*, Corcoran Gallery of Art, Washington, D.C. (toured the United States and Canada)
1981 *Whitney Biennial*, Whitney Museum, New York

Collections:

Metropolitan Museum of Art, New York; Museum of Modern Art, New York; International Center of Photography, New York; International Museum of Photography, George Eastman House, Rochester, New York; Philadelphia Museum of Art; Princeton Art Museum, New Jersey; Chrysler Museum, Norfolk, Virginia; St. Louis Museum; Washington Arts Consortium, Seattle; Australian National Gallery, Canberra.

Publications:

By CLARK: books—*Tulsa*, New York 1971; *Teen Lust*, portfolio of 7 photos, Tulsa, Oklahoma 1974; *Tulsa*, portfolio of 10 photos, New York 1975; *Teenage Lust*, Millerton, New York 1982; article—interview in *Photography Between Covers* by Thomas Dugan, Rochester, New York 1979.

On CLARK; books—*Darkroom*, edited by Eleanor Lewis, New York 1977; *A Book of Photographs from the Collection fo Sam Wagstaff*, designed by

Arne Lewis, New York 1978; *SX-70 Art*, edited by Ralph Gibson, New York 1979; *The Photograph Collector's Guide* by Lee D. Witkin and Barbara London, Boston and London 1979; *Light Readings: A Photography Critic's Writings 1968-1978* by A.D. Coleman, New York 1979; *3 New Yorker Fotografen*, exhibition catalogue, with texts by Dieter Hall, Jean-Christophe Ammann, and Sam Wagstaff, Basel 1982; articles—"Larry Clark: Tulsa" by Italo Zannier in *Fotografia Italiana* (Milan), April 1973; "Larry Clark" in *Camera* (Lucerne), May 1980; "Larry Clark: Adieu Junkies" in *Photo* (Paris), September 1980; "New York: Larry Clark, Robert Freidus Gallery" by Lynn Zelevansky in *Flash Art* (Milan), January/February 1981.

Like that of Robert Frank, who must certainly be counted as a spiritual forebear, Larry Clark's reputation was both immediately established and largely

Larry Clark: *Gun/Flag* from *Tulsa*, 1971

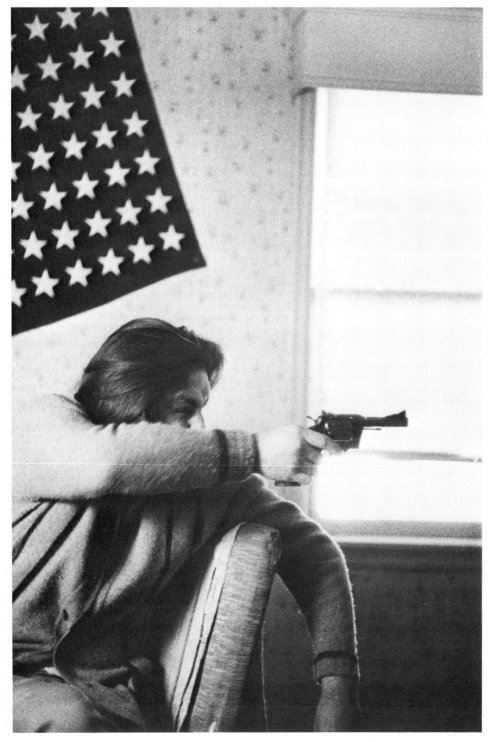

based on the publication of a single book. The now legendary *Tulsa*, long out of print and because of a lawsuit, never re-issued, is a gritty and wholly unsentimentalized chronicle of the violent and blasted lives of the friends of his youth, for several of whom *Tulsa* came to serve as epitaph. During the 1960's, in a double role as witness and participant, Clark assiduously recorded a Middle American netherworld bounded and defined by amphetamine addiction; a closed world of speed freaks whose emblem and device are respectively the needle and the gun. *Tulsa* traces their dark passage throughout the Vietnam war years as they evolve in the photographs from shorthaired rednecks to longhaired addicts, a passage punctuated by anomic sex, by beatings (of girlfriends, of informers), gunshot wounds, the ubiquitous needle, and death (of a baby, of Clark's two close friends). *Tulsa* concludes with photographs of the younger brothers and sisters of Clark's friends, hanging out and shooting up, initiating (it

would appear) a reprise of all that came before, an apt coda to Clark's quintessentially American heart of darkness.

Althouth Clark has cited Dorothea Lange and Eugene Smith as important influences, the socially committed ethos of the former and the sentimental humanism of the latter have played little part in his work. It is in fact the very absence of such liberal and distancing sentiments that contributes to the particular power of his photographs and separates them so emphatically from the comparable (in terms of subject matter) work of Bruce Davidson or Danny Lyon. Pathos and compassion, those staples of much photographic documentation of American subculture, be it of the poor, the marginal, or the criminal, are utterly abolished in Clark's abrasive and non-rhetorical images. Insisting on his status as participant rather than detached observer, Clark accepts the milieux he photographs on its own terms, neither moralizing nor anecdotalizing his subjects.

Following the internal logic of the later photographs in *Tulsa*, Clark's next body of work evolved into the series entitled *Teenage Lust*, to be published this year (1982) by Aperture. But these photographs done in the 70's, although probably destined to be as shocking to many sensibilities as were the *Tulsa* pictures by virtue of their casual acceptance and graphic depiction of adolescent sexuality, are in fact less sensational and disturbing than their subject matter would lead one to expect. In part this is due to the greater degree of formal mediation—of artfulness—that Clark brought to bear in making the photographs. Between *Tulsa* and *Teenage Lust*, Clark had inevitably lost the raw charge of the primitive in the process of becoming a more self-conscious and sophisticated photographer. But perhaps even more significantly, the very nature of the subject matter compelled Clark to assume the role of voyeur and thus to forfeit the absolute intimacy, and hence, identification, that gave *Tulsa* its special authority and power.

Clark's most recent work is an ongoing documentation of what has been termed the "feral youth" of New York City, the adolescent and pre-adolescent boys who survive as hustlers, thieves, and small-time dope dealers on 42nd Street. As with his previous projects, the point of departure is the privileged knowledge of the insider in a subculture, here derived from the preliminary months of gaining the confidence of the youths, insinuating the camera to the degree that it ceases to be an intrusive and unnatural presence.

Clark quite correctly recognizes that his projects have nothing to do with the values and imperatives of conventional photojournalism. Speaking of his 42nd Street work he has said "If this project looked like photojournalism, even if it told the truth, I would probably burn it." Clark's fascination with and attraction to the outlaw, the fringe, the forbidden, the dangerous, is more than tinged by romanticism, linking him more to the *poète maudit* than the documentarian. As Clark gets older, and his subjects younger (and more "other," as are the largely Hispanic boys he is now photographing), it remains to be seen whether he will again find the perfect congruence of subject and sensibility that made *Tulsa* such a unique and powerful achievement.

—Abigail Solomon-Godeau

CLERGUE, Lucien (Georges).

French. Born in Arles, 14 August 1934. Educated at the Lycée Frederic-Mistral, Arles, 1948-52; self-taught in photography. Married Yolande Wartel in 1963; children: Anne and Olivia. Freelance photographer and teacher, Arles, since 1960. Founder, *Rencontres Internationales de la Photographie*, Arles, 1970; Artistic Consultant, *Festival of Arles*, 1970-75. Instructor in Photography, University of Provence, Marseilles, since 1976, and New School for Social Research, New York, since 1979. Member of the Administrative Council, Fondation Nationale de la Photographie, Lyons, since 1979. Recipient: Prix Louis Lumière, for film, 1966. LL.D.: University of Provence, 1979. Member, Academie d'Arles, 1974; Chevalier, Ordre National du Merité, 1980. Address: B.P. 84, 13632 Arles, France.

Individual Exhibitions:

1958 Kunstgewerbemuseum, Zurich
1960 Musée Réattu, Arles, France
1961 Museum of Modern Art, New York
1962 Musée des Arts Décoratifs, Paris
 Folkwang Museum, Essen
1963 Kunstgewerbemuseum, Zurich (retrospective)
1964 Gewerbemuseum, Basle
 München Stadtmuseum, Munich
1965 Worcester Museum of Art, Massachusetts
1969 Moderna Museet, Stockholm
1970 Art Institute of Chicago
 Galerie de France, Paris
 Kunsthalle, Dusseldorf
 Kunstsenter Sonja Henie, Oslo
1971 Chateau-Musée, Lunéville, France
 Maison de la Culture, Amiens, France
1972 Witkin Gallery, New York
1973 Jacques Baruch Gallery, Chicago
 Hommage à Picasso, at the *Festival d'Avignon*, France
 University of Reading, Berkshire
 Institute of Contemporary Arts, London
1974 Leopold-Hoesch Museum, Duren, West Germany
 Musée des Beaux-Arts, Ixelles, Brussels
 Israel Museum, Jerusalem
1975 French Institute/Alliance Francaise, New York
 French Institute, Copenhagen
 Bibliothèque Nationale, Abidjan, Ivory Coast
1976 Jacques Baruch Gallery, Chicago
 Galerie Municipale du Chateau d'Eau, Toulouse
1977 French Institute, West Berlin
 Galleria II Diaframma, Milan
1978 Musée Réattu, Arles, France
 Galerie Le Balcon des Arts, Paris
 Shadai Gallery, Tokyo
1979 Witkin Gallery, New York
 Jacques Baruch Gallery, Chicago
 G. Ray Hawkins Gallery, Los Angeles
 Musée Nicéphore Niepce, Chalon-sur-Saône, France
 Gallery Portfolio, Lausanne
1980 Editions Gallery, Houston
 Centre Georges Pompidou, Paris
 Gallery Portfolio, Lausanne
 Galleria II Diaframma, Milan
1981 Equivalents Gallery, Seattle, Washington
 Picasso, Hall du Livre, Nancy, France

Selected Group Exhibitions:

1964 *The Painter and the Photograph*, University of New Mexico, Albuquerque
1968 *L'Oeil Objectif*, Musée Cantini, Marseilles (with Denis Brihat, Robert Doisneau and Jean-Pierre Sudre)
1975 *The Nude*, at *Rencontres Internationales de la Photographie*, Arles, France
1978 *The Nude*, Musée Fabre, Montpellier, France
1979 *Les Photographes Imaginaires*, Palais de la Découverte, Paris

Collections:

Bibliothèque Nationale, Paris; Centre Georges Pompidou, Paris; Israel Museum, Jerusalem; Shadai College, Tokyo; Museum of Modern Art, New York; Metropolitan Museum of Art, New York; Art Institute of Chicago; Center for Creative Photography, University of Arizona, Tucson; Gernsheim Collection, University of Texas at Austin.

Publications:

By CLERGUE: books—*Corps Memorable*, with poems by Paul Eluard and Jean Cocteau, Paris 1957, 1969; *Poesie der Photographie*, with texts by Jean Cocteau and Jean-Marie Magnan, Cologne 1960; *Birth of Aphrodite*, with poems by Federico Garcia Lorca, Brussels, New York, Stuttgart and Paris 1963; *Toros Muertos*, with texts by Jean Cocteau and Jean-Marie Magnan, Brussels, New York, Stuttgart and Paris 1963; *Lucien Clergue: A Retrospective Monograph*, with texts by Jean Cocteau and others, Zurich 1963; *Numero Uno: A Portrait of Antonio Ordonez in 24 Photographs*, with text by Jean Cocteau, Paris 1963; *Le Taureau au Corps*, with text by Daniel Schmitt, Paris 1963; *Le Testament d'Orphée*, with text by Jean Cocteau, Monaco 1963; *El Cordobes*, with texts by Jean-Marie Magnan and others, Paris 1965; *Le Temple Tauromacique*, with text by Jean-Marie Magnan, Paris 1968; *Née de la Vague*, Paris 1968, 1978, as *Nude of the Sea*, New York 1980; *Genese*, with poems by St. John Perse, Paris 1973; *Lucien Clergue*, with text by Michel Tournier, Paris 1974; *Le Quart d'Heure du Taureau*, with text by Jean-Marie Magnan, Paris 1976; *Camargue Secrete*, with text by Mario Prassinos, Paris 1976; *Musique aux Doigts*, with text by Manitas de Plata, Paris 1976; *La Camarque est au Bout des Chemins*, Marseilles 1978, 1981; *Belle des Sables*, Marseilles 1979; *The Best Nudes*, designed by Eikoh Hosoe, Tokyo 1979; *Langage des Sables*, with a foreword by Roland Barthes, Marseilles 1980; *Les Saltimbanques*, Marseilles 1980; *Practical Nude in Photography*, New York and London 1982; portfolios—*Caco au Grand Herbier*, 20 photos, with a foreword by the model, Arles, France 1978; *Jeux de l'Eté*, 12 photos, Arles, France 1980; *Chicago Suite*, 5 photos, Arles, France 1980; *Pablo Picasso*, 15 photos, Arles, France 1981; *Urban Nude*, 12 photos, with a foreword by Jain Kelly, New York 1981; *Nude of the Sea*, 11 photos, New York 1981; films—*Drame du Taureau*, 1965; *Delta del Sel*, 1966; *Sables*, 1968; *Manitas de Plata*, television film 1968; *Picasso: Guerre, Amour et Paix*, television film, 1971.

On CLERGUE: books—*The History of the Nude in Photography* by Peter Lacey and Anthony La Rotonda, New York 1964; *The Painter and the Photograph: From Delacroix to Warhol* by Van Deren Coke, Albuquerque, New Mexico 1964, 1972; *A Picture History of Photography* by Peter Pollack, revised edition, New York 1969; *The Photograph Collector's Guide* by Lee D. Witkin and Barbara London, Boston and London 1979; *Nude: Theory*, edited by Jain Kelly, New York 1979; articles—"Artistes et Modeles: Lucien Clergue" in *Photo* (Paris), May 1969; "Ni Limites, ni Frontieres" in *La Galerie* (Paris), November 1971; "Lucien Clergue" in *Modern Photography Annual*, New York 1972; "Lucien Clergue: She/Sea" in *Zoom* (Paris), no. 21, 1973; "Lucien Clergue" by Ruth Spencer in *British Journal of Photography* (London), 20 December 1974; "Urban Nudes: Lucien Clergue" by J. Brody in *Camera 35* (New York), April 1978.

Freedom in photography is my major interest. It is why I worked in a factory until 1959, so that I could continue to do the kind of photography I wanted to do. Since 1960 I have been free to do what I like—and no boss, no director of any agency, can order me to do anything.

Three subjects are my main interest: death, life, and a kind of no-man's-land in between. The death of the bull at the bullfight, the nude female in true nature, landscape, seascape, sandscape, are the essentials of my permanent research—to find the beginning of our world and of ourselves.

Lucien Clergue: From *Née de la Vague*, 1968

I try to build a story, like I did with *Camargue Secrete* or with *Langage des Sables*. The difficulty for a photographer is the fact that he is producing "fine" photographs, and he forgets sometimes to remember to what they belong. It's one thing to know how to read and write; it's another to know how to put together all those words.

My master was Edward Weston: the way he looks at the woman as she is, or at a vegetable as it is—this influenced me very much. The technical expertise of such a man is not mine. I try, in using a 35mm camera, to be as fresh as possible. But I'm not saying that I will never use a larger camera. I am prepared to learn how to work with a large camera (I already have a 4 x 5 camera and three lenses). I still remember what my friend Picasso used to say: "It takes time to become young." I do hope that I have years enough ahead of me to discover my childhood.
—Lucien Clergue

"My mother had very Puritanical ideas about sex and women. However they might appear, they were Evil...." So Lucien Clergue once said in an interview. It is only a very short mental step to endow him with a guilt complex that he tried to exorcise by photographing nude women. But that is too simple an explanation, too superficial; it does nothing to account either for his success or for his skill as a photographer. Undoubtedly, there is something else behind his photographs—his shyness, for example, which still dogs him even now that he is famous. "To tell the truth, the first nudes I did, which I've still never exhibited, were just a good excuse to have a naked girl in front of me. Since then I've been unveiling a whole world, extolling woman. Hence the symbols: woman and water. I wanted to be a ballet-dancer and a bullfighter, but I didn't have the capacity or the courage; I've taken possession of the world thanks to photography." So Clergue tells us. But are a poet's explanations the best guide to his poetry? Surely not. He is too deeply involved. Clergue has also and most certainly been influenced in his development by the environment in which he has worked—Provence, which has always attracted artists and poets.

Clergue photographs female nudes, but he also photographs dead animals, abandoned cemeteries; an entire book of his photographs is dedicated to the death of the bull in the bullring. Eros *and* thanatos, then? Maybe so. But beyond this simple classification there is something else, a pagan vein, a joy in living justified and made possible by its antithesis, death. It is the essential vision of life of the Latin world. "First they will publish your nudes, then the rest," his friend Picasso prophesied when he was still an unknown provincial amateur photographer. And the prophecy came true.

Today Clergue is better known for his nudes than for his other pictures, nudes that bear his special stamp. His models are not the ambiguous adolescents of Hamilton, still less the mysterious figures of Newton. His models are women of flesh and blood, with opulent figures and glowing skin. Woman as portrayed by Clergue is never idealized, romantic, ambiguous, mysterious; she is a woman who enjoys being alive and does not hide it. A passion for life shines out of these pictures; there is no sense or suggestion or intellectualist intervention.

"I brought my models down to the beach and made them go into the water. The sea is a destroyer, even in photography, and it can sometimes happen that it is stronger than oneself. Its waves do not readily allow a slender girl's body to stand quite still...." That is how Clergue explains his first series of nudes. Since then he has looked for other backgrounds, other landscapes in which to set his statuesque bodies. There are the nudes of the woods, the "urban nudes" of New York. At the window, on the balconies of skyscrapers, his models with their majestic forms contrast strangely with the city below with its chaotic traffic. Clergue, it seems, wants to demonstrate again the eternal contrast between nature and culture, between culture and civilization.
—Edo Prando

CLIFT, William.

American. Born in Boston, Massachusetts, 5 January 1944. Educated at Browne and Nichols High School, Cambridge, Massachusetts, 1957-61; mainly self-taught in photography, but attended workshop under Paul Caponigro, Boston, 1959; studied humanities at Columbia University, New York, 1962. Married Vida Chesnulis in 1971; children: Charis, Carola and William. Charter Member, Association of Heliographers, New York, 1962; commercial architectural photographer, with Stephen Gersh, as Helios Photography, Cambridge, Massachusetts, 1963-71. Freelance photographer, Santa Fe, New Mexico, since 1971. Recipient: Massachusetts Council on the Arts and Humanities Commission, 1970; National Endowment for the Arts Photography Fellowship, 1972, 1979; Guggenheim Photography Fellowship, 1974, 1980; A.T. & T. Photography Project Participant, 1978. Address: Post Office Box 6035, Santa Fe, New Mexico 87502, U.S.A.

Individual Exhibitions:

1963 Cafe Florian, Boston
1964 Gallery Archives of Heliography, New York (with Scott Hyde)
1969 Carl Siembab Gallery, Boston
 University of Oregon, Eugene
1970 *Old City Hall, Boston*, New City Hall, Boston (travelled to the University of Massachusetts, Amherst; Berkshire Museum, Pittsfield, Massachusetts; Williams College, Williamstown, Massachusetts; Addison Gallery, Andover, Massachusetts; Wheaton College, Norton, Massachusetts;

and Worcester Art Museum, Massachusetts, 1971; and Creative Photography Gallery, Massachusetts Institute of Technology, Cambridge, 1972)
1972 Carl Siembab Gallery, Boston
1973 *New Mexico Landscapes*, St. John's College, Santa Fe, New Mexico
1974 Boston Public Library
1975 Fine Arts Museum, Santa Fe, New Mexico (with Arthur Lazar)
1977 Photographers Gallery and Workshop, Melbourne
 Eliot Porter/Laura Gilpin/William Clift, Horwitch Gallery, Santa Fe, New Mexico
1978 Australian Centre for Photography, Sydney
1979 Susan Spiritus Gallery, Newport Beach, California
 Focus Gallery, San Francisco
 Fine Arts Museum, Santa Fe, New Mexico
1980 Creative Photography Gallery, Massachusetts Institute of Technology, Cambridge
 William Lyons Gallery, Coconut Grove, Miami
 Atlanta Gallery of Photography
1981 Phoenix Art Museum, Arizona
 Jeb Gallery, Providence, Rhode Island
 Images Gallery, Cincinnati, Ohio
 Ansel Adams/Eliot Porter/William Clift, Cronin Gallery, Houston
 Sheldon Art Gallery, University of Nebraska, Lincoln

Selected Group Exhibitions:

1963 *Association of Heliographers*, Lever House, New York
1973 *6 New Mexico Photographers*, Museum of Fine Arts, Santa Fe, New Mexico
1976 *12 Artists Working in New Mexico*, University of New Mexico, Albuquerque
1977 *The Great West: Real/Ideal*, University of Colorado, Boulder (toured the United States)
1978 *Court House: A Photographic Document*, Art Institute of Chicago (toured the United States, 1978-79)
 Mirrors and Windows: American Photography since 1960, Museum of Modern Art, New York (toured the United States,

William Clift: *Factory Butte, Utah*, 1975

1978-80)
Landscape, Vision Gallery, Boston
1979 *Photography in New Mexico*, University of New Mexico, Albuquerque
American Images: New Work by 20 Contemporary Photographers, Corcoran Gallery, Washington, D.C. (toured the United States, 1979-80; travelled to the American Academy, Rome, 1981)
1981 *Photography in the National Parks*, Oakland Art Museum, California

Collections:

Museum of Modern Art, New York; Metropolitan Museum of Art, New York; Museum of Fine Arts, Boston; Boston Public Library; Library of Congress, Washington, D.C.; Art Institute of Chicago; Denver Art Museum; University of New Mexico, Albuquerque; Center for Creative Photography, University of Arizona, Tucson; Bibliothèque Nationale, Paris.

Publications:

By CLIFT: books—*Old Boston City Hall*, portfolio of 108 photos, Boston 1971; *New Mexico*, portfolio of 8 photos, Santa Fe, New Mexico 1975; *Beacon Hill: A Walking Tour*, with text by A. McVoy McIntyre, Boston 1975; *Court House*, portfolio of 6 photos, Santa Fe, New Mexico 1979; articles—"Introduction" to *The Darkness and the Light: Photos by Doris Ulmann*, New York 1974; "Court House" in *Vision Magazine* (Melbourne), November/December 1977.

On CLIFT: books—*The Great West: Real/Ideal*, exhibition catalogue, edited by Gary Metz, Boulder, Colorado 1977; *Mirrors and Windows: American Photography since 1960* by John Szarkowski, New York 1978; *Court House*, edited by Richard Pare, New York 1978; *American Images: New Work by Twenty Contemporary Photographers*, edited by Renato Danese, New York 1979; *Photography in New Mexico*, edited by Van Deren Coke, Albuquerque, New Mexico 1979; *Photography in the National Parks*, edited by Robert Ketchum, New York 1981.

At a time when the spontaneous gesture in the form of snapshots has been glorified by installation on the walls of our art museums, William Clift has worked with a sense of the seriousness of his medium. His photographs are significant not only for what they document, but also as wonderful prints.

Clarity of thought and vision characterizes Clift's photographs—in his choice of subject; in their composition and structure; and in his use of light. All of these elements are integrated in the completed prints. These works have centered, over the years, on two principal themes: architectural subjects, such as his earlier work in Boston and his more recent photographs of courthouses of the United States; and landscapes, especially of the American Southwest where he now lives. The seeming simplicity of these subjects, however, covers many possible levels of meaning, so that an appreciation of the full complexity of his photographs may depend on other levels of analysis.

First and foremost, there is the sheer beauty of his prints. Clift is a superb craftsman; his intense vision is best expressed through the physical presence of his prints, which are suffused with an understanding of light, of tonalities, and balance that is rare indeed in photography today. At the dark end of the photographic scale, noticeable in many of the courthouse series, he achieves these qualities by his ability to give life to the shadowed areas in the print, while at the opposite end of the scale, especially in the high-key desert landscapes, he has created some of his

most masterly work. His prints in the highest keys—whites on white—are often his finest, with their extraordinary brilliance and subtlety, the brilliance of the print a perfect echo of the light and color of a dream landscape. Indeed, so rich is his use of the black-white scale that color would seem garish and untrue to what is before his camera.

If Clift's print quality and structure impose an order on his photographs which makes them works of art, there is also a more abstract level from which other meanings emerge. For Clift's photographs may also be taken as quiet expressions of two forms of human ritual which impose order on chaos: law and religion. They seem to be a subtle thread which runs through many of the photographs—knowingly or not, one cannot tell. In the architectural forms, indoors and out, as well as in the trappings of justice shown within the courthouse walls, we feel the somber weight of the law. Similarly, while observing some of nature's most anti-human landscapes, we feel that Clift has tamed wildness, material few can cope with. At times, in certain other of his Southwest landscapes, we find Clift's respectful choice of places sacred to the Indians of the region—sometimes a group of found sacred objects, a sign, a stone, a magic mountain—ways which cultures other than ours evolved to deal with the powers of the natural world long before we came on the scene with cameras and modern means for the making of works of art. Throughout this work, the absence of the human figure gives Clift's prints an additional symbolic weight.

None of this could be done without intelligence—a trait not always present in artists, and mistakenly all too often taken for granted. But William Clift is intelligent, and that is probably one reason his photographs are so satisfying. He has been, and remains, his own man. In photography, as well in today's art world, that is extraordinary.

—Doris Bry

COBURN, Alvin Langdon.
British. Born in Boston, Massachusetts, 11 June 1882; emigrated to Britain, 1912: naturalized, 1932. Educated at Chauncey Hall School, Dorchester, Massachuestts, 1891-95; studied photography with his cousin F. Holland Day, New York, 1898; under Arthur Dow, Summer School of Photography, Ipswich, Massachusetts, 1903; London County Council School of Photo-engraving, London, 1906. Married Edith Clement in 1912 (died, 1957). First photographs, Los Angeles, California, 1890. Freelance portrait photographer, with own studio, New York, 1901-02; worked in photographic studio of Gertrude Käsebier, New York, 1902-03; independent photographer, in Boston, 1903-04, in London, 1904-09, 1912-28, in California and Grand Canyon, Arizona, 1910-11, in Harlech, Wales, 1918-44, and in Colwyn Bay, Wales, 1945-66; associated with Wyndham Lewis and Vorticist group, producing "Vortograph" photos, London, 1917-18; abandoned photography, 1922-25, resumed photographic activity on visit to Madeira, Spain, 1956-57. Organizer, with F. Holland Day, *American Pictorial Photography* exhibition, London, 1899-1900; Founder-Member, with Alfred Stieglitz, *q.v.*, and others, Photo-Secession, New York, 1902; Founder, with Gertrude Käsebier, Karl F. Struss and Clarence White, Pictorial Photographers of America, New York, 1915. Recipient: Honorary Ovate of the Welsh Gorsedd, 1927. Honorary Fellow, Royal Photographic Society, London, 1931. *Died* (in Colwyn Bay) *23 October 1966.*

Individual Exhibitions:

1900 Salon of Photography, London
1903 Camera Club, New York
1906 Royal Photographic Society, London
Amateur Photographic Association, Liverpool
1907 291 ("Little" Gallery), New York
1908 Goupil Galleries, London (with Baron de Meyer)
1913 Goupil Galleries, London
1917 *Vortographs and Paintings*, Camera Club, London
Vortographs and Paintings, Goupil Galleries, London
1924 Royal Photographic Society, London
1957 Royal Photographic Society, London
1962 Reading University, Berkshire
1966 Camden Arts Centre, London (toured Britain)
1972 Light Gallery, New York
1976 Photopia Gallery, Philadelphia (retrospective)
1977 International Museum of Photography, George Eastman House, Rochester, New York (toured the U.K.)
1978 Impressions Gallery, York, England
1979 International Museum of Photography, George Eastman House, Rochester, New York
Prakapas Gallery, New York
1980 Panopticon Gallery, Boston
1981 *Photographs and Watercolors*, Janet Lehr Inc., New York
Men of Mark, Sack's Gallery, Toronto

Selected Group Exhibitions:

1900 *New School of American Pictorial Photography*, Royal Photographic Society, London (travelled to Photo-Club, Paris)
1914 *American Invitational Collection*, Royal Photographic Society, London
1959 *Hundert Jahre Photographie 1839-1939*, Museum Folkwang, Essen (travelled to Cologne and Frankfurt)
1960 *Photo-Secession*, International Museum of Photography, George Eastman House, Rochester, New York
1967 *Photography in the 20th Century*, National Gallery of Canada, Ottawa (toured Canada and the United States, 1967-73)
1973 *Photography into Art*, Camden Arts Centre, London
1974 *Photography in America*, Whitney Museum, New York
1977 *Concerning Photography*, The Photographers' Gallery, London (travelled to Spectro Workshop, Newcastle upon Tyne)
1978 *Tusen och en bild/1001 Pictures*, Moderna Museet, Stockholm
1979 *Photography Rediscovered: American Photographs 1900-1930*, Whitney Museum, New York (travelled to Art Institute of Chicago)

Collections:

International Museum of Photography, George Eastman House, Rochester, New York (400 prints and 14,000 negatives); University of Maryland, Baltimore; Art Institute of Chicago; Detroit Institute of Arts, Michigan; University of Louisville, Kentucky; New Orleans Museum of Art; University of Kansas Museum of Art, Lawrence; University of Texas at Austin; University of New Mexico, Albuquerque; Royal Photographic Society, London.

Publications:

By COBURN: books—*London*, with text by Hilaire

Belloc, London and New York 1909; *New York*, with a foreword by H.G. Wells, London and New York 1910; *Men of Mark*, London and New York 1913; *Moor Park, Rickmansworth* with an introduction by Lady Ebury, London and New York 1913; *The Book of Harlech*, Harlech, Wales 1920; *More Men of Mark*, London 1922; *A Portfolio of Sixteen Photographs by Alvin Langdon Coburn*, with an introduction by Nancy Newhall, Rochester, New York 1962; *Alvin Langdon Coburn: An Autobiography*, edited by Helmut and Alison Gernsheim, London and New York 1966; books illustrated—*The Blue Grass Cookbook* by Minnie C. Fox, New York 1904; *The Novels and Tales of Henry James*, 24 Vols., London 1907-09, New York 1908; *The Intelligence of Flowers* by Maurice Maeterlinck, New York 1907; *Piccadilly to Pall Mall* by Ralph Nevill and Charles Edward Jerringham, London 1908; *Mark Twain* by Archibald Henderson, London 1910, New York 1911; *The Door in the Wall and Other Stories* by H.G. Wells, New York and London 1911; *The Cloud* by Percy Bysshe Shelley, Los Angeles 1912; *London* by G.K. Chesterton, London and Minneapolis, Minnesota 1914; *Fairy Gold, A Play for Children and Grown-Ups Who Have Not Grown Up*, with music by Sir Greville Bantock, London 1938; *Edinburgh: Picturesque Notes* by Robert Louis Stevenson, with a preface by Janet Adam Smith, London 1954; articles—"Ozotype: A Few Notes on a New Process" in *Photo-Era* (Boston), August 1900; "My Best Picture" in *Photographic News* (London), 1 February 1907; "Men of Mark" in *Forum* (London), vol. 50, 1913; "Alvin Langdon Coburn, Artist-Photographer, by Himself" in *Pall Mall Magazine* (London), vol. 51, 1913; "Photogravure" in *Platinum Print* (New York), October 1913; "British Pictorial Photography" in *Platinum Print* (New York), February 1915; "The Old Masters of Photography" in *Century Magazine* (New York), October 1915; "The Future of Pictorial Photography" in *Photograms of the Year*, London 1916; "Astrological Portraiture" in *The Photographic Journal* (London), vol. 63, 1923; "Photography and the Quest of Beauty" in *The Photographic Journal* (London), vol. 64, 1924; "Bernard Shaw, Photographer" in *Photoguide Magazine* (London), December 1950; "Frederick H. Evans" in *Image* (Rochester, New York), vol. 2, 1953; "Retrospect" in *The Photographic Journal* (London), vol. 98, 1958; "Photographic Adventures" in *The Photographic Journal* (London), vol. 102, 1962; radio broadcasts—*Illustrating Henry James by Photography*, BBC, London 1953, 1955; *Photographing George Meredith*, BBC, London 1958; *Musicians in Focus*, BBC, London 1960.

On COBURN: books—*Alvin Langdon Coburn: Photographs*, exhibition catalogue, with preface by George Bernard Shaw, London 1906; *Camera Pictures by Alvin Langdon Coburn*, exhibition catalogue, with an introduction by W. Howe Downes, London 1913; *Vortographs and Paintings by Alvin Langdon Coburn*, exhibition catalogue, with text by Ezra Pound, London 1917; *Photo-Secession: Photography as a Fine Art* by Robert M. Doty, with a foreword by Beaumont Newhall, Rochester, New York 1960; *Grosse Photographen unseres Jahrhunderts* by L. Fritz Gruber, Berlin, Darmstadt and Vienna 1964; *Alvin Langdon Coburn 1882-1966*, exhibition catalogue, by Paul Blatchford, London 1966; *Photographers on Photography*, edited by Nathan Lyons, New York 1966; *Photography in the Twentieth Century* by Nathan Lyons, New York 1967; *Photography into Art*, exhibition catalogue, by Colin Osman, Ainslie Ellis and Margaret Harker, London 1973; *Looking at Photographs: 100 Pictures from the Collection of the Museum of Modern Art* by John Szarkowski, New York 1973; *Camera Work: A Critical Anthology*, edited by Jonathan Green, New York 1973; *Photography in America*, edited by Robert Doty, with an introduction by Minor White, New York and London 1974; *L'Arte nella Societa: Fotografia, Cinema, Videotape* by

Daniela Palazzoli and others, Milan 1976; *Concerning Photography*, exhibition catalogue, edited by Jonathan Bayer, London 1977; *Fotografische Künstlerbildnesse*, exhibition catalogue, by Dieter Rönte, Evelyn Weiss and Jeane von Oppenheim, Cologne 1977; *Geschichte der Fotografie im 20. Jahrhundert/Photography in the 20th Century* by Petr Tausk, Cologne 1977, London 1980; *The Collection of Alfred Stieglitz* by Weston J. Naef, New York 1978; *Tusen och en bild*, exhibition catalogue, by Ake Sidwall, Sune Jonsson and Ulf Hard af Segerstad, Stockholm 1978; *The Valiant Knights of Daguerre: Selected Critical Essays on Photography and Profiles of Photographic Pioneers* by Sadakichi Hartmann, edited by Harry W. Lawton and George Know, Berkeley, California 1978; *Amerikanische Landschaftsphotographie 1860-1978*, exhibition catalogue, by Klaus-Jürgen Sembach, Munich 1978; *Amerika Fotografie 1920-1940* by Erika Billeter, Berne 1979; *Photography Rediscovered: American Photographs 1900-1930* by David Travis, New York 1979; *A Ten Year Salute* by Lee D. Witkin, with foreword by Carol Brown, Danbury, New Hampshire 1979; *Dada Photomontagen*, exhibition catalogue, by Carl-Albrecht Haenlein, Hannover 1979; *The Photograph Collector's Guide* by Lee D. Witkin and Barbara London, Boston and London 1979.

Alvin Langdon Coburn was an idealist in all senses of the word: he was imaginative, visionary, sought excellence, pictured people and landscapes in ideal forms and believed that perfect goodness could be discovered in everything.

While he was still a teenager his photographs attracted the attention of influential pictorial photographers (that is, photographers whose desire was to make a picture that reflected their own moods rather than record a socially or commercially significant event). At the age of 18 he was included in the significant exhibition, *New School of American Pictorial Photography*, organized by F. Holland Day and hung in the venerable halls of the Royal Photographic Society in 1900. The largely introspective, personal photographs created a stir. In 1904 Alfred Stieglitz devoted one issue of his quarterly, *Camera Work*, to Coburn's work.

In 1904 Coburn began to make portraits of Europe's leading men of the arts and letters. Although he also photographed painters and dancers, he seems to have been more involved with poets and writers, including George Bernard Shaw, H.G. Wells, and Maurice Maeterlinck. Indeed, his work received an early appreciation from Shaw, he collaborated with both Henry James and H.G. Wells in a series of frontispieces for their books, and Ezra Pound wrote an anonymous introduction to his Vorticism exhibition of 1917.

Much of Coburn's earlier work had been abstract—influenced by Japanese decorative style, Americanized by Ernest F. Fenollosa and Arthur Wesley Dow. The basic premise of early pictures, such as "The Dragon" (1903), involved the massing of shapes on the flattened picture plane. (Dow, in particular, was interested in painting from new vantage points as evidenced in his oil, "The Blue Dragon," of 1892.) While still recognizable as an aerial view of a river, the image also functioned as a decorative personal statement. In striving to purify photography, Coburn created a body of influential photographs. His aerial views, particularly the group exhibited in 1913 as *New York from Its Pinnacles*, precede the work of the Bauhaus and Moholy-Nagy by more than 6 years.

Like the aerial views, the Vortographs also emphasized design, but to the exclusion of everything else. Vortography consisted of images made by inserting the lens of a camera through a triangle of mirrors. With the resulting kaleidoscopic fractured forms, Coburn hoped to wrench pictorial photography away from the quaint, familiar images into a modern sensibility emphasizing pure form on the flat picture surface. It was a very telling gesture.

While Vorticism was a logical step in Coburn's pictorial work, its break with representational form sent shock waves through the pictorialist camp.

Recognizing that print quality was of utmost importance if the photographer's feeling for the subject was to be conveyed, Coburn became a master of several different printing processes, most notably gum-platinum. This double process allowed for a greater range of tones—from the delicate grays of the platinum through the deep colors of the gum. In this way, heavy shadows could be juxtaposed to shimmering highlights as in his pictures of Venice canals or Liverpool harbor.

In his desire for perfection and control, Coburn learned photogravure printing so that the mechanical reproductions of his negatives would be as fine, in their own way, as his photographs. He produced over 40,000 photogravures at his press in London. Because the original photographic negative was used to make the gravure plate, and because of the care taken in printing, Coburn considered the resulting photogravures original prints.

Coburn was drawn to the spiritual and mysterious; he even named his home "Awen," a Welsh work for "inspiration." He made a long series of photographs of the great megaliths of the British Isles—ancient ritual places. George Bernard Shaw wrote that Coburn's aim was "to convey a mood and not to impart local information" (*Autobiography*, p. 44). Though Shaw was writing about his landscape work, the same concern for expressing the soul or moral center informed all Coburn's work. The melding of strong design with the metaphysical gives the work its quiet intensity.

—Marianne Fulton

COHEN, Lynne.
Canadian. Born in Racine, Wisconsin, U.S.A., 3 July 1944; emigrated to Canada, 1973. Educated at Horlick High School, Racine, 1959-62; studied at University College, London, England, 1964-65; University of Wisconsin, Madison, 1965-67, B.S. 1967; University of Michigan, Ann Arbor, 1968; Eastern Michigan University, Ypsilanti, 1968-69, M.A. 1969. Married Andrew Lugg in 1968. Artist and photographer, based in Ottawa since 1973. Teaching Fellow, 1968, Lecturer, 1969-70, and Instructor, 1970-73, Eastern Michigan University; Instructor, Algonquin College, Ottawa, 1973-75; Instructor, 1974-81, and Assistant Professor, 1981-82, University of Ottawa. Recipient: Canada Council Award, 1975, 1978, 1979-80; Ontario Arts Council Special Project Grant, 1978. Agents: Yajima Gallery, 307 St. Catherine West, Montreal; and Yarlow-Salzman Gallery, 211 Avenue Road, Toronto. Address: 216 Metcalfe, Apartment 3, Ottawa, Ontario K2P 1R1, Canada.

Individual Exhibitions:

1973 A-Space Gallery, Toronto
1975 University of New Mexico, Albuquerque
 Yajima Gallery, Montreal
1978 *Futuric Scientific*, International Center of Photography, New York
 Galerie Delphire/Nouvel Observateur, Paris
 Carpenter Center, Harvard University, Cambridge, Massachusetts
1979 Yarlow-Salzman Gallery, Toronto
 Lightwork Gallery, Syracuse, New York
1981 The Floating Gallery, Winnipeg

Selected Group Exhibitions:

1973 *Photography: Midwest Invitational*, Walker Art Center, Minneapolis

Alvin Langdon Coburn: *W.B. Yeats* Courtesy International Museum of Photography, George Eastman House, Rochester, New York

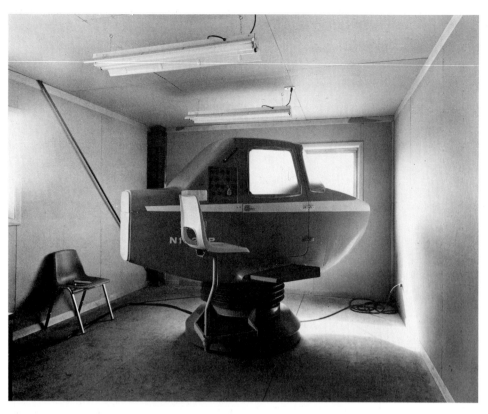

Lynne Cohen: *Classroom in a Flying School, Erie International Airport, Pennsylvania*, 1980

1976 *5 Photographers*, Owens Art Gallery, Sackville, New Brunswick
 The Photographers' Choice, Witkin Gallery, New York
 New Acquisitions, University of New Mexico, Albuquerque
 Destination Europe: 6 Canadian Photographers, Optica Galerie, Montreal
1977 *Rooms* (Winter Penthouse Exhibition), Museum of Modern Art, New York
1979 *The Banff Purchase*, Walter Phillips Gallery, Banff, Alberta (toured Canada)
1980 *Environments*, National Film Board of Canada, Ottawa
1981 *Suite, Serie, Sequence*, Cultural Centre, Nantes, France

Collections:

Public Archives of Canada, Ottawa; National Gallery of Canada, Ottawa; Museum of Contemporary Art, Montreal; Walter Phillips Gallery, Banff, Alberta; Edmonton Art Gallery, Alberta; Mount Allison University, Sackville, New Brunswick; International Museum of Photography, George Eastman House, Rochester, New York; Art Institute of Chicago; University of New Mexico Art Museum, Albuquerque; Bibliothèque Nationale, Paris.

Publications:

On COHEN: books—*The Photographers' Choice*,

edited by Kelly Wise, Danbury, New Hampshire 1975; *The Female Eye*, Ottawa 1975; *Exposure*, Toronto 1975; *The Banff Purchase*, with text by Penny Cousineau, Toronto 1979; articles—"Photos Reflect Our Culture" by Henri Man Barendse in the *New Mexico Daily Lobo* (Albuquerque), 12 February 1974; "Lynn Cohen: Interiors—Portfolio" by William Jenkins in *Image* (Rochester, New York), September 1974; "Gallery Roundup" by Henry Lehmann in *The Montreal Star*, 17 September 1975; article by Penny Cousineau in *Parachute* (Montreal), Autumn 1976; "The Emptiness of Our Empty Rooms" by Owen Edwards in the *Saturday Review* (New York), 8 July 1978; 'Photography: The Banff Purchase" by Gail Fisher-Taylor in *Artmagazine* (Toronto), May/June 1979; "Walter Phillips Gallery" by Nancy Tousley in *Vanguard* (Vancouver), October 1979; "Photography: The Banff Purchase" by Gail Fisher-Taylor in *Artmagazine* (Toronto), February/March 1980; "The Banff Purchase: Tentative Beginnings" by Derek Bennett in *Printletter* (Zurich), March/April 1980.

Formica is everywhere in Lynne Cohen's visions of an unpeopled land of filing cabinets and potted plants. Her subjects are empty rooms, often classrooms (like her stark "Classroom in a Mortuary Science School", Pittsburgh, 1980), lobbies in apartment buildings, community centre halls, and Shriners' boardrooms. Her spaces resonate with loneliness, like stage sets for a play by Samuel Beckett. There's an element of gentle irony and sad, quirky humour in the precision of her imagery too—its extreme frontality, the way the scene in so many of her works is exactly parallel to the picture plane (lately she's become more interested in oblique space). The scenes are bare and stark, with little abstract elements and absurd details—a small plaster statue of the Venus de Milo is plugged into a pool in front of a mobile home, an office has bizarre wallpaper. Often a just visible ceiling adds to the general claustrophobia. "The rooms pose for me," Cohen says—and they seem to be talking back.

Cohen has been working with her 8" x 10" view camera since 1972: her prints are immaculately black and white. Her way of looking at culture as revealed by objects and the spaces between them has been carefully tutored, a product of her training as a sculptor and painter. Her anonymous places in strange cities suggest her own feelings about herself—that she is alien, a visitor. For Cohen, there's clearly something ironic about the world. Her work is a testament to photography's folk culture.

—Joan Murray

Mark Cohen: *Untitled Photograph*, 1975

COHEN, Mark.
American. Born in Wilkes-Barre, Pennsylvania, 24 August 1943. Educated at Forty Fort High School, Pennsylvania, 1957-61; Pennsylvania State University, University Park, 1961-63; Wilkes College, Wilkes-Barre, 1963-66. Married Lillian Russin in 1965; sons: Benjamin and Isaac. Photographer since 1956; established Mark Cohen Studio, Wilkes-Barre, 1966. Instructor, Kings College, Wilkes-Barre, 1967-71; Wilkes College, 1971-76; Princeton University, New Jersey, 1977; Rhode Island School of Design, Providence, 1979; and Cooper Union School of Art, New York, 1980. Recipient: Guggenheim Fellowship, 1971, 1976; National Endowment for the Arts Award, 1975. Address: Mark Cohen Studio, 32 West South Street, Wilkes-Barre, Pennsylvania 18702, U.S.A.

Individual Exhibitions:

1962 Pennsylvania State University, University Park
1965 Wilkes College, Wilkes-Barre, Pennsylvania
1973 Museum of Modern Art, New York
1974 International Museum of Photography, George Eastman House, Rochester, New York
 Light Gallery, New York
1975 Art Institute of Chicago
 Light Gallery, New York
1976 Iowa University Art Gallery, Iowa City
 English Photographs, Visual Studies, Workshop, Rochester, New York
1977 Castelli Graphics, New York
1978 Castelli Graphics, New York
 Robert Self Gallery, London
1979 *3 Americans*, Moderna Museet, Stockholm (with Lewis Baltz and Eve Sonneman; travelled to the Alborg Kunstmuseum, Denmark; Kunstpavillionen, Esbjerg, Denmark; Tranegarden, Gentofte, Copenhagen; and Henie-Onstad Museum, Oslo, 1980)
1981 *Recent Photographs*, Pennsylvania Academy of Fine Arts, Philadelphia
 Corcoran Gallery, Washington, D.C.

Selected Group Exhibitions:

1968 *Vision and Expression*, International Museum of Photography, George Eastman House, Rochester, New York (toured the United States, 1969-71)
1970 *New Photographers*, Museum of Modern Art, New York
1971 *New Acquisitions*, Museum of Modern Art, New York
1973 *Documentary Photography*, Tyler School of Art, Philadelphia
1975 *Photography in America*, Whitney Museum, New York
1976 *Other Eyes*, Hayward Gallery, London (toured the U.K.)
1977 *10 Photographes Contemporains*, Galerie Zabriskie, Paris
 Unposed Portraits, Whitney Museum, New York
1978 *Mirrors and Windows: American Photography since 1960*, Museum of Modern Art, New York (toured the United States, 1978-80)
1979 *Burchard/Cohen/Hallman/Mertin*, Southwest Missouri State University, Springfield

Publications:

By COHEN: article—"Mark Cohen," interview, with Michael Sigrin, in *Camera* (Lucerne), March 1980.

On COHEN: books—*Vision and Expression*, edited by Nathan Lyons, New York 1968; *Photography in America*, edited by Robert Doty, with an introduction by Minor White, New York 1974; articles— "Mark Cohen" in *Creative Camera Yearbook*, edited by Peter Turner, London 1976; "Persistence of Vision" by Kenneth Poli in *Popular Photography* (New York), April 1977; "New York: Mark Cohen, Castelli Graphics" by Leo Rubinfein in *Artforum* (New York), April 1977; "Mark Cohen" by Allan Porter in *Camera* (Lucerne), November 1977; "Mark Cohen" by Carol Squiers in *Artforum* (New York), March 1978; review by Sally Eauclaire in *Art in America* (New York), June 1979; "Mark Cohen's Other Realities" by Julia Scully and Andy Grundberg in *Modern Photography* (New York), November 1979.

Photography may be the most difficult art in which to develop a truly original style. Dealing in images based on the real world, a photographer needs both extraordinary craftsmanship and a restless imagination to add a distinguishing *cachet* to his work. So, it is refreshing to find a still-young photographer who is a complete original with a style so distinct that his prints can often be attributed to him at sight, even without the signature "Mark Cohen."

For many observers, Cohen's images are an acquired taste. Fragmented, often harshly lit and visually disheveled, chaotic and surreal, they at first tend to baffle, even repel the viewer. But if he continues to look and search, a viewer soon begins to find rewards. Mark Cohen's best images are visually powerful and communicate in a strikingly direct and non-verbal way. Although they are not obviously "about" anything, Cohen pictures often set the viewer to musing, following his thoughts through the labyrinth of his own mind. This can be anything from a pleasant to an extremely unpleasant experience. But it is a proof of aliveness—both in the photographer and his audience—that is doubly welcome at a time when so much photography leaves one either bored or repelled.

Despite its uniqueness, a Cohen photograph is "straight"—made with purely photographic equipment and materials. There are no artful scratches, water-colors, sequins, burns or wool stitching added to the print to point out the photographer's originality. The individuality comes from Cohen's mind, vision—and a certain amount of chance.

Most of Mark Cohen's images are totally spontaneous. His working methods, as described by someone who accompanied him on one of his picture-hunting strolls, can be as fantastic as his photographs. Approaching his subject, he holds a 35mm camera with 28mm superwide angle lens attached, in one hand. The lens, prefocused for close work, takes in much of the subject. As he engages his subject in conversation, Cohen snaps pictures, seemingly at random as he talks, moving the camera up, down, out to the side, shooting without looking through the finder, trusting to experience, skill and the reactions of his subject to the encounter with the photographer to provide him with startling images.

Like other artists in other media before him, Mark Cohen has continued to experiment, to change approaches and techniques to expand his growth in photography. For a while, he was fascinated with flash illuminations and combined flash and low daylight. More recently he has been doing large color prints.

Cohen admits to being under urgent, internally generated pressure to produce new work constantly. Yet when he leaves his home or studio to go out to make pictures, he has no clear concept of what he is looking for. It is life, people, the photographer, chance, impulse, emotion and intuition interacting that produce Mark Cohen images.

—Kenneth Poli

COKE, (Frank) Van Deren.

American. Born in Lexington, Kentucky, 4 July 1921. Educated at Woodberry Forest Preparatory School, Orange, Virginia, 1935-39; University of Kentucky, Lexington, 1939-42, A.B. in history and art history; Indiana University, Bloomington, 1957-58, M.F.A. in art history and sculpture; Harvard University, Cambridge, Massachusetts, summers 1959, 1960, 1961; studied photography with Nicholas Haz, 1939, at the Clarence White School of Photography, New York, 1940, and with Ansel Adams, 1952, 1955. Served in the United States Navy, 1942-45. Married Eleanor Barton in 1943 (divorced, 1980); children: Sterling and Eleanor. Photographer since 1936. Assistant Professor, University of Florida, Gainesville, 1958-61; Associate Professor, Arizona State University, Tempe, 1961-62; Director of the Art Museum and Professor of Art, 1962-68, 1972-79, and Chairman of the Department of Art, 1962-70, University of New Mexico, Albuquerque; Director, International Museum of Photography, George Eastman House, Rochester, New York, 1970-72. Director, Department of Photography, San Francisco Museum of Modern Art, since 1979. Visiting Lecturer, St. Martin's School of Art, London, 1968; Distinguished Visiting Professor, University of California at Davis, 1974. Recipient: Photography International Award, 1955, 1956, 1957; International Prize, *Modern Photography*, 1956; International Prize, *U.S. Camera*, 1957, 1958, 1960; New Talent USA Award, *Art in America*, 1960; Guggenheim Fellowship, 1975. Address: Office of the Director, Department of Photography, San Francisco Museum of Modern Art, McAllister Street at Van Ness Avenue, San Francisco, California 94102, U.S.A.

Individual Exhibitions:

1940 University of Kentucky, Lexington
1955 Caravan Galleries, New York
 University of Texas at Austin
1956 International Museum of Photography, George Eastman House, Rochester, New York
1957 A Photographer's Gallery, New York (with Ralph Eugene Meatyard)
1958 University of Florida, Gainesville
1959 Davison Art Center, Wesleyan University, Middletown, Connecticut
 Tulane University, New Orleans
 University of Kentucky, Lexington
1960 University of Florida, Gainesville
1961 International Museum of Photography, George Eastman House, Rochester, New York
1962 Arizona State University, Tempe
 Carl Siembab Gallery, Boston
1963 Phoenix Art Museum, Arizona
1965 Florida State University, Tallahasee
1967 University of Oregon, Eugene
 University of New Hampshire, Durham
1968 Quivira Gallery, Corrales, New Mexico
 Quivira Gallery, Corrales, New Mexico (with Ralph Eugene Meatyard)
1972 Focus Gallery, San Francisco
 Madison Art Center, Wisconsin
1973 Witkin Gallery, New York
1974 Oakland Art Museum, California
1975 Galerie Die Brucke, Vienna
 Galerie Nagel, West Berlin
1976 Schoelkopf Gallery, New York
 La Photogalerie, Paris
 Susan Spiritus Gallery, Newport Beach, California
1978 Kansas State University, Wichita
1980 University of Wisconsin at Menominie
1981 University of New Mexico, Albuquerque (retrospective)

Selected Group Exhibitions:

1960 *Fotografi della Nuova Generazione*, Milan
1962 *Les Grands Photographes de Notres Temps*, Versailles
1967 *Photography U.S.A. '67*, De Cordova Museum, Lincoln, Massachusetts
1969 *13 Photographers*, Pratt Institute, Brooklyn, New York
1973 *Light and Lens*, Hudson River Museum, Yonkers, New York
1974 *National Invitational*, Virginia Commonwealth University, Richmond
 Synthetic Color, Southern Illinois University, Carbondale
1977 *Helen Gee and the Limelight*, Carlton Gallery, New York

Painting in the Age of Photography, Kunsthaus, Zurich
1978 Photographie New Mexico, Centre Culturel Americain, Paris

Collections:

Museum of Modern Art, New York; International Museum of Photography, George Eastman House, Rochester, New York; Addison Gallery of American Art, Andover, Massachusetts; Smithsonian Institution, Washington, D.C.; University of Kentucky, Lexington; Sheldon Memorial Art Gallery, University of Nebraska, Lincoln; Denver Art Museum; University of New Mexico, Albuquerque; Arizona State University, Tempe; San Francisco Museum of Modern Art; National Gallery of Canada, Ottawa.

Publications:

By COKE: books—Young Photographers, exhibition catalogue, Albuquerque, New Mexico 1968; The Painter and the Photograph: From Delacroix to Warhol, Albuquerque, New Mexico 1974; One Hundred Years of Photographic History, editor, Albuquerque, New Mexico 1975; Photography in New Mexico, Albuquerque, New Mexico 1979; Fabricated to Be Photographed, exhibition catalogue, San Francisco 1979; Photography's Response to Constructivism, exhibition catalogue, San Francisco 1980; Avant-Garde Photography in Germany 1919-1939, exhibition catalogue, San Francisco 1981; articles—"The Photographs of Eugene Meatyard" in Aperture (Rochester, New York), no. 4, 1959; "60's Continuum" in Image (Rochester, New York), March 1972; "Notes on Walker Evan and W. Eugene Smith" in Art International (Lugano), June 1972; "Wider View I" in Image (Rochester, New York), July 1972; "Dorothea Lange" in Modern Photography (New York), no. 5, 1973; "Georgio

Van Deren Coke: **Homage to Richard Hamilton, 1970**

Sommer" in UNM Art Museum Bulletin (Albuquerque), no. 9, 1975: "An Interview with Van Deren Coke," with James Hajicek, in Northlight 8 (Tempe, Arizona), November 1978.

On COKE: books—Van Deren Coke: Photographs 1956-1973 by Henry Holmes Smith and Gerald Nordland, Albuquerque, New Mexico 1973; History of Photography Instruction: A Report of Present Trends and Future Directions by Donald Lokuta, Union, New Jersey 1975; Die Geschichte der Fotografie im 20. Jahrhundert/History of Photography in the 20th Century by Petr Tausk, Cologne 1977, London 1980: articles—"Cycles into Darkness" by Joan Murray in Artweek (Oakland, California), March 1974; "Is the Photography Class an Anachronism" by Robert Routh in Petersen's Photographic Magazine (Los Angeles), no. 11, 1976; "Taccuino Americano," edited by G.R. Namias in Progresso Fotografico (Milan), March 1978.

It is very difficult to make art with a camera.
—Van Deren Coke

Although he is known primarily as an educator, a scholar, and, more recently, as the innovative Director of Photography at the San Francisco Museum of Modern Art, Van Deren Coke originally came to the medium as a practicing photographer. He was inspired by traditional masters of West Coast view camera photography such as Ansel Adams and Edward Weston, and he made photographs that reflected their straight, purist heritage. Documentary scenes (a statue of Christ in a crate, the front of a Museum of the Old West), figure studies (his wife sleeping, a young girl on a bed), and found imagery (the word GOD sprayed on a wall in expressionistic style, a gruesome dessicated rodent lying on a wooden floor), though they carried ideas to which he was committed, gave way to photo montages in

which the processes and techniques more directly articluated his visual concerns.

Directly inspired by the Rayographs of Man Ray and the Schadographs of Christian Schad, Coke's manipulated photographic prints embody the mystery he aspired to attain. They combine pictures from newspapers, images from old ambrotype plates, and straight and double exposed photographs of real scenes together on photographic paper that has been selectively solarized and often includes, in photogram fashion, a shadow of the hand that has put them all together. An oppressive sense of melancholy weighs heavily on the autobiographical subjects which come from art history as well as personal history, intuition, and dream. The combination of elements comes not from rational choice but from subjective, emotional attraction to the subjects and intuitive, visual attraction to the arrangements. Even his most recent color works—which are straight cibachrome prints—contain a strong element of ambiguity mixed with a slight dose of surrealism.

All of his photographs deny easy reading, making the viewer absorb the totality of the image in order to experience the full impact of Coke's inescapable fascination with the passage of time, and the eventuality of death.

—Ted Hedgpeth

COLLIER, John (Jr.).
American. Born in Sparkhill, New York, 22 May 1913. Studied painting, under Maynard Dixon, California School of Fine Arts, now San Francisco Art Institute, 1931-35; mainly self-taught in photography, but assisted initially by Dorothea Lange, from 1935. Served in the United States Merchant Marine, 1943-45. Married Mary Trumbull. First photographic project, University of California Bancroft Library, Berkeley, 1938; Assistant to commercial photographer Gabriel Moulin, San Francisco, 1939-40; photographer, under Roy E. Stryker, Farm Security Administration, throughout the United States, 1941-42, Office of War Information, Rhode Island and New Mexico, 1942-43, and Standard Oil Company of New Jersey, 1945-49; also worked with anthropologist Anibal Buitrón, Otavalo study project, Ecuador, 1946; with anthropologists Alexander H. Leighton and Allan R. Holmberg, in Canada, Navajo Indian Reservation, and Peru, 1951-54. Freelance photographer, working for Fortune, Ladies Home Journal, etc., since 1949; has concentrated on anthropological photo studies, since 1955. Professor of Education and Anthropology, California State University, San Francisco; Instructor in Photography, San Francisco Art Institute. Recipient: Wennergen Fellowship, 1950; Guggenheim Fellowship, 1957. Address: Muir Beach, Sausalito, California 94965; and General Delivery, Ranchos de Taos, New Mexico 87557, U.S.A.

Selected Group Exhibitions:

1955 FSA Anniversary Show, Brooklyn Museum, New York
1962 The Bitter Years: FSA Photographs 1935-41, Museum of Modern Art, New York (toured the United States)
1968 Just Before the War, Newport Harbor Art Museum, Newport Beach, California
1976 FSA Photographers, Witkin Gallery, New York
1978 Roy Stryker: Humane Propagandist, International Museum of Photography, George Eastman House, Rochester, New York

1979 *Images de l'Amérique en Crise: Photos de la FSA*, Centre Georges Pompidou, Paris
Amerika Fotografie 1920-1940, Kunsthaus, Zurich
1980 *Les Années Ameres de l'Amérique en Crise 1935-42*, Galerie Municipale du Chateau d'Eau, Toulouse, France
Images of America: Photography from the FSA, Sonoma State University, California
Amerika: Traum und Depression 1920-40, Kunstverein, Hamburg (toured West Germany)

Collections:

Museum of Modern Art, New York; Library of Congress, Washington, D.C.; University of New Mexico, Albuquerque; San Francisco Art Institute.

Publications:

By COLLIER: books—*The Awakening Valley*, with Anibal Buitrón, Chicago 1949; *Visual Anthropology: Photography as a Research Method*, New York 1967; *Alaskan Eskimo Education: A Film Analysis of Cultural Confrontation in the Classroom*, New York 1973; article—"Navajo Housing in Transition," with M.A. Tremblay and T.T. Sasakai in *America Indigena* (Mexico City), vol. 14, no. 3, 1954.

On COLLIER: books—*Poverty and Politics: The Rise and Fall of the FSA* by Sidney Baldwin, Chapel Hill, North Carolina 1968; *The Years of Bitterness and Pride: FSA Photographs 1934-1943*, edited by Haig Akamakjian, compiled by Jerry Kearns and Leroy Bellamy, New York 1975; *Portrait of a Decade: Roy Stryker and the Development of Documentary Photography in the Thirties* by F. Jack Hurley, Baton Rouge, Louisiana 1972, New York 1977; *A Vision Shared: A Classic Portrait of America and Its People 1935-43*, edited by Hank O'Neal, New York and London 1976; *Dorothea Lange: A Photograper's Life* by Milton Meltzer, New York 1978; *Amerika Fotografie 1920-1940* by Erika Billeter, Berne 1979.

John Collier's ideas on the status of his photography are suggestive: he has said, for instance, that he would not be interested in a compilation of his pictures "as art"; "being there" was more important than "the print"; the photograph, rather, is a "testament" to being there, a record. While such views might seem to place the emphasis fundamentally on the phenomena of the material universe—and he has also said that the photographer, unlike the painter, cannot photograph "what is in his head"—I suspect that this degree of reverence for materiality is actually more akin to transcendentalism.

He has always been attracted to sequential stories, to film-making and, especially, to the photo-essay. An accomplished writer, from his fine descriptive letters to Roy Stryker, his first employer at the Farm Security Administration in the 1940's, to the present, it is as if words emphasize the movement through time which the photograph simultaneously denies and affirms. From this perspective, perhaps his most exciting work is *The Awakening Valley* on Otavalo, Ecuador, with its stunning views of the Andes, journeys to and from market, the processes of crafts, and people in all their variety.

His father, John Collier Snr, was President F.D. Roosevelt's radical Commissioner for Indian Affairs. As he was brought up to be aware of and respectful towards other cultures, it is not surprising that the bulk of Collier's photography has been devoted to anthropological subjects, whether pictures of munitions factory life for the FSA, Native American tribal activities, or Canadian Maritime communities. And in both his conversation and writing—

especially his classic *Visual Anthropology*—he views photographs as a means to materialize people themselves through such things as their worn doorsteps, the fabric of their houses, etc. His famous portrait of "Grandfather Romero, Trampas, New Mexico," 1943, depicts an old man oddly situated in the bottom left of the frame with part of his bed in the bottom right and a large expanse of wall behind him—at least he seems oddly situated until we realize that that is precisely the point: behind him, like a religious tryptich, is a picture of Jesus, a genre print and, between them, a group of family snapshots and the elaborately framed portrait of a young man in military uniform. These objects visually balance Romero in the picture and literally indicate the rounds of his life: religion, family, traditional community activities and the place he lays his head.

—G.M. Gidley

CONNOR, Linda (Stevens).
American. Born in New York City, 18 November 1944. Studied photography, under Harry Callahan, at the Rhode Island School of Design, Providence, 1962-66, B.F.A. 1967; and under Aaron Siskind at the Institute of Design, Illinois Institute of Technology, Chicago, 1966-69, M.S. 1969. Freelance photographer, now based in San Francisco, since 1966. Instructor, San Francisco Art Institute, since 1969 (held Graduate Chair, 1975; Co-Chairperson, Photography Department, 1973-75). Has also taught at San Francisco State University, 1972; California College of Arts and Crafts, Summer 1970, Spring 1973; University of California Extension at Berkeley, 1973; and School of the Museum of Fine Arts, Boston, Fall 1978. Recipient: U.I.C.A. Faculty Grant, California, 1973; National Endowment for the Arts Individual Grant, 1976, and Photo Survey Grant, 1981; A.T. and T. Photography Project Grant, 1978; Guggenheim Fellowship, 1979. Agent: Light Gallery, 724 Fifth Avenue, New York, New York 10019. Address: c/o Department of Photography, San Francisco Art Institute, 800 Chestnut Street, San Francisco, California 94133, U.S.A.

Individual Exhibitions:

1969 School of the Dayton Art Institute, Ohio
1970 San Francisco Art Institute
1971 Focus Gallery, San Francisco
Corcoran Photographic Workshop, Washington, D.C.
Lomis School, Connecticut
School of the Art Institute of Chicago
1972 Let A Dark, San Rafael, California
3 Photographers, St. Mary's College, Notre Dame, Indiana
1973 Hallway Gallery, San Francisco Art Institute
Light Gallery, New York
3 American Photographers: Imogen Cunningham, Linda Connor, Judy Dater, Musée Réattu, Arles, France
Linda Connor/Michael Bishop, University of Rhode Island, Kingston
1974 Tyler School of Art, Philadelphia
Portland School of Art, Oregon
Merramec Community College, St. Louis
1975 University of Colorado, Boulder
218 Gallery, Memphis, Tennessee

John Collier: *Just Before the War: White Tower Hamburger Stand*, late 1930's Courtesy Library of Congress/Victoria and Albert Museum, London

Center Gallery, University of California Berkeley Extension, San Francisco
Slightly Sloping Gallery, Visual Studies Workshop, Rochester, New York
1976 Spectrum Gallery, Tucson, Arizona
Susan Spiritus Gallery, Newport Beach, California
Center Gallery, Sun Valley, Idaho
Center for Photographic Studies, Louisville, Kentucky
1977 Bard College, Annandale-on-Hudson, New York
De Young Memorial Museum, San Francisco
1978 Light Gallery, New York
Linda Connor and Nicholas Nixon, Massachusetts College of Art, Boston
1979 Los Angeles Institute of Contemporary Art
1980 Light Factory, Charlotte, North Carolina
Eclipse Gallery, Boulder, Colorado
Light Gallery, Los Angeles
Landscape Images: Recent Photographs by Linda Connor, Judy Fiskin, Ruth Thorne-Thomsen, La Jolla Museum of Contemporary Art, California
1981 *Images of Asia*, Light Gallery, New York
North Light Gallery, Arizona State University, Tempe

Linda Connor: Images Past and Present, Vision Gallery, Boston
Frank Gohlke/Linda Connor, Film in the Cities Gallery, St. Paul, Minnesota
Ancient Currents Gallery, San Francisco
Silver Image Gallery, Ohio State University, Columbus

Selected Group Exhibitions:

1969 *Vision and Expression*, International Museum of Photography, George Eastman House, Rochester, New York (toured the United States, 1969-71)
1973 *Light and Lens*, Hudson River Museum, Yonkers, New York
1974 *Private Realities*, Museum of Fine Arts, Boston
14 American Photographers, Baltimore Museum of Art (travelled to the Newport Harbor Art Museum, California; La Jolla Museum of Contemporary Art, California; Walker Art Center, Minneapolis; and Fort Worth Art Museum, Texas)
1977 *The Less Than Sharp Show*, Center for Contemporary Photography, Chicago
The Great West: Real/Ideal, University of

Colorado, Boulder (subsequently Smithsonian Institution travelling exhibition: toured the United States)
1978 *One-of-a-Kind Color*, Franklin Institute, Philadelphia
Mirrors and Windows: American Photography since 1960, Museum of Modern Art, New York (toured the United States, 1978-80)
1980 *New Landscapes, Part II*, Friends of Photography, Carmel, California
1981 *American Photographers and the National Parks*, Corcoran Gallery, Washington, D.C. (toured the United States)

Collections:

Museum of Modern Art, New York; International Museum of Photography, George Eastman House, Rochester, New York; Visual Studies Workshop, Rochester, New York; Museum of Fine Arts, Boston; Polaroid Corporation Collection, Cambridge, Massachusetts; Art Institute of Chicago; High Museum, Atlanta; Center for Creative Photography, University of Arizona, Tucson; San Francisco Museum of Modern Art; Australian National Gallery, Canberra.

Publications:

By CONNOR: book—*Solos*, Millerton, New York 1979.

On CONNOR: books—*Be-Ing Without Clothes* by Minor White, Millerton, New York 1970; *Private Realities*, exhibition catalogue, Boston 1974; *14 American Photographers*, exhibition catalogue, Baltimore 1974; *The Less Than Sharp Show*, exhibition catalogue, Chicago 1977; *Darkroom*, New York 1977; *Mirrors and Windows: American Photography since 1960* by John Szarkowski, New York 1978; *American Images: New Work by 20 Contemporary Photographers*, edited by Renato Danese, New York 1979; *American Photographers and the National Parks*, New York 1981; articles—"Singular Developments: Polaroid's Paean to Color" by Allen Robertson in *TWA/Ambassador* (St. Paul, Minnesota), December 1979; "Linda Connor, Light Gallery" by Lynn Zelevansky in *Flash Art* (Milan), Summer 1981; "Currents: American Photography Today" in *Modern Photography* (New York), August 1981.

Linda Connor: *Seven Sacred Pools, Maui, Hawaii*, 1978

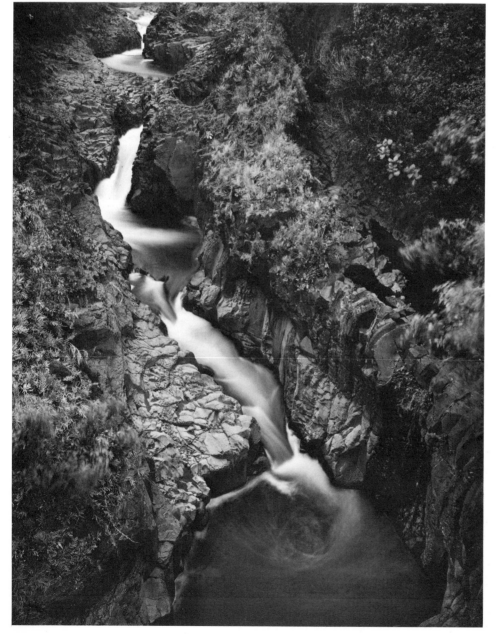

I can clearly recall watching the clouds moving past my window and perceiving, for the first time, their passage around the earth; my breathless investigations of snowflakes on my sleeve before they would melt; the intricate patterns of an Oriental rug which, decades later, I would recognize again instantly.

As a child I was alone amidst the substance and power of the world, an awed and fascinated witness. Photography re-establishes that state of absorption and wonderment, of unfiltered experience. It both grounds and nurtures my imagination.

Discipline and an attitude of openness provide the proper medium for the flow of creative energy. It is a privilege to serve and transform this elusive force; it enriches my life, surpasses my knowledge, and remains far more profound than I.

—Linda Connor

For Linda Connor, more than for most photographers, the act of photographing is a conscious probing of her subconscious, rather than an expression of an emotion toward the subject—an act of discovery rather than a confirmation of self-recognition. This has led, as the work of years has been gathered, to a disparate group of images, bound together by the strong thread of a formal structure,

initiated, she believes, by her admiration for the work of Walker Evans. In the late 1960's Connor photographed collage-like arrangements of photographs, some distinctly biographical, such as portraits from her mother's high-school yearbook; the production involved negative and print manipulation and some hand-coloring. From this she moved to still-life arrangements; the material she collected for them continued to suggest the appeal to her of subjects with a personally sentimental history. It reflected as well her exploration of the relationship between art and nature—a reproduction of Botticelli's *Venus* combined with shells, for instance. She also recycled earlier photographs of her own, combining them with found objects or reproductions of fine and folk art in unlikely juxtapositions that produced, for her, revelatory images.

This search for revelation has continued in Connor's view photographs. The earliest of these were taken with a camera her great-aunt had used when she studied with Clarence White, an 8 x 10 Century with a lens as soft as an astigmatic eye. The prints were produced by contact and toned with gold-chloride, a procedure used more for its somewhat antique effect than for notions of purity. Because of the soft focus and the blossom of ambient light that appeared around the center of the image, these photographs of landscapes and objects in them have a mysterious, tantalizing effect. The subject, though recognizable, can not be fully grasped, and the failure of definition often suggests something other than what is actually portrayed.

After publishing these soft-focus photographs in her book *Solos*, Connor started using a view camera with a hard lens. Her object then became to find subjects that even when fully revealed would appear surreal. Her search for personally meaningful subject matter—which she most often has found in non-Western cultures, in ancient architecture and in wilderness—has taken her to Central America, to the Far East and Europe, as well as to the Southwest of the United States. While her photographs in these various locations may include people, more often she places a ritual site, an ancient tree or an inscription in stone at the center of them. She makes these photographs of objects as animated as those with people in them through her attention to tone and continuous line, which provides a sort of gesture.

The visual jolt of an image that transcends reality is felt in Linda Connor's best photographs. That is what she is really after. "When my pictures stop telling me things," she says, "I will stop making them."

—Anita V. Mozley

COOPER, Thomas Joshua.

American. Born in San Francisco, California, 19 December 1946. Educated at Arcata High School, California, 1960-64; studied art, philosophy and literature, Humboldt State University, Arcata, California, 1965-69, B.A. 1969; photography, under Van Deren Coke, Jim Kraft, Richard Rudisill and Beaumont Newhall, University of New Mexico, Albuquerque, 1970-72, M.A. Independent photographer, in England, 1976-79, in the United States, since 1979. Teacher of Photography, Arcata High School, California, 1969; Instructor of Photography, College of the Redwoods Community College, Eureka, California, 1970; Teacher, Dana Elementary School, Nipoma, California, 1971; Visiting Lecturer in Photography, Institute of American Indian Art, Sante Fe, New Mexico, 1973; Senior Lecturer in Photography and History of Photography, and Course Director, Trent Polytechnic, Nottingham, England, 1973-76. Visiting Assistant Professor of Art, Humboldt State University, Arcata, California, since 1979. Recipient: James D. Phalen Award in Art, Oakland Museum of Art, California, 1971; New Mexico Biennial Fine Art Award, New Mexico Museum of Fine Art, 1973; National Endowment for the Arts Grant, 1978. Photography Bursar for Arts Council of Great Britain, with Joseph Koudelka, 1976-77. Address: P.O. Box 265, Arcata, California 95521, U.S.A.

Individual Exhibitions:

1971 *I See the God in You*, The Art Center, San Luis Obispo, California
1972 *The Fields We Know: A Myth of Recollection*, University of New Mexico Fine Art Museum, Albuquerque
1973 *Sweet Play*, Quivera Gallery, Albuquerque, New Mexico
The Shado Gallery, Portland, Oregon
1974 *She Rain*, The Midland Group Gallery, Nottingham, England
Indications, The Photographers' Gallery, London
1975 *Remnants and Prenotations*, The Arnolfini Gallery, Bristol, England (with Paul Hill)
The Warwick Gallery, England (with Paul Hill)
The Spectrum Art Photographic Gallery, Barcelona
3 Photographers, Galleria Il Diaframma, Milan (with Paul Hill and John Blakemore)
1976 The Friends of Photography Gallery, Carmel, California (with Paul Hill; travelled to the University of Oregon Art Museum, Eugene)
1977 *3 Photographers: Cooper, Hill, Moore*, The Focus Gallery, San Francisco (with Paul Hill and Raymond Moore)
Images of Our Mortality, The Robert Self Gallery, London
1979 *Paysages*, Bibliothèque Nationale, Paris
A Place In Between, College of the Redwoods Art Gallery, Eureka, California (with watercolorist Robert Benson; toured the United States)
1981 *Intimations*, Northcoast Art Gallery, Arcata, California (with fiber sculptor Beckie Evans)
Dos Hombres—Dos Estilos: Thomas Cooper/Tom Knight, Teatro Juarez, Guanajuato, Mexico

Selected Group Exhibitions:

1971 *James D. Phelen Awards Exhibition*, Oakland Museum of Art, California
1972 *New Mexico Biennial Fine Art Exhibition*, New Mexico Museum of Fine Art, Santa Fe
1974 *New Photography: British Arts Council Juried Travelling Exhibition*, Midland Group Gallery, Nottingham, England (toured the U.K.)
1976 *Open Photography: British Arts Council Juried Travelling Exhibition*, Midland Group Gallery, Nottingham, England (toured the U.K.)
Other Eyes: Concepts in Vision, Arts Council of Great Britain, London (toured the U.K.)
1978 *Critic's Choice*, Institute of Contemporary Arts, London
Photomiscellany: 120 Years of International Photographic History, Angus Stokes Gallery, Bakewell, Derbyshire, England
1979 *3 Perspectives on Photography*, Hayward Gallery, London
1980 *A Survey of British Photography 1935-1979*, Arts Council of Great Britain, London
1981 *New Works of Contemporary Art and Music*, Fruit Market Gallery, Edinburgh

Collections:

Center for Creative Photography, University of Arizona, Tucson; University of New Mexico, Albuquerque; Oakland Museum, California; Humboldt State University, Arcata, California; National Gallery of Canada, Ottawa; Arts Council of Great Britain, London; Open University, London; Victoria and Albert Museum, London; Trent Polytechnic, Nottingham, England; Bibliothèque Nationale, Paris.

By COOPER: books—*The Reflecting Pool*, Arcata,

Thomas Joshua Cooper: *Ritual Indication*, Alton, Staffordshire, England, 1977

California 1969; *Remnants and Prenotations*, exhibition catalogue, with Paul Hill, London 1975; *Dialogue with Photography*, with Paul Hill, New York, London and Madrid 1979; articles—"The Carlotta House" in *Hilltopper Review* (Arcata, California), 1967; "Such Were the Joys..." in *Hilltopper Review* (Arcata, California), 1968; "Can British Photography Emerge from the Dark Ages?" with Paul Hill, in *Creative Camera* (London), September 1974; "Paul Strand: An Appreciation," with Paul Hill, in *British Journal of Photography*, (London), 13 February 1976; "Imogen: A Celebration," with Gerry Badger, in *The British Journal of Photography Annual*, London 1978.

On COOPER: books—*New Photography*, exhibition catalogue, by Jean-Claude Lemagny and Aaron Scharf, Nottingham, England 1974; *Open Photography*, exhibition catalogue, by Allan Porter and Keith Arnatt, Nottingham, England 1976; *Other Eyes*, exhibition catalogue, by Peter Turner, London 1976; *Photomiscellany: 120 Years of International Photographic History*, exhibition catalogue, by Angus Stokes, Bakewell, Derbyshire 1978; *Critics Choice*, exhibition catalogue, by John McEwen, London 1978; *Perspectives on Landscape: British Image 5*, selected and edited by Bill Gaskins, London 1978; *Photography in New Mexico* by Van Deren Coke, Albuquerque, New Mexico 1979; *Three Perspectives on Photography: Recent Photography in Britain*, exhibition catalogue, by Paul Hill, London 1979; *The History of Photography in the 20th Century* by Petr Tausk, Cologne 1977, London 1980; *New Works of Contemporary Art and Music*, edited by Graeme Murray, Edinburgh 1981; article—"The British Obsession—About to Pay Off" by William Messer in *U.S. Camera Annual*, New York 1977.

My photographs are meditations; it is as simple as that. They are concerned with myths and rituals of the land, and with a yearning to more fully comprehend them. For over a decade I have been involved in concentrated research into the attitudes of the mythic and the meditative in photography. My photographs generally suggest these researches by containing three primary areas of inquiry: Ritual Indications, Ritual Guardians, and Ritual Grounds. It is around such ritual "sightings" that both the conceptual and formal basis for my work occurs.

The works are often autobiographical in reference, always sequentially structured, and invariably reliquarily involved. Early "primitive" myths and legends from North America and the British Isles seem to inspire the work and to infuse its making. The works are, however, constructions, illusions, inventions—*discoveries*.

Photography is the form of my art. Myth is the essence. For me, photography must always be a function and a process of Heart. My photographs, then, are more the products of revelation than that of actual direct documentation of place.

—Thomas Joshua Cooper

Fostered in the University of New Mexico, one of the great epicentres of creative photography, the work of Thomas Joshua Cooper is neither a means for producing a simulacrum of the external world nor simply a poetic interpretation of it. It is a very personal way to transcend the reality of time and place.

Cooper speaks of his photography as "a medium of creative visual expression in which the process of self-discovery provides the motivation for making the image." In some degree that is the recondite truth in the work of most sensitive photographers, even when the ostensible aim is documentation or reportage. But for Cooper mundane appearances provide the vehicle for an intensely introspective

exploration of a world within. Deep, dark recesses of wooded and rocky landscapes or weathered moorland and seasides bathed in strange light characterize his work. During the years 1973-77 the English landscape became Cooper's sanctuary. The titles of those photographs taken in Shropshire, Staffordshire and Derbyshire (each area is identified) from 1975-77 reveal both a metaphysical intent and a veneration for place: "Ritual Ground, Harborough Rocks"; "Ritual Indication Near Alton"; "Ceremonial Veil, Nescliffe." All speak of an obsession with the eternal values attached to natural objects and settings, or those reclaimed by nature. England's "sacred groves" and notions of mythological sources have especially activated Cooper's latent instinct for these things.

Paradoxically, illusion and the believability of the photograph are themselves, Cooper says, powerful means for effecting a return to self-revelation through the mythical world. Solitude, stillness and illumination are terms used by Cooper to describe the states of nature required for his meditations. His photographs are charged with quietude. Often the scenes seem illumined for an instant by some piercing extra-earthly light. He knows what his camera sees! In recognizing such moments, Thomas Joshua Cooper stirs our memories in profound ways. His photographs are strangely familiar. They seem to tell us less about nature than about ourselves.

—Aaron Scharf

CORDIER, Pierre.

Belgian. Born in Brussels, 28 January 1933. Studied political and administrative sciences at the Université Libre, Brussels, 1952-55, and photography with Otto Steinert, in Saarbrucken, 1958. Served in the Belgian Army, in Longerich, Germany, 1955-57. Has worked with "Chemigrams" (chemically-produced images on photosensitive materials), Brussels, since 1956; also, freelance photographer, Brussels, 1957-67. Instructor, Ecole Nationale Supérieure d'Arts Visuels, Brussels, since 1965. Corresponding Member, Deutsche Gesellschaft für Photographie (DGPh), since 1971. Agents: Galerie Paule Pia, Kammenstraat 57, B-2000 Antwerp; and Galerie d'Art Actuel Anne van Horenbeeck, Chaussée de Charleroi 183, B-1060 Brussels. Address: rue Reigersvliet 20, B-1040 Brussels, Belgium.

Individual Exhibitions:

1962 *Pierre Cordier*, Studio 28, Paris
1964 *Chimigrammes de Pierre Cordier*, Galerie Vanderborght, Brussels
1967 *Denis Brihat/Pierre Cordier/Jean-Pierre Sudre*, Galerie Artek, Helsinki
1970 *Chimigrammi di Pierre Cordier*, Galleria Il Diaframma, Milan
1974 *Chimigrammes de Pierre Cordier*, Galerie Michel Vokaer, Brussels
1975 *Pierre Cordier: Chimigrammes*, Galerie du Disque Rouge, Brussels (travelled to Gesbanque, Amis du Musée, Verviers, Belgium)
1976 *Pierre Cordier: Chimigrammi*, Galeria Spectrum, Barcelona
 Pierre Cordier: Chemigramme, Galerie Die Brücke, Vienna
 20 Ans de Chimigrammes, Palais des Beaux-Arts, Brussels (retrospective; travelled to the Maison de la Culture, Namur, Belgium, 1977)
1977 *Chimigrammes de Pierre Cordier*, Galerie du Château d'Eau, Toulouse (retrospective)

 20 Years of Chemigrams, Neikrug Galleries, New York
 Chemigrammen van Pierre Cordier, Galerie Paule Pia, Antwerp
1979 *Pierre Cordier: Chimigrammes*, Bibliothèque Nationale, Paris
1980 *Pierre Cordier*, Galerie Anne Van Horenbeeck, Brussels
 Pierre Cordier, Atelier Charles De Trooz, Louvain-la-Neuve, Belgium
 Pierre Cordier: Chimigrammes, Musée Réattu, Arles, France (retrospective; travelled to the Musée Nicéphore Niepce, Chalon-sur-Saône, France)

Selected Group Exhibitions:

1958 *Subjektive Fotografie III*, at *Photokina*, Cologne
1967 *A European Experiment*, Museum of Modern Art, New York
1968 *Generative Fotografie*, Kunsthaus, Bielefeld, West Germany
1969 *Vision and Expression*, International Museum of Photography, George Eastman House, Rochester, New York (toured the United States, 1969-71)
1971 *Contemporary Photographs I*, Fogg Art Museum, Harvard University, Cambridge, Massachusetts
1972 *Octave of Prayer*, Massachusetts Institute of Technology, Cambridge
 Wege zur Computer Kunst, Federal Institute of Technology, Zurich (toured Germany and Switzerland)
1978 *Modern and Experimental Colour Photography*, The Photographers' Gallery, London
1979 *Les Photographs Imaginaires*, Palais de la Decouverte, Paris
1980 *Photographia: La Linea Sottile*, Gallerie Flaviana, Locarno, Switzerland
 Art et Photographie, Kunst en Kamera, Galerie C.G.E.R., Brussels

Collections:

Ministry of Culture, Brussels; Musées Royaux des Beaux-Arts, Brussels; Het Sterckshof Museum, Antwerp; Folkwang Museum, Esseng; Bibliothèque Nationale, Paris; Museum of Modern Art, New York; International Museum of Photography, George Eastman House, Rochester, New York; Fogg Art Museum, Harvard University, Cambridge, Massachusetts; Gernsheim Collection, University of Texas at Austin; Center for Creative Photography, University of Arizona, Tucson.

Publications:

By CORDIER: books—*Chimigrammes*, with an introduction by Jean-Michel Folon, Brussels 1974; *20 Years of Chemigrams*, with an interview by Pierre Baudson, Brussels 1976; articles—"Billet de Saarbrücken" in *Contact* (Brussels), May/June 1958; "Dialogue avec les faiseurs d'Images" in *L'Arc* (Aix-en-Provence, France), April 1963; "11 apunti sui chimigrammi" in *Centro Culturale Fiat* (Turin), January 1972; "Denis Brihat" in *Lens en Mens* (Antwerp), February 1976; "John Vink" in *Zoom* (Paris), December 1979; "I Fotografins Gränsområde" in *Album* (Helsinborg, Sweden), January/March 1980; "The Secrets of Chemigrams and Photo-Chemigrams" in *Print Letter* (Zurich), March/April 1980; film—*Start*, with Marc Lobet, 1976.

On CORDIER: books—*Selbstportraits* by Otto Steinert, Gütersloh, Germany 1961; *L'Arte Moderna 121: La Fotografia* by Grytzko Mascioni, Milan 1967; *Il Linguaggio Fotografico* by Renzo Chini, Turin 1968; *The Picture History of Photography* by

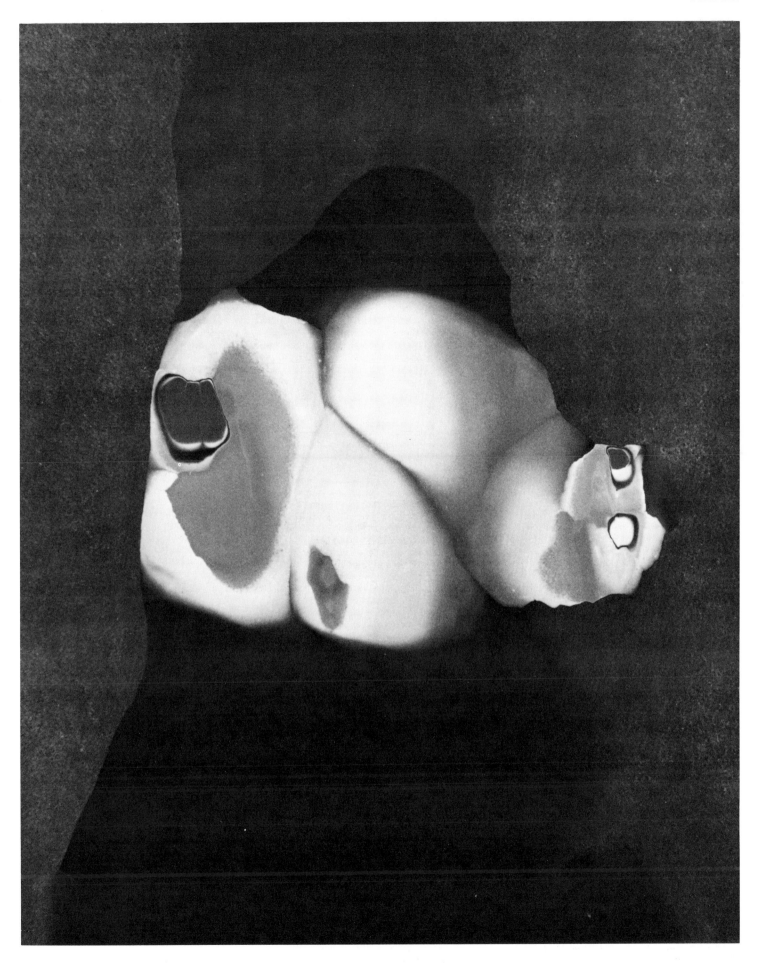

Pierre Cordier: *Chemigram 28/5/61*, 1961

Peter Pollack, New York 1969; *Photography Without a Camera* by Patra Holter, London 1972; *Photographis*, edited by Walter Herdeg, Zurich 1973; *Apparative Kunst* by Herbert W. Franke and Gottfried Jäger, Cologne 1973; *Generative Fotografie* by Gottfried Jäger and K. Holzhäuser, Ravensburg, Germany 1975; *Die Geschichte der Fotografie im 20. Jahrhundert* by Petr Tausk, Cologne 1977, London 1980; *Lexikon der Fotografie*, edited by Hugo Schöttle, Cologne 1978; *Time-Life Photography Yearbook*, edited by Ed Brash, New York 1979; articles—"Pierre Cordier" by Allan Porter in *Camera* (Lucerne), May 1971; "Pierre Cordier, uitvinder van de chemigraphie" by Else M. Hooykaas in *Foto* (Amersfoort, Netherlands), September 1970; "Pierre Cordier and His Chemigrams" by Charles Rohonyi in *Novum-Gebrauchsgraphik* (Munich), August 1972; "Chemigrams-Chimigrammes" by Gottfried Jäger in *Graphis* (Zurich), no. 164, 1972; "Chimigrammes, oeuvre ouverte" by Carole Naggar in *Zoom* (Paris), March 1975; "Chemigraphy" by Ed Scully in *Modern Photography* (New York), September 1976; "Technique Alternative" by Roberto Salbitani in *Progresso Fotografico* (Milan), November 1978; "Pierre Cordier" by Jean-Claude Lemagny in *Connaissance des Arts* (Paris), March 1980; "Images Aléatoires de l'Inconnu" by Yves Aubry in *Zoom* (Paris), June 1980.

Painters nowadays ask themselves many questions: what is a painting? What is it to paint? I ask the same questions about photography.

Photography is the "bisociation" (Arthur Koestler) of two sciences: chemistry and optics. And yet, photographers and painters almost always use only optics, pictures made with cameras, and they ignore the creative possibilities of chemistry. The first pioneers (Niépce, Daguerre, Talbot, Bayard) mostly invented photographic chemistry, because the Camera Obscura—and its optics—had already existed for several centuries and were readily used by painters. One can therefore deduce that the chemigram, being the systematic use of photographic chemistry, is more related to the research of the photographic pioneers than to that of the modern photographers.

The CHEMIGRAM (1956) owes its existence to the localized action of chemical substances on a photosensitive surface, without the use of the camera, enlarger or darkroom. From "chemistry" and the Greek "gramma," a written sign, the word "chemigram" conveys both the technique and the resulting image. The chemigram results from the encounter of two chemistries: one is solid, that of the photosensitive surface; the other is liquid, that of the developer and fixer. The developer is the equivalent of the pencil: it produces the blacks and the colors. The fixer, used before the developer, neutralizes its effect and thus produces the white; its role is similar to that of an eraser which, in this case, precedes the pencil. Like a camera, the localizing substances determine the forms and structures of the chemigram. These substances are numberless: they can be hard, soft, oily, dry, sticky, or brittle. By varying these three elements separately or together (photosensitive surfaces, localizing substances, and developer-fixer), the possibilities available to the chemigram process are infinite.

Chemigram = Photography? In conventional photography, the effects of light are localized by the camera, and the developer and fixer act upon the whole photosensitized surface. Inversely, in the chemigram process, light plays only a passive role on the whole photosensitive surface, and the developer and fixer are localized, either successively or simultaneously.

Chemigram = Painting? In painting, matter is applied, accumulated, preserved. It is thus used in an additive manner, by sedimentation. A chemigram, however, is produced by erosion. It is the result of a subtractive action. Indeed, matter is first applied, then gradually eroded until it reaches the absence of matter particular to photography. Thus, lines or shapes are never applied as they are in painting; they are produced by negative action, resulting not from the accumulation of matter but rather by the retraction and elimination of that same matter which creates it.

Chemigram = Photography *and* Painting? The chemigram has no place of its own: it is a painting for a photographer, and a photograph for a painter. This proves that there are at least two possible readings: one by inclusion, the other by exclusion. One interpretation would consist of saying that it combines painting and photography in various ways that are all conveyed by the conjunction "and." Examples: 1) Painting has always been a manual process, in opposition to photography which is a direct physico-chemical process. A chemigram is both one and the other at the same time. 2) The surface in a painting is progressively annexed, again in opposition to photography where the whole surface is treated at once. The chemigram does both at the same time. 3) A painting is unique (and cannot be multiplied); a photograph is multiple (it is directly linked to reproduction). A chemigram, once again, is both at the same time.

One could go on, to describe what a chemigram really is: doing so would define its essential characteristic as being not the conjunction of two elements (photography and painting) but rather the realization of their disparity.

—Pierre Cordier

Pierre Cordier calls his technique "chemigram." He consistently exploits the nuances of photo-chemicals and coloured dyes acting on photographic emulsions (developers, fixatives and toning materials as examples) without recourse to the camera and other conventional photographic means. Conventional procedures are reversed in order to extend the range of form, tone and colour. Often the fixing solution is used before the developer. Sometimes the solutions are employed simultaneously. Moreover, calculated alterations in the dilution or saturation of these baths, in temperature and immersion time, will produce effects which, carefully noted by Cordier, can, with a degree of precision, be repeated. To concentrate these general effects of colour and tone (in a sense to "draw" the shapes and contours making up the image) Cordier uses what he calls "localizing substances," which in fact replace the camera.

Even the darkroom is superfluous, for chemigrams can be made in full light. Though indispensable in the process, light itself plays a minimal role. The versatility of chemigram techniques is great. Accidental and often striking aberrations occur as an inevitable consequence of operating by such methods. "Chance is my best collaborator," says Cordier, "but it only favours a receptive medium."

Unique images are produced when the base employed directly is photographic paper. If, however, a photographic film or plate is used initially, as in ordinary photographic processes, this negative can be the source of multiple prints virtually identical in appearance.

Cordier has employed his cameraless methods since 1956. The soft, muted colours of his earlier chemigrams for which fixatives and developers were used are permanent; those requiring the application of dyes for heightening the colours less so. Chemigrams do not simply augment a tradition stretching from Fox Talbot to Man Ray and Moholy-Nagy, but bring "light painting" to a colouristic fulfilment in the context of contemporary imagery. Pierre Cordier *invented* the chemigram technique in the true sense of the word. In essence, he produces works which visually combine characteristics attributable both to photography and painting. By a diversity of highly refined techniques Cordier, in his choice of images, is able to marry the impersonal tonal fluency of photography with the painter's "touch." In an important sense his explorations echo the perennial Surrealist concern with the violation of materials and its concommitants in bringing to light new pictorial mechanisms. These means for giving expression to inspiration make tangible the Surrealist idea of a "photography of the mind." In this way Cordier is able to explore an inner and very personal imagery, yet present it in an impersonal and concrete way. However recondite chemigrams may appear, they are, in a photographic way, believable—as are, for example, crystalline fragments viewed through an electron microscope.

Cordier's synthesis of art and science is entirely in keeping with contemporary preoccupations reflected in cinema, television, video-recording, holography and computer-generated images. As in those media, the artist guides the machine. The means, though vital, play a passive role.

Colour is essential in Cordier's chemigrams. In his commanding hands, it has become immensely efficacious, and so versatile that it can even be chosen (in Cordier's words) "according to a programme similar to Goethe's theory of colours." The hues achieved in his later work, their rich metallic tones mostly derived from photo-emulsion dyes, are wholly compatible with his synthetic light-chemical means. With dyes, Cordier's range of colour is greatly enlarged: cyan, magenta, cobalt blues, chrome greens, alizarin crimson, cadmium yellows and orange make it possible, with the earlier earth colours, to embrace the whole chromatic spectrum.

Though hazard must play its part in Cordier's procedures, it is only within the parameters set by the artist himself. As in painting, the construction of a chemigram is mutable and extensive in time. It is not, as in most conventional photography, instantaneous. Moreover, far from being mass-produced, it sometimes takes Cordier several days to complete one or two chemigrams.

Cordier's subjects, for all their impersonality and uniformity in tonal rendering, appear as organic entities made by the machine, evocative and inviting interpretation. This is so partly by virtue of the medium's intrinsic properties, but mainly I suspect at Cordier's bidding. A subliminal sense of growth is often conveyed: objects or forms appear in genesis or in transition. They materialize or dissolve in improbable ways. This implied movement—indeed, life force—is enhanced by Cordier's predilection for sequential imagery. The source is occasionally in the early consecutive series photographs of Muybridge or in the chronophotography of Marey. Cordier pays homage to both these pioneers in several enigmatic series of photo-chemigrams based on their photographs.

—Aaron Scharf

CORPRON, Carlotta M.

American. Born in Blue Earth, Minnesota, 9 December 1901. Educated at English boarding schools, Himalayan Mountains, India, 1905-20; University of Omaha, Nebraska, 1920; studied art, Michigan State Normal College, now Eastern Michigan University, Ypsilanti, 1920-25, B.S. 1925; Teachers College, Columbia University, New York, 1926, M.A. 1926; University of Chicago, 1933; photographic technique, Art Center School, Los Angeles, 1936; private photographic studies, under Gyorgy Kepes, Texas Women's University, Denton, 1944. Independent photographer, since 1933. Instructor in Design, Michigan State Normal College, Ypsilanti, 1926; Instructor in Design and Art Education, Women's College of Alabama, now Huntington College, Montgomery, 1926-28; Instructor in Design, Art History and Creative Photography, Texas

Women's University, Denton, 1935 until her retirement, 1968. Agent: Marcuse Pfeifer Gallery, 825 Madison Avenue, New York, New York 10021. Address: 206 Forest, Denton, Texas 76201, U.S.A.

Individual Exhibitions:

1948 Dallas Museum of Fine Arts
1952 Louisiana Art Commission, Baton Rouge
1953 Art Institute of Chicago
University of Georgia, Athens
1954 Women's University of North Carolina, Chapel Hill
1955 Ohio University, Athens
1977 *Carlotta Corpron: Form and Light: 1942-1949*, Marcuse Pfeifer Gallery, New York
1978 Galleria del Milione, Milan
1980 Texas Women's University, Denton
Carlotta Corpron: Designer with Light, Amon Carter Museum, Fort Worth, Texas

Selected Group Exhibitions:

1944 *Captured Light*, Norlyst Gallery, New York
1945 *Design with Light*, Art Alliance, Philadelphia
1951 *Contemporary Photography*, Contemporary Arts Association, Houston
1952 *Abstraction in Photography*, Museum of Modern Art, New York
1975 *Women of Photography: An Historical Survey*, San Francisco Museum of Art
1978 *Works on Paper: Southwest 1978*, Dallas Museum of Fine Arts

1979 *Recollections: 10 Women of Photography*, International Center of Photography, New York (toured the United States)
1980 *Photography's Response to Constructivism*, San Francisco Museum of Art
Light Abstractions, University of Missouri, St. Louis

Collections:

Museum of Modern Art, New York; Art Institute of Chicago; University of Indiana, Bloomington; New Orleans Museum of Art, Louisiana; Amon Carter Museum of Western Art, Fort Worth, Texas; Dallas Museum of Fine Arts; Center for Creative Photography, University of Arizona, Tucson.

Publications:

By CORPRON: articles—"Designing with Light" in *Design* (New York), October 1949; "Light as a Creative Medium" in *Art Education* (New York), May 1962.

On CORPRON: books—*The Language of Vision* by Gyorgy Kepes, Chicago 1944; *Vision in Motion* by László Moholy-Nagy, Chicago 1947; *The New Landscape in Art and Science* by Gyorgy Kepes, Chicago 1956; *Women of Photography: An Historical Survey*, edited by Margery Mann and Anne Noggle, San Francisco 1975; *Works on Paper: Southwest 1978*, exhibition catalogue, by Robert M. Murdoch, Dallas, Texas 1978; *Recollections: Ten Women of Photography*, edited by Margaretta

K. Mitchell, New York 1979; *Light and Abstraction*, exhibition catalogue, by Jean S. Tucker, St. Louis, Missouri 1980; *Carlotta Corpron: Designer with Light*, exhibition catalogue, with text by Martha A. Sandweiss, foreword by Gyorgy Kepes, Austin, Texas and London 1980; articles—"A Creative Approach to Photography" by Mabel E. Maxey in *Texas Trends in Art Education* (Dallas, Texas), Autumn 1960; "Carlotta Corpron" by Paula E. Bennett in *Photographic Portfolio* (Dallas, Texas), June 1979; "The Language of Light" by Ken Barrow in *Texas Artist* (Dallas), September 1981.

Light can literally illumine a commonplace object; model and outline form; bend and follow curves or straight lines; pass through openings and transparent objects to create wonderful patterns; create new and exciting shapes when reflected from surfaces which distort familiar objects; and dramatically emphasize textures. With all of these fascinating possibilities, the creative photographer never lacks inspiration or subjects for photographs with inner vitality and interest.

I photographed for the great joy and satisfaction I experienced. I was particularly interested in working with glass, plastics, and all surfaces and materials that reflect and refract light. When an idea for a new series evolved, I spent hours exploring the subject with LIGHT. I was fascinated by the geometric purity of a glass cube, and the wonderful patterns that were formed as the lights played over and through it. Suddenly, I saw a picture in the ground glass of the camera that I wanted to capture.

My designs with Light were the natural result of having been both a Design and Creative Photography teacher for many years. I considered myself fortunate because my vocation and avocation merged.

My photographs represent ten years of exciting, intensive experimentation. After 1955, due to serious health problems, I had to discontinue spending long hours in the darkrooms. My teaching schedule was very heavy, including History of Art courses, Advertising Design, Sophomore and Freshman Design—as well as Creative Photography.

My problem through the years is that I have been neither "fish nor fowl," that is, photographers could not understand what I was doing, and very few artists were willing to accept photography as art. I really had photographed to please myself, not anyone else. If my work has any value it is due to its originality and my design background. Light always determined the character of the photograph, and I never approached any subject matter with preconceived ideas.

The subject matter of my work can be classified as follows: nature—flowers, leaves, shells, etc.; light drawings—moving lights in amusement parks; light follows form studies; light through glass cubes and glass bricks—forming designs; space compositions with eggs distorted in reflecting surfaces; fluid light designs reflected from plastic; solarization of flowers and portraits.

—Carlotta M. Corpron

Carlotta M. Corpron speaks of herself as a "designer with light," a title that accurately describes her creative expression in photography. As a full-time teacher of design, art history and photography, she managed to spend a decade of spare time, nights and weekends, to create a remarkable collection of elegant black and white light abstractions.

She first started photographing during the 1930's when she tried to interest students in her class of textile design to study patterns in nature through the use of a close-up lens. Later in the early 1940's at Texas Women's University in Denton, Texas, she was asked to develop a course in creative photography. She began working with light the way a painter works with color. She encouraged students to make photograms (designs of light and shadow made without a camera on sensitized paper). In 1942

Carlotta M. Corporn: *Space Composition with Chambered Nautilus*, 1948

Moholy-Nagy, the director of the Institute of Design in Chicago, led a light workshop in Denton; Carlotta assisted, teaching the students to work with a "light modulator," made by folding and bending white paper against the light source so as to create patterns from the interplay of light and form.

Carlotta Corpron, however, credits the visit of another member of the Institute of Design in Chicago, Gyorgy Kepes, with the true guidance of her vision. Kepes spent part of 1944 at North Texas State University working on his seminal book *Language of Vision*. Kepes advised Corpron to work in the controlled setting of a light box in order to completely control the light source. She made such a 2 x 3 foot portable studio where subtle amounts of light from long exposures could be allowed to dwell on the subject, perhaps something as simple as cut paper. In order to create even more abstract shapes through repetition of form the photographer often reversed or overlapped the negative. Her experiments often produced a new kind of metaphorical imagery inspiring the photographer to use fanciful titles such as "Wind Between the Worlds." In some compositions, she shone light through and reflected it from paper weights and glass bricks, cubes and sheets of plastic; in others she used the pattern of light and shadow created with venetian blinds.

The light abstractions by Carlotta Corpron can be grouped according to different technical uses of light. They include a series she calls "Nature Studies" that show her personal delight in lighting natural forms in new ways; another called "Light Drawings" in which she has tracked moving lights at night to create lively abstract rhythms; "Light Patterns," a series which explores the light and shadow of light reflected by and through cut and folded and different translucent materials; "Light Follows Form," which are experiments with light changing on sculpture and space compositions which work with illusions of depth and reflection; "Fluid Light Designs" in which the photographer has transcended the material and captured light as a subject in itself. There seemed to be no end to her capacity to imagine new light designs until illness during the 1950's compelled her to cease experimentation. She continued to teach until her retirement in 1968 and now prints her work for a new generation of admirers.

The light abstractions of Carlotta Corpron are proof of the strength of her own teaching methods which encouraged students to experiment, to create something new out of material and the imagination. Her own experiments with reflections and refractions of light combine a clear understanding of optical phenomena with a poetic vision of nature to produce visual metaphors for that visible energy we call light.

—Margaretta K. Mitchell

Raúl Corrales: *Caracas, Venezuela,* **1959**

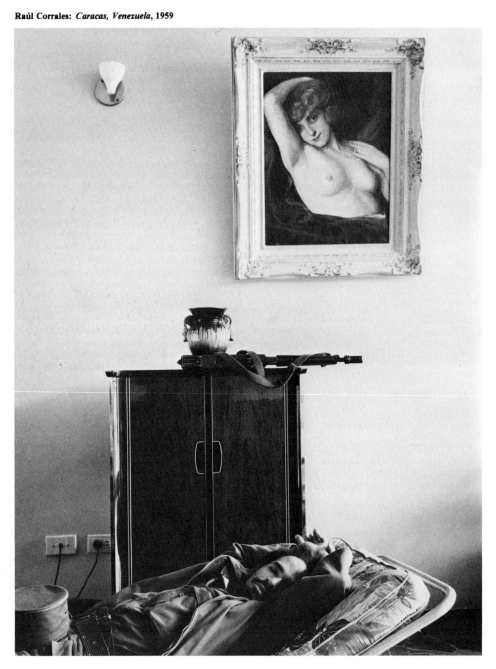

CORRALES, Raúl.

Cuban. Born Raúl Corral Varela in Ciego de Avila, Cuba, 29 January 1925. Educated at C. Arenal High School, Havana; studied graphics technology, Manuel Marquez Sterling School of Press (newspaper) Production, Havana, 1957-59. Married Norma Lopez Martinez in 1953; children: Raúl, Norma and Saul. Photographer, *Noticias de Hoy* newspaper, Havana, 1945-53; *Revista Carteles* magazine, Havana, 1953-59; and *Periodico Revolución* newspaper, Havana, 1959-62; advertising photographer, Publicitaria Siboney company, Havana, 1957-59; Graphics Editor, *INRA Cuba* magazine, Havana, 1959-62; Director, Central Photo Department, Academia de Ciencias, Havana, 1962-73; Section Director, Consejo de Estado, Havana, 1964-80. Recipient: First Prize, *Salon Nacional de Artes Plasticas*, UNEAC, 1979; First Prize, *Salon E. Hart Davalos*, Havana, 1979; Grand Prize, *Salon Nacional*, Havana, 1980; Ministry of Culture Prize, *Salon Nacional*, 1980. Address: c/o Union Nacional de Escritores y Artistas de Cuba (UNEAC), 17 y H-Vedado, Havana, Cuba.

Individual Exhibitions:

1980 Galeria de La Habana (retrospective)
35 con la 35, Casa de la Cultura, Ciego de Avila, Cuba (retrospective; travelled to Union Nacional de Escritores y Artistas de Cuba, Santiago de Cuba)
Salon de Premiados, Galeria L, University of Havana

Selected Group Exhibitions:

1960 *10 Años de Revolución*, Museo de Bellas Artes, Havana (toured Europe and Asia)
1967 *Muestra de la Cultura Cubana*, Pabellon Cuba, Havana
1968 *Salon de Mayo*, Pabellon Cuba, Havana
1978 *Muestra de la Cultura Cubana*, Palacio de Bellas Artes, Mexico City
Coloquio de la Fotografía Latinoamericana, Mexico City
Historia de la Fotografíía Cubana, Palacio de Bellas Artes, Mexico City
Hecho en Latinoamerica, Museo de Arte Moderno, Mexico City (travelled to *Venezia '79*)
1979 *Salon Nacional de Artes Plasticas*, Union Nacional de Escritores y Artistas de Cuba, Havana
Soirée Latinoamericain, Arles, France
1980 *Dos Momentos Revolucionarios*, Consejo Mexicano de Fotografía, Mexico City

Collections:

Union de Escritores y Artistas de Cuba, Havana; Instituto Nacional de Bellas Artes, Museo de Bellas Artes, Mexico City; Consejo Mexicano de Fotografía, Mexico City; House of Culture, Prague.

Publications:

By CORRALES: books—*Geografía de Cuba*, with text by A.N. Jiménez, Havana 1959; *Cuba Z.D.A.*, with text by Lisandro Otero, Havana 1959; *Así es mi Patria*, with text by A.N. Jiménez, Havana 1960; *Un Año de Liberación Agraria*, with text by the Ministerio de Relaciones Exteriores, Havana 1960; *La Liberación de las Islas*, with text by A.N. Jiménez, Havana 1961; *Patria o Muerte*, with text by A.N. Jiménez, Havana 1961; *Cuba*, Moscow 1961; *Nazim Hikmet*, with poems by Hikmet, Milan 1961; *Nicolás Guillén*, with poems by Guillén, Milan 1964; *Jorn-Cuba*, with texts by G. Limbour, A. Saura, W. Lam and C. Franqui, Turin 1970; *Obra Gráfica Casa de las Americas*, Mexico City 1979; *Cuevas y Pictografías*, with text by A.N. Jiménez, Havana 1980.

On CORRALES: books—*Hecho en Latinoamerica*, exhibition catalogue, Mexico City 1978; *Venezia '79: La Fotografia*, edited by Daniela Palazzoli, Vittorio Sgarbi and Italo Zannier, Milan and New York 1979; *Historia de la Fotografía Cubana* by Maria Eugenia Haya, Mexico City 1979; *Raul Corrales: 35 con la 35* by Gerardo Mosquera, Havana 1980; articles—"Premios del Salon de la UNEAC" by A. Alonso in *Juventud Rebelde* (Havana), December 1979; "La Imagen en Dos Tiempos" by Angel Tomas in *El Caiman Barbudo* (Havana), December 1979; "Arte y Testimonio" by M. Sanchez Alfonso in *Revolución y Cultura* (Havana), January 1980; "35 con la 35" by Ele Nussa in *Bohemia* (Havana), July 1980; "De Reportero a Reportero" by A. Fleitas in *Juventud Rebelde* (Havana), August 1980; "Sobre la Fotografia Cubana" by Maria E. Haya in *Revolución y Cultura* (Havana), no. 93, 1980.

Man makes and records history. Somebody in this world must photograph that history in order that future generations may have the chance of seeing those images which we create today. I've had the experience of living through a time of profound and radical socio-economic change in my country.

As a photographer closely concerned with my own time, I have not remained indifferent to events. In order not to be so, it has been sufficient to follow what the Consejo Mexicano de Fotografía has laid down as its objectives: "that the photographer concerned with the spirit of his own time must face the responsibilty of interpreting, with the help of his images, the beauty and the conflict, the triumphs and the defeats and the aspirations of his own people." Class division and conflict was what hit me most in my first years as a photographer and upon that I based my work. I feel one can find the best of my work in the products of that period. My work, independent of any aesthetic considerations, is, in effect, a visual testimony.

—Raúl Corrales

It could be said that Raúl Corrales developed his skills as a photographer in pre-revolutionary Cuba and that, after the Revolution, he was able to exploit that skill as a particularly appropriate means of documenting the attempts of his society to break away from the vices born of the decadent institutions of the previous regime. Prior to the revolution his photographs often had to consist of propaganda images, enforced indoctrination; despite this limitation, he succeeded in transcending such tendentious material to subtly register the facts, documenting social reality in various newspapers and magazines.

His development reveals both his honesty and a passion for his work—particularly in his capacity as the editor of the work of other photographers. Of humble origin, Corrales has retained a spirit of humility, which is always the principal attribute of those who, like himself, are disposed to help and make themselves accessible to beginners. He is a very important historical figure in Cuban photography, for his contribution was made during the most significant and turbulent period of that country's history, a time of transition from a government imposed to one freely accepted by the people. His heroic figures are the people themselves, and his themes are their contributions to the creation of a new era. Recently, after a long period spent in organizing and documenting his country's historic photograpic archives, Corrales (along with Cuban artists in other disciplines) has been able to rejoin the artistic mainstream in Latin America.

In the variety of his work one recognizes rigor and spontaneity, in well-balanced proportions, which inform and simultaneously reveal his own sentiments concerning his subjects. The rigor is present not so much in the purely visual and formal aspects of his work as in the content and in the range of information offered. The spontaneity is of a kind derived from experience: it is one that allows him to sensitively emphasize the important and transcendental aspects of the witnessed fact.

—Lázaro Blanco

COSINDAS, Marie.

American. Born in Boston, Massachusetts, in 1925. Educated in schools in Boston; studied at Modern School of Fashion Design, Boston; studied painting at the Boston Museum School; attended photography workshops, under Ansel Adams, 1961, and Minor White, 1963, 1964. Worked as illustrator and designer, 1945-60. Freelance photographer, Boston, since 1960. Instructor, Colorado College Summer Photo Workshops, Colorado Springs, 1972-78; Artist-in-Residence, Dartmouth College, Hanover, New Hampshire, 1976; Visiting Lecturer in Visual and Environmental Studies, Harvard University, Cambridge, Massachusetts, 1977-78. Recipient: Artist-in-Television Award, WGBH/Rockefeller Foundation, Boston, 1967; Guggenheim Fellowship, 1967; National Academy of Television Arts and Sciences Award, 1976. D.F.A. Moore College of Art, Philadelphia, 1967. Address: 770 Boylston Street, Boston, Massachusetts, U.S.A.

Individual Exhibitions:

1962 University of New Hampshire, Durham
1963 Arlington Street Church, Boston
Harvard University, Cambridge, Massachusetts
1964 National Shawmut Bank, Boston
3 Women Photographers, International Museum of Photography, George Eastman House, Rochester, New York
1966 *Polaroid Color Photographs*, Museum of Fine Arts, Boston
Polaroid Color Photographs, Museum of Modern Art, New York
Philadelphia College of Art
2 Photographers, Gropper Galleries, Cambridge, Massachusetts
1967 *Polacolor Photographs*, University of North Carolina, Chapel Hill
Polaroid Color Photographs, Art Institute of Chicago
40 Polaroid Color Photographs, at *10th Festival of Two Worlds*, Spoleto, Italy
1968 *Polaroid Color Photographs*, Currier Gallery of Art, Manchester, New Hampshire
3 Women Photographers, Moore College of Art, Philadelphia (with Barbara Crane and Naomi Savage)
Portraits in Beauty, Kenyon and Eckhardt, New York

4 x 5 Polaroid Color Photos, at *Photokina '68*, Cologne
1969 Louisburg College, North Carolina
Bi-National Cultural Institute, Mexico City (and Monterrey, Mexico)
University of Wisconsin, Madison
Marie Cosindas: A Color Retrospective, Brockton Art Center, Massachusetts
1971 *Polaroid Color Photographs*, University of Connecticut, Storrs
1976 *Artsist-in-Residence Exhibition*, Dartmouth College, Hanover, New Hampshire
Polaroid Photos 1960-76, Institute of Contemporary Art, Boston
1977 Amsterdam Art Center
New Faculty Show, Carpenter Center, Harvard University, Cambridge, Massachusetts
Künstlerhaus, Vienna
1980 Art Institute of Chicago

Selected Group Exhibitions:

1966 *American Photography: The 60's*, Sheldon Memorial Art Gallery, University of Nebraska, Lincoln
1967 *Photography in the 20th Century*, National Gallery of Canada, Ottawa (toured Canada and the United States, 1967-73)
1968 *Color Photographs*, Friends of Photography, Carmel, California
1972 *Photovision '72*, Boston Center for the Arts
1975 *In Just Seconds*, International Center of Photography, New York
1977 *A Century of Fashion Photography*, Boston Atheneum
In Transition: A Century of the Museum School, Museum of Fine Arts, Boston
1978 *4 Decades of Diffusion Transfer*, Het Sterckshof Museum, Antwerp
Mirrors and Windows: American Photography since 1960, Museum of Modern Art, New York (toured the United States, 1978-80)
1979 *One of a Kind: Polaroid Color*, Corcoran Gallery, Washington, D.C. (toured the United States)

Collections:

Museum of Modern Art, New York; Metropolitan Museum of Art, New York; Visual Studies Workshop, Rochester, New York; International Museum of Photography, George Eastman House, Rochester, New York; Addison Gallery of American Art, Andover, Massachusetts; Polaroid Corporation, Cambridge, Massachusetts; Art Institute of Chicago; Exchange National Bank, Chicago; University of Nebraska, Lincoln; National Gallery of Canada, Ottawa.

Publications:

By COSINDAS: book—*Marie Cosindas: Color Photographs*, with text by Tom Wolfe, Boston 1978 (includes bibliography).

On COSINDAS: books—*Marie Cosindas: Polaroid Color Photographs*, exhibition catalogue, with text by John Szarkowski, New York 1966; *Photography in the 20th Century* by Nathan Lyons, New York 1967; *This Fabulous Century*, by the Time-Life editors, New York 1969; *A Picture History of Photography* by Peter Pollack, New York 1969; *Discovery: Inner and Outer Worlds Portfolio II*, by Friends of Photography, Carmel, California 1970; *Photography Year 1973*, by the Time-Life editors, New York 1973; *Faces and Facades*, with texts by L. Fritz Gruber and Peter C. Bunnell, edited by the

Polaroid Corporation, Cambridge, Massachusetts, 1977; *Polaroid Land Photography* by Ansel Adams, revised edition, Boston 1978; *Mirrors and Windows: American Photography since 1960* by John Szarkowski, New York 1978; *The Photography Collector's Guide* by Lee D. Witkin and Barbara London, Boston and London 1979; *One of a Kind: Recent Polaroid Color Photography*, with a preface by Belinda Rathbone, introduction by Eugenia Parry Janis, Boston 1979; articles—"A Show of Color" by Margaret R. Weiss in *Saturday Review* (New York), 24 September 1966; "Beyond Realism" in *Life* (New York), 3 May 1968; "Marie Cosindas" in *Photographs: Sheldon Memorial Art Gallery Collection, University of Nebraska*, with an introduction by Norman A. Geske, Lincoln 1977; "Singular Developments: Polaroid's Paean to Color" by Allen Robertson in *TWA/Ambassador* (St. Paul, Minnesota), December 1979.

It has been the fate of color photographs to remind us either of advertising, of illustrations, or of paintings. The photographic museum world does not recognize advertising or illustrations as art, and when a photograph does remind us of a painting, the painting is almost always better.

The photographs of Marie Cosindas also remind us of paintings. The difference is that her photographs are better. Perhaps this is why Cosindas is the only successful art photographer I know of who readily accepts the idea that her photographs do indeed look like paintings. It may also be relevant that she began as a painter.

Cosindas was the first serious photographer to explore successfully the possibilities of Polaroid color film. Important photographers had rejected the 60 second process as trifling, color as inconsequential, and the 4" by 5" print size as impossibly small. Cosindas took advantage of the quick prints to make endless experiments for each picture, she turned the inconsequential color into the lushest and most sensual photographs ever seen, and she contrived her shots so well that smallness transformed paper into precious gems. The likes of her pictures had never been seen before in the photographic world. Many tried to imitate her, but no one seemed to be able to make Polaroid do what she could make it do. Even when it became known that she used her own view camera rather than the Polaroid camera; that she used natural light rather than artificial; and that she experimented by varying color filters, development time, and temperature for every picture, no one could achieve the heat and lushness of her pictures.

Everything is calculated in a Cosindas still-life—whether it is a portrait of a person or an object. Her use of sensual materials, flowers, exotic clothes, and evocative objects make her pictures look old fashioned, timeless, and slightly overripe. They hover on the line between the decadent and the superbly gorgeous. Sittings proceed with long periods of trial and error. The subject sooner or later relaxes, wipes off his public face, and portrays the expression and posture which makes for a serious portrait rather than a superficial one. They are simply the person revealed—not the person transformed into strangeness by being caught off guard.

It took courage for Cosindas to go against the fashion of art photography. Photography of the 1960's emphasized black and white unstaged street pictures of unimportant people and places. This aesthetic is still with us. Cosindas is a strong woman with an independent mind and was not to be influenced by such fashion. She made it in the art world by producing exactly the kind of picture she wanted.

Cosindas has also been successful in the world of commercial photography. Not as others by doing one kind of work for commerce and another for art, but by producing the same kind of work for both. Her portraits are for people as well as of people; the still lifes for corporate advertising hang on museum walls. Cosindas does not need to teach at a university or have another job to support her photography. She earns a comfortable living through her work and she never compromises. She is in many ways the purest example of what a photographer should be.

—Barbara Norfleet

Gerry Cranham: *John Hollowbread, Tottenham Hotspurs Goalkeeper, White Hart Lane*, England, 1964

CRANHAM, Gerry.

British. Born in Farnborough, Hampshire, 1 February 1929. Educated at Hawley School, 1934-39, Cove School, 1939-41, and Salesian College, Farnborough, 1941-43. Served as a Corporal with the Royal Electrical and Mechanical Engineers (REME), 1948-53. Married Nancy June Payn in 1952; children: Nigel, Yvonne, Paul, Valerie, and Mark. Worked as an apprentice in the aircraft industry, in Reading, Berkshire, 1943-48, and as an engineering draftsman, Balham, London, 1953-59. Also an athlete, competing at middle distance and cross country events, 1943-53: ran for County Berkshire, Reading Athletic Club, and the Herne Hill Harriers: 2nd in Junior AAA Championships, 1946; Winner, Southern Junior Half Mile, 1945, 1946; Inter-Services Half Mile Champion, 1952; retired, 1954; Part-Time Running Coach, Herne Hill Harriers, Tooting Bec, London, 1954-60. First photographs, London, 1957; freelance sports photographer, working for the *Evening News, The Observer, Sunday Times, South London Press, Sports Illustrated, Athletics Weekly,* etc., London, 1960-68 and since 1971; also, Contract Photographer, *Sports Illustrated,* Time-Life Inc., London, 1968-70. Recipient: Sports Photographer of the Year Award, London, 1972, 1978; British Racing Photographer of the Year Award, London, 1972. Fellow, Royal Institute of Incorporated Photographers, 1974, and Royal Photographic Society, 1975. Address: 80 Fairdene Road, Coulsdon, Surrey CR3 1RE, England.

Individual Exhibitions:

1962 Kodak Gallery, London
1971 *Sports Photographs by Gerry Cranham,* Victoria and Albert Museum, London (toured the U.K.)

Selected Group Exhibitions:

1964 *Motor Racing,* Kodak Gallery, London
1968 *Man in Sport,* Baltimore Museum of Art
1973 *A Matter of Style,* The Photographers' Gallery, London

Collections:

Victoria and Albert Museum, London; Baltimore Museum of Art.

Publications:

By CRANHAM: books—*The Professionals,* with text by Geoffrey Nicholson, London 1964; *100 Years of Wimbledon,* London 1977; *The Guinness Guide to Steeplechasing,* with text by Richard Pitman and John Oaksey, London 1979; *Trevor Francis,* with text by Rob Hughes, Kingswood, Surrey 1980.

On CRANHAM: books—*Sports Photographs by Gerry Cranham,* exhibition catalogue, by Geoffrey Nicholson and George Hughes, London 1971; *The Magic Image* by Cecil Beaton and Gail Buckland, London and Boston 1975; *Exploring Photography* by Bryn Campbell, London 1978; articles—"Gerry Cranham" in *British Journal of Photography* (London), 15 February 1963; "British Press Picture of the Year" in *British Journal of Photography* (London), 22 December 1967; "Gerry Cranham—'Mr. Motion'" by George Hughes in *Amateur Photographer* (London), 7 August 1968; "Capturing the Magic Moment" by George Hughes in *Amateur Photographer* (London), 17 June 1970; "Gerry Cranham" by Michael McNay in *The Guardian* (London), 2 April 1971; "Pictures at an Exhibition" in *The Guardian* (London), 14 April 1971; "Master of Sporting Prints" in the *Croydon Advertiser* (Surrey), 16 April 1971; "Gerry Cranham" by Clement Freud in the *Financial Times* (London), 15 April 1971; "Commonwealth Games: Photographs by Gerry Cranham" in the *Illustrated London News,* January 1974; "Gerry Cranham: Motor Racing Photographs" in the *Illustrated London News,* December 1974; "Voir des Fractions de Seconde" in *Zoom* (Paris), May 1976; "In Action to Capture Action" in *Racemaker and The Horseman* (London), May 1977; "What's Behind It" in *Amateur Photographer* (London), 23 November 1977; "Sports Diary" by John Rodda in *The Guardian* (London), January 1978; "How Photographers Work: Gerry Cranham" by John Lovesey in *You and Your Camera* (London), 2 May 1979.

As a former athlete, having a love for sport and understanding for the competitor, it was natural that I should become a sports photographer, and, to a great extent, I had an inside advantage.

It is through sport that I have learnt to become a technician, able to use the camera to show my visual impressions. I have a deep interest in art, and from an early basic training in this subject I was provided with the insight to all the important factors (composition, lighting and simplicity) of a picture. Great painters—Breughel, Monet, Renoir, to name a few—have inspired me particularly in the use of colour and an awareness of other subject matter to shoot.

In my work over the last eighteen years I have endeavoured to use the principles mentioned above and to widen the approach to sport, coming away from the "conventional" whenever an opportunity is presented. I try hard to achieve the best results possible, and am very critical of my efforts.

The present-day photographer faces increasing competition, and, with the help of advanced improvements in equipment and materials, standards are rising. The popularity of photographic literature, exhibition galleries and competitions are an encouragement to both the professional and amateur photographer.

—Gerry Cranham

Gerry Cranham is a perfectionist, a sports photographer who has never been content with available techniques and equipment—not to mention the usual positions and angles from which it has been thought acceptable to tackle this arduous task. He has become famous not only for his talent but also for his determination and his constant and successful search for new and interesting points of view that will really give the viewer the sense of speed of the racehorse, the strain of the athlete, the bursting tension involved in all sports well done.

Sports photography holds a somewhat isolated place in general reportage: hardly ever exhibited or seen as being "socially meaningful," it nevertheless has an ardent and loyal following and a hierarchy of its own. Gerry Cranham has transcended this special category; he has had a large exhibition at the Victoria and Albert Museum in London, and he has done a great deal to win respect for that part of the profession that must be the toughest on its protagonists barring only the war photographer at the front line!

Sports events repeat themselves relentlessly, and, with deadlines to meet and daily pages to fill, many sports photographers emulate their subject. To keep up a consistently high standard, in all weather and conditions, and to find the unusual requires both technique and application of a higher order, and that is what has given Gerry Cranham the leadership in his profession over the years. One may remember isolated great shots from other photographers, but for many people the words "sports photography" mean Cranham first and the rest a way behind.

Being a perfectionist also means for Gerry Cranham being able to get the real message across clearly. If, for instance, he uses blur as an indication of speed, the subject is still there, is readable, well-composed and clear. The master's touch.

—Sue Davies

CUMMING, Robert.

American. Born in Worcester, Massachusetts, 7 October 1943. Studied painting at the Massachusetts College of Art, Boston, 1961-65, B.F.A. 1965, and at the University of Illinois, Urbana, 1965-67, M.F.A. 1967. Married Sandra Staples in 1969; daughter: Avonell. Professional artist since 1967, photographer since 1972. Instructor, University of Wisconsin at Milwaukee, 1967-70; Assistant Professor, California State College at Fullerton, 1970-72, California State University at Long Beach, 1972-74, University of California at Riverside, 1973, University of California at Los Angeles Extension, 1974-77, Otis Art Institute, Los Angeles, 1975-76, Orange Coast College, Costa Mesa, California, 1976, California Institute of the Arts, Valencia, 1976-77, and University of California at Irvine, 1977-78. Since 1978, Associate Professor, Hartford Art School, West Hartford, Connecticut. Recipient: Elmer Winter Sculpture Award, Milwaukee Art Center, 1968; Frank Logan Sculpture Award, Art Institute of Chicago, 1969; Sculpture Purchase Prize, San Diego State College, California, 1972; National Endowment for the Arts Fellowship, 1972, 1976; Guggenheim Fellowship, 1980-81. Agent: Gilbert Gallery, 218 East Ontario Street, Chicago, Illinois 60611. Address: 1604 North Grand, West Suffield, Connecticut 06093, U.S.A.

Individual Exhibitions:

1973 Phoenix College, Arizona
California Institute of the Arts, Valencia
John Gibson Gallery, New York
University of California at Irvine
The Photograph as Object, Metaphor and Document of Concept: Robert Heinecken, Minor White and Robert Cumming, California State University at Long Beach
1975 Verelst-Poirer Galerie, Brussels
John Gibson Gallery, New York
A Space Gallery, Toronto
1976 University of Iowa, Iowa City
Newspace Gallery, Los Angeles
Los Angeles Institute of Contemporary Art
1977 Artons, Calgary, Alberta
John Gibson Gallery, New York
1978 University of Rhode Island, Kingston
Grossmont College, El Cajon, California
Thomas-Lewallen Gallery, Los Angeles
Real Artways, Hartford, Connecticut
Gilbert Gallery, Chicago
1979 Friends of Photography, Carmel, California (retrospective)
Institute of Modern Art, Brisbane, Queensland (retrospective; travelled to the Ewing-Paton Gallery, University of Melbourne; Burnie Art Gallery, Tasmania; Experimental Art Foundation, Adelaide, South Australia; and Australian Centre for Photography, Sydney, 1979-81)
Callis/Cumming, Blue Sky Gallery, Portland, Oregon (with Jo Ann Callis)
Evergreen State College, Olympia, Washington
Nova Gallery, Vancouver
Gilbert Gallery, Chicago
1980 Bard College, Annandale-on-Hudson, New York
Film in the Cities Gallery, Minneapolis
Gilbert Gallery, Chicago

Selected Group Exhibitions:

1976 *Commissioned Video Works,* University of California, Berkeley
Pan Pacific Biennale, Auckland, New Zealand
The Artist and the Photograph, Israel Museum, Jerusalem
1977 *Biennale de Paris,* Musée d'Art Moderne, Paris
Whitney Biennial, Whitney Museum, New York

1978 *23 Photographers: 23 Directions*, Walker
Art Gallery, Liverpool
*Mirrors and Windows: American Photo-
graphy since 1960*, Museum of Modern
Art, New York (toured the United States)
1979 *Lis '79*, National Museum of Modern Art,
Lisbon
Fabricated to Be Photographed, San Fran-
cisco Museum of Modern Art
1980 *Aspects of the 70's*, De Cordova Museum,
Lincoln, Massachusetts

Collections:

Museum of Modern Art, New York; Johnson
Library, Cornell University, Ithaca, New York;
Hopkins Center, Dartmouth College, Hanover,
New Hampshire; Corcoran Gallery of Art, Wash-
ington, D.C.; Art Institute of Chicago; Museum of
Fine Arts, Houston; University of New Mexico,
Albuquerque; Academy of Motion Picture Arts and
Sciences, Los Angeles.

Publications:

By CUMMING: books—*Picture Fictions*, Los
Angeles 1971, 1973; *The Weight of Franchise Meat*,
Los Angeles 1971; *A Training in the Arts*, Toronto
1973; *Discourse on Domestic Disorder*, Los Angeles
1975; *Interruptions in Landscape and Logic*, Los
Angeles 1977; *Equilibrium and the Rotary Disc*,
Providence, Rhode Island 1980; *Robert Cumming:
Drawings for Props and Photographs*, Adelaide
1980; "Through Western Eyes," interview,
with Leo Rubinfein, in *Art in America* (New York),
September 1978.

On CUMMING: books—*Robert Cumming: Nation's
Capitol in Photographs* by Jane Livingston, Wash-
ington, D.C. 1976; *Robert Cumming: Photographs*
by James Alinder, Carmel, California 1979; arti-
cles—"Robert Cumming" by P. Kraniak in *Tempest*
(Milwaukee), Fall 1970; "Robert Cumming's Ec-
centric Illusions" by Patricia Foschi in *Artforum*
(New York), June 1975; "The Directorial Mode" by

A.D. Coleman in *Artforum* (New York), September
1976; "The Photographer and the Drawing: Fitch,
Misrach, Cumming" by L. Fishman in *Creative
Camera* (London), August 1977; "Robert Cum-
ming" by I. Applebaum in *Impressions* (Toronto),
June 1978; "Robert Cumming: Trucage; Falsehoods"
by J. Hugunin in *Afterimage* (Rochester, New
York), December 1978; "Robert Cumming: Objects
and Their Photographs" by R. Keziere in *Vanguard*
(Vancouver), December 1978; "Robert Cumming's
Recent Work" by J. Hugunin in *LAICA Journal*
(Los Angeles), March 1979.

My work progresses seriously—despite the doubt
and despite the suspicions of folly—much the same
as it did 15 years ago. The works of the 1960's (when
I defined myself primarily as a sculptor) represented
an approach to art making as a means to under-
standing the world through its objects and pheno-
mena. Once one understood, I thought, a very broad
(but finite) set of systems—engineering, psychology,
philosophy, etc.—much of the inexplicable would
clear aside and one would come to see the rough
shape of a "truth" or "reality." One only had to
apply oneself diligently to the details of currently
accepted "universals," principles and theorems
governing cause and effect throughout the cosmos.

Instead of an emergent clarity of overview, the
whole became a detail-laden morass with no specific
shape. Voices of intellectual and creative brilliance
lead the way and provide frequent short-cuts. But,
indiscriminately listened to, the more the answers of
their own accord expand the central paradox. Logic
and rationale begin to rebound in hazy conceptual
spaces...contradictions abound...dualistic dilemmas
go unchecked...and the whole swells accordingly.

Now my work still looks to satisfactory answers
to questions I have about the world. The work, like
the world, incorporates the false echoes and detours
as part of its natural by-product. Pragmatically, it
looks earnestly for nuts and bolts solutions, but
accepts now too the permanent presence of mystery.
The compulsion of the earlier work to "make sense"
is simply seen as the common inner need to assert
order over chaos. That each of us through life draws
up a satisfactory, orderly shape, its simple propor-

tions the result of a lifetimes' alterations, is an
intriguing proposition. Suspiciously, the emergent
profile resembles that of its owner, despite claims of
objectivity. I think, from birth, we're given the oner-
ous task of filling in details; I think the work of any
successful artist must transmit, in covert visual
terms, the results of that personal fabrication.

—Robert Cumming

An undercurrent for decades, conceptual art emerged
as a formal movement in the 1960's as an extreme
response of the dictum "less is more." Its philoso-
phical roots lie in the belief that ideas are the most
important human product; presentation through an
actual art object is secondary. Taken to its logical
extreme, this theory implies that art ultimately has
no physical object. While a few visual artists found
the idea of art without objects appealing in its pure
form, most felt the need for a vehicle to share their
ideas with an audience. Photography was often the
medium selected for that sharing because of its util-
ity in the documentation of ideas. It thus entered at
the core of the conceptual movement. Of the several
artists who refined their use of photography while
maintaining a distinctly conceptual approach, Robert
Cumming is one of the most important.

As a child, Cumming was a self-taught and com-
pulsive artist. His formal art education, which
included both bachelor's and master's degrees,
initially focused on drawing and painting, but later
on sculpture and, finally, photography. While his
primary statement over the past few years has been
in photography, he continues to work actively in
other media. In fact, he calls on his skills as a sculp-
tor to construct the basic "subject matter" for many
of his photographs. For most photographers the
object to be photographed is raw material. For
Cumming, the objects which he constructs to be
used in his photographs are an inherent part of the
creative process as well as subjects.

The evolution of Cumming's photography over
the past decade, on close inspection, shows both
continuity and change. The change is not always
clear, however, because Cumming often returns to
earlier themes. His themes include interruptions in
landscape and logic, reappraisal of everyday objects,
debunking of the polished presentation of art pho-
tographs, ironic and absurd reversals of the expected,
distorted time relationships, reconsideration of form
and function, out-and-out illusionism and magic
tricks, satires on the misreading of natural pheno-
mena, and sardonic commentaries on the history of
art and photography. To present these ideas as pho-
tographs, Cumming has purposefully directed the
objects placed in front of the camera; he has care-
fully constructed and arranged them to provide the
visual expression of his concept.

A central theme in Cumming's work is his desire
to remind us that we are looking at a photograph; he
wants his "hand" to show. He often includes the
floodlights, the source of illumination of the photo-
graph, within the frame. Cumming usually leaves
more around the edges of the subject than we expect;
he does not fill the frame with the central subject,
but allows us to see its context.

The relationship between the amount of time
spent conceptualizing, constructing and photo-
graphing in Cumming's work is radically different
from what we commonly expect in photography. Of
course the percentages vary with each piece, but
Cummings spends perhaps an average of 45% of his
time thinking, 45% building the subject—100 mos-
quitos, for example—and 10% actually making the
picture.

Despite a long standing public notion that photo-
graphs tell the truth, that they can and should be
believed, there is abundant evidence that *all* photo-
graphs are replete with lies and fabrications. At the
very most they give us a modest monocular appear-
ance of one aspect of a subject. Amazingly, we still

Robert Cumming: *Dental X-Rays*, 1980

routinely expect approximate truth from still photographs, and we are nonplussed when confronted with sleight of hand. For Cumming, illusionism and artifice are fundamental, and as with the magician, we are advised not to pose technical questions, but simply to enjoy.

The captions which accompany Cumming's photographs are sometimes merely labels, yet often they are vital links to understanding. While drawing on the narrative abilities of the photograph, Cumming uses the captions to spark out interpretation. He points out connections which the viewer may not have been able to determine from the photographs alone. However, Cumming has also been known to add a caption that leads nowhere.

While most conceptual artists use photography merely as a tool to document their ideas, Cumming is concerned with the medium of photography itself. His photographs, with their environmental backgrounds, are considerably more interesting as pictures than are typical conceptual documents. Cumming has also chosen the 8 x 10 view camera as the instrument for his picture making. He selected the format for its ability to resolve detail, but he does not place emphasis on other potential advantages of the large negative. It would seem too fussy for him to be concerned with elegant fine prints; after all, craft must not dominate concept. It is clear, however, when viewing Cumming's original prints, that there has been an overall refinement in his craft during the past decade.

One of the most consistently appealing aspects of his photographs is that they are metaphors which can be appreciated on many levels. Robert Cumming is a magician who seems to be explaining the secret of his magic, but is one step ahead of us.

—James Alinder

CUNNINGHAM, Imogen.

American. Born in Portland, Oregon, 12 April 1883. Educated in Seattle public shcools; studied chemistry at the University of Washington, Seattle, and photographic chemistry at the Technische Hochschule, Dresden, 1909-10. Married the printmaker Roi Partridge in 1915 (divorced, 1934); son: Rondal. Began photographing in 1901; worked in the studio of the photographer Edward S. Curtis, Seattle, 1907-09; established own studio, Seattle, 1910-16; moved to San Francisco and established studio, 1917, and worked there until her death, 1976; created series of "plant studies," 1922-29; did freelance work for *Vanity Fair* magazine, 1931-36; Founder Member, with Willard Van Dyke, Ansel Adams, Edward Weston, Sonya Noskowiak, John Paul Edwards and Henry Swift, Group f/64, San Francisco, 1932-35. Visiting Instructor in Photography, California College of Arts and Crafts, Oakland: Ansel Adams Workshop, Yosemite Park, California; and at the San Francisco Art Institute. Founded the Imogen Cunningham Trust, San Francisco, 1974. Recipient: Guggenheim Fellowship, 1970; Artist of the Year Award, San Francisco Art Commission, 1973; Summa Laude Dignatus Award, University of Washington, 1974. D.F.A.: California College of Arts and Crafts, 1969. *Died* (in San Francisco) *24 June 1976.*

Individual Exhibitions:

1912 Brooklyn Institute of Arts and Sciences, New York

1932 Los Angeles County Museum of Art
 M.H. de Young Memorial Museum, San Francisco
1935 Dallas Art Museum
1936 E.B. Crocker Art Gallery, Sacramento, California
1951 San Francisco Museum of Art
1953 Mills College, Oakland, California
1956 Cincinnati Museum of Art, Ohio
 Limelight Gallery, New York
1957 Oakland Art Museum, California
1959 Oakland Public Museum, California
1961 International Museum of Photography, George Eastman House, Rochester, New York
1964 San Francisco Museum of Art
 Art Institute of Chicago
1965 Henry Gallery, University of Washington, Seattle
1967 *Imogen Cunningham: Photographs 1921-1967*, Stanford University Art Gallery, California
1968 California College of Arts and Crafts, Oakland
 North Beach and Haight-Ashbury, Focus Gallery, San Francisco
1969 Siembab Gallery, Boston
 Women, Cameras and Images I, Smithsonian Institution, Washington, D.C.
 Phoenix College Library, Arizona
1970 M.H. de Young Memorial Museum, San Francisco
1971 Seattle Art Museum
 Friends of Photography, Carmel, California
 Bathhouse Gallery, Milwaukee
 Atholl McBean Gallery, San Francisco Art Institute
1972 Mt. Angel Abbey, Oregon
 Ohio Silver Gallery, Los Angeles
1973 Witkin Gallery, New York
 Metropolitan Museum of Art, New York
 Musée Réattu, Arles, France (with Judy Dater and Linda Connor)
 Artist of the Year, Capricorn Asunder Gallery, San Francisco
1974 *Imogen!...Imogen Cunningham Photographs 1910-1973*, Henry Art Gallery, University of Washington, Seattle
1977 *Imogen Cunningham: 75 Years as a Photographer*, Union Gallery, University of Michigan, Ann Arbor
1979 *Imogen Cunningham: 75 Anni di Fotografia*, Galleria-Libreria Pan, Rome
1981 *Imogen Cunningham: Vintage and Modern Photographs*, David Mancini Gallery, Philadelphia
 Photographs of People over 90 Years of Age, Milwaukee Art Center

Selected Group Exhibitions:

1929 *Film und Foto*, Deutscher Werkbund, Stuttgart
1932 *Group f/64*, M.H. de Young Memorial Museum, San Francisco
1937 *Photography 1839-1937*, Museum of Modern Art, New York
1940 *A Pageant of Photography*, at the *Golden Gate International Exposition*, San Francisco
1959 *Photography at Mid-Century*, International Museum of Photography, George Eastman House, Rochester, New York (toured the United States)
1970 *Platinum Prints*, Friends of Photography, Carmel, California
1972 *The Multiple Image*, Massachusetts Institute of Technology, Cambridge
1973 *Images of Imogen 1903-73*, Focus Gallery, San Francisco (travelled to the Henry Art Gallery, University of Washington, Seattle, where it appeared with the one-woman

show *Imogen Cunningham Photographs 1910-1973*, 1974)
1974 *Photography in America*, Whitney Museum, New York
1979 *A Survey of the Nude in Photography*, Witkin Gallery, New York

Collections:

Imogen Cunningham Trust, Berkeley, California; Henry Swift Collection, San Francisco Museum of Modern Art; Oakland Museum, California; Center for Creative Photography, University of Arizona, Tucson; Art Institute of Chicago; International Museum of Photography, George Eastman House, Rochester, New York; Museum of Modern Art, New York; Metropolitan Museum of Art, New York; Library of Congress, Washington, D.C.; Smithsonian Institution, Washington, D.C.

Publications:

By CUNNINGHAM: books of photographs—*Imogen Cunningham: Photographs*, with in intoduction by Margery Mann, Seattle and London 1970 (includes bibliography); *After Ninety*, with an introduction by Margaretta Mitchell, Seattle and London 1977; other books—*Imogen Cunningham: Portraits, Ideas and Design*, interviews, with Edna Tartaul Daniel, Berkeley, California 1961; articles—"Imogen Cunningham," interview, in *Interviews with Master Photographers* by James Danziger and Barnaby Conrad III, New York and London 1977; "Imogen Cunningham," interview, in *Dialogue with Photography* by Paul Hill and Thomas Cooper, London 1979.

On CUNNINGHAM: books—*Imogen Cunningham* (Aperture monograph), Millerton, New York 1964; *Imogen Cunningham: Photographs 1921-1967*, exhibition catalogue, by Beaumont Newhall, Stanford, California 1967; *Imogen!...Imogen Cunningham Photographs 1910-1973*, exhibition catalogue, by Margery Mann, Seattle and London 1974; *Imogen Cunningham: A Portrait* by Judy Dater, Boston and London 1979; articles—"Imogen Cunningham" by Norman Hall in *Photography* (London), May 1960; "Imogen Cunningham" by George M. Craven in *Aperture* (Millerton, New York), November 1964; "Imogen Cunningham" by Margery Mann in *Infinity* (New York), November 1966; "Imogen Cunningham" by Bill Jay in *Album* (London), June 1970; "Photographs by Imogen Cunningham" by Colin Osman in *Creative Camera* (London), July 1971; "Group f/64" by Allan Porter in *Camera* (Lucerne), February 1973; "Abigail Heyman and Imogen Cunningham" by A.D. Coleman in the *New York Times*, 30 June 1974, reprinted in his book *Light Readings: A Photography Critic's Writings 1968-1978*, New York 1979; "Homage to Imogen," special issue of *Camera* (Lucerne), October 1975.

Her career spanned the first three-quarters of the 20th century, paralleling and at times advancing the major directions of the period's art photography. Imogen Cunningham began in 1901, when she was 19, as an amateur correspondent of a photography school. In 1907, after a lapse in her interest in the medium, she saw the work of Gertrude Käsebier and was moved to give again to photography the energy she had been devoting to painting and drawing. On her return to Seattle in 1910 from a year at the Dresden Polytechnic, where she studied photochemistry, she opened a portrait studio; the light, settings and poses were natural, in the Käsebier manner. Outside of the studio, she took her view camera to Seattle's misty woods, where she draped friends in exotic cloths and posed them in tableaux representing scenes from William Morris's prose romance *The Wood Beyond the World*, the poetry

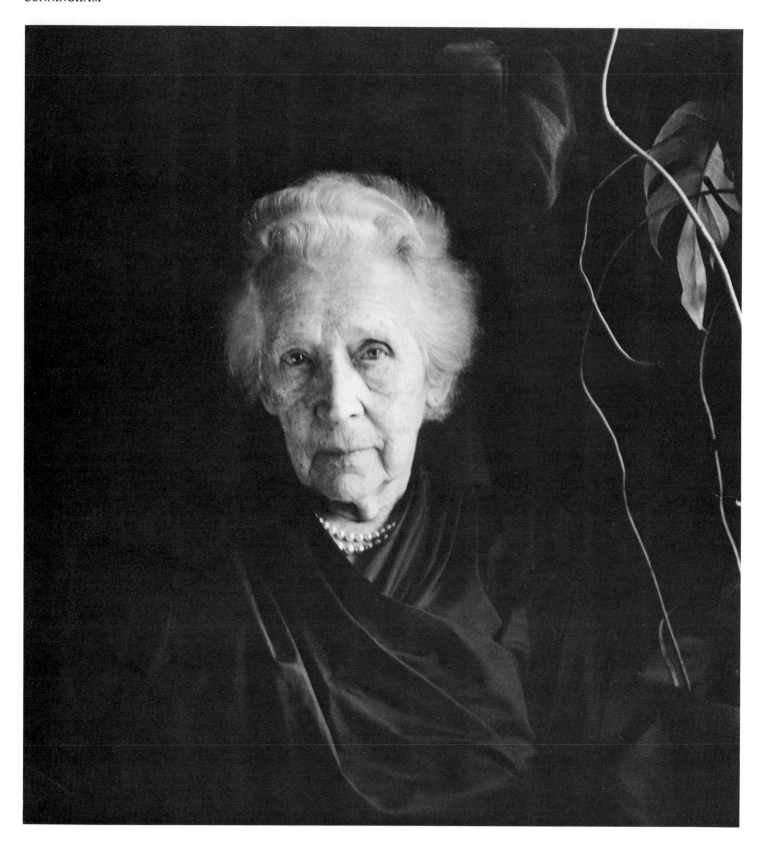

Imogen Cunningham: *Age and Its Symbols*, **1958** Courtesy Art Institute of Chicago

of Swinburne, and moral themes such as "Conscience" and "Eve Repentant." She hired a family of models and posed them naked over reflecting pools, affording revelations that shocked Seattle when the photographs were exhibited in 1915. After marriage and the birth of three sons, she moved with her family to Northern California. There, in the 1920's, she joined in the general rejection of pictorialism that Stieglitz had evidenced by at least 1915. She was then in touch with Edward Weston and Margrethe Mather; the double portraits that she made of the pair just before Weston went to Mexico in 1923 mark the beginning of her break with the earlier style. She quickly moved to a mode that put her at the forefront of the international style of the 1920's: in 1925, she produced "Magnolia Blossom," the first of a series of closeups of plant forms that were exhibited in 1929 at the Stuttgart *Film und Foto* exhibition. The group, which included "Glacial Lily," "Callas," "Rubber Plant," "Agave," "Aloe Bud" and others, were seen as among the most powerful demonstrations of the impulse toward the abstract in photography that typified the decade.

Edward Weston's essay for the *Film und Foto* catalogue looked forward to another development, strictly American, that she and Weston shared. In it, he equated impressionism with skepticism, and declared that photography is "a way of extreme exactitude...honest, straightforward and free of compromise when it is used purely." Within three years a group of seven West Coast photographers sympathetic with Weston's example exhibited together in San Francisco. They called themselves Group f/64, signifying the shutter stop that would produce the greatest detail in depth on their preferred view cameras. Besides Cunningham and Weston, the members of f/64 were Ansel Adams, John Paul Edwards, Sonya Noskowiak, Henry Swift and Willard Van Dyke. Ansel Adams recognized the variety of individual approaches that the fact of organization tended to obscure: "the variety of approach, emotional and intellectual—of subject material, of tonal values, of style—which we evidence in our respective fields is proof sufficient that pure photography is not a *metier* of rigid and restricted rule. It can interpret with beauty and power the wide spectrum of emotional experience." Cunningham's sub-

ject matter became increasingly portraits, especially after she opened a professional portrait studio in San Francisco in the mid-1930s. During these years she thought of herself as a portraitist of individuals; the portrayal of American society that occupied the photographers of the Farm Security Administration was not, she stated, for her. A commission from *Vanity Fair* to photograph Herbert Hoover led her to introduce herself thus: "I am not a snapshot candid camera worker—but try to the best of my ability to establish a feeling of confidence between my sitter and myself and what I call an honest portrait, not a caricature."

Until 1939, when she first used a Rolleiflex, she made portraits with an 8 x 10 view camera or a 4 x 5 Graflex. After that she used the Rollei for portraits, but preferred a larger camera on a tripod for still subjects. By 1965 she had photographed so many artists and craftsmen of the West Coast that a publisher proposed that they be gathered into a volume called *West Coast Creators*. But her field was not limited to local artists, and among her finest portraits are those of José Limon, Merce Cunningham, Darius Milhuad, Amadee Ozenfant, Lionel Feininger, Gertrude Stein, John Masefield, Marianne Moore, Stephen Spender, Alfred Stieglitz, Morris Graves, Minor White, and Theodore Roethke. A list of these portraits constitutes a selective *Who's Who* in the arts during the years of her greatest portrait activity, c. 1935-1965. Many of the portraits remain the most convincing representation we have of their subjects. They share her absolute respect for the sitter as an individual whose identity is regarded at a distance; the sitter's mood and style dominates, not the photographer's. She does not introduce props, but takes them as she finds them: who can forget that Stieglitz stands in front of a painting by O'Keeffe, that the bemused Feininger has a passion flower in his buttonhole, that Roethke sits by a concrete wall inscribed with a ragged "R"?

At the same time that she practiced a straight use of her medium, she also investigated unstraight ways and printing processes to produce intense statements of private meanings. She acknowledged that "unreality is interesting to me but difficult, in such an exact medium, to achieve." Her way out of this difficulty was a way she practiced early: a nega-

tive print, 1929; a double exposure, 1931. In later portraits ("Dream Walking," 1968; "Warning," 1970; "Pentimento," 1973), she combined negatives to produce images that continued the dreamlike scenarios of her 1912-1914 illustrations.

The body of work by which she is widely known is but a small part of that produced throughout the years of her career. It has been skimmed from the top, the "artistic" cream of her whole production. The rest includes, to name typical examples, color covers for *Sunset* magazine, a Southern Pacific Railroad poster, 103 shots of a wedding that she covered with her photographer son Rondal, documentary photographs of the weavings and ceramics of craftsmen, bound booklets of photographs of children: all of the bread-and-butter part of her working life that we disregard in the gallery and museum world of today.

In the last years of her life she was overwhelmed by interviews, students seeking advice, and preparations for important exhibitions that were finally offered to her. She also had a major photographic project in mind. She was consciously pursuing it in 1974, when she went to Fidaglio Island, near Seattle, to photograph the 93 year-old father of a friend. While she prepared herself for death in an orderly, practical way, she explored the worlds of her peers, people over 90, for the experience of its approach that could be derived, both for her own and others' use, from her photographs. Making these portraits of her contemporaries occupied her until June 1976, when she was still planning a trip up the California coast to Elk, where a friend had found an ancient Indian basketmaker for her to photograph. But she died that month, and the book that resulted from her project is without the photograph of the basketmaker.

Throughout her life Imogen Cunningham had thought of herself as a self-employed photographer. She had believed that work was essential to life; it was through work, she had said in 1914, that "the human mind finds a form in which to express itself." Near the end of her life, after over half a century of hard and often unrewarded work, she could still say, "To have real work is the only way to live."

—Anita V. Mozley

D

DABAC, Tošo.

Yugoslav. Born in Nova Rača, 18 May 1907. Educated at grammar school in Zagreb, 1918-26; studied law at the University of Zagreb, 1926-27; self-taught in photography. Married Julija Grill in 1937. Advertising Manager, Metro-Goldwyn Mayer Agency, Zagreb, 1928-32; freelance photographer, in Zagreb, 1932 until his death, 1970: established Studio Tošo Dabac, 1940. Honorary Member, Belgian Royal Circle of Photography (CREPSA), 1948; Master of Art Photography, Yugoslav Federation of Photography, 1951; Honorary Member, International Federation of Photographic Art (FIAP), 1957; Member of the Art Commission, International Federation of Art Photography, 1957-70. *Died* (in Zagreb) *9 May 1970.*

Individual Exhibitions:

1940 Photo Club Salon, Debreczin, Hungary
1948 Salon Ulrich, Zagreb (with Mladen Grčević and Marijan Szabo)
1953 Society of Architects, Zagreb
1967 Art Gallery, Čačak, Yugoslavia
1968 Museum of Arts and Crafts, Zagreb (retrospective)
1971 *Tošo Dabac 1907-1970*, Zodiac Gallery, Osijek, Yugoslavia (travelled to the City Museum, Bjelovar, Yugoslavia)
1972 *Tošo Dabac and His Atelier*, Kunstverein, Mannheim
 Art Photography Gallery, Zagreb

Tošo Dabac: *Road to the Guillotine, 1932-35*

Selected Group Exhibitions:

1933 *Internationale Photographische Ausstellung*, Lucerne
1934 *Asahi Shinbun Photo Salon*, Tokyo
1937 *Invitational Salon*, San Francisco
1938 *Fotografie Italiane, Ungheresi, Jugoslave*, Turin
1939 *Centennial Exhibition*, New York
1951 *International Photo Competition*, Lucerne
1952 *Popular Photography Competition*, New York
1958 *Exposition FIAP*, Antwerp
1964 *Was ist der Mensch, Stern* magazine travelling exhibition
1975 *I Grandi Autori FIAP*, Padua

Collections:

Arts and Crafts Museum, Zagreb; Museum of Modern Art, Zagreb.

Publications:

By DABAC: books illustrated—*Metropola Hrvata* by J. Horvat, Zagreb 1943; *Bakić* by M. Prelog, Zagreb 1958; *Fresken und Ikonen* by O. Bihalji-Merin, Munich 1958; *Ivan Meštrović* by Z. Grum, Zagreb 1961; *Zagreb* by M. Stilinovic, Zagreb 1961; *Bogumilska skulptura* by O. Bihalji-Merin, Belgrade 1962; *Augustinčić* by M. Krleža, Zagreb 1968.

On DABAC: books—*Tošo Dabac* by O. Bihalji-Merin, Belgrade 1967; *Tošo Dabac, Photographer* by R. Putar, Zagreb 1980; articles—"Majstor fot. T. Dabac" by Z. Blažina in *Zagreb Panorama*, February 1966; "Tošo Dabac" by O. Bihalji-Merin in *Foto-Kino Revija* (Belgrade), May 1968; "U povodu Dabca" by Z. Domljan in *Zivot umjetnosti* (Zagreb), no. 6, 1968; "Retrospoktiva Toše Dabca" by R. Putar in *Sinteza* (Ljubljana), October 1968; "Tošo Dabac" by O. Bihalji-Merin in *Umetnost* (Belgrade), July/September 1970; "Tošo Dabac" by Z. Corak in *Kaleidoskop*, Zagreb 1970; "Toso Dabac" by O. Bihalji-Merin in *Spot* (Zagreb), no. 1, 1972.

The years of Depression: beggars, landless peasants and unemployed workers in the streets of Zagreb. Hard days, but just the right days for a born observer with a camera, willing to descend to the depths of human misery. In 1932 (when he was 23) Tošo Dabac accepted that challenge and threw himself into the midst of life in those bad times. His early honest and direct photographs of beggars were both a revelation and, for himself, a means of self-discovery: they gave him the courage to turn his passion and evident vocation into a profession.

Sensitive as he was, with his sympathy for the disgraced and injured, Dabac continued to produce a series of truly remarkable documents and penetrating interpretations of how people actually lived. He did not pose his subjects; he took them wherever they were, in groups waiting for food or as isolated and nameless human beings in a miserable environment. Subsequently, his interest widened to portraiture, folklore, landscape, animals and architecture, and he made cycles on these subjects comprising thousands of photographs. But, from time to time, he continued his record of life in the streets, people in flea-markets, processions, itinerant clowns—he became the chronicler of the town to which he was passionately bound until the end of his life.

After 1935, having exhibited in international salons and taken part in various competitions, Dabac began to be influenced increasingly by classical pictorial photography. His original, precursory documentary style of the earlier period was partially changed: his work now showed a sympathy to "art" photography with all its pictorial rules of composition; he showed a marked inclination to idealization and lyrical optimism. His work of this period made a substantial contribution to the creation and affirmation of the so-called "Zagreb School of Art Photography," which was internationally known by the late 1930's and influenced a whole generation of Yugoslav photographers until 1954.

In this new manner Dabac once again succeeded in creating a personal style and approach to photography. He was particularly successful in portraiture. The human face had been and remained his greatest obsession. He seemed to be able to penetrate the psyche of his models, and he always found the most appropriate way to express his own vision of humanity. For years Dabac travelled from one end of Yugoslavia to the other, creating a composite picture of his native country, recording with the

same comprehension the remains of old glory and the manifestations of modern life.

Because of his tireless "public" activity, particularly in illustrating books and magazines, he gained a great reputation and became the most popular photographer in Yugoslavia.

Yet, looking back at the complete work of Tošo Dabac from a contemporary standpoint, I find that I most appreciate his earliest period, his spontaneous approach to the people of the street, in which he reveals himself to be one of the great forerunners of modern documentary photography.

—Nada Grčević

DAHL-WOLFE, Louise.

American. Born Louise Dahl in Alameda, California, 19 November 1895. Studied design and color under Rudolph Schaeffer, and painting under Frank Van Sloan, at the San Francisco Institute of Art, day classes 1914-17, night classes 1921-22; studied design and decoration in New York, 1923, and architecture at Columbia University, New York, Summer 1923; mainly self-taught in photography, but influenced initially, in the early 1920's, by the work of photographer Anne Brigman. Married the painter and sculptor Meyer (Mike) Wolfe in 1928. Electric sign designer for the Federal Electric Company, San Francisco, 1920-22; assistant to an interior decorator, New York, 1923; assistant to the decorator Beth Armstrong, at Armstrong, Carter and Kenyon, San Francisco, 1924; worked for Stroheim and Roman wholesale fabrics company, San Francisco, 1925-1927; travelled with the photographer/journalist Consuela Kanaga in Europe, 1927-28; worked for the interior decorating firm Hofstatten and Company, New York, 1929; concentrated on photography, San Francisco, 1930-32 and Gatlinburg, Great Smoky Mountains, Tennessee, 1932-33; maintained own photographic studio in New York, 1933-60: freelance advertising and fashion photographer, working for *Woman's Home Companion*, and for the stores Saks Fifth Avenue and Bonwit Teller, New York, 1933-36; Staff Fashion Photographer, under editor Carmel Snow, *Harper's Bazaar*, New York, 1936-58; freelance magazine photographer, working for *Vogue*, New York, 1958-59, and *Sports Illustrated*, New York, 1958-60; now retired. Recipient: Art Directors Club of New York Medal, 1939, and Award, 1941. Address: 48 Broad Street, Flemington, New Jersey 08822, U.S.A.

Individual Exhibitions:

1955 Southern Vermont Art Center, Manchester (with Meyer Wolfe)
1965 *Louise Dahl-Wolfe: Photographs/Meyer Wolfe: Sculpture and Drawings*, Country Art Gallery, Westbury, Long Island, New York

Selected Group Exhibitions:

1937 *Photography 1839-1937*, Museum of Modern Art, New York
1961 *Fashion: 7 Decades*, Hofstra University, Hempstead, New York
1975 *Women of Photography: An Historical Survey*, San Francisco Museum of Modern Art (travelled to the Sidney Janis Gallery, New York, 1976)
1977 *The History of Fashion Photography*, International Museum of Photography, George Eastman House, Rochester, New York (travelled to the San Francisco Museum of Modern Art; Cincinnati Art Institute; and the Museum of Fine Arts, St. Petersburg, Florida)
1979 *Recollections: 10 Women of Photography*, International Center of Photography, New York (toured the United States)
1980 *Fashion Photographs*, Tennessee Fine Arts Museum at Cheekwood, Nashville

Collections:

Fashion Institute of Technology, New York; Museum of Modern Art, New York; International Museum of Photography, George Eastman House, Rochester, New York; San Francisco Museum of Modern Art.

Publications:

By DAHL-WOLFE: articles—"America's Outstanding Woman Photographers," interview, with Kary H. Lasch, in *Foto* (Stockholm), no. 9, 1950; "Louise Dahl-Wolfe" in *Inter/View* (New York), February 1981.

On DAHL-WOLFE: books—*The Wheels of Fashion* by Phyllis Lee Levin, New York 1965; *Harper's Bazaar: 100 Years of the American Female* by Jane Trahey, New York 1967; *American Fashion* by Sarah Tomerlin Lee, New York 1975, London 1976; *Women of Photography: An Historical Survey*, exhibition catalogue, by Margery Mann and Ann Noggle, San Francisco 1975; *The Magic Image* by Cecil Beaton and Gail Buckland, London and Boston 1975; *The Photograph Collector's Guide* by Lee D. Witkin and Barbara London, Boston and London 1979; *The History of Fashion Photography* by Nancy Hall-Duncan, New York 1979; *Recollections: Ten Women of Photography* by Margaretta Mitchell, New York 1979; articles—"World History of Photography on Exhibition at the Museum of Modern Art" in the *New York Times*, 17 March 1937; "Look Behind Success" by Helen Morgan in *You* (New York), Summer 1940; "Good Housekeeping Finds Out What a Woman Photographer Does" in *Good Housekeeping* (New York), August 1941; "La Photos de Louise Dahl-Wolfe" in *Norte* (Mexico City), October 1942; "Great American Photographers 1: Louise Dahl-Wolfe" in *Pageant* (New York), September 1947; "The Individualist" by Sarah Tomerlin Lee in *House Beautiful* (New

Louise Dahl-Wolfe: *Bettina, in the Studio of Jacques Fath*, Paris, 1950

York), March 1965; "Louise Dahl-Wolfe: Quiet at Home" in the *New York Times*, 16 December 1973; "Louise Dahl-Wolfe: A Discerning Eye, A Cordial Heart" in the *Nashville Tennessean*, 1 June 1980; "Profile: Louise Dahl-Wolfe" by Vicki Goldberg in *American Photographer* (New York), June 1981.

Upon thinking over my long career in photography, particularly the years spent on *Harper's Bazaar*, I've arrived at the following conclusion, that if there were any successes, they were due to the knowledge I gained from the 5 years I spent at the San Francisco Institute of Art and also from the opportunity of working under an outstanding editor, Carmel Snow.

It is easy to learn the technique of the camera by oneself, but by working in design I learned the principles of good design and composition. Drawing from the nude in life class made me aware of the grace and flow of line, body movements, and the differences in the way a male poses from that of a female. This was helpful in photographing fashion.

I was exceedingly fortunate in studying color with a great teacher, Rudolph Schaeffer, who at the age of 90 is still teaching the art and science of color in San Francisco.

—Louise Dahl-Wolfe

Although Louise Dahl-Wolfe is known primarily as a fashion photographer whose achievement equals or surpasses that of her contemporaries, such as Horst, Cecil Beaton and Richard Avedon, she has also created a significant body of portrait and landscape work. Dahl-Wolfe credits her study at the San Francisco Institute of Art with training her eye for composition and color. In particular, she cites the influence of her instructor, Rudolph Schaeffer, who was one of the few teachers in the U.S. at the time to encourage the use of intense "Fauve" color. In 1916, the Diaghilev Ballet's visit to San Francisco provided further inspiration for the imaginative settings and unusual color harmonies for which she became know. Indeed, the exquisite interiors which she created for her own home, a renovated farmhouse in Frenchtown, New Jersey, served as the backdrop for some of the most memorable of the fashion photographs which she made during her 22-year career with *Harper's Bazaar*.

Dahl-Wolfe became interested in photography in 1921 when she was shown the Pictorialist photographer Anne Brigman's studies of nudes posed against the cypress trees on Point Lobos. The dramatic poses and averted faces of Brigman's nudes may have influenced Dahl-Wolfe's approach to the model, just as her Tennessee-born artist-husband Meyer Wolfe may have expanded her innate interest in people of all nationalities and social levels to include blacks and rural poor. Dahl-Wolfe was also impressed with the work of another San Francisco based photographer, Francis Bruguière, but it is unlikely that his abstractions had any direct influence on her resolutely representational style.

Dahl-Wolfe met and later married Meyer Wolfe on a trip to Europe and North Africa in 1928, and her first published photograph was a portrait of a Mrs. Ramsey which was made in her husband's home state of Tennessee. "Tennessee Mountain Woman" (*Vanity Fair*, November 1933) presages the Farm Security Administration photography of the Depression, but Dahl-Wolfe was less concerned with documenting poverty than with reflecting the personality of the sitter. Framing an intricately-lined face, Mrs. Ramsey's 25 year-old straw hat has a poignant elegance which constitutes a naive counterpart to the sophisticated young models in Paulette hats which Dahl-Wolfe set against the Louvre in May 1950. The same direct address of the camera marks Dahl-Wolfe's portraits of the bedridden Colette (1951) and the starkly-lit, androgynous face of Cecil Beaton (1950).

Color fashion photography was in its infancy

when Dahl-Wolfe began experimenting with the Kodak "one-shot" camera. She gained experience by photographing shoes and accessories before receiving her first fashion assignment in 1937. With the advent of 8 x 10" Kodachrome transparencies several years later, Dahl-Wolfe's instinct for elegance was unleashed, and her control of color ranges was extraordinary from the beginning. In her justifiably famous "discovery" photograph of Lauren Bacall for the cover of the March 1943 *Harper's*, for instance, Dahl-Wolfe accentuates a nearly monochrome composition with three touches of red, each of a different intensity and hue, yet not appearing applied as do most strong colors in photographs from this period. Again, in a picture of a Dior gown made by a window inside Richelieu's Palace in Paris, Dahl-Wolfe highlights the champagne colors of the dress and decor with a multicolored shawl.

Dahl-Wolfe was able to maintain such virtuousity by color-correcting all of her plates for the engraver. As a result, her more than 600 pages for *Harper's* are comparable in quality to the gravures in *Camera Work*, which served as her standard, and in subtlety to the prints of Paul Outerbridge, whose "Music" (c. 1924), clipped from a magazine reproduction, hangs by Dahl-Wolfe's bed even today.

Dahl-Wolfe feels that publishing standards are too lax and the photographer's role too compromised by editorial control for great fashion photography to exist today. Her perfectionism—her insistence that her work can only be reproduced under the most exacting criteria—has in part contributed to the lack of publications on this important artist and gracious woman. An exhibition of her portrait and landscape work, organized by International Exhibitions (Smithsonian Institution) and circulating throughout the United States in 1982, should help redress the imbalanced historical view of the photography of the 1940's and 50's.

—Pamela Allara

D'ALESSANDRO, Robert.

American. Born in New York City, 29 November 1942. Educated at Islip High School, Islip, New York, 1956-60; studied graphic design at the Pratt Institute, New York, 1960-65, B.F.A. 1965; Peace Corps Volunteer in Brazil, 1965; studied photography and drawing at Brooklyn College, New York, 1969-71, M.F.A. 1971. Married Sara Hankinson in 1965. Freelance photographer, New York, since 1968. Instructor in Advanced and Basic Photography, New School for Social Research, New York, and Adjunct Instructor in Basic Photography and Art, Brooklyn College, New York, 1970-72; Associate Adjunct Professor of Graduate Photography, New York University, 1972; Photographer-in-Residence, University of New Mexico, Albuquerque, 1973. Since 1974, Assistant Professor of Photography, Brooklyn College. Recipient: Judges' Prize, *City of Man* exhibition, University of Chicago, 1970; Creative Artists Public Service Grant, New York, 1971; First Prize, Mount Holyoke College Art Museum Exhibition, Massachusetts, 1971; National Endowment for the Arts Grant, 1975. Address: Art Department, Brooklyn College, Avenue H and Flatbush Avenue, Brooklyn, New York 11210, U.S.A.

Individual Exhibitions:

1972 *The Life Fantastic*, Floating Foundation of Photography, New York

 3 Young American Photographers: Fredrich Cantor, Paul Diamond, Robert D'Alessandro, The Photographers' Gallery, London

1973 *Letters to My Congressman*, Washington Gallery of Photography, Washington, D.C.

1977 *Glory*, International Museum of Photography, George Eastman House, Rochester, New York (travelled to Galerie Nagel, West Berlin)

1982 Marcuse Pfeifer Gallery, New York

Selected Group Exhibitions:

1968 *Photography '68*, International Museum of Photography, George Eastman House, Rochester, New York

Robert D'Alessandro: *Elephant's Journey*, 1976

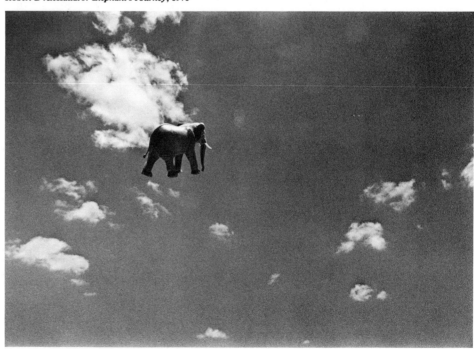

Collections:

New School for Social Research, New York; James Van Der Zee Institute, New York; International Museum of Photography, George Eastman House, Rochester, New York; Lincoln First Bank, Rochester, New York; University of New Mexico, Albuquerque; Ryerson Polytechnical Institute, Toronto; National Gallery of Canada, Ottawa; Bibliothèque Nationale, Paris.

Publications:

By D'ALESSANDRO: book—*Glory*, New York 1973; articles—"Teaching Photography," interview with Marian Stanley, in *Grain* (Brooklyn, New York), 1974; "Robert D'Alessandro: Portfolio from Glory," interview with Jacob Deschin, in *Popular Photography Annual*, New York 1976; "Teaching in Individualism," interview with Scott Hornstein, in *Photograph Magazine* (New York), September 1976.

On D'ALESSANDRO: books—*Vision and Expression*, edited by Nathan Lyons, New York 1968; *Light Readings* by A.D. Coleman, New York 1979; *The Photographers' Cookbook*, edited by Deborah Barsel, Rochester, New York 1979; *Photography in New Mexico from Daguerrotype to the Present*, edited by Van Dern Coke, Albuquerque, New Mexico 1979.

I photograph what is interesting to me at the time. This changes as my life moves along.

For me, my work is about change—change in my awareness of what life is and can be. I move from one theme to the next, trying to see more clearly.

—Robert D'Alessandro

The photographic work of Robert D'Alessandro is varied and complex. Few have viewed its entirety, and those who have, without knowing the man, might be hard pressed to account for its logic. He is perhaps best known for his satirical depiction of the American myth. These images are clever, lively, and sustained descriptions of the character and acts of Americans. In the grand traditions of satire, his images falsify characters and transgress proper limits in the service of exposing what is defective, blameworthy or vicious in public administration and conduct, or in personal morals. However, it would be a mistake to think of his work as being solely concerned with condemning political statements about what is wrong with America.

D'Alessandro's vision and his use of the camera to express it are very much a product of the world he depicts. He is of the post-war generation of Americans who grew up being visually informed by the early days of television. Uncountable hours by this generation were spent studying intensely a framed image of not only the culture of the 1950's but also the popular visual culture of the 1920's, 30's, and 40's. So much of early television fare was comprised of movies and cartoons produced for other generations. Without a doubt, whether consciously or unconsciously absorbed, this visual and cultural education lies at the foundation of D'Alessandro's vision, as it does for many other American visual artists.

Of further influence is American urban life. A child growing up in an urban environment must keep its eyes wide open and must be informed of harsh realities in order to survive. One must be "street-wise" and all that that implies. One of the basic tools of survival in the city is a sense of humor, which given the above influences and daily stimulae, becomes quite complex and highly developed. Surely, D'Alessandro was called a "wise-guy" more than

once, and, indeed, he is just that.

Fate has allowed D'Alessandro to further develop his visual tastes and appetites. He definitely is among the best informed of today's American photographers about the traditions of photography and painting. He fully realizes the peculiar tool which is the camera. He knows how to use the frame to capture and reveal information. He knows the powerful time-magic that is uniquely available to him with the photographic imaging medium.

Central to his personality and survival is that he is aware. Aware belongs to the knowledge which is needful for one's own sake in the regulation of interests. It refers to matters of ordinary, common or practical information, or to any facts or truths as bearing upon ourselves. Such knowledge is the result of observation and experience. When we are aware of a thing, we bear in mind its relative nature and consequences. Thus, whether of the ruins of Brooklyn or the skies of New Mexico, each of D'Alessandro's images are evidence of what he is aware of. He is aware of much that is threatening, false and unpleasant. But also, he is aware of much that is humorous, ironic and magical. He has a particular eye out for evidence of the metaphysical. Any of his images can give proof of one, some, or all of the above. For this reason, his images often transcend the limits of the subject and have tremendous appeal to others aware of the same.

D'Alessandro's work is proof that he is aware, and when it is offered to the public, it is an invitation and inducement to beware.

—Grant B. Romer

D'AMICO, Alicia.

Argentinian. Born in Buenos Aires, 6 October 1933. Studied art at the Escuela Nacional de Bellas Artes, Buenos Aires, 1947-53, Dip. 1953; art history in Paris (French Government Scholarship), 1955; photography in the studio of her father Luis D'Amico, Buenos Aires, 1957, and color photography at Kodak, Rochester, New York, 1960; student-assistant, studio of Annemarie Heinrich, Buenos Aires, 1960. Freelance photographer, with joint studio with Sara Facio, *q.v.*, as Alicia D'Amico/Sara Facio, Fotografías, Buenos Aires, since 1960. Editor of the Photographic Section, *La Nación* newspaper, Buenos Aires, 1966-74, and *La Azotea* magazine, Buenos Aires, 1973-80. Recipient: Artist Award, Fédération International de l'Art Photographique, 1965; Olivetti-Comunidad Award, Buenos Aires, 1968; Book Prize, Congress of Books, Vienna, 1969. Address: Juncal 1470-P.B., Buenos Aires 1062, Argentina.

Individual Exhibitions with Sara Facio:

Alicia D'Amico: *La Sombra*, 1962

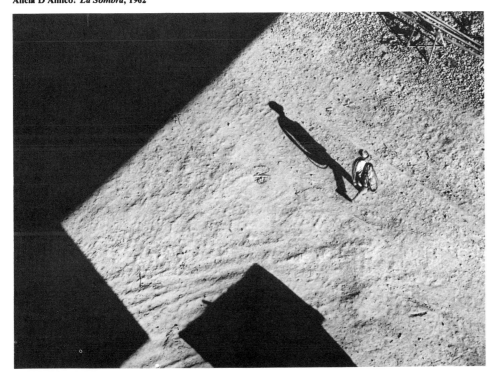

Selected Group Exhibitions:

Collections:

Bibliothèque Nationale, Paris.

Publications:

By D'AMICO: books—*Buenos Aires, Buenos Aires*,
with Sara Facio, Buenos Aires 1968; *Argentina*,
with text by H.S. Ferns, London 1969; *Geografía de
Pablo Neruda*, with Sara Facio, Barcelona 1973;
Retratos y Autorretratos, with Sara Facio, Buenos
Aires 1974; *Humanario*, with Sara Facio, Buenos
Aires 1976; *Como tomar Fotografías*, with Sara
Facio, Buenos Aires 1977; *Rostros de Buenos Aires*,
Buenos Aires 1978; *Argentine Turistique*, Paris
1978; articles—"Todas la realidades, la realidad" in
La Nación (Buenos Aires), 31 January 1967; "Histo-
ria de una pasion..." in *La Nación* (Buenos Aires), 25
July 1967; "Stieglitz: el antes y el despues" in *La
Nación* (Buenos Aires) 6 January 1970; "Oh, aquel-
los fotógrafos" in *La Nación* (Buenos Aires), 21 July
1970; "El legado de la Bauhaus" in *La Nación*
(Buenos Aires), 8 September 1970; "El Muchacho
de la cámara" in *La Nación* (Buenos Aires), 22 Sep-
tember 1970; "Henri Cartier-Bresson" in *Fotografía
Universal* (Buenos Aires), August 1971; "El rol
fotográfico" in *La Nación* (Buenos Aires), 16
November 1971; "El impacto visual" in *La Nación*
(Buenos Aires), 18 July 1972; "La opinión de cada
uno" in *La Nación* (Buenos Aires), 26 September
1972; "La fotografía social" in *Hecho en Latino-
america*, exhibition catalogue, Mexico City 1978;
"Mexico—May 1978" in *Camera* (Lucerne), no. 10,
1978.

On D'AMICO: book—*Territorios* by Julio Cor-
tázar, Mexico City 1978; articles—"3 Photo-
graphes..." by Ives Lorelle in *Le Photographe*
(Paris), October 1968; "Pablo Neruda..." by Michel
Nuridsany in *Le Figaro* (Paris), 14 January 1974;
"Geografía Doméstica" in *El Correo Catalan* (Bar-
celona), 24 January 1974; "El escritor y su espejo" in
La Nación (Buenos Aires), 24 February 1974; "La
Azotea presentó Humanario" in *Fotografía Univer-
sal* (Buenos Aires), April 1976; "Fotografía en A" by
M.C. Orive in *Artes Visuales* (Mexico City), May
1976; "Vision de un mundo..." by O.H. Villordo in
La Nación (Buenos Aires), 23 May 1976; "Human-
ity in Camera" by Robert Cox in the *Buenos Aires
Herald*, 23 October 1976; "La Argentina presente"
in *Foco* (Buenos Aires), no. 22, 1979.

Nowadays anyone can use a camera with accuracy.
In the midst of so many records, documents, and
conventional illustrations, photographers who choose
photography as a means of expression have to be
much more aware of the world and of their sur-
roundings. In the "civilization of the image" a cer-
tain kind of photography becomes a marginal activ-
ity within the vortex of meaningless graphics that
surround us.

I do not believe in the objectivity of a photog-
rapher. It is perhaps for this reason that the medium
which most resembles reality seems to me more and
more difficult. The compromise which most attracts
me, and which I most appreciate in other photog-
raphers, is to achieve a successful image through
one's own subjectivity.

—Alicia D'Amico

Contemporary society has been described as a "civil-
ization of consumer goods and pictures." And even
the pictures are consumed—worn out, rather—at a
dizzying rate, in bombardments from the mass
media. The public's voracious appetite for photo-
graphic documentation has caused the photographer,
engaged in an endless search for some freshly shock-
ing event, to forget the feeling of *pietas*. Press photo-
graphy is becoming more and more a pretext for
the exhibition of dreadful horrors than a search for
the true essence of man. Yet a true, a humane,

photo-journalism ought to engage the photographer
in constant reflection on the significance of events
and a consciousness of essential values. Reflection
and consciousness are the moral bases of the work of
Alicia D'Amico.

D'Amico's approach to external realities is based
on a profound respect for the feelings of other peo-
ple, the people depicted and the people who look at
her photographs. She reveals the true man—his joy,
hopelessness, meanness, greatness, pity and fero-
city—through descriptive details in an harmonious
photography that aims not to evoke morbid curios-
ity but to penetrate. In practice, the picture that
makes a violent impact leaves only a superficial
impression: the instant reaction disappears almost
as soon as it is aroused. Since the photo is not the
fruit of reflection, it cannot stimulate reflection.
D'Amico's photography—and that of all those who

Jacques Darche: *Paris*, 1955

practice humane photo-journalism—combines awareness of solid reality with what lies within it, and her vision does penetrate our consciousness. The photo is no longer purely representational, a visual depiction of events, but involves implication, an expression of values and universal concepts.

Perhaps it is no longer even important that certain events, captured at a certain place and time, should be printed on a piece of photographic paper. Such subjects have been transformed into symbols of the human condition, of feelings, of emotions, and transformed into historical proclamations, social declarations—but are they? The very limitations of time and space in objective photography preclude any kind of real outline of the essence of man; they might just as well be replaced by a general caption: "Earth, any year." It is in this context that we can understand how Alicia D'Amico's documentary photographs perform the function appropriate to creative photography: the communication not so much of information about the visible world as about the intangible world of the individual.

Even the composition of her pictures transmits her message. The choice of point-of-view, the color contrasts, the highlights and black areas, the geometrical balance of the figures that form a background to the action of the subject—all are symbolic elements. Every symbol embodies some etymological meaning. Comprehension of the message comes with perceptive coordination of the totality of the symbols.

—Giuliana Scimé

homogeneous high quality in which "mistakes" are rare.

As he died in 1965, we cannot ask him about his view of his place in contemporary photography. What can be said is that his photographic work provides a link between the romanticism of the postwar photographers such as Brassaï or Doisneau and the modern photographers of the 1970's.

Darche seems to have been one of the first to understand that one can combine spaces and graphics. He juxtaposes volumes and obtains images which he seems, in a way, to have constructed like a montage, giving the impression of photographs within a photograph. He draws from the banal a magical impression and transforms the ordinary into the extraordinary.

It was only after his death, when quantities of his films were developed, that experts became aware of the quality of the photographic work that he had left behind.

—Colette Ziwès

DATER, Judy.

American. Born Judy Rose Lichtenfeld in Hollywood, California, 21 June 1941. Educated at Fairfax High School, Los Angeles, 1956-59; University of California at Los Angeles, 1959-62; studied photography, under Jack Welpott, San Francisco State University, 1962-66, B.A. 1963, M.A. 1966. Married Dennis Dater in 1962 (divorced, 1964); Jack Welpott in 1970 (divorced, 1978). Freelance photographer, in California, since 1967. Instructor in Photography, University of Calfornia Extension, San Francisco, 1966-74, and San Francisco Art Institute, 1974-78. Recipient: Dorothea Lange Award, Oakland Art Museum, California, 1974; National Endowment for the Arts Photography Fellowship, 1976; Guggenheim Photography Fellowship, 1978. Agents: Witkin Gallery, 41 East 57th Street, New York, New York 10022; Grapestake Gallery, 2876 California Street, San Francisco, California 94115. Address: Box 709, San Anselmo, California 94960, U.S.A.

Individual Exhibitions:

1965 Aardvark Gallery, San Francisco
1972 School of the Art Institute of Chicago
 Witkin Gallery, New York

Judy Dater: *Nehemiah's Back*, 1975

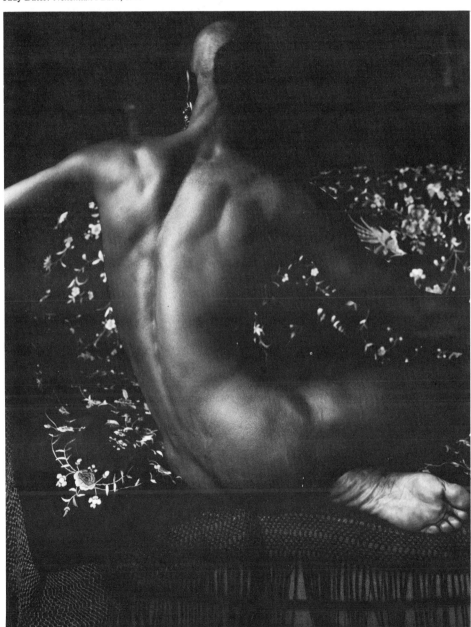

DARCHE, Jacques.

French. Born in Riom (Puy de Dôme), 8 February 1920. Studied at the Ecole des Beaux-Arts, Montpellier, 1938-42. Served in the French Army, 1939-40. Married Rosie Maurel in 1950 (divorced, 1958); children: Jean and Hélène. Worked as an illustrator for *Parisien Libéré*, 1945-47; worked with Lhopital on book design as Artistic Director of the Club Francais du Livre, Paris, 1947-55; Artistic Director, Club des Editeurs, Paris, 1956, 1961; also, poster designer, illustrator and freelance photographer for books, posters, record covers, etc., for Editions Pauvert and others, Paris, 1950 until his death, 1965. Recipient: Gold Medal, *Biennale of Graphic Arts*, Milan, 1958. *Died* (in Paris) *26 July 1965*.

Collections:

Bibliothèque Nationale, Paris.

Publications:

On DARCHE: article—"Jacques Darche, Photographe" by Jean Massin in *Arts et Techniques Graphique* (Paris), January/February 1971.

The professional activity of Jacques Darche was not photography but the creation of books and advertising/publicity materials. He never thought of himself as a professional photographer; indeed, 2/3 of his photographic production was not even developed until after his death. Not because he was uninterested, but because "catching the moment" was sufficient for him. He never exhibited his photographs in a gallery. And he practiced his profession as graphic artist and illustrator to the end of his life. Yet he *was* a photographer: he actively took photographs from 1950 to 1965, and his work is of a remarkable and

1973 University of Maryland, Baltimore
Center for Photographic Studies, University of Louisville, Kentucky
University of Colorado, Boulder
Musée Réattu, Arles, France (with Imogen Cunningham and Linda Connor)
Women, International Museum of Photography, George Eastman House, Rochester, New York (with Jack Welpott)
1974 Oakland Museum, California
1975 Silver Image Gallery, Tacoma, Washington
Spectrum Gallery, Tucson, Arizona
1976 Evergreen State College, Olympia, Washington
1977 Susan Spiritus Gallery, Newport Beach, California
Grapestake Gallery, San Francisco
1978 Witkin Gallery, New York
1979 Contemporary Arts Center, New Orleans
Kimball Art Center, Park City, Utah
Yuen Lui Gallery, Seattle, Washington
G. Ray Hawkins Gallery, Los Angeles
1980 Delaware Technical College, Wilmington
Photography Southwest, Scottsdale, Arizona
Jeb Gallery, Providence, Rhode Island
1981 Orange Coast College, Costa Mesa, California
University of North Dakota, Grand Forks
Atlanta Gallery, Georgia
Catskill Center of Photography, Woodstock, New York
Camera Obscura Gallery, Denver, Colorado
Spectrum Gallery, Fresno, California
1982 *New Work*, Yuen Lui Gallery, Seattle

Selected Group Exhibitions:

1967 *Light⁷*, Massachusetts Institute of Technology, Cambridge
1968 *Vision and Expression*, International Museum of Photography, George Eastman House, Rochester, New York
1973 *60's Continuum*, International Museum of Photography, George Eastman House, Rochester, New York
1974 *Photography in America*, Whitney Museum, New York
1975 *Women of Photography*, San Francisco Museum of Art
1977 *The Great West: Real/Ideal*, University of Colorado, Boulder
1978 *Tusen och en bild (1000 Pictures)*, Moderna Museet, Stockholm
Mirrors and Windows, Museum of Modern Art, New York (toured the United States, 1978-80)
1979 *Attitudes*, Santa Barbara Museum of Art, California
Photographie als Kunst 1879-1979/Kunst als Photographie 1949-1979, Tiroler Landesmuseum Ferdinandeum, Innsbruck, Austria (travelled to Neue Galerie am Wolfgang Gurlitt Museum, Linz; Neue Galerie am Landesmuseum Johanneum, Graz; Museum des 20. Jahrhunderts, Vienna)

Collections:

Museum of Modern Art, New York; International Museum of Photography, George Eastman House, Rochester, New York; Museum of Fine Arts, Boston; Fogg Art Museum, Harvard University, Cambridge, Massachusetts; Center for Creative Photography, University of Arizona, Tucson; San Francisco Museum of Art, California; Oakland Museum, California; Bibliothèque Nationale, Paris; Moderna Museet, Stockholm.

Publications:

By DATER: books—*Women and Other Visions*, with Jack Welpott, introduction by Henry Holmes Smith, New York 1975; *Imogen Cunningham: A Portrait*, editor, Boston and London 1979.

On DATER: books—*Photography Year 1973*, by Time-Life editors, New York 1973; *The Woman's Eye* by Anne Tucker, New York 1974; *Faces* by Ben Maddow, Boston 1978; *Darkroom II*, edited by Jain Kelly, New York 1978; *A Ten Year Salute*, edited by Lee D. Witkin, New York 1979; *The Photograph Collector's Guide* by Lee D. Witkin and Barbara London, Boston and London 1979; *Light Readings: A Photography Critic's Writings 1968-1978* by A.D. Coleman, New York 1979; *Contact* by Ralph Gibson, New York 1980; articles—"Judy Dater" by Shelley Rice in *Ms.* (New York), June 1978; "Bay Area Photography" by Hal Fisher in *Picture Magazine* (Los Angeles), June 1979; "Judy Dater and Jack Welpott," interview with Gilles Walinski, in *Zoom* (Paris), November/December 1979; "Judy Dater" by Richard S. Street in *Pacific Sun* (San Rafael, California), 1-7 February 1980.

From the beginning people have been my favorite subject. The human face and body attracted me in all its infinite variety. I built my photographs around the person I had chosen. An evolution began, starting with self-portraits, then with friends, and ultimately with strangers.

I find my themes ebb and flow. The earliest portraits were done in the landscape. Occasionally an uninhabited landscape would materialize, but generally a person dominated. I moved closer with my camera and eventually concentrated on interior environmental portraits.

Lately, the landscape is re-emerging in my photographs, and I have a renewed interest in the self-portrait. My life and work reflect each other. Photography allows me to visually explore my deepest feelings and dreams. It is a way for me to share some magic private moments.

—Judy Dater

When Judy Dater says that her work is rooted in 19th century portraiture, she pays homage to a tradition which goes back to the beginning of photography. The desire to see oneself rendered with such amazing clarity and naturalistic detail (which the most meticulous painting could not begin to match) made portraiture incredibly popular in those early years of photography. Even today, after the novelty has worn off, photographic renderings of the human face carry an intense appeal. Dater has updated the tradition by using available natural light instead of artificial, studio illumination, and by employing a classical, straightforward approach to undercut the romanticism of the past. Using a 4" x 5" view camera, which reflects the influence of California's f64 school, she makes fine black-and-white prints that in themselves have a sensuous appeal.

She selects her subjects intuitively, first through her attraction to them, and then through their willingness to be photographed. Working with Jack Welpott on her well-known book *Women and Other Visions*, she chose somewhat bohemian, urban women and photographed them clothed and unclothed in their home environments. These photographs examine female identity through costume and role playing, and they question both personal and societal attitudes toward sexuality.

In Dater's pictures the naked body is often less revealing than the face. Her knack is to allow people's experience to appear in their posture and facial expression, then click the shutter. The total expression her subjects adopt exposes elements of both their conscious and their unconscious persona, making the viewer confront some essential quality of personality which often remains hidden in the movement of everyday life.

While she is careful about imposing her point of view on the subject, Dater often allows suggestive symbols to appear. When she photographs Cheri, whose expression and exposed body belie years of experience, standing naked holding a long, horizontal picture of an army regiment, Dater is not making a literal statement about Cheri's sex life; she is simply indicating what a woman's experience can sometimes seem like. Similarly, when she photographs Joyce Goldstein in her kitchen with utensils hanging over her head, Dater emphasizes Goldstein's individual strength of character; yet she subtly manages to raise some questions about the roles contemporary women choose to adopt.

The dynamic quality of Dater's work comes from her understanding of the inherent mystery of the photographic portrait, which conceals as much as it reveals. The feeling that you know something special about the person in the picture is always undercut by your inability to say what it is; the descriptive truth of the photograph is always balanced by its theatrical and fictional nature. Judy Dater takes full advantage of this duality: her photographs offer the rich tonalities and the engaging detail of traditional black-and-white photographs, but they focus on ephemeral, elusive qualities which no camera can really record.

—Ted Hedgpeth

DAVIDSON, Bruce.
American. Born in Oak Park, Illinois (Chicago) in 1933. Educated at Hebrew School, Oak Park, 1945-47; Oak Park High School, 1948-51; studied photography, under Ralph Hattersley, Rochester Institute of Technology, New York, 1951-54, and painting, philosophy and photography, under Herbert Matter, Alexey Brodovitch, and Josef Albers, Yale University, New Haven, Connecticut, 1955. Served in the United States Army, in Georgia, Arizona and France, 1955-57. Married Emily Davidson in 1967; children: Jenny and Anna. Worked as an apprentice to photographer Al Cox, Oak Park, 1947; Darkroom Technician, Eastman Kodak, Rochester, 1954-55; freelance photographer, working for *Life*, *Réalités*, *Du*, *Esquire*, *Queen*, *Look*, *Vogue*, etc., in New York, Paris and Los Angeles, since 1958; Member, Magnum Photos co-operative agency, New York and Paris, since 1958. Instructor, *Life* magazine program for young photographers, New York, 1958; Instructor in Photography, School of Visual Arts, New York, 1964; also conducts private photography workshops. Recipient: Guggenheim Fellowship, 1959, 1962; National Endowment for the Arts grant, 1970; American Film Institute grant, 1970, 1972, and A.F.I. Critics Prize, 1971. Agent: Magnum Photos, New York. Address: c/o Magnum Photos, 251 Park Avenue South, New York, New York 10010, U.S.A.

Individual Exhibitions:

1965 Art Institute of Chicago
International Museum of Photography, George Eastman House, Rochester, New York
San Francisco Museum of Art
1966 Museum of Modern Art, New York
Moderna Museet, Stockholm
1970 Museum of Modern Art, New York
1971 San Francisco Museum of Art
1976 Addison Gallery, Andover, Massachusetts
1979 FNAC Gallery, Paris
Galerie Delpire, Paris
Galerie Fiolet, Amsterdam
1982 Douglas Kenyon Gallery, Chicago

Bruce Davidson: *Untitled*, **1962** Courtesy Art Institute of Chicago

Selected Group Exhibitions:

1959 *Photography at Mid-Century*, International Museum of Photography, George Eastman House, Rochester, New York
1960 *The World as Seen by Magnum*, Takashimaya Department Store, Tokyo (and world tour)
1962 *Ideas in Images*, American Federation of Arts, New York (and world tour)
1966 *Contemporary Photography since 1950*, International Museum of Photography, George Eastman House, Rochester, New York (toured the United States)
 Towards a Social Landscape, International Museum of Photography, George Eastman House, Rochester, New York
1972 *4 Directions in Modern Photography: Paul Caponigro, John T. Hill, Jerry N. Uelsmann, Bruce Davidson*, Yale University Art Gallery, New Haven, Connecticut
1973 *The Concerned Photographer 2*, Israel Museum, Jerusalem (toured Europe)
1974 *Photography in America*, Whitney Museum, New York
1977 *Concerning Photography*, The Photographers' Gallery, London (travelled to the Spectro Workshop, Newcastle upon Tyne)
1980 *6 Photographers*, Newark Museum, New Jersey

Collections:

Museum of Modern Art, New York; International Museum of Photography, George Eastman House, Rochester, New York; Visual Studies Workshop, Rochester, New York; Yale University, New Haven, Connecticut; Addison Gallery of American Art, Andover, Massachusetts; Carpenter Center and Fogg Art Museum, Harvard University, Cambridge, Massachusetts; Art Institute of Chicago; University of Nebraska, Lincoln; Norton Simon Museum, Pasadena, California.

Publications:

By DAVIDSON: books—*The Negro American*, edited by T. Parsons and K. Clark, New York 1966; *East 100th Street*, with an introduction by John Szarkowski, Cambridge, Massachusetts 1970; *Subsistence U.S.A.*, with Carol Hill, New York 1973; *Photographing Children*, with others, edited by Time-Life, New York 1973; *Bruce Davidson: Photographs*, with an introduction by Henry Geldzahler, New York and London 1979; article—"What Photography Means to Me" in *Popular Photography* (New York), May 1962; films—*On Your Way Up*, 1966; *Living Off the Land*, 1970; *Zoo Doctor*, series, 1971; *Isaac Singer's Nightmare and Mrs. Pupko's Beard*, 1972; *Enemies: A Love Story*, screenplay, 1979.

On DAVIDSON: books—*Photography of the World '60*, edited by Hiromu Hara, Ihei Kimura and others, Tokyo and New York 1960; *Towards a Social Landscape: Contemporary Photographers*, edited by Nathan Lyons, New York 1966; *American Photography in the 20th Century* by Nathan Lyons, New York 1967; *America in Crisis: Photographs for Magnum*, edited by Charles Harbutt and Lee Jones, with an essay by Mitchel Levitas, New York 1969; *New Photography USA*, exhibition catalogue, by John Szarkowski, Arturo Carlo Quintavalle and Massimo Mussini, Parma, Italy 1971; *The Concerned Photographer 2*, edited by Cornell Capa, New York and London 1972; *Photography in America*, edited by Robert Doty, with an introduction by Minor White, New York and London 1974; *The Magic Image* by Cecil Beaton and Gail Buckland, London and Boston 1975; *Other Eyes*, exhibition catalogue, by Peter Turner, London 1976; *Concerning Photography*, exhibition catalogue, by Jonathan Bayer and others, London 1977; *Photographs: Sheldon Memorial Art Gallery Collection, University of Nebraska*, with an introduction by Norman A. Geske, Lincoln, Nebraska 1977; *Geschichte der Fotografie im 20. Jahrhundert / Photography in the 20th Century* by Petr Tausk, Cologne 1977, London 1980; *Mirrors and Windows: American Photography since 1960* by John Szarkowski, New York 1978; *Light Readings: A Photography Critic's Writings 1968-1978* by A.D. Coleman, New York 1979; *The Vogue Book of Fashion Photography* by Polly Devlin, with an introduction by Alexander Liberman, London 1979; *The Photograph Collector's Guide* by Lee D. Witkin and Barbara London, Boston and London 1979; articles—"The Bruce Davidson Show" by David Vestal, in *Infinity* (New York), August 1966; "Bruce Davidson: New York, East 100th Street", in *Du* (Zurich), March 1969; "Bruce Davidson: Photographe en Liberté", in *Photo* (Paris), October 1969; "Bruce Davidson", in *Infinity* (New York), September 1970; "East 100th Street: A Review by Jonathan Green", in *Aperture* (Rochester, New York), no. 16, 1971; "Concerned Photographers" by Cornell Capa, in *Zoom* (Paris), no. 16, 1973; "Bruce Davidson", in *Progresso Fotografico* (Milan), December 1973; "Bruce Davidson: A Guided Tour", in *Exposure* (New York), Spring 1979; "Bruce Davidson" by C.G. Cupic, in the *International Herald Tribune* (Paris), 3 July 1979.

At 24, some 22 years ago, and only two years out of the United States Army, Bruce Davidson was the youngest member of Magnum, then and now the definitive photographers' cooperative agency. Like many (perhaps most) outstanding photographers, he had been using a camera since his early teens, moving single-mindedly toward becoming a professional with obvious success.

But it takes more than energy and purposefulness to join the foremost group of one's peers at such an early age. It also takes talent so impressive that it cannot be ignored, even in a profession that has long been glutted with it.

Bruce Davidson's talent is for the poetry of everyday life. It combines a vision that sees beauty in the meanest of surroundings with a sensibility that prevents sentiment from dissolving into sentimentality. His is a partisan way of seeing that speaks out on behalf of the poor, the old, the ill—a sympathetic voice that will not let us ignore those whom it is more comfortable to overlook in a sometimes conscienceless world. Perhaps because so many of his subjects tend to be the overlooked members of our society, Davidson's photographs are often suffused with both sympathy and a gentle sadness. Not the shocked outrage of a W. Eugene Smith or a Don McCullin, but a strong concern that these people must be given attention, seen and appreciated for their humanity.

Thus, much of his work is in low key, shadowy, subdued, but telling in its observation and choice of moment and detail. The latter two aspects are always strong in a Davidson photograph. In a single photo in an early essay on a widow whose late husband was a friend of many French impressionist painters, for example, four simple picture elements sum up the old woman's past and present. Featured are her hands, arranging flowers in a vase; hinted at in the shadows, we see a suggestion of her face; and looming large, next to the flowers, the fragment of a painting, perhaps by one of the friends of her late husband. So much of her story is conjured up by these simple details.

Another memorable Davidson image shows a dwarf circus clown standing in the rain, smoking a cigarette, circus tents visible behind him, a sad expression on his face. Again, a few simple elements tell a life story with the speed and impact of an uppercut.

Even in sports photography, Davidson eschews the frantic action and emotion to express instead the stresses of the players. The tension of a sidelined footballer is shown not by his face (only the chin of which is visible), but by a closeup of his hands tightly twisting a towel as he watches the action on the field.

Unlike many of his contemporary photojournalists, Bruce Davidson is not completely self-taught. He graduated from Rochester Institute of Technology and worked as a photographic illustrator before becoming a full-time photojournalist. For many years, he worked with the classic tool of the photojournalist—the Leica.

But in doing his classic project *East 100th Street*, Davidson turned to the 4 x 5 view camera as his recording tool. It provided a sharp break with the style that had built his reputation. To begin with, the 4 x 5 camera had to be tripod-mounted. There could not be grabbing of the precise split-second during continuing action. Nor could there be a quick retreat should the subject object with violence to the taking of his picture. So, *East 100th Street* was not a two-day picture essay. Rather it was a two-year project that involved visiting, and getting to know and be known by the people who populate that block in New York City's East Harlem. It involved trust, friendship and cooperation among the photographer and his new friends as he documented their faces and their lives.

His choice of a larger-format camera and a deliberate approach to the subject has seemingly made his sympathies and eye for detail even more piercing. Areas that were once shadowed and coarse-grained in earlier pictures are opened up so that we may see clearly into every crumbling, littered inch of his subjects' home territory. But if it is less shadowy than before, Davidson's lighting is no less dolorous. And, although many of his subjects are children and lovers, virtually no smiles are to be seen on Bruce Davidson's East 100th Street.

In mid-career, Bruce Davidson's vision remains sharp, sympathetic and full of poetry; his picture-making style adapts gracefully to either small or large-format camera, and his images remain timeless because they spring from the basic emotions, troubles and triumphs that will always be understood by viewers related to one another by common humanity.

—Kenneth Poli

DAVIES, Bevan.

American. Born in Chicago, Illinois, 8 October 1941. Educated at Waller High School, Chicago; University of Chicago, for 2 years. Married Michele Vallery in 1970; daughter: Stephanie. Worked as a drummer in jazz and dance bands, and taught percussion players, Chicago, 1957-64. Photographer since 1965. Guest Lecturer, New York University, New York, 1978, and Napier College, Edinburgh, 1979. Recipient: National Endowment for the Arts grant, 1977, 1979. Agent: Sonnabend Gallery, 420 West Broadway, New York, New York 10012. Address: 431 West Broadway, New York, New York 10012, U.S.A.

Individual Exhibitions:

1969 Gotham Book Mart, New York
1976 Sonnabend Gallery, New York
 Broxton Gallery, Westwood, California
1977 International Museum of Photography, Rochester, New York
 Palais des Beaux-Arts, Brussels

1978 Sonnabend Gallery, New York
 Galleriaforma, Genoa
1979 Galerie Wilde, Cologne

Selected Group Exhibitions:

1964 *Photography '64*, International Museum of
 Photography, Rochester, New York
1976 *New York—Downtown Manhattan—Soho*,
 Akademie der Künste, Berlin
1977 *Photography as an Art Form*, Ringling
 Museum of Art, Sarasota, Florida
 *Contemporary American Photographic
 Works*, Museum of Fine Arts, Houston
 (travelled to the Museum of Contem-
 porary Art, Chicago, and the La Jolla
 Museum of Contemporary Art, Califor-
 nia)
1978 *Summer Group Exhibition*, Sonnabend Gal-
 lery, New York
1979 *Space in Two Dimensions*, Museum of Fine
 Arts, Houston
 *American Images: New Work by 20 Contem-
 porary Photographers*, Corcoran Gallery,
 Washington, D.C. (travelled to the Inter-
 national Center of Photography, New
 York, and the Museum of Fine Arts,
 Houston)

Collections:

Art Institute of Chicago; International Museum of
Photography, Rochester, New York; Museum of
Fine Arts, Houston.

Publications:

On DAVIES: books—*Contemporary American
Photographic Works*, exhibition catalogue, edited
by Lewis Baltz, Houston 1977; *American Images*,
edited by Renato Danese, New York 1979; *Photog-
raphie als Kunst, Kunst als Photographie* by Peter
Weiermair, Vienna 1979; *Presences* by Marilyn A.
Zeitlin, Reading, Pennsylvania 1980; articles—
"Document: The American Point of View" by Allan
Porter in *Camera* (Lucerne), May 1978; "Deepening
the Definition of the Art" by Gene Thornton in the
New York Times, 31 December 1978; "Post-Modern
Photography: It Doesn't Look 'Modern' At All" by
Gene Thornton in *Art News* (New York), April
1979; "Photo Works Laid Back with Sobriety" by
David Elliott in the *Chicago Sun-Times*, 20 May
1979.

The motivations for being an artist are simply too
complex to allow me to make an intelligent state-
ment. Contemporary cynicism and old-fashioned
Protestant ethics are uncomfortable bedfellows, and
I don't feel capable of evaluating how and to what
degree they affect me and my work.

—Bevan Davies

Bevan Davies' observation that the camera should
be allowed to "see by itself" articulated one of the
major ambitions of American photography in the
1970's. The bankruptcy of the dominant photo-
graphic styles of the 1960's contributed to the dis-
trust that Davies and others of his generation felt
toward "style" as the distinguishing element of
serious photography. From this basis Davies pro-
ceeded to investigate the fundamental conditions in
which a photograph might function as a work of art.
The result of this investigation has been a body of
photographs based upon the principles of economy,
clarity, and disinterested intelligence.

If Davies' esthetic has been reductive and self-
critical, his results have not been, in any sense, dim-
inished. In Davies' work the world appears to pre-
sent itself, and it is for precisely this reason that
Davies' photographs provide a rewarding expe-
rience for the viewer.

Davies' work is conspicuously public in content
and rigorous in execution. He has taken as his sub-
jects prominent buildings, some of inherent archi-
tecural or historic interest, others whose chief claim
on our attention is that they occupy and define
substantial areas of the urban environment. In both
cases Davies' mode is presentational. He does not
confer distinction upon his subjects nor does he
deny their essential dignity; his photographs neither
condescend nor do they aggrandize. In this respect
his work has been likened to that of the Bechers,
although for obvious reasons of methodological dif-
ference it would be inaccurate to extend this com-
parison too far.

Davies' photographs acknowledge no interest in
the transient, the aleatory, the anecdotal, or the
gratuitous. Consequently, they have proved to be a
maddening, if uncalculated, affront to viewers whose
grasp of photographic esthetics is confined to the
simplistic formulas of candid street photography.

Davies' works with an 8" x 10" camera, a point
worth mentioning only to illustrate his commitment
to a deliberate work method and his insistence that
the camera define equally and precisely each object
within its field of vision.

Davies' prints are 16" x 20," and the visual power
of these expansive and richly detailed surfaces is
difficult to deny. Nevertheless, it is obvious that
Davies' concern is not with the production of hand-
some objects *per se*; rather, they are the logical
outcome of his vision and method. The properties of
Davies' prints are the result of necessity, rather than
style. The size and resolution of his prints is required
to convey the density of information that is the
cornerstone of his vision. The harsh, glossy surfaces,
with their unavoidable commercial associations, act
to subvert any sense of preciousness. The final effect
of these astringent and carefully-made images is
curiously anti-decorative, in keeping with Davies'
seriousness of purpose.

Bevan Davies has made a significant and fun-
damental contribution to contemporary American
photography; his work is a testament to the intrinsic
strength of the photographic image and suggests its
significance in the context of contemporary art.

—Lewis Baltz

DAVIS, Bob (Robert James Davis).

Australian. Born in Melbourne, Victoria, 8 August
1944. Educated at various schools in Australia; self-
taught in photography. Cinematographer and pho-
tographer, Department of Film Production, Hobart,
Tasmania, 1963-65; freelance photographer, in
Sydney, 1965-70, in London and Japan, 1970-78, in
Hong Kong, since 1978. Co-Director, The Stock
House photo library/agency, Hong Kong, since
1980. Agents: Church Street Photographic Centre,
384 Church Street, Richmond, Victoria 3121, Aus-
tralia; Aspect Picture Library, 73 Kingsmead Avenue,
Worcester Park, Surrey KT4 8U2, England. Address:
The Stock House, 101 Yue Yuet Building, 43-55
Wyndham Street, Hong Kong.

Individual Exhibitions:

1974 *Light and Shade of Europe: Color Photo-
 graphs*, Pentax Gallery, Tokyo
1979 *Faces of Japan*, Australian Centre of Photog-
 raphy, Sydney (travelled to Church Street
 Photographic Centre, Melbourne, 1980)
1980 *China*, at the *Hong Kong Arts Festival*

Publications:

By DAVIS: books—*Faces of Japan*, paperback,
Tokyo 1974, as hard cover with an introduction by
Murray Sayle, Tokyo 1978; *A Day in the Life of
Australia*, Tokyo 1981; article—"Winnie the Pooh"
in *Observer Colour Magazine* (London), December
1973.

On DAVIS: articles—"Bob Davis" in *British Jour-
nal of Photography Annual*, London 1971; "Portfo-
lio: Bob Davis" in *British Journal of Photography*
(London), April 1971; "Bob Davis" in *British Jour-
nal of Photography* (London), July 1971; "Bob
Davis" in *The Image* (London), February 1973;
"Bob Davis" in *British Journal of Photography*
(London), June 1973; "Bob Davis" in *Photo Tech-
nic* (London), February 1974; "Bob Davis" in *Brit-
ish Journal of Photography Annual*, London 1975;

Bevan Davies: *Glasgow*, 1979

Bob Davis: *Sumo Wrestlers, Dewanoumi Stable*, Tokyo, 1974

"Faces of Japan" in *The Australian* (Sydney), March 1979; "Bob Davis" in *British Journal of Photography* (London), March 1979; "Bob Davis: Portfolio" in *Zoom* (Paris), May 1979; "Travel Photography" by Jim Bell in *You and Your Camera* (London), June 1980; "A Day in the Life of Australia" in *Life* (New York), October 1981.

Photography to me has become my lifestyle; it supplies me with work (I am a commercial photographer), it allows me to travel and experience segments of life otherwise closed to most people, and it keeps me well enough to enable me to take time off for my own projects—mainly black-and-white, a sort of Jekyll and Hyde existence—colour for com-

mercial projects, black-and-white for my personal work, in which I prefer to sum up and define my subject in a single exposure in an un-cropped frame.
—Bob Davis

Bob Davis is essentially a travel photographer who works in colour with 35mm SLR cameras; but at the same time he also shoots black-and-white reportage using Leicas.

The colour work is eminently suitable for uses such as travel advertising, airline calendars and posters, magazines and brochures. It presents a picturesque world of invitingly exotic subjects in lush colours. But Davis manages to be romantic without cloying the palette. The pictures are toughened by an acute sense of perception and by their strong graphic design. The "design" is the careful arrangement of the main lines of the subject in the composition, such as strong patterns of shadows in flat plains or the receding lines of a road or pathway in a landscape. The "sense of perception" comes from the reportage feel of the work. Davis does not shoot "picture postcards"; he takes the kind of pictures *you* would want to take on holiday to preserve, in idealized form, pleasant memories. It is very satisfying.

The black-and-white work is after the style of Cartier-Bresson, to judge by the 88 plates in *Faces of Japan*. This contains a few pictures where the subject is reacting to the camera, but in most of them the photographer is making a point of not being noticed. However, the pictures seem more cluttered and less engaged than Bresson's: the people seem more distant, and the photographs do not persuade us to care about their lives. Japan is, of course, more cluttered than Europe, and to the Japanese an Australian is an alien, a mad foreigner, so a direct comparison is unfair: the reportage photographer shoots what he finds. However, he is responsible for his choice of subject. Davis *seems* to want to be not too involved, physically and emotionally, even if he was in fact being kept at a distance. The result is that Davis's view of Japan does not take you very deeply into it. He photographs the surface contrasts of traditional Japanese life (the kimonos, lanterns, Sumo wrestlers) with contemporary aspects (transistor radios, Coca Cola, motorbikes), but many of these shots would be improved by the presence of colour, which often brings its own emotional qualities to scenes that are anaemic in black and white.

Many of the reportage pictures show the same type of strong graphic arrangement as the colour work, though often an unacceptable subject is included in the frame. In travel photography terms, an "unacceptable subject" is the overflowing wastepaper bin at the edge of the lake (plate 83) or the wrecked car which despoils the beautiful beach (plate 60). Davis places these unsightly objects smack in the front of his black and white pictures as if in protest against the colour shots where he would go to even greater pains to exclude them.

It is almost as though the black-and-white pictures are a secret conscience, a counterweight to the warm and wonderful world he portrays in colour. However, if forced to choose between the two, take the colour.

—Jack Schofield

Joe Deal: *Colton, California*, from the series *The Fault Zone*, 1978

DEAL, Joe.

American. Born in Topeka, Kansas, 12 August 1947. Studied at Kansas City Art Institute, 1967-70, B.F.A. 1970; University of New Mexico, Albuquerque, 1973-74, M.A. 1974, M.F.A. 1978. Photographer since 1969. Director of Exhibitions, International Museum of Photography, George Eastman

House, Rochester, New York, 1975-76. Since 1976, Assistant Professor of Art, University of California at Riverside. Recipient: National Endowment for the Arts Photography Fellowship, 1977, 1980. Agent: Light Gallery, 724 Fifth Avenue, New York, New York 10019. Address: 3007 Chestnut, Riverside, California 92501, U.S.A.

Individual Exhibitions:

1973 Light Gallery, New York
1975 Light Gallery, New York
1976 Orange Coast College, Costa Mesa, California
1977 University of California at Riverside
1978 Light Gallery, New York
 Los Angeles Institute of Contemporary Art
 University of New Mexico, Albuquerque
 University of Arkansas, Little Rock
1980 Colorado Mountain College, Breckenridge
1981 Light Gallery, Los Angeles
 Joe Deal: The Fault Zone / William Larson: Recent Color Work from Arizona, Light Gallery, New York

Selected Group Exhibitions:

1972 *Summer Light*, Light Gallery, New York
1973 *Sharp-Focus Realism: A New Perspective*, Pace Editions, New York
1974 *10 American Photographers*, The Photographers' Gallery, London
1975 *New Topographics: Photographs of a Man-Altered Landscape*, International Museum of Photography, George Eastman House, Rochester, New York (travelled to the Otis Art Institute, Los Angeles, and Princeton University, New Jersey)
1977 *Contemporary American Photographic Works*, Museum of Fine Arts, Houston (travelled to the La Jolla Art Museum, California)
 Cityscapes: San Francisco and Los Angeles, San Francisco Museums Downtown Center
 The Great West: Real/Ideal, University of Colorado, Boulder (toured the United States)
1978 *Baltz/Deal/Gohlke/Shore/Toth*, Werkstatt für Photographie der VHS Kreuzberg, Berlin
1979 *New California Views*, International Center of Photography, New York (travelled to the Minneapolis Institute of Art, and Mills College, Oakland, California)
1980 *Contemporary Photography*, Jeffrey Fuller Fine Art, Philadelphia

Collections:

Museum of Modern Art, New York; International Museum of Photography, George Eastman House, Rochester, New York; Minneapolis Institute of Art; University of Louisville, Kentucky; University of Colorado, Boulder; University of New Mexico, Albuquerque; Center for Creative Photography, University of Arizona, Tucson; Museum of Fine Arts, Houston; Neue Sammlung, Munich.

Publications:

On DEAL: books—*New Topographics: Photographs of a Man-Altered Landscape*, exhibition catalogue, by William Jenkins, Rochester, New York 1975; *Photographer's Choice*, edited by Kelly Wise, Danbury, New Hampshire 1975; *The Light Gallery Catalogue of Contemporary Photography*, New York 1976; *Contemporary American Photographic Works*, exhibition catalogue, by Lewis Baltz and John Upton, Houston 1977; *The Great West: Real/*

Ideal, exhibition catalogue, edited by Sandy Hume, Ellen Manchester, and Gary Metz, Boulder, Colorado 1977; *New California Views*, portfolio, edited by Victor Landweber and Arthur Ollman, Los Angeles 1979; articles—"Route 66 Revisited: New Landscape Photography" by Carter Ratcliff in *Art in America* (New York), January/February 1976; "Joe Deal: New Topographics" by James Hajicek and Bill Jay in *Northlight 4* (Tempe, Arizona), 1977; "Aspekte der Amerikanischen Fotografie der Gegenwart" by Janet Borden in *Dumont Foto 1: Fotokunst und Fotodesign International*, edited by Hugo Schöttle, Cologne 1978; "Joe Deal's Optical Democracy" by James Hugunin in *Afterimage* (Rochester, New York), February 1979.

Early in his career, Joe Deal photographed decisively shaped natural objects and strictly rectangular architecture: pines clipped to cones, bulbous cacti, square white plaster, linear dark metal. All these textures and the shapes that were made of them were conjoined in coherent, deliberately designed photographs. Increasingly, the area of the photograph given over to expansive nature, or what was left of it as it was prepared for man's invasion, was extended. An ecological concern became evident as he focused, for instance, on land cut through with barbaric swathes, the preparations for what we call, without a trace of irony, its development. In his photographs, the land was seen as impotent, while the houses bred. Along with this messier subject came an increasing complication of the image; strictness of design gave way to a sense for existing disorder, the disorder of change. He moved from close focus on discrete objects to as wide a view as his square format camera would admit, from exclusiveness to inclusiveness. This interest in the man-altered landscape, shared by a number of American photographers in the 1970's, was exhibited at the International Museum of Photography in 1975 under the title *New Topographics*. Deal, however, differed from others in the exhibition in his advancing freedom from self-conscious stylization.

When he became a resident of Southern California in 1976, Deal was well-prepared for one subject that he found in that population-explosive area. In "Beach Cities," a series made in 1978-79, he presented powerful arguments for the incompatability of those two terms; read rightly, his images of urbanized sea shores were photographic object lessons. In his most recent series, "The Fault Zone," 1978-80, he goes beyond depiction or analysis. The physical incidents in his view are given in a pictorially tense structure that is analogous to the tension between subterranean and superficial events. Man's artifacts depend from the sides of the square frames of these recent photographs; porches and roadways, concrete beginnings (or remains?) seem perched and tentative on the inscrutable earth. His nominal subject is the landscape of earthquake country, but his essential subject is time—man's time and the earth's time. As an artist, Deal has thus moved from well-designed description to philosophic comment. Throughout his career, his mode has been coolly dispassionate, reminiscent of that of the 19th century survey photographer, Tomothy O'Sullivan. His straight technique is consistently impeccable.

—Anita V. Mozley

DeCARAVA, Roy.

American. Born in New York City, 9 December 1919. Educated in New York public schools, 1924-38, including Textile High School, 1934-38; studied architecture and sculpture, and painting with Byron Thomas and Morris Kantor, at Cooper Union Institute, New York, 1938-40; painting with Elton Fax and printmaking, Harlem Art Center, New York, 1940-42; and drawing and painting with Charles White, at George Washington Carver Art School, New York, 1944-45. Served as a topographical draftsman in the United States Army, 1943. Married Sherry Turner in 1970; children: Susan, Wendy and Laura. Worked in New York as a sign painter and display artist, 1936-37, technical draftsman, 1939-42, and commercial artist and illustrator, 1944-58. Freelance photographer, in New York, working for various advertising agencies, recording and television companies, and such magazines as *Scientific American*, *Fortune*, *McCall's*, *Look*, *Newsweek*, *Time*, *Life*, 1959-68 and since 1975; Contract Photographer, *Sports Illustrated* magazine, New York, 1968-75. Founder-Director, A Photographers Gallery, New York, 1954-56; Founder-Director, Kamoinge Workshop for black photographers, New York, 1963-66; Member, Curatorial Council, Studio Museum, Harlem, New York, 1976. Adjunct Professor of Photography, Cooper Union Institute, New York, 1969-72. Associate Professor, 1975-78, and since 1978 Professor of Art, Hunter College, New York. Chairman, Committee to End Discrimination Against Black Photographers, American Society of Magazine Photographers, 1963-66. Recipient: Guggenheim Photography Fellowship, 1952; Art Service Award, Mt. Morris United Presbyterian Church, New York, 1969; Benin Creative Photography Award, 1972; Artistic and Cultural Achievement Award, Community Museum of Brooklyn, New York, 1979. Honorary Citizen of Houston, Texas, 1975. Agent: Witkin Gallery, 41 East 57th Street, New York, New York 10022. Address: 81 Halsey Street, Brooklyn, New York 11216, U.S.A.

Individual Exhibitions:

1950 Forty-Fourth Street Gallery, New York
1951 Countee Cullen Branch, New York Public Library
1954 *Guggenheim Photographs*, Little Gallery, New York Public Library
1955 A Photographers Gallery, New York
1956 Camera Club of New York
1967 *US*, Countee Cullen Branch, New York Public Library
1969 *Thru Black Eyes*, Studio Museum, Harlem, New York
1970 Sheldon Memorial Art Center, University of Nebraska, Lincoln
1974 *Photographic Perspectives*, University of Massachusetts, Amherst
1975 Museum of Fine Arts, Houston
1976 *The Nation's Capitol in Photographs*, Corcoran Gallery, Washington, D.C.
 Benin Gallery, New York
1977 Witkin Gallery, New York
 Light Work Gallery, Syracuse, New York
1978 Port Washington Public Library, New York
1980 Friends of Photography, Carmel, California
 Akron Art Institute, Ohio

Selected Group Exhibitions:

1953 *Always the Young Strangers*, Museum of Modern Art, New York
1955 *The Family of Man*, Museum of Modern Art, New York (and world tour)
1957 *70 Photographers Look at New York*, Museum of Modern Art, New York
1958 *6 Modern Masters*, IFA Galleries, New York
1964 *Photography in the Fine Arts*, Metropolitan Museum of Art, New York

1967 *Photography in the 20th Century*, National Gallery of Canada, Ottawa (toured Canada and the United States, 1967-73)

1974 *Photography in America*, Whitney Museum, New York

1978 *Mirrors and Windows: American Photography since 1960*, Museum of Modern Art, New York (1978-80)

1980 *Photography of the 50's*, Center for Creative Photography, University of Arizona, Tucson

Collections:

Museum of Modern Art, New York; Metropolitan Museum of Art, New York; Harlem Art Collection, New York State Office Building, New York; Andover Art Gallery, Phillips Academy, Andover, Massachusetts; Corcoran Gallery, Washington, D.C.; Atlanta University; Sheldon Memorial Art Gallery, University of Nebraska, Lincoln; Museum of Fine Arts, Houston; Center for Creative Photography, University of Arizona, Tucson.

Publications:

By DeCARAVA: book—*The Sweet Flypaper of Life*, with text by Langston Hughes, New York 1955, 1967.

On DeCARAVA: books—*Photography in the 20th Century* by Nathan Lyons, New York 1967; *Roy DeCarava, Photographer*, exhibition catalogue, with text by James Alinder, Lincoln, Nebraska 1970; *Black Photographers Annual*, New York 1975; *Roy DeCarava: Photographs*, exhibition catalogue, with text by Alvia Wardlaw Short, Houston 1975; *Roy DeCarava: The Nation's Capitol in Photographs*, with text by Jane Livingston and Frances Fralin, Washington, D.C. 1976; *Mirrors and Windows: American Photography since 1960* by John Szarkowski, New York 1978; *Light Readings: A Photography Critic's Writings 1968-1978* by A.D. Coleman, New York 1979; *American Images: New Work by 20 Contemporary Photographers*, edited by Renato Danese, New York 1979; *The Photograph Collector's Guide* by Lee D. Witkin and Barbara London, Boston and London 1979; *Photography of the 50's*, exhibition catalogue, by Helen Gee, Tucson, Arizona 1980.

Photography allows me to be of use by enabling me to share my concerns and my priorities with others, known and unknown.

—Roy DeCarava

Roy DeCarava could be described as an exponent of a black point of view, the creator of a black aesthetic, an interpreter of black experience. All of these claims are demonstrable, and certainly their validity is nowhere better demonstrated than in his remarkable collaboration with Langston Hughes in his first book *The Sweet Flypaper of Life*. There is in these images the warmth of total identification and their truth is unmistakable, and yet if his work is compared with that of another black artist, James Van Der Zee, a significant difference makes itself felt. DeCarava is seen to have broken out of the ghetto of color and exercises his vision and sensibility in a world much less enclosed and exclusive. It is apparent that he is able to look at and see human beings, black and white, with a straightforward sympathy and insight.

DeCarava has said: "Most photographers are motivated by form. I'm motivated by content." Form in his work is by no means a negligible quality. His images are structured with a rightness that reveals the completely unself-conscious craftsman.

The moment seized by the click of the camera or, if as may be, by the choice made in the darkroom, is the only one, the one that contains the insight that defines the picture. In this, his sense of form is instinctive, utterly simple and, in effect, invisible. No structures of climate or emotion or process stand between the eye of the photographer and his witnessing of the subject. His images are as a whole tonally dark, sometimes suggesting a mood of thoughtful melancholy, but it is clear in the rapport that links every image with the sensibility of the photographer, that his sense of the content of his subject is one of recognition.

And in the very act of recognition, DeCarava is set apart from the multitude of photographers who specialize in an uncritical record of the commonplace of everyday experience. His images have nothing of the look of the accidental or the irrelevant, nothing of the bland monotony of thousands of shots taken, from which one is selected as somehow more significant than the rest. He sees and catches, with inevitable rightness, the entire ambience of living, the wash of light along a street, the abstractions of walls and windows, of surfaces and voids, and invests them with a richness of tone and texture that makes these places and events palpable to the senses and evidence to the mind of the human experience which has shaped them.

—Norman A. Geske

Roy DeCarava: *Man Coming Up Subway Stairs*, 1952

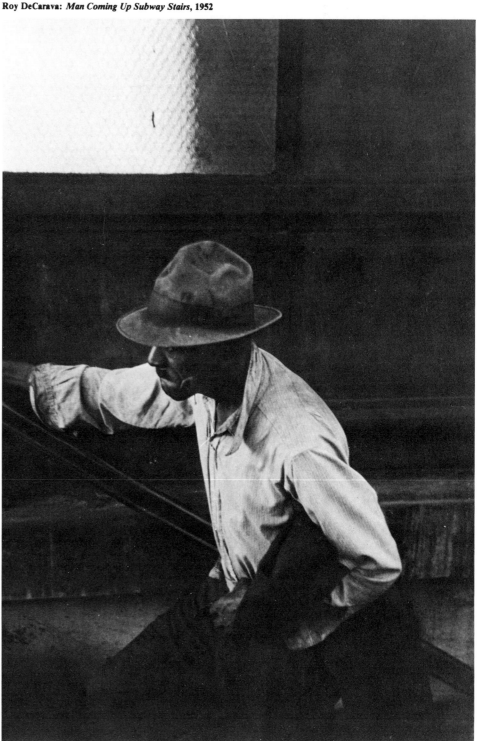

DeCOCK, Liliane.

American. Born in Belgium in 1939; emigrated to the United States, 1960, subsequently naturalized. Married the publisher Douglas Morgan in 1972. Freelance photographer. Worked as photographic assistant to Ansel Adams, Carmel, California, 1963-72. Trustee, Friends of Photography, Carmel. Recipient: Guggenheim Fellowship, 1972. Address: c/o Morgan and Morgan, 145 Palisades Street, Dobbs Ferry, New York 10522, U.S.A.

Individual Exhibitions:

1968	Jacksonville Museum of Art, Florida
	Friends of Photography, Carmel, California
1969	University of California at Berkeley
	Harnell College, Salinas, California
1970	Bathhouse Gallery, Milwaukee
	International Museum of Photography, George Eastman House, Rochester, New York
1971	Massachusetts Institute of Technology, Cambridge
1972	Limited Image Gallery, Chicago
	Film-Com Gallery, Berwyn, Pennsylvania
	Witkin Gallery, New York
	University of Rhode Island, Kingston
1980	Milwaukee Center of Photography

Selected Group Exhibitions:

1980 *De Fotografie in Belgie 1940-1980*, Het Sterckshof Museum, Deurne-Antwerp

Collections:

Princeton University, New Jersey; Exchange National Bank, Chicago; Amon Carter Museum of Western Art, Fort Worth, Texas; Phoenix College, Arizona; Glendale College, California; Norton Simon Art Museum, Pasadena, California

Publications:

By DeCOCK: book—*Liliane DeCock: Photographs*, with a foreword by Ansel Adams, New York 1973.

On DeCOCK: book—*De Fotografie in Belgie 1940-1980*, exhibition catalogue, by Roger Coenen and Karel van Deuren, Antwerp 1980.

The photographic landscape is always a fragment. A person can be glanced from head to toe; the earth's skin just stretches too far. Even from as far back as the moon, only half the earth is visible. Landscapes are landscapes within landscapes, atomized chunks of earth cut loose by the camera, intimating the character of the greater surround. Oddly enough, to fragment, to tease with the frame, to swerve attention from the picture to its edges or outside it has not been a traditional imperative or strength of the landscape photographer. Rather, the chosen views of masters such as Ansel Adams and Wynn Bullock impart wholeness and completeness, such that we come to experience the scene firsthand, as if we too had been there, standing beside the photographer at the moment of recording, sensing peripherally, seeing it all.

Such is the essence of the land in the landscapes of the Belgian-born photographer Liliane DeCock. In one striking example, a cloud mass swathes the face of Yosemite's *El Capitan* with steamy softness, never subduing the majesty of the precipice over which the translucent, enveloping wisps roll. We see the fragment, yet feel the totality.

Frame evaporates in other DeCock landscapes. In one of these, a spinning windmill generator on a prairie near Santa Fe, New Mexico spits and scatters thunder clouds every which way, becoming itself the eye of the gathering storm, the center of our undivided attention.

As it appears, DeCock's photographs are as much about the weather as they are about the land. Her camera often points upward. With a kind of ascensional gesture of the tripod head heavenward, DeCock embraces the elements as equal collaborators with the earth in formulating the picture. Sky becomes background transfigured. A storm front in Nevada sweeps our eyes up with the billowing clouds, like a balloon released from underwater, or as in many of her architectural images of pinnacled barnroofs, like a congregation standing in unison. It is indeed uncanny that these photographs of uplift and optimism should begin their creative life upside down on the ground glass of DeCock's view camera. Earth above, sky below. Perhaps her intention in making images that exhilarate, subconscious though that driving force may be, is a matter of compensation for the ground glass, or could it be more likely that these magnificent celebrations of the American West are instead an eloquent compensation for Belgian flatness.

—Arno Rafael Minkkinen

DEKKERS, Ger(rit Hendrik).

Dutch. Born in Borne, 21 August 1929. Educated at Secondary school in Hengelo, 1942-46; studied graphics at the Academy of Art, Enschede, 1950-54. Served in the Dutch Army, in Indonesia, 1948-50. Married Hilda Hartsuiker in 1954; children: Henriette and Jose. Freelance artist and photographer, Enschede, 1954-76, and in Giethoorn, since 1976. Member, Photo Section, Gebonden Kunstenfederatie (GKf), since 1969. Recipient: Dutch Ministry of Culture Grant, 1970, 1971, 1975, 1976; City of Amsterdam Stipendium 1976. Agents: Galerie M, Haus Weitmar, 463 Bochum-Weitmar, West Germany; and Galerie Nouvelles Images, Westeinde 22, The Hague, Netherlands. Address: Dwarsgracht 31, 8355 CV Giethoorn, Netherlands.

Individual Exhibitions:

1972 *Ger Dekkers: Landscape Perceptions*, Rijksmuseum Kröller-Müller, Otterlo, Netherlands
1973 *Ger Dekkers: Landscape Perceptions*, Museum Bochum-Kunstsammlung, Bochum, West Germany
 Ger Dekkers: Landscape Perceptions, Neue Galerie-Kunstsammlung Ludwig, Aachen, West Germany
1974 *Ger Dekkers: Landscape Perceptions*, Stedelijk Museum, Amsterdam
 Ger Dekkers: Landscape Perceptions, Haagse Gemeentemuseum, The Hague
1975 *Ger Dekkers: Landscape Perceptions*, Palais des Beaux-Arts, Brussels
 Ger Dekkers: Landscape Perceptions, Galleria del Cavallino, Venice
1976 *Ger Dekkers: Landscape Perceptions*, Kunstmuseum, Aarhus, Denmark
 Ger Dekkers: Landscape Perceptions, Print Gallery Pieter Brattinga, Amsterdam
 Ger Dekkers: Landscape Perceptions, Galerie M, Bochum, West Germany
1977 *Planned Landscapes*, Rijksmuseum Kröller-Müller, Otterlo, Netherlands
 Plastic, Museum Boymans-van Beuningen, Rotterdam
1978 *Plastic*, Gemeentemuseum, Arnhem, Netherlands
 Planned Landscapes, De Vishal, Haarlem, Netherlands
1979 *New Dutch Landscapes*, Hayden Gallery, Massachusetts Institute of Technology, Cambridge
 Planned Landscapes, Print Gallery Pieter Brattinga, Amsterdam
 Planned Landscapes, Provincaal Begijnhof, Hasselt, Belgium
1980 *Planned Landscapes*, Kunstcentrum Markt 17, Enschede, Netherlands
 Planned Landscapes, Rijksplanologische Dienst, The Hague
1981 *Planned Landscapes*, Studium Generale, Wageningen, Netherlands
 Planned Landscapes, Städtische Galerie, Nordhorn, West Germany

Selected Group Exhibitions:

1969 *Atelier 6*, Stedelijk Museum, Amsterdam
1971 *Sonsbeek '71*, Central Station, Amsterdam
1974 *Projekt '74*, Kunsthalle, Cologne
1977 *Sequenzen*, Kunstverein, Hamburg
 Documenta 6, Museum Fridericianum, Kassel, West Germany

Liliane DeCock: *Barn and Smoke Stacks*, Moss Landing, California, 1967 Courtesy Art Institute of Chicago

Museum of Drawers, Kunsthaus, Zurich (now permanent installation)

1978 *Fotografie in Nederland 1940-75*, Stedelijk Museum, Amsterdam

Photography as Art/Art as Photography, Fotoforum, Kassel, West Germany (and world tour)

1979 *To Do with Nature*, travelling exhibition, (toured the Netherlands, Sweden, Belgium, Germany, Denmark, and Portugal, 1979-81)

Photographie als Kunst 1879-1979, Tiroler Landesmuseum Ferdinandeum, Innsbruck, Austria (travelled to the Neue Galerie am Wolfgang Gurlitt Museum, Linz, Austria; Neue Galerie am Landesmuseum Joanneum, Graz, Austria; and Museum des 20. Jahrhunderts, Vienna)

Collections:

Rijksmuseum Kröller-Müller, Otterlo, Netherlands; Stedelijk Museum, Amsterdam; Museum Boymans-van Beuningen, Rotterdam; Haagse Gemeentemuseum, The Hague; Gemeentemuseum, Arnhem, Netherlands; Ministry of Culture, The Hague; Posts-Telegraph-Telephone (P.T.T.), The Hague; Museum Ludwig, Cologne; Kunsthalle, Hamburg; Museum Bochum-Kunstsammlung, Bochum, West Germany.

Publications:

By DEKKERS: book—*Planned Landscapes: 25 Horizons*, with an introduction by R.W.D. Oxenaar, Amsterdam 1977.

Ger Dekkers: *16 Ditches, Flevoland* (originals in color), 1980

On DEKKERS: books—*Ger Dekkers: Landscape Perceptions*, exhibition catalogue, with text by R.W.D. Oxenaar, Otterlo, Netherlands 1972; *Ger Dekkers: Landscape Perceptions*, exhibition catalogue, with text by P. Spielmann, Bochum, West Germany 1973; *Ger Dekkers: Landscape Perceptions 1968-1975*, exhibition catalogue, with text by J.L. Locher and M. Schneckenburger, The Hague 1974; *Fotografie in Nederland 1940-1975*, exhibition catalogue, with text by Els Barents, Ingeborg Leyerzapf and others, The Hague 1978; *New Dutch Landscape*, exhibition catalogue, by Marc S. Gerstein, Cambridge, Massachusetts 1979; articles— "Demonstrative Fotografie" by Hans Gercke in *Das Kunstwerk* (Baden-Baden), March 1974; "Ger Dekkers" in *Flash Art* (Milan), December 1974/January 1975; "Ger Dekkers" by A. Von Berswordt-Wallrabe in *M-Bochum* (Bochum, West Germany), no. 3, 1976; "Ger Dekkers" by Betty van Garrel in *Volker Post* (Rotterdam), no. 4, 1978; "Ger Dekkers" by Dolf Welling in *Holland Herald* (Amsterdam), July 1979; "Ger Dekkers" by H.P. Platz in *Basler Magazin* (Basle), January 1980; "Ger Dekkers" by Fred Hazelhoff in *Foto* (Hilversum, Netherlands), September 1980; "Ger Dekkers" by Herman v. Buuren in *Bijvoorbeeld* (Amsterdam), no. 2, 1981.

My actual subject is the effect that our culture has on landscape. The Dutch landscape with its polders provides an excellent example.

I am aware that my work is a personal expression, in which my personality is one factor. My principal action—to record a situation that I encounter—I experience myself as an intruder.

My concern with the subject and its surroundings does not go further than emotionally choosing the angle of the camera and focussing it, and later on making a selection and carefully completing the process.

The horizon acts as a middle line in the square pictures: this gives a continuous line that runs throughout the series and thus the whole project.

The medium I use is another factor.

I find only a limited number of phototechnical possibilities important. It is not the gimmicks of photography that mean the most to me, but its very irrevocability, its inevitability. From these factors, but mainly, I hope, from its essence, my work derives its validity.

—Ger Dekkers

Until recently comparatively unknown, Ger Dekkers was first recognized for his photographs on calendars while he was working as a photographic collaborator with a graphic designer in a small commerical firm in Enschede. Then, at the *Atelier 6* exhibition at Amsterdam's Stedelijk Museum in 1969, Dekkers received attention from the art world as well. At that time, his work consisted of single photographs of landscape subjects. Simple, clear situations in which space, pattern and order were presented in a calm, precise and austere manner. What attracted the subsequent widespread critical attention was that Dekkers' photos were not commonplace: they have an unmistakable concept and shape of their own, and the undeniable presence of works of art.

The point of departure for his colour photographs is the desire to record situations in the landscape arising from man-made alterations, vegetation, weather conditions, or fauna. He never manipulates or interferes with his subject matter. The moment of choice and insight are important. He neither works with special exposures or exposure-times nor with extreme optical angles. For him developing and printing are first and foremost technical, not creative, processes. Only the position of the camera, the framing of the photograph, angle of light and time of day are allowed to determine the final picture. His aim is always a matter-of-fact realistic reproduction of some part of reality. The photos show a preference for great shapes, or a few simple shapes are grouped well-balanced round the centre or along one of the diagonals of the picture surface. The viewer is made more aware of spatiality, and hence the "ordinary" may be experienced as novel once more.

Dekkers began to make series of photos in 1971, the visible principles of ordering being a uniform size of 100 x 100cm and a limitation to a series of 4 related photographs. The total absence of human beings is typical. That is: the personal presence of human beings. Numerous traces of human existence are evident, even strongly emphasized—coloured tubes of synthetic material on a lawn, goalposts, electric cables, road surfaces, ensilaged grass, etc. Dekkers does not observe landscape as a piece of unspoilt scenery. Visible tension between culture and nature is the central theme. He has recently occupied himself with the way culture literally penetrates into nature and transforms it: a straightened ditch, purposeful plantings of a row of trees, a ploughed-up plot of land, etc. The series are arranged into analogous shots of allied objects, but also into series of various photos of the same subject with only a slight but continuous shift of viewpoint. Occasionally, a similar series is added, but taken at a different season. The different locations, distances and details fall into sequence with a continuous horizon. One's eye follows the camera, takes up position and joins it in its directional swings. This imbues the motif with spatial rhythms to produce landscapes of triptych-like unity.

Since 1973, Dekkers has been concerned with the coastal areas of Holland, and with the polders in particular. The polder is a paradigm of human intervention in nature, as it is land that has been reclaimed from the sea. Every feature of the landscape, every bit of woods and farmland has been planned and created by man in these programmed new spaces of Holland which are laid out as on a drawing-board in a mass of straight lines. In Dekkers' photos, the horizon line remains a major visual

component—a flat horizon which bisects the square image as nearly as possible: it remains in a fixed position through parts of the series and through a set of *Planned Landscapes* as a whole. Dekkers imposes order on the already highly-ordered landscape.

He divides his work into *Landscape Situations*, akin to art areas like "land art" or "earth works", and *Objects in a Landscape*, similar to "ready-mades" or "objets trouvés," with a certain surreal or superreal flavour. These art terms indicate that Dekkers looks at his themes in the context of his time, and his insights are related to the vision of many contemporary artists.

Dekkers is often compared to his compatriot photo-artist Jan Dibbets. But whereas Dibbets visualizes a concept of perception criticism, Dekkers remains in the sphere of immediate cognition. For Dibbets, who corrects perspective and rectifies both the camera lens and the eye, photography is a means of posing theoretical problems which have more to do with determinations of time than of place. Dekkers never tries to change the landscape, but sums up its angles and verses the eye in differentiated perception.

More importantly, however, in Dekkers' photographic groups, the work of art does not exist without the photographs. They are not mere clues to a process of mental and visual deduction, nor is their process the primary thing. The series are complete and self-sufficient. For Dekkers, the series is ultimately an account of a continuous and psychological response to the landscape.

—Colin Naylor

DELANO, Jack.
American. Born Jack Ovcharov in Kiev, Russia, 1 August 1914; emigrated to the United States, and subsequently naturalized. Educated at the Settlement Music School, Philadelphia, 1925-33 (scholarship student: studied violin, viola, and composition); Central High School, Philadelphia, 1928-32; Pennsylvania Academy of Fine Arts, Philadelphia, 1932-37 (Cresson Travelling Scholar, 1936-37), Dip. 1937. Served in the Air Transport Command, United States Army Corps of Engineers, 1943-46: Captain. Married Irene Esser in 1940; children: Pablo and Laura. Took first photographs while travelling in Europe, 1936-37; photographer with the Works Progress Administration (WPA) Project, New York, 1937-39; freelance photographer, working mainly for the United Fund, New York, 1939-40; Staff Photographer, under Roy Stryker, Farm Security Administration, Washington, D.C., and throughout the United States and Puerto Rico, 1940-43; Photographer, Government of Puerto Rico, 1946-47; Director of Motion Picture Services, Government of Puerto Rico, 1947-53; independent filmmaker, San Juan, Puerto Rico, 1953-57; Director of Programming, Puerto Rican Educational Television, 1957-64; General Manager, Puerto Rican Government Radio and Television Service, 1969; independent photographer, filmmaker, book illustrator, and graphics consultant, and music teacher at the Puerto Rico Conservatory, 1969-79. Since 1979, working as a photographer on grant from the National Endowment for the Humanities. Recipient: Guggenheim Fellowship in Photography, 1945;

Unesco Travelling Fellowship, Europe and Asia, 1960; Children's Art Books Award, with Irene Delano, Brooklyn Museum, New York, 1973; National Endowment for the Arts Grant, 1979. Agent: Sonnabend Gallery, 420 West Broadway, New York, New York 10012. Address: R.F.D. 2, Box 8-BB, Rio Piedras, Puerto Rico 00928.

Individual Exhibitions:

1938 *Anthracite Coal Miners*, Pennsylvania Railroad Station Gallery, Philadelphia
1977 Sonnabend Gallery, New York
1978 Art Students League, San Juan, Puerto Rico
1979 *Our Humility, Our Pride*, Springfield Museum of Fine Arts, Massachusetts

Selected Group Exhibitions:

1955 *The Family of Man*, Museum of Modern Art, New York (and world tour)
1962 *The Bitter Years*, Museum of Modern Art, New York
1976 *FSA Photographers*, Witkin Gallery, New York
1977 *Documenta 6*, Kassel, West Germany
1978 *Work*, Fine Arts Museum, San Francisco
1979 *Images de l'Amerique en Crise*, Centre Georges Pompidou, Paris
1980 *Les Années Ameres de l'Amerique en Crise*, Galerie Municipale du Chateau d'Eau, Toulouse, France

Jack Delano: *Children of a Poor Family, South Carolina*, 1941

DELANO

Collections:

Library of Congress, Washington, D.C.; New York Public Library; International Museum of Photography, George Eastman House, Rochester, New York; University of Louisville, Kentucky; Institute of Puerto Rican Culture, San Juan.

Publications:

By DELANO: book—*The Iron Horse at War*, with text by James Valle, Berkeley, California 1977; articles—"Educational TV in Puerto Rico" in the *San Juan Star*, 1964; "Documentary Photography" in *Southern Exposure* (Chapel Hill, North Carolina), 1977.

On DELANO: books—*Portrait of a Decade* by Jack Hurley, Baton Rouge, Louisiana 1972; *In This Proud Land* by Roy E. Stryker and Nancy Wood, Greenwich, Connecticut 1973; *A Vision Shared: A Classic Portrait of America and Its People 1935-43*, edited by Hank O'Neal, New York and London 1976; *Les Années Ameres de l'Amerique en Crise 1935-1942*, exhibition catalogue, by Jean Dieuzaide, Toulouse 1980; articles—"Jack Delano: Clicking in Puerto Rico for 30 Years" by Erin Hart in the *Sunday San Juan Star*, June 1975; "FSA Color" by Sally Stein in *Modern Photography* (New York), January 1979; "Jack Delano: Interview" by Ed Miller in *Combinations: A Journal of Photography* (Greenfield Center, New York), July 1979.

During the course of his career Jack Delano has worked, often simultaneously, as photographer, director of a national television service, book designer and composer. His interest in photography began in 1936 when, an art student in Pennsylvania, he travelled to Europe and took along a camera in order to record his trip visually. Four years later he was to join the Historical Section on the Farm Security Administration on the recommendation of Paul Strand.

At that time the FSA was very successful, with a record of important work behind it, and was preparing for its transition to the new kinds of work which would be necessary in time of war. Delano contributed greatly to the work of the Section, travelling first to Virginia and then on an extended journey around the Southern states. He also managed to work in some unique locations, so far as the Section was concerned. Alone of all FSA photographers he was sent overseas in order to document life in the Virgin Islands and in Puerto Rico—which was later to become his permanent home. Even within America itself he managed to gain access to locations formerly considered closed to the photographer. For example, he penetrated a defense plant and also was allowed to work inside Greensboro County Jail. The powerful photographs he took within that institution exemplify two major aims of documentary photography: they are moving representations of people living under extreme conditions and a straight record of the nature of life in a Southern jail at the time.

Jack Delano's work has been influenced by the work produced by other FSA photographers, notably by that of Walker Evans. In common with Evans he belongs to that group of photographers whose aim is to reveal, to demonstrate, the nature of things at a stroke, within the frame of a single, definitive photograph. This imposes on the photographer an exceptional concern for technique and consideration for compositional detail. In simple technical terms it meant, for example, that Delano often used an 8 x 10 camera rather than a 35 mm. But the use of a large format camera and a highly developed concern with composition must not be seen as an obsession with form. Delano has always been primarily concerned with recording and interpreting the ways of life and condition of human beings around the

world. His work has a unity and an integrity which transcends any formal considerations and made him into a fine and important documentary photographer.

—Derrick Price

DEL TIN, Toni.

Italian. Born in Maniago (PN), 1 February 1912. Educated at the Scuola di Paolo Sarpi, Venice, 1922-30; self-taught in photography. Served in the Italian Army, 1940-45. Married Olga Girotto in 1942; son: Donny. Director of Ditta Pagnan export/import business in Padua. Also a photographer, from 1950. Member, La Gondola group of photographers, Venice, 1955-63. Recipient: Gold Medal, *Concours d'Art Photographique*, Paris, 1953; Diploma, Foto-Cine Club Bandeirante, Sao Paulo, Brazil, 1954; Artiste Award, Federation Internationale de l'Art Photographique (AFIAP), 1955. Agent: Galleria del Cavallino, San Marco 1725, 30124 Venice. Estate: Olga del Tin, via Torino 18, 35100 Padua, Italy. *Died* (in Padua) *25 October 1973.*

Individual Exhibitions:

1952 *Lavoro dell'Uomo/Serenita*, Photo-Club, Tangiers

Toni Del Tin: *Nozze a Burano,* 1957

Sirena, Circolo Fotografico Corrado Ricci, Ravenna
1955 *Lo Zingaro*, Photo Guild, Frankfurt
Quattro Soldi di Felicita, A.D.A.F.A. Gallery, Cremona, Italy
1957 *Nozze a Burano*, at the *Photo Exhibition*, Karlstad, Sweden

Selected Group Exhibitions:

1952 *Salon Internationale*, Amicale Photographique, Roubaix, France
Mostra Nazional Fotografico Artistica, Circolo Fotografico Corrado Ricci, Ravenna
1954 *Salon Internacional*, Barcelona
1955 *Salao Internacional di Fotografia*, Sao Paulo, Brazil (and 1956)
1956 *Concurso Internazionale Fotografico Artistica*, Cineclub, Biella, Italy
1958 *Bifota*, Berlin
Salon Internacional, Barcelona
1980 *30 Anni di Fotografia a Venezia*, Palazzo Fortuny, Venice

Publications:

On DEL TIN: books—*Photography Yearbook*, edited by Norman Hall and Basil Burton, London 1955; *Anuario Brasileiro de Fotografia*, Sao Paulo, Brazil 1957; *The Picture History of Photography* by Peter Pollack, New York 1958, Milan 1959, 2nd edition New York 1969; *Bifota*, exhibition catalogue, by Heinz Bronowski, Berlin 1958; *70 Anni di Fotografia in Italia* by Italo Zannier, Modena 1978; *30 Anni di Fotografia a Venezia: Il Circolo "La Gondola" 1948-1978*, exhibition catalogue, by Italo Zannier, Venice 1980.

The history of photography in Italy has been characterized, in one way or another, by the tenets of "art photography," particularly since the Second World War: the newly-founded photographic clubs and societies, which attracted all those who were interested in this medium of expression, followed the "artistic" line, which was, after all, a central theme in discussions of photography throughout the world. While photojournalism was being reformed, after 20 years of censorship under the Fascists, around news magazines like *Tempo*, which, with Longanesi's *Omnibus*, was the first popular illustrated paper in Italy, and *Oggi*, *Epoca*, *L'Europeo*, etc., using the old but still functional press photograph agencies like Publifoto, Vedo, Farabola, etc.—at this time, some groups of young photographers, often amateurs, began agitating for an enquiry into the language and creative theories of photography, both through a few specialist journals (*Ferrania*, *Fotografia*, *Il Progresso Fotografico*, *Diorama*) and through discussions in the clubs themselves, which for years in Italy, given the absence of any organized official system of photographic education, carried out the function of schools.

The year 1947 saw the foundation of the group called "La Bussola" (The Compass)—Cavalli, Veronesi, Finazzi, Leiss, Vender—which could be compared with the Club 30 x 40 in Paris. It made its mark at once, both at home and internationally, with visual experiments based on "high key" solarization and geometric composition—an Italian style, luminous and precise. There was a clear cultural relationship with certain 20th century painting (notably Carrà and Morandi), and it provided an escape from the most obvious function of photography, that of "documentation," which it systematically rejected. This stance was apparent from the beginning: La Bussola published its first manifesto in *Ferrania* in May 1947.

In Venice in November of the same year, "La Gondola" group was founded; it was explicitly

based on the theories of "La Bussola," and among its founders were Monti, Bresciani, Scottola and Bolognini. Later they were joined by Toni Del Tin. He had a great influence on the style of this Venetian group, which very soon made an impression in European exhibitions, not merely in the salons of the pictorialist snapshot but also in such avant-garde institutions as Otto Steinert's *Subjektive Fotografie*, the influence of which had been strongly felt in Italy since the end of the 1950's.

The "School of La Gondola," as this Venetian club was soon dubbed and of which Del Tin was one of the masters, "has developed," Turroni wrote in an essay on Italian photography, "with study, tenacity and that innate delicacy that belongs to the artists of the lagoon, the main line of Italian photography, that of the aestheticizing Arcadia, of distant esoteric and literary relationships."

In those years Del Tin closely followed the activities of the new European photographers, particularly Bischof, who seemed, with his delicate pictures, to be half-way between "documentary" photography and "art" photography, those alternatives that remain for many photographers a perpetually teasing problem. "We believe in photography as an art," wrote Cavalli in the La Bussola manifesto, and he found a chorus of supporting voices, among them that of Del Tin, who at that time "felt the need to raise photography to the level of a modern art form." But, after a while, Del Tin began to withdraw from so narrow a view; he rejected hedonism; he applied himself to a serious study of other European photographers, about whom it was at last possible to learn through a now copious literature. Besides the work of Bischof, he studied that of Doisneau, Izis, and Boubat, from whom he extracted the qualities that appealed to his Venetian sensibility. He loved the dazzling light of the lagoon, which he renders in bright, clear pictures with a kind of sharp definition that others—like Gianni Berengo-Gardin, himself a "student" of La Gondola in the 1950's—have inherited and developed in a photography that has escaped from provincialism and from those art photography aesthetics of which, ironically, Del Tin was himself an influential protagonist in the years after the war.

—Italo Zannier

DEMACHY, (Leon) Robert.

French. Born in Saint Germain-en-Laye, Paris, 7 July 1859. Educated at Jesuit School, Paris; self-taught in photography. Served as volunteer in French Navy, 1877. Married Julia Adelia Delano in 1893 (divorced, 1909); sons: Charles and Jacques. Independent amateur photographer, Paris, 1882-1914; ceased photographic work completely in 1914, and thereafter concentrated on sketching, in Paris, 1914-16, and in Hennequeville, 1916-36. Member of the Editorial Committee, *La Revue de Photographie*, Photo-Club de Paris, 1894-1902. Member, Société Française de Photographie, Paris, 1882; Member, The Linked Ring Brotherhood, London, 1905. Honorary Member, Royal Photographic Society, London, 1905. Chevalier de la Légion d'Honneur, France, 1905. *Died* (in Hennequeville, near Trouville, France), *29 December 1936*.

Individual Exhibitions:

1895 Photo-Club de Paris
1901 Royal Photographic Society, London
1904 Royal Photographic Society, London
1907 Royal Photographic Society, London
Cercle Artistique et Litteraire, Brussels
1910 Royal Photographic Society, London
1911 Society of Amateur Artists, Paris
Demachy Studio, Paris
1931 Studio Saint-Jacques, Paris (retrospective; with Cammille Puyo)
1973 Royal Photographic Society, London
1977 Musée Nicéphore Niepce, Chalon-sur-Saône, France
1980 Trianon de Bagatelle, Paris (travelled to Palazzo Fortuny, Venice, 1981)

Selected Group Exhibitions:

1892 *International Exhibition of Photography*, Palais des Beaux-Arts, Paris
1894 *The Photographic Salon*, London (and annually, 1894-1904)
Exhibition of Photographic Art (Photo Club de Paris), Galerie Durand-Ruel, Paris
1900 *Photos from Newark Camera Club*, Association Building, Newark, Ohio

Robert Demachy: *Tuna Boats at Concarneau*, 1910

1959 *Hundert Jahre Photographie 1839-1939*, Museum Folkwang, Essen (travelled to Cologne and Frankfurt)

1965 *Un Siècle de Photographie*, Musée des Arts Décoratifs, Paris

1979 *Paris-Moscou 1900-1930*, Centre Georges Pompidou, Paris

Collections:

Bibliothèque Nationale, Paris; Photo-Club de Paris; Société Française de Photographie, Paris; Royal Photographic Society, London; Metropolitan Museum of Art, New York; Gernsheim Collection, University of Texas at Austin.

Publications:

By DEMACHY: book—*Photo-Aquatint or the Gum Bichromate Process*, with Alfred Maskell, London 1897, as *Le Procède à la Gomme Bichromatée*, Paris 1898; *Gum Bichromate Printing*, with others, London 1905; *Les Procèdes d'Art en Photographie*, with Camille Puyo, Paris 1906; *How to Make Oil and Bromoil Prints*, with C.H. Hewitt, London 1908; *How to Make Oil and Bromoil Prints: The Rawlins Process*, London 1908; *Le Report des Epreuves à l'Huile*, Paris 1912; *How to Make Oil and Bromoil Prints in Monochrome and Colour*, with others, London 1914; *Robert Demachy: Un Portfolio de Seize Photographies Rares*, with a text by Romeo Martinez, Lausanne 1975; New York 1978. *Robert Demachy 1859-1936: Photographs and Essays*, edited by Bill Jay, London and New York 1974; articles—"The Paris Photographic Salon" in *British Journal of Photography* (London), 30 July and 6 August 1897; "The Gum Bichromate Process" in *The Photographic Journal* (London), 28 April 1898; "A Few Notes on the Gum Bichromate Process" in *Photographic Times* (London), vol. 30, no. 8, 1898; "The Training of the Photographer in View of Pictorial Results" in *American Annual of Photography and Photographic Times Almanac*, New York 1901; "The American School of Photography in Paris" in *Camera Notes* (New York), vol. 5, no. 1, 1901-02; "Open Letter on the State of Pictorial Photography in France and England" in *Camera Work* (New York), no. 18, 1904; "Notes by Mr. Demachy on His Prints" in *The Practical Photographer*, London 1905; "My Experience of the Rawlins Process" in *Camera Work* (New York), October 1906; "Bromide and Oils" in *Amateur Photographer* (London), 2 April 1907; "On the Oil Process" in *Amateur Photographer* (London), 9 July 1907; "On the Oil Transfer Process" in *The Photographic Journal* (London), July 1911.

On DEMACHY: books—*Photographers on Photography*, edited by Nathan Lyons, New York 1966; *The Magic Image* by Cecil Beaton and Gail Buckland, London and Boston 1975; *Geschichte der Fotografie im 20. Jahrhundert/Photography in the 20th Century* by Petr Tausk, Cologne 1977, London 1980; *Robert Demachy*, exhibition catalogue, edited by Paul Jay, Chalon-sur-Saône 1977; *The Collection of Alfred Stieglitz* by Weston J. Naef, New York 1978; *The Photograph Collector's Guide* by Lee D. Witkin and Barbara London, Boston and London 1979; *The Linked Ring* by Margaret Harker, London 1979; *Robert Demachy: Fotografo*, exhibition catalogue, by Carole Naggar, Milan 1980; articles—"The Exhibition of Works by Robert Demachy" in *Photography* (London), vol. 13, no. 655, 1901; "Notes on Three Examples of the Work of Robert Demachy" by Frederick H. Evans in *Amateur Photographer* (London), 12 November 1903; "The Pictorial Work of Robert Demachy" in *The Practical Photographer*, edited by F.C. Lambert, London 1904; "Robert Demachy" by Joseph T. Keiley, in *Camera Work* (New York), no. 5, 1904;

"M. Demachy's Oil Prints at the Royal Photographic Society" in *British Journal of Photography* (London), 14 June 1907; "Robert Demachy" by Margaret Harker in *Photographic Journal* (London), July 1973; entire issue of *Camera* (Lucerne), December 1974.

For more than 40 years, from 1894-1934, Robert Demachy was recognized as the greatest photographic artist that France had produced. The son of a prosperous Parisian banker, he could afford to devote most of his life to his enthusiasms. He was a talented painter and an accomplished violinist as well as being a distinguished photographer. Demachy's work gained rapid recognition for its evocative and expressive interpretation of beauty in his own inimitable style. His subjects almost invariably included people, mostly women and young girls, who provided the inspiration for his exquisite semi-draped nudes, the genre studies of slender little ballet dancers waiting "off-stage" for their turn, and people in groups or singly in idealized landscapes and picturesque street scenes.

Demachy's success and recognition as a photographer was due to his artistic insights and ability to select his subjects for their aesthetic qualities, as well as his command of the medium, especially the controlled printing processes of Photo-Aquatinting (Gum Bichromate printing) and Oil Pigment Painting, which he and Alfred Maskell pioneered and developed. The control which these processes permitted enabled him to give prominence to those parts of the subject he considered merited attention at the same time that he was able to reduce unwanted detail and eliminate undesirable features. This combination of artistic and technical skills resulted in photographic imagery of unique distinction.

The period during which he produced his exhibition photographs—c. 1890-c. 1914—was characterized by the Secession Movement in photography, the imagery being located within Pictorialism. The influence of the Aesthetic Movement and Symbolism in painting is reflected in photographs of this period, and Demachy's work is no exception. Many of his photographs convey meaning over and above the factual information they impart. For instance, "Dans les Bois" features a young girl, her hair and gossamer clothing shimmering in the "contrejour" lighting, in a woodland clearing. Why is she there alone? What is she thinking as she looks demurely towards the camera? Is she flesh and blood or a figment of the imagination?—a wood sprite, perhaps? In "En Bretagne III" Demachy has brought together three women, a child and a young boy. They are curiously dis-associated, and yet the picture is held together by the vibrant forward thrust of the boy's body, the steady gaze of one of the women who, with the child, watches a passing procession (hinted rather than stated), and the blatant hostility of the two peasant women who are seated together in the foreground. It is a fascinating photograph.

All the Demachy portraits have more to offer than facial and figure resemblances. None more so than his *jeunes filles du ballet*. These photographs convey the spirit and atmosphere of the twilight world behind the stage and the superb bodily rhythms and postures, even in repose, of the small dancers. Some of his portraits reveal Demachy's interest in Art Nouveau, and his subjects, decorative in themselves, are dressed in the typical flowing draperies: the photographs are sanguine gum prints. "Coquetterie," a delightful study of two semi-draped nudes, has sensuous rhythms and nuances of light and shade enhanced by Demachy's discreet control of the medium.

Many of Demachy's photographs have qualities long associated with painting, charcoal drawing and aquatinting, but not with photographic imagery: his work and that of Alfred Maskell was original and stimulated others to follow suit. His detractors denounce his work as being imitative of these media.

Demachy would strongly deny such a charge, claiming with vehemence that it is the end result that matters, not the means to achieve that end. In his articulate writings he went to some pains to point out that it is not manipulative ability with the medium of photography which produces the work of art but the knowledge of *where* to put the accents, *where* to reduce detail and *where* to subdue or emphasize form, rather than how to do it.

—Margaret Harker

den HOLLANDER, Paul.

Dutch. Born in Breda, 5 July 1950. Studied at St. Joost Academy of Fine Arts, Breda, 1968-73. Married Annemarie Aardewerk in 1980. Freelance photographer, Breda, since 1976. Recipient: City of Breda Prize, 1973; Grand Prix International de la Recherche Photographique, Arles, 1981. Address: Haagweg 386, 4813, XG Breda, The Netherlands.

Individual Exhibitions:

1976 Canon Photo Gallery, Amsterdam
1978 Galerij Paule Pia, Antwerp
 A.B.N. Gallery, Amsterdam
 Centro Culturale, Modena, Italy
1979 Fotomania, Barcelona
 Internationaal Cultureel Centrum, Antwerp
 Galerie Phot'Oeil, Paris
 Canon Photo Gallery, Amsterdam
1980 Kruithuis Cultural Centre, Den Bosch, Netherlands
 Galerie Voir, Toulouse
 Photographic Centre, Athens
 Photogallery, Thessaloniki
 Cultural Centre, Hasselt, Belgium
1981 Canon Photo Gallery, Geneva
 Galleria Il Diaframma, Milan
 Galerie Suzanne Kupfer, Nidau-Biel, Switzerland

Selected Group Exhibitions:

1972 *Ooggetuige*, Ministry of Cultural Affairs, Amsterdam (toured The Netherlands)
1978 *Photography since 1955*, at *Arte Fiera*, Bologna
1979 *Fotofacetten*, Kruithuis Cultural Centre, Den Bosch, Netherlands
 Aspecten der Hedendaagse Fotografie, Stedelijk Museum, Schiedam, Netherlands
 Dutch Landscape, Canon Photo Gallery, Amsterdam
 Fotografie als Kunst/Kunst als Fotografie, Tiroler Landesmuseum, Innsbruck
 Foto 78, Ministry of Cultural Affairs, Amsterdam (toured The Netherlands)
1980 *Triennale Internationale de Photographie*, Palais des Beaux-Arts, Charleroi, Belgium
 New Dutch Photography, Canon Photo Gallery, Paris

Collections:

Stedelijk Museum, Amsterdam; University of Leiden; Musée Royale des Beaux-Arts, Brussels; Het Sterckshof, Antwerp; Musée Nicéphore Niepce, Chalon-sur-Saône, France; Bibliothèque Nationale, Paris.

Publications:

On den HOLLANDER: books—*Kunst als Fotografie/Fotografie als Kunst*, exhibition catalogue, by Peter Weiermair, Innsbruck 1979; *Nederlands Landschap/Dutch Landscape*, exhibition catalogue, by Lorenzo Merlo, Amsterdam 1979; *New Dutch Photography* by Lorenzo Merlo, Amsterdam 1980.

Paul den Hollander once said: "I take photographs to allow other people to share my experiences. My photography is an image-reflection of what goes on in myself." With that statement, he almost places himself in the tradition of the New Objectivity—photography as a means to realize your place in the world and as a medium to convey it to others.

den Hollander's photographs are compositionally balanced and reveal a quiet world in which people create things then leave them behind, almost as if they are no longer important—cultural/social landscapes, parks, roads, farmland, towns and buildings. Often his works are almost graphic illustrations of abstract structures: sides of houses, a row of garden chairs, line reflections near a stair-shaft, the architecture of Versailles.

The human being plays only a passive, impersonal role in his work. He is shown as a blurred passer-by or as a shadow in his own landscape. No need to distinguish him. Sometimes he is suggested only in the form of a departing car, a piece of paper thrown away, or footprints in the sand.

den Hollander tries to record with his technically and compositionally fine photographs the continuously changing process of the world. "In my photographs everything is equally important," he says. "The landscape is not a background nor is the passer-by most important. I aim to create so that space and the human being merge together. I do not analyze situations in which reality collapses. It is of more importance to keep the experience of totality—and is it not true that in reality things happen by accident and none of the elements has our exclusive attention?"

—A. de Jonge-Vermeulen

Paul den Hollander: *Brighton,* 1978

de NOOIJER, Paul (us).

Dutch. Born in Eindhoven, 15 June 1943. Studied industrial design at the Akademie voor Industriele Vormgeving, Eindhoven, 1960-65. Married Francoise Neeteson in 1965; son: Menno. Freelance advertising/illustration photographer, Eindhoven, 1968-73. Freelance photographer and filmmaker, Eindhovern, since 1974. Guest Instructor, Vrije Akademie, The Hague, 1974; Instructor in Photography, G.I.K.O., Helmond, 1975-76; Guest Lecturer, Adademie St. Joost, Breda, 1978, and Academy of Arnhem, 1978; Guest Instructor, Gerrit Rietveld Akademie, Amsterdam, 1979. Since 1978, Instructor, Akademie voor Beeldende Vorming, Tilburg. Recipient: Municipal Prize, Eindhoven, 1968; Grand Prix Internationale de la Photographie, Royan, France, 1974; Bronze Medal, *International Triennale of Photography*, Fribourg, 1975; Dutch Ministry of Cultural Affairs Fellowship, 1975, 1976, 1977; First Prize, *West Deutsche Kurz Film Tage*, Oberhausen, 1979. Address: Postbus 943, 5600 AX Eindhoven, Netherlands.

Individual Exhibitions:

1974	Canon Photo Gallery, Amsterdam
	Galleria Il Diaframma, Milan
	Art Center, Venlo, Netherlands
1975	Galleria Broletto, Varese, Italy
	Galerie 5.6, Ghent
	Galeria Spectrum, Barcelona
	Photographers Gallery, Melbourne
	't Meyhuis, Helmond, Netherlands
1976	Galerie 2.8, Mechelen, Belgium
	Cultureel Centrum, Tilburg, Netherlands
1977	Galerie Fiolet, Amsterdam
	Stedelijk Van Abbemuseum, Eindhoven, Netherlands
1978	Photographers Gallery, Saskatoon, Saskatchewan
	Photo/Graphic Gallery, Seattle
	Nikon Gallery, Zurich
	Galerie Jesus Moreno, Geneva
	Galerij Paule Pia, Antwerp
	Trockenpresse Galerie für Fotografie, Berlin
	Photo Art Gallery, Basle

Selected Group Exhibitions:

1974	*Salon Internationale de la Recherche Photographique*, Royan, France

	4 Dutch Photographers, Fotogalerie Die Brücke, Vienna (travelled to the Internationaal Cultureel Centrum, Antwerp)
	Op-th-iek, University of Eindhoven, Netherlands
1975	*6 Dutch Photographers*, The Photographers' Gallery, London
	Sequences, Stedelijk Museum, Amsterdam
	Fantastic Photography in Europe, at Rencontres Internationales de la Photographie, Arles, France (toured Europe and the United States, 1976-79)
1978	*Tusen och En Bild/1000 Pictures*, Moderna Museet, Stockholm
1979	*Beelden van de Eigen Werkelijkheid*, Van Reekum Museum, Apeldoorn, Netherlands

Collections:

Stedelijk Museum, Amsterdam; Ministry of Cultural Affairs, Amsterdam; Prentenkabinet, Rijksuniversiteit Leiden, Netherlands; Stedelijk Van Abbemuseum, Eindhoven, Netherlands; Bibliothèque Nationale, Paris; Moderna Museet, Stockholm.

Publications:

By de NOOIJER: books—*Losing One's Head*, with an introduction by Ingeborg Th. Leijerzapf, Eindhoven, Netherlands 1978; *Losing One's Photos*, Eindhoven, Netherlands 1981; articles—"Pierrot" in *Avenue* (Amsterdam), no. 2, 1977; "De Jaguar Club" in *Avenue* (Amsterdam), no. 7, 1977; "Moderne Architectuur" in *Avenue* (Amsterdam), no. 10, 1977; films—*The Pie*, 1975; *Say Goodbye*, 1975; *Extra Ball*, 1976; *Transformation*, 1976; *Review*, 1976; *Tarzan and Jane*, 1977.

On de NOOIJER: books—*Geschichte der Fotografie im 20. Jahrhunderts/Photography in the 20th Century* by Petr Tausk, Cologne 1977, London 1980; *Dumont Foto 1*, edited by Hugo Schöttle, Cologne 1978; *La Photographie Fantastique* by Attilio Colombo, Paris 1979; *Beelden van de Eigen Werkelnkeid* by Jerven Ober, Apeldoorn, Netherlands 1979; articles—"Royan: Le Festival '74" by Jean-Claude Gautrand in *Photo Review* (Paris), June 1974; "Paul de Nooijer" by Jean Gohelle in *Le Nouveau Photocinema* (Paris), no. 11, 1974; "Imagenes-Imaginadas" by Jean-Claude Gautrand in *Nueva Lente* (Barcelona), April 1975; "Paul de Nooijer: Between Concept and Intuition" by Marco Misani in *Print Letter* (Zurich), 9/10, 1978; "Paul de Nooijer: Tussen Retro en Veto" by Filip Tas in *De Standaard* (Antwerp), 13 October 1978; "Paul de Nooijer" by Aloys Ginjaar in *Foto* (Amsterdam), no. 9, 1978; "Paul de Nooijer" by Frits Oppenoorth in *Avenue* (Amsterdam), no. 3, 1979.

If I had to choose the two contemporary photographers who have most known how to construct a more intense personal world by means of the absurd, I would choose Les Krims in the United States and Paul de Nooijer in Europe. Both possess a particular morbidity—the former is caustic, the latter sarcastic—and for both of them the image is a provocation, but the photos of de Nooijer are more fantastic, more humorous.

If we accept Umberto Eco's thesis that artistic reaction distinguishes different levels of codification, then without a doubt the psychological and aesthetic would be the most preponderant in de Nooijer's work. In effect, if we carefully examine his photographic world, we discover a series of constants: a delight in certain fetishes; oppressive surroundings; dramatic landscapes; similar but always surprising incongruities. Is an image by de Nooijer a re-play of a nightmare or is the world really like that, at least for those who have been endowed with perspicacity?

This same question is still incessantly asked about the work of Hieronymus Bosch, and the uncertainty that he provoked is still his major attraction. This comparison should not seem completely inappropriate, since both artists share in good measure the same "ironic space." What distinguishes them, naturally, is the ontology of the different languages they employ. Bosch moved his brushes according to the dictates of his lucid imagination. De Nooijer implies that all we see in the cliché comes from the truth. The very creator oversteps the mere photographer in order to enter into the scenography, into the *mise-en-scène* or into the art of the "happening." The model actors represent their roles in a wild theatrical representation that has a finality, an end established in a photosensitized format. Why does de Nooijer choose the photographic medium as the vehicle of his conceptions? Evidently for the (apparent) fidelity of reproduction. The scenes are elaborated with such detail, the facial expressions are so apt, that it is

best to reproduce them as they are, very precisely.

But, fortunately, Paul de Nooijer is not a purist; he does employ the creative resources of photography to reinforce the general effect of his work. And they are so well realized that his aesthetic code is one of the most identifiable among contemporary photographers of the actual. Two elements are most typical: a bold texture, which adds a certain turbulence while it compresses the planes and creates a more pictorial resolution; and the use of the wide-angle lens to amend reality, distorting the human body and creating impossible spaces. His non-purist attitude sometimes carries him away—for example, when he paints prints by hand, producing a coloration of "short-circuit hallucination."

No one is ever going to know whether de Nooijer is a genius who experiences revelations or a lunatic who experiences fantasies—but it does not much matter, just so long as he continues using his expressive facilities and his dominion over his medium in

the ways he has done so far. For we need revolutionaries of the collective conscience, who keep alive a vision of the "great theatre of the absurd"—that is to say, life.

—Joan Fontcuberta

Paul de Nooijer: *Upstairs, Downstairs,* 1978

DEPARDON, Raymond.

French. Born in Villefranche-sur-Saône, 6 July 1942. Studied at an agricultural school in Lyons. Served in the French Army, as a war reporter in Algeria, 1962-63. Worked as an assistant to a commercial photographer, Paris, 1958-60; photographer with Agence Dalmas, Paris, working for *Life, Paris-Match,* etc. 1960-62, 1963-66. Freelance photojournalist, Paris, since 1967. Founder Member, with Gilles Caron, Hugues Vassal and Hubert Henrotte, Agence Gamma photographers agency, Paris, 1967-70. Member, Magnum Photos, Paris, since 1978. Recipient: Prix Georges Sadoul, for film, 1980. Address: c/o Magnum Photos, 2 rue Christine, 75006 Paris, France.

Individual Exhibitions:

1974 *Chili,* Galerie FNAC, Paris (with David Burnett and Charles Geretsen)

Selected Group Exhibitions:

1981 *Paris Magnum,* Palais du Luxembourg, Paris

Publications:

By DEPARDON: books—*Chili,* with David Burnett and Charles Geretsen, Paris 1973; *Tchad: Images de Guerre,* Paris 1978; *Notes Arfuyen X,* Paris 1979; films—*Ian Pallach,* 1969; *Yemen,* 1972; *Tibesti Two,* 1976; *Numeros Zeros,* 1977; *Reportages,* 1981; *San Clemente,* 1981; articles—"Raymond Depardon: Le Profil du Photographe Journaliste de 1980," interview, with Robert Y. Pledge, in *Zoom* (Paris), December 1970; Interview in *Cahiers du Cinema* (Paris), December 1979; "Reportages: Un Film de Raymond Depardon," interview, with Michael Maingois, in *Zoom* (Paris), July/August 1981.

On DEPARDON: articles—"Raymond Depardon: Auschwitz: La Memoire" in *Photo* (Paris), May 1979; "Photojournalism's Fearless Point Man" in *American Photographer* (New York), September 1980.

What is it, then, that makes Raymond Depardon run?

A certain intellectual discomfort and internal contradictions. That, at least, is his own analysis. One is tempted to believe that this analysis is erroneous because the individual and the photographs are harmonious and express generous bursts of humanism. But the facts and the intentions of his life and work demonstrate his lucidity.

Depardon has belonged to several agencies—he even founded one of them: Gamma—but he seems always to have felt an uneasiness in such groupings, both morally and materially, and he is never able to decide whether to remain independent: put another way, he feels at ease neither in an agency nor outside of one. He avoids like the plague that which he calls

the "pseudo-artistic ghetto of the photograph" and the tendency to create "beautiful" pictures. But his own pictures are beautiful, even when they bear witness to tragedy, which comes from another kind of restlessness ("I am torn," he says, "between aestheticism and content"). Above all, he dreads the picture that bears the conventional mark of the photojournalist ("a kind of cowboy romantic"), but he well realizes—another complication—that his own notoriety came to him from his perilous campaigns in those regions where blood was flowing—and where he was forced, against his own nature and a nauseating fear, to play the hero of reportage. He works alone, but he devoutly asks for the judgment of his peers. He yearns for authenticity, but he suffers in his professional relations with those "in high places" from having to behave as a character of convention ("the photographer, this puppet, this buffoon") in charge of trying to validate the "show business" game of politicians. He is a photographer, but he says (it is not necessary to believe him) that "this is by accident," brought about by the cinema. And when he places himself behind the camera to shoot films that he knows are commercially unviable, do we see that in his vision? His brothers, the photojournalists—that is to say, himself—are detached from that primary function which fascinates and consumes him. Voilà, it is tied together; the introspection is recorded on film.

Far from sterilizing him, his uncertainties stimulate Depardon. So high does he tower—even if he is not alone—over French photojournalism. That agencies now treat reporters better than they did—to a great extent, his colleagues owe that change to him. That photographs are used that are faithful to the spirit of the photographer, without an alteration of meaning—for this, they are also indebted. That the exploitation of bloody scenes has been denounced—for this too, credit is due him. That the spirit of Capa lives, that it is possible for a photographer to adhere to a cause, that there has been a restoration of an attitude of militancy in photography—for all of these things, we are indebted to Depardon. Beyond the work, in which the strength and quality are beyond dispute, there is a great leader in the man himself.

—Roger Therond

DESCAMPS, Bernard.
French. Born in Paris, 16 January 1947. Studied biology at the University of Paris, 1967-72, D.Sc. 1972. Married Marie Claude in 1969; children: Regis and Sebastien. Scientific Research Assistant and Instructor, University of Paris, 1971-75. Professional freelance photographer, Paris and Chinon, since 1975. Agent: Galerie Agathe Gaillare, 3 rue du Pont Louis-Philippe, 75004 Paris; and Suzan Kupfer, Photogalerie 11, 11 rue Principale, 2560 Nidau, Switzerland. Address: Le Pressoir, 37500 Chinon, France.

Individual Exhibitions:

1973 Odeon Photo, Paris
1974 Galerie-Librairie de Seine, Paris
 Creative Camera Gallery, London
1975 Galerie M, Bochum, West Germany (with Florence Henri)
 Shado Gallery, Oregon City, Oregon
1976 Ilford Gallery, Brussels
 Canon Photo Gallery, Amsterdam
1977 Galerie Noir et Blanc, Paris
 Galerie L'Oeil 2000, Chateauroux, France

Städtisches Museum, Leverkusen, West Germany (with André Kertesz)
1978 Museé d'Art Moderne, Centre Georges Pompidou, Paris
1979 Musée Réattu, Arles, France
 Galerie Pennings, Eindhoven, Netherlands
1980 Galerie Le Stenope, Nice
1981 Galerie Agathe Gaillard, Paris
 Photogalerie 11, Nidau, Switzerland
 Atelier Photo-Regard, Blois, France

Selected Group Exhibitions:

1975 *4 Photographes*, Bibliothèque Nationale, Paris (with Plossu, Bruno, and Kuligowski)
1977 *La Photographie Créatrice aux XX Siècle*, Centre Georges Pompidou, Paris
1978 *La Photographie Actuelle en France 1978*, Galerie Contrejour, Paris (and world tour, 1978-81)
 Concerning Photography, The Photographers' Gallery, London (travelled to the Spectro Workshop, Newcastle-upon-Tyne)
1979 *6 Photographes en Quête de Banlieues*, Centre Georges Pompidou, Paris (with Doisneau, Le Querrec, Raimond-Dityvon, Lattés, and Freire)
 Bruxelles Photographique, L'Association Intercommunale Culturelle, Brussels (toured Belgium, and travelled to the Centre Culturel Belge, Paris)
1980 *10 Photographes pour le Patrimoine*, Centre Georges Pompidou, Paris

Collections:

Bibliothèque Nationale, Paris; Musée d'Art Moderne, Paris; Musée Réattu, Arles, France; Musée Cantini, Marseilles; Fondation Nationale de la Photo, Lyons; Stedelijk Museum, Amsterdam; Städtisches Museum, Monchengladbach, West Germany.

Publications:

By DESCAMPS: books—*Rencontres*, Paris 1976; *Bernard Descamps: Photographies*, Leverkusen, West Germany 1977; article—text in *10 Photographes pour le Patrimonie*, exhibition catalogue, Paris 1980.

On DESCAMPS: books—*Bernard Descamps: Photographies*, exhibition catalogue, with introduction by Jean-Claude Gautrand, Chateauxroux, France 1978; *Histoire de la Photographie Française* by Claude Nori, Paris 1978; *Jeune Photographie*, Lyons 1980. articles—by Allan Porter in *Camera* (Lucerne), November 1974; by Roger Doloy in *Arte Fotografico* (Madrid), April 1976; by Robert Lescure in *Photo Revue* (Paris), February 1979; in *Creative Camera* (London), June 1979; in *Photo Reporter* (Paris), December 1979; in *Fotografie* (Göttingen), no. 9, 1979; by Maurice Genevoix in *Culture et Communication* (Paris), November 1980.

Photography to me nowadays is something simple—I mean, in the way I go about it.

The camera is the extension, both natural and indispensable, of my visual sensibility, a recorder of feelings and visions.

My photographs are an encounter, a profound but instantaneous interchange between a moment of myself and a "subject," whether it be an object, place, situation or individual.

My technique is minimal, neutral, so that I may remain faithful and close to this encounter which is so fragile and difficult to capture.

Every day I capture in flight a flood of fleeting images: they make up a "different reality," whether it is *the* reality" or *my* reality," my image of the world, myself through my encounters.

I walk alone, recording my emotions in everyday space, where I travel according to chance desires.

Among the multitude of captured images, there are sometimes those that go beyond self, which are ahead of me, which are a result of my dreams and hidden desires, of my subconscious. It is usually these images that I select, which through interpretative printing, become photographs.

—Bernard Descamps

There is an age-old antagonism between "image" and "word" in which, in general, extreme positions have prevailed. Yet the Gutenburg world has not disappeared with the world of Niepce, nor will it disappear with the world of Marconi. They merely influence and compliment one another.

Bernard Descamps: *Untitled*, 1979

The image is a poly-semantic statement or message—i.e., subject to various possible interpretations. For this reason, many photos carry a legend which clearly defines the meaning. What might seem a limitation to effective communication is actually a great advantage to effective expression, or so, at least, some photographers believe.

Observing the works of Bernard Descamps, for example, one asks himself: why are they so ambiguous? Why does Descamps make ambiguity his banner? An initial response might be that from the ambiguous nature of the image stems its evocative power. Another response, no less valid, is that the photographer might assume reality itself to be ambiguous. From this metaphysical revelation, the photographer would wish to demonstrate that things are as we wish to see them—that their arrangement in a given context and their more or less paradoxical relationship to that context depends on the consciousness of the observer. Reality does not exist in and of itself but as a function of our experience. Perhaps from here one can go a step further to the theoretical contribution of Minor White when he affirms that creation stems from the "mystical state of seeing." Descamps seems to suggest, in addition, that reality itself is affirmed and even shaped by our vision.

Without a doubt, external reality, like its representation, allows many readings—from the literal interpretation defined by cultural conventions to the intuitive interpretation found in the work of Descamps. Here commonplace objects come to reveal occult dimensions, at times mystical, at times absurd, but always in conflict with the familiarity of the objects. In his own words, Descamps deals with "subversion of the glance." And this subversion is supported by an unusual and turbulent aesthetic. The work of Descamps is sufficiently agile so as not to require a set of stylistic tables. Empty spaces and imbalances predominate. The graphic constitution of the image appears at times baroque owing to the great density of elements which introduce new information.

There is no gratuitous formalism, but rather the opposite, the maximum economy of means, a naked vision, a piece of reality captured through the rectangular window of the camera. Disproving the effects of all concession to gratuitous aesthetics, Descamps shapes a final image with precision, despite the risk of its being interpreted contrarily. He reaches a reality-image interaction without artificiality despite the danger that the spectator might view it as creative barrenness. These seem to be the norms that Descamps has imposed upon himself in his strange, rigorous and enduring "ambiguous vision."

—Joan Fontcuberta

DIAS, Pavel.

Czechoslovak. Born in Brno, 9 December 1938. Studied drawing and photography, under K.O. Hrubý, at the Middle Art School, Brno, 1954-58, and photography and filmmaking, at the Academy of Musical Arts, Prague, 1958-63. Married Hilda Misurova in 1961; son: Marek. Assistant Cameraman, Czechoslovak Film Studio, Gottwaldov; subsequently Photographer, Barrandov Film Studio, Prague, 1959-61, and Central Institute of Folk Arts, Prague, 1963-65. Freelance photographer, working for *Mladý svet, Svet v obrazech*, etc., Prague, since 1965. Member, Czech Art Photography Society, and Union of Czech Journalists. Address (studio): Makarenkova 51, 120 00 Prague, Czechoslovakia.

Individual Exhibitions:

1961 *Bartušek/Dias/Hucek*, Lucerna Ciné, Prague
1963 Jaromir Funke Fotokabinett, Brno, Czechoslovakia
1964 Malostranská beseda, Prague
1965 Gallery, Luhačovice, Czechoslovakia
 Klutzr House, Gottwaldov, Czechoslovakia
1966 Foto-Gallery, Děčín, Czechoslovakia
1979 *Without Blinkers*, Gallery D, Prague
 Torso, Osvětim Museum, Osvětim, Poland (travelled to Sachsenhausen Museum, Oranienburg, East Germany, 1980)
1980 *Turf*, Gallery Pardubce, Pradubice, Czechoslovakia
1981 *Without Blinkers*, Jaromir Funke Fotokabinett, Brno, Czechoslovakia

Selected Group Exhibitions:

1963 *Photographers of Mladý svět*, Prague

Publications:

On DIAS: articles—"Chceme vidět život ve vsem" by J. Spousta in *Ceskoslovenská Fotografie* (Prague), no. 3, 1961; "Medailon-foto" in *Mladý svět* (Prague),

Pavel Dias: From the series *Without Blinkers*, 1979

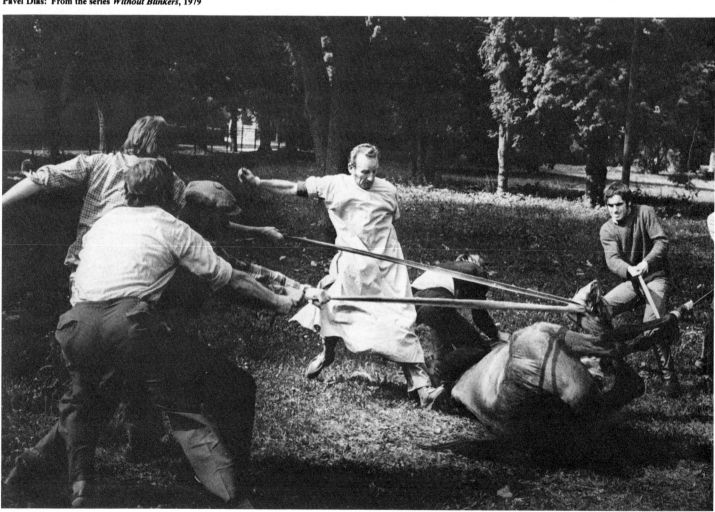

no. 2, 1962; "Pavel Dias fotograf" by I. Soeldner in *MY 64* (Prague), no. 4, 1964; "Medailon Pavel Dias" in *Ceskoslovenská televize* (Prague), no. 5, 1964; "Paris by Pavel Dias" in *Svět v obrazech* (Prague), no. 2, 1969; "Pavel Dias" by K. Dvořák in *Ceskoslovenská Fotografie* (Prague), no. 4, 1969; "Mongolsko by Pavel Dias" in *Mladý svět* (Prague), no. 7, 1969; "Concentration Camps" in *Mladý svět* (Prague), no. 2, 1974; "Torso" by O. in *Ceskoslovenská Fotografie* (Prague), no. 5, 1979; "Pavel Dias" by Karel Dvořák in *Fotografie* (Prague), no. 12, 1979; "Pavel Dias" in *Ceskoslovenská televize*, (Prague), no. 1, 1981.

I was interested at first in drawing, and for that reason I enrolled at the Střední uměleckoprmyslová škola (Middle Art School) in Brno. But Professor K.O. Hrubý at the school influenced me in the direction of photography. I discovered that photography, far from being only a technically strict reproduction of reality, is a formally technical art. And Steichen's book *The Family of Man* had a strong impact on me. My interest in drawing gradually lessened, and I began working at the film studio in Gottwaldov and at the Barrandov Film Studio in Prague. These meetings, and meetings with film directors, cameramen and actors, my contributions to daily newspapers and magazines, meetings with newsmen, and, most importantly, the events of my daily life, were all very important for the formation of my views. After completing my studies at the film faculty in Prague, I began to concentrate on documentary photography. I studied the works of Cartier-Bresson, Robert Capa, Werner Bischof, David Seymour, Dorothea Lange, etc. Among Czech photographers the great influence was the Photo-Film Group of the Left Front, mainly R. Kohn. My photos were published in some cultural magazines. After a couple of years of freelance photojournalism, I discovered something about myself: I prefer to work with thematic series or cycles.

My first important series was of Nazi concentration camps, photos taken 20 or 30 years after the Second World War. These photos document impressions created by the places and their local details—thirty years after the events. I also took photos of more recent human horror, and the resultant series got the name *Torso*. It is meant as a warning.

Another theme is horses, the people around them, and their world. The horse has always been man's best helper; nevertheless, the number of horses in the world today is less than it used to be, and some breeds are nearly extinct. I believe, however, that the horse—a long-time friend and natural partner of man—will, in this "over-civilized" world, again become important as an aid to man's psychological balance. The horse will, in future, serve more than just its historical roles of transport and war-machine.

One of the main and inevitable parts of this series is racing and its milieu. This series is called *The Face of the Horserace*, and the book I am preparing is called *Without Blinkers*. While shooting "on location," I meet men of a very large family, people of different nations and different skin color, who have one common interest—horses. It is just one of the possible ways of understanding the world by means of a universal language, by photography.

Photography as a specific means of expression, speaking with a common understandable language all over the world, and by its ability to express the truth, must help to uphold mankind's highest ideals. In my work, that's what I strive to do. At the same time, I am fully aware that to do it well is by far the most difficult part of photography.

—Pavel Dias

Pavel Dias was one of the first artists to receive a complete photographic education at university level in Czechoslovakia. After his studies at the Film and TV Faculty of the Academy of Musical Arts in Prague he came to regard the "live" image as the most interesting and most appropriate to his own notions regarding the nature of photography. Although he frequently works on assignment for various journals, Dias does not believe that his kind of work ought to be reproduced exclusively on the printed page of weeklies or books; rather, he is one of those photographers who prefers to present his oeuvre in the form of original prints. Naturally, it follows that Dias is convinced that in using an image as an autonomous work of art it is necessary to select those photographs that are informed by personal emotion in the act of observation. For this reason—the final goal, as it were—he prefers always to choose those subjects that attract him, regardless of whether he will be able to publish the results. He confirms the theory that the decision "what to photograph" may be the ultimate creative act in photography.

One of his most extraordinary conceptions has been a cycle on former Nazi concentration camps. His subject was actually the reaction of contemporary visitors to these camps—the faces of visitors revealing that uncomprehending sorrow that it was possible for humans to inflict such atrocities on their fellow men. Dias does not show the horror—nor the vision of the photographers who accompanied the Allied troops into the camps in 1945—but bases the rather complex expression of this cycle purely on the emotions of contemporaries who were highly moved by these places redolent of memory.

The most recent of his cycles concerns horses. When looking at these photographs it is impossible not to feel the ways in which the photographer meditated on the changing status of these animals in an era when the tractor took over their role in agriculture in most countries. For this series Dias has visited Mongolia, in order to photograph big herds of horses, and has also visited important breeding farms in Europe. He has photographed numerous horse-races and steeple-chases, again in various parts of the world, and he has tried to convey the relationship of jockeys and other people of the turf world to the thoroughbred animals. He does so in a very personal way. Dias possesses a sensitivity for both very dynamic and for nearly static situations which enables him to express different messages from image to image. They are always of a striking and creative character.

—Petr Tausk

DIBBETS, Jan.

Dutch. Born Gerardus Johannes Maria Dibbets in Weert, Netherlands, 9 May 1941. Educated at Bisschoppelijk College, Weert, 1953-59; studied art, Academie voor Beeldende an Bouwedde Kunsten, Tilburg, 1959-63; private painting studies, with Jan Gregor, Eindhoven, 1961-63; St. Martin's School of Art, London, 1967; self-taught in photography. Married Bianka Francisca de Poorter in 1967; son: Hiske Karool. Independent photographic artist, Amsterdam, since 1963. Co-founder, with Reiner Lucassen and Ger van Elk, International Institute for the Re-education of Artists, Amsterdam, 1968. Art Instructor, Enschede, 1964-67, and Atelier 63, Haarlem, 1968-71; Visiting Artist, Nova Scotia College of Art and Design, Halifax, 1971. Recipient: British Council Scholarship, London 1967; Heineken Prize, The Hague, 1969; Cassandra Foundation Award, New York, 1971. Agent: Art and Project, Willemsparkweg 36, 1007 Amsterdam, Netherlands. Address: Boerhaveplein 6, 1091 Amsterdam, Netherlands.

Individual Exhibitions:

1965 Galerie 845, Amsterdam
 Galerie Swart, Amsterdam (and 1966, 1967)
1968 Galerie Konrad Fischer, Dusseldorf
1969 Seth Siegelaub Gallery, New York
 Videogalerie Gerry Schum, Dusseldorf
 Art and Project, Amsterdam
 Museum Haus Lange, Krefeld, West Germany
1970 Galerie Yvon Lambert, Paris
 Galleria Françoise Lambert, Milan
 Zentrum für Aktuelle Kunst, Aachen, West Germany
 Aktionsraum 1, Munich
 Videogalerie Gerry Schum, Dusseldorf
1971 Galleria Gian Enzo Sperone, Turin
 Galerie Konrad Fischer, Dusseldorf
 Art and Project, Amsterdam
 Stedelijk Van Abbemuseum, Eindhoven, Netherlands
1972 Galerie MTL, Brussels
 Galerie Yvon Lambert, Paris
 Jack Wendler Gallery, London
 Galleria Toselli, Milan
 Israel Museum, Jerusalem
 Stedelijk Museum, Amsterdam
1973 Leo Castelli Gallery, New York
 Galleria Sperone-Fischer, Rome
 Galerie Konrad Fischer, Dusseldorf
 Art and Project, Amsterdam
 Kabinett für Aktuelle Kunst, Bremerhaven, West Germany
 Jack Wendler Gallery, London
1974 Galleria Gian Enzo Sperone, Turin
 Galerie Rolf Preisig, Basle
 Galerie Yvon Lambert, Paris
 Galerie Konrad Fischer, Dusseldorf
1975 Galerie MTL, Brussels
 Art and Project, Amsterdam
 Cusack Gallery, Houston
 Claire Copley Gallery, Los Angeles
 Leo Castelli Gallery, New York
 Jan Dibbets: Autumn Melody, Kunstmuseum, Lucerne
 Scottish Arts Council Gallery, Edinburgh (travelled to Arnolfini Gallery, Bristol; Chapter Arts Centre, Cardiff; and the Museum of Modern Art, Oxford)
1980 Kunsthalle, Berne

Selected Group Exhibitions:

1970 *Information*, Museum of Modern Art, New York
1971 *Guggenheim International*, Guggenheim Museum, New York
1972 *Konzept-Kunst*, Kunstmuseum, Basle
 Biennale, Venice
1974 *Photokina '74*, Cologne
 Contemporanea, Parcheggio Villa Borghese, Rome
 Projekt '74, Kunsthalle, Cologne
1977 *ROSC '77*, Municipal Gallery of Modern Art, Dublin
1978 *23 Photographers/23 Directions*, Walker Art Gallery, Liverpool
1979 *Photographie als Kunst 1879-1979/Kunst als Photographie 1949-1979*, Tiroler Landesmuseum Ferdinandeum, Innsbruck, Austria (travelled to Neue Galerie am Wolfgang Gurlitt Museum, Linz, Austria; Neue Galerie am Landesmuseum Joanneum, Graz, Austria; and Museum des 20. Jahrhunderts, Vienna)

Collections:

Stedelijk Museum, Amsterdam; Haagse Gemeentemuseum, The Hague; Kaiser Wilhelm Museum, Krefeld, West Germany; Von der Heydt Museum, Wuppertal, West Germany.

Publications:

By DIBBETS: book—*Robin Redbreast's Territory: Sculpture 1969, April-June*, Cologne and New York 1970; articles—"Voor Beeldende Kunst Moet Je Kunnen Kijken" in *Museumjournaal (Amsterdam), no. 13*, 1968; "Jan Dibbets: TV as Fireplace" in *Interfunktionen* (Cologne), no. 4, 1970; "Jan Dibbets: Interview" in *Avalanche* (New York), Fall 1970; "Jan Dibbets in Conversation with Charlotte Townsend" in *Artscanda* (Toronto), August/September 1971; films and videotapes—*Land Art*, 1968; *Fire/Feuer/Feu/Vuur*, 1968; *12 Hours Ride Objects with Correction of Perspective*, 1969; *Painting 1*, 1970; *Painting 2*, 1970; *Vertical-Horizontal-Diagonal-Square*, 1970; *Horizon I: Sea*, 1970; *Horizon II: Sea*, 1971; *Horizon III: Sea*, 1971; *Vibrating Horizon*, 1971; *Venetian Blinds*, 1971; *Video: 2 Diagonals*, 1971; *Video: 3 Diagonals*, 1971.

On DIBBETS: books—*Jan Dibbets: Autumn Melody*, exhibition catalogue, with text by Jean-Christophe Amman, Lucerne 1975; *Jan Dibbets*, exhibition catalogue, with text by Barbara Reise and M.M.M. Vos, Edinburgh 1976; *23 Photographers/23 Directions*, exhibition catalogue, by Valerie Lloyd, Liverpool 1978; *Photographie als Kunst 1879-1979/Kunst als Photographie 1949-1979*, exhibition catalogue, 2 vols., by Peter Weiermair, Innsbruck, Austria 1979; articles—"Notities over het Werk van Jan Dibbets" by Carel Blotkamp in *Musemjournaal* (Amsterdam), July 1971; "Notes on Jan Dibbets: Contemporary Nature to Realistic Classicism in the Dutch Tradition" by Barbara Reise in *Studio International* (London), June 1972; "Jan Dibbets: Biennale de Venise" by Irmeline Lebeer in *L'Art Vivant* (Paris), June/July 1972; "Jan Dibbets: A Perspective Correction" by Barbara Reise in *Art News* (New York), Summer 1972; "Modes of Visual Experience: New Works by Jan Dibbets" by Rudi H. Fuchs in *Studio International* (London), January 1973; "Some Work by Jan Dibbets" by M. Vos in *Flash Art* (Milan), January 1973; "Jan Dibbets: The Photograph and the Photographed" by Bruce Boice in *Artforum* (New York), April 1973; "The Art of Discovering Conflicts in Perception" by A. von Graevenitz in *Data* (Milan), Summer 1973; "Jan Dibbets" in *Art Annual*, New York 1973/74; "Jan Dibbets at Jack Wendler Gallery" by Lynda Morris in *Studio International* (London), no. 187, 1974.

Many established prejudices encourage an elitist distinction between artists and photographers—who are also artists. It is often thought, at least in some quarters of the art world, that *artists'* photographs are inherently "high art" and somehow superior to "mere" photography. Jan Dibbets is one of those who use photographs, but identify themselves primarily with the art world and its concerns.

Dibbets' move to photography in 1968, after a period of making abstract paintings, grew out of his reflection on the fundamental relationship between art and reality. In fact, his approach to photography was initially related to concept art. For a show in 1970 at the Galerie Yvon Lambert in Paris, for instance, he photographed the walls of the gallery, which he had divided up into numbered sections. The 14 resultant photos were subsequently exhibited over the corresponding numbers. He also reconstructed the pattern of the walls in several series of photographs on a separate sheet. A ground plan of the gallery was added. The emphasis of this work—as in most "concept" art—still lay fairly strongly on the idea, but soon Dibbets developed a more delicate balance between concept and realization through his rich and meticulous application of sequential photography.

Dibbets' preference for sequential photography springs from an intuitive understanding of the phenomenological characteristics of photography. Because the characteristics of "art photography" do not interest him, the singular relationship between photography and reality offers him—as far as the individual photo is concerned—little scope for his creativity as an artist. But the possibilities afforded by the photographic sequence are totally different. The structure of the sequence spans the fragmentary and descriptive nature of the individual photographs.

Dibbets uses photographs within the framework of abstraction: not as a means of producing aesthetic images, but of developing a way of seeing.

He shifts our attention from the object that is photographed to the camera taking the photograph. In "Comets" (1973) the structure of the work is based on a meticulous combination of the choice of motif on the one hand and the manipulation of the camera on the other. In "Perspective Corrections" the position of the camera is the result of careful calculation. In the series "Panoramas," "Dutch Mountains" and "Comets," the camera is rotated around different axes, taking photos at regular intervals; in another group of works, the structure is obtained by using increasing shutter speeds, or by registering natural and artificial changes of light. Slight changes in light and shade are also recorded every 10 minutes in "The Shortest Day" (1970); the camera rotates on a perpendicular axis taking a photo every 15 degrees.

The rise of photography was accompanied last century by a deterioration of descriptive painting—"from today, painting is dead." But Dibbets' interest in light and colour, in abstract structure, in the expressive qualities of visually perceptible reality, are a painter's concerns, even though he uses photographs instead of paint and brushes. He has discovered in photography a possibility for grafting visual art onto nature once more. The photograph is not used as a means of documentation; his concern is with the final image shown by the photographs.

Leaving an exhibition of Dibbets' photo-works, a critic exclaimed in surprise: "But that man Dibbets is a real painter." And Dibbets, standing nearby, answered: "So I am."

—Colin Naylor

DIEUZAIDE, Jean.

Pseudonym: Yan. French. Born in Grenade-sur-Garonne, 20 June 1921. Educated at secondary school in Nice, 1938-40; did preparatory year for Saint-Cyr Military School, but left because of the war. Married Jacqueline Manuquet in 1950; children: Michel and Marie-Francoise. Freelance photographer, in Toulouse, since 1944: Founder and Art Director, Galerie du Château d'Eau, Toulouse, since 1974; established Jean Dieuzaide Gallery, Toulouse, 1976. Instructor in Photography Workshops, *Rencontres Internationales de Photographie*, Arles, France, since 1969. Instructor, Ecole Audiovisuelle de Saint-Cloud, Paris, 1978. Chairman, Artistic Committee, Fédération Internationale d'Art Photographique (FIAP), since 1970. Recipient: French Cup for Portraits, Fédération Internationale de d'Art Photographique, 1951; Niepce Prize, 1955; International Prize, Colour Tourist Poster Competition, New Delhi, 1956; French Cup for Industrial Research and Edouard Belin Medal, Fédération Internationale de l'Art Photographique, 1957; French National Prize for Posters, 1959; Nadar Book Prize, 1961; French Cup for Landscape Photography, Fédération Internationale d'Art Photographique, 1967; Lucien Lorell Cup, Bordeaux, 1969; Clemence Isaure Prize, Languedoc Academy, 1979. Honorary Member, French Committee of Photographic Art, 1969. Chevalier, Order of Merit, France, 1966. Address: 7 rue Erasme, 31400 Toulouse, France.

Individual Exhibitions:

1948 Publicity Club, Paris
1952 Inter-Club, Toulouse
1955 Galerie d'Orsay, Paris
 Knights of St. Joan, Toulouse
1960 Augustin Museum, Toulouse
1961 Municipal Museum, Sete, France
1962 Galeria Imagen y Sonido, Barcelona
 Pavillon de Marsan, Paris
1963 Municipal Museum, Tel Aviv
1964 Cloister Gallery, Moissac, France
1965 Cultural Center, Toulouse
1966 Rangueil University, Toulouse
1967 Association of Culture and Photographic Art, Avignon
1968 Maison des Quatres Vents, Paris
1969 Fiat Cultural Center, Turin
1970 Musée Réattu, Arles, France
 Toussaint Gallery, Angers, France
1971 Galerie de l'Oeuvre, Toulouse
 Cultural Center, Toulouse
 Galerie La Demeure, Paris
1976 Ecole des Beaux-Arts, Tourcoing, France
1977 Musée Nicéphore Niepce, Chalon-sur-Saône, France
1978 Galerij Paule Pia, Antwerp
1979 *Dialogue avec la Lumière*, Credit Commercial de France, Toulouse
1981 Galerie Le Trepied, Geneva

Selected Group Exhibitions:

1952 *Photokina '52*, Cologne
1961 *Romanesque Art*, Episcopal Museum, Vich, Spain (toured Europe)
1969 *L'Oeil Ecoute*, at the *International Modern Art Exhibition*, Avignon
 Man's Earth, Pavillon France, Montreal (and world tour)
1972 *15 French Photographers*, National Museum, Moscow
1980 *7 Photographers*, University of Oklahoma, Norman

Collections:

Bibliothèque Nationale, Paris; City of Paris Collection: Musée Réattu, Arles, France; Musée Nicéphore Niepce, Chalon-sur-Saône, France; Musée Cantini, Marseilles; Het Sterckshof Museum, Antwerp; Metropolitan Museum of Art, New York; Virginia Museum, Norfolk.

Publications:

By DIEUZAIDE: books—*The South of Spain*, with text by Jean Sermet, Paris 1953; *St. Sernin de Toulouse*, with text by Jean Peyrade, Toulouse 1955; *Spain*, with text by Yves Bottineau, Paris 1955; *Portugal*, with text by Yves Bottineau, Paris 1956; *Pictures of Alsace*, with text by Victor Beyer, Paris 1956; *Sardinia*, with text by Antonio Borio, Paris 1957; *Treasures of Turkey*, with text by Ml de St-Pierre, Paris 1957; *Roussillon Roman*, with text by Marcel Durliat, La Pierre que Vire, France 1958; *Basque Country*, with text by Rd Ritter, Paris 1958; *Béarn-Bigorre*, with text by Rd Ritter, Paris 1958; *History of Toulouse*, with text by Ph. Wolff, Toulouse 1958; *Blue Guide of the Pyrenees*, with text by P. de Gorsse, Paris 1959; *Romanesque Quercy*, with text by M. Vidal, La Pierre qui Vire, France 1959; *Catalogne Romane*, with text by Edouardo Junyent, La Pierre qui Vire, France 1960; *The Ways to Santiago*, with text by Yves Bottineau, Paris 1961; *Toulouse and Haut-Languedoc*, with text by Robert Mesuret, Toulouse 1961; *Voix et Images de Toulouse*, with text by Ph. Wolff, Toulouse 1962; *L'Art Roman en Espagne*, with text by Marcel Durliat, Paris 1962; *My Pyrenees*, with text by Raymond

Escholier, Paris 1962; *Rouergue Roman*, with text by G. Gaillard, La Pierre qui Vire, France 1963; *Toulouse*, with text by Pierre Cabanne, Toulouse 1963; *Splendours of Spain*, with text by Yves Bottineau, Paris 1964; *St. Foy de Conques*, with text by Mère E. de Solms, La Pierre qui Vire, France 1965; *Romanesque Art*, with text by A. Fernandes Arenas, Barcelona 1965; *Los Caminos de Santiago*, with text by Yves Bottineau, Barcelona, 1965; *Rutas del Romanico*, with text by Subias Galter, Barcelona 1965; *Périgord*, with text by Paul Fènelon, Paris 1966; *History of Languedoc*, with text by Nougier/Gallet, Toulouse 1967; *El movimento romanico en Espagna*, with text by Blai Bonnet, Barcelona 1967; *Toulouse, City of Fate*, with text by René Mauriès, Toulouse 1974; *My Adventure with Pitch*, with text by Jean Claude Lemagny, Toulouse 1975; *Albi*, with text by Pierre de Gorsse, Toulouse 1977; *Toulouse as It Was in the Nineties*, with text by M. St. Saens, Toulouse 1978.

People often think it is necessary to go to the far ends of the world to act as a photographer. But photography is not synonymous with being removed from one's usual surroundings; it also has to do with rediscovering the common things of everyday life that we can no longer see, things we do not take the time to see. The thousands of objects that share our intimacy have something to tell us, but our eye does not listen to them: they play with light to draw our attention, and they are surely sorry for our indifference, as they feel they are a part of ourselves.

Jean Dieuzaide: *La Petite Fille au Lapin*, Portugal, 1954

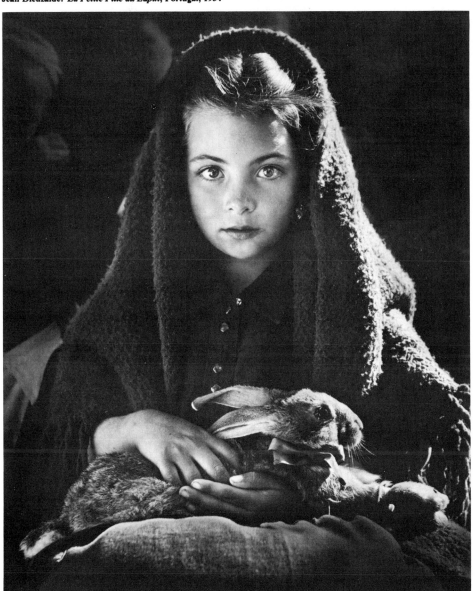

I really don't care much whether I create "Art" with my pictures or not.

For always my inward joy, that which I can't be deprived of without being shut in a dark closet, is to look at the *interplays of light* and photograph them: light gives richness to the swaying of a solid, a form, a body, a tool, a trifle. It makes all my being vibrate intensely, and sometimes it brings a small tear of joy to the corner of my eye, escaping as a visual expression of my gratitude.

Without light nothing exists, and there is no more liberty. With it everything is present, simple, precise, and matter to think about, be it a grain of flesh or flesh of stone: it is a marvellous present offered us to gather the pictures and sensations which help us to understand better others and ourselves.

It is a sin not to acknowledge it; it is our duty to make it understood—and photography is here to help us do it. I would even say that it is here to make us rediscover the "spiritual" way to which so many young people aspire and from which our stupid world separates them as well as ourselves. Since I saw the "cabbage leaf" as photographed by Weston, I have had a much greater respect for the cabbage....

Photography helped me to rediscover the leaf of a tree, then the tree itself, then the landscape of which it is a part and the man who comes to speak with it or to rest in its shadow.

The look of that man made me understand that he had many things to teach me—about himself, his life, his problems which are also mine: rich with the lessons received since antiquity, passing through the Middle Ages, he made me understand that his experience could be of some use to me; he called my attention to this rapport between surfaces and proportions arising from nature and pure science and ruled by a simple mechanism which is the very means of communication of all time.

Finally, this man made me understand that the same rapport must also exist spontaneously in any work, artistic or not, so that man may perceive it; otherwise, he rejects it as he rejects physically a bitter perfume, a sour fruit, a harsh noise or contact with lifeless flesh.

There is no doubt that the game of proportions in any work created by the hand of a man known as an artist is nothing less than the transposition of certain laws of equilibrium and relationship in which we find a permanent example in all living organisms put on earth by the "prodigious clock-maker" of whom Voltaire spoke. Fatuity makes us blind to everything that is obvious and to that which is offered daily and *freely* to each of us.

To me, photography is now one of the rare means by which we can make man understand the stupidiy of his megalomania and *wash* humanity clean of this sin of pride, but to come to it we must learn again how to look at things humbly and without hate, respecting man and everything that surrounds him, even far beyond our unreliable eyes.

Science, art, light, mysticism—they will doubtless be the essential components of our next civilization: photography comes in its time to help us to this desirable evolution. Light, essential to photography, reveals the truth. Plato wrote, more than two thousand years ago, "Beauty is the splendor of truth."

—Jean Dieuzaide

If anyone can be said to be at one with photography, it is surely Jean Dieuzaide. Not only, like many others, has he devoted his entire life to photography, but he has also made himself its apostle. Where others strive for their own interest and for personal success, Dieuzaide struggles for photography—so that it may be better understood, so that it may be better defended, so that, at last, it may enjoy an appropriate status among the arts.

Dieuzaide is, however, first of all a photographer, and one of the characteristics of his career is the great variety of photographic styles in which he has practiced. He began to establish a reputation as a recorder of events with his portrait of General de Gaulle in Toulouse in 1944. As an illustrator he has excelled in descriptive regional photography; he has collaborated for many years with a variety of writers on books about the regions of France and other countries. He has been an industrial photographer and an advertising photographer. Artistically eclectic, he has also been technically ingenious. In 1949, for example, he had a water-tight box constructed to his own specifications so that he might shoot under water. His taste for action has also led him to aerial photography. And he must be one of the few photographers (maybe the only photographer) to have taken photos from astride the shoulders of a tightrope walker: "The Marriage of the Tightrope Walkers" (1954), published in *Life*. Given this range of activity, it is not surprising that his archives contain nearly 300,000 pictures, 6 x 6, 24 x 36, color and black-and-white, all appropriately catalogued.

Yet if Dieuzaide has excelled in all genres, and has been recognized by an impressive series of awards, there are still high points in his work—his architectural photographs, for example. They bear witness—whether they are of industrial architecture, the architecture of landscape or the architecture of objects—to his vast culture and to the perfection of his vision in relation to the composition of masses. Also noteworthy are the products of his passion for the region of his birth, the southwest. Long before it was fashionable to do so, he felt all the strength and sincerity of regional life; he was an early ecologist and never lost contact with nature, the most humble

Michael Disfarmer: *Untitled*, c. 1939-46

DISFARMER, Michael.

American. Born Michael Meyer, in Indiana, in 1894; later assumed the name Disfarmer. Educated in local schools in Heber Springs, Arkansas, 1890-99. Served in the United States Army, 1916-18. Worked on his father's farm, also as a night-watchman in a local rice mill, in Heber Springs, from 1901; later separated from his family and began making photographs; maintained own portrait studio on Main Street, Heber Springs, 1930-59. *Died* (in Heber Springs) *in 1959*.

Individual Exhibitions:

1976 Arkansas Art Center, Little Rock
1977 International Center of Photography, New York
 Port Washington Public Library, New York
1980 Blue Sky Gallery, Portland, Oregon
 Salford '80, England

Collections:

Peter Miller, The Group Inc., Little Rock, Arkansas; Metropolitan Museum of Art, New York; Museum of Modern Art, New York; Julia Scully Collection, New York; International Center of Photography, New York.

Publications:

By DISFARMER: portfolio—*The Heber Springs Portraits*, 10 prints, printed by Peter Miller, Little Rock, Arkansas 1977.

On DISFARMER: book—*Disfarmer: The Heber Springs Portraits 1939-46* by Julia Scully and Peter Miller, Danbury, New Hampshire 1976; articles—"Portraits from a Missing Time" by Julia Scully in *Modern Photography* (New York), November 1976; "Michael Disfarmer: Portraits from Heber Springs, Arkansas 1939-46" in *Creative Camera* (London), December 1976; "A Studio on Main Street" in *Photography Year 1977*, by the Time-Life editors, New York 1977; review in the *Smithsonian Magazine* (Washington, D.C.), March 1977; "Disfarmer: Heber Springs Portraits" by Joe Novak in *Camera 35* (New York), November 1977; "A Humanist View" by Lou Stettner in *Camera 35* (New York), January 1979.

The known work of Mike Disfarmer, consisting of several thousand portraits made between approximately 1939 and 1946, forms an important sociological and historical document. Limited geographically to a small town in Arkansas, the photographs portray a microcosm of the small town culture of mid-America during the years in which it was being sorely tried by the upheaval of World War II. The strength of the work depends essentially on three elements: the character of the subjects, the time in which they were recorded, and the genius of the photographer.

The sitters who came to Disfarmer's studio in Heber Springs, Arkansas, were largely farmers. Inbred, extremely poor and provincial, they were descendents of Anglo-Saxon farming stock. Their faces and stances reveal a combination of pride, simplicity and stoicism.

Also evident in the portraits is the experience of the war. Almost all of their lives were directly affected and the pictures disclose both tangible and evidential clues to this fact: men pose in new uniforms before leaving for combat; women wear insignia representing the branches of Service of their sons and husbands; children dress in scaled-down versions of military garb. In the faces of these families one sees both anguished uncertainty and an abiding endurance.

The naive genius of Mike Disfarmer is attested to

manifestations of which are celebrated in his photographs.

Emotion plays a great part in his work, emotion continually contained, expressed in the very great sensuality of the photographs. Dieuzaide belongs to that generation of photographers who brought great love to photography: expression, essentially in black-and-white, passes through, as it were, a complete mastery of technique, from the taking of a shot to the work in the laboratory, in the service of sensitivity. To the formal perfection of the composition is added a restitution of the subject in all its graininess or smoothness. Dieuzaide's photographs are very tactile; they invite touch, a caress. The sensuality which seeps from the sensitive surface is present in all his photography, but it finds its most complete achievement in the work entitled *My Adventure with Pitch*. From 1956 to 1960 he concentrated on this work, creating a series of photographs of rare sensual abstraction and strength, which he did not show publicly until 1968. This work reveals one of his most particular characteristics, his vision of a nature of symbolic significance beyond form, beyond

literal content. His pictures bear witness to that mysterious exchange produced in nature: the lowliest vegetable, the dankest marsh, speak to us of totality, of beauty within which Dieuzaide sees the manifestation of God.

The year 1971 marked a turning point in his career. Since then he has more and more deserted his own work to devote himself to the social activity of exhibitions and the publication of texts and manifestos. A sad choice, because an artist who has not completed his own creation remains continually torn by his need to produce new images. The time he has devoted to the popularization of photography— notably at the Galerie du Château d'Eau in Toulouse, opened in 1974, where so far there have been more than 50 exhibitions—has taken away the freedom necessary for artistic work. It remains to be seen whether the need to invent obstacles is a process peculiar to Jean Dieuzaide's creative methods, whether those obstacles are the difficulty against which he must now struggle to reach his own emotional resources.

—Ginette Bléry

by the clarity with which he revealed this society in this period. His technique matched in simplicity and directness the character of his subjects. He used north light and 3¼ x 5½ inch glass negatives to produce evenly-lit, sharply detailed images. His backgrounds were the simplest: either a black roll-down shade or a white wall inexplicably striped with black. Abjuring artifice, he did a minimum of posing and arranging (an occasional bench or table served for seating some subjects), and, clearly, he rarely attempted to coax an expression.

The technical excellence of the images which reveal every story-telling detail of face and clothing, and the remarkable openness of the faces, combine to convey a powerful impression of the quality of life at that particular time and place in American history.

Disfarmer, whose real name was Meyer (he believed he had been separated from his original family during a tornado), apparently aspired to be no more than a small town portraitist. A virtual hermit, he died in his studio in 1959; it and his possessions (including the known glass plates) were sold by a local bank for a few dollars. His work came to light in 1976 with the publication of *Disfarmer: The Heber Springs Portraits, 1939-1946*, and it was recognized immediately as a major contribution to American photography.

—Julia Scully

Miodrag Djordjević: *V.J., Deportee to Auschwitz No. 49865*, 1952

DJORDJEVIĆ, Miodrag (Borislav).

Yugoslav. Born in Valjevo, 12 December 1919. Educated at high school in Negotin, 1935-39; studied medicine at the University of Belgrade, 1939-49, M.D. 1968; self-taught in photography. Served in the Yugoslav National Liberation Army, 1941-45. Married Branka Petrovic in 1956 (divorced, 1968); married Dušanka Miljkovic in 1978; son: Nenad. Freelance artist and photographer, Belgrade, since 1947. Professor of Photography, School of Design, Belgrade, 1968-78. Since 1978, Head of the Photography and Film Department, Medical Center, University of Belgrade. Recipient: Janez Puhar Award, *Yugoslav Photography Exhibition*, 1953; First Prize, *International Exhibition of Photography*, FIAP, Cologne, 1956; First Prize, *Exposicion Internacional Universitaria de Fotografia de Montant*, Madrid, 1957; Golden Plate Award, *Yugoslav Photography Exhibition*, Osjek, 1958; Artist of Photography Award, 1961, and Award of Excellence, 1972, Federation Internationale de l'Art Photographique (FIAP); ULUPUS Award, Belgrade, 1963; Master of Photography Award, Association of Photographers of Yugoslavia, 1969; *October Salon* Award, Belgrade, 1975. Agents: Singidunum, Knez Mihajlova 40, 11000 Belgrade; and B. Moravec's Gallery, rua Augusta, Sao Paulo, Brazil. Address (studio): Stanka Vraza 6, 11000 Belgrade, Yugoslavia.

Individual Exhibitions:

1951 *Mountains*, Dom žljeznicara, Belgrade
1952 *Landscapes*, Stanko Vraz, Belgrade
1957 Grafički kolektiv, Belgrade
1961 *Wystawa fotografi*, Cultural House, Nova Huta, Poland
1963 *Nature-Man*, Museum of Applied Arts, Belgrade
Abstract-Concrete, City Museum, Subotica, Yugoslavia (travelled to the City Museum, Rovinj, Yugoslavia, 1964)

1966 *Retrospective 1944-1966*, Nadežda Petrović, Čačak, Yugoslavia
10 Nudes and a Portrait, Grafički kolektiv, Belgrade
Somatic Metaphors, City Museum, Rovinj, Yugoslavia
1967 *Vystava 80 fotografi*, Dum Panu z Kunštatu, Brno, Czechoslovakia
1968 *A Woman and Stone*, Kamen mali, Cavtat, Yugoslavia
1970 *Photo-Design*, Applied Arts Gallery, Belgrade
Artists' Portraits, GUF Gallery, Zagreb
1971 *Portraits of Artists of Belgrade*, Museum of Applied Arts, Belgrade (travelled to the Cultural House, Čačak, Yugoslavia, 1972)
1972 *Kunst-fotos*, Stadtmuseum, Erlangen, West Germany
Students' Centre, Novi Sad, Yugoslavia
1976 *Nascimento de Megalopole*, Avenida das Nacoes Gallery, Brasilia (travelled to the Tower Gallery, Niš, Yugoslavia, 1977)
1977 *100 Photographics and Photopictures*, Museu de Arte Moderna, Sao Paulo

1978 *Luminokinets*, Museum of Modern Arts, Belgrade (travelled to the Museum of Modern Arts, Skopje, Yugoslavia, 1979, and Gallery of Modern Arts, Zagreb, 1980)
1979 Gallery of Arts, Shanghai

Selected Group Exhibitions:

1952 *1st Exhibition of Yugoslav Photographers*, Dom Sindikata, Belgrade
1958 *Photos by ULUPUS Members*, Museum of Applied Arts, Belgrade
1965 *October Salon of Arts and Applied Arts*, Museum of Applied Arts and Cvijeta Gallery, Belgrade (and annually until 1979)
ULUPUS Exhibition, Museum of Applied Arts and Cvijeta Gallery, Belgrade (and annually until 1979)
1969 *Contemporary Yugoslav Photography*, Nadežda Petrović, Čačak, Yugoslavia
1970 *Serbian Photography*, Museum of Applied

Arts, Belgrade

1974 *5th International Biennale of Posters*, National Museum, Warsaw

1975 *BIO 6*, Gospodarsko rastavišče, Ljubljana, Yugoslavia

ZGRAF 75, Gallery of Arts, Zagreb

1978 *1st Triennial of Plastic Arts*, Collegium Artisticum, Sarajevo, Yugoslavia

1979 *Photographic Media*, Museum of Modern Arts, Belgrade

Collections:

Museum of Applied Arts, Belgrade; Museum of Modern Arts, Belgrade; Serbian Academy of Science and Arts, Belgrade; Museum of Modern Arts, Skopje, Yugoslavia; Gallery of Contemporary Arts, Zagreb; Monastery Chilander, Athos, Greece; Museu de Arte Contemporante, Sao Paulo; Museu de Arte Moderna, Sao Paulo.

Publications:

By DJORDJEVIĆ: books—*Studenica*, with an introduction by Mandić Sveta, Belgrade 1963; *Rovinj*, with an introduction by Anton Paulentić, Belgrade 1963; *Art on the Soil of Yugoslavia: From Prehistoric Times to the Present*, with others, edited by France Stele, Belgrade and Sarajevo 1971; *Istorija Beograda*, 3 volumes, edited by Vasa Cubrilović, Belgrade 1974; *Icônes Byzantines*, edited by Paul Johannes Müller, Paris 1977; *Hilander*, with an introduction by Pavle Savić, Belgrade 1978; *Tisnikar*, with an introduction by Nebojša Tomaševic, Belgrade 1979; *China*, with others, with an introduction by No Myth, Belgrade and New York 1980; articles—"Fotograf mora da napravisliku" in *Foto-kino revija* (Belgrade), May 1971; "Fotogafija Anastasa Jovanovića" in *Sveska 32 Galerije SANU* (Belgrade), August 1977; "Jusuf Karč" in *Katalog izlozbe FSJ* (Belgrade), November 1979; "Anastas Jovanović, the First Serbian Photographer" in *History of Photography* (University Park, Pennsylvania), April 1980.

On DJORDJEVIĆ: books—*42 Photographs: Nature-Man* by Mića Popović, Belgrade 1963; *Portret: beogradskih umetnika* by Lazar Trifunović, Belgrade 1971; *Portreti umetnika* by Zvonimir Golob, Zagreb 1972; *Foto-grafica e foto quadros de Miodrag Djordjević* by Oto Bihalji Merin, Sao Paulo 1977; *Razgovor sa Miodragom Djordjevićem* by Irina Subotić, Belgrade 1978; articles—"Priroda-čovek" by Dragoslav Djordjević in *Borba* (Belgrade), April 1963; "Pogled ptice" by Mića Popović in *Umetnost* (Belgrade), April 1968; "Miodrag Djordjević" by Masaru Katzumie in *Graphic Design* (Tokyo), December 1975; "Izložba Dr. Miodraga Djordjevića u Brazilu" by Grozdana Sarčević in *Industrijsko Oblikovanje* (Belgrade), April 1976; "Miodrag Djordjević" by Ernestina Karman in *Folha de Tarde* (Sao Paulo), April 1977; "Miodrag Djordjević" by Alberto Beuttenmüller in *Visao* (Rio de Janeiro), April 1977; "Fotoslikarstvo Miodraga Djordjevića" by Gordana Harašić in *Covjek i prostor* (Zagreb), June 1977; "Povodom izložbe u Muzeju moderne umetnosti u Sao Paulo" by Oto Bihalji Merin in *Umetnost* (Belgrade), October 1977; "Miodrag Djordjević" by Josip Depolo in *Oko* (Zagreb), August 1980.

If you ask me why I take photographs, that is like asking me why I breathe. It is through photography that I have for many years studied life and the dynamics of existence; I react to the signs, symbols and sounds that surround me. My initial impulse is to photograph everything that I see and also that which I do not see but which I feel is hidden within a second layer of the visible, everything that moves and yet does not move at all, everything that I love or hate, that inspires or irritates me. To me it is still a game, and only a game, my game of life.

From my earliest days I have felt the need to express myself through the fine arts: I learned to draw, I studied sculpture, so that I would finally have an eye capable of seeing, of knowing.

All my sense impressions become images; music, touch, taste convert spontaneously into lively pictures.

I create by playing, but that does not exclude my accumulated experience and knowledge; I experiment consciously, I search, I test, I make mistakes, I reject, I adopt.

I sort out my negatives into related groups and come back to them when I am free from the business and social activities; in peace and with complete concentration, I select and bring together the results of similar experiments and in this way my various cycles of photographs are born. They are never definitive, and afterwards, in my work, they intersect, cross fertilize and generate new ones.... Cycles: *Somatic Metamorphoses, Abstraction Equal to the Concrete, Poetic Fantasy, Luminokinetic*, and others.

Once the photo-negative process is completed, I work on the photograph with different techniques and technologies. I think that everything in art is allowed that contributes to the artist's expression. Personally I use anything that can ennoble and humanize the photograph.

I pay attention to size because I think that it is an important part of the composition. I look very carefully for the true dimension of each image destined for exhibition, also taking into account its relationship in space.

Dealing with photography in general—I think that it must finally break away from the dogmatic and academic norms that have imposed limitations on it for years and prevented its development. It is essential that photography should quite freely start permeating through the great family of the fine arts, while still retaining the original characteristics of the photographic medium.

—Miodrag Djordjević

The search for a photography that will be not only an extension of the eye but also an extension of the mind could be said to be the constant preoccupation of Miodrag Djordjević, an explorer in the field of imaginative photography.

Djordjevic's early fascination with photography was caused by mountains, by the grandeur of the Alpine landscape, to which he devoted his first complete photographic cycle nearly 30 years ago. That first step was within the tradition of pictorial photography, but he soon turned his attention to the depiction of people in a realistic manner. At the same time, he began a new cycle of photographs of macrostructures, which led him to the thesis that "abstract equals concrete." From then on, the combination of the two visions, the realistic and the abstract, became the principal concern of his work. Balancing the two extremes, and juxtaposing objective with imaginative, constructive with destructive, static with dynamic, humanistic with spiritual, he came very close to the limits of graphic art. In his Laser cycle, he drew patterns and lines by means of various light sources, then subsequently dyed his photographic canvases by hand.

From time to time Djordjević has exhibited the results of his experiments, arranging several thematic cycles for viewing at once. Because of his continuous searching, the cycles are not necessarily sharply delimited; they permeate each other, some cycles originate others. Yet, within this continuous change, there is a single constant, his joy in experimentation. Djordjević's favorite cycle is fantastic, a kind of poetic fiction. In it he combines two or more different and unexpected contents by means of multiple overprinting, and in this way creates a strange, surrealistic atmosphere. A small but very interesting part of this cycle consists of portraits obtained by reverse double printing of a single negative. With this method he creates non-existing physiognomies of a peculiar and striking expression.

Djordjević's efforts in photographic exploration were crowned by a very successful one-man show at the Museu de Arte Moderna in Sao Paulo in 1977. Since then he has been involved with new cycles and, simultaneously, with new means of visual communication, as well as with illustrating books about modern and ancient art, especially Byzantine painting and, most recently, Chinese art and architecture.

—Nada Grčević

DLUBAK, Zbigniew.

Polish. Born in Radonsko, 26 April 1921. Self-taught in photography. Independent painter since 1946, and freelance photographer since 1948. Chief Editor, *Fotografia* magazine, Warsaw, 1953-72; Member, Editorial Committee, *Polish Art Review*, 1971-72. Founder Member, Grupa 55 artists group, 1955-56; Co-Founder, Galeria Permafo, Wroclaw, 1970-74. President, Union of Polish Art Photographers (ZPAP), since 1979. Recipient: Kosciuszkowsko Foundation Scholarship, U.S.A., 1972. Address: Pulawska 24a. M. 26, 02-512 Warsaw, Poland.

Individual Exhibitions:

1948 Club of Young Artists and Scientists, Warsaw

1967 *Ikonosfera 1*, Contemporary Gallery, Warsaw

1970 International Press and Book Club Ruch, Warsaw

Ikonosfera 2, Galeria Od Nowa, Poznan

1971 *Mutanty* and *Relop*, Galeriā Bod Mona Liza, Wroclaw (with Natalia Lach-Lachowicz and Andrzej Lachowicz; travelled to the Contemporary Gallery, Warsaw)

Tautologie, Galeria Permafo, Wroclaw

Contemporary Gallery, Warsaw

Ocean, Galeria Permafo, Wroclaw

1974 *Gestykulacje*, Gallery of Actual Art "Znak," Bialystock, Poland

Galeria 72, Chelm, Poland

1975 *Fotografia*, Galeria Labirynt, Lublin, Poland

Systemy, Galeria Remont, Warsaw

1976 *Gestykulacje* and *Systemy*, Salon of Contemporary Art, Lodz

1978 *Desymbolizaoje*, Museum of Fine Arts, Lodz

1981 *Zbigniew Dlubak: Fotografia*, Institute Polonais, Paris

Selected Group Exhibitions:

1948 *Modern Polish Photography: Polish Association of Photography*, Club of Young Artists and Scientists, Warsaw

1957 *Exhibition of Modern Art*, Zacheta Galeria, Warsaw

1966 *All-Polish Exhibition of Utilitarian Photography*, Zacheta Galeria, Warsaw

1973 *Permafo Group*, Galeria Remont, Warsaw

1974 *Permafo Group*, Galerie Paramedia, West Berlin

1975 *Modern Polish Photography*, Jose Clement Orosco Gallery, Mexico City

1976 *17 Contemporary Artists from Poland*, Albright-Knox Art Gallery, Buffalo, New York

Zbigniew Dlubak: *Ocean*, 1973

1978 *Identifications*, at *Rencontres Internationales de la Photographie*, Arles, France
1979 *Fotografia Polska 1839-1979*, International Center of Photography, New York (travelled to the Museum of Contemporary Art, Chicago, Zacheta Galeria, Warsaw, Museum of Fine Arts, Lodz, and the Whitechapel Art Gallery, London, 1979-80)
1981 *Photographie Polonaise 1900-1981*, Centre Georges Pompidou, Paris

Collections:

National Museum of Art, Warsaw; National Museum of Art, Poznan; National Museum of Art, Wroclaw; Museum of Contemporary Art, Lodz; Kunsthalle, Bochum, West Germany; Museum of Modern Art, New York.

Publications:

By DLUBAK: book—*Wybrane Teksty o Sztuce*, Warsaw 1977; articles—"Z rozmyslan o fotografice" in *Swiat Fotografii* (Warsaw), nos. 9/10, 1948, no. 11, 1949; "Uwagi o sytuacji w fotografice polskiej" in *Fotografia* (Warsaw), no. 2, 1953; "Na marginesie IV Ogolnopolskiej Wystawy Fotografiki" in *Fotografia* (Warsaw), no. 7, 1954; "O Specyficznych Cechach Fotografiki" in *Fotografia* (Warsaw), no. 6, 1955; "O Fotografii Nowoczesney Avangardowosci" in *Fotografia* (Warsaw), no. 10, 1956; "O Metaforze Fotograficznej" in *Fotografia* (Warsaw), no. 1, 1957; "Patrzac na Fotografie," series of essays, in *Ty i Ja* (Warsaw), nos. 4-12, 1963, nos. 1-7, 1964; "Problemy Pogranicza Fotografii i Plastyki" in *Fotografia* (Warsaw), no. 12, 1966; "Podawac w Watpliwosc" in *Fotografia* (Warsaw), no. 8, 1969; statement in *Tautologie*, exhibition catalogue, Wroclaw 1971; "Sztuka Poza Swiaten Znaczen" in *Biuletyn ZPAP* (Warsaw), no. 3/4, 1976; "Uwagi o Sztuce i Fotografii" in *Odra* (Wroclaw), no. 6, 1977.

On DLUBAK: books—*Wsrod Polskich Mistrzow Kamery* by L. Grabowski, Warsaw 1964; *Przygody Plastyczne Fotografii* by U. Czartoryska, Warsaw 1965; *Od Pop-Artu do Sztuki Konceptualnej* by U. Czartoryska, Warsaw 1974; *Historia Fotografii Warszawskiej* by W. Zdzarski, Warsaw 1974; *Nowa Sztuka Polska 1945-1978* by A. Kepinska, Warsaw 1981; articles—"Spotkania Fotografii z Plastyka" by U. Czartoryska in *Fotografia* (Warsaw), no. 11, 1960; "Dlubak, Zbrozyna i Epizod G55" by J. Bogucki in *Kultura* (Warsaw), no. 6, 1966; "Gzlowiek z Kamera: Zbigniew Dlubak" by J. Garztecki in *Fotografia* (Warsaw), no. 12, 1976; "Tworzyno i Wyobraznia" by U. Czartoryska in *Projekt* (Warsaw), no. 1, 1969; "Tautologia Zbigniewa Dlubaka" by A. Dzieduszycki in *Fotografia* (Warsaw), no. 10, 1971; "Pseudoavangarda" by W. Borowski in *Kultura* (Warsaw), no. 12, 1975; "Systemy i Gestykulaoje" by J. Ladnowska in *Sztuka* (Warsaw), no. 5, 1976; "Zbigniew Dlubak" by J. Olek in *Nuri* (Wroclaw), no. 10, 1977; "Desymbolizaoja" by E.M. Malkowska in *Literatura* (Warsaw), no. 14, 1979; film—*Zywa Galeria* (An Alive Gallery), by Jozef Robakowski, 1975.

In 1948 an exhibition on *Modern Polish Photography* opened in Warsaw. In an introduction to the catalogue Zbigniew Dlubak wrote: "The convention of naturalism has exerted such strong pressure on our artistic consciousness that we are not courageous enough to eschew from art this unnecessary ballast, and reach for other more fruitful and not yet fully exploited means—the suggestiveness of forms and their associational value. Instead of treating these aspects marginally we should give them full expression and in them look for new potential in photography—to enrich its scope and raise it to a high standard of artistic expression."

Dlubak's artistic manifesto was based on a formal link between photography and its practical technique (with photographic paper as the basic creative element), yet he also linked it ideologically with the fine arts and even with more general cultural trends. Also the use of the intellect ("associational value") was emphasized as an essential element of creativity and of perception in photography. Dlubak followed this programme with few modifications throughout the post-war years.

His early photographs showed close-ups of small objects, strong enlargements of plant fibre, embryonic forms—in other words, the structure of the micro-world. These photographs, moving beyond the boundaries of legibility and at the same time full of a strange surrealistic atmosphere, consciously used poetic metaphor, exemplified by the titles of the photographs, such as "Children Dream about Birds," and by a series of illustrations to Pablo Neruda's poem "Magellan's Heart." Later Dlubak moved away from this surrealistic photography, presenting simple and banal, uninteresting, even ugly subjects. This series of photographs, conceived in opposition to current artistic fashion, bore the title "Existences."

The next significant trend in Dlubak's photography can be seen in the series "Ikonosfera" (Iconosphere; 1967). The most expressive work is "Ikonosfera 1," which consists of a labyrinth of chaotically suspended, "drying out" photographs representing nudes and other subjects of everyday life. This theme was an interesting attempt to use photography not only for recording single shots but also for recording a consciously treated, prearranged space, forcing the viewer into physical and intellectual contact with the elements of an artist's environment.

In Dlubak's photography of recent years, the 1970's, there is a domination of tendencies which urge a revision of the traditional image of photography (the photograph as a work of art) and the need to redefine its essence: this work is influenced by the conceptual art of Joseph Kosuth and his polemics. It started in 1970 with a series "Gestykulacje" (Gesticulations), followed by "Tautologie" and "Systemy" (Systems) in the next years. Dlubak concentrated increasingly on descriptions of the way art functions in particular cultural contexts, and this brought him to a revision of contemporary definitions and to a neutralization or even the outright destruction of traditionally established meanings in art. A significant role was played in these reductionist actions by the theory of unism painting created back in 1927 by Wladyslaw Strzeminski. Strzeminski contrasted rich baroque composition with unist composition based on the extreme simplicity and purity of elements making up a visual picture. Following this destructive direction, Dlubak created a series under the title "Desymbolizaoje" (Desymbolization) where with the use of repetitions, distortions and deformations of highly meaningful and symbolic themes (taken, for example, from the history of painting or from the mythology of religion) he achieved works wherein the separate fragments of this theme inter-relate, mutually eclipsing one another.

"In this way," he claims, "the general structure of art reveals itself. The new avant-garde should therefore be involved in experiments desymbolizing existing and new artworks, in all elements of their meaning. New works should create situations in which the desymbolization results from their structure and becomes the only sensible form of perception."

All of these works suggest that photography is a way of seeing the world in which artistic values are not inherently contained in a work of art, nor should they impose themselves on the subjective valuation of the viewer. Art is the process of forming an artistic idea, an idea which discloses itself with empty visual signs. Its value is defined through changing meanings which exist in a particular cultural context.

—Ryszard Bobrowski

DOISNEAU, Robert.

French. Born in Gentilly, Seine, 14 April 1912. Educated at schools in Gentilly; studied lithography at the Ecole Estienne, Paris, 1926-29. Served in the French Army Infantry, 1939-40, and with the French Resistance, 1940-45. Married Pierrette Chaumaison in 1934; daughters: Annette and Francine. Worked as an engraver and lithographer, Paris, 1929-31; photographer since 1930: photographic assistant to André Vigneau, Paris, 1931-33; Industrial Photographer, Renault Car Company, Billancourt, Paris, 1934-39. Photojournalist and magazine photographer, working for *Excelsior*, *Point de Vue*, *Life*, *Fortune*, *Noir et Blanc*, *Paris-Match*, *Vogue* (1949-52), etc., Paris, since 1945: Member, Alliance Photo Agency, later known as Adep, Paris, 1945; Member,

Rapho Agency, Paris, since 1946. Recipient: Kodak Prize, 1947; Niépce Prize, 1956. Lives in Paris. Address: c/o Rapho, 8 rue d'Alger, 75001 Paris, France.

Individual Exhibitions:

1951	*Le Monde des Spectacles*, La Fontaine des Quatre Saisons, Paris
1959	Limelight Gallery, New York
1960	Art Institute of Chicago
1968	Bibliothèque Nationale, Paris
1972	International Museum of Photography, George Eastman House, Rochester, New York
1974	Galerie Municipale du Château d'Eau, Toulouse
	Vieille Charité, Marseilles
	Witkin Gallery, New York
1975	Galerie Bardawil, Paris
	La Galerie et Fils, Brussels
	Musée des Arts Décoratifs, Nantes, France
	Musée Réattu, Arles, France
1976	Photo Art, Basle
	Town Hall, Dieppe, France
1978	*Ne Bougeons Plus!*, Galerie Agathe Gaillard, Paris
	Witkin Gallery, New York
	Musée Nicéphore Niepce, Chalon-sur-Saône, France
1979	Musée Eugène Boudin, Honfleur, France
	Paris: Les Passants que Passent, Musée d'Art Moderne, Paris
	Quelques Secondes d'Éternité, Galerie Municipale du Château d'Eau, Toulouse
1981	Grapestake Gallery, San Francisco
	Gallery for Fine Photography, New Orleans

Selected Group Exhibitions:

1951	*5 French Photographers: Brassaï/Cartier-Bresson/Doisneau/Izis/Ronis*, Museum of Modern Art, New York
1954	*Great Photographs*, Limelight Gallery, New York
1965	*6 Photographes de Paris*, Musée des Arts Décoratifs, Paris
1968	*L'Oeil Objectif*, Musée Cantini, Marselles (with Denis Brihat, Lucien Clergue, and Jean-Pierre Sudre)
1972	*Boubat/Brassaï/Cartier-Bresson/Doisneau/Izis/Ronis*, French Embassy, Moscow
1975	*Le Mobilier Urbain*, Bibliothèque Nationale, Paris
1977	*6 Photographes en Quête de Banlieue*, Centre Georges Pompidou, Paris
	Concerning Photography, The Photographers' Gallery, London (travelled to the Spectro Workshop, Newcastle upon Tyne)

Collections:

Musée d'Art Moderne, Paris; Bibliothèque Nationale, Paris; Musée Nicéphore Niepce, Chalon-sur-Saône, France; Victoria and Albert Museum, London; Museum of Modern Art, New York; International Museum of Photography, George Eastman House, Rochester, New York; New Orleans Museum of Art; Center for Creative Photography, University of Arizona, Tucson.

Publications:

By DOISNEAU: books—*Le Banlieue de Paris*, with text by Blaise Cendrars, Paris 1949; *Sortilèges de Paris*, with text by François Cali, Paris 1952; *Les Parisiens Tels Qu'ils Sont*, with text by Robert Giraud and Michel Ragon, Paris 1954; *Instantanées de Paris*, Paris 1955; *1,2,3,4,5—Compter en s'Amusant*, Lausanne 1955; *Paris Parade*, London 1956; *Pour que Paris Soit*, with text by Elsa Triolet, Paris 1956; *Gosses de Paris*, with text by Jean Donques, Paris 1956; *Nicolas Schöfer*, Neuchâtal, Switzerland 1963; *Marius le Forestier*, with text by Dominique Halévy, Paris 1964; *Le royaume d'argot*, with text by Robert Giraud, Paris 1965; *Epouvantables Épouvantails*, Paris 1965; *Catherine la danseuse*, with text by Michèle Manceaux, Paris 1966; *Témoins de la vie quotidienne*, with text by Roger Lecotte and Jacques Dubois, Paris 1971; *My Paris*, with text by Maurice Chevalier, New York 1972; *Le Paris de Robert Doisneau et Max-Pol Fouchet*, Paris 1974; *Manuel de St.-Germain des Prés*, with text by Boris Vian, Paris 1974; *La Loire*, Paris 1978; *Trois Secondes d'Éternité*, Paris 1979; *Doisneau*, portfolio, New York 1979; *L'Enfant et la Colombe*, with text by James Sage, Paris 1979; *Robert Doisneau*, Paris 1980; *Le Mal de Paris*, with text by Clement Lepidis, Paris 1980; interviews—with Aloys Ginjaar in *Foto* (Amersfoort, Netherlands), September 1976; with Walter Rosenblum in *Popular Photography* (New York), January 1977; in *Dialogue with Photography* by Paul Hill and Thomas Cooper, London 1979; in *Voyons Voir: 8 Photographes*, edited by Pierre Borhan, Paris 1980.

On DOISNEAU: books—*The Picture History of Photography* by Peter Pollack, New York 1958; *The Magic Image* by Cecil Beaton and Gail Buckland, London and Boston 1975; *La Photographie Française des Origines à nos Jours* by Claude Nori, Paris 1978; articles—"Robert Doisneau" by Peter Pollack in *Infinity* (New York), February 1959; "Le Secret du Succès pour l'Agence Rapho" by Yves Lorelle in *Le Photographe* (Paris), October 1965; "Robert Doisneau et la Recherche des Moments Perdus" by Jean-Claude Gautrand in *Phototribune* (Paris), no. 1, 1969; "Le Paris de Robert Doisneau" by Jean-Jacques Deutsch in *Photo-Cinéma* (Paris), January 1973; "Doisneau le Photographe fait Tourner Thuiland le Pottier" by Eveline Schlumberger in *Connaissance des Arts* (Paris), February 1973; "Robert Doisneau" by Michel Nuridsany in *Le Figaro* (Paris), 5 August 1974; "Harbutt et Doisneau" by Jean-Jacques Naudet in *Photo* (Paris), August 1974; "Robert Doisneau" by Jean Leroy in *Photo Revue* (Paris), February 1975; film—*Trois Jours, Trois Photographes* (Doisneau, Sieff and Barbey), Paris 1979.

My photographs are completely subjective. In particular, they grasp that "unevenness" that goes against the order of things. They show the world as I would like it to be at all times. And, for me, this world exists...because I create photographic proof of it. I don't wish to pretend to be the wretched photographer who goes (comfortably) to photograph the poor. And I don't want to make photographs that say to people: "look at what wretches you are, look at how ugly your life is." On the contrary, I try to slip in softly, "Look at that which I have seen. You passed near to it today, but look for yourselves, and tomorrow you will find things around you that will make you laugh or move you."

—Robert Doisneau

For more than thirty years, Robert Doisneau has been photographing ordinary people engaged in unexceptional activities. However, his concern is not with the boredom or the banalities of everyday life. He has evolved a personal variant of "decisive instant" street photography in order to reveal fragile moments of urban existence that are bouyant with warmth, feeling and wit.

Soon after graduating from Ecole Estienne, where he studied printing arts, Doisneau began a career in commercial photography, first in the studio of André Vigneau and later as an industrial photographer for Renault Motor Company. At the end of World War II, following a period in the French Army and the Resistance, he decided to seek economic security as a fashion photographer for *Vogue* magazine, an interlude he later characterized as "...an absolute mistake, a kind of prostitution." Eventually his free-lance photography was handled by an agency headed by Charles Rado, an arrangement that allowed Doisneau to devote more time to street photography in Paris and its environs.

In the early 1930's Doisneau became interested in the possibilities of the 35 mm camera through his admiration of the work of Brassaï and Kertesz, which he saw in Paris. His own images of street life often contrast nature and machinery, youth and age, laughter and sorrow, giving plastic form to his conviction that in a culture dominated by technology, one must cherish the most basic human responses. In seeking out unexpected moments of frailty, humor or even ridiculousness, Doisneau proclaims the uniqueness of the individual. Above all, by making the fortuitous permanent, he has upset the proscribed routine of existence and substituted a world of enhanced sensibility.

As is evident in a number of images, including the well known one of the married couple regarding the objects in an art dealer's display window, Doisneau employs satire as a corrective for the presumptuousness he feels is endemic in bureaucratized societies. In this, he continues a visual tradition exemplified by Daumier and other 19th century graphic artists. But he also is convinced that of itself ridicule is too simplistic a reaction, and prefers to portray situations in which the complex interplay between individuals and their surroundings is only slowly revealed, and then on several levels of meaning.

As is true of a number of photographers who address the passing scene with a small camera, Doisneau's aesthetic approach is intuitive. Less ingenious than Bresson's, it nevertheless reveals the sophistication of an eye that can create a seamless harmony between reality and pictorial necessity. Furthermore, the exceptional visual variety in Doisneau's images, including close-ups, long shots, distortion, sharply focused and blurry forms, indicates that the photographer does not approach his subject with a preconceived aesthetic formula but lets the moment create the form.

Like Atget, whose work he admires, Doisneau is a romantic who has sought to arrest time. As economic relationships have changed and neighborhoods have been destroyed, he has used the camera to rescue architecture, artifact gesture and expression from the technological dust-bin. His document of Les Halles, the Paris produce market that was dismantled to modernize the area around the Centre Pompidou, is concerned with an irrecoverable physical environment that encompassed a disorderly but creative humanity. As such, it was a consummate subject for Doisneau's lens.

Doisneau claims that his interest is in "survival"—in leaving on earth a record of his own brief visit. In his case, he has given vivid life to the ephemeral. Through his special sensitivity to the feelings and textures of his own time and place, he has made the anonymous passing moment poignant and redemptive.

—Naomi Rosenblum

Robert Doisneau: *L'Enfer*, 1952

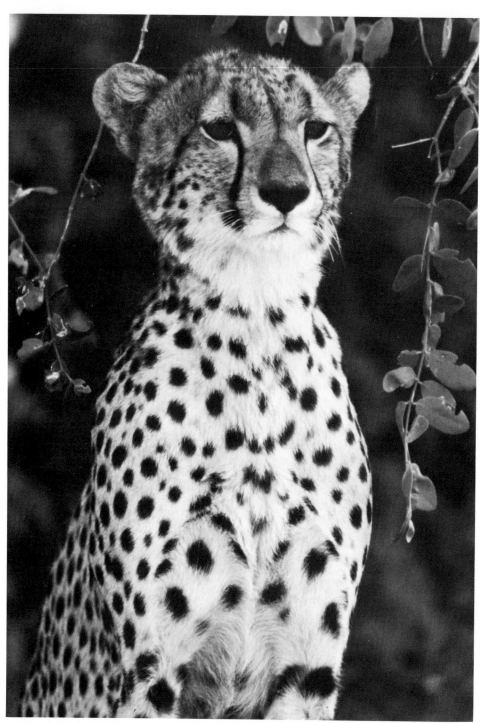

John Dominis: *Portrait of a Cheetah*, Amboselli National Park, Kenya, 1966

DOMINIS, John.

American. Born in Los Angeles, California, 27 June 1921. Studied photography, under C.A. Bach, Fremont High School, Los Angeles, 1936-40; and filmmaking, at the University of Southern California, Los Angeles, 1940-44. Served as a Photographer in the United States Air Force, in Japan, 1944-46: 2nd Lieutenant. Married Frances Clausen in 1948 (died, 1974); children: Paul, Dori and Greg. Freelance photographer in Japan, working for *Saturday Evening Post, Colliers, Life,* etc., 1946-48; freelance photographer for Three Lions picture agency, New York, 1948-50. Associated with Time-Life since 1950: Staff Photographer, *Life* magazine, New York, 1950-74 (covered the Korean War; worked in *Life* bureaus in Atlanta, San Francisco, Dallas, and Chicago, also in Singapore and Hong Kong, as Southeast Asian Photographer, 1956-62; based in New York from 1964); Picture Editor, *Peo-*

ple magazine, New York, 1975-78, and *Sports Illustrated* magazine, New York, since 1978. Recipient: Photographer of the Year Award, University of Missouri, Columbia, 1966; White House Photographer of the Year, 1967. Address: *Sports Illustrated*, Time and Life Building, Rockefeller Center, New York, New York 10020, U.S.A.

Individual Exhibitions:

1970 Nikon Gallery, New York

Selected Group Exhibitions:

1951 *Memorable Life Photographs*, Museum of Modern Art, New York

Collections:

Time-Life Inc., New York; Museum of Modern Art, New York.

Publications:

By DOMINIS: books—*The Forbidden Forest*, with text by Darrell Berrigan, Tokyo 1947; *The Cats of Africa*, with text by Maitland Edey, New York 1968; *Life Great Dinners*, with text by Eleanor Graves, New York 1970; *Caribbean Wilderness*, with text by Peter Wood, New York 1975; *Adirondack Wilderness*, with text by Li Barnett, New York 1976.

On DOMINIS: books—*Memorable Life Photographs*, with text by Edward Steichen, New York 1951; *Life Photographers: Their Careers and Favorite Pictures*, edited by Stanley Rayfield, New York 1957.

I love photojournalism, with all of the opportunities to witness great events and to pursue the most variety in assignments.

At this time, I also admire the work of young photographers and gallery photographers who are very creative and imaginative. I like the manipulations of the black-and-white and color prints that they employ; it is stimulating to me, and has advanced the breadth of photography immeasurably since my days at *Life* magazine.

—John Dominis

One of Time Inc.'s most versatile photographers, John Dominis joined the staff of *Life* in 1950. Like several other *Life* staffers, Dominis began his apprenticeship to photography in C.A. Bach's class in practical photojournalism at Fremont High School in Los Angeles, where he practiced shooting high school sports and eventually succeeded in selling occasional prints to a local sports editor.

Also, like many *Life* contemporaries, Dominis served in World War II as a combat photographer. Stationed with the Air Force in Japan, he began an affectionate association with the Orient that has continued throughout his career. He remained in Japan after the war, freelancing for American magazines, and produced a book of photographs of Japanese children, *The Forbidden Forest*.

As a *Life* staffer, Dominis covered the Korean War before returning to America for several years to work in various *Life* bureaus. In 1956 he went east again and spent six years in Singapore and Hong Kong as the magazine's Southeast Asian photographer, sending back poignant coverage from that war-torn part of the world. Using his sharply-honed reportorial skills to the utmost, Dominis covered Indonesia's movement toward independence, reported on the beginning of the Laotian conflict in 1958, and was one of the few American photographers present to record the civil strife in Vietnam that was the prelude to American involvement.

After being transferred permanently to New York in 1964, Dominis developed his talents in a new direction, covering Broadway shows and such entertainers as Frank Sinatra, Steve McQueen, Dustin Hoffman, and Robert Redford. His coverage of President Kennedy in the early 1960's earned him the White House Photographer's Award in 1967.

In addition to his coverage of sports and personalities, and his vivid reportage, Dominis has contributed to many Time-Life books on a wide variety of subjects. He showed his editorial abilities in 1975 when he assumed duties as picture editor of Time Inc.'s newly-launched *People* magazine, where he was responsible for staff and freelance photographers. Since 1978, following in the footsteps of Mark Kauffman, another Bach alumnus, Dominis has been picture editor at *Sports Illustrated*.

—Maren Stange

DOMON, Ken.

Japanese. Born in Sakata City, Yamagata Prefecture in 1909. Studied at University, Tokyo, 1932; apprentice at Kotaro Miyauchi Photo Studio, Tokyo, 1933-35. Staff photographer, Nihon Kobo Studio, Tokyo, from 1935. Freelance photographer, since 1945. Member, Society for Promotion of International Cultural Relations, 1939; Founder, Shudan Photo group, 1950; Vice President, Japan Photographers Society, 1959. Recipient: Photographic Culture Prize, 1942; Photographer of the Year Award, Japan Photo Critics Association, 1958; Mainichi Photo Prize, 1958; Minister of Education Award of Arts, 1959; Photographic Society of Japan Award, 1960; Japan Journalists Congress Award, 1960; Grand Prix, *International Exhibition of News Photographs*, The Hague, 1960; Mainichi Art Award, Tokyo, 1961; The Kan Kikuchi Award, 1971. Address: 903 Kojimachi Sky Mansion, 4-8 Kojimachi, Chiyoda-ku, Tokyo 102, Japan.

Individual Exhibitions:

1955 *Children of Downtown Tokyo*, Takashimaya Department Store, Tokyo
1960 *Children of Chikuho Coal Mines*, Fuji Photo Salon, Tokyo
1968 *Days of Hatred and Disappointment: Hiroshima*, Ginza Nikon Salon, Tokyo
1972 *Pilgrimages to Ancient Temples*, Odakyu Department Store, Tokyo
1973 *Bunraku*, Waho Gallery, Tokyo
1981 Shadai Gallery, Tokyo

Selected Group Exhibitions:

1974 *New Japanese Photography*, Museum of Modern Art, New York (toured the United States)
1979 *Japanese Photography Today and Its Origin*, Galleria d'Arte Moderna, Bologna (travelled to the Palazzo Reale, Milan; Palais des Beaux-Arts, Brussels; Institute of Contemporary Arts, London)

Publications:

By DOMON: books—*Fubo*, Tokyo 1953; *Hiroshima*, Tokyo 1958; *Children of Chikuho Coal Mines*, Tokyo 1960; *Rumie's Daddy Is Dead*, Tokyo 1960; *Pilgrimage to Ancient Temples*, 4 vols., Tokyo 1963-71; *Taishi-no-Midera: The Taji*, Tokyo 1965; *Bunraku*, Osaka 1972; *The Todai-ji*, Tokyo 1973; *Living Hiroshima*, Tokyo 1978.

On DOMON: books—*Photography of the World '60*, edited by Hiromu Hara, Ihei Kimura and others Tokyo and New York 1960; *New Japanese Photography*, exhibition catalogue, by John Szarkowski and Shoji Yamagishi, New York 1974; *Japanese Photography Today and Its Origin* by Attilio Colombo and Isabella Doniselli, Bologna 1979.

Ken Domon became a photographer in the late 1930's, a decade in which Japan moved towards an economic domination of South East Asia, the occupation of Manchuria and finally towards world war. Domon was still a young man when war was declared. The dramatic and terrible events of the decade were to shape his photography for the span of his working life. As a result of radical student activities he was expelled from university in 1932 and then started an apprenticeship at the Kotaro Miyauchi Photo Studio, after which he joined the Nihon Kobo agency. During this period of rapid industrialisation, there was great social unrest and the rise of the authoritarian power of the state. Though a Marxist photo-collective had been established by Kimura, much of Japanese photography was an imitative, shallow pictorialism. The war, surrender and Occupation made such photographic material irrelevant. Domon faced the aftermath

Benedykt Jerzy Dorys: From *Kazimierz on the Vistula*, 1931-32

with a cold objectivity; it may well have been the only way to accommodate such a disaster. Domon's new realism replaced the abundant, obsolete trivia of glamour and nude photography from the war years. Hiroshima was the turning point.

In October 1950 he established the Shudan Photo group to spearhead his new realism in the midst of the Occupation and the first stirrings of national recovery. The Shudan group held eight annual exhibitions in conjunction with western photographers including Bourke-White, Eugene Smith, Irving Pen, Cartier-Bresson and Bill Brandt. Japan was emerging from the isolation prevalent for nearly two decades.

As well as establishing a new realist school, Domon was recording classical Japanese art. Between 1940 and 1954 he photographed Muro-ji, the temple close to the Muro river near Nara. On the banks of the river he photographed the giant figure of Miroku carved in the rock. Within the temple he photographed the sculpture, which includes the finest examples of carving from the Heian period of Esoteric Buddhism. He isolated the details of the limbs and the expressive hand gestures. With the skill he applied to sculpture, he also recorded the horrifying scars of Hiroshima. The photographs were published as a book in 1958. It contained formal and explicit portraits of the victims, their scar tissue and skin grafts and detailed photographs of surgery. The nearest modern parallel to this book is Eugene Smith's Minamata document. However appalling the scars, there is also the hint of survival. Twenty years after that publication Domon returned to publish another stage in the recovery in *Living Hiroshima*.

He continued to reaffirm his interest in traditional Japan with the publication and exhibition of his work on the *Bunraku*, *The Pilgrimages to Ancient Temples*, and *Todai-ji*. This assertion of his native tradition has been paralleled by his uncompromising documentary work, including his work with Tomatsu in the "Hiroshima-Nagasaki Document" (1961).

By the early 1960's, Japanese economic recovery was accelerating rapidly. The Shudan group was replaced by the new wave of the Junin-no-me and Vivo groups. Modern Japanese photography was established. Ken Domon had been the pioneer.

—Mark Holborn

DORYS, Benedykt Jerzy.

Polish. Born in Kalisz, 25 May 1901. Educated at the Humanistic Grammar School, Kalisz, 1910-19; studied violin at Music School, Kalisz, 1918-22; self-taught in photography. Served in the Polish Army, 1920, and in the defence of Warsaw, 1939. Married Halina Preger in 1928. Photographer since 1914: maintained a studio in Warsaw, Photo-Dorys, 1929-39, 1947-49. Founder Member, 1946, Member of the Qualifying Commission, 1946-47, Member of the General Council, 1947-50, Secretary, 1950-52, and Vice-President of the General Council, 1952-56, Chairman and Member of the Bar of Conscience, 1956-81, also Member and Chairman of the Artistic Commission, 1953-58, and Chairman of the Qualifying Commission of the Warsaw section, 1969-72, of the Union of Polish Art Photographers (UPAP); Founder Member, Warsaw Photographic Society, 1947; Founder Member of the Photo-Section, 1947, Secretary of the Council, 1956-59, and Member of the Board of Conscience, 1959-78, Zaiks authors society, Warsaw. Recipient: 10th Anniversary of the Polish People's Republic Medal, 1955; Gold Cross of Merit, Poland, 1955; Award of Excellence, 1957, and Honorary Excellence Award, 1968, Federation Internationale de l'Art Photographique (FIAP); Ministry and Culture and Art Award, 1960, 1973, 1975; Honorary Member, 1961, Silver Medal, 1960, and Gold Medal, 1974, Union of Polish Art Photographers (UPAP); Cavalier Cross, 1964, and Commandery Cross, 1980, Order of Polonia Restituta; Golden Badge of Merit, 1968, and Commemorative Medal, 1978, Zaiks authors society, Warsaw; 30th Anniversary of the Polish People's Republic Medal, 1974; Jan Bulhak Medal, Warsaw, 1976; Culture Activist's Badge, Poland, 1978. Address: Nowy Swiat 29, ap. 29, 00-029 Warsaw, Poland.

Individual Exhibitions:

1929 Polish Photographic Society, Warsaw
1960 Ministry of Culture and Art Guardhouse Gallery, Warsaw (retrospective; toured Poland)
1974 *Actors and Fashions of the 1930's*, UPAP Gallery, Warsaw (toured Poland)
 Men of Polish Arts and Culture, UPAP-PSP Gallery, Warsaw

1977 *Kazimierz on the Vistula 1931-32*, UPAP Gallery, Warsaw

Selected Group Exhibitions:

1977 *Polish Creative Photography until 1939*, National Museum, Wroclaw, Poland
1978 *Polish Portraiture 1840-1939*, UPAP Gallery, Warsaw
1979 *Fotografia Polska*, International Center of Photography, New York (travelled to the Museum of Contemporary Art, Chicago, and the Whitechapel Art Gallery, London)
1980 *Fotografia Polska 1840-1939*, Galeria Zacheta, Warsaw (travelled to the Museum of Arts, Lodz, Poland)
The Art of Reportage, National Museum, Wroclaw, Poland (travelled to the Museum of Arts, Lodz, Poland)

Collections:

National Museum, Wroclaw, Poland; Museum of Arts, Lodz, Poland.

Publications:

By DORYS: book—*Kazimierz on the Vistula, 1931*, with an introduction by Romuald Klosiewicz, Warsaw 1979.

On DORYS: books—*Among the Polish Masters of the Camera* by Lech Grabowski, Warsaw 1964; *History of Warsaw Photography* by Waclaw Zdzarski, Warsaw 1974; articles—"An Exhibition of B.J. Dorys' Photographs" by Jerzy Ficowski in *New Culture* (Warsaw), 20 November 1960; "Blue Sheets" by A. Rudnicki in *Swiat* (Warsaw), 20 November 1960; "Photographer and Musician" by W. Kicinski in *Trybuna Ludu* (Warsaw), 23 November 1960; "The Work of B.J. Dorys" by M. Sadzewicz in *Stolica* (Warsaw), 4 December 1960; "Afterthoughts on Authenticity" by U. Czartoryska in *Fotografia* (Warsaw), January 1961; "The Versatile Dorys" by O. Galdynski in *Pomorze* (Bydgoszcz, Gdansk and Szczecin, Poland), 1-15 March 1961; "The First Photographic Reportage" by Jerzy Busza in *Culture* (Warsaw), 19 June 1977; "The Leica Folly in Kazimierz" by R. Klosiewicz in *Photography* (Warsaw), June 1977; films—*By the Vistula*, directed by M. Kwiatkowska, commentary by Maria Kuncewicz, 1961; *Photo-Dorys*, TV film, directed by Urszula Litynska, 1980.

Some personal details: I started to photograph in 1914, whilst studying music, the violin. Since 1926 I have been active in the Polish Society of Amateur Photographers, later known as the Polish Photographic Society, in Warsaw. I concentrated on landscape, architectural, nude and portrait photography. I have mastered such techniques as the duplicate, the gum, the bromoil, the transfer, mono-and polychromatic, and others. Since 1927, I have contributed to many exhibitions of artistic photography in Poland and abroad, receiving many medals, awards and honorable mentions. All evidence of this activity was destroyed during the war, the occupation and the Warsaw Insurrection.

Portraiture interests me most. I opened a photo studio in Warsaw in 1929. I have made a tremendous number of portraits of men of culture, the arts, science and politics. I also do fashion, commercial photography, etc. In 1931-32 I made a large series of photographs entitled *Kazimierz on the Vistula*, which is regarded as the first photographic reportage to be made in Poland. A part of that work was exhibited for the first time in my retrospective show in 1960.

I don't feel entitled to cast a critical eye on my photography or to state my views on photography in general. I am tolerant enough not to make evaluations of a photograph dependent on when it was made or upon the problems in which it indulges. The abuse of photography marks the limits of my tolerance. I think that there simply happen to be good and bad photographs. I think that in my own work I have managed to remain true to myself. As far as the future is concerned, I hope that, in its evolution, photography doesn't lose what I consider to be its most essential, almost innate, aspect—namely, its ability to penetrate and interpret the phenomena of the world that surrounds us, and its ability to make visible that which is invisible.

—Benedykt Jerzy Dorys

Benedykt Jerzy Dorys was to have been a musician. In his early years he studied violin, and he intended to devote himself to music as a form of expression. But, instead, he became a photographer, though no ordinary one. Right at the beginning of his long and varied career Dorys became a portrait photographer of people who were well-known and famous—actresses, politicians, artists, the elegant people. His photography was elegant to match—carefully designed, well-mannered, pretty. There was no place in it for ugliness, for protest, or for destruction. Now and then one can find in these portraits wisdom or sometimes a reflective mood, but it is a buoyant and cheerful reflectiveness. There is no question that throughout this early period Dorys was a happy man; so also was his photography.

Yet, in the history of Polish photography Dorys is known not only as an elegant contributor to the portrait tradition but also as the founder of modern camera reportage. In the years 1931-32 Dorys went twice to Kazimierz on the Vistula, a small, picturesque and neglected town populated mainly by Jews. It was not the picturesque which interested Dorys. As always, he was fascinated by people. Not his usual subjects—but people met by chance, often dirty, dishevelled, people of the street and gutter.

And this work from Kazimierz is something quite startling in his career. Wrestling with his subject, Dorys is now inelegant in capturing the dynamics of the street, impulsively captured in snapshots with a 35 millimetre camera. This large series contains much that has now gone forever, things that were then the center of the world for this small provincial town. It is a world of trade and of bitter, anguished destitution, a world of circus attractions, of the music of gypsies, of slums and barefooted children in the street; a world of calm, people as if arrested in time, a world of hopeless waiting and helplessness. It

Ed Douglas (as alter ego Glenson Tealeaf): *Murrumbidgee Power Spot*, 1980

is remarkable that Dorys saw in Kazimierz not those things for which the town was famous but what few people would at that time have perceived: a world stopped in time as though waiting for its own catastrophe. In these photographs, often hurriedly and secretly taken, accidentally composed, there is silence and anxiety; one feels a poignant drama, as if misfortune waits just around the corner.

"Kazimierz on the Vistula" constitutes a sociological study of a town's life. It is also, and perhaps primarily, a study of man. For if there is a common denominator in his radically varied output, it is man. Man is the theme to which Dorys has always remained faithful, whether he was photographing the elegant world of urban Warasaw or taking the group portrait of a dying community.

—Ryszard Bobrowski

DOUGLAS, Ed(ward).

American (Australian resident). Born in San Rafael, California, 6 May 1943; emigrated to Australia, 1973. Educated at Wade Thomas Primary School, San Anselmo, California, 1949-57; Sir Francis Drake High School, San Anselmo, 1957-61; studied fine arts and photography, under Lou Callait, College of Marin, California, 1961-63, A.A. 1963; San Francisco Art Institute, under Joe Humphrey, Geraldine Sharpe, and Blair Stapp, 1964; San Francisco State University, under Don Worth, John Gutmann, Jack Welpott, and Imogen Cunningham, 1965-69, B.A. 1967, M.A. 1969. Married Nancy Wehrheim in 1964 (divorced, 1969). Photographer since 1963. Worked as a boat-builder near San Francisco, 1964-65; teaching assistant to Imogen Cunningham, San Francisco State University, 1968-69; Instructor in Photography, College of Marin, 1969-73; farmed in Nimbin, New South Wales, 1973-76; Instructor, Sydney College of the Arts, 1976-77. Since 1977, Head of the Photography Section, South Australian School of Art, Adelaide. Founder-Member, with Jack Welpott, Judy Dater, Linda Connor, Don Worth and others, Visual Dialogue Foundation, San Francisco, 1969. Recipient: Australian Arts Council Grant, 1976, 1981. Agent: The Australian

Centre for Photography, 76a Paddington Street, Paddington, New South Wales 2021. Address: 26 Sturt Street, Grange, South Australia 5022, Australia.

Individual Exhibitions:

1971 Anima Mundi Gallery, Mill Valley, California
1972 Diablo Valley Junior College, Concord, California
 Hartnell College, Salinas, California
 Studio Gallery, Bolinas, California
1975 Hogarth Gallery, Sydney
1976 Sydney College of the Arts
1980 *2 Photographers*, Contemporary Art Society, Adelaide (with John Coates)

Selected Group Exhibitions:

1970 *California Photogrphers*, University of California at Davis
 Serial Imagery, Purdue University, Lafayette, Indiana
1971 *XV Le Provencal*, at the *Festival of Avignon Photomedia*, Pasadena Art Museum, California
 Visual Dialogue, Musée Réattu, Arles, France
1975 *California Photographers*, National Gallery, Melbourne
1976 *Blue Gum Invitational Exhibition*, State Gallery, Hobart
1978 *Series Show*, National Gallery, Melbourne
1980 *8 South Australian Photographers*, Australian Centre for Photography, Sydney
 Contemporary Australian Photographers, Art Gallery of South Australia, Adelaide

Collections:

Australian Centre for Photography, Sydney; Phillip Morris Collection, Melbourne; Gallery of South Australia, Adelaide; Museum of Modern Art, New York; International Museum of Photography, George Eastman House, Rochester, New York; San Francisco Museum of Modern Art; Bibliothèque Nationale, Paris; Open University, England.

Publications:

By DOUGLAS: articles—"The Gypsy Truck" (photographic series) in *Earth Garden* (Sydney), March 1974; "Search and Discovery" in *Light Vision* (Melbourne), November/December 1977.

On DOUGLAS: books—*California Photographers*, exhibition catalogue, Davis, California 1970; *New Photography Australia: A Selective Survey*, edited by Graham Howe, Sydney 1974; *Australian Photography 1976*, edited by Laurence LeGuay, Sydney 1976; *Australian Photography: A Contemporary View* by Laurence LeGuay, Sydney 1978; *Australian Photographers: The Phillip Morris Collection*, Melbourne 1979; article—"Visual Dialogue Photographers: Portfolio" in *Album* (London), October 1970.

The medium of photography appeals to me because personal images can be made by drawing material from normal experiences or projected fantasies and both are accepted as "real" *because* the image is a photograph. Further, in following this course over the last few years, I have produced a trail of images that have come to be something like "my personal myth."

Lately I have extended this myth, and I have begun to express two sides of my personal nature which do not necessarily agree aesthetically or philosophically. The irony between these two sides or "characters" has become my subject matter. Both characters are photographers who enjoy the other's point of view, but they maintain their differences and their ironic nature. I have used my own name, Ed Douglas, for one of the characters and named the other Glenson Tealeaf.

I have long been aware of my personal diversity of interests. Living in the city, I long for the open spaces of the country; living in the country, I long for the activity and excitement of the city. If I am too long doing practical things that primarily involve the physical side of experience, I long for the abstract and free-flowing possibilities of the intellect. This duality has become the essence of my two characters.

Ed Douglas makes photographs of an idea nature that are extensions of his more detached and, at times, fickle intellectual nature. Glenson Tealeaf photographs the people and places that are dear to him. Tealeaf is an earthy romantic who aspires to being a primitive. Most of his photographs are blurred or out of focus.

The publishers of this book requested work from me, Ed Douglas, but I have sent on a photograph by Glenson Tealeaf because his work is small in scale and will reproduce more accurately. The photograph was taken in January 1980 while Tealeaf and a lady-friend, known as L., paddled a kayak nearly 500 miles down the Murrumbidgee River in southeastern Australia. The photograph was taken at a spot Glenson claims to be an ancient Aboriginal sacred site.

—Ed Douglas

Ed Douglas is a sharp professional with a soft focus—aware of all the angles but never letting go of his belief in the natural gentle side of man.

He explores this dichotomy in his photographs, where there is the hard reality of the picture but always an enigma or, better, an illusion of something else. Art and illlusion; illusion and reality. Douglas works with the age-old duality of art as a central premise of his work.

Douglas usually explores it in self-images, following a very conscious duality in himself: art school lecturer and alter ego, the primitive man called Glenson Tealeaf—the one aggressive, assertive, sharp, harsh, conforming to the demands of professional life; the other accepting, receptive, sensitive to the nuances of nature. Neither can live easily in the other's environment, and it is, of course, the tensions between the two which give Douglas's photographs their edge.

Douglas started using self-portraits against an environment in California in the late 1960's, an important image being *Self Portrait with Taurus-Ego Figure*, a slow exposure resulting in a shadowy, illusory figure—of Douglas the artist—against a fresco of dubious merit shown in full clarity. A further image, in Arles, made of layers of pale tones, shows the disappearing artist stiffly standing near an almost tactile advertisement for the "reality" of beauty "aid." The human being is ephemeral compared with his material products.

For his first years in Australia, living on a farm in northern New South Wales, Douglas continued his exploration of dual roles, with objects literally superimposed over alien environments, as for example, his images of man on the moon collaged over the Australian desert. Later, the harshness and threats of returning to city life, in Sydney in 1976, were translated in a series on plants struggling to live amidst the concrete of the metropolis. In these works (reproduced in the short-lived Australian photographic magazine *Light Vision*), the ideas of the earlier self-images are repeated in the metaphor of these other natural creatures trying to maintain some sense of self-worth: other soft focuses amidst the harsh, bright shapes of the material city. And again, ironically (like the man who is essential to the production of the fresco and the beauty advertisement), these plants are essential to physical and mental and spiritual health of their seeming "sponsors."

The Glenson Tealeaf series, made in South Australia, again leads from this concern. Now the previous illusive, threatened, natural man takes on a substantial persona. In his own quiet way, Glenson Tealeaf asserts the values of his being: the softness of focus, the delicacy of colour, the seeming low-key but subtly, sweetly all-pervasive wholeness of the chosen subjects; the absence of hard, sharp aggression. This is indeed a positive statement, even a triumph, only attained after difficult and on-going personal struggle. For still, over all Glenson's work watches—and judges—the other side, the professional man, Ed Douglas himself.

—Alison Carroll

DRAHOS, Tom.

French. Born in Jabloń, Czechoslovakia, 17 November 1947; emigrated to France, 1968: naturalized, 1978. Studied at the Cinema Academy, Prague, 1967-68; Institut des Hautes Etudes du Cinéma, Paris, 1969-72. Married Christine Gennetier in 1977; son: Alexis. Photographer, in Paris, since 1968. Agent: Galerie Ufficio dell'Arte/Créatis, 44 rue Quincampoix, 75004 Paris. Address: 52 rue Montmartre, 75002 Paris, France.

Individual Exhibitions:

1980 *Mémoire d'Egypte*, Voir Photogalerie, Toulouse
 Ufficio dell'Arte, Paris
 Ikon Gallery, Birmingham

Selected Group Exhibitions:

1973 *Séquences*, Musée d'Art Moderne, Paris
1974 *Révisions*, Institut de l'Environnement, Paris
1980 *Biennale*, Paris
 Ils Se Disent Peintres; Ils Se Disent Photographers, Musée d'Art Moderne, Paris

Collections:

Bibliothèque Nationale, Paris; Musée d'Art Moderne, Paris

Publications:

On DRAHOS: book—*Album Photographique* by Pierre de Fenoyl, Paris 1979; articles—"Humains" by Allan Porter in *Camera* (Lucerne), January 1970; articles by F. Petri in *Nuova Fotografia* (Naples), August 1971; by J. Deutsch in *Le Nouveau Photo* (Paris), July 1972; by A. Pozner in *Zoom* (Paris), November 1973; by J. Rueda in *Nueva Lente* (Madrid), January 1977; by Carole Naggar in *Zoom* (Paris), May/June 1977.

Photography, like all art, passes by three essential axes: sensation, ability, and knowledge. All art has to be a path without compromise, a determination of the predominant essentials of contemporary life. Whoever makes a true analysis of our surrounding reality will never refuse to accept the fine line between beauty and ugliness and will reject all mediocrity in whatever form. In his eyes a perfect work is achieved only by rejecting all ambiguity and false artifice. He knows that each work demands an ethic and a rigor without which it will be banal and dull; he attacks all conventional ideas and the conscience of the age to reach his true creative dimensions. It is in his affirmation or—on the contrary—

in his questionning that he depicts his environment without bothering about its reactions. In this respect he is in a privileged position; at the same time, he is also a prime target. Attached to the phenomena peculiar to Man, he is not embarrassed by any of their manifestations and uses all his strength to find a new definition of life.

After its beginning, when it borrowed much from painting, photography has gradually, over the years, detached itself from pictorial imitations to find its own nature. While contemporary painting now is being influenced by photography, the image of the surface sensitive to the action of light enters a new phase. Although photographic film was devised to record visible reality, nowadays we witness numerous experiments in which the photographer tries to record an "invisible" materiality; the photographer is no longer content to record the evidence; he wants to interpret or even create it.

Without doubt, it is in this direction, in which the photographer insists on his own intervention and participation in the creation of the image in all its complexity, that photography will find its own freedom and its true development. The photographer's eye will cease to be passive and impotent; it will, on the contrary, suggest new dimensions of sensitivity, extend creativity, and push forward towards new and unknown spheres. To be sure, the vocation of photography will remain the same, but its future development will make us reconsider its true significance.

—Tom Drahos

For many young, questing photographers, the "real" is no longer a genuine subject matter. They prefer to invent and then fix a world which bears witness to their visions, to play with representation, to recount

their explorations. Optical illusions, ladders, graphic work form the stage settings of Tom Drahos' work.

Drahos' photographs make conceptual worlds concrete and bring together our various fears—of mutants, of the atomic age, the pressure of daily life, the element of the absurd: threatening forces, but always fixed and frozen. We are reminded of the clarity of certain parts of his Czechoslovakian heritage and his determination to define his role as an artist.

In his quest, in his slow progress towards perfection of subject matter, lighting, and the evocation of moods, Drahos has not been taken in, either by the world around him or by photography itself. He practices the art of clear-sightedness.

—Christian Caujolle

DRIES, Antoon.
Belgian. Born in Antwerp, 14 October 1910. Educated at the School for Dentistry, Antwerp, 1931-35; self-taught in photography. Married Dora Verbert in 1937; children: Luc and Ilse. Dental surgeon, Antwerp, since 1935. Freelance photographer, Antwerp. Member since 1938, and Vice-President since 1939, Photoclub "Iris," Antwerp. Address: Lange Lozanastraat 43, 2000 Antwerp, Belgium.

Tom Drahos: *Les Métamorphoses de Robois,* 1980

Individual Exhibitions:

1961 *Tensions,* Galerie du Studio 8, Paris
1962 *Tensions,* Studio De Braeckeleer, Antwerp
 Tensions, Studio Rik Wouters, Brussels
1965 *Photos 1940-1965,* Looszaal Koninklijke Maatschappy voor Dierkunde, Antwerp
1968 *Natuur-Vorm-Makrie,* Huidevetters Huis, Brugge, Belgium
1971 *Jan Dries: Sculptures,* Galerie Jeanne Buytaert, Antwerp
1974 *Sequences,* International Cultureel Centrum, Antwerp
1976 *Sequences II,* Galerie Jeanne Buytaert, Antwerp
1977 *Beneath the Oaks,* Provinciaal Centrum Arenburg, Antwerp
1979 *House, Garden and Kitchen,* Galerie Jeanne Buytaert, Antwerp (travelled to Gallery 68, Hoensbroek, Netherlands)
1981 *House, Garden and Kitchen,* Galerie Drieghe, Wetteren, Belgium

Selected Group Exhibitions:

1956 *Contemporary Photography,* Galerie St. Laurent, Brussels
1959 *Foto,* Hessenhuis, Antwerp
1960 *5 Belgian Photographers,* Värmlands Museum, Karlstad, Sweden
1964 *Europa Foto,* Esslingen, West Germany (travelled to Hamburg, Cologne, and Ludwigshafen)
1967 *Photo-Graphie,* Albert I Library, Brussels
1969 *Photomundi,* Philips Showroom, Eindhoven, Netherlands
1976 *15 Photographers from Flanders,* Künstlerhaus, Vienna (travelled to Cologne, West Germany, and Chalon-sur-Saône, France)
1978 *3/4 Century Photokring "Iris,"* Het Sterckshof Museum, Deurne-Antwerp
1980 *Camera Belgiea (Europalia),* Gallery C.J.F.R., Brussels
 De Fotografie in Belgie 1940-1980, Het Sterckshof Museum, Deurne-Antwerp

Collections:

Provinciaal Museum voor Kunstambachten Het Sterckhof, Deurne-Antwerp; Galerie Jeanne Buytaert, Antwerp; Belgian State Archives, Brussels; Bibliothèque Nationale, Paris.

Publications:

By DRIES: articles—"Fotosalon in Het Stadhuis van Brussel" in *Fotografie* (Eindhoven, Netherlands), no. 1, 1956; "Fotografi del B.A.G." in *Fotografia* (Milan), May 1956; "Fotografie d'Oggi" in *Fotografia* (Milan), February 1957; "Photographie d'Aujourd'hui" in *Aujourd'hui Art et Architecture* (Paris), June 1957; "Photographie Moderne" in *Flash* (Brussels), December 1957; "Antoine Dries" in *Les Beaux-Arts,* (Brussels), March 1959; "Blick nach Draussen" in *Fotopost* (Mannheim, West Germany), February 1960; "Belgisk Fotografi i Dag" in *Nordisk Tidskrift för Fotografi* (Gothenburg, Sweden), May 1960; "Old and New Photography in Brussels" in *Foto-Tribune* (Antwerp), August 1962; "Photographie" in *L'Arc* (Aix-en-Provence, France), Spring 1962; "Antoon Dries: Poète de l'Image" in *Asahi Pentax Family* (Brussels), September 1966.

On DRIES: book—*De Fotografie in Belgie 1940-1980,* exhibition catalogue, by Roger Coenen and Karel van Deuren, Antwerp 1980; articles—"Antoine Dries" by Julien Coulommier in *Foto* (Doetichem, Netherlands), April 1955; "Spanningen in de Fotograaf Antoine Dries" by Julien Coulommier in *Focus* (Haarlem, Netherlands), April 1961; "Antoon

Dries fotografeert Kunstgalery" by Filip Tas in *De Standaard* (Antwerp), March 1976; "Antoon Dries: De Fotograaf en de Objectiviteit" by Ludo Bekkes in *Kunstbeeld* (Alphen aan de Rijn, Netherlands), January 1980; "Antoon Dries: Objectieve Fotografie" by Karel van Deuren in *Foto* (Doetichem, Netherlands), January 1981; "Quatre Regards de Chez Nous" by Guy Vaes in *Le Nouvel Impact* (Brussels), June 1981.

To put it briefly, what I am doing now is a sort of beholding of the simple reality around me, registering it, without transposition or dramatization, in photo-series which are in parallel with abstract thought.

—Antoon Dries

What is noteworthy in the enormous oeuvre of Antoon Dries, apart from its continuously high artistic quality, is that it alters and evolves just as life itself changes. In the late 1930's Dries began to take photographs as exercises in photographic techniques and classical composition. After World War II, he identified with the subjective photography propagated by Steinert, but then moved on. In an unbroken process of both condensation and invention, he has moved to a style that says more with less visual information. His most recent work is endowed with a touch of Japanese asceticism.

Since 1970 he has worked mainly, as he says, in "series and sequences or at least joined or confronted photos." Yet each individual photo is important; each is of excellent quality. The accent is more on the print than on the conveying of "concept." It is perhaps correct to say that each series of prints is an attempt to integrate time, to visualize an organic process, to establish relativities. In their subtle variations on a theme, the series might be said to show a musical structure. It is extraordinarily enthralling and original work which requires the observer's close attention.

Above all, Antoon Dries looks at the wondrous phenomena that occur all around us with a strong personal response—the melting of a snow-flake, the drying up of a puddle, and slow rotting and shrivelling of fruit.

—Karel van Deuren

DRTIKOL, Frantisek.
Czechoslovakian. Born in Pribram, 3 March 1883. Educated at a school in Pribram, 1893-98; studied photography, under G.H. Emmerich and Hans Spürl, Lehr-und Versuchsanstalt für Photographie, Munich, 1901-03. Served in the Czech Army, 1904-07. Worked in photo studio, Pribram, 1899-1901, and as a photographic assistant in various studios in Munich, 1904, 1907-10; established own photo studio, Prague, 1910-35, concentrating on portraits, 1910-14, and on nude studies, 1918-35; Member, Artel co-operative agency, Prague; abandoned photography to concentrate on painting, meditation and oriental philosophy, Prague, 1935-61. Recipient: Bronze Medal, *Internationale Ausstellung für Photographie und Graphische Kunst*, Mainz, Germany, 1903. *Died* (in Prague) *in 1961.*

Individual Exhibitions:

1972 *Fotograf Frantisek Drtikol: Tvorba z Let 1903-35*, Museum of Decorative Arts, Prague (retrospective)
1973 *Frantisek Drtikol*, at *SICOF*, Milan
1974 The Photographers' Gallery, London
 Royal Photographic Society, London
1977 Secession Gallery, Victoria, British Columbia (with Baron de Meyer)

Selected Group Exhibitions:

1903 *Internationale Ausstellung für Photographie und Graphische Kunst*, Mainz, Germany
1973 *Photography into Art*, Camden Arts Centre, London
1979 *Photographic Surrealism*, New Gallery of Contemporary Art, Cleveland, Ohio (travelled to Dayton Art Institute, Ohio; and Brooklyn Museum, New York)
 Dans l'Objectif des Années 30, Hotel Prince des Galles, Paris

Collections:

Museum of Decorative Arts, Prague (20,000 prints); International Museum of Photography, George Eastman House, Rochester, New York.

Publications:

By DRTIKOL: books—*Prague Courts and Backyards*, with Augustin Skarda, Prague 1911; *Les Nus de Drtikol*, edited by A. Calavas, Paris 1929; *Zena na Svetle/Women in Light*, Prague 1940; *Frantisek Drtikol: Portfolio*, 9 photos, Rochester, New York 1975.

On DRTIKOL: books—*Fotograf Frantisek Drtikol: Tvorba z Let 1903-35*, exhibition catalogue, by Anna Farova, Prague 1972; *Photography into Art*, exhibition catalogue, by Colin Osman, Ainslie Ellis and Margaret Harker, London 1973; *Frantisek Drtikol*, exhibition catalogue, by Anna Farova, Milan 1973; *The Magic Image* by Cecil Beaton and Gail Buckland, London and Boston, 1975; *Geschichte*

Antoon Dries: From the series *Photos of House, Garden and Kitchen*, 1978

Frantisek Drtikol: *Wave, 1927*

der Fotografie im 20. Jahrhundert/Photography in the 20th Century by Petr Tausk, Cologne 1977, London 1980; *Photographic Surrealism*, exhibition catalogue, by Nancy Hall-Duncan, Cleveland, Ohio 1979.

When the Museum of Decorative Arts in Prague mounted its 1972 retrospective of a Czech photographer who had died virtually forgotten a decade earlier, the event forced the re-assessment of a man who had not only once achieved international fame but also had prefigured and influenced the aesthetic of the Bauhaus—Frantisek Drtikol.

A pupil of G.H. Emmerich and Hans Spürl at the College of Photography in Munich, Drtikol had come under the influence of the decorative trend of Jugendstil or Art Nouveau and its literary symbolism. Following a period as an assistant in several Munich commercial photo studios, he returned to Czechoslovakia in 1910 and set up his own studio for portrait photography in Prague. His early work (sold through the co-operative Artel) was a kind of pictorialist soft-focus, his models adopting rhythmic ballet poses amidst crumpled drapes of buttermuslin. Particularly famous for his series of pictures of well-known writers, artists, and early aviators, Drtikol became one of the most revered portrait photographers of the First World War period, and he was much in demand for lectures to amateur and professional photo societies alike. His friend Augustin Skarda, editor of the review *Photographic Horizon*, encouraged his work out-of-doors, and these landscapes were collected into his book *Prague Courts and Backyards*, published in 1911.

After 1920, consistent with current artistic trends, Drtikol's pictorial decorativism changed to a new perception of space and light. He now concentrated on nude studies, a "modernistic" effect being accentuated by the use of an arc lamp to cast harsh shadows. It was this more dramatic studio arrangement of light and form which is often cited as having influenced the then emergent Bauhaus style. His allegorical compositions, often using plywood props and backgrounds that he made himself, emphasized a harmony of line rather than any kind of sexual symbolism—indeed, he was perhaps the father of what later became known as "glamour interpretation." In the 1930's, these compositions, in which the otherwise naked models now wore cloche hats, increasingly involved "cubist" forms, and by 1935 Drtikol was creating almost abstract photos with figurines or painted plywood shapes substituted for live models.

And then, at the age of 52, when he had reached the climax of international fame, Drtikol abandoned photography entirely—to withdraw into painting, into mysticism. Never again did he take up the camera to express his vision of the female form, a vision that had obsessed him for 30 years. During World War Two he bequeathed to the Museum of Decorative Arts all of his photographs which he considered to be of any artistic merit (including more than 20,000 prints), along with his collection of literary documents concerning his life and work.

—Colin Naylor

DUNCAN, David Douglas.
American. Born in Kansas City, Missouri, 23 January 1916. Studied archaeology at the University of Arizona, Tucson, 1935, and marine zoology and deep-sea diving at the University of Miami, 1935-38, B.A. 1938. Served as a combat photographer in the United States Marine Corps, in the South Pacific, 1943-46: Lieutenant-Colonel; Legion of Merit, Distinguished Flying Cross, Air Medal, and Purple Heart. Married Leila Khanki in 1947 (divorced, 1962); married Sheila Macauley in 1962. Has worked as a boxer, deep-sea diver, airline publicity photographer, etc.; photographer, foreign press correspondent and art historian, since 1938: Official Cameraman, Michael Lerner Chile/Peru Expedition, for the American Museum of Natural History, New York, 1940-41; Photographer and Chile/Peru Coordinator, Office of Inter-American Affairs, Washington, D.C., 1941-42; Staff Photographer, *Life* Magazine, in Palestine, Greece, Korea and Indo-China, 1946-56; freelance photographer, working for *Collier's, Life*, ABC-TV, NBC-TV, etc., in the U.S.S.R., Vietnam, the United States and Europe, since 1966. Recipient: Gold Medal, *U.S. Camera*, 1950; Overseas Press Club Award, 1951; Robert Capa Gold Medal, 1968; Photographer of the Year Award, American Society of Magazine Photographers, 1968. Honorary Khan of the Qashqui Tribe, Iran. Address: Castellaras 53, Mouans-Sartoux, Alps Maritime 06, France.

Individual Exhibitions:

1971 William Rockhill Nelson Gallery, Kansas City, Missouri (retrospective)
1972 Whitney Museum, New York
1981 *250 Photographs of Picasso*, Sidney Janis Gallery, New York

Selected Group Exhibitions:

1951 *Memorable Life Photographs*, Museum of Modern Art, New York
1964 *The Painter and the Photograph: From Delacroix to Warhol*, University of New Mexico, Albuquerque
1967 *Photography in the 20th Century*, National Gallery of Canada, Ottawa (toured Canada and the United States, 1967-73)
1977 *Documenta 6*, Kassel, West Germany
1980 *Photography of the 50's*, International Center of Photography, New York (travelled to the Center for Creative Photography, University of Arizona, Tucson; Minneapolis Institute of Arts; California State University at Long Beach; and Delaware Art Museum, Wilmington)

Collections:

Time-Life Library, New York; International Museum of Photography, George Eastman House, Rochester, New York.

Publications:

By DUNCAN: books—*This is War!*, New York and London 1951; *The Private World of Pablo Picasso*,

New York 1958; *The Kremlin*, London 1960; *Picasso's Picassos*, London 1961, 1968; *Yankee Nomad*, London 1966; *War Without Heroes*, New York 1970; London 1971; *Portfolio*, Lausanne 1972; *Prismatics: Exploring a New World*, Paris 1972, London and Dusseldorf 1973; *Goodbye Picasso*, New York and London 1974; *The Silent Studio*, London 1976.

On DUNCAN: books—*Memorable Life Photographs*, with text by Edward Steichen, New York 1951; *The Painter and the Photograph: From Delacroix to Warhol* by Van Deren Coke, Albuquerque, New Mexico 1964, 1972; *Photography in the 20th Century* by Nathan Lyons, New York 1967; *The Magic Image* by Cecil Beaton and Gail Buckland, London and Boston 1975; *Documenta 6*, exhibition catalogue, by Klaus Honnef and Evelyn Weiss, Kassel and Cologne 1977; *Geschichte der Fotografie im 20. Jahrhundert / Photography in the 20th Century* by Petr Tausk, Cologne 1977, London 1980; *Photography of the 50's: An American Perspective* by Helen Gee, Tucson, Arizona 1980; articles—"Korea: David Douglas Duncan" in *U.S. Camera Annual 1951*, edited by Tom Maloney, New York 1950; "Seized Moment" in *Time* (New York), 20 September 1971; "David Douglas Duncan" in *Modern Photography Annual*, New York 1972; "Duncan Photo Show Is First at Whitney" by G. Fraser in the *New York Times*, 15 June 1972; "Les Prismatiques de David Douglas Duncan" in *Zoom* (Paris), no. 20, 1973; "Living Masters of Photography" by Allan Porter in *Camera* (Lucerne), June 1974.

Yankee Nomad is the title of one of David Douglas Duncan's books and an apt title it is. Duncan has been all over the place—a photo-journalist with Everywhere as his location. He has caught fishermen in Mexico; shrines in Japan; Christmas in Kansas City; bullfights in Spain; flying in small planes; golf amid the oil pipelines of the Middle East; sheep, painted for easier spotting by their shepherds, in Ireland. He has done portraits of Eisenhower and Farouk, recorded Lord Mountbatten during the last days of British rule in India. Out of all his observations of historic places, persons and events has come a deep insight into history with overtones of the ironic along with something of the resignation of a seasoned fighting man.

Duncan has been an active Marine and "gone to war" gung ho. He has covered the French in Vietnam, bomber missions, Palestinian terrorism, warriors in south Iran, the Korean war. A number of his images of exhausted G.I.'s have become contemporary icons, immediately recognized as true pictures of the awfulness of war. He has managed to convey such things as fear, death, destruction, the terrain, the weather of combat along with the trivia of cigarettes, coffee, idiosyncrasies of clothing, beards. But above all he has got on paper the haunted and haunting expression in soldiers' eyes.

This response to eyes may be one of the reasons for Duncan's other great subject: Pablo Picasso. Duncan took countless photographs of Picasso over many years, thereby superbly documenting one of this century's great artists. One of the outstanding features of Picasso's face were his big dark eyes with their humor and sadness and relentless scrutiny. Duncan "snuck" into the artist's life, capturing not only the famous eyes but also his work and play, "fair weather and foul," night and day. His camera has recorded how Picasso went about making his art, what he worked on, where he worked. And, by way of compliment, he documented Picasso's world of loved ones, associates, friends, homes, landscapes, games—not to mention such things as Picasso in his underpants, Picasso in an Indian war bonnet, and, of course, Picasso's eyes peering through the cut-out eyes of one of his playful drawings.

—Ralph Pomeroy

DUPAIN, Max.

Australian. Born in Sydney, New South Wales, 22 April 1911. Educated at Sydney Grammar School, under F.G. Phillips, 1925-30; studied drawing and painting, East Sydney Technical College and Julian Ashton School, Sydney, 1933-35; photographic apprentice to Cecil Bostock, Sydney, 1930-34. Served as a camouflage officer, Royal Australian Air Force, in Australia, New Guinea, and the Admiralty Islands, 1939-45; Photographer, Department of Information, Canberra, 1945-47. Married Diana Illingworth in 1945; children: Danina and Rex. Freelance industrial, architectural, fashion, portrait and advertising photographer, Sydney, 1934-39, and since 1947: established Max Dupain and Associates Pty. Ltd., Sydney, 1961. Photography Critic, *Sydney Morning Herald*, 1980-81. Recipient: Silver Jubilee Medal, 1977. Honorary Fellow, Royal Australian Institute of Architects, 1980. Agent: The Australian Centre for Photography, 76a Paddington Street, Paddington, New South Wales 2021. Address: c/o Max Dupain and Associated Pty. Ltd., Unit 13, Valetta Building, Campbell Street, Artarmon, New South Wales 2064, Australia.

Individual Exhibitions:

1938 University of Sydney

Max Dupain: Stair Rail, 1975

1960 University of New England, Armidale, New South Wales
1962 *No Time to Spare*, David Jones Gallery, Sydney
1967 *Australian Colonial Architecture*, Art Gallery of New South Wales, Sydney
Old and New Buildings, Manly Art Gallery, Sydney
1969 *Burley Griffin's Architecture*, Castlecrag, Sydney
From Amateur to Top Professional, Photographic Society of New South Wales, Sydney
1973 *Sydney Opera House*, at the *Triennale*, Milan
1975 Australian Centre for Photography, Sydney (retrospective)
National Gallery of Victoria, Melbourne (retrospective)
1978 Church Street Photographic Centre, Melbourne (retrospective)
Max Dupain: New Work, Powell Street Gallery, Melbourne
1980 *Max Dupain: Retrospective 1930-1980*, Art Gallery of New South Wales, Sydney
Max Dupain: Architectural Photographs, Australian Centre for Photography, Sydney

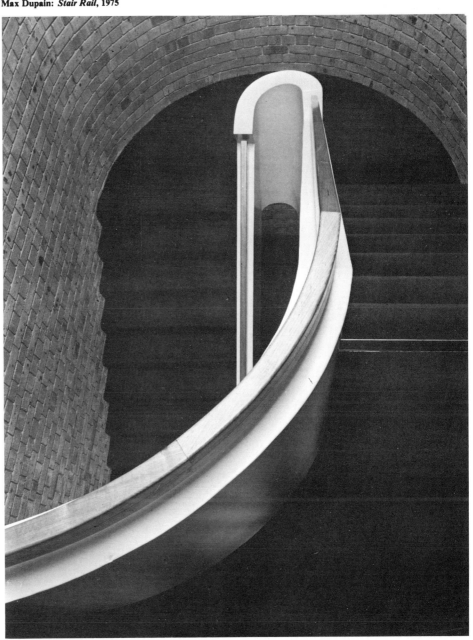

213

1981 The Photographers' Gallery, London

Selected Group Exhibitions:

1932 *Salon Internationale de Photographie*, Paris
1934 *London Salon of Photography*
 Victorian Salon of Photography, Melbourne
1955 *Six Photographers*, David Jones Gallery,
 Sydney
1960 *Third Sydney International Exhibition of
 Photography*
1979 *Australian Pictorial Photography*, Art Gallery
 of New South Wales, Sydney
1980 *The 30's*, Erwin Museum and Art Gallery,
 Sydney
 *International Photography: The Last 10
 Years*, Australian National Gallery, Can-
 berra

Collections:

Australian National Gallery, Canberra; National
Gallery of Victoria, Melbourne; Adelaide Art Gallery;
Hobart Art Gallery.

Publications:

By DUPAIN: books—*Max Dupain: Photographs*,
with an introduction by Hal Missingham, Sydney
1948; *Georgian Architecture in Australia*, with texts
by Morton Herman, Marjorie Barnard and Daniel
Thomas, Sydney 1963; *Australia Square, Sydney*,
Sydney 1967; *Sydney Builds an Opera House*, edited
by Oswald Ziegler, Sydney 1973; *The Golden Decade
of Australian Architecture*, with text by James
Broadbent, Sydney 1978; *Francis Greenway: A
Celebration*, with an introduction by J.M. Freeland,
Sydney 1980; *Old Colonial Buildings of Australia*,
with an introduction by J.M. Freeland, Sydney
1980; articles—"Man Ray" in *The Home Magazine*
(Sydney), October 1935; "The Photography of Henri
Mallard" in *Building the Sydney Harbour Bridge*,
Sydney 1976.

On DUPAIN: books—*Australian Photography*,
annual, edited by Oswald Ziegler, Sydney 1947;
Creative Camera Collection 5, edited by Colin
Osman and Peter Turner, London 1978; *Max
Dupain: 50 Years Work*, with text by Gael Newton,
Sydney 1980; articles—"Australian Camera Per-
sonalities" by Laurence Le Guay in *Contemporary
Photography* (Sydney), January/February 1947;
"Max Dupain" by Gael Newton and others, in spe-
cial monograph issue of *Light Vision* (Melbourne),
May/June 1978.

The technique of etching and that of oil and water-
colour painting and sculpture has not changed basi-
cally for hundreds of years. They are established
mediums. What remains to be done with them is
forever an eternity of exploration and adventure.

Not so with photography. Every month in the
picture magazines there are pages devoted to new
gadgets, new flash units, new automatic devices with
which to do something differently and more quickly
than before; in short, to gratify the whims of
mechanically minded amateur photographers and
create a profitable industry out of profitless indul-
gence.

Those who practice this gadget-ridden "folk art of
20th century people" have substituted "nostalgia"
for "opium." Because in the long run this element,
this photo soporific, is the sum total of their efforts.

After nearly half a century of pretty close involve-
ment in photography I'm convinced that we have to
assess the product of this art of ours by its signifi-
cance. So much of it is banal and trivial and mean-
ingless. There is currently a rash of urban landscapes
appearing in every magazine you pick up, and the
majority of these pictures are boring and proletarian.

On the other hand, there are photographers with a
great sense of discipline, who work with unsophisti-
cated equipment and who possess an acute sense of
selection and spontaneous composition. They are
able to extract every ounce of pictorial sensibility
from their subject, and I support their doctrine to
the last. Sensitivity, piercing awareness, emotional
and intellectual involvement, self-discipline are some
of the elements which create that rapport with the
subject, be it a rock or a woman or a woman on a
rock!

Once this is established—and it takes only frac-
tions of seconds—the camera takes over. But with-
out that subjective liaison as the first flash upon the
inward eye, the result is almost always sterile and
useless.

Subject matter comes to you, you don't go to it (as
in Russian television—it watches you!). Like a
theme which comes to a composer; straight from
heaven; three or four notes and you've got it to work
on, to elaborate, improvise, exercise counterpoint
until you have a symphony or concerto based on
that original theme of several notes.

Likewise you may be on a walk through the bush,
a street, a park, or driving to work, and spontane-
ously an inner voice will call out to you and, behold,
there it is. Although I shoot extemporaneously a lot
of the time, I prefer to have half a dozen shots in my
mind. Probably I have seen them many times under
different conditions and have been thinking about
them. The moment will come when I shall go to
them and make the photographs (in black and
white)! I find the contemplation of the subject brings
it closer to you, and when you are there face to face
and under the stress of knowing this is it and there's
no turning back, something just goes bang inside
and it's all over. I'm sorry I cannot give you a for-
mula for this one; but I stress two things, simplicity
and directness. This means reduction of the subject
to elementary or even symbolic terms, by devious
selection of viewpoint, by lighting, by after-treatment.
I do not always print the total negative. This practice
has become a bit of a fetish. What the hell. The result
is all that matters. Also I work mostly in black and
white—it suits my will to interpret and dramatize. I
have more control with black and white, without
which the personal element is lost forever.

Working as a professional photographer in insu-
lar Australia has been my self-chosen lot. In such a
"cultural backwater," as Norman Lindsay expressed
it, mental stimulation is anything but over-plus,
especially the further one moves into the rural
regions. So one is thrown up against one's inner
resources, and visual excitement comes from over
there by proxy in picture books and printed text;
music, poetry, painting and sculpture provide the
vital ingredients for soul fodder in the local scene.
Direct influential impact is at half-strength capacity.
I think this is a good thing if one has the courage and
endurance to sustain and promote his individuality
by sheer brute assertion of belief in himself. God
help those who can't muster this will unless they
migrate, absorb and return to us, temporarily stimu-
lated and refreshed, but possibly as other human
beings lost to their real selves in the wilderness of the
world's pictorial paradise.

After reading over what I have written, I am
reminded of an article by Beatrice Faust in an issue
of *Light Vision*. She declares, "There is an incredible
amount of bullshit being written and spoken about
photography," simultaneously adding her share to
the heap! At the same time, she issues an alert
against the seduction of words. No doubt her find-
ings are correct, but they do not pertain only to
photography; the whole subjective world is full of it.
The prime endeavour of art critics and writers about
aesthetic matters is to enlarge the chimera which is
emitted by their subject and recreate the dictum that
"all is illusion." Let's not talk too much; there is a
great deal of material out there to be taken hold of,
grappled with and hammered down into beautiful
photographic prints. Let's get on with it.

By the way, this credo establishes a very personal

attitude to the art I practice. Great art is *not* per-
sona; it's impersonal. Shakespeare is not personal,
he embraces all men. Beethoven is not personal, he
reaches heights beyond this earth. How about Rem-
brandt? That light is divine. Listen to the Gods
entering Valhalla in Wagner's *Rhinegold*, and think
of photography. I dare you!

—Max Dupain

Max Dupain is possibly *the* photographer extra-
ordinary of present-day Australia. His formative
years in the late 1920's and early 1930's were beset by
visual clichés emanating from the pictorial, salon
school of photography which boasted a vast follow-
ing. Bromoil prints, misty landscapes and the ubi-
quitous S curve of "the line of grace" were every-
where to be seen on exhibition walls. Dupain too
produced some of these sentimental works—and did
them very well. But quite suddenly—and perhaps by
accident—he discovered a new world that dealt with
reality and the power of industrial form. From this
modernism stance he has never since retreated.

An early picture dated 1932 at a stone quarry with
demanding diagonal shadows was followed closely
by a superb image of grain silos towering into a clear
Australian sky. The concrete forms vibrated within
the frame edge of the picture to unleash a new visual
strength. This was Dupain's radical turning point; it
set him apart from his contemporaries in Australia
and related his work directly to the international
understanding of the documentary approach. When
later (1947) he read *Grierson on Documentary* it
served to reinforce his attitudes. He was particularly
impressed by the great film-maker's definition of
Documentary as "the creative treatment of actual-
ity," and he used this quotation to support his philo-
sophy on many future occasions.

Should it be surprising that Dupain became a
leader in modern Australian photography, it is even
more surprising that his personal images continued
to be produced alongside a varied output of com-
mercial work which included architecture, industry,
fashion, portraits and product advertising. For
many successful Australian photographers there is
no time or inclination for personal production after
commercial activities, but for Dupain the two have
always gone hand in hand. Even today, at 70, his
outpourings in both fields are as prodigious as ever.
He continues to drive himself as remorselessly as he
ever did in younger years.

Dupain found photography as his means of ex-
pression during his years at Sydney Grammar
School. It was here that he won his first award for
"the productive use of spare time" with an exhibi-
tion of landscape photographs. This was in 1928 at
the age of seventeen. Since that time he has received
many prizes and awards, the most recent being an
honorary fellowship of the Royal Australian Insti-
tute of Architects for his services to the photography
of architecture. His first retrospective was mounted
by The Australian Centre for Photography in 1975,
and 1980 saw a further retrospective at The Art
Gallery of New South Wales. Both these exhibitions
paid long overdue tribute to a major Australian
artist.

Writing in the recently published monograph
Max Dupain, Gael Newton states: "Max Dupain
has created a body of work unmatched by his con-
temporaries.... His best images simultaneously belong
to Australian culture and to the expression of the
modern era which first inspired his work in 1931."

—David Moore

DUTTON, Allen A(yers).

American. Born in Kingman, Arizona, 13 April 1922. Educated at Mohave County Union High School, Kingman, 1936-40; Los Angeles Art Center, 1940-41; Arizona State University, Tempe, 1941-42, 1945-47, M.A. in education 1947; Bennington College, Vermont, 1961 (John Hay Fellow); San Francisco Art Institute, 1964. Served as a staff-sergeant in the United States Army, in the U.S.A. and North Africa, 1942-46. Married Harriet E. Freeberg in 1946 (divorced, 1962); married Mary Ann Enloe in 1963; children: Nels, Elizabeth and Wendy. Worked as an entomologist, Arizona Agro Chemicals, Phoenix, 1948-54; Instructor, North Phoenix High School, 1954-61. Freelance photographer, Arizona, since 1964. Instructor in Photography, Phoenix College, 1961-68 and since 1969. Film Producer, Encyclopaedia Brittanica Films, Chicago, 1968-69. Agents: Vision Gallery, 216 Newbury Street, Boston, Massachusetts 02116; and Photography Southwest Gallery, 4223 North Marshall Way, Scottsdale, Arizona. Address: 4925 West Banff Lane, Glendale, Arizona 85306, U.S.A.

Individual Exhibitions:

1964	Union Gallery, Phoenix, Arizona
1965	Arizona State University, Tempe
1967	Phoenix College, Arizona
1970	Instituto Mexicano-Norteamericano, Mexico City
1973	Nikon Salon, Tokyo
1974	Galeria Garcia, Carefree, Arizona
1976	Shinju Gallery, Tokyo
	Galleria Il Diaframma, Milan (and Galleria Il Diaframma, Florence and Rome)
	Focus Gallery, San Francisco
1977	Galerie Bardiwill, Paris
	Massachusetts Institute of Technology, Cambridge
1978	Photography Southwest Gallery, Scottsdale, Arizona
1979	Northlight, Tempe, Arizona
1980	Photography Southwest Gallery, Scottsdale, Arizona
	Phoenix College, Phoenix, Arizona

Selected Group Exhibitions:

1968	*Light*, Hayden Gallery, Massachusetts Institute of Technology, Cambridge
1972	*Multiple Image*, University of Rhode Island, Kingston
	Octave of Prayer, Hayden Gallery, Massachusetts Institute of Technology, Cambridge
1978	*The Great West: Real/Ideal*, University of Colorado, Boulder (toured the United States)
	Self-Portrayal, Friends of Photography, Carmel, California
1980	*Silver Sensibilities*, Newhouse Gallery, Staten Island, New York

Collections:

Museum of Modern Art, New York; University of Kentucky, Lexington; University of New Mexico, Albuquerque; Arizona State University, Tempe; Phoenix College, Arizona; Bibliothèque Nationale, Paris; Tokyo College of Photography.

Publications:

By DUTTON: books—*Mental Retardation: An Image*, Phoenix, Arizona 1968; *The Great Stone Tit*, Tempe, Arizona 1974; *A.A. Dutton's Compendium of Relevant But Unreported 20th Century Phenomena*, Phoenix, Arizona 1977; *Hide and Seek*, portfolio, Phoenix, Arizona 1979; *Fantastic Photographs Folio 1*, portfolio, Phoenix, Arizona 1980.

On DUTTON: book—*Photography for Collectors: The West*, edited by James Alinder, Carmel, California 1980; article—"Allen A. Dutton," special monograph issue of *Northlight* (Tempe, Arizona), May 1977.

The advent of photography caused a revolution in the graphic arts. This medium made it possible to accurately record aspects of the world which, until then, had only been hinted at. The photograph's ability to give us as realistic a record of the visual world in two dimensions is unsurpassed and yet seldom used today with the sharpest intent. The documentary photograph has alternately been venerated and left to languish.

I feel that I am in a small degree unique in that I have used the photographic image not only to record my libido but also the physical environment in which I live. For more than a decade I have been an exponent and practitioner of the photomontage. I feel that this mode of using the photographic image is most valid when my business has been that of documenting my own psyche. I also contend that when I turn my attention to the physical world, the documentary camera style, which so vivified the photography of the last half of the 19th century, is most appropriate. This is why I generally utilize an 8" x 10" view camera at such times. It lends itself to making as accurate a record of the physical characteristics of this world as any photographic tool ever has.

I enjoy recording every minute detail of the desert where I live. I discover in my photographs more than I ever can when I contemplate the Arizona landscape directly. Unfortunately, many contemporary photographers attempt to use a 35mm camera to do what the large-view camera does so well. When they are seduced by the ease of use of the small hand camera for this purpose, I am sure that everyone is the loser.

—Allen A. Dutton

Claiming that his paintings could never look like his dreams, Allen Dutton turned to photography to create his own private world of surrealistic imagery. In his exploration of both personal and societal fetishes and in his re-creation of dreams, he has produced many strange but engaging images.

The Great Stone Tit is an irreverant look at "titenvy," which in Dutton's vernacular is a counterpart to penisenvy. Sometimes attacked by feminists as chauvinist, sexist, and exploitive, this book is actually meant as a humorous tribute to womankind. The pages and pages of large and small womens' breasts are aimed more at the obsessions of men than those of women. As he says in the introduction, "He [man], therefore, has developed an overpowering titenvy which far surpasses any envy displayed by women."

The title of Dutton's later book, *A.A. Dutton's Compendium of Relevant But Unreported 20th Century Phenomena*, is a good indication of the somewhat farsical nature of his concerns. In this work a rambling text, made up of fables, parables, and pseudo-critical essays, accompanies his surrealist inspired photo montages. Here he creates an entire universe of fictional characters, events, heroes, religious rites, truths (which he numbers 1 through 57), legends and myths. Dr. Amy Abletung, world-renowned symbologist from the Center for Creative Symbology located at Mount Grundy, Iowa, adds to the volume a half dozen mock-serious psychological profiles of Dutton's individual pictures; Tungger Rasmussen, "a connoisseur of various sundry and arcane pastimes," is purported to be author of a number of verses accompanying the photos; and Shibo Lethum, an artist working around the time 2,351,012 B.C., is supposed to have contributed a master print showing 29 buttocks. The rest of the compendium is filled with truths (such as "Diligence should be exercised in the care and maintenance of vegetable gardens and external sex organs, for when either is neglected they can easily become overgrown and unproductive") and many other indescribable myths and fables surrounding photographs of parts of bodies and nude women in totally fabricated dreamscapes.

More than anything, Dutton's work seems designed to challenge a viewer's sense of believability, and to push him into the nether realms of imagination.

—Ted Hedgpeth

Allen A. Dutton: *Oh Come All Yellow or Green*, 1974

Harold E. Edgerton: *Golf Drive by Densmore Shute* (1938) from *Seeing the Unseen*, 1977 Courtesy Art Institute of Chicago

EDGERTON, Harold E(ugene).

American. Born in Fremont, Nebraska, 6 April 1903. Raised and educated in Aurora, Nebraska, 1914-21; studied at the University of Nebraska, Lincoln, 1921-25, B.S. 1925; Massachusetts Institute of Technology, Cambridge, 1926-27, M.S. 1927, D.Sc. 1931. Served as a consultant to the United States Army, in Italy, France and England, 1942-43. Married Esther May Garrett in 1928; children: Mary, William, and Robert. Worked as an electrical engineer, Nebraska Power and Light Company, Aurora, 1919-21, and General Electric Company, Schenectady, New York, 1926. Teacher of electrical engineering, Massachusetts Institute of Technology, Cambridge, since 1928 (now Emeritus). Independent photographer, developer of stroboscopis high-speed motion and still photography equipment, Cambridge, since 1930. Founder Partner, 1947, and Honorary Chairman of the Board until retirement, 1972, Edgerton, Germeshausen and Grier (now EG&G Inc.), technical and scientific products and services, Cambridge. Recipient: Potts Medal, Franklin Institute, Philadelphia, 1941; Royal Photographic Society Medal, London, 1944; Gold Medal, National Geographic Society, Washington, D.C., 1968; Albert A. Michelson Medal, American Optical Society, 1969; Culture Award, Deutsche Gesellschaft für Photographie (DGPh), West Germany, 1981. Member, National Academy of Sciences, 1964, and National Academy of Engineering, 1966. Agents: Vision Gallery, 216 Newbury Street, Boston, Massachusetts 02116; and Stephen Wirtz Gallery, 345 Sutter Street, San Francisco, California 94108. Address: Room 4-405, Massachusetts Institute of Technology, Cambridge, Massachusetts 02139, U.S.A.

Individual Exhibitions:

1976 *Seeing the Unseen*, Ikon Gallery, Birmingham, England (travelled to the Photographers' Gallery, London; Hatton Gallery, Newcastle upon Tyne; Midland Group Gallery, Nottingham; Museum of Modern Art, Oxford; and Arnolfini Gallery, Bristol)
1977 Margaret Compton Gallery, Massachusetts Institute of Technology, Cambridge
 Vision Gallery, Boston
 Stephen Wirtz Gallery, San Francisco
 G. Ray Hawkins Gallery, Los Angeles
1978 Galerie Agathe Gaillard, Paris
1980 Museum of Science, Boston
1981 Gallery of Photographs, New Haven, Connecticut
 Haverford College, Pennsylvania
1982 University of Nebraska, Lincoln

Selected Group Exhibitions:

1959 *Hundert Jahre Photographie 1839-1939*, Museum Folkwang, Essen (travelled to Cologne and Frankfurt)
1960 *The Sense of Abstraction*, Museum of Modern Art, New York
1964 *The Painter and the Photograph: From Delacroix to Warhol*, University of New Mexico, Albuquerque
1978 *Tusen och En Bild/1001 Pictures*, Moderna Museet, Stockholm
 Photos from the Sam Wagstaff Collection, Corcoran Gallery, Washington, D.C. (toured the United States and Canada)
1979 *Fleeting Gestures: Dance Photographs*, International Center of Photography, New York (travelled to *Venezia '79* and to The Photographers' Gallery, London)
 Life: The First Decade 1936-45, Grey Art Gallery, New York University
 Amerika Fotografie 1920-40, Kunsthaus, Zurich

Collections:

Massachusetts Institute of Technology, Cambridge; International Museum of Photography, George Eastman House, Rochester, New York; Plainsman Museum, Aurora, Nebraska; Gernsheim Collection, University of Texas at Austin; Science Museum, London; Bibliothèque Nationale, Paris; Centre Georges Pompidou, Paris; Moderna Museet, Stockholm.

Publications:

By EDGERTON: book—*Flash! Seeing the Unseen by Ultra-High-Speed Photography*, with J.R. Killian, Boston 1939, 1954; *Electronic Flash, Strobe*, New York 1970, as paperback, Cambridge, Massachusetts 1979; *Seeing the Unseen*, portfolio, with an introduction by Geoffrey W. Holt, Cambridge, Massachusetts 1977; *Moments of Vision: The Stroboscopic Revolution in Photography*, with James R. Killian Jr., Cambridge, Massachusetts 1979.

On EDGERTON: books—*Hundert Jahre Photographie 1839-1939 aus der Sammlung Gernsheim*, exhibition catalogue, by Helmut and Alison Gernsheim, Essen 1959; *Polaroid Portfolio No. 1*, edited by John Wolbarst, New York 1959; *The Painter and the Photograph: From Delacroix to Warhol* by Van Deren Coke, Albuquerque, New Mexico 1964, 1972; *Looking at Photographs: 100 Pictures from the Collection of the Museum of Modern Art* by John Szarkowski, New York 1973; *The Magic Image* by Cecil Beaton and Gail Buckland, London and Boston 1975; *Geschichte der Fotografie im 20. Jahrhundert/Photography in the 20th Century* by Petr Tausk, Cologne 1977, London 1980; *Tusen och en Bild*, exhibition catalogue, by Ake Sidwall, Sune Jonsson and Ulf Hard af Segerstad, Stockholm 1978; *A Book of Photographs from the Collection of Sam Wagstaff*, designed by Arne Lewis, New York 1978; *Amerika Fotografie 1920-1940* by Erika Billeter, Berne 1979; *Life: The First Decade 1936-1945* by Robert Littman, Ralph Graves and Doris C. O'Neill, New York 1979, London 1980; *The Photograph Collector's Guide* by Lee D. Witkin and Barbara London, Boston and London 1979; articles—"Edgerton Magique" in *Photo* (Paris), March 1979; "Papa Flash's Magic Strobes" in *Photography Year 1980*, by the Time-Life editors, New York 1980.

As I see it, photography is entirely dependent upon light energy. Perhaps I am biased, but electronic flash is the best known method today of producing high-intensity flashes that can be controlled. Once strobe sources became available, multiple applications have immediately followed, not only in conventional photography, but in a myriad collection of ever developing scientific projects.

An old article in the *British Journal of Photography* (September, 1864), when referring to Fox-Talbot's relatively weak spark experiments, stated, "...further progress in this direction would not be difficult." So correct, but it has taken over 100 years for electronic flash to become a commonly used source of light for all types of photography.

The modern xenon-filled flash lamp, in contrast to the open spark of early days, as a photographic source, has three important qualifications: (1) the lamp can be made to operate at relatively low voltages: (2) the lamp is an efficient converter of electrical to radiant energy; and (3) the spectral distribution of energy is such that daylight color emulsions can be used.

A commercial market analysis made a few years ago predicted that flash photography was "out" since the improved films and lenses made photography possible with available light. Just the opposite has happened. The electronic flash, especially for portable photography, has blossomed since now a very *small* unit can serve because of fast lenses and films. However, the use of chemical flash bulbs has decreased, because they were too powerful and also they needed to be changed after each use.

Speciality electronic flash units for bullet photography (1 millionth of a second flash duration), golf ball close ups (1/100,000 of a second), birds (1/10,000 of a second) are now in demand since the conventional flash units in the market place have exposure times of greater than 1/1000 of a second. Photographs without blur are desired. The future of electronic flash is very bright!

—Harold E. Edgerton

Dr. Harold Edgerton is a photographer of extended vision. More exactly, he is a scientist who uses photography to extend the capabilities of the human eye to micro-second vision. How radical is this accomplishment—for Edgerton has virtually changed the way we see in the 20th century—is the measure of his contribution to photography.

Dr. Edgerton's idea was simple but revolutionary. In 1931 he combined the camera with the stroboscope, a device invented in 1832, in which a moving object was viewed either through a slotted disk or by

flashes of light. Edgerton utilized blinding-bright flashes of light, electrical discharges from neon-filled tubes, which could be very accurately controlled. The exposure was made in the infinitesimally small periods of time—as fast as one fifty-thousandth to one-millionth of a second—that the light flashed, thus overcoming the restrictions of a normal camera's mechanical shutter which could only open to top speeds of 1/1500th of a second. Since the camera and flash were synchronized and the speed of the flash could be made to equal that of a moving object, the object appeared to be standing still. This literally allowed objects to be photographed in mid-flight: water hung in mid-air, a speeding bullet was stopped before our very eyes, and a hummingbird's wings were transfixed in flight. The motion could be photographed as a single image, or superimposed in multiples of up to 600 per second, or linked to a motion picture camera to produce moving high-speed images.

One of the most important reasons that high-speed stroboscopic photography can not be ignored is that it has virtually changed our notion of time. Edgerton has said of his photographs that they embody the possibility for "time itself to be chopped up into small bits and frozen so that it suits our needs and wishes." Timing on a micro-scale nearly impossible to imagine is essential to this work. Thus, through photography we are able to see bodies moving through units of time so small they could not have been imagined by previous generations.

There are many implications to Edgerton's work. Not only has his stroboscopic photography been the foundation for the development of modern electronic flash, but he has also taken strobe to the depths of the ocean to reveal another unseen realm. This oceanographic work includes designing water-tight cameras and strobes, working aboard the *Calypso* with Jacques-Yves Cousteau, and developing sonar devices for geological research and underwater archaeological exploration.

All of Edgerton's photographs exploit potentials of the medium overlooked by an art-dominated view of photography. Edgerton considers himself primarily an electrical engineer; these photographs are primarily scientific documents. They were taken and are put to the uses of photographic evidence of phenomena and are, as Geoffrey Holt stated, "as neatly conclusive as the lengthiest equations." They have allowed scientists to chart the unknown, to see the previously unseen, and to analyze principles such as those governing impact, flight and velocity.

Yet these photographs, though they embody rational principles, exist also in the realm of wonder. They bring the marvel of our existence to us simply and directly, translating the aspects of science into a universal language which can be appreciated by the layman. They are assessible and many are familiar, but their wonder and significance can not be forgotten.

—Nancy Hall-Duncan

EDWARDS, Mark.

British. Born in London, 12 June 1947. Educated at Sibford School, Banbury, 1958-63; studied at the Guildford School of Art, Surrey, 1965-68, Dip.A.A. 1968. Freelance photojournalist, London, since 1968. Address: 199A Shooters Hill Road, Blackheath, London SE3, England.

Individual Exhibitions:

1975 Serpentine Gallery, London

1977 *Film Ends*, The Photographers' Gallery, London (with Chris Steele-Perkins; travelled to the International Center of Photography, New York)
1979 *Christiania*, The Photographers' Gallery, London (travelled to the Galleri Loppen, Copenhagen, 1980)

Selected Group Exhibitions:

1971 *8 Young Photographers*, The Photographers' Gallery, London
1972 *The Inquisitive Eye*, Institute of Contemporary Arts, London
The Face of Bengal, Half Moon Gallery, London
1975 *Young British Photographers*, The Photographers' Gallery, London (toured Europe, the United States and Canada)

Publications:

By EDWARDS: books—*Photography*, London 1979; *Christiania*, Copenhagen 1979.

On EDWARDS: exhibition catalogues—*8 Young Photographers*, London 1971; *Young British Photographers*, London 1975; *Film Ends*, London 1979; articles—"Portfolio: Mark Edwards" in *British Journal of Photography* (London), 11 June 1971; "Mark Edwards: Pictures from India" in *Creative Camera* (London), July 1971.

What I learn from my travels is that behind the obvious economic and cultural differences (which the camera describes so well), human beings are fundamentally the same—the same worries and aspirations, problems with the neighbours, the same boredom and loneliness. It doesn't matter where you look: in a remote Nepalese village or an oasis in the Sahara Desert, New York or London.

One of the most striking similarities is the way individuals all over the world weave their own identities into that of a group—the village, the city, the political left or right, or religion. These divisions create the climate for the contradictions and terrible cruelties most journalists spend their lives recording.

Ideologies have become tremendously important, and people themselves no longer matter. Rather than continue to record the sensational outcome of this fragmentation—the fighting for power—I want to draw attention to the causes of these problems at their root—but not in the sentimental way shown in *Family of Man*.

—Mark Edwards

Some photographers are remembered for a number of single images; the hallmark of Mark Edwards' achievement is a consistent and single-minded attempt to approach documentary photography in a more coherent and thematic fashion. He studied photography at the Guildford School of Art in the late 1960's, and a series of his nudes was published in *Creative Camera* in 1968. Since then he has devoted himself to documentary photography and travelled extensively in Europe and Asia.

Edwards takes his work very seriously. He clearly feels that someone who points a camera at starving and desperate people to capture in 1/500 of a second an isolated image that may last forever is taking on a tremendous responsibility. He must examine the causes of social upheaval fully and honestly, not merely present striking images of poverty and conflict. Edwards has, therefore, devoted a great deal of time to his projects. He spent nearly two years in India between 1969 and 1973. Some powerful images have emerged: the decomposing body in the Ganges, with the Taj Mahal in the background; the ravaged face of a man carrying his dead wife.

His work is natural and not over-composed. He photographs the day-to-day activities of a society different from our own and in doing so shows the environment its people operate in so clearly that he gives not only a vivid picture of the activities themselves but also succeeds in setting them in a context that offers us a fresh and novel view of a society we have known only superficially. His pictures are effective as images, not because of a deliberate or imposed dynamism in their composition but because he succeeds in bringing out the essential power and tension inherent in the people and events that he is portraying.

Edwards' major project to date comes out of two years spent in Christiania, a squatters' colony outside Copenhagen. In this work he has gone beyond straight reportage photography in an attempt to present the community in the fullest possible way. He has also produced this work in a book for which he himself has written a stimulating text that points up and is itself given added force by more than 400 photographs which act as a visual commentary.

He has also put together two major exhibitions,

Mark Edwards: *Torsten and Metta in Their Home*, from the series *Christiania*, 1979

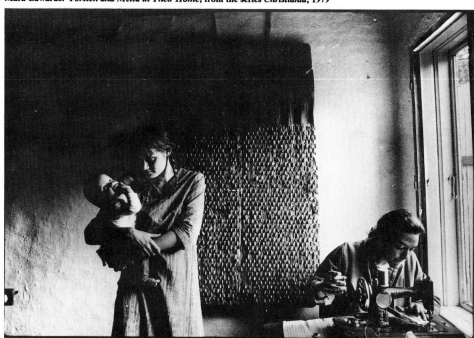

Young British Photographers, which toured both in Europe and the United States, and *Film Ends*, which was made up from the discarded first frames of films and was shown at the Photographers' Gallery in London and the International Center of Photography in New York.

—Catharine Sanders

EGGLESTON, William.

American. Born in Memphis, Tennessee, in July 1937. Educated at public school in Sumner, Mississippi; Webb School, Bell Buckle, Tennessee; Vanderbilt University, Nashville, Tennessee; Delta State College, Cleveland, Mississippi; and University of Mississippi, Oxford. Married to Rosa Eggleston; children: William, Andrea, and Winston. Freelance photographer, Memphis and Washington, D.C., since 1962. Lecturer in Visual and Environmental Studies, Carpenter Center, Harvard University, Cambridge, Massachusetts, 1974; Researcher in Color Video, Massachusetts Institute of Technology, Cambridge, 1978-79. Recipient: Guggenheim Fellowship, 1974; National Endowment for the Arts Photographer's Fellowship, 1975, and Arts Survey Grant, 1978. Agent: Jo C. Tartt, Jr. Address: c/o Jo C. Tartt, Jr., 1347 Connecticut Avenue N.W., Suite 1, Washington, D.C. 20036, U.S.A.

Individual Exhibitions:

1974 Jefferson Place Gallery, Washington, D.C.
1975 Carpenter Center, Harvard University, Cambridge, Massachusetts
1976 *William Eggleston's Guide*, Museum of Modern Art, New York (travelled to the Seattle Art Museum; Santa Barbara Museum of Art, California; Wight Galleries, University of California at Los Angeles; Reed College Art Gallery, Portland, Oregon; and University of Maryland Art Galleries, College Park)
1977 Brooks Memorial Art Gallery, Memphis, Tennessee
Castelli Graphics, New York
Allan Frumkin Gallery, Chicago
Lunn Gallery, Washington, D.C.
Grapestake Gallery, San Francisco
William Eggleston/William Christenberry, Morgan Gallery, Shawnee Mission, Kansas
1978 *Color Photographs*, Cronin Gallery, Houston (with Nicholas Nixon)
1980 *Troubled Waters*, Charles Cowles Gallery, New York

Selected Group Exhibitions:

1974 *Straight Color*, Rochester Institute of Technology, New York
1975 *14 American Photographers*, Baltimore Museum of Art (travelled to Newport Harbor Art Museum, California; La Jolla Museum of Contemporary Art, California; Walker Art Center, Minneapolis; and Fort Worth Art Museum, Texas)
Color Photography: Inventors and Innovators 1850-1975, Yale University Art Gallery, New Haven, Connecticut
1976 *Spectrum*, Rochester Institute of Technology, New York
1977 *The Contemporary South*, United States Information Agency travelling exhibition organized by the New Orleans Museum of Art
Contemporary Color Photography, Indiana University, Bloomington
Contemporary American Photographic Works, Museum of Fine Arts, Houston (travelled to the Museum of Contemporary Art, Chicago; La Jolla Museum of Contemporary Art, California; and Newport Harbor Art Museum, California)
1978 *Amerikanische Landschaftsphotographie 1860-1978*, Neue Sammlung, Munich
Mirrors and Windows: American Photography since 1960, Museum of Modern Art, New York (toured the United States, 1978-80)
1979 *American Images: New Work by 20 Contemporary Photographers*, Corcoran Gallery, Washington, D.C. (travelled to the International Center of Photography, New York; Museum of Fine Arts, Houston; Minneapolis Institute of Arts; and Indianapolis Institute of Arts, 1980; and American Academy, Rome, 1981)

Collections:

Museum of Modern Art, New York; Corcoran Gallery of Art, Washington, D.C.; National Collection of Fine Arts, Washington, D.C.; Brooks Memorial Art Gallery, Memphis, Tennessee; New Orleans Museum of Art; Museum of Fine Arts, Houston.

Publications:

By EGGLESTON: books—*14 Pictures*, portfolio, Washington, D.C. 1974; *William Eggleston's Guide*, edited by and with text by John Szarkowski, New York 1976; *Election Eve*, with a preface by Lloyd Fonvielle, New York 1977; *Troubled Waters*, portfolio, New York 1978.

On EGGLESTON: books—*14 American Photographers*, exhibition catalogue, edited by Renato Danese, Baltimore 1975; *Amerikanische Landschaftsphotographie 1869-1978*, exhibition catalogue, Munich 1978; *Mirrors and Windows: American Photography since 1960* by John Szarkowski, New York 1978; *American Images: New York by 20 Contemporary Photographers*, edited by Renato Danese, New York 1979; articles—"Photography: A Different Kind of Art" by John Szarkowski in the *New York Times Sunday Magazine*, 13 April 1975; "The Commonplace in Living Color" in *Photography Year 1976*, by the Time-Life editors, New York 1976; "New Frontiers in Color" by Douglas Davis in *Newsweek* (New York), 19 April 1976; "Art: Focus on Photo Shows" by Hilton Kramer in the *New York Times*, 28 May 1976; "Photographed Silence" by Malcolm Preston in *Newsday* (Long Island, New York), 10 June 1976; "MOMA Lowers the Color Bar" by Sean Callahan in *New York*, 28 June 1976; "Seeing Pictures" by Julia Scully in *Modern Photography* (New York), August 1976; "The Colors of William Eggleston" by Joan Murray in *Artweek* (Oakland, California), 18 September 1976; "How to Mystify Color Photography" by Max Kozloff in *Artforum* (New York), November 1976; "The Second Generation of Color Photographers" by Allan Porter in *Camera* (Lucerne), July 1977; "William Eggleston, Charles Cowles Gallery" by Lynn Zelevansky in *Flash Art* (Milan), January/February 1981.

If William Eggleston's photographs had been in black-and-white they would not have been noticed. They do not make us laugh, they do not shock or titilate us, they do not make us marvel at how he managed to stage the world so perfectly. But Eggleston's photographs are in color; he was one of the first serious photographers to take advantage of new color technologies. His first color work was shown at the Museum of Modern Art in 1976. The prints were made from color slides. The hues in color slides are intense and contrasty—superreal. Eggleston had large dye transfer prints made from his slides and was able to reduce contrast, increase saturation, and to reproduce on paper this superreal quality of color slides. The result was incredible. A worn out farm truck abandoned in a field glows with an inner heat—it is transformed into a gorgeous object. In the same way road signs caught by the setting sun are transformed into incandescent jewels. The colors glow the way out-of-tune TV colors glow. Those who know Eggleston's work now see the beauty in the commonplace, in the fantasy world of objects shining in a setting sun. He has freed our senses. Eggleston likes to stay up late and sleep into the afternoon. His is a good fit between lifestyle, technology, and choice of subject matter.

Eggleston makes no fetish of discovery. His pictures are straightforward; they neither strive for the accidental, the sensational, the shocking, nor for the clever juxtaposition of unlikely objects and precise organization of diverse forms. They do share, however, a few of the other characteristics of the candid snapshot. Eggleston chooses the same kind of unimportant places and people, and his pictures have the seemingly unsophisticated casualness of snapshots. The difference is that Eggleston's are totally lacking in either the intrusiveness or the cuteness of much snapshot art photography. If there is irony in his pictures it is in the subject matter, not in the condescending attitude of the photographer. His goal seems to be to capture the normal moment which is always quietly present. He takes his pictures in the places he knows best—Memphis and Northern Mississippi. It might be said that his pictures are more like the snapshots that amateurs take of friends and places than they are like the snapshots taken by other art photographers for museum walls.

Eggleston's banal and slightly decadent subject matter combines with his honorable attitude toward reality to save his pictures from any touch of sentimentality. He is, nonetheless, a romantic. His more recent works of sky and nature, using a larger camera and exchanging color negatives for slides, insures his position as a romantic. These may be the photographs he wanted to take all along, but only after shocking the art world into accepting color photography as serious and important could he indulge himself and make the pictures which earlier might have been foolishly rejected as the work of a talented camera club enthusiast.

—Barbara Norfleet

See Color Plates.

EHM, Josef.

Czechoslovakian. Born in Habartov, 1 August 1909. Educated at public school in Poděbrady, Czechoslovakia, 1923-27; apprentice in the portrait studio of K. Podlipný, Poděbrady, Czechoslavakia, 1923-27. Married Marie Nesměrakova in 1956. Worked as a photographer in various studios, Prague, 1927-34; Instructor, State Graphic School, Prague, 1934-46, 1960-67; freelance photographer, Prague, 1946-60, and since 1967. Contributing Editor, *Fotograficky Obzor* magazine, Prague, 1939-42. Recipient: Silver Medal, *Professional Photographers Exhibition*, Prague, 1938; Silver Medal, *International Photography Exhibition*, Poland, 1956; Silver Medal,

Bifota Exhibition, Berlin, 1958; Silver Medal, *International Exhibition of Photography*, Budapest, 1958; Memorial Award, Panorama Publishers, Prague, 1979. Address: U. Smaltovny 20 E, CS-17000 Prague 7, Czechoslovakia.

Individual Exhibitions:

1947 SVU Purkyně Gallery, Prague (retrospective)
1948 Photographic Society, Plzeň, Czechoslovakia (retrospective)
1957 Photographic Society, Pardubice, Czechoslovakia (retrospective)

Selected Group Exhibitions:

1936 *International Exhibition of Photography*, Mánes Gallery, Prague
1939 *100 Years of Photography*, Museum of Decorative Arts, Prague
1948 *Czechoslovak Photography*, toured Switzerland
1950 *Members' Exhibition*, Mánes Gallery, Prague

Josef Ehm: *Study of the Nude*, 1962

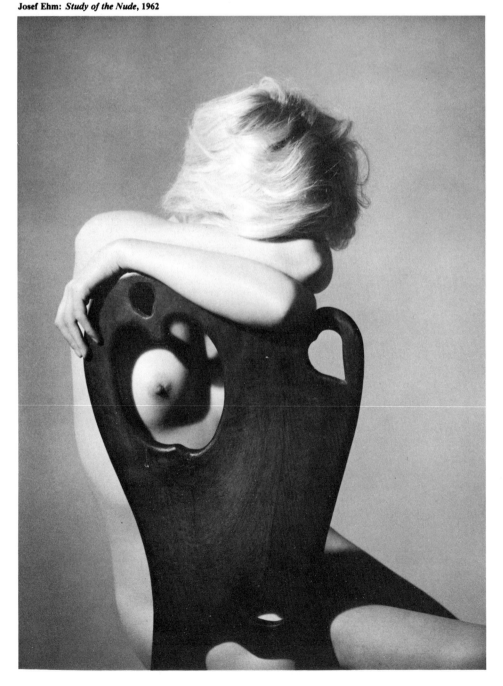

1958 *Czechoslovak Photography*, U Hybernu, Prague
1959 *Union of Fine Artists Exhibition*, Mánes Gallery, Prague
1970 *Cien Grabados y Cien Fotografias*, Museo Universitario, Mexico City
1975 *The Lyricism of Czech Photography*, Municipal Museum, Freiburg, West Germany
1979 *Czech Photography 1918-78*, Fotoforum, Kassel, West Germany

Collections:

Museum of Decorative Arts, Prague; Moravian Gallery, Brno, Czechoslovakia.

Publications:

By EHM: books—*St. George Church*, with text by Cibulka, Prague 1936; *The Sculptor Myslbek*, with text by V.V. Stech, Prague 1939; *The Sculptor Myslbek*, with text by V. Volavka, Prague 1942; *Prague*, with text by V.V. Stech, Prague 1948; *Glass Dream*, with text by N. Papoušková, Prague 1949; *Italian Majolics*, with text by J. Vydrová, Prague 1955; *Bohemian Porcelain*, with text by E. Poche, Prague 1956; *Prague of Yesterday and Today*, with text by E. Poche, Prague 1958, 1965; *Czech Gothic Sculpture*, with text by A. Kutal, Prague 1962; *Czech Castles and Chateaux*, with text by J. Wagner, Prague 1971; *Prague*, with text by Frantisek Kožík, Prague 1973; *Prague's Interiors*, with text by E. Poche, Prague 1973; *Prague in Colour*, with text by J. Janáček, Prague 1979; article—"Interview with Josef Ehm," with Jiří Macku, in *Revue Fotografie* (Prague), no. 3, 1972.

On EHM: books—*Modern Czech Photography* by Karel Teige, Prague 1943; *Josef Ehm* by Jiří Mašín, Prague 1961; *Josef Ehm—Profile* by Jiří Mašín, Prague 1963; *The Ways of Modern Photography* by Ludvík Souček, Prague 1964; *History of Photography* by Rudolph Skopec, Prague 1964; *Art Which Can Be Done by Everybody?* by V. Zykmund, Prague 1964; *The Portrait in Photography* by Ludvik Baran, Prague 1965; *Encyclopedia of Practical Photography* by Petr Tausk and others, Prague 1972; *Fotografie im 20. Jahrhundert* by Petr Tausk, Cologne 1977, London 1979; *Josef Ehm: Portfolio* by Petr Tausk, Prague 1980; articles—"Czechoslovak Photography" by Karel Teige in *Blok* (Brno, Czechoslovakia), 1948; "The 60th Birthday of Josef Ehm" by Petr Tausk in *Kvety* (Prague), no. 30, 1969; "Dear Josef Ehm" by Jiří Macku in *Ceskoslovensko Fotografie* (Prague), August 1969; "Josef Ehm" by Petr Tausk in *Revue Fotografie* (Prague), no. 3, 1979; "Roots of Modern Photography in Czechoslovakia" by Petr Tausk in *History of Photography* (University Park, Pennsylvania), no. 3, 1979.

I think that depicting by means of photography is of a documentary nature. I have always enjoyed taking photographs for my own pleasure, but at the same time I have never been ashamed to take photos purely for purposes of information. All of the art of the Gothic, Renaissance, and the Baroque was done on commission, and we admire still the greatness of these works. I believe that no photographer should be offended if he is forced to do a large part of his work on public or official commission—so long as he can make it good and approach it creatively.
—Josef Ehm

Josef Ehm became a photographer in Czechoslovakia in the second half of the 1920's. According to the custom of the time, he started his career as an apprentice in a portrait studio, and there he acquired the brilliantly precise craftsmanship and respect for the qualities of the image that were to characterize his work in all the years that have followed.

Throughout his apprenticeship and his first jobs in various Prague studios, Ehm was concerned not merely with mastering the fundamentals, but even more with finding his own way, his means to self-expression. This search is particularly obvious in those photographs he made outside the studio, in his images from nature and the landscape—though, in fact, throughout this period of experimentation, he never neglected his own further development in portraiture.

Because of the great quality of his often unconventional results, Ehm was appointed to the faculty of the Photographic Department of the State Graphic School in Prague in 1934. As a teacher he felt it was his responsibility to create all kinds of images as examples for his students. His oeuvre was thus enriched by photographs of architectural and artistic monuments, as well as by reportage, advertising photographs, and still-lifes. And, during these years, he also missed no opportunity to continue to experiment, to define the limits to which creative photography might be extended. He created Photograms; he developed unusual laboratory techniques.

Enthusiasm for anything new and his spontaneous joy in daring creative experiments led him quite legitimately into the ranks of the artistic avant-garde of the 1930's. In this community he came under the influence of surrealism, which in his case meant the poetry of the everyday world as revealed through the *objet trouvé*. And, as was not unusual in Czechoslovakia at the time, in Ehm's attempts to emphasize the modest poetry of reality, surrealistic influences were colored by the precepts of the "New Objectivity."

Shortly after World War II he left his post at the State Graphic School to devote himself to creating photographs for numerous books, and today he is well-known for numerous picture-volumes on Prague, Czechoslovak castles, and various artistic treasures. Yet, apart from these books, Josef Ehm still continues to create his own freely conceived photographs, in which one notes a uninterrupted continuity in his work, which was always meant to convey joy and, above all, genuine feeling.

—Petr Tausk

EISENSTAEDT, Alfred.

American. Born in Dierschau, West Prussia, now Poland, 6 December 1898; emigrated to the United States, 1935, and subsequently naturalized. Educated at the Hohenzollern Gymnasium, Berlin, 1906-12; University of Berlin, 1913-16; self-taught in photography. Served in the German Army, 1916-18. Worked as a belt and button salesman, Berlin, 1919-29; also active as a freelance photographer and photojournalist, mainly for *Weltspiegel* magazine, Berlin, 1927-29; photojournalist, with Pacific and Atlantic Picture Agency, later part of Associated Press, and working for *Berliner Illustrierte Zeitung*, etc., Berlin and Paris, 1929-35; freelance photographer, New York, working for *Harper's Bazaar*, *Vogue*, *Town and Country*, etc., 1935-36; Staff Photographer, *Life* magazine, New York, from 1936. Recipient: Photographer of the Year Award, Britannica Books, 1951; Clifton C. Edom Award, 1953; Culture Prize, Deutsche Gesellschaft für Photographie (DGPh), 1962; International Understanding Award, 1967; *Popular Photography* Award, 1968; Joseph A. Sprague Award, National Press Photographers Association, 1971. Address: Room 2850, Time-Life Building, Rockefeller Center, New York, New York 10020, U.S.A.

Individual Exhibitions:

1955 *2 Photographers: Alfred Eisenstaedt and Walter Rosenblum*, Philadelphia College of Art
1966 *Witness to Our Time*, Time-Life Building, New York
1981 International Center of Photography, New York (retrospective)
Eisenstaedt: Germany, Canadian Centre of Photography, Toronto
In Deutschland, Fotomuseum, Munich

Selected Group Exhibitions:

1951 *Memorable Life Photographs*, Museum of Modern Art, New York
1959 *Hundert Jahre Photographie 1839-1939*, Museum Folkwang, Essen (travelled to Cologne and Frankfurt)
1967 *Photography in the 20th Century*, National Gallery of Canada, Ottawa (toured Canada and the United States, 1967-73)

1974 *Photography in America*, Whitney Museum, New York
1979 *Life: The First Decade 1936-45*, Grey Art Gallery, New York University

Collections:

Time-Life Library, New York; International Center of Photography, New York; International Museum of Photography, George Eastman House, Rochester, New York; National Gallery of Canada, Ottawa; Royal Photographic Society, London.

Publications:

By EISENSTAEDT: books—*Witness to Our Time*, New York 1966; *The Eye of Eisenstaedt*, as told to Arthur Goldsmith, New York 1969; *Martha's Vineyard*, with text by Henry Beetle Hough, New York 1970; *Witness to Nature*, New York 1971; *Wimbledon: A Celebration*, with text by John McPhee, New York and London 1972; *People*, New York 1973; *Panoptikum*, Lucerne and Frankfurt 1973; *Eisenstaedt's Album: 50 Years of Friends and Acquaintances*, New York and London 1976; *Eisenstaedt's Guide to Photography*, New York 1978; *Eisenstaedt: Germany*, Washington, D.C. 1981.

On EISENSTAEDT: books—*Memorable Life Photographs*, with text by Edward Steichen, New York 1951; *Life Photographers: Their Careers and Favorite Pictures*, edited by Stanley Rayfield, New York 1957; *Hundert Jahre Photographie aus der Sammlung Gernsheim*, exhibition catalogue, by Helmut and Alison Gernsheim, Essen 1959; *Photography in the 20th Century* by Nathan Lyons, New York 1967; *Deutschland: Beginn des Modernen Photojournalismus* by Tim N. Gidal, Frankfurt 1972; *Photography in America*, edited by Robert Doty, with an introduction by Minor White, New York and London 1974; *The Magic Image* by Cecil Beaton and Gail Buckland, London and Boston 1975; *Geschichte der Fotografie im 20. Jahrhundert/Photography in the 20th Century* by Petr Tausk, Cologne 1977, London 1980; *Great Photographic Essays from Life* by Maitland Edey, Boston 1978; *Amerika Fotografie 1920-1940* by Erika Billeter, Berne 1979; *Life: The First Decade 1936-1945* by Robert Littman, Ralph Graves and Doris C. O'Neill, New York 1979, London 1980; The *Photograph Collector's Guide* by Lee D. Witkin and Barbara London, Boston and London 1979; articles—"Legend in Our Times: Alfred Eisenstaedt" by Arthur Goldsmith in *Infinity* (New York), September 1971; "Alfred Eisenstaedt" in *Modern Photography Annual*, New York 1972; "Why I Use an SLR: Alfred Eisenstaedt, Peter Turner, Neal Boenzi" by R. Busch in *Popular Photography* (New York), May 1973; "Eisenstaedt's People" by Arthur Goldsmith in *Popular Photography* (New York), December 1973; "Allemagne Année 30" in *Photo* (Paris), April 1981.

No man stands taller in the ranks of photojournalists than does Alfred Eisenstaedt at 5'4". Now 83, Eisenstaedt is still vigorous, still working, still filled with the enthusiasm for photography that started him on his career in Germany between the first and second World Wars.

Like many of his colleagues on *Life* magazine in the '30s, Eisenstaedt was (and remains) a generalist, with no particular area of specialty for his photographs—although he's at his best working with people. For more than five decades "Eisie" has photographed the important, the unimportant, the famous and the infamous people whose doings change or inform the world they inhabit. In the late 1920s in Berlin he photographed, among other theater personalities, the young Marlene Dietrich, just become a star for her work in *The Blue Angel*.

His portrait of a glowering Joseph Goebbels, Nazi propaganda minister, made in 1933, is almost a definitive picture of the sinister spirit of the Hitler regime. Another Eisenstaedt classic shows merely the cracked, bare soles of the feet of an Ethiopian soldier during his country's war with Italy. This simple, powerful image evokes many overtones of the miseries of war.

Great physical energy is packed into Alfred Eisenstaedt's small frame. He is a disciplined sit-up and push-up devotee, walks a great deal, carrying a pedometer to keep track of his daily mileage. His reward for living strenuously is the stamina and appearance of a man in his mid-60's.

To go with Eisenstaedt, even out to lunch, is to break into a slow trot to keep up with the rapidly moving octogenarian ahead of you who threatens to disappear in the distance if your pace is too leisurely.

On the job, too, he is all action, moving swiftly from spot to spot, looking for the proper perspective and viewpoint, checking the light, leaving, if necessary, to return hours later when the light is right. As he works with people, Eisenstaedt maintains a stream of commentary—questions, commands, observations—designed to distract the subject, to put him or her at ease, to make the all-seeing lens of his camera invisible.

When Eisenstaedt learned his craft, lenses were slow and/or less than needle sharp, films were unresponsive and coarse-grained in most cases. Nevertheless, he helped to pioneer the small, maneuverable camera that has today become the hallmark of the photojournalist. First with a little Ernemann taking glass plates, later with the Leica using 35-mm roll film, Eisenstaedt made his photo essays, whenever possible, by light that existed on the scene. This led often to slow exposures of a quarter- or a half-second with the camera mounted on a tripod. The process removed a certain amount of spontaneity (what subject could stay unaware of a tripod-mounted camera?) but gave a natural "here's-how-it-was" atmosphere to the scene by preserving the actual lighting rather than substituting bright lamps of flash. He was a pioneer of today's "existing-light" photography.

Colorful as a personality, Eisenstaedt is otherwise conservative as photojournalists go. He is an unflamboyant dresser, has no recorded vices other than (as some colleagues would have it) regular exercise. His manner is mild and friendly. On the job, he is intensely concentrated, yet shoots minimally—enough to provide his editor with variety, yet not with the motor-winder abandon exhibited by some of his peers.

The balanced Eisenstaedt personality is evident in many of his photographs. Seldom are they passionately partisan, angry, shocking, derogatory. Humor is often there—visual, human, perhaps the hardest kind to bring off successfully. Affection, symbolism and the revealing side glance that gives character to a photo essay are there. An Eisenstaedt photograph is cleanly composed, perhaps through disciplines learned when 35-mm photographers had to make every square millimeter of negative space count to preserve technical quality in the print.

His pictures have rarely been labeled as great art. And yet their consistent excellence over a half-century gives them a staying power that many of the images by lately-acclaimed artist-photographers sadly lack. There is nothing trendy or temporary in Eisenstaedt's approach. His images are products of dispassionate observation tempered with the reactions, likes and dislikes of an urban personality—visually refined and distilled by the eye of the definitive photojournalist.

—Kenneth Poli

ELETA, Sandra.

Panamanian. Born in Panama, 4 September 1942. Educated at Elizabeth Seton High School, New York, 1959-60; studied art history at Finch College, New York, 1961-64, and literature at the New School for Social Research, New York, 1970-71. Painter, in Spain, 1964-67; worked in the Art Department of Campagnani and Quelquejeu, Panama, 1968-69; Art Guide/Lecturer, Metropolitan Museum of Art, New York, 1970-71; Instructor of Photography, Universidad de San Jose, Costa Rica, 1972-73. Freelance photographer, Panama, since 1974, working for Latin American periodicals, 1974-76, and on the Portobelo study project, since 1976. Address: Post Office Box 157, Panama, Zone 1, Republic of Panama.

Individual Exhibitions:

1975 *Solentiname*, Center for Inter-American Relations, New York
1979 *3 American Women*, Canon Photo Gallery, Amsterdam
1980 *Portobelo*, Consejo Venezolano de Fotografia, Caracas

Selected Group Exhibitions:

1976 *The Latin Woman*, McGraw-Hill Exhibition Center, New York
1978 *Ritos y Minorias*, La Photogaleria, Madrid
Muestra de Fotografia Latinoamericana Contemporanea, Museo de Arte Moderno, Mexico City
1979 *Venezia '79*
Rencontres Internationales de la Photographie, Arles, France

Collections:

Museo de Arte Moderno, Mexico City; Bibliothèque Nationale, Paris.

Publications:

By ELETA: books—*Portobelo*, Buenos Aires 1981; *Solentiname*, with text by Ernesto Cardenal, Wuppertal, Germany 1981.

On ELETA: book—*Hecho en Latinoamerica*, edited by the Consejo Mexicano de Fotografia, Mexico City 1978; articles—"Portobelo o la Magia del Espacio" by Edison Simons in *Zoom* (Madrid), 31 January 1978; "Three American Women" in *Reflexions* (Amsterdam), March 1979; article by Michel Nuridsany in *Le Figaro* (Paris), 17 July 1979; article in *Camera* (Lucerne), January 1980; "Las Tribolaciones del Señor Vatifafotti" by Paolo Gasparini in *Bulletin of Consejo Venezolano de Fotografia* (Caracas), May 1980.

My development as a photographer is parallel to my personal development. As a former painter, I found it to be a lonely mental world and, having the need for a more physical way of expressing myself, turned to photography. At the beginning my pictures were closed in: I used to photograph cryptic symbols, worlds in the shadows, in a perpetual alienation. In my first workshop I was forced to become more real, to participate with my work in the daily task of living.

To participate—that was the word that opened the world for me. Since then I have been involved in the process of navigating to the vital center of being, where establishing contact and participating in the flow of life are open possibilities. Being and seeing merge as in the moments of poetic epiphanies; vision becomes an extension of the totality of being.

The eye doesn't respond solely to the mechanical, conditioned vision. The visionary poets have been able to travel, sometimes, around the eye; some photographers too (and as filmmaker Jean-Luc Godard once said, "To look around oneself—that is to be free"). Part of the new dimension that contemporary photography has offered: the great range of feeling and subjectivity to explore reality. Visionaries like Gene Smith, Bill Brandt, Diane Arbus, and Robert Frank mastered the documentary style by adding a strong personal dimension, deep psychological insight—and sometimes by using reality as a symbol to convey another reality, rendering visible the invisible. Reality as such was perceived on many different levels, contemporary styles of photography being enriched with different ideas generated by various branches of photography, which now converge as part of a natural process of assimilation.

—Sandra Eleta

"I try to reach, as deeply as possible, within the theme, searching for a dialogue, rather than chasing after separate moments." And for Sandra Eleta the theme is always the same: people, human beings. It is difficult to think of her photographing buildings or stones or landscapes. All of her photographs are portraits. Portraits with or without a background. Human beings clothed in all their dignity, their strength, even their invisible reality—but never naked, vulnerable, or weak.

Sandra Eleta feels herself incapable of photojournalism or of catching decisive moments. When she does work in that way, she suffers; it is simply not her style. Nor do we find any evidence of a search for particular composition or particular illumination. The contrary is true: everything is simple. The emphasis is on detail, anything that can reveal the subjective commentary, the theme.

She worked from the beginning with a Hasselblad with a normal lens (80 mm). Later she added a Leica and Nikon, each of them having only one lens. Changing lenses seems to her as inconceivable as changing eyes. Each camera has its own way of seeing things. When she starts with a theme, she experiments with different film and its various sensitivities and with her cameras: once she has decided which medium is the most appropriate to her purposes, she forgets the technicalities to concentrate on theme.

Apart from her first essay on the Nicaraguan poet Ernesto Cardenal and his work in Solentiname, the most important and successful of her work is the series on Portobelo and its inhabitants, a people full of dignity, independence, and magic. Her work on three peasant women from the Valley of Tonosi is especially fine. She describes them: "work becomes rite, dance, celebration of the cycles of sowing and reaping; they are priestesses of eternal laboring." She captures with great success the incredible inner beauty of these three women.

There is a further series of photographs taken in the house of relatives in Madrid. All the servants, cooks, helpers, drivers, butlers are included, portrayed while at their individual tasks, in their own places within that world—with their pride, their ambitions, their fleeting jealousies, and perhaps their unconscious emulation of their masters' attitudes. In this series of photographs, as in the others, Sandra Eleta does not denounce or condemn. She has searched for the profound truth of her theme. She portrays her subjects with wit and with joy and as human beings rather than clichés. Every one of the characters portrayed reveals himself or herself totally, even the aunt—surprisingly, because the portrait of the aunt seems to be of somebody already not of this world, someone who has left only a ghostly form behind. The aunt was delighted with the photo: she said it looked exactly as she felt. But

Sandra Eleta: *Ventura y Palanca* **from the series** *Portobelo*, 1977

the series remains unfinished.

During the last year Sandra Eleta has been working with color, always in Portobelo and the Atlantic coast of her country. She says: "I feel less prejudice against using color now. I think I have found some new depth, and I have tried hard to escape the commonplace. I have very substantial material and will continue to polish my work."

Compared to the excessive sybaritic searching of the photography of Europe and the United States, the photography of Sandra Eleta seems not merely very Latin America but also very important, because it is a return to the essence and truth of human beings.

—Maria Cristina Orive

ELISOFON, Eliot.

American. Born in New York City, 17 April 1911. Studied at Fordham University, New York, 1929-33, B.S. 1933. Served in the United States Army, 1942-45. Married Mavis Lyons in 1941 (divorced, 1946); married Joan Baker Spear in 1950 (divorced, 1965); children: Elin and Jill. Freelance magazine photographer, working for *Life, Mademoiselle*, etc., New York, 1937-42; Staff Photographer, *Life* magazine, New York, travelling in South America, Africa, Pacific Islands, Japan and Europe, 1942-64; freelance photographer, working for *Smithsonian*, and other journals, New York and Washington, D.C., 1964 until his death, 1973. Also independent painter in watercolor. Color consultant on films *Moulin Rouge*, 1952, *Bell, Book and Candle*, 1958, *Warlord*, 1962, and the *Greatest Story Ever Told*, 1965; Creative Director, *Black African Heritage* ABC-TV series, 1966-67. Founder-Member and Curatorial Associate, Museum of African Art, Washington, D.C. Visiting Lecturer and Instructor, Dallas Theater Center; Yale University, New Haven, Connecticut; Syracuse University, New York; Radcliffe College, Cambridge, Massachusetts; Wellesley College, Massachusetts; Sarah Lawrence College, Bronxville, New York; Museum of Modern Art, New York; School of the Art Institute of Chicago, etc. Honorary Research Associate, Harvard University, Cambridge, Massachusetts, 1961. *Died* (in New York City) *7 April 1973*.

Individual Exhibitions:

1937 New School for Social Research, New York
1958 Durlacher Brothers, New York
1960 Durlacher Brothers, New York
1969 Gekkoso Gallery, Tokyo (watercolors)

Selected Group Exhibitions:

1951 *Memorable Life Photographs*, Museum of Modern Art, New York
1964 *The Painter and the Photograph: From Delacroix to Warhol*, University of New Mexico, Albuquerque
1979 *Life: The First Decade 1936-1945*, Grey Art Gallery, New York University

Collections:

Museum of Modern Art, New York; Fogg Art Museum, Cambridge, Massachusetts; Colby College, Maine; Pennsylvania Academy of Fine Arts, Philadelphia; Philadelphia Museum of Art, Pennsylvania; Dallas Museum of Fine Arts, Texas; Honolulu Academy of Art, Hawaii; National Museum of Western Art, Tokyo.

Publications:

By ELISOFON: books—*Food Is a Four-Letter Word*, New York 1948; *The Art of Indian Asia*, illustrations, New York 1955; *The Sculpture of Africa*, with text by William Fagg, London 1958; *Color Photography*, New York 1961, London 1962; *The Nile*, with an introduction by Laurens van der Post, London 1964; *The Hollywood Style*, with text by Arthur Knight, London 1969; *Java Diary*, New York 1969; *Indian Cookbook*, illustrations, New York 1969; *A Week in Leonora's World: Puerto Rico*, New York and London 1971; *Erotic Spirituality: The Vision of Konarak*, with text by Alan Watts, New York and London 1971, 1974; *Zaire: A Week in Joseph's World*, New York and London 1973; articles—"Nets by Eliot Elisofon" in *U.S. Camera Annual 1952*, edited by Tom Maloney, New York 1951; "Peru and Chile by Eliot Elisofon" in *U.S. Camera Annual 1953*, edited by Tom Maloney, New York 1952; "Africa by Eliot Elisofon" in *U.S. Camera Annual 1954*, edited by Tom Maloney, New York 1953; "Color in Paradise by Eliot Elisofon" in *U.S. Camera Annual 1956*, edited by Tom Maloney, New York 1955; "An Eleventh-Hour Effort to Save Java's Borobudur Temple" in *The Smithsonian* (Washington, D.C.), June 1973; films—*Black African Heritage*, 4 one-hour television documentaries, 1966-67.

On ELISOFON: books—*Memorable Life Photographs*, with text by Edward Steichen, New York 1951; *The Painter and the Photograph: From Delacroix to Warhol* by Van Deren Coke, Albuquerque, New Mexico 1972; *Life: The First Decade 1936-1945* by Robert Littman, Ralph Graves and Doris C. O'Neill, New York 1979, London 1980.

Eliot Elisofon was like some romantic explorer: he was in thrall to the exotic, the "far away," the *terra incognita* of the freshly observed. He skillfully documented treasures of African art and, just as skillfully, captured the particularities of places.

Elisofon loved to find the exact flora and fauna that, in their natural setting, revealed why one place differed from another. Through displacement of perspective, he would create a new view of some great monument—the pyramids in Egypt, for example. The directness of his approach resulted in a great deal of information: how things look, how *people* look.

He also showed us animals in action; great rivers from the air; people working or resting; light on ruins; a swarm of locusts; elephants at peace with pelicans. Elisofon's photographs caught light at work creating compositions, the intense drama of sculpture in the open air.

—Ralph Pomeroy

ELLIS, Rennie.

Australian. Born in Melbourne, 11 November 1940. Educated at Brighton Grammar School, Melbourne, 1951-58; University of Melbourne, 1959; studied advertising at Royal Melbourne Institute of Technology, 1960-62, 1966, Dip.Adv. 1966; self-taught in photography. Married Carol Silk in 1966 (divorced, 1978); son: Joshua. Television Producer, Orr, Skate and Associates, Melbourne, 1960-62; Copy Chief, Jackson Wain Advertising, Melbourne, 1966-67; Creative Director, Monahan Dayman Advertising, Melbourne, 1967-69. Freelance photographer, filmmaker, and writer, Melbourne, since 1969: established studio, Rennie Ellis and Associates, 1975. Founder-Director, Brummel's Gallery of Photography, Melbourne, 1972-80, and Scoopix Photo Library, Melbourne, 1975. Part-time Lecturer in Creative Writing, Preston Institute of Technology, Melbourne, 1973. Recipient: Silver Medallion, Art Directors Club of Melbourne, 1972; United Nations "Habitat" Award for Australia, 1976; Visual Arts Board Grant, Australia Council, 1976. Address: Rennie Ellis and Associates, 154 Greville Street, Prahran, Victoria 3181, Australia.

Individual Exhibitions:

1971 *Kings Cross, Sydney*, Yellow House, Sydney

Eliot Elisofon: *Peruvian Group #1, 1950* Courtesy Art Institute of Chicago

(travelled to Gallery A, Melbourne)
1975 *Aussies All*, 500 Collins Street, Melbourne
1976 *Heroes and Anti-Heroes*, The Photographers' Gallery, Melbourne
1978 *The Way of Flesh*, Australian Centre for Photography, Sydney

Selected Group Exhibitions:

1973 *Children*, Brummels Gallery of Photography, Melbourne
1975 *Snapshots*, Australian Centre for Photography, Sydney
 Recent Australian Photography, touring exhibition (toured the Far East)
1977 *Five Photographers*, Benalla Art Gallery, Benalla, Victoria
1978 *5th Philip Morris Arts Grant Exhibition*, at the *Adelaide Festival of Arts*
1979 *Australian Photographers*, Hyde Park, Sydney
1980 *Through the Looking Glass*, Ray Hughes Gallery, Brisbane

Collections:

Australian National Gallery, Canberra; National Gallery of Victoria, Melbourne; Australian Centre for Photography, Sydney; Tasmanian Museum and Art Gallery, Hobart; Bibliotheque Nationale, Paris.

Publications:

By ELLIS: books—*Kings Cross, Sydney*, with Wes Stacey, Melbourne 1971; *Australian Graffiti*, Melbourne 1975; *Ketut Lives in Bali*, with Stan Marks, London 1977; *L'Australie*, with Ursula Marcus, Zurich 1978; *Australian Graffiti Revisited*, Melbourne 1979; articles—"Follow the Fence, Follow Your Nose" in *Walkabout* (Melbourne), October 1970; "Once a Jolly Oddball" in *Pol* (Sydney), vol. 5, no. 7, 1973; "Recognizing Snaps as Art" in *Nation Review* (Melbourne), 5 October 1973; "A Taste of Honeys" in *Man* (Sydney), November 1973; "Ikons of the Dreaming" in *BHP Journal* (Melbourne), March 1975; "Mykonos" in *Vogue Men* (Sydney), July 1977; "The Pool Where Parisians Meet" in *The Age* (Melbourne), 30 July 1977; "Rennie Ellis on Looking at Photographs" in *Light Vision* (Melbourne), September 1977; "The Driving Force Behind LRB" in *Australian Playboy* (Sydney), February 1980; "The Legend Lives On" in *Detours* (Sydney), Winter 1980.

On ELLIS: articles—"Rennie Ellis: Brummels Gallery" in *Professional Photography in Australia* (Melbourne), July 1973; "Rennie Ellis, Photographer" in *Australian Photography* (Sydney), June 1976; "Youthful Celebration of Fleshly Pleasures" by Sandra McGrath in *The Australian* (Sydney), 31 January 1978; "Camera on the Threshold" by Nancy Borlace in *Sydney Morning Herald*, 4 February 1978.

While I make a living as a commercial photographer, the medium is also my vehicle for self-expression—my art form, if you like. I take photographs for fun, for the people it brings me into contact with, for the doors it unlocks, for the thresholds it allows me to cross. I like to put myself in "a state of grace with chance." My presence with a camera often triggers off the image I capture. I like to document things that happen around me, the situations I find myself in, my friends. I like to photograph interesting ladies I find in the street. I like to embrace the moment. I like adventures and I collect images. I respond to things erotic and things bizarre. Perhaps my photographs give visual form to vague feelings and fantasies that I have. Maybe.
—Rennie Ellis

The most significant aspect of Rennie Ellis's photography is his overriding concern with images and ideas, as opposed to virtuoso displays of technical facility. This does not mean that he pays no attention to technique. For Ellis, technique is merely a means to an end. The first image should reach out, engage the interest of the viewer, and perhaps change his way of seeing a specific aspect of the world around him.

Ellis is an enthusiastic supporter of education in the Aesthetics of Photography. He believes that the way one looks at photographs is as important as learning how to use a camera and puddle around in the dark room. While bemoaning the lack of tradition in Australian photography, Ellis believes that the last five years have seen great advances in terms of critical sensitivity to the underlying subtleties and inner motivations of the photographic artist.

He explains his personal attitude to his art as follows: "Taking photographs is very important to me; it somehow helps me to define my place in the universe."

At times he has expressed doubts about the significance of the photographer's art, compared to that of a painter, printmaker or filmmaker, but is reassured by public response to the photographic image in the gallery context.

At a symposium at Prahran C.A.E. on April 30th, 1977, Ellis commented:

I think photography is full of contradiction, full of mysteries, and I hope its potential for innovation is as great as any of the art forms, because the way I see it, the boundaries of our visual experience are limitless—the horizons keep on receding!

He summed up his ideas about his own work and what he feels should be the attitude of other practitioners by quoting Alfred Steiglitz: "Art or not art, that's immaterial. I continue on my own way, seeking my own truth ever affirming today."

Ellis, founder of the Pentax-Brummels Gallery of Photography in Melbourne, has exhibited regularly since 1971, presenting one-man shows with telling insights into aspects of the human condition as he sees it.

In his Sydney exhibition *The Way of Flesh* Ellis incorporated lively written commentaries to embellish his photographic images of the human body in all its glory and ugliness. Goddesses sunbaking on rooftops in Hydra stimulated an erotic viewer response, while overweight Australian males swilling beer from tins invoked laughter and repulsion. In a sense these works provided viewers with an almost voyeuristic pleasure, akin to peeking into someone's private diary. Ellis revealed much about himself and his subjects with a refreshing honesty.

After *The Way of Flesh* exhibition he set about documenting interesting aspects of Australian railway stations, no doubt spurred on by the knowledge that the original architectural delights which heralded the coming of the steam train in Australia were doomed to extinction by the rapid onslaught of progress.

—Arthur McIntyre

Rennie Ellis: *My Son Joshua Learning to Swim*, 1973

ERFURTH, Hugo.

German. Born in Halle, 14 October 1874. Educated at the Parish School, Niederschona, 1880; Kreuzgymnasium, Dresden, 1884; Handelsschule, Dresden, 1886-92; studied art at the Academy of Arts, Dresden, 1892-96; photographic apprentice to the court photographer Hoffert, Dresden, 1892-96. Married Helene Reuther in 1898; children: Wolfgang, Gottfried and Annemarie. Established own portrait studio, Dresden, 1896-1906, and at Lüttichau-Palais, Dresden, 1906-34 (photograms and industrial photographs from 1925); established studio in Cologne, 1934-43, and in Gaienhofen am Bodensee, 1943-48. Organizer, Photography Section, *Dresden Great Exhibition*, 1904. Professor of Advertising Photography, under Professor Theimann, College of Book Production, Leipzig, 1914. Member, Deutscher Werkbund, 1908; Founder-Member, 1919-48, and Chairman of the Jury, 1924-48, Gesellschaft Deutscher Lichtbildner (GDL). Recipient: Silver Medal, *International Amateur Photography Exhibition*, Erfurt, Germany, 1894; Society of Photographers Award, Amsterdam, 1895; Fotografia Artistica Award,

Hugo Erfurth: *The Writer Annette Kolb*, **Cologne, 1928** Courtesy Galerie Wilde, Cologne

Turin, 1903; Weimar German Photographers Association Award, 1903; Gold Medal, *Arts and Crafts Exhibition*, Dresden, 1906; Photographers Association of America Award, 1907; Award, *Internationale Austellung*, Dresden, 1909; Gold Medal, Saxon Photographers Union, Dresden, 1909; Ehrenpreis, City of Leipzig, 1922; State Medal of the German Reich, Frankfurt, 1926; Kamera-Club of Oslo Award, 1926; Award, *International Press Exhibition*, Cologne, 1928; Achievement Award for German Handicrafts, Frankfurt, 1939. *Died* (in Gaienhofen am Bodensee) *14 February 1948.*

Individual Exhibitions:

1903 Deutsche Photographen-Verein, Dresden
1907 Oskar Bohr Galerie, Dresden
1947 Wessenberg Galerie, Konstanz
1961 Folkwang Museum, Essen
1964 Stadtische Galerie, Siegen, West Germany
1974 Agfa-Gevaert AG Foto-Historama, Leverkusen, West Germany
1976 Fotomuseum, Munich

Selected Group Exhibitions:

1906 *Art Photography*, at the *World's Fair*, St. Louis
1909 *Internationale Austellung*, Dresden
1928 *Neue Wege der Photographie*, Kunstverein, Jena, Germany
1929 *Film und Foto*, Deutscher Werkbund, Stuttgart
1951 *Photokina*, Cologne (and 1976)
1977 *Fotografische Künstlerbildnisse*, Museum Ludwig, Cologne
Documenta 6, Kassel, West Germany
1978 *Neue Sachlichkeit and German Realism of the 20's*, Hayward Gallery, London
1979 *Fleeting Gestures: Dance Photographs*, International Center of Photography, New York (travelled to The Photographers' Gallery, London)
Film und Foto der 20er Jahre, Württembergische Kunstverein, Stuttgart (travelled to Museum Folkwang, Essen; Werkbundarchiv, Berlin; Kunsthaus, Zurich; Kunstverein, Hamburg; and Museum des 20. Jahrhunderts, Vienna)

Collections:

Museum Folkwang, Essen; Staatliche Landesbildstelle, Hamburg; Agfa-Gevaert Foto-Historama, Leverkusen, West Germany; L. Fritz Gruber, Cologne; Gottfried Erfurth, Gaienhofen, West Germany. (Hugo Erfurth's own picture archive in Cologne was destroyed by wartime bombing, 1943)

Publications:

By ERFURTH: books—*Photographic Portraits: A List of Portraits of Famous Personalities*, Dresden 1917; *Portraits: Hugo Erfurth, Portrait Photographer*, Dresden 1930; article—"Wie Duhrkoop, Erfurth, Grainer, Smith, Traut Arbeiten" in *Photographische Kunst* (Munich), 15 April 1910.

On ERFURTH: books—*Meister de Kamera Erzählen* by Wilhelm Schoppe, Halle 1937; *Hugo Erfurth*, exhibition catalogue, by Will Grohmann, Konstanz, West Germany 1947; *Hugo Erfurth, Sechsunddreissig Künstlerbildnisse*, with texts by J.A. Schmoll, Otto Steinert and Hermann Schardt, Essen 1960; *Bildnisse Hugo Erfurth*, exhibition catalogue, by Otto Steinert, Essen 1961; *Hugo Erfurth: Bildnisse*, edited by Otto Steinert and J.A. Schmoll, Gutersloh, West Germany 1961; *Uber Hugo Erfurth*, exhibition catalogue, by L. Fritz

Gruber, Siegen, West Germany 1964; *The Magic Image* by Cecil Beaton and Gail Buckland, London and Boston 1975; *Hugo Erfurth 1874-1948: Der Fotograf der Goldenen Zwanziger Jahre*, edited by Bernd Lohse, Seebruck am Chiemsee, West Germany 1977; *Documenta 6/Band 2*, exhibition catalogue, edited by Klaus Honnef and Evelyn Weiss, Kassel, West Germany 1977; *Fotografische Künstlerbildnisse*, exhibition catalogue, by Dieter Ronte, Evelyn Weiss and Jeane von Oppenheim, Cologne 1977; *Geschichte der Fotografie im 20. Jahrhundert/Photography in the 20th Century* by Petr Tausk, Cologne 1977, London 1980; *Photographen der 20er Jahre* by Karl Steinorth, Munich 1979; *Film und Foto der 20er Jahre*, exhibition catalogue, by Ute Eskildsen and Jan Christopher Horak, Stuttgart 1979; *Internationale Ausstellung des Deutschen Werkbundes "Film und Foto" 1929*, facsimile reprint, edited by Karl Steinorth, Stuttgart 1979; *Fotografie 1919-1979, Made in Germany: Die GDL Fotografen*, edited by Fritz Kempe, Bernd Lohse, and others, Frankfurt 1979; articles—"Hugo Erfurth zum 70. Geburtstag" by Walter Holzhausen in *Gebrauchsgraphik* (Berlin), vol. 7, no. 20, 1943-44; "Fotos ohne Unterschrift" by Alfred Döblin in *Das Kunstwerk* (Baden-Baden, West Germany), no. 12, 1946-47; "Hugo Erfurth: Ein Erinnerungsblatt" by L. Fritz Gruber in *Photo-Magazin* (Munich), December 1949; "Hugo Erfurth, der Altmeister der Deutschen Porträtfotografie" by Martin Hansch in *Moderne Fototechnik* (Ludwigsburg), June 1971; "Hugo Erfurth 1874-1971" in *Creative Camera* (London), July 1973; "Drei Grosse Menschenschilderer" by Bernd Lohse in *Foto-Magazin* (Munich), November 1975; "Faces from Germany's Golden Years" in *Photography Year 1979*, by the Time-Life editiors, New York 1979.

For almost half a century Hugo Erfurth was one of the most vigorous personalities in German photography. To some people, Erfurth is the photographer whose portraits of great artists and leading intellectuals, produced mainly in the 1920's, bear the unmistakable stamp of his personality: they belong to the essential stock of the great art of photographic portraiture. But to others he is the influential organizer and highest arbitrator in the circle of his colleagues. From almost a quarter of a century—from 1924 to 1948—he presided over the jury of the Gesellschaft Deutscher Lichtbildner (GDL), and therefore the selection committee of this group (founded in 1919), which united prominent professional photographers. Admission to the society and annual exhibition participation depended on the jury's judgment, and it is clear that Erfurth used his post to create an enormously impressive influence on the standard of quality within his profession. He radiated a natural authority, and he held his position unchallenged for so long because the wealth, individual character and excellence of his own work was abundantly clear to everyone.

Erfurth began his career before the turn of the century, first of all as an amateur, then as an ordinary studio photographer. But he took part enthusiastically in the pictorial endeavor of the time—open air portraits, dance and nude studies—and gradually set his studio portraits free from the traditions of "atelier photography." The atmosphere of Dresden and its renowned Academy was a further determinant in his development. It was in Dresden before the First World War that the group of artists known as Die Brücke (The Bridge) was founded (with Kirchner, Heckel, Schmidt-Rottluff); later, Otto Dix and Oskar Kokoschka taught at the Academy; and Klee, Kandinsky and Gropius—and other great artists and personalities, from Gerhart Hauptmann to Henry Ford—were frequent visitors. And anyone who came to Dresden was obliged to make an appointment for a portrait sitting with Erfurth, who lived and worked in an old palace in the heart of the city.

The vigor that marks the portraits produced by Erfurth at his greatest is not due only to a particular

printing process—the oil pigment print which allowed the manual treatment of essential features and at which Erfurth was a master; it also had to do with his basically simple photographic technique (natural front or side lighting in his studio with its man-height windows); and, above all, it had to do with his capacity for psychological insight. The artists and literati portrayed accepted him as their equal.

Erfurth's extensive work other than portraits is less well-known: during the bombing attacks of the Second World War, he gave priority to protecting his portraits, and the rest of his archives became a victim of the flames.

—Bernd Lohse

ERWITT, Elliott.

American. Born, of American parents, in Paris, France, in 1928. Educated in Milan, 1935-38, in Paris, 1938-39, in New York, 1940, and in Hollywood, 1942-44; studied at Los Angeles City College, 1945-47; studied film at the New School for Social Research, New York, 1948-50. Serviced as a photographic assistant in the United States Army Signal Corps, in Germany and France, 1951-53. Twice married; children: Jennifer, George, David, Misha and Ellen. Worked as a drugstore sales and photographic darkroom assistant, Los Angeles, 1947-48; film cameraman in France, 1949-50; photographic assistant, Valentino Sarra Studio, New York, 1950; staff photographer, under Roy E. Stryker, for Standard Oil Company of New Jersey and Pittsburgh Photo Library, 1950-52; freelance photographer, working for *Collier's, Look, Life, Holiday*, etc., New York, since 1953. Member of Magnum Photos co-operative agency, New York and Paris, since 1953 (President, Magnum, New York, 1966). Agent: Magnum Photos. Address: c/o Magnum Photos, 251 Park Avenue South, New York, New York 10010, U.S.A.

Individual Exhibitions:

1947 Artists Club, New Orleans
1957 Limelight Gallery, New York
1963 Smithsonian Institution, Washington, D.C.
1965 Museum of Modern Art, New York
1971 The Photographers' Gallery, London
1972 Art Institute of Chicago
1974 *Son of a Bitch*, Witkin Gallery, New York
1978 *Elliott Erwitt at 50*, Witkin Gallery, New York
1979 Jeb Gallery, Providence, Rhode Island
Kunsthaus, Zurich
1981 Canon Photo Gallery, Geneva (with Marius Hermanovicz)
Douglas Kenyon Gallery, Chicago (with Arthur Bell)

Selected Group Exhibitions:

1966 *The Photographer's Eye*, Museum of Modern Art, New York
American Photography: The 60's, Sheldon Memorial Art Gallery, University of Nebraska, Lincoln
1967 *Photography in the 20th Century*, National Gallery of Canada, Ottawa (toured Canada and the United States, 1967-73)
1977 *Concerning Photography*, The Photographers' Gallery, London (travelled to the Spectro Workshop, Newcastle upon Tyne)

1978 *Mirrors and Windows: American Photography since 1960*, Museum of Modern Art, New York (toured the United States, 1978-80)

1979 *American Images: New Work by 20 Contemporary Photographers*, Corcoran Gallery, Washington, D.C. (travelled to the International Center of Photography, New York; Museum of Fine Arts, Houston; Minneapolis Institute of Arts; and Indianapolis Institute of Arts, 1980; and American Academy, Rome, 1981)

10th Anniversary Show, Witkin Gallery, New York

1980 *Photography of the 50's*, International Center of Photography, New York (travelled to the Center for Creative Photography, University of Arizona, Tucson; Minneapolis Institute of Arts; California State University at Long Beach; Delaware Art Museum, Wilmington)

1981 *Dog Show No. 1*, Nikon Fotogalerie, Zurich

Collections:

Museum of Modern Art, New York; Smithsonian Institution, Washington, D.C.; Art Institute of Chicago; New Orleans Museum of Art; Bibliothèque Nationale, Paris.

Publications:

By ERWITT: books—*Observations on American Architecture*, with text by Ivan Chermayeff, New York and London 1972; *Photographs and Anti-Photographs*, with text by Sam Holmes and John Szarkowski, Greenwich, Connecticut and London 1972; *The Private Experience: Elliott Erwitt*, with text by Sean Callahan, Los Angeles and London 1974; *Untitled*, portfolio of 10 photos, with an introduction by Peter C. Bunnell, New York 1974; *Son of a Bitch*, with text by P.G. Wodehouse, New York 1974; *15 Photographs*, portfolio, Geneva 1977; *Recent Developments*, with an introduction by Wilfred Sheed, New York 1978: films—*Dustin Hoffman*; *Arthur Penn*; *Beauty Knows No Pain*; *Red, White and Bluegrass*.

On ERWITT: books—*American Photography: The 60's*, exhibition catalogue, Lincoln, Nebraska 1966; *Photography in the 20th Century* by Nathan Lyons, New York 1967; *America in Crisis: Photographs for Magnum*, edited by Charles Harbutt and Lee Jones, with an essay by Michael Levitas, New York 1969; *Looking at Photographs* by John Szarkowski, New York 1973; *Interviews with Master Photographers*, edited by James Danziger and Barnaby Conrad III, New York and London 1977; *Geschichte der Fotografie im 20. Jahrhundert/Photography in the 20th Century* by Petr Tausk, Cologne 1977, London 1980; *Concerning Photography*, exhibition catalogue, by Jonathan Bayer and others, London 1977; *Mirrors and Windows: American Photography since 1960* by John Szarkowski, New York 1978; *A Ten Year Salute* by Lee D. Witkin, with a foreword by Carol Brown, Danbury, New Hampshire 1979; *American Images: New Work by 20 Contemporary Photographers*, edited by Renato Danese, New York 1979; *Contact: Theory*, edited by Ralph Gibson, New York 1980; *Photography of the 50's: An American Perspective* by Helen Gee, Tucson, Arizona 1980; articles—"Elliott Erwitt: Improbable Photographs" by Arthur Goldsmith in *Infinity* (New York), August 1965; "Travelling Photographer" in *Infinity* (New York), October 1967; "Elliott Erwitt," with an introduction by P.G. Wodehouse, in *Album* (London), no. 12, 1970; "A Superbly Printed Sense of Fun: Elliott Erwitt, The Photographers' Gallery" by Ainslie Ellis in the *British Journal of Photography* (London), 9 July 1971; "Elliott Erwitt ou le Sourire à Fleur d'Objectif" in *Photo* (Paris), September 1971; "The Man Who Kept Something for Himself" by Sam Holmes in *Infinity* (New York), May 1972; "Elliott Erwitt" in *The Image* (London), no. 8, 1972; "Les Animaux Tristes d'Elliott Erwitt" in *Photo* (Paris), November 1972; "Elliott Erwitt, Photographs and Anti-Photographs" in *Photography Year 1973*, New York 1973; "Elliott Erwitt" in *Creative Camera* (London), March 1973; "Elliott Erwitt" in *Camera* (Lucerne), April 1973; "Elliott Erwitt" in *Zoom* (Paris), November/December 1974; "Elliott Erwitt" in *News Reporter* (Paris), January 1976.

Humor has never been as highly regarded in the visual arts as it has in literature, perhaps because no one can hold a laugh too long, and literature has sufficient social grace to move along. The hybrid forms, like theater and film, fare better than the visual arts alone, but recently painting, sculpture, and especially still photography have been making some headway. It may be that the rise of absurdist and black humor in the postwar era has made more acceptable a photographic view that the world is a comic stage where men and animals accidentally fall into an unrehearsed ballet set up by a subversive set designer. Cartier-Bresson gave a boost to the notion that humor in photography might be valuable by proving that a serious photographer could also be funny. Doisneau carried the cause forward with pic-

Elliott Erwitt: *Guanajuato, Mexico,* **1955** Courtesy Art Institute of Chicago

tures that proved a photographer with a funny bone, or at least one with his delicate understanding of the poignancy of life, could maintain an amazingly high standard. Elliott Erwitt, who clearly learned from both, polishes up the idea that a humorous photographer can be a serious man as well.

Erwitt's work swerves between journalism and formalism. He can build on a spare, eccentric, but highly controlled sense of design, holding his formal strategies as reserve weapons, always at the ready, not always at the front. One minute he catches the psychological tremor in a news event (see his 1959 pictures of Nixon and Kruschev's "kitchen debate" in Moscow); the next minute he compares the zigzag outline of a gull's body to the zigzag balconies that modern architects and poured concrete have foisted on Florida. Sometimes he has a quirky view of space, where objects shift slightly out of proportion or out of place, much as normal patterns of behavior do when he regards them closely. In his pictures, one small staccato mark—a walking man, a kite, a bird—gathers an odd force in a great empty field. Then, too, feet, paws, and socks assume a new importance when viewed at ankle height. Whether the aim is humor or graphic design, Erwitt can achieve an absolute poise of unrelated elements.

The main thrust of his work lies in his comic awareness of the gap between nobility and reality or between subject and setting, which blunder unpredictably into rhyme or battle with each other. He has forged a happy alliance with incongruity. A stolid matron in Las Vegas plies the metal arm of a ferocious cowboy slot machine. A couple wages intense and oblivious conversation between screaming mummies in Guanajuato. Erwitt's humor also depends heavily on visual puns, like that of the woman seen through a set of open shelves on which are two round pieces of fruit which stand for her breasts. He capitalizes on visual obstacles: a woman in a middle eastern *chador* walks past a flag that takes the place of her head. Mostly he concentrates on the disparity between the orderly world we imagined was out there and the actual place they sneaked in on us for daily use.

Dogs inhabit this real world. Sometimes they have their humans with them on the other end of a leash. Erwitt has a lot of sympathy for dogs (he is said to have had a growling contest with a strange dog once, and won). Dogs are rather like humans with a few mistakes in the engineering. They know shame, grow fat, assume ungainly postures, and lead the life of misfits among other bewildered creatures. Dogs comment succinctly on human activities. In 1962, Erwitt took three pictures of Nelson Rockefeller politicking on a street corner. In the first, a mutt watched closely, in the second he turned aside, and in the third he moved away to lift his leg.

That dogs, as Auden said, go on with their doggy life no matter what happens around them, is a reminder that there are no accidents in Erwitt's pictures. He uses the kind of accident and chance coincidence that "serious" photographers like William Klein and Robert Frank gave status in the 50's, but he uses them as proofs that the world is a silly predicament we have agreed to inhabit. It does have its ideals. The Parthenon was one, Brasilia another, but a small dog can show up either one for an empty bastion. Anyway, human beings are always shaping trees and carving stones, and somehow the shapers and carvers never end up looking as neat as their endeavors. Erwitt apparently doesn't think this place that people and dogs have been plunked into is particularly welcoming. It does have its enjoyments, but a good many of these would suggest to a reasonable person that we are in a pickle. Three of Erwitt's movies trace the gargantuan effort and emotional tension involved in reaching such goals as marching in a brief costume between the halves of a football game. No one in Erwitt's viewfinder has any large measure of control. The camera alone proves the rebellious nature of the environment, where statues make faces behind the innocent, and cannons take aim at bus stops. Sometimes a person does retain authority over, say, a broom, or perhaps the model, if only the model, or an area to be bombed.

But limited or not, furred or otherwise, the inhabitants of Erwitt's terrain cock an eye, stick out a tongue, and keep on moving. They do not move through a wide range of emotions—at times they are touching, more often wry. But they provoke a smile the first, the second and third times around. That can only mean that we are amused with us. How grand of Mr. Erwitt to introduce us to our inconsequential selves.

—Vicki Goldberg

EVANS, Walker.

American. Born in St. Louis, Missouri, 3 November 1903. Educated at Loomis School, Windsor, Connecticut, until 1922; Phillips Academy, Andover, Massachusetts, 1922; Williams College, Williamstown, Massachusetts, 1922-23; Sorbonne, Paris, 1926-27; mainly self-taught in photography. Married and divorced twice. Worked in the Public Library, New York City, 1923-25; freelance photographer, New York, from 1928; Staff Photographer, under Roy Stryker, Farm Security Administration (FSA), mainly in the Southern United States, 1935-37; Associate Editor and Photographer, *Fortune* magazine, New York, 1945-65; retired from professional photography, 1965. Professor of Graphic Arts, 1964-74, and Emeritus Professor, 1974-75, Yale University, New Haven, Connecticut; Artist-in-Residence, Dartmouth College, Hanover, New Hampshire, 1972. Recipient: Guggenheim Fellowship, 1940, 1941, 1959; Carnegie Corporation Award, New York, 1962; Mark Rothko Foundation Grant, New York, 1973. D.Litt., Williams College, 1968. Fellow, American Academy of Arts and Sciences, 1968; Member, National Institute of Arts and Letters, Washington, D.C., 1973. *Died* (in New Haven, Connecticut) *10 April 1975*.

Individual Exhibitions:

1931 *Photographs by 3 Americans*, John Becker Gallery, New York (with Ralph Steiner and Margaret Bourke-White)
1932 *Walker Evans and George Platt Lynes*, Julien Levy Gallery, New York
1933 *Walker Evans: Photographs of 19th Century Houses*, Museum of Modern Art, New York
1935 *Documentary and Anti-Graphic*, Julien Levy Gallery, New York (with Henri Cartier-Bresson and Manual Alvarez Bravo)
1938 *Walker Evans: American Photographs*, Museum of Modern Art, New York (toured the United States)
1948 Art Institute of Chicago
1962 *Walker Evans: American Photographs*, Museum of Modern Art, New York (toured the United States and Canada)
1964 Art Institute of Chicago
1966 *Walker Evans' Subway*, Museum of Modern Art, New York
 Robert Schoelkopf Gallery, New York
 National Gallery of Canada, Ottawa (toured Canada)
1970 *Walker Evans: Paintings and Photographs*, Century Association, New York
1971 Robert Schoelkopf Gallery, New York
 Museum of Modern Art, New York (retrospective)
1972 Yale University, New Haven, Connecticut
1973 Robert Schoelkopf Gallery, New York
1974 Robert Schoelkopf Gallery, New York
1975 Kluuvin Galleria, Helsinki
1976 Bibliothèque Royale, Brussels
 Museum of Modern Art, New York (toured the United States and Europe)
 America Observed: Etchings by Edward Hopper, Photographs by Walker Evans, California Palace of the Legion of Honor, San Francisco (also shown at Acherbach Foundation for Fine Art, San Francisco)
1977 Cronin Gallery, Houston
 Robert Schoelkopf Gallery, New York
1978 Sidney Janis Gallery, New York
 Walker Evans at Fortune 1945-1965, Wellesley College, Massachusetts
1981 Milwaukee Art Center (with Ralph Steiner)
 Walker Evans: 250 Photographies, Galerie Baudoin Lebon, Paris
 Walker Evans and Robert Frank: An Essay on Influence, Fraenkel Gallery, San Francisco
 Photographs of Chicago by Walker Evans, Kelmscott Gallery, Chicago

Selected Group Exhibitions:

1936 *Fantastic Art, Dada and Surrealism*, Museum of Modern Art, New York
1937 *Photography 1839-1937*, Museum of Modern Art, New York
1938 *First International Photographic Exposition*, Grand Central Palace, New York
1939 *Art in Our Time: 7 American Photographers*, Museum of Modern Art, New York
1962 *The Bitter Years: FSA Photographs 1935-41*, Museum of Modern Art, New York (toured the United States and Canada)
1976 *Photographs from the Julien Levy Collection, Starting with Atget*, Art Institute of Chicago
1978 *Photos from the Sam Wagstaff Collection*, Corcoran Gallery, Washington, D.C. (toured the United States and Canada)
1979 *Images de l'Amerique en Crise*, Centre Georges Pompidou, Paris
1980 *The Magical Eye*, National Gallery of Canada, Ottawa (toured Canada)
 Instantanées, Centre Georges Pompidou, Paris

Collections:

Museum of Modern Art, New York; Metropolitan Museum of Art, New York; Yale University, New Haven, Connecticut; Wadsworth Atheneum, Hartford, Connecticut; Fogg Art Museum, Harvard University, Cambridge, Massachusetts; Library of Congress, Washington, D.C.; New Orleans Museum of Art; University of New Mexico, Albuquerque; San Francisco Museum of Modern Art; National Gallery of Canada, Ottawa.

Publications:

By EVANS: books—*The Bridge*, with text by Hart Crane, Paris and New York 1930; *The Crime of Cuba*, with text by Carleton Beals, Philadelphia 1933, New York 1970; *African Negro Art*, with text by J.J. Sweeney, New York 1935; *American Photographs*, with text by Lincoln Kirstein, New York 1938, 1962, 1975; *Let Us Now Praise Famous Men*, with text by James Agee, New York 1941, Boston 1960, New York 1966; *Wheaton College Photographs*, with text by J. Edgar Park, Norton, Massachusetts 1941; *The Mangrove Coast*, with text by Karl Bickel, New York 1942; *African Folk Tales and Sculpture*, with text by Paul Radin and James Johnson Sweeney, New York 1952, 1964, revised edition,

Walker Evans: *Alabama Cotton Tenant Farmer's Wife* from *Let Us Now Praise Famous Men,* **1941** Courtesy Art Institute of Chicago

as 2 vols., *African Folktales*, with text by Paul Radin, and *African Sculpture*, with text by James Johnson Sweeney, Princeton, New Jersey 1970; *Many Are Called*, with an introduction by James Agee, Boston 1966; *Message from the Interior*, with an afterword by John Szarkowski, New York 1966; *Walker Evans*, portfolio of 14 photos, with an introduction by Robert Penn Warren, New Haven, Connecticut 1971; *Selected Photographs*, portfolio of 15 photos, with an introduction by Lionel Trilling, New York 1974; *I*, portfolio of 15 photos, New Haven, Connecticut and Washington, D.C. 1977; *Walker Evans: First and Last*, New York and London 1978; articles—"The Reappearance of Photography" in *Hound and Horn* (Concord, New Hampshire), October-December 1931; "Labor Anonymous" in *Fortune* (New York), November 1946; "Chicago" in *Fortune* (New York), February 1947; "In the Heart of the Black Belt" in *Fortune* (New York), August 1948; "The Wreckers" in *Fortune* (New York), May 1951; "The U.S. Depot" in *Fortune* (New York), February 1953; "Over California" in *Fortune* (New York), March 1954; "The Congressional" in *Fortune* (New York), November 1955; "These Dark Satanic Mills" in *Fortune* (New York), April 1956; "Robert Frank" in *U.S. Camera Annual 1958*, New York 1957; "The Last of Railroad Steam" in *Fortune* (New York), September 1958; "James Agee in 1936" in *Atlantic* (Boston), July 1960; "When 'Downtown' Was a Beautiful Mess" in *Fortune* (New York), January 1962; "Those Little Screens" in *Harper's Bazaar* (New York), February 1963; "Walker Evans on Himself" in *Exposure* (New York), February 1977.

On EVANS: books—*Fantastic Art, Dada And Surrealism*, edited by Alfred H. Barr Jr., New York 1936, 1937; *Walker Evans: Photographs*, with an introduction by John Szarkowski, New York 1971, London 1972; *Walker Evans: Photographs for the Farm Security Administration 1935-38*, with an introduction by Jerald C. Maddox, New York 1973; *Documentary Expression in Thirties America* by William Stott, New York 1973, London 1976; *Walker Evans: Photographs from the "Let Us Now Praise Famous Men" Project*, edited by William Stott and David Farmer, Austin, Texas 1974; *Photography in America*, edited by Robert Doty, with an introduction by Minor White, New York and London 1974; *The Years of Bitterness and Pride: FSA Photographs 1935-1943*, compiled by Jerry Kearns and Leroy Bellamy, edited by Hiak Akmakjian, New York 1975; *A Vision Shared: A Classic Portrait of America and Its People 1935-43*, edited by Hank O'Neal, New York and London 1976; *America Observed: Etchings by Edward Hopper, Photographs by Walker Evans*, exhibition catalogue, San Francisco 1976; *Photographs from the Julien Levy Collection, Starting with Atget*, exhibition catalogue, by David Travis, Chicago 1976; *Walker Evans: Photographs*, exhibition catalogue, by Valerie Lloyd, London 1976; *Concerning Photography*, exhibition catalogue, edited by Jonathan Bayer, London 1977; *Photographs: Sheldon Memorial Art Gallery Collection, University of Nebraska*, with an introduction by Norman A. Geske, Lincoln 1977; *Images of the South: Visits with Eudora Welty and Walker Evans*, edited by Carol Lynn Yellin, Memphis, Tennessee 1977; *A Book of Photographs from the Collection of Sam Wagstaff*, designed by Arne Lewis, New York 1978; *Walker Evans at Fortune 1945-1965*, exhibition catalogue, by Leslie K. Baier, Wellesley, Massachusetts 1978; *The Presence of Walker Evans* by Alan Trachtenberg, Boston 1978; *Life: The First Decade 1936-1945* by Robert Littman, Ralph Graves and Doris C. O'Neill, New York 1979, London 1980; *SX-70 Art*, edited by Ralph Gibson, New York 1979; *A Ten Year Salute*

Danbury, New Hampshire 1979; *The Photograph Collector's Guide* by Lee D. Witkin and Barbara London, Boston and London 1979; *Les Années Ameres de l'Amerique en Crise 1935-1942*, exhibition catalogue, by Jean Dieuzaide, Toulouse, France 1980; *Instantanées* exhibition catalogue, by Michel Nuridsany, Paris 1980; articles—"Evans' Brilliant Camera Records Modern America" by Martha Davidson in *Art News* (New York), 8 October 1938; "Walker Evans' Photographs of America" by Thomas Dabney Mabry in *Harper's Bazaar* (New York), 1 November 1938; "Photographs by Walker Evans" by Lincoln Kirstein in *Print* (New York), February 1957; "Walker Evans: American Photographs" by Josephine Herbst in *Arts Magazine* (New York), November 1962; "Walker Evans: Photography as Representation" by Sidney Tillim in *Artforum* (New York), March 1967; "Notes on Walker Evans and W. Eugene Smith" by Van Deren Coke in *Art International* (Lugano, Switzerland), June 1971; "Walker Evans: A Crusty Colossus" in *Photography Year 1976* by Time-Life editors, New York 1976; "An Introduction to Evans' Work and His Recollections" by Peter C. Bunnell in *Exposure* (New York), February 1977; "Walker Evans" by M. Maingois in *Zoom* (Paris), April 1981, film—*Walker Evans: His Time, His Presence, His Silence* by Sedat Pakay, 1969.

* * *

Since his 1971 retrospective at the Museum of Modern Art, Walker Evans has been generally acknowledged America's finest documentary photographer of this century and the artist who more than any other created the image Americans have of the Great Depression of the 1930's.

The special character of his work—his style and tone—is recognized to have influenced photographers, filmmakers, graphic artists, and indeed artists in other fields. His style has been described as straight, direct, unhurried, unobtrusive, transparent; his tone, as calm, timeless, staring, silent, sad, nostalgic. All these words are true but in a sense misleading. They point attention to the mystery of Evans' art, which can't be satisfactorily defined, and away from his pictures themselves and what matters most in each of them: the subject.

Consider one of Evans' photographs from *Let Us Now Praise Famous Men*, the classic documentary book on Southern tenant farming he did with the writer James Agee. The photo is a full-length portrait of the sharecropper farmwife the book calls Sadie Ricketts. Mrs. Ricketts is wearing a dress she made of an undyed canvaslike material. She is looking at the camera with her arms at her side, her right hand gently holding back her skirt so that the dress hangs better. There is a piece of paper and bits of trash—leaves? food?—at her feet. Her feet are bare.

This is the sort of picture Evans always took. Its subject is human (Mrs. Ricketts) or of human contrivance (Mrs. Ricketts' way of standing, her very special dress). "I am for man's work and the civilization he's built," Evans said. "Nature bores me as an art form." The subject, though "lower class," is decent. Mrs. Ricketts' dress is dirty but the dirt is the rubbed-in residue of many washings; Mrs. Ricketts wears the dress as though it were clean. The three safety pins holding its bodice closed are carefully set parallel, making them an ornament. Mrs. Ricketts is not taken off guard in a piteous or dramatic candid. On the contrary, she presents herself as she is willing to be seen, directly, consciously, to us, the viewers. In Evans' world, the critic Lincoln Kirstein noted, "even the inanimate things, bureau drawers, pots, tires, bricks, signs, seem waiting in their own patient dignity, posing for their pictures."

For Evans, it is the subject that counts—here, Sadie Ricketts and what she visibly and actually is. Behind her, left and right, are awkward clusters of hands, arms, pieces of her children. This awkward-

ness does not matter. The point of the photo is not silky composition, as it would be in, say, an Edward Weston picture. The point is Mrs. Ricketts, her face and dress, the way she presents her body, her worried regal diffidence. Evans might have agreed that the background was awkward, cluttered. "I find a howling error in composition, because something is in the wrong place, and I leave it there," he once said. "God arranged that; I wouldn't touch it."

Evans didn't change his subjects physically, and he did what he could not to change them *spiritually*. He tried to add nothing to them: no ideology, no polemic, no extrinsic excitement, no razzmatazz technique. His reluctance to polemicize helped lose him the best job he ever had, photographing rural America for the New Deal's Farm Security Administration. His hatred of sham excitements kept him from usual photojournalism and made him impatient with the technical extravagances of "concerned" photographers who pep up their photos with faux-casual framing, vignetting, bleach-enhanced chiaroscuro. Such techniques are spectacular but wrong, Evans thought, because they draw attention from the picture's subject. Of two virtuoso photographers he once remarked, "They do the perfect thing with the camera, and you say ohh and ahh, how perfect. Then you don't get their content clearly enough, however. As in typography and printing, technique shouldn't arrest you."

Content was what counted, the subject itself. The chief reason the subjects in Evans' photos matter is of course that they are, like Mrs. Ricketts, beautiful. As I have argued elsewhere, Evans showed the lives and appurtenances of the poor to be works of art. This was a magnificent achievement, the central imaginative act of the Depression. He put the life of the poor in a frame, the photograph itself, wherein sensitive onlookers could see its aesthetic respectability.

In ways difficult to pin down Evans' vision of beauty was influenced by the Purist aesthetic of the 1920's. Though his work is scrupulously "straight," the effect he achieves in his best-known pictures of the 1930's, like the portrait of Mrs. Ricketts, has some of the neatness and bright permanence of streamlining. Part of his greatness, in fact, may be to bring together the two major 1930's aesthetics: documentary and Art Deco.

Since there is a purism in his work, though, is he not liable to the same criticism that the Marxist critic Walter Benjamin leveled at the German Neue Sachlichkeit (New Objectivist) photographers? Is Evans not guilty of beautifying hardship and thus "mystifying," camouflaging, social wrongs? Evans himself was deeply aware of this question—which is much discussed in *Let Us Now Praise Famous Men*—and knew it couldn't be settled to his own or others' satisfaction. He wanted to insist on both the beauty of his subjects *and* the obscenity of the social conditions in which their beauty grew. The beauty he documented, then, is not a gentle thing; "it's not beauty in the conventional sense," he said. It is beauty with blood on it, beauty tragic twice over: because of the abominable conditions that fed it and because it could not be recognized or appreciated by those who created it.

Of those of us who can appreciate it, this beauty asks a lot. It asks us, for example, to see that Mrs. Ricketts didn't want to be dressed as she was and yet still was proud of the dress she had made. Evans didn't mind asking a lot; he once said, "If an audience can only be moved by a picture of someone with his guts pouring out, they're not a very interesting audience." He wanted to bring his audience subjects whose beauty would not only amaze them but appall them—move them, as he was moved, to wonder, compassion, anger, self-hatred. For most of his career Evans didn't have the audience he needed; he has us now.

—William Stott

FACIO, Sara.

Argentinian. Born in Buenos Aires, 18 April 1932. Studied drawing and painting at the Escuela Nacional de Bellas Artes, Buenos Aires, 1947-53; studied color photography at Kodak, Rochester, New York, 1960; studied photography in the studio of Luis D'Amico, Buenos Aires. 1957-59, and the studio of Annemarie Heinrich, Buenos Aires, 1960; studied color photography at Agfa, Buenos Aires, 1965. Freelance photographer, with joint studio with Alicia D'Amico, *q.v.*, as Alicia D'Amico/Sara Facio, Fotografías, Buenos Aires, since 1960. Editor of the Photographic Section, *La Nación* newspaper, Buenos Aires, 1966-74, and *Autoclub* magazine, Buenos Aires, 1970-74. Editor, La Azotea photograpic book publishers, Buenos Aires, since 1973. Recipient: National Salon of Argentina Prize, 1964; Bifota Medal, Berlin, 1965; Artist Award, Fédération International de l'Art Photographique, 1967; Olivetti-Communidad Award, Buenos Aires, 1968; Book Prize, Congress of Books, Vienna, 1969. Address: Juncal 1470-P.B., Buenos Aires 1062, Argentina.

Individual Exhibitions (with Alicia D'Amico):

1963 *Escritores Argentinos*, Galería Rioboo, Buenos Aires (travelled to the Biblioteca Nacional, Mexico City)
1964 *Mutaciones*, Galería Lirolay, Buenos Aires
1965 *Escritores Argentinos*, Consejo Deliberante, Buenos Aires
50 Fotografías, Agfa-Gevaert Gallery, Buenos Aires (travelled to Image 65, Cordoba, Argentina)
1966 *"Luv" en Fotografía*, Casa del Teatro, Buenos Aires (travelled to the Rosario Gallery, Argentina)
1967 *Fotografías Premiadas*, Image 67, Cordoba, Argentina
1968 *Buenos Aires, Buenos Aires*, Peña Fotográfica, Rosario, Argentina (toured Argentina, 1968-70)

Selected Group Exhibitions:

1963 *La Selección Argentina*, Federación Argentina de Fotografia, Buenos Aires (toured Germany, Belgium, Greece, and Colombia)
1977 *Maestros de la Fotografía Argentina*, YMCA Salon, Buenos Aires
1978 *Hecho en Latinoamérica*, Museo de Arte Moderno, Mexico City (travelled to *Venezia '79*)
Argentine Exhibition, House of Friendship, Moscow

Collections:

Bibliothèque Nationale, Paris.

Publications:

By FACIO: books—*Buenos Aires, Buenos Aires*, with Alicia D'Amico, Buenos Aires 1968; *Geografía de Pablo Neruda*, with Alicia D'Amico, Buenos Aires 1973; *Seven Voices*, with Rita Guibert, New York 1973; *Retratos y Autorretratos*, with Alicia D'Amico, Buenos Aires 1974; *Hasta aquí*, with Mario Benedetti, Buenos Aires 1974; *Humanario*, with Alicia D'Amico, Buenos Aires 1976; *Cancionero Contra...*, with Maria Elena Walsh, Buenos Aires 1976; *Cómo tomar Fotografías*, with Alicia D'Amico, Buenos Aires 1977; *Rostros de Buenos Aires*, Buenos Aires 1978; *Actos de Fe en Guatemala*, with M.C. Orive, Buenos Aires 1980; articles—"Juegos de J. Cortázar" in *La Nación* (Buenos Aires), 4 May 1967; "San Pablo 67; no fué" in *La Nación* (Buenos Aires), 12 September 1967; "Edward Weston" in *La Nación* (Buenos Aires), 26 November 1968; "Denis Gabor: Holograma" in *La Nación* (Buenos Aires), 12 February 1972; "Tambien la mujeres" and "Tikal, encuentro..." in *La Nación* (Buenos Aires), 10 August 1972; "Francoise Giroud" in *La Nación* (Buenos Aires), 10 December 1972; "Steichen siempre foto" in *La Nación* (Buenos Aires), 2 April 1973; "Tim, humor para vivir" in *La Nación* (Buenos Aires), 30 December 1973; "Jeanine Niepce" in *Crisis Magazine* (Buenos Aires), 3 April 1974; "Fotografía es Cultura" in *Diario Clarin* (Buenos Aires), 20 March 1980.

On FACIO: books—*Territorios* by Julio Cortázar, Mexico City 1978; *Photography Yearbook*, by Time-Life editors, New York 1979; articles—"Approche a la Vie" by Ives Lorelle in *Photo-Cinema* (Paris), February 1968; "Tercera Fundación" by Tomás E. Marinex in *Primera Plana* (Buenos Aires), 13 August 1968; "Pablo Neruda..." by Michel Nuridsany in *Le Figaro* (Paris), 14 January 1974; "Itinerario por..." by Robert Saladrigas in *Destino* (Barcelona), 16 February 1974; "Dos Fotografas" by Nestor Barreiro in *Vandidades* (Santiago), May 1976; "Fotografía en A" by M.C. Orvie in *Artes Visuales* (Mexico City), May 1976; "Humanity in Camera" by Robert Cox in the *Buenos Aires Herald*, 23 October 1976; "Sara Facio, caza..." by Vilma Colina in *Convicción* (Buenos Aires), 11 May 1980.

I came to photography by way of a long apprenticeship in classical art. Painting, with its decorative aestheticism somehow implying—even in a physical sense—an evasion of reality, proved a disappointment; and I discovered instead that photography was the perfect medium for representing the reality that I saw around me. I noticed that each individual photographer, according to his level of intensity, could demonstrate his own particular brand of reality subjectively, with credibility, giving it a personal touch that was different.

It was a late discovery, but in the 1960's, from the

Sara Facio: *Aproximación a la Vida*, 1963

age of about 30, I began to dedicate myself entirely to photography. It is my profession, at which I make my living; it is my means of self-expression. For the past twenty years I have been reading, writing, and taking pictures without interruption. I have remained faithful to realism and naturalism, without using artificial aids for lighting, taking the pictures, or laboratory work; and, in general, I base my work on the human figure. Those photographers whose work affects me most are those who take the same direction. I am not dazzled by sheer technique or enormous scale.

Another reason for my commitment to realism is the awareness that I cannot dissociate myself from my own context—my country, my city, my people. I have travelled widely, learned to know other cultures and races, and have, indeed, photographed them and written about them. But it is only in Argentina that I somehow feel authentic and secure—photographing my own people, whether well-known or anonymous. I feel the urge to record them with my camera and to show them to the world—writers, artists, dancers, townsfolk, and peasants. Argentina has no colorful folklore, "picturesque" natives, or gaudy and exotic costumes. There is no special architecture or handicrafts, nor are there any quaint established customs. Everything is "antiphotogenic." It is a constant challenge to take good pictures that are natural and lively, when faced with subjects that have so little visual attraction.

A few months ago, during a journey to the almost unpopulated north of my enormous country, while taking photographs of the desolate landscapes, I felt the overwhelming need to incorporate *myself* into that landscape, so strong was the anxiety I felt at the absence of any living soul. Thus came about my latest series, *Autopaisajes* ("Self-Landscape"). Perhaps, quite apart from the way in which my photographs need people, there was also a need in me to be included quite literally and physically. Probably that is the ultimate way of linking myself indissolubly with this abiding passion I feel for photography.

—Sara Facio

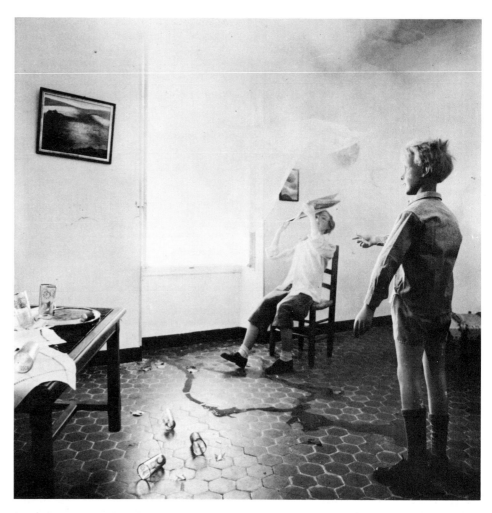

Bernard Faucon: *Le Verre Cassé*, 1980

A year or so before he died, Steichen said: "The mission of photography is to explain man to man and every man to himself." This is indeed the very essence of every kind of photographic picture, and is still more true in photography that has a social commitment. Photography, in fact, which never has been the faithful mirror of objective reality, is none the less an interpretation of reality that enables us to know both the single individual and the whole community. In the final analysis the task of social photography is really to translate into pictures the events, situations and personalities that form part of our daily life, which, added together, express man and his nature. That is the method that Sara Facio follows in her work; every one of her pictures seeks to describe some detail, however minute, of the historic period in which we live.

Her photographs seldom depict the sensational or unusual; Sara Facio is far from being one of those legendary, fascinating press photographers who are always on the spot whenever and wherever there is hot news. Paradoxically, our historical narrative is unfolded through unhistorical photographs. A great event is of course the tip of a submerged iceberg, the visible part, but by no means the whole, though it gives us facts that are basic to our understanding of the entire phenomenon. Facio records moments in life for what they are worth, claiming no special significance for them, but despite their modesty, they are representative of contemporary society.

For Sara Facio photography is the most suitable medium to fix the moment which can never be repeated. And that is the true key to the creativity of the photographer who, faced by a world in continuous evolution, chooses a picture, a tiny piece of life, in order to transmit a personal concept of it. Every picture thus represents a purely subjective reaction and may be interpreted by the viewer equally subjectively. But there does exist a common linguistic code between photographer and viewer that makes an intelligible communication possible. The code consists of the commonplaceness of the event represented; it is in fact that which every one of us knows very well by instinct but cannot isolate from the whole visual panorama. This then is a photography that does not remain circumscribed by the limits of mere reproduction of the concrete world. The picture chosen is transformed into evidence, indelible and immutable, of a fugitive reality obliterated as soon as it comes into being. Like an enormous jigsaw puzzle, the sum of all this evidence makes up an authentic portrait, but certainly an incomplete, partial one, since Sara Facio is not so absurdly presumptuous as to claim that her photography is a full record of objectivity.

Rather, her sensibility, her feelings and emotions are the psychological instruments that enable her to penetrate the world around her. And it is with those same instruments that the public can start on its voyage of exploration through her pictures. Thanks to the balance in them between concrete information and emotive expressivity, Sara Facio's photographs stimulate the mechanism of intellectual perception and the processes of psychological intuition in the beholder.

The mission of photography is thereby realized: the photographer describes a part of external reality with the visual story, helping to enhance our consciousness of the world; at the same time she conveys an emotional response, giving us the means to look deeper into ourselves.

—Giuliana Scimé

FAUCON, Bernard.

French. Born in Apt-en-Provence, 12 September 1950. Educated at the Lycée d'Apt, 1962-69; studied at the Sorbonne, Paris, under Jacques Maritain, 1969-73, M.Ph. 1973; studied photography under Jean-Claude Larrieu. Freelance photographer, in Paris and Apt, since 1976. Recipient: Prix de la Premiere Edition de la Ville de Paris, 1979. Agents: Galerie Agathe Gaillard, 3 rue du Pont Louis-Philippe, 75004 Paris; and Castelli Graphics, 4 East 77th Street, New York, New York 10021, U.S.A. Address: 16 rue de la Goutte d'Or, 75018 Paris, France.

Individual Exhibitions:

1977 Loplop, Paris
1979 *Plaisirs Jeux et Voyages*, Galerie Agathe Gaillard, Paris
 Fotomania, Barcelona
 Castelli Graphics, New York
1980 Canon Photo Gallery, Geneva
1981 Castelli Photographs, New York

Selected Group Exhibitions:

1980 *Biennale*, Paris
 Invented Images, University of California at Santa Barbara

Collections:

Bibliothèque Nationale, Paris.

Publications:

By FAUCON: book—*Les Grandes Vacances*, Paris 1980, as *Summer Camp*, New York 1981.

On FAUCON: books—*Invented Images*, exhibition catalogue, by Phyllis Pons, Santa Barbara, California 1980; *Quinze Critiques/Quinze Photographes*, Paris 1981; articles—"Bernard Faucon" by Roland Barthes in *Zoom* (Paris), November 1978; "Les Plaisirs d'Enfance" by Hervé Guibert in *Le Monde* (Paris), 5 April 1979; "L'Enfance Rêvée" by Michel Nuridsany in *Le Figaro* (Paris), 10 April 1979; "Bernard Faucon" by André Laude in *Les Nouvelles Litteraires* (Paris), 26 April 1979.

It is the setting that controls the entire frame. I do not cut the landscape but try to incorporate as vast an area as possible—to create a world without limits. Sometimes it takes me two whole days to decide on how to do it. The setting must act as a background; it must be precisely delineated; but, nevertheless, it must retain a certain fragility in rather the same way as does the square shape of the film I use, which emphasizes the sky and so gives rise to unexpected resonances.

Next, it is time to people the landscape—a laborious task. I move things from one place to another; I excavate, pull things around, put them into the ground, join them together—great feats of ingenuity! and a constant struggle against the wind and weather, not to mention the perversity of inanimate objects.

Finally, I add the lighting. I recreate the entire illumination, even out of doors. I take no notice of photography in achieving the right effect. I draw my own lines onto the countryside, and when they do not suffice I deploy great panels of aluminium, or mirrors, or white sheets. I will even use gunpowder, controlled quantitites of herbicide, yellow ochre—even sugar!

When the whole thing has worked out, the scene comes alive. Not with "theatrical" life, but with the life of an image whose apotheosis is in the moment of its happening, in the "click."

Then, immediately afterwards, I pull it all apart; tidy up; remove all traces. I allow myself no way of return.

—Bernard Faucon

We must never stop at the apparent "subject matter" of a photograph. Only the treatment counts: the affirmation, by means of a style, of a specific point of view, organized around several fundamental elements of photographic expression. For a long time regarded merely as a "photographer of models, childhood and stage productions," Bernard Faucon surprised those who would restrict him to that simple world and produced new works without characters—indoor scenes and scenes of the countryside. In fact, this young French photographer, one of the most passionate of his generation, has worked steadily and scrupulously on particular expressive elements, which he successfully combines, and announced to the world that he is to be recognized as a poet and metaphysician.

Using square formats, organizing a world in which he never settles for the mere reconstruction of reality, he has gradually produced compositions of rare precision and played unexpected games with "ordinary pictures" (advertisements, religious images and so on). He is one of those who has chosen to work in color, but integrates it into his own view of things and wisely never makes the play of colors his primary aim. Because he tries to produce only those pictures which could not be done in black and white and because he is in control of the whole color process, he belongs to that new generation of photographers who are perfectly aware of the possibilities and limitations of the medium—the photographers who have finally come of age.

—Christian Caujolle.

See Color Plates

FEININGER, Andreas.

American. Born in Paris, 27 December 1906. Educated at public schools in Germany; studied cabinet-making, under Walter Gropius, at the Bauhaus, Weimar, 1922-25, and architecture at the Bauschule, Weimar, 1925-25, and at the Staatliche Bauschule, Zerbst, Germany, 1926-28; self-taught in photography. Married Gertrud Wysse Hägg in 1933; son: Tomas. Practising architect, Dessau and Hamburg, 1928-31; Assistant Architect, Office of Le Corbusier, Paris, 1932-33; architectural and industrial photographer, Stockholm, 1933-39; freelance photojournalist, with Black Star Photo Agency, New York, 1940-41; War Correspondent/Photographer, United States Office of War Information, 1941-42; Staff Photographer, *Life* magazine, New York, 1943-62. Freelance photographer, New York and Connecticut, since 1962. Instructor in Creative Photocommunications, New York University, 1972. Recipient: Bronze Medal, Fotografiska Föreningen, Stockholm, 1938, 1939; Gold Medal, Art Directors Club of Metropolitan Washington, 1965; Robert Leavitt Award, American Society of Magazine Photographers, 1966. Address: 18 Elizabeth Lane, New Milford, Connecticut 06776, U.S.A.

Individual Exhibitions:

1957 *The Anatomy of Nature*, American Museum of Natural History, New York (travelled to the Smithsonian Institution, Washington, D.C.)
 Pratt Institute, Brooklyn, New York
1961 Carl Siembab Gallery, Boston
 Heinz Held Gallery, Cologne
1963 *The World Through My Eyes*, Smithsonian Institution, Washington, D.C. (retrospective)
 Landesbildstelle, Hamburg
1965 Cambridge Art Association, Massachusetts
 New York in Farbe, Deutsche Gesellschaft für Photographie, Cologne
1967 Trinity College, Hartford, Connecticut
 New Haven Festival of Arts, Connecticut
1968 Heckscher Museum, Huntington, Long Island, New York
1970 Oakland Museum, California
1972 Neikrug Galleries, New York
 Shells, American Museum of Natural History, New York
1976 International Center of Photography, New York (retrospective)
1978 *New York in the 40's*, New York Historical Society

Selected Group Exhibitions:

1948 *50 Photographs by 50 Photographers*, Museum of Modern Art, New York
1955 *The Family of Man*, Museum of Modern Art, New York (and world tour)
1958 *70 Photographers Look at New York*, Museum of Modern Art, New York
1959 *Photography at Mid-Century*, International Museum of Photography, George Eastman House, Rochester, New York
1960 *Photography in the Fine Arts*, Metropolitan Museum of Art, New York
1962 *Ideas in Images*, American Federation of Arts, New York (toured the United States)
1967 *Once Visible*, Museum of Modern Art, New York
1971 *Photo-Eye of the 20's*, International Museum of Photography, George Eastman House, Rochester, New York (travelled to the Museum of Modern Art, New York)
1980 *Avant-Garde Photography in Germany 1918-1939*, San Francisco Museum of Modern Art
 Photography in the 50's, Center for Creative Photography, University of Arizona, Tucson

Collections:

Center for Creative Photography, University of Arizona, Tucson (archives); Metropolitan Museum of Art, New York; Museum of Modern Art, New York; International Center of Photography, New York; International Museum of Photography, George Eastman House, Rochester, New York; Carpenter Center for the Visual Arts, Harvard University, Cambridge, Massachusetts; Smithsonian Institution, Washington, D.C., New Orleans Museum of Art; Victoria and Albert Museum, London; Bibliothèque Nationale, Paris.

Publications:

By FEININGER: books of photographs—*Stockholm*, Stockholm 1936; *New Paths in Photography*, Boston 1939; *New York*, with text by John Erskine and Jacqueline Judge, New York and Chicago 1945; *The Face of New York*, with text by Susan Lyman, New York 1954; *Changing America*, with text by Patricia Dyett, New York 1955; *The Anatomy of Nature*, New York 1956, Munich 1957, Barcelona 1962; *Man and Stone*, Dusseldorf 1960, New York 1961, Amsterdam 1962; *Maids, Madonnas and Witches*, with text by Henry Miller and J. Bon, Cologne 1960, New York and London 1961; *The World Through My Eyes*, New York, Dusseldorf, Milan and Amsterdam 1963; *New York*, with text by Kate Simon, New York and Dusseldorf 1964; *Lyonel Feininger: City at the Edge of the World*, New York and Munich 1965; *Forms of Nature and Life*, New York, London and Dusseldorf 1966; *Trees*, New York, London and Dusseldorf 1968; *Shells*, with text by William K. Emerson, New York, London, Dusseldorf and Milan 1972; *Roots of Art*, New York, London, Dusseldorf and Milan 1975; *The Mountains of the Mind*, New York and Dusseldorf 1977, as *Nature Close Up*, 1981; *New York in the Forties*, with text by John von Hartz, New York 1978; *Feininger's Hamburg*, Dusseldorf 1980; *Feininger's Chicago, 1941*, New York 1980; photographic textbooks—*Menschen vor der Kamera*, Halle, Germany 1934; *Selbst Entwickeln und Kopieren*, Harzburg, Germany 1935; *Vergrössern, Leicht Gemacht*, Harzburg, Germany 1935; *Entwicken Kopieren Vergrössern*, Harzburg, Germany 1936; *Aufnahmetechnik*, Harzburg, Germany 1936; *Fotografische Gestaltung*, Harzburg, Germany 1937; *Motive in Gegenlicht*, Harzburg, Germany 1939; *Feininger on Photography*, Chicago and New York

1949, 2nd edition, New York 1953; *Advanced Photography*, New York 1952; *Successful Photography*, New York 1954, Stockholm 1956, Helsinki 1957, Dusseldorf 1959, Milan 1961, 2nd edition, New York 1975; *Successful Color Photography*, New York 1954, Stockholm 1957, Helsinki 1958, Dusseldorf 1959, Milan 1962, 4th edition, New York 1966; *The Creative Photographer*, New York 1955, Dusseldorf and Stockholm 1958, Bucarest 1967, 2nd edition, New York 1975; *Total Picture Control*, New York and Dusseldorf 1961, London and Copenhagen 1962, Prague 1968, Barcelona 1969, Amsterdam 1973, 2nd edition, New York 1970; *The Complete Photographer*, New York, Dusseldorf and Amsterdam 1965, London and Milan 1966, Tokyo 1969, Prague 1971, Barcelona 1972; *The Color Photo Book*, New York, Dusseldorf, London and Amsterdam 1969; *Basic Color Photography*, New York, Dusseldorf and London 1972, Milan and Helsinki 1974; *Photographic Seeing*, New York 1973; *Principles of Composition in Photography*, New York and London 1973, Dusseldorf 1974; *Darkroom Techniques*, 2 volumes, New York 1974; *The Perfect Photograph*, New York 1974; *Light and Lighting in Photography*, New York 1976, Dusseldorf 1980.

On FEININGER: books—*Grosse Photographen unseres Jahrhunderts* by Fritz Gruber, Dusseldorf 1964; *The Picture History of Photography* by Peter Pollack, second edition, New York 1969; *Andreas Feininger* by Ralph Hattersley, New York 1973; articles—in *Modern Photography* (New York), December 1949; *Popular Photography* (New York), February 1964; *Infinity* (New York), November 1968; and *Modern Photography* (New York), August 1973.

Photography, as I see it, is a picture-language, a form of communication. This, of course, implies that a photograph, at least as far as I am concerned, must have something to communicate that is of interest to the viewer. A photograph that fails in this respect is, in my opinion, worthless.

I believe that the key to good photography is interest on the part of the photographer, *not* in photography but in his subject. Unless a potential subject "speaks to me," I wouldn't consider photographing it. Only if I feel "turned on" by a subject can I hope to make pictures capable of evoking a response in other people.

As in speech or in writing, in photography, too, a statement can be presented well or badly. A well-presented statement is, of course, more effective and enjoyable than a badly-presented one. In photography, this makes it important to pay attention to the technical execution of the picture—the form of presentation. But while photo-technique is important, it should never be more than a means to an end. Excessive preoccupation with the technical aspects of photography shifts the emphasis from the end to the means. Basically, in my opinion, an interesting visual statement badly presented is still preferable to the technically most accomplished picture that has nothing to say. The first, at least, is meaningful, whereas the second is a total waste of the viewer's time.

To me, good presentation means three things: clarity, simplicity, organization. I found this most easy to accomplish by keeping my means and equipment simple.

I always strive to produce images which show the viewer *more* than he would (and often could) have seen had he been confronted with my subject in reality. A photograph which shows only what anybody can see in reality is visually less valuable and informative than one that shows the viewer something which he wouldn't or couldn't have seen, something he didn't know or something he hadn't thought of before. The first is merely a record, while the second can enrich and stimulate the mind.

Despite a superficial similarity in regard to construction, important functional differences exist between the human eye and the camera. As a result, eye and camera "see" the same subject differently. Unless a photographer takes these differences into account, is able to "see in terms of photography," and acts accordingly, his pictures are bound to be inferior to the experience that triggered them.

On the other hand, the camera can also show us *more* than we were able to see at the moment the picture was taken. Examples are certain types of tele- and wide-angle photographs, extreme close-ups, pictures in cylindrical and spherical perspectives, high-speed photographs, stroboscopic motion studies, time exposures involving blur as a means of symbolizing subject motion, selectively focussed images, double exposures and superimpositions, pictures taken on infra-red film, X-ray photographs, and so on. However, to make the most of such opportunities, it is essential that the photographer is able to think and see in terms of photography.

—Andreas Feininger

Andreas Feininger is one of the great pioneers who made photography into what it is today. He and his peers found a medium that was struggling to express itself and turned it into a great visual language capable of communicating literally millions of things. Photography has grown so influential that life in a modern culture would hardly make sense without it. Everywhere you turn are photographs, and they all have something to say. But it was men like Feininger who first made them speak clearly.

Photography has never been easy to understand, for it works on the non-verbal level. Many have tried to explain it and have failed. Equipped with a piercing intellect, Feininger has provided successful explanations for many years and shows no sign of stopping. He is justly famous for his books on photography, though he has also written on other subjects. Thirty-two of his books have been published in America, and he has been translated into thirteen foreign languages. He is a great favorite of librarians, for he writes clearly and logically about a very abstruse subject. His explanations are the best available.

Trained as an architect, Feininger is still very interested in structures and constructions, photographing them with both power and sensitivity. He finds them in man-made things and in nature and is primarily a photographer of objects. He is fascinated by the myriad forms of organization that he finds and in the relationship between form and function. You can almost always tell how the objects in his photographs will function, for that is his intent. If he photographs a bone, for example, you can see how its structure makes it function well as a support.

Feininger looks at the camera as an instrument of discovery related to the telescope and the microscope. His pictures help viewers to discover things that they wouldn't ordinarily see. His typical photograph is a veritable feast of things waiting to be seen. He firmly believes that the photographer's vision is his most important asset and that he should use it to show the wonders of the world to those less well endowed. He is especially good at making people see what he wants them to see. In this sense his pictures have great power, though he is also a master of subtleties.

Feininger's hero is the person who can really see. Such a person must have a hyper-acute awareness of the surrounding world, must have eyes as sensitive as a child's, must be fully conscious of the things he is looking at. The person who really sees is always fascinated with the idea, finding his vision an endless source of amazement. Thus it is with Feininger himself—he is constantly discovering new things to marvel at. Fortunately he is able to communicate this feeling to others with his photographs.

A part of good seeing is to know what light can do, because vision depends on it entirely. Thus photographers concentrate their attention both on ambient lightings and on lightings fully under their control, striving to make themselves fully aware of what they are looking at. In both areas Feininger is the expert's expert. The ambient lightings that he chooses to use usually emphasize power, while his controlled lightings put the accent on great subtlety. Though his controlled lightings are masterful they are never tricky. Very often they are as simple as can be, for simplicity may fill the bill.

Through his definitive books Feininger is probably the world's foremost teacher of photography. Many thousands of people have been led to a sound understanding of this difficult medium, led firmly and with authority by this master teacher. His work as a writer-teacher may lead some to overlook his other accomplishments, however. For example, he was one of the select few who developed magazine photojournalism into its present form. For twenty years he was a staff photographer on *Life* magazine, then as now the acknowledged leader in photojournalism. While there he participated in hundreds of decisions that helped shape the art. Though inclined to be shy, he always stood up for his own opinions, which were always well-reasoned and logical. So he left a definite mark on the magazine. He did 346 assignments for *Life* — in magazine photojournalism this is a great many. He left *Life* in 1962 to devote himself to his own work, which has kept him very busy ever since.

Feininger's favorite tools are the telephoto lens and the close-up camera. He has personally built four telephoto cameras and three close-up cameras, highly specialized instruments of a kind not available commercially. The telephoto lens gives him the perspectives that he likes and helps him maintain certain size relationships in his subjects. The close-up camera enables him to photograph very small objects—seashells, rocks, insects, structures created by insects, and so on. He is especially interested in small things, often making them appear very large in his pictures.

Feininger works almost exclusively in black-and-white, for it gives him much greater control over the ultimate appearance of his pictures than color. It is also much simpler and helps keep down the cost of book production. On the other hand, he did a lot of color work for *Life* and earned a considerable reputation as a color photographer.

Feininger's entire photographic archive will go to the Center for Creative Photography in Tucson, Arizona, where it will be available to scholars and for study. The transfer has largely taken place already. The archive will include thousands of negatives and prints, scrapbooks, reviews of exhibitions and books, personal papers and documents, and a complete set of Feininger's books. Since he is a very careful and methodical person, the archive is in splendid shape.

In sum, Andreas Feininger is a great historical figure in photography whom everyone should know about.

—Ralph Hattersley

Andreas Feininger: *Venus Comb Shell*, 1970

FICHTER, Robert W(hitten).

American. Born in Fort Meyers, Florida, 30 December 1939. Educated at P.K. Yonge High School, Gainesville, Florida, 1954-58; studied printmaking and painting, University of Florida, Gainesville, under Jerry N. Uelsmann, 1959-63, B.F.A. 1963; photography and printmaking, under Henry Holmes Smith, Indiana University, Bloomington, 1963-66, M.F.A. 1966. Independent photographer, since 1966. Assistant Curator of Exhibitions, George Eastman House, Rochester, New York, 1966-68. Visiting Instructor in Photography, University of Florida, Gainesville, 1967; Instructor, Penland Craft School, North Carolina, Summers, 1968, 1970, 1971; Assistant Professor, 1968-70, Lecturer, 1971, Visiting Associate Professor, 1976, University of California at Los Angeles; Visiting Artist, Art Institute of Chicago, 1977. Associate Professor, Florida State University, Tallahassee, since 1972. Recipient: National Endowment for the Arts Grant, 1980. Agent: Robert Freidus Gallery Inc., 158 Lafayette Street, New York, New York 10013. Address: c/o Department of Art, Florida State University, Tallahassee, Florida 32306, U.S.A.

Individual Exhibitions:

1968 *Robert Fichter's Trips*, International Museum of Photography, George Eastman House, Rochester, New York
1970 *Recent Photo-Drawings*, University of California at Davis
1972 Infinite Gallery, Seattle
 Center of the Eye, Aspen, Colorado
 Visual Studies Workshop, Rochester, New York (toured the United States)
1974 Light Gallery, New York
 School of the Art Institute of Chicago
1975 University of New Mexico, Albuquerque
1976 Light Gallery, New York
1978 Cameraworks Gallery, San Francisco
1980 Robert Freidus Gallery, New York
 Northlight Gallery, Tempe, Arizona
 Gulf Coast Gallery, Tampa, Florida
1981 Robert Freidus Gallery, New York

Selected Group Exhibitions:

1967 *4 Photographers*, Riverside Gallery, Rochester, New York
1968 *Contemporary Photographers*, University of California at Los Angeles
1969 *Serial/Modular Imagery*, Purdue University, Lafayette, Indiana (toured the United States)
1970 *The Photograph as Object 1843-1969*, National Gallery of Canada, Ottawa (toured Canada)
 California Photographers 1970, University of California at Davis (travelled to Oakland Museum, California; Pasadena Art Museum, California)
1972 *60's Continuum*, International Museum of Photography, George Eastman House, Rochester, New York
1973 *Photography into Art*, Scottish Arts Council Gallery, Edinburgh
1977 *Painting in the Age of Photography*, Kunsthaus, Zurich
1980 *Invented Images*, University of California at Santa Barbara
1981 *Whitney Biennial*, Whitney Museum, New York

Collections:

International Museum of Photography, George Eastman House, Rochester, New York; Visual Studies Workshop, Rochester, New York; Museum of Fine Arts, Boston; Princeton University, New Jersey; Museum of Fine Arts, St. Petersburg, Florida; Minneapolis Institute of Art, Minnesota; Los Angeles County Museum of Art; Pasadena Art Museum, California; National Gallery of Canada, Ottawa; Australian National Gallery, Canberra, A.C.T.

Publications:

On FICHTER: books—*California Photographers 1970*, exhibition catalogue, by Fred R. Parker, Davis, California 1970; *Into the 70's: Photographic Images by 16 Artists/Photographers*, exhibition catalogue, by Tom Muir Wilson, Orrel E. Thompson and Robert M. Doty, Akron, Ohio 1970; *Photography into Art*, exhibition catalogue, by Pat Gilmour, Edinburgh 1973; *Light and Lens: Methods of Photography*, exhibition catalogue, by Donald L. Werner and Dennis Longwell, New York 1973; *The Great West: Real/Ideal*, edited by Sandy Hume and others, Boulder, Colorado 1977; *The Photograph Collector's Guide* by Lee D. Witkin and Barbara London, Boston and London 1979; article—"Photography: Charles Traub and Robert Fichter" by Hal Fischer in *Artweek* (Oakland, California), 16 September 1978.

I am a student of photography—not a photographer.

Photography is an ad hoc device for me; I use it to record, to amplify, to distort, to simplify, to complicate the images that I receive from this poor, glad, sad, radiant universe.

My work lies at the fringe of what most people would call photography. I work from "straight" to "funny" and back. I am currently trying to make my work much more direct, less diagrammatic, and in general richer and more intense. I use my hand as often as my lens.

The theory of photography as a creative means of self-expression is one I derived from studying with Jerry Uelsmann and Henry Holmes Smith—both marvellous poet-photographers and photo-intellects.

I hope someday to make a "photo-icon" that will float through time and that will be used to transfigure man's existence, should biology survive the nuclear age.

—Robert W. Fichter

One notable aspect of contemporary photography is the softening, perhaps actual breakdown, of its ertswhile clearly defined borders. A great many photographers, no longer satisfied with their lack of hands-on participation in the final product, have incorporated painting, drawing, and printmaking techniques into their photographic imagery. Yet few photographers have managed to dismantle and shuffle off the confines of the medium as easily as Robert Fichter. The body of his work is more diverse in both approach and technique than an essay of this length could acknowledge with justice; his recent 20 x 24 color Polaroids, however, do represent an adequate and distinctive summary of his work to date and an extraordinary example of what can be achieved within that format.

In the now substantial body of work from the 20 x 24 camera sponsored by the Polaroid Corporation, a specific mode emerges from and characterizes the various photographers' results. The camera, by its enormous size and non-mobility, seems to demand the kind of careful, often laborious, compilations of things, patterns, textures and colors that most artists bring to it. Were it not for the work of Fichter, we might also think the procedure demanded a certain mordant seriousness as well. Fichter seems enough at ease with the technique to be able to relinquish the diamond-hard focus, the meticulous rendering of photographic detail and the sense of a space densely stuffed. He uses a loose, raw drawing style which unleashes a primitive, intense energy that belies the hours required to set up these compositions. Fichter also uses the tear-off, negative material, the residue of other prints, in some images, which lends them a ghostly, mysterious backdrop, a kind of mirage of past images. Many of his scenes are primarily painted or drawn; Fichter thus imbues the well-chosen photographic elements with heightened significance.

Eugenia Parry Janis noted in her introduction to *One of a Kind* (Boston, 1980), that this camera encourages photographers into a peculiar kind of hermeticism. They fill the frame with quantities of quirky objects primarily to revel in their shape, color and texture, in their objectness. It is a lavish indulgence in materialism. Fichter, by contrast with most, constructs pictures to be deciphered, personal

Robert W. Fichter: *Oil Can Portrait* Courtesy Art Institute of Chicago

observations on contemporary affairs. Against the background of a gaudy, gold-fringed Lackland Air Force Base souvenir scarf are toy Indians, cowboys, soldiers and space monsters and a picture of forest animals, perhaps reminiscent of earlier, more bucolic times. Fichter is comfortable and experienced in working with the additive mode; unlike many photographers, he is used to beginning with a blank space or page.

In seeing a number of Fichter's Polaroids, one recognizes recurrent symbols and a personal iconology. A toy dinosaur skeleton frequents the scenes as a reminder, one suspects, of great beasts, once powerful and now extinct. The military references are profuse with emphasis on the underlying violence of conquering the frontier, whether that frontier is the American West or outer space. Animals of all kinds abound: a stuffed bird, drawn dogs, pinned butterflies, a plastic crab, and the imaginary "born again art ass." This world is whimsical and sometimes cartoonlike, but the apparent playfulness underscores the ultimate irony of his messages.

In an idiosyncratic language, Fichter comments upon a world that exists beyond the narrow confines of art photography. His 20 x 24 color Polaroids have all of the bejewelled brilliance that characterizes the format without the epicurean weightlessness. In disregarding the limits of the medium and format alike, and with a healthy dose of irreverence, Fichter has infused his constructed toy world with topical and personal significance. A compelling mixture of drollery and irony gives this work its tautness and its unexpected bite.

—Dana Asbury

FIEGER, Erwin.

German. Born in Toplei, Czechoslovakia, 10 December 1928; emigrated to West Germany, and subsequently naturalized. Studied commercial art and graphics, under Eugen Funk, Staatliche Akademie der Bildenden Kunste, Stuttgart, 1951-55; self-taught in photography. Freelance photographer, Germany and Italy, since 1956; has concentrated on color photography since 1962. Member, Gesellschaft Deutscher Lichtbildner (GDL), 1960-62. Recipient: Nadar Prize, France, 1969; Cultural Prize, Deutsche Gesellschaft für Photographie (DGPh), 1974. Address: La Lama Casa le Mura, Castelfranco di Sopra, Italy.

Selected Group Exhibitions:

1974 *Photokina '74*, Cologne
1979 *Deutsch Fotografie nach 1945*, Kunstverein, Kassel, West Germany (toured West Germany)

Collections:

Deutsche Gesellschaft für Photographie, Cologne; Gesellschaft Deutscher Lichtbildner, Stuttgart.

Publications:

By FIEGER: books—*Farbiges London*, Dusseldorf 1962; *Grand Prix*, Stuttgart 1963; *13 Photo Essays*, with a preface by Helmut Gernsheim, Dusseldorf 1969; *Japan: Sunrise Island*, Dusseldorf 1971;

Olympia: Sapporo, Munich 1972; *Olympia: Munich*, 1972; *Mexico*, Dusseldorf 1973; *Life—Foto*, Dusseldorf 1973; *Ski WM St. Moritz*, Munich 1974; *Fussball WM Germany*, Munich 1974; *Winterolympiade Innsbruck*, Munich 1976; *Sommerolympiade Montreal*, Munich 1976; *Was die Menscheit bewegt*, Munich 1977; *Ski WM Garmisch-Lathi*, Munich 1978; *Fussball WM Argentinien*, Munich 1978; *Die Zukunft unserer Kinder*, Munich 1979.

On FIEGER: books—*Geschichte der Fotografie im 20. Jahrhundert/Photography in the 20th Century* by Petr Tausk, Cologne 1977, London 1980; *Deutsche Fotografie nach 1945/German Photography after 1945* by Floris Neususs, Wolfgang Kemp and Petra Benteler, Kassel, West Germany 1979; *Fotografie 1919-1979, Made in Germany: Die GDL-Fotografen*, edited by Fritz Kempe, Bernd Lohse and others, Frankfurt 1979; articles—"Erwin Fieger: Photo-Essays" in *German Photography Annual*, Stuttgart 1970; "Magnet Japan" in *German Photographic Annual*, Stuttgart 1972; "Erwin Fieger" in *Zoom* (Paris), September/October 1972.

In our photographic age the concerned photographer is in danger of being drowned by a flood of illustrators. Our senses are being blunted by seeing too much and understanding too little. Aware of this danger, Erwin Fieger discovered a new conception and interpretation. The impact of his telephoto-lens close-ups are breathtaking, marking a personal style that proved to be a landmark influence on reportage photography. Fieger's colour photo-essays on cities and countries raised the power of photographic expression to hitherto unknown heights. From his first book, *Farbiges London* (1962), to his fabulous album on Japan ten years later, and others following it, we are confronted with the work of an outstanding photographer, gifted with the vision of an artist. A great sensitivity for poetical situations and an ability to transform a fleeting impression into a permanent design of high aesthetic value led the former graphic designer to the creation of unusual images. He directs our attention to things we have seen, and yet not noticed. The isolation of the subject from its surroundings, the "freezing" of a fleeting impression, the closing-in on a detail—they all contribute to the novel way of interpretation and unexpected grandeur.

The lenses of our eyes are of short focal length and have consequently great depth of focus. This makes it possible for us to view near and far objects in quick alternation. The zoom lens which Fieger chiefly employs has only a small depth of focus. The desired picture plane is sharp, everything in front or behind it appears unsharp, throwing the subject in focus into greater relief. The, to us, unaccustomed television, the blurring of colour outlines due to comparatively long exposure times, the snatching of a detail out of the immense mosaic of reality, allow a very personal interpretation which fascinates on account of its revelation of entirely new visual effects.

Fieger's photo-essays are optical voyages of discovery into uncharted territories. He is on the whole not concerned with documentation in the established sense, with the representation of facts or events. Our discovery lies in his "shorthand" impressions of what he saw, and the magic of colour. The importance of his essays lies in the originality of his vision and the purely aesthetic pleasure of his interpretation. Landscape motifs are rendered symbolically; their geographical region is only of secondary importance to satisfy our curiosity. His people are types: Indians, Japanese, Africans, Mexicans—not representatives of a social class; they are solely human beings whose faces, gestures, joy or grief express everything without words. Describing his work for someone who does not know it is difficult. Seeing it opens new worlds. Fieger works for a

small, discriminating public, appreciative and willing to pay for the highest printing quality achievable. The reproductions in his folio volumes are as good as original prints, which, surprisingly, Fieger neither makes nor sells from his 35mm diapositives. Respect for his medium and individual expression oblige him to continue on his chosen path rather than dancing to the dictates of picture editors.

—Helmut Gernsheim

FIGUEROA FLORES, Gabriel.

Mexican. Born in Mexico City, 16 October 1952. Educated at the German School, Mexico City, 1956-65; Universidad Iberoamericana, Mexico City, 1971-74; attended Ansel Adams Photography Workshop, Yosemite Park, California, 1973; studied mass media communications at the Polytechnic of Central London, 1974-77, B.A. Photog. 1977. Served in the Mexican Army, 1967-68. Freelance photographer, Mexico City, since 1978. Agent: Galeria Juan Martin, Calle de Amberes 17, Mexico 6, D.F. Address: Alberto Zamora 39, Mexico 21, D.F., Mexico.

Individual Exhibitions:

1978 *3 Jovenes Fotografos*, Galeria Juan Martin, Mexico City (with Pablo Ortiz Monasterio and Julieta Gimenez Cacho)
1980 Galeria Juan Martin, Mexico City

Selected Group Exhibitions:

1978 *Los Fotografos Eligen*, Galeria Arvil, Mexico City
1979 *Fotografia Urbana*, Galeria B. Franklin, Mexico City
1981 *Astrazione e Realta*, Galleria Flaviana, Locarno, Switzerland

Publications:

By FIGUEROA FLORES: book—*Caminos y Mano de Obra*, Mexico City 1976; articles—"La Fotografia in Messico" in *Fotografia Italiana* (Milan), February 1979; "Los Fotografos Crtesanos" in *Siempre* (Mexico City), August 1979; "Mulege" in *New West Magazine* (Los Angeles), August 1979; "Gabriel Figueroa Flores: Fotografias" in *Arquitecto* (Mexico City), August 1980.

One always tries to find a commitment in life. Some people are completely dedicated for many years, to a specific activity. I have spent my life trying to find out if I have a commitment, and what it might be.

What I do most—and perhaps this is my commitment—is to make objective my subjective feelings through a mental process and via a language. I respond to visual stimuli because of my early training and education. I realize that this could be compared to a digestive process: one sees, learns, retains, blends, distorts and so on, until one day something from all those inputs becomes a coherent part (or parts) of another process which transforms those previous experiences.

What I photograph is a condensation of my previous thought processes. These images tell about other lines of process in a specific place and time: a

man's trace or gesture, even the most insignificant or trivial accident, becomes very important to me, because it is part of our unconscious made manifest, leaving a temporary—sometimes even permanent—wound in our world.

Objects—worn out, faded, torn, scratched, beaten, repainted, demolished, oxidized, left behind: all these are evidence of a particular moment, representing visually my idea of what is significant. The colour of these impressions acts as a form in itself, not merely as a factor serving to delimit the forms of the objects.

I seek harmony with the outer visual world, and, when I find it, I make a picture or several images until they are integrated to my system; then, I begin again.

—Gabriel Figueroa Flores

Gabriel Figueroa Flores is an unconventional photographer who has annihilated the graphic traditions of his country. Mexican representative art—painting, sculpture, film and photography—performs an essentially didactic and narrative role. To avoid the visual temptations that lead inevitably to folklore, and the ideological influences that lead to the imitation of hallowed models, Flores has had to engage in a profound analysis of his historic inheritance, from which has come a visual representation that is essential and severe, purged of symbols and free of preconceived plans.

His pictures are pictures of real life, of things that exist but of which we are often unaware, tangled up as they are with so many other things that make their presence felt much more conspicuously.

Flores uses the photographic medium as a selector of aesthetic banality. His is a refined intellectual operation to recover a microcosm and, at the same time, to scale down the actual meaning of artistic

expression. In effect, through his work he reaffirms that creative photography is wholly subjective and makes no claim to be an all-embracing, exhaustive representation of "truth." Absolute truth does not exist. What does exist is a number of probable, individual truths, no less valid for that reason, and it is only through the assemblying of such individual truths that we can approach a real truth.

With Flores, photography, too often interpreted as a faithful representation, once more finds its true dimensions as a recorder of minute realities. The camera is not an extension of the eye, which in every microsecond takes in an infinite series of objects that are then lost to our consciousness. Its function is to isolate different elements, to restore to each one its predominance over the others. The grating over a manhole cover, the body of a truck, the walls of a room, the structure of an individual wall—all take on again their true meaning in our visual world.

While it is easy enough for all of us to perceive beauty where centuries of tradition and culture have taught us to see it—in a flower, a face, a landscape, a sunset—it is far from easy to discover it where we never knew it existed. The photo thus becomes a sensitive interpretation, the communication of an emotional message.

The use of color has a basic function in that emotional message and is fully justified by the balanced relationships between form and structure of spaces. It is also the element that reveals the subtle tension between the rational and emotional. In fact, the graphic structure of Flores' pictures is based on simple linear geometry, and violent color contrasts fill them with pathos and give them vivid life. Black and yellow, red and deep blue, grey and orange define the spatial rhythms and smooth the outlines. The severity of the form loses its hardness, and a whole world of visual emotions breaks out from the rectangle of photographic paper that momentarily

contained them.

Another characteristic of Flores' photographs is the absence of people. People are suggested by the details of the objects photographed. Every detail carries unmistakable traces of the human race, as the organizer of harmonic forms and violator of nature, as the creator of order and of passion. These poles have been set up by Flores in his pictures, creating works that are both exciting and mysterious. The excitement and mystery of the photographic process become metaphors of human nature.

—Giuliana Scimé

Gabriel Figueroa Flores: *Street Design* (original in color), 1977

FINK, Larry.
American. Born in Brooklyn, New York, 3 November 1941. Educated at Stockbridge High School, Massachusetts; Coe College, Cedar Rapids, Iowa; and New School for Social Research, New York; studied photography, privately, with Lisette Model, New York. Freelance photographer. Instructor, Parsons School of Design, New York, 1967-72, and New School for Social Research, New York, 1968-72; Assistant Professor, Kingsborough Community College, New York, 1969-73; Instructor, Lehigh University, Bethlehem, Pennsylvania, 1976; Walker Evans Professor of Photography, 1977-78, and Professor, 1978, Yale University, New Haven, Connecticut; Instructor, International Center of Photography, New York, 1977, and Cooper Union, New York, 1979. Recipient: Creative Artists Public Service Grant, New York State Council on the Arts, 1971, 1974; Guggenheim Fellowship, 1976, 1979; National Endowment for the Arts Photography Fellowship, 1978. Agent: Light Gallery, 724 Fifth Avenue, New York, New York 10019. Address: Post Office Box 295, Martins Creek, Pennsylvania 18063, U.S.A.

Individual Exhibitions:

1960 *Cannes Film Festival*
1971 Paley and Lowe Gallery, New York
1972 Harcus-Krakow Gallery, Boston
1973 Light Works, Syracuse, New York
 Ohio Wesleyan University, Delaware
 Diana Gallery, New York
 Yale Summer School, New Haven, Connecticut
1975 Muhlenberg College, Allentown, Pennsylvania
 Cedar Crest College, Allentown, Pennsylvania
 Kirkland College, Clinton, New York
 Midtown Y Gallery, New York
1976 Bucks County Community College, Newtown, Pennsylvania
 St. Lawrence University, Canton, New York
 Light Works, Syracuse, New York
 Broxton Gallery, Los Angeles
 Carl Solway Gallery, Cincinnati, Ohio
1977 Yale University, New Haven, Connecticut
 University of Arizona, Tucson
1978 Sander Gallery, Washington, D.C.
 Lehigh University, Bethlehem, Pennsylvania
 Hayden Gallery, Massachusetts Institute of Technology, Cambridge
1979 Museum of Modern Art, New York
1980 Light Gallery, New York
1981 San Francisco Museum of Modern Art (with Joel Sternfeld)

Larry Fink/Andreas Müller-Pohle/Michael Schmidt, Kunstmuseum, Dusseldorf

Selected Group Exhibitions:

1968 *Great Photographs*, American Society of Magazine Photographers, New York

1970 *Metropolitan Middle Class*, Massachusetts Institute of Technology, Cambridge

1973 *The Jew in New York*, Midtown Y Gallery, New York

1976 *Celebration*, Floating Foundation of Photography, New York

1978 *Summer Light*, Light Gallery, New York
Mirrors and Windows: American Photography since 1960, Museum of Modern Art, New York (toured the United States, 1978-80)

1979 *American Images: New Work by 20 Contemporary Photographers*, Corcoran Gallery, Washington, D.C. (travelled to the International Center of Photography, New York; Museum of Fine Arts, Houston; Minneapolis Institute of Arts; and Indianapolis Institute of Arts, 1980; and American Academy, Rome, 1981)
Photographie als Kunst 1879-1979, Tiroler Landesmuseum Ferdinandeum, Innsbruck, Austria (travelled to the Neue Galerie am Wolfgang Gurlitt Museum, Linz, Austria; Neue Galerie am Landesmuseum Joanneum, Graz, Austria; and Museum des 20. Jahrhunderts, Vienna)

Collections:

Museum of Modern Art, New York; Museum of Fine Arts, Boston; Corcoran Gallery, Washington, D.C.

Publications:

By FINK: books—*Un Printemps à New York*, with Marc Albert Levin, Paris 1969; *Tour de Force*, with Marc Albert Levin, Paris 1969.

On FINK: books—*Mirrors and Windows: American Photography since 1960* by John Szarkowski, New York 1978; *American Images: New Work by 20 Contemporary Photographers*, edited by Renato Danese, New York 1979; *Photographie als Kunst 1879-1979/Kunst als Photographie 1949-1979*, exhibition catalogue, 2 vols., by Peter Weiermair, Innsbruck, Austria 1979; articles—"Larry Fink: San Gennaro Festival" in *Print* (New York), January/February 1973; "New Work: Larry Fink, Light Gallery" by Lynn Zelevansky in *Flash Art* (Milan), Summer 1980.

Perhaps Larry Fink's photographs are best described under the rubric "new social photography." Like other "new" types of photography—documentary, landscape, topography—Fink's social documents have become "new" because they are made with an added detachment and self-consciousness unavailable to those who originally dealt with the then-fresh subject matter.

Clearly reliant on the styles of Robert Frank, Garry Winogrand, Diane Arbus and his teacher Lisette Model, Fink's work reflects not only the mood of the period in American life that he photographs, but also the currency of the social and artistic forces and institutions that have developed and formed him as an artist. Travelling in both the urban and the quasi-rural social landscapes, Fink specializes in the types and activities found in lower middle class locales and gatherings. Having studied the lessons in romance offered by America's tradition of photographer-travellers who have explored the country through photography since the Western expeditions, Fink has learned how to heroicize the capture of "quintessential" American scenes and moments. His forte is the carefully framed 2¼ image in black and white, highlighted by flash or other harsh lighting, and printed in high contrast to bring out all the details.

Equally transparent as his lower middle class subjects are opaque, however, is the story to be read in Fink's photographs of his own development as photographer-artist-teacher. In their detachment from the lives and habits of the people they show, Fink's photographs are highly expressive of his own social point of view; they suggest that he photographs a social milieu from which he himself has narrowly escaped. Fink seems at once closer to and less comfortable with his subjects than are Frank, Winogrand or Arbus.

Fink is a highly successful teacher, capable of not only stylistic proficiency and grace but also the ability to convey the fundamentals of these accomp-

Larry Fink: *First Communion*, Bronx, New York, 1961

lishments to younger photographers. Nor is this success surprising, for the work itself pays unabashed homage to art school training, trends in collecting, and curatorial tastes—the agents, certainly, of his rescue from that very lower middle class which he photographs. In the unself-conscious grins and the television-inspired, banal gesture of his subjects, all too lovingly caught, one senses the artist's faint sigh of relief—"there but for the grace of God go I"—and realizes anew the power of photography in American life today.

—Maren Stange

Publications:

By FINSLER: book—*Mein Weg zur Fotografie: 30 Aufnahmen aus den 20er Jahre*, Zurich 1971; article—"Hans Finsler: Das Bild der Photographie," in special issue of *Du* (Zurich), March 1964.

On FINSLER: books—*Photographes Suisses depuis 1840 à nos Jours*, exhibition catalogue, by Manuel Gasser, Hugo Loetscher, Walter Binder and Rosellina Burri-Bischof, Zurich 1974; *The Magic Image* by Cecil Beaton and Gail Buckland, London and Boston 1975; *Fotografie der 30er Jahre: Eine Anthologie*, edited by Hans-Jürgen Syberberg, Munich 1977; *Neue Sachlichkeit and German Realism of the Twenties*, exhibition catalogue, edited by Wieland Schmied and Ute Eskildsen, London 1978; *Germany: The New Photography 1927-33*, edited by David Mellor, London 1978; *Das Experimentelle Photo in Deutschland 1918-1940* by Emilio Bertonati, Munich 1978; *Film und Foto der 20er Jahre*, exhibition catalogue, by Ute Eskildsen and Jan Christopher Horak, Stuttgart 1979; *Fotografie 1919-1979, Made in Germany: Die GDL-Fotografen*, edited by Fritz Kempe, Bernd Lohse and others, Frankfurt 1979; *Photographie als Kunst 1879-1979/Kunst als Photographie 1949-1979*, exhibition catalogue, 2 vols., by Peter Weiermair, Innsbruck 1979; *Photographen der 20er Jahre* by Karl Steinorth, Munich 1979; *Internationale Ausstellung des Deutschen Werkbundes "Film und Foto" 1929*, facsimile reprint, edited by Karl Steinorth, Munich 1979; *Avant-Garde Photography in Germany 1919-1939*, exhibition catalogue, by Van Deren Coke, Ute Eskildsen and Bernd Lohse, San Francisco 1980; articles—"Film und Foto, Ausstellung des Deutschen Werkbundes" by Karl Sommer in *Essener Allgemeine Zeitung*, 26 May 1929; "Exhibition in Stuttgart, June 1929, and Its Effects" by Andor Kraszna-Krausz in *Close-Up* (London), February 1930; "Hans Finsler" in *Camera* (Lucerne), January 1972; "Hans Finsler: Il Suo Primo Maestro" in *Fotografia Italiana* (Milan), September 1973.

FINSLER, Hans.

Swiss. Born in Zurich, 7 December 1891. Studied architecture at the Technische Hochschule, Munich, 1909-14; studied art history in Munich, 1914-18; self-taught in photography. Independent photographer, Halle and Zurich, 1922-72. Librarian and Professor in Art History, Kunstgewerbeschule, Halle, Germany, 1922-32 (founded class for "object photography," 1927-32); Head of Photography, Kunstgewerbeschule, Zurich, 1932-58. President, Swiss Werkbund, Zurich, 1932. *Died* (in Zurich) *in 1972.*

Individual Exhibitions:

1970　*My Way to Photography*, IBM Gallery, New York (toured the United States)
1971　Galerie 58, Rapperswil, Switzerland

Selected Group Exhibitions:

1929　*Film und Foto*, Deutscher Werkbund, Stuttgart
1974　*Photographes Suisses depuis 1840 à nos Jours*, Kunsthaus, Zurich
1978　*Neue Sachlichkeit and German Realism of the 20's*, Hayward Gallery, London
　　　Das Experimentelle Photo in Deutschland 1918-1940, Galleria del Levante, Munich
1979　*Photographie als Kunst 1879-1979/Kunst als Photographie 1949-1979*, Tiroler Landesmuseum Ferdinandeum, Innsbruck, Austria (travelled to Neue Galerie am Wolfgang Gurlitt Museum, Linz, Austria; Neue Galerie am Landesmuseum Joanneum, Graz, Austria; and Museum des 20. Jahrhunderts, Vienna)
　　　Film und Foto der 20er Jahre, Württembergische Kunstverein, Stuttgart (travelled to Museum Folkwang, Essen; Werkbundarchiv, Berlin; Kunsthaus, Zurich; Kunstverein, Hamburg; Museum des 20. Jahrhunderts, Vienna)
1980　*Masks, Mannequins and Dolls*, Prakapas Gallery, New York
　　　Avant-Garde Photography in Germany 1919-1939, San Francisco Museum of Modern Art (toured the United States)
1981　*Germany: The New Vision*, Fraenkel Gallery, San Francisco

Collections:

Kunstgewerbemuseum, Zurich; Kunstgewerbeschule, Halle, East Germany.

Hans Finsler: *Machine for Chocolate*, c. 1928　Courtesy Galerie Wilde, Cologne

In the 1950's in America, the photographic community became aware that a disproportionately large number of photographers doing work of distinction came from small Switzerland. Werner Bischof's *Famine in India*, Emil Schulthess' books on Africa, the work of Robert Frank, who was the first non-American to be awarded a Guggenheim, Rene Groebli's experimental color, had all attracted attention. These photographers came from Zurich, and though they were not all exactly students of Hans Finsler's, those that were not had a connection: Schulthess had been an auditor during Finsler's first year of teaching there, and Frank had served part of his photographic apprenticeship with one of Finsler's former teaching assistants. What marks all these photographers and many students of Finsler's is that each one has a style all his own, each one has pursued a different area of interest and subject matter, each one developed or changed along the route of his professional life, each one straddled more than one discipline and pioneered in some way. True, Hans Finsler is perhaps the only prominent photography teacher to have taught so long in one place: from 1932 to 1958 he taught The Photography Class, which was part of the four year course at the Zurich Kunstgewerbeschule—though in some years there was only room for one student.

What was Hans Finsler's secret? It was not that he had been taught photography by a famous person. It was not that he discussed his own work with his students; not that he published his teachings in books; not that he was a colorful personality; not that he kept changing his course. He was self-taught; he kept his own work out of view, until long after he retired; his occasional articles and lectures have never been collected. He was a reserved-seeming person, and if any color were associated with him, it would be grey; neither market opportunity nor fashion swayed his teaching.

His students learned to understand cause and effect of every phase of the photographic process. In a quiet atmosphere, they learned to do, to solve formal problems, to look, to concentrate, and, above all, to make mistakes. He let them discover for themselves. In his quiet way, he indicated rather than pointed. He spotted his students' inclinations, sometimes before they did themselves. He provided criticism, but did not discourage.

His own photography was formed during the post-World War I era in Germany, when basic questions were being asked in an effort to arrive at a new mode of being. It is only because of his extreme modesty that these pioneering interpretations of the beauty of the functional are not better known.

Few teachers, however, are remembered as eagerly and with as much appreciation, in retrospect.

—Inge Bondi

FITCH, Steve.

American. Born in Tucson, Arizona, 16 August 1949. Educated at the University of California at Davis, 1967-68, and University of California, Berkeley, 1968-71, B.A. in anthropology 1971; San Francisco Art Institute, 1977; University of New Mexico, Albuquerque, 1978, M.A. in photography 1978. Married A. Lynn Grimes in 1980. Photographer since 1965. Instructor, A.S.U.C. Studio, University of California, Berkeley, 1971-77; Teaching Assistant, University of New Mexico, 1978. Visiting Lecturer, 1979-80, and since 1980 Assistant Professor of Art, University of Colorado, Boulder. Recipient: National Endowment for the Arts Photography Grant, 1973, 1975. Agents: Simon Lowinsky Gallery, 228 Grant Avenue, San Francisco, California 94108; and Susan Spiritus Gallery, 3336 Via Lido, Newport Beach, California 92663. Address: 801 LaFarge, Louisville, Colorado 80027; or Post Office Box 4626, Berkeley, California 94704; permanent address—870 Helen Avenue, Ukiah, California 95482, U.S.A.

Individual Exhibitions:

1975 Darkroom Workshop Gallery, Berkeley, California
University Art Museum, Berkeley, California
Shado Gallery, Oregon City, Oregon
Sacramento State University, California
1976 Orange Coast College, Costa Mesa, California
College of Marin, Kentfield, California
1977 Santa Fe Gallery of Photography, New Mexico
1979 Foto Gallery, New York
Blue Sky Gallery, Portland, Oregon
1980 Simon Lowinsky Gallery, San Francisco

Selected Group Exhibitions:

1973 *Places*, San Francisco Art Institute
1974 *Light and Substance*, University of New Mexico, Albuquerque
1975 *Young American Photographers*, Kalamazoo Institute of Arts, Michigan
1977 *Radical Photography and Bay Area Innovators*, Sacred Heart School, Menlo Park, California
12 California Photographers, toured Australia and New Zealand

1978 *The Aesthetics of Graffiti*, San Francisco Museum of Modern Art
Color Photographs: 5 Photographers, Friends of Photography, Carmel, California
1979 *Attitudes: Photography in the 70's*, Santa Barbara Museum of Art, California
8 x 10, Susan Spiritus Gallery, Newport Beach, California
1980 *Beyond Color*, San Francisco Museum of Modern Art

Collections:

Museum of Modern Art, New York; Museum of Fine Arts, Boston; Fogg Art Museum, Harvard University, Cambridge, Massachusetts; Rhode Island School of Design, Providence; Minneapolis Institute of the Arts; Houston Museum of Fine Arts; University of New Mexico, Albuquerque; Center for Creative Photography, University of Arizona, Tucson; Oakland Art Museum, California; Grunwald Center for the Graphic Arts, University of California at Los Angeles.

Publications:

By FITCH: book—*Diesels and Dinosaurs*, Berkeley, California 1976; articles—"The Recording of Maya Sculpture" in *Berkeley Archaeological Research Facility Reports* (Berkeley, California), no. 16, 1972; "Personal Notes on Teaching the History of Photography" in *Exposure* (Chicago), Spring 1981.

On FITCH: books—*Light and Substance*, exhibition catalogue, by Ralph Bogardus, Albuquerque,

Steve Fitch: *Grants Pass*, Oregon, 1975

New Mexico 1973; *Beyond Color*, exhibition catalogue, by Louise Katzman, San Francisco 1980; articles—"Roadwork" by Lois Fishman in *Afterimage* (Rochester, New York), May/June 1975; "Transformation of the Ordinary" by Dana Asbury in *Artweek* (Oakland, California), 26 November 1977; "Interactive Visions" by Ted Hedgpeth in *Artweek* (Oakland, California), 9 February 1980; "Review" by Hal Fischer in *Artforum* (New York), May 1980; "Shows We've Seen" by Natalie Canavor in *Popular Photography* (New York), June 1980.

The photographs I make are primarily observations about the American vernacular, in particular the highway and strip developments of the West. Details of this vernacular include drive-in movie theatres, motels, neon and neon signs, billboards, styles of landscaping, even the road itself.

Why I am interested in photographing this sort of evidence is difficult to explain. A simple reason is that I wish to document it—for my own purposes as well as in an archival sense: for the society. Another, more complicated and perhaps mystical reason is that I feel an attachment and profound respect for both the experience of the road and the physical facts of it.

How I formally approach this experience and these facts as an artist varies. Much of my work has been—and continues to be—done at night. As a result I use an assortment of light sources (singly and in combination): ambient sky light, strobe, artificial street and neon lighting, the headlights of my truck. I have always been interested in the nuances of the photographic process: how can I affect or alter the image by using a particular process or photographing with a certain attitude about time and place in mind. Originally, I began to work at night because I was curious about what photographs made then would look like, and I felt it was necessary for the subject matter that I was photographing (for example, neon signs).

I consider photography to be an important means for collecting, transmitting and storing information as well as a curious set of possibilities for altering and commenting on that information. Also, it is an important source of ideas for drawings, constructions, expeditions. Not only does the medium allow me a chance to exercise my obsessions; it also gives me an opportunity to understand and perhaps explain their importance.

—Steve Fitch

Steve Fitch's first book, *Diesels and Dinosaurs*, has its source in family vacations he took as a child, but it was realized when he later wandered the western highways alone and with his friends. It is a personal documentary revealing his romantic attraction to this uniquely American phenomenon. The photographs concentrate on single iconic aspects of the experience; billboards, neon and handpainted signs, building facades, drive-in movies, a truckstop waitress, and anonymous motels are preserved within the borders of these black and white photos. What makes this more than a routine documentary study, though, is the recurring motif of semi-trucks that dominate the highways and wooden prehistoric creatures that populate roadside attractions. His focus on these elements carries the metaphorical implication that these diesels are like modern day dinosaurs moving slowly toward extinction.

After this project Fitch's concerns shifted away from the documentary image toward an interest in the picture as an entity in itself, separate from its subject. His series of bushes illuminated by strong flash at night were technically and stylistically innovative studies which not only signalled a new direction in his work, but opened up new avenues for many other photographers as well. Their sophisticated use of space, perspective, color, and movement was meant to create new forms of content in the image.

The large, color prints which followed (for which he mastered the dye-transfer process) were a natural outgrowth of his technical experimentation and his fascination with roadsigns. Vibrant, saturated color and captivating movement in the photograph itself recreate the visual intensity of neon seen in the darkness of the desert highways. The signature piece of this series contains a pulsating orange neon arrow mounted on a shimmering steel pole. Set against a deep purple sky, it illuminates an unreal scene as it points diagonally down to unrecognizable squiggles of light. The thematic implication of this and many other works in this group is that all photographs act like signs because they direct viewers back to the world they have captured. The irony, of course, is that like the arrow-sign in his picture, Fitch's photographs always point to an unreal, imaginative world.

—Ted Hedgpeth

FONTANA, Franco.

Italian. Born in Modena, 9 December 1933. Educated in Modena schools; self-taught in photography. Married; daughters: Laura and Andrea. Freelance photographer, Modena, since 1961. Agents: PPS Galerie, 1 Feldstrasse, Hochhaus, Hamburg 4, West Germany; and G. Ray Hawkins Gallery, 9002 Melrose Avenue, Los Angeles, California 90069, U.S.A. Address: Via R. Benzi 40, 41010 Cognento, Modena, Italy.

Individual Exhibitions:

1965 Subalpina Società Fotografica, Turin
1968 Sala di Cultura, Commune di Modena
1970 Centro Culturale Pirelli, Milan

Franco Fontana: *Presenzassenza* (original in color), 1979

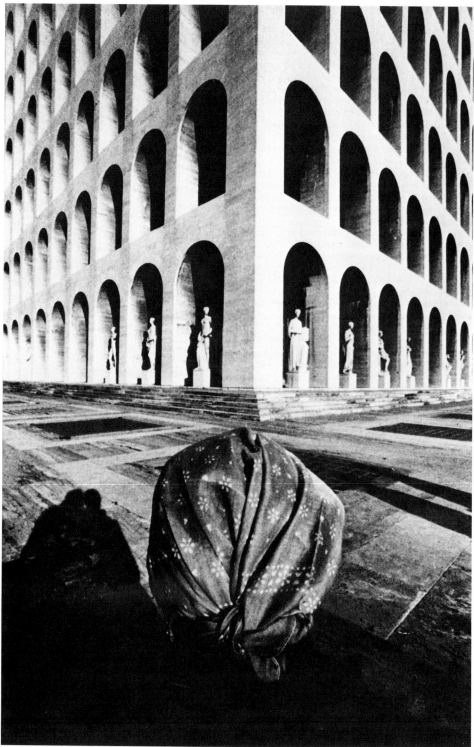

Centro Attività Visive, Palazzo dei Diamanti, Ferrara, Italy
Sala Esposizioni, Isolato San Rocco, Reggio Emilia, Italy
Saletta 70, Modena
Galleria dell'Immagine/Il Diaframma, Milan
1971 Scuola di Belle Arti, Somma Lombardo, Italy
Associazione Fotografica Napoletana, Naples
Galleria Tempo, Bologna
Palazzo del Turismo, Rovereto, Italy
1972 Palazzo dei Musei, Modena
Fotogalerie Die Brücke, Vienna
Galleria Il Camauro, Venice
Neue Galerie, Klagenfurt, Austria
Artemide Showroom, Milan
Artemide Showroom, Naples
1973 Sala della Rocca, Vignola, Italy
The Photographers' Gallery, London
1974 Galleria Documenta, Turin
Canon Photo Gallery, Amsterdam
Galleria dell'Immagine/Il Diaframma, Milan
Galleria Il Broletto, Varese, Italy
Galleria Il Gelso, Lodi, Italy
Palazzo d'Accursio, Bologna
Palazzo Strozzi, Florence
1975 Fotogalerie 5.6, Ghent
Galeria Spectrum, Barcelona
Galerie Nagel, Berlin
Internationaal Cultureel Centrum, Antwerp
Galerie Spectrum, Brussels
Fotogalerie in Forum Stadtpark, Graz, Austria
1976 Sala delle Scuderie in Pilotta, Parma
The Darkroom, Chicago
Canon Photo Gallery, Geneva
La Photogaleria, Madrid
Mariani Showroom, Lucca, Italy
Galerie Optica, Montreal
Deja Vu Gallery, Toronto
St. Gallen Photogalerie, St. Gallen, Switzerland
Museu de Arte de Sao Paulo, Brazil
Galleria del Cavallino, Venice
1977 Galleria Il Diaframma, Brescia, Italy
Chiesa di Sn. Caterina, Treviso, Italy
Salon de Actos, Alicante, Spain
Palazzo Broletto, Novara, Italy
Galleria Ghelfi, Vicenza, Italy
Galleria La Città, Verona
Arte Centrum, Bilbao, Spain
Image Gallery, New Orleans
Photo Art Gallery, Basle
Galerie Dieuzaide, Toulouse
The Photographers' Gallery, London
Galerie Lange Irschl, Monaco
Galeria Spectrum Canon, Barcelona
1978 Nikon Gallery, Zurich
The Photographic Gallery, Southampton, England
Escuela Tecnica Superior de Arquitectura, La Coruna, Spain
Galleria Il Diaframma, Milan
Galleria d'Arte Moderna Emilio Mazzoli, Modena
Galleria Spectrum Canon, Zaragoza, Spain
Galeria Yem, Alcoy, Spain
1979 Galleria Il Vicola, Genoa
The Photographic Gallery, Dublin
Galleria Fonte d'Abisso, Modena
Foto Cine Club San Paolo, Turin
Cine Foto Club, Portomaggiore, Italy
Palazzo Pallavicino, Busseto, Italy
Fiaf 1979, Pescara, Italy
The Photographic Gallery, South Yarra, Victoria, Australia
Canon Photo Gallery, Amsterdam
Gruppo Artistico Leonardo, Cremona, Italy
Fotogalerij Paule Pia, Antwerp
White Gallery, Tel Aviv

Jane Corkin Gallery, Toronto
Nuova Galleria, Treviso, Italy
Galleria d'Arte Moderna Rondanini, Rome
The Space Gallery, New York
The Photographic Gallery, Melbourne
1980 Galleria Ideogramma, Turin
Focus Gallery, San Francisco
FNAC Forum, Paris
Galerie Koffiehuisje, Hasselt, Belgium
Centro Internacional de Fotografia, Barcelona
Galleria Ikona, Venice
G. Ray Hawkins Gallery, Los Angeles
Galleria Diaframma, Brescia, Italy
Galleria Fotografis, Bologna
Galerie Fiolet, Amsterdam
The Photographic Gallery, Dublin
Galleria Grandangola, Padua
Photographic Center, Athens
Galleria d'Arte Moderna Rondanini, Rome
Galleria Agora, Turin
1981 Forum Gallery, Nice
Rizzoli Gallery, New York
Jane Corkin Gallery, Toronto
Silver Image Gallery, Seattle
Galeria Photo Copy, La Coruna, Spain
FNAC Centre Jaude, Clermont-Ferrand, France
Nagase Salon, Tokyo
Shadai Gallery, Tokyo
Chiostro di San Nicolo, Spoleto, Italy
Galerie Vogt, Zurich
Galerie Viviane Esders, Paris
Galleria Ikona, Venice
Galleria Il Diaframma, Milan
Photo Art Gallery, Frankfurt

Selected Group Exhibitions:

1973 *Modern Experimental Color Photography*, The Photographers' Gallery, London
Triennale, Milan
1974 *Aspects of Photography*, at *Photokina '74*, Cologne
1975 *Aspetti della Natura*, at *SICOF*, Milan
Salon de la Photo, Paris
1978 *Tusen och En Bild*, Moderna Museet, Stockholm
Biennale, Venice
1980 *19 Fotographos Italianos*, Museo de Arte Carrillo Gil, Mexico City
1981 *Astrazione e Realtà*, Galleria Flaviana, Locarno, Switzerland
Color and Colored Photographs, San Francisco Museum of Modern Art

Collections:

Museo della Fotografia, University of Parma; Galleria d'Arte Moderna, Ferrara, Italy; Bibliothèque Nationale, Paris; Musée Réattu, Arles, France; Musée Cantini, Marseilles; Musée d'Art et d'Histoire, Fribourg, Switzerland; Photographic Museum, Helsinki; Museum of Modern Art, New York; International Museum of Photography, George Eastman House, Rochester, New York; Art Museum, University of New Mexico, Albuquerque.

Publications:

By FONTANA: books—*Modena una Città*, with text by Pier Paolo Preti, Modena 1971; *Terra da Leggere*, with text by Pier Paolo Preti, Modena 1975; *Bologna: Il Volto della Città*, with text by Pier Luigi Cervellati, Modena 1975; *Franco Fontana*, with text by Giuliana Ferrari, Parma, Italy 1976; *Laggiù gli uomini*, with text by Enzo Biagi, Modena 1977; *Franco Fontana: Skyline*, with an introduction by Helmut Gernsheim, Milan and Paris 1978; *Paesaggio Urbano: Selezione d'Immagini*, with text by Angelo Schwarz, Monza, Italy 1980.

On FONTANA: books—*Immagini del Colore*, exhibition catalogue, by C. Bonvicini, P. Racanicchi, F. Vaccari and others, Modena, Italy 1968; *Subject: Landscape*, exhibition catalogue, by Pier Paolo Preti, Amsterdam and London 1974; *Photography Year*, by the Time-Life editors, New York 1975; *Bolaffi Arte*, Turin 1976; *British Journal of Photography Annual*, London 1979; *Contact Theory*, New York 1980; *Das Imaginare Photo Museum*, Cologne 1981; *Histoire Mondiale de la Photographie en Couleurs*, Paris 1981; articles—"La Materia che non Vediamo" by Pier Paolo Preti in *Ottagono* (Milan), September 1972; "Si Puo Fare Ancora del Paesaggio? Franco Fontana" by Pier Paolo Preti in *Fotografia Italiana* (Milan), July 1974; "Paesaggio come Franco Fontana" by Giuseppe Turroni in *Nuova Fotografia* (Milan), June 1975; "Significato come Valore di Scambio" by A.C. Quintavalle in *Il Mulino* (Bologna), December 1975; "Nuove Realtà" by Antonio Pitta in *Ottagono* (Milan), September 1976; "Franco Fontana" by Sean Callahan in *American Photographer* (New York), October 1978; "The Landscape as Nude" by David Steigman in *Popular Photography* (New York), December 1978; "Franco Fontana" by A.C. Quintavalle in *Zoom* (Paris), August 1979; "Ein Meister aus Modena" by Rolf Paltzer in *Art* (Hamburg), November 1979; "Landscapist" by Michael Edelson in *Newsweek* (New York), 15 September 1980; "A Lens to Serve a Vision" by David Livingston in *Maclean's* (Toronto), 6 April 1981; "Lecon de Coleurs" in *Photo Reporter* (Paris), July 1981.

My story as a photographer began in 1961, and my work then was connected to amateur circles.

At the beginning I was not following any specific line of research; I just photographed any subject around me that was beautiful in itself: sunsets, reflected light, etc. Anyone can recognize the beauty of nature, and I was nothing but a re-producer of images, a re-presenter of facts—things that were not mine. But behind the camera there was still no man, no discoverer of hidden realities.

Very slowly and with much humility I started to feel conscious of my own inner requirements, and my attention was concentrated on rustic dwellings, on windows, facades, walls corroded by time— investigating their materiality. This first conscious experiment marks the beginning of my personal research, aiming for a progressive essentiality, which I believe has been consistent in its development during all the years since then.

My best known work is on the natural landscape. I try to isolate, in space and time, that which is normally dispersed and mixed up with an infinity of details. This work of cleansing, of extracting a few essential elements from the entirety that presents itself to the human eye, has to do with one of my inner requirements: to achieve an harmonic unity through the elimination of all disturbing natural elements. In this way, a landscape is born which is made up by subtle relations of space, form, drawing and color.

The fascination of the image lies in the play between reality—the lens has registered what was actually in front of my camera—and seeming unreality. This is a clear example of how the camera should be at the service of man, and not vice versa.

As compared to other artistic forms, photography is the most castrating: between intention and realization the camera imposes its limits. The photographer is kept tied by a strong umbilical cord to a variety of alien situations: subject, light, time, color, etc. A photographer could hardly express his own creativeness if he had to live in a single room— unlike an author, a painter or a musician. The photographer has to do violence to reality, or at least to what is believed to be reality. In fact, reality, in its absolute signification, does not exist and escapes from our daily experience.

Accustomed as we are to rational analysis, we mortify imagination by preventing it from endowing the surrounding world with original and unconsuetudinary significance. Imagination is the great force that provokes, stimulates and puts images into action—and gives life to them by penetrating beneath the surface. The subjects and situations we photograph are a pretext for communicating our interior experiences. Our personal story appears through the images: a lamp is not merely a lamp, it loses its concrete connotations; in the moment we see it, the lamp becomes a projection of a part of ourselves.

The fascination of an image lies in the violence that created it, a violence which is necessary to shake off the mental attitudes that make our looking blind.

We are the bearers and witnesses of the only possible significance.

Objectivity is always and in any case destined to escape our grasp.

—Franco Fontana

With his investigations of the world of concrete forms, Franco Fontana overturns the erroneous and superficial conceptions we have of reality. That reality that surrounds us—that which we believe to be "truth"—is built on spatial relationships according to the rules of perspective: every object exists within the function of every other, and we perceive its position on the basis of successive planes. Amid all the visual information that the eye takes in at any given time, Fontana emphasizes only certain details which are concealed in the whole so that we never "see" them.

He was attracted in the 1960's by the capacity of light to create new plastic forms which do not really exist, and he went on in the following years to refine his vision until he had removed from his work everything that was redundant. His picture is simple, but certainly not simplistic, pure in form and strictly balanced in color, showing us a representation of a reality existent but unknown. Fontana enables us to penetrate a new spatial dimension, freeing us from the physical and intellectual constrictions to which we are slaves.

And even if his pictures are often completely abstract—we lose the connotation of the subject represented and can no longer recognize it as something known and familiar—they are still a "record of reality." The old debate between those who argue for a pure photography and those who support freedom in the employment of the medium—that argument is settled, paradoxically, in Fontana's work: it is a representation of the real with no technical elaboration or manipulation during the photochemical-mechanical process. There is just his capacity to see, to select, that enables him to extract certain elements from the immense panorama of the concrete world. But he carries out a rigorous analysis of that world and provides us, in the photographic medium, with a tool for the free interpretation of it unprejudiced by cultural conditioning or social and environmental situations.

It is equally clear that his photographs, albeit a documentary record, do not conform to the commonly accepted meaning of that term, either in the kind of information they give us or in the unusual design of their composition. But Fontana extends the meaning of documentary photography, recording the vitality of a universe parallel to and intermixed with the universe more evident to our ordinary perception; and, at the same time, he also extends the use of the photographic medium, which in his hands reveals that other universe.

He may be regarded as an innovator of contemporary creative photography and as the author of a new visual language. His landscapes, assembled with the refinement of an extremely sensitive eye, represent a moment of intimate reflection on the tangible world; they have the quality of a biographical confession. His refusal to reproduce scenes of life as we know it—either contaminated nature or urban sprawl—and his preference for the unveiling of the secrets of the harmonious relationships contained in them, reveal a special way of thinking. Fontana uses photography to lay bare the emotions, sensations, anxieties and disturbances of an artist never content with the surface of things.

The "information" that he gives us is completely subjective; it awakens the mechanism of emotional intuition in us, enabling us to know ourselves, and especially the world we live in, more deeply.

Fontana's inimitable language nullifies the rules of ordinary perception and overturns conceptions of space and form, the bases of our visual culture. His forms exist in a new relation with space in which the perspective planes are abolished—and, in that, Fontana's picture is perfectly in line with the reality of the photographic object, which is of necessity bi-dimensional.

Even Fontana's partiality for using color underlines the function of analytical realism in his photography. It is always a natural color. Indeed, he never uses either filters or any other technical refinements, because "everything is there already in the infinite scenery of nature."

—Giuliana Scimé

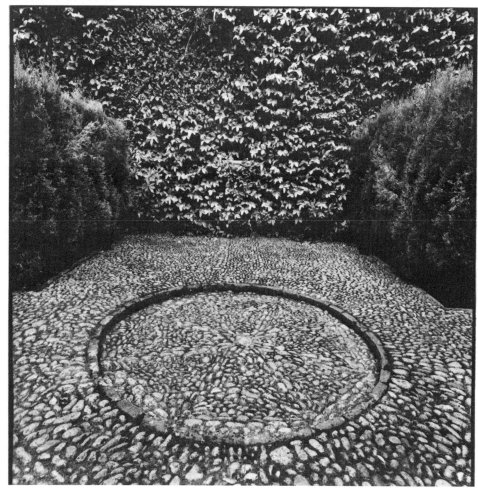

FONTCUBERTA, Joan.

Spanish. Born in Barcelona, 24 February 1955. Studied journalism and advertising at the University of Barcelona, Faculty of Communications, 1971-77; self-taught in photography. Photographer since 1972. Copywriter, Danis-Benton and Bowles, advertising agency, Barcelona, 1973-76; freelance photographer, with NYACA, Barcelona, 1976-80. Established Studio 122, with filmmaker Lorenzo Soler, graphic designer Albert Ripoll, and photographer Manuel Úbeda, Barcelona, 1980. Instructor, Grup Taller d'Art Fotogràfic, Barcelona, 1975-76, and Faculty of Communications, University of Barcelona, 1977-78. Since 1977, Instructor, CEI (Center for Image Studies), Barcelona; since 1980, Professor of Photography, Faculty of Fine Arts, University of Barcelona. Columnist, *Nueva Lente* magazine, Madrid, 1975-78. Columnist, *El Correo Catalán* newspaper, Barcelona, since 1977, and *La Vanguardia* newspaper, Barcelona, since 1979; Barcelona Correspondent, *American Photographer*, since 1980; Co-Founder and Co-Editor of *Photovision*, Madrid, since 1981. Co-Founder, Foto FAD, and editor of its publication *La Titafolla*, Barcelona, 1975; Co-Founder, Grup Alabern, Barcelona, 1976; Co-Founder, 1977, Vice-President, 1977-79, and editor of its publications *Fotodossier* and *B.N.C. Fotografia*, 1977-79, Anfa FAD, Barcelona. Address: Avda. Infanta Carlota 113, Barcelona 29, Spain.

Individual Exhibitions:

1974 Sala Aixela, Barcelona
Galería Spectrum, Barcelona
1975 La Photogalería, Madrid
1976 Galería Spectrum, Barcelona
1977 Canon Photo Gallery, Amsterdam
Galerie Upsilon, Nantes, France
Galería Tretze, Valencia
Galeria A, Vilafranca, Spain
1978 Canon Photo Gallery, Geneva

Galerie 31, Vevey, Switzerland
Galeria Fotomanía, Barcelona
Galerie Voir, Toulouse
Galerie de l'Image, Liège
1979 Galerie Agathe Gaillard, Paris
Il Laboratorio d'If, Palermo
Galerie Trockenpresse, Berlin
Galería Tretze, Valencia
Fotogalerie Pennings, Eindhoven, Netherlands
Work Gallery, Zurich
1980 Paule Pia Fotogalerij, Antwerp
Canon Photo Gallery, Amsterdam
The White Gallery, Tel Aviv
Galerie 11, Nidau, Switzerland
Photographic Center of Athens
1981 FNAC Gallery, Les Halles, Paris
FNAC Gallery, Strasbourg
Rudi Renner Fotogalerie, Munich
Novum Fotogalerie, Hannover
The Photographic Gallery, Cardiff
ARPA Gallery, Bordeaux
Centro Civico Irnerio, Bologna
Galeria 491, Barcelona

Selected Group Exhibitions:

1976 *European Photography*, Allen Street Gallery, Dallas
Fantastic Photography in Europe, at *Rencontres Internationales de la Photographie*, Arles, France (toured Europe, 1976-78)
1977 *Grup Alabern*, Galerie de l'Instant, Paris (travelled to Galleria Altre Immagini Politecnico, Rome)
Grupa Junij '78 & '79, toured Yugoslavia
1978 *New Spanish Photography*, at *Rencontres Internationales de la Photographie*, Arles, France
1979 *Curator's Choice: European Photography*, at *Venezia '79*
Fotografía Española: Exposición Límite, Spanish Tourist Office, New York
Die Zweite Avantgarde der Fotografia, Fotogalerie 68, Hoensbroek, Netherlands
1980 *Photographia: La Linea Sottile*, Galleria Flaviana, Locarno, Switzerland
Spanish Photography, The Night Gallery, London

Collections:

Fundació Joan Miró, Barcelona; Bibliothèque Nationale, Paris; Musée Réattu, Arles, France; Galerie Municipale à Chateau d'Eau, Toulouse; Musée d'Art Moderne, Brussels; Polaroid Collection, Amsterdam; Metropolitan Museum of Art, New York; Centro Cultural Hidalgo, Michuca, Mexico.

Publications:

By FONTCUBERTA: books—*Joan Fontcuberta: Fotografías*, Zaragoza, Spain 1976; *Derrière l'Arbre (Duchamp no ha comprendido Rembrandt)*, Barcelona 1976; *Platja 30.9.75*, Barcelona 1976; *Pintades*, Barcelona 1977; *Joan Brossa: Poems Objecte*, with Brossa, Barcelona 1978; articles—"La Photo Catalane et ses Fantômes" in *Contrejour* (Paris), March/April 1977; "La Subversion Photographique de la Réalité" in *The Village Cry* (Basle), September 1977; "La Fotografía Revisa els seus Origens" in *Avui* (Barcelona), 11 June 1978; "Contravisiones: la subversión fotografica de la realidad" in *Nueva Lente* (Madrid), no. 75, 1978, reprinted in *Fotografie* (Göttingen), August 1978; "Apología de la 5a Generación" in *Nueva Lente* (Madrid), no. 76/77, 1978; "La Fotografia contra la Realtà" in *Il Diaframma: Fotografia Italiana* (Milan), August 1978; "Participación Española en Arles" in *Estudios pro Arte* (Barcelona), October 1978; "Fotografías al Cuadrado" in *Batik* (Barcelona), April 1979; "Fotografía Española y la Búsqueda del Tiempo Perdido" in *Batik* (Barcelona), June 1979; "Arte y Fotografia: El Intelecto Contra la Sensibilidad" in *El Correo Catalan* (Barcelona), 3 November 1979; "Percepción y Vanguardia Fotografica" in *Zoom* (Madrid), November 1979; "Photography in Spain: An Effort of Private Initiative" in *Print Letter* (Zurich), March 1980; "Spanish Photography in the 80's: Normalization or Loss of Identity" in *European Photography* (Göttingen), April 1980; "1965-1976: La Consolidacion de la Fotografía Creativa" in *Enciclopedia Espasa: Supplement*, Barcelona 1980; "Pla Janini: Axis of Catalan Photography" in *Camera* (Lucerne), December 1980.

On FONTCUBERTA: articles—"Joan Fontcuberta, en quête du point sublime" by José Vigo in *Contrejour* (Paris), no. 2, 1976; "Joan Fontcuberta" by Roberto Salbitani in *Progresso Fotografico* (Milan), June 1977; "Joan Fontcuberta" by Daniel Giralt-Miracle in *Avui* (Barcelona), 15 January 1978; "Joan Fontcuberta" by Josep Rigol in *Zoom* (Madrid), no. 20, 1978; "Joan Fontcuberta en Fotomania" by Matias Antolin in *Ozono* (Madrid), June 1978; "Fantástico Fontcuberta" by Jorid Socias in *La Calle* (Madrid), 2-8 January 1979; "Fontcuberta chez Agathe Gaillard" by Hervé Guibert in *Le Monde* (Paris), 24 January 1979; "La Fotografía Miente" by A. Torralva and J. Valenzuela in *Valencia Semanal*, 18-25 March 1979; "Fontcuberta Fotografa anche la Solitude" by Gian Mauro Costa in *Il Diario* (Palermo), 23 March 1979; "Raffinate Techniche di Manipolazione" by Eduardo Rebulla in *L'Ora* (Palermo), 30 March 1979; "Erwachen aus Einerlangen Agonie" by Rolf Paltzer in *Art* (Hamburg), no. 1, 1979; "Fontcuberta" by Francesc Miralles in *Zoom* (Paris), no. 67, 1979; "Joan Fontcuberta: Animalesche Visionen" by Jörg Kirchbaum in *Zoom* (Munich), March 1980; "Fontcuberta" in *Camera* (Lucerne), November 1980.

The photographer is, in my opinion, a specialist in looking. His mission is to filter his own vision of the world and to offer a personal view in which he firstly says something about himself and then something of his times and their social forces.

In my own work I am interested in transmitting, above all, an atmosphere of mystery. I believe that all means to this end are valid, from the distortions required to express an oneiric world, including the distillation of enigma itself, to the incongruities produced by chance in representing the same reality.

Recently, this concern has been prevalent in my work. I think it is ascribable to a certain development—or, at least, to a certain maturity—in photographic language. Previously, my images were more direct and shocking; later, they possibly reached a more subtle level, which demanded the definite, personal, and poetic interpretation of the spectator. To me, participation by the spectator is important: the creative cycle in the visual arts is completed through the artist-audience symbiosis; it adds new significance to the work; it helps to make it even richer. In this sense I see photography as a stimulation of the imagination of the spectator. This is a part of the philosophy of "open photography," which is evocative, as opposed to "closed" or descriptive photography—for instance, photojournalism or the photography of advertisements.

Formally I pursue two basic interests: composition (that is, the design and placement of elements in space) and texture. Composition is the vital element in the translation of sensations into silver images. I use texture afterwards to increase the sensual charge of the image. It is vital for me to furnish my work with this "sensual tension." That is what drives me to take a photograph of determined subjects in a determined manner.

—Joan Fontcuberta

Until a few years ago Spain was considered to be one of the last bastions of that original, classic surrealism found chiefly under authoritarian political regimes and in isolation from international evolution in the arts—a surrealism whose obsolete weapons seem to us still appropriate only where they are directed against an even more obsolete kind of society. Since the death of Franco there has been a change in Spain's socio-cultural conditions towards a progressive opening up and liberalization. And so opportunities have developed for artists and photographers to broaden their range of themes and to refine their repertoire of expression. Joan Fontcuberta has not only analysed and systematically expressed the changed conditions of Spanish photography; he also visibly reflects them in his own photographic work.

Fontcuberta's early works in surrealistic style between 1973 and 1976 are simple, direct and, at times, based on an unequivocal idea: a bird leaving behind it the vapour trails of a jet fighter; a hand rising from a flower pot being cut off by hedge shears; a man stabbing himself in the forehead with a fork—shock montages that provoke and challenge the spectator unawares, which also soon yield their "mystery."

Fontcuberta himself describes as an important development in perception and maturity his ability to give up by degrees such artificial, staged and manipulated subjects and to express his ideas in a more subtle manner. He discovered that the surreal, the mysterious, the enigmatic do not need to be constructed but are present in visible reality itself. After 1976 his works show first of all gloomy arrangements in which snakes and fishes, ivy and moss occur as elements of a complex symbolism; the gentle hint replaces the loud accusation, the poetic cypher takes the place of the direct provocation. And in his portfolio "Animals," completed in 1977, and in his work after 1978 he has finally given up artificial arrangement; direct vision now determines his pictures. The visual strangeness changes to ever more frequent experimental methods to win from his subjects—found in museums, parks and zoos—a sometimes magical, sometimes fantastic, but always disturbing, enigmatic and provocative vision. The photographer's eye takes over the task previously performed by the process of thought.

However much Joan Fontcuberta's earliest works may differ from his latest work, he has in fact not greatly revised his basic concept, which he himself describes as "anti documentary" and which he has formulated in his theory of "Countervision." The technical manipulation, staging and visual strangeness are only different but equally legitimate methods in the realization of the same basic aim: to raise an objection to the prevailing concept of reality and to interpret the world in defiance of conventional views.

—Andreas Müller-Pohle

FRANCK, Martine.

Belgian. Born in Antwerp, 2 April 1938. Educated at primary schools in New York and Arizona, 1942-44, and Heathfield School, Ascot, England, 1947-54; studied at the University of Madrid, 1956-57, and the Ecole du Louvre, Paris, 1958-63. Married the photographer Henri Cartier-Bresson, *q.v.*, in 1970. First photographs, in China, Japan, and India, 1963; photographic assistant to Eliot Elisofon and Gjon Mili, Time-Life Photo Laboratories, Paris, 1964; freelance photographer, working for *Life, Fortune, Sports Illustrated, New York Times, Vogue,* etc., Paris, since 1965; also, photographer for the Théâtre du Soleil co-operative, Paris, since 1965. Member, Vu photographers agency, Paris, 1970-71. Founder Member, Viva photographers Agency, Paris, 1972-79; Associate Member, Magnum Photos co-operative agency, Paris, since 1980. Address: c/o Magnum Photos, 2 rue Christine, 75006 Paris, France.

Individual Exhibitions:

1971 *Le Theatre du Soleil*, Galerie Rencontre, Paris
1974 *La Paroisse St.-Pierre de Chaillot*, Chaillot-Galliera, Paris
1976 *Marchés et Foires*, Les Amis des Arts, Reillanne, Provence, France
 Le Quartier Beaubourg, Centre Georges Pompidou, Paris
1978 Carlton Gallery, New York
1979 Pentax Gallery, Tokyo
 Northern Images, Side Gallery, Newcastle upon Tyne
 Photogalerie Portfolio, Lausanne
1980 Galerie A.M.C., Mulhouse, France
 Galerie Agathe Gaillard, Paris
1981 Musée Nicéphore Niepce, Chalon-sur-Saône, France

Selected Group Exhibitions:

1973 *Viva: Familles en France*, Galleria Il Diaframma, Milan (travelled to the French Consulate, New York; The Photographers' Gallery, London; Internationaal Cultureel Centrum, Antwerp; and Optica Gallery, Montreal)
1974 *There Is No Female Eye*, Neikrug Galleries, New York (toured the United States)
1975 *La Femme*, FNAC, Paris
1976 *French Photography*, French Consulate, New York (toured the United States)
1977 *Le Photojournalisme*, Musée Galliera, Paris
 The Viva Group, Side Gallery, Newcastle upon Tyne
1979 *Paris 1979: Les Parisiens*, Salon de la Photo, Paris
1980 *Jeune Photographie*, Fondation Nationale de la Photographie, Lyons
 La Statuaire Parisienne d'Atget à nos Jours, Musée Bourdelle, Paris
 De Fotografie in Belgie 1940-80, Het Sterckshof Museum, Antwerp

Collections:

Bibliothèque Nationale, Paris; Ministère de la Culture, Paris; Ministère des Affaires Etrangères, Paris; Musée Cantini, Marselles; Musée Nicéphore Niepce, Chalon-sur-Saône, France; Museum of Modern Art, New York; Metropolitan Museum of Art, New York.

Publications:

By FRANCK: books—*Etienne Martin, Sculpteur,* with text by Michel Ragon, Brussels 1970; *La Sculpture de Cardenas*, with text by Jose Pierre, Brussels

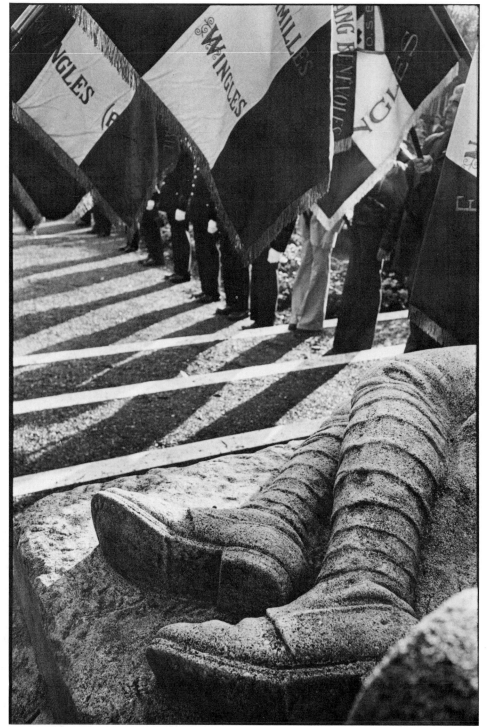

Martine Franck: *Wingles, Nord de la France*, 1977

1971; *Le Théâtre du Soleil: 1789,* Paris 1971; *Le Théâtre du Soleil: 1793,* Paris 1972; *Martine Franck,* with preface by Ariane Mnouchkine, Paris 1976; *Quartier Beaubourg,* exhibition catalogue, Paris 1977; *Les Luberons,* with text by Yves Berger, Paris 1978; *Le Temps de Vieillir,* with text by Robert Doisneau and Dr. L. Kaprio, Paris 1980.

On FRANCK: articles—"Martine Franck" in *Leica Photography* (New York), vol. 27, no. 1, 1974; "Martine Franck" in *Creative Camera* (London), November 1974; "Martine Franck" by Anna Farova in *Revue Fotografie* (Prague), no. 2, 1976; "Martine Franck" by Shoji Yamagishi in *Mainichi Camera* (Tokyo), June 1976; "Martine Franck" in *Camera* (Lucerne), June 1976; "Martine Franck" in *Zoom* (Paris), November 1977; "Portrait: Martine Franck" in *Le Nouveau Photo Cinema* (Paris), April 1979;

"Martine Franck" in *Asahi Pentax Annual,* Tokyo 1979; "Le Temps de Vieillir" in *Photo* (Paris), October 1980.

If we look at the history of photography we discover the continual presence of women. Perhaps they directed their attention more towards the portrait which was a kind of work more in keeping with the constraints of their lives; nevertheless, since the beginnings of photo-reportage, women such as Margaret Bourke-White and Dorothea Lange have made their impression as remarkable witnesses of their time. Nowadays they are much more numerous, and I see in that the sign of an evolution in our society which gradually allows women greater freedom. For a certain time, for reasons usually associated with their family life, many choose not to

roam the world. If because of this they are more limited in their choice of themes, it is not because of their feminine nature but because of the conditions of their lives. A good photographer is not always a globetrotter. Photographers do not have to model themselves on a certain kind of reporter. They have to try to be themselves. If women do not have any more difficulty than men in selling their photographs through an agency, they *can* have difficulty when it comes to photographic commissions, even assuming that they have already overcome resistance to their work and its "seriousness"—a difficulty that women encounter in all professions.

I really do not think that there is a specifically feminine as opposed to a masculine view. Our view depends on our sensitivity, on our being, on our personality. I do not think either that one can tell whether a photograph has been taken by a man or a woman. On the other hand, one can recognize the style of this man or that woman. Certain women have taken extraordinary war photographs: I am thinking particularly of those of Cathy Leroy in Vietnam and of those of Susan Meiselas in Nicaragua. All their pictures are as powerful and overwhelming as those of their male colleagues.

We all have latent elements, attributed traditionally to the other sex, which photography can in fact reveal. It is not because a photograph has been taken by a woman that I necessarily acclaim it.

As for myself, I feel concerned by what goes on in the world and involved in my surroundings. I don't want merely to "document," I want to know why a certain thing disturbs or attracts me and how a situation can affect the person involved. I do not try to create a situation, and I never work in a studio; I try rather to understand and grasp reality. In photography I have found a language that suits me.

My studies of the history of art would have led me to follow a profession involving writing, but I do not like writing—nor do I particularly like talking about photography! If I do have something to say, I hope that it shows in my pictures. I think that everything can be painted because painting can transform reality, but not everything can be photographed and the photographer often comes home empty-handed with pictures that often have a documentary interest but that rarely go beyond that. One has to remain available and extremely tenacious, admit that many subjects produce nothing...and then, sometimes, the miracle happens, without warning.

—Martine Franck

In Paris in 1972 Martine Franck, together with six other young photographers, founded the Viva agency and remained one of its moving spirits until 1979 when the agency collapsed due to the departure of its best personnel. Now she is associated with the Magnum agency, which draws increasingly from the crucible of the May 1968 generation.

If the social and progressive preoccupations of Viva were obvious, it is extremely difficult to perceive a common style or particular aesthetic method, although Cartier-Bresson's influence was apparent, at least in the vision of what could be photographed. At the heart of the agency, Martine Franck developed an original approach based on aesthetic rigour, and gradually she affirmed her own personality. Her photograph of a provincial swimming pool, taken in 1976 and published with success, marks an important step in the development of her style and, as a point of reference, allows a detailed study of her particular characteristics.

Background and form are perfectly united in this picture and provoke cultural, social, existential and poetic reflection. Spontaneity has no place here, for everything down to the smallest detail is perceived, imagined, revealed and planned with remarkable intelligence. The composition draws together four important elements, four actions, four subjects, which act in keeping with an unequal tension. This work makes one think of the paintings of Pietro della Francesca or of Indian mural paintings and of

the miniatures of the Mogul school and of Rajastan where people move in groups of three or four. The difference in contemporary photography—and with Martine Franck, in particular—is that the God Krishna has been replaced by the common man, by an anonymous being in an urban environment that makes of him both hero and victim.

In her last book, *Le Temps de Vieillir*, Martine Franck deals with a typically photographic theme which functions on three levels—as it were, on three superimposed epidermic layers—so that the portrait of old age is fixed as ferociously present, as a testimony of the past and of childhood, and finally as an inexorable reflection of death. Within this mask of old age, and in the functioning of the common man articulated by threads that often imprison him (sometimes provoking a grating humor)—in this slice of life freshly cut from reality, everything acts as enigma rather than as testimony.

One of the great lessons of contemporary photography, in which Martine Franck finds her place, is to teach us to react, to investigate a problem, to interpret reality for what it is—a photographic framework, a matter of choice, a political action where we, as spectators and actors, have something to say.

—Claude Nori

FRANK, Robert.

Swiss. Born in Zurich, in 1924; moved to the United States, 1947, and to Canada, 1969. Educated at schools in Zurich; apprenticed to the photographer Herman Eidenbenz, Basle, 1940-41, and to Michael Wolgesinger, Zurich 1942; also influenced by the photographer Gotthard Schuh. Still Photographer, Gloria Films, Zurich, 1943-44; freelance photographer, Zurich, 1945-47; freelance photographer, under Alexey Brodovitch, for *Harper's Bazaar*, and for *Fortune, Life, Look*, etc., New York, 1948, in Europe, 1949-51, and New York, 1951-55; independent photographer and filmmaker, New York, 1956-69, in Cape Breton, Nova Scotia, since 1969. Concentrated on filmmaking, with Allen Ginsberg, Larry Rivers, Peter Orlovsky and Jack Kerouac, New York, 1958; Founder Member, with Shirley Clarke, Jonas Mekas, Peter Bogdanovich, Gregory Markopoulos and others, New American Cinema Group, New York, 1960, and Film-Makers Cooperative, New York 1962. Visiting Instructor in Filmmaking, University of California at Davis, 1977. Recipient: Guggenheim Fellowhip, 1955; First Prize, *San Francisco Film Festival*, 1959. Address: Mabou, Cape Breton, Nova Scotia, Canada.

Individual Exhibitions:

1948 Museum of Modern Art, New York
1955 Helmhaus, Zurich
1962 Museum of Modern Art, New York (with Harry Callahan)
1976 Kunsthaus, Zurich
1979 Galerie Zabriskie, Paris
1980 Scottish Photography Group, Edinburgh (travelled to the Institute of Contemporary Arts, London)
 Art Gallery of Ontario, Toronto (retrospective)
1981 *Walker Evans and Robert Frank: An Essay on Influence*, Fraenkel Gallery, San Francisco

Selected Group Exhibitions:

1954 *Great Photographs*, Limelight Gallery, New York
1955 *The Family of Man*, Museum of Modern Art, New York (and world tour)
1964 *Purchase Award Photos from Krannert*, University of Illinois, Urbana (toured the United States)
1967 *Photography in the 20th Century*, National Gallery of Canada, Ottawa (toured Canada and the United States, 1967-73)
1972 *11 American Photographers*, Hofstra University, Hempstead, New York
1974 *Photography in America*, Whitney Museum, New York
1978 *Photos from the Sam Wagstaff Collection*, Corcoran Gallery, Washington, D.C. (toured the United States and Canada)
1979 *Photographie als Kunst 1879-1979/Kunst als Photographie 1949-1979*, Tiroler Landesmuseum Ferdinandeum, Innsbruck, Austria (travelled to the Neue Galerie am Wolfgang Gurlitt Museum, Linz, Austria; Neue Galerie am Landesmuseum Joaneum, Graz, Austria; and the Museum des 20. Jahrhunderts, Vienna)
1980 *Photography of the 50's*, International Center of Photography, New York (travelled to the Center for Creative Photography, University of Arizona, Tucson; Minneapolis Institute of Arts; California State University at Long Beach; Delaware Art Museum, Wilmington)
1981 *Robert Frank Forward*, Fraenkel Gallery, San Francisco

Collections:

Museum of Modern Art, New York; International Museum of Photography, George Eastman House, Rochester, New York; Philadelphia Museum of Art; Smithsonian Institution, Washington, D.C.; Art Institute of Chicago; National Gallery of Canada, Ottawa.

Publications:

By FRANK: books—*New York Is*, New York 1955; *Indiens pas morts*, with Werner Bischof and Pierre Berger, with text by Georges Arnaud, Paris 1956, as *From Incas to Indians*, with an introduction by Manuel Tuñan de Lara, New York 1956; *Les Américains*, edited by Alain Bosquet, Paris 1958, as *The Americans*, with an introduction by Jack Kerouac, New York 1959, revised editions Millerton, New York 1969, 1978, *Pull My Daisy*, with Jack Kerouac and Alfred Leslie, New York 1961; *Zero Mostel Reads a Book*, New York 1963; *The Lines of My Hand*, Tokyo 1971; Los Angeles 1972; *Robert Frank*, with an introduction by Rudi Wurlitzer, Millerton, New York 1976 (includes bibliography); articles—"Bus Ride Through New York: The Bridge from Photography to Cinematography" in *Camera* (Lucerne), no. 45, 1966; "Films: Entertainment Shacked Up with Art" in *Arts* (New York), no. 41, 1967; "The Lines of My Hand" and "Uneasy Words While Waiting: Robert Frank Interviewed by Sean Kernan" in *U.S. Camera/Camera 35 Annual*, New York 1972; "Dialogue Between Robert Frank and Walker Evans" in *Still* (New Haven, Connecticut), no. 3, 1973; films—*Pull My Daisy*, 1959; *The Sin of Jesus*, 1961; *O.K. End Here*, 1963; *Me and My Brother*, 1968; *Conversation in Vermont*, 1969; *Life Raft—Earth*, 1969; *About Me: A Musical*, 1971; *Cocksucker Blues*, 1972; *Keep Busy*, with Rudi Wurlitzer, 1975; *Life Dances On*, 1980.

On FRANK: books—*Photographers on Photography*, edited by Nathan Lyons, New York 1966; *Photography in the 20th Century* by Nathan Lyons,

Robert Frank: *U.S. 285, New Mexico* from *The Americans*, **1958** Courtesy Art Institute of Chicago

248

New York 1967; *New Documents*, exhibition catalogue, with text by John Szarkowski, New York 1967; *11 American Photographers*, exhibition catalogue, by Robert Doty and Robert Littman, Hempstead, New York 1972; *Looking at Photographs* by John Szarkowski, New York 1973; *Une Histoire du Cinema*, exhibition catalogue, by Peter Kubelka and others, Paris 1976; *Concerning Photography*, exhibition catalogue, by Jonathan Bayer and others, London 1977; *Photography Within the Humanities*, edited by Eugenia Parry Janis and Wendy MacNeil, Danbury, New Hampshire 1977; *A Book of Photographs from the Collection of Sam Wagstaff*, designed by Arne Lewis, New York 1978; *Photographie als Kunst 1879-1979/Kunst als Photographie 1949-1979*, exhibition catalogue, 2 volumes, by Peter Weiermair, Innsbruck, Austria 1979; *Light Readings: A Photography Critic's Writings 1968-1978* by A.D. Coleman, New York 1979; *The Photograph Collector's Guide* by Lee D. Witkin and Barbara London, Boston and London 1979; *Photography of the 50's*, exhibition catalogue, by Helen Gee, Tucson, Arizona 1980; *Walker Evans and Robert Frank: An Essay on Influence* by Tod Papageorge, New Haven, Connecticut 1981; articles— "Robert Frank" in *Camera* (Lucerne), no. 12, 1949; "A Letter Addressed to Robert Frank" by Gotthard Schuh in *Camera* (Lucerne), no. 8, 1957; "Robert Frank" by Walker Evans in *U.S. Camera Annual*, New York 1958; "Black and White Are the Colors of Robert Frank" by Edna Bennett in *Aperture* (Rochester, New York), no. 1, 1961; "Der Photograph Robert Frank" by Willy Rotzler and Hugo Loetscher, special issue of *Du* (Zurich), January 1962; "Robert Frank: The Americans" in *Creative Camera* (London), January 1969; "Robert Frank" in *Camera* (Lucerne), March 1969; "Robert Frank's Dilemma" by Gene Thornton in the *New York Times*, 20 August 1972; "Robert Frank: Seeing Through the Rain" by Charles Hagen in *Afterimage* (Rochester, New York), February 1973; "Robert Frank: An Appreciation" by Ian Jeffrey in *Photographic Journal* (London), July 1973; "Walker Evans, Robert Frank and the Landscape of Dissociation" by William Stott in *Artscanada* (Toronto), December 1974; "Robert Frank's Most Recent Work Part of His Exhibition" by Maia-Mari Sutnik in *The Gallery* (Toronto), February 1980.

I wished my photographs (the old ones) would move—or talk—to be a little more alive. But I can't talk for them. That's why there's so much written about photography today—by "experts." Contemporary photography is competent, often exquisite. It's easy to look at, and I prefer it if it's not in colour and not about whores in India or South America. The few photographs I'm trying to make show my interior against the landscape I'm in. At times I put in words—Soup—Strength—Fate—Blind.

—Robert Frank

During the first half of the history of photography— a short and comparatively sweet seventy years— cameras were basically heavy, cumbersome, and unyielding as the mules and camels that hauled the machinery across the continents. Added to this intractability of mechanical means, light sensitive materials, by 1980's standards, were semi-conscious at best. Not surprisingly, most photographers focused their cameras on easy targets—people forsworn not to bat an eyelash or occasional immobile knick-knacks and the like. Even in photographs taken worlds away by daring itinerants, the impression left was that life stood still, that nothing happened. Whether the photograph depicted a battle-scarred Sioux warrior or a white picket fence, the emphasis rested on the noun and the adjectives used to embellish it. While Stieglitz caught the breath of horses as early as 1893 and little Lartigue the spill and splash of family friends some dozen years later, the verb,

the controlling factor on the noun, had little influence or business in photography's early development. It wasn't until after the First World War, in fact, with the advent of small, hand-held cameras and faster films that the fluidity of real events finally opened to unmitigated scrutiny. Photography became, to carry the metaphor to its logical conclusion, a completed sentence.

Some photographers, like Henri Cartier-Bresson, made the moment, the verb, decisive. Others, like André Kertész and Bill Brandt, ultimately placed their sympathies alongside the noun. In the middle was Robert Frank, who, influenced in part by these masters from Europe as well as in part by the astringent, verbless images of Walker Evans in America, blended both the subject and the action, the noun and the verb, with exquisite clarity, compassion, and grace.

It was in 1947 that Robert Frank left Switzerland on a steamer bound for New York, one of several auspicious journeys he would make in his life. Once he got to America, his break with traditional modes of photography, perhaps precipitated by the sudden withdrawal from Swiss serenity, was immediate, clear-cut and self-propelled. It was, for Frank, an irrevocable shift in life style as much as life vision.

From the first photographs on, taken in the streets of New York and later in Paris and London, Spain and Peru, one discovers performers and performances inextricably woven in what can best be described as the real feel of life. Indeed, as sentences, the photographs of Robert Frank are among the most complex and intelligent ever made in photography.

Moments are caught as they reflect the ironies and agonies of life, not for the joys of abstraction or symmetry. The moment itself never engulfs the person, yet the person is never without the moment. No matter what the mood or circumstance, people preserve their identities as human beings, maintain their physical and emotional integrity. Whether expressions are resilient or forbearing, despondent or gleeful, there is always a countenance that must be confronted and reckoned with. Even when their faces are concealed—covered by a hand in the midst of a shoe shine or by an unruly flag when watching a parade, Frank's protagonists never appear exploited, mere faceless pawns in some clever graphic scheme.

Frank's things—the jukeboxes, the cars, the barbershop chairs, the stars and the stripes—radiate the human presence of the people that surround them, inhabit them, accelerate them, adore them, swear by them. They bring in the sound effects, like the glowing jukebox in New York that visually blares away.

There are those who regard Frank's achievement primarily on visual grounds, pointing out how he roughed up the medium with a blurry, blinding vision that left whole sections of the picture out-of-focus, horizon lines helter-skelter, and edges messy with the residue of careless cropping. Yet considering the messages of Frank's pictures, as dreary as they sometimes could be, it is difficult to tolerate such claims. More convincing would be to say that by forcing photography to conform to and obey the beat of life, Frank was able to seize upon some of life's most haunting, poignant, tragicomic, sad, bizarre, and crazy phenomena. Ultimately, feeling overshadows appearance.

There is the picture of two passers-by in Paris, one reaching for a coin, the other holding a tulip behind his back, neither aware of the actions of the other. The picture counters life's random absurdity with the dignity of human courtesy and kindness. Then, in drizzling London, in what may be his most famous early photograph, Frank captures a little girl racing down the street, a bundle of energy dissolving fast. Looming in the picture's foreground sits a hearse, the back door of death swung wide open. The child's foot race against the inevitable is simply out of a dream.

In 1955, and it is legend now, Robert Frank, riding on a Guggenheim fellowship, rented a used

car, packed in the family, and criss-crossed America. Sweeping through big cities and backroads, stopping in poolhalls, parks, barrooms, bus depots, assembly lines and lunch counters, Frank photographed what he saw. His ground rules were clear: "With these photographs, I have attempted to show a cross-section of the American population. My effort was to express it simply and without confusion. The view is personal and, therefore, various facets of American life and society have been ignored," he wrote later of his experience. The book based on these photographs with the simple title, *The Americans*, was first published in France, then a year later in America. Why it wasn't published first in the United States is self-evident from the pictures. Frank's personal view was not the view of America Americans wished to see or acknowledge, especially when coming from an outsider.

Affluent, free, and deep in the middle of an American dream that blanketed the memories of Hiroshima and the Holocaust, Americans didn't want to be caught dimeless in front of the jukebox, have their cocktail parties ruined by a funeral procession, or be reminded that blacks on a bus actually rode in the back. No one much appreciated seeing the stars and stripes so translucent, hanging across a fourth of July picnic like prison bars, or church and state— St. Francis and City Hall—separated by a greasy garage.

It was the great symbol of the American dream— the car—the perfect get-away machine, the king of the road, that Robert Frank celebrated in what is perhaps his best known photograph. Parked on a street in Long Beach, California, a car is draped by a shimmering, silvery sheet, covering it all, right to the tip of the radio antenna. Flanked by two majestic palm tree pillars, the automobile-in-absentia becomes a veritable curbside altarpiece, a holy vessel.

On U.S. Highway 66, between Winslow and Flagstaff, Arizona (next plate in the book), automobile worship turns suddenly sour. Instead of a liturgical vestment, a beaten bedspread covers a corpse or two at the scene of an accident. Our sorrow lies not with the victims, but with the witnesses huddled but alone in the lightly falling snow—the snow James Joyce describes in the final story of *Dubliners* as "falling faintly through the universe and faintly falling like the descent of their last end, upon all the living and the dead."

Americans have little appetite for despair, remorse, or depressive boredom. Like miserable diseases, such feelings in life are best to avoid if you can. To Europeans, like Frank, the grim, darker aspects are part and parcel of life's ups and downs, its give and take. In *The Americans*, Robert Frank, who would later in his life know despair and pain at its highest pitches with the loss of his daughter in a plane crash over Guatemala, dared to raise such existential questions. Perhaps because photography couldn't answer them fully, Robert Frank put aside the still camera in 1958 and moved on to the ultimate visual verb, the making of films.

Living in Nova Scotia, Canada since 1969 and with a dozen or more films, like *Pull My Daisy, Keep Busy*, and *Cocksucker Blues* to his credit, Robert Frank has returned to a kind of photography that resembles the game of solitaire. Snapshots of gelid landscapes replete with mailboxes, telephone lines, clotheslines, and horizon lines are combined with postcards and assembled into collages, then painted, often the blues and oranges of gas stove flames. Some are hand scrawled with words that couldn't be more perspicuous: "The wind will blow the fire of pain across everyone in time"; or in dripping paint across a mirror reflecting a doll-sized skeleton held in a hand: "Sick of goodbyes"; or of his lost daughter: "She was 21 years and she lived in this house and I think of Andrea every day."

Frank also continues to film, dedicating his most recent film, *Life Dances On*, also to his daughter's memory. In the harrowing final scene, Andrea's face appears for the first time, super-imposed over the jagged Canadian coastline. While it is impossible for

Leonard Freed: *Suspect in the Back of a Police Car* from *Police Work*, 1981

anyone to interpret someone else's private intentions, could it be that in this film, steered by its title, Frank encompasses and conquers the grief of eternal separation. The existential predicament of those left behind to continue their lives can be resolved, he seems to faintly voice, not by forgetting, but rather by embracing the beautiful ghosts that will haunt us. Only then can we move on with life and become again its governor.

Ultimately, words written about the films and photographs of Robert Frank will always sit on the dull edge of the knife. Frank himself has written, "The best would be no writing at all."

—Arno Rafael Minkkinen

FREED, Leonard.

American. Born in Brooklyn, New York, 23 October 1929. Educated at Tilden High School, Brooklyn, 1944-48; studied painting; self-taught in photography. Married Brigitte Kluck; daughter: Elke. Freelance photographer, New York, since 1958, working most recently for the London *Sunday Times Magazine*, *New York Times Magazine*, *Der Stern* and *GEO*. Member, Magnum Photos co-operative agency, New York, since 1970. Taught at the New School for Social Research, New York. Recipient: National Endowment for the Arts Grant, 1980. Address: c/o Magnum, 251 Park Avenue South, New York, New York 10010, U.S.A.

Individual Exhibitions:

1967 *What is Man*, Roman Catholic Benedictine Nuns of Cockfosters, London
1973 *The Spectre of Violence*, The Photographers' Gallery, London
1980 *Made in Germany 1970*, Museum Folkwang, Essen

Selected Group Exhibitions:

1967 *The Concerned Photographer*, Riverside Museum, New York (and world tour)
1968 *2nd World Exhibition of Photography*, Pressehaus Stern, Hamburg (and world tour)
1973 *Inside Whitechapel*, Whitechapel Art Gallery, London
1974 *Celebrations*, Hayden Gallery, Massachusetts Institute of Technology, Cambridge

Collections:

Riverside Museum, New York; International Center of Photography, New York; Museum Folkwang, Essen; Stedelijk Museum, Amsterdam; Bibliothèque Nationale, Paris.

Publications:

By FREED: books—*Joden van Amsterdam*, Amsterdam 1959; *Deutsche Juden Heute*, Munich 1965; *Black in White America*, New York 1968; *Made in Germany 1970*, Munich 1970, as *Leonard Freed's Germany*, New York and London 1971; *Police Work*, New York 1981; films—*Dansende Vromen*, 1963; *The Negro in America*, 1966.

On FREED: books—*2nd World Exhibition of Photography*, exhibition catalogue, edited by Karl Pawek, Hamburg 1968; *The Concerned Photographer*, edited by Cornell Capa, New York 1969; *Inside Whitechapel*, exhibition catalogue, by John Furse, London 1973; *The Spectre of Violence*, exhibition catalogue, by Sue Davies, London 1973; *Geschichte der Fotografie im 20. Jahrhundert/Photography in the 20th Century* by Petr Tausk, Cologne 1977, London 1980; articles—"Leonard Freed: Portfolio for the Concerned Photographer" in *Infinity* (New York), October 1967; "The Concerned Photographer," special issue of *Contemporary Photographer* (Culpeper, Virginia), vol. 6, no. 2, 1968; "Leonard Freed" in *Camera* (Lucerne), May 1969; "Deauville: Photographs by Leonard Freed" in *Du* (Zurich), August 1969; "Way Out Westbeth: A Photographic Essay by Leonard Freed" in *Avantgarde* (New York), Summer 1971; "Leonard Freed" in *Modern Photography Annual*, New York 1972; "Leonard Freed's Germany" in *Creative Camera* (London), January 1972; "Leonard Freed à New York: Une Nuit commes les Autres" in *Photo* (Paris), May 1973; "Leonard Freed" in *The Image* (London), vol. 2, no. 6, 1974; "Leonard Freed: Vive les Flics New-Yorkais" in *Photo* (Paris), October 1980; "La Police, C'Est Nous" in *Photo* (Paris), April 1981.

To get the eye, the head and the heart together on the same sight-line—that was the goal of the founding fathers of the Magnum agency. Leonard Freed is a member of Magnum and has conformed absolutely to their precepts. His interest in social affairs is not a mere fashion, born perhaps from the pressure of the roaring 60's: Freed is not of an age to have grown up culturally in that period, and he shows it in his pictures. He is not a man disenchanted with the lens, one of those photographers who, using as an excuse the dullness of everyday life, the absence of any kind of decisive moment, make convenient alibis for themselves to produce pictures expressing intimate experiences. He does not take refuge in contemplation of the misfortunes of the photographer rather than those of the photographed. At the same time Freed's interest in the dramatic situations in life was not born in dangerous times when it was fashionable to play at revolution, fighting it with a camera round one's neck. Freed was born at the time of the great American slump of 1929, and when he began to take photographs it was to document the life of the Jewish community in New York, their problems and their hopes. After the Second World War a journey to Europe reinforced his interest in the Jewish problem. Cineaste and photographer, he produces pictures of denunciation, cruel pictures, as it were a warning to the guilty conscience. The problem of the blacks, the Six Days war, the Germany of the period of reconstruction: he is not one who sings of optimism, even if, paradoxically, his denunciation has implicit in it the hope for a better tomorrow—a tomorrow to which, perhaps, his pictures too can contribute.

A dream, an optimistic presumption about the powers of photography? "Suddenly," Freed said at the opening in 1967 of the New York exhibition *The Concerned Photographer*, in which he took part with five colleagues, "suddenly I feel that I belong to a tradition...." It is the same tradition that informs Luce's famous program for the new-born *Life*: "...to see life, see the world, be witness to great events, peer into the faces of the poor, the mad, to understand the shadows of the jungle, hidden things, to see, to rejoice in seeing, to be spiritually enriched...." For his spiritual enrichment Freed does not hesitate to throw reality in your face, the reality he has picked as his objective. It is the reality of the people, of the man. He does not like to photograph objects or backgrounds. There in the foreground are the people, the faces of the people, the bodies of the people. He does not go looking for the man's reflection in objects; he does not look for the tracks of his passing. He looks the man directly in the face, frankly and loyally.

There is great humanism in this placing of the human figure at the centre of interest, with no deceit or false pity. Even when his pictures seem rough and cruel, there is never less in the photographer of what the Romans called *pietas*. A humble approach to the subject, but with a capacity to grow angry, to cry out against injustices. Freed does not go in for "beautiful photography," photography in the Cartier-Bresson manner, unless it is to catch our eye. For him the age-old argument about the relative importance of content and form has clearly been settled in favour of the former.

—Edo Prando

FREEDMAN, Jill.

American. Born in Pittsburgh, Pennsylvania, in October 1939. Studied sociology and anthropology at the University of Pittsburgh; self-taught in photography. Formerly worked as a musician. Photographer, based in New York. Address: 181 Sullivan Street, Brooklyn, New York 11231, U.S.A.

Individual Exhibitions:

1968 *From Points of View on Resurrection City*, Brooklyn Children's Museum, New York
1972 Soho Photo Gallery, New York
1974 The Photographers' Gallery, London
1976 Nikon Gallery, Zurich
1978 Galerie Trockenpresse, Berlin
1979 Hippolyte Gallery, Helsinki
1981 Photograph Gallery, New York

Selected Group Exhibitions:

1969 *Vision and Expression*, International Museum of Photography, George Eastman House, Rochester, New York

Publications:

By FREEDMAN: books—*Old News: Resurrection City*, New York 1970; *Circus Days*, New York 1975; *Firehouse*, with text by Dennis Smith, New York 1977; *Street Cops*, New York 1981; article—"Circus" in *U.S. Camera/Camera 35 Annual*, New York 1975.

On FREEDMAN: books—*Photography Annual*, New York 1969; *World Photography* by Bryn Campbell, London 1980; articles—"Jill Freedman: Welfare Hotel" in *Print* (New York), January/February 1973; "Jill Freedman's Street Gallery" by Y. Kalmus in *Camera 35* (New York), November 1973.

Jill Freedman is a most unusual and independent photographer. Her involvement with her subjects becomes total, whether that involvement is for a period of months or even years. Her first book *Old News: Resurrection City*, told of the poor people's march on Washington, and from it to *Circus Days* (a three-month period spent with circus people, moving on every night after the show) to her latest book, *Street Cops*, about the New York police, she has lived and breathed the subjects, from taking the pictures right through to the final design and writing of the texts.

At a time when it is more fashionable to provide a cool look at the world, Freedman is totally committed to everything she does. Her uncompromising attitude means that she has little time for the "photo-scene," and apart from some occasional one-off assignments, she prefers to live from one book to the next without allegiances to any particular newspaper, magazine or agency. Such independence makes it necessary for her to be particularly hard on herself—self-discipline demands more over a long period than working with any kind of group with whom one can share responsibilities. And this discipline extends to her ruthless sorting and sifting of her work, to make sure that only the best is seen.

Luckily, through all this intensity, there shines a rare sense of humour. Compassion there certainly is, a fine sense of composition, and an eye that seeks and finds the secret and quiet moments as well as the dramatic ones without ever giving the impression of being that of an outsider. If the world belongs to Jill Freedman, she also belongs to it—the Irish pub musicians, the brave fireman or the old beaten down-and-out are all part of the same world. She is not showing us things in the hope that we will change them, just that we will admit them to our minds, and agree that the human condition, however imperfect, is the one that we share: by coming to terms with it we may get some hard knocks, but we certainly get the best highs too—and with her help, some truly great pictures.

—Sue Davies

FREIXA, Ferran.

Spanish. Born in Barcelona, 11 November 1950. Educated at Escola Laietana, Barcelona, 1964-66; studied drawing and painting, Escola Massana and Cercle Artistic St. Lluc, Barcelona, 1965-68; mainly self-taught in photography. Served in the Spanish Army, Barcelona, 1968-69. Freelance photographer and graphic designer, establishing own studio, Barcelona, since 1969. Agent: Cristina Zelich, Infanta Carlota 113, Barcelona 29, Spain. Address: Provenca 285 entlo., Barcelona 37, Spain.

Individual Exhibitions:

1976 La Photogaleria, Madrid
 FAD (Foment de les Arts Decoratives), Barcelona
1977 Galeria Rosa Bisbe, Barcelona
 Galeria Lletra Menuda, Ciutadella-Menorca, Spain
 Galeria Fotoarte, Bilbao, Spain
 Galeria Spectrum-Canon, Barcelona
 Galeria Il Diaframma-Canon, Milan
1978 Atelier-Galerie de Photographie, Aix-en-Provence, France
1979 Galerie Demi-Teinte, Paris
 Galeria Fotomania, Barcelona
 La Photogaleria, Madrid
 Sala de Imagen (Caja de Ahorros), Castellón, Spain
 Galeria Desalt, Gerona, Spain
1980 Galeria Spectrum-Canon, Gerona, Spain

Selected Group Exhibitions:

1973 *La Bella y la Bestia*, Galeria Da Barra, Barcelona

1976 *El Fotògraf Fotografiat*, Casal de La Floresta, Barcelona
1977 *Photographies d'Architecture*, Chez Rove/Vinci 1840, Paris
 9 Fotografos Catalanes, La Photogaleria, Madrid
1978 *Fotografía Española Contemporánea*, Centro Cultural Juana Mordó, Madrid
 Triennale Internationale de Photographie, Musée d'Art et d'Histoire, Fribourg, Switzerland
1979 *Expo Límite*, Oficina de Turismo Español, New York
 4 Punts de Vista, Galeria Lleonart, Barcelona
1980 *Autorretratos*, Galeria Fotomania, Barcelona
 Spanish Photography, The Night Gallery, London

Collections:

Musée d'Art et d'Histoire, Fribourg, Switzerland; Bibliothèque Nationale, Paris.

Publications:

By FREIXA: book—*Pollen d'Entrecuix*, with text by Joan Brossa, Barcelona 1978; articles—"Portafolio Holanda" in *Zoom* (Madrid), October 1976; "Sotto il sole di Minorca" in *Il Fotografo* (Milan), September 1977; "Exposición Límite" in *Nueva Lente* (Madrid), March 1979; "Spanish Photography" in *European Photography* (Göttingen), April/June 1980.

On FREIXA: article—"Conversaciones en el Laboratorio" by Jordi Palarea Fonts in *Flash-Foto* (Barcelona), November 1980.

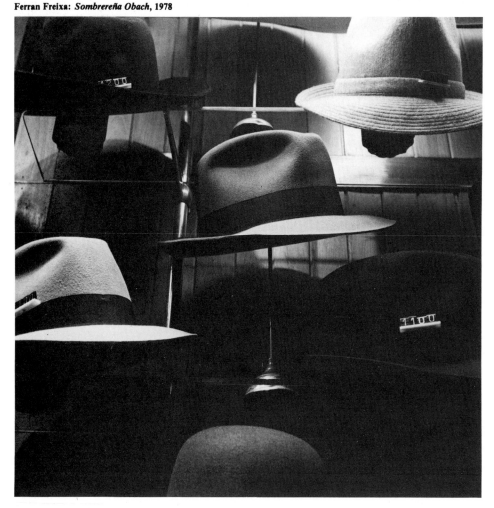

Ferran Freixa: *Sombrereña Obach*, 1978

The series "Escaparates" of 1978-79 suggests a change in the work of Ferran Freixa. The same elements as in his previous two series ("Holanda" in 1976 and "Menorca" in 1976-77) are still present, and these elements demonstrate a continuity in his work. But there are also differences, much more subtle than they at first appear to be.

As far as composition is concerned, Freixa constantly maintains the principle of not presenting us with an object in its totality but with merely a fragment. In terms of technique, he presents us with a negative which is free from any previous or subsequent manipulation. Thematically, he analyzes those elements that evoke lost worlds or worlds nearing their ends. In "Holanda" the Dutch houses evoke the bourgeoisie of the 17th and 18th centuries. The sculptured walls and aristocratic houses in "Menorca" are reminders of the presence of the English on the island during the 18th century. And in "Escaparates" the shop windows of Barcelona are a kind of final evidence of the world of the artisans' guilds, a world that is vanishing before our eyes. The work of Ferran Freixa, in other words, always obliges the viewer to make some effort of the imagination. His work is highly suggestive and intellectual.

So much the series have in common. Yet, in the current work, there is a difference—because of its concrete theme; because of his use of a different focal distance. The objects he now depicts are invariably of a smaller dimension than the subjects of "Holanda" and "Menorca": they are seen more closely and they are personal—some gloves, a hat. The theme is bold and to be "read," but the photos of "Escaparates" distance us from an atmosphere of analysis; they evoke an immediate emotional response, bringing us nearer to humanity.

—Francesc Miralles

FREUND, Gisèle.

French. Born in Berlin, Germany, 19 December 1912; emigrated to France, 1933: naturalized, 1936. Studied sociology and art history at the University of Freiburg im Breisgau, 1931; under Karl Mannheim and Norbert Elias, Institute for Social Sciences, University of Frankfurt, 1932-33; and at the Sorbonne, Paris, 1933-36, Ph.D. in sociology and art 1936. Married Pierre Blum in 1937 (divorced, 1948). Freelance journalist and writer, working for *Life, Weekly Illustrated, Vu, Picture Post, Paris-Match, Du,* etc., in Paris, 1935-40, 1946-50, and since 1953. Fled Nazis, to Lot, France 1940-42; Photographer and Assistant Film Producer to members of the Louis Jouvet Theatre Company, Argentina and Chile, 1943-44; Photojournalist, France Libre propaganda services, Argentina, 1944-45; freelance photographer in Mexico, 1950-52. Member Magnum Photos co-operative agency, Paris, 1947-54. President, French Federation of Creative Photographers, since 1977; Trustee, Fondation Nationale de la Photographie Francaise, since 1978. Recipient: Kulturpreis, Deutsche Gesellschaft für Photographie (DGPh), 1978; Grand Prix National des Arts, France, 1980. Agents: Sidney Janis Gallery, 6 West 57th Street, New York, New York 10019, U.S.A.; Harcus Krakow Gallery, 7 Newbury Street, Boston, Massachusetts 02116, U.S.A.; Galerie Agathe Gaillard, 3 rue du Pont Louis-Philippe, 75004 Paris; Galerie Rudolf Kicken, Albertusstrasse 47-49, Cologne, West Germany; and Watari Gallery, 3-7-6 Jingumae, Shibuya-ku, Tokyo 150, Japan. Address: B.P. 509, 75666 Paris, Cedex 14, France.

Individual Exhibitions:

1939 *Ecrivains célèbres*, Galerie Adrienne Monnier, Paris
 Peggy Guggenheim Jeune Gallery, London
1942 Amigos del Arte, Buenos Aires
1945 Palacio de Bellas Artes, Valparaiso, Chile
1946 *Amerique Latine*, Maison de l'Amerique Latine, Paris
1963 Bibliothèque Nationale, Paris'
1964 French Institute, London
1965 Princeton Art Museum, New Jersey
1968 *Au Pays des Visages 1938-68*, Musée d'Art Moderne de la Ville, Paris
 Fondation Royaumont, Asnières, France
 Maison de la Culture, Grenoble, France
1971 Musée de la Cataye, Mont-de-Marsan, France
 Musée de la Cataye, Pau, France
 Musée Municipale, Angoulème, France
1972 Association Mulhousienne pour la Culture, Mulhouse, France
 Maison de la Culture, Dôle, France
 Centre Culturel des Premontres, Pont-à-Mousson, France
1973 Musée Sandelin, Saint-Omer, France
 Theatre Gerard Philippe, Saint-Denis, France
 La Mairie, Amboise, France
 Centre Culturel, St. Savin-sur-Cartempe, France
 Descartes Huis, Amsterdam
 Comite d'Enterprise E.D.F., Chatou, France
 Musée d'Art et d'Histoire, Nimes, France
1974 Maison de la Culture, Cannes
 Maison de la Culture, Brive-la-Gaillarde, France
 Maison de la Culture, St.-Ouen-L'Aumone, France
 Maison de la Culture, Aquitaine, France
 Association Bourguignonne, Dijon, France
1975 Maison de la Culture, Rennes, France
 Maison de la Culture, Fougeres, France
 Maison de la Culture, Laval, France
 Robert Schoelkopf Gallery, New York
1976 Focus Gallery, San Francisco

1977 *Fotografien 1932-1977*, Rheinisches Landesmuseum, Bonn (retrospective)
 Fotoforum der Gesamthochschule, Kassel, West Germany (retrospective)
1978 Galerie Dreiseitel, Cologne
 Galerie Lange-Irschl, Munich
 Musée Réattu, Arles, France
 Galerie La Hune, Paris
 Watari Gallery, Tokyo
 Shadai Gallery, Tokyo
 Mirvish Gallery, Toronto
 Harcus Krakow Gallery, Boston
1979 Sidney Janis Gallery, New York
1980 Galerie Agathe Gaillard, Paris
 Photo Art Gallery, Basle
 Canon Gallery, Geneva
1981 Axiom Gallery, Melbourne
 Galerie Rudolf Kicken, Cologne
 Galerie Municipale du Château d'Eau, Toulouse

Selected Group Exhibitions:

1951 *Memorable Life Photographs*, Museum of Modern Art, New York
1961 *Salon International de la Photographie*, Bibliothéque Nationale, Paris
1963 *Das Französische Porträt im 20. Jahrhundert*, Akademie der Künste, Berlin (travelled to the Kunsthalle, Dusseldorf)
1965 *Femmes Photographes*, Les 30/40, Paris
1966 *Commemoration Joyce*, Centre Culturel Americain, Paris
1972 *Photographes Français*, Moscow Museum, U.S.S.R.
1975 *Hommage à Tériade*, Grand Palais, Paris (travelled to the Royal Academy of Art, London)
 Women of Photography, San Francisco Museum of Art (toured the United States, 1975-77)

Gisèle Freund: *Virginia Woolf*, 1939

1977 *Photographes Français*, Centre Beaubourg, Paris
1981 *Les Réalismes*, Centre Beaubourg, Paris

Collections:

Bibliothèque Nationale, Paris; Musée Réattu, Arles, France; Stedelijk Museum, Amsterdam; Moderna Museet, Stockholm; Shadai Gallery, Tokyo; International Museum of Photography, George Eastman House, Rochester, New York; Princeton University, New Jersey; Center for Creative Photography, University of Arizona, Tucson.

Publications:

By FREUND: books—*La Photographie en France au 19me Siècle*, Paris 1936, Buenos Aires 1947, Munich 1968; *Mexique Précolombien*, Neuchâtel, France 1954, Munich 1955; *James Joyce in Paris: His Final Years*, New York 1965, London 1966; *Le Monde et Ma Camera*, Paris 1970, New York 1974; *Photographie et Société*, Paris 1974, 1975, Turin, Barcelona, Munich, Boston, Stockholm and London 1980; *Memoires de l'Oeil*, Paris and Frankfurt 1977; *Gisèle Freund*, portfolio, Washington, D.C. 1978; articles—"A French Woman Visits the North and Asks: Is This Your England?" in *Weekly Illustrated* (London), 5 October 1935; "Northern England," under pseudonym "Girix," in *Life* (New York), 14 December 1936; article in *Arts et Metiers Graphiques* (Paris), no. 65, 1937; "David Octavius Hill" in *Verve* (Paris), October 1939; "Some Scenes from the Economic War Front of Parisian Fashions" in *Life* (New York), 15 April 1940; "Kein Schnappschuss, Kein Pose: Langzeitaufnahmen einer Epoche," interview with Georg Puttnies, in *Frankfurter Allgemeine Zeitung*, 3 April 1975.

On FREUND: books—*Memorable Life Photographs* with text by Edward Steichen, New York 1951; *Au Pays des Visages 1938-1968*, exhibition catalogue, by Pierre Gaudibert, Paris 1968; *Women of Photography*, exhibition catalogue, by Margery Mann, San Francisco 1975; *Gisèle Freund: Fotografien 1932-1977*, exhibition catalogue, by Klaus Honnef, Bonn 1977; articles—"Au Pays des Figures" by Adrienne Monnier in *Verve* (Paris), no. 5/6, 1939; "Miroirs Francs" by Annette Vaillant in *Les Nouvelles Litteraires* (Paris), 28 March 1963; "Oh Young Men, Oh Young Comrades" by Cyril Connolly in the *Sunday Times Magazine* (London), 22 December 1963; "The Key to Inner Character" by Geraldine Fabrikant in *Ms* (New York), March 1975; "Gisèle Freund" in *Kunstforum International* (Mainz), vol. 16, 1976; "Gisèle Freund" by Fritz J. Oberli in *Camera* (Lucerne), November 1978; "Gisèle Freund" by Rosellina Burri-Bischof in *Du* (Zurich), January 1981.

To create a photograph which possesses originality, an emotion that nobody before has expressed, is as difficult as it is for a painter to realize a painting which expresses new ideas. Newspapers, magazines and books publish every day millions of photographs, but it is extremely seldom that one discovers a great work among this multitude, one that touches the heart and enchants the spirit.

Yet it seems so easy to take a photograph! One forgets that, apart from the technical aspects, photography can be a mental creation and the affirmation of a personality. What is marvellous about photography is that its possibilities are infinite; there aren't any subjects "done to death," for, as Brassaï says: "A fresh eye can still disclose anew unknown aspects."

To reveal man to man, to be a universal language accessible to all—that, for me, is the prime task of photography.

—Gisèle Freund

In her touching memoirs and reflections on the art of photography, *Le Monde et Ma Camera* (1970), Gisèle Freund makes the surprising confession that originally she had wanted to be a sociologist "because the diversity of social problems fascinated me." She became a photographer out of necessity, she continues, "and I never regretted it, for I soon understood that my most vital concerns were directed toward the individual, with his sorrows and hopes and anguishes. My camera led me to pay special heed to that which I took most to heart: a gesture, a sign, an isolated expression. Gradually, I came to believe that everything was summed up in the human face." And although she also describes herself as a "photo-reporter" and has taken memorable pictures of her visits to Argentina and Mexico, she is primarily a portraitist. Her photographs of Joyce, Virginia Woolf, Colette and André Malraux (many of them done in color as early as 1938) are probably the best-known "literary" portraits of our time, but the impressive list of artists and intellectuals who sat for her should not suggest that she is a kind of court photographer. There is nothing idealized about most of these portraits: she does not disguise the muted terror in Virginia Woolf's eyes, for example, or Malraux's fierce arrogance. What she looks for is the "symbolic essence of an individual."

About the art of photography in general she remarks that while an observer takes in countless details when he glances at a scene, the camera remains fixed. It must select, it must choose, and thereby gains its special power: "it captures an isolated reality in a fraction of a second. The immediate present thus takes on a symbolic value." But at the same time "*I* am the one who decides at exactly what moment the button must be pressed.... And in the end, the intrinsic value of a photograph depends on the photographer's ability to select, among a mass of impressive and jumbled details, those that reveal the most meaning." Thus the expressive value of a photograph depends ultimately on the character of the photographer and the point of view he chooses. With Gisèle Freund that point of view is poised, objective, even classical in its assumption that there are essences to be revealed, and at the same time alert to the intensity of the particular moment. "My goal," she writes, "has always been to make my camera the witness of the time in which I live."

—Elmer Borklund

FRIEDLANDER, Lee.
American. Born in Aberdeen, Washington, 14 July 1934. Studied photography, under Edward Kaminski, Art Center School, Los Angeles, 1953-55. Began photographing, 1948; freelance photographer, working for *Esquire*, *McCall's*, *Collier's*, *Art in America*, etc., since 1955. Artist-in-Residence, University of Minnesota, Minneapolis, 1966; Guest Lecturer, University of California at Los Angeles, 1970; Melon Professor of Fine Arts, Rice University, Houston, 1977. Recipient: Guggenheim Fellowship, 1960, 1962, 1977; National Endowment for the Arts Fellowship, 1972. Address: 44 South Mountain Road, New City, New York, U.S.A.

Individual Exhibitions:

1963 International Museum of Photography, George Eastman House, Rochester, New York
1967 *New Documents*, Museum of Modern Art, New York (with Diane Arbus and Garry Winogrand; toured the United States, 1967-75)
1968 University of California at Los Angeles
1970 Garrick Fine Arts Gallery, Philadelphia
1971 *Gatherings I Got Myself Invited To*, Focus Gallery, San Francisco
1972 Focus Gallery, San Francisco
Gatherings, Museum of Modern Art, New York
Witkin Gallery, New York
1973 Jefferson Place Gallery, Washington, D.C.
Galerie Wilde, Cologne
East Street Gallery, Grinnell, Iowa
1974 Museum of Modern Art, New York
1975 Broxton Gallery, Los Angeles
Museum of Modern Art, New York
1976 *Portfolios*, Minneapolis Institute of Arts
Kunsthaus, Zurich
Texas Center for Photographic Studies, Dallas
The Nation's Capital in Photographs, Corcoran Gallery, Washington, D.C.
Yajima Galerie, Montreal
1977 *The American Monument*, Institute of Contemporary Art, Boston (toured the United States)
Light Gallery, New York
Cronin Gallery, Houston
Center for Contemporary Photography, Chicago
1978 Hudson River Museum, Yonkers, New York
Galerie Zabriskie, Paris
Light Gallery, New York
1979 Fraenkel Gallery, New York (retrospective)
1980 Work Gallery, Zurich
1981 Zeb Gallery, Providence, Rhode Island
California Museum of Photography, University of California at Riverside
Arbres et Fleurs, Galerie Zabriskie, Paris

Selected Group Exhibitions:

1966 *Contemporary Photography since 1950*, International Museum of Photography, George Eastman House, Rochester, New York (toured the United States)
1967 *Photography in the 20th Century*, National Gallery of Canada, Ottawa (toured Canada and the United States, 1967-73)
1975 *4 Amerikanische Photographen: Friedlander/Gibson/Krims/Michals*, Stadtisches Museum, Leverkusen, West Germany
1976 *Peculiar to Photography*, University of New Mexico, Albuquerque
1977 *Contemporary American Photographic Works*, Museum of Fine Arts, Houston (travelled to the Museum of Contemporary Art, Chicago; La Jolla Museum of Contemporary Art, California; and Newport Harbor Art Museum, California)
1978 *23 Photographers/23 Directions*, Walker Art Gallery, Liverpool
1979 *Photographie als Kunst 1879-1979/Kunst als Photographie 1949-1979*, Tiroler Landesmuseum Ferdinandeum, Innsbruck, Austria (travelled to the Neue Galerie am Wolfgang Gurlitt Museum, Linz, Austria; Neue Galerie am Landesmuseum Joanneum, Graz, Austria; and Museum des 20. Jahrhunderts, Vienna)
1980 *Old and Modern Masters of Photography*, Victoria and Albert Museum, London (toured the U.K.)
1981 *Robert Frank Forward*, Fraenkel Gallery, San Francisco
5 Portfolios/6 Artists, National Gallery of Canada, Ottawa

Collections:

Museum of Modern Art, New York; Museum of

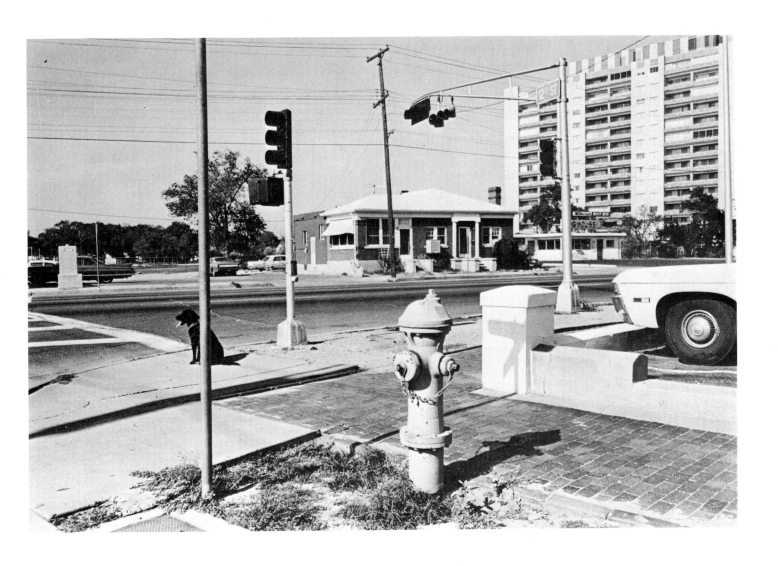

Lee Friedlander: *Albuquerque*, **1972** Courtesy Art Institute of Chicago

Fine Arts, Boston; Fogg Art Museum, Harvard University, Cambridge, Massachusetts; Smithsonian Institution, Washington, D.C.; New Orleans Museum of Art; University of Kansas, Lawrence; University of New Mexico, Albuquerque; San Francisco Museum of Modern Art; University of California at Los Angeles; National Gallery of Canada, Ottawa.

Publications:

By FRIEDLANDER: books—*Work from the Same House*, with Jim Dine, London and New York, 1969; *Photographs by Lee Friedlander and Etchings by Jim Dine*, portfolio of 16 photos and etchings, London 1969; *Self-Portrait*, New City, New York 1970; *E.J. Bellocq: Storyville Portraits*, editor, New York 1970; *15 Photographs by Lee Friedlander*, portfolio, with an introduction by Walker Evans, New York 1973; *Photographs of Flowers*, portfolio of 15 photos, New York 1975; *The American Monument*, with text by Leslie George Katz, New York 1976; *The Nation's Capital in Photographs 1976*, exhibition catalogue, with an introduction by Jane Livingston, Washington, D.C. 1976; *Lee Friedlander: Photographs*, New City, New York 1978; *Flowers and Trees*, portfolio of 40 photos, New York 1981; articles—"Looking at Television" in *Current* (New York), April 1963; "The Little Screens" in *Harper's Bazaar* (New York), February 1963; "E.J. Bellocq: Storyville Portraits" in *Camera* (Lucerne), December 1971.

On FRIEDLANDER: books—*Photography in the 20th Century* by Nathan Lyons, New York 1967; *New Photography USA*, exhibition catalogue, by John Szarkowski, Arturo Quintavalle and Massimo Mussini, Parma, Italy 1971; *Peculiar to Photography*, exhibition catalogue, by Van Deren Coke, Thomas F. Barrow and others, Albuquerque, New Mexico 1976; *Geschichte der Fotografie im 20. Jahrhundert/Photography in the 20th Century* by Petr Tausk, Cologne 1977, London 1980; *Contemporary American Photographic Works*, edited by Lewis Baltz, Houston 1977; *The Magic Image* by Cecil Beaton and Gail Buckland, London and Boston 1975; *Concerning Photography*, exhibition catalogue, by Jonathan Bayer, Peter Turner, Ian Jeffrey and Ainslie Ellis, London 1977; *Photographs: Sheldon Memorial Art Gallery Collection, University of Nebraska*, with an introduction by Norman A. Geske, Lincoln, Nebraska 1977; *Tusen och En Bild*, exhibition catalogue, by Ake Sidwall, Rune Jonsson and Ulf Hard af Segerstad, Stockholm 1978; *Mirrors and Windows: American Photography since 1960* by John Szarkowski, New York 1978; *23 Photographers/23 Directions*, exhibition catalogue, by Valerie Lloyd, Liverpool 1978; *Photographie als Kunst 1879-1979/Kunst als Photographie 1949-1979*, exhibition catalogue, 2 vols., by Peter Weiermair, Innsbruck, Austria 1979; *Old and Modern Masters of Photography*, exhibition catalogue, by Mark Haworth-Booth, London 1980; articles—"Lee Friedlander" by James Thrall Soby in *Art in America* (New York), June 1960; "The Little Screens" by Walker Evans in *Harper's Bazaar* (New York), February 1963; "Lee Friedlander: 5 Portraits" in *Creative Camera* (London), April 1969; "Lee Friedlander" in *Camera* (Lucerne), January 1969; "E.J. Bellocq: Storyville Portraits, from Prints by Lee Friedlander" in *Creative Camera* (London), August 1971; "Lee Friedlander: Self-Portraits" in *Creative Camera* (London), September 1971; "Le Foto di Friedlander" by Ugo Mulas in *NAC* (Milan), January 1972; "Lee Friedlander: Self Portrait" by J. Kelly in *Art in America* (New York), May/June 1972; "Lee Friedlander" in *Documentary Photography*, by the Time-Life editors, New York 1973; "Lee Friedlander" in *Photo* (Paris), February 1974; "All of a Sudden Friedlander Seems Passé" by Gene Thornton in the *New York Times*, 15 December 1974; "Lee Friedlander" by Gerry Badger in the

British Journal of Photography (London), 5 March 1976.

One of the most significant American photographers of the past four decades, Lee Friedlander photographs the social landscape as an unobserved observer. His photographs are resolutely visual, but they deny themselves the customary assertions and annunciatory associations of vernacular photography. Quite often an enigma to the viewer, they seek their own inherence of form. Why, may be asked, photograph a dog with his tongue lolling out waiting at a street corner in Albuquerque, New Mexico? Why too, a monument of a rifleman with a klatch of pigeons fluttering at its base? Friedlander's work is deceiving with its understatement, its carefree manner, as if he just happened to be somewhere in urban America one day and also just happened to snap a picture. Of course, his photographs escape the innocence of a snapshot. Their meaning cannot be reduced to a phrase of facile interpretation.

Friedlander has created a formidable body of work: reflections in store front windows; urban landscapes with and without people; a series of American monuments; closeups of people frolicking at social gatherings and lounging within the privacies of their homes; and a study of trees and flowers, the ways their forms inhabit urban spaces.

Friedlander is the master of store front reflections in which clouds, a plane, a drugstore menu, a saleswoman or customer, and a glittering movie marquee across the street all gracefully mix as on a brilliant groundglass. What lies behind a window and what is reflected in its shiny surface unite in a two dimensional format that, accordian-style, expands and contracts in gradations of space. In these photographs his presence is often inserted as a shadow or partially concealed form, his face opaqued by the camera or a telltale part of his body merging into the flux of detail. By shooting from within a store or a phone booth, sometimes he will reverse the accustomed perspective, achieving a similar result.

The urban landscapes are broad reaches of space where parts of buildings, curbing, parked cars, telephone lines, unaware pedestrians, streetlamps, and awnings oddly relate and intersect. Flat and unassuming, the photographs interest one by their precision of detail and stubborn refusal to make interpretative comment. Perhaps because they are so fresh and originally conceived, they are not immediately winsome. But indeed they are unalloyed, real. They observe what most Americans pass by unblinkingly each day, doubtless some of the artifacts of contemporary urban culture. Neither self-consciousness nor self-congratulation taints these images. Many are shot in bright sunlight, and when printed the contrast of shadows and highlights is downplayed. Their impact is dry with a lingering assertion; what they behold is subtle, witty, as unique as the taste of hotdogs or roasted chestnuts served by a street vendor.

An extended portrait of monuments in America and their unintentionally amusing and banal placements has taken Friedlander throughout the country. With deadpan alertness, his photographs tout bronze figures and stone sculptures, their backs turned to a clutter of drab school buildings and brassy Thom McAn and Coca-Cola signs and towering flagpoles which intrude like jealous cousins at a picnic.

The tree for Friedlander has become another kind of monument. Reminiscent of his work with store front reflections, his photographs in the mid-70's began to cast trees as though they were unappreciated yet dominant objects of the American landscape. With such raw and unpromising subjects, Friedlander has fashioned some enduring photographs; his trees, their branches tangled and bare, offer an almost transparent surface through which other objects of the social landscape emerge.

A trademark of his work is a hand or an object like a plaster urn or a fire hydrant placed somewhere

in the foreground of the photograph, a device allowing him to heighten the illusion of space. Another trademark is the unobtrusive nature in which he photographs. The human figures that snare his attention are rarely aware of his presence, as if before they can truly lock him into their thoughts he has already turned away.

Friedlander is not a causer, nor a satirist who pleads for change. His is the visual scholarship of an historian. He makes no towering social indictments or judgments. He has created a rich and diverse lexicon of urban America. People are certainly part of that lexicon, but his abiding fascination with them seems rooted in the ways they move in and inhabit their familiar spaces.

The apparent eclecticism of his subject matter is an index of his assurance and versatility. With a small, hand held camera and a hawk's eye for the unnoticed, he has forged an unmistakable style. Though easeful on the viewer's eyes, Friedlander's photographs are difficult and original conceptions. Their cohesions are intangible and secure, as if bound by invisible thread. What others would pass by as unphotographic, he gently tucks into his lexicon: an unpeopled street with a deep shadow splayed across it like a langorous whale; or a woman asleep, arms upthrust over her eyes, her head sunk softly between two pillows. His vision, his style, his wordless visual assertions have unequivocally affected the ways many contemporary American photographers envisage the urban environment.

—Kelly Wise

FRIEDMAN, Benno.

American. Born in New York City, 28 March 1945. Educated at Brandeis University, Waltham, Massachusetts, 1962-66, B.A. (honors) in fine arts 1966. Photographer since 1966; established studio in New York City. Artist-in-Residence, Massachusetts College of Art, Boston, 1972-73. Recipient: *Photovision '72* Award, Boston; Massachusetts Council on the Arts and Humanities Fellowship, 1975; New York State Creative Arts Program Services Grant, 1978. Address: 26 West 20th Street, New York, New York 10011, U.S.A.

Individual Exhibitions:

1969 Underground Gallery, New York
1972 Andover Museum of Art, Massachusetts
 Massachusetts College of Art, Boston
1973 Light Gallery, New York
 Tucson Art Center, Arizona
1975 Light Gallery, New York
1976 Center for Creative Phtography, University
 of Arizona, Tucson
 Light Gallery, New York
1977 Light Gallery, New York
 Port Washington Library, Port Washington,
 New York
 Yajima Gallery, Montreal
1978 Arco Center for the Arts, Los Angeles
 Light Gallery, New York
1980 Asher-Faure Gallery, Los Angeles
 Honey Shop Gallery, Lenox, Massachusetts
 Susan Spiritus Gallery, Newport Beach, California
1981 Fotobond BNAFV, The Hague

1982 Susan Spiritus Gallery, Newport Beach, California

Selected Group Exhibitions:

1970 *Recent Acquisitions*, Museum of Modern Art, New York
1972 *60's Continuum*, International Museum of Photography, George Eastman House, Rochester, New York
1973 *Light and Lens: Methods of Photography*, Hudson River Museum, Yonkers, New York
1974 *Private Realities*, Museum of Fine Arts, Boston
1976 *Photo/Synthesis*, Herbert F. Johnson Museum, Cornell University, Ithaca, New York
 Contrasts: Two Directions in 20th Century American Photography, International Center of Photography, New York
1979 *One of a Kind: Polaroid Color*, Corcoran Gallery, Washington, D.C. (toured the United States)
 The Photographer's Hand, International Museum of Photography, George Eastman House, Rochester, New York
1981 *The Markers*, San Francisco Museum of Modern Art

Collections:

Museum of Modern Art, New York; Wertheim and Company, New York; International Museum of Photography, George Eastman House, Rochester, New York; Vassar College, Poughkeepsie, New York; Museum of Fine Arts, Boston; Fogg Art Museum, Harvard University, Cambridge, Massachusetts; Massachusetts Institute of Technology, Cambridge; Virginia Museum of Fine Arts, Richmond; Australian National Gallery, Canberra.

Publications:

On FRIEDMAN: book—*Darkroom Dynamics*, edited by Jim Stone, New York 1979; articles—in *Art in America* (New York) February/March 1970; in *Esquire* (New York), March 1976.

I do not believe in the distinction between "pure" and altered photography. Black and white. It is all shades of grey. All photographs are both manipulated and manipulating. Webster: "...to control or change especially by artful or unfair means so as to achieve a desired end...." The pure photographic moment (if the beast lives at all) is that fraction of an instant during which the image is perceived and desired, but prior to the moment of acquisition (the click of the shutter). All that follows is less than pure.

The realization/actualization of the photograph is manipulated by the photographer, and the image content of the photograph manipulates the viewer/audience. Process and narration. There is no 100% anything in our universe. No photograph is the exclusive product of either narration or process, yet so many photographers love their images without loving their photographs.

All photographs are manipulated, in that each step, each photographic process from image-collecting to print drying, is a variable (choice of camera, lens, developer, temperature, paper, etc., etc.). Each decision in this familiar family of activities is a specific alteration/manipulation, affected by and affecting each other. Using Spot-Tone is a manipulation...it is a choice to spot out a dust mark or scratch; it is no less a photograph if everything but the scratch is blackened.

Photography is manipulating in the illusions it has created and successfully perpetuated. The illusion of truth. The illusion of honesty. The illusion of substance. The illusion of a mirror. The illusion of reality. The only reality a photograph conforms to is that of being a photograph. All photographs could have been conceived and actualized on a film-lot in Hollywood. Today that is well within our illusionary abilities. All photographs are in substance no more than the outcome of a restricted reaction of silver salts to light and chemical bathing. All photographs at best only resemble things with which we are familiar. Our imaginations supply the missing details.

Today's photographic technology makes it available to man, chimpanzee, and computer. It is the faculties of critical choice that distinguish the deliberate from the random. Both chimp and man can make art; only man can be an artist. Computers have eliminated the necessity for the chimp's hand: a camera mounted and programmed to fire automatically, attended by blind technicians, the film processed and printed by machine....

Commitment, evolution, exploration and intent. It is not enough to make well-printed, well-composed photographs. They are the cheapest form of visual currency, filling our publications, overflowing from the libraries; the silver has become more precious than the imagery.

Uneven edges, not-squared corner angles, erasures, alternate and superimposed rectangles, corrections, broken lines, reaffirmed demarcations, fingerprints, smudges, possibilities of mistakes, errors in the initial ordering process, statements replaced by questions: my attempt to define a series of visual interrelationships between the shaky, imperfect hand of man and the frozen exactitude of machine.

A wondrous and exciting time in the photographic experience is the transitional, alchemical time between neutral, undefined white paper and the finality of a fully developed print; the process of becoming, rather than the definiteness of having become. The Cubists struggled to reveal a multiplicity of facets and angles of the same object within a single frame...both this and that, frontal and profile, seen from above and at eye level. I wrestle with the quality of absolute in photography—breaking it open, leaving room for additional information from other sources...a tree, photographically cut in half; what of its other half? I help reunite the two...reaffirming significant patterns, combinations of shapes, spatial relationships...an end, the edge is here, no—there, no—further over...this image is a segment ripped from a larger unphotographed place, an incomplete fraction which, like a single bone to an anthropologist, excites and reveals by its presence even that much more that is still yet unknown.
—Benno Friedman

Benno Friedman: *Untitled*, from the *British Isles* series, 1980

The nature of Benno Friedman's work is such that some controversy exists as to whether it should be considered as photography at all. To photography purists, the extent of his manipulation of the print—bleaching, coloring, painting, and now, in his most recent work, re-drawing the image in pencil—raises questions about how far a photograph can be transformed and reworked and still remain a photograph. However, Friedman's insistence that the photograph is by definition an image made with a camera, and not a transcription of reality, is fully in keeping with the modernist dictum that a photograph is a photograph, be it a seemingly unmediated documentary image or an extensively manipulated abstraction. Whether the latter constitutes a *good* photograph is of course another question.

As Friedman's work has evolved, his real subject matter, *proprement dit*, can be said to be the very properties of photographic imagery. In calling attention to the arbitrary conventions and technical determinants of the photograph (the crop, the frame, the shape, and the properties of abstraction and flattening which derive from the camera registering the world in two-dimensional monochrome) he is above all asserting the fictional quality of photography. Much of his recent work, for example, involves either an extension of the image beyond its borders, a partial vignetting of the photographic image within the frame, or a pencilled continuation and elaboration of the image. Such devices emphasize that the most fundamental of photographic properties—the crop—is itself a convention, a fiction, a formal construction. Further, the presentation of two types of image making (the hand drawn and the photographed) within a single pictorial field asserts the primacy of image making as such and undercuts the tendency to privilege the photographic as more real or optically truthful. In Friedman's photographs, both elements have equal weight and neither element is more or less true than the other.

In much the same way that Friedman expands the image beyond the frame to allude to the physical world which continues and extends outside of the photographic crop, so too does his use of color refer to the reality excluded by the photograph. The imposition of arbitrary or unnatural hand coloring implies both the true colors of the natural world and the monochrome conversion that occurs in a black and white photograph (color photography imposes its own fictions).

Because the 140 year old battle to legitimize photography as art has been waged on painting's terms, it is not surprising that even now art photographers such as Friedman emphasize the "made" rather than the "taken" aspects of photography. The modernist insistence on the autonomous and self-referential nature of art informs a good deal of contemporary photography and Friedman's work is very much within this tradition. But inasmuch as the formalist criteria employed in modernist criticism involve such concepts as truth to materials, it is an open question as to whether photography can renounce its indexical relation to the world and still succeed as photography. Friedman takes as his aesthetic foundation and modus operandi these notions of autonomy and self-referentiality. By consistently producing images that challenge conventional assumptions of what constitutes the photographic, and which often approach total abstraction, he can be seen to have carried the position to its logical extreme.

—Abigail Solomon-Godeau

FRISSELL, Toni.

American. Born in New York City, 10 March 1907. Educated at Lincoln School, New York, 1914-20; Miss Porter's School, Farmington, Connecticut, 1920-25; mainly self-taught in photography, but influenced by brother Varick, a documentary filmmaker. Married Francis McNeill Bacon III in 1932; children: Varick and Sidney. Caption writer, 1930-31, and Fashion Photographer, 1931-42, *Vogue* magazine, New York; Official Photographer, American Red Cross, also working for the Women's Army Corps, United States Air Force and Office of War Information, in England and Scotland, 1941, 1944-45; freelance photographer, New York, working for *Harper's Bazaar, Life, Look, Vogue,* and *Sports Illustrated,* from 1942; now retired. Address: 77 Harbor Road, St. James, Long Island, New York 11780, U.S.A.

Individual Exhibitions:

1961 *A Number of Things,* IBM Gallery, New York (retrospective; toured the United States)
1967 *View from My Camera,* Philadelphia Museum of Art (toured the United States)
1975 *The King Ranch,* Amon Carter Museum, Fort Worth, Texas (toured the United States)

Selected Group Exhibitions:

1955 *The Family of Man,* Museum of Modern Art, New York (and world tour)
1968 *Man in Sport,* Baltimore Museum of Art (toured the United States)
1975 *Fashion Photography: 6 Decades,* Hofstra University, Hempstead, New York (toured the United States)
1976 *Women Look at Women,* Library of Congress, Washington, D.C. (toured the United States)
1977 *The History of Fashion Photography,* International Museum of Photography, George Eastman House, Rochester, New York (travelled to the Brooklyn Museum, New York; San Francisco Museum of Modern Art; Cincinnati Art Institute; and Museum of Fine Arts, St. Petersburg, Florida)
1979 *The Fashionable World,* Stephen White Gallery, Los Angeles
 Recollections: 10 Women of Photography, International Center of Photography, New York (toured the United States)

Collections:

Library of Congress, Washington, D.C. (main collection); Metropolitan Museum of Art, New York; Fashion Institute of Technology, New York; International Museum of Photography, George Eastman House, Rochester, New York.

Publications:

By FRISSELL: books—*A Child's Garden of Verses,* with poems by Robert Louis Stevenson, New York 1944; *The Happy Island,* New York 1946; *Toni Frissell's Mother Goose,* New York 1948; *The King Ranch,* with others, with an introduction by Holland McCombs, Fort Worth, Texas and New York 1975; article—"I Went to England for the American Red Cross" in *Vogue* (New York), 1 February 1943.

On FRISSELL: books—*The Studio,* by Time-Life editors, New York 1972; *The Vogue Book of Fashion Photography* by Polly Devlin, with an introduction by Alexander Liberman, London 1979;

The History of Fashion Photography by Nancy Hall-Duncan, New York 1979; *Recollections: 10 Women of Photography,* edited by Margaretta K. Mitchell, New York 1979; articles—"American Aces: Toni Frissell" by Frank Crowninshield in *U.S. Camera* (New York), December 1939; "Toni Frissell: A Number of Things" in *Photography Annual 1962,* New York 1961; "When the Cameraman Is a Woman" in the *Chicago Sunday American Magazine,* 25 October 1964; "Toni Frissell: Portfolio" in *Infinity* (New York), December 1967; "Toni Frissell Bacon: 'I'm Sixty-Six and I Love It'" in *Vogue* (New York), June 1973.

For the photographer Toni Frissell the camera was an extension of her eye, leading her to adventures in every part of the world. Her career was initiated by a series of summer pictures of her young friends called "Beauties at Newport," published by *Town and Country* in 1931. From there she began an eleven-year career as a staff photographer for *Vogue.* In the 1940's she turned free lance, working over the years for many journals including *Harper's Bazaar, Sports Illustrated,* and *Life.*

Best known for her work in fashion, Toni Frissell was the first to work out-of-doors and on location with models, promoting the casual, unselfconscious, scrubbed, sporty look which she herself exemplified. As a sports photographer she was one of few women photographers included in an exhibition called *Man in Sport* in 1968 at the Baltimore Museum of Art. She and her husband love travel and sports, and assignments have taken them over the years to ski in remote areas of the Alps, and to visit unusual, privately held places such as Medway Plantation and the King Ranch. Her most proud moment came when she traveled to Europe with both the Red Cross and the Air Corps during World War II, bringing back photo documents of their work.

After the war, her interests turned from fashion to people and events. She was drawn particularly to the British for much of her photojournalism during this period. One of the great treasures in the Frissell Collection is a series of photographs of Winston Churchill and his family, and over the next decade Toni Frissell recorded the way of life of the upper class in Britain—nannies and their prams in Hyde Park, royalty at garden parties and fox hunts, dukes and duchesses behind the scenes at the coronation of Queen Elizabeth II in 1953 and a series of fine portraits of families and children.

If her camera was a passport to a wide world of action, sports and glamour, she also created her own storybook at home, using family and friends to pose much as the Andrew Wyeth family and neighbors posed for the painter. Some of her most personal work portrays children dressed up in old costumes. In her mind the camera has the innocence of a child's vision. When her own two children were young, Toni made many photographs of them, some illustrating Robert Louis Stevenson's *A Child's Garden of Verses,* published in book form in 1944, and others illustrating *Mother Goose* published in 1948.

A Frissell photograph is a straightforward record of the photographer's response to the moment or the person. She photographed the worlds in which she lived and traveled as she let her subjects speak for themselves.

Both Hallmark and IBM have sponsored solo shows of a broad cross-section of her work. And her complete collection, now in the Library of Congress, stands as a remarkable record of a stratum of society. Most of the time she herself was as much a participant as a spectator, a fact that gives to her photographs the comfortable inside view: a midcentury album. As Toni Frissell comments in *Recollections: 10 Women of Photography,* "I've been lucky to observe a segment of society as it was lived and I think that my work will have greater value in the next century as a record of a vanished way of life."

—Margaretta K. Mitchell

FUJII, Hideki.

Japanese. Born in Tokyo in 1934. Educated in Tokyo schools; studied photography at Nihon University, Tokyo. Worked as an assistant to the photographer Shotato Akiyama, Tokyo, then as a fashion and magazine photographer for Fujin Seikatsusha publishing company, working for *Fukuzo* magazine, then as an advertising photographer with the Nihon Design Center, Tokyo; currently freelance advertising and fashion photographer. Address: 4396-2 Iiyama, Atsugi-shi, Kanagawa Prefecture 243-02, Japan.

Hideki Fujii is a fashion photographer in modern Japan. He was born in Tokyo in 1934, and became interested in photography while still in high school. He joined an amateur photographic society, and eventually his interest became more serious. At that time, quite by chance, he happened to photograph a cinema on fire: that snapshot was published in a newspaper, a decisive factor in Fujii's electing to enter photography professionally. He studied at the Department of Photography, Nihon University, and while there, he was employed as an assistant to the professional photographer Shotaro Akiyama. Having spent three years as Akiyama's assistant, he joined the publishing house Fujin Seikatsusha. There, he took fashion photographs for the magazine *Fukuzo* (Costume). He quit after three years, and joined the Nihon Design Center, an advertising agency, where he was in the commercial photography department. After another three years, he left to freelance.

Fujii says that he had gradually acquired the basic techniques during these formative years: in the first three years with Akiyama, he mastered the rudiments of photographic art; in the second term of three years with Fujin Seikatsusha he added the techniques of fashion photography to his repertoire; in the final three years with Nihon Design Center he began to appreciate the commercial aspects of photography. His experiences in these years must have been invaluable in the making of his mature photographic sensibility.

The first major commission Fujii received as a freelance came from Max Factor. Prior to this, he had met a model, Hiromi Oka, with whom he had done a series of sessions; it was mainly on the strength of these photographs that Max Factor were persuaded to hire him. The first poster he produced for them employed a photo from one of those sessions with Oka. The collaboration between Oka and Fujii rocketed them to pre-eminence in the fashion world.

Fujii is a perfectionist, trying every technical experiment to fix his image in print. He is exceptional in his explorations, devoting much time and effort to his work: it is almost abnormal the effort he puts into a single image. Someone unfamiliar with his work as whole, on seeing him at work, might think him simply a technician. Yet his techniques of fixing, with their artisan-like overtones, are most intriguing and must be very difficult for others to emulate. As for the almost-stylized, noble and beautiful images Fujii creates—these are beyond technique.

Lately, he has taken another direction, towards the aesthetic of the oriental, using female portraiture to investigate the exotic East. These photographs have been particularly appreciated in Europe and in the United States.

—Takao Kajiwara

See Color Plates

FUKASE, Masahisa.

Japanese. Born in Bifuka, Hokkaido, 25 February 1934. Studied photography at the Nihon University, Tokyo, Dip.Photog. 1956. Married Yohko Fukase (now divorced). Worked as a photographer for the Daiichi Advertising Company, Tokyo, 1956-65, and for the Nihon Design Center and Kawada Shobo, Tokyo, 1965-68. Freelance photographer, Tokyo, since 1968. Recipient: Nobuo Ina Prize, Tokyo, 1977. Address: Room 501, 2-33-16 Jingumae, Shibuya-ku, Tokyo, Japan.

Individual Exhibitions:

1960 *Sky over an Oil Refinery*, Konishiroku Gallery, Tokyo
1961 *A Slaughterhouse*, Ginza Gallery, Tokyo
1973 *Big Fight*, Waren House, Seibu, Tokyo
1976 *Aha!/Crows*, Ginza Nikon Salon, Tokyo (also shown at Shinjuku Nikon Salon, Tokyo, and Nikon Salon, Osaka)
1978 *Yohko*, Nikon Salon, Tokyo (also shown at Shinjuku Nikon Salon, Tokyo)
1979 *Blackbirds*, Ginza Nikon Salon, Tokyo (also shown at Shinjuku Nikon Salon, and Nikon Salon, Osaka)
1981 *Blackbirds—Tokyo*, Ginza Nikon Salon, Tokyo (also shown at Nikon Salon, Osaka)

Selected Group Exhibitions:

1974 *New Japanese Photography*, Museum of Modern Art, New York (toured the United States)
1977 *Neue Fotografie aus Japan*, Kulturhaus, Graz, Austria (travelled to Vienna)

Masahisa Fukase

1979 *Japanese Photography Today and Its Origins*, Galleria d'Arte Moderna, Bologna (travelled to the Palazzo Reale, Milan; Palais des Beaux-Arts, Brussels; and the Institute of Contemporary Arts, London) *Japan: A Self-Portrait*, International Center of Photography, New York

Collections:

Nihon University, Tokyo; Museum of Modern Art, Tokyo.

Publications:

By FUKASE: books—*Homo Ludens*, Tokyo 1971; *Yohko*, Tokyo 1978; *The Straw Hat Cat*, Tokyo 1978.

On FUKASE: books—*New Japanese Photography*, exhibition catalogue, by John Szarkowski and Shoji Yamagishi, New York 1974; *Neue Fotografie aus Japan*, exhibition catalogue, by Otto Breicha, Ben Watanabe and John Szarkowski, Graz and Vienna 1977; *Japanese Photography Today and Its Origin*, exhibition catalogue, by Attilio Colombo and Isabella Doniselli, Bologna 1979; *Japan: A Self-Portrait*, exhibition catalogue, by Shoji Yamagishi, Cornell Capa and Taeko Tomioka, New York 1979.

The exhibition *New Japanese Photography* at the Museum of Modern Art in New York in 1974 included work by Masahisa Fukase, who had used his wife Yohko as a model. There have been several examples of the intimacy between photographer and model emanating throughout their mutual work, notably Weston's pictures of Charis and Callahan's pictures of Eleanor. Fukase was attempting to explore neither Weston's sensuality nor Callahan's plastic, sculptural sense. His intimacy with Yohko surfaced in a long, narrative drama with Yohko at the centre of the stage and himself as both voyeur/spectator and leading protagonist. He continued to photograph Yohko until 1976. In the wake of their divorce he returned to his native Hokkaido. The chance picture of a flock of crows crytallised images of solitude and death appropriate to his sombre mood, and he began a series on the birds. He photographed the crow in the snow and in the night, the bird as symbol and the bird in death. The silver eye and black silhouette were photographed in a similar convention to sumi-e ink painting, like brush strokes in the sky. The crows became a running image punctuating the Yohko series to which he returned and exhibited and published in 1978.

The complete series opens with the black silhouette of the crow in flight followed by a macabre image of dead flesh—two pigs on hooks hang against the blood-splattered walls of the slaughterhouse. Yohko appears in white on her wedding day; the optimism is soon destroyed on masked walks across the wastelands of Tokyo housing. The intimate domesticity is broken by Yohko in rehearsal then in performance on the Noh stage. The drama continues in the fields, by the coast and in a northern town, until Yohko is transported to the back streets of New York, a stranger hurrying on the sidewalk or lost among the winos of some Bowery slum. The personal relationship is charted to the final separation with Yohko resolute again on the Noh stage and Fukase himself left with a final image of a sky swarming with crows.

Fukase's series sustains an intimate but deeply melancholic narrative. In his recent work, exhibited in Europe in 1979, he has moved from such personal exposure to a much more formal use of an old, large format Anbako camera in a reaction back to the meticulous detail of early photography.

—Mark Holborn

FULTON, Hamish.
British. Born in London in 1946. Educated at Hammersmith School of Art, London, 1964-65; St. Martin's School of Art, London, 1966-68; Royal College of Art, London, 1968-69. Professional artist since 1970. Address: c/o Waddington Galleries, 34 Cork Street, London W1, England.

Individual Exhibitions:

1969 Galerie Konrad Fischer, Dusseldorf
1970 Galleria Sperone, Turin
1971 Galerie Konrad Fischer, Dusseldorf
 Situation, London
 Richard Demarco Gallery, Edinburgh
1972 Galleria Sperone, Turin
 Art and Project, Amsterdam
 Galleria Toselli, Milan
 Galerie Konrad Fischer, Dusseldorf
 Museum of Modern Art, Oxford
 Galerie Yvon Lambert, Paris
1973 Kabinett für Aktuelle Kunst, Bremerhaven
 Stedelijk Museum, Amsterdam
 Galleria Sperone-Fischer, Rome
 Situation, London
 Galerie Yvon Lambert, Paris
 Art and Project-M.T.L., Antwerp
1974 Galleria Marilena Bonomo, Bari, Italy
 Museum of Modern Art, Oxford
 Galleria Sperone, Turin
 Galerie Konrad Fischer, Dusseldorf
1975 Art and Project, Amsterdam
 Galerie Rolf Preisig, Basle
 P.M.J. Self Gallery, London
 Kunstmuseum, Basle
1976 Sperone-Westwater-Fischer Gallery, New York
 Cusack Gallery, Houston
 Institute of Contemporary Arts, London
 Hester van Royen Gallery, London
 Robert Self Gallery, London
 Claire Copley Gallery, Los Angeles
1977 Galerie Rolf Preisig, Basle

Hamish Fulton: *Cusco to Cusco: A Circular Road Walk*, **Peru, 1974**

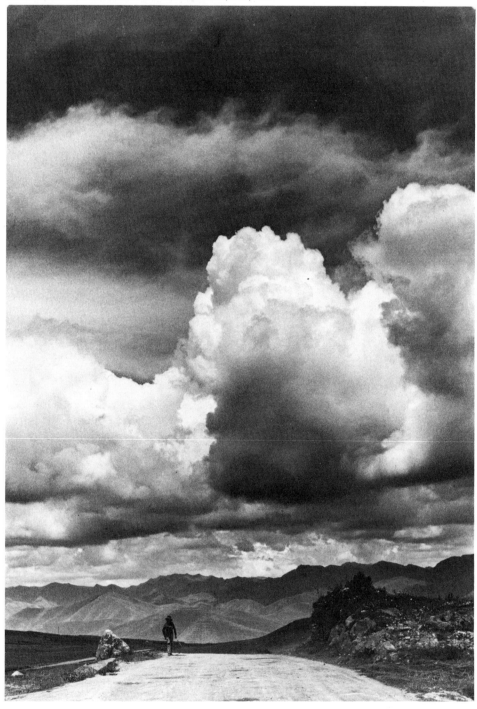

City Museum, Canterbury, Kent
Stedelijk Van Abbemuseum, Eindhoven, Netherlands
Robert Self Gallery, London
Sonnabend Gallery, New York
1978 Galerie Konrad Fischer, Dusseldorf
Galerie Nancy Gillespie/Eliszabeth de Laage, Paris
Museum of Modern Art, New York (project exhibition)
Centre d'Art Contemporain, Geneva
Galerie Tanit, Munich
1979 Whitechapel Art Gallery, London
Galerie Rolf Preisig, Basle
Art and Project, Amsterdam
1980 Galerie Gillespie de Laage, Paris
Thackrey and Robertson Gallery, San Francisco
Sperone-Westwater-Fischer Gallery, New York

Selected Group Exhibitions:

1969 *Konzeption/Conception*, Städtisches Museum, Leverkusen, West Germany
1970 *Information*, Museum of Modern Art, New York
1972 *Documenta 5*, Kassel, West Germany
1973 *Medium Fotografie*, Städtisches Museum, Leverkusen, West Germany
1974 *Project 74*, Kunsthalle, Cologne
1975 *Artists over Land*, Arnolfini Gallery, Bristol
1978 *Art as Photography, Photography as Art*, Institute of Contemporary Arts, London
23 Photographers/23 Directions, Walker Art Gallery, Liverpool
1980 *The British Art Show*, Mappin Art Gallery, Sheffield (toured the U.K.)

Collections:

Tate Gallery, London: Arts Council of Great Britain, London; British Council, London; Stedelijk Museum, Amsterdam; Kunstmuseum, Basle; Musée d'Art Moderne, Paris; Art Gallery of South Australia, Adelaide; Museum of Modern Art, New York; Metropolitan Museum of Art, New York; National Gallery of Canada, Ottawa.

Publications:

By FULTON: books of photographs—*Hollow Lane*, London 1971; *The Sweet Grass Hills of Montana*, Turin 1971; *10 Views of Brockmans Mount*, Amsterdam 1973; *Hamish Fulton*, 1974; *Skyline Ridge*, London 1977; *Nepal 1975*, Eindhoven, Netherlands 1977; *Nine Works, 1969-1973*, London 1977; *Roads and Paths*, Munich 1978.

My work is about the experience of walking. The framed artwork is about a state of mind—it cannot convey the experience of the walk. A walk has a life of its own; it does not need to be made into art. I am an artist and choose to make my artworks from real life experiences. All the walks I make are easy. I prefer to go out into the world and be influenced and changed by events rather than work from my imagination in one fixed place.

—Hamish Fulton

Hamish Fulton is a sculptor who takes photographs, and the photographs become the exhibited art. His concern is not documentary reportage, but the photograph as a kind of souvenir, memento, allusive metaphor, for his work. Definition, print quality, brilliance of composition, accuracy of description of the observed scene are thus not necessar-

ily part of the work, which is not in any event professional photography in the usual sense.

The action of his work—walking through landscape—takes place throughout the world; sometimes he works alone, sometimes he walks with friends. His photographs, very often strongly horizontal in bias so that the spectator has a sense of walking as a passage through time which crosses space, are grainy, and typically unpeopled. Photographs are usually taken with the forward thrust of the walk, not looking backwards. A number of books of his photographs have been published, and photographs as exhibited and as published are captioned. But the captions may not be directly descriptive of the photograph, rather an amplification of mood, feeling or even observation that has taken place beyond the picture frame. A few, or hundreds of photographs may be taken on each walk. Invariably only a very few are used.

It may well be argued that what Fulton has done is to join in with his own distinctive way of working and looking in a tradition that is specifically British, even, perhaps, English: the romantic attitude towards the meaning of landscape, the desire to be part of it as well as to show it. Thus Fulton's photographs are paradigms of effort. While normally a half hidden reaction to a photograph is a belief in its authenticity—no matter how much our conscious mind may grasp the fact, in fact, of a photograph's having been manipulated, handled, treated—the reaction to captioned framed photographs by Fulton (which are sometimes isolated, sometimes in series) is a variation: the photograph is a proof not of itself, the authenticity of the depicted scene, but of Fulton's activity in the landscape, of his presence.

Some of his work has indeed extracted segments of landscape, or landscape seen through time, as in Brockman's Mount, a hill in Kent near his home, which he photographed over a period of nearly a year, to produce *10 Views*, under varying conditions of light, time, weather, atmosphere. *Hollow Lane* shows in photographs part of the Pilgrims Way between Canterbury and Winchester. After 1973 Fulton decided that work did not exist without the relationship of his walking in landscape: much of the walked landscape has been over well-worn tracks, paths, old ways, particularly poignant in remote landscapes. At some point in the activity, Fulton, who hardly ever acts in the landscape, other than walking through it (that is, unlike other land sculptors, he does not rearrange landscape elements such as stones or pieces of wood to form manipulated sculptures in the natural environment), decides that a certain view, or segment, coinciding with his feelings, distills the work: this distillation is confirmed in a photograph, or photographs. Thus the photograph is an analogue for the experience of the walk. "Views are chosen because they symbolize the walk." This is borne out by the titles for exhibitions and publications: for example, *Skyline Ridge*, "16 Selected Walks," or *Roads and Paths*.

Interestingly, Fulton claims not to be interested in Western landscape painting, but rather in the Oriental landscape tradition. Certainly in terms of certain Eastern attitudes towards the importance simply of being and feeling, this is understandable.

The photographs exist as an expression of that being and feeling: for instance, the size of the photograph reflects his attitude and feeling toward the walk in landscape it commemorates. Fulton does not develop or print his photographs, and he uses a hand-held camera, working exclusively in black-and-white.

By his use of photography in this way Fulton implicity questions traditional views of art and photography. Certainly his photographs are not professional in the commonly held view of the term. Yet fundamentally images convey experience, and with its combination of caption and image, in art work exhibited on gallery walls, in the pages of magazines and periodicals, and in books, Fulton's work is amongst that which has expanded the public response to the individual experience of landscape—remote,

exotic, near and intimate. Again, it is the "examination of life" which is the impetus behind Fulton's work.

—Marina Vaizey

FUNKE, Jaromír.
Czechoslovak. Born in Skuteč, 1 August 1896. Educated at Kolín Gymnasium, Czechoslavakia, 1906-15; studied medicine, 1915-18, then law, 1918-22, at Charles University, Prague; studied aesthetics at the University of Bratislava, 1932-33. Married Anna Kellerová in 1935; daughter: Miloslava. Freelance photographer, Prague, 1922 until his death, 1945. Instructor, School of Arts and Crafts, Bratislava, 1931-35; Professor, State Graphic School, Prague, 1934-44; worked for the DORKA Co-operative, Prague, 1944-45. Agent: Galerie Rudolf Kicken, Albertusstrasse 47-49, D-5000 Cologne 1, West Germany. *Died* (in Prague) 22 March 1945.

Individual Exhibitions:

1931 Aventinum, Prague
Kolin in Photographs, Kolín, Czechoslavakia
1935 Družstevni Práce, Prague (retrospective)
1936 School of Arts and Crafts, Bratislava (retrospective)
1940 *Louny in Photographs*, Louny Museum, Czechoslavakia
1943 *St. Bartholemew's Cathedral*, Kolín Museum, Czechoslavakia
1946 Kolín Museum, Czechoslavakia (and 1947, 1953; retrospectives)
1958 Fotokabinett Jaromír Funke, Brno, Czechoslavakia (retrospective)
1960 Kolín Museum, Czechoslavakia (retrospective)
1965 Vincenc Kramář Gallery, Prague (retrospective)
1971 Profil Gallery, Bratislava (retrospective)
1976 Kolín Museum, Czechoslavakia (retrospective)
Galerie Lichttropfen, Aachen, West Germany (retrospective)
1977 Stadtisches Museum, Bochum, West Germany (retrospective)
1978 Galerie Nagel, Berlin
Galerie Louis-Philippe, Paris

Selected Group Exhibitions:

1924 *Association of Czech Clubs*, Prague
1927 *Czech Photographic Society Exhibition*, Prague (and 1929)
1931 *Czech Studio*, Aventinum, Prague
1933 *Social Photography*, Left Front Film-Photo Group, Bratislava
1936 *International Exhibition of Photography*, SVU Mánes Gallery, Prague
1938 *SVU Mánes Photo Section*, SVU Mánes Gallery, Prague
1939 *100 Years of Czech Photography*, Museum of Decorative Arts, Prague
1940 *Photo-Amateurs Club Exhibition*, Kolín Museum, Czechoslovakia
1981 *Germany: The New Vision*, Fraenkel Gallery, San Francisco

Collections:

Museum of Decorative Arts, Prague; Moravian Gallery, Brno, Czechoslavakia; Neue Sammlung, Munich; Folkwang Museum, Essen; Museum of Fine Arts, Boston; New Orleans Museum of Art; Museum of Fine Arts, Houston; University of New Mexico, Albuquerque; San Francisco Museum of Modern Art.

Publications:

By FUNKE: books—*Fotografie vidí povrch* (*Photography Sees the Surface*), editor, with Ladislav Sutnar, Prague 1935; *Svatovíské Triforium* (*Triforium of St. Vitus*), with an introduction by Zdeněk Kalista, Prague 1946; *Pražske Kostely* (*Churches of Prague*), with an introduction by Vojtěch Volavka, Prague 1946; *Muj Kolín* (*My Kolin*), with an introduction by J. Janik, Prague 1947; *Jaromír Funke*,

with an introduction by Antonín Dufek, Prague 1979; portfolios—*Karolinský cyclus* (*Cycle of Charles IV*), Prague 1943; *Svatovitsky cyclus* (*Cycle of St. Vitus*), Prague 1943; *Tynsky cyklus*, Prague 1943; *Mikulášský cyklus* (*Cycle of St. Nicholas*), Prague 1944; *Jakubský cyklus* (*Cycle of St. James*), Prague, 1944; *Bílkova Křížova cesta* (*Bílek's Sculptures: The Way to Golgotha*), Prague 1944; articles—"Krajinářská fotografie" in *Fotografický Obzor* (Prague), no. 1, 1925; "K výstavě dr. Ružicky v CFKA v Praze" in *Fotografický Obzor* (Prague), vol. 33, no. 6, 1925; "Man Ray" in *Fotografický Obzor* (Prague), vol. 35, 1927; "Fotogenické zátiší" in *Foto* (Prague), no. 2, 1928; "Předmluva" in *2. Clenská výstava CSF*, Prague 1929; "II. mezinárodní výstava fotografií v Mánesu" in *Jak žijeme* (Prague), no. 2, 1933; "Fotografie zustane fotografií in *Volné směry* (Prague), 1935, reprinted in *Fotografie* (Prague), no. 3, 1946; "Od pictorialismu k emoční fotografii" in *Fotografický Obzor* (Prague), no. 7, 1936; "O staré fotografii" in *Světozor* (Prague), no. 29, 1936; "Fotografujte domov" in *Ceská Fotografie*

1940, Prague 1940; "Fotografovaný člověk" in *Fotografický Obzor* (Prague), no. 3, 1940; "Fotografovaná krajina" in *Fotograficky Obzor* (Prague), no. 6, 1940; "Od fotogramu k emoci" in *Fotografický Obzor* (Prague), no. 11, 1940, reprinted in *Revue Fotografie* (Prague), no. 1, 1976; "Kritický výběr" in *Fotografický Obzor* (Prague), no. 1, 1941.

On FUNKE: books—*Jaromír Funke* by Lubomír Linhart, Prague 1960; *Jaromír Funke: Fotografie* by Ludvík Souček, Prague 1970; articles—"Jaromír Funke" by Petr Tausk in *Camera* (Lucerne), January 1977; "Avantgardní československy fotograf Jaromír Funke 1896-1945" by Z. Kirschner in *Fotografie* (Prague), no. 1, 1978; "Jaromír Funke" by Anna Fárová in *Creative Camera* (London), January 1978.

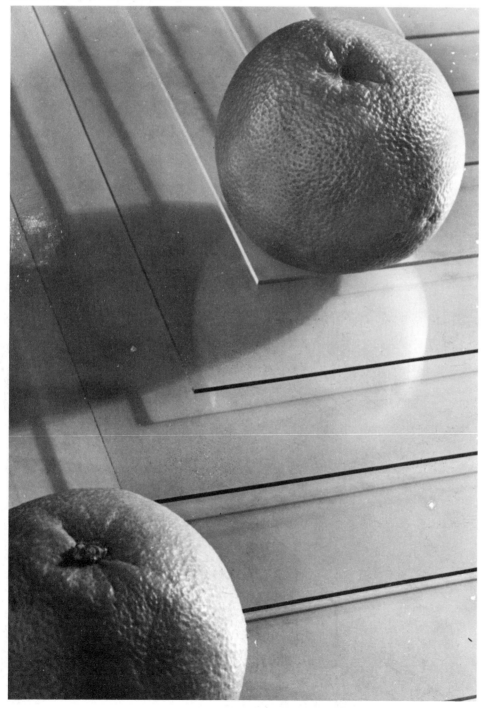

Jaromír Funke: From *Photography Sees the Surface*, 1935

Jaromír Funke was, after Josef Sudek, the most important photographer in Czechoslovakia during the 1920's and 30's. The beginning of his creative work was very near to the "Straight Photography" of Stieglitz: he attempted to find his photographic subjects in the real world; he respected the untouchability of negatives when enlarging them into positives on bromsilver papers; and he regarded the primary image as of ultimate importance. In the latter half of the 1920's Funke was influenced simultaneously by the surrealistic approach and by the "New Objectivity." Quite often he amalgamated both these trends in images expressing his admiration for the hidden beauty of arrangements formed by chance in the everyday world.

Yet, a sense of poetry was for Funke the main driving force of his work, and thus surrealism, in its more provocative forms, tended to lose out to his usual concerns; likewise, his version of the "New Objectivity" never tended to a sober or even cold depiction of reality. The best way to describe the influence of these trends in his work is to note that very often Funke photographed an *objet trouvé* that resembled a surreal vision and did so with the greatest possible richness of detail, as was typical of other adherents of the "New Objectivity" at that time.

Another manifestation of his attraction to surrealism was in the creative photographic games he played—with, say, a bottle or another trivial object, a mirror and light, creating an interesting arrangement, an interesting composition of forms. Some of these images, though created in a purely photographic way, looked like photogrammes.

Although Funke used in his work impulses from the subconscious with success, he was also a theoretician, and some of his best photographs were the result of an endeavour to confirm one of his own theories in practice. His intellectual approach predestined Funke to teach photography, first in Bratislava and then in the State Graphic School in Prague. His pedagogical activity helped him to broaden still further his research into the nature of photography, which in turn enabled him to a better understanding of the perimeters of his own creative work, the pure use of the proper medium.

—Petr Tausk

G

GAGLIANI, Oliver (Lewis).

American. Born in Placerville, California, 11 February 1917. Educated in South San Francisco schools, 1928-37; studied music at San Francisco State College, now California State University at San Francisco, 1940-42; studied at the California School of Fine Arts, now San Francisco Art Institute, 1946, and studied engineering at the Heald College of Engineering, San Francisco, 1951-53; mainly self-taught in photography, but attended workshops under Ansel Adams, Minor White, and Ruth Bernhard. Served as an aircraft mechanic in the United States Army, in the Pacific, 1942-45. Married Laura Frugoli in 1948; children: Laurence and Olivia. Independent photographer, San Francisco, since 1948. Instructor in Photography, South San Francisco High School, 1967-69, University of California Extension at San Francisco, 1969-74, Image Circle, Berkeley, California, 1970-71, and Zone System Workshop, Ansel Adams Gallery, Yosemite, California, 1974-75; Graduate Instructor in Photography, California State University at San Francisco, 1973-74; also, instructor in private photography workshops, San Francisco, since 1965. Founder Member, Visual Dialogue Foundation, San Francisco, 1969; Advisory Trustee, Friends of Photography, Carmel, California, 1974-76. Recipient: National Endowment for the Arts Grant, 1976; Fisher Grant, University of Arizona, Tucson. Address: 605 Rocca Avenue, South San Francisco, California 94080, U.S.A.

Individual Exhibitions:

1953 Peninsula Art Association, San Mateo, California
1954 California Palace of the Legion of Honor, San Francisco
1955 International Museum of Photography, George Eastman House, Rochester, New York
1958 *California State Park Series*, Oakland Public Museum, California (travelled to the Santa Barbara Museum of Art, California)
1961 *Color in the Photographic Print*, San Francisco Museum of Art (travelled to Indiana University, Bloomington, 1962, and Fresno State University, California, 1963)
1964 Underground Gallery, New York
1968 *The Magic of the Image*, Focus Gallery, San Francisco (travelled to Arizona State University, Tempe)
1969 *The Visual Dialogue of Oliver Gagliani*,
Camera Work Gallery, Costa Mesa, California
University of Iowa, Iowa City
International Museum of Photography, George Eastman House, Rochester, New York (with Todd Walker)
1970 Ohio State University, Columbus
Bakersfield College, California
Middle Tennessee State University, Murfreesboro
1971 St. Mary's Art Center, Virginia City, Nevada
1974 Witkin Gallery, New York
1975 Diablo Valley College Art Gallery, Pleasant Hill, California
1976 Printworks Gallery, Seattle
Chapman College, Orange, California
1977 *Festival of Tasmania*, Hobart
Photographer's Gallery, Melbourne
1978 Neary Gallery, Santa Cruz, California
Photosynthesis, Fresno, California
Glanville Gallery, Perth, Western Australia
1979 Galleria Il Diaframma, Milan (toured Europe)
Photogallery International, Tokyo
1980 Yuen Lui Gallery, Seattle
Afterimage, Dallas
1981 Daniels Gallery, Carmel, California
Susan Spiritus Gallery, Newport Beach, California
Jeb Gallery, Providence, Rhode Island

Selected Group Exhibitions:

1954 *9 Bay Area Photographers*, Photographers Gallery, San Francisco
1959 *9 Photographers from the West Coast*, Indiana University, Bloomington
1967 *Oliver Gagliani's 1966 Workshop*, San Francisco State College
1968 *Light⁷*, Massachusetts Institute of Technology, Cambridge
The Magic of the Image, Focus Gallery, San Francisco
1969 *Vision and Expression*, International Museum of Photography, George Eastman House, Rochester, New York (toured the United States, 1969-71)
10 Teachers of Creative Photography, Lawson Gallery, San Francisco
1973 *Polaroid Photography*, Focus Gallery, San Francisco (travelled to the Neikrug Gallery, New York)
1976 *American Photography of the 20th Century*, Mt. St. Mary's College, Los Angeles
1977 *The Great West: Real/Ideal*, University of Colorado, Boulder (subsequently Smithsonian Institution travelling exhibition: toured the United States)

Collections:

Museum of Modern Art, New York; Intnl. Museum

Oliver Gagliani

of Photography, George Eastman House, Rochester, New York; Visual Studies Workshop, Rochester, New York; Massachusetts Institute of Technology, Cambridge; Art Institute of Chicago; Center of the Eye, Sun Valley, Idaho; Phoenix College, Arizona; Pasadena Art Museum, California; San Francisco Museum of Modern Art; Bibliothèque Nationale, Paris.

Publications:

By GAGLIANI: books—*Color Portfolio Number One*, San Francisco 1960; *Oliver Gagliani*, with introductions by Van Deren Coke and Leland Rice, and an afterword by Jack Welpott, Menlo Park, California 1975; *Oliver Gagliani*, portfolio of 4 photos, Sunnyvale, California 1978; film—*One Final Expression*, 1974.

On GAGLIANI: books—*Light⁷*, edited by Minor White, Rochester, New York 1968; *Vision and Expression* by Nathan Lyons, New York 1969; *The Great West: Real/Ideal* edited by Sandy Hume and others, Boulder, Colorado 1977; *The Photograph Collector's Guide* by Lee D. Witkin and Barbara London, Boston and London 1979; articles—"Gallery: Oliver Gagliani in *American Photographer* (New York), February 1980.

Everything that exists in this world, whether it be a tree or a rock, a building or a chair, every object has a life of its own. It is a living thing to me, a being that exists within a given span of time. At some point it was put together, it had its birth as a unit, then it fills its life span of so many years, and eventually reaches decay and death. The problems it faces are the same problems that face human beings. And from the experience of these problems, these objects have gained a special wisdom.

I believe that the only thing we are after as human beings, the only real goal of this life, is to acquire wisdom, the knowledge of something outside of ourselves which in turn gives a further knowledge of ourselves. Everything else is secondary. And from these objects of the world, from their own lives which often far outlast our own, we can acquire a wisdom which would otherwise be inaccessible to us. It is the photographer, through the medium of light, who must confront these objects directly, not as he would like them to be, but as they are in themselves. It is the measure of his success as to how deeply he is able to perceive the life which they have experienced, and penetrate the surface to tap the wisdom which they have to offer.

—Oliver Gagliani

Oliver Gagliani is one of those poets of the lens who focus their attention on the smallest things around us. A broken-down wall, a broken window, a corner of the landscape—these are for him, and through his pictures also for us, a whole universe. He takes objects and images that look ordinary and humdrum and draws from them a visual symphony that helps us to understand the world better.

The word symphony is not used by chance. Gagliani began by studying music. Only later, at a mature age, did he take up photography. As he himself tells us, two exhibitions that he saw in San Francisco just after the war made a great impression on him. One was by Paul Strand, the other by Weston. "The contrast that Strand could make between light and shade, between object and space, was marvellous," says Gagliani. "It made me think of music, which I had been studying for a long time." We can find abundant traces in his photographs of this passion of his for grey tones and the arrangement of masses and planes in the composition of the picture. It is no coincidence that, at the beginning of his career as a photographer, he attended a workshop run by Ansel Adams. The whole of Gagliani's work

is shot through with this master's vision, his love of nature. Gagliani opens up to us a secret world of lights and shadows, of spaces, of textures. His representations are never pointless, but reveal the inward essence of things. Heir to the great American photographic tradition known as the West Coast School, in photography he leads, and to some extent has actually outrun, the path of hyper-realism. The object depicted has reference to something else, something that goes beyond the mere object itself. Gagliani's reality is reinvented, transfigured. We can also find distant echoes of the school of Subjective Photography, and this has preserved him from empty exercises in form without content. His photographs are not imitations of abstractism but are always recognizable as pictures of something, of perfectly definite objects, even if the significance of them transcends the pure and simple descriptive datum. The photographic medium is adapted to the need to extend our perception; a process of search that magnifies and makes memorable the signals received by the human eye.

Gagliani does not simply look; he succeeds in seeing, and in making us see. His technique is highly refined, very precise; like every good workman, he attributes great importance to it without becoming subject to it. A complete tonal scale of greys, a strict and subtle framing, cannot be improvised. They are the result of long study, many trials, many failures, many experiments. Gagliani does not take his photographs on the spur of the moment; he holds them within himself for a long time until they emerge, almost by magic, and easily. "You have to establish a kind of understanding with your subject," he says. "You have to go all around it, you have to observe it for a long time, until this mutual exchange, the atmosphere that is created, enables you to take the right picture, the picture that, more than any others, is full of meaning."

Mindful of his musical studies, Gagliani has not forgotten that, in photography too, accurate execution lies behind the success of a work. The greatest composer's sonata will make a poor effect if it is played by a bad musician. In the same way, in the pictures that Gagliani wants to produce, and does indeed produce, form and content must go strictly arm in arm. Each serves the other in a reciprocal exchange, resulting in a work inseparable into two parts. Hence the fascination of his pictures and of the poetry that shines out from them.

—Edo Prando

Banff Centre School of Fine Arts, Alberta, 1981. Agent: Yajima/Galerie, 307 Ste. Catherine West, Montreal, Quebec H2X 2A3. Address: 3510 Addington Avenue, Montreal, Quebec H4A 3G6, Canada.

Individual Exhibitions:

1971 Art Gallery of Vancouver
 Art Gallery of Edmonton, Alberta
1972 Mendel Art Gallery, Saskatoon, Saskatchewan
 Sir George Williams University, Montreal
 Yellowknife Library and Art Centre, Yukon
1973 Moose Jaw Art Gallery, Saskatchewan
 Mount St. Vincent University, Halifax, Nova Scotia
 Université de Sherbrooke, Quebec
 York University, Toronto
 Owens Art Gallery, Mount Allison University, Sackville, New Brunswick
1974 Memorial University, St. John, Newfoundland
1975 Yajima/Galerie, Montreal
1978 *Paintings-Drawings-Photographs*, Musée des Beaux-Arts, Montreal (travelled to the National Gallery of Canada, Ottawa, Vancouver Art Gallery, and Art Gallery of Ontario, Toronto, 1979; and Winnipeg Art Gallery, 1980)

Selected Group Exhibitions:

1972 *5 Montreal Photographers*, Optica Gallery, Montreal
1975 *5 Canadian Photographers*, Mount Allison University, Sackville, New Brunswick
1976 *Destination Europe*, Art Gallery of Ontario, Toronto (travelled to The Photographers' Gallery London, and Galleria Il Diaframma, Milan)
1979 *The Banff Purchase*, Walter Phillips Gallery, Banff, Alberta
 An Exhibition of Photography in Canada, Edmonton Art Gallery, Alberta (travelled to Glenbow Institute, Calgary, Alberta, and Mendel Art Gallery, Saskatoon, Saskatchewan)

Collections:

National Gallery of Canada, Ottawa; Canada Council Art Bank, Ottawa; Department of External Affairs, Ottawa; Musée d'Art Contemporain, Quebec; Montreal Museum of Fine Arts; Walter Phillips Gallery, Banff Centre, Alberta; Owens Art Gallery, Mount Allison University, Sackville, New Brunswick.

Publications:

On GAGNON: books—*Charles Gagnon*, exhibition catalogue, with text by Philip Fry, Montreal 1978; *The Banff Purchase: A Survey of Photography in Canada* by Penny Cousineau, Banff and Toronto 1980; articles—"Charles Gagnon" by N. Theriault in *Vie des Arts* (Montreal), December 1968; "Charles Gagnon" by D. Corbeil in *Artscanada* (Toronto), April 1970; "Charles Gagnon" by G. Guerra in *Ovo/Photo* (Montreal), June 1974; "A Canadian Portfolio" by Geoffrey James in *Artscanada* (Toronto), December 1974; "Two Exhibitions" by Penny Cousineau in *Parachute* (Montreal), Fall 1976; "Charles Gagnon—Making and Trying" by Philip Fry in *Parachute* (Montreal), Fall 1977; "Charles Gagnon: Das Fenêtre sur l'Ambigu" by Gilles Toupin in *La Presse* (Montreal), 21 October 1978; "Charles Gagnon: Le Culte de l'Ambiguité" by L. Lamy in *Vie des Arts* (Montreal), Spring 1979; "Charles Gagnon: The Ambiguous Object" by David Burnett in *Vanguard* (Vancouver), June 1979;

GAGNON, Charles.

Canadian. Born in Montreal, Quebec, 23 May 1934. Studied at College Stanislas, Montreal, 1942-48; Loyola College, Montreal, 1948-50; Parsons School of Design, New York, 1956-57; New York University, 1956-57; New York School of Design, 1958-59. Married Michiko Yajima in 1960; children: Monika, Erika and Eames. Designer, Harvey Probber Inc., New York, 1959-60; Founder-Director and Designer, Charles F. Gagnon Inc., and Gagnon/Valkus Inc., Montreal, 1961-68. Independent photographer, Montreal, since 1968. Also a painter. Associate Professor, Department of Communication Arts, Concordia University, Montreal, 1967-75. Professor, Department of Visual Communication Arts, University of Ottawa, since 1975. Recipient: Design Award, New York School of Design, 1959; Canada Council Award, 1961, 1969, 1978; National Award, and Donald Cameron Medal,

"Charles Gagnon's Point of View" by Dore Ashton in *Artscanada* (Toronto), August 1979; "Focusing on Urban and Inner Landscapes" by Georges Bogardi in *Chimo* (Montreal), May 1981.

Among some thoughts/ Works of art raise questions rather than answer them/ Talking about my own work too specifically is contradictory to its aim/ I am not interested in raising such questions directly about anything in particular but possibly to record a catalyptic non-event which rang true at the time (for me)/ Art is but a distillation concocted at a particular time and place (not about a particular time and place) thru unknown filters permitting us to clarify for ourselves what "being" is about/ Someone wrote: "Art is the mirror conscience of the soul"/ In my work I am concerned with communion rather than communication/ The material stuff of the arts which is normally labeled "the formal issues" is but a part of the vocabulary not the content itself/ The content hinted by the work really comes from the interaction between it (the work) and the spectator, and the quality of this interaction is to a great extent the responsibility of the viewer, although it is not as much a question of effort as it is a matter of compatability/ When I photograph I don't "make" anything; I don't have to. It's all around me for the seeing and taking. The seeing amazes me. The taking confirms that I am.

—Charles Gagnon

"It's the photographer's mind that clicks—not the camera's shutter," says Charles Gagnon. His subtle photographs investigate the fascination of the ordinary. They concern non-events, "nothing," Gagnon says—"irreverent irrelevance." He's not only seeing (and using) his environment as a work of art but choosing things stopped and still, or out of context (they're supposed to serve a function but don't). The effect in his photographs is of suspense: something is going to happen, but the viewer is not sure what it is. In a way, the results recall early de Chirico or Magritte. But Gagnon has a serious intent: it is society which is out of order, malfunctioning. In "Exit—Montreal" (1973), his most stripped down formal presentation, the light over the closed door is on—and there's an alarm system visible. The potential of danger from a mysterious source exists.

Gagnon's photographs are charged with spiritual and mental truths. They imply the tensions, ambiguities, and contradictions of life. For him, the camera is a tool which forces him to look at the "unbelievable" world which surrounds him. It's in the dark room, his "altar," where everything comes together. Gagnon prints dark to capture the richness and intensity of what he sees, and bring the viewer closer to the print. "The situation creates a conflict of territory between the photograph's pregnant moment and the viewer's private world."

—Joan Murray

Charles Gagnon: *9:45 p.m., Banff, Alberta*, 1979

75, 1978-79. Freelance photographer, with own studio, Har-Nevo Street, Tel Aviv, since 1977. Address: 6 Shalom-Aleichem Street, Ramat-Hasharon 47265, Israel.

Individual Exhibitions:

1980 White Gallery, Tel Aviv

Selected Group Exhibitions:

1978 *Hard Sale/ Soft Sale*, White Gallery, Tel Aviv
1979 *Polaroid Photos*, White Gallery, Tel Aviv
1980 *Photographers' Exhibition*, Artist's House Gallery, Tel Aviv
1981 *10 Israeli Photographers*, White Gallery, Tel Aviv

Avi Ganor: *Advertising Photo for Parker Pens* (original in color), 1980

GANOR, Avi.

Israeli. Born in Kfar-Saba, 8 October 1950. Educated at Hasharon High School, Neve-Magen, 1964-68; studied aeronautics at the Technion Institute of Technology, Haifa, 1969-73; studied at the San Francisco Art Institute, 1975, Pratt Institute, New York, 1976, and Parsons School of Design, New York, 1977. Married Ofra Steinman in 1977. Instructor, Bezalel Art Academy, Jerusalem, 1973-

Collections:

Tel Aviv Museum; White Gallery, Tel Aviv; Bezalel Art Academy, Jerusalem; Israel Museum, Jerusalem; The Photographers' Gallery, London.

Publications:

On GANOR: articles—"Suddenly I See a Photograph" by Ronit Shanie in *Yedioth-Ahronoth* (Tel Aviv), 28 March 1980; "A Matter of Time" by Adam Baruch in *Yedioth-Ahronoth* (Tel Aviv), 11 April 1980.

Avi Ganor is one of a handful of people in Israel who are feeding fresh photographic ideas to the public through the wide dissemination of commercial images. He is, however, operating in a market that he describes as "small and poor": "It's good there is what there is, but there isn't much. Israel is not a society with a high level of consumption. Therefore advertising is not a top developmental priority, nor should it be."

What does this mean in practice? At the most obvious level, it means a lot more organizational work for the photographer: an elaborate back-up industry simply does not exist. There are, for example, no agents to represent him to clients, no bureaux through which to book models, no stylists, no color retouchers. In fact, he can't even use Kodachrome, because there is no place in all of the Middle East to get it processed. Also, a small, restrained economy can only allot small budgets. Ganor sees himself as one of a group of photographers who've recently returned to Israel after studying abroad. "We've brought new blood to what was a pretty ossified, conventional scene. We have as much imagination or technical competence as our peers in New York or Paris, but we don't have as much money to explore our ideas." Because Israel is a very small country—there are, after all, fewer than four million of us—Ganor cannot afford that discipline which is also a luxury, style. "Style is a positive word elsewhere, something you're constantly urged to develop, to make yourself recognizable. That just doesn't go in a small market that is quickly saturated. Here I am under constant, anxiety-producing pressure to change all the time, to come up with new ideas all the time. Nor is there such a thing as specialization; it might be surreal fashion today and a complicated technical shot tomorrow."

Nevertheless, Ganor, who has the round, curl-framed face of a mischievous cherub, is very happy about his profession. He is convinced that photography's future lies with commercial photographers because, like pianists, they practice their craft every day. They work primarily in color, and Ganor has no doubt that color will soon dominate photography. Also, as commercial photography mirrors the values of the society that commissions it, the photographs increase in value over time, becoming eloquent historical records.

Ganor looks to his commercial colleagues as much for their personal work as for their professional work. His own deepest commitment, for example, is to the development of his self-assignment—street photography: "People are photography's true subject and, for me, the only interesting reality." He believes that photography as a medium has barely begun to express its potential. He feels much the same about himself: "My photographs are temporary achievements in a process of constant research. I'm creating raw material. I need to live more life before I start making conclusions."
—Bonnie Boxer

GARANIN, Anatoli.

Russian. Born in Moscow in May 1912. Educated in Moscow schools, 1919-29; self-taught in music and art. Worked as a photojournalist for various Soviet newspapers and magazines prior to the Second World War; during the war worked as reporter for *Frontovaya Illustracia*; after the war, Special Photo-Correspondent for *Soviet Union* magazine, then served as photographer to Nikita Krushchev, and travelled with him around the world. Currently, Special Correspondent of *Soviet Union* magazine; also affiliated with the avant-garde Moscow theatre Na Tagance. Lives in Moscow.

Individual Exhibitions:

1965 *Anatoli Garanin*, Moscow (has toured in various countries since 1965)
1976 *Music and Theatre in the Photographs of Anatoli Garanin*, Prague

Selected Group Exhibitions:

1975 *Soviet War Photography*, Prague

Anatoli Garanin

Publications:

On GARANIN: books—*They Photographed the War: Soviet War Photography 1941-45* by Daniela Mrázková and Vladimír Remeš, Prague 1975; *The Russian War* by Daniela Mrázková and Vladimír Remeš, New York 1977, London 1978; *Von Moskau nach Berlin* by Daniela Mrázková and Vladimír Remeš, Munich 1979.

Although he has worked all of his life as a photojournalist, Anatoli Garanin is by no means a prototype of the press photographer as usually imagined by the public. True, he is spontaneous and has amazingly quick reactions, always managing to be at the right spot at the right time, but the outward drama of events does not attract him. Through his photographs he prefers to ponder, feel and delve into the innermost soul of man. He main themes are the concealed dramas that take place far below the surface of the visible world.

Garanin was 29 years old when he joined the ranks of photographers of the "Great Patriotic War." By that time he had been on the staff of a newspaper for 9 years: he was a self-made photog-

rapher, and he was terrified of the war. It was alien to his longing for harmony, which came from his passionate love of music. War was a denial of the basic values of his life, of the humanism that he advocated. Also, it brought with it the kind of great dramas he had always tried to avoid. Garanin does not now know whether it was a feeling of gross injustice or hatred which helped him overcome his dislike of the horrors of war and his fear, but one thing is certain: that the brooding, sensitive and timid Garanin produced photographs during the war at least one of which—"Death of a Soldier"—ranks with Dmitri Balterman's famous "Sorrow" and Robert Capa's "Falling Loyalist." Everything is there: the determination and daily cares; the heroism of a soldier fighting for his country; the moment of fateful death, which each soldier expects subconsciously at any moment of the fighting while at the same time believing that is will not happen to him.

Music and the theatre—these are the two great loves in the life of Anatoli Garanin and the two great themes of his photographs. He is fond of classical, majestic music, above all the music of the period from the 9th to the 18th centuries. When listening to music, he closes his eyes; his face takes on an expression of bliss, and his whole being, despite his physical robustness, seems to float ethereally in harmony with the wonderful melodies. At concerts he does not so much photograph the musicians as the music itself. With brilliant skill he displays the range of tones of photography from soft, tinged grey to dense black, all the time seeking further means of expression to convey the emotions filling the innermost soul of man, stirred by the harmonic sequence of tones. He makes use of blurred contours, distortion, movement and counter-movement which, together with his extraordinary sense of the formal aspect of his pictures, create the sought-after atmosphere.

As for the theatre—it is again the desire to express the depth of the communicated idea and the emotional experience that has taken Garanin through all of Moscow's theatres, to end, finally, on the avant-garde scene of Sovremennik, Maloy Bronnoy and the theatre Na Tagantse. Whenever a new play is being produced there, Garanin suffers from a particular kind of illness: he does not see or hear; he lives only for the play.

"The theory of murmurs"—that is what Garanin calls the various methods of "distorting the photo in the interest of giving it a special arrangement in space—for depth and emotional impact." That is why, with his fingers, he casts a kind of magic spell in front of the lens, not hesitating to cover up part of the picture; that is why, in his attempt to attain the right expression, he so often works with haziness and minute detail, which in his concept finally becomes the central theme of the picture. He is constantly seeking, playing on his theme, and patiently returning to it again and again in repetitions.

This ardent passion, however, is not reserved solely for music and the theatre; Garanin photographs with the same enthusiasm workers' meetings, the life of a long-distance truck driver, the work of a librarian, the mental zeal of a scholar—in short, everything he encounters as a photo-reporter for a weekly magazine. Every assignment seems to become his own personal concern. Almost always the result is an exacting psychological testimony, mostly presented in numerous series of pictures bearing witness to the people of his country and time. His photographs of musicians and actors express a kind of inverse pathos: his people are serious, concentrated; their performances seem to emanate from a strong internal tension, as if the traditionally sorrowful Russian soul were resounding in its human fate, as if the sensitive soul of Garanin himself were resounding, reminiscent of his ancestors and of the tragic figures of great Russian classical literature. The modest Garanin is one of the great personalities of contemporary Soviet photography.

—Daniela Mrázková

GARNETT, William A.

American. Born in Chicago, Illinois, 26 December 1916. Educated at John Muir High School, Pasadena, California; Art Center School, Pasadena. Served as a cameraman in the United States Army Signal Corps during World War II. Married Eula Garnett in 1942; has 3 children. Freelance photographer, in California, since 1947; noted for aerial photography. Photographer for *Life* magazine, New York, and for *Fortune* magazine, New York, since 1954. Fellow in Advanced Visual Studies, Massachusetts Institute of Technology, Cambridge, 1967. Professor of Design, University of California, Berkeley, since 1969. Recipient: Guggenheim Fellowship, 1953, 1956, 1975. Address: 1286 Congress Valley Road, Napa, California 94558, U.S.A.

Individual Exhibitions:

1955 International Museum of Photography, George Eastman House, Rochester, New York
1979 Robert Mondavi Winery, Oakville, California
1980 University of Oregon, Eugene
 William Lyons Gallery, Coconut Grove, Florida

Douglas Elliott Gallery, San Francisco
Friends of Photography, Carmel, California
Silver Image Gallery, Seattle, Washington
Daniel Wolf Gallery, New York
1981 The Halsted Gallery, Birmingham, Michigan

Selected Group Exhibitions:

1955 *The Family of Man*, Museum of Modern Art, New York (and world tour)
1956 *Diogenes IV*, Museum of Modern Art, New York
1967 *Photography in the 20th Century*, National Gallery of Canada, Ottawa (toured Canada and the United States, 1967-73)
1976 *100 Master Photographers*, Museum of Modern Art, New York
1978 *Landscapes in Photography 1859-1978*, Vision Gallery, Boston
1979 *The Photographer and the National Parks*, The White House, Washington, D.C.
1980 *A Survey of Western Landscape Photography 1950-1980*, Crocker Art Institute, Sacramento, California
1981 *Our Beautiful Earth: The View from Air and Space*, National Air and Space Museum, Washington, D.C.

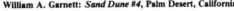

William A. Garnett: *Sand Dune #4*, Palm Desert, California

Collections:

Museum of Modern Art, New York; Metropolitan Museum, New York; Gilman Paper Company, New York; Polaroid Corporation, Cambridge, Massachusetts; Smithsonian Institution, Washington, D.C.; John Deere Corporation, Moline, Illinois; Pentax Corporation, Japan.

Publications:

By GARNETT: books—*The American Aesthetic*, with text by Nathaniel Alexander Owings, New York 1969; *The Leica Manual*, Dobbs Ferry, New York 1973.

On GARNETT: books—*The World from Above* by Hanns Reich, New York 1966; *Photography in the 20th Century* by Nathan Lyons, New York 1967; *Airborne Camera* by Beaumont Newhall, New York 1969; *Landscape: Theory* by Ralph Gibson, New York 1980; articles—"Over California" by Walker Evans in *Fortune* (New York), March 1954; "The Eye of Bill Garnett Looks Down on the Commonplace and Sees Art" by Edward Parks in *Smithsonian* (Washington, D.C.), May 1977; "William Garnett" by Eric Lax in *American Photographer* (New York), February 1980.

William Garnett has been making aerial photographs for more than three decades; his infatuation with the view from above began as a child when he took an airplane sightseeing tour. He began his career in commercial photography in the 1930's, but it was not until after World War II that he was able to combine flying with photography. His early aerial photographs were made for commercial clients, but the reputation for his personal, creative work spread rapidly.

Garnett pioneered the use of oblique light in aerial photography, and prefers to photograph the dramatic forms of the landscape when they are illuminated by the early morning or evening sun. He uses his hand-polished silver 1955 Cessna 170-B not only as transportation to reach his subjects, but also as an active tool in the creation of his images. Working at an altitude ranging from a few hundred to several thousand feet, and at a speed of up to 100 miles per hour, he keeps his light meters in a holster in the plane's window and his cameras—each equipped with a lens of a different focal length, permanently set at infinity—tucked away behind him in the cockpit.

Once he has located a potential subject he circles the area to study the changing patterns of light and land below, framing the picture both by selection of altitude and lens-length. By moving laterally he is able to place the reflection of the sun in an exact relationship to land forms, or to select certain tones or colors in ground-water reflecting the sky. Once his subject has been determined he circles again, opens the cockpit window, aims the camera behind the wing-strut and makes the exposure at the exact point where the photograph had been visualized.

In the air Garnett faces the same problems of pollution and natural haze—in magnified form—that ground photographers must confront. Added to these problems are the effects of plane vibration, ground speed and the resolution by the lens of objects photographed at great distances, plus the demands of the concentration required to fly his plane and to watch for other air traffic.

The details of Garnett's photographic technique in the air become all the more fascinating when they are seen in the context of the exquisite photographs he produces. Aerial photographs are always intriguing because of their unusual point of view. The popularity of pictures sent to earth from satellites or from the planetary space-probes have demonstrated this. Garnett is not satisfied, however, simply to depict the land below him. He abstracts sections

from the landscape and often has a greater interest in the forms and textures within his camera's view than in the geographical or geological descriptions of those forms.

The diversity he is able to achieve in images of similar subject matter is clearly seen in the series of photographs he made during the 1950's in a few square miles of Death Valley. Through the combination of the ever-changing landscape and his active manipulation of the camera's position in relation to the light transforming the land, Garnett made a remarkably varied group of photographs.

Other clearly defined groups of work exist in his oeuvre, including a continuing series of reflections of the sun in the landscape made in many different parts of the country, and an on-going investigation of patterns in cultivated farm land. Garnett has also actively worked in color, and has made a series of large, 24" x 36" prints. Many of these have unexpected colors that result from the response of the film to the oblique light on his subjects and to the unusual coloring he finds in many of the land forms he photographs.

—David Featherstone

GATEWOOD, Charles.
American. Born in Chicago, Illinois, 8 November 1942. Educated at Parkview High School, Springfield, Missouri, 1956-60; University of Missouri, Columbia, 1960-64, B.A. in anthropology 1963; University of Stockholm, 1964-66; self-taught in photography. Staff Photographer, *Manhattan Tribune* newspaper, New York, 1969-73. Freelance photographer, New York, since 1974. Lecturer in Photography, New York University, 1972, Educational Alliance, New York, 1974-77, International Center of Photography, New York, 1975-77, San Francisco Art Institute, 1977, and Rutgers University, New Brunswick, New Jersey, 1977, 1979; Artist-in-Residence, Light Work, Syracuse University, Syracuse, New York, 1976. Recipient: Creative Artists Public Service Photography Fellowship, New York, 1974, 1977; American Institute of Graphic Arts Award, 1975; Catskill Center for Photography Grant, Woodstock, New York, 1980. Agent: Robert Samuel Gallery, 795 Broadway, New York, New York 10003. Address: Box 745, Woodstock, New York 12498, U.S.A.

Individual Exhibitions:

1968 Lewison Gallery, City College of New York
1972 Light Gallery, New York
1975 Neikrug Gallery, New York
 Brummels Gallery, Melbourne
1976 Australian Centre for Photography, Sydney
1977 University of West Virginia, Morgantown
 X-1000, Levitan Gallery, New York
1978 *Wall Stret*, Stieglitz Gallery, New York
 Forbidden Photographs, Light Work, Syracuse University, Syracuse, New York (travelled to the Project Arts Center, Cambridge, Massachusetts)
 Contemporary Arts Center, New Orleans
 Galerie Contrejour, Paris
 Catskill Center for Photography, Woodstock, New York
 Metropolitan State College, Denver
 University of Colorado, Boulder
 Fat Tuesday, Midtown YMHA, New York (with George W. Gardner)
1979 Galerie Voir, Toulouse

 Pushing Ink, Neikrug Gallery, New York (with Spider Webb)
1981 *Forbidden Photographs*, Robert Samuel Gallery, New York

Selected Group Exhibitions:

1967 *Photography U.S.A. '67*, De Cordova Museum, Lincoln, Massachusetts
1971 *Images of Concern*, Neikrug Gallery, New York (travelled to the Focus Gallery, San Francisco
1972 *Octave of Prayer*, Hayden Gallery, Massachusetts Institute of Technology, Cambridge
1974 *Celebrations*, Hayden Gallery, Massachusetts Institute of Technology, Cambridge
1975 *Young American Photographers*, Kalamazoo Institute of Art, Michigan
1976 *Exposition Phot-Univers*, Musée Francais de la Photographie, Bièvres, France
1977 *Rated X*, Neikrug Gallery, New York (and 1978, 1979, 1980)
1978 *The Grotesque in Photography*, Art Resources of Connecticut, New Haven
1979 *Humor and Satire*, Kleinart Gallery, Woodstock, New York
1980 *Art in a World Gone Mad*, Art Awareness Gallery, Lexington, New York

Collections:

International Center of Photography, New York; Light Work, Syracuse University, Syracuse, New York; Portland Museum of Art, Maine; Kalamazoo Institute of Art, Michigan; Musée Francais de la Photographie, Bièvres, France.

Publications:

By GATEWOOD: books—*Sidetripping*, with text by William S. Burroughs, New York 1975; *People in Focus*, New York 1977; *X-1000*, with Spider Webb and Marco Vassi, New York 1977; *Pushing Ink*, with Spider Webb and Marco Vassi, New York 1979. *Forbidden Photographs*, Woodstock, New York 1981.

On GATEWOOD: articles—"Thomas Barrow and Charles Gatewood" in *Light Readings: A Photography Critic's Writings 1968-1978* by A.D. Coleman, New York 1979; "Why Does Charlie Do Those Things?" by Casey Allen in *Camera 35* (New York), March 1980.

I quote A.D. Coleman: "Once the idea of any work enters the bloodstream of a culture, its vehicle becomes a corpse—exquisite, perhaps, but a corpse nonetheless. The calling of the artist is not simply to be a manufacturer of objects, a craftsman, but to be a progenitor of new myths, new truths, new definitions."

My new book, *Forbidden Photographs*, is a new experiment in defining and developing such a visionary expressionism. Please publish my address: I welcome correspondence.

—Charles Gatewood

One of the earliest photographs in *Sidetripping* contains, in capital letters, the words "See life as it really is! 24hrs. Pay up front!" That just about sums up the book, which is photographed in capital letters too. Charles Gatewood shoots life not only "in the raw" but also flat on its back, masturbating in front of a mixed audience. He must have the sort of instinct for sex that Weegee had for crime and death. It draws him, as a moth is drawn to a naked candle flame.

Sidetripping: like the moth, Gatewood will never master the art of flying straight. But like the moth, he shows no fear of situations that are, to say the least, threatening and could be highly dangerous. There is nothing sneaky about his approach: he stares his subjects right in the face, or in the nipple or the crotch. He clearly does not hide the camera, or his own presence, and some of his subjects are reacting to, or acting for, the camera. He emphasizes the nature of his approach by placing his subjects near the centre of the frame, and by using direct flash in poor lighting—again, like Weegee and the newspapers' other crime photographers.

But this is not to say his compositions are artless: far from it. Though they are made to appear casual, to persuade you they are simply a "slice of life," they are tightly cropped for impact, and usually only essential information is retained in the frame.

More important than framing, however, is timing. A lot of pictures have been captured because of the photographer's sharp eye and quick reactions. For example, he has caught a policeman in the act of expectorating into a waste-basket labelled "our city," which could illustrate any low-life version of Cartier-Bresson's account of the "Decisive Moment." More often the timing shows in the capturing of precise expressions: the twisted ones that convince us that normal people are actually quite bizarre, and the human ones which persuade us that those bizarre-looking people are actually quite normal. For example, there's a woman standing on a bar with her knickers partly down to show off her backside (and a reversed sign, Hot Sausages, in the mirror): from the smile on her face she could easily be someone you'd chat to on the bus. The two girls, shirts lifted, comparing their breasts on the subway, could easily be from the local library.... Most of Gatewood's subjects are not down-and-outs, like those in Anders Petersen's pictures taken in the Lehmitz café in Hamburg; nor is there the undercurrent of violence which runs through Seiji Kurata's *Flash Up* book. Gatewood's subjects probably enjoyed their normal, middle-class upbringing before they decided that being weird might be more fun. Gatewood's pictures are quite fun too, with the added spice of being slightly threatening.

—Jack Schofield

Charles Gatewood: *Untitled*, 1981

GAUTRAND, Jean-Claude.

French. Born in Sains-en-Gohelle, Pas de Calais, 19 December 1932. Educated at the Lycée Colbert, Paris, baccalauréat 1951; mainly self-taught in photography. Married Gisèle Gautrand in 1955 (died, 1965); daughter: Brigitte; married Dominique Gautrand in 1968 (divorced, 1973); son: Philippe. Has worked for the French Postal Service (PTT), in Paris, since 1952: currently, Superintendent. Joined the PTT Photo Club, 1956; professional photographer, since 1958. Also, contributor as journalist/critic/historian to *Jeune Photographie, Photo Tribune, Point de Vue, Photo Revue, Le Nouveau Photo-Cinéma, Le Photographe, Nueva Lente, Fotografia Italiana, Photo Journal*, etc. Founder Member, with Jean Louis Moré and Gérard Contant, Gamma Photo Group, Paris, 1963, and, with Jean Dieuzaide and others, Libre-Expression Photo Group, Paris, 1964; Vice-President, 1968, and President, 1976-79, 30 x 40 Photo Club, Paris. Founder, and Cultural and Artistic Counsellor for the Photography Section, *Festival d'Art Contemporain*, Royan, France, since 1972; Member of the Council,

Rencontres Internationales de la Photographie, Arles, France, since 1976, and Fondation Nationale de la Photographie, since 1978. Recipient: Grand Prix, Fédération Internationale de Photographie (FIAP), 1965; Grand Prix de la Photo d'Avant Garde, Spain, 1967; Grand Prix des Arts, City of Marseilles, 1969. Address: 45 rue d'Avron, 75020 Paris, France.

Individual Exhibitions:

1967 Société Francaise de Photographie, Paris
1968 FNAC, Paris
 Grand Prix Musée Cantini, Galerie des Quatre Vents, Marseilles
1970 Galerie Toussaint, Angers, France

1972 *L'Assassinat de Baltard*, Centre International de Séjour, Paris (travelled to the Centre Culturel, Limoges, France, and the Centre Culturel, Gueret, France)
1974 Neikrug Gallery, New York (retrospective)

Since 1977 M. Gautrand has exhibited variations on the theme *Forteresses du Dérisoire*:

1977 Artcurial, Paris
 La Photogalerie, Paris
 Rencontres Internationales de la Photographie, Arles, France
 Galerie du Chateau d'Eau, Toulouse
 Galerie des Philosophes, Geneva
 Galerie 74, Vienna
 The Photographers' Gallery, London

Jean-Claude Gautrand: From *Forteresses du Dérisoire*, 1977

1978 Musée Nicéphore Niepce, Chalon-sur-Saône,
France
Galerie FNAC, Strasbourg
Galerie FNAC, Metz, France
Galerie FNAC, Grenoble, France
Galerie FNAC, Lyons
1979 Galerie Paule Pia, Antwerp
1980 Galerie ARPA, Bordeaux
Work Gallery, Zurich
Mai de Flandres, Bergues, France

Selected Group Exhibitions:

1963 *Photography '63*, International Museum of
Photography, George Eastman House,
Rochester, New York
1965 *Groupe Libre-Expression*, Société Française
de Photographie, Paris (and 1966, 1971)
1972 *Biennale de Paris*
1975 *Triennale de la Photographie*, Musée d'Art
et d'Histoire, Fribourg
1977 *Collection Bibliothèque Nationale*, Centre
Georges Pompidou, Paris
1979 *The Concrete Eye*, French Cultural Center,
New York (toured American universities)
1980 *5 French Photographers*, Australian Center
for Photography, Sydney
Des Clés et des Serrures, Canon Photo
Gallery, Geneva

Collections:

Bibliothèque Nationale, Paris; Collection des Affaires
Culturels, City of Paris; Musée Réattu, Arles,
France; Musée Cantini, Marseilles; Musée Nicé-
phore Niepce, Chalon-sur-Saône, France; Musée
des Arts Décoratifs, Nantes, France; Musée du Cha-
teau d'Eau, Toulouse, France; Musée du Toulon,
France; International Museum of Photography,
George Eastman House, Rochester, New York.

Publications:

By GAUTRAND: books—*Libre-Expression I*,
exhibition catalogue, editor, Paris 1965; *Murs de
Mai 1968*, Brussels 1967; *Libre-Expression V*, exhi-
bition catalogue, editor, Paris 1971; *L'Assassinat de
Baltard*, Paris 1972; *Forteresses du Dérisoire*, with
text by Jean-Pierre Raynaud and Georg Ramseger,
Paris 1977; articles—numerous articles on photog-
raphers in *Photo-Ciné Revue* (Paris), April 1966-
July 1975; "Les Grandes Maitres de la Photo-
graphie," series, in *Point de Vue* (Paris), 1973-76;
"La Place de la Photographie dans l'Art Contempo-
rain" in *Photo-Ciné-Guide*, Paris 1974; numerous
articles on photographers in *Nouveau Photo-Cinéma*
(Paris), June 1975-July 1979; "Photographie Au-
jourd'hui" in *Photo-Ciné-Guide*, Paris 1978; "Une
Histoire de la Photographie" in *Photo-Journal*
(Paris), November 1979-July 1980; "Les Plus Belles
Photos de Paris," series, in *Point de Vue* (Paris),
1980-81; "L'Appareil et ses Applications Créatives"
in *Almanach de la Photographie '81*, Paris 1981;
"Cent Cinquante Ans de Portraits" in *Photo-Ciné-
Guide*, Paris 1981; "Histoire du Surréalisme en Pho-
tographie" in *Images* (Paris), no. 1, 1981.

On GAUTRAND: books—*Jean-Claude Gautrand*,
exhibition catalogue, with text by Jean Dieuzaide,
Toulouse 1977; *Jean-Claude Gautrand*, exhibition
catalogue, with text by Paul Jay, Chalon-sur-Saône,
France 1978; articles—"Jean-Claude Gautrand" by
Maurice Bernard in *Photo-Ciné Revue* (Paris), June
1967; "Jean-Claude Gautrand" by Robert Doloy in
Arte Fotografico (Madrid), November 1969; "Jean-
Claude Gautrand" by Roberto Salbitani in *Pro-
gresso Fotografico* (Milan), August 1972; "Jean-
Claude Guatrand" in *Photo* (Paris), September
1972; "Jean-Claude Gautrand" by Pablo Perez

Minguez in *Nueva Lente* (Madrid), February 1973;
"Jean-Claude Gautrand" by Michel Nuridsany in
Arts et Techniques Graphiques (Paris), May 1974;
"Jean-Claude Gautrand" in *Camera* (Lucerne), April
1977; "Jean-Claude Gautrand: l'Illusioniste" by
Michel Cournot in *Nouveau Photo-Cinema* (Paris),
May 1977; "Jean-Claude Gautrand: An Interview
and Series Portfolio," with an interview by Bernard
Plossu, in *Minolta Mirror* (Tokyo), 1977.

My photography is based on two essential elements:
form and light. These two elements interact with
each other to create images that go beyond simple
reality to a personal and passionate subjectivism. It
is a photographic style that asks more for imagina-
tion than for observation: the viewer cannot remain
passive. For me, photography that doe not include
magic and mystery reveals itself immediately and is
only, at best, anecdotal.

I have been strongly influenced by the rigor and
poetry of Straight Photography, but also, and espe-
cially, by the wealth of possibilities in Otto Steinert's
Subjective Photography.

I work with themes in time and space, to form
long series of photographs which I call "poems of
imagery." Each photograph should be considered as
a word in a sentence; each sentence offers its mean-
ing within the total context of the "poem." A subject
unveils itself only little by little; it must revolve to
invest itself and thus restore its body, its mystery, its
relationship to the environment and especially to the
photographer.

My principal series are: La Galet (1967), which
illustrates one of the myths about the world's origin;
Les Boues Rouge (1970), on industrial pollution;
Les Murs de Mai (1968), on revolutionary graffiti;
L'Assassinat de Baltard (1972), an indictment of the
destruction of a cultural patrimony; Forteresses du
Dérisoire (1977), a testimony on human pride, a
passionate discourse, and a genuine archaeological
work.

Focussing on the life and death of things, these
series are often cries of revolt; they are commitments
against injustice, effacement, and oblivion. Oblivion
and death are everywhere, like an obsession idea
that pierces the mystery of deep shadows, immersing
these lyrical images.

—Jean-Claude Gautrand

French photography is above all strongly character-
ized by documentary and photojournalism. Photog-
raphers such as Eugène Atget, Henri Le Secq,
Charles Nègre, Victor Regnault, Cartier-Bresson
and Robert Doisneau have created the framework
for our national photography, traditionally dedi-
cated to rendering social testimony in a sincerely
socialist spirit. Man is always at the center; it is
towards him that in the end the photographer's
attention is directed. When one thinks of misery, of
exploitation, of work, it is always to a face or to a
body in action that our visual memory responds.
So-called "committed" photography therefore has
more to do with the subject photographed (a worker
leaving a factory, for example) than to the progres-
sive vision of the photographer himself, and some-
times photos of this kind, with this kind of social
pretension, do not ultimately serve the good cause
because of the banality of their internal functioning.

Jean-Claude Gautrand belongs half-way between
this documentary tradition and a naturalistic trend
that developed in the French Midi during the 1960's
in the work of such photographers as Denis Brihat,
Jean-Pierre Sudre, Jean Dieuzaide and Lucien
Clergue, all of whom were definitely influenced by
the School of Weston. These artists select as sub-
jects, whatever they may be, that which will allow
them to create maximumly effective metaphors of
their interior lives.

Gautrand was one of the founders of the group
Libre-Expression, the manifesto of which attempted
to create the basis of a new kind of subjectivity.

From his first book, *Murs de Mai*, through *L'Assas-
sinat de Baltard*, to *Forteresses du Dérisoire*, Gau-
trand has followed a path that has put him in the
midst of social tensions and political occurrences,
the result of his willingness to record the presence of
man in architectural constructions and structures.
His photographs immortalize human activity; at the
same time, they are creative spaces—because of
their great technical quality and because of Gau-
trand's consummate craftsmanship in printing. One
feels that Gautrand (and the other "naturalists")
wants to re-establish the concept of the artisan, to
"work" the material, in hand-to-hand combat, as it
were, with the gelatin. For, if it is important to show
all the gestural and subversive beauty of the graffiti,
it is also necessary to understand the wall, that
which permitted the graffiti's existence.

Sometimes using a wide-angle lens and a red fil-
ter, Jean-Claude Gautrand creates grandiose and
dramatic images. Their lyricism excites the senses. It
can also deaden the political message—if one does
not wish to *read* his photographs as within a global
perspective. Gautrand occupies a special place in
French photography, a position in which it is diffi-
cult to exist, between the "decisive moment" of
Cartier-Bresson and the "charming" aestheticism of
the pictorial tradition.

—Claude Nori

GELPKE, André.
German. Born in Beienrode, Gifhorn, 15 March
1947. Educated at volksschule in Beienrode and
Rheydt, 1953-59, and gymnasium in Rheydt and
Krefeld, 1959-62; studied photography, under Otto
Steinert, Folkwangschule, Essen, 1969-74. Served
as an infantryman in the German Army, in Bremen,
1967-68. Bricklayer, cement worker, and truck
driver, 1962-67. Photographer since 1974: Founder-
Member, Visum Photo Agency, Essen, now Ham-
burg, 1975-78; freelance photographer, Essen, since
1978. Member, Gesellschaft Deutsche Lichtbildner
(GDL), 1975-78. Address: Postfach 230249, Mei-
senburgstrasse 49, 4300 Essen 1, West Germany.

Individual Exhibitions:

1974 Galerie Schürmann und Kicken, Aachen,
West Germany
1975 Galerie Spectrum im Kunstmuseum, Hann-
over
1979 Galerie Krebaum, Weinheim, West Germany
Galerij Paule Pia Antwerp
University of Salzburg
1980 *Ein Monolog: Ein Dialog*, Sander Gallery,
Washington, D.C. (travelled to Work Gal-
lery, Zurich)
Vernissagen, Museum Folkwang, Essen

Selected Group Exhibitions:

1977 *German Photography*, Arles, France
1978 *Bildjournalismus*, Museum Folkwang,
Essen
1979 *Venezia '79*
Deutsche Fotografie nach 1945, Kunst-
verein, Kassel, West Germany (toured
West Germany)
Portraits, Bibliothèque Nationale, Paris
1980 *Vorstellungen und Wirklichkeit: 7 Aspekte*

Subjektiver Fotografie, Städtisches Museum, Leverkusen, West Germany (travelled to the Künstlerhaus, Vienna, and Fundució Joan Miró, Barrclona, 1980; Palais des Beaux-Arts, Brussels, 1981)
Neue Wege in der Fotografie, Kunstmuseum, Dusseldorf
Absage an das Einzelbild, Museum Folkwang, Essen
Das Imaginäre Photomuseum, Kunsthalle, Cologne

Collections:

Museum Folkwang, Essen; Neue Sammlung, Munich; Münchner Stadtmuseum, Munich; Stedelijk Museum, Amsterdam; Bibliothèque Nationale, Paris.

André Gelpke: *Mann mit Brille*, 1978

Publications:

By GELPKE: articles—texts in *André Gelpke*, exhibition catalogue, Hannover 1975; "Die Autorität Steinerts" in *Print Letter* (Zurich), no. 9, 1977; "Sextheater" in *Fotografie* (Göttingen), no. 8, 1978; text in *Neue Wege in der Fotografie*, exhibition catalogue, Munich 1980.

On GELPKE: books—*Deutsche Fotografie nach 1945*, exhibition catalogue, by Floris Neusüss, Petra Benteler, and Wolfgang Kemp, Kassel, West Germany 1979; *Fotografie 1919-1979, Made in Germany: Die GDL-Fotografen*, edited by Fritz Kempe, Bernd Lohse and others, Frankfurt 1979; *Vorstellungen und Wirklichkeit*, exhibition catalogue, by Dieter Wellershof, Vienna and Cologne 1980; articles—"André Gelpke: Auswahl" by Allan Porter in *Camera* (Lucerne), no. 11, 1970; "André Gelpke" in *Creative Camera* (London), July 1972; "Foto-Galerie" by Peter Sager in *Zeitmagazin* (Hamburg), no. 49, 1977; "Neue Experimente" by Allan Porter in *Camera* (Lucerne), no. 4, 1977; "André Gelpke" by Jög Kirchbaum in *Fotografie* (Göttingen), no. 5, 1978; "Die Verweigerte Ansicht" by Peter Sager in *Zeitmagazin* (Hamburg), no. 43, 1979; "Vernissagen" by Rolf Paltzer in *Art* (Hamburg), no. 6, 1980.

In this visual age, when our consciousness of reality is increasingly permeated by the actualities of television, photography and advertising, my aim is to present the photographic-bureaucratic fact collector with a selection of my reality clippings from an only apparent "pseudo reality" and thereby to bring about a new questioning of reality.

Even though I have worked for many years as a photojournalist, the medium has continued to bewilder me deeply. While I have the feeling on the one hand that photography has altered or expanded my consciousness, I am certain that it has, on the other hand, and to the same extent, led to a contraction of my awareness. For example, the indirect reality of a printed image of war which lies open in an illustrated magazine on the dining table next to the soup tureen doesn't prevent us from going on eating. The information that this image carries no longer reaches our manipulated consciousness. Reality, conditioned by the remoteness of such happenings, by the torrent of such images of cruelty, becomes fiction.

I am not interested in supplying such "real fiction." I am interested in tracking down just this encounter of "war report and soup tureen" so that I can demonstrate it with photographic means and thereby make visible a "counter-reality."

The answer to the question, can photography be art, is, for me, to be found in the fact that artistic creation consists as much in the rejection of what is false as in the selection of the right solution to a self-imposed problem.

Photography is primarily a school of seeing. And there is the question of the head behind the camera, the "what" and "how" it sees, the way it reproduces this "what" with the necessary "photo apparatus." Since the discovery of photography, this "reproduction" has always been the starting point of all art criticism.

And since, with most of them, we are dealing with a particularly work-shy and failed form of human existence, art critics have naturally very quickly recognized the use for their own purposes of this "reproducibility." One critic, for example, visits exhibitions only fleetingly and simply uses photographs as a means to review painting. Shall we now say that that which was always only an aid to easier work is now suddenly an art in itself? Seeing is only a part of reality, and this lofty stance can have nothing to do with reality. The inspiration, the divinely gifted hand that creates, is missing.

Another kind of critic considers that photography's only claim to art (with the emphasis on "only") lies precisely in its capacity to "reproduce." But isn't this opinion only a wish to clarify the relationship between painting and photography?—caused by the discovery of photography and the consequences for naturalistic painting? If it has to do with "you can do this" and "I can do that," then art comes down to "being able to."

And on the so-called "photography art scene" there are now many photographers who resign themselves to this "fixing of boundaries" and see everything as everyone else sees it. The photographer sees a car and reproduces it; the viewer says, "Look, a car," and thinks that instead of a picture he sees a car in front of him. The picture is, therefore, anonymous; it is defined according to "classification."

A third kind of critic is a fetishist of the unique. He is not very interested in the creation of the picture; he is interested in the fact that it can be reproduced, that one print from the original negative cannot be distinguished from another: the prints are not "original." This kind of critic understands art

GELPKE

only in terms of its "rarity value."

In fact, most critics of photography are not at all interested in what is to be seen in the photograph. They do not judge the image but the conditions of its manufacture and whether or not it can be traded. Any more serious analysis is feared.

Photography, with its multiple print (and I consider this the most important form of diffusion for photography), is accessible to a wide public. For this reason, I think photography can be compared to literature—I think literature most closely resembles photography's true nature...the literature of images, from the cheap novel for sale on every corner to the poetry that is little understood and not much sold. In the same way that literature is classified—essay, poetry, novel, journalism, etc.—so photography and its current practitioners can also be classified, so that the public, the reader, can choose between, say, the cheap photographic novel and good photographic prose. Criticism, and appraisal, of these genres does not need to involve comparisons: one would not compare a textbook with a volume of verse. We must, instead, establish criteria against which any one of the photographic genres can be judged according to its "quality."

—André Gelpke

Andre Gelpke tends to speak of two categories when referring to his work: the monologues (introspection) and the dialogues (relationships with the external). There is no opposition between them—they are complimentary because they basically try to exercise two distinct types of vision upon the same reality: sensual vision and intellectual vision.

Sensual vision would be that which involves the senses, which, for example, relate to an atmosphere or the sensation of temperature. The camera acts spontaneously as an extension of sensibility—it functions more to the rhythm of the heart than of the mind. The photographs included in the touring show *Vorstellungen und Wirklichkeit* (most of which belong to the series entitled "Sea Pieces") constitute good examples of this sensual vision. In them Gelpke uses a precise visual rhetoric: violence of light, tension of space, a predilection for compact masses and for geometric forms, fragmented frames, etc. It is not a question, as Dieter Wellershof states, of "pure exercises of vision," or, at least, it is not only a question of this. Beyond the appearance of simply visual gymnastics there is an underlying energy of greater expressive potential. Although these images also have a metaphysical dimension— as do those of Herbert List with which there are certain formal similarities—there is not so much a search for the enigma of the *objet trouvé* as for the banality of the situation, for the congelation of its static and immobile qualities, and for the "decisive moment of light." The first two of these are essentially painterly characteristics, as in the work of Magritte, but the third is essentially photographic.

The intellectual vision, on the one hand, would be that which withdraws from the aesthetic and favors content. We can clearly see this aspect if we compare the aforementioned works with the series titled "Plastic People" and "Sankt Pauli." In these the photographer shows evidence of greater reflection, and his ethical attitude becomes clear. The camera appears much more controlled because the goal is more precise. Again, Gelpke knows how to use visual rhetoric intelligently: direct shots in the best documentary tradition, which dignify the faces of the transvestites and strippers of the red-light district of Hamburg, thereby permitting the spectator to take part in an intimate one-to-one encounter. In contrast, he uses a fine and disturbing irony in the series "Plastic People," using a "decapitated" frame which emphasizes the extravagant details of certain social rituals such as receptions and *vernissages*. As in the images of Larry Fink, the use of flash emphasizes the character of the scene.

The history of photography has advanced through successive dialects, doctrines, and binary methods

which negate one another. At the moment, we think the medium has reached its maturity, and there is no need to demand radical or dogmatic positions. He who understands photography in this way and knows how to creatively combine attitudes which appear antagonistic—sensuality and intellect in this case—is in a position to bequeath us a body of work as fruitful as that of Gelpke.

—Joan Fontcuberta

GENTHE, Arnold.
American. Born in Berlin, Germany, 8 January 1869; emigrated to the United States, 1896: naturalized, 1918. Educated in Korbach, Frankfurt, and at Wilhelm Gymnasium, Hamburg, until 1888; studied philology, University of Jena, Germany, 1888-90, 1892-94, doctorate 1894; University of Berlin, 1891; languages, Sorbonne, Paris, 1894-95. Language tutor to Heinz von Schroeder, San Francisco, 1897-1902; commercial portrait photographer, establishing own studio on Sutter Street, San Francisco, 1897-1906; independent photographer, associating with writers Jack London, Mary Austin, etc., mainly at second studio, Carmel, California, 1902-11; freelance magazine photographer, concentrating on dance and theatrical portraits, and establishing studio on Fifth Avenue, New York, 1911 until his death, 1942. Recipient: First Prize for Best Collection, *Los Angeles Salon of Photography*, 1902. Died (in New Milford, Connecticut) 9 August 1942.

Individual Exhibitions:

1910 Photographs of Japan, Vickerey Gallery, San Francisco
1930 Photographs of Greece, American-Anderson Galleries, New York
1941 Theatrical Portraits, Museum of the City of New York
1975 Arnold Genthe 1869-1942, Staten Island Museum, New York (retrospective)
1978 Thackrey and Robertson Gallery, San Francisco

Selected Group Exhibitions:

1901 4th Philadelphia Salon of Photography
1902 Los Angeles Salon of Photography
1904 St. Louis Exposition
1910 International Exhibition of Pictorial Photography, Albright Art Gallery, Buffalo, New York
1959 Hundert Jahre Photographie 1839-1939, Museum Folkwang, Essen (travelled to Cologne and Frankfurt)
1967 Photography in the 20th Century, National Gallery of Canada, Ottawa (toured Canada and the United States, 1967-73)
1974 Photography in America, Whitney Museum, New York
1975 Fashion 1900-1939, Victoria and Albert Museum, London
1978 Photos from the Sam Wagstaff Collection, Corcoran Gallery, Washington, D.C. (toured the United States and Canada)
1979 Photographie als Kunst 1879-1979, Tiroler Landesmuseum Ferdinandeum, Innsbruck, Austria (travelled to Neue Galerie am Wolfgang Gurlitt Museum, Linz, Austria; Neue Galerie am Landesmuseum Joanneum, Graz, Austria; and Museum des 20. Jahrhunderts, Vienna)

Collections:

Metropolitan Museum of Art, New York; New York Historical Society (4,000 prints); International Museum of Photography, George Eastman House, Rochester, New York; Library of Congress, Washington, D.C. (negatives of San Francisco earthquake and fire); Smithsonian Institution, Washington, D.C.; Art Institute of Chicago; New Orleans Museum of Art; Gernsheim Collection, University of Texas at Austin; California Palace of the Legion of Honor, San Francisco (20,000 glass-plate and film negatives, 500 prints, 384 autochrome plates); Oakland Art Museum, California.

Publications:

By GENTHE: books—Deutsches Slang, Strasbourg 1892; De Lucani Codice Erlangensi, Jena, Germany 1894; Letters of Hegel to Goethe, editor, Jena, Germany 1895; Pictures of Old Chinatown, with text by Will Irwin, New York 1908, revised edition as Old Chinatown: A Book of Pictures by Arnold Genthe, New York 1913; The Yellow Jacket: A Chinese Play Done in a Chinese Manner, with text by George C. Hazelton, Jr. and Harry Benrimo, Indianapolis 1913; Sanctuary: A Bird Masque, with text by Percy MacKaye, New York 1913; The Book of the Dance, with an introduction by Sheamus O'Sheel, New York 1916, Boston 1920; 400 Japanese Color Prints Collected by Arnold Genthe, auction catalogue, New York 1917; The Gardens of Kijkuit, New York 1917; Impressions of Old New Orleans, with a foreword by Grace King, New York 1926; Isadora Duncan: Twenty-Four Studies, with a foreword by Max Eastman, New York and London 1929; As I Remember, autobiography, New York 1936, London 1937; Highlights and Shadows, with others, New York 1937; Walt Whitman in Camden: A Selection of Prose from Specimen Days, with a preface by Christopher Morley, Camden, New Jersey 1938; articles—"Rebellion in Photography" in Overland Monthly (San Francisco), August 1901; "The Chinese Question" in Overland Monthly (San Francisco), October 1901; "The Human Side of Portrait Photography" in Camera Craft (San Francisco), December 1934; "The Ageless Luster of Greece and Rhodes" in National Geographic (Washington, D.C.), April 1938.

On GENTHE: books—A Picture History of Photography by Peter Pollack, New York 1958, 1969; Hundert Jahre Photographie 1839-1939, aus der Sammlung Gernsheim, London, exhibition catalogue, by Helmut and Alison Gernsheim, Essen 1959; Photography of the World '60, edited by Hiromu Hara, Ihei Kimura and others, Tokyo and New York 1960; Photography in the 20th Century by Nathan Lyons, New York 1967; Photography in America, edited by Robert Doty, with an introduction by Minor White, New York 1974; Fashion 1900-1939, exhibition catalogue, by Valerie Lloyd and others, London 1975; Arnold Genthe 1869-1942, exhibition catalogue, Staten Island, New York 1975; Geschichte der Fotografie im 20. Jahrhundert/Photography in the 20th Century by Petr Tausk, Cologne 1977, London 1980; Documenta 6/Band 2, exhibition catalogue, edited by Klaus Honnef and Evelyn Weiss, Kassel and Cologne 1977; A Book of Photographs from the Collection of Sam Wagstaff, designed by Arne Lewis, New York 1978; The Collection of Alfred Stieglitz by Weston J. Naef, New York 1978; Amerika Fotografie 1920-1940 by Erika Billeter, Berne 1979; Photographie als Kunst 1879-1979/Kunst als Photographie 1949-1979, exhibition catalogue, 2 vols., by Peter Weiermair, Innsbruck, Austria 1979; The History of Fashion Photography by Nancy Hall-Duncan, New York 1979; Photography Rediscovered: American Photographs 1900-1930 by David Travis, New York 1979; The Photograph Collector's Guide by Lee D. Witkin and Barbara London, Boston and

272

Arnold Genthe: *Ruins of the Hearst Building, San Francisco Earthquake Fire, April 1906* (print by Ansel Adams)
Courtesy Art Institute of Chicago

ticularly painterly outlook on photography, making him see it as an art of large masses and delicate brush strokes. In this light, his earthquake views—houses like "leaning towers" on Sutter Street, or firemen spraying a building, a great snake of hosepipe almost arbitrarily filling the foreground, or tents seen higgledy-piggledy in a refuge camp—possess a sharpness and a sheer presence that is sometimes lacking in the products of his more deliberate artistic aspirations.

—G.M. Gidley

GERNSHEIM, Helmut (Erich Robert).
British. Born in Munich, Germany, 1 March 1913; emigrated to England, 1937: naturalized, 1946; settled in Switzerland, 1965. Educated at St. Anna College, Augsburg, Germany, 1931-33; studied art history at the University of Munich, 1933-34; photography at the Bayerische Lehr-und Versuchsanstalt für Lichtbildwesen, Munich, 1934-36, and colour photography at Uvachrome, Munich, 1936-37. Married Alison Eames in 1942 (died, 1969); married Irene Guenin in 1971. Professional photographer, 1936-45 (Photographer for the Warburg Institute, London, 1942-45); photo-historian and collector since 1945: established Gernsheim Collection of Historic Photographs, 1945 (at University of Texas at Austin, since 1964). Co-Editor, *Yearbook of Photography*, London, 1953-55; Adviser, Granada Television, Manchester, 1958-62. Since 1968, Editorial Adviser to *Encyclopaedia Britannica*, Chicago. Lecturer in the History of Photography and African Art, Franklin College, Lugano, Switzerland, 1971-72; Lecturer in the History of Photography, Unesco, Venice, 1979; Distinguished Visiting Professor, University of Texas at Austin, Spring 1979, and Arizona State University, Tempe, Spring 1981. British Representative, *World Exhibition of Photography*, Lucerne, 1952, and Unesco Conference on Photography, Paris, 1955; Chairman, History of Photography, *Rencontres Internationales de Photographie*, Arles, France, 1978. Trustee, Stiftung für Photographie, Zurich, since 1975. Curator/organizer of numerous photographic exhibitions, including: *Masterpieces of Victorian Photography*, Victoria and Albert Museum, London, 1951; Historical Section, *World Exhibition of Photography*, Lucerne, 1952; *A Century of Photography from the Gernsheim Collection*, Art Museum, Gothenburg, 1956, Nordisk Museum, Stockholm, and *Triennale*, Milan, 1957; *Portraits of 19th Century Authors from the Gernsheim Collection*, Folio Society, London, 1958; *Hundert Jahre Photographie 1839-1939*, Folkwang Museum, Essen, and Wallraf-Richartz Museum, Cologne, 1959, City Art Gallery, Frankfurt, 1960; *The History of Photography from the Gernsheim Collection*, Art Museum, Newcastle upon Tyne, 1960; *120 Jahre Photographie aus der Gernsheim Sammlung*, Stadtmuseum, Munich, 1961; *Creative Photography 1826 to the Present from the Gernsheim Collection*, in 4 parts, at Wayne State University, Institute of Arts, Historical Museum, and the Public Library, all Detroit, 1963; *200 Color Photographs by Berko, Fontana, Henle, Dal Gal, Sudre, Gianella Recently Acquired for the Gernsheim Collection*, Michener Gallery, University of Texas at Austin, 1979; etc. Recipient: American Photographers Association Award, 1955; Kulturpreis, Deutsche Gesellschaft für Photographie, 1959; Order of Merit, German Federal Republic, 1970; Gold Medal, Accademia Italia, Parma, 1980. Knight

London 1979; articles—"A Photographer of Japan: Arnold Genthe" by Sidney Allan (Sadakichi Hartmann) in *Photographic Times* (New York), December 1910; "Dr. Arnold Genthe" by Will Irwin in *American Magazine* (New York), May 1913; "How Arnold Genthe Uses Sunlight to Capture Beauty" in *Craftsman* (San Francisco), November 1915; "The Last Stylist" by Robert W. Marks in *Coronet* (Chicago), November 1938; "Arnold Genthe: Obituary" in *The New York Times*, 11 August 1942, 12 August 1942, 15 October 1942; "Genthe Collection" by Paul Vanderbilt in *Quarterly Journal of Current Acquisitions* (Washington, D.C.), May 1951; "Arnold Genthe: Gentleman Photographer" by James C. Kaufmann in *Image* (Rochester, New York), September/December 1977.

Arnold Genthe's means of livelihood was the portrait studio, under his direction a kind of photographic salon where the rich, the celebrated—and, of course, the talented—came to converse and to sit for their likenesses. He achieved striking studies of such figures as Ignace Paderewski, Jack London and Greta Garbo by capturing them—as he put it—"in a carefully considered pattern of light and shade," using "soft tones," at an unexpected moment when he could bring out "essential features" rather

than "unimportant detail." But it could also be argued that his claim to lasting recognition as a photographic artist has a firmer base in his work outside the confines of his studio—some of it unpremeditated, even haphazard, such as his much-reproduced views of the aftermath of the 1906 San Francisco earthquake.

Even earlier, as Genthe's friend Will Irwin remembered, he had frequented "the shadows and recesses of [San Francisco's] Chinatown," his "little camera half-hidden," searching out the exotic, more alien aspects of Chinese life—the seamed face of a merchant with his bodyguard, or "slave girls," or a line of children, each hanging onto the pigtail of the preceding one. Shaemas O'Sheel, who wrote the preface for Genthe's *The Book of the Dance*, with its reproductions of early colour photographs and other studies, believed that there was no "arrested motion" in such pictures, "but motion as it flows and is." In fact, like those in *Isadora Duncan*, although they have a flickering, half-seen quality which makes them ethereal, these views are rather static. There is a similar feel to his purposely blurred architectural pictures of John D. Rockefeller's home in *The Gardens of Kijkuit* and in the aptly named *Impressions of Old New Orleans*.

It is as if Genthe's years of collecting Japanese prints and his travels in the Orient gave him a par-

of Mark Twain, 1969; Honorary Fellow, Photographic Historical Society of New York, 1978; Honorary Member, Club Daguerre, Frankfurt, 1980. Address: Residenza Tamporiva, Via Tamporiva 28, CH-6976 Castagnola, Switzerland.

Individual Exhibitions:

1937 *Photographs of the Munich Marionette Theatre*, at the *World Exhibition*, Paris
Old Master Drawings Gallery, Stratford Place, London
1938 Old Master Drawings Gallery, Stratford Place, London
1945 *Westminster Abbey*, Courtauld Institute of Art, London
Churchill Club, London (6 exhibitions of work for the National Buildings Record, 1945-46)
1946 *St. Paul's Cathedral*, Courtauld Institute of Art, London
1948 Royal Photographic Society, London

Selected Group Exhibitions:

1944 *National Building Record*, National Gallery, London
1964 *The Painter & the Photograph: From Delacroix to Warhol*, University of New Mexico, Albuquerque

Collections:

Folkwang Museum, Essen; Fotografiska Museet, Stockholm; International Museum of Photography, George Eastman House, Rochester, New York.

Publications:

By GERNSHEIM: books—*New Photo Vision*, London 1942; *Julia Margaret Cameron*, London 1948, Millerton, New York 1975; *Focus on Architecture and Sculpture*, London 1949; *Lewis Carroll, Photographer*, London 1949, 1968; *Beautiful London*, London 1950, 1960; *Masterpieces of Victorian Photography*, London 1951; *The Man Behind the Camera*, London 1948, New York 1979; *Those Impossible English*, with Quentin Bell, London 1952; *Roger Fenton, Photographer of the Crimean War*, with Alison Gernsheim, London and New York 1954, 1973; *The History of Photography*, London and New York 1955, 1969; *Churchill: His Life in Photographs*, London and New York 1955; *L.J.M. Daguerre*, with Alison Gernsheim, London and New York 1956, 1969; *Queen Victoria: A Biography in Word and Picture*, with Alison Gernsheim, London and New York 1959; *Historic Events 1839-1939*, with Alison Gernsheim, London and New York 1960; *Edward VII and Queen Alexandra: A Biography in Word and Picture*, with Alison Gernsheim, London 1962; *Creative Photography: Aesthetic Trends*, London and Boston 1962, New York 1975; *A Concise History of Photography*, with Alison Gernsheim, London and New York 1965, 1971; *Alvin Langdon Coburn, Photographer*, with Alison Gernsheim, London and New York 1966, 1978; articles—more than 230 articles in European and American publications, interview—in *Dialogue with Photography*, edited by Paul Hill and Thomas Cooper, London and New York 1979.

On GERNSHEIM: books—*Fotografica '67* by Bo Lagercrantz, Stockholm 1966; *The Painter and the Photograph: From Delacroix to Warhol* by Van Deren Coke, Albuquerque, New Mexico 1972; articles—in *Photography* (London), February 1939; by Sir Kenneth Clark in *Architectural Review* (London), July 1943; in *Statesman and Nation*

Helmut Gernsheim: *Untitled*, 1935

(London), June 1944; by Fritz Gruber in *Foto Magazin* (Munich), May 1952; by Otto Zoff in *Das Kunstwerk* (Baden-Baden), October 1958; by Beaumont Newhall in *Image* (Rochester, New York), September 1959; by Rudolf Skopec in *Ceskoslovenska Fotografie* (Prague), December 1961; by Ulla Bergstrand-Wilhsson in *Foto* (Stockholm), January 1962; by Allan Porter in *Camera* (Lucerne), October 1968; by Angelo Schwartz in *Fotografia Italiana* (Milan), December 1977.

I have been brought up in the spirit of "Neue Sachlichkeit," which established itself in the early 1920's as a reaction against the manipulated, arty Salon pictures of the previous generation. They were an expression of late Victorian grandeur, fake photographs simulating High Art. The new realism was a return to the origins of photography—a truthful mirror-image of the world around us. Paul Strand and Albert Renger-Patzsch, the founders of modern photography, even believed they had attained objectivity, yet this was a mistake. All creative photography is bound to be subjective, a personal viewpoint and expression of the man behind the camera.

Though my eight years' activity as a professional photographer (1936-45) has been completely overshadowed by my work as an historian and collector, I still take hundreds of colour shots every year on my extensive travels, which have taken me to every continent. They are my impressions of distant countries, their beauty and squalor, the people and customs, flora, fauna, and architecture. No one, apart from my wife and a few friends, has seen them—yet an invitation for a retrospective is on the agenda, and, other work permitting, will be fulfilled.

Meanwhile, I am content to admire, advise, and sometimes criticize the pictures others produce. Only a small percentage of the annual output can satisfy a critical eye, and mine has been sharpened by a lifetime's study of art, ancient and modern, classical and primitive, good, mediocre and bad. I

have acquired an instinctive response to it, and, to judge by the reputation enjoyed by the various art collections I have put together, my perception has been sound. A photograph has to speak to me. If it fails to strike a chord, if it is meaningless, tasteless, contrived, badly composed, or in some other way assails my eyes, my susceptibility shrinks to zero. Some noise pretending to be modern music has the same effect on my ears.

Great reputations are usually justified, but nowadays they can also be acquired by manipulation. I use solely my eyes. Quality speaks for itself and requires no publicity hand-out and no recommendations. I delight in supporting photographers whose work fails to gain official recognition—if it impresses me. I fought too many battles with the blind and ignorant myself, not as a photographer but in my efforts to get photography officially recognized and appreciated by museums. Many 19th century photographers—and quite a few contemporary ones—owe their present renown to a happy crossing of our paths. Reputations rise and fall, and none of the entrants in the present volume has any control over the vagaries of time. Whether your name or mine will survive and be resurrected in fifty years' time in a *Who Was Who* is fascinating speculation but not important. The Romans said: *Carpe Diem*—take your chance.

It is easy to make photographs, but difficult to master photography. Hence the disproportionately high percentage of meaningless or boring images that find their way into print via editors lacking in critical discernment. A frightening mental emptiness, visual illiteracy and sensationalism are debasing the contemporary photo-scene. Let us beware of accepting every yearning for instant success as a trend-setter. There is no substitute for hard work, talent, intelligence, sound judgement, and experience—and without these there will be no creative photography.

—Helmut Gernsheim

Helmut Gernsheim is both a photographer and a photo historian. The two activites have complemented each other. His knowledge of photographic history has helped Gernsheim the photographer to "feel through" the evolution of his medium and thus to better find his own orientation. And his experiences as a photographer have formed a sound base for Gernsheim the historian from which to devise his authoritative and meaningful interpretations of the varous events in the history of creative photography.

Gernsheim discovered for himself the characteristic properties of the photograph very early in his career. He came to appreciate the particular ability of the camera to depict the real world with the greatest possible exactness, and he meditated on the appropriate ways to use the medium for creative self-expression. Probably this intellectual approach was what led him, before the Second World War, to embrace the "New Objectivity." Perhaps, too, his profound knowledge of German photography as it had evolved during the 1920's, and his special training in color photography by means of the Uvachrome technique, brought him to a belief in straightforward contact to achieve a truthful depicting of reality. Whatever the reasons, Gernsheim devoted himself to images of details in which he discovered interesting forms. This approach served him well whether he was depicting the works of man (piano hammers, for instance) or the works of nature. Often he experimented with strongly magnified images, which allowed him to present (for instance) the surprising architecture of plants. He liked also to explore perspective as a means toward creative interpretation—for instance, his downward view of a spiral staircase at St. Paul's Cathedral in London. Though his career as a professional photographer was a comparatively short one, he created photographs, whatever his subject or his method, that were always accomplished with perfect technique, a reflection of his belief in precise work.

Georg Gerster

That belief is as clearly reflected in his later work as a photo historian, for which he is now best known, internationally known, to the general public. Before Gernsheim, in collaboration with his wife Alison, published his fundamental book on the history of photography, there existed only a few publications, of which probably the most important were the works by Josef Maria Eder and Beaumont Newhall. Eder was concerned mainly with the evolution of technique; Newhall chose the approach of following the creative trends. The accomplishment of Gernsheim in *The History of Photography*, first published in 1955, was to have combined these subjects, to have added the crucial subject of the use of photographs by human society, and to have offered this amalgam with a scholarship, precision and control that remain unique. Gernsheim, with Eder and Newhall, must be counted as one of the very few gifted and important historians of photography.

—Petr Tausk

GERSTER, Georg.

Swiss. Born in Winterthur, 30 April 1928. Educated in gymnasium in Winterthur, 1941-47; studied German literature and philology, University of Zurich, 1947-53, Ph.D. 1953; self-taught in photography. Science Editor, *Die Weltwoche* weekly newspaper, Zurich, 1952-56. Freelance scientific and aerial writer-photographer, working for *Neue Zürcher Zeitung, National Geographic Magazine, Sunday Times Magazine, Geo,* etc., Zurich, since 1956; also, Contract Advertising Photographer, Swissair national airline, Zurich, since 1960. Recipient: Die Goldene Blende, Germany, 1973; Ehrengabe des Kantons Zurich, 1974; Prix Nadar, Paris, 1976; Picture of the Year Award, University of Missouri, Columbia, 1976; Anerkennungsgabe der Stadt Winterthur, 1977. Agents: John Hillelson Agency, 145 Fleet Street, London EC4A 2BU, England; Witkin Gallery, 41 East 57th Street, New York, New York 10019, U.S.A. Address: Tobelhusstrasse 24, 8126 Zumikon-Zurich, Switzerland.

Individual Exhibitions:

1965 *Swissair: North America,* at the *Basle Trade Fair*
1966 *Swissair: Africa,* at the *Basle Trade Fair*
1967 *Swissair: South America,* at the *Basle Trade Fair*
1968 *Swissair: North America,* at the *Basle Trade Fair*
1969 *Swissair: Japan,* at the *Basle Trade Fair*
1970 *Swissair Worldwide,* at the *Basle Trade Fair*
1971 *Swissair: USA,* at the *Basle Trade Fair*
1975 *Der Mensch auf Seiner Erde* (toured Switzerland and Austria)
1979 *Le Pain et le Sel: Vues Aériennes,* Centre Kodak, Paris (toured France, 1979-81)

Selected Group Exhibitions:

1980 *Our Beautiful Earth: The View from Air and Space,* National Air and Space Museum, Washington, D.C. (toured the United States)

Collections:

Swissair National Airlines, Zurich; Smithsonian Institution, Washington, D.C.

Publications:

By GERSTER: books—*Die Leidigen Dichter,* thesis, Zurich 1954; *Eine Stunde mit...,* Frankfurt and Berlin 1956, as *Aus der Werkstatt des Wissens 1,* Frankfurt and Berlin 1962; *Aus der Werkstatt des Wissens 2,* Frankfurt and Berlin 1958; *Sahara: Reiche Fruchtbare Wüste,* Berlin, Frankfurt and Vienna 1959, as *Sahara: Desert of Destiny,* London 1960, New York 1961; *Sinai: Land der Offenbarung,* Berlin, Frankfurt and Vienna 1961, as *Sinai,* Paris 1962, new edition, Zurich 1970; *Augenschein in Alaska,* Berne 1961; *Nubien: Goldland am Nil,* Zurich 1964; *Faras: Die Kathedrale aus dem Wüstensand,* with text by K. Michalowski, Zurich and Cologne 1966; *The World Saves Abu Simbel,* Berlin and Vienna 1968; *Kirchen im Fels,* Stuttgart 1968, as *L'Art Ethiopien,* Paris 1968, as *Churches in Rock,* London and New York 1970, new edition, Zurich 1972; *Frozen Frontier,* brochure, Zurich 1969; *The Nubians: Peaceful People in Egypt,* with text by Robert A. Fernea, Austin, Texas 1973;

Aethiopien: Das Dach Afrikas/L'Ethiopie: Toit de l'Afrique, Zurich 1974; *Der Mensch auf Seiner Erde: Eine Befragung in Flugbildern/La Terre de l'Homme: Vues Aériennes*, Zurich 1975, as *Grand Darth from Above*, London and New York 1976, paperback edition (one half of original) as *Flights of Discovery*, The London and New York 1978; *Brot und Salz: Flugbilder/Le Pain et le Sel*, Zurich and Paris 1980.

On GERSTER: article—"Sky High Portraits of the Earth" in *Photography Year 1980*, by the Time-Life editors, New York 1980.

When my plans for an aerial view of the earth were beginning to crystallize, I still uninhibitedly indulged, as I flew, in a hedonism of the eyes. I was sometimes completely overpowered by the beauty—it was always there, lying in wait for me, and I had nothing but an arsenal of cameras with which to confront it. The calligraphy of roads, the graphics of plantations, the unwitting art of salt recovery ponds and the mosaics of small cultivated fields still delight me and tempt me to board planes. But in addition to this beauty "out of the blue," and of equal importance, I am now aware of the information gained from the air. The aerial view by far exceeds the ground-level view in informational content; occasionally it even achieves something like the quadrature of the circle: the volume of information grows with abstraction. Admittedly, first doubts are stirred by the realization that even Man's worst offenses are aesthetically upgraded by sufficient distance. The automobile scrapyard in a natural setting is an eyesore on the ground, but even from kite-flying heights it is transformed into an attractive multicolored design. And as for the profuse, untidy settlement growth that eats into field, forest and meadow: at jet altitudes, if not lower, the eye begins to recognize a gratifying order in the chaos. Contemplation from a spacecraft redeems the earth from Man completely: to a lunar astronaut it appears as a habitable, though perhaps uninhabited, blue planet. This phenomenon of redemption through distance is the one drawback of an approach that otherwise has only advantages. Distance creates clarity and transforms the single image into a symbol: into an accusation here, a hymn of praise there, a manifesto everywhere. Coincidence turns to fact. On the ground we worry about an inventory of what is, but the lofty contemplation of the aerial photograph shows us also what might be—it is a stocktaking of our chances. Aerial photography x-rays the environments created by Man and reveals the intensity of the ecological give-and-take. It follows Man on his precarious way between foolishness and efficiency, conquest and coercion; manifests Man's conflict between the biblical order to subdue the earth and the necessity, only recently recognized, to submit himself to it. The currently popular condemnation of Man, which sees him as an incurable disease of his own planet, passes judgment without trial. I regard my aerial photographs as the interrogation of the accused; but if they plead at all, it is for one who has built up rather than against one who has destroyed.

—Georg Gerster

If aerial photography were simple, the work of Georg Gerster would not be so highly prized. But just as a cart-load of monkeys will not type Shakespeare, so a dozen orbiting satellites will not produce the kind of picture that Gerster has become almost uniquely famous for.

His pictures have something in common with modern art in offering colourful patterns, full of repeated motifs, of a flat "canvas." Then—unlike modern art—the eye finds and identifies objects, and the picture suddenly acquires scale and depth. Gerster varies the height and angle of his shots, so they are not all equally easy to "read." However, the joy of this recognition is a potent force in his photography.

With the joy of recognition comes the pleasure of seeing something from a new and therefore refreshing angle. Even rail yards and quarries take on a certain charm when seen from above, with massive tipper-trucks seeming like toys in a sandpit. In some cases the distance lends an unwarranted enchantment to the view, and Gerster appreciates that the aerial view is not an unalloyed benefit.

In some shots an extra favor is the discovery of order in what has previously seemed to be chaos. A town or a patchwork of fields or an irrigated landscape which seems, from ground level, to be a jumble can, from the air, be seen to have an organized or even an organic appearance. The result is that order is brought out of chaos, which is a satisfying experience.

Gerster rarely produces the complete abstract or "puzzle picture" with an interesting form but no informational content. Nor does he produce the sort of record shot which is so common in an aerial view, but which is only of real interest to people whose houses are in the picture. It is his combination of the factors of strong design with revelation that make his pictures so enjoyable. It makes them effective both in books like the magnificent *Grand Design* and as eye-stopping posters stuck on the wall advertising Swissair, who have used so many of the pictures.

—Jack Schofield

GHIRRI, Luigi.
Italian. Born in Scandiano, Reggio Emilia, 5 January 1943. Divorced; daughter; Ilaria. Freelance photographer, in Modena, since 1971. Agent: Galleria Rondanini, Piazza Rondanini 48, Rome. Address: Via San Giacomo 38, 41100 Modena, Italy.

Individual Exhibitions:

1973 Sette Arti Club, Modena
1974 *Paesaggi di Cartone*, Galleria Il Diaframma, Milan (travelled to Galleria Il Gelso, Lodi, Italy)
 Colazione sull'Erba, Galleria Il Diaframma Sud, Naples (travelled to Galleria Nadar, Pisa, and Galleria Comunale, Modena, 1975)
1975 *Atlante*, Galleria Documenta, Turin (travelled to the Canon Gallery, Geneva, 1976)
 Canon Gallery, Amsterdam
 Centro Divulgazione, Castano Primoli, Italy (travelled to the Galleria Comunale, Fusignano, Italy)
1976 Forum Stadtpark, Graz, Austria
 Galleria Rondanini, Rome
 Photographic Gallery, University of Southampton
1978 *Kodachrome* Galerie Contrejour, Paris (travelled to the Studio Fossati, Alessandria, Italy, Laboratorio d'If, Palermo, and the Fotostudio, Treviso, Italy, 1979; and Galleria Photo 13, Cagliari, Italy, 1980)
1979 Galleria CSAC, University of Parma
 Still Life, FNAC, Paris (travelled to FNAC, Metz, France, Galerie Stenope, Nice, and the Light Gallery, New York, 1980)
1980 Palazzo dei Diamanti, Ferrara, Italy (travelled to the Galleria Rondanini, Rome)

Selected Group Exhibitions:

1976 *Photography as Art/Art as Photography*, Maison Européenne de la Photographie, Chalon-sur Saône, France (and world tour)
 Introduction, at *Photokina '76*, Cologne
1977 *Personali*, at *SICOF*, Milan
1978 *Fotografie Italiana*, at *Rencontres Internationales de la Photographie*, Arles, France
 Arte e Natura, at the *Biennale*, Venice
1979 *Venezia '79*
 Iconicittà, Padiglione Arte Contemporanea, Ferrara, Italy
 Symposium über Fotografie, Forum Stadtpark, Graz, Austria
1980 *Das Imaginare Photo-Museum*, at *Photokina '80*, Cologne

Luigi Ghirri: From *Still Life* (original in color), 1978

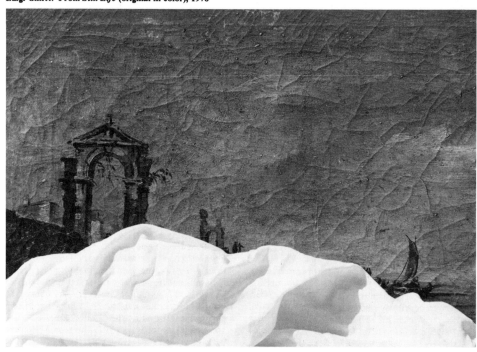

Ils se disent peintres..., Musée d'Art Moderne, Paris

Collections:

Centro Studi e Archivio della Communicazione, Parma, Italy; Bibliothèque Nationale, Paris; Musée Réattu, Arles, France; Museum of Modern Art, New York.

Publications:

By GHIRRI; books—*Kodachrome*, Modena and Paris 1978; *Luigi Ghirri*, Parma and Milan 1979.

On GHIRRI; books—*Photography Yearbook*, by the Time-Life editors, New York 1975; *70 Anni di Fotografia Italiana* by Italo Zannier, Modena 1979; *Venezia '79: La Fotografia*, edited by Daniela Palazzoli, Vittorio Sgarbi and Italo Zannier, Milan and New York 1979; *Photokina 1980: Glanzichter der Photographie*, edited by L. Fritz Gruber, Cologne 1980; articles—"Inventer le Reel" by Michel Nuridsany in *Le Figaro* (Paris), 31 October 1978; "Inventer le Reel" by Michel Nuridsany in *Le Figaro* (Paris), 14 November 1979; "Un Art Trompeur" by Jean-Claude Lemagny in *Connaissance des Arts* (Paris), no. 337, 1980; "Luigi Ghirri" by George Tatge in *Artforum* (New York), January 1981.

In 1969 the photo taken from the space shuttle on its way to the Moon was published in all newspapers: this was the first photograph of the world.

The picture pursued for centuries by man was presented to our eyes, containing contemporarily all the preceding images, incomplete, all books written, all signs deciphered and not.

It was not only a picture of the world, but the picture which contained all pictures of the world: graffiti, frescoes, prints, paintings, writings, photographs, books, films. Simultaneously the representation of the world and all the representations of the world in one time only.

On the other hand, this total view, this *redescription* of everything, destroyed one more possibility of translating the hieroglyphic whole. The power of containing everything vanished in front of the impossibility of seeing everything at the same time.

The event and its representation, to see and to be contained, reappeared to man as not sufficient to solve eternal questions. This possibility of *total duplication*, however, allowed us to glimpse the possibility of deciphering the hieroglyph; we had the two poles of doubt and of the secular mystery the picture of the atom and the picture of the world, finally one in front of the other. The space between the infinitely small and the infinitely big was filled by the infinitely complex problem: man and his life, nature. The need for information and consciousness thus arises between two extreme points, oscillating from the microscope to the telescope in order to be able to translate and interpret reality or the hieroglyph.

My work rises from the necessity and the desire to interpret and translate the sign and meaning of this sum of hieroglyphs. So, not only a reality that is easily identifiable or highly loaded with symbols, but also thought, imagination, the fantastic, and strange meanings.

The photograph is extremely important for the goal that I have set myself because of certain characteristic features of its language, which I shall try to explain:

The cancellation of the space surrounding the framed part is for me as important as the represented part; it is because of this cancellation that the picture assumes a meaning and becomes measurable.

At the same time, the picture continues in the *visible part* of the cancellation, and it invites us to *see* the rest of the not-represented reality.

This double aspect of representation and cancellation not only evokes the absence of limits (excluding any idea of completeness, of a finished thing), but also it indicates something that cannot be delimited—the real.

The possibility of seeing and penetrating the universe of reality involves passing through all the known cultural representations and models, which have been given to us as definite and decisive, and our relationship with reality and life is the same as that of the picture from the satellite with the earth itself.

So the photograph, with its indeterminates, is privileged: it is able to go beyond the symbolism of definite representations to which a certain value of *truth* has been given. The possibility of analysis in time, in the space of signs that form the reality whose completeness has always slipped our minds, thus permits the photograph, because of its *fragmentary character*, to be closer to things that cannot be delimited, that is, physical existence.

That is why I am not interested in "pictures" or "decisive moments," or the study or analysis of their language as an end in itself, aesthetics, the concept or totalizing idea, the emotions of the photographer, the well-bred quotation, the search for a new aesthetic creed, the use of a style.

I am occupied with *seeing* clearly. That is why I am interested in all possible functions, without separating any one from the whole; I wish to assume them totally in order to show and render recognizable, at one time or another, the hieroglyphs I have met.

The daily encounter with reality, with the fictions and the surrogates, the ambiguities, poetical or alienating, seems to deny any way out of the labyrinth, the walls of which are always increasingly illusive, even to the point of our confusing ourselves with them. The meaning that I try to give to my work is that of verification, of how it is still possible to wish to face the way of knowledge, possible at last to tell the real identity of man, of things, from the image of man, of life.

—Luigi Ghirri

The discussion between those who are partisans of conceptual art and those who are partisans of an expression more emotive and formally rich will find a point of equilibrium in the work of Luigi Ghirri. His photos, usually created in series, represent a moderation between intellect and sensibility, which is to say that they are images clearly realized within the function of a concept—paradoxically, they are reflections upon the same image, each time more pointed, in a progressive process that the creator himself has classified as "intellectual strip-tease"— but without falling into excessive seriousness, boredom or lack of imagination which plagues many conceptual photographers. Ghirri, instead, boasts an irony that alone would justify his creative labor.

It is difficult to talk in general terms of photographic activity as prolific—at times even dangerously excessive—but it is the aspect of irony which seems fundamental to me. The paradox and *trompe de l'oeil* are rhetorical devices which time and again, and with a peculiar visual intelligence, appear to be the leitmotif of Ghirri's creations. With our civilization remaining as a backdrop, he creates a sort of critical X-ray photograph of this image-oriented civilization—that is to say, of the multiplicity of images which it produces and consumes, of its mass production, of its depersonalization, of its decontextualization, and, above all, of its "thingification" (an image is today an object-thing more than a representation of some-thing).

To a certain extent, this is reminiscent of "pop": the taste for the industrial image, for its "parasitic" elements such as the photomechanical fraud—the *decollages*, the reflection which the paper itself produces, etc.—for the "*objet trouvé*" (which in this case would be called the "*image trouvé*") or for "*kitsch*" imagery.

Without doubt, it is for these reasons which Jean-Claude Lemagny—one of those who best knows Ghirri's work—affirms that in him "we find ourselves in contact with two artifices: that of the modern world and that of color photography." It is a modern world evidently filtered through a lens which is both cunning and implacably critical. The question of color deserves special attention. The color in Ghirri's photography turns out to be a means that is consubstantial with the very nature of both the medium and the world (a world which we view in color). Color photography appears more neutral, more transparent, renouncing the artificiality and the artiness to which a priori black-and-white lends itself by pure cultural convention. Nevertheless, it is obviously not a question of an innocent or naive use of color, but one full of intention. Approaching the inoffensive aesthetic of the amateur, with its mass-produced, fully automated snapshots, Ghirri uses the same weapons of the ambient contemporary sensibility suitable to the capitalistic world, but purely in order to disqualify it. In this way the factor of color—as well as many other factors—constitutes a profound subversion of the sensibility of the system.

—Joan Fontcuberta

GIACOMELLI, Mario.

Italian. Born in Senigallia, Ancona, 1 August 1925. Educated at schools in Senigallia, 1935-40; studied typography; self-taught in photography. Served in the Italian Army, 1944. Married Anna Giacomelli in 1954; children: Rita, Neris and Simone. Professional typographer, and independent photographer, Senigallia. Agent: Galleria Il Diaframma, Via Brera 10, 20121 Milan. Address: Via Mastai 24, 60019 Senigallia, Ancona, Italy.

Individual Exhibitions:

1966 *Breve Omaggio*, Novara, Italy
1979 Visual Studies Workshop, Rochester, New York (with Joseph Jachna)
1980 *Brandt/Giacomelli/Macijauskas*, Galerie et Fils, Brussels (with Bill Brandt and Alexandras Macijauskas)
1981 Contrasts/Visions Gallery, London
1982 Photography Gallery, Philadelphia

Selected Group Exhibitions:

1967 *Photography in the 20th Century*, National Gallery of Canada, Ottawa (toured Canada and the United States, 1967-73)
1975 *The Land: 20th Century Landscape Photographs Selected by Bill Brandt*, Victoria and Albert Museum, London (travelled to the National Gallery, Edinburgh; Ulster Museum, Belfast; and National Museum of Wales, Cardiff, 1976)

Collections:

Galleria Il Diaframma, Milan; Università di Parma, Italy; Bibliothèque Nationale, Paris; Victoria and Albert Museum, London; Museum of Modern Art, New York; International Museum of Photography, George Eastman House, Rochester, New York.

Mario Giacomelli: *Seminarians*, 1962

Publications:

On GIACOMELLI: books—*Nuova Fotografia Italiana* by Giuseppe Turroni, Milan 1959; *Breve Omaggio*, exhibition catalogue, by Paolo Monti, Novara, Italy 1966; *Photography in the 20th Century* by Nathan Lyons, New York 1967; *Primo Almanacco Fotografico Italiano*, edited by Lanfranco Colombo and Roberta Clerici, Milan 1969; *The Print*, by Time-Life editors, New York 1972; *Looking at Photographs* by John Szarkowski, New York 1973; *The Magic Image* by Cecil Beaton and Gail Buckland, London and Boston 1975; *The Land: 20th Century Landscape Photographs Selected by Bill Brandt*, exhibition catalogue, edited by Mark Haworth-Booth, London 1975; *Geschichte der Fotografie im 20. Jahrhundert / Photography in the 20th Century* by Petr Tausk, Cologne 1977, London 1980; *Mario Giacomelli* by Arturo C. Quintavalle, and others, Parma, Italy 1980; articles—"Giacomelli, Prima e Secunda Maniera" by Giuseppe Turroni in *Fotografia* (Milan), May 1959; "Grande Artista" by S. Genovali in *Regione Marche* (Ancona), July 1960; "Io Non Ho Mani" by P. Racanicchi in *Popular Photography* (Milan), February 1964; "Giacomelli" by Nathan Lyons in *Popular Photography* (New York), September 1965; "Giacomelli" by Attilio Colombo in *Progresso Fotografico* (Milan), October 1974; "Giacomelli" by Arturo Schwartz in *Fotografia Italiana* (Milan), May 1978; "Giacomelli" by Hervé Guibert in *Le Monde* (Paris), January 1980.

Mario Giacomelli lives in a small town, Senigallia, on the shores of the Adriatic Sea, where the original spirit of the Italian mentality remained virtually untouched by foreign influences for a long time. Because he is very shy by nature, Giacomelli never felt himself entirely at home in the big cities of the North: the traffic, the newly acquired customs, seemed to him completely at odds with national traditions. The environment in which he was born and in which he has lived his entire life has formed his mental background and attitudes. Giacomelli likes everything, intuitively, that has been typical of the old Italy. In the arts in general he has preferred works that represent the purest domestic approach. Thus among his favorite poets he reserves a place of honor for Giacomo Leopardi, traditionally beloved by the whole nation, whose work is considered to be among the most pessimistic in the world's literature. And on the wall of Giacomelli's darkroom there is a small photograph showing the face of the painter Giorgio Morandi whose still-lifes have profoundly penetrated his subconscious.

This close connection to his native ground is significant in Giacomelli's interpretation of the inner truth of the Italian reality. His optical communications have always been based on his belief that he had something important to say about the world, and he never takes the camera into his hands before he feels that he has found the right relation to his subject. He is the kind of photographer whose activity is based more on intuition than on theoretical reasoning, and the means by which he determines themes for future photographs could be described as purely emotional. The time needed for this "ripening of ideas" often lasts a few months, but once he is sure of his orientation he takes his images without hesitation and quite quickly.

Giacomelli has never worked according to the trial-and-error method of many photojournalists. Although a great part of his work belongs to the realm of "live" photography, he is able to enlarge about 80% of his negatives into definitive prints. Using a little-known camera, Kobell Press, he takes on one strip of film only 10 photographs: he saves his spare shots, prepared to take more pictures if still better situations occur.

In Italy the sun shines from the bright blue sky, and the white walls of the houses reflect the sun. At night the towns and cities are full of light, and the atmosphere is gay. However, under the apparent jollity of the surface there is sorrow, mourning and a fear of death, deep within the Italian soul. Giacomelli discovered very early on his own way to resonate this melancholic sense in his photographs—not only through the choice of motif but also in his use of dark tones. The scenes from Italian country life in Abruzzi, where the village women wear black clothes, is a good and logical rendering of some of his favorite motifs.

Giacomelli likes the high contrast between the pictures of persons and the white walls of houses in the background, because within such contrasts forms become most evident. For this reason he also uses high contrast paper. Sometimes, the profound contrast of black-clad people and white backgrounds creates an almost graphic effect—as, for instance, in the cycle showing young seminarians playing in the snow. The "solution" of these photos suggests that his sense for interesting forms was combined closely with an art in choosing the right moment for both an eloquent and poetic depiction.

Giacomelli does not like to hurry. Similarly, just as he needs time to become acquainted with his subject, so he often does not make his definitive enlargement immediately after developing his film. Sometimes he first makes only a small contact-print, which he observes until he has determined his solution. This "second ripening" can sometimes take as much as a few weeks.

Of course, this kind of pure work with forms is also characteristic of his landscape photographs, which have been an important part of Giacomelli's oeuvre from the very beginning. In fact, landscape has served him well, given his particular methods of working: it has allowed him to meditate on his subject, to ripen his vision, without the time-limit imposed by live images. His training (from youth) in typography and his life, his whole culture of seeing, come together in these works.

—Petr Tausk

GIANELLA, Victor.
Swiss. Born in Paris, France, 5 January 1918; settled in Switzerland, 1949. Studied typography and book production under Georges Lecomte at the Ecole Estienne, Paris, 1934-37. Served in the 18th Regiment of Engineers, French Army, Nancy, 1938-40; deported, as prisoner-of-war, to work-camp, Vienna, 1942-45. Married Clara Darana in 1947; children: Francois and Daniel. Freelance photographer since 1969. Agent: Galleria d'Arte, Via St. Maria 14, 6850 Mendrisio, Switzerland. Address: CH-6911 Brusino-Arsizio, Ticino, Switzerland.

Individual Exhibitions:

Victor Gianella: *Carré 679*, Antibes, 1977

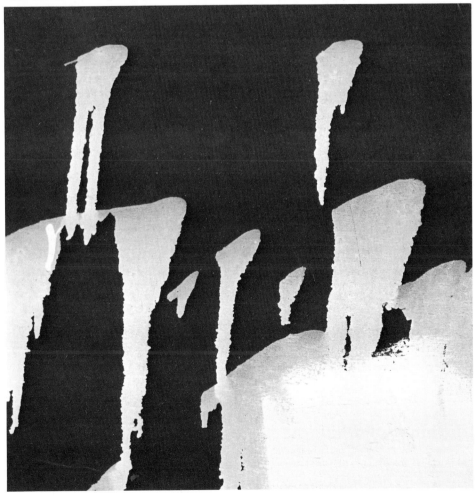

Selected Group Exhibitions:

1974 *Swiss Photography from 1840 until Today*, Kunsthaus, Zurich (travelled to the Villa Malpensata, Lugano, and Musée Ratch, Geneva)

1975 *Triennale de la Photographie*, Musée d'Art et d'Histoire, Fribourg

1979 *Modern European Color Photography*, Michener Gallery, University of Texas

1981 *Astrazione e Realta*, Galleria Flaviana, Locarno, Switzerland

Collections:

Bibliothèque Nationale, Paris; Fotoforum der Gesamthochschule, Kassel, West Germany; Gernsheim Collection, University of Texas at Austin.

Publications:

On GIANELLA: book—*Triennale de la Photographie*, exhibition catalogue, Fribourg 1975; articles—*Photographie*, leaflet, by Helmut Gernsheim, Mendrisio, Switzerland, 1979; "Victor Gianella" by Giuliana Scimé in *Cenobio* (Lugano), January/February 1979; "Collection Shows Photos and Art" by Laura Fatal in *The Daily Texan* (Austin), April 1979.

I have taken photographs since my youth. My development, however, dates from 1968-69. How can I explain the reasons for this development? A choice, an abstraction? I might even dare to say: "the heart has reasons that reason does not understand." Or then I might also say that "poetry is loved rather than understood."

For me, taking photographs is neither work nor a profession; it is, on the contrary, a necessity, a duty. It is like travel unlimited by time or space, towards distant shores, towards a kind of infinite....

It is true that I enjoy taking photographs of simple insignificant everyday objects, trying to give them form and soul. I would even like to make them worthy of admiration—like the "great things" of this world.

Contemporary photography is very rich in interesting subjects. Today, perhaps reason eclipses everything else. But, tomorrow, might it not be the heart?

—Victor Gianella

Photography is a form of abstraction, a selection from nature, a segment. Complete abstraction—the reduction to a minimum of lines—is the most difficult form of composition, and probably no one is so much the master of this Mondrian-like way of seeing in photography as Victor Gianella.

His work is not achieved, as some people assume, by cropping in the enlarger but by careful selection before shooting. In the apparent simplicity of composition lies long practice in reducing the image to its fundamental elements. The more a detail is isolated from its context and seen in juxtaposition to another fragment normally not associated with it in our minds, the stranger is the visual effect. We fail to recognize the subject altogether, and the fragment assumes a life of its own.

Gianella is fascinated by this fragmentation of the visible world into facets that remain hidden to most of us. His magic images, transcending the reality of the object, are painterly in conception yet achieved by purely photographic means. They are all of everyday subjects, such as close-ups of children's balloons, a gas ring, a rent in a tent, brush strokes, bore-holes in metal.

These and other superb colour compositions make him the most original abstract expressionist in photography.

—Helmut Gernsheim

GIBSON, Ralph.

American. Born in Los Angeles, California, 16 January 1939. Educated at Notre Dame High School, North Hollywood, 1952-56; studied photography while serving in the United States Navy, Mediterranean Fleet, 1956-60, and at the San Francisco Art Institute, 1960-61. Photographer since 1961: worked as an assistant to Dorothea Lange, San Francisco, 1961-62; worked for Robert Frank on the film *Me and My Brother*, New York, 1967-69; cameraman on *Conversations in Vermont*, 1969; moved to New York, and established a studio there, 1969. Founder-Director, Lustrum Press, New York, since 1969. Founder Member, with Frosty Meyers, Larry Clark, Rich Ferrar, and Larry Bennett, Sex 'n' Drugs Band, New York, 1975. Recipient: National Endowment for the Arts Photography Fellowship, 1973, 1975; Creative Artists Public Service Grant, New York, 1977; DAAD Exchange Fellowship, Berlin, 1975. Agent: Castelli Photographs, 4 East 77th Street, New York, New York 10021. Address: 331 West Broadway, New York, New York 10013, U.S.A.

Individual Exhibitions:

1970 San Francisco Art Institute
1971 Focus Gallery, San Francisco
1972 Pasadena Art Museum, California
1973 Centre Culturel Americain, Paris
International Museum of Photography, George Eastman House, Rochester, New York
Galerie Wilde, Cologne
1974 Miami-Dade Community College
Wilkes College, Wilkes-Barre, Pennsylvania
Palais des Beaux-Arts, Brussels
1975 Hoesch Museum, Düren, West Germany
Galerie Agathe Gaillard, Paris
Photopia Gallery, Philadelphia (with Mary Ellen Mark)
Madison Art Center, Wisconsin
Broxton Gallery, Los Angeles
1976 University of Guelph, Ontario
Castelli Graphics, New York
Baltimore Museum of Art
Moderna Museet, Stockholm
Focus Gallery, San Francisco
Light Impressions, Rochester, New York
Galerie Fiolet, Amsterdam
Silver Image, Tacoma, Washington
Texas Center for Photographic Studies, Dallas
Center for Contemporary Photography, Chicago
Photogenesis, Columbus, Ohio
Galerie Jean Dieuzaide, Toulouse
1977 *Brandt/Gibson/Klein*, Vrije Universiteit, Amsterdam (with Bill Brandt and Aart Klein)
Van Reekum Galerij, Apeldoorn, Netherlands
Galerie Agathe Gaillard, Paris
Moderna Museet, Stockholm
CEPA Gallery, Buffalo, New York
Silver Image Gallery, Seattle
Museum of Modern Art, Oxford
Side Gallery, Newcastle upon Tyne, England
Photographers' Gallery, Melbourne
Galerie Breiting, Berlin
1978 Robert Self Gallery, London
Castelli Graphics, New York
Center for Creative Photography, University of Arizona, Tucson
Camera Obscura, Stockholm
Photographers' Gallery, Melbourne
Galerie Daniel Templon, Paris
Galerie Fiolet, Amsterdam
Van Reekum Galerij, Apeldoorn, Netherlands
Museum of Modern Art, Brisbane
Galerie Givaudan, Geneva

Atlanta Gallery of Photography
1979 Werkstatt für Photographie, Berlin
Canon Photo Galerie, Geneva
Grapestake Gallery, San Francisco
I.C.A. Museum of Art, Richmond, Virginia
Galerie Pennings, Eindhoven, Netherlands
Nouvelle Image, The Hague
1980 Castelli Graphics, New York
Kunstmuseum, Dusseldorf
Galleria Arco d'Alibert, Rome
The Black Series, The Photography Gallery, Cardiff
Olympus Showroom, Hamburg
Open Eye Gallery, Liverpool
Night Gallery, London
1981 P.P.S. Gallery, Hamburg
Galleria La Giudecca, Venice
Sprenger Museum, Hannover
Silver Image Gallery, Seattle

Selected Group Exhibitions:

1967 *12 Photographers of the American Social Landscape*, Brandeis University, Waltham, Massachusetts
1970 *U.S.A. in Your Heart*, San Francisco Art Institute
1973 *Contemporanea*, Parcheggio della Villa Borghese, Rome
1975 *Rencontres Internationales de la Photographie*, Arles, France
4 Amerikanische Photographen: Friedlander/Gibson/Krims/Michals, Städtischer Museum, Leverkusen, West Germany
1977 *Concerning Photography*, The Photographers' Gallery, London (travelled to the Spectro Workshop, Newcastle upon Tyne)
1978 *23 Photographers/23 Directions*, Walker Art Gallery, Liverpool
Mirrors and Windows: American Photography since 1960, Museum of Modern Art, New York (toured the United States, 1978-80)
1979 *Photographie als Kunst 1879-1979/Kunst als Photographie 1949-1979*, Tiroler Landesmuseum Ferdinandeum, Innsbruck, Austria (travelled to the Neue Galerie am Wolfgang Gurlitt Museum, Linz, Austria; Neue Galerie am Landesmuseum Joanneum, Graz, Austria; and the Museum des 20. Jahrhunderts, Vienna)
1980 *Zeitgenössische Amerikanische Photographie*, Galerie Rudolf Kicken, Cologne

Collections:

Museum of Modern Art, New York; International Museum of Photography, George Eastman House, Rochester, New York; Fogg Art Museum, Harvard University, Cambridge, Massachusetts; High Museum of Art, Atlanta; Norton Simon Museum of Art, Pasadena, California; San Francisco Museum of Modern Art; National Gallery of Canada, Ottawa; Bibliothèque Nationale, Paris; Victoria and Albert Museum, London; Fotografiska Museet, Moderna Museet, Stockholm.

Publications:

By GIBSON: books—*The Strip*, Los Angeles 1966; *The Hawk*, Indianapolis 1968; *The American Civil Liberties Union Calendar*, New York 1969; *The Somnambulist*, New York 1970; *Deja-Vu*, New York 1973; *Days at Sea*, New York 1974; *Mit Konkreten Bildern die Welt Ordnen*, portfolio, with text by Rolf Paltzer, Hamburg 1980; articles—"A Statement on the Photographic Print Market" in *Print Letter* (Zurich), September/October 1979; interview in *Photography Between Covers* by Thomas Dugan, Rochester, New York 1979.

Ralph Gibson: From *Quadrants*, 1975

On GIBSON: books—*Ralph Gibson*, exhibition catalogue, by Ake Sidwall and Leif Wigh, Stockholm 1976; *Nude: Theory* by Jain Kelly, New York 1979; *The Black Series*, exhibition catalogue, by Ian Walker, Cardiff 1980; articles—"Ralph Gibson: The Somnambulist" in *Creative Camera* (London), November 1971; "Ralph Gibson" in *Photography Annual 1972*, New York 1972; "Ralph Gibson: Deja-Vu" by A.D. Coleman in the *New York Times*, 25 February 1973, reprinted in Coleman's *Light Readings: A Photography Critic's Writings 1968-1978*, New York 1979; "Ralph Gibson: Pictures from Deja-Vu" by H.M. Kinzer in *35mm Photography* (New York), Spring 1973; "Ralph Gibson" in *Photo* (Paris), September 1973; "Ralph Gibson" in *Modern Photography Annual*, New York 1973; "Ralph Gibson: The Future Returns" in *US Camera/Camera 35 Annual*, New York 1973; "Ralph Gibson" by Douglas Davis in *Newsweek* (New York), 18 November 1974; "Ralph Gibson" in the *British Journal of Photography* (London), 20 December 1974; "Ralph Gibson" by William Wilson in the *Los Angeles Times*, 13 June 1975; "Ralph Gibson: How He Creates His Fractional Images" in *Popular Photography* (New York), April 1977; "An Imaginary Interview with Ralph Gibson" in *Camera* (Lucerne), April 1979; "Ralph Gibson's Early Work" by Cynthia Gano Lewis in *Center for Creative Photography No. 10* (Tucson, Arizona), October 1979; "Formalism Stretched to Vacuity" by Hal Fischer in *Artweek* (Oakland, California), 12 January 1980.

I have been involved with this image since it was made, in 1975. It satisfies my need for structure, content, surrealism, religion, society, etc. I can still vividly recall the moment I made this photograph. It was a moment of clarity.

—Ralph Gibson

Ralph Gibson's art is one of structure, analogy, and sequence. Individually, his pictures have a broad and compelling organization and consequent force such that they can stand as autonomous works, yet it is in the progressive building of image upon image that their full meaning is realized. Characteristically working in series, Gibson endeavors to amplify each image by all those around it, so that the subtleties of each emerge in the context of the others.

This process permits—or more to the point, demands—the effort of his audience, who must become partners with him in discovery. Since sequence is vital to the logic of this process, the photographer needs an absolute control over it—thus the photographic book, unburdened with verbal accounts and functioning to physically preserve the sequence, has become the ideal medium for Gibson's work. Implicit in this is a revised concept of just what constitutes a finished work. The silver image, emerging from the darkroom to live on as artifact, is less to the point than the series of which it is a part; "a work," as an artistic totality encompassing thought, plan and intention, means the whole series. And the book, rather than suggesting a secondary status as once-removed from the original, becomes in effect the original in that it is the final product of the artist's insight and exercise of control.

The Trilogy of books from the early 1970's (*The Somnambulist*; *Deja-Vu*; *Days at Sea*) have in common the editorial acumen which associates itself directly with the creative process rather than with a secondary act of sorting and piecing together. The enchantment with the potential of the carefully planned book has resulted in a considerable contribution to the field through Gibson's Lustrum Press.

By-and-large, the content of Gibson's images is elusive and even mysterious. The human form is generalized beyond the associative specificity of portraiture; by way of this, individuals in the pictures, denied as they are those props and signs of distinct locale, are elevated to a plateau of human-kind-ness. The result is an invitation to metaphysi-

cal speculation based on the images, yet (much to their advantage) the pictures utterly lack the rhetorical grandiosity that so often emerges from pictures alluding to the state of mankind in the world and the universe.

Frequently figures appear as but fragments. This draws attention to the framing of the shot, one of the photographer's most powerful tools. Edge is critical, as are the proportions of the rectangle and the tensions established by forcing the compositional thrust of the image to the periphery. Such pictures, though, ring with an organic completeness of structure, so that this device connotes nothing fortuitous in the process of picture-making or the encounter with a subject. While capitalizing on the properties of the small hand-held camera, the photographer virtually discards the stylistic tradition associated with 35mm work.

The technical conditions of Gibson's work are at odds with the current ideal of the richly tonal print. He aims for a maximum saturation of the blacks at the expense of (irrelevant) detail, and maximizes the harshness of grain with contrasty printing that abbreviates the tonal scale. Every technical decision has a reverberation in the aesthetic quality of the image: in Gibson's photographs the local textures of objects sacrifice a degree of their identity to the quality of the surface of the picture; space contracts as spatial clues are submerged; the sheer graphic punch of the two-dimensional image compels attention.

The structural distinctiveness of the pictures often depends as well on the isolation of parts, to the degree that the authority Gibson can invest in parts forestalls one's speculations about the whole. His "The Priest" typifies the taut severity of design that one finds again and again. The painstaking calculation of the relative visual weights of sky and black frock yields a variation of shape and tension of positive and negative space which results in a solemn austerity of conception, a monumentality defiant in the face of a visual world of flux and ephemeral appearance.

Gibson's sophisticated analogical thinking—or analogical intuition of eye—is another persistent trait. It is best exemplified in *Deja-Vu*, wherein pairs of images of different size confront one another in each spread. In some pairs, the comparison back and forth is based on a formal similarity of objects one would not generally associate. This is a testimony not just to one person's capacity of recognition, but to an innate syntactical feature of the medium itself. Gibson is attuned not just to the potentials of the visible world, but to the unique capacity of photography to rebuild that world. In one instance, the collar of a sailor reacts with the curve of a newspaper in the adjacent frame; in another, a figure cut by the edge is completed by the arm of a different figure in a different setting—the arm outstretched and holding a gun. The shock value of this (a recurrent symbol) is less effective (and more overtly contrived) than the purely photographic aspect of the pair.

Other analogies are less explicit. The windblown hair of a woman is compared to a cloud. The remarkable quality of this pairing and others of the same sort is a capacity to evoke sensation beyond the visual. The tactile conjuring of Gibson's work is often downright synaesthetic: a limited vocabulary of repeated but differently inflected motifs excites the broadest range of responses.

Finally, while many photographers seem to consciously establish a gulf between themselves and their work, Gibson's seems intensely personal. In a sense, the pictures are autobiographic, but so obliquely that their public accessibility is not diminished. Their meaning is in a realm of suggestion rather than fact; they are equally capable of rewarding eye, mind, and whatever it is that some dare to call soul.

—Roger Baldwin

GIDAL, Tim N(achum).

American/Israeli. Born Ignaz Gidalewitsch, of Russian parents, in Munich, Germany, 18 May 1909; emigrated to Israel, 1936: naturalized, 1975; emigrated to the United States, 1947: naturalized, 1953. Educated at the Neves Real-Gymnasium, Munich, 1928; studied art history, history and economics at the University of Munich, 1928-29, University of Berlin, 1929-31, and University of Basle, 1933-35, Ph.D. 1935. Served as Chief Staff Reporter, *Parade* magazine, British 8th Army, North Africa and Mediterranean, 1942-43, and with the British 14th Army in China, Burma, India, and the Middle East, 1943-44: Captain. Married Sonia Epstein in 1944 (divorced, 1970); son: Peter; married Pia Lis in 1980. Photo-reporter and journalist, working for the *Münchner Illustrierte Zeitung*, *Woche*, etc., Berlin, 1929-33, and for British and American magazines in Palestine, 1936-38; Principal Photo-Reporter, under Stefan Lorant, *Picture Post*, London, 1938-40; freelance photographer, Jerusalem, 1940-42, 1945-48; Editorial Consultant, *Life* magazine, New York, 1959-54; Lecturer in Visual Communications, New School for Social Reserach, New York, 1955-58; writer/photographer, 1955-70. Since 1971, Senior Lecturer in Visual Communication, Hebrew University of Jerusalem. Recipient: Kalvin Prize, Israel Museum, Jerusalem, 1980. Fellow, Royal Photographic Society, 1965; Corresponding Member, Deutsche Gesellschaft für Photographie, 1972. Agents: The Photographers' Gallery, 8 Great Newport Street, London WC2, England; and Witkin Gallery, 41 East 57th Street, New York, New York 10019, U.S.A. Address: 16 Nili Street, Jerusalem, Israel.

Individual Exhibitions:

1937 Steimatzky Gallery, Jerusalem
1974 Galerie Schürmann and Kicken, Aachen, West Germany
1975 *Tim Gidal: In the 30's*, Israel Museum, Jerusalem (travelled to The Photographers' Gallery, London, 1976; Witkin Gallery, New York, 1978; Galerie Nagel, Berlin, and Galerie Photo Art, Basle, 1979; Gundlach Galerie, Hamburg, and Foto-Museum, Munich, 1981)
1981 *Tim Gidal: In the 40's*, Israel Museum, Jerusalem (travelled to The Photographers' Gallery, London)
Polish Jewry, 1932, Neikrug Galleries, New York

Selected Group Exhibitions:

1978 *Photokina '78*, Cologne
1980 *Avant-Garde Photography in Germany 1919-39*, San Francisco Museum of Modern Art (toured the United States, 1981-82)

Collections:

Vistoria and Albert Museum London; Berlinische Galerie, Berlin; Photo Museum, Munich; Israel Museum, Jerusalem; International Museum of Photography, George Eastman House, Rochester, New York; Gernsheim Collection, University of Texas at Austin; City Art Museum, Melbourne.

Publications:

By GIDAL; books—*Bildberichterstattung und Presse/Picture Reporting and the Press*, Tübingen, Germany 1935, 1952; *Kinder in Eretz Israel*, Berlin 1936; *Israel Year*, Berlin 1936; *Meir Shfea*, New York 1947; *This Is Israel*, with Robert Capa and Jerry Cooke, New York 1948; *My Village*, series (23 books), with Sonia Gidal, New York 1956-70; *Modern Photojournalism: Origin and Evolution 1910-*

1933, Frankfurt and Lucerne 1972, New York 1973; *Everybody Lives in Communities*, Boston 1972; *Ewiges Jerusalem/Eternal* Jerusalem, Lucerne 1980. articles—"Eye Witness"in *Der Bildjournalist* (Leverkusen, West Germany), no. 1-2, 1967 and no. 1-2, 1968; "Photojournalism's First Two Decades" in *35mm Photography* (New York), Summer 1974; "Letter to Young Photographers" in *Creative Camera International Yearbook*, London 1978; "Working for *Picture Post*" in *Creative Camera* (London), Winter 1980-81; "Modern Photojournalism: The First Years" in *Creative Camera* (London), January 1981.

On GIDAL: books—*The Magic Image* by Cecil Beaton and Gail Buckland, London and Boston 1975; *Tim Gidal: In the 30's*, exhibition catalogue, Jerusalem 1975; *Geschichte der Photographie im 20. Jahrhundert/History of Photography in the 20th Century* by Petr Tausk, Cologne 1977, London 1980; *The Photograph Collector's Guide* by Lee D. Witkin and Barbara London, Boston and London 1979; *100 Years and 30: Photography in Palestine/Israel 1840-1978*, Jerusalem 1979; articles—"Tim Gidal" by Colin Osman in *Creative Camera* (London), September 1974; "Tim Gidal" by Bernd Lohse in *Camera* (Lucerne), January 1975; "Tim Gidal: Before the Storm" in *London Magazine*, December 1976; "The Revolution in Reportage" by Gene Thornton in the *New York Times*, 23 April 1978; "Tim Gidal" by Colin Osman in *Creative Camera* (London), May 1979.

Photography was always an essential part of my adult life. As a photographer, I published in many magazines, from the early German illustrated magazines (since 1929) to *Life* and *Look* and, with great pleasure, in *Picture Post*, where I had the chance to create visual novellas or essays.

But the greater part of my photographs I did, a private passion, for myself, as a great experience of life itself. This explains the fact that for more than 40 years I never contributed to a photographic magazine, never sent photos to exhibitions. These photographs were, as a rule, seen only by my friends. Those photos, at least, that went beyond the stage of contact prints (one exception: 1937 in Jerusalem, for my friends).

In 1974 I decided to exhibit my photos of the 30's. I had one-man shows (about 120 photos) at the Israel Museum in Jerusalem (1975), The Photographers' Gallery, London (1976), Witkin Gallery, New York (1978), and the Nagel Gallery in Berlin (1979). I had much fun when I showed people my photos (most of them had not known my name) and watched the startled expressions on their faces.

Cecil Beaton and Gail Buckland, Colin Osman of *Creative Camera*, and Allan Porter of *Camera* were the first to publish my photos in their books and magazines. The *taking* of the photos, not the showing, was, and is, for me, of the essence.

My photos, I like to think, are variations on the everlasting theme of the tragi-comedy of human life, facets of life itself. In contrast to, say, Henri Cartier-Bresson, I do not wait until the formal quality of the selected rectangle in my viewfinder satisfies a constructivist formal urge. I am directed, I believe, more by intuition and participation, which leads on occasion to a sort of participation mystique.

My photos should show what I saw and experienced. I can't explain them; I have no mission. The viewer can take what attracts him (or leave it). But it gives me much satisfaction when some, especially younger, people "are sent" by some of my pictures—as the saying went in the 1960's.

As a rule, I do not crop my photos. As a rule, cropping destroys their meaning (at least for me). Some editors cursed me, because they found it almost impossible to crop my pictures, which amused me.

I admire amongst the younger photographers, for example, Eva Rubinstein, Heinrich Riebesehl, Hans Schmidt (Berlin), Marco Fontana. He is the only one I once tried to imitate. I admire some of my opposites: Aaron Siskind, Erwin Blumenfeld, some of Penn's and Avedon's work.

Good Art is good Art, bad Art is horrible art. Good paintings are good paintings, bad paintings are bad. Good photography is good photography, bad photography is bad, and much of the new pictorialism and imitation of third-class literature is bad photography. So is most of what is called "conceptual photography," because it tries to imitate literature and shows only a first draft.

But, as I say, there is much good photography around, especially amongst those younger photographers who go their own way and don't try to imitate.

—Tim N. Gidal

Tim N. Gidal: *Hamlet*, Stratford upon Avon, 1939

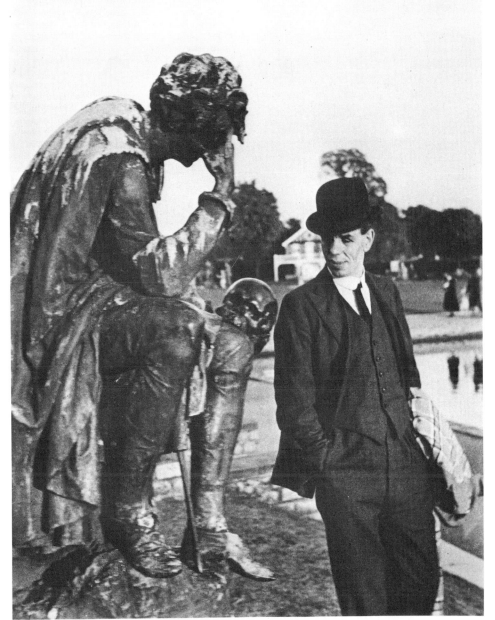

Tim Gidal's engaging summary of his career in photography suggests an initially puzzling distinction between his public and private work. He tells us that he enjoyed providing "visual novellas and essays" for German and British illustrated magazines during the 30's and 40's; and yet he also speaks of photographs made during that same period which had their origin in a purely "private passion," which were rarely exhibited or reproduced and are not to be explained—at least by their creator—in terms of any conscious goal or mission.

Gidal's public career is closely associated with the rise of photojournalism in Germany between 1929 and 1933. In his own lively account of this influential movement, *Modern Photojournalism: Origin and Evolution 1910-1933*, he asserts that unlike "aesthetic" photography, photojournalism "took its cues not from art or literature, but from the many and varied aspects of the *condition humaine* itself." Photojournalism should provide "a visual historical documentation of the events, social conditions, culture, and civilization—as well as the barbarism and lack of culture—of a given time. Didactically defined, it is the instigator of political agitation. The motto of the photojournalist—in our time—is the phrase 'Yo lo vi' which Goya scribbled under one of his battle scenes." Walter Bosshard, Felix Man, Martin Munkacsi, Erich Salomon and some of his other colleagues might not have agreed wholeheartedly with this rousing definition of photojournalism, but Gidal's own political sensitivity and commitment are obvious. And for all their diversity, he goes on, each of the major photojournalists had a central motif. In his own case, he explains, it was simply "Gesture and Expression: Man in the Community."

As for the private work, at least some of which

appeared in two of his major exhibitions, *In the 30's* and *In the 40's*, Gidal remarks that he was motivated by innate sympathy: his theme remains "the tragicomedy of human life." In one of the quieter moments of *Photojournalism* he observes that the photographer must have "a talent for observation and the ability to experience and participate intensely and...sensitivity, empathy and intuition for capturing the essential quality of the whole in the single picture." Moreover, to be "worthy of his camera," the photographer "must identify himself with the human problems which, tangibly or intangibly, have to form the basic core of his work." Shortly after making this last statement, he alludes briefly to Martin Buber, and it is tempting to speculate that his respect for Buber may help explain an essential connection between Gidal's public and private work. Although Gidal does not refer to it explicitly, Buber's conception of the "I-It" as opposed to the "I-Thou" relationship is probably crucial here. Very briefly, the I-It attitude refers to our visual treatment of objects and other persons simply as objects, to be used as need or desire dictates. The I-Thou attitude, however, refers to our sense of others as existences in themselves: it involves a moral, reciprocal relationship, a true encounter with the other in himself. Authentic existence for Buber is a "meeting," although we are unable to sustain the encounter for very long. "Without *It* man cannot live. But he who lives with *It* alone is not a man."

Gidal's photojournalism is frankly rhetorical and deals with such "meetings" in the realm of large, public concerns. But his private work is concerned with the same problems as they appear in the details of daily living, in what Professor Carl Frankenstein calls ordinary events in ordinary lives and "the absurd in the performances of life"—in the embarrassing encounter, for example, between a faded Bright Young Thing and Hamlet. Gidal's technique remains constant: sympathetic penetration and an attempt to discover—and to share with the viewer—what it must have felt like to be alive and vulnerable at a particular moment. Gidal himself says modestly that these private reflections have no "mission." But this is surely too self-effacing: trust the tale, D.H. Lawrence once advised, not the teller.

—Elmer Borklund

Laura Gilpin: *Gertrude Käsebier* Courtesy Art Institute of Chicago

GILPIN, Laura.

American. Born in Colorado Springs, Colorado, 22 April 1891. Educated at Baldwin School, Bryn Mawr, Pennsylvania, and Rosemary Hall School, Greenwich, Connecticut, 1904-08; studied photography, under Max Weber and Paul Anderson, Clarence White School, New York, 1916-18; did graduate studies in photogravure, under Anton Bruehl, Bernard Horn and Clarence White, New York, 1918. Independent professional photographer, from 1915: staff photographer, Central City Opera House Association (University of Denver), Colorado, 1932-36; chief photographer, Boeing Aircraft Company, Wichita, Kansas, 1942-45; concentrated on Navaho Indian photography project, Santa Fe, New Mexico, 1946-68; Canyon de Chelly project, Santa Fe, 1968-79. Instructor in Photography, Chappell School of Art, Denver, 1926-30; Colorado Springs Fine Arts Center, 1930, 1940-41. Regional Vice-President, Pictorial Photographers of America, 1930; Chairman, Indian Arts Fund, Santa Fe, New Mexico, 1958. Recipient: Medal, International Salon, Madrid 1935; Award of Merit, Photographic Society of America 1947; Honored Photographer, St. John's College, Santa Fe, New Mexico, 1966; Appreciation Award, Indian Arts and Crafts Board, United States Department of the Interior, 1967; Southwest Library Association Award, 1969; Western Heritage Award, 1969; Headline Award, Theta Sigma Phi Society of Women in Journalism and Communications, Albuquerque, New Mexico, 1970; Hidalgo de Calificada Nobleza Award, State of New Mexico, 1970; Research Grant, School of American Research, Santa Fe, New Mexico, 1971; Fine Arts Award, Industrial Photographers of the Southwest, 1971; Brotherhood Award, National Conference of Christians and Jews, 1972; Governor's Award, State of New Mexico, 1974; Guggenheim Fellowship, 1975. D.H.L.: University of New Mexico, Albuquerque, 1970. Honorary Life Member of the Board, School of American Research, Santa Fe, New Mexico, 1967; Honorary Colonel, Aide-de-Camp, to Governor of New Mexico, 1970. Associate, Royal Photographic Society, London, 1930. Estate: Mr. Gerald Richardson, 703 Don Felix Street, Santa Fe, New Mexico 87501. *Died* (in Santa Fe) *30 November 1979.*

Individual Exhibitions:

1918 Clarence H. White School, New York
Camera Club Galleries, New York
1924 Pictorial Photographers of America, New York
Baltimore Photographic Club
1933 Denver Art Museum
1934 Library of Congress, Washington, D.C.
Taylor Museum for Southwestern Studies, Colorado Springs
American Museum of Natural History, New York
1935 Beacon School, Wellesley, Massachusetts
1936 J.B. Speed Museum, Louisville, Kentucky
Taylor Museum for Southwestern Studies, Colorado Springs
1946 Museo Arqueologico e Historico de Yucatan, Merida, Mexico
1948 *Follow the Rio Grande*, Colorado Springs Fine Arts Center
1949 Santa Barbara Museum of Art, California
Galeria Mexico, Santa Fe, New Mexico
The Town Hall Club, New York
Portal Gallery, First National Bank, Santa Fe, New Mexico
Dallas Museum of Fine Arts
1951 Roswell Art Center, New Mexico
The Arts Club, Washington, D.C.
Wichita Art Association, Kansas
1953 *The Architecture of John Gaw Meem*, Fine Arts Museum of New Mexico, Santa Fe
1955 Tucson Art Center, Arizona
The Arts Club, Washington, D.C.

1956 American Museum of Natural History, New York
1957 Laboratory of Anthropology, Santa Fe, New Mexico
International Museum of Photography, George Eastman House, Rochester, New York
1958 Colorado Springs Fine Art Center
Fine Arts Museum of New Mexico, Santa Fe (with Eliot Porter)
1960 Nelson Gallery of Art, Kansas City
1962 Fine Arts Museum of New Mexico, Santa Fe (with Eliot Porter and Todd Webb)
1965 Tucson Fine Arts Association, Arizona
1966 *50th Anniversary Exhibition*, St. John's College, Santa Fe, New Mexico
1968 *Rio Grande: River of the Arid Land*, Museum of Albuquerque, New Mexico
Museum of the Southwest, Midland, Texas
The Enduring Navaho, Amon Carter Museum, Fort Worth, Texas
1969 West Texas Museum, Texas Technological University, Lubbock
Communication from the Reservation, Riverside Museum, New York (photos by Gilpin; with Southwestern Indian artefacts)
1970 *Retrospective 1923-1968*, Institute of American Indian Arts, Santa Fe, New Mexico
Oklahoma City Art Museum
Colorado Springs Fine Arts Center
1971 St. John's College, Santa Fe, New Mexico
1972 *Churches and Public Buildings by Architect John Gaw Meem*, St. John's College, Santa Fe, New Mexico
1973 Witkin Gallery, New York
1974 Farmington Museum, New Mexico
Laura Gilpin: Retrospective, Museum of New Mexico, Santa Fe (toured the United States)
1977 *Laura Gilpin/William Clift/Eliot Porter*, Horwitch Gallery, Santa Fe, New Mexico
1978 *Laura Gilpin: Photographer*, National Cowboy Hall of Fame and Western Heritage Center, Oklahoma City
Amon Carter Museum, Fort Worth, Texas (retrospective)
1979 *Laura Gilpin: Ranch School Photographs*, The Los Alamos Historical Society, New Mexico
1980 Witkin Gallery, New York

Selected Group Exhibitions:

1975 *Women of Photography*, San Francisco Museum of Art (toured the United States, 1975-77)
1977 *5 Santa Fe Photographers*, Horwitch Gallery, Santa Fe, New Mexico
Photographs: Sheldon Memorial Art Gallery Collection, University of Nebraska, Lincoln
1979 *Photography Rediscovered: American Photographs 1900-1930*, Whitney Museum, New York (travelled to Art Institute of Chicago)
10th Anniversary Show, Witkin Gallery, New York
The History of Photography in New Mexico, University of New Mexico, Albuquerque (travelled to Tyler Museum of Art, Texas; and Roswell Museum, New Mexico)
Recollections: 10 Women of Photography, International Center of Photography, New York (toured the United States)
1981 *11 Photographers of Santa Fe*, at *Rencontres Internationales de la Photographie*, Arles, France
Masterworks from the Photography Collection, Amon Carter Museum, Fort Worth, Texas
American Photographers and the National Parks, Corcoran Gallery, Washington, D.C. (toured the United States, 1981-83)

Collections:

Amon Carter Museum, Fort Worth, Texas (26,000 negatives, 20,000 photos, library and personal papers); Museum of Modern Art, New York; International Museum of Photography, George Eastman House, Rochester, New York; Library of Congress, Washington, D.C.; Smithsonian Institution, Washington, D.C.; Princeton University, New Jersey; Colorado Springs Fine Arts Center; Center for Creative Photography, University of Arizona, Tucson; University of New Mexico, Albuquerque; Museum of New Mexico, Santa Fe.

Publications:

By GILPIN: books—*The Pikes Peak Regions: Reproductions from a Series of Photographs by Laura Gilpin*, Colorado Springs 1926; *The Mesa Verde National Park: Reproductions from a Series of Photographs*, Colorado Springs 1927; *The Pueblos: A Camera Chronicle*, New York 1941; *Temples in Yucatan: A Camera Chronicle of Chichen Itza*, New York 1948; *The Rio Grande: River of Destiny*, New York 1949; *The Enduring Navaho*, Austin, Texas and London 1968; articles—interview and comment in *Gazette* (Colorado Springs), 4 July 1920; "Some Thoughts on Portraiture" in *Portraiture by Photography*, brochure, Colorado Springs, 1920; "Historic Architecture Photography: The Southwest" in *The Complete Photographer: Volume 6*, New York 1942; "Portraiture" in *Graphic Graflex Photography*, New York 1945; "Rio Grande Country" in *U.S. Camera* (New York), February 1950; pictures and commentary in *Photography: The Selected Image* by Gerald Lang and James Baker, University Park, Pennsylvania 1978.

On GILPIN: books—*Laura Gilpin: Retrospective 1910-1974*, exhibition catalogue, with texts by Anne Noggle and others, Sante Fe, New Mexico 1974; *Women of Photography: An Historical Survey* by Margey Mann and Anne Noggle, San Francisco 1975; *Color Photography: Inventors and Innovators 1850-1975* exhibition catalogue, by Laura Geringer, New Haven, Connecticut 1975; *Aspects of American Photography 1976*, exhibition catalogue, by Jean S. Tucker, St. Louis, Missouri 1976; *The Great West: Real/Ideal*, edited by Sandy Hume and others, Boulder, Colorado 1977; *Photographs: The Sheldon Memorial Art Gallery Collection, University of Nebraska*, with an introduction by Norman A. Geske, Lincoln, Nebraska 1977; *Dialogue with Photography*, edited by Paul Hill and Thomas Cooper, London 1979; *Recollections: 10 Women of Photography*, edited by Margaretta K. Mitchell, New York 1979; *Photography Rediscovered: American Photographs 1900-1930* by David Travis, New York 1979; *A Ten Year Salute* by Lee D. Witkin, with a foreword by Carol Brown, Danbury, New Hampshire 1979; *The Photograph Collector's Guide* by Lee D. Witkin and Barbara London, Boston and London 1979; articles—"Laura Gilpin, Photographer of the Southwest" by David Vestal in *Popular Photography* (New York), February 1977; "The Photography of Laura Gilpin" by Marni Sandweiss in *Four Winds* (Austin, Texas), vol. 1, no. 4, 1980.

*

Laura Gilpin was an artist whose affinity for her chosen subject, the landscape and native cultures of the American Southwest, was such that her life's work has become a part of the primary documentation of these places and people. For almost 60 years she devoted her energies and consummate skill to the depiction of the society and environment of the Pueblo and Navajo people. Unlike her predecessors in the field she was not limited in her procedures and point of view to the creation of an exclusively anthropological record of disappearing patterns of life. While commanding her attention and respect, the "old ways" were seen in the context of the many changes affecting Indian life in the 20th century and the resulting archive of many thousands of prints is imbued with the remarkable rapport that operated between the artist and her subjects.

It is interesting to note that Laura Gilpin, like so many of her contemporaries, began as a pictorialist, producing autochrome and platinum prints of notably artistic character. In her maturity the character of her work changed, moving away from the soft focus ideal which she had learned in the Clarence White School and ultimately achieving the objective clarity and warmth of tone which was the special quality of her style.

In her several books, the landscape, architecture and people of her chosen world achieved a kind of classic definition in the public mind which in recent years, with the proliferation of photographic exhibitions, has been enhanced by the recognition of her impeccable craftsmanship in printing. In these books, particularly in *The Enduring Navajo*, she demonstrated her very considerable skill as a writer and proponent of social and environmental integrity.

Taken as a whole Laura Gilpin's work represents the function of photography as a social art at its highest level, embodying history in the terms of visual experience.

—Norman A. Geske

GIOLI, Paolo.

Italian. Born in Sarzano di Rovigo, 12 October 1942. Educated at Schools in Rovigo and Venice. Married Carla Schiesari in 1969. Freelance photographer and filmmaker, Rovigo and Milan, since 1968; has worked with Polaroid color photography since 1977. Recipient: Premio Italia, for photography, Verona, 1976. Agent: Paolo Vampa, Via Colli della Farnesina 98, 00194 Rome. Address: Via Lorenteggio 157, Milan; and Via G. Magro 2, 45100 Rovigo, Italy.

Individual Exhibitions:

1977 *Il Tempo della Ricerca Ritrovata*, Galleria Il Diaframma, Milan (travelled to Libreria e Galleria Pan, Rome, 1978)
1978 *Terra di Land*, Galleria Il Diaframma, Milan (travelled to Libreria e Galleria Pan, Rome)
1979 *Antropolaroid*, Galleria Il Diaframma, Milan
1981 *A Hippolyte Bayard Gran Positivo*, at *SICOF 1981*, Milan

Selected Group Exhibitions:

1978 *Fotografia Italiana*, at *Rencontres Internationales de la Photographie*, Arles, France
1979 *Il Ritratto*, at *SICOF 1979*, Milan
Venezia '79
The Italian Eye, Alternative Center for International Arts, New York
Triennale, Milan
1980 *Fotografia e Immagine dell'Architettura*, Galleria d'Arte Moderna, Bologna
Camera Incantate/Espansione dell'Immagine, Palazzo Reale, Milan
La Linea Sottile, Galleria Flaviana, Locarno, Switzerland
Fotomedia 2, Pinacoteca Comunale, Ravenna, Italy

1981 *Linee della Ricerca Artistica in Italia 1960-80*, Palazzo delle Esposizioni, Rome

Collections:

Centro Studi e Archivio della Comunicazione, University of Parma, Italy; Polaroid Collection, Amsterdam; Hartkamp Collection, Amsterdam.

Publications:

By GIOLI: books—*Immagini Disturbata da un Intenso Parassita*, lithographic portfolio, Rome 1974; *Ispezione e Tracciamento sul Rettangolo*, lithographic portfolio, Rome 1975; *Dadathustra*, lithographic portfolio, Rome 1976; *Paolo Gioli: Monografia Fotografica*, Milan 1977; *Paolo Gioli: Spiracolografie*, with a preface by Ando Gilardi, Milan 1980; articles—"Architettura nello Spazio Stenopeico" in *Fotografia e Immagine dell'Architettura*, exhibition catalogue, Bologna 1980; "A

Hippolyte Bayard Gran Positivo" in *SICOF '81*, exhibition catalogue, Milan 1981; films—*Passando da una Situazione ad un'Altra*, 1968; *Tracce di Tracce*, 1969; *Commutazioni con Mutazione*, 1969; *Immagini Disturbate da un Intenso Parassita*, 1970; *Secondo il Mio Occhio di Vetro*, 1971; Immagini Reali/Immagini Virtuali, 1972; *Del Tuffarsi e dell'Annegarsi*, 1972; *Cineforon*, 1972; *Anonimatografo*, 1972 *Ispezione e Tracciamento sul Rettangolo*, 1973; *Geometrico Continuo*, 1973; *Hillarisdoppio*, 1973; *Traumatografo*, 1973; *Film per Flauto da Presa*, 1973; *Figure Instabili nella Vegetazione*, 1974; *Quando la Pellicola è Calda*, 1974; *Schermo Inciso*, 1978; *Schermo-Schermo*, 1978; *L'Operatore Perforato*, 1979.

On GIOLI: books—*Catalogo Bolaffi per la Fotografia No. 2*, 1977-78, Turin 1977; *70 Anni di Fotografia Italiana* by Italo Zannier, Milan 1978; *Guida alla Critica Fotografica* by G. Turroni, Milan 1980; *Fotomedia 2*, exhibition catalogue, with an essay by Daniela Palazzoli, Ravenna 1980; articles—"Paolo Gioli e il Magnifico Bottone" by Ando Gilardi in *Il*

Diaframma/Fotografia Italiana (Milan), June 1977; "Paolo Gioli e il Magnifico Bottone" by Ando Gilardi in *Il Diaframma/Fotografia Italiana* (Milan), June 1977; "Paolo Gioli: La Fotografia Vergine" by Ando Gilardi in *Photo Italiana* (Milan), February 1979; "Zeitgenössische Fotografie in Italien" by Italo Zannier in *Zoom* (Munich), August 1980; "Dentro al Labirinto: Meandri Pubblici Ecc." by G. Bonini in *Progresso Fotografico* (Milan), February 1981; "Paolo Gioli: Le Strane Fotocamere" by Eduardo Prando in *Fotografare* (Milan), March 1981; "Paolo Gioli: Antropolaroid" in *Zoom* (Milan), April 1981.

*

Paolo Gioli: Polaroid SX-70 Stenopeica: *Composizione Diretta* (original in color), 1979

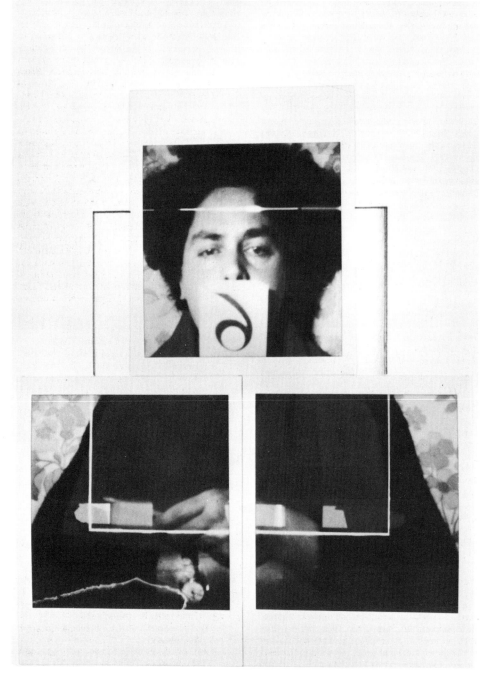

My prevalent tendency to blend creative techniques with techniques from the history of art is the result of my conviction that it is an extremely complicated matter to understand the contamination, the spectacular invasions, that follow one after another in the disciplines of science and expression. For myself, I believe that I have reached such complexity within research that I no longer really know which lines are going to lead to which changes.

I should like to re-examine photographic history, and if that quest involves sensitive material, my own working materials, that is pure chance. Perhaps what I mean *is* primarily material, dusted and treated with technological sediment, starting from the countless anthropological bifurcations that such a combination has to offer.

What interests me enormously is the formidable capacity of photo-sensitive material to distort and fantasticate, nearly always dramatically, everything it touches. Thus, my interest must involve a thorough examination of all that has happened in the history of photography, by way of that which has manipulated it even as it fed it—chemistry.

The Polaroid, that most delicate membrane, iconophotography, is a liquid incunabulum of modern history.

I have take in the pinhole as a "viewpoint," both plastic and ideological. I discovered the pinhole picture because I had no camera. Later this picture provoked a fascination with the scene portrayed: I was fascinated by the purity of this "poor" method of filming, by the equally pure reproduction—not poor at all but absolutely marvellous.

I am not aiming at an academic thesis but at a definite way of comprehending space through a point in space. Thus the fade-in effect; the magnificent figures all around us conveyed by the purest ways; with no shutters, no stopping down, no focussing.

Cibachrome, that voluptuous technological page printed from subtle marks traced in secret, is a page of enchanted iridescence.

—Paolo Gioli

One of the first people in Italy (1970) to draw attention to the urgent need for some kind of check on photography's capacity for documentary visualization was Ugo Mulas, who upset the traditional conviction that photography should be a medium for the objective representation of reality. Mulas's ideas, his experiments with the language of photography (*La Fotografia*, 1973), were something of a revelation and aroused interest in many cultural circles. Above all, his work was a stimulus to interest in the uses of the photographic image, so challenging in the immediacy of its communication, an interest that many artists then working in the field of "conceptualism" pursued following the vogue of "pop art"—which, in its turn, had suggested a whole new range of expressive possibilities inherent in the very "mechanicalness" of photography, a concern previously regarded as of secondary importance, as non-creative.

Paoli Gioli took up photography while the polemics provoked by Mulas's investigations were still going on and while a mannerism imported from America and France was spreading, one that was to characterize modern Italian photography after the

general crisis of photographic journalism in the 1970's had revived "art photography" as an interesting solution.

Gioli's interest in photography (as well as his interest in film and video-tape) was chiefly one of experimentation, an effort to locate and specify the creative possibilities offered by modern technology, which now determines not only photography but also every other kind of communicative function in the modern world. And it was via this very technology—so sophisticated, so amazingly complex—that Gioli moved to his meditation on the media, a meditation that has involved almost a physiological rejection as an anecdote to their pervasive penetration of the unconscious. With a jesting, playing, quixotic provocativeness, Gioli has become a ruthless debunker of the photographic medium, waxing especially ironic about its "technique," or rather its technicality, which must now, in his view, become an end in itself if one wants to avoid the risk of the stereotype, the repetitive banalities of daily picture output, which leads to collective hypnosis and an inevitable vulgarization of the image.

"Technical investigations, based on the revival and reconsideration of 'primordial' methods and equipment for photography," writes Piergiorgio Dragone, are for Gioli the starting-point of an argument that inevitably comes up against the basic problem of the nature of the photographic image, its essential ambiguity. Gioli, always a Jack-of-all-trades, has actually himself created various devices and methods the brilliant simplicity of which have enabled him to achieve unexpected explorations of the "real"—often far distant not only from convention but also from any ordinary documentation. Photo-finishes obtained by making the film move during the shot by means of a lever fitted to a simple camera; manipulations of the "sandwich" of Polaroid film whereby the photo is directly transferred to pieces of paper or silk; *spiracolografie* ("aperture-graphs") obtained with a wooden camera obscura as ingenious as it is precarious; stenopeic (pin-hole) aperture, which he uses for a reinterpretation of urban space according to archaic principles of "perspective"—Gioli has in fact examined countless new possibilities with an instinctive freshness and often with brilliant skill.

Gioli's photography is manageable, accessible, because of the unexpected, brilliant visual inventions; it is often also a game by which he aspires to "return to the technical immediacy of the origins of photography" (Daniela Palazzoli, *Fotomedia Due*, 1980). Gioli's journey, then, is one backwards into the development of photographic language, starting from the most advanced technology, particularly that of photo-sensitive materials, in search of the primordial, elementary imprints of light, to rediscover the origin of vision and at the same time create exciting illusions of reality.

—Italo Zannier

GLASS, Douglas.

British. Born in New Zealand in 1901; emigrated to England, 1926. Studied painting at the Central School of Arts and Crafts, London; mainly self-taught in photography. Worked as a cow-hand, sheep-shearer, drover, etc., in New Zealand, 1918-26; worked as a drapery salesman in London, 1927-29; freelance lecturer and journalist, London, contributing to newspapers in Christchurch, Amsterdam, Warsaw and Vienna, 1929-32; independent painter, London, 1932-41; photographer for the Ministry of Information, London and Brixham, Devon, 1941-42; freelance photographer, working for *Vogue*, the Belgian Government in Exile, and as a portrait photographer, London, 1942-45; Chief Public Information Officer/Photographer, United Nations Relief and Rehabilitation Administration (UNRRA), in Germany, 1945-47; freelance photographer, Sydney, Australia, 1947-49; photographer, for the "Portrait Gallery" series, *Sunday Times* newspaper, London, 1949-61; relinquished photography, to concentrate on painting, Kent, from 1962. *Died* (in Kent) *25 June 1978.*

Individual Exhibitions:

1953 Kodak Gallery, London
1978 *Reflected Glory: Photographs by Douglas Glass*, Swiss Cottage Library, London (toured the U.K.)

Publications:

By GLASS: books—*The Saturday Book*, with others, London 1942; *The Bread We Eat*, with text by Margaret Fisher, London and Glasgow 1944; *Break the Pot, Make the Pot*, with text by Margaret Fisher, London and Glasgow 1946.

On GLASS: books—*The Magic Image* by Cecil Beaton and Gail Buckland, London and Boston 1975; *Reflected Glory: Photographs by Douglas Glass*, exhibition catalogue, with an introduction by David Mellor, Rye, Sussex 1978.

The photo-portraits of Douglas Glass were long neglected, until a travelling exhibition in 1978 brought them to public attention in England once again. The photographs were a weekly feature of *The Sunday Times*, London, from 1949 until 1961, eagerly looked forward to for their wittily differentiated explorations of character: the characters of the great, the good, the important, the creative—more than just of that new vogue, personality. The photo-historian David Mellor has adduced modesty as one of the ingredients of Glass' success. But what is the nature of that success? Unlike the work of far more overblown and dramatic, even melodramatic, portrait photographers, Glass somehow allows his subjects full room to breathe, and identifies them with the minimum of props—a silk neck scarf for the designer Norman Hartnell, an easel for Giacometti, the trumpet for Satchmo, a portrait of Brassaï that not only looks like Brassaï but also looks like a Brassaï photograph. Coming to England from New Zealand, where he had worked on the sheep station where Samuel Butler had pondered over *Erewhon*, Glass eventually trained briefly at the Central School, and in his own words "pursued the career of an unsuccessful artist" until "photography took him by accident." He thought of photography as an "effective visual shorthand."

Glass came to Britain to meet Henry Festing-Jones, biographer of Samuel Butler, and he met many leading literary figures in the 1920's whom he interviewed and about whom he wrote; he also lectured widely in Europe on the Maori of New Zealand and about New Zealand itself, illustrating his lectures with slides and films. He had quantities of varied jobs, spent much of the 1930's painting, and

after the war worked as a photographer for UNRRA, documenting the displaced persons of Europe. In the 1930's he identified with the avant-garde in painting, notably constructivism, and perhaps his interest in the social implications of the theories behind such art, and the refinement in composition such abstraction calls upon, are implicit in the strongly structured, unsentimental yet strongly felt portrait photographs.

The "accident" that led him to photography was the war, from which injury prohibited his active military participation; he was authorised by Kenneth Clark, in his capacity as Chairman of the War Artists' Advisory Committee, who was anxious to get away from the "conventional" portrait. Glass' painter's eye also allowed him to delight in the photograph's ability to find the telling detail, and he took many photographs of wartime England and London.

During the war he also took portraits of children and, from about 1943, adults. As David Mellor recounts, though, Glass became fundamentally disillusioned and pessimistic about the plight of the European refugees, and felt he was restricted after the war from photographing that plight in any accurate or telling manner by bureaucratic troubles: he left Europe for Australia, only to be summoned back in 1949 after several of his portrait photographs, of people he had had been introduced to by Augustus John, appeared in *The Sunday Times*, leading to the series called "Portrait Gallery."

The portraits for which Glass is best know combine the intimate and the grand; that is, the subjects appear human, relaxed, un-pompous, at ease. From Charles Addams to Evelyn Waugh, Cole Porter to Dame Myra Hess, Glass' photographs exhibit sympathy, an easy subtle use of props (we can have a good guess at what the people do who are the subjects, even if we don't recognize them). Because he hardly ever, if ever, photographed people who were famous as "personalities" only, whether his subjects were the people of London, the fishermen of Brixham, or people famous through their work, there is invariably a sense of reality, even at times a very elegant reality. Glass' portraits tell the truth with grace. The profiles published by anonymous authors in *The Sunday Times*, into which Glass' photograph of the subject was integrated, would make a fascinating re-issue for any social historian; one is hard put to it to decide whether word or image tells us more. The image is certainly an intense summation of character. Cecil Beaton has pointed out Glass' fascinatingly wayward way with light, used to enliven even the dullest subject.

—Marina Vaizey

GLINN, Burt.

American. Born in Pittsburgh, Pennsylvania, 23 July 1925. Educated at Schenley High School, Pittsburgh, 1939-43; Harvard College, Cambridge, Massachusetts, 1943, 1946-49, B.A. 1949 (Dana Reed Award, 1949); mainly self-taught in photography. Served as an artilleryman, United States Army, in the United States and Germany, 1943-46: Lieutenant. Married Elena Prohaska in 1981. Assistant Photographer, 1949-50, and Photographer, under editor Wilson Hicks, 1950, *Life* magazine, New York. Freelance photographer, New York,

since 1950: commissions include—industrial photography for Pepsico, General Motors, Richardson-Merrill, Xerox, Revlon, Bristol-Myers, AMF, Seagrams, Inland Steel, Goldman Sachs, Warner Communications, etc.; advertising photography for IBM, TWA, British Airways, Chase Manhattan Bank, Seagrams, ITT, etc.; magazine photography for *Holiday, Esquire, Fortune, Travel and Leisure, Life, Paris-Match, Newsweek*, etc.; also, Contributing Editor, *New York Magazine*, 1974-77. Member since 1952, and President, 1972-74, Magnum Photos Inc., New York. President, American Society of Magazine Photographers, 1980-81. Recipient: Matthew Brady Magazine Photographer of the Year Award, University of Missouri and *Encyclopaedia Britannica*, 1960; Overseas Press Club Award, 1967; Gold Medal, Art Directors Club of New York, 1972; Gold Medal, *Financial World*, New York, 1979. Agents: Magnum Photos Inc., 251 Park Avenue South, New York, New York 10010; and Elena Prohaska Fine Arts, 61 East 77th Street, New York, New York 10021. Address: 41 Central Park West, New York, New York 10023, U.S.A.

Individual Exhibitions:

1976 Nikon House Gallery, New York (with George Haling)
1978 The Photographers' Gallery, London

Selected Group Exhibitions:

1955 *The Family of Man*, Museum of Modern Art, New York (and world tour)
1979 *This Is Magnum*, Takashimaya Department store, Tokyo

1980 *This Is Magnum*, Galerie Le Clôitre, St. Ursanne Switzerland

Collections:

International Center of Photography, New York; Museum of Modern Art, New York; Harvard College, Cambridge, Massachusetts; Kimberley-Clark Corporation, Neenah, Wisconsin.

Publications:

By GLINN: books—*A Portrait of All the Russias*, with text by Laurens van der Post, New York and London 1967; *A Portrait of Japan*, with text by Laurens van der Post, New York and London 1968; articles—"Otto Preminger" in *Esquire* (New York), March 1961; "Burt Glinn" in *Camera* (Lucerne), August 1962; "The Art of Discovering Pictures" in *Professional Photographer*, February 1978; interview in *Photographers on Photography*, edited by Jerry C. LaPlante, New York 1979; "The Avalanche since Ice on the Roof" in *American Showcase 1980*, New York 1980; "Photography Now and Then" in *The American Society of Magazine Photographers at 35*, New York 1980.

On GLINN: books—*The Family of Man*, with text by Edward Steichen, New York 1955; *America in Crisis: Photographs for Magnum*, edited by Charles Harbutt and Lee Jones, with an essay by Michael Levitas, New York 1969; articles—"Burt Glinn's Japan" in *Photography Annual 1963*, New York 1962; "Burt Glinn: A Portrait of All the Russias" in *Creative Camera* (London) July 1968; "Photographers' Photographer: Burt Glinn, The Epitome of Professionalism in That Complicated Art of Picture Taking" by Michael Edelson in *FlightTime*, June 1976; "Burt Glinn: The Right Lens for the Right Look" by Mary O'Grady in *Modern Photography* (New York), August 1977; "The Costly New Look" by Arlene Hershman and G. Bruce Knecht in *Dun's Review*, June 1981.

Burt Glinn: *Krushchev at the Lincoln Memorial*, Washington, D.C.

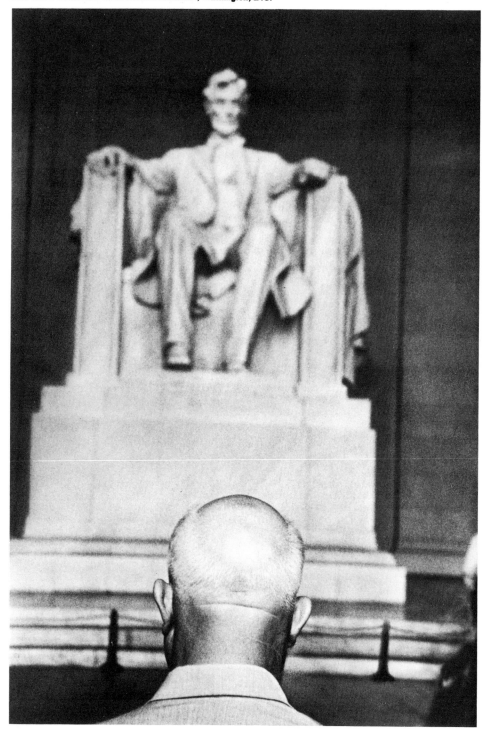

I have been taking pictures for a living for more than 30 years. A lot of people think of me as an old professional. I like to think of myself merely as experienced. At least I am experienced enough to view this literary exercise with some doubt. The problem with writing about photography is that taking pictures seems so simple. Of course, it is not, but explanations why it is not have led to some very defensive, somber, arcane, and pretentious prose.

Some of this has slopped back onto the taking of pictures. This is not the most encouraging thing to come out of the growing interest in photography. Pretentiousness has done more harm to good photography than automated exposure.

I became a photographer almost by accident, and I stayed a photographer over all these years because I like taking pictures. It is a wonderful way to make a living. It does get me around and keeps me out in the air.

However, it is not a life without complications. I make my living completely from photography, and, mostly as a result of my photographic exercises working on an essentially acquisitive nature, my appetites are hardly monastic. As a result, I spend a lot of my photographic time working for large corporations, either for advertising or for corporate reports. It is serious work, and I take it very seriously. Even though I do it very well—humility is neither a common nor useful trait in our work—the selection of my work for this book is not industrial. Even the most sophisticated commercial assignments have very specific goals, and, handsome and striking as some of the pictures may be, this specificity deprives them of what I hope is the depth and complexity of the other part of my work.

That other part has evolved into a kind of cultural

journalism-cum-anthropology. It started with assignments from *Holiday* magazine in the fifties and sixties when *Holiday* magazine was really a magazine. These assignments, at least for me, were a kind of unrestricted grant. Frank Zachary, the art director and dominant figure on the magazine, once sent me on their most expensive assignment—four months to photograph an entire issue on the then not too open Soviet Union. His only instructions were, "Hey kid, I want you to take some snaps of Russia."

Over the years, shooting wherever assignments took me, I began to discover a pattern in the pictures I liked best. I have come to believe that all societies, from the most primitive to the most sophisticated, are driven by similar fears, myths, and superstitions. As a result, all their rituals, no matter how different their appearance, have a certain basic similarity. Most of my personal favourites, among all the pictures I have taken, document these varieties of religious experience. At the simplest level, the New Guinea woman with her collection of Bird of Paradise feathers and seashells is satisfying the same urge as the top-hatted, frock-coated gentleman in the Royal Enclosure at Ascot. There are more icons of Lenin in Moscow than there are images of Christ in Rome. In getting to this place I have discovered a basic attitude that works for me. It is not writ in stone and it may not be true for everyone else, or even for anyone else. But for my photography I have come to believe in the superiority of discovery to invention. What is important is not what I make happen, but what happens to me. I can work in a studio, but I would rather work in the world. Even in my industrial work when I have created a situation, I try to keep it as loose and unconstructed as possible so that there is the maximum chance for fortuitous accident to happen and be recognized and photographed.

I am not fond of technique for its own sake, and I do not use lenses for effects: I use them to take pictures. Even in the most restrictive assignments I try to avoid preconception. Our world is so flooded with photographic images that when we preconceive, we end up, probably unwittingly, taking pictures of pictures we have already seen.

I work most of the time in color because I see in color. It is a fact, it is there. I react to minimal color, and my feeling is that color alone is not enough. Color photographs must have the same discipline of content and structure that good black-and-white photographs have. If I made black-and-white prints of the color pictures I like best, they would not be the same and they probably would not be as good, but they would still have real photographic value.

I am glad I am a photographer. I am afraid I am a bit promiscuous because I enjoy it all, even when I know better. It forces me to start each day with fresh eyes. I have even been lucky in my timing. Photography is young enough and I am old enough so that even in my middle years I have been able to sit with, eat with, drink with, and exchange truthful exaggerations with most of the people whose work I have admired. I look forward to a lot more years of all of this and a lot more photographs. Our world in photography is changing at an almost unimaginable pace—and who knows—it may even be for the better.

—Burt Glinn

Burt Glinn can justly lay claim to the title of New York's freelance photographer *par excellence*. Not only a long-time member but also a three-term president of Magnum, the international photographers' cooperative agency, Glinn has excelled at skillful and stylish photography of subject matter ranging from Fidel Castro's revolution in Cuba to Revlon's annual report.

At Harvard in the late 1940's Glinn was photographer and photography editor for the *Crimson*, where he attracted the attention of talent scouts for *Life* and other picture magazines. Beginning as a photographer's assistant at *Life*, he quickly parlayed that position into part-time freelance work for the magazine as well as developing a clientele at other publications. He began a career that included both reportage and the kind of spectacular travel coverage that earned him complete issues of *Holiday* magazine devoted throughout to his color photographs of the South Seas (October/November 1960), Japan (October 1961), Mexico (October 1962), Russia (October 1963), and California (October 1965). His reportorial range, developed in the 1950's and 60's, now seems almost limitless: Glinn has covered the Sinai War, the U.S. Marines' invasion of Lebanon, Khrushchev's tour of the United States, and several American political conventions, and he has produced sensitive profiles of such personalities as Sammy Davis Jr. and Robert Kennedy. Throughout, he has remained resolutely freelance.

Glinn is known as something of an "editor's photographer," both for his ability to turn in consistently solid high quality pictures and for his wide intellectual interests, his knowledge of politics and current affairs. Perhaps his early *Crimson* experience encouraged his abilities to develop editorial ideas and to bring a fresh approach to material that others might find stale.

Glinn was one of the original contributing editors to *New York Magazine* and continued in the capacity until 1977. He has also served as President of the American Society of Magazine Photographers. In recent years, Glenn has developed numerous corporate and advertising clients. And, in addition to the prizes for his magazine work, Glinn has also been awarded the Gold Medal from the Art Directors Club of New York for the best print ad of the year (his Foster-Grant sun glasses ads) and *Financial World*'s Gold Medal for the best annual report of 1979 (Warner Communications).

—Maren Stange

GLOAGUEN, Hervé.
French. Born in Rennes, 11 May 1937. Assistant to the photographer Gilles Ehrmann, Paris, 1963; freelance photographer, mainly for Réalités magazine, Paris, 1964-71. Founder-Member, Viva photographers agency, Paris, since 1972. Address: c/o Viva, 10 rue Saint Marc, 75002 Paris, France.

Individual Exhibitions:

1974 *Photographs of Contemporary Artists*, Musée d'Art Moderne (A.R.C.), Paris
1977 Galerie Gloux, Concarneau, France
1980 *30 Photographs*, at *Albi Festival of Photography*, France

Selected Group Exhibitions:

1973 *Viva: Familles en France*, Galleria Il Diaframma, Milan (toured Europe, the United States and Canada, 1973-76)
1977 *Photojournalisme*, Musée Galliera, Paris
1978 *European Colour Photography*, The Photographers' Gallery, London

Collections:

Bibliothèque Nationale, Paris; Musée Nicéphore Niepce, Chalon-sur-Saône, France.

Publications:

By GLOAGUEN: books—*L'Art Actuel en France*, with text by Anne Tronche, Paris 1973; *La Loire Angevine*, with text by Gaston Humeau, Paris 1979; *Lyon*, Paris 1981; *Hervé Gloaguen: Photographies*, Paris 1981.

On GLOAGUEN: books—*Photographie Actuelle en France*, Paris 1976; *A Certain Image of French Photography*, Paris 1977; *La Photographie Francaise des Origines à nos Jours* by Claude Nori, Paris 1978; *European Colour Photography*, exhibition catalogue, by Sue Davies, Bryn Campbell and Michael Langford, London 1978; articles—"Gloaguen: 2 Ans de Travail dans l'Intimité de 8 Artistes Contemporains" in *Photo* (Paris), July 1972; "Gloaguen" in *Progresso Fotografico* (Milan), April 1974; "Gloaguen" in *Zoom* (Paris), November 1974;

Hervé Gloaguen: *Sweden*, 1973

"Hervé Gloaguen Fotografier Förändrar inte Menö-
kar Medvetenheten" in *Aktuell Fotografi* (Hels-
ingborg, Sweden), September 1978.

I started as a photojournalist because I wanted to see
the world, because I wanted to show the good and
bad sides of life and people, and because I was
feeling guilty. Also because, in those days, galleries,
museums and books were not presenting photog-
raphy as they do today.

Like many photographers of my generation, I
find the photojournalist-witness kind of situation
stimulating but frustrating. We have been influ-
enced by Robert Frank and have developed a more
contradictory and ambiguous sense of information.
I think that my own photographs are the result of a
constant struggle between information and self-
portrait.

My attitude can be irritating to many people, and
painful for the photographer, and that is how I have
been able to produce, perhaps, some good photo-
graphs.

—Hervé Gloaguen

Hervé Gloaguen likes the jazz of New Orleans. He
likes to work with others, and thinks that in the Viva
group he has found a slightly similar ensemble. At
the same time, he believes that photography is a
solitary pursuit: his pictures are obsessed with soli-
tude, the coldness of the modern town, the clinical
atmosphere of a laboratory. He looks for a gesture
of sympathy, a hint of warmth, a suggestion of
co-operation to challenge a stiff and congealed
universe.

His pictures are discreet. They are very graphic,
but do not play with the effects of depth, do not
create volume by contrasts of light—and their
human presences are ambiguous. For example, a
factory girl, in her working clothes, taken from a
distance, looks sideways. The photo is simple, but
the delicacy of the face, the thin lips, the high fore-
head under slightly tilted headgear, the elegance of
the high collar under the chin, assert, in the abstrac-
tion of the context, a resistance to the environment
that is both fragile and monumental. And, as with
this portrait, Gloaguen's photos are never over-
loaded. He does not look for complexity in the
composition. Like Robert Doisneau, he seems to
have created his oeuvre inadvertently, by playing the
bad pupil, by accepting rules only the better to get
around them.

This art is sentimental; it is an art of the game and
therefore of ambiguity. It belongs to a French tradi-
tion, but it has found its own theme. Although
Gloaguen is very professional (he respects the rules
because he loves the game), he does not look for
great themes; he keeps to a minor register and jumps
from one subject to another.

His own impression is that he chose photography
for its inconsequence and frivolity—so that he could
continue to play and run away in even the most
tragic circumstances. He has too much humor to
take himself seriously, but he also recognizes himself
in the man whom he saw one time in Poland, in an
industrial landscape, running away from a nightmare.

—Jean-François Chevrier

GNEVASHEV, Igor.
Russian. Born in Moscow in 1941. Educated in
Moscow schools, 1948-58; apprentice in a printing
house, Moscow, 1958-61; self-taught in photography.
Served in the Soviet Army, 1961-63. Photographer
for a printing house in Moscow, 1963-70. Photog-
rapher for the magazine *Soviet Film*, Moscow, since
1970. Address: Petrovsko-razumovski proezd d.16,
kv.13, 103287 Moscow, U.S.S.R.

Individual Exhibitions:

1976 *Native Land*, House of Film, Moscow

Selected Group Exhibitions:

1978 *Contemporary Soviet Photography*, Komorná
Galéria, Bratislava, Czechoslovakia

Collections:

Daniela Mrázková Collection, Prague.

Publications:

On GNEVASHEV: books—*Soviet Photo Yearbook*,
Moscow 1974, 1975; article—"The Contemplations
of Igor Gnevashev" by Daniela Mrázková in *Ces-
koslovenská Fotografie* (Prague), no. 12, 1981.

Although from the 1920's to the present day photo-
journalism has been and continues to be the most
powerful force in Soviet photography, there is now,
in the work of some of the younger generation, a
complex structure of means of expression which, as
a whole, clearly recedes from a concentration on
"outer reality" to work with the symbolism of signs

Igor Gnevashev: *Untitled*, 1973

and meanings. This work, which is internally dramatic and ideologically imperative, tells of the emotions experienced by contemporary man. Igor Gnevashev is one of its outstanding exponents. He works as a photographer for a film magazine, but in his freelance work he concentrates on seeking verities, the firm roots of man in life. This search brings him again and again to nature, to the traditional life of the country, to the simple and artless ways of places unaffected by civilization.

Like his contemporary and professional colleague Mikola Gnisyuk, he strongly evokes national feelings. But while the Ukrainian Gnisyuk possesses a Chekhov-like irony and Gogolian wit, so that finally nothing is holy to him, the Russian Gnevashev is a sensitive, injured intellectual who, in his revolt as a human being bruised by the processes of modern civilization, takes refuge amidst fields and meadows, dreamy, melancholy Turgenyev settings. His pictures are marked by the delicate nostalgia of an uprooted person: former ways of life have lost their clear-cut character; the new ways have failed to take it on. He seems constantly to be longing for the return of the old, traditional, peasant Russia. It is that world he is searching for in his travels to the country; he finds peace in its remnants. And, again while Gnisyuk arranges reality to suit his visions (and even adjusts it in the laboratory), Gnevashev seeks his vision in reality itself; while Gnisyuk dresses up reality in traditional national colors Gnevashev goes after it unadorned, seeks it out, holds it in stasis. He is a gentle poet, a sensitive interpreter of national memory.

Gnevashev belongs to the generation that became involved with photography in the early 1960's, not only unburdened by the schematics of the previous period but also unschooled by contacts with former developments in Soviet photography. And that is how Gnevashev started to photograph, not branded and not taught by anyone, using a cheap, popular Lyubityel camera. Before that he had been fond of drawing street scenes, but, just like Talbot, he too realized that it was quicker, more accurate and easier to draw with the help of light, and that the result was more credible. Even then, as a very young man, he believed in the truth of life, which he absorbed fully, leaving the printing office where he worked as an apprentice to run outside during his lunch hour and take some snapshots. Later, he worked the night shift so as to be able to take advantage of the sunlight and devote himself to his hobby during the day. And thus, out of a rather naively comprehended notion of creative freedom, he came to resist all the pre-ordained themes and slogans of contemporary photojournalism.

Ten years later, when he became a photographer for a film magazine, he was, according to his own statements, strong enough and ready to defend his particular point of view. He knew that "no one could break, change or influence" him, that he would preserve his original, pure and spontaneous approach to photography, and that he "would not begin to lie." His career now is to a certain extent ideal for him, for it enables him to be constantly in contact with people, their fate and environment.

—Daniela Mrázková

GNISYUK, Mikola.

Russian. Born in Perekorenzy, Ukraine, 2 January 1944. Studied at the School of Music, Riga, Latvia, 1959-64; studied photography, Institute of Journalism, Moscow, 1974-76. Served in a regimental band of the Red Army. Married Tatiana Gnisyuk in 1967; son: Alijosha. Cameraman, Film-Studio of Riga, 1964-68. Photography Correspondent, *Sovietsky Ekran* (Soviet Screen) magazine, Moscow, since 1968. Recipient: Best Photomaterial of the Year Award, *Sovietsky Ekran* magazine, Moscow, 1971, 1974, 1975, 1976, 1978; Bronze Medal, *Interpress Photo 77*, Moscow, 1977; Best Photography Award, *Novinny Kinoekrana* magazine, Kiev, 1979. Address: c/o *Sovietsky Ekran*, 5B Tchasovaya Ulitza, Moscow 125319, U.S.S.R.

Individual Exhibitions:

1967 Dom Kino, Riga, Latvia

Mikola Gnisyuk: *Portrait-I,* 1976

1975 Dom Kino, Moscow
 Palace of Science and Culture, Budapest
 Municipal Exhibition Hall, Sentandre, Hungary
1976 House of Friendship, Moscow
1977 Skarpa Exhibition Hall, Warsaw
 Dom Kino, Riga, Latvia
1981 Palace of Science and Culture, Sofia, Bulgaria
 Dom Kino, Sofia, Bulgaria

Selected Group Exhibitions:

1968 *Man and Sea*, Belgrade, Yugoslavia
 The Woman, City Museum of History, Riga, Latvia
1970 *All-Union Annual Exhibition of Photography*, Permanent Exhibit of Economic Achievement, Moscow
1977 *USSR: 60 Years*, State Exhibition Hall,

Moscow
Interpress Photo 77, State Exhibition Hall, Moscow
1981 *All-Union Photo Exhibition*, Association of Soviet Artists Hall, Moscow

Publications:

By GNISYUK: books: *Crossing of Parallels*, with text by Valery Fomin, Moscow 1976; *The Serious Frivolous Man*, with text by Eldar Rijazanov, Moscow 1978; Gnisyuk's photos are also featured in *Ekran Yearbook*, edited by Galina Doimatovskaya, Moscow 1970, 1971, 1973, 1974, 1975.

On GNISYUK: book—*Photographer Mikola Gnisyuk* by Victor Demin, Moscow 1982; articles—"A Romantic of Blissful Moments" by Victorija Tokareva in *Nedelija* (Moscow), April 1977; "Portraits" by Andrezej Kolodzynski in *Film* (Warsaw), November 1977; "A Photographer" by Danuta Rago in *Perspectives* (Warsaw), November 1977; "Photography Without Secrets" by Alexander Lipkov in *Sovetskoye Foto* (Moscow), June 1978; "Smiling Sun" by Vladimir Remeš in *Ceskoslovenska Fotografie* (Prague), August 1978.

His work as a photographer with the Moscow film magazine *Sovietsky Ekran* (Soviet Screen) forces Mikola Gnisyuk constantly to think up new approaches, new ways and means to depict the in-itself rather stereotyped world of film production and the life of people connected with that world—film stars, directors, scriptwriters—as well as the situations in the studio and out-of-doors in which films are produced. The need to popularize film workers and to bring them closer to a broad public in an unusual way also helps him in his freelance work.

The significance of Gnisyuk's photographs is always slightly oblique, for they appear playful and jocose. For example, he understands very well that one may make fun in a gentle way of a real personality during portraiture as a means of accentuating his or her greatness, and that important sentiments and ideas are all the more imperative the more casually they are presented.

Gnisyuk is never concerned only with capturing the character of a person, a place or a moment; he always aims higher: his pictures usually contain a wise, generally valid truth about contemporary man. It comes from the smiling, understanding, all-embracing philosophy of a country boy, happily combining the nice naivety of folk art with lyrical pensiveness and dreamy sensibility. There is a permanent place in his Ukrainian way of thinking not only for the sentimental groan of the accordian but also for gay Gogolian laughter. And thus he is able to depict even the somewhat exclusive world of artists as if it were a paraphrase of the figures of Russian classical literature, uprooted by fate, while at the same time using pure photographic modern tricks and irony.

He partly inherited this sense of playfulness and irony and partly cultivated it in the photographically fascinating environment of Riga, Latvia. He first went there as a boy, at the time when the Riga Photo Club and particularly its inspiration—Gunar Binde—were fully engaged in post-surrealist experiments. There, in Riga, Gnisyuk, established himself as a newsreel cameraman; there, he became acquainted with the environment in which he still moves; there, he developed as a photographer who in 1968, against rather fierce competition, won a contest for the job of photographer on a national film magazine. There he came to realize, too, that his almost irritating naturalness—"the naive herdsman from an Ukrainian village"—was a quality as valuable as, say, the ingenious costume chosen by Chaplin. At the same time, because he is an intuitive psychologist, an outstanding connoisseur of life and human nature, Gnisyuk manages to make himself so

unobtrusive that his subjects are actually able to look at themselves through his eyes.

Gnisyuk likes to use premeditated arrangements and set-ups. In his photos we usually have a mixture of Gogolian persiflage and surrealist mannerism, so that the inexperienced observer may find it difficult to guess whether the artist is serious or whether he is just saucily bantering when he poses his friend and colleague Gnevashev and his wife in the window of a cottage dressed as villagers, or when he photographs a well-known film director with a fly on his forehead.

—Vladimír Remeš

GODWIN, Fay.

British. Born Fay Simmonds in Berlin Germany, 17 February 1931. Educated at various schools all over the world (father a diplomat). Married; sons: Nicholas and Jeremy. Freelance photographer, London, since 1970. Recipient: Arts Council Bursary in Photography, 1978. Agents: Anthony Stokes Ltd., 3 Langley Court, London WC2; and The Photographers' Gallery, London. Lives in London. Address: c/o The Photographers' Gallery, 8 Great Newport Street, London WC2, England.

Individual Exhibitions:

1974 *Writers Portraits/Young Music Makers*, Swiss Cottage Library, London

1975 *Ridgeway*, Anthony Stokes Ltd., London (and simultaneously at the Photographic Gallery, University of Southampton; subsequently toured the U.K.)
1977 *Drovers' Roads, Wales*, Anthony Stokes Ltd., London (and simultaneously at the Oriel Bookshop, Welsh Arts Council, Cardiff)
The Oil Rush, Aberdeen Art Gallery, Scotland (travelled to the National Theatre, London)
1978 *Drovers' Roads, Wales and Ridgeway*, Chester Arts Centre
1979 *Calder Valley*, Anthony Stokes Ltd., London (and simultaneously at the Impressions Gallery, York, and Open Eye, Liverpool; travelled to the Ulster Museum, Belfast, and Photographic Gallery, Dublin, 1980)
1980 *Selected Landscapes*, Aarhus Photographic Museum, Denmark
East Neuk, Crawford Arts Centre, St. Andrews, Scotland (with local photographers)
1981 *Romney Marsh*, Anthony Stokes Ltd., London (and simultaneously at the Rye Art Gallery, Sussex)

Selected Group Exhibitions:

1976 *The Land: 20th Century Landscape Photographs Selected by Bill Brandt*, Victoria and Albert Museum, London
1978 *Sussex Photographers*, Rye Art Gallery, Sussex
1979 *Wales*, Mostyn Art Gallery, Llandudno, Wales
1980 *British Art 1940-1980*, Hayward Gallery, London
Fairies, Brighton Museum, Sussex

Fay Godwin: *Markerstone, Old London-Harlech Road*, from *The Drovers' Roads of Wales*, 1976

Collections:

Victoria and Albert Museum, London; Department of the Environment, London; Arts Council of Great Britain, London; National Portrait Gallery, London; Aberdeen Art Gallery, Scotland; Royal Library, Copenhagen; Bibliothèque Nationale, Paris.

Publications:

By GODWIN: books—*The Oldest Road: An Exploration of the Ridgeway*, with text by J.R.L. Anderson, London 1975; *The Oil Rush*, with text by Mervyn Jones, London 1976; *The Drovers' Roads of Wales*, with text by Shirley Toulson, London 1977; *Islands*, with text by John Fowles, London 1978; *Remains of Elmet*, with text by Ted Hughes, London 1979; *Romney Marsh and the Royal Military Canal*, with text by Richard Ingrams, London 1980; *The Whisky Roads of Scotland*, with text by Derek Cooper, London 1981; *Tess: The Story of a Guide Dog*, with text by Peter Purves, London 1981.

On GODWIN: articles—by Lesley Adamson in *The Guardian* (London), 28 July 1976; by William Packer in the *Financial Times* (London), 11 October 1977 and 15 May 1979; by Mark Haworth-Booth in *Art Monthly* (London), no. 27, 1979; by John Taylor in *Ten-8* (Birmingham), Autumn 1979.

Freelance photographer, mainly known for landscapes in the U.K., but also very interested in many other aspects of the U.K. If I could write a good statement, I would be a writer rather than a photographer. I feel that any statement I can make is to be found in my work.

—Fay Godwin

The British landscape's intimacy of scale, diversity in kind, and the infinite subtleness of its textural variations are altogether matched by the qualities of the light. In the nature of things, then, only rarely can the experience of an encounter with this landscape be adequately recapitulated in a photographic image. All too often photographer's accounts range in gist from the vapidly charming, through the tedious, to falsely theatrical. Few photographers have either the sensitivity to place or the mastery of material necessary to produce a body of work consistently true to the spirit of this subject.

Fay Godwin is one of the small number whose photographic studies of landscape have a felicity which flows from their rightness, rather than from any gentling of her view of the places photographed. Indeed, some convey a sense of formidable, cold hardness. Many are located in the old, used lands formed by the activities of predecessor tribes, ranging from bronze age agriculturists to early industrial man. The marks of each upon the earth are recorded by Fay Godwin with such impartial completeness that the limitations on information lie with the perceiver, rather than in the image.

Her photographs have wide currency in the guidebooks, less conventional than many, of which she is co-author, and as illustrations to essays dealing with the land and to the poems of Ted Hughes. Fay Godwin's images survive remarkably well the cheap reproductive processes inevitable to some of them. Higher printing standards, as seen for example, in *Remains of Elmet*, remind the viewer of her interest in the photograph as fine print.

Although the inherent qualities of a photographic print come first to mind in questions regarding its status as fine print or illustration, Fay Godwin's work emphasizes the importance of the context of presentation to the establishment of this status. Whereas the photographs as illustrations become associated through textual linkage, her images presented for themselves, and isolated by framing and hanging, remain very much a collection of individual items, whose connection is incidental and at the discretion of the viewer. Either conclusion brings its own train of perceptual consequences which substantially govern the viewing experience.

Fay Godwin has demonstrated that, whatever the risk to the fine printmaker of the subject before the camera becoming obscured by the process of realisation, she has the skill and determination to serve subject and medium equally well. This is true even when, as usual for landscape, the subject is primary to an extent that, at first encounter, the medium is almost wholly effaced by it.

—Philip Stokes

GOHLKE, Frank.

American. Born in Wichita Falls, Texas, 3 April 1942. Educated at Wichita Falls High School, Wichita Falls, Texas, 1957-60; Davidson College, North Carolina, 1960-63; University of Texas at Austin, 1960-64 B.A. in English literature 1964; Yale University, New Haven, Connecticut, 1964-67, M.A. in English literature 1967; studied photography with Paul Caponigro, Bethel, Connecticut, 1967-68. Married Madelon Sprengnether in 1966 (divorced, 1981); daughter: Jessica Lee. Freelance photographer since 1967. Adjunct Instructor, Middlebury College, Vermont, 1968-71; Teacher, Blake Schools, Minneapolis, 1973-75; Assistant Professor, University of Minnesota Extension, Minneapolis, 1975-79; Visiting Instructor in Art, Colorado College, Colorado Springs, 1977-81; Visiting Professor, Carleton College, Northfield, Minnesota, 1980, and Yale University Graduate School, 1981. Recipient: Guggenheim Fellowship, 1975; Minnesota State Arts Council Fellowship, 1973; Seagram Bicentennial Courthouse Project Award, 1975; National Endowment for the Arts Fellowship, 1977; Bush Foundation Artists Fellowship, 1979. Agent: Light Gallery, 724 Fifth Avenue, New York, New York 10019. Address: 1322 Adams N.E., Minneapolis, Minnesota 55413, U.S.A.

Individual Exhibitions:

1969 Middlebury College, Vermont
1971 Underground Gallery, New York
1974 International Museum of Photography, George Eastman House, Rochester, New York

Frank Gohlke: *Driveway*, San Francisco, 1979

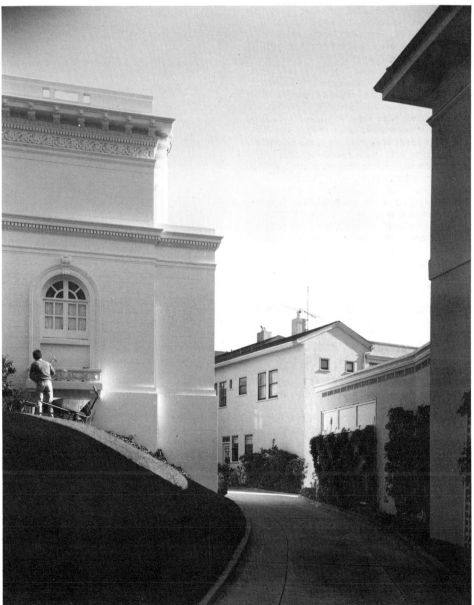

Art Institute of Chicago
1975 Light Gallery, New York
 Amon Carter Museum, Fort Worth, Texas
1977 Viterbo College, La Crosse, Wisconsin
 Boston Museum School
1978 University of Nebraska, Lincoln
 Museum of Modern Art, New York
 Light Gallery, New York
1980 University of Massachusetts, Amherst
 Carleton College, Northfield, Minnesota
1981 Kalamazoo Institute of Arts, Michigan
 Light Gallery, New York

Selected Group Exhibitions:

1972 *60' Continuum*, International Museum of
 Photography, George Eastman House,
 Rochester, New York
1973 *Photographers: Midwest Invitational*, Walker
 Art Center, Minneapolis
1975 *New Topographics: Photographs of a Man-
 Altered Landscape*, International Museum
 of Photography, George Eastman House,
 Rochester, New York (travelled to the Otis
 Art Institute, Los Angeles, and Princeton
 University Art Museum, New Jersey)
1976 *Recent American Still Photography*, Fruit
 Market Gallery, Edinburgh
1978 *Minnesota Survey: 6 Photographers*, Min-
 neapolis Institute of Arts
 *Mirrors and Windows: American Photog-
 raphy since 1960*, Museum of Modern
 Art, New York (toured the United States,
 1978-80)
1979 *Photographers of the 70's*, Art Institute of
 Chicago
 *American Images: New Work by 20 Con-
 temporary Photographers*, Corcoran Gal-
 lery, Washington, D.C. (travelled to the
 International Center of Photography, New
 York; Museum of Fine Arts, Houston;
 Minneapolis Institute of Arts; and India-
 napolis Institute of Arts, 1980; American
 Academy, Rome, 1981)
1980 *New Landscapes, Part II*, Friends of Pho-
 tography, Carmel, California

Collections:

Museum of Modern Art, New York; International
Museum of Photography, George Eastman House
Rochester, New York; Art Institute of Chicago;
Minneapolis Institute of Arts; Museum of Fine
Arts, Houston; Amon Carter Museum of Western
Art, Fort Worth, Texas; Santa Barbara Museum of
Art, California; Die Neue Sammlung, Munich;
National Gallery of Australia, Canberra.

Publications:

By GOHLKE: articles—"Frank Gohlke" in *Camera*
(Lucerne), May 1976; introductory essay in *Photo-
graphs*, edited by Ben Lifson, El Cajon, California
1977; in *Darkroom 2*, edited by Jain Kelly, New
York 1978; "Silos of Life" in the *New York Times*,
18 January 1979; "A Photographer's View of Grain
Elevators" in *GTA Digest* (Minneapolis), March/
April 1979; "Frank Gohlke: An Interview," special
issue of *Northlight* (Tempe, Arizona), vol. 10, 1979;
videotape—*Prairie Castles*, co-director, St. Paul,
Minnesota 1979.

On GOHLKE: books—*New Topographics: Photo-
graphs of a Man-Altered Landscape*, edited by Wil-
liam Jenkins, Rochester, New York 1975; *Court
House*, edited by Richard Pare, New York 1978;
*Mirrors and Windows: American Photography since
1960* by John Szarkowski, New York 1978; *Ameri-
can Images: New Work by 20 Contemporary Pho-
tographers*, edited by Renato Danese, New York

1979; *Photography and Beauty* by Robert Adams
and others, Millerton, New York 1981; articles—
"Route 66 Revisited: The New Landscape Photog-
raphy" by Carter Ratcliff in *Art in America* (New
York), January/February 1976; "Frank Gohlke's
Entrance into the Provinces" by Ben Lifson in the
Village Voice (New York), 8 May 1978; "Showing
an America of Wheat and Wheaties" by Sami Klein
in *Minneapolis Star*, 16 June 1979; "Midwest Icons"
by Peter Picard in *Minnesota Daily* (Minneapolis),
26 October 1979.

A sense of taking and being taken by the world (and
I want to insist on the erotic edge of that word) is
central to my understanding of photography. My
perceptions depend, tautologically, on what there is
to see. The world forms my ideas and imaginings;
but I'm also aware that I give form to the world in
the act of seeing and photographing it; and if I
manage to do it right, it's a form which is peculiar to
me. The paradox is that you only do that which is
uniquely yours by forgetting yourself, by losing
yourself in the world you photograph.

The photograph I want to make (which I never
will, because it is unmakable) would replicate that
experience of self-loss and recovery in all its com-
plexity, intensity, temporal depth and conviction of
utter completeness, as if for that moment the whole
universe is concentrated there. That's quite a bit to
expect from a flat piece of paper with some grey
smudges on it, but thanks to metaphor we can give a
persuasive illusion that such is the case. The things
described in a photograph are akin to the words of a
poem, and the form of the photograph is analogous
to the poem's structure. Word and structure, thing
and form, act upon one another. The form mirrors
the movement of the mind and feelings, as the possi-
bility of the photograph is first sensed, then pursued,
and finally given a shape. The photograph is itself a
gesture, a compound of the gesture of the world and
the gesture of the photographer in response to it.

If I were forced to come up with one word to
characterize my photography, the word would be
"lyrical." Lyricism as a mode strives to give each
impulse, each curve of emotion, the form that is
unique to it and unrepeatable. It is concerned to
describe with fidelity and clarity that interaction
between inner and outer realities that is the occasion
for the photograph. For me, that implies that the
appearances, the physical things and the spaces they
inhabit must be rendered with the same fidelity and
clarity. Whatever system there is in my work grows
out of a body of encounters which have things in
common, and so will have resolutions in common.

What I'm looking for is a way of photographing
that is internally consistent, but that will also allow
me to photograph *anything* I want without a sense
of strain, dislocation or anomaly. My ideal style
involves the disappearance of an obvious "style"
altogether. Pure transparency is the goal, but of
course it's unattainable. It is the effort toward the
goal that feeds the imagination.

—Frank Gohlke

The groundglass of a camera has always been dead
set against the idea of a landscape. Aiming essen-
tially down at the land with a viewfinder that is
positioned essentially upright is a kind of delight in a
dilemma that all landscape photographers in some
fashion or other have faced. Frank Gohlke, who has
been photographing the flat world of the American
Mid-West from Texas to Minnesota for the last
decade, regards the levelness of the land—the prone
prairie that must somehow be lifted vertically on its
feet—as "an active force in the landscape [and not
simply] a passive container of objects." Describing
the sensation of driving through the plains of Kan-
sas and the Texas Panhandle, Gohlke writes, "I felt
the presence of space rather than the absence of
things."

In such vastness as Gohlke has photographed, we
welcome interruptions that would secure focus and

bearing, "things" that would calm our distended,
often disoriented, optic nerves. For Frank Gohlke,
as well as for most temporally-minded true-believers
on the plains, that blessed intermission, that resting
point of focus, has been the grain elevator. Out there
in all that recumbency, these sky-scraping, perpen-
dicular refreshments not only mark where road and
rail intersect, they are the beacon for a mini-city of
workers who gravitate from hundreds of miles out
to toil in their shadows. "Grain elevators," Gohlke
writes, "exist in the present, testaments to the time-
less but immediately crucial powers of soil and sun,
water and wind. The future they anticipate is next
year's harvest, not eternity."

The excitement of discovery often draws an artist
within surface sight of the subject. Such, it appears,
was the nature of Frank Gohlke's quest on the
prairie. The earliest photographs are frame-filled
with the gleaming sheet metal or chipped clapboards
of the granaries. The images are replete with razor-
sharp creases between abutting columns and walls,
creases so impeccable they resemble paper folded in
half and pressed tightly between two fingers.

In subsequent years, Gohlke pulled away from the
elevators, sometimes so far back that telephone lines
clearly visible at the edges of his frame vanished in
the center of his prints. While the elevators were still
in sight, sky and land flooded the scene.

In a three-dimensional world, heaven and earth
never touch. In a photograph, there's no way to keep
them apart. The horizon line where the contact is
made—that endless line of obfuscating conclusions
that Gohlke characterizes as being "unreachable
except by sight"—behaves as catalyst and kingpin in
a number of these mid-1970's pushed-back land-
scapes. The horizon line causes us to consider at
which distances Gohlke's landmarkers actually lie as
well as what particular relationships among them
are formed. In a photograph taken in Perryton,
Texas in 1973, for example, Gohlke establishes an
engaging equivalence in scale and function between
the dividing line (normally tiny) on a highway and
the white columns of a grain elevator (normally
colossal) in the distance. Seen (and photographed)
from one specific spot, and one specific spot only,
the road dashes and the elevator columns are in
perfect line, the one over the other. What's more—
and it is indeed astounding to witness this in the
photograph—both are rendered in exactly the same
size. The dashes mark the path ahead, the towers
indicate how far there is to go.

Gohlke addresses not only formal equivalencies,
but also mechanical laws interacting with human
aspirations. In "Near Kinsley, Kansas," 1973, the
elevators are reduced to the size of trees, the man-
made and the natural standing neck and neck on the
horizon reaching for the firmament. "Physical
orientation," Gohlke states in his writings, "is never
far distant from spiritual orientation." A woman
from Texas once told him, "Our churches don't need
steeples; we have grain elevators."

Gohlke's handling of "decisive distance and deci-
sive place" gains momentum as the hallmark of his
vision in much of his recent work, not just of grain
elevators and their surroundings, but of prairie-
sized parking lots, amusement parks, sports com-
plexes, marsh fires, power stations, and highway
construction sites. There is the image taken in Albu-
querque, New Mexico in 1977 of what appears to be,
at first sight, one half of a freshly paved highway
(seen parallel to the film plane). The other lane (tiny
and far away in the flatness of the landscape) easily
consolidates the moderately light traffic of the day.
Upon closer inspection, however, we realize—and it
works like a charm every time—that Gohlke has, in
fact, positioned the traffic, the road lights and power
line poles precisely on top of a smoothly cemented
wall. Certainly it is an uplifting landscape, if not a
classic.

—Arno Rafael Minkkinen

GOLDEN, Judith.

American. Born Judith Greene in Chicago, Illinois, 29 November 1934. Studied at the School of the Art Institute of Chicago, 1968-73, B.F.A. 1973; University of California at Davis, 1973-75 (Chancellor's Fellowship, 1974; Regents' Fellowship, 1975), M.F.A. 1975. Married David Golden in 1955 (divorced, 1968); children: David and Lucinda. Freelance photographer, in California, since 1973. Visiting Lecturer, University of California at Los Angeles, 1975-79, University of California at Davis, 1980, and California College of Arts and Crafts, Oakland, 1980. Recipient: National Endowment for the Arts Photography Fellowship, 1979. Agents: G. Ray Hawkins Gallery, 9002 Melrose Avenue, Los Angeles, California 90069; and Quay Gallery, 560 Sutter Street, San Franscisco, California 94102. Address: 773 Minna Street, San Francisco, California 94103, U.S.A.

Individual Exhibitions:

1977 University of Colorado, Boulder
University of California at San Francisco
School of the Art Institute of Chicago
The Women's Building, Los Angeles
1978 Orange Coast College, Costa Mesa, California
Portland School of Art, Maine
G. Ray Hawkins Gallery, Los Angeles
1979 Quay Gallery, San Francisco
1980 Galerie Nagel, West Berlin
1981 Photo/Trans/Forms, San Francisco (with Joanne Leonard) Museum of Modern Art
Quay Gallery, San Francisco

Selected Group Exhibitions:

1977 Contemporary Photography, Fogg Art Museum, Harvard University, Cambridge, Massachusetts
Modern Photography, Seattle Art Museum
1978 Silver and Ink, Oakland Museum, California
20th Century Photography: 1959 to the Present, University of New Mexico, Albuquerque
1979 Translations: Photographic Images with New Forms, Cornell University, Ithaca, New York
Attitudes: Photography in the 70's, Santa Barbara Museum of Art, California
4 California Photographers, Light Gallery, New York
1980 Rated X, Photographica Gallery, New York
1981 Contemporary Hand-Colored Photographs, de Saisset Museum, University of Santa Clara, California
A Look at the Boundaries, Memorial Union Gallery, University of California at Davis

Collections:

Museum of Modern Art, New York; International Museum of Photography, George Eastman House, Rochester, New York; Fogg Art Museum, Harvard University, Cambridge, Massachusetts; Portland Museum of Art, Maine; University of New Mexico, Albuquerque; Center for Creative Photography, University of Arizona, Tucson; Los Angeles County Museum of Art; San Francisco Museum of Modern Art; Oakland Museum of Art, California.

Publications:

On GOLDEN: books—In/Sights: Self-Portraits by Women, edited by Joyce Tenneson Cohen, Boston 1978, London 1979; Self-Portrayal: The Photographer's Image, Carmel, California 1979; articles— "Judith Golden's Explorations of Self" by Joan

Murray in Artweek (Oakland, California), 26 March 1977; "Discoveries: Judith Golden" in Time-Life Photography Annual, New York 1978; "Judith Golden and Sherrie Sheen" by Barbara Noah in Art in America (New York), March 1978; "Judith Golden" by David Fehey in G. Ray Hawkins Photo-Bulletin (Los Angeles), September 1978; "Judith Golden's Self-Portrait Fantasies" by Diana Portner in Artweek (Oakland, California), 16 September 1978; "Dialogue with Judith Golden" by Diana Portner in Bulletin of the Los Angeles Center for Photographic Studies, October 1978; "Forbidden Fantasies" by Ted Hedgpeth in Artweek (Oakland, California), 27 September 1979.

My work deals with the photographic illusion of reality and fantasy situations; a juxtaposition of a real and an unreal world.

—Judith Golden

Trained as a painter and printmaker, Judith Golden was not interested in straight photography's somewhat passive role of recording the world. Instead, she looked on photography as a tool to generate images containing a high degree of believability.

Thus she began to integrate photography with printing techniques to create imaginative works based on popular myths and fantasies.

Her meticulously crafted, one-of-a-kind pieces which grew out of this combination are accomplished with a series of color toners, hand-applied paints, and various other devices including stitching cloth borders around the pictures and attaching hair, ribbon, and other items to their surfaces. Although some prints rely on purely photographic illusionism—her most recent works, in fact, are straight color prints—they all exploit the convincing realism inherent in the photographic process.

When discussing her work, Golden expresses a longstanding interest in the ways we are made to conform to mass media images. Using herself as model—which makes these essentially self-portraits—she tries on different costumes, takes on different roles, or substitutes her face for that of some famous person. In the "People Magazine" series, her face appears through a hole cut out of the magazine's cover which contains recognizable features of such stars as Louise Lasser and Woody Allen; in the series entitled "Ode to Hollywood" her face appears in place of the heroine in made-over movie posters; and in the portrait series "Chameleon," she assumes other identities so totally she herself becomes unrecognizable. The thoroughly illusionistic quality of

Judith Golden: *Self-Portrait Fantasy Series #1: Chameleon, Sweet Sue*, 1975

the images—which makes the fantasy seem very real—underscores Golden's message about the seductive nature of roles fabricated by the media.

"Forbidden Fantasies," her series of explicit sexual fantasies made from retouched reproductions of a 16th century Chinese marriage manual, illustrates Golden's sense of humor as well as her daring honesty. Expressions of delight on the pasted-on faces and lavishly colored genitals make her private desires (she is shown in the body of a Chinese maiden having sex with famous artists like Henry Miller, Picasso, Edward Weston, and Robert Heinecken) embarrassingly public. With these images, as with her others, Golden seems to be saying that it is OK to have such fantasies. Using herself as example, she is encouraging her viewers to develop their imaginations in order to create and to live out their own personal fantasies.

—Ted Hedgpeth

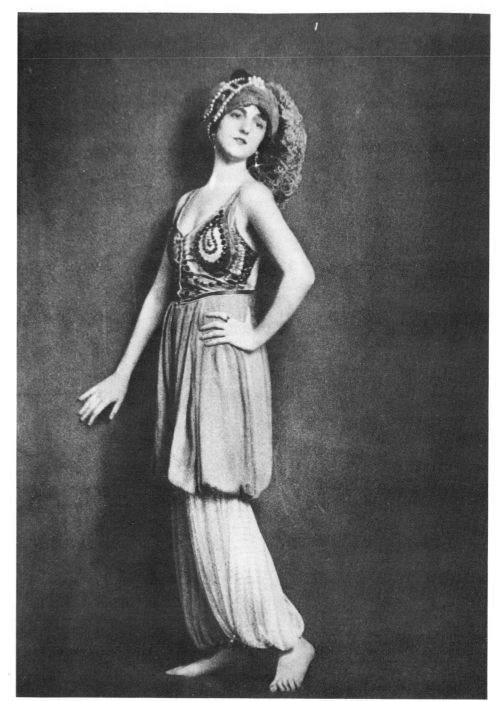

Henry B. Goodwin: *The Dancer Gabo Falk*, 1917

GOODWIN, Henry B(uergel).

Born Heinrich Karl Hugo Goodwin Buergel in Munich, Germany, 20 February 1878; emigrated to Sweden, 1905: naturalized, 1907. Studied philology at the Universities of Munich, Copenhagen and Leipzig, c. 1896-1903, Dr. Phil., Leipzig, 1903; mainly self-taught in photography, but influenced by Nicola Perscheid from c. 1900. Married Ida Engelke in 1909. Assistant Professor in German Language, Uppsala University, 1905-09; Lexicographer, Norstedt and Söner publishing company, Stockholm, 1909-15. Professional portrait photographer, establishing Kamerabilden Studio, Stockholm, 1915 until his death, 1931; also a horticulturist, Stockholm, c. 1925-31. Visiting Lecturer, Swedish Photographers Association, 1914, and Royal Photographic Society, London, 1922. Scandinavian Correspondent, *Photograms of the Year* annuals, London, 1914-c. 1921. *Died* (in Saltsjöbaden, Stockholm) *11 September 1931*.

Individual Exhibitions:

1915 *Kamerabildner*, Konstsalongen Varia, Stockholm
1917 A.P. Little Gallery, London
1918 *Kamerabildner*, B.T.-Centralens Udstillingslokale, Copenhagen
1922 Royal Photographic Society, London

Selected Group Exhibitions:

1914 *London Salon of Photography* (and 1916-21)
1924 *Internationella Fotografiutställningen*, Liljevalchs Konsthall, Stockholm
1928 *Andra Internationella Fotografiska Salongen*, Konstnärshuset, Stockholm
1929 *Internationella Fotografiutställningen*, Konsthallen, Gothenburg
1934 *Internationella Fotografiutställningen*, Liljevalchs Konsthall, Stockholm
1980 *Bäckströms Bilder*, Moderna Museet, Stockholm

Collections:

Moderna Museet, Stockholm; Kungliga Biblioteket, Stockholm; Stockholms Stadsmuseum.

Publications:

By GOODWIN: books—Konstnärsporträtt, Stockholm 1977; *Anders de Wahl: En Festskrift*, Stockholm 1919; *Kamerabilden*, Stockholm 1929; *Cyko-Handbok för Yrkesfotografer*, Stockholm 1919; *Komedianten*, Stockholm 1919; *Troll och Tott*, Stockholm 1924; *Hennes Höghet av New York*, Stockholm 1925; *Dr. Goodwins Lilla Katekes*, Stockholm 1928.

On GOODWIN: books—*Bäckströms Bilder*, exhibition catalogue, by Ake Sidwall and Leif Wigh, Stockholm 1980; *Fotograferna och det Svenska Landskapet* by Leif Wigh, Helsingborg, Sweden 1982; articles—"Henry Buergel Goodwin" by Curt Götlin in *Fotonyheterna* (Stockholm), no. 7, 1971; "Henry B. Goodwin, Svensk Porträttfotograf" by Bo Nilsson in *Fotografiskt Album* (Helsingborg, Sweden), no. 1, 1980; "Dr. Henry B. Goodwin: Kamerabildens Obestridde Mästere" by Leif Wigh in *Scandinavia Today*, exhibition catalogue, Minneapolis 1982.

In the year of 1908 Henry G. Buergel, a German philologist, came to Sweden. For the first few years he gave lectures at the University of Uppsala, employment he obtained because of his knowledge of the Old Scandinavian and Icelandic languages. His studies had taken him to the universities of Leipzig, Munich and Copenhagen and also to Oxford. After the years at the University of Uppsala he took an office job with the publishing firm of Norstedt & Söner as a lexicographer. But even during these first years in Sweden he had shown a sound knowledge in photography in both a technical and an aesthetic sense. He had also succeeded in provoking the establishment with his (at that time) radical views on photographic picture creativity. One of his ideas was that photographic picture artists created "camera pictures"—as opposed to the photographs that every Tom, Dick and Harry took on Sunday excursions. He also appeared at the Photographic

Society, Stockholm, and lectured on his views and on foreign photographers. He had acquired the greater part of his knowledge from the well-known German portrait photographer Nicola Perscheid, who had been a childhood friend.

In 1915 Goodwin left the field of languages and set up as a photographer by establishing the Studio Kamerabilden (the Camera Picture) at Strandvägen in Stockholm. He had previously changed his name from the German-sounding Henry G. Buergel to the more Anglo-Saxon Henry B. Goodwin. His new studio attracted stage people, the intellectuals and the artists who were in fashion. His prices were sky high, way above those of his rivals, and only the rich and propertied went to Dr. Goodwin's studio. The famous Swedish actress Naima Wifstrand would willingly tell you her opinion that Goodwin was *much* too expensive—but in return he did always serve "tea and sympathy."

Goodwin also had a knack for making capital from his contacts, which irritated other portrait photographers in Stockholm. He published several books of works from his studio, including *Konstnärsporträtt* and *Anders de Wahl: En Festskrift*, as well as the textbook *Kamerabilden*.

Goodwin's work can be divided into three different periods. His earliest works are in the pictorial manner; he was one of the precursors of Swedish pictorialism during the years of the First World War. His pictures from this period have the characteristic softness, lack of sharpness and a not uninteresting "elevated" air typical of the pictorialist manner. He was also the Scandinavian Correspondent for *Photograms of the Year* and a Fellow of the Royal Photographic Society. He visited London willingly, and probably wished to suggest in Sweden that he was of British descent.

His second period involved work that was closer to everyday life, more down-to-earth, and it was during this period that he left his studio to take pictures outdoors. The studio was no longer essential to him except as a means of support—but he would not admit that fact, not even to himself.

Toward the end of the 1920's he came in contact with the New Objectivity during a visit to Germany, and after that he rejected some of his earlier ideals. In his book *Kamerabilden* he presented the German photographer Albert Renger-Patzsch, the leading figure of the New Objectivity. Inspired by Renger-Patzsch's photographs, Goodwin began to photograph the vegetation in his garden in Saltsjöbaden. Like Renger-Patzsch he moved nearer to a concept of motif and even used more dramatic angles to express his new ideas. During this period Goodwin also became a horticulturalist and corresponded with people around the world about the best methods of growing roses.

Goodwin's photographs influenced some of the amateurs in the Stockholm Photographic Society and inspired them to improve the quality of their own pictures. Now, 50 years after his death, Goodwin's photographs still impress as some of the most eminent photographs of the pictorial era in Sweden.

—Leif Wigh

GORO, Fritz.

American. Born in Bremen, Germany, 20 April 1901; emigrated to France, 1933, to the United States, 1936: naturalized, 1944. Educated at the Lessing Gymnasium, Berlin, until 1919; studied at the State School of Applied Arts, Berlin, 1919-21, and at the Bauhaus School, Weimar, 1921-23. Married the sculptress Grete Goro; has one son. Worked in the Magazine Division of Ullstein Publishing House, Berlin, as art director, designer, writer and editor, 1924-28; Assistant to the Managing Director, and editor, designer and art director, *Münchner Illustrierte*, Munich, 1928-33; freelance photographer, Paris, 1933-36, and New York, working mainly for *Life* magazine, 1936-44; Science Staff Photographer, *Life* magazine, New York, 1944-66, and for *Life* on contract, 1966-71; freelance science photographer, working mainly for *Scientific American* and for the Research Division of the Polaroid Corporation, since 1971. Regents Professor, University of California at San Diego, 1969; Visiting Fellow, Yale University, New Haven, Connecticut, 1969-70. Recipient: American Medical Association Award, 1948; National Society for Medical Research Award, 1949; 4 Art Directors Club of New York/American Institute of Graphic Arts Awards, 1974-75; New York Microscopical Society Award, 1977; Society of Photographic Scientists and Engineers Award, 1977; Life Achievement Award, American Society of Magazine Photographers, 1978; Louis Schmidt Award, Biological Photographic Association, 1980. Fellow, Biological Photographic Association, 1969, and New York Microscopical Society, 1976. Address: 324 North Bedford Road, Chappaqua, New York 10514, U.S.A.

Individual Exhibitions:

1969 Loewe Art Gallery, University of Miami
1981 *Microcosmos*, Polaroid Corporation, Cambridge, Massachusetts (travelled to the Chappaqua, New York Library, 1982)

Selected Group Exhibitions:

1951 *Memorable Life Photographs*, Museum of Modern Art, New York
1955 *The Family of Man*, Museum of Modern Art, New York (and world tour)
1979 *Life: The First Decade 1936-1945*, Grey Art Gallery, New York University

Publications:

By GORO: article—"Footnotes from a Member of the Jubilee," with Kay Reese, in *Infinity* (New York), January 1971.

On GORO: books—*Memorable Life Photographs*, with text by Edward Steichen, New York 1951; *Life Photographers: Their Careers and Favorite Pictures*, edited by Stanley Rayfield, New York 1957; *Life: The First Decade 1936-1945* by Robert Littman, Ralph Graves and Doris C. O'Neill, New York 1979, London 1980.

It all happened by chance in 1937. Fritz Goro was photographing the beaches of Cape Cod for *Life* when the editors of the magazine assigned him to check out the Wood's Hole Marine Biological Laboratory along the coast of Massachusetts. It was Goro's first acquaintance with science and oceanography and was to influence the rest of his life. Today his name is not only closely associated with photography of science, but also Fritz Goro is one of the very few recognized microscopists in the world.

Born in Germany, Goro was trained as a designer and sculptor at the State School of Applied Arts in Berlin as well as at the Bauhaus. He became the youngest designer/writer on the staff of the *Berliner Illustrierte* (Ullstein Verlag) and somewhat later an executive at the *Münchner Illustrierte*. In 1933, Goro and his sculptress wife Grete fled from Nazi Germany to Paris, literally leaving all their belongings behind them. They both became freelance photographers, and some of their work was published in magazines such as *Vogue* and *Vue*. In 1936 they moved to New York, where Fritz Goro has worked for *Life* ever since.

Life was very supportive and interested in scientific experiments and, after the Wood's Hole episode, assigned Goro as scientific photographer for marine sciences and marine biology without strings attached to his time. Thus Goro was able to develop his own very precise approach to scientific photography, his own optical equipment and his own highly personal style. In 1938 he photographed the pioneering work of Enrico Fermi with the fission of uranium, and he has ever since worked on nuclear physics and nuclear chemistry. In 1942 he made his first essay for Polaroid on quinine; he has continued to experiment with Polaroid technologies to this day. In 1945 he made the first photographs in color of blood circulation in living animals. In the 60's he worked intensely on the structure of DNA and RNA.

Widely travelled, including various expeditions to the Arctic, Fritz Goro works now mostly out of his own darkroom-laboratory set up in his home. Many of his present assignments come from well-known scientific companies and magazines such as *Scientific American*.

Goro's pictures, taken with microscopes and specially designed lenses and lighting, reach far beyond the recording of items invisible to the naked eye. His continuous search to make understandable images out of abstract concepts has resulted in the most sophisticated and beautiful photographs in which science blends intimately with art.

—Ruth Spencer

See Color Plates

GOSSAGE, John R.

American. Born in New York City, 15 March 1946. Studied photography privately with Lisette Model, Alexey Brodovitch, and Bruce Davidson, New York, 1962-64. Married Denise Sines in 1975. Freelance photographer, New York, 1963-65, and Washington, D.C., since 1965. Instructor of Photography, Graduate School, Department of Art, University of Maryland, College Park, since 1977. Recipient: Washington Gallery of Modern Art Fund Award, 1969, 1970; National Endowment for the Arts Short Term Project Grant, 1973, and Photography Grant, 1974, 1978; Stern Family Foundation Grant, 1974. Agents: Catelli Graphics, 4 East 77th Street, New York, New York 10021; Lunn Gallery/Graphics International, 3243 P Street N.W., Washington, D.C. 20007; and Richard Hines Gallery, 2030 Fifth Avenue, Seattle, Washington 98121. Address: 1875 Mintwood Place N.W., Apartment 23, Washington, D.C. 20009, U.S.A.

Individual Exhibitions:

1963 Camera Infinity Gallery, New York
1968 Hinkley Brohel Gallery, Washington, D.C.
1971 Ohio University, Athens
1972 *John Gossage: Photographs/Anne Truitt: Color Fields*, Pyramid Gallery, Washington, D.C.
1974 *Cultivation and Neglect*, Jefferson Place

Gallery, Washington, D.C.
1976 Castelli Graphics, New York
Max Protetch Gallery, Washington, D.C.
Better Neighborhoods of Greater Washington, Corcoran Gallery of Art, Washington, D.C.
1978 *Gardens*, Castelli Graphics, New York (travelled to Wekstatt für Photographie der VHS Kreuzberg, Berlin)
1980 Castelli Graphics, New York
Lunn Gallery, Washington, D.C.

Selected Group Exhibitions:

1975 *14 American Photographers*, Baltimore Museum of Art (travelled to Newport Harbor Museum, Newport Beach, California; La Jolla Museum, California; Walker Art Center, Minneapolis; Fort Worth Art Museum, Texas)
1976 *Peculiar to Photography*, University of New Mexico, Albuquerque
1977 *Contemporary American Photographic Works*, Museum of Fine Arts, Houston (travelled to the Museum of Contemporary Art, Chicago; La Jolla Museum, California; Newport Harbor Art Museum, Newport Beach, California)

Photographic Landscapes, International Museum of Photography, George Eastman House, Rochester, New York
Biennale, Paris
1978 *23 Photographers/23 Directions*, Walker Art Gallery, Liverpool
1979 *Paysages*, Bibliothèque Nationale, Paris
American Images: New Work by Twenty Contemporary Photographers, Corcoran Gallery, Washington, D.C. (travelled to the International Center of Photography, New York, Museum of Fine Arts, Houston, Minneapolis Institute of Arts, and Indianapolis Institute of Arts, 1980; and American Academy, Rome, 1981)

Collections:

Museum of Modern Art, New York; International Museum of Photography, George Eastman House, Rochester, New York; Princeton University, New Jersey; Pan American Union, Washington, D.C.; Corcoran Gallery of Art, Washington, D.C.; Philadelphia Museum of Art; Museum of Fine Arts, St. Petersburg, Florida; Museum of Fine Arts, Houston; Bibliothèque Nationale, Paris; Australian National Gallery, Canberra.

Publications:

By GOSSAGE: books—*Gardens*, with text by Walter Hopps, New York and Washington, D.C. 1978; *American Images*, New York 1979; article—"Blow Up: The Story of Photography in Today's Art Market" in the *New York Times*, 12 October 1975.

On GOSSAGE: books—*14 American Photographers*, exhibition catalogue, by Renato Danese, Baltimore 1975; *Time-Life Textbook of Photography*, edited by John and Barbara Upton, Boston 1976; *Better Neighborhoods of Greater Washington*, exhibition catalogue, by Jane Livingston, Washington, D.C. 1976; articles—"As They See Themselves" in Esquire (New York), July 1965; "John R. Gossage" in *Camera* (Lucerne), August 1970; "Photos by John R. Gossage" in *Camera* (Lucerne), September 1973; "Four Photographs of John Gossage" in *The Georgia Review* (Durham, North Carolina), Winter 1975; "New York: John R. Gossage, Leo Castelli Gallery Uptown" by Phil Patton in *Artforum* (New York), April 1976; "Galleries" by Paul Richard in the *Washington Post*, 12 April 1976; "John R. Gossage" by Jane Livingston and Allan Porter in *Camera* (Lucerne), March 1977; "Gardens" by Noel Frackman in *Artsmagazine* (New York), May 1978; "Art in Washington" in *Art in America* (New York), July/August 1978.

John R. Gossage: *Untitled*, 1978

John Gossage's photographs stand in the mainstream tradition of Atget, Evans, Frank, and Friedlander. Like them his concerns are with the world, and, like them, he has a keen appreciation of the world's ironies. What distinguishes Gossage's work is his ability to extend and enrich his traditional base while, often in the same image, using his vision to remark upon the procedures, accomplishments, and occasional pretensions of the documentary point of view. All photographs are subversive; Gossage's a bit more so than most.

The complexity and subtlety of Gossage's images have made him the center of much critical controversy. To accept Gossage's work one must also accept, or at least stipulate to, his assertions about the possibilities of photographic seeing. On this point Gossage is uncompromising. While Gossage's work has never been sufficiently anecdotal to a broad public, it is difficult to think of another photographer of his generation who has enjoyed a more profound influence within the field, or whose work has been more widely imitated.

Gossage's work from the 1970's (*Cultivation and Neglect*, 1974; the book, *Gardens*, with Walter Hopps, 1978) established the formal vocabulary and philosophic intentions that characterize his particular vision. Much of this work derives its authority from the apparent contradictions that Gossage introduces between the superficial confusion of elements within the photographic frame and the sophisticated, often nearly hidden, structure of the image. His subjects are often mean and trivial and are presented in such a way as to subvert the viewer's hierarchies of significance, yet the photographs themselves are intelligent, witty, and often perversely beautiful.

In his most recent portfolios (*Seattle*, 1979; *Chevy Chase*, 1979-80) Gossage has shown himself unwilling to repeat the strategies of his earlier work. These newer works employ a tighter formal structure and make more explicit use of deep pictorial space. This, along with an increased concern for detail, has allowed Gossage to further objectify and externalize his interests and to turn his attentions to subjects of broader documentary possibilities while retaining his characteristic fascination with the ambiguities of photographic vision.

—Lewis Baltz

GOWIN, Emmet.

American. Born in Danville, Virginia, 22 December 1941. Studied at the Richmond Professional Institute, Virginia, 1961-65, B.F.A. 1965; studied photography, under Harry Callahan, at the Rhode Island School of Design, Providence, 1965-67, M.F.A. 1967. Married Edith Morris in 1964; children: Elijah and Isaac. Independent photographer, since 1967. Graduate Assistant Instructor in Photography, Rhode Island School of Design, 1966-67; Instructor in Photography, Dayton Art Institute, 1967-71, and Bucks County Community College, Newtown, Pennsylvania, 1971. Recipient: Guggenheim Fellowship, 1974; National Endowment for the Arts grant, 1977. Agent: Light Gallery, New York. Address: c/o Light Gallery, 724 Fifth Avenue, New York, New York 10019, U.S.A.

Individual Exhibitions:

1968 University of Richmond, Virginia
Dayton Art Institute, Ohio
Illinois Institute of Technology, Chicago
1969 International Museum of Photography, George Eastman House, Rochester, New York
1971 Massachusetts Institute of Technology, Cambridge
Photographs by Robert Adams and Emmet Gowin, Museum of Modern Art, New York
The Photographers' Gallery, London
1972 Light Gallery, New York
Art Institute of Chicago
1973 Friends of Photography, Carmel, California
Light Gallery, New York
1974 Galerie Lichttropfen, Aachen, West Germany
La Photogalerie, Paris
Light Gallery, New York
1976 Light Gallery, New York
1977 Susan Spiritus Gallery, Newport Beach, California
1981 Photography Gallery, Philadelphia

Selected Group Exhibitions:

1969 *Vision and Expression*, International Museum of Photography, George Eastman House, Rochester, New York (toured the United States, 1969-71)
1970 *Be-Ing Without Clothes*, Hayden Gallery, Massachusetts Institute of Technology, Cambridge (toured the United States)
1971 *Contemporary Photographers*, Fogg Art Museum, Harvard University, Cambridge, Massachusetts
1972 *60's Continuum*, International Museum of Photography, George Eastman House, Rochester, New York
1973 *Light and Lens: Methods of Photography*, Hudson River Museum, Yonkers, New York
1974 *Photography in America*, Whitney Museum, New York
1975 *Celebrations*, Massachusetts Institute of Technology, Cambridge
1978 *Mirrors and Windows: American Photography since 1960*, Museum of Modern Art, New York (toured the United States, 1978-80)
1979 *Photographie als Kunst 1879-1979/Kunst als Photographie 1949-1979*, Tiroler Landesmuseum Ferdinandeum, Innsbruck, Austria (travelled to the Neue Galerie am Wolfgang Gurlitt Museum, Linz, Austria; Neue Galerie am Landesmuseum Joanneum, Graz, Austria; and the Museum des 20. Jahrhunderts, Vienna)
1980 *The Portrait Extended*, Museum of Contemporary Art, Chicago

Collections:

Museum of Modern Art, New York; Rhode Island School of Design, Providence; Fogg Art Museum, Harvard University, Cambridge, Massachusetts; Dayton Art Institute, Ohio; Cincinnati Art Museum, Ohio; Art Institute of Chicago; Minneapolis Institute of Arts; University of Kansas, Lawrence; University of New Mexico, Albuquerque; National Gallery of Canada, Ottawa.

Publications:

By GOWIN: book—*Emmet Gowin: Photographs*, New York 1976.

On GOWIN: books—*Vision and Expression* by Nathan Lyons, New York 1969; *Be-Ing Without Clothes*, exhibition catalogue, by Minor White, Cambridge, Massachusetts and Millerton, New York 1970; *11 American Photographers*, exhibition catalogue, by Robert Doty and Robert Littman, Hempstead, New York 1972; *Light and Lens: Methods of Photography*, edited by Donald L. Werner and Dennis Longwell, New York 1973; *Celebrations*, edited by Minor White and Jonathan Green, Cambridge, Massachusetts, and Millerton, New York 1974; *Photography in America*, edited by Robert Doty, with an introduction by Minor White, New York and London 1974; *The Snapshot*, edited by Jonathan Green, Millerton, New York 1974; *Private Realities: Recent American Photography*, exhibition catalogue, by Clifford S. Ackley, Boston 1974; *The Land: 20th Century Landscape Photographs Selected by Bill Brandt*, exhibition catalogue, edited by Mark Haworth-Booth, London 1975; *Photographs: Sheldon Memorial Art Gallery Collection*, University of Nebraska, with an introduction by Norman A. Geske, Lincoln, Nebraska 1977; *Geschichte der Fotografie im 20. Jahrhundert/Photography in the 20th Century* by Petr Tausk, Cologne 1977, London 1980; *Mirrors and Windows: American Photography since 1960* by John Szarkowski, New York 1978; *Darkroom 2*, edited by Jain Kelly, New York 1978; *Light Readings: A Photography Critic's Writings 1968-1978* by A.D. Coleman, New York 1979; *Photographie als Kunst 1879-1979/Kunst als Photographie 1949-1979*, exhibition catalogue, 2 volumes, by Peter Weiermair, Innsbruck, Austria 1979; articles—"Emmet Gowin" in *Album* (London), nos. 5 and 6, 1970; "Photographs: Emmet Gowin" in *Aperture* (Rochester, New York), no. 2, 1971; "Emmet Gowin" in *Camera Mainichi* (Tokyo), October 1972.

Emmet Gowin's photographs are deceptively simple; many appear to be straightforward pictures of family life in a small town and others look casual—they are not. In them an intensely personal iconography is presented as a manifestation of universal experience. The mixture of life's basic elements, pregnancy, death, children, slaughter, unite into a finely tempered moral energy that cuts through the common scene.

Gowin's pictures of people and places in Danville, Virginia, are a head-on collision of the forthright with the mysterious which seems to say that this place, this person is both unique and universal. The cycles of life appear with ritualistic intensity heightened in many pictures by the use of vignetting.

Photographs of Edith, Gowin's wife, recur throughout his work. She seems at times to be the soul of his work, a symbolic center that ties all together. Her image fluctuates between a very real mother/housewife to an eternal feminine force. In these shifting roles she represents a paradox of the metaphysical in the physical and the timeless within constant change. In one of his best known pictures, "Edith, Danville, Virginia, 1971," she sits at the foot of their bed, one hand placed behind her head, one hand on her knee; a wooden horse sits in the window. The undulant, sculptural pose breaks into the severely horizontal lines of the bed, rugs and windows. The paradoxical suggestion of a typical artificial, showgirl pose is completely arrested by the stillness of the contemplative female presence in the simple room.

By comparison the European landscapes are lighter and more open. The textural complexity of the detail disperses the heavier ambiguous symbolism of the Danville pictures. Less autobiographical, the images still extol the riches of the earth. The subject matter, composition and the exquisite printing

Emmet Gowin: *Edith, Ruth and Mae*, Danville, Virginia, 1967 Courtesy Center for Creative Photography, Tucson

recall the work of Gowin's mentor, Frederick Sommer. Gowin's view has become more expansive and the tonal variations and print detail have become more delicate, marking a major stylistic change from his early moodier prints.

—Marianne Fulton

GRCEVIĆ, Mladen.

Yugoslav. Born in Zagreb, 8 October 1918. Educated at the University of Zagreb, 1937-42, B.L. in law 1942, and 1956-60, B.A. in art history 1960, M.A. in art history 1965. Married Nada Suljak in 1943. Instructor, School of Graphic Arts, Zagreb, 1946-52; Professor, Academy of Applied Arts,

Zagreb, 1952-54. Freelance photographer and art historian, Zagreb, since 1954. Master of Art Photography, Yugoslav Federation of Photography, 1954. Honorary Member, National Federation of Photographic Societies of France (FNSPF), 1955, and International Federation of Photographic Art (FIAP), 1967 (Member of the Art Commission, FIAP, since 1972). Address: Dvorničićeva 19, 41000 Zagreb, Yugoslavia.

Individual Exhibitions:

1944 Salon Ulrich, Zagreb
1945 *Naša Istra*, Salon Ulrich, Zagreb
1948 *Dabac/Grčević/Szabo*, Salon Ulrich, Zagreb
1954 Galerie Yougoslave, Paris (travelled to the Yugoslav Tourist Office, London)
1956 Cairo Art Gallery (travelled to the Public Relations Department, Rangoon)
From London to Hong Kong, Salon LIKUM, Zagreb (travelled to the Photo Club Gallery, Osijek, Yugoslavia, 1957)
1970 *Quest for Man*, Art Gallery, Sisak, Yugoslavia

Selected Group Exhibitions:

1951 *World Exhibition of Photography*, Lucerne
1952 *Photokina*, Cologne
Swedish Master Competition, Stockholm
1953 *Marine Photography*, Mariners' Museum, Newport News, Virginia (travelled to the Smithsonian Institution, Washington, D.C.)
1954 *PSA International Exhibition*, Chicago
1964 *Was ist der Mensch*, *Stern* magazine travelling exhibition
1968 *Die Frau*, *Stern* magazine travelling exhibition
1970 *Asia*, at *Photokina*, Cologne
1973 *Unterwegs zum Paradies*, *Stern* magazine travelling exhibition
1977 *Die Kinder Dieser Welt*, *Stern* magazine travelling exhibition

Collections:

Arts and Crafts Museum, Zagreb; Permanent Collection of Photography, Havdrup, Denmark; Photographic Association of Bengal, Calcutta; The Mariners' Museum, Newport News, Virginia; Smithsonian Institution, Washington, D.C.

Publications:

By GRCEVIC: books—*Yougoslavie*, with text by L. Peillard, Paris 1955; *Dalmatien*, with text by K. Edschmid, Munich 1961; *Situla Art*, with text by J. Kastelic, Belgrade and New York 1965; *Icons from Macedonia*, with text by K. Balabanov, Belgrade 1969; *Gold and Silver of Zadar*, with text by M. Krleža, Zagreb 1971; *Sibenik*, with text by S. Grubišić, Zagreb 1971; *Poreč*, with text by Z. Crnja, Pazin, Yugoslavia 1975; *Early Croatian Heritage*, with text by S. Gunjača, Zagreb 1976; *Zadar*, with text by V. Cestarić, Zadar, Yugoslavia 1978; articles—"Grand Succès de la Photographie Française à Zagreb" in *Photo-Cinéma* (Paris), July 1955; "Za jednu univerzalnu povijest fotografije" in *Zivot umjetnosti* (Zagreb), no. 6, 1968; "Mladen Grčević," interview, in *Fotografie* (Leipzig), December 1975; "The Beginnings of Art Photography in Zagreb" in *Zagrebačka fotografija Almanac*, Zagreb 1978; "Die Anfänge der künstlerischen Amateurfotografie in Zagreb" in *Fotografie* (Leipzig), no. 7, 1980.

On GRCEVIĆ: book—*Mladen Grčević* by Oto Bihalji-Merin, Belgrade 1973; articles—"Photos de Mladen Grčević" by R. Andreani in *Photo-Ciné Revue* (Paris), November 1954; "Mladen Grčević" by G. Paterne in *Photo-Cinéma* (Paris), April 1955; "Un Maitre Photographe Expose au Caire" by R. Mosseri in *Progrès Egyptien* (Cairo), May 1956; "Mladen Grčević" by Z. Jeremić in *Foto-Kino Revija* (Belgrade), January 1972; "In Search of Man" by B. Aleksić in *Review* (Belgrade), October 1974.

The first period of my photographic activity belonged to the sphere of pictorial photography. It was a time of learning, of gaining the security and discipline of the camera, of mastering the composition and searching for order in the chaotic picture of the world. It culminated in one-man shows in London and Paris in 1954.

A considerable change occurred during my journey to Africa, South Asia, and the Far East in 1955-56. Fascinated, and at the same time shocked, by the drama and dynamics of life among a tumult of races and religions, I spontaneously arrived at a particular variant of *Life* photography, with an accent on humanity and social criticism. In my quest for man in this immense and unknown vastness, I found love and hatred, self-contentment and wisdom, fatalism and loneliness. Taking photographs, I was no longer attracted by the exotic but by the

Mladen Grčević: *India*, 1955

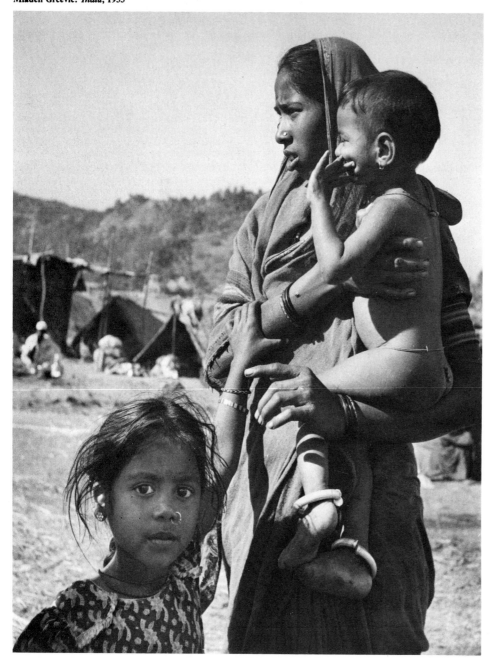

truth behind the visible.

I am still a passionate traveller. My camera does not cease to capture the contrasts of life equally in Mexico or in Brazil as in Kenya and Japan. I still inquisitively penetrate the human and social dimensions, as well as the dimension of time—especially in contact with ancient cultures, where the time-distance becomes more impressive than the terrestrial one. These trips into time brought me into contact with the historical course of art. Being both a photographer and an art historian, I started to illustrate and design books dealing with the art of several epochs. I tried to create a synthesis of a strictly scientific approach with the personal view of a photographer.

There is one sphere more, one that I have repeatedly entered during the 40 years of my work as a photographer: that of experimental photography. In 1965 I finally published some interesting results of photographic multiplication. For a *Life* photographer it would have been an unexpected digression, but in my case I believe it was the result of an unconscious necessity to transcend the boundaries of the natural world and to penetrate the trans-human world of form, an expanded and still unknown multi-dimensional space.

Nevertheless, I did not change my views on "creative" photography. Out of the complex and broad spectrum of contemporary photography, I still have the deepest appreciation for that work that is directed towards the human being and the complicated problems of his existence. That attitude makes for a deeply engaged photography that is still primarily searching for the truth behind the visible.
—Mladen Grčević

If it is true that contemporary photography has its roots in life and is fed by life, then that might just be the right starting point for viewing and understanding the photographic work of Mladen Grčević. For years Grčević recorded with his camera the story of human life—from its most primitive manifestations to its most civilized—in different parts of the globe.

The first phase of his work however, was within the traditions of the so-called "Zagreb School of Photography," which was, at that time, internationally known for its specific style and typical national content. With his photographs in this manner—photographs of the land, its life and people—Grčević gained a considerable reputation in his native country.

In the early 1950's Grčević was the first and only photographer among the group of outstanding Yugoslav modern artists who began to exhibit in Paris. His one-man show there in 1954 brought him invitations for other exhibitions in London, Cairo and Rangoon, as well as offers from well-known publishing houses and photographic magazines. His intense photographic activity in Paris also involved a resolute break with tradition.

In 1955 Grčević undertook a long journey to remote parts of the Middle and Far East. That journey was the beginning of a new—and, in my opinion, the most significant—phase in his photographic career. Confronted with life in uncommon and unexpected manifestations in the very cradle of mankind, he tried to find adequate means of photographic expression, and spontaneously came to what might be called a "meditative verism." There is some social criticism in these striking pictures, but there is still more of humanity and profound sympathy. When he focused on common people while at work, in the street, or contemplating in temples, he was successful in capturing expressions not only of bitterness and fatality, but also of serenity, dignity, and nobility. In these pictures the inner psychological reality is more important than any visual or social one: they make one think. It is obvious now that Grčević's 1955 photographs signalled a modern concept of documentary, the "truth" of which was confirmed by public response when these pictures appeared in contemporary publications or were

shown in the travelling exhibitions organized by *Stern* magazine.

Thereafter Grčević developed a more public career, presenting his photographs in numerous magazines and illustrating more than 100 books in nine different countries. As well, he has become a complete maker of books—as creator of the concept, author, photographer, and graphic designer. If one had to select the most successful work of this kind, it would have to be his photographic interpretation of prehistoric *Situla Art*, published in Belgrade and New York in 1965, which was nominated by the *New York Times* as one of the year's best art books.
—Nada Grčević

GRIFFIN, Brian.

British. Born in Birmingham, 13 April 1948. Educated at Halesowen Technical School, Worcestershire, 1959-64, O.N.C. in mechanical engineering 1968; Dudley College of Further Education, Worcestershire, 1964-69; studied photography at the Manchester Polytechnic, 1969-72, Dip.Photog. 1972. Married Frances Newman in 1980. Worked as estimating engineer for British Steel Corporation, Birmingham, 1966-69. Freelance photographer, London, since 1972: established Brian Griffin Studio, Rotherhithe, 1980. Agent: The Photographers' Gallery, 8 Great Newport Street, London WC2. Address (studio): 121/123 Rotherhithe Street, Rotherhithe, London SE16, England.

Individual Exhibitions:

1978 *Portrait of Our Time*, The Photographers' Gallery, London

Brian Griffin: *Marshall McLuhan*, Toronto, 1978

1980 *1979*, Photogallery, St. Leonard's-on-Sea, Sussex

1981 *Rock n' Roll and The Office*, Contrasts Gallery, London

Selected Group Exhibitions:

1975 *Young British Photographers*, Museum of Modern Art, Oxford

1979 *Three Perspectives on Photography*, Hayward Gallery, London

Collections:

Victoria and Albert Museum, London; Arts Council of Great Britain, London; British Council, London.

Publications:

By GRIFFIN: books—*Brian Griffin: Copyright 1978*, London 1978; *Power*, London 1981.

On GRIFFIN: books—*Exploring Photography* by Bryn Campbell, London 1979; *Three Perspectives on Photography*, exhibition catalogue, by Paul Hill, Angela Kelly and John Tagg, London 1979; article—by Clive Lancaster in *British Journal of Photography Annual 1980*, London 1979.

Photographers draw their inspiration from a variety of sources—some from nature, others from the beauty of men and women, still others from chunks of rocks or wood. Brian Griffin will have none of these. His life was always firmly rooted in the city and its inhabitants.

Born into an industrial community near Birmingham, Griffin started his adult life as a minor executive in an engineering firm. Not long after he had started in that career he suddenly decided to switch to photography. Three years' course at the Manchester Polytechnic gave him a start, but not much else. He did there, he says, some uninteresting fashion and polished a number of still-life tables. In 1972, as a mature 25 year old, he found himself pounding the streets of London in search of work. It took him four months to find. His industrial background paid off, for his first assignment—and the beginning of his distinctive style—was a commission to photograph a business tycoon for the magazine *Management Today*. His strongly designed, simple but original image caught the eye of his editors, and a new career was born.

Now Griffin is known mainly for these politically biased, cold, stilted, disrespectful portraits of a number of industrialists, directors and politicians. These photos are always very graphic, with large areas of black and white, and most of them are based on an unusual, often startling idea. A little later he consolidated his style with a series of rock 'n' roll personalities, mainly for *The Rolling Stone*. With both groups his portrayal, he insists, comes only from his own strong opinions and tendencies. He feels that his photographs are never superficial, but always committed and involved, springing from personal beliefs and also from intuition. In fact, he acts, in his characterization of the sitters, from instantaneous impression. This—the on-the-spot impression rather than a pre-sitting study—gives him his idea for the image, which he proceeds to create by careful arrangement of props and lights. Although he considers himself a "straight" photographer, Griffin does not hesitate to prearrange and fabricate his pictures almost entirely.

After his involvement with portraiture, which lasted several years, he has allowed his portrait sessions to become far less frequent; in fact, he does not want to do any more portraits of tycoons. He feels that this phase of his work is now thoroughly

exhausted. Now, the majority of his work comes from advertising, which, like his portraiture, has come initially from his industrial beginnings. Most of his early advertising was based on industry and on the use of "high finance" figureheads. Currently, Griffin's work is very varied. Since opening his own studio, he has, of necessity, been dealing with still-life—but the city and its people are still the predominant themes of his work.

—Jorge Lewinski

GRIFFITHS, Philip Jones. *See* JONES GRIFFITHS, Philip

GRIGNANI, Franco.

Italian. Born in Pieve Porto Morone, Pavia, 4 February 1908. Educated at the Istituto Tecnico and Liceo Scientifico, Pavia; studied at the Polytechnic of Architecture, Turin, 1933, but never practised as an architect; mainly self-taught in photography. Served as a Lieutenant in the Italian Army Artillery, 1939-43. Married Jeanne Michot in 1942; daughters: Daniela and Manuela. Freelance painter, designer, graphic artist and photographer, Milan, since 1932: Art Director for Alfieri and Lacroix, printers, and *Bellezza d'Italia* magazine, Milan, 1948-64. Art Director, *Pubblicità in Italia* editions, Milan, since 1954. Participated in the second Futurist movement, Milan, in the 1930's; Founder Member, Gruppo Exhibition Design, Milan, 1969. Recipient: Gold Medal for Publicity/Advertising, Milan, 1954; Gold Medal, *Triennale*, Milan, 1957; Silver Lion Award, Il Ponte photographic group, Venice, 1962; Gold Medal, Centro Culturale G. Puecher, Milan, 1974. Member, Alliance Graphique Internationale, 1951; Honorary Member, Society of Typographic Arts, Chicago, 1967. Address: Via Banca di Savoia 7, 20122 Milan, Italy.

Individual Exhibitions:

1958 *Experiments in Abstract Photography*, Libreria Salto, Milan
 Photographs for Graphic Design, Libreria Comunale, Milan
 Experiments in Dissolving View, Libreria Salto, Milan

1960 *Experiments in Visual Tension*, Libreria Salto, Milan
 Experimental Photographics, Normandy House STA Gallery, Chicago

1967 *18 Years of Creative Research*, Centro Culturale Pirelli, Milan

1970 500 D Gallery, Chicago

1975 *Methodology of Vision*, Museo Rotonda Besana, Milan (retrospective)

1977 *Experimental Paintings and Photographs*, Museo de Bellas Artes, Caracas (retrospective)

1979 *Experimental Paintings and Photographs*, Salone Comunale, Reggio Emilia, Italy (retrospective)

1980 *Projection of 79 Slides*, at the *Congress of the Alliance Graphique Internationale*, Munich

1981 *Experimental and Graphic Photography*, Galleria Flaviana, Locarno, Switzerland
 Lorenzelli Arte, Milan

Selected Group Exhibitions:

1962 *Gruppo Il Ponte*, at the *1st National Gold Lion Exhibition*, Venice

1963 *2nd Competition for Black and White Photography*, Bollate, Milan

1970 *Creative Photography*, Centro Gamma, Trieste

1972 *Biennale*, Venice
 Technology Versus Man, Salone Arengario, Milan

1977 *Between Painting and Photography*, Acireale, Sicily

1978 *Italian Photographers*, Musée Réattu, Arles, France

1979 *Venezia '79*

1980 *Cine-Graphia: La Linea in Movimento*, Galleria Flaviana, Locarno, Switzerland

1981 *La Linea Sutil*, Foro de Arte Contemporaneo, Mexico City

Collections:

Museum of Modern Art, New York; Stedelijk Museum, Amsterdam; Museum of Modern Art, Warsaw; Victoria and Albert Museum, London.

Publications:

By GRIGNANI: articles—"Photographie et Graphique" in *Camera* (Lucerne), June 1957; "Concerto in MI b¹" in *Linea Grafica* (Milan), May/June 1963; "La Fotografia Grafica" in special issue of *Pubblirama Italiano* (Milan), 1963; "Franco Grignani" in *Graphis* (Zurich), no. 108, 1963.

On GRIGNANI: books—*Fotografia* by Ermanno Scopinich, Milan 1943; *Fotografi Italiana*, Milan 1953; *Nuova Fotografia Italiana* by Giuseppe Turroni, Milan 1959; *Photo-Graphism International* by Tobias M. Bartel, Munich 1965; *Optical Illusions and the Visual Arts* by Ronald G. Carraher, New York and London 1966; *Franco Grignani: Graphic Designer in Europe*, Tokyo 1971; *Franco Grignani: Arte come Sperimentazione e Metodo*, Rome 1974; *Una Metodologia della Visione* by Giulio Carlo Argan and Guido Montana, Milan 1975; *Franco Grignani: El Sentido de una Larga Busqueda* by Giulio Carlo Argan, Caracas 1977; *70 Anni di Fotografia in Italia* by Italo Zannier, Modena, Italy 1978; *Franco Grignani: Il Segno come Matrice, Il Fenomeno come Variabilita Analitica* by Giuseppe Turroni, Milan 1978; *Mostra Antologica di Franco Grignani*, exhibition catalogue, by Bruno D'Amore and Giuseppe Berti, Reggio Emilia, Italy 1979; *Venezia '79: La Fotografia*, Milan and New York 1979; *Cine-Graphia: La Linea in Movimento*, exhibition catalogue, by Giuliana Scimé, Locarno, Switzerland 1980; articles—"Franco Grignani" in *Idea* (Tokyo), June 1961; "Franco Grignani, ricerca pura" by Giovanni Brunazzi in *Graphicus* (Turin), July/August 1967; "Franco Grignani and His Experimental Graphics" by Katzumie Masaru in *Graphic Design* (Tokyo), no. 28, 1967; "Franco Grignani and His Characteristic Graphic Style" by Raimund Hrabak in *Novum Gebrauchsgraphik* (Munich), February 1972; "Franco Grignani: A Methodology of Vision" by Stanley Mason in *Graphis* (Zurich), vol. 180, 1976; "Il Movimento" by Giuliana Scimé in *Il Diaframma* (Milan), October/November 1980; "Subpercezioni 1949-52 di Franco Grignani" by Arturo Carlo Quintavalle in *Enciclopedia Practica per Fotografare*, Milan 1981.

I have long thought that graphic design, though maintaining its essential character as a "service" to visual communication, must be supported by a wide range of experimental experiences from which one can attain the desired freedom from the routine of daily activities. Urgency conditioning quality; thematic limitations dwarfing creativity; certain style coherences—all combine to fetter the graphic designer's individual character.

I have done my best to oppose such external conditioning, and tried to widen the range of my own activities, concentrating on major experimental work that often overlaps into scientific fields such as psychology and physics. With the influence and adaptation of these scientific resources, graphic design can find its own evolution in new ways of expression. My tendency to experiment—and more especially to borrow from various scientific disciplines—probably comes from my having studied architecture. My experimental work isn't restricted merely to a mathematical framework; I have, for instance, worked with optical distortion and structural tension.

The human eye "sees" through emotion and suggestion; therefore, simple geometry and balanced composition don't provide the necessary stress for triggering off a reaction in the human eye. Advertisements are seen mostly side-by-side with other advertisements, and this proximity calls for an expression of physical autonomy (by "autonomy" I mean a traumatic value that instantly catches the viewer's eye, making him feel uneasy, perceiving the irregularity caused by tension).

Graphic design is nowadays the chief means by which cultural change is disseminated, because it can be mechanically reproduced. Every day we browse through a newspaper; our eyes receive a sequence of images from posters; we are constantly and unconsciously absorbing messages. It is evident that the graphic designer is a fundamental power in the modern world: he pours culture out onto the streets; he distributes culture to ordinary people via our mass communications.

My experimental research is of different kinds:

The flou period: My research was devoted to creating indefinite images or signs, intended to stimulate observation and creativity. This study, afterwards, included incomplete images (by means of photographic cuts) whose informational content was a stimulant to thought.

Research on distortions: The reality of an image is optically altered in order to compete with the logic imposed by the human eye. An attentive eye will absorb new visual discoveries beyond the rules of logic, when shapes are anthropomorphous, free from geometric limitations, free from any man-made structure. The result is one of visual trauma, due to the dynamics and individuality imposed on what is frequently an otherwise orderly geometric space. After distortions I turned—as a natural development of these studies—to a period of *tension in shapes and space*.

The breaking-up of the "even-ness" of a space brings about tensions that are more vividly experienced because of the physical uneasiness they create and the consequent process of re-orientation they call for, while—ultimately—creating a stimulus towards the completion of the proposed image. All these are fundamental phenomena of visual communication.

Nevertheless, we can say that even a human expression, bodily posture or gesture can create tension. Their power to create tension is equal to the effects caused by a certain space, or imbalance in tonal or color quantities, or by spoken or non-vocalized words.

Visual induction: by which I mean stimulus, concentration and absorption. Good examples are: any circular shape; shapes based on a radical-stressed balance; shapes having a focalizing, compelling core.

Recently I began to concentrate on art: that is, painting. The borderline, however, between graphic design and painting is rather blurred. But, because of the absence of any restraint, painting gives me the illusion of a wide-ranging freedom.

I have always been interested in photography, especially as an element of graphic design (so-called "vanguard photography"). Photography must not be simply good documentation, even poetic documentation. It must intrigue through the use of light, chemistry, etc. In my work there is little drawing. What drawing exists has always been modified through photography or optical equipment to make it express a different sort of sign.

Currently, I am involved in research on periodical images (that is, the creation of an organized structure by repeating a basic shape or sign, mostly a very simple one). The result is an altered geometry, usually computer-programmed to create a multi-directional spreading of the image. The observer is thus unconsciously compelled to re-coordinate the perspective distortions and finally to become involved in visual communication.

During the last few years much has been said about visual communication: human nature tends to seek solutions, discover the unknown, ask why things are as they are. Communication is not simply "seeing." Appearances in the visual world that are already filed in one's experience are uninteresting. The task of the graphic designer is not merely to stick printed texts on cardboard; he must attempt new and individual graphic experiments, since these are the "vital humus" from which he can draw those elements that will make his message a valid and lasting one.

—Franco Grignani

Franco Grignani: *Negro*, 1951

Italian photography, especially in the first decades of the century, was led astray by the attractions of "pictorialism" with all of its attendant *kitsch*, and only began to break free in the 1940's with the decline in power of the Fascist regime, a regime that had forced many people into a photography of evasion, which had, in effect, stifled any opportunity for a genuine photo-journalism. There were, however, some who even during that period had begun to make valuable contacts with European cultural movements, with countries where photography had long since assumed a specific role of its own as an autonomous medium of expression, particularly among the *avant-garde*. In fact, it was a group of architects, designers, illustrators, painters—artists quite outside the world of professional, or even of amateur, photography—who recognized that photography could allow them a new visual analysis of reality and space and who created a movement which has had a profound influence on the work of many creative artists in architecture and design. By the 1930's the rhetorical message of Second Futurism, though it had stimulated photographers such as Tato, Bertieri and Wulz for almost 20 years after the explosive "photo-dynamic" phenomenon of the Bragaglia brothers, was becoming exhausted—yet, at the same time, this group of architects and designers (from Pagano to Steiner, from Peressuti to Comencini) was organizing itself around the editorial offices of Gio Ponti's journal *Domus*, which from then on became an important reference point for photography as well. Working in the group at that time were Luigi Veronesi, who had already experimented with abstract photography in 1928, and Antonio Boggeri, whose exciting photographic experiments were mirrored in the advertisements he was then producing. It was in this context that Franco Grignani took up photography in 1930.

Grignani came to photography with a compelling curiosity about everything that this medium of expression would allow him to reveal about that

mysterious reality that he envisaged as beyond visible appearances and the conventions of the traditional picture. And, ever since his first experiments, Grignani has been exploring this unknown "landscape," which exists in a dimension into which photography allows him to penetrate, to visualize, with a "mechanical" precision that has become the hallmark of his style—just as it was of the severe experiments of the Bauhaus, at the beginning a cultural reference point for Grignani as were the theories of the *Gestalt*.

"I knew all about photography," Grignani has written, "but the lens gave me only the ordinary picture; what I was looking for then was more disparate media—moving lenses, sheets of glass, condensers, prisms, water, oil"—any medium, in other words, that would lead him to a "transfiguration" of ordinary, objective reality. But his photographic creativity was also controlled by a remarkable scientific strictness, something almost compulsive. It has characterized all of his work. "His research," writes G.C. Argan, "aims essentially at pinpointing the thought processes that develop not beyond perception but within it...."

The imaginary, the invisible, the fantastic are expressed in photographic rectangles that Grignani constructs with a geometrical precision by means of rhythms that are suggested to him primarily on the philosophical, conceptual level by those "existential problems of our technological civilization which are beyond the physical limits of the human eye."

Through a progression of optical-visual experiments, Grignani has discovered the "importance of reality changed through the internal tensions of the *distortion*, the *flux*, of pictures"; it is a graphic art ("multiple writing," as D'Amore puts it) of what is outside our immediate capacity to perceive but the cryptic language of which is revealed by photography, a language in which the *symbol* emerges and is freed from the physical object that gives rise to it, becoming itself the sole subject of the picture.

His optical research of the 1960's bears a certain resemblance to that of Vasarely and Bridget Riley, but it originates from studies in 1949-52 of *subperception* ("analysis of total space through the analysis of lateral space") and of *distortion*, obtained from an interpretation of the "specular surfaces of buildings, of metals, of the paintwork of car bodies"—but also against "the mechanicity of typography." He followed this work with research in 1959 on "permutation," derived from experiments on moire, whose reticular systems he is now studying, and he also spent some time, in 1967-68, on the analysis of structures described as "fluctuating," "diachronic," "radial" and "periodic," these last being almost identifiable with the work of others on the cinematographic photogram. After his studies in 1969 of "psychoplastic" and "isoplastic," which are "volumetries to be read mentally, experienced in a time too swift for the human eye," and his studies in 1975 on "concealed diagonals," Franco Grignani is at present carrying out increasingly significant research on the concept of "space," which he says "is eternally in equilibrium between the abstract and the concrete"—as indeed his own photographs regularly tend to demonstrate.

—Italo Zannier

GROEBLI, René.

Swiss. Born in Zurich, 9 October 1927. Educated at elementary and high schools in Zurich, until 1944; studied photography, under Hans Finsler, Kunstgewerbeschule, Zurich, 1944-45. Married Rita Dürmüller in 1951. Apprenticed to documentary filmmakers Central Film and Gloria Film, Zurich, 1945-47. Freelance photographer, since 1948: stringer for *Life* magazine, Zurich, 1948-51; with Black Star Agency, London, 1951-54, also worked for *Picture Post*, *Time* , *Life*, *Photography*, etc., 1951-54; concentrated on color, working as freelance advertising and industrial photographer, Zurich, since 1953; established Studio Groebli and Partner AG, Zurich, 1955. Addresses: Morgenthalerstrasse 115a, 8038 Zurich, Switzerland; 17 Lower Addison Gardens, London W14 8BG, England.

Individual Exhibitions:

1949 Anlikerkeller, Berne
1950 Galerie 16, Zurich
1978 *New York*, Portfolio Gallery, Lausanne, Switzerland
 Fantasies, Images Gallery, New York
 New York, at *Rencontres Internationales de la Photographie*, Arles France

1979 *Fantasies*, Neufeld Galerie, St. Gall, Switzerland
 Fantasies, Galerie Jean Dieuzaide, Toulouse
 Reverie sur New York, FNAC, Centre St. Jacques, Mulhouse, France (toured France)
1980 *Fantasies*, Galerie Contact, Bordeaux
 Babylon, Babylon, Galerie Limbach, Cologne

Selected Group Exhibitions:

1953 *Kollegium Schweizer Photographen*, Helmhaus, Zurich
1955 *Family of Man*, Museum of Modern Art, New York (and world tour)
1974 *Photographes Suisses Depuis 1840 à Nos Jours*, Kunsthaus, Zurich (toured the United States)
1976 *Fantastic Photography in Europe*, at Rencontres Internationales de la Photographie, Arles, France (toured Europe and the United States, 1976-79)
1981 *European Museums Collect*, Kunsthaus, Zurich (toured Europe)

René Groebli: *Down to Hell*, 1978

Collections:

Kunsthaus, Zurich; Museum Folkwang, Essen.

Publications:

By GROEBLI: books—*Magie der Schiene/Rail Magic*, Zurich and London 1949; *Das Auge der Liebe/The Eye of Love*, with text by Basil Burton, Zurich and London 1954; *Variation*, Teufen, Switzerland and New York 1965; *Variation 2*, Teufen, Switzerland and New York 1971; *Fantasies*, with an introduction by J. Hennessey, London 1978; article—"How I Work in Color" in *Popular Photography* (New York), April 1962.

On GROEBLI: book—*Schweizer Künstler*, Zurich 1964; articles—"Vision of Love" in *U.S. Camera Annual*, New York 1957; "René Groebli Photo: Variation 2" by M. Nakamura in *Idea* (Tokyo), September 1971; "New Portraits by René Groebli" in *Camera 35* (New York), June 1973.

René Groebli has never been afraid to break a taboo. For him the documentary is but a dull relation to the world of imagination. Dominant in his work is a sense of what is prevailing, a Zeitgeist of what pleases and of what disturbs now.

A few years ago, Groebli decided to concentrate on his own work and on commissions he can execute freely in his own style. Formerly he worked much in the studio, pioneered in lighting, manipulated dye transfers into montage. His color dazzled, his techniques puzzled. Now, in more muted tones, he expresses surreal contemporary verities, as in "Babylon-Babylon". In this work Groebli invested his feelings for New York in 1976: attraction for its dynamic, but also repulsion, fear of it. In "Going Down to Hell" a blurred, blue spaceman, with horns reminiscent of the devil, descends, all alone on his side of the moving staircase, while its upward-moving counterpart is filled with people. All but his figure is in porous black and white. The picture gives off an eerie premonition. Will today's technological gain—the man on the moon, the shuttle in space—will they deteriorate as the subway, yesterday's gain, has deteriorated into a threatening conveyance, where murder takes place?

Feelings of power and terror and isolation, because of the fast moving tempo of our time, of alienation by technological pollution—that is what we are experiencing now. Groebli enlarged on his vision by making a mural 2m. x 2.50 of this picture. Composed of a grid of 12 sections, "Going Down to Hell" has inserted into it a neon tube, bent into a dart of lightning, so that when you confront the larger than life apparition you can imagine him hurling it.

René Groebli's satisfaction continues to come, as it always has, in completing every stage of the imagery he makes. His medium now is a combination of black and white and cibachrome. Past techniques are specified in his books *Variation* and *Variation 2*, a treasure trove of recipes for craft magic. He has always been a wanderer, searching out new techniques, to meet his inner needs. His first publication, then in black and white, was a visualization of what it feels like to "get away." It was 1949; the medium was the train. His blurred pictures were then defamed as mistakes. Five years later, he published his *The Eye of Love*, a sensitive tale of what he felt then—in Paris. That lyrical world is now a memory, not only for Groebli. Anticipation has been displaced by knowledge.

—Inge Bondi

GROOVER, Jan.

American. Born in Plainfield, New Jersey, in 1943. Studied painting at the Pratt Institute, New York, 1961-65, B.F.A. 1965; Ohio State University, Columbus, 1966-70, M.F.A. 1970. Freelance photographer, New York, since 1971. Instructor, University of Hartford, Connecticut, 1970-73. Recipient: Creative Artists Public Service Grant, 1974, 1977; National Endowment for the Arts Grant, 1978; Guggenheim Fellowship, 1979. Agent: Sonnabend Gallery, New York. Address: c/o Sonnabend Gallery, 420 West Broadway, New York, New York 10012, U.S.A.

Individual Exhibitions:

1974 Light Gallery, New York
1976 Max Protetch Gallery, New York
 The Nation's Capital in Photographs, Corcoran Gallery, Washington, D.C.
 Max Protetch Gallery, Washington, D.C.
 International Museum of Photography, George Eastman House, Rochester, New York
1977 Sonnabend Gallery, New York
 Galerie Sonnabend, Paris
 Baltimore Museum of Art
 Galleria Bruna Soletti, Milan
1978 Sonnabend Gallery, New York
 Whitney Museum, New York (with David Haxton
 Viewpoints, Walker Art Center, Minneapolis (with Michael Manzavrakos)
1979 Thomas Segal Gallery, Boston
 Waddington Galleries II, London
 Akron Art Institute, Ohio
 Wright State University, Dayton, Ohio
 Galerie Sonnabend, Paris
 Galerie Wilde, Cologne
1980 Rutgers University Art Gallery, New Brunswick, New Jersey
 Sonnabend Gallery, New York
 Bard College, Annandale-on-Hudson, New York
 Hansen Fuller Gallery, San Francisco
 Milwaukee Art Museum

Galerie Fiolet, Amsterdam
1981 Light Gallery, New York

Selected Group Exhibitions:

1975 *(Photo) (Photo)²...(Photo)ⁿ: Sequenced Photographs*, University of Maryland, College Park (travelled to San Francisco Museum of Art, and University of Texas at Austin)
1976 *Photographers' Choice*, Mount St. Mary's Art Gallery, Los Angeles (travelled to Enjay Gallery, Boston and Witkin Gallery, New York)
1977 *Contemporary American Photographic Works*, Museum of Fine Arts, Houston
 Locations in Time, International Museum of Photography, George Eastman House, Rochester, New York
1978 *Mirrors and Windows: American Photography since 1960*, Museum of Modern Art, New York (toured the United States, 1978-80)
1979 *American Photography in the 1970's*, Art Institute of Chicago
 Photographie als Kunst 1879-1979/Kunst als Photographie 1949-1979, Tiroler Landesmuseum Ferdinandeum, Innsbruck, Austria (travelled to Neue Galerie am Wolfgang Gurlitt Museum, Linz, Austria; Neue Galerie am Landesmuseum Joanneum, Graz, Austria; and Museum des 20. Jahrhunderts, Vienna)
 American Images: New Work by 20 American Photographers, Corcoran Gallery, Washington, D.C. (travelled to the International Center of Photography, New York; Museum of Fine Arts, Houston; Minneapolis Institute of Arts; Indianapolis Institute of Arts, 1980; and American Academy, Rome, 1981)
1980 *Polacolor: A Survey of Color and Scale in Recent Polaroid Photographs*, Philadelphia College of Art
1981 *Color Photography: New Images*, University of California at San Diego

Jan Groover: *Untitled*, 1980

Collections:

Museum of Modern Art, New York; Metropolitan Museum of Art, New York; Whitney Museum of American Art, New York; International Museum of Photography, George Eastman House, Rochester, New York; Museum of Fine Arts, Houston; Centre Georges Pompidou, Paris.

Publications:

By GROOVER: book—*Jan Groover*, with an introduction by Jane Livingston, Washington, D.C. 1976; article—"The Medium Is the Use" in *Artforum* (New York), November 1973.

On GROOVER: books—*The Photographers' Choice*, edited by Kelly Wise, Danbury, New Hampshire 1975; *The Nation's Capital in Photographs*, exhibition catalogue, Washington, D.C. 1976; *Mirrors and Windows: American Photography since 1960* by John Szarkowski, New York 1978; *American Images: New Work by 20 Contemporary Photographers*, edited by Renato Danese, New York 1979; *Photographie als Kunst 1879-1979/Kunst als Photographie 1949-1979*, exhibition catalogue, 2 vols., by Peter Weiermair, Innsbruck 1979; articles—"Photographs in Sequence" by Joan Murray in *Artweek* (Oakland, California), 4 October 1975; "Jan Groover" by Phil Patton in *Artforum* (New York), April 1976; "Jan Groover's Abstractions Embrace the World" by Ben Lifson in *Village Voice* (New York), November 1978; "Jan Groover: Degrees of Transparencies Illustrated" by Jeff Perrone in *Artforum* (New York), January 1979; "Jan Groover at Sonnabend" by Pepe Karmel in *Art in America* (New York), May 1980; "Susan Rankaitis' Materiality, Jan Groover's Structuralism" by Mark Johnstone in *Artweek* (Oakland, California), 14 February 1981.

Jan Groover began photographing in 1971, producing color diptychs and triptychs which are still perhaps her best-known works. Her artistic choices were clearly taken: she rejected sociologically-oriented "street" photography and embraced formal aesthetics, conceptual art, and systemic imagery. Groover's double and triple images, whose subjects were vehicles passing a significant landmark, illustrated changes which happened in a short span of time, playing in a sophisticated way with the stop-action imagery of Eadweard Muybridge which she so admired. Rather than Muybridge's analysis of movement, however, Groover's interest was in formal and coloristic changes and the manipulation of space within and between the images. Groover's training as a painter (at Pratt and Ohio State University) thus informed but did not determine her artistic position.

Groover next experimented with different kinds of space changes. During a trip to Washington D.C. in 1975 she changed her shooting procedure so that the camera rather than the subject moved. The basic concerns remained the same, but the results and formal discoveries differed.

As Groover became less interested in the systemic nature of images and increasingly concerned with photographic form, she began producing "single image" photographs. Her photographic variables changed as well: artificial replaced natural light, found images were replaced with constructed compositions, and inherent color gave way to reflected hue. Most significant, however, was the increasingly baroque use of form and space.

The still-lifes of plant forms and kitchen objects, to which Groover turned next, constitute her most accomplished and intelligent use of the medium to date. The real subject is the content of color photography, which is both accepted (for these *are* very beautiful color images) and questioned. Silver foil and flatware, mirrors and verigated plants are used

to create disjunctures and distortions that raise the question of spatial integrity in photographs. The surface of objects, their space and the effects of reflected colored light changes constantly with the reflected objects, severely threatening the integrity of the objects photographed and our preconceptions about photographic replication. In addition, the images are printed slightly larger than lifesize, which tampers with our sense of bodily scale and plays subtly with traditions of photographic seeing by altering our normal compensation for scale in looking at photographs.

Most recently, Jan Groover has signalled a new direction in her photography by beginning to shoot portraits in black and white. Though still in the experimental stage, this departure will undoubtedly open new formal directions in which Groover can continue her intelligent questioning of photographic form.

—Nancy Hall-Duncan

GROSSMAN, Sid(ney).

American. Born in New York City, 25 June 1913. Studied at the City College of New York, 1932-34; studied painting at the Hans Hofmann School, New York, 1949-55; self-taught in photography. Served in the Public Relations Section of the 6th Army Air Corps, in Panama, 1943-46. Married Emma Marion Hille in 1941 (divorced); married Mariam Echelman in 1949; son: Adam. Freelance social documentary photographer, New York, 1934-55 (worked for the Works Progress Administration in the late 1930's). Founder Member, with Sol Libsohn and others, 1934-49, Instructor in Documentary Photography, 1938-49, Executive Secretary, 1939-41, 1946, and Director of the School, 1941-47, Film and Photo League, New York. *Died* (in New York) *31 December 1955.*

Individual Exhibitions:

1961 *Sid Grossman: Parts I and II*, Image Gallery, New York (2 retrospectives)
1981 *Sidney Grossman: Photographs 1936-55*, Museum of Fine Arts, Houston (retrospective)

Sid Grossman: *Jumping Girl*, Aguadulce, Panama, c. 1945 Print by David Vestal

Selected Group Exhibitions:

1939 *Instructors' Exhibition*, Photo League, New York
1940 *Membership Exhibition*, at *American Artists Congress*, New York
 Image of Freedom, Museum of Modern Art, New York
1944 *Photography Today*, ACA Gallery, New York
1948 *In and Out of Focus*, Museum of Modern Art, New York
 This Is the Photo League, Photo League, New York
1951 *Realism in Photography*, ACA Gallery, New York
1978 *Photographic Crossroads: The Photo League*, National Gallery of Canada, Ottawa (travelled to the International Center of Photography, New York; Museum of Fine Arts, Houston; and Minneapolis Institute of Arts)

Collections:

Museum of Fine Arts, Houston (about 6,000 negatives, 2,500 prints); Museum of the City of New York; Museum of Modern Art, New York; Center for Creative Photography, University of Arizona, Tucson.

Publications:

By GROSSMAN: book—*Journey to the Cape: Photographs by Sid Grossman*, with text by Millard Lampell, New York 1959; articles—in *Photo Notes* (New York), monthly magazine of the Photo League, 1938-51, reprinted by the Visual Studies Workshop, Rochester, New York 1977.

On GROSSMAN: books—*This Is the Photo League*, with an introduction by Nancy Newhall, New York 1948; *Photographic Crossroads: The Photo League* by Anne Tucker, Ottawa 1978; *Sidney Grossman: Photographs 1936-55*, exhibition catalogue, by Anne Tucker, Houston 1981; article—"Photographic Crossroads: The Photo League" by Anne Tucker in *NGC Journal* (Ottawa), 6 April 1978.

Sid Grossman's life and work moved from idealistic collectivism toward individualism for twenty years. From beginning to end, his photographs had guts.

Two early influences were Lewis Hine and Paul Strand. He knew them both. Hine's social concern and Strand's perfectionism are important elements in Grossman's work. The Farm Security Administration photographers, especially Dorothea Lange, also made an impression.

His early work was done together with Sol Libsohn in New York. Like other members of the Photo League, they believed photography should serve a social purpose. Grossman's street pictures from the 1930's typically show spirited or defeated people enduring hard times.

In 1939 or '40, he went west to Oklahoma and Arkansas to photograph poor farmers, and came back with pictures that began to define his unique style. His shooting was straight and factual, but in printing he used intensive manipulation to wring the utmost out of each negative. The photographs clearly show this forced, tortured printing, which he never tried to hide. It was appropriate, and the prints carry conviction.

One picture from that trip, the portrait of a farmer, Henry Modjilin, is a good example. Almost every tone in the negative was changed drastically in printing; partly to clarify space, but mostly to dramatize this gaunt man's eloquent face, body, and gesturing hand. Each finger, individually, is separated from the wall behind it by local manipulation in printing—fanatical and typical. No trouble was too great for a picture he cared about.

In World War II he was in the U.S. Army Air Corps, working in photo labs in Central America. He photographed when he could. He made strong, compassionate photographs of poor villagers and Indians in Guatamala. A key picture from there, his "Jumping Girl" (accompanying photograph), violated a tabu of the time by showing her movement as a blur. In Portobello, Panama, he photographed the *Black Christ Festival*—flash pictures that were almost impossible to print—but he printed them with astonishing mastery.

After the war he went back to New York and lived meagerly on small photographic jobs. Among these were a series of portraits of folksingers, done, he told me, for $5 a job, for an organization called People's Songs. These include strong photographs of Woody Guthrie, Leadbelly, Big Bill Broonzy, Billie Holiday and Pete Seeger, among others. (*Mademoiselle*, strangely, published a portfolio of these in the late 1940s.)

Until then most of his work was done on sheet film with a press camera. Now he began to use smaller cameras which let him work more freely. His 1947 Coney Island series shows this new spontaneity, and uses new forms—he called them *explosive* shapes, moving out from the center—and there is a new tenderness in the printing. These pictures are rich, soft, sensuous and lively.

In 1948 he began to use 35mm (I know, because I lent him the camera) and photographed the *San Gennaro Festival* in New York. Some of these pictures have a frightening intensity; others are gentle.

In 1949 he broke with the Photo League and discovered Cape Cod. From then on his winters were spent in New York, and the rest of the time he was in Provincetown. It was a new life for him. Some of his Cape Cod pictures are a lyrical celebration of nature—completely new to him—and others, pictures of people and places, show the vitality and the decay of the local culture.

In New York he did a series on the ballet: dancers in rehearsal and backstage. The light was dim and the film slow, so he used forced development by necessity; yet no tone was slighted or unconsidered in the prints. These are beautiful, lyrical pictures. They show no romantic illusions and are the more moving because of that. (*Dance* magazine published a portfolio of these.)

He began to study painting with Hans Hofmann, and made a beautiful photograph of Hofmann (with Grossman's luck, this was printed in an art magazine with the credit, "Photo by Snossman"; the editors misread Hofmann's handwriting).

Sid Grossman's photography changed greatly from year to year; it was always strong. He received no popular recognition though he had considerable influence among photographers. A few pictures were published in magazines and annuals during his life, and one book of his photographs was published after his death: *Journey to the Cape*, with words by Millard Lampell. (It came out at the same time as Robert Frank's *The Americans*, and it may have been the better of the two books. Neither one sold.)

He died on the last day of 1955 at the age of 42. It's time his photographs were seen.

—David Vestal

H

HAAS, Ernst.

Austrian. Born in Vienna, 2 March 1921; moved to the United States, 1950. Studied medicine in Vienna; subsequently studied photography at the Graphische Lehr- und Versuchsanstalt, Vienna. Married; children: Alexander and Victoria. Freelance photographer, in Paris, 1948-50, and in New York, working for *Life, Paris-Match, Esquire, Holiday, Queen, Look*, etc., since 1950. Member, Magnum Photos co-operative agency, Paris and New York, since 1949. Stills Photographer on films *The Bible, Little Big Man, Hello Dolly*, etc. Lecturer (one week a year), Maine Photographic Workshop, Rockport, and Anderson Ranch Foundation, Aspen, Colorado, since 1975. Recipient: Newhouse Award, Syracuse University, New York, 1958; Der Kulturpreis, Deutsche Gesellschaft für Photographie (DGPh), 1972; Honor Roll Award, American Society of Magazine Photographers, 1952; Wilson Hicks Award, University of Miami, 1978; State of New York Executive Chamber Citation, 1979; Merit Award, Art Directors Club of New York, 1980. Address (studio): 853 Seventh Avenue, New York, New York 10019, U.S.A.

Individual Exhibitions:

1947 *Homecoming of Austrian Prisoners of War*, Red Cross Headquarters, Vienna
1962 *Ernst Haas: Color Photography*, Museum of Modern Art, New York
1964 *Poetry in Color*, IBM Gallery, New York
1968 *Angkor and Bali: Two Worlds of Ernst Haas*, Asia House, New York
1971 *The Creation*, Rizzoli Gallery, New York (travelled to *Photokina*, Cologne, 1972)
1978 *In Germany*, at *Photokina*, Cologne
1980 *Ernst Haas: Retrospective: 1960-1980*, Museum of Art, Sao Paulo, Brazil

Selected Group Exhibitions:

1951 *Memorable Life Photographs*, Museum of Modern Art, New York
1960 *The Sense of Abstraction*, Museum of Modern Art, New York
 The World as Seen by Magnum Photographers, Takashimaya Department Store, Tokyo
1966 *American Photography: The 60's*, Sheldon Memorial Art Gallery, University of Nebraska, Lincoln
1967 *Photography in the 20th Century*, National Gallery of Canada, Ottawa (toured Canada and the United States, 1967-73)
1970 *The Concerned Photographer 2*, Israel Museum, Jerusalem (toured Europe)
1973 *Photography into Art*, Camden Arts Centre, London
1978 *Mirrors and Windows: American Photography since 1960*, Museum of Modern Art, New York (toured the United States, 1978-80)

1979 *Photographie als Kunst 1879-1979*, Tiroler Landesmuseum Ferdinandeum, Innsbruck, Austria (travelled to the Neue Galerie am Wolfgang Gurlitt Museum, Linz, Austria; Neue Galerie am Landesmuseum Joanneum, Graz, Austria; and Museum des 20. Jahrhunderts, Vienna)
1980 *Photography of the 50's*, International Center of Photography, New York (travelled to the Center for Creative Photography, University of Arizona, Tucson; Minneapolis Institute of Arts; California State University at Long Beach; and the Delaware Art Museum, Wilmington)

Collections:

Museum of Modern Art, New York; International Center of Photography, New York; International Museum of Photography, George Eastman House, Rochester, New York; Exchange National Bank, Chicago; Royal Society of Photography Collection, Bath, England; Museum des 20. Jahrhunderts, Vienna.

Publications:

By HAAS: books—*The Creation*, New York, Paris and London 1971; *In America*, New York and London 1975; *Ende und Anfang*, with text by Hellmut Andics, Dusseldorf and Vienna 1975; *In Germany*, with text by Thilo Koch, Dusseldorf, Vienna and New York 1976; *Himalayan Pilgrimage*, with text by Gisela Minke, New York and London 1978; *Realm of Light*, edited by Samuel Walker, New York 1979; *The Joy of Photography*, Rochester, New York 1979; *The Joy of Photography II*, Rochester, New York 1981; also, contributor to many books in the Time-Life book series—color portfolio for the "Photography" series; *The Grand Canyon* and *Cactus Country* for the "Wilderness" series; and *Venice* for the "Great Cities" series; articles—"Man and Nature: The Wilderness Debate" in *GEO* (New York), July 1979; "Cloudland of the Spirits: Himalaya" in *Life* (New York), November 1979.

On HAAS: books—*Memorable Life Photographs*, with text by Edward Steichen, New York 1951; *Photography of the World '60*, edited by Hiromu Hara, Ihei Kimura and others, Tokyo and New York 1960; *Photography in the 20th Century* by Nathan Lyons, New York 1967; *The Concerned Photographer 2*, edited by Cornell Capa, New York and London 1972; *Photography into Art*, exhibition catalogue, by Colin Osman, Ainslie Ellis and Margaret Harker, London 1973; *The Magic Image* by Cecil Beaton and Gail Buckland, London and Boston 1975; *Geschichte der Fotografie im 20. Jahrhundert/Photography in the 20th Century* by Petr Tausk, Cologne 1977, London 1980; *Mirrors and Windows: American Photography since 1960* by John Szarkowski, New York 1978; *Photographie als*

Kunst 1879-1979/Kunst als Photographie 1949-1979, exhibition catalogue, 2 volumes, by Peter Weiermair, Innsbruck, Austria 1979; *Photography of the 50's*, exhibition catalogue, by Helen Gee, Tucson, Arizona 1980; articles—"Classics of Photography: Ernst Haas" by Inge Bondi in *Modern Photography* (New York), July 1970; "Ernst Haas Poem" in *Camera* (Lucerne), October 1970; "Ernst Haas" in *Modern Photography Annual*, New York 1972; "Ernst Haas" in *Color*, by the Time-Life editors, New York 1972; "Ernst Haas" in *Camera Mainichi* (Tokyo), July 1973; "Close-Up on Nature" in *Amateur Photographer* (London), 19 September 1973; "Ernst Haas" by Andre Laude in *Zoom* (Paris), June/July 1974; "Ernst Haas" by Inge Bondi in *Die Weltwoche* (Zurich), 13 October 1976; "New York" in *Zoom* (Paris), November/December 1979; "7 Maitres du Paysage" in *Photocinema* (Paris), May 1980.

At my age the scales of what I did and what I still have to do is in constant movement and competition. For me, photography became a language with which I have learned to write both prose and poetry.

Whatever I did and do, it always became the extension of my interests. The interrelationship of all senses and arts is very important to me. I wanted to connect photography with words through books and articles, with music through audio-visuals. In exhibits, single pictures have to speak their pure visual language. I want to be open to everything in this world, and I am even willing to unlearn.

Important is the end result of your works, the opus; therefore, I want to be remembered much more by a total vision than a few perfect single pictures.

—Ernst Haas

The visual has inspired Ernst Haas to give us successive innovations in photography. Their purpose: to communicate reality on all its planes, from the seen to the sensed, to the metaphysical. Expression and impression, the subjective and the objective mirror in his oeuvre the multiplicity of perception that enriches our lives. Though Haas is generally identified with color, he himself refers to differentiation between it and black and white, as "racism." In his work in both, form and content coincide at their peak, accentuating each other. In both, his vision has been radical, his solutions original. Edward Steichen described him as a free spirit, untrammeled by tradition.

Even as a child in Vienna, Haas looked at life as he saw fit. The changing shapes, movement of hues of clouds were more rewarding to him than the stereotyped information of the classroom. He was sent home from photography school. His work was too individual; he would not conform. In hungry, postwar Vienna, he traded with his mother's help a pound of butter for a camera and photographed: among the ruins, serene, two little girls with bare bottoms were taking a sunbath; a young soldier stuffed his artificial foot into his rucksack, adjusting

to reality—one leg and a crutch; like a wish or premonition, birds flew over the ruins.

It was a time for hope and new beginnings. He had made a magazine connection. On a fashion assignment to be photographed at the railway station, Haas' models were late. A train brought prisoners of war, returning home from Russia. Ernst's photographs of the waiting, tense relatives, of their searching in the crowd, of reunions, of resignation to more waiting, were published. Bob Capa saw them and invited Haas to join the then small band of Magnum photographers. Now Haas flew, like the birds he had photographed over the ruins of Europe on assignment, and when *Life* offered him a job he preferred winging his photographic life, which soon took him to the United States.

Fascinated and frustrated, he could not get New York into his lens. In the changing light of the New Mexico desert, again on the fringe of an assignment, he encountered another milestone in his life: color. In his "Magic Images of New York", a story which *Life* published on 24 pages, at a time when color was used little and then to make subject matter more real, color transformed reality. Brooklyn Bridge in a haze of gold at dusk became every immigrant's symbol of hope; orange reflections in which a peacock struts on 42nd Street remind us that, in this city, the impossible can be beautiful. A swing in Central Park speaks of the exhiliration of riding high; a pile of junked cars, a skyscraper in the background, tells us that extravagant waste is part of it all. A smudge of oil on the road turns into an angel with an aureole. In Haas' New York, color accentuates mood, induces sensations, activates the viewer to participate. To do the same for Venice, a city whose presence is shrouded in associations of the past, Haas photographed it in November mists. The muted glow of lamps on cafe tables in the Piazza San Marco seems to come from long ago; calm greys echo the low vibrations of a guitar, gondolas loom out of the blue.

As the brilliant reflections of traffic moving in New York's glass facades turned into shimmering images of buildings reflected in canals, so the slow motion of gliding gondolas was electrified in his next essay, "Bullfight". With delicate colors, with indeterminate outlines, Haas accentuated the fast changing beauty and unity of toreador and bull, hypnotised in their ritual, a minuet of death. This was the prelude to Haas' exploration of speed in sport, called "Motion", which matched, with its blurred effect, the exuberance of the 50's in the United States far better than any story concentrating on the specific could.

All these essays can now be seen only in the pages of old copies of *Life* magazine, yet their impact revised the vernacular of color, which, up to the publication of this work, had been only colored photography.

The Museum of Modern Art commemorated ten years of Ernst Haas' color by devoting to his work its first exhibition in that medium. Five years after it had appeared, Haas' concept of motion was still so new that a statement on it by him was included. He, however, was already far into his next project, which was published almost a decade later as his first book, *The Creation*.

It is a visualization of the story of Genesis, but also a code to Haas' way of seeing and photographing, going far beyond his previous work. His *In America*, *Ende und Anfang*, (End and Beginning, his b/w Vienna photographs), *In Germany* and *Himalaya Pilgrimage* followed, but much remains unseen and unpublished.

Though in his approach to the visual, Ernst Haas regards himself as an impatient painter, his day to day work consists of commercial assignments. While solving his client's problems, he has moments of quietude when the good accident provides for images which evoke the most frequent response from his viewers.

Ernst Haas' recent color photographs speak more plainly than ever their message in that language he has invented that does not follow the logic of words, but radiates the quintessence of those polar forces that make up the wheel of life. Awareness, endurance and discipline have led Ernst Haas to beauty, dignity and tolerance. With gentle humour, he pursues the absolute in truth. To achieve it in photography, he says, you have to give of yourself, while taking your picture. Then the circle is closed. If not, there is no contact.

—Inge Bondi

See Color Plates

HAHN, Betty.

American. Born in Chicago, Illinois, 11 October 1940. Studied under Henry Holmes Smith at Indiana University, Bloomington, A.B. in art 1963, M.F.A. in photography 1966, and with Nathan Lyons at the Visual Studies Workshop, Rochester, New York, 1967-68. Married Daniel Andrews in 1970. Freelance photographer. Assistant Professor of Photography, Rochester Institute of Technology, 1969-75. Since 1976, Associate Professor of Photography, University of New Mexico, Albuquerque. Recipient: Pratt Graphics Center Award, New York, 1971; Purchase Award, Sheldon Memorial Art Gallery, University of Nebraska, Lincoln, 1972; National Endowment for the Arts Fellowship, 1974, 1979; New York State Council on the Arts Grant, 1975; Research Grant, University of New Mexico, 1977. Agent: Witkin Gallery, 243 East 60th Street, New York, New York 10022. Address: c/o Art Department, University of New Mexico, Albuquerque, New Mexico 87131, U.S.A.

Individual Exhibitions:

1966 Fine Arts Museum, Indiana University, Bloomington
1968 Cabrillo College, Aptos, California (with Gayle Smalley)
1969 Smithsonian Institution, Washington, D.C. (with Gayle Smalley)
1971 Center for Photographic Studies, Louisville, Kentucky
1973 *Betty Hahn: Photo Images*, Riverside Studio, Rochester, New York
 Witkin Gallery, New York
1974 *Betty Hahn: Stitched Gum Bichromate Prints*, Focus Gallery, San Francisco
1976 *Betty Hahn and Steve Hale*, Nexus Gallery, Atlanta
 Betty Hahn: Passing Shots, New England

Betty Hahn: *Botanical Layout: Leaves*, 1979

School of Photography, Boston
1977 Archetype Gallery, New Haven, Connecticut
Sheldon Art Gallery, University of Nebraska, Lincoln
Southern Illinois University, Carbondale
1978 *2 from Albuquerque*, Susan Spiritus Gallery, Newport Beach, California (with Thomas Barrow)
Blue Sky Gallery, Portland, Oregon
Sandstone Gallery, Rochester, New York
1979 Witkin Gallery, New York
Miami-Dade Junior College
1980 Washington Project of the Arts, Washington, D.C.
Wildine Galleries, Albuquerque, New Mexico
1981 *Betty Hahn: It's a Mystery*, Colorado Mountain College, Breckenridge
Crime, Center for Creative Photography, University of Arizona, Tucson
1982 *20 x 24 Color Polaroids*, Looking Glass Photography Gallery, Royal Oak, Michigan

Selected Group Exhibitions:

1967 *Photography in the 20th Century*, National Gallery of Canada, Ottawa (toured Canada and the United States, 1967-73)
1969 *Vision and Expression*, International Museum of Photography, George Eastman House, Rochester, New York (toured the United States and Canada, 1969-71)
1972 *Photography into Art*, Camden Arts Centre, London
1973 *New Images 1939-1973*, Smithsonian Institution, Washington, D.C.
1975 *Photographs for the Collection*, National Gallery of Canada, Ottawa
Women of Photography, Sidney Janis Gallery, New York
1977 *The Great West: Real/Ideal*, University of Colorado, Boulder (subsequently Smithsonian Institution travelling exhibition; toured the United States)
1978 *Photography: New Mexico*, Centre Culturel Americain, Paris
Contemporary Photography, Walker Art Gallery, Liverpool
1979 *20 x 24 Light*, Light Gallery, New York

Collections:

Museum of Modern Art, New York; International Museum of Photography, George Eastman House, Rochester, New York; Smithsonian Institution, Washington, D.C.; Virginia Museum of Fine Art, Richmond; Art Institute of Chicago; Pasadena Art Museum, California; San Francisco Museum of Modern Art; Crocker Art Museum, Sacramento, California; National Gallery of Canada, Ottawa; Bibliothèque Nationale, Paris.

Publications:

By HAHN: articles—"Henry Holmes Smith: Speaking with a Genuine Voice" in *Image* (Rochester, New York), December 1973; "Betty Hahn: On Gum Bichromate Printing" in *Darkroom*, edited by Eleanor Lewis, New York 1977; "Photo Artist Betty Hahn," interview, with Brad Hill, in *Black and White* (Albuquerque, New Mexico), July 1980.

On HAHN: articles—"Woman Photographer Betty Hahn" by Robert Sobieszek in *Ceskoslovenska Fotografie* (Prague), no. 2, 1973; "Anne Noggle/ Betty Hahn" by Lois Fishman in *Artweek* (Oakland, California), 24 November 1974; "Mums and Kitsch" by Dana Asbury in *Afterimage* (Rochester, New York), Summer 1979; "Large Scale Exuberance" by

Dana Asbury in *Artweek* (Oakland, California), 17 May 1980.

The work of Betty Hahn displays a wide range of process, techniques, and imagery, but despite its variance, her work retains a coherence because of the recurrent themes that weave throughout her many innovations. Hahn's career now spans nearly 20 years; during this time she has constantly investigated new ways to make pictures, from stitched photo-canvases to toy cameras.

Photography in the western world may be a nearly universal folk art, and one interest evident in Hahn's work is in the naive, snapshot roots of the medium. Her earliest works use family album imagery in casual shots of children, friends and groups, underscoring the informality with bright colors and bold brushstrokes of the hand-applied emulsions. Just as this early work predates the renewed interest in the snapshot, evidenced by Jonathan Green's book *The Snapshot* (1974), so her Mick-a-matic series (c. 1976) prefigures the popularity among art photographers of the Diana and other toy cameras. In this series, Hahn uses the softness and distortion of the plastic lens to romanticize her vernacular and nostalgic imagery; pink flamingos and carnival horses, closely viewed and unsituated, take on a dreamlike presence. In some of her most recent 20 x 24 color Polaroids, still-lifes comprised of clippings and memorabilia recall a family member in a sentimental but elegant composition. Using the simplest and most naive techniques or state-of-the-art technology, Hahn explores photography's ability to preserve the past and the almost fetishistic appeal that photographs as surrogates have maintained since the first elaborately encased daguerreotypes.

Akin to this examination of the folk roots and vernacular symbols of photography is Betty Hahn's attraction to the American hero; she explored at great length the figure of the Lone Ranger in an extended series using, with one image, numerous combinations of techniques and variations. The symbol was well-chosen; not only did it represent a tongue-in-cheek statement about media heroism but also a protracted look at the persistence of the photograph. Despite Hahn's drawing on and extreme manipulation of the image, throughout the series it clings to that unmistakable quality—"photographicness."

If the cowboy on his horse occupies a solid place in American mythology as the virile loner, it is a place he shares in the popular imagination with the detective. Hahn's series of set-up color photographs posing as documents of the scene of the crime amplifies the mystique of crime detection, as do her recent color Polaroid arrangements of clues to fictional crimes. Hahn plays with her role, the artist as detective, and understands that it is the persistence of the photograph that makes crime photography so compelling. As in Antonioni's movie *Blow-Up* (1966), there is a superstitious and sometimes obsessive belief in the photograph's ability to yield clues or answers if examined minutely enough. There has been a curious popular reluctance to admit the limitations of photography; Hahn focuses upon those limitations and the myths and draws them out in these series that are both visually exciting and culturally abundant.

Another recurrent theme in Betty Hahn's work is her attraction to flowers. From the Mick-a-matic pictures of gardens bathed in warm afternoon light to her groups of mums in large blue and brown prints with extensive use of paint and handwork to her most recent 20 x 24 color Polaroids, "Botanical Layouts", the flower remains both a fragile and feminine symbol of beauty and an element which evokes a wealth of art historical tradition. Hahn uses the conventions of 18th century botanical prints, Japanese prints, and some of Piet Mondrian's devices from his chrysanthemum series, yet her mastery of the characteristics of hand-applied emulsions or the jewel-like renditions of large format contact prints make this body of work both

evocative and fresh.

Botanical layouts, publicity stills, family album snapshots or wherever Hahn finds inspiration for her imagery, it all unites around an investigation of a popular use of the photograph. She amplifies the inherent charm of her subject matter with her sophistication as a designer and colorist.

—Dana Asbury

HAJEK-HALKE, Heinz.

German. Born in Berlin, 1 December 1898. Educated in Argentina, until 1910, in Berlin, 1910-15; studied painting, Königlichen Kunstschule, Berlin, under Emil Orlik and Baluschek, 1915-16, 1919-23; mainly self-taught in photography, but influenced by photojournalist Willi Ruge, Berlin, from 1925. Served in the German Army, 1917-19; served as aerial photographer, Dornier Company, Friedrichshafen/Bodensee, 1939-44: prisoner-of-war, France, escaped 1945. Worked as copperplate printer, poster designer, and press illustrator, for Presseverlag Dr. Dammart, Berlin, 1919-23; worked on a fishing boat, Hamburg, 1923-25; photojournalist and advertising photographer, working for Presse-Photo agency, Berlin, 1925-33; scientific and biological photographer, as Heinz Halke, Bodensee (Lake Constance), 1933-37; filmmaker on snake farm, Brazil, 1937-38; after escape from prisoner-of-war camp, founder-proprietor, snake venom farm, West Berlin, 1945-47. Independent photographer and photomontagist, West Berlin, since 1947. Member, via Toni Schneiders, Fotoform group of photographers, Saarbrücken, 1949-54. Instructor in Photography and Photomontage, Kunstgewerbeschule, Berlin-Charlottenburg, 1925; Lecturer in Photo-Graphics, Hochschule für Bildende Künste, West Berlin, from 1955. Member, Deutsche Gesellschaft für Photographie (DGPh), 1955; Gesellschaft für Deutsche Lichtbildner, (GDL), 1957. Recipient: Culture Award, Deutsche Gesellschaft für Photographie, 1965; David Octavius Hill Medal, Gesellschaft Deutsche Lichtbildner (GDL), 1978. Guest of Honor, *Rencontres Internationales de la Photographie*, Arles, France, 1977; Honorary Professor, Bürgermeister of Berlin, 1978. Address: Wernerstrasse 5-7, 1000 Berlin 33, Germany.

Individual Exhibitions:

1954 *Foto-Grafik*, Suermondt-Museum, Aachen, West Germany
1956 *Lichtgrafik*, Franklin-Institut, Lindau, West Germany
Foto-Grafik, Museum für Angewandte Kunst, Vienna
1957 *Herbert Bayer—Hajek-Halke*, Kunstgewerbemuseum, Zurich
Lichtgrafik, Deutsche Gesellschaft für Photographie, Cologne
1958 *Lichtgrafik*, Landesbildstelle, Hamburg
Lichtgrafik, Virchow-Krankenhaus, Berlin (with Paul Dierke's *Plastik*)
1959 *Fotografia Sperimentale di H-H*, Biblioteca Communale, Milan
Angenendt, Coppens, Hajek-Halke, Palazzo Azienda di Soggiorno, Pescara, Italy
1960 *Deutsche Lichtgrafik Werke von Hajek-Halke*, National Museum of Modern Art, Tokyo (travelled to the Fuji-Photo Salon, Osaka, Japan)
1965 *Lichtgrafik*, Werkkunstschule, Bielefeld, West Germany

Deutsche Gesellschaft für Photographie, Cologne
1966 Modus Department Store, Berlin
Lichtgrafik, Galerie am Dom, Frankfurt
1967 *Lichtgrafik*, Galerie Clarissa, Hannover
1968 *Lichtgrafik*, Galerie Seestrasse 67, Ludwigsburg, West Germany
Lichtgrafik, Carleton University, Ottawa
Lichtgrafik, University of Montreal
1969 *Lichtgrafik*, Galleria dell'Immagine di Popular Photography Italiana, Milan
Lichtgrafik, Museum Het Sterckshof, Deurne/Antwerp
1970 *Fotografie—Fotografik—Lichtgrafik*, Landesbildstelle, Berlin
1978 *Die Freiheit des Fotografen: Montagen/Collagen/Lichtgrafiken*, Fotomuseum in Stadtmuseum, Munich
Heinz Hajek-Halke: Fotografie, Foto-Grafik, Licht-Grafik, Galerie Werner Kunze, West Berlin
1979 *Fotografie—Fotografik—Lichtgrafik*, Galerie Lewi, Hamburg
Lichtgrafik, Galerie Duc et Camroux, Paris
1980 *Lichtgrafik*, Foto-Art-Galerie, Basle

Selected Group Exhibitions:

1968 *Light⁷*, Massachusetts Institute of Technology, Cambridge

1979 *Deutsche Fotografie nach 1945*, Kunstverein, Kassel, West Germany (toured West Germany)
1980 *Photographia: La Linea Sottile*, Galleria Flaviana, Locarno, Switzerland
Avant-Garde Photography in Germany 1919-1939, San Francisco Museum of Modern Art (toured the United States, 1981-82)

Collections:

Kunstbibliothek, Berlin; Kupferstich-Kabinett, Berlin; Landesgalerie, Hannover; Kestner Museum, Hannover; Museum für Kunst und Gewerbe, Hamburg; Museum Folkwang, Essen; Foto-Historama der Agfa-Gevaert AG, Leverkusen, West Germany; Stadtmuseum, Munich; Museum Het Sterckshof, Deurne/Antwerp; Museum of Modern Art, New York.

Publications:

By HAJEK-HALKE: books—*Experimentelle Fotografie*, Bonn 1955; *Magie der Farbenfotografie*, with text by W. Boje, Dusseldorf 1961; *Lichtgrafik*, Dusseldorf and Vienna 1964, as *Abstract Pictures on Film*, London 1965.

Heinz Hajek-Halke: *Das Gläserne Monument*, 1946

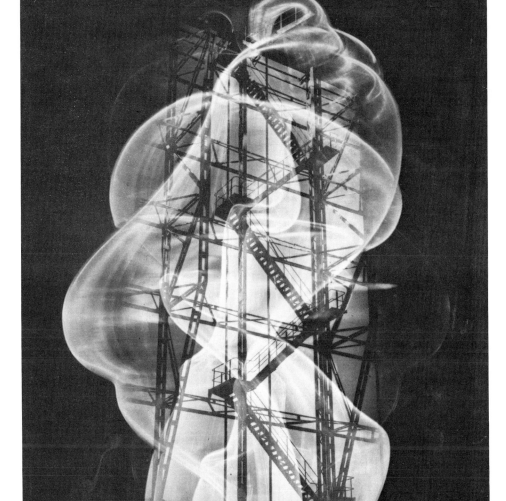

On HAJEK-HALKE: books—*Europa-Camera* by Kurt Zentner and Bernd Lohse, Frankfurt 1951; *Subjektive Fotografie I* by Otto Steinert, Munich 1952; *Akt International* by Otto Steinert, Munich 1954; *Das Aktfoto* by Herbert Rittlinger, Dusseldorf 1954; *Subjektive Fotografie II* by Otto Steinert, Munich 1955; *Photography of the World*, Tokyo 1957; *Photographie Heute* by G. Basner, Bernd Lohse and Niels Reuter, Frankfurt 1958; *Parteilichkeit im Foto* by Berthold Beiler, Halle, East Germany 1959; *Deutsche Lichtgrafik Werke von Heinz Hajek-Halke*, exhibition catalogue, with an introduction by Arryo Orsi, Tokyo 1960; *Fotografisk Arsbok '60*, Stockholm 1960; *Selbstportraits* by Otto Steinert, Berlin 1961; *Fetisch des Jahrhunderts* by Fritz Kempe, Dusseldorf 1964; *Die Welt der Camera*, Lucerne 1964; *Esthètique du Nu dans la Monde* by Lucien Lorelle, Paris 1964; *Werbarium der Zwanziger Jahre*, Hamburg 1965; *Light⁷*, edited by Minor White, Rochester, New York 1968; *Generative Fotografie* by Gottfried Jäger and Karl Martin Holzhäuser, Ravensburg, West Germany 1975; *Geschichte der Fotografie im 20. Jahrhundert/Photography in the 20th Century* by Petr Tausk, Cologne 1977, London 1980; *Heinz Hajek-Halke*, exhibition catalogue, Göttingen, West Germany 1978; *Heinz Hajek-Halke: Fotografie, Foto-Grafik, Lichtgrafik*, exhibition catalogue, with an introduction by Eberhard Roters, West Berlin 1978; *Deutsche Fotografie nach 1945/German Photography after 1945* by Floris Neusüss, Wolfgang Kemp and Petra Benteler, Kassel, West Germany 1979; *Fotografie 1919-1979, Made in Germany: Die GDL-Fotografen*, edited by Fritz Kempe, Bernard Lohse, and others, Frankfurt 1979; *Photographia: La Linea Sottile*, exhibition catalogue, by Rinaldo Bianda and Giuliana Scimé, Locarno, Switzerland 1980; *Avant-Garde Photography in Germany 1919-1939*, exhibition catalogue, by Van Deren Coke, Ute Eskildsen and Bernd Lohse, San Francisco 1980.

Heinz Hajek-Halke, who really wanted to be a painter, became a master of experimental photography in Germany with his *Lichtgrafiken*.

He was born in Berlin in 1898, the son of a painter, and he studied in that city at the arts academy under Emil Orlik. After the First World War he designed film posters, became a press illustrator, then a photojournalist and an advertising phoptographer. Even during this early period, at the end of the 1920's, his first photo-montages had begun to appear, among them the exemplary work, "Evil Gossip": three gentlemen in frock coats and top hats talk together in a street which, at the same time, is the torso of a recumbent female nude—body and asphalt, nude and street, two levels of image and sensation, superimposed to produce a double entendre, a doubly sensual new image. In works such as this Hajek-Halke reflected the photomontages of the Dadaists and Surrealists, particularly the pictures of the Berlin Dadaists, Hanna Höch, John Heartfield, and Raoul Hausmann.

How suggestively—with cross exposure, cross copying and mounting—reality could be photographically altered, and with what virtuosity Hajek-Halke could carry it out, was also recognized by the Nazis. In 1933 they asked him to falsify documentary photographs for the Ministry of Propaganda. Hajek-Halke avoided their grasp by moving to Lake Constance where he specialized in macro-photographs in the field of small animal biology. In 1939, however, he was obliged to serve as works and flight photographer at the Dornier factories in Friedrichshafen.

After the war Hajek-Halke founded a snake farm in order to finance a new set of photographic equipment from the sale of snake venom to the pharmaceutical industry. And during this period he began to make photogrammes and *lichtgrafiken*, without a camera, in the tradition of the photogrammes of Man Ray, Christian Schad and Moholy-Nagy. Hajek-Halke's work became abstract yet at

the same time, in the sense of the photographic medium, highly concrete. His artistic, object-less photography extended from the luminogramme, the recording of tracks of light, to the graphic and chemical treatment of the film negative. It is a poetic photography in parallel with nature, with art, just as much related to the informal painting of the 1950's as to the structures and organic processes of nature.

In 1955 the Berlin Hochschule für Bildende Künste appointed him Dozent für Foto-Grafik— the first professorship of this kind in a German arts academy. An alchemist among photographers of the 20th century, Heinz Hajek-Halke also became known to a wide public with his books *Experimentelle Fotografie* and *Lichtgrafik*.

—Peter Sager

HALÁSZ, Gyula. *See* **BRASSAI.**

HALLMAN, Gary.
American. Born in St. Paul, Minnesota, in 1940. Studied art and photography and filmmaking, under Jerome Liebling, University of Minnesota, Minneapolis, 1966-71, B.A. 1969, M.F.A. 1971. Independent photographer, Minneapolis, since 1971. Instructor in Photography, St. Paul Art Center, Minnesota, 1968-70, University of Minnesota Extension, Minneapolis, 1969-70, and Studio Arts Department, University of Minnesota, Minneapolis, 1970-76. Recipient: National Endowment for the Arts grant, 1975; Research Grant, University of Minnesota, 1976; Artist's Fellowship, Bush Foundation, 1976. Agent: Light Gallery, New York. Address: c/o Light Gallery, 724 Fifth Avenue, New York, New York, 10019, U.S.A.

Individual Exhibitions:

1969 University of Minnesota, Minneapolis
1970 Minnesota Museum of Art, St. Paul
1971 Art Center, Rochester, Minnesota
1972 Minneapolis Institute of Arts
Carleton College, Northfield, Minnesota
Rhode Island School of Design, Providence
1975 International Museum of Photography, George Eastman House, Rochester, New York
St. Cloud State College, Minnesota
Light Gallery, New York
1976 Viterbo College, La Crosse, Wisconsin

Selected Group Exhibitions:

1968 *Young Photographers*, University of New Mexico, Albuquerque
1972 *60's Continuum*, International Museum of Photography, George Eastman House, Rochester, New York
1973 *Photographers Midwest Invitational*, Walker Art Center, Minneapolis

Light and Lens: Methods of Photography, Hudson River Museum, Yonkers, New York
1974 *Photography Unlimited*, Fogg Art Museum, Harvard University, Cambridge, Massachusetts
14 American Photographers, Baltimore Museum of Art (travelled to the Newport Harbor Art Museum, California, and La Jolla Museum of Contemporary Art, California, 1975; Walker Art Center, Minneapolis, and Fort Worth Art Museum, Texas, 1976)
1976 *Peculiar to Photography*, University of New Mexico, Albuquerque
1977 *The Less Than Sharp Show*, Chicago Center for Contemporary Photography
1978 *Mirrors and Windows: American Photography since 1960*, Museum of Modern Art, New York (toured the United States, 1978-80)
1979 *Burchard/Colen/Hallman/Mertin*, Southwest Missouri State University, Springfield

Collections:

Museum of Modern Art, New York; International Museum of Photography, George Eastman House, Rochester, New York; Princeton University, New Jersey; Museum of Fine Arts, Boston; Fogg Art Museum, Harvard University, Cambridge, Massachusetts; New Orleans Museum of Art; Museum of Fine Arts, St. Petersburg, Florida; Center for Arts and Humanitites, Sun Valley, Idaho; University of New Mexico, Albuquerque; National Gallery of Canada, Ottawa.

Publications:

On HALLMAN: books—*Young Photographers*, exhibition catalogue, with text by Van Deren Coke, Albuquerque, New Mexico 1968; *60's Continuum*, exhibition catalogue, with text by Van Deren Coke, Rochester, New York 1972; *Light and Lens: Methods of Photography*, edited by Donald L. Werner and Dennis Longwell, New York 1973; *14 American Photographers*, exhibition catalogue, with text by Renato Danese, Baltimore 1974; *Peculiar to Photography*, exhibition catalogue, with text by Van Deren Coke, Thomas F. Barrow and others, Albuquerque, New Mexico 1976; *Mirrors and Windows: American Photography since 1960* by John Szarkowski, New York 1978; *The Photograph Collector's Guide* by Lee D. Witkin and Barbara London, Boston and London 1979; article—"Review: Photography of Gary Hallman" by E. William Peterson in *Image* (Rochester, New York), September 1974.

Gary Hallman is a university-trained photographer, within a pattern of study that has become the dominant mode in the education of American photographers since the 1960's. Hallman attended the University of Minnesota as an art major and later entered into a master of fine arts program where he studied photography, film, sculpture, and art history. This kind of training for Hallman and many of his colleagues in the Society for Photographic Education is now a consistent national pattern for thousands of photographers who now share similar concepts and critical ideas.

In the past there was no discernible pattern of training in the careers of major photographers. A group such as Berenice Abbott, W. Eugene Smith, Dorothea Lange, and Edward Weston would have no similarity in their training. The one consistency that their careers reveal is that they all worked as commercial photographers. They all interacted with clients, editors, or advertising executives, and their work reflected some of these collaborative tensions.

Hallman and his colleagues generally earn their living by teaching, and their work is more private and self supported. Hallman's friends are artists in all media, and Hallman is completely conversant with most critical currents in the arts. He is probably more allied to the other arts than he is to commercial or journalistic photography. Hallman feels free to have his images reflect conceptual, formal or straight photography as he pursues a broad range of subject and idea. He among many photographers regard *Art Forum* and *Art News* magazines as the arbiters of taste and concern—different from that generation that sought out *Life* and *Look* magazines.

Hallman's series of 30 x 40 inch toned impressionistic landscapes made in the early 1970's brought him quick recognition as an artist capable of sensuous metaphoric images. These photographs, though starting from a negative, are concerned with the interplay of shape, surface and subtle toning, all achieving an atmosphere of elegance far removed from the original negative. Other work of Hallman's has been a series of conceptual pieces relating to events and places in his studio, and more recently he has begun to work in color.

His work relates to the world of museums and galleries and the audiences they serve. He is always probing, experimenting and changing. Attempts at predicting the nature of his future work are difficult; we can be sure only of exciting surprise.

—Jerome Liebling

HALSMAN, Philippe.
American. Born in Riga, Latvia, 2 May 1906; emigrated to the United States, 1940: naturalized, 1949. Educated at Vidus Skola, Riga, 1922-24, B.A. 1924; studied electrical engineering, Technische Hochschule, Dresden, Germany, 1924-28; studied at the Sorbonne, Paris, 1931; self-taught in photography. Married Yvonne Moser in 1937; children: Irene Alene and Jane Ellen. Worked as part-time freelance photographer, mainly for Ullstein publishing house in Berlin, while still a student, 1924-28; then moved to Paris; freelance portrait and fashion photographer with own studio in Paris working for *Vogue, Vu, Voila*, etc., 1931-40; freelance photographer, New York, working for *Life, Saturday Evening Post, Look*, etc., 1941-79. Instructor, Famous Photographers School, Westport, Connecticut, 1969-79. President, American Society of Magazine Photographers, New York, 1944, 1954. Recipient: 10 Greatest Photographers Award, *Popular Photography*, New York, 1958; Newhouse Award, 1963; Golden Plate Award, American Academy of Achievement, 1967; Life Achievement Award, American Society of Magazine Photographers, 1975. *Died* (in New York) *25 June 1979.*

Individual Exhibitions

1979 International Center of Photography, New York (retrospective)
1981 Foto Galerij Paule Pia, Antwerp, Belgium

Selected Group Exhibitions:

1951 *Memorable Life Photographs*, Museum of Modern Art, New York
1965 *12 International Photographers*, Gallery of Modern Art, New York

1978 *Photos from the Sam Wagstaff Collection*, Corcoran Gallery of Art, Washington, D.C. (toured the United States and Canada)
1979 *Fleeting Gestures: Dance Photographs*, International Center of Photography, New York (travelled to The Photographers' Gallery, London; and *Venezia '79*)
 Life: The First Decade 1936-1945, Grey Art Gallery, New York University (toured the United States)
 Photographie als Kunst 1879-1979, Tiroler Landesmuseum Ferdinandeum, Innsbruck, Austria (travelled to Neue Galerie am Wolfgang Gurlitt Museum, Linz, Austria; Neue Galerie am Landesmuseum Joanneum, Graz, Austria; and Museum des 20. Jahrhunderts, Vienna)
 Photographic Surrealism, New Gallery of Contemporary Art, Cleveland (travelled to Dayton Art Institute, Ohio; and Brooklyn Museum, New York)
1980 *Photography of the 50's*, International Center of Photography, New York (travelled to Center for Creative Photography, University of Arizona, Tucson; Minneapolis Institute of Arts; California State University at Long Beach; and Delaware Art Museum, Wilmington)

Collections:

Metropolitan Museum of Art, New York; Museum of Modern Art, New York; Life Picture Collection, New York; International Center of Photography, New York; Smithsonian Institution, Washington, D.C.; Library of Congress, Washington, D.C.; New Orleans Museum of Art; Royal Photographic Society, London.

Publications:

By HALSMAN: books—*The Frenchman: A Photographic Interview with Fernandel*, New York 1949, London 1950; *The Candidate*, New York 1952; *Piccoli*, New York 1953; *Dali's Mustache: A Photographic Interview with Salvador Dali*, New York 1954; *Polaroid Portfolio no. 1*, with others, edited by John Wolbarst, New York 1959; *Philippe Halsman's Jump Book*, New York and London 1959; *Halsman on the Creation of Photographic Ideas*, New York and London 1961; *Halsman: Sight and Insight*, New York 1972; *Halsman*, with an introduction by Owen Edwards, New York 1979; *Photographers on Photography*, edited by Jerry C. LaPlante, New York 1979; articles—"Artificial Light" in *Popular Photography Annual*, New York 1957; "Philippe Halsman Interview," with Casey Allen, in *Camera 35* (New York), July 1978; "Marilyn Jumps" in *American Photographer* (New York), March 1979; film—*For a Livable America*.

On HALSMAN: books—*Memorable Life Photographs*, with text by Edward Steichen, New York 1951; *The Magic Image* by Cecil Beaton and Gail Buckland, London and Boston 1975; *Geschichte der Fotografie im 20. Jahrhundert / Photography in the 20th Century* by Petr Tausk, Cologne 1977, London 1980; *A Book of Photographs from the Collection of Sam Wagstaff*, designed by Arne Lewis, New York 1978; *Life: The First Decade 1936-1945* by Ralph Littman, Ralph Graves and Doris C. O'Neill, New York 1979, London 1980; *Photographie als Kunst 1879-1979/Kunst als Photographie 1949-1979*, exhibition catalogue, 2 vols., by Peter Weiermair, Innsbruck, Austria 1979; *Photographic Surrealism*, exhibition catalogue, edited by Nancy Hall-Duncan, Cleveland 1979; *Halsman*, exhibition catalogue, by Owen Edwards, New York 1979; *The Photograph Collector's Guide* by Lee D. Witkin and Barbara London, Boston and London 1979; *Photography of the 50's*,

exhibition catalogue, by Helen Gee, Tucson, Arizona 1980; articles—"Philippe Halsman" in *U.S. Camera Annual 1952*, edited by Tom Maloney, New York 1951; "Halsman: Sight and Insight" in *Popular Photography* (New York), August 1973; "Philippe Halsman's Mini Course in Portrait Lighting" by Renee Bruns in *Popular Photography* (New York), November 1973; "Philippe Halsman" by Ruth Spencer in the *British Journal of Photography* (London), 10 October 1975; "Halsman on Portraits" by Janet Nelson in the *New York Times*, 9 April 1978; "Fantasies of Philippe" by Charles Reynolds in *Popular Photography* (New York), July 1979; "Philippe Halsman 1906-1979" by Arthur Goldsmith in *Popular Photography* (New York), September 1979; "Halsman: A Tribute" by Owen Edwards in *Portfolio* (New York), October/November 1979.

Latvian-born Philippe Halsman achieved his greatest photographic reputation in the United States as a master of graphically powerful, psychologically penetrating, and technically superb portraiture. During the heyday of the old (weekly) *Life* magazine, Halsman's photographs frequently appeared on its pages, and he is the only photographer ever to make the cover 100 times; in fact, he added one more for good measure. In addition to his portraiture, Halsman also found time to express a rich, delightful sense of fantasy in the vein of surrealism, concocting outrageous visual puns and startling juxtapositions of images. In the latter work he often collaborated with his long-time acquaintance, Salvador Dali.

The son of a dentist, Halsman left his native Riga during his teens to study electrical engineering in Dresden for three years. He then moved to Paris where the stimulating intellectual climate of the 20's was more to his liking. He decided to abandon engineering for the world of arts and letters, first as a poet (writing in French) and then increasingly as a photographer. An interest in psychology led him to photographic portraiture. He believed that through an understanding of psychology it was possible for a photographer "to capture the essence of a human being." In later developing his theory of "psychological portraiture," he wrote: "Very often it is not the good photographer who makes the good portrait but the good psychologist. In many sittings I have felt that what I said to the client was more important than what I did with my camera and my lights."

Rebelling against the soft-focus pictorial style then in vogue, he believed that making sharply-focused images was the only proper way to use a camera, and he remained passionately dedicated to image sharpness thereafter. He sought clarity and precision in his images as he did in his thinking and writing. Although emphasizing that technique was only a means to an end, he became a master technician. "Each technical step must contribute.... This is the meaning of the interrelation of technique and emotion," he said. "An uncut diamond has only a potential value. Only after it is cut and polished does it shine in the dark."

By the time World War II broke out, Halsman had established himself as a successful portrait photographer in Paris; his clients included leading personalities in the avant garde cultural scene there such as André Malraux and Jean Cocteau. As the German army approached Paris in 1940, Halsman, his French wife, Yvonne, and their baby daughter left for New York on an emergency visa obtained with the help of Albert Einstein.

Before long, Halsman began to earn a new reputation and receive even greater success in the United States than he had in Paris. Although never on the staff of *Life*, he achieved his greatest fame through assignments for that publication. During many years of active relationship with *Life* and other leading picture magazines, Halsman photographed many of the most celebrated personalities of the times: Winston Churchill, Albert Einstein, The Duke and

Duchess of Windsor, John F. Kennedy, Marilyn Monroe, Bertrand Russell, Matisse, Chagall, Joan Baez, and many others. Some of these Halsman portraits, especially the 1947 Einstein portrait, have become the definitive image of the person photographed, indelibly burned into the retina and brains of millions of people. Three have been issued as U.S. postage stamps.

In addition to his more serious work, Halsman pursued the whimsical, fantastic aspect of his personality. Among the most striking of his studio-created surrealism is "Dali Atomicus" in which the painter is caught in mid-air amidst levitating furniture, flying cats, and a stream of water. Halsman's books include *The Frenchman, Piccoli*, a non-photographic fairy tale which has since been translated into three languages, *Dali's Mustache, Philippe Halsman's Jumpbook*, which reveals famous people jumping, and *Halsman on the Creation of Photographic Ideas*, an exposition of his psychological and visual theories.

During the last years of his life Halsman was plagued by ill-health and fits of depression, although he continued to carry out magazine assignments and continue his portrait practice on a limited scale. Shortly before his death in 1979 he completed work on a major retrospective exhibition at Manhattan's International Center of Photography, which reflected both his achievements as a portrait photographer and his imaginative play with the absurdity of vision.

The heritage of his portraits includes images in which emotion and technique merge in sharp focus, capturing the "quintessential" aspects of a human personality that always was his goal. However, the originality and imagination of his created photographs, made for his own amusement, are not submerged by his more serious work, revealing as they do a vision both whimsical and disturbing. He belongs to both the tradition of portraiture and that of surrealism.

—Arthur Goldsmith

HAMAYA, Hiroshi.
Japanese. Born in Tokyo, 28 March 1915. Educated at Kanto Daiichi High School, Tokyo, 1929-33; mainly self-taught in photography. Married Asa Nanbu in 1948. Freelance photographer, Tokyo, 1937-45, Takada City, Niigata Prefecture, 1945-52, and in Oiso, Kanagawa Prefecture, since 1952; Contributing Photographer, Magnum Photos co-operative agency, New York and Paris, since 1960. Has photographed in Manchuria, 1940, 1942, in China, 1956, in Thailand, 1960, Western Europe, 1963, the United States, Mexico and Canada, 1967, 1969, 1973, Nepal, 1974, Australia and the South Pacific, 1975, Greenland, 1976, Nepal, 1978, Algeria and Turkey, 1979, China, 1980, and Australia, 1981. Agent: Magnum Photos, 251 Park Avenue South, New York, New York 10010, and 2 rue Christine, 75006 Paris. Address: 534 Higashikoiso, Oiso-machi, Kanagawa-ken 255, Japan.

Individual Exhibitions:

1946 *Heavy Snowfall in 1945 in Takada*, Izumoya Gallery, Takada, Niigata Prefecture
1947 *7 Artists in Echigo*, Daishi Bank Hall, Takada, Niigata Prefecture, Japan
1957 *The Red China I Saw*, Takashimaya Department Store, Tokyo
1959 *Ook Dit is Japan*, Leiden Museum, Holland
1960 *The Document of Grief and Anger*, Matsuya Gallery, Tokyo

1969 *Ha*
1970 *Nat*
1981 *Hiro*
 Tal
 Hal

Selected Group

1959 *Biennale*
 Venice
1960 *The World*
 maya Dep
 tour)
1965 *12 Photogra*
 New York
1972 *The Concerne*
 Institution,
1979 *Japan: A Self-P*
 of Photography
 Venezia '79
 Japanese Photograp
 Galleria d'Arte Mo
 elled to the Palazzo
 des Beaux-Arts, Bruss
 of Contemporary Arts, London)

Collections:

National Museum of Modern Art, Tokyo; Bibliothèque Nationale, Paris; Museum of Modern Art, New York; International Museum of Photography, George Eastman House, Rochester, New York.

Publications:

By HAMAYA: books—*Yuki Guni* (*The Snow Country*), Tokyo 1956; *Ura Nihon* (*Back Regions of Japan*), Tokyo 1957; *Umruch-Hsinchiang, China/Urumchi, The Remote City*, Tokyo 1957; *The Red China I Saw*, Tokyo 1958; *Contemporary Japanese Photography: A Volume of Selected Works by Hiroshi Hamaya*, Tokyo 1958; *Children in Japan*, Tokyo 1959; *Det Gomda Japan*, Stockholm 1960; *A Record of Anger and Sorrow*, Tokyo 1960; *Landscapes of Japan*, with an introduction by Taro Tsujimura, Tokyo 1964; *Latentimage Afterimage: Hiroshi Hamaya's Memoirs*, Tokyo 1971; *American America*, Tokyo 1971; *Nature*, portfolio, Tokyo 1971; *A Treasury of Japanese Poetry*, Tokyo 1972; *Yaichi Aizu: Portfolio of a Master Calligrapher*, Tokyo 1972; *Tokyo 1936*, with Katsuya Nakamura, Tokyo 1974; *Landscape of Japan National Park*, Tokyo 1975; *Mount Fuji: A Lone Peak*, Tokyo 1978; *Summer Shots: Antarctic Peninsula*, Tokyo 1979; *Hiroshi Hamaya: 50 Years of Photography*, in 2 volumes: *Aspects of Nature* and *Aspects of Life*, Tokyo 1981.

On HAMAYA: books—*The Concerned Photographer 2*, edited by Cornell Capa, New York and London 1972; *Japan: A Self-Portrait*, edited by Shoji Yamagishi and Cornell Capa, New York 1979; *Japanese Photography Today and Its Origins* by Attilio Colombo and Isabella Doniselli, Bologna, Italy 1979; articles—"River, Swamp, Sea and Fire Mountains: Pictures of Japan by Hiroshi Hamaya" in *Du* (Zurich), February 1970; "Hiroshi Hamaya" in *Camera* (Lucerne), July 1970; "Hiroshi Hamaya" in *Modern Photography Annual*, New York 1972; "The Concerned Photographers" by Cornell Capa in *Zoom* (Paris), no. 16, 1973.

From the preface to *Landscapes of Japan*, 1964:
 It has been 33 years since I began photography, and 31 years since the time that I decided to take up photography as my life's work. During all this

HAMILTON

David Hamil
land 1976;
Germany 197
Même," inte
Claude Rair
cember 1970

On HAMIL
fie im 20.
Century by
1980; articl
Hamilton"
December
Photo Wo
"Hamiltor
February

In photo
show an

characters.

Japan is of the monsoon type. The Japanese Fudo has complicated features related to the extensive long longitudinal position of Japan from north to south, with its intensive climatic changes. Within this Fudo, our ancestors cultivated not only the tropical rice plant but also wheat, oats and barley. This was accomplished through active co-operation and intermingling of Man and Fudo. And I felt, with my study of people, that I had to study the Fudo in close relation with people. This was at the time I began taking pictures of Ura Nihon. The result was another series, *Ura Nihon* (Back Regions of Japan) which recorded my travels in these parts. In that book I wrote that my purpose was for "man to understand man, so that the Japanese may understand the Japanese." And I thought that I had come to understand the Japanese rather well as a result of my wanderings all over Japan; however, I also began to realize more and more the difficulty of really knowing my own people.

In 1960 Japan was plunged into a sort of political crisis that reminded one of the night before a revolution. Never before had the Japanese people evinced so much concern for political issues as at that time. And I, who never took pictures of political happenings, felt that I had to make a record of this historical period. During that year—from May 20 to June 22—I took pictures of every aspect of the times to the limit of my ability and energy, and completed a full and precise record. This resulted in another documentary series, *A Record of Anger and Sorrow*.

The Japanese, who had lived through a long history as though they had no relation to politics, had shown, at this particular point, an unexpected awareness of politics. But it was only a momentary phenomenon. The heightening of awareness was transitory. A superficial economic prosperity supplanted it. I do not speak in an abstract way. I have walked through all parts of Japan, experiencing things by myself, seeing and feeling things through my own experience, and, through having seen the actual ways of living of the people, I have come to understand the unscientific thinking habits of the Japanese. Their tendency is to limit their thinking only to their own feelings, to build their lives upon it. This unscientific and strictly private habit of thinking has darkened the history of my people.

I wondered why I was always so obsessed with people, particularly about common people, the masses of the lowest social stratum. During history class in school, I often wondered why history should always stress royalty, the aristocrats, and the warriors. I would have learned history better, as my own personal problem, through studying the lives of common people and how they had lived through the ages. Those facts are connected to our present problems, and they can show us future direction.

Later, in 1960, I was led to think again about the problem of historical necessity and the influence of Fudo on the people. If one goes deep into the subject, one comes finally to People and Nature: the problem of the Japanese and Japanese soil. Since we have lost sight of the Japanese people, the kind of people they are, I decided to look instead and deeply only at the land. I felt the urgency to find out and see for myself what kind of land Japan is.

To look intently at nature—that was something I had never even thought about. For me, it was a completely new subject.

Although I have travelled through all the regions of Japan, I have never been particularly conscious of nature in itself. Always, for me, there were people in nature. I became conscious of nature itself for the first time in 1956 in China. When I flew over the desert between Kwantung province and Sinkiang, I was overwhelmed by the vastness of nature. The desert that spread out in that most interior part of earth made me imagine the earth's skin in primordial times; it made me think of the earth as becoming fossilized in the blowing cosmic wind. This was an extreme world that shut out the lives of plants and animals.

ures of adolescents, for example, which merely
rouse the usual erotic fantasies). His work is pretty-
pretty and decorative, and he knows how to market
t successfully. The individual photos of the last
entury became collector's items; now Hamilton
urns out millions of copies of his conventional pic-
ures. But it would be pointless to admire the petti-
ness or cultivate the paradox that because the public
acks visual sophistication he will leave his mark on
he history of photography.

—Christian Caujolle

HAMMARSKIÖLD, Hans (Arvid).

Swedish. Born in Stockholm, 17 May 1925. Edu-
ated at The Östra Real, Stockholm, 1936-44; self-
taught in photography. Married Caroline Hebbe in
1951 (divorced, 1976); children: Suzanne, Viveca,
nd Richard; married Magdalena Ander in 1978.
Photographer, Bellander Studio, Stockholm, 1950,
nd *Vogue* Studios, Condé Nast Publications, Lon-
on, 1955-56. Freelance photographer, Stockholm,
nce 1957. Member, Tio Fotografer group, Stock-
olm, since 1958. Agents: Camera Obscura, Kak-
brinken 5, 11127 Stockholm; and Stephen White
Gallery, 835 North La Cienaga, Los Angeles, Cali-
ornia 90069. Address: 7 Östermalmsgatan, 11424
Stockholm, Sweden.

Individual Exhibitions:

1951 Rotohallen, Stockholm
1956 *London*, Institute of Contemporary Arts,
 London (travelled to Artek, Stockholm,
 1958)
1962 *Swedish Design*, Svensk Form, Stockholm
1979 Camera Obscura, Stockholm (retrospective)
 Douglas Elliott Gallery, San Francisco
 (retrospective)
1981 Stephen White Gallery, Los Angeles

Selected Group Exhibitions:

1949 *Unga Fotografer*, Rotohallen, Stockholm
1951 *Jeunes Photographes Suédoises*, Galerie Ko-
 dak, Paris
 Subjektive Fotografie, State Art and Crafts
 School, Saarbrucken (and 1954)
1953 *Postwar European Photography*, Museum
 of Modern Art, New York (toured the
 United States, 1953-56)
1955 *The Family of Man*, Museum of Modern
 Art, New York (and world tour)
1958 *Fotokonst '58*, Lunds Konsthall, Lund,
 Sweden
1962 *Svenskarna sedda av 11 fotografer*, Mod-
 erna Museet, Stockholm
1970 *Tio Fotografer*, Bibliothèque Nationale,
 Paris
1971 *Contemporary Photographs from Sweden*,
 Library of Congress, Washington, D.C.
1978 *Tusen och En Bild/1001 Pictures*, Moderna
 Museet, Stockholm

Collections:

Fotografiska Museet, Stockholm; Bibliothèque
Nationale, Paris; Museum of Modern Art, New
York; Library of Congress, Washington, D.C.

Publications:

By HAMMARSKIÖLD: books—*Objektivt sett*, Stockholm 1955; *Billa och jag*, Stockholm 1959; *Lillasyster och jag*, Stockholm 1960; articles— "Nature in November" in *Photography* (London), November 1954; "Hammarskiöld's London" in *Photography* (London), March 1957; "An Idea Was Born" in *Tio Bulletin* (Stockholm), no. 1, 1959.

On HAMMARSKIÖLD: books—*Tusen och en bild/1001 Pictures* exhibition catalogue, by Ake Sidwall, Sune Jonsson and Ulf Hard af Segerstad, Stockholm 1978; *Hans Hammarskiöld* by Rune Jonsson, Helsingborg, Sweden 1979; articles—"Guest of Honour" in *Photography* (London), March 1952; "Hans Hammarskiöld" in *Photography* (London), October 1958.

I started off as a freelance photographer in 1950 working mainly with fashion and pictures stories for Swedish magazines. During 1955-56 I was a staff photographer at British *Vogue* and *House and Garden* doing fashion, portraits, advertising, food and interiors. I came back to Sweden in 1957, where I have been a freelance photographer since then. I became a member of the group Tio when it started in 1958, and during the period 1958-68 I continued to do picture stories, food photography, still lifes, portraits and also industrial photography.

In 1968 I was asked to make a multi-screen show for a Swedish company, and I have since then worked mainly with multi-screen shows and industrial photography. Besides that type of work, I have done a lot of nature photography, which has been my special interest since I got my camera. My old nature pictures were in black-and-white. Today they are mainly in colour. I use a lot of them in my multi-screen shows, but I also print some on Cibachrome for my gallery shows. I have by now made about twenty multi-screen shows, and the two biggest have been with 36 projectors each for permanent showing at the Swedish company Asea, in Vasteras. They have been running since 1972, and will soon be replaced by two new programs of the same size.

—Hans Hammarskiöld

At the end of the 1940's a kind of change of generations took place in Swedish photography. Hans Hammarskiöld was one of "The Young" (*De Unga*), and, along with his contemporaries, he used provocative exaggeration to underline his dissociation from the pre-war generation. The old rules about grey scale and fine grain were casually slung on the dungheap—which itself often became a favorite motif. For in their subject matter, too, the new generation tried to distance itself from the conventional photographers and their ingratiating motif-world.

After their isolation during the Second World War, many of the younger Swedish photographers turned their sights towards Paris; a number of them even moved there for short or extended periods of time. But Hammarskiöld's interests were directed west of Paris. He visited the United States early in his career and made contact with its leading photographers—W. Eugene Smith, Irving Penn and Edward Steichen. So it is not surprising that Hammarskiöld's pictures from the 1950's show American influences, notably those of Weston and Callahan—razor-sharp representations of surface structures and details of nature, in which form is more important than the matter-of-fact pictures of species. The pictures are often characterized by a deep solemnity and a decorative line-play, in which the accentuated silhouettes have a constructive function.

But in these works there are also traces of the national romanticism that dominated Swedish photography during the 1930's and 40's. And it may be worth noting, too, that Hammarskiöld made his competition debut with a romantic picture of a backlighted ploughman.

Hammarskiöld's engagement as a photographer on *Vogue* and *House and Garden* in London in 1955 and 1956 resulted in a renewal in his pictorial expression. Besides doing his commercial work, he wandered around London and took reportage photos with a small-picture camera in the spirit of Cartier-Bresson. He exhibited the pictures in Stockholm and other cities, and the critics wrote ecstatically that he had succeeded in capturing the London of Sherlock Holmes and Dickens. Mood and light were accentuated. The confident idiomatic expression was still there but was now combined with a more descriptive content.

In the course of time Hammarskiöld had come to be regarded as a typical black-and-white photographer. Few were as expert as he at mastering the graphic construction of a picture in clearly defined grey tones. No doubt many people thought he had betrayed his ideals, therefore, when in the late 1960's he began increasingly to work in color. These pictures were primarily used for multi-screen shows or were examples of the Cibachrome method.

In choosing his subjects Hammarskiöld often returns to his work from the 1950's—severely cut details of nature, with distinctly decorative value. He has at times been criticized for this work, for in it

little is seen of the violation of nature by the industrial world. Challenged on this point in an interview Hammarskiöld responded that many other photographers already specialize in this aspect of nature in the modern world. "But I prefer doing it the opposite way. To show the beauty and magic in nature. To try to make people see and feel what's really at stake."

—Rune Jonsson

HARBUTT, Charles.
American. Born in Camden, New Jersey, 29 July 1935. Educated at Marquette University, Milwaukee, 1952-56, B.S. in journalism 1956. Married Alberta Steves in 1958 (divorced, 1978); children: Sarah, Charles, and Damian; married Joan Liftin in 1978. Associate Editor, *Jubilee* magazine, New York, 1956-59; freelance magazine photographer,

Hans Hammarskiöld: *Caroline*, 1955

New York, 1959-63. Since 1963, Photographer with Magnum Photos Inc., co-operative photo agency, New York and Paris (President, Magnum, New York, 1970-72, 1976-78). Photographic Consultant, New York City Planning Commission, 1968-70. Lecturer, Cooper Union and Pratt Institute, New York, 1970-72; Visiting Artist, Art Institute of Chicago, 1975, Rhode Island School of Design, Providence, 1976, and Massachusetts Institute of Technology, Cambridge, 1978. Vice-President, American Society of Magazine Photographers, 1970-71. Recipient: Magazine Photography Award, University of Missouri, Columbia, 1969; Gold Medal, *Atlanta Film Festival*, 1970; Creative Artists Public Service Award, New York, 1972; Photo Book of the Year Award, *Rencontres Internationales de Photographie*, Arles, France, 1974. Lives in New York. Address: c/o Magnum Photos Inc., 251 Park Avenue South, New York, New York 10010, U.S.A.; or Magnum Photos, 2 rue Christine, 75006 Paris, France.

Individual Exhibitions:

1960 Image Gallery, New York
1966 Marquette University, Milwaukee
1967 Art Institute of Chicago
1971 Center of The Eye, Aspen, Colorado
 Raffi Laboratory, New York
 Imageworks, Boston
1972 Pace College, New York
1974 SoHo Photo, New York
 Midtown Young Men's Hebrew Association, New York
 Photography Place, Berwyn, Pennsylvania
 Galleria Il Diaframma, Milan
 Photogalerie, Paris
1975 The Photographers' Gallery, London
 University of Syracuse, New York
 Photopia Gallery, Philadelphia
 Musée Réattu, Arles, France
 Museum of Science and Industry, Chicago
1976 Kalamazoo Art Institute, Michigan
 Poisson Banane, Arles, France
 Vassar College, Poughkeepsie, New York
 Bennington College, Vermont
 Panopticon Gallery, Boston
1977 Infinite Eye Gallery, Milwaukee
 University of Dayton, Ohio
 Galerie Fiolet, Amsterdam
1978 *Sympathetic Explorations: Kertész/Harbutt*, Plains Art Museum, Moorhead, Minnesota
1979 Broward College, Fort Lauderdale, Florida
 Catskill Center for the Arts, Woodstock, New York
1980 *Salford '80*, England
1981 Douglas Kenyon Gallery, Chicago (with Rutger Ten Broeke)

Selected Group Exhibitions:

1960 *Photography as Fine Art*, Metropolitan Museum of Art, New York
1965 *The Picture Essay*, Museum of Modern Art, New York
1967 *Photography in the 20th Century*, National Gallery of Canada, Ottawa (toured Canada and the United States, 1967-73)
1974 *Photography in America*, Whitney Museum, New York
1976 *Other Eyes*, Hayward Gallery, London (toured the U.K.)
1977 *La Photographie Créatrice au XXee Siècle*, Musée National d'Art Moderne, Centre Pompidou, Paris
1978 *Tusen och En Bild*, Moderna Museet, Stockholm
 Mirrors and Windows: American Photography since 1960, Museum of Modern Art, New York (toured the United States, 1978-80)

Collections:

Museum of Modern Art, New York; Metropolitan Museum of Art, New York; International Museum of Photography, George Eastman House, Rochester, New York; Smithsonian Institution, Washington, D.C.; Art Institute of Chicago; New Orleans Museum of Art; University of Nebraska, Lincoln; University of Manchester, England; Bibliotheque Nationale, Paris; Moderna Museet, Stockholm.

Publications:

By HARBUTT: books—*America in Crisis*, with others (also editor), New York 1969; *The Plan for the City of New York*, 6 volumes, with the New York City Planning Commission, Cambridge, Massachusetts 1970; *Travelog*, Cambridge, Massachusetts 1973; articles—"The Multi-Level Picture Story" in *Contemporary Photographer* (Boston) 1965; "The Concerned Photographer" in *Album* (London), no. 9, 1970; "The Harbutt Workshop" in *Modern Photography* (New York), January-April 1976.

On HARBUTT: exhibition catalogues—*Sympathetic Explorations: Kertész/Harbutt* by Andy Grundberg, Moorhead, Minnesota 1978; *Tusen och En Bild* exhibition catalogue by Ake Sidwall, Sune Jonsson and Ulf Hard af Segerstad, Stockholm 1978; article—"In Search of the Honest Photograph" by Julia Scully and Andy Grundberg in *Modern Photography* (New York), July 1979.

I take pictures because it gives me pleasure. Having taught for ten years, I feel to say more is idiocy.

—Charles Harbutt

In her book *Flashback! The 50's*, Eve Arnold recalls that she was trying to understand the difference between the photography of the 50's and the 70's, so she called her friend and fellow Magnum photographer Charles Harbutt and asked him. "Oh that's easy," he said. "Photography in the 50's was about people. Now it's about photography." Harbutt's own photography seems to have followed this line of development (Arnold's hasn't), and not just because of the trumpeted death of the established markets for photojournalistic work.

Originally Harbutt stopped being a writer and started being a photographer because photographers had to *be* there. It required more contact with reality. His photography developed in the great reportage style of the Magnum agency. He photographed the 6-Day War for *Paris-Match* and *Newsweek*, Spiro Agnew for *Life*, ghettos for *Look* and so on. The culmination of this "concerned" style came with the book he edited, *America in Crisis*, which was photographed by Magnum members and included many of his own pictures.

But by this time Harbutt was trying to find a new way of taking pictures: one that more truly represented his own experience of the world. Now that he saw this as alien and fragmentary, it no longer fitted the journalistic tradition in which he had been working. Part of the stimulus for this reconsideration was provided by reality in the form of a speeding bullet. In May 1967, he recalls, "I turned casually around a high-noon street in Aden to see the hammer drawing back on a pistol aimed at me."

His reconsideration resulted in a new style and an award-winning book, *Travelog*. For a while he called the new style "Superbanalisme," perhaps because he was focusing on the trivialities of everyday life instead of the "Great Themes." The implied mockery hid the fact that he was involved in a radical reassessment of the relationships between photography and reality and photography and art.

Thus many of the pictures in *Travelog* are concerned with identifying areas of reality that the camera records in a way that is different from our everyday experience of them. For example: reflections in windows and puddles, lighted windows, clouds, shadows, and pictures with pictures. To the camera's eye these phantoms are just as real as solid objects. Also Harbutt experimented with breaking the rules of composition that had fundamentally been derived from painting, in the search for a specifically photographic aesthetic. He used wide-angle distortion, tilting the camera, cut people's heads off *etc.* The resulting book is by no means consistent. Some pictures are *avant garde* while others are reportage, but the effects are always interesting.

Underneath the philosophical overlay, Harbutt's photography tells another story—of depersonalisation and the search for human contact. In most of the pictures in the book, people are cut off—you see only their legs or shoulders or whatever—or they are behind glass, or safely sealed inside their cars, or distant, or in their own little groups which exclude the photographer. The few people who relate to the photographer directly include a beaming man on an advertising poster, a distant beauty queen on a passing carnival float, and a small child with a gun. It is the geometrical lines of the city buildings, the patterns of walls, windows and pavements, that dominate the pictures, while the figures are isolated in the space. In a sense this is as cold and alienating a vision as it sounds. In another sense, the photographs themselves are a warm act of communication and a way of sharing the beauty of their formal conception. In *Travelog* Harbutt is making the simplest and most basic statement, "I am here." I photograph, therefore I am.

—Jack Schofield

HARDY, Bert.

British. Born Albert Hardy in London, 19 May 1913. Educated at Friar Street Elementary School, London, 1918-27; self-taught in photography. Served as a photographer in the British Army, in France and Germany, 1942-46. Married Sheila Marshall in 1965; children (from first marriage): Michael and Terence. Worked as a messenger and laboratory assistant, Central Photo Services, London, 1927-36; Photographer, for William Davis, General Photographic Agency, London, contributing to *Illustrated London News*, *Tatler*, *Sphere*, etc., 1936-39; Founder-Director, with Bertram Collins, Criterion Press photo agency, London, 1939-40; Staff Photographer, *Picture Post*, London, 1941-57; freelance advertising photographer, London, 1958-63. Founder-Director, with Gerry Grove, Grove Hardy Ltd. photo processing company, London, since 1960; has also farmed in Limpsfield Chart, Surrey, since 1964. Recipient: *Encyclopaedia Britannica* Award, 1948, 1950, 1951, 1952; Gold Medal, *Unifoto*, 1951; National Outdoor Advertising Award, 1960. Address: Chartlands Farm, Limpsfield Chart, Surrey, England.

Individual Exhibitions:

1974 Maidenhead Public Library, Berkshire (toured the U.K.)
1975 *3 from Picture Post*, The Photographers' Gallery, London (with Thurston Hopkins and Kurt Hutton; toured the U.K., 1976-77)
1978 Photo Gallery, St. Leonards on Sea, Sussex

Selected Group Exhibitions:

1955 *The Family of Man*, Museum of Modern

Art, New York (and world tour)
1972 *Personal Views 1850-1970*, British Council, London (toured Europe)
1975 *The Real Thing: An Anthology of British Photographs 1840-1950*, Hayward Gallery, London (toured the U.K.)

Collections:

Radio Times Hulton Picture Library, London; Arts Council of Great Britain, London; Imperial War Museum, London (war pictures, 1942-46).

Publications:

By HARDY: book—*Bert Hardy, Photojournalist*, with an introduction by Tom Hopkinson, London 1975; articles—"How I Photograph People" in *Photography* (London), June 1949; "Bert Hardy: Comment Je Photographe les Gens" in *Photo-Monde* (Paris), November 1952; "Bert Hardy: Comment Je Photographe le Mouvement" in *Photo-Monde* (Paris), March 1953; "Covering the Berlin Conference" in *Photography* (London), March 1954; "On Using a Miniature" in *Photography* (London), April 1956; "Anything for a Story" in *Creative Camera* (London), December 1971.

On HARDY: books—*Picture Post 1938-50* by Tom Hopkinson, London 1970; *Personal Views 1850-1970*, exhibition catalogue, with an introduction by Bill Jay, London 1972; *The Magic Image* by Cecil Beaton and Gail Buckland, London and Boston 1975; *The Camera at War* by Jorge Lewinski, London and New York 1978; *Pictures on a Page* by Harold Evans, London 1978; *Cameramen at War* by Ian Grant, Cambridge 1980; articles—"Bert Hardy's Piccadilly Story" in *Photography* (London), August 1953; "Bert Hardy" in *Camera* (Lucerne), August 1954; "Bert Hardy" by Harry Deverson in *Camera World* (London), November 1956; "What Photography Means to Bert Hardy" in *Popular Photography* (New York), October 1957; "A Day in the Life of a Ghost That Won't Lie Down" by Lionel Birch in *Creative Camera* (London), April 1973; "Giants of Fleet Street: Bert Hardy" by Leslie S. Shaw in the *British Journal of Photography* (London), 25 July and 1 August 1980.

Bert Hardy: *Two Boys in the Gorbals*, 1948

By sheer luck I became a photographer. It was the first job I got when I left school at the age of 14. I had no choice, as I needed the job to help my parents support our large family. I think I was very lucky, because I took to photography naturally; also, the period of the 35mm was just, but only just, starting. In the early days I learned only photo-processing, which it is essential to know about if you are going to be a successful photographer. As a photographer I was completely self-taught, chiefly by trial and error on old plate cameras. It was when I got my first 35mm camera—a Leica—that my photographic talent emerged, but from the beginning I did photographic sequences, now known as photo-journalism. I also made use of the 35mm camera's large aperture lenses fl.4 and used natural light no matter how poor. I never used flash, which in those early days was flash-bulbs; there were no electronics.

When *Picture Post* was launched in October 1938, I started to get stories published in it almost immediately through the firm I then worked for, General Photographic Agency. Later, In 1941, I joined the staff of the magazine and worked for it until it closed in 1957, except for my service as an Army Photographer from June 1942 until September 1946. After *Picture Post* folded I went into advertising. I retired gradually from serious photography from about 1967 and now happily farm, still taking a few photographs and retaining an interest in photography through my processing business, Grove Hardy Ltd.

—Bert Hardy

During his working life Bert Hardy was looked on as a photojournalist devoted to his craft, with a gift for being in the right place at the crucial moment and for making memorable pictures out of what he saw. Today he is coming to be considered one of the great recorders of social conditions in the tradition of John Thomson, Jacob Riis and Lewis Hine. "He belongs", one critic wrote, "to a British tradition which favours anecdote and human incident. He pictures people as characters, and his work is a rich source for any study of the folk-life of Britain, a modern continuation of the graphic tradition of Hogarth and Rowlandson."

From birth Hardy's life was cast in the classic mould of the poor boy who makes good by his own efforts: "We lived in a tenement. My father was a splint maker, a right old drunk. My mother went out charring. There were seven kids. I left school on a Friday afternoon, aged 14. On Saturday morning I answered a 'Boy Wanted' notice in a film developing and printing works. My job was to cycle round chemists, collect films and process them, and deliver the films back. Pay was ten bob a week...."

When he joined *Picture Post* early in the war Hardy's talent began to flower. He was ready to tackle anything, and his pictures of the Blitz were among the finest—and the closest to the action—taken by any cameraman. Later as an Army Photographer he roamed the world, photographing terrible sights, without ever losing his capacity to feel intensely the suffering he recorded. On entering the concentration camp at Luneberg, he says, "I was so sick with rage I could hardly take pictures."

Back in Britain after the war he moved, imperceptibly and almost unconsciously, into photographing the social scene, particularly life from the underside. His pictures in the Gorbals, and the Elephant and Castle before its demolition, have become classics, but what today are regarded as exposures were for him a recording of the flow of life as it goes on—not a denunciation but a tribute to the way humans cope with what life brings them, made with admiration and affection, not, like the Luneberg pictures, out of rage. In making them, however, Hardy learned something new about himself. As a man and a photographer he had long since found his strength, but he now began to realise that he was also—though he never used the word—an artist: "When I left the Gorbals I had a rare feeling, and then when I saw my pictures, I realized for the first time what I could do."

Though in his work he has ranged over a vast field, making pictures over half the world and of many of the great men of our day, in the end Hardy always comes back to the individual, the ordinary man or woman and—with a special perception but no sentimentality—the child. He has to feel and to make contact; it is impossible for him to be just a lens. Now retired to the country, he still misses taking pictures.... "although it used to kill me with nerves. I've never used a light meter or a rangefinder in my life. It's not my style. What would I like to photograph now? People. Faces. That man over there talking with his hands. Ordinary things. Life happening. I've always got on with ordinary people."

—Tom Hopkinson

HARTMANN, Erich.
American. Born in Munich, Germany, 29 July 1922; emigrated to the United States in 1938: naturalized, 1943. Educated at primary school, Munich, 1928-38; and at night school in the United States; self-taught in photography, but influenced by Alexei Brodovitch, E.H. Cassidy and Werner Bischof. Served in the United States Army, in Europe, 1943-45. Married Ruth E. Bains in 1946; children: Nicholas and Celia. Freelance photographer, New York and Maine, since 1946: industrial and advertising photography for IBM, Mead Paper, Bristol Myers, Boeing, Litton Industries, RCA, Merck, Ford Motor Company, Citroen, etc.; magazine and newspaper photography for *Fortune, The Daily Telegraph, The Sunday Times*, and *The Sun*, London, *Johns Hopkins Magazine, Venture, US Geo, Stern, Travel and Leisure, Americana*, etc.; Member, Magnum Photos, New York and Paris, since 1952. Lecturer, School of Journalism of Syracuse University, New York, 1969-70; Lecturer, New York University, since 1971. Recipient: Art Directors Award, New

York, 1968, 1977; *Photokina* Award, 1972; Address: c/o Magnum Photos Inc., 251 Park Avenue South, New York, New York 10010, U.S.A.

Individual Exhibitions:

1956 *Sunday under the Bridge*, Museum of the City of New York
1962 *Our Daily Bread*, New York Coliseum (travelled to the Department of Agriculture Gallery, Washington, D.C., 1963)
1971 *Mannequin Factory*, The Underground Gallery, New York
1973 *Europe in Space*, The Photographers' Gallery, London
1976 *Carnet de Voyage*, Photogalerie, Paris
1977 *Photographs with a Laser*, AIGA Gallery, New York
1978 *Play of Light*, Neikrug Gallery, New York
1979 *Mannequins and Lasers*, Galerie Fiolet, Amsterdam
1981 *Vu du Train*, Galerie Olympus, Paris

Selected Group Exhibitions:

1972 *Photokina*, Cologne

1979 *This Is Magnum*, Takashimaya Department Store, Tokyo
1980 *Magnum*, Galerie Le Cloître Hotel de Ville, St. Ursanne, Switzerland

Collections:

Museum of Modern Art, New York; Museum of the City of New York.

Publications:

By HARTMANN: book—*Au Clair de la Terre*, with text by Georges Bardawil, Brussels 1972.

On HARTMANN: books—*This Is Magnum*, exhibition catalogue, Tokyo 1979; *Magnum Photos*, exhibition catalogue, St. Ursanne, Switzerland, and Paris 1980.

Photographing combines the disciplines of craft with the ambiguities of language. It is a way of speaking which (I discovered by accident) suits my temperament.

I have a long-standing preoccupation with "commonplace" subject matter, especially with the world of working and of technology, the world in which we are inescapably imbedded. Thus a good deal of my work is autobiographical.

I suspect that photography will continue to waver between the counterpoints of technique and meaning and that, as now, most photographs will have form without content or vice versa. But, as now, among the millions of photographers there will always be some (it takes only a few) who will be able to make form and content into a clear and personal record of what they saw and felt in their time.

Those photographs will endure and that, in the end, is the purpose of the exercise.

—Erich Hartmann

Erich Hartmann claims a preoccupation with the commonplace; however, his idea of the "commonplace," hardly common, is based on an interest in industry and high technology, out of which he has developed an expertise in laser photography. To date he has exhibited several collections of his laser work in Europe and America.

Hartmann's photography is distinguished by an unstinting concern for documentary authenticity combined with great precision of composition. Whether his subject is the flourescent-lit plastic circuitry of an analog computer or the sunny greensward of an English garden, Hartmann renders its mood, its colors, its very presence with an image that seems to represent precisely the essence of the object.

It is no doubt Hartmann's ability to bring out the fascinating and even the poetic in the technological world that has attracted his numerous corporate and advertising clients. A master of technique, he does not hesitate to use the surprising angle or the unusual lens; however, his effect is always authenticity rather than manipulation. Since the 1950's Hartmann has published regular portfolios on industry and the industrial landscape in *Fortune* in the U.S. and the *Daily Telegraph Magazine* in London.

A measure of his versatility is Hartmann's contribution to *Au Clair de la Terre*, a book on the development of European space satellites. Hartmann's hundreds of photographs cover the full range of satellite production and use from the physics seminar to the testing lab to, as Hartmann puts it, the "ideas, speculations and intentions" that inevitably accompany man's penetration of space. In his sensitive visual realizations of such intangibles, Hartmann has made use of techniques that refract and filter light in fascinating ways—how well he understands that the root-meaning of the word "photography" is "light-writing!" As Hartmann knows, the images so achieved are symbolic rather than descriptive, and they help to express the optimistic mood that accompanies scientific and technological achievement. Yet, like all Hartmann's photographs, they express as well his precise vision and his pride in superior craftsmanship.

—Maren Stange

Erich Hartmann: *Leonard Hardin, Wheat Farmer, Centralia, Kansas*, from *Our Daily Bread*, 1962

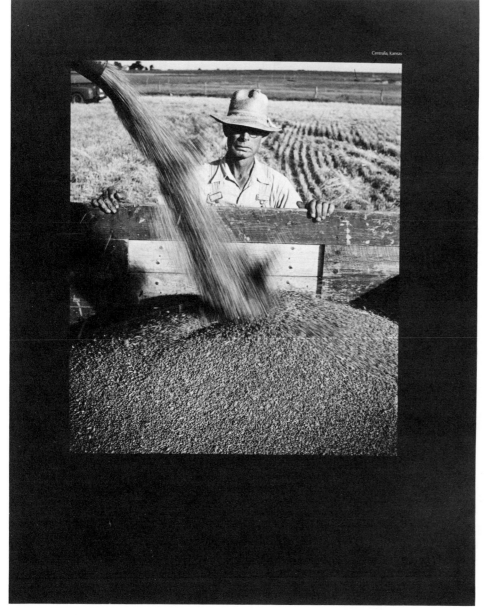

HARTWIG, Edward.
Polish. Born in Moscow, of Polish parents, 6 September 1909. Educated at a gymnasium in Lublin, Poland; studied under Professor Rudolph Kopitz and Professor Hans Daimler at the Graphische Institut, Vienna, 1932-34. Married Helena Jagiello in 1931; daughters: Danuta and Eva. Instructor in Art, College of Engineering, Lublin, 1937-38. Freelance photographer in Warsaw, since 1938. Member of the Editorial Board, *Almanach of Polish Art*

Photography, Warsaw, 1969-74. Co-Founder, 1953, Vice-President (and President of the Art Council), 1953-63, and Member of the Art Council, 1963-80, Polish Art Photographers Union; International Committee Member, Fédération Internationale de l'Art Photographique (FIAP), 1969-74. Recipient: Award for Achievements in Art Photography, City of Warsaw, 1961; Annual Cultural Award, Polish Ministry of Culture, 1965; Medal of the City of Bordeaux, France, 1968; Medal of the City of Paris, 1979. Honorary Member, Union of Polish Art Photographers (ZPAF), Warsaw, Fédération Internationale de l'Art Photographique (FIAP), Union of Czechoslovak Photographers, Union of Rumanian Photographers, Union of Danish Photographers, Photo Club, Linz, Austria, and the Photo Club, Bordeaux. Agent: Gallery of the Polish Art Photographers Union (ZPAF), Plac Zamkowy 8, Warsaw. Address: A1. Jerozolimskie 31/10, 00-508 Warsaw, Poland.

Individual Exhibitions:

1937 City Museum, Lublin, Poland
1944 City Museum, Lublin, Poland
1954 National Museum Wroclaw, Poland
1957 Zacheta Gallery, Warsaw
1959 Société Francaise de Photographie, Paris
1962 *Behind the Theatrical Scenes*, Palace of Culture, Warsaw (toured Europe and the United States)
 Gallery of the Central Bureau of Artistic Exhibitions/Union of Polish Art Photographers, Toruń, Poland (travelled to Gdansk)
1965 Art Foto Gallery, Prague
1971 Société Francaise de Photographie, Paris
1972 Zacheta Gallery, Warsaw
1975 *Behind the Theatrical Scenes*, travelling exhibition (toured Poland and the United States)
 Foto Gallery, Bratislava, Czechoslovakia
1979 Budapesti-Fotoclub, Budapest
 My World 1930-78, Zacheta Gallery, Warsaw (retrospective)
1980 Bureau of Artistic Exhibitions Gallery, Toruń, Poland
 Union of Polish Art Photographers Gallery, Warsaw (retrospective)

Selected Group Exhibitions:

1965 *Photokina*, Cologne
1969 *10 Photographers of the World*, Neustadt Galerie, Vienna
1975 *10 Great Art Photographers of FIAP*, at the *FIAP International Congress*, Padua
1976 *10 European Photographers*, Gallery of the Cracow Photographic Society

Collections:

Museum of Contemporary Art, Lodz, Poland; National Museum, Wroclaw, Poland; Murray Forbes Collection, Cambridge, Massachusetts.

Publications:

By HARTWIG: books—*Photo-Graphics*, Warsaw, 1958, 1960; *My Country*, Warsaw 1960; *Acropolis*, Warsaw 1962; *Pieniny*, Warsaw 1963, 1966; *Cracow*, Warsaw 1965, 1969; *Behind the Theatrical Scenes*, Warsaw 1969; *Warsaw*, Warsaw 1974, 1978; portfolios—*Edward Hartwig*, Prague 1966; *Edward Hartwig: Photographic Subjects*, Warsaw 1978; *Edward Hartwig: Photographic Impressions*, Warsaw 1979.

On HARTWIG: article—by Fritz Kempe in *Foto Magazin* (Munich), no. 1, 1971.

Edward Hartwig has created a large and diverse output of photographs.

In the beginning he was a photographer of nature, and landscape is a theme to which he has repeatedly returned throughout his career. This interest developed very early in his life: in his teens he wished to become a painter and took classes in drawing and painting, and, although he never did become a painter, his work has always shown a fascination with nature, the soil and the landscape—traditional subjects in the fine arts. Hartwig's landscapes are not empty or depersonalized; quite frequently (especially in his work of the inter-war years) there are people in them, people within their own landscapes. He is not only a photographer of landscape but also an ethnographer.

Hartwig was educated in fine arts at the Graphische Institut in Vienna, where he attended life classes and studied portraiture in the studio of Rudolph Kopitz. Among the courses he took there were photography and graphics, which involved a wide range of technical experiments at the "boundaries" of those subjects. This experience was to play a significant part in his work, for, later, he was to apply various formal experiments to his photographs. Frequently they were technical experiments in his darkroom, involving processes such as overexposure, superimposition, numerous optical effects with light, mirrors, etc. These treatments so radically transformed the character of his work that, in a sense, it ceased to be photography and became a sort of photo-graphics. It is relevant that Hartwig was involved with this kind of photography in the 1950's and 60's, a period in which expressive abstraction and the continuous questioning of traditional art-forms predominated.

No presentation of Hartwig's photography would be complete without mentioning his interest in the theatre. Not only has he produced numerous photographs about that art form—including the series *Behind the Theatrical Scenes*—but also his photography itself has much in common with the theatre—dynamism, situational arrangement, a certain exoticness, a sense of the unusual.

Edward Hartwig occupies a quite significant position in the history of Polish photography. He is noted for his interest in traditional landscape and portrait photography; at the same time, he is known for his continuous search for new forms and methods, a search in which his photographic ideas run parallel with various trends in painting.

—Ryszard Bobrowski

Edward Hartwig: *Zacheta Exhibition*, 1957

HASKINS, Sam(uel Joseph).

South African. Born in Kroonstad, 11 November 1926. Educated at Helpmekaar High School, Johannesburg; studied graphics at the Witwatersrand Technical College, Johannesburg, and photography at Bolt Court School, London, 1947-50. Married Alida Elzabe van Heerden in 1952; sons: Ludwig and Konrad. Freelance graphic artist, Johannesburg and London, until 1948. Freelance book, fashion and advertising photographer, London, since 1950: established Haskins Studio and Haskins Press, London. Recipient: Prix Nadar, France, 1964; Silver Medal, *International Art Book Competition*, 1969; Gold Medal, Art Directors Club of New York, 1974; Book of the Year Award, Kodak, 1980. Fellow, Royal Photographic Society, and Society of Industrial Artists and Designers, London. Address: 9A Calonne Road, London SW19, England.

Individual Exhibitions:

1953 *Haskins Photographs*, Castle Mansions, Johannesburg
1960 *Photographic Illustration*, Orrco Theatre, Johannesburg
1970 *Sam Haskins*, Pentax Gallery, Tokyo
 Sam Haskins 70, Isetan Gallery, Tokyo
1972 *Haskins Posters*, The Photographers' Gallery, London (travelled to the FNAC Gallery, Paris, 1973, and the Camera Gallery, Amsterdam, 1974)
1973 *The Girls*, Isetan Gallery, Tokyo
1976 *Scandinavian Landscape*, Isetan Gallery, Tokyo
 Calendar '77, Pentax Gallery, London

1979 *New Work*, Pentax Gallery, London
1980 *Photo Graphics*, National Theatre, London (travelled to the Kodak Gallery, London, Sainsbury Centre, Norwich, and Royal Photographic Society Gallery, Bath, 1980; and Hillhead Gallery, Glasgow, Pentax Gallery, Rotterdam, Pentax Gallery, Zurich, Pentax Forum Gallery, Tokyo, and Marjorie Neikrug Gallery, New York, 1981)

Selected Group Exhibitions:

1970 *4 Masters of Erotic Photography*, at *Photokina '70*, Cologne (toured Europe)
1972 *Who Are You*, Gimpel Fils, London
1973 *The Top 10 Photographers*, McMaster University, Hamilton, Ontario

Publications:

By HASKINS: books—*5 Girls*, New York 1962, 1967; *Cowboy Kate and Other Stories*, with an introduction by Normal Hall, London 1964, 1976; *November Girl*, with text by Desmond Skirrow, London 1966; *African Image*, with a foreword by L. Fritz Gruber, London 1967; *Haskins Posters*, London and Zurich 1972; *Photo Graphics*, Geneva 1980.

On HASKINS: books—*4 Meister der Erotischen Fotografie: Dokumentation einer Fotoausstellung*, with texts by Robbe-Grillet, Mishima, Naumann and Cau, Munich 1970; *Art Directors' Index to Photographers 2*, London 1971; *Graphis Posters 1974*, edited by Walter Herdeg, Zurich 1974; *Eve Today*, Chicago 1974; *Masterpieces of Erotic Photography*, London 1979; *Geschichte der Fotografie im 20. Jahrhundert/Photography in the 20th Century* by Petr Tausk, Cologne 1977, London 1980; articles—"Glamor by Sam Haskins" in *Photography Annual 1963*, New York 1962; "Five Girls" by Andreas Feininger in *Infinity* (New York), March 1963; "Sam Haskins" in *Camera* (Lucerne), April 1969; "Sam Haskins" by Ulf Sjostedt in *Hasselblad* (Gothenburg, Sweden), no. 4, 1969; "Four Masters of Erotic Photography, Photographers' Gallery" by G.S. Whittet in *Art and Artists* (London), August 1971; "Haskins: The Man, The Photographer, The Technician" by J. Shire in *Photo Technique* (London), November 1972; "The Apple in Sam's Eye" by J. Sandilands in the *Daily Telegraph Magazine* (London), 13 October 1972; "Sam Haskins: The Apple" by Shoji Yamagishi in *Camera Mainichi* (Tokyo), June 1973; "Sam Haskins" by J. Boivin in *Zoom* (Paris), no. 16, 1973; "Sam Haskins: Fashion Photographs" in the *Daily Telegraph Magazine* (London), 8 November 1974; "Art: Fun and Eros" by L. A. Mannheim in *Modern Photography* (New York), August 1975; "Sam Haskins' Photo-Graphics" by Walter Nurnberg in *British Journal of Photography* (London), 22 August 1980; "Sam Haskins: Paper Chaste" in *American Photographer* (New York), April 1981; film—*Sam Haskins*, directed by W. Webb, London 1973.

Artists do not owe the world anything—least of all explanations.

—Sam Haskins

Born in South Africa, Sam Haskins was perhaps fascinated from his youth with the ritual sculptures made from wood by the natives. For early on in his work one sees a certain dreamlike quality that ripens into a predilection for the surrealistic features hidden in reality as well as for unexpected juxtapositions. In his studio in London there is a great collection of various found-objects, either bought by him in second-hand shops around the world or discovered among other people's discards. Haskins likes

creative games. He will, for example, reassemble familiar products into a new kind of object, the tangible result of an accidental vision. Some of these creations have become known through his photographs, where they function as supplements to the complete composition.

The fame of Sam Haskins is closely connected with his photographs of nudes. His wonderful sense for the surrealistic was already apparent in his early book *Cowboy Kate* in which he created charming visions of an unclothed girl acting as sheriff hunting a felon. It is marvellous persiflage, a meeting of the worlds of glamour and the western.

The creative fantasies are, however, combined with an unerring sense of composition: surprising subjects are shown to have an epic content, expressed in a perfect form. Perhaps that is why so many of his images have been used on large size calendars and for posters: they are dominating photos, yet they repay continual contemplation.

Sam Haskins: *Dancer*, 1978

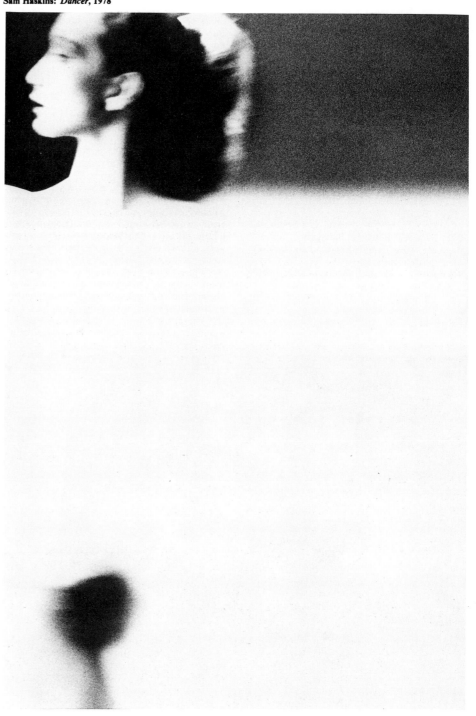

Haskins' images are perhaps most dramatic when they are of these worlds of his own construction; however, this is not the only approach that he has used in his work. He has taken a great number of pictures of native life in South Africa—ritual dances, the hunt that still involves primitive weapons—and discovered in these motifs some almost magical features. In his magnificent book *African Image* he juxtaposed these photographs with, on opposite pages, images of old idols—and the comparison serves to emphasize the poetry of his subconscious sources.

Thus the same mental and emotional impetus informs such apparently quite different subjects as nudes and the customs of natives.

—Petr Tausk

HASSNER, Rune.
Swedish. Born in Österlund, 13 August 1928. Studied photography with Rolf Winquist, Stockholm, 1947-49. Married Eva Polasek in 1958. Freelance photographer, Paris, 1949-57, and Stockholm, since 1957; Founder-Member, Tio Fotografer group, Stockholm, since 1958. Address: Bastugatan 12B, 11720 Stockholm, Sweden.

Individual Exhibitions:

1951 Rotohallen, Stockholm
1962 *Indian Village*, Pub Gallery, Stockholm
Nimba, Museum of Art, Eskilstuna, Sweden

Selected Group Exhibitions:

1949 *Unga Fotografer*, Rotohallen, Stockholm
1951 *Jeunes Photographes Suédoises*, Galerie Kodak, Paris
Subjektive Fotografie 1, Staatliche Schule für Kunst und Handwerk, Saarbrucken (and 2, 1954)
1958 *Fotokonst 1958*, City Art Gallery, Lund, Sweden
1959 *Young European Photography*, Van Abbemuseum, Eindhoven, Netherlands
1963 *Photography '63*, International Museum of Photography, George Eastman House, Rochester, New York
1971 *Contemporary Photographs from Sweden*, Library of Congress, Washington, D.C. (toured the United States)
1976 *Tio Fotografer*, Galerie Aronowitsch, Stockholm
1977 *Tio Fotografer*, at *Rencontres Internationales de Photographie*, Arles, France (travelled to La Photogalerie, Paris)

Collections:

Moderna Museet, Stockholm; Norsk Fotohistorisk Forening, Oslo; Museum of Photography (Valokuvamuseon), Helsinki; Bibliothèque Nationale, Paris; Library of Congress, Washington, D.C.

Publications:

By HASSNER: books—*Parispromenad*, with text by Sven Aurén, Stockholm 1951; *Sköna Frankrike*, with text by Sven Stolpe, Stockholm 1953; *Jambo*, with text by O. Strandberg, Stockholm 1954; *Lättjans Öar*, with text by O. Strandberg and Hassner, Stockholm 1956; *Det Nya Kina*, Stockholm 1957; *Vår Indiska By*, with text by S.O. Andersson, Stockholm 1962; *Edouard Boubat*, exhibition catalogue, Stockholm 1967; *Jacob A. Riis: Reporter med Kamera i New Yorks Slum*, Stockholm 1970; *Rolf Winquist*, exhibition catalogue, Stockholm 1970; *De Bittra Åren*, exhibition catalogue, Stockholm 1970; *André Kertész*, exhibition catalogue, Stockholm 1971; *Jacob A. Riis*, exhibition catalogue, Essen 1971; *Hur den Andra Hälften Levde*, exhibition catalogue, Stockholm 1972; *Erich Salomon*, exhibition catalogue, Stockholm 1974; *Felix H. Man*, exhibition catalogue, Stockholm 1975; *Bilder för Miljoner*, Stockholm 1977; articles—"Sir Jake och Survey-Fotograferna" in *Populär Fotografi* (Helsingborg, Sweden), September 1970; "David Douglas Duncan och Krig Utan Hjältar in *Fotonyheterna* (Stockholm), no. 5, 1972; "När kulturrevolutionen kom till USA" in *Paletten* (Gothenburg), January 1976; "Rol & Meurisse" in *Aktuell Fotgrafi* (Helsingborg, Sweden), December 1978; "Mass Observation, Picture Post och Humphrey Spender" in *Aktuell Fotografi* (Helsingborg, Sweden), November 1980.

On HASSNER: articles—"Rune Hassner: From Morocco to Cape Town" by B. Dobell in *U.S. Camera* (New York), January 1955; "Entretien avec Rune Hassner" by Romeo Martinez in *Camera* (Lucerne), September 1956; "Rune Hassner: Världsreporter" by B. Gustafsson in *Foto* (Stockholm), March 1962; "Rune Hassner, Star Photographer" by Norman Hall in *Photography Yearbook*, London 1963; "Rune Hassner: Forskande Fotograf" by Kurt Bergengren in *Fotonyheterna* (Stockholm), no. 10, 1970.

During the Second World War neutral Sweden experienced an increase in national pride. In photography this found expression in romantic-patriotic imagery. The idyllic dominated the photo-club competitions and exhibitions—far removed from the tragic reality outside the country's borders. When the war was over, there was, not surprisingly, a counter-reaction among the country's young photographers. They reacted not only against charmingly seductive images of reality, as reflected in these photographs, but also against an idiom which had become a stereotype. In 1949 a group of young photographers organized an exhibition in Stockholm: it amounted to open provocation. These 11 photographers were dubbed "De Unga" (The Young). But they had no long-term objectives, and after their attack on the photographic establishment, each one returned to his own speciality: fashion, journalism, nature photography, etc. Rune Hassner was the one who came to represent the young radicals in print. He readily entered into polemics in the trade journals with his older and shocked colleagues. His literary style was just as hard-hitting as his pictorial.

Having attempted to demolish the photographic idyll with both words and pictures, Hassner left for Paris, along with a number of other young Swedish photographers. In France he quickly established himself as a creator of reportage, and he supplied the Swedish newspapers with photos from the worlds of culture, politics and fashion. But for preference he would saunter around and photograph daily life, and these photos were the basis of two books. At the same time he provided Swedish photographic periodicals with reports on the new European photography.

Hassner's photographic ideals were similar to those of the more personally and poetically engaged photojournalists. Experimental photography—as for example in the exhibition *Subjektive Fotografie*—he found largely meaningless and superficially picturesque. His attacks on the experimental as well as the romantically idyllic may seem inconsistent, but, as he asserted, he felt that photographs should communicate something essential about our surroundings, not function as playgrounds for aesthetic games.

During the 1950's Hassner produced another three books—on Africa, the West Indies and China, the last with his own text. After this period, like many of his colleagues in the Tio group, he gradually became involved with motion pictures. He has made more than 30 documentary films for Swedish Television, many of them about photographers and photographic history. His interest in the latter is also evidenced by books and by the number of his articles in journals.

During recent years, therefore, Rune Hassner has appeared mostly in the roles of filmmaker, photographic historian and teacher—but at the same time he has continued collecting his visual impressions in still photography, a medium that is still obviously very close to his heart.

—Rune Jonsson

Rune Hassner: *Mukhmelpur, India*, 1963

HAUSMANN, Raoul.
Austrian. Born in Vienna, 12 July 1886. Studied painting with his father Victor Hausmann, Vienna, until 1901; also studied at the Akademie der Schöne Künste, Berlin, 1901; mainly self-taught in photography. Worked as independent illustrator and critic, Berlin, 1907-12; independent painter, sculptor, writer and photomontagist, associating with *Der Sturm* group, 1912, and *Aktion* group, 1914, and with Dadaist artists (as "le Dadasophe"), 1919-21, in Berlin, 1912-21, in Prague, 1921, and in Hannover, 1923; abandoned painting, Berlin, 1923; concentrated on photography and writing, Berlin and Cologne, 1927-33, in Spain and France, 1933-39; lived in Peyrat-le-Château, France, 1939-44; worked mainly as painter, publicist and writer, Limoges, France, 1944 until his death, 1971. Founder-Editor, *Der Dada* review, Berlin, 1919; Organizer, with George Grosz and John Heartfield, first *Dada Exhibition*, Berlin, 1919; member, *Novembergruppe* artists' group, Berlin, 1919; contributing editor, *A bis Z* magazine, Cologne, 1930. *Died* (in Limoges) *1 February 1971.*

Individual Exhibitions:

1931 Staatliches Museum, Berlin
1936 Musée des Arts et Metiers, Zurich
 Arts and Crafts Museum, Prague
1947 Galerie Chamoleau, Limoges, France
1949 Galerie Graphique, Paris
1952 Otto Steinert School, Saarbrucken, West
 Germany
1953 Galerie D'Orsay, Paris
1961 Museum of Contemporary Art, Dallas
1963 Galleria de Grattacielo Pagani, Milan
1966 Bodley Gallery, New York
1967 Moderna Museet, Stockholm
1978 *40 Photos 1931-57*, Galerie L'Oeil 2000,
 Chateauroux, France
1979 *Kamerfotografie: Raoul Hausmann and
 Verena von Gagern*, Neue Sammlung,
 Munich
1980 Berlinische Gallery, West Berlin
 Konsthall, Malmo Sweden
1981 Kunstverein, Frankfurt (with Hannah
 Höch)

Selected Group Exhibitions:

1936 *International Photographic Exhibition*,
 Salon of Photography, Prague
1937 *Fantastic Art, Dada and Surrealism*, Mu-
 seum of Modern Art, New York
1961 *The Art of Assemblage*, Museum of Modern
 Art, New York (toured the United States)
1962 *Poèmes et Bois: Photomontages*, Institute of
 Contemporary Arts, London
1964 *The Painter and the Photograph; From
 Delacroix to Warhol*, University of New
 Mexico, Albuquerque
1967 *Collages '67*, Kunsthaus, Zurich (travelled to
 Kunstverein, Cologne)
1969 *Die Fotomontage*, Stadttheater, Ingolstadt,
 West Germany
1979 *Dada Photomontagen*, Kestner Gesellschaft,
 Hannover
 *Photographie als Kunst 1879-1979/Kunst
 als Photographie 1949-1979*, Tiroler
 Landesmuseum Ferdinandeum, Innsbruck,
 Austria (travelled to Neue Galerie am
 Wolfgang Gurlitt Museum, Linz, Austria;
 Neue Galerie am Landesmuseum Joan-
 neum, Graz, Austria; and Museum des 20.
 Jahrhunderts, Vienna)
1980 *Avant-Garde Photography in Germany,
 1919-1929*, San Francisco Museum of
 Modern Art (toured the United States
 1981-82)

Collections:

Marthe Prevot, Atelier Raoul Hausmann, Limoges,
France; Centre de Documentations des Arts Plas-
tiques, Paris; Musée d'Art Moderne, Paris; Na-
tionalgalerie, West Berlin; Tate Gallery, London.

Publications:

By HAUSMANN: books—*Material der Malerei,
Plastik, Architektur*, Berlin 1918; *Hurra! Hurra!
Hurra!*, Berlin 1920, Steinbach, West Germany
1970; *A Return to Objectivity in Art*, manifesto,
Berlin 1920; *Traite des Questions san Solutions
Importants*, Basle 1957; *Courrier Dada*, Paris 1958;
Poèmes et Bois, Paris 1961; *Siebessachen*, Stuttgart
1961; *Pin and the Story of Pin*, with Kurt Schwit-
ters, London 1962; *Portefeuilles avec Sept Lithog-
raphies*, Milan 1963; *Hylt, ein Traumsein in Spa-
nien*, Frankfurt 1969; *Melanographie*, Paris 1969;
Sensonalité Excentrique, Cambridge, England 1969;
Sagemorcin, Brussels 1969; *Am Anfang War Dada*,

Steinbach, West Germany 1970, 1972; *Les Mani-
festes et Satires Dada*, edited by Sabine Wolf, Paris
1975; *Je ne suis pas un Photographe*, Paris 1975;
Raoul Hausmann, portfolio of 12 photos, edited by
Roger Vulliez, Nice 1978; articles—"Du Film par-
lant a l'Optophonetique" in *G* (Berlin), no. 1, 1923;
"Viking Eggeling" in *A bis Z* (Cologne), no. 9, 1930;
"Photomontage" in *A bis Z* (Cologne), no. 22, 1932;
"Formaldialektik der Fotografie" in *A bis Z* (Co-
logne), no. 24, 1932; "Que voit le Photographe" in
Das Deutsche Lichtbild (Berlin), 1933; "Ibiza" in
Camera (Lucerne), 1936; "Photomontage Phone-
tique" in *Plastique* (Paris), no. 1, 1937; "Photogra-
phie en Couleur" in *Camera* (Lucerne), 1937; "Possi-
bilités de la Photographie Infrarouge" in *Fotogra-
ficki* (Prague), no. 1, 1938; "Techniques et Conditions
du Photogramme" in *Camera* (Lucerne), no. 4,
1957; "Photographie Subjective" in *Camera* (Lu-
cerne), no. 3, 1959; "Je n'etais pas un Photographe"
in *Blätter und Bilder* (Berlin), no. 1, 1959; "Dada,
Anti-Art and Photomontage" in *Image* (Rochester,
New York), vol. 14, no. 3, 1971; "La Photographie
Moderne comme Processus Mental" in *Projectoires*
(Paris), no. 1, 1975.

On HAUSMANN: books—*Dada: Monograph of a
Movement* by Willy Verkauf, Teufen, Switzerland
1957, London and New York 1975; *Dada: Art and
Anti-Art* by Hans Richter, Brussels 1965; *Die Col-
lage* by Herta Wescher, Cologne 1968; *Fotomon-
tage: Geschichte und Wesen einer Kunstform*, exhi-
bition catalogue, by Richard Hiepe, Ingolstadt,
West Germany 1969; *Prologomenes à une Mono-
graphie de Raoul Hausmann* by J.F. Bory, Paris
1972; *The Painter and the Photograph: From Dela-
croix to Warhol* by Van Deren Coke, Albuquerque,
New Mexico 1972; *Photographie als Künstlerisches
Experiment* by Willy Rotzler, Lucerne and Frank-
furt 1974; *Raoul Hausmann*, exhibition catalogue,
Paris 1974; *Photomontage* by Dawn Ades, London
1976; *Geschichte der Fotografie im 20. Jahrhun-
dert/Photography in the 20th Century* by Petr
Tausk, Cologne 1977, London 1980; *Dada and Sur-
realism Reviewed*, exhibition catalogue, by Dawn
Ades, London 1978; *Das Experimentelle Photo in
Deutschland 1918-40* by Emilio Bertonati, Munich
1978; *Raoul Hausmann: Kamera Fotografien 1927-
1957* by Andreas Haus, Munich and Paris 1979;
*Photographie als Kunst 1879-1979/Kunst als Pho-
tographie 1949-1979*, exhibition catalogue, 2 vols.,
by Peter Weiermair, Innsbruck, Austria 1979; *Dada
Photomontagen*, exhibition catalogue, by Carl-
Albrecht Haenlein and others, Hannover 1979;
Experimental Photography, exhibition catalogue,
by Dawn Ades, London 1980; *Avant-Garde Photog-
raphy in Germany 1919-1939*, exhibition catalogue,
by Van Deren Coke, Ute Eskildsen and Bernd
Lohse, San Francisco 1980.

The bloody and dislocating events of the First
World War gave rise to a number of new artistic
movements, to new ideas about the relationship
between art and society and to new modes of expres-
sion within the arts. Unlike any other, Dada was a
new spirit in art, a spirit which was not only anti
science and government, but was also anti-art. Dada
was against many other things; its subsequent fame
rests on its unremitting refusal to accept life, art or
culture as they were. As it was not an organized
movement, its adherents throughout Europe found
their own ways of working and organizing. In Ber-
lin, because of the political situation in which they
found themselves, Dadaists became involved with
revolutionary political movements while retaining
their spirit of lively nihilism.

Raoul Hausmann, an influential member of the
Berlin group, was talented in a number of arts; he
worked as a painter and sculptor and composed a
number of abstract and phonetic poems which, in true
dadaist style, attempted to dislocate the sound of
words from any system of meaning. Hausmann took
part in many Dada events and was an editor of the

magazine *Der Dada*; his subsequent reputation,
however, was based not on poetry or writing but on
the art objects he constructed and on the new status
and social location which these helped to give to art.

Hausmann together with another member of the
group, Hannah Höch, claimed to have invented
photomontage and, although this technique has a
longer history than the Dadaists knew, he certainly
used it in innovatory ways. He collaged newspaper
cuttings, advertisements, type and photographs into
dynamic forms layered with meaning. Hausmann
said of the Berlin Dadaists that they wanted to be
engineers rather than artists, and the integration of
ordinary, unconsidered material into his work was
partly in the service of this ambition: to strip art of
its claims to reverence and almost sacred prestige.
At the same time, Hausmann was aware of the for-
mal characteristics of the technique and of its
immense possibilities as a new way of representing
the world. He regarded photomontage as possessing
a new power for propaganda and described it as "an
explosive mixture of different points of view and
levels, more extreme in its complexity than Futurist
painting." Hausmann's best work does demonstrate
this, but the complexity of points of view and levels
often led his work into over elaborate forms which,
lacking a central thematic or compositional unity,
disperse the spectator's energy and transform the
work into being merely an interesting assembly of
discrete items.

—Derrick Price

HÄUSSER, Robert.

German. Born in Stuttgart, 8 November 1924. Edu-
cated at gymnasium in Stuttgart, until 1941; Graph-
ische Fachschule, Stuttgart, 1941-42; Meisterschule
für Handwerk und Kunst, Weimar, 1950, Meister-
diplom, 1950. Served in the German Army, 1944-45.
Married Elfriede Meyer in 1946; daughter: Regine.
Photographer since 1950: established studio, Mann-
heim, 1952. Member since 1950, Jury Chairman,
1965-68, Executive Director, 1976-80, and since
1980 Acting Chairman, Gesellschaft Deutscher
Lichtbildner (GDL); Member, Deutsche Gesellschaft
für Photographie, since 1960, and Deutschen
Werkbundes, since 1960; Founder-Member, Bund
Freischaffender Fotodesigner (BFF), since 1969;
Member, Deutschen Künstlerbundes, since 1979,
and Neuen Darmstädter Sezession, since 1980.
Recipient: Silver Medal, Swedish Master Competi-
tion, 1950; *Photokina*-Plaque, Cologne, 1960; Gold
Medal, *Biennale*, Venice, 1961; Special Prize, City
of San Remo, Italy, 1963; German City Prize, 1965;
Schiller Plaque, City of Mannheim, 1977. Agents:
Benteler Galleries Inc., 3830 University Boulevard,
Houston, Texas 77005, U.S.A.; Galerie Margarethe
Lauter, D-6800 Mannheim 1; and Galerie Rudolf
Kicken, Albertusstrasse 47-49, D-5000 Cologne 1.
Address: Ladenburgerstrasse 23, D-6800 Mannheim
31, West Germany.

Individual Exhibitions:

1959 Galerie Probst, Mannheim
1960 Landesbildstelle, Hamburg
 Swansea-Toulon-Mannheim, Reise-Museum,
 Mannheim
1961 *Toulon-Mannheim*, Toulon Opera
1970 Galeria Van der Voort, Ibiza, Spain
1971 Kunstverein, Augsburg, West Germany
1972 Kunsthalle, Mannheim

Leopold-Hoesch-Museum, Düren, West Germany
Konfrontatie, Van Abbemuseum, Eindhoven, Netherlands
Magischer Realismus, Institut für Moderne Kunst, Nuremberg
Kunsthalle, Cologne
Die Neue Sammlung, Munich
1973 Kunsthalle, Bielefeld, West Germany
Kunstmuseum, Bonn
Paula-Modersohn-Becker-Haus, Bremen
Kulturhaus, Soest, West Germany
1974 Museum am Dom, Lubeck
1975 *Magischer Realismus*, Galerie der Deutsche Gesellschaft für Photographie, Cologne
1977 Galerie Spectrum, Hannover
1978 Galerie Lauter, Mannheim (partial retrospective)
Industriefotografie and *Magischer Realismus*, Kulturhaus der BASF, Ludwigshafen, West Germany
1979 Kunstverein, Pforzheim, West Germany

Selected Group Exhibitions:

1961 *Biennale*, Venice
1963 *Angewandte Kunst in Europa nach 1945*, Museum für Kunst und Gewerbe, Hamburg
1969 *Vision and Expression*, International Museum of Photography, George Eastman House, Rochester, New York
1971 *Eros en el Arte Actual*, Galeria Vandres, Madrid
1973 *Das kleinste Museum-Tabu Format*, Kunstverein, Wolfsburg, West Germany (travelled to the Kunsthalle, Baden-Baden, West Germany)
1975 *Fotoauge—gestern und heute*, Württembergischer Kunstverein, Stuttgart
1976 *Deutscher Künstlerbund*, Kunsthalle, Mannheim (and subsequent annual exhibitions, 1977-80)
1977 *Fotografie 1842-1977*, Museum für Kunst und Gewerbe, Hamburg
1979 *Deutsche Fotografie nach 1945*, Kunstverein, Kassel, West Germany (toured West Germany)

Collections:

Kunsthalle, Mannheim; Leopold-Hoesch-Museum, Düren, West Germany; Städtische Kunstsammlungen, Wilhelm-Hack-Museum, Ludwigshafen, West Germany; Museum Folkwang, Essen; Staatliches Museum für Kunst und Gewerbe, Hamburg; Die Neue Sammlung, Munich; Stedelijk Van Abbemuseum, Eindhoven, Netherlands; Museum of Modern Art, New York; International Museum of Photography, George Eastman House, Rochester, New York; Gernsheim Collection, University of Texas at Austin.

Publications:

By HÄUSSER: books—*Ein Fotograf sieht Mannheim*, Mannheim 1957; *Heidelberg*, Konstanz 1961; *Welt am Oberrhein*, Karlsruhe 1961, 1962, 1963; *Aus unseren Fenstern*, Mannheim 1962; *Das Elsass*, Karlsruhe 1962; *Weinland Baden*, Mannheim 1969; *Ladenburg*, Mannheim 1970; *Gelsenkirchen*, Dusseldorf 1970; *Der Bildhauer Hans Nagel*, Nuremberg 1971; *Der Maler K.F. Dahmen*, Munich 1972; *Mannheim*, Mannheim 1975; *Die Welt der Oper*, Karlsruhe 1977; *Weinland Pfalz*, Mannheim 1979; *Das Geschenk der Erde*, Dusseldorf 1980; articles—"Zur Fotografie in der Kunstszene" in *Kunstreport* (Berlin), no. 2/3, 1975; "Fragen an einen Fotografen" in *Werk und Zeit* (Darmstadt), no. 6, 1976; "Spuren und Zeichen im Um-Raun" in *Leica Fotografie* (Frankfurt), no. 7, 1978; "Uber die Kunst, Kunst zu fotografieren" in *Leica Fotografie* (Frankfurt), no. 6, 1980.

On HÄUSSER: books—*Ein Meister der neuen Ding-Magie*, exhibition catalogue, by Juliana Roh, Augsburg, West Germany 1970; *Robert Häusser* by Heinz Fuchs, Mannheim 1972; *Robert Häusser: Fotografische Bilder*, exhibition catalogue, by Horst Keller, Cologne 1972; *Robert Häusser: Konfrontatie*, exhibition catalogue, by Jan Leering, Eindhoven, Netherlands 1972; *Robert Häusser*, exhibition catalogue, by J.W. von Moltke, Bielefeld, West Germany 1973; *Die Fremdheit des Vertrauten* by Ulrich Weisner, Lubeck 1974; *Geschichte der Fotografie im 20. Jahrhundert/History of Photography in the 20th Century* by Petr Tausk, Cologne 1977, London 1980; articles—"Robert Häusser" by Robert

d'Hooghe in *Foto Prisma* (Dusseldorf), October 1958; "Robert Häusser" in *Das Deutsche Lichtbild*, portfolio, Stuttgart 1959; "Robert Häusser: Meister der Leica" by Fritz Kempe in *Leica Fotografie* (Frankfurt), no. 6, 1971; "Kamera-Magie" by E. Pfeiffer-Belli in *Süddeutsche Zeitung* (Munich), 29 July 1971; "Robert Häusser: Poetischer Naturalismus" by Rainer Fabian in *Die Welt* (Hamburg), 17 August 1971; "Robert Häusser: Fotografischer Realismus" by Juliana Roh in *Gebrauchsgraphik* (Munich), no. 10, 1972; "Robert Häusser: Erfüllung durch Fotografie und Lebenskunst" by Gunther Lensch in *Foto-Magazin* (Munich), December 1974; "Zwei Weisen sich ein Bild zu machen" by R. Skasa-Weiss in *Stuttgarter Zeitung*, 2 October 1975; "Magie der Banalität" by Hugo Schöttle in *Leica Fotografie* (Frankfurt), no. 1, 1976; "Robert Häusser" by Hans Christian Adam in *Fotografie* (Riesweiler, West Germany), no. 4, 1977.

I use photography not to try to produce an autonomous picture of reality; what interests me is an interpretation of reality. I find it more important to evoke the creative quality of reality than to compose a picture of the world.

Photography ensures that I stay within the bounds of reality and that along the way I may perhaps make visible a further reality. Such pictures are records not as reproductions but as the making visible of an inner state by visual and optical articulation. If this is successful, the picture is conclusive. It means analysis, recognition and an adequate formal proficiency. The discovery of form is accounted for by the content because form serves content, illuminates it, and is determined by it. But the discovery of form presupposes the discovery of content: an analysis of the visible and invisible. This spiritual process requires us to question and learn by listening to the inner reality which hides behind the visible. It is the other dimension which constitutes existence: the essential. But I will have nothing to do with formal tricks, however great their aesthetic appeal. They are, and remain, only decorative.

> I take that which is,
> I ask what is? and I try to show that
> Which is.

—Robert Häusser

Robert Häusser is something of a classic in modern post-war German photography. It is difficult to think of any other contemporary photographer who has, over a period of 30 years, followed so straight a course in the shaping, development and consistent pursuit of his own creative handwriting. For Häusser photography is a medium with not only strict graphic principles but also its own laws, with which the photographer can interpret both his environment and his own personal world.

Häusser's black-and-white landscapes of the 1950's and 60's are rich in contrast and are distinguished by their perfect stillness. They are nearly always devoid of people. If a human figure is included, it is frozen to a black silhouette or signifies by its transitoriness, by the blurring of an isolated movement within otherwise rigid elements of the picture, that complete stillness will return immediately.

Even the subjects of Häusser's pictures are not important; they serve only to construct the whole. Häusser takes up the principles of "land art": he finds impressive lines in the man-made environment. He reduces everything (by selective cutting, black-and-white contrast and other creative possibilities of photography) that could trigger an idea other than that which he wishes for his composition; he "subtracts" objects until there remains only what is important to the picture in the way of strong shapes and lines.

In recent years Häusser's realism has become

Robert Häusser: *J.R. 5.9.70*, 1970

increasingly subjective and now contains mysterious, magical elements: he adds to his pictures (as always void of all superfluity) objects, forms, veiled bodies; he leaves a human figure to perform in a room otherwise reduced to abstraction (the series "Wing," 1976). The veiling: the enigma under the white cloth, the desire for a resolution—this stimulus to fantasy is increasingly evident in his photographs.

One of Häusser's best-known photographs shows a racing car, wrapped in awnings like a Christo, with severe black/white contrast on a concrete road—a picture that symbolizes bridled energy. Häusser's photographs, however coldly and graphically rationalized, have an unbridled strength.

—Hans Christian Adam

HEARTFIELD, John.

German. Born Helmut Herzfelde in Schmargendorf, Berlin, 19 June 1891; adopted anglicized name, "John Heartfield," 1916. Educated in Salzburg, Austria, until 1905; Volksschule, Wiesbaden, Germany, 1905-07; studied painting and drawing, studio of Hermann Bouffier, Wiesbaden, 1905-06; studied art, under Julius Diez, Maximilian Dasio and Robert Engels, Kunstgewerbeschule, Munich, 1907-11; under Ernst Neumann, Kunst- und Handwerkschule, Berlin-Charlottenburg, 1912-14; mainly self-taught in photomontage, in collaboration with George Grósz, Berlin, from 1916. Served in the German Army, 1914-16. Married 3 times; children: Tom and Eva. Worked as apprentice to bookseller Heinrich Heuss, Wiesbaden, 1906; commercial artist, Bauer Brothers paper manufacturers, Mannheim, 1911-12; film designer and director, with Grunbaum brothers, and for Universum Film (UFA), Berlin, 1916-19, also with George Grosz on "Trickfilm," Berlin, 1918; Founder-member, Berlin Dada group of artists, 1918; editor, with brother Wieland Herzfelde, Malik publishing House, 1918, Die Neue Jugend magazine, 1918, and Jederman sein eigener Fussball and Die Pleite magazines, 1919-20, all Berlin; and with George Grosz and Raoul Hausmann, Dada 3 magazine, Berlin, 1919-20, and Der Knüppel magazine, Berlin, 1923-27; Artistic Director, Max Reinhardt theatre, Berlin, 1921-23; Secretary, Association of Communist Artists, Berlin, 1924; freelance satirical photomontagist, working mainly with Malik Verlag, Berlin, 1924-33, with Arbeiter Illustrierte Zeitung, Berlin, 1927-33, and for Arbeiter Illustrierte Zeitung (re-titled Volks Illustrierte, 1936), in Prague, 1933-38 (deprived of German citizenship, 1934); freelance photomontagist, graphic and theatrical designer, working for Lilliput, Picture Post, Lindsay Drummond books and Penguin Books, London, 1938-39, 1941-50 (interned in several camps, England, 1940); settled in Leipzig, 1950-56; worked as graphic and theatre designer, for Bertolt Brecht's Berliner Ensemble, Deutsches Theater, Kammerspiele Theater, East Berlin, 1951-61; Professor, Deutsche Akademie der Künste, East Berlin, 1960 until his death, 1968. Recipient: First Prize for Mural Design, at Werkbund Exhibition, Cologne, 1914; German National Prize for Art and Literature, DDR, 1957; Fighter Against Fascism Medal, DDR, 1958; Peace Prize, Government of the DDR, 1961; Karl Marx Order, DDR, 1967. Honorary Member, German Association of Graphic Artists, DDR, 1956; Czechoslovak Artists Association, Prague, 1956; Union of German Artists of the Plastic Arts, DDR, 1956. Member, Akademie der Künste, East Berlin, 1960. Died (in East Berlin) 26 April 1968.

Individual Exhibitions:

1937 Mánes Gallery, Prague
1938 ACA Gallery, New York
1939 One Man's War Against Hitler, Arcade Gallery, London
1957 Deutsche Akademie der Künste, East Berlin (travelled to Erfurt and Halle)
1961 Pavilion der Kunst, East Berlin
1966 Galleria Il Fonte di Spade, Rome
 John Heartfield: Photomontages, Institute of Contemporary Arts, London (travelled to Hatton Gallery, Newcastle upon Tyne)
 Neue Gesellschaft für Bildende Kunst, West Berlin
1970 Gardner Centre for the Arts, Brighton, Sussex (toured Britain)
 Deutsche Akademie der Künste, East Berlin
1975 Stedelijk Van Abbemuseum, Eindhoven, Netherlands
1976 Galerie Ronessance, Zurich
 Neue Nationalgalerie, West Berlin
1977 Elefanten Press Galerie, West Berlin (toured Europe)
1980 Camden Arts Centre, London

Selected Group Exhibitions:

1920 First International Dada Fair, Otto Burckhard Gallery, Berlin
1929 Film und Foto, Deutscher Werkbund, Stuttgart
1934 International Caricature Exhibition, Mánes Gallery, Prague
1966 Der Malik-Verlag, 1916-47, International Pavilion, at the Berlin Fair
1973 Photography into Art, Camden Arts Centre, London
1978 Neue Sachlichkeit and German Realism of the 20's, Hayward Gallery, London
 Dada and Surrealism Reviewed, Hayward Gallery, London
1979 Film und Foto der 20er Jahre, Württembergische Kunstverein, Stuttgart (travelled to Museum Folkwang, Essen; Werkbundarchiv, Berlin; Kunsthaus, Zurich; Kunstverein, Hamburg; and Museum des 20. Jahrhunderts, Vienna)
1980 The Magical Eye, National Gallery of Canada, Ottawa (toured Canada)
1981 Germany: The New Vision, Fraenkel Gallery, San Francisco

Collections:

John Heartfield Archive, Deutsche Akademie der Künste, East Berlin; Institute für Marxismus-Leninismus, East Berlin; Verlag der Kunst, Dresden; Nationalgalerie, West Berlin; Universitätsbibliothek, Bremen, West Germany.

Publications:

By HEARTFIELD: books—Deutschland, Deutschland, Über Alles, with text by Kurt Tucholsky, Berlin 1929, new edition Hamburg 1964, subtitled A Picture Book, translated by Anne Halley, with an afterword by Harry Zohn, Amherst, Massachusetts 1972; John Heartfield: Photomontagen zur Zeitgeschichte, edited by Konrad Farner, Zurich 1945; John Heartfield: 12 Fotomontagen aus dem Jahren 1930-31/Krieg im Frieden: Fotomontagen zur Zeit 1930-38, edited by Karl Hanser, Munich 1973; John Heartfield: 33 Fotomontagen, with text by Gertrud Heartfield, Dresden 1974; Photomontages of the Nazi Period: John Heartfield, with texts by Peter Selz, Wieland Herzfelde and others, New York and London 1977; articles—"Der Kunstlump," with George Grosz, in Der Gegner (Berlin), nos. 1-6, 1919; "Entfesselter Kitsch, Entfesselter Kunst" in

Haus der Deutschen Kunst, catalogue, Berlin 1937; "Daumier im Reich" in German Anti-Nazi Monthly (London), 1942; "Meine Kunst als Waffe" in Neue Deutsche Presse (East Berlin), 1957.

Heartfield's photomontages were published in almost every issue of Arbeiter Illustrierte Zeitung, in Berlin, 1928-33, and in Prague, 1933-38 (AIZ was re-titled Volks Illustrierte, 1936-38).

On HEARTFIELD: books—John Heartfield et la Beauté Revolutionnaire by Louis Aragon, Paris 1935; John Heartfield: Eine Monographie by Sergei Tretyakov, Moscow 1936; John Heartfield und die Kunst der Fotomontage, with texts by Bodo Uhse and others, East Berlin 1957; John Heartfield: Leben und Werke by Wieland Herzfelde, Dresden 1962; John Heartfield: Photomontages, exhibition catalogue, London 1969; John Heartfield, Dresden 1970; The Painter and the Photograph: From Delacroix to Warhol by Van Deren Coke, Albuquerque, New Mexico 1972; Photography into Art, exhibition catalogue, by Colin Osman, Ainslie Ellis and Margaret Harker, London 1973; John Heartfield 1891-1968: Photomontages, exhibition catalogue, by Elbrig de Groot and Hein Reedijk, Eindhoven, Netherlands 1975; Photomontage by Dawn Ades, London and New York 1976; Heartfield, exhibition catalogue, with an introduction by Roland Marz, West Berlin 1976; L'Arte nella Società: Fotografia, Cinema, Videotape by Daniela Palazzoli and others, Milan 1976; John Heartfield, exhibition catalogue, by Marco Pinkus, Zurich 1976; Montage: John Heartfield: Von Club Dada zur Arbeiter-Illustrierte Zeitung by Eckhard Siepmann, West Berlin 1977; Geschichte der Fotografie im 20. Jahrhundert/Photography in the 20th Century by Petr Tausk, Cologne 1977, London 1980; John Heartfield in Selbstzeugnissen und Bilddokumenten by Michael Toteberg, Hamburg 1978; Germany: The New Photography 1927-33, edited by David Mellor, London 1978; Neue Sachlichkeit and German Realism of the 20's, exhibition catalogue, by Ute Eskildsen, Wieland Schmied and others, London 1978; Photographen der 20er Jahre by Karl Steinorth, Munich 1979; Film und Foto der 20er Jahre, exhibition catalogue, by Ute Eskildsen and Jan Christopher Horak, Stuttgart 1979; Experimental Photography, exhibition catalogue, by Dawn Ades, London 1980; films—John Heartfield: An Artist of the People, 1959; John Heartfield: Fotomontagen, by Helmut Herbst, 1977.

In 1917 Richard Huelsenbeck travelled from Zurich to Berlin carrying what Hans Richter has called "the bacillus of Dada." Born in the First World War, Dada was the name given by a group of artists to their enterprise of subverting existing culture and society. It was an enterprise that proclaimed its opposition to patriotism, religion, nationalism and family. But this opposition was not mounted in the service of "Art," for Dada, a movement of artists, was also against art.

Within a few years of Dada's arrival in Germany that country had lost the war and the Kaiser had been forced to abdicate. In Berlin the Spartacist group—effectively the German communist party—had mounted a revolution which had been suppressed and its leaders murdered. Berlin Dada was to be the only group that was closely connected with revolutionary political struggle—not surprisingly, for its meetings were held in a city that was creating workers' councils and where street fighting was taking place.

Among the original members of the Communist Party were George Grosz, Wieland Herzfelde and his brother, Helmut, who as a mark of disdain for German nationalism during the war had anglicized his name to John Heartfield. In their attack on art the Berlin Dadaists focussed their attention on Expressionism because it was, so far as the art public was concerned, still the leading avant-garde move-

MADRID 1936

¡NO PASARAN! ¡PASAREMOS!
Sie kommen nicht durch! Wir kommen durch!

Fotomontage: John Heartfield

John Heartfield: Photomontage from *AIZ*, 1930's Courtesy Galerie Wilde, Cologne

ment. It was not in painting, however, that Berlin Dada was to make its own most important contribution to art, but in the development of a technique called photomontage. Akin to collage but taking photographs as the basic material, photomontage involves cutting up photographs obtained from a variety of sources, including newspapers, and reassembling them into new combinations. Dadaists used this technique in order to make posters, book jackets, illustrations and propaganda.

Characteristically, there is confusion about who initiated the practice: Hannah Höch and Raoul Hausmann vie for the honour with George Grosz and John Heartfield. Certainly, both groups regarded it as an extremely important mode of representation. What is especially interesting about it is the contribution it made to the definition of the nature of photography. Compared with the manifest contrivance of a painting, photographs lay an implicit claim to innocence, to be nothing more or less than a representation of how things are. Some kinds of photomontage undermine this claim to natural authenticity. Photomontage also allowed the Dadaists to work on image making without having to consider themselves artists, for they were only assembling pre-existing elements into a form which would not be hung in a gallery but mass produced. They often described themselves as "engineers," by which they indicated that they were less interested in developing a personal iconography of art than in using mass produced material in order to reappraise or subvert "reality".

Although John Heartfield was to move away from his early dadaist stance to a committed political position, he took this idea with him, developed and refined it and used it as a major political weapon. His political struggle was waged primarily not at the level of industrial work or street demonstration, but at the level of the examination and redefinition of the representation of social and political life—the level, that is, of ideology. Bertolt Brecht said: "Less than at any time does a *simple reproduction* of *reality* tell us anything about reality. A photograph of the Krupp works or GEC yields almost nothing about these institutions. Reality proper has slipped into the functional. The reification of human relationships...no longer reveals these relationships. Therefore something has actually to be *constructed*, something artificial, something set up." This almost exactly expresses the intention of Heartfield's work which was, through contrivance and artifice, to construct a new vision of the "reality" that was endlessly reproduced in newspapers and magazines. Working slowly and methodically he would take a photograph and by assembling it into a new form with other photographs endow it with a new, politically charged meaning. Heartfield always cut up actual photographs, rather than working on multiple images in a darkroom. Technically, his work is superb and his best photomontages—many of which were published in the anti-fascist magazine *Arbeiter Illustrierte Zeitung*—carry the directness and power that have made him the best known and most influential worker in this field.

After the Nazi party came to power Heartfield was forced to leave Germany and take up residence first in Prague and then in England. Although some of his work was used by English magazines, he did not manage to produce in exile a body of work which was in any way comparable to that which he had created in Berlin. The subtle lines of connection between political events and the characteristic mode of their representation were not clear to him in a foreign country, and the people with whom he had worked were dispersed around the world. Nevertheless, during his most productive years Heartfield not only made incomparable photographs, but also offered the most serious and developed challenge to the view that a photograph can be a simple, unmediated representation of reality.

—Derrick Price

HEATH, David (Martin).

American. Born in Philadelphia, Pennsylvania, 27 June 1931; landed immigrant in Canada since 1970. Educated at Germantown High School, Philadelphia, 1945-47; studied art at the Philadelphia College of Art, 1954-55, and photography, under Richard Nickel, at the Institute of Design, Illinois Institute of Technology, Chicago, 1955-56; studied photography, under W. Eugene Smith, at the New School for Social Research, New York, 1959, and in Smith's Photo Workshop, New York, 1961. Served in the 3rd Infantry Division of the United States Army, in Korea, 1952-54. Married Angelika Karin de Kornfeld in 1970 (divorced, 1975). Photographer since 1947. Darkroom assistant in a commercial photofinishing firm, Philadelphia, 1948-52; Photographic Assistant, Shigeta-Wright Studio, Chicago, 1955-56; Photographic Assistant to Wingate Paine, Carl Fischer and Bert Stern, New York, 1957-65. Instructor in Photography, School of the Dayton Art Institute, Ohio, 1965-67; Assistant Professor, Moore College of Art, Philadelphia, 1967-70. Since 1970, Professor of Photography, Ryerson Polytechnical Institute, Toronto. Artist-in-Residence, University of Minnesota, Minneapolis, 1965; Visual Studies Workshop, Rochester, New York, 1976-77; and International Center of Photography, New York, 1978. Recipient: Guggenheim Fellowship in Photography, 1963, 1964. Address: Department of Film and Photography, Ryerson Polytechnical Institute, 122 Bond Street, Toronto, Ontario M5B 1E8, Canada.

Individual Exhibitions:

1958 *Neither Peace Nor War*, 7 Arts Gallery, New York
1961 Image Gallery, New York
1963 *A Dialogue with Solitude*, Art Institute of Chicago (travelled to the International Museum of Photography, George Eastman House, Rochester, New York, 1964)
1964 *David Heath/Paul Caponigro*, Heliography Gallery, New York
1965 *Work in Progress*, Westbank Gallery, Minneapolis
1968 Phoenix College, Arizona
 David Heath/Richard Garrod, Focus Gallery, San Francisco
1969 *Beyond the Gates of Eden* (audio-visual show), University of Connecticut, Storrs
1971 *An Epiphany* (audio-visual show), Society for Photographic Education, Chicago
1973 *Le Grand Album Ordinaire* (audio-visual show), Ryerson Polytechnical Institute, Toronto
1979 *Songs of Innocence*, Walter Phillips Gallery, Banff, Alberta
1980 *Ars Moriendi: A Masque* (audio-visual show), Rochester Institute of Technology, Rochester, New York
1981 *A Dialogue with Solitude and SX-70 Polaroid Works*, National Gallery of Canada, Ottawa

Selected Group Exhibitions:

1963 *Photos from the Permanent Collection*, Museum of Modern Art, New York
 Photography '63, International Museum of Photography, George Eastman House, Rochester, New York
1964 *Association of Heliographers*, Lever House, New York
1965 *Recent Acquisitions*, Museum of Modern Art, New York
1966 *Guggenheim Fellows in Photography*, Philadelphia College of Art
1968 *Contemporary Photographs*, University of California at Los Angeles

1970 *Contemporary Photography*, Peale House, Philadelphia
1974 *Photography in America*, Whitney Museum, New York
1978 *Mirrors and Windows: American Photography since 1960*, Museum of Modern Art, New York (toured the United States, 1978-80)
1980 *The Magical Eye*, National Gallery of Canada, Ottawa (toured Canada)

Collections:

National Gallery of Canada, Ottawa; National Film Board of Canada, Ottawa; Museum of Modern Art, New York; Yeshiva University, New York; International Museum of Photography, George Eastman House, Rochester, New York; University of Rochester, New York; Philadelphia Museum of Art; Art Institute of Chicago; Minneapolis Art Gallery; University of California at Los Angeles.

Publications:

By HEATH: book—*A Dialogue with Solitude*, with a foreword by Hugh Edwards, New York 1965; article—"Portfolio '64" in *Contemporary Photographer* (Culpeper, Virginia), Fall 1964.

On HEATH: articles—"A Dialogue with Solitude" by Linda Knox in *Aperture* (Millerton, New York), no. 4, 1966; "Le Grand Album Ordinaire" by Charles Hagen in *Afterimage* (Rochester, New York), February 1974; "David Heath: A Dialogue with Solitude" by James Borcoman in *National Gallery of Canada Journal* (Ottawa), October 1979.

Introduction: David Heath's Folly, David Heath's Doubt: small drolleries from a life in progress:

Ah! you, this glorious crowd so hell-bent on celebration, and you scholars, you most of all who best love a festival...come! and share my bread of bitterness, my salt and vinegar of contrition. Then together might we hear God's laughter at the shattering of the world.

Envoi: Valediction Forbidding Mourning, with Apologies to John Donne:

Maintaining myself in a state of doubt
I sit among the crazy shapes both time and objects take,
having wanted to give to this age its emblematic beast.

Having sought after new knowledge through means of experience
and declaimed old truths through the crafting of my art,
I find I have lost the wit for such inspired madness,
seeing the imposture in it all.

Now in the autumn twilight
of my 49th turn through the gravity of time's grief,
I languor before Hell's gates
listening to the Pleiades wail that I am none,
nor can my sun renew.

For I am a dead thing
in whom no love has wrought its true alchemy,
no quintessence transmuted
from dull privations and lean emptiness.

Study me then, you
who out of the demiurge of communion shall lovers be
at the next world (that is, the next spring),
and make of me what you will,
and from this long journey out of self

take small mappings
of your heart's found truths.

Sweet lovers, for whose sake the greater sun
at wintertime to the goat is run
to fetch new lust and give it you—
Enjoy our summer all!

—David Heath

Moved by the emotional power of a story in *Life* magazine, Dave Heath began to photograph seriously in the late 1940's. By the middle 1950's he was successfully attempting to expand the expressive potential of the extended photo-essay. His book, *A Dialogue with Solitude*, created in 1961 and finally published in 1965, pushed that form into a personal and poetic dimension which was almost unique at that time and which has rarely been matched to this day.

In the late 1960's Heath found the largely unexplored and technically uncertain medium of the slide-tape program singularly suited to his needs. During the next decade he produced a number of slide-tapes ("Beyond the Gates of Eden" (1969); "An Epiphany'" (1971); "Le Grand Album Ordinaire" (1974); and "Ars Moriendi" (1980)) which have exponentially enlarged the creative potential of the medium.

Heath has always been particularly aware of the powerful forces of isolation and community on the human condition, and he has addressed his art to comment upon those events and actions of humanity that display these basic influences most clearly at work. In his own search for community, Heath has drawn sustenance (as well as specific materials for his art) from his wide ranging through the arts and their histories. He uses the music and literature, the poetry, painting and photography of both the past and the present in his own work. And his own work is informed with the despair and passion of his search for a meaning in life and with the compassion and hope of his answers, which he finds in the large community of human creativity.

William Johnson

HEDGES, Nick.
British. Born in Bromsgrove, Worcestershire, 31 December 1943. Educated at Kings School, Worcester, 1955-62; studied photography, under Ted Martin, at the Birmingham College of Art and Design, 1964-68. Married Diana Roberts in 1977; children: Ruth and Annie. Photographer and researcher, Shelter National Campaign for the Homeless, London, 1968-72. Freelance photographer since 1972. Part-time Lecturer, Polytechnic of Central London, 1972-76, and Derby College of Art and Technology, 1976-77; West Midlands Arts Association Fellow in Photography, Wolverhampton Polytechnic, 1976-78. Since 1980, Lecturer in Photography, West Midlands College of Higher Education, Walsall. Address: 3 Belvidere Road, Highgate, Walsall, West Midlands, England.

Individual Exhibitions:

1971 *Shelter Photographs*, Impressions Gallery, York
 Shelter Photographs, Half Moon Gallery, London
 Shelter Photographs, Royal Photographic Society Gallery, London

David Heath: *New York City*, **1964**

1972 *Shelter Photographs*, Kodak Gallery, London
1973 *3 Photographers*, Victoria and Albert Museum, London (with Cristabel Melian and Sylvester Jacobs)
1976 *Worship in Wolverhampton*, Wolverhampton Art Gallery
1977 *Factory Photographs*, Birmingham Arts Laboratory
1978 *Factory Photographs*, Half Moon Gallery, London (toured the U.K.)
1979 *Mental Handicap*, Pentax Gallery, London (travelled to the Midland Arts Centre, Birmingham)
1980 *Factory Photographs*, Side Gallery, Newcastle upon Tyne
1981 *The Fishing Industry*, Side Gallery, Newcastle upon Tyne

Selected Group Exhibitions:

1976 *Problem in the City*, Institute of Contemporary Arts, London
1978 *Art for Society*, Whitechapel Art Gallery, London
 Photokina '78, Cologne
1979 *Un Certain Art Anglais*, ARC Galerie, Paris
 Contemporary Portraits, Half Moon Gallery, London

Collections:

Victoria and Albert Museum, London; National Portrait Gallery, London; West Midlands Arts Association, Stafford.

Publications:

By HEDGES: books—*Shelter Reports* (5), London 1968-72; *Factory Photographs*, with text by Huw Beynon, London 1981; articles—interview, with Ainslie Ellis, in *British Journal of Photography* (London), 23 December 1969; "Problem in the City" in *Camera Work* (London), no. 1, 1976; "Factory Fantasies" in *Camera Work* (London), no. 6, 1977; "Factory Photographs" in *Camera Work* (London), no. 10, 1978; "Charity Begins at Home" in *Photography/Politics* (London), no. 1, 1979; "Documentary Photography" in *Ten-8* (Birmingham), 1981.

Nick Hedges: *Blast Furnace Worker, British Steel Corporation*, Bilston, 1976

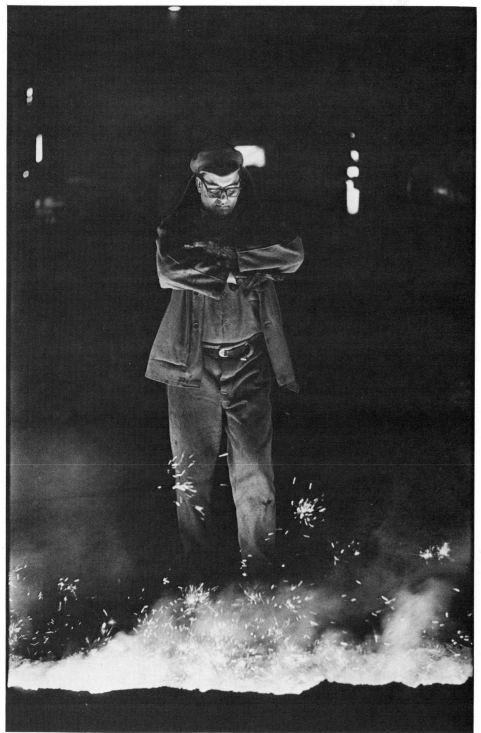

I am a documentary photographer, and I have always worked within the convention that accepts and uses photography as a substitute for reality. Most of my work has, from choice, been for agencies of social reform. More recently I have chosen to photograph aspects of contemporary society which have been largely uncelebrated by the conventional mass media: working life in factories and aspects of life amongst ethnic minority communities.

Whilst I am interested in the current debate which questions the "reading" of photographs as substitutes for reality, I prefer to work within the documentary tradition. I want to try to find new ways to create a fuller context for documentary photographs.

I do not like the trend towards a purely gallery existence for fine art photographs, nor the trend towards introspection in photography. I like photographs to be published and used, rather than strung along the walls in a gallery.

—Nick Hedges

Nick Hedges produces photographs which document aspects of working people's lives. The images achieve public circulation through being exhibited and through their use as illustrations to printed material, generally intended to record or influence social conditions. By acknowledging the different demands of his photographs' functions, Nick Hedges not only assures their maximum effectiveness, but also, inevitably, builds into them the clearest demonstration of the paradoxes inherent in the documentary mode.

For even if it should be that his central intention in making a set of images is towards establishing self knowledge and a group consciousness among his subjects, one might reasonably suspect that the numerically largest and most influential audience will be the regular gallery goers and readers of serious publications. The vehemence of the exchanges amongst certain commentators from these groups, as they attempt the Procrustean task of imposing Nick Hedges' images upon their contradictory stereotypes, has tended to obscure the actual record, that his exhibitions attract the widest popular interest in venues far removed from the fashionable circuit. That in truth the audience is probably made up to a relatively minor extent of the traditional "us" with "our" traditions of seemly composure or ritual rage in the face of "their" sufferings and hard times. And if commentators' perceptiveness withers as their vehemence burgeons, his unschooled audience can exercise its advantage, and experience the photographs in a way which does justice to their informational richness.

Questions as to how information from the world shall be selected and converted into the photographic record may be answered in purely technical terms, but every choice of technique is shadowed by an aesthetic counterpart. His concern for efficacy in communication leads Nick Hedges into making his final prints with a sharp and distinctive consonance between the qualities of his images, which has from time to time exposed him to accusations of aestheticising for its own sake.

Whether these charges are justified, or important, or even represent an inevitable concomitant of successful communication are problems for each maker

or viewer to deal with. To someone so involved in the world and his craft as Nick Hedges is, the relationships between informational and aesthetic factors must be of major influence upon the evolution of his photography; and the way in which they are reconciled and balanced will be fascinating to watch.

—Philip Stokes

HEINECKEN, Robert.

American. Born in Denver, Colorado, 29 December 1931. Educated at the Polytechnic High School, Riverside, California, 1945-49; University of California at Los Angeles, 1951-53, 1958-60, B.A. 1959, M.A. 1960. Served as a Jet Fighter Pilot in the United States Marine Corps, 1953-57: Captain. Married Janet Marion Storey in 1955 (divorced, 1980); children: Kathe, Geoffrey, and Karol. Photographer/artist since 1960. Professor, Department of Art, University of California at Los Angeles, since 1960. Instructor, Advanced Studies Workshop, George Eastman House, Rochester, New York, 1967, State University of New York at Buffalo, 1969, San Francisco Art Institute, 1970, School of the Art Institute of Chicago, 1970, and Harvard University, Cambridge, Massachusetts, 1971. Chairman of the Board of Directors, Society for Photographic Education, 1970-72; Trustee, Friends of Photography, Carmel, California, 1974-75. Recipient: Guggenheim Fellowship, 1976; National Endowment for the Arts grant, 1977. Agent: Light Gallery, 724 Fifth Avenue, New York, New York 10019. Address: Department of Art, University of California, 405 Hilgard Avenue, Los Angeles, California 90024, U.S.A.

Individual Exhibitions:

1964 Mount St. Mary College of Fine Arts, Los Angeles
1965 Long Beach Museum of Art, California (with Coar and Rink)
1966 California State University at Los Angeles
 Mills College Art Gallery, Oakland, California
1968 Focus Gallery, San Francisco
1969 Occidental College, Los Angeles
1970 Phoenix College Art Gallery, Arizona
 Witkin Gallery, New York
 California State University at Northridge (with Daryl Curran and Bart Parker)
1971 University of Oregon Art Gallery, Eugene
 University of Colorado Art Gallery, Boulder
1972 Pasadena City College Gallery, California
 University of Rhode Island, Kingston
 Pasadena Art Museum, California
1973 California State College at San Bernardino
 The Photograph as Object, Metaphor and Document of Concept: Robert Heinecken, Minor White and Robert Cumming, California State University at Long Beach
 Friends of Photography, Carmel, California
 Light Gallery, New York
1974 Madison Art Center, Wisconsin
1976 Light Gallery, New York
 Texas Center for Photographic Studies, Dallas
 International Museum of Photography, George Eastman House, Rochester, New York

1978 Old Dominion University Gallery, Norfolk, Virginia
 Center for Contemporary Photography, Chicago
 San Francisco Museum of Modern Art
 Frederick Wight Art Gallery, University of California at Los Angeles
 Susan Spiritus Gallery, Newport Beach, California
1979 Light Gallery, New York
 Sesnon Gallery, University of California at Santa Cruz
 University of Northern Illinois Art Gallery, DeKalb
 Forum Stadtpark, Graz, Austria
1980 University of Nevada Art Gallery, Las Vegas

Selected Group Exhibitions:

1967 *The Persistence of Vision*, International Museum of Photography, George Eastman House, Rochester, New York (toured the United States, 1967-70)
 Photography in the 20th Century, National Gallery of Canada, Ottawa (toured Canada and the United States, 1967-73)
1969 *Vision and Expression*, International Museum of Photography, George Eastman House, Rochester, New York (toured the United States, 1969-71)
1970 *Photography into Sculpture*, Museum of Modern Art, New York
 Into the 70's, Akron Art Institute, Ohio
1974 *Photography in America*, Whitney Museum, New York
1978 *23 Photographers/23 Directions*, Walker Art Gallery, Liverpool
 Mirrors and Windows: American Photography since 1960, Museum of Modern Art, New York (toured the United States 1978-80)
1979 *Contemporary American Photographs*, at *Venezia '79*
 Symposia über Fotografie, Forum Stadtpark, Graz, Austria

Collections:

Museum of Modern Art, New York; University of Nebraska, Lincoln; Museum of Fine Arts, Houston; University of New Mexico, Albuquerque; Center for Creative Photography, University of Arizona, Tucson; Norton Simon Art Museum, Pasadena, California; Pomona College, Claremont, California; San Francisco Museum of Modern Art; Oakland Art Museum, California; University of Washington, Seattle.

Publications:

By HEINECKEN: books—*Are You Rea*, portfolio, Los Angeles 1968; *Mansmag*, portfolio, Los Angeles 1969; *Just Good Eats for U Diner*, portfolio, Los Angeles 1971; *He/She*, Chicago 1980; articles— "The Photograph: Not a Picture of, but an Object about" in *ADLA* (Los Angeles), October 1965; "Manipulative Photography" in *Contemporary Photographer* (Boston), August 1969; statement in *Continuum*, exhibition catalogue, Los Angeles 1970; "Teaching Interview" in *Photography: Source and Resource*, University Park, Pennsylvania 1973; "Eulogy" in *William Doherty*, exhibition catalogue, Los Angeles 1973; "On Change and Exchange" in *Untitled 7/8* (Carmel, California), April 1974; introduction to *UCLA Collection of Contemporary Photographs*, exhibition catalogue, Los Angeles 1976; "Robert Heinecken: An Interview" in *Afterimage* (Rochester, New York), April 1976; "Introduction: Emerging Los Angeles Photographers" in *Untitled 11* (Carmel, California), October 1977.

On HEINECKEN: book—*Heinecken*, edited by James Enyeart, Carmel, California 1980; articles— "The Photography of Robert Heinecken" by Carl Belz in *Camera* (Lucerne), January 1968; "Heinecken: A Man for All Dimensions" by A.D. Coleman in the *New York Times*, 2 August 1970, reprinted in Coleman's *Light Readings: A Photography Critic's Writings 1968-1978*, New York 1979; "Heinecken: Photograph as Object" by John Upton in *The Photograph as Object, Metaphor and Document of Concept: Robert Heinecken, Minor White, and Robert Cumming*, exhibition catalogue, Long Beach, California 1973; "Phenomenology of Sex" by James Hugunin in *Dumb Ox* (Los Angeles), Fall 1977; "The Medium as Subject" by Charles Desmarais and "Space-Time and the Syzygy" by Candida Finkel in *Exposure* (Lincoln, Nebraska), December 1977; "Two Decades of Work" by Hal Fischer in *Artweek* (Oakland, California), September 1978; "Robert Heinecken" by William Jenkins in *Image* (Rochester, New York), September 1978; "He/She: Heinecken's SX-70 Conversations" by Carl Toth in *Afterimage* (Rochester, New York), May 1979; "Relations: Some Work by Robert Heinecken" by Irene Borger in *Exposure* (Lincoln, Nebraska), Summer 1979; "Provoking Without Judging" by Mark Johnstone in *Artweek* (Oakland, California), 5 December 1981.

I am involved in using subjective artifice to produce photographic evidence and in using photographic evidence to create subjective artifice, and am interested in the confusion which results.

—Robert Heinecken

Robert Heinecken was university trained in printmaking, and then adapted the photograph to his interests in problems of content and form. In the 1960's he assembled similarly shaped photographs of water, wood, clouds and a nude onto slices from a large prismatic solid, arranged so that the nine slices could be turned to make different combinations of original subjects yet retain the general gestalt. He fragmented a nude over a cube, which was shown mounted on one corner, an orientation that forces the viewer to see three parts of the body at any one time, in a visual/verbal interplay reminiscent of some of the problems of Duchamp and of cubist art. During the late 1960's he published a portfolio of 25 prints entitled *Are You Rea*, which combined investigation of the medium, formal relationships, and social-emotional implications drawn from the images. By examining hundreds of fashion magazines and other popular magazines of the time, Heinecken found enough pages which, when examined on a light-table, revealed pictures and words on opposite sides that interacted in useful ways. By using the page as a negative and exposing an offset printing plate directly, he was able to print a tonally reversed image that provided information from the change-operation montages he had discovered. The total content is a bitter comment on the values of American society in the 1960's.

He examined the common sexual concerns of the times in a series of large assembled images which were then reproduced in photolithographed versions, sometimes with color added. The "Cliche Vary" set was composed of three large assembled pieces of photographs on sensitized canvas: "Cliche Vary/Autoeroticism, -Fetishism, -Lesbianism," all done in the mid-1970's. The photographs were printed from negatives supplied in undeveloped rolls from the soft-pornographic sales houses that flourish in southern California. The straight image was then drawn and painted on, as well as being montaged, repeated, and overprinted to achieve the final complex relationship he desired.

Heineken writes of his own work: "...because I was never in a school situation where someone said 'This is the way a photograph is supposed to look,' I was completely free to cut them up, combine them,

331

or do anything.... Some of my enthusiam for the photograph was based on the fact that there was some residual illusion of reality in it always, no matter what I did to it...." Heinecken is concerned both with what the art materials will do and with the social implications that are covertly dealt with in his art. In the "Cliche Vary" series he is using the word cliché to deal with the social meaning of the word and "cliche vary" as a pun on the term for the hand-made negative of photographic art history, plus of course the variations on the themes of this central cliché of our culture, the search for sexual expression without emotional content.

By the end of the 1970s, his art work had carried him further from the act of photographing in a traditional sense. He produced a series of SX70 prints showing himself, women, cluttered rooms, and other bits and pieces of a life, accompanied by short dialogues written in a blunt, schoolbook style beneath the mounted prints. These pungent dialogues between He and She are sometimes painful, often evocative, and in conjunction with the photographs remind a viewer of the Italian cartoon books that are so popular on the Continent. The immensely personal and specifically erotic SX70 prints were replaced, in a published small book of these dialogues, with deliberately bland and depersonalized drygoods advertising photographs masked so as to appear to be SX70 prints, creating an artistic abstraction from the deeply personal and often painful initial image/word structure. Heinecken, like most of the photographers who manipulate, or who permit the word to interact with the photograph, appears to be within a continuation of an essentially romantic tradition, finding new forms

with which to express himself in an era that is very strongly classical in spirit.

—Arnold Gassan

HEINEMANN, Jürgen.

German. Born in Osnabrück, Germany, 13 September 1934. Studied photography under Otto Steinert, in Saarbrücken, 1954-58, and in Essen, 1959-62. Photojournalist, working for *Ruhrwort*, since 1962; has made numerous trips to South America, mainly for the Catholic Church organization Adveniat, since 1962. Part-time Instructor in Photojournalism, Fachhochschule, Dortmund, and Fachhochscule, Würzburg. Member, Gesellschaft Deutsche Lichtbildner (GDL), since 1962. Address: Demberg 40, 4330 Mühlheim-Ruhr, West Germany.

Selected Group Exhibitions:

1956 *Photokina '56*, Cologne

1968 *2nd World Exhibition of Photography*, Pressehaus Stern, Hamburg (and world tour)
1979 *Deutsche Fotografie nach 1945*, Kasseler Kunstverein, Kassel, West Germany (toured West Germany)

Publications:

On HEINEMANN: books—*2nd World Exhibition of Photography*, exhibition catalogue, edited by Karl Pawek, Hamburg 1968; *Fotografie 1919-1979, Made in Germany: Die GDL-Fotografen*, edited by Fritz Kempe, Bernd Lohse and others, Frankfurt 1979; *Deutsche Fotografie nach 1945/German Photography after 1945* by Floris Neusüss, Wolfgang Kemp and Petra Benteler, Kassel, West Germany 1979.

Can one pursue humanitarian photography as a profession? That the answer to this question is yes can be proved by many examples from history: one thinks, for example, of Jacob Riis and Lewis Hine who, with the aid of the camera, fought against the slum conditions of New York and the exploitation of child labour in the United States—or of Chim, founder member in 1947 of Magnum, whose main concern was the fate of children in post-war Europe. It would not occur to Jürgen Heinemann, a quiet, reserved, reflective man, to compare his own work with such renowned historic figures. Nevertheless, he follows in their tradition—in a contemporary manner.

Robert Heinecken: *Space-Time Metamorphosis #2*

Heinemann was born in 1934 in the Ruhr area of Germany into the family of a salesman; both his parents and his brother took pictures as a hobby, and he soon learned to handle a camera. As he was only 14 years old at the time, it was, of course, a completely automatic box camera. But as time went on his secret interest in the world of art went so far that, though he too seemed destined to become a salesman, he privately dreamed of being allowed to take photographs for the rest of his life. Then a handshake with Theodor Heuss, the first president of the Federal Republic of Germany, led to a definite decision, for in a junior photography competition in 1956 Heinemann was among the prize winners. The direct consequence was that he went to Saarbrucken to see a certain Professor Otto Steinert, and as Steinert was prepared to take him into his class, Heinemann said goodbye to the life of a salesman. The study of the first volume of Steinert's *Subjective Photography* had already made his future path clear to him. In 1959 Heinemann followed his teacher to the Folkwang School in Essen. In vacations he toured Europe, almost as a tramp, taking photographs.

Even before he completed his studies in photography in 1962, Heinemann had begun working for the newspaper *Ruhrwort* (The Ruhr Word). It was a Catholic Church publication for the industrial area of the Ruhr, and it attempted to reach its public with modern publicity methods, particularly with lively press photography. The paper's connection with the Catholic humanitarian organizations Misereor and Adveniat, which in the undeveloped countries help in the fight against hunger with practical development aid, also became an interest for Heinemann: he made his first journeys to South America in 1962 and 1963, and thereafter made a lengthy journey each summer, mainly for Adveniat.

What does the photographic work from such journeys look like? It is as many-sided and diverse as the human problems—according to the country—encountered by the ecclisiastical aid organizations and missionary societies. It is part of Heinemann's individuality that he does not concentrate on "official" photographs—as, for example, the mechanics of food distribution. The depiction of such problems are, of course, also part of his commission, but Heinemann's particular and splendid forte is in conveying everyday human interest scenes. He photographs with a feeling for the "decisive moment" with an instinctive sense of pictorial composition, in the pattern of Cartier-Bresson. Perhaps he will photograph the radiant happiness on the face of a peasant in El Salvador, who has merely been able to find work in a distant town and can return only on Sundays to his family in their wretched hut in the remote village. Or the moving scenes that occur when—in the destitute drought areas of North Eastern Brazil—a child dies and only the small playmates accompany the tiny coffin, adorned with their gifts of flowers, to the cemetery where it will be buried in a hastily dug hole in the ground.

—Bernd Lohse

HELMER-PETERSEN, Keld.

Danish. Born in Copenhagen, 23 August 1920. Educated at the Metropolitan Gymnasium, Copenhagen, 1931-37; studied English at Trinity College, Cambridge, 1938-39; studied photography, under Harry Callahan, at the Institute of Design, Illinois Institute of Technology, Chicago, 1950-51. Served in the Civil Defense Corps, Copenhagen, 1943. Married Birthe Dalsgaard in 1945; children: Jan and Finn. Photographer since 1939; established studio, Copenhagen, 1955. Camera Assistant, Minerva Film, Copenhagen, 1948; Film and Video Cameraman, Danish State Radio and Television, Copenhagen, 1951-54. Instructor in Photography, School of Interior Design, Copenhagen, 1951, and School of Graphic Arts, Copenhagen, 1960-63. Since 1964, Lecturer and Instructor, Department of Visual Communication, School of Architecture, Royal Academy of Arts, Copenhagen. Agents: Galerie Kicken und Schürmann, Albertusstrasse 47-49, 5000 Cologne 1, West Germany; and André Wauters Fine Arts, 1100 Madison Avenue, New York, New York 10028, U.S.A. Address: Kristianiagade 14, 2100 Copenhagen, Denmark.

Individual Exhibitions:

1954 *Experiment and Documentation*, Charlottenborg, Copenhagen (travelled to the Röhsska Museet, Gothenburg, Sweden, 1955)

1962 Stiftsmuseum, Viborg, Denmark
 Helmer-Petersen and Renger-Patzsch, Dansk Centralbibliotek, Flensburg, West Germany

1965 Galleri Exi, Odense, Denmark
 Queedens Gård, Ribe, Denmark

1970 Centralbiblioteket, Nakskov, Denmark
 Hjørring Museum, Denmark

1980 *Color Photographs by Keld Helmer-Petersen*, American-Scandinavian Foundation, New York

Selected Group Exhibitions:

1954 *Post-War European Photography*, Museum of Modern Art, New York

1955 *Subjektive Fotografie*, Saarbrucken

1958 *12 International Photographers*, Värmlands Museum, Karlstad, Sweden

1965 *Strukturer*, Ole Palsby, Copenhagen

1966 *5 Danish Designers*, Museum of Arts and Crafts, Copenhagen

1975 *Gråtoner*, Museum of Arts and Crafts, Copenhagen

1976 *Charlottenborgs Forårsudstilling*, Charlottenborg, Copenhagen

1979 *7th Biennale of Photography of the Baltic Countries*, National Museum, Gdansk, Poland

Collections:

Royal Library, Copenhagen; Stiftung für die Fotografie, Zurich; Museum of Modern Art, New York.

Publications:

By HELMER-PETERSEN: books—*122 Colour Photographs*, Copenhagen 1949; *Colour Before the Camera*, London 1952; *Fragments of a City*, Copenhagen 1960; *Romansk Billedhuggerkunst i Viborg Amts Kirker*, Viborg, Denmark 1963; *København*, Copenhagen 1965; articles—"On Photographic Experimentation" in *Fra A til Z* (Copenhagen), no. 3, 1952; "Den Fotografiske Udtryksform" in *Vindrosen* (Copenhagen), March 1954; "A New Personality: Jørn Utzon" in *Zodiac* (Milan), no. 5, 1959; "Fotografen og billedet" in *Flensborg Avis* (Flensburg, West Germany), 8 May 1962; "Fjaes" in *Vindrosen* (Copenhagen), no. 2, 1963; "2 Svenske Grafikere" in *Dansk Kunsthåndvaerk* (Copenhagen), no. 8, 1963.

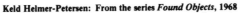

Keld Helmer-Petersen: From the series *Found Objects*, 1968

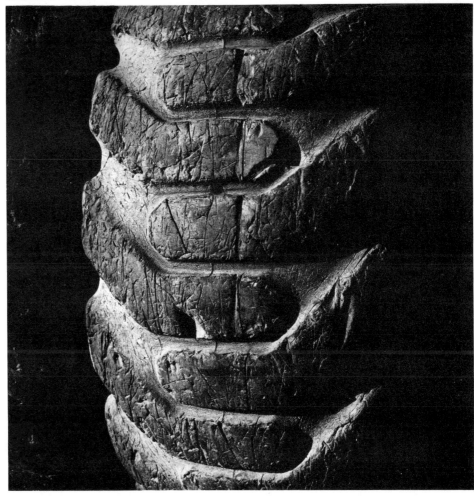

On HELMER-PETERSEN: book—*Die Geschichte der Fotografie im 20. Jahrhundert/History of Photography in the 20th Century* by Petr Tausk, Cologne 1977, London 1980; articles—"Camera Abstractions" by Wilson Hicks in *Life* (New York), 28 November 1949; "Helmer-Petersen, Kopenhagen" by Ludwig Ebenhoh in *Gebrauchsgraphik* (Munich), no. 4, 1954; "Von der Phantasie des Auges" by Robert d'Hooghe in *Leica-Fotografie* (Frankfurt), May/June 1954; "Black on White" by Willa Percival in *Infinity* (New York), November 1954; "Patterns in Line" in *U.S. Camera* (New York), January 1957; "Fra et besog i bygningen" by Palle Nielsen in *Perspektiv* (Copenhagen), no. 5, 1960; "Der Experimentator" by Bruno Schleifer in *Foto Prisma* (Dusseldorf), September 1962; "Crop as You See" by Jacqueline Balish in *Modern Photography* (New York), June 1963; "Keld Helmer-Petersen" by Vance Jonson in *CA Magazine* (Palo Alto, California), no. 9/10, 1963; "Strukturer" by Henrik Bramsen in *Dansk Kunsthåndvaerk* (Copenhagen), no. 3, 1966.

I am inspired by the look of things that man has put his mark on, their strangeness, their visual power, even their magic, and—not least—the way they often take on the appearance of works of art. I would like my photographs to become as powerful as the work of the artists I admire most, be they composers, sculptors, architects, engineers, graphic artists, painters or photographers.

I suppose I should be labelled a purist and a formalist in that I strive for simplicity and clarity of expression. The viewer should be struck by carefully balanced compositions, bold graphic patterns, and impeccable craftsmanship.

In later years I have, however, also become increasingly attracted to what I imagine should be called surrealism, in that I would also like there to be in my pictures something more and beyond what meets the eye. Something like a subconscious appeal to the imagination, when the eye has been satisfied. This extra layer of meaning is what to me makes a picture really interesting and of lasting value.

Man himself or the portrayal of the human condition in a direct sense is not my concern, much as I admire the artists who can turn this kind of subject matter into forceful imagery.

I would like my statements to excite the mind and eye no matter how humble or apparently ordinary the subject, and to be able to stand the test of time and of being hung on the wall. To achieve this, we enter the realm of the photographer's creative means and methods, such as lighting, rendering of texture, grey tones, minute definition, size and format. I would strive to enrich the vocabulary of photography through constant experimentation and refinement, thus keeping photography abreast with the best achievements of the related arts. I see no reason for photography's not rising to the level of, and achieving the status of, a respected graphic medium, and finding its way into more and more museum collections all over the world—besides playing its inferior role as a slave of the mass picture industry.

—Keld Helmer-Petersen

The primary characteristic of the work of Keld Helmer-Petersen has to do with his sensitive vision, a vision that exists within a respectful concern for the proper function of photography. All of his images reveal an honest approach to that part of the world that he has chosen as his subject. He does not manipulate reality; his photographs are always truthful.

Perhaps the clue to his work is that he attempts to choose the right way, given their nature, to photograph his various subjects. In the case of his photos of modern iron constructions, he often reduces the tonal composition to black-and-white because in this way, through contrast, he can better show the beauty and spirit of the engineers' work. On the

other hand, in his depiction of traces left by trucks on sand, he uses the ability of photography to show great richness of detail, interpreting his subject as a landscape of marvellous hills and mountains.

Helmer-Petersen also responds to the times in which we live (whether that reaction is conscious or not is irrelevant). Besides photographing the constructions of contemporary engineers, he has shown actual changes in our environment. The problem of waste is growing considerably in every industrially developed country. The reaction to this problem need not be the same in every photographer—and the reaction need not be specifically critical. Poetic and striking forms can be found in that which human society changes by its use into waste, and it is surely a measure of Helmer-Petersen's art the extent to which he is able to present his "found objects" by means of well-chosen perspective and lighting in such a way that everyone understands his interpretation at first glance. He possesses the sensitivity that is necessary for both the discovering and the depicting of the fascinating by-products of contemporary everyday life.

Helmer-Petersen presents his subjects in both black-and-white and colour, but perhaps his colour work is better known. For it is probably true to say that his book *122 Colour Photographs*, published in 1949, was the first really modern publication to be composed of unusual colour-images of the surprising objects of a modest reality.

—Petr Tausk

HENDERSON, Nigel.
Born in St. John's Wood, London, 1 April 1917. Educated at Stowe School, Buckingham, 1931-33; studied biology, Chelsea Polytechnic, London, 1935-36; drawing and painting, Slade School of Fine Art, London 1945-49 (ex-serviceman's study grant); mainly self-taught in photography. Served as a pilot in the Coastal Command, Royal Air Force, with 608 Squadron, Thornaby, Yorkshire, 1939-45: Flight Lieutenant. Married anthropologist Karin Judith Stephen in 1943 (died, 1972); children: Jo, Justin, Edward and Stephen. Worked as an assistant to the picture-restorer Dr. Helmut Ruhemann, National Gallery, London, 1936-39. Freelance documentary photographer, working occasionally for *Vogue, Flair, Architectual Review* and *Melody Maker*, in London, 1948-52, in Essex, since 1952. Founder-Member, with Eduardo Paolozzi, Lawrence Alloway, Richard Hamilton and others, Independent Group, Institute of Contemporary Arts, London, 1952-54. Founder-Director, with Eduardo Paolozzi, Hammer Prints Ltd., wallpaper, textile and ceramic design company, Landermere Quay, Essex, 1955-61. Part-Time Instructor in Creative Photography, Central School of Arts and Crafts, London, 1951-53, and Colchester School of Art, Essex, 1957-65. Lecturer in Charge of Photography Department, Norwich School of Art, Norfolk, 1965-68, and since 1972. Recipient: Edwin Austin Abbey Senior Scholarship, London, 1969. Agent: Anthony D'Offay Gallery, 9 Dering Street, New Bond Street, London W1. Address: The Kings Head, Landermere Quay, Thorpe-le-Soken, Clacton-on-Sea, Essex CO16 ONL, England.

Individual Exhibitions:

1953 *Photo-Images*, Institute of Contemporary Arts, London

1957 Arts Council Gallery, Cambridge, England (with Eduardo Paolozzi)

1960 School of Architecture, Cambridge University, England

1961 *Photo-Images, Collages, Paintings*, Institute of Contemporary Arts, London

1977 *Photographs, Collages, Paintings*, Kettle's Yard, Cambridge, England (retrospective)
 Paintings, Collages, Photos, Anthony D'Offay Gallery, London

1978 *Photographs of Bethnal Green 1949-52*, Midland Group Gallery, Nottingham

Nigel Henderson: *The Troxy, Stepney*, London, 1949

Selected Group Exhibitions:

1953 *Parallel of Life and Art*, Institute of Contemporary Arts, London
1954 *Collages and Objects*, Institute of Contemporary Arts, London
1956 *This Is Tomorrow*, Whitechapel Art Gallery, London

Collections:

Tate Gallery, London; Victoria and Albert Museum, London; Arts Council of Great Britain, London; Eastern Arts Association, Cambridge; Welsh National Gallery, Cardiff; Museum of Modern Art, New York.

Publications:

On HENDERSON: books—*Nigel Henderson: Photographs, Collages, Paintings*, exhibition catalogue, with text by Frank Whitford, Cambridge 1977; *Nigel Henderson: Photographs of Bethnal Green 1949-52*, exhibition catalogue, Nottingham, England 1978; articles—"Notes Towards a Chronology Based on Conversations with the Artist" (by Anne Seymour) in *Nigel Henderson: Paintings, Collages and Photographs*, exhibition catalogue, London 1977; "Nigel Henderson" by David Mellor, interview by Dave Hoffman and Shirley Read, in *Camerawork* (London), September 1978; "Four Years in the Life of Nigel Henderson" in *British Journal of Photography*, (London) January 1979.

When I got involved in photography after the War, I worked, as it were, on two fronts, each reflecting important aspects of my life at that time, which were:
1. I had been given a ex-serviceman's grant to study at the Slade School of Fine Art.
2. My wife, who had studied anthropology in America under Margaret Mead, had been offered a job running a newly-conceived course on sociology in Bethnal Green in the East End of London. It was a condition of her appointment that she should live in the borough.
1. My work at the Slade School was drawing exclusively in the Life Room. I was not very gifted at drawing. I had no facility. It was an uphill struggle to try to delineate, as accurately as I could, what I saw before me. No more than that—an attempt to gain some skill—some small command of what I was about.
2. My wife (nee Judith Stephen) and I both had public school backgrounds. We knew we must experience alienation living in a completely working-class environment. Always a rather withdrawn person, this alienation intensified the feeling that I had that I was watching live theatre. My neighbors seemed to be living out their lives in response to some pre-determined script, as if under post-hypnotic suggestion. The social rites were very strongly moulded, coercive, and seemed to me (because of their unfamiliarity) exotic—however absurd this may sound.

"Limitation of means creates style," said the French painter Georges Braque of painting. I thought this was true of the life around me, as I recognized a sort of poetic homogeneity linking the tired faces of people, of houses, of pavements, of prams and utensils. I soon wanted to get some of this down, and decided to try my hand with a camera.

By the time I had acquired an enlarger, I was in my third year of study at the Slade. Photography was taboo there; I worked at home, buying large quantities of Government Surplus papers cheaply, so that I could print down anything I had a mind to. I was really excited by the simple change of scale of things, and by the possibilities of the photogram. I drew on glass and I floated liquids on it as well. I was involved in a kind of drawing. I would cut out ravelled pieces of cloth and mesh and that war-time glass substitute, and shove them into the enlarger to investigate their projections. The bomb sites were, of course, goldmines of semi-transmuted things, fused, torn, twisted, corroded, eroded. Gradually, this aspect of my work began to predominate, and I began to think of myself as an image-maker working in the medium of photography. This is how I would describe myself now.

—Nigel Henderson

In subject matter, in the way he combines photographic with other elements, and in his attitude towards his work, Nigel Henderson is highly unusual. Brought up in a world of art and artists, he started work as a picture restorer, helped with the hanging of exhibitions, began himself to draw, paint and make collages. After the war, in which he saw the world largely from the air, he and his wife settled in the East End where he started to make photograms, using debris from bomb sites. Later, excited by the "very strong, coherent and highly exotic image of Bethnal Green," he turned to a special kind of documentary photography.

Regarding the detritus of city streets as though he had just arrived from Saturn or a coral beach, he photographed broken hoardings, pieces of sacking, torn posters, roofless dwellings. One of his best-known pictures shows a small tobacconist-cum-sweetshop almost entirely obscured by placards and advertisements. "I want to release an energy of image from trivial data. I feel happiest among discarded things, vituperative fragments cast casually from life, with the fizz of vitality still about them."

To handle such "vituperative fragments" he made use of double exposure, overprints, distortion, crumpling of negatives, drawing on the unexposed film—indeed of every kind of darkroom manipulation—to produce prints, collages or photographic murals. He has created designs for wallpapers and textiles, and made experiments with ceramics. His productions have links with those of surrealist painters, many of whom as a young man he knew and talked to, through a similiar exploitation of casual effects to stimulate memory and imagination.

His own attitude towards his work is completely unpretentious. He never received any formal photographic training, but picked up what knowledge he needed "largely on the linoleum floor of the bathroom." Nor did he ever, he says, "decide that I wanted to be a photographer. I felt I'd like to try taking a camera around with me," and his aim in shooting a picture is "just to get the image in, not to kill it at a blow."

Today, making his living mainly through teaching, he operates in a No-Man's-Land between a variety of art forms, employing a medley of techniques on the basis of a wide experience. The results are regarded with respect, not only by galleries, critics and sociologists, but also by many conventional photographers.

—Tom Hopkinson

HENLE, Fritz.

American. Born in Dortmund, Germany, 9 June 1909; emigrated to the United States, 1936: naturalized, 1942. Educated at gymnasium in Dortmund, 1920-29; University of Heidelberg, 1930, and University of Munich, 1930; studied photography, under Hanna Seewald, at the Bayrische Staatslehranstalt für Lichtbildwesen, Munich, 1930-31, Dip. Photog. 1931. Married Atti van den Berg in 1938 (divorced, 1952); son: Jan; married Marguerite Williams in 1954; children: Maria, Tina, and Martin. Assistant, under Clarence Kennedy, Smith College, Florence, 1931-33; Publicity Photographer, Lloyd Triestino, Trieste, 1934-36; Contract Photographer, *Life* magazine, New York, 1937-41; Photographer, Office of War Information, Washington, D.C., 1942-45; Contract Photographer, under Alexey Brodovitch, *Harper's Bazaar*, New York, 1945-50; Staff Photographer, City Service Oil Company, New York 1951-58; established home and studio, St. Croix, Virgin Islands, 1958; Photographer, European Travel Commission, New York, 1959-62; freelance photographer, in St. Croix, since 1962. Artist-in-Residence, Trinity University, San Antonio, Texas, 1978. Member, Gesellschaft Deutsche Lichtbildner (GDL), 1954-59. Founder Member and Trustee, American Society of Magazine Photographers. Recipient: Photo prizes, *Photography*, New York, 1948, 1950, 1951, 1952, 1954, 1955, 1957; Award of Excellence, Art Directors' Club of Philadelphia, 1954; Picture Contest Prize, *Popular Photography*, New York, 1960. Member, Virgin Islands Academy of Arts and Letters, 1972. Agent: Witkin Gallery, 41 East 57th Street, New York, New York 10022. Address: Post Office Box 723, Christiansted, St. Croix, United States Virgin Islands 00820.

Individual Exhibitions:

1936 *Japan*, Mitsubishi Department Store, Tokyo
1937 *Japan and China*, Rockefeller Plaza Lobby, New York
1943 *Mexico*, private showing in New York
1950 *Hawaii*, Museum of Natural History, New York
1953 New York Camera Club
1954 *Caribbean*, Smithsonian Institution, Washington, D.C. (toured the United States)
1956 *Industrial/Oil Photos*, International Museum of Photography, George Eastman House, Rochester, New York
1957 *Caribbean Movies*, International Museum of Photography, George Eastman House, Rochester, New York
1958 *Caribbean*, Government House, Christiansted, St. Croix, Virgin Islands
1960 *American Virgin Islands in Color*, Government House, Christiansted, St. Croix, Virgin Islands
1962 Staatliche Landesbildstelle, Hamburg
1967 Exhibition Hall, Rollei Werke, Braunschweig, West Germany
1970 Institute of Culture, University of Puerto Rico, San Juan (retrospective)
1971 *American Virgin Islands in Color*, Exhibition Hall, Rollei Werke, Braunschweig, West Germany
1974 New York Cultural Center (retrospective)
1975 Galleria de las Americas, San Juan, Puerto Rico (retrospective)
1976 Galerie am Schloss, Wolfenbuttel, West Germany (retrospective)
1977 Art Museum, Allentown, Pennsylvania (retrospective)
1978 Trinity University, San Antonio, Texas (retrospective)
 Michener Gallery, University of Texas at Austin (retrospective)
1979 *Color Photographs*, Trinity University, San Antonio, Texas
1980 *Fritz Henle: A 50 Year Retrospective*, Witkin Gallery, New York

Selected Group Exhibitions:

1978 *Color and Casals*, University of Texas at Austin

APA International Exhibition of Photography, Tokyo

1980 *Body Electric: Color*, Squibb Institute, Princeton, New Jersey

1981 *Germany: The New Vision*, Fraenkel Gallery, San Francisco

Collections:

Museum of Modern Art, New York; International Center of Photography, New York; International Museum of Photography, George Eastman House, Rochester, New York; Lehigh University, Allentown, Pennsylvania; Gernsheim Collection, University of Texas at Austin; Center for Creative Photography, University of Arizona, Tucson; Foto-Historama Agfa-Gevaert, Leverkusen, West Germany; Landesbildstelle, Hamburg; Fritz Gruber Collection, Cologne; Stadt Museum, Munich.

Publications:

By HENLE: books—*This Is Japan*, with text by Takayasu Senzoku, Munich 1937; *China*, with text by Kwok Ying Fung, New York 1943; *Mexico*, Chicago 1945; *Paris*, with text by Elliot Paul, New York 1947; *Hawaii*, with text by Norman Wright, New York 1948; *The Virgin Islands*, with text by Vivienne Winterry, New York 1949; *Fritz Henle's Rollei*, with text by Vivienne Winterry, New York 1950; *Fritz Henle's Figure Studies*, with an introduction by

Jacquelyn Judge, New York 1954, London 1957; *Great Photographs 2: Fritz Henle*, edited by Norman Hall and Basil Burton, London 1954; *Fritz Henle's Guide to Rollei Photography*, with George B. Wright, New York 1956; *The Caribbean: A Journey with Pictures*, with P.E. Knapp, New York and London 1957; *Photography for Everyone*, with H.M. Kinzer, New York 1959; *Holiday in Europe*, with text by Anne Fremantle, and an introduction by Patrick Dennis, New York and London 1963; *A New Guide to Rollei Photography*, with H.M. Kinzer, New York and London 1965; *The American Virgin Islands*, colorprint portfolio, 1971; *Casals*, with text by Pablo and Marta Casals, New York 1975; *The Rolleiflex SL66 and SLX Way*, with text by L. Andrew Mannheim, London 1975; *Fritz Henle*, with a foreword by Allan Porter, New York 1975.

On HENLE: book—*Fotografie 1919-1979, Made in Germany: Die GDL-Fotografen* edited by Fritz Kempe, Bernd Lohse and others, Frankfurt 1979; articles—"Fritz Henle" in *Popular Photography* (New York), March 1964; "Focus on Fritz Henle" in *Popular Photography* (New York), November 1964; "Fritz Henle" by Beaumont Newhall in *Infinity* (New York), March 1968; "Fritz Henle: Forty Years on Top" by Julia Scully in *Modern Photography* (New York), March 1970; "Fritz Henle" in *Westermann Monatshefte* (Braunschweig, West Germany), February 1972; "Fritz Henle" in *Modern Photography* (New York), March 1972; article by Allan Porter in *Camera* (Lucerne), June 1969; "Fritz Henle" in *Foto Magazin* (Munich), March 1980; "Fritz Henle" in *Humboldt* (Berne), March 1980; "Art: Fritz Henle, Witkin Gallery" by Grace Glueck in the *New York Times*, 2 May 1980; "Who, What,

Where" by Grace Naismith in *Overseas Press Club Bulletin* (New York), 15 May 1980.

One fact which I never emphasized in articles about myself is that I am actually "self-taught." My studies at the Photographic School in Munich merely added to the knowledge which I had already acquired, and, realizing this, my marvellously intuitive and spontaneous teacher, Hanna Seewald, made it possible for me to enter the second year of the curriculum immediately. Her decision was based on a portfolio of my work which I had shown to her and the school's director, for this made it clear to them that I was more than well acquainted with darkroom techniques and that I had spent a considerable amount of time patiently trying to solve problems to which I had wanted to find my own solutions.

It was never enough for me to simply capture an impression on film. As early as the late 1920's I had been impressed by "craftsmanship," and it was this that had led me to set up a small darkroom in the basement of our house in Heidelberg. I cannot count the numbers of hours I spent there, sometimes late into the night, sometimes on the point of desperation when I seemed unable to print a particularly difficult picture which was important to me!

Much of this early work was lost during the war years, but fortunately I took the pictures which were closest to me in America.

I cannot emphasize too strongly the importance of making the darkroom a vital and integral part of one's domain as a photographer. I have done my own darkroom work throughout my career—even when I was working for *Life*, where we had all the facilities imaginable at our disposal for the production of first-class negatives and prints. Later, during the 1950's, when my interest became focused on the Caribbean, I was lucky enough to make the acquaintance of Pat and Julio Motal: to work with them in the darkroom was a marvellous experience, for they were true artists and their experience and virtuosity led to a relationship in which I felt I could entrust my films and printing to them when I was far away on assignments. This relationship became even more important when I decided to leave New York and settle on St. Croix in the American Virgin Islands, for there is a scarcity of water in these islands which makes it impossible to run a successful darkroom.

Not all my work is in black and white, however, and with the advent of Kodak's Ektachrome films I finally found a medium equal to Kodachrome. (It was impossible to use the latter successfully with my Rolleiflex—a fact which at times caused me some distress.)

During the early 1950's, when I first became acquainted with the Caribbean, I also made my first movies there, and two movies of Trinidadian dancers—Geoffrey Holder and his group—have become classics and are now in the collection of George Eastman House and in the Gernsheim Collection at the University of Texas in Austin.

As a photographer who was fascinated from the very beginning by the large square format of the Rolleiflex, I found it impossible to break away from this camera. I am most enthusiastic about the groundglass and the immediacy of composition which it provides, and I trained myself straight away to fill the frame so completely with the image as I had visualized it that cropping was in most cases not only unnecessary but would have actually spoiled the concept of the picture.

I first became acquainted with the Rolleiflex at the Photographic School in Munich in 1930. Across the street from the school was the store, run by Mr. Letzgus, which provided the school with all the necessary materials. Although I did not have the money to buy the camera, my mind was nevertheless made up, and the more I worked with the school's large studio-type cameras, the less convinced I was that they could provide the means for me to express myself in the future. I remember confiding in a fellow student about my admiration for the Rollei-

Fritz Henle: *Pablo Casals and His Wife Martita*, 1973

flex, and her somewhat amused and incredulous reaction hurt my feelings since she was very pretty and we were fond of each other; from then on I decided to keep my other love to myself! In order to become the owner of my first Rolleiflex, I worked long nights in the darkroom doing cheap prints for a drugstore. This was rather an ordeal, since I had to make do with only a few hours' sleep as well as having to prepare for school the next day. But my determination lent me the necessary stamina, and a few months later I was able to surprise my classmates with pictures taken with this "tiny" camera.

Since that time I have stuck to the Rolleiflex. When I came to America in 1936 I realized that very few photographers had broken away from the larger formats, so in order to compete I never showed a sheet of contact prints—that would have been impossible. My editors would look at only 8" x 10" pictures, and I was able to produce beautiful enlargements in this size from my Rollei negatives.

The "secret" came out when the famous Swiss photographer and graphic artist Herbert Matter kindly offered me the use of his darkroom in New York and took a picture of me for the photographers' column in *Life* magazine to accompany my story "Texas High School," which appeared on the cover and twelve pages of the magazine. This was in 1937, a time in which such large coverage was unprecedented, and the question of my "small" camera was never brought up again. It would in any case have ceased to be a problem, since many of the European photographers who emigrated to the United States at that time brought with them not only an entirely new and vigorous way of seeing, but also their equipment, which was new for America. At this time, in 1938, I was working with Alfred Eisenstaedt on a revolutionary idea for the world of fashion. We took our models out of the studio into the lovely countryside of New England; Eisenstaedt worked with his Leica and I with my Rollei, and we achieved some beautifully candid results. The editors of *Life* assured us that we had helped to usher in a new era in fashion—"outdoor fashions"—and it appears that they were right.

Like the rest of us "newcomers," I could probably have stayed with *Life* if I had wanted to. But not everyone fits into the same pattern of development, and during my year in Florence in 1932 and long trips to India and the Far East between 1933 and 1936, I tasted a creative freedom which—despite the loneliness and difficulties of these years in which I was entirely dependent on my own ingenuity—I was unable to find again. This became especially clear when I asked *Life* to send me to Paris to photograph the city, and particularly its inhabitants, in a time in which the impending catastrophe of World War II was latent in the atmosphere. My wish was granted, and I remember these weeks as a tense and vitally interesting period. I was fascinated by the people, and they readily accepted me although my French is not fluent. A photographer is like an actor on the stage: the more self-possessed he is, the more successfully he is able to hide his tension and become part of the show—the show which is life itself. To capture this show in a visual form is, for me, the true meaning of photography. Participation of this kind brings both joy and agony, and the necessary self-imposed discipline can sometimes become a torture. The element of the unknown is always present; one can never be sure...and this results in a great and—at times—almost unbearable intensity. It is this intensity alone which can lead to the creation of valuable and lasting impressions. I experienced this intensity in Paris, as I had on occasions during my trips to India, China, and Japan, and it became increasingly difficult for me to fit into a preconceived framework. I remember the make-shift darkroom which I set up in an attic in Montmartre, the excitement with which I developed my films, and the endless hours which followed—I only had one small tank in which to develop dozens of rolls. I felt sure that I had captured the people of Paris, and all that was necessary was for a skilled writer to collaborate in the creation of a fine story for *Life* magazine.

When I returned to New York, however, my collection was returned, complete with the films—an utter failure. I was in despair. How could I ever find happiness expressing myself?

Many years passed, and a most horrible war went into its final stages. Paris was liberated. A call reached me from the *New York Times*: "Have you ever been to Paris?" Back in 1938, in my disillusionment, I had locked up my Paris negatives in a small safe. Now, a few minutes after receiving the call, I set to work enlarging negative after negative—there must have been about 150 prints by the end, and late that afternoon I presented them to the editor of the *New York Times*, Madame Lazareff, herself a French refugee. Few words were exchanged; she was extremely emotional, and so was I. Next Sunday the paper's magazine section published my pictures of the people of Paris on the cover and four inside pages—images which still spoke the same vivid language that they had spoken five years previously. In fact, they now seemed even more alive, because now I had a reason for my story even more eloquent than before.

At this time I worked closely with Alexei Brodovitch—a man whom I greatly admired, and the combination of his fine vision and my creativity resulted in some of the finest pages in *Harper's Bazaar*. This great artist accepted my approach without question, and I well remember how proud I felt when I visited his art department and saw large photostats of my pictures, some of which have since become well known. My photographs of the "Desert Plant, Nievis—Mexican Indian Beauty" and the almost giddy spiral of the "Lights of New York" all covered full pages in *Harper's Bazaar*; but our greatest accomplishment was the book *Paris* for which Brodovitch did the layout. The picture which struck him most was "Madame Niska," and this, too, was published on a full page in the magazine. I was also represented on the fashion pages, and here again I broke away from the usual style by photographing "fashion in motion."

The years I spent with *Life* taught me a lot; the war years spent taking photographs for the government and my years as a fashion photographer were full of exciting experiences. Over and over again, it became clear that I did my best work when left to find my own solutions. I disliked routine work, and what interested me was finding the beauty in seemingly ordinary subjects.

The place where I decided to make my home, the American Virgin Islands, had never really been fully understood. Its magnificence had been largely overlooked, and one of my more recent achievements is the creation of a collection of pictures of these islands which had previously only been known through pretty picture postcards. In order to gain the freedom to devote myself to this project, I applied for a grant from the Council of the Arts in 1969, and I was most gratified when I received support which by far exceeded my expectations. I immersed myself completely in photographing the islands, and the result was published as a portfolio about 13 inches square, with 24 color pictures mounted individually. These pictures were printed in heliogravure in Switzerland in a rather unusual technique—all the photographs were reproduced from original dye transfer prints, a method which enabled the craftsmen at the Bucher publishing house in Lucerne to have complete control of the rendition of all the colors.

In 1970, *Modern Photography* honored me with a ten-page article entitled "Forty Years at the Top." I was slightly embarrassed by this title, since I am a quiet man by nature and I never force myself into the limelight. I was extremely gratified by the article, however, for I must admit that there have been times when I felt that my work has not received the recognition it deserves. The article was beautifully written by Julia Scully, and the title is really intended to attract the amateur. But how can one be really "on the top?" If we forget about the financial implications, it would appear to me that "top" means the success of a creative artist to express himself through the quality and beauty of his work. "Top" is where the never-ending urge for fulfilment is being realized. And, indeed, it is only when I can truthfully say that I have approached a certain pinnacle with some of my photographs that I can be happy as an artist.

As recently as May 1972, I was able to prove this to myself once again. Not far from my home, on the large neighboring island of Puerto Rico, lived the great musician Pablo Casals. The Institute of Culture of the Government of Puerto Rico invited me to exhibit some of my work in the museum in Old San Juan, a magnificent convent which provided a marvellous background for the show. This was just before the *Casals Festival*, and I expressed my desire to photograph the maestro. The result of the first sitting impressed the great artist and humanitarian so much that he exclaimed, "Beyond photography!" He then went to his cello and repeated the music which he had played while I had photographed him, and, when he had finished, he took the photograph, wrote a few bars of the music—a Bach saraband—and dedicated it to me. This to me *was* the "top," and at the same time I realized how very rare such moments are in the life of a photographer.

To be "on top" is to stand on a hill in 1936 and see the sacred mountain of Fujiyama in the far distance; no pollution hid its beauty then, and it seemed to be floating in the air, like an image on a delicate Japanese silk screen. "On top" is a lonesome plant in the desert—symbol of the eternal struggle for survival. "On top" are the people of Paris—the old man in his almost tragic pose in the deserted street, the "Lady and the God" in a harmony of pose with an element of humor, and the angry "Madame Niska" trying desperately to convince a passer-by of her talents.

These and other pictures are like crystals which have grown over a period of time and now come together to form a composition. They are part of a process of continued development. I consider myself fortunate. "Forty Years on the Top" does not in fact mean much in a lifetime dedicated to photography; more important is the knowledge that, with each step, I can create new possibilities for myself, all of them influenced by a purity of vision and a passionate desire for beauty. Words alone have never satisfied me—it is all too easy to lose oneself in debates on the value of photography. For me, it is the image which counts.

* * *

The preceding thoughts, though I wrote them a few years ago, are as fresh in my mind as they would be today. Photography is making great strides. It is a newborn art. 150 years mean little in the history of mankind. The trends which we experience today have existed practically from the moment that photography became reality. Only relatively few photographers will ever reach the top. To many the medium is a constant struggle—the forced desire to express themselves in ever new ways. And how many ways are there really? It seems there is no limit, and that the only true expression is the way we conceive life in its endless variety and beauty.

—Fritz Henle

"The photographer is like an actor on the stage: the more self-possessed he is, the more successfully he is able to hide his tension and become part of the show—the show which is life itself. To capture this show in a visual form is, for me, the true meaning of photography." In this neat statement Fritz Henle summed up the essence of his work. He has been an observer with the camera for five decades, travelling round the world showing the face of cities, the beauty of scenery, and the life of the people. In

addition he became known for the first fashion photographs taken out of doors, and for a series of brilliant beach nude studies. Though Henle worked for long periods for *Fortune, Life, Harper's Bazaar* and *Holiday*, he prefers being his own boss, which excludes the necessity of having to adapt one's own ideas to those of an editor.

His first book appeared soon after his student days in Munich. His last books include a portfolio of colour shots of the Virgin Islands where he made his home since 1958, as well as a book to accompany his retrospective. In between there have been the fine reportages of Japan and Paris, the moving series on Pablo Casals shortly before his death, and much else. Throughout his life in photography Henle remained faithful to the same camera-make, which has earned him the nickname "Mr. Rolleiflex". Indeed, his vision has adapted itself so well to the square format that he hardly ever has to crop his pictures.

Surprisingly, Henle's work of the 1930's and 1940's does not look "dated." Quite the contrary, it looks very advanced for the time, for Henle had a liking for unorthodox views and angle shots right from the beginning of his career in 1930. One of his pictures of that year is called "Rain": a corner of a wet road is illuminated by a street lamp; a tree is silhouetted against the faint light; the whole scene is photographed from above. Very concise. Nothing superfluous. Typical Henle. Arriving in New York from Germany six years later, he created one of his first New World pictures: a car radiator grille from below against the backdrop of the towering RCA building. Back in Paris he spotted a woman resting her feet underneath the huge sculpture of a rivergod apparently doing the same. The harmony of pose combined with the humorous element to make an unforgettable picture.

Like most of the classic photographers Henle stresses the "Art of Seeing." He finds beauty in everyday subjects, and the world full of beauty. He is of a happy, positive nature and shuns all discord, in life as in work. Having viewed the world through his lens for 50 years, he has found it a novel experience in the last few years to see the public viewing the world through his images, which are "the expression of my love of life in all its variety."

—Helmut Gernsheim

HENRI, Florence.

Swiss. Born in New York City, 28 June 1893. Studied piano, under Egon Petri and Ferruccio Busoni, Berlin, 1911-14; studied painting, Academy of Fine Arts, Berlin, under Schwitters, 1914, Hans Hofmann School of Arts, Munich 1915-19, at the Académie André L'Hote, Paris, 1922-23, and under Fernand Léger and Amedee Ozenfant, at the Académie Moderne, Paris, 1924-25; studied painting and photography, under Josef Albers and László Moholy-Nagy, at the Bauhaus, Dessau, Germany, 1927. Married a Swiss national, Charles Coster, in the 1930's; subsequently divorced. Freelance portrait, fashion and advertising photographer, Paris, 1929-63: maintained a studio in Paris, and also taught photography there, 1928-47; associated with the Cercle et Carré group of artists, Paris, in the 1930's. Also a painter: exhibitions—Galerie Nebelung, Dusseldorf, 1952; Studio für Neue Kunst, Wuppertal, 1953; Duisburger Bucherstube, Duisburg, 1953; Hanover Gallery, London, 1969; and Galerie Lowepelz, Zurich, 1979. Has lived in Bellival, France, concentrating on painting, since 1963. Address: c/o Galleria Martini & Ronchetti, via Roma 9, 16121 Genoa, Italy.

Individual Exhibitions:

1930 Studio 28, Paris
1931 Galerie Laxer Normand, Paris
1933 *Photoausstellung Florence Henri*, Museum Folkwang, Essen (travelled to the Galerie La Pleiade, Paris, 1934)
1974 Galleria Martini & Ronchetti, Genoa
1975 Martini and Ronchetti Gallery, New York
Galerie M, Bochum, West Germany (with Bernard Descamps)
Galleria Martano, Turin
1976 Galleria Milano, Milan
Galleria Pan, Rome
Aspekte der Photographie der 20er Jahre, Westfälischer Kunstverein, Munster, West Germany
Staatliche Kunsthalle, Baden-Baden, West Germany
M.L. D'Arc Gallery, New York
1977 Galleria Martini & Ronchetti, Genoa
1978 University of Parma, Italy
Musée d'Art Moderne de La Ville, Paris
Galleria Narciso, Turin
1979 Galleria G7, Bologna
Aspetti di un Percorso, Banco di Chivari, Genoa
Villa Romana, Florence
The Photographers' Gallery, London

Selected Group Exhibitions:

1925 *L'Art d'Aujourd'hui*, Syndicat des Antiquaires, Paris
1929 *Photographie der Gegenwart*, Museum Folkwang, Essen
Film und Foto, Deutscher Werkbund, Stuttgart
1932 *Modern European Photography*, Julien Levy Gallery, New York
1937 *Foto '37*, Stedelijk Museum, Amsterdam
1970 *Photo Eye of the 20's*, Museum of Modern Art, New York (toured the United States)
1975 *Women of Photography*, San Francisco Museum of Modern Art (toured the United States, 1975-77)
1978 *Paris-Berlin*, Centre Georges Pompidou, Paris
1980 *Avant-Garde Photography in Germany 1919-39*, San Francisco Museum of Modern Art (toured the United States, 1981-82)
1981 *Germany: The New Vision*, Fraenkel Gallery, San Francisco

Collections:

Bibliothèque Nationale, Paris; Centre Georges Pom-

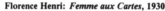

Florence Henri: *Femme aux Cartes*, 1930

pidou, Paris; Museum Folkwang, Essen; University of Parma; Museum of Modern Art, New York; San Francisco Museum of Modern Art.

Publications:

On HENRI: exhibition catalogues—*Florence Henri* by Ester de Miro, Genoa 1974; *Florence Henri: Una Rieflessione sulla Fotografia* by Maurizio Fagiolo, Turin 1975; *Florence Henri: Aspekte der Photographie der 20er Jahre* by Herbert Molderings, Munster, West Germany 1976; *Florence Henri* by Suzanne Pagé and Herbert Molderings, Paris 1978; *Florence Henri: Aspetti di un Percorso* by G. Marcenaro, G. Martini, and A. Ronchetti, Genoa 1979; articles— "Florence Henri" by László Moholy-Nagy in *I 10* (Amsterdam), 1928; "Florence Henri: A Grand Dame of Photography" by Romeo E. Martinez, in *Camera* (Lucerne), September 1967; "Florence Henri" in *Creative Camera* (London), July 1972; "Le Fotografie alla Seconda di Florence Henri" by Claudio Marra in *G7 Studio* (Bologna), January 1979.

Born in New York in 1893 of a French father and a German mother, Florence Henri, on the death of her mother, left for Silesia where she settled in with her mother's family; there, she learned to play the piano. At the age of 9 she moved to Paris, at 11 to Vienna, at 13 to England (the Isle of Wight). When she was 16 her father died and she settled in Rome. There she was to meet the most brilliant artistic avant-garde of her time: the futurists and in particular Marinetti. Her life was to be a mirror image of her youth: a series of changes and encounters. Her friends, her contacts, were Arp, Moholy-Nagy, Maiakowsky, Lissitsky, Léger, Larionov, Delaunay, Mondrian, Gropius. There were no photographers (or very few) among her artistic liaisons. Her interest changed from music to painting. A determining factor in her future life, however, was a period she spent at the Bauhaus in 1927 where her teacher was Moholy-Nagy. It was probably he who caused her to choose photography as her preferred means of expression.

Almost immediately that she determined what her career was to be, Florence Henri devoted herself to the most exacting research. While pictorialists were trying to ape the painting of 50 years before, applying purely and simply recipes invented by others for another medium, Henri, taking into account the most vital developments in the plastic arts of her time (painting, cinema), invented, along with a few others, a new language for photography at a time when photography was beginning to enjoy a rebirth. Moholy-Nagy dreamed of a camera employing the dark chamber but eliminating the representation of perspective, a camera fitted with lenses and mirrors able to catch an all-round view of the subject, creating "light frescoes," optical compositions that could not be achieved with canvas, brush and paint. Florence Henri followed this direction of research when in her portraits, self-portraits and still-lifes, she used mirrors to multiply the image and its reflections, to distort space and alter planes, awakening our astonished perception with mysterious but simple images, surprisingly rigorous in their subtle luminosity—or when she photographed glass surfaces, transparent and at the same time reflective, recording readymade superimposed images, in the manner of photos produced 40 years later by Friedlander.

Florence Henri, who now lives in a small village in the Oise, has generally been forgotten. But over the past few years—thanks particularly to the Musée d'Art Moderne (ARC) Paris, to Suzanne Pagé and Catherine Thiek—her remarkable and exciting work is gradually being rediscovered. Contact with it evokes in the observer, in its very ambiguity, a feeling of joy and excitement provided today by very few other artists.

—Michel Nuridsany

HERRAEZ GOMEZ, Fernando.

Spanish. Born in San Fernando, near Cadiz, 26 September 1948. Educated at a school in San Fernando, 1958-65; self-taught in photography. Served in Spanish Army, 1967-68. Independent photographer, Madrid, since 1972. Agent: Canon Gallery, Reestraat 19, Amsterdam, Netherlands. Address: Calle San Cristobal no. 10-5°, San Fernando, Cadiz, Spain.

Individual Exhibitions:

1978 *Village Festivity in Spain*, Canon Gallery, Amsterdam (travelled to Galerie Trockenpresse, West Berlin)
 Caja de Ahorros, Pamplona, Spain

1979 Galerie Contrejour, Paris
1980 Photographic Center, Athens
1981 Galerie AAA, Brussels
 Galerie Delpire, Paris

Selected Group Exhibitions:

1978 *Ritos y Minorias*, Photogaleria, Madrid
1980 *Madrid: Photojournalism*, The Poetry Centre, London

Collections:

Museo de Arte Moderno, Cuenca, Spain; Stedelijk Museum, Amsterdam.

Fernando Herraez Gomez: *Untitled*, 1976

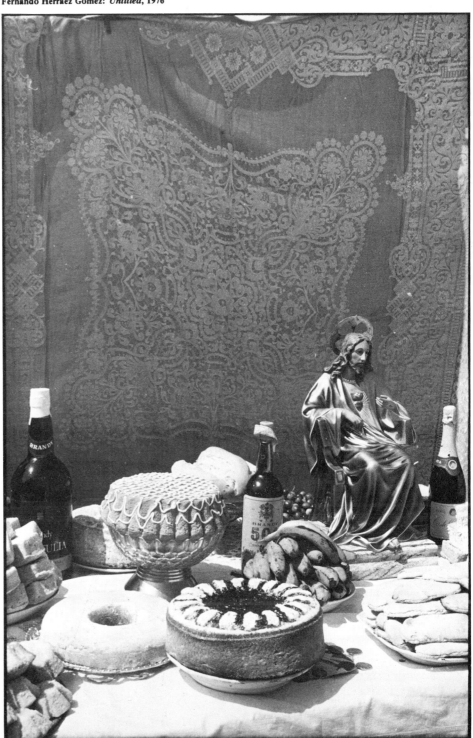

Publications:

By HERRAEZ: book—*España, Años y Leguas*, with Ramón Zabalza, Madrid 1980; articles—"Bloed, Pijn en Pret" in *Panorama* (Haarlem), 3 August 1979; "Het Rijke Roomse Iberie" in *Avenue* (Amsterdam), January 1980.

On HERRAEZ: articles—"Photographie Actual en Espagne" by Belen Agosti in *Contrejour* (Paris), March/April 1976; "Fernando Herraez" by Ignacio Barceló in *Arte Fotografico* (Madrid), December 1976; "Portfolio of the Month: Fernando Herraez" by Lorenzo Merlo in *Reflexions* (Amsterdam), January 1978; "Fernando Herraez" by Ramón Zabalza in *Zoom* (Madrid), December 1978; "L'Oeil Iberique" by Jacques Marchois in *Photo-Reporter* (Paris), March 1979; "Bede Vaarten en Processies" by Wim Broekman in *Foto* (Amersfoort, Netherlands), May 1979; "Spanish Photography in the 80's" by Joan Fontcuberta in *European Photography* (Göttingen), April 1980.

For the past 8 years, I have been working on a single theme—that of fiestas in Spain and Portugal. At present I am working on new projects but still with my own subjective perspective, using the subject merely as a pretext for making photographs.

As far as the type of work I am developing is concerned, there is no official financial support in Spain.

Concerning the world of photography, my preferences include the work of Arbus, Robert Frank, Weegee, Bellocq, but very few others.

—Fernando Herraez Gomez

Among young Spanish photographers committed to creative photography, Fernando Herraez is important for his extremely descriptive style. Basically, his photography concentrates on the man in the street, avoiding bitter social commentary or any other kind of moralistic analysis.

Herraez was born in Andalusia and is a devoted observer of human behavior within communities hardened by the difficulties of agricultural life. Also because of his background, he does not look for extreme attitudes or for obvious expressiveness in his subjects. He is not a spectator (as one without a deep knowledge of his subject would be), ready and over-eager to achieve an easy photographic impact. His works have a deliberate slowness. They describe one kind of common life from the point of view of his own beliefs and his own symbols. The aspects of his subjects that most interest him are those that are least controlled and most casual—but they are full of realism and naturalness, derived from a profound knowledge of tradition.

From this perspective, his depictions of Spanish fiestas are compelling: with great skill, his camera captures images of the street, groups or individuals; there is great sensitivity to the customs involved, but he does not rely on obvious effects. He is interested in ceremonies, temporal rites, particularly those originally inspired by religious fervor that have both penetrated the popular consciousness and eventually lost their liturgical origins and developed a more complex symbolism.

Herraez's images are not so much concerned with a depiction of the celebration itself as with that of the conflict between the daily ambience of a place and its atmosphere during fiesta, when everyday life experiences a temporary transformation. Aesthetic qualities, psychology and existential aspects are mixed in his images. No matter what the subject, however, his camera does not register it rigidly, according to some program; he allows, always, the co-existence of different aspects, the varied facets of human attitudes.

Herraez almost never allows people to pose. He waits for the simple gesture, deep and revealing but not too anecdotic. In the seriousness, distractions, concentration and meetings of his subjects, he finds his images, keys to the manners of a people. His photographs do not depict ebullience; they go directly to the telling of a moment that has to do with communal realities, that manifests all the weight of popular culture—a boy playing with a cross, an Easter procession, the running for *toros*, holy scenes, masked people.... Seen by Fernando Herraez they reveal much more than just their external forms.

—M. Teresa Blanch

HERS, François.

Belgian. Born in Brussels, 20 March 1943; moved to Paris in 1968. Educated at secondary schools in Belgium, Saint Michel in Brussels and Cardinal Mercier in Braine l'Alleud; self-taught in photography. Freelance photographer, Paris, since 1968. Founder Member, with Hervé Gloaguen, Guy Le Querrec, Martine Franck, Claude Raimond-Dityvon, and others, Viva photographers group, Paris, since 1972. Recipient: Fondation Nationale de la Photographie Fellowship, Lyons, 1976; Ministère de la Culture Belge Grant, 1978. Address: 5 rue Santos Dumont, 75015 Paris, France.

Individual Exhibitions:

1981 *Intérieurs: Photographies de François Hers et Sophie Ristelhueber*, Centre Georges Pompidou, Paris

Selected Group Exhibitions:

1973 *Viva: Familles en France*, Galeria 11 Diaframma, Milan (travelled to the French Consulate, New York; The Photographers' Gallery, London; International Cultureel Centrum, Antwerp; and Optica Gallery, Montreal, 1973-76)

Francois Hers: *Autisme*, Paris, 1971

1974 *Viva Photographers*, Centaur Gallery, Montreal
1975 *Viva*, French Cultural Center, New York
 Rencontres Internationales de Photographie, Arles, France
1976 *Viva Fotografien*, Galerie Wilde, Cologne
1977 *Photos from Viva*, Side Gallery, Newcastle upon Tyne
 10 Ans de Photojournalisme en France, Musée Galliera, Paris
 A Certain Image of French Photography, Fondation Nationale de la Photographie (Lyons) travelling exhibition (toured the United States)
1980 *Biennale de Paris*, Musée d'Art Moderne, Paris
 Political Photographs, Project Studio One, New York

Collections:

Bibliothèque Nationale, Paris; Fondation Nationale de la Photographie, Lyons.

Publications:

By HERS: books—*Intérieurs: Photographies de François Hers et Sophie Ristelhueber*, with an introduction by Jean-François Chevrier, Brussels and Paris 1981; *François Hers: Le Récit*, with text by Jean-François Chevrier, Paris 1981; articles—Reportage sur la Police" in *Zoom* (Paris), no. 32, 1975; "Les Reporters pendant la Révolution Portugaise" in *Photo* (Paris), no. 99, 1975.

On HERS: article—"Viva Looks at Family Life" in *Amateur Photographer* (London), 7 March 1973; radio broadcast—"François Hers: Photographe," French Radio, November 1980.

What is the function of photography? I find the answer to this question, which determines all my work, in certain images. I find it, too, in the performances I produce when the opportunity arises or where I find it necessary.

1967: "Take photos or take them from your family albums and tell the story of your life from birth to death." With the selection that

resulted I carried out a commission to decorate a large wall in a factory with images.

1969: In a multinational advertising agency on the occasion of a preview, I took a photograph of each employee, enlarged it to the format of an advertising poster and exhibited it in the precise position where each employee worked.

1970: At a workshop in one of the Beaux-Arts schools, on the theme, What is photography? I placed my cameras on a table and asked the students in turn and when they felt like it to be photographer and photographed.

1971: At a center for mentally and physically handicapped children I took photos and projected them without comment. The children recognized themselves as in reality, but the medical personnel didn't recognize the children with whom they lived all the time.

1972: Co-Founder of the Viva group. I suggested that each member report on the theme, "Family Life." Each of us lived for some weeks with a family in France. We produced an exhibition of these reportages that circulated throughout Europe and North America but was rejected in France.

1976: For a commission on the "40th Anniversary of Holidays with Pay" I photographed the French on holiday and composed an ethnographic record under the headings, *Initiation—Memory—Totems.*

1977: Intervention in a retrospective exhibition on photojournalism. I produced a mural panel of 2 x 5 metres made up of six photos which show that all press photography is a fiction—a fiction which I create which does not need captions.

1976/
79: I produced a photographic and autobiographical fiction in the form of a book and an exhibition. I returned to my country, Belgium, and searched there for the secular and contemporary myths of my culture.

1980: An exposure of myself as a reporter. I studied the relationship of the photographer and his subject. The subject is naked; my left hand enters the frame and comes into contact with him; my right hand takes the photograph.

1981: *François Hers: Récit*—a book. A summing up and two complex ensembles—images, texts, lay-outs.

—François Hers

François Hers is careful to present his photographs in groups which are relevant to him as "reportage." The term signifies a manner of reflecting on photography; it is also a method of reflecting *by* photography—the contradictions of which he does not try to avoid. His work involves a balance between reasoning and spontaneity, which is not so apparent in each individual photo (as it would be, say, with Cartier-Bresson, who is a rather distant influence) as in the group or movement created by the whole. His improvisation is guided by an initial decision: it defines the aim of the reportage, its final state, and the necessary technical resources, but it also involves the right of freedom along the way.

In his view every photographic investigation is an action: if it is necessary, it is worth carrying through. He defines for himself its preliminary significance. In certain instances this approach could be related to conceptual research and extend far beyond the photographic context. But Hers acknowledges that the "meaning" of the action undertaken is basically unforeseeable.

Hers is not much attracted to that unique and irreplaceable miracle-photography practiced by a large school, more or less successfully, in France. He does not look for that balance between availability and mastery of chance, but he does admit that anyone who works with the instantaneous commits

himself to a long and mainly unconscious adventure without reliable points of reference.

Hers is not searching for the photographic "happening." He likes to say that he does not know how to see, that he perceives atmosphere rather than visual organization. He readily goes very close to his subject until he can touch it. These characteristics suggest a comparison with William Klein.

His reportage, in fact, involves two contradictory and yet complementary tendencies: the need for decision, for preliminary and considered choice, and the inability of any image to satisfy a search which is in principle indefinite, because it is, of course, autobiographical. It is not surprising that the greatest number of pictures in his book *François Hers: Récit* are of Belgium where he was born and lived for a long time.

—Jean-François Chevrier

HEYMAN, Abigail.

American. Born in Danbury, Connecticut, in 1942. Studied at Sarah Lawrence College, Bronxville, New York, B.A. 1964; studied photography under Ken Heyman (no relation) and Charles Harbutt, 1967. Freelance photographer, working for *Life, Time,* the *New York Times, Ms.,* etc., New York, since 1967. Affiliate Member, Magnum Photos cooperative agency, New York. Visiting Instructor, International Center of Photography, New York, New School for Social Research, New York, and Apeiron Workshops, Rochester, New York. Address: 40 West 12th Street, New York, New York 10014, U.S.A.

Individual Exhibitions:

1975 Friends of Photography, Carmel, California (with Paul Caponigro)
1979 Arizona State University, Tempe

Publications:

By HEYMAN: book—*Growing Up Female: A Personal Photo-Journal,* New York 1974.

On HEYMAN: articles—"Abigail Heyman and Imogen Cunningham" by A.D. Coleman in the *New York Times,* 30 June 1974, reprinted in Coleman's *Light Readings: A Photography Critic's Writings 1968-1978,* New York 1979; "Abigail Heyman" in *In/Sights: Self-Portraits by Women,* edited by Joyce Tenneson Cohen, London 1979.

Abigail Heyman is known primarily for the feminist-inspired works found in her book, *Growing Up Female: A Personal Photo-Journal,* which is an attempt to document, to capture, a sense of the struggle all women experience growing up in a male-dominated society. As she says in her introduction, "This book is about women, and their lives as women, from one feminist's point of view. It is about what women are doing and what they are feeling, and how they are relating to their mates, their children, their friends, their interests, and themselves."

The photographs show girls and women engaged in activities that promote the kinds of stereotyped roles which often lead to isolation, frustration, and alienation. Scenes such as girls playing with dolls;

children playing hospital in which the boys are doctors and the girls are nurses; pensive young women tending children while the husband eats by himself; or another woman sitting alone at the laundromat—all present a strong and consciously biased point of view. Because the images come from autobiographical experience and deep personal feeling, they leave little room for debate. Much of their effect comes from the intensity of feeling from which they were created.

When Heyman photographed for "Espejo," a project documenting the Mexican-American culture in California, she naturally focused on the female experience. Weddings and other rituals provided scenes in which to study clothing, attitudes, and expressions of these women who exist in a milieu dominated by an overtly macho sensibility. But because these girls and women come from a different cultural background than she does, Heyman's photographs are somewhat reserved; they are less judgmental than her other works. Nevertheless, her basic sympathy for women's identity struggle in a male-oriented culture still shows through. Her ardent concern for this issue is matched only by her strong desire not to separate her art from her life. She obviously believes that photography should reflect the realities of our lives.

—Ted Hedgpeth

HILL, Paul.

British. Born in Ludlow, Shropshire, 15 December 1941. Educated at Ludlow Grammar School, 1952-55; Oswestry Boys' High School, Shropshire, 1955-58; self-taught in photography. Married Angela Starkey in 1964; children: Samantha and Dominic. Reporter, *Border Counties Advertiser* newspaper, Oswestry, 1959-61; Outdoor Pursuits Instructor, Plas Gwynant, North Wales, 1962; Reporter and Columnist, *Express and Star* group, Wolverhampton, 1962-65; freelance photographer, working for *The Observer, Telegraph Magazine, Financial Times, Radio Times, New Society, The Guardian,* etc., London, 1965-74. Since 1976, Founder-Director, The Photographers' Place workshop and study centre, Bradbourne, Derbyshire. Part-time Lecturer, 1971-74, Senior Lecturer, 1974-76, and Principal Lecturer in Creative Photography, 1976-78, Trent Polytechnic, Nottingham; Visiting Lecturer, Derby Lonsdale College of Higher Education, 1980-81. Since 1978, Visiting Lecturer, Sheffield Polytechnic. Chairman, Photography Committee, West Midlands Arts Association, 1974-75; Secretary, Society for Photographic Education, 1974-75; Member of the Photography Committee, 1977-80, and Chairman of the Support to Photographers Committee, 1978, Arts Council of Great Britain. Recipient: Midland Press Photographer of the Year Award, 1967. Address: The Photographers' Place, Bradbourne, Ashbourne, Derbyshire DE6 1PB, England.

Individual Exhibitions:

1971 Wolverhampton Art Gallery
1972 The Photographers' Gallery, London
1973 Birmingham Repertory Theatre
1975 *Remnants and Prenotations,* Arnolfini Gallery, Bristol

The Warwick Gallery, England (with Thomas Joshua Cooper)
3 Photographers, Galleria Il Diaframma, Milan (with Thomas Joshua Cooper and John Blakemore)
1976 *Tom Cooper and Paul Hill*, Friends of Photography, Carmel, California (travelled to the University of Oregon, Eugene)
1977 *3 Photographers: Cooper, Hill, Moore*, Focus Gallery, San Francisco (with Thomas Joshua Cooper and Raymond Moore)
La Photo Galerie, Madrid
Photographers' Gallery, Melbourne
Fotogaleriet, Oslo
1978 Robert Self Gallery, London
Arnolfini Gallery, Bristol
Canon Photo Gallery, Amsterdam
1979 Photographic Gallery, Cardiff
Ian Birksted Gallery, Hampstead, London
Spectro Arts Workshop, Newcastle upon Tyne
Salzburg College, Austria
Photogallery, St. Leonards-on-Sea, Sussex
1980 Graves Art Gallery, Sheffield
Sudley Art Gallery, Liverpool
1981 Camden Arts Centre, London
Contrasts Visions Gallery, London
Work Gallery, Zurich
Leeds Playhouse Gallery

Selected Group Exhibitions:

1966 *World Press*, The Hague
1973 *Serpentine Photography '73*, Serpentine Gallery, London
1975 *Young British Photographers*, Museum of Modern Art, Oxford (toured Europe and the United States)
1977 *Photography into Art*, Kassel, West Germany (toured Europe and the United States)
1979 *Contemporary European Photography*, at *Venezia '79*
1980 *Old and Modern Masters of Photography*, Victoria and Albert Museum, London
1981 *Photography as Medium*, British Council, London (and world tour)

Paul Hill: *Girl in Striped Shirt*, Matlock Bath, 1976

Collections:

British Council, London; Victoria and Albert Museum, London; Arts Council of Great Britain, London; Department of the Environment, London; Graves Art Gallery, Sheffield; West Midlands Arts Association, Sheffield; East Midlands Arts Association, Loughborough; Gwent College of Higher Education Library, Newport; Bibliotheque Nationale, Paris; Moderna Museet, Stockholm; Visual Studies Workshop, Rochester, New York.

Publications:

By HILL: books—*Dialogue with Photography*, with Thomas Cooper, London and New York 1979; *Understanding Photography*, London and New York 1981; articles—"Cause for Concern" in *Photography* (London), October 1969; "Covering the Candidates" in *Photography* (London), November 1970; "Is Photography a Non-Art?" in *Artefact* (Loughborough), no. 1, 1972; "Photojournalism—The British Obsession" in *Photographic Journal* (London), November 1973; "Can British Photography Emerge from the Dark Ages?," with Thomas Cooper, in *Creative Camera* (London), September 1974; "Apropos Great Britain" and "Apropos Arles" in *Camera* (Lucerne), August and November 1976; "Young Contemporaries: Introduction" in *Creative Camera Yearbook*, London 1977; "Photographic Truth, Metaphor and Individual Expression" in *3 Perspectives on Photography*, exhibition catalogue, London 1979; "Photo-initiatives in Europe: The Photographers' Place" in *European Photography* (Göttingen), July/September 1980; film—script and commentary, with Thomas Cooper, for *Arena: Paul Strand*, BBC Television, 1976.

On HILL: books—*Serpentine Photography '73*, exhibition catalogue, by Peter Turner, London 1973; *Young British Photographers*, exhibition catalogue, by Chris Steele-Perkins and Mark Edwards, Oxford 1975; *Photography into Art*, exhibition catalogue, edited by Floris Neusüss, Kassel, West Germany 1977; *Geschichte der Photographie im 20. Jahrhundert/History of Photography in the 20th Century* by Petr Tausk, Cologne 1977, London 1980; *Exploring Photography* by Bryn Campbell, London 1978; *Photography as Medium*, exhibition catalogue, by Teresa Gleadowe, London 1981; *About 70 Photographs*, edited by Chris Steele-Perkins and William Messer, London 1981; articles—"Camera Flashes of Pure Insight" by Anthony Everitt in the *Birmingham Post*, June 1971; "Paul Hill" by Robert Ray in *The Guardian* (London), June 1971; "On View" by Ainslie Ellis in *British Journal of Photography* (London), 23 May 1975; "Paul Hill and Thomas Cooper" in *Artweek* (Oakland, California), 17 July 1976; "Shows We've Seen" in *Popular Photography* (New York), November 1976; "Three British Photographers" in *Artweek* (Oakland, California), 22 January 1977; "Singular Realities" in *The Guardian* (London), March 1977; "Paul Hill and the New British Photography" by Els Sincebaugh in *Camera 35* (New York), November 1977; "Paul Hill: Dynamic in British Photography" by Inge Bondi in *Printletter* (Zurich), January 1978; "Art Review" by Marina Vaizey in the *Sunday Times* (London), 5 February 1978; "Art: Welds and Weaves" by John McEwan in *The Spectator* (London), 11 February 1978; "Photography" by Caroline Tisdall in *The Guardian* (London), 29 January 1979; "Britain's New Wave" in *Modern Photography* (New York), February 1979; "Photomaster Class" in *The Observer Magazine* (London), 8 April 1979; "Viewed: Paul Hill" in the *British Journal of Photography* (London), 13 July 1979; "Photography: Social and Sensual" by Sarah Kent in *Fotografie als Kunst*, Cologne 1979; "Contemporary European Photography" by Sue Davies in *Photography: Venezia '79*, Milan and New York 1979.

Photography has provided me with a vehicle for exploring and observing both the external and the internal. No other medium can do these things as well as photography can. The symbiotic relationship between form and content in photography gives it great power. But the monumental importance of its unique qualities is rarely considered. This only reflects the myopia of most people when considering something so ubiquitous as photography. This ignorance also reflects the lamentable state of visual education, in both practice and theory. Considering the welter of photographic imagery bombarding us each day, this neglect is inexcusable.

Photography is more than Art—and it is more than a vehicle for information. The subject matter in my photographs is crucial, but I hope the images transcend the purely representational. For me, the photographic print *is* the "event," not an "objective" record of what was in front of the camera at the time of exposure. First-hand experience of the actual world is a different "event," which I find too complicated, or too transitory, to record. The camera anchors me to an idea or a place, and this helps me filter out the surplus and superficial elements in order that I might get somewhere near the essence of my existence.

—Paul Hill

Paul Hill's life in photography has been shaped by his conviction that the photographic record is more than a simple inventory of appearances. The discovery of what, for him, is the nature of that further dimension, and the need to communicate with others about it, led Paul Hill away from commercial photographic documentation towards an area most readily described as a fine art orientated practice, located within the context of photographic education.

Happy conincidences of chance and directed effort have brought about Paul Hill's progress through major institutions, such as Trent Polytechnic and the Arts Council, to a situation in which, running his own small photographic workshops, he has largely reconciled the different aspects of his ambitions.

Certain parallels may be inferred in the evolution of Paul Hill's photographs. Those made during the first phases of his commitment to photography considered as art were presented at the Arnolfini

Gallery, during 1975, under the generic title *Prenotations*. Their tenor is urban and technological. The angularities, burn outs and fragmentations bring an atmosphere of the synthetic and the mass-produced even to those images dealing with the natural and the craft-made. Dictates of framing and the effects of abnormal brightness ranges are imposed as a major component of a perceiver's experience of the photographs, and contribute to the sense of stressfulness evoked. Indeed, the title itself refers to the idea that the moments shown contain disquieting, enigmatic prefigurations of impending events.

Although subsequent work remained visually tense, as a result of his concern with the dynamics and ambiguities available through the employment of unconventional framing techniques, certain shifts in emphasis, especially the increasingly domestic subject matter, led to a great reduction in the anxiety to be seen in Paul Hill's images.

Since living in the Derbyshire countryside Paul Hill has made what he considers to be an inevitable further move into photographs dealing with the landscape in terms of man's marks upon it, while continuing to attend to the properties of the photographic medium as a mark-making process. The keynote is now one of contemplation and balance, rather than agitation. As Paul Hill says: "I feel that I am attempting to reach my psychological 'bedrock' which I am certain is unaffected by chronological time."

—Philip Stokes

HILLIARD, John.

British. Born in Lancaster, 29 March 1945. Studied at Lancaster College of Art, 1962-64; St. Martin's School of Art, London, 1964-67, Dip. A.D. 1967. Artist and photographer since 1967. Part-time Instructor, Somerset College of Art, Taunton, 1968-71. Part-time Lecturer, Brighton Polytechnic, 1969-76, and since 1979. Recipient: Visual Arts Fellowship, Northern Arts Association, 1976-78. Agents: Lisson Gallery, 56 Whitfield Street, London W1, England; John Gibson Gallery 392 West Broadway, New York, New York 10012, U.S.A.; and Galerie Durand-Dessert, 43 rue de Montmorency, 75003 Paris, France. Address: 97 Balfour Street, London SE17, England.

Individual Exhibitions:

1969 Camden Arts Centre, London
1970 Lisson Gallery, London
1971 Lisson Gallery, London
1973 Lisson Gallery, London
1974 Museum of Modern Art, Oxford
 Galleria Toselli, Milan
1975 Lisson Gallery, London
 Galleria Banco, Brescia, Italy
1976 Galerie Hetzler + Keller, Stuttgart
 Galerie Durand-Dessert, Paris
 Robert Self Gallery, Newcastle upon Tyne
1977 Badischer Kunstverein, Karlsruhe
 Galerie Durand-Dessert, Paris
 Paul Maenz Gallery, Cologne
1978 Galerie Akumulatory 2, Poznan, Poland
 Galleria Banco, Brescia, Italy
 Studio Paola Betti, Milan
 John Gibson Gallery, New York
 Lisson Gallery, London
 Laing Art Gallery, Newcastle upon Tyne

1979 Ikon Gallery, Birmingham
 Galerie Foksal, Warsaw
 Galerie Durand-Dessert, Paris
1980 Galerie Max Hetzler, Stuttgart
 Lisson Gallery, London

Selected Group Exhibitions:

1971 *New English Enquiry*, at the *Bienal de São Paulo*
 Prospect '71, Kunsthalle, Dusseldorf
1972 *The New Art*, Hayward Gallery, London
1976 *Arte Inglese Oggi*, Palazzo Reale, Milan
 The Artist and the Photograph, Israel Museum, Jerusalem
1977 *Malerei und Photographie im Dialog*, Kunsthaus, Zurich
 Documenta 6, Kassel, West Germany
 Hayward Annual, Hayward Gallery, London
 Biennale, Musée d'Art Moderne, Paris
1979 *Photographie als Kunst 1879-1979*, Tiroler Landesmuseum Ferdinandeum, Innsbruck, Austria (travelled to Neue Galerie am Wolfgang Gurlitt Museum, Linz, Austria; Neue Galerie am Landesmuseum Joanneum, Graz, Austria; and Museum des 20. Jahrhunderts, Vienna)

Collections:

Tate Gallery, London; Victoria and Albert Museum, London; Leeds City Art Gallery; Centre Georges Pompidou, Paris; Musée d'Art Moderne, Grenoble; Musée d'Art Moderne, Toulon; Kunsthalle, Hamburg; Kunsthaus, Zurich; Museum of Fine Arts, Lodz, Poland; Art Gallery of South Australia, Adelaide.

Publications:

By HILLIARD: books—*Elemental Conditioning*, Oxford 1974; *Black Depths, White Expanse*, London 1976; *From the Northern Counties*, London 1978; articles—"Unpopulated Rural Black and White Exteriors, Populated Urban Colored Interiors" in *Aspects* (London), Winter 1977; "John Hilliard," interview, with Ian Kirkwood, in *Art Log* (London), Summer 1978; "John Hilliard," interview, with Colin Painter, in *Aspects* (London), Autumn 1978.

On HILLIARD: books—*The New Art*, exhibition catalogue, by Anne Seymour, London 1972; *Arte Inglese Oggi*, exhibition catalogue, by Luca Venturi and others, Milan 1976; *Analytical Photography* by Manfred Schmalreide, Karlsruhe 1977; *Fotografie als Kunst/Kunst als Fotografie* by Floris Neusüss, Cologne 1979; *Kunst als Photographie* by Peter Weiermair, Innsbruck 1979; articles—"3 Pieces by John Hilliard" in *Studio International* (London), April 1972; "Artist as Filmmaker" by Annabel Nicolson in *Art and Artists* (London), December 1972; "From Sculpture to Photography: John Hilliard and the Issue of Self-Awareness in Medium Use" by Richard Cork in *Studio International* (London), July/August 1975.

I used photography initially as artists have been able to do for approximately a hundred and thirty years: to document what I'd made. It's accepted that photography represents art in this way. If you want to go and see paintings by Magritte, you very likely go and pick up a book which photographically reproduces Magritte paintings, rather than making trips to a number of museums in different parts of the world. Artists habitually make photographic records of their work, and we accept this form of representation as true and adequate. Now because a lot of

John Hilliard: *Disturbance*, 1978

DISTURBANCE

artists in the late 60's began to work in transient manners (perhaps using materials that were subject to very rapid disintegration or, for example, using their own bodily actions in performance), the situation came about where that work could have no enduring temporal existence. But it could be photographically preserved, and in that sense it *could* endure, and, moreover, because the photograph functioned to preserve the work, then it also became the only *form* of the work. The photograph took on a value of a new kind; it actually *replaced* the work, it was put forward *as* work. That being the case, it follows that very likely that type of work of which the photograph is both form and representation might be convened in deference to that photograph. The fact of my recognition of (and involvment in) this emergent practice and then of the kind of problems it seemed to throw up motivated my initial engagement with photography.

* * *

It's a commonplace of photography that within a single negative there may be both extremely thin and extremely dense areas, such that in a resulting print (of reasonable contrast) an emphasis on shadow detail will entail a loss of information in the highlight areas, and vice versa. Clearly, the decision of how to print in such circumstances is potentially a decision to conceal/reveal one set of information rather than another—a source of considerable influence over subsequent interpretation (even when the subject matter is deliberately low-keyed and undramatic).

Each pair of prints reproduced here is made from the same negative, the inevitably emphatic contrasts enforcing depiction only within three tonal extremities of black-and-white photography. The flexibility/ambiguity of the captions, and their tonal opposition, serve both to reflect similar characteristics within the pictorial content and to stimulate particular readings (indicating signifiers contained/revealed variously within the shadow areas, within the highlight areas, and, as a rule, within the shape formed by the interface of the two). The prints are usually joined to form a single image in order to facilitate a clear, uninterrupted division into areas of black, grey and white, to reiterate (through the uncertainty of the composite identity) the ambiguous nature of the work, and to allow all the various elements of the work to be conjoined in a unified, holistic model.
—John Hilliard

An approach to photography which takes no account of the traditions built up around the medium by photographers has enabled John Hilliard to build up his own set of premises as he explores its nature.

Prior to 1970, when this systematic exploration began, Hilliard used photography in various contexts to document and to realize the qualities of his sculpture. Although the nature of the photographic medium is a determinant vital to all Hilliard's images produced during that time, its existence as only part of a system whose roots are elsewhere inevitably and effectively masks the specifically photographic issues.

The piece *Sixty Seconds of Light*, 1970, demonstrates the effect upon photographic film of a series of twelve exposures, in increments of five seconds, showing a darkroom timer which indicates the time of each exposure upon its dial. This was the first of a group of pieces related in the sense that all dealt systematically with the photographic process, as revealed in records of progressive change in technical parameters.

The works from 1974, known collectively as *Elemental Conditioning*, differ in that Hilliard elects to hold the photo-chemical conditions constant, and to direct the viewer's attention to the interactions of cropping with titling and their control of the meaning of an image/text unity.

More recently, in *From the Northern Counties*,

both threads have been brought together by pairing, sometimes joining, prints which each take account only of highlight or of shadow details in the same scene; and, by allowing the same title for both to interact with the different results, to suggest ambiguities of meaning between the two aspects of the image.

From a traditional photographer's viewpoint, the first impression of the early work is that it is no more than darkroom exercises, a publication of knowledge usually evidenced by graphs and step wedges and assumed in every use of the photographic process. Those pieces where photo-chemical conditions approximate to a norm can be seen as in a sense not photographic at all, since the medium merely subserves independently existing concepts. The eventual amalgamation of these two aspects might then look like an imposition of non-photographic influences upon sterile didacticism: a coupling inauspicious for its offspring.

Yet it is also the case that the first, deliberately naive-seeming investigations demonstrate more of the nature of photographic process than is likely to be perceived when their counterparts take place incidentally to some other objective. They are, moreover, related to the ideas and practices in fields thought of as remote from photography, and so offer new potential for thinking about relationships between all the areas involved. Hilliard's further moves along the media interfaces have provided more clarifications and growth points—and an aesthetic experience of some elegance and austerity, for the perceiver able to disembarrass himself of certain conventions.

—Philip Stokes

HINE, Lewis W(ickes).
American. Born in Oshkosh, Wisconsin, 26 September 1874. Educated at State Normal School, Oshkosh, until 1892; studied stenography, drawing and sculpture, Oshkosh, 1892-1900; sociology and pedagogy, University of Chicago, 1900-01, 1902; School of Education, New York University, 1901-02, 1903-05, Pd.M (Education), 1905; sociology, Graduate School of Arts and Sciences, Columbia University, New York, 1907; self-taught in photography. Served in the American Red Cross, in New York, France, Balkans, Italy and Greece, 1918-20: Captain. Married Sara Ann Rich in 1904 (died, 1939); son: Corydon. Worked in furniture factory, clothing store, water filter company, and a bank, Oshkosh, 1892-1900; Instructor in Nature Study and Geography, and Official School Photographer, under Frank Manny, Ethical Culture School, New York, 1901-08; freelance sociological photographer, and Exhibitions Director, for National Child Labor Committee, New York and throughout United States, 1906-18, 1921-22, and for *Survey* magazine, Milbank Foundation, National Consumer's League, Amalgamated Clothing Workers Union, and other agencies, New York, 1919, 1922-29; documented construction of the Empire State Building, New York, 1930-31; Rural Survey Photographer, American Red Cross, in Kentucky and Arkansas, 1931, for the Tennessee Valley Authority, 1933, and for Rural Electrification Administration, 1934-35; Head Photographer, National Research Project, Works Projects Administration, in Holyoke, Massachusetts, and in New Jersey and Pennsylvania, 1936-37; freelance photographer, New York, working occasionally for *Hartford Courant* and *Fortune*, 1938-40. Recipient: Art Directors Club Medal, New York, 1924; Best Children's Book of the Year Award,

Child Study Association. 1932. *Died* (in Hastings-on-Hudson, New York), *4 November 1940*.

Individual Exhibitions:

1919 Women's Club, Hastings-on-Hudson, New York
1920 Civic Art Club, New York
 National Arts Club, New York
1928 Advertising Club, New York
1929 Russell Sage Foundation, New York
1931 Yonkers Art Museum, New York
1939 Riverside Museum, New York (retrospective; travelled to Des Moines, Iowa; and Albany, New York)
 Photo League, New York
1970 Witkin Gallery, New York
1971 Halsted 831 Gallery, Birmingham, Michigan
 Focus Gallery, San Francisco
1973 Paine Art Center, Oshkosh, Wisconsin
 Vassar College, Poughkeepsie, New York
 Witkin Gallery, New York
1974 Mulvane Art Center, Washburn University, Topeka, Kansas
1975 Lunn Gallery/Graphics International, Washington, D.C.
1977 Brooklyn Museum, New York (retrospective; toured the United States)
 University of California, Berkeley
 Denver Art Museum
 Chicago Historical Society
 Carnegie Institute, Pittsburgh
 Yale University, New Haven, Connecticut
 Mulvane Art Center, Washburn University, Topeka, Kansas
1980 Galerie A. Nagel, West Berlin
 La Ramise du Parc, Paris
1981 *Child Labor Photographs*, Lunn Gallery, Washington, D.C.
 Milwaukee Art Center, Wisconsin

(Hine's photographs also formed the most substantial part of numerous National Child Labor Committee exhibitions, throughout the United States, 1908-29.)

Selected Group Exhibitions:

1967 *Photography in the 20th Century*, National Gallery of Canada, Ottawa (toured Canada and the United States, 1967-73)
1972 *Hur den andra halften levde*, Moderna Museet, Stockholm
1974 *Photography in America*, Whitney Museum, New York
1977 *Documenta 6*, Museum Fridericianum, Kassel, West Germany
1978 *Photos from the Sam Wagstaff Collection*, Corcoran Gallery, Washington, D.C. (toured the United States and Canada)
 Tusen och en bild/1001 Pictures, Moderna Museet, Stockholm
1979 *Photography Rediscovered: American Photographs 1900-1930*, Whitney Museum, New York (travelled to the Art Institute of Chicago)
 Amerika Fotografie 1920-1940, Kunsthaus, Zurich
1980 *The Magical Eye: Definitions of Photography*, National Gallery of Canada, Ottawa (toured Canada)
 Old and Modern Masters of Photography, Victoria and Albert Museum, London (toured Britain)

Collections:

Lewis Hine Archive, International Museum of Photography, George Eastman House, Rochester, New York; New York Public Library; Avery Library,

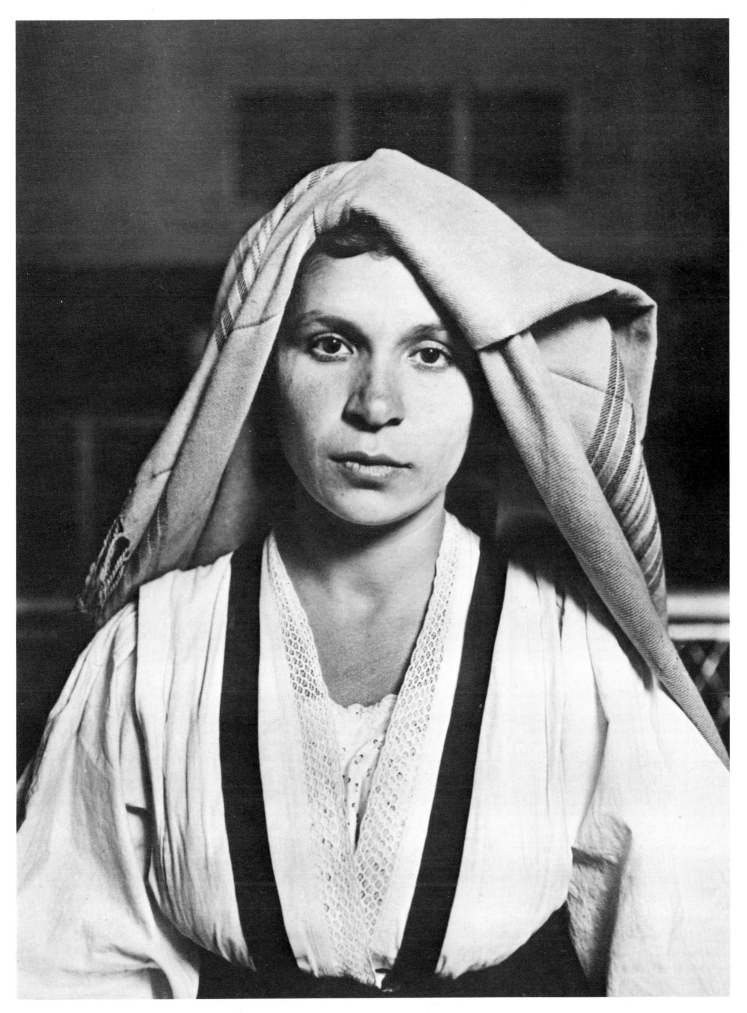

Lewis W. Hine: *Italian Immigrant* **from the portfolio** *Lewis W. Hine 1874-1940,* **1942** Courtesy Art Institute of Chicago

Columbia University, New York; University of Maryland, Baltimore; American Red Cross Headquarters, Washington, D.C.; Library of Congress, Washington, D.C.; National Archives, Washington, D.C.; Art Institute of Chicago; University of Minnesota, Minneapolis; New Orleans Museum of Art.

Publications:

By HINE: books—*Men at Work*, New York 1932, 1977; *Technological Change*, with David Weintraub, Philadelphia 1937; *Lewis Hine 1874-1940*, 2 portfolios of 4 photos each, with an introduction by Marynn Older, New York 1942; *In Ordering Use This Number 1756 Hine Photo Company*, portfolio of 12 photos, edited by Thomas F. Barrow, Rochester, New York 1970; *Portfolio 1*, 10 photos, Rochester, New York 1974; *Lewis W. Hine Document*, portfolio of 16 photos, with an introduction by Naomi Rosenblum, New York 1977; books illustrated—*Neglected Neighbors in the National Capital* by Charles F. Weller, Philadelphia 1909; *Women and the Trades* by Elizabeth Beardsley Butler, New York 1909; *Homestead: The Households of a Mill Town* by Margaret F. Byington, New York 1910; *Our Slavic Fellow Citizens* by Emily Greene Balch, New York 1910; *The Steel Workers* by John A. Fitch, New York 1910; *Work, Accidents and the Law* by Crystal Eastman, New York 1910; *The Pittsburgh Survey: Findings in Six Volumes*, edited by Paul Underwood Kellogg, New York 1911; *Artificial Flower Makers* by Mary Van Kleeck, New York 1913; *Women in the Bookbinding Trade* by Mary Van Kleeck, New York 1913; *The Old World in the New* by Edward Alsworth Ross, New York 1914; *The Pittsburgh District Frontage*, with texts by Lattimore, Devine, Woods and others, New York 1914; *Wage Earning in Pittsburgh*, edited by Paul Underwood Kellogg, New York 1914; *West Side Studies: Boyhood and Lawlessness*, edited by Pauline Goldmark, New York, 1914; *Working Girls in Evening Schools* by Mary Van Kleeck, New York 1914; *Street Land: Its Little People and Big Problems* by Philip Davis and Grace Kroll, Boston 1915; *A Seasonal Industry: A Study of the Millinery Trade in New York* by Mary Van Kleeck, New York 1917; *The Human Cost of War* by Homer Folks, New York and London 1920; *Our Foreigners: A Chronicle of Americans in the Making* by Samuel P. Orth, New Haven, Connecticut 1920; *Rural Child Welfare*, edited by Edward Clopper, New York 1922; *American Economic Life and the Means of Its Improvement*, with texts by Thomas Munro, Rexford Guy Tugwell and Roy Stryker, New York 1925; *Health on Farm and Village* by C.E.A. Winslow, New York 1931; *Empire State: A History*, New York 1931; *Through the Threads of the Shelton Looms: An Interpretation of the Creation of Beautiful Fabrics*, New York 1933; *Skyscraper* by Else H. Naumburg, Clara Lamber and Lucy Sprague Mitchell, New York 1933; *Back Woods America* by Charles Morrow Wilson, Chapel Hill, North Carolina 1935; *Job Satisfaction* by Robert Hopcock, New York and London 1935; *Metropolis: An American City in Photographs* by Agnes Rogers, New York 1935; *Development of the Tennessee Valley*, Washington, D.C. 1936; *Log of the TVA* by Arthur E. Morgan, New York 1936; articles—"The School Camera" in *The Elementary School Teacher* (New York), March 1906; "The Silhouette in Photography" in *The Photographic Times* (New York), November 1906; "Photography in the School" in *The Photographic Times* (New York), August 1908; "Communication" in *The Survey* (New York), 30 April 1910; etc.

On HINE: books—*Lewis W. Hine and the American Social Conscience* by Judith Mara Gutman, New York 1967 (includes bibliography); *Photography in the 20th Century* by Nathan Lyons, New York 1967; *Hur den andre halften levda/How the*

Other Half Lives, exhibition catalogue, by Rune Hassner, Stockholm 1972; *Photography in America*, edited by Robert Doty, with an introduction by Minor White, New York 1974; *Lewis W. Hine 1874-1940: Two Perspectives* by Judith Mara Gutman, New York 1974; *The Eye of Conscience: Photographers and Social Change* by Milton Meltzer and Bernard Cole, Chicago 1974; *America and Lewis Hine: Photographs 1904-1940* by Alan Trachtenberg, Walter and Naomi Rosenblum, Millerton, New York 1976 (includes bibliography); *Geschichte der Fotografie im 20. Jahrhundert/Photography in the 20th Century* by Petr Tausk, Cologne 1977, London 1980; *Concerning Photography*, edited by Jonathan Bayer, London 1977; *Documenta 6/Band 2*, exhibition catalogue, edited by Klaus Honnef and Evelyn Weiss, Kassel and Cologne 1977; *Photographs: Sheldon Memorial Art Gallery Collection, University of Nebraska*, with an introduction by Norman A. Geske, Lincoln, Nebraska 1977; *Tusen och en bild*, exhibition catalogue, by Åke Sidwall, Sune Jonsson and Ulf Hard af Segerstad, Stockholm 1978; *A Book of Photographs from the Collection of Sam Wagstaff*, designed by Arne Lewis, New York 1978; *Amerika Fotografie 1920-1940* by Erika Billeter, Berne 1979; *Lewis Wickes Hine's Interpretive Photography*, compiled by Jonathan Doherty, Rochester, New York 1979; *Photography Rediscovered: American Photographs 1900-1930* by David Travis, New York 1979; *A Ten Year Salute* by Lee D. Witkin, with a foreword by Carol Brown, Danbury, New Hampshire 1979; *The Photograph Collector's Guide* by Lee D. Witkin and Barbara London, Boston and London 1979; *Old and Modern Masters of Photography*, exhibition catalogue, edited by Mark Haworth-Booth, London 1980; *Lewis W. Hine: Child Labor Photographs*, exhibition catalogue, by Jane Livingston, Washington, D.C. 1981.

Growing up with 19th century moral convictions and moving as an adult into the new century's urban and industrial expectations, Lewis W. Hine used the camera in the hopes it would perfect the world's vision of man's potential. He hoped the camera would expose society's ills, do away with injustice, establish a rightful place for men and women of all classes and leave mankind free to create a new world order. To achieve this, he abandoned prevailing modes of photography, ignored the practices conjured by his contemporary art photographers, created new uses for the camera and shaped a vibrant new form of expression through the camera.

Reaching into the heart of all photographic expression—the camera's use of light—Hine exclaimed at a conference called in 1909 to discuss the plight of child labor, "Let there be light." He wanted light to illuminate the problems created by exploitation—of child labor, of immigrants and of all working people. He wanted light to drown out the social and political supports keeping such ills alive and to illuminate, at the same time, the purity of his subjects.

The phrase originally came from Burnes-Jones, a British artist who was reared in the William Morris arts and crafts movement of the late 19th century, a movement that tried to blend the artistic refinements and social purpose found in hand-made crafts with the machine age. Absorbing that Jonesian meaning into his vision of the world, Hine saw "light" as catalyst and protagonist. It would allow the purity of mankind to flower while exposing the ills threatening to strangle mankind's growth. For Hine, the diffuse, impressionist-type light of Alfred Stieglitz and Edward Steichen, of Alexander Coburn and Gertrude Käsebier would never do. It would only dispel the camera's power and defuse mankind's potential for growth. The camera needed direct light. Wedding the camera's fundamental technology to his social expectations, he pioneered the creation of an expressionistic documentary style of picture-making. In the first decades of the 20th century, he called it "Social Photography."

Most of Hine's pictures in this social photography vein were made from 1905-1915. There, focusing on children who were drawn into textile mills, factories, mines, fisheries, girls who accompanied their mothers into spinning rooms, boys who accompanied their fathers into duffing rooms—many paid by the employer as part of a family and not for their individual labor—Hine trained his camera. Fostered by his twin concerns to expose the ills surrounding his subject and let the majesty of his subjects flower, his photographs recorded the nobility of human beings. His pictures from this period are generally of two kinds: portraits and group scenes.

His portraits, unusual for the time, are generally full face, waist-high confrontational statements lit so that the viewer defers to the subject's eyes, often boldly illuminated by the possibility of a new day. The eyes in these photographs mobilize the picture's activity, the picture's light illuminating those eyes so they catch the viewer's attention directly. The group scenes range from set pieces taken in tenement apartments to candid-type scenes caught outside of factories. Both play on a kind of movement that keeps the viewer's eye moving through the picture plane from left to right. Sometimes part of the subject is cut off at the left: all the more jarring—and commanding—to the viewer. When a figure is not cut off, part of the setting—white pickets in a fence, a high chair in a tenement—carry the viewer's eye off the edge of the picture. Hine always took the viewer through the entire scene, the viewer's eye taking in every element before leaving the picture.

Floundering by 1915—as he saw his hopes dashed by the onset of World War I—he was quick to join in some purposeful activity and went with the Red Cross on a survey mission to Europe in 1918 that documented the plight of war refugees from Serbia and Italy. When he returned to America, he thought he saw the whirl of the 1920's industrial and technological activity creating a power that was human in origin. He thought he saw new possibilities. Man, he thought, would triumph with the new technology. Now calling his photography "Interpretive Photography," he widened his focus, raised his sights and began to portray the majesty of man's tie to this new machinery. This brought him to the documentation of the construction of the Empire State Building in 1930-31, a series that suggests the pinnacle of expectation Americans could realize through technology. These pictures soar in the sky as they delicately catch man's balance against infinity.

In retrospect, many of these 1920's photographs lack the spell-binding character of his earlier ones. In those, his subjects' eyes often commanded the viewer's attention. As if held by a magnetic power, the viewer could not turn away. The photos from the 1920's *try* to grip the viewer. They show the power of the machine, emphasizing the machine's inner workings so romantically that many of the machines look as if they possessed eyes. But as much as these machines mobilized the picture's activity, and as much as they grabbed the viewer's attention, they never spoke with the power of humanity.

Hine photographed little in the early years of the 1930's but created a little-known, magnificent portrait of depressed America in 1936-37. Sobered and anguished by technology's failure to produce a marvelous new world—as his Victorian sensibilities would have had the story end—Hine portrayed America in a no-win game. In this series, which he took for a U.S. government project investigating technological unemployment—a WPA project—he seems to tell us that the only redeeming quality humans possess in a society torn by depression is their close intimate sense of right and wrong. In one of the pictures, a man touchingly holds a doll's head—in a factory—as if it were a child's. Was America so enraptured by the dawn of life—and so contained by its contemporary society—that its members displaced their passion to center their love on inanimate objects? Sadly, Hine seems to tell us that Americans were losing power over their lives: they could not create this intimate world in their

own homes with their own families. (His photographs of families at home are filled with dark brooding moments, a far cry from the bold-eyed people—in wretched conditions—of his earliest photographs.) In another photograph, women sit behind spinning machines in a stocking factory, their rounded forms and gentle smiles warming the angular deco panels behind them. Americans must accept the framework of a depressed society. The soaring power to create, he seems to tell us as his life was nearing its end, is gone. In its stead, is a retrenched, contained America.

—Judith Mara Gutman

HIRO.

Japanese. Born Yasuhiro Wakabayashi in Shanghai, China, 3 November 1930; moved to Tokyo, 1946, New York, 1954. Educated at Japan Public School, Tsingtao, China, 1937-38; Peking High School, 1942-46; Daiichi High School, Tokyo, 1946-49; studied under Alexey Brodovitch at the New School for Social Research, New York, 1956-58. Married Elizabeth K. Clark in 1959; sons: Gregory and H. Clark. Assistant to Rouben Samberg, New York, 1954-55; Assistant to Richard Avedon, New York, 1956-57, and Associate, Avedon Studio, 1958-71; Personal Assistant to Alexey Brodovitch, New York, 1958-60. Established Hiro Studio, New York, 1958; freelance magazine and fashion photographer, working mainly for *Harper's Bazaar* and *Opera News*, New York, since 1958 (Staff Photographer, *Harper's Bazaar*, 1966-74). Recipient: Gold Medal, Art Directors Club of New York, 1968; Photographer of the Year Award, American Society of Magazine Photographers, 1969; Newhouse Citation, Syracuse University, Syracuse, New York, 1972; Society of Publication Designers Award, 1979. Agent: Norma Stevens, 1075 Park Avenue, New York, New York 10028. Address (studio): 50 Central Park West, New York, New York 10023, U.S.A.

Selected Group Exhibitions:

1959 *Photography in the Fine Arts*, Metropolitan Museum of Art, New York
1968 *One Hundred Years of Harper's Bazaar*, Hallmark Gallery, New York
1972 *Alexey Brodovitch and His Influence*, Philadelphia College of Art
1974 *Color* (American Institute of Graphic Arts), Whitney Museum, New York
1975 *Fashion Photography: 6 Decades*. Emily Lowe Gallery, Hofstra University, Hempstead, New York (toured the United States)
1977 *Fashion Photography*, International Museum of Photography, George Eastman House, Rochester, New York (travelled to the Brooklyn Museum, New York; San Francisco Museum of Modern Art; Cincinnati Art Institute, Ohio; and Museum of Fine Arts, St. Petersburg, Florida)

Collections:

International Museum of Photography, George Eastman House, Rochester, New York.

Publications:

By HIRO: book—*Hiro*, designed by Marvin Israel, New York 1983; articles—"Photo Interviews Hiro" in *Photo World* (New York), May 1964; "Hiro," interview, with Pucci Meyer, in *Zoom* (Paris), July/August 1972.

On HIRO: books—*The Magic Image* by Cecil Beaton and Gail Buckland, London and Boston 1975; *The History of Fashion Photography* by Nancy Hall-Duncan, New York 1979; articles—"Hiro" by Richard Avedon in *Camera* (Lucerne), August 1965; "Hiro" by M. Caen and R. Pledge in *Zoom* (Paris), no. 13, 1972.

Hiros's photographic work combines elegant simplicity and immediate impact. It combines the features of great advertising—clarity and appeal—into masterpieces of fashion and product photography. His ability to transform ordinary objects into items of intense desirability depends in large part on his brilliant use of sumptuous color, pure design and a presentation that affords his product larger-than-lifesize monumentality.

In his use of color Hiro is both a master craftsman and darkroom perfectionist. He is capable of brilliant technical effects with strobe and neon light—which is so easily gaudy or tawdry in the hands of a lesser master—as well as eye-catching combinations of highly-saturated color. This use of color is the stuff of which advertising dreams are made, both more brilliant and more beautiful than reality.

The advertising impact of Hiro's work also lies in his presentation of objects—from a simple scarf to Tiffany jewels—as monumental icons having uncanny presence, scale and importance of their own. One example is the photograph of pyramid-sized Cartier watches set in a luminous lunar landscape of vivid green and shocking blue. Each image incorporates one such eye-catching feature: such ads as the diamond-and-ruby pendant hung on the leg of a Black Angus steer or the diamond necklace circling

Hiro: *Donna Mitchell, Craters of the Moon, Idaho,* 1968

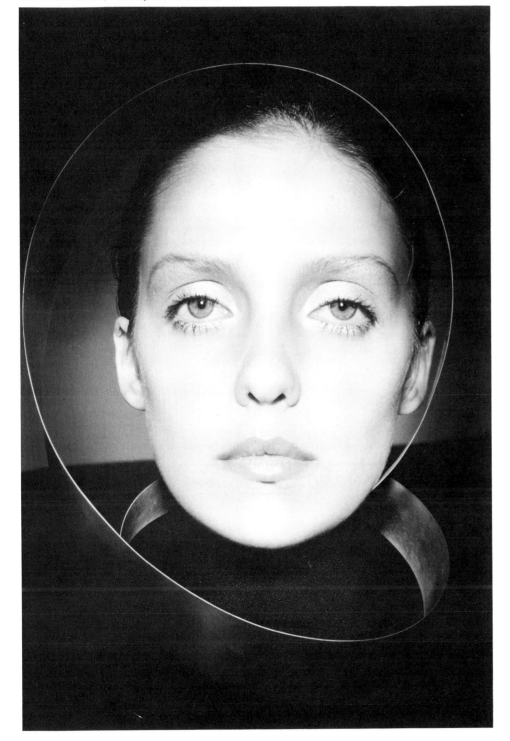

a silver-scaled fish are unforgettable.

Hiro sees his role of fashion photographer as that of a reporter. "The beauty of photographs alone," he insists, "doesn't mean anything." He aims for contemporary meaning, and his work often incorporates space-age or socially-oriented imagery. To illustrate a lipstick, for instance, he took a close-up of a woman popping a pill, that ubiquitous contemporary commodity, between her lips.

It may come as a surprise to many that Hiro's work includes much serious work beyond fashion and advertising. For many years he has been doing portraiture, still-life, touching informal shots of children, and even landscape. This more personal

side of his work, deeply-felt images which nonetheless show the same scrupulous attention to pure design, are part of a forthcoming book of Hiro's work planned for 1983.

—Nancy Hall-Duncan

Thomas Höpker: *Tourists near Cairo*, 1959

HÖPKER, Thomas.

German. Born in Munich, 10 June 1936. Educated at schools in Munich, Stuttgart, and Hamburg, 1942-56; studied history of art and archaeology at the universities of Göttingen and Munich, 1956-59; self-taught in photography. Married the writer-reporter Eva Windmüller in 1968; son: Fabrian. Photographer since 1959: Photojournalist and Contract Photographer at *Münchner Illustrierte*, 1959-61, *Kristall*, Hamburg, 1961-64, and *Stern*, Hamburg, from 1964; Correspondent for *Stern* in East Berlin, 1974-76, and in New York, 1976-78; Executive Editor of U.S. edition of *Geo*, New York, 1978-81; freelance photographer, New York, since 1981. Member, Gesellschaft Deutscher Lichtbildner (GDL), 1956-73. Member, Deutsche Gesellschaft für Photographie (DGPh), and Bund Freischaffender Foto-Designer (BFF). Recipient: *Photokina* Award, 1955, 1957; Kulturpreis der DGPh, 1966; Bundesverdienstkreuz, 1975. Agents: Anne Hamann, Triftstrasse 10, Munich 22; and Woodfin Camp, 415 Madison Avenue, New York, New York 10017. Address: 250 East 63rd Street, New York, New York 10021, U.S.A.

Individual Exhibitions:

1956 Landesbildstelle, Hamburg
1975 Overbeck Gesellschaft, Lübeck
1977 Stadtmuseum, Munich
1978 Rizzoli Gallery, New York
1979 PPS Gallery, Tokyo
1980 W. Camp Gallery, Washington

Selected Group Exhibitions:

1966 *1st World Exhibition of Photography*, Pressehaus Stern, Hamburg (and world tour)
1968 *2nd World Exhibition of Photography*, Pressehaus Stern, Hamburg (and world tour)
1976 *Photokina '76*, Cologne
1979 *Fran Jonasson till Armstrong-Jones*, Moderna Museet, Stockholm
 Deutsche Fotografie nach 1945, Kasseler Kunstverein, Kassel, West Germany

Collections:

Münchner Stadtmuseum; Bibliothèque Nationale, Paris.

Publications:

By HÖPKER: books—*Yatum Papa*, Stuttgart 1963; *Horst Janssen*, Hamburg 1967; *Berliner Wande*, with text by G. Kunert, Munich 1976; *Leben in der DDR*, with text by Eva Windmüller, Hamburg 1977; *Expeditionen in Kunstliche Garten*, with Heinz Mack, Hamburg 1977; *Vienna*, London 1978; documentary films for TV—*Washington: The New Rome?*, 1973; *Canada*, 1974; *Arabati*, 1973; *Rain in Arabati*, 1975.

On HÖPKER: books—*2nd World Exhibition of Photography*, exhibition catalogue, edited by Karl Pawek, Hamburg 1968; *Geschichte der Fotografie im 20. Jahrhundert/Photography in the 20th Century* by Petr Tausk, Cologne 1977, London 1980; *Fotografie 1919-1979, Made in Germany: Die GDL-Fotografen*, edited by Fritz Kempe, Bernd Lohse and others, Frankfurt 1979; *Deutsche Fotografie nach 1945/German Photography after 1945* by Floris Neusüss, Wolfgang Kemp and Petra Benteler, Kassel 1979; *World Photography*, edited by Bryn Campbell, London 1981; articles—"E Domani si Riparte: Thomas Höpker Obiettivo Tutto" in *Fotografia Italiana* (Milan), April 1973; article in *Camera 35* (New York), April 1981.

I have always considered myself a photo-reporter, a journalist who communicates ideas, observations and opinions through photographs. My pictures are primarily meant to be shown on the pages of a magazine or a newspaper—to be viewed and discarded. So I have always felt ill at ease whenever my photographs have appeared on the walls of a museum or gallery, become part of a collection or are discussed or treated like artwork.

Though I have worked mostly in color and the aesthetics of a photograph are very important to me—I know that composition and color can easily become overpowering, decorative elements in an otherwise mindless picture. There are too many good looking but meaningless photographs around. Any photographer, but especially the photojournalist, should clearly know what he wants to communicate before he lifts his camera. Good photographers have strong opinions and convictions. I don't believe in the cold-eyed "objective" reporter. A balanced view can be as bland to the mind as a balanced composition can be boring to the eye.

—Thomas Höpker

Thomas Höpker's sensitive intelligence, spontaneity and instinct for the right moment have made him into one of the most successful photojournalists of our time. He was lucky enough to acquire the technical fundamentals as it were by "playing" and step-by-step experimentation at the very early age of 14, without having to burden himself with too much theory. As well, he was greatly interested in art, and that interest is apparent in his early photographs in which he looks for formal aesthetic solutions and pays less attention to content. He found a solution in a severely formed picture construction, which schooled his vision in such a way that the method actually had the effect of emphasing content—to the benefit of his later work as a photojournalist. In his later work, as in his early pictures, Höpker limited himself to the essential and achieved an impressive picture density that became his trademark.

After 6 semesters studying art history, and encouraged by his increasing success as a photographer, Höpker decided to make photography his profession. He became a photojournalist for *Münchner Illustrierte* and *Kristall*, then, after 1964, commissioned by *Stern*, he photographed all over the world his great and now internationally recognized reportages.

Höpker has favored coverage of the constant change in human existence, of anonymous grief in distant lands, famine in India or the leper problem in Ethiopia. He has sought constantly to give expression to his deep sympathy for the grief and suffering of others, and to bring this distress to the attention of readers of the great illustrated magazines of the western world—and to do so as realistically as possible (without repulsing readers), so that support for the distressed might be more quickly and extensively set in motion. Yet, as far as possible, he avoided sensational reports; he also reserved the right to say no to certain commissions.

And Höpker became well-known not only for this kind of reportage but also for his social situation-reports on the monotony of life in a welfare state or on the frightening lack of fantasy among people in countries where no life-threatening poverty prevailed, where there were no droughts or epidemics. Those who have seen his photo-report on the training of American Marines feel through these pictures the senselessness of war more than through any equally gripping coverage of the actual events of war. The brutality of the training has so marked the young recruits that their faces show the dread.

Höpker is also known for his perceptive portraits—for example, of the designer Horst Janssen. Before he created his portraits, Höpker met with Janssen frequently so that the two men could get to know one another more closely. Then, when the time came, Janssen felt that the actual photographing was a joint venture, a new means of expression for

himself, in that he and Höpker could stimulate each other with new ideas. And when he was to portray Cassius Clay, Höpker very patiently waited until he was able to persuade this capricious and uncomfortable partner to co-operate, so giving him the pictures that he wanted.

In 1968 Höpker expressed his own opinion of the work of the photojournalist: "I often ask myself what the future of photo-journalism will be. The merry-go-round of sensations turns ever more quickly. Love, birth, death, all human situations have already been photographed in a masterly manner. There are already signs of fatigue. Every taboo in photography is already breached, every shock has been given. Perhaps we shall soon learn once more to appreciate peace and simplicity." And Höpker has always looked for peace and simplicity in his own missions, because those qualities must also be

present within the general "loudness," because the merry-go-round must occasionally be slowed down a little.

Höpker's photos show us not only what has happened, that which the technical apparatus of the camera was able to capture, but also the invisible, that which lies under the surface and gives life to a photo. And if a photo provides more than the quickly grasped pictorial information, therein lies the skill of the photographer.

—Jürgen Wilde

Thurston Hopkins: *Battersea*, London, 1954

HOPKINS, (Godfrey) Thurston.

British. Born in London, 16 April 1913. Educated at Salesian College, Burwash, Sussex, 1927-28; Montpellier College, Brighton, 1929-30; studied magazine illustration at the Brighton College of Art, 1931-33. Served as a photographer with the Royal Air Force, in Italy and the Middle East, 1940-45. Married the photographer Grace Fyfe Robertson in 1956; children: Joanna and Robert. Press Photographer, Photopress Agency, London, 1936-37; freelance photojournalist, London, 1946-50; Photojournalist, *Picture Post*, London, 1950-57; freelance advertising photographer, with studio in Chiswick, London, 1959-68; now retired. Columnist ("The Professional Scene"), *Photography*, London, 1969-70. Lecturer in Editorial Photographic Studies, Guildford School of Photography, now West Surrey College of Art, 1969-77. Address: Cambridge Lodge, London Road, Uckfield, Sussex TN22 1HA, England.

Individual Exhibitions:

1974 British Council, London (toured Europe)
1975 *3 From Picture Post*, The Photographers' Gallery, London with (Kurt Hutton and Bert Hardy; toured the U.K., 1976-77)

Selected Group Exhibitions:

1955 *Picture Post Photography*, Kodak Gallery, Kingsway, London
British Press Photographs of the Year, London (and 1957)
1962 *1st International Colour Photography Exhibition*, London
1972 *Personal Views 1850-1970*, British Council, London (toured Europe)

Collections:

Victoria and Albert Museum, London; Hulton Picture Library, *Radio Times*, London; British Council, London; Museum Folkwang, Essen.

Publications:

By HOPKINS: book—*Thurston Hopkins*, with an introduction by Robert Muller, London 1977; article—review of Tom Hopkinson's *Picture Post* in *British Journal of Photography* (London) 18 December 1970.

On HOPKINS: book—*Geschichte der Photographie im 20. Jahrhundert/History of Photography in the 20th Century* by Petr Tausk, Cologne 1977, London 1980; articles—"Thurston Hopkins" by Bill Jay in *Album* (London), April 1970; "Thurston Hopkins: Man of the Streets" by G.H. in *Amateur Photographer* (London), 18 May 1977.

I became a photographer by chance, without any training to speak of. Knowing nothing of the technical side of the profession, I allowed myself to be sent on assignments in competition with seasoned Fleet Street cameramen. In my innocence, I would sometimes ask them what exposure to use, since my primitive press camera had no set shutter speeds, and exposure meters were unknown. Only occasionally did they deliberately mislead me!

I never intended to remain in photography. I had trained as a graphic illustrator, and I would probably have gone back to using the pencil and brush but for the war. Service overseas infected me with a desire to travel while at the same time it came to my notice that a particular type of photography—photojournalism—could give me this opportunity. What I really enjoyed about photojournalism was

gaining admission to places, and meeting people, otherwise difficult to see. I also enjoyed overcoming difficulites placed in my way, and I've always believed that taking photographs under rough conditions produces a quality—a non-technical quality—often lacking in work produced when everything is going with you. In those days you often heard British photojournalists grumbling at the limited miniature equipment they had to make do with for some time after the war: no super-wide-angle lenses, no through-lens-metering, no zoom lenses then. I myself looked enviously at the masses of glittering equipment *Life* photographers carried around with them.

Undoubtedly, there have been gains from the vastly improved equipment available since that time, but I remain unconvinced that, on the whole, it has enabled photographers to produce more impressive work—at least in the field of photojournalism. Cartier-Bresson could have done his entire life's work on an early Leica, and there would have been no falling off of his quality, his superb quality. Is it too much to suggest that the photographer who has so many exciting items of equipment to choose from has just that little less time to spare for human reaction? The marvellous photographs of Dr. Erich Salomon are human in a way that few photographs are today; I love the *absence* of technical perfection in these moving images. Ruskin suggested that Turner would have produced great art by dipping a blunt stick in mud. Young photographers should ponder this remark; there's a great deal of truth in it.

Recently, a magazine tried to "tempt me out of retirement." Out of curiosity, I inquired how much they were prepared to pay, and was shocked to learn that the page rate was no more that it had been twenty years ago! A sad comment on the state of photojournalism today.

I no longer use the camera as a means of communication, and I've had my fill of foreign travel. I'm lucky enough to have come full circle: I'm back with the pencil and brush, and no deadlines to meet.

—Thurston Hopkins

Thurston Hopkins is a British photojournalist who spent some of his best years with *Picture Post*, whose service he entered after acquiring a great deal of experience in the Photographic Unit of the Royal Air Force during the war and as a freelancer in London during the late 1940's. His works are rich in a variety of subjects, produced in response to the needs of various editors—yet, despite the great variety, his work does reveal something like a personal style. His usual subject, man, is customarily caught in his typical social environment—for instance, the old woman in the Liverpool slums, the Rev. Reindorp amongst his parishioners, the party-goers in Highgate. Moreover, the pictorial elements of that environment are not "passive:" they eloquently complement the human subject with pertinent information about the quality of the milieu itself.

His interest in the character and destiny of man led Hopkins to search for significant situations both in his own country and abroad. Like most modern photojournalists, Hopkins has been a great traveller, and always his travels have yielded photographs that convey his particular kind of impression, no matter how different the subject. As usual, his ability to make the one represent the many is obvious, the ability (and not an inconsequential one) to select the right representative from an unknown people in order to vividly characterize all the inhabitants of a certain area. Hopkins has also shown a predilection for musicians and singers, depicting them in situations during performance that express something of their artistic and mental background.

Although the motivation of Hopkins' photography is probably a desire to convey information about human life and human problems in a comprehensible way, he has also created successful images that depict the unique atmosphere of place. Obviously,

the two efforts are connected, for Hopkins undoubtedly feels that the spaces in which people live are as important as the people themselves in any integral communication of humanistic values.

—Petr Tausk

HOPPÉ, E(mil) O(tto).

British. Born in Munich, Germany, 14 April 1878; emigrated to Britain, 1900: subsequently naturalized. Educated in Paris and Vienna, until 1898; mainly self-taught in photography. Served in the German Army, 1895-97. Married Marion Bliersbach in 1905. Worked as till clerk, Deutsche Bank, London, 1900-07; as amateur photographer, joined Royal Photographic Society, 1903; became professional portrait photographer, London, with own studio in Barons Court, 1907-11, in Baker Street, 1911-13, and in South Kensington, 1913-39; established second studio in New York, 1919-21, 1926; worked as freelance fashion, theatre, travel and portrait photographer, travelling in Europe, United States, India, Ceylon, Australia and East Indies, 1919-39, concentrating on travel photography from 1925; Director, Dorien Leigh photographic agency London, from 1939. Founder-Member, London Salon of Photography, 1909; Art Editor, *Colour* magazine, London, 1913; Founder-Member, The Plough Theatre Club, London, 1917. Recipient: Royal Photographic Society Fellowship, 1907. *Died (in London), 9 December 1972.*

Individual Exhibitions:

1910 Royal Photographic Society, London
1913 Goupil Galleries, London
1922 Goupil Galleries, London
1927 Dover Gallery, London
Asahi Shimban Showroom, Tokyo
1930 David Jones Department Store, Sydney, Australia
1954 *A Half Century of Photography*, Foyles Gallery, London (toured Germany, India and the Far East)
1968 Kodak Gallery, London
1978 *Cities and Industry*, Impressions Gallery, York
Camera Portraits, National Portrait Gallery, London
1979 *Industrial Photographs 1928*, Sonnabend Gallery, New York

Selected Group Exhibitions:

1909 *International Exhibition of Photography*, Dresden
1922 *International Theatre Exhibition*, Victoria and Albert Museum, London
1959 *Hundert Jahre Photographie 1839-1939*, Museum Folkwang, Essen (travelled to Cologne and Frankfurt)
1975 *Fashion 1900-1939*, Victoria and Albert Museum, London
1977 *Fashion Photography*, International Museum of Photography, George Eastman House, Rochester, New York (travelled to Brooklyn Museum, New York; San Francisco Museum of Modern Art; Cincinnati Art Institute, Ohio; and Museum of Fine Arts, St. Petersburg, Florida)
1978 *Pictorial Photography in Britain 1900-20*,

Hayward Gallery, London (toured the U.K.)

1980 *The Queen Mother: A Celebration*, National Portrait Gallery, London
Old and Modern Masters of Photography, Victoria and Albert Museum, London (toured the U.K.)

Collections:

Mansell Collection, London; National Portrait Gallery, London; Victoria and Albert Museum, London; Royal Photographic Society, London; Kodak Museum, Harrow, Middlesex; International Museum of Photography, George Eastman House, Rochester, New York; Gernsheim Collection, University of Texas at Austin.

Publications:

By HOPPÉ: books—*Studies from the Russian Ballet* by E.O. Hoppé and Bert, London 1913; *Gods of Modern Grub Street: Impressions of Contemporary Authors*, with text by Arthur St. John Adcock, London 1913, as *The Glory That Was Grub Street*, London 1928; *The Book of Fair Women*, with an introduction by Richard King, London 1922; *Taken from Life*, with J.D. Beresford, London 1922; *In Gipsy Camp and Royal Palace: Wanderings in Rumania*, London 1924; *London Types Taken from Life*, with text by William P. Ridge, London 1926; *40 London Statues and Public Monuments*, with text by Tancred Borenius, London 1926; *Picturesque Great Britain: The Architecture and Landscape*, Berlin and New York 1926, London 1927; *The United States of America*, London 1927, as *Romantic America: Picturesque United States*, New York 1927; *Romantiker Kleinstadt (Cities Time Has Passed By)*, Munich 1929; *Story of the Gipsies*, with text by Konrad Beresvici, London 1929; *Deutsche Arbeit: Bilder von Wiederaufstieg Deutschlands*, with an introduction by Bruno H. Burgel, Berlin 1930; *Deutschland: Landschaft und Baukunst*, with an introduction by Ricarda Huch, Berlin 1931; *Unterwegs (In Passing)*, Berlin 1931; *The Fifth Continent*, London 1931; *London*, London 1932; *Round the World with a Camera*, London 1934; *The Image of London*, London 1935; *The Face of Mother India*, with text by Katherine Mayo, London 1935; *A Camera on Unknown London*, London 1936; *The London of George VI*, London 1937; *Country Days*, illustrations, with text by A.G. Street, London 1940; *One Hundred Thousand Exposures: The Success of a Photographer*, with an introduction by Cecil Beaton, London 1945; *The World's People and How They Live*, with others, London 1946; *Rural London in Pictures*, London 1951; *Blaue Berge von Jamaica (Blue Waters of Jamaica)*, Berlin 1956; *Pirates, Buccaneers and Gentlemen Adventurers*, London 1972; article—"My Credo" in *British Journal of Photography* (London), 1 October 1971.

On HOPPÉ: books—*Hundert Jahre Photographie 1839-1939, aus der Sammlung Gernsheim, London*, exhibition catalogue, by Helmut and Alison Gernsheim, Essen 1959; *Creative Photography: Aesthetic Trends 1839-1960* by Helmut Gernsheim, London 1962; *The Magic Image* by Cecil Beaton and Gail Buckland, Boston and London 1975; *Fashion 1900-1939*, exhibition catalogue, by Valerie Lloyd and others, London 1975; *Geschichte der Fotografie im 20. Jahrhundert/Photography in the 20th Century* by Petr Tausk, Cologne 1977, London 1980; *Camera Portraits by E.O. Poppé*, exhibition catalogue, with text by Terence Pepper, London 1978 (includes bibliography); *Cities and Industry: Camera Pictures by E.O. Hoppé*, exhibition catalogue, by Ian Jeffery, Val Williams and Terence Pepper, York 1978; *Pictorial Photography in Britain 1900-1920*, exhibition catalogue, by John Taylor, London 1978; *The History of Fashion Photography* by Nancy Hall-Duncan, New York 1979; *The Photograph Collector's Guide* by Lee D. Witkin and Barbara London, Boston and London 1979; *Old and Modern Masters of Photography*, exhibition catalogue, by Mark Haworth-Booth, London 1980; articles—"E.O. Hoppé: Design Modesty" in *British Journal of Photography* (London), 25 December 1970; "Obituary: Mr. E.O. Hoppé" in *The Times* (London), 13 December 1972.

E. O. Hoppé: *Lady Lavery and Arab Attendant*, 1914 Courtesy Mr. Terence Pepper, London

The work of E.O. Hoppé demonstrates a consistency of dedication and attainment that is arguably unrivalled in the field of European photography. It is a consistency that becomes still more remarkable if one considers both the diversity of his subject-matter and the depth of coverage achieved.

Hoppé's entry into the practice, if not the profession, of photography was made in London at the turn of the century when the medium became his adopted hobby. In London he came in contact with such distinguished "amateurs" as Alvin Langdon Coburn and J.C. Warburg, and joined the Royal Photographic Society in 1903. Yet by 1907, the year in which he was awarded the much coveted fellowship of the R.P.S., Hoppé's success in exhibitions was such that he was encouraged to leave his post at the Deutsche Bank in order to open a portrait studio, a move that was to lay the basis of his lifelong

commitment to the extension of photography's commercial and artistic potential.

However, as Hoppé recalls in his autobiography, the medium was at that time "in the outer suburbs of the professions" and still suffering from the rigid division of art from commerce that had constituted the *raison d'être* of the pictorialists, a division of both labour and expertise that tended to relegate commercial practice to a utilitarian position that precluded the very possibility of art. The struggles of Hoppé's early career were accordingly fought out within the terms of two interrelated concerns: the promotion of photography as an art form independent of other graphic media, and the aspiration toward high standards of craftsmanship and professionalism that would serve to elevate the medium's commercial standing.

In practical terms such attitudes led Hoppé to break from conventional standards of portraiture. He shunned the incongruous backdrops and ballustrades of Edwardian studio practice in favour of the fashionable simplicity of a drawing-room setting and sought a more informal and naturalistic view that focused upon his sitters' moods and gestures. Later he introduced the idea of environmental portraiture by taking his camera to the sitter's own home. By 1918 Hoppé had established himself as a fashionable society portraitist who appeared both sympathetic to his clients' aspirations and conscious of his role as mediator of their public image. Sombre and often melancholic, his portraits display an intimacy and conciseness of rendition that has perhaps been equalled only in the work of Hugo Erfurth and Julia Margaret Cameron.

After 1925 Hoppé concentrated upon topographical and landscape photography, with some of his most outstanding pictures appearing in the famous "Orbis Terrarum" series. In *Picturesque Great Britain* he portrayed the nation's countryside and ancient architectural heritage and presented a vision of a land as yet largely unsullied by the grime and squalor of urban life, while his later book on the United States fused the imposing qualities of the American landscape with the equally overpowering structures of industry and commerce—a strategy that was more in keeping with both American and modernist sensibilities.

Such apparent discrepancies abound in almost all of E.O. Hoppé's work, yet it would be a mistake to regard these as the result of a careless or dilettantish approach. Rather, they are powerful indicators of both his receptivity to, and promotion of, those new areas of picture-making that were to rapidly secure the medium's status as a malleable, if not wholly impartial, mediator of our times.

—Brian Stokoe

HOREIS, William (Richard, Sr.).
American. Born in New York City, 11 October 1945. Educated at New Utrecht High School, New York, 1962-66; studied graphic arts at New York City Community College, 1968-69; mainly self-taught in photography. Married Marjorie Ann Crouch in 1969; son: William Richard (Beejai). Independent photographer, Toronto, since 1974. Guest Lecturer, York University, Toronto, 1975; Ontario College of Art, Toronto, 1975, 1979; Center for Creative Studies, Detroit, 1976; Camera Canada College, University of Ottawa, 1977. Recipient: Ontario Arts Council Grant, 1975, 1977; Canada Council Grant, 1976. Agent: Jane Corkin Gallery, 144 Front Street West, Suite 620, Toronto, Ontario M5J 1G2. Address: 1 DeForest Road, Toronto, Ontario M6S 1H5, Canada.

Individual Exhibitions:

1979 Jane Corkin Gallery, Toronto
National Film Board of Canada, Ottawa
(with Suzanne Bloom and Stephen Livick)

Selected Group Exhibitions:

1975 *Exposure*, Art Gallery of Ontario, Toronto (toured Canada)
1976 *21*, National Film Board of Canada, Ottawa
1977 *Arte Fiera '77*, Bologna, Italy
Art 8, 77, Basle, Switzerland
1979 *Opening Exhibition*, Jane Corkin Gallery, Toronto
1980 *Contemporary Photographers*, Jane Corkin Gallery, Toronto
Salon d'Été, Jane Corkin Gallery, Toronto

Collections:

Ontario Arts Council, Toronto; National Film Board of Canada, Ottawa; Seagrams Collection, Montreal; Bibliothèque Nationale, Paris.

Publications:

By HOREIS: article—"Carbon-Carbro: A History and the Method" in *Camera Canada* (Toronto), December 1976.

On HOREIS: books—*Exposure*, exhibition catalogue, by Glenda Milrod and others, Toronto 1975; *Twelve Canadians*, edited by Jane Corkin, Toronto 1980; articles—"Photography as an Art Form and as an Investment" in *Toronto Life*, September 1975; "The Frozen-Image Renaissance" by Adele Freedman in *Toronto Life*, May 1977.

I've been asked for a statement. Writing not being my medium (puts me in an uncomfortable position) I'll leave you with words written by others:

Adele Freedman—"Some photographers go shooting every day, some every week. William Horeis shoots once a year and spends the rest of his time printing. 'I literally spend all my time in a 6 x 12 room in the dark,' he chuckles, but his good humor and geniality prove that the cloistered life hasn't harmed him.

"Horeis makes beautiful images. He thinks there's enough misery in the world without adding more. 'Everything I do is conceptual,' he says. 'When someone buys an image, he's buying something of me.' He does single images only, no series, no stories. He sees, records, passes on.

"Horeis photographs as he finds. Opening the door of a hotel room in Portugal, he sees three oranges bound to a table by cobwebs and a chair at an inviting angle: he takes it. The arrangement is so spontaneous, it looks posed."

Carol Marino—"When photography was first invented, there were many who thought that at last technology could be harnassed in the service of art. Art has proven to be troublesome, and only a small percentage of those why try, succeed. William Horeis is one who succeeds."

—William Horeis

William Horeis creates intimate, precious photographic images of extraordinary beauty using a process that few other photographers would have the patience or inclination to attempt. Horeis works almost exclusively in the demanding technique of the carbon print. By way of a very condensed explanation: carbro prints are made by transferring the photographic image from a conventional silver-bromide print to a carbon pigment sheet, and then placing this carbon image in permanent contact with a paper support. This description does not, however, begin to explain the complexity of the process, the multitude of determining factors involved, and the skill and patience required of the artist who chooses to work with it. Horeis' involvement with and mastery of carbro printing is total. From negative image to finished print, which he mounts on hand-made paper, he controls each detailed aspect of the production of the work. To complete just one of these prints can often require a period of time exceeding one month. During this intense period of involvement with the image, the artist builds, alters and refines the image to its completed state, the print we eventually see on the gallery wall.

When we view Horeis' work, we are immediately aware of the visual signature of the carbro process. Yet at the same time we realize that these images do not rely solely on this intricate and fascinating technology in order to succeed. This art is more transcendent of, than bound to, its process. With an unerring eye for the optimal in composition, Horeis creates photographs that are exquisite explorations of tone. His images can, and often do, re-define

William Horeis: *Marcel*, Paris, 1980

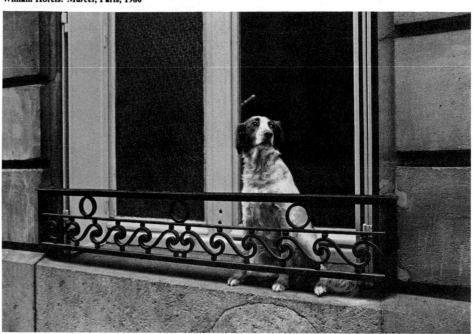

black, white and grey as we know them. The dark areas of his prints contain a wealth of visual information, and his mid-tones suggest an opalescent luminosity. Horeis has used this masterful knowledge of light to produce photographs of elegance and serenity, images which convey a strong sense of their own spirituality. This spirituality is further heightened by the carbro process itself—the image seems to float up off the paper towards us in a subtle extension of the traditional dimensionality of the photographic image.

Perhaps no better illlustration of the integrity of Horeis' art can be given than the following. In 1980, Horeis travelled to France and lived in and around Paris for about a month, producing during that time 25 new images. Upon his return to Canada, Horeis faced two important realities: firstly, the cost of materials that he required for the carbro prints had been steadily escalating to the point where it had almost become prohibitive; secondly, were he to make only one print of each of his new images, it would take three years to finish the printing. He elected to produce the series as traditional silver prints, although he intends to reprint later in carbro. In these new works we see again the scrupulous attention to detail, the exacting detail and poetic elegance that characterized the earlier work. Little, or nothing, has changed. In a medium that is generally and too often overly occupied with concerns of technique, the photographs of William Horeis are a quiet and extraordinary fusion of art and process.

—Bradford G. Gorman

HORST, Horst P(aul).

American. Born in Weissenfels, Germany, 14 August 1906; emigrated to the United States, 1935; naturalized, 1942. Educated at the Oberrealschule, Weissenfels, 1912-20; studied architecture at the Kunstgewerbeschule, Hamburg, 1926-28; student-apprentice, studio of the architect Le Corbusier, Paris, 1930. Served in the United States Army, 1942-45: Technical Sergeant. Photographer, with George Hoyningen-Huene, in the *Vogue* magazine studios, Condé Nast Publications, Paris, 1932-35, and in the Condé Nast Studios, New York (*Vogue*), since 1935; maintained Horst Studio, East 55th Street, New York, 1952-70. Address: 166 East 63rd Street, New York, New York 10021, U.S.A.

Individual Exhibitions:

1974 Sonnabend Gallery, New York
1976 Sonnabend Gallery, New York
1977 Sonnabend Gallery, New York
1978 Galerie Sonnabend, Paris
1980 Sonnabend Gallery, New York
1981 Galerie Contretype, Brussels

Selected Group Exhibitions:

1975 *Fashion 1900-1939*, Victoria and Albert Museum, London
1977 *Documenta 6*, Kassel, West Germany
Fashion Photography, International Museum of Photography, George Eastman House, Rochester, New York (travelled to the Brooklyn Museum, New York; San Francisco Museum of Modern Art; Cincinnati Art Museum, Ohio; and the Museum of Fine Arts, St. Petersburg, Florida)
1979 *Fleeting Gestures: Dance Photography*, International Center of Photography, New York (travelled to The Photographers' Gallery, London; and *Venezia '79*)
Photographie als Kunst 1879-1979, Tiroler Landesmuseum Ferdinandeum, Innsbruck, Austria (travelled to the Neue Galerie am Wolfgang Gurlitt Museum, Linz, Austria; Neue Galerie am Landesmuseum Joanneum, Graz, Austria; and the Museum des 20. Jahrhunderts, Vienna)
The Fashionable World, Stephen White Gallery, Los Angeles
1980 *La Mode*, Galerie Zabriskie, Paris
Allure, International Center of Photography, New York

Collections:

Metropolitan Museum of Art, New York.

Publications:

By HORST: books—*Photographs of a Decade*, New York 1945; *Orientals*, editor, New York 1945; *Patterns from Nature*, New York 1946; *Vogue's Book of Houses, Gardens, People*, with text by V. Lawford, New York and London 1963; *Salute to the Thirties*, with George Hoyningen-Huene, New York and London 1971.

On HORST: books—*The Magic Image* by Cecil Beaton and Gail Buckland, London and Boston 1975; *Documenta 6/Band 2*, exhibition catalogue, edited by Klaus Honnef and Evelyn Weiss, Kassel, West Germany 1977; *Photographie als Kunst 1879-1979/Kunst als Photographie 1949-1979*, exhibition catalogue, 2 volumes, by Peter Weiermair, Innsbruck, Austria 1979; *The History of Fashion Photography* by Nancy Hall-Duncan, New York 1979; articles— "H.P. Horst" in *The Studio*, by Time-Life editors, New York 1972; "Horst" by P. Beard and R. Kent in *Inter/View* (New York), April 1974; "New York: H.P. Horst, Sonnabend Gallery" in *Artforum* (New York), May 1974; "Horst in Fashion" by Barbara Rose in *Vogue* (New York), May 1976; "Women in Fashion: Horst" in *Photo World* (New York), April/May 1977.

I like taking photographs, because I like life. And I like photographing people best of all, because most of all I love humanity.

—Horst P. Horst

Horst: *Evening Gown by Alix, Modelled by Lud*, 1938

When Horst P. Horst began to photograph for *Vogue* in 1932, fashion photography was still largely in thrall to the style introduced by Steichen in the 1920's and subsequently refined by Hoyningen-Huene. Horst, who had originally come to Paris to study architecture with Le Corbusier, turned instead to photography after making the acquaintance of Hoyningen-Huene, and his own earliest work echoes Hoyningen-Huene's cool classicism. Models were photographed with meticulous precision under artificial lights; studio sets were austere; backgrounds were plain or severely geometric.

Within a few years, however, Horst developed a more frankly ornamental style that was unmistakably his own. His combination of extravagant visual fantasy and vibrant sensuality sets his fashion photographs quite apart from those of *Vogue's* two other principal photographers of the 1930's, Steichen and Cecil Beaton. Gradually introducing more imaginatively furnished sets and drapery, Horst arranged his tableaux with an eye for elegant undulating lines and sophisticated lighting effects. Amid rich surroundings, his model's face might be thrown unexpectedly into silhouette, giving rise to a mood of calculated mystery and anticipation.

In addition to his fashion photographs, Horst produced during the 1930's a series of highly-regarded portraits of the leading personalities of the day, including Dietrich, Dali, Cocteau, and the Duke and Duchess of Windsor. Often done outside the studio, these portraits lack the formal perfection of Horst's fashion work, but effectively transmit the air of sometimes desperate gaiety that marked the period between the wars. Although he remains active, and has published highly successful interior studies and patterned abstractions from natural forms, Horst continues to be irrevocably linked with the sensibility of the 1930's.

—Christopher Phillips

HORVAT, Frank.

Italian. Born in Abbazia, 28 April 1928. Educated at secondary school in Lugano, Switzerland, 1939-45; studied drawing at the Accademia di Brera, Milan, 1948-49. Married Maria Terese Lorenzetti in 1956; sons: Michel, Lorenzo and Marco; married Marie Louise Pierson in 1966; son: David; married Alexandria De Leal in 1979; daughter: Sara-Fiammetta. Worked as a graphic artist in various advertising agencies, Milan, 1949-50. Freelance photographer, working for *Epoca, Paris-Match, Picture Post, Life, Jardin des Modes, Elle, Vogue, Harper's Bazaar, Glamour, Esquire*, in Milan, Paris, London and New York, since 1951: settled in Paris, working for the American news agency Black Star, 1956; Associate Photographer, Magnum Photos co-operative agency, Paris, 1959-62; established Frank Horvat Studio, Boulogne-Billancourt, 1968. Address: Frank Horvat Studio, 5 rue de l'Ancienne Mairie, 92100 Boulogne-Billancourt, France.

Individual Exhibitions:

1977　*Trees*, Musée des Arts Décoratifs, Nantes, France (travelled to the International Center of Photography, New York, 1978, and The Photographers' Gallery, London, 1979)

Selected Group Exhibitions:

1955　*The Family of Man*, Museum of Modern Art, New York (and world tour)

Collections:

Bibliothèque Nationale, Paris; Musée des Arts Décoratifs, Nantes, France.

Publications:

By HORVAT: books—*Television*, Lausanne 1962; *Strip-Tease*, Lausanne 1962; *The Tree*, with text by John Fowles, London 1978.

On HORVAT: book—*The History of the Nude in Photography* by Peter Lacey, London 1964, 1969; articles—"Les Photographes Aiment-ils les Mannequins" in *Elle* (Paris), 8 April 1974; "Frank Horvat" in *Zoom* (Paris), November 1977; "Les Bonheurs de Horvat" in *Photo* (Paris), February 1981.

I must admit that—in the beginning—photography seemed to me the easiest way to express something. This was when I was twenty years old, and just mature enough to realize that my poems were not very good and my drawings even worse.

Rather than sitting in front of a blank page, I would pick up my camera and go searching. There was always something on a contact sheet that

Frank Horvat: *Calcutta*, 1972

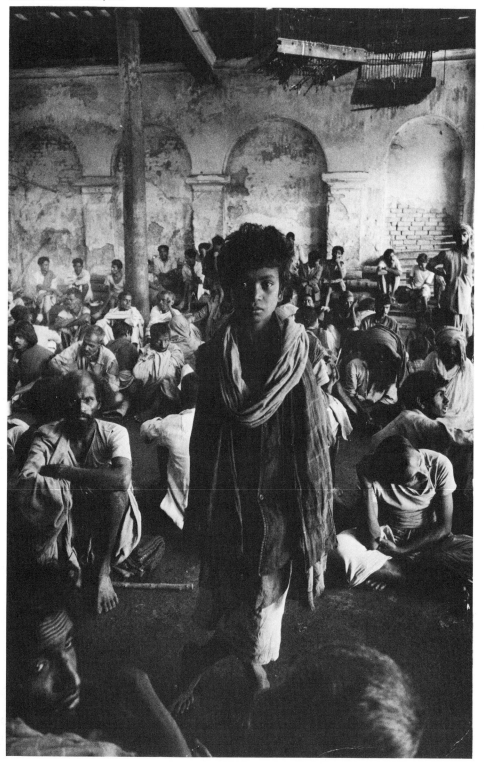

seemed worth printing and looked as if I had had something to say. When necessary, I would go to the extreme heresy of enlarging some minute part of a negative (the printer down the street hated the moment when he saw me arriving with detailed instructions about how to do so).

In time, I started to understand the fundamental difficulty of photography—as a counterpart to its fundamental easiness. One can visualize this difficult by comparing the millions of miles of film that have been made and processed to the few thousand photographs worth being preserved for posterity.

But even now, thirty years later, I feel that I have only begun to understand: had I really understood the difficulty, my film would remain as blank as the paper in front of which I was sitting as a young man.

Actually this happens from time to time: I then say to myself that photography is the art of not pressing the button, of refusing an infinite number of possibilities, expressions, angles, lighting effects, which do not coincide exactly with my accumulated expectation.

For this is the photographer's work, as I see it: to look at things for hours, days, or weeks, to walk and look until something is created in the mind which is not an image or even the negative of an image, but an emptiness, *the need* for an image (for an image like an archetype or an idea in the Platonic sense). And only after this preparation has been completed, lift the camera to the eye and let the millions of possible visual combinations run through the viewfinder, just as a computer lets the endless series of possible figures run through its mechanism, until it clicks and stops at the figure that it was programmed to find.

(This metaphor is only partly correct: a computer can do nothing but accept passively the series of figures that are fed into it, while the photographer can be active in creating the visual combination that fits his "programme" either by explicitly directing what is in front of his lens, or by one of many more subtle, less explicit ways of causing things to happen.)

In fact, photography appears to me now, just as it did thirty years ago, as a job at once too easy and too difficult. It is too easy to have the whole wealth of the visible world laid out in front of oneself, and to be able to own it by merely pressing a button. Too difficult to have to find, within the messy infinity of all possible visual combinations, the one and only instant and angle in which every detail shall have found its order and its place, to coincide with the archetype in the mind.

The word "order" is certainly one of my key words. I feel deeply threatened by the idea of entropy, by the lack of order in general, and by the messiness of the contemporary world in particular. The one thing that I would like to leave behind me is just a tiny bit of order at least within the fragment of the world that I can frame and stop in my viewfinder.

To "stop" would be my second key word—stop *time*, of course. This was most certainly my first and deepest motivation when, at the age of sixteen, I sold my collection of postage stamps in order to buy a second-hand Retinamat camera. There is nothing original about this illusion of stopping time. It makes the stockholders of Eastman Kodak earn the millions of dollars they are earning. It also gives some very high ups and some very low downs, just like a narcotic. One of the downs is the feeling that I get in front of my drawers full of contact sheets and transparencies that I have the courage neither to file nor throw away. Not only because I hate the feeling of dust on my fingers, but also because it is unbearable to have to face a time that is no more.

The third keyword is one that I hesitate to name: "grace"—in an almost theological sense. If I had to estimate how many times I have pushed that button (at an average of a thousand 36-exposure films per year), I would end up with a seven digit figure. I know that through the efforts of my eyes and my legs, through my gimmicks and my stubbornness, I have been able many times to make the composition in the viewfinder coincide with the archetype in the

mind. But of some photographs—not many of them, somewhere between ten and fifteen—I know that I did not make them: they have been given to me. They are probably the ones that are worth being preserved.

—Frank Horvat

Some students of contemporary photography were, no doubt, quite startled to find the name of Frank Horvat on the cover of a beautiful book (published in 1978) entirely devoted to colour photographs of trees. The book came out just in time for an exhibition of Horvat's colour prints (printed in Paris by Fresson process) at the Photographers' Gallery in London (it had previously been shown in Nantes and New York). Everyone seriously interested in creative photography naturally knew Horvat's name, but everyone associated him with his lively and original fashion photography and even more so with his sensitive reportage, certainly not with these monumental and delicate photographs of trees.

And yet these photos were merely confirmation of Horvat's versatility; they also made many people realize how much Horvat has been underestimated, mainly because of his own modesty and love of privacy. The exhibition and the book also underlined the fact that Horvat is always totally true to his own very high standards. All his work is based on deep and thorough pre-visualisation and careful mental preparation for each successive subject, and a key element of his work is a profound order in all his images. He says himself that he "feels deeply threatened by the idea of entropy, by the lack of order in general and by the messiness of the contemporary world in particular." And because of that threat he has always tried to bring harmony and discipline "at least within the fragment of world that I can frame and stop in my viewfinder."

Frank Horvat bought his first camera at the age of 16 (in exchange for a stamp collection), and after studies in graphics and some two years in an advertising agency, he got his first photographic essay published in a magazine. Soon he turned his back on the world of advertising and started his career as a freelance journalist, travelling extensively in India

and joining "Black Star" news agency. In 1957 he took his first fashion pictures, being the first to pioneer 35mm. reportage technique for glossy fashion magazines, and soon found himself in great demand by the leading international publications.

Fashion and journalism still occupy Horvat to this day. While working regularly for *Harper's Bazaar*, *Glamour* and *Esquire*, among many others, Horvat has still managed, in the meantime, to publish two books (*Television* and *Strip-Tease*) and fit in a long journey around the world for German *Revue* magazine and do twelve essays on capitals of the world. From about 1964 advertising photography began to feature prominently in his work schedule, but in the last 10 years his house in Provence (where the tree project originated) has allowed him periods of rest and reflection.

Soon his new book, a retrospective review of his 30 years of photography, will be published, and another exciting colour project is also the pipeline— but its subject must remain a secret for the present.

—Jorge Lewinski

HOSKING, Eric (John).
British. Born in London, 2 October 1909. Educated at the Stationers' Company School, Hornsey, London, 1919-25; self-taught in photography. Married Dorothy Sleigh in 1939; children: Margaret, Robin, and David. Worked as an apprentice, Stewart and Arden motor-car dealers, London, 1925-26; Clerk/Salesman, George Johnston Ltd., motor parts dealers, London, 1926-29. Freelance bird and wildlife photographer, working for *The Times, Daily Mirror, Weekly Illustrated, Picture Post, Country Life, News Chronicle*, etc., London, since 1929. Photographic Editor, *New Naturalist*, London, 1942-80; Nature Editor, *Daily Mail* School-Aid Publications, London, 1945-47; Photographic Editor, *Brit-*

Eric Hosking: *Barn Owl with Vole*, 1948

ish Birds magazine, London, 1960-76. Director of Photography, Coto Donana Expedition, Spain, 1956, 1957; Leader, Cazoria Valley Expedition, Spain, 1959; Director of Photography, British Ornithologists Expedition, Bulgaria, 1960, and Hungary, 1961; Member: Mountfort Expedition, Jordan, 1963; British Expedition in Jordan, 1965, and Pakistan, 1966; World Wildlife Fund Expedition, Pakistan, 1967; and Lindblad Expedition, Galapagos Islands, 1970; Kenya and Rhodesia, 1972; Tanzania and Kenya, 1974, 1977; Seychelles, 1978; India and Nepal, 1979. Vice-President, Royal Society for the Protection of Birds, 1947-80; Member of the Council, 1950-56, and Member of the Fellowship and Associateship Admissions Committee, 1951-56, 1960-65, 1970-80, Royal Photographic Society; Chairman, Photographic Advisory Committee, Nature Conservancy, London, 1953-73; President, Zoological Photographic Club, London, 1959; Vice-President, Nature Photographic Society, London, 1960; Vice-President, British Ornithologists' Union, 1969-72. Recipient: Wildlife Photography Medal, *Country Life* magazine, London, 1950; Cherry Kearton Award, Royal Geographical Society, 1968; Kodak Award, 1969; Gold Medal, Royal Society for the Protection of Birds, 1974; Silver Medal, Zoological Society, London, 1975. Fellow, Institute of Incorporated Photographers, London, Honorary Vice-President, London Natural History Society, 1959; Honorary Vice-President, British Naturalists' Association, 1962; Honorary Fellow, Royal Photographic Society, 1967. O.B.E. (Officer, Order of the British Empire), 1977. Address: 20 Crouch Hall Road, London N8 8HX, England.

Individual Exhibitions:

1932 Royal Photographic Society, London
1957 Kodak Gallery, Kingsway, London
1967 Royal Photographic Society, London
1979 Kodak Gallery, High Holborn, London
 Olympus Gallery, London
 Brotherton Gallery, London
1980 Fox Talbot Museum, Lacock, Wiltshire

Selected Group Exhibitions:

1950 *Country Life International Wildlife Photography Exhibition*, London
1981 *Points of View*, Kodak Gallery, London

Publications:

By HOSKING: books—*Friends of the Zoo*, with Cyril Newberry, London 1932; *Intimate Sketches from Bird Life*, London 1940; *The Art of Bird Photography*, with C.W. Newberry, London 1944; *Birds of the Day*, London 1944; *Birds of the Night*, London 1945; *More Birds of the Day*, London 1946; *The Swallow*, London 1946; *Masterpieces of Bird Photography*, with H. Lowes, London 1947; *Birds in Action*, with C.W. Newberry, London 1949; *Birds Fighting*, London 1955; *Bird Photography as a Hobby*, London 1961; *Nesting Birds, Eggs and Fledglings*, London 1967; *An Eye for a Bird* (autobiography), with F.W. Lane, London 1970, 1973; *Wildlife Photography*, with John Gooders, London 1973, 1976; *Minsmere*, with Herbert Axell, London 1977; *Birds of Britain*, with Herbert Axell, London 1978; *A Passion for Birds*, with Kevin MacDonnell, London 1979.

Eric Hosking has also illustrated more than 900 books on nature and wildlife, since 1929.

Eric Hosking has been called the world's greatest bird photographer—with good reason. Challengers appear from time to time, but, fine photographers as they may be, they have not overtaken him.

During the 50 years that he has been a professional wildlife photographer, Hosking has been totally dedicated to nature photography and, apart from his family, has had no other interest. At the outset of his career he gained inspiration from Richard Kearton—his boyhood hero—who established a reputation for photographing birds in the early years of the 20th century. Whenever Kearton was scheduled to lecture in North London, Hosking met him at the station and carried his slides for him. Dedication and enthusiasm are vital ingredients, but of themselves they are insufficient to attain the pinnacle of fame; however, these qualities may have produced the mysterious X factor which singles Hosking out from other photographers. He has built on the traditions of bird watching initiated by Gilbert White more than two centuries ago, and developed the remarkable ability of knowing bird behavior so intimately that he can anticipate the action he wishes to photograph in the split second necessary to fire the camera shutter. In addition to knowledge, he has a great love for all living things: "A true bird photographer is primarily interested in the welfare of the birds and will go to great trouble to disturb them as little as possible. The birds must come first."

Hosking has a natural and unerring "eye for a picture," an inborn aesthetic appreciation of good design, and a remarkable facility for capturing the right moment. The animals, birds or butterflies in his photographs are featured to perfection in appropriate surroundings and, when occasion permits, are decorative as well. His photographs give great pleasure, not only because they communicate so well but also because they are aesthetically admirable.

Until 1947 Hosking used a quarter plate Sanderson camera on a tripod, and in 1935 he was the first photographer in Britain to use Sashalite flash bulbs for natural history subjects. He claims that this technique (advanced for the period) resulted in the production of one of his most famous photographs, a barn owl carrying a large rat to its nest. He took the cap off the lens in darkness, waited for the sound of the bird returning to the nest, and then fired the flash bulb.

The biggest problem he faced was the photography of birds in flight. In 1946-47 Dr. Philip Henry of the British Cotton Research Establishment in Manchester built him electronic flash equipment weighing more than 100 weight with another 40 pounds weight of battery. One 5/1,000 of a second gave excellent exposures, but human reactions are not sufficiently quick to fire the shutter at that precise fraction of a second. Henry therefore devised an ancillary system whereby the birds photographed themselves when they passed through the light beam of a photo-electric cell. Hosking's most famous photograph, "Barn Owl in Flight in Heraldic Pose," was produced (in 1948) while he was experimenting with this equipment.

Although modern electronic technology associated with skilled camera operation is essential to the achievement of high standards in nature photography, even more important is the initial visualization of the subject, the determination of viewpoint, and the final decision on selection from the several exposures made of the same subject. Hosking has that kind of vital "know-how." Although birds are his favourite subject, his most outstanding photographs are of owls, and he has travelled all over the world photographing animals, insects, fish, wild flowers, trees and the range of animals in captivity. 250,000 black-and-white photographs and 100,000 colour transparencies are recorded, indexed and filed in his archives, which includes documentation of 2,000 species of birds. At an age when most people take life more easily, it is still an adventure for Eric Hosking: "It is hard to say what future electronic developments are in store, but the photography of birds in flight becomes more and more exciting as time goes by."

—Margaret Harker

HOSOE, Eikoh.

Japanese. Born Toshihiro Hosoe in Yonezawa, Yamagata Prefecture, 18 March 1933. Studied at the Tokyo College of Photography (Tokyo Shashin Daigaku), 1951-54. Married Misako Imai in 1962; children: Kenji, Kanako, and Kumiko. Freelance photographer, Tokyo, since 1954. Professor of Photography, Tokyo Institute of Polytechnics, since 1975. Recipient: Photographer of the Year Award, Japan Photo Critics Association, 1963; Art Award, Ministry of Education, 1970. Agent: Light Gallery, 724 Fifth Avenue, New York, New York 10019, U.S.A. Address: 5 Aizumicho, Shinjuku-ku, Tokyo 160, Japan.

Individual Exhibitions:

1956 *An American Girl in Tokyo*, Konishiroku Gallery, Ginza, Tokyo
1960 *Man and Woman*, Konishiroku Gallery, Ginza, Tokyo
1969 *Kamaitachi*, Nikon Salon, Ginza, Tokyo
 Man and Woman, Smithsonian Institution, Washington, D.C.
1973 *Eikoh Hosoe*, Light Gallery, New York (partial retrospective)
1975 *Simon: A Private Landscape*, Light Gallery, New York
1977 *Gaudi*, Nikon Salon, Ginza, Tokyo (travelled to the Nikon Salon, Shinjuku, Tokyo, and the Nikon Salon, Osaka)
1979 *Eikoh Hosoe: Retrospective*, Photographers' Gallery, Melbourne
 Ralph Eugene Meatyard: Photographs/ Eikoe Hosoe: Kamaitachi, Silver Image Gallery, Ohio State University, Columbus
1980 *Ordeal by Roses and Kamaitachi*, FNAC Forum, Paris
1981 *Eikoh Hosoe: Retrospective with Recent Works*, Galerij Paule Pia, Antwerp
1982 *The Human Figure 1960-1980*, International Museum of Photography, George Eastman House, Rochester, New York

Selected Group Exhibitions:

1967 *Photography in the 20th Century*, National Gallery of Canada, Ottawa (toured Canada and the United States, 1967-73)
1974 *New Japanese Photography*, Museum of Modern Art, New York
1976 *Japanese Contemporary Photography*, Städtisches Museum, Graz, Austria
1979 *Japanese Photography Today and Its Origin*, Galleria d'Arte Moderna, Bologna (travelled to the Palazzo Reale, Milan; Palais des Beaux-Arts, Brussels; and the Institution of Contemporary Arts, London)
1981 *Astrazione e Realtà*, Galleria Flaviana, Locarno, Switzerland

Collections:

Shadai Gallery, Tokyo; Nihin University, Tokyo; Museum of Modern Art, New York; International Museum of Photography, George Eastman House, Rochester, New York; Smithsonian Institution, Washington, D.C.; National Gallery of Canada, Ottawa; Victoria and Albert Museum, London; Bibliothèque Nationale, Paris; National Gallery of Australia, Canberra.

Publications:

By HOSOE: books—*Man and Woman*, with an introduction by Van der Elsken, Tokyo 1961; *Killed by Roses*, with a preface by Yukio Mishima, Tokyo

Eikoh Hosoe: From the series *Man and Woman*, 1960

1963, reissued in different form as *Ordeal by Roses*, Tokyo 1971; *Why, Mother, Why? The Tragedy and Triumph of a Little Girl—in Poetry and Pictures*, with Miyuki Furuta, Tokyo 1965; *Takachan and I*, with Betty Lifton, New York 1967; *A Dog's Guide to Tokyo*, with Betty Lifton, New York 1969; *Kamaitachi*, with a preface by Shuzo Takiguchi, Tokyo 1969; *Return to Hiroshima*, with Betty Lifton, New York 1970; *Embrace*, with a preface by Yukio Mishima, Tokyo 1971; article—interview in *Photography Between Covers* by Thomas Dugan, Rochester, New York 1979.

On HOSOE: books—*Gendai Shashin No Kenkyu/A Study of Contemporary Photography* by Nobuya Yoshimura, Tokyo 1967; *Photography in the Twentieth Century* by Nathan Lyons, New York 1967; *New Japanese Photography*, exhibition catalogue, by John Szarkowski and Shoji Yamagishi, New York 1974.

Photography is the way of my life, in which I always seek after anything that is new to me.

Whenever I am about to take photographs, I devise a hypothesis—in other words, prejudice or preconception, or perhaps it is a mixture of both. It has to do with curiosity. I do not care whether the style of my photography is old or new. What I do care about is that it provides me with a certain kind of stimulation. If I start with a particular prejudice and decide it is unfair, then I'll go on to discover something fresh—this often happens. The greater the metamorphosis, the greater the excitement. If, however, my prejudice is confirmed, then I realize that it is no longer prejudice but hypothesis. If it is a true hypothesis, then I must offer the proof in my photography. Because I am a photographer.

Regarding my works: let me briefly describe some of my experiences.

Man and Woman (1961) began with curiosity, my questioning of *Genesis* II, 23:

Now this, at last—
bone from my bones,
flesh from my flesh!—
this shall be called woman,
for from man was this taken.

Embrace (1971) is an extension of *Man and Woman* in a more developed form. My question still remains, though....

Ordeal by Roses (1963) was started as an effort at destruction of iconoclasm, that of the great Yukio Mishima; it also involved great respect for my subject. Destruction should be followed by reconstruction, and the project actually grew into a subjective documentary of Mishima based on my own imagination and vision of truth.

Kamaitachi (1969) was started as a record of my memories of World War II when I was evacuated to the countryside at the age of 11. The camera cannot express what you cannot see before your own eyes, yet that is precisely what a photographer often wishes to record with his camera. What does he do then? In my case, I had the co-operation of my friend, a great dancer named Tatsumi Hijikata. This series is also a subjective documentary of Hijikata in the countryside to which I had been evacuated. My intention was to photograph the total background, including the landscapes. Hijikata was a great catalyst. By throwing a stone into a pond you can see a beautiful ripple. I wanted to photograph the ripple, large or small, complete or a portion of it—as well as the dancer himself.

Surprised by the apparition of the dancer, the local farmers were at first apprehensive, but soon they began to laugh and they went on laughing. In their laughter I heard again the same laughter I had heard as a boy in that country. The night was dark and cold. The trees were like monsters in the darkness, and the far mountains were like a gigantic snake lying on the ground. There were many local

folktales. Children enjoyed them, but they were often frightened. "Kamaitachi" was one of them: it frightened everyone.

"Gaudi," which has haunted me and on which I am now working, was started in curiosity, by questioning, and prejudice mixed with ignorance, love mixed with hate. I first saw Gaudi's architecture in Barcelona in 1964. I was completely overwhelmed. I could hardly take photographs; I simply stood and observed. When I returned to Barcelona in 1977, thirteen years had passed; I had prepared myself spiritually, I had studied. All of my complex thoughts and emotions regarding Gaudi suddenly became a question, whether what Gaudi had been searching for and had partially realized might have been Zen. Maybe another kind of Zen, produced on the opposite side of the world. That is my simply inspired intuition. During the past four years I have visited Barcelona six times, and my intuition has become firm: Yes, Gaudi must be Zen. This is now hypothesis. It may be just a prejudice. Who knows! But if it is a true hypothesis, then I must give proof of it in my photography. God help me.

—Eikoh Hosoe

Visual perception is kaleidoscopic in nature; that is, it is made of smaller bits of information, and whether they be cultural, personal, innate, or archetypal, they are in a constant state of flux. For Japanese photographer Eikoh Hosoe, born in 1933, his world and its traditions and dreams ran headlong into the Western world of the 20th century, and his photographic interpretations reflect the many facets of this confrontation.

Harmony or "wa," with its aesthetic ideal of a restrained and melancholic beauty, is a very central theme of Japanese life, and was indelibly upset by these changes. The focus now was on more demonic and atavistic aspects of the world, which intensified a naturally subjective and random approach to artistic expression.

The Japanese approach toward photography is also based in the Eastern sensibility of intuitive feeling as opposed to formalized reality. The photographer, Hosoe, through evocation and the power of suggestion, uses the image created as an indication of his personal experiences and intent, and the viewer must be the final interpreter of the picture.

Another important facet of artistic Japanese tradition is the influence of Zen in all aspects of life. It teaches that a seeker can find the eternal, the transcendence, in the simplest finite detail. Reaching Japan in the 12th century, Zen Buddhism stresses the "cultivation of the little," a mode that combines nature and intuition, expressed in terms that are refined, intimate, and disciplined. Devotees seek the ultimate insight, "satori," that Buddha received in Nirvana. This knowledge of non-ordinary reality, or abrupt enlightenment through a sudden grasp of reality, occurred for Eikoh Hosoe on a certain day in 1960. This experience inspired his body of work entitled "Man and Woman," which has been described by Nobuya Yoshimura as "a work made in a spirit completely opposite to that of pornography." In other words, this "...shows a group of naked men and women with every trace of pornography fastidiously removed." Hosoe's contemporary interpretation of eroticism developed from Japanese artistic genre and photographic milieu.

The wood block print—borrowed from the Dutch and known in Japan as "Ukiyo-e," or pictures of the floating world—developed in the 17th and 18th centuries for the emerging lower classes. The "Ukiyo-e" prints by Harunobu, Utamaro, Hokusai, and Hiroshige, with their dynamic composition and their graphically erotic and sometimes pornographic subjects and themes, attained world-wide recognition. Their influence on Western artists, among them painter James Abbott McNeill Whistler, in turn affected the Pictorialists, Coburn, Steichen, and White, whose similar styles are characterized by soft focus, deep shadows, and strong linear compositions.

Photographically, it was not until the 1920's that serious art photography of the nude began in Japan, and the results left some critics viewing the pictures as romanticized and sentimental.

Against the diverse, evolving tapestry of Japanese artistic development, Hosoe chose to continue his photographic exploration of the nude, known as "Embrace," almost immediately after completion of "Man and Woman" in 1961. However, it was not shown until 10 years later because a photographic exhibition of Bill Brandt's "Perspective of Nude" showing in Japan at that time, greatly resembled those in "Embrace," so according to Hosoe, "I stopped working on it for a time."

"Embrace," with its strict adherence to form and graphic detail, depicts Hosoe's confrontation with the Japanese approach to the nude figure and the new attitudes toward sexuality in Japan, and yet maintains certain classical formality. Much as Weston with his exquisite studies of line and form in his nude photographs saw the need for tension between opposites as necessary, so, too, has Hosoe in the ultra whiteness of woman and the rich, deep blackness of man. In Hosoe's prints the whiteness of the female form as a lyrical reflection of traditional Japanese woman and the blackness of man as in the black things and dark places of primordial fears of mysterious memory are seen as images of classical Japan.

For the Japanese artist, whether it be the painter following the tradition of "emakimono," the long, narrow, horizontal scroll which when unrolled portrays a procession or progressive scenes whose conscious placement reflects the visual narrative, or Hosoe as a contemporary photographer whose many bodies of work are singular images seen in the context of a common theme—these works are meant to be seen as a series or in book form, as is much of post-World War II Japanese photography. This expression—the flow—and the relationship of photographic images in a conscious effort to form a continuity of thought and vision is a particular aspect of Japanese photography today.

Using this form, Hosoe continued to explore allegorical symbols with the publication of *Kamaitachi* in 1969, known also in the world of superstition and legend as "The Weasel's Sickle." Hosoe collaborated in this work with the renowned dancer, Tatsumi Hijikata. Hosoe felt this was not theatrical photography, "but is that rare case where the camera obscura itself becomes the theater." The Kamaitachi, which according to popular legend may be a "lacerated wound caused by a state of vacuum which is produced partially in the air, owing to a small whirlwind," is a drama of madness triggered by jealousy. Recalling the myths and superstitions of his youth, Hosoe recreates episodically this traditional Japanese fable. The villagers are participants as eyewitnesses to a strange dancer—is he an earthly creature or phantasmagorical? Perhaps they see in him the lost image of the magician priest, forgotten in the remote past.

Between "Man and Woman" and "Embrace," Hosoe completed another large body of work, "Ordeal by Roses," for which he used novelist Yukio Mishima as a model. Hosoe once again explored the strengths, fears, and weaknesses of man while luring him to that other reality. As Mishima states, "The world to which I was abducted under the spell of his lens was abnormal, warped, sarcastic, grotesque, savage, and promiscuous...yet there was a clear undercurrent of lyricism murmuring gently through its unseen conduits."

Against the recurring themes of pessimism and melancholia, the intuitive and necessarily personal experiencing of reality, Hosoe's view of fantastical and mysterious images emerge in his cinematic approach to photography. His photographs have attained "Shibui," that point where beauty reaches great subtlety and achieves a restrained elegance. Through his visual acuity toward design and his personal expression in the tonality of his prints, Hosoe seeks the universality of form in his photo-

graphs and communicates his personal involvement effectively.

—Monica R. Cipnic

HOWE, Graham.

Australian. Born in Sydney, 18 April 1950. Studied photography and film at the Prahran College of Advanced Education, Melbourne, 1970-71, Dip. Art/Design 1971; studied photography at the University of California at Los Angeles, 1976-79, M.A. 1978, M.F.A. 1979. Married Jacqueline Markham in 1978. Freelance photographer, London, Sydney, and now Los Angeles, since 1972. Exhibitions Designer, The Photographers' Gallery, London, 1972-73; Research Assistant, Royal Photographic Society, London, 1973-74; Director, Australian Centre for Photography, Sydney, 1974-75. Since 1976, Curator of the Graham Nash Photographic Collection, San Francisco. Address: 6637 Drexel Avenue, Los Angeles, California 90048, U.S.A.

Individual Exhibitions:

1979 Photography Department Gallery, Orange Coast College, Costa Mesa, California
1980 Photographers' Gallery, Melbourne
1982 Australia Centre for Photography, Sydney

Selected Group Exhibitions:

1973 *Serpentine Photography*, Serpentine Gallery, London
1977 *300 Photographies: Collection Bibliothèque Nationale*, Centre Georges Pompidou, Paris
1978 *The Photograph as Artifice*, California State University at Long Beach (travelled to Grossmont College Art Gallery, El Cajon, California, 1978; Friends of Photography, Carmel, California, and Santa Barbara Museum of Art, California, 1979)
1979 *Southern California Invitational*, University of Southern California, Los Angeles
Attitudes: Photography in the 1970's, Santa Barbara Museum of Art, California
1980 *Invented Images*, University of California at Santa Barbara
1981 *Landscape Directives*, Los Angeles Center for Photographic Studies (with Carl Toth, Grey Crawford, and Jack D. Teemer, Jr.)

Collections:

Metropolitan Museum of Art, New York; Museum of Modern Art, New York; International Center of Photography, New York; Minneapolis Institute of Art; Museum of Fine Arts, Houston; Center for Creative Photography, University of Arizona, Tucson; Los Angeles County Museum of Art; University of California at Los Angeles; Bibliothèque Nationale, Paris; National Gallery of Victoria, Melbourne.

Publications:

By HOWE: books—*Aspects of Australian Photography*, Sydney 1974; *New Photography Australia: A Selective Survey*, Sydney 1974; *Paul Outerbridge Jr.*, Los Angeles 1976; *Two Views of Manzanar: Ansel Adams and Toyo Miyatake*, with Jacqueline Markham, Scott Rankin, and Patrick Nagatani, Los Angeles 1978; *The Graham Nash Collection*, San Francisco 1978; *Paul Outerbridge: Photographs*, New York and London 1980; articles—"Paul Outerbridge: From Cubism to Fetishism" in *Artforum* (New York), Summer 1977; "Paul Outerbridge: Precisionist/Fetishism" in *Photo Bulletin* (Los Angeles), December 1978; "Paul Outerbridge Jr.: Photographs" in *Print Letter* (Zurich), May/June 1980; "Hand-Colored Photographs" in *Picture Magazine* (Los Angeles), August 1980.

On HOWE: books—*Creative Camera Yearbook*, London 1978; *Invented Images*, exhibition catalogue, by Phyllis Plous and Steven Cortright, Santa Barbara, California 1980; articles—"Sneaker in the Sky Revisited" in *Light Vision* (Melbourne), January/February 1978; "Graham Howe" in *Fotografie* (Göttingen), May 1978; "Camera Vision/Viewer Perception" by Mark Johnstone in *Artweek* (Oakland, California), 6 January 1979.

Driven by an urge to confront the exhausting complexity of the natural environment with man's often lazy intellectual synthesis of that environment into visual understanding, Graham Howe has moved in his photographs through distinct directional periods, always nagging the viewer visually. Though born in Australia, Howe has had a peripatetic life in varied cities and countries, which has contributed to his recognition of the complexity and nature of the visual problems inherent with seeing and rationalizing what we see.

In the Australian land and cityscapes, the seemingly casual and haphazard urban elements became the earliest fibers of a support system of seeing. Howe's fascination with tree, fence, and shadow placement initiated a mounting urge to link and align forms in the given environment. In ordering the elements by shape, tonality, and askewed angulation, Howe introduced both a sense of logic and the earliest inklings of the physical and intellectual means by which he structures and manipulates the picture's reality.

In 1975-78, in extensive view camera work in the American Southwest deserts, he introduced the sparse open space as a flat field, ready to be activated by the photographer into spatial illusions and misdescriptions. In this simpler, less cluttered environment, the order of Howe's logic was more evident. With leaner subject matter, the objects for their own sake are less significant, and the idea of the picture can advance considerably. Through the linear clarity of telephone and cactus poles and black tar roads bisecting white sand hills, an architecturally drafted attitude of severe tonal and linear relationships emerged. These photographs draped strong frontal verticals and horizontals over diminishing desert spaces, coming closer to the essence of drawing and the "academic description" of space using the linear tricks of perspective.

Seeing grids everywhere in the landscape, Howe next explored their most essential forms as Renaissance perspective games on a still-life table. In "Jacob Cream Crackers", 1977, the biscuits appear as impossibly distorted trapeziod shapes which contradict their characteristic square. Their tin container also swells at the proximal end as though Howe had hybridized his props with built-in accelerating perspective. Even with the discovery that the grid, in fact, generates the misdescription, the eye is seduced more by what it sees than by what scientific rationalization insists is true. These compulsively ordered illusions at once fool and convince the viewer to both trust and never believe what their eye or the photograph tells them.

Leaving the leanness of the desert and the grid series for extensive European travel in 1978, Howe rethought a rich and dense environment with the prescience of his earlier vision of spatial ambiguity. While sympathetic with his earliest urban photography, the sophistication of illusion and successful misdescription of space in the European work surpassed the Australian pictures.

In his "Manipulated Landscapes," Howe combined the richness and texture of in-field composition with the compulsive, hyper-intellectual ordering of the grid series and boldly created pre-meditated tableaux of illusions, using props in the landscape. Hand-painted lines and shadows and alien paraphenalia both blend with and aggravate the environment they have entered. The "how to draw" pictures continued this perceptual quiz while in no way apologizing to the graduate school method of "cor-

Graham Howe: *Jacob Cream Crackers*, 1977

rect" artistic tradition.

Perhaps expurgating the heavier hand of the artist's involvement, Howe's "Multifoliate Landscapes" and "Australian Landscapes" series involve no messing with the elements; rather, a clearer idea of basic ingredients and his technical maturation show subtle landscape distortions and function as effectively as the manipulated fields of earlier works.

Gentle manipulation, intelligent selection and supreme wit continue to animate Graham Howe's photographs and remind the confounded viewer that seeing may not always be believing, but that it can be if it is convincing enough.

—Jacqueline Markham

HOYNINGEN-HUENE, George.

American. Born in St. Petersburg, Russia, 4 September 1900; emigrated to the United States, 1935; subsequently naturalized. Educated at Lutheran Preparatory School, and Imperial Lyceum, St. Petersburg, 1910-13; Yalta Gymnasium, Yalta, Russia, 1916; studied art, Académie de la Grande Chaumiére, Paris, 1919-20; and at studio of André Lhote, Paris, 1922-24; self-taught in photography. Served in British Expeditionary Force of Instructors, in Batum, Novorossisk, Katerinador and Tagarog, Southern Russia, 1918-20. Worked as translator, movie extra in Epinay Studios, and sketch artist for YTER Company (his sister's dressmaking business), Paris, 1921-24; freelance sketch artist for *Harper's Bazaar* and *Jardin des Modes*, Paris, 1921-24; staff illustrator and studio decorator, *Vogue*, Paris, 1924-25; Chief Photographer, *Vogue*, Paris, 1926-29, and New York, 1929-31; photographer for Condé Nast Publications, Hollywood, California and Berlin, 1931-32; Staff Fashion Photographer, under editor Carmel Snow and designer Alexey Brodovitch, *Harper's Bazaar* magazine, New York, 1935-45; Color Consultant, to filmmaker George Cukor and others, Hollywood, 1946-68. Also independent filmmaker, mostly of short films, Hollywood, 1947-68. Instructor in Photography, Art Center School, Los Angeles, from 1946. Agent: Sonnabend Gallery, 420 West Broadway, New York, New York 10012. *Died* (in Los Angeles) *in September 1968.*

Individual Exhibitions:

1970 *Huene and the Fashionable Image*, Los Angeles County Museum of Art
1974 *1930's Portraits and Fashion Photographs*, Sonnabend Gallery, New York
1977 *Photographs by Hoyningen-Huene*, Sonnabend Gallery, New York
1980 *Eye for Elegance*, International Center of Photography, New York (travelled to Musée Carnavalet, Paris; Long Beach Art Museum, California; Walker Art Center, Minneapolis, Minnesota; The Photographers' Gallery, London; and Baltimore Museum of Art, Maryland)

Selected Group Exhibitions:

1928 *Premier Salon Indépendant de la Photographie*, Salon de l'Escalier, Paris
1929 *Film und Foto*, Deutscher Werkbund, Stuttgart
1965 *Fashion Photography: 6 Decades*, Hofstra University, Hempstead, New York (travelled to Kornblee Gallery, New York)

1975 *Fashion 1900-1939*, Victoria and Albert Museum, London
1977 *The History of Fashion Photography*, International Museum of Photography, George Eastman House, Rochester, New York (travelled to Brooklyn Museum, New York; San Francisco Museum of Modern Art; Cincinnati Art Institute, Ohio; and Museum of Fine Arts, St. Petersburg, Florida)
1978 *Neue Sachlichkeit and German Realism of the 20's*, Hayward Gallery, London
Paris-Berlin 1900-1933, Centre Georges Pompidou, Paris
1979 *Photographie als Kunst 1879-1979*, Tiroler Landesmuseum Ferdinandeum, Innsbruck, Austria (travelled to Neue Galerie am Wolfgang Gurlitt Museum, Linz, Austria; Neue Galerie am Landesmuseum Joanneum, Graz, Austria; and Museum des 20. Jahrhunderts, Vienna)
The Fashionable World, Stephen White Gallery, Los Angeles
Film und Foto der 20er Jahre, Württembergische Kunstverein, Stuttgart (travelled to Museum Folkwang, Essen; Werkbundarchiv, West Berlin; Kunsthaus, Zurich; Kunstverein, Hamburg; and Museum des 20. Jahrhunderts, Vienna)

Collections:

Condé Nast Publications, New York; International Center of Photography, New York; H.P. Horst Collection, New York; International Museum of Photography, George Eastman House, Rochester, New York; Metropolitan Museum of Art, New York; Museum of Fine Arts, Boston; New Orleans Museum of Art; University of Southern California, Los Angeles.

By HOYNINGEN-HUENE: books—*Man Ray/ George Hoyningen-Huene*, portfolio of fashion photos, Paris, 1924-25; *Hollywood Movie Stars*, portfolio, New York 1929; *Meisterbildnisse*, with text by H.K. Frenzel, Berlin 1932; *African Mirage: The Record of a Journey*, New York and London 1938; *Hellas: A Tribute to Classical Greece*, editor, with Hugh Chisholm and Alexander Koiransky, New York 1943; *Egypt*, with text by George Steindorff, New York 1943, 1945; *Mexico Eterno: Tres Panoramas*, with text by Alfonso Reyes, Mexico City 1966, as *Mexican Heritage*, New York 1946; *Baalbek Palmyra*, with text by David M. Robinson, New York 1946; films—*Fashion at Vogue*, 1925; *Atlantide*, with others, 1927; untitled amateur film, with Serge Lifar, 1927; *Daphne: The Virgin of the Golden Laurels*, 1951; screenplays—*The Loves of Carmen*, 1946; *Salome*, 1946; *Passion*, with E. Lee Husey, 1946; film color co-ordinator on—*A Star Is Born*, 1954; *The Adventures of Hajji Baba*, 1954; *The Rains of Ranjipur*, 1955; *Bhowani Junction*, 1956; *Les Girls*, 1957; *Merry Andrew*, 1958; *The Five Pennies*, 1959; *Breath of Scandal*, 1960; *Heller in Pink Tights*, 1960; *It Started in Naples*, 1960; *Let's Make Love*, 1960; *The Chapman Report*, 1962; *A New Kind of Love*, 1963.

On HOYNINGEN-HUENE: books—*The World of Carmel Snow* by Carmel Snow and Mary Aswell, New York 1962; *A Life in Photography* by Edward Steichen, New York 1963; *Harper's Bazaar: 100 Years of the American Female* by Jane Trahey, New York 1967; *Hoyningen-Huene*, exhibition catalogue, with text by Oreste Pucciani, Los Angeles 1970; *Salute to the Thirties: Photographs by Horst and George Hoyningen-Huene*, edited by H.P. Horst, with text by Valentine Lawford, with a foreword by Janet Flanner, New York and London 1971; *The Magic Image* by Cecil Beaton and Gail Buckland,

London and Boston 1975; *Fashion 1900-1939*, exhibition catalogue, by Valerie Lloyd and others, London 1975; *American Fashion* by Sarah Tomerlin Lee, New York 1975, London 1976; *The World of Fashion* by Eleanor Lambert, New York 1976; *Documenta 6/Band 2*, exhibition catalogue, by Klaus Honnef and Evelyn Weiss, Kassel and Cologne 1977; *Geschichte der Fotografie im 20. Jahrhundert/Photography in the 20th Century* by Petr Tausk, Cologne 1977, London 1980; *Fotografie der 20er Jahre: Eine Anthologie*, edited by Hans-Jürgen Syberberg, Munich 1977; *Neue Schlichkeit and German Realism of the Twenties*, exhibition catalogue, by Wieland Schmied, Ute Eskildsen and others, London 1978; *Germany: The New Photography 1927-33*, edited by David Mellor, London 1978; *Paris-Berlin 1900-1933*, exhibition catalogue, by H. Molderings, W. Spies, G. Metken and others, Paris 1978; *The Vogue Book of Fashion Photography 1919-1979* by Polly Devlin, with an introduction by Alexander Liberman, New York and London 1979; *The History of Fashion Photography* by Nancy Hall-Duncan, New York 1979; *Film und Foto der 20er Jahre*, exhibition catalogue, by Ute Eskildsen and Jan Christopher Horak, Stuttgart 1979; *Photographie als Kunst 1879-1979/Kunst als Photographie 1949-1979*, exhibition catalogue, 2 vols., by Peter Weiermair, Innsbruck, Austria 1979; *Amerika Fotografie 1920-1940* by Erika Billeter, Berne 1979; *Eye for Elegance: George Hoyningen-Huene*, exhibition catalogue, by William A. Ewing, New York 1980; articles—"Film und Foto, Ausstellung des Deutschen Werkbundes" by Karl Sommer in *Essener Allgemeine Zeitung*, 26 May 1929; "Exhibition in Stuttgart, June 1929, and Its Effects" by Andor Kraszna-Krausz in *Close-Up* (London), February 1930; "Advertising to Women by Photography" by J. Everard in *Communication Arts* (New York), July 1934; "They Chose Photography—by Accident" by Robert W. Marks in *Minicam* (New York), June 1941; "Background to Fashion: Surrealism in Fashion Advertising" in *Art and Industry* (New York), February 1942; "Hoyningen-Huene" by Tom Maloney in *U.S. Camera Annual 1951*, New York 1950; "Blow-Out: The Decline and Fall of the Fashion Photographer" by Owen Edwards in *New York Magazine*, 28 May 1973; "Horst on Fashion Photography" by Joe Deal in *Image* (Rochester, New York), September 1975; "Photography: Men Without Props" by Janet Malcolm in *The New Yorker*, 22 September 1975; "Hoyningen-Huene—Carnavalet: L'Age Flamboyant de la Photo de Mode" in *Photo* (Paris), November 1980.

The First World War and the Russian Revolution brought irrevocable changes to the society described by Proust, the formalized world of the Guermantes. New social credos were emerging, and with them a new style of life. George Hoyningen-Huene, whose early life was spent in the rarified atmosphere of the court of Tzar Nicholas, would add his own considerable sense of elegance to this emerging era, creating a style of photography that in many ways perfectly captured its essence.

Huene was born in St. Petersburg, Russia in 1900, son of Baron Barthold von Hoyningen-Huene, chief equerry to the Tzar, and of Ann Lothrop of Detroit, daughter of the American Ambassador to Russia. During the Revolution the Hoyningen-Huene family escaped to England and eventually to France where his sister opened a dress shop. It was through connections of his mother and sister that Huene was able to secure work making fashion sketches for the French edition of *Vogue* magazine. He also designed backgrounds for photography sittings, and, as the story goes, one day the photographer failed to show and Huene took the picture. From this beginning, almost immediately Huene was given fashion assignments for which in most cases the sitters were drawn from the glamorous worlds of society and the theatre. So, against all reasonable expectations, Huene

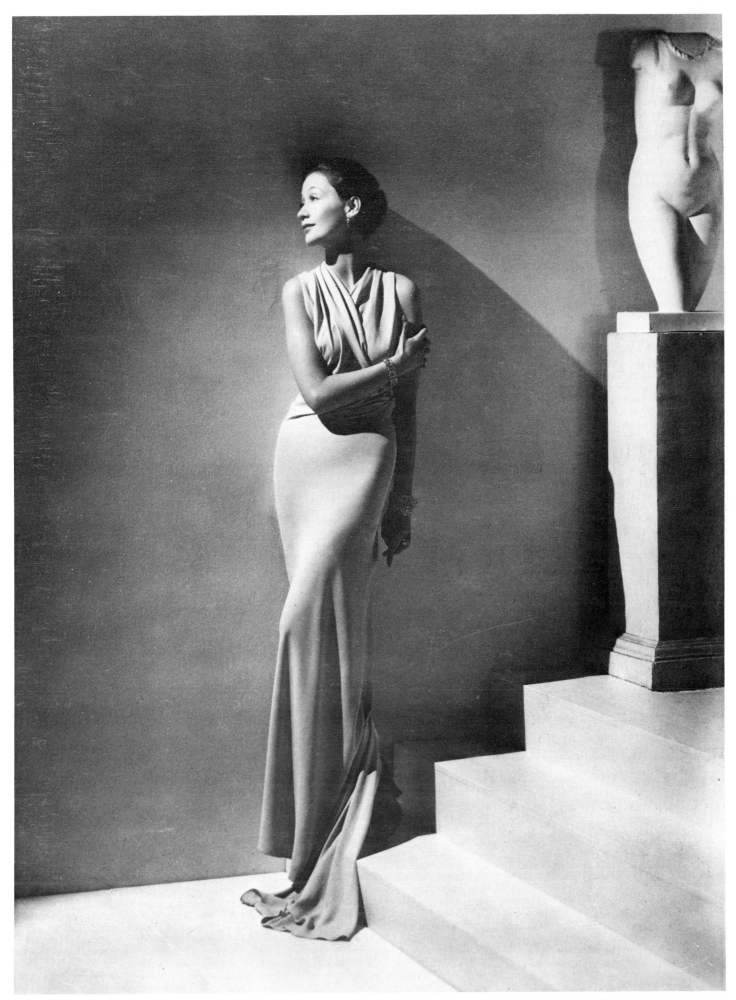

George Hoyningen-Huene: *Miss Koopman, Fashion Augusta Bernard*, 1934

became one of fashion and society's great chroniclers, working first for Paris *Vogue* and then for *Harper's Bazaar* in New York.

For a time Huene experimented with pattern, line and mathematical form in the manner of the constructionists (he briefly studied with cubist painter André Lhote). This avant-garde approach, the angular, stripped-down, machine-made aesthetic, was an important influence on painting, interior and theatrical design of the time, as well as on photography.

Huene possessed the ability to gauge proportion exquisitely, especially the tension of empty space. He had a sophisticated sense of decoration, and experimented with constructing elaborate sets which seem to contain the models in the frame of the photograph. Huene also was expert with lighting (he claimed to have learned lighting while working as a movie extra in Paris) and experimented with advanced techniques. All of these elements contributed great fidelity, tonal richness and clarity of detail to his work. Along with them there is a sense of isolation which Huene managed to translate into a metaphor for elegance, a metaphor that has remained paramount to fashion photography.

In the mid-1930's Huene's creative ability was stimulated by travel. He eventually published five books on Egypt, Africa, Greece, the Middle East and Mexico. He looked at natives and classic ruins much as he did at fashion models and still life. The shadows make their own patterns and abstraction. He sees a Greek torso against a cloudless sky in much the same way as a Mme. Grès evening dress before a plain backdrop. Architecture became his new preoccupation.

After the end of the Second World War and the resumption of the Paris couture, Huene decided that elegance and style were dead and the life he knew and appreciated would soon change. In 1946 he decided to move to Hollywood. There he eventually collaborated with film director George Cukor, a longtime friend, on the development of color film aesthetics. This enabled Huene to become personally involved with the direction, filming, make-up, costume, decor and generally all aspects of film making. At the same time, he taught photography at

The Art Center School in Los Angeles, where he shared his great experience and his techniques with the next generation of commercial artists.

From his own notes and from comments remembered by his friend Horst, it is clear that Huene never felt that photographing for a fashion magazine was anything but a means of livelihood.

He had a vision of a remote and elusive feminine ideal best portrayed, he felt, by the serenity of classic Greek sculpture. In his own most characteristic pictures, there is a sense of statuesque monumentality, humanized by the sitter's air of tranquility—an irresistible image that women sought to make their own by wearing clothes like those photographed.

—John Esten

HUBMANN, Hanns.

German. Born in Freden/Leine, near Hannover, 21 June 1910. Educated at schools in Darmstadt until 1928; studied paper engineering at the Technische Hochschule, Darmstadt, 1928-31; photography, at the Staatslehranstalt für Lichtbildwesen, Munich, 1931. Married Elisabeth Lisl in 1934; children: Hans Peter, Ursula, and Andreas. Worked as a part-time freelance photojournalist, mainly for the *Münchner Illustrierte* and advertising agencies, Munich, 1931-35; Staff Photographer, *Berliner Illustrirte*, 1935-45: war reporter for *Signal* magazine in Berlin and at the front, 1940-45; Chief Photographer, *Stars and Stripes*, United States Army newspaper, Berlin, 1945-48. Staff Photographer, 1948-63, and since 1963 Chief Photographer, *Quick* magazine, Munich (also freelanced for *Life*, etc., 1948-78). Address: Angersdorf 2, 8311 Kröning 1, West Germany.

Individual Exhibitions:

1980 Stadtmuseum, Munich

Selected Group Exhibitions:

1950 *Photokina*, Cologne
1979 *Deutsche Fotografie nach 1945*, Kasseler Kunstverein, Kassel, West Germany

Collections:

By HUBMANN: books—*Moskau*, Munich 1958; *Moskau, Metropole des Ostens*, Hamburg 1959; *New York, Metropole des Westens*, Hamburg 1959; *Die letzten Cowboys*, Reutlingen, West Germany 1961; *Fotoreporter sehen die Welt*, Munich 1968; *Gesehen und Geschossen*, with an introduction by Franz Hugo Mosslang, Munich 1969; *Kinder—Kinder*, with text by Ruth Gassmann, Rosenheim, West Germany 1970; *Bergfoto heute*, Munich 1971; *Garten der Traüme*, Munich 1973; *Die Stachlige Muse*, Munich 1974; *Und Kein Bisschen Weise*, illustrations, text by Curt Jürgens, Munich 1976.

On HUBMANN: books—*Photography of the World '60*, edited by Hiromu Hara, Ihei Kimura and others, Tokyo and New York 1960; *Geschichte der Fotografie im 20. Jahrhundert/Photography in the 20th Century* by Petr Tausk, Cologne 1977, London 1980; *Deutsche Fotografie nach 1945/German Photography after 1945* by Floris Neusüss, Wolfgang Kemp and Petra Benteler, Kassel, West Germany 1979.

Actually, Hanns Hubmann should have become an engineer in paper technology. But in 1930, inspired by the colorful goings-on at an international "Student Olympics" organized by his university, he photographed the event. The pictures were immediately published, he was paid well for his work, and the student, just ready for his first exams, was advised to devote what a picture editor correctly diagnosed as his natural gift to the (at that time) exciting new profession of press photographer. He went to work as a part-time freelance photojournalist. The most important illustrated journal of the day, the *Berliner Illustrirte* of the Ullstein publishing house, soon noticed and hired him, and his great moment came in 1936 when the Olympic Games took place in Berlin. Today, more than half a century after he began, Hubmann is still at it, still active. Hardly anyone—except, of course, Alfred Eisenstaedt—is as much living proof as Hubmann that press photography keeps one young. But one must be born to it. Whoever has experienced Hubmann in action or whoever has had the opportunity to rummage through his well-stocked picture collection and to listen to his running commentary, will have no doubt about that.

Hubmann is an example of that phenomenon of a man predestined to be completely devoted to his work and to a certain extent sacrificing his whole self to it. In action he is all eye, striving for his goal—here amiably persuasive, there energetically surmounting barriers. Then, in the actual process of taking photographs, there is a complete change of gear: from the eye via the professional subconscious to the shutter finger. With one aim only, in the service of the press: to catch the interesting perspective, the right moment, in such a way that the editorial staff will say, These are just the pictures we need for our story.

Hubmann has always worked in this way, as an illustrator for journals—before Hitler he worked for a Munich photo-agency; after the 1936 Olympics he worked for *Berliner Illustrirte*; during the war for its offshoot *Signal*; after the war for the American *Stars and Stripes*; and when it again became possible to produce German illustrated journals, he

Hanns Hubmann: *The S.A. Marching at the Berlin Olympics*, 1936

played a leading role in 1948 in the founding and creation of *Quick*: he still works for this journal today.

The statesmen, potentates, prominent artists, actors and sportsmen whom he has captured in his pictures are legion—as are also the scenes from working life, from war-time, from the distressing years after the war. They are always striking, appropriate for the requirements of his medium, and often one step ahead of the competition. The skill is in his preparation, in concentrated amiability, in the art of persuasion, but above all in his sure instinct for pictorial form. Hubmann's photos—for which, in fact, he himself has claimed neither a particular "style" nor any conscious desire for form—are as diverse, as colorful and as multifarious as life itself. They are never boring.

—Bernd Lohse

HUJAR, Peter.

American. Born in Trenton, New Jersey, 11 October 1934. Educated in New York City schools; High School of Industrial Art, New York, graduated 1952; Trappist novitiate, in Kentucky, for 2 years. Worked as a blackjack dealer, Havana, 1955-56; co-owner of a mink ranch in Argentina, 1957-58; worked as an assistant to various commercial photographers, New York, 1958-62; lived and worked in Italy, 1962-65; worked as an assistant photographer, New York, 1965-67; freelance photographer, with own studio, New York, since 1967 (did commercial/fashion work for advertising agencies and magazines, notably *Harper's Bazaar*, until 1971). Recipient: Fulbright Grant, 1962; Creative Artists Public Service Grant, 1976; National Endowment for the Arts Grant, 1977, 1980. Address: c/o Marcuse Pfeifer Gallery, 825 Madison Avenue, New York, New York 10021, U.S.A.

Individual Exhibitions:

1975 *Portfolio*, Foto Gallery, New York
1977 *New York Portraits*, Marcuse Pfeifer Gallery, New York
 Catskill Center for Photography, Woodstock, New York
1979 Public Library, Port Washington, New York
 Recent Photographs, Marcuse Pfeifer Gallery, New York
1980 La Remise du Parc, Paris
1981 *Portraits and Landscapes*, Robert Samuel Gallery, New York
1982 *3 New Yorker Fotografen: Peter Hujar/ Larry Clark/Robert Mapplethorpe*, Kunsthalle, Basel

Selected Group Exhibitions:

1975 *Coming of Age in America*, Midtown YMHA, New York (toured the United States)
1976 *Celebration of Life Below 14th Street*, Floating Foundation of Photography, New York
1977 *New York: The City and People*, Yale School of Art, New Haven, Connecticut
 Contemporary Photographs, Baltimore Museum of Art
1978 *The Male Nude*, Marcuse Pfeifer Gallery, New York

1979 *The Male Image*, Robert Samuel Gallery, New York
1980 *The Figure and Man-made Environments*, Allbright College, Reading, Pennsylvania
1981 *New American Nudes*, Massachusetts Institute of Technology, Cambridge

Collections:

Fordham University, Bronx, New York; Princeton University Museum, New Jersey; New Orleans Museum of Art; San Francisco Museum of Modern Art.

Publications:

By HUJAR: books—*Portraits in Life and Death*, with an introduction by Susan Sontag, New York 1976, London 1977; *The Grotesque in Photography*, with others, edited by A.D. Coleman, New York 1977.

On HUJAR: books—*The Photograph Collector's Guide* by Lee D. Witkin and Barbara London, Boston and London 1979; *New American Nudes* by Arno Rafael Minkkinen, New York 1981; *3 New Yorker Fotografen*, exhibition catalogue, with texts by Dieter Hall, Jean-Christophe Ammann and Sam Wagstaff, Basel 1982; articles—"Pictures from the Underground" by Henry Post in *Viva* (New York), April 1976; "Peter Hujar" by Henry Post in *Art in America* (New York), November/December 1976; "Death Leads the Dance with Life" by Owen Edwards in the *Village Voice* (New York), 13 December 1976; "Disfarmer's Naivete and Hujar's Sophistication" by Gene Thornton in the *New York Times*, 16 January 1977; "Peter Hujar and the Nature of Identity" by Richard Whelan in *Christopher Street* (New York), May 1979; "Peter Hujar at Marcuse Pfeifer" by Rene Ricard in *Art in America* (New York), December 1979; "Hujar's Progress" by Ben Lifson in the *Village Voice* (New York), 10 December 1979; "An Intense Silence" by Hervé Guibert in *Le Monde* (Paris), 3 August 1980.

Peter Hujar has created a powerful group of portraits of his friends who belong to New York's "underground" creative elite. These images are among his best-known works because they were published as *Portraits in Life and Death* in 1976.

In many of the most interesting portraits he uses the mode of the reclining figure, something rarely found in photography and yet standard fare for painting and sculpture from all periods. When asked about this, Hujar begs the question by saying that most of his friends live in lofts where furniture other than a bed is almost non-existent. The effect of these portraits, however, is quite extraordinary, giving us a glimpse of his subject at a moment of total repose and yet not totally unselfconscious. The self-consciousness has turned inward and become reflection. These people seem to be alone rather than in the room with a photographer. They are not "on stage," even though some of them are in costume. And, in fact, many of them have let go of their defenses, revealing vulnerability and fragility.

Along with these portraits Hujar has exhibited two other series, portraits of New York buildings in 1977 and portraits of farm animals in 1979. In all of this work there is an intensity that is often disquieting to his viewers. I watched a young man respond positively to a picture of a wall in Italy that had been

Peter Hujar: *Edwin Denby*, 1975

in Hujar's second New York exhibition. After looking at it for a while, the viewer suddenly explained that, although he had at first been attracted to this powerful image, it suddenly had "taken over," and he felt that it might become overwhelming. Although unrelated to this incident, Hujar responded to just such a feeling in an interview when he said: "I think of my photographs as pieces of paper that have a life of their own. The whole story has to be on that paper. It is amazing that photographs can have such power."

—Marcuse Pfeifer

HURN, David.

British. Born in Redhill, Surrey, 21 July 1934. Educated at Hardy's School, Dorset, 1948-52; Royal Military Academy, Sandhurst, 1952-54; self-taught in photography. Married Alita Naughton in 1964 (divorced, 1971); daughter: Sian. Photographer since 1955; Assistant Photographer to Michael Peto and George Varjas at Reflex Agency, London, 1955-57; freelance photographer/photojournalist, working for *Life*, *Sunday Times Magazine*, etc., in London, 1957-70, and in Wales, since 1971; Member, Magnum Photos co-operative agency, New York and Paris, since 1967. Head of the School of Documentary Photography and Film, Gwent College of Higher Education, Newport, since 1973. Distinguished Visiting Artist and Adjunct Professor, Arizona State University, Tempe, 1979-80. Editorial Adviser, with Bill Jay, *Album* photographic magazine, London, 1971. Member of the Photography Committee, 1972-77, and of the Arts Panel, 1975-77, Arts Council of Great Britain. Member, Photography Committee, Council for National Academic Awards, London, since 1978. Recipient: Welsh Arts Council Award, 1971; Kodak Photographic Bursary, 1975; U.K./U.S.A. Bicentennial Fellow, 1979-80. Agent: Magnum Photos, 251 Park Avenue South, New York, New York 10010, and 2 rue Christine, 75006 Paris, France. Address: Prospect Cottage, Tintern, Gwent, Wales.

Individual Exhibitions:

1971 Serpentine Gallery, London
1973 Bibliothèque Nationale, Paris
 Neikrug Gallery, New York
1974 *Wales in Black and White*, National Museum of Wales, Cardiff
 The Photographers' Gallery, London
1976 *Rencontres Internationales de Photographie*, Arles, France
 Centre d'Animation Culturelle, Douai, France
1977 FNAC Etoile Gallery, Paris
 Arnolfini Gallery, Bristol
 Ecole des Beaux-Arts, Angers, France
 Musée du Chateau d'Eau, Toulouse
 Rheinisches Landesmuseum, Bonn
 Rathaus, Augsburg, Germany
 Stadtbucherei, Stuttgart
1978 Städtisches Museum, Bochum, West Germany
 Northlight Gallery, Arizona State University, Tempe
 Culturele Raad, Leeuwarden, Netherlands
 Openbare Bibliotheek, Arnhem, Netherlands
 Canon Photo Gallery, Amsterdam
 Cultureel Centrum, Winterswijk, Netherlands

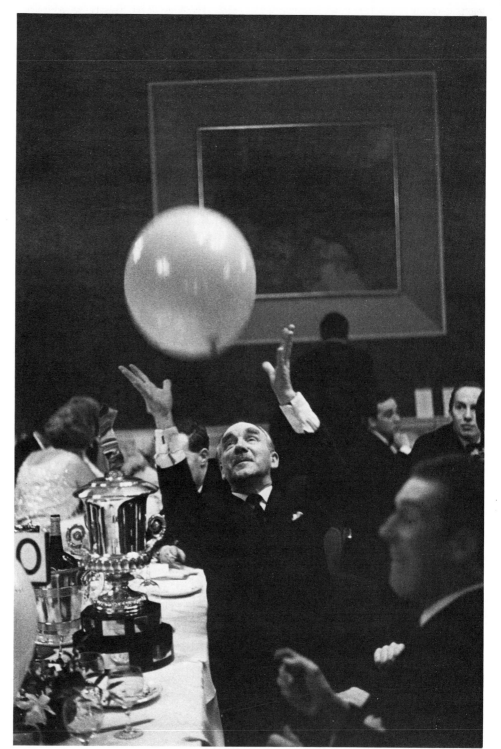

David Hurn: *Happy Times at the MG Car Owners' Ball*, Edinburgh, 1967

University of Idaho, Moscow
 Galeria Spectrum, Barcelona
 Galeria Spectrum, Zaragoza, Spain
1979 San Carlos Opera House, Lisbon
 University of New Mexico, Albuquerque
 Texas Christian University, Fort Worth
1980 Fifth Avenue Gallery, Scottsdale, Arizona

Selected Group Exhibitions:

1971 *Personal Views 1850-1970*, British Council Gallery, London (toured Europe)
1978 *18 Photographes Européens: Images des Hommes*, Belgian Ministry of Culture touring exhibition, (toured Europe)

1980 *Visitors to Arizona 1846-1980*, Phoenix Art Museum, Arizona

Collections:

Fox Talbot Museum, Lacock, Wiltshire; Arts Council of Great Britain, London; Welsh Arts Council, Cardiff; Contemporary Arts Society for Wales, Cardiff; Bibliothèque Nationale, Paris; International Center of Photography, New York; International Museum of Photography, George Eastman House, Rochester, New York; Minneapolis Institute of Arts; Amon Carter Museum of Western Art, Fort Worth, Texas; Center for Creative Photography, University of Arizona, Tucson.

Publications:

By HURN: books—*Wales in Black and White*, exhibition catalogue, Cardiff 1974; *David Hurn: Photographs 1956-1976*, with an introduction by Tom Hopkinson, London 1979; articles—"A Revolution in Photo Teaching?" in *Amateur Photographer* (London), 13 June 1973; "David Hurn," interview, with Martine Voyeux, in *Zoom* (Paris), May/June 1977; "The Picture Story" in *Camerawork* (London), no. 9, 1979.

On HURN: articles—"David Hurn: Springtime in Paris" in *Photography* (London), April 1958; "David Hurn, Magnum" in *Creative Camera Owner* (London), September 1967; "Photographs by David Hurn, Magnum" in *Creative Camera* (London), April 1971; "Portfolio: David Hurn" in *British Journal of Photography* (London) 28 May 1971; "David Hurn" in *Photo* (Paris), September 1971; "Photogallery" in *Designer* (London), October 1971; "David Hurn" in *British Journal of Photography Annual 1972*, edited by Geoffrey Crawley and Mark Butler, London 1971; "Personal Views 1850-1970" in *Creative Camera* (London), May 1972; "David Hurn" in *Zoom* (Paris), November/December 1972; "Wales in Black and White" by Ainslie Ellis in *British Journal of Photography* (London), 29 November 1974; "What Is Wales?" in *Amateur Photographer* (London), 11 December 1974; "David Hurn: Photographs in Wales" in *Creative Camera* (London), December 1974; "David Hurn ou le Scrupule" in *Photo* (Paris), January 1981.

In previous ages the word "art" was used to cover all forms of human skill. The Greeks believed that these skills were given by the Gods to man for the purpose of improving the conditions of his life. In a real sense, photography has fulfilled the Greek ideal of art; it should not only "improve" the photographer but also "improve" the world.

There are many genres in photography—none more inherently important than the other.

It is the goal of man to be actually what he is potentially. Each photographer should be stretching his interest to its limit. The expression of a piece of art is really the expression of the life of the artist.

—David Hurn

While a cadet at the Royal Military College, Sandhurst, David Hurn started taking photographs, not in order to express himself artistically, but to be allowed out of the place at night: the darkrooms lay outside the College. "My very first reportage was on the daily life of my companions, and what I saw through my viewfinder made me profoundly pacifist." His first big opportunity came when he went to Budapest to cover the Hungarian Rising and its suppression by the Russians. *Life* Magazine bought his pictures, and his career as photojournalist was launched dramatically. Ten years later he was invited to join Magnum, and he has achieved success in the varied fields of film, fashion, industrial and advertising photography. But today Hurn has put such work behind him: "What I work for nowadays is almost entirely myself. I hardly do anything for international magazines or colour supplements. I prefer shooting the pictures I want to shoot, even if I have to endure the disappointment of their not being published."

The kind of pictures he now shoots are those which sum up a situation in a single frame instead of spreading it out over a series, and he looks for his revealing images in precisely those areas most photographers avoid—the small-scale event, local flower show or group outing, where those taking part have a common interest to focus their attention, while he prowls around unnoticed. "People to me are always more interesting than anything else, for people are always liable to make a surprising gesture and to reveal their inner emotions in some unexpected

way.... The key to everything is that one must have a genuine feeling, a respect, almost an affection, for those involved, and the urge to record exactly what one sees."

With such basic honesty of approach, Hurn is able to enter the private worlds of others—even those as private as a drag ball, two strippers in bed together, nuns caring for the dying—with no suggestion of intrusion or betrayal. He reveals without exposing, and his pictures arouse amusement without ridicule. "I'm just the opposite of those domineering characters who rush in and take charge of everything. I hide behind my camera. This helps to conceal my nervousness, and allows me to be present where I should not dare to penetrate without such defence."

Though he operates by intuition, he analyses afterwards exactly what he did, and why. "When my films are developed I spend a long time on them, looking through them closely, again and again. Then I mark them with coloured Chinagraph pencils, go once more through all the ones I've marked, and finally decide which ones to print. I do a great deal, though not all, of my own printing."

Unusually thoughtful about his own work and about photography in general, David Hurn has a strong streak of the teacher in him; as the director of his own course in Newport, he combines respect for his students' views and capabilities with lucidity in the expression of his own, plus the powerful effect of personal example.

—Tom Hopkinson

HUTTON, Kurt.

British. Born Kurt Hubschmann in Strasbourg, in 1893; emigrated to Britain, 1934: naturalized, 1949; adopted the name "Hutton" in 1937. Educated at gymnasium in Strasbourg, 1903-10; studied law at Oxford University, 1911-13; self-taught in photography. Served as a cavalry officer in the German Army, 1914-18 (invalided out, 1918): Iron Cross, 2nd class; also served in the film unit of the British Army, 1942-46. Married Gretl Hutton in 1920; son: Peter. Professional portrait photographer, in partnership with Fran Engelhardt, Engelhardt and Hubschmann Studio, Berlin, 1923-30; photojournalist, under Simon Guttman and Felix H. Man, Dephot (Deutsche Photodienst) co-operative photographers Agency, Berlin, 1930-34; Staff Photographer, under Stefan Lorant, *Weekly Illustrated*, London, 1934-37, and under Lorant and, later, Tom Hopkinson, *Picture Post* magazine, London, 1938-40, 1941-50 (interned as enemy alien, Isle of Man, 1940-41); retired from full-time photographic work, 1951. *Died* (in Aldeburgh, Suffolk) *in 1960*.

Individual Exhibitions:

1974　Gallery, Aldeburgh, Suffolk (toured Europe)
1975　*3 from Picture Post*, The Photographers' Gallery, London (with Bert Hardy and Thurston Hopkins; toured the U.K., 1976-77)

Selected Group Exhibitions:

1955　*Picture Post Photography*, Kodak Gallery, Kingsway, London
1959　*Hundert Jahre Photographie 1839-1939*, Museum Folkwang, Essen (travelled to Cologne and Frankfurt)

1972　*Personal Views 1850-1970*, British Council, London (toured Europe)
1979　*The 30's: British Art and Design Before the War*, Hayward Gallery, London

Collections:

Creative Camera Collection, London; *Radio Times* Hulton Picture Library, London; Gernsheim Collection, University of Texas at Austin.

Publications:

By HUTTON: book—*Masters of Modern Photography: Speaking Likeness, Photographs by Kurt Hutton*, edited by Andor Kraszna-Krausz, London 1947.

On HUTTON: books—*Hundert Jahre Photographie 1839-1939, aus der Sammlung Gernsheim*, exhibition catalogue, by Helmut and Alison Gernsheim, Essen 1959; *Creative Photography: Aesthetic Trends 1839-1960* by Helmut Gernsheim, London 1962; *Picture Post 1938-50*, edited by Tom Hopkinson, London 1970; *Geschichte der Fotografie im 20. Jahrhundert/Photography in the 20th Century* by Petr Tausk, Cologne 1977, London 1980; *The 30's: British Art and Design Before the War*, exhibition catalogue, by Ian Jeffrey, William Feaver, Brian Lacey and others, London 1979; article—"Kurt Hutton 1893-1960" by Colin Osman in *Creative Camera Yearbook 1976*, London 1975.

The achievement of Kurt Hutton as a photographer derived as much from his friendly, sympathetic nature as from his professional skill and conscientiousness. In deciding on a career, after serving as a cavalry officer in World War I, he hesitated over photography because, though it had always interested him, he was reluctant to turn an enjoyable hobby into a means of livelihood. Having finally opened a portrait studio, he was bored by the work, which he readily gave up for the greater freedom of photojournalism. That early experience, however, stood him in good stead: he retained the capacity to study a face and make the best of it, so that women looked prettier and children more lively and natural in his pictures.

Of those working with the miniature camera in Britain, Hutton was in one sense the truest photojournalist, exploiting to the utmost the cinematic possibilities of 35mm cameras and high-speed film. One of the first picture stories he made after his arrival was of two small children in a nursery school helping themselves to one another's food, and in many of the stories he covered there would be a similar rapid action sequence, constituting a story within a story.

Though he had the courage and adaptability to make a success of tough assignments, Hutton's most typical and effective work was done on a human, intimate level. He found delightful pictures that others would overlook—in an old people's home, a village wedding, an elderly woman trying on hats in a store, or children going back to school. His work was full of humour, but never without sympathy. Most magazine photographers like to discuss their work with the editor, some wanting it used at greater length, others needing reassurance. With Hutton it would be a different motive: he wanted to be sure, not that a picture would be used, but that one that might distress its subject would be left out.

A number of the people he met on assignment would later write and keep in touch with him. Shortly before World War II he had photographed King George VI, then Duke of York, at one of his holiday camps for boys. Seven years later, when *Picture Post* had arranged to photograph the king looking through his stamp collection, he sent a suggestion that the same photographer might take the pictures.

Coming to England as a German at a time when Nazism was becoming recognized as the national enemy, Hubschmann—for he had not then become Hutton—faced many difficulties. But his command of English, resulting from a year or two's study at Oxford before World War I, his good humour and his refusal to be upset, carried him through, and his return from wartime internment on the Isle of Man was celebrated with a party by the whole staff of *Picture Post*.

It would be misleading to write about Kurt Hutton entirely as an individual, for he was in fact one half of a pair. His wife Gretl, as knowledgeable as himself about photography, thought up many of the ideas that he would carry out, and planned the method of approach. She was his most severe and most appreciative critic, and it was she, too, through her remarkable expertise as darkroom worker and retoucher, who produced the finished result.

—Tom Hopkinson

HYDE, Scott.

American. Born in Montevideo, Minnesota in 1926. Studied at the Art Center School, Los Angeles; Art Students League, New York; Columbia University, New York; and Pratt Graphics Center, New York. Photographer for Condé Nast Publications, New York, 1947-49. Freelance photographer, New York, since 1950. Recipient: Guggenheim Fellowship in Photography, 1972; New York State Council of the Arts Grant, 1972, 1975. Address: 215 East 4th Street, New York, New York 10009, U.S.A.

Individual Exhibitions:

1964 Gallery Archives of Heliography, New York (with William Clift)

Selected Group Exhibitions:

1967 *Photography in the 20th Century*, National Gallery of Canada, Ottawa (toured Canada and the United States, 1967-73)
1970 *Into the 70's: Photographic Images by 16 Artists/Photographers*, Akron Art Institute, Ohio
1971 *Photo/Graphics*, International Museum of Photography, George Eastman House, Rochester, New York
 Photography Invitational, Arkansas Arts Center, Little Rock
1973 *Photography into Art*, Scottish Arts Council Gallery, Edinburgh
1974 *Synthetic Color*, Southern Illinois University, Carbondale
1978 *Mirrors and Windows: American Photography since 1960*, Museum of Modern Art, New York (toured the United States, 1978-80)

Collections:

Museum of Modern Art, New York; Metropolitan Museum of Art, New York; International Museum of Photography, George Eastman House, Rochester, New York; Everson Museum of Art, Syracuse, New York; Smithsonian Institution, Washington, D.C.; High Museum of Art, Atlanta; Pasadena Art Museum, California; National Gallery of Canada, Ottawa; Bibliothèque Nationale, Paris; Musée Français de la Photographie, Bièvres, France.

Publications:

By HYDE: books—*CAPS Book*, New York 1975; *Dust Map*, Jersey City, New Jersey 1979; *The Real Great Society Album*, Jersey City, New Jersey 1979.

On HYDE: books—*Photography in the 20th Century* by Nathan Lyons, New York 1967; *Into the 70's: Photographic Images by 16 Artists/Photographers*, exhibition catalogue, by Robert Doty and Tom Muir Wilson, Akron, Ohio 1970; *Photo/Graphics*, exhibition catalogue, with text by Van Deren Coke, Rochester, New York 1971; *Photography into Art*, exhibition catalogue, by Pat Gilmour, Edinburgh 1973; *Modern Photography Annual*, New York 1974; article—"Pictures by Scott Hyde" by Syl Labrot in *Aperture* (Millerton, New York), Summer 1970.

Although I regard myself as a photographer, my medium of first choice is offset lithography. I do not use lithography as a reproductive medium, but rather design the pictures with this medium in mind. Most of my pictures are in color, but I seldom use color films. Instead I photograph in black & white and then print several images together in different colors. Images may be disparate (a montage), or may be a single subject photographed several times with some differences between the images such as: different color filters, subject movements, camera movements, changing light conditions, etc. My original camera negatives are used to make a set of enlarged negatives on litho films for imprinting onto the zinc plates used in offset lithography. When I am invited to have a picture published, as for instance in this book, I submit a set of litho negatives and specify the color each is to be printed. I regard a picture printed in this way as a kind of "original" print, since no "reproductive" steps are involved. If I am satisfied with the way the picture looks, I do not permit that picture to be published again.

There are several advantages to this method of work: the first is that, although the picture may be "mass-produced," it is more directly my picture than a reproduction would be. Secondly, these prints, consisting of only varnish ink on paper are structurally much simpler than conventional photographic color print materials, so they have potentially better archival stability. This advantage naturally depends on the quality of ink and paper used. A third advantage is the low price per print, due to the high speed and efficiency of the presses. And finally, the mass-production of an original art work creates an interesting situation because these prints lose practically all value as Art Objects. The art establishment (including the photographic-art establishment) is predicated on the exhibit and exchange of "unique art objects." Even the limited, numbered-edition print (the invention of 19th century art dealers) is, by definition, limited. What validity, as Art, can a picture retain if it exists in thousands of unsigned copies, yet is not a reproduction? This question interests me.

—Scott Hyde

The capacity inherent in photography to generate inexpensive multiples has been a central concern for Scott Hyde. This long-term commitment to photography as a means for the production of economically accessible imagery has led Hyde to the rejection of what he's called "the autograph club"—that approach to photography and its dissemination which emphasizes the unique or limited-edition print, rendered certifiably precious by the authenticated touch of its maker's hand.

As an alternative, Hyde since the 1960's has pioneered in the exploration of offset lithography as a primary vehicle for the photographer, accepting it not simply as a device for reproducing already-existing images but as an end in itself, a key component in the creative act. He has approached offset as a printmaking technique, and has pursued the creation of a body of visual imagery which investigates the distinctive characteristics of the offset process.

Synthetic color, variations on themes, montages created directly on the press and a simple but effective form of stereographic imagery are some of the technical and structural issues which Hyde has successfully addressed. He has consistently stressed the importance of process over product, and has built the elements of experiment and surprise into his working method, through tactics such as submitting image components to printers in forms which require the press operators to become collaborators in the image-making act.

Underlying these strategies has been a dedication to the democratization of the photographic image as object, through the production of multiples in the largest possible quantities. Some of Hyde's images—those which have achieved their final form on the pages of large-circulation magazines and newspapers been published in "editions" of 100,000 and more.

Hyde's vision itself is by turns lyric and satiric. His lyricism manifests itself most consistently in his contemplations of the natural landscape, which examine such phenomena as clouds, the rippling of water and the dappling of sunlight on leaves in an attentive, almost pastoral mode. He turns a more bemused eye on the urban landscape, often juxtaposing it to image elements which render the urban scene absurd, as in his montage, "The Judgement of Paris with the Astor Place Luncheonette." Another aspect of his work is directed towards a structural analysis of photographic encoding and offset printing, exemplified by such pieces as the book *Dust Map* and the single-sheet piece "Dust, Scratches, and Newton's Rings meets Hickeys, Streaks, and Misregistrations," a collaboration with printer/poet Larry Zirlin.

Through his persistent inquiry into the possibilities of the offset process, Hyde has directly or indirectly influenced many younger photographers and artists who have come to see the photographic print as an intermediary step en route to an offset print or book, and who have come to understand that the dissemination of one's work is as crucial a matter as its production.

—A.D. Coleman

See Color Plates

ICHIMURA, Tetsuya.

Japanese. Born in Nagasaki, 10 June 1930. Studied literature at Nihon University, Tokyo; self-taught in photography. Married Ayako Hamaguchi in 1974; daughters: Miku and Mirei. Freelance photographer, Tokyo, since 1959. Recipient: Special Prize, *International City Photo Exhibition*, Tokyo, 1959. Address: 825 Horiuchi, Hamaya-machi, Miura-gun, Kanagawa, Japan.

Individual Exhibitions:

1963 *Love and Lost*, Fuji Foto Salon, Tokyo
1972 *The Woman and The Man*, Ginza Matsuya Department Store, Tokyo (with Tatsuki and Kano)
1973 *Messenger, and City of Port Nagasaki*, Canon Salon, Tokyo
 Actress Michiko Saga, Shibuya Seibu Department Store, Tokyo
1976 *The Nude*, Canon Salon, Tokyo
1981 *An Afterimage of Britain*, Olympus Gallery, Tokyo

Selected Group Exhibitions:

1973 *Critics' Choice*, Neikrug Galleries, New York
1974 *New Japanese Photography*, Museum of Modern Art, New York
1977 *Neue Fotografie aus Japan*, Kulturhaus, Graz, Austria (travelled to the Museum des 20. Jahrhunderts, Vienna)

Collection:

Museum of Modern Art, New York.

Publications:

By ICHIMURA: books—*Dialogue of Eros*, with Hosoe and Okura, Tokyo 1969; *Salome*, Tokyo 1970; *Come Up*, Tokyo 1971; *The Last Remaining Mystery: The Maya Inca Civilization*, Tokyo 1975; *Thought in Photography*, Tokyo 1978; *Impressions of Japan*, with text by Tsutomu Minakami, Tokyo 1978.

On ICHIMURA: books—*New Japanese Photography*, exhibition catalogue, by John Szarkowski and Shoji Yamagishi, New York 1974; *Neue Fotografie aus Japan*, exhibition catalogue, by Otto Breicha, Ben Watanabe and John Szarkowski, Graz and Vienna 1977; articles—"Tetsuya Ichimura: Nagasaki" in *Camera Mainichi* (Tokyo), August 1973; "New Japanese Photography" in *Camera Mainichi* (Tokyo), June 1974.

Photography keeps records; it records objects and events. But there are two ways it may do so.

There is the mechanical photograph, the photograph achieved by mechanical means. One can say of such pictures that they have achieved exact records through mechanics, without human feelings.

But the man who wishes to take a photograph that will truly convey war or the events of history or love—he wishes, too, to convey his thought, his soul, as well as simply create a mechanical reproduction. Such photographs are taken by men who are truly living contemporary life.

However, some people would say that the photograph is the origin and the product of the mass media, that it is just another product and process in the vast quantity of print. What, then, in this age, is the "human" photograph?

When I think about my own themes, I know that I am especially concerned with pollution, nuclear weapons, war, the big gulf between the rich and the poor, racial discrimination and religious war. But, whatever the theme, I would like to think that the photograph is a document of the human soul, the product of human eyes, which are, in turn, the agents of God.

It is my belief that the photographer must be one of his own subjects, one of the human beings in the world before the camera; otherwise, no real photograph happens, even if it seems accurately to record objects and events.

—Tetsuya Ichimura

After completing one year of studies in Nihon University's preparatory course, Tetsuya Ichimura began taking photographs as he worked through as many as ten odd-jobs. In 1959 he won a special prize at the *International City Photo Exhibition*. He turned professional after that success.

Ichimura looks at Japanese sexuality in an idealistic manner. While his photographs are sensuous and erotic, they also focus on the peculiar juxtaposition between life and death.

—Norihiko Matsumoto

IGNATOVICH, (Vjesvolovich) Boris.

Russian. Born in Slutzk, Ukraine, in 1899. Educated at schools in Slutzk, 1909-14; mainly self-taught in photography, but studied photographic history and theory and was influenced by the artist Lebedev. Served as war reporter, on 30th Army newspaper *Boyevove Znamya* (*Fighting Battalion*), 1941-43. Married the photographer Yelizaveta Ignatovich. Worked as a journalist, for *Severo-Donezki Kom-*

Tetsuya Ichimura: *Dragon*, 1981

munist and *Krasnaya Svezda*, in Charkov, Ukraine, 1918-20; Editor, *Krasnaya Bachkiriya* magazine, Charkov, 1920-21, and *Gornyak* (*Mineworker*) magazine, Moscow, 1921-22; editor of several humorous magazines, Leningrad, 1922-25; Photojournalist and Picture-Editor, for *Ogonyok* (*Little Fire*), *Prozhektor* (*Reflector*), *Krasnaya Niva* (*Red Bank*), *Bednota* (*Poverty*) magazines, Moscow, 1926-30; worked as a motion picture cameraman, Moscow, 1930-32; Photo-reporter, working for *SSSR na Stroike* (*USSR under Construction*), *Heute, Wetchernaya Moskva* and *Aufbau Moskva* (*The Development of Moscow*) magazines, 1933-41; freelance photojournalist, working with the Soyuzfoto agency, and concentrating on colour photography, Moscow, from 1945. Delegate, with playwright Majakowski, First Rosta Conference, 1920; Organizer, with Alexander Rodchenko, 1926-28, and Leader, 1928-29, *Oktyabr* creative art group, Moscow; also, Head of Association of Photo-reporters, Press House, Moscow; Leader of "Brigade Ignatovich" photo group, at Soyuzfoto agency, Moscow; and Member, Association of Artists of Grekowstudios, Moscow. *Died* (in Moscow) *in June 1976*.

Individual Exhibitions:

1948 *Landscapes of My Homeland*, Moscow
1969 Ignatovich Residence, Moscow (70th birthday retrospective)

Selected Group Exhibitions:

1929 *Film und Foto*, Deutscher Werkbund, Stuttgart
1979 *Film und Foto der 20er Jahre*, Württembergische Kunstverein, Stuttgart (travelled to Museum Folkwang, Essen; Werkbundarchiv, Berlin; Kunsthaus, Zurich; Kunstverein, Hamburg; and Museum des 20. Jahrhunderts, Vienna)
 Paris-Moscou 1900-1930, Centre Georges Pompidou, Paris

Collections:

K. Ignatovich, Moscow; Soyuzfoto, Moscow.

Publications:

By IGNATOVICH: book—*The State Collection of Weapons in the Kremlin*, Moscow 1969.

On IGNATOVICH: books—*Boris Ignatovich* by Leonid Volkov-Lannit, Moscow 1973; *Fotografie der 30er Jahre: Eine Anthologie*, edited by Hans-Jürgen Syberberg, Munich 1977; *Geschichte der Fotografie im 20. Jahrhundert/Photography in the 20th Century* by Petr Tausk, Cologne 1977, London 1980; *Film und Foto der 20er Jahre*, exhibition catalogue, by Ute Eskildsen and Jan Christopher Horak, Stuttgart 1979; *Internationale Ausstellung des Deutschen Werkbundes "Film und Foto" 1929*, facsimile reprint, edited by Karl Steinorth, Stuttgart 1979; *Sowjetische Fotografen 1917-40* by S. Morosov, A. Vartanov, G. Tschulakov, O. Suslova and L. Uchtomskaya, Leipzig and West Berlin 1980; articles—"Boris V. Ignatovich 1910-1976" in *Photography Year 1977*, by Time-Life editors, New York 1977; "Photographie Creative" by Romeo Martinez and A.N. Lavrentiev in *Paris-Moscou 1900-1930*, exhibition catalogue, Paris 1979; "Camera Eye" by Allan Porter, and "The International Werkbund Exhibition 'Film und Foto' Stuttgart 1929" by Karl Steinorth in *Camera* (Lucerne), October 1979; "Soviet Photography Between the World Wars 1917-1941" by Daniela Mrázková and Vladimír Remeš in *Camera* (Lucerne), June 1981.

Boris Ignatovich started his career in 1918, at the age of 19, as a journalist. He began to photograph in 1923 when he was given a simple Kodak folding camera. The results of his first attempts were surprisingly good, and in 1926 he changed from journalist to photojournalist and went on to work for various illustrated journals. For two years, from 1930 until 1932, he worked in motion pictures as a cameraman. After he returned to photojournalism, he created magnificent images in Donbass about the beauty of human labor. From 1937 until the outbreak of the war he chiefly portrayed life in Moscow. Like most of his colleagues, he spent the first half of the 1940's photographing the front line battles against the German invaders. And in peacetime he again enlarged his interest, this time moving on to color photography, in which he very soon produced significant results.

Ignatovich belonged to the first generation of Soviet photographers who highly esteemed the significance of images showing important situations in human life. He showed an infallible sense for the right choice of moment, the moment at which the photographed event possessed the most narrative intensity. Very early on in his career he recognized the importance of photographs that depicted the various motifs of human life when nothing extraordinary was happening. Simultaneously, he discovered that such work requires solutions of the utmost photographic sensitivity and imagination.

This depiction of everyday life was the significant and very difficult task that inspired Ignatovich, throughout his career, to new photographic methods and means. Earlier than Cartier-Bresson, indeed in the 1920's, Ignatovich was already applying the principle of the "decisive moment." Ignatovich not only tried to mediate epic information, but also he tried to express poetically the atmosphere, the environment, in which an event took place. He seems always to have felt keenly and accurately when it was advisable to come as near as possible to the action in order to distinctly depict the expression of individual persons, or when it was best to move to the wider environment, the depiction of the "outer space" of an event, when that would provide the means, the pictorial elements, necessary to establish the emotional effect that he wanted to convey. Perhaps, in this respect, he had well learned the lessons

of his experience in motion pictures.

—Petr Tausk

IKKO. See NARAHARA, Ikko.

IONESCO, Irèna.
French. Born in Paris, 3 September 1935. Educated in Constanza, Rumania; returned to Paris, 1951. Painter, since 1951, and photographer, since 1966, in Paris. Address: 16 Boulevard Soult, 76012 Paris, France.

Individual Exhibitions:

1970 Jalmar Gallery, Amsterdam
1973 The Photographers' Gallery, London
1974 Le Doigt dans l'Oeil Galerie, Bordeaux
 Galleria Spectrum, Barcelona
 Galerie Nikon, Paris
1980 Canon Photo Gallery, Geneva (with Serge Borner)

Publications:

By IONESCO: Books—*Liliacees Langoureuses aux Parfums d'Arbie*, Paris 1974; *Femmes san Tain*, Paris 1975; *Litanies pour une Amante Funebre*, Milan 1976; *Nocturnes*, New York 1976; *Ecstasy*, Chicago 1977; *Temple aux Miroirs*, with Alain Robbe-Grillet, Paris 1977; article—interview, with Mike Treasure, in the *British Journal of Photography* (London), 30 November 1973.

Boris Ignatovich: *The First of May*, Moscow, 1929

On IONESCO: books—*Photography Year 1977*, by the Time-Life editors, New York 1977; *Women on Women*, with an introduction by Katharine Hola-bird, London 1978; *Irèna Ionesco*, with texts by Bernard Letu and André Laude, Paris 1979; *Collection Images Obliques*, vol. 6: *Irèna Ionesco: Cent Onze Photographies Erotiques*, with a preface by Pierre Bourgeade, Lyons 1980; articles—"Un Monde Mysterieux: Irèna Ionesco" in *Le Nouveau Photocinema* (Paris), April 1973; "Irèna Ionesco: Portraits d'Eva" in *Le Nouveau Photocinema* (Paris), March 1974; "Le Serail d'Irèna Ionesco" by André Pieyre de Mandiargues in *L'Oeil* (Paris), September 1974; "Irèna Ionesco: Style 80" in *Photo* (Paris), December 1979.

Irèna Ionesco directs, and through her photographs presents, *tableaux* from that theatre of femininity in which the acts are, for the most part, played out partly hidden behind the facade of everyday existence. The settings, with their profuse and heterogeneous objects, are in the line of descent running via Flaubert's *Salammbô* and Gustave Moreau's paintings; are from the garden where Joris Huysmans nurtured the etiolated prolixities of *À Rebours*. Yet the women and the heat are Baudelairean entirely.

An uncanny appositeness in Irèna Ionesco's handling of her material offers exact *correspondances* for the heady blend of incense with human and artificial perfumes one apprehends as pervading the heavily enclosed interiors in which she works. The women are, moreover, seen to present themselves as participants in enigmatic acts of ritual, of fetishism, of fantasy or of catatonia. Never, though, does one become even tentatively certain as to what were the larger situations from which the single images have been extracted. One's thoughts are left to migrate into the general Symbolist, Decadent irony of corruption and death as co-extensive with the most perfect, exotic florescence.

Again, the viewer implied as an essential presence outside all Irèna Ionesco's images is, one senses, destined to share the identity of the perceiver of the photograph; and so never participate, but remain invisible, condemned to the febrile passivity suffered by Baudelaire in the presence of his Black Venus.

Irèna Ionesco's choices of subject matter, medium and the mode of combining them, make her images entirely suitable for the visual aspect of a joint excursion with Alain Robbe-Grillet into the *nouveau roman*. Probably, it was only the publication of *Temple aux Miroirs* which fully justified a view of the Ionesco photographs as more than a specialised revival of the Decadent aesthetic. The atemporalities, the initial attractiveness of a *chosiste* reading, and the eventual understanding of the book's images in terms of a visual *écriture*, all lead, as Heath said of Robbe-Grillet's texts, to a response to the activity of the work, to its construction, rather than to the work as means of arrival at the notion of a story, or other like product.

That such features of interpretation are affirmed by the structuring of the photographs into the *Temple* fiction is not a denial that any of them could have been engendered as a response to earlier encounters with the images: it is a fleshing out of what otherwise would have remained hypotheses cautious in the shadows of conventional readings of this body of work; which, it turns out, is far from being restricted to the mere expression of nostalgia for a previous Fall.

—Philip Stokes

Irèna Ionesco

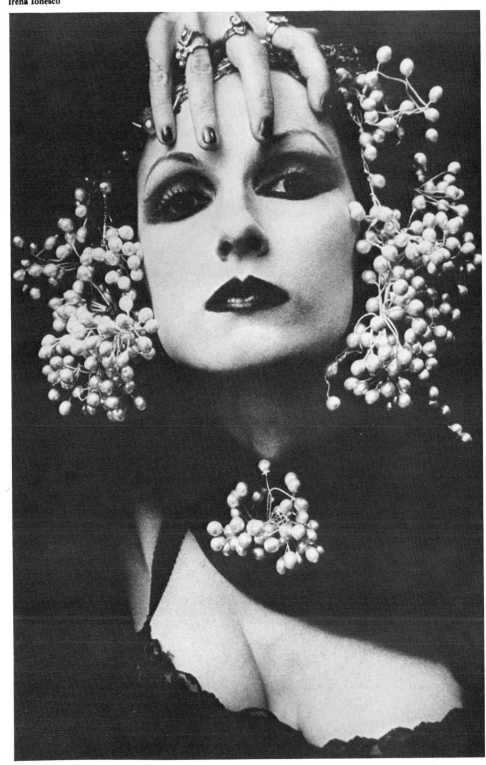

ISHIMOTO, Yasuhiro.

Japanese. Born in San Francisco, California, U.S.A., to Japanese parents, 14 June 1921; grew up in Kochi City, Japan; returned to the United States, 1939; emigrated to Japan, 1961: naturalized, 1969. Educated in Kochi City (attended agriculture school there) until 1939; studied agriculture at the University of California, 1940-42, and architecture at Northwestern University, Chicago, 1946-48 (interned in a relocation camp, Armach, Colorado, 1942-44); studied photography, under Harry Callahan and Aaron Siskind, Institute of Design, Illinois Institute of Technology, Chicago, 1948-52, B.S. 1952. Married Shige Ishimoto in 1956. Freelance photographer, Tokyo, 1953-58, Chicago, 1958-61, and Tokyo, since 1961. Lecturer, Tokyo Institute of Photography, 1973. Recipient: Young Photographers Contest Prize, *Life* magazine, 1950; Moholy-Nagy Prize, Chicago, 1951, 1952; Society of Japanese Photography Critics Prize, 1958; Mainichi Art Prize, Tokyo, 1970; Minister of Education's Prize, Japan, 1978. Address: 601 Daiya Mansion, 7-11 Kitashinagawa 6-chome, Shinagawa-ku, Tokyo 141, Japan.

Individual Exhibitions:

1953 Museum of Modern Art, New York
1954 Takemiya Gallery, Tokyo
1960 Art Institute of Chicago
1961 Museum of Modern Art, New York
1962 *Chicago, Chicago*, Shirokiya Gallery, Tokyo
1977 *Den Shingonin Ryokai Mandala*, Seibu Museum of Art, Tokyo

Selected Group Exhibitions:

1967 *Photography in the 20th Century*, National Gallery of Canada, Ottawa (toured Canada and the United States, 1967-73)

1974 *New Japanese Photography*, Museum of Modern Art, New York

1977 *The Photographer and the City*, Museum of Contemporary Art, Chicago

1979 *Japanese Photography Today and Its Origin*, Galleria d'Arte Moderna, Bologna (travelled to the Palazzo Reale, Milan; Palais dex Beaux-Arts, Brussels; and the Institute of Contemporary Arts, London)

1980 *The New Vision*, Cultural Center, Chicago
Photographers at the Institute of Design, Gilbert Gallery, Chicago

Collections:

National Museum of Modern Art, Tokyo; Museum of Modern Art, New York; Art Institute of Chicago.

Publications:

By ISHIMOTO: books—*Aru Hi, Aru Tokoro* (Someday, Somewhere), with an introduction by Tsumoto Watanabe, Tokyo 1958; *Katsura*, with texts by Walter Gropius and Kenzo Tange, New Haven, Connecticut 1960; *Chicago, Chicago*, with text by Smizo Takiguchi, Tokyo 1969; *The City*, Tokyo 1971; *Tokyo*, Tokyo 1971; *The Document of Human Revolution*, with Haru Tomiyama, Tokyo 1973; *The World of Kenmochi*, Tokyo 1976; *Den Shingonin Ryokai Mandala*, Tokyo 1977; *Journey to the Kunsaki*, Tokyo 1978; *Kura*, Tokyo 1980; *Islam: Space and Design*, Tokyo 1980; *Dry-Landscape Gardens*, Tokyo 1980; *Master Carver Denchu*, Tokyo 1980; *The Illusion of Yamataikoku*, Tokyo 1980.

On ISHIMOTO: books—*Photography in the 20th Century* by Nathan Lyons, New York 1967; *New Japanese Photography*, exhibition catalogue, by John Szarkowski and Shoji Yamagishi, New York 1974; *The Photographer and the City*, exhibition catalogue, by Gail Buckland, Chicago 1977; *Japanese Photography Today and Its Origin* by Attilio Colombo and Isabella Doniselli, Bologna, 1979; article—"New Japanese Photography, The Museum of Modern Art" in *Camera Mainichi* (Tokyo), June 1974.

Yasuhiro Ishimoto was born in San Francisco in 1921, to Japanese parents who had immigrated to the United States. He went to Japan with his parents in 1924, and spent his childhood in Kochi City until he graduated from agricultural school. He returned to America in 1939, this time on his own. The next year he entered the Agricultural School at the University of California, but his studies were interrupted by World War II and he spent two years in a detention camp in Colorado. In 1946, after the end of the war, he entered the School of Architecture at Northwestern University, Chicago. Two years later he transferred to the Institute of Design, where he studied photography under the direction of Harry Callahan from whom he learned the creative basics of the medium. While there, he was a prize winner in a contest for young photographers sponsored by *Life* magazine. In 1951 and 1952 he received the Moholy-Nagy Prize. In 1953 he returned to Japan, where he photographed the Katsura Palace. He remained in Japan until 1958, then returned to Chicago with his new wife. During his stay in Japan his work had been exhibited and he had published a book, *Aru Hi, Aru Tokoro* (Someday, Somewhere), in 1958. That same year he had received the annual prize of the Society of Japanese Photography Critics. In 1960 his book *Katsura* was published by Yale University Press, and it gave him a new impetus to explore Japan. In 1961 he returned to Japan again; in the following year he mounted an exhibition *Chicago, Chicago*. In 1969 he obtained Japanese nationality.

Given his personal background, it is understandable that Ishimoto's photography should be based on a strong plastic sensibility and excellent technique, both of which he learned at the Institute of Design. These skills lend his photographs a very cool, sharp appearance, detached from any kind of romantic involvement. He is able to tackle any subject (man or object) with an almost piercing visual intelligence. Nevertheless, there is a deep-seated humanity about his photographs which ensures for his cool images a contact with reality. Sometimes that humanity even reaches the level of the poetic.

At first, when he came to Japan, Ishimoto had intended photographing traditional Japanese architecture, but as a result of photographing the Katsura Palace he developed an interest in the larger questions of the nature of Japanese-ness and Japanese culture. In 1977 he presented an exhibition, later published in book form, which he called *Den Shingonin Ryokai Mandala* (the Ryokai Mandala, a Treasure from the Shingonin): it has been Ishimoto's most celebrated work. It comprises close-up shots showing every detail of the Ryokai Mandala, which has been stored in the Shingonin, at Toji Temple, Kyoto, for a thousand years. Ishimoto does not simply replicate the mandala but makes us appreciate his creative agility. This will be the future course he will follow, I am sure.

Yasuhiro Ishimoto has been a unique photographer of Japan, and, after Ken Domon, he must be the most important photographer of his generation.

—Takao Kajiwara

ITURBIDE, Graciela.
Mexican. Born in Mexico City, 16 May 1942. Educated at Sagrado Corazon School, San Luis Potosi, Mexico, 1958-61; Centro de Estudios Cinematograficos (CUEC), Mexico City, 1969-72; private photographic studies, as assistant to Manuel Alvarez Bravo, Mexico City, 1970-72. Freelance photographer, working for Instituto Nacional Indigenista, Secretaria de Comunicaciones, and various magazines, Mexico City, since 1970; also filmmaker, Mexico City, since 1969. Founder-Member, Foro de Arte Contemporáneo, Mexico City; Member, Consejo Mexicano de Fotografía, Mexico City. Address: Ortega 20, Coyoacan, Mexico 21, D.F., Mexico.

Individual Exhibitions:

1975 *Three Women Photographers*, Galería José Clemente Orozco, Mexico City

1976 *Three Mexican Photographers*, Midtown Gallery, New York (with Collete Urbajtel and Paulina Lavista)

1979 Casa de Cultura, Juchitán, Oaxaca, Mexico

1980 Casa del Lago, Mexico City

Selected Group Exhibitions:

1976 *10 Photographers*, Salón de la Plástica Mexicana, Mexico City

1978 *Primera Muestra de Fotografía Latinoaméricana*, Museo de Arte Moderna, Mexico City

Contemporary Photography in Mexico: 9 Photographers, Northlight Gallery, Arizona State University, Tempe (travelled to University of Arizona, Tucson)

4 Young Mexican Photographers, Corcoran Gallery, Washington, D.C.

1979 *Opera Inconclusa*, Foro de Arte Contemporáneo, Mexico City

7 Women Photographers, Foro de Arte Contemporáneo, Mexico City

1980 *7 Portafolios Mexicanos*, Centre Culturel Mexicain, Paris (travelled to Picasso Museum, Antibes, France)

Primera Bienal de Fotografía, Auditorio Nacional, Mexico City

1981 *Segunda Muestra de Fotografía Latinoaméricana*, Palacio de Bellas Artos, Mexico City

Fotografie Lateinamerika, Kunsthaus, Zurich

Yasuhiro Ishimoto

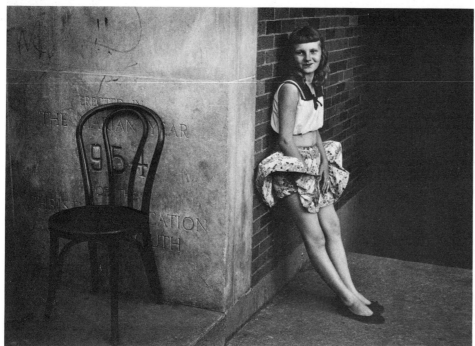

Collections:

Consejo Mexicano de Fotografía, Mexico City; Casa de la Cultura, Juchitán, Oaxaca, Mexico; Bibliothèque Nationale, Paris.

Publications:

By ITURBIDE: book—*Los que Viven en la Arena*, with text by Luis Barjau, Mexico City 1981; films—*The Life of Jose Luis Cuevas*, 1969; *Elecciones*, 1970; *Crates*, with Alfredo Joskowicz, 1971.

On ITURBIDE: books—*Avándaro*, with text by Luis Carrión, Mexico City 1971; *Contemporary Photography in Mexico: 9 Photographers*, exhibition catalogue, by Terence Pitts and Rene Verdugo, Tucson 1978; *Hecho en Latinoamérica*, edited by Pedro Meyer, Mexico City 1978; *Desnudo Fotográfico*, with text by Mariano Flores Castro, Mexico City 1980; *7 Portafolios Mexicanos*, exhibition catalogue, with text by Raquel Tibol, Mexico City 1980; articles—"La Fotografía de Graciela Iturbide" by Alfredo Joskowicz in *Artes Visuales* (Mexico City), Winter 1975; "Graciela Iturbide" in *Photocinema* (Paris), 1977; "Presencias" in *Arquitecto* (Mexico City), no. 10, 1978; "Fotografías de Graciela Iturbide" in *Rehilete* (Mexico City), February 1980; "Graciela Iturbide: La Sembradora de Imagenes" in *La Semana de Belles Artes* (Mexico City), 19 March 1980; "Graciela Iturbide: Artista Fotografa" in *La Letra y la Imagen* (Mexico City), 20 April 1980; "Mexico: New Images of an Ancient Land" in *Camera 35* (New York), February 1981.

Photography is a way of life. I write, I draw with light my daily experiences; I retain in images casual external encounters and internal finalities.

I seek to trap life in the reality that surrounds me, without forgetting that therein lie my dreams, my symbols, my imagination.

In human beings I search to discover my own nostalgia.

—Graciela Iturbide

Photographing people is a very difficult task; it is even more so if the people happen to be Mexican Indians. Socio-economic contrasts are extremely sharp in Mexico, and there is a great deal of mistrust among social classes. The Indians have been mercilessly exploited for the past five centuries. Their culture, their religion, their economic system, their family structure, and their relation to nature and to their fellow men have been continuously subject to the cruellest forms of aggression ever since the Spanish Conquest. Some have tried to assimilate in a hopeless struggle to become white men; others chose to retreat, to shut themselves within their ancient traditions, full of resentment towards the white man and mistrusting any attempt at communication. Besides, there is a belief—not as preposterous as it may seem—that the camera steals the photographed person's soul. Every day the tourist attacks the inhabitants of Indian villages with his brandished camera. He grabs disrespectfully whatever he can as false proof of his presence in these places, as something exotic to show to friends. For the Indian, the white man is someone who steals his land, his traditions, and his soul. It is the accomplishment of Graciela Iturbide that, with all of these obstacles, she has been able to come close to these people.

Iturbide has such tact and respect that her subjects show themselves before her in all their natural poise and dignity. There is, in her work, no search for the picturesque, but only an innocent and somewhat romantic attempt to find human integrity and that vital link with the environment that Indian people still keep. It is this link and this integrity that appeal to Iturbide, for they are traits that have been almost lost by the inhabitants of such chaotic places

as Mexico City and the other gigantic capitals of the Western world.

"Nuestra Senora de las Iguanas" (the accompanying photograph) is one example. She is an Indian from Juchitan, Oaxaca, a region of scarce economic resources but of great artistic and mythological wealth, the land of the Mixteco-Zapoteca cultures. Accomplishing this photograph required many days. Iturbide had to bridge the gap between herself and this woman so as to reach a kind of communion, subtle and sincere. She even helped her to sell tomatoes and iguanas in the market place until the woman agreed to face the camera without hiding. The similarity between this photograph and some of the work of Francisco Toledo, a painter from Juchitan, its not coincidental. The mysterious unity between man and animal, the poetry and the throbbing myths involved in this bonding, are part of everyday life in Juchitan.

In the few years that Graciela Iturbide has been working in photography she has consistently achieved what many other photographers acquire only in their mature work—a genuine respect for the person facing the camera, a profound sense of his or her existence. This is particularly true when her subject is a woman; indeed, it could be said that Iturbide is particularly a photographer of Woman.

She approaches her subject delicately, and allows herself to be touched to the same extent that she attempts to touch with her camera. She doesn't grab images; she earns them. What Graciela Iturbide obtains—the permission to touch a human being— she returns to whomever stops to contemplate her work. She caresses with her camera, both her subject and the beholder of her work.

—Katya Mandoki

Graciela Iturbide: *Nuestra Señora de las Iguanas*, 1979

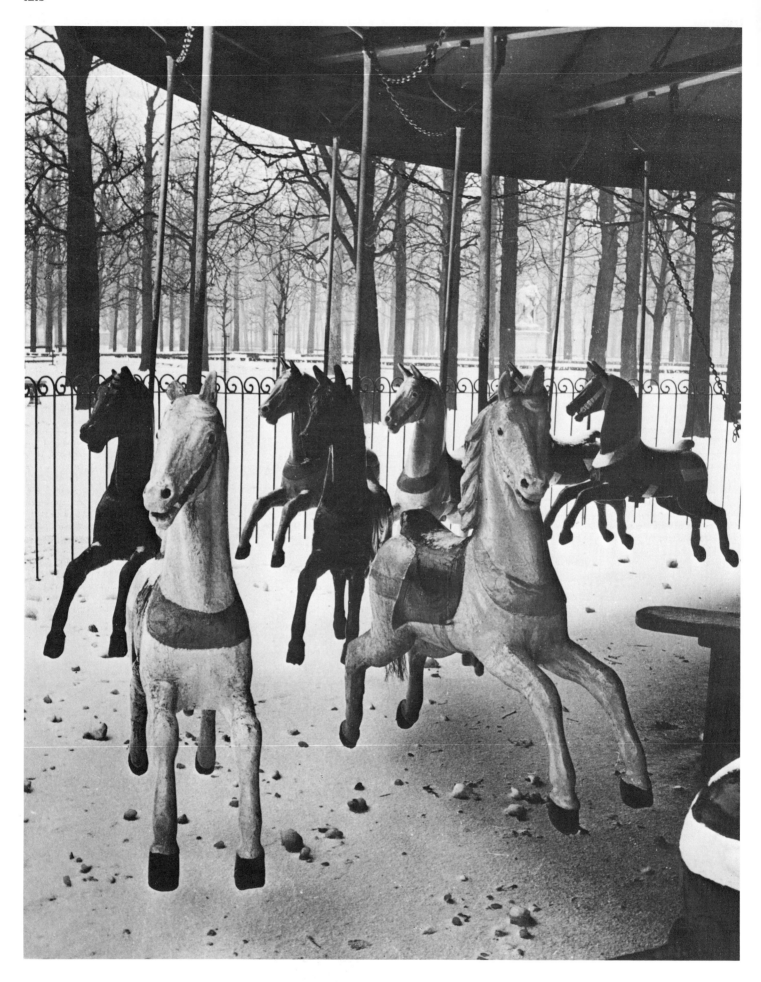

Izis: *Carousel in the Tuileries*, **Paris** Courtesy Art Institute of Chicago

IZIS.

French. Born Israel Bidermanas in Mariampole, Lithuania, now Mariampol'ye, U.S.S.R., 17 January 1911; emigrated to France, 1930: naturalized 1946. Educated at schools in Lithuania, 1921-26; apprentice in a photographic studio. Freelance photographer, establishing own portrait studio, Paris, 1930-39; worked as a photo-retoucher, and active in the French Resistance, adopting the name "Izis," Limoges, France, 1940-44; freelance photographer, Paris, 1945-49; Staff Photographer, *Paris-Match* magazine, 1949-69; freelance magazine photographer, Paris, 1970 until his death, 1980. *Died* (in Paris) *16 May 1980.*

Individual Exhibitions:

1944 *Ceux de Grammont*, Musée du Limoges, France
 Limoges en Novembre, Musée du Limoges, France
1955 Art Institute of Chicago
1957 Limelight Gallery, New York
1966 *Cirques d'Izis*, Musée du Limoges, France
1972 Museum of Modern Art, Tel Aviv
1975 Galerie Agathe Gaillard, Paris
1977 Galerie Nagel, West Berlin
 Fête à Paris, Carlton Gallery, New York
1978 Musée Réattu, Arles, France

Selected Group Exhibitions:

1951 *5 French Photographers: Brassaï/Cartier-Bresson/Doisneau/Izis/Ronis*, Museum of Modern Art, New York
1954 *Great Photographs*, Limelight Gallery, New York
1955 *The Family of Man*, Museum of Modern Art, New York (and world tour)
1972 *Boubat/Brassaï/Cartier-Bresson/Doisneau/Ronis/Iris*, French Embassy, Moscow
1976 *Other Eyes*, Arts Council of Great Britain travelling exhibition (toured the U.K.)

Collections:

Bibliothèque Nationale, Paris; Musée Réattu, Arles, France; Musée du Limoges, France; Museum of Modern Art, New York; Art Institute of Chicago.

Publications:

By IZIS: books—*Paris des Reves*, with text by Jacques Prévert, with foreword by Jean Cocteau, Paris 1950, as *Paris Enchanted*, London 1952; *Grand Bal du Printemps*, with text by Jacques Prévert, Paris 1951; *Charmes de Londres*, with text by Jacques Prévert, Paris 1952, as *Gala Day: London*, London 1952; *Paradis Terrestie*, with text by Colette, Paris 1953; *People of the Queen*, London 1954; *Israel*, with a foreword by André Malraux, Paris 1956; *Le Cirque d'Izis*, with text by Jacques Prévert, Paris 1965; *Paris des Poètes*, with text by Jacques Prévert, Paris 1967; *Le Monde de Chagall*, with text by Roy McMullen, Paris 1969.

On IZIS: books—*Moderni Francouzska Fotografie/Modern French Photography* by J.A. Keim, Prague 1966; *Other Eyes*, exhibition catalogue, by Peter Turner, London 1976; *Geschichte der Fotografie im 20. Jahrhundert/Photography in the 20th Century* by Petr Tausk, Cologne 1977, London 1980; articles—"Izis: Paris in the 50's" in *Creative Camera* (London), November 1976; "Izis" in *Camera* (Lucerne), January 1979; "Izis: Un Hommage" by Roger Therond in *Photo* (Paris), June 1980.

It's certain that in the green pastures that now make up his universe Izis is still a photographer, and his poetic inspiration flowers better there than here below.

He entered photography at the age of 13 by modest means: he worked in the sort of studio where ordinary people have the great moments of their lives fixed on paper. But he took from this kind of apprenticeship an essential rule: truth first. He never forgot it, even though he went on to great success. At the age of 20 he had established his own rather more chic studio in Paris; he was, remarkably, self-employed and successful in a strange city; during the German Occupation, which all but cost him his life, he immortalized in pictures his comrades in the Resistance; he created a number of books; and for 20 years he collaborated on a great magazine, *Paris-Match*—yet he never once departed from those ethics based on honesty. (Well, actually, he did fib once: in a conversation with an editor, Izis assured him that he knew all about color photography, the consequence of which was that he was forced to buy his first color film and his first light meter, and succumb to modernism and artifice!)

In any "who's who" of photography, Izis the remarkable, the loner, should always be perceived as "different." Eternally faithful to his old Rolleiflex (against the generalized style of 24 x 36), always stingy in his shots (against the modern, machine-gun approach), he took few pictures; he knew how to wait ("like a fisherman waiting for a nibble," he said) until the exact, significant scene presented itself to him. As for his instinctive technique—without flash and without the famous light meter—it was so sure that he never miscalculated. The results inevitably reveal meaning, construction, balance, and the thought and emotion of the artist. Stillness, tenderness and beauty are evident in those series in which he made himself a specialist: painters, poets, writers, carnival and circus people, illustrious characters, the people of Paris—and above all and always Paris itself, the city that dazzled the immigrant from a difficult past. And there is not a picture of his that does not tell of the gratitude of the heart, the brotherhood and bond between photographer and model, an ardent need to share the joy—or sorrow—of the subject.

Is Izis, then, a pure humanist poet of photography? Yes and no. Yes, because his works have a rare precision and luminescent composition; they are carriers of a dreamlike, diffuse dimension, of a "supplementary soul," sometimes of an unreality which is the heart itself of "poetic realism." His "Cracheur de Feu," for example, is a phantasmagorical flower of which all the fascination, appropriately, comes from the scientific exactitude of presentation. And no, too, because Izis also flays the world: he is deferential with the greats of the world, but he lingers on the forgotten, the castaways of life, the damned (like the writers Céline and Léautaud). At some point one asks oneself: could Izis secretly have been, rather than a poet, a militant philosopher?

—Roger Therond

JACHNA, Joseph D.

American. Born in Chicago, Illinois, 12 September 1935. Educated at Chicago Vocational High School, 1949-53; studied art education and photography, under Harry Callahan and Aaron Siskind, at the Institute of Design, Illinois Institute of Technology, Chicago, 1953-54, 1955-61, B.S. Art Ed. 1958, M.S. Photography 1961. Married Virginia Kemper in 1962; children: Timothy, Heidi and Jody. Worked part-time as a photo assistant, Derwin Studio Darkroom, Chicago, 1953-54; photo-technician, Eastman Kodak Laboratories, Chicago, 1954; photographer's assistant, DeSort commercial photo-illustration studio, Chicago, 1956-58. Freelance photographer, Chicago, since 1961. Instructor in Photography, Institute of Design, 1961-69, and at University of Illinois at Chicago Circle, since 1969. Recipient: Ferguson Foundation Grant, Friends of Photography, Carmel, California, 1973; National Endowment for the Arts Grant, 1976; Illinois Arts Council Grant, 1979; Guggenheim Fellowship for Photography, 1980. Agent: Jeffrey Fuller Gallery, 2108 Spruce Street, Philadelphia, Pennsylvania. Address: 5707 West 89th Place, Oak Lawn, Illinois 60453, U.S.A.

Individual Exhibitions:

1961 Art Institute of Chicago
1963 St. Mary's College, Notre Dame, Indiana
1965 University of Illinois, Chicago
1970 Lightfall Gallery, Evanston Art Center, Illinois

University of Wisconsin, Milwaukee
1974 Center for Photographic Studies, Louisville, Kentucky
 Friends of Photography, Carmel, California
 Tyler School of Art/Moore College of Art, Philadelphia
 Nikon Photo Salon (2 galleries), Tokyo
1975 University of Notre Dame, Indiana
 Afterimage Gallery, Dallas
1977 *Iceland/Wisconsin/Upper Michigan*, University of Illinois at Chicago Circle
1979 Visual Studies Workshop Gallery, Rochester, New York
1980 *Light Touching Silver: Photographs by Joseph D. Jachna*, Chicago Center for Contemporary Photography
1981 Focus Gallery, San Francisco (with George Krause)
 Perihelion Gallery, Milwaukee (with Marija Petrauskas)

Selected Group Exhibitions:

1963 *Contemporary Photographers*, Art Institute of Chicago
1966 *American Photography: The 60's*, University of Nebraska, Lincoln
1967 *Photography U.S.A.*, De Cordova Museum, Lincoln, Massachusetts
1968 *Light⁷*, Massachusetts Institute of Technology, Cambridge
1973 *Photography: Midwest Invitational*, Walker Art Center, Minneapolis

1975 *For You, Aaron*, Renaissance Society Gallery, University of Chicago
1977 *Photographers and the City*, Museum of Contemporary Art, Chicago
 The Target Collection of American Photography, Museum of Fine Arts, Houston
1978 *Spaces*, Museum of Art, Rhode Island School of Design, Providence
1981 *Second Sight*, Carpenter Center for the Visual Arts, Harvard University, Cambridge, Massachusetts

Collections:

Museum of Modern Art, New York; International Museum of Photography, George Eastman House, Rochester, New York; Massachusetts Institute of Technology, Cambridge; Art Institute of Chicago; Exchange National Bank, Chicago; Museum of Contemporary Art, Chicago; Center for Photographic Studies, Louisville, Kentucky; University of Kansas Art Museum, Lawrence; Center for Creative Photography, University of Arizona, Tucson; Friends of Photography, Carmel, California.

Publications:

On JACHNA: books—*Photography in the 20th Century* by Nathan Lyons, New York 1967; *Be-Ing Without Clothes*, exhibition catalogue, by Minor White, Millerton, New York 1970; *Untitled 14*, Friends of Photography exhibition catalogue, Carmel, California 1973; *Language of Light*, exhibition catalogue, by James Enyeart, Lawrence, Kansas 1974; *Photography Year 1974*, by the Time-Life editors, New York 1974; *The Target Collection of American Photography*, exhibition catalogue, by Anne Tucker, Houston 1977; *Light Touching Silver: Photographs by Joseph D. Jachna*, exhibition catalogue, with an introduction by Steven Klindt, Chicago 1980; articles—"New Talent U.S.A.: Photography" in *Art in America* (New York), no. 1, 1962; "Joseph Jachna" by Charles Desmarais in *Artweek* (Oakland, California), 4 May 1974; "Joseph Jachna," special issue of *Asahi Camera* (Tokyo), April 1975; "Joseph Jachna: Door County Landscapes" by John B. Turner in *Photo-Forum* (Auckland, New Zealand), June/July 1975.

An important aspect of my working attitude is a primary concern with "basics"—tones, focus, light, etc.—and those elements of a picture which are visual, visible, describable and controllable. Certain other aspects, perhaps the really important ones, which deal with its meaning or "spirit" will always enter the picture when the controllable elements are properly attended to, and so it has become, more or less, a credo to pay attention to certain details, to work carefully and intelligently on them, so that the desired result can occur.

The making of a photograph is an act of intelli-

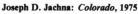

Joseph D. Jachna: *Colorado*, 1975

gence and an act of discovery: knowledge is brought to the process so that knowledge can be gained, and none of this knowledge needs a verbal counterpart. A photograph often has a counterpart in life, in music, a poem or a song, but these are never substitutes. The photograph is its own full explanation, and the joy of it is to look at it.

—Joseph D. Jachna

Joseph D. Jachna is primarily a photographer of nature. Educated at the Institute of Design under Aaron Siskind and Harry Callahan, he reflects in his early work the Bauhaus simplicity of that institution and combines something of the attention to abstract form of Siskind with the precision and delicacy of Callahan.

Jachna works primarily in black and white, pushing the formal and expressive qualities of tonality to their limits. Black vs. white takes on an almost symbolic significance. Many images employ a recurring line, usually a curve, suggestive of the yin-yang symbol, a line which divides yet at the same time admits and accepts the underlying duality, or complementary quality of nature.

His iconography is established through a progression of simple, archetypal juxtapositions: white snow vs. black hill, egg vs. weathered wood, mirror vs. landscape, hand vs. cloud, fist vs. nude. The earliest landscapes are what we might term non-manipulative, "window" images which are at the same time carefully organized, simplified, condensed, suggesting metaphors. The progression of his work can be seen as that from objective to self-reflexive, from more or less passive photographer to an open acknowledgement of the forming quality of vision.

Self-reflexivity literally breaks through the picture plane in a dramatic series made in 1969 in Door County, Wisconsin. In this series the extended hand of the photographer literally juts into the picture frame and becomes part of the landscape. The series evolves into a progression of hands holding shards, pieces of mirrors, surfaces which reflect, instead of the expected visage of the photographer, the face of nature. Nature is held up for examination, yet at the same time nature and self are merged. The hand holding the mirror is abstracted, reduced to simple, dark, almost phallic shapes, which dance about the reflected image of nature. Through an implied yet restrained eroticism, the metaphor of man's "merging" with nature is consummated in a wonderfully understated, yet visually exhilarating, fashion. This series is spectacular in its sense of energy and in the realization and acceptance of the creative will of the photographer.

Through a grant from the National Endowment for the Arts in 1976, Jachna travelled to Iceland, and continued, in large format land- and sky-scapes, the merging of his own "mark" with the expanse of nature. The tangibility of the grain structure of these images now meshes the protrusion of the photographer, his arm or hand, into an elemental cohesiveness with the Icelandic panorama.

More recently, a series of "snow angels," imprints of the bodies of children upon freshly fallen snow, serves to underscore Jachna's metaphor: nature, and the imprint of the human form, literally, upon that nature. Jachna sees the human impingement upon nature as strong, insistent, giving form, but a form that is also transitory, as it is in itself inextricably meshed with the "stuff" of nature: the clouds will pass, the snow will melt, taking with it the imprint of human activity. Permanence is gained only through the event of the image-making itself.

—Carole Harmel

JACOBI, Lotte (Johanna).

American. Born in Thorn, West Prussia, Germany, 17 August 1896; emigrated to the United States, 1935; naturalized, 1940. Educated at the Königliche Louisenschule, Posen, 1902-12; studied art history and literature, Academy of Posen, 1912-16; Bavarian State Academy of Photography, Munich, and, art history, University of Munich, 1925-27; graphics, art history, French and literature, University of New Hampshire, Durham, 1961-62; etching and engraving, with S.W. Hayter, Atelier 17, Paris, 1962-63. Married Fritz Honig in 1916 (divorced, 1924); son: John Frank; married the publisher Erich Reiss in 1940 (died, 1951). Director, Jacobi Studio of Photography (family business), Berlin, 1927-35; freelance photographer, with a studio there, New York, 1935-55; also maintained a gallery in New York, 1952-55. Since 1955, has lived and worked in Deering, New Hampshire. Proprietor, Jacobi Studio and Gallery, Deering, 1963-70. A Founder, Department of Photography, Currier Gallery of Art, Manchester, New Hampshire, 1970 (Honorary Curator of Photography, 1972-78) Recipient: Silver Medal, Royal Photography Salon, Tokyo, 1931; First Prize, British War Relief Photography Competition, *Life* magazine, New York, 1941; First Prize, New Hampshire Art Association, 1970. D.F.A.: University of New Hampshire, Durham, 1974; D.H.L.: New England College, Henniker, New Hampshire, 1978. Agent: Doris Bry, 11 East 73rd Street, New York, New York 10021. Address: Old County Road, Box 228, Deering, New Hampshire 03244, U.S.A.

Individual Exhibitions:

1937 Jacobi Studio, 24 West 59th Street, New York
1941 Jacobi Studio, 154 West 54th Street, New York
 Direction Gallery, New York
1948 Norlyst Gallery, New York
1952 Ohio University College, Athens
1953 University College of Education, New Paltz, New York
1955 Jacobi Gallery, 46 West 52nd Street, New York
1957 Sharon Arts Center, Peterboro, New Hampshire
1959 Currier Gallery of Art, Manchester, New Hampshire (retrospective; travelled to Brandeis University, Waltham, Massachusetts, and the University of New Hampshire, Durham, 1960, and the University of Ohio, Athens, 1961)
1962 Colby Junior College, New London, New Hampshire
1964 303 Gallery, New York (retrospective)
 Institute of Arts and Sciences, Manchester, New Hampshire
 Templehof Art Gallery, Temple, New Hampshire
1965 Middlebury College Library, Vermont
 New England College, Henniker, New Hampshire
 University of Chicago
1966 Mr. and Mrs. Roger McCollester House, Irvington-on-Hudson, New York
 Two Photographers, Gropper Galleries, Cambridge, Massachusetts (with Marie Cosindas)
1967 Community Church Art Gallery, New York
1968 New England College, Henniker, New Hampshire
1969 Concord Public Library, New Hampshire
1972 N.H. Belknap College, Center Harbor, New Hampshire
 Staatliche Landesbildstelle, Hamburg
1973 Folkwang Museum, Essen (travelled to the Städtisches Museum, Munich, 1974)
1974 University of New Hampshire, Durham
 Light Gallery, New York

Sharon Arts Center, Peterboro, New Hampshire
 Washington Gallery of Photography, Washington, D.C.
1975 University of New Hampshire, Durham
 New England College, Henniker, New Hampshire
1976 Photo-Graphics Workshop, New Canaan, Connecticut
 Arts and Sciences Center, Nashua, New Hampshire
 William Benton Museum of Art, Storrs, Connecticut
1977 Danforth Museum, Framingham, Massachusetts
 Kimmell-Cohn Gallery, New York
 Allan Frumkin Gallery, Chicago
 Manchester Institute of Arts and Sciences, New Hampshire
1978 University of Maryland, Baltimore
 New Hampshire Art Association, Manchester
1979 Studio 139, Portsmouth, New Hampshire
1980 Theater on the Sea, Portsmouth, New Hampshire
1981 *Lotte Jacobi: Begegnungen*, Münchner Stadtmuseum, Munich

Selected Group Exhibitions:

1930 *Das Lichtbild*, Munich
1937 *Dance Photographs*, Brooklyn Museum, New York
1948 *In and Out of Focus*, Museum of Modern Art, New York
1955 *Subjektive Fotografie 2*, State School of Arts, Saarbrucken (and *Subjektive Fotografie 3*, 1958)
1960 *The Sense of Abstraction*, Museum of Modern Art, New York
1968 *Photography USA*, De Cordova Museum, Lincoln, Massachusetts
1975 *Women of Photography*, San Francisco Museum of Art (toured the United States)
1979 *Recollections: 10 Women of Photography*, International Center of Photography, New York (toured the United States)
1980 *Light Abstractions*, University of Missouri, St. Louis
 Avant-Garde Photography in Germany 1919-39, San Francisco Museum of Modern Art (toured the United States)

Collections:

Museum of Modern Art, New York; Metropolitan Museum of Art, New York; Massachusetts Institute of Technology, Cambridge; Wellesley College Museum, Massachusetts; Addison Gallery of American Art, Phillips Academy, Andover, Massachusetts; Currier Gallery of Art, Manchester, New Hampshire; Bryn Mawr College, Pennsylvania; Smithsonian Institution, Washington, D.C.; Folkwang Museum, Essen; Staatliche Landesbildstelle, Hamburg.

Publications:

By JACOBI: portfolios—*Portraits Before 1940*, 1978; *Portraits of Albert Einstein 1927-1938*, 1978; *Dance and Theater*, 1979; also, illustrations for numerous books and brochures in Germany and America, since 1938.

On JACOBI: books—*Designing with Light on Paper and Film* by Robert W. Cooke, Worcester, Massachusetts 1969; *Photography Without a Camera* by Patra Holter, New York and London 1972; *Lotte Jacobi: Menschen von Gestern und Heute—Fotografische Porträts, Skizzen und Dokumentationen*, exhibition catalogue, Essen 1973; *Lotte Jacobi* by

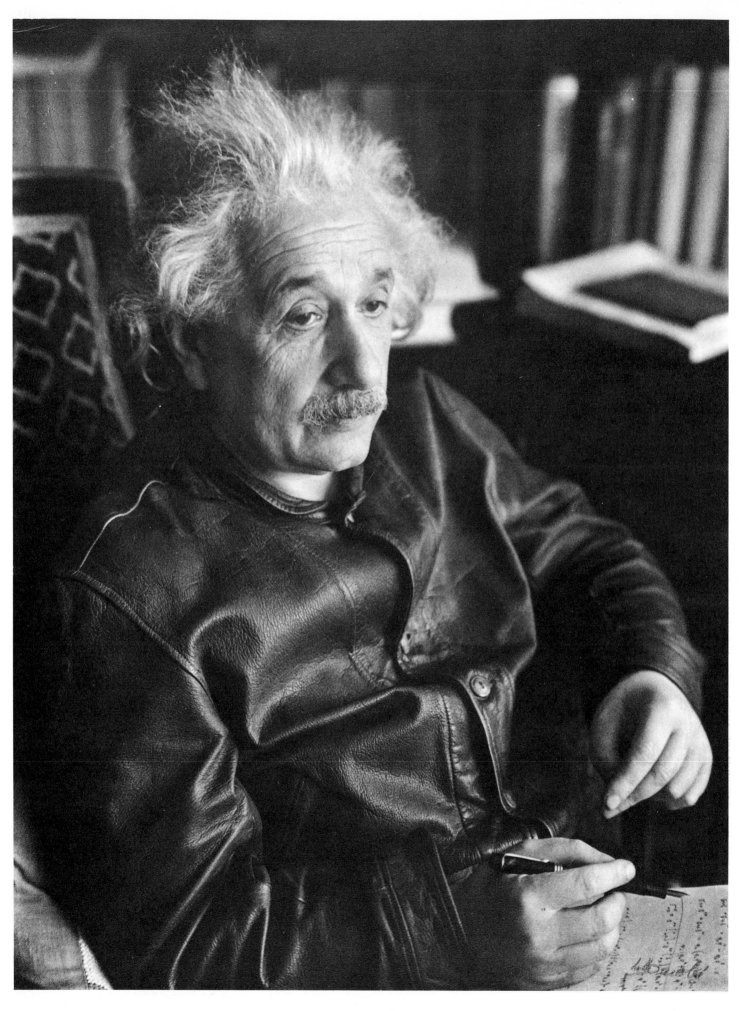

Lotte Jacobi: *Albert Einstein*, **1938**

James A. Fasanelli, Danbury, New Hampshire 1979; *Recollections: 10 Women of Photography*, edited by Margaretta K. Mitchell, New York 1979; *Avant-Garde Photography in Germany 1919-1939*, exhibition catalogue, by Van Deren Coke, Ute Eskildsen and Bernd Lohse, San Francisco 1980.

Too much is written about "Photography"!

I think it speaks for itself. If it doesn't, there is something wrong with "it" or with the photographer.

Too many are interested in the "technique" of photography. You should study all you can about technique—but, when you are taking or making pictures, the technique should be in your fingertips, your body; your mind and concern should be with your object, your "victim," whether it is a person, an animal, a landscape, a town or city, or a "non-objective" subject.

—Lotte Jacobi

Lotte Jacobi was a fourth-generation photographer in a family of photographers—almost predestined to her profession. (It was around 1840 that her great-grandfather purchased equipment and a license to practice from Daguerre himself.) As a child she hoped to be an actress and was thus drawn as a photographer to make theater portraits; she also worked for magazines and newspapers. She made portraits full-time for the Jacobi Studio in Berlin until she left Germany for the United States in 1935. Her early work is in itself a unique composite portrait of German culture after the First World War.

The photographer's American work is no less important as witness to a culture. In a career which spans almost 70 years, Lotte Jacobi has made likenesses of many famous people, and, like it or not, a portraitist is known in part by the fame of her sitters: Lil Dagover, Sonja Heinie, Peter Lorre, Lotte Lenya, Kurt Weill, Käthe Kollwitz, Theodore Dreiser, Max Liebermann, Laszlo Moholy-Nagy, Marc Chagall, Pablo Casals, Yehudi Menuhin, Max Reinhardt, Kostantin Stanislawski, Edward Steichen, Eleanor Roosevelt, Alfred Stieglitz, Thomas Mann, Erich Mendelsohn, Marianne Moore, Paul Tillich, J.D. Salinger, Paul Strand, Mary Wigman, Robert Frost and Albert Einstein.

Once in New York, she opened a portrait studio with her sister. She was greatly aided in establishing herself by Albert Einstein who, when approached by them, told *Life* magazine to use a portrait which Jacobi would take. For another assignment she was the first woman admitted on the floor of the Stock Exchange during trading hours.

Lotte Jacobi claims no special approach to the technique of portraiture beyond the capacity of the photographer to develop intuition and keep her own personality out of the portrait as much as possible. Her work is natural, personal, often casual and conversational. These qualities are hallmarks of the Jacobi style; like the actress who knows how to disappear into the role she plays, the photographer becomes a medium for her subject. The subject is helped to forget the camera. In her own words, "I only photograph what I see; my style is the style of the people I photograph. In my portraits I refuse to photograph *myself*, as do so many other photographers."

Lotte Jacobi speaks in a disarmingly simple manner of her approach to the act of photographic portraiture, but the compassion, integrity and unpretentiousness of her artistic intentions is rock-solid. She has an intuitive sense of design which shows itself most clearly in her early work from Germany; the American portraits become increasingly informal. But all her work shows an independent and honest observation of life, one which does not indulge in generalities but rather embraces individuality. Thus a gesture or an expression of the sitter is used by Lotte Jacobi to reveal a particular personality, not to create a preconceived type.

The life-work of Lotte Jacobi also includes a series of light inventions called "photogenics," distinct from photograms because they are made not only without a camera but also without any recognizable objects. She describes the technique as drawing on photo-sensitized paper by moving the light source, glass or cellophane to allow subtle nuances in the play of light. It is in this work that the intuition of the artist is most visible as she creates a work of art from such minimal materials.

In her life as in her work Lotte keeps things simple and straightforward. She left New York in 1955 and now lives on a wooded road in New Hampshire where she continues to photograph and more and more frequently to meet with new generations of student photographers. She encourages them to see for themselves.

—Margaretta K. Mitchell

JANSEN, Arno.

German. Born in Aachen, 13 February 1938. Studied graphic design at Folkwangschule, Essen, 1957-59, and photography, under Otto Steinert, at the Folkwangschule, 1959-63. Married Danièle Chausson in 1974; daughter: Elodie. Photographer and commercial artist for the City of Braunschweig, 1964-65. Freelance photographer, Cologne, since 1965. Instructor, School of Fine Arts, Braunschweig, 1964-65. Since 1965, Head of Photographic Studies, Kölner Werkschulen, now the Department of Art at the Fachhochschule, Cologne: Professor since 1973. Member, Deutsche Gesellschaft für Photographie (DGPh), 1971, and Gesellschaft Deutscher Lichtbildner (GDL), 1978. Address: Ubierring 40, D-5000 Cologne 1, West Germany.

Individual Exhibitions:

1962 Galerie Die Brücke, Dusseldorf
1967 Galerie Brebaum, Dusseldorf
1970 *Realistik und Phantastik*, Staatliche Landesbildstelle, Hamburg
1971 Studio Dumont, Cologne
1972 Studio 41, Duisburg
1979 Art Studio, Cologne
 Work Gallery, Zurich
1980 Werkstattgalerie, Bad Godesberg, West Germany
1981 Galerie Renner, Munich
 Goethe Institut, Toulouse

Selected Group Exhibitions:

1979 *Fotografie 1919-1979*, Stadtmuseum, Munich
1980 *Vorstellungen und Wirklichkeit: 7 Aspekte subjektiver Fotografie*, Städtisches Museum, Leverkusen, West Germany (travelled to the Künstlerhaus, Vienna, Fundació Joan Miró, Barcelona, 1980; and Palais des Beaux-Arts, Brussels, 1981)
1981 *New German Photography*, The Photographers' Gallery, London (toured the U.K., 1981-82)

Arno Jansen: *Tentakeln,* 1979

Collections:

Staatliche Landesbildstelle, Hamburg; Bibliothèque Nationale, Paris; Polaroid Collection, Amsterdam; Stadtmuseum-Fotomuseum, Munich.

Publications:

By JANSEN: books—*Arno Jansen: Braunschweig*, Braunschweig 1965; *Arno Jansen: Rüsselsheim—Bilder einer Stadt*, Rüsselsheim, West Germany 1969; articles—"Meine Fotografien sind meine Reflexionen," interview with Jörg Krichbaum, in *Fotografie* (Göttingen), no. 6, 1978; "Arno Jansen" in *Dumont Foto 1*, Cologne 1978; "Photos by Arno Jansen" in *Ambit* (London), no. 77, 1979; "Arno Jansen: Portfolio" in *Fotografie* (Göttingen), no. 9, 1979; "Arno Jansen" in *Zoom* (Munich), November 1979.

On JANSEN: book—*Vorstellungen und Wirklichkeit: 7 Aspekte subjektiver Fotografie*, exhibition catalogue, by Dieter Wellershof, Cologne 1980; articles—"Arno Jansen" by L. Fritz Gruber in *Fotografie* (Göttingen), no. 9, 1979; "Vergessene Stilleben" by Jörg Krichbaum in *Zoom* (Munich), November 1979.

The photographs that I've taken in the past few years are concerned with still life. This classical theme in art—which is often understood merely as a kind of formal expression and valued for its charm—gains significance for me to the extent that it offers other possibilities beyond the compositional: a sensual play with forms, materials, surfaces and shades of colour; the making of artistic worlds of fantasy comprehensible.

Objects excite my fantasies. I am interested in the inter-relationships between subject and object, in the question of inner and outer identity, and in time: a desire to follow up the past by means of its relics. What were the circumstances? Who were the people connected with them at the time. These finds are also fetishes, icons, and souvenirs for me: devoid of their original function, they have become magical objects, independent entities. As the result of new combinations they encounter each other on another level, become very eloquent, conveying complexes of thought and metaphorically reflecting inner fears, aggression, sexuality, death and decay.

The medium of photography is in my view especially suited to stressing the existence of things, to interpreting them in a way different from the painted picture or any other art object, but it can also give to those things a certain documentary presence and permanence.

—Arno Jansen

Arno Jansen's still-lifes—his principal theme in recent years—represent a particular speciality in contemporary photography in so far as he deals not with compositions of "found" subject matter, which have a tendency to become stylized, but with an exact, almost documentary, reproduction of artistically arranged objects or groups of objects. These photos do not suggest affinities with particular photographic tendencies so much as they remind the viewer of the impressively contained world of the still-life painting of Giorgio Morandi.

To a certain extent, this similarity has to do with Jansen's choice of subject matter: the spare arrangement of color- and rust-speckled tin cans, for example, carefully disposed according to their relative proportions, immediately calls to mind the bottle compositions of the Italian painter. And, at the same time, it is also the restrained manner, the occasional detachment *vis à vis* the subject matter, or, in the color photographs, the atmospheric components of the picture, which in general bring these works close to painted still-life. Yet—and this is a

vital point—these features are produced with distinctly photographic methods. Although the respective objects or groups of objects are not altered by their deliberate arrangement, in the photograph they nevertheless gain a dimension, which clearly goes beyond the purely factual, even if this is occasionally only by suggestion. Ingenious lighting unexpectedly relieves them, in the play of light and shade, of their commonplace banality and brings to such objects suggestions of strangeness and mystery, raises them to the level of the icon—or at least allows them to function as relics of no obvious significance.

Notwithstanding this tendency to "private mythologies," these photographs have documentary aspects, because, for once, the prevailing central perspective corresponds precisely to the presentational character of the arrangement of objects. Central perspective—to quote an observation of Dieter Wellershof—doesn't touch the objects, "it does not cut or distort them," but simply sets things in front of us. That is to say, in a certain sense, it distances the viewer. In this way Jansen achieves stylistic composure in calculated contrast to the thematic over-enhancement of his mainly deliberately simple composition of objects.

This description may suggest a question: if these artistic arrangements are already in themselves complete, autonomous works, why must they also be photographed? The answer is simple: because the direct presentation would leave the things as they stand in their directness, whereas through photography they will at least be brought into the realm of duality.

"Light, for example"—to cite Dieter Wellershof again—"emotionalizes the objects, defines them or lets them fade away, so that in this way photography proves itself an artistic medium, thanks to which objects can be seen better and differently." In other words, the things themselves are not directly Arno Jansen's subject matter; his subject is the associative meanings released by the photograph. Only when photographed do the objects appear—for the photographer as well as for the viewer—as evocative evidence of subjective experience and reality.

—Rolf Wedewer

JARCHÉ, James.

British (of French origin). Born in Rotherhithe, London, in September 1890. Educated at St. Olave's Grammar School, London, 1901-04, and at a boarding school in Ramsgate, Kent, 1904-06; studied photography with his father, London, 1901-04. Served as CSM, 1st Army Corps School of Physical Training and Bayonet Fighting, Bethune, London, 1914-18: Sergeant-Major. Worked as press photographer for the *Daily Telegraph* newspaper, London and Home Counties, 1906-07; photographic apprentice, Argent Archer studios, Bond Street, London, 1907; press photographer, World's Graphic Press agency, Fleet Street, London, 1908-12; Staff Photographer, *Daily Sketch* newspaper, London and Manchester, 1912-29; photographer for Odhams Press, working mainly on *Daily Herald* and *Weekly Illustrated* (later, *Illustrated*), London, 1930-53; Press Photographer, *Daily Mail*, London, 1953 until his retirement, 1959. Agent: Popperfoto, 24 Bride Lane, London EC4. *Died* (in London) *6 August 1965.*

Individual Exhibitions:

1980 Brewery Arts Centre, Kendal, England (retrospective)

1982 *James Jarché: Press Picture Pioneer*, Impressions Gallery, York

Selected Group Exhibitions:

1959 *Hundert Jahre Photographie 1839-1939*, Museum Folkwang, Essen (travelled to Cologne and Frankfurt)

1975 *The Real Thing: An Anthology of British Photographs 1840-1950*, Hayward Gallery, London (toured the U.K.)

1979 *The 30's: British Art and Design Before the War*, Hayward Gallery, London

Collections:

Popperfoto, London; Imperial War Museum, London; Kodak Museum, Harrow, Middlesex; Gernsheim Collection, University of Texas at Austin.

Publications:

By JARCHÉ: book—*People I Have Shot*, London 1935; articles—"Taking Pictures for the Press" in *Weekly Illustrated* (London), 1 September 1934; "Royalty I Have Shot" in *Passing Show* (London), 22 September 1934; "David Lloyd George" in *Illustrated* (London), 16 January 1944; "How to Take a Pin-Up," with Anne Crawford, in *Illustrated* (London), 27 May 1944; "1907-1947 Photographed by James Jarché" in *Illustrated* (London), 29 March 1947.

On JARCHÉ: books—*Hundert Jahre Photographie 1839-1939, aus der Sammlung Gernsheim, London*, exhibition catalogue, by Helmut and Alison Gernsheim, Essen 1959; *The Real Thing: An Anthology of British Photographs 1840-1950*, exhibition catalogue, by Ian Jeffrey and David Mellor, London 1975; *Thirties: British Art and Design Before the War*, exhibition catalogue, by Ian Jeffrey, William Feaver, Brian Lacey and others, London 1979; *James Jarché 1891-1965: Press Picture Pioneer*, edited by Derek Smith, London 1980; articles—"Jarché: Portrait of a 'Big Man'" by Ainslie Ellis in *Good Photography* (London), April 1959; "Obituary: James Jarché" in *The Times* (London), 9 August 1965, and in *Photographic Journal* (London), December 1965; "James Jarché: The Durham Miners' Gala 1935" in *Creative Camera* (London), September 1971.

James Jarché was a successful newspaper photographer who switched to magazine work in middle life, but went back to Fleet Street for the final years before his retirement in 1959.

"Born over a barrel of Hypo," according to his own description, Jimmy as a small boy was already helping his father on "police jobs" in the East End of London, as well as with his more conventional studio work. Powerfully-built—he was a World Amateur Wrestling Champion before he was 20—and with a jovial extroverted nature, Jarché was well-equipped by nature for success in the hard world of Fleet Street cameramen. Quick-witted and adaptable, he would get the better of his colleagues on some news assignment during the day, and in the evening amuse them with his skill as conjurer, ventriloquist and story-teller. One of his party tricks was to imitate any language—German, French, Spanish, Italian—without actually speaking it, in a manner that delighted any linguist. It was also of practical use to him in getting past police and other official barriers.

Jarché made his mark in Fleet Street by "scoops"—single pictures of big occasions or important people, often secured against great difficulty—using the heavy single-shot cameras of his day which demanded strength to hold steady as well as skill in securing the

essential picture. Even when he took to the miniature camera—and he was one of the first daily newspaper men to adopt it—he never altogether shook off his original way of approach. Despite the different possibilities which such cameras as the Leica opened up, his magazine work for *Weekly Illustrated* and later for *Illustrated*, still tended to produce a big picture or two, plus some surrounding shots which were often variations of his main picture, rather than the "story told through the lens" of the photojournalist.

On stories of a quieter nature, offering the opportunity for a more thoughtful approach, Jarché inclined to fall back on some cliché such as the familiar line-up of figures or bunch of smiling faces. But on a job which appealed to his news sense and aroused his competitive spirit, he was an outstanding operator. Daily newspaper work was his true field, and he showed himself true to his own nature by returning to it.

—Tom Hopkinson

JODAS, Miroslav.

Czechoslovak. Born in Prague, 30 November 1932. Educated at a basic school in Prague, 1938-47; Professional School of Goldsmith's Art, Prague, 1947-50; self-taught in photography. Married Marcela Kratka in 1953; children: Marek and Lucie. Worked in a hospital in Prague, 1950-54; Goldsmith, for Soluna, Prague, since 1954. Independent photographer, Prague, since 1967. Recipient: Silver Medal, *International Photo Exhibition*, Neuchatel, Switzerland, 1959; Gold Medal, 1964, and Bronze Medal, 1966, *Foto-Session*, Prerov, Czechoslovakia. Address: Na Ladách 6, Dejvice, Prague 6, Czechoslovakia.

Individual Exhibitions:

1959 *Animals in the Zoo*, Gallery in St. Mary Street, Pilsen, Czechoslovakia
1960 *Photographs by Miroslav Jodas*, Club in Nekázanka Street, Prague
 Animals in the Zoo, Osvětová Beseda Club, Ceská Lípa, Czechoslovakia
1964 *Photographs by Miroslav Jodas*, Club in Nekázanka Street, Prague
1970 *Photographs 1965-70*, Town Gallery, Ostrov nad Ohri, Czechoslovakia (travelled to the Gallery Dum pánu z Kunštátu, Brno, Czechoslovakia, 1971)
1972 *Jazz in Photography*, Theatre Reduta, Prague

Selected Group Exhibitions:

1959 *International Photo Exhibition*, Neuchatel, Switzerland
1964 *Foto-Session*, Přerov, Czechoslovakia
 Foto-Nova, Photography Club, Bologna (and 1965)
1966 *Foto-Session*, Přerov, Czechoslovakia
 Foto-Nova, Photography Club, Beirut
1967 *7 + 7*, Spála Gallery, Prague
1968 *SCVU Exhibition*, Municipal Building, Prague

Collections:

Moravian Gallery, Brno, Czechoslovakia; Ministry of Foreign Affairs, Prague.

Publications:

By JODAS: books—*Udeřila naše hodina (Our Time Has Come)*, with poems by various authors, Prague 1964; *Den, který nebyl (The Day That Wasn't)*, novel by J. Kadlec, Prague 1965; *Jazz Inspiration*, with poems by various authors, Prague 1969; *Music and People*, with text by A. Hostomská, Prague 1969.

On JODAS: book—*Miroslav Jodas: Fotografie 1965-70*, exhibition catalogue, by Anna Fárová, Ostrov nad Ohri, Czechoslovakia 1970.

Miroslav Jodas has created an oeuvre in which there can be found various genres of photography, a great richness of subject matter, and even slightly different photographic approaches, evidence of his search for the appropriate way to depict the chosen subject. Yet, despite the many-sided character of his work, it is possible to feel that all of these images were taken by the same photographer.

From the beginning of his career until the present, Jodas has always shown a predilection for the portrait. He likes to depict the human face both in tranquility and in dynamic movement. Painters, writers, photographers and other artists have posed for him in their studios. He prefers to photograph each person in the "space" in which he logically belongs; he composes the figure with regard to the interesting motifs of his or her environment. Conversely, in his shots of jazz musicians he includes very little of their environment, preferring to concentrate attention on their faces in the dynamic and ecstatic atmosphere of performance. Yet, whatever his method, his solutions are highly individualistic, since Jodas tries always to express his own relationship toward his subject.

In order to delineate the responses of his subjects, Jodas sometimes prepares cycles of portraits of the same person, in which he endeavors to point out some relativity of expression. By moving successively with his camera toward a stationary model, he forms a sequence of responses.

Another kind of subject beloved by Miroslav Jodas is the still-life, a mode he almost approximates in his series of portraits of artists in their studios. Later, he was attracted to similar, chance arrangements in the real world. Among his "found" still-lifes have been faded flowers on tombstones in old cemeteries or an empty cyclists' arena, in which the surprising forms resemble slightly surrealistic pictures.

Jodas has also photographed landscapes of a part of the Czech countryside not very often visited by tourists: he has always been attracted to the beauty of the modest environments of everyday life. In this respect, his work is typical of Czech photography, in which the poetical interpretation of the real world has a long tradition.

—Petr Tausk

JOEL, Yale.

American. Born in 1919. Educated at Theodore Roosevelt High School, Bronx, New York. Served as combat photographer, United States Army Pictorial Service, 1942-46. Worked as assistant to photographer Herbert Matter, New York, 1938-40; associated with Cornell Capa, New York, 1939; freelance photographer, working for *Picture Post*, etc., New York, 1939-42; staff photographer, *Life* magazine, in Washington, D.C., Paris, Boston and New York, from 1947; now freelance advertising and industrial photographer. Recipient: Magazine Photographer of the Year Award, 1953. Address: Woodybrook Lane, Croton-on-Hudson, New York, U.S.A.

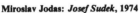

Miroslav Jodas: *Josef Sudek*, 1974

Selected Group Exhibitions:

1951 *Memorable Life Photographs*, Museum of Modern Art, New York
1968 *2nd World Exhibition of Photography*, Pressehaus Stern, Hamburg (and world tour)

Publications:

On JOEL: books—*Memorable Life Photographs*, with text by Edward Steichen, New York 1951; *Life Photographers: Their Careers and Favorite Pictures*, edited by Stanley Rayfield, New York 1957; *2nd World Exhibition of Photography*, exhibition catalogue, edited by Karl Pawek, Hamburg 1968.

In 1939, twenty-year-old Yale Joel scored his first major freelance success—a *Picture Post* story on Czechoslovak refugees in New York—in collaboration with his friend Cornell Capa. During World War II Joel served as a combat photographer in the Army Pictorial Service for four years, and in 1947 he joined the staff of *Life* magazine and has worked out of *Life*'s Paris, Boston, and New York bureaus.

Joel built a reputation in the 1940's and '50's as "photographer of the impossible." Always interested in expanding the frontiers of his craft, Joel's accomplishments ranged from macro-photography to studio simulation of speed to infra-red lighting. He can claim such photographic coups as a group portrait of all 1500 Disneyworld employees, a view of the Rockettes chorus line in perfect formation, echoed in elegantly elongated shadows along the stage floor, and an infra-red shot of an experimental subject enduring sensory deprivation in a totally dark chamber.

Joel contributed covers, news, and photoessays on a wide variety of subjects. Viewing the professional photographer as a problem-solver, he relished assignments that required the use of special, arcane equipment, carefully orchestrated set-ups, and special effects. Thus it was that Joel helped *Life* celebrate the completion of the new Time-Life Building with an extraordinary picture that managed to show the entire structure from top to bottom—a picture for which Joel used an 80-year-old wooden view camera with a bubble-shaped extreme wide-angle lens. But Joel also brought his special lively touch to human subject matter including portraiture of show business personalities, children and young people, and, especially, the pageantry of parades and celebrations. His photographs of John F. Kennedy's inauguration and Pope Paul VI's visit to New York in 1965 are among his most impressive images.

Such versatility and inventiveness were soon recognized and Joel was named Magazine Photographer of the Year in 1953 and runner-up in 1955. His career has also included the illustration and production of several children's books as well as numerous teaching activities. In addition to his own workshops at Croton-on-Hudson, Joel has taught at the International Center of Photography and Hunter College in New York. Today he is active in advertising and industrial photography and continues work in editorial photojournalism.

—Maren Stange

JOHNSON, Tore.

Swedish. Born in Saint-Leu la Foret, near Paris, 8 January 1928. Educated at Viggbyholmsskolan, Viggbyholm, Sweden, 1943-48; apprentice/assistant to Karl W. Gullers, Studio Gullers, Stockholm, 1948. Married Marianne Axelsson in 1961 (divorced, 1966); son: Olof. Freelance photographer, working for various Swedish and foreign magazines and book publishers, Paris, 1948-51, New York, 1952-53, and Stockholm, 1954 until his death, 1980. Founder Member, Tio Fotografer group, Stockholm, 1958-80. Recipient: Swedish-American Society grant, 1952. *Died* (in Stockholm) *14 May 1980*.

Selected Group Exhibitions:

1949 *Unga Fotografer*, Rotohallen, Stockholm
1951 *Jeunes Photographes Suedoises*, Galerie Kodak, Paris
Subjektive Fotografie, Saarbrucken, West Germany
1958 *Fotokonst 1958*, Lunds Konsthall, Lund, Sweden
1959 *Tio Fotografer: Hundra Bilder*, Svensk Form, Konstfackskolan, Stockholm
1962 *Svenskarna Sedda av ll Fotografer*, Moderna Museet, Stockholm
1971 *Contemporary Photographers from Sweden*, Library of Congress, Washington, D.C.
1976 *Tio Fotografer*, Galerie Aronowitsch, Stockholm

1977 *Tio Fotografer*, at *Rencontres Internationales de Photographie*, Arles, France (travelled to La Photogalerie, Paris)

Collections:

Norsk Fotohistorisk Forening, Oslo; Finska Fotografiska Museet, Helsinki; Bibliothèque Nationale, Paris; Library of Congress, Washington, D.C.

Publications:

By JOHNSON: books—*Paris Hemliga Tecken*, with text by Göran Schildt, Stockholm 1952; *Okänt Paris*, with text by Ivar Lo-Johansson, Stockholm 1954; *Skulptur*, Stockholm 1958; *Färdmän Från Isarna*, with text by Jan Sundfeldt, Stockholm 1964; *LKAB i Bild*, with text by Sven Brunnsjö, Stockholm 1965; *Hallarna i Paris*, with text by Sven Aurén, Stockholm 1967; *Den Sociala Fotobildboken*, with text by Ivar Lo-Johansson, Stockholm 1977.

On JOHNSON: books—*Svenskarna Sedda av ll Fotografer*, exhibition catalogue, by K.G. Pontus Hultén and Stig Claeson, Stockholm 1962; *Visitor's Views: Swedish Travellers in the U.S. from the 17th to the 20th Century* by Karl Sjunnesson, Trelleborg, Sweden 1976.

Tore Johnson: *The Girl from the Seine*, Paris, 1951

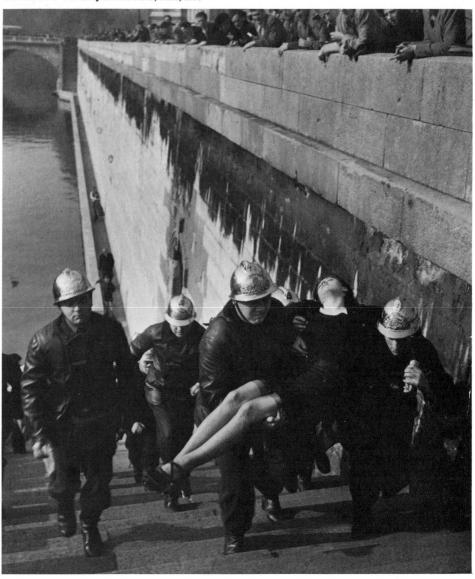

In the years when Europe began to recover from the wounds inflicted by the Second World War, Paris became an important meeting place—and center for ideas—for a new generation of photographs. Tore Johnson was one of the many who went there. During his stay in Paris at the beginning of the 1950's, he matured as a camera artist—and emerged as a photographic portrayer of Paris in the footsteps of Kertész and Brassaï. But he showed a clearly individual stamp from the very start.

Johnson worked as a freelance photographer and was employed by Swedish magazines; for a time, he was a stringer for Magnum; and, in two books, he produced a fastidious selection of pictures. *Paris Hemliga Tecken* contains acute observations of everyday events and finely catches the atmosphere of the time. Like Kertész, Johnson had a penchant for the odd, the bizarre. He looked at the world around him with warmth and humour. *Okänt Paris* was produced in collaboration with the swedish writer Ivar Lo-Johansson. It is a social study of the Paris of the poor, the sick, and the defeated. Johnson depicted the dark side of the metropolis with insight and with respect. Of many picture books about Paris, *Okänt Paris* is one of the very few that contains a penetrating visual report on the social conditions among the poorer section of the community. It can, in parts, be compared to Lewis Hines' earlier work in the United States, which Johnson did not come to know until later.

Other fine series of photographs were gathered during a visit to New York and during many years of wandering through his home town of Stockholm. It was mainly the big city and its people which Johnson depicted—places and people he came to know intimately—a delicate interpretation of his own impressions and the "secret signs" of city life. But a severe sense of self-criticism caused him to leave the greater part of this rich material unpublished.

Commissions from magazines often led Johnson to a confrontation with a more brutal reality, which he visualized as a true "concerned photographer": the famine in Kasai during the Congo crisis; a massacre of seals in the Gulf of Bothnia; a mineworkers' strike in northern Sweden. Another interesting aspect of Johnson's work are his colour studies of nature, collected on long journeys into the Arctic. The grandeur and the silence in the barren landscapes and snowy wastes emerge and are emphasized in forceful compositions and in delicately balanced, subtle colours. And, in his last years, Johnson began to explore, with camera and microscope, a world of images invisible to the naked eye—close-up studies of vitamin crystals, which were published in *GEO* in 1980. Without having to respond to demands for scientific or journalistic significance, Johnson presented in these works his artistic discoveries of form and colour.

The strength of Johnson's work lies, however, in his compassionate, poetic studies in black-and-white of his fellow citizens in happiness and in grief.
—Rune Hassner

JONES, Harold (Henry).

American. Born in Morristown, New Jersey, 29 September 1940. Educated at Morristown High School, 1955-59; studied painting at the Newark School of Fine and Industrial Art, New Jersey, 1959-63, photography at the Maryland Institute of Art, Baltimore, 1963-65, B.F.A. 1965, and photography and art history at the University of New Mexico, Albuquerque, 1965-68, M.F.A. 1972. Married

Frances Ellen Murray in 1970; children: Rebecca and Star Ann. Advertising Chairman, Gallery 61, Newark, 1962-63; Wedding Photographer, Udel Studios, Baltimore, 1964; Official School Photographer, Maryland Art Institute, 1964; Portrait Photographer, Jordan Studios, Baltimore, 1965-66; Gallery and Technical Adviser, Quivira Bookshop and Gallery, Corrales, New Mexico, 1966-67; Assistant, University of New Mexico Art Museum, 1966-68; Assistant Curator, 1969, and Associate Curator, 1970-71, George Eastman House, Rochester, New York; Director, Light Gallery, New York, 1971-75. Instructor in Painting and Drawing, Barelas Community Center, Albuquerque, 1966-67; Visiting Lecturer in Photography, University of Rochester 1970-71, and Cooper Union, New York, 1971-72; Adjunct Associate Professor of Art History, Queens College, New York, 1974-75. Director of the Center for Creative Photography, 1975-77, and since 1977 Coordinator of the Photography Program, University of Arizona, Tucson. Recipient: Eastman House Fellowship, 1967; Smithsonian Institution Travel Grant 1976; Gold Award, University and College Designers Association, 1977; National Endowment for the Arts Grant and Photographers Fellowship, 1977. Agents: Light Gallery, 724 Fifth Avenue, New York, New York 10019, and 800 North La Cienega Boulevard, Los Angeles, California 90024. Address: Department of Art, University of Arizona, Tucson, Arizona 85721, U.S.A.

Individual Exhibitions:

1969 University of California at Davis
1970 Photographic Workshop, Rochester, New York
Barnes Gallery, Loomis Institute, Windsor, Connecticut
1972 Madison Arts Center, Wisconsin
1973 University of Massachusetts at Boston
1974 Soho Photo Gallery, New York
1976 Spectrum Gallery, Tucson, Arizona
Light Gallery, New York
1977 Kresge Art Center, Michigan State University, East Lansing
Hang-Up Gallery, Tucson, Arizona
1978 *Lightning*, Neal Slavin Studio, New York
Bayard Gallery, Orange Coast College, Costa Mesa, California
Harris 125 Gallery, University of Southern California, Los Angeles

Harold Jones: *Still Life with Ice*, 1978

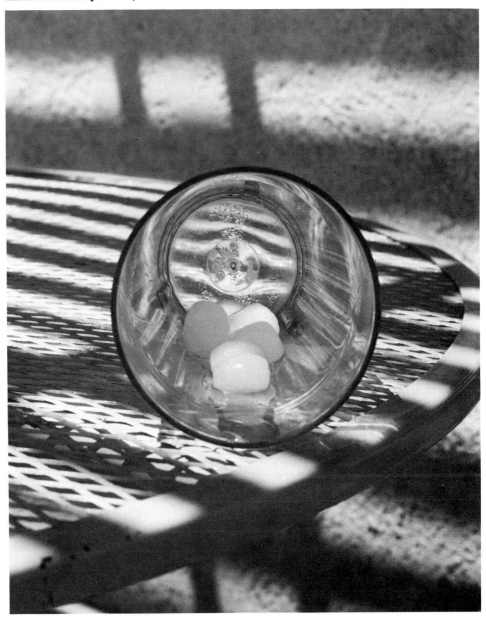

1979 Northlight Gallery, Arizona State University, Tempe

Slocumb Gallery, East Tennessee State University, Johnson City

1980 Light Factory Gallery, Charlotte, North Carolina

Light Gallery, New York

Selected Group Exhibitions:

1970 *Photosynthesis*, Oakland College of Arts and Crafts, California

1972 *60's Continuum*, International Museum of Photography, George Eastman House, Rochester, New York

1973 *New Images 1839-1973*, Smithsonian Institution, Washington, D.C.

1974 *New Images in Photography*, Lowe Art Museum, University of Miami

1977 *Photographic Landscapes*, International Museum of Photography, George Eastman House, Rochester, New York

The Great West: Real/Ideal, University of Colorado, Boulder (subsequently Smithsonian Institution travelling exhibition; toured the United States)

1979 *Attitudes: Photography in the 1970's*, Santa Barbara Museum of Art, California

The Wet Show, Joseph Gross Gallery, University of Arizona, Tucson

1980 *Mondo Arizona*, Joseph Gross Gallery, University of Arizona, Tucson

1981 *Contemporary Hand-Colored Photographs*, de Saisset Art Gallery, University of Santa Clara, California

Collections:

Museum of Modern Art, New York; International Museum of Photography, George Eastman House, Rochester, New York; Rhode Island School of Design, Providence; University of Louisville, Kentucky; University of Colorado, Boulder; Santa Fe Museum, New Mexico; Arizona State University, Tempe; Center for Creative Photography, University of Arizona, Tucson; Norton Simon Museum of Art, Pasadena, California; University of California at Los Angeles Art Museum; National Gallery of Canada, Ottawa.

Publications:

By JONES: articles—"The Influence of Thomas Barrow upon Mother Nature's Inventions" in *Album* (London), May 1970; "The 50's: A Renaissance in Photography" in *The Photographer's Choice*, edited by Kelly Wise, Danbury, New Hampshire 1975; "Harold Jones: Interview" in *New Times* (Tempe, Arizona), Summer 1975; "A Touch of Class" in *Tucson Daily Citizen*, 21 December 1976; "Harold Jones and Mark Cohen" in *Popular Photography* (New York), April 1977; "Harold Jones: Interview" in *Perspectives*, San Francisco 1978; introduction to *Contemporary California Photography*, exhibition catalogue, San Francisco 1978; "Harold Jones: Interview" in *Photobulletin* (Los Angeles), January 1978; "Photography" in *Twenty Arizona Artists*, exhibition catalogue, Phoenix, Arizona 1978; "Five Quotations" in *Northlight* (Tempe, Arizona), November 1978.

On JONES: articles—"Harold Jones" by Van Deren Coke in *Creative Camera* (London), August 1969; "Harold Jones: Leaving the Light" in the *Village Voice* (New York), 16 June 1975; Harold Jones: Photographs in Balance" in *Artweek* (Oakland, California), 30 October 1976.

It is not as simple as black and white. There is no clear, distinct picture in my mind of what photography is or isn't. It generates elegance in so many dialects of vision that I am constantly awed at its flexibility. From Heinrich Kühn's landscapes to Harold Edgerton's stroboscopic wonders, from Weegee's New York to Helmut Newton's sirens, from 19 million snapshots made every day in the U.S.A. to the postcards bought on Harvard Square, photography speaks as an articulate, many-tongued creature. Yet, I fully acknowledge Oscar Wilde's observation, "Photography has the remarkable power to turn wine into water."

While I have been making photographs since 1963, it has only been during the last five years that I have been able to do so on almost a daily basis. From 1968 to 1975, as director of Light Gallery, my time and energy were dedicated to the ideas and work of other photographers; in late 1975, I had an opportunity to devote more time to finding out where my *own* sensibilities began and into what directions they might extend. In late 1977 I changed occupations to a position that intensified my desire for research into the realm of photography. I consciously avoided taking on a "project." I wanted to see what would happen if I allowed my photographs to evolve from within my own visual and intellectual instincts. I photographed a wide range of subject matter intuitively, allowing the direction to reveal itself naturally. The photographs became the markers. They animated memory and my sense of touch for the presence of things. Slowly I discovered a sense for the harmony of parts, and from the pictures I began to realize that a sonata form of observation was emerging, informed with excited wonder.

I work in four modes; that is, I continually have bodies of work in progress in four areas: black and white silver prints; drawings on photographs; black and white Polaroids; and color slides. I constantly make color slides, which function for me as a way of sketching, note-taking. To discuss all the reasons why color slides interest me would consume more space than is practical here. Put briefly, the formal and emotional characteristics by which color animates image matter is of great interest to me. I consider the slides to be an important part of my work. The black and white prints, drawings, and Polaroids deal much more with formal examinations and questions posed by the "optical unconscious." The concept of optical unconscious is mentioned by Walter Benjamin in his *Short History of Photography*:

It is possible, however roughly, to describe the way somebody walks, but it is impossible to say anything about that fraction of a second when a person *starts to walk*. Photography with its various aids (lenses, enlargements) can reveal this moment. Photography makes aware for the first time the optical unconscious. Structural qualities, cellular tissue, which form the natural business of technology and medicine are all much more closely related to the camera than to atmospheric landscape or the expressive portrait. At the same time, photography uncovers in this material physiognomic aspects of pictorial words which live in the smallest things, perceptible yet covert enough to find shelter in daydreams, but which, once enlarged and capable of formulation, show the difference between technology and magic to be entirely a matter of historical variables.

My work is an unfolding biography. The exposure is made when a number of signals swing into a moment of harmony; become coherent to generate a sense of wonder. The photograph is the object that begins and allows recall; it becomes first the point of entry, then the bridge between emotion and intellect. The photograph is the end, and the photograph is the beginning.

—Harold Jones

Harold Jones speaks of his work as a conversation with photography. There is evidently a lot to be said about vision and history by both partners in the dialogue.

Jones' style of work reveals an inquisitive, restless mind. He moves easily between straight gelatin silver work and the synthetic images. He will paint on or tear a black-and-white photograph, will arrange objects to be photographed as a still life or make a straight 4" x 5" contact print of an urban scene. He explores one idea, such as the effect of hand-coloring a particular object, then breaks the pattern and moves on. This searching spirit is in the best tradition of photographic ideas.

In his work of the 1960's—black and white photographs resplendent with green cows or red wrought-iron benches—we are well aware of his presence. The hand (voice?) of the photographer indicates the surface of the print, its potential and shortcomings with candor and wit. In later work the painted additions take on the tonal range of the gelatin silver photograph and perceptual confusion increases. What is photographic? What is the true field of the image?

His subjects are simple and generally unspectacular: a glass of water, his back yard, a gleaming white chair, light from a window at dusk, but each functions as an investigation into and a comment on the possibilities of the medium. This is not an over-intellectualizing of photography. The photographs are organizations of concrete facts, models of reality, or rather photography's transformation of the obvious. Jones remains neutral in his approach to the subject matter—his conversation is with photography itself not the nature of landscape or green cows. One picture appears to be circles within circles. This design can be translated as a glass with ice, laying on its side on a round table without reducing the graphic power of the image.

Harold Jones thinks a good deal about photography. It is part of his everyday life. He has a lot to say and he is also, apparently, a very good listener.

—Marianne Fulton

JONES, Pirkle.

American. Born in Shreveport, Louisiana, 2 January 1914. Educated at Lima High School, Ohio, 1928-31; studied photography, under Ansel Adams and Minor White, at the California School of Fine Arts, now the San Francisco Art Institute, 1946-49. Served as a Warrant Officer, Signal Corps, 37th Infantry Division, United States Army, in the South Pacific, 1941-46: Bronze Star. Married Ruth-Marion Baruch in 1949. Worked as a machine operator at Lima Sole and Heel Company, 1933-41. Freelance photographer, San Francisco, since 1949. Assistant to Ansel Adams, San Francisco, 1949-52. Instructor in Photography, California School of Fine Arts, 1953-58, and San Francisco Art Institute, since 1970. Recipient: National Endowment for the Arts Photography Fellowship, 1977. Agents: Focus Gallery, 2146 Union Street, San Francisco, California 94123; J. Hunt Galleries, 3011 East 25th Street, Minneapolis, Minnesota 55406; and Photo Gallery International, 2-5-18 Toranomon, Minato-ku, Tokyo 105, Japan. Address: 663 Lovell Avenue, Mill Valley, California 94941, U.S.A.

Individual Exhibitions:

1947 Public Library, Lima, Ohio
1952 Ansel Adams Gallery, San Francisco
1955 International Museum of Photography, George Eastman House, Rochester, New York (retrospective)
1957 *Building an Oil Refinery*, San Francisco Academy of Sciences
1960 *California Roadside Council Exhibition*, The Capital, Sacramento, California
Death of a Valley, San Francisco Museum of Art (with Dorothea Lange; travelled to the Oakland Museum, California; Art Institute of Chicago; and the University of California at Davis)
1963 *The Story of a Winery*, Smithsonian Institution, Washington, D.C. (with Ansel Adams; toured the United States)
1964 *Walnut Grove: Portrait of a Town*, San Francisco Museum of Art (with Ruth-Marion Baruch)
1965 American Federation of Arts, Carmel, California (retrospective)
1967 Bay Window Gallery, Mendocino, California
Photography Center, Carmel, California
1968 *Portfolio Two*, California Redwood Gallery, San Francisco
Photographic Essay on the Black Panthers, De Young Museum, San Francisco (with Ruth-Marion Baruch; travelled to the Studio Museum, Harlem, New York; Dartmouth College, Hanover, New Hampshire; and the University of California at Santa Cruz)
1969 Underground Gallery, New York (retrospective)
1970 *Gate Five*, Ikon Gallery, Monterey, California (travelled to the Focus Gallery, San Francisco)
1971 Tintype Gallery, Tiburon, California (retrospective)
1972 *Portfolio Two*, The Studio Gallery, Bolinas, California
1973 The Photography Place, Berwyn, Pennsylvania

Shado' Gallery, Oregon City, Oregon
1977 *Portraits of Adams, Lange, Sheeler, Weston*, San Francisco Art Institute
The Sculpture of Annette Rosenshine, San Francisco Art Institute

Selected Group Exhibitions:

1954 *Perceptions*, San Francisco Museum of Art
1956 *This Is the American Earth*, California Academy of Sciences, San Francisco (and world tour)
1957 *I Hear America Singing*, Kongresshalle, Berlin (travelled to Tokyo)
1959 *Photographer's Choice*, Indiana University, Bloomington
Images of Love, Limelight Gallery, New York
1960 *Photography at Mid-Century*, International Museum of Photography, George Eastman House, Rochester, New York (toured the United States)
1967 *Photography in the 20th Century*, National Gallery of Canada, Ottawa (toured Canada and the United States, 1967-73)
1973 *Octave of Prayer*, Massachusetts Institute of Technology, Cambridge
1975 *The Land: 20th Century Landscape Photographs Selected by Bill Brandt*, Victoria and Albert Museum, London (travelled to the National Gallery, Edinburgh; Ulster Museum, Belfast; and National Museum of Wales, Cardiff)
1979 *Messages from the West Coast: 3*, Photo Gallery International, Tokyo

Collections:

Library of Congress, Washington, D.C.; Art Institute of Chicago; Adams Collection, University of Arizona, Tucson; Amon Carter Museum, Fort Worth, Texas; San Francisco Museum of Modern Art; Oakland Museum, California.

Publications:

By JONES: books—*Portfolio One*, with text by Charles P. Johnson, San Francisco 1955; *Death of a Valley*, with Dorothea Lange, Millerton, New York 1960; *Portfolio Two*, with an introduction by Ansel Adams, Mill Valley, California 1968; *The Vanguard: A Photographic Essay on the Black Panthers*, with Ruth-Marion Baruch, Boston 1970; articles—"House and Home Photography" in *Encyclopedia of Photography*, New York 1957; "Nature Photography XXII" in *Pacific Discovery* (San Francisco), January/February 1967; "In Tandem: Pirkle Jones and Ruth-Marion Baruch," interview with Phiz Mezey, in *Darkroom Magazine* (San Francisco), December 1977.

On JONES: articles—"Pirkle Jones, Photographer" by Ansel Adams in *U.S. Camera* (New York), October 1952; "Pirkle Jones Portfolio" by Nancy Newhall in *Aperture* (Rochester, New York), vol. 4, no. 2, 1956; "Short Run Color" by Minor White in *Image* (Rochester, New York), March 1957; "Pirkle Jones" by Robert Holmes in *British Journal of Photography* (London), 17 October 1980.

I am interested in the single image as an aesthetic expression and in documentary photography. I demand content in my work, and I am not interested in style for its own sake. Examples of my work as single images appear in many publications and collections. *Portfolio Two* are original prints, with a foreword by Ansel Adams, self published in 1968.

Four large bodies of my work have appeared:

1) In 1956 I collaborated with Dorothea Lange on a project in the Berryessa Valley in California. In this rich farm valley homes were being destroyed, people and livestock moved out, trees cut down and burned—everything had to go to make ready for the water that was to come after a large dam was completed. This price for progress was paid for by those who lived in the valley, so that others might have the benefits of more water. This poignant essay is considered an important contribution to photography. Published in *Aperture* and exhibited at the San Francisco Museum of Art, the Art Institute of Chicago, Oakland Museum, California, and the University of California at Davis, this essay appeared as *Death of a Valley*.

2) In 1968 I worked with Ruth-Marion Baruch on the essay called "A Photographic Essay on the Black Panthers." This controversial political essay is on the Black Panther movement in the San Francisco Bay area. We photographed all the top leaders, gatherings, programs and related images of this movement. The exhibition of over 120 photographs was designed and produced by the two of us, shown at the De Young Museum of Art in San Francisco, December 1969 to January 1970, also at the Studio Museum in Harlem, New York, at the Hopkins Center at Dartmouth College, and at the University of California at Santa Cruz. The book, *The Vanguard: A Photographic Essay on the Black Panthers*, was published by Beacon Press in 1970.

3) "Gate Five" is a study of a large houseboat community which lives on the edge of San Francisco Bay in Sausalito, California. This large collection of photographs is in an unpublished form: 44 pages of text and about 125 finished fine prints in the collection of the photographer. Photographs of this alternative lifestyle were made in 1969 and 1970, with a few in 1971. Only small sections of this essay have been exhibited. Six black-and-white photographs from this essay are in the permanent collection of the San Francisco Museum of Modern Art.

4) "The Salt Marsh Series" and "The Rock Series" are two collections of work from nature produced in 1978-79; two additional series of photographs were produced in 1980, "The Tanbark Oak Series" and "The Madrono Series."

—Pirkle Jones

Pirkle Jones: *Garden Detail*, San Francisco, 1947

Although he had exhibited his photographs in pictorial salons before he entered the U.S. Army in 1941, his studies with Ansel Adams and Minor White at the California School of Fine Arts in the late 1940's were decisive influences on Pirkle Jones and his photography. They taught him the technique for which both were to become famous and of which he soon became a master—the production of the full range of tones of which film and paper are capable if exposed and developed according to what has since then become widely known as the zone system. And Adams and White each contributed something more personal to his education, each a different message and each, apparently, equally appealing to Jones's character and temperament. From the example of Adams, the ardent champion of wilderness and park conservation, Jones learned that artistic photographs could also make political statements; from White's work and teaching, he realized how fine an instrument the camera can be for self-exploration and the rendering of personal emotion. The combination of the two, reflecting the oddity of his combined names (Gertrude Stein would have said *induced* by them) have been constant in subsequent years: *Pirkle*, the poet; *Jones*, the social witness.

It is hard to understand, except as a fault in general perception, why his large body of work has not yet received the major recognition that is due it. Perhaps it is his lack of exaggeration. He sees things in their appropriate scale and sense: mountains are not molehills, nor are people isolated zombies. He uses his camera sympathetically, and sympathy is not "exciting" enough for today's jaded taste. His photographs record what a generous temperament as well as a trained eye feels and sees. The style of each photograph is derived from the immediate subject as he experiences it; nothing is stylishly imposed.

His most personally explored subjects have been aspects of the California landscape—wooded and pastured lands, sandy and rocky beaches, plant patterns, and portraits of fellow photographers—Charles Sheeler, Ansel Adams, Edward Weston, Dorothea Lange. His investigations of American, particularly Californian, society have included *Death of a Valley* (with Dorothea Lange), "Walnut Grove: Portrait of a Town" (with his wife, the poet and photographer Ruth-Marion Baruch), and *The Vanguard: A Photographic Essay on the Black Panthers* (also with Ruth-Marion Baruch). Each of these essays includes portraits, architectural details and long views that locate the story. They are combined in a thoughtfully edited sequence to present a powerful interpretation of its subjects. Each is a statement against what the authors considered a social injustice.

Pirkle Jones's most recent project is making photographs on Mount Tamalpais, near his home in Marin County, north of San Francisco. The photographs that he has made so far of the land and growth there, taken at close range, are consistent with his earlier introspective landscapes, and speak as well of his long mastery of photographic form.

—Anita V. Mozley

JONES GRIFFITHS, Philip.

British. Born in Rhuddlan, Wales, in 1936. Educated in local schools; studied pharmacy; self-taught in photography. Worked as a freelance press photographer and cameraman for Granada Television, Manchester. Full-time freelance press and reportage photographer, working *The Observer Magazine, Town, Queen, Look, Life, McCall's, The Sunday Times Magazine*, the *New York Times*, etc., in London, Rhodesia, Zambia, Zanzibar, Vietnam, etc., since 1961. Member, Magnum Photos co-operative agency, Paris and New York. Lecturer in Photography, Royal College of Art, London. Address: c/o Ed Barber, Half Moon Photography Workshop, 119 Roman Road, London E2, England.

Selected Group Exhibitions:

1967 *Photography in the 20th Century*, National Gallery of Canada, Ottawa (toured Canada and the United States, 1967-73)

Publications:

By JONES GRIFFITHS: book—*Vietnam Inc.*, New York 1971; article—"Philip Jones Griffiths," interview, with Andrew de Lory, in the *British Journal of Photography Annual*, London 1975.

On JONES GRIFFITHS: books—*Photography in the 20th Century* by Nathan Lyons, New York 1967; *America in Crisis: Photographs for Magnum*, edited by Charles Harbutt and Lee Jones, with an essay by Mitchel Levitas, New York 1969; *War*, edited by A.R. Leventhal, New York 1973; *The Magic Image* by Cecil Beaton and Gail Buckland, London and Boston 1975; *Geschichte der Fotografie im 20. Jahrhundert/Photography in the 20th Century* by Petr Tausk, Cologne 1977, London 1980; *The Camera at War* by Jorge Lewinski, London and New York 1978; articles—"Philip Jones Griffiths" in *Modern Photography Annual*, New York 1972; "Vietnam Inc.: Philip Jones Griffiths" by S. MacPherson in the *British Journal of Photography* (London), 17 March 1972; "Philip Jones Griffiths: Vietnam Inc." in *Zoom* (Paris), June/July 1974.

Philip Jones Griffiths was born in a small village in Wales in the same year as *Picture Post*. *Picture Post* and *Illustrated* were his window on the world while he was growing up, and brought him to dream of being a photographer. He studied pharmacy ("counting pills", he calls it) and thought about becoming a freelance, and *Picture Post* and *Illustrated* closed down. Thus he lost his most suitable potential market before he'd even started. Nevertheless, Jones Griffiths did eventually stop counting pills and start freelancing, going full time in 1961. He worked for most of the prestigious picture magazines and travelled the world shooting stories. Eventually he wound up in Vietnam, where he spent about three years from July 1966 to June 1968 plus 1970.

Early on he realized he was not going to sell many of his Vietnam pictures, as the American press was still "gung ho" about the war. However, he had a lucky break when he photographed Jackie Kennedy for a week in Cambodia and the rival Black Star films were sent to Manila by mistake. That left the field clear for him and he made money. He used it to help finance his Vietnam photography, with the idea of eventually publishing it as a book.

Vietnam was a wonderful war for photographers in terms of the cooperation they got in taking their shots. However the media still controlled what was published, and for them it had two main overlapping phases. First there was the war as morally-uplifting, supreme spectacle, with the soldiers as the representatives of freedom showing such positive qualities as courage and valour. (David Douglas

Duncan had established this genre with his book on Korea, *This Is War*.) As horror was piled on horror and the public became numbed to the violence, this shaded into a second phase where more and more sensational pictures were published, essentially glorifying horror and mindless violence—until revulsion finally set in. (Duncan's Vietnam book was *War Without Heroes*.)

In both these phases, the war was seen from the point of view of the American soldier, and that was not how Philip Jones Griffith saw it at all. He put the war in the context of how it must look to an ordinary Vietnamese peasant, in the light of the country's history and culture. It must have very quickly become clear to him that the American involvement was doomed to failure, and he methodically photographed the processes by which that failure was to become more and more evident. The resulting pictures—with an essential text—were published as a book, *Vietnam Inc.*, in 1971.

Vietnam Inc. is certainly the most powerful book about the Vietnam war, and probably the best book about any war anywhere. On its publication it must have come as a bombshell to any American readers who were still pro-war, and certainly it provided the anti-war movement of the time with some of its most rational, sensitive and intelligible arguments against continuing the fighting. The book probably saved lives, and would probably have saved more if it had been more widely disseminated. It is the one book that neither glorifies the fighting, nor concentrates on the savagery and horror of the results. It is the one book that shows the utter vulnerability of the Vietnamese in the face of the superior American firepower, yet shows how the underlying resilience of their culture would win out against anything less than total genocide. It was, it is, a great work of humanity, and with every year that passes the essential rightness of Jones Griffiths' judgement becomes more and more clear.

In his excellent book *The Camera at War*, Jorge Lewinski describes it thus: it gives "a balanced viewpoint...a comprehensive, profound image of the totality of war, the way it affects soldier and civilian alike, the way the two become intertwined and together create the environment of a country at war. *Vietnam Inc.* is in the nature of a diary, but also a dissection of war into its various segments. Layer after layer, the facets of the war, the groups of people connected or affected by it, are uncovered and magnified under Griffiths' lens. The country, the village, its inhabitants; the American war machine, its origins, operation, constituent parts, its human elements of soldiers and administrators—the interactions and relationships between the cultures of east and west, corruption, graft, drug-taking, prostitution; the degeneration of the soldiers; the misery of the people; the devastation; the slaughter. Griffiths's book has been skilfully assembled—its effect is cumulative; the visual narrative becomes sadder and grimmer as the story progresses. It begins with almost gay pictures of a beautiful, serene Vietnamese village and ends with shattering images of a shattered people, maimed or thrust into insanity by degradation and the constant fear of death.... The book is a great documentary on war in its distressing totality."

Within this structure there is a great variety of pictures of many and various subjects, and they all work to the final end, the impact of the book. To pick out one or two for mention is rather like picking phrases out of a poem—ultimately meaningless. However, there are some pictures embedded in *Vietnam Inc.* that, on their own, are among the most emotionally powerful and memorable war pictures ever published in that they neither glamourize war nor do they work simply by shocking, in the sense of being gruesome to look at. It is the psychological impact, the emotional content, that is significant.

One picture shows a soldier sitting in an ornate chair, with his feet up on a window with his gun pointing out into the street. Clearly he is prepared to shoot anything that moves. Underneath his chair is a

child's naked, broken doll. Another picture of a dark interior shows two soldiers about to rape a Vietnamese girl. One of the men has his mouth open as though about to bite, and the girl has twisted her head away. Like many of Jones Griffiths' pictures it is full of vital detail, like the sunglasses left on the bed and the wedding ring on the soldier's hand. A third picture shows a figure holding a terrible hand up to a face that is completely covered in bandages. A label tied to the wrist carries the words "VNC FEMALE".

Philip Jones Griffiths has taken many fine war pictures in countries as different as Vietnam, Israel and Northern Ireland. All have deserved a better showing in the national press than they have received. Hopefully, however, he will not produce another book like *Vietnam Inc.*, because no "end" can ultimately justify means that deserve this kind of treatment from a great photographer.

—Jack Schofield

JONSSON, (Olof) Sune.

Swedish. Born in Nyåker, Västerbotten, 20 December 1930. Studied English, literature and ethnology at the University of Stockholm, and the University of Uppsala, B.A. 1961; mainly self-taught in photography. Married Stina Mobrink in 1959. Photographer since the early 1950's. Editor, Swedish Broadcasting company, Umeå, 1962-65; freelance editor/photographer, working on photo-documentary projects, for the LT Publishing Company, Stockholm, 1966-70. Part-Time Photographer, Västerbottens Museum, Umeå, since 1968. Recipient: Författarstipendium, 1965; Svenska Turistföreningens Silverplakett, 1970; Samfundet de Nios Stora Pris, 1972; Kungliga Vetenskapsakademien Award, 1973; Tidskriften Fotos Stora Fotografpriset, 1980; Kungl. Gustav Adolfs Adademien Award, 1981. Address: Skolgatan 30, S-902 46 Umeå, Sweden.

Individual Exhibitions:

1960 *Inpå livet*, Bankpassagen Gallery, Hötorgscity, Stockholm (travelled to the Nutida Konst Gallery, Uppsala, and the Kopparhatten Gallery, Umeå, 1961)
1962 *Den stora Flyttningen*, Västerbottens Museum, Umeå (travelled to the Norrbottens Museum, Luleå, Sweden, Stadsmuseet, Sundsvall, Sweden and the Värmlands Museum, Karlstad, Sweden)
1965 *Kongo*, Västerbottens Museum, Umeå (travelled to the Dalarnas Museum, Falun, Sweden)
1968 *Prag Augusti 1968*, Västerbottens Museum, Umeå (toured Sweden)
1975 *Landskap och Redskap*, Västerbottens Museum, Umeå
1980 *Dagar vid havet*, Västerbottens Museum, Umeå (travelled to Gallery 1 x 1, Helsingborg)

Selected Group Exhibitions:

1962 *Svenskarna Sedda av 11 Fotografer*, Moderna Museet, Stockholm
1978 *Tusen och en bild*, Moderna Museet, Stockholm
1979 *Svenskt landskap*, Moderna Museet, Stockholm

Collections:

Västerbottens Museum, Umeå; Moderna Museet, Stockholm.

Publications:

By JONSSON: books (photographs and text, unless noted)—*Byn med det blå huset*, Stockholm 1959, 1972; *Timotejvägen*, Stockholm 1961; *Hundhålet*, short stories, Stockholm 1962; *Bilder av Nådens barn*, Stockholm 1963; *Utmark*, with verse by Sigvard Karlsson, Stockholm 1963; *Bilder från den stora flyttningen*, Stockholm 1964; *Bilder av Kongo*, Stockholm 1965; *Torpet Åsen på Brännsjöskogen*, with drawings by Kurt Sundberg (text by Jonsson), Solna, Sweden 1965; *Sammankomst i elden*, Stockholm 1966; *Bilder från bondens år*, Stockholm 1967; *Prag, Augusti 1968*, Stockholm 1968; *Saltlake och blodvälling* by Lisa Johansson (edited by Jonsson), Stockholm 1968; *Brobyggarna*, novel, Stockholm 1969; *Minnesbok över den svenske bonden*, Stockholm 1971; *Stationskarl Albin E. Anderssons minne*, novel, 1974; *Karl Lärkas Dalarna*, editor (also wrote introduction), Stockholm 1974; *Jordabok*, Stockholm 1976; *Örtabok*, Stockholm 1979; *Dagar vid havet*, Stockholm and Helsingborg 1981; *Om sommaren om hösten bittida sent*, verse by Bo Johansson, Stockholm 1981; articles—"Populärt eller dokumentärt" in *Populär Fotografi* (Helsingborg), no. 10. 1968; "Om fotografen Olof Perssons Storhet" in *Konstrevy* (Stockholm), no. 44, 1968; "Tankar om den dokumentära metoden" in *Populär Fotografi* (Helsingborg), no. 2, 1970; "Nio funderingar kring 125-delen" in *1000 och en bild*, Stockholm 1979.

On JONSSON: books—*Fotografisk Årsbok* by Kurt Bergengren, Stockholm 1960; *Bländande bilder* by Leif Wigh, Stockholm 1981; *Fotograferna och det svenska landskapet* by Leif Wigh, Stockholm 1982; articles—"Sune Jonsson" by Pär Rittsel in *Foto* (Stockholm), no. 1, 1981; "Dokumentärfotografens arbete" by Sverker Sörlin in *Vertex* (Umeå), no. 5, 1981; "Ivar Lo är min chefsideolog" by Sverker Sörlin in *FIB/Kulturfront* (Stockholm), no. 18, 1981.

As an ethnologist it is my wish to mediate to contemporary and future readers of my books and pictures the people of my own province, Västerbotten in northern Sweden, their environment, way of living, their economic, religious and social conditions and above all to depict the life of such minorities that have got into a scrape, are being slowly ruined and in the end disappearing from the social scene because of new economic structures and values. With my photographs, short stories and novels I want to make better situated groups in society understand and value those who are not so well off, established and vigorous. The ultimate purpose (I am a museum official) is of course to give future generations (even if imperfect and rhapsodical) an account of some of the ways of living and working in my own time.

—Sune Jonsson

In 1959 Sune Jonsson made his debut with a book about a town in northern Sweden, which became something of a milestone in Swedish photographic literature. Its format was unpretentious, but it was full of pictures the like of which were at that time rare in Sweden. People with a knowledge of photographic history might well see certain similarities with the pictures of the F.S.A. photographers of the United States in the 1930's and with August Sander's pictures of Germany between the wars. Furthermore, the sensitive stories in the book were of a quality not normally found in photographic books, and the captions were in themselves small poems— limpid in formulation and concise in style.

Sune Jonsson thus established his individuality right from the start, by mastering pictorial as well as written language. The pictures were made with tenderness and showed the simple, quiet life of sparsely populated northern Sweden. As well, the concentration on a limited area and on a few people set this book apart from the very different "tourist picture" books, that were popular at the time. Here the spectator came close to ordinary Swedes, and behind the everyday exterior he found strong personalities whose changing fortunes were brought to life by the text. In these life-stories there is always a central truth, on which the author spins his tale, freely and subjectively. At times the biographies are developed into whole stories. An interesting combination of fact and fiction.

Sune Jonsson's photographic method was soon imitated widely by Swedish amateur photographers.

Sune Jonsson: *Former State Crofter Leo Abrahamsson with Wife Olga*, Retreat Housing, Norra Tresund, Vilhelmina, 1961

Pictures of immobile, sitting people became numerous in competitions and exhibitions. But in his subsequent books Sune Jonsson showed that he also had the observant press photographer's ability to capture sudden events. The static style of the first book had been determined by its subject: that many old people, for various reasons, are forced into a life of inactivity.

In the early 1950's Sune Jonsson had made pictures of the type which dominated the photo-club movement of the day: car tracks in snow and graphic forms. But his interest in documentary pictures was awakened by the now famous 1955 exhibition *The Family of Man*. In a manifesto he talks of a pictorial language that should be comprehensible to hairdressers and car mechanics. He talks ironically about the photo-clubs' competition photos, their discussions about technique and theories of composition.

After his first book he produced another twelve, in addition to his work as a field technician at the Västerbotten Museum in Umeå, which includes film as well as photography. About the former he has said in an interview: "Film is vastly more documentary. While the still photograph represents a moment caught accidentally and subjectively, film can reproduce a precisely defined passage of time."

In 1979 Sune Jonsson published a colour book of flora. For 1981-82 he plans another colour book of flowers, a book with pictures of coastal landscapes, illustrations to a book of poetry and a new novel. He is a versatile person, who is able to unite poetical nuances with objectivity.

—Rune Jonsson

JOSEPHSON, Kenneth.

American. Born in Detroit, Michigan, 1 July 1932. Educated at Eastern High School, Detroit, 1948-50; Rochester Institute of Technology, Rochester, New York, 1951-53, 1955-57, B.F.A. 1957; Institute of Design, Illinois Institute of Technology, Chicago, under Harry Callahan and Aaron Siskind, 1958-60, M.S. 1960. Served in the United States Army, 1953-55. Married Carol Compeau in 1954 (died, 1958); Sherrill Petro in 1960 (divorced, 1972); and Sally Garen in 1973 (divorced, 1978); children: Matthew, Bradley, and Anissa. Photographer, Chrysler Corporation, Detroit, 1957-58. Freelance photographer, Chicago, since 1958. Professor, School of the Art Institute of Chicago, since 1961. Exchange Teacher, Konstfackskolan, Stockholm, 1966-67; Associate Professor, University of Hawaii, Honolulu, 1967-68; Visiting Professor, Institute of Design, Illinois Institute of Technology, 1969, Rhode Island School of Design, Providence, 1973, University of Minnesota, Minneapolis, 1974, and Tyler School of Art, Temple University, Philadelphia, 1975. Recipient: Guggenheim Fellowship, 1972; National Endowment for the Arts Grant, 1975, 1979. Agents: The Workshop Gallery, Visual Studies Workshop, 31 Prince Street, Rochester, New York 14607; and Young Hoffman Gallery, 215 West Superior Street, Chicago, Illinois 60610. Address: 2648 West 21st Place, Chicago, Illinois 60608, U.S.A.

Individual Exhibitions:

1966 Konstfackskolan, Stockholm
1971 Visual Studies Workshop, Rochester, New York
 Art Institute of Chicago

1973 State University of New York at Buffalo
 University of Rochester, New York
 Nova Scotia College of Design, Halifax
1974 291 Gallery, Milan
 University of Iowa, Iowa City
 College of Marin, Kentfield, California
1976 Cameraworks Gallery, Los Angeles
 Galerie die Brücke, Vienna
1977 Purdue University, Lafayette, Indiana
 Barat College, Lake Forest, Illinois
1978 Ulrich Museum of Art, Wichita, Kansas
 Neuberger Museum, Purchase, New York
 University of Southern Illinois, Carbondale
 Fotoforum der Gesamthochschule, Kassel, West Germany
 Gallery Sansmon, Moncton, New Brunswick
1979 P.P.S. Gallery, Hamburg
 The Photographers' Gallery, London
 Open Eye Gallery, Liverpool
1981 Young Hoffman Gallery, Chicago (with sculptor Bruce Nauman)
1982 Northwestern University Gallery, Evanston, Illinois (retrospective)
 Photo Gallery, Orange Coast College, Costa Mesa, California

Selected Group Exhibitions:

1964 *The Photographer's Eye*, Museum of Modern Art, New York
1967 *Photography in the 20th Century*, National Gallery of Canada, Ottawa (toured Canada and the United States, 1967-73)
1973 *Contemporanea*, Parcheggio Villa Borghese, Rome
1977 *The Photographer and the City*, Museum of Contemporary Art, Chicago
 Painting in the Age of Photography, Kunsthaus, Zurich
1978 *Spaces*, Rhode Island School of Design, Providence
 Tusen och En Bild/1001 Pictures, Moderna Museet, Stockholm
 Mirrors and Windows: American Photography since 1960, Museum of Modern Art, New York (toured the United States, 1978-80)
1979 *American Photography*, Art Institute of Chicago

Kenneth Josephson: *Polapan*, 1973

1980 *A New Vision*, Light Gallery, New York

Collections:

Museum of Modern Art, New York; Joseph E. Seagram and Sons, New York; International Museum of Photography, George Eastman House, Rochester, New York; Museum of Fine Arts, Boston; Rhode Island School of Design, Providence; Art Institute of Chicago; Museum of Fine Arts, Houston; University of New Mexico, Albuquerque; Center for Creative Photography, University of Arizona, Tucson; University of California at Los Angeles; Bibliothèque Nationale, Paris.

Publications:

By JOSEPHSON: books—*The Bread Book*, Chicago 1973; *Portfolio: Kenneth Josephson*, with an introduction by Alex Sweetman, Louisville, Kentucky 1975; *Underware*, portfolio, with others, Chicago 1976; *Kenneth Josephson*, postcard portfolio, New York 1980.

On JOSEPHSON: books—*Photography Yearbook*, Stockholm 1968; *Looking at Photographs* by John Szarkowski, New York 1973; *The Photographer's Choice*, edited by Kelly Wise, Danbury, New Hampshire 1975; *The Photographer and the City*, exhibition catalog, by Gail Buckland, Chicago 1977; *Spaces*, exhibition catalogue, by Diana L. Johnson, Providence, Rhode Island 1978; *Chicago: The City and Its Artists 1945-1978* by Diane Kirkpatrick, Ann Arbor, Michigan 1978; *Mirrors and Windows*, exhibition catalogue, by John Szarkowski, New York 1978; *Kenneth Josephson: The Illusion of the Picture*, exhibition catalogue, by Floris Neusüss, Kassel, West Germany 1978; *Nude: Theory*, edited by Jain Kelly, New York 1979; articles—"New American Imagery" in *Camera* (Lucerne), May 1974; "Reading the Bread Book" by Alex Sweetman in *Afterimage* (Rochester, New York), March 1974; "Photos Within Photographs" by Max Kozloff in *Artforum* (Oakland, California) 14 February 1976.

The heart of my method is this: a clue from one photograph leads to an idea for another. At times the subject matter suggests a method of working and vice versa. Sometimes I seek out some specific sub-

ject matter with a planned picture in mind, but as I become involved with the subject a very different picture may result.

While attempting to resolve an idea, I can never predict which source will supply the clue necessary for its completion. This clue might be furnished by the form and movement of the subject, a type or quality of light observed, an unrelated image viewed somewhere, some music, or a few words read or heard. The best procedure for me to follow is to involve myself completely with a number of problems, then move from one to another, and return to each for the purpose of re-evaluation. Time lapse is the most important factor in this procedure.

Many of my photographs are about the medium of photography, about how photography works. I have a group of images called the "History of Photography Series," which I began about 1970, and to which I've been adding every since. In the "History Series" I sometimes make a picture in the style of another photographer. Sometimes the subject matter, by itself, carries the idea of someone's work. Then, too, many of the photographs have to do with photographic processes or historical movements; these are images that make a kind of off-handed reference to the evolution of the medium.

I would like to point out that I approach some of my work from a somewhat humorous point of view. I think that's been lacking in the history of photography. It's all too serious. Ultimately, my aim is to make a visual statement rather than a verbal statement about our medium because I think it is an important thing to do.

—Kenneth Josephson

The idea of making photographs about photography is a vital one that has taken numerous forms in the last two decades. The work of Kenneth Josephson examines the act of picture-making and the inherent paradox of photographic representation with humor and wit. From the fact that photographs are illusionistic representations of the exterior world, Josephson extracts comments upon the nature of that illusion and upon the relationship of the object to the object photographed. The automatic tendency of photographs to flatten space and the dissolution of scale when objects are juxtaposed are the basis of Josephson's most successful and widely reproduced images. Josephson describes the range of his pictures when he says, "My work is about the following: expressions of visual ideas made possible by the photographic medium; the special reality of photographs; humor and surrealism; chance and accident; manipulative photography; snapshots."

The pictures in which he uses already existing photographs address the issue of different levels of reality that can be represented at one time, on the same plane. Sometimes Josephson approaches the problem with utter simplicity as in his photograph of a brick wall with a picture of bricks taped to its center. There is no spatial illusion here; in the paucity of elements, one is drawn to the accuracy of scale reproduction between the bricks and the photograph of bricks and to the breakdown in the illusion, where a corner of the photo peels up off the wall, calling attention to its two-dimensional existence. However simple the concept, its illustrations are rich with variations in perspective, scale, illusionistic effect. A hand holds out a postcard view of a castle in Drottningholm, Sweden, comparing it to the actual castle, and despite radical shifts in scale, we have no trouble reading the image for what is going on. Josephson examines what we take for granted—the peculiarity of photographic language, and his point is not that photos lie but that the syntax of the language breaks down, flies apart, and yet still communicates. As Marshall McLuhan noted, photographs and pictures are the means whereby we know the world; one can hardly imagine what it would mean to be a visual illiterate. Thus, a picture of a ship sitting on the horizon of a "real" ocean signals no communication gap whatsoever.

Josephson diagrams this language further in his images that employ the vocabulary of snapshots. A shadow of a man appears to be holding a baby who is really lying on the ground. Taking the classic "mistakes" of amateur photographers, Josephson gives new artistic purpose to misjudged cropping, unsuspected shadows, and centrally placed compositions.

Many of the photographs employ two distinct modes of language, which may confound the meaning of the statement but, remarkably enough, do not confuse the viewer of the photograph. Josephson often uses the device of a hand intruding into the frame from the lower left—a pointing gesture, communication on its most rudimentary level, and yet this hand often holds a measuring tool, signalling the precise, sophisticated language of mathematics. However ludicrous we know the idea to be of measuring the Tetons with a twelve-inch ruler, Josephson makes some sense of it by reducing the comparison between the mountain range and a map of the mountain range to the two-dimensional space of a photograph. Any tourist who has ever photographed a companion holding up the tower of Pisa knows the gag, but Josephson has removed the gag to the realm of art photography and imbued an old joke with new meaning in terms of the medium and how we read it.

On many occasions photographers have expanded our appreciation of the world by looking more closely at something we usually ignore; Josephson continues in that tradition, not necessarily by examining the banal detail, but by taking apart the convention whereby we read and understand the visual documents of the physical world.

—Dana Asbury

JOYCE, Paul.
British. Born in Winchester, Hampshire, 27 December 1940. Educated at Dulwich College, London, 1950-59. Married Stevie Bezencenet in 1975; daughter: Katherine. Freelance photographer, London; also, writer and director of films, plays and television plays. Agent: Witkin Gallery, 41 East 57th Street, New York, New York 10022, U.S.A. Lives in London. Address: c/o Fraser and Dunlop (Scripts) Ltd., 91 Regent Street, London W1R 8RU, England.

Individual Exhibitions:

1977 *Welsh Landscape*, Photographic Gallery, University of Southampton
1978 *Elders*, National Portrait Gallery, London
Landscape, Galleria Il Diaframma, Milan
1980 *From Edge to Edge*, Photographic Gallery, Cardiff

Selected Group Exhibitions:

1974 *New Photography*, Midland Group Gallery, Nottingham
1977 *Summer Show 4*, Serpentine Gallery, London
1978 *Singular Realities*, Side Gallery, Newcastle upon Tyne
Faces and Facades, Institute of Contemporary Arts, London
1979 *9 Contemporary Photographers*, Witkin Gallery, New York
The Native Land, Mostyn Gallery, Llandudno, Wales
Portraits, at *SICOF*, Milan
1980 *British Art 1940-1980*, Hayward Gallery, London
Contempoorary British Photographers, Adelaide Festival of the Arts, Australia

Collections:

National Portrait Gallery, London; Victoria and Albert Museum, London; Tate Gallery, London; Department of the Environment, London; Welsh Arts Council, Cardiff; Bibliothèque Nationale, Paris.

Publications:

By JOYCE: book—*From Edge to Edge*, with essays by Jonathan Williams and Ian Jeffrey, Cardiff and London 1981; articles—in *British Journal of Photography* (London), 19 November 1976; "Wider Still" in *Amateur Photographer* (London), 23 February 1977; "The Photographic Scene in London" in *Contemporary Review* (London), May 1978; "Questioning Landscape: On the Nature of Landscape Photography in General and the Work of Paul Joyce in Particular," interview, with Ainslie Ellis, in *British Journal of Photography* (London), 25 April 1980.

On JOYCE: books—*Summer Show 4*, exhibition catalogue, by Aaron Scharf, London 1977; *Singular Realities*, exhibition catalogue, by Gerry Badger, Newcastle upon Tyne 1978; *Perspectives on Landscape*, edited by Bill Gaskins, London 1978; *9 Contemporary Photographers*, exhibition catalogue, New York 1979; *Photography Year Book 1979*, London 1979; *The Arts Council Collection*, catalogue, by Isobel Johnstone, London 1980; articles—in *Fotografia Italiana* (Milan), June 1977; "Elders" by Walter Nurnberg in *British Journal of Photography* (London), 20 January 1978.

There is a primal human response to light, verging on the organic. Eyes, limbs, emotions move towards it. We bathe in it. Small wonder that artists struggle

Paul Joyce: *Elements: The Foothills of Snowdon*, 1976

to capture its special qualities. For the photographer, who uses light as a constant tool in trade, the frustrations and rewards can be equally intense. Certain fine prints transmit light so brightly that it is painful to gaze at the source. Perhaps this is the reason so many photographers, who hate darkrooms, spend so much time in them. We practice alchemy with a cold light, and with fine silver as the ultimate goal.

—Paul Joyce

Paul Joyce began his working life in the Bank of England, became a film director, a theatre director, a writer of television plays, and a still photographer. Recently he directed four episodes of "Dr. Who" for the BBC. When it comes to photography, Paul Joyce told Ainslie Ellis in the *British Journal of Photography* (25 April 1980) that he was more interested in writers like Graham Greene and Thomas Hardy and Father G.M. Hopkins than in photographers. (He will speak only of Paul Nash and Bill Brandt.) He is divorced, has a venerable Morris Minor, has a conservative demeanour, and lives in the Borough of Chelsea in London.

Someone recently sent me a list of what he considered the purposes of reportorial prose: to entertain, amuse, assess, shed light, inform, pay homage and encourage thought. Most members of the Literary Merchants Sodality seem to "sink to the occasion" and write (very difficultly) about themselves only, offering little response to what they are supposedly considering. If you write about Harry Callahan's photography, then write as clear as a bell and light as a syllabub. His work *is light*—in all its engaging senses.

From this desk in the library at Corn Close, I regularly look out across the valley of the River Dee to a cluster of Scotch pines in a field of grass. The light in Dentdale, Cumbria is unusually dim and the pines are inconspicuous and unremarkable. But, let the late sun shine its rays up the dale—particularly in a month like October—and the trees become transfigured, with the forms of the foliage and the trunks and those of the elongated shadows endlessly fascinating to the eye. The air is as cool and palpable as amber. Everything is seen "in a new light." Which is what Paul Joyce's photographs are about—a turn-on, as they say.

Paul Joyce has photographed the landscape in Wales extensively, and also in Lancashire, and, recently, in Cumbria. He writes about light in his statement above. He says another useful thing: "I seldom think about photography, except when I'm doing it, and not much then, come to that. Life goes on around the camera, and you can't capture it all,

not even with a panoramic."

An obviously active and attentive man. The mountains and the remote valleys should consider themselves lucky. To give Paul Joyce a last quote: "Have you ever noticed how we are much more concerned with people who ignore us, than those who listen to us with different degrees of intensity? I am obsessed with nature, for it never fails to offer me sublime indifference."

—Jonathan Williams

JUMONJI, Bishin.

Japanese. Born in Yokohama in 1947. Educated at Technical High School, Kanagawa; Technological Institute, Institute for Industrial Design, Kanagawa Prefectural Industrial Science School. Worked as assistant to photographer Kishin Shinoyama, Tokyo, 1969-71. Freelance photographer, Tokyo, since 1971. Recipient: Tokyo Art Directors Club Prize, 1975. Address: 7-12-28 Roppongi, Minato-ku, Tokyo 106, Japan.

Individual Exhibitions:

1977 Canon Photo Gallery, Amsterdam
 La Photogaleria, Madrid
1978 Galleria Il Diaframma/Canon, Milan

Selected Group Exhibitions:

1973 *Photos Selected by Critics*, Neikrug Gallery, New York
1974 *New Japanese Photography*, Museum of Modern Art, New York (toured the United States)
1977 *Neue Fotografie aus Japan*, Kulturhaus, Graz, Austria (toured Europe, 1977-79)
1978 *Rencontres Internationales de la Photographie*, Arles France
1979 *Japanese Photography Today and Its Origin*, Galleria d'Arte Moderna, Bologna (travelled to Palazzo Reale, Milan; Palais des

Beaux-Arts, Brussels; and Institute of Contemporary Arts, London)

Publications:

On JUMONJI: books—*New Japanese Photography*, exhibition catalogue, by John Szarkowski and Shoji Yamagishi, New York 1974; *Neue Fotografie aus Japan*, exhibition catalogue, by Otto Breicha, Ben Watanabe and John Szarkowski, Graz and Vienna 1977; *Japanese Photography Today and Its Origin*, exhibition catalogue, by Attilio Colombo and Isabella Doniselli, Bologna 1979; article—"Bishin Jumonji" in *Zoom* (Paris), June 1981.

Photography is a great medium for jokes—usually mildly surrealistic and based on visual puns; but, as is usually the way with puns, the joke tends to wear thin very quickly, even when it is not downright embarrassing. Photographers with a real sense of wit or humour are rare birds indeed. In the present context of Japanese photography, where so many are struggling with intense seriousness to come to terms with Western intellectual theory and the international avant-garde, or to recapture a rapidly-disappearing sense of national past, the amazing fantasies of Bishin Jumonji are doubly welcome. Despite his comparative youth, Jumonji is already established as a stylish humorist who deserves to be taken seriously.

Jumonji succeeds with his fantasies largely because of his attention to detail and willingness to take creative risks. His underwater picture of a naked girl on a bicycle and two men in business suits and goggles—one nonchalantly reading a newspaper—could easily have had the air of one of the more portentous 60's happenings. It is saved by the obvious humour with which the scene has been staged, the sense that everyone is enjoying the joke (confirmed by the grin on the girl's face), and the expertise of the actual photography.

To be convincing, and thus amusing, the fantasy has to be presented with the high-gloss polish of advertising—which itself depends on fantasies of a slightly different kind. Set-ups such as this, or Jumonji's photograph of a manically-miming guitarist in a subway train, or a boxer hurtling crazily backwards out of the ring toward a crouching group of pressmen, are the products of considerable resources in terms of time, energy, equipment and people. They turn the advertising world on its head, using its skills and techniques to express funny and cheerful fantasies that make serious points about life.

—Tom Evans

KALISHER, Simpson.
American. Born in New York City, 27 July 1926.
Educated at Christopher Columbus High School,
Bronx, New York, 1939-43; Indiana University,
Bloomington, 1943-44, 1946-48, B.A. in history
1948; self-taught in photography. Served as an
infantryman in the United States Army, in Ger-
many, 1944-46: Corporal. Married Ilse Kahn in
1954 (divorced, 1968); son: Jesse; married Colby
Harris in 1968; children: Amy, David and Allon.
Freelance photographer, New York, since 1948.
Teacher of Photography, School of Visual Arts,
New York, since 1980. Agent: Witkin Gallery, 41
East 57th Street, New York, New York 10022.
Address: Roxbury, Connecticut 06783, U.S.A.

Individual Exhibitions:

1961 Image Gallery, New York
1962 International Museum of Photography,
George Eastman House, Rochester, New
York
1963 Art Institute of Chicago
1980 Voltaire Gallery, New Milford, Connecticut

Selected Group Exhibitions:

1951 *Young Photographers*, Museum of Modern
Art, New York
1958 *Photography at Mid-Century*, International
Museum of Photography, George East-
man House, Rochester, New York (toured
the United States)
1964 *Four Directions in Photography*, Albright-
Knox Art Gallery, Buffalo, New York
1967 *History of the Picture Story*, Museum of
Modern Art, New York
1968 *Harlem on My Mind*, Metropolitan Museum
of Art, New York
12 Photographers of the Social Landscape,
Poses Institute, Waltham, Massachusetts
1975 *Photography in America*, Whitney Museum,
New York
1978 *Discovering America*, Art Institute of
Chicago
Photography as Social Literature, Farming-
ham Valley Arts Center, Avon, Connecti-
cut
*Mirrors and Windows: American Photog-
raphy since 1960*, Museum of Modern
Art, New York (toured the United States,
1978-80)

Collections:

Museum of Modern Art, New York; International
Museum of Photography, George Eastman House,
Rochester, New York; Art Institute of Chicago.

Publications:

By KALISHER: books—*Railroad Men: Photo-
graphs and Collected Stories*, with an introduction

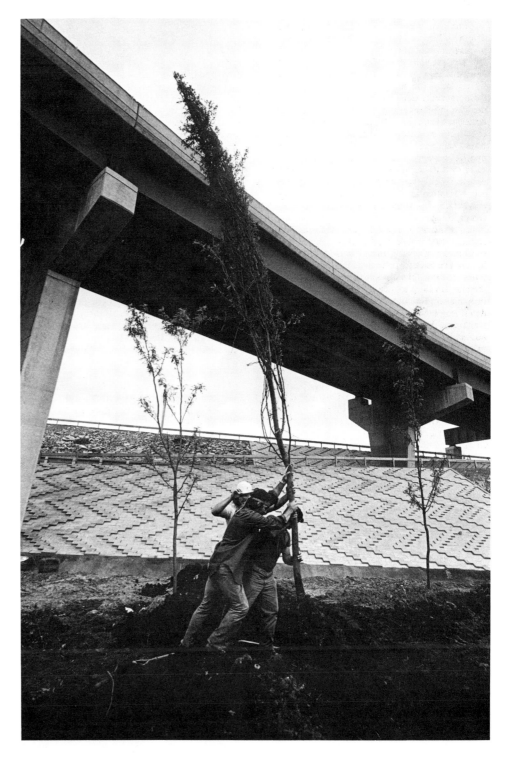

Simpson Kalisher: *Untitled,* 1972

by Jonathan Williams, New York 1961; *Propaganda and Other Photographs*, with an introduction by Russel Baker, and afterword by Allen Schoener, Danbury, New Hampshire 1977; illustrations for *Clinical Sociology* by Glassner and Freedman, New York and London 1979.

On KALISHER: books—*12 Photographers of the American Social Landscape* by Thomas H. Garver, New York 1967; *Photography in America*, edited by Robert Doty, with an introduction by Minor White, New York and London 1974; article—"Book Review: Railroad Men" by Hugh Edwards in *Infinity* (New York), March 1962.

Putting into words what I try to put into pictures is like asking a dancer to perform ankle deep in mud. Oh, it is so labored.

I think I got some of my meaning into the epilogue of *Railroad Men*: Photography is "more than the imagery produced on paper." I am less concerned with tickling the silver granules into standing at attention, saluting me as their master and conquerer, than I am with relating to the concepts the photograph represents. One can master the technical skills in photography quite early, but how to incorporate one's growth and maturity into the work is the ongoing challenge. *Propaganda* is not simply "another" book, or even a "better" one. In my view it is a more mature one.

My third book shall be different again; the pictures are of trees and the text will be taken from several dreams I have had about being a photographer. I worry about this project. Trees are so corny, and I suspect my narrative will be a downer. But it's as if my books are sequenced to show an ever-widening insight into photography, into the world and into myself. I feel I must do book three before I can go with the fourth. Yes, there are other projects I would like to get into, and I look forward to them with some joy. All of this while I maintain a fairly active professional career unconcerned with such introspections.

—Simpson Kalisher

Simpson Kalisher works out of his studio in Roxbury, Connecticut and makes a living from commercial jobs. To paraphrase Dr. Samuel Johnson: "Any man who takes photographs for reasons other than money is a fool." The only problem is that Kalisher's job-work has tended to obscure the fact that he is a fine ironist and political satirist with a camera, and that he is quite as much of an "art" photographer as, say, Robert Frank. Another problem that follows on from this, now that I think of it, is that it is hard to see many of his prints. He is not on view in many of the galleries where such excellent work might be expected.

Back in the early 1960's I wrote a note for his first book, *Railroad Men*, a sequence of photographs and prose vignettes, an extremely honest and discrete series of observations of an old-fashioned brotherhood of American working men. I liked the way Kalisher saw these (mostly) elderly men as practising a vocation, and that vocation carried with it the idea of service to the body politic. "The conductor and the Pullman porters have that inevitability of presence that the canon and acolytes of a cathedral have. They wear their vestments as a blazon of belief in what they are doing. It is completely tacit."

Kalisher's second book, *Propaganda* (my copy is unfortunately on a mountain in North Carolina while I sit here writing a few words in the Cumbrian Dales) is another matter: social comment, if you like. Plenty of wit and plenty of vitriol. A dark look at our parlous republic. Dark, but not sour. There is an admirable quiet and solemnity in the way Simpson Kalisher sees things. What makes me again think of Robert Frank is the fact that Kalisher is never some tub-thumping Marxist hack. He is never short on "pictorial values," though this is getting to

be a sin in some critical quarters, particularly amongst those criticasters who can't hit the floor with their hat as regards literary values.

Mature photographers, unlike aging violinists, do not lose their tone. We need more books from Simpson Kalisher and more attention for a distinguished body of work. Can we afford to ignore photographers this good? We ignore pianists as stylish as Herbie Nichols. Yet, some of us fans vaguely remember "Piano Legs" Hickman, who committed no fewer than 91 errors while playing third base in 118 games for the New York Giants during the season of 1903. A funny country we live in.

—Jonathan Williams

KALLÁY, Karol.

Czechoslovak. Born in Cadca, Czechoslovakia, 26 April 1926. Educated at the High School of Technology, Bratislava, 1945-49, Dip.Ing. 1949; thereafter studied law for 3 years; self-taught in photography, but influenced by the work of Henri Cartier-Bresson, William Klein, Robert Frank and Bill Brandt. Married Zdenka Soukupová in 1950; sons: Karol and Martin. Freelance photographer, in Bratislava, since 1950: established studio, 1967; fashion photographer for *Moda*, Bratislava, since 1956, *Saison*, Berlin, 1960-72, *Jardin des Modes*, Paris, 1965-66, and *Sibylle*, Berlin, 1965-76. Head of the Photography Section, Union of Slovak Artists, Bratislava, since 1960. Recipient: *Popular Photography* Prize, New York, 1957; Most Beautiful Book on Czechoslovakia Prize, Ministry of Culture, Prague, 1972, 1973; Book Prize, *Internationale Buchausstellung*, Unesco, Leipzig, 1977. Fellow, Fédération Internationale de l'Art Photographique,

1970. Agent: Slovart, Gottwaldovo Mámestie, Bratislava. Address: Fándlyho 12, 80100 Bratislava, Czechoslovakia.

Individual Exhibitions:

1956 Municipal Gallery, Bratislava
1960 Gallery of Kunstat, Brno, Czechoslovakia
1961 Union of Artists Gallery, Bratislava
1965 Municipal Gallery, East Berlin
1967 Municipal Gallery, East Berlin
1968 Czechoslovak Cultural Centre, Baghdad
 Czechoslovak Cultural Centre, Cairo
1969 Czechoslovak Cultural Centre, Sofia
 Czechoslovak Cultural Centre, Budapest
1970 Czechoslovak Cultural Centre, Warsaw
 Czechoslovak Cultural Centre, Bucharest
 Czechoslovak Pavilion, at *Expo 70*, Osaka, Japan
1973 Municipal Gallery, Prague
 Municipal Gallery, Bratislava
 Lenin Library, Moscow
1974 Municipal Gallery, Bratislava
 Czechoslovak Cultural Centre, Sofia
 Czechoslovak Cultural Centre, Warsaw
1979 Galerie Stadt Berlin, East Berlin

Selected Group Exhibitions:

1960 *Contemporary Czechoslovak Photography*, travelling exhibition (toured the world, 1960-70)
1976 *Lyric Sources in Czechoslovak Photography*, International Museum of Photography, George Eastman House, Rochester, New York

Collections:

Municipal Gallery, Brno, Czechoslovakia; National Gallery, Bratislava.

Publications:

By KALLÁY: books—*Slovak Rivers*, Martin,

Karol Kalláy: *Harlem*, New York, 1967

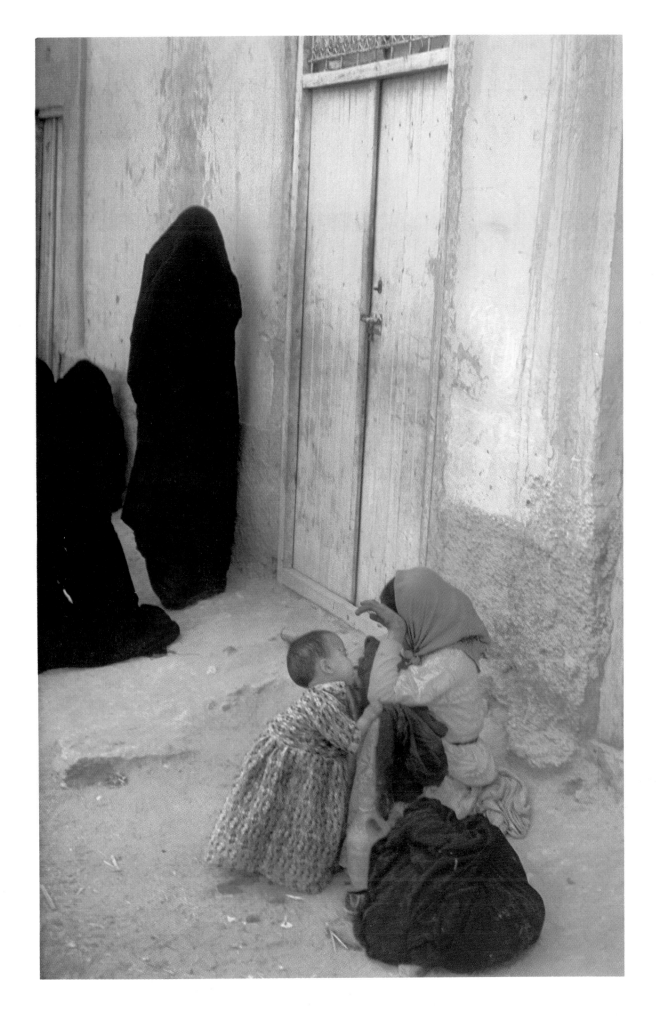

Ferenc Berko: *Woman and Child*, Morocco, 1978

Olivia Parker: *Site I*, 1980

Brian Brake: Image from *Sydney*, 1980

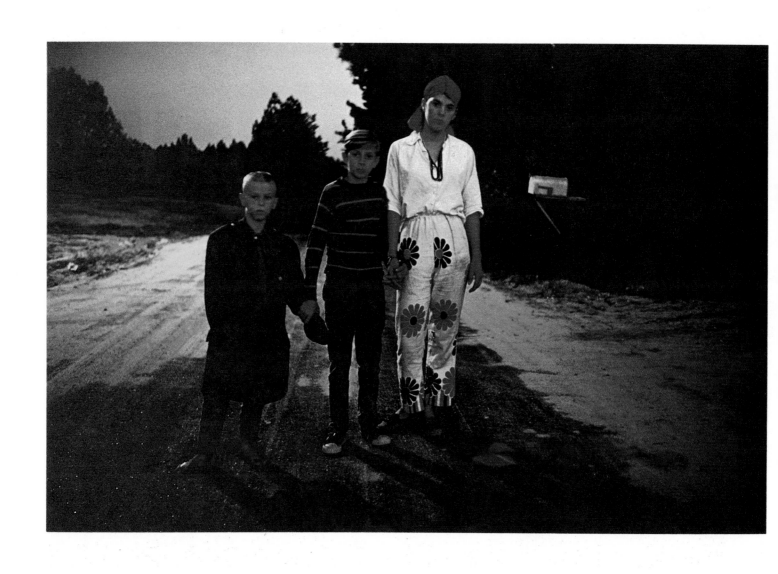

William Eggleston: *Halloween*, **Morton, Mississippi, 1970** Courtesy Art Institute of Chicago

Stephen Livick: *Untitled,* 1981

Joel Meyerowitz: *Hartwig House, Truro,* **1976** Courtesy Art Institute of Chicago

Kishin Shinoyama: *House*, 1975

Ernst Haas: *Arizona, near Glenn Canyon Dam*

Yoshikazu Shirakawa: *Monument Valley in the Morning Glow*, 1981

David Robinson: *Red Boat, Burano,* from *Reflections,* 1978

Eliot Porter: *Abandoned Farm, Iceland,* 1972

Cole Weston: *Aspens*, Utah, 1978

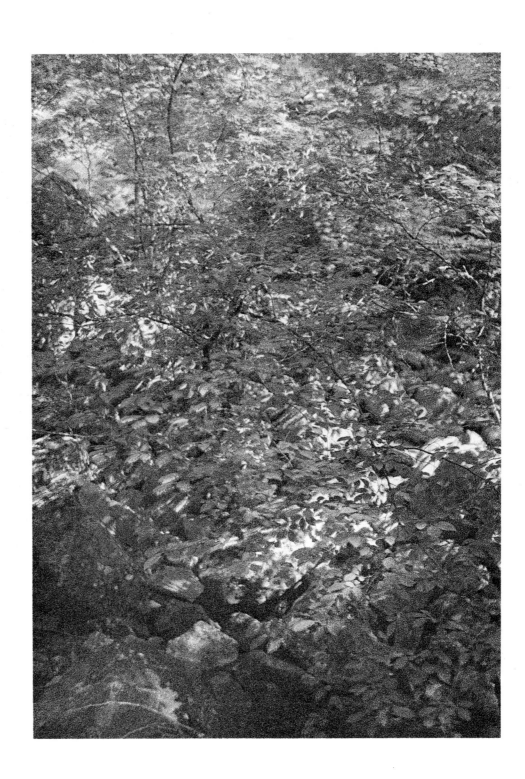

Scott Hyde: Image for *Contemporary Photographers*, 1982

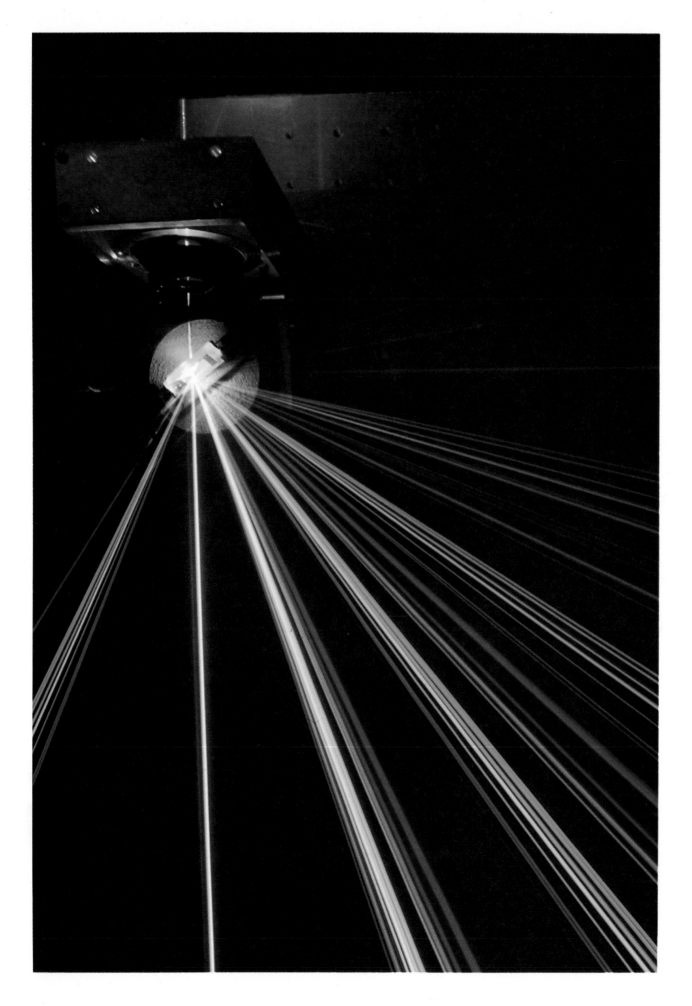

Fritz Goro: *Helium-Selenium Metal Vapor Laser* (originally appeared on cover of *Scientific American*), 1973

Hideki Fujii: *Flame*, 1981

Bernard Faucon: *Le Banquet*, 1978

Czechoslovakia 1954; *Slovak National Theatre*, Bratislava 1961; *Italy Today*, London 1963; *Slovakia*, Prague 1963; *A Day of Wonders*, Bratislava 1963; *New York*, East Berlin 1967; *Mexico City*, East Berlin 1968; *Moscow*, Bratislava 1972; *Song of Slovakia*, Bratislava 1973; *The Slovak National Uprising 1944*, Bratislava 1974; *Venice*, East Berlin 1976; *Slovakia*, East Berlin 1980; *Just Stone and Wood*, Bratislava 1980; *Tokyo*, East Berlin 1981; article—"It is a Long Way to Nachodka" in *Geo* (New York), April 1979 and in *Geo* (Paris), July 1980.

On KALLÁY: book—*Karol Kalláy* by Lubor Kara, Prague 1963.

Through my photographs I have always tried to express what I really saw and felt. I saw people in their happiness and misery, in their wealth and poverty.

I always took up an attitude, according to my heart, reason, feelings and morals.

—Karol Kalláy

Only a relatively small number of well-known photographers can be said to be all-rounders in their choice of themes, genres and images. Karol Kalláy is one of these rather exceptional personalities. In his native country Kalláy is known mainly as a top fashion photographer, but he feels offended if anyone attempts to characterize him by so restrictive a label. Besides his fashion work, Kalláy has always been strongly attracted by spontaneous photography, and his greatest joy has been in preparing picture volumes about life in various countries.

When reacting creatively to vivid situations, his approach is based on coming as near as possible to events: he often uses a camera equipped with a wide angle lens. Of no less importance is his sense for the typical in the actions of people in different parts of the world: he is gifted with an ability to record his discoveries in images of great immediacy. It could be said that he belongs to that group of photographers who are specialists in capturing actions that are indicative yet, in fact, reveal nothing extraordinary happening.

Kalláy seems to grasp very well the most important aspect of each different genre of photography. He is as adept at portraying the interesting situation in his "live" images as he is in creating the best formal arrangements in his landscapes.

Kalláy is accustomed to photographing both indoors and outdoors. He maintains a very well equipped studio in which he makes portraits and fashion photographs. From time to time, too, he likes to experiment by using various attachments to his lenses—sometimes bought, sometimes constructed by himself. He wants to search through all the possibilities that photography offers. He is as active in black and white as in colour, and he obviously respects the inherent nature of each medium. He is, in short, an enthusiast. And, like most all-rounders, Kalláy often uses experiences gained in one genre in other genres, in appropriately modified form. Thus, he enriches his work with a surprising freshness.

—Petr Tausk

KALVELIS, Jonas.

Lithuanian. Born in the Kupiskio district, 11 March 1925. Studied land organization at the Agricultural Training College, Kaunas, Lithuania, 1953-58; mainly self-taught in photography. Married Brone Davolyte in 1958 (divorced, 1971); daughter: Rasa. Worked as a technician for the Institute of Forestry of the Lithuanian SSR, Kaunas, 1948-54. Since 1954, Head of the Photo Laboratory, Institute of Planning of Water Resources, Kaunas. Recipient: Artist Award, 1976, and Silver Medal, 1977, Federation Internationale de l'Art Photographique (FIAP); Grand Prize, *Amber Land* exhibition, Siauliai, Lithuania, 1977; FNSPF Diploma, *Auteurop 78* exhibition, Paris, 1978; Ministry of Foreign Affairs Medal, *Phot-Univers* exhibition, Bievres, France, 1978. Address: c/o (agent) Photographic Art Society of Lithuania, Pionieru 8, Vilnius 232600, Lithuania, U.S.S.R.

Individual Exhibitions:

1974 Photo Salon, Plovdiv, Bulgaria
1975 Photography Salon, Vilnius, Lithuania
1979 Palace of Cutlure, Gorzow, Poland

Selected Group Exhibitions:

1973 *Europaische Fotografen*, Rathaus, Charlottenburg, West Berlin
1974 *Trenutak Covjeka*, Fotoklub Maglaj, Yugoslavia
Zlatno Oko, Palace of Culture, Novy Sad, Yugoslavia
Auteurop, Cheminot-Montparnasse, Paris

1975 *Fotoforum*, Palace of Culture, Ruzomberok, Czechoslovakia
1976 *IFO-Scanbaltic*, Exhibition Gallery, Rostock, East Germany
1977 *Salon Mondiale de Photographie*, Virton, Belgium
Amber Land, Photography Museum, Siauliai, Lithuania
1978 *Auteurop*, Cheminot-Montparnasse, Paris
Phot-Univers, Musée Français de la Photographie, Bievres, France

Collections:

Photography Museum, Siauliai, Lithuania; Musée Français de la Photographie, Bievres, France.

Publications:

By KALVELIS: book—*Jonas Kalvelis*, with an introduction by Algirdas Gaizutis, Kaunas, Lithuania 1975.

On KALVELIS: book—*Lietuvos Fotografija*, with an introduction by Romualdas Pacesa, Vilnius, Lithuania 1978; article—"Moment of New Truth" by Viktor Diomin in *Sovietskoye Photo* (Moscow), December 1978.

Nature is by itself the author of its own art. The task is to be able to notice it and convey it to others.

—Jonas Kalvelis

Jonas Kalvelis: *Dunes No. 7, 1974*

Some photographers work continuously and for years on the same subject, developing it and varying it—as musicians who have mastered their instruments may work and re-work their interpretations of particular compositions. In photography such orientation may create not only mastery but also an ability to convey, within the favorite subject, the photographer's inner nature and devotion.

Nature, the environment without people, has been Jonas Kalvelis's main subject. As photos of nature predominate in his work, it is not unfair to call him a "nature photographer." Forests, trees, snowy valleys and sand drifts—they are the environments in which Kalvelis feels at home—as part of the whole, as someone who comes very close to his trees and flowers to study them in detail. Characteristically, he focusses on one part of the whole, and the result is always the opposite of the accidental: the photos are well-composed, purposeful, perfect in their black-and-white tonality. Kalvelis's purity of feeling toward nature expresses itself in the outward appearance of the photos, in a graphic style that stresses his sincerity and at the same time suggests the specific form from within the general. What might be called Kalvelis's intimate relations with nature are so beautiful and so precisely conveyed that they can be enjoyed by those who view his work as well.

If his favorite subject is the forest, then his second love must surely be the sand dunes of the wild-life preserve on the western coast of Lithuania. His great masterpiece of recent years (which has put him in the avant-garde of Lithuanian photographers) is the series *Sand Drifts in Neringa*. In his photos of the dunes we have Kalvelis's characteristic stance—not the cold, emotionless observer but the conveyor of secrets and realities not revealed in the work of his predecessors. These secrets—the essence of the dunes—are not profound; they are available to anyone who pauses for longer than the casual passer-by, who looks for textures, who observes from above or below—the observer, in short, who takes the time to look.

Kalvelis is not just a recorder of the beauty of the simple forms of nature; because of his absolute devotion to his subject, he preserves beauty at the same time that he conveys the joy of discovery.

—Peeter Tooming

KANE, Art.
American. Born Arthur Kanofsky in the Bronx, New York City, 9 April 1925. Educated in New York public schools; studied photography at the Cooper Union, New York, 1940-41, 1946-50. Served in the United States Army, in Europe, 1942-45. Twice married and divorced: sons: Jonathan and Anthony. Layout Desginer, *Esquire* magazine, New York, 1950-52; Art Director, *Seventeen* magazine, New York, 1952-56; Art Director, Irving Serwer Advertising Agency, New York, 1956-59; freelance advertising, magazine and television photographer, working for *Look*, *Life*, *McCall's*, *Vogue*, *Queen*, etc., in New York, 1959-73; Corporate Design Director, *Penthouse* and *Viva* magazines, New York, 1973-74; resumed freelance career, 1975. Address: 1181 Broadway, New York, New York 10001, U.S.A.

Selected Group Exhibitions:

1981 *Dog Show No. 1*, Nikon Fotogalerie, Zurich

Publications:

By KANE: books—*The Persuasive Image: Art Kane*, with text by John Poppy, Los Angeles and London 1975; *The Great Cities: Rio de Janeiro*, with text by Douglas Botting, New York 1978; articles—"Too Many Photographers—Too Many Photographs" in *Infinity* (New York), June 1963; "Art Kane," interview, in *Zoom* (Madrid), no. 14, 1978; "Art Kane; I Love Marcella," interview, with Jeanne Brody, in *Camera 35* (New York), May 1978.

On KANE: books—*Geschichte der Fotografie im 20. Jahrhundert / Photography in the 20th Century* by Petr Tausk, Cologne 1977, London 1980; *The Vogue Book of Fashion Photography* by Polly Devlin, with an introduction by Alexander Liberman, London 1979; *The History Of Fashion Photography* by Nancy Hall-Duncan, New York 1979, as *Histoire de la Photographie de Mode*, Paris 1979.

Possibly Art Kane was not the first "Pop" photographer, but only the most famous and the most important. He was Pop in admitting straight away that he was not trying to record the *real* world (if such a thing should exist) in his photographs. He was Pop in simplifying his graphic approach to reproduce bold, simple, direct images, often using bright colours. He was Pop in his willingness to try new lenses (extreme wide-angles and telephotos), to make montages, double-exposures, slide sandwiches..."anything goes." He was also Pop in the literal sense, in that he quickly became associated with the musicians of the Swinging 60's, photographing many of them and even illustrating their songs. He photographed Bob Dylan, The Who, Jefferson Airplane (*Life* cover, June 28, 1968) and many more. He illustrated Beatles songs ("A Day in the Life," "Strawberry Fields," "Eleanor Rigby") and Dylan songs ("Blowing in the Wind," "With God on Our Side," "Lay Lady Lay") and many others.

This was a flowering of his first involvement with professional photography. His first assignment was for *Esquire* in 1957: photographing the great jazzmen. He did it brilliantly and it won him the first of many awards. One of the jazz-men was Louis Armstrong. Kane flew him, and an old rocking chair, into the desert and photographed him against the setting sun—a shot inspired by the song "Old Rockin' Chair". Of course it was set up, and of course it was corny, but there was one over-riding factor: *it worked*.

Kane applied himself to advertising and editorial work in similar ways after that, for major clients and the great picture magazines such as *Life*, *Look*, *Twen*, *Vogue* and *McCall's*. Like any commercial artist, he illustrated things. He drew roughs, he manipulated colours, he did what needed doing to make it new. What he did was important because he thought big thoughts and executed them in ways that would reach a big audience. On rare occasions he might tackle reportage work. He once did a feature on truck drivers for *Esquire*. Earlier he had entitled one of his talks "Color Is a Liar!" Not surprisingly he insisted on shooting the feature in black and white.

With benefit of hindsight, one sees that one of his most successful projects was photographing "The Waters of Venice" for *Look*. His approaches ran from the sublime—using a slide sandwich to turn St. Mark's Square into a closed world—to the ridiculous—clogging up a canal with 200 dead pigeons. The "lead" picture of Venice drowning is unforgettable.

In the early 1970's he returned to his original profession—art director—joining *Penthouse* and *Viva* magazines. It turned out to be not the right job for him. Better forgotten now are the exotic "pubic hairstyles" (worn by Penthouse Pets) which Kane photographed in closeup, and also the "copulation sequence" in a kitchen, which has unfortunately

been preserved in the pretentious *Masterpieces of Erotic Photography* collection. However, when he returned to photography it was with renewed vigour. He opened a new studio in 1975 and equipped it with flash—previously he had been known as an available light photographer. Later, working with a new model called Marcella he produced a particularly imaginative portfolio of new work, much of it taken outside at night with hand-held flash.

In spite of all this, it remains difficult to form a just opinion of Art Kane's work: so many of the ideas he pioneered were picked up immediately by other photographers, who promptly worked them to death. Only one of his pictures seems to have been permanently added to the national consciousness, and that is "Star Spangled Banner." It shows the Stars and Stripes dominating the frame, with a thin strip of sky and a group of young people at the top of the frame. The shot was taken for *Look* in 1962 to illustrate the preamble to the American Constitution ("We the people..."). The shot has been much mauled by imitators, but it survives.

Nor does Kane seem to have produced any worthwhile personal work during his commercial career. It seems strange that a man who is internationally recognized as an important photographer, and who has had a major influence on commercial photography for 20 years, should not have produced a definitive work to preserve his memory.

—Jack Schofield

KARSH, Yousuf.
Canadian. Born in Mardin, Armenia, Turkey, 23 December 1908; emigrated to Canada, 1924: naturalized, 1946. Studied photography under the portrait photographer John H. Garo, Boston, 1928-31. Married Solange Gauthier in 1939 (died, 1961); married Estrellita Maria Nachbar in 1962. Worked as an assistant in his uncle's portrait photography studio, Sherbrooke, Montreal, 1926-28. Established the Karsh Studio, Ottawa, specializing in portrait photography, since 1932. Visiting Professor of Photography, Ohio University, Athens, 1967-69; Visiting Professor of Fine Arts, Emerson College, Boston, 1972-73, 1973-74. Photographic Adviser, *Expo '70*, Osaka, Japan. Trustee, Photographic Arts and Sciences Foundation, since 1970. Recipient: Canada Council Medal, 1965; Canadian Centennial Medal, 1967; Master of Photographic Arts Award, Professional Photographers Association of Canada, 1970; U.S. Presidential Citation, 1971; First Gold Medal, National Association of Photographic Art, 1974; President's Cabinet Annual Award, University of Detroit, 1979; Achievement in Life Award, *Encyclopaedia Britannica*, 1980. LL.D.: Queen's University, Kingston, Ontario, 1960; Carleton University, Ottawa, 1960; D.H.L.: Dartmouth College, Hanover, New Hampshire, 1961; Ohio University, Athens, 1966; Mount Allison University, Sackville, New Brunswick, 1968; Emerson College, Boston, 1969; D.C.L.: Bishop's University, Lennoxville, Quebec, 1969; D.F.A.: University of Massachusetts, Amherst, 1979; University of Hartford, Connecticut, 1980; Tufts University, Medford, Massachusetts, 1981. Honorary Fellow, Royal Photographic Society, London, 1970; Member, Royal Canadian Academy of Arts, 1975. O.C. (Officer, Order of Canada), 1968. Address: Chateau Laurier Hotel, Suite 660, Ottawa, Ontario K1N 8S7, Canada.

Individual Exhibitions:

1959 National Gallery of Canada, Ottawa

Yousuf Karsh: *Winston Churchill*, 30 December 1941

1967 *Men Who Make Our World*, at the Canadian Pavilion, *Expo '67*, Montreal (toured Canada, the United States and Europe, 1967-81; entire exhibition acquired by the Museum of Modern Art, Tokyo; National Gallery of Australia, Canberra; and the Province of Alberta)

1973 Santa Barbara Museum of Art, California (with Margaret Bourke-White)

Selected Group Exhibitions:

1967 *Photography in the 20th Century*, National Gallery of Canada, Ottawa (toured Canada and the United States, 1967-73)

1977 *Fotografische Künstlerbildnisse*, Museum Ludwig, Cologne

1979 *Life: The First Decade 1936-45*, Grey Art Gallery, New York University
Photographie als Kunst 1879-1979/Kunst als Photographie 1949-1979, Tiroler Landesmuseum, Innsbruck, Austria (travelled to the Neue Galerie am Wolfgang Gurlitt Museum, Linz, Austria; Neue Galerie am Landesmuseum Joanneum, Graz, Austria; and the Museum des 20. Jahrhunderts, Vienna)

Collections:

Government of Alberta; National Gallery of Canada, Ottawa; Museum of Modern Art, New York; Metropolitan Museum of Art, New York; International Museum of Photography, George Eastman House, Rochester, New York; Art Institute of Chicago; St. Louis Art Museum; National Portrait Gallery, London; Museum of Modern Art, Tokyo.

Publications:

By KARSH: books—*Faces of Destiny*, New York and London 1946; *This Is the Mass*, with text by Henri Daniel-Rops and Fulton J. Sheen, New York and Kingswood, Surrey 1958, and with text by Henri Daniel-Rops and Paul-Emile Cardinal Leger, Paris 1959; *Portraits of Greatness*, London, Toronto and New York 1959; *This Is Rome*, with text by Fulton J. Sheen and H.V. Morton, New York 1959, Kingswood, Surrey 1960; *This Is the Holy Land*, with text by Fulton J. Sheen and H.V. Morton, New York 1960, Kingswood, Surrey 1961; *In Search of Greatness: Reflections of Yousuf Karsh* (autobiography), Toronto and New York 1962, London 1963; *These Are the Sacraments*, with text by Fulton J. Sheen, New York 1962; *The Warren Court*, with text by John P. Frank, New York 1965; *Karsh Portfolio*, Toronto and New York 1967; *Faces of Our Time*, Toronto 1971; *Karsh Portraits*, Toronto and Boston 1976; *Karsh Canadians*, Toronto 1978; article—interview in *Interviews with Master Photographers* by James Danziger and Barnaby Conrad III, New York and London 1977.

On KARSH: books—*Photographs of Yousuf Karsh: Men Who Make Our World*, exhibition catalogue, Montreal 1967; *Photography in the 20th Century* by Nathan Lyons, New York 1967; *Fotografische Kunstlerbildnisse*, exhibition catalogue, by Dieter Ronte, Evelyn Weiss and Jeane von Oppenheim, Cologne 1977; *Life: The First Decade 1936-1945* by Robert Littman, Ralph Graves and Doris C. O'Neill, New York 1979, London 1980; *Photographie als Kunst 1879-1979/Kunst als Photographie 1949-1979*, exhibition catalogue, 2 volumes, by Peter Weiermair, Innsbruck 1979; articles—"A Collection of Photographs" in *Aperture* (Millerton, New York), Fall 1969; "Karsh of Ottawa" in *Image* (Rochester, New York), no. 1, 1973; "Karsh of Ottawa" by G. Hughes in *Amateur Photographer* (London), 4 December 1974; "The Many Faces of Yousuf Karsh"

by Adrian Waller in the *Reader's Digest* (New York), December 1976; Yousuf Karsh, Photographer: The Legend Who Captures Legends" by Hank Whittemore in *Parade* (New York), 3 December 1978.

One of the questions I am asked more frequently is why my best known portraits tend to be those of famous persons, rather than of ordinary people whose faces might provide interesting studies for their own sake. It is true that the photographs that have given me the greatest satisfaction are, with a few notable exceptions, those of people of consequence, although by no means of consequence in the same field or for the same reason. They have included scientists, labour leaders, captains of industry, physicians, film stars, directors, composers, statesmen, clergymen, military leaders, princes and presidents. I have also been interested in the "common man," and have made countless photographs of people of all kinds. But I have not as a rule felt the same challenge when photographing people who have no special contribution, good or bad, to the world. In fact, my reactions to these people are probably quite similar to the reactions of viewers and readers. I seriously doubt if the interpretation of an unknown face is likely to have interest equal to that of a known personality, either to a photographer or to those who view his work. The best proof of this is that my portraits of famous people are better known than any of my other photographs.

My quest in making a photograph is for a quality that I know exists in the personality before me, for what I sometimes call the "inward power"; and I am more anxious to capture that, or at least to interpret it to my own satisfaction, than I am to create the facsimile of an interesting figure with no depth of soul. Candid portraiture often has unposed, human interest, but I am seeking more than a study of physical features for their own sake—sometimes this could even be accomplished by using professional models. I am hoping to capture abstract virtues or traits of personality, and I concentrate all my efforts to accomplish this when taking a photograph. Before I begin, I will have studied my subject to the best of my ability, and within broad limits know what I am hoping to find, and what I hope to be able to interpret successfully. The qualities that have attracted me to the subject are those that will satisfy me if I can portray them in the photograph, and that will most probably satisfy viewers of the picture as well. My personal interest in ordinary people is unlimited, but I am fascinated by the challenge of portraying true greatness adequately with my camera.

Steichen was seeking something quite different when he brought together that unforgettable exhibition *The Family of Man*. This was not a collection of portraits, but was a highly successful record of interpretations of human emotions, and human interests.

I believe that it is the artist's job to accomplish at least two things—to stir the emotions of the viewer and to lay bare the soul of his subject. When my own emotions have been stirred, I hope I can succeed in stirring those of others. But it is the mind and soul of the personality before my camera that interests me most, and the greater the mind and soul, the greater my interest.

I think it was Bernard Shaw who first observed that even a genius is 98% ordinary. It is the task of the photographer to bring out the remaining 2%. When one sees that residuum of greatness before one's camera, one must recognize it in a flash. There is a brief moment when all there is in a man's mind and soul and spirit may be reflected through his eyes, his hands, his attitude. This is the moment to record. This is the elusive "moment of truth."

—Yousuf Karsh

In 1918 the massacres in his home town of Mardin,

in the Armenian part of Turkey, forced young Yousuf Karsh to flee his native land. He went to Canada to live with his uncle, a studio portrait photographer who introduced his nephew to the rudiments of the profession. A three-year apprenticeship to John H. Garo of Boston, a portrait photographer and fellow Armenian who Karsh remembers as a "stimulating and inspiring teacher", completed his photographic education. In 1931 Karsh returned to Canada, and after briefly debating whether to study surgery, opened the portrait studio in Ottawa that would earn him the world-wide reputation: "Karsh of Ottawa".

Yousuf Karsh has devoted his photographic career to making portraits of famous and powerful leaders of his time. When he first set up his studio, Ottawa was a small but fast-growing city, and Karsh saw to it that his business grew at the same rate. Political connections made a crucial difference. His skill as a portrait photographer was acclaimed by the Governor-General's son, which led to introductions to (and commissions from) members of the government and visiting dignitaries. The Prime Minister, a friend and patron, arranged for Karsh perhaps the most important sitting of his career—with Sir Winston Churchill. This portrait, the result of a two minute session, shows a tough Churchill, leaning forward slightly, with a hard determined look in his eye and a clenched jaw. The picture became symbolic of the British people's indomitable fighting spirit, and it brought Karsh great fame.

Karsh's career of documenting fame and power through portraits of world leaders was launched. The Canadian Government asked him to go to England to do a series of portraits of British wartime leaders. On assignment from *Life* Karsh photographed American war leaders. In 1946, at the close of World War II, Karsh published his first book, *Faces of Destiny*, a collection of portraits of the men who had taken the Allies to victory.

After the war ended, Karsh's interests expanded beyond military and political leaders. He has photographed "people of consequence" who have made a major contribution to the world. His subjects are leaders in all fields: science, industry, the arts, politics, education, sports, religion. Sometimes he travels half-way around the world for a half-hour sitting.

As a portraitist, Karsh's style is formal. He uses light to model the faces before his camera in a sculptural way, rendering the human presence monumental. Karsh is a consummate craftsman. His compositions are tight and exact. The backgrounds used are simple and often solid black. No props or decorations detract from the direct approach to the subject. Karsh's portraits are visual idealizations of the public image and legend of the individuals who confront his camera.

—Sarah Putnam

KAWADA, Kikuji.

Japanese. Born in Ibaragi Prefecture, 1 January 1933. Educated at Rikkyo High School, Tokyo, 1948-51; studied economics at Rikkyo University, Tokyo, 1951-55, AB.D. 1955; self-taught in photography. Married Nakako Ohnuki in 1957; son: Norio. Freelance photographer, Tokyo, since 1959. Address: 3-8 Sadoharachyo, Ichigaya Shinjukuku, Tokyo 162, Japan.

Individual Exhibitions:

1959	*The Sea*, Fuji Photo Salon, Ginza, Tokyo
1961	*The Map*, Fuji Photo Salon, Ginza, Tokyo
1968	*Sacré Atavism*, Nikon Salon, Ginza, Tokyo
1976	Shadai Gallery, Shinjuku, Tokyo

Selected Group Exhibitions:

1957	*10 Photographers' Eyes*, Konishiroku Gallery, Ginza, Tokyo
1962	*"Non" Exhibition*, Matsuya Department Store, Ginza, Tokyo
1963	*Contemporary Japanese Photographs*, National Museum of Modern Art, Tokyo
1974	*New Japanese Photography*, Museum of Modern Art, New York
1977	*Neue Fotografie aus Japan*, Kulturhaus der Stadt, Graz, Austria, (travelled to Museum des 20. Jahrhunderts, Vienna)
1979	*Japan: A Self-Portrait*, International Center of Photography, New York

Collections:

Museum of Modern Art, New York.

Publications:

By KAWADA: books—*The Map*, Tokyo 1965; *Sacré Atavism*, Tokyo 1971; *Cosmos of the Dream King, Ludwig II*, Tokyo 1979.

On KAWADA: books—*Essays on Contemporary Photography* by Nobuya Yoshimura, Tokyo 1970; *New Japanese Photography*, exhibition catalogue, by John Szarkowski and Shoji Yamagishi, New York 1974; articles—"Kikuji Kawada" by Tatsuo Fukushima in *Camera Age* (Tokyo), October 1966; "Kikuji Kawada" by Arthur Goldsmith in *Popular Photography* (New York), June 1975; "Zu Kikuji Kawada Foto-Serie 'Los Caprichos'" by Otto Breicha in *Protokolle* (Vienna), no. 1, 1977.

I always seek for the analogical power in photography.

—Kikuji Kawada

Kikuji Kawada grew up during the Second World War and the immediate post-war years, and the composition of his works reflects the spiritual experience of those years.

This experience is most evident in his works, *The Map, Sacré Atavism*, and *Cosmos of the Dream King, Ludwig II*. In *Sacré Atavism* he pursued a theme of grotesque beauty and recorded impressions of his trip to Europe.

—Norihiko Matsumoto

KEIGHLEY, Alexander.

British. Born in Keighley, Yorkshire, 3 February 1861. Educated at Dame School, Steeton, Yorkshire, 1867-71; Old Grammar School, Steeton, 1872-77; studied, under Thomas Huxley, School of Mines, now the Royal College of Science, London, 1877-80; self-taught in photography, but influenced by work of Henry Peach Robinson, from 1883. Married Lily Howroyd in 1905 (died, 1924); son: Gilbert Alexander. Worked from factory assistant up to director, Sugden Keighley Company family textile firm, Keighley, Yorkshire, 1886-1932. Independent amateur photographer, mainly of travel and natural history, in Egypt, South Africa, etc., 1883 until his death, 1947. Founder-Member, Keighley Scientific and Literary Society, Yorkshire, 1879; President, Bradford Photographic Society, Yorkshire, 1898; Elected Member (adopting pseudonym "Forrester"), Linked Ring fellowship of photographers, London, 1900. Recipient: First Prize, *Amateur Photographer Competition*, London, 1887. Member, 1911, Fellow, 1912, and Honorary Fellow, 1924, Royal Photographic Society, London. *Died (in Keighley, Yorkshire) in 1947.*

Individual Exhibitions:

1910	Royal Photographic Society, London
1920	New York Camera Club, New York
1933	Hampshire House, London
1943	Royal Photographic Society, London
	Bradford Art Gallery, Yorkshire
1947	Royal Photographic Society, London (memorial retrospective)

Selected Group Exhibitions:

1889	*Annual Exhibition*, Royal Photographic Society, London
1978	*Pictorial Photography in Britain 1900-1920*, Hayward Gallery, London (toured Britain)

Collections:

Royal Photographic Society, London.

Publications:

On KEIGHLEY: books—*Alexander Keighley: A Memorial*, edited by Royal Photographic Society, London 1947; *The Magic Image* by Cecil Beaton and Gail Buckland, Boston and London 1975; *Pictorial Photography in Britain 1900-1920*, exhibition catalogue, by John Taylor, London 1978; *The Linked Ring* by Margaret Harker, London 1979.

For nearly 50 years, from 1899 until his death in 1947, Alexander Keighley was regarded as a leading pictorial photographer by devotees of the many amateur photographic societies of Great Britain. His early photographs, 1883-1884, reveal that he emulated the work of certain celebrated photographers, producing photographs of genre subjects in sharp focus throughout. "Children of the City," 1889, illustrative of "And the children's feet are weary/and their hearts with toil oppressed," used as a sub-title, is reminiscent of "Poor Joe" and other studies of ragged boys by O.G. Rejlander. Neither photographer photographed real street urchins but selected friends' children who could hold the pose for time exposures. Keighley, like Rejlander, attired his young models in torn and dirty clothing but the well kempt hair, clean hands and refined features give away the boys' true condition. "Gathering Water-lilies," c.1889, is a Naturalistic style photograph and was undoubtedly based on the famous Emerson photograph of that title. In 1887 Emerson awarded Keighley first prize in the Amateur Photographer competition for "The See-Saw" which featured children at play, a sharp focus genre study.

In the years which followed Keighley's personal style underwent a radical change. He was converted to Impressionistic photography, doubtless influenced by Davison and other Linked Ring photographers (he was elected to the Ring in 1900). "My Lady's Garden" received great approbation in 1899 and set the scene for future productions. It shows the exemplary care with which Keighley assembled the picture components into a harmonious whole. The lady, in profile, just left of centre touches a climbing rose, the sundial in the foreground to the right provides the necessary balance and perspective, the peacock is caught in the act of moving "across stage" from sundial to lady, the large trees in the back-

Kikuji Kawada: *Floating Fish*, from the series *Los Caprichos*, Tokyo, 1975

ground give shelter and privacy. It is an Edwardian scene, full of nostalgia.

Keighley was influenced by the writings and photographs of H.P. Robinson. His interest was in narrative interpretation; portraiture did not appeal to him. The people he included in his photographs are intended to represent the themes which he illustrated. In the majority of his photographs they are not recognisable, the features being so indistinct they are virtually faceless or they have their backs to the camera. He deliberately used this depersonalisation technique to concentrate the viewer's attention on the theme. Many of his subjects were romantic fantasies, treated symbolically, with Biblical allusions such as "The Olive Branch," 1904; "Peace," 1903, which features a shepherd and his flock in the foreground with a Middle Eastern dwelling beyond and a sparse landscape in the distance (Keighley's own favourite, it was displayed on the wall in his study); and "The Dayspring from on High," 1917, a beautiful pictorial study of trees with sunlight filtering through. Other favourite topics were simple domestic scenes such as "Grace Before Meat," 1901, and "The Family," 1936; and classical landscapes,

for example "The Rest Is Silence," 1909. "Fantasy," 1913, and "Spring Idyll," 1904, are both woodland scenes with nymphs dancing in a clearing in the former and with seated shepherd and shepherdess in the latter. Both could have been inspired by the paintings of Corot.

Keighley used a simple quarter plate camera. He made whole plate glass positives from the cut film negatives, worked on them with dyes and pencil, and from the modified positives made 16" x 20" or larger glass negatives which were printed by contact onto carbon paper. This procedure introduced a degree of unreality into his imagery and heightened the impression of fantasy and lyricism which he succeeded in conveying. Keighley's prints do not bear close inspection—the image disintegrates—but at the correct viewing distance the image fuses together into a coherent visual narrative.

—Margaret Harker

Alexander Keighley: *The White Sail*, 1901

KEMPE, Fritz (Fried Maximilian).

German. Born in Greifswald, now East Germany, 22 October 1909. Educated at Greifswald Gymnasium, 1915-25; studied photography under his father Max Kempe, Greifswald, 1925-27; Dip.Photog. with distinction, Halle an der Saale, Berlin, 1938. Served in the German Army, 1939-45 (British prisoner-of-war, Feldwebel, 1945). Married Erika Wiegand in 1946; children: Stephan and Elisabeth. Proprietor, Photo-Kempe photography shop, Greifswald, 1929-38; Director, Studios für Werbe- und Industrie-Photographie, Berlin, 1938-39; press chief of a welfare organization in Hamburg, 1945-49, and Editor, *Hamburg Allgemeine Zeitung*, 1946-48; Director, Staatliche Landesbildstelle, Hamburg, 1949-74. Founder, 1952, and Honorary Director since 1977, History of Photography Collection, Museum für Kunst und Gewerbe, Hamburg. Recipient: Culture Prize, Deutsche Gesellschaft für Photographie (DGPh), 1964; David Octavius Hill Medal, Gesellschaft Deutscher Lichtbildner (GDL), 1974; Grand Silver Prize, City of Hamburg, 1974; Kodak Photography Book Prize 1976, 1977; Erich-Stenger Prize for photographic history, Deutsche Gesellschaft für Photographie (DGPh), 1979. Member, Freien Akademie der Künste, Hamburg. Honorary Member, DGPh, GDL, Verband Deutscher Amateurfotografen-Vereine, Österreichische Gesellschaft für Photographie, Bundesgremium für Schulphotographie, Hamburger Gesellschaft für Filmkunde, Bund Freischaffender Foto-Designer (BFF), Justus Brinckmann-Gesellschaft, Hamburg, Club Daguerre, Photographic Historical Society of New York, and Fédération Internationale de l'Art Photographique (FIAP). Agent: PPS-Galerie F.C. Gundlach, Feldstrasse/Hochhaus 1, 2000 Hamburg 4. Address: Eilbeker Weg 65a, D-2 Hamburg 76, West Germany.

Individual Exhibitions:

1959 *Hamburger: Hundert Porträts 1949-59*, Museum für Hamburgische Geschichte, Hamburg
1964 *Hamburger: Photographische Porträts*, Museum für Hamburgische Geschichte, Hamburg (travelled to the Deutsche Gesellschaft für Photographie, Cologne, 1965)
1970 *Hamburger und ihre Gäste*, B.A.T. Haus, Hamburg
1972 *Hamburger*, Valokuvamuseon Studio, Helsinki
1973 *Fotografierte Künstler*, Städtisches Museum, Flensburg, West Germany (with Bernd Jansen)
1974 *5 Jahrzehnte Photographie*, Museum für Kunst und Gewerbe, Hamburg
1975 *Portraits*, Galerie Spectrum, Hannover
1976 *Künstlerporträts*, Freie Akademie der Künste, Hamburg
1978 *Fotografierte Fotografen*, Leitz-Galerie, Wetzlar, West Germany
1980 *Die Zeit in den Gesichtern*, PPS-Galerie, Hamburg

Selected Group Exhibitions:

1965 *Gesellschaft Deutscher Lichtbildner*, Institute für Neue Technische Form, Darmstadt (travelled to the Haus am Lützoplatz, West Berlin, 1966)
1969 *Foto Selection: 50 Jahre GDL*, Museum für Kunst und Gewerbe, Hamburg
1975 *Gesellschaft Deutscher Lichtbildner*, Haus Industrieform, Essen
1978 *Later 20th Century Photography*, University of New Mexico, Albuquerque
Tusen och En Bild, Moderna Museet, Stockholm
1979 *Deutsche Photographie nach 1945*, Kasseler Kunstverein, Kassel, West Germany (toured West Germany)

Fritz Kempe: *Max Ernst*, 1964

Fotografie 1919-1979, Made in Germany, Die GDL Fotografen, Fotomuseum, Munich

Collections:

Museum für Kunst und Gewerbe, Hamburg; Folkwang Museum, Essen; Det Kongelike Bibliotek, Copenhagen; Fotografiska Museet, Moderna Museet, Stockholm; International Museum of Photography, George Eastman House, Rochester, New York; University of New Mexico, Albuquerque; San Francisco Museum of Modern Art.

Publications:

By KEMPE: books—*Der Film in der Jugend—und Erwachsenenbildung*, Seebruck, West Germany 1952; *Von Meisterfotos lernen*, Dusseldorf 1958; *Film: Technik, Gestaltung, Wirkung*, Braunschweig, West Germany 1958; *Die Welt der Photographie*, with others, Dusseldorf 1962; *Hamburger*, with text by Bernhard Meyer-Marwitz, Hamburg 1963; *Die anonymen Miterzieher unserer Jugend*, Munich 1963; *Fetisch des Jahrhunderts*, Dusseldorf 1964; *Gesellschaft Deutscher Lichtbildner, Eine Dokumentation*, with Heinrich Freytag, Essen 1969; *Das Bild und die Wirklichkeit*, Munich 1974; *One Hundred Years of Photographic History: Essays in Honor of Beaumont Newhall*, with others, edited by Van Deren Coke, Albuquerque, New Mexico 1975; *Vor der Camera: Zur Geschichte der Photographie in Hamburg*, Hamburg 1976; *Photographie: Zwischen Daguerreotypie und Kunstphotographie*, Hamburg 1977; *Daguerreotypie in Deutschland: Vom Charme der frühen Fotografie*, Seebruck and Munich 1979; *Albert Renger-Patzsch: 100 Photographien 1928*, Cologne 1979; *Dokumente der Photographie 1: Nikola Perscheid/Arthur Benda/Madame d'Ora*, Hamburg 1980; *La Photographie Artistique en Allemagne vers 1900*, Stuttgart 1980.

On KEMPE: book—*Fritz Kempe: 5 Jahrzehnte Photographie*, exhibition catalogue, by Heinz Spielmann and others, Hamburg 1974 (includes bibliography); articles—"Fritz Kempe als Porträtist" by Herman Speer in *Foto-Prisma* (Dusseldorf), October 1963; "Fritz Kempe wird 60" by Liselotte Strelow in *Foto-Prisma* (Dusseldorf), October 1969; "Fritz Kempe: Der Dokumentarische Porträtist" by Günther Lensch in *Fachkontakt* (Dusseldorf), March 1974; "Fotos sollen Menschen nicht demaskieren" by Inge Mösch in *Hamburger Abendblatt*, March 1976; "Laudatio zur Verleihung des Erich Stenger-Preis" by Rolf H. Krauss in *DGPh Intern* (Cologne), February 1979; "Fritz Kempe zum Siebzigsten" by Bernd Lohse in *Photo-Antiquaria* (Frankfurt), March 1979; "Fritz Kempe: Porträtist mit Kamera und Feder" by Hugo Schöttle in *Leica-Fotografie* (Frankfurt), August 1979; "Fotograf, Fotopublizist, Anreger un Förderer" by Karl Steinorth in *81 Format* (Karlsruhe), September 1979; "Fritz Kempe: Der Chronist, der 70 wird" by Bernd Lohse in *Foto-Magazin* (Munich), October 1979; "Seine Fotos hängen in den Galerien der Welt" by Liselotte Strelow in *Die Welt* (Hamburg), October 1979.

I was born in the university town of Greifswald, Pomerania, the son of the photographer Max Kempe. Inflation from 1919 to 1923 ate into my father's means and made it necessary for him to take me away from gymnasium to become his apprentice. I was not very happy either as an apprentice or as the owner of a photographic shop (1929-38). The pleasure I had in a studio for industrial and advertising photography (October 1938-November 1939) was upset by the war. After my release from English captivity in October 1945, I found no work as a photo-reporter in Hamburg—even though my Leica was my only possession to have survived the war. So I became the public relations chief of a welfare organization and the editor of a Hamburg newspaper. I wrote about social topics, composed glosses, essays and short stories. Writing became my own quite personal method of expression; I thought no more about photography.

In 1949 I took over direction of the Staatliche Landesbildstelle in Hamburg, where I remained for 25 years. The photographic centres in Germany have the task of providing schools with audiovisual teaching aids, which, in part, they also produce. I extended the technical and pedagogic activity of the Hamburg Landesbildstelle to include an overall pedagogy of the medium of photography. In 1950 I introduced the lecture series "What One Should Know about Film," which was later extended to the three photographic media, photography, film, and television. In 1952 I started to hold exhibitions showing the work of the great masters as well as unknown young photographers and the work of the photo-clubs. The photo gallery of the Staatlichen Landesbildstelle is the oldest in Europe. In all, I have organized more than 300 photographic exhibitions in Hamburg.

In 1952 I founded the Hamburg *History of Photography Collection*, which in 1974 comprised more than 30,000 photographs, cameras and books including many incunabula and the whole of *Camera-Work*. Since 1977, in an honorary capacity, I have administered the collection, which is now in the Museum für Kunst und Gewerbe.

In 1949 I also began to take photographs again: I portrayed politicians, businessmen, scholars and artists of importance to the city of Hamburg. In addition, I supported the Hamburg Art and Culture Prizes and local photographers. The collection *Hamburger und ihre Gäste* includes about 1,300 portraits. As I no longer have a studio at my disposal, I work with the Leicaflex and with available light, which has made a considerable difference in the style of my photographs. As I portray in this way people whom I have already photographed in a studio ten, twenty or twenty-years ago, exciting companion pictures arise. My exhibition in 1980 at F.C. Gundlach's PPS-Galerie in Hamburg showed how *Die Zeit in den Gesichtern* leaves its mark. This kind of photography of people fascinates me and has become a passion. Thanks to the support of my friend F.C. Gundlach, I am able to pursue it further.

Everything that I have photographed, investigated, collected or written comes from my historic interest in photography: the biographies that I wrote about friends who are now dead, the many biographic/iconographic reports, the essays about young photographers whom I was able to promote through my exhibitions and publications. Among my late friends I count Albert Renger-Patzsch and Otto Steinert as the closest; I miss them very much. In the meantime some of the younger photographers have become better known, if not yet famous. I look at the sensitive photography of the most recent times with sympathy and with a curiosity to know where it will yet lead us.

—Fritz Kempe

Fritz Kempe learned his craft in Greifswald, that small Pomerian town well known from the paintings of Caspar David Friedrichs. In the 1930's the town was still steeped in the past, just as the great romantic painter had portrayed it, and Kempe's specialized photography shop was at that time very progressive. Cameras, film and all articles required by the amateur photographer were for sale; clients' films were developed and printed. Kempe's own remaining photographs from those days consist chiefly of bromide emulsion prints which continue the tradition of "fine art photography." Kempe still shows particular affection for that period in photographic history; he has preserved, collected, publicized and interpreted it with an impressive passion since the early 1960's. His own works have, without doubt, paved the way for the growing appreciation of the period, but they, in contrast to him, remained almost unknown until his Hamburg retrospective in 1974.

Because of the political situation, Kempe left the Greifswald shop in 1938 to open his own studio for industrial and advertising photography in Berlin. Apart from the ordinary commissions, he created aesthetically balanced pictures of Berlin and smaller towns in the region. Photographs of the then famous film actress Margot Hielscher were the beginning of his portraits, which, after 1950, were to bring Kempe a growing reputation.

As for most young men of his generation, the war was for Kempe a drastic caesura. In the years after 1945 he worked as a journalist. Here he, as it were, rose from the ranks in a second craft, that of writing. Apart from photography, writing is now his most important activity. The sheer number of his publications is impressive: more than 500 books, articles and catalogues have appeared since 1946, including certain monographs that are now standard works in the history of photography. His books *Vor der Camera* and *Photographie: Zwischen Daguerreotypie und Kunstphotographie* were honored with Kodak Prizes in 1976 and 1977, and *Daguerreotypie in Deutschland* received the 1979 Erich Stenger Prize of the Deutschen Gesellschaft für Photographie. Without Kempe's contribution, significant chapters on the German photography of the 19th and early 20th centuries would hardly be known.

And without his introduction many a now well-known photographer of the younger generation would not have found such quick and effective access to the public. From the early 1950's, as Director of the Staatliche Landesbildstelle, Kempe produced exhibitions on an almost monthly basis, the majority of them introducing young photographers. He also organized the larger annual exhibitions at the Museum für Kunst und Gewerbe, many of which travelled to other cities.

In 1952 Kempe took over from the Museum für Kunst und Gewerbe its stock of daguerreotypes and other photographic materials from the time around 1900 and built it up into a comprehensive collection: with around 45,000 pictures and several hundred pieces of photographic equipment, it has become the most important collection of fine art photography in the German Federal Republic. In 1977 it was returned to the Museum für Kunst und Gewerbe, where Fritz Kempe continues as Honorary Director, to maintain and promote it.

Although doing so was certainly not included in his responsibilities as Director of the Landesbildstelle, Kempe has continuously taken photographs of local politicians, celebrities and officials, and, in so doing, has created a first-class documentation of his time and place. There is hardly a personality in the arts, politics and public life who has worked in or had links with Hamburg since 1950 who is not now represented in Kempe's archives, some of them repeatedly over long periods of time. Kempe has never manipulated portraits. His pictures, which are never modified by work in the darkroom, are distinguished by their honesty and spontaneity, by their simplicity, and by his precise observation of appearance, gesture and behavior. His subjects have included Max Ernst and Hans Richter, Oskar Kokoscha and Josef von Sternberg, Albert Renger-Patzsch and Max Bill. Kempe has created, with a suggestive, evocative realism, a portrait of a people of an entire region over a period of more than three decades.

—Heinz Spielmann

KEPES, Gyorgy.

American. Born in Selyp, Hungary, 4 October 1906; emigrated to the United States, 1937: naturalized, 1956. Studied art, under Istvan Csok, at the Academy of Arts, Budapest, 1924-28, M.A. 1928; self-taught in photography. Independent painter and filmmaker, associating with Munka Art Group, Budapest, 1929-30; worked as an exhibition, stage and graphic designer, Berlin, 1930-32, 1934-36; Designer, studio of László Moholy-Nagy, London, 1936-37. Independent painter, photographer, and teacher, in the United States, since 1937. Head, Light and Color Department, New Bauhaus School, later the Institute of Design, Chicago, 1938-43; Professor of Design, North Texas State College, Denton, and Brooklyn College, New York, 1943-45; Professor of Visual Design, 1946-66, Founder-Director of the Center for Advanced Visual Studies, 1967-70, and Institute Professor, 1970-74, Massachusetts Institute of Technology, Cambridge. Visiting Instructor, Art Directors Club, Chicago, 1939; Visiting Professor, Harvard University, Cambridge, Massachusetts, 1965; Visiting Lecturer, University of California at Los Angeles, 1969; Visiting Artist, University of Hawaii, Honolulu, 1970; Painter-in-Residence, American Academy, Rome, 1974; Bicentennial Professor, University of Utah, Salt Lake City, 1975; Andrew Mellon Professor, Rice University, Houston, 1976; Artist-in-Residence, Dartmouth College, Hanover, New Hampshire, 1977; Distinguished Visiting Louis D. Beaumont Professor, Washington University, St. Louis, 1978; Kern Institute Professor in Communications, Rochester Institute of Technology, New York, 1981. Recipient: Typographical Arts Award, American Institute of Graphic Art, 1947; Guggenheim Fellowship, 1960; Silver Medal, Architectural League of New York, 1961; Fine Arts Award, American Institute of Architects, 1968. Fellow, Rhode Island School of Design, Providence, 1981. Fellow, American Academy of Arts and Sciences; Member, National Institute of Arts and Letters; Academician, National Academy of Design; Member, Hall of Fame, Art Directors Club of New York. Agents: Saidenberg Gallery, New York; and Alpha Gallery, Boston. Address: 90 Larchwood Drive, Cambridge, Massachusetts 02138, U.S.A.

Individual Exhibitions:

1939 Katherine Kuh Gallery, Chicago
 Grand Rapids Art Museum, Michigan (with Jean Helion and László Moholy-Nagy)
1944 Art Institute of Chicago
1951 Currier Gallery of Art, Manchester, New Hampshire
 Margaret Brown Gallery, Boston
1952 San Diego Fine Arts Gallery, California
 San Francisco Museum of Art
 University of California, Berkeley
1953 DeCordova Museum, Lincoln, Massachusetts
 Margaret Brown Gallery, Boston
1954 Cranbrook Academy of Art, Bloomfield Hills, Michigan
 Municipal Arts Center, Long Beach, California
 San Francisco Museum of Art
1955 Margaret Brown Gallery, Boston
 Stedelijk Museum, Amsterdam
1956 Fitchburg Art Museum, Massachusetts
1957 Everson Museum of Art, Syracuse, New York
 Museum of Fine Arts, Dallas
1958 Centro Culturale Olivetti, Ivrea, Italy
 Galleria di Via Montenapoleone, Milan
 Galleria Il Numero, Florence
 Galleria dell'Obelisco, Rome
1959 Baltimore Museum of Art
 Hayden Gallery, Massachusetts Institute of Technology, Cambridge
 Howard Wise Gallery, Cleveland
 Museum of Fine Arts, Dallas

 Museum of Fine Arts, Houston
 Swetzoff Gallery, Boston
1960 Saidenberg Gallery, New York
 Swetzoff Gallery, Boston
1962 Swetzoff Gallery, Boston
1963 Saidenberg Gallery, New York
 Swetzoff Gallery, Boston
1965 Swetzoff Gallery, Boston
1966 Marion Koogler McNay Institute, San Antonio, Texas
 Phoenix Art Museum, Arizona
 Saidenberg Gallery, New York
 Swetzoff Gallery, Boston
1967 Phillips Exeter Academy, New Hampshire
 Southern Methodist University, Dallas
1968 Alpha Gallery, Boston
 Galerie Moos, Montreal
 Saidenberg Gallery, New York
1970 Saidenberg Gallery, New York
1972 Alpha Gallery, Boston
 Galerie Moos, Montreal
 Saidenberg Gallery, New York
1973 Museum of Science, Boston
1974 Alpha Gallery, Boston
1975 Galleria dell'Obelisco, Rome
1976 Kunstlerhaus, Vienna
 Mucsarnok, Budapest
1977 Alpha Gallery, Boston
 Baushaus-Archiv Museum für Gestaltung, West Berlin
 Dartmouth College, Hanover, New Hampshire
 Prakapas Gallery, New York
 Robinson Gallery, Houston
 Vision Gallery, Boston
 Stephen Wirtz Gallery, San Francisco
1978 Steinberg Gallery, Washington University, St. Louis
 Hayden Gallery, Massachusetts Institute of Technology, Cambridge
 Henry Gallery, University of Washington, Seattle

Selected Group Exhibitions:

1929 *Artist New Society*, K.U.T., Budapest
1944 *Abstract and Surrealist Art in the U.S.A.*, Cincinnati Art Museum, Ohio (toured the United States)
1946 *Design with Light*, Philadelphia Art Alliance
1956 *Cross Currents*, Time-Life Building, New York
1959 *The Sense of Abstraction*, Museum of Modern Art, New York
1965 *Photography in America 1850-1965*, Yale University, New Haven, Connecticut
1976 *Expozicio: Foto/Muveszet*, Hatvany Lajos Museum, Hatvan, Hungary
1978 *Das Experimentelle Photo in Deutschland 1918-40*, Galleria del Levante, Munich
1979 *Photographic Surrealism*, New Gallery of Contemporary Art, Cleveland (travelled to Dayton Art Institute, Ohio, and Brooklyn Museum, New York, 1980)
1980 *Avant-Garde Photography in Germany 1919-39*, San Francisco Museum of Modern Art (toured the United States 1981-82)

Collections:

Museum of Modern Art, New York; Whitney Museum, New York; Rhode Island School of Design, Providence; Museum of Fine Arts, Boston; Fogg Art Museum, Harvard University, Cambridge, Massachusetts; Massachusetts Institute of Technology, Cambridge; Art Institute of Chicago; San Francisco Museum of Modern Art; Bauhaus Archiv, West Berlin; National Museum of Fine Arts, Budapest.

Publications:

By KEPES: books—*Tul a Valon*, with Gyorgy Dan, Budapest 1925; *Language of Vision*, Chicago 1944; *Graphic Forms: The Art as Related to the Book*, Cambridge, Massachusetts 1949; *The New Landscape in Art and Science*, Chicago 1956; *The Education of Vision*, editor, New York 1965; *Structure in Art and Science*, editor, New York 1965; *The Nature and Art of Motion*, editor, New York 1965; *Light as a Creative Medium*, with Bernard I. Cohen, Cambridge, Massachusetts 1965; *Module, Symmetry, Proportion, Rhythm*, editor, New York 1966; *Sign, Image, Symbol*, editor, New York 1966; *The Man-Made Object*, editor, New York 1966; *The Center for Advanced Visual Studies*, Cambridge, Massachusetts 1967; *Arts of Environment*, editor, New York 1972; *El Arte y la Technologia*, Bogota 1973; *Gyorgy Kepes Kialliasa*, with an introduction by Eva Korner, Budapest 1976; *Portfolio of Photographs by Gyorgy Kepes*, with an introduction by Philip Hofer, Boston 1977; *Gyorgy Kepes Irasai*, edited by Ferenc Bodri, Budapest 1978; *Gyorgy Kepes: The MIT Years 1945-1977*, with text by Judith Wechsler and Jan Van der Marck, Cambridge, Massachusetts 1978; articles—"On Photography" in *Arts and Architecture* (Los Angeles), August 1946; "Form and Motion" in *Arts and Architecure* (Los Angeles), July/August 1948; "New Landscape in Art and Science" in *Art in America* (New York), October 1955; "Creating with Light" in *Art in America* (New York), vol. 80, no. 4, 1960; "Light and Form" in *Arts and Architecture* (Los Angeles), May 1960; "Light as a Creative Medium" in *Arts and Architecture* (Los Angeles), October 1966; "Light and Design" in *Design Quarterly* (Minneapolis), no. 68, 1967; "László Moholy-Nagy: The Bauhaus Tradition" in *Print* (New York), January 1969.

On KEPES: books—*The Picture History of Photography* by Peter Pollack, New York 1958, 1969; *Das Experimentelle Photo in Deutschland 1918-1940* by Emilio Bertonati, Munich 1978; *Photographic Surrealism*, exhibition catalogue, by Nancy Hall-Duncan, Cleveland 1979; *Avant-Garde Photography in Germany 1919-1939*, exhibition catalogue, by Van Deren Coke, Ute Eskildsen and Bernd Lohse, San Francisco 1980.

In what is generally considered an unusual combination of talents for a visual artist, Gyorgy Kepes talks about his aims for his art as succinctly as his art reveals those ideals. Just as unusually, and just as successfully, Kepes melds his social and personal goals into a giant exploration of the universe. Painter, photographer and architectural redesigner, Kepes turns these—generally conceived—separated, even fragmented parts of human experience into a dynamic thrust that combines art and science and creates a giant explosion of forms. Kepes hopes these forms will awaken, and perhaps help direct, the development of mankind's positive sensibilities. The common denominator for his work, aims and ideas is the presence, and vigor, of light. He is drawn to—one might say consumed by—the way light gives form to the formless.

As a redesigner of spaces, Kepes takes a space such as Boston's harbor and plans to turn that entire space into a Gateway—into a redefined unit of light, his plan reverberating with structuralist/cubist overtones. As a painter, he takes a canvas and registers different degrees of form through tonalities that light alone creates. But it is through his photographs—and their necessary and basic use of light—that he shapes his freest designs with the world. Breaking loose from the given spaces he receives as an architectural redesigner and the predictable spaces he works with as a painter, he freshly conceives of a new world of forms through the camera. In one photograph, an eye rests upon an eye. In another, a moving object is depicted—moving—

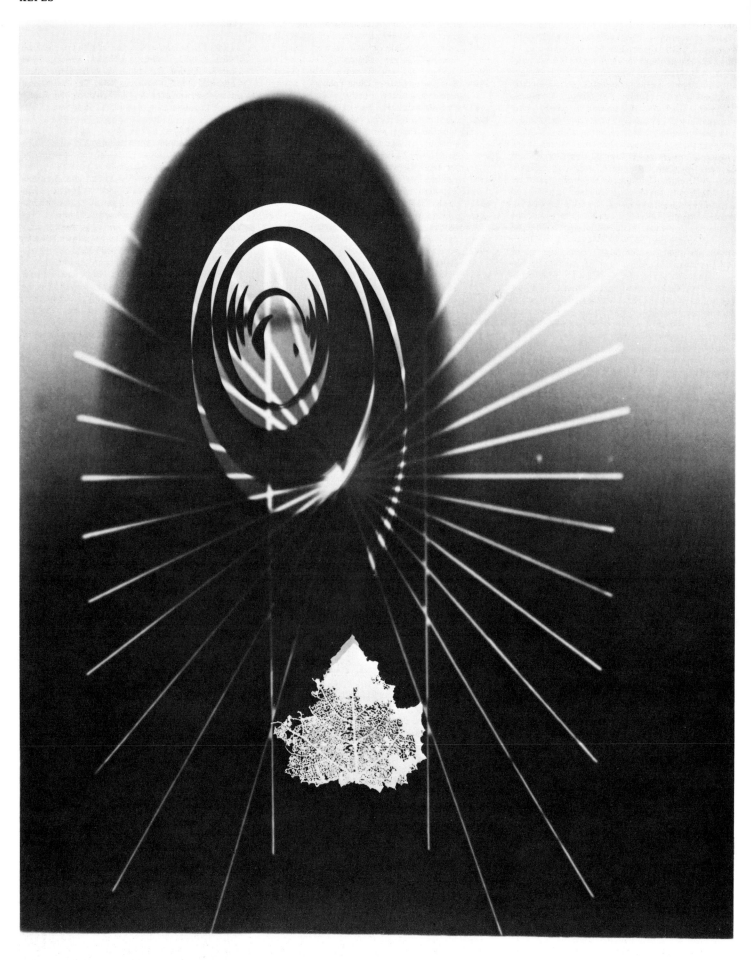

Gyorgy Kepes: *Photogram* Courtesy Art Institute of Chicago

only to be dispersed through the air in another part of the photograph. The camera allows him to develop layers of experience as he creates and shapes those experiences into forms that would otherwise remain formless in a fragmented world. It also allows him to combine his lyrical and structuralist freedoms into new forms. For, ultimately, it is a world without form—threatening to dissolve into personal, social and creative chaos—that worries and spurs him.

Kepes' photographs are rooted in understandings that come from Moholy-Nagy (he was, in a manner of speaking, a Moholy-Nagy student) and Herbert Bayer, an anti-Fascist German photographer of the 1920's and 30's. Starting with light-expressive collages that expose some of the intensity of a Fascist ideology, on the one hand, and the fears wrought by a socially and economically depressed world on the other, Kepes places objects in these early photographs in a timeless space. Many of these spaces are triangular and trapezoidal, reminiscent of the structuralist forms that infected the consciousness of the 1920's. Becoming more influenced by the world that light creates—rather than illuminates—Kepes experiments with photograms, his photograms depicting the form that objects take when seen as light-filled forms alone. Although these photographs are filled with movement—as visually attractive entities are—for the most part they are not concerned with movement. They are not about movement. They are primarily concerned with, and about, shapes and spaces.

By the 1940's and right through the 1970's, Kepes' photographs develop an interest in the movement that people, but mainly objects, create. Sometimes he depicts that movement as a relatively static phenomenon which has degenerated into pattern alone. At other times, he more excitedly depicts that movement with soaring possibilities. At still other times he catches the flair of that movement by subtly controlling the light and revealing the quiet cultures contained within that movement. It's as if Kepes has become aware of time as an element in his art, as if time has joined his considerations of space and helped shape these objects. It's as if these objects take on a form because of their own history, and their own development as forms. Their own composition—sometimes extravagant—and developed over the ages—now enters their existence. Unswerving in his belief about the way light gives shape to forms, Kepes uses light to give these forms a dimension. As forms alone, they stand over time. More sophisticated than his earlier forms, they echo some of the 1970's formalist concerns. But much more basically, they reflect Kepes' sensibilities. Refined, lyrical and fulsome, they tell the world that chaos has been kept at bay, that it is possible to create a world of dynamic forms that lift the expression of science and art onto new planes.

—Judith Mara Gutman

KEPPLER, Victor.

American. Born in New York City, 30 September 1904. Educated at Stuyvesant High School, New York, 1918-22; self-taught in photography. Worked for the United States Treasury during World War II. Married Josephine Windmann in 1924; children: Herbert and Victoria. Worked as a movie extra, designer, photo-printer, and part-time photographer, New York, 1916-20; photographer, Fingerprint Bureau, New York, 1926-28; freelance advertising and magazine photographer, working for U.S. Steel, Dupont, Westinghouse, Alcoa, General Electric, Corning Glass, Kodak, etc., and for *Saturday Evening Post, American Magazine, Woman's Home Companion, Ladies Home Journal, New York Woman, Hollywood Woman, Better Homes and Gardens, Cosmopolitan*, etc., New York, 1928-61; Founder, Director and President, Famous Photographers School, Westport, Connecticut, 1961-72; now retired. President and Director, The Photographic Administrators, New York, 1972-78; Creative Director, New Security Concept, Fairfield, Connecticut, 1976-78. Consultant, Hartford Insurance Group, Connecticut, since 1964; Creative Consultant, C.B. Dolge Company, Westport, since 1973. Member, Europhot professional photographers group, Brussels, since 1971. Trustee, Photography Hall of Fame. Recipient: Harvard Award, 1944; Gold Medal, Art Directors Club, New York, 1958, Cleveland, 1958, Chicago, 1959, Philadelphia, 1959, Boston, 1960; Photographers Hall of Fame Award, Santa Barbara, California, 1970; Distinguished Medal for Achievement, City College of New York, 1980. Address: 11 Ferry Lane West, Westport, Connecticut 06880, U.S.A.

Collections:

Newhouse Communications Center, Syracuse University, New York; International Museum of Photography, George Eastman House, Rochester, New York; Philadelphia Museum of Art; Nimitz Library, United States Naval Academy, Annapolis, Maryland; Smithsonian Institution, Washington, D.C.

Publications:

By KEPPLER: books—*The Eighth Art: A Life of Color Photography*, with a foreword by Bruce Barton, New York 1938; *Commercial Photography*, New York 1940; *Your Future in Photography*, New York 1970; *Victor Keppler: Man + Camera: A Photographic Autobiography*, with a foreword by Beaumont Newhall, New York 1970.

On KEPPLER: articles—"Victor Keppler: Legend in Our Times" in *Infinity* (New York), August 1971; "Pioneers of Commercial Color: Bruehl, Keppler, Muray, Outerbridge, Steichen" by Diana Edkins in *Modern Photography* (New York), September 1978.

Victor Keppler: *Judy Canova*, 1945

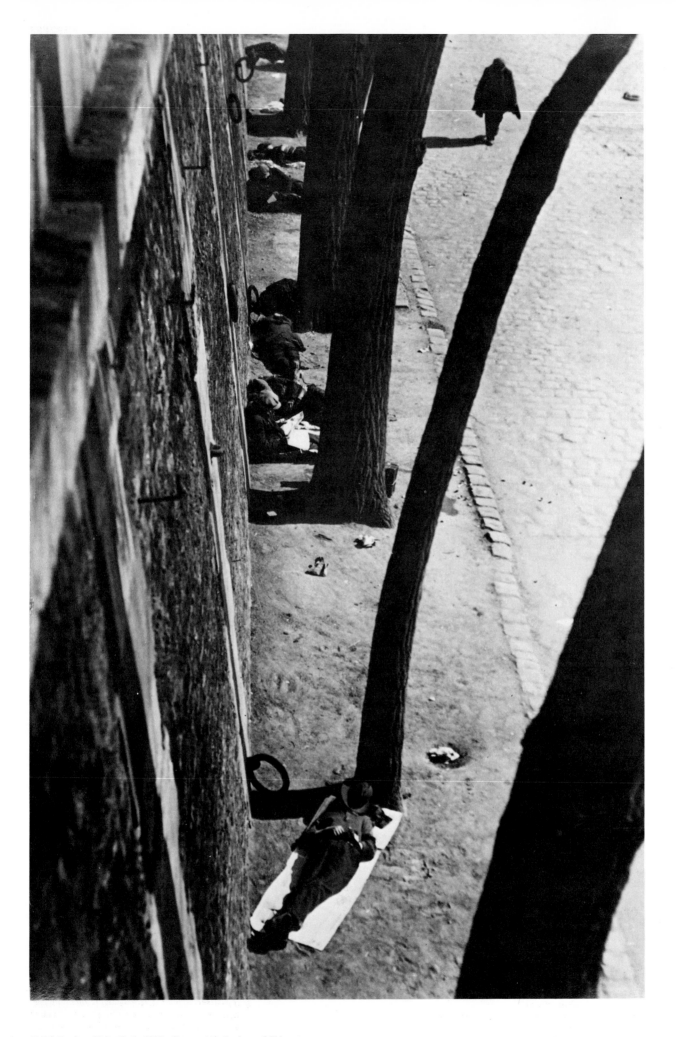

André Kertész: *Siesta*, Paris, 1927 Courtesy Art Institute of Chicago

In the 1920's, as advances in printing technology made possible the greatly-improved reproduction of photographs on the printed page, large commercial studios sprang up to meet the photographic needs of advertisers. Victor Keppler, by reason of his striking images, ceaseless energy, and flamboyant personality, became one of New York's best-known advertising photographers. For more than four decades he was an active force on New York's commercial photographic scene.

What makes for a successful advertising photograph? Is it one that win awards, or one that aims to sell the product? Keppler could boast triumphs on both counts: he won more than his share of recognition from the New York Art Directors Club, yet maintained a reputation for extraordinary attention to the needs of his clients. Keppler knew precisely the value of working on demand for demanding clients, and charged them accordingly; often he taped a couple of aspirin to the bottom of his bill.

From the beginning Keppler proved adept at incorporating into advertising images the trends of the other visual arts. In the 1920's, he combined razor-sharp realism with cubist-derived geometric patterning in cigarette advertisements. In the 1930's, he mastered the elaborate studio lighting techniques popularized by Hollywood, while at the same time bringing the look of documentary photography to his series for the American Tobacco Company. In the 1950's, Keppler learned from photo-journalism how realistic settings, spontaneous action, and natural lighting might be used to great advantage.

From the early 1930's Keppler established a reputation as one of the leading color photographers in advertising. Working primarily in the difficult carbro color process, he produced a great many vivid, eye-stopping photographic illustrations for advertisements and magazine covers. In his book *The Eighth Art*, Keppler demonstrates the understanding of the technical side of color photography that accounted for his success with it.

Keppler's autobiography, *Man + Camera*, is one of the most complete examinations of the career of an advertising photographer. It throws revealing light on the relations between the business and cultural environments and photographic technology, and is marked throughout by Keppler's own high spirits.

—Christopher Phillips

KERTÉSZ, André.

American. Born Andor Kertész in Budapest, Hungary, 2 July 1894; emigrated to France, 1925, and to the United States, 1936: naturalized, 1944. Studied at the Academy of Commerce, Budapest, 1910-12; self-taught in photography. Served in the Austro-Hungarian Army in Poland, Albania, and Rumania, 1914-15. Married Elisabeth Sali in 1933. Photographer since 1912. Worked as an accounts clerk, Budapest Stock Exchange, 1912-14, 1918-25; freelance photographer, working for *Frankfurt Illustrierte, Berliner Illustrierte, Uhu, Strasburger Illustrierte, Le Nazionale di Fiorenza, Vu, Sourire, The Times* (London), etc., Paris, 1925-35; Contract Photographer, Keystone Studios, New York, 1936-37; freelance magazine photographer, for *Harper's Bazaar, Vogue, Town and Country, American Magazine, Collier's, Coronet, Look*, etc., New York, 1937-49; Contract Photographer, Condé Nast Publications, New York, 1949-62; freelance photogra-

pher, New York, since 1962. Recipient: Photography Competition Prize, *Borsszem Janko* magazine, Budapest, 1916; Silver Medal, *Exposition Coloniale*, Paris, 1930; Gold Medal, *4th Mostra Biennale Internazionale della Fotografia*, Venice, 1963; Guggenheim Fellowship, 1974; Mayor's Award, New York, 1977; University of Salford Award, England, 1980. Member of Honor, American Society of Magazine Photographers, 1965. Commander, Order of Arts and Letters, France, 1977. Address: 2 Fifth Avenue, New York, New York 10011, U.S.A.

Individual Exhibitions:

1927 Galerie Le Sacre du Printemps, Paris
1946 Art Institute of Chicago
1962 Long Island University, New York
1963 Bibliothèque Nationale, Paris
 Modern Age Studio, New York
1964 Museum of Modern Art, New York
1971 Moderna Museet, Stockholm
 Magyar Nemzeti Galeria, Budapest
1972 Valokuvamuseum, Helsinki
1973 Hallmark Gallery, New York
 Light Gallery, New York
1976 Wesleyan University, Middletown, Connecticut
 French Cultural Institute, New York
1977 Centre Beaubourg, Paris
1978 *Sympathetic Explorations: Kertész/Harbutt*, Plains Art Museum, Moorhead, Minnesota
1979 Serpentine Gallery, London
 Kiva Gallery, Boston
1980 Salford University, England
 Galerie Agathe Gaillard, Paris (with Gilles Ehrmann)
1981 *Vintage Prints*, Galerie Wilde, Cologne

Selected Group Exhibitions:

1928 *Premier Salon Indépendant de la Photographie*, Salon de l'Escalier, Paris
1929 *Film und Foto*, Deutscher Werkbund, Stuttgart
1932 *Modern European Photography*, Julien Levy Gallery, New York
1934 *Photographies*, Salon Leleu, Paris
 Les Photographes, Galerie de la Pleiade, Paris
1937 *Photography 1848-1937*, Museum of Modern Art, New York
1967 *The Concerned Photographer*, Riverside Museum, New York (and world tour)
1977 *Documenta 6*, Kassel, West Germany
1978 *Neue Sachlichkeit and German Realism of the 20's*, Hayward Gallery, London
1979 *La Photographie Francaise 1925-1940*, Galerie Zabriskie, Paris (and Zabriskie Gallery, New York)

Collections:

Museum of Modern Art, New York; International Museum of Photography, George Eastman House, Rochester, New York; Smithsonian Institution, Washington, D.C.; Carpenter Center, Harvard University, Cambridge, Massachusetts; Detroit Institute of Arts; Art Institute of Chicago; New Orleans Museum of Art; University of Nebraska, Lincoln; Center for Creative Photography, University of Arizona, Tucson; Musée d'Art Moderne, Paris.

Publications:

By KERTÉSZ: books—*Enfants*, with text by Ja-

boune, Paris 1933; *Paris Vu par André Kertész*, with text by Pierre MacOrlan, Paris 1934; *Nos Amis des Bêtes*, with text by Jaboune, Paris 1936; *Les Cathedrales du Vin*, with text by Pierre Hamp, Paris 1937; *Day of Paris*, with text by George Davis, Paris 1945; *André Kertész, Photographer*, with text by John Szarkowski, New York 1964; *On Reading*, New York 1971; *Foto*, Budapest 1972; *André Kertész: Sixty Years of Photography*, with poems by Paul Dermée, New York and London 1972; *J'Aime Paris: Photographs since the 1920's*, New York 1974; *Washington Square*, with an introduction by Brendan Gill, New York 1975; *Of New York*, New York 1976; *Distortions*, with an introduction by Hilton Kramer, New York 1976; *André Kertész*, edited by Aperture, Millerton, New York 1976; *André Kertész: Landscapes* and *Americana* and *Birds* and *Portraits*, all edited by Nicolas Ducrot, New York 1979; *From My Window*, Boston 1981; articles—interview in *Dialogue with Photography* by Paul Hill and Thomas Cooper, London 1979; interview in *Voyons Voir: 8 Photographes*, edited by Pierre Borhan, Paris 1980.

On KERTÉSZ: books—*André Kertész: Photographies*, exhibition catalogue, Paris 1963; *André Kertész* by Anna Farova, New York 1964; *André Kertész*, exhibition catalogue, by Colin Ford, London 1979; articles—"Photo Kertész" by Montpar in *Chantecler* (Paris), 19 March 1927; "La Photographie, est-elle un art?" by Jean Gallotti in *L'Art Vivant* (Paris), 1 March 1929; "Kertész et son miroir" by Bertrand Guegan in *Arts et Metiers Graphiques* (Paris), no. 37, 1933; "André Kertész: Day of Paris" by Bruce Downes in *Popular Photography* (New York), no. 6, 1945; "André Kertész" by William Hoseman in *Infinity* (New York), no. 4, 1959; "My Friend André Kertész" by Brassaï in *Camera* (Lucerne), no. 4, 1963; "André Kertész, Photographer" by Margaret R. Weiss in *Saturday Review* (New York), 20 December 1964; "André Kertész: A Meeting of Friends" by Bill Jay in *Creative Camera* (London), August 1969; "A Triumph for the Innocent Eye: The Work of André Kertész" by Ainslie Ellis in *British Journal of Photography* (London), 20 October 1972; "André Kertész at 80" by D.S. Gelatt in *Popular Photography* (New York), November 1974; "The Master of the Moment" by Carole Kismaric in the *Sunday Times Magazine* (London), 13 January 1980; film—*A Window on the Square*, BBC Television, directed by Michael Macintyre, 1980.

I started photography instinctively. I never tried to imitate or copy any painting or graphic work; photography itself was the medium by which I strove to express my impressions and feelings. As with every art, in photography the most important thing is that we feel fully what we are doing.

—André Kertész

André Kertész was one of the first photographers to work spontaneously with a small, hand-held camera, catching things as they happened; and he is still one of the best. But he has never been limited; he works just as well with a tripod-mounted camera in a studio.

No one seems to think of Kertész as a photographer with a special gift for design; yet, in an understated way, he excels at design. Because of that skill, he is one of the very few first-rank black-and-white photographers whose pictures do not depend on excellent printing. That's fortunate, because for many years his darkroom work has been done by others and seldom to the standard that his photographs deserve. Even in technically undistinguished prints, his pictures keep their strength and much of their subtlety. When printed well, of course, they get even better. And that is because he photographs

403

consistently with rigorous, extreme formal clarity. The design does not call attention to itself. His sense of form seems innate: it is not the kind that can be learned in an art school. And it is never all there as to the picture. He uses it quietly as a means to an end, and so efficiently that it goes unnoticed. In this he is far different from those photographers whose pictures shout "design!" and have little else to show us. They are clever poster-makers; he is a thoughtful and intuitive artist. They strain for effect; he achieves it without letting the effort show.

Something seldom noted: another demonstration of Kertész's design sense. In the 1930's he did the excellent layout for Robert Capa's first book, *Death in the Making*, about the Spanish civil war. Capa was then a young protegé of Kertész. Unfortunately, this book was printed very poorly. It would be worth republishing with Kertész's layout intact, and this time with good halftone reproduction.

His work is economical, without waste motion. As one of the first photojournalists, Kertész would go out to cover a news event and he'd bring back 8 or 12 exposures, not 59 rolls. And those few frames told the story. Intelligent and discriminating seeing is more useful than a motor-driven camera.

Kertész has humor and irony, and has needed them. After a brilliant start in Europe, first as a boy in Hungary and as a young officer in the Austro-Hungarian Army during World War I (excellent photographs survive from those times), then after the war in Paris, where he earned prompt recognition, he came to the United States before World War II. His contract with Condé Nast seemed to offer full scope for his talent and initiative, but it didn't work out that way. Through the 1940's and '50's the work he did for them was mostly the conventional photography of well-decorated houses that is standard in magazines that specialize in gracious living rather than real life. It was a trap. He did this work beautifully and became identified with it. (At the time I had seen nothing else from him and thought of him as one of those highly skilled hacks who earn a comfortable living by doing what is expected.) Luckily for us, Kertész never forgot who he was and never stopped doing his own work, which no one saw, often taking personal pictures on the way to and from the pretty-house assignments.

In the early 1960's he came out from behind that curtain. Some personal pictures were published in *Infinity*, the magazine of the American Society of Magazine Photographers, and some were exhibited at the Museum of Modern Art in New York. They were revelations.

This emergence must have gratified Kertész: people began to see that he was a unique and remarkable artist. It did not solve his problems, since the commercial demand for subtle perception does not exist. But from then on there have increasingly been outlets for his real work—exhibitions and books.

Kertész has had good reason to be bitter, and he still has some bitterness, I think. He is skeptical, but has never descended to cynicism.

His special gift is to see and record the absurd and touching sights of ordinary life with poignance and clarity, on the wing as they fly past, so that the rest of us can see and appreciate them too. His photographs have grace, wit and compassion. They are warm, not cold. The bizarre interests him and he photographs it, but not as a freak show. He smiles; he doesn't sneer. His work reminds us that while people are certainly odd they are not all fools or all evil. They aren't all intelligent or pleasant, either, but something good is there for those who can see it. Kertész shows it to us.

—David Vestal

KESSEL, Dmitri.

American. Born in Kiev, now U.S.S.R., 20 August 1902; emigrated to the United States, 1923: naturalized, 1929. Educated at the Nemirov Gymnasium and at the Paltava Military Academy, Poltava, Russia, graduated 1918; studied at the Industrial Chemistry Institute, Moscow, 1921-22; studied at the New York City College, and photography at the Rabinovitch School of Photography, New York, 1934. Served in the Ukrainian Army, 1918, and as an officer in the Red Army, during the Russian/Polish War, 1919-21. Married Shirley Farmer in 1964. Worked at various odd jobs, for a fur exporter, and as a correspondent for Russian newspapers, New York, 1923-34; freelance industrial, advertising and reportage photographer, working for *Fortune*, *Life*, *Colliers*, *Saturday Evening Post*, etc., New York, 1934-42; War Correspondent, on contract to *Life*, 1942-44; Staff Photographer, *Life*, 1944-67; Contract Photographer, *Time* magazine, 1967-72; freelance photographer, working for *Smithsonian Magazine*, Time-Life Books, *Life*, etc., since 1972. Recipient: Order of Excellence, Spanish Morocco, 1949; Gold Medal, City of Ravenna, Italy, 1959; Knighthood, Italian Government, 1965; Order of Tadj, Iran, 1966. Address: 46 Avenue Gabriel, 75016 Paris, France.

Selected Group Exhibitions:

1951 *Memorable Life Photographs*, Museum of Modern Art, New York
1955 *The Family of Man*, Museum of Modern Art, New York (and world tour)
1979 *Life: The First Decade 1936-45*, Grey Art Gallery, New York University

Collections:

Metropolitan Museum of Art, New York; Time-Life Library, New York.

Publications:

By KESSEL: book—*The Splendors of Christendom*, Lausanne, Switzerland 1964.

On KESSEL: books—*Memorable Life Photographs*, with text by Edward Steichen, New York 1951; *Life Photographers: Their Careers and Favorite Pictures*, edited by Stanley Rayfield, New York 1957; *Travel Photography*, by the Time-Life editors, New York 1973; *The Magic Image* by Cecil Beaton and Gail Buckland, London and Boston 1975; *Life: The First Decade 1936-1945* by Robert Littman, Ralph Graves and Doris C. O'Neill, New York 1979, London 1980.

Even as a boy, Dmitri Kessel took pictures with a Brownie camera. After he left his father's beet plantation in Podolia district of the Ukraine at the age of 10, to go to school, he graduated from military academy in 1918 with a commission in the Ukrainian Army. He promptly got himself into trouble for taking amateur photos of the massacre of a Polish Army unit, in which 200 men were killed by Ukrainian peasants. He recalls that an army officer smashed his camera with its heavy glass plates over his head. In the turmoil of the Polish-Russian war of 1920-21, Kessel was twice imprisoned; he finally made his way to the U.S.A., arriving in New York in 1923.

After a series of odd jobs, including working for a fur exporter and manufacturer and as a correspondent for Russian language periodicals, he became interested in the combination of journalism and photography. He took a course in photography from the renowned Rabinovitch, from whom he principally learned self-criticism. Gradually, after

photographing the New York streets, buses, overhead railways and unfamiliar people, Kessel specialized in industrial photography on assignments from advertising agencies and American corporations. His first assignment for Time-Life's *Fortune* magazine came in 1935, and he joined *Life's* staff of photographers in 1944.

It is for his work as a news cameraman on these magazines that he is best known. His outstanding pictures of violence—the Congo, the British sweep into Greece, the Greek Civil War, the German retreat of 1945—are the work of a tried-and-tough newsman. At one time during the Greek civil war, Kessel stood directly in the firing line to take pictures, although he knew they stood little chance of getting published. When asked why he had done such a "crazy" thing, he said: "Somebody had to take them". After World War II, Kessel worked mainly out of *Life's* Paris bureau until 1956, covering the Middle East oil crisis, the Haganah Army in Palestine, Franco's post-war Spain, and stories from China, Ceylon, Japan, India, Siam, South and Central America.

But, apart from his hard-hitting news pictures, Kessel has an intense response to beauty: his record of the soaring majesty of many great churches and cathedrals—often taking several long exposure shots to achieve—are world famous. The extraordinary fidelity of his colour studies of the Vatican, the Sistine Chapel, St. Mark's in Venice, the mosaics of Ravenna, the sculpture of Bernini and Michelangelo have a monumental quality that is technically beyond comparison.

—Colin Naylor

KIFFL, Erika.

Austrian. Born in Karlsbad, Czechoslovakia, 19 December 1939. Studied graphics, under Joseph Fassbender, Fachhochschule, Krefeld, West Germany, 1957-59, and graphic design and photography, under Walter Breker, Kunstakademie, Dusseldorf, 1959-61. Art Director, *Elegante Welt* fashion magazine, Dusseldorf, 1961-65; Art Buyer, TEAM Publicity Agency, Dusseldorf, 1965-68; freelance representative for foreign photographers in Dusseldorf, 1968-75. Freelance photographer, Dusseldorf, since 1979. Address: Lindemannstrasse 3, D-4000 Dusseldorf 1, West Germany.

Individual Exhibitions:

1978 *Künstler in ihrem Atelier*, Staatsgalerie, Stuttgart (toured Germany and Austria, 1978-81)
1980 *Ateliersituation Österreich*, Galerie Heike Curtze, Dusseldorf (travelled to the Sammlung Fotografis, Vienna)
1981 *Raum-Sequenzen*, PPS Galerie, Hamburg (travelled to the Fotomuseum, Munich)

Selected Group Exhibitions:

1981 *New German Photography*, The Photographers' Gallery, London

Collections:

Kunstmuseum, Dusseldorf; Stadtgeschichtliches

Museum, Dusseldorf; Neue Sammlung, Munich; Staatsgalerie, Stuttgart; Kunsthalle, Hamburg; Institut für Moderne Kunst, Nuremberg; Sammlung Fotografis, Vienna.

Publications:

By KIFFL: books—*Künstler in ihrem Atelier*, with a foreword by Jörg Krichbaum, Munich 1979; *Foto-Symposion Schloss Mickeln*, Munich 1980; *Raum-Sequenzen*, with text by Helmut Heissenbüttel, Munich 1980.

On KIFFL: articles—"Künstler und Räume" by Ingrid Bacher in *Professional Camera* (Munich), February 1979; "Erika Kiffl" by Jörg Krichbaum in *Zoom* (Munich), March 1980; "Räume" by Christiane Zillinger in *Architektur und Wohnen* (Hamburg), September 1980; "New Germany Photography" by Rupert Martin in *European Photography* (Göttingen), December 1980.

My experience of the world comes from looking, and I try, by giving form to reality, to come to terms with my own reality and to clarify my point of view.

My photographs are a reaction to my surroundings and an action in the process I call life by which I capture and create my own reality.

My photographs are a message to people who know how to look, who can, by looking at my pictures, find themselves in touch with me.

In this way I take part in events.

I take photographs in studios because they are, for me, mysterious places where something is happening which has a lot to do with my own longing to express myself.

Artists' studios and what happens in them have

Erika Kiffl: From *Raum-Sequenzen*, 1979

always exerted an extraordinary fascination which either paralyzes or inspires me.

I have discovered my own pictures by travelling as a spectator through artists' studios.

—Erika Kiffl

The starting point for Erika Kiffl's photographs is not other photographs, nor the supposedly continuous contemplation of reality however modified, but the development of painting in the last two decades. So it follows that her vision is not to be judged according to traditional photographic criteria—as, for example, "realistic," "romantic," "poetic," "objective," etc. From her direct exposure to the artistic work at the Kunstakademie in Dusseldorf over the past 20 years (Graubner, Girke, Richter, Geiger, Beuys, Haese, Heerich, Klapheck, Uecker, among others), she has gained a feeling for new artistic ways of seeing and also found her theme—rooms.

In her series *Künstler in ihrem Atelier* (Artists in Their Studios), Kiffl has tried to discover and to portray creatively and photographically the ways in which the room—the studio—influences the work of individual artists. Her technique, however, is not painterly; she does not "paint" with the camera. She has made a particular camera lens system her own (quadrangular/square view-finder), and includes within this field of vision the most important components of the room and its natural light forms. Apart from the angles and corners which directly characterize the form (the "cube" of the room), light is the most important element in her pictures. Like a mute stage manager, light gives to the objects their significance and their roles, intermingling brilliance and darkness, the known and the unknown, the present and the past. Within this field of tension the artist is only occasionally present, and the objects

themselves contribute to the impression of silent communication: empty chairs, working tools left lying around and specially laid apart, and, above all, materials. All of these objects and materials emit an intensity appropriate to our conception of the place in which an artist would set out to create an atmosphere conducive to his work.

After this series, it was only consistent that Erika Kiffl should completely renounce people and concentrate on rooms themselves. Her latest series, *Raum-Sequenzen*, continues the working methods of *Künstler in ihrem Atelier*, but here she turns her attention from the materials of the artist (the particular studio as a source of inspiration) to other questions relating to space. Some of these photos could have come from the Robbe-Grillet novel/film *Last Year in Marienbad*.

—Ulrich Bischoff

KILLIP, Chris(topher).

British. Born in Douglas, Isle of Man, 11 July 1946. Educated at Douglas High School, 1957-62; self-taught in photography. Worked as a photographic assistant to various photographers, London, 1963-69. Freelance photographer, London, since 1970. Photography Fellow, Northern Arts, Newcastle upon Tyne, 1975-76; Director, Side Gallery of Photography, Newcastle upon Tyne, 1977-78; Photographer-in-Residence, University College, Cardiff, 1979-80. Recipient: Photography Grant, Arts Council of Great Britain, 1973, 1974, 1977. Agents: David Dawson Gallery, Metropolitan Wharf, Wapping Wall, London E1, and Witkin Gallery, 41 East 57th Street, New York, New York 10022, U.S.A. Lives in London. Address: c/o Side Gallery, Newcastle upon Tyne, England.

Individual Exhibitions:

1977 *Photos of North East England*, Side Gallery, Newcastle upon Tyne
1980 *Isle of Man*, Side Gallery, Newcastle upon Tyne (toured the U.K., 1980-83)

Selected Group Exhibitions:

1977 *Concerning Photography*, The Photographers' Gallery, London (travelled to Spectro Workshop, Newcastle upon Tyne)
1980 *Old and Modern Masters of Photography*, Victoria and Albert Museum, London (toured the U.K.)
 Work from the Arts Council Collection, Hayward Gallery, London
 Recent Acquisitions, Victoria and Albert Museum, London

Collections:

Victoria and Albert Museum, London; The Photographers' Gallery, London; Bibliothèque Nationale, Paris.

Publications:

By KILLIP: book—*Isle of Man: A Book about the*

Manx, with an introduction by John Berger, London 1980; article—"Lewis Hine" in *Side Gallery Bulletin* (Newcastle upon Tyne), 1977.

On KILLIP: books—*British Image 2*, edited by the Arts Council, London 1976; *Concerning Photography*, exhibition catalogue, edited by Jonathan Bayer, London 1977; *Creative Camera Yearbook*, edited by Colin Osman and Peter Turner, London 1975; *Exploring Photography* by Bryn Campbell, London 1978; *About 70 Photographs*, edited by Chris Steele-Perkins and Bill Messer, London 1981; articles—"Chris Killip" in *Creative Camera* (London), May 1977; "Chris Killip" by Shoji Yamagishi in *Camera Mainichi* (Tokyo), July 1978; "Har Finns Mina Rötter" by Peter Turner in *Aktuell Fotografi* (Helsingborg, Sweden), November 1980.

After four years of working in London for various studios, Chris Killip returned to his home in the Isle of Man, and his first published photo-essay was on the TT races there. Then he brought the large format camera to explore the island, its people and places, and began a serious and very beautiful study that was finally published in book form in 1980. These pictures have been widely seen and appreciated both in exhibitions and in magazines, but the book has finally made them widely available in a production the standard of which really does justice to the originals.

Killip has continued to use the large format camera to make portraits and undertake both editorial and advertising assignments, but his importance to photography lies also in his wide interests, the help he has given to the Side Gallery (Newcastle upon Tyne) in particular, and his influence through his work in the gallery on younger photographers.

The print quality and intensity of the Isle of Man portraits and landscapes were somewhat reminiscent of the work of Strand, but because his subjects were mostly people and places that he knew well, Killip was able to make a somewhat more relaxed and realistic study, and keeping the art of the camera under tight control actually allowed him to convey much valuable information as well as an impressive beauty and quality of vision to the viewer.

Chris Killip is unusual in that he is willing to take considerable time over any subject—not simply each photograph, but the whole series must be right, and his attention to detail and the clarity of the print quality all contribute to the satisfaction that one feels when looking at one of his pictures individually. These are no snap-shots but the considered study of an intelligent mind that searches beneath the surface to bring out the essential spirit of his subject, whether it be a person or a place, and the resulting timeless quality in the best of the photographs ensure them of a constant place in our memories once we have studied them.

—Sue Davies

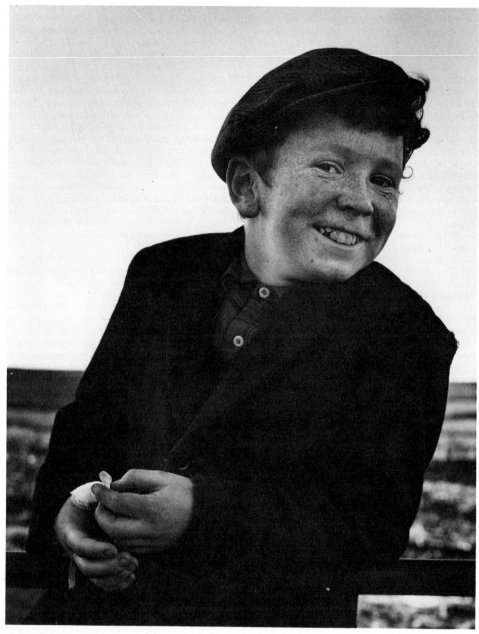

Chris Killip: From the *Isle of Man*, 1980 Courtesy Arts Council of Great Britain

KIMURA, Ihei.
Japanese. Born in Tokyo, 12 December 1901. Educated at Kyoka Commercial High School, Tokyo, graduated 1916; self-taught in photography. Opened own photo studio, Tokyo, 1924; worked for the Advertising Department of Kaoh Soap Company, Tokyo, 1930; Founder-Member, Nihon Kobo Photo Studio, Tokyo, 1933-34; news photographer, working with Younosuke Natori, for the *Berliner Illustrirten Zeitung*; staff member, *Sun Photo News*, Tokyo, 1947; freelance photographer, Tokyo, 1948 until his death, 1974. First President, Japan Photographers Society, 1950-58, and thereafter Adviser to the Society. Recipient: Kan Kikuchi Prize, Ministry of Education, Tokyo, 1956. *Died* (in Tokyo) *31 May 1974.*

Individual Exhibitions:

1933 *Portraits of Japanese Artists*, Kinokuniya Gallery, Ginza, Tokyo
1939 *Japan Through a Leica*, Mitsukoshi Gallery, Ginza, Tokyo
1955 *Ihei Kimura's Travels Abroad*, travelling exhibition (toured Japan)
1956 *Impressions of Europe*, Takashimaya Gallery, Tokyo

1966 *Stage of Zenshinza*, Fuji Photo Salon, Tokyo
1968 *The Vision of Ihei Kimura*, Nikon Salon, Tokyo
1969 *The Vision of Ihei Kimura II*, Nikon Salon, Tokyo
1970 *The Vision of Ihei Kimura III*, Nikon Salon, Tokyo (travelled to Osaka and Kyoto, 1970-71)
1972 *Travels in China*, Nikon Salon, Tokyo (travelled to Kyoto and Osaka, 1972-73)

Selected Group Exhibitions:

1934 *Documentary Photography*, Kinokuniya Gallery, Ginza, Tokyo
1963 *Grosse Photographen Unseres Jahrhunderts*, at *Photokina*, Cologne
1979 *Japanese Photography Today and Its Origin*, Galleria d'Arte Moderna, Bologna, Italy (travelled to the Palazzo Reale, Milan; Palais des Beaux-Arts, Brussels; and the Institute of Contemporary Arts, London)

Publications:

By KIMURA: books—*Photography of the World*

'60, editor, with Hiroshi Hara and others, Tokyo and New York 1960; *A Collection of Ihei Kimura's Best Photographs*, with an introduction by Kenzo Nakajima and Yoshio Watanabe, 3 volumes, Tokyo 1980; article—"Asakusa" in *Asahi Camera* (Tokyo), April 1973, May 1973.

On KIMURA: books—*Select Pictures*, exhibition catalogue, by Asahi Shinbunsha, Tokyo 1954; *Impressions of Europe*, exhibition catalogue, by Asahi Shinbunsha, Tokyo 1956; *Grosse Photographen Unseres Jahrhunderts*, edited by L. Fritz Gruber, Dusseldorf 1963, Vienna 1964; *Japanese Photography Today and Its Origin*, exhibition catalogue, by Attilio Colombo, Lorenzo Merlo and Isabella Doniselli, Bologna, Italy 1979; articles—"Ihei Kimura" by J. Olivier in *Jardin des Arts* (Paris), March/April 1973; "Lavish Homage to a Japanese Pioneer" by John Neary in *Photography Year 1980* by Time-Life editors, New York 1980.

Ihei Kimura, who died in 1974 at the age of 73, was one of the pioneers of modern Japanese photography and the first to practice his art professionally in Japan.

Kimura, born in 1901, was given a toy box-camera in 1910. By 1920 he had mastered the basic processes of photography in a Tokyo studio, and by 1924 he had opened his own studio. However, by 1926 he had lost interest in the techniques of studio production, had become more involved in the artistic composition of photographic images, and so joined an amateur photographic club. Dr. Eikener, who was then head of an airship company, came to Japan in 1929; he owned a Leica camera which fascinated Kimura. He purchased a Leica A-type in the following year, when he entered the advertising department of the Kaoh Soap Company. Kimura became a master of the Leica, and used it thereafter exclusively until his death. While with the Kaoh Company, he was very much influenced by Hideshige Ohta, who was then chief executive of the advertising department.

In 1933 an exhibition of Kimura's work, *Portraits of Japanese Artists*, was well received, due to both the inherent brilliance of the photographs and their technical virtuosity.

There are many critics and historians who have discussed Kimura's photography, and there seems to be general agreement that Kimura's approach was informed by a sensibility to the common man. Thus it was that he approached the essence of reality in a very natural manner. I agree with this consensus: Kimura self-consciously adopted this stance in his lifetime of photographing—influenced by his former colleague Ohta and by Nobuo Ina, a photographic critic who became Kimura's theoretician and friend.

Kimura, who played an active role both before and during the Second World War as one of the pioneers of modern Japanese photography, was also one of the most highly acclaimed photographers in the years after the war. That was the period when Cartier-Bresson's photographs were first brought into Japan, for an exhibition arranged by Jun Miki in 1951. The exhibition was a revelation for Kimura: he declared that every photographer should model himself after Cartier-Bresson, and from then on Kimura never took a photograph that wasn't spontaneous and informal. The following year Kimura took a series of photos of Akita Prefecture, which was possibly one of the creative peaks in his career.

Kimura continued all his life to take photographs of people in their daily lives; he normally used a 50mm lens on his Leica, which gave his photographs a perspective similar to that of a man's eyes. Possibly for that reason, there does not seem to be a camera at all between the object and Kimura the photographer. Naturalism was axiomatic to his art. "Uniqueness in ordinariness"—that is how Ihei Kimura will be remembered.

—Takao Kajiwara

KIRSTEL, Richard.

American. Studied photography, under Ralph Hattersley and Minor White, Rochester Institute of Technology, Rochester, New York, and, under Aaron Siskind and Harry Callahan, Institute of Design, Illinois Institute of Technology, Chicago. Freelance photographer. Instructor, Maryland Institute College of Art, Baltimore. Address: 212 East Biddle Street, Baltimore, Maryland 21202, U.S.A.

Individual Exhibitions:

1969 Exposure Gallery, New York

Selected Group Exhibitions:

1970 *Be-Ing Without Clothers*, Hayden Gallery, Massachusetts Institute of Technology, Cambridge

Publications:

By KIRSTEL: book—*Pas de Deux*, with an introduction by Nat Hentoff, New York 1970.

On KIRSTEL: articles—"Richard Kirstel: *Pas de Deux*" by A.D. Coleman in the *Village Voice* (New York), reprinted in Coleman's *Light Readings: A Photography Critic's Writings 1968-1978*, New York 1979; "Richard Kirstel: Is This the Scopes Trial of Photography?" by A.D. Coleman in the *New York Times*, 8 November 1970; "Poetic Justice I" by A.D. Coleman in the *Village Voice* (New York), 4 March 1971; "Poetic Justice II" by A.D. Coleman in the *Village Voice* (New York), 11 March 1971.

Theater, myth and the psychosocial disturbances of our epoch are the linked concerns which run throughout the work of Richard Kirstel. Using such archetypal motifs as darkness, violence and water, his imagery dissects the psychoids of contemporary Western culture.

Because the issues he addresses invariably concern the human condition, the central presences in his images are almost always human—or, if not, such facsimiles thereof as African tribal sculpture (one of his earliest subjects) or dolls, which he has explored for over a decade, using the doll not as a nostalgia-evoking signifier but as a human simulacrum or totem. Agreeing with William Butler Yeats that the only subjects fit for the contemplation of the mature mind are sex and death, Kirstel has considered those themes at length: sexuality in the two sequences which comprise his book *Pas de Deux*, and death in a number of works, most notably the sequences "Water Babies" and "Florida Condo."

Additionally, his work has explored such corollarly concerns as madness and the grotesque. The result is a major body of imagery which has been highly controversial—subject to much debate and even (in the case of *Pas de Deux*) to legal prosecution.

Kirstel employs the silver print exclusively as his vehicle. His studies under Minor White and Ralph Hattersley at the Rochester Institute of Technology, and with Aaron Siskind and Harry Callahan at the Institute of Design, grounded him in the classic tradition of photographic printmaking. Since then he has become a virtuoso printmaker who chooses to work in silver primarily because it makes possible the crafting of an extraordinarily subtle and highly personalized space, which is essential to his imagery.

Perhaps due to this meditative relationship with the printmaker's craft, Kirstel's photographic attitude is a contemplative one. He works with deliberate slowness, allowing little accident into his pictures. Opposed in principle to the so-called "snapshot aesthetic," he believes that "the camera is not just a net to be used to harvest images like a school of fish, but rather is a probe to explore the space of [my] existence."

Serial form is also essential to the approach to photography which Kirstel has defined as "extended realism." His stance is that of the epic poet or dramatist. Thus virtually all his imagery is conceptualized and resolved in sequences or suites, a conscious rejection of "the notion that the individual photograph is a complete statement." This commitment has led him to an investigation of the poetics of photography as well as the connections between this visual medium and sculpture, theater, and language itself.

A theorist and teacher as well as an image-maker, Kirstel has lectured and written essays on these and other subjects for a number of publications. A current work-in-progress is a book-length study, *Speculations On Imagery*, directed (like most of his writing) toward defining and analysing the linguistic infra-structure of photography as a communicative process—an attempt to build a comprehensive hermeneutic understanding of the medium.

The combination of his writing, his teaching and his imagery has earned Kirstel a reputation as a "photographer's photographer."

—A.D. Coleman

KLEIN, Aart.

Dutch. Born in Amsterdam, 2 August 1909. Educated at 8th B.H.S. High School, Amsterdam, 1922-25; self-taught in photography. Served in the Dutch Army Infantry, 1939-40; Sergeant; and as a Dutch war correspondent (rank of Captain), 1945. Married Johanna Magdalena Lindenberg in 1936; sons: Marcel and Edwin. Photojournalist and documentary photographer, working for the Polygoon Agency, Amsterdam, 1940, Schimmelpenningh, The Hague, 1940-41, Stadhuisfotograaf, Haarlem, 1941-42, Brusse Bureau, Amsterdam, 1942, and as a freelance photographer for *Algemeen Handelsblad, De Telegraaf, De Geillustreerede Pers, Vrij Nederland*, etc., Amsterdam, since 1946. Agent: Galerie Fiolet, Herengracht 86, Amsterdam. Address: Amsteldijk 7, 1074 HP Amsterdam, The Netherlands.

Individual Exhibitions:

1964 *Bilder ohne Worte*, Staatliche Landesbildstelle, Hamburg
1965 De Drommedaris, Enkhuizen, Netherlands
1966 Jongerencafé Schuttershof, Heerlen, Netherlands
 Akademie voor Beeldende Kunsten, Arnhem, Netherlands
1968 *Images Sans Mots*, Galerie Montalembert, Paris (travelled to the Centre Culturel Communal, Chatillon, France)
1972 Bibliothèque Nationale, Paris
1973 Polytechnical Museum, Moscow
 Stedelijk Museum, Amsterdam
1974 Galerie Fiolet, Amsterdam
 Staatliche Landesbildstelle, Hamburg
1977 *Brandt/Gibson/Klein*, Vrije Universiteit, Amsterdam (with Bill Brandt and Ralph Gibson)
1978 Galerij Paule Pia, Antwerp

Selected Group Exhibitions:

1948 *Foto '48*, Stedelijk Museum, Amsterdam
1952 *Weltausstellung der Fotografie*, Kunsthaus, Lucerne
1954 *Subjektive Fotografie 2*, Staatliche Schule für Kunst und Handwerk, Saarbrucken
1958 *Gebonden Kunstenfederatie* (Fotografen), Rijksuniversiteit, Leiden
1961 *Dag Amsterdam*, Stedelijk Museum, Amsterdam
1968 *The Door*, Museum of Contemporary Crafts, New York
Mostra di Fotografia, Bergamo, Italy
1975 *The Land: 20th Century Landscape Photographs Selected by Bill Brandt*, Victoria and Albert Museum, London (travelled to the National Gallery, Edinburgh; Ulster Museum, Belfast; and National Museum of Wales, Cardiff, 1976)
1978 *Fotografie in Nederland 1940-75*, Stedelijk Museum, Amsterdam
1979 *Fotografie in Nederland 1920-40*, Haags Gemeentemuseum, The Hague

Collections:

Stedelijk Museum, Amsterdam; Prentenkabinett, Rijksuniversiteit, Leiden; Museum für Kunst und Gewerbe, Hamburg; Bibliothèque Nationale, Paris; Victoria and Albert Museum, London.

Publications:

By KLEIN: books—*Amsterdam/Rotterdam: Two Cities Rhapsody*, Baarn, Netherlands 1959; *Delta: Poort van Europa*, Amersfoort, Netherlands 1962; *Delta: Stromen Land in Beweging*, Amersfoort, Netherlands 1967.

On KLEIN: books—*Photography Yearbook*, edited by Norman Hall, London 1963; *Aart Klein*, exhibition catalogue, by Wil Bertheux, Amsterdam 1973; *The Land: 20th Century Landscape Photographs Selected by Bill Brandt*, exhibition catalogue, edited by Mark Haworth-Booth, London 1975; *Fotografie in Nederland 1940-1975*, exhibition catalogue, by Els Barents, The Hague 1978; *Fotografie in Nederland 1920-1940*, exhibition catalogue, by Flip Bool and Kees Broos, The Hague 1979; articles—"Gesprek met Aart Klein" by Jaco Groot and Paul Mertz in *Streven* (Amsterdam), December 1965; "Portfolio: Aart Klein" by Colin Osman in *Creative Camera* (London), May 1970; "Uber Aart Klein aus Holland" by Fritz Kempe in *Moderne Fototechnik*, August 1970; "Aart Klein: Designs with White Light and Black Paper" by Willem Coumans in *Foto* (Doetinchem, Netherlands), December 1970.

I have always asked myself: is a zebra a black horse with white stripes, or a white horse with black stripes? The question remains.

In photography we speak of black and white photography, or black-on-white photography. I think it is white on black. Without light for our eye, all is black; a negative that did not catch light gives a black print. Each photo is the result of placing or catching light on a plane that is originally black. It depends on the quantity of light which impression the photo will make. A great quantity of white on the black brings the picture to the graphic print. But the photo is a matter of white-on-black.

* * *

The men on the moon made a wonderful picture of the world globe in a black heaven. It is all sharp and colourful. But there was war on earth, and hunger, and dinners, and demonstrations against the war; there were people dying, children were born, there was love-making, there was fighting in the streets. And on this wonderful picture you see nothing of that at all.

It is, therefore, that I say, it is the photographer who must cut pieces out of reality, or make pieces from his fantasies. In one picture you can't show all that is going on. Neither is it necessary.

—Aart Klein

It was after 1950 that Aart Klein's photography first acquired its own unique characteristics. Prior to that time he had occupied himself with ordinary journalistic and theatre photography. But, from 1950, it became more and more apparent to him that his most important concern was not so much the actual subject as the way in which it was printed. He acquired his personal way of developing, contrasting black/white, sometimes even excluding any grey tones. His photographs achieved a graphic character.

Klein always refers to white/black photography, rather than black/white, because, he says, "the light, the white, is put on the black paper." By printing in this way, he has been able to emphasize that which is important and to allow unimportant details to disappear. He analyzes the accompanying photograph as follows: "There is a lawn with a million blades of grass, but you cannot see any of them because, for me, the light on the crosses was more important for my photograph."

It is the case, however, that though Klein maintains that his subject is not important, he is, in fact, attracted to objects that already have a strong black/white contrast and a certain line structure—for instance, a building in scaffolding, bridges, viaducts, and also the wrinkled horizontal/vertical accent. He calls his photographs "images without words."

They do not need any text; they are self-explanatory, because he focuses always on the essential. Because of his almost playful interest in form and line, and because of the character of his photographs, his work is often referred to as "architectural" photography of photographic "construction."

Klein has produced some rather large books in which he has been able to work out his ideas and principles in detail. the best-known is *Delta: Stromen Land in Beweging* (*Delta: Land of Streams in Movement*).

Yet, finally, his photographs lack any social message. Klein uses photography as a means of expressing himself artistically, and his goal is to produce photographs of graphic quality.

A. de Jonge-Vermeulen

Aart Klein: *American War Cemetery, Margraten, Holland*, 1960

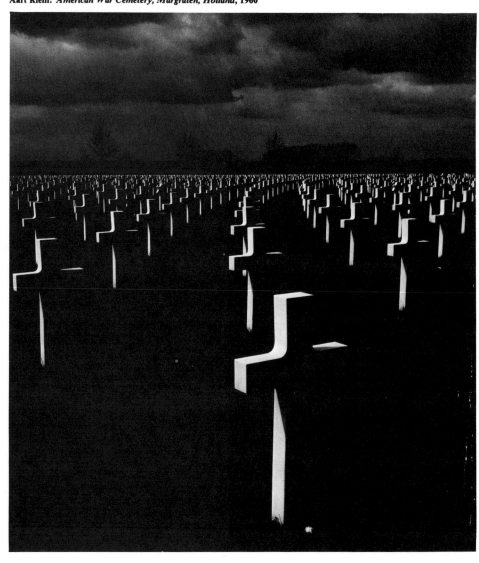

KLEIN, William.

American. Born in New York City in 1928. Studied social sciences at City College of New York, and art at the Sorbonne, Paris, 1948; studied painting, with the artist Fernand Leger, Paris, 1948-50; self-taught in photography. Served in the United States Army, working as a cartoonist etc. for the *Stars and Stripes* army newspaper, Germany and France, 1945-48. Independent painter, Paris, 1950-54; Contract Fashion Photographer, under Alexander Liberman, then Art Director, *Vogue* magazine, Paris, and also freelanced for *Domus*, etc., Paris, 1955-65; abandoned still photography to concentrate on filmmaking, Paris, from 1965. Recipient: Prix Nadar, Paris, 1957; Top Photographer Award, *Photokina*, Cologne, 1963; Grand Prix, *Festival Internationale de Tours*, 1965; Prix Jean Vigo, Paris, 1967. Address: 5 rue des Medicis, Paris 6, France.

Individual Exhibitions:

1961 Fuji Gallery, Tokyo
1967 Stedelijk Museum, Amsterdam
1978 The Photographers' Gallery, London (toured the U.K.)
Galerie Fiolet, Amsterdam
Apeldoorn Museum, Netherlands (toured the Netherlands)
1979 Fondation Nationale de la Photographie, Lyons (toured France)
Canon Photo Gallery, Geneva
1980 Museum of Modern Art, New York
1981 Centre Beaubourg, Paris
Galerie Zabriskie, Paris
Centre Culturel Americain, Paris
Light Gallery, New York
Cinematheque, Paris (films)
Ikona Gallery, Venice
Light Gallery, Los Angeles
The Photographers' Gallery, London (audiovisuals)
1982 Centre Beaubourg, Paris

Selected Group Exhibitions:

1963 *Photokina*, Cologne
1967 *Photography in the 20th Century*, National Gallery of Canada, Ottawa (toured Canada and the United States, 1967-73)
1968 *2nd World Exhibition of Photography*, Pressehaus Stern, Hamburg (and world tour)
1977 *Concerning Photography*, The Photographers' Gallery, London (travelled to the Spectro Workshop, Newcastle upon Tyne)
Fashion Photography, International Museum of Photography, George Eastman House, Rochester, New York (travelled to the Brooklyn Museum, New York; San Francisco Museum of Modern Art; Cincinnati Art Institute, Ohio; and the Museum of Fine Arts, St. Petersburg, Florida)
1978 *10 Photographers from Atget to Klein*, Massachusetts Institute of Technology, Cambridge
Rencontres Internationales de la Photographie, Arles, France
1979 *Photographie als Kunst 1879-1979/Kunst als Photographie 1949-1979*, Tiroler Landesmuseum Ferdinandeum, Innsbruck, Austria (travelled to the Neue Galerie am Wolfgang Gurlitt Museum, Linz, Austria; Neue Galerie am Landesmuseum Joanneum, Graz, Austria; and the Museum des 20. Jahrhunderts, Vienna)
1980 *Old and Modern Masters of Photography*, Victoria and Albert Museum, London (toured the U.K.)
Photography of the 50's, International Center of Photography, New York (travelled to the Center for Creative Photography, University of Arizona, Tucson; Minneapolis Institute of Arts; California State University at Long Beach; and the Delaware Art Museum, Wilmington)

Collections:

Museum of Modern Art, New York; Metropolitan Museum of Art, New York; Stedelijk Museum, Amsterdam; Bibliothèque Nationale, Paris; National Museum of Modern Art, Tokyo.

Publications:

By KLEIN: books—*New York*, Paris and London 1956; *Rome*, London 1960; *Moscow*, New York 1964; *Tokyo*, New York 1964; *William Klein*, portfolio, with text by Alain Jouffroy, Paris 1978; *William Klein: Photographs*, with text by John Heilpern, Millerton, New York, London and Paris 1981; films—*Broadway by Light*, 1959; *Cassius the Great*, 1965; *Qui etes-vous Polly Magoo?*, 1967; *Loin du Vietnam*, with Alain Resnais, Jean-Luc Godard, Chris Marker and others, 1967; *Mr. Freedom*, 1968; *Pan-African Cultural Festival*, 1970; *Eldridge Cleaver, Black Panther*, 1969; *Le Grand Cafe*, television series, 1972; *Muhammad Ali the Greatest*, 1974; *The Model Couple*, 1976; *Hollywood, California*, 1977; *Maydays*, 1978; *Music City U.S.A.*, 1979; *The Little Richard Story*, 1980.

On KLEIN: books—*Photography in the 20th Century* by Nathan Lyons, New York 1967; *2nd World Exhibition of Photography*, exhibition catalogue, edited by Karl Pawek, Hamburg 1968; *The Magic Image* by Cecil Beaton and Gail Buckland, London and Boston 1975; *Concerning Photography*, exhibition catalogue, by Jonathan Bayer and others, London 1977; *Geschichte der Fotografie im 20. Jahrhundert/Photography in the 20th Century* by Petr Tausk, Cologne 1977, London 1980; *Photographie als Kunst 1879-1979/Kunst als Photographie 1949-1979*, exhibition catalogue, 2 vols., by Peter Weiermair, Innsbruck, Austria 1979; *The History of Fashion Photography* by Nancy Hall-Duncan, New York 1979; *The Vogue Book of Fashion Photography* by Polly Devlin, with an introduction by Alexander Liberman, New York and London 1979; *Old and Modern Masters of Photography*, exhibition catalogue, by Mark Haworth-Booth, London 1980; *Voyons Voir: 8 Photographes*, edited by Pierre Borhan, Paris 1980; *Photography of the 50's: An American Perspective* by Helen Gee, Tucson, Arizona 1980; *William Klein: Photographer, Filmmaker* by Katherine Tweedie, Rochester, New York 1982; articles—"William Klein" in *Camera* (Lucerne), March 1969; "William Klein" by Alain Jouffroy in *Zoom* (Paris), July/August 1973; "William Klein" in *Creative Camera* (London), July 1974; "William Klein" in *Photo* (Paris), March 1979; "William Klein: Apocalypse" by Allan Porter, in special monograph issue of *Camera* (Lucerne), May 1981; "Another Star Is Born" by Jan Zita Grover in *Afterimage* (Rochester, New York), January 1982.

Although American-expatriate William Klein's active involvement with photography was relatively brief—and sandwiched between other, longer careers as painter and filmmaker—he has had a profound, and controversial, effect upon the medium. "This isn't photography," declared a publisher, about Klein's photographs of New York, "this is shit!"

A more sympathetic commentator, John Heilpern, wrote in his introduction to Aperture's recent Klein monograph, "William Klein's pictures, like Klein himself, never quite seemed to belong.... Yet his pictures, which began as a furious protest against the establishment, influenced a whole generation of photographers."

Perhaps the most balanced appreciation, however, comes from Museum of Modern Art curator John Szarkowski, who wrote: "Klein's photographs of twenty years ago were perhaps the most uncompromising of their time. They were the boldest, and superficially the most scrofulous—the most distanced from the accepted standards of formal quality. His pictures weren't that easy to like when they were new. I'm not so sure they're that easy to like now. They're still bursting with their own kind of graphic muscle and visual sensation. They really extend what life can look like in pictures. They enlarge the vocabulary.... The very quality of Klein's kind of response enabled him to take pictures that live in the mind, but perhaps it led inevitably to a short photographic life."

When William Klein, an American painter in Paris, turned to photography in the early 1950's, he was either unaware of, or chose to ignore, the "accepted rules" of the medium. Thus, according to Heilpern, in developing his then-unique style, Klein "experimented with flash, wide-angle, grab shots, abstraction, blur, close-up, accidents, deformations, harsh printing, special layouts, and inking." In the process, he created powerful, gritty, crowded, ugly—often unlikable—and very exciting city pictures.

In Rome, Moscow, Tokyo, and especially his native New York (each would become the subject of one of four self-designed books published between 1956-1964), Klein perceived urban life (paradoxically) through the eyes of an innocent who had long ago shed his innocence. He was the watcher who, despite knowing what to expect, still confronts the world with awe and wonder. The frames of his pictures explode, forced outward by pressures built from the scene's own tensions and from a visual technique which piles on significant details to the bursting point.

William Klein was born in 1928. Twenty years later, after a stint in the Army, he found himself in Paris, and stayed, studying painting briefly with Fernand Leger. During a 1952 exhibition of his paintings in Rome, Klein's interests in time, motion and the reproducibility of his work led to his first experiments in photography. Within two years, he was the *enfant terrible* of the medium, and had also accepted an offer from Alexander Liberman to become a fashion photographer for *Vogue*.

By 1962, however, Klein had virtually abandoned still photography for filmmaking. Among his best-known films are: *Who Are You, Polly Magoo?*, *Far From Vietnam*, *Mr. Freedom*, and *Eldridge Cleaver, Black Panther*.

—Stu Cohen

KOLKO, Berenice.

American. Born in Grayewo, Poland, 2 November 1905; emigrated to the United States, 1920, and subsequently naturalized; returned to Europe, 1932, then returned to the United States, 1940; lived in Mexico from 1951. Studied photography under Rudolf Kopitz, 1937-40; worked as a darkroom technician for Lockheed Aviation, Los Angeles, 1942; photographer in the Women's Army Corps, 1944. Freelance photographer, Mexico City, from 1951. *Died* (in Mexico City) *15 December 1970.*

Individual Exhibitions:

1955 *Mujeres de Mexico*, Instituto Nacional de

Bellas Artes, Mexico City (travelled to the Los Angeles County Museum; De Young Memorial Museum, San Francisco; and Ontario Museum, Toronto)

1956 Centro Deportivo Israelita, Mexico City
Casa de los Amigos, Oaxaca, Mexico
1959 Casa de Mexico, Cité Universitaire, Paris
1960 Museo de Arte Moderno, Mexico City (and Instituto Nacional de Bellas Artes, Mexico City
1961 University of Guanajuato, Mexico
1963 *Rostros de Israel*, Instituto Nacional de Bellas Artes, Mexico City (and Galeria Chapultepec, Mexico City
Casa de la Juventid, Mexico City (toured Mexican military camps, hospitals and schools)
Teatro de la Paz, San Luis Potos, Mexico (and Institutio Nacional de Bellas Artes, Mexico City)
1964 Monterrey, Nuevo Leon, Mexico (travelled to the Instituto Nacional de Bellas Artes, Mexico City)
1965 *Rostros de Etiopia*, Museo de Arte Moderno, Mexico City
1969 *El Eclipse*, Casa del Lago, Bosque de Chapultepec, Mexico City

Selected Group Exhibitions:

1959 *Pan-American Games Exhibition*, Museum of Science and Industry, Chicago
1960 *150 Años de la Independencia de Mexico*, Museum of Modern Art, Miami
1963 *Paisajes Humanos y Fisicos de Asia*, Jornados de la Patria y la Cultura, Puebla, Mexico

Collections:

Los Angeles County Museum; Museo Nacional de Antropologia e Historia, Mexico City; Ontario Museum, Toronto; Stedelijk Museum, Amsterdam.

Publications:

By KOLKO: books—*Rostros de Israel*, Mexico City 1963; *Rostros de Mexico*, Mexico City 1965; *Semblantes Mexicanos*, Mexico City 1968.

Berenice Kolko arrived in Mexico at precisely the time when she would find it possible to postulate the idea that it was valid to publish photographs as ends in themselves.

Her images, all of a documentary nature, are at times resolved in a mannered style and sometimes are defective in technique. They belong to a kind of photography which does not reach the fullest expression possible in the medium, but one which is simplistic in its aesthetic concepts, emphasizing illustrative qualities rather than the intrinsic potential of the subject. As documents, they capture well enough, but superficially, the appearance of various Mexican types, from the underprivileged to the "personalities" of the artistic, scientific and literary worlds. Rarely does she penetrate the barriers of convention to show the subject's attitude to life. Her work, then, is a display of possibilities, abstract exegesis, and a demonstration of the way to use the medium simply to document.

Berenice Kolko also represents a trend that exists even today in photography: the foreign photographer who, arriving in Mexico, makes his money from the sale of "set views" of "primitive" peoples. More than anything else, such images reveal that the photographer, inexplicably, mysteriously, robs the soul, fills the subject with terror, and simultaneously exploits the exotic qualities and those customs so alien to the civilized European and the materialistic

North American alike.

Most of Kolko's work in Mexico was executed during the 1960's. She was born in Poland and spent the major part of her life in the United States. In Mexico she found the inspiration and the right conditions to develop a prolific output, none of it of any great quality. What, then, explains the great attention her work has received?

That attention has more to do with Kolko's moment in history than with her qualities as a photographer. In 1965, when her book *Rostros de Mexico* was published, the public was not accustomed to books exclusively dedicated to photographic images with only a brief explanatory text. The importance of Kolko lies in the attention she managed to direct towards her effort. Her tenacity and persistency helped her to achieve the publication of her work in one of the first books dedicated to the exploration of the possiblities of using photographs, apparently unconnected, assembled under an ambiguous classification. The method allowed her an unusual freedom of treatment and gave her work an unprecedented and wide-spread popularity in Mexico.

—Lázaro Blanco

KOPOSOV, Gennadi.

Russian. Born in Leningrad, in July 1938. Educated at schools in Leningrad, 1945-55, and at the Merchant Marine School in Riga, Latvia, 1955-57; self-taught in photography. Served in the Soviet Army, 1957-59. Photo Lab Assistant, Research Institute, Leningrad, 1959; Photographer for TASS (Soviet press agency), Leningrad, 1960. Since 1960, Special Photo-Correspondent for *Ogonyok* magazine, Moscow. Chairman, Photojournalists Section, U.S.S.R. Union of Journalists, 1975-78. Recipient: First

Prize, *World Press Photo Exhibition*, Holland, 1964; First Prize, *Interpressphoto Travelling Exhibition*, 1965. Address: Ogonyok Magazine, Moscow-Centre, U.S.S.R.

Selected Group Exhibitions:

1964 *World Press Photo* travelling exhibition
1965 *Interpressphoto* travelling exhibition
1971 *The Soviet Union in Photography* travelling exhibition (toured Prague, Moscow, Budapest, Berlin, Warsaw, Paris, etc.)

Koposov's work has also appeared in the annual exhibitions of *Ogonyok* magazine and the Novosti Agency, Moscow.

Collections:

Ogonyok Magazine, Moscow; Novosti Agency, Moscow; Daniela Mrázková Collection, Prague.

Publications:

By KOPOSOV: books—*V fokuse fotoreporter* (*In Front of the Photoreporter's Camera*), with Lev Sherstennikov, Moscow 1967; *My/We!*, with Lev Sherstennikov, Moscow 1970; *Pod nogami ostrov ledyannyj* (*Glacial Island*) Moscow 1972; *Hallo Siberia!*, with Lev Sherstennikov, Moscow 1972.

On KOPOSOV: books—*Foto SSSR*, by the Sovetskoye Foto editors, annually since 1970; "Photoreporters of Ogonyok" by Daniela Mrázková in *Revue Fotografie* (Prague), no. 4, 1972.

Gennadi Koposov's work was moulded from the outset by the requirements of Soviet picture magazines—in his case the biggest and oldest of the Soviet weeklies, *Ogonyok*, founded in 1923, where Koposov has been employed since the age of 22. His job has provided him with great opportunities for travel throughout the vast territory of the U.S.S.R.,

Gennadi Koposov: *-55° C.*, 1963

including regions hardly accessible to the rest of the population (Siberia, the North and South poles, the Far East), with generous conditions regarding his time, which have enabled him to devote a great deal of time to work on one theme, and finally with a somewhat exclusive professional and social position; at the same time, however, he was restricted in his work, by the general standard of a journal directed at the broadest section of the population and by propaganda tasks, which are the motive power of Soviet journalism, even pictorial journalism. And yet, finally, Koposov is the principal representative of the Soviet photojournalists of the early 1960's who were able to make their own way and take advantage of the liberalization that came about with the end of the tough Stalinist era.

Instead of the schematic picture stories that had become common in the press, this new generation of photojournalists once again introduced into Soviet photography themes from everyday life, a fresh perception, and emotion. They replaced overtly expressive and thematic photography with work that conveyed the artist's unique partialities and his individual vision. Just like its predecessor, the generation of the 1920's and 30's, it opened up to the public the near and far regions of an immense country; it popularized the country's program of industrialization that had been interrupted by the war; and it propagated the message of settlement on and economic usage of virgin lands and untapped mineral resources. Of course, all of this done with the inevitable pathos of Soviet art.

Koposov and his fellow reporters did not so much focus on man himself and his problems, his changing style of living during the period in which the echoes of war still made themselves felt, as concentrate on the conditions under which a citizen, now seen as a civilian, fulfilled his tasks and contributed to the implementation of the important set aims of the whole of society. That is why Koposov puts such emphasis on expressing the whole atmosphere of the depicted environment, of places fascinating because of their rough and yet romantically imagined exclusiveness and scope. That is why he makes use of arrangement, even montage processes, and various graphic devices, such as graining.

His most typical theme is the North, those places where temperatures drop to minus 50-60 degrees centigrade. Here, in the polar night, amidst snowstorms and blizzards, with scattered light, Koposov can make use of his talent for working under difficult lighting conditions, and give way to his fancy for using light effects to separate the essential from the non-essential, mixing light and darkness, with the silhouettes of people and things turning into spectres.

Koposov introduces artistic elements into reportage—artistic means of expression and artistic schemas of composition. He links his photographs into broader thematic units. With his friend, the editor Lev Sherstennikov, with whom he has worked closely for many years, he has been a pioneer in the U.S.S.R. with his thematic books of photographs, some of which they published themselves at the end of the 1960's and early 70's.

The leadership and influence of the leading reporter of *Ogonyok*, Dmitri Baltermans, an outstanding photographer of the preceding generation, also contributed to Koposov's development, and he in turn became a significant figure in the feature photography of the 60's and early 70's. However, Koposov was unable to keep up or acclimatize himself to the subsequent movement, that of the newest generation of Soviet press photographers, with its interest in the sociological documentary.

—Daniela Mrázková

KOUDELKA, Josef.

Czechoslovak. Born in Boskovice, Moravia, 10 January 1938; left Czechoslovakia in 1970, and became British resident, 1971, and French resident, 1980. Studied aeronautical engineering at the Technical University, Prague, 1956-61, Dip.Ing. 1961. Worked as an aeronautical engineer in Prague, 1961-67; also worked part-time as a freelance photographer, contributing to *Divadlo* (*Theatre*) magazine, Prague, 1961-65, and as Official Photographer to the Theatre za Branou, Prague, 1965-70 (full-time photographer from 1967). Member, Union of Czechoslovak Artists, 1965-70. Freelance photographer with the Magnum photo agency, Paris and New York, working in London, 1971-80, and in Paris, since 1980. Recipient: Annual Award for Theatre Photography, Union of Czechoslovak Artists, 1967; Robert Capa Memorial Award, 1970; British Council Photography Grant, 1972, 1973; Photography Bursary, Arts Council of Great Britain, 1976; Prix Nadar, Paris, 1978; United States National Endowment for the Arts Photography Grant, 1980. Agents: Magnum; and, Galerie Delpire, 13 rue de l'Abbaye, Paris 6, France; Helen Wright, The Atelier Group, 135 East 74th Street, New York, New York 10021, U.S.A.; John Hillelson Agency, 145 Fleet Street, London EC4, England. Address: c/o Magnum, 2 rue Christine, 75006 Paris, France.

Individual Exhibitions:

Selected Group Exhibitions:

Collections:

Victoria and Albert Museum, London; Arts Council of Great Britain, London; Ministry of Culture, Brussels; Kunsthaus, Zurich; Stedelijk Museum, Amsterdam; Galerie in Forum Stadtpark, Graz, Austria; Museum of Modern Art, New York; Philadelphia Museum of Art.

Publications:

By KOUDELKA: books—*Diskutujeme o moralce dneska* (*Discussion of Contemporary Morals*), Prague 1965; *Alfred Jarry's Ubu Roi*, edited by the Prague Institute of Theatre, Prague 1966; *Koudelka: Gypsies*, edited by Robert Delpire, with text by Willy New, Millerton, New York 1975, as *Koudelka—Gitans: La Fin du Voyage*, Paris 1977.

On KOUDELKA: books—*Looking at Photographs: 100 Pictures from the Collection of the Museum of Modern Art* by John Szarkowski, New York 1973; *Celebrations*, with text by Minor White, Millerton, New York 1974; *The Magic Image* by Cecil Beaton and Gail Buckland, Boston and London 1975; *Popular Photography Annual*, New York 1976; *British Image 2: Photographs by Ian Berry, Chris Killip, Josef Koudelka, Marketa Luskacova, Dennis Wright, Patrick Ward*, edited by the Arts Council, London 1976; *Concerning Photography*, exhibition catalogue, by Jonathan Bayer, Peter Turner, Ian Jeffrey and Ainslie Ellis, London 1977; *Faces*, edited by Ben Maddow, Boston 1979; *Venezia '79: La Fotografia*, edited by Daniela Palazzoli, Vittoria Sgarbi and Italo Zannier, Milan and New York 1979; articles—"Josef Koudelka: Gipsy" in *Camera* (Lucerne), March 1970; "Josef Koudelka" by Allan Porter and Daniel Sallenari, special monograph issue of *Camera* (Lucerne), August 1979.

Josef Koudelka's early training as a photographer of the theatre gives him his way of transforming the world; his pictures have theatrical emotional content—gestures are exaggerated, intense expressions are etched on faces, and the bodies of his people are taut with suppressed vitality. His photographs are as clear as a stage set; no matter the number of objects or people within his frame, each is placed with perfect formal simplicity that makes each picture aesthetically just right. There is no chaos, no jumble. Each picture has a story that goes with it, a plot, but the sense is of mystery and ambiguity. The scene is important and the secrets and history of life are buried there if only the people in the pictures could speak, or if Koudelka had written a text to go with his pictures. But while Koudelka's wide angle lens sees the whole stage, he offers no words to help the viewer.

The genius of Koudelka goes beyond his ability to see and capture from the ongoing world scenes as perfect as posed theatre pictures; you know his pictures are real life—not posed, not faked. A theatre picture gives itself away; it is too posed, too exaggerated, too intent on narrative—you know it is not real life. Koudelka has managed to take from theatre photography all of its virtues and to have avoided all of its weaknesses. He gives us photography of formal perfection, of high emotional content, in which subject matter is always the most important consideration.

The people Koudelka photographs do not have the advanced education that leads to coveted careers and occupations; they are not people of power, money, or possessions. They are from a forgotten time—a time when life was simpler, agrarian, and filled with ancient festivals and traditional religious ceremonies. The pictures are complex and often include many people who are involved with one another. But there is little or no eye contact between these people and they never smile at each other or at us. His gypsies are not the gypsies of laughter, music, and dance; rather, they are gypsies resigned to their fate of being forever persecuted and always on the margin of society. Life in the small villages

Josef Koudelka

and rural areas is desolate, lonely, and filled with an undercurrent of fear. There is none of the romantic idealization of rural life often found in art and literature.

The hardness and seriousness of the lives of Koudelka's people is mitigated by the sense of passion, meaning, earthiness, and camaraderie that is also felt in these photographs. These people have too harsh a life to be lighthearted, but they appear to be part of an ancient traditional world where they have absolute knowledge of what is important, what are the correct values. Birth, marriage, death, traditional community rituals, and simple activities with families and friends—these are life's serious and important events. They do not need to invent their lives.

In contrast to most of today's art photographers, who earn their living by being academics, by giving workshops and lectures, by doing commercial photographic work, or by having unrelated careers and jobs, Koudelka appears to survive without any of the ties to institutions or accumulation of the goods and comforts of life that a dependable income allows. He is more or less a nomad, making his home where he happens to be. He lives photography: taking pictures is his life. This passionate concentrated effort produces photographs you cannot ignore— they have extraordinary vitality and impact. It is exhausting to see an exhibition of Koudelka photographs, to be confronted with so intense a portrayal of daily life in so many images at one time.

The remote world pictured by Koudelka may be disappearing, succumbing to technology and urbanization. But Koudelka shows us the vitality and passion of these backwaters of modern life.

—Barbara Norfleet

KRAUSE, George.

American. Born in Philadelphia, Pennsylvania, 24 January 1937. Educated at Bok Vocational High School, Philadelphia, 1950-54; studied drawing, painting, graphics and design, then photography, at Philadelphia College of Art, 1954-57, 1959-60. Served in the United States Army, 1957-59. Married Patsy Johnson in 1959 (divorced, 1979); children: George and Kathryn. Graphics Designer and Photography Assistant with Samuel Maitin, Seymour Mednick and Dan Moerder, Philadelphia, 1960-67; professional advertising photographer, working for Time-Life Books, Houghton Mifflin publishers, *Show Magazine, Harper's Bazaar, McCall's, Sports Illustrated, Horizon*, etc., New York, 1968-75. Part-time Instructor, Fliesher Art Memorial, Philadelphia, and Swarthmore College, Pennsylvania, 1958-59; Instructor in Photography, Fliesher Art Memorial, Philadelphia, 1970-72, and Brooklyn College, New York, 1972-73; Associate Professor and Head of Photography, Bucks County Community College, Pennsylvania, 1973-75. Since 1975, Professor and Head of the Department of Photography, University of Houston. Visiting Associate Professor, Instituto Allende, San Miguel de Allende, Mexico, 1978; Photographer-in-Residence, American Academy, Rome, 1979-80. Recipient: Fulbright-Hays Fellowship, 1963; Guggenheim Fellowship, 1967, 1976-77; Alumni Award, Philadelphia College of Art, 1970;

National Endowment for the Arts Grant, 1972, 1979-80; Prix de Rome, 1976-77. Agent: David Mancini Gallery, 5020 Montrose Street, Houston, Texas 77006, U.S.A., and Mancini Gallery, 2031 Locust Street, Philadelphia, Pennsylvania 19103, U.S.A. Address: 420 East 25th Street, Houston, Texas 77008, U.S.A.

Individual Exhibitions:

1970 Museo de Bellas Artes, Caracas
1971 Moravian College, Bethlehem, Pennsylvania
 Photographer's Place, Berwyn, Pennsylvania
1972 Pennsylvania State University, University Park
 International Museum of Photography, George Eastman House, Rochester, New York
 Witkin Gallery, New York
1973 Pennsylvania Academy of Fine Arts, Philadelphia
 Briarcliff College, Briarcliff Manor, New York
1974 Photopia, Philadelphia
 Gallery of Photography, Vancouver
 Museo de Bellas Artes, Caracas
1975 Philadelphia Print Club
1976 Photopia Gallery, Philadelphia
 Museo de Bellas Artes, Bogota
 Afterimage, Dallas
 Cronin Gallery, Houston
 Enjay Gallery, Boston
1977 Gallery of Photography, Vancouver
 American Academy, Rome
1978 Witkin Gallery, New York

George Krause: *Fountain Head*, Philadelphia, 1970

413

Museum of Fine Arts, Houston
1979 Milwaukee Center for Photography
Rochester Institute of Technology, New York
1980 American Academy, Rome
Mancini Gallery, Houston
Hills Gallery, Denver
1981 Focus Gallery, San Francisco

Selected Group Exhibitions:

1963 *Five Unrelated Photographers*, Museum of Modern Art, New York
1964 *The Photographer's Eye*, Museum of Modern Art, New York
Six Photographers, International Museum of Photography, George Eastman House, Rochester, New York
1965 *Recent Acquisitions*, Museum of Modern Art, New York
1967 *Photography in the 20th Century*, National Gallery of Canada, Ottawa (toured Canada and the United States, 1967-73)
1971 *Five Young Americans*, Museum of Modern Art, New York (toured South America)
1975 *Photography in America*, Whitney Museum, New York
1977 *Annual Exhibition*, American Academy, Rome
1978 *Mirrors and Windows: American Photography since 1960*, Museum of Modern Art, New York (toured the United States, 1978-80)
1979 *Self as Subject*, Scudder Gallery, Durham, New Hampshire
1980 *Annual Exhibition*, American Academy, Rome

Collections:

Museum of Modern Art, New York; International Museum of Photography, George Eastman House, Rochester, New York; Addison Gallery of American Art, Andover, Massachusetts; Museum of Fine Arts, Boston; Philadelphia Museum of Art; Library of Congress, Washington, D.C.; Gernsheim Collection, University of Texas at Austin; Museum of Fine Arts, Houston; Museo de Bellas Artes, Caracas; Bibliothèque Nationale, Paris.

Publications:

By KRAUSE: books—*Saints and Martyrs*, portfolio, with an introduction by Carol Kismaric, Philadelphia 1976; *George Krause 1960-1970*, portfolio, with an introduction by Mark Power, Philadelphia 1980; *George Krause I*, with an introduction by Mark Power, Haverford, Pennsylvania 1972; articles—"Intensification" in *Darkroom*, edited by Eleanor Lewis, New York 1977; "Editing" in *Contact*, edited by Ralph Gibson, New York 1980.

On KRAUSE: books—*Photography in the 20th Century* by Nathan Lyons, New York 1967; *Looking at Photographs* by John Szarkowski, New York 1973; *Photography in America*, edited by Robert Doty, with an introduction by Minor White, 1974; *Mirrors and Windows: American Photography since 1960*, exhibition catalogue, by John Szarkowski, New York 1978; *The Photograph Collector's Guide* by Lee D. Witkin and Barbara London, Boston 1979; articles—"Two Young Philadelphians: Don Donaghy and George Krause" by Murray Weiss in *Contemporary Photographer* (Culpeper, Virginia), Fall 1962; "Young Talent" in *Art in America* (New York), June 1963; "Malaguena" in *Camera* (Lucerne), January 1966; "Saints, Martyrs and Everyday Mysteries" by C. Stevens in *Print* (New York), November/December 1970.

My work is about the real medium of photography as interpreted through the idea of fantasy.
—George Krause

An artist can be said to have reached maturity when the acclaim for recent accomplishments accords with the glories bestowed upon past achievements. Gems will always stand apart no matter when they are first conceived or executed, but it is a measure of quite some success to be able to maintain recent work on par with the past and vice-versa—have past work easily recollected, like a brand-name, in the face of the new. Only after several decades in a photographer's career can the staying power of singular images or completed bodies of work begin to assert convincing authority. While most 20-year veterans continue to be known primarily for recent hurrahs, there are those, like George Krause, whose past work remains every bit as vital and engrossing as the work they are producing today.

A 1980 photograph of a nude woman swishing a white sheet above her head in Krause's studio in Rome recalls his 1964 photograph of an elderly Spanish woman plodding down the street unknowingly stalked by her own shadow. Form and content are equal collaborators in making the pictures then, and now. The white sheet and the black shadow—the one protean and buoyant, the other coiled and menacing—characterize the life and death impulses that have become the cornerstones of Krause's sensibilities. There is the 1963 photograph of a white stallion rolling in a field. Squeezed into the top half of the frame, the kinetic beast has little room to rise. Echoes of gunshot fill the air. There is the 1970 photograph (reproduced here) of the face of a black boy holding his breath underneath a rushing fountain. His round, cherubic features are transformed by the water's flow into stone. And there is the 1971 image of collapsed concrete in a plaza in Buenos Aires that measures the length and width of a coffin.

But Krause's tightest handshake with death, his warmest embrace of life, occurs in his serial works. "Qui Riposa" and "Saints and Martyrs," both from the 1960's, affirm Christianity's inveterate fetishism with the ritual of death, while "i Nudi," from the late 70's, celebrates the mysteries of erotic fantasy.

The "Qui Ripose" photographs, many of which were taken in sunny San Francisco cemeteries, crop close to tombs and cross carrying faded photographs of long gone loved ones. The series permeates our senses with chilling warmth, like the first cold days of spring.

"Saints and Martyrs," by contrast, petrifies. Rummaging through the basement vaults of Indo-Hispanic churches in Mexico and South America, Krause photographed the blood-spattered, white-washed, broken-boned statues of Christ and other worshipped heroes and heroines of the church. Some of these man-made saints are caught clawing their way out of finely-quilted caskets, others are seen wrapped in sheets up to their necks and tagged as inventory, while still others are photographed through cellophane, the cry of their grief and anguish suffocated forever. This, without a doubt, is murder in the cathedral.

Krause's most recent series takes a surprising switch to the subject of the nude. The work coincides with Krause's tenure as photography's first Prix de Rome fellowship recipient. With Rome by his side, it's no wonder Krause imbues these "i Nudi" nudes with the lineaments and atmosphere of Renaissance altarpieces. One bony male nude with knees slightly bent is like the thief beside the savior. Others appear to have just come down from the cross. The female "i Nudi" nudes, on the other hand, are triumphant, full of flesh, or then pitch black with only radiating white cotton panties lowered to the knees or glowing necklaces to reveal their presence in the studio. Lead us not into temptation.

Keenly aware of the camera at his command and the darkroom at his disposal, George Krause has emerged time and again with his tiny prints of dazzling intensity, fantasy and passion. What we see in the world but don't notice, what we feel about life and death but haven't been able to visualize, George Krause buries in our memory with his camera.
—Arno Rafael Minkkinen

KRIMS, Les(lie Robert).
American. Born in New York City, 16 August 1943. Studied at Cooper Union, New York, B.F.A. 1964; Pratt Institute, Brooklyn, New York, M.F.A. 1967. Married Leslie Korda in 1968 (divorced, 1972). Freelance photographer since 1967. Assistant Instructor in Photography and Printmaking, Pratt Institute, Brooklyn, New York, 1966-67; Instructor in Photography, Rochester Institute of Technology, New York, 1967-69. Since 1969, Professor, State University of New York at Buffalo. Recipient: Artistic Decorators Inc. Award, 1969; Research Grant, State University of New York, 1970, 1971; New York State Council on the Arts Grant, 1971; National Education Association Fellowship, 1971, 1972; National Endowment for the Arts Fellowship, 1971, 1972, 1976; Creative Artists Public Service Grant, 1973, 1975. Address: 187 Linwood Avenue, Buffalo, New York 14209, U.S.A.

Individual Exhibitions:

1966 Pratt Institute, Brooklyn, New York
1969 Focus Gallery, San Francisco
International Museum of Photography, George Eastman House, Rochester, New York
Akron Art Institute, Ohio
Witkin Gallery, New York (with Wynn Bullock)
Garrick Fine Arts Gallery, Philadelphia
1970 Galleria Il Diaframma, Milan
Fictions, Galleri Prisma IV, Lund, Sweden
1971 International Museum of Photography, George Eastman House, Rochester, New York
Moore College, Philadelphia
University of Colorado, Boulder
Silver Image Gallery, Ohio State University, Columbus
Toronto Gallery of Photography
1972 Witkin Gallery, New York
Album Fotogalerie, Cologne
Internationaal Cultureel Centrum, Antwerp
1973 Boston University
Photogalerie Wilde, Cologne
1974 Galerie Delpire, Paris
Light Impressions Gallery, Rochester, New York
Galleria Documenta, Turin
Galleria Photografica Nadar, Pisa
1975 *Fictcryptokrimsographs*, Visual Studies Workshop, Rochester, New York
Light Gallery, New York
Shadai Gallery, Tokyo
Galerie Die Brücke, Vienna
Yajima/Galerie, Montreal
Nina Freudenheim Gallery, Buffalo, New York
1976 University of Colorado, Boulder

Les Krims: *...Buffalo Fashion: Watch Your P's and Jews; True; A Breadline; and Oxymorons (Big Morons),* 1979

Ohio Wesleyan University, Delaware
*Fictcryptokrimsographs and Kodalith
 Images*, Galerie Jollenbeck, Cologne
Colgate University, Hamilton, New York
Suzette Schochet Gallery, Newport, Rhode
 Island
Musée Galliera, Paris
One Eye Open, One Eye Closed, Alberta
 College of Art, Calgary
Galerie Nagel, Berlin
1977 *Kodalith Images*, Galerie ABF, Hamburg
Canon Photo Gallery, Geneva
Arbus/Krims/Michals, Galerie Schellmann
 und Kluser, Munich (with Diane Arbus
 and Duane Michals)
1978 *Academic Art 1974-77*, Canon Photo Gallery,
 Amsterdam
Galerij Paule Pia, Antwerp
Church Street Photographic Centre, Mel-
 bourne
Nova Gallery, Vancouver
1979 Paul Cava Gallery, Philadelphia
1980 *Please*, Phototheque of Thessaloniki, Greece
Idiosyncratic Pictures, Galerie Fiolet,
 Amsterdam

Selected Group Exhibitions:

1969 *Vision and Expression*, International Mu-
 seum of Photography, George Eastman
 House, Rochester, New York (toured the
 United States, 1969-71)
1970 *The Photograph as Object*, National Gallery
 of Canada, Ottawa
1971 *Photographs of Women*, Museum of Mod-
 ern Art, New York
1972 *The Expanded Photograph*, Philadelphia
 Civic Center
1973 *Critic's Choice*, Neikrug Gallery, New York
1975 *4 Americanische Photographen: Friedlan-
 der/Gibson/Krims/Michals*, Stätisches
 Museum, Leverkusen, West Germany
1976 *Photographie: Rochester*, Centre Culturel
 Americain, Paris
1977 *Foto-Sequenties*, Stedelijk Museum, Am-
 sterdam
1978 *Fantastic Photography in the U.S.A.*, Canon
 Photo Gallery, Amsterdam (toured
 Europe and the United States, 1978-80)
1980 *Photography: Recent Directions*, De Cor-
 dova Museum, Lincoln, Massachusetts

Collections:

Museum of Modern Art, New York; International
Museum of Photography, George Eastman House,
Rochester, New York; Museum of Fine Arts, Bos-
ton; Library of Congress, Washington, D.C.; Min-
neapolis Institute of Arts; University of Kansas,
Lawrence; University of New Mexico, Albuquerque;
National Gallery of Canada, Ottawa; Tokyo Col-
lege of Photography.

Publications:

By KRIMS: books—*8 Photographs: Leslie Krims*,
New York 1970; *The Little People of America*,
Rochester, New York 1972; *The Deerslayers*,
Rochester, New York 1972; *The Incredible Case of
the Stack o'Wheat Murders*, Rochester, New York
1972; *Making Chicken Soup*, Buffalo, New York
1972; *Fictcryptokrimsographs*, Buffalo, New York
1975; *Les Krims: Kodalith Images 1968-1975*, 32
postcards, Vienna 1976; *Idiosyncratic Pictures*,
portfolio of 15 photos, 1980.

On KRIMS: books—*The Art of Photography* by
Time-Life editors, New York 1971; *Photography in
America*, edited by Robert Doty, with an introduc-
tion by Minor White, New York 1974; *Private Real-
ities: Recent American Photography* by Clifford
Ackley, Boston 1974; *The Photography Catalog*,
edited by Norman Snyder, New York 1976; *Mirrors
and Windows: American Photography since 1960*
by John Szarkowski, New York 1978; articles—
"Les Krims: 4 Photographs That Drove a Man to
Crime" by A.D. Coleman in the *New York Times*,
11 April 1971; "Incisions in History/Segments of
Eternity" by Hollis Frampton in *Artforum* (New
York), October 1974; "Violated Instants: Lucas
Samaras and Les Krims" by A.D. Coleman in
Camera 35 (New York), July 1976; "Creating Pho-
tographs" by Peggy Sealform in the *New York
Times*, 10 October 1976; "Pieges à Temps" in *Nou-
vel Observateur* (Paris), June 1977; "Currents: Amer-
ican Photography Today" by Julia Scully in *Mod-
ern Photography* (New York), March 1979; "Singular
Developments" by Allen Robertson in *TWA Am-
bassador* (St. Paul, Minnesota), December 1979.

Les Krims' photographs are fresh, raw, humorous,
and sometimes offensive. Krims roughly probes the
unhealed wounds of contemporary America with an
un-clean scalpel. His photographs reveal cancerous
growths rudely hid under the flesh of our everyday
experiences; his camera opens the wounds with
satire.

Les Krims has photographed midgets, murders,
and mutilated women. He has documented the kid-
napping of his own son, and he has photographed
his nude aging mother and labeled her in his caption
a "giant monster." Krims' photographs make us
squirm. Yet, they always make us look.

Best known, and undoubtedly least loved, is
Krims' book of Polaroid SX-70s called *Fictcrypto-
krimsographs*. In this small book, Krims has given
play to his sexual fantasies. Most of the photo-
graphs depict naked women posing for the camera
in familiar home situations. By scoring or punctur-
ing the SX-70 prints, Krims has manipulated the
photographs—obscuring the background and mash-
ing the figures. The effect is a titillating display of
mutilated women (one dog, three men, and a frog).
In one photograph, "Meatgrinder, Triangle Fiction,
1974" a woman's breast is put through a meat-
grinder. In another, "Broom Optical Illusion, 1974"
a broomstick has been shoved up a woman's vagina
until it emerges from her mouth.

These pictures are grotesque and revolting. Yet at
the same time they fascinate. As much as we may
disapprove, these are very honest and apparently
common fantasies, played out over and over in
common pornography. Krims insists in the title and
in many of the captions that these are fictions. The
extreme manipulation of the photograph suggests
that the artist is stepping back from the scene to
survey the subject. Krims does not use these tech-
niques to excuse himself (he obviously makes no
effort to find excuses) but to insist that we too step
back and look at this bizarre but very real phenom-
enon.

It is hard for a critic with any sense of political or
social responsibility to approve of these degrading
photographs. But the issue is much more compli-
cated. In very few other examples of contemporary
photography has such a highly charged political
issue as the abuse of women been so directly con-
fronted. Judging from Krims' entire body of work, it
is clear that he is less promulgating one side of the
controversy than he is forcing a discussion of the
issue.

Not all of Krims' work is quite this controversial.
His latest work jokingly promotes toy farm animals
as sex objects. Clearly, throughout his entire oeuvre,
Krims exposes our society's weak points and en-
courages us to take a closer look. His amazing imag-
ination and, not to be slighted, his ribald sense of
humor, insures that we will indeed look.

—Ken Winokur

KRIZ, Vilem.

American. Born in Prague, Czechoslovakia, 4 Oc-
tober 1921; emigrated to the United States, 1952:
naturalized, 1958. Studied photography, under
Jaromir Funke, Josef Ehm and Frantisek Drtikol,
State Academy of Graphical Arts, Prague, 1940-46;
also studied at the Ecole Cinématographique et
Photographique, Paris, 1947. Married Jarmila Ves-
ela in 1945; children: Gabriel and Dominica. Worked
as a press photographer and reporter, Prague, 1945-
46; foreign correspondent for Czech newspapers,
Paris, 1946-48; freelance photographer, associating
with surrealistic artists, Paris, 1948-52; settled in
Berkeley, California, as freelance photographer,
1952-58, then in Montreal, 1958-60; worked in the
photographic department of the Metropolitan Mu-
seum of Art, New York, 1960-64; returned to Berke-
ley, 1964. Has taught photography, since 1964, at
various California colleges, including Mills College,
Oakland; Holy Names College, Oakland; and Uni-
versity of California, Berkeley. Since 1974, Profes-
sor of Photography, California College of Arts and
Crafts, Oakland. Agents: Focus Gallery, 2146 Union
Street, San Francisco, California 94123; and Gilbert
Gallery, 218 East Ontario Street, Chicago, Illinois
60611. Address: 1905 Bonita Avenue, Berkeley,
California 94704, U.S.A.

Individual Exhibitions:

1942 Town Hall, Strakonice, Czechoslovakia
1948 Maison Monaco, Cité Universitaire, Paris
1957 International Museum of Photography,
 George Eastman House, Rochester, New
 York
1965 ASUC Studio, University of California,
 Berkeley
1966 James Kennedy Art Gallery, Oakland,
 California
1967 M.H. de Young Memorial Museum, San
 Francisco (retrospective)
 Humboldt State College, Arcata, New York
1968 James Kennedy Art Gallery, Oakland,
 California (retrospective)
1970 Bathhouse Gallery, Milwaukee, Wisconsin
 Man's Faith, Suffering and Hope, Mills
 College Chapel, Oakland, California
 University of Lancaster, England
1971 San Francisco Museum of Art
 Santa Barbara Museum of Art, California
1973 Focus Gallery, San Francisco
1976 University of Oregon, Eugene
 Darkroom Workshop Gallery, Berkeley,
 California
1977 Light Work Gallery, Syracuse University,
 New York (retrospective)
 Stephen Wirtz Art Gallery, San Francisco
 San Jose Museum of Art, California
 Kimmel/Cohn Gallery, New York
1978 California College of Arts and Crafts,
 Oakland
 Gilbert Gallery, Chicago
1979 Art Academy, Cincinnati, Ohio (retro-
 spective)
 University of Osaka, Japan
 Sun Gallery, Osaka, Japan
 Friends of Photography, Carmel, California
 (retrospective)

Selected Group Exhibitions:

1940 *7 in September*, Smetana Museum, Prague
1949 *International Manifestation of Art*, Maison
 Monaco, Cité Universitaire, Paris
1953 *Post-War European Photography*, Museum
 of Modern Art, New York (toured the
 United States, 1953-56)
1963 *Photography in the Fine Arts*, Metropolitan
 Museum of Art, New York (toured the
 United States, 1963-68)
1967 *Photography in the 20th Century*, National

Gallery of Canada, Ottawa (toured Canada and the United States, 1967-73)
1978 *Fantastic Photography in the U.S.A.*, Canon Gallery, Amsterdam (toured Europe and the United States)
1980 *Hommage à Giorgio de Chirico*, Art Pavilion, Ljubljana, Yugoslavia (toured Europe)

Collections:

Metropolitan Museum of Art, New York; Museum of Modern Art, New York; International Museum of Photography, George Eastman House, Rochester, New York; Museum of Fine Arts, Boston; Cincinnati Art Museum, Ohio; Museum of Fine Arts, Dallas; Santa Barbara Museum of Art, California; San Francisco Museum of Art; Crocker Art Gallery, Sacramento, California; Museum of Decorative Arts, Prague.

Publications:

By KRIZ: books—*Everlasting Beauty*, Prague 1939; *In Another Time*, Prague 1940; *They Come Alive Again*, Prague 1942; *Conversation, Une Invitation au Dialogue*, with an introduction by A. Hyatt Mayor, New York 1963; *Kriz: Surrealism and Symbolism*, with an introduction by Alfred Frankenstein, Berkeley, California 1971; *Sirague City*, Berkeley, California 1975; *Séance*, with an introduction by Thomas Albright, Berkeley, California 1979; *Vilem Kriz: Photographs*, edited by David Featherstone, Carmel, California 1979; *10 Surreal-Postcards*, Berkeley, California 1980.

On KRIZ: book—*Vilem Kriz, Surrealist* by David Featherstone, Carmel, California 1979; articles—"Vilem Kriz: A Poignant, Gentle Surrealism" in *Creative Camera* (London), January 1970; "Vilem Kriz's Photographs Have Eyes" by Donald Key in the *Milwaukee Journal*, 20 September 1970; "Photographer's Masterful Spirit of Surrealism" by Thomas Albright in the *San Francisco Chronicle*, 15 January 1971; "Vilem Kriz, Gentle Mystic" by Joan Murray in *Artweek* (Oakland, California), 6 February 1971; "An Old Master of Photography" by Thomas Albright in the *San Francisco Chronicle*, 28 March 1977; "Vilez Kriz: Mythic Surrealism with a Shutterless Camera" by Leslie Goldberg in *San Francisco Bay Guardian*, 2 June 1978; "Surreal Life Drama" by Michael Goldberg in *New West* (San Francisco), 4 June 1979; "Vilem Kriz and His World of Dreams" by Helen Benedict in the *Independent and Gazette Sunday Magazine* (Berkeley, California), 28 December 1980.

A photograph is not art when it strives to look like a painting, and a painting fails as art when it begins to resemble a photograph.

I formulated that concept forty years ago, and I believe that it is as true today as it was then.

—Vilem Kriz

After almost a century and a half of photographic practice, and a similar period of critical controversy, it is disappointing to note that popular notions of photographic art continue to hinge on the photographer's role as a recorder of the picturesque. It is not, of course, my purpose to deny that there is any such role, nor to detract from the merit of photographers who are primarily keen observers of the world around us. On the other hand, no art criticism is ultimately viable without some hierarchy of values, and in my hierarchy the imaginative and creative artist outranks the alert recorder of things, no matter how sensitive or ingenious. A painter can begin with an empty canvas, and can proceed to fill it with images which need have no direct relationship with the world outside, images which may be pure products of his mind. That "art is a process of turning mind into matter" may be a simplistic definition, but it is for many purposes a very useful one. Certainly, it transcends all notions of art as a natural by-product of technical competence. Photographers can and do live up to this definition, but only with great difficulty, which is after all why really great practitioners are few and far between.

Of all conceivable photographic styles, photomontage represents one of the most congenial ways of following the creative, as distinct from the interpretive, path. The montage artist uses photographs which have their origin in the real world around us, and assembles them in a manner that transcends reality and creates new visual sensations. Objects always become symbols in surrealist hands, but since the component photographs of a montage can themselves be manipulated, photomontage can go beyond surrealism also.

Along these lines Vilem Kriz is an accomplished master. A comparison of his work with the creations of Jerry N. Uelsmann is inevitable, but it is not a simple matter, especially not for an admirer of both artists. Indeed, the comparison raises problems which go to the root of photographic aesthetics. Photographs by Kriz are "in the same medium," but they are in no sense imitative, and whereas Uelsmann often appeals to a sense of grandeur, Kriz touches more intimate human emotions. He does so with unerring and imaginative skill which reveals what we universally admire in an artist: deep insight into the nature of things. In my own view, Vilem Kriz is one of the really outstanding photographers of our time. Among his publications are *Conversation* and *Sirague City*. A representative selection of his work can be found in David Featherstone's monograph *Vilem Kriz: Photographs*, published in 1979 by the Friends of Photography of Carmel, California.

—H.K. Henisch

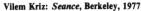

Vilem Kriz: *Seance*, Berkeley, 1977

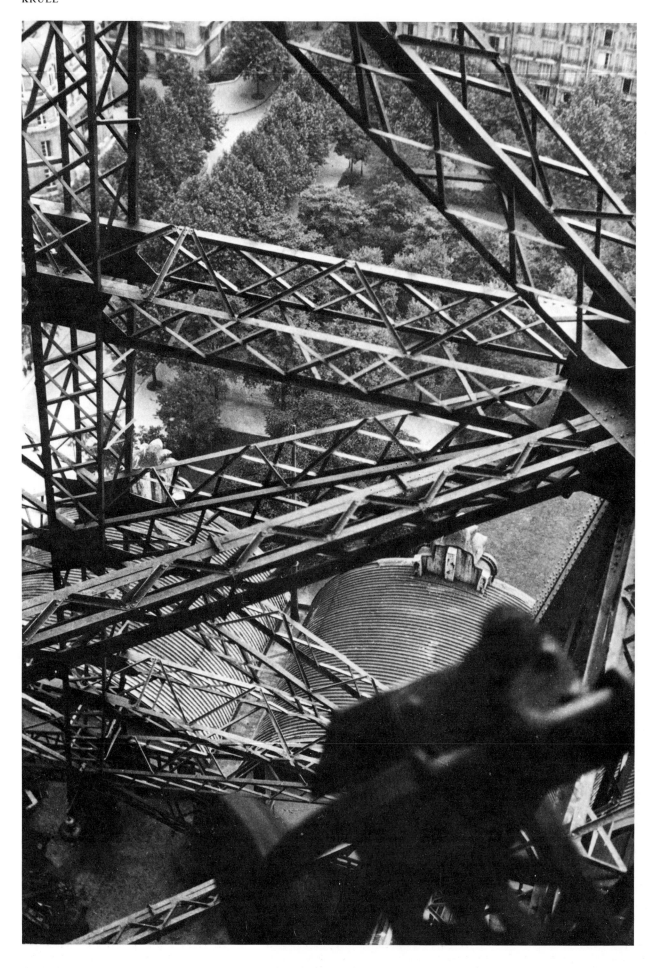

Germaine Krull: *Eiffel Tower*, **Paris, 1926**

KRULL, Germaine.
French. Born, of German nationality, in Wilda, Poznan, Poland, 29 November 1897. Educated in Paris, until 1909; studied photography, Bayerische Staatslehranstalt für Lichtbildwesen, Munich, 1916-18, M.A. 1918. Married the Dutch filmmaker Joris Ivens in 1937 (divorced, 1943). Freelance portrait photographer, establishing own studio, Munich, 1919-20, in Berlin, 1920-21; freelance architectural and industrial photographer, Amsterdam and Rotterdam (associating with Eli Lotar, Man Ray, and André Kertész, working for *Der Querschnitt, Varietés, Die Dame* and *Das Kunstblatt* magazines), 1921-24; freelance advertising, industrial, fashion, and portrait photographer, Paris (associating with Berenice Abbott, André Malraux, André Gide, Colette, Jean Cocteau, René Clair, Sonia and Robert Delaunay, and Louis Jouvet), working for *Vu, Arts et Metiers Graphiques, Voila, Marianne, Bifur, L'Art Vivant, Jazz, L'Art et Médicine* and *Synthése* magazines, and for Peugeot, Citroën, Electricité de France, Columbia Records, etc.), 1924-32; freelance photographer, travelling in the south of France and throughout Europe, 1932-40; Director, photo propaganda service of France Libre (Free French Army), Brazzaville, Africa, 1941-43, in Algiers, 1943-44; war correspondent and photographer, working for the illustrated newspaper *Rafale* and resistance newspaper *Liberation, Combat et Resistance*, in Germany and Italy, 1943-45, and in Indochina, 1946; independent photographer and Director, Oriental Hotel, Bangkok (also travelling to Thailand, Burma, Nepal, India, Tibet and throughout Europe), 1947-65; retired to north of India, living with refugees from Tibet who follow the Dalai Lama, since 1965. Agent: Galerie Wilde, Cologne. Address: c/o Galerie Wilde, Auf dem Berlich 6, 5000 Cologne 1, West Germany.

Individual Exhibitions:

1943 Centre de l'Information de la France Combattante, Algiers
1967 *Germaine Krull 1927-1967*, Musée du Cinéma, Paris
 Musée de la Ville, Nancy, France
1968 Alliance Française, Delhi
1977 *Germaine Krull: Photographien 1922-1967*, Rheinisches Landesmuseum, Bonn (80th birthday retrospective)
1980 Galerie Wilde, Cologne
 Stedelijk Museum, Amsterdam

Selected Group Exhibitions:

1925 *Abbott/Krull/Kertész/Lotar/Man Ray*, Galerie de l'Escalier, Paris
1926 *Salon d'Automne*, Paris
1928 *Premier Salon Independant de la Photographie*, Salon de l'Escalier, Paris
1929 *Film und Foto*, Deutscher Werkbund, Stuttgart
1932 *Exposition Internationale de la Photographie*, Palais des Beaux-Arts, Brussels (travelled to Lakenhal, Leiden, Netherlands; and Kunstzaal Van Hasselt, Rotterdam)
1977 *Documenta 6*, Museum Fridericianum, Kassel, West Germany
1978 *Paris-Berlin 1900-1933*, Centre Georges Pompidou, Paris
1979 *Film und Foto der 20er Jahre*, Württembergische Kunstverein, Stuttgart (travelled to Museum Folkwang, Essen; Werkbundarchiv, West Berlin; Kunsthaus, Zurich; Kunstverein, Hamburg; and Museum des 20. Jahrhunderts, Vienna)
1979 *Neue Sachlichkeit and German Realism of the 20's*, Hayward Gallery, London
 La Photographie Francaise 1925-1940, Galerie Zabriskie, Paris (travelled to Zabriskie Gallery, New York)

Collections:

Bibliothèque Nationale, Paris; Museum Folkwang, Essen; Museum Ludwig, Cologne; Rheinisches Landesmuseum, Bonn; Prentenkabinet der Rijksuniversiteit, Leiden, Netherlands; Stedelijk Museum, Amsterdam; Filmmuseum, Amsterdam; Metropolitan Museum of Art, New York.

Publications:

By KRULL: books—*Métal*, with text by Florent Fels, Paris 1927; *100 x Paris*, with text by Florent Fels, Berlin 1929; *The Afgh-Stuccos of the N.R.F. Collection*, with text by J. Strzygowsky, Paris 1929; *Etudes de Nu*, Paris 1930; *Le Valois*, with text by Gerard de Nerval, Paris 1930; *Paris*, with text by Adolf Hamann, Stockholm 1930; *La Chatte* by Colette, illustrator, Paris 1930; *Photographes Nouveaux: Germaine Krull*, with text by Pierre McOrland, Paris 1931; *La Route Paris-Méditerranée*, with text by Paul Morand, Paris 1931; *La Route Paris-Biarritz*, with text by Claude Ferrère, Paris 1931; *La Folle d'Iteville*, with text by Georges Simenon, Paris 1931; *L'Affaire des 7*, with text by Georges Simenon, Paris 1931; *Marseille*, with text by André Suares, Paris 1935; *Ballets de Monte Carlo*, Monte Carlo 1936; *Una Ciclada Antiga do Brasil*, with text by Paul Lino and Roberto Couto, Rio de Janeiro 1943; *La Bataille d'Alsace*, with text by Roger Vailland, Paris 1944; *Chiengmai*, with text by Lotus, Bangkok 1948; *Bangkok: Siam's City of Angels*, with text by Dorothea Melchers, London 1964; *Tales from Siam*, with text by Dorothea Melchers, London 1966; *Tibetans in India*, with text by Guatsho Tshering, Bombay 1968; *Germaine Krull: Fotografien 1922-1966*, with text by Christoph B. Ruger and Klaus Honnef, Bonn 1977; *Portfolio: Metal*, 14 photographs, Cologne 1980; article—"Germaine Krull," interview, with Inge Bondi, in *Printletter* (Zurich), May 1978.

On KRULL: books—*Der Akt*, Munich 1920; *Paris*, by Mario von Bucovich and Paul Morand, Paris 1928; *Mer, Marines, Marins* by Paul Valéry, Paris 1930; *Visages de Paris* by André Warnod, Paris 1930; *Germaine Krull 1927-1967*, exhibition catalogue, with text by Henri Langlois, Paris 1967; *Fotografie der 30er Jahre: Eine Anthologie*, edited by Hans Jürgen Syberberg, Munich 1977; *Documenta 6/Band 2*, exhibition catalogue, by Klaus Honnef and Evelyn Weiss, Kassel and Cologne 1977; *Neue Sachlichkeit and German Realism of the 20's*, exhibition catalogue, by Wieland Schmied, Ute Eskildsen and others, London 1978; *Paris-Berlin 1900-1933*, exhibition catalogue, by H. Molderings, W. Spies, G. Metken and others, Paris 1978; *Paris-Moscou 1900-1930*, exhibition catalogue, by Pontus Hulten, Jean Millier, Alexander Khaltourine and others, Paris 1979; *Film und Foto der 20er Jahre*, exhibition catalogue, by Ute Eskildsen and Jan Christopher Horak, Stuttgart 1979; *Photographen der 20er Jahre* by Karl Steinorth, Munich 1979; articles—special photographic issues of *Arts et Metiers Graphiques* (Paris), 1930, 1931, 1932.

It is very difficult for me to say anything about photography, because the activity has become an all-pervasive "sport." The small-format has spoiled the real intention of the artist; it may sound old-fashioned, but an artist has to give something of himself to his picutres. But, nowadays, this doesn't happen often.

All my life, I have tried to show reality, and have always tried to create something new. My last effort in that direction was shown at my exhibition in Paris, where I exhibited a small number of experimental color pictures. I called them "Silpagrams." It was an attempt to get out of the traditional color photo setup by the use of color itself. André Malraux was very keen and interested in them—but,

unfortunately, they did not inspire or encourage any young photographers, so I distributed the work among friends in the hope that some of the younger photographers will get some new ideas from it.

Photography is still a very young art, and needs time to grow—only it will have to grow out of commercial and amateur photography. The photographer who is dedicated to his work must return to basic work in the laboratory. He or she must learn anew to love photography.

Now that I am living in India, I have very little to do with professional photography.

—Germaine Krull

Years ago, in his essay, "Kleine Geschichte der Photographie," Walter Benjamin mentioned Atget, Blossfeldt, Sander and Germaine Krull in the same breath. A new evaluation of photography was being made in the early 1970's, and as a result, photogalleries were founded and new magazines sprang up devoted to the topic of "photography as art." But even so, experts were still unable to answer the question, "Why did Benjamin list Germain Krull?" or to determine what it was that made her work important for him. Her work had in fact fallen into obscurity, even though (at the instigation of her friend, André Malraux) there had been a large exhibition of her photographs, *Germaine Krull 1927-1967* held at the Musée du Cinéma in Paris.

Neither her revolutionary book *Métal* nor her fascinating work for the French illustrated magazines (especially *Vu*) have made their way into various reference books devoted the the history of photography. Benjamin must have known this work and been greatly impressed with it during a time like our own, when museums, galleries and publishing houses were enthusiastic about photography.

During World War II Germaine Krull lost all of the work she had done prior to 1945 and which had been so important in establishing her significance for the history of photography. After 1945 she lived in Bangkok and was not able to revive her reputation as a photographer, nor was she interested in doing so. She had developed new interests, taken advantage of new opportunities, and wished to make a final break with the neurotic, commercialized civilization of post-war Europe. Since 1945 she has lived in the northern part of India with the refugee followers of the Dalai Lama.

Anyone who meets Germaine Krull today senses immediately the strength, energy and determination which were necessary for a woman to make her mark in the Paris of the 1920's. The subject matter of her work—the Eiffel Tower, the Paris Metro, the markets and the tramps and the play of electric lights—were not the usual subjects for a woman and once again illustrate her strength. Very soon important figures like Robert Delaunay, Jean Cocteau, Man Ray and the young and alert André Malraux came to admire her work and pay tribute to it. In a letter to her Jean Cocteau wrote "You are a mirror which recreates things. With the help of your darkroom you allow a new world to spring into being, a world which encompasses both technical and intellectual dimensions." And Man Ray—indicating something about his own vanity—told her, "Germaine, you and I are the greatest photographers of our time, I in the old sense and you in the modern one."

The theme "métal" fascinated Germaine Krull in the early years following her education in Munich. From 1922 to 1924 the cranes, vertical lift-bridges, ships and machinery of Rotterdam and Amsterdam were her subjects. In Paris she continued this work, not in order to document modern technology but from an emotional fascination and desire to portray visually such concepts as power, speed, elegance and precision. It is not surprising that in his enthusiasm for the world of machines she had created Robert Delaunay was able to gain permission for her to show her work in the 1926 *Salon d'Automne*, usually reserved for the work of painters and sculptors

(unfortunately this was the only time photography was permitted in the Salon). The result of her participation here was the publication of *Métal* by Edition Calavas in 1927.

In the 1920's Gallimard put out a series called *Peintres Nouveaux*. Because of Germaine Krull's success—and the recommendation of André Malraux—Gallimard was encouraged to publish a new series, *Photographes Nouveaux*, even though conservative publishers were far from willing to accept photography as an artistic medium. Gallimard's decision made open-minded young intellectuals like Malraux, Camille Recht, Florent Fels and Pierre McOrlan all the more excited. In his introduction to the first volume in the series, *Photographes Nouveaux: Germaine Krull*, McOrlon wrote, "Of the works of all those poetic and precise witnesses of the 'colorful life' since 1918, I am particularly fond of the pictures of GK, no doubt because we react similarly to certain things in the plastic arts, GK is a northerner through and through and is, therefore, predestined to understand the unimaginably complex possibilities of photography. This talented and self-confident artist, a great reporter and poet of everyday life, is interested in every element of the world of men and machines—that is, in everything which constitutes and expresses the colorful and fantastic life of today. Whether GK transforms the world of machinery into a kind of stunning symphony or whether she literally plays with the lights of Paris between the Place Pigalle and the Place de la Bastille, she never tells simple stories. Instead, she extracts mysterious details which most people miss but which her lens uncovers."

During the 50's and 60's Germaine Krull was seized by the desire to photograph the culture and great art works of Buddhism. The places and works of art themselves lie beyond our reach, but thanks to the work of Germaine Krull they are now visible to us.

—Jürgen Wilde

KÜHN, (Carl Christian) Heinrich.

Austrian. Born in Dresden, Germany, 25 February 1866. Educated at the Gymnasium of the Holy Cross, Dresden; studied botany and medicine in Leipzig, Berlin and Freiburg, 1885-87; studied at the Institute for Pathological Anatomy, University of Innsbruck, Austria (did first experiments in microphotography, under Professor G.A. Pommern), 1887-88. Served in the 2nd Company of the 2nd Grenadiers, Kaiser Wilhelm of Prussia Regiment, 1885. Married Ema Rosa Katzing in 1894 (died, 1905); children: Carl, Edeltrude, Hans and Charlotte. Photographer from 1888; freelance photographer, mainly of portraits, in Vienna, where he worked with Hugo Henneberg and Hans Watzek on multiple gum-bichromate processes, 1888-1906, Innsbruck, 1906-20, and Birgitz, near Innsbruck, 1920 until his death, 1944 (worked as a commercial photographer, mainly for magazines, 1923-30, and as a researcher and designer for photo-optical companies in Austria and Germany, 1923-35; also, inventor of cameras and new film materials, 1925-40). Founder-Director, Schule für Künstlerische Photographie, Innsbruck, 1914-20. Editor, with Watzek and Henneberg, *Das Kleeblatt* magazine, Vienna, 1897; Contributing Editor, *Photographische Rundschau* magazine, Vienna, from 1927. Organizer, *Internationale Vereinigung von Kunstphotographen*, international photo exhibition, Dresden,

1909. Corresponding Member, Gesellschaft zur Förderung der Amateurphotographie, Hamburg, 1895; Member, Linked Ring, London, 1896. Recipient: Honor Award, Vienna Camera Club, 1895; Jubilee Medal, Photographische Gesellschaft, Dortmund, 1930. Honorary doctorate: University of Innsbruck, 1937. Honorary Member, Vienna Photo-Klub, 1903, Vienna Camera Club, 1905, and Verehrlichen Vereinigung Bildenden Künstler, Innsbruck, 1936. *Died* (in Birgitz) *9 October 1944.*

Individual Exhibitions:

1909 Museum Ferdinandeum, Innsbruck
1911 Galerie Thannhauser, Munich
1915 *Sonderausstellung Bildmässinger Photographie von Heinrich Kühn*, Kunstgewerbemuseum, Berlin
1952 *Gedächtnis Ausstellung Heinrich Kühn*, at *Photokina*, Cologne
1976 *Heinrich Kühn 1866-1944*, Galerie im Taxispalais, Innsbruck
1978 Fotomuseum im Stadtmuseum, Munich
 Galerie Block, Innsbruck
 Heinrich Kühn 1866-1944, Museum Folkwang, Essen

Kunsthaus, Zurich
1981 Neue Galerie, Linz, Austria
 Galerie Kicken, Cologne
 Galerie zur Stockeregg, Zurich

Selected Group Exhibitions:

1908 *Jubilee Exhibition of the Vienna Camera Club*, Galerie Miethke, Vienna
1910 *International Exhibition of Pictorial Photography*, Albright Art Gallery, Buffalo, New York
1911 *London Secession*, Newman Art Gallery, London
1925 *Kipo-Kino und Photo*, Funkhaus, Berlin
1933 *Die Camera*, Deutschen Arbeitsfront, Berlin
1964 *Kunstphotographie um 1900*, Museum Folkwang, Essen (travelled to the Landesbildstelle, Hamburg)
1973 *The Painterly Photograph*, Metropolitan Museum of Art, New York
1978 *Künstlerische Fotografie*, Museum Ludwig, Cologne
 Photos from the Sam Wagstaff Collection, Corcoran Gallery of Art, Washington, D.C.

Heinrich Kühn: *Phlox*, c. 1910 Courtesy National Gallery of Canada, Ottawa

1979　*Photographie als Kunst 1879-1979*, Tiroler Landesmuseum Ferdinandeum, Innsbruck (travelled to the Neue Galerie am Wolfgang Gurlitt Museum, Linz, Austria; Neue Galerie am Landesmuseum Joanneum, Graz, Austria; and the Museum des 20. Jahrhunderts, Vienna)

Collections:

Schönitzer-Kühn Family, Birgitz, Austria; Museum Folkwang, Essen; Metropolitan Museum of Art, New York; International Museum of Photography, George Eastman House, Rochester, New York; Yale University, New Haven, Connecticut; Smithsonian Institution, Washington, D.C.; Art Institute of Chicago; Gernsheim Collection, University of Texas at Austin; National Gallery of Canada, Ottawa.

Publications:

By KÜHN: books—*Technik der Lichtbildnerei*, Halle, Germany 1921; *Zur Photographischen Technik*, Halle, Germany 1926; articles—"Braune Platindrücke" in *Wiener Photographische Blätter*, no. 3, 1896; "Clarence H. White" in *Photographische Rundschau* (Vienna), no. 62, 1925; "Zum Thema 'Belichtungsspielraum'" in *Photographische Rundschau* (Vienna), no. 63, 1926; Die Jubiläumsausgabe der Rhedenschen Belichtungstabelle" in *Photographische Rundschau* (Vienna), no 64, 1927; "Aus dem Werkstatt des Photographen" in *Die Atelier des Photographen* (Vienna), no. 35, 1928; "Der Deutschen Lichtbildern" in *Das Deutsche Lichtbild 1931*, Berlin 1930; "Vom Nimbus der Schwarzen Kunst" in *Das Deutsche Lichtbild 1936*, Berlin 1935.

On KÜHN: books—*Die Kunst in der Photographie* by Alfred Buschbeck, Berlin 1898; *Gummidrücke von Hugo Henneberg, Wien; Heinrich Kühn, Innsbruck; Hans Watzek, Wien*, edited by F. Matthies-Masuren, Halle, Germany 1902; *Heinrich Kühn 1866-1944*, exhibition catalogue, by Hermann Speer, Innsbruck 1976; *Geschichte der Fotografie im 20. Jahrhundert/ Photography in the 20th Century* by Petr Tausk, Cologne 1977, London 1980; *Heinrich Kühn (1866-1944) Photographien* by Peter Weiermair, Innsbruck 1978; *Heinrich Kühn 1866-1944*, exhibition catalogue, by Ute Eskildsen, Odette M. Appel and others, Essen 1978; *The Collection of Alfred Stieglitz* by Weston J. Naef, New York 1978; *A Book of Photographs from the Collection of Sam Wagstaff*, New York 1978; *Photographie als Kunst 1879-1979/Kunst als Photographie 1949-1979*, exhibition catalogue, 2 vols., by Peter Weiermair, Innsbruck 1979; *The Photograph Collector's Guide* by Lee D. Witkin and Barbara London, Boston and London 1979; articles—"Das Geheimnis Seelischer Stimmung in Bildern" by F. Carstanjen in *Die Photographische Kunst im Jahre 1903*, edited by F. Matthies-Masuren, Halle, Germany 1903; "Hugo Henneberg, Heinrich Kühn and Hans Watzek" by F. Matthies-Masuren in *Camera Work* (New York), no. 13, 1906; "Heinrich Kühn" in *Apollo* (Dresden), no. 20, 1915; "Heinrich Kühns Lichtildnerschule in Innsbruck" in *Wiener Mitteilungen*, no. 25, 1920; "Heinrich Kühn" by Robert Sobieszek in *Image* (Rochester, New York), December 1971; "Heinrich Kühn, der Altmeister der Photographie aus Birgitz" by Hubert Vogt in *Das Fenster* (Innsbruck), no. 15, 1975; "Heinrich Kühn 1866-1944" by Peter Galassi in *Photo-Secession*, exhibition catalogue, Washington, D.C. 1977; "Heinrich Kühn 1866-1944," special issue of *Camera* (Lucerne), June 1977; "Heinrich Kühn: From Another Time" by Inge Bondi and Lotte Schönitzer-Kühn in *Printletter* (Zurich), November/December 1981.

Debates about the status of photography as an art are usually variations on the venerable debate about the status of art itself and its relationship to nature or "reality." In painting, sculpture and the verbal arts there are very few naive realists who would argue—in public—that the best art is the most painstakingly "life-like." In photography, however, the debate goes on: there are those who assert that it is the special power of the photographer to record a particular, historical moment in all its concreteness and immediacy; and there are those who believe that the photographer is above all an artist who can and should manipulate his material to express as vividly as possible his individual impressions of reality. And the debate goes on, of course, because of vested interests and the stubborn conviction that complex questions will yield to either-or reasoning.

Heinrich Kühn is perhaps the purest example of the "aesthetic" photographer that the history of the medium can provide. "The first prerequisite for the birth of a picture," he wrote, "is to know exactly what you want. There is no point in taking pictures left and right and then seeing what has been achieved...for where strict, honest self-criticism is lacking there can never be anything worth-while. This self-criticism must begin at the moment that the photographer discovers a piece of nature *and experiences the desire to capture what he sees and feels.... Everyone sees differently.*" One of Kühn's earliest critics, Matthies-Masuren, knew exactly what was at stake: in itself, he observed, photography emphasizes unimportant and trivial details "while the impression of the whole is almost entirely lost.... A photograph taken in the sun shows no trace of local tone, softness, breadth, unity, or even harmony. The facility with which photographers are enabled to give the smallest and most unimportant details with wonderful accuracy is very seductive, and is the greatest obstacle in the way of *the employment of photography as a means of artistic self-expression.... The aim of the artist is to recreate the impression which the aspect of nature has produced upon him. This requires the well-considered suppression of details and the toning down of hard and sharp lines.*" The passages which I have emphasized here demonstrate that for both Kühn and Matthies-Masuren, the photographer, like the painter, is free to select, suppress and rearrange—in short to give a personal shape to what he has seen and felt. The photographer, Kühn asserted, "must control nature. For it is now within his powers to translate colors into their monochromatic values; and if the negative should show any discord, the gun process enables him at will to attune the discordant elements in the print. Thus, on the one hand, he can subdue or entirely suppress anything too prominent in the less important parts of the picture, while, on the other hand, he can emphasize all the subleties where they are interesting and of importance for a pictorial effect. This naturally requires mastery of the technique. The apparatus, the soulless machine, must be subservient, the personality and its demands must dominate. The craftsman becomes an artist."

But what kind of artist? An Ingres or a Delacroix? Arnold Bennett or Virginia Woolf? Looking at Kühn's delicate biochromates and astonishingly sophisticated prints today, viewers may have an uneasy feeling that they are looking at neither a photograph nor a painting, but rather at a kind of etherialized photograph of a painting from some vaguely remembered school or genre. "I drew my inspirations," Kühn admitted, "from frequent visits to art-galleries and especially to the exhibitions of the Munich Secession. The landscapes of Peterson, Dill, and others opened my eyes." It was the Munich Secession, Robert Sobieszek has pointed out, that served as "the primary vehicle for importing French ideas into Germany." Kühn's favorite subjects, he argues, were for the most part "the same subjects found to be popular by the painters: landscapes, genre scenes and intimate portraits"; and he goes on to note Kühn's particular debts to Franz von Lenbach, Wilhelm Leibl and Hans Thoma. Contrary to

what we like to think, the eye is rarely innocent. Only the extraordinary artist of any sort has the capacity to see something more than others have given him the power to see.

—Elmer Borklund

KUMLER, Kipton (Cornelius).
American. Born in Cleveland, Ohio, 20 June 1940. Educated at Cornell University, Ithaca, New York, 1958-63, B.E.E. 1963, M.E.E. 1967; Harvard University, Cambridge, Massachusetts, 1967-69, M.B.A. 1969; studied photography, under Minor White, Massachusetts Institute of Technology, Cambridge, 1968-69, and with Paul Caponigro, 1970. Served in the United States Navy, 1963-67. Married Katherine Alice Coe in 1969; children: Aden and Emily. Freelance photographer, Boston, since 1970; studio established, Lexington, Massachusetts, 1976. Senior Consultant, Arthur D. Little Company, Cambridge, 1969-79. Since 1979, President, Lexington Consulting Group. Instructor in Basic Photography, Project Inc., Cambridge, 1969-72; Instructor in Advanced Photography, Image Works, Cambridge, 1974, and Maine Photographic Workshops, Rockport, 1977-80; Field Faculty Adviser, Goddard College, Plainfield, Vermont, 1977-78. Recipient: National Endowment for the Arts Survey Grant, 1976, 1980; Massachusetts Arts and Humanities Foundation Grant, 1977. Agent: Harcus Krakow Gallery, 7 Newbury Street, Boston, Massachusetts 02116. Address: 34 Grant Street, Lexington, Massachusetts 02173, U.S.A.

Individual Exhibitions:

1974　Creative Photography Gallery, Massachusetts Institute of Technology, Cambridge
　　　Carl Siembab Gallery, Boston
1975　Robert Schoelkopf Gallery, New York
1976　Douglas Kenyon Gallery, Chicago
1977　Jewett Arts Center, Wellesley College, Massachusetts (with the painters Janowitz and Mazur)
　　　Cronin Gallery, Houston
1978　Grapestake Gallery, San Francisco
　　　New Jersey Museum, Trenton
1979　The Photography Place, Philadelphia
1980　Cronin Gallery, Houston
　　　Harcus Krakow Gallery, Boston
　　　Worcester Art Museum, Massachusetts

Collections:

Metropolitan Museum of Art, New York; Museum of Modern Art, New York; International Museum of Photography, George Eastman House, Rochester, New York; Rhode Island School of Design, Providence; Museum of Fine Arts, Boston; Worcester Art Museum, Massachusetts; Addison Gallery, Andover, Massachusetts; Cornell University, Ithaca, New York; Museum of Fine Arts, Houston; Amon Carter Museum, Fort Worth, Texas; Bibliothèque Nationale, Paris; Victoria and Albert Museum, London.

Publications:

By KUMLER: books—*Kipton Kumler: Photographs*, Boston 1975; *A Portfolio of Plants*, with an

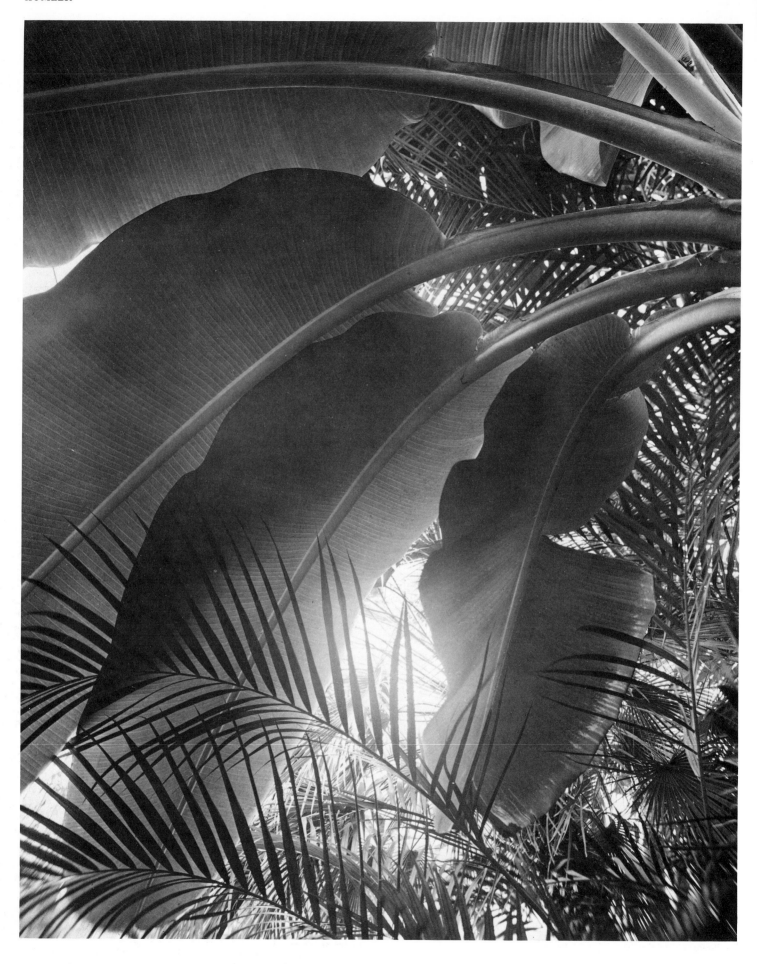

Kipton Kumler: *Fronds*, Wellesley, 1972

introduction by Hilton Kramer, Lexington, Massachusetts 1977; *Plant Leaves*, Boston 1978; article—interview in *Printletter* (Zurich), November 1977.

On KUMLER: books—*Janowitz/Kumler/Mazur*, exhibition catalogue, Wellesley, Massachusetts 1977; *Art of the State*, Danbury, New Hampshire 1978; *The Platinum Print*, Rochester, New York 1979; articles—"Kipton Kumler" in *Fox* (New York), May 1972; "Workshops" in *Camera* (Lucerne), June 1972; "Kipton Kumler" in *British Journal of Photography* (London), Spring 1973; "Kipton Kumler" in *Popular Photography* (New York), February 1975.

In my photographic work I am interested in what has been called natural symbolism, i.e. the use of objects in/from nature to reveal/suggest another quality or level of experience. This experience resides entirely in the print and not in extraneous apologies.

I see photography as a medium in which old distinctions between "selecting" and "creating" are confounded. The ability within large formal photography to create a new context, coupled with its inherent authenticity, is a powerful tool with which the 20th century artist can work. Clouds, landscapes, still-lifes, plants—all the traditional subject matter of photography and the other arts continue to offer the basic material with which to create contemplative visual experience.

—Kipton Kumler

Kipton Kumler is one of the most sensitive and talented of the younger photographers. Although his work has been exhibited throughout the United States and, to a lesser extent, in Europe, Kumler does not promote himself, nor is he pushed by the galleries that represent him. Slowly and steadily he has established himself as a freelance art photographer.

Kumler's favorite subjects are plants, landscapes and architecture. Mainly working with 8 x 10 cameras, he captures not only detailed visual information, but also, through his emotional relationship with his subjects, creates very personal and true images. His plant pictures, for example, allow the viewer to enter the realm of their "souls," feel their vibrations. Such results are achieved by his prolific artistic vision in combination with his special printing technique. Kumler prefers to produce platinum and palladium prints, which give an almost three-dimensional impression of the subjects; the grey tones are much softer than in the usual silver prints, and depth is not lost in the black areas of the images. He has developed his technique through long tests and intensive studies of the best possible supporting papers and other materials. In 1977, he produced one result of this work, a very beautiful portfolio of 10 images of plants in a limited edition of 50 copies. In his introduction, art critic Hilton Kramer states: "His pictures have the delicacy of chamber music, the intimacy too, and the sustained emotion that comes from being so close to the details of articulation. In these pictures, elegance lives on easy terms with austerity."

Kipton Kumler is currently working on two new series, one realized in Persia, the other consisting of still-lifes of garlic, onions and kitchen implements made directly from negatives shot and processed for platinum printing.

His studies under Minor White and Paul Caponigro gave Kumler a solid base for a career as a traditional photographer. His love for the beauty of nature and his artistic skill have allowed him to grow during the past ten years to a modern and mature photographer with a body of work of lasting value.

—Marco Misani

KURATA, Seiji.

Japanese. Born in Tokyo, 12 July 1945. Studied painting at Tokyo University of Arts; studied at the Photographic Workshop School, under Daidoh Moriyama, Tokyo. Freelance photographer, Tokyo, since 1976; also, independent filmmaker of animated cartoons. Recipient: Kimura Ihei Award, Asahi Press, Tokyo. Address: 173, 46-48 Oyamaka-naicho, Itabashi, Tokyo, Japan.

Individual Exhibitions:

1978 Canon Photo Gallery, Amsterdam
1979 *Street Photo Random*, Nikon Salon, Tokyo (travelled to the Nikon Salon, Osaka, 1980)

Selected Group Exhibitions:

1978 *Photokina '78*, Cologne
1979 *Japanese Photography Today and Its Origin*, Galleria d'Arte Moderna, Bologna (toured Europe)
1981 *Photo Session '81; Snapshots*, Konishiroku Gallery, Tokyo

Collections:

Museum für Kinst und Gewerbe, Hamburg.

Publications:

By KURATA: book—*Flash Up: Street Photo Random, Tokyo 1975-1979*, with an introduction by Akira Hasegawa, Tokyo 1980.

On KURATA: books—*Japanese Photography Today and Its Origin*, exhibition catalogue, by Attilio Colombo and Isabella Doniselli, Bologna 1979; *Nude Photography of Japan*, with text by Shiroyasu Suzuki and Akira Hasegawa, Tokyo 1981.

Photography involves selecting a small areas of space, time and reality. That this is so is particularly obvious in the photographs of Seiji Kurata. Of course, every photograph must have its share of these properties, for they are, after all, the conceptual frame of photography—but in Kurata's work the power of photography to limit, to "focus," is particularly striking.

Another characteristic of photography is its power of documentary realism, its ability to capture the life of man and the interaction of man and society. This power was notably exploited by the American photographer Weegee—and it is exploited in a similar way by Kurata in his depictions of the scandalous night world of Tokyo. Because his strobe is much stronger than Weegee's flash, Kurata has been able to record all the more vividly the human bodies and objects which float in the night world. His images portray a people somewhere between holiness and tribalism, and the "scandalous" content is not exactly sought out; it is rather the inevitable outcome of the kinds of customs and traditions not just Tokyo man but all of us are trapped in.

—Kineo Kuwabara

KUSCYNSKYJ, Taras.

Czechoslovak. Born in Prague, 25 May 1932. Studied architecture at the Technical University, Prague, 1954-61; self-taught in photography. Married Alena Spirit in 1955; children: Zina, Radka, and Halka. Town Planner, Fotravinoprojekt, Prague, 1961-65. Freelance photographer, Prague, since 1965; established photo-studio at Cenovice, near Kutná hora, Czechoslovakia, 1967. Address: Hradešínská 49, 101 00 Prague 10-Vinohrady, Czechoslovakia.

Individual Exhibitions:

1963 *Girls*, University of Hořice, Czechoslovakia (travelled to Malostranská záložna, Prague, 1963; Klub energetiky, Prague, 1964, Theater Paravan, Prague, 1965, and Galery Ceskoslovenska spisovatel, Prague, 1966)
1967 *Girls and Glass*, Blaricum Gallery, Laren, Netherlands
1968 *Girls*, Theater Kladivadlo, Ústí, Czechoslovakia (travelled to the Gallery of Mladá Fronta, Prague, 1969)
1969 *Taras Kuščynskyj: Retrospective*, FOMA Gallery, Prague (travelled to Dum umění, Brno, Czechoslovakia, 1969, M Gallery, Karlovy Vary, Czechoslovakia, and Gallery of SCUV, Prague, 1970, and Moravian Gallery, Brno, 1971)
1971 *Girls and Jewellery*, Galerie Lobmeyr, Vienna
1973 *Taras Kuščynskyj: Retrospective*, Pentax Gallery, Tokyo
1974 *Taras Kuščynskyj: Retrospective*, North Bohemian Museum, Liberec, Czechoslovakia
Girls, Gallery Karolina, Prague
Taras Kuščynskyj: Retrospective, Gallery Dominik, Plzeň, Czechoslovakia
1975 *Portraits*, Gallery of Arts, Hodonín, Czechoslovakia
1976 *Taras Kuščynskyj: Retrospective*, Podlipanske Museum, Ceský Brod, Czechoslovakia (travelled to the Museum of Frenštát, Czechoslovakia, Castle Gallery, Nový Jičín, Czechoslovakia, J.A. Komenský Museum, Uherský Brod, Czechoslovakia, and FOMA Gallery, Ostrava, Czechoslovakia, 1977, and Castle Gallery, Teplice, Czechoslovakia, and Castle Gallery, Valašské Meziříč, Czechoslovakia, 1978)
1979 *Portraits*, Gallery DH, Olomouc, Czechoslovakia

Selected Group Exhibitions:

1969 *Czechoslovak Photography 1918-68*, Municipal Gallery, Prague
1971 *Czechoslovak Photography 1968-70*, Moravian Gallery, Brno, Czechoslovakia
1973 *Czechoslovak Photography 1971-72*, Moravian Gallery, Brno, Czechoslovakia
Lyricism of Czechoslovak Photography, SICOF, Milan
1974 *Biennale of Applied Graphics*, Moravian Gallery, Brno, Czechoslovakia
1975 *Czechoslovakia 1975*, Ministry of Culture, Prague
1979 *Tschechoslovakische Photographie 1918-1978*, Fotoforum, Kassel, West Germany

Collections:

Moravian Gallery, Brno, Czechoslovakia; North Bohemian Museum, Liberec, Czechoslovakia; Asahi-Pentax Gallery, Tokyo.

Publications:

By KUSCYNSKYJ: book—*Big Beat and Arithmetic*, with poems by Milena Lukešová, Prague 1967.

On KUSCYNSKYJ: books—*Encyclopaedia of Practical Photography* by Petr Tausk, Prague 1972; *Asahi Pentax Annual*, Tokyo 1974; *Geschichte der Photographie im 20. Jahrhundert / Photography in the 20th Century* by Petr Tausk, Cologne 1977, London 1980; articles—"Taras Kuščynskyj" by Petr Tausk in *Fotografia Italiana* (Milan), March 1969; "Taras—der Meister der einfachen Mittel" by F. Meisnitzer in *Foto Magazin* (Munich), December 1971; "Nudes by Taras Kuščynskyj" in *Pentax Family* (Tokyo), no. 6, 1973; "Taras Kuščynskyj" in *Color Foto* (Munich), August 1975; "Reklamas fotografas" by Aivars Akis in *Maksla* (Riga, Latvia), no. 3, 1976; "Taras Kuščynskyj" by Petr Tausk in *British Journal of Photography* (London), May 1977.

Photography is the only branch of art which is able to depict instant situations that are emotionally active. This is true even for arranged photographs. I endeavour to create works in accordance with this idea.

—Taras Kuščynskyj

The photographic work of Taras Kuščynskyj is various; it includes portraits, fashion images, still-lifes of Czech glass used for advertising purposes, and landscapes. Perhaps the common denominator in so diverse an output is style: Kuščynskyj graduated in architecture from the Technical University of Prague, and his studies seem to have instilled in him a basic respect for, and comprehension of, composition and structure, whatever the subject.

Kuščynskyj achieved his first success as a photographer with his images of girls' faces. Because he showed a fresh approach to portraits of feminine beauty, he was soon receiving fashion commissions. In his fashion work he has always operated on the quite sincere principle that his model is not a doll clad in a particular dress, mechanically obeying the photographer's directions, but a collaborator, a person with a particular mental and spiritual life. He has tried to convey personality as well as fashion. Similarly, in his photographs of nudes he gives his models freedom to behave as they wish within the appropriate environment. Given this attitude, it is not surprising that he doesn't care much for working in a studio. His best nudes were created in woods and meadows, reflecting his view that the human body "fits" best in nature. His fashion photographs, too, are often shot in natural environments, and quite often they involve a slightly surreal atmosphere.

In spite of his fame in Czechoslovakia, Kuščynskyj creates only a small part of his work on assignment; he wishes to use photography mainly for the expression of his own emotions, and he fears the kinds of compromises imposed by editors and experts in advertising.

Kuščynskyj belongs to that group of photographers who see the final step of the creative process as the original print. He is a perfect technician, proud of the technical quality of his positives. Since the selling of photographic originals is rather in its infancy in Czechoslovakia, however, Kuščynskyj has looked for other outlets for his photographs, outlets that will allow him to distribute his photographs as he originally intended. One such outlet has been posters, which can be printed with great care and do not involve subjugating photos to text. Another outlet has been the large calendar for which he can produce his work in what he regards as a suitable format. Both posters and calendars have also allowed him to find customers for the landscapes that he creates at random during his tours throughout the country, images that reveal his admiration for the pleasant shapes of woods, fields and hills in a romantic atmosphere.

Kuščynskyj is also sincerely concerned to teach people to esteem the autonomous art of photography, and, perhaps more than any other contemporary Czech photographer, he exhibits his work organized in cycles.

He has many admirers, especially among the younger generation, who like to decorate their walls with his posters.

—Petr Tausk

Taras Kuščynskyj: *Quite Alone*, 1978

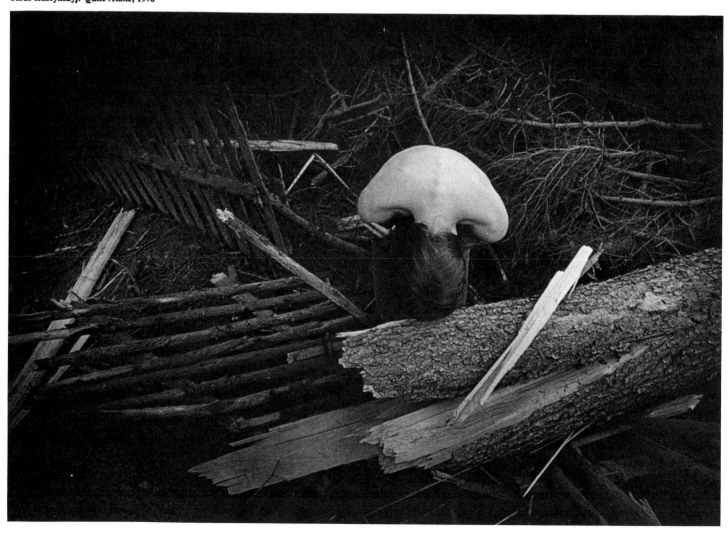

KUWABARA, Kineo.
Japanese. Born in Tokyo, 9 December 1913. Educated at Tokyo Municipal Dai-Ni High School, 1927-31; self-taught in photography. Married Mie Inoue in 1940. Photographer since 1934. Chief Editor, *Ars Camera*, Tokyo, 1948-53; *Sankei Camera*, Tokyo, 1954-59; *Camera Geijutsu*, Tokyo, 1960-65; *The Photo Image*, Tokyo, 1969-73; and *Shyashin Hihyo* (*Photo Review*), Tokyo, 1974-76. Professor, College of Tama Art School, Kawasaki, 1965-70. Since 1972, Professor at the Tokyo College of Photography. President, Japan Photocritics Association, 1954-65. Director, Japan Photographic Association, 1954-65, and since 1979. Recipient: Annual Prize, Japan Photographic Association, 1975. Agent: Zeit-Foto Salon, 1-4 Nihonbashi-Muromachi, Chuo-ku, Tokyo. Address: 2-711, 2-chome 5, Kamiyoga, Setagaya-ku, Tokyo 158, Japan.

Individual Exhibitions:

1973 *Tokyo 1936*, Nikon Salon, Ginza (also shown at Nikon Salon, Shinjuku, Tokyo, 1973; Shimizu Gallery, Tokyo, and Ikebukuro Parco, Tokyo, 1974; and Kitasenju Midoriya, Tokyo, 1975)
1975 *Manchuria 1940*, Nikon Salon, Ginza, Tokyo
1976 *Tokyo 1936-1975*, Photo Gallery Prism, Tokyo
1977 *Fantastic Tokyo*, Minolta Photo Space, Tokyo
1979 *Paris Quotidien*, Zeit-Foto Salon, Tokyo
 Canal Cities: Venice and Amsterdam, Olympus Gallery, Tokyo
1980 *Tokyo 1936*, Zeit-Foto Salon, Tokyo
1981 Ufficio dell'Arte, Paris

Selected Group Exhibitions:

1942 *Tokyo Photo Artists*, Ginza Mitsukoshi Gallery, Tokyo
1943 *Tokyo Photo Artists*, Ginza Mitsukoshi Gallery, Tokyo
1975 *First Tokyo-Ten Exhibition*, Metropolitan Art Museum, Tokyo

Collections:

Tokyo College of Photography.

Publications:

By KUWABARA: books—*Tokyo 1936*, with texts by Katsuya Nakamura and Hiroshi Hamaya, Tokyo 1974; *Manchuria 1940*, with text by Katsuya Nakamura, Tokyo 1974; *Memories of My Photographic Life*, with text by Katsuya Nakamura, Tokyo 1977; *Fantastic City*, with text by Katsuya Nakamura, Tokyo 1977; *Tokyo Days*, with text by Tetsuo Shirai, Tokyo 1978; articles—"Conscious and Unconscious of Photo Image" in special issue of *Brain* (Tokyo), March 1977; "The Exhibition '15 Photographers' " in *Gendai no me* (Tokyo) October 1977; "Scenery in Which Human Meets Objects" in *Gendai-Shi Techo* (Tokyo), August 1978; "Memory of Photography after World War II" in special issue of *Asahi Camera* (Tokyo), July 1979; "World Candid Photography" in *The Mainichi* (Tokyo), 10 July 1980.

On KUWABARA: articles—"Editorial" in *The Asahi* (Tokyo), May 1974; "Book Review" by Seijun Suzuki In *Nippoin Dokusho Shinbun* (Tokyo), June 1974; "Book Review" by Takeshi Yasuda in *Asahi Journal* (Tokyo), June 1974; "Book Review: Approach II" by Mutsuo Sakata in *Quarterly Design* (Tokyo), Summer 1974; "About Nostalgia" by Tatsuhiko Shibusawa in *Umi* (Tokyo), August 1974; "Oval Eye" by Yuko Deguchi in *Chi no Koko-gaku*, Tokyo 1975; "Editorial" in *The Mainichi* (Tokyo), January 1975; "Kineo Kuwabara" in *Zoom* (Paris), June 1981.

It is obvious from my biography that I am an essayist on photography as well as a photographer; also, I've written general articles for newspapers and magazines.

Since 1974, when I had a photo exhibition entitled *Tokyo 1936*—which was also published in book form—I've often written about Tokyo during the period of the 1930's.

I've been a lecturer at photography colleges for the past ten years: it gives me great pleasure to talk with the younger generation.

And I have also been involved in the editorial planning of a series of photographic books.

So my daily life in Tokyo is very busy: I like to do as much as I can.

But, more than any of this work, I like taking photographs best. It makes my mind free.

Since 1930, I have used a Leica camera, which has meant that 35mm has been my main means of expression. The subjects I shoot are scenes from everyday life—most of them are snapshots of Tokyo. My files of negatives are full of this kind of work.

For me, taking photographs is a means of representing what life is about, and, as a consequence, I

Kineo Kuwabara: *Okinawa*, 1978

don't care about any other "aims" of photography. But, having been an editor for about twenty years after the end of World War II, I tend to look at photographs by others in an open-minded way; I try to keep an objective view about the latest trends.

Whatever else it may be, photography means talking about oneself via the subjects chosen in the viewfinder. Unable to escape from the domain of photography, my face can be seen in every image, in every one of my pictures: and that is my main concern and ideal in photographic art. Yet, if anyone should ask me, "What, where, is your face?"—well, I could not possibly explain in this brief statement.

—Kineo Kuwabara

As an amateur photographer during the 1930's, Kineo Kuwabara made the life of common people his main subject. Since then, he has been noted as a photography critic, and for his work, for 30 years, as editor of some of the most influential photography magazines in Japan. Forty years after the time of his early work, in 1973, his exhibition, *Tokyo 1936*, surprised the world of photography. There, in these works, the lives of the urban dwellers in the Tokyo of the 1930's were captured live.

The images reflected the individualism of the masses, and they were raw documentary beyond the scope of any general thematic definition.

—Norihiko Matsumoto

LABROT, Syl.

American. Born in New Orleans, Louisiana, in 1929. Studied at Yale University, New Haven, Connecticut, 1948-49; studied creative photography at the University of Colorado, Boulder, 1956-57. Married twice. Freelance magazine photographer, in Colorado, associated with the Shostal Agency, New York, and working for *Life, Saturday Evening Post, Ladies Home Journal*, etc., 1954-57; concentrated on own photography, Easton, Connecticut, 1957-59, and on painting, then again on photography, Easton, Connecticut, 1960-72, and in New York, 1972, until his death, 1977. Instructor in Graphics and Photography, Visual Studies Workshop, Rochester, New York. *Died* (in New York City), in *July 1977*.

Individual Exhibitions:

1958 International Museum of Photography, George Eastman House, Rochester, New York
1960 *Under the Sun*, Poindexter Gallery, New York (with Walter Chappell and Nathan Lyons)
1977 *3 Photographic Visions*, Ohio University, Athens (with De Lappa and Baltz)

Selected Group Exhibitions:

1958 *Abstraction in Photography*, Museum of Modern Art, New York
1960 *The Sense of Abstraction*, Museum of Modern Art, New York
1962 *10 Photographers*, Schuman Gallery, Rochester, New York
1967 *Photography in the 20th Century*, National Gallery of Canada, Ottawa (toured Canada and the United States, 1967-73)
1974 *Photography in America*, Whitney Museum, New York

Collections:

Museum of Modern Art, New York; International Museum of Photography, George Eastman House, Rochester, New York; Visual Studies Workshop, Rochester, New York; Exchange National Bank, Chicago; National Gallery of Canada, Ottawa.

Publications:

By LABROT: books—*Under the Sun: The Abstract Art of Camera Vision*, with Walter Chappell and Nathan Lyons, New York 1960; *Pleasure Beach*, Rochester, New York 1976; articles—"Work in Progress" in *Afterimage* (Rochester, New York), September 1974; interview in *Photography Between Covers* by Thomas Dugan, Rochester, New York 1979.

On LABROT: books—*Photography in the 20th Century* by Nathan Lyons, New York 1967; *Photography in America*, edited by Robert Doty, with an introduction by Minor White, New York 1974; *3 Photographic Visions*, exhibition catalogue, by Arnold Gassan, Athens, Ohio 1977; articles—"Syl Labrot 1929-1977" by Arnold Gassan and "Pleasure Beach," book review, in *Exposure* (New York), September 1977; "Syl Labrot 1929-77" in *Photography Year 1978*, by Time-Life editors, New York 1978.

Syl Labrot began making photographs for the most sentimental of reasons when his first child was born. Having attended Yale for a year and then moving to Colorado, Syl never completed his undergraduate degree but dropped out to become a photographer. Born of a wealthy Louisiana family whose wealth was based on creosote, a wood preservative, Syl bowed to his father's insistence that he make his hobbies pay, and quickly Syl became a successful commercial photographer. He was trained in photography mostly by himself, with inevitable assistance from fellow amateurs and professionals—initially in the Boulder Camera Club, and then in intense discussions with working professionals in Colorado. By the end of a year, Syl was self-supporting, and within three years was one of the best selling photographers in the Shostal Agency collection, a commercial distributing center in New York.

By 1957, three years after he began making pictures, the successful production of elegantly conceived fishing and hunting promotional photographs began to bore him, and he became more interested in formal problems of color, flatness, and the qualities of the color print. After a week's tutoring by a Dye Transfer technician in Colorado Springs, Syl began making his own prints. A few months later he advanced to Carbro printing because that process offered a more suitable print. At the end of 1957 he had a portfolio of 10 prints which he presented to the Museum of Modern Art and other galleries, and found immediate acceptance. Few of his prints survive, however, because of two disastrous fires which successively demolished his house after he moved from Colorado to Connecticut. His photographs keynoted the MoMA exhibit *Abstraction in Photography*, mounted by Steichen in 1958, and he published what he felt were the best examples of the early work in *Under the Sun*, a troika of photographic work by Nathan Lyons and Walter Chappell and himself. In the text, Labrot comments: "From the start of my work in photography I saw the camera image as something quite separate from the reality perceived by the eye...it presented its own sense of space.... My work moved away from this objective reality to try to discover what the print itself was...."

By the time that book was published, Syl had already stopped photographing and begun painting. For several years he produced photographically detailed, large-scale acrylic paintings that explored the same scenes his camera had recorded but allowed him the tactility of the paint. Later in the 1960's he returned to photography and began work-

ing toward a new printmaking which dominated his work until his death: the exploration of direct control of the photo-offset printing process. The conclusion of these explorations was *Pleasure Beach*, a book which he wrote, photographed, and produced himself. The color transparencies, separations, half-tones, stripping, typesetting, and printing supervision are all by the photographer. The printing press became his new medium.

His concerns were for discovered relationships between color and form and associations implicit in the photograph as they inter-related to the suggestions of the forms in the picture. The book becomes a subtle, complex narrative beginning with a witty, tongue-in-cheek description by Syl of his "invention of color" (as he recapitulated all the color printmaking processes, he came to half-believe he had invented them anew, a poetic sensation all artists must feel at some point) and concluding with a sequence of double-exposed manipulated images of ancient stones, delicate nudes, patterns like a maze, and a prescient cloud of rubble that floats in indeterminate space. The book recapitulates his entire work, beginning with the same color images that excited Steichen and continuing past the painting done in the 1960's and early 1970's—photographic realism to color-field geometric investigations—and concluding with a personal poetry of photographic printmaking. He compared the book to music in a letter written just before his death in the early summer of 1977: "The book is the most spontaneous piece of work I have ever done, and it was very much the result of major changes going on in my life...it is very definitely [like Stravinsky's *Le Sacre*] but things have somehow run away with themselves... and there is somehow not the control that exists in all the other work. It seems to be rather a case of there being just enough control to keep things from really running amuck."

Labrot was greatly concerned by what he called the "conceptual poverty" of most color photography. He realized in the late 1950's that he was ahead of the market when he left photography and turned to painting, but when he took up the camera again he found that color had become very nearly a fad. "It does hurt to have Eggleston, Shore, etc., get so much exposure. Not that I mind their work, it just doesn't seem like much and if I were just beginning in the field I would wonder where I was going to get the money to pay for having all my 16 x 20 color prints printed.... It turns color photography into a matter or being rich, or having a foundation grant pay for your color." The heart of this plaint was, as always, aesthetics. "I am a printmaker, and see photography as a printmaking medium.... The look of the object is what speaks to me. K + L [a commercial laboratory in New York City] may turn out an excellent print, but it's the standard machinery of Kodak—not the expressive prints of a photographer; and the color photographer who goes that route signs an aesthetic contract: he must play within bounds of the conventional look of a 'color photograph'."

—Arnold Gassan

LAIZEROVITZ, Daniel.

Uruguayan. Born in Montevideo, 27 September 1952. Educated at España/Iava School, Montevideo, 1958-71; studied psychology at the University of Montevideo, 1972-73; studied photography at the Photo Club Uruguayo, Montevideo, 1974-76, Dip. Photg. 1976. Married Judith Isaac in 1973 (divorced, 1976). Freelance photographer, Uruguay and Switzerland, since 1976. Advertising Photographer, Consorcio Americano de Publicidad agency, Montevideo, 1977-79; News Photographer, *El Telegrafo* newspaper, Paysandu, Uruguay, 1978-79; Photographer for *Imagenes* magazine, Montevideo, 1978-79. Member, Board of Governors, Foto Club Uruguayo, 1976-77. Recipient: Best Photography of the Year Award, Uruguay, 1978. Address: 56 rue de Berne, 1201 Geneva, Switzerland.

Selected Group Exhibitions:

1976　*Triennale of Photography*, Zadar, Yugoslavia
1978　*Biennale FIAP*, Athens
　　　Uruguay Institute of Visual Arts Exhibition, Club Brasilero, Montevideo
　　　Blanco y Negro, Galeria del Notariado, Montevideo
1979　*lst Latin American Colloquim of Photography*, Mexico City
　　　Hecho en Latinoamérica, at *Venezia '79*
　　　Vivencias, Galeria del Notariado, Montevideo
　　　Rencontres Internationales de la Photographie, Arles, France

Collections:

Mexican Photographic Society, Mexico City.

Publications:

On LAIZEROVITZ: book—*Photography: Venezia '79*, Milan and New York 1979; articles—in *Mundo Color* (Montevideo), 27 August 1978; *El Telegrafo* (Paysandu, Uruguay), 7 October 1978, 20 November 1978, and 6 January 1979; *Imagenes* (Montevideo), no. 16, 1979; *Printletter* (Zurich), July/August 1980.

I discovered photography at a difficult stage of my life when it became a most important tool for expressing my feelings and thoughts. After this first stage (in which I experimented mainly in the field of symbolic photography), and feeling that I had to make a choice and define myself in my photographs, I made a 90 degree turn as a photographer, trying to capture images of everyday life.

Being a Latin American, I committed myself to interpreting and analyzing—through my photographs—our society and its symptoms of sickness.

Gradually I started to feel immersed in a common current, together with many other photographers, seeking to face the responsibilites of showing mirror images of conflicts and the struggle of people seeking freedom and justice.

—Daniel Laizerovitz

Every day the mass media offer us two kinds of pictures in violent contradiction to each other: crude and disgusting horror pictures (tortures and massacres, natural disasters and man-made accidents) and, as if by way of contrast, images of grace (beauty, youth, health and economic prosperity). We gradually come to believe that real life is comprised of these two extremes: the first external and removed from us, the second close, inviting imitation. But there is another reality, which is ordinary and likely to be overlooked. Plain daily life has neither the visual impact of the social document nor the glamour of the luxury advertisement. Yet it is precisely through the big and little events of our normal visual world that we are able to know and understand man and society better.

Daniel Laizerovitz depicts in his pictures that world of men and things without a history: unknown people met in the street, everyday happenings, shop windows, walls, posters, notices—all things that we recognize and with which we can identify. Photography is an extremely simple medium of communication, equally accessible to everyone, and Laizerovitz uses it like a language to converse with the public. He likes to play with reality, but he shuns the dogmatism of certain photographers who claim to be giving us an all-embracing, exhaustive picture, in which, in fact, the violence of the visual impact cancels out any other kind of communication. Laizerovitz's work tends instead to establish a relationship of active fellowship, and to suggest that everyone of us, if only to a small extent, is responsible for some aspects of the society in which we live.

Yet, even if Laizerovitz's subjects are those people and visual events we come across every day, there is always something disturbing about them. They are, after all, people and events that break the rules of the regulated, composed society we feel it ought to be. The poor, the old, the handicapped—we prefer to ignore them, or, better still, to shut them away in the ghettos of social exclusion. Laizerovitz forces us to become aware of this section of humanity. But his eye is deeply sympathetic; he is not looking for the shocking, nor, on the other hand, has he any moralistic intention. Indeed, his pictures almost always have a touch of humor, which radically upsets the objective situation and lightens the emotional reaction. He does not really set out to move us, or preach to us, just to make us think about the condition of

Daniel Laizerovitz: *Montevideo*, 1978

the common man.

And the common man—our next-door neighbor, our colleague at work, the man in the street—is, in Laizerovitz's photographs, oppressed by an almost tangible solitude. And when we consider that his pictures never contain any precise connotation of place or time—they might have been taken in any corner of the earth—we realize that the solitude of the single individual portrayed becomes a metaphor for the solitude of man in contemporary society, man by himself.

We communicate with words and gestures that are wholly inadequate for our actual needs. Complete communication is a Utopia. Photography—at least as it is practiced by Daniel Laizerovitz—tends to break down the barrier of incomprehension.

—Giuliana Scimé

LAKE, Suzy.

American. Born Suzanne Marx in Detroit, Michigan, 14 June 1947. Educated at schools in Detroit, studied at Western Michigan University, Kalamazoo, 1965-66, Wayne State University, Detroit, 1966-68; and Concordia University, Montreal, 1976-78, M.F.A. 1978. Influenced by painter Guido Molinari and sculptor Hugh Leroy. Married Roger Lake in 1968 (divorced); Alexander Neumann in 1976; daughter: Danika. Independent photographer, since 1971, establishing own studio in Montreal, 1971-74, 1976-78, in Toronto, since 1978. Instructor, Montreal Museum School of Art and Design, 1969-74, 1975-76; Loyola Photography Workshop, Montreal, 1975-78; Concordia University, Montreal, 1976-77; University of Guelph, Ontario, 1978-79, 1981; York University, Toronto, 1980-81. Cofounder, Véhicule Art Inc. art gallery, Montreal, 1971. Recipient: Concordia Fellowship, Montreal, 1972; Canada Council Grant, 1972, 1974, 1975, 1978, 1981; Quebec Provincial Grant, 1973. Agent: Sable Castelli Gallery, 33 Hazelton Avenue, Toronto, Ontario. Address: 1436 Queen Street West, Toronto, Ontario M6K 1M2, Canada.

Individual Exhibitions:

1974 Transformations, Galerie Gilles Gheerbrant, Montreal
1976 Loyola Photography Workshop, Montreal
1977 Choreographed Puppets, Galerie Optica, Montreal
1978 Impositions, Art Gallery of Ontario, Toronto
 Sable Castelli Gallery, Toronto
 imPOSITIONS, Vancouver Art Gallery
 The Image Co-op, Northfield, Vermont
1979 Are You Talking to Me, Sable Castelli Gallery, Toronto (travelled to Galerie Optica, Montreal; and Mendel Art Gallery, Saskatoon, Saskatchewan)
1980 Mohawk College, Hamilton, Ontario
1981 Whitewater Gallery, North Bay, Ontario
 Locations Rehearsing, Sable Castelli Gallery, Toronto
 Whitby Art Gallery, Ontario
1982 Art Gallery of Hamilton, Ontario

Selected Group Exhibitions:

1974 Camerart, Galerie Optica, Montreal (travelled to Canadian Cultural Centre, Paris)
1976 Identité/Identifications, Centre d'Art Plastiques Contemporains, Bordeaux (toured France)
1977 Transparent Things, Vancouver Art Gallery (travelled to London Art Gallery, Ontario; Alberta College of Art, Edmonton; Art Gallery of Greater Victoria, British Columbia; and Dalhousie Art Gallery, New Brunswick)
1978 New Tendencies, Musée d'Art Contemporain, Montreal
 Performance Festival, Museum of Fine Arts, Montreal
1979 Fleeting Gestures: Dance Photographs, International Center of Photography, New York (travelled to The Photographers' Gallery, London, and Venezia 79)
 Winnipeg Perspective 1979: Photo/Extended Dimensions, Winnipeg Art Gallery, Manitoba
1980 Annual Dalhousie Drawing Exhibition, Dalhousie Art Gallery, Halifax, Nova Scotia
1981 Viewpoint 29 x 9, travelling exhibition (toured Ontario)

Collections:

Art Gallery of Ontario, Toronto; London Art Gallery, Ontario; Canada Council Art Bank, Ottawa; National Film Board of Canada, Ottawa; Musée d'Art Contemporain, Montreal; Montreal Museum of Fine Arts; Southern Alberta Art Gallery, Lethbridge; Winnipeg Art Gallery, Manitoba; Vancouver Art Gallery.

Publications:

On LAKE: books—Camerart, exhibition catalogue, by Chantal Pontbriand, Montreal 1974; The Winnipeg Perspective 1979: Photo/Extended Dimension, exhibition catalogue, by Roger L. Selby and Karyn Allen, Winnipeg 1979; Are You Talking to Me?, exhibition catalogue, with text by Bruce Ferguson, Saskatoon, Saskatchewan 1980; articles—"Seven Canadian Photographers" by Ann Thomas in Artscanada (Toronto), May 1977; "Suzy Lake and Sorel Cohen" by Diana Nemiroff in Artscanada (Toronto), May 1977; "Suzy Lake" by Joanne Danzker in Vanguard (Vancouver), March 1978; "Canadian Artists with Cameras" by Bill Ewing in Art News (New York), April 1978; "Suzy Lake: Impositions" by Diana Nemiroff in Parachute (Montreal), Spring 1978.

Before using film or tape, I "bumped through" the more traditional media, only to find these media weren't accommodating "what I was trying to get at." From my standpoint with these media, if the rhythm did become animated enough, the gesture became too graphically beautiful or the image too painterly, etc. (and what did that have to do with Pierre Vallieres, moon shots, the Chicago Seven trial, crushed idealism, "Gunsmoke," anyway?) I wanted to break down the distance between the object and audience; to extend the act of looking to include a more direct act of discovering, experiencing, and making.

Although terms like body art, self-referential art, and autobiographical art tend to crop up, I'm not particularly concerned to keep within those definitions. I use my own image as "someone"; yet, it is important to de-particularize the situation of that person, to allow the viewer to identify with the issue from his or her point of view. Also, by using my portrait as the image to be adapted, I infer the constant as "victim."

Since the early 70's, the work has continued to visually deal with ramifications of identity, angst, vulnerability, etc.... We are a multiplicity of personalities, evolved from our own history of influences, events, or situations, both on voluntary and involuntary levels.

The sequencing of "imPOSITIONS" (1977) and "Are You Talking to Me" (1979) uses a different system of ordering than the early work. The varied sizes and juxtaposition of images set an attitude or environment through an irregular rhythm. Tampering with the negative and the prints' scale also serve to create a sense of disorientation. The single image offers the audience situational (metaphoric) information about the image; whereas, the sequence parallels that information with a sense about that activity.

—Suzy Lake

Suzy Lake has been immersed in an ongoing analysis which concerns personality and identity and the accompanying ramifications. The earlier work involved the transference of identity through role playing, whereas the current series, "Are You Talking to Me?...", 1979, focuses on the more basic concerns of "being" and the implied anxiety inherent in those things which are difficult to control.

This complex investigation has led to the creation of symbols of auto-expression and vulnerability in which Lake stages a variety of psychodramas, photo-performances. The "Transformation" series, 1974, focuses on the artist in a state of literal change, for example, "Suzy Lake as Gary W. Smith". The viewer is initially startled by this process with its threatening implications. This exploration of the ambiguities of identity becomes even more compelling in "imPOSITIONS", 1977, a series of large-scale photo-murals in which the artist is wrapped and bound, her voice piercing the silence and articulating the fine line between freedom and imprisonment. The psychological implications of this condition are emphasized by the use of techniques and processes such as stretching the negative and longer time exposures. The starkness of the black and

Suzy Lake: From *Are You Talking to Me*, 1979

white, together with the life-sized scale, contribute to the overall angst.

The sheer scale of the work is compelling, drawing the viewer into an anxious confrontation. Lake has exploited the power of the photographic medium and has utilized its inherent characteristics to a most powerful degree.

The relationship of the work to aspects of theatre—dance, mime, puppetry—is evident. Lake's work is never static. "Vertical Pull", 1977, a series of twelve black-and-white photographs, shows the artist falling down a staircase; it is gripping because of its sense of movement and our apprehension of the potential danger in the act. Furthermore, the serial nature of the work implies that the event is a seemingly endless process (it is like seeing a metaphor for your life passing before your eyes in intervals).

In "Are You Talking to Me?...", 1979, a series of 63 colour and black-and-white photographs, Lake presents an acutely fine balance between anxious, conflicting sensations: fear and revelation; trust and mistrust; sorrow and relief. It is a kind of silent confessional, a combined process of break*down* and break*through*. The implications of self-portraiture are transferred to a universal realm.

The life-size photographs, of varying scale, are installed in a sequential manner which literally wraps the room in images. Some are stretched and all are registered at the mouth, which is hand-tinted. What results is an evironmental reaction with the viewer that is difficult to ignore. The imagery is filmic, in that the viewer is enveloped by everchanging movement. It is no longer Lake's full body struggling to be released from bondage. Ironically, the bondage is more intense when she is free of physically restraining factors. The highly refined drawing element is ambiguous despite the implied realism.

The rhythm set up by the continual flow of images creates a conversational storyline of undetermined content.

The anxiety is one of freedom/captivity. The expression and style of the work underlines the multi-dimensional nature of this quest. Nuances of gesture and the subtle, varying facial expressions and stances are arresting. It is this heightened sense of emotional confrontation—simultaneously direct and open-ended—that is the core of Lake's refined approach and investigation. Although her image is departicularized, the camera allows every detail to be visible. The images are a metaphor for a blurred reality. Subtleties disappear as the viewer is confronted with these images, images with persistent haunting power. "Are You Talking to Me?..." is an invocation demanding participation of the audience in a manner not unlike a theatrical performance. The series functions as an emotionally rich Greek chorus, which achieves a provisional sort of controlled hysteria.

—Karyn Allen

Michel Lambeth: *James Reaney*, 1962

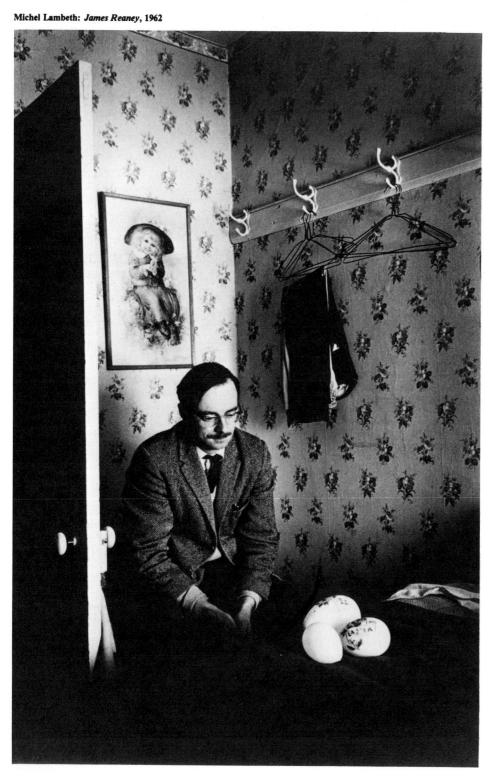

LAMBETH, Michel.

Canadian. Born in Toronto, 21 April 1923. Studied sculpture, drawing and anatomy at Guildford School of Art, Surrey, England, and Sir John Cass School of Art, London, Atelier Ossip Zakine and Ecole du Louvre, Paris, and University of Toronto (General Arts), 1945-49. Served in the Canadian Army in Europe, 1942-45. Married Fran Lambeth in the early 1950's (later separated). Freelance writer, filmmaker, photographer, photojournalist and publisher, Toronto, 1948 until his death, 1977. Also worked as a clerk, Toronto City Hall, 1952-59. Co-Founder, Mind and Sight photography gallery, Toronto, 1972. Tutor in Photography and Fellow of Bethune College, York University, Downsview, Ontario, 1971; Teacher, Ryerson Polytechnical Institute, Toronto, 1972. Associate Artist, Toronto Free Theatre, 1973-77. Member, American Society of Magazine Photographers, 1962-66; Member, Canadian Artists' Representation, and Committee to Strengthen Canadian Culture. Recipient: First Amateur Class Award, Canadian Film Awards, Montreal, 1954; Film Honorarium, Young Men's Canadian Club, 1954; Toronto Art Directors Club Award, 1961; Canadian Centennial Medal, 1967; Canada Council Senior Grant, 1968; Ontario Arts Council Grant, 1972, 1974. Agents: The Isaacs Gallery, 832 Yonge Street, Toronto; and Canadian Centre of Photography, 596 Markham Street, Toronto, Ontario M5G 2L8. *Died* (by suicide; in Toronto) *9 April 1977.*

Individual Exhibitions:

1948 Galerie du Dragon, Paris
1961 *50 Photographs*, Towne Cinema, Toronto
1965 The Isaacs Gallery, Toronto
 Art Institute of Ontario travelling exhibition (toured Canada, 1965-66)
1969 *Encounter by Michel Lambeth*, National Film Board of Canada, Ottawa
1970 *Simplicity of Man in an Automated Age*, at *Expo 70*, Osaka, Japan
1971 York University, Downview, Ontario
1972 Canadian Department of External Affairs travelling exhibition (toured New York City boroughs and travelled to the Light Impressions Gallery, Rochester, New York)

1974 *Images of Mexico*, Toronto Free Theatre (exhibition changed and enlarged through 1975)
1979 *Michel Lambeth: A Retrospective*, Photo Gallery, Ottawa (works printed by Michael Torosian; toured Canada, 1979-81)

Selected Group Exhibitions:

1967 *Gallery Artists*, The Isaacs Gallery, Toronto
1970 *Man and His Drugs Pavilion*, at the *Canadian National Exhibition*, Toronto
1972 *Festival d'Avignon*, France
1973 *Critic's Choice*, Neikrug Gallery, New York

Collections:

Still Photography Division, National Film Board of Canada, Ottawa; National Photography Collection, Public Archives of Canada, Ottawa; Canadian Centre for Photography, Toronto.

Publications:

By LAMBETH: books—*Made in Canada*, Toronto 1967; *Neuscapes*, portfolio, Toronto 1967; *As We Walk*, with poems by Anastasia Erland, Toronto 1968; articles—"Robert Frank—Americans: Photographs" in *Canadian Forum* (Toronto), August 1960; "Lutz Dille: The Bertold Brecht of the Camera" in *Arts/Canada* (Toronto), December 1969; "The Confessions of a Tree Taster" in *Di'al-og Quarterly* (Toronto), Fall 1971; "2-Year Odyssey, Photographing Quebec—Pierre Gaudard" in *The Star* (Toronto), 20 November 1971; "Honesty the Hallmark: B.A. King Photographs at Witkin, New York" in *The Star* (Toronto), 24 December 1971; "Tom Gibson at Merton" in *Proof Only* (Toronto), 15 January 1974.

On LAMBETH: articles—"Biographical Note" by P. Pocock in *Canadian Art* (Toronto), November/December 1961; "The Momento-of-Truth Photography of Michel Lambeth" by R. Fulford in *Saturday Night* (Toronto), June 1977; "A Tribute to Michel Lambeth" by J. Wieland in *Artmagazine* (Toronto), December/February 1977-78; "A Belated Recognition for a Street Photographer" by R. Fulford in *The Star* (Toronto), 13 January 1979; "Hard-Edged and Artful Encounters" by D. Livingston in *Maclean's* (Toronto), 26 March 1979; "The Fifties Focus: Retrospective Toronto—The Late Michel Lambeth" by Michael Torosian in *Toronto Life*, June 1981.

So with a negative, salts of iron,
one makes one's personal history
an almost indelible mark in time
a pause, as one great poet said,
a pause in the clock.

These meditative words were written in 1974 by Michel Lambeth, an artist and a man of extreme moods and complexity. At once overwhelmingly generous and kind, a romantic at heart, a poet, a teacher, an articulate critic, and a conservationist (of landscapes, trees, and early photography), he was a man of great spirit and enthusiasm whose experience of wartime combat caused him to be frequently melancholy. Passionate in his fight for Canadian cultural independence and a strong nationalist, he was a politicized activist in the service of the disadvantaged. Most significantly, he was a brilliant photographer.

The images he left behind on his death in 1977 aimed at the heart of life, the drama of human beings living very ordinary lives—yet full of and reverberating with emotions: loneliness, pain, anxiety, hope, love, celebrations and illuminating silences. In the immediacy of both personal and external environments, these experiences also became Lambeth's. His photographs never overstated, never indulged or imposed, never sentimentalized, but were full of clarity and compelling directness. His subjects reveal reality with the kind of veracity and integrity that belongs to the truly best in art. Unequivocally, his photographs are indelible marks in time.

Lambeth's main body of work is from the period 1955 to 1970. During World War II he served with a regiment as a tank gunner for the allies in Germany. After demobilization he turned to the study of sculpture and drawing, first in England, then in Paris. In 1948 he returned to Canada, and worked for several years as a clerk in Toronto's City Hall. There he discovered a cache of historical photographs, which were later published as *Made in Canada*. His youthful enthusiasm for trees became a life-long interest, partially because of his rediscovery of the camera, the means to render his fascination in "permanent images." Also, he became familiar with the work of Cartier-Bresson, Brassaï, Kertész, Walker Evans, Bill Brandt, and Robert Frank: he admired them, and their work contributed to his decision to take up photography seriously.

Lambeth respected the unencumbered capabilities of his 35mm Leica, and he was particularly responsive to the temporal in photography. But, though often cited as Canada's Cartier-Bresson, Lambeth expressed, through his own personal struggles, a belief and conviction beyond that of the "decisive moment." Although he too chose to roam the streets and public places (railway stations, markets, parades, gardens, museums, shops), and photographed his friends and fellow artists, progressively in his photographs the most fundamental values of human endeavour quietly transcend external moments of time—moments we see as fractions appear seemingly without an end. His words (in 1971) synthesize his vision clearly:

In his confrontation with reality, esoteric as it may sound, the photographer compounds a totality of work which, for me, is an actual graphic representation of what he really IS. Feeling, as expressed in emotional freedom with photography, becomes at once a diary of a monument to the particular unique existence of one man or woman, much as it does in any other medium but especially when an artist uses it. I believe that what our Greek-derived, science-bound word "photography" fails to say is said succinctly in a two-ideogram character by the Japanese: THE REFLECTION OF EXISTENCE.

As an independent photographer, Lambeth had established his reputation by the mid-1960's. His work appeared prominently in *Star Weekly*, *Saturday Night*, *McLean's*, *Life*, *Time* and many daily publications. At intervals he exhibited in group and one-man shows in Canada, the United States and Japan. His last major work was at the Toronto Free Theatre, documenting their productions. In 1973-74 he exhibited there a small selection of images taken earlier in Mexico. But, while Lambeth's work was highly visible during the 1960's, it seldom provided him with a living. He often turned to writing criticism or to giving workshops in creative photography. During the 1970's he drifted from photography to becoming a committed spokesman for Canadian Artists' Representation (C.A.R.), a trade association of artists; at the same time, he was also a member of the Committee to Strengthen Canadian Culture. Often enraged and intensely quarrelsome, Lambeth had, by the mid-1970's, allowed his photographic aspirations to be diminished by his personal anguish, chaos, and deep depressions. After a brief stable period, he killed himself in April 1977 at the age of 53. Ironically, during this time of a resurgent photographic boom he never quite achieved the stature deserved by his great talents. His failure to do so had to do with his mercurial nature and his desire to work independently—sometimes with intense productivity, sometimes faltering in disorder, but always searching within his own nature for that "pause" that so many of his photographs captured.

One of Lambeth's most remarkable images was of a hard-working Quebeçois family in St. Nil, Gaspé, in 1964. His singular observations triggered a series of photographs that would combine to connect a story of an event with unfolding rich human messages in picture form—reflecting homage to Walker Evans. Yet, Lambeth's work transcended a balance of realism and classical discipline to create a taut and precise synthesis of time and place, of the deeply moving process of life. Tragically, for a person who was so moved by the very process of life and living, Lambeth died alone, forgotten by those he had once served with zest and with his extraordinary photographs, but deeply remembered by those few friends and admirers whose lives his vision and compassion had touched.

—Maia-Mari Sutnik

LANGE, Dorothea.
American. Born in Hoboken, New Jersey, 26 May 1895. Educated at Public School 62, Hudson, New York, 1901-06; Wadleigh High School, New York, 1907-13; Training School for Teachers, New York 1914-17; studied photography, Clarence White School, Columbia University, New York, 1917. Married the painter, Maynard Dixon in 1920 (divorced, 1935); children: Daniel and John; married Paul Schuster Taylor in 1935. Worked as assistant in studios of several photographers, including Scott-Beatty and Arnold Genthe, New York, 1912-17; photo-finisher, Marsh's Dry Goods and Photo-Supply Store, San Francisco, 1918; freelance photographer, establishing own studio in San Francisco, 1919-34 (Associated with Group f.64, 1934), in Berkeley, California, 1935 until her death, 1965. Collaborated with Paul Taylor as photo-reporter (officially as "typist"), California Rural Rehabilitation Administration (Resettlement Administration, later Farm Security Administration-F.S.A., under Roy E. Stryker, *q.v.*, from 1935), San Francisco, 1934-39; for United States War Relocation Agency, San Francisco, 1942; Office of War Information, in San Francisco, 1943-45; for *Life* magazine, New York, 1954-55; freelance photo-reporter in Asia, 1958-59, in South America, 1960, in Egypt and Middle East, 1962-63. Instructor in Photography, California School of Fine Arts, now San Francisco Art Institute, 1957. Recipient: Guggenheim Fellowship, 1941. *Died* (in Marin County, California), *11 October 1965*.

Individual Exhibitions:

1934 Brockhurst Studio (Willard Van Dyke Studio), Oakland, California
1960 *Death of a Valley*, San Francisco Museum of Art (with Pirkle Jones; travelled to the Oakland Art Museum, California; Art Institute of Chicago; and the University of California at Davis)
1961 Bibliotecas Comunale, Milan
1966 Museum of Modern Art, New York (retrospective)
 Worcester Art Museum, Massachusetts
 Oakland Art Museum, California
1967 Amon Carter Museum, Fort Worth, Texas
1971 Oakland Art Museum, California

1973 Victoria and Albert Museum, London
1978 Oakland Art Museum, California

Selected Group Exhibitions:

1949 *6 Women Photographers*, Museum of Modern Art, New York
1955 *The Family of Man*, Museum of Modern Art, New York (and world tour)
1961 *USA-FSA*, University of Louisville, Kentucky (toured the United States)
1962 *The Bitter Years: FSA Photographs 1935-41*, Museum of Modern Art, New York (toured the United States)
1967 *Photography in the 20th Century*, National Gallery of Canada, Ottawa (toured Canada and the United States, 1967-73)
1975 *Women of Photography*, San Francisco Museum of Art, California (toured the United States 1975-77)
 The Land: 20th Century Landscape Photographs Selected by Bill Brandt, Victoria and Albert Museum, London (travelled to the National Gallery, Edinburgh; Ulster Museum, Belfast; and National Museum of Wales, Cardiff, 1976)
1979 *Photographie als Kunst 1879-1979*, Tiroler Landesmuseum Ferdinandeum, Innsbruck, Austria (travelled to Neue Galerie am Wolfgang Gurlitt Museum, Linz, Austria; Neue Galerie am Landesmuseum Joanneum, Graz, Austria; and Museum des 20 Jahrhunderts, Vienna)
 Images de l'Amérique en Crise: Photos de la FSA, Centre Georges Pompidou, Paris
1980 *Amerika: Traum und Depression 1920-40*, Kunstverein, Hamburg (toured West Germany)

Collections:

Museum of Modern Art, New York; New York Public Library; International Museum of Photography, George Eastman House, Rochester, New York; Library of Congress, Washington, D.C.; University of Minnesota, Minneapolis; Photographic Archives, University of Louisville, Kentucky (Stryker Archives); University of Nebraska, Lincoln; Amon Carter Museum of Western Art, Fort Worth, Texas; University of New Mexico, Albuquerque; San Francisco Museum of Modern Art.

Publications:

By LANGE: books—*Land of the Free*, with verse by Archibald Macleish, New York and London 1938; *An American Exodus: A Record of Human Erosion*, with Paul S. Taylor, New York 1939, New Haven, Connecticut, Oakland, California and London 1969, New York 1975; *Death of a Valley*, with Pirkle Jones, Millerton, New York 1960; *Dorothea Lange*, with an introduction by George Elliott, New York 1966; *Dorothea Lange Looks at the American Country Woman*, with text by Beaumont Newhall, Fort Worth and Los Angeles 1967; *Dorothea Lange: The Making of a Documentary Photographer*, interviews with Suzanne Ries, Berkeley, California 1968; *Executive Order 9066: The Internment of 110,000 Japanese Americans*, with texts by Maisie and Richard Conrat, San Francisco 1972; *To a Cabin*, with Margaretta K. Mitchell, New York 1973; *Dorothea Lange: Farm Security Photographs 1935-1939*, 2 vols., with an introduction by Robert J. Doherty, Glencoe, Illinois 1981; articles—"Fortune's Wheel," with Ansel Adams, in *Fortune* (New York), vol. 31, no. 2, 1945; "Miss Lange's Counsel: Photographer Advises Use of Picture Themes" in *New York Times*, 7 December 1952; "The Assignment I'll Never Forget: Migrant Mother" in *Popular Photography* (New York), vol. 46, no. 2, 1960;

"Death of a Valley," with Pirkle Jones, in *Aperture* (Rochester, New York), vol. 8, no. 3, 1960; "Remembrance of Asia" in *Photography Annual* (New York), 1964; "Documentary Photography" and "Photographing the Familiar" in *Photographers on Photography*, edited by Nathan Lyons, New York 1966.

On LANGE: books—*Masters of Photography* by Beaumont and Nancy Newhall, New York 1958; *Hundert Jahre Photographie 1839-1939 aus der Sammlung Gernsheim, London*, exhibition catalogue, by Helmut and Alison Gernsheim, Essen 1959; *The Bitter Years*, with text by Edward Steichen, New York 1962; *A Piece of Lettuce* by George P. Elliott, New York 1964; *Photography in the 20th Century* by Nathan Lyons, New York 1967; *Just Before the War: Urban America as Seen by Photographers of the FSA*, edited by Thomas H. Garver, Boston 1968; *Poverty and Politics: The Rise and Decline of the Farm Security Administration* by Sidney Baldwin, Chapel Hill, North Carolina 1968; *Portrait of a Decade* by F. Jack Hurley, Baton Rouge, Louisiana 1972; *The Woman's Eye*, edited by Anne Tucker, New York 1973; *In this Proud Land: America 1935-1943 as Seen in the FSA Photographs* by Roy E. Stryker and Nancy Wood, Greenwich, Connecticut 1973; *Documentary Expression and Thirties America* by William Stott, New York 1973; *The Eye of Conscience: Photographers and Social Change* by Milton Meltzer and Bernard Cole, Chicago 1974; *Social Documentary Photography in the USA* by Robert J. Doherty, New York 1974; *Photography in America*, edited by Robert Doty, with an introduction by Minor White, New York and London 1974; *The Years of Bitterness and Pride: FSA Photographs 1934-1943*, edited by Hiak Akmakjian, compiled by Jerry Kearns and Leroy Bellamy, New York 1975; *The Land: 20th Century Landscape Photographs Selected by Bill Brandt*, exhibition catalogue, edited by Mark Haworth-Booth, London 1975; *The Magic Image* by Cecil Beaton and Gail Buckland, Boston and London 1975; *Women of Photography: An Historical Survey*, edited by Margey Mann and Ann Noggle, San Francisco 1975; *A Vision Shared: A Classic Portrait of America and Its People 1935-43*, edited by Hank O'Neil, New York and London 1976; *Masters of the Camera* by Gene Thornton, New York 1976; *Geschichte der Fotografie im 20. Jahrhundert/Photography in the 20th Century* by Petr Tausk, Cologne 1977, London 1980; *Documenta 6/Band 2*, exhibition catalogue, edited by Klaus Honnef and Evelyn Weiss, Kassel and Cologne 1977; *The American Farm: A Photographic History* by Maisie and Richard Conrat, San Francisco 1977; *Photographs: Sheldon Memorial Art Gallery Collection, University of Nebraska*, with an introduction by Norman A. Geske, Lincoln, Nebraska 1977; *Dorothea Lange: A Photographer's Life* by Milton Meltzer, New York 1978; *Celebrating a Collection: The Work of Dorothea Lange* by Therese Thau Heyman, Oakland, California 1978; *A Ten Year Salute* by Lee D. Witkin, with a foreword by Carol Brown, Danbury, New Hampshire 1979; *Amerika Fotografie 1920-1940* by Erika Billeter, Berne 1979; *Photographie als Kunst 1879-1979/Kunst als Photographie 1949-1979*, exhibition catalogue, 2 vols., by Peter Weiermair, Innsbruck 1979; *Les Années Ameres de l'Amérique en Crise 1935-1942*, exhibition catalogue, by Jean Dieuzaide, Toulouse, France 1980; *Amerika: Traum und Depression 1920/40*, exhibition catalogue by Hubertus Gassner, Hamburg 1980; *Dorothea Lange and the Documentary Tradition* by Karin Becker Ohrn, Baton Rouge, Louisiana 1980; films—*Dorothea Lange, Part One: Under the Trees*, television film by Philip Green and Robert Katz, 1965; *Dorothea Lange, Part Two: The Closer for Me*, television film, by Philip Green and Robert Katz, 1965.

Dorothea Lange made a substantial contribution to photography. Her best known work was done during a five-year period from 1935 through 1939 when she worked for the Resettlement Administration (later Farm Security Administration) (RA/FSA), under the direction of Roy Stryker. Lange's work prior to and subsequent to the RA/FSA days is less well known but warrants study, for it holds the promise of important elements vital to the full understanding of her contribution to photography.

Recent publications such as Therese Heyman's *Celebrating a Collection: The Work of Dorothea Lange* touch briefly on Lange's early work as a portrait photographer. Her portraits reveal her to be a romantic, sensitive and poetic photographer. Without extensive study of her work from this period, it is difficult to assess it in relation to any new or novel approaches in portraiture. There seems to be little evidence to assume she had found her forte in portraiture. There is evidence to support her discontent with being a society photographer. In search of "photographing the people that my life touched," Lange turned to photographing the streets of San Francisco as subject matter.

Lange's photographs of labor unrest in the early years of the depression were eventually exhibited at Willard Van Dyke's Gallery where they caught the attention of Paul Schuster Taylor. Taylor, whom Lange later married, enlisted Lange's aid in preparing reports on the migrant agricultural workers' housing problems. Their work ultimately brought about the first federally sponsored housing project in this country. It is not entirely clear how the Taylor/Lange reports came to the attention of Tugwell or Stryker, both of whom had responsibilities for the RA/FSA project. There is speculation, unsupported at present, that the Taylor/Lange reports had to do with the founding of the RA/FSA Historical Section. Whatever may have happened, Stryker hired Lange and she began an intensive period of recording the life of the migrant workers, usually called "Okies" regardless of where they came from.

The "Okies" despaired of surviving throughout the Great Plains in the throes of dust storms and drought and headed west for the promised land. Lange recorded their arrival and portrayed their disillusionment. Lange was quite subjective and almost obsessed with the cirucumstances of her subjects and her work. Her correspondence with Stryker reflects her sense of urgency and her passionate concern for her subjects and her intense commitment to her work. When Stryker was unable to fund her expenses, she paid for them out of her own pocket.

Lange photographed in 22 of the 48 states for the RA/FSA. Most of these photographs concentrate on the migrants, sharecroppers and tenant farmers in the south and the west. Strangely, although Lange created THE symbol of the depression with her "Migrant Mother" photograph, only slightly more than 200 of her more than 4,500 pictures for the RA/FSA have turned up in books published since 1938. It is ironic that Lange omitted the "Migrant Mother" from her own book, *An American Exodus: A Record of Human Erosion* which she authored with Paul Taylor.

Lange was an artist who wanted total control over her pictures. Stryker demanded she send her negatives to Washington where the lab would make the necessary prints for distribution. Lange balked at this, but finally gave in. This issue left scars on the relationship, and Lange often disagreed with Stryker's assignments, suggesting alternates. Stryker became less tolerant with her "artistic" demands and when a budget crunch came, he terminated Lange's contract with the FSA. One senses this was no great tragedy as Lange seemed very tired and depressed with her work, for she saw no tangible results of her efforts.

Lange's FSA work has long been connected with Steinbeck's *Grapes of Wrath*. Paul Taylor maintains they had no contact before the writing of the book, yet there are many coincidences that should

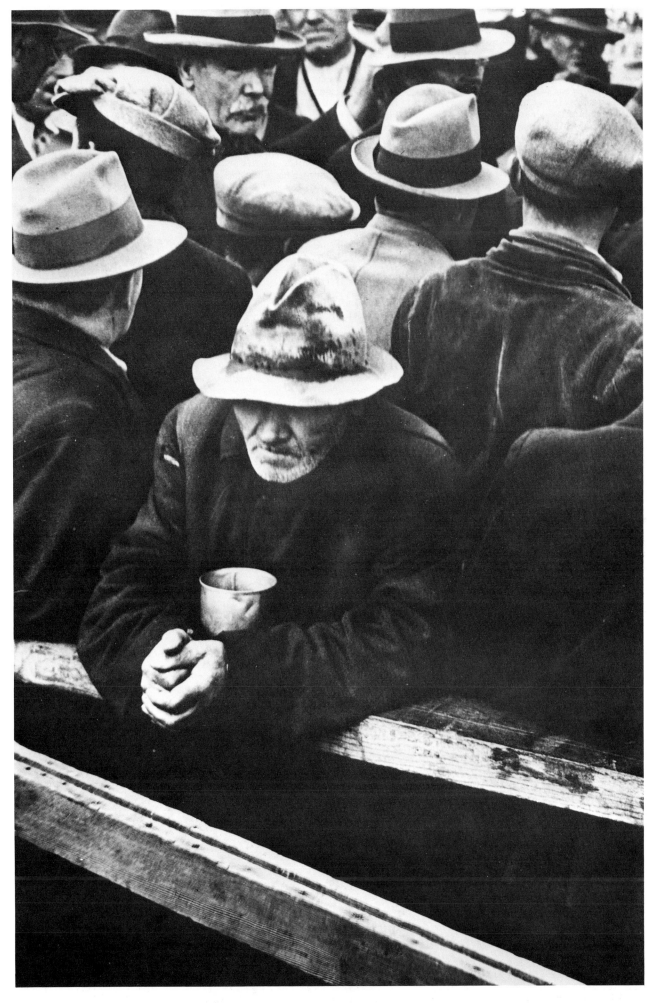

Dorothea Lange: *White Angel Bread Line*, **San Francisco, 1933** Courtesy Art Institute of Chicago

not be overlooked. In 1936, Steinbeck did a series of six articles for a San Francisco paper that were illustrated with Lange photographs. These articles were later published in pamphlet form as *Their Blood Is Strong*. Tom Collins, to whom Steinbeck dedicated the second part of *Grapes*, was an FSA Camp Director who was extensively photographed by Lange at about the same time Collins was working with Steinbeck on the first version of *Grapes*. Ultimately, Collins was hired as a technical director for the movie of *Grapes* and used Lange's photographs to guide the movie's authenticity.

From the end of the FSA work, Lange used her camera less intensively. It seems that without a compelling cause, her desire to work diminished. When a cause arose, such as the internment of the Japanese during World War II, Lange was inspired to use her skills for the cause; otherwise, she turned to picturing her family and friends. She did a brief stint with *Life*, but she described the post-war period as a "blank" and considered herself handicapped with poor health. Lange did accompany her husband on trips to the Mideast and produced some very dramatic and remarkable pictures in Egypt. And Lange and Pirkle Jones became angry over a dam that would destroy a beautiful valley. Together they collaborated and published their statement in *Death of a Valley*.

This small, shy, insecure woman had a strong sense of justice which sparked a silent fury that came to light in the strong emotion of her photographs. With a camera in her hand, she became a giant.

—Robert J. Doherty

William Larson: *Untitled*, 1979

LARSON, William.

American. Born in North Tonawanda, New York, 14 October 1942. Educated at Starpoint Central High School, Pendelton, New York, 1956-60; State University of New York at Buffalo, 1960-64, B.S. in art 1964; studied art and history at the University of Siena, 1964; and photography, under Aaron Siskind, Wynn Bullock and Arthur Siegel, at the Institute of Design, Illinois Institute of Technology, Chicago, 1966-68, M.S. 1968. Married Catherine Jansen in 1973; daughter: Erika. Photographer, Feldkamp-Malloy Design Studio, Chicago, 1967-68. Freelance photographer, Philadelphia, since 1968. Professor, Tyler School of Art, Temple University, Philadelphia, since 1968. Visiting Professor, University of Arizona, Tucson, 1980-81. Recipient: National Endowment for the Arts Fellowship, 1971, 1979; Best Colour Photographer Award, *Triennale de la Photographie*, Fribourg, Switzerland, 1978. Agent: Light Gallery, 724 Fifth Avenue, New York, New York 10019. Address: 152 Heacock Lane, Wyncote, Pennsylvania 19095, U.S.A.

Individual Exhibitions:

1970 Maryland Art Institute, Baltimore
1972 State University of New York at Potsdam
1973 Light Gallery, New York
 Chicago Center for Contemporary Photography
1975 Light Gallery, New York
 Philadelphia Print Club (with Emmet Gowin and Steve Williams)
1976 University of Tennessee, Knoxville
 University of South Dakota, Vermillion
1977 Art Institute of Chicago
 Light Gallery, New York

Southern Illinois University, Carbondale
 University of Oregon, Eugene
1978 Light Gallery, New York
 Camerawork Gallery, San Francisco
 Pittsburgh Film Makers
1979 Bard College, Annandale-on-Hudson, New York
 Light Gallery, New York
1980 Los Angeles Institute of Contemporary Art
1981 *Joe Deal: The Fault Zone/William Larson: Recent Color Work from Arizona*, Light Gallery, New York
1982 *William Larson/László Moholy-Nagy*, Center for Creative Photography, University of Arizona, Tucson

Selected Group Exhibitions:

1974 *Photography Unlimited*, Harvard University, Cambridge, Massachusetts
1976 *3 Centuries of American Art*, Philadelphia Museum of Art
1978 *Artworks/Bookworks*, Los Angeles Institute of Contemporary Art
 Spaces, Rhode Island School of Design, Providence
 American Color Photography, Massachusetts Institute of Technology, Cambridge
 Mirrors and Windows: American Photography since 1960, Museum of Modern Art, New York (toured the United States, 1978-80)
1979 *Attitudes: Photography in the 1970's*, Santa Barbara Museum of Art, California
 Electroworks, International Museum of Photography, George Eastman House, Rochester, New York
1980 *Polacolor*, Light Gallery, New York
 The Holographer's Vision, Franklin Institute, Philadelphia

Collections:

Museum of Modern Art, New York; Rhode Island School of Design, Providence; University of Hartford, Connecticut; Philadelphia Museum of Art; Princeton University, New Jersey; University of Louisville, Kentucky; New Orleans Museum of Art; American Arts Documentation Centre, University of Exeter, Devon, England; National Gallery of Australia, Canberra.

Publications:

By LARSON: books—*Fireflies*, Philadelphia 1976; *Big Pictures, Little Pictures*, Philadelphia 1980; articles—"The Figure in Motion" in *Camera* (Lucerne), April 1970; "Photographic Reality" in *Mundus Artium* (Athens, Ohio), Spring 1971; "The Human Figure in Motion" in *Modern Photography* (New York), April 1971.

On LARSON: books—*The Great Themes*, edited by Carole Kismaric, New York 1970; *The Art of Photography*, edited by Carole Kismaric, New York 1971; *Light and Lens*, edited by Donald Werner, New York 1973; *Photographer's Choice*, edited by Kelly Wise, Danbury, New Hampshire 1975; *Three Centuries of American Art*, edited by Will Stapp, Philadelphia 1976; *Spaces*, edited by Aaron Siskind, Providence, Rhode Island 1978; *One of a Kind*, edited by Belinda Rathbone, Cambridge, Massachusetts 1979; *William Larson* (Aperture portfolio) by Michael Hoffman and Carole Kismaric, Millerton, New York 1981; articles—"New Frontiers in Color" by Douglas Davis in *Newsweek* (New York), 19 April 1976; "William Larson: Time and Structure" by Skip Atwater in *Afterimage* (Rochester, New York), December 1976.

My work currently centers on domestic and local landscape situations which are photographed in color. I like the balance achieved between descriptive photographic detail and a subjective color palette which supports my basic instincts for picturemaking.

—William Larson

A constant feature of William Larson's work is his use of photography to transmit information about the medium itself. This theme is at least equal in importance to Larson's messages about the outside world, and most of his output displays both aspects in varying degrees.

One of Larson's earlier concerns was with making images that extend the possibilities in photographic rendering of space/time relationships beyond any analogy to human perception yet still within the limits of logical photographic process. Whereas certain work with serial images did involve a fictive element, Larson's series "The Figure in Motion" elegantly demonstrates how the familiar human body, and an innovative if basically self-evident process of photographic recording using travelling film, may together produce images at once wholly strange and wholly true to both the subject and the system that made them.

The direction of Larson's enquiry has since shifted somewhat away from considerations of the medium as total system and more towards an examination of sets of properties within it. In *Fireflies*, the effect of using facsimile machines to transmit photographic and other fragments down telephone lines, and reconstitute them into visual form, draws attention to the nature of the basic information that survives—despite the incompleteness of the component images, and despite the severe filtering and high noise levels introduced by translation from visual to electrical modes and back again via crude transducers and narrow bandwidths.

Larson's excursions into Polaroid—notably *Little Pictures* on SX-70 and *Big Pictures* on 20" x 24" Polacolor—demonstrate a progression within the main theme. The early *Little Pictures*, however Matissean the tenor of their content, are unequivocally from SX-70 technology, and from that follows colour rendering and the rationale of lighting effects. Graphic artefacts such as colour patches, grey scales, register marks and waxon crayons in the later *Little Pictures*, focus attention even more sharply on how light has been transmuted to dye, at the same time as the formal composition and tactics of illusionism become complex and purely photographic. In the *Big Pictures*, presented whole, so that they could only be Polacolor 20" x 24", the work is not only photographic in content, consisting almost entirely of studio equipment, but also the principal subjects are the effects and enigmas of lighting, focus and colours.

Examination of Larson's photography invites the supplementary conclusion that the interactions of the most careful syntax, and the most standardized technical controls, leave intriguing areas of indeterminacy and question about the medium—an encouraging and salutory reminder of the complexity of things.

—Philip Stokes

LARTIGUE, Jacques-Henri (Charles Auguste).
French. Born in Courbevoie, Seine, 13 June 1894. Educated privately; studied painting, under Jean-Paul Laurens, Decheneau and Baschet, Académie Julian, Paris, 1915-16; self-taught in photography. Served as a volunteer in the French Army, 1914-18. Married Madeleine (Bibi) Messager in 1919; son: Dani; Marcelle Paolucci in 1934; and Florette Orméa in 1945. Took first photographs, Courbevoie, 1902; painter, since 1915 (numerous one-man exhibitions of paintings, 1922-78); particularly known as a photographer since the late 1960's. Vice-President, Gens d'Images, Paris, 1954. Recipient: Gold Medal, City of Paris. Chevalier de la Légion d'Honneur, 1975; Commander des Arts et Lettres, Paris, 1981. Donated life's work to the French nation, 1979: c/o Mme. Isabelle Jammes, Conservateur, Association des Amis de Jacques-Henri Lartigue, Grand Palais des Champs-Elysées, Avenue Franklin D. Roosevelt, Porte C, 75008 Paris. Address: 102 rue de Longchamp, 75116 Paris, France.

Individual Exhibitions:

1963 *The Photographs of Jacques-Henri Lartigue,* Museum of Modern Art, New York
1966 *Photokina,* Cologne
1968 The Photographers Gallery, at Architectural Furniture, New York
1969 *Festival d'Avignon*
1971 L'Oeil de Verre, Lille
 The Photographers' Gallery, London (toured the U.K., and travelled to Marseilles, Le Havre, and Hamburg, 1972-73)
1972 Witkin Gallery, New York
 Neikrug Gallery, New York
1973 Salle des Etats, Dijon
 Centre Culturel et Social, Limoges
 Musée Municipal, Brest
 Friends of Photography, Carmel, California
1974 Galerie de Doigt dans l'Oeil, Bordeaux
 Center for Photographic Art, Chicago
 Bibliothèque Nationale, Montreal
1975 Galerie Optica, Montreal (travelled to the Yarlow Fine Arts Gallery, Toronto; French Institute, New York; Visual Studies Workshop, Rochester, New York; Art Gallery of Ontario, Toronto; Columbia College, Chicago; and the International Center of Photography, New York, 1975)
 Bibliothèque Municipale, Mulhouse, France
 Witkin Gallery, New York
 Lartigue 8 x 80, Musée des Arts Décoratifs, Paris (travelled to *Europalia 75,* Ghent and Antwerp, 1975; Chambery, France, and Musée de Clamency, France, 1976)
 Galerie Delpire, Paris
 Galerie Municipale du Chateau d'Eau, Toulouse
 Festival d'Arles, France
 Van Gogh Museum, Amsterdam
1976 Centre d'Action Culturelle, Macon
 Nouvelle Bibliothèque, Romorantin, France
 Frantel, Rheims
 Maison des Jeunes et de la Culture, St. Etienne de Rouvay, France
 Seibu Art Museum, Tokyo
 Schiedams Museum, Netherlands
 Arnhems Museum, Netherlands
1977 Centre de la Part Dieu, Lyons
1978 Palais de l'Europe, Menton, France
 Centre International de Grasse, France
 Maison Européenne de la Photographie, Chalon-sur-Saône, France
 Tolarno Gallery, St. Kilda, Victoria, Australia
1979 Grenier à Sel, Honfleur, France
1980 *Bonjour Monsieur Lartigue,* Grand Palais, Paris (restrospective; travelled to the Fondation Nationale de la Photographie, Lyons, 1981)

Selected Group Exhibitions:

1955 *Photographies des Gens d'Images,* Galerie d'Orsay, Paris (and 1956)
1965 *Un Siècle de Photographie,* Musée des Arts Décoratifs, Paris
1973 *Annual Festival,* Birmingham, Alabama
1975 *The Land: 20th Century Landscape Photographs Selected by Bill Brandt,* Victoria and Albert Museum, London (travelled to the National Gallery, Edinburgh; Ulster Museum, Belfast; and National Museum of Wales, Cardiff, 1976)
 Cents Ans de Couleurs, Salon de la Photographie, Paris
1976 *Festival Ducos du Hauron,* Agen, France
1977 *Photographie Créatice du XXème Siècle,* Centre Georges Pompidou, Paris
1979 *Fleeting Gestures: Dance Photographs,* International Center of Photography, New York (travelled to The Photographers' Gallery, London, and *Venezia '79*)

Collections:

Association des Amis de Jacques-Henri Lartigue, Grand Palais, Paris (archives; 200,000 documents); Museum of Modern Art, New York; International Museum of Photography, George Eastman House, Rochester, New York; Allen Memorial Art Museum, Oberlin, Ohio; Detroit Institute of Arts; Art Institute of Chicago; Minneapolis Institute of Arts; University of Nebraska, Lincoln; Center for Creative Photography, University of Arizona, Tucson; San Francisco Museum of Modern Art.

Publications:

By LARTIGUE: books—*Les Photographies de J.-H. Lartigue: Un Album Famille de la Belle Epoque,* edited by Jean Fondin, Lausanne 1966, as *Boyhood Photos of J.-H. Lartigue: The Family Album of a Gilded Age,* New York 1966; *Diary of a Century,* edited by Richard Avedon, New York 1970, London 1971, as *Photo-Tagebuch unseres Jahrhunderts,* Lucerne 1971, as *Instants de Ma Vie,* Paris 1973; *Portfolio J.-H. Lartigue,* portfolio of 10 photos, with an introduction by Anaïs Nin, New York 1972; *J.-H. Lartigue et les Femmes,* Paris 1973, London and New York 1974; *Das Fest des Grossen Rüpüskul,* with text by Elisabeth Borchers, Frankfurt 1973; *J.-H. Lartigue et les Autos,* Paris 1974; *Mémoires sans Mémoires* (extracts from his journal), Paris 1975; *Mon Livre de Photographie,* Paris 1977; *Portfolio J.-H. Lartigue 1903-1916,* portfolio of 10 photos, New York 1978; *Les Femmes aux Cigarettes,* with a preface by Lartigue, New York 1980; *Les Autochromes de J.-H. Lartigue 1912-1927,* Paris 1980, New York 1981; articles—"Jacques-Henri Lartigue," interview, in *Dialogue with Photography* by Paul Hill and Thomas Cooper, London 1979; "Jacques-Henri Lartigue," interview in *Voyons Voir: 8 Photographes* by Pierre Borhan, Paris 1980.

On LARTIGUE: books—*The Photographs of Jacques-Henri Lartigue,* exhibition catalogue, with an introduction by John Szarkowski, New York 1963; *Looking at Photographs* by John Szarkowski, New York 1973; *The Land: 20th Century Landscape Photographs Selected by Bill Brandt,* exhibition catalogue, edited by Mark Haworth-Booth, London 1975; *Lartigue 8 x 80,* exhibition catalogue, Paris 1975; *Histoire de la Photographie 2: J.-H. Lartigue,* Paris and New York 1976; *Photographs: Sheldon Memorial Art Gallery Collection, University of Nebraska,* with an introduction by Norman A. Geske, Lincoln, Nebraska 1977; *Drei Klassiken der Fotografie: Lartigue, Kertesz, Steichen,* edited by Rogner Bernhard, 1978; *The Vogue Book of Fashion Photography* by Polly Devlin, with an

Jacques-Henri Lartigue: *Sur la Route de Houlgate, avec Marie, Bibi et Jean le Chauffeur, Automobile Hispano Suiza 32 hp.*, 1929

introduction by Alexander Liberman, New York and London 1979; *Bonjour Monsieur Lartigue*, booklet to accompany exhibition, edited by the Association des Amis de Jacques-Henri Lartigue, Paris 1980; articles—"The Photographs of Jacques-Henri Lartigue" by John Szarkowski in *Museum of Modern Art Bulletin* (New York), no. 1, 1963; "Lartigue: The Happy Man" by Lionel Birch in the *Daily Telegraph Magazine* (London), 19 March 1971; "Spin of Delight: The Photography of Jacques-Henri Lartigue" by Ainslie Ellis in *British Journal of Photography* (London), 14 May 1971; "Jacques-Henri Lartigue: The Pursuit of Humour and Life" in *The Times* (London), 19 May 1971; "Jacques-Henri Lartigue: The Photographers' Gallery" by Oswell Blakeston in *Arts Review* (London), 22 May 1971; "Jacques-Henri Lartigue: Later Pictures" in *Creative Camera* (London), June 1971; "Mercurial Quietude: Cartier-Bresson and Lartigue" by Max Kozloff in *Art in America* (New York), January/February 1972; "The Colour Photographs of Jacques-Henri Lartigue" in the *Sunday Times Magazine* (London), 27 August 1972; "Lartigue: Les Femmes et Moi" in *Photo* (Paris), September 1972; "Lartigue ou l'Oeil du Matin" in *Zoom* (Paris), no. 11, 1972; "Jacques-Henri Lartigue" in *Documentary Photography*, by the Time-Life editors, New York 1973; "New York Letter: Jacques-Henri Lartigue" by S. Schwartz in *Art International* (Lugano), January 1973; "Lartigue in London" in *Photographic Journal* (London), August 1973; "Le Lancelot de Robert Bresson par Lartigue" in *Photo* (Paris), September 1973; "Jacques-Henri Lartigue" in *Photo* (Paris), November 1973; "The Eyes of an Optimist" in the *Sunday Times Magazine* (London), 17 February 1974; "Les Photographes, Aiment-ils les Mannequins" in *Elle* (Paris), 8 April 1974; "J.-H. Lartigue et son piege d'oeil" by Michel Tournier in *L'Oeil* (Paris), December 1974; films—*Le Magicien* by Claude Fayard, 1966; *La Famille Lartigue* by Robert Hughes, 1970; *Jacques-Henri Lartigue* by Claude Gallot, 1971-72; *Jacques-Henri Lartigue* by Claude Ventura, 1974; *Jacques-Henri Lartigue, Un Photographe* by Fernand Moscovitz, 1980; *Jacques-Henri Lartigue, Peintre et Photographe* by Francois Reichenbach, 1980.

Spring is here. The struggle has begun. Struggle against the brightened fog, struggle against the plum trees in bloom, against the wind, against the light, against all the elusive beauties.

We do not "fight" against them. We fight to try to become a hyphen between them and the small human result. And this hyphen, we can become it only if God sends us an angel.

I enter at the back of an old country chapel, like a nest of stones poised in silence.... And suddenly, there, God permits it! He permits me to speak to Him about this angel that might come to me.

1965

My memory, a sort of file installed in my brain, keeps things, things in the process of happening that immediately become of the past.

There I recover dates, facts, data, but nothing of the mysterious imponderables that enchant me and that I love and that love me, then escape. So I write (and sometimes I am even reduced to taking pictures), as if I were trying to catch a smoke-ring in a butterfly net, and then my human "intellect" persuades me that all is lost, annihilated, nothingness Then, a little country bell rings, or a blackbird sings, a fragrance passes by—and all is resurrected. Though, not quite; not resurrected to begin again—I don't deserve that. But resurrected in order to show, to say to me (and therefore to allow me to smile): "Look, I am not dead."

1971

I must choose photographs for my book about women. There are hundreds of 6 x 6's to look at, Florette on one side, me on the other. Subtle colors now washed out, rotten, removed. Dead friends. Countries disfigured by "progress." Desperate, perhaps, this bankruptcy, and yet not completely, this "box of preserves." I will keep for many months the fleeting "blue bird" and make it fly in my imagination, and soon, deaf to the reasons of my reason, I will begin again to search, to recapture, to preserve, the "bluebirds."

1973

If no one can ever catch the "bluebird," Claude Monet caught his feathers.

1963
—Jacques-Henri Lartigue (from his journal)

The most popular of French photographers, the one that America "discovered" and covered with honors, the one whose work the French Republic now officially collects and disseminates—that is Jacques-Henri Lartigue, who has always claimed that he is not a photographer. On his passport, the description of profession reads, "Artist-Painter." And he has said: "For me, photography is, certainly, a passion. But I am only an amateur." A mischievous nuance, a charming whim perhaps, but it does reveal an authentic modesty, and rather than diminish the public's admiration for him and his work, it enhances it.

At the age of seven, at the beginning of this century, Lartigue received a camera as a gift from his father, and from then on, day after day, he would try to "fix" scenes of his domestic life, having been allowed by the conditions of his life sufficient leisure to do so. These conditions were neither common nor rare. But as Richard Avedon has rightly observed, "Hundreds of children from the same social milieu received cameras, but they never became Lartigues." Only the grace of God and—if one may use the word—an authentic genius explain the difference. Yet there were some fortuitous circumstances.

Some drunks drink sad alcohol; some rich people possess dismal money. Not Lartigue's parents. With them, money was, as it were, merry. The first bit of good luck in his favor was that he learned about money not as the stuff of vanity or deadly pomp but of joyous handouts. For his family, avant-garde for their time, everything was greatly loved; they were intoxicated by their Golden Age, with its arts of living, its discoveries and its naivetés: the automobile, the airplane, the phonograph, the cinema, photography (which his father, a financier, had already discovered), sports of every kind, travel, the sea, the snow—and the array of gadgets, like the inflatable suit which (in theory at least) allowed the wearer to drift in a gentle current without getting wet. There were, in short, a profusion of subjects for Lartigue, a child of that time and class, to capture. When the children—Maurice, the eldest; Jacques-Henri, the younger; and their cousins—devised new toys, we, too, can see them: there is the bobsled on bicycle wheels pulled by a donkey to the top of a hill (a photo), which then comes down the slope at breakneck speed (another photo), producing a series of "sensational scenes," not least of which is its demise (still another photo).

A second bit of good luck was that Lartigue had the opportunity, at 20, to direct his own destiny—to do what he wanted to do, with parental approval. After entering the Académie Julian, thanks mainly to the instruction of the painter Jean-Paul Laurens, he perfected his graphic talent, which was, until then, essentially primitive. And a third bit of good luck was that, in teaching himself photography, he avoided the sterility of pictorial academicism. Perhaps that is the reason for the distinction he makes: he calls himself a painter and not a photographer because he *learned* one and not the other. The distinction is less specious than it may seem, even though the two disciplines are subject to certain common laws. Lartigue has been successful as a painter (his paintings, since 1922, have been highly prized), but when he photographs he does not do so according to any of the rules he mastered as a painter; he creates photographs, now as then, by pure intuition.

Perhaps too, and not facetiously, one could mention another fortunate circumstance: Lartigue was born under the sign of Gemini, which suggests a gift for social relationships, a great precocity, and, especially, an eternal youthfulness which defies, both physically and mentally, the assault of time. That description does fit Lartigue: the precocious, eternal adolescent, who was at first a little Mozart, who, now an octogenarion, remains as active, as inquisitive, as mischievous, as impish as when he was eight years old. He and his pictures ignore chronology. His "Interieur en Auvergne," the work one would assume of a mature man, dates from when he was 16; his "Fleurs des Champs," a photo that he could have produced at 12, dates from only yesterday. In his "albums" youth is presented as of all ages; life, happiness and irony burst forth there with universal simplicity and generosity of spirit. That, finally, is Lartigue's style.

And this is what makes his work so remarkable: his pictures are almost never that which one would actually see in a family album (consider Bibi surprised on the toilet in an indiscreet posture), but neither are they what we expect to find in magazines. He is not really a reporter, he is more like a *paparazzo*: beautiful women walking in the Bois de Boulogne, caught off-guard; losing gamblers leaving Auteuil racetrack. He is also (depending on one's perspective) a fashion photographer *honoris causa*, a theatrical photographer, a photojournalist, a portrait photographer; his subjects include the arts, sciences, technology, society. He photographs anything and everything but not from any creative stance or intellectual imperative but as from his own great curiosity. His pictures are the records, the thoughts, of an emotionally alive and active man. They speak freely and make him, as John Szarkowski has noted, "the precursor of all that has been vital and of interest in the milieu of our times."

Life—that is Lartigue's photographic genre. That is his amusement, his delight—and ours too, of course. An anecdote will illustrate his unalterable "amateurishness" and disarming good-naturedness:

One day, a figure of great importance asked Lartigue to do his portrait, and Lartigue agreed (perhaps the only commissioned portrait of his career). At the appointed time, Lartigue arrived in the courtyard of the palatial home of his potential subject—driving his antique, scrap-metal Citroen 2 CV. Before beginning the session, he put himself at his ease by putting on his slippers, as he would do at home. Between pictures he took a break and, as it was lunchtime, his wife (and assistant) had provided picnic provisions in a basket (a technical detail: the sandwiches prepared by the Lartigues are always encircled at both ends by rubber bands, to avoid incidents).

All of these details are indicative of the Lartigue style, which, on this occasion, was being put at the official service of the former president of the Republic, M. Giscard d'Estaing.

It is true, then: neither he nor his photographs have aged. When we immerse ourselves in his work, in an album, neither do we. That is the miracle we mean when we say Lartigue.

—Roger Therond

LAUGHLIN, Clarence John.
American. Born in Lake Charles, Louisiana, 14 August 1905; lived on a plantation near New Iberia, Louisiana, 1905-10, then moved with his parents to New Orleans. Educated at elementary school and high school (for 1 year) in New Orleans, 1911-18; self-taught in photography. Served in the United States Army, at the Signal Corps Photographic Unit, Long Island City, New York, 1942-43, and with the United States Office of Strategic Services, Washington, D.C., 1943-46. Married 4 times. Worked as a bank clerk in New Orleans, 1924-35. Photographer since 1945. Civil Service Photographer, for the United States Engineer Corps, on the Mississippi River, and in New Orleans and Vicksburg, Louisiana, 1936-40; Fashion Photographer, *Vogue* studios, New York, 1940-41; worked for the Photography Department, National Archives, Washington, D.C., 1941-42; freelance architectural photographer, New Orleans, 1946-74. Since 1974 engaged mainly in writing and creating large personal library (now more than 32,000 volumes), mostly on all aspects of fantasy and the fantastic. Associate of Research, University of Louisville, Kentucky, since 1968: established archives (bulk of collection of 17,000 sheet film negatives), at the University of Louisville, 1970. Address: 5227 Marigny Street, New Orleans, Louisiana 70122, U.S.A.

Individual Exhibitions:

More than 200 exhibitions throughout the United States since 1935, including:

1936 Delgado Museum of Art, New Orleans
1939 Princeton University Art Gallery, New Jersey
1940 Julian Levy Gallery, New York (with Eugène Atget)
1942 New School for Social Research, New York
1946 Walker Art Center, Minneapolis
The Camera as a Third Eye, Philadelphia Museum of Art (first personally designed circulating show)
1948 San Francisco Museum of Art
Ghosts Along the Mississippi, Phillips Gallery, Washington, D.C. (toured the United States, 1948-56)
Seattle Art Museum
1949 Northwestern University, Evanston, Illinois
The Camera as a Third Eye, with Stieglitz' *Equivalents*, Phillips Gallery, Washington, D.C.
1950 Massachusetts Institute of Technology, Cambridge
1951 Stanford University Art Gallery, California
1952 Art Institute of Chicago
1953 *Louisiana Plantation Photos*, United States Department of State travelling exhibition (toured Germany)
1954 Cleveland Museum of Art
1956 Wadsworth Atheneum, Hartford, Connecticut
1957 Los Angeles County Museum of Art
The Bronze Age to Brancusi, Detroit Institute of Art (toured the United States)
1962 Smithsonian Institution, Washington, D.C.
1965 *Old Milwaukee Rediscovered*, Milwaukee Public Museum, Wisconsin (toured the United States)
1967 *Phoenix Re-Arisen*, Carson Pirie Scott Auditorium, Chicago (toured the United States)
1973 *The Personal Eye*, Philadelphia Museum of Art (retrospective)
New Orleans Museum of Art
1976 Museum of Contemporary Art, Chicago
Chicago Center for Contemporary Photography
Minneapolis Institute of Arts
1980 *Louisiana Plantations*, Tulane University Library, New Orleans

Selected Group Exhibitions:

1949 *Mississippi Panorama*, City Art Museum, St. Louis
1955 *4 Photographers: Abbott, Atget, Laughlin, Stieglitz*, Yale University, New Haven, Connecticut
1959 *Photography at Mid-Century*, International Museum of Photography, George Eastman House, Rochester, New York (toured the United States)
Photographer's Choice, Indiana University, Bloomington
1961 *Salon Internationale du Portrait Photographique*, Bibliothèque Nationale, Paris
1962 *Subjektive Fotografie 2*, Cologne (toured West Germany)
1976 *Photographs from the Julien Levy Collection, Starting with Atget*, Art Institute of Chicago
American Photography: Past into Present, Seattle Art Museum
1977 *Concerning Photography*, The Photographers' Gallery, London (travelled to the Spectro Workshop, Newcastle upon Tyne)
1978 *40 American Photographers*, Crocker Art Gallery, Sacramento, California

Collections:

University of Louisville, Kentucky (archives); Metropolitan Museum of Art, New York; Museum of Modern Art, New York; International Museum of Photography, George Eastman House, Rochester, New York; Phillips Gallery, Washington, D.C.; Smithsonian Institution, Washington, D.C.; Stieglitz Center, Philadelphia Museum of Art; New Orleans Museum of Art; Art Institute of Chicago; Gernsheim Collection, University of Texas at Austin; Bibliothèque Nationale, Paris.

Publications:

By LAUGHLIN: books—*New Orleans and Its Living Past*, with text by David L. Cohn, Boston 1941; *Ghosts Along the Mississippi*, New York 1948; *Photographs of Victorian Chicago*, Washington, D.C. 1968; articles—"Unexplored New Orleans" in *Magazine of Art* (New York), July 1939; "Poems of Desolation" in *New Directions in Prose and Poetry 1941*, New York 1941; "Ghosts Along the Mississippi" in *Harper's Bazaar* (New York), 1 March 1942; Speaking of Pictures...New Orleans Has Lovely Old Ironwork" in *Life* (New York), 6 April 1942; "The Architecture of New Orleans" in *Architectural Review* (London), August 1946; "Plantation Architecture in Louisiana" in *Architectural Review* (London), December 1947; "The Cemeteries of New Orleans" in *Architectural Review* (London), February 1948; "Moss Phantom" in *Mademoiselle* (New York), April 1948; "Variety from Standardization" in *Architectural Review* (London), April 1948; "Symbolic Photography: The Camera as a 'Third Eye' " in *Professional Photographer* (Cleveland), September 1951; "Seven Ways to See a Tree" in *Modern Photography* (New York), September 1952; "Backgrounds and Models," in 2 parts, in *Art Photography Magazine* (Chicago), April and May 1956; "Ultra Modern: Out of Date" in *Harper's Bazaar* (New York), March 1956; "Inner Vision in Photography" in *New World Writing 15*, New York 1959; "Why? Because" in *Modern Photography* (New York), August 1961; "Louisiana Fantasy" in *Architectural Review* (London), May 1967; "American Fantastica" in *L'Oeil Magazine* (Paris), February 1967; "The Third World of Photography: Beyond Documentation and Purism" in *Photo Bulletin* (Los Angeles), March 1979; "Men and Buildings: American Victorian Architecture" in *Perspecta* (New Haven, Connecticut), no. 17, 1981.

On LAUGHLIN: books—*Modern Photography 1937-38*, edited by C.G. Holme, London and New York 1938; *U.S. Camera 1940*, edited by T.J. Maloney, New York 1939; *Famous Photographs*, edited by Willard Morgan, New York 1948; *A Concise History of Photography* by Helmut and Alison Gernsheim, London 1965; *The Photographer's Eye* by John Szarkowski, New York 1966; *Looking at Photographs* by John Szarkowski, New York 1973; *Clarence John Laughlin: The Personal Eye*, with an introduction by Jonathan Williams, Millerton, New York 1973; *The Magic Image* by Cecil Beaton and Gail Buckland, Boston and London 1975; *American Photography: Past into Present*, edited by Anita Ventura Mozley, Seattle 1976; *Photographs from the Julien Levy Collection, Starting with Atget*, exhibition catalogue, by David Travis, Chicago 1976; *Concerning Photography*, exhibition catalogue, by Jonathan Bayer and others, London 1977; *Light Readings: A Photography Critic's Writings 1968-1978* by A.D. Coleman, New York 1979; *Center for Creative Photography No. 10: Clarence John Laughlin* by Henry Holmes Smith and Terence Pitts, Tucson, Arizona 1979; *The Photograph Collector's Guide* by Lee D. Witkin and Barbara London, Boston and London 1979; articles—"Let's Talk Photography" by Bruce Downes in *Photography Magazine* (New York), April 1951; article by Emil Schulthess in *Du* (Zurich), April 1954; article by Fritz Gruber in *Foto Prisma* (Dusseldorf), February 1960; "3 American Phantasts: Bullock, Sommer, and Laughlin" by Jonathan Williams in *Aperture* (Millerton, New York), no. 3, 1961; "Potentials of Creative Photography" in *Camera* (Lucerne), July 1968; "Les Fleurs du Mal" in *Arts in Society* (Madison, Wisconsin), no. 3, 1963; "A Significant Magic" in *New Orleans Magazine*, November 1971; "Clarence John Laughlin: Phantoms and Metaphors" by Mary Louise Tucker in *Modern Photography* (New York), April 1977.

The creative photographer should be able to put the stamp of *his* way of seeing on whatever material he touches—just as in the case of the creative painter or poet. This means that the object in the photograph must be so treated, or so grasped (not merely in technical terms, but in terms of the pre-sensitizing of an individual imagination, and the subsequent projection of this individual imagination through the so-called "impersonal" lens) that the object *does* become personal—by acquiring meanings *beyond* itself. In fine, the object is then photographed in terms of what this individual human imagination has *projected* into it. It is *only* when the photograph presents the object so that the meanings conveyed *transcend* the meaning of the object as a *thing-in-itself* that photography becomes art.

It should be stressed that I did not start out as a photographer but, instead, as a writer. Whether for good or ill, this fact has inspired and colored many of my concepts. In addition, through photography I have also tried to tie together and further my active interests in painting, in poetry, in psychology, and in architecture. Whatever value my photography has, it is *only* because of these other interests.

One of my basic feelings is that the mind, and the heart alike, of the photographer must be dedicated to the glory, the magic, and the mystery of light. The mystery of time, the magic of light, the enigma of reality—and their interrelationships—are my constant themes and preoccupations. Because of these metaphysical and poetic preoccupations, I frequently attempt to show in my work, in various ways, the unreality of the "real" and the reality of the "unreal." This may result, at times, in some disturbing effects. But art *should* be disturbing; it should make us both think *and* feel; it should infect the subconscious as well as the conscious mind; it should never allow complacency or condone the status quo.

My central position, therefore, is one of *extreme romanticism*—the concept of "reality" as being, innately, mystery and magic; the intuitive awareness

Clarence John Laughlin: *A Vision of Dead Desire*, 1954

of the power of the "unknown"—which human beings are afraid to realize, and which none of their religious and intellectual systems can really take into account. This romanticism revolves upon the feeling that the world is far stranger than we think; that the "reality"; and that the human imagination is the key to this hidden, and more inclusive, "reality." This position is now completely out of fashion.

As a corollary, I attempt, through much of my work, to animate all things—even so-called "inanimate" objects—with the spirit of man. I have come, by degrees, to realize that this extremely animistic projection rises, ultimately, from my profound fear and disquiet over the accelerating mechanization of man's life and the resultant attempts to stamp out individuality in all the spheres of man's activity—this whole process being one of the dominant expressions of our military-industrial society.

The physical object, to me, is merely a stepping-stone to an inner world where the object, with the help of subconscious drives and focused perceptions, becomes transmuted into a symbol whose life is beyond the life of the objects we know and whose meaning is a *truly human* meaning. By dealing with the object in this way the creative photographer sets free the *human contents* of objects, and imparts humanity to the inhuman world around him.

Everything that I see must become *personal*; otherwise, it is dead and mechanical. Our only chance to escape the blight of mechanization, of acting and thinking alike, of the huge machine that society is becoming, is to restore life to all things through the saving and beneficent power of the human imagination. This is my personal belief, my hope for humanity, and the power that enabled me to continue my work, under difficult conditions, through many years—despite the indifference, and lack of approval of those who have set themselves up, in this country, as the arbiters of "modern" photography.
—Clarence John Laughlin

Clarence John Laughlin—in action.... Let's see, it must be about nine o'clock in the morning in the Crescent City. Out in the Marigny District near the Lake, the venerable and bodacious one, the greatest master ever to live in New Orleans, is polishing off his version of breakfast: some cold red-beans-and-rice, chased with a big glass of Dr. Pepper, laced with 10,000 units of vitamin-C, the crystalline sort. Refreshed and not dismayed by this fare, he will soon move back to the brick, temperature-controlled studio he has had built behind the house to provide decent quarters for his 15,000 to 20,000 books and a small darkroom for his use. The shelves in the library go to the ceiling and are built as a maze. In the very center is a long table. There CJL will spend this morning studying the recent monumental volume on the Ideal Dream Palace of the Postman Cheval. The book probably costs more than it cost the Postman to build the blessed thing, but money is no object when it helps build fires for the phantasmagorical and fathomless Laughlin imagination. After more red beans at lunch or maybe a poorboy sandwich and celery tonic, back in the labyrinth to study Archimboldo and Grandville and today's new arrival: a tome on the architecture of the Place Stanislaus in Nancy.

Clarence, as we say in southern parlance, is a genuine catbird, and anyone with bat brains ought to betake himself or herself to Louisiana to see him sitting there in the catbird seat. (There are even a few other reasons for going to New Orleans, though the place has become a shabby, venal, conventioneer city with considerably less charm and good creole cooking than it once had. It's a bit dangerous now as well. But, Preservation Hall is still there for music. And Bill Russell, that extra-ordinary jazz archivist and ragtime fiddle-player, still lives there. And George Dureau, painter and photographer, lives there. Talk about bodacious. In the way of the world, these men hardly know the two others exist. I wonder if the few ivory-billed woodpeckers left on

the Texas coast recognize each other?)

Clarence John Laughlin was born in Lake Charles, Louisiana in 1905 and later lived on a plantation near New Iberia. He remains as volatile as Tabasco sauce, though a bad leg has slowed him down to a walking speed only twice as fast as most of the earth's population. He looks like Frank Lloyd Wright, with just enough of the ventriloquist's dummy in *Dead of Night* to make it spooky. For there certainly is something preternatural about CJL and his ability to unearth mysteries with his camera. I feel confident you could point Clarence down that street of drab, ordinary, public housing in Chartres and his psychic antennae, like a dowser's rod, would quickly point to La Maison de Picassiette, whose mosaic'd wonders are hidden from plain view. He is the genius of Ignored Ghastliness, the Eldritch, the Psychopompous, the Metamorphic, the Mephitic, the Fearsome, and the Downright Astonishing.

I make lists of "People To Talk About The Next Time I See Clarence": viz., St. EOM of the Land of Pasaquan, the Rev. Howard Finster, Boosie Jackson, Virgil Finlay, Abe Merritt, Henry Dorsey, Clarence Schmidt, Edgar Tolson, Atget, Robert Barlow, H.P. Lovecraft, Balthus, Jess Colins, Enid Foster, Henry Clews, Hans Bellmer, Lord Berners, Edward James, Redon, Richard Dadd, Sara Losh, Conlon Nancarrow, Beatrix Potter, Ivan Albright, Tolkien, William Burges, Raymond Isidore, Sorabji, William Hope Hodgson, Raymond Moore, Count Orsini, Delius, Squire Waterton, Barbara Jones, Mervyn Peake, Gallé, Trevor Winkfield, John Furnival, Baron Corvo, Glen Baxter, Lou Harrison, Cyril Scott, and Voysey.... Is there enough filé powder in the gumbo to suit you?

I've been insisting for years that Clarence John Laughlin deserves to be named a "National Treasure," for who has done more to record and salvage and cherish an America that has almost been destroyed in just one generation. I think he works harder, against more stupid obstacles, than any artist I ever met—nearly 50 years on the job. Never enough space, never enough time, never enough money, never enough serious response. The Ford and MacArthur Foundations will, somehow, never hear of him. The Atgets and Laughlins of this world are both noble and nearly invisible.

The late Weeks Hall, that delightful and impossible painter, raconteur, and occupant of one of the most marvellous of plantation houses, "The Shadows-on-the-Teche," wrote these gracious words about CJL: "The direction of this talent has fortunately been succored by its environment. His city wears an air, confirmed and expressed by its Carnival, of fantasy sobered always by thoughts of mortality. His New Orleans is also the Paris of Meryon, the Bermuda of *The Tempest*, and the Brussels of Ensor. His achievement consists in the fact that these prints are *not* photographs of these places and these things, but are photographed symbols of his thoughts about them...."

May the red beans and Dr. Pepper turn into ambrosia, and ichor flow through his veins for many years to come!

—Jonathan Williams

LEBECK, Robert.

German. Born in Berlin, 21 March 1929. Educated at high school in Berlin, until 1943, and in Donaueschingen, 1946-48; studied at the University of Zurich, 1948-49, and Columbia University, New York, 1949-51; self-taught in photography. Served as an assistant in the German Air Force, and as an artilleryman in the German Army, Berlin and Stettin, 1944-45 (prisoner-of-war, 1945). Married Heike Rennert in 1963 (divorced, 1977); married Elke Droescher in 1978; daughter: Anna. Staff Photographer, *Heidelberger Tageblatt* newspaper, 1952-55; Frankfurt Office Editor, *Revue* magazine, Munich, 1955-59; Staff Photographer, *Kristall* magazine, Hamburg, 1960-61, 1964-65, and *Stern* magazine, in Hamburg, 1962-63, New York, 1966-68, and in Hamburg, 1969-77 and since 1979; Editor-in-Chief, *GEO* magazine, Hamburg, 1977-78. Agent: Galerie Droescher, 140 Elbchaussee, 2000 Hamburg 50. Address: 140 Elbchaussee, 2000 Hamburg 50, West Germany.

Individual Exhibitions:

1962 *Tokio-Moskau-Leopoldville*, Museum für Kunst und Gewerbe, Hamburg (toured West Germany)

Selected Group Exhibitions:

1968 *2nd World Exhibition of Photography*, Pressehaus Stern, Hamburg (and world tour)
1969 *Vision and Expression*, International Museum of Photography, George Eastman House, Rochester, New York (toured the United States, 1969-71)
1972 *Universalisten*, at *Photokina*, Cologne (with Don McCullin, Jack Garofalo and Mara de Biasi)
1979 *Deutsche Fotografie nach 1945*, Kunstverein, Kassel, West Germany (toured West Germany)
1980 *Das Imaginäre Photomuseum*, at *Photokina*, Cologne

Collections:

Museum für Kunst und Gewerbe, Hamburg; Museum Folkwang, Essen; Agfa Foto-Historama, Leverkusen, West Germany; Stadtmuseum, Munich; International Museum of Photography, George Eastman House, Rochester, New York.

Publications:

By LEBECK: books—*Afrika im Jahre Null: Eine Kristall-Reportage*, Hamburg 1961; *Der Abenteurer*, with text by Georg Stefan Troller, Gütersloh, West Germany 1968; *In Memoriam*, with text by Fritz Kempe, Dortmund 1980.

On LEBECK: books—*World Exhibition of Photography*, exhibition catalogue, edited by Karl Pawek, Hamburg 1968; *Vision and Expression* by Nathan Lyons, New York 1969; *Famous Photographers Annual*, New York 1969; *Fotografie 1919-1979, Made in Germany: Die GDL-Fotografen*, edited by Fritz Kempe, Bernd Lohse and others, Frankfurt 1979; *Deutsche Fotografie nach 1945* by Floris Neusüss, Wolfgang Kemp and Petra Benteler, Kassel, West Germany 1979; articles—"Benjamin" by Fritz Kempe in *Foto Prisma* (Dusseldorf), July 1962; "Robert Lebeck" by Fritz Kempe in *Leica Fotografie* (Frankfurt), March 1963; "Star Photographer" by Derek Stevens in *International Yearbook*, London 1967; "Reportage: Robert Lebeck" by Mary Thomas in *U.S. Camera World Annual*, New York 1968; "Robert Lebeck" by Fritz Kempe in *Foto*

Magazine (Munich), June 1970; "Robert Lebeck" by Georg Stefan Troller in *Westermann* (Braunschweig, West Germany), May 1977; "Robert Lebeck" by Fritz Kempe in *Foto Magazine* (Munich), January 1980; "Robert Lebeck" by Fritz Kempe in *Photo* (Munich), June 1981.

I am a journalist.

—Robert Lebeck

Among German photographers of the last quarter of a century there is scarcely another whose notions about pictures have been so influenced by the globe itself, a model of which Robert Lebeck received as a gift when he was eight years old. There are few countries that Lebeck does not know and from which, sooner or later, he has not brought back photographs that have become famous. Seen from today's perspective, Lebeck's progress from unknown to sought-after photographer now seems logical, despite all the leaps and changes: the progression seems logical, that is, from a study of ethnology, to activity for the press in the province of Heidelberg and for an illustrated magazine in Frankfurt, to the Hamburg Press Centre. Hamburg is now his fixed station; it is also an ideal place for him to leave from on his travels and a place to which he gladly returns.

Lebeck's curiosity about the world could have caused him to become a successful ethnologist. That he did not he owes to an American government order to report for the Korean War, which he escaped by returning to Europe in 1951. In the early 50's, not averse to hard work in less attractive fields, he gained experience not only as a photo-reporter and editor in all its facets but also, when necessary, as a railway engine cleaner and kitchen hand. His character is now marked by an assurance and matter-of-factness in relation to differing metiers, by a tranquillity born of assurance and an assurance born of tranquillity in the quick reaction to an unrepeatable moment. Lebeck's vision combines practicality and the capacity for artistic perception. His fascination with the instant keeps him from excessive clarity; his aesthetic preserves his "snapshots" from obsolescence.

His almost nonchalant candor about the world as it is determines his choice of themes and motifs. Even his most penetrating pictures, his most serious themes, remain free from pathos. Lebeck catches the greatness of a moment in the portrayal of an unpretentious surprising detail. His most famous picture to date (accompanying this entry) is valid as an example of his photography: during the Congo's celebration of independence an African snatches away the Belgian king's sabre, and the childlike action of the unknown man makes world history visible and concrete.

And, indeed, Lebeck, with his remarkable flair for events, has often been able to catch that moment of which photojournalists dream. But sometimes, because of late editorial decisions or other circumstances, he has arrived (according to reporter's rules) "too late"—yet the pictures he then achieves show that though Lebeck's talent may respond to the actual event, it is not wholly dependent on some crucial instant—for example, there is his photo of Chou en Lai dancing at the end of a party or his photo of onlookers clambering up walls to get a glimpse of the coffin of the dead Pope. He reacts to the right moment; he reacts just as decisively to its "future"—in either case, without ever losing his composure.

Georg Stefan Troller, with whom Lebeck travelled to Alaska and the South Seas in 1966-67, said of his friend that he is not a man for posterity. The comment may be just, particularly if one considers Lebeck's negligent treatment of his own photographs, which he has never arranged methodically. It is not, however, true of his treatment of the photos of others. Since 1967 he has collected photographs, initially picture post-cards (his collection now numbers about 20,000), then unpretentious pictures that gave permanence to particular moments, and still later he concentrated on the early days of photography: in this work, he shows a pronounced flair and a feeling for quality. He has exhibited these photos in Hamburg, and plans an exquisitely printed series of monographs on his collection.

The third sphere that Lebeck commands to perfection is that of editor. When in the late 50's he ran the Frankfurt office of the illustrated magazine *Revue*, he took the photographs, developed and printed them, sought out topical themes, wrote texts, and concerned himself with layout. He made use of this training when he took over the chief editorship of the magazine *GEO*.

Another facet of the man is that he is in constant association with modern art, with painters and sculptors as well as photographers. This interest has persisted from his student days in New York, when he was a constant visitor to the Museum of Modern Art, up to the present: his wife Elke Droescher runs a gallery in Hamburg. It may be that contemporary art, in all its facets, is a decisive correction in all of Lebeck's work and activities.

—Heinz Spielmann

Robert Lebeck: *Stealing the Symbol of Power from the White King of Belgium*, **Independence Day, The Congo, 1960**

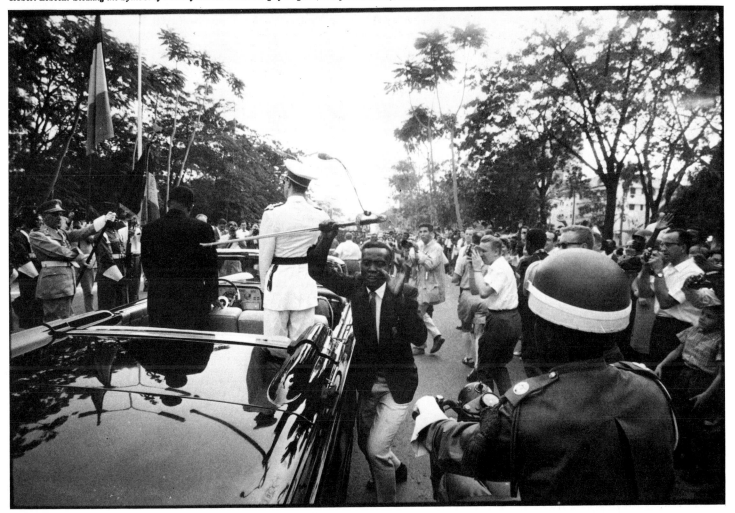

LEE, Russell.
American. Born in Ottawa, Illinois, 21 July 1903. Educated at the Culver Military Academy, Indiana, 1917-21; studied chemistry at Lehigh University, Bethlehem, Pennsylvania, 1921-25, and painting at the California School of Fine Arts, now the San Francisco Art Institute, 1929-31, and, under John Sloan, Art Students League, New York, 1931-35; self-taught in photography. Served as reconnaissance photographer, and Head of the Still Picture Section, United States Army Air Transport Command Overseas Technical Unit, 1943-45. Married Doris Emrick in 1927 (divorced, 1939); married Jean Smith in 1939. Worked for Certainteed Products Company, Marseilles, Illinois, 1925-29; manager of the Certainteed Roofing Company in Kansas City, Missouri, 1929; independent painter, California and New York, 1929-35; Staff Photographer, under Roy E. Stryker, Historical Section of the Resettlement Administration, later the Farm Security Administration, Washington, D.C. and throughout the United States, 1936-42; Photographer, Office of War Information, throughout the U.S., 1941-42; Medical Report Photographer, Coal Mines Administration, Department of the Interior, Washington, D.C., 1946-47; industrial and magazine photographer, 1947-65; independent photographer, since 1965. Director, 1949-56, and Instructor, 1956-76, University of Missouri Photo Workshop, Columbia; Instructor in Photography, University of Texas at Austin, 1965-73. Agent: Witkin Gallery, 41 East 57th St., New York, New York 10022, U.S.A. Address: 3110 West Avenue, Austin, Texas 78705, U.S.A.

Individual Exhibitions:

1965 *Russell Lee: Retrospective Exhibition 1934-1964*, University of Texas at Austin (travelled to the Witte Museum, San Antonio, Texas, 1965, and the Smithsonian Institution, Washington, D.C., 1966)
1978 Witkin Gallery, New York (retrospective)
1979 Brookdale Community College, Lincroft, New Jersey
1980 *Pie Town, New Mexico*, Side Gallery, Newcastle upon Tyne, England

Selected Group Exhibitions:

1938 *International Photographic Exposition*, Grand Central Palace, New York
1962 *The Bitter Years*, Museum of Modern Art, New York
1967 *Photography in the 20th Century*, National Gallery of Canada, Ottawa (toured Canada and the United States, 1967-73)
1974 *Photography in America*, Whitney Museum, New York
1976 *A Vision Shared: The F.S.A.*, Witkin Gallery, New York
1977 *Documenta 6*, Kassel, West Germany
1979 *Images de l'Amérique en Crise: Photos de la F.S.A.*, Centre Georges Pompidou, Paris
 Photographie als Kunst 1879-1979/Kunst als Photographie 1949-1979, Tiroler Landesmuseum Ferdinandeum, Innsbruck, Austria (travelled to the Neue Galerie am Wolfgang Gurlitt Museum, Linz, Austria; Neue Galerie am Landesmuseum Joanneum, Graz, Austria; Museum des 20. Jahrhunderts, Vienna)
 Amerika Fotografie 1920-1940, Kunsthaus, Zurich
 10th Anniversary Show, Witkin Gallery, New York
1980 *Les Années Ameres de l'Amérique en Crise 1935-1942*, Galerie Municipale du Chateau d'Eau, Toulouse

Collections:

Museum of Fine Arts, Boston; Library of Congress, Washington, D.C.; National Archives, Washington, D.C.; University of Louisville, Kentucky; Museum of Fine Arts, St. Petersburg, Florida; University of Minnesota, Minneapolis; University of Texas at Austin; Center for Creative Photography, University of Arizona, Tucson.

Publications:

By LEE: books—*A Medical Survey of the Bituminous Coal Industry*, with others, edited by J.T. Boone, Washington, D.C. 1947; *Image of Italy*, with text by William Arrowsmith, Austin, Texas 1960; *Executive Order 9066: The Internment of 110,00 Japanese Americans*, with text by Maisie Conrat and Richard Conrat, San Francisco 1972; article—"An Interview with Russell Lee," with Rob Powell, in the *British Journal of Photography* (London), 10 October 1980.

On LEE: books—*Russell Lee: Retrospective Exhibition 1934-1964*, exhibition catalogue, Austin, Texas 1965; *Photography in the 20th Century* by Nathan Lyons, New York 1967; *Portrait of a Decade: Roy Stryker and the Development of Documentary Photography in the 30's* by F. Jack Hurley, Baton Rouge, Louisiana 1972, New York 1977; *The Years of Bitterness and Pride: F.S.A. Photographs 1935-1943*, compiled by Jerry Kearns and Leroy Bellamy, edited by Hiag Akmakjian, New York 1975; *A Vision Shared: A Classic Portrait of America and Its People 1935-1943*, edited by Hank O'Neal, New York and London 1976; *Documenta 6/Band 2*, exhibition catalogue, by Klaus Honnef and Evelyn Weiss, Kassel and Cologne 1977; *Russell Lee: Photographer* by F. Jack Hurley, New York 1978; *Amerika Fotografie 1920-1940* by Erika Billeter, Berne 1979; *A Ten Year Salute* by Lee D. Witkin, with a foreword by Carol Brown, Danbury, New Hampshire 1979; *Les Années Ameres de l'Amérique en Crise 1935-1942*, exhibition catalogue, by Jean Dieuzaide, Toulouse 1980; articles—"Pie Town, New Mexico: Photos by Russell Lee" in *U.S. Camera* (New York), October 1941; "Image of Italy" by William Arrowsmith in *Texas Quarterly* (Austin), no. 4, 1961; "Russell Lee" by F. Jack Hurley in *Image* (Rochester, New York), September 1973; "Russell Lee: Pie Town" in *Creative Camera* (London), July/August 1980.

I have been primarily concerned with documenting the social scene at a particular time and place. Ideally, the resulting, captioned photographs should be part of a file accessible to all people. Prints from the original negatives should be available for a small fee.

The Farm Security Administration File in the Library of Congress, Washington, D.C. and the Photographic Files of the National Archives, Washington, D.C., are such examples.

—Russell Lee

When Russell Lee joined the Historical Section of the Resettlement Administration (later the Farm Security Administration) in 1936 he had been taking photographs for only a year or two. Trained as a chemical engineer, he became interested in painting and, finding himself to be weak in the skills of draughtsmanship, he bought a 35mm Contax camera which he intended to use as an aid to drawing. But photography moved from being adjunct to painting to the central and most important means of expression for Lee. By the time he left the FSA Lee had not only taken more photographs than any other member of the Section, he had also laid down the foundation of his approach to the task of documentary photography. He had created a notable body of work and established a reputation that was to grow with the years into the recognition that he is a major figure in the development of American documentary photography.

Roy Stryker, the director of the Historical Section of the FSA, created, with a comparatively small amount of financial assistance from the government, an organization which allowed a number of very important photographers to function and develop. Stryker's personal contribution to this exercise cannot be overlooked, and many people have testified to the importance of his influence. However, no one man no matter how dedicated and inspired could have "produced" Walker Evans, Dorothea Lange, Arthur Rothstein, Russell Lee, et al in other circumstances or in another society. The conditions of social, economic and cultural life in the U.S.A. in the 1930's have been written about in great detail, and no account of Lee's work can ignore the nature of that society or the institutional form through which his early, and shaping, work was achieved.

Especially in Germany, Britain and the U.S.A. the 30's were a very fruitful period for the development of new forms of documentary expression. Poverty and injustice were endemic, but they co-existed alongside wealth, power, and a growing confidence and affluence of certain sections of these societies. The task of the FSA photographer was to record the way of life and condition of certain groups within American society. They were expected to travel around the country, especially in those areas most damaged and broken, and return to Washington evidence which would flesh out the statistics and "objective" accounts of social scientists. This they all did; what the best of them did also was to find new visual forms through which poverty, suffering and human dignity in the face of extreme hardship could be represented. In the process they changed the nature of documentary photography, but more importantly they made visible formerly hidden aspects of American life.

In this process Lee played an extremely important part, yet his work is still not as well-known as that of some of his colleagues at the FSA, such as Walker Evans or Dorothea Lange. One reason for this is that Russell Lee has never organized his work around the concept of producing a single striking photograph which would act as a crystallization, a visual summation of a scene or a situation. Rather than imposing meaning on reality by means of a single dramatic photograph, Lee teases meaning out of the appearance of things. In his very informative book, *Russell Lee Photographer*, F. Jack Hurley has written: "Once in a great while, a photographer comes along whose work is so objective and precise that it can almost be called transparent. That is, it represents what existed in front of the camera with very little intrusion by the photographer. Russell Lee's work has often had this quality of transparency." We know what Hurley means here, for Lee's best photographs do display that shock of apparently unmediated authenticity that all great documentary photographs possess. At the same time we must remember that such works are the product of human skill and artifice, that there is no way of peeling off a photograph directly from reality, only ways of creating images from the available elements of the real world.

Lee's great power as a photographer arises out of the way in which he relates to the subjects of his photographs. We never feel that they have been caught unfairly off-guard, or that the camera lens is functioning as an unwelcome intruder on a scene. Instead, Lee involves himself closely with his subjects and presents us with images that unpick the essence of a task, a moment, a relationship, then re-presents them to us transformed and newly integrated in a way that neither appropriates their uniqueness into a solemn statement about the "human condition" nor loses their sense of transcending the particularity of immediate time and place within which they were taken. There is a quality of calm and of apparent simplicity in many of Lee's images which produces in the spectator a special, often emotionally charged, knowledge about the meaning of things.

Russell Lee: *Community Sing*, **Pietown, New Mexico, 1940**

This ability of Russell Lee's is the product of great technical skill—an ability to relate to people and a very special way of seeing the world. It makes him a magnificent photographer of community, of the lived relationships between people. But this excellence is not to be found only in his early work. After the war Lee worked for Standard Oil as an industrial photographer, and much of this later work is marked by the same qualities—as is the great body of work he has produced since that time in several countries and many places.

—Derrick Price

LEIPZIG, Arthur.

American. Born in Brooklyn, New York, 25 October 1918. Educated at Erasmus Hall High School, Brooklyn; studied photography, under Sid Grossman, 1942, and Paul Strand, 1946, at the Photo League, New York. Married Mildred Levin in 1942; children: Joel and Judith. Photographer since 1942: Photography Assignment Editor, 1942, and Staff Photographer, 1942-46, *PM* newspaper, Long Island, New York; freelance press photographer and photojournalist, New York, since 1947. Member, Photo League, New York, 1942-49. Professor of Art and Director of Photography, C.W. Post College, Long Island University, Greenvale, New York, since 1968. Member, Editorial Board, *Infinity* magazine, New York, 1960-63. Member, Fine Arts Board, Nassau County Museum, Long Island, New York, 1973-75; Member, Board of Directors, Long Island Baroque Ensemble, 1978-80. Recipient: National Urban League Photography Award, 1962; Annual Art Directors Award, New York, 1969; Research Grant, Long Island University, 1979, 1980. Address: 378 Glen Avenue, Sea Cliff, New York 11579, U.S.A.

Individual Exhibitions:

1975 Nassau County Museum of Fine Art, Roslyn, Long Island, New York (retrospective)
1977 Midtown YMCA Gallery, New York
1980 Port Washington Library, New York
1982 *Photographs of Jewish Life Around the World*, Nassau County Museum of Fine Art, Roslyn, Long Island, New York

Selected Group Exhibitions:

1946 *New Faces*, Museum of Modern Art, New York
1951 *Xmas Sale of Photographs*, Museum of Modern Art, New York
1955 *The Family of Man*, Museum of Modern Art, New York (and world tour)
1958 *Photographs from the Museum Collection*, Museum of Modern Art, New York
1961 *Photography in the Fine Arts*, Metropolitan Museum of Art, New York (and *Photography in the Fine Arts*, 1962)
1967 *Man and His World*, at Expo '67, Montreal
1978 *Children's Games*, Midtown YMCA Gallery, New York
 Photographic Crossroads: The Photo League, National Gallery of Canada, Ottawa (travelled to the International Center of Photography, New York; Museum of Fine Arts, Houston; and Minneapolis Institute of Arts)

1979 *Urban Open Spaces*, Cooper-Hewitt Museum, New York

Collections:

Museum of Modern Art, New York; Midtown YMCA Gallery, New York; Brooklyn Museum, New York; International Museum of Photography, George Eastman House, Rochester, New York; Visual Studies Workshop, Rochester, New York; Museum of Fine Arts, Houston; National Gallery of Canada, Ottawa; Pablo Casals Museum, San Juan, Puerto Rico.

Publications:

By LEIPZIG: articles—"Old Africa's 'People of the Village'" in *Natural History Magazine* (New York), April and May 1964; "Arthur Leipzig," interview, in *Documentary Photography*, New York 1973; "The Enclave of Ancianos: An Andean Shangri-La" in *Hospital Practice* (New York), October 1973; "Six Great Teachers Tell How They Work" in *Popular Photography* (New York), Summer 1974; "Photography and Social Change" in *Ventures in Research*, edited by Richard R. Griffith, New York 1979; "They're Called The Strangers," photo-essay, with text by Sidney C. Schaefer, in *Newsday* (New York), 8 July 1980.

On LEIPZIG: books—*The Family of Man*, edited by Edward Steichen, New York 1955; *Photographic Crossroads: The Photo League* by Anne Tucker, New York 1978; articles—"Arthur Leipzig, Photographer" by Malcolm Preston in *Newsweek* (New York), 13 February 1980; "Striking a Delicate Balance" by David L. Shirey in the *New York Times*, 24 February 1980.

Arthur Leipzig: *Honduras: Death of a Child*, 1962

For me, photography is an exciting way of making order out of a chaotic world. Using my camera both as a connection to, and a separation from, the world, I have been able to observe the world and myself. Photography has helped me learn much about both.

I have been concerned mainly with exploring the human condition and human relationships. People are always changing. Photographing them is a challenge. I am not an intellectual photographer; my images are visceral responses to the world. However, I study my prints very closely. What I have done on a pre-conscious level—composition, content, etc.—must be understood on a conscious level. Only through such a process can I grow. My work is straightforward and direct. I use no gimmicks or trendy styles to shock and overwhelm the viewer. If I can communicate my sensitivity to others, if I can make them see and feel some of the things I see and feel, then I am satisfied.

—Arthur Leipzig

Styles in music, art and literature which achieve immediate and enormous fame frequently fall into disrepute with the next generation of writers, composers and artists. It is natural and necessary for the next generation to rebel. Whether or not a style—once discredited—receives attention from subsequent generations is the true test of its value.

Many of the photographs and photographers which appeared in Edward Steichen's exhibition *The Family of Man* have been in obligatory eclipse and are now receiving renewed interest and appreciation. The sweetness of those pictures and the photographers' compassion toward their subject have been very much out of fashion for two decades. To say that Arthur Leipzig's work has been in eclipse is not to imply that he hasn't been working—making new photographs, exhibiting and publishing his work. It's just that his style of photography has generally been ignored by the major museums and art photography magazines in the existentialist, art-for-art's sake decades.

Leipzig is a photojournalist and a teacher. He resists labeling his photographic style, but documentary is the label applied most often. It is the most appropriate label because collecting evidence is an important part of the photographic process for Leipzig. But he considers it is even more important to clearly state his feelings about what he documents.

As a beginning photographer in 1942, Leipzig joined the Photo League, a group of amateur and professional documentary photographers that existed in New York City between 1936-1951. He was attracted by the League's low school fees and darkroom fees and enrolled in Sid Grossman's class in documentary photography. "Two weeks in Sid's Class," Leipzig said in an interview, "and I knew what I wanted to be. I photograph the way I feel, and the League helped me to learn to do that."

He was an active member of the League until 1949, serving on various committees and teaching in the school. In the spring of 1949 he was one of the League members admitted to an advanced photography class taught by Paul Strand. Strand's discipline regarding craftsmanship and composition were an important influence. The other great influence from the Photo League was W. Eugene Smith, especially Smith's war pictures. "Smith caught me with much more feeling than any other photographer had up to that time. I loved Cartier-Bresson's work, but he never got to me in that emotional way as Smith did."

Leipzig left the League because the success of his free lance career demanded more and more of his time. As a free lance photographer he has traveled through the Arabic countries, to India, Africa, South America and the Arctic. Like most serious journalists, when he travels he makes photographs for his clients and makes other pictures for himself. He also photographs his family and the people of Long Island where he lives and teaches.

His photographs are emotive, generous, and frequently humorous.

—Anne W. Tucker

LENART, Branko.

Austrian. Born in Ptuj, Yugoslavia, 15 June 1948; emigrated to Austria, 1954: naturalized, 1961. Educated at Oeversee Gymnasium, Graz, Austria, 1959-63; studied at the Teachers Training College, Graz, Austria, 1972-77; attended various photography workshops, with Duane Michals, Ralph Gibson, Mary Ellen Mark, Peter Schlessinger, and Lewis Baltz, Arles and Graz, 1976-80. Served in the Austrian Army, 1967-68. Married Friederike Mark in 1979. Freelance photographer since 1972. Instructor, Pädagogische Institut, Graz, 1979-80. Instructor, Höhere Technische Bundes Lehranstalt, Graz, since 1979, and Pädagogische Akademie, Graz, since 1980. Artist-in-Residence, Apeiron Workshops, Millerton, New York, 1980. Recipient: Obelisk Award, *Photokina*, Cologne, 1968; French Government Grant, 1973; Photography Grant, Styrian Government, Austria, 1976, 1979; Award for Instant Photography, Polaroid Austria, 1980. Agents: The Photographers' Gallery, 8 Great Newport Street, London WC2, England; and Fotogalerie Forum Stadtpark, Stadtpark 1, A-8010 Graz. Address: Glaserweg 5, A-8053 Graz, Austria.

Individual Exhibitions:

1973 *On the Road*, Ganggalerie im Rathaus, Graz, Austria (travelled to the Galerie im Taxispalais, Innsbruck, 1974)
 Frankreich Subjektiv, Institut Français, Graz, Austria
1975 *Mirrorgraphs*, Galleria Il Diaframma, Milan (travelled to the Fotogalerie Forum, Graz, Austria)
1976 *Selfportraits*, The Photographers' Gallery, London (travelled to the Fotogalerija, Koper, Yugoslavia, and Focus, Ljubljana, Yugoslavia, 1976; and Trockenpresse, West Berlin, and Photowerkstatt, Heddesheim, West Germany, 1977)
 Arles Workshops, Audiovisuelles Zentrum, Graz, Austria
1977 *Presenting Photographers*, Kulturhaus, Graz, Austria
1978 *Ausstellungsbesucher*, Kulturhaus, Graz, Austria
1979 *Seascapes*, Galerij Paule Pia, Antwerp (travelled to the Galerie Lang, Graz, Austria, 1980)

Selected Group Exhibitions:

1970 *8 Austrian Photographers*, at *SICOF*, Milan
 Europäische Fotografen, Palais Charlottenburg, West Berlin
1974 *Kreative Fotografie Österreich*, Museum des 20. Jahrhunderts, Vienna
1975 *Bregenz Sehen*, Palais Thurn und Taxis, Bregenz, Austria
1976 *Triennale de la Photographie*, Musée d'Art et Histoire, Fribourg, Switzerland
1977 *Leben mit der Stadt*, Kulturhaus, Graz, Austria
1978 *Hommage à Marcel Duchamp* Moderna Galerija, Ljubljana, Yugoslavia (travelled

to the Collegium Artisticum, Sarajevo, Yugoslavia)
1980 *Metaphysical Presence*, Razstavišče Jacopič, Ljubljana, Yugoslavia (travelled to the Paviljon Zuzorič, Belgrade)

Collections:

Kulturna Skupnost Slovenie, Ljubljana, Yugoslavia; Ministerium für Unterricht und Kunst, Vienna; Sammlung Österreichischer Fotografie, Rupertinum, Salzburg; Bibliothèque Nationale, Paris; Musée Francais de la Photographie, Bièvres, France; Photogalerie Jean Dieuzaide, Toulouse; Musée d'Art et d'Histoire, Fribourg, Switzerland; The Photographers' Gallery, London.

Publications:

By LENART: articles—"Arles Workshops" in *Spot* (Zagreb), June 1976; "Presenting Photographers" in *Protokolle* (Vienna), August 1977; "5 Jahre Sammlung Fotografis" in *European Photography* (Göttingen), October 1980.

On LENART: book—*Creative Camera Yearbook 1977*, edited by Colin Osman and Peter Turner, London 1976; articles—"Non fanno cosi/anche le volpi" by Giuseppe Turroni in *Fotografia Italiana* (Milan), April 1972; "Réalité Difformé" in *Photographie Nouvelle* (Paris), October 1972; "Styrians" in *Protokolle* (Vienna), July 1974; "Branko Lenart" by Attilio Colombo in *Progresso Fotografico* (Milan), February 1977; "Ausstellungsbesucher" in *Protokolle* (Vienna), September 1978.

I believe that every man has an historical obligation to his culture in general as well as to the specific time and society in which he lives. Hence it follows—in my opinion—that the important function of photography is to document the manifestations of culture.

Formerly, the main interest in my photography was man portrayed in extraordinary situations. Now I am more interested in common situations, in man in his own individual domain, and in the changes that occur through human action in the world around us.

In this regard I see my work as political in a broad sense, as a sociological study with visual means. However, I don't regard my work as being only documentary in the sense that authorship is invisible or interchangeable. I feel that it is not possible (or desirable) to isolate photography totally from the personality of the photographer, his individual experiences and his ideology.

Every classification into categories is problematic and usually confusing. If I were to describe or characterize my photography, I would designate it as "subjective topography." In my view, in photography as well as in reality, the magical and mythological aspect should not be excluded.

—Branko Lenart

Is documentation the essence of the photographic medium? Theoreticians and those versed in the visual arts after Niepce all must have asked themselves this question at one time or another. Recently the question has achieved a new currency, and documentalism appears to have found its place as one of the most solid tendencies of our time. And we must begin to separate the various degrees of documentalism which are being practiced.

Branko Lenart, like many others of his generation, is a late convert to documentalism. The fact that he was previously interested in more experimental creative forms has, without doubt, now left him with a greater subjectivism in the use he makes of the camera. Lenart designates his works as "subjective topography," and with that description he

445

indicates that the establishment of documentalism has hardly supplanted the old polemic between objectivity and subjectivity. It has simply displaced it to another level—a level in which one of the extremes would be represented by those who advocate the total neutrality of the camera—as Bevan Davis says,"...the effort being made to let the camera almost see by itself"—and those who advocate a personal interaction between the theme and creator (a position which Verena von Gagern, for example, has categorized as "romantic documentalism"). The difference lies in the scope we give to the world "almost."

In this panorama, Branko Lenart's contribution comes close to what I would classify as "existential topographic history." I refer to something whose purpose is descriptive of a natural or urban topography, but which supersedes a mere formalism or the mere aesthetic effect of leaving constant the existential environment of the creator. (In this sense, the very statement of the photographer which is included here is sufficiently eloquent.) Therefore we find ourselves looking at interpretations of reality rather than mere reproductions. It is obvious that all photography, including the most apparent reproductions, implies an effort of interpretation, but in the case of Lenart it is so striking as to constitute a transgression of the conventional rules of traditional documentalism: frontal perspective, clarity of composition, distinction between figure and background, etc. To disobey these rules as Lenart does and, for example, to obtain labyrinth-like visual images, with a chaotic density of information, with a compactness of textures, etc., implies dominating the medium rather than allowing it to dominate. It implies, finally, a freedom of expression that radical documentalism represses.

—Joan Fontcuberta

LENNARD, Erica.

American. Born in November 1950. Studied at the San Francisco Art Institute. Freelance photographer, New York and Paris, since 1973. Address: 874 Broadway, New York, New York, U.S.A.; or, 227 rue St. Moulin, 75003 Paris, France.

Individual Exhibitions:

1977 Canon Photo Gallery, Amsterdam (with John Herstein)

Selected Group Exhibitions:

1978 *Tusen och En Bild*, Moderna Museet, Stockholm

Collections:

International Museum of Photography, George Eastman House, Rochester, New York; La Photogalerie, Paris; Bibliothèque Nationale, Paris.

Publications:

By LENNARD: books—*Sunday*, with Elizabeth Lennard, New York 1973; *Les Femmes, Les Soeurs*, Paris 1977.

On LENNARD: books—*Creative Camera Yearbook*, London 1975; *Tusen och En Bild*, exhibition catalogue, by Ake Sidwall, Sune Jonsson and Ulf Hard af Segerstad, Stockholm 1978; *Contact: Theory*, edited by Ralph Gibson, New York 1980; articles—"Erica et Elizabeth Lennard" in *Le Nouveau Photocinéma* (Paris), January 1974; "The Arms of Venus: Erica Lennard" in *Camera* (Lucerne), September 1975; "Portfolio: Erica Lennard" in the *British Journal of Photography* (London), 3 October 1975.

Precise, calm, and perfectly formed, the photographic world of Erica Lennard clings to moments of visual passion, of striking attitudes. Portraits of women, the body of the beloved, landscapes—

everything must be structured by light, by an imperceptible arresting of time, a soft perpetuation of the moment.

Erica Lennard is remarkably professional, typical of those who know how to take advantage of the market for art photography. The exceptional quality of her prints, soft and yet perfectly solid, is the work of a masterful sensibility. Her black-and-white parks, her women in grey, flowing tones—like her fashion photography, everything she does is above all expressive of a certain seductive ambiance: a sensuous world which the photograph protects and which exists only because of the photograph. But isn't this precisely the great strength of photography, to disclose an inner world on rectangles riveted to reality?

—Christian Caujolle

LEONARD, Joanne.

American. Born in Los Angeles, California, 8 September 1940. Educated at Hollywood High School, Los Angeles, 1955-58; University of California, Berkeley, 1958-62, B.A. 1962; did post-graduate work at San Francisco State College, 1963-64; studied photography with the anthropological photographer John Collier Jr., San Francisco State College, 1964. Divorced; daughter: Julia. Freelance photographer since 1964. Instructor in Photography, San Francisco Art Institute, 1973-75, and Mills College, Oakland, California, 1975-78. Since 1978, Assistant Professor of Art, University of Michigan, Ann Arbor. Recipient: Phelan Award, 1971; National Endowment for the Arts Photo Survey Grant, 1977, Agents: Gallery Paule Anglim, 710 Montgomery Street, San Francisco, California; and Blixt Gallery, Nichols Arcade, Ann Arbor, Michigan. Address: 1319 Pomona Road, Ann Arbor, Michigan 48103, U.S.A.

Individual Exhibitions:

1968 *Our Town*, M.H. de Young Memorial Art Museum, San Francisco
Hopkins Center, Dartmouth College, Hanover, New Hampshire
1969 Seligman Gallery, Seattle, Washington
1971 San Francisco Museum of Art (with Chris Enos and Irene Poon)
1973 Wall Street Gallery, Spokane, Washington
1974 Photic Gallery, Maryland Institute of Art, Baltimore (with Jacqueline Livingston)
San Francisco Art Institute
1975 Bristol Polytechnic Art Gallery, England
1977 *Recent Works*, Davis Gallery, Stephens College, Columbia, Missouri
1978 *Twins: A Visual Connection*, Lincoln Gallery, Santa Rosa, California (with Eleanor Rubin)
1980 *Inside and Beyond*, Laguna Gloria Art Museum, Austin, Texas
1981 *Photo-Trans-Forms by Judith Golden and Joanne Leonard*, San Francisco Museum of Modern Art

Selected Group Exhibitions:

1969 *Vision and Expression*, International Museum of Photography, George Eastman House, Rochester, New York (toured the United States, 1969-71)

Branko Lenart: From the series *Tito in Reproductions*, 1980

Collections:

International Museum of Photography, George Eastman House, Rochester, New York; United States Department of State, Washington, D.C.; Stanford University, California; San Francisco Museum of Modern Art; Crocker Art Museum, Sacramento, California; American Arts Documentation Center, University of Exeter, Devon, England.

Publications:

On LEONARD: books—*Vision and Expression*, exhibition catalogue, edited by Nathan Lyons, Rochester, New York 1969; *Women See Men*, edited by Ripp, Kalmus and Wiesenfeld, New York 1977; *In/Sights: Self-Portraits by Women*, edited by Joyce Tenneson Cohen, New York and London 1979; *Inside and Beyond*, exhibition catalogue, with an essay by Lucy Lippard, Austin, Texas 1980; articles—"Flash! Here's Looking at You, Kid" by Nancy Stevens in *American Photographer* (New York), January 1979; "Self-Portraits" by Hall Fischer in *Infinity* (New York), Winter 1979; "The Undressed Man" by Vicki Goldberg in *Saturday Review* (New York), 26 May 1979; "The Traditional Side" by Cathy Curtis in *Artweek* (Oakland, California), December 1979; "Photography as Art: Joanne Leonard's Free Photographic Experimentation Redefines the Medium" by Kathryn Bolger in *New American Statesman* (Austin, Texas), 4 February 1980; "Literary Images" by Nancy Rose Kaufman in *Artweek* (Oakland, California), 6 March 1980

During the past ten years the focus of my work has moved from social documentary photography toward personal documentary, in an attempt to represent internal states of mind rather than the outside world.

My recent collage and photographic work has drawn increasingly upon common household objects as material and image. I have made photogram pieces using household objects and used household images to suggest states of mind by photographing interiors and views looking out of windows. The interiors represent reality-based experience and are contrasted with views out of windows (often incorporating collage) which suggest fantasy experience.

The documentary aspects of my work, as well as the aesthetic aspects described above, are also served by photographing interiors. The views inside homes provide a framework for visual investigation of the ways in which the occupants interact with our technological culture. The images tend to catalogue the products of technology brought into the home and show how the occupants use technology to go about the "dailyness of life," as Gertrude Stein put it. The photographs also show how, by personalizing a living space, the subjects combat some of the alienating aspects of a technological culture and its products. Because of the emphasis on home technology, the images may be particularly revealing about women's lives in technological culture.

—Joanne Leonard

Joanne Leonard's first exhibition, seen in 1968, was titled *Our Town*. The pronoun indicates the personal impulse that directed her exploration of the lives of women in the black community of West Oakland, California, a community whose doors were closed to most white women of her generation. She did not have to write a travel program or learn a foreign language to be admitted to their bedrooms and kitchens; her subjects were friends and neighbors. In her attention to the lives and traditional loci of women, one also feels the throb of a feminist vein. This, too, has been a constant in her work, reaching at times a beat too bloody to bear. Autobiography is, however, more often generalized than made explicit; for the most part, she extends evidence of her experience in ways that make it universally acceptable and applicable. This is accomplished by putting her highly developed graphic intelligence, formed through her studies of art, at the service of her expressive generosity, a personal characteristic refined and formalized in studies that led to her work with the anthropologist and photographer John Collier, Jr.

Early in her career, she was an avowed documentarian. While she continues to photograph from life, she also often turns to collage, usually in periods of personal change. In their distillations of particular experience, the collages have been to her like dreamwork, from which she awakes refreshed and informed. Like dreams or cinema, collage as she uses it is dense with fast cuts that layer autobiography with history, photographs she has taken with reproductions of graphic art or with her own painting. The historical reference takes the heat out of the autobiographical content, which ranges from the most intimate female grief—rejected love or miscarried birth—to such quotidian subjects as the high-tech paraphernalia that she and other women collect in their homes. The collages are produced in series: "Dreams and Nightmares" (1972), "Journals" (1973), "Dream Kitchens" (1979). The individual pictures are like apports of a seance, what materializes when the spirit is invoked. They are as concrete as poems.

Her straight photography, presented in the comforting square format of her reflex camera, studies the mysteries of still subjects: interiors of the homes of women she knows, and of her own; sleeping animals and children. She occasionally pairs photographs of the same scene taken in a sequence that shows change. In her straight still photographs, no less than in the collages, she charges her subjects with surreal meanings.

—Anita V. Mozley

LEONARDI, Cesare.

Italian. Born in Modena, 3 June 1935. Educated at Liceo Scientifico, Modena; studied archeitecture, under Quaroni, Ricci, Savioli and Libera, at the University of Florence, 1956-62; self-taught in photography. Married Donata Annigoni in 1974; children: Claudia, Elena, and Paola. Freelance photographer, Modena, since 1950; also practising architect,

Joanne Leonard: *Can Opener and Blender with Starry Sky* from the series *Dream Kitchen*, 1979

in partnership with Franca Stagi, Modena, since 1961. Address: Viale Nicola Fabrizi 1, 41100 Modena, Italy.

Individual Exhibitions:

1976 *Cesare Leonardi: Fotografie 1950-1976*, Sale della Rocca, Vignola-Modena, Italy
1978 *Cesare Leonardi: La Città di Modena*, Galleria Civica, Modena, Italy
Galleria Il Diaframma, Milan
3 Artistes de L'Ecole de Modène, Galerie Olivetti, Paris

Selected Group Exhibitions:

1959 *Salon of Photography*, London

1978 *Rencontres Internationales de la Photographie*, Arles, France

Collections:

Museo della Fotografia, University of Parma, Italy; Bibliothèque Nationale, Paris.

Publications:

On LEONARDI: exhibition catalogues—*Cesare Leonardi: Fotografie 1950-1976* by Emilio Mattioli, Modena, Italy 1976; *Cesare Leonardi: La Città di Modena*, with a foreword by Emilio Mattioli, Modena, Italy 1978.

I am mainly concerned with the city—signs, objects, streets, houses, etc., as day and night follow each other. I use the camera to the limit of its possibilities and generally in an unorthodox way—with double or triple exposures, as for the *Segnali*.

Another subject is the shadow of buildings on other buildings. I am generally interested in urban "systems."

—Cesare Leonardi

An architect by training and by profession, Cesare Leonardi uses the camera "like an amateur": photography for Leonardi is not so much an expressive medium as a tool for research into planning, for intellectual enrichment, for investigation of the environment and the architecture of the city. Ever since the time of the photographs he took in the first years of his career (1953-54)—pictures of great buildings mirrored in the shop-windows of Florence—his interest in the details of urban planning and his continual study of the location and the role of green areas have been mixed with a variety of reportages (there is an important one on a district in Turin). But Leonardi is not much interested in recording what already exists; his cities, his green areas, are photographed in series of thousands of pictures that at times become thick wedges of marks, for transformation to project material in due course.

Thus, for example, the 5,000 photographs taken of *Carpinus betulus* (the hornbeam) in spring, summer, autumn and winter at different times of day and night became the base for the design of the Amendola Park at Reggio Emilio, in which Leonardi the architect relies on the research done by Leonardi the photographer in his decision to put a lighthouse 40m (130 ft) high in the park, with searchlights at the top slowly and constantly revolving at night to pierce the dark once every hour, like luminous sundials. Or the city of Modena is photographed in three different seasons at different times of day, when the shadows fall clearly to make distinct patterns that distort the shape of the buildings, almost creating a duplicate of them. Or again, road signs are manipulated by under-exposure and sandwich effect so as to create a new visual code. Taking photographs becomes for Leonardi a way of transforming a park, a city, a system of road signs, of capturing its latent structures, of interpreting it in an unconventional way that contradicts the system of Renaissance perspective.

Urban architecture is subjected to metamorphosis; it fluctuates, creating new forms that produce anomalous results. If it all comes from the research of the architect, there is no doubt that the results can also be of interest to the semiologist or the art critic. Cesare Leonardi's research is basically on the *transcription* of visual features. He uses no additional aids or optical devices, though he does vary the time and manner of the exposures, particularly in his use of unusual angulation. From it all there emerges a sort of challenge that suggests different ways of locating the building, the tree, the road sign in an urban context in which the system of references can be varied—in effect modifying an entire cultural code.

—Attilio Colombo

Cesare Leonardi: *Segnale* (original in color), 1978

LEVERANT, Robert.

American. Born in Boston, Massachusetts, 5 July 1939. Educated at Brookline High School, Massachusetts, 1953-57; studied philosophy and American literature, Middlebury College, Vermont, 1957-62, B.A. 1962; studied painting with Jack Wolfe, Stoughton, Massachusetts, 1962-63; studied with Zen Master Kirpal Singh Suzuki Roshi, San Francisco, 1963-66; with spiritual master Singh, San Francisco and New Delhi, 1968-74; mainly self-taught in photography. Divorced. Photographer since 1966. Photo Reporter, *Burlington Free Press*, Vermont, 1963-64; Production Manager, Stover and Associates, Commercial printers, San Francisco, 1964-66; freelance commercial architectural and portrait photographer, San Francisco, 1966-72, 1975-78; Executive Director, 1750 Arch Inc. and Conimicut Foundation, music recording and performance company, Berkeley, California. 1972-75. Production Manager, Addison-Wesley Publishing Company, School Division, Menlo Park, California, since 1978. Founding Board Member, Camerawork Gallery, San Francisco, 1978-80. Recipient: Annual Latent Image Award, *Village Voice*, New York, 1969; Mark in Time Award, Glide Foundation, San Francisco, 1971; Best Cover Design Award, American Institute for Graphic Arts, 1973. Address: Post Office Box 9444, Berkeley, California 94709, U.S.A.

Individual Exhibitions:

1970 *Color Images*, Images Gallery, San Francisco
1972 *New Works*, Images Gallery, San Francisco
1974 Palmer Gallery, New York

Collections:

Institute of Contemporary Art, Boston; San Francisco Museum of Modern Art.

Publications:

By LEVERANT: books—*Zen in the Art of Photography*, San Francisco 1969; *On the Transmission of Photography*, San Francisco 1972; *Kirpal Singh: A Visual Biography*, San Francisco 1975; *Photographic Notations*, San Francisco 1980; numerous articles in professional journals.

On LEVERANT: articles—review by Norman Schreiber in *Modern Photography* (New York), January 1981; "Book Review: Photographic Notations" by Mark Melnicove in *Combinations* (New London, Connecticut), March 1981.

My work as photographer: 1) commercial (interiors, portraits, locations, print production); 2) occasional teaching; 3) personal or "art" (color scapes, portraits, b/w space-time continuums, the book form); 4) writer of articles; 5) service work (founding board member of San Francisco Camerawork Gallery, host/organizer of Photographers for Socio/Political Action, professional services at cost to persons and organizations who cannot afford it).

How did these pursuits come about? I needed to earn a living in a competitive situation; a curious mind. My background? I studied painting and sculpture from ages 8 to 16; thus my eye as to space, tension, surface, texture, depth, illusion, iconography, manner, beauty, etc. had been trained in classical Eastern and Western and contemporary notions long before I entered photography. After some 15 years, my models for photographs still remain some poems, plays, pieces of music, paintings and sculpture, and philosophic tracts.

Some of my considerations when engaged in photography (a contemporary image-gathering, image-making, and image-presentation system) are: the pictorial subject, the ideational subject, the photographic medium, the viewer's headspace. (Degas said he didn't paint what he saw, but what would enable them to see the thing he had.)

Photographically, in my personal work, I'm into allusion, not illusion (my commercial work). To do this, likeness must be shattered: the closer-in to the real (Noumenon), the more the likeness (the Phenomenon, or appearance) needs to be shattered. I do this not through abstraction (and thus violate one of the *sine qua nons* of photography, which is likeness) but by making likeness secondary—the ground rather than figure in the image. The vehicles I'm currently using for this are space and time, modalities natural to the subject, the medium, the idea, and the viewer's perceptual apparatus. In short: space is my content, and time my form, or vice-versa, depending on the situation.

Thus I produce what could be called inferior and boring, i.e., non-decorative and non-sensation oriented photographs—long sequences, continuums of imperfect moments of life-forms in filled and empty space. The ostensible subject is not viewed in isolation, apart from the whole. The strategy for the image-gathering -making, and -presentation come from the deep and repeated contact with and study of the subject. The strategy arises out of the subject's natural rhythms, not my own or my own sense of them. The photographs are of the co-ordinates of space and time, fixed nodal points which the subject generates. When photographing, I experience the joy of participating in the discovery and sharing of significant relations within reality without the imposition of my subjective ideas, personal whims, concepts, etc. on reality.

In addition, I like the book form. I write, design, illustrate, produce and self-publish texts about once every three years, which are mass-distributed; one has sold some 25,000 copies, another has earned international design and production recognition. Each, in design and concept, involves a different exploration of what now emerges, after 13 years, as a common theme: human scale and the limits of photography. I will soon produce just pictorial books utilizing the sequential nature of the book medium.

—Robert Leverant

Although Robert Leverant has been a professional photographer since 1966, he is more prolific as a writer than as a photographer. His most important book, released in 1969, is *Zen in the Art of Photography*, a statement on photography from a Zen perspective. *Transmission of Photography*, with text and pictures, followed three years later, and his most recent work is *Photographic Notations*—"a thinking book," as he describes it, "one which purposely demands engagement, because I feel the medium keeps us from engagement, trains us not to go below the surfaces, trains us to seek the easy and the obvious...."

Leverant went into photography imagining that he could simultaneously pursue his interest in poetry, but very soon he began to devote himself full-time to photography. He was also, at the time, studying North Indian music as well as classical Western music, but he came to feel that it would take him years just to get a grasp of these subjects; with photography, he could make a more important contribution. His eye had been trained as a child through painting and later through study with Jack Wolfe.

He started his photographic career in 1967/68 by selling framed color prints. Such photos are now so common that it is hard to conceive what pioneering work he and two of his friends on the West Coast were actually doing then. The public was not ready; the photographic world still thought in black-and-white.

Since then, as a photographer, Robert Leverant has been active in various ways: in commercial work—interiors, locations, and portraits; in personal expression work—from color slides, color prints (largely landscapes, sunscapes, and seascapes) to black-and-white classical and more recently to structural work, space-time continuums for which shutter action is determined by subject; and as a teacher at workshops at centers such as Mendocino, Camerawork Gallery, California College of Arts and Crafts, etc. But, as he wrote to me in a letter, he likes the book form more than gallery walls. He has produced all of his books himself; he will go on to produce others: he now believes that people don't have time to read, that the material of books needs to be presented in more visual terms.

Recently, Robert Leverant took a trip to India, and he continues to challenge the unknown to broaden his spirit and his work.

—Marco Misani

LEVITT, Helen.

American. Born in New York, New York, 31 August 1918. Educated at New Utrecht High School, New York; studied at the Art Students' League, New York, 1956-57. Freelance photographer, New York; also, a filmmaker, intermittently, since 1947. Recipient: Photography Fellowship, Museum of Modern Art, New York, 1946; Guggenheim Fellowship, 1959, 1960; Ford Foundation Film Grant, 1964; Creative Artists Public Service Fellowship (CAPS), New York, 1974. Agent: Daniel Wolf Gallery, 30 West 57th Street, New York, New York 10019. Address: 4 East 12th Street, New York, New York 10003, U.S.A.

Individual Exhibitions:

1943 *Helen Levitt: Photographs of Children*, Museum of Modern Art, New York

Robert Leverant: Sequence from *Racetrack*, 1980

1949 Photo League, New York (with John Candilario)
1952 Institute of Design, Illinois Institute of Technology, Chicago (with Frederick Sommer)
1954 *3 Photographers*, Caravan Gallery, New York
1963 *3 Photographers in Color*, Museum of Modern Art, New York (with Roman Vishniac and William Garnett)
1974 *Projects: Helen Levitt in Color*, Museum of Modern Art, New York (slide show)
1975 Pratt Institute, Brooklyn, New York
1976 Nexus Gallery, Atlanta, Georgia
1977 Carlton Gallery, New York
1980 Corcoran Gallery, Washington, D.C.
 Sidney Janis Gallery, New York
 Helen Levitt: Color Photographs, Grossmont College, El Cajon, California
1981 *Matrix 66: Helen Levitt*, Matrix Gallery,

Wadsworth Atheneum, Hartford, Connecticut

Selected Group Exhibitions:

1949 *6 Women Photographers*, Museum of Modern Art, New York
1955 *The Family of Man*, Museum of Modern Art, New York (and world tour)
1965 *Photography in America 1850-1965*, Yale University, New Haven, Connecticut
1968 *Harlem on My Mind*, Metropolitan Museum of Art, New York
1973 *Landscape/Cityscape*, Metropolitan Museum of Art, New York
1976 *100 Master Photographs*, Museum of Modern Art, New York (toured the United States)

1977 *New York: The City and Its People*, Yale University, New Haven, Connecticut
1978 *Mirrors and Windows: American Photography since 1960*, Museum of Modern Art, New York (toured the United States, 1978-80)
1979 *Venzia '79*
1981 *The New Color: A Decade of Color Photography*, Everson Art Museum, Syracuse, New York

Collections:

New York Public Library; Museum of Modern Art, New York; Metropolitan Museum of Art, New York; Corcoran Gallery, Washington, D.C.; Exchange National Bank, Chicago; Springfield Art Museum, Missouri; Museum of Fine Arts, Houston.

Publications:

By LEVITT: book—*A Way of Seeing: Photographs of New York*, with text by James Agee, New York 1965, 1981; films—*The Quiet One*, with James Agee and Janice Loeb, 1949; *In the Street*, with James Agee and Janice Loeb, 1952.

On LEVITT: books—*The History of Photography from 1839 to the Present Day* by Beaumont Newhall, New York 1949; *The Family of Man*, with text by Edward Steichen, New York 1955; *Photography in the Twentieth Century* by Nathan Lyons, New York 1967; *Harlem on My Mind*, edited by Allon Schoener, New York 1968; *Quality: Its Image in the Arts*, edited by Louis Kronenberger, New York 1969; *Looking at Photographs: 100 Pictures from the Collection of the Museum of Modern Art* by John Szarkowski, New York 1973; *The Magic Image* by Cecil Beaton and Gail Buckland, London and Boston 1975; *Faces: A Narrative History of the Portrait in Photography*, edited by Ben Maddow, Boston 1977; *Mirrors and Windows: American Photography since 1960* by John Szarkowski, New York 1978; *Venezia '79: La Fotografia*, edited by Daniela Palazzoli, Vittorio Sgarbi and Italo Zannier, Milan and New York 1979; *The Photograph Collector's Guide* by Lee D. Witkin and Barbara London, Boston and London 1979; *Helen Levitt*, exhibition catalogue, with an introduction by Jane Livingston, Washington, D.C. 1980; *Helen Levitt: Color Photographs*, with an introduction by Roberta Hellman and Marvin Hoshino, El Cajon, California 1980; *American Children: Photographs from the Collection of the Museum of Modern Art*, edited by Susan Kismaric, New York 1980; articles—"The Art of Poetic Accident: The Photographs of Cartier-Bresson and Helen Levitt" by James Thrall Soby in *Minicam* (New York), March 1943; "Helen Levitt's Photographs: Children of New York and Mexico" by Edna Bennett in *U.S. Camera* (New York), May 1943; "Sidewalk Primitives" in the *New York Times Magazine*, 22 October 1950; "Photography: New Frontiers in Color" by Douglas Davis and Mary Rourke in *Newsweek* (New York), 19 April 1976; "Levitt Comes in Color Too" by Roberta Hellman and Marvin Hoshino in the *Village Voice* (New York), 24 January 1977; "Fenêtres sur l'Insolite" by Julio Cortazar in *Nouvel Observateur* (Paris), June 1977; "Helen Levitt at Carlton" by Andy Grundberg in *Art in America* (New York), July 1977; "The Photographs of Helen Levitt" by Roberta Hellman and Marvin Hoshino in *Massachusetts Review* (Boston), Winter 1978; "Her Eye Is on the City" by Owen Edwards in the *New York Times Magazine*, 5 April 1980; "Helen Levitt" by Colin Westerbeck in *Art Forum* (New York), May 1980.

I am interested in photographing what I see on the streets. In the 1940's I photographed in black-and-

Helen Levitt: *Mexico, 1941*

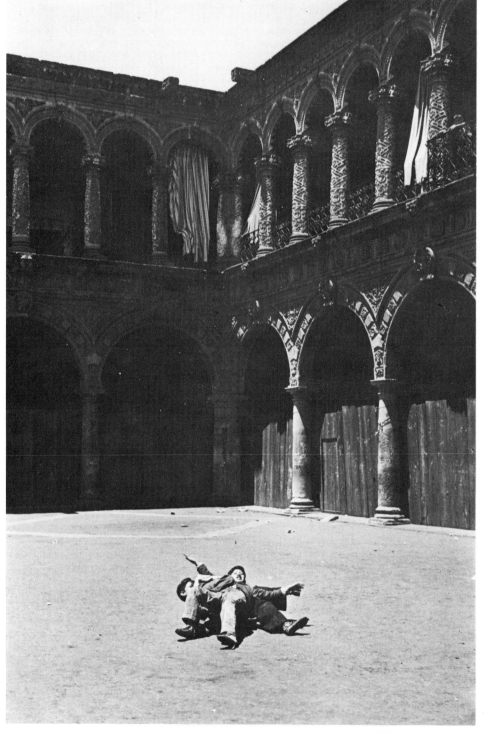

white; for the last 10 years I have been photographing in color.

—Helen Levitt

Helen Levitt has fashioned an expressive visual reality from the formless flux and movement of street life in New York. At first in black-and-white still photography, subsequently in film and then in color transparency materials, she has used the camera to reveal an unimaginable world of toughness, grace and gaiety, especially among the young. Starting in the late 1930's Levitt has photographed mainly in ethnic and working class neighborhoods because so much of daily life there takes place in the streets. In her effort to seize the most expressive moment, she often has found it necessary to use a prism lens on her Leica so that her own activity would go unnoticed. She is an observer rather than a participant—a passerby who is enchanted with the human panorama and treasures its special moments.

The impetus for Levitt's style was an exhibition during the 30's of the work of Henri Cartier-Bresson at the Julien Levy Gallery. Surrealist images, also shown by Levy, further enlarged her vision of photography's potential for capturing the mysteries of street life. But while the actual moment of exposure is as decisive for Levitt as it is for Bresson, her work is lyrical and poetic rather than ominous and intense. A benign acceptance of the human condition is expressed in images that are informed by wit and humor. Frequently they visually integrate the ordinary and the unexpected, as in a group of children around an empty mirror frame.

At first glance, Levitt's images seem artless, like the most fortunate of snapshots, but hers is a sophisticated sense of organization that does not call attention to itself. Intuitively, she has constructed a seamless unity of form and meaning that is difficult to analyze and impossible to dissect.

In addition to encapsulating poignant moments, Levitt's images serve another purpose. While she would disavow a role as a sociologist or historian, the early photographs, made during the 40's, reveal a texture of communal life that seems light years away from the harsh climate of today. People seem less embattled and the environment less hostile, as children play out their fantasies clothed in handkerchiefs and paper boxes. Toy guns really seem like toys, and the images of street battles have no menace. There is poverty and pain in a number of the photographs, but today's viewer experiences a sense of loss—a feeling of diminished humanity for having allowed the perversion of what was a more humane scenario.

In 1945, encouraged by James Agee and Janice Loeb, Levitt became involved in film. Using simple 16mm equipment that allowed the camera to be used waist high to avoid notice, she and Loeb returned to the same neighborhoods to create *In The Street*, released in 1952, which projected the same fusion of artless innocence and sophisticated vision that had informed the earlier still photographs. Levitt continued in film, assisting Janice Loeb and Sidney Meyers on *The Quiet One* and working on several other documentaries.

As the recipient of two Guggenheim grants in 1959 and 60, Levitt began again to work with a still camera using color materials. Her approach continues to be intuitive. While she is still engaged by the entire scene, in which color is only one element, her discriminating eye is now attuned to the harmonies and dissonances of hue as well as to expressive gesture and spatial configuration. As always, the aesthetic structure of Levitt's work is implied rather than brandished as she continues to see bouyant ephemeral moments in an increasingly hostile environment.

—Naomi Rosenblum

LEWCZYŃSKI, Jerzy.

Polish. Born in Tomaszow Lubelski, 14 March 1924. Studied engineering at Silesian Technical University, Gliwice, 1945-51, Dip.Ing. 1951; also studied photography, under Tadeusz Maciejko, Gliwice, 1951-56. Served as an officer in the Polish Resistance Movement, 1939-45. Married Maria Lotocka in 1947; children: Bozena and Grazyna. Professional photographer, Gliwice, since 1956. Member, Photographic Association of Gliwice, since 1951, Union of Polish Art Photographers, since 1956, and Fédération Internationale de l'Art Photographique (FIAP), since 1963. Recipient: Award of Merit, Sociedade Fulminense de Fotografia, Rio de Janeiro, 1957; Gold Medal, *Photographers of the New Generation* exhibition, Pescara, Italy, 1960. Agent: Union of Polish Art Photographers, Plac Zamkowy 8, Warsaw. Address: Skrytka Post Office, Box 71, 44100 Gliwice, Poland.

Individual Exhibitions:

1958 Krzywe Kolo Gallery, Warsaw
1959 Photographic Association Gallery, Gliwice, Poland
1968 Prezentacje Club, Torun, Poland
1976 *Cimiteria*, Polish Art Photographers Gallery, Cracow, Poland
1979 Wokewódzki Dom Kultury, Legnica, Poland
 Negatives, Foto-Medium-Art Gallery, Wroclaw, Poland

Selected Group Exhibitions:

1960 *Photographers of the New Generation*, Pescara, Italy
1961 *Fotografen aus Polen*, Gesellschaft für Deutsche Photographie, Cologne
1968 *Fotografia Subiektywna*, Biuro Wystaw Artystycznych, Cracow, Poland
1971 *Fotografowie Poszukujacy*, Galeria Współczesna, Warsaw
1972 *Schöpferische Fotografie*, at *Photokina*, Cologne
1979 *Fotografia Polska 1839-1979*, International Center of Photography, New York (travelled to the Museum of Contemporary Art, Chicago; Galeria Zacheta, Warsaw; Museum of Fine Arts, Lodz, Poland; and Whitechapel Gallery, London)

Collections:

National Museum, Wroclaw, Poland; Museum of Fine Arts, Lodz, Poland.

Jerzy Lewczyński: *Polish Story*, 1976

Publications:

By LEWCZYŃSKI: article—"Fotograf Floris Michael Neusüss in *Fotografia* (Warsaw), April 1974.

On LEWCZYŃSKI: book—*Penetracje Fotograficzne* by Alfred Ligocki, Cracow 1979; articles—"Fotografi della Nuova Generazione" in *Fotografia Italiana* (Rome), no. 9, 1960; "Sztuka Scalania Swiata" by Jerzy Busza in *Kultura* (Warsaw), no. 37, 1977; "Photography: An Interrupted Past" by Ben Lifson in the *Village Voice* (New York), 27 August 1979.

I belong to the active originators of the new trend called subjective photography, and produce photos of objects and situations which later serve as a basis for fiction sets. I use old photos and documents to make tales about life and death.

I also make poetic photos. I suggest some new trends such as naive photography, or, recently, the archaeology of the photo based on the sculpture of negatives.

My works are very humanistic and often have a social or sociological background.

—Jerzy Lewczyński

Quite often in the history of art some artist refers to or even to a certain extent copies the art of the past. There are obvious examples of painters who have gone back to the paintings of the old masters and consciously re-created them in a search for new interpretations. The various versions that exist of da Vinci's *Mona Lisa* are a good example. Photography, of course, is a much younger art form, and today is usually a more interesting subject for contemporary photographers than yesterday. Jerzy Lewczyński is an exception, a photographer who doesn't hesitate to take trips into the past. Indeed, his work seems to exist simultaneously in both past and present. Lewczyński is particularly interested in the simple photographs taken by amateurs—often found by chance, often banal, lacking in any special prettiness or ugliness. For him an accidentally uncovered archive, a family album or even a back-street rubbish heap hold promise of intellectual and artistic adventure.

Lewczyński dissects the structure of the photographs that he finds by isolating and enlarging selected fragments, then "re-setting" them with the original; or, he may juxtapose various images similar in form but different in content, thereby giving them a completely new meaning.

In his best known photographic work, "Nysa 1945" (1971), Lewczyński presents a composition that consists of an old photograph showing a typical scene from 1945 in Poland (an overcrowded train standing at a provincial station) with fragments of the same photograph (enlarged portraits of passengers) mounted around the original photograph.

This kind of presentation reveals two characteristics of photography: realism, with its tendency to oversimplification, and synthesis and the subjective approach, with its tendency to analysis. It also represents a personal reflection on the emotional "potential" inherent in photography. This emotionalism is peculiar to Lewczyński who, despite his experimental and formal interests, differs distinctly from other Polish contemporary photographers, whose work is generally analytical, cool, and self-involved.

—Ryszard Bobrowski

Alexander Liberman: *Picasso*, 1954

LIBERMAN, Alexander.

American. Born in Kiev, Russia, in 1912; lived in Paris, 1924-41; emigrated to the United States, 1941: naturalized, 1946. Educated at University School, Hastings, Sussex, England, 1921-22; St. Pirans School, Maidenhead, Berkshire, England, 1923-24; Ecole des Roches, Paris, 1924-27; studied philosophy and mathematices, Sorbonne, Paris, 1927-30; studied painting, under André Lhote, Paris, 1931; studied architecture, under Auguste Perret, at the Ecole Speciale d'Architecture, Paris, 1931-32, and at the Ecole des Beaux-Arts, Paris, 1932-33. Served in the French Army, 1940. Married Tatiana Yacovleff du Plessix in 1942; daughter: Francine. Worked as part-time design assistant to Cassandre, Paris, 1931-32; Art Director, then Managing Editor, under Lucien Vogel, *Vu* magazine, Paris, 1933-36; full-time painter since 1936, photographer since 1949, and sculptor since 1958; layout artist, 1941-43, and Art Director, 1943, *Vogue* magazine, New York, then Art Director, 1944-61, and Editorial Director, from 1962, Condé Nast Publications, United States and Europe. Recipient: Gold Medal for Design, *Exposition Internationale*, Paris, 1937. D.F.A.: Rhode Island School of Design, Providence, 1980. Agent: André Emmerich Gallery, 41 East 57th Street, New York, New York 10022. Address: 173 East 70th Street, New York, New York 10021, U.S.A.

Individual Exhibitions:

1959 *The Artist in His Studio*, Museum of Modern Art, New York
1961 Musée des Arts Décoratifs, Paris
1977 Storm King Art Center, Mountainville, New York (retrospective)

Also numerous exhibitions of paintings and sculptures. See *Contemporary Artists.*

Collections:

Museum of Modern Art, New York; Metropolitan Museum of Art, New York; Condé Nast Publications, New York; Yale University, New Haven, Connecticut; Smithsonian Institution, Washington, D.C.; Virginia Museum of Fine Arts, Richmond; Art Institute of Chicago; Bibliothèque Nationale, Paris.

Publications:

By LIBERMAN: books—*The Art and Technique of Color Photography: A Treasury of Color Photographs by the Staff Photographers of Vogue, House and Garden and Glamour*, editor, with an introduction by A.B. Louchheim, New York 1951; *The Artist in His Studio*, New York 1960; *The World in Vogue*, editor, with B. Holme, K. Tweed and J. Davis, New York 1963; *Greece, Gods and Art*, New York 1968; introduction to *The Vogue Book of Fashion Photography*, edited by Polly Devlin, London 1979; films— *La Femme Francaise dans l'Art*, 1936.

On LIBERMAN: books—*The History of Fashion Photography* by Nancy Hall-Duncan, New York 1979; *Alexander Liberman: Monograph* by Barbara Rose, New York 1981; articles—"Alexander Liberman: Aquatints, Paintings, Photographs and Sculpture" by Frederic Tuten in *Artsmagazine* (New York), June 1977; "Alexander Liberman at Storm King" by Carter Ratcliff in *Art in America* (New York), November/December 1977; "Liberman Staying in Vogue" by Marie Winn in the *New York Times*, 12 May 1979.

Alexander Liberman brings himself as a maker of art to the task of photographing art and artists. His great interest is in recording the excitement of creators and their creations in terms of personality and individuality. Whether it is a ruined masterpiece set in a Greek landscape or a painter's studio in Provence, he means to show us *what it is like.* In the painter's case, he focuses on the most personal of places—the studio. We learn what tools are used, what post cards and reproductions are pinned up for inspiration, what objects collected, what landscape exists nearby. In the case of Greece, we are shown the long known newly: marble against rock, hollyhocks (for color) before columns, grass-grown fragments, sequences of terrain, degrees of ruin. A picture of the Parthenon at sunset contains a battery of effects worthy of a 19th century Romantic painter. And yet, it is Liberman's intensely modern viewpoint that enables him to risk the banality of famous beauty.

—Ralph Pomeroy

LICHTSTEINER, Rudolf.

Swiss. Born in Winterthur in 1938. Self-taught in photography. Freelance photographer, Zurich, since 1972. Head of the Photography Department, Kunstgewerbeschule, Zurich, since 1976. Recipient: Swiss Applied Arts Grant (3), 1958-61; Niépce Prize, with M. Garanger, 1966. Agent: Work Gallery, Trittligasse 24, 8001 Zurich. Address: Badenerstrasse 123, 8004 Zurich, Switzerland.

Rudolf Lichtsteiner: *Zeit und Augenblick,* 1979

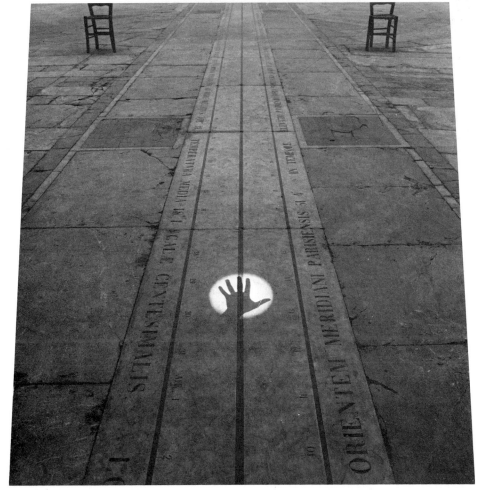

Individual Exhibitions:

1973 Galleria Il Diaframma, Milan
1974 Galleria Documenta, Turin
 Canon Photo Gallery, Amsterdam
1975 Wilhelm Lehmbruck Museum, Duisburg, West Germany (retrospective)
1976 Galerij Paule Pia, Antwerp
 Galerie im Forum Stadtpark, Graz, Austria
 Galleria Blu, Milan
1977 Galerie Maurer, Zurich
1980 *Baum-Werke*, Photo-Galerie, Kunsthaus, Zurich
 Canon Photo Gallery, Geneva

Selected Group Exhibitions:

1966 *Prix Nicéphore Niepce*, Chalon-sur-Saône, France
1974 *Fotografie in der Schweiz 1840 bis Heute*, Kunsthaus, Zurich
1975 *Festival d'Art Contemporain*, Royan, France
 Photography as Art/Art as Photography, Maison Européene de la Photographie, Chalon-sur-Saône, France (and world tour)
1976 *Fantastic Photography in Europe*, at Rencontres Internationales de la Photographie, Arles, France, (toured Europe and the United States, 1976-78)
1977 *Photography as Art/Art as Photography II*, Fotoforum, Kassel, West Germany (and world tour)
1978 *Photography as Art/Art as Photography III*, Fotoforum, Kassel, West Germany (and world tour)
1979 *Steirische Herbst*, Galerie im Forum Stadtpark, Graz, Austria
1980 *Photographia: La Linea Sottile*, Galleria Flaviana, Locarno, Switzerland

Collections:

Kunsthaus, Zurich; Stedelijk Museum, Amsterdam.

Publications:

On LICHTSTEINER: books—*Fotografie in der*

Jerome Liebling: *Confirmation Dress*, Malaga, Spain, 1967

Schweiz 1840 bis Heute, exhibition catalogue, by Hugo Loetscher, Walter Binder and Rosellina Burri-Bischof, Zurich 1974; *Fotografie als Kunst* by Floris M. Neusüss, Cologne 1979; *Photographia: La Linea Sottile*, exhibition catalogue, by Rinaldo Bianda and Giuliana Scime, Locarno, Switzerland 1980; *Baum-Werke/Oevres d'Arbre: Rudolf Lichtsteiner*, exhibition catalogue, with text by Francis Ponge, Zurich and Geneva 1980.

The posing/manipulation of objects in space and their subsequent dematerialization by means of photographic reshaping are both phases of a *single* process, in which an arrangement of objects in space must be invented anew for every work. A picture, this one picture, cut out from its surroundings, from a coincidental/overflowing reality, is thus also the result of admitted confinements/oversimplifications/miniaturizations; but it is *also* a deliberate clarification of a camouflaging, a fine discrimination or the feeling of a moment....

Only a *contrived* picture, following an invented reality, seems to make possible for me (as well as for the photographic image-maker) the decisive artistic freedom of expression.

—Rudolf Lichtsteiner

Rudolf Lichtsteiner stages photographs (most often in series of two to seven photos, sometimes just one) that attract us with their beauty, the clarity of their representation and the enigma of their content. We may simply enjoy looking at them, savouring their mystery, or pause with them to unravel their meaning, which need not coincide with what the author had in mind.

Lichtsteiner originally wanted to become a painter. Much later he began to work with photographs, first as a retoucher, then as an advertising photographer, exploring the manipulated and set-up photograph. Sporadically he did journalistic work. The degree of phantasy in the former and the truncated truth of the latter did not satisfy his need for a more profound reality in his work.

The polarity of emotion and intellect, and that polarity in his own creativity; nature and what man does to it, how he tries to harness it, may misuse it, but cannot conquer it—these are the kinds of considerations that Lichtsteiner endeavors to make

visible. He develops his themes by means of a "Script," but his dramatizations do not follow chronological or rational laws. They are arrived at and decoded by associations which may derive from the common usage of the objects shown, through displacement, as in a dream, or by looking at language in a way akin to that of Freud. The silences or spaces between the photographs accentuate and fertilize the poignancy of his visual messages. Man is not shown. His imprint or intervention—footprints or hands—speak of human existence more eloquently than any specific figure.

As Lichtsteiner's concerns are with making invisible reality physically visible, as in a play on a stage, it follows that he is also interested in setting the stage for his photographs. His catalogue *Baum-Werke* has to be turned around, as he had to turn around words and relationships to arrive at his "Script." Its binding is green, and in the exhibition at the Kunsthaus, plants interacted with his prints in an installation that was, if not unconventional, different, and in harmony with his work.

In the future, Rudolf Lichtsteiner hopes to move more and more, philosophically and physically, into a unified world of words and images related to environment.

For the past four years, Lichtsteiner has been teaching the Photography Class at the Kunstgewerbeschule in Zurich. He has encouraged individual talent and inclination. Lichtsteiner regards his teaching as an important part of his creative life, an exchange of stimulus, which fertilizes his creative work, though it curtails the time he can give to it.

—Inge Bondi

LIEBLING, Jerome.

American. Born in New York City, 16 April 1924. Educated at Lafayette High School, Brooklyn, New York, 1940-42; studied art and photography, under Walter Rosenblum, Ad Reinhardt and Milton Brown, Brooklyn College, New York, 1942, 1946-48; filmmaking, under Lewis Jacobs, Leo Hurwitz and Paul Falkenberg, New School for Social Research, New York, 1948-49; photography, under Paul Strand, Photo League, New York, 1947-49. Served in the United States Army, in North Africa, Italy, France, England, Ireland, and Germany, 1942-45. Married Phyllis Levine in 1949 (divorced, 1969); children: Madeline, Tina, Adam, Daniella, and Rachel. Photographer since 1947, and filmmaker since 1949. Professor of Photography, University of Minnesota, Minneapolis, 1949-69. Since 1970, Professor of Photography, Hampshire College, Amherst, Massachusetts. Visiting Professor, State University of New York at New Paltz, 1957-58, and Yale University, New Haven, Connecticut, 1976-77. Founder Member, Society for Photographic Education, 1961. Recipient: Screen Producers Guild Award, 1951; New Talent U.S.A. Award, American Federation of Arts, 1956; First Prize, *San Francisco Film Festival*, 1960; Documentary Award, *Festival dei Popoli*, Florence, 1964; National Endowment for the Arts Grant, 1972, 1979, 1980; Massachusetts Arts and Humanities Award, 1975; Guggenheim Fellowship, 1976. Agent: Sandra Berler, 7002 Connecticut Avenue, Chevy Chase, Maryland. Address: 39 Dana Street, Amherst, Massachusetts 01002, U.S.A.

Individual Exhibitions:

1948 Walker Art Center, Minneapolis

1951 Portland Art Museum, Oregon
1957 International Museum of Photography, George Eastman House, Rochester, New York
1960 Limelight Gallery, New York
1963 *100 Photographs*, Walker Art Center, Minneapolis
1977 Vision Gallery, Boston
1978 Friends of Photography, Carmel, California (retrospective)
University of California at San Diego
1980 Corcoran Gallery of Art, Washington, D.C.

Selected Group Exhibitions:

1963 *5 Unrelated Photographers*, Museum of Modern Art, New York
1967 *The Camera as Witness*, at *Expo '67*, Montreal
1976 *The Bus Show*, on city buses, New York
1978 *14 New England Photographers*, Museum of Fine Arts, Boston
Photographic Crossroads: The Photo League, National Gallery of Canada, Ottawa (travelled to the International Center of Photography, New York; Museum of Fine Arts, Houston; and Minneapolis Institute of Fine Arts)
Photos from the Sam Wagstaff Collection, Corcoran Gallery of Art, Washington, D.C. (toured the United States, Canada and Europe)
Mirrors and Windows: American Photography since 1960, Museum of Modern Art, New York (toured the United States, 1978-80)
1980 *Photo Politic*, Project Studio I (P.S.I.), Queens, New York
1981 *American Children*, Museum of Modern Art, New York

Collections:

Museum of Modern Art, New York; International Museum of Photography, George Eastman House, Rochester, New York; Museum of Fine Arts, Boston; Fogg Art Museum, Harvard University, Cambridge, Massachusetts; Yale University, New Haven, Connecticut; Library of Congress, Washington, D.C.; Corcoran Gallery of Art, Washington, D.C.; Minneapolis Institute of Art; Center for Creative Photography, University of Arizona, Tucson.

Publications:

By LIEBLING: books—*The Face of Minneapolis*, with Don Morrison, Minneapolis 1966; *Photography: Current Perspectives*, editor, Rochester, New York 1979; films—*The Tree Is Dead*, with Allen Downs, 1955; *Pow-Wow*, 1961 *The Old Man*, with Allen Downs, 1965.

On LIEBLING: books—*The Photography Catalog*, edited by Norman Snyder, New York 1976; *Photographs: Sheldon Memorial Art Gallery Collection, University of Nebraska*, with an introduction by Norman A. Geske, Lincoln, Nebraska 1977; *Faces*, edited by Ben Maddow, Boston 1977; *Mirrors and Windows: American Photography since 1960* by John Szarkowski, New York 1978; *Untitled 15: Jerome Liebling Photographs*, with text by Estelle Jussim, Carmel, California 1978; *New York Street Kids*, edited by the New York City Historical Museum, New York 1978; *The Sam Wagstaff Collection*, edited by Sam Wagstaff, New York 1978; *Jerome Liebling: Photographs*, exhibition catalogue, with text by Jane Livingston, Washington, D.C. 1980.

I would like this series of quotes from three prominent photography critics to be my statement:

Estelle Jussim, in the monograph *Untitled 15: Jerome Liebling Photographs* (Friends of Photography, 1978): "He has pushed still photography to its absolute limits as a message system, he has wrenched from paper images, the utmost which they, as a visual communication medium, can deliver.... A photographer of considerable formal means, with superb ability to make us feel, whose conscience offers a gripping testament of faith in humanity."

Alan Trachtenberg in his introduction to my portfolio, 1977: "Liebling's work goes against the grain of contemporary fashion. His pictures are not tense with ironic subversions. They are not clever statements about photography itself. They take the world seriously. He is romantic without apology. Human desire is the unifying motif of his pictures' desire for grace, for transcendence.... The unspeakable power of the mundane to move, to impress, to coerce us into recognitions: this is an authentic power of photography itself."

Jane Livingston, Associate Director of the Corcoran Gallery of Art, Washington, D.C. in her monograph on my work: "More and more we see that Liebling's humanity, his heritage and way of life, find literal expression in his work and communicate to us in the most immediate sense his own experience. The work is sometimes about guilt and expiation, sometimes about sheer desire, sometimes empathy. But these "contents" are not quite in the end the main point. The color work is really at its best a simple flirtation with esthetic excitement."

—Jerome Liebling

Jerome Liebling is a photographer of still and motion pictures, an educator of young photographers, an organizer of photographic colloquia, and a melancholy humanist. For more than 30 years his imagery has been concerned with the unenviable and imperative human destinies that most individuals seek to forget or avoid. His camera lens has sought out the afflicted; he has photographed individuals in unfathomable occupations and circumstances; and he has exposed the putrescence of the cadavers that we all become.

A consistent disputant of conventional attitudes, Liebling has refashioned the affirming humanism of his first teachers—Walter Rosenblum at Brooklyn College and Paul Strand at the Photo League. His war experiences and the horror of the Holocaust confirmed his growing awareness of the human potential for inflicting as well as suffering pain. Since then, his attempt has been to make these perceptions more than real, through images whose force is concentrated in rigorously disciplined linear, spatial and tonal relationships.

Liebling's formal visual training in the Bauhaus aesthetic may seem at odds with his fervent emotional intentions. But just as he redirected the humanism of his mentors, he has reconceived Bauhaus aesthetic ideas to encapsulate his own rage and compassion. At times he selects an unusual but expressive portion of his subject, as in the springing curves of the lower half of an infant torso to affirm the vitality of new life. The featureless bowed head and careful hands of a blind man eating becomes a metaphor not only for sightlessness, but for the photographer's compassionate concern for the indignities that the afflicted endure. Liebling has made the economy of means that is at the heart of Bauhaus aesthetic doctrine reverberate with emotional intensity.

Humor is less apparent in Liebling's work, although one of his earliest films is a genial spoof of the foolishness of big college football rites. A series of images of politicians on the hustings, made intermittantly throughout the 1960's and 70's, displays a mordant view that is an unsettling as it is humorous.

In his earliest photographs, made even before his Army service in 1942, Liebling sought to discomfit his family by presenting them with images of the urban poor whose existence they had chosen to ignore. He has continued to use his camera as a prod to complacency, impelling the comfortable viewer to face the unspeakable. His impolitic images keep presenting reminders of what is shut away or disregarded until, against our will, we are made to confront both inhumanity and mortality.

—Naomi Rosenblum

LIST, Herbert.
German. Born in Hamburg, 7 October 1903. Educated at Johanneumschule, Hamburg, 1912-20; studied German, briefly, in Heidelberg, 1922; commercial studies, Hamburg, 1923-24; mainly self-taught in photography, but assisted initially by the photographer Andreas Feininger, *q.v.*, from 1930. Served in the German Army, Norway, 1944-45. Worked as clerk-apprentice, Landfried Coffee Company, Heidelberg, 1921-23; assistant buyer, in family coffee import business, Hamburg, 1925-26, travelling in Brazil, Guatemala, San Salvador, Costa Rica and the United States, 1926-28; Company Clerk, then Partner, List and Heineken family company, Hamburg, 1928-36; professional magazine photographer, working for *Vogue, Harper's Bazaar, Verve, Life*, etc., in London, Paris and Athens, 1936-41, and in Munich, working mainly for *Du*, 1945-60; temporary editor, *Heute* magazine, Munich, 1946; gradually abandoned photography to concentrate on collection of Italian 16th-18th-century drawings, Munich, 1960 until his death, 1975. Member, Gesellschaft Deutscher Lichtbildner (GDL), 1964-73. Recipient: David Octavius Hill Prize, Gesellschaft Deutscher Lichtbildner, 1964. Estate: c/o Max Scheler, Hoffman und Campe, Harvesterhuder Weg 45, 2000 Hamburg 13, West Germany. *Died* (in Munich) *4 April 1975.*

Individual Exhibitions:

1937 Galerie du Chasseur d'Images, Paris
1977 Kunsthaus, Zurich
1980 Galerie Lange-Irschl, Munich
CCD Galerie, Dusseldorf
1981 The Photographers' Gallery, London
Galleria Il Diaframma/Canon, Milan
International Center of Photography, New York
Galerie Lange-Irschl, Munich

Selected Group Exhibitions:

1977 *Fotografische Künstlerbildnisse*, Museum Ludwig, Cologne
1978 *Das Experimentelle Photo in Deutschland 1918-40*, Galleria del Levante, Munich
1979 *Photographie als Kunst 1879-1979*, Tiroler Landesmuseum Ferdinandeum, Innsbruck, Austria (travelled to Neue Galerie am Wolfgang Gurlitt Museum, Linz, Austria; Neue Galerie am Landesmuseum Joanneum, Graz, Austria; Museum des 20. Jahrhunderts, Vienna)
Från Jonasson til Armstrong-Jones, Moderna Museet, Stockholm
Photographic Surrealism, New Gallery of Contemporary Art, Cleveland (travelled to Dayton Art Institute, Ohio; and Brooklyn Museum, New York)

1980 *Avant-Garde Photography in Germany 1919-1939*, San Francisco Museum of Modern Art (toured the United States)
1981 *Dog Show No. 1*, Nikon Fotogalerie, Zurich
Landschaften, PPS-Galerie, Hamburg

Collections:

PPS-Galerie, Hamburg; Museum of Modern Art, New York; Sander Gallery, Washington, D.C.; San Francisco Museum of Modern Art.

Publications:

By LIST: books—*Licht über Hellas*, Munich 1953; *Rome*, with text by Hans Mollier, Munich 1955; *Caribia*, Hamburg 1958; *Dom, Bilder und Eindrücke*, with text by Ingeborg Bachmann, Biberach, West Germany 1960; *Napoli*, with text by Vittorio de Sica, Gutersloh, West Germany 1962; *Bildwerke aus Nigeria/Nigerian Images*, with text by William Fagg, Munich, London, Paris and New York 1963; *Zeitlupe Null*, portfolio, Hamburg 1980.

On LIST: books—*Photography of the World '60*, edited by Hiromu Hara, Ihei Kimura and others, Tokyo and New York 1960; *The Magic Image* by Cecil Beaton and Gail Buckland, London and Boston 1975; *Herbert List: Fotografien 1930-1970*, with text by Günter Metken, Munich 1976, London 1980, New York 1981; *Fotografie der 30er Jahre*, edited by Hans-Jürgen Syberberg, Munich 1977; *Geschichte der Fotografie im 20. Jahrhundert/Photography in the 20th Century* by Petr Tausk, Cologne 1977, London 1980; *Herbert List: Portraits*, edited by Max Scheler, with a foreword by Manuel Gasser, Hamburg 1977; *Fotografische Künstlerbildnisse*, exhibition catalogue, by Dieter Rönte, Evelyn Weiss and Jeane von Oppenheim, Cologne 1977; *Italienische Zeichnungen des 16.-18. Jahrhunderts: Eine Ausstellung zum Andenken an Herbert List*, exhibition catalogue, by Herbert Pee and Eckhard Schaar, Munich 1977; *Das Experimentelle Photo in Deutschland 1918-1940* by Emilio Bertonati, Munich 1978; *Photographie als Kunst 1879-1979/Kunst als Photographie 1949-1979*, exhibition catalogue, 2 vols., by Peter Weiermair, Innsbruck, Austria 1979; *Fotografie 1919-1979, Made in Germany: Die GDL Fotografen*, edited by Fritz Kempe, Bernd Lohse and others, Frankfurt 1979; *Deutsche Fotografie nach 1945/German Photography after 1945* by Floris Neusüss, Wolfgang Kemp and Petra Benteler, Kassel, West Germany 1979; *Photographic Surrealism*, exhibition catalogue, by Nancy Hall-Duncan, Cleveland, Ohio 1979; *Avant-Garde Photography in Germany 1919-1939*, exhibition catalogue, by Van Deren Coke, Ute Eskildsen and Bernd Lohse, San Francisco 1980; *Herbert List: Fotografia Metafisica*, with text by Günter Metken, edited by Max Scheler, Munich, London and New York 1980; articles—special issue of *Du* (Zurich), November 1966; "Herbert List," special issue of *Du* (Zurich), July 1973; "Herbert List 1903-1975" in *Photography Year 1976*, by the Time-Life editors, New York 1976; "List's Photographs Acclaimed Once Again" by Inge Bondi in *Printletter* (Zurich), November/ December 1976.

One of his best-known pictures is of a glass of water; in the water there is a fish; the glass is on a balustrade, and behind the balustrade is the glittering sea—"Santorin, 1937." The immeasurable becomes visible in a dreamlike, real, paradoxical cypher. A clearly outlined object becomes the magical subject of our comtemplation. Herbert List's best photographs are so simple in their composition and so subtle in their allusions: pictures in which the visible becomes a release for the invisible, for the background of visions. It is not gratuitous that List once wanted to place as a motto in front of a collection of his photographs a quotation from Novalis: "The external is the internal exalted in a mysterious state."

Born in Hamburg in 1903, List was at first active in his father's coffee import business. Interested in a variety of cultural matters, he got to know George Freund Gundolf, Gustav Gründgens, and the young Stephen Spender; he learned the technical basis of photography from Andreas Feininger. A hobby became a profession when the "non-Aryan" List had to leave Germany in 1936. He went to Paris via London, and in a short time was successful; his photos appeared in *Vogue, Verve, Harper's, Life*.

It was the Paris of the surrealists, whose arts of transformation were being taken up even in the refined decor of fashion photography (in the work of Cecil Beaton, for example). The surrealistic inspirations and analogies are recognizable in List's work. "The plastic arts," he wrote (naturally including photography in his definition), "the plastic arts are vision made visible." If Salvador Dali painted "dream photographs" with hyper-realistic sharpness of detail, List, in fact, photographed them, with the declared intention of "catching in pictures the magic of visions."

To describe List's method, Günter Metken coined the term "Fotografia Metafisica," after the paintings of the Pittura Metafisica movement. List himself spoke of the "mysterious marriages that exist between table and chair, glass and bottle." The atmosphere of the metaphysical still-life is common to all his pictures, whether he photographs lodgers at the Casa Verdi listening to music as if in a dream or a trance, or whether he portrays the painter Morandi in his studio. Even if they always had the character of spare-time work, of casual work carried out for pure amusement, portraits were always one of List's principal genres, from the portraits of Parisian artists of the 1940's to those of the cultural elite of East and West Berlin in the 60's.

Licht über Hellas, prepared by List in 1937-38, which first appeared as a volume of photographs in 1953, was not the usual Western retrospective reflection, and reception of the book was belated and uncomprehending. For it was, with its monumental fragments, an hallucinatory Hellas, closer to Piranesi's fantastic ruins than to a worship of classical beauty. And in 1945, in glaring direct light, in snow or sun, List photographed the destroyed city of Munich, the German Athens, the humanist facades of an inhuman regime.

As abruptly as he had begun, List ceased to take photographs. During the last 15 years of his life he dedicated himself only to his collection of Italian drawings of the 16th to 18th centuries—almost as if he himself did not wish to contribute any more to the flood of photographs of our time. Almost unnoticed by the public, List died in 1975—and yet his oeuvre is of equal rank with that of his illustrious contemporaries, Cartier-Bresson, Brassaï and Bill Brandt.

—Peter Sager

Herbert List: *Dog and Legs*, **Portofino, 1936** Courtesy PPS Galerie, Hamburg

LIVICK, Stephen.

Canadian. Born in Castleford, England, 11 February 1945. Educated at Rosemount High School, Montreal, 1959-63; Sir George Williams University, Montreal, 1963-67. Married Selina Depelteau in 1971 (divorced 1975); Karen Johns in 1974. Worked as photographer, CIP Photo Studio, Montreal, 1965-68; Photo-Place Studio, Montreal, 1968-70; Penthouse Studio, Montreal, 1970-71. TDF Studio, Toronto, 1971-72; color-printer, Benjamin Films, Toronto, 1972-74. Independent photographer, Dorchester, Ontario, since 1974. Recipient: Ontario Art Council Photo Award, 1975, 1976, 1978; Canada Council B Award, 1976, 1977, 1979. Agents: Lunn Gallery, 406 Seventh St. N.W., Washington, D.C. 20004, U.S.A.; Jane Corkin Gallery, 144 Front Street West, Toronto M5J 1G2, Ontario. Address: Post Office Box 126, Dorchester, Ontario N0L 1G0, Canada.

Individual Exhibitions:

1972 Centaur Gallery, Montreal
1973 London Art Gallery, Ontario
1975 International Museum of Photography, George Eastman House, Rochester, New York
1976 David Mirvish Gallery, Toronto
London Regional Art Gallery, Ontario (travelled to local Ontario galleries, 1976-77)
Photography Gallery, Bowmanville, Ontario
1977 David Mirvish Gallery, Toronto
1978 Baltimore Museum of Art, Maryland
Lunn Gallery/Graphics International, Washington, D.C.
Gallery Graphics, Ottawa
International Museum of Photography, George Eastman House, Rochester, New York (toured the United States and Canada, 1978-81)
1979 Jane Corkin Gallery, Toronto
National Film Board of Canada, Ottawa (with Suzanne Bloom and William Horris)
1980 Jane Corkin Gallery, Toronto
Art Gallery of Ontario, Toronto (travelled to local Ontario galleries, 1980-81)
1981 Jane Corkin Gallery, Toronto
McIntosh Gallery, University of Western Ontario, London

Selected Group Exhibitions:

1975 *Permanent Collection Exhibition*, National Art Gallery, Ottawa
1976 *"21"*, National Film Board, Ottawa
1977 *Focal Point*, Art Gallery of Ontario, Toronto
Permanent Collection Exhibition, National Art Gallery, Ottawa
Photographic Landscapes, International Museum of Photography, George Eastman House, Rochester, New York
1978 *Sweet Immortality*, Edmonton Art Gallery, Alberta
1979 *The Platinum Print*, Rochester Institute of Technology, New York
1980 *Invisible Light*, Smithsonian Institution, Washington, D.C.
1981 *Second Sight*, Carpenter Center for the Visual Arts, Cambridge, Massachusetts

Collections:

National Gallery of Canada, Ottawa; National Film Board of Canada, Ottawa; Canadian Art Bank, Ottawa; Museum of Modern Art, New York; International Museum of Photography, George Eastman House, Rochester, New York; Fogg Art Museum, Cambridge, Massachusetts; Baltimore Museum of Art, Maryland.

Publications:

On LIVICK: books—*Photography Year 1978* by Time-Life editors, New York 1977; *The Platinum Print* by John Hafey and Tom Shillea, Rochester, New York 1979; *12 Canadians* by Jane Corkin, Toronto 1981; articles—"Stephen Livick" by Allan Porter in *Camera* (Lucerne), January 1978; "Stephen Livick" by Colin Osman in *Creative Camera* (London), June 1979; "Photography" by David Livingstone in *MacLean's* (Toronto), November 1980; "Photography" by David Livingstone in *MacLean's* (Toronto), September 1981.

For me, writing a personal statement is awkward. I consider my photographs to be my statement. Photography is something that is just in me. Even as a seven-year old, I was running around with a box "brownie" and could hardly wait for the prints to be returned from the drug store. Being an image maker was not a conscious decision on my part—I've never really considered anything else. There are many choices in photography: anything from commercial to fine art, equipment to processes; it is easy to get lost in your choices and forget that all that really matters is the image. I feel contemporary photographers are very fortunate—today, it is possible to survive in the art market, and in the future we will look back to find that we have been living in an exciting period of photographic history.

—Stephen Livick

Stephen Livick photographs the other half of America—the half Diane Arbus missed. He finds the same feelings—wonder, dismay, and an overwhelming sorrow—in ordinary people. His close-ups, central images, engage the viewer, often with the too horribly true, like his mother and baby in Coshocton, Ohio (1981). Livick's work is a visual history of his insight, like his image of the girl at a New Wave Rock concert. She looks at the viewer through oddly shaped glasses, a determined visionary.

Livick grew out of a background in commercial photography—he hated it. He wants to re-shape what photography is all about. His work has impact and monumental scale. He photographs with colour transparency film, has the transparencies separated by laser technology then uses watercolour pigments mixed with gum arabic on Arches paper to get the final result, a 30" x 30" full colour gum print.

Livick's people reveal his passion—the distilled essence of Middle America. His subjects turn into voyeurs themselves: they are not so much innocent as skeptical. "I've never found clowns funny," he says. Often he uses them as sympathetic, powerful revelations of the human psyche. The things people wear on their faces—paint or glasses—reveal their alienation. Stephen Livick's vision is of a compelling, haunting, too-real world.

—Joan Murray

See Color Plates

LOKAJSKI, Eugeniusz.

Polish. Born in Warsaw, 30 December 1909. Educated at Rej Gimnasium, Warsaw, 1920-27; studied athletics, Central Institute of Physical Education, Warsaw, 1932-35; self-taught in photography. Served in Polish Army, 1930-32, and, under pseudonym "Brok" in Polish underground resistance, Warsaw, 1940-44: 2nd Lieutenant. Independent photographer, Warsaw, 1935 until his death, 1944. Assistant Instructor, Central Institute of Physical Education, Warsaw, 1935-39; Polish national javelin champion, 1936, javelin competitor, Olympic Games, Berlin, 1936. *Died* (during the Warsaw Uprising) *25 September 1944*.

Individual Exhibitions:

1978 *The Warsaw Uprising*, Eugeniusz Lokajski School, Lodz, Poland
1979 *Eugeniusz Lokajski*: Photographer, St. Cross Church, Warsaw
1980 *The Warsaw Uprising*, St. Anna Church, Warsaw

Selected Group Exhibitions:

1979 *Fotografia Polska 1839-1979*, International Center of Photography, New York (travelled to Museum of Contemporary Art, Chicago; Galeria Zacheta, Warsaw; Museum of Fine Arts, Lodz, Poland; and Whitechapel Art Gallery, London)
1981 *Photographie Polonaise 1900-1981*, Centre Georges Pompidou, Paris

Collections:

Zofia Domanska, Warsaw.

Publications:

On LOKAJSKI: book—*Historia Fotografii Warszawskiej* by Waclaw Zdzarski, Warsaw 1974; articles—"Powstanie Warszawskie," edited by Wladyslaw Bartoszewski, in special edition of *Stolica* (Warsaw), August 1957; "Genek: Czyli sila Prawdomownych Obrazow" by Alicja Skierko in *Ekran* (Warsaw), no. 50, 1968; "Portret Cstowieka" in *Magazyn Filmowy* (Warsaw), no. 25, 1968; "Czlowiek z Kamera" by Juliusz Garztecki in *Fotografia* (Warsaw), October 1969; "Dwa Portrety" by Jeky Gizycki in *Ekran* (Warsaw), no. 11, 1969.

Not what I dreamed about
but what I cried with blood,
this I see....
Krzysztof Kamil Baczynski

Of all the national uprisings in Polish history, the Warsaw Uprising was certainly the most horrible. This dramatic struggle by Warsaw inhabitants to free the country's capital city from the superior forces of Hitler's army resulted in total defeat: defeat of the people, many of whom lost their lives in the ruins of Warsaw, defeat of the city, which was destroyed, and, finally, defeat of the national culture, dramatically robbed of its best talents and works of art.

The Warsaw Uprising was recorded by camera at every stage. Among the many who took photographs, the most interesting, and, at the same time, the most tragic, was Eugeniusz Lokajski, a graduate of the Warsaw Academy of Sport, a national javelin champion, and a participant in the Olympic Games in Berlin. He had worked for the underground under the pseudonym "Brok," and he fought in the Warsaw Uprising with the rank of Second Lieutenant. As an officer, he took part in many important bat-

tles, among them the conquest of the German Police Headquarters and the Central Telephone Exchange. With his ever-present camera, he took photographs of guerilla attacks, battles over the barricades, friends' funerals, injured soldiers, and street fires. These photographs, summarizing a picture of heroic battle—a battle fought for each street, each house, each floor—are a record of the desperate hope, dramatic defence and final annihilation of Warsaw.

Lokajski's photographs are so heroic and staggering that they cannot be classified merely within the framework of traditional photography. Taken on the threshold of what seemed to be the end of the world and its inhabitants, they are at the same time witness to the highest price which a photographer can pay for achieving his goal—his own life. Lokajski shared the fate of the Warsaw for which he fought; he died with his camera on the streets of Warsaw in the summer of 1944.

—Ryszard Bobrowski

LOTAR, Eli.

French. Born, of Rumanian parents, in Paris, in January 1905; returned to France, 1923: naturalized, 1926. Educated in Bucharest until 1923. Served in the French Army, 1940-45. Married Elisabeth Lotar in 1939 (divorced, 1955, died 1980); had one daughter. Worked as a laborer, bricklayer, film extra, etc., Nice, 1924-26, and as a garage mechanic, Paris, 1926-27; Photographic Assistant, 1927-28, and Partner, 1928-30, Germaine Krull Studio, Paris; worked for *Vu, Bifur, Variétés (Brussels), Arts et Metiers Graphiques, Jazz,* etc., Paris, 1929-30; established own photographic studio, with surrealist poet Jacques-André Boiffard, Paris, 1930; also worked as filmmaker, with Jean Painlevé, Paris, 1929-30, and with Joris Ivens (Krull's husband), Amsterdam, 1930-33; freelance photographer, Paris, 1934 until his death, 1969; lived with the sculptor Alberto Giacometti, Paris, 1963-65. *Died* (in Paris) *10 May 1969.*

Selected Group Exhibitions:

1929 *Film und Foto,* Stuttgart
1930 *Photographie d'Aujourd'hui,* Galerie d'Art Contemporain, Paris
Groupe Annuel des Photographes, Galerie de la Pléiade, Paris
1931 *Photographes d'Aujourd'hui,* Galerie de la Plume d'Or, Paris
1932 *International Photographers,* Brooklyn Museum, New York
Modern European Photography, Julien Levy Gallery, New York
1976 *Photographs from the Julien Levy Collection, Starting with Atget,* Art Institute of Chicago
1978 *Paris-Berlin 1900-1933,* Centre Georges Pompidou, Paris
1979 *Paris-Moscou 1900-1930,* Centre Georges Pompidou, Paris
1980 *Experimental Photography,* Stills Gallery, Edinburgh (toured the U.K.)

Collections:

Bibliothèque Nationale, Paris; Art Institute of Chicago; Galerie Wilde, Cologne.

Publications:

By LOTAR—*Voyage en Grece,* Paris c. 1937.

On LOTAR: books—*Photographs from the Julian Levy Collection, Starting with Atget,* exhibition catalogue, by David Travis, Chicago 1976; *Fotografie der 30er Jahre: Eine Anthologie,* edited by Hans-Jürgen Syberberg, Munich 1977; *Paris-Berlin 1900-1933,* exhibition catalogue, by H. Molderings, W. Spies, G. Metken and others, Paris 1978; *Paris-Moscou 1900-1930,* exhibition catalogue, by Romeo Martinez, A.N. Lavrentiev and others, Paris 1979; *Experimental Photography,* exhibition catalogue, by Dawn Ades, London 1980.

By what standards are we to judge the significance of a figure in a particular medium like photography? In general, of course, we have to have extensive knowledge of his work. It is his personal style, his books and exhibitions which will entitle him to a place in history and the reference books. But in the case of Eli Lotar it is impossible to apply these standards. He published no books and exhibited for only a short period between 1928 and 1932. He is known by relatively few photographs from this period—photographs which we often come across by chance, in scattered periodicals. Thus we have to ask what it is that has aroused interest in Eli Lotar and makes him worth including in *Contemporary Photographers.* Is it because of discoveries we might make if only we could fathom his life? Do we hope someday to find presumably lost work which would justify the importance some critics have already granted him? In any event it is undeniable that what little we do know about his life has prompted different critics, working independently of each other, to consider his work and to try to find out more about his life.

From his wife (whom he married in 1939 in Paris and from whom he was separated in 1955) we know that Eli Lotar led a very unsettled and disorganized life. He was quick to become enthusiastic about something, but as soon as it required perseverance and discipline, he would turn to something else. It was his enthusiasm for the photography of André Kertész and Germaine Krull which triggered his desire to become a photographer, but after a short time he was attracted to the charms of film-making and hoped to gain a foothold by working as a stills-photographer for various directors. He was unsuccessful at this in Paris and tried his luck under Joris Ivens in Holland; he was unsuccessful there as well,

Eugeniusz Lokajski: *German Prisoners,* Warsaw Uprising, 1944

Eugeniusz Lokajski: *Torn Portraits of Hitler after Hard-Fought Victory,* Warsaw Uprising, 1944

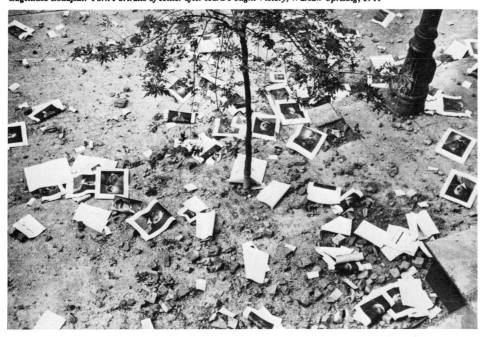

and in less than three years was back in Paris. His capriciousness and rapid switches from job to job indicate nothing about his talent as a photographer, of course, which must be deduced from the photographs themselves. But here too we are prevented from making firm judgments, since the photographs we do know about were made under the powerful influence of his "master," Germaine Krull. For these reasons I prefer to drop the question of his artistic achievement.

The list of jobs which appears in the biographical information above does not represent any real knowledge of life, although at first glance it might seem to do so, especially since we like to link these things together in the biographies of distinguished artists. The jobs simply attest to his inability to come to terms with life. If he had a job to do, he often failed to meet deadlines or was distracted by an interest in some other endeavor. It is hardly surprising, then, that from the time he separated from his wife until his death in 1969—a period of 14 years—he changed his residence more than 10 times. In doing so he often left behind everything which was either a burden or not essential to his life, and this included his negatives and photographs. Thus he lost forever the chance of making a name for himself as a photographer. Nothing remains to distinguish him except an impressive set of photographs of Alberto Giacometti (with whom he lived during the early 60's)—and the enticing mystery of a missing *oeuvre* by a possibly great artist.

—Jürgen Wilde

Eli Lotar: *Variétés*, Brussels, 1929 Courtesy Galerie Wilde, Cologne

LOTTI, Giorgio.

Italian. Born in Milan, 14 January 1937. Studied photography at Scuola di Fotografia, Milan. Served in the Italian Army for 18 months. Married; has 2 children. Freelance photo-reporter, establishing advertising studio, Milan, since 1960; photojournalist for *Epoca* magazine, Milan, since 1964. Recipient: Montecatini Prize, 1969; Prora-Canon Prize, 1970; World Understanding Award for Photojournalism, University of Missouri, Columbia, 1973; Scanno Prize, 1981. Address: Via Bordighera 29, Milan, Italy.

Individual Exhibitions:

Lotti has had more than 70 exhibitions in Italy since 1964 on the following themes: "Flood in Florence," 1966-67; "Sea," 1967-77; "Venice Is Dying," 1968; "Pollution in Italy," 1970; "The Poisoned Cathedral," 1972; "China," 1973; "Woman and Sun," 1975; "La Scala Theatre," 1977; "Ballet," 1980; and "Earthquake in Irpinia, Italy," 1981.

Selected Group Exhibitions:

1968 *2nd World Exhibition of Photography*, Pressehaus Stern, Hamburg (and world tour)
1973 *The Concerned Photographer*, at *SICOF*, Milan
1975 *The Land: 20th Century Landscape Photographs Selected by Bill Brandt*, Victoria and Albert Museum, London (travelled to the National Gallery, Edinburgh; Ulster Museum, Belfast; and the National Museum of Wales, Cardiff, 1976)
1977 *10 Italian Photographers/10 Japanese Photographers*, Modern Art Museum, Tokyo
1979 *Magazzini del Sale*, at *Venezia '79*
 The Italian Eye, Alternative Center for International Art, New York
1981 *Omaggio al Fotogiornalismo Italiano: 21 Fotografi*, Scanno, Italy

Collections:

Centro Studi, Università di Parma, Italy; Bibliothèque Nationale, Paris; Victoria and Albert Museum, London.

Publications:

By LOTTI: books—*Venice Is Dying*, with text by Giorgio Bassani and Gianfranco Fagiuoli, Milan 1970; *The Poisoned Cathedral*, with text by Giuseppe Grazzini, Cremona, Italy 1972; *Motocross*, with text by Michele Verrini, Verona 1974; *Ski*, with text by Guido Oddo, Verona 1976; *Basket*, with text by Aldo Giordani, Verona 1976; *La Scala Theatre*, with text by Raoul Radice, Verona 1978; *La Scala Theatre*, pamphlet, Monza, Italy 1978; *The New China*, pamphlet, Como, Italy 1980; *Ballet*, pamphlet, Como, Italy 1981; *Ballet*, with text by Mario Pasi, Monza, Italy 1981; *Sea Light*, with text by Vittorio G. Rossi, Como, Italy 1981.

On LOTTI: books—*2nd World Exhibition of Photography*, exhibition catalogue, by Karl Pawek, Hamburg 1968; *Primo Almanacco Fotografico Italiani*, edited by Lanfranco Colombo and Roberta Clerici, Milan 1969; *The Land: 20th Century Landscape Photographs Selected by Bill Brandt*, exhibition catalogue, edited by Mark Haworth-Booth, London 1975; *Photojournalism* by Cliff Edom, Dubuque, Iowa 1976; *Catalogo Nazionale Bolaffi della Fotografia*, Turin 1976; *Geschichte der Fotografie im 20. Jahrhundert/Photography in the 20th Century* by Petr Tausk, Cologne 1977, London 1980; *70 Anni di Fotografia in Italia* by Italo Zannier, Modena, Italy 1978; *Dument Foto 1*, Cologne

1978; *Exploring Photography*, London 1978; *Venezia: La Fotografia '79*, exhibition catalogue, with text by Carlo Bertelli Electa, Milan 1979; *Dumont Foto 2*, Cologne 1980; *Des Murs dans la Ville*, with text by Gilles de Bure, Paris 1981; articles—"Mare" by Fabio Consiglio in *Nuova Fotografia* (Naples), June 1972; "Il Duomo Avvelenato" by Angelo Schwarz in *Fotografia Italiana* (Milan), December 1972; "Si è Rotto il Vaso Cinese" by Pier Paolo Preti in *Fotografia Italiana* (Milan), May 1973; "Giorgio Lotti World Understanding Award" in *News Photographers*, October 1974; "Giorgio Lotti Cultura è Tecnica all Ricerca dei Simboli che Toccano il Sentimento" by M. Capobussi in *Progresso Fotografico* (Milan), December 1975; "Visage de la Photo Italienne: Giorgio Lotti" in *News Reporter* (Paris), March 1977; "Tre Anni all Scala" by Giampiero Carli Balolla in *Il Fotografo* (Milan), February 1978; "Giorgio Lotti" by Attilio Colombo, special monograph issue of *Progresso Fotografico* (Milan), September 1978; "Una preziosissima Fotografia di Zhou en Lai" by Yuan Huaquin in *Remin Ribao* (Peking, China), March 1979; "Giorgio Lotti" by Carlo Arturo Quintavalle in *Enciclopedia Pratica per Fotografare*, Milan 1979; "Danza è Bello" by Mario Pasi in *Il Diaframma* (Milan), February 1981; "I Nuovi Maestri del Colore" by Daniela Palazzoli in *Bolaffi Arte* (Turin), May 1981.

For me photography is an art which allows me to express the joy of living.

—Giorgio Lotti

Giorgio Lotti joined the great illustrated news magazine *Epoca* (of which he is now an outstanding member of the photographic staff) after some concentrated experience in press photography with a number of different agencies. With them he acquired a great professional skill at being "on the spot" and achieving a swift synthesis of events with his camera, often rendering them in pictures of great evocative effect.

There are two basic characteristics in Giorgio Lotti's reportage. First and foremost, his themes: especially with subjects that he has chosen for himself (often working independently of the requirements of his paper), he has a cool capacity for indignation born of a social conscience tempered as it were with a melancholy prudence. In Italy, in particular, he is famous for his work on Venice, dilapidated and abandoned, on Milan Cathedral poisoned by the smog, on the Po delta after the flood. The other feature of Lotti's pictures is his urgent desire to know and to take part, as if his camera were an instrument for sharing other people's experiences rather than simply depicting them. He seldom photographs anyone he has not got to know, and every portrait, every sitting, is preceded by a long dialogue (sometimes face to face, sometimes through scrupulous correspondence) with the subject he is about to face. These characteristics inform his work on the Alaska of Jack London or the China of Chou En-lai, the Scala in Milan, the evidence of corruption that he has pursued all over Italy, his sports reports, and the hundreds of great personages that he has presented to the readers of his magazine.

The extreme respect with which Lotti treats his subjects is all of a piece with the great respect that he accords his public. A most careful craftsman, intolerant of imprecision, he gives us intelligently structured, highly concentrated photographs arranged in a narrative sequence that is concise but of great psychological impact. A master narrator, often by the use of particular details, Lotti displays a notably fresh approach to reportage and to photographic illustration.

In these two fields an essential role is also played by his vivid feeling for color, graphically lively and very carefully controlled in composition and in expressive motives, revealing the spirit not merely of the reporter but also of the artist. And that is something that appears too, not only in some of his journalistic work (his portrait of Chou En-lai, for instance) but in his graphic studies of the sea, the sun, the snow—richly creative and expressive pictures.

—Attilio Colombo

Giorgio Lotti: *The Sea* (original in color), 1970

LOUNEMA, Risto.

Finnish. Born in Pori, 10 April 1939. Educated at Helsingin Kaksoisyhteislyseo, Helsinki, 1956-59; studied photographic chemistry at the University of Helsinki, 1960-71 (Student Art Prize, 1967; Finnish Cultural Foundation Scholarship, 1969), B.S. 1966, M.S. 1971. Served in the Finnish Army, 1959-60. Married Inari Viljamaa in 1966; children: Tomi and Teppo. Took first photographs, 1952; professional freelance photographer, Helsinki, since 1962 (in Lapland, 1971-74). Member, 1962, and Vice-Chairman, 1969-70 and since 1971, and Chairman, 1970-71, Photographic Museum Society of Finland, Helsinki. Member, Finnish Union of Journalists, and International Federation of Journalists, 1971-78. Recipient: 3 Silver Medals, 7 Bronze Medals, *World and Its People* photo contest, *World's Fair*, New York, 1964; Photo Artists Personal State Prize, Helsinki, 1967; 2 Silver Medals, Nikon Photo Contest International, Tokyo, 1971; Artist's Award, Lapland District Art Commission, 1972; Journalism Scholarship, Ministry of Education, Helsinki, 1978. Address: Pihlajatie 18 A 9, SF-00270 Helsinki 27, Finland.

Individual Exhibitions:

1967 *Arctica*, Art Saloon Pinx, Helsinki (travelled to the Library, Rovaniemi, Finland, and the Library, Luleå, Sweden, 1968)
1969 *Reidar Särestöniemi*, Library, Rovaniemi, Finland
1971 *Reindeer*, Murmansk Museum, U.S.S.R.

Selected Group Exhibitions:

1964 *The World and Its People*, at the *World's Fair*, New York
1975 *The Land: 20th Century Landscape Photographs Selected by Bill Brandt*, Victoria and Albert Museum, London (travelled to the National Gallery, Edinburgh; Ulster Museum, Belfast; and National Museum of Wales, Cardiff, 1976)

Collections:

Victoria and Albert Museum, London; Carl Zeiss Collection, Opton, Oberkochen, West Germany; Murmansk Museum, U.S.S.R.; International Museum of Photography, George Eastman House, Rochester, New York.

Publications:

By LOUNEMA: book—*Linnanmäki*, Helsinki 1970; articles—"State of Abasement in Our Photobooks" in *Valokuvaaja* (Helsinki), January 1968; "What Is Camera Art and Who Makes It" in *Valokuvaaja* (Helsinki), June 1968; "Critics on Photobooks" in *Uusi-Foto* (Helsinki), March 1978 and February 1979; "Photography as Fine Art" in *Kameralehti* (Helsinki), August 1979; "National Geographic Magazine" in *Kameralehti* (Helsinki), February 1980; films—*Linnanmäki*, 1971; *Hirvi*, 1972; *Pakkasen Maa*, 1972; *Koilliskaira*, 1972; *Poroelo*, 1973; *Murmansk*, 1973; *Käsivarsi*, 1973; *Peikko*, 1975; *Maan Arpi*, 1975; *Joutsen*, 1976.

On LOUNEMA: articles—"Solen" in *Foto* (Stockholm), December 1964; "Risto Lounema" in *Photoalmanach International*, Dusseldorf 1965; "Die Sonne als Bildelement" in *Foto Prisma* (Dusseldorf), July 1965; "Cielo Nordico" in *Foto Magazin Italiana* (Como), July 1965; "Sun" in *Photography Annual*, New York 1966; "Risto Lounema" in *Foto Prisma* (Dusseldorf), November 1966; "Fotografiert, Wenn die Nacht Auffliegt" in *Spiegelreflex*

Praxis (Dusseldorf), June 1967; "Kaksi kuvaa Arctica-Näyttelystä" by Kimmo Eskola in *Valokuvaaja* (Helsinki), June 1967; "Arktista Eksotiikaa" by Hilja Raviniemi in *Kameralehti* (Helsinki), September 1967; "Mit Tele und Weitwinkel auf Renntierfang" in *Spiegelreflex Praxis* (Dusseldorf), February 1968; "Perspective 2000" in *Spiegelreflex Praxis* (Dusseldorf), August 1969; "Moderne Nordlandstudie" in *Spiegelreflex Praxis* (Dusseldorf), December 1969; "Risto Lounema" by Risto Laine in *Kameralehti* (Helsinki), January 1970; "Risto Lounema: Linnanmäki" by P.K. Jaskari in *Kameralehti* (Helsinki), April 1970; "Så här Skall en Fotobok Göras" by Åke Emmer in *Foto* (Stockholm), November 1970; "Na Snimkah-Olenevody" by B. Sokolow in *Polarnaja Pravda* (Murmansk, U.S.S.R.), April 1971; "Gesicht" in *Reflex* (Dusseldorf), October 1972; "Snimki Rasskazyvajut o Prirode i Ljudjah" by A. Telegin in *Arktik Star* (Murmansk, U.S.S.R.), April 1973; "The Era of Magazine Photography's Sorrow and Joy" by Pauli Myllymäki in *Finnish Photographic Yearbook*, Helsinki 1977; "Risto Louneman Kriittinen Puheenvuoro" by Tapani Kovanen in *Kameralehti* (Helsinki), June 1979.

After becoming a professional photojournalist in 1962, it soon became clear to me what was happening to Finnish photography. Photojournalism was dead, and creative photography was subordinated to the medium's use in propaganda for the system. Marxism and Maoism were the only orthodox doctrines and criteria. Even today they are the basis for education in the field.

At the end of the decade photography was officially incorporated within the state administration. Thereafter, state photography, and only state photography, has been supported. The amount of support by now comes to millions of dollars.

A totalitarian system has always been strange to me. Right from the beginning I have wanted to act as a freelance photographer: I believe that a photographer is an interpreter of his time, not a state official receiving a regular salary. I appreciate the western cultural idea of the freedom of art, not subject to the orders and instructions of the establishment. In addition, I have chosen the "wrong" subjects; the landscape, sun and moon, themes that do not interest politicians but have always fascinated mankind.

I am, therefore, because of my attitude, someone who does not exist, set aside, separated from the money flow.

The value of a photographer is not, however, estimated in dollars or rubles. It is judged by the general public, critics, and the future. This undoubted fact gives me new strength.

—Risto Lounema

Finland sits high on the forehead of the globe, braced between the Baltic Sea and the Soviet Union. While nearly one-fourth of the country rests above the Arctic Circle, Gulf Stream currents give Finland gentle, civilized summers. Lean and flat, with as much lake surface as birch and pine acreage in some regions, Finland stretches as far as the eye can see.

This land of less than five million people, it is a photographer's paradise. Nights are never dark; twilight merely drifts, unannounced, into dawn. Above the Arctic Circle, it is possible to watch the sun set, then, in the very same minute, watch the sun rise. Land, lakes, and sky create a 24-hour natural light studio.

In winter the laws of darkness prevail. Reciprocity failure becomes a photographer's household word. Luckily, the Finnish language is rich with curses. In northern Lapland, lack of sunlight turns the land into solid, unbroken sheets of ice and snow; a gelid serenity falls upon the landscape several hours each afternoon as a red dot of sunlight, never high off the horizon, throws its pale fire across the icy blue tundra.

It is not surprising that such schizophrenic visitations of the sun would impassion Finnish photographers, like Risto Lounema, as much as they have aroused and inspired Finland's most beloved poets, painters, sculptors, designers and composers. The awe and affection Finns, in general, feel for their natural environment has always had its greatest impact on the souls of Finnish artists. Indeed, it can be said that some of the very best art of Finland has been an art about nature. Certainly Lounema's determination to arrest the effulgent splendors of Finland's natural forces, as revealed in his grain-textured photographs of the sun and moon—of birds migrating just above the treetops—approaches the very pinnacle of such movitations.

—Arno Rafael Minkkinen

Risto Lounema: *Winter Moon above Archipelago,* 1964

LUSKACOVÁ, Markéta.

Czechoslovak/British. Born in Prague, 29 August 1944; emigrated to Britain, 1975. Studied social sciences and journalism at Charles University, Prague, 1961-67, B.A. 1967; also attended the technical photography course, Academy of Film Arts, Prague, 1967-69. Married the writer Franz Wurm in 1971 (separated, 1975); subsequently lived with the photographer Chris Killip; son: Matthew. Worked as a freelance photographer for Theatre Behind the Gate, Prague, 1970-71, and for *Zdravi* (Czech Red Cross) magazine, 1972-73; freelance photographer, based mainly in Zurich, 1973-74. Freelance photographer, in London, since 1975. Member, Photography Section, Czech Artists Union, 1969; with Magnum Agency, Paris, 1976-80. Recipient: Czech Artists Union Fellowship, 1970-71; Arts Council of Great Britain Award, 1975, 1976. Address: 63 Blenheim Crescent, London W11, England.

Individual Exhibitions:

1972 *Pilgrimages*, Theatre Behind the Gate, Prague
1973 *3 Photographers*, Roundnice, Czechoslovakia
 3 Czechs, Galerie Wilde, Cologne
1974 *3 Photographers*, Bibliothèque Nationale, Paris

Selected Group Exhibitions:

1969 *Czechoslovakian Photography*, Obecni Dum, Prague
1975 *Women of Photography*, San Francisco Museum of Art (toured the United States, 1975-77)
1978 *Beaches in the North East*, Side Gallery, Newcastle upon Tyne (travelled to the University of Cardiff)
1980 *Photographs from the Arts Council Collection*, Hayward Gallery, London
1981 *Leisure Time in North Tyneside*, Side Gallery, Newcastle upon Tyne

Collections:

Arts Council of Great Britain, London; Victoria and Albert Museum, London; Moravian Art Gallery, Brno, Czechoslovakia; Museum of Decorative Arts, Prague; Galerie Wilde, Cologne; Bibliothèque Nationale, Paris; San Francisco Museum of Modern Art.

Publications:

On LUSKACOVÁ: books—*3 Photographers*, exhibition catalogue, by Anna Fárová, Roundnice, Czechoslovakia 1973; *British Image 2*, edited by the Arts Council, London 1976; articles—"Portfolio: Markéta Luskačová" in *Camera* (Lucerne), August 1969; "Markéta Luskačová" in *Creative Camera* (London), October 1971; article by Daniela Mrázková in *Ceskoslovenské Fotografie* (Prague), March 1973; article in *Creative Camera* (London), November 1973; "Markéta Luskačová" by Allan Porter in *Camera* (Lucerne), July 1974; article in *Du* (Zurich), December 1974; "Markéta Luskačová" in *Creative Camera Yearbook 1976*, London 1975; article in *Camera Mainichi* (Tokyo), December 1976; article in *Photocinéma* (Paris), August 1977.

I began to take photographs when I needed to illustrate my thesis on traditional religion in Czechoslovakia. After more than 10 years' full-time involvement in photography, I still consider that my work at its best is a way of practising sociology of a rather odd kind.

I am very concerned with the aesthetics of photography, but not for its own sake. My interest is primarily in subject. I like to take my time to get close to the subject. I usually compose my photographs in series of images but work so that each picture, both visually and in human terms, is strong enough to exist on its own.

Since I came to live in Western Europe I have worked as a photo-journalist. I enjoy the experience. I think that *Tagesanzeiger* in Zurich has recognized the nature of my work and used it well.

—Markéta Luskačová

Markéta Luskačová left Czechchoslovakia in the early 1970's; she settled in London in 1975 as a free-lance photographer working for magazines as a photo-journalist and concentrating on picture essays rather than on immediate news stories. Her series on street musicians in London and on the house run by Erin Pizzy for battered mothers and babies reflect her interest in the social conditions of our time and certainly stem from her early studies in the social sciences.

There is perhaps a pervading aura of gloom and despair in many of her photographs. Partly, of course, this has to do with the subject matter, but it is enhanced by her printing, which she uses to underline her emotional reaction to situations. Even the series on the seaside finds the adults huddled against the wind; the skies are grey and forbidding. However, in the children Luskačová clearly finds hope for the future: they laugh and move with an innocence that is particularly touching when contrasted to the adult life around them.

The first series of her pictures seen in the West was the documentary on the Czech pilgrimage, and it was clear from these photos that what could have been merely a document became in the hands and with the eyes of Luskačová a great deal more. It is not simply because these people are strange to us that they are so moving; the strong composition and graphic quality of the pictures simply reinforces the intense interest and compassion of the photographer for them as human beings.

Compassion is the common thread through all of her photographs, whether they be of rather unsavoury characters to be found around the street-markets of London or the street musicians and down-and-outs in other parts of town: she passes no judgment on them, but rather on our society. And, where society has seemingly removed the dignity of human beings, Luskačová strives through her photographs to give it back to them. Her pictures of children remind us that life promises things that we can make possible only by conscious effort at every level, and her strength lies in her ability to make us feel personally involved in working for a better future for these and all our children.

—Sue Davies

Markéta Luskačová: *Sleeping Children* from the series *Sumiac*, 1971

LYNES, George Platt.

American. Born in East Orange, New Jersey, 15 April 1907. Educated in private schools in New Jersey until 1925; studied briefly at Yale University, New Haven, Connecticut, 1926; self-taught in photography. Worked as a salesman at Brentano's bookstore, New York, 1926; publisher of books and booklets by Gertrude Stein, René Crevel and Ernest Hemingway, as Stable Publications, New York, 1926; Proprietor, Park Place Bookshop, Englewood, New Jersey, 1927-28; freelance portrait photographer, Paris and New York, 1928-32; established studio in New York, 1932; Head of *Vogue* studios, Hollywood, California, 1946-48; freelance magazine and fashion photographer, working for *Town and Country, Harper's Bazaar, Vogue*, etc., New York, 1948 until his death, 1955. Agent: Sonnabend Gallery, 420 West Broadway, New York, New York 10012. *Died (in New York) in 1955.*

Individual Exhibitions:

1928 *Portrait Photographs*, Park Place Bookshop, Englewood, New Jersey
1932 *Walker Evans and George Platt Lynes*, Julien Levy Gallery, New York
 Leggett Gallery, New York

1934 Julien Levy Gallery, New York

1941 *200 Portraits and Less Formal Pictures*, Pierre Matisse Gallery, New York

1960 *Portraits*, Art Institute of Chicago

1977 Sonnabend Gallery, New York (retrospective)

1979 Nicholas Wilder Gallery, Los Angeles

1980 Robert Samuel Gallery, New York (with Robert Crowl)

Institute of Contemporary Art, Boston (with Florine Stetlheimer)

1981 *Photographs 1931-1955*, Robert Miller Gallery, New York

Selected Group Exhibitions:

1936 *Fantastic Art, Dada and Surrealism*, Museum of Modern Art, New York

1967 *Photography in the 20th Century*, National Gallery of Canada, Ottawa (toured Canada and the United States, 1967-73)

1976 *Photographs from the Julien Levy Collection, Starting with Atget*, Art Institute of Chicago

1977 *Documenta 6*, Museum Fridericianum, Kassel, West Germany

Fotographische Künstlerbildnisse, Museum Ludwig, Cologne

1979 *Photographie als Kunst 1879-1979*, Tiroler Landesmuseum, Innsbruck, Austria (travelled to the Neue Galerie am Wolfgang Gurlitt Museum, Linz, Austria; Neue Galerie am Landesmuseum Joanneum, Graz, Austria; and Museum des 20. Jahrhunderts, Vienna)

A Survey of the Nude in Photography, Witkin Gallery, New York

Photographic Surrealism, New Gallery of Contemporary Art, Cleveland (travelled to the Dayton Art Institute, Ohio, and the Brooklyn Museum, New York)

Fleeting Gestures: Dance Photographs, International Center of Photography, New York (travelled to The Photographers' Gallery, London, and *Venezia '79*)

1981 *The Nude in Photography*, San Francisco Museum of Modern Art

Collections:

Metropolitan Museum of Art, New York; Museum of Modern Art, New York; New York Public Library, Lincoln Center; International Museum of Photography, George Eastman House, Rochester, New York; Smith College, Northampton, Massachusetts; Institute for Sex Research, Bloomington, Indiana; Art Institute of Chicago.

Publications:

By LYNES: books—*The New York City Ballet*, with Martha Swope, text by Lincoln Kirstein, New York 1973; *George Platt Lynes: Photographs 1931-55*, edited by Jack Woody, Pasadena, California 1981; article—"Ballet: George Platt Lynes," special issue of *Dance Index* (New York), December 1944.

On LYNES: books—*12 American Photographers*, exhibition catalogue, by Ebria Feinblatt, Los Angeles 1948; *Photography in the 20th Century* by Nathan Lyons, New York 1967; *The Magic Image* by Cecil Beaton and Gail Buckland, London and Boston 1975; *Photographs from the Julien Levy Collection, Starting with Atget*, exhibition catalogue, by David Travis, Chicago 1976; *Documenta 6/Band 2*, exhibition catalogue, edited by Klaus Honnef and Evelyn Weiss, Kassel and Cologne 1977; *Fotografie der 30er Jahre*, edited by Hans-Jürgen Syberberg, Munich 1977; *Fotografische Künstlerbildnisse*, exhibition catalogue, by Dieter Rönte, Evelyn Weiss and Jeane von Oppenheim, Cologne 1977; *The History of Fashion Photography* by Nancy Hall-Duncan, New York and Paris 1979; *Photographic Surrealism*, exhibition catalogue, by Nancy Hall-Duncan, Cleveland 1979; *Photographie als Kunst 1879-1979/Kunst als Photographie 1949-1979*, exhibition catalogue, 2 vols., by Peter Weiermair, Innsbruck, Austria 1979; *The Photograph Collector's Guide* by Lee D. Witkin and Barbara London, Boston and London 1979; articles—"Studio Fashions: George Platt Lynes—Fashion and Portrait Photographer" by Philip Andrews in *The Complete Photographer* (New York), vol. 6, no. 26, 1942; "Platt-Lynes" in *Photo* (Paris), February 1981.

George Platt Lynes: *Marsden Hartley*, 1943 Courtesy Art Institute of Chicago

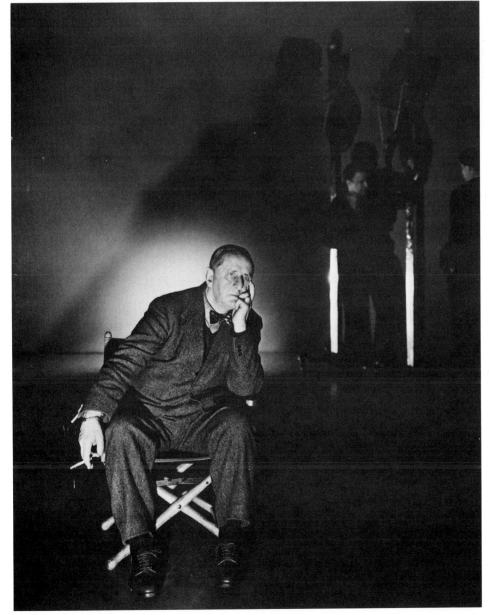

During his painfully short career George Platt Lynes managed to make a name for himself in at least three quite different branches of photography. He is probably best-known at the moment for his male nudes—rather unfairly so and sometimes for the wrong reasons, since, as Sir Kenneth Clark has pointed out, there is a ponderable difference between the naked and the nude. By current standards Lynes' nudes are decidedly soft-core: they are sensuous but not insistently erotic; they are frequently campy and sometimes concerned with nothing more than the unexpected play of light and shadow over a small body area. For a number of years Lynes also worked for *Vogue* and evidently produced remarkable work there as well; but at the time of his death he left instructions that his fashion negatives be destroyed. "This was a pity," Lincoln Kirsten has commented, "but he grew to dislike the automatic and factitious shiftings of the mode by which he made his living."

His portraits, Kirsten goes on, represent his "great work": Lynes "fixed the face of nearly every artist and writer and musician of importance in his epoch, in a unique attitude. He has seen their faces as a symbol of the particular quality of their essential talent, not as a melodramatic mask which reflects the corroboration of a public icon.... Sometimes he used accessories in the manner of symbolic badges; sometimes an object found around the studio suggested itself as a good positive or negative complementary shape.... He chose characteristic silhouettes, stance, cant of heads on necks, the placement of fingers, which somehow stamped the sitter. One tool he used supremely was flattery, not in his final focus, but as the slow or staccato approach to it. He wanted you to look your best—that is: most yourself."

Not all the portraits deserve this handsome tribute. There are a good many which look like malicious parodies of Hollywood publicity shots: the melodramatically over-lit, kitsch portraits of Edna Ferber and Katherine Anne Porter, for example, and even worse, a series called "Edith Sitwell Crowned." But there are many more which are even finer than Kirsten suggests: a superlative 1931 portrait of Gertrude Stein, a startling 1935 portrait of

Danny Lyon: *Track, McHenry, Illinois,* **1966** Courtesy Art Institute of Chicago

Colette, and by far the most revealing portrait ever made of the elusive T.S. Eliot. At his best—and there are many other examples which might be cited—Lynes was the equal of Gisèle Freund at her best. It is something of a scandal that in the age of image junkies, as Susan Sontag calls us, so few of these memorable works have ever been reproduced.

—Elmer Borklund

LYON, Danny.

American. Born in Brooklyn, New York, 16 March 1942. Studied history at the University of Chicago, 1959-63, B.A. 1963 (Staff Member and Photographer, Student Non-Violent Coordinating Committee, 1963); self-taught in photography. Staff Photographer, Chicago Outlaws motorcyclists' club, 1965-66; independent photographer, Latin America and New Mexico, since 1967; also filmmaker, since 1969. Associate, Magnum Photos co-operative agency, New York, since 1967. Recipient: Guggenheim Fellowship in Photography, 1969, in Filmmaking, 1979. Address: c/o Bleak Beauty, 191 Chrystie Street, 5A, New York, New York 10002, U.S.A.

Individual Exhibitions:

1966 Art Institute of Chicago
1968 South Street Museum, New York
1969 Art Institute of Chicago
1970 San Francisco Art Institute
 Rice University, Houston
 Fogg Art Museum, Harvard University, Cambridge, Massachusetts
1971 University of Chicago
1972 University of Nebraska, Lincoln
1973 10 Years of Photographs, Newport Harbor Art Museum, Newport Beach, California
1980 Simon Lowinsky Gallery, San Francisco
1981 Photograph Gallery, New York
 Equivalents Gallery, Seattle
1982 Philadelphia Museum of Art

Selected Group Exhibitions:

1966 The Photographer's Eye, Museum of Modern Art, New York
 Toward a Social Landscape, International Museum of Photography, George Eastman House, Rochester, New York
 Contemporary Photography since 1950, International Museum of Photography, George Eastman House, Rochester, New York
 American Photography: The 60's, University of Nebraska, Lincoln
1967 12 Photographers of the American Social Landscape, Brandeis University, Waltham, Massachusetts
 Photography in the 20th Century, National Gallery of Canada, Ottawa (toured Canada and the United States, 1967-73)
1974 Photography in America, Whitney Museum, New York
1977 The Photographer and the City, Museum of Contemporary Art, Chicago
 Concerning Photography, The Photographers' Gallery, London (travelled to the Spectro Workshop, Newcastle upon Tyne)

1978 Mirrors and Windows: American Photography since 1960, Museum of Modern Art, New York (toured the United States, 1978-80)

Collections:

Philadelphia Museum of Art; Art Institute of Chicago; University of Nebraska, Lincoln; Museum of Fine Arts, Houston; University of New Mexico, Albuquerque; University of California at Los Angeles.

Publications:

By LYON: books—The Movement, with text by Lorraine Hansberry, New York 1964, as A Matter of Colour, London 1964; The Bikeriders, New York 1968; The Destruction of Lower Manhattan, New York 1969; Conversations with the Dead, New York 1971; The Autobiography of Billy George McCune, editor, San Francisco 1973; The Paper Negative, Bernalillo, New Mexico 1980; Pictures from the New World, Millerton, New York 1981; films—Social Sciences, 1969; Llanito, 1971; El Mojado, 1973; Los Niños Abandonados, 1975; Dear Mark, 1975-80; Little Boy, 1977.

On LYON: books—The Photographer's Eye by John Szarkowski, New York 1966; American Photography: The 60's, exhibition catalogue, Lincoln, Nebraska 1966; Toward a Social Landscape: Contemporary Photographers, exhibition catalogue, by Nathan Lyons, New York 1966; 12 Photographers of the American Social Landscape, exhibition catalogue, by Thomas H. Garver, Waltham, Massachusetts 1967; Photography in the 20th Century, exhibition catalogue, by Nathan Lyons, New York 1967; America in Crisis: Photographs for Magnum, edited by Charles Harbutt and Lee Jones, with an essay by Michael Levitas, New York 1969; Danny Lyon: 10 Years of Photographs, exhibition catalogue, with text by Thomas H. Garver, Newport Beach, California 1973 (includes bibliography); Photography in America, edited by Robert Doty, with an introduction by Minor White, New York and London 1974; Photographs: Sheldon Memorial Art Gallery Collection, University of Nebraska, with an introduction by Norman A. Geske, Lincoln, Nebraska 1977; Concerning Photography, edited by Jonathan Bayer and others, London 1977; The Photographer and the City, exhibition catalogue, by Gail Buckland, Chicago 1977; Mirrors and Windows: American Photography since 1960 by John Szarkowski, New York 1978; Light Readings: A Photography Critic's Writings 1968-1978 by A.D. Coleman, New York 1979; articles—"Danny Lyon" in Du (Zurich), October 1965; "Danny Lyon" in Camera (Lucerne), February 1977.

Photographers traditionally have worked in silence, putting everything into the picture, that small area, measured in inches, that they have staked out. I have never done that, but have usually presented my photographs in books with a text. In the texts I have spoken through other people's voices, sometimes out of respect for what they had to say, and sometimes as a disguise for myself.

—Danny Lyon

Danny Lyon's sympathetic documentary photographs have always been based on direct participation. The Movement, his first book, grew out of political involvement rather than artistic or journalistic interest. As a member of the Student Non-Violent Coordinating Committee, he experienced first hand all that he photographed of the early 60's Civil Rights Movement. After that he bought a motorcycle and spent two years riding with a group

of bikers to make a sensitive and perceptive book, The Bikeriders, which looks past the obvious attraction of bikers as anti-social outlaws to explore the often ritualistic sources of their activity. In these pictures he focuses on their costumes, their expressions and their gestures, and he shows the roles they assume as they gather to laugh and drink together.

In his next well-known project and book, Conversations with the Dead, Lyon takes on the difficult task of documenting life in Texas prisons. Always aware of the problematic relationship between photography and social change, Lyon didn't pretend that his study would alter the conditions or that it could even capture the full extent of the inmates' struggles. As he says in the introduction, "The material I have collected doesn't approach for a moment the feeling you get standing for two minutes in the corridor of Ellis." Yet the very completion of the project conveys his commitment to these men living in captivity. His straightforward, sometimes lyrical photographs, which consciously avoid simple condemnation of the ever-present guards or the oppressive regimen, create a vehicle through which the inmates can speak. Lyon's particular strength, then, resides in his willingness to submerge his own personality in order to allow the prisoners a voice.

The autobiographical nature of his most recent book, The Paper Negative, brings to light Lyon's current struggle to produce meaningful images. The text, spoken in the third person using a pseudonym, is a narrative woven loosely around the images which blends realistic occurrence with emblematic event and carries a subtle ambivalence through each of its episodes. His letter to the president of the National Endowment for the Arts (concerning an $8,000 grant he had received) which begins the book, reveals his underlying dilemma: "Finally I can only state that I have failed you in your choice of grantee, for I have not documented life in the Valley of the Rio Grande. I have lived there, but tens of thousands of others have been doing that for years and that alone would hardly qualify them for a grant." Although he is an accepted resident in his community, he is unnaturally separated from its people because of his strange privilege—a privilege he shares with most white Americans.

The photographs of this book are more objective, more detached than his earlier works. They show people and their surroundings as they appear, not as he would like them to appear. The significance of Lyon's message lies in the fact that he doesn't espouse simplistic humanism; he isn't searching for easy answers to social problems, he isn't trying to instill a false sense of solidarity with other peoples. Various pictures of prostitutes and street urchins reflect an acceptance that goes beyond empathy or compassion, and pictures such as the one of two young men working on a car's engine, a father calmly cleaning a gun in front of his wife and child, or others of field workers deny a reading that judges the people or draws any immediate conclusions. The power of these, and all his photographs, comes from the sensitive rendering of particular human situations presented with an unsettling irony that makes you question your own feelings. His images resonate with ambivalence, yet they resonate with life.

—Ted Hedgpeth

LYONS, Joan.

American. Born in New York City in 1937. Educated at Alfred University, Alfred, New York, B.F.A. 1957; studied photography at the State University of New York at Buffalo, M.F.A. 1973. Married Nathan Lyons; children: Elizabeth, David, Ethan. Independent photographer. Instructor since 1971, and Coordinator of the Workshop Press since 1972, Visual Studies Workshop, Rochester, New York. Recipient: Creative Artists Public Service Grant, 1975, 1981. Address: c/o Visual Studies Workshop, 31 Prince Street, Rochester, New York 14607, U.S.A.

Individual Exhibitions:

1963 Schuman Gallery, Rochester, New York
1965 Schuman Gallery, Rochester, New York
Alfred University, Alfred, New York (with Nathan Lyons)
1969 Nazareth Arts Center, Rochester, New York
1970 Schuman Gallery, Rochester, New York
1975 Jorganson Gallery, University of Connecticut, Storrs (with Eileen Cowan)
Moncton Arts Center, New Brunswick, Canada
Picker Gallery, Colgate University, Hamilton, New York (with Scott Hyde)

1977 University of Colorado, Boulder (with Paul Diamond)
1979 Catskill Center for Photography, Woodstock, New York
1981 Portland School of Art, Oregon

Selected Group Exhibitions:

1963 *Western New York Exhibition*, Albright Knox Gallery, Buffalo, New York
1969 *The Serial Image*, Purdue University, Lafayette, Indiana
1970 *Into the 70's: Photographic Images by 16 Artists/Photographers*, Akron Art Institute, Ohio
1975 *Women of Photography*, San Francisco Museum of Modern Art (toured the United States, 1975-77)
Photographic Process as Medium, Rutgers University Art Galley, New Brunswick, New Jersey
1976 *Photographie: Rochester, New York*, Centre Culturel American, Paris
1978 *Mirrors and Windows: American Photography since 1960*, Museum of Modern Art, New York (toured the United States, 1978-80)
1979 *4 Rochester Women Artists*, State University College Gallery, Brockport, New York
Attitudes: Photography in the 1970's, Santa

Barbara Museum of Art, California
1980 *Visual Studies Workshop: The First Decade*, Pratt Manhattan Center, New York

Collections:

Museum of Modern Art, New York; Seagram Collection, New York; Visual Studies Workshop, Rochester, New York; Memorial Art Gallery, Rochester, New York; International Museum of Photography, George Eastman House, Rochester, New York; Art Gallery, Princeton, New Jersey; Exchange National Bank, Chicago; Museum of Fine Arts, Houston; Center for Creative Photography, University of Arizona, Tucson; National Gallery of Canada, Ottawa.

Publications:

By LYONS: books—*Self Impressions*, 1972, *In Hand*, 1973; *Wonder Woman*, with Julie McGrath, 1973; *Busform Shadows*, 1973; *Bride Book Red to Green*, Rochester, New York 1975; *Abby Rogers to Her Grand-Daughter*, with text by Abby Rogers, New York 1977; *Perspectives I to VIII*, 1978; *Full Moon*, 1978; *Sunspots*, 1978; *Spine*, with Philip Zimmerman, New York 1980; article—interview in *Photography Between Covers* by Tom Dugan, Rochester, New York 1979.

On LYONS: books—*In the 70's: Photographic Images by 16 Artists/Photographers*, exhibition catalogue, with text by Tom Muir Wilson, Orrel E. Thompson and Robert M. Doty, Akron, Ohio 1970; *Photographic Process as Medium*, exhibition catalogue, with text by Rosanne T. Livingston, New Brunswick, New Jersey 1975; *The Photographers' Choice*, edited by Kelly Wise, Danbury, New Hampshire 1975; *Geschichte der Fotografie im 20. Jahrhundert/Photography in the 20th Century* by Petr Tausk, Cologne 1977, London 1980; *Mirrors and Windows: American Photography since 1960* by John Szarkowski, New York 1978; articles—"New Directions in Photography" in the *Christian Science Monitor* (Boston), 3 January 1977; "Portraits" by Julia Scully in *Modern Photography* (New York), June 1977; in the *Smithsonian Magazine* (Washington, D.C.), October 1980.

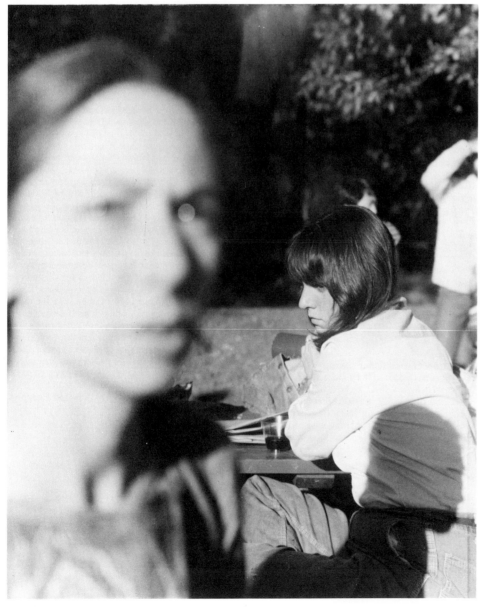

Joan Lyons: From *Presences* (originally color offset lithograph), 1981

Work is about process.
The shape it takes is the evidence of process.
The process of forming the work
The process of forming the worker
Are inseparable
I work with what is available, a variety of optical devices.
I work through complexity, to something simple and direct.
This distillation process becomes more evident as time goes on.
I want at those things that are evident;
How I see, not conventions of seeing.
What visual recording is about.
How systems shape data.
It is organic and about growth.

—Joan Lyons

The work of Joan Lyons evades traditional categorization. In her quest for self-expression, she has done copy printing, lithography, xerox drawing, offset printing, and bookmaking. Her images are made using printing and drawing as well as photographic processes. As she said when being interviewed by Tom Dugan in *Photographers Between Covers*, "I can't separate that out in my head and say that one is printmaking and one is photographing—they're all imaging."

Her work of the last decade has concentrated on

isolating objects in her immediate environment, preserving and transforming them through process. She has done plant studies, self-portraits, work about fabrics, and a number of books based on women's experience. Prints made with a Haloid-Xerox machine in black and color toners use organic plant forms to create pattern motifs reminiscent of illuminated manuscripts, weaving and architectural decoration. A group of self-portraits, life-size and confrontational, challenge the stereotype of images of women. Because they were pieced together from multiple transfers they have a slightly awkward, sometimes slightly grotesque presence which suggests that these representations are aspects of the female archetype rather than portraits of an individual.

Lyons is founder and coordinator of the Visual Studies Workshop Press, committed to the development and production of books by artists and photographers. She has printed a number of her own books as well. *Wonder Woman*, a book done in collaboration with poet Julie McGrath, features a housewife at her ironing board who spends her time preparing seduction speeches for male heros such as Charles Atlas and Sherlock Holmes, but who is later transformed into the comic strip version of Wonder Woman.

Bride Book illustrates the way in which Lyons' subjects and themes grow out of the techniques she employs. Intrigued by the successively lighter copies produced when turning off the ink supply of the printing press, she hit on the idea of simultaneous contrast (developed by the painter Josef Albers) in which two complementary colors of equal value make the image (a found portrait of a 1940's bride) disappear in the center of the page.

One of her more popular works, *Abby Rogers to Her Grand-Daughter*, is based on a letter found by one of her students which described a girl's childhood in a small town in the late 19th century. Since it has to do with the handing down of Abby Rogers' quilt, Lyons illustrated the letter with quilt fragments and other Victoriana. With this book, as with her art in general, she has attempted to move beyond the narrow art audience and appeal to anyone interested in a woman's personal story.

—Ted Hedgpeth

MacGREGOR, Greg(ory).

American. Born in La Crosse, Wisconsin, 13 February 1941. Educated at Logan High School, La Crosse, 1955-59; studied physics at the University of Wisconsin, Madison; studied photography, under Jack Welpott, Don Worth, Ruth Bernhard, Jerry Uelsmann and Henry Holmes Smith, at San Francisco State University, 1969-70, M.A. 1971. Independent photographer since 1966. Research Physicist, Lawrence Laboratory, University of California, Livermore, 1966-70; Assistant Professor of Art, Lone Mountain College, San Francisco, 1970-78. Assistant Professor of Art, University of California at Hayward, since 1980. Vice-President, Camerawork Gallery, San Francisco, 1979-81. Western Region Chairman, 1976-80, and National Conference Chairman, 1981, Society for Photographic Education. Agents: O.K. Harris, 383 West Broadway, New York, New York 10012; Equivalents Gallery, 1822 Broadway, Seattle, Washington; and Carson-Sapire Gallery, 1411 Market Street, Denver, Colorado. Address: 6481 Colby Street, Oakland, California 94618, U.S.A.

Individual Exhibitions:

1971 Brickwall Gallery, Berkeley, California
 California Silver Rush, Percy West Gallery, California College of Arts and Crafts, Oakland

1972 Memorial Union Art Gallery, University of California at Davis
 Heat Resistant Photographs, Student Union Gallery, University of California, Berkeley

1973 *Silver Eyebright and Epos*, Meramec Community College, St. Louis
 Contemporary Object as Symbol, Silver Image Gallery, Ohio State University, Columbus (travelled to Middle Tennessee State University, Murfreesboro, 1974)

1975 *Deus Ex Machina*, Center for Photographic Studies, University of Louisville, Kentucky
 Friends of Photography Gallery, Carmel, California

1976 *Oddities and the Western Landscape*, Focus Gallery, San Francisco
 The Western Landscape: An Alternative Approach, Mendocino County Museum, California

1977 *Deus Ex Machina*, Canon Photo Gallery, Amsterdam (travelled to the Galerie Image, Liège, and the Photo Redaction Galerie, Paris)
 Remains, Hyppolyte Bayard Memorial Gallery, Orange Coast College, Costa Mesa, California (travelled to the Photo Gallery, New York, 1978)

1979 *Three from California*, Florissant Valley College, St. Louis
 Deus Ex Machina, O.K. Harris Gallery, New York

1980 *Remains*, Lawson-DeCelle Gallery, San Francisco
 Explosions, Tyler School of Art Gallery, Temple University, Philadelphia

1981 *Color*, Pacific Light Gallery, Santa Cruz, California

Selected Group Exhibitions:

1970 *Photomedia U.S.A.*, San Diego State College, California

1972 *Contemporary Photographs*, University of Nebraska, Lincoln

1974 *Photographs from Drug Experience*, Siegfried Gallery, Athens, Ohio
 New Photographics 74, Central Washington State College, Ellensberg

1978 *On the Go*, Fine Arts Museum, San Francisco
 Color, Massachusetts Institute of Technology, Cambridge

1979 *Ten Photographers*, Equivalents Gallery, Seattle
 Attitudes: Photography in the 1970's, Santa Barbara Museum of Art, California

1981 *Contemporary Photoworks*, Albuquerque United Artists, New Mexico
 Contemporary Hand-Colored Photos, De Saisset Museum, Santa Clara, California

Collections:

Museum of Modern Art, New York; International Museum of Photography, George Eastman House, Rochester, New York; Art Institute of Chicago; Middle Tennessee State University, Murfreesboro; Graham Nash Collection, Los Angeles; Pasadena Art Museum, California; Southwestern College, Chula Vista, California; San Francisco Museum of Modern Art; California State University at San Francisco; Oakland Art Museum, California.

Publications:

By MacGREGOR: books—*Deus Ex Machina*, Berkeley, California 1975; *Darkroom Dynamics*, contributing editor, Marblehead, Massachusetts 1979; *Explosions: A Self-Help Book for the Handyman*, San Francisco 1980.

On MacGREGOR: articles—"Heat Resistant Photography" in *Artweek* (Oakland, California), 4 November 1972; "Deus ex Machina" in *Artweek* (Oakland, California), 5 April 1975; "7 Photographers" in *Artweek* (Oakland, California), 19 April 1975; "Photography" in *Artweek* (Oakland, California), 24 January 1976; "Explosions" in *Archetype* (San Francisco), vol. 2, 1979; "San Francisco" in *Artforum* (New York), May 1980; "Proof Sheet" in *Popular Photography* (New York), June 1980; "Playing with Matches" in *Wet Magazine* (Santa

Greg MacGregor: *Poodle-Shaped Explosion in the Vicinity of Cumulus Clouds, U.S. Route 70*, Colorado, 1978

Monica, California), December 1980; "A Dialogue on the Work" in *Picture* (Santa Fe Springs, California), no. 17, 1981.

During the past 15 years my involvement with photography has resulted in many apparent changes in the way my actual photographs look. I am referring here to style. I have gone from straight black-and-white to hand-painted toned images, to multiple printing, to straight color type C prints, and now to considering painting onto color photographs. I see these as stylistic changes only, sometimes responding to shifts in what I consider mainstream influences and sometimes just a whim to test out a new technique. This all of course results in a very abrupt change in the way the photograph looks. Beneath all this, however, are some fundamental concerns that I operate within which serve as my basic subject.

Among them is a commitment to challenge the way we *look* at photographs. To this end I play a lot with the believability of the photo image and challenge it critically, sometimes through recording phoney events. In other cases, such as *Deus Ex Machina*, through the use of believable multiple printing techniques. I challenge the use of the camera as a faithful data-taker, and consequently its ability to tell the truth.

As for specific subject matter: often I deal with some intersection of technology or science and society. I believe art should relate back to life, not art. And since I see a genuine conflict, beauty and confusion between my previous profession as a scientist and my present as an artist, I cannot ignore its influences in my art.

—Greg MacGregor

After working for a number of years as an experimental physicist, Greg MacGregor turned to photography and art in order to explore the world of fantasy and imagination. His images reflect the dual nature of his background, and they exploit the inherent duality of all photographs: they are made believable by a machine-like precision of description which is, in actuality, a total illusion. In his exploration of this paradox, MacGregor's manipulated photographs question the camera's ability to record the world accurately.

His book *Deus Ex Machina* contains a set of black-and-white photographs using multiple printing techniques to create surrealistic scenes pitting man against machine. Real and toy airplanes, helicopters, and automobiles appear in preposterous situations rendered believable by the camera's unblinking eye. *Explosions*, a series of pictures which straightforwardly record absurd events, is a satire on the do-it-yourself craze which swept America. In pseudo-scientific jargon one is instructed on how to herd chickens with fireworks, how to blow up your own office chair, or simply how to create interesting explosions. Showing the influence of performance art as well as earthworks, these pieces mirror our society's cultivation of senseless acts.

Images in a series entitled "Remains" show desolate landscapes littered with strange residue. Hand colored to heighten their fictional quality, they contain a silence in which the debris is charged with an eerie presence. In these prints, the skeleton of an unknown vehicle is made to look like a prehistoric relic, or the black space of a key-shaped hole in a concrete walk becomes an enigmatic symbol of the world's mysteries. Each picture contains a nearly recognizable, but yet unreal scene which seems to be frozen in time like a fossil.

MacGregor's most recent works are large, color photographs of graders, harvesters, dumptrucks, tractors, steamrollers, and other heavy equipment. Inspired by photo-realist painting, these are statically composed, objective pictures treating these American-made vehicles as icons. Using flat areas of primary color and subtly altered perspectives, he makes these objects look like Pop Art toys created for nothing more than pure aesthetic enjoyment. These images, like MacGregor's others, are about our society's love-hate relationship with machines, and they focus on that point where technology intersects normal life.

—Ted Hedgpeth

MACIJAUSKAS, Aleksandras.

Lithuanian. Born in Kaunas, 16 May 1938. Educated at the Kaunas Secondary School, 1945-62; studied philosophy at the University of Marxism-Leninism, Kaunas, 1976-77. Married Nijole Burdaite in 1959; children: Aukse and Marius. Worked in a machine-tool plant, Kaunas, 1956-67. Photographer since 1963. Photo-Correspondent, *Vakarines Naujienos* newspaper, Kaunas, 1967-73. Executive Secretary, Kaunas Branch of the Photographic Art Society of the Lithuanian S.S.R., since 1973. Recipient: First Prize, *International Photo Exhibition*, Ruzomberok, Czechoslovakia, 1969; First Prize, *Golden Eye '73* exhibition, Novy Sad, Yugoslavia, 1973; First Prize, *Exhibition of Jokes*, Kapsukas, Lithuania, 1973, 1976, 1979; Grand Prix, *I Salon International*, Orleans, France, 1975; Artist Award, Fédération Internationale de l'Art Photographique (FIAP), 1976; Special Prize, *Triennale of Photography*, Fribourg, Switzerland, 1978; First Prize, *Man and Earth* exhibition, Plateliai, Lithuania, 1980. Agent: Photographic Art Society of the Lithuanian S.S.R., Pionieriu 8, Vilnius 232600, Lithuanian S.S.R. Address: Taikos pr. 63-56, Kaunas 233036, Lithuanian S.S.R., U.S.S.R.

Individual Exhibitions:

1968 Ciurlionis Museum, Kaunas, Lithuania
1969 Union of Journalists, Moscow
1970 House of Print Trades Workers, Riga, Latvia
Mala Galerija, Bratislava, Czechoslovakia (retrospective)
Art Museum, Ruzomberok, Czechoslovakia
1971 House of Culture, Siauliai, Lithuania
People's Ethnographical Museum, Leningrad
1974 Tribina Maldih, Novy Sad, Yugoslavia (retrospective)
Bibliothèque Nationale, Paris
1975 Hotel de Ville, Arles, France
1976 Galeria Fotografiki, Warsaw (retrospective)
1977 Galeria Fotografiki, Krakow, Poland (retrospective)
House of Culture, Brno, Czechoslovakia (retrospective)
Musée Réattu, Arles, France
Photoclub A.P. 27, Brussels
1979 Museum of Photography, Siauliai, Lithuania
Galerie et Fils, Brussels
Art Criticism Institute, Moscow
House of Culture, Kishinev, Moldavian S.S.R. (retrospective)
House of Culture, Tiraspol, Moldavian S.S.R.
Prakapas Gallery, New York
1980 Photography Gallery, Kaunas, Lithuania
House of Culture, Burgas, Bulgaria
United Nations Library, New York
Brandt/Giacomelli/Macijauskas, Galerie et Fils, Brussels
1981 *3 Europeans: Michel Szulc Krzyzanowski,*

Wilhelm Schürmann, Aleksandras Macijauskas, San Francisco Museum of Modern Art

Selected Group Exhibitions:

1969 *9 Lithuanian Photographers*, Union of Journalists, Moscow
International Photo Exhibition, Ruzomberok, Czechoslovakia
1973 *Golden Eye '73*, Novy Sad, Yugoslavia
Exhibition of Jokes, Kapsukas, Lithuania (and 1976, 1979)
1975 *Salon International*, Orleans, France
1978 *Triennale of Photography*, Fribourg, Switzerland
18 Photographes Européens: Images des Hommes, Belgian Ministry of Culture travelling exhibition (toured Europe)
1979 *Man and Earth*, House of Culture, Plateliai, Lithuania
Venezia 79

Collections:

Photography Museum, Siauliai, Lithuania; Bibliothèque Nationale, Paris; Musée Français de la Photographie, Bièvres, France; Musée Réattu, Arles, France; Musée d'Art et d'Histoire, Fribourg, Switzerland; University of New Mexico, Albuquerque; San Francisco Museum of Modern Art.

Publications:

On MACIJAUSKAS: books—*Aleksandras Macijauskas*, exhibition catalogue, with text by Skirmantas Valiulis, Kaunas, Lithuania 1971; *Aleksandras Macijauskas*, exhibition catalogue, with text by Romuald Losewicz, Warsaw 1976; *Aleksandras Macijauskas*, exhibition catalogue, with text by Daniela Mrazkova, Brno, Czechoslovakia 1977; *Aleksandras Macijauskas*, exhibition catalogue, with text by A. Dabulskis, Kaunas, Lithuania 1977; *Lietuvos Fotografija*, with an introduction by Romualdas Pacesa, Vilnius, Lithuania 1978; *Aleksandras Macijauskas: Veterinary Clinic*, exhibition catalogue, with text by Romaualdas Neimantas, Kaunas, Lithuania 1979; articles— "Aleksandras Macijauskas and His Dreams" by Daniela Mrazkova in *Fotografie* (Prague), January 1969; "World Photography: Aleksandras Macijauskas" in *Foto Kino Revija* (Belgrade), October 1973; "International Portfolio: Aleksandras Macijauskas in the Market" by Skirmantas Valiulis in *Photography* (London), January 1976; "New Approach, New Solution" by V. Stigneyev in *Sovetskoye Foto* (Moscow), February 1978; "Black-White Markets by Aleksandras Macijauskas" by Barbara Xczcucka in *Fotografia* (Warsaw), February 1978; "A Veterinarian in Close-Up" by Gene Thornton in the *New York Times*, 11 November 1979; "Reality from a Different Angle" by Vladas Braziunas in *Literature and Art* (Vilnius, Lithuania), 15 March 1980.

Tell the truth, only the truth, and once more the truth—if you consider yourself a humanist.

—Aleksandras Macijauskas

One feels certain that the favorite subject of Aleksandras Macijauskas is man. This was as true at the beginning of his career in the 1960's as it is now, but his choice of themes has changed and become narrower. In his case, it is reasonable to talk about "themes" and "treatment" because, given his methods and the photographic results, Macijauskas seems variously to be a scientist, an historian, or a sociologist within the field of photography. Long ago he

stopped working with single shots, and instead has tried to explore his favorite themes in long series that are created over several years. Perhaps there is nothing new in such a method: every serious and extensive photo series requires solid study of the subject, a "getting into" the spirit of its environment. There are other similar works in world photography. But his various series—such as "Market" or "Veterinary Clinic"—are as striking in their comprehensive essence as in their visual solutions.

Macijauskas shoots only with a wide-angle lens, and he is not afraid of an immediate relationship with his subject. Usually when one tries to shoot "close-up" with a tele-lens, even if the intention is to get to the essentials of the subject, one remains a bystander, an outsider—but Macijauskas, in attempting the same shot, comes very close to his model; there is no effect of distancing. The story is not "observed"; it is very close to him. The result is that his reportage has a unique character and charm. As should happen in any good documentary, the general views and close-ups, the rhythms and moods, change, are orchestrated. And, though the close-up concentration on the model does produce the effect of portraiture, the environment, the background, is always precisely rendered.

Because Macijauskas is never the by-stander, because he is always at the center of the events of his photo, he misses no crucial detail. In "Market" or "Veterinary Clinic" such details are, for example,

the "look" of a bird or an animal; a goose in a basket, a sheep or a piglet in a housewife's lap; a kitten or a cow on an operating table. And, always, whatever the immediate interest of the photo, we note the human: as well as the animals in the forefront we can still see clearly, in the background, the active, the enterprising people, the masters of the animals, who may or may not understand them.

Macijauskas is not one of those photographers who shoots "beautiful" scenes; there is always tension and conflict in his works, be it a conflict between people, between man and animal, or between the model and the photographer himself. Unusual shooting angles and the deformations caused by the wide-angle lens also help to raise the tension in his photos.

The work of Aleksandras Macijauskas is a very stimulating example of the dynamism of contemporary photo-reportage.

—Peeter Tooming

MAGGS, Arnaud.
Canadian. Born in Montreal, Quebec, 5 May 1926. Educated at Westmount High School, Quebec, 1941-44; studied drawing, Scuola di Belle Arti di Brera, Milan, 1959; Artists Workshop, Toronto, 1974; self-taught in photography. Served as air gunner in the Royal Canadian Air Force, 1944: Sergeant. Married Margaret Frew in 1950 (divorced, 1971); children: Laurence, Toby and Caitlan. Worked as freelance graphic designer, Toronto, 1954-63. Freelance photographer and designer, Toronto, since 1966. Recipient: Gold Medal, *Canadian Graphica* show, 1966; Canada Council Senior Arts Grant, 1969, 1981. Agent: Jane Corkin Gallery, 144 Front Street West, Toronto, Ontario. Address: 24 Noble Street, Toronto, Ontario M6K 2C8, Canada.

Individual Exhibitions:

1971 *Baby Pictures*, Baldwin Street Gallery, Toronto
1972 *Brussels Townsfolk*, Brussels Mainstreet, Ontario
1973 *Movie Directors*, Revue Repertory Theatre, Toronto
1978 *64 Portrait Studies*, David Mirvish Gallery, Toronto
 Nova Scotia College of Art and Design, Halifax

Aleksandras Macijauskas: *In the Veterinary Clinic*, 1977

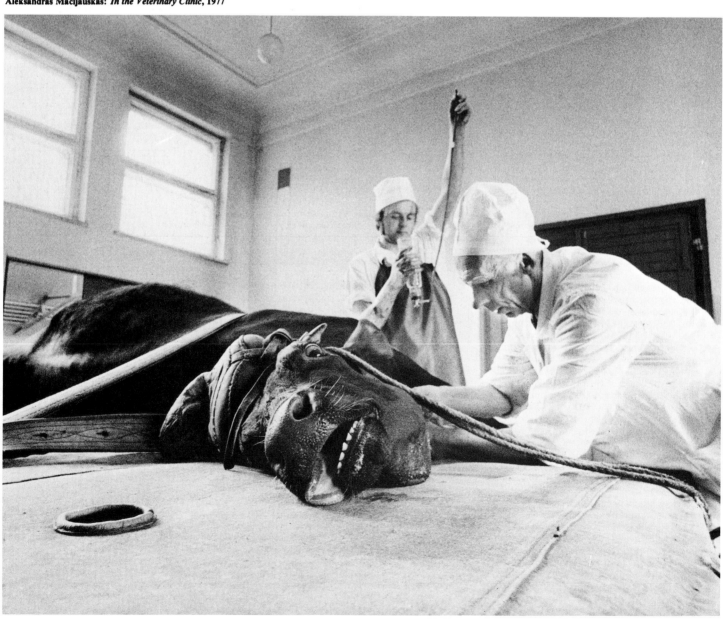

1979 *Ledoyen Series*, YYZ, Toronto
1980 Centre Culturel Canadien, Paris
Image Co-op Gallery, Montpelier, Vermont
Three Photographers, Open Space Gallery,
Victoria, British Columbia (with Shin
Sugino and Jennifer Dickson)
1981 *Studies for Downwind*, Mercer Union,
Toronto

Selected Group Exhibitions:

1977 *Seven Photographers*, National Film Board
of Canada, Ottawa
Five Photographers, York University,
Toronto
1978 *Sweet Immortality*, Edmonton Art Gallery,
Alberta
Canadian Connection, Neikrug Gallery, New
York
1979 *Photo Extended Dimensions*, Winnipeg Art
Gallery, Manitoba
Opening Exhibition, Jane Corkin Gallery,
Toronto
1981 *Realism: Structure and Illusion*, Mac-
Donald-Stewart Art Centre, Guelph,
Ontario

Collections:

Edmonton Art Gallery, Alberta; Canada Council
Art Bank, Ottawa; National Film Board of Canada,
Ottawa; Bibliothèque Nationale, Paris.

Publications:

On MAGGS: books—*Arnaud Maggs*, exhibition
catalogue, by David MacWilliam, Paris 1980; *12
Canadians: Contemporary Canadian Photography*,
edited by Jane Corkin, Toronto 1981; articles—"64
Portrait Studies at David Mirvish Gallery" by
Raphael Bendahan in *Artists Review* (Toronto),
May 1978; "Arnaud Maggs at YYZ" by David
MacWilliam in *Vanguard* (Vancouver), January
1980; "Calculated Expression" by Martha Fleming
in *Afterimage* (Rochester, New York), January
1982.

When I was forty years old I felt a sudden urge to
become a photographer. Up until then I had never
been interested in the subject. It wasn't even a hobby
of mine. I bought a used Nikon, and in order to earn
a living, I started doing fashion pictures for maga-
zines. I had a lot of fun and got quite good at it. I'd
been a graphic designer to begin with, so the transi-
tion wasn't difficult. I even managed to keep a lot of
my same clients. Instead of using my designs and
drawings, they started using my photographs. My
life seems to run in seven year cycles, and one day I
realized that this particular cycle had completed
itself and that it was time for a change.

I sold my camera (I had a Hasselblad at this point)
and decided to go back to art school. Drawing
seemed to be a good place to begin, so I started
attending life classes and anatomy classes. It was the
type of discipline I needed at this point and it helped
me to see, something I'd forgotten how to do. Grad-
ually I became aware of the shapes of people's heads,
and this interest led me to start taking pictures of
some of the models I'd been drawing.

I think that through drawing and observing the
head, I was able to see it in a different way, and I
wanted to show what I saw through photography.
Edward Weston did this very successfully with his
peppers and cabbages. He taught us to see things
with his particular vision. For my part, I began to
photograph the head in a very analytical fashion, in
an attempt to remove the association with conven-
tional portraiture. My first series, "64 Portrait Stud-
ies," showed 32 men and women in four rows of

sixteen pictures per row, the first and third row in
profile, the second and fourth row in frontal posi-
tion. More recently, I have begun to do pieces where
I take a predetermined number of pictures and show
the whole thing, in the order in which it was taken.

The other night I was watching Ansel Adams on
TV, and he said the history of photography has just
begun. What an exciting thought!

—Arnaud Maggs

For Arnaud Maggs, portraits are analytic experi-
ments, variations on a theme. He sometimes prede-
termines his pieces, using three front and three side
portraits against a plain, white background, two
people per roll. He often uses the whole shoot
unedited, complete with the actual physical evidence
of film, as in the twelve rolls with which he photo-
graphed André Kertész. (He placed Kertész in a
chair that revolved and photographed him in twelve
positions according to a clock on the floor.)

Maggs catalogues in a way that recalls August
Sander, but his types vary more in their head shapes.
He prefers extremes, and is interested by the strange-
ness of the commonplace. "You'd never guess the
front view from the side or vice versa—it's a sur-
prise," he points out.

His "64 Portrait Studies" (1976-78) are the mas-
terpieces of his formal, structured, highly-disciplined
work. Almost ugly, the individuals recall news or
documentary photographs: they have the same
bored, bland look. The repetition of forms is an echo
from his long experience in the design field. Arnaud
Maggs participates in portraiture's rites—his camera
stutters a person who is more real than real.

—Joan Murray

MAGRITTE, René (Francois Ghislain).
Belgian. Born in Lessines, Hainault, 21 November
1898. Educated at Châtelet and Charleroi, Belgium,
until 1914; studied, under Victor Servranckx, Acadé-
mie des Beaux-Arts, Brussels, 1916-18; first experi-
mental photomontages, 1929, but mainly self-taught
in photography, from 1956. Served as infantryman,
Belgian Army, Beverloo and Antwerp, 1921-22.
Married Georgette-Marie-Florence Berger in 1922.
Worked as a wallpaper designer and graphic artist,
Peters Lacroix Company, Haren, 1919-21; poster
designer and graphic artist, for Norine and Paul-
Gustave Van Hecke fashions, and for Samuel Furs,
etc., Brussels, 1923-27, 1930-31; painter and writer,
associating with surrealist artists, in Brussels, 1923-
27, 1931-67, in Le Perreux-sur-Marne, near Paris,
1927-30. Active as amateur photographer, Brussels,
1956-67. Editor, with E.L.T. Mesens, *Oseophage*
and *Marie* reviews, Brussels, 1925-26; Contributor,
La Voix du Peuple communist newspaper, Brussels,
1936. Recipient: Guggenheim Prize for Belgium,
1956. *Died* (in Brussels-Schaerbek) *15 August 1967.*

Individual Exhibitions:

1927 Le Centaure, Brussels
1928 Galerie L'Epoque, Brussels
1929 Bourse du Travail, Charleroi, Belgium
1931 Galerie Giso, Brussels
1933 Palais des Beaux-Arts, Brussels
1935 Sozialistische Studiekring, Ghent
1936 Julien Levy Gallery, New York
1937 Julien Levy Gallery, New York
1938 London Gallery, London
1941 Galerie Dietrich, Brussels
1943 Galerie Cosyn, Brussels
1944 Galerie Dietrich, Brussels
1946 Galerie Dietrich, Brussels
1947 Hugo Gallery, New York

Arnaud Maggs: *Kunstakademie: Detail #253*, 1980

Société des Beaux-Arts, Verviers, Belgium
1948 Galerie Dietrich, Brussels
 Hugo Gallery, New York
 Galerie du Faubourg, Paris
 Copley Galleries, Hollywood, California
1949 Galerie Cosyn, Brussels
1950 Galerie Le Parc, Charleroi, Belgium
1951 Galerie Dietrich, Brussels
 Galerie Dietrich, Brussels
 Galerie Cosyn, Brussels
 Hugo Gallery, New York
1953 Galleria dell'Obelisco, Rome
 La Sirene, Brussels
 Temps Meles, Verviers, Belgium
 Galerie Le Carne, Liège
 Lefevre Gallery, London
 Sidney Janis Gallery, New York
1954 Galerie Dietrich, Brussels
 Maison des Loisirs, La Louviere, Belgium
 Sidney Janis Gallery, New York
1955 State Museum, Luxembourg
 Galerie Pastoe, Brussels
 Galerie Cahiers d'Art, Paris
1957 Iolas Galley, New York
1958 Galerie Cahiers d'Art, Paris
1959 Iolas Gallery, New York
 Musée des Beaux-Arts d'Ixelles, Brussels
 Bodley Gallery, New York
1960 Galerie Rive Droite, Paris
 Museum for Contemporary Art, Dallas
 (retrospective)
 Musée des Beaux-Arts, Liège
1961 Obelisk Gallery, London
 Grosvenor Gallery, London
 Albert Landry Gallery, New York
1962 Galleria Galatea, Turin, Italy
 Walker Art Center, Minneapolis
 Bodley Gallery, New York
 Iolas Gallery, New York
 Galleria Schwarz, Milan
 Casino Communal, Knokke-le-Zoute, Belgium
1963 Galleria l'Attico, Rome
1964 University of Chicago
 Arkansas Art Center, Little Rock
 Hanover Gallery, London
 University of St. Thomas, Houston
1965 Galerie Zwirner, Cologne
 Galleria Notizie, Turin, Italy
 Museum of Modern Art, New York (toured the United States)
 Iolas Gallery, New York
1966 Zwemmer Gallery, London
1967 Moderna Museet, Stockholm
 Museum Boymans-van Beuningen, Rotterdam
1969 Tate Gallery, London (retrospective)
 Kestner-Gesellschaft, Hannover (retrospective)
 Kunsthaus, Zurich (retrospective)
1971 Galerie Isy Brachot, Knokke-le-Zoute, Belgium
 National Museum of Modern Art, Tokyo (travelled to Museum of Modern Art, Kyoto, Japan)
1972 Gimpel and Hanover Galerie, Zurich
1973 Marlborough Fine Art, London
1975 Davlyn Gallery, New York
1976 Staatliche Kunsthalle, Baden-Baden
 Rice University, Houston (retrospective)
1977 Bibliothèque Municipale, Bordeaux
1978 Midland Group Gallery, Nottingham, England
 Palais des Beaux-Arts, Brussels (retrospective; travelled to Centre Georges Pompidou, Paris)
1979 Galerie Isy Brachot, Brussels

Selected Group Exhibitions:

1923 Ca Ira, Cercle Royal Artistique, Antwerp
1928 Surrealist Group, Galerie l'Epoque, Brussels
1933 Le Surrealisme, Galerie Pierre Colle, Paris
1936 Fantastic Art, Dada and Surrealism, Museum of Modern Art, New York
1945 Surrealist Diversity, Arcade Gallery, London
1954 Collages and Objects, Institute of Contemporary Arts, London
1977 Künstlerphotographien im XX. Jahrhundert, Kestner-Gesellschaft, Hannover
1978 Dada and Surrealism Reviewed, Hayward Gallery, London
1979 Photographic Surrealism, New Gallery of Contemporary Art, Cleveland (travelled to Dayton Art Institute, Ohio; Brooklyn Museum, New York)
 Dada Photomontagen, Kestner-Gesellschaft, Hannover

Collections:

Ministère de l'Education National et de la Culture, Brussels; Palais des Beaux-Arts, Brussels; Musée Royal des Beaux-Arts, Antwerp; Casino, Knokke-le-Zoute, Belgium; Palais des Beaux-Arts, Charleroi, Belgium; Kunsthaus, Zurich; Museum of Modern Art, New York; Los Angeles County Museum of Art; Art Gallery of Ontario, Toronto; National Gallery of Victoria, Melbourne.

Publications:

By MAGRITTE: books—La Destination: Lettres à Marcel Marien, Brussels 1971, 1977; René Magritte: Manifestes et Autres Ecrits, Brussels 1972; Le Fait Accompli, Brussels 1973; La Belle Captive, with text by Alain Robbe-Grillet, Lausanne, Switzerland and Paris 1975; 82 Lettres de René Magritte à Mirabelle Dors et Maurice Rapin, Paris 1976; René Magritte: Die Truglosen Bilder, Bioskop und Photographie, with texts by Wolfgang Becker, Louis Scutenaire and Schuldt, Cologne 1976; La Fidelité des Images: René Magritte, Le Cinematographe et la Photographie, portfolio of 16 photos, with texts by Louis Scutenaire, Brussels and Hamburg 1976; Les Couleurs de la Nuit, Brussels 1978; Croquer les Idées, Brussels 1978; articles—"Aux Quatre Chemins" in Surrealist Drawings, exhibition catalogue, Paris 1935; statement in Le Bulletin (London), no. 12, 1939; "James Ensor" in Le Drapeau Rouge (Brussels), 1945; "Dix Tableaux, Precedes de Descriptions" in Le Miroir Infidele, Brussels 1946; statement in René Magritte, exhibition catalogue, Dallas 1960.

On MAGRITTE: books—Magritte by Marcel Marien, Brussels 1943; René Magritte by Louis Scutenaire, Brussels 1948; Magritte by James Thrall Soby, New York 1965; René Magritte by Patrick Waldberg, Brussels 1965; Magritte, exhibition catalogue, by David Sylvester, London 1969; Magritte by Suzi Gablik, London 1970; Magritte: Poète Visible by Philippe Robert-Jones, Brussels 1972; René Magritte by A.M. Hammacher, London 1974; René Magritte: Signes et Images by Harry Torczyner, Paris and New York 1977; Magritte by Jacques Dopagne, Paris 1977, London and New York 1979; Avec Magritte by Louis Scutenaire, Brussels 1977; Künstlerphotographien im XX. Jahrhundert, exhibition catalogue, edited by Carl-Albrecht Haenlein, Hannover 1977; Retrospective Magritte, exhibition catalogue, by Jean Clair, David Sylvester and others, Brussels and Paris 1978; Magritte by Richard Calvocoressi, London 1979; Photographic Surrealism, exhibition catalogue, by Nancy Hall-Duncan, Cleveland, Ohio 1979; Dada Photomontagen, exhibition catalogue, by Carl-Albrecht Haenlein and others, Hannover 1979; articles—"Die Truglosen Bilder: René Magritte, Kinematograph und Fotografie" by R. Puvogel in Das Kunstwerk (Baden-Baden), no. 3, 1976; "René Magritte, The Playful Photographer" by Jan Sjoby in International Herald Tribune (Paris), 27 May 1976.

The conventions of René Magritte's graphic style, and at certain points the content of his work, leave no doubt that he had absorbed both the geometry and the implications of photographic vision, and could deploy them freely in his propositions about language and the world. While comprehensive answers to the inevitable questions about specific incidents of photographic influence on the paintings are yet to be offered, the collection of Magritte's photographs assembled by Louis Scutenaire under the title of La Fidelité des Images offers some intriguing parallels to the mainstream of Magritte's production.

In technical casualness and informality, these photographs look like any set of snapshots of a group of friends, acting up for the camera. But it soon becomes clear that Magritte's involvement was, first and foremost, that of a director, who appeared as much before as he worked behind the camera, and that this is a primary distinguishing factor for these photographs.

From time to time the similarities to the paintings are uncanny, with hatted, sometimes bowler hatted and overcoated men in large spaces, even by the sea. And the shadows on the clothing of the people photographed walking away down a barren road in "Sur la route du Kansas" so closely resemble Magritte's painted shadows, while the general appearance of the scene reinforces the title's reference to American visual documentation of the period; and the image was made in Brussels.

Above all, Magritte generates the wit of these photographs out of the triangular encounter between perceiver, image and title, and the mystery of the gap which separates them. For the given meanings of the visual and verbal components are always, to varying degree, discrepant; while, equally, we feel the juxtaposition imposes an obligation on us to find coincidence, despite all logic.

In "Le bonheur du jour" (The Writing Table) three people stare fixedly at a pigeonhole. One may say with confidence that there is absolutely no physical or functional resemblance between image and title: yet does not a writing table have pigeonholes? The arbitrariness of the linguistic connection adds a new dimension to the family fun-shot.

There is thus no doubt that René Magritte's photography has a significant part in the Surrealist and broader linguistic arena so long occupied by his paintings and sculpture.

—Philip Stokes

MAGUBANE, Peter.

South African. Born in Vrededorp, Johannesburg, 18 January 1932. Educated at the Lutheran School and Western Native High School, Sophiatown, Johannesburg, 1950-55; mainly self-taught in photography. Married and divorced twice; children: Fikile, Linda, and Vusi. Worked (during school holidays) as a messenger, driver, tea-boy, etc., 1951-54, and as a photographer, under Tom Hopkinson and Jürgen Schadeberg, 1954-63, Drum magazine, Johannesburg; freelance press photographer, London and the United States, 1963-65, and in Johannesburg, 1965-66. Began work for Rand Daily Mail, Johannesburg, 1967: detained by police and kept in solitary confinement, May 1969-September 1970; placed under Banning Orders and forced to resign from Rand Daily Mail, October 1970-October 1975; also detained and kept in solitary confinement for 98 days, 1971; resumed employment with the Rand Daily Mail, 1975; again detained, with other Black newsmen, for 123 days during Soweto Riots, 1976.

Also, freelance photographer for *Time* magazine, in Johannesburg, since 1978. Recipient: First Prize, South African Best Press Picture Contest, 1958; 10 Best British Cameramen Award, 1962; Gold and Bronze Plaque, 1963, and Bronze Plaque, 1964, Professional Photographers Contest, Johannesburg; Enterprising Journalism Award, Stellenbosch Farmers Winery, Johannesburg, 1976; Nicholas Tomalin Award, *The Sunday Times*, London, 1976; Janusz Korezak Literary Award, United States, 1980; Ford Foundation grant, to study cinematography in the United States, 1981. Agent: Black Star, New York, New York. Address: c/o Alfred A. Knopf, 201 East 50th Street, New York, New York 10022, U.S.A.

Individual Exhibitions:

1963 Adler Fielding Gallery, Johannesburg
1964 London School of Printing
1974 Carlton Centre, Johannesburg
1975 Durban Art Centre
1976 Shell House Gallery, Cape Town
1977 Pentax Gallery, Johannesburg
 Pentax Gallery, Tokyo
 United Nations Gallery, New York
1978 International Center of Photography, New York
1980 Interfaith Center, New York
 Bennett College, Greensboro, North Carolina
1981 Cultural Center, Stockholm

Selected Group Exhibitions:

1966 *World Press Photo*, The Hague (and 1967, 1968)
1979 *The Year of the Child*, Carlton Centre, Johannesburg

Publications:

By MAGUBANE: books—*The World of Children*, with others, London 1966; *Federation of Black Women in South Africa*, Durban, South Africa 1976; *Black as I Am*, Los Angeles 1978; *Magubane's South Africa*, New York and London 1978; *Soweto*, with Marshal Lee, Cape Town 1978; *Soweto Speaks*, with Jill Johnson, Johannesburg 1979; *The Living Dead: Black South African Children*, New York 1982.

On MAGUBANE: article—"A Poignant Cry from the Beloved Country" in *Photography Year 1979*, by the Time-Life editors, New York 1979.

The kind of work I have been doing since I became a photographer mostly has political implications. Unfortunately in a country like South Africa one is forced to concentrate on more serious subjects than just the ordinary cheesecake, and working in South Africa doesn't give you a very wide scope. I have recently realized that there is quite a lot that I have missed photographically by not having left and worked outside South Africa. Now that I am outside South Africa, I begin to see pictures in a different way. I am exposed to the work of a great number of the world's best cameramen, and in South Africa one does not have that chance. I still hope to improve the little knowledge I have of photography, and once I've done that I will go back to my country and pass it on to the aspiring photographers of all races. My camera does not see color. I also do not see color.

—Peter Magubane

To have become an internationally renowned photographer against all the handicaps of a black South African childhood is a unique achievement. What made it possible for Peter Magubane was, above all, his determined eagerness to learn. Starting as a messenger on the magazine *Drum*, he became tea boy then driver. As driver he would carry Bob Gosani, the cameraman, round on jobs and watch the way he operated. He learned from Bob, from a young German photographer, Jürgen Schadeberg, and from anyone who would teach him anything. After driving all day, he trudged through the streets of Johannesburg at night, shooting pictures with a camera paid for by his father, a vegetable hawker. "I would go back to the office to process, and finally I would sleep there, because there was no transport that would take me back to Sophiatown at that time of night."

Appointed to *Drum*'s staff, he was inevitably drawn into photographing black resistance and white oppression, covering African political gatherings, arrests, and the celebrated "treason trials" of the 1950's, during which he was himself arrested three times. But these were to be only the first taste of many painful clashes with authority. At times he would come into the office bruised and bleeding, once so covered in bandages that his editor failed to recognize him.

His courage and endurance became legendary. In all, simply for photographing life as black people experience it in their own country, Magubane has spent 586 days in solitary confinement, plus six further months in jail; he has been beaten up, interrogated for five days without being allowed to sleep, and finally suffered five years of "banning." Amongst many other hardships, "banning" meant that he could no longer operate as a cameraman because he could never be in the company of more than one person at a time.

Throughout it all he continued to "think photography," even when forbidden to take pictures. In October 1975, when the ban was lifted, he went back to the *Rand Daily Mail* which now employed him: "It was like being back from the dead. But it was uphill, because I had lost my photographer's eye and was not accustomed to mingling with people freely." But, having recovered his eye by constant practice, he now started to take better pictures than he had ever done, and by the time of the great Soweto riots of black schoolchildren which started in June 1976, he had come into his full mastery, above all in the use of space. The amount of sky, the extent of background, room for the fiery action to move into...he was allowing it all with the assurance of a great photographer. His pictures from Soweto went round the world. Award after award started to come his way. He was invited to America; editors clamoured for his pictures and publishers for books.

Through it all Peter Magubane has remained completely level-headed, dignified, free from hatred, and still eager to go on learning. He says: "I do not know what will happen next to me. I shall go on working in South Africa, taking the best pictures that I can. I hope they will not all be of violence."

—Tom Hopkinson

MAHR, Mari.

Hungarian/New Zealander. Born Marianne Weiner in Santiago, Chile, 16 March 1941; emigrated to Hungary, 1948; settle in England, 1973. Studied at the School of Journalism, Budapest, 1961-64, Dip. Journ. 1964; Polytechnic of Central London, 1972-76, B.A. in photographic arts 1976. Married the Hungarian Gyula Mahr in 1959 (divorced, 1972); daughter: Julie; married the New Zealander Graham Percy in 1977. Freelance photographer, London, since 1976. Recipient: Greater London Arts Association Award, 1980. Address: 20 Sispara Gardens, London SW18, England.

Individual Exhibitions:

1977 The Photographers' Gallery, London
 Canon Photo Gallery, Amsterdam (with Christian Vogt)
1978 Riverside Studios, London
1979 Galerie ABF, Hamburg
 Galerie Art Something, Amsterdam
 Light Factory, Charlotte, North Carolina
1980 Open Eye Gallery, Liverpool
1982 *3 Women*, Moira Kelly Fine Art Gallery, London

Selected Group Exhibitions:

1978 *Fantastic Photography in Europe*, at *Rencontres Internationales de la Photographie*, Arles, France (toured Europe and

Peter Magubane: *Two Brothers the Day after Their Mother Died in a Car Crash, Meadowlands, near Johannesburg, 26 December 1975*

the United States, 1976-78)
Hommage à Marcel Duchamp, International Group Junij, Ljubljana, Yugoslavia
1979 *European Colour Photography*, The Photographers' Gallery, London
1980 *Photography as Art/Art as Photography*, Fotoforum Kassel, West Germany (and world tour)
Photographia: La Linea Sottile, Galleria Flaviana, Locarno, Switzerland
Contemporary Colour Photography/Salford '80, The Photographers' Gallery, Salford, England
Summer Show 2, Serpentine Gallery, London

Collections:

Arts Council of Great Britain, London.

Publications:

On MAHR: exhibition catalogues—*European Colour Photography*, London 1979; *Photographia: La Linea Sottile* by Giuliana Scimé and Rinaldo Bianda, Locarno, Switzerland 1980; articles—in *Creative Camera* (London), February 1980; *Camera* (Lucerne), August 1980.

All my images seem to come from reading books, looking at movies...looking at exhibitions. Although the events and situations that strike me might be quite specific, what I eventually photograph is an expression of my own reaction. I organize very tightly, choose very severely and take very few pictures. I think that making photographs is both very easy (too easy)...and very difficult.

—Mari Mahr

Photography can be compared to a party game: the players learn the rules, then win or lose depending on their skill. But there will always be some players who want to analyze the rules and try to work out new tactical moves. Experimental photographers are like those players: when they have mastered the basic techniques of the photographic process, they engage in a tireless search for more and new visual solutions. This taste for experiment, this curiosity about the enormous unexplored potential of the photographic medium, is innate in the work of Mari Mahr. Her investigations spring from her need to find perfect forms to represent our interior lives.

Mahr resolves the obvious difficulties of such a goal by trying out different techniques—not chosen capriciously or casually, still less because they are a challenge or an indication of the effectiveness of her manual and inventive skills. She selects a particular photographic process precisely because it is consistent with some visual demand that, formally, can be satified in no other way. The relationship between concept, subject and technique in her work is a very strict one; these three elements in the intellectual and operational execution of her work constitute the essential factors in the creation of the image.

Mari Mahr captures with photography the fugitive pictures that exist in the mind, related perhaps to dreams, the imagination or memory. These pictures can be made "real" in photographs when they can be evoked by some tangible object in our exterior life—sometimes another picture, a drawing in an encyclopaedia, a frame in a film. The picture thus found is the image of the other, interior picture: it has been transformed to make it capable of symbolic representation. To paraphrase Proust, her work is a "search for the lost picture," which, besides stressing the value of the particular experiment, examines the functioning of visual memory and perception. Her pictures thus function at more than one level, bringing back forgotten acquaintances, sensations and impulses, and often, because of the kind of response they provoke, causing a momentary bewilderment in the beholder. In fact, the persons and objects represented, though they have real outlines and shapes, though they are objects from the "real" world, tend to lose their identity within the memory they suggest, or within recollections that may or may not be true: perhaps the event occurred, perhaps it exists only in our imagination.

The essential concept on which all of Mahr's working experiments are based is a questioning of the mystery and riddle of man's inner life. That question is posed even by the formal expression of the picture, which forces us to flat read it, very much as we interpret dreams or recollections. The picture in fact consists of only a few elements, nearly all on the same plane. The visual field has neither depth nor width. Every detail is in close-up. Nothing is subordinated and nothing is emphasized as we look at the whole, so that the picture seems to swell, to burst out of the spatial limits of which it is composed.

—Giuliana Scimé

MAKAROV, Alexandr.
Russian. Born in Warsaw, in June 1936. Educated in schools in Riga, Latvia; studied play direction at the Moscow Institute of Culture, 1954-58. Served in the Soviet Army, 1958-60. Director for Soviet Television, Moscow, 1960-62. Photo-Correspondent, Novosti Agency, Moscow, since 1962. Address: Garibaldy nr. 15, korp. I, Flat 110, 117335 Moscow, U.S.S.R.

Individual Exhibitions:

1974 *U.S.S.R.: The Country and People*, travelling exhibition (toured Budapest, Belgrade, Paris, Prague, Warsaw, Havana, Berlin, Casablanca and Madrid, 1974-77)

Selected Group Exhibitions:

Annual Novosti Agency Exhibitions, Moscow, since 1962

Collections:

Novosti Agency Archives, Moscow.

Publications:

On MAKAROV: book—*Soviet Photography* by Vaclav Jiru, Prague 1974; article—"The New World" in *Revue Fotografia* (Prague), 1977.

To photograph systematically a special sphere of human activity is essential to most Soviet photojournalists, almost an inevitable adjunct to their main work. And from time to time it happens that what starts as a private hobby with only minimal practical application comes to exert a decisive influence on the photographer's development and growth, creating the foundation for his creative personality. That is the case with Alexandr Makarov and his photographs of the ballet.

The ballet, the traditional expression of culture of the Russian artistocracy, is now in fact as popular with the broad mass of people in the U.S.S.R. as is, say, the circus and its artists. It is the most photographed of artistic activities, and as a result photos of the ballet are often no better than the standard of pre-fabricated themes, used as journalistic schemas to express high cultural living standards. But thanks to the real masters of photography of stage art—for example, Anatoli Garanin—serious photography of the ballet is on a very high level, and anyone who wishes to excel at it faces fierce competition.

Alexandr Makarov came to take up ballet photography after his professional training. He had shown an active interest as a boy in the theatre; at the same time, he was fond of photography. He cultivated those interests further when studying direction at the Moscow Institute of Culture and while working in television. Two decades of working as an agency photographer developed his abilities as a universal reporter—but at the same time he took the opportunity to follow his interest in a specific field of

Mari Mahr: *Motion Pictures: Garbo 3*

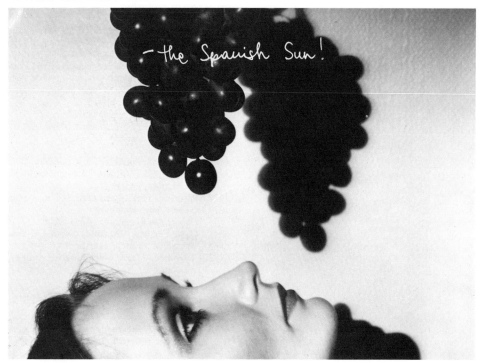

culture. He has for several years now been taking pictures of some of the outstanding figures in Soviet ballet with such perserverance that it is almost as if he were their personal photograper. Prima Ballerina Nadyezhda Pavlova appears in photographs in his archives when she was still in the 5th form at school, and Makarov has gone from that inspiration to create several large cycles devoted to such contemporary stars as Natalie Bessmertnovova, Yuri Grigorovich, Maris Liepa, etc.

Like Anatoli Garanin, Makarov also focuses his interest primarily on the sources of artistic achievement. He is interested in the environment, the nervous tension and the process of supreme mental and physical concentration. He is fascinated by the peculiar atmosphere of "backstage," that world that is practically inaccessible and unknown to the public. He does not attempt to capture human or artistic individuality; he does not express the unity of the personality and its immediate surroundings; instead, he emphasizes the anonymity, the daily drudgery, fatigue, enthusiasm, and pure joy at success that any other work may bring with it too.

In doing so he makes successful use of the frontal view, and he works with expressive close-ups and contrast grain, but he finds that what offers him most scope is the so-called Garanin "shumy"—two contrast planes of photographs, against a very diffuse background, often creating a closed darker edge framing the picture, against which, with the help of a spotlight with a small stage reflector, the decisive moment of action to which the photographer wishes to draw our attention is accentuated to stand out bright and clear. This method produces the desired effect, evoking the feeling of maximum concentration, revealing the internal mental processes of action which are usually hidden from the audiences's eyes but in reality are only relatively distant. Dynamic photography of this kind, which is slightly reminiscent of looking through a microscope, naturally cultivates all the features of that aesthetic stylization which is usually achieved only afterwards in the laboratory, when deliberate underexposure is counterbalanced by the drastic effect of developers. The results that Makarov achieves are among the best in Soviet photography.

—Vladimír Remeš

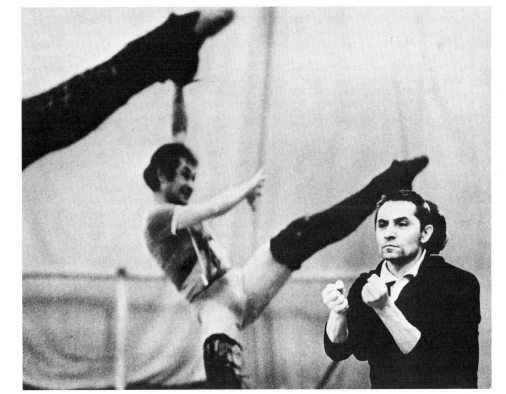

Alexandr Makarov: *Ballet Rehearsal*, 1974

valls Museum, Sundsvall, Sweden, 1976)
1981 Fotograficentrum, Stockholm (retrospective)

Selected Group Exhibitions:

1949 *Unga Fotografer*, Rotohallen, Stockholm
1951 *Jeunes Photographes Suedoises*, Galerie Kodak, Paris
1954 *Svartvitt: Svensk Fotografi av Idag*, Nationalmuseum, Stockholm
1958 *Fotokonst 1958*, Lunds Konsthall, Lund, Sweden
1970 *Tenstaborna: Foto/Film/Bild*, Liljevalchs Konsthall, Stockholm
1971 *Contemporary Photographs from Sweden*, Library of Congress, Washington, D.C.

1976 *Tio Fotografer*, Galerie Aronowitsch, Stockholm
1977 *Tio Fotografer*, La Photogalerie, Paris
 Reflexions no. 1, Canon Photo Gallery, Amsterdam

Collections:

Moderna Museet, Stockholm; Valokuvamuseon, Helsinki; Norsk Fotohistorisk Forening, Oslo; Bibliothèque Nationale, Paris; Library of Congress, Washington, D.C.

Publications:

By MALMBERG: books—*Fädernas Kyrka*, with

Hans Malmberg: *Vipeholm Hospital*, Lund, Sweden, 1953

MALMBERG, Hans.

Swedish. Born in Stockholm, 20 September 1927. Studied photography at Stockholm Vocational School, 1941-43. Served as photographer, Royal Swedish Navy, 1948. Married Margret Gudmundsdottir in 1950 (divorced, 1964); children: Leif, Kristina and Åsa; married Agneta Mälargård in 1970; son: Linus. Photographer, with Pressfoto Meyerhöffer, Stockholm, 1943-46; Partner, with Sven Eriksson-Gillsäter, Pressfoto-Bildnytt Agency/Studio, Stockholm, 1947-48; freelance photojournalist, aerial photographer and filmmaker, working for *Se, Vi, Stockholms-Tidningen*, etc., Stockholm, 1949 until his death, 1977. Founder-Member, Tio Fotografer group, Stockholm, 1958-77. Recipient: Kulturpreis, Deutsche Gesellschaft für Photographie (DGPh), 1966. Estate: Agneta Malmberg, Ryttmästarvägen 73, 16224 Vällingby, Sweden. *Died* (in Bergvik, Sweden) *30 August 1977.*

Individual Exhibitions:

1975 *Hans Malmberg: Bilder 1946-1975*, Moderna Museet, Stockholm (travelled to the Sunds-

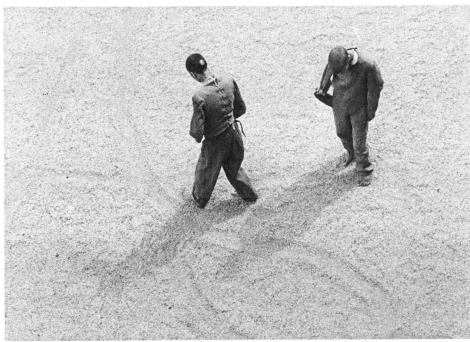

text by Josef Oliv, Stockholm 1950; *Island*, with text by Helgi P. Briem, Stockholm 1951; *Närmare Dig!*, with Bo Setterlind, Stockholm 1951; *Dalälven: Industrifloden*, with text by Sven Rydberg, Stockholm 1957; *Nils Holgerssons Underbara Resa*, with text by Tage and Kathrine Aurell, Stockholm 1962; *I Eviga Skogen*, with text by Gunnel Linde, Stockholm 1966; illustrations for *Svensk Färg-TV* by Bertil Allander, Halmstad, Sweden 1969; articles— "Fotgrafera Flyg" in *Foto* (Stockholm), September 1949; "Kameraskott i Stridslinjen" in *Foto* (Stockholm), December 1950; "Fotografering Förbjuden" in *Foto* (Stockholm), March 1952; "Rapport från Hanoi" in *Vi* (Stockholm), 1968.

On MALMBERG: book—*Hans Malmberg: Bilder 1946-1975*, exhibition catalogue, Stockholm 1975; articles—"Hans Malmbergs Bildportfölj" by Tor Alm in *Nordisk Tidskrift för Fotografi* (Gothenburg), no. 3, 1959; "Helivision och Travelling Matte Hjälmedel för Nils Holgersson" in *Fotonyheterna* (Stockholm), no. 8, 1962; "Hans Malmbergs Metod för Trickbild på Färgdia Skapade Unik Apparatur" in *Fotonyheterna* (Stockholm), no. 9, 1962; "Fotograferade Barn" by Ulla Bergstrand in *Sydsvenska Dagbladet* (Malmo), 12 December 1968; "Hans Malmberg: En Riktig Fotograf" by Kurt Bergengren in *Aftonbladet* (Stockholm), 14 June 1975; "Hans Malmberg: Världsfotograf som Skildrar Förorterna med Ömhet" in *Expressen* (Stockholm), 17 July 1975; "Fotojournalistikens Stora Tid före Televisionen" by Kurt Bergengren and "Fotografen som Fick en Blomma av Onkel Ho" by Lars Westman in *Bildtidning* (Stockholm), special issue, 1981.

Hans Malmberg belonged to a group of young Swedish photographers who, after the Second World War, came out in opposition to the ideals of the older generation of Swedish photographers. The differences between the two groups were exposed at an exhibition held in 1949: its title, and the motto for the young photographers, was *Unga Fotografer*— Young Photographers. Many of these same photographer were later, in 1958, to found the now well-known Swedish photographers cooperative and picture agency, Tio Fotografer (Ten Photographers).

What the young photographers principally objected to was the romantic sentimentality of the older generation. The national romantic style in Sweden had developed from the neo-classical ideals of the 1930's, influenced by the German photography published in *Das Deutsche Lichtbild* toward the end of 1930. The young photographers drew their inspiration from the photo-reportage in such magazines as *Life, Look, Picture Post, Paris Match* and *Réalités*, as well as from the *U.S. Camera Annual*, published in 1948. Their style had developed during the dark years of the war and was intensified during the years after the war.

Hans Malmberg was the one of the group that was most influenced by the photographers Henri Cartier-Bresson and W. Eugene Smith. He also shared Cartier-Bresson's ideal of the "decisive moment."

Malmberg received his education as a photographer at the Stockholm Stads Yrkesskola (Stockholm Vocational School), and from 1943-46 he was employed at the Pressfoto Meyerhöffer agency, where he worked out the style he would later develop to perfection. Together with his friend Sven Gillsäter, he started Pressfoto-Bildnytt, a photo agency that soon became well-known: the demand for news photos was great before the TV Age, and editors found that Malmberg was an outstanding photographer for their needs. He was thereafter sent round the world with various well-known Swedish reporters. His photographs from the Korean War attracted a great deal of attention when they were published in the weekly magazine *Se*: they show the drama of the front-line with sharp observation and humanity.

During the 1960's Malmberg travelled extensively, around the world, for various Swedish companies, describing in photos how Swedish products are used abroad. While doing this work, he was often fascinated by events around him, and he shot many photos extraneous to his actual missions. His apprehension was of that extraordinary kind that took his photograph before other photographers had even got their cameras ready. He always wore his Leica on his chest and managed to capture vivid and unusual events in the life of the big cities that he visited. He seemed to "create" photos where no one else could see anything happening.

Malmberg was a warm and sensible man, but he had an unusual side to his character. There was a neurotic restlessness that kept him always on the move. He was always chasing something that few could perceive, and it was only his closest friends that knew what was driving him. Some people called him a reporter, others a journalist, or a photojournalist. Malmberg didn't like titles; in his opinion, he "collected moments"—an expression he borrowed from the German author Heinrich Böll in his novel *Ansichten eines Clown*.

In 1975 the Fotografiska Museet in Stockholm showed Malmberg's pictures in a retrospective exhibition. Documentary photography was then very important in Sweden, the show was a great success, and Malmberg, with all his travels and adventures, became an idol for a new generation of Swedish photographers. Such fame is usually short-lived, but Malmberg's popularity has been maintained. His photos demonstrate that he was one of Sweden's best photo-journalists: they are an outstanding record of a whole era, from World War Two to the death of the great photo magazines.

—Leif Wigh

MALYSHEV, Vasili.

Russian. Born in Moscow in 1900. Educated in schools in Moscow, 1907-17. Served in the Red Army, 1917-22. Worked as a photographer for various newspapers in the U.S.S.R. prior to World War II; fate unknown during the war; photographer for Sovinformburo (Soviet Information Bureau), Moscow, 1945-55; photographer for the Novosti Agency/APN, Moscow, 1955-68; now retired. Agent: Novosti Agency, Moscow. Address: Kutusovsky pr. nr. 30/32, Flat 524, G-19 Moscow, U.S.S.R.

Individual Exhibitions:

1970 *Portraits of Contemporaries*, Dom druzby Gallery, Moscow (70th birthday retrospective)
1977 *Selected Portraits*, House of Soviet Culture, Prague
1980 *Selected Portraits*, House of Art, Sofia, Bulgaria

Selected Group Exhibitions:

1955 *Novosti Agency Exhibition*, Moscow (and annually until 1968)

Collections:

Novosti Agency/APN Collection, Moscow.

Publications:

On MALYSHEV: book—*Soviet Photo '74*, Moscow 1974; article—"Mir kotoryj plenjaet" by Ludmila Klodt in *Sovetskoye Foto* (Moscow), no. 10, 1980.

In 1956, when the personality cult of Stalin had been officially condemned in the Soviet Union and the roots of schematism in Soviet culture criticized, an exhibition of the work of photojournalists was held in Moscow that presaged the beginnings of a return to a former simplicity of content and expression. Among its most progressive participants was Vasili Malyshev.

He was working as a reporter, actually for an agency, but he made a name for himself with his portraits.

He became involved in photography at a time when—thanks to such outstanding personalities as Moysey Nappelbaum and Abram Sterenberg— portrait photography was of a very high standard. This was so despite the fact that during the post-revolutionary years portraiture, along with some other genres such as landscape and still-life, had practically ceased to exist: they were considered to be a bourgeois legacy. But new blood was gradually instilled into portraiture by experimenting photographers and reporters who made it special by their formal approach and unassuming ordinariness. They freed it from studio impediments; they worked with small-size cameras in the open air. Some time later, with the coming of schematism in the 1930's, the portrait as a genre was again suppressed—above all, by "identification" photography on commission and by official, self-important and pompous iconography. Emphasis on the classical portrait, the result of perfect craftsmanship, as well as an attempt to bring out the innermost life of the sitter—these were the contributions made by Malyshev to the revival of that genre that had perhaps most seriously been marred by the mistakes of that period. However, in contrast to his outstanding predecessors—for example Nappelbaum, who was able to make functional use of the methods of modern painting in photography, or Sterenberg, who developed expressiveness—Malyshev promoted the revival of an already outmoded style, the attempt to bring photography closer to classical painting. This is especially true of his colour portraits.

Malyshev takes pictures mainly of official figures—statesmen, politicians, artists, meritorious workers in various spheres. In his way he frees them of their myths when presenting them to the public, without, however, depriving them of their halo of exclusiveness. He portrays ordinary people too, and in fact he does infuse his commission work, even studio portraits and to a certain extent also advertising and propaganda work, with a certain creative ambition. But it is his "Portraits of Contemporaries" which has made the greatest impression: he goes on adding to it for exhibition purposes, and it has, naturally, aroused both enthusiasm and criticism. Malyshev's contribution to Soviet photography is in his revival of the portrait genre.

—Vladimír Remeš

Vasili Malyshev: *Portrait of the Georgian Actress Sophico Cianreli*, 1974

MAN, Felix H(ans).

British. Born Hans Felix Siegismund Baumann in Freiburg im Breisgau, Germany, 30 November 1893; adopted the professional name Felix H. Man, 1929; emigrated to England, 1934: naturalized, 1948; moved to the Continent, 1958, settling first in Sorengo, near Lugano, Switzerland, 1961, and in Rome since 1972. Studied fine art and art history at the University of Berlin, 1912-14, University of Munich, 1914, and the Kunstgewerbeschule, Munich, 1918-21. Served as an officer in the German Army, 1914-18. Took first photos, 1904, first documentary reportage photos in the trenches on the Western Front, 1915; professional photographer since 1928. Draughtsman, *Berliner Zeitung am Mittag* magazine, and freelance photographer for *Tempo* and *Morgenpost*, Berlin, 1927-28; Production Chief, with Umbo (Otto Umbehr), for Dephot (Deutsche Photodienst) co-operative press agency, Berlin, 1928; Principal Contributor, *Münchner Illustrierte Presse*, Munich, 1929-32, and for *Berliner Illustrirte*, for which he travelled in Finland, Sweden, North Africa, the United States and Canada, 1932-34; Co-Founder, with Stefan Lorant, *Weekly Illustrated* magazine, London, 1934; Special Assignments Photographer, under the pseudonym "Lensman," *Daily Mirror* newspaper, London, 1935-36; Founder Member and Chief Contributor, 1938-45, and Colour Specialist, 1948-50, *Picture Post* magazine, London; Special Assignments Photographer, for *Harper's Bazaar*, London, 1942, for Time-Life publications, London, 1951-52, and for the *Sunday Times* newspaper, London, 1957-58. Editor, *Europaeische Graphik* lithography portfolios, Munich, 1961-75. Recipient: Culture Prize, Deutsche Gesellschaft für Photographie, 1965; Cross of Merit, First Class, 1968, and Great Cross, 1980, of the Federal Republic of Germany. Address: 30 via Giubbonari, 00186 Rome, Italy; or 306 Keyes House, Dolphin Square, London SW1, England.

Individual Exhibitions:

1961 Galerie Loehr, Frankfurt
1965 Deutsche Gesellschaft für Photographie, Cologne
1967 Landesbildstelle, Hamburg
1968 Landesbildstelle, West Berlin
1971 *Felix H. Man: Pionier des Bildjournalismus*, Münchner Stadtmuseum, Munich
1972 Stadtgalerie Schwarzes Kloster, Freiburg im Breisgau, West Germany
1975 Moderna Museet, Stockholm
 Malmö Konsthall, Sweden
1976 Västerbottens Iäns Museum, Umeå, Sweden
 Biblioteca Germanica, Rome
 Reportage Portraits, National Portrait Gallery, London
 Museum of Decorative Art, Copenhagen
1977 Goethe Institute / National Book League, London
 Source Gallery, Edinburgh
1978 Goethe Institute / Neikrug Gallery, New York
 The Gallery, Toronto
 Goethe Institute, Montreal
 High Museum of Art, Atlanta
 Ulrich Museum, Wichita, Kansas
 Goethe Institute, Buenos Aires
 Museo de Bellas Artes, Cordoba, Spain
 Goethe Institute, Lisbon
 Instituto Aleman, Madrid
 Goethe Institute, Barcelona
 60 Years of Photography, Kunsthaus, Bielefeld, West Germany (travelled to the Kunstverein, Frankfurt, and the Museum Ludwig, Aachen, West Germany)
1979 Kunstverein, Hamburg
 Galleria Il Diaframma, Milan
 Goethe Institute, Naples
 Galleria Giulia, Rome
 Goethe Institute, Bordeaux
 DGPh Kongresshalle, West Berlin
1981 *Canada 50 Years Ago*, Palazzo Braschi, Rome
 60 Years of Photography, Bibliothèque Nationale and Goethe Institute, Paris
 Photos 1929-76, Galerie Photo Art, Basle

Selected Group Exhibitions:

1959 *Hundert Jahre Photographie 1839-1939*, Museum Folkwang, Essen (travelled to Cologne and Frankfurt)
1967 *Photography in the 20th Century*, National Gallery of Canada, Ottawa (toured Canada and the United States, 1967-73)
1968 *Europa '68*, Bergamo, Italy
1977 *Dublin Festival*
 Documenta 6, Kassel, West Germany
1978 *Neue Sachlichkeit and German Realism of the 1920's*, Hayward Gallery, London
 Tusen och En Bild, Moderna Museet, Stockholm
1979 *The 30's: British Art and Design Before the War*, Hayward Gallery, London
1980 *Avant-Garde Photography in Germany 1919-39*, San Francisco Museum of Modern Art (toured the United States)

Collections:

National Portrait Gallery, London; Bibliothèque Nationale, Paris; Moderna Museet, Stockholm; Münchner Stadtmuseum, Munich; Museum Folkwang, Essen; Staatliche Landesbildstelle, Hamburg; Foto-Historama Agfa-Gevaert, Leverkusen, West Germany; International Museum of Photography, George Eastman House, Rochester, New York; University of Texas at Austin; San Francisco Museum of Modern Art.

Publications:

By MAN: books—*150 Years of Artists' Lithographs*, with an introduction by James Laver, London 1953; *Eight European Artists*, with introductions by Graham Greene and Jean Cassou, London 1954; *Lithography in England 1801-10*, New York 1963, Hamburg 1967; *Europaeische Graphik*, 10 volumes, Munich 1963-75; *Artists' Lithographs: A World History from Senefelder to the Present Day*, London and New York 1970; *The Complete Graphic Works of Graham Sutherland*, catalogue raisonée, Munich 1971; *Homage to Senefelder*, exhibition catalogue, London 1971; *Felix H. Man: Photo Classics IV*, portfolio, edited by Helmut Gernsheim, London 1972; *Felix H. Man: Reportage Portraits*, exhibition catalogue, London 1976; *Felix H. Man: 60 Jahre Photographie*, Beilefeld, West Germany 1978; articles—"Das Europaeische Museum für Photographie" in *Die Welt* (Hamburg), 8 December 1972; "The Beginning of Photo-Journalism" in *Die Welt* (Hamburg), 1 March 1974; "William Henry Fox Talbot, Inventor of the Negative Process" in *Die Welt* (Hamburg), 16 September 1977; "Each Exposure Must Be a Hit" in *Die Welt* (Hamburg), 28 February 1978; "From the Beginning of Photojournalism" in *DGPh Intern* (Cologne), no. 3, 1978; "Reply to Dr. Tim Gidal" in *DGPh Intern* (Cologne), no. 2, 1979; "Der Fotograf im Frack" in *Frankfurter Allgemeine Zeitung*, 12 May 1979.

On MAN: books—*The Man Behind the Camera* by Helmut Gernsheim, London 1948; *Creative Photography* by Helmut Gernsheim, London and Boston 1962, 1975; *A Concise History of Photography* by Helmut and Alison Gernsheim, London and New York, 1965, 1971; *Photography in the Twentieth Century* by Nathan Lyons, New York 1967; *Felix H. Man: Pionier des Bildjournalismus*, exhibition catalogue, Munich 1971; *Photographie et Société* by Gisèle Freund, Paris 1974; *Dictionary of Photography* by Jorge Lewinski, London 1977; *Documenta 6/Band 2*, exhibition catalogue, by Klaus Honnef and Evelyn Weiss, Cologne 1977; *Bilder for Miljoner* by Rune Hassner, Stockholm 1977; *150 Jahre Photographie* by Klaus Honnef, Mainz 1977; *Felix H. Man*, exhibition catalogue, with an introduction by Tom Hopkinson, London 1977; *Geschichte der Photographie im 20. Jahrhundert/History of Photography in the 20th Century* by Petr Tausk, Cologne 1977, London 1980; *Lexicon der Fotografie* by Hugo Schöttle, Cologne 1978; articles—"Photographs of Artists" by Tom Hopkinson in *The Spectator* (London), 21 May 1954; "Felix Man: An Appreciation" by Helmut Gernsheim in *Photography* (London), July 1954; "Felix H. Man: Fotograf und Kunstexperte" by Fritz Kempe in *Foto Prisma* (Stuttgart), October 1965; "Felix H. Man, Ein Pionier" by Helmut Gernsheim in *Camera* (Lucerne), April 1967; "Felix H. Man: A 75th Birthday Tribute" by Helmut Gernsheim in *Camera* (Lucerne), November 1968; "The Father of Photojournalism" in the *New York Times*, 14 May 1971; "Photographs by Felix H. Man" by Helmut Gernsheim in *Creative Camera* (London), July 1972; "Felix H. Man Gets Double Exposure" by Vivien Raynor in the *New York Times*, 27 January 1978;

"Felix H. Man, Photo-Journaliste" in *La Presse* (Montreal), 14 October 1978.

No aspect of the history of photography and its principles has been dealt with in such a distorted way as what we call the "new photo-journalism." To go back to the beginning: pictorial journalism was not invented; it came into existence, at the end of the 1920's, as a logical outcome of attempts by editors of illustrated weeklies to join single pictures, mostly travel pictures, into a single unit by adding a lengthy connecting text. But this was not yet photo-journalism, nor can the documentary photographs of such photographers as Lewis Hine or Jacob Riis during the last century be regarded as something other than descriptions of the bare facts of certain conditions or the recording of actual happenings in posed or flashed photographs.

Even in the 1850's draughtsman were illustrating events through series of pictures for the then proliferating illustrated magazines in Europe and overseas. But these drawings had their origin in most cases in the imagination of their creators, and as such had no real documentary value. As a matter of fact, the idea of describing happenings in pictures in print goes back to the end of the 15th century when the discovery of America by Columbus was illustrated in a sequence of woodcuts.

But the new photo-journalism was built on quite different principles. Though the form of the pictorial essay remained as its basis, as did what was later called "candid camera," which had been practiced long before by Stieglitz, Paul Martin, Benjamin Stone and others in open-air pictures, a number of new facets were added, the result of which was that photography entered an absolutely new phase. New principles hitherto neglected were introduced, and subjects until then thought to be impossible for the camera, particularly in the field of indoor photography, now played the most important part.

Though, as I have said, some attempts to tell a story in pictures had been made before, the actual breakthrough came in 1929 (earlier attempts remained sporadic and did not involve all spheres of life).

The aims of the photo-journalist are similar to those of a writer, but the photo-journalist uses the camera instead of the pen and tells his story with his own means—the lens. While the feature writer of an important newspaper usually specializes in one or another subject, the photo-journalist has to be at home in all fields—in art, literature, science, politics, etc. He has to compose his final essay on the spot, while the writer can do this in comfort at home from notes he has taken; he can even add from his imagination. But the man who works with the camera must have the qualities of a journalist, a reporter and an artist all at the same time. His mastery of the technical side of photography must be complete. His hands must have the skill of an expert, his vision must be a pictorial one, and his knowledge of human nature must be many-sided.

The concept of an appropriate psychological moment at which to take a picture also played an important part in the development of photo-journalism; it was based on Lessing's "fruitful moment," as described by him in *Laocoon*. This concept and its accompanying method were used by the protagonists of pictorial journalism years before the French claimed to have invented this type of picture taking. Great efforts were made to penetrate the surface of things by means of a mechanical gadget in order to give more than a mere optical record; by careful selection, the accidental remained controlled. It has often been said that the camera, a mechanical instrument, can record only what is there. That is true. But not everybody can see what is there, and a creative mind will use the little glass eye with quite a different attitude and outcome, achieving a result not to be compared with optical appearance only.

The great difference was that this new interpretation was not only a selective one to the highest

degree—but if the task was to photograph human beings, this task was approached by returning to simplicity, rejecting all artificial means, giving the psychological factor preference. When taking indoor photographs, the photographer had to work only with available light. If additional lamps or flashlight were used, they would disturb the atmosphere and alter the natural forms. At the same time, the photographer tried to remain as unobtrusive as possible. The old method of "smile" and "hold it" were thrown overboard; on the contrary, natural activity was welcomed.

The first photo-journalists had a great sense of responsibility; they did not commit acts of indiscretion. They were invited to important functions as guests, and they mingled with other guests, becoming practically invisible.

There were also technical difficulties which in those early days had to be overcome. Again and again writers on photography say that it was the miniature camera that brought pictorial journalism into existence—a misleading statement. For many months I personally used a Nettle Camera 6:9 cm, fitted with an Ernostar 1:2, 8, with glass plates, for some of the very first indoor essays, changing over to the Ermanox only later and to the Leica in the second half of 1932. But even with the Ermanox, taking photographs indoors by available light was no walkover, as the time of exposure varied between ¼ and 1 second, and photos could be taken only from a tripod. As the negative material consisted of glass plates only, the number of photographs that could be taken was limited, and every exposure had to be a success. After 1933, when Leitz introduced interchangeable lenses and film became less coarse and of greater sensitivity, the progress of photojournalism was altered for the worse by the newcomers, many of whom never understood the real principles of the movement. Hundreds of photographs were taken, half of which were blown up in order to provide a means of selection of the 10 or 15 best ones. In a book on photo-journalism published by Time-Life, an editor even praised this method of photo-journalism, which is based only on the accidental.

The new photo-journalism broadened their picture of the world for millions of people; the camera penetrated areas which until then had remained obscure for the ordinary spectator. Many of the subjects we discovered 50 years ago were explored later on, again, by television.

With today's highly-developed technical means, it appears easy to photograph what for the first protagonists was new land. However, though one can repeat the outer form, the question still remains: has not the intensity and the strong expressive character of those photographs of 50 years ago been lost? hasn't the process become more superficial? To observe all the original rules is not sufficient; it is the conception of the man behind the camera and his own recognizable signature that matter.

At the same time as this new development started, portrait photography took an entirely new form. The live portrait came into existence, leaving the posed studio portrait behind. This type of portraiture based on natural facts has today become commonplace, adopted by the majority of newspaper photographers.

The influence of the new photo-journalism on the development of photography has, until now, been grossly under-rated. Critics and historians did not realize that this new vision did not consist only of a new outer form, but that a new pictorial conception was actually the nucleus of such work. To classify this work only as presswork is a devaluation.

—Felix H. Man

Now approaching his 90th year, Felix H. Man has lived through the dramatic phase of magazine journalism; his active period from the beginning of the

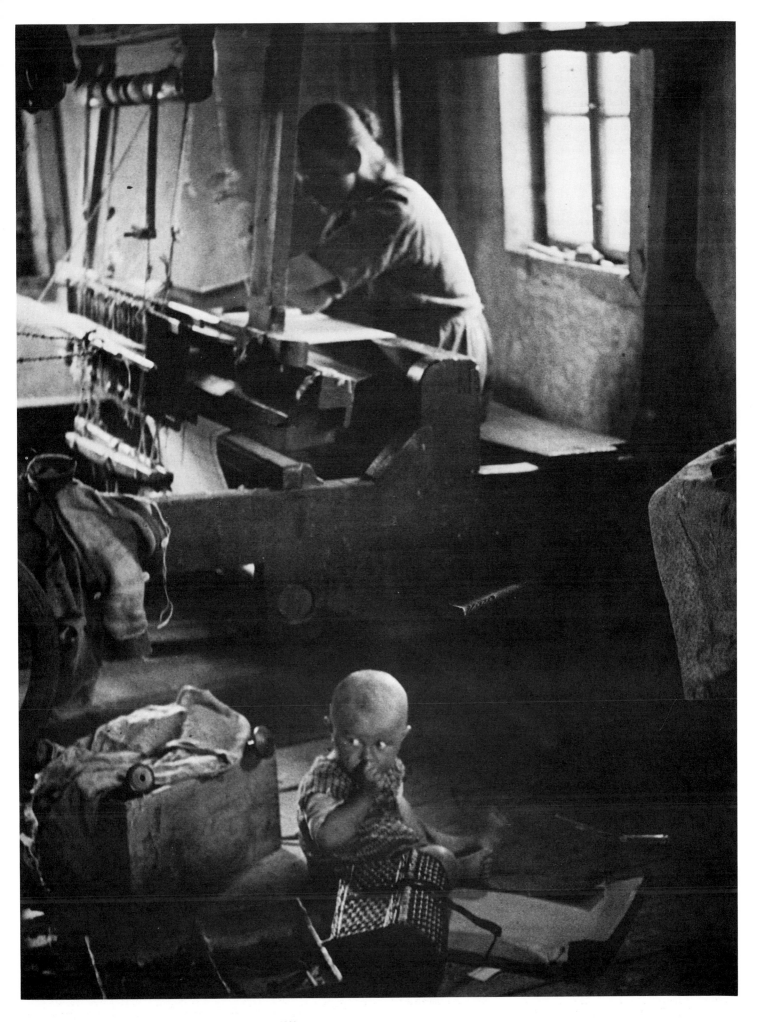

Felix H. Man: *Home of a Poor Handweaver, Glatzer Mountains,* 1930

First World War covers half the entire history of photography. His contribution to photo-journalism, to colour photography and to art history have been immense; he has also by example and advice helped several generations of younger cameramen to raise the level of their own achievement.

From the late 1920's when he began working in Germany for the *Münchner Illustrierte* and the *Berliner Illustrirte*, Man has always been a photographer for the great occasion. He has indeed made many delightful picture series out of simple scenes such as a country shooting party or the life of a village. But it has been the challenge of the unique opportunity, such as his visit to Mussolini at the height of his power—the first by any magazine photographer—which brought out his most memorable work. His long-range view of Mussolini at his desk, shot on sudden inspiration from the door when he was expected to come forward and be introduced, has possibly been reproduced more frequently than any other picture of the same period.

Every photojournalist must have acquired the capacity to cut the precise significant action—both in space and time—out of the passing scene, and to do this effectively must have developed a considerable knowledge of people in the public eye, political events, and the current scene in art and sport. But in addition to the essentials, Man had certain qualities apparent to anyone who worked with him.

The first was his intense concentration. Having once established the conditions (of lighting and so on) under which he was operating, he would never look down at his camera. But, leaving all necessary adjustments to his well-trained hands, he would prowl around a theatrical rehearsal or a minister's office, shooting picture after picture without once taking his eyes off the scene in front of him. Second, was his photographic memory, which was extraor-

dinary. No other cameraman, in this writer's experience, could come back from a day's work and hand his films in to the darkroom with the instruction: "On the first film print numbers 8, 12, 14, 19 and 23. On the second, numbers..." and so on.

Allied to this was his economy in operation. Trained as an artist and as a layout man, he was constantly visualizing each picture story in page form as he was taking it. As a result he shot very little which was not likely to be used, or at least capable of being used—though he would often shoot the key pictures in both "portrait" and "landscape" shape in order to give the layout editor a choice. Where a less experienced operator would come back with several hundred exposures, Man would be content to have exposed only a couple of films, but all that was needed would be there.

Finally he was, when on the job, extremely patient. By no means the easiest of colleagues in daily life, he showed in pursuit of a picture story the patience and resourcefulness of a practised angler, trying in this and that direction, arguing—even pleading, something quite alien to his everyday nature—to secure some co-operation he required.

To these qualities Man added others which, though not strictly "photographic," made a valuable addition to his general armoury. He had an excellent educational background, which he had extended by wide reading and much travel. He had studied art, practised drawing, painting and etching, and produced authoritative works on the subject of artists' lithographs. All this undoubtedly helped him to get on easy terms with his subjects when he was making his notable series of artists at work—Picasso, Matisse, Chagall, Henry Moore and others. He had an exceptional knowledge and love of music; and his sense of history enabled him to understand the events he was recording day by day, in terms of the past and of the

world scene as a whole.

Both in Felix Man's character and his method of approach to any work he undertook, there was a strong element of the scholar and academic. His choice of the arduous life of a photojournalist, when much easier careers were open to him, was due at least partly to his recognition of photography as the most effective medium for expressing and recording the tensions, complexities and dramas of the modern world.

—Tom Hopkinson

MANOS, Constantine.

American. Born in South Carolina in 1934. Educated at the University of South Carolina, B.A. in English. Freelance photographer, Boston, since 1964. Member, Magnum Photos co-operative agency, New York, since 1964. Recipient: Art Directors Club of New York Award, 1966. Agency: Magnum Photos, 251 Park Avenue South, New York, New York 10010. Address: 26 Rutland Square, Boston, Massachusetts 02118, U.S.A.

Individual Exhibitions:

1972 *A Greek Portfolio*, Art Institute of Chicago

Constantine Manos: *Offerings for the Dead, Easter Sunday, Malia, Crete*, from *A Greek Portfolio*, 1972

Collections:

Museum of Modern Art, New York.

Publications:

By MANOS: books—*A Greek Portfolio*, New York and London 1972; *Bostonians*, Boston 1975.

On MANOS: book—*America in Crisis: Photographs for Magnum*, edited by Charles Harbutt and Lee Jones, with an essay by Mitchel Levitas, New York 1969; article—"Where's Boston" by Bob Schwalberg in *Popular Photography* (New York), November 1976.

"By his unique nature each human being defies generalities, and no two people are the same. The individual is constantly changing in relation to time, his environment, and other people. Selecting a split second in which to arrest this passage through time is the unique magic of the camera" (from *A Greek Portfolio* by Constantine Manos).

A photojournalist and a commercial photographer, a member of Magnum for 17 years, Constantine Manos is best known for his books, *A Greek Portfolio* and *Bostonians*, and for his work on the multimedia presentation "Where's Boston." These three works display Manos' fine ability to envision the subtleties of the complex lives around him and to render them gracefully on film.

A Greek Portfolio, published in 1972, is a record of Manos' leisurely journey through the Greek countryside. The emphasis of the pictures is on the quiet lives of the people he encountered. Manos, a Greek himself, has infiltrated their lives and used his unobtrusive Leica to record his own experiences with these people. We see them eating, working and worshipping. As he clearly states in his introduction, he does not try to give a vague portrait of this complex culture, but simply tries to make his own journey available to others through these photographs. The book allows us to be very successful tourists. We see the sights and marvel at the manifest differences between our cultures. Most importantly, though, since Manos himself is an insider, we are permitted a glimpse at unguarded and often very personal experiences that we as outsiders would not have experienced.

Manos' book *Bostonians* and the multimedia presentation "Where's Boston" work in a similar fashion. "Where's Boston" is specifically directed at outsiders. Set up in a small theater in a tourist area of downtown Boston, "Where's Boston" is an introduction to the city. Amazingly, even Bostonians (this writer counts himself among that group) have reacted favorably to this p.r. job for the city. Manos, the principal photographer, along with the organizers and writers of the show, have created an astoundingly rich and balanced view of our town. They only half-heartedly repeat the banal praises of "cultural Boston" and eagerly delve into a more sophisticated critique of the city. They energetically pursue a view of Boston's ethnic diversity and point out the manifest problems that it has created. They give a good feel for the geography, the climate, the architecture—in short, an overview in 55 minutes of a very complicated subject.

The book *Bostonians* (a spinoff of the "Where's Boston" project) clearly demonstrates how Manos was instrumental in producing this excellent show. *Bostonians* is much like *A Greek Portfolio*. Manos deals with the specifics of individual people in nonstereotypical situations. He observes the multifarious textures of the city's people and neighborhoods and presents the reader with a careful balance. He has included everything from a stripper in Boston's famed Combat Zone, to an I.R.A. rally. Manos includes the bluebloods on wealthy Beacon Hill and a baseball game at Fenway Park. The book contains fishermen, firemen, and a bassoon-piano duet.

Bostonians actively records the temporal element of its rapidly changing subject. This is not just any Boston, but Boston in 1974. It is just before the Bicentennial and after the political activism that swept the city. It is a time of particular clothes and hair styles, of particular social problems and cultural attributes. Manos has wisely made this a record of a specific and limited subject, one which works equally well as a tourist guide and as a serious document of our town.

One of the goals of photojournalism so frequently expressed and so infrequently fulfilled is that the photographer should develop an understanding, even a sympathy, for the subject he is documenting. Manos has chosen to photograph the subjects he is already inside. His pictures present that intimate view to those who are not.

—Ken Winokur

MAN RAY.

American. Born Emmanuel Rudnitzky, in Philadelphia, Pennsylvania, 27 August 1890. Studied art at evening classes in various schools, including the National Academy of Design, New York, 1908-12; studied life-drawing at the Francisco Ferrer Social Center, New York, 1912-13; self-taught in photography, from 1915. Married Adon (Donna) Lacroix in 1914 (divorced, 1918); lived with Alice (Kiki) Prin, 1924-30; married Juliet Browner in 1946. Independent painter and sculptor, from 1911: worked as part-time designer in an advertising agency, New York, 1913-19; freelance photographer, filmmaker and painter, associating with Surrealist artists, Paris, 1921-40; freelance fashion photographer and painter, Hollywood, California, 1940-50; independent artist, concentrating on own photography and painting, Paris and Cadaques, Spain, 1951 until his death, 1976. Founder-Member, with Marcel Duchamp and Walter Arensberg, Society of Independent Artists, New York, 1915, with Marcel Duchamp and Francis Picabia, New York Dadaist movement, New York, 1917, and with Marcel Duchamp, Katherine Dreier and others, Société Anonyme, New York, 1920. Editor, with Henri S. Reynolds and Adolf Wolff, only issue of *TNT* magazine, New York, 1919, and with Marcel Duchamp, only issue of *New York Dada* magazine, New York, 1921. Instructor in Photography, Art Center School, Los Angeles, 1942-50. Recipient: Gold Medal for Photography, *Biennale*, Venice, 1961. *Died* (in Paris) *18 November 1976.*

Individual Exhibitions:

1915	Daniel Gallery, New York (and 1916, 1919)
1921	Librairie 6, Paris
1926	*Rayographs and Objects*, Galerie Surrealiste, Paris
	Photographs and Paintings, Daniel Gallery, New York
1927	Daniel Gallery, New York
1928	Galerie Surrealiste, Paris
1929	*Photographic Compositions by Man Ray*, Arts Club, Chicago
	Galerie Myrbor, Paris
	Rayographs and Paintings, Galerie Quatre Chemins, Paris
	Galerie Van Leer, Paris
1931	Galerie Alexandre III, Cannes
1932	Galerie Chez Dacharry, Paris
	Julien Levy Gallery, New York

	Galerie Vignon, Paris
1934	Lund Humphries and Company, London (and 1935)
	Lund Humphries and Company, London
1935	*Photographs and Rayographs*, Wadsworth Atheneum, Hartford, Connecticut
	Photographs and Drawings, Art Center School, Los Angeles
	Rayographs and Paintings, Galerie Adlan, Barcelona
	Galerie aux Cahiers d'Art, Paris
1936	Curt Valentin Gallery, New York
1937	Galerie Jeanne Bucher, Paris
	Palais des Beaux-Arts, Brussels (with Yves Tanguy and René Magritte)
1939	Galerie de Beaunne, Paris (travelled to the London Gallery)
1941	Frank Perls Galleries, Los Angeles
	M.H. de Young Memorial Museum, San Francisco
1943	Santa Barbara Museum of Art, California
1944	Pasadena Art Institute, California
1945	Los Angeles County Museum of History, Science and Art
1946	Circle Gallery, Los Angeles
1948	Copley Gallery, Hollywood, California
1951	Galerie Berggruen, Paris
1953	Paul Kantor Gallery, Los Angeles
1954	Galerie Furstenberg, Paris
1956	Galerie l'Etoile Scellée, Paris
	Musée de Tours, France (with Max Ernst and Dorothea Tanning)
1959	Galerie Rive Droite, Paris
	Alexander Iolas Gallery, New York
	Mayer Gallery, New York
	Galerie Larcade, Paris
	Institute of Contemporary Arts, London
1960	Esther Robles Gallery, Los Angeles
1962	*Man Ray: L'Oeuvre Photographique*, Bibliothèque Nationale, Paris
	Galerie Rive Droite, Paris
1963	Cordier and Ekstrom, New York
	Musée D'Amiens, France
	Cavendish Gallery, London
	Princeton University, New Jersey
	LGA Austellungsraum, Stuttgart
1964	Galleria Schwarz, Milan
1965	Cordier and Ekstrom, New York
1966	Los Angeles County Museum of Art (retrospective)
1968	Martha Jackson Gallery, New York
	Galerie der Spiegel, Cologne
1969	Hanover Gallery, London
	2 Generations of Photographs: Man Ray and Naomi Savage New Jersey State Museum, Trenton
	Galerie Alphonse Chave, Venice
	Studio Marconi, Milan
	Galleria Il Fauno, Turin
1970	Galerie Richard Foncke, Ghent
	Galleria del Cavallino, Venice
	Galerie XXme Siècle, Paris
	Galleria La Chioccoloa, Padua
	Noah Goldowsky Gallery, New York
	Museum Boymans-van Beuningen, Rotterdam (retrospective; travelled to Musée d'Art Moderne, Paris, and Louisiana Museum, Humlebaek, Denmark)
	Philadelphia Museum of Art
1971	Galleria Milano, Milan
	Salone Annunciata, Milan
	Galleria Il Fauno, Turin
	Galerie Suzanne Visat, Paris
1972	Galleria Gissi, Turin (travelled to Galerie Françoise Tournie, Paris, and Galleria dell'Arte Libreria Pictogramma, Rome)
	Galerie des 4 Mouvements, Paris
	Galleria Il Fauno, Turin
1973	Metropolitan Museum of Art, New York
	Galerie im Lenbachhaus, Munich (with Marcel Duchamp and Francis Picabia)
1974	New York Cultural Center (travelled to Institute of Contemporary Arts, London,

481

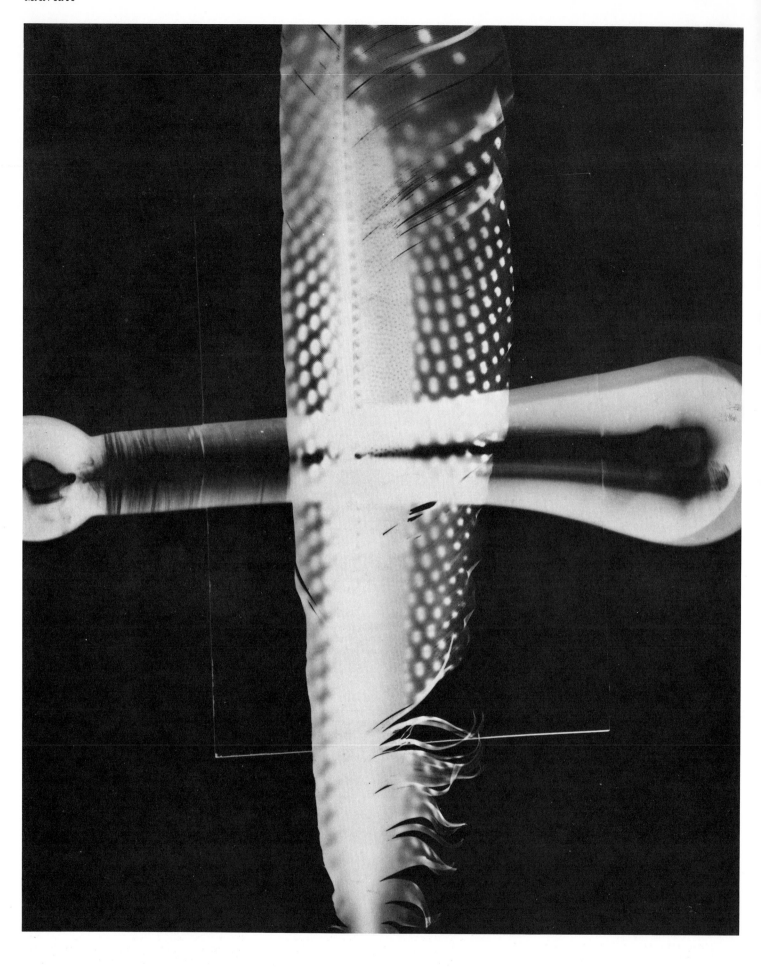

Man Ray: *Untitled Rayograph,* **1923** Courtesy Art Institute of Chicago

and Galleria Il Fauno, Turin)
Alexander Iolas Gallery, New York
Galerie Alexandre Iolas, Paris
1975 Mayor Gallery, Athens
G. Ray Hawkins Gallery, Los Angeles
Palazzo dell'Esposzione, Rome
Galleria Il Fauno, Turin, Italy
Mayor Gallery, London
Studio Marconi, Milan
1976 *Man Ray: Fotografia*, at the *Biennale*, Venice
1977 Kimmel/Cohn, New York
Kiva Gallery, Boston
1978 *Vintage Photographs, Solarizations and Rayographs*, Allan Frumkin Gallery, Chicago
1979 *Man Ray: Inventionen und Interpretationen*, Kunstverein, Frankfurt (travelled to Kunsthalle, Basle)
1980 Prakapas Gallery, New York
Galeria Eude, Barcelona (toured Spain)
1981 *Man Ray: Photographe*, Centre Pompidou, Paris
Vintage Photographs, Knoedler Gallery, London

Selected Group Exhibitions:

1928 *1st Independent Salon of Photography*, Salon de l'Escalier, Paris
1929 *Film und Foto*, Deutscher Werkbund, Stuttgart
1959 *Hundert Jahre Photographie 1839-1939*, Museum Folkwang, Essen (travelled to Cologne and Frankfurt)
1964 *The Painter and the Photograph: From Delacroix to Warhol*, University of New Mexico, Albuquerque
1967 *Photography in the 20th Century*, National Gallery of Canada, Ottawa (toured Canada and the United States, 1967-73)
1971 *Photo Eye of the 20's*, University of South Florida, Tampa (travelled to Pasadena, Des Moines, Seattle, Minneapolis and Chicago)
1977 *The History of Fashion Photography*, International Museum of Photography, George Eastman House, Rochester, New York (travelled to Brooklyn Museum, New York; San Francisco Museum of Modern Art; Cincinnati Art Institute, Ohio; and Museum of Fine Arts, St. Petersburg, Florida)
1979 *Photographie als Kunst 1879-1979*, Tiroler Landesmuseum Ferdinandeum, Innsbruck, Austria (travelled to Neue Galerie am Wolfgang Gurlitt Museum, Linz, Austria; Neue Galerie am Landesmuseum Joanneum, Graz; and the Museum des 20. Jahrhunderts, Vienna)
1979 *Photographic Surrealism*, New Gallery of Contemporary Art, Cleveland, Ohio (travelled to Dayton Art Institute, Ohio, and the Brooklyn Museum, New York)
1980 *Experimental Photography*, Stills Gallery, Edinburgh (toured Britain)

Collections:

Museum of Modern Art, New York; International Museum of Photography, George Eastman House, Rochester, New York; Yale University, New Haven, Connecticut, Art Institute of Chicago; New Orleans Museum or Art; University of Kansas, Lawrence; University of New Mexico, Albuquerque; Oakland Museum, California; Provinciaal Museum voor Kunstambachten, Deurne-Antwerp; Musée d'Art Moderne, Paris.

Publications:

By MAN RAY: books—*Les Champs Délicieux: Album de Photographies*, portfolio of rayographs, with a preface by Tristan Tzara, Paris 1922; *Man Ray*, with text by Georges Ribemont-Dessaignes, Paris 1924; *Man Ray/George Hoyningen-Huene*, portfolio of fashion photos, Paris 1924-25; *Revolving Doors, 1916-17*, Paris 1926, Turin 1972; *Kiki Souvenirs*, Paris 1929; *Electricité*, portfolio of 10 rayographs, with an introduction by Pierre Bost, Paris 1931; *Man Ray Photographies, 1920-1934, Paris*, with text and poems by André Breton, Paul Eluard, Tristan Tzara and others, Paris 1934, reprinted as *Man Ray: Photographs, 1920-1934*, with an introduction by A.D. Coleman, New York 1975, and as *Man Ray: Photographien, Paris, 1920-1934*, with text by Andreas Haus, Munich 1980; *Facile*, with poems by Paul Eluard, Paris 1935; *Les Mains Libres*, with Paul Eluard, Paris 1937; *La Photographie n'est pas l'Art*, manifesto, with a foreword by André Breton, Paris 1937; *Alphabet for Adults*, Beverly Hills, California 1948; *To Be Continued Unnoticed*, Beverly Hill, California 1948; *Man Ray: L'Oeuvre Photographique*, exhibition catalogue, with text by Jean Adhemar and others, Paris 1962; *Man Ray: Self-Portrait*, Boston 1963; *Man Ray: 12 Photographs 1921-28*, portfolio, New York 1963; *Man Ray: Portraits*, with text by L. Fritz Gruber, Gutersloh, West Germany and Paris 1963; *Man Ray: Tous les Films que J'ai Realisé*, Paris 1965; *Les Mannequins*, Paris 1966; *Les Invendables*, portfolio, Vence, France 1969; *Mr. and Mrs. Woodman*, portfolio, Amsterdam 1970; *Oggetti d'Affezione: Rayographs*, with text by C.G. Argan, Turin 1970; *Man Ray: Les Voies Lactées*, New York 1974; *Man Ray: Femmes 1930-35*, portfolio of 26 photos, Milan 1981; articles—"Man Ray: Rayograms" in *Surrealisme A.S.D.L.R.* (Paris), December 1931; "Sur le Realisme Photographique" in *Cahiers d'Art* (Paris), no. 10, 1935; "La Photographie qui Console" in *XXme Siècle* (Paris), no. 2, 1938; "Is Photography Necessary?" in *Modern Photography* (New York), November 1957; "Man Ray: The Fiery Elf," interview with Morris Gordon, in *Infinity* (New York), October 1962; "Man Ray on the Future," interview with Ed Hirsch and Ben Zar, in *Popular Photography* (New York), January 1967; "Man Ray," interview with Paul Hill and Thomas Cooper in *Camera* (Lucerne), February 1975; films—*The Return to Reason*, 1923; *Emak Bakia*, 1926; *L'Etoile de Mer*, 1928; *The Mystery of the Chateau of Dice*, 1929.

On MAN RAY: books—*Un Siècle de Photographie de Niepce à Man Ray*, exhibition catalogue, by Laurent Roosens, Paris 1965; *Man Ray*, with an introduction by Jules Langsner, Los Angeles 1966; *Man Ray: 60 Years of Liberties* by Louis Aragon, Jean Arp and others, Milan 1971; *The Painter and the Photograph: From Delacroix to Warhol* by Van Deren Coke, Albuquerque, New Mexico 1972; *Man Ray* by Janus, Milan 1973; *Photography in America*, edited by Robert Doty, with an introduction by Minor White, New York 1974; *Man Ray* by Roland Penrose, London 1975; *The Magic Image* by Cecil Beaton and Gail Buckland, London and Boston 1975; *American Fashion* by Sara Tomerlin Lee, New York 1975, London 1976; *Une Histoire du Cinema*, exhibition catalogue, by Peter Kubelka and others, Paris 1976; *Photomontage* by Dawn Ades, London 1976; *Man Ray: The Rigour of the Imagination* by Arturo Schwarz, Milan 1977; *Man Ray: L'Immagine Fotografica/Man Ray: The Photographic Image* by Janus, Milan 1977, London 1980; *Man Ray: Inventionen und Interpretationen*, exhibition catalogue, by G. Bussmann and others, Frankfurt 1979; *Photographen der 20er Jahre* by Karl Steinorth, Munich 1979; *Photographic Surrealism*, exhibition catalogue, by Nancy Hall-Duncan, Cleveland, Ohio 1979; *The History of Fashion Photography* by Nancy Hall-Duncan, New York and Paris 1979; *The Vogue Book of Fashion Photography* by Polly Devlin, New York and London 1979; *The Photograph Collector's Guide* by Lee D. Witkin and Barbara London, Boston and London 1979; *Man Ray: Photographe*, exhibition catalogue, with text by Jean-Hubert Martin, Paris 1981.

Although he was familiar with the work of Alfred Stieglitz when he was a struggling young artist in New York, Man Ray did not take up photography until he reached Paris in the early 20's; and he did so then, it appears, out of need rather than desire. Unable to sell his paintings—which were for the most part crude imitations of the early Cubists—he turned to fashion photography and, a little later, portraiture. He was extraordinarily successful in both areas, at least in part because he remembered what he had learned from Stieglitz and *Camera Work*. In 1921, Jed Perl explains, his approach caused something of a sensation: "Man Ray favored natural light, sharp, clear contrast, and informal poses. All this seemed quite fresh at a time when pictorialism was still the style favored by commercial photographers in both Europe and the United States.... By the 1920's the soft-focus effects, asymmetrical compositions and anecdotal subjects that seemed advanced 30 years before no longer had the power to arrest. Man Ray had known Alfred Stieglitz fairly well back in New York, in the years when Stieglitz had rejected pictorialism completely, and had been influenced by the master's dictum: 'No diffused focus. Just the straight goods.' He was among the first to carry the new, clean-lined photographic work to Paris and into commercial work." As for the portraits, they are powerful, uncompromising and anything but flattering in the usual sense. And at least one of them, a 1932 portrait of Arnold Schönberg, is one of the great photoportraits of the century.

But it was his new freedom to pursue experimental work which excited Man Ray. "Photography," he once asserted, "is not art"—a statement which has to be understood in the context of the period and his close association with the Dadaists and Surrealists. "Art," as Man Ray uses the term here, means the bourgeois conception of art, the complacent view that of course the artist attempts to reproduce "reality" by means of decorum and rational control. For this conception of art Man Ray, Marcel Duchamp, André Breton, among many others, had nothing but contempt. It was chance, the irrational and the deliberate frustration of bourgeois standards which mattered; and it was the new taste for such things which accounts for the enthusiasm that Man Ray's Rayographs and Solarizations soon generated. Indeed it was "chance" which led to the discovery of the Rayographs, as Roland Penrose tells the story: "[Ray] worked late into the night in his improvised dark-room, developing the plates he had exposed during the day, and making contact prints on sheets of paper spread out under the glass negative on a table lit by an electric light bulb hanging from the ceiling. It was this primitive set-up that made possible a startling development in photography, when he inadvertently placed a few objects on a sensitized sheet under the light. To his surprise, an image grew before his eyes on the paper under the light, 'not quite a simple silhouette of the objects, as in a straight photograph, but distorted and refracted by the glass more or less in contact with the paper and standing out against a black background, the part directly exposed to the light'.... 'Taking whatever objects came to hand,' he tells us, 'my hotel room key, a handkerchief, some pencils, a brush, a candle, a piece of twine...I made a few more prints, excitedly, enjoying myself immensely.'... On seeing the prints, Tristan Tzara was at once very excited and claimed that they were 'pure Dada'. Man Ray tells us, 'Tzara came to my room that night; we made some Rayographs together, he disposing matches on the paper, breaking up the matchbox itself for an object, and burning holes with a cigarette in a piece of paper, while I made cones and triangles and wire spirals, all of which produced astonishing results.' " The results seem less astonishing today, and the theory behind such more or less aleatory "creation"

naive or even somewhat hypocritical (after all, someone has to find the found object and label it as such for others). Man Ray's work has been praised often enough for its spontaneity, as if that were a good in itself, for its originality (a claim hard to justify, since he may well have been familiar with Christian Schad's experiments), and for its unexpected wit, in his paintings and photographs alike (Man Ray refused to distinguish between the two as different "arts"). But viewers who expect to find in these works anything like the inventiveness or wit of Duchamp or Miro and Klee will be badly disappointed. The legacy which Dadism handed on to photography is a dubious one, as Susan Sontag argues in *On Photography*.

Looking back at his experimental work many years later, Man Ray made some extraordinary statements, now fairly well-known (perhaps for their magniloquence rather than their coherence or descriptive value). In any event, the Rayographs and Solarizations are, in his own words, "oxidized residues, fixed by light and chemical elements, of living organisms. No plastic expression can ever be more than the residue of an experience. The recognition of an image that has tragically survived an experience, recalling the event more or less clearly, like the undisturbed ashes of an object consumed by flames, the recognition of this object so little representative and so fragile, and its simple identification on the part of the observer with a similar personal experience, precludes all psychoanalytical classification or assimilation into an arbitrary decorative system." It is hard to know how far to take rhetoric like this. Man Ray may well have intended these words as a description of his chance, "cameraless" photographs, but they may be even more relevant to his best photoportraits. The notion of the photograph as the residue, the survivor of a mortal experience in time has been developed recently by

Roland Barthes with real eloquence. What the authentic photograph tells us—what the photograph of Gertrude Stein or Arnold Schönberg or one's mother as a child tells us—is, finally, *this was and now is gone*.

Man Ray himself would probably be impatient with such theorizing. He was quixotic, playful, and, to quote Jed Perl once again, "cared little for politics, for aesthetics, for the elaborate self-justifications of many of his Surrealist friends. One lived one's life and did what one did.... [His work] reflects with pure Data *esprit* the glee of spontaneous discovery." Yet the nagging question remains: discovery of what? A bit of twine? A shattered matchbox? The freedom Man Ray and his friends revelled in may have been a kind of self-indulgence, a levelling rather than a liberating nihilism.

—Elmer Borklund

MANTE, Harald.

German. Born in Berlin, 29 March 1936. Educated at the Realgymnasium, Wiesbaden, 1950-54; studied painting and graphic design (on scholarship), under Vincent Weber, Werkkunstschule, Wiesbaden, 1957-61; self-taught in photography, 1960-64. Married Karen Entzeroth in 1960; children: Christof and Elke. Freelance photographer, working for *Twen, Stern, Epoca, Bild der Zeit*, etc., since 1965. Instructor in Photography and Graphic-Design, Werk-kunstschule, Wiesbaden, 1967-71, and Fachhochscule, Wuppertal, 1971-73. Since 1974, Professor of Free and Experimental Color-Photography for Photo-Designers, Fachhochschule, Dortmund. Member, Deutsche Gesellschaft für Photography, (DGPh) 1971; Bund Freischaffender Fotodesigner (BFF), 1973; Gesellschaft Deutscher Lichtbildner (GDL), 1974; Club-Daguerre, Frankfurt, 1976. Recipient: Kodak Award for Best Calendar, Graphic Club, Stuttgart, 1980, 1981; Bronze Medal, Art Directors Club of Germany, 1981. Address: Sonnenstrasse 116, 4600 Dortmund 1, West Germany.

Individual Exhibitions:

1966 *Irland*, Irish Tourist Board, Frankfurt
1968 *Reisefotografie*, Volkhochschule, Monchen-Gladbach
1974 *Multiple Objekte*, Galerie "Die Insel", Hamburg
 Multiple Objekte, Galerie im Schauspielhaus, Wuppertal, West Germany
1976 *Serien und Sequenzen*, Haus der Kunst, Hamburg
1978 *Serien und Sequenzen*, Galerie Keller-Holk, Wiedenbrück, West Germany
 Serien und Sequenzen, PPS-Galerie, Hamburg
 Serien und Sequenzen, Mendel Art Gallery, Saskatoon, Saskatchewan
1979 *Serien und Sequenzen*, Deutsche Gesellschaft für Photographie, Cologne
 Serien und Sequenzen, Galerie 66, Hoensbroeck, Netherlands
1980 *Serien und Sequenzen*, Kunstverein, Bruchsal, West Germany
 Serien und Sequenzen, Galerie an der Farbmühle, Wuppertal, West Germany
 Toskana, Canada und Sequenzen, Galerie Stadtbildstelle, Würzburg, West Germany
1981 *Toskana, Canada und Sequenzen*, Galerie der Deutschen Bank, West Berlin
 Toskana, Canada und Sequenzen, Galerie des Rathauses, Aalen, West Germany
 Spiegelungen, Canada, Sequenzen, Galerie St. Johann, Saarbrücken, West Germany

Selected Group Exhibitions:

1968 *2nd World Exhibition of Photography*, Pressehaus Stern, Hamburg (and world tour)
1972 *5 Foto-Designer*, Galerie Keresztes, Nuremberg
1977 *Sequencer und Künstler*, Landesmuseum, Darmstadt
1978 *Form und Farbe im Foto: Harald Mante und Studenten*, Landesbildstelle, Bremen, West Germany (travelled to Höhere Graphische Galerie, Vienna; Landesbildstelle, Stuttgart; and Deutsche Gesellschaft für Photographie, Cologne, 1979-80)
1979 *60 Jahre GDL*, Stadtmuseum, Munich
1980 *30 Member BFF*, Albrecht-Dürer Museum, Nuremberg

Collections:

Sammlung Land Baden-Württemberg, Stuttgart; L. Fritz Gruber Collection, Cologne; Saskatoon Art Gallery, Saskatchewan.

Publications:

By MANTE: books—*Bildaufbau*, Ravensburg, West Germany 1969; *Farb-Design*, Ravensburg, West Germany 1971; *Die Spiegelreflex-Fotografie*, with text by Axel Brück, 1975; *Form und Farbe im Foto*, Munich 1977; *Farbig Sehen und Gestalten*, Schaffhausen, West Germany 1980; *Toskana-Umbrien*,

Harald Mante: *Volkswagen* (original in color), 1972

Munich 1981; *Österreich*, Munich 1982; *Objektive Creativ Nutzen*, photos and text with Josef H. Neumann, Schaffhausen, West Germany 1982; articles—"Bildgestaltung" in *Fotomagazin* (Munich), January-December 1971; "Bewusst Sehen" in *Color-Foto* (Munich), July 1973-June 1975; "Farbig Sehen" in *Photographie* (Schaffhausen, West Germany), January 1979-December 1980; "Experimental Gestalten" in *Photographie* (Schaffhausen, West Germany), January-June 1981; "Objektive Creativ Nutzen" in *Photographie* (Schaffhausen, West Germany), January 1981-December 1982.

On MANTE: books—*2nd World Exhibition of Photography*, exhibition catalogue, edited by Karl Pawek, Hamburg 1968; *Fotografie 1919-1979, Made in Germany: Die GDL Fotografen*, edited by Fritz Kempe, Bernd Lohse and others, Frankfurt 1979; *Dumontfoto 1*, edited by Hugo Schöttle, Cologne 1978; *Dumontfoto 2*, edited by Hugo Schöttle, Cologne 1979; *Lexikon der Fotografie*, edited by Hugo Schöttle, Cologne 1979; *Amerika-Amerika*, Hamburg 1980.

In addition to shifts of interest within the medium—e.g., from black/white to color or from the single image to series and sequences—my work has been characterized by its format. During the first phase of my work, I used a Contarex and lenses ranging from 15 to 250mm. Black/white and color photography were equally juxtaposed. I was dedicated largely to the single image, the pursuit of the outstanding photograph (1960-1969). Series came about purely by means of amassing single images—e.g., doors, windows, facades.

Exhibitions and publications on travel themes were supplemented by means of "touristic subjects." My earliest books were illustrated with the best results of this initial phase.

By winning first prize in a photo competition, I was able to buy my first 6 x 6 camera (a Rollei SL 66). The work which followed (1968-74) was a reflection of my fondness for detail in nature, technology and culture. I took photographs of all kinds of structures, colors and forms, involving countless different kinds of subjects. The result, in the space of 6 years, was over 100 series of up to 200 Ektachrome slides. These detailed photographs led eventually to serial (multiple) montages, usually of 8 identical prints mounted around a similar or contrasting center.

A commission from the Minolta Camera Company led me (in 1974) back to the miniature format, and, in turn, to Kodachrome film. With Axel Brück, I was to develop a book for amateurs. This project stimulated in me a renewed search for the single image.

The first series and sequences in color appeared at this time, and this form of expression has since been my favorite in terms of style. The thematic complexities of time/space, light and subject make up the content of the series and sequences—from the smallest, comprised of only 2 photos, to the largest, comprised of 36 or more photos.

Other areas of my work include experimental form and "photography as an art form."

In 1980, I undertook a commission to prepare a photographic picture book on Tuscany/Umbria which was followed by a volume on Austria in 1981.

My entire activity can be classified as being within the scope of the formal-aesthetic. My goal is the highest finesse in form and color—the subjects themselves usually take second priority. I tolerate and jest with my colleagues who use the medium of photography differently—e.g., those who are active photojournalists or those who work in the area of new objective photography—and I expect the same tolerance.

I love the medium.

—Harald Mante

Harald Mante's photographic activity is multifaceted—in addition to being a freelance photographer, he also teaches and writes about photography. He began as a self-taught amateur photographer, but was not satisfied with the results and felt that he must express himself differently from the usually prescribed textbook manner. His study of the problems which constitute the basic roots of creativity led him to recognize the underlying nature of photography.

Mante can be viewed as a great master of composition—both in black/white and color. He prefers the latter, no doubt, because he likes to surprise his audience with marvelous arrangements of details found in modest, commonplace subjects. He is able to concentrate his interest on the main aspect of the subject and to omit everything which would detract from the significance of the effect he is trying to achieve. At the same time, he does not manipulate his subjects, but captures them in a situation which enhances his motif.

Mante's creative exploration of the world is closely aligned with his entire intellectual background. He endeavors to react with the world around him, and his choice of subject matter is characteristic of the present state of civilization and the objects of contemporary life. For example, traffic signs or a series of gaily painted cars indicate his effort to interpret, poetically, a particular aspect of modern life. Mante combines similar images into series and sequences, thereby creating a more complex expression.

In his outlook on reality, Mante attempts to respect time, space, light and subject, all of which are aspects of the unique situation which he attempts to depict. While he often concentrates on detail, he does not isolate the subject from its environment—this is particularly evident in sequences where the identity of single images becomes evident by means of comparison.

—Petr Tausk

MANTZ, Werner.

German. Born in Cologne, 28 April 1901. Educated at the Oberrealschule, Cologne; studied photography at the Bayerischen Lehr-und Versuchsanstalt, Munich, 1920-21. Married Marg. Schmidt in 1939; has 3 children. Took first photos, Cologne, 1915; amateur photographer, mainly of the city of Cologne and the Bergisches Land area, Nordrhein-Westphalia,

Werner Mantz: *Berliner Tagblitt House (Mendelssohn) and Church (Bartling) at the Pressa Exhibition*, Cologne, **1928** Courtesy Galerie Rudolf Kicken, Cologne

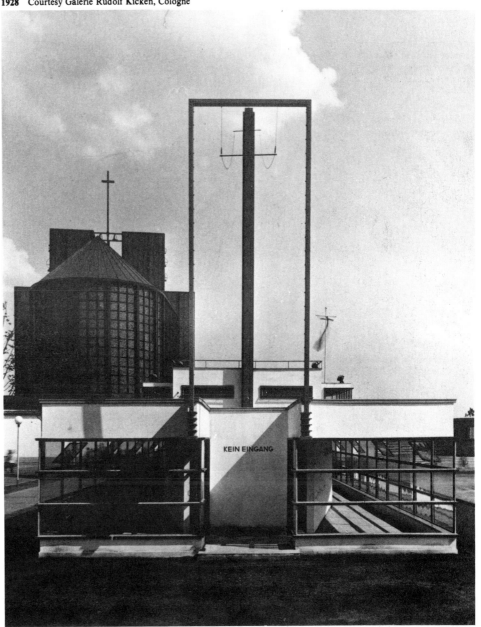

1915-20; professional portrait photographer, establishing own studio, Cologne, 1921-26; freelance architectural photographer, working for the City of Cologne, and for the architect Wilhelm Riphahn and other architects, Cologne, 1927-38; estalished second studio, Maastricht, Netherlands, 1932: portrait and child photographer, Maastricht, 1938 until his retirement, 1971. Agent: Galerie Rudolf Kicken, Albertusstrasse 47-49, 5000 Cologne 1, West Germany. Address: Cramignonstraat 19, NL-6245 Eijsden, Netherlands.

Individual Exhibitions:

1976 Galerie Lichttropfen, Aachen, West Germany
1977 Felicity Samuel Gallery, London
 Galerie Gillespie-De Laage, Paris (with Bernhard and Hilla Becher and P. Weller)
1978 *Fotografien 1926-1938*, Rheinisches Landesmuseum, Bonn
1981 Musée Réattu, Arles, France

Selected Group Exhibitions:

1931 *Exposition Internationale*, Brussels
1932 *Vereinigung Kölner Fachphotographen*, Kunstgewerbemuseum, Cologne
1975 *Vom Dadamax zum Grungurtel*, Kölner Kunstverein, Cologne
1976 *Internationale Kunstmesse*, Basle (and 1977)
1977 *Documenta 6*, Museum Fridericianum, Kassel, West Germany
 4 Deutsche Fotografen, Galerie Spectrum, Hannover
1978 *Neue Sachlichkeit and German Realism of the 20's*, Hayward Gallery, London
1979 *Photographie als Kunst 1879-1979*, Tiroler Landesmuseum Ferdinandeum, Innsbruck, Austria (travelled to the Neue Galerie am Wolfgang Gurlitt Museum, Linz, Austria; Neue Galerie am Landesmuseum Joanneum, Graz, Austria; Museum des 20. Jahrhunderts, Vienna)
1980 *Avant-Garde Photography in Germany 1919-39*, San Francisco Museum of Modern Art (toured the United States, 1980-81)
1981 *Germany: The New Vision*, Fraenkel Gallery, San Francisco

Collections:

Museum Folkwang, Essen; Rheinisches Landesmuseum, Bonn; Moderna Museet, Stockholm; Victoria and Albert Museum, London; Gillmann Paper Company, New York; Seagram Company, New York; Sam Wagstaff Collection, New York; Princeton University, New Jersey; New Orleans Museum of Art; University of New Mexico, Albuquerque.

Publications:

By MANTZ: book—*Portfolio Werner Mantz*, by Galerie Schurmann und Kicken, Aachen, West Germany 1977.

On MANTZ: books—*Vom Dadamax zum Grungurtel: Köln in der Zwanziger Jahre*, exhibition catalogue, Cologne 1975; *Documenta 6/Band 2*, exhibition catalogue, by Klaus Honnef and Evelyn Weiss, Kassel and Cologne 1977; *Geschichte der Fotografie im 20. Jahrhundert/Photography in the 20th Century* by Petr Tausk, Cologne 1977, London 1980; *Neue Sachlichkeit and German Realism of the 20's*, exhibition catalogue, by Wieland Schmied, Ute Eskildsen and others, London 1978; *Werner Mantz: Fotografien 1926-1938*, exhibition catalogue, by Klaus Honnef, Bonn 1978; *Tusen och en Bild*, exhi-

bition catalogue, Åke Sidwall, Sune Jonsson and Ulf Hard af Segerstad, Stockholm 1978; *Photographie als Kunst 1879-1979/Kunst als Photographie 1949-79*, exhibition catalogue, 2 vols., by Peter Weiermair, Innsbruck, Austria 1979; *Avant-Garde Photography in Germany 1919-1939*, exhibition catalogue, by Van Deren Coke, Ute Eskildsen and Bernd Lohse, San Francisco 1980.

Werner Mantz is a pure professional of the kind that unites the craftsman of art history with the Hollywood film director. The professional photographer arrived in the 1920's when advanced technology brought to an end the epoch of the inventor photographer such as Benjamin, the first epoch in the history of photography.

Mantz began as an amateur. He perfected his knowledge by studying for four terms at the Bayerischen Lehr-und Versuchsanstalt in Munich. His early photographic attempts, while he was still a schoolboy during the First World War, show that it was to be documentary rather than artistic intentions that would determine his career in photography. And, indeed, Mantz never attempted to obtain the precious artificiality of so-called art photography. His interest was in a contemporary historical statement, not the revelation of aesthetic values in photography. He subordinated art, as it were, to content, until he was able finally to remove any discrepancy between the two components.

Mantz's whole photographic career took place within the framework of the professional photographer. Apart from his first documentations of a Cologne destroyed by bombing raids and damaged by the effect of a flood catastrophe, all his important photographs come from accepted professional practice. He succeeded first as a portraitist, then, thanks to the mediations of a Cologne artist whose sculptures he regularly photographed, he found his photographic destiny as a photographer of architecture. A photographic commission brought him to the notice of the leading Cologne architect Wilhelm Riphahn. Mantz's lucid, sober style corresponded remarkably with Riphahn's ideas about architecture. In the following years he worked exclusively for Riphahn and other important representatives of the new objective manner such as Falck, Kreis, Klotz, Lüttgen, Mendelsohn, Neubert, Bruno Paul, Ruff, Schumacher and Wirminghaus.

His 18 x 24 photographs were expressions of the architectural interpretation of functionalism. Mantz recorded his subjects mainly in morning light. He used the sharply cast shadows to lend to the buildings mass, relief and volume and in so doing created a vivid depiction of structure. He recorded, as photographic motif, from the front or diagonally. With the final "setting" he conveyed the scale of the photographed building complex or interiors, and his way of seeing and photographing demonstrated the functional aspects of the portrayed objects—individual buildings, building complexes, interiors, installations/fittings. The pictorial "idea" does not in any way attempt to make itself independent of these subjects.

Mantz's photographic work not only documents an artistically important building style but also, at the same time, provides a perfect example of functionalist photography in contrast to the "superelevation" of photographic reality in the work of Albert Renger-Patzsch or to the careful diagnosis of a particular time in that of August Sander. Yet, in spite of his functionalism, his interiors in particular convey a magical quality that, above all, is to be attributed to the fact that mathematically calculated scales exist in the relationships between the installed objects and the surrounding space.

For Mantz's precise photographs the concrete, an historic feeling for life, and a vision of reality in which this is reflected, merge steadfastly into one another. They blend together into an indissoluble

unity. This seamless accord also guarantees them an importance beyond time.

—Klaus Honnef

MAPPLETHORPE, Robert.

American. Born in New York City, 4 November 1946. Educated at Pratt Institute, Brooklyn, New York, 1963-70. Underground film-maker, New York, 1965-70; photographer, collagist, assemblagist, New York, 1970-72. Independent photographer, New York, since 1972. Agent: Robert Miller Gallery, 724 Fifth Avenue, New York, New York 10019. Address (studio): 24 Bond Street, New York, New York 10012, U.S.A.

Individual Exhibitions:

1976 *Polaroids*, Light Gallery, New York
1977 *Portraits*, Holly Solomon Gallery, New York
 Pictures, The Kitchen, SoHo, New York
 Flowers, Holly Solomon Gallery, New York
1978 Corcoran Gallery, Washington, D.C.
 Simon Lowinsky Gallery, San Francisco
 Langdon Street Gallery, San Francisco
 Chrysler Museum, Norfolk, Virginia
 Portraits of Patti Smith, Robert Miller Gallery, New York
 La Remise du Parc, Paris
1979 *Trade-Off*, International Center of Photography, New York (with Lynn Davis)
 Robert Miller Gallery, New York
 Texas Gallery, Houston
 Photos 1970-75, Robert Samuel Gallery, New York
1980 *Blacks and Whites*, Lawson/De Celle Gallery, San Francisco
 Galerie Jurka, Amsterdam
 Vision Gallery, Boston
1981 *Black Males*, Robert Miller Gallery, New York
 Steinernes Haus, Frankfurter Kunstverein, Frankfurt
 PPS Galerie, Hamburg
 Fraenkel Gallery, San Francisco
1982 *3 New Yorker Fotografen: Peter Hujar/Larry Clark/Robert Mapplethorpe*, Kunsthalle, Basel

Selected Group Exhibitions:

1977 *The Collection of Sam Wagstaff*, Corcoran Gallery, Washington, D.C. (travelled to the Grey Gallery, New York University)
 Documenta 6, Kassel, West Germany
1978 *Rated X*, Neikrug Gallery, New York
 Mirrors and Windows: American Photography since 1960, Museum of Modern Art, New York (toured the United States, 1978-80)
1979 *Artists by Artists*, Whitney Museum Downtown, New York
 Attitudes, Santa Barbara Museum of Art, California
 Photographie als Kunst 1879-1979, Tiroler Landesmuseum Ferdinandeum, Innsbruck, Austria (travelled to the Neue Galerie am Wolfgang Gurlitt Museum, Linz, Austria; Neue Galerie am Landesmuseum Joanneum, Graz, Austria; and Museum des 20. Jahrhunderts, Vienna)

1980 *In Photography: Color as Subject*, School of Visual Arts, New York

Secret Paintings, Jehu Gallery, San Francisco

1981 *Whitney Biennial*, Whitney Museum, New York

Publications:

By MAPPLETHORPE: books—*Robert Mapplethorpe Photographs*, with text by Mario Amaya, Norfolk, Virginia 1978; *Robert Mapplethorpe: Fotos/Photographs*, with an introduction by Rein von der Fuhr, Amsterdam 1979; *Robert Mapplethorpe: Black Males*, with text by Edmund White, Amsterdam 1980.

On MAPPLETHORPE: books—*Documenta 6/Band 2*, exhibtion catalogue, by Klaus Honnef and Evelyn Weiss, Kassel, West Germany 1977; *Mirrors and Windows: American Photography since 1960* by John Szarkowski, New York 1978; *Photographie als Kunst 1879-1979/Kunst als Photographie 1949-1979*, exhibition catalogue, 2 volumes, by Peter Weiermair, Innsbruck, Austria 1979; *Contact: Theory*, edited by Ralph Gibson, New York 1980; *Robert Mapplethorpe*, exhibition catalogue, with text by Peter Weiermair, Frankfurt 1981; *3 New Yorker Fotografen*, exhibition catalogue, with texts by Dieter Hall, Jean-Christophe Ammann, and Sam Wagstaff, Basel 1980; articles—"Hotel Chelsea" by Gerd Schiff in *Du* (Zurich), May 1971; "Robert Mapplethorpe," special issue of *Creatis* (Paris), 1978; "The Yin and the Yang of Robert Mapplethorpe" by Inge Bondi in *Print Letter* (Zurich), January/February 1978.

In Robert Mapplethorpe's images, the square format dominates, as does stark composition, cold revealing light, precise focus, and a pristine clarity which is reminiscent of the Northern Renaissance painters. He works almost exclusively in black and white.

The idea of "still life" is central to Mapplethorpe's work, for whether he is photographing actual still-lifes, or human bodies formally "arranged" before his lens, a sense of classical composition prevails. In his still-lifes of flower arrangements, "posed" against a plain backdrop, natural colors are reduced to pristine black and white, and emphasis passes to the delineation of form as revealed by the cold light. Everything extraneous is removed—the arrangements exist isolated from their natural origins in a kind of vacuum. There is a definite sense of space, both surrounding the "arrangement" and separating the viewer from it. The sensuality evoked addresses itself to the sense of sight, rather than that of touch. We are asked to contemplate, but not participate in, an act of beauty.

The same sense of formal arrangement extends to Mapplethorpe's investigation of the human body, which is his major theme. Generally he poses his models against neutral backdrop paper, often including the edges of the roll to emphasize the sense of "arrangement," of being posed. Bodies are treated as "objects"—as part of a still-life composition. Often body parts are isolated, such as a pair of hands, a torso, or a pair of feet. The 1981 "Vincent" is a minimal, extremely powerful image of masculine, muscled arms folded across a chest. The model poses against a dark background, which merges mysteriously with the shadowed edges of the body. Mapplethorpe often emphasizes the inherent power of the human form through concentration on a glistening musculature, as in his series of black male nudes and the female body builder Lisa Lyon. Many of the later series were shot outdoors, contrasting the landscape of the body with a natural landscape.

Beyond the formal arrangement of limbs, body parts, light and shadow and tonality—Mapplethorpe pursues a disturbing, even shattering investigation of male sexuality and the iconography of power. Concentrating on powerful male bodies, he juxtaposes them with the accoutrements of sado-machocism: chains, leather, binding, etc., building careful still-lifes out of his often shocking material. The formal restraints, the cool scrutiny placed upon this powerful, often disturbing material make these controversial images among his strongest.

Mapplethorpe's portraits exhibit the same sense of arrangement and Vermeer-like clarity of light, even when he moves to locations outside his studio. Especially in his portraits of women, such as the 1971 "Holly Solomon," reclining on a couch, languidly holding a cigarette, a more intimate mood prevails. Attention and sensitivity to fabric and abstract design dominates such images as the 1979 "Physsis Tweel," where the subject faces away from the camera, so that all we see is her long curly hair, polka dot dress, white glove and hat. Mapplethorpe encompasses an extraordinary range, evoking responses which extend from shock and power, to intimacy and tenderness.

—Carole Harmel

Robert Mapplethorpe: *Nude (Lisa Lyons)*, 1981 Courtesy Robert Miller Gallery, New York

MARGOLIS, Richard.
American. Born in Lorain, Ohio, 10 June 1943. Educated at University of the Americas, Mexico City; studied photo-journalism at Kent State University, Ohio, B.S. 1969; Rochester Institute of Technology, New York, M.F.A. 1978; also attended the Visual Studies Workshop, Rochester. Married Marianne Fulton in 1969. Owner/Operator, Photo Graphics commercial and industrial photography studio, Kent, Ohio, 1969-72. Freelance commercial photographer, Rochester, since 1972 (photographic darkroom assistant, International Museum of Photography, Goerge Eastman House, Rochester, 1975-76). Lecturer in Photography, Nazareth College, Rochester, since 1979. Recipient: Creative Artists Public Service Grant, New York, 1977-78. Agents: Foto, 492 Broome Street, New York, New York 10012; Steven Rose Gallery, 23 Miner Street, Boston, Massachusetts 02215; and Kathleen Ewing Gallery, 3020 K Street N.W., Washington, D.C. 20007. Address: 113 Cypress Street, Rochester, New York 14620, U.S.A.

Individual Exhibitions:

1975 New England School of Photography, Boston

1976 Foto, New York
Ohio State University, Columbus
Photographer's Gallery, Saskatoon, Saskatchewan
Panopticon, Boston
Millersville State College, Pennsylvania
Monroe Community College, Rochester, New York

1977 University of Delaware, Newark
Gallery Graphics, Ottawa
Photoworks, Richmond, Virginia
St. Lawrence University, Canton, New York
University of Dayton, Ohio

1978 Carpenter Center, Harvard University, Cambridge, Massachusetts

CEPA/Hallwalls, Buffalo, New York
New England School of Photography, Boston
1979 International Museum of Photography, George Eastman House, Rochester, New York
Lehigh University, Bethlehem, Pennsylvania
Antioch College, Yellow Springs, Ohio
Utah State University, Logan
Foto, New York
Yuen Lui Gallery, Seattle
St. Mary's College, Notre Dame, Indiana
Memorial Art Gallery, Rochester, New York
Kenan Art Center, Lockport, New York
1980 Andover Gallery, Massachusetts
English Landscapes, Light Factory Gallery, Charlotte, North Carolina
1981 Kathleen Ewing Gallery, Washington, D.C.
Foto, New York
Camden Arts Centre, London

Selected Group Exhibitions:

1976 *Contemporary Stereo*, Hallwalls, Buffalo, New York
1978 *Some Twenty Odd Visions*, Blue Sky Gallery, Seattle
130 Years of Ohio Photography, Columbus Gallery of Art, Ohio
1979 *The Residual Landscape*, Addison Gallery, Andover, Massachusetts
Foto Uno, Casa Aboy, Puerto Rico
Contemporary Expression in Photography, Catskill Center for Photography, Woodstock, New York
Intentions and Techniques, Lehigh University, Bethlehem, Pennsylvania
1980 *Manipulated Landscape*, State University of New York at Geneseo
Personal Landscapes, Artworks Gallery, Rochester, New York
Finnfoto, Satakunta Museum, Pori, Finland

Collections:

Museum of Modern Art, New York; International Museum of Photography, George Eastman House, Rochester, New York; St. Lawrence University, Canton, New York; Yale University Art Gallery, New Haven, Connecticut; Addison Gallery of American Art, Andover, Massachusetts; Lehigh University, Bethelehem, Pennsylvania; Library of Congress, Washington, D.C.; High Museum of Art, Atlanta; Victoria and Albert Museum, London; Bibliothèque Nationale, Paris.

Publications:

By MARGOLIS: articles—"Kinds of Photographs" in *Creative Camera* (London), April 1978; "Fire at George Eastman House" in *Creative Camera* (London), November 1978; "Richard Margolis" in *Ten 8* (Birmingham, England), Autumn 1979.

On MARGOLIS: articles—"Three on the Edge" by Ben Lifson in the *Village Voice* (New York), 16 April 1979; "Raveling the Knot" by Owen Edwards in *Saturday Review* (New York), 28 April 1979.

I have more in common with printmakers than with most photographers because it is the quality of the photograph, the surface, texture, tone, color and edge that interests me more than the "subject." I have thought about making photographs that do not have any subject. The subject is just the pretext; it is everything else that fascinates me.

I like or appreciate photographs that indicate that they were deliberately created. Photographs that were "taken" usually don't impress me. I respond to artifice and intentionality. Some photographs are images, not just snapshots, because their deliberate composition indicates that they were created by an intelligence. Communication is possible through intelligent beings, and through my photographs I feel that communication can occur backward or forward in time. I am responding to images from the last century, and am leaving images for the next century.

Photographs that are not about the place, but are responses to the place, are more interesting to me than those that represent accurately. In fact, the more accurate and "truthful" the representation, the less I want to look at it. I would rather see the subject for myself. The photograph, then, is only an imitation and not an object in its own right. But those photographs that are subject interpretations and use the original "reality" only as raw material can be true creations and therefore add something to our visual heritage. That is something!

Art is about choices, and photographers are responsible for the way their pictures look. To claim that the image is the way it is because that is the way the subject looked is to deny that there was a choice. I am creating the world the way I want it to be. I am responsible.

—Richard Margolis

Richard Margolis is an artist working in the tradition of 19th century Romanticism. His photographs of landscape are transformations of the real world. The light, the formal elements and the treatment of the exposure render a mystical and classical view of a world where all is well and beautiful. Antecedents of Margolis' work are certainly Frederick Evans' evocative images of trees and landscape, while the sylistic impact of his prints comes directly from the work of the Photo-Secessionists, although the techniques differ. Margolis has taken his inspiration from sources considered important historically but not influential in the period of sharp focus Realism, all-consuming Formalism, or manipulation, making Margolis something of a pioneer. He communicates sensation rather than thought.

His work is split into the earlier brown-toned night images and the later daytime images. The nocturnal works are made by long exposure with the focus changed from sharp to soft and the selective addition of flash to the existing ambient light. The night pictures of places have the feeling of a stage set where all of the elements are adjusted to just the right effect. Margolis plays the formal magician to an everyday world.

His later daytime images, mostly of English gardens and landscape, have much the same feeling. In printing these photographs in straight black and white, relying more on unmanipulated exposure, Margolis makes framing most important, although he occasionally uses altered focus and fractured light. He demonstrates a view of landscape which makes the viewer aware of the unseen forces, powers and mythic elements which inhabit those gardens, paths and fields illuminated so strangely.

Richard Margolis is calling forth these spirits in his images with the sensibility of an earlier time, but there's no mistake that his view of either the urban or rural world is populated by contemporary demons. His photographs are beautiful, but the dangers of the present world, urban decay and violence, man seedy and disappearing, lurk in the shadows.

—James L. Sheldon

Richard Margolis: *Rousham, England*, 1979

MARK, Mary Ellen.
American. Born in Philadelphia, Pennsylvania, 20 March 1940. Educated at Cheltenham High School, Philadelphia, 1954-58; University of Pennsylvania, Philadelphia, 1958-62, B.A. in Fine Arts, and Annenberg School of Communications, University of Pennsylvania, 1963-64, M.A. in Communications 1964; photographed in Turkey, as a Fulbright Scholar, 1965-66. Freelance photographer: established studio, New York, 1966; Member, Magnum Photos, New York and Paris, 1976-81. Has also lectured at numerous photographic workshops and in lecture series, throughout the United States, 1974-81. Recipient: United States Information Agency Grant, 1975; National Endowment for the Arts Photography Fellowship, 1977, 1979; Creative Artists Public Service Grant, New York, 1977; Commission, Bell System Project, 1979; Page One Award, Newspaper Guild of New York, 1980; Feature Picture Story Award, Pictures of the Year Competition, University of Missouri, Columbia, 1981; First Prize, Robert F. Kennedy Journalism Awards, 1981. Gal-

lery: Castelli Graphics, 4 East 77th Street, New York, New York 10012; agent: Lee Gross Associates, 366 Madison Avenue, New York, New York 10017. Address (studio): 143 Prince Street, New York, New York 10012, U.S.A.

Individual Exhibitions:

1975 Photopia Gallery, Philadelphia (with Ralph Gibson)
1976 The Photographers' Gallery, London
Forum Stadtpark, Graz, Austria
1977 Santa Barbara Museum of Art, California
Bibliothèque Nationale, Paris
Port Washington Library, New York
Creative Photography Library, Massachusetts Institute of Technology, Cambridge (with Burk Uzzle)
1978 Castelli Graphics, New York
Boise Gallery of Art, Idaho
Photography Gallery, Yarra, Victoria, Australia
1979 *Ward 81*, Museum of Art, University of Oregon, Eugene
Ward 81/Bars, Galerie Nagel, Berlin
1981 *Falkland Road*, Castelli Graphics, New York (travelled to the Olympus Gallery, London, 1981; and University of California at Santa Cruz and at Riverside, 1982)
1982 Photography Gallery, Drew University, Madison, New Jersey

Selected Group Shows:

1969 *Vision and Expression*, International Museum of Photography, George Eastman House, Rochester, New York (toured the United States, 1969-71)
1972 *Photokina*, Cologne
1975 *Women Photographers*, Neikrug Gallery, New York
Women of Photography, San Francisco Museum of Art (travelled to the Sidney Janis Gallery, New York, 1976)
1977 *8 American Female Photographers*, Iran/America Society Cultural Center, Tehran
1979 *American Images: New Work by 20 Contemporary Photographers*, Corcoran Gallery, Washington, D.C. (toured the United States, 1979-81)
Portraits, Bibliothèque Nationale, Paris
Photographie als Kunst 1879-1979, Tiroler Landesmuseum Ferdinandeum, Innsbruck (travelled to the Neue Galerie am Wolfgang Gurlitt Museum, Linz, Austria; Neue Galerie am Landesmuseum Joanneum, Graz, Austria; and the Museum des 20. Jahrhunderts, Vienna)
1980 *Likely Stories*, Castelli Graphics, New York

Collections:

Bibliothèque Nationale, Paris; Australian National Gallery, Canberra.

Publications:

By MARK: books—*The Photojournalist: Two Women Explore the Modern World and the Emotions of Individuals*, with Annie Leibovitz, New York 1974; *Passport*, New York 1974; *Ward 81*, with text by Karen Folger Jacobs, New York 1979; *Falkland Road*, New York 1981.

On MARK: books—*Vision and Expression* by Nathan Lyons, New York 1969; *Great Themes*, by the Time-Life editors, New York 1970; *Geschichte der Fotografie im 20. Jahrhundert/Photography in the 20th Century* by Petr Tausk, Cologne 1977, London 1980; *SX-70 Art*, edited by Ralph Gibson, New York 1979; *American Images: New Work by 20 Contemporary Photographers*, edited by Renato Danese, New York 1979; *Photographie als Kunst 1879-1979/Kunst als Photographie 1949-1979*, exhibition catalogue, 2 volumes, by Peter Weiermair, Innsbruck 1979; *Contact: Theory*, edited by Ralph Gibson, New York 1980; articles—"Assignment in Turkey by Mary Ellen Mark" in *U.S. Camera Annual 1968*, edited by Tom Maloney, New York 1967; "The Human Face of Mental Illness" in *Photography Year 1977*, by the Time-Life editors, New York 1977; "Falkland Road: Mary Ellen Mark" in *American Photographer* (New York), April 1981; "Falkland Road" in *Photo* (Paris), October 1981.

I've been taking pictures for 17 years. My work has consistently been within the tradition of social documentary photography. Throughout the years I have been striving to find social documentary projects which I both wanted to photograph and felt were important to photography. I have also tried to grow as a photographer and to find original ways of visualizing each new theme.

After graduation, I was awarded a Fulbright Scholarship to spend a year photographing Turkey. This was my first opportunity to work for a long period of time on one theme. It was a year of important development for me; since then I have tried to find the time and means to devote long periods of time to specific projects.

Here is a brief description of a few of the projects that I have worked on in the past:

In the late 1960's I did a series of pictures on the drug problem in England, showing the superficial joys of "shooting up" and the horror of the aftermath. In the early 70's I spent several months in Asia, photographing the pilgrimage of Western youth trying to adapt to a culture completely alien to their own. I also spent time in Northern Ireland photographing both Protestant and Catholic women, to depict the effects of the war on their lives. A number of the pictures from the many different projects that I worked on during my first 10 years of photographing are included in a book I did called *Passport*, published in 1974.

In 1979 I published *Ward 81*. The photographs were taken in 1976 in a maximum security ward for women in the Oregon State Mental Hospital. I was permitted to live in the ward with the women for two months. In my photographs I tried to give some insight into the anxieties and mood changes of these women, as well as show the conditions of their confinement.

In 1977 I spent several months photographing in bars all over the New York and New Jersey area. The pictures were exhibited in Europe and published in *Camera* in September 1977. In 1979 I was asked to participate in the "Commissioned Artist with the Bell System" project. Each of 20 American photographers was asked to produce a portfolio of new work photographed in America. The project I chose was on teenage pregnancy. I photographed a 15-year-old girl and her 14-year-old boyfriend before, during, and after the birth of their baby. The end result was a book of the 20 portfolios called *American Images*, edited by Renato Danese, and also a travelling exhibition.

For the past 12 years I have been travelling to India. I made many trips there and waited several years before I felt I could do difficult documentary statements about this fascinating and complicated culture. During the past two years I have worked on three large photographic projects in India. In 1978-79 I spent three months with a community of prostitutes in Bombay. This work became the book *Falkland Road*. Later in 1979 I returned to India and worked on two more projects. I spent three months travelling in various parts of the country with snake charmers, street acrobats, monkey trainers, magicians, etc. The street performers of India are in a tradition that has been passed down from father to son over generations. Both the terrible conditions that poverty brings and modern influences are forcing the new generation to abandon their traditional heritage. I chose this subject both because I am fascinated by the art form and also because I felt it was necessary to photograph it while it still exists.

In January 1980 I spent one month photographing Mother Teresa and her Missions of Charity in Calcutta. Since I first travelled to India in 1968, Mother Teresa, the Bengali people that her mission serves, and especially Calcutta itself have represented an aspect of India and its humanity that I desperately wanted to photograph. The photographs I made in January were published in *Life* in July 1980. When I left Calcutta in February 1980 I knew I had to return and make a much longer statement in a book form. I returned in 1981 to complete the project.

—Mary Ellen Mark

Mary Ellen Mark is a photojournalist, a photographer who "peels away layers of convention" to

Mary Ellen Mark: *Dos Chiquitas*, 1973

report on her subject. It is this ability to find the truth and express it photographically, combined with the compassion of her depiction, that has made her a favorite photographer for magazines such as *Life, Time, Paris Match, Epoca, Stern, Ms., U.S. Camera, Infinity* and *Leica Magazine*.

Being a photojournalist has meant travelling internationally on assignment for Mark. This aspect of photography has, by her own admission, changed both her personality and her life. "I would die if I felt I had to be confined...live in a house and stay in one place. I don't want to feel that I'm missing out on experiencing as much as I can. For me, experiencing is knowing people all over the world and being able to photograph.... I think being a transient person...manifests itself in every aspect of my life, certainly in my work, in all my relationships.... I don't think I was like this ten years ago when I started to photograph" (interview with Eleanor Lewis in *Passport*).

Mark had the "instant recognition" that she wanted to be a photographer while she was studying photojournalism at the University of Pennsylvania's Annenberg School of Communications. A year after graduating, she was photographing in Turkey on a Fulbright Scholarship and two years later *Look* published her first major magazine article, a photographic report on London's St. Clement's Drug Unit and the English approach to treatment of heroin addiction. Since then she has produced numerous articles on a broad range of subjects—from the quality of life in the Women's Army Corps and the militancy of Protestants from the Ulster Defense Alliance to the migration to India of young Americans and Europeans disillusioned with Western culture.

It is the human condition which is the true subject of Mark's photographs. Her focus is on people: people of all ages, professions and nationalities. Her metier is the "journalistic portrait," in which she shows her subjects with honesty and compassion. The difficulty of photographing exotic peoples, she feels, is becoming clichéd, but she overcomes the problem with a very direct method of shooting and by using black-and-white film, which she feels forces her to "get to the essentials."

For Mary Ellen Mark photography is an adventurous experience, a tool of exploration, and a way of relating to the world and its people. Her portraits are formed by journalistic objectivity and are both more factual and more compassionate than those of a photographer like Diane Arbus. This can be seen

by comparing Mark's portraits of drug addicts, runaways and transvestites with similar subjects photographed by Arbus. Arbus' work accentuates the deviant and outcast nature of each individual's effort to come to terms with his or her identity; Mark's work is instead relatively non-judgmental, trying to find the truth of each person's existence.

One of Mark's most touching documents is that of the mental patients of Ward 81. An assignment to cover the film *One Flew Over the Cuckoo's Nest*, shot on location at the Oregon State (Mental) Hospital, led to her interest in the subject. In February 1976 Mark and the writer and social scientist Karen Folger were granted special permission to live for over one month in Ward 81, a women's security ward whose inmates were dangerous either to themselves or others. Seen through photography (published in book form), the cruel existence of these deranged women is both compelling and very real.

It is hoped that Mary Ellen Mark will continue to travel the world with her Leica, producing the type of picture for which she is already well-known. We can only hope, too, that she continues to document our world, thereby telling us something of its scope and meaning through photography.

—Nancy Hall-Duncan

MARTINCEK, Martin.

Czechoslovak. Born in Liptovský Peter, Slovakia, 30 January 1913. Studied law at Komenský University, Bratislava, 1932-37, J.D. 1937; self-taught in photography. Married the painter Ester Simerová in 1946. Judge, then State Attorney, Bratislava, 1937-51; Lawyer, Komunále služby, in Liptovský Mikuláš, 1951-57, and Director of the Museum of Literature and History, Liptovský Mikuláš, 1957-61. Professional photographer, Liptovský Mikuláš, and Member of the Slovak Union of Artists, Bratislava, since 1961. Recipient: First Prize, Tourist Photography Competition, Union of Czech Tourists, 1957; Gold Medal, Musée des Nations, Neuchatel,

Switzerland, 1958; Grand Prize, Portrait in Photographic Art Competition, Fenykepesz szovetseg, Budapest, 1959; Silver Medal, *Bienal de Sao Paulo*, 1965; Silver Medal, *International Book Exhibition*, Leipzig, 1965; Artist of Merit Award, from the Czechoslovak Government, 1970; Award of Excellence, Fédération Internationale de l'Art Photographique (FIAP), 1970; Most Beautiful Book of the Year Award, National Literary Art Memorial, Prague, and Slovak Center of Culture, Bratislava, 1970, 1973, 1976, 1979; Memorial Medal, Union of Slovak Artists, 1971. Address: Kukucinova 9, Liptovský Mikuláš, Czechoslovakia.

Individual Exhibitions:

1962 Museum of Literature, Liptovský Mikuláš, Czechoslovakia
1963 *The Structure of Wood and Water*, Laterna Magica, Prague
 Dum pánu z Kunstátu, Brno, Czechoslovakia
1967 Slovak National Gallery, Bratislava
1968 Gallery of the Capital, Prague (in co-operation with the National Gallery, Prague, and the Slovak National Gallery, Bratislava)
 Cultural Center, Budapest (travelled to Sofia, East Berlin, Havana, and Cairo)
1969 *Cycles*, Dum pánu z Kunstátu, Brno, Czechoslovakia (travelled to the Municipal Gallery, Gottwaldov, Czechoslovakia)
 Gallery P.M. Bohúňa, Liptovský Mikuláš, Czechoslovakia
1970 Cultural Center, Baghdad
1973 Interkamera, Prague
1975 Ministry of Foreign Affairs Exhibition, Prague (toured Western Europe and Japan)
1978 *Mountains and Brooks*, Gallery of the Capital, Bratislava (travelled to the Gallery of the Capital, Prague, 1979)

Selected Group Exhibitions:

1967 *International Exhibition of Photography*, at Expo '67, Montreal
 Photography in the Fine Arts, Metropolitan Museum, New York
 World Press-Foto, The Hague
1968 *Europa '68*, Bergamo, Italy
 Die Frau, Stern magazine travelling exhibition
1970 *Czech Graphics and Photography*, Mexico City
1977 *Weltausstellung der Photographie: Kinder dieser Welt*, touring exhibition

Collections:

National Gallery, Prague; National Gallery, Bratislava; Gallery of Banska Bystrica, Czechoslovakia; Gallery of Liptovský Mikuláš, Czechoslovakia; Tatranská Galerie, Poprad, Czechoslovakia.

Publications:

By MARTINCEK: books—*The Undiscovered World*, Bratislava and Prague 1964; *Respect Is Your Due*, Banska Bystrica, Czechoslovakia 1967; *People in the Mountains*, with text by M. Rúfus, Bratislava 1969; *Lights in Waves*, with text by O. Plávka, Bratislava 1969; *Cradle*, with text by M. Rufus, Martin, Czechoslovakia 1972; *Hill People*, with text by A. Matuška, Martin, Czechoslovakia 1975; *Mountain*, with text by M. Rúfus, Martin, Czechoslovakia 1978; *Praise of Water*, Martin, Czechoslovakia 1981; articles—"M. Martinček a sokoldalú fényképesz" in *Foto* (Budapest), no. 12, 1961; "Art in Wood" in *Photography* (London), July 1963; "The

Martin Martinček: *The Slovak Hills*, 1976

Expressive Potentialities of Photography" in *Graphics* (Zurich), no. 108, 1963; "Just Water" in *Photography* (London), November 1964; "Lebenslauf eines Rolleigrafen" in *Rolleigraphie* (Munich), June 1965; "Liptov Region of M. Martinček" in *Výtvarníctvo* (Bratislava), no. 5, 1968; "Slowakei" in *Foto-Magazin* (Munich), August 1970; "La Photographie Tchecoslovaque" in *Photo-Cine Revue* (Paris), no. 12, 1971; "Martin Martinček" in *Photography* (London), May 1974; "Fotografen aus aller Welt" in *Foto-Magazin* (Munich), October 1978; "The Seventh Book of Photographs by Martin Martinček" in *Ceskoslovensko Fotografie* (Prague), no. 11, 1978.

On MARTINCEK: books—*Martin Martinček* by Zora Rampáková, Prague 1976; *Martinček* by Ludovít Hlaváč, Martin, Czechoslovakia 1978; *Martin Martinček* by Karel Dvořák, Prague 1979; articles—"Photographer of His Own Nation" by Vladimír Remeš in *Fotografie 73* (Prague), no. 1, 1973; "Martin Martinček, Chronist seiner Heimat" by Karl Dvořák in *Fotografie* (Leipzig), no. 9, 1973; "Just Photography" by Ivan Kučma in *Nove Slovo* (Bratislava), 19 June 1975; "A Visit to the Atelier of M. Martinček" by M. Zábojníková in *Tvorba* (Prague), no. 4, 1975; "The Past of Slovak Photography" in *Lidova Demokracie* (Prague), 13 August 1975; "Visit to the Atelier M. Martinček" by Ludovít Hlaváč in *Ceskoslovenska Fotografie* (Prague), no. 12, 1976; "Martin Martinček" by Ludovít Hlaváč in *Pyramida* (Bratislava), no. 4, 1979.

The Slovak Socialist Republic is the main part of the Czechoslovak Socialist Republic, and is famous especially for its lovely landscape. Liptov—the region in which I live and work—is a lovely place: high mountains with deep romantic brooks and forests. The people in our mountains, especially the older generation, are rich in personality; they possess a significant creative poetic power and an extraordinary vitality.

I have been inspired by talks, discussions, the fates and the activities of the hillside people of Liptov. Their life-style has a special order and a permanent ritual. These people are deeply unified with their mother country. From our mutual understanding came a friendship which taught me the way to show their life in my photo-books *Respect Is Your Due, Hill People,* and *Cradle.*

When the same peoples have remained in a certain region for hundreds and hundreds of years, always respecting everything given and allowed by the country—the relationship gives a special color to that country, and the special face of the country, with its fixed features, remains in the memory of generation after generation. In the symbiosis of landscape and people there appears a reciprocal formation: the land forms the people, and the people create the landscape.

The way of the photographer to photography is rather long. If the photographer feels love toward mankind in his blood, people understand it—particularly the hill people, who are not talkative, but remain withdrawn and suspicious. If someone is kept in their hearts for many years, he has proved himself a friend. I very well understand human pain and problems as a result of my previous profession as a judge, and I have learned to know and appreciate people who can overcome their problems and succeed.

I live in the mountains where, as the poem says, "from the children's spoon up to the altar, everything was made of wood, and death in the saddle was death under a falling tree...." I often think about the written and unwritten traditions of the deep Slovak mountains and their inhabitants. The result was a cycle of photographs *The Undiscovered World* in which I tried to discover the many thousands of faces of wood in the world's history is written. Wood that has fallen in the mountains, smoothed and piled and chopped, as well as the wood left silent somewhere, undiscovered and beyond our notice.

After *The Undiscovered World* cycle of photos, I worked on a further publication, *Lights in Waves.* I tried to show the unknown face of the river, or just a tiny part of those phenomena appearing in waves/ripples of water for a millisecond before disappearing forever. I was fascinated by the features of chaotic waves.

When I had finished yet another cycle of photos, *Stones Are Alive,* I arrived at a well-known truth, that the landscape and its people are influenced mutually, and that natural structures like wood, stone, water, etc. affect everyday activities—building a house, getting dressed, using tools, making art—everything that involves the use of these materials. The structure of these materials gives the final touch to art. The structure of hill-fields resembles the face of piled wood. The same structure is found even in textiles. The rich natural forms that are around us created our famous culture of lace production and inspire the mountain people in their poetic creation of dances and folk songs.

In my latest work I have returned again to the photography of nature, and the result has been the publications *Mountain* and *Praise of Water.* I purposely returned to well-known subjects because I hoped to discover what I still did not know.

To express some truth about my work, I should like to paraphrase the words of T.S. Eliot:

> ...In photography are many windows which are not magical and through which we do not see a rough and dangerous sea, but in spite of this fact, they are very good windows.... When we talk about our photographers we should not investigate so actively whether they are good or great; we should just consider whether they are authentic, and let the most important judge—time—decide.
>
> —Martin Martinček

The photographic work of Martin Martinček can be divided into two autonomous parts, differing from each other not only through choice of subjects but also in their approach to reality.

The first is dedicated to the Slovakian landscape and to the old people living in small villages there. In these works Martinček has celebrated in his own way the ancient traditions and spirit of the Liptov district where he was born, a part of Slovakia typical of the whole with its mountains and woods full of nature's beauty. If the driving force of these images is Martinček's sincere love of his native land, it is not surprising that the results tend to a highly emotional interpretation of reality; the very choice of subject, under such circumstances, obviously involves a certain romanticism. For the visualization of his feelings, Martinček has called on all of his photographic skills, yet the images produced are not overwrought but notable for their simplicity and directness. After many years during which he used black-and-white exclusively, Martinček found in color a new dimension in which to render his subject. His latest landscape photographs are of fine and hazy hues in delicate compositions.

The second part of this work has to do with his discovery of metaphors on the surfaces of various modest objects. A typical cycle of such images is of textures found on pieces of wood, fantastic forms that resemble human figures and animals. Another series of images suggests the features of a variety of objects found in the patterns formed by the play of light and shadow on the surfaces of mountain brooks. Another is of the surprising configurations on stones which he came across during his long walks in the hills: the integral effect of these images comprises both contour and surface texture. In all of these works, Martinček could be said to have produced his own variation of the surrealist principle of the *objet trouvé.*

Although both parts of his work involved diverse goals, they have in common not only their creator but also their environment. Martinček has, in other words, reacted in diverse ways to the poetry of the world immediately around him.

—Petr Tausk

MASCLET, Daniel.
French. Born in Blois, 1 April 1892. Educated privately in drawing, music, Russian and English, Blois, 1898-1914; also studied cello with the master Gruet at Cros de Saint Ange, 1902-09; self-taught in photography. Served in the French Army, 1914-18. Married; had one son. Worked as a professional cellist, Paris, 1920-25; introduced to photography by Robert Demachy, 1920; worked as assistant photographer to Baron de Meyer, *Harper's Bazaar;* Fashion Photographer, under editor Lucien Vogel, *Vogue,* Paris, 1925-28. Freelance photographer, Paris, from 1929. Founder, *Salon International du Nu Photographique,* Paris, 1933. Founder-Instructor, School of Photographic Aesthetics, Paris, from 1949. Recipient: Coupe de France du Portrait, 1966, 1967. Honorary President, 20 x 40 Group. *Died* (in Paris) *15 September 1969.*

Individual Exhibitions:

1977 Galerie Agathe Gaillard, Paris
1979 *Fotografien 50er Jahre,* Museum Folkwang, Essen
1981 Musée Ancien de Grignon, France

Selected Group Exhibitions:

1933 *Salon International du Nu Photographique,* Paris

Collections:

Bibliothèque Nationale, Paris; Condé Nast Publications, Paris; Museum Folkwang, Essen.

Publications:

By MASCLET: books—*Nus,* Paris 1934; *Le Paysage en Photographie,* Paris 1935, 1946; *Reflexions sur le Portrait en Photographie,* Paris 1976.

On MASCLET: book—*The Magic Image* by Cecil Beaton and Gail Buckland, Boston and London 1975; articles—"Daniel Masclet: To Specialize Is to Become Bored" by Cora Alsberg in *Modern Photography* (New York), March 1954; "Photographie Francaise 1840-1940" in *Camera* (Lucerne), February 1974.

A photographer who is not widely known, who is already somewhat forgotten by the younger generation, Daniel Masclet occupies an important place in the evolution of French photography. With Lucien Lorelle and Emmanuel Sougez, Masclet changed its direction away from a certain formal severity, from a certain creative strictness. A passionate man, Masclet did not content himself merely with imposing a nobility on portraiture, for which he is still remembered, but he as well enlivened photographic life in France from 1920 until his death. He wrote

491

two books, *Nus* and *Le Paysage en Photographie*, and numerous texts on portraiture collected as *Reflexions sur le Portrait en Photographie*. He wrote numerous articles, actively participated in the life of the photography clubs, was Honorary President of 30 x 40, and won countless awards in national and international competitions. Photographer, writer, philosopher, incisive debater, unpaid adviser, he held a place in the foreground of French photography for nearly 50 years.

Masclet belonged to a large family of naval officers, and he brought to photography a rich and varied cultural background. A musician, he brought to the photograph a sense of rhythm and the rigor of one who seeks precise execution. He drew from Goya, Rembrandt and from the early Flemish artists a firm aesthetic grounding. Versed in the work of semanticists like Korzybski, in Oriental and Western philosophy, in the works of Jung, Gurdjieff and the Zen writers, he saw photography almost as a militant art, divorced from any kind of commercial conception, a discipline in the quest for perfection.

A "gifted child," as we would say now, he began to read at the age of 3 and at 10 had devoured every photographic treatise. He had been trained as a cellist, but after the First World War he began to frequent the Paris Photo Club (the 30 x 40) where he met Robert Demachy who introduced him to Baron de Meyer. He became de Meyer's assistant at *Harper's Bazaar*, then worked at *Vogue* under the direction of Lucien Vogel. The decisive event of his photographic life, however, occurred in 1933—what he himself called "la grande rencontre"—the revelation of the work of Edward Weston. After that, Masclet rejected work he called "good for the nearsighted," became convinced that photography had no reason to envy painting, that it had had and would have its own development, and that clarity was an essential part of that development. He bought himself a Linhof 13 x 18 equipped with a Tessar lens. Now an independent photographer, he practised only for the love of his art.

Although Masclet was to become illustrious in all photographic genres—still-lifes, landscapes, etc.—it is in portraiture that he made his most notable and probably lasting contribution. He knew how to give the photographed face the intensity of life—an intensity that almost bursts from the paper. His ideas have now become the accepted precepts of portraiture:

"I light my models so that they do not look lighted. Above all, there must be no lighting 'effects'." "A

beautiful portrait is not achieved on the basis of rules or formulas; it is not 'artistic' because it is precise or blurred or because it conforms to some standard norm.... One makes a success of it if one has a passion for and a love of faces, and it is beautiful when the artist extracts it from nothingness in the instant of greatest significance—a precise moment, incapable of being recaptured, infallible, in which we perceive the atoms of the soul in the mirror of the eyes.... A beautiful portrait: it is the image of God."

—Ginette Bléry

MATHYS, Max (Eugen).

Swiss. Born in Berne, 6 August 1933. Educated at primary and elementary schools in Alchenstorf/Berne, 1940-49, and public school in Berne, 1950; served apprenticeship as housepainter, 1950-53; studied graphic design, under Armin Hofmann, at the Allgemeine Gewerbeschule, Basle, 1955-60; mainly self-taught in photography. Served in the Swiss Militia, 1953-83. Married Elisabeth Singeisen in 1971; children: Lukas, Johanna and Samuel. Worked as a housepainter, 1950-53; Designer, under Fridolin Muller, Erwin Halpern advertising agency, Zurich, 1960-63. Freelance photographer, Berne, since 1963. Instructor in Photography, Kunstgewerbeschule, Basle, since 1967. Recipient: National Stipendium for Photography, Switzerland, 1962, 1966, 1967; Poster of the Year Award, with Armin Hofmann, Switzerland, 1963, 1965, 1967; *Nature '68* Calendar Award, Germany, 1968; Graphic Design Prize, *Deutsche Drucker* and *Graphic Design Germany* magazines, 1967-68. Address: Hauptstrasse 17, 4132 Muttenz bei Basel, Switzerland.

Individual Exhibitions:

1967 *Abstract Landscape*, Galerie Leiser Wolpe, Zurich

1969 *Nature's Structure*, Photogallery, New York
1973 *Zeit: Raum*, Josephshaus Kollegium, Schwyz, Switzerland
1975 *2 Landschaften: Emmental und Toscana*, Paulus-Akademie, Zurich
1978 *Stein und Landschaften*, Zumstein Gallery, Berne
1979 *Stein und Landschaften*, Leitz Gallery, Wetzlar, West Germany
1980 *Feldkulturen*, Kulturmühle Gallery, Lützelflüh, Switzerland

Selected Group Exhibitions:

1964 *Leica: Photos from the World*, Leica School of Berlin
1967 *15 Graphic Designeres of the Gewerbeschule*, Gewerbemuseum, Basle (toured Boston, Philadelphia, Kansas City, and Chicago)
1970 *Biennale de la Photographie Internationale*, Paris
 Creative Photography, Galerie Impact, Lausanne
1974 *Photography in Switzerland from 1840 to Today*, Kunsthaus, Zurich
1975 *The Land: 20th Century Landscape Photographs Selected by Bill Brandt*, Victoria and Albert Museum, London (toured the United Kingdom)
 Triennale de Photographie, Fribourg
1978 *International Photography Salon*, Tokyo

Collections:

University of Cologne; Kunsthaus, Zurich

Publications:

By MATHYS: books—*Nature '68*, calendar, Stuttgart 1967; *Sky '75*, calendar, Stuttgart 1974; articles—"The Stones of a River," with Armin Hofmann, in *Camera* (Lucerne), no. 3, 1967; "Water and Stones" in *Gebrauchsgraphik* (Munich), July 1968; "From Week to Week" in *Du* (Zurich), October 1971.

On MATHYS: books—*Photography in Switzerland from 1840 to Today*, exhibition catalogue, by Manuel Gasser, Hugo Loetscher, Walter Binder and Rosellina Burri-Bischof, Zurich 1974; *The Land: 20th Century Landscape Photographs Selected by Bill Brandt*, exhibition catalogue, edited by Mark Haworth-Booth, London 1975.

My working aims: to show the difference of structures, the colour and composition of places throughout the world, beginning with Switzerland—then Italy—Germany—and so on.

To photograph the moods of the sky at different times and seasons.

To use the camera as an artist does his brush.

To open people's eyes to details they often miss and to reveal Nature's many-sided face—the things that move me.

To reach perfection in my technique—at least the nearest possible to it.

—Max Mathys

Max Mathys came to the fore in the 1960's with a new and individual approach to the concept of landscape photography. He turned towards it with a natural inclination and a rare exclusiveness, becoming, in the two decades of his work, one of the most prominent landscape photographers. Of his own accord he has said: "I make use of my camera as a painter wields his brush." And: "I try to show the difference in structure and colour composition of the most differing places in this world." Indeed we

Max Mathys: *Stone Structure*, **Valley of Verzasca, 1964**

discover in Max Mathys that which, in a painter, we would consider an outstanding quality: the individual touch. These photographs are the result of an artistic perception which has remained constant for 20 years. Mathys' approach to his pictures stems from a visionary view of landscape which gives an astonishing unity to his work.

Max Mathys is no romantic landscape photographer identifying himself with an all-enveloping experience of nature. He observes composition and colour from a distance and with an unerring eye. He dissolves landscape into structures. It is divided into geometric fields, spreading out like a carpet, flat, without beginning, without end. The eye of the beholder enlarges it, pursues its geometric pattern. One never discovers depth of field, shortenings of perspective. The experience of geometric abstract painting lies behind these photographs.

Colours are used as softly as in many Paul Klee water colours. In his strong attachment to the laws of colour and form there is evidence of the sound artistic education which preceded Mathys' professional life as a photographer. Here is a photographer in search of principles of order in form. Colour is here the starting point of seeing. It is the more substantial element of the composition, without trimmings.

Much is spoken about "form" in photography. Max Mathys shows it. It remains amazing that these landscape compositions do not seem to copy what is actually there—although the camera of course only copies. But Mathys knows how to reveal nature's abstract values. Even in a series of photographs in the Verzasca Valley, in which he follows the river's course, this vision remains preserved in abstract—or should one say absolute—forms. Large is different from small and smaller, from hard and flowing.

And there is something else which is very remarkable in this photographic work: the preoccupation with time. "A Little Landscape Photographed During the Course of a Year" is one of the first substantial works of this unconventional photographer. He photographed the same view for a year. A cycle on the seasons resulted—demonstrated by a single tiny piece of earth. Such work requires patience, perseverance, a feeling for the flow of time. He has also photographed a violent storm. Every two minutes. The storm momentarily alters the landscape. In all the sequences that Max Mathys has produced of a landscape the subject is not only the landscape but also always time.

His work makes one think involuntarily of the cloud studies, the "equivalents," which Alfred Stieglitz produced over the years. Max Mathys is the first photographer after Stieglitz to treat this theme. But with Mathys it belongs to the concept of his photographic vision. He is one of the first photographers to use the sequence as an artistic means. In so doing he placed himself at the beginning of a photographic development which governed the 70's and which, as conceptual photography, started a new chapter in the history of photography.

—Erika Billeter

MATTER, Herbert.
Swiss. Born in Engelberg, Switzerland, in 1907; emigrated to the United States, 1936. Studied painting in Geneva, 1925-27, and painting and drawing at the Academie Moderne, Paris, 1928-29; self-taught in photography. Photographer since 1929: freelance designer and photographer, working with the poster artist A.M. Cassandre and the architect Le Corbusier, and for Deberny et Peignot design company, Paris, 1929-32; designer of photomontage posters for the Swiss National Tourist Office, Zurich, 1932-36; freelance photographer, working for *Harper's Bazaar*, *Vogue*, etc., New York, 1936-46; Staff Photographer, Condé Nast Publications, New York, 1946-57. Freelance designer and photographer, New York, since 1958. Designer, Swiss Pavilion and Corning Glass Pavilion, *World's Fair*, New York, 1939; Design and Advertising Consultant, Knoll International, New York, 1946-66; Design Consultant, New Haven Railroad, 1954-55; Design Adviser, Guggenheim Museum, New York, and Museum of Fine Arts, Houston, 1958-68; Graphics Consultant, New York Studio School, 1964-78. Professor of Photography, Yale University, New Haven, Connecticut, 1952-76. Agent: Marlborough Gallery, New York. Address: c/o Marlborough Gallery, 40 West 57th Street, New York, New York 10019, U.S.A.

Individual Exhibitions:

1943 Pierre Matisse Gallery, New York (travelled to the Arts Club, Chicago, and the Los Angeles County Museum of Art)
1962 American Institute of Graphic Arts, New York
1978 Yale University, New Haven, Connecticut (retrospective)
Kunsthaus, Zurich
1979 *Selected Photographs 1929-1979*, Marlborough Gallery, New York

Selected Group Exhibitions:

1969 *Die Fotomontage*, Stadttheater, Ingolstadt, West Germany
1972 *Knoll au Musée*, Musée des Arts Décoratifs, Paris
1979 *Photographie als Kunst 1879-1979*, Tiroler Landesmuseum Ferdinandeum, Innsbruck, Austria (travelled to the Neue Galerie am Wolfgang Gurlitt Museum, Linz, Austria; Neue Galerie am Landesmuseum Joanneum, Graz, Austria; and Museum des 20. Jahrhunderts, Vienna)

Herbert Matter: *Dancer* Courtesy Art Institute of Chicago

Collections:

Kunstgewerbemuseum, Zurich; Musée des Arts Décoratifs, Paris; Condé Nast Publications, New York; International Museum of Photography, George Eastman House, Rochester, New York.

Publications:

By MATTER: book—*13 Photographs: Alberto Giacometti and Sculpture*, portfolio, with Ives-Sillman, New York 1978; film—*The Works of Calder*, 1949.

On MATTER: books—*Herbert Matter: Photographs*, exhibition brochure, with text by James Johnson Sweeney, New York 1943; *Die Fotomontage: Geschichte und Wesen einer Kunstform*, exhibition catalogue, by Richard Hiepe, Ingolstadt, West Germany 1969; *Knoll au Musée*, exhibition catalogue, by Christian Rae, Paris 1972; *Photographie als Kunst 1879-1979 / Kunst als Photographie 1949-1979*, exhibition catalogue, 2 vols., by Peter Weiermair, Innsbruck, Austria 1979; *The Vogue Book of Fashion Photography* by Polly Devlin, with an introduction by Alexander Liberman, London 1979.

Herbert Matter is the very opposite of a photographic purist: he considers the photographic process open to experimentation at any point. His approach combines Swiss ingenuity and Swiss precision, revealed in his work's graphic impact, its sophisticated handling of line and form, and the unexpected uses to which he puts familiar subject matter. Matter has used photography as a bridge between art and industry, and has consciously sought out clients who encouraged him to employ the full range of his imaginative capacity.

After training as an academic painter in his native Switzerland, Matter was awakened to the possibilities of modern art in Paris, where he studied under Ozenfant and Le Corbusier in the 1920's. Following the example of Man Ray and Moholy-Nagy, of whose work he was keenly aware, he taught himself photography, and began to employ the camera as an instrument of graphic design. Matter worked for a period in the Paris studio of Charles Peignot, publisher of the periodical *Arts et Metiers Graphiques*, in which some of his earliest photographs appeared. His work first attracted wide attention in the early 1930's, when he designed a series of striking posters combining photography, typography, and applied color in a fresh, light-hearted manner.

When he came to the United States in 1936, Matter at first found his brand of "graphic photography" not much in demand. However, he established himself in New York with the help of Alexey Brodovitch, the innovative art director of *Harper's Bazaar*, who hired him to take fashion photographs. Through the 1960's, Matter's work appeared regularly in the editorial and advertising pages of magazines such as *Vogue*, *Town and Country*, and *Harper's Bazaar*. His continuing interest in the application of photography to graphic design led him to devise new forms of exhibitions using photographs as the chief element. Matter designed the interior of the Swiss Pavilion at the 1939 New York *World's Fair* using giant photomurals, and later prepared a number of lively installations for Edward Steichen at the Museum of Modern Art.

—Christopher Phillips

MAYES, Elaine.

American. Born in Berkeley, California, 1 October 1938. Educated at Stanford University, California, 1955-59, B.A. 1959; San Francisco Art Institute, under Paul Hassel and John Collier, 1959-61; also attended summer photography workshops, under Minor White, 1962, 1963. Married Bill Arnold in 1975 (divorced, 1980). Photographer since 1960. Worked as a freelance commercial photographer, San Francisco, 1960-67; Assistant Professor, University of Minnesota, Minneapolis, 1968-70. Associate Professor of Film and Photography, Hampshire College, Amherst, Massachusetts, since 1971. Part-Time Instructor, 1970, and Visiting Artist, 1976, 1979, San Francisco Art Institute; Associate Professor, Pratt Institute, Brooklyn, New York, 1979; Instructor, Cooper Union, New York, 1979; Instructor, International Center of Photography, New York, 1979-80. Recipient: Federal Bureau of Public Roads Fellowship, California, 1966; National Endowment for the Arts Photography Fellowship, 1971, 1978; Production Grant, Royal Film Archives of Belgium, 1974. Agent: Marcuse Pfeifer, 825 Madison Avenue, New York, New York 10021. Address: 18 Mercer Street, New York, New York 10013, U.S.A.

Individual Exhibitions:

1969 *We Are the Haight-Ashbury*, Minneapolis Institute of Arts (travelled to Massachusetts Institute of Technology, Cambridge)
1970 *35 Recent Photographs*, San Francisco Art Institute
1972 *Autolandscapes and Rooms on the East Side of the Science Building*, Hampshire College, Amherst, Massachusetts
Autolandscapes, Williams College, Williamstown, Massachusetts
1973 *Recent Photographs*, Gallery 115, Santa Cruz, California
20 Photographs, Rhode Island School of Design, Providence
1974 *50 Photographs*, MFA Gallery, Rochester Institute of Technology, Rochester, New York
1975 *Elaine Mayes' Photographs*, Portland School of Art, Maine
50 Photographs, Bennington College, Vermont
1976 *50 Photographs*, Pratt Institute, Brooklyn, New York
2 Photographers: Bill Arnold and Elaine Mayes, Lightwork, Syracuse, New York (travelled to the San Francisco Art Institute)
1977 *50 Photographs*, Columbia Gallery of Photography, Missouri
35 Photographs, Image Space, Cambridge, Massachusetts
1978 *Landscapes*, Marcuse Pfeifer Gallery, New York
1980 *Long Island Photographs*, Hampshire College, Amherst, Massachusetts

Selected Group Exhibitions:

1970 *New Acquisitions*, Museum of Modern Art, New York
1971 *Photographs of Women*, Museum of Modern Art, New York
1973 *Landscape / Citycape*, Metropolitan Museum of Art, New York
1974 *8 x 10*, Dallas Museum of Art
1977 *Photography and the Landscape*, International Museum of Photography, George Eastman House, Rochester, New York
1978 *14 New England Photographers*, Museum of Fine Arts, Boston
1980 *The Long Island Project*, Hofstra University, Hempstead, Long Island, New York

Collections:

Museum of Modern Art, New York; Metropolitan Museum of Art, New York; International Museum of Photography, George Eastman House, Rochester, New York; Museum of Fine Arts, Boston; Fogg Art Museum, Harvard University, Cambridge, Massachusetts; Minneapolis Institute of Art; Dallas Museum of Art; San Francisco Art Institute.

Publications:

By MAYES: books—*When I Dance*, Lafayette, California 1969; *Love Needs Care*, with text by John Luce and David Smith, Boston 1971; *The City*, with text by Alan Trachtenberg, New York 1971; article—"Long Tonal Range" in *Darkroom*, edited by Eleanor Lewis, New York 1977; films—*The Clouds*, with Jerome Liebling, 1969; *Fall*, 1972.

On MAYES: articles—"Elaine Mayes" in *Art in America* (New York), January 1978; "Photography and the Landscape" by Julia Scully in *Modern Photography* (New York), February 1978; "The Wagstaff Collection" in *Horizon* (New York), February 1978; "Aspects of Some Contemporary American Photographers" by Jane Bordon in *Dumont Foto 1: Fotokunst und Fotodesign International*, Cologne 1979; "The Long Island Project" by Andy Grundberg in *Modern Photography* (New York), March 1979; "Color Photography" by Andy Grundberg in *Soho News* (New York), 21 May 1979.

Although she was a student of painting while she attended the San Francisco Art Institute, Elaine Mayes had had her interest captured by photography by the time she completed her studies in 1961. For the next seven years she worked as a freelance commercial photographer. Her photographs appeared in such national publications as *The Saturday Evening Post*, *Sports Illustrated*, and *Esquire*. She photographed the Haight Asbury area of San Francisco, documenting the flower children of the late 1960's in a series of sensitive and direct black-and-white portraits. In 1968, when she was offered a position teaching photography at the University of Minnesota, she gave up her commercial work, and moved to Minneapolis. She has been teaching and making personal photographs ever since.

Mayes was appointed to the faculty of Hampshire College in 1971, where she is currently an associate professor of film and photography. She has made several films, including *The Clouds* (with Jerome Liebling), and *Fall*, an award-winning short film. Her images have been published in many photography magazines. A recipient of numerous grants, Mayes was one of the documentary photographers who worked on *The Long Island Project*.

Mayes considers herself a "straight" photographer. That is to say, she doesn't construct situations or manipulate images—she photographs what is there. In her personal work, this directness of technique both contradicts and contributes to an oblique and abstract quality in the images. At a Mobil station the flying horse sign beams through the mist with an extra-terrestrial glow. The car below it floats out of the dark like some great sea monster. This scenario is ordinary and recognizable, but certainly not familiar. Mayes' subjects are mundane and uneventful landscapes of our daily lives. What brings the images to life is the mystery of light and space conveyed. There is a tension in this mystery, which is in curious juxtaposition to the serenity in the wide range and even gradation of tones.

—Sarah Putnam

MAYNE, Roger.

British. Born in Cambridge, 5 May 1929. Educated at the Rugby School, Warwickshire, 1942-47; studied chemistry at Balliol College, Oxford, 1947-51; self-taught in photography. Married the playwright Ann Jellicoe in 1962; children: Katkin and Tom. Freelance photographer, London, since 1954; moved to Dorset, 1975. Visiting Lecturer, Bath Academy of Art, Corsham, Wiltshire, 1966-69. Agent: The Photographers' Gallery, 8 Great Newport Street, London WC2. Address: Colway Manor, Lyme Regis, Dorset DT7 3HD, England.

Individual Exhibitions:

1956 Dryden Gallery, George Eastman House, Rochester, New York
Institute of Contemporary Arts, London
1959 A.I.A. Gallery, London
Nova Huta, near Kracow, Poland (travelled to Warsaw, 1960)
1960 Royal Court Theatre Foyer, London
1962 *La Strada*, Biblioteca Communale, Milan
1965 Arnolfini Gallery, Bristol
1967 University of Sussex, Brighton
1972 *Daughter and Son*, Half Moon Gallery, London (travelled to the Arnolfini Gallery, Bristol, 1974; Galleria Il Diaframma, Milan, 1977)
1974 *Photographs 1964-73*, The Photographers' Gallery, London
1978 *Landscape Photographs*, Institute of Contemporary Arts, London (travelled to Dorset County Museum, Dorchester, and Plymouth Arts Centre, Devon, 1979; Newlyn Art Gallery, Penzance, Cornwall, 1980; and Parnham House, near Beaminster, Dorset, 1981)

Selected Group Exhibitions:

1955 *Subjective Fotografie 2*, Saarbrucken
1959 *Photography at Mid-Century*, International Museum of Photography, George Eastman House, Rochester, New York
1960 *Fotografi della Nuova Generazione*, Galleria d'Arte Moderna, Milan
1963 *Photography '63*, International Museum of Photography, George Eastman House, Rochester, New York
1964 *Weltausstellung der Photographie*, touring exhibition
1967 *Modfot 1*, R.W.S. Galleries, London
Modern Photography, Victoria and Albert Museum, London (toured England)
1978 *Art for Society*, Whitechapel Art Gallery, London
Objects the V. and A. Collects, Victoria and Albert Museum, London
1979 *Documentary Photography*, Midland Group, Nottingham

Collections:

Department of the Environment, London; Victoria and Albert Museum, London; Bibliothèque Nationale, Paris; Museum of Modern Art, New York; International Museum of Photography, George Eastman House, Rochester, New York; Art Institute of Chicago; Los Angeles County Museum of Art.

Publications:

By MAYNE: books—*Things Being Various*, London 1967; *Shell Guide to Devon*, with text by Ann Jellicoe, London 1975; articles—"Pictorialism at a Dead End" in *Amateur Photographer* (London), 24 October 1956; "Photography and Realism" in *Universities and Left Review* (London), Spring 1959; "Great Victorian Photographs" in *Creative Camera* (London), October 1972; "An Unfashionable Opinion" in *Camerawork* (London), no. 6, 1977.

On MAYNE: books—*Subjective Fotografie 2*, exhibition catalogue, Saarbrucken 1955; *Roger Mayne: Photographs 1964-73*, exhibition catalogue, with an introduction by David Piper, London 1974; *The Picture History of Photography* by Peter Pollack, New York 1977; *Geschichte der Photographie im 20. Jahrhundert/History of Photography in the 20th Century* by Petr Tausk, Cologne 1977, London 1980; articles—"Poetry and Poverty in W10" by Colin MacInnes in *The Observer* (London), 21 January 1962; "Roger Mayne: Photographs from Spain" in *Creative Camera* (London), March 1972; "Two Men So Different: Roger Mayne and Kurt Hutton" by G. Hughes in *Amateur Photographer* (London), 10 July 1974; "Do You Remember?" in *Amateur Photographer* (London), 11 September 1974; "The British Obsession" by William Messer in *U.S. Camera 77*, New York 1977; "Magical Show: Roger Mayne, ICA" by John Russell Taylor in *The Times* (London), 1 November 1978.

My primary interest in photography is as an art—the end product being the print to be exhibited or to be contemplated on a wall. However, I think a confusion has arisen over my personal work because the subject matter was superficially photojournalistic and more recently topographical. Such a confusion can arise because photography is first and foremost a new kind of language, subject to all the uses—mundane or commercial or serious—that any language can be put to. The dividing line between serious photojournalistic and documentary photographs on the one hand and a certain kind of artistic photograph on the other is a narrow and often subtle one. In fact, the only real clue may be that the artistic photograph can sustain endless viewings (but of course to most people a photograph is something looked at once).

In painting today an artistic intent is usually clear (even if nullified by lack of ability, or playing the market). Photography has taken over many of the tasks painting used to do. Thus nobody is going to confuse Lichtenstein with a comic strip; it is recognized that he has used and refined a particular visual language for his own ends.

I see the present state of photography as a rather barren one. Of course a great volume of work is being done, but photography is much too much polarised to two extremes. On the one hand there is the arty, with the traditional "fine print" at one end of the spectrum and the cult of the banal and formless at the other. On the other hand, there is photography where content is all important. This can range from documentary with a very political (left wing) bias, to an attempt to glorify fashion and commercial photography. I find myself in the unfashionable middle road, having come late to the Cartier-Bresson idiom, a consolidator rather than an innovator. It must, however, be remembered that though this idiom is out of fashion in art photographic circles (too straight for the arty; and for the political it is either sneaky to take people unawares, or a liberty to impose a composition on reality—especially if horrendous like war or poverty), the recent Cartier-Bresson exhibitions at Edinburgh and the Hayward received a great response from the public. But then there seems little relation between the tastes of even an informed public and that of the small group that leads artistic fashions.

I think the false state of photography arises from its deep inferiority complex. Photography also shares the isolation of the other arts from society; but I think it has rather chosen to do this—potentially, photography going in the right direction could help to bridge the gap. There is still reason enough for feeling insecure. The battle for photography to be accepted as art is won; but in England certainly, photographs are still not regarded as art objects to be collected or put on walls. The effect of all this is to encourage would-be artistic photographers to be arty. They have by various tricks and manipulations to show that they are being creative. I maintain that the photographer must be true to his medium, which is to record reality; and that he shows his creativity by the care with which he selects his imagery and the preciseness with which he organizes it in the picture space. The arty photograph may be visually striking or intruiging at first sight, but will soon pall; good photographs true to the medium often emerge from a context of dullness. For example, I looked at the 400 Atgets in the V & A collection. They are mostly boring architectural records, except to the student of certain kinds of architecture (they were purchased by the museum at the turn of the century purely as record photographs); however, one in ten suddenly takes off, because the subject was right for Atget's marvellous eye. And these photographs can be looked at again and again. In the Cartier-Bresson idiom the less good photographs usually retain the human interest, but are visually a

Roger Mayne: *Sunday Evening Below the Acropolis*, 1965

mess. Every so often a photograph occurs where everything falls into its place. In between are the tantalising cases where one wished the virtues of two or three similar images could be combined, for no individual one quite comes off.

There are certain beliefs in photography that I am opposed to. It seems that photography is setting up its own kind of aesthetic, perhaps again out of this sense of inferiority that I have mentioned. There are those in the photographic world (the "specialists" as Hockney calls such people) who accuse the general artistic public of having no real understanding of the medium. I myself would question how much the "specialists" understand art in general. For I feel there is a common ground to all the arts; and that art can be fully appreciated by an interested and experienced public, even if it lacks specific expertise in the medium in question.

The question of size is where I differ most of all from other photographers. For me, finding the correct size of print for the image is of crucial importance. Various things influence the size—e.g., the scale of the subject, the kind of forms in the image, the complexity of the composition, In addition, photographs on a wall require to be larger than when looked at in the hand or in a book. All painters and sculptors are aware of the importance of scale, and will instinctively adapt to whatever scale they happen to be working in. Matisse even went so far as to say that a painter must change the forms somewhat when working up an idea to a larger scale. Thus I find the attitude of the photographic world quite incomprehensible. No doubt I am regarded as a lunatic, but at least I can't be accused of being lazy. I think a lot about the right range of scale for each picture; and do the enlarging myself—up to 4 ft.

A side issue of the standardization of size by most photographers is that most photographic exhibitions are very dull in presentation. The Kertész exhibition, occupying a large space like the Serpentine Gallery—a single line of 10 x 8 prints—is a case in point. Better to look at the pictures in a book. Again, I was very disappointed that Cartier-Bresson's definitive selection of his work should be all at the relatively small size of 13½" x 9". Many of the images that had impressed at 36" x 24" in his V & A show 10 years back just got lost.

One side of the photographic aesthetic is the cult of the fine print, and the concept of print quality, but this is a faction within photography similar to those one gets in any art. The fine print implies a small size as part of the feeling of print quality comes from an illusion of seeing more detail than the eye can take in. The danger, however, is that certain things in the picture can easily be missed if the image is insufficiently enlarged (historically, Victorian photographers could make only contact prints and generally speaking used large cameras, which of course gave very fine detail—later a mystique arose that contact prints were superior to enlargements). The large camera approach, with, as often as not, contact prints may suit certain individuals admirably, e.g., Weston, Strand; but I thing it is too narrow an idea to become one of the tenets of art photography. It would be rather like saying that an early Flemish portrait leaves no room for the 6 ft. portraits of Velasquez or Goya; or that the handling of paint in Renaissance painting excludes the much rougher handling of impressionism or post-impressionism. Course grain, blurr and out of focus are as much part of the vocabulary of photography as extreme fine detail.

Artistic values will always be controversial. Also I am more certain, the older I get, that shifts of taste are purely a question of fashion, and not necessarily tied up with what the more general artistic public are thinking.

The reasons for taste are complex and often psychological. The broad situation as I see it is that many principles are involved in the creation of art, but that there are divergences of opinion as to what these are—sometimes to the extent that people may hold completely opposite views. Balance, conviction, life are qualities not much in dispute. Skill or craftsmanship I would say are not always essential—there are times when there is a choice of priorities. Does one have spontaneity at the expense of accuracy or technique? For me, yes. Economy of means is something I value (not to be confused with over-simplification) but which is liable to make a work difficult, for it has to do with expressing the essence of something (not to be confused with a stereotype) rather than surface realism. The two qualities that are really decisive (and as a result give me the feeling that the better my work might become, the less likely it is to be widely appreciated) are austerity and tension. This last idea I find difficult to explain briefly; but for me tension is not only the very life blood of art, but also that which can make art uncomfortable and disturbing.

—Roger Mayne

Roger Mayne's nature has inclined him to respond flexibly to the pressures and opportunites of life. He believes that an artist should tackle anything, and seeks variety rather than obsessive singlemindedness.

A search for "a kind of childhood I didn't have," and being "at the bottom of the pecking order myself" let him early to exercise his passionate engagement with photography, especially in its social documentary aspect. His emphasis was on the life and energy of children and young people, against their decaying urban environments. Roger Mayne believes that he was being carried along by the strength of the subject matter in his street photographs, and that the strength given by his artistic maturity appeared later.

In terms of a major theme: it becomes evident in the photographic record of his children, which began with the birth of daughter Katkin in 1966. Moving from the characteristic documentary stance of an outsider observing less fortunate others, Roger Mayne was now able to produce images whose intensity derived from his intimacy with the subjects, rather than from the drama of adverse circumstances. It is the evocation of the unfolding of ordinary existence which carries over into his recent landscape photography. Even when, as is often the case, it is empty of figures, this work is so definitely and unassumingly about daily human life that to encounter these very specific images is to encounter both the social and universal dimensions of being.

As happens not infrequently to artists whose care is for their work before professional wheeling and dealing, Roger Mayne has found himself with less and less affinity to the photographic scene. Coupled with this has been the realization that there are aspects of the world not readily treated through photography, with its virtually determinate composition and its emphasis on tone and texture before qualities of outline. The characters of drawing and etching, on the other hand, make up this lack; and Roger Mayne is now committed to the pursuit of their possibilities in priority to those offered by the photographic medium. His investigation of landscape continues, and life drawing is a fertile area that nude photography never really was.

—Philip Stokes

McBEAN, Angus.

British. Born in Newbridge, Monmouthshire, South Wales, 8 June 1904. Educated at Monmouth Grammar School, 1915-21; self-taught in photography. Married Helena Wood in 1923 (separated, 1924). Worked as bank clerk, Midland Bank, Newport and Brynmawr, Monmouthshire, 1923-26; shop assistant, Liberty's department store, London, 1926-33; photographic assistant, studio of Hugh Cecil, London, 1934-35. Freelance portrait and theatre photographer, since 1935; established own studio, Victoria, London, 1935-45; in Covent Garden, London, 1945-60; in Islington, London, 1960-66; and in Eye, Suffork, England, since 1966. Fellow, Royal Institute of British Photographers. Agent: Impressions Gallery of Photography, 17 Colliergate, York, England. Address: Flemings Hall, Eye, Suffolk 1P23 7QF, England.

Individual Exhibitions:

1934 Pirates Den Tea Shop, Hay Hill, London
1964 *Shakespeare's Plays*, Kodak Gallery, London
1971 *Thirty Years of Opera*, The Maltings Opera House, Snape, Suffolk
1976 *A Darker Side of the Moon*, Impressions Gallery, York (retrospective; toured the U.K.; augmented version, National Theatre, London, 1978)
1980 *Photographs 1934-1960*, Rex Irwin Gallery, Sydney

Selected Group Exhibitions:

1959 *Hundert Jahre Photographie 1839-1939*, Folkwang Museum, Essen (travelled to Cologne and Frankfurt)
1980 *Modern British Photography 1919-1939*, Museum of Modern Art, Oxford (travelled to Leeds Polytechnic; University of East Anglia; University of Sussex; Bolton Museum and Art Gallery; City Museum and Art Gallery, Worcester; Newport Museum and Art Gallery)

Collections:

National Portrait Gallery, London; Victoria and Albert Museum, London; Theatre Museum, London; Royal Photographic Society, London; Kodak Museum, Harrow, London; Australian National Gallery, Canberra; Harvard University, Cambridge, Massachusetts.

Publications:

By McBEAN: books—*Shakespeare Memorial Theatre, 1946-48*, with text by Ivor Brown, London 1949, and following books, every two years, until 1964; articles—"Results of a Battle" in *British Journal of Photography* (London), 23 February 1940; "Photographing Beauty" in *Picture Post* (London), January 1940; "Restoration Theatre" in *Vogue* (London), August 1980.

On McBEAN: books—*Hundert Jahre Photographie 1839-1939 aus der Sammlung Gernsheim, London*, exhibition catalogue, by Helmut and Alison Gernsheim, Essen 1959; *The Magic Image* by Cecil Beaton and Gail Buckland, London and Boston 1975; *Modern British Photography 1919-1939*, exhibition catalogue, by David Mellor, London 1980; articles—"Angus McBean" by Helmut Gernsheim in *Photo Monde* (Paris), February 1955; "Angus McBean" by Mark Owen in *British Journal of Photography* (London), December 1964; "Angus McBean" by Val Williams in *Amateur Photographer* (London), June 1976; "Angus McBean" by Stewart

Angus McBean: *Frances Day* Courtesy The Photographers' Gallery, London

for the *Sketch* magazine weekly for 3 years before the war, and *The Tatler* for about 2 years after the war. These were perfectly straight photographs of full-sized constructions which included some personality. They were intended seriously only as photography, and although many of them were, I think, pleasing pictures, they were not intended as "fine art." Indeed, I doubt that the camera can aspire to this distinction. They have always caused controversy; when, towards the end of the first series, *Picture Post* asked me to construct and photograph one of these pictures for an article 6 pages long, many people were outraged—*British Journal of Photography* going so far as to call me a "charlatan" and no photographer. Well, they are still calling Dali a charlatan, but no one says he is no draughtsman! As recently as this month I have had an exhibition in Sydney, Australia (July 8-26, 1980), and a critic describing himself as a "purist photographer" dismissed my "surrealist" work as kitsch. This didn't prevent the show being a virtual sell-out, with pictures going to art galleries in Canberra, Sydney and Newcastle.

Of course I know what is meant by a "purist photographer"; for many years I was one, recording what was in front of the camera and developing it to Messrs. Kodak's time-temperature formula. But surely the term is meaningless: a photograph is, by definition, an image produced by light and any such image is a pure photograph, even if a camera is not used at all.

Most of my photography is reasonably straight, but it was with my Christmas cards that I let myself go, using every device known to me—even the adamantly forbidden "mucking about in the darkroom." These went out for 30 years in great numbers, but it was only about 5 years ago when one of them came up at Christies saleroom and sold for £240 that I realized that all those vintage prints in a drawer upstairs were worth a lot of money.

—Angus McBean

"Theatre is Romance," Angus McBean once declared. Surrealist romance became his trademark in artfully contrived tableaux, sharp-edged reflections of Victorian play acting: in the 1930's his photos created a flavour as heady and strong as the fashionable cocktails of the period. He mixed, and mismatched, with sardonic elaboration in order to add piquant flavour, a dash of nostalgia, and a knowingness which made spectators collaborators in a world of make-believe. From December 1937, McBean contributed a weekly photo-portrait for the *Sketch*, affectionately quirky.

Born in Wales, McBean worked first as a bank clerk. After coming to London, he worked at Liberty's, and in the 1920's made for himself masks and dolls, marionettes, from real life and the imagination. This sense of how to use props led to the imaginative creation of settings in which to photograph his personalities, settings which underlined interpretations of character. McBean was eventually commissioned by Ivor Novello to make masks for the production of *The Happy Hypocrite* and became a theatrical photographer, supplying the front-of-house photographs that advertised the delights within. These photographs were usually published. However, the majority of McBean's vast audience would absorb his imagery without realizing its authorship: as one commentator put it when discussing McBean, his photographs were "outside almost every theatre in England for 30 years."

Yet McBean carried forward his theatrical traditions to a new world of pop music publicized by the potency of television: in the 1950's and 60's he photographed Tommy Steele, Motown, the Beatles. Stage-struck and camera-mad, McBean has described himself. Rarely can such interests have been so creatively intertwined, and perhaps McBean's interest in the theatre, props, and the creation of illusion led to his ability to use any technique that came to hand, mind and eye for creative, effective

Scotney in *Art and Artists* (London), July 1976; "The Works of Angus McBean" by Trevor Gett in *Australian Photography* (Sydney), October 1978; "Angus McBean" by Roger Clark in *British Journal of Photography* (London), 17 August 1979; "Angus McBean" by Jake Wallis in *Creative Camera* (London), February 1980; "The Great Eye" by Sandra McGrath in *The Weekend Australian* (Sydney), 5 July 1980.

With one Scottish grandfather who provided the name and some genes, I was born and brought up in a colliery village in Monmouthshire and call myself Welsh. After school, I became a bank clerk, but soon—in search of "Art"—I became a shop assistant in Liberty's in London, where I didn't find art, but learned to handle people—a vital weapon in the armoury of a portrait photographer. Luckily, after seven years I lost this job and, although it was the jobless 1930's, I grew a beard to demonstrate that I was not seeking one. I spent a year at home making masks for both decoration and use on the stage and taking photographs. I had found Art. I held a small exhibition of my work in a small teashop in Hay Hill, London, and there met Hugh Cecil whose temple to photography was next door, and became for a year his assistant, learning a great deal I didn't know before about photography.

After a year, in 1934, I opened my first studio in a basement in Belgrave Road, Victoria, and started photographing theatre shows for no payment, selling the results to the *Sketch* and other magazines—meeting stars like Ivor Novello, Vivien Leigh, Ralph Richardson, and going to the Old Vic every change of play and getting Lawrence Olivier into a corner of the stage and under a light and taking a couple of shots—now the only pictorial record of these historic performances. My publication successes gradually won me the position of official photographer to the Old Vic, Sadlers Wells, Stratford-on-Avon, Glyndebourne, and, finally the great empire of the commercial theatre, H.M. Tennent, under the management of "Binkie" Beaumont.

Now I was probably the no. 1 photographer for 30 golden years of the English theatre. This is most certainly my most important work, a fact recognized by Harvard University Library who bought all my important negatives: 4½ tons of glass, 48,000 exposures which are now cared for and serviced by them. When I gave up stage photography in 1963, I had photographed all of Shakespeare's plays in major productions: *Hamlet*, 14 times, and *Macbeth*, 16 times.

But it is not my stage work which now causes the present interest in my work. It is the series of so-called "surrealist pictures," photographs in the surrealist manner of stage and other personalities, done

photographs. He usually built sets in the studio, and is best known for the use of sand from which fragments of his models might emerge: the face, part of a body. He played about with scale, so that what we would think of as monumental would appear miniature, and vice-versa. He was famous in the profession for his annual Christmas cards, which starting in 1936, were always a photographic joke, playing about with photographic conventions and idioms, with tricky multiple exposures, montages, multiple printings, and of course the use of props, which became his trademark.

He had a fine eye for physical structure and physical appearance; he picked out Audrey Hepburn from a West End chorus line to advertise a beauty product.

Television and a new gitty realism (and a concomitant lack of glamour) in the theatre limited McBean's career: he also felt that the better he got, the duller his images became—a curious paradox. "Anyone can be a photographer," he declared; "it is the subject matter which makes a great photographer." By the end of the 1960's he decided to stop photographing professionally: yet his photographs of the theatre for three decades, his pop record album covers, his surreal portraits of characters and personalities, are all exceedingly well known: his interpretations of his own period have entered the pool of shared visual culture, with imagery he contrived now so accepted as to have become commonplace in advertising campaigns devised in America and Britain by art directors who probably are unaware of the origination of the ideas they use. McBean continues to photograph: portraits and buildings.

—Marina Vaizey

McBRIDE, Will.

American. Born in St. Louis, Missouri, 10 January 1931. Studied illustration under Norman Rockwell at the Academy of Design, New York; also studied at the Art Institute of Chicago, Detroit Society of Arts and Crafts, and Syracuse University, New York; studied German at the Free University, Berlin, 1955-57. Served as a photographer in the 1st Infantry Division, United States Army, Wurzburg, Germany, 1953-55. Married Barbara Wilke in 1959 (separated, 1969); sons: Shawn, Robin, Brian. Freelance photographer, working for *Life*, *Look*, *Stern*, *Paris-Match*, and particularly for *Twen*, etc., in Berlin, 1955-61, in Munich, 1961-72, based in Casoli, Italy, working as photojournalist and sculptor, since 1972. Recipient: Gold Medal, Art Directors Club of Germany, 1968, 1969, 1972, and of New York, 1970. Address: 55060 Casoli di Camaiore, Provincia di Lucca, Italy.

Individual Exhibitions:

1972 Galerie Christoph Durr, Munich
1978 Galleria d'If, Palermo
1980 Commune di Camaiore, Italy
1981 *Will McBride: Autobiographie*, PPS Galerie, Hamburg

Selected Group Exhibitions:

1957 *5 Young American Artists in Berlin*, Amerika Haus, West Berlin
1979 *Deutsche Fotografie nach 1945*, Kasseler Kunstverein, Kassel, West Germany (toured West Germany)

Publications:

By McBRIDE: books—*Berlin und die Berliner*, with Lynn Millar, West Berlin 1958; *Adenauer: A Portrait*, Munich 1965; *Zeig Mal*, with a foreword by Helmut Kendler, Wuppertal, West Germany 1974; *The Photo-Essay*, with Paul Fusco, text by Tom Moran, New York and London 1974; *Show Me*, with text by H. Fleischauer, New York 1975, London 1976; *The Lord's Prayer*, Wuppertal, West Germany 1978; *Siddhartha*, Kehl am Rhein, West Germany 1982; *Will McBride's Photographic Diary*, 1982; article—"Will McBride: Siddhartha" in *Zoom* (Paris), November/December 1971.

On McBRIDE: book—*Deutsche Fotografie nach 1945/German Photography after 1945* by Floris Neusüss, Wolfgang Kemp and Petra Benteler, Kassel, West Germany 1979; articles—"Photographs and Reflections of Will McBride" in *U.S. Camera Annual 1970*, edited by Cranston Jones, New York 1969; "Will McBride" in *Camera* (Lucerne), April 1969; "Das ist der neue Mensch: Eine Vision von Will McBride" in *Twen* (Munich), May 1970; "McBride: Un Certain Regard de Notre Epoque" in *Photo* (Paris), April 1972; "Will McBride: L'Amour aux Cent Visages" in *Photo* (Paris), December 1972; "The Knapsack Classics" in the *Daily Telegraph Magazine* (London), 18 May 1973; "Schottland: Fotos Will McBride" in *Stern* (Hamburg), 20 May 1974.

Will McBride was a supernova of a photographer. He was totally unknown in the dark days of the 50's, and he seemed to vanish without trace in the 70's, but in the decade in between he lit up the whole world of contemporary photography, via the pages of *Twen* magazine in Munich and his book *Siddhartha*.

McBride was a painter and sculptor who became a photographer by chance. He discovered David Douglas Duncan's book *The Private World of Pablo Picasso*, and with typically impulsive directness went off to see him. Duncan, not Picasso. Another chance was finding Willy Fleckhaus, who had not yet launched *Twen* but started McBride off with assignments for *Quick*. By such accidents a man who had recently been discharged from the U.S. army and married a German girl, and who had seemed to have few prospects in his adopted country, was set to become one of the most famous figures in the photography of the day.

Twen was the best-designed magazine of all time. It was the most dramatic, the most vivid, the most direct, the freshest, and published photography of a consistent quality and level of imagination that has never been matched. *Twen* did not report on the world, it created it. Fleckhaus filled the large pages with big pictures, relegating the text to neat blocks set off with bold headings and areas of white space: it was revolutionary at the time. The pictures used revolutionary new effects such as super-saturated colours, exaggerated grain, extreme wide-angle distortion and so on. Fleckhaus often reproduced photographs so that the subjects were larger than life—sometimes much larger. A pair of lips in *Twen* could appear over 30cm across! Also, *Twen* had no coyness about showing nudes, and even pubic hair. Fleckhaus showed black men with white women, both nearly naked and touching. It was strong stuff for a respectable magazine in an age when airbrush retouching was still *de rigueur*. The point of all this is that McBride's style was exactly *Twen*'s: they made a combination of the ideal photographer with the ideal magazine. But it must also be observed that *Twen* still looked like *Twen* when it contained no pictures by Will McBride, and McBride still looked like *Twen* even when he did things on his own. (Pete Turner, Art Kane and Hans Feurer were among Fleckhaus's other favorite photographers, and at this time they all had styles that were similar to McBride's. Who knows who influenced who?)

McBride had the ideal mentor and the ideal outlet; all he needed was the ideal subject. Fleckhaus found it for him: Hermann Hesse's *Siddhartha*. McBride strongly identified himself with the hero, and immediately organized a trip to India to shoot the story. As always he sketched out the series of pictures before he shot them—he worked graphically, like an art director. He used all the tricks, shooting many of the pictures with ultra wide (20mm, 24mm) lenses from very close distances. The set was published in *Twen*, and later McBride laid out a brilliant 56-page portfolio in the French magazine *Zoom* including 40 pages from *Siddhartha*.

It was his apotheosis. Shortly after that return from India his wife left him, taking the three chil-

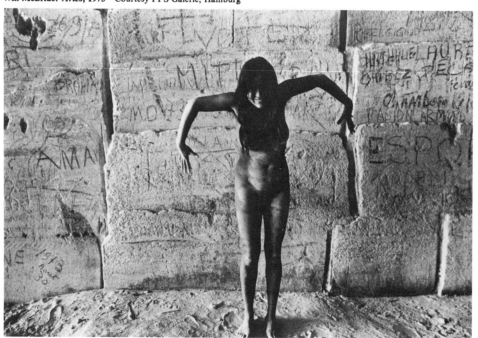

Will McBride: *Arles*, 1975 Courtesy PPS Galerie, Hamburg

dren. He gradually lost all his advertising clients. *Twen* went out of business as the bravado and optimism of the 60's gave way to the pessimism of the 70's. McBride simply ran out of money and had to close down his studio. He talked of giving up photography, as he felt he had seen too much, and, anyway, no photograph ever had the passion of his interior world.

Even so, the passion he captured in *Siddhartha* and in his "Dictionary of Sex" project is extraordinary. It is a passion for skin rather than of sex—for acres of skin, full of texture and glowingly warm and human and eminently touchable. McBride photographed skin with a terrifying intensity, and he paid a terrible price for his success. Remember that.

—Jack Schofield

McCOMBE, Leonard.

American. Born in Douglas, Isle of Man, United Kingdom, in 1923; emigrated to the United States, 1945; naturalized, 1953. Self-taught in photography. Professional photographer, 1939-72: Staff Photographer, under Tom Hopkinson, *Picture Post* magazine, London, during World War II, then Staff Photographer, *Life* magazine, New York, 1945 until he retired from photography, on demise of *Life*, 1972. Recipient: Magazine Photographer of the Year Award, New York, 1949, 1954. Fellow, Royal Photographic Society, London, 1944. Address: Briermere Farms, 77 Sound Avenue, Riverhead, New York 11901, U.S.A.

Selected Group Exhibitions:

1951 *Memorable Life Photographs*, Museum of Modern Art, New York
1979 *Life: The First Decade*, Grey Art Gallery, New York University

Publications:

By McCOMBE: book—*You Are My Love*, New York 1952; articles—"The Private Life of Gwyned Filling" in *Life* (New York), 1948; "I See My Love" in *Life* (New York), 18 August 1951.

On McCOMBE: books—*Memorable Life Photographs*, with text by Edward Steichen, New York 1951; *Life Photographers: Their Careers and Favorite Pictures*, edited by Stanley Rayfield, New York 1957; *Photography Today*, edited by Norman Hall, London 1957; *Life: The First Decade 1936-1945* by Robert Littman, Ralph Graves and Doris C. O'Neill, New York 1979, London 1980; articles—"Leonard McCombe" in *U.S. Camera Annual 1952*, edited by Tom Maloney, New York 1951; "The Real Mc-Combe" by Ronald H. Bailey in *American Photographer* (New York), December 1978.

British-born Leonard McCombe published his first pictures in *Life* magazine in 1945; they showed Americans the shocking sight of displaced German civilians, many among them sick and starving, crowded into refugee trains waiting to leave Berlin station. McCombe has spent the war years photographing in the grim cities of Warsaw and Berlin for *Picture Post* and other British publications, but when *Life* Photography Editor Wilson Hicks succeeded in bringing him to America, he made a point

of assigning the young photographer a first essay on the "warm, fat and happy people" at Jones Beach. Thus began a long association with *Life* which allowed this energetic and intelligent photographer to publish prolifically right up until *Life's* final issue in 1972.

The 23-year-old McCombe was not overwhelmingly impressed with America at first, complaining of "the constant speed, the aggressive nasal whine, the wet heat, the bitter squint of the crowd, the assembly-line look of American life and the new crisis every hour." However, he took the occasion of adopting American citizenship in 1953 to assemble a personal essay acknowledging his eventual acceptance of and affection for his new country. Casting back through seven years of photography ranging in subject from New York career girls to Navaho Indians, from South American political revolution to the life of Texas cowboys, McCombe highlighted important moments among the impressions and adventures that had constituted his period of adjustment.

McCombe had been elected to England's Royal Photographic Society at twenty-one—its youngest member—and Americans were equally quick to recognize his talent. He was named Magazine Photographer of the Year in 1949 and again in 1954. Most striking among McCombe's achievements are his insightful photographs of people. Although his work is occasionally reminiscent of Walker Evans' or Dorothea Lange's stark Depression-era studies of Americans, McCombe was nevertheless among the first to undertake the candid, psychologically-oriented essays that *Life* excelled at in the 1950's and which influenced the *cinéma verité* movement in film in the 1960's. In his justly-celebrated 1948 essay on a New York career girl, "The Private Life of Gwyned Filling," the photographs move in time through Gwyned's busy day, each unposed shot cleverly revealing some new quality in its subject that adds to the essay's complex representation of her life. Whether his sharp eye for the characteristic and idiosyncratic was the result of McCombe's English strangeness to American life or, more likely, the native originality of a thoughtful observer, his photo-essays constitute an extraordinary collection of sharply-drawn American vignettes.

McCombe always carried a camera and used it, like a diary, to record impressions and reactions. Over the years he continued to contribute essays on personal subjects. The last of these, in *Life's* penultimate issue, shows the traditional style in which his family celebrated Christmas at their farm on Long Island. If McCombe's later photographs lack some of the intensity of his earlier work, they nevertheless demonstrate the subtlety, attentiveness, and human warmth that make him a master photojournalist.

—Maren Stange

McCORMICK, Ron(ald).

British. Born in Liverpool, 26 July 1947. Studied fine art at Liverpool College of Art, 1964-68, Dip. A.D. 1968; painting, at the Royal College of Art, London, 1968-71; self-taught in photography. Married Linda Bond in 1969; children: Nancy and Joel. Worked in community publishing project, Stepney, London, 1971-72; freelance reportage photographer, London, 1971-79; Director, Half Moon Photography Gallery, London, 1971-73, and Side Gallery of Photography Newcastle upon Tyne, 1976-77. Independent photographer, since 1979. Visiting Tutor, Barking College of Technology, London, 1972-73; North East London Polytechnic, 1972-75, and Sheffield Polytechnic, 1975-78; Artist-in-Residence, Newport College of Art, Wales, 1977-78; Visiting Tutor, Newcastle Polytechnic, Newcastle upon Tyne, 1979. Lecturer in Documentary Photography, Gwent College of Higher Education, Newport, Wales, since 1979. Recipient: Arts Council Award, 1974; Welsh Arts Council Award, 1978; Northern Arts Award, 1979. Address: 164 Stow Hill, Newport, Gwent NPT 4FZ, Wales.

Ron McCormick: *Newport*, 1981

Individual Exhibitions:

1971 *Neighbours: Spitalfields to Whitechapel*, Half Moon Gallery, London
1973 *Oldham: 2 Views*, Oldham Art Gallery and Museum, Lancashire (with Kevin Keegan)
2 Views: Southend, Beecroft Art Gallery, Southend
2 Views, The Photographers' Gallery, London
1974 *Festival*, Half Moon Gallery, London
1977 La Photogaleria, Madrid
1979 Oriel/Welsh Arts Council Gallery, Cardiff
The Photographic Gallery, Southampton
Ceolfrith Arts Centre, Sunderland

Selected Group Exhibitions:

1972 *Summer Show*, Serpentine Galley, London
This Is Whitechapel, Whitechapel Art Gallery, London
1973 *Inside Whitechapel*, Whitechapel Art Gallery, London
1975 *Young British Photographers*, Museum of Modern Art, Oxford
The Performance Show, The Photographic Gallery, Southampton
The Camera and the Craftsman, Waterloo Place Gallery, London
Problem in the City, Institute of Contemporary Arts, London
1976 *Rencontres Internationales de la Photographie*, Arles, France
1981 *Evidence of Things Seen*, Newport Museum and Art Gallery, Wales
1982 *Contemporary British Photographers*, Massachusetts Institute of Technology, Cambridge

Collections:

Arts Council of Great Britain, London; Royal Town Planning Institute, London; Crafts Advisory Committee, London; Oldham Art Gallery and Museum, Lancashire; Welsh Arts Council, Cardiff; Bibliothèque Nationale, Paris.

Publications:

By McCORMICK: books—*Young British Photographers*, with others, London 1975; *The Camera and the Craftsman*, with others, London 1975; *New British Image*, editor, London 1977.

On McCORMICK: books—*Oldham: 2 Views—Photographs by Ron McCormick and Kevin Keegan*, exhibition catalogue, with comment by Arthur Dooley, Oldham, Lancashire 1973; *Ron McCormick*, exhibition brochure, Cardiff 1979; *British Journal of Photography Annual 1980*, London 1979; article—"Southampton—Photography: Ron McCormick" by Hugh Adams in *The Guardian* (London), 10 August 1979.

Ron McCormick has had a variety of roles, sometimes simultaneously, in the world of British photography. Primarily a documentary photographer, although trained as a painter, he has administered photography galleries (Half Moon, London; Side, Newcastle), been a member of Arts Council committees, received awards, and is now a teacher in one of the liveliest photography departments in Britain, that of Gwent, in Newport, Wales.

Several times he received commissions from the Whitechapel Art Gallery, London, to photograph Whitechapel itself, the results effectively exhibited in large exhibitions which contained work by divers hands. McCormick's eye is both sensitive and acute, sharply conclusive and imaginative. His eye in particular for the human local colour that makes a locale is discerning, for he manages to be telling and memorable without being sentimental or slick. He can also be reformist: the influential *Problem in the City* exhibition at the Institute of Contemporary Arts, London, laconically demonstrated the self-inflicted horrors of urban planning that have spread in British life.

McCormick is exceptionally effective at composition, in finding what is there, but managing by framing and the exercise of subtle choice, to distill, refine, exaggerate, in such a way that the spectator believes in the truth of what the photographer has found. *Problem in the City*, on which McCormick collaborated with two other photographers, was outstanding because within the documentary tradition, and at a time when vigorous lobbying on the part of disadvantaged groups was a feature of British life, the images managed to tell a scarifying story without being overtly sensational. The photographs were compassionate, dispassionate, "worked" as images without losing or compromising their reportorial quality.

If McCormick's photographs have recently become more private, less documentary-narrative, that is a reflection of the period, which has become more inward. His photographs remain both striking and understated, and the cumulative body of work affecting, substantial, and stimulating. McCormick is gradually evolving from the documentary and reportorial to an attitude which is personal, individual—colour is becoming increasingly important—yet still based on observation. It is more monument, less narrative, with a natural dignity found in the appearances of things usually passed over and disregarded. McCormick's is an evolving talent.

—Marina Vaizey

McCULLIN, Don(ald).

British. Born in London, 9 October 1935. Educated at Tollington Park Secondary Modern School, London, 1945-48; studied painting at Hammersmith School of Arts and Crafts, London, 1948-50 (Trade Arts Scholarship). Served as a photographic assistant in aerial reconnaissance, Royal Air Force, in Egypt, East Africa and Cyprus, 1953-55. Worked as a dining-car attendant, British Railways, London-to-Manchester and London-to-Liverpool trains, 1951-52; colour-mixer, Larkins Cartoon Studios, London, 1952-53, 1956-60; freelance photojournalist, working mainly for *The Observer* newspaper, London, in Berlin, Cyprus, etc., 1961-64; Staff Photographer, *The Sunday Times* newspaper, London, in the Congo, Vietnam, Cambodia, Biafra, India, Pakistan, Northern Ireland, etc., since 1964. Member, Magnum Photos co-operative agency, Paris and New York. Recipient: World Press Photographer Award, 1965; Gold Medal for Photography, Warsaw, 1964. Address: c/o The Sunday Times, 200 Grays Inn Road, London WC1, England.

Individual Exhibitions:

1980 *Hearts of Darkness*, Victoria and Albert Museum, London (travelled to the International Center of Photography, New York, 1981)

Selected Group Exhibitions:

1972 *4 Internationally Famous Magazine Photog-raphers*, at *Photokina 72*, Cologne
The Concerned Photographer 2, Israel Museum, Jerusalem (toured Europe)
1980 *Old and Modern Masters of Photography*, Victoria and Albert Museum, London (toured Britain)

Collections:

Victoria and Albert Museum, London; Museum of Modern Art, New York; International Center of Photography, New York; International Museum of Photography, George Eastman House, Rochester, New York.

Publications:

By McCULLIN: books—*The Destruction Business*, London 1971, as *Is Anyone Taking Notice?*, Cambridge, Massachusetts 1973; *The Homecoming*, London 1979; *Don McCullin: Hearts of Darkness*, with an introduction by John Le Carré, London 1980; articles—"Why Them and Not Me?" in the *Sunday Times Magazine* (London), 12 July 1970; interview, with Bill Jay, in *Zoom* (Paris), January/February 1972.

On McCULLIN: books—*The Face of Life: Photographs Chosen by "The Observer,"* edited by Cliff Hopkinson, London 1959; *America in Crisis: Photographs for Magnum*, edited by Charles Harbutt and Lee Jones, with an essay by Mitchel Levitas, New York 1969; *The Concerned Photographer 2*, edited by Cornell Capa, New York and London 1972; *The Magic Image* by Cecil Beaton and Gail Buckland, London and Boston 1975; *Geschichte der Fotografie im 20. Jahrhundert/Photography in the 20th Century* by Petr Tausk, Cologne 1977, London 1980; *Old and Modern Masters of Photography*, exhibition catalogue, by Mark Haworth-Booth, London 1980; articles—"Don McCullin" in *Album* (London), December 1970; "Photographs by Don McCullin" in *Creative Camera* (London), May 1971; "Two Worlds: The Photographs of Gilles Caron and Don McCullin" by Ainslie Ellis in the *British Journal of Photography* (London), 4 June 1971; "Don McCullin: I Want to Be the Toughest War Photographer in the World" by Robert Y. Pledge in *Zoom* (Paris), January/February 1972; "Donald McCullin: War Photographs" in the *Sunday Times Magazine* (London), 25 June 1972; "Donald MCullin" in *Zoom* (Paris), no. 10, 1972; "McCullin" in *The Image* (London), no. 12, 1973; "The Concerned Photographer" by Cornell Capa in *Zoom* (Paris), no. 16, 1973; "McCullin: Ici Londres" in *Photo* (Paris), December 1979; "Don McCullin: Taming the Real" by David Moore and "Don McCullin" by Mark Haworth-Booth in *Creative Camera* (London), March/April 1981.

Don McCullin's work emerges from photojournalism, but its importance transcends the journalistic conventions. He has combined cool, effective professionalism with a rare compassion. His photographs were first published in *The Observer* newspaper, and his work developed with the formation of the Sunday colour supplements in London. Throughout the 1960's and early 70's McCullin operated through that most public medium, the magazine, the contrasts of which both exaggerate and insulate the reader from any horror portrayed. *The Sunday Times Magazine*, for which McCullin has worked since the mid-1960's, has used his work ambitiously and has given him unprecedented space and emphasis. His great ability has been to find formal, often heroic, single images, the intensity of which question all the surrounding contents of the magazine in which they appear. His work was perfect for challenging the rapidly consumable, ephemeral nature of the medium.

His first published story was of his own street gang, The Guv'nors of Seven Sisters Road, in 1958. They form part of McCullin's raw autobiography. There is a famous picture of the gang posing in a half-demolished house, standing framed by the rafters. From the start McCullin was able to contain the chaos and violence within a structure. His early British pictures are the work of a young man with a bitter conscience looking for a style. He was rapidly absorbing the work of other photographers. The unemployed sifting through coal dust for fuel or wheeling their sacks on bicycles across a northern plain are close to Brandt's work of the 30's. There is his deceptive photograph of the sheep in the early morning from 1961. It appears like a quiet, rural scene, until you realize it is Caledonian market, and they are being herded to their inevitable slaughter at dawn. McCullin's intuition had sensed death, which was to be the significant preoccupation of much of his career.

His work in Cyprus in 1964 won him an international reputation and the World Press Photographer Award. Surrounded by 5,000 Greek irregulars, he charged his pictures in the streets of Liamassol with the adrenalin of the street drama and the appalling grief of the tragedy. The victims were gunned down in their front rooms. He was able to mark his pictures with a domestic intimacy, which touched the most vulnerable areas of our own response. One of the triggers to that response was evident in a quiet, mournful interior, when a boy kneels by the body of his father in silent, suspended grief, close to an iconographic form or a religious passion.

McCullin was in Vietnam during the Tet offensive of 1968. In the midst of the battle, amongst the debris, through a fragmented, dazed two weeks, McCullin found order. Charred uprights frame the athletic gesture of a negro hurling a grenade. A wounded man lies between the silhouette of a bayonet and the line of a drip stand. Details like rings, bracelets and watches glitter amongst the bodies as intimate forms in a zone where everything is smashed. There is his famous picture of the dead Vietcong with ammunition spilled across his open wallet and the photographs of his family. Using all the sentiments of propagandists, McCullin pointed his camera at the other side, at the anonymous adversary. A soldier shot in the legs is carried by his two companions in the form of a Deposition from the Cross. The icon surfaced from the reflexes of battle.

McCullin could contain not only conflict but also history. In the Congo in 1967 in a single photograph of a white mercenary with a gun and a black family with a bowl, he touched a root of colonial conflict. In Biafra, where the history of the Republic was diminished to three years and the children reduced to skeletal forms, he photographed as relentlessly as he has from Beirut to Belfast.

His later work in Britain is an attempt to re-establish himself in the calmer pulses of the English landscape. His *Homecoming* contained photographs of the northern ghetto of Bradford and the East Anglian countryside beneath dark skies. Britain looked like a combat zone.

Don McCullin epitomises the role of witness to the despair of our time.

—Mark Holborn

MEATYARD, Ralph Eugene.

Born in Normal, Illinois, 15 May 1925. Educated at University High School, Normal, 1938-43; entered Navy V-12 program, Williams College, Williamstown, Massachusetts, 1943-44; apprentice optician, Dow Optical Company, Chicago, 1946-49; licensed optician, 1949; studied at Illinois Wesleyan University, Bloomington, 1950; studied photography, under Van Deren Coke, University of Kentucky, Lexington, 1954-55; under Henry Holmes Smith and Minor White, University of Indiana, Bloomington, 1956. Served as a medical corpsman and interpreter, United States Navy, Norfolk, Virginia, 1944-46. Married Madelyn McKinney in 1946; children: Michael, Christopher, and Melissa. Optician, Gailey Eye Clinic, Bloomington, Illinois, 1949-50, and Tinder-Krauss-Tinder, Lexington, Kentucky, 1950-67; Founder-Director, Eyeglasses of Kentucky optical business, Lexington, Kentucky, 1967-72. Also, independent photographer, Lexington, 1953 until his death, 1972. Recipient: New Talent USA Award, 1961. Agent: Witkin Gallery, 41 East 57th Street, New York, New York 10019. Estate: Madelyn Q. and Christopher Meatyard, 418 Kingsway Drive, Lexington, Kentucky 40502, U.S.A. *Died* (in Lexington, Kentucky) *7 May 1972.*

Individual Exhibitions:

1957	A Photographer's Gallery, New York (with Van Deren Coke)
1959	Tulane University, New Orleans
1961	Morehead State College, Kentucky
	University of Florida, Gainesville
1962	Carl Siembab Gallery, Boston
	University of Florida, Gainesville
1963	Arizona State University, Tempe
	University of Florida, Gainesville
1965	University of New Mexico, Albuquerque
1966	Arizona State University, Tempe
1967	Bellarmine College, Louisville, Kentucky
	University of New Mexico, Albuquerque
	J.B. Speed Museum, Louisville, Kentucky (with Walt Lowe)
1968	Doctor's Park, Lexington, Kentucky
	Quivira Gallery, Corrales, New Mexico (with Van Deren Coke)
1970	Center for Photographic Studies, Louisville, Kentucky
	Ohio State University, Athens
	University of Kentucky, Lexington
1971	Art Institute of Chicago
	International Museum of Photography, George Eastman House, Rochester, New York
	J.B. Speed Museum, Louisville, Kentucky
	Jefferson Community College, Watertown, New York
	Picker Gallery, Colgate University, Hamilton, New York
	Steinrock Gallery, Lexington, Kentucky
1972	Charles W. Bowers Memorial Museum, Santa Ana, California
	Columbia College, Chicago
	Cortland Free Library, New York
	Doctor's Park, Lexington, Kentucky
	Focus Gallery, San Francisco
	Light Impressions, Rochester, New York
	Logan Helm Woodford County Library, Versailles, Kentucky
	Matrix, Hartford, Connecticut
	Northeast Louisiana State College, Monroe
	Watson Gallery, Elmira College, New York
1973	Cincinnati Art Academy, Ohio
	University of Delaware, Newark
	Witkin Gallery, New York
1974	Colorado Springs Fine Arts Center
	Oakton College, Morton Grove, Illinois
	J.B. Speed Museum, Louisville, Kentucky (with Henry Holmes Smith)
	Carl Siembab Gallery, Boston
	Madison Art Center, Wisconsin
1976	Illinois State University, Normal (retrospective; travelled to the Woodson Art Museum, Wausau, Wisconsin; American Cultural Center, Paris; and University Art Galleries, Santa Barbara, California; then toured art centers of Kentucky)
1977	Williams College, Williamstown, Massachusetts
	Western Carolina University, Cullowhee, North Carolina
1979	*Ralph Eugene Meatyard: Photographs/Eikoe Hosoe: Kamaitachi*, Silver Image Gallery, Ohio State University, Columbus
	Meatyard: Photography, Ulrich Museum of Art, Wichita State University, Kansas
	Mankato State University, Minnesota
1981	Yuen Lui Gallery, Seattle

Selected Group Exhibitions:

1954	*Hartford International Exhibition of Photography*, Wadsworth Atheneum, Hartford, Connecticut
1956	*Creative Photography*, University of Kentucky, Lexington
1959	*Photographer's Choice*, Indiana University, Bloomington
	Sense of Abstraction, Museum of Modern Art, New York
1960	*Fotografia della Nuova Generazione*, Milan
1966	*American Photography: The 60's*, Sheldon Memorial Art Gallery, University of Nebraska, Lincoln
1967	*Photography in the 20th Century*, National Gallery of Canada, Ottawa (toured Canada and the United States, 1967-73)
1968	*Five Photographers*, University of Nebraska, Lincoln
1974	*Photography in America*, Whitney Museum, New York
1979	*Photographic Surrealism*, New Gallery of Contemporary Art, Cleveland (travelled to Dayton Art Institute, Ohio; and Brooklyn Museum, New York, 1980)

Collections:

Metropolitan Museum of Art, New York; Museum of Modern Art, New York; International Museum of Photography, George Eastman House, Rochester, New York; Visual Studies Workshop, Rochester, New York; Massachusetts Institute of Technology, Cambridge; Smithsonian Institution, Washington, D.C.; University of Louisville, Kentucky; University of Nebraska, Lincoln; University of New Mexico, Albuquerque; University of California at Los Angeles.

Publications:

By MEATYARD: books—*Ralph Eugene Meatyard*, edited by Jonathan Greene, with texts by Arnold Gassan and Wendell Berry, Lexington, Kentucky 1970; *The Unforeseen Wilderness*, with text by Wendell Berry, Lexington 1971; *The Family Album of Lucybelle Crater*, with text by Jonathan Williams and others, Millerton, New York 1974; *Portfolio Three: Ralph Eugene Meatyard*, portfolio of 10 photos, with an introduction by Van Deren Coke, Louisville 1974; *Ralph Eugene Meatyard*, set of slides, Rochester, New York 1976; *Slide Set 2: Ralph Eugene Meatyard*, New York 1976; *Slide Set 3: Ralph Eugene Meatyard*, New York 1980; articles—"Statement" in *Photographer's Choice no. 1*, exhibition pamphlet, Bloomington, Indiana 1959; "Thomas Merton Eulogized: 'Very Much with World'" in *The Kentucky Kernel* (Lexington), 13 December 1968; "Remembering F.v.d.C." in *The Kentucky Review* (Lexington), Autumn 1969.

Ralph Eugene Meatyard: *Untitled,* **1959**

On MEATYARD: books—*American Photography: The 60's*, exhibition catalogue, Lincoln, Nebraska 1966; *Photography in the Twentieth Century* by Nathan Lyons, New York 1967; *Five Photographers*, exhibition catalogue, with an introduction by Michael McLoughlin, Lincoln, Nebraska 1968; *Ralph Eugene Meatyard*, edited by James Baker Hall, Millerton, New York, Dusseldorf, and Toronto 1974; *Photography in America*, edited by Robert Doty, with an introduction by Minor White, New York 1974; *Ralph Eugene Meatyard: A Retrospective*, exhibition catalogue, by Van Deren Coke, Normal, Illinois 1976; *The Photographs of Ralph Eugene Meatyard*, exhibition catalogue, by Susan Dodge Peters, Williamstown, Massachusetts 1977; *The Grotesque in Photography* by A.D. Coleman, New York 1977; *Geschichte der Fotografie im 20. Jahrhundert / Photography in the 20th Century*, by Petr Tausk, Cologne 1977, London 1980; *Photographic Surrealism*, exhibition catalogue, by Nancy Hall-Duncan, Cleveland 1979; *The Photograph Collector's Guide* by Lee D. Witkin and Barbara London, Boston and London 1979; *A Ten Year Salute* by Lee D. Witkin, Danbury, New Hampshire 1979; articles—"A Vote of Confidence for Coke and Meatyard" by George Wright in *Village Voice* (New York), 30 January 1957; "The Photographs of Ralph Eugene Meatyard" by Van Deren Coke in *Aperture* (New York), Winter 1959; "The Strange World of Ralph Eugene Meatyard" by James Baker Hall in *Popular Photography* (New York), July 1969; "From Dolls and Masks to Lynchings" by A.D. Coleman in *New York Times*, 11 March 1973; "Photographs by Ralph Eugene Meatyard" in *Creative Camera* (London), April 1974; "Ralph Eugene Meatyard" in *Camera* (Lucerne), July 1974; "Meatyard" by Max Kozloff in *Artforum* (New York), November 1974.

Ralph Eugene Meatyard was born in Normal, Illinois. It's as simple as that. But no one ever believed Gene's name or where he was born. O ye of little faith—I know a man named David Borgia Duck and have been to Wetwang in the East Riding of Yorkshire and to Braggadocio in Missouri.

I heard of Gene Meatyard from that canny, passionate, irascible photographer/teacher, Henry Holmes Smith, and drove to see him in Lexington, Kentucky in 1960. And saw him regularly until his death in 1972. He was a good-looking man with a mildly saturnine air and an unexpected history of ill-health. He never spoke of such troubles or said a word about his photographs. But, he'd happily show you 200 new prints in the family parlor if you asked him. He had a pretty wife and three kids. They lived half way down the next block in a tidy neighborhood. He looked like he might play pretty decent golf on his Saturday afternoons and then putter about in a basement workshop. He worked as an optician, grinding lenses, and had a company in a little shopping-center called "Eyeglasses of Kentucky." (The exhibitions of prints he mounted on its walls made it one of the best galleries in all of Kentucky.) Just an ordinary guy. Like Franz Schubert or Henry James, he could make the "ordinary" scare you to death or sing like a bird.

Gene's reading was all over the ballpark but his attention very honed down. If you wrote poetry, he read it—there are few people like that on the planet. He seemed thoroughly at ease in Blue-Grass Limbo. A rube he wasn't. He rode quietly around in "The Strange," like city folks used to ride out to "The Country."

John Russell remarks of Eugène Atget that "he knew what was worth looking at." I suspect that we have very little sense yet of the range of Gene Meatyard's eye. The spooky pictures have pride of place, but that is a distortion. There are thousands of unfamiliar prints, and more thousands of negatives that have still never been printed. Meatyard's printing was limited to his two weeks of annual vacation. His weekends were reserved for shooting the exterior world of central Kentucky and his particular interior monologues: the growth and changes in his family and friends, the sequences using masks such as *The Family Album of Lucybelle Crater*. Lucybelle was everybody in the world. That's a lot of folks.

Where to place him or how to rank him? This inscrutable, affable, kind man occupied his "own" place with an assurance that reminds me of other American originals: Albert Pinkham Ryder, John Flanagan, Bruce Goff, Scott Joplin. They all came from Normal. They are also forms of mutating viruses and super-cosmic titanisms from another galaxy. Remember "The Invasion of the Body-Snatchers"? That feller cutting the grass—is that Gene Meatyard?

—Jonathan Williams

MEHTA, Ashvin.

Indian. Born in Surat, Gujarat, 17 July 1931. Studied medical biochemistry, Bombay University, 1952-55, M.Sc. 1955; mainly self-taught in photography, but initially influenced by R.R. Bhardwaj. Married Tilottama Dave in 1959. Worked as Publicity Manager for several pharmaceutical companies, including Glaxo Laboratories, British Drug Houses and Mac Laboratories, Bombay, 1956-73. Freelance photographer, in Bombay, 1973-81, and in Valsad, since 1981. Recipient: Photography Project Grant, Excel Industries, Bombay, 1976. Address: "Tulsi," Tithal, Valsad 396006, India.

Individual Exhibitions:

1966 *Abstracts and Patterns*, Chemould Art Gallery, Bombay
1968 *The Single Eye: A Second Meaning*, Jehangir Art Gallery, Bombay
1971 *Human Form*, Jehangir Art Gallery, Bombay
1972 *Photo-Graphics*, Jehangir Art Gallery, Bombay
1973 *Sea Images One*, Jehangir Art Gallery, Bombay
1975 *Sea Images Two*, Jehangir Art Gallery, Bombay
1977 *Scattered Aeons*, Jehangir Art Gallery, Bombay
1978 *Living with Trees*, Jehangir Art Gallery, Bombay
1980 *Leaves and Grasses*, Chemould Art Gallery, Bombay

Selected Group Exhibitions:

1972 *Creative Eye*, at the *National Exhibition of Photography*, Rabindra Bhavan, Delhi
1973 *Today's India*, Kodak Gallery, New York
1982 *Festival of Indian Arts*, The Photographers' Gallery, London

Collections:

Bibliothèque Nationale, Paris.

Publications:

By MEHTA: articles—"Ashvin Mehta" in *Camera* (Lucerne), January 1967; "Ashvin Mehta: A Youth Times Interview with Saleem Peeradina" in *Youth Times* (Delhi), 11 June 1976; "Apropos India" in *Camera* (Lucerne), May 1978.

On MEHTA: articles—"Stillness and Calm in His Pictures" by Mira Savera in *Junior Statesman* (Calcutta), 13 January 1973; "Ashvin Mehta" in *Camera Mainichi* (Tokyo), November 1977.

According to Indian philosophy, the five elements—earth, water, fire, wind and sky (or space)—are the Gods who form the limbs of the Formless. In this sense, my nature-photography is an attempt at His portrayal, and I succeed to the extent that I am able to capture the elements not merely as elements but as his limbs.

One may ignore or strongly disapprove of such a mix-up of photography and so-called "religious sentiment." But if one pauses to consider the process of creation (in an artist), the final creation can rarely invoke eternity unless one was in touch with it at the time of creation. To look upon the elements as just elements or much more, therefore, does matter; a certain frame of mind can result in "construction," and another, not a frame of mind but a state of communion, results in "creation." All constructions are products of Time, and vanish in Time, in spite of glitter and apparent brilliance. The creations outlive Time and make one experience timelessness, both for the viewer and the creator.

In my photography, I celebrate the Gods, and through them, sing of Him who has neither age nor form. I celebrate, whether I am photographing the ethereal sunshine after a snow-storm in the Himalayas, or a single, tender tree standing resolutely against the shadows of an entire forest. I celebrate, whether I am photographing the mother earth embracing the vast cloudless sky with a few prickly shrubs, or the sea-breakers enticing stolid rocks.

—Ashvin Mehta

Ashvin Mehta's photos are immediately recognizable. Fetchingly alive with unusual combinations of elements, they also become cool, dispassionate abstractions. Even his nudes echo this duality: they lose their identification with human form—for a moment—to become abstract landscapes of the body only to gradually fall into place as representations of human form. Mehta uses a 50mm. lens and comes in close upon his subjects—a pattern in sand is etched by the water's sweep, a massive rock stands on a cliff, a wisp of sea grass bends to the wind in a textured grainy surround. But however commonplace (and beautiful by normal Western standards) these subjects may be, Mehta organizes them into a combination of surprises. A rock, for instance, that stands in the middle distance looms powerfully over a foreground feature, while that foreground feature itself—a tiny tree—upstages that powerful statement to upset our expectations for the role and place of an object in the foreground. The blackened space between a woman's shoulders and her strands of long hair becomes the central organizing feature in a photograph of solids and wisps. Mehta's photographs thrive on unusual combinations of elements. But more, they gain strength through an unusual organization of these elements. In most Mehta photographs it's difficult to identify a base line. One turns a photo around many times before deciding which is up and which is down. Standard Western notions of how to depict, and where to place, heavy objects are thrown to the winds just as accepted Western understandings of how one normally depicts, and where one normally places, big objects are cast aside. Mehta restructures reality, while viewers look at a cosmic world, a world that goes beyond identifiable worlds of physical reality.

In this sense, Mehta is in the tradition of 19th century Indian photography which overhauled Western traditional understandings of pictorial

space—and the camera's use—to create a system of imagery that was related to Indian miniature painting and Indian conceptual systems. In this century, however, and not the last, and giving current form and shape to his ideas, Mehta pays homage to Hindu understandings of godliness. This understanding stresses the Gods, which are seen as five basic elements: wind, water, earth, fire and sky (space), all of which, in turn, are seen as limbs of the Formless. Mehta celebrates the Gods by singing of Him who has neither Form nor age, but who appears (to Mehta) in nature. Producing secular, and sophisticated, representations of the Formless, Mehta creates a photographic portrait of Him.

His success comes from emphasizing space as an entity, and from seeing light, and non-light, as subjects. Many of Mehta's photographs are filled with massive black centers, a rock, for instance, that may be 5 feet away photographed, under natural light, so that is appears as a totally black object mid-way into the distance, its form played against a whitened sky. Just as characteristically, Mehta turns light itself into an object, many of his photographs growing out of a softened hole of white—as if it were a melded sun—somewhere off-center, molding fragile wisps of grass and textured, grainy sand into a sumptuous and sensuous picture. Still others grow out of a masterfully muted band of white running vertically, horizontally or diagonally through the picture, combining a voluptuous mixture of patterns, textures and objects into a whole. Of humans and

nature, abstractions as they are detailed renderings of the world, Mehta's pictures are filled with the generative sources of life.

—Judith Mara Gutman

MEISELAS, Susan.
American. Born in Baltimore, Maryland, 21 June 1948. Educated in public schools, graduated from Colorado Rocky Mountain School, 1966; studied at Sarah Lawrence College, Bronxville, New York, 1966-70, B.A. 1970; Harvard University Graduate School of Education, Cambridge, Massachusetts, 1970-71, M.Ed. 1971; self-taught in photography. Worked as assistant film editor to Frederick Wiseman, Cambridge, Massachusetts, 1970-71; photography adviser in New York City public schools, with Community Resources Institute, 1971-73; Artist-in-Residence, for schools throughout South Carolina and Mississippi, 1973-74; consultant, Polaroid

Foundation, Cambridge, 1974; photographic adviser in mill town of Lando, South Carolina, 1975; Instructor in Photography, Center for Understanding Media, New School for Social Research, New York, 1975-76. Freelance photographer, working for the *New York Times, Harper's, Time, Life, Geo,* etc., New York, since 1975; Member, Magnum Photos co-operative agency, New York and Paris, since 1976. Recipient: Robert Capa Gold Medal, Overseas Press Club, 1978. Address: c/o Magnum Photos Inc., 251 Park Avenue South, New York, New York 10010, U.S.A.

Individual Exhibitions:

1974 218 Gallery, Memphis, Tennessee
1975 CEPA Gallery, Buffalo, New York
1976 A.M. Sachs Gallery, New York
 Wellesley College, Massachusetts
1977 Images Gallery, New Orleans
1981 FNAC Gallery, Paris

Selected Group Exhibitions:

1974 *Conference on Visual Anthropology,* Temple University, Philadelphia
 Carnival Strippers, Brockton Art Center, Massachusetts
1975 *International Women's Art Festival,* Fashion Institute of Technology, New York
1976 *Womanview,* University of Iowa, Iowa City
1981 *Color Photography,* Fogg Museum, Harvard University, Cambridge, Massachusetts
 Salvador, Half Moon Gallery, London

Collections:

Fogg Museum, Harvard University, Cambridge, Massachusetts.

Publications:

By MEISELAS: books—*Learn to See,* editor, Cambridge, Massachusetts 1975; *Carnival Strippers,* New York 1976; *Nicaragua,* New York 1981.

On MEISELAS: articles—"Susan Meiselas" by Larry Shames in *American Photographer* (New York), March 1981; "Fragments of History" by Stu Cohen in the *Boston Phoenix,* 30 June 1981.

Few photojournalists publish two good books by the age of 32—and, it is tempting to add, especially if they are female. Few women win the Robert Capa Prize for the "best photographic reporting or interpretation from abroad requiring exceptional courage and enterprise." Meiselas was only the second woman to have received this award. Clearly she is something of a phenomenon.

The two books are *Carnival Strippers* and *Nicaragua.* It could be argued that the first book covers a "natural" subject for a woman photographer, the strippers being perhaps less apprehensive about being photographed in their off-duty moments than if there was a man behind the camera (I do not argue this view myself.) *Nicaragua,* however, is not open to this kind of attack. Meiselas's colour pictures of the war stand on a par with any war photography in colour by any other photographer, male or female. In neither of these reportages does she flinch from her subject matter, though it is often unpleasant. In other respects, however, the two approaches are quite different—and this is interesting because it illustrates Meiselas's range as a photographer.

Carnival Strippers is a black-and-white reportage on the striptease artistes who travel with fairs round the small New England towns. Meiselas followed

Ashvin Mehta: *Sea Abstract,* 1972

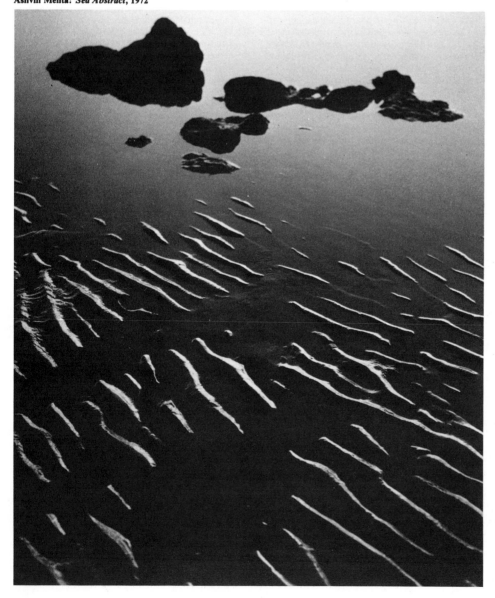

them for four summers recording the routines the girls used to attract customers, their performances, and quieter moments such as back-stage card playing. A lot of pictures were taken in low light, and the graininess of the pictures reinforces the seedy atmosphere of bare boards and blankets which surrounds these not-very-beautiful girls with their flabby bodies and crude gyrations. Meiselas does not flatter her subjects, and the results may not be to everyone's taste, but their undeniable qualities were sufficient to propel her into the Magnum picture agency in 1977. She photographed in Chad and Cuba before travelling to Nicaragua. A war had been going on there since 1972, when Sandina raised an army of peasants to fight the U.S. forces, but the west showed little further interest after the Marines were withdrawn. Meiselas went there in 1978 on the strength of an article in the *New York Times*. She was not on assignment (didn't have enough film), but when the revolution erupted she was there. Through Magnum, her pictures were quickly published round the world. She had a head start over the recognized war photographers, and did not let the advantage go.

Unlike *Carnival Strippers*, she photographed Nicaragua largely in colour, producing sharp, bright results. Often she has managed to produce striking compositions, too: a solitary figure balances a tank or a burning car; masked guerillas are counterpointed by watching housewives. Some of the groups are so precisely balanced they could have been posed, but Meiselas manages the same precision in her framing even when capturing an isolated instant (for example, see plates 13, 18, 33 and 39 in *Nicaragua*).

The results ought to look—like so much colour war photography—false, like stills from an expensive movie. They don't, for two reasons. First, Meiselas focuses on atrocities that are beyond even Hollywood's most appalling visualizations. These carry that unarguable stamp of authenticity no art can devise. And second, through her camera, Meiselas generates a sense of fraternity with the rebels. She is clearly on their side, and she is clearly out to enlist the viewers's sympathy for these poor and down-trodden people. It may not square with every photographer's idea of photojournalism, but it certainly produces a powerful result.

Nicaragua is not as comprehensive or as well integrated a condemnation of war as, say, Philip Jones Griffiths' *Vietnam Inc.*, nor is *Carnival*

Strippers without its flaws, but many photographers have travelled farther and fared worse. Meiselas has the talent, obviously, and she seems to have the commitment that well could make her, in the future, one of the greatest photojournalists of all.

—Jack Schofield

Susan Meiselas: From *Nicaragua*, 1981

MERISIO, Pepi (Giuseppe).

Italian. Born in Caravaggio, Bergamo, 10 August 1931. Educated at elementary school in Caravaggio, 1941, Istituto Salesiano Treviglio, Bergamo, 1942-50, and the Università Cattolica, Milan, 1951-55. Married Anna Maria Bosio in 1959; children: Luca and Marta. Amateur photographer, Bergamo, 1947-60; professional freelance photographer, Bergamo, working for *Du, Camera, Famiglia Cristina, Touring Club Italiano, Paris-Match, Stern, Look, Réalités*, etc., since 1960: Principal Photographic Collaborator, *Epoca* magazine, Milan, 1963-72. Recipient: First Prize, Istituto Geografico Militare, Florence, 1957, 1960; First Prize, Centro Turistico Giovanile, Rome, 1957; Special Color Prize, Motta Ferrania, Milan, 1958, 1959; First Prize for Photography, Pondicherry, India, 1958; Carlo Erba Prize, Bambini d'Italia, Milan, 1958, 1961, 1963; First Prize, *Mostra Concorso di Ancona*, 1959; City of Munich Prize, 1959; First Prize, *Festival of Color*, Como, 1961; First Prize for Photography, Valmalenco, 1962; First Prize for Photography, La Rocca, Assisi, 1963; *Popular Photography* Prize, 1963; First Prize, Racconto e Reportage Fotografico, Fermo, 1963; First Prize, *Mostra Concorso*, Assisi, 1963; First Prize, Premio Nazionale Fotoreporters, Milan, 1964; First Prize, Communicazioni Visive, Genoa, 1965. Address: Via Noli 4, 24100 Bergamo, Italy.

Individual Exhibitions:

1961 Galleria XX Settembre, Bergamo

1962 Galleria Dalmine, Dalmine, Italy
1965 Circolo Fotografico Veronese, Verona
1966 Galleria La Torre, Lecco, Italy
 Galleria Italsider, Piombino, Italy
 Circolo Fotografico Milanese, Milan
1970 Galleria dell'Immagine, Rome
1976 Circolo Fotografico, Domodossola, Italy
1978 Musée Nicéphore Niepce, Chalon-sur-Saône, France
 Galerie de Ville, Macon, France
 Casino Municipale, San Pellegrino Terme, Italy
1979 Galleria Il Diaframma, Milan
 Galleria La Nuova Fotografia, Treviso, Italy
1980 Helmhaus, Zurich
 Galerie Herder, Freiburg
 Stadtgalerie, Altdorf, Switzerland
1981 Shopping Center Galerie, Emmen, Switzerland
 Shopping Center Galerie, Winterthur, Switzerland
 Galleria Serfontana, Chiasso, Switzerland
 Amicizia dei Popoli Convention, Rimini
 Tenda Circo al Vigentino, Milan
 Il Buco Fotografico, Catania, Italy
 Museo Diocesano, Mantua, Italy

Selected Group Exhibitions:

1958 *Expo-Den-X*, Copenhagen
1960 *Italian Photography in Japan*, Tokyo
1961 *Festival of Italian Photography*, Montpellier, France
1965 *Giornalismo e Comunicazione Visiva*, Genoa
1966 *Interpress Photo*, Moscow
1968 *2nd World Exhibition of Photography*, Pressehaus Stern, Hamburg (and world tour)
 Europa '68, Bergamo (and *Europa '70*)
1976 *Camera: 10 years*, Lucerne
1979 *Venezia '79*
1980 *SICOF*, Milan

Collections:

Università di Parma; Centro per la Cultura nella Fotografia, Fermo, Italy; Bibliothèque Nationale, Paris; Musée Réattu, Arles, France; Musée Nicéphore Niepce, Chalon-sur-Saône, France; International Museum of Photography, George Eastman House, Rochester, New York.

Publications:

By MERISIO: books—*Bodini*, Milan 1964; *Lo Sviluppo e la Pace nel Mondo*, Rome 1968; *Terra di Bergamo*, 3 vols., Bergamo 1969; *A Casa sotto il Sole*, Milan 1970; *Architettura del Rinascimento*, Milan 1971; *Prima dell'Ultima Stagione*, Milan 1971; *Lovere Antica...*, Genoa 1972; *Mi Chiamano Donna*, Milan 1972; *Siena*, Siena 1972; *Il Po*, Milan 1973; *Il Gargano*, Milan 1973; *Immagine di un'altra Lombardia*, Milan 1974; *Italia*, Zurich and Bergamo 1975; *Alla Sera*, Bergamo 1975; *Toscana*, Zurich, Bergamo and Bologna 1976; *Motor*, Milan 1976; *Antiche Città di Lombardia*, Zurich, Bergamo and Bologna 1976; *Puglia*, Zurich, Bergamo and Bologna 1977; *Valle d'Esino*, Bergamo 1977; *Veneto di Terraferma*, Zurich, Bergamo and Bologna 1978; *Marine Marchigiane*, Bergamo 1978; *Vivere nelle Alpi*, Zurich, Bergamo and Bologna 1979; *Sicilia*, Zurich, Bergamo and Bologna 1979; *Montagna Viva*, Milan 1979; *Paolo VI: Le Chiavi Pesanti*, Milan 1979; *Il Cuore della Marca*, Bergamo 1979; *Idea di Bergamo*, Bergamo 1980; *Quei Monti Azzurri*, Bergamo 1980; *I Lieti Colli*, Bergamo 1981; *Liguria*, Bologna 1981; *Il Cantico dell'Umbria*, Bergamo 1981; *Sacri Monti delle Alpi*, Milan 1981.

On MERISIO: articles—"Pepi Merisio," with texts by Attilio Colombo and Alberto Piovani, special issue of *Progresso Fotografico* (Milan), April 1980.

What does photography mean to me? So many things—a whole world; let me try to sum it up briefly. I believe that photography is a "discursive" means of expression; it is "writing with the light," one of the most immediate ways of communicating facts and emotions available to man. A means, then, that has merits and limitations derived from its specific qualities. I believe that the first aim of photography is "to seize the *instant*," as it were to take possession of the fleeting, changing moment (and this not only in press photography; there is always a moment plucked out from the progress of time in posed photography, in portraits, in landscapes...). The delection of the instant is the photographer's first moment of creativity. Every picture, however

analytical it may be in the sum of the details of which it consists, is always a synthesis of a "moment" halted and picked out among so many others.

Another specific, fundamental element, I feel, is the search for the best rendering of the *detail* as the element that characterizes the structure and the material of things—"detail" which is not just concentration on the surface material but a study of surfaces, volumes and perspective. It is a deeper understanding of the manifold aspects of reality. That is why I do not care for informal photography, which I feel lacks this basic, concrete link with life and objects.

As a photographer I have long been mainly interested in the Italian country: the people, the work, the land. It is fundamental to me that every picture, every shot, should portray the "environment" and the situations in which the faces, the people and things exist, so as to constitute an accurate arrangement of place and time. So insistent foregrounds are

very rare. It is rather a search for cordial participation.

—Pepi Merisio

Pepi Merisio is the singer, the bard, the poet of a small-scale Italy. His world is that of the region of Bergamo, in whose ways he was brought up and which constitutes the recurrent basis of his work as a photographer. He shows the themes of country life, a deeply felt devotion, people confined to the borders of history, a timeless world rooted deep in the millennia. He tells of this world as someone who is part of it, identifying his models—without moralizing or lamenting—in the dignity and humanity of the people he photographs. His many tours of India or Africa, the south of Italy or Turkey, and most of all of his own region, have given us what may be one of the last portraits of country life living and complete—particularly that life in Italy. His last years of this kind of activity were characterized by a kind of vehement passion, fuelled by his awareness that this world was rapidly crumbling under the blows of our consumer culture. Today, only a few years on, there are many subjects, themes and places that survive only because of his pictures, which portray a way of life that may be lost forever.

Merisio's portrait of Italy (collected in many books of photographs, all marked by his quite unmistakable style) is informed by a method that tends to avoid anything that could be called "news." Even the basic element of the photographic process—its quality of instantaneousness—becomes more an obligatory factor than a freely chosen means of expression. Every picture is, as it were, constructed without reference to time, with a balanced sense of composition. There is little room for dynamic figuration. The photographer's lens evokes archetypes, models, emblems, each of which is a synthesis. What is so surprising is that these effects are obtained by deliberately avoiding emphasis: reduction of light, unusual angles, starkly contrasting tones, compression of planes—all of these devices are foreign to Merisio's style.

The documentary and emotional value of Merisio's photographs does not depend on a particularly brilliant personal style, but appears rather by way of the most normal of expressive instrumentation. He prefers focal depths that do not alter the proportions of shape and volume; he uses a vast range of tonal shades, giving the figuration a compact structure so that each picture approaches the greatest possible objectivity. But every picture forms part of a vast collective panorama, a highly charged view of a unique moment which is slowly fading away. Every picture reveals something of the heart of the rural world. And all Merisio's photographs have an expressive balance that faithfully mirrors the inward form of their creator's own spirit.

—Attilio Colombo

Pepi Merisio: *Palm Sunday*

MERTIN, Roger.

American. Born in Bridgeport, Connecticut, 9 December 1942. Studied at the University of Bridgeport, 1960-61; Rochester Institute of Technology, New York, 1961-65, B.F.A. in photography 1965; studied in private workshops, under Nathan Lyons, Rochester, 1963-64, 1965-66, and at the Visual Studies Workshop, Rochester, 1969-72, M.F.A. 1972. Married Joan Schultz in 1964 (divorced, 1972). Photographer since 1962. Worked as a photographic technician, Eastman Kodak Company, Rochester, 1965-66; Head of the Reproduction Center, 1966-67, and Assistant Curator, 1968-69, George Eastman House, Rochester. Instructor, Rochester Institute of Technology, 1969-74. Instructor, 1973-74, and since 1975 Assistant Professor of Photographic Arts, University of Rochester. Recipient: Creative Artists Public Service Fellowship, New York, 1974; Guggenheim Photography Fellowship, 1974; National Endowment for the Arts Photography Fellowship, 1976. Agents: Light Gallery, 724 Fifth Avenue, New York, New York 10019; Visual Studies Workshop, 31 Prince Street, Rochester, New York 14607; and Vision Gallery, 216 Newbury Street, Boston, Massachusetts 02116. Address: 18 Upton Park, Rochester, New York 14607, U.S.A.

Individual Exhibitions:

1966 International Museum of Photography, George Eastman House, Rochester, New York
1969 University of California at Davis
1970 *Plastic Love Dream*, Do Not Bend Gallery, London
1972 *Photos: August 9-September 12, 1971*, Toronto Gallery of Photography
1973 Light Gallery, New York
1974 Galerie Stampa, Basle
1975 Light Gallery, New York
1976 Afterimage Gallery, Dallas
1978 Center for Contemporary Photography, Chicago
 Visual Studies Workshop, Rochester, New York
1979 Sun Valley Center for Arts and Humanities, Idaho
 Rockwell Kent Gallery, Plattsburgh, New York
 Light Work, Syracuse, New York
1980 Light Gallery, New York
1981 Friends of Photography, Carmel, California (with Larry S. Ferguson and Frank Gohlke)

Selected Group Exhibitions:

1966 *Seeing Photographically*, International Museum of Photography, George Eastman House, Rochester, New York
1967 *Contemporary Photographers IV*, International Museum of Photography, George Eastman House, Rochester, New York
 Photography in the 20th Century, National Gallery of Canada, Ottawa (toured Canada and the United States, 1967-73)
1969 *The Photograph as Object 1843-1969*, National Gallery of Canada, Ottawa (toured Canada)
1971 *Figure in Landscape*, International Museum of Photography, George Eastman House, Rochester, New York
1974 *Photography Unlimited*, Fogg Art Museum, Harvard University, Cambridge, Massachusetts
1976 *Photographie: Rochester, New York*, Centre Culturel Americain, Paris
1977 *Great West: Real/Ideal*, University of Colorado, Boulder (subsequently Smithsonian Institution travelling exhibition; toured the United States)
1978 *Mirrors and Windows: American Photography since 1960*, Museum of Modern Art, New York (toured the United States, 1978-80)
1979 *American Photography in the 70's*, Art Institute of Chicago

Collections:

Museum of Modern Art, New York; International Museum of Photography, George Eastman House, Rochester, New York; Visual Studies Workshop, Rochester, New York; Museum of Fine Arts, Boston; Princeton University, New Jersey; Art Institute of Chicago; Minneapolis Institute of Art; Bibliothèque Nationale, Paris; National Gallery of Canada, Ottawa; Australian National Gallery, Canberra.

Publications:

By MERTIN: book—*Roger Mertin: Records 1976-78*, edited by Charles Desmarais, Chicago 1978.

On MERTIN: books—*Photography in the Twentieth Century* by Nathan Lyons, New York 1967; *Vision and Expression*, edited by Nathan Lyons, New York 1969; *The Print* by Time-Life editors, New York 1970; *The Great West: Real/Ideal*, exhibition catalogue, edited by Sandy Hume, Ellen Manchester and Gary Metz, Boulder, Colorado 1977; *Mirrors and Windows: American Photography since 1960*, exhibition catalogue, by John Szarkowski, New York 1978; *The Photograph Collector's Guide* by Lee D. Witkin and Barbara London, Boston and London 1979; *One of a Kind: Recent Polaroid Photography*, edited by Belinda Rathbone, Boston 1979; *Nude*, edited by Constance Sullivan, New York 1980; articles—"Notes upon Rising from a Plastic Love Dream" by Gary Metz in *Album* (London), August 1970; "Hoops: Eight Photographs" by Joe Flaherty in *New Lazarus Review* (Utica, New York) 1979; "Meditations on a Blue Photograph" by Gary Metz in *Untitled* (Carmel, California), no. 23, 1980.

Roger Mertin: *Lordship CT*, 1978

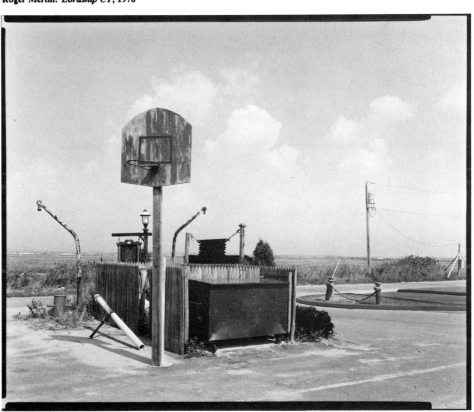

It is my conviction that the statement a photographer makes be in the photographs.

—Roger Mertin

All of the works of Roger Mertin bear witness to his respect for the qualities of the unmanipulated photograph. From his early (c. 1967) moderately scaled photographs of shop windows to the more recent (c. 1977) large format images of trees, he has made pictures of great beauty and sensuality. The prints are skillfully made and comparable to the magnificent prints of Minor White and Paul Caponigro. However, comparison with these two photographers is limited to technical excellence. White's and Caponigro's desire for transcendence through abstraction in much of their work is far removed from Mertin's aims, which appear to be concerned with the creation of a variety of cultural catalogues.

When Mertin works with the human figure, elements are introduced that will prevent any contemplation of timelessness or universality. For example, in the series "Plastic Love Dream" (c. 1969) the figures are usually wrapped in plastic sheeting, a contemporary material that obviates any comparison with the romantic figure photography of the turn of the century or even the erotic presence of Edward Weston's photographs of women. In fact, the figure in Mertin's work often appears as incidental to the materials included and the light patterns being created and recorded.

In Mertin's series of pictures of trees and of basketball goals, the meaning again does not reside in the ostensible subject. His images of trees have often been compared to those of Eugène Atget, but they really have very little in common except the subject matter. Atget's trees appear as massive sentinels in the Positivistic French gardens. Conversely, Mertin's trees traverse a range of ambiguities: he observes with a guileless curiosity horticultural forms of bondage; "freakishly" deformed trees; and trees that appear to have no distinguishing characteristics save existence. Herein lies his elegant comprehension of one of photography's fundamental attributes, ambiguity. The pictures are nominally about trees, but they are really an extraordinarily rich documentation of the effluvium that is an everyday component

of American culture.

Mertin has obviously looked at a great many photographs and fully understood, for instance, that the central figure in a Lewis Hine portrait is never the "only" thing in the picture. The highly active picture plane that Mertin creates may be interpreted in numerous ways, from Weston's often cited "...the thing itself" to a virtual palimpsest of our age's methods and mores. But one is never quite certain. The air of ambiguity prevails.

—Thomas F. Barrow

METZKER, Ray K.

American. Born in Milwaukee, Wisconsin, 10 September 1931. Educated at Whitefish Bay High School, Wisconsin, 1945-49; studied art at Beloit College, Wisconsin, 1949-53, B.A. 1953; and photography, under Harry Callahan and Aaron Siskind, Institute of Design, Illinois Institute of Technology, Chicago, 1956-59, M.S. 1959. Served in the United States Army, in Korea, 1954-56. Freelance photographer since 1959. Instructor in Photography, 1962-78, and since 1978 Professor, Philadelphia College of Art (Chairman of the Photography/Film Department, 1978-79). Visiting Associate Professor, University of New Mexico, Albuquerque, 1970-72; Adjunct Professor, Rhode Island School of Design, Providence, 1977; Adjunct Visiting Professor, Columbia College, Chicago, 1980. Recipient: Guggenheim Fellowship, 1966, 1979; National Endowment for the Arts Fellowship, 1974. Agent: Light Gallery, 724 Fifth Avenue, New York, New York 10019. Address: 733 South 6th Street, Philadelphia, Pennsylvania 19147, U.S.A.

Individual Exhibitions:

1959 Art Institute of Chicago
1967 Museum of Modern Art, New York
1968 Photographer's Gallery, New York (with Paul Caponigro)
1971 University of New Mexico, Albuquerque
1974 Print Club of Philadelphia
Dayton College of Art, Ohio
1976 Picture Gallery, Zurich
1978 Marian Locks Gallery, Philadelphia
International Center of Photography, New York
1979 Center for Contemporary Photography, Chicago
Light Gallery, New York
Galerie Delpire, Paris
1980 Pennsylvania Academy of Fine Arts, Philadelphia
Sand Creatures, Light Gallery, New York

Selected Group Exhibitions:

1959 *Photography in the Fine Arts I*, Metropolitan Museum of Art, New York
1962 *Photography USA*, DeCordova Museum, Lincoln, Massachusetts
1966 *American Photography: The 1960's*, University of Nebraska, Lincoln
1970 *New Photography U.S.A.*, Museum of Modern Art, New York (and world tour)
1971 *The Figure and the Landscape*, International Museum of Photography, George Eastman House, Rochester, New York

1973 *Landscape/Cityscape*, Metropolitan Museum of Art, New York
1977 *The Photographer and the City*, Museum of Contemporary Art, Chicago
1978 *Mirrors and Windows: American Photography since 1960*, Museum of Modern Art, New York (toured the United States, 1978-80)
1979 *Venezia '79*
1980 *Aspects of the 70's*, DeCordova Museum, Lincoln, Massachusetts

Collections:

Museum of Modern Art, New York; International Museum of Photography, George Eastman House, Rochester, New York; Rhode Island School of Design, Providence; Smithsonian Institution, Washington, D.C.; Art Institute of Chicago; Exchange National Bank, Chicago; Krannert Museum, University of Illinois, Urbana; Sheldon Memorial Art Gallery, University of Nebraska, Lincoln; University of California at Los Angeles Art Galleries; Bibliothèque Nationale, Paris.

Publications:

By METZKER: books—*Portfolio II—Discovery: Inner and Outer Worlds*, Carmel, California 1970; *Sand Creatures*, Millerton, New York 1979; article—"Ray K. Metzker," interview, with Chuck Isaacs, in *Afterimage* (Rochester, New York), November 1978.

On METZKER: books—*The Persistence of Vision* by Nathan Lyons, New York 1967; *Photography in the 20th Century* by Nathan Lyons, New York 1967; *Looking at Photographs* by John Szarkowski, New York 1973; *The Photographer's Choice*, edited by Kelly Wise, Danbury, New Hampshire 1975; *Geschichte der Fotografie im 20. Jahrhundert/The History of Photography in the 20th Century* by Petr Tausk, Cologne 1977, London 1980; *Mirrors and Windows: American Photography since 1960*, exhibition catalogue, by John Szarkowski, New York 1978; articles—"New Talent U.S.A.: Photography" in *Art in America* (New York), no. 1, 1961; "Ray K. Metzker" in *Aperture* (Millerton, New York), Fall 1967; "Ray Metzker's Consideration of Light" by Christopher Sieberling in *Exposure* (Rochester, New York), September 1977; "Currents: American Photography Today" by Andy Grundberg and Julia Scully in *Modern Photography* (New York), November 1978; "Exhibitions: Ray Metzker" by Owen Edwards in *American Photographer* (New York), November 1978; "Ray K. Metzker at Marion Locks" by Janet Kardon in *Art in America* (New York), November/December 1978; "Ray Metzker" by Peter C. Bunnell in *Print Collector's Newsletter* (New York), January/February 1979.

"Event" has been a key term for the way a photograph has to work for me. It's been with me a long time. It certainly was important in the Loop, where I would see the street activity, then I would see those relationships developing, and I would feel something fall into place. It wasn't that I came up to something and said, Isn't that a nice arrangement. It was a sense of the tension, of knowing that these things were moving and also that they had come into a position where the tensions were right. After a while, it could happen simply with light. It would have that sense of something coming to place where it wasn't at rest; it wasn't going to be there in a permanent way. For me, a lot of things were just dominant images, like the side of a barn, which is very rich tonally—but there's no event there. I can identify it as being rich material for a photograph, but there's something that's too static about it. In a way, you don't have to wait for anything. I think that's what happens, what continues to happen, but it's become more abstract and more rarefied. I may be only underscoring a photographic interpretation of moment. There's an excitement based on action. In a world where all things seem be changing—either acting on or being acted upon—the camera is best suited to deal with those changes. Photographers are victims of paradox—tracking the impermanent to make it permanent.

There's a kind of duality in me: on the one hand I started out dealing with events, the description of the street, the description of the city, description of situations people find themselves in, people relating to themselves. Let's call it the visible. But there's something else in me that wants to deal with the other side. The results may be read as visual mysteries. I think that's a very strong pull. There's one need, acting out of restraint, that acknowledges the subject, and an attempt to represent it. But other

Ray K. Metzker: *Untitled*, 1977, from the series *Pictus Interruptus*

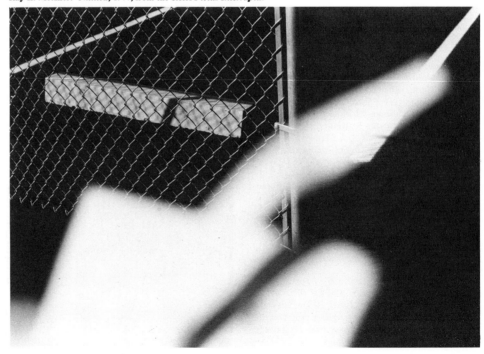

times something else says, Go and leave it behind. I think that maybe the "Pictus Interruptus" series is a sort of mid-point. I'm conscious of that duality, but who knows where it's going?

A lot of my work is about events, but I also think a lot of it is about fragmentation. There's probably a connection between three terms: event, fragmentation, and synthesis. The point of entry for me was the event. But when you go back to so many of the things I've done, even to Chicago, there's always that interest in fragmenting as a way of changing a situation, a means of transforming it. When I finally go into the composite series, I'm willing to synthesize. It's necessary, in the putting-together, to have a sense of structure. Often that is established by identifying and building around an event.

You have to break something down in order to have the parts to synthesize. If something's complete, there's no need to synthesize—it's complete. In journalism, the photograph is *of* an event, whereas in my later work, the photograph *is* the event. The viewer is expected to look into the photography, to see what is there and how it is related—that is, how one part is acting on another.

—Ray K. Metzker

Ray K. Metzker is one of the most inventive and pioneering of contemporary American photographers. Trained by Harry Callahan and Aaron Siskind, influenced by painters and sculptors like Matisse, Frank Stella, and Jean Tinguely and composers such as Stravinsky, Bartok, and Chavez, he displays an original experimental and creative vision. The force of his image selection is as remarkable as his singlemindedness in exploring the photographic medium. Metzker's innovative use of the photographic elements—formal inter-relationships, visual patterning, tonal contrasts, print-size, focus, etc.—demonstrate a distinct personal form and style. He challenges habitual and conventional expectations and responses with regard to the image. His "scanning and whooping," as he puts it, is an exciting definitional exploration of the medium. His originality is evidenced in this basic approach—to explore the problems and properties of the medium, to define photography by making images of conviction and resolution. With such determination and imaginativeness, Metzker for more than 20 years has tried and succeeded in manipulating the formal elements to make images that communicate an expressive statement—for photography to stand

autonomously as an image yet *be* something simultaneously. By thus inviting viewers to experience a photograph in a radical way, he remains (to quote him) "an intellectual wanderer." But there is a distinct intuitive and visceral force in his imagery which cannot be minimized, clearly illustrated in his series on Chicago and Atlantic City and in the "Pictus" series.

In the 1950's Metzker's photography consisted primarily of single-image prints and a kind of formalism in patterning. But he got tired of the "predictability" and "frozen arrangements" of the single frame. So he moved to "the composite, collected and related moments employing methods of combination, repetition and superimposition." Even in those early photographs one finds his originality and exploratory zeal and determination, for instance in his pictures in the Loop in Chicago. His sense of the spatial geometry, keen patterning, powerful image selection—tracking down the moment to the point of merger of the environment and the people—and the subtlety of inter-relationships within a particular image demonstrate Metzker's singleminded approach to the medium as an expressive statement of form and emotive tone. The "Sand Creatures" series is as evocative as it is captivating in its patterning. In his photographs of Chicago, Philadelphia, and Atlantic City the tonal contrasts match in a unique way the juxtapositional patterning of figures and the environment, which instantly directs the viewers to a new way of looking at the images.

Metzker extends this exacting and captivating patterning into his multiple-image photographs depicting the nature of urban living. Starkly lit faces or objects in the midst of stark blackness document particular details as well as, through the method of repetition, juxtaposition, and sequencing, make a metaphoric statement about the city life—its vitality, multiplicity, disconnectedness, and solitude. The abstract designs in his multiple-images, too, express a certain kind of kinetic force and musicality as the entire roll of film unfolds as one single strip with no interruption or as the varied frame-formats present themselves. What also strikes as extraordinary in these photographs of the 1950's and 60's is the artist's fusion of the intellectual/conceptional attitude and the intuitive power so clearly consummated in his images of the 70's.

Metzker's "Pictus" series records the stunning growth of a visual artist. He has again deliberately and expertly manipulated the medium for newer

and more challenging expressive forms and visual experience. In the early 70's Metzker made several photographs in New Mexico; they mark a transition. The strong contrast and graininess of the print—a distinct tonal richness and luminosity of the middle zones, the manipulation of shadows, and the juxtapositioning of clouds, walls, concrete block buildings, doorways, and plants in his Albuquerque series—reveal an innovative mind, passionate and relentless. The significant aspect of these New Mexico photographs is the way in which Metzker has used the pictorial space and organized the obvious objects in the image not for information or description, for obstruction and interruption are so blatant and deliberate, but to tease us to reflect. These pictures demand a readjustment—a perceptual revolution; each suggests a paradox, as it were, not only in the whimsicality of formats and patterns, but also in the unpredictability and complexity of composition and the dynamics of contrariness.

The 1977 "Pictus Interruptus" series, though compositionally comparatively straightforward, introduces us to a stunning visual experience. In these pictures, taken mostly in Greece and Philadelphia, close objects (hands, papers, etc.) are blurred or flattened out, but the distant objects—clouds, sails, etc.—remain sharp and defined. The close objects are the interrupting elements interposed between the lens and the subject—rooftop nightsky, Greek islandscape, sidewalks, streets, and clouds. The interruptors are kept purposely unidentifiable, "neutral." As such, they simultaneously destroy part of the subject and reconstruct the image. Then there is the device of textual contrast and continuous tonality. In other words, Metzker has now manipulated the properties of the medium in a challengingly paradoxical way. Scales and focus do not mesh; the negative space is used both as void and volume; dematerialization and delineation alternate; and scale and space are in unexpected juxtaposition. Thus he has ventured into one of the most threatening and bewildering areas in any creative endeavour—balancing ambiguity, paradox, and imagination, fusing concept and intuition into an effective expressive mode. And Metzker has triumphed. In intensity and lyricality and through daring imagination, Ray Metzker has radicalized the medium of photography and tantalized viewers to experience his photographs—especially the "Pictus" series—as an act of courage and inventiveness and a state of visual transcendence.

—Deba P. Patnaik

Pedro Meyer: *Guerillero Herido*, Nicaragua, 1979

MEYER, Pedro.
Mexican. Born in Madrid, Spain, 6 October 1935; emigrated to Mexico, 1937: naturalized, 1942. Studied at the Babson Institute of Business Administration, Boston, B.S. 1956; self-taught in photography. Served as a private in the Mexican Army, 1952. Married Eugenia Meyer in 1958; son: Pablo. Freelance photographer, Mexico City, since 1974. President, Secundaria de la Escuela Montessori de la Ciudad de Mexico, 1969-71. President, Consejo Mexicano de Fotografía, Mexico City, since 1977. Address: Apartado 10-670, Mexico 10, D.F., Mexico.

Individual Exhibitions:

1964 *Variaciones de Color sobre un Tema: Chapultepec*, Club Fotografico de Mexico,

Mexico City (also shown at the Instituto Mexicano-Norteamericano de Relaciones Culturales, 1964, Instituto Anglo-Mexicano de Cultura, Sociedad Dante Alieghieri, and Club de Periodistas de Mexico, 1965, and Centro Asturiano de Mexico, and Escuela de Diseño y Artesania, 1967—all Mexico City)

1965 *Doce Minutos*, Instituto Anglo-Mexicano de Cultura, Mexico City

1972 *Fototestimonio: Israel, Febrero de 1972*, Instituto Cultural Mexicano-Israeli, Mexico City

Quien Estuvo en Avandaro?, Instituto Cultural Mexicano-Israeli, Mexico City

1973 *Retrospectiva de Pedro Meyer*, Instituto Mexicano-Norteamericano de Relaciones Culturales, Mexico City

1976 *Fotografias de Pedro Meyer*, Casa del Lago, Mexico City (travelled to the *Mostra Mercato d'Arte Contemporaneo*, Bologna, Italy, 1977)

Alvarez Bravo/Pedro Meyer/Lazaro Blanco, Galleria Il Diaframma, Milan

Pedro Meyer and George Tice, Enjay Gallery, Boston

1978 *Testimonios Sandinistas I*, Casa del Lago, Mexico City (travelled to the Universidad Central de Venezuela, Caracas; Casa de la Americas, Havana; University of Texas at Austin; and Campo San Benneto, Venice, 1979)

Retrato Contemporaneo en Mexico, Museo Alvar Carrillo Gil, Mexico City

1980 *Testimonios Sandinistas I y II*, Casa de la Cultura, Queretaro, Mexico

De Mi Tierra: Realidades, Leyendas y Mitos, Museo de Imagem e de Som, Sao Paulo, Brazil

Selected Group Exhibitions:

1976 *The Photographer's Choice*, Witkin Gallery, New York

1977 *Salon Nacional de Artes Plasticas*, Palacio de Bellas Artes, Mexico City

1978 *Contemporary Photography in Mexico*, University of Arizona, Tucson

Hecho en Latinoamerica, Museo de Arte Moderno, Mexico City (travelled to *Venezia 79*)

1980 *Fotografia Mexicana Contemporanea*, Casa de las Americas, Havana

Bienal de Fotografia Mexicana, Instituto Nacional de Bellas Artes, Mexico City

7 Portafolios Mexicanos, Centre Culturel du Mexique, Paris (travelled to the Picasso Museum, Antibes, France)

Collections:

Casa del Lago, Universidad Nacional Autonoma de Mexico, Mexico City; Casa de las Americas, Havana; Museum of Fine Arts, Boston; Addison Gallery of American Art, Andover, Massachusetts; Babson College, Wellesley, Massachusetts; Center for Creative Photography, University of Arizona, Tucson; Bibliothèque Nationale, Paris.

Publications:

By MEYER: books—*La Noche de Tlatelolco*, Mexico City 1971; *Y las Cosas que le Pasan al Homore*, portfolio, Mexico City 1977; *Negromex en Blanco y Negro*, portfolio, Mexico City 1977; *Hecho en Latinoamerica*, editor, Mexico City 1978; articles— "Introduction" to *Memorias del Primer Cologuio Latinoamericano de Fotografia*, Mexico City 1973; "Dignidades" in *Revista Arquitecto* (Mexico City), May 1977; "Y Despues del Coloquio..." in *Semana*

de Bellas Artes (Mexico City), August 1978; "Ernesto Cardenal entre Rifles M-1" in *Uno Mas Uno* (Mexico City), November 1978; "Introduction" to *XX Aniversario Casa de las Americas*, exhibition catalogue, Mexico City 1979; article in *Symposium uber Fotografie*, Graz, Austria 1980; "Letter from Nicaragua" in *American Photographer* (New York), January 1980; "Sobre la Fotografia Cubana" in *Semana de Bellas Artes* (Mexico City), July 1980.

On MEYER: books—*The Photographers' Choice*, edited by Kelly Wise , Danbury, New Hampshire 1971; *Retrospectiva de Pedro Meyer*, exhibition catalogue, by Carlos Monsivais, Mexico City 1973; *Time-Life Photography Yearbook 1979*, New York 1979; *7 Portafolios Mexicanos*, exhibition catalogue, Mexico City 1980; articles—"Foto Imagenes de Pedro Meyer" in *Fotomundo* (Mexico City), March 1970; "Los Trabajos de Pedro Meyer" by Raquel Tibol in *Gaceta UNAM* (Mexico City), July 1976; "Le Immagini dell'Anima Messicana" by Edo Prando in *Fotografia Italiana* (Milan), March 1977; "Evocacion Juenos y Metafoeras" by Yolande Sierra in *El* (Mexico City), March 1977; "Seis Abstracciones Concretas" by Raquel Tibol in *Proceso* (Mexico City), January 1978; "Nicaraguan Kuuat" by Marjaana Mykkanen in *Nakopiiri* (Helsinki), January 1979; "L'Obiettivo Mitra de Meyer" in *Il Diario* (Venice), July 1979; "Que Puede Decir la Fotografia de una Revolucion" by Nestor Garcia Canclini in *Casa de las Americas* (Havana), January 1980.

*

With the expanded participation of photography in all of our present-day activities—from the artistic to the highly sophisticated technological research, from commercial ventures (advertising, objets d'art, etc.) to political involvement (posters, photojournalism, etc.)—we can find untold applications today where the necessary questions about the medium and the involvement of the photographer are just beginning to be sufficiently studied. The production of this book is obviously within these current developments. Such a reference book as *Contemporary Photographers* has brought to my attention the problems involved in passing judgement on the work of photographers from all over the world. Which men and women deserve the distinction of being included in such a reference book? On what merits? What possible criteria can be employed for such a wide spectrum of participants? These questions have led me to reconsider first of all the images that photographers are producing and how they are being evaluated.

No photograph can avoid some manner of communication, even the most inane snapshot. As long as we are confronted with some kind of a picture, we have access to information from which one can derive meaning. The substance might be totally banal and still provide us with evidence which fosters insight: its import need not be of an essential nature for the photograph to have some value. An interesting image is not necessarily an important one. So if we conclude that any photograph communicates something, what differentiates the superb from the run of the mill picture? Which rules are we to abide by in order to discriminate the "best" among billions of images. Important photos are supposedly few and far between; a very productive photographer will not have more than a few dozen of them, over a lifetime. The images—be they individual pictures or series—are assumed to be those that distill with a maximum of efficiency the "essential values" of mankind. What these essential values are supposed to be is certainly a subject of great controversy—so let us try to agree on what they are not. They are neither universal nor timeless. So, in essence, we can arrive at the conclusion that "important photographs" are not only images of the subjects recorded but also a reflection of those social values that find substance and meaning in them, at a specific point in time.

A society that caters mainly to material values

and the status quo will have a tendency to consider works as "important" if they have a potential for successful marketing. Their contents should be sanitized sufficiently so as not to ask discomforting questions. A more enlightened society will, of course, discount any speculative considerations and will value highly meaningful content. In between these two alternatives we can obviously find crossroads. As photographs travel from nation to nation, from one culture to another, their signification will be read in multiple ways. We are thus faced with non-universal standards for judging a "great photograph"—contrary to popular belief that photography is a "universal language" and therefore subject to a widespread common denominator of appreciation and understanding. Not only do we have cultural implications to deal with, but also the political and socio-economic conditions of the environment that have determined both the viewer and the photographer.

Rather than trying to find fault with this enterprise of selection, I would rather like to establish an awareness of the subjective nature of this process, or, for that matter, any proposition that engulfs such a diverse and heterogeneous group of people and their motivations to photograph. A distinction such as this book bestows upon those selected is a matter to be taken with a certain cautiousness, as it represents only a valid but very fallible reference in evaluating those who have been considered to be in some way contributors to photography.

—Pedro Meyer

*

In general, when a photographer rejects the more obvious of the variety of possibilities offered to him by the medium and chooses the simplicity and directness of the "straight shot," without subterfuge or special rhetoric, he is someone who believes in his ability to distil with his lens all the expressive nuances of his subject. Pedro Meyer is such a photographer. Without distancing himself from reality, he has created work that is a transparent and vital testimony to his confidence in his own purposes.

Meyer photographs from *within*; he photographs from the "heart." It is an abrasive photography by a modern humanist who sees, who feels, and who thinks, but who, at times, cannot suppress his own impetuousness.

It is also a photography from *without*, from within the body politic yet for the whole community (a particular conflict in Latin America). Throughout its history, documentary photography has not experienced any great aesthetic revolution, apart from technological progress—yet, as far as ideas are concerned, it has involved a virtual unending variety of controversial aesthetic postures. Some critics of "documentary" would define the role of the photographer as that of a neutral witness; others would say that he must be a committed spokesman for his time and society. As a Mexican, Meyer is in a peculiar cultural and political situation, and his work always reveals his commitment with an almost belligerent strength.

He manages, however, to transcend that belligerency in his respect for his subject, for the human being on the other side of the camera: his subject is never presented as an instrument of ideological conviction, even if that subject consents to be used for such a purpose. For Meyer is well aware that manifesto-photography is, by its very nature, self-discrediting. (It is worth noting that this feeling of respect, even of affection, between the photographer and his subject is rapidly becoming a sign of distinction shared by very few contemporary photographers.)

Lewis Hine said that everything in need of improvement and deserving of contemplation was worth photographing. That definition has become a cliché. Just the same, taking into account the differences of time, distance, culture and history, it does very well describe the development of Pedro Meyer.

—Joan Fontcuberta

MEYEROWITZ, Joel.

American. Born in New York City, 3 June 1938.
Educated at James Monroe High School, New
York, 1951-55; studied painting and medical draw-
ing, Ohio State University, Columbus, 1956-59,
B.F.A. 1959; self-taught in photography. Married
Vivian Bower in 1963; children: Sasha and Ariel.
Worked as advertising art director, New York,
1959-63. Independent photographer, New York,
since 1963. Adjunct Professor of Photography,
1971-79, and Mellon Lecturer in Photography,
1977, Cooper Union, New York. Associate Profes-
sor of Photography, Princeton University, New Jer-
sey, since 1977. Recipient: Guggenheim Fellowship,
1970, 1978; Creative Artists Public Serivce Grant,
New York, 1976; St. Louis Art Commission Grant,
1977; National Endowment for the Arts Grant,
1978; National Endowment for the Humanities
Grant, with Colin Westerbeck, Jr., 1978; Photog-
rapher of the Year Award, Friends of Photography,
Carmel, California, 1981. Agent: Witkin Gallery, 41
East 57th Street, New York, New York 10022.
Address: 817 West End Avenue, New York, New
York 10025, U.S.A.

Individual Exhibitions:

1966 International Museum of Photography,
George Eastman House, Rochester, New
York
1968 *My European Trip*, Museum of Modern Art,
New York
1977 *New Color Photographs*, Witkin Gallery,
New York
1978 *Cape Light*, Museum of Fine Arts, Boston
1979 University of Arizona, Tucson
Galerie Zabriskie, Paris
Akron Art Institute, Ohio
1980 *St. Louis and the Arch*, City Art Museum, St
Louis
San Francisco Museum of Modern Art
Stedelijk Museum, Amsterdam
1982 *New Portraits*, Witkin Gallery, New York
Yuen Lui Gallery, Seattle

Selected Group Exhibitions:

1966 *The Photographer's Eye*, Museum of Mod-
ern Art, New York
1967 *Photography in the 20th Century*, National
Gallery of Canada, Ottawa (toured Can-
ada and the United States, 1967-73)
1970 *10 Americans*, at *Expo 70*, Osaka, Japan
1971 *New Photography U.S.A.*, Museum of
Modern Art, New York (toured the Uni-
ted States and Canada)
1977 *Inner Light*, Museum of Fine Arts, Boston
American Photography, Philadelphia Mu-
seum of Art
1978 *Mirrors and Windows: American Photog-
raphy since 1960*, Museum of Modern Art,
New York (toured the United States,
1978-80)
1979 *American Images: New Work by 20 Con-
temporary Photographers*, Corcoran Gal-
lery, Washington, D.C. (travelled to the
International Center of Photography, New
York; Museum of Fine Arts, Houston;
Minneapolis Institute of Arts; and India-
napolis Institute of Arts, 1980; and Amer-
ican Academy, Rome, 1981)
1981 *American Photographers and the National
Parks*, Corcoran Gallery, Washington,
D.C. (toured the United States, 1981-83)
New Color, International Center for Photog-
raphy, New York

Collections:

Museum of Modern Art, New York; Joseph Sea-
gram and Sons Inc., New York; International
Museum of Photography, George Eastman House,
Rochester, New York; Museum of Fine Arts, Bos-
ton; Philadelphia Museum of Art; Virginia Museum
of Fine Arts, Richmond; Art Institute of Chicago;
City Art Museum, St. Louis.

Publications:

By MEYEROWITZ: books—*The Cape*, portfolio
of 15 photos, New York 1977; *Cape Light: Color
Photographs* by Joel Meyerowitz, with a foreword
by Clifford S. Ackley, interview by Bruce K. Mac-
donald, Boston 1978; *Bay/Sky/Porch*, portfolio,
New York, 1979; *St. Louis and the Arch*, with a
foreword by James N. Wood, Boston 1981; *French
Portfolio*, 12 photos, San Francisco 1981.

On MEYEROWITZ: books—*Photography in the
20th Century* by Nathan Lyons, New York 1967;
Vision and Expression, edited by Nathan Lyons,
New York 1969; *New Photography U.S.A.*, exhibi-
tion catalogue, by John Szarkowski, Arturo Quin-
tavalle and Massimo Mussini, Parma, Italy 1971;
The City: American Experience, edited by Alan
Trachtenberg and Peter C. Bunnell, New York 1971;
*Looking at Photographs: 100 Pictures from the Col-
lection of the Museum of Modern Art* by John
Szarkowski, New York 1973; *The Snapshot*, edited
by Jonathan Green, Millerton, New York 1974;
Faces: A History of the Portrait by Ben Maddow,
New York 1976; *Mirrors and Windows: American
Photography since 1960* by John Szarkowski, New
York 1978; *American Images: New Work by 20
Contemporary Photographers*, edited by Renato
Danese, New York 1979; *The Photograph Collec-
tor's Guide* by Lee D. Witkin and Barbara London,
Boston and London 1979; *Joel Meyerowitz*, exhibi-
tion catalogue, by Els Barents, Amsterdam 1980;
World Photography by Bryn Campbell, London
1981; *The New Color* by Sally Eavclaire, New York
1981; *Nude* by Constance Sullivan, New York 1981;
*Visions and Images: American Photographers on
Photography*, videotape conversations with Bar-
bara Lee Diamonstein, New York 1981; articles—
"Joel Meyerowitz: Rainbow" in *Camera Mainichi*
(Tokyo), November 1973; "Photography: The Com-
ing of Age of Color" by Max Kozloff in *Artforum*
(New York), January 1975; "Joel Meyerowitz" by
Max Kozloff in *Aperture* (Rochester, New York),
no. 78, 1977; "Joel Meyerowitz" in *Camera* (Lu-
cerne), September 1977; "Two Themes in Stylistic
Counterpoint" in *Photography Year 1978*, by the
Time-Life editors, New York 1978; "Joel Meyero-
witz" in *American Photographer* (New York), August
1978; "Joel Meyerowitz" in *Photo* (Paris), May
1979; "The Masterly Style of Meyerowitz" by Gene
Thornton in the *New York Times*, 10 August 1980;
"Joel Meyerowitz" by Lisbet Nilson in *American
Photographer* (New York), September 1981.

Joel Meyerowitz began photographing in New York
City in the early 1960's, following the tradition of
"street" photography in which Cartier-Bresson,
Robert Frank—from whom his desire to photo-
graph initially came—and, more recently, Garry
Winogrand, Lee Friedlander and Tony Ray-Jones
are major figures. He shot initially in black-and-
white (slides) using the small 35mm Leica, and, in
the Leica tradition of reportage, the focus was gen-
erally on behavior in public surroundings. This style
of photograph involves instantaneous decisions
which result in images that are unusual, surprising,
and often full of the irony and wit which is the
essence of life. By using such a camera one is able to
be unobtrusive and thereby to capture people and
events which do not lose their reality and sponta-
neity by becoming posed. As Max Kozloff has
remarked, "a certain invisibility comes to light, the
kind of split-second episode that appears between
our normal perceptions and is typically absorbed
and erased by them. However mundane, [Meyero-
witz's] subject matter exists in this 'Beyond,' an arti-
ficial limbo whose unintended grace he pursues with
a true mania."

When color film became available, it was gener-
ally scoffed at by serious photographers largely
because it produced an unrealistic color quality, did
not allow the photographer much artistic latitude in
the darkroom, and was much too slow for the active
photographer. These obstacles were rapidly being
overcome—as was some of the prejudice against the
use of color film—by the time Meyerowitz began to
develop as a photographer. Clifford Ackley has said
of Meyerowitz that he is one of those few photog-
raphers "who has most successfully made the transi-
tion from seeing in terms of black-and-white tonali-
ties to seeing wholly in terms of color." Meyerowitz
himself confirms this in his later photographs and
says that color is always a part of experience—color
film responds to the whole spectrum of visible light:
"a color photograph gives you a chance to remember
how things look and feel in color. It enables you to
have feelings along the full wavelength of the spec-
trum, to retrieve emotions that were bred in you in
infancy.... Color suggests that light itself is a sub-
ject.... You don't have to have grand subject
matter...."

In shooting his street scenes, Meyerowitz often
uses a fast shutter speed (up to 1000/sec.) and a
flash. As Max Kozloff points out this "startles out
all kinds of information which he himself could not
have seen well. It also casts distortions back through
spaces that seem freely created.... The film inno-
cently accentuates this hybrid character of light,
whether interior or exterior, which the human eye
glosses over and averages out. The restoration of
such luminous differences—and they can only be
realized in color—is an aggressive act. And highly
formalized."

In 1976 and 1977, Meyerowitz began to photo-
graph Cape Cod in the area of Provincetown—
rather in the tradition of Edward Hopper and
Walker Evans—studying the light and landscape.
For this he gave up the Leica in favor of a bulky
vintage (1938) Deardorff field view camera which
allowed him to make negatives which could be
printed by contact rather than by enlarging a slide.
He also used a slow speed color film (exposures were
often 4-10 minutes at f90; and the average daytime
exposure was ½ second at f90). The results of his
sensitive photography and skillful printing pro-
duced photographs of a striking clarity and detail
which were virtually grainless and recorded the fin-
est nuances of color. There is a much different
essence to be found in these photographs in which he
has captured the unique juncture of sky, sea and
land than in his urban photographs with their dis-
tances and irony. Indeed, as Kozloff has said, "the
sensibility at work resembles a cross between Henri
Cartier-Bresson and Edward Hopper, improbable
as that may seem."

—Michael Held

See Color Plates

Duane Michals: *Kim Novak*, **1961** Courtesy Art Institute of Chicago

MICHALS, Duane (Stephen).

American. Born in McKeesport, Pennsylvania in 1932. Educated at McKeesport Technical High School; studied art at the University of Denver, 1949-53, B.A. 1953; studied at Parsons School of Design, New York, 1956-57; self-taught in photography. Assistant Art Director, *Dance Magazine*, New York, 1957; Paste-Up Artist, *Look* magazine, New York, 1957-58; worked as in design studio, New York, 1958. Freelance photographer, working for *Vogue, Esquire, Mademoiselle, Horizon, Scientific American*, etc., New York, since 1958; first sequence photos, New York, 1966. Lecturer, New York School of Visual Arts. Recipient: Creative Artists Public Service Award, New York, 1975. Agents: Sidney Janis Gallery, 6 West 57th Street, New York, New York 10019; and Galerie Wilde, Auf dem Berlich 6, D-5000 Cologne 1. Address: c/o Sidney Janis Gallery, 110 West 57th Street, New York, New York 10019, U.S.A.

Individual Exhibitions:

1963 Underground Gallery, New York (and 1965, 1968)
1968 Art Institute of Chicago
1970 Museum of Modern Art, New York
1971 International Museum of Photography, George Eastman House, Rochester, New York
1972 Museum of New Mexico, Albuquerque
 San Francisco Art Institute
1973 Galerie Delpire, Paris
 Internationaal Cultureel Centrum, Antwerp
 Kölnischer Kunstverein, Cologne
1974 Frankfurter Kunstverein, Frankfurt
 Galleria 291, Milan
 Galleria Documenta, Turin
 School of Visual Arts, New York
 Light Gallery, New York
1975 Light Gallery, New York
 Broxton Gallery, Los Angeles
1976 Galerie Jacques Bosser, Paris
 Sidney Janis Gallery, New York
 Galerie Die Brücke, Vienna
 Texas Center for Photographic Studies, Dallas
 Contemporary Arts Center, Cincinnati, Ohio
 Ohio State University, Columbus
 Felix Handschin Galerie, Basle
 Douglas Drake Gallery, Kansas City, Missouri
1977 Galerie Breiting, Berlin
 Galerie Paul Maenz, Cologne
 G. Ray Hawkins Gallery, Los Angeles
 Philadelphia College of Art
 Arbus/Krims/Michals, Galerie Schellmann und Kluser, Munich (with Diane Arbus and Les Krims)
 Focus Gallery, San Francisco
1978 Douglas Drake Gallery, Kansas City, Kansas
 The Collection at 24, Miami
 Camera Obscura, Stockholm
 Galerie Fiolet, Amsterdam
 Sidney Janis Gallery, New York
 Galerie Wilde, Cologne
 Akron Art Institute, Ohio
 Duane Michals and Nicholas Africano, Nancy Lurie Gallery, Chicago
1979 La Remise du Parc, Paris
 Canon Photo Gallery, Geneva
 Douglas Drake Gallery, Kansas City, Kansas
 The Collection at 24, Miami
 University of Denver
 Galerie Wilde, Cologne
 Nouvelle Image, The Hague
 Nova Gallery, Vancouver
1980 Carl Solway Gallery, Cincinnati, Ohio

Selected Group Exhibitions:

1966 *American Photography: The 60's*, University of Nebraska, Lincoln
1967 *Photography in the 20th Century*, National Gallery of Canada, Ottawa (toured Canada and the United States, 1967-73)
1968 *The City*, Smithsonian Institution, Washington, D.C.
1970 *Be-ing Without Clothes*, Hayden Gallery, Massachusetts Institute of Technology, Cambridge
1974 *Photography in America*, Whitney Museum, New York
1975 *4 Amerikanische Photographes: Friedlander/Gibson/Krims/Michals*, Städtisches Museum, Leverkusen, West Germany
1976 *Real, Unreal, Surreal*, San Diego State University, California
1977 *Whitney Biennial*, Whitney Museum, New York
1978 *Mirrors and Windows: American Photography since 1960*, Museum of Modern Art, New York (toured the United States, 1978-80)

Collections:

Museum of Modern Art, New York; International Museum of Photography, George Eastman House, Rochester, New York; Smithsonian Institution, Washington, D.C.; Art Institute of Chicago; Museum of New Mexico, Albuquerque; University of New Mexico, Albuquerque; University of California at Los Angeles; Norton Simon Museum, Pasadena, California.

Publications:

By MICHALS: books—*Sequences*, New York and Milan 1970; *The Journey of the Spirit After Death*, New York 1971; *Things Are Queer*, Cologne 1973; *Chance Meeting*, Cologne 1973; *Paradise Regained*, Cologne and Antwerp 1973; *Duane Michals: The Photographic Illusion*, with text by Ronald H. Bailey, Los Angeles 1975; *Take One and See Mount Fujiyama and Other Stories*, under pseudonym Stefan Mihal, New York 1976; *Real Dreams*, Danbury, New Hampshire and Paris 1977; *The Wonders of Egypt*, Paris 1978; *Homage to Cavafy: Ten Poems by Constantine Cavafy/Ten Photographs by Duane Michals*, Danbury, New Hampshire 1978; *Changes*, Paris 1980.

On MICHALS: books—*Toward a Social Landscape: Contemporary Photographers*, edited by Nathan Lyons, New York 1966; *Photography in the 20th Century* by Nathan Lyons, New York 1967; *Photography in America*, edited by Robert Doty, with an introduction by Minor White, New York and London 1974; *The Magic Image* by Cecil Beaton and Gail Buckland, London and Boston 1975; *L'Arte nella Società: Fotografia, Cinema, Videotape* by Daniela Palazzoli and others, Milan 1976; *Kunstlerphotographien im 20. Jahrhundert*, exhibition catalogue, edited by Carl-Albrecht Haenlein, Hannover 1977; *Mirrors and Windows: American Photography since 1960* by John Szarkowski, New York 1978; *Photography Between the Covers* by Thomas Dugan, Rochester, New York 1979; *Light Readings: A Photography Critic's Writings 1968-1979* by A.D. Coleman, New York 1979; *Nude: Theory*, edited by Jain Kelly, New York 1979; *The Vogue Book of Fashion Photography* by Polly Devlin, with an introduction by Alexander Liberman, New York and London 1979; articles—"Duane Michals: People and Places" by Martin Fox in *Print* (New York), March/April 1966; "Duane Michals: Sequences" in *Camera* (Lucerne), July 1969; "Sequences: Duane Michals" in *Image* (Rochester, New York), August 1971; "Duane Michals: How Do You Photograph Chance?" in *Popular Photography* (New York), December 1971; "Duane Michals: The Journey of the Spirit After Death" by A.D. Coleman in the *Village Voice* (New York), 30 March 1972; "Duane Michals" by Carter Ratcliff in *Print Collector's Newsletter* (New York), September/October 1975; "De l'Autre Cote du Miroir, Duane Michals" by Carole Naggar in *Zoom* (Paris), October 1976; "Duane Michals Says It Is No Accident That You Are Reading This" by Shelley Rice in the *Village Voice* (New York), 8 November 1976; "Real Dreams" by Vicki Goldberg in *Photograph* (New York), no. 3, 1977; "Duane Michals: The Sequences and Beyond" by Julia Scully and Andy Grundberg in *Modern Photography* (New York), March 1979.

Duane Michals, convinced that photography cannot represent reality, dwells on the invisible: dream, loss, death, myth, spirit. He has photographed an angel falling from grace, the arrival of death, the spirit leaving the body. Most urgently, he has sought to undermine accepted complacencies, to pose, if not necessarily to answer, questions about the nature of reality, photography, and art. Michals strains against both the conventions and limitations of the medium. As he does not choose to play safe, his ambitions have at times outstripped his gifts, but it may be said of Michals as of few photographers that his work, even when it fails, is seldom without invention.

Michals took his first photographs, portraits of Russians, with a borrowed camera on a trip in 1958. Soon after, he moved into commercial photography, then in 1964 began a personal project of photographing empty places around the city—laundromats, buses, coffee shops. In 1966 he began the sequences by which he is best known. Like geiger counters of the spirit, his narratives could detect a galaxy in a man waiting on a subway platform, or trace the lineaments of anxiety in an empty overcoat.

Chafing at photography's restrictions and its limited offer of information, Michals began making multiple exposure portraits and single images and sequences that told peculiar little stories. They were stories without beginning or end, imaginary tales that unfolded like still movies of the mind at work. Serial photographs have intrigued photographers from stereographers to Nadar to Stieglitz, but Michals' sensibilities were shaped mainly by painting. He says the art of Magritte and Di Chirico convinced him that certain philosophical questions he had in mind could be posed graphically. And so he proceeded to set down his graphic riddles: dreams without sleep, fantasies without corrective reality, paragraphs with echoes rather than periods at their close.

The stories dwelt often on love and sexual fantasy, loss, masturbation, guilt and violence and death, and also on the radiance that Eastern mysticism allots to every man. In *Homage to Cavafy* of 1978 he began to make explicit certain homosexual themes. He limned the fears of children—"Margaret Finds a Box" and it carries her off—and those of adults, dreaming obsessively to a glove or a pair of shoes that means too much, only to find that objects vanish, and even their own reflections melt away.

In Michals' open-ended narratives, the vital issues in photography and perception start to unravel. "This Photograph Is My Proof" deals with photography as evidence. The caption says, "She did love me! It did happen. Look, see for yourself!" Poignant enough, to ask the eyes to bear witness to what is lost, but as the picture is certainly posed, in some respect it did *not* really happen—the photographic proof is a wanton fiction. Writing captions on pictures (begun in a small way in 1971, then more extensively in 1974) was in itself a kind of challenge to photographic laws. The written messages declared that photographs were not pure but could be explicitly as well as implicitly literary. Michals' photographs are deliberately impure on several counts. He parades the weaknesses and mistakes of the medium,

513

its blurs and double exposures, not to define a specifically photographic way of seeing but to picture what cannot be seen by eye or camera. His tinkering is evident. An angel's wings are clearly fake, and mistakes in the hand-written captions are crossed out, as if to insist that a human being is in charge of his machine.

"Something's Queer," a fine sequence in which the camera, as it moves farther back, reveals stunning new information in every frame, offers another proof that a photograph is not necessarily what it seems. Here context is all. Reality (whatever that is) is an ample concept; a single photograph is too narrow to contain it. "Alice's Mirror," which ends with the mirror that gave us the view being smashed to bits, suggests that both photography and perception are illusions. Michals' model of reality might have come from Plato's cave. He writes, "I am a reflection photographing other reflections within a reflection." And in "The Man Who Invented Himself" he proposes that the world and its events are constructs of the mind.

"The Spirit Leaves the Body after Death" builds logically on the proposition that visible reality is illusory by photographing the invisible. "A Failed Attempt to Photograph Reality" consists solely of a written message, implying that where reality is nothing, a photographer may not be a photographer nor a photograph a photograph. "Someone Left a Message for You" is a sequence of pictures of a hand writing in mirror script: "As you read this, I am entering your mind." Thus does the photographer communicate by virtue of the written word, the idea made visible. The viewer must participate actively if communication is to take place. A mirror must be found and held up to the image, a nice twist on the proverbial mirror of reality. Michals' 1978 and 1980 gallery shows included photographs altered by painting elements directly on the picture or around its edges, further confounding the purity of the medium and hinting that painting and photography are equally incapable of depicting what we think of as reality but might yet form an alliance to arrive at some other realm of experience.

A kind of relentless ordinariness clings to Michal's photographs. They are simply composed in unexceptionable domestic settings or bare interiors. Into this commonplace, the extraordinary steps unannounced, as myth, guilt, and philosophical conundrum take awkward and compelling shape on photographic paper. It must be admitted that Michals' writing does not always measure up to either his photographs or his thought, that his drawing is weak and his painting not always up to the mark. But when his thought and expression meet on equal terms, the results are unsettling, provocative, haunting—they open doors in the mind, and never bother to close them again.

—Vicki Goldberg

MIDORIKAWA, Yoichi.

Japanese. Born in Okumachi, Okayama Prefecture, Tokyo, 4 March 1915. Educated at local schools; studied dentistry, Nihon University, Tokyo, 1932-36; self-taught in photography. Married Sadako Midorikawa in 1942; children: Mizuko, Koichi and Shoko. Dental surgeon, Okayama City, also independent photographer, Okayama, since 1936. Professor, Nippon Photography School, Tokyo. Juror, Nikakai Photographic Competition, annually since 1955; Chairman, Japanese Society of Photography. Recipient: First Prize, 1953, and Prime Minister's Prize, 1973, Nikakai Photographic Competition; First Prize, Camera Geijitsu Photographic Competition, 1960; Society of Photography Critics Prize, 1962; Japan Society of Photography Prize, 1963. Address: (studio) 12-23 Ekimoto-cho, Okayamashi, Japan.

Individual Exhibitions:

1943 *2 Methods of Agriculture*, Chiyoda Gallery, Tokyo
1946 *Okayama Castle*, Temmaya Department Store, Okayama, Japan
1948 *Women*, Fuji Photo Salon, Tokyo
1951 *Kurashiki*, Muramatsu Gallery, Tokyo
1952 *Osaka*, Matsushima Gallery, Tokyo
1959 *Europe*, Takashimaya Department Store, Tokyo (toured Japan)
1964 *The Seto Inland Sea*, Sakura Gallery, Tokyo
1975 *The Landscapes of Japan*, Fuji Photo Salon, Tokyo (toured Japan)
1979 *Setouchi Ryojo*, Minoruta Photo Salon, Tokyo (transferred to Osaka)
1982 *Imperial Palace*, Minoruta Photo Salon, Tokyo (travelled to Osaka and Okayama)

Selected Group Exhibitions:

1957 *6 Photographers*, Fuji Photo Salon, Tokyo (travelled to Osaka)
1970 *Yoichi Midorikawa and Photographers of West Japan*, Pentax Gallery, Tokyo
1975 *The Land: 20th Century Landscape Photographs Selected by Bill Brandt*, Victoria and Albert Museum, London (travelled to the National Gallery, Edinburgh; Ulster Museum, Belfast; and National Museum of Wales, Cardiff, 1976)

Collections:

Victoria and Albert Museum, London; Bibliothèque Nationale, Paris.

Publications:

By MIDORIKAWA: books—*Woman*, Tokyo 1950; *Kompira*, with an introduction by Yoshinobu Nakamura, Tokyo 1956; *Japon-Japonais*, with text by Charles Henri Favrod, Lausanne 1959; *The Inland Sea*, 10 vols., Tokyo 1962-80; *General Landscapes of Japan*, 9 vols., Tokyo 1967-81; *These Splendored Isles*, Tokyo 1969; *Kyoto*, 2 vols., Tokyo 1970-78; *The Inland Sea*, with an introduction by Donald Ritchie, Tokyo 1971; *The Works of Yoichi Midorikawa*, edited by Toji Shimizu, Tokyo 1980; *A Hundred Stories of Old Clocks*, 3 vols., Tokyo 1973-76; *Okayama*, 6 vols., Tokyo 1980-81.

On MIDORIKAWA: book—*The Land: Twentieth Century Landscape Photographs Selected by Bill Brandt*, exhibition catalogue, edited by Mark Haworth-Booth, London 1975.

Yoichi Midorikawa is one of the most representative of landscape photographers in Japan today. He was born in 1915 at Okumachi, Okayama Prefecture, in the Sanyo District, close to Setonaikai, the inland sea of Japan. The setting in which he grew up was that of a beautiful body of water and its surrounding terrain. When he entered dental school, he began to take photographs; on graduation, he opened a dental clinic in Okayama City, and at the same time his interest in photography grew, and some of his prints were published. His early works featured women as subjects, and these photos have been collected and published. But gradually Midorikawa became more and more interested in landscape, and he set about recording the inland sea he knew so well: the result has been singularly successful.

Perhaps because of his professional role as a dentist, which demands such skills, Midorikawa has always brought to his photography small-scale and subtle techniques, particularly in his early and middle periods. It is rare to find work from this period that isn't both surprising and technically refined. Double exposures are common, as are montages and other methods and techniques. Yet, despite the variety of technical devices, the photographs have a kind of light-hearted vividness and show evidence of his maturing aesthetic.

Shoji Ueda was born and raised in the Sanin District, on the other side of the mountain range dividing Sanin from Midorikawa's birthplace. Ueda's birthplace was a very dark, forbidding landscape that is known as *Ura Nihon* (Back of Japan), and his work generally is solemn, filled with shadows. Obviously, then, for these two well-known photographers, there is a correlation, almost an entente, between genius loci and their work. These two contrasting Japanese photographers have substantially opposing characters and styles, yet they understand each other: they have been on good terms since childhood.

In 1959 Mikorikawa travelled through Europe for 4 months on a photographic tour. He was struck by the beauty and majesty of the landscapes he encountered, but in the end was forced to conclude that landscapes in Japan were enough for him—they enjoyed the changes of the four seasons; they had a variety of plants, trees, mountains, rivers, etc. When he returned home he began a series of landscapes throughout Japan. It was the time at which color photography came into general use in Japan—and Midorikawa, too, adopted color. And, indeed, his design sense seemed all the more appropriate in color, so much so that he came to be known as "the magician of color."

If one contemplates the work of Midorikawa, then the most appropriate appellation and description of his achievements is as a "designer of landscape." Of late, though, his photographic style has begun to change. Midorikawa has exhibited less decorative, more precise compositions. The photographs have a striking simplicity. It may be that he has come to the conclusion that his final understanding of landscape should be rendered with this kind of directness. In any event, most of Midorikawa's photographs have been published in picture books, numbering to date about 30. He can be said to work basically through the medium of publication, where both the changes and accomplishments of his photography are now available to everyone.

—Takao Kajiwara

MIKHAILOVSKY, Wilhelm.

Russian. Born in Donetck, 2 October 1942. Educated at Secondary School 6, 1950-60; Technical College, Konstantinovka, 1960-63. Married Vera Makarova in 1967; children: Eduard, Julia, and Wilhelm. Worked as a technician at the Latvijas Stikls factory, Riga, 1966-73; Staff Photographer, Project Institute, Riga, 1973-76. Staff Photographer, *Maksla* art magazine, Riga, since 1976. Member, Union of U.S.S.R. Journalists, 1979. Recipient: Gold Medal, Photographic Society of America, 1974; Silver Medal, 1975, 1978, 1979, 1980, Gold Medal, 1976, 1978, 1979, 1981, Bronze Medal, 1980, and Artist Excellence Award, 1979, Fédération International de l'Art Photographique (FIAP); Niepce Medal (3), France, 1979; Gold Medal, Fédération Belge des Photographiques, 1977; Gold Medal, Kzakowskie Towarzystwo Fotograficzne, Poland, 1979; Verband Deutscher Amateurfotografen Vereine Prize, West Germany, 1979. Address: Sejas 69-6, Riga 226058, Latvia, U.S.S.R.

Individual Exhibitions:

1976 City Historical Museum, Tallin
1977 Poztoky Castle, Prague
 Fotokabinett Jaromir Funke, Brno, Czechoslovakia
1978 House of Friendship, Moscow
1980 Museum of Latvian History, Riga
 Cultural Centre, Colombo, Ceylon

Selected Group Exhibitions:

1975 *FIAP Jubilee Exhibition*, Gruppo Fotografico, Turin
 International Salon of Japan, Asahi Shimbun, Tokyo (and annually to 1980)
1978 *Exposition Mondiale d'Art Photographique*, Mairie, Paris (travelled to the Palais des Congrès, Versailles)
 Phot Europ, Kodak Gallery, London
 Auteurop '78, Salle Maine-Montparnasse, Paris
 World Press Photo, Rijksmuseum Vincent Van Gogh, Amsterdam
1979 *Europäische Fotografen*, Rathaus Tempelhof, West Berlin
 Prinfot, Barcelona
1980 *Auteurop '80*, Salle Maine-Montparnasse, Paris

Wilhelm Mikhailovsky: *Commandment*, 1979

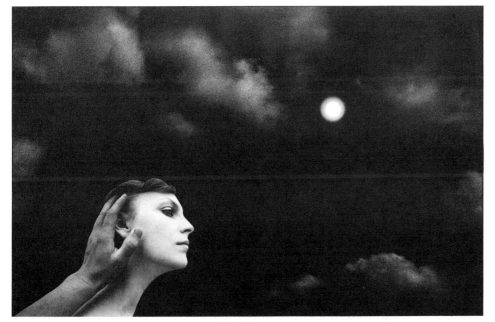

Collections:

Latvian Society for International Friendship and Culture, Riga; Fotografijos Muziejus, Siauliai, Lithuania; TASS Agency Collection, Moscow; Collection Historique de FIAP, Berne; Musée Français de la Photographie, Bièvres, France.

Publications:

By MIKHAILOVSKY: books—*Atklasme* (*Revelation*), Riga 1981; *Wilhelm Mikhailovsky*, Moscow 1981; articles—"The Boundlessness of the Instant" in *Maksla* (Riga), August 1979; "Das Ziel: Einprägsame Aufnahmen" in *Fotografie* (Leipzig), April 1980; "Photography: The Reality of Transformation" in *Maksla* (Riga), June 1980.

On MIKHAILOVSKY: books—*Dumont Foto 1*, edited by Hugo Schöttle, Cologne 1978; *Vilhelms Mihailovskis*, exhibition catalogue, Riga 1979; *Dumont Foto 2*, edited by Hugo Schöttle, Cologne 1980; articles—"Good Day, Wilhelm Mikhailovsky!" by Ansis Epners in *Literature and Art* (Riga), January 1978; "Wilhelm Mikhailovsky's Secret" by Andris Rozenbergs in *Maksla* (Riga), March 1979; "Wilhelm Mikhailovsky and Contemporary Soviet Photography" by Daniela Mrázková in *Czechoslovenska Fotografie* (Prague), November 1979; "Mikhailovsky: His Subjects, His Images" by Sergey Vetrow in *Sovetskoye Foto* (Moscow), February 1980; "World Photographers: Wilhelm Mikhailovsky" in *Foto Revij* (Belgrade), September 1980; "A Big Thought Is Coming" by Atis Skalbergs in *Zvaigzne* (Riga), April 1980; "Wilhelm Mikhailovsky" by Josef Mašin in *Fotografie* (Prague), January 1981.

Painting and poetry, in which I have always been interested, helped me to find my perception of the world. Then I discovered photography.

I began to photograph in 1968. Soon photography became the main thing in my life: I completely devoted myself to this constant, exhausting and inspiring work.

The basis of my creative process is my method of montage.

I exclude the use of reproduction. Many of my works, in essence, are unique originals: in the process of creating I project from 2 to 7 negatives on the light-sensitive surfaces of the future "original."

Through photography, I come to know the real world—wonderful and astonishing. Photography has caused me the acutest pain as well as the joy of perception, which cannot be compared with anything else. I always feel a debt of gratitude, to it and to the audience, the co-operator in the creation.

Photography? Photography! Photography....

—Wilhelm Mikhailovsky

His work for periodicals has led Wilhelm Mikhailovsky to take up reportage, but his creative personality is brought out fully only in his freelance photographs. Their significance is mainly the result of complex montage processes. By linking unconnected motives and elements, Mikhailovsky provokes meditation on the generally valid, eternal and indisputable truths, those values that do not change with time or geography. He brings them up to date, confronting them according to contemporary life-styles.

In the past his montages were structurally more complicated, not unlike those of his Lithuanian colleague Vitaly Butyrin, attempts at an ideological solution to the mystery of the origin and presentation of life. Later, he passed on to a simpler subject, the contemplations of the natural conflicts between man rooted in tradition and advancing civilization. Towards the end of the 1970's, his work moved into a third phase, a kind of pictorial cosmology, an impressive presentation of the problems of the destiny of man not only as a cosmopolitan terrestrial but also as an inhabitant of the universe. The technique of montage here, too, allows him at will to accentuate the expression of the ecstatic suggestive compositions. These pictorial visions, which are more unambiguous as to their significance and more sober in expression, do not free man from his everyday cares, do not rid him of the humdrum existence of the human race, but they do dramatically present a message that emphasizes how trite all these everyday worries are, how negligible in comparison with the laws and order of the eternal universe.

Mikhailovsky replaces the mystery of our life in nature on earth with a vision of cosmic mystery. Not in order to express a desire for the greater justice of a higher, perfectly-arranged world, but to celebrate eternal, everlasting life by presenting the question of the dialectical relationship of terrestrial existence in a broader, only recently discovered and explored space. This, of course, is also the creative program of associative photography—to express the sensibility and imagination of contemporary man encountered in many different localities. But Mikhailovsky's lively, inspiring and to a great extent festive expression is unusual in that it does not express the disillusion and scepticism of a member of the consumer society who realizes that, in the end, society turns all the achievements of civilization against man and his naturalness. Mikhailovsky's vision does not involve the usual sense of utter hopelessness; on the contrary, he looks upon this complex set of problems as a challenge, as an inevitable process of changing styles of living, as a means (about which he is optimistic) of seeking after other forms of existence.

Mikhailovsky makes use in his pictorial compositions of the results of his work as a reporter as well as a free-lance photographer. He has a fondness for figures and landscape as well as black-and-white montage. He links his compositions in broad cycles, the captions of which are eloquent in their way and precisely define the boundaries of the artist's intention: Beginning, Sources, Reconstruction Humanus, Sensibility, Renaissance, etc. He has had great success at photographic exhibitions with these works. He has not yet had the opportunity to make other use of them—for example, in book form. His first portfolio about old Riga and its inhabitants is sober; it is based on his reportage. For his second book—which he has been planning for several years—he wants to have more of a free hand. He has called it *Man at Work*, and, in pictorial metaphor and symbol, he intends to deal with the purpose of man's existence. In comparison with the ideologically similar-minded Butyrin, Mikhailovsky's expression

is more civil and simple, less pompous and less subject to surrealist transformations.

—Daniela Mrázková

MILI, Gjon.

American. Born in Kerce, Southern Albania, 28 November 1904; emigrated to the United States, 1923; subsequently naturalized. Educated at schools in Bucharest until 1920; studied electrical engineering, Massachusetts Institute of Technology, Cambridge, 1923-27, B.S. 1927; mainly self-taught in photography, but worked initially with Harold E. Edgerton. Lighting Research Engineer, Westinghouse Electrical and Manufacturing Company, Cambridge, 1928-38: developed biplane tunsten filament lamp and lights for color photography, 1930-35, and worked on experimental and high-speed photography, with Edgerton, at M.I.T., 1938. Freelance photographer, working for *Life* and other magazines, New York, since 1939; also, a filmmaker, since 1944. Visiting Lecturer, Yale University, New Haven, Connecticut, 1969; Instructor in Photography, Sarah Lawrence College summer project, Lacoste, France, 1972, 1973, 1974; Instructor in Photography, Hunter College, New York, 1973. Recipient: American Society of Magazine Photographers Award, 1963. Address: Life Magazine, Time-Life Building, Rockefeller Center, New York, New York 10020, U.S.A.

Individual Exhibitions:

1942 *Dancers in Movement*, Museum of Modern Art, New York
1946 Paris Galerie, Paris
1952 *On Picasso*, Museum of Modern Art, New York (with Robert Capa)
1964 Time-Life Building, New York
1970 Lincoln Center for the Performing Arts, New York
 Musée Réattu, Arles, France
1971 Musée des Arts Décoratifs, Paris
1979 Compton Gallery, Massachusetts Institute of Technology, Cambridge
1980 International Center of Photography, New York (retrospective)
1981 Musée Arleton, Arles, France

Selected Group Exhibitions:

1951 *Memorable Life Photographs*, Museum of Modern Art, New York
1975 *Photography Within the Humanities*, Jewett Arts Center, Wellesley College, Massachusetts
1979 *Fleeting Gestures: Dance Photographs*, International Center of Photography, New York (travelled to *Venezia '79*, and The Photographers' Gallery, London)
 Life: The First Decade 1936-45, Grey Art Gallery, New York University

Collections:

Museum of Modern Art, New York; Time-Life Library, New York; Massachusetts Institute of Technology, Cambridge; Bibliothèque Nationale, Paris.

Publications:

By MILI: books—*Photographs of Picasso by Gjon Mili and Robert Capa*, New York 1950; *The Magic of the Opera*, New York 1960; *Picasso et la Troisieme Dimension/ Picasso's Third Dimension*, Paris and New York 1970; *Gjon Mili: Photographs and Recollections*, Boston 1980; articles in *Life* (New York)—"Gjon Mili Photographs Ballet Dancers at High Speed," 19 February 1940; "World Charter," 23 July 1945; "Bad Little Good Girl," 24 December 1951; "World of Sean O'Casey," 25 July 1954; "Queen of Cathedrals," 15 December 1961; "The Relentless Spectre of Brecht," 18 September 1964; "Mr. B. Talks about Ballet," 11 June 1965; "Serenade to 90 Years of Greatness," 11 November 1966; "An American Masterpiece," 3 October 1969; "The Me Nobody Knows," 4 September 1970; "A Mother's Legacy," 26 May 1972; "29 Years Ago in Life," 25 August 1972; films—*Jamming the Blues*, 1944; *Raoul Dufy Paints, New York*, 1950; *Casals, Prades Festival*, 1950; *Jean Babilee, Dancer*, 1951; *Salvador Dali*, 1951; *Stomping for Mili, Brubeck Jazz Quartet*, 1955; *Eisenstaedt Photographs "The Tall Man"*, 1955; *"Tempest": Filmmaking on Location*, 1958; *Henri Cartier-Bresson, Photographer*, 1958; *Homage to Picasso*, 1967.

On MILI: books—*Gjon Mili*, exhibition catalogue, with an introduction by Jean-Paul Sartre, Paris 1946; *Memorable Life Photographs*, with text by Edward Steichen, New York 1951; *Gjon Mili: Photographies*, exhibition catalogue, Paris 1971; *The Magic Image* by Cecil Beaton and Gail Buckland, London and Boston 1975; *The Photography Catalogue*, edited by Norman Snyder, New York 1976; *Photography Within the Humanities*, edited by Eugenia Parry Janis and Wendy McNeil, Danbury, New Hampshire 1977; *Geschichte der Fotografie im 20. Jahrhundert/ Photography in the 20th Century* by Petr Tausk, Cologne 1977, London 1980; *The Vogue Book of Fashion Photography* by Polly Devlin, with an introduction by Alexander Liberman, London 1979; *Life: The First Decade 1936-1945* by Robert Littman, Ralph Graves and Doris C. O'Neill, New York 1979, London 1980; articles—"Gjon Mili: Sauvees du Fe, Quelques Etudes du Patriarche de la Photo" in *Photo* (Paris), July 1971; "Gjon Mili: Photographer King" by Sean Callahan in the *Village Voice* (New York), 26 May 1975; "Photography as Theology" by Sean Callahan in *American Photographer* (New York), November 1980; "Views of Big Cities and Studies of People in Motion" by Gene Thornton in the *New York Times*, 30 November 1980.

Few photographers are given the privilege (or the talent) to leave a truly distinctive mark on a medium that is available to scores of millions. Photography is based on reality, and its strength lies in its ability to split seconds and to observe dispassionately every detail of the world in front of the lens. Only by his unique, strong vision of the world, or by extending the ability of photography to record what man's limited senses cannot see, can a photographer leave his own stamp on his photography.

The limitations of the medium made it difficult, perhaps impossible, to tell a daguerreotype by Daguerre from one by another early practitioner. The same is true of calotypes by Talbot.

But as materials and equipment loosened their grip on the photographer's vision and imagination, individual workers began to mark their work with a personal style of seeing. Technology became an important factor in releasing individual style as the medium matured. The action studies of Muybridge and Marey, completely removed from the mainstream of their era, come to mind. And the images of the precocious Jacques-Henri Lartigue, combining high-speed photography with a unique way of seeing, are another example of *cachet* apart from contemporary work.

But it remained for Gjon Mili, working in the late 1930's with the then-new stroboscopic electronic flash lamps perfected by Dr. Harold Edgerton of the Massachusetts Institute of Technology, to bring the viewer a new way of looking at the world. Leaving his career as an electrical engineer, Mili experimented for several months with this new light source that could divide a second's worth of action into thousands of individual images, or make a single piercingly sharp image of a bullet in flight. It was a unique marriage of a new technology and a photographer whose vision, understanding and appreciation of it were superbly suited to one another. The imagination of artists working in other media had produced a few memorable pictures that analyzed action by breaking it down into successive pictures. But Mili was the first to provide controlled, clear, scientifically valid yet imaginative and beautiful images that would otherwise have remained hidden from human vision.

Their strength was such that the editors of the two-year-old *Life* magazine began to give him many assignments to picture sports, dance and theater action to be used in its pages. And since these pages reached unprecedentedly large numbers of readers, the new way of seeing soon entered the consciousness of *Life*'s readers across the world.

Mili's association with that magazine continues even today. And, as a recent retrospective show at New York City's International Center of Photography bore out, his work has hardly been limited to his strobe-flash specialty.

Over the years Mili has photographed famous people—artists, writers, actors, dancers, even historic archcriminals like the infamous Nazi Eichmann. Unlike one by Arnold Newman or Yousuf Karsh, a Mili portrait does not instantly reveal its maker. Many of his people pictures look very much like those by other fellow *Life* staff photographers of the era. But this very fact gives them a variety and appropriateness that are sometimes missing in the work of more stylized photographers. Those of political personalities had often to be done on the spot with little chance to direct or light the subject ideally. But the meticulous craftsmanship, the command of the medium that distinguish a Mili photograph, wipe away the distractions. The technical difficulties are never beyond control.

But perhaps the work that truly shows a masterly combination of both craft and art are Mili's pictures of statuary. His pictures of both ancient Greek and modern statues and bas reliefs truly bring alive the presence and intent of the sculptor. Mili's means to his end are the same as those of any other photographer—choice of lighting angle to dramatize the sculpture. But the choice! A group of Roman guards on a bas-relief, lit subtly from below, photographed in a close-in composition that concentrates attention on the faces, becomes a menacing, conspiratorial group. Rodin's *The Burghers of Calais*, limned by the light of a setting sun, seem almost to breathe and talk to one another as they consult, faces troubled, within the Hirshhorn Sculpture Garden. Mili's feeling and respect for stone and metal, if not unique, are certainly rare among photographers.

The sustained high level of quality that marks Gjon Mili's output can be credited to his breadth of appreciation for literature and the arts, history, dance and theater. It is a characteristic he shares with a number of his contemporaries, like Cartier-Bresson and Kertész. To this broad cultural base he adds the consummate mastery of his medium that has made many Mili photographs classics of both innovation and vision.

—Kenneth Poli

Gjon Mili: *Arshile Gorky*, **1946**

MINICK, Roger.

American. Born in Ramona, Oklahoma, 13 July 1944. Educated at Pacific High School, San Bernardino, California; University of California, Berkeley, 1964-69, B.A. in history 1969. Married Joyce Johnson in 1972. Worked as a medical orderly, San Bernardino County Hospital, California, 1962-64; Darkroom Assistant, 1965-70, and Director, 1970-75, A.S.U.C. Studio, University of California, Berkeley. Freelance photographer, California, since 1975. Recipient: Guggenheim Fellowship in Photography, 1972; National Endowment for the Arts Photo Survey Grant, 1977, 1978; Photo Survey Award, Tennessee Valley Authority, 1981. Agents: Grapestake Gallery, 2876 California Street, San Francisco, California 94115; Douglas Kenyon Gallery, 155 East Ohio Street, Chicago, Illinois 60611; Witkin Gallery, 41 East 57th Street, New York, N.Y. 10022. Address: 732 Kentucky Street, Vallejo, California 94590, U.S.A.

Individual Exhibitions:

1971 *Ozark and Delta Images*, Friends of Photography, Carmel, California
1975 *Ozark Photographs*, University Art Museum, Berkeley, California
 Two Views from the West: Roger Minick and Richard Misrach, International Center of Photography, New York
1976 *Rural Photographs*, Creative Photography Gallery, Massachusetts Institute of Technology, Cambridge
1977 *Rural Photographs*, Light Work Gallery, Syracuse, New York
 Roger Minick: Retrospective, Hunter Museum of Art, Chattanooga, Tennessee
 Roger Minick and Ted Orland, Focus Gallery, San Francisco
1978 *Ozark and Delta Images*, Images Gallery, New Orleans
1980 *Roger Minick: Retrospective*, Douglas Kenyon Gallery, Chicago

1981 *Sightseer Series*, Grapestake Gallery, San Francisco
1982 Witkin Gallery, New York

Selected Group Exhibitions:

1968 *Studio '68*, Friends of Photography, Carmel, California
1973 *Places*, San Francisco Art Institute
1976 *L.A. X 6*, Mount St. Mary's College, Los Angeles
1978 *Espejo*, Center for Contemporary Photography, Chicago
1979 *Attitudes: Photography in the 1970's*, Santa Barbara Museum of Art, California
 Fotografie im Alltag Amerikas, Kunstgewerbemuseum, Zurich
1980 *New California Views*, Mills College, Oakland, California
1981 *America's National Parks*, Oakland Museum, California

Collections:

Museum of Modern Art, New York; Seagram Collection, New York; Guggenheim Memorial Foundation, New York; Fogg Art Museum, Harvard University, Cambridge, Massachusetts; Exchange National Bank, Chicago; Hunter Museum of Art, Chattanooga, Tennessee; Museum of Fine Arts, Houston; Center for Creative Photography, University of Arizona, Tucson; San Francisco Museum of Modern Art.

Publications:

By MINICK: books—*Delta West*, with Dave Bohm, San Francisco 1969; *Hills of Home*, San Francisco 1975.

On MINICK: books—*Latent Image* by Joel D.

Levinson, San Francisco 1978; *Light Readings: A Photography Critic's Writings 1968-1978* by A.D. Coleman, New York 1979; *New California Views*, exhibition catalogue, by Therese Heyman, Los Angeles 1979; articles—"Roger Minick: Delta West" by A.D. Coleman in the *Village Voice* (New York), 25 June 1970; "Delta West" by Margery Mann in *Popular Photography* (New York), July 1970; "Ozark Exhibition" by Joan Murray in *Artweek* (Oakland, California), 15 February 1975; "Hills of Home" by Michael Kernan in *The Smithsonian* (Washington, D.C.), December 1975; "Exhibit in L.A." by Robert Mautner in *Artweek* (Oakland, California), 13 November 1976; "L.A. Exhibit" by Natalie Canavor in *Popular Photography* (New York), April 1978; "Exhibition at Douglas Kenyon Gallery" by David Elliott in the *Chicago Sun-Times*, 15 June 1980.

With my various photographic projects, I have been largely interested in people and how they interact with their environment. Generally, I have concentrated on particular regions that embody unique lifestyles. My approach—as with my projects on the Ozarks of Arkansas and the Sacramento Delta—has often been to photograph people amidst surrounding architectural or natural features I feel to be most succinctly representative of a region.

With the mural-portrait series in East Los Angeles, I made portraits that juxtaposed the intensity of the barrio murals with the pride of the Chicano people themselves. In an earlier series from my Southern California work, where I photographed shoppers in shopping malls, I tried to show the tensions resulting from visually bringing together middle-class buyers with the futuristic, hermetically-sealed places of consumerism. Also, in this same project on Southern California, I made a series of photographs of peopleless, urban landscapes, many of which were taken from inside a moving car while driving the freeways. Allowing the interior of the automobile to become an adjunct to the composition, and striving to capture the fleeting configurations caused by the movement, I found this point of view compatible with Southern California's preoccupation with the automobile.

In another project on "undocumented workers," possibly the most photo-essay-like of all my work, I have attempted to examine the conditions of agricultural workers in the United States, particularly the Mexican Nationals. By photographing all aspects of their difficult existence, from their meagre camp life to their exhausting work in the fields, I have sought to suggest some of the realities of American agriculture.

In my most recent work, the "Sightseer Series," I have photographed, in black-and-white and color, tourists at the overlooks to national parks and monuments. I have posed individuals, groups, families, and motor homes against the postcard-like backdrops. I feel that this uniquely American ritual of stopping at the overlooks, with all its extravagant behavior and trappings, stands to change dramatically as our worsening energy situation alters our once-thought secure love affair with the automobile. With the American landscape becoming less accessible, one would hope our present insulated relationship with the landscape might become a richer experience.

—Roger Minick

Roger Minick is a thoroughly modern documentary photographer. Since *Hills of Home* and *Delta West*, excellent, traditional photographic studies of people in rural environments, his work has grown increasingly objective, increasingly open. Without turning his back on his earlier work, Minick has changed with the times, updating the tradition of documentary photography.

His work is characterized by fine craftsmanship, extreme sensitivity, and a high degree of integrity. The clarity of detail, the richness of color, and the

Roger Minick: *Bryce Canyon National Park* **from the** *Sightseer Series*, 1979

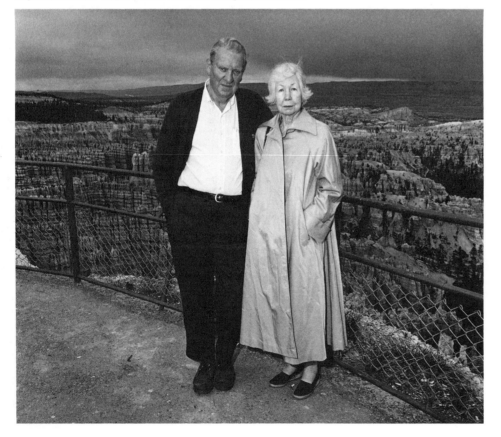

full tonal range make all his pictures eminently inviting: to view them is to feel part of the real place, to get a sense of the real people they contain. His attention to light quality and compositional nuance emphasize his concern not only for the subjects he has chosen, but also for the viewer he is addressing. Minick does a tremendous amount of work on each of his projects in order to capture and re-create as fully as possible the way in which people interact with their environments. He tries to present them as accurately as possible, and he is always sensitive to their private dreams and desires.

Even though his photographs imply an acceptance of the people, they don't always imply an acceptance of their situations. His images for the "Espejo" project, done in a barrio of East Los Angeles juxtaposing the distinct pride of the Chicano people with vigorous wall murals found in their communities, raise questions about the plight of Chicano peoples in the American culture. And while his study of middle class shoppers in Southern California malls is sympathetic to the people involved in this activity, his photographs reveal the dehumanizing sterility of these environments, and question Americans' odd obsession to consume material goods.

The recent "Sightseer Series" focuses on a common cultural activity (automobile excursions) and documents it in a neutral, almost sociological manner. The photographs show individuals and groups of people standing in front of metal rails and small brick walls on roadside stops which overlook such natural wonders as Monument Valley, Yosemite, and the Grand Canyon. Dressed out of Sears catalogs and gift shops, the people offer an odd contrast to their natural surroundings. An aura of unreality, heightened by the backdrop quality of the vistas, dominates each scene, and as they pose only a little more seriously than they have for hundreds of family snapshots, the people appear oblivious to the incongruity they introduce.

Yet the straightforward, non-ironic tone of these photographs implies an acceptance which transcends social satire. As he enlarges our conception of the landscape to include ourselves and each other, Minick seems to be suggesting that the tourist has become a real, perhaps even natural, part of American scenery. Here, as in his other works, Minick uses photography to present a perceptive examination of societal habits and states of mind.

—Ted Hedgpeth

Industrial Design), Helsinki, 1974-76; Assistant Professor of Photography, Massachusetts Institute of Technology, Cambridge, 1977-81, Since 1981, Assistant Professor, Philadelphia College of Art. Editor-in-Chief, *Views: A Journal of Photography in New England*, Boston, 1980-81. Agent: Yuen Lui Gallery, 906 Pine Street, Seattle, Washington 98101. Address: 5 Bells Court, Philadelphia, Pennsylvania 19106, U.S.A.

Individual Exhibitions:

1972 Soho Photo Gallery, New York
 Spectrum Gallery, Tucson, Arizona (travelled to Projects Inc., Cambridge, Massachusetts, and Community Darkrooms, Syracuse University, New York, 1973)
1973 Woods Gerry Mansion, Rhode Island School of Design, Providence
1974 Valokuvamuseo, Helsinki
1976 Wäinö Aaltosen Museo, Turku, Finland
 Moderna Museet, Stockholm
1977 Red Eye Galley, Rhode Island School of Design, Providence
1979 Yuen Lui Gallery, Seattle
 Canon Photo Gallery, Amsterdam
1980 Crealde School of Art, Winter Park, Florida
1981 Bemidji State University, Minnesota

Selected Group Exhibitions:

1974 *Variety Show II*, Humboldt State University Arcata, California
 Photography as a Fine Art, University of Florida, Gainesville
1976 *Fantastic Photography in Europe*, at Rencontres Internationales de la Photographie, Arles, France (toured Europe and the United States, 1976-79)
1978 *Tusen och En Bild/1001 Pictures*, Moderna Museet, Stockholm
 The Male Nude, Marcuse Pfeifer Gallery, New York
 Photo Exhibition and Print Auction, Neary Gallery, Santa Cruz, California
1979 *The History of the Nude*, Kiva Gallery, Boston

The Contemporary Photographic Book, Addison Gallery of American Art, Andover, Massachusetts
1980 *Into the 80's: New England Photography*, Keene State College, New Hampshire
 Funny Photographs, Marcuse Pfeifer Gallery, New York

Collections:

Addison Gallery of American Art, Andover, Massachusetts; Rhode Island School of Design, Providence; Center for Creative Photography, University of Arizona, Tucson; Fotografiska Museet, Moderna Museet, Stockholm; Wäinö Aaltosen Museo, Turku, Finland.

Publications:

By MINKKINEN: books—*Frostbite*, with an introduction by Z. Kwitney, Dobbs Ferry, New York 1978; *New American Nudes: Recent Trends and Attitudes*, editor, Dobbs Ferry, New York 1981; articles—"Young Photographers in America" in *Valokuva* (Helsinki), May 1974; "One by One" in *Valokuva* (Helsinki), November 1976; "The Automobile as Viewfinder" in *Views* (Boston), Fall 1979; "Nixon at Vision" in *Views* (Boston), vol.1, no. 2, 1979; "Christopher James" in *Views* (Boston), vol. 1, no.3, 1980; "The Flames of Solos" in *Views* (Boston), Spring 1980; "Merger of the Mediums" in *Views* (Boston), Summer 1980; "The Power of a Single Photograph" in *Views* (Boston), Fall 1980.

On MINKKINEN: books—*Photography Annual* by the Time-Life editors, New York 1974; *Fantastic Photography in Europe*, exhibition catalogue, by Lorenzo Merlo, Amsterdam 1977; *Self-Portrayal*, edited by Friends of Photography, Carmel, California 1978; *Tusen och en Bild/Thousand and One Pictures*, exhibition catalogue, by Åke Sidwall, Stockholm 1978; *Fantastic Photography*, edited by Lorenzo Merlo and Claude Nori, with an introduction by Attilio Colombo, New York 1979; articles—review by A.D. Coleman in the *Village Voice* (New York), July 1972; "Arno Rafael Minkkinen" in *Foto-Smal-Film* (Copenhagen), April 1974; "Arno

Arno Rafael Minkkinen: *Beach Pond, Connecticut*, 1974

MINKKINEN, Arno Rafael.
American. Born in Helsinki, Finland, 4 June 1945; emigrated to the United States, 1951: naturalized, 1967. Educated at Fort Hamilton High School, Brooklyn, New York, 1959-63; Wagner Collge, Staten Island, New York, 1963-67 (Editor, *Wagner Literary Magazine*, 1965-66), B.A. in English 1967; attended Wagner College Study Program, Bregenz, Austria, 1967; studied photography, under George Tice, at the New School for Social Research, New York, 1970-71, and under John Benson at Apeiron Workshops, Millerton, New York, 1971; studied under Ralph Hattersley at the School of Visual Arts, New York, 1971-72, and, under Harry Callahan and Aaron Siskind, at Rhode Island School of Design, Providence, 1972-74 (Teaching Assistant, 1973-74), M.F.A. in photography 1974. Married Sandra Jean Hughes in 1969; son: Daniel. Worked as a copywriter in various advertising agencies, New York, 1967-72, 1976-77. Lecturer, Lahden Taideoppilaitos (Art Institute), Lahti, Finland, and Instructor in Photography, Taideteollinen Korkeakoulu (Institute of

Rafael Minkkinen" in *Mellande* (Stockholm), no. 1, 1976; "American Photography" in *Valokuva* (Helsinki), May 1976; "Arno Rafael Minkkinen" in *Popular Photography Annual*, New York 1978; "Arno Rafael Minkkinen" in *Le Nouveau Photocinema* (Paris), June 1978; "The History of the Nude" in the *Boston Phoenix*, 20 March 1979; "Arno Rafael Minkkinen" by James Burns in *Northwest Photography* (Seattle), May 1979; "Arno Rafael Minkkinen" in *Reflections* (Amsterdam), September 1979; "The Photographer as Autobiographer" by Ted Wolner in *Camera 35* (New York), October 1979; "Arno Rafael Minkkinen" by Roberta Valtorta in *Progresso Fotografico* (Milan), June 1980.

An artist is much easier to define than art. Paintings, poems, or photographs are works of art in their ability to affect us, strike inward resonances, and eventually remain in our memory. By this definition even a snapshot, carelessly taken yet visually enlightening, can stand on solid ground as a work of art. But is the picture-taker an artist? If he or she can work the same magic over and over again, probably so.

None of my self-portraits are multiple images. But if they appear to have that quality, that's when, to me, they're most successful.

I never see the completed image in the camera, only the background. When the fixer has cleared the negative, that's when I find out how the idea turned out. There is reality. There is imagination. Somewhere in between is my photograph.

Being alone with oneself is central to self-portraiture. There are many who cannot deal with portraits of the self because they cannot deal with being alone.

—Arno Rafael Minkkinen

For the past decade Arno Rafael Minkkinen has been making self-portraits. His imagery derives from a romantic and surreal imagination and acquires much of its vitality from the wind-drenched elements of earth and water in which he the photographer and subject cavort. Born in Helsinki, Finland, holding undergraduate and graduate degrees in English and art, a former copywriter for an advertising agency, Minkkinen embues his work with a personal solitude and fascination with being. Against wide natural expanses he asserts his own form. He makes the viewer shiver with his capers in snow and northland brine.

Drawn from the imagination, contrived with the aid of a tripod, cable release, and an occasional assistant, his photographs are distinctly his own. Almost exclusively, he chooses to appear, whatever part of him, in the nude. His photographs are arresting sometimes because of their sleight-of-hand (feet briskly striding over water; his lower torso hurled like a frozen blanket into the wind) and also because they express feelings that others might leave undisclosed. Photography for Minkkinen is a frank and bracing dialogue with self.

A one-time student of Harry Callahan and Aaron Siskind, Minkkinen creates visual metaphors with his long, sinewy body. Save for a canoe or a paddle or the litter of his own just-shed clothing, he eschews props. His photographs confront the viewer straighton. Unabashedly open and sexual, they attest to feelings of expansiveness as wide as some of the fjords and deserted lakes which serve as their backdrops. Snow, sea, tide-pools, mist, clouds, waterfall, a frothy beach, an outcropping of rock touching the sea—water in its protean forms is a nourishing element in his work.

His images embrace a spectrum of feelings. The surreal: a leg dangling unaccountably over the bow of a beached boat. The masochistic: a capped swimmer taking a high and downward stroke with a gleaming dagger. The serene and prayerful: a torso levitating before the altar of a softly-lit curtain. The

comic: a canoist surprised that her paddle has dredged up the white derriere of a man. The absurd: a foot thrusting back and out of the snow as though it were a marker for an unlikely burial. The paternal: a baby sitting upright like a ragdoll, lifting his head to a fatherly presence confirmed solely by legs crossed like tent poles and cut off at the knees. The grotesque: a shrunken man squatting on a table, a jacket touching his toes as though he were only half a body. The lyrical: two feet swinging high in a tree against a chalky sky.

Off and on during the 70's, Minkkinen has tried to make other kinds of photographs, removing himself as the subject. Now he has dedicated himself anew to self-portraiture. Both in color and black-and-white, his recent work casts himself again as subject, alone or with a member of his family. These kinds of images, he claims, may engage him for the rest of his life.

—Kelly Wise

MISRACH, Richard.

American. Born in Los Angeles, California, 11 July 1949. Educated at University High School, Los Angeles, 1964-67; University of California, Berkeley, 1967-71, B.A. in psychology 1971 (Phi Beta Kappa). Freelance photographer, California, since 1971. Instructor, A.S.U.C. Studio, University of California, Berkeley, 1971-77. Recipient: National Endowment for the Arts Fellowship, 1973, 1977; Western Books Award, 1975; Ferguson Grant, Friends of Photography, 1976; Guggenheim Fellowship in Photography, 1978. Agent: Grapestake Gallery, 2876 California Street, San Francisco, California 94115. Address: 1420 45th Street, Emeryville, California 94609, U.S.A.

Individual Exhibitions:

1975 *Two Views from the West: Roger Minick and Richard Misrach*, International Center of Photography, New York
1976 Madison Art Center, Wisconsin
1977 Oakland Art Museum, California
 ARCO Center for the Visual Arts, Los Angeles
1978 Silver Image Gallery, Seattle
 University of Oregon, Eugene
1979 G. Ray Hawkins Gallery, Los Angeles
 Camera Obscura Gallery, Stockholm
 Cronin Gallery, Houston
 Centre Georges Pompidou, Paris
 Grapestake Gallery, San Francisco
1980 Paul Cava Gallery, Philadelphia
 Silver Image Gallery, Seattle
 Richard Misrach and Debra Bloomfield, The Photographers' Gallery, London
 Young Hoffman Gallery, Chicago
 G. Ray Hawkins Gallery, Los Angeles
1981 *Colour Photographs*, Galerie Claude Givaudan, Geneva, Switzerland (with Jean-Claude Blanc and Jean-Marie Bustamante)
1982 Grapestake Gallery, San Francisco

Selected Group Exhibitions:

1977 *Summer Light*, Light Gallery, New York
1978 *Mirrors and Windows: American Photography since 1960*, Museum of Modern Art, New York (toured the United States, 1978-80)
1979 *American Images: New Work by 20 Contemporary Photographers*, Corcoran Gallery, Washington, D.C. (travelled to International Center of Photography, New

Richard Misrach: *Hawaii XVII* (original in color), 1978

York; Museum of Fine Arts, Houston; Minneapolis Institute of Arts; Indianapolis Institute of Arts, 1980; and American Academy, Rome, 1981)

Color: A Spectrum of Recent Photography, Milwaukee Art Center, Wisconsin

Landscape Photographers and America's National Parks, White House, Washington, D.C.

1980 *Recent Color Photography*, Sewall Art Gallery, Houston

Beyond Color, San Francisco Museum of Modern Art

1981 *Whitney Biennial*, Whitney Museum, New York

Collections:

Museum of Modern Art, New York; Library of Congress, Washington, D.C.; Smithsonian Institution, Washington, D.C.; Kalamazoo Institute for the Arts, Michigan; Museum of Fine Arts, Houston; ARCO Center for the Visual Arts, Los Angeles; San Francisco Museum of Modern Art; Oakland Museum, California; Crocker Art Museum, Sacramento, California; Centre Georges Pompidou, Paris.

Publications:

By MISRACH: books—*Telegraph 3 a.m.*, Berkeley, California 1974; *A Photographic Book*, San Francisco 1979; *Hawaii*, portfolio, San Francisco 1980; *Richard Misrach: Stonehenge*, portfolio, Emeryville, California 1981; articles—"The Photographer and the Drawing" in *Creative Camera* (London), August 1977; "Richard Misrach," interview, with David Fahey, in *G. Ray Hawkins Newsletter* (Los Angeles), 1979.

On MISRACH: books—*Mirrors and Windows*, exhibition catalogue, by John Szarkowski, New York 1978; *American Images* by Renato Danese, New York 1979; articles—"Eyes of the West" in *New West* (Los Angeles), November 1978; "Stopping the World: Photograph as Myth" by Irene Borger in *Exposure* (New York), Fall 1979; "Richard Misrach: Words and Images" by Carter Ratcliff in *Print*

Collector's Newsletter (New York), January 1980; "Ruins by Night" by Natalie Canavor in *Popular Photography* (New York), May 1980.

Although he began as a documentary photographer with the book *Telegraph 3 a.m.*—which records the active and unique street life of Berkeley in the early 1970's—Richard Misrach is known more for his nighttime studies of cactus, stones, and palm trees. This work, important for its experimental and innovative qualities, established Misrach as a major photographic voice of the 70's. His publication, carrying the nontitle (*A Photographic Book*), is an attempt at a purely visual book. It contains not a single word (or number) on its pages that would compete with the visual images; the necessary information of his name, Library of Congress number, publisher, and price is carried on the book's spine. Inside are equally innovative photographs made at night in desolate reaches of the Mojave Desert, using long exposures and a strong flash to capture scenes only a camera could have recorded.

Formally and stylistically bold, these pictures of desert plants flirt with static compositions by placing the main objects in the center of a square format, and by altering the window-like look of most photographs by including the uneven, black border of the negative. Technically they show a successful experimentation with the process of split toning, giving the pictures a combination of warm reddish-brown hues and cold, silvery tones; and conceptually they emphasize the act of photographing by changing the time reference within the image. Instead of capturing an instant in the night, they subtly suggest passing time by the shooting stars that appear in the night skies, and by the light of dawn that often begins to erode the darkness of the backgrounds. These photographs transform desert cactus into icons, and they convey a secular sort of mysticism which asks viewers to meditate on the object and the scene in the same way the photographer did as the exposure was being made.

The large, color photographs which followed are less about the act of photographing than about the photograph itself. Although they appear to be similar in conception and intent—straightforward pictures of foliage taken at night using strong flash—they are products of a changing consciousness in

photography. These images are about turning the world into pictures. Detached from their subject matter, they examine the process of turning three-dimensional reality into two-dimensional surfaces.

Despite the differences, though, all of Misrach's later works are tied together by his desire to separate photographs from words, ideas, and religious notions. He is an explorer in the realm of the purely photographic image; he wants to strip the image bare until it stands alone, communicating its visual message without the help (or hindrance) of words.

—Ted Hedgpeth

MITCHELL, Michael.
Canadian. Born in Hamilton, Ontario, 3 November 1943. Ecucated at Whitby District High School, Ontario, 1958-63; studied art history, and anthropology, University of Toronto, Ontario 1963-69 (Ontario Graduate Fellowship, 1967-68; University of Toronto Open Fellowship, 1968-69), B.A. 1967, M.A. 1968; anthropological research in Southern Mexico, University of North Carolina, Chapel Hill, 1968-69; photography, Ryerson Polytechnical Institute, Toronto, 1970-72, Advanced Studies Diploma 1972. Married Annick Noelle Kassner in 1976; son: Jake. Freelance art and magazine photographer, Toronto, since 1972. Instructor, Sheridan College, Toronto, 1974-75; Ontario College of Art, Toronto, 1980-82. Board Member, Harbourfront Art Gallery, Toronto, 1979; President, Toronto Photographers' Co-operative, 1980-81; Editorial Board Member, *Photo Communique* magazine, Toronto, 1980-81. Recipient: Ontario Arts Council Grant, 1972; Art Annual Award, Los Angeles, 1976; Award of Merit, Art Directors Club of Toronto, 1977; Award of Excellence (2), *STA 100 Show*, Chicago, 1978. Addresses: (studio) 641 Queen Street East, Toronto, Ontario M4M 1G4; (home) 1 Grant Street, Toronto, Ontario M4M 2H4, Canada.

Individual Exhibitions:

1978 *Nightlife*, Art Galley of Ontario, Toronto (travelled to the London Regional Art Gallery, Ontario; Kitchener-Waterloo Art Gallery, Kitchener, Ontario; Art Gallery of Algoma, Sault Sainte Marie, Ontario; and Woodstock Art Gallery, Ontario)

Selected Group Exhibitions:

1973 *Selected Young Artists of Ontario*, Sir Sanford Fleming College, Peterborough, Ontario

1975 *Zoosight*, Art Gallery of Ontario, Toronto (toured Canada)

Exposure, Art Gallery of Ontario, Toronto (toured Canada)

1976 *Focal Point*, Art Gallery of Ontario, Toronto

1978 *Imagées Colorées*, Optica Gallery, Montreal, Quebec

Tusen och En Bild, Moderna Museet, Stockholm

1980 *Toronto*, Optica Gallery, Montreal, Quebec

Farbwerke, Kunsthaus, Zurich

1981 *Photojournalism*, National Film Board of Canada Gallery, Ottawa

Le Troisième Salon, Jane Corkin Gallery, Toronto

Michael Mitchell: *Black Landscape, Patricia, Alberta* (original in color), 1979

Collections:

Art Gallery of Ontario, Toronto; National Film Board of Canada, Ottawa; Moderna Museet, Stockholm.

Publications:

By MITCHELL: books—*Fighting Back*, portfolio of 20 photos, with text by Graham Fraser, Toronto 1972; *Nightlife*, with an introduction by Allan Porter, Toronto 1978; *Monsters of the Gilded Age: The Photography of Charles Eisenmann*, Toronto 1979; *Singing Songs to the Spirit: The Culture History of the Inuit*, Ottawa 1980; articles—"Legacy" in *Weekend Magazine* (Toronto), November 1977; "At the Grindstone: The Photography of Charles Eisenmann" in *Photo Communique* (Toronto), March 1980; "Round and Round the Telephone Pole: The Photography of Robert Frank" in *Parachute: Art Contemporain* (Montreal), Summer 1980; "The Latinos" in *Today Magazine* (Toronto), October 1980; "The Magic Box" in *Photo Communique* (Toronto), Spring 1981.

On MITCHELL: books—*Exposure*, exhibition catalogue, by Glenda Milrod and others, Toronto 1975; *Tusen och En Bild*, exhibition catalogue, by Ake Sidwall, Sune Jonsson an Ulf Hard af Segerstad, Stockholm 1978; articles—"Michael Mitchell" by Allan Porter in *Camera* (Lucerne), January 1978; "Nightlife" by Thomas Tritscher in *Artmagazine* (Toronto), March 1978; "Sequencing in Nightlife" by David Harris in *Artists Review* (Toronto), March 1978; "Notebook" by Robert Fulford in *Saturday Night* (Toronto), April 1980.

I came to photography late. When I picked up a camera to learn photography, I thought I had found a congenial if somewhat facile medium. However, I soon discovered that the process of arranging a few tones on a small piece of paper so as to make that paper talk was an extremely difficult undertaking. In a few years I was to compound those difficulties by switching to colour. I now worked in a medium that seemed to have no tradition and no satisfactory models. While my photography has continued to address those things that have always concerned photographers—the extraordinary fact of our presence on this planet and what we do to each other while we are here—it has also been very much a visual enquiry into the making of colour photographs. During the seven years that I have been working exclusively in colour, I have attempted to define colour photography by first making visual jokes in colour, and then through several years of making night photographs by flash that pulled colour out of a black limbo. More recently, I have reversed this strategy by making large format colour photographs of landscapes into which I physically insert a large black cube that is both a man-derived presence in landscape as well as an absence of colour and an absence of the very stuff of photography—light.

Before I turned to photography, I spent a number of years vacillating between working in anthropology and doing painting, sculpture and writing. I was torn between two conflicting directions, the attempt to reach some sort of understanding through the analysis of objective record and the desire to comprehend things by exploring the subjective and the expressionistic. Neither path was completely true nor exclusive of the other, and it seems to me now that photography is the perfect embodiment of this tension. While the individual photograph can be viewed simply as an exquisite two-dimensional record of fact—say appearance of a landscape—it can at the same time resonate with deep associative meanings and provoke new experience. I can't think of a more intractable medium to work in nor one that could be so rich.

—Michael Mitchell

It was only in the 1970's that a large number of photographers began to work in colour. With only a limited, largely commercial tradition to draw upon, these photographers adopted various formal strategies to explore the possibilities of colour. Each strategy became a means of testing an aspect of colour, whether as a way of structuring a photograph or of dealing with the experiences of life. The two most recent examples of Michael Mitchell's photographic work—*Nightlife* (1974-77) and a current series of landscapes (begun in 1978)—approach the problem of colour in different ways.

Nightlife consists, for the most part, of portraits made at night. Within a relatively shallow space and against a black background, the forms in vivid colours emerge, each given an additional rawness through the use of flash; extraneous, descriptive information disappears leaving a few vital colours. If the strategy used in this body of work can be characterised as one of simplification and intensification, the landscape photographs work with the camera's ability of recording information within a deep space. A black square was placed in a landscape before each photograph was taken. Depending upon its relative size and position, this square draws attention to a quality of the land, the regularity of a row of trees, the random pattern of stones in a desert landscape. Furthermore, the square occupies an ambiguous spatial position: it is simultaneously a hole punched through the landscape from which all colour is absent and a two-dimensional shape that appears to float in the landscape. The square rests in the landscape and asserts the pictorial flatness of the photograph.

Each formal approach is appropriate to the theme of each series. *Nightlife* deals with the isolation experienced by modern man, whether this isolation is understood in psychological or spiritual terms. Night is the time of day when certain characteristic activities were photographed, and, on a visual level, is the means of visually isolating the figures from their surroundings. This isolation allows the portraits to participate in the larger metaphors of night.

While *Nightlife* treats aspects of a literary theme, the landscape photographs deal with a recurrent subject in Canadian art: the Canadian character has often been understood in terms of the surrounding land. However, colour landscape photography has become largely a calendar art, in which colour is valued for its sentimental associations. The deliberate placement of the black square in the landscape acts as a distancing device, a means of revitalizing what has become a very limiting tradition. The secret beauty of the landscape can once more be seen with fresh eyes.

Although apparently quite disparate, both series deal with colour as a means of synthesizing experiences of life.

—David Harris

MODEL, Lisette.

American. Born Elise Felic Amelie Seybert in Vienna, Austria, 10 November 1906; emigrated to the United States, 1937, and subsequently naturalized. Educated privately in Vienna; studied music with Arnold Schoenberg, Vienna, and for many years associated with his circle, then studied music in Paris; self-taught in photography, from 1937. Married the painter Evsa Model in 1936 (died, 1976). Photographer, under Ralph Steiner, *PM* newspaper, Long Island, New York, 1940-41; freelance photographer, New York, working for *Harper's Bazaar*, *Look*, *Ladies Home Journal*, etc., 1941-53; independent photographer, New York, since 1953. Instructor in Photography, San Francisco Institute of Fine Arts, 1947. Since 1950, Instructor in Photography, New School for Social Research, New York. Recipient: Guggenheim Fellowship, 1965. Honorary Member, American Society of Magazine Photographers, 1968; Honored Photographer, *Rencontres Internationales de la Photographie*, Arles, France, 1978. Address: 137 Seventh Avenue South, New York, New York 10014, U.S.A.

Individual Exhibitions:

1941 Photo League, New York
1943 Art Institute of Chicago
1946 California Palace of the Legion of Honor, San Francisco
1949 Museum of Modern Art, New York (toured the United States)
1975 Focus Gallery, San Francisco
1976 Sander Gallery, Washington, D.C.
1977 Bucks County Community College, Newtown, Pennsylvania
 Galerie Zabriskie, Paris (with Diane Arbus and Rosalind Solomon)
1979 Vision Gallery, Boston
 Port Washington Public Library, New York (with August Sander)
1980 Galerie Fiolet, Amsterdam
1981 Galerie Viviane Esders, Paris

Selected Group Exhibitions:

1940 *60 Photographers: A Survey of Camera Aesthetics*, Museum of Modern Art, New York
1943 *Action Photography*, Museum of Modern Art, New York
1949 *4 Photographers: Model/Croner/Callahan/Brandt*, Museum of Modern Art, New York
1954 *Great Photographs*, Limelight Gallery, New York
1955 *The Family of Man*, Museum of Modern Art, New York (and world tour)
1967 *Photography in the 20th Century*, National Gallery of Canada, Ottawa (toured Canada and the United States, 1967-73)
1975 *Women of Photography*, San Francisco Museum of Art (toured the United States, 1975-77)
1977 *Concerning Photography*, The Photographers' Gallery, London (travelled to the Spectro Workshop, Newcastle upon Tyne)
1979 *Photographie als Kunst 1879-1979*, Tiroler Landesmuseum Ferdinandeum, Innsbruck, Austria (travelled to the Neue Galerie am Wolfgang Gurlitt Museum, Linz, Austria; Neue Galerie am Landesmuseum Joanneum, Graz, Austria; and the Museum des 20. Jahrhunderts, Vienna)
1980 *Photography of the 50's*, International Center of Photography, New York (travelled to the Center for Contemporary Photography, University of Arizona, Tucson; Minneapolis Institute of Arts; California State University at Long Beach; and the Delaware Art Museum, Wilmington)

Collections:

Museum of Modern Art, New York; International Museum of Photography, George Eastman House,

Lisette Model: *Promenade des Anglais,* **1937** Courtesy Sander Gallery, Washington, D.C.

Rochester, New York; Smithsonian Institution, Washington, D.C.; New Orleans Museum of Art.

Publications:

By MODEL: books—*Lisette Model: Portfolio*, 75 photographs, edited by Lunn Gallery, Washington, D.C. 1976; *12 Photographs*, portfolio, with an introduction by Berenice Abbott, Washington, D.C. 1977; *Lisette Model: An Aperture Monograph*, with a preface by Berenice Abbott, designed by Marvin Israel, New York 1979; article—"Letter to the Editor" in *U.S. Camera* (New York), October 1944.

On MODEL: books—*The Family of Man*, edited by Edward Steichen, New York 1955; *Photography in the 20th Century* by Nathan Lyons, New York 1967; *The Snapshot* by Jonathan Green, New York 1974; *Helen Gee and the Limelight: A Pioneering Photography Gallery of the 50's*, exhibition catalogue, edited by Jonathan Bayer and others, London 1977; *Tusen och En Bild*, exhibition catalogue, by Ake Sidwall, Sune Jonsson and Ulf Hard af Segerstad, Stockholm 1978; *A Book of Photographs from the Collection of Sam Wagstaff*, designed by Arne Lewis, New York 1978; *Darkroom 2*, edited by Jain Kelly, New York 1978; *Photographie als Kunst 1879-1979/Kunst als Photographie 1949-1979*, exhibition catalogue, 2 vols., by Peter Weiermair, Innsbruck, Austria 1979; *Instantanés*, exhibition catalogue, by Michel Nuridsany, Paris 1980; *Photography of the 50's: An American Perspective* by Helen Gee, Tucson, Arizona 1980; articles—"Lisette Model, Exploratory Camera: A Rationale for the Miniature Camera" by Minor White in *Aperture* (Rochester, New York), vol. 1, no. 1, 1952; "Lisette Model" by Mary Alice McAlpin in *Popular Photography* (New York), November 1961; "Talking about Lisette" by David Vestal in *Infinity* (New York), March 1964; "Photographs by Lisette Model" in *Creative Camera* (London), November 1969; "Lisette Model: Keeping the Legend Intact" in *Infinity* (New York), January 1973; "Lisette Model" in *Creative Camera Yearbook*, London 1975; "Lisette with Love" by Louis Stettner in *Camera 35* (New York), June 1975; "The Comparative Art of Lisette Model and Barbara Morgan" by Benjamin Forgey in the *Washington Star*, 3 October 1976; "Lisette Model: Re-emergence from the Legend" in *Aperture* (Millerton, New York), September/October 1977; "Lisette Model" by Allan Porter, in special issue of *Camera* (Lucerne), no. 12, 1977.

Lisette Model has made a lasting contribution not only as a photographer, but also as one of the medium's finest teachers. "It is not important whether one likes or dislikes a photograph; the important thing is to find out what it's all about," she has said, and the notion underlies a vital aspect of her talent as a teacher.

She does not talk much about her ways of teaching; she feels about this subject as she does about interviews: she is willing to tell you everything and answer all questions, but in the translation from spoken to written word something is lost—and maybe one should not explain at all.

Diane Arbus was a very close friend and diligent student who started in the mid-1950's attending classes and then had a steady stream of feedback from Lisette, constant contact and discussions, understanding and support that ended only when Arbus died. But Arbus was not at all the only important student to emerge. Others like Charles Pratt, Larry Fink and Rosalind Solomon are taking their places in American photography.

—Allan Porter

MODOTTI, Tina.

Mexican. Born Assunta Adelaide Luigia Modotti, in Udine, Italy, 16 August 1896; emigrated to the United States, 1918, Mexico, 1923. Educated in Austria and Italy, until 1908; studied photography with Edward Weston, *q.v.*, Los Angeles and Mexico City, 1921-25. Married Roubaix (Robo) de l'Abrie Richey in 1917 (died, 1922); Julio Antonio Mella in 1928 (died, 1929); and Carlos Contrera (Vittorio Vidali) in 1929. Worked in a textile factory, Udine, 1908-13 and a silk factory, San Francisco, 1913-14; freelance dressmaker, San Francisco, 1914-17; film actress, appearing in *Tiger Lady* (1921), etc., Hollywood, California, 1920-21; independent photographer and revolutionary activist, associating with Edward Weston, Mexico City, 1922-25, 1927-30; Contributing Editor, *Mexican Folkways* magazine, 1927-30; occasional photographer, Berlin, 1930; relinquished photography while living in Moscow, 1931-34, France, 1934, and Madrid and Valencia, 1935-38; Reporter, *Ayuda* republican newspaper, Madrid, 1936-38, and worked for various underground and revolutionary movements, and for International Red Aid (Socorro Rojo), Madrid, 1936-38; lived in Mexico City, 1939-42. Member, Union GmbH, press photographers association, Berlin, 1930. *Died* (in Mexico City) *6 January 1942.*

Individual Exhibitions:

1924 Aztec Land Shop, Mexico City (with Edward Weston
1925 Museo del Estado, Guadalajara, Mexico (with Edward Weston)
1926 Sal de Arte, Mexico City (with Edward Weston)
1929 National Library, Mexico City
1942 Inez Amor Galleria de Arte, Mexico City
1977 Steichen Gallery, Museum of Modern Art, New York

 Ex Libris, New York (with Edward Weston)

Tina Modotti: *Mexico, 1920's* Print by David Vestal

1978 Galleria dell'Obelisco, Rome
Omaggio a Tina Modotti, at Festival Internazionale delle Donne, Arezzo, Italy
1980 Tina Modetti Rewolucjonistka 1896-1942, Museum of Fine Arts, Lodz, Poland (retrospective)

Selected Group Exhibitions:

1975 Women of Photography, San Francisco Museum of Art (toured the United States)
1980 Masks, Mannequins and Dolls, Prakapas Gallery, New York

Collections:

Vittorio Vidali, Udine, Italy; Museum of Modern Art, New York; International Museum of Photography, George Eastman House, Rochester, New York; Oakland Art Museum, California.

Publications:

By MODOTTI: books—The Book of Robo, contributor, by Roubaix de l'Abrie Richey, with an introduction by John Cowper Powys, Los Angeles 1923; Idols Behind Altars, illustrations, with Edward Weston, text by Anita Brenner, New York 1929; Portrait of Mexico, illustrations, with Manuel Alvarez Bravo and Lupercio, text by Bertram D. Wolfe and Diego Rivera, New York 1937; article—"On Photography" in Mexican Folkways (Mexico City), October-December 1929.

On MODOTTI: books—Tina Modotti: Garibaldina e Artista, with texts by several authors, Udine, Italy 1973; Looking at Photographs by John Szarkowski, New York 1973; Tina Modotti: A Fragile Life by Mildred Constantine, New York 1975; Women of Photography: An Historical Survey, exhibition catalogue, by Margery Mann and Ann Noggle, San Francisco 1975; Omaggio a Tina Modotti, exhibition catalogue, Arezzo, Italy 1978; Tina Modotti: Fotografa e Rivoluzionaria by Vittorio Vidali, Rafael Alberti, Piero Berengo Gardin, Uliano Lucas and Maria Caronia, Milan 1979; The Photograph Collector's Guide by Lee D. Witkin and Barbara London, Boston and London 1979; Tina Modotti Rewolucjonistka 1896-1942, exhibition catalogue, Lodz, Poland 1980; articles—"Edward Weston and Tina Modotti" by Diego Rivera in Mexican Folkways (Mexico City), April/May 1926; "Tina Modotti" in Form, Revista de Artes Plasticas (Mexico City), No. 4, 1927; "Tina Modotti" by Carleton Beals in Creative Art (New York), February 1929; "Tina Modotti" in Transition (Paris), February 1929; "Tina's Trajectory" by David Vestal in Infinity (New York), February 1966; "Ten Photographs by Tina Modotti" in Massachusetts Review (Cambridge), no. 13, 1972; "Sesso, Arte, Violenza e Marxismo," special issue of Bolaffiarte (Turin), 1977.

Many male photographers have had the unsettling experience of showing their wives or girl friends how to take and print photographs, and then of being struck with envy at the strong and beautiful work that promptly resulted. Edward Weston, as far as I know, never said anything like this about Tina Modotti; but that's what happened between them, and he must have felt it. In a very short time her photography was fully equal to his.

Tina Modotti taught him as well as she learned from him. In 1923 she brought him into a circle of painters in Mexico that included Diego Rivera, Dr. Atl, Clemente Orozco, Jean Charlot and many other lively and able artists. This was the first group that recognized Weston's artistry for what it was, and he was duly pleased and impressed.

The Mexican revolution was still hot, and that suited Tina, a revolutionary all her adult life. This led her to make photographs that would not have occurred to Weston: a picture of a workers' demonstration, hundreds of men in sunlit straw sombreros, seen from above; a still life of a guitar, an ear of corn, and a bandolier of rifle cartridges to symbolize the union of art, labor and struggle. Such agitprop ideas now seem trite, but these photographs remain beautiful.

Weston liked workers and peasants almost as much as he liked the poets and painters he knew and took pictures of; he didn't go out of his way to photograph ordinary people. But Tina set out to photograph Mexican Indian women in their daily lives, and did it beautifully.

Her work often shows a forthright vitality seldom found in Weston's work. If you look at his exceptionally strong portrait of the woman poet, Nahui Olín, beside any of Tina's Mexican women, you see that his is a man's view and hers, equally strong, is a woman's.

Not always. I doubt that Tina would have joined any modern women's movement: she already felt free. I think she would rather be considered a photographer than a woman photographer. Some photographs she took on trips made with Weston are hard to tell from his. In general, though, her eye is more relaxed than his, though just as disciplined. Her work is less formal. She made some semi-abstract photographs that go beyond most of his in subtlety and lyricism. Two pale platinum prints of a white church ceiling and stairway are good examples. Perhaps Tina's influence led Weston to make some of his best and least tight photographs while they were together in Mexico.

Tina earned her living after Weston left by photographing paintings—often murals in places that were hard to light and photograph. The excellence of these technically exacting jobs shows that she was a first-class craftsman. It was far from being a case of all feeling and just enough technique to get by. Vision, feeling and craft: she had it all.

Mexico was important to her work. Her few known photographs made in Germany in 1930 seem remote and detached; they lack the guts and immediacy of her Mexican work.

In Europe in the 1930's she stopped photographing to concentrate on political work. She was a devout communist. After several political years spent in Germany, Russia, and civil-war Spain, she returned to Mexico. There she apparently meant to start photographing again; then she died suddenly in 1942.

Her life was dramatic, a spy story full of art, love and death. Anita Brenner, for whose book, Idols Behind Altars, Tina and Weston made many photographs of Mexican folk art, including the wall paintings on pulquerías, spoke of "Tina's trajectory." This was right. Her rise was sudden and high, and she came down as fast. Like the Japanese printmaker Sharaku, she spent only a short time making pictures that are exceptional and will live indefinitely. His main job was acting; hers was revolution.

—David Vestal

MOHOLY, Lucia.

British. Born Lucia Schulz in Prague, in Czech-speaking Austria, now Czechoslovakia; lived in Germany until 1932; moved to Paris, 1933; settled in England, 1934; naturalized 1947. Studied philosophy, philology and art history at Prague University, 1916-18; studied photographic technology, privately, in Weimar, 1923; photographic science/history, graphic art and book production, Akademie für Graphische Kunste and Buchgewerbe, Leipzig, 1924-25; architectural photography and design at the Bauhaus, Weimar, 1923-25, and Dessau, 1926-28. Married the painter and photographer László Moholy-Nagy, q.v., in 1921 (divorced, 1934). Worked as an editorial reader in various publishing houses, including Kurt Wolff and Ernst Rowohlt, in Leipzig and Berlin, 1919-21; created first experimental photograms, with Moholy-Nagy, Berlin, 1922; established private studio for art photography, Dessau, 1925-28; Stage Photographer, State Opera, Berlin, 1928-29; Head of the Photographic Department, Itten School of Art, Berlin, 1929-32. Freelance photographer, London, and Lecturer at the London School of Printing and Graphic Art and the Central School of Arts and Crafts, London, from 1934. Organizer, with Arundell Esdaile, Manuscript Copying Programme, on behalf of the American Council of Learned Societies, stationed at Cambridge and London, 1939-45; subsequently specialized in scientific aspects of photography, and served as Unesco expert for scientific documentation in the Middle East, chiefly at Ankara and Istanbul, 1952-53, 1956-57; English Language Editor, Graphic publishing house, Zurich, 1959-61; Foreign Correspondent, Burlington Magazine, London, 1962-79. Fellow, Royal Photographic Society, 1948; Honorary Member, Association Internationale des Critiques d'Art, 1975; Individual Member, European Society of the History of Photography, 1979. Address: Rotfluhstrasse 10, 8702 Zollikon-Zurich, Switzerland.

Individual Exhibitions:

1979 English Protraits, National Portrait Gallery, London
1981 Architektur Bauhaus/Portraits Deutschland, 20er Jahre/Portraits England, 30er Jahre, Galerie Renée Ziegler, Zurich

Selected Group Exhibitions:

1928 Neue Wege der Photographie, Kunstverein, Jena, Germany
1929 Film und Foto, Deutscher Werkbund, Stuttgart
1968 50 Jahre Bauhaus, Württembergischer Kunstverein, Stuttgart (toured Europe, the United States, and Japan)
1976 Photographs from the Julien Levy Collection, Starting with Atget, Art Institute of Chicago
1978 Neue Sachlichkeit and German Realism of the 20's, Hayward Gallery, London
1979 Film und Foto der 20er Jahre, Württembergischer Kunstverein, Stuttgart (travelled to Museum Folkwang, Essen; Werkbundarchiv, Berlin; Kunsthaus, Zurich; Kunstverein, Hamburg; and Museum des 20. Jahrhunderts, Vienna)
1980 Photokina, Cologne
Avant-Garde Photography in Germany 1919-1939, San Francisco Museum of Modern Art (toured the United States, 1981-82)
1981 Germany: The New Vision, Fraenkel Gallery, San Francisco

Collections:

Neue Sammlung, Munich; Fritz Gruber Collection,

Museum Ludwig, Cologne; National Portrait Gallery, London; Metropolitan Museum of Art, New York; Art Institute of Chicago; San Francisco Museum of Modern Art.

Publications:

By MOHOLY: books—*Bauhaus Books*, co-editor, Weimar and Dessau 1925-30; *A Hundred Years of Photography 1839-1939*, London 1939; *Who's Who in Graphic Art*, co-editor, Zurich 1962; *Marginalien zu Moholy-Nagy/Marginal Notes*, Krefeld, West Germany 1971; articles—"Das Bauhaus Bild" in *Werk* (Zurich), June 1968; "Fragen der Interpretation" in *Bauhaus und Bauhäusler*, edited by Eckhard Neumann, Berne and Stuttgart 1971; "Bauhaus in Rückblick" in *Du* (Zurich), March 1977; "Moholy-Nagy und die Anfänge der Kinetischen Plastik" in *Werk/Archithese* (Zurich), November/December 1979.

On MOHOLY: books—*Photographs from the Julien Levy Collection, Starting with Atget*, exhibition catalogue, by David Travis, Chicago 1976; *Germany: The New Photography 1927-33*, edited by David Mellor, London 1978; *Neue Sachlichkeit and German Realism of the 20's*, exhibition catalogue, edited by Wieland Schmied and Ute Eskildsen, London 1978; *English Portraits*, exhibition leaflet, by Colin Ford, London 1979; *Avant-Garde Photography in Germany 1919-1939*, exhibition catalogue, by Van Deren Coke, Ute Eskildsen and Bernd Lohse, San Francisco 1980; articles—"Lucia Moholy" by Allan Porter in *Camera* (Lucerne), February 1978; "Fotografie am Bauhaus" in *Fotografie* (Leipzig), November 1979; "Modernist Lucia Moholy Rediscovered" by Inge Bondi in *Printletter* (Zurich), May/June 1981; "From the Margins to the Centre: Lucia Moholy" by Margaret Harker in *British Journal of Photography Annual*, London 1981.

Lucia Moholy's work was predicated on acute understanding, shaped into a design which illuminates the subject matter she chose to photograph. Her solutions have the simplicity inherent in visual analysis. Her work is informative, truthful, functional and harmonious. Her mastery of all aspects of the photographic process is evident. The path she chose so many years ago, in 1923, in response to her environment appears to us today sound and efficacious. Her photographic work falls into three categories, portraits, architecture and reportage.

Lucia's portraits are character readings. They are straight-forward, yet intimate. Taken close-up they often show the face only. There are no props to indicate status. They are moulded in light and have a strong graphic element. Psychological insight and distinctive design are judiciously blended and make them memorable. They are divided into two groups, those taken in Germany, dating from 1923 to 1929, and those taken in England from 1935 to 1938. In Germany, Lucia photographed friends and colleagues. In England, her work was partly an attempt at earning a living, but again she was part of the circle she photographed. In Germany, many of her sitters were artists: among them, Theo and Nelly van Doesburg, Florence Henri, Heinrich Jacoby, László Moholy-Nagy, Georg Muche, Franz Roh, Hinnerk Scheper, though also "Mother Mayer" and "Mrs. Binder" and others. In England, they were mainly intellectuals, among them Professor P.M.S. (later Lord) Blackett, Ruth Fry, Edward Garnett, Margaret Goldsmith, Sir Alfred Hopkinson, K.C., The Countess of Oxford and Asquith, Professor Michael Polanyi, and also Mrs. Palmer, charlady.

To date architecture has hardly been celebrated by photography as subject matter. Edouard Baldus, Frederick Evans and Edward Steichen photographed monuments, cathedrals, the Acropolis. Examples of topography and fine photographs of the views of houses are not lacking, but a view alone does not

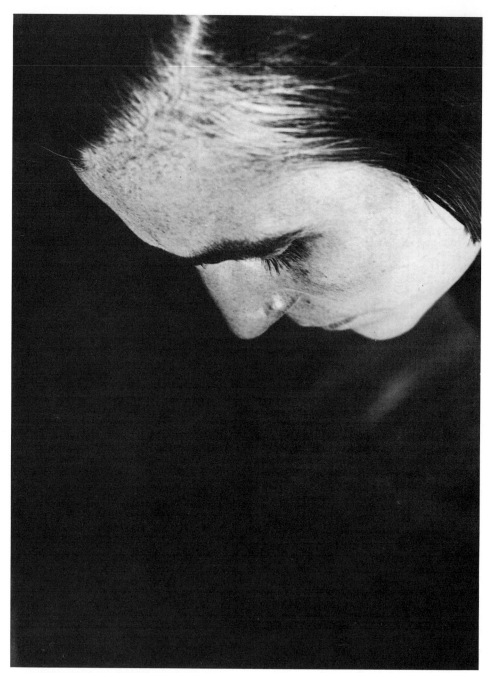

Lucia Moholy: *Portrait of Mrs. Binder*, 1925

exhaust the esthetic and functional values of the building. Lucia Moholy's photographs of the Bauhaus buildings at Dessau do just that. To translate these functional buildings into two-dimensional pictures on 18 x 24 cm. glass negatives required an eye schooled in geometry and stereometry. There is a great deal of architectural knowledge in the conception of these photographs. There is besides this another element, such as the fine-lined reflections of leafless trees in the facade of glass, the clumps of yet unmelted snow in the unplanted soil, which adds a subtle premonition of a new spring these buildings might usher in. Many of those photographs were used to illustrate architectural textbooks. Lately they have come to be appreciated on their own merit.

Lucia Moholy's association with the Bauhaus began in Weimar in 1923, when her husband of two years (married in 1921) was appointed a "Meister" there. She had studied philosophy, philology and history of art in her native Prague and had done work in journalism and publishing. Lucia settled on photography, as satisfying to her inclinations for art as well as science, and, essential to her beliefs, alive

to the spirit of the time and place. To gain practical experience in the different fields of photography, she worked in a commercial studio and to extend her knowledge of the photomechanical processes, she enrolled in the nearby, then famous for these subjects, Akademie für Graphische Kunste and Buchgewerbe in Leipzig. Already the previous year, the young couple had, as a result of their discussions on the properties of productive, as against reproductive application of artistic media, experimented with photograms as a means of expanding visual awareness. Lucia's photographs, the photograms they made together and László Moholy-Nagy's paintings of that period are in the same key of restrained elegance and reserved emotion.

It was Lucia who formulated into precise thoughts and accurate German Moholy-Nagy's much-quoted early writings. With her training in philology, she was at home in German, French, English and Czech; László only in Hungarian, though he spoke broken German. Artistry, not polished thought, was his forte. Intellectual cooperation turned their early years into a heady progression of creative endeavours. Lucia was not only active in photography,

but also gave much of her time, knowledge and experience to the editorial and publishing activities required by the Bauhaus Books. Moholy-Nagy's *Malerei, Photographie, Film* was published in 1925 as No. 8 in that successful series. In No. 12 on the architecture of the Bauhaus itself, *Bauhausbauten, Dessau,* by Walter Gropius, published in 1930, after the Moholys had left, more than a quarter of the photographs are by Lucia. (This latter book was reprinted in 1974 by Florian Kupferberg, Mainz, Germany.)

During the summer of 1930, Lucia, already living on her own, went on a three-month trip to Yugoslavia. She who had started out with 18 x 24 glass negatives now switched to a miniature camera, in order to photograph life and scenery in the by-ways of that then rarely visited country. She traveled all the way to the Albanian border, on the coast and inland into the Velebit Mountains. Whether landscapes or with action, and there is plenty of movement, especially among the gypsies, the photos are composed in keeping with a pleasantly ordered inner discipline. Though the subject matter is varied, this "take" of more than one hundred photographs has the cohesion of a personal style, a balancing between meaning and rhythm. This group, though unknown, is pivotal in the development of Lucia's work. It is the bridge between her Continental and English worlds. Lucia left Nazi Germany in 1933, first for Paris, where she was unable to work, then for England, where she arrived in June 1934.

In spite of hard times in England, Lucia's work soon flourished. In 1938 she was commissioned by the then only three-year-old Penguin paper-back publishers (the first of their kind in England) to write a history of photography. *A Hundred Years of Photography* came out on the eve of the war, selling 40,000 copies within two years. Out of print since, it has been acclaimed by connoisseurs and students who have access to it. It is not generally realized that this is actually the first English-language history of photography. Of course in 1937, the catalogue had been published that, after the war, became Beaumont Newhall's *History of Photography,* but Lucia, living in England, had not heard of it.

Even today, Lucia is more interested in the here-and-now activity of her work than in showing her past performance in photographs, which came to an end in 1938. She is at work on her autobiography, which will supply a great deal of documentation on her activities. Close study of dates reveals already now that she was in fact a perpetual pioneer. When finally all the data of the photography of the 1920's and 30's will have come to light, and have been set side by side, Lucia's portraits, architecture, stage photographs and reportage may turn out to be the most modern in concept of composition and use of light. In her architecture and reportage she was the first to have worked with that kind of depth. It is useful to realize that there was no architectural faculty at the Bauhaus until 1927 and no photography class until 1929, by which time Lucia was already teaching in Berlin.

Like so many emigré photographers, Lucia is missing a considerable number of her negatives. They passed without her knowledge or approval into unqualified hands. She has not yet given up hope of retrieving them.

—Inge Bondi

MOHOLY-NAGY, László.

American. Born László Nagy, in Bacsborsod, near the village of Mohol, South Hungary, 20 July 1895; emigrated to the United States, 1937: naturalized, 1944. Studied law at the University of Budapest, 1913-14, 1918-19; mainly self-taught in photography, in cooperation with Lucia Moholy, from 1922. Served as artillery officer, Austro-Hungarian Army Entertainment Unit, on Russian front and in Italy, 1914-17 (invalided out to Odessa and Galicia, 1917). Married Lucia Schulz in 1921 (i.e., Lucia Moholy, *q.v.*; divorced, 1934); married Sibyl Pietzsch in 1934. Independent painter and writer, associating with Dadaist and Constructivist artists, in Vienna and Berlin, 1919-23; first experimental photograms, with Lucia Moholy, Berlin, 1922, and films, Dessau, 1925; Head of Metal Workshop, then Administrator of Foundation Course, Staatliche Bauhaus, in Weimar, Germany, 1923-25, and in Dessau, Germany, 1925-28; State Designer, Kroll Opera and Piscator Theatres, Berlin, 1928-31; also operated commercial design office, Berlin, 1928-34; Chief Designer, International Textiles, Amsterdam, 1934-35; filmmaker, photographer, advertising and exhibition designer, working for Isokon Furniture Company, Imperial Airways, London Transport, Simpson's Store, etc., London, 1935-37; Founder-Director, New Bauhaus School, Chicago, 1937 (closed, 1938), and School of Design, Chicago (from 1944: Institute of Design, now part of the Illinois Institute of Technology), 1938 until his death, 1946. Contributing Editor, *Horizont* art quarterly, Vienna, 1919; Photography Editor, *I-10* monthly art review, Amsterdam, 1927. Member, Abstraction-Creation art Group, Paris, 1932; American Abstract Artists, 1941-46; Co-Founder, Council for a Democratic Hungary, Chicago, 1943; Director, American Designers' Institute. *Died* (in Chicago) *24 November 1946.*

Individual Exhibitions:

1922 Galerie der Sturm, Berlin
 Kestner-Gesellschaft, Hannover (with El Lissitzky)
1931 Delphic Studios, New York
1934 Stedelijk Museum, Amsterdam (retrospective)
 Hungarian National Gallery, Budapest
 National Museum, Stockholm
1935 Royal Photographic Society, London
1936 London Gallery, London
1937 American Federation of Arts, New York
 New London Gallery, London
1939 Grand Rapids Art Museum, Michigan (with Gyorgy Kepes and Jean Helion)
1947 Guggenheim Museum, New York
 Art Institute of Chicago
1948 Contemporary Art Museum, Houston
1950 *Works of Art by Moholy-Nagy,* Harvard University, Cambridge, Massachusetts
 Rose Fried Gallery, New York
 Colorado Fine Arts Center, Colorado Springs
1953 Kunsthaus, Zurich
1955 Limelight Gallery, New York
1956 Kunstkabinett Klihm, Munich
1957 Kleeman Galleries, New York
1959 Kunstkabinett Klihm, Munich
1961 New London Gallery, London
 Kunsthalle, Mannheim, West Germany
1962 Galleria Blu, Milan
 Kunstkabinett Klihm, Munich
1965 Museum of Fine Arts, Brno, Czechoslovakia
1966 Kunstkabinett Klihm, Munich
1967 Van Abbemuseum, Eindhoven, Netherlands
1968 Marlborough Fine Art, London
1969 Museum of Contemporary Art, Chicago
1971 *Foto Moholy-Nagy,* Galerie Klihm, Munich (toured Germany and the Netherlands)
1974 Württembergische Kunstverein, Stuttgart

(travelled to Kölnischer Kunstverein, Cologne; and Kunstgewerbemuseum, Zurich)
 Hatvan Museum, Hungary
1975 *Photographs of Moholy Nagy from the William Larson Collection,* Claremont College, California (travelled to Pomona College, California; Scripps College, Claremont, California; San Francisco Museum of Art; and University of New Mexico, Albuquerque)
 Magyar Nemzeti Galeria, Budapest
1976 Musée des Arts Décoratifs, Paris
1977 Photogaleria, Madrid
1979 Galerie Breiting, West Berlin
1980 Institute of Contemporary Arts, London (toured Britain)
1982 *William Larson/László Moholy-Nagy,* Center for Creative Photography, University of Arizona, Tucson

Selected Group Exhibitions:

1929 *Film und Foto,* Deutscher Werkbund, Stuttgart
1932 *Modern European Photography,* Julien Levy Gallery, New York
1936 *Fantastic Art, Dada and Surrealism,* Museum of Modern Art, New York
1938 *Bauhaus 1919-1938,* Museum of Modern Art, New York
1959 *Hundert Jahre Photographie 1839-1939,* Museum Folkwang, Essen (travelled to Cologne and Frankfurt)
1976 *Photographs from the Julien Levy Collection, Starting with Atget,* Art Institute of Chicago
1978 *Das Experimentelle Photo in Deutschland 1918-40,* Galleria del Levante, Munich
1979 *Photographie als Kunst 1879-1979,* Tiroler Landesmuseum Ferdinandeum, Innsbruck, Austria (travelled to Neue Galerie am Wolfgang Gurlitt Museum, Linz, Austria; Neue Galerie am Landesmuseum Joanneum, Graz, Austria; and Museum des 20, Jahrhunderts, Vienna)
1980 *Avant-Garde Photography in Germany 1919-1939,* San Francisco Museum of Modern Art (toured the United States)
1981 *Germany: The New Vision,* Fraenkel Gallery, San Francisco

Collections:

Museum of Modern Art, New York; International Museum of Photography, George Eastman House, Rochester, New York; Art Institute of Chicago; Gernsheim Collection, University of Texas at Austin; San Francisco Museum of Modern Art; Sammlung Hattula and Hansruedi Hag-Moholy-Nagy, Zurich; Kunstgewerbemuseum, Zurich; Bauhaus Archive, Darmstadt, West Germany; Museum Folkwang, Essen; Het Sterckshof Museum, Deurne-Antwerp, Belgium.

Publications:

By MOHOLY-NAGY: books—*Malerei, Fotografie, Film,* Munich 1925, as *Painting, Photography, Film,* Cambridge, Massachusetts and London 1969; *Von Material zu Architektur,* Munich 1929, as *The New Vision,* New York 1932; *L. Moholy-Nagy: 60 Fotos,* edited with an introduction by Franz Roh, Berlin 1930; *The Street Markets of London,* with text by Mary Benedetta, London 1936, New York 1972; *An Eton Portrait,* with text by Bernard Fergusson, London 1937, as *Portrait of Eton,* London 1949; *An Oxford University Chest,* with text by John Betjeman, London 1939; *The New Vision: Fundamentals of Design, Painting, Sculpture, Architecture,* London 1939; *A New Vision and Abstract of an Artist,* Chicago 1946; *Vision in*

László Moholy-Nagy: *Berlin Radio Tower*, **1932** Courtesy Art Institute of Chicago

Motion, Chicago 1947; *Moholy-Nagy: Photographs, Photograms and Photomontages*, edited by Beaumont Newhall, New York 1971; *Moholy-Nagy: Photographs and Photograms*, with text by Andreas Haus, Munich 1978, London and New York 1980; articles—"Produktion-Reproduktion" in *De Stijl* (Leiden), July 1922; "Light as a Means of Plastic Expression" in *Broom* (Berlin), March 1923; "Foto-plastische Reklame" in *Offset* (Leipzig), vol. 7, 1926; "Die Beispiellose Fotografie" in *I-10* (Amsterdam), no. 1, 1927; "Fotografie Ist Lechtgestaltung" in *Bauhaus Buch* (Dessau, Germany), vol. 2, no. 1, 1928; "The Future of the Photographic Process" in *Transition* (Paris), February 1929; "Experimentale Fotografie" in *Das Neue Frankfurt*, vol. 3, no. 3, 1929; "Problem des Neuen Films" in *Die Form* (Berlin), vol. 7, no. 5, 1932; "How Photography Revolutionizes Vision" in *The Listener* (London), November 1933; "A New Instrument of Vision" and "From Pigment to Light" in special issue of *Telehor* (Brno, Czechoslovakia), 1936; "Light Architecture" in *Industrial Arts* (London), Spring 1936; "Photography in a Flash" in *Industrial Arts* (London), Winter 1936; "Light Painting" in *Circle: International Survey of Constructive Art*, edited by J.L. Martin, B. Nicholson and N. Gabo, London 1937; "Education and the Bauhaus" in *Focus* (London), Winter 1938; "Painting with Light—A New Medium of Expression" in *The Penrose Annual: 41*, London 1939; "Make a Light Modulator" in *Minicam* (New York), March 1940; "Space-Time and the Photographer" in *American Annual of Photography*, Boston 1942; "The Coming World of Photography" in *Popular Photography* (New York), February 1944; "On Art and the Photograph" in *Technology Review* (Cambridge, Massachusetts), June 1945; films—*Berliner Stilleben*, 1929; *Marseille Vieux Port*, 1929; *Lichtspiel Schwarz-Weiss-Grau*, 1930; *Tonendes ABC*, 1932; *Zigeuner*, 1933; *Architekturkongress Athen*, 1933; *Street Picture, Finland*, 1933; *Life of the Lobster*, 1935; *The New Architecture at the London Zoo*, 1936.

On MOHOLY-NAGY: books—*László Moholy-Nagy*, exhibition catalogue, by Alexander Dorner, Katharine Kuh and Carl Schiewind, Chicago 1947; *Art and Photography* by Sibyl Moholy-Nagy, Chicago 1949; *Works of Art by Moholy-Nagy*, exhibition catalogue, by John Coolidge, Cambridge, Massachusetts 1950; *Moholy-Nagy: Experiment in Totality* by Sibyl Moholy-Nagy, with an introduction by Walter Gropius, New York 1950; *Ungegenständliche Photographie* by Antonio Hernandez, Basle 1960; *Das Bauhaus 1919-1933* by Hans M. Wingler, Cologne 1962; *Bauhaus and Bauhaus People*, edited by Eckhard Neumann, Frankfurt 1964, Berne 1971; *50 Years Bauhaus*, exhibition catalogue, by Wulf Herzogenrath, Stuttgart and London 1968; *Moholy-Nagy*, edited by Richard Kostelanetz, New York 1970 (includes bibliography); *Foto Moholy-Nagy*, exhibition catalogue, edited by Galerie Klihm, Munich 1971; *Moholy-Nagy: Marginal Notes* by Lucia Moholy, Krefeld, Germany 1972; *László Moholy-Nagy: Fotografie, Fotogramme, Fotoplastiken*, edited by Bauhaus Archiv, Berlin 1972; *László Moholy-Nagy* by Hannah Weitenmeier and others, Stuttgart 1974, Paris 1976; *Photographs of Moholy-Nagy from the William Larson Collection*, exhibition catalogue, edited by Leland D. Rice and David W. Steadman, Claremont, California 1975; *László Moholy-Nagy: Pittura, Fotografia, Film* by Giovanni Rondolino, with preface by Giulio Carlo Argan, Turin, Italy 1975; *Photographs from the Julien Levy Collection, Starting with Atget*, exhibition catalogue, by David Travis, Chicago 1976; *Photomontage* by Dawn Ades, London 1976; *Fotografie der 30er Jahre: Eine Anthologie*, edited by Hans-Jürgen Syberberg, Munich 1977; *Das Experimentelle Photo in Deutschland 1918-40* by Emilio Bertonati, Munich 1978; *Germany: The New Photography 1927-33*, edited by David Mellor, London 1978; *Photographen der 20er Jahre* by Karl Steinorth, Munich 1979; *Film*

und Foto der 20er Jahre by Ute Eskildsen and Jan Christopher Horak, Stuttgart 1979; *Experimental Photography*, exhibition catalogue, by Dawn Ades, London 1980; *Avant-Garde Photography in Germany 1919-39*, exhibition catalogue, by Van Deren Coke, Ute Eskildsen and Bernd Lohse, San Francisco 1980; articles—"Film und Foto, Ausstellung des Deutschen Werkbundes" by Karl Sommer in *Essener Allgemeine Zeitung*, 26 May 1929; "Exhibition in Stuttgart and Its Effects" by Andor Kraszna-Krausz in *Close-Up* (London), February 1930; "The Photography of Moholy-Nagy" by Beaumont Newhall in *The Kenyon Review* (Gambier, Ohio), Summer 1941; "Memorial to a Man-Sided Non-Objectivist" by Thomas Hess in *Art News* (New York), June 1947; "Notes on the Life and Work of László Moholy-Nagy, Painter-Universalist" by Siegfried Giedion in *The Architects Yearbook*, London 1949; "From the Bauhaus: László Moholy-Nagy" in *Camera* (Lucerne), April 1967; "Moholy-Nagy and Light-Art as an Art of the Future" by Jasia Reichardt in *Studio International* (London), November 1967; "László Moholy-Nagy: The Bauhaus Tradition" by Gyorgy Kepes in *Print* (New York), vol. 23, no. 1, 1969; "Fragen der Interpretation" by Lucia Moholy in *Bauhaus and Bauhaus People*, edited by Eckhard Neumann, Frankfurt 1964, Berne 1971; "A Portfolio of Images Never Before Published by a Master Who Influenced Modern Design" by Renée Bruns in *Popular Photography* (New York), August 1974; "Photography and Moholy-Nagy's Do-It-Yourself Aesthetic" by Caroline Fawkes in *Studio International* (London), July/August 1975; "Fotografie am Bauhaus" in *Fotografie* (Leipzig), November 1979.

* * *

In his article "Produktion-Reproduktion," published in *De Stijl* (July 1922), László Moholy-Nagy first stated his thesis that "creative endeavors are only valid if they produce new relationships." He proposed to do this in photography by eliminating the object as a reflector of light and fixing the play of light directly on the light-sensitive bromide plate. Moholy's first photographic experiments, begun in 1922 in collaboration with his wife Lucia, were made by placing objects on sensitive photographic paper and exposing them to daylight. He called the results "photograms," a word that had the overtone of compressed communication by its analogy to "telegram." Whether or not Moholy had prior knowledge of similar experiments by Man Ray is yet to be settled, but he clearly developed the process according to his own direction.

In early 1923 Moholy was invited by Walter Gropius to join the faculty at the Bauhaus, where he headed the Metal Workshop and then became director of the foundation course. While at the Bauhaus, he and Lucia continued their experiments with photograms, and Moholy also began to photograph with a camera. During his days as an artist in Berlin from 1920 to 1923 he had been influenced by the abstract art of Lissitzky and Malevich as well as the Russian Constructivists and the collages of Kurt Schwitters. Later, he translated the avant-garde's concerns with texture, light, space and the dynamism of the diagonal into his photographs. Those of the 1925-1930 period are characterized by the odd detail or the unusual perspective. All reveal a strong formal construction. Pictures from Paris, for example, show the high entrance of a cathedral shot as a textured diagonal and the dense iron grillwork of the Eiffel Tower shot from below as an intricate pattern of curved and straight steel lines moving in all directions.

In 1925, Moholy's first book, *Malerei, Fotografie, Film*, was published as Number 8 in the series of Bauhaus books edited by himself and Gropius. In this book, Moholy first outlined his comprehensive photographic program which was to be fully articulated at the Deutsche Werkbund's *Film and Foto* exhibition in Stuttgart in 1929. The premise of the program was that the photograph could reveal that

which could not be observed or would not be noticed by the human eye. Besides the photogram, Moholy mentioned the projection of images on top of each other and side by side, extreme close-ups or unusual angles to reveal unnoticed properties of objects such as texture or form, negative prints, photomontages and various other examples. The book also included photographic samples of these techniques by himself and others.

Following the book's publication, Moholy continued to reveal the unusual properties of objects and people in his photographs and to explore the abstract effects of manipulated light in his photograms. At the same time, he produced a collection of "photoplastics," photographic fragments combined with drawn elements. These had some relation to the photomontages of Hausmann, Hoch and Heartfield, but they were not as dense and had a strong interplay between the fragments and the surrounding space. The emotional situations which Moholy avoided in his photographs and photograms were confronted by him in the "photoplastics," which convey a personal drama absent in his other work. Many of these were collected in the book *L. Moholy-Nagy: 60 Fotos* (1930), edited with an introduction by the critic Franz Roh. For the 1929 *Film and Foto* exhibition, Roh and Jan Tschichold published a collection of photographs called *Photo-Eye*, which illustrated the diverse possibilities of the photograph previously outlined by Moholy.

In a 1923 essay "The New Typography" Moholy presented his concept of "typofoto," a combination of photographs and typography which would provide a more objective communication of subject matter. Moholy criticized books in which the photographs were only secondary and advocated an integration of type and photo with the information to be divided between the two. Moholy's typofoto ideas were brilliantly demonstrated in his three books, for which he selected the photographs and did the layouts: *Malerei, Fotografie, Film*; *Von Material zu Architektur* (1929), published in English as *The New Vision*; and *Vision in Motion* (1947). He also applied the typofoto concept to numerous photographic advertisements and designs for periodicals.

Moholy left the Bauhaus in 1928, and in 1934 he departed Germany for Amsterdam where he experimented with color photography for a Dutch printing firm before moving to England the following year. In England he produced three photographic books, which, unlike his theoretical books, were all documentary collections: *Street Markets of London, An Eton Portrait* and *An Oxford University Chest*. In 1937 he was invited to Chicago to head a new design school based on Bauhaus principles. Called the New Bauhaus, it failed after a year and was reconstituted first as the School of Design and then as the Institute of Design. At the Bauhaus in Germany Moholy had taught photography informally to a few students, but in Chicago photography was instituted as an integral part of the curriculum. Moholy campaigned tirelessly for the new design pedagogy in the United States and was instrumental in the spread of photographic education there. His early death in 1946 at the age of 51 cut short a brilliant career of far-ranging experimentation in many media.

—Victor Margolin

MONASTERIO, Pablo. *See* **ORTIZ MONA-STERIO, Pablo.**

MOON, Sarah.

French. Born Marielle Hadengue, in England, in 1940. Studied drawing in art school; self-taught in photography. Worked as a fashion model in Paris during the 1960's. Freelance fashion photographer, working for designer Jean Cacharel, and for *Marie-Claire, Harper's Bazaar, Nova, Vogue, Elle, Votre Beauté, Stern,* etc., Paris, since 1968. Address: 19 Avenue du Général Leclerc, Paris 14, France.

Individual Exhibitions:

1975 Galerie Delpire, Paris.

Selected Group Exhibitions:

1968 *Modinsolite,* Galerie Delpire, Paris
1972 *Fashion Photography,* The Photographers'
 Gallery, London
 Photokina '72, Cologne
1974 *Women Photographers,* at *Photokina '74,*
 Cologne
1977 *Fashion Photography,* International Mu-
 seum of Photography, George Eastman
 House, Rochester, New York (travelled to
 the Brooklyn Museum, New York; San
 Francisco Museum of Modern Art; Cin-
 cinnati Art Institute, Ohio; and the Mu-
 seum of Fine Arts, St. Petersburg, Flor-
 ida)
1980 *Instantanés,* Centre Georges Pompidou,
 Paris

Collections:

Bibliothèque Nationale, Paris; International Museum of Photography, George Eastman House, Rochester, New York; Fashion Institute of Technology, New York.

Publications:

By MOON: book—*Modinsolite,* Paris 1975.

On MOON: books—*Geschichte der Fotografie im 20. Jahrhundert/Photography in the 20th Century* by Petr Tausk, Cologne 1977, London 1980; *Women On Women,* with an introduction by Katharine Holabird, New York 1978; *The Vogue Book of Fashion Photography* by Polly Devlin, with an introduction by Alexander Liberman, London 1979; *The History of Fashion Photography* by Nancy Hall-Duncan, New York 1979, as *Histoire de la Photographie de Mode,* Paris 1979; *Instantanés,* exhibition catalogue, by Michel Nuridsany, Paris 1980; articles—"Sarah Moon" by Bernard Noel in *Zoom* (Paris), January/February 1972; "A Radical Turn of Fashion in *Photography Year 1976,* by the Time-Life editors, New York 1976.

The arrival of Sarah Moon in the world of fashion photography happened in a remarkable way in 1968. She participated in the *Modinsolite* exhibition organized by Delpire for Kodak, which presented the avant-garde of fashion photography. She had just arrived on the scene, but she very soon made her impression—a new way to look at women, a new way to treat the photographic image, and a totally subjective vision of space.

To women and to fashion Moon attributed aggressiveness; she objected to the "soft" woman, the woman of nuance, dream and mystery. The photos that she produced then for Woolmark and Cacharel, her first clients, helped to transform the image of femininity and were both the product of, and in harmony with, the feminist movement that rejected the image of woman-as-object.

Sarah Moon's own life does not lack originality. Although she trained in art, circumstances caused her to become a model. It was while seeing fashion photographers at work, watching them set their scenes, adjust their lighting, that she learned the basic principles of the trade. She began to take her own pictures, at first only with friends, but photography soon became more than just an avocation. A professional now for more than ten years, Moon always prepares her shots meticulously, very often designing them in detail beforehand. She likes to work with models she knows well with whom she can create a certain intimacy. For her, the quality of relations between people at the moment of the shot is essential to the complicated achievement of her pictures.

The major portion of Sarah Moon's work is commissions for fashion photography or photographs advertising various products for women. In this genre of photography man rarely intrudes his physical presence; instead, he is a mirror, that which makes woman question her own image. As long as the commissions are not too tightly predetermined, with imposed body types or suggestions for how the photos should be accomplished, and as long as there are assurances that the product need not obstruct all other concerns in the photo, then Sarah Moon is willing to take pictures within the constraints of the genre.

A trend in photography is toward a type of work that is more and more interventionist. Moon takes little pleasure in this kind of creation, but she is involved in a personal search. The dream world is very important in her work; her pictures often lead us into a world of little girls who dream of fat cats, a world bewitched. When man appears, then very often the picture moves towards a more disturbing surrealism; a dangerous mystery seems to inhere; we pass from magic to evil spells. These are photographs in which the bizarre and unusual confront ordinary reality.

Technically, Moon was one of the first photographers to attempt to push the sensitivity of color film to its limit in order to obtain the textured effect which brings a certain softness to her pictures. She also frequently employs cinematic shooting techniques, particularly that of back projection, which permit her to create this exceptional world where reality and the dream, nature and the interior of houses, physical space and memory develop an intimate interweaving—denying Euclidean space and carrying us into her own personal space.

—Ginette Bléry

MOORE, David.

Australian. Born in Sydney, New South Wales, 6 April 1927. Educated at Tudor House School, Moss Vale, New South Wales, 1939-40; Geelong Grammar School, Victoria, 1941-45. Served as a seaman in the Royal Australian Navy, 1945-46. Married Jennifer Flintoff in 1955 (divorced, 1968); children: Karen, Michael, Lisa, and Matthew. Assistant, Russell Roberts Photographic Studios, Sydney, 1946-47, and Max Dupain Photo Studio, Sydney, 1947-51. Freelance photographer, in London, 1951-58, and Sydney, since 1958. Recipient: Special Prize, *The World and Its People* exhibition, *World's Fair,* New York, 1965; 5 First Prizes, *Pacific Photographic Fair,* Melbourne, 1967; First Prize, Colour Section, Nikon International Photographic Competition, 1971; Commonwealth Award for Service to Professional Photography, Australia, 1979. Agents: Axiom Gallery, 29 Gipps Street, Melbourne, Victoria 3121; Australian Centre for Photography, 76A Paddington Street, Paddington, New South Wales 2021; Witkin Gallery, 41 East 57th Street, New York, New York 10022, U.S.A.; and Black Star Inc., 450 Park Avenue South, New York, New York 10016, U.S.A. Address: 68 Middle Street, McMahon's Point, New South Wales 2060, Australia.

Individual Exhibitions:

1953 *People in Photographs,* Architectural Asso-
 ciation, London
1958 *Seven Years a Stranger,* Macquarie Galler-
 ies, Sydney (travelled to the Museum of
 Modern Art, Melbourne)
1976 The Photographers' Gallery, London
 Retrospective 1940-1976, Australian Centre
 for Photography, Sydney (travelled to the
 Brummels Gallery, Melbourne, 1976, and
 the Orange, New South Wales *Festival of
 the Arts,* 1977; and toured New Zealand,
 1978-79)
1980 *Photographs by Design,* Axiom Gallery,
 Melbourne (travelled to the Macquarie
 Galleries, Sydney)

Selected Group Exhibitions:

1952 *World Exhibition of Photography,* Kunst-
 museum, Lucerne
1955 *The Family of Man,* Museum of Modern
 Art, New York (and world tour)
1967 *Photography in the Fine Arts,* Metropolitan
 Museum of Art, New York
 Pacific Photographic Fair, Melbourne
1969 *The Perceptive Eye,* National Gallery of
 Victoria, Melbourne
1973 *Work in Progress,* Brummels Gallery, Mel-
 bourne
1975 *Recent Australian Photography,* Department
 of Foreign Affairs, Canberra (toured South
 East Asia)
1979 *The Philip Morris Collection,* outdoor exhi-
 bition, Sydney

Collections:

Art Gallery of New South Wales, Sydney; National Gallery of Victoria, Melbourne; Art Gallery of South Australia, Adelaide; Australian National Gallery, Canberra; Museum of Modern Art, New York; Smithsonian Institution, Washington, D.C.; Bibliothèque Nationale, Paris.

Publications:

By MOORE: books—*Australia and New Zealand,* with Time-Life Editors, New York 1964; *Isles of the South Pacific,* Washington, D.C. 1968; *Finland Creates,* with Jack Fields, text by Pekka Suhonen, Jyvaskyla, Finland 1976.

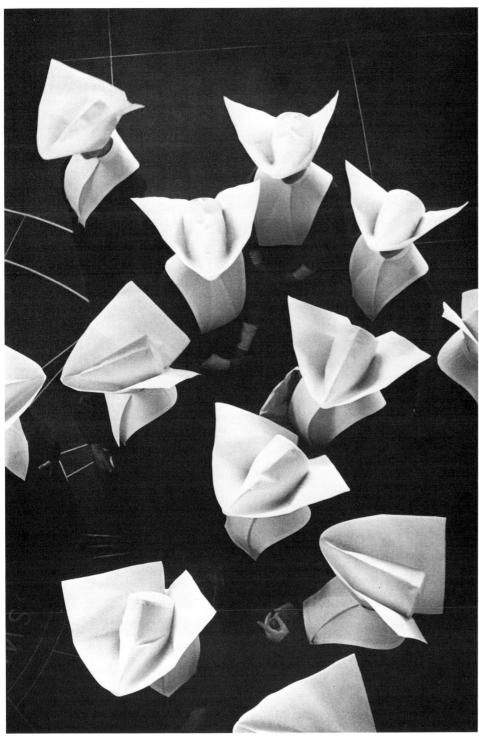

David Moore: *Sisters of Charity*, Washington, D.C., 1956

Sydney photographer David Moore was for many years a photojournalist. He was weaned on the images of Edward Weston, Cartier-Bresson, Eugene Smith and many noted World War II photographers, and for a number of post-war years he prowled the precincts of such magazines as *Life, Look* and *Picture Post*, serving a rough apprenticeship, based mainly in London. On his return to Australia in 1958 he continued working as a freelance, on a worldwide basis, for magazine clients and for several agencies.

Moore works exclusively with 35mm, and, like a number of other documentary photographers, he has passed through a number of phases to reach a partial transformation of his personal vision. His present idiom culminated in a recent exhibition of his work, *Photographs by Design*. His new images embrace the abstract and are largely in sharp contradiction to his earlier work.

The son of an architect, Moore very nearly adopted that profession, and his new black-and-white images show variations that embrace a strong architectural theme: he has deliberately cut out and shifted shapes to suit himself in the form of clinical collages, which relate not only to design but also to reality and sometimes deliberately evade the perimeters of the print itself.

These works indicate an acceptance of discipline that distills an essence from the ordinary and an appreciation of pure visual form which indulges in an arbitrary method of manipulating subject matter in tonal and spatial relationships. He embraces form and content as a whole.

Moore feels today that the documentary type photograph "ended up dulling our responses to pictures." He further comments that a "new photographic intellect is emerging" that allows "the viewer to become personally involved instead of becoming a voyeur of life through the open window of the photograph," that the new photographic intellectuals are "concerned with the soft spread of time rather than the selected moment."

Yet, to appraise Moore's work as a whole, it seems necessary, also, to appreciate his earlier stimulating images of people relative to their environment who also communicate with the viewer. Photography is primarily concerned with communication, and although Moore's earlier work may appear more human and emotional, it is perhaps just as valid as his abstract work and may prove more valuable in the future.

—Laurence Le Guay

On MOORE: book—*David Moore*, edited by Ian McKenzie, Melbourne 1980; articles—"David Moore" in *Camera* (Lucerne), August 1968; "David Moore" by John Williams in *Art and Australia* (Sydney), July/September 1976; "David Moore," in *Photo-Forum* (Auckland), October/November 1977.

Photographers are inevitably influenced by the work of fellow photographers and quite often by other examples of creative expression. Fortunately, my own influences have been many and varied since the late 1940's when I first began to regard photography as a serious occupation.

The study of photographs by Edward Weston and Walker Evans opened doors which led on to Dorothea Lange, Brassaï, Kertész, Brandt, Cartier-Bresson, Newman and Callahan. Additionally, documentary films such as *The River, The Plough That Broke the Plains* and *Louisiana Boy* were strong, early influences.

During the 1960's and 1970's contemporary painters and sculptors imparted a stimulation which tended to alter my perspective to photography. Alexander Calder and Ellsworth Kelly were two such artists.

A family background of architecture, coupled with a close association with designers, has tended to discipline my photography in formal areas. Photojournalism (which I practised for many years) has ceased to hold a position of supremacy in my interest today. Whilst I shall continue to recognize the importance of documentary evidence in photography, I am personally more interested in what can be done with the photograph from an intellectual point of view.

—David Moore

MOORE, Raymond.
British. Born in Wallasey, Cheshire, 26 August 1920. Studied design at Wallasey School of Art, 1937-40; Royal College of Art, London, 1947-50, A.R.C.A. 1950; studied with Minor White, Massachusetts Institute of Technology, Cambridge, 1970. Served in the Royal Air Force, 1940-46. Freelance photographer since 1955. Lecturer in Creative Photography, Watford College of Art, Hertfordshire, 1956-74; Senior Lecturer in Creative Photography, Trent Polytechnic, Nottingham, 1975-78. Recipient: Arts Council Bursary, 1978. Address: 30 Eden Street, Stanwix, Carlisle CA3 9LR, England.

Individual Exhibitions:

1959 Regent Street Polytechnic, London

1962 Artists International Association Gallery, London
1967 *Modfor 1: Raymond Moore*, R.W.S. Gallery, London (toured the U.K. and Europe)
1968 Welsh Arts Council Gallery, Cardiff (toured the U.K.)
1970 International Museum of Photography, George Eastman House, Rochester, New York
1971 Carl Siembab Gallery, Boston
Art Institute of Chicago (retrospective)
1973 The Photographers' Gallery, London
1976 Thackrey and Robertson, San Francisco
1977 *3 Photographers: Cooper, Hill, Moore*, Focus Gallery, San Francisco (with Thomas Joshua Cooper and Paul Hill)
1978 The Photographic Gallery, Cardiff
1980 Salzburg College, Austria
1981 Hayward Gallery, London (retrospective)
1982 Royal Photographic Society, Bath

Selected Group Exhibitions:

1975 *The Land: 20th Century Landscape Photographs Selected by Bill Brandt*, Victoria and Albert Museum, London (travelled to the National Gallery, Edinburgh; Ulster Museum, Belfast; and the National Museum of Wales, Cardiff, 1976)
1977 *Photographs: Sheldon Memorial Art Gallery Collection*, University of Nebraska, Lincoln
Concerning Photography, The Photographers' Gallery, London (travelled to Spectro Workshop, Newcastle upon Tyne)
1979 *Three Perspectives on Photography*, Hayward Gallery, London
1980 *Metaphysical Presence*, in Grupa Junij '80, Ljubljana, Yugoslavia
Première Triennale Internationale de Photographie, Charleroi, Belgium

Collections:

Victoria and Albert Museum, London; Welsh Arts Council, Cardiff; Contemporary Art Society for Wales, Cardiff; University College of Wales, Aberystwyth; Bibliothèque Nationale, Paris; Art Institute of Chicago; Gernsheim Collection, University

of Texas at Austin; University of New Mexico, Albuquerque.

Publications:

By MOORE: articles—"Photographs by Raymond Moore" in *Creative Camera* (London), June 1973; interview, with Ian Jeffrey, in *Creative Camera* (London), March/April 1981.

On MOORE: books—*The Concise History of Photography* by Helmut and Alison Gernsheim, London and New York 1965; *Photographs by Raymond Moore*, exhibition catalogue, Cardiff 1968; *Colour Photography* by Eric de Maré, London 1968; *Art Without Boundaries* by Gerald Woods, London 1972; *The Magic Image* by Cecil Beaton and Gail Buckland, London and Boston 1975; *Concerning Photography*, exhibition catalogue, by Jonathan Bayer, Peter Turner, Ian Jeffrey, and Ainslie Ellis, London 1977; *Photographs: Sheldon Memorial Art Gallery Collection*, exhibition catalogue, by Norman A. Geske, Lincoln, Nebraska 1977; *Geschichte der Photographie im 20. Jahrhundert/History of Photography in the 20th Century* by Petr Tausk, Cologne 1977, London 1980; *Exploring Photography* by Bryn Campbell, London 1978, New York 1979; *Creative Techniques in Landscape Photography* by Gerald Woods and John Williams, London 1980; articles—"The Light and the Vision: The Work of Raymond Moore" by Robert D. McClelland in *British Journal of Photography* (London), 29 August 1969; "Tides of Man and Nature" by Minor White in *Penrose Annual*, London 1971; "Photographs by Raymond Moore" in *Creative Camera* (London), June 1972; "Portfolio: Raymond Moore" in *Camera* (Lucerne), August 1976; "Raymond Moore" in *Creative Camera Yearbook*, London 1977; article by Clive Lancaster in *British Journal of Photography* (London), 5 June 1981.

The single perceptive photograph can suggest the presence of a world that remains almost invisible because of our human limitations defined by time and space. Human fragility and the practical demands of life seldom render us capable of reacting with sufficient awareness to record the image of a happening at maximum intensity. In fact, we spend most of our lives in blinkers, insensitive to the import of what is around us. If we were only capable

of transcending our space-time limits to some extent, we could witness happenings undreamt of. At this moment there must be fantastic relationships between the things we call objects, but no-one there to record them. Natural happenings eclipsed and lost in time. All we can do is to cultivate a state of awareness within ourselves, and allow the images to come through unfettered. Amongst the dross, the pertinent ones will serve as hints or signposts to a state of greater visual perception.

Photographs, and particularly groups of photographs, can serve as catalysts to thought and feeling; their limits are measured simply by the persons taking them. Whether the viewer's reaction is exactly the same as the photographer's is immaterial, as long as the photographs are sufficiently provocative to produce some reaction and increased awareness. They occur through the person (both photographer and viewer) just as much as the image is created through the lens. The person is like a very particular lens. Keep the lens clean and uncluttered by preconception. The more preoccupied you are the less freedom you have to act. Only the relaxed mind and body can truly react. Conscious preconception means insensitivity to the ever-present NOW.

—Raymond Moore

Raymond Moore talks about his work sparingly and well. He describes his subject as the "no man's land between the real and fantasy—the mystery in the commonplace—the uncommonness of the commonplace" (Welsh Arts Council catalogue, 1968). In a recent interview with Ian Jeffrey he spoke of being drawn to an "edge of civilization" where obvious valuations do not apply. "If I were dropped into a slum area I don't think I'd want to photograph. I'd have to move out towards the edge. Definite statements have something of preaching about them. I prefer to tease out or to unravel what's going on" (*Creative Camera*, March/April 1981). His photographs are neither documentary nor realist but as a collective whole form a precise and poetic interpretation of chosen aspects of post-war Britain. Moore's Britain is a land of dislocation, spiritual absenteeism, ambiguous signs and economic amnesia. He sets himself to discern new patterns and new life in all this. A method of chance collage brings the ordinary evidence of experience into relationship—not by gluing fragments together but by observing symmetries, superimpositions and likenesses.

A critic wrote in response to Moore's major Hayward Gallery exhibition of 1981 that the photographs brought to mind this line from Wallace Stevens: "a little string speaks for a crowd of voices" (Clive Lancaster, *British Journal of Photography* 5 June 1981). The quotation aptly evokes Moore's art of implication, which is strikingly linear and has analogies with music. Speaking of certain passages in Arnold Bax, Moore said that he discovers "other people's work through my own, and generally find more to dwell on and to hold onto within music and poetry than photography." The perfectionism of Moore's use of the tonal scale in his exhibition prints makes them among the most satisfying anywhere today.

The following stylistic pointers may be useful. Moore was trained as a painter in the 1940's and speaks of the style he adopted (he destroyed his paintings later) as deriving from the Euston Road School of the previous decade, which took the surface of urban life as subject. As if in reaction to this, a period of pure abstraction followed in the 1950's. He was impressed by the brave effort to find a new direction for photography of Otto Steinert (*Subjektive Fotografie*, 1952). Other significant points of contact are with aspects of Nash, Kertész, Callahan and Bravo. Moore developed from the experimental geometry of his early photographs (1956) to pictures which are deeply marked by urban life and more intricately ordered in line, plane and tonality. His photographs digest more and more of appearance, notably of the North West, while assuming more

Raymond Moore: *Hampshire*, 1973

surprising freedom of structure. What Jonathan Williams calls "the pleasing democracy of content" in Moore's photographs involves a place for his achievement in the social as well as art histories of this period.

—Mark Haworth-Booth

MORATH, Inge(borg).

American. Born in Graz, Austria, 27 May 1923; moved to the United States, 1962: naturalized, 1963. Educated in Alsace, Darmstadt and Berlin; studied romance languages at Berlin University, and the University of Bucharest. Married the journalist Lionel Birch in 1951 (divorced, 1954); the playwright Arthur Miller in 1962; daughter: Rebecca. Worked as a cleaner, farmhand, etc., on compulsory labor service, East Prussia, and did war service in aircraft factory, Tempelhof Airdrome, Berlin, during World War II; Editorial Translator and Interpreter, United States Information Service Publications, Salzburg, Austria, 1946-49; freelance radio writer for Red-White-Red Radio Network, and Literary Editor, *Der Optimist* magazine, Vienna, 1950; Austrian Editor, *Heute* magazine, Vienna, 1951; photographic apprentice to the photojournalist Simon Guttman, London, 1952. Since 1953, Member of Magnum Photos, Paris and New York, and freelance photographer, working for *Life, Paris-Match, Holiday, Saturday Evening Post*, etc., in Europe and the United States. Researcher and assistant to photographer Henri Cartier-Bresson, on numerous trips throughout Europe and the United States, 1953, 1954. Lecturer, Cooper Union, New York, 1971-72. Agent: Neikrug Gallery, 224 East 68th Street, New York, New York 10021. Lives in Roxbury, Connecticut. Address: c/o Magnum Photos, 251 Park Avenue South, New York, New York 10010, U.S.A.

Individual Exhibitions:

1956 Wuehrle Gallery, Vienna
1958 Leitz Gallery, New York
1959 Overseas Press Club, New York
1964 Art Institute of Chicago
1969 Oliver Wolcott Memorial Library, Litchfield, Connecticut
 Russia, Rizzoli Gallery, New York
1971 Andover Art Museum, Massachusetts
1972 University of Miami
1974 Power Center for the Performing Arts, University of Michigan, Ann Arbor
1976 Carlton Gallery, New York
 Neikrug Gallery, New York
1979 *Photographs of China*, Grand Rapids Art Museum, Michigan
1980 *Photographs of China*, Kunsthaus, Zurich
 Photographs of China, Museum des 20. Jahrhunderts, Vienna

Selected Group Exhibitions:

1956 *Magnum Photographers*, at *Photokina*, Cologne
1960 *The World as Seen by Magnum*, Takashimaya Department Store, Tokyo (and world tour)
1967 *The Camera as Witness*, at *Expo '67*, Montreal

Collections:

Metropolitan Museum of Art, New York; International Center of Photography, New York; Rhode Island School of Design, Providence; Fogg Art Museum, Harvard University, Cambridge, Massachusetts; Art Institute of Chicago; Bibliothèque Nationale, Paris; Kunsthaus, Zurich.

Publications:

By MORATH: books—*Guerre à la Tristesse/Fiesta in Pamplona*, with text by Dominique Aubier, Paris 1954; *Venice Observed*, with text by Mary McCarthy, Lausanne, Paris and New York 1956; *Bring Forth the Children*, with Yul Brynner, New York 1960; *Tunisia*, with Marc Riboud and André Martin, texts by Claude Roy and Paul Sebag, Paris and New York 1961; *From Persia to Iran*, with text by Edouard Sablier, New York 1961, Paris 1967; *Le Masque*, with Saul Steinberg, Paris 1967; *In Russia*, with text by Arthur Miller, Lucerne, New York and London 1969, 1974; *East West Exercises*, with text by Ruth Bluestone, New York 1973; *In the Country*, with text by Arthur Miller, Lucerne, New York and London 1977; *My Sister Life*, with translations of Boris Pasternak poems by Olga Andreyev Carlisle, New York 1977; *Chinese Encounters*, with text by Arthur Miller, New York and Lucerne 1979; article—"Anti-Photographer Masks," with Saul Steinberg, in *Creative Camera* (London), February 1969.

On MORATH: book—*Grosse Photographen unserer Zeit: Inge Morath*, edited by Raoul Martinez, text by Olga Carlisle, Lucerne and Frankfurt 1975; articles—"A Collection of Photographs" in *Aperture* (Millerton, New York), Fall 1969; "Inge Morath" in *Camera* (Lucerne), November 1969; "New England Heute: Zehn Aufnahmen von Inge Morath" in *Du* (Zurich), March 1973.

Perhaps I can do my life like a telegram:
 Both parents scientists, of old Austrian families, gave me a sense of structure, form, from which to imagine the new. They moved about Europe, so my school was French one year, German next, and I bilingual and patriotically bi-partisan, detached. Longed for China after uncle returned with immense Oriental tales, and grandmother, an early suffragette, occultist, bridge champion further widened door-

way to life's infinities. Finished high school in Berlin, followed by Hitler regime's obligatory year of "labor service," cleaning latrines, milking cows, shovelling manure in eastern Prussia. Incredibly idiotic military discipline. Enter Berlin University, studying romance language, plus semester at University of Bucharest, finishing exams under heavy bombing which destroyed home, one younger brother died. Drafted to war service in aircraft factory at Tempelhof Airdrome, finally ended it by joining refugee trek for weeks on foot, reunited with parents in Salzburg, then controlled by U.S. Third Division.
 Vienna euphoric then for young people no longer marching in step. Unbounded energy, everything possible, we were like prisoners freed. Job as editorial translator-interpreter U.S. Information Service, radio writing, magazine articles for political-literary *Der Optimist*, finally Austrian editor *Heute* magazine. Text for photographs Erich Lessing, Ernst Trabant brought attention of Robert Capa, who invited Haas and me to join his new photographers' co-operative, Magnum Photos, in Paris. New friends there were David Seymour, George Rodger, Henri Cartier-Bresson, whose assistant and researcher I later became. Still pre-Cold War, we shared common suffering of war and hope of humane consciousness rising, so photography was both tool and its beauty a magical blow against destructiveness, a deep basis for sharp standards and self-discipline. Moving over Europe on stories with Haas, sometimes in box cars on bread and sausage or sumptuously dining in exquisite places when editors came, movie directors, one week Hamburg, the next Italy, now starting to see texts in English, learning to read contact sheets. Reading always—Rilke, Musil, Kafka, Trakl, Mann, Ortega y Gasset when still in Austria, seeing first astounding American play by Saroyan, see Brecht, Hans Weigel's satires, and the education of the coffee house, Ingeborg Bachmann's lyric poems and Arnold Keyserling's Oriental philosophy. Marriage to Lionel Birch, English journalist, spurred reading Shaw, Shakespeare, study of cricket and country pubs and upper class stuttering, but it was a mistake which Houseman, Yeats, Joyce could not mend, and we divorced in a year. The English girls more independent than we were, sexually more related, whimsical, wilful, eccentric. Despite many English friends I missed photographers. At Tate Gallery, British Museum, galleries often looking at paintings to rinse my eyes but I was not a born painter. Finally took out my second-hand Contax, long-owned Christmas present, and found a language. Became apprenticed to Simon Guttmann in

Inge Morath: *Soldiers on Yuan Dynasty Maitreya on "Peak That Flew Here from Afar,"* Hangzhou, China, 1979

London, one of the founders of the *Berliner Illustrierte* considered "Father of Photo-Journalism," quirky and old, had Bob Capa working for him and taught me mercilessly, also how to throw sixpence in gas heater for heating his shaving water, also that a photo comes from inside. Important because I was ashamed to speak German after the War, a millstone of guilt, so a picture was like daring to say "love."

Great event was Robert Capa's inviting me to join Magnum now as a photographer on strength of my pictures and text on French workman priest which was three months in doing. Living in hotels, small digs, did movie coverages, stories, any assignment that came along from roses in the Parc de Bagatelles to Soho and Mayfair. Plus working with Henri Cartier-Bresson as researcher and taking my own pictures. Now I had enough metier to absorb the essence. A hunting running, flying time; from Bresson and my own education and spirit came the conviction of composition, the constant alert, truth to the subject, ruthlessness when there was something to photograph. Cartier-Bresson's endless patience till he found the right place from which to photograph a Castilian landscape. Plus reading Aragon now, André Breton and Dad, Gerard de Nerval, Agrippa d'Aubigne, Koestler, Sartre, Gide, de Beauvoir, Camus, Rene Char, Michaud. The Louvre for the eyes, the Orangerie, the provincial museums, the Loire Valley, Normandy, Montherlant, Moliere, Louis Jouvet, the Pitoeffs, the streets of Paris, cabarets, nightclubs, food, wine, bistros. I buy my own apartment in Paris.

And new friends in the Calders, Janet Flanner, editor Robert Delpire, Americans living in Paris, Marie Louise Bousquet, masterful Teriade, editor of *Verve*, struggling with Cartier-Bresson and producing *The Decisive Moment*. His house in St. Jean Cap Ferrat with the tree Matisse painted in his dining room corner to make it look bigger and Chagall's paintings in the salon to match his flowers. For editor Robert Delpire my first book, *Fiesta in Pamplona*, with Dominique Aubier's profound text, and first big story on a woman, Mercedes Formica, Spanish lawyer. Robert Capa announces me as fully fledged.

Fluent now in Spanish, immersion in Spanish culture. Reading Lorca, Gongora, Cervantes, Unamuno, Spinoza. The Prado, the great private collection, the light of Zurbaran, films of Bunuel and others forbidden in Nazi time. All over Spain, on foot, Landrover. Meet Balenciaga and become elegant. *From Persia to Iran*, after *Venice Observed* with Mary McCarthy. Photographing in U.S., South Africa, Middle East, Mexico, South America, another book *Tunisia*, another on refugees with Yul Brynner. Learn much from Gjon Mili in New York, as a person and first great technician I met, musical evenings with Sascha Schneider and great Chinese food, Saul Steinberg, a one-man civilization, meet the New York Magnums, Cornell Capa now in charge after Bob's death, meet Dave Duncan and Bernie Quint from *Life*, that fortress of photojournalism and a room full of photographic equipment like out of a mad dream. Grateful to people at *Holiday* magazine for wonderful assignments. Learn about strobes and posing actors from Mili. Stay no longer anywhere than time needed for photographing, many hellos, adieus, letterwriting, airplane and train reading of American novelists, hear first real jazz in Harlem. My rusty university Rumanian serves well while doing big story of River Danube from source to the Delta embracing North European to Slav to Latin cultures which are combined in my own Austrian family and roots. Back with Cartier-Bresson for a cross U.S. car trip and covering movie *The Misfits* with other Magnums.

Marry Arthur Miller, January 1962, living in Chelsea Hotel at first, continuing work as before until daughter Rebecca is born, then photographing closer to home. A complete record of Kazan's production of Arthur's play *After the Fall*, and begin *Connecticut* as seen by strange European. New friends, the Harrison Salisburys, Robert Osbornes,

Olga and Henry Carlisle, Francine and Cleve Grey, Libermans, Styrons and new-old Calders who are neighbors. Growing differently now, more plant-like, in one place. Fascinating to live with the different vision of the writer. Nostalgia for Europe so annually we travel there, twice to Russia. Learn Russian with Olga Carlisle. Book *In Russia* with Arthur's text. We three to Hong Kong, Japan, Thailand, Cambodia just before it blows up. Studying Chinese now, waiting for our visas. Teach two courses at Cooper Union, lecture at Wilson Hicks Conference in Miami. Preparing show for Neuberger Museum in Purchase, New York. Am now a photographer for twenty years, drawn to the dream-like, the static in the flow, the soul in the landscapes, rooms, faces. Like what one aims at in meditations, the eternal interior. To free myself of beloved traditions, discovering them again as my own inventions, so as to go on growing.

—Inge Morath

Inge Morath shares with a number of her fellow photographers the gift of "capturing" places and things as well as people. Her images of the Middle East reveal a profound ability to picture things in such a way that we are allowed to see what we haven't actually experienced: ducks perched on a laundry ledge; fabric drying in the sun; an elaborate, people-less room of chandeliers and glass; rug-making and weaving; architectural ruins; "knights of muscle"; oil-responsible "modernity." She has a brilliant sense of place, of the surprising couched in the commonplace, whether it be Africa or Russia or New England.

Ordinary people at their business of being human or celebrated artists are equally interesting as a result of her insight. A detail of architecture, a cart full of musicians, create for us an instant of participation. In Russia—students, a horse-drawn sleigh, prison guards, a statue against trees, Dostoevsky territory, Onegin's bench, Leningrad seen from a fortress roof, Pasternak's grave strewn with flowers and fruit—all testify to Morath's special talent.

And in her book of "illustrations" for poems by Pasternak she achieves superb "equivalents" to linguistic passion, images of great clarity and enhancement. A blue glass supporting a spray of lilies of the valley. A wedding. The peculiar stare of family photographs. Wild blackberries. A person seated at the piano. All commonplace things brought to rarity.

—Ralph Pomeroy

MORGAN, Barbara.

American. Born Barbara Brooks Johnson in Buffalo, Kansas, 8 July 1900; grew up in Southern California. Educated at Pomona High School, California, 1917-19; studied art at the University of California at Los Angeles, 1919-23; mainly self-taught in photography. Married the photographer Willard D. Morgan in 1925 (died, 1967); sons: Douglas and Lloyd. Painter and occasional photographer, Los Angeles, 1923-30; also, Art Instructor, San Fernando High School, California, 1923, 1924, and Instructor in Design, Landscape and Woodcut, University of California at Los Angeles, 1925-30, and Writer, Managing Editor, then Editor, *Light and Dark* magazine, U.C.L.A., 1928; moved to New York, 1930, and established studio there, 1931; concentrated on painting, 1925-35 (one-man show of

paintings and graphics, Mellon Gallery, Philadelphia, 1934, and Sherman Gallery, New York, 1961); full-time photographer since 1935; established studio in Scarsdale, New York, 1941. Member, Photo League, New York, in the 1930's. Photo Picture Editor, Morgan and Lester, subsequently Morgan and Morgan Inc., publishers, Hastings-on-Hudson, New York, in the 1940's, and Co-Owner, with Willard D. Morgan, Morgan and Morgan Inc., 1950-60. Recipient: Trade Book Clinic Award, American Institute of Graphic Arts, 1941; National Endowment for the Arts Grant, 1975. Fellow, Philadelphia Museum of Art, 1970. D.F.A.: Marquette University, Milwaukee, 1978. Address: Barbara Morgan Studio, 120 High Point Road, Scarsdale, New York 10583, U.S.A.

Individual Exhibitions:

1938 *Dance Photographs*, Y.M.H.A., Lexington Avenue, New York

1939 *Dance Photographs*, University of Minnesota, Minneapolis
 Duke University, Durham, North Carolina
 Kamin Dance Gallery, New York
 A Portfolio of the Dance, Columbia University, New York
 Wheaton College, Norton, Massachusetts

1940 Dock Street Theatre, Charleston, South Carolina
 Greenwich Library, Connecticut
 Photographs of the Dance, Photo League, New York
 Pratt Institute, Brooklyn, New York
 University of Minnesota, Minneapolis

1941 Wesleyan University, Middletown, Connecticut
 Baltimore Museum of Art

1943 *Modern Dance in Photography*, Carleton College, Northfield, Minnesota
 Y.M.H.A., Lexington Avenue, New York

1944 Black Mountain College, Beria, North Carolina
 The Dance, at the *1st Annual Arts Forum*, Women's College, University of North Carolina, Greensboro

1945 Jewish Community Center, Detroit
 Modern American Dance, Museum of Modern Art, New York (travelled to the United Nations Conference, San Francisco, then toured Latin America)

1946 University of Redlands, California
 University of Minnesota, Minneapolis
 University of Wisconsin, Madison
 Dance Photographs, at the *World Youth Festival*, Prague

1952 *Summer's Children*, Bankers Federal Savings and Loan, New York
 Summer's Children, New York Public Library

1955 *Summer's Children*, International Museum of Photography, George Eastman House, Rochester, New York

1956 *Summer's Children*, Kodak Center, Grand Central Terminal, New York

1957 Parents' Magazine Gallery, New York

1959 *Dance Photographs*, at the *12th American Dance Festival*, Connecticut College, New London

1962 Arizona State University, Tempe

1964 International Museum of Photography, George Eastman House, Rochester, New York
 Société Française de Photographie, Paris

1965 Briarcliff Public Library, Briarcliff Manor, New York
 Carnegie Institute of Technology, Pittsburgh
 Paintings and Photographs, Ceejee Galleries, Los Angeles
 Center for Photographic Studies, University of Louisville, Kentucky

1969 Long Island University, Brooklyn Center,

Barbara Morgan: *Martha Graham: Letter to the World (kick)*, 1940

New York
Spectrum 2, Witkin Gallery, New York (with Naomi Savage and Nancy Sirkis)
1970 *Barbara Morgan: Women, Cameras and Images IV*, Smithsonian Institution, Washington, D.C.
Friends of Photography Gallery, Carmel, California
1971 831 Gallery, Birmingham, Michigan
Montclair Art Museum, New Jersey
Phoenix Evening College, Arizona
Utah State University, Logan
1972 Amon Carter Museum, Fort Worth, Texas
Focus Gallery, San Francisco
Museum of Modern Art, New York
Ohio Silver Gallery, Los Angeles
1973 Pasadena Art Museum, California
1974 Institute of American Indian Art, Santa Fe, New Mexico
1977 Gallery, Hastings-on-Hudson, New York
Marquette University, Milwaukee, Wisconsin
University of Nebraska, Lincoln
1979 Ohio University College of Fine Art, Athens
Photomontages, International Museum of Photography, George Eastman House, Rochester, New York
Baldwin Street Gallery, Toronto
1980 Vision Gallery, Boston
1981 *Photomontages et Danses*, Galerie Zabriskie, Paris

Selected Group Exhibitions:

1938 *International Photographic Exhibition*, Grand Central Palace, New York
1944 *A Century of Photography*, Museum of Modern Art, New York
1948 *This Is the Photo League*, Photo League, New York
1954 *This Is the American Earth*, California Academy of Science and the Sierra Club, San Francisco (toured the United States)
1955 *The Family of Man*, Museum of Modern Art, New York (and world tour)
1960 *Photography in the Fine Arts*, Metropolitan Museum of Art, New York
1967 *Photography in the 20th Century*, National Gallery of Canada, Ottawa (toured Canada and the United States, 1967-73)
1970 *Be-Ing Without Clothes*, Hayden Gallery, Massachusetts Institute of Technology, Cambridge (toured the United States)
1974 *Photography in America*, Whitney Museum, New York
1979 *Fleeting Gestures: Dance Photographs*, International Center of Photography, New York (travelled to the Photographers' Gallery, London, and Venezia '79)
1980 *Light Abstractions*, University of Missouri, St. Louis

Collections:

Museum of Modern Art, New York; Metropolitan Museum of Art, New York; International Museum of Photography, George Eastman House, Rochester, New York; Addison Gallery, Andover, Massachusetts; Massachusetts Institute of Technology, Cambridge; Philadelphia Museum of Art; Princeton University, New Jersey; Smithsonian Institution, Washington, D.C.; Library of Congress, Washington, D.C.; Exchange National Bank, Chicago.

Publications:

By MORGAN: books—*Martha Graham: Sixteen Dances in Photographs*, New York 1941, 1980; *Prestini's Art in Wood*, with text by Edgar Kaufmann Jr., Lake Forest, Illinois 1950; *Summer's Children: A Photographic Cycle of Life at Camp*, New York 1951; picture editor and designer of *The World of Albert Schweitzer* by Erica Anderson and Eugene Exman, New York 1955; *Barbara Morgan* (*Aperture* monograph), edited by Minor White, Millerton, New York 1964; *Barbara Morgan*, with an introduction by Peter C. Bunnell, New York 1972; *Barbara Morgan Dance Portfolio*, 10 photos, New York 1977; *Barbara Morgan: Photomontage*, with an introduction by Marianne Margolis, New York 1980; articles—"Photomontage" in *Miniature Camera Work*, New York 1938; "In Focus: Photography, The Youngest Visual Art" in *Magazine of Art* (New York), November 1942; "Modern Dance" in *Popular Photography* (New York), June 1945; "Photographing the Dance" in *Graphic Graflex Photography* by Willard D. Morgan and Henry M. Lester, New York 1952; "Kinetic Designs in Photography" in *Aperture* (Millerton, New York), no. 4, 1953; "Aspects of Photographic Interpretation" in *General Semantics Bulletin* (Lakeville, Connecticut), nos. 30 and 31, 1963, 1964; "Abstraction in Photography," "Dance Photography" and "Photomontage" in *Encyclopedia of Photography*, New York 1963, 1964; "My Creative Experience with Photomontage" in *Image* (Rochester, New York), nos. 5-6, 1971; interview in the *New York Times*, 19 June 1975.

On MORGAN: books—*The History of Photography from 1839 to the Present Day* by Beaumont Newhall, New York 1949, 1964; *25 Years of American Dance*, edited by Doris Hering, New York 1954; *Photography in the 20th Century* by Nathan Lyons, New York 1967; *Photography in America*, edited by Robert Doty, with an introduction by Minor White, New York and London 1974; *The Magic Image* by Cecil Beaton and Gail Buckland, London and Boston 1975; *Photographs: Shelton Memorial Art Gallery Collection, University of Nebraska*, with an introduction by Norman A. Geske, Lincoln, Nebraska 1977; *Geschichte der Fotografie im 20. Jahrhundert/Photography in the 20th Century* by Petr Tausk, Cologne 1977, London 1980; *Amerika Fotografie 1920-1940* by Erika Billeter, Berne 1979; *Recollections: 10 Women of Photography*, edited by Margaretta K. Mitchell, New York 1979; articles—"Barbara Morgan: Painter Turned Photographer" by Etna M. Kelley in *Photography* (New York), September 1938; "Book Review: Summer's Children" by Berenice Abbott in *American Photography* (New York), November 1951; "Great American Photographers: Barbara Morgan" by Fritz Neugass in *Camera* (Lucerne), February 1952; "Barbara Morgan" in *Encyclopedia of Photography*, volume 13, New York 1964; special issue of *Aperture* (Millerton, New York), no. 1, 1964; "Die vielen Geschichten der Barbara Morgan" by Fritz Neugass in *Foto Magazin* (Munich), July 1965; "Barbara Morgan: Permanence Through Perseverance" by Jacob Deschin in *Photography Annual*, New York 1971; "Barbara Morgan: One of America's Great Photographers Reflects a Decade of Dance 1935-1945" by Doris Hering in *Dance Magazine* (New York), July 1971; Barbara Morgan: Fotografe Tussen Twee Wereldoorlogen" by Jan Coppens in *Foto* (Amsterdam), July 1972; "Barbara Morgan" by Ruth Spencer in *British Journal of Photography* (London), 13 June 1975.

Basic to all the themes of my photographs, photomontage, dance, light drawings, people and nature, is my deep interest in expressing life forces of rhythmic vitality. My interest in photomontage comes basically from a philosophical interest in making metaphor comparisons: a fossil or a shell against the forms of the city. Since I was originally a painter and primarily interested in abstraction, the use of visual metaphors in photomontage is one of my primary expressive urges. Photomontage allows me to express the complexity of today's world, its multiplicity and diversity.

The dance photographs were inspired originally by having experienced Southwest Indian rituals during three summers of exploration; their use of dance to unify the people with the life forces, and not merely as entertainment, was a major influence. I saw in Martha Graham's dances a similar interest in the Southwest Indian experiences. This mutual interest between Martha Graham and myself inspired me to do a book of photographs on her dances.

In doing people, I think of them in terms of their relation to today's world, and not merely as individuals. My photographs of people express a concern with human values in our mechcanical world. I sometimes find ironic comparisons.

The photographs of children are primarily from a period in my own life when my own children were growing up. Experience of this period inspired my book of photographs, *Summer's Children*.

I see the photographs of nature as metaphors of cosmic dances: the corn leaf, for example, exhibits in rhythmic metre nature's life force.

All of my photographs represent a search for the invisible energies of life. I try to express these inner life forces through the exterior visual forms.

—Barbara Morgan

Five decades of Barbara Morgan's photography demonstrate an unusual versatility, vitality, and richness. With her formal training in painting and design and her later involvement in Asian and Native American thought, her career in photography is one of definite choice, dedication, and an attempt to delineate the magic and mystery of the mind, spirit, and nature. Her photography is an interpretative expression, and in this respect she shows a remarkable independence and originality when compared with other American photographers of the 1930s and '40s.

Inspired by her "whimsical-philosophical" father's idea of "dancing atoms," by her photo-historian husband, Willard Morgan, and by the metaphoric nature of poetry, Morgan's primary concerns in photography have not been formalistic, but symbolic, psychic, and ideational. One may say, she is not a radical experimenter or a towering pioneer. The dynamics of her art work on a different level. Her portraits, light drawings, straight photographs of nature and man-made objects, photomontages, and dance images display an ordering of "material facts raised to imagination," teasing the viewer to thought and reflection. To this chemistry she adds a distinct quality of playfulness, irony, and humor. This gives her imagery—"unforced meditation," to borrow her words—a genuine sense of human concern and value.

Take for instance, the images entitled, "Pure Energy and Neurotic Man," "Hearst over the People," "City Shell," or "Leaf Floating in City." In the first image the abstract light drawing juxtaposed by a grabbing forked hand in the upper right-hand corner of the dark background is a startling patterning of irony, lyricism, and realism. Morgan's social conscience and concern for mankind—a powerful component in almost all of her photomontages—are acutely felt in the "Hearst" image, where the irony is most devastating. "City Shell"—a superb photographic composition with spots of light faintly glimmering in the upper-half dark area of the frame, the lighted shell with four shadowed walking figures on it, and the geometric balance of a half-slanted skyscraper—is a poignant image potent with physical and psychological force. The visual dynamics in "Leaf Floating" are at once lyrical, symbolic, and ironic, a white transparent maple-leaf magnifying, as it were, the skyscraper-jungle of the modern urban habitation. The tiny lighted windows give an eerie feeling of emptiness and blindness rather than of dwelling and looking out.

Though they are not her original invention, Morgan's photomontages carry the emphatic signature of the artist, and certainly constitute, next to the dance images, her most significant contribution to

photography. She remarks that they allow her to express "the complexity of today's world;" they grow out of a "philosophical" urge, and are "visual metaphors"—"metaphoric comparisons." The photomontages are striking for their technical mastery— the keen way the ultimate image has been composed and constructed, the way time and space have been combined and encapsulated. More importantly, they are enduring for their inherent meaning— layers of meanings: social, political, moral, and philosophical—her "vision of the human condition, of human awareness," be it "Spring On Madison Square," "Saeta: Ice on Window," or "Wild-Bee Honeycomb Skyscraper."

When we turn to her images like "Corn Stalks Growing," "Briarlock," "Emerging," or "Martha Graham: Lamentation," we find the same competence and inventiveness fusing elements of whimsy, spiritual metaphors, and human awareness. "Corn Stalks Growing" generates sensations of pure lyricism and whimsy and a kind of "rhythmic vitality" also felt in "Beech Tree II," "Corn Stalk," and "Corn Leaf Rhythm." "Lamentation" is an absorbing double-image of spiritual and psychic metamorphosis. "City Sound," "Resurrection in The Junkyard," and "Fossil in Formation" convey Morgan's sense of the fantastic and the literal as well as her purposefulness and metaphoric intent. In almost all her photographs, there is authenticity, personal integrity, and simplification of the form so that the subject of her photography does not lose its own vitality and reality in the process of metaphoric suggestion.

Morgan's simplification of form and respect for the subject can be witnessed in her portraits of Sheeler, Le Corbusier, in "Lloyd's Head," "Amaryllis Bud," "Willard's Fist," and "The Stump" as well as in the pictures in *Summer's Children*. One cannot but perceive her particular vision of life, nature, harmony, and significance. Willard's fist jutting out from the left-hand corner of the picture is a fist at the head of a robust hairy hand; but, it is also a picture of a definite sensation and emotion. Lloyd's dark statuesque head from the back, with the left ear and contour of left cheek showing, goes beyond being just a head propped on a neck. It suggests a process, as do the two amaryllis photographs. In the same way, the photographs of children in a summer-camp are a poetic portrayal of experience and process. What totally undercuts any trace of didacticism in her work is her "whimsicality," her sense of cosmic inter-relatedness, and human signification inherent in what she sees, feels, and composes. Her abstract light drawings partake of this vision as fully as do her stunning dance photographs and the photographs in *Summer's Children*, which is not a linear documentation of events, but a subtle evocation of feelings, processes, and experiences.

In the best of her abstract light drawings, such as "Samadhi," "Emanations" and "Cadenza," Morgan's playful imagination creates moments of essentialized feeling and experience. The form, movement, and color—white against black—in these images are indeed, to use her own words, "ecstatic gestures" conveying vitality, harmony, and stillness.

"Except for the point, the still point," writes T.S. Eliot in *Four Quartets*, "there would be no dance, and there is only the dance." Barbara Morgan's dance photographs constitute a visualization of Eliot's thought. The intriguing fact is that in all the different kinds of photographs taken at various points in her career—of a stump, part of a leg, a light drawing, a photomontage composed of discordant and startling elements, or a dance gesture—a sense of awareness and harmony dominates. There is always economy and selectivity—the crystallization of the physical and psychological moment—in these photographs. If her photomontage is prompted by, what she calls, "simultaneous-intake, multiple-awareness, and synthesized-comprehension" inevitable to our Space Age, her dance photographs evoke the feeling and experience our age needs urgently.

Unquestionably, Morgan's dance photographs, started in the 1930's, are extraordinary expressions of those "invisible...inner life forces" that all of her photographs endeavour to communicate. They also signify a kind of ritualistic kinetics—dramas of mobility in immobility and immobility in mobility. Isolated gestures and motifs, forms and movements are caught with such vitality and rigour, such austerity and richness, that they inspire a profound realization. She has explained her working method as "previsualization"—emptying mind and allowing the "memorable gestures which inspired the idea to replay," and, thus, attuning oneself to "essentials." This process not only empowers Morgan with a perfect sense of timing, space, light, and an awareness of the most ecstatic and heightened moment of a gesture, but enables her to recreate the moment with a sense of transcendence, for example in "Letter to the World," "Extasis," "Deep Song," "El Penitente," and "Lamentation." The unique feature in these dance-photographs is that the human body and the gesture are so vitally heightened and realized. No part of the body is made into an abstraction or etherealized; on the contrary, it is treated with such eloquence and intensity that hands, feet, necklines, fingers, even veins contribute totally to the climactic experience. Then, there are the folds of the costumes, as in "Imperial Gesture" or "Lamentation" series. Morgan's "Kick," "Swirl," "Chaconne," "El Flagellante," "Torso," "Totem Ancestor," and "War Theme" are but a few of the most powerful and unforgettable examples of "spiritual and esthetic unification." This is the culminating experience— the moment when Barbara Morgan helps us to realize the Yeatsian vision of the dance and dancer becoming one.

—Deba P. Patnaik

MORINAGA, Jun.
Japanese. Born in Nagasaki City, 11 November 1937. Educated at a private high school, Ryukoku, Saga-City, 1953-56; studied photography, Nihon University, Tokyo, 1956-60; assistant to W. Eugene Smith, Tokyo, 1961-62. Married Yoko Kimura in 1975; daughter: Mayumi. Worked as commercial photographer, for Toppan Printing Company, Tokyo, 1963-68; independent photographer, establishing own studio, Shibuya-ku, Tokyo, since 1969. Lecturer, Photography Department, Nihon University, Tokyo, 1970-71. Recipient: New Figure Prize, Japan Photo Critics Association, 1970; Japan Photo Association Prize, 1980. Address: (studio) 1306-GO, 16-16-5 chome, Sendagaya, Shibuya-ku, Tokyo, Japan.

Individual Exhibitions:

1969 *Moment Is Monument*, Nikon Salon, Tokyo
1971 *Original Prints 1960-71*, Shunju Gallery, Tokyo
1975 *On the Waves*, Nikon Salon, Tokyo
1978 *View of Japanese Cities*, Nikon Salon, Tokyo
1979 *River: Its Shadow of Shadows*, UNAC Salon, Tokyo
1981 *Original Prints*, Akagi Gallery, Fukuoka, Japan

Selected Group Exhibitions:

1976 *Original Prints*, Ginza Gallery, Tokyo
1977 *Neue Photographie aus Japan*, Kulturhaus, Graz, Austria (travelled to the Museum des 20. Jahrhunderts, Vienna)
1979 *Japan: A Self-Portrait*, International Center of Photography, New York

Collections:

Photography Department, Nihon University, Tokyo; Photography Department, Kyushu-Sangyo University, Fukuoka, Japan.

Publications:

By MORINAGA: book—*River: Its Shadow of Shadows*, with an introduction by W. Eugene Smith, edited by Kazuhiko Motomura, Tokyo 1980.

Jun Morinaga: *The Waves*, 1972

In 1980 Jun Morinaga published a book, *River: Its Shadow of Shadows*, of photographs selected from a series taken at the beginning of 1960: they show canals and other river-scapes in Tokyo. Although they depict images of river banks and water surfaces, for the most part these pictures are of the waters of pollution, for example gutters and drains. Morinaga must have had some revolting experiences while taking these photographs, for most of them are in close-up.

Although the book is a photo-portrait of kinds of canals, there is something else present too: as we scan the photographs, we come to see an anti-world of decay and corruption. It is not unlike the cosmos as seen from a satellite. At the same time those strange objects floating in the water call to mind cancer cells, jarring us from time to time.

Having taken those photographs, Morinaga then had the opportunity to act as Eugene Smith's assistant when Smith came to Japan. Morinaga was very impressed with Smith's meticulous print work, and his own prints came to be more carefully composed. His attitude to the original print gave a lead to other Japanese photographers in the 1970's.

Morinaga has been tackling landscape and scenery by means of highly symbolic gestures, some of which have been shown in his one-person exhibitions and in magazine features.

It is reasonable to expect the unexpected from him in the future.

—Kineo Kuwabara

MORIYAMA, Daidoh.

Japanese. Born in Ikeda City, Osaka, in 1938. Studied design at the Municipal High School of Industrial Arts, Osaka; and studied photography under Takeji Iwayima, Osaka, and Eikoh Hosoe, Tokyo, 1960-63. Worked as a graphic designer in Tokyo, 1958-63. Freelance photographer, Tokyo, since 1963. Member, Vivo group of photographers, Tokyo. Recipient: Most Promising Photographer Award, Japan Photography Critics Association, 1967. Address:4-7-15 Zushi, Zushi-shi, Kanagawa 249, Japan.

Individual Exhibitions:

1970 *Scandal*, Dick Plaza, Tokyo
1974 *Another Country*, Shimizu Gallery, Tokyo
19775 *Tono Monogatari*, Nikon Salon, Tokyo
1976 *Gosho Gawara*, Nikon Salon, Tokyo

Selected Group Exhibitions:

1974 *New Japanese Photography*, Museum of Modern Art, New York
1977 *Neue Fotografie aus Japan*, Kulturhaus, Graz, Austria (travelled to the Museum des 20. Jahrhunderts, Vienna)
1979 *Japan: A Self-Portrait*, International Center of Photography, New York

Collections:

National Museum of Modern Art, Tokyo; Museum of Modern Art, New York; International Center of Photography, New York.

Publications:

By MORIYAMA: books—*Japan Photo Theatre I*, Tokyo 1968; *Goodbye Photography*, Tokyo 1972; *Document*, 6 vols., Tokyo 1972-; *Hunter*, Tokyo 1975; *Tono Monogatari*, Tokyo 1976; *Japan Photo Theatre II*, Tokyo 1978.

On MORIYAMA: books—*New Japanese Photography*, exhibition catalogue, by John Szarkowski and Shoji Yamagishi, New York 1974; *Neue Fotografie aus Japan*, exhibition catalogue, by Otto Breicha, Ben Watanabe and John Szarkowski, Graz and Vienna 1977; *Japan: A Self-Portrait*, exhibition catalogue, by Shoji Yamagishi, Cornell Capa and Taeko Tomioka, New York 1979.

Daidoh Moriyama is the leading exponent of an abrasive new wave of Japanese photography. By challenging accepted photographic conventions, he has moved very close to the chaotic pulse of Tokyo or Osaka, the cities in which he has lived. The form and order of traditional Japanese aesthetics have been discarded by Moriyama, in order to discover a new language of glaring juxtaposition. The strange associations of a dense, multi-layered, hybrid, urban life are his resources. He presents his pictures as disjointed images. They correspond accurately to the fragmented experience of the inhabitants of such a city. It is a dangerous course, for there is no logic, and the city itself contradicts all notions of what an outsider might understand as a "Japanese" quality.

Moriyama worked first as a graphic designer. He studied photography under Takeji Iwamiya in Osaka, then Eikoh Hosoe in Tokyo. Iwamiya is a master of the large format camera, and Hosoe is a meticulous craftsman. Moriyama, however, prints with a grainy, high contrast technique. He photographs from unpredictable angles, often placing his camera very close to his subject. He broke new ground in Japan when he first saw William Klein's "New York", "Moscow" and "Tokyo" series. Klein demonstrated new possibilities beyond previous ideas of form, but Moriyama moved his camera still closer to his subject, dispensing with impressions of scale. He would photograph a cabbage in the market on the same scale as he photographed a volcanic crater.

Tomatsu had opened up a new area of "subjective documentary" and was a great influence in Japan with the Vivo group in the early 1960's. Moriyama's work surfaced at the time when Japanese photography was ripe for a new appraisal outside Japan. In 1974 work from his early series "Japan Photo Theatre I" and "A Hunter" was exhibited together with Tomatsu's Nippon series at the *New Japanese Photography* exhibition at the Museum of Modern Art in New York. The "Nippon Theatre I" series concentrated on travelling actors, including backstage scenes, but produced some frightening associations. Moriyama photographed close to the frenzied mouth of an entertainer on stage, or printed the blurred image of an underground actress together with the sinister glance of a real beggar crawling on his knees. His approach was relentless and direct. In the "Hunter" series he focussed an entire frame on a prowling stray dog, or presented the image of a whore running over the garbage of a Yokosuka alley, a victim of the predatory city where Moriyama himself stalked with his camera.

In a later series "Another Country," his work played tricks of illusion between concrete, immediate reality and a bizarre, alien world, the surface of which his camera scanned without logic. A cow in a field appeared as neither beast nor monument; the roof of a temple was a flattened design next to the flower pattern of kimono cloth. In "Japan Photo Theatre II" all his imagery was derived from Tokyo. It is a dark, grainy, surreal world where the shop window dummy meets the crotch of the passerby, and a giant pig wanders an empty street. The final photograph is of the city lights glaring through a fading sky like a city of an inestimable future.

—Mark Holborn

MORRIS, Wright (Marion).

American. Born in Central City, Nebraska, 6 January 1910. Educated at Lakeview High School, Chicago, 1925-28; Crane College, Chicago, 1929-30; Pomona College, Claremont, California, 1930-33; self-taught in photography. Married Mary Ellen Finfrock in 1934 (divorced, 1961); Josephine Kantor in 1961. Writer and photographer, in California, 1934-38, in Middlebury, Connecticut, 1938-42, in California, 1942-43, in Bryn Mawr, Pennsylvania, 1943-58 and in Mill Valley, California, since 1962. Professor of Creative Writing, California State University, San Francisco, 1962-75; Distinguished Visiting Professor, University of Nebraska, Lincoln, 1975. Recipient: Guggenheim Fellowship, 1942, 1947, 1954; National Book Award, 1956; National Institute of Arts and Letters Award, 1960; Rockefeller Foundation Grant, 1967; Marie Sandoz Award, Nebraska Library Association, 1975; American Book Award, 1980. Honorary Doctorate, Westminster College, Missouri, 1968; University of Nebraska, Lincoln, 1968; Pomona College, Claremont, California, 1973. Honorary Fellow, Modern Language Association, 1975; Senior Fellow, National Endowment for the Humanities, 1976. Member, National Institute of Arts and Letters, 1970; American Academy of Arts and Sciences, 1972. Address: 341 Laurel Way, Mill Valley, California 94941, U.S.A.

Individual Exhibitions:

1940 *The Inhabitants*, New School for Social Research, New York
1975 *Structures and Artifacts: Photographs 1933-54*, Sheldon Memorial Art Gallery, University of Nebraska, Lincoln (retrospective; toured the United States, 1975-80)
1976 Prakapas Gallery, New York
1977 Prakapas Gallery, New York
1979 *Matrix*, University of California at Berkeley
1980 Witkin Gallery, New York
1981 Witkin Gallery, New York
 Northlight Gallery, Tempe, Arizona (with Ralph Steiner)

Selected Group Exhibitions:

1966 *The Photographer's Eye*, Museum of Modern Art, New York
1974 *Photography in America*, Whitney Museum, New York
1977 *Photographs: Sheldon Memorial Art Gallery Collection*, University of Nebraska, Lincoln

Collections:

Museum of Modern Art, New York; Boston Museum of Art; Sheldon Memorial Art Gallery, University of Nebraska, Lincoln; Houston Museum of Fine Arts; San Francisco Museum of Modern Art.

Publications:

By MORRIS: books—*My Uncle Dudley* (novel), New York 1942; *The Man Who Was There* (novel), New York 1945; *The Inhabitants* (photo-text), New York 1946, 1972; *The Home Place* (photo-text), New York 1948, Lincoln, Nebraska 1968; *The World in the Attic* (novel), New York 1949; *Man and Boy* (novel), New York 1951, London 1952; *The Works of Love* (novel), New York 1952; *The Deep Sleep* (novel), New York 1953, London 1954; *The Huge Season* (novel), New York 1954, London 1955; *The Field of Vision* (novel), New York 1956, London 1957; *Love Among the Cannibals* (novel), New York 1957, London 1958; *The Territory Ahead* (essays), New York 1958, London 1964; *Ceremony in Lone Tree* (novel), New York 1960, London 1961;

Wright Morris: *Basin: Eddie Cahow's Barbershop, Chapman, Nebraska,* **1947**

The Mississippi River Reader, editor, New York 1962; *What a Way to Go* (novel), New York 1962; *Cause for Wonder* (novel), New York 1963; *One Day* (novel), New York 1965; *In Orbit* (novel), New York 1967; *A Bill of Rites, A Bill of Wrongs, A Bill of Goods* (essays), New York 1968; *God's Country and My People* (photo-text), New York 1968; *Wright Morris: A Reader*, with an introduction by Granville Hicks, New York 1970; *Green Grass, Blue Sky, White House* (short stories), Los Angeles 1970; *Fire Sermon* (novel), New York 1971; *Love Affair: A Venetian Journal* (photo-text), New York 1972; *War Games* (novel), Los Angeles 1972; *A Life* (novel), New York 1973; *Here Is Einbaum* (short stories), Los Angeles 1973; *About Fiction: Reverent Reflections on the Nature of Fiction with Irreverent Observations on Writers, Readers, and Other Abuses*, New York 1975; *The Cat's Meow* (short stories), Los Angeles 1975; *Real Losses, Imaginary Gains* (short stories), New York 1976; *The Fork River Space Project* (novel), New York 1977; *Conversations with Wright Morris: Critical Views and Responses*, edited by Robert E. Knoll, Lincoln, Nebraska 1977; *Earthly Delights, Unearthly Adornments: American Writers as Image Makers*, New York 1978; *Plains Song: For Female Voices* (novel), New York 1980; *Will's Boy*, New York 1981.

On MORRIS: books—*Wright Morris* by David Madden, New York 1965; *The Photographer's Eye* by John Szarkowski, New York 1966; *Wright Morris* by Leon Howard, Minneapolis 1968; *Quality: Its Image in the Arts*, edited by Louis Kronenberger, New York 1969; *Looking at Photographs* by John Szarkowski, New York 1973; *Photography in America*, edited by Robert Doty, with an introduction by Minor White, New York 1974; *Wright Morris: Structures and Artifacts: Photographs 1933-54*, exhibition catalogue, with texts by Norman A. Geske and Jim Alinder, Lincoln, Nebraska 1975; *Photographs: Sheldon Memorial Art Gallery Collection, University of Nebraska*, exhibition catalogue, with an introduction by Norman A. Geske, Lincoln, Nebraska 1977; *The Novels of Wright Morris: A Critical Interpretation* by G.P. Crump, Lincoln, Nebraska 1978 (includes bibliography); *Light Readings: A Photography Critic's Writings 1968-1978* by A.D. Coleman, New York 1979; *The Photograph Collector's Guide* by Lee D. Witkin and Barbara London, Boston and London 1979; articles—"Wright Morris: An Introduction and Photographic Chronology" by Jim Alinder in *Exposure* (New York), February 1976; "Wright Morris: You Can Go Home Again" by James Alinder in *Modern Photography* (New York), March 1978.

It is my feeling that the absence of people in my photographs enhances their presence in the structures and artifacts.

The people absent from the photographs are explicitly present in the text in my photo-text books, where verbal images enhance those that are visual.

—Wright Morris

In sensitive hands, the camera's optically accurate discerning qualities increase our willingness to accept the photograph as evidence and, too, as an object of creation, feeling and emotion.

The photographs of Wright Morris present structures and artifacts of earlier decades photographed in the 1930's, 40's and 50's. The visual organization of his photographs is classic: Morris stands face-to-face with these objects. The results are clear, precise and well organized. The photographs inform us of facts and also move us emotionally. It is their intention to be works of art and they are.

Although Morris brought a camera for vacation snaps in 1933, his serious concern with photography began with his purchase of a Rolleiflex in 1935. He then began with a brief foray in the great pictorialist tradition with a series of cloud photographs, but, as

the initial magic wore off, Morris shifted his visual concern to the less obviously romantic backyards and alleys of Pomona, California. His roots in Nebraska were also significant in his development, and they serve as well as subject matter for many of his later photographs.

Morris's growth as a photographer paralleled in time his development as a writer. While photography would like to lay first claim to Morris, his larger reputation rests on his pre-eminence as a novelist. Among his eighteen novels, for example, *The Field of Vision* received the National Book Award in 1956 and *Plains Song* won the American Book Award in 1980. His unique contribution to the history of photography lies in the combination of his words with his pictures on an equally powerful level.

In 1938, Morris moved to the East Coast and the auto trip proved a real eye-opener. "I saw the American landscape crowded with ruins I wanted to salvage. The Depression created a world of objects toward which I felt affectionate and possessive. I ran a high fever of enthusiasm and believed myself chosen to record this history before it was gone," he has said. Morris acquired a 3¼ x 4¼in. view camera, and his photographic documentation of America's structures and artifacts resumed with vigor.

The next year, 1939, a critical creative leap occurred in his work. For some time he had been writing poetically dense prose paragraphs. Suddenly he realized the direct relationship between his writing and his photographs. The meaning of each was enhanced by the other, although the words never directly expained a photograph, nor vice versa. The visual and the written images were joined in the mind's eye. Work on the idea developed into a photo/text project called *The Inhabitants*. Further impetus came from a Guggenheim Fellowship in Photography granted to Morris in 1942 (the first had gone to Edward Weston in 1937). Work on *The Inhabitants* was completed and it was published in 1946.

In 1947, Morris received a second Guggenheim, enabling him to again extend the possibilities of the photo/text. For this work, titled *The Home Place*, Morris used a 4 x 5 in. view camera. The title refers to Morris's Nebraska. Beginning in 1942, Morris had stopped to talk and photograph in and around Chapman, Nebraska. Many of the conversations were with the town barber, Eddie Cahow, who had known Morris's mother and father. Through these Nebraska small-town experiences with lost relatives and old family friends, his roots became concrete and communicable. Previously, he says, "I had known little about my past except what I had conjured up in my fiction." The photographs from these sometimes extended visits are of the fabric of rural American life. *The Home Place* is a small, novel-sized volume rather than a large picture book like *The Inhabitants*. Also, it is designed with a continuous text, rather than having each photograph coupled with a paragraph of text as in *The Inhabitants*.

The Home Place was published in 1948; Morris continued to photograph in 1950's but with less intensity as the demands of his career as a novelist dominated. Some two decades elapsed before he again combined words and pictures. In part because of the constant demand for *The Inhabitants* and *The Home Place*, which had long been out-of-print, and in part because he felt that time had put different perspectives on his writing, Morris created a new, largely autobiographical text to go with the earlier photographs. This third photo/text is titled *God's Country and My People*: it was published in 1968. While *God's Country* may prove to be the summation of Morris's statement, the previous photo/texts wear well. All three are currently available in reprints.

Each of the photographs makes a particular statement about the objects included within the frame and also a general statement about the ceaseless replacement of objects in our culture. While they have several levels of meaning, Morris's intention was not primarily social comment. In part,

these artifacts become secular icons. Though people rarely make personal appearances in Morris photographs, their presence pervades all his work.

The photographs of Wright Morris present with formal elegance, precision and clarity an emotional and intellectual commitment to the commonplace, to the structures and artifacts of a time now disappeared. These pictures are the visible essence of that era, and they may begin to indicate to us what of the present needs to be salvaged.

—James Alinder

MUDFORD, Grant.

Australian. Born in Sydney, New South Wales, 21 March 1944. Studied architecture at the University of New South Wales, Sydney, 1963-64; self-taught in photography. Freelance commercial photographer, in Sydney, 1965-74; also worked as a cinematographer on short films, Sydney; established studio, Los Angeles, 1977. Recipient: Visual Arts Travel Grant, Australia Council for the Arts, 1974, 1977; Photography Fellowship, National Endowment for the Arts, 1980. Agents: Light Gallery, 724 Fifth Avenue, New York, New York 10019; and Rosamund Felsen Gallery, 669 North La Cienega Boulevard, Los Angeles, California 90069. Address: 5619 West 4th Street, Apartment 2, Los Angeles, California 90036, U.S.A.

Individual Exhibitions:

1972 Bonython Gallery, Sydney
1973 Realities Gallery, Melbourne
 Llewellyn Gallery, Adelaide
1976 Light Gallery, New York
1977 Australian Centre for Photography, Sydney
 Powell Street Gallery, Melbourne
 The Photographers' Gallery, London
 Light Gallery, New York
1979 Hirshhorn Museum and Sculpture Garden,
 Smithsonian Institution, Washington, D.C.
 Diane Brown Gallery, Washington, D.C.
 Rosamund Felsen Gallery, Los Angeles
 Light Gallery, New York

Selected Group Exhibitions:

1974 *Aspects of Australian Photography*, Australian Centre for Photography, Sydney
1975 *The Land*, Victoria and Albert Museum, London
1976 *New Directions in American Landscape*, Silver Image Gallery, Tacoma, Washington
1978 *New York, New York*, Light Gallery, New York
1979 *Photographic Directions: Los Angeles 1979*, Security Pacific Bank, Los Angeles
 Industrial Sights, Whitney Museum Downtown, New York

Collections:

Australian National Gallery, Canberra; Phillip Morris Collection, Melbourne; National Gallery of Victoria, Melbourne; Victoria and Albert Museum, London; Museum of Modern Art, New York;

Grant Mudford: *Mex*, 1976

International Museum of Photography, George Eastman House, Rochester, New York; Library of Congress, Washington, D.C.; Graham Nash Collection, Los Angeles; Security Pacific Bank, Los Angeles.

Publications:

By MUDFORD: article—"Grant Mudford" in *Inter/View* (New York), June 1979.

On MUDFORD: books—*New Photography Australia: A Selected Survey* by Graham Howe, Sydney 1974; *The Land,* exhibition catalogue, edited by Mark Haworth-Booth, London 1975; *Australian Photography,* edited by Laurence Le Guay, Sydney 1976; *Collecting Photographs: A Guide to the New Art Boom* by Landt and Lisl Dennis, New York 1977; *Australian Photography: A Contemporary View,* edited by Laurence Le Guay, Sydney 1979; *Grant Mudford: Photographs,* exhibition catalogue, by Charles Millard, Washington, D.C. 1979; articles—"Grant Mudford" in *Foto File* (New York), Spring 1973; "Grant Mudford" in *The Observer* (London), 30 November 1975; "Grant Mudford" in *Creative Camera International Yearbook,* London 1976; "Grant Mudford" by Allan Moult in *Australian Camera and Cine* (Sydney), February 1977; "Grant Mudford—American Photos" in *Creative Camera* (London), April 1977; "Technology Transformed" by Nancy Stevens in the *Village Voice* (New York), 23 May 1977; "Unbeguiled in a Wasteland Paradise" in *LAICA Journal* (Los Angeles), October 1978; "Grant Mudford" by Graham Howe and Jacqueline Markham in *Camera* (Lucerne), April 1979; "Grant Mudford and Capturing Ascetic Vision" by Benjamin Forgey in the *Washington Star,* 8 July 1979; "Gallery—Grant Mudford" by Nancy Stevens in *American Photographer* (New York), September 1979; "A Tour of Los Angeles Galleries" in the *New York Times,* 2 December 1979; "Single Room, $3.20" in *Art News* (New York), March 1980.

After studying architecture in the mid-1960's, Grant Mudford became a commercial photographer in his home town of Sydney, Australia. He soon turned from advertising to pursue his increasing photographic interest in the Australian "outback" and its rural architecture. It was here that his concerns for spatial ambiguity and the plasticity of light developed. Mudford's convincingly disciplined photographs fulfill the expectation of compositional elegance, then dematerialize the rational geometry they suggest by challenging preconceptions about objects represented photographically. These are not simply sophisticated photographs of buildings, but of the conceptual abstraction advanced by the buildings' existence.

Each large size photograph is a planar arrangement of tone and texture calmly asserting its perfect geometric alignment, achieved with perspective correcting lenses. and Mudford's point of view. The undetectable landscape distortion begins the subtle interruption of how to read these pictures. Mudford's vision describes a knowingly three-dimensional form in confounding, two-dimensional symbols. In "Los Angeles," 1978, the perspective of a receding wall above an arrow acts less as a dynamic moving through space than as a flat, calligraphic organizing device like the painted-on arrow itself. In "New Orleans," 1975, the telephone wires are splayed slashes on a flat field, losing their functional identity to the atmospheric condition existing only in Mudford's world of rematerialized matter.

If we cannot be shown what we expect to see, our visual needs must be satisfied by a unique condition that suspends our ready disbelief. At close range this is the achievement of Mudford's highly granular surface—going beyond emulsion on the paper's skin—which at once defines each object and obliterates it. The success of a Mudford image is the integ-

rity with which these structures exist in their own rarified envelope of space, defining both the surface shapes and the spatial atmosphere they become. When looking closely, we are momentarily unsure if the subject is the film's enlarged granularity or the mottled articulation of a stucco facade. After all, a photograph is not "real" in the sense of a painting's plasticity, not "real" in the aspect of palpable sculpture; a photograph is only the paper on which it is printed. And yet, any paper that could so masterfully exist between the tactility of stucco and the expectation of its own enlarged photographic grain participates in exploring the artist's distinct attitude toward materials and his medium. All things in the photograph exist, at some point, of the same atmospheric matter, constructivist "tattoos" where the pigmented forms and flesh are one; and it is Mudford's choice of shapes, meticulously organized and compulsively constructed, that contains this protoplasm in the discrete forms that explain their two-dimensional identity.

In "Mex," 1976, the stucco wall corresponds tonally and texturally to the dirt of the ground, while the distant wall framed by the doorway seems made of sky. All surfaces and spaces seem made of the same protoplasmic "stuff." The tonal quality of this pointillist grain spatially equates areas that are separate and distinct in the "logical" world. Negative and positive space frequently invert: sky and wall homogenize tonally, made more compelling by the two-dimensional structural containers that insist it is not so. For Mudford, both the paper and the architectural shapes give up their material identities and functional implications and become substance and surface transformed.

—Jacqueline Markham

MULAS, Ugo.
Italian. Born in Pozzolengo, near Desenzano del Garda, Brescia, in 1928. Educated in Desenzano, until 1936; studied law in Milan, 1948-52; studied drawing at the Accademia di Brera, Milan, 1951-52; self-taught in photography. Served in the Italian Army, 1945-48. Worked as caption-writer in a photo-agency, Milan, 1952-53; stage photographer, for Giorgio Strehler, Milan, 1954-64; also freelance fashion, industrial and magazine photographer, Milan, from 1954; concentrated on photos of artists at the *Biennale,* Venice, and later in the United States, 1954-68; worked on a series of experimental "Verifiche" photos, Milan, 1970 until his death, 1973. *Died* (in Milan) *2 March 1973.*

Individual Exhibitions:

1967 Galleria Il Diaframma, Milan
1969 *Campo Urbano,* Como, Italy
1971 *Künstler in New York 1964,* Kammerkunsthalle, Berne
1973 *Ugo Mulas: Immagini e Testi,* University of Parma, Italy
1974 *Ugo Mulas: Fotografo,* Kunsthalle, Basle
1977 Canon Photo Gallery, Geneve

Selected Group Exhibitions:

1972 *Combattimento per un'Immagine,* Museo d'Arte Moderna, Turin
1973 *Contemporanea,* Parcheggio Villa Borghese,

Rome
1977 *Documenta 6,* Museum Fridericianum, Kassel, West Germany
Photography as Art/Art as Photography 2, Fotoforum, Kassel, West Germany (and world tour)

Collections:

University of Parma, Italy; Kunsthalle, Basle.

Publications:

By MULAS: books—*Invito a Venezia,* Milan 1960; *David Smith,* Philadelphia, 1962; *New York: The Art Scene,* with text by Alan Solomon, New York 1967, as *New York: Arte e Persone,* Milan 1968; *Alik Cavaliere,* with text by Guido Ballo, Milan and Turin 1967; *Con Marianne Moore,* with Annalisa Cima, Milan 1968; *Allegria di Ungeretti,* with Anna Cima, Milan 1969; *Campo Urbano,* Como, Italy 1969; *Calder,* with text by H.H. Arnason, New York and Milan 1971; *Fausto Melotti: Lo Spazio Inquieto,* Turin 1971; *Verifiche,* portfolio, Milan 1972; *Marcel Duchamp,* portfolio of 10 photos, Milan 1973; *Fotografare l'Arte,* with text by Pietro Consagra and Umberto Eco, Milan 1973; *Libro per le Sculture di Arnaldo Pomodoro,* with text by Sam Hunter, Milan 1974.

On MULAS: books—*Combattimento per un'Immagine,* catalogue, Turin 1972; *Ugo Mulas: Immagini exhibition e Testi,* with text by Arturo C. Quintavalle, Parma, Italy 1973; *Ugo Mulas: La Fotografia* by Paolo Fossati, Turin 1973; *Ugo Mulas: Fotografo,* exhibition catalogue, Basle 1974; *Documenta 6/ Band 2,* exhibition catalogue, edited by Klaus Honnef and Evelyn Weiss, Kassel and Cologne 1977; *Photography as Art/Art as Photography 2,* exhibition catalogue, by Floris Neusüss, Kassel, West Germany 1977; *Geschichte der Fotografie im 20. Jahrhundert/Photography in the 20th Century* by Petr Tausk, Cologne 1977, London 1980; articles—"L'Ultima Fotografia di Ugo Mulas" by Ando Gilardi in *Photo 13* (Milan), May 1973; "Ugo Mulas" by A. Arcani, D. Palazzoli and U. Eco in *Fotografia Italiana* (Milan), May 1973; "Ugo Mulas: Verifications" by Ulrich Keller in *Afterimage* (Rochester, New York), May 1980.

Ugo Mulas provides an essential point of reference in the debate on photography as an art. During his lifetime he was mainly valued as a highly sensitive photographer of artists. After his first years in the Bohemian atmosphere of Milan's Via Brera (where the painters, writers, journalists and photographers lived), where in the early 1950's he tried out new paths in "concerned" reportage, Mulas suddenly recognized his true vocation, when, already an artist himself, he decided to devote himself to telling the story of art. This stage began with the Venice Biennale of 1954, and he remained as the *Biennale's* official photographer until 1968. From a number of Italian artists—Ernst, Fautrier, Giacometti, Guttuso, Campigli—he went on in the mid-60's, thanks to his friendship with Leo Castelli and Alan Solomon, to look at the avant-garde in America. He made penetrating portraits of Duchamp, Newman, Oldenburg, Stella, Rauschenberg, Dine, Warhol, Segal; his book *New York: The Art Scene* contains these experiments in the synthesis of contemporary art. His last work on artists was dedicated to Italians—Burri, Fontana, Consagra, Pomodore—and to Calder, who was a great friend of his.

Involved as he was in "interpreting" the world and the vision of artists by means of photography, Mulas finally came to investigate the medium that he himself used, the actual objectivity of the photographic process, and the photographer's involvement in the "reading" of a picture, an artist, a sculp-

ture. His enquiries gave rise, starting early in the 60's, to the famous *Verifiche*. Looking into the conceptual value of the instruments of photography, Mulas came to the conclusion that the photographer should aim for the precise definition of a field in which he can contemplate the view in front of his lens; the picture will then create itself, by virtue of what Franco Vaccari was later to call "unconscious technology." In this phase "the material itself becomes the picture" and helps to determine the final result. Seeking the mechanism by which this happens, Mulas examined all the different elements of the operation of photography: negative, optics, enlargement, exposures, the development of the negative, lighting, the self-portrait. His approach was not that of a beginner who wants to learn a technique, but that of a craftsman wishing "to touch with my hands the sensation of operations that I have repeated a hundred times a day for many years."

From this research into photographic language Mulas discovered that in the end the photographic process—once the field of "vision" has been accurately delimited—leads the photographer exactly where he himself wants to go. For Ugo Mulas, photography was finally a vehicle that makes personal intervention possible and then ceases to be a convenient alibi for the so-called "neutrality" of the photographer.

—Attilio Colombo

MÜLLER-POHLE, Andreas.

German. Born in Braunschweig, 19 July 1951. Educated at Herder School, Kassel, 1962-70; studied economics and communications at University of Hannover, 1973-74, and University of Göttingen, 1974-79. Married Brigitte Schadwinkel in 1979. Freelance photographer, Göttingen, since 1974. Editor, *Fotografie* magazine, Göttingen, 1978-79, and *European Photography*, Göttingen, since 1980. Teaching Assistant, Communications Department, University of Göttingen, since 1980. Address: Stargarder Weg 18, 3400 Göttingen, West Germany.

Individual Exhibitions:

1978 Galerie Trockenpresse, West Berlin
 Galerie im Kettenlädle, Stuttgart
1979 Art Studio, Cologne
 Work Gallery, Zurich
1981 Galerie Remus, Dusseldorf
 Galerie Renner, Munich
 Novum-Galerie, Hannover
 Larry Fink / Andreas Müller-Pohle / Michael Schmidt, Kunstmuseum, Dusseldorf

Selected Group Exhibitions:

1980 *Vorstellungen und Wirklichkeit: 7 Aspekte Subjektiver Fotografie*, Städtisches Museum Schloss Morsbroich, Leverkusen, West Germany (travelled to the Künstlerhaus, Vienna; Fundació Joan Miró, Barcelona, 1980; and Palais des Beaux-Arts, Brussels, 1981)
1981 *New German Photogrpahy*, The Photographers' Gallery, London
 Astrazione e Realtà, Galleria Flaviana, Locarno, Switzerland

Collections:

Museum für Kunst und Gewerbe, Hamburg; Polaroid Collection, Amsterdam; Bibliothèque Nationale, Paris.

Publications:

By MÜLLER-POHLE: articles—"Was ist Fotografie?" in *Fotografie* (Göttingen), no. 5, 1978; "Die Zweite Avantgarde der Fotografie" in *Fotografie* (Göttingen), no. 7, 1978; "Andreas Müller-Pohle: About Visual-Questioning," interview with Marco Misani, in *Printletter* (Zurich), no. 23, 1979; "Serie—Zyklus—Sequenz—Tableau" in *European Photography* (Göttingen), no. 1, 1980; "Uber das Licht: Aspekte einer fotografischen Lichtästhetik" in *Dumont Foto 2*, edited by Hugo Schöttle, Cologne 1980; "Visualismus" in *European Photography* (Göttingen), no. 3, 1980.

On MÜLLER-POHLE: books—*Vorstellungen und Wirklichkeit: 7 Aspekte Subjektiver Fotografie*, edited by Rolf Wedewer, Cologne 1980; *Die Geschichte der Fotografie im 20. Jahrhundert / History of Photography in the 20th Century* by Petr Tausk, Cologne 1977, London 1980; article—"Fotografie—ein gedanklicher Prozess" by Jörg Krichbaum in *Fotografie* (Göttingen), no. 6, 1978.

Photography is for me a means of making visible the visual world: the unlimited world of light and matter which we only catch a glimpse of at exceptional moments. Life itself forces us to forego this experience, and thus it is the task of art to disclose the sensual world to us—the visual, acoustic and tangible world—and to confront us with the exceptions.

Photography is for me a means of giving visual order to the world, of giving form and shape to the visible. It is the structure that makes something effective, not the thing itself. In my photographs I take an interest in the concrete object only insofar as it helps towards creating the order I'm aiming at—as a conveyor of an abstract, timeless message.

Photography: a means of making the visual world visible in the contexts of order appropriate to it.

—Andreas Müller-Pohle

30-year old Andreas Müller-Pohle belongs to a small group of young German photographers who are at once artists, theorists and editors. His photographs have appeared in several German publications, but internationally he is, as yet, relatively unknown. Although his photographs cannot be termed "conceptual," they are more meaningful from an intellectual than from an emotional perspective. His own statement above well conveys his point of view.

Yet Müller-Pohle's photographs are much less complicated than his assertions and theories imply. He devotes himself exclusively to black-and-white photography, concentrating on a few image-defining elements. Although at the outset of his career he was strongly influenced by Ralph Gibson, today he attempts his own visual path. After an initial cycle, "Konstellation," he has worked on a project with the title "Extractions." Through the device of a certain lack of sharpness, the pictures achieve somewhat more dynamism, which for him creates a new means to abstraction. He plans to publich this cycle, which should eventually include 40 to 50 photographs.

In addition to his photographic and theoretical work Müller-Pohle has published his own quarterly, *European Photography*, since 1979. In it he presents primarily his theories and themes in texts and pictures, restricting himself to black-and-white photographs.

—Marco Misani

Andreas Müller-Pohle: *0322, from the cycle Extractions*, 1980

MUNKACSI, Martin.

American. Born Martin Marmorstein, in Kolozs-var, district of Munkacsi, Hungary, now Cluj-Napoca, Rumania, 18 May 1896; family name changed to Munkacsi, c. 1902; emigrated to the United States, 1934, subsequently naturalized. Educated in Dicso-Szent-Marton, Hungary, until 1907; mainly self-taught in photography. Served in Austro-Hungarian Army, 1915-18. Married 3 times; daughter: Joan. Worked as apprentice house-painter, Budapest, 1911-13; writer-reporter for *Az Est, Pesti Naplo, Szinhazi Elet* newspapers and magazines, Budapest, 1914-21; sports photographer-editor. *Az Est* newspaper and *Theatre Life* weekly review, Budapest, 1921-27; Contract Photographer, Ullstein Verlag publishers, working for *Berliner Illustrierte Zeitung, Die Dame, Koralle* and *Uhu* magazines, 1927-30; freelance magazine and press photographer, contributing to *The Studio, Harper's Bazaar, Das Deutsche Lichtbild, Photographie, Modern Photography*, etc., Berlin and New York, 1930-33; Contract Fashion Photographer, Hearst Newspapers Inc., working for *Harper's Bazaar, Town and Country, Good Housekeeping, Pictorial Review, Life*, etc., New York, 1934-40; Contract Photographer, *Ladies' Home Journal*, New York, 1940-46: freelance photographer, working for King Features, Henry Ford, Reynolds Company, and film cameraman and lighting designer for television films, New York, 1946 until his death, 1963. Estate: Joan Munkacsi Hammes, 12 Charles Street, New York, New York, U.S.A. *Died* (in New York) *14 July 1963.*

Individual Exhibitions:

1978 *Spontaneity and Style*, International Center of Photography, New York (toured the United States and Europe)

Selected Group Exhibitions:

1937 *Photography 1839-1937*, Museum of Modern Art, New York
1940 *Tudor City Artist and Photographers*, Tudor City, New York
1965 *Glamour Portraits*, Museum of Modern Art, New York
1975 *Fashion 1900-1939*, Victoria and Albert Museum, London (toured Britain)
1977 *Fashion Photography: Six Decades*, Hofstra University, Hempstead, New York
 Fashion Photography, International Museum of Photography, Rochester, New York (travelled to Brooklyn Museum, New York; San Francisco Museum of Modern Art; Cincinnati Art Institute, Ohio; and Museum of Fine Arts, St. Petersburg, Florida)
1979 *Life: The First Decade*, Grey Art Gallery, New York University (toured the United States)
 Fleeting Gestures: Dance Photographs, International Center of Photography, New York (travelled to The Photographers' Gallery, London, and *Venezia '79*)
1980 *Avant-Garde Photography in Germany 1919-1939*, San Francisco Museum of Modern Art (toured the United States)

Collections:

Joan Munkacsi Hammes, New York; Harper's Bazaar, New York; Museum of Modern Art, New York; International Center of Photography, New York; International Museum of Photography, George Eastman House, Rochester, New York; San Francisco Museum of Modern Art.

Publications:

By MUNKACSI: books—*How America Lives*, New York 1941; *Fool's Apprentice*, autobiography, New York 1945; *Munkacsi: Nudes*, New York 1951; *Style in Motion: Munkacsi Photographs of the 20's and 30's*, edited by Nancy White and John Esten, New York 1979; articles—"Think While You Shoot" in *Harper's Bazaar* (New York), November 1935; "Must They Be Sharp" in *Photography* (New York), Fall 1947; "Light Up Your Darkroom" in *Universal Photo Almanac*, New York 1951; untitled article in *Popular Photography* (New York), November 1963; film—*Bob's Declaration of Independence*, 1954.

On MUNKACSI: books—*Deutschland: Beginn des Modernen Photojournalismus* by Tim N. Gidal, Lucerne and Frankfurt 1972; *Fashion Photography*, exhibition catalogue, by Gene Thornton, Hempstead, New York 1975; *Fashion 1900-1939*, exhibition catalogue, by Valerie Lloyd and others, London 1975; *The Magic Image* by Cecil Beaton and Gail Buckland, Boston and London 1975; *The Beginning of Realism in Fashion Photography*, exhibition catalogue, by Nancy Hall-Duncan, Rochester, New York 1977; *Fotografie der 30er Jahre: Eine Anthologie*, edited by Hans-Jürgen Syberberg, Munich 1977; *Geschichte der Fotografie im 20. Jahrhundert/Photography in the 20th Century* by Petr Tausk, Cologne 1977, London 1980; *Germany: The New Photography 1927-33*, edited by David Mellor, London 1978; *Munkacsi: Spontaneity and Style*, exhibition catalogue, with text by Colin Osman, New York 1978; *Life: The First Decade 1936-1945* by Robert Littman, Ralph Graves and Doris C. O'Neill, New York 1979, London 1980; *The History of Fashion Photography* by Nancy Hall-Duncan, New York 1979, as *Histoire de la Photographie de Mode*, Paris 1979; *Avant-Garde Photography in Germany 1919-1939*, exhibition catalogue, by Van Deren Coke, Ute Eskildsen and Bernd Lohse, San Francisco 1980; *Retrospektive Fotografie: Munkacsi*, with text by Raimund Hoghe, Bielefeld and Dusseldorf, West Germany 1980; articles—"Portrait of Munkacsi" by Robert W. Marks in *Coronet* (New York), January 1940; "Munkacsi" by Richard Avedon in *Harper's Bazaar* (New York), June 1964; "Glamour Portraits" by P.F. Althaus in *Camera* (Lucerne), November 1965; "Photo-Journalism, the Legendary Twenties" by Bernd Lohse in *Camera* (Lucerne), April 1967; "Blow-Out: The Decline and Fall of the Fashion Photographer" by Owen Edwards in *New York*, 28 May 1967; "Photography" by Janel Malcolm in *The New Yorker*, 22 September 1975; "Munkacsi" by Colin Osman in *Creative Camera Yearbook 1977*, London 1976; "From Rags to Photographic Riches" by Owen Edwards in the *New York Times Magazine*, 6 November 1977; "L'Éternel Munkacsi" in *Photo* (Paris), October 1978; "Making Fashion Come Alive" in *Photography Year 1979*, by the Time-Life editors, New York 1979.

From the beginning of his career in 1921 as a sports photographer for the Hungarian newspaper *Az Est*, Martin Munkacsi was a professional photographer. For him photography was first of all a means of livelihood, one he pursued successfully from Berlin to America, from a very lucrative contract as a journalistic photographer with the publishers Ullstein Verlag to fashion assignments for *Harper's Bazaar*. He made no effort to disguise his interest in the financial rewards of his work, having remarked that "a picture isn't worth a thousand words, it's worth a thousand bucks."

But while he probably would have rejected the idea of photography for art's sake, Munkacsi was open to the influences around him. His association with the Ullstein Press exposed him to a movement which came to be known as the New Photography, which coincided precisely with his time in Berlin. In philosophical and esthetic terms, it was a revolution.

The New Photography rejected all photography that imitated the other visual arts, especially painting. It called for photographers to embrace the medium's unique properties, its almost limitless creative possibilities.

Munkacsi experimented with many of these ideas and added some of his own. Some of these were: the pivotal point in the center of a picture that gives an otherwise static image great vitality; the inverted figure; a juxtaposition of two unrelated elements in the same photograph; an inclination toward surreal ideas.

In 1933 Munkacsi first came to America, on an assignment for the *Berliner Illustrierte Zeitung*. While in New York his photographs were shown to Carmel Snow, newly appointed editor of *Harper's Bazaar*. Mrs. Snow had a vision of a new style in fashion magazine reportage and was quick to grasp the potential of the Hungarian's work. She assigned him a bathing suit feature that had actually already been photographed in the studio.

In her autobiography, she recalled the day of the shooting, which was a cold, dreary one, on location at Piping Rock Beach. This was already an innovation: fashion at that time was simply not shot outdoors; even sailing pictures were done in a studio. Through an interpreter (Munkacsi couldn't then speak English), he finally made the model, Lucille Brokaw, understand what he wanted her to do, which was to run toward him. The resulting picture, a typical American girl in action out of doors, was entirely different from anything that had been done before in fashion photography. It was the first action photograph made for fashion and started a trend that is still with us.

Soon after the bathing suit assignment, Mrs. Snow offered Munkacsi a contract and he quickly became involved in a field that provided him with a new vehicle for self-expression. This he exploited to the full, drawing on the influences and innovations of his Berlin period. He brought spontaneity to fashion photography and an unconventional sense of style; for the first time, the clothes seem to have been designed for real people in real-life situations.

Nancy White, who succeeded Mrs. Snow as editor of *Harper's Bazaar*, said of Munkacsi, "he was the kinetic man." This could be taken quite literally. He shot from above, from below, in the water, strapped to the side of a moving racing car, and he always got his picture. One is amazed at his infallible eye, especially considering he was working with the limitations of the 4 x 5 camera. Everything is arrested at the salient moment.

Looking at his work as a whole, a number of themes appear consistently from the early sports photographs to his last assignments for the *Bazaar* in 1963. Movement: the subjects are running, jumping, diving, driving, splashing. Soccer players dive for the ball, which spins in midair; a man with coffee cup in hand, bounces off a wall; Lucille Brokaw runs along the beach. Water: people swim in it, wade in it, float in it, are splashed by it. Umbrellas: on the beach, in the rain, covering all but the legs of a recumbent nude. And in the picture of Garbo on holiday, all we see of the elusive star (who is carrying a large beach umbrella) are her two legs. Animals: there is an extra-ordinary early shot of a dog in the air above a man's extended arm and hand; a later photograph of Mrs. Ringling, on a circus horse; another of Laura Delano with her Irish setters; and later still, the famous series of white animals on white backgrounds. He used extreme angles and unexpected locations: from above he shot crowds of people walking on a sidewalk; posed a model in an incomplete building at the *World's Fair*, photographed another from below as she stood at the top of a subway stair. We look up at Joan Crawford in a picture he took from the bottom of an empty swimming pool.

Munkacsi had the interests, vitality and ego of five people. His energy and perceptive eye were at the service of a lively, original intelligence, which, when brought to bear on fashion photography,

Nickolas Muray: *Clarence Darrow*, 1925

swept away old, stale conventions. The ideas he introduced are now common currency and no longer shock by their unconventionality. But his way of looking at things is still valid, and the pictures seem as fresh and contemporary today as they did when he photographed them.

—John Esten

Gallico, New York 1967, paperback version (without Gallico text) as *Muray's Celebrity Portraits of the Twenties and Thirties*, with an introduction by Marianne Fulton Margolis, New York 1978; *Nickolas Muray*, portfolio of 12 photos, Rochester, New York 1978.

On MURAY: books—*The Magic Image* by Cecil Beaton and Gail Buckland, Boston and London 1975; *The Vogue Book of Fashion Photography* by Polly Devlin, with an introduction by Alexander Liberman, New York and London 1979; *Amerika Fotografie 1920-1940* by Erika Billeter, Berne 1979; articles—"Portraits in Nostalgia" in the *New York Times Magazine*, 5 April 1964; "Nickolas Muray: Time for a Leisurely Lunch" by Jacob Deschin in *Popular Photography* (New York), October 1965.

in what Muray considered one of his best pictures, looks manicured and embalmed. He retouched rather freely, etching away years from a sweet smiling Billie Burke no longer young; paring down movie stars' bellies; soft-focusing Ethel Barrymore as if she had been photographed through wool. On the other hand, his photographs of Coolidge, Hoover, and Roosevelt are straight-forward proof that the White House had its glamour too, but even in his most theatrical work he eschewed artificiality.

Over the years, Muray's fashion photographs in several magazines gave evidence of his achievement in this direction, and he was actively working until his death. A large, coffee-table book, *The Revealing Eye*, was published several years ago and, more recently, it was re-issued in paperback, giving permanent evidence to Muray's remarkable gifts as well as his limitations.

—Bruce Kellner

MURAY, Nickolas.

American. Born in Szeged, Hungary, 15 February 1892; emigrated to the United States, 1913; subsequently naturalized. Studied lithography, photography and photo-engraving, Graphic Arts School, Budapest, 1904-08; color photo-engraving, State Technical School, Berlin, 1909-11. Served as a Flight Lieutenant in the United States Civil Air Patrol during World War II. Married Margaret Schwab; children: Nickolas and Mimi. Worked as journeyman engraver, Hungary and Germany, 1908-09; photo-engraver, Ullstein Verlag Publishers, Berlin, 1911-13; color-printer, for a printing company, Greenpoint, Brooklyn, New York, 1913-16; color print processor, Condé Nast Publications, New York, 1916-18, 1920-21, in Chicago, 1918-19; freelance advertising, fashion, commercial and magazine photographer, establishing own portrait studio, and working for *Vanity Fair, Ladies' Home Journal, Harper's Bazaar, Vogue, McCall's, Dance Magazine*, etc., New York, 1921-65. United States fencing competitor, Olympic Games, 1928, 1932, 1936 (U.S. Sabre Champion, 1927-28); fencing judge, *Olympic Games*, Tokyo, 1964. *Died* (in New York) 2 November 1965.

Individual Exhibitions:

1974 International Museum of Photography, George Eastman House, Rochester, New York (retrospective)
1978 Prakapas Gallery, New York

Selected Group Exhibitions:

1965 *The 20's Revisited*, Gallery of Modern Art, New York
1979 *Fleeting Gestures: Dance Photographs*, International Center of Photography, New York (travelled to The Photographers' Gallery, London; and *Venezia '79)*
 Amerika Fotografi 1920-1940, Kunsthaus, Zurich

Collections:

International Museum of Photography, George Eastman House, Rochester, New York (major collection of his work); Museum of Modern Art, New York; American Museum of Photography, Philadelphia; Royal Photographic Society, London.

Publications:

By MURAY: books—*Pre-Columbian Art*, New York 1958; *The Revealing Eye*, with text by Paul

Nickolas Muray became recognized as a successful photographer of celebrated personalities during the 1920's, through techniques he had developed from skills learned as an apprentice in childhood, first studying lithographic reproduction in Hungary and, later, experimenting with color separation in Germany. The artistry that marked his best work, however, was uniquely his own.

After arriving in New York, at the age of 21, he was hired as an engraver by the Condé Nast organization, responsible for the popular magazine, *Vanity Fair*, in which much of Muray's own work later appeared. Shortly thereafter, Muray opened his own studio in Greenwich Village, and for the next four decades he worked steadily as a private photographer (simultaneously recognized as one of the great party-givers of the 20's, as an olympic fencing champion, and as a flight lieutenant in the Civil Air Patrol—such dashing roles matching the élan of his photography). His portraits were easily identifiable, beginning with the brooding glamour of a popular actress of the period, Florence Reed, dramatically lighted and in soft focus. Later, he became particularly successful in photographing dancers like Martha Graham, Ito Machiko, and Ruth St. Denis, capturing the sweep of their draperies and costumes, their kinetic gestures, their physical control, even in obviously posed photographs dominated by a sense of strong animation.

Occasionally, Muray's wit burst from the frame itself, as in his portrait of Harold Ross of *The New Yorker* whose wiry crew-cut disappears out of the top of the picture as if it might continue on up indefinitely. Muray's humor also graced his portraits of Helen Hayes as Cleopatra in 1925, looking more like a kewpie doll on the midway than a serpent on the Nile; of Gertrude Lawrence, her dished profile in a blur of bright light and the folds of her gilded costume in sharp detail; of Fred and Adele Astaire caught mid-step in a dance routine. But these are perhaps less successful than at least three non-theatrical photographs of enduring power: the lawyer Clarence Darrow, benign and relaxed and looking like the sobriquet given to Heywood Broun, "an unmade bed"; Babe Ruth in his baseball uniform, an All-American middle-aged boy, forever defining "clean-cut"; and the painter Claude Monet, an old man in smock and straw hat, softened to suggest the romantic haze of his own water lilies.

Writers like F. Scott Fitzgerald, Langston Hughes, and D.H. Lawrence, captured at the height of their matinée idol good looks; a quizzical Willa Cather; a chi-chi Carl Van Vechten in his silk dressing gown; and a wickedly smiling George Bernard Shaw recreate the literary atmosphere of the 20's. Muray's sensitivity to the individual chic of singers and actresses recreates the period's glamour as well. During the 30's, his photographs sometimes took on a more silvery Hollywood gloss, not always successfully: Humphrey Bogart, is too natty, for example, to please his tough guy fans; and Marlene Dietrich,

MYDANS, Carl.

American. Born in Boston, Massachusetts, 20 May 1907. Educated at Medford High School, Massachusetts, 1926; Boston University School of Journalism, 1926-30, B.S. journalism 1930. Married Shelley Smith in 1938; children: Seth Anthony and Shelley. Worked as a reporter for *American Banker*, New York, 1931-35; photographer with the Farm Security Administration, Washington, D.C., under Roy Stryker, 1935-36; Photographer/Correspondent, *Life* magazine, New York, 1936-72: War Correspondent, Russo-Finnish Winter War, 1939, fall of France, 1940, war in Europe (Casino, Rome, Florence, and France), and war in the Pacific, 1942-45 (prisoner of war in the Philippines and China, 1942-43); Head of the Time-Life Bureau in Tokyo, 1945-48; War Correspondent in Korea, 1950, 1951, and in Vietnam, 1968. Since 1972, Photographer/Correspondent for *Time* magazine, New York. Recipient: Gold Achievement Award, *U.S. Camera*, 1951. D.H.: Boston University, 1960. Address: 212 Hemmocks Road, Larchmont, New York 10538, U.S.A.

Selected Group Exhibitions:

1938 *Farm Security Administration Exhibition*, at the *First International Photographic Exposition*, Grand Central Palace, New York
1951 *Memorable Life Photographs*, Museum of Modern Art, New York
1955 *FSA Anniversary Show*, Brooklyn Museum, New York
1962 *The Bitter Years: FSA Photographs 1935-41*, Museum of Modern Art, New York (toured the United States)
1977 *A Vision Shared: The FSA*, Witkin Gallery, New York
 The FSA: People and Places of America, Santa Barbara Museum of Art, California
1979 *Images de l'Amerique en Crise: Photographies de la FSA*, Centre Georges Pompidou, Paris
 Life: The First Decade, Grey Art Gallery,

Carl Mydans: *Collapse of the Hiwa Department Store in the Fukui Earthquake,* **Japan, 1948**

New York University
1980 *Amerika*: *Traum and Depression 1920-40*,
Kunstverein, Hamburg (toured West
Germany)
Années Amères de l'Amerique en Crise,
Galerie Municipale du Château d'Eau,
Toulouse

Collections:

Library of Congress, Washington, D.C.; Time-Life
Inc., New York

Publications:

By MYDANS: books—*More Than Meets the Eye*,
autobiography, New York 1959; *The Violent Peace*,
with Shelley Mydans, New York 1968; *China: A
Visual Adventure*, with Michael Demarest, New
York 1979.

On MYDANS: book—*Memorable Life Photographs*, with text by Edward Steichen, New York
1951; *Life Photographers: Their Careers and Favorite Pictures*, edited by Stanley Rayfield, New York
1957; *Travel Photography*, by the editors of Time-
Life, New York 1973; *The Years of Bitterness and
Pride*: *FSA Photographs 1935-1943*, compiled by
Jerry Kearns and Leroy Bellamy, edited by Hiak
Akmakjian, New York 1975; *A Vision Shared: A
Classic Portrait of America and Its People*, edited
by Hank O'Neal, New York and London 1976; *Life*:
The First Decade 1936-1945 by Robert Littman,
Ralph Graves and Doris C. O'Neill, New York 1979,
London 1980; *A Ten Year Salute* by Lee D. Witkin,

with a foreword by Carol Brown, Danbury, New
Hampshire 1979; *Les Années Amères de l'Amerique
en Crise 1935-1942*, exhibition catalogue, by Jean
Dieuzaide, Toulouse, France 1980; articles—"The
Story of Carl Mydens" by J.G. Lootens in *U.S.
Camera* (New York), December 1939; "Korea: Carl
Mydans" in *U.S. Camera Annual 1951*, edited by
Tom Maloney, New York 1950.

I am a photo journalist, beginning first with the U.S.
Farm Security Administration photo coverage of
the United States (1934/35), a government financed
project. My photographs on this project, together
with those of some dozen other photographers, now
reside in the United States Library of Congress, and
are viewed as a major historical document of the
Depression years.

In 1936 I joined the newly forming *Life* magazine
before its first issue appeared. And I remained on its
active staff for more than 35 years, until it folded in
1972. Since then I have continued as a photo journalist for *Time* (sister publication) and other publications; and am working on both text and photographic books.

—Carl Mydans

When, in 1935, under the innovative leadership of
Roy Stryker, the Farm Security Administration
established an "Historical Section," Carl Mydans
moved from another branch of the organization in
order to work as a photographer on Stryker's team.
Trained as a journalist, Mydans bought a Contax
35mm. camera in 1931 and extended his journalism
to include the visual recording of events by working
as a free-lance photographer. Although his stay with
the Historical Section was very brief, he helped to
establish its pattern of work and its objectives.
Equally, he gained through the experience a way of
approaching the task of a photographer that was to
influence both the character and the style of his
subsequent work.

Mydans made an extended field trip to the Southern States of the U.S.A. where his assignment was to
document the cotton industry for the Section. He
accomplished this task, but few of his exposures
were concerned with a cool examination of the techniques of growing and producing cotton. Rather, he
recorded with great skill and compassion, and often
against the strongly expressed wishes of the white
planters, the lives of the poor, the dispossessed and
the exploited.

In the fine division of genres into which photographers are often classified, Mydans must be described as a photojournalist rather than a documentary photographer. In 1936 he moved to the newly
formed *Life* magazine, which was then known as
Project X but was to become a major institution in
American life and one of the world's best known and
most influential photo magazines. At *Life* Mydans
was able to draw on his talents both as a journalist
and as a photographer. He was to have a long and
distinguished career with the magazine and was a
formative influence on its style and aims. He has
said of it: "We had an insatiable drive to search out
every fact of American life, photograph it and hold
it up proudly like a mirror to a pleased and astonished readership.... America had an impact on us
and each week we made an impact on America."

—Derrick Price

NAGARAJAN, T(ambarahalli) S(ubramania).
Indian. Born in Hunchadakatte, Karnataka, 13
October 1932. Educated at Municipal High School,
Doddaballapur, 1946-47, Municipal High School,
Malavalli, 1947-48, and Maharajah's High School,
Mysore, 1948-49; studied English, physics and
mathematics at Yuvaraja's College, Mysore, 1949-
53, B.Sc. 1953. Married Meenakshi Mahalingam
Iyer in 1958; daughters: Kalyani and Vasanti. Free-
lance photographer, Mysore, 1953-56; Picture Edi-
tor, *Yojana* journal of the Planning Commission,
New Delhi, 1956-72; Photographic Officer, Minis-
try of External Affairs, New Delhi, 1972-75; Direc-
tor of the Photo Division, Ministry of Information
and Broadcasting, New Delhi, 1976-78. Freelance
photographer, New Delhi, since 1978. Recipient:
Human Interest Photo Award, Press Institute of
India, New Delhi, 1968; National Photo Award, All
India Fine Arts and Crafts Society, New Delhi,
1976; Unesco Prize, Asian Cultural Centre, Tokyo,
1977. Agent: Camera Press Ltd., Russell Court,
Coram Street, London WC1, England. Address:
6/41 Western Extension, New Delhi 110005, India.

Individual Exhibitions:

1966 *Young Eyes*, All India Fine Arts and Crafts
 Society, New Delhi
1969 *Around a River, Around a Tower*, All India
 Fine Arts and Crafts Society, New Delhi
1970 *Banaras-Madurai*, Jehangir Art Gallery,
 Bombay

Publications:

By NAGARAJAN: books—*The Sikhs Today*, with
text by Khushwant Singh, Calcutta 1959; *It Hap-
pened in a Village*, New Delhi 1960; *This India*, with
text by Sheila Dhar, New Delhi 1973; *Indira Gandhi*,
picture editor, text by G.D. Khosla, Faridabad,
India 1974; *The Spirit of India*, picture editor, Bom-
bay 1975; *India: Portrait of a People*, picture editor,
New Delhi 1976; *Sanjay Gandhi*, editor, text by
Maneka Gandhi, Bombay 1980; *Report on the State
of Photojournalism in India*, New Delhi 1980;
Exploring Karnataka, picture editor, photographs
by T.S. Satyan, text by H.Y. Sharada Prasad,
Bangalore, India 1981; articles—"Transistor in India"
in *Illustrated Weekly of India* (Bombay), 10 May
1970; "J. Krishnamurti" in *Illustrated Weekly of
India* (Bombay), 31 January 1971; "Ma Ananda-
maye" in *Illustrated Weekly of India* (Bombay), 30
April 1972; "Taj Watching" in *Pacific Travel News*
(San Francisco), November 1974; "In the South of
India" in *Pacific* (Tokyo), no. 1, 1976; "Photojour-
nalism in India" in *Illustrated Weekly of India*
(Bombay), 28 May 1978; "Doors" in *Pacific* (Tokyo),
no. 3, 1980; "Benaras: The Eternal City" in *Taj
Magazine* (Bombay), March 1980.

On NAGARAJAN: articles—"Life Through a Lens"
in *Yojana* (New Delhi), February 1969; "Nagarajan"

T. S. Nagarajan: *Heiress to a Life of Grace and Plenty*, Delhi, 1973

by Chitrangada in *Shankar's Weekly* (New Delhi), 16 February 1969; "Pilgrimage with a Camera" in *The Statesman* (New Delhi), February 1969; "Anti-Glory Nagarajan" in *Enlite* (New Delhi), March 1969; "Assignment India" in *Yojana* (New Delhi), August 1972; "A Ballad Maker in Pictures" in *Sird News Magazine* (New Delhi), October 1972; "T.S. Nagarajan" in *Illustrated Weekly of India* (Bombay), 22 January 1978.

I turned to photography by an accidental realization. One day, during my undergraduate days in my home town, Mysore, in the south of India, I was driven by an impish desire to write a piece on the sudden death of "Irawata," the Maharaja's elephant, much loved by the people of Mysore as a dear old friend. A leading Indian weekly published the story ("A Mysore Gentleman Passes Away") with an unsatisfactory photograph of the elephant which I had bought from a local studio. A few weeks later, the editor, an Irishman, sent me a copy of the magazine with my story, along with a cheque and a note urging me to take to the camera "If I had ambitions of making a success of my career as a journalist." I took to photography without a second thought. The years that followed proved in ample measure that the editor was right.

Today, 27 years after the death of "Irawata," I have an elephant with a camera on its mount as my professional symbol.

I started as a freelance, but did rather a long stint with the Indian government as its official photographer before I resigned in 1978 to become a freelance once again. It was my privilege as picture editor of *Yojana*, the journal of the Indian Planning Commission, to record for well over a decade the planned economic development of the country. This enabled me to see India as is given to no man, reflecting as my viewfinder did the beauty and the ugliness and the colour and the potential of India; its men and women building their own future, its temples old and new. It was then, while recording this exciting change in the life and landscape of the country, I preferred to be not a photographer of cement and steel and inaugural ceremonies, but a photographer of people.

I believe that a country is people. While photographing people, a photographer neither petrifies them, nor does he make them act. They move, they work, they laugh, they suffer. And he himself becomes part of their movement, their work, their laughter and their pain. He gets involved.

All art, the cynic says, is a form of escapism. The artist creates an image of things as he sees them with his mind and soul, but rarely with his eyes. The photographer, on the other hand, sees life as you and I see it. Most photographers record on bromide that which is obvious, without any effort to discover the poetry and pathos, the joys and sorrows of life. But there are among them, only a few, who use their portable mechanism to capture the beauty and glory of life's rarest moments. Their creations transcend the photographer's routine and become works of art in the truest sense of the term.

My life has been exciting with my camera. I am grateful to have been a photographer. I use Nikons. But my camera does nothing. It neither makes the picture nor prevents me from taking it. It only helps in achieving an idea, an approach, a sort of direction and, perhaps, a philosophy.

—T.S. Nagarajan

T.S. Nagarajan is one of the foremost chroniclers of social change in India. His work encompasses a great variety of themes, places and moods, and is marked by strength and directness. Apart from their high craftsmanship, his pictures have intellectual depth; they make one think. The interaction of tradition and modernity fascinates him. His features on the temple towns of Banares and Madurai are successful essays in capturing the perennial that changes continuously and in subtle ways. His photographs on the induction of technology into rural life and on themes such as family planning and the spread of education have been very widely published. He is more at home in black-and-white, although he has done some notable work in colour.

It is easy for photographers in India to become sentimental and whimsical. Nagarajan avoids both these pitfalls with his self-control and his sturdy sense of context and relevance. He spurns the merely decorative or the contrived. He has an eye, however, for the dramatic, the paradoxical, even the humorous, as long as it is natural. He has not cared to do much "celebrity" photography; he is more interested in society than in Society. To him, photography "is not a poor relation of high art. The photographer should have artistry. But when he pursues aesthetic values too sedulously, the picture he produces will be playing the ape to another art form rather than expressing the true nature of the medium of photography. It is the prerogative of the camera to record the present as a reliable witness."

What has moulded Nagarajan's outlook is his own long experience as a photographer of the Indian Planning Commission's journal, *Yojana*. The position provided him with the opportunity to travel to every part of India and record rural and urban change; even more pertinently, it placed him among sociologists and economists through whom he gained a deep understanding of the development process. Another advantage was that, although he was a government photographer, he was not required to cover the day-to-day events of officialdom. Magazine work and his involvement with exhibitions helped him to develop an editorial eye, which has stood him in good stead in his work as picture editor of photographic essays on Indira Gandhi and Sanjay Gandhi and on *India: Portrait of a People*.

After heading the Photo Division of the Government of India, Nagarajan quit government service to become a freelance photojournalist. He has held exhibitions in New Delhi and Bombay, and his work has appeared in the leading journals of many countries.

—H.Y. Sharada Prasad

NAITOH, Masatoshi.

Japanese. Born in Tokyo, 18 April 1938. Studied chemistry, Waseda University, Tokyo; self-taught in photography. Married Kazuko Naitoh in 1969; children: Shizue and Shokichi. Worked in the Research Department of Kurashiki Rayon Company, Tokyo. Now, freelance photographer, Tokyo. Recipient: Nika Award, 1963; New Photographer Award, Japan Photo Critics Association, 1966. Address: 2-25-11 Honamanuma, Suginami-ku, Tokyo, Japan.

Individual Exhibitions:

1966　*Japanese Mummies*, Tokyo
　　　Homunculus, Tokyo
1970　*Exploding Baba*, Tokyo
1973　*Sanrizuka Heta Buraku*, Tokyo

Selected Group Exhibitions:

1971　*10th Modern Japanese Art Exhibition*, Tokyo

1974　*New Japanese Photography*, Museum of Modern Art, New York

Collections:

Museum of Modern Art, Tokyo; Museum of Modern Art, New York.

Publications:

By NAITOH: books—*The Study of Mummy Worship*, Tokyo 1974; *Tales of Tohno*, Tokyo 1978; *Baba: Folk Religion of the Tohoku*, with an introduction by Akira Hasegawa, Tokyo 1979; *Dewa Sanzan*, Tokyo 1980.

On NAITOH: book—*New Japanese Photography*, exhibition catalogue, by John Szarkowski and Shoji Yamagishi, New York 1974.

Masatoshi Naitoh is unique among Japanese photographers. Perhaps it is better, more accurate, to call him a researcher in folklore who uses photography as an instrument, rather than a photographer per se.

Naitoh was born in Tokyo in 1938. While studying applied chemistry in the Faculty of Technology at Waseda University, he enjoyed photography as a hobby and was a member of the University Camera Club. In those days he had already achieved a special kind of expression, which became clearer when he later turned "professional"; he used inventive photographic techniques, contrary to the prevalent realism of the period. When he graduated he entered the Research Department of the Kurashiki Rayon Company. His field of research was in the creation of new life forms, but that was not potentially a very profitable line of enquiry as far as the company was concerned, and after a year he left—though now that the whole field of bio-chemistry is being more widely investigated, Naitoh's work, in retrospect, seems ingenious. Eventually Naitoh went back to things photographic, and his former hobby became his profession.

He began with a series of "S-F Photos," using his expertise as a chemist in the making of surreal fantasies. He quickly lost interest in that series and turned to an examination of the practice of mummification in Japan and elsewhere, an obsession that has lasted to the present time. A collection of his photographs of mummies was shown in 1966: it created a sensation and earned Naitoh the New Photographer Award of the Japan Photo Critics Association. Naitoh's photographs of mummies are very vivid, dynamic, prompting one to imagine that Naitoh has shared the long history of the mummies themselves. Naitoh, who as a chemist first set out to create new bio-chemical life forms, now as a photographer seemed to be aiming to capture the essence of human life forms dormant in the mummies.

These comments may suggest that Naitoh is some kind of monomaniac, but in fact the discovery and investigation of mummies led him to the study of folklore, those kinds of human beliefs without which mummies could not have existed. He concentrated on observances in the Tohoku region as well as the inhabitants of that region. The common idea informing the works he produced is that of recording the fullness of lives of those who have been marginalized in our modern economy, who yet maintain vital links with their own local cultures.

Today, Naitoh is still taking photographs, but he is much more passionately involved with the anthropology of everyday life. Given his history, it is probably reasonable to assume that this study must, in time, find an even newer form of photographic expression within his work.

—Takao Kajiwara

NAKAMURA, Masaya.

Japanese. Born in Yokohama, 29 March 1926. Studied photography at Tokyo Fine Arts High School; studied photochemistry at Chiba University. Served in the Japanese Army, 1942-46. Married Mitsue Sharaishi in 1958; daughter, Mami. Professional photographer, working as news cameraman, and portrait and fashion photographer, Tokyo, since 1949; established Masaya Studio, Chinjuku-ku, Tokyo, 1958-64, Minato-ku, Tokyo, since 1966. President, Japan Advertising Photographers' Association, since 1958. Member, Nika-Kai Department of Photography, Tokyo, since 1966. Recipient: News Photography Prize, Japan Photo Critics Association, 1957; Art Directors Club of New York 1966. Address: Masaya Studio, Kaneko Building, 1-2-9 Nishiazabu, Minato-ku, Tokyo, Japan.

Individual Exhibitions:

1957 *Young Nudes*, Fuji Photo Salon, Tokyo
1960 *Nudes*, Fuji Photo Salon, Tokyo
 Nues Japonais, Galerie Oluloy, Paris
1962 *Women*, Fuji Photo Salon, Tokyo
1964 *Nudes*, Fuji Photo Salon, Tokyo
1968 *Girl, Girl, Girl*, Fuji Photo Salon, Tokyo
1969 *Nudes East and West*, Fuji Photo Salon, Tokyo
 Autumn Gale, Nikon Salon, Tokyo
1970 *Nude Photo, Paris and Japanese Women*, Mitsukoshi Department Store, Osaka
1971 *Ema Nude in Africa*, Tokyo Department Store, Tokyo
1972 *Paris Blue*, Gallery Nire, Urawa, Japan
1973 *Flora Flora*, Takashimaya Department Store, Kyoto
 Child Vinci, Getuko Photo Gallery, Tokyo
 Stop and Go, Fuji Photo Salon, Tokyo
1974 *Pandora's Flute*, Ginza Wako, Tokyo
 Miro, Nikon Salon, Tokyo
 Winds of Change, Pentax Gallery, Tokyo
1975 *Woman in Kyto*, Canon Salon, Tokyo
1976 *My Work*, Fuji Photo Salon, Tokyo
1977 *Scenery with Nudes*, Minolta Photo Space, Tokyo
 Bretagne: Sa Lumière et Son Souffle, Contax Gallery, Tokyo
1978 *Spark (Nude)*, Canon Salon, Tokyo
1979 *Rainbow Hue*, Canon Salon, Tokyo
 Woman: The Four Seasons, Olympus Gallery, Tokyo
1980 *Slot Machine*, Event Space, Tokyo
1981 *Japanese Spirit "Iki,"* Fuji Photo Salon, Tokyo
 Kabuki Actor, Tokizio, the Fifth, Minolta Photo Space, Tokyo

Selected Group Exhibitions:

1957 *Eyes of 10*, Konishirok Gallery, Tokyo
1961 *Group "Non,"* Matsuya Department Store, Tokyo
1964 *Olympic Art Exhibition*, Matsuya Department Store, Tokyo
1970 *Nudes of the World*, Tokyo
1979 *Japanese Photography Today and Its Origin*, Galleria d'Arte Moderna, Bologna, Italy (toured Europe)

Collections:

San Francisco Museum of Modern Art.

Publications:

By NAKAMURA: books—*Nues Japonais*, Paris 1960; *Young Nudes*, edited by Koen Shigemori, Tokyo 1961; *Nudes East and West*, with text by Shoji Yamagishi, Tokyo 1969; *Ema Nude in Africa*, with text by Kenichiro Tamada, Tokyo 1971; *My Work*, with text by Shinrio Chono, Tokyo 1976; *Woman's Angle*, with text by Tatsuo Shirai, Tokyo 1977; *Women's Sphere*, with text by Kenichiro Tamada, Tokyo 1978; *Japanese Spirit "Iki,"* with text by Koen Shigemori, Tokyo 1980; *Kabuki Actor, Tokizio, the Fifth*, with text by Konichiro Tamada, Tokyo 1980; articles—"Multilateral" in *Asahi Camera* (Tokyo), December 1963; "Vivace!" in *Asahi Camera* (Tokyo), April 1969; "Nude in Okinawa" in *Asahi Camera* (Tokyo), April 1970; "Paris, Light and Shadow" and "Since Then" in *Nippon Camera* (Tokyo), February 1971; "Flora Flora" in *Asahi Camera* (Tokyo), April 1973; "The Blood" in *Asahi Camera* (Tokyo), February 1975; "Twin" in *Nippon Camera* (Tokyo), February 1975;

Masatoshi Naitoh

"Autumn in Kyoto" in *Asahi Camera* (Tokyo), September 1976; "Sic Faces" in *Nippon Camera* (Tokyo), January 1977; "As She Is..." in *Nippon Camera* (Tokyo), June 1977; "Slot Machine" in *Camera Mainichi* (Tokyo), April 1980; "Blown Eve" in *Nippon Camera* (Tokyo), January 1981.

On NAKAMURA: book—*Japanese Photography Today and Its Origin* by Attilio Colombo and Isabella Doniselli, Bologna, Italy 1979; article—"A World of Women" in *Popular Photography's Woman 1972*, New York 1972.

Masaya Nakamura, who was born in 1926 in Yokohama, is a graduate of Tokyo Fine Arts High School, with a major in photography. After working for Yomiuri Newspapers and Eiga Sekaisha, he joined Waseda Studios; he became a freelancer in 1955.

The subject of his work—whether it be commercials, still-lifes, fashion photography or nudes—is always women. His photographs are often symbolic. Such adjectives as "witty," "gentle," "emotional," "passionate" and "sensuous" all appropriately describe his photography.

—Norihiko Matsumoto

NAMUTH, Hans.

American. Born in Essen, Germany, 17 March 1915; emigrated to the United States, 1941: naturalized, 1943. Educated at the Humboldt Oberrealschule, Essen, 1925-31; studied with Joseph Breitenbach, Paris, 1937-38, and with Breitenbach and Alexey Brodovitch at the New School for Social Research, New York, 1946-47. Served in the French Foreign Legion, 1939-40, and in the United States Army Intelligence Service, in Europe, 1943-45: Purple Heart; Croix de Guerre; Medaille du Maroc. Married Carmen P. de Herrera in 1943; children: Tessa and Peter. Freelance photographer, working for *Vu, Life*, etc., Paris and Majorca, 1935-38 (covered Spanish Civil War for *Vu* and other magazines, 1936-37), and for *Life, Look, Time, Newsweek, Harper's Bazaar, Vogue*, etc., New York, since 1946; established studio, New York, 1950; also, freelance filmmaker since 1951. Recipient: Merit Award, Film Council of Greater Boston, 1952; Association of Business Publishers Award, 1955; Art Directors Club of New York Award, 1956, 1959; Public Service Award, United States Department of State, 1958; Art Directors Club of Philadelphia Award, 1959. Agent: Castelli Graphics, 4 East 77th Street, New York, New York 10021. Address: 157 West 54th Street, New York, New York 10019, U.S.A.

Individual Exhibitions:

1949 *Guatemala: The Land, The People*, Museum of Natural History, New York (travelled to Pan-American Union, Washington, D.C., and the American Federation of Arts, New York, 1950)
1955 *Guatemala: The Land, The People*, American Federation of Arts, New York

1958 *17 American Painters*, at the *World's Fair*, Brussels
1959 *17 American Painters*, Stable Gallery, New York
1967 *Pollock*, Museum of Modern Art, New York
1973 *American Artists*, Castelli Gallery, New York
1974 *American Artists*, Corcoran Gallery, Washington, D.C.
1975 *Early American Tools*, Castelli Gallery, New York (travelled to the Washington Gallery of Photography, Washington, D.C.; Water Mill Museum, New York; and Guild Hall, East Hampton, New York, 1975; and the Broxton Gallery, Los Angeles, 1976)
1976 *The Spanish Civil War*, Castelli Graphics, New York
 Living Together, Benson Gallery, Bridgehampton, Long Island, New York
1978 *Small Retrospective*, Himelfarb Gallery, Water Mill, Long Island, New York
1979 *Todos Santos*, Castelli Graphics, New York (travelled to the Parrish Art Museum, Southampton, Long Island, New York)
 Jackson Pollock, Museum of Modern Art, Oxford
 Jackson Pollock: 63 Prints, Musée d'Art Moderne de la Ville, Paris (travelled to the Stedelijk Museum, Amsterdam)
1980 *Pictures from the War in Spain 1936-37*, Galerie Fiolet, Amsterdam
 Pollock Painting, Castelli Graphics, New York (travelled to the Magnuson Lee Gallery, Boston, and the Margo Leavin Gallery, San Francisco, 1981)
1981 *Artists 1950-1981: A Personal View*, Pace Gallery, New York

Selected Group Exhibitions:

1975 *The Photographer and the Artist*, Sidney Janis Gallery, New York
1979 *Self-Portraits*, Center for Creative Photography, University of Arizona, Tucson

Collections:

Metropolitan Museum of Art, New York; Museum of Modern Art, New York; Virginia Museum of Fine Arts, Richmond; Tulane University, New Orleans; Cleveland Art Museum; Center for Creative Photography, University of Arizona, Tucson; Los Angeles County Museum of Art; Fondation de la Photographie, Lyons; Museum Folkwang, Essen.

Publications:

By NAMUTH: books—*52 Artists*, New York 1973; *American Masters*, with text by Brian O'Doherty, New York 1973; *Early American Tools*, New York 1975; *L'Atelier de Jackson Pollock*, with text by Rosalind Krauss and Francis V. O'Connor, Paris 1978; *Pollock Painting*, New York 1980; *Artists 1950-1981: a Personal View*, New York 1981; films (with Paul Falkenberg)—*Jackson Pollock*, 1951; *Willem de Kooning, the Painter*, 1958; *Homage to the Square*, 1969; *The Brancusi Retrospective at the Guggenheim*, 1970; *Centennial at the Grand Palais*, 1971; *Louis I. Kahn, Architect*, 1972.

On NAMUTH: article—"Hans Namuth" in *Camera* (Lucerne), January 1979.

I remember Alexey Brodovitch's words to his class (in 1947 or thereabouts): "You can't be a photographer from 9 to 5. You are a 24-hour photographer or you are not a photographer."

Alexey Brodovitch left his mark on me as he did on everyone whose life he touched.

Hans Namuth: *Edward Albee*, 1980

Today I realize that there are still many fields in art—as in photography—still unexplored. I find new directions and new ideas almost daily.

—Hans Namuth

Hans Namuth's photographs occupy a special position in contemporary photography, balanced between the separate worlds of art and of art photography.

Namuth's earliest published and exhibited images are a series of documentary photographs, made collaboratively with Georg Reisner in Madrid during the Spanish Civil War. In the late 1940's, Namuth began to photograph in Guatemala, documenting areas that he revisits to the present time. But it was in the 1950's, after his studies with Alexey Brodovitch and Joseph Breitenbach, that Namuth began what has become his most widely recognized contribution to photography, the documentation of artists at work. Beginning with his classic study of Jackson Pollock in his studio (1950-51), Namuth continued to document the early Abstract Expressionist painters at work. His style, one of naturalness and freshness, separates his work from other photographers who have covered similar subject matter. Rather than emphasize a formality of composition that would mystify his subjects, Namuth sought a calmer approach—showing artists at work, in their studios, etc. The work succeeds without unnecessary bravado. There is an air of collaboration, not competition, between the artist and the photographer. This pursuit continues to the present date, and has expanded to include photographs of artists of later generations, architects and other art world personages.

In the mid 1970's, Namuth embarked upon another extensive series, titled Early American Tools. Using an 8 x 10 camera in an outdoor studio, Namuth has documented the modest tools used to build in the 18th century. Besides merely photographing these objects, Namuth's methods transform the simple objects into sculptural entities, beautiful in form and ambiguous in scale. This body of work, published in 1975, continues as Namuth discovers new pieces to enhance the grouping.

A third example of the serial nature of Namuth's work is a series of portraits made in Todos Santos, a small hill village in Guatemala. In subsequent trips to the area over three decades, Namuth has documented the rituals and local environment. In the late 1970's he began an ambition project to photograph all the inhabitants of the village. This humane compilation has produced beautiful images and serves as a rich source of anthropological information. All phases of village life are represented by local personages—shamans, farmers, politicians, etc.

Paralleling his interest in portraiture, Namuth has produced a series of films (in association with Paul Falkenberg) on various artists: Jackson Pollock, Josef Albers, Willem de Kooning, Brancusi, Louis Kahn and Alexander Calder. These films, when considered as an extension of his still photography, secure Namuth an interesting position in the world of the arts, as both artist and artist's witness.

—Marvin Heiferman

NARAHARA, Ikko.

Signs original prints as Ikko. Japanese. Born in Fukuoka, 3 November 1931. Educated at Matsue High School, Matsue, 1948-50; studied law at Chuo University, Tokyo, 1950-54, B.A. 1954; studied art history at Waseda University, Tokyo, 1954-59, M.A. 1959. Married Keiko Nakagawa in 1958. Free-lance photographer, Tokyo, since 1956. Founder Member, with Hosoe, Tomatsu, Kawada, Sato, and Tanno, Vivo Ltd. photographers agency, Tokyo, 1959-61. Recipient: Most Promising Photographer Award, 1959, and Photographer of the Year Award, 1967, Japan Photo Critics Association; Mainichi Arts Award, 1967; Arts Award, Ministry of Education, 1968. Address: Villa Fresca 702, 2-30-16 Jingumae, Shibuya-ku, Tokyo, Japan.

Individual Exhibitions:

1956 Man and His Land, Matsushima Gallery, Tokyo
1958 Domains, Fuji Photo Salon, Tokyo (travelled to the Fuji Salon, Osaka)
1959 Image of Castle, Marunouchi Gallery, Tokyo
1960 Blue Yokohama, Gekko Gallery, Tokyo
 Land of Chaos, Fuji Photo Salon, Tokyo
1965 España Gran Tarde, Fuji Photo Salon, Tokyo (and at the Ichi Bankan Gallery and Seibu Gallery, Tokyo, 1970)
1972 Celebration of Life, Seibu Gallery, Tokyo
1973 Ikko, International Museum of Photography, George Eastman House, Rochester, New York (then at the Neikrug Gallery and Nikon House, New York)
1974 Ikko's America, Nikon Salon, Tokyo (travelled to the Nikon Salon, Osaka)
1975 Ikko, Light Gallery, New York
1976 Where Time Has Stopped, Shadai Gallery, Tokyo
1977 B'way 1973-74, Iida Gallery, Tokyo
1978 Piazza San Marco, Wako Hall, Tokyo
1979 Journey to a Land So Near and Yet So Far, Nikon Salon, Iida Gallery, and Unac Salon, Tokyo (travelled to the Nikon Salon, Osaka; and Ban Gallery, Osaka)
1980 Light in Venezia, Nikon Salon, Tokyo
 Light and Waves, Maruzen Gallery, Tokyo
1981 The Photographers' Gallery, London

Selected Group Exhibitions:

1957 The Eyes of 10 Men, Konishiroku Gallery, Tokyo (and 1958, 1959)
1961 Non, Natsuya Gallery, Tokyo
 10 Contemporaries, Museum of Modern Art, Tokyo (and 1966)
1973 New Japanese Photography, Museum of Modern Art, New York
1977 Neue Fotografie aus Japan, Kulturhaus, Graz, Austria (travelled to the Museum des 20. Jahrhunderts, Vienna)
1978 Vivo, Santa Barbara Museum of Art, California
1979 Japan: A Self-Portrait, International Center of Photography, New York
 Japanese Photography Today and Its Origin, Galleria d'Arte Moderna, Bologna (travelled to the Palazzo Reale, Milan; Palais des Beaux-Arts, Brussels; and the Institute of Contemporary Arts, London)
 Venezia '79
 Fleeting Gestures: Dance Photographs, International Center of Photography, New York (travelled to The Photographers' Gallery, London, and Venezia '79)

Collections:

Nihon University, Tokyo; Tokyo Polytechnic Institute; Kyushu Sangyo University, Fukuoka, Japan; Kyushu Zokei Junior College, Fukuoka; Bibliothèque Nationale, Paris; Museum of Modern Art, New York; International Museum of Photography, George Eastman House, Rochester, New York; Museum of Fine Arts, Boston.

Publications:

By NARAHARA: books—Where Time Has Stopped, Tokyo 1967; España Gran Tarde, Tokyo 1969; The World of Kazuo Yagi, Tokyo 1969; Japanesque, Tokyo 1970; Man and His Land, Tokyo 1971; Celebration of Life, Tokyo 1972; Where Time Has Vanished, Tokyo 1975; Seven from Ikko, portfolio, with an introduction by Shuzo Takiguchi, Tokyo 1977; Domains, Tokyo 1978; Journey to a Land So Near and Yet So Far, Tokyo 1979; Light and Waves, with an introduction by J.G. Ballard, Tokyo 1980; Borpici di Luce: Piazza San Marco, Tokyo 1981.

On NARAHARA: books—Man and His Land by Masakazu Yamazaki, Tokyo 1971; Modern Photography Annual, New York 1972; New Japanese Photography, exhibition catalogue, by Shoji Yamagishi, New York 1973; Creative Camera Yearbook, London 1978; Journey to a Land So Near and Yet So Far, exhibition catalogue, by Koen Shigemori, Tokyo 1979; Japan: A Self-Portrait, exhibition catalogue, by Shoji Yamagishi, New York 1979; articles—by Allan Porter in Camera (Lucerne), September 1966; by Julia Scully in Modern Photography (New York), March 1968; by Richard Busch in Popular Photography (New York), August 1975; by Marline Voyeux in Zoom (Paris), June 1978.

Photography is....
 Photography is window with my mind within, world without.
 Photography is experience and expression of light.
 Photography is visual science fiction.
 Photography is fossil of life.
 Photography is frozen time and space.
 Photography is continuity and discontinuity.
 Photography is hidden dimension of cosmos.
 Photography is presage of future.
 Photography is direct and cryptic.
 Photography is intuition.
 Photography is dream.
 Photography reveals myself.

—Ikko Narahara

Ikko's reputation is largely based on his work outside Japan, especially his two major series, Where Time Has Stopped and Where Time Has Vanished. His travels and exhibitions in America and Europe have gained him wide, international recognition.

After graduating as a student of art history, Ikko Narahara returned to the area of Japan where he had grown up. With no photographic training, he borrowed his father's camera to document two corresponding worlds close to his home, drawing parallels between the village of Kurogami, which had been ruined and isolated by a volcanic eruption, and the artificial island of Hajima, known locally as "Warship Island" because of its strange shape, a coal mine surrounded by a concrete wall 30 feet high. This project was the start of a pattern that was to emerge through much of his later work. Ikko was attracted to the isolated, closed community that encapsulated the forces of a much wider human condition. The correspondence was between the village isolated by nature and the island isolated by the needs of society. He exhibited this work in 1956 in the exhibition Man and His Land, which was a surprising success. He continued the theme in 1958 with his document of a women's prison in Wakayama

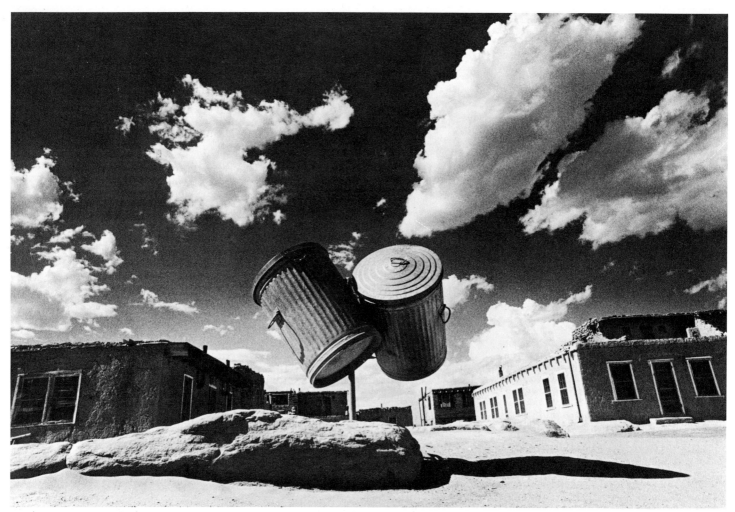

Ikko Narahara: *Two Garbage Cans, Indian Village, New Mexico,* 1972, from the book *Where Time Has Vanished*

City compared with a Trappist monastery at Hakodate on Hokkaido. The world of silent retreat was compared to one of brutal ostracism. This work was to appear in the book *Man and His Land* and was reprinted in *Domains*.

Ikko's first exhibition did not conform to the predominant style of photorealism, but was unorthodox, subjective and conceptual. The critics viewed it as a challenge to existing photo conventions, and they heralded him as a "new realist." Ken Domon, the master of a classic Japanese realism, was shortly to declare that "the first phase of Realism is over." The critic Tatsuo Fukishima subsequently asked Ikko and Eikoh Hosoe, who had recently held his own first exhibition (the narrative series "An American Girl in Tokyo," 1956), to cover an arts festival. This joint venture lead to the formation of the *Junin-no-me*, The Eyes of Ten.

By the end of the 1950's Japan was undergoing a great social upheaval following in the wake of the Occupation. The new, subjective style of Ikko and Hosoe was most appropriate for recording a country in rapid transition to economic strength and the development of a modern society with all the tensions and contradictions it contained. The critic Fukishima coordinated the work of Ikko, Hosoe and Tomatsu, together with the other members of the *Junin-no-me* group. The group was not an agency, but was formed to participate in collective exhibitions, the first of which was held at the Konishiroku Gallery in Tokyo in May 1957; subsequent exhibitions were held in 1958 and 1959. Ikko went on with Hosoe and Tomatsu to form the Vivo group, a collective agency of six photographers from the core of the *Junin-no-me*. The Vivo group exhibited until January 1962. The formation of these two groups marked the beginning of a modern Japanese photography, which was not imitative of, but quite distinguished from, developments of photography in the West.

Following the breakup of Vivo, Ikko went to Europe for three years. On his return, the results of his travels were published in his first book, *Where Time Has Stopped*. In contrast to the claustrophobic view of his first series, Ikko presented the expansive perspective of man in motion, with all the stimulation of a new, alien culture. He had grown up in a Japan that had been devastated; with the exception of Kyoto, every city had been bombed. In Europe he confronted the fabric of history that had survived the World War: it was a striking contrast to the concrete of his reconstructed native Japan. To hold that perspective, he attempted, as his title suggests, to freeze his image, not as in the minimal time of photographic exposure, but as in a long corridor of history. He photographed the stifled body of the man from Pompeii and framed him in his glass case. He looked for the dark shadows in the lanes of a Renaissance city or the form of arches on a Roman aqueduct. It was an overtly surreal Europe straight out of the conventions of de Chirico, in which classical architecture formed a backdrop to a play of mysterious shadow. These pictures are not inhabited by people but haunted by their shadows as giant, distorted silhouettes on stone walls. Ikko has indicated that the source of this imagery was the silhouette of the disintegrated man whose shadow appears on the wall at the site of the epicentre of the explosion at Hiroshima. "For many decades," he has said, "we will evolve through history in the company of this shadow."

In 1969 he published *España Gran Tarde*, a celebration of Spain and the bullring. Spanish tradition, with its flamboyance and passion, was immensely attractive to anyone from a more austere Japanese background. His Spanish work was closer to subjective or pictorial documentary as exemplified by Eugene Smith's "Spanish Village" series of 1951.

From 1970 to 1974 Ikko lived in New York and travelled widely in America. Unlike his European series, in his American series, *Where Time Has Vanished*, he created the illusion of America as a land with no past but a continual present. Many of the pictures have a flat, expansive sense of space. One is very conscious of his skies, which harbour lightning or neat, white Magritte clouds, which trigger the familiar surrealist connotation. He still found his silhouettes against frosted glass or in the shadow of a child on tarmac. There is the picture of the garbage cans flying down a village street in New Mexico, which was widely published, but more impressive is the shadow of the car driving through the Arizona desert. It is a distorted streak along the American highway, speeding past the surface of things to Ikko's vacant, timeless zone.

The most recent exhibitions of Japanese photography in Europe and New York have included work that Ikko did in 1969 at the Sojiji Temple in Tsurumi, which is a Zen temple of the Soto sect. The series is called "Silence." The exhibition of the series was a result of Ikko's new perspective on his own country on his return from abroad. It forms a logical third part to his other two major series and a reassertion of his Japanese identity, in common with the leading photographers of his generation. In this series he had no need to develop the borrowed imagery of an alien culture, but, true to the spirit of the subject, has found that vacant zone in his observations of the practice of zazen. It is a still world in which even the faces of the statues have been removed to leave a hollowed, black space, and the shaved heads of those who sit in zazen reveal no more than masks.

—Mark Holborn

NASH, Paul.

British. Born in London, 11 May 1889. Educated at Colet Court Preparatory School, London, 1898-1903; St. Paul's School, London, 1903-06; studied art at Chelsea Polytechnic, London, 1906-08; London County Council Art School, London, 1908, 1912; Slade School of Fine Art, London, 1910-11; self-taught in photography. Served as Official War Artist, British Army, 1917-19, 1940-44: Lieutenant. Married Margaret Theodosia Odeh in 1914. Independent painter, graphic and textile designer, associating with artists and writers Ben Nicholson, Roger Fry, Siegfried Sassoon, Rupert Brooke, C.R.W. Nevinson, Edward Burra, etc., London, Hampshire and Dorset, 1912-46; independent photographer, 1930-46. Art Critic, under occasional pseudonym Robert Derriman, *New Witness* magazine, London, 1919, *Weekend Review*, London, 1930-33, *The Listener*, London, 1931-35. Assistant Instructor, School of Design, Royal College of Art, London, 1924-25, 1938-40. President and Chairman, Society of Industrial Artists, London, 1932-34; Founder Member, with Henry Moore and others, Unit One group of artists, London, 1933. Member, London Artists Association, 1927. Died (in Boscombe, Hampshire, England), 11 July 1946.

Individual Exhibitions:

1939 Gordon Fraser Gallery, Cambridge
1943 Council for the Encouragement of Music and the Arts, London (toured Britain)
1945 Cheltenham Art Gallery
1951 *Paul Nash's Camera*, Arts Council Gallery, London (toured Britain)
1973 *Document and Image*, Tate Gallery, London
1978 *A Private World of Photography*, Fischer Fine Art, London
Paul Nash: Photographer, British Council, London (toured Europe, Africa and Far East)

Selected Group Exhibitions:

1979 *Photographic Surrealism*, New Gallery of Contemporary Art, Cleveland, Ohio (travelled to Dayton Art Institute, Ohio; and Brooklyn Museum, New York)
1980 *Modern British Photography 1919-1939*, Museum of Modern Art, Oxford (travelled to Leeds Polytechnic, Yorkshire; University of East Anglia, Norwich; University of Sussex, Brighton; City Museum and Art Gallery, Worcester; and Newport Museum and Art Gallery, Wales)

Collections:

Tate Gallery, London (all of Nash's extant negatives); Arts Council of Great Britain, London; British Council, London; Imperial War Museum, London; Victoria and Albert Museum, London; Leeds City Art Gallery, Yorkshire; Musée d'Art Moderne, Paris; National Gallery of Canada, Ottawa; Santa Barbara Museum of Art, California.

Publications:

By NASH: books—*Places*, London 1922; *Room and Book*, 1932; *Shell Guide to Dorset*, London 1936; *Monster Field: A Discovery Recorded*, Oxford 1946; *Aerial Flowers*, Oxford 1947; *Outline: An Autobiography and Other Writings*, London 1949; *Paul Nash: Fertile Image*, edited by Margaret Nash, London 1951, 1975; *Poet and Painter, Being Correspondence of Gordon Bottomley and Paul Nash*, edited by C.C. Abbott and Anthony Bertram, Oxford 1955; *A Private World of Photographers by Paul Nash*, portfolio, with an introduction by John Piper, London 1978; articles—"Photography and Modern Art" in *The Listener* (London), vol. 8, 1932; "Unit One: A New Group of Artists" in *The Times* (London), June 1933; "Unit One" in *The Listener* (London), July 1933; "For, But Not With" in *Axis* (London), January 1935; "Swangage of Seaside Surrealism" in *Architectural Review* (London), April 1936; "The Object" in *Architectural Review* (London), November 1936; "A Characteristic" in *Architectural Record* (New York), March 1937; "The Life of the Inanimate Object" in *Country Life* (London), May 1937; "Unseen Landscapes" in *Country Life* (London), May 1938; "The Giant's Stride" in *Architectural Review* (London), September 1939; "The Personality of Planes" in *Vogue* (London), March 1942.

On NASH: books—*Paul Nash's Camera*, exhibition catalogue, edited by Margaret Nash, London 1951; *Paul Nash: The Portrait of an Artist* by Anthony Bertram, London 1955; *Paul Nash 1889-1946* by Sir John Rothenstein, London 1961; *Paul Nash: Master of the Image 1889-1946* by Margot Eates, London 1973; *The Complete Graphic Work of Paul Nash* by Alexander Postan, London 1973; *Paul Nash's Photographs: Document and Image*, exhibition catalogue, with an introduction by Andrew Causey, London 1973; *Photomontage* by Dawn Ades, London 1976; *Photographic Surrealism*, exhibition catalogue, by Nancy Hall-Duncan, Cleveland, Ohio, 1979; *Modern British Photography 1919-1939*, exhibition catalogue, by David Mellor, London 1980; *Paul Nash* by Andrew Causey, Oxford 1980; articles—"The Photography of Paul Nash" in *Creative Camera* (London), June 1973; "Paul Nash" by Christian Caujolle in *Album Photographique* (Paris), October 1979.

For information about Paul Nash as artist, consult *Contemporary Artists*.

A photographer by chance—a painter who worried about his photos being more appreciated than his paintings—Paul Nash is primarily interesting because of his place in the history of photography. He took few unforgettable pictures. He had a style that was at once both naive and terribly sophisticated. But he was a different species.

Nash looked to nature for pureness of forms, visual surprises that he could use in his pictorial abstractions. He quickly grasped the camera's potential for fixing details in an often arid world, for subject matter, for unique perspective. What ultimately caught his interest in photography was its dependence on specific occasion.

Well before the arrival of conceptual photography, with its very particular "look," Nash was adept at witty pictures, often repetitive, which depicted the environment with a surprising kind of sham naiveté. His own particular kind of avant-garde photos—though they derive their meaning primarily from their relationship to their creator—prepared the way for the photograph of contemplation.

Nash's photos, concerned with speculating about the validity of notions of the "documentary," at least had the merit of sparing us that habitual self-regard of the work of more recent photographers with which they could be compared.

—Christian Caujolle

Rafael Navarro: *Diptico #10*, 1978

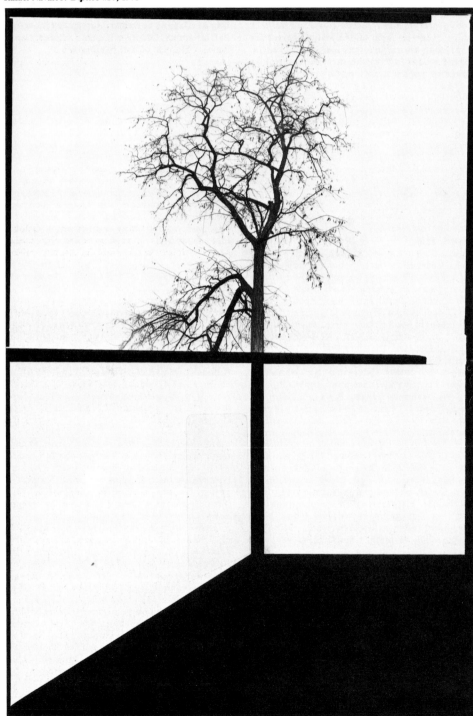

NAVARRO, Rafael.

Spanish. Born in Zaragoza, 8 October 1940. Self-taught in photography. Served in the Spanish Army/Air Force, 1960-62. Married Rosa Jera in 1965; children: Cesar, Alejandro, Sergio, Eduardo, Isabel and Pablo. Freelance photographer, Zaragoza, since 1973. Founder Member, with Joan Fontcuberta, Pere Formigera and Manel Escluso, Grupo Alabern photographers, Barcelona, since 1977. President, Sociedad Fotográfica de Zaragoza, 1974; Spanish Representative, Consejo Latinoamerica de Fotografia, 1978. Recipient: Artist Award, Federation Internationale de l'Art Photographique (FIAP), 1976. Agent: Mme. Michele Chomette, 240 bis Boulevard Saint-Germain, 75007 Paris, France. Address: Torres de San Lamberto 37-A, Zaragoza-11, Spain.

Individual Exhibitions:

1973　Galeria Prisma, Zaragoza, Spain
1974　Galeria Antonio Machado, Madrid
　　　Galeria Aixelá, Barcelona
1975　Galeria Spectrum, Barcelona
1976　Galeria Prisma, Zaragoza, Spain
　　　Galeria de C.F.C., Santiago de Chile
　　　Galeria Spectrum, Ibiza
　　　Sala de la Sociedad Fotográfica de Guipuzcoa, San Sebastian, Spain
　　　Galeria Tau, San Celoni, Spain
　　　Aula de Cultura Guecho, Bilbao, Spain
1977　Galerie de l'Instant, Paris
　　　Galeria La Tralla, Vich, Spain
　　　Galeria Altre Immagini, Rome
　　　Galeria Spectrum-Canon, Zaragoza, Spain
1978　Canon Photo Gallery, Geneva
　　　Galerie 31, Vevey, Switzerland
　　　Galeria Tau, San Celoni, Spain
　　　Fotomania, Barcelona
　　　Galeria de Arte de Caja Ahorros Provincial, Tarragona, Spain
1979　Galeria Pepe Rebollo, Zaragoza, Spain
　　　Galleria II Laboratorio d'If, Palermo, Italy
　　　Canon Photo Gallery, Amsterdam
　　　Galeria Lo Mico Nu, Lerida, Spain
　　　The White Gallery, Tel Aviv
　　　Sala Bellas Artes, Guadalajara, Mexico
1980　Foto Kit Galeria, Vitoria, Spain
　　　Galerij Paule Pia, Antwerp
　　　Photographic Center, Athens
　　　Sala de la Sociedad Fotográfica de Guipuzcoa, San Sebastian, Spain
　　　Galeria Tretze, Valencia, Spain
1981　Sala Zurbaran del Ateneo de Sevilla
　　　Galeria Costa-3 de Zaragoza
　　　Instituto Cultural Hispano-Mexicano, Mexico City

Selected Group Exhibitions:

1976　*Seis Fotografos*, Escuela Superior de Bellas Artes, Madrid
　　　Muestra Fotografia Española, Galeria Multitud, Madrid
1978　*La Fotografia Española*, Centro Juana Mordo, Madrid
　　　Hommage à Marcel Duchamp, Modern Gallery, Ljubljana, Yugoslavia
　　　Internationale Kunstmesse: Art 9, '78, Basle
　　　Rencontres Internationales de la Photographie, Arles, France
1979　*New Photographers from Spain*, Spanish National Tourist Office, New York
1980　*Hommage à Giorgio de Chirico*, Modern Gallery, Ljubljana, Yugoslavia
　　　Spanish Photography, Night Gallery, London
　　　Photographia: La Linea Sottile, Galleria Flaviana, Locarno, Switzerland

Collections:

Bibliothèque Nationale, Paris; Musée Réattu, Arles,

France; Musée d'Art Moderne, Brussels; Harkamp Collection, Amsterdam; Museum of Contemporary Art, Skopje, Yugoslavia; Centro Hidalgo, Mexico City.

Publications:

On NAVARRO: books—*50 Años de Fotografía en Zaragoza*, Zaragoza, Spain 1973; *Anuario Fotografico Española '74*, edited by Carlos Perez, Madrid 1974; *Everfoto 3*, edited by Carlos Perez, Madrid 1975; *Cotecflash 3*, edited by Francisco Torres, Barcelona 1976; *La Photographie Fantastique* by Attilio Colombo, Paris 1979; articles—"Brujas" by Pablo Perez M. in *Nueva Lente* (Madrid), October 1973; "La Femme Gelatine" by Claude Nori in Contrejour (Paris), March 1976; "Rafael Navarro" in *Reflexion* (Amsterdam), May 1979; Dipticos" by Ignacio Barceló in *Arte Fotografico* (Madrid), May 1979; "Juxtapositions" in *Petersen's Photographic Magazine* (Los Angeles), June 1979; "Spanish Photography in the 80's" by Joan Fontcuberta in *European Photography* (Göttingen), April 1980; "Presencias Metafisicas" by Joan Fontcuberta in *Nueva Lente* (Madrid), October 1980.

"Why are you a photographer?" has been the inevitable question since the very moment I started off; but my answer has undergone several changes through time, and I hope that it will go on changing in the future.

At the beginning I used to think that I had "a special feeling" for photos, and that was why I felt compelled to create pictures.

It didn't take me long to realize that I was actually using my photographs as a means of pouring out something burning inside me which I was not able to recognize, and even less able to tackle.

That made me understand that my flair for photographic expression had been purely casual and had only depended upon the circumstances which made me familiar with photography at the very moment I started needing to express my own self—full of disorder, counterpoints, taboos and inhibitions. Today, I am fully aware that my images have a lot of self-analysis in them, and I can even see among them some lousy self-portraits.

I cannot guess if all this comes true with my audience, but, anyway, I am not really interested in sending specific messages. I simply try to awaken certain emotions in those who observe (or should I say read?) my images—images which I intentionally impregnate with certain sensations. That is how, given a series of scattered clues, the spectator should create his or her own subjective interpretation and build up a personal response to the image.

My tendency towards introversion prevents me from direct communication with the people I happen to meet, and that aspect of my personality is obviously also present in my work—even though I want my photos to act as a counterpoint and not as a continuum of myself.

I openly introduce a lot of personal clues, which are hardly understandable to people who don't know me well; nevertheless, I have luckily had the opportunity to verify that these clues can be discovered by those who, even not knowing me, have a standpoint similar to my own.

I have never tried to stand up as a model of photographic expression, but I should be most glad if I succeeded in achieving sincerity in my work.

—Rafael Navarro

Within the prolific creativity of Rafael Navarro, it is with "Involución" (1976) and "Agur" (1977) and, most of all, with the series "Dípticos" (initiated in 1978) that his photographic expression reaches a true maturity. From this perspective, his earlier works now seem to be exercises to acquire and to discipline his creative potential and, as such, without any special importance for contemporary photography.

In "Involución," however, a message appears along with a more genuine and personal format treatment: the oppression-liberation dialectic of mankind expressed symbolically through the limitations of the negative itself. The confines of the photographic image represent the very same confines of vital space in which the photographic author moves. It is a vital space circumscribed by two principal forces: those dictates, moral and cultural, which form one's subsconscious, and the socio-political reality in which the artist has developed.

A work of art is, of course, a reflection of the artist's personal circumstances. But in the case of Navarro this dependency appears with more clarity than in most artists, suggesting the autobiographical, even the "therapeutic." Photography as an art form becomes equivalent to an arena of freedom wherein lies the possibility of evoking images that the artist can then utilize to escape from his own drama. In this way Navarro is a true representative of the artists and intellectuals of his generation. His attitude and personal contradictions are a sociological product of post-war Spain, that is to say, of the Franco era, characterized by a very difficult restructuring of the economy; culture viewed as subversion; a rigid Catholic morality; authoritarianism and discipline; a respect for tradition; and anachronistic familial values.

The work of Navarro can be compared to that of J.A. Labordeta in popular song and poetry. Although this comparison may seem inappropriate, there can be no doubt that their similarities go beyond that of simply sharing the same geographical and cultural origin—Aragon. In both the idea of rejecting the harsh and oppressive surrounding reality is the same, as is the poetic evasion in which they both take refuge. The "Involución" portfolio certainly contains the same sentiments as these verses by Labordeta:

> So you see
> We have gone surging forth
> With harsh, uncertain voices
> Of despair.

In the "Dípticos" the poetic space tends to broaden and universalize. Using the same graphic recourse throughout, Navarro arranges two distinct images whose confrontation creates a new meaning which is, according to him, "a subtle sensation, impossible to suggest with only one photograph." In effect, this binary arrangement permits a greater wealth of possibilities and amplifies the thematic and stylistic field enormously. As the Gestalt psychologists have long recognized, in the perception of visual images the whole is greater than the sum of its parts. The system doesn't attempt to develop aesthetic innovations. It simply allows a method of expression from which a whole series of messages emerge through the opposition of two primary concepts: presence versus absence, materialism vs. spirituality, life vs. death, mobility vs. immobility, tension vs. pacifity, light vs. dark, hot vs. cold, natural vs. artificial, etc. And, naturally, behind this simple mechanism one encounters the complex unfolding of Navarro's inner life: the melancholia, the agony, the solitude, the rage, the placidity, the love, the humor, etc., as though he were taking inventory of his psychic states.

Although Rafael Navarro carefully guards this subjective world of his behind a language of fairly obscure symbolism, there is no doubt that those who have had intensely the same feelings will recognize in "Dípticos" the keys to these experiences.

—Joan Fontcuberta

NETTLES, Bea.
American. Born in Gainesville, Florida, 17 October 1946. Educated at Yonge High School, Gainesville, 1960-64; University of Florida, Gainesville, 1964-68,

Bea Nettles: *C and Seagulls*, 1977

B.F.A. 1968; University of Illinois, Champaign-Urbana, 1968-70, M.F.A. 1970. Married Lionel Suntop in 1974; children: Rachel and Gavin. Freelance photographer, Rochester, New York, since 1970. Instructor in Photography, Nazareth College, Rochester, 1970-71, Tyler School of Art, Temple University, Philadelphia, 1972-74, and Visual Studies Workshop, Rochester, 1974-75. Instructor in Photography, Rochester Institute of Technology, 1971-72 and since 1976; currently, Associate Professor. Recipient: Creative Artists Public Service Grant, New York, 1976; National Endowment for the Arts Photography Fellowship, 1979. Address: 232 Vassar Street, Rochester, New York 14607, U.S.A.

Individual Exhibitions:

1970 *Images and Swamp Dreams*, International Museum of Photography, George Eastman House, Rochester, New York
1971 *Spring Dreams and Cloth*, University of Georgia, Athens
Plastic Mythology/Ecology Apology, Light Impressions, Rochester, New York
Puffed Parades, Slocumb Gallery, Johnson City, Tennessee
1972 Latent Image Gallery, Houston
Center of the Eye Gallery, Aspen, Colorado
Heart Attacks and Photo Fantasies, Light Gallery, New York
1973 Birmingham Art Gallery, University of Alabama at Birmingham
Snapshots of the Elements, Madison Art Center, Wisconsin (travelled to the Spectrum Gallery, Tucson, Arizona, 1974)
1974 *Two Recent Books*, School of the Art Institute of Chicago
1975 *Everyday Oddities*, Center for Photo Studies, Louisville, Kentucky
Woman's Art Centre of Moncton, New Brunswick, Canada
Inky Press Images, MFA Gallery, Rochester Institute of Technology, New York
1976 *Selected Images*, CEPA Gallery, Buffalo, New York
1977 *Photospectus*, Reading Museum, Pennsylvania
Moonbeams and Dreams, Focus Gallery, San Francisco
1978 *Moonbeams and Dreams*, Witkin Gallery, New York
The Photography Place, Philadelphia
1979 *Birthday Party: Images of 1 Year*, Light Impressions, Rochester, New York
Flamingo in the Dark, Orange Coast College, Costa Mesa, California
1980 *Recent Work*, Film in the Cities, Minneapolis

Selected Group Exhibitions:

1970 *Photography into Sculpture*, Museum of Modern Art, New York
1971 *Figure in Landscape*, International Museum of Photography, George Eastman House, Rochester, New York
1972 *Photo Media*, Museum of Contemporary Crafts, New York
60's Continuum, International Museum of Photography, George Eastman House, Rochester, New York
1974 *10 American Photographers*, The Photographers' Gallery, London
1976 *Photographie: Rochester, N.Y.*, Centre Culturel American, Paris
1978 *Fantastic Photography in the U.S.A.*, Canon Photo Gallery, Amsterdam (toured Europe and United States, 1978-80)
1979 *Attitudes: Photography in the 1970's*, Santa Barbara Museum of Art, California
Art for the Vice-President's House from

N.E. Museums, at Vice-President Mondales's House, Washington, D.C.
1980 *Photographia: La Linea Sottile*, Galleria Flaviana, Locarno, Switzerland

Collections:

Metropolitan Museum of Art, New York; International Museum of Photography, George Eastman House, Rochester, New York; Baltimore Museum of Art; St. Petersburg Museum of Art, Florida; University of Kansas, Lawrence; Museum of Fine Arts, Houston; Center for Creative Photography, University of Arizona, Tucson; Whatcom Museum of History and Art, Bellingham, Washington; Honolulu Academy of the Arts; National Gallery of Canada, Ottawa.

Publications:

By NETTLES: books—*Breaking the Rules: A Photo Media Cookbook*, Rochester, New York 1977; *Flamingo in the Dark: Images by Bea Nettles*, Rochester, New York 1979; also more than 15 books and card decks in limited editions since 1972; article—interview in *Photography Between Covers* by Thomas Dugan, Rochester, New York 1979.

On NETTLES: books—*The Woman's Eye* by Anne Tucker, New York 1973; *Aspects of American Photography 1976*, exhibition catalogue, by J. Tucker, St. Louis 1976; *The Less Than Sharp Show*, exhibition catalogue, by Howard Kaplan, Chicago 1977; *In/Sights: Self-Portraits by Women*, edited by Joyce Cohen, Boston and London 1978; *The Photograph Collector's Guide* by Lee D. Witkin and Barbara London, Boston and London 1979.

I first took photography as a senior art major at the University of Florida in 1967. Due to the encouragement of my first teacher, Robert Fichter, I began to relate photographic imagery to the other work that I was doing.

In 1968 I moved to Illinois to begin graduate work in painting. During that two year period, I began to incorporate photographic elements into more of my work. It was here that I began to stitch paper photographic prints together and eventually experimented with techniques of making cloth photographs.

From 1970-72 I worked extensively in mixed-media techniques. I freely incorporated stitching, hand coloring, plastics and drawing with my images. In the summer of 1972 I began to photograph with an inexpensive plastic instamatic camera. The resulting "straight" prints were sequenced, and two groups were made into limited edition books on an offset press.

It was at this point that I became fascinated with the possibilities of offset printing, and for almost three years I worked entirely in this medium, producing 10 different titles. They were distributed by Light Impressions, Rochester, New York, and are now mostly out of print. In this way these works reached an extensive audience.

I am currently working on a group of large unique images in the medium Kwik Print. Over 60 of these images appear in my color book *Flamingo in the Dark: Images by Bea Nettles*. I am continuing to investigate and share my life, my fantasies, and dreams. As always, I'm trying to stretch and share the limits of my imagination: that is why and how I continue my work.

—Bea Nettles

Bea Nettles is an innovator. She employs a vast array of processes and techniques to create her autobiographical, fantastic imagery. While studying painting and printmaking she began to include photographic imagery into her canvases and printing

plates; soon after that she moved on to explore hand coloring, photo linen, and other photographic mixed media possibilities, until she had done plastic quilts, mirror topped tables, and a whole range of sculpture and collage. Since then she has utilized many of these techniques in a variety of projects. She has self-published (and sometimes actually printed) a number of books—ranging from handmade, limited edition works, including children's books and books of her mother's poetry, to a fairly standard hardbound photographic book—and she has completed a set of original playing cards (Old Maid), and a contemporary interpretation of the Tarot Deck. Finally she has gathered the knowledge from all her experimentation to publish *Breaking the Rules: A Photo Media Cookbook*, which proved to be a popular guide to all sorts of photographic concoctions.

Nettles believes in *making*, rather than *taking* her photographs. She can go for months without using her camera because she often assembles her works from a stock of already existing imagery. Her work finds it source as much in her imagination as in the real world. Her fondness for antiques, fabrics, quilts, and other visual things like illustrated books and rare photographs provides her opportunity to discover intriguing images she might not have found while looking through the lens of a camera. She also values the mental image offered by writers, and the subconscious images that make their appearances in dreams. Like the Surrealists with whom she identifies, Nettles relys on intuition to form and shape her works.

The most common subjects and themes in her prints are the home, familiar landscapes, friends, motherhood, typical events, and a sense of self. Using archetypal symbols—like water, moon, bird, face, tree—in unique combinations, she creates dream-like fantasies in which past and present fuse to invoke a sense of myth. Autobiographical events are transformed into shared experiences, and personal memories become parts of a common consciousness in the public dreams of Bea Nettles.

—Ted Hedgpeth

NEUSÜSS, Floris M(ichael).

German. Born in Lennep, Rhineland, 3 March 1937. Educated at Röntgen-Gymnasium, Lennep, 1948-56; studied, under Ernst Oberhoff, Werkkunstschule, Wuppertal, Germany, 1956-58; under Hanna Seewald, Bayerische Staatslehranstalt für Fotografie, Munich, 1958-60; under Heinz Hajek-Halke and Helmut Lortz, Hochschule für Bildende Künste, Berlin, 1960-62. Worked in Staatliche Museen Berlin Photo-studio, Berlin, 1962-63; worked in Studio of Experimental Photography, Munich, 1963-66. Independent artist, exhibition organizer and photographer, Berlin, Vienna and Munich, since 1966. Instructor, then Professor, in Experimental Photography, Hochschule für Bildende Künste (now part of the University of Kassel), since 1971; Founder-Director, Fotoforum, Hochschule für Bildende Künste, Kassel, since 1972. Agents: PPS Galerie, Hoch Haus 1, Feldstrasse, 2 Hamburg 4; Sander Gallery, 2600 Connecticut Avenue N.W., Washington, D.C. 20008, U.S.A.; Benteler Galleries, 3830 University Boulevard, Houston, Texas 77005, U.S.A. Address: Menzelstrasse 15, 3500 Kassel, West Germany.

Individual Exhibitions:

1963 Galerie in der Hiltonkolonnade, West Berlin

Galerie Brebaum, Dusseldorf
Photokina '63, Cologne
1964 Staatliche Landesbildstelle, Hamburg
Galerie Nächst St. Stephan, Vienna
1965 Galerie des Jeunes, Paris
1966 Staatliche Werkkunstschule, Kassel, West Germany
Galerie im Europa Center, West Berlin
1967 Schauspielhaus, Staatstheater Kassel, West Germany
Galerie Nächst St. Stephan, Vienna
1968 Galerie Porta, Wuppertal, West Germany
Galerie Clarissa, Hannover
1972 Studio Kausch, Kassel, West Germany
1973 Galleria Il Diaframma, Milan
1974 Galerie Nagel, West Berlin
Galeria Fotografiki ZPAF, Warsaw
1976 Galerie Photo Art, Basle
The Photographers' Gallery, London
1977 Galerie Spectrum, Hannover
Retrospective 1957-1977, Kasseler Kunstverein, West Germany
1978 *Terre-Eau-Feu-Air*, Canon Galerie, Geneva

Galerija Suvremene Umjetnosti, Zagreb, Yugoslavia
1980 *Die Fotografie war bereits Erfunden*, Anelie Brusten Galerie, Wuppertal, West Germany

Selected Group Exhibitions:

1967 *Biennale de Paris*, Musée d'Art Moderne, Paris
1968 *Photokina '68*, Cologne
1969 *Vision and Expression*, International Museum of Photography, George Eastman House, Rochester, New York (toured the United States, 1969-71)
1970 *Der Bildungstrieb der Stoffe*, Kunsthalle, Nuremberg, West Germany
1974 *Künstleraktionen in Schaufenstern*, Württembergische Kunstverein, Stuttgart
1975 *Fotografie 1929-1975*, Württembergische Kunstverein, Stuttgart

1976 *Fantastic Photography in Europe*, at Rencontres Internationales de la Photographie, Arles, France (toured Europe and the United States, 1976-79)
1977 *Über Fotografie*, Westfälischer Kunstverein, Munster, West Germany
1979 *Deutsche Fotografie nach 1945*, Kassel, West Germany (toured West Germany)
1981 *Erweiterte Fotografie*, Wiener Sezession, Vienna

Collections:

Museum Folkwang, Essen; Kunstmuseum, Hannover; Museum Ludwig, Cologne; Museum für Kunst und Gewerbe, Hamburg; Münchner Stadtmuseum, Munich; Bibliothèque Nationale, Paris; International Museum of Photography, George Eastman House, Rochester, New York; Visual Studies Workshop, Rochester, New York; Gernsheim Collection, University of Texas at Austin; University of New Mexico, Albuquerque.

Publications:

By NEUSÜSS: books—*Einführung in die Technologie der Schwarz-Weiss-Fotografie*, Kassel, West Germany 1974; *Photography as Art/Art as Photography*, exhibition catalogue, with Peter Böttcher, Kassel, West Germany 1975; *Fotografie an der Gesamtschule Kassel*, Kassel, West Germany 1976; *Figuren und Massstäbe 1961-1976*, exhibition catalogue, London 1976; *Kunstforum, Sonderband: Die Fotografie*, Mainz 1976; *Photography as Art/Art as Photography II*, exhibition catalogue, Kassel, West Germany 1977; *Fotografien 1957-1977*, Kassel, West Germany 1977; *Berufsbild Foto-Design*, with Volker Rattemeyer, Bielefeld, West Germany 1977; *Flugtraum und Körperauflösung*, Kassel, West Germany 1977; *Deutsche Fotografie nach 1945*, editor, with Petra Benteler, Kassel, West Germany 1979; *Fotografie als Kunst/Kunst als Fotografie: Das Medium Fotografie in der bildenden Kunst Europas ab 1968*, editor, Cologne 1979; *Fotografie in Kassel 1840 bis Heute—Kassel in Fotografien*, editor with W. Kemp, Munich 1981; *Medium Fotografie*, exhibition catalogue series, editor, Kassel, West Germany 1978-; articles—"Interview: Floris M. Neusüss," with Philippe Dampenon, in *Le Nouveau Grand Angle* (Paris), May 1978; "Interview mit Floris M. Neusüss und Bildbeitrag zu 'Körperauflösungen'" in *Baseler Magazine* (Basle), August 1978; "It's Not a Question of Photography" in *European Photography* (Göttingen), October/November 1980.

On NEUSÜSS: books—*Das Deutsche Lichtbild*, annual, by O. Steinart and W. Strache, Stuttgart 1960; *Photography Without a Camera* by P. Holter, New York 1972; *Romain: Die Fotografie* by Klaus Honnef, Frankfurt 1976; *Die Geschichte der Fotografie im 20. Jahrhundert/Photography in the 20th Century* by Petr Tausk, Cologne 1977, London 1980; *Über Fotografie* by H. Molderings, Munster 1977; *Dumont Foto 1*, edited by Hugo Schottle, Cologne 1978; *La Photographie Fantastique* by Lorenzo Merlo and Claude Nori, Paris 1979; *Fotografie 1919-1979; Made in Germany: Die GDL-Fotografen*, edited by F. Kempe, B. Lohse, H. Fuchs, W. Boje and others, Frankfurt 1979; *Photographia: La Linea Sottile*, exhibition catalogue, by Rinaldo Bianda and Giuliana Scimé, Locarno, Switzerland 1980; articles—"Lichtgrafik von Floris M. Neusüss" by Franz Roh in *Gebrauchsgrafik* (Munich), September 1964; "Floris M. Neusüss und seine Skurrilien" by Fritz Kempe in *Foto Rundschau* (Dusseldorf), March 1965; "Floris M. Neusüss" by Kazumi Masaru in *Graphic* (Tokyo), October 1967; "Floris M. Neusüss: Photograms" by Julia Scully in *Modern Photography* (New York), May 1970; "Sequence" in *Camera* (Lucerne), February 1971; "Photo Scale: Floris Michael Neusüss"

Floris M. Neusüss: *Self-Portrait*, 1972

in *Camera* (Lucerne), February 1975; "Floris M. Neusüss et la Fotoforum" by Gisèle Freunde in *Zoom* (Paris), August/September 1977; "Floris M. Neusüss" by Willem Coumans in *Foto Nederlandse* (Amsterdam), March 1978; television films—*Floris M. Neusüss: Experimentelle Fotografie*, directed by Ingeborg Euler, 1968; *Rencontres Internationales de Photographie: Interview with Floris M. Neusüss*, 1977; *Aspekte der Fotografie: Floris M. Neusüss, Schöpfer Neuer Bildweten* by Fritz Gruber, 1978; *An der Wiege der Fotografie: Floris M. Neusüss und Seine Studenten in Chalon-sur-Saône* by Hartmut Schwenk, 1978; *Kunstlerportrait Floris M. Neusüss* by Bettina von Cube, 1979.

Photographs are the most important part of my work. The principle of a photogram is that an object is laid on sensitive paper in the dark, is exposed to light, and then developed. This photographic method without a camera portrays the subject—or, as in my work: people—in original size, or rather lifesize, as shadows. The photogram is a process which brings the subject of the picture into direct contact with the photographic basis of the picture—in all other photographic processes the lens comes between the picture-subject and the sensitive material.

From the beginning photography was a decisive factor in my artistic career. I gave up the study of painting in Wuppertal to be instructed in photography, and after that continued my studies at the Hochschule für Bildende Künste, Berlin, in Hajek-Halke's photography class. In the course of my studies I came to know the work of Moholy-Nagy and Man Ray and was particularly fascinated by their photograms. Both added objects to their collages, abstract and constructivist (Moholy) or surreal (Man Ray)—very rarely, a "human reference," a hand or a head, was portrayed, and then not as a reference to reality but rather as an intensification of the surreal and enigmatic aspect.

In three ways my work has gone beyond that of the pioneers of the photogram: first, in my choice of subject, for the portrayal of the whole human body opens up a realistic dimension with a decisive influence on the image; second, in the combination of photography and painting, for the development of the exposed photographic paper in the photographic developer—a process which one cannot carry out afterwards with photographs developed according to the rules—becomes, in some of my works, an act of deliberate control, as in painting: I take the development process "in hand," in that I dip brush, sponge or rag in the developer and bring forth the picture by wiping the paper. In this way I produce a controlled, painterly plane which brings out the photographically registered form and at the same time dissolves it by superimposing the wiped structure on the figure. While Moholy and Man Ray had to decide on the unalterable appearance of their pictures at the moment of exposure, I do not make up my mind even during the development process and in some works do not bring anything to a conclusion in that I do not fix the pictures. ("Wiped photograms originated in 1963-64 during and after a visit to Vienna and contact with the "St. Stephan Gallery Group"—Hollega, Mikl, Prachensky, Rainer.)

The third aspect is the production of color: non-fixing means that the undeveloped areas of the pictures are constantly changing color through the years. Moholy's desire for color in the photogram remained unfilled, and he believed that "the greatest hope for the future will be to master the colored photogram." He was thinking, certainly, about the production of photograms on a color photography basis. My colored photograms originated, however, from the behavior of color on black-and-white photographic paper developed under specific conditions.
—Floris M. Neusüss

It is the important film theorist André Bazin who has made the most illuminating comments on the magical qualities of photography. He sees in the photographic image not merely a reproduction of reality, but also believes that a kind of ontological transfer takes place during the process of reproduction in which the subject transmits a portion of its own being to the picture. This magical dimension was present in the earliest photographs and gives them a significance above and beyond their aesthetic value. Over the years, however, the medium has lost a good deal of its magic. The mass production of photographs has created the illusion of a photographic reality which replaces actual reality. This "second-hand" reality in turn imposes a collective, generalized view of reality upon us, so that to some extent the photographs of the latter part of the 20th century are almost exclusively copies of copies.

Floris Neusüss has taken into account this historical development and its implications. He was trained first as a printer and then turned to the study of photography, going back to its origins. This proved valuable because it led to his well-known homages to the pioneers of photography, but also has an anthropological significance as well. Neusüss is the only modern photographer of consequence who has regained an awareness of the magical side of photography.

Neusüss' photograms give us life-sized silhouettes of his subjects. In Greek mythology, when men died they entered the realm of the shades ruled over by Psyche, goddess of the soul. Although less consoling than the Christian view, the Greek view also allowed for a kind of immortality. Now, in capturing the image of the living in a photograph, we also express a natural wish for some kind of survival. It follows, then, that in a sense we can overcome death, if only by making an authentic image of the living.

Aware of the levelling social tendencies of the past 150 years, Neusüss remains somewhat sceptical. It is only the shadowy outline of his models which remains on the light-sensitive paper. Thus Neusüss is an innovator, since the pioneers of photography, Man Ray and Moholy-Nagy (whose work he encountered in his studies) limited themselves to abstractions from concrete forms and the arrangement of formal patterns. Moreover, these pioneers were fascinated by light rather than by shadows, since shadows are identity-less. Yet we also know from folk-tales that whoever loses his shadow loses his identity. Thus we have the "faceless" figures of post-modern industrial society; Neusüss emphasizes this situation by bringing his own physical presence into his identity-less pictures.

Like a painter, Neusüss controls the development of his photograms and thus prevents the process from becoming automatic. At the same time he foregoes the "fixing" stage and thereby surrenders the photographic process to the force of time. He breaks the hermeneutic circle which photography has imposed upon reality and disturbs its course by his deliberate artistic operations. The spontaneous reality of fantasy takes the place of photographic illusion and manifests itself in the visual effects of these operations. This is true as well of his earlier dream images and their systematic analysis of the syntax of photography (his 1:1 images, for example, and his self-portraits). All ot these experiments constitute a complete body of artistic photography whose purpose is to understand the relationship between reality and photography. Thus Neusüss succeeds in penetrating the "image-curtain" which hangs in front of reality.

—Klaus Honnef

NEWMAN, Arnold (Abner).

American. Born in New York City, 3 March 1918. Educated at public schools, Atlantic City, New Jersey and Miami Beach, Florida, 1925-36; studied art at the University of Miami, 1936-38. Married Augusta Rubenstein in 1949; sons: Eric and David. Assistant portrait photographer to Leon Perskie, Philadelphia, and in same chain of studios, Baltimore and Allentown, Pennsylvania, 1938-39; Manager, Tooley-Myron Photo Studio, West Palm Beach, Florida, 1939-41; Director, Newman Portrait Studio, Miami Beach, 1942-45. Owner and President, Arnold Newman Studios Inc., New York, since 1946. Adviser on Photography, Israel Museum, Jerusalem, since 1965. Visiting Professor of Photography, Cooper Union, New York, since 1975. Recipient: *Photokina* Award, Cologne, 1951; First Annual Photojournalism Conference Award, University of Miami, 1957; Philadelphia Museum College of Art Citation, 1961; Newhouse Citation, Syracuse University, New York, 1961; University of Miami Citation, 1963; Gold Medal, *Biennale Internazionale della Fotografia*, Venice, 1963; Life Achievement Award, American Society of Magazine Photographers, 1975. D.F.A.: University of Miami, 1981. Agent: Light Gallery, 524 Fifth Avenue, New York, New York 10019. Address: Arnold Newman Studios Inc., 39 West 67th Street, New York, New York 10023, U.S.A.

Individual Exhibitions:

1941 A.D. Gallery, New York (with Ben Rose)
 Artists Through the Camera, Brooklyn Museum, New York
1945 *Artists Look Like This*, Philadelphia Museum of Art (toured the United States)
1951 The Camera Club, New York
 Photographs 1938-1950, Milwaukee Art Institute
1953 *Color and Black and White*, Ed Weiner Gallery, Provincetown, Massachusetts
 Arnold Newman: Retrospective, Art Institute of Chicago
1955 *Collective Work*, Portland Art Museum, Oregon
1956 Santa Barbara Museum of Art, California
 Photographs 1940-1954, Ohio University, Athens
 Miami Beach Art Center
1958 *Portraits*, Cincinnati Art Museum, Ohio
1961 *Portraits*, Phoenix Art Museum, Arizona
1963 *Portraits*, at the *Biennale Internazionale della Fotografia*, Venice
1972 Light Gallery, New York
 Photographs from Three Decades, International Museum of Photography, George Eastman House, Rochester, New York (has toured the United States, since 1972; travelled to Japan, 1980)
1974 Light Gallery, New York
1975 The Photographers' Gallery, London
1976 Galerie Fiolet, Amsterdam
1977 Delaware Art Museum, Wilmington
 Light Gallery, New York
1978 Silver Image Gallery, Seattle
 Portraits, Israel Museum, Jerusalem
 Portraits, Tel Aviv Museum of Art
1979 *The Great British*, National Portrait Gallery, London (travelled to the Light Gallery, New York)
1980 *Galerie Créatis, Paris*
 Artists, Light Gallery, New York
1981 Snite Museum of Art, University of Notre Dame, Indiana
 Atlanta Gallery of Photography
 P.G.I. Gallery, Tokyo

Selected Group Exhibitions:

1943 *Masters of Photography*, Museum of Modern Art, New York

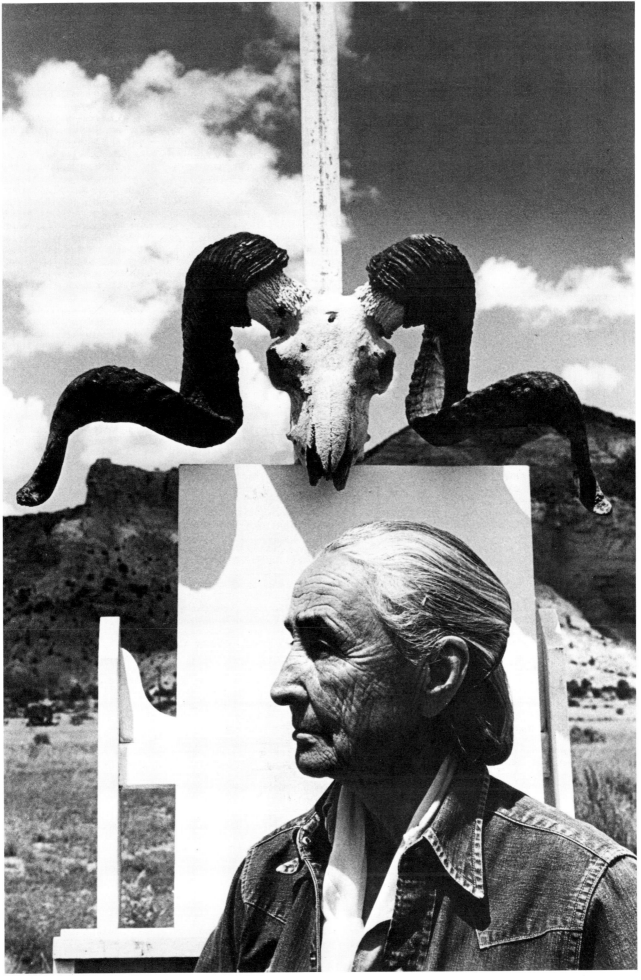

Arnold Newman: *Georgia O'Keeffe*, Ghost Ranch, New Mexico, 1968

561

1948 *In and Out of Focus*, Museum of Modern Art, New York

1953 *Contemporary American Photography*, National Museum of Modern Art, Tokyo

1957 *Faces in American Art*, Metropolitan Museum of Art, New York

1959 *Photography at Mid-Century*, International Museum of Photography, George Eastman House, Rochester, New York

1964 *The Photographer's Eye*, Museum of Modern Art, New York

1968 *Photography in the 20th Century*, National Gallery of Canada, Ottawa (toured Canada and the United States, 1967-73)

1970 *The Camera and the Human Facade*, Smithsonian Institution, Washington, D.C.

1972 *Portrait of the Artist*, Metropolitan Museum of Art, New York

Collections:

Metropolitan Museum of Art, New York; Museum of Modern Art, New York; International Museum of Photography, George Eastman House, Rochester, New York; Philadelphia Museum of Art; Smithsonian Institution, Washington, D.C.; Art Institute of Chicago; National Portrait Gallery, London; Moderna Museet, Stockholm; Israel Museum, Jerusalem.

Publications:

By NEWMAN: books—*Happytown Tales*, with Lawrence Tremblay, Coral Gables, Florida 1944; *Bravo Stravinsky*, with text by Robert Craft, Cleveland 1967; *One Mind's Eye: The Portraits and Other Photographs by Arnold Newman*, with an introduction by Robert Sobieszek, and a foreword by Beaumont Newhall, Boston and London 1974; *Faces U.S.A.*, with a foreword by Thomas Thompson, New York 1978; *The Great British*, with text by George Perry, London and Boston 1979; *Artists: Portraits from Four Decades*, with a foreword by Henry Geldzahler, Boston and London 1980; articles—"Portrait of an Artist" in *Minicam Photography* (Cincinnati, Ohio), November 1945; "Arnold Newman on Portraiture" in *Popular Photography* (New York), May 1957; "Arnold Newman's Europe" in *Popular Photography* (New York), March 1964; interview in *Interviews with Master Photographers* by James Danziger and Barnaby Conrad III, London 1977; "Peer Group" in *Camera Arts* (New York), January/February 1981.

On NEWMAN: books—*The History of Photography* by Beaumont Newhall, New York 1949, 1954; *Famous Portraits*, edited by L. Fritz Gruber, New York 1960; *The Encyclopaedia of Photography*, edited by H.M. Kinzer, New York 1964; *The Picture History of Photography* by Peter Pollack, revised edition, New York 1969; *Looking at Photographs* by John Szarkowski, New York 1973; *The Magic Image* by Cecil Beaton and Gail Buckland, London and Boston 1975; *Faces: A Narrative History of the Portrait* by Ben Maddow, Boston 1977; *Current Biography*, volume 41, number 10, edited by Charles Moritz, New York 1980; articles—"Arnold Newman" by Fritz Neugass in *Camera* (Lucerne), June 1953; "On Assignment with Arnold Newman" by Arthur Goldsmith in Popular Photography (New York), May 1957; "American Artists" by Nan Rosenthal in *Art in America* (New York), June 1965; "Les Teles Couronees d'Arnold Newman" by Evelyne Jesenof in *Photo* (Paris), June 1973; "A Lesson in Portraiture from a Master" by Arthur Goldsmith in *Popular Photography* (New York), November 1973; "Arnold Newman" by Trevor Gett in *Australian Photography* (Melbourne), October 1980; film—*The Image Makers: The Environment of Arnold Newman*, Nebraska Educational Television Network film, 1977.

While I am best known for my portraits, I work in many areas of photography. To restrict oneself is to diminish one's creative thinking and opportunities. Above all, a good portrait must first be a good photograph. There is no separation, no dividing line between a photograph that includes a person and all other photographs.

I am not as interested in documentation as I am in conveying my impressions of individuals by means of the ever-expanding language of my medium including all its experimental forms. Although my approach has become popularly known as environmental portraiture (photographing my subjects in their own milieu), it only suggests a part of what I have been and am doing.

Overlooked is that my approach is also "symbolic" and "impressionistic" or whatever label one cares to use. I am suspicious of labels and rules, which soon become academies and prisons for any art form. The only thing that matters is the final image and what it conveys.

—Arnold Newman

The portraits of Arnold Newman express both a lifelong fascination with the practitioners of contemporary art and the vision they shaped. As a leading exponent, although not the originator, of "environmental portraiture," Newman has achieved a vivid personal style which fuses formal aspects of photography with the personality of the human being portrayed by relating the sitter to suggestive details in his immediate surroundings.

Born in New York City in 1918, the son of a clothing manufacturer, Newman grew up during the hard times of the Great Depression. After the stock market crash of 1929, the family moved to Miami Beach where the father was involved in leasing hotels for the tourist trade. His early interest in and aptitude for art were encouraged by his parents, and he received an art scholarship from the University of Miami. Because of financial difficulties, he never graduated, but in 1981 the University conferred upon him an honorary degree.

Accepting a welcome offer of a job as an apprentice in a photographic firm in Philadelphia, he made the move and learned the fundamentals of commercial portraiture while continuing his art studies at the Philadelphia School of Industrial Arts. During visits to New York in 1941 he had the opportunity to meet Alfred Steiglitz and Beaumont Newhall, both of whom viewed his personal portraits and encouraged him. A joint exhibition at New York's A.D. Gallery, with Ben Rose, a friend and former Boy Scout patrol leader, helped launch Newman's career.

During the war years Newman operated a highly successful portrait studio in Miami Beach, but in 1946 he moved to New York where he soon began to receive important, and lucrative, assignments from *Life* and *Harper's Bazaar*, whose brilliant, demanding art director, Alexey Brodovitch, was an important influence on his growth as a photographer. During this period he made what is perhaps his single most famous image, a portrait of Igor Stravinsky dominated by the black shape of his open piano against a blank wall. The graphic power of this image, with its telling juxtaposition of man and instrument, firmly established the Newman style of portraiture.

Meanwhile, Newman married Augusta Rubenstein, sons were born and the family set up a comfortable menage on Manhattan's West Side where apartment neighbors and friends included fellow-portrait photographer Philippe Halsman and his wife. Simultaneously, Newman continued to maintain his contacts with New York's art world at the time of its great post World War II blossoming.

During this period he fine-tuned his art and craft, winning respect not only for the power of his vision and his warmth of rapport with difficult personalities, but also as a darkroom perfectionist. He was kept busy with many journalistic and business portrait assignments, including a notable series of *New York Times* staffers for an advertising campaign commissioned by the newpaper. Although the controlled, meticulous approach he preferred naturally lent itself to large-format view cameras, he began to work effectively with mobile 35-mm cameras and wide-angle lenses.

Newman has been widely exhibited in one-man and group shows during the years, and named one of the world's 10 greatest photographers during a 1958 *Popular Photography* poll. He supplied the photographs for the book, *Bravo Stravinsky*, authored by Robert Craft in 1967. *One Mind's Eye*, a collection of his portraits, was published in 1974. However, it was the major retrospective of his portraits of American artists at Light gallery, and an accompanying book, *Artists: Portraits from Four Decades*, that most fully realized his lifelong efforts to produce a comprehensive portrait gallery of the leading painters and sculptors of our time.

Newman's style is so distinctive that its surface formula can easily be imitated, which it often has. But there is much more to it than the simple posing of a subject among examples of his work or the tools of his trade. To achieve a fusion that comes alive both as a work of art and a valid human statement is difficult, and Newman himself does not always succeed. In his most successful work, however, the effect is remarkable: the formal elements of shape, value, lighting, and texture express the personality and suggest the style of the individual portrayed. The effeminate, elegant, arrogant personality of fellow-photographer Sir Cecil Beaton flows into a roccoco environment of ornate rugs, crystal chandeliers and fragile furniture, to create a seamless web. The power and orderly precision of Alfred Krupp becomes an extension of, or a projection onto, the factory assembly line framed behind him.

—Arthur Goldsmith

NEWTON, Helmut.

Australian. Born in Berlin, Germany, 31 October 1920; emigrated to Australia; later settled in Paris. Educated at Heinrich von Treitschke Realgymnasium, Berlin, 1928-32; American School, Berlin, 1933-35. Served in Australian Army, 1940-45: Private. Married the photographer and actress June F. Browne (pseudonyms: June Brunell, Alice Springs) in 1948. Apprentice to fashion and theatre photographer Eva (Else Simon), Berlin, 1936-40; freelance photographer, Sydney, in the mid-1940's; freelance photographer, working for *Jardin des Modes*, *Elle*, *Queen*, *Playboy*, *Nova*, *Marie-Claire*, etc., since 1958, now particularly for *Stern* and French and American editions of *Vogue*. Recipient: Best Photography Award, Art Directors Club, Tokyo, 1976; American Institute of Graphic Arts Award, 1977, 1980; Gold Medal, Art Directors Club, Germany, 1978, 1979. Agents: Xavier Moreau Inc., 111 West 57th Street, New York, New York 10019, U.S.A.; John Dunnicliff, Art Directions, 34 Quai Henri IV, 75004 Paris. Address: 20 rue de l'Abbé de l'Epée, 75005 Paris, France.

Individual Exhibitions:

1975 Nikon Galerie, Paris
 Canon Photo Gallery, Amsterdam

1976 The Photographers' Gallery, London (with

Hideki Fujii)
Nicholas Wilder Gallery, Los Angeles
1978 Marlborough Gallery, New York
1979 Centre Culturel Americain, Paris
Canon Photo Gallery, Geneva
Silver Image Gallery, Seattle, Washington
1981 Galerie Daniel Templon, Paris

Selected Group Exhibitions:

1975 *Fashion Photography: 6 Decades*, Emily Lowe Gallery, Hofstra University, Hempstead, New York (toured the United States)
1977 *Fashion Photography*, International Museum of Photography, Goerge Eastman House, Rochester, New York (travelled to the Brooklyn Museum, New York; San Francisco Museum of Modern Art; Cincinnati Art Institute, Ohio; and Museum of Fine Arts, St. Petersburg, Florida)
1979 *Fleeting Gestures: Dance Photographs*, International Center of Photography, New York (travelled to The Photographers' Gallery, London, and *Venezia '79*)
La Mode, Galerie Zabriskie, Paris
Photographie als Kunst 1879-1979, Tiroler Landesmuseum, Innsbruck, Austria (travelled to Neue Galerie am Wolfgang Gurlitt Museum, Linz, Austria; Neue Galerie am Landesmuseum Joanneum, Graz, Austria; and Museum des 20. Jahrhunderts, Vienna)
1980 *Instantanés*, Centre Georges Pompidou, Paris

Collections:

Condé Nast Publications Inc., Paris and New York; Bibliothèque Nationale, Paris; Fashion Institute of Technology, New York; Museum of Modern Art, New York; International Museum of Photography, George Eastman House, Rochester, New York.

Publications:

By NEWTON: books—*White Women/Femmes Secretes*, with an introduction by Philippe Garner, New York, London, Munich and Paris 1976; *Sleepless Night/Nuits Blanches*, New York, London, Munich and Paris 1978; *Helmut Newton: Special Collection: 24 Photo Lithos*, New York, London, Munich and Paris 1979; articles—"Helmut Newton: I Think the 'Ideal' Nude Is Erotic" in *Nude: Theory*, edited by Jain Kelly, New York 1979; "Helmut Newton," interview, with Yves Aubry, in *Zoom* (London), November/December 1979; "Helmut Newton Talks to Maud Molyneux," interview, in *Viz* (London), no. 12, 1980.

On NEWTON: books—*Design and Art Direction '68*, London 1968; *Design and Art Direction '69*, London 1969; *The Magic Image* by Cecil Beaton and Gail Buckland, London and Boston 1975; *Photography Year 1976*, by the Time-Life editors, New York 1976; *La Photographie Française des Origines à nos Jours* by Claude Nori, Paris and London 1978; *Geschichte der Fotografie im 20. Jahrhundert/Photography in the 20th Century* by Petr Tausk, Cologne 1977, London 1980; *The Vogue Book of Fashion Photography* by Polly Devlin, with an introduction by Alexander Liberman, New York and London 1979; *The History of Fashion Photography* by Nancy Hall-Duncan, New York and Paris 1979; *Photographie als Kunst 1879-1979/Kunst als Photographie 1949-1979*, exhibition catalogue, 2 vols., by Peter Weiermair, Innsbruck 1979; *SX-70 Art*, edited by Ralph Gibson, New York 1979; *Instantanés*, exhibition catalogue, by Michael Nuridsany, Paris 1980; *Art at Auction 1979-80: Sotheby*

Parke Bernet, London 1980; *Contemporary Decorative Arts from 1940 to the Present* by Philippe Garner, London and New York 1980; articles—"C'est la Nouvelle Loi de Newton" in *Photo* (Paris), October 1971; "Vogue Paris" by Claude Nori in *Progresso Fotografico* (Milan), December 1973; "Insight: Helmut Newton" in *Camera* (Lucerne), March 1974; "Helmut Newton" in *The Image* (London), vol. 2, no. 5, 1974; "Helmut Newton: Erotica/Fashion Photos" in *Oui* (Paris), August 1974; "My October Child: Helmut Newton" in *Camera* (Lucerne), September 1974; "A Return to Roundness in All the Right Places" by Michael Roberts in *The Sunday Times* (London), 3 January 1976; "Meet the Wife" by Christopher War in the *Daily Mirror* (London), 7 January 1976; "They Bare It All for the Sake of Fashion" by Patricia Morgan in *The Sun* (London), 24 January 1976; "Helmut Newton and Hideki Fujii" by William Packer in the *Financial Times* (London), 29 January 1976; "Helmut Newton: Women Observed" in *Penthouse Photo World* (New York), February/March 1977; "Helmut Newton: Women as Erotica" in *Penthouse Photo World* (New York), April/May 1977; "I Professionati: Helmut Newton" in *Fotografia Italiana* (Milan), September 1977; "Cheres Confrères" in *Photo* (Paris), March 1979; "Brutality Chic" by Rosetta Brooks in *ZG* (London), no. 2, 1980; "La Fine Fleur d'Helmut Newton" in *Photo* (Paris), October 1980; film—*Helmut Newton*, Thames-TV documentary, by Michael Whyte, 1978.

Helmut Newton is first and foremost a fashion photographer, following the tradition created by Adolphe de Meyer and developed by Hoyningen-Huene, Steichen, Munkacsi, Blumenfeld, Horst, Penn and Avedon. His photographs are perfectly suited to the purposes for which they were made—indeed, Newton surpasses the work of his predecessors in this respect and undermines their achievements by introducing an element of social criticism which is subliminal, perhaps unconscious and in any event nearly hidden by the alluring world he depicts: a luxurious, indolent world of *fin-de-siècle* hotels, strange landscapes surrounding French and Italian castles, and the cold, veneered splendors of fashionable New York and Paris apartment buildings. The atmosphere in which his beautiful, intense mannequins move tends to conceal the critical undercurrent, so that his work differs only slightly from that of other great fashion photographers, with the possible exception of Deborah Turbeville.

The critical undertone of his work is apparent in the formal grip he has on the subjects he portrays, his models and the fashionable (and sometimes shady) worlds they inhabit. But the totally artifical atmosphere of traditional fashion photography is missing in Newton's work, and we can begin to sense a latent imaginative realm of fantasies, dreams and nightmares. His photographs are not merely tasteful, thoroughly developed compositions, but reflections of a view of reality full of muted desires, buried memories, aggressive sexual obsessions and forbidden yearnings which appeal directly to the expectations of a decadent culture. These photographs disclose the hidden as well as the overt cruelties of male sexual fantasies and the desire to oppress and subjugate one's partner. They heighten our sense of modern man as a creature caught in the torments of regulated behavior, forced to appear respectable yet at the same time the victim of the desolation and ennui of modern life.

The point of view which governs Newton's camera is that of the voyeur, reducing women to sexual machines always ready to perform. His photographs consciously acknowledge this voyeurism—in fact is one of his central themes. But the point of view of the photographer himself is ambiguous. He presents his subjects with equalled refinement, suggestive and at the same time super-cool, at times almost ritualized. It is difficult to resist these images, with their high degree of affect-potential, but at the same

time they radiate something extremely disturbing, as if De Sade's fantasies were suddenly to appear in a fashion magazine. For the viewer the most unsettling part of the experience is that he accepts the manner of representation without blinking an eye—unless, of course, he is already critical of the reality being depicted.

—Klaus Honnef

NEYRA, José Luis.

Mexican. Born in Mexico City, 9 July 1930. Educated at preparatory, primary and secondary schools in Mexico City, 1936-49; trained as a chiropodist, Mexico City, 1948-51; studied at the Escuela de Periodismo, Mexico City, 1950; School of Law, Universidad Nacional Autonoma, Mexico City, 1951-52; and School of Film Studies, Mexico City, 1970. Served in the Mexican Army, 1949. Has practiced as a chiropodist, Mexico City, since 1951. Freelance photographer, Mexico City, since 1966. Member, Grupo 35, 6 x 6 photographers' group, Mexico City, 1968-70. Council Member, Club Fotografico de Mexico, Mexico City, 1964-67; Founder-Member and Co-Director, Consejo Mexicano de Fotografía, Mexico City, 1977-81, and of *Coloquio Latinoamericano de Fotografía I and II*, Mexico City, 1979-81; Founder Member, Casa de la Fotografía (C.M.F.), Mexico City, 1980. Recipient: First Jury Prize, *Concurso Internacional de Fotografía*, Caracas, Venezuela, 1979; First Prize, *Bienal de Fotografía*, Mexico City, 1980. Address: Play Olas Altas 472, Mexico 13, D.F., Mexico.

Individual Exhibitions:

1971 Centro Social General Ignacio Zaragoza, Mexico City
Escuela Nacional de Artes Plásticas, Universidad Nacional Autónoma, Mexico City
1972 *Fotometamorfismo*, Galerías de la Ciudad Mexico, Mexico City
Casa del Lago, Universidad Nacional Autónoma, Mexico City
1974 Instituto Nacional de Bellas Artes, Mexico City
1975 *Fotoformas*, Casa del Lago, Universidad Nacional Autónoma, Mexico City
1979 *Las Ventanas*, Instituto del Seguro Social, Mexico City
1980 *Convergencias*, Instituto Nacional de Bellas Artes, Mexico City

Selected Group Exhibitions:

1969 *Grupo 35, 6 x 6 Fotografías*, New York Public Library, Hudson Park
1977 *Sección Bienal de Gráfica*, Palacio de Bellas Artes, Mexico City
1978 *Hecho en Latinoamerica*, Museo de Arte Moderno, Mexico City (travelled to *Venezia '79*)
Contemporary Mexican Photographers, Meridian House, Washington, D.C. (travelled to Nexus Gallery, Atlanta, Georgia)

1979 *Concurso Internacional de Fotografía*, Centro Integradas, Caracas, Venezuela
 Sección Bienal de Gráfica, Instituto Nacional de Bellas Artes, Mexico City
 6 Artistas Contemporaneos, Instituto Nacional de Bellas Artes, Mexico City
1980 *7 Portafolios Mexicanos*, Centre Culturel du Mexique, Paris (travelled to the Picasso Museum, Antibes, France)
 Bienal de Fotografía Mexicana, Instituto Nacional de Bellas Artes, Mexico City
1981 *Fotografie Lateinamerika*, Kunsthaus, Zurich

Collections:

Casa del Lago, Universidad Nacional Autónoma de México, Mexico City; Consejo Mexicano de Fotografía, Mexico City; Subsecretaría Forestal y de la Fauna S.A.R.H., Mexico City; Centro de Artes Integrada, Caracas, Venezuela; Casa de las Americas, Havana, Cuba; Bibliothèque Nationale, Paris.

Publications:

By NEYRA: books—*A Flower Guide to Mexico*, with others, Mexico City 1971; *Tequila, Mezcal y Pulque*, with others, Mexico City 1972; *El Paisaje de México*, with others, Mexico City 1972; *El Paisaje del Espectáculo en México*, with others, Mexico City 1974; *Convergencias*, exhibition catalogue, Mexico City 1980; article—"Fotometamorfismo" in *Revista de Bellas Artes* (Mexico City), May/June 1974.

On NEYRA: books—*Photography Year Book*, London 1971; *Enciclopedia de México*, edited by José Rogelio Alvarez, Mexico City 1975; *Hecho en Latinoamerica*, exhibition catalogue, edited by the Consejo Mexicano de Fotografía, Mexico City 1978; *El Niño y la Estructura*, exhibition catalogue, Caracas 1979; *7 Portafolios Mexicanos*, Mexico City 1980; articles—"Las Ventanas" by Alfredo Cardona P. in *Novedades* (Mexico City), 26 October 1971; "Las Ventanas" by Pedro Bayona in *Fotoguía* (Mexico City), January 1972; "Fotometamorfismo" by Emma Rueda in *El Nacional* (Mexico City), 6 February 1972; "Viernes en el Arte" by Ana Maria Longi in *El Heraldo* (Mexico City), 10 March 1972; "Perfiles de México" by Alfredo Cardona P. in *El Dia* (Mexico City), 19 May 1973; "Diaporama de J.L. Neyra" by Macario Matus in *El Dia* (Mexico City), 12 December 1973; "José Luis Neyra" by Noemí Atamoros in *Excelsior* (Mexico City), 23 June 1974; "Realidad en Blanco y Negro" by Marco A. Gutierrez in *El Nacional* (Mexico City), 25 June 1974; "Un Arte Cotidiano" by Francisco Zapata in *Ovaciones* (Mexico City), 7 July 1974; "La Imagen mi Expresión" by Angel Trejo in *Fotoguía* (Mexico City), September 1974; "Fotoformas" by Emma Rueda in *El Nacion* (Mexico City), 4 April 1975, "Convergencias" by Esther Vázquez Ramos in *Galeria* (Mexico City), December 1980.

The spontaneous image that contains those vital elements which give a wider definition of the human being in all circumstances and in all places—that is the image I strive to achieve. The contribution of a personal "opinion" is the determinant factor which allows the image to register something other than a simple statement of fact. This "opinion" is the particular vision of the author; the relationship of the selected elements—its pattern and, above all, its spirit—animates everything.

"Convergencias," the title of a recent one-man show, was concerned with the relationship between two images within a single frame. The spectator was invited to relate the two images in his own mind with total freedom—the author hoped thereby to achieve a more personal interpretation.

—José Luis Neyra

For José Luis Neyra there exist two well-differentiated photographic worlds. In one, careful selection and harmonic, effective and purely visual relationships are all-important; in the other, a commentary on what occurs suddenly and must be recorded quickly before it disappears is essential. The combining of these two facets—the careful with the apparent neglect of formal values—offers the most complete insight into Neyra's work.

Observing his mode of working and the end product, one recognizes both an intrinsic logic and a constant affinity. There is a difference between what is conceptually organized, what is visually organized, and that which is spontaneous, casual and free from formalism. The latter, being so close to what we apprehend as an "instantaneous enhancement of the visual narrative" places it on a different aesthetic level, the direct consequence of the photographer's intuitive solution. In this kind of random photography, obviously technical difficulties lead to failure in the great majority of cases. It is also clear that a photographer adopting this working method needs to take a much greater number of shots than one who is in total control—for instance, the photographer in a studio. Neyra succeeds because of his passion, his immutable tenacity and his ubiquitous sincerity.

The irony is that his apparently superficial and instantly recognizable images almost invariably cloak a profound speculation which is not always recognized. The failure to read below the surface seems to be a characteristic peculiar to the Mexican people, but it is, in fact, universal. And it is also true that it is his profound knowledge of the problems of Mexican Life that gives Neyra the necessary authority to communicate his message in a universally comprehensible manner.

Perhaps there is a third aspect of his work—a third photographic world. This is one in which the ultimate images of the previous two become associated in order (paradoxically) to allow a confrontation of ideas. In this way he attains a new stance, one

José Luis Neyra: *Convergencia*, 1980

Lennart Nilsson: *Portrait of a Cardiac Infarct* Courtesy The Photographers' Gallery, London

that has developed through time. This new world is directly related to an aesthetic evolution in his practice; it is also a demonstration that he is involved in a constant process of reappraising his work—thus reinvigorating or renewing it. It is similarly evident that, in a world of photographic images, there is a constant possibility of constructing new images from conjunctions of existing, unique images. This is particularly the case if the former are considered fragments, susceptible to rearrangements within the format of the photograph.

Neyra's juxtapositions—he calls them "convergencias"—result in units combing two separate spatio-temporal themes, which happen to be appropriate for elaborate contextual complication. Their interaction—which is not merely of a visual nature—demands the spectator's profound attention. More attention is demanded than any of the single works ever require. The observer who abandons his initial resistance and stops to look a little longer, however, will find himself gradually seduced and given an extremely worthwhile experience.

—Lázaro Blanco

NILSSON, Lennart.

Swedish. Born in Strangnas, 24 August 1922. Educated in local schools. Married Birgit Svensson. Worked as freelance press photographer, Stockholm; now microbiological and medical photographer, Stockholm; has also worked with the film director Ingmar Bergman. Recipient: Photographer of the Year Award, University of Missouri, Columbia, 1965; Picture of the Year Award, National Press Photographers Association (U.S.A.), 1965; American Heart Association Medal, 1968; Europhot Prize, 1970; Hasselblad Prize, 1981. Address: Hudiksvallsgatan 5, Stockholm, Sweden.

Individual Exhibitions:

1973 Moderna Museet, Stockholm

Selected Group Exhibitions:

1962 *Svenskarna sedda av 11 Fotografer*, Moderna Museet, Stockholm

Collections:

Moderna Museet, Stockholm.

Publications:

By NILSSON: books—*Sweden in Profiles*, with text by Gustaf Nasstrom and others, Stockholm 1954; *Ants*, Stockholm 1959; *Stromkarl/The Power Team*, with text by Charlie Cederholm, Stockholm 1960; *Life in the Sea*, with text by Gosta Jagersten, London 1961; *The Salvation Army in Sweden*, Stockholm 1963; *The Everyday Miracle: A Child Is Born*, with text by Axel Ingelman-Sundberg and Claes Wirsen, Stockholm 1965, New York 1966, London 1967; *Ett Ar Med Kungen*, with text by Kerstin Bernadotta, Stockholm 1967; *Sex i Samhallet*, with text by Rigitta Linner, Stockholm 1968; *Svenska Lok och Motorvagnar 1/1—1969*, with Ulf Diehl, Stockholm 1969; *Dakkan: En Bok om Samer-*

nas Slojd, with text by Israel Ruong, Stockholm 1971; *Behold Man*, with Jan Lindberg, text by David H. Ingvar and others, Stockholm 1973; *The Human Body*, Stockholm 1974.

On NILSSON: books—*Svenskarna sedda av 11 Fotografer*, exhibition catalogue, by K.G. Pontus Hulten and Stig Claeson, Stockholm 1962; *Photography as a Tool*, by the Time-Life editors, New York 1972; *The Magic Image* by Cecil Beaton and Gail Buckland, London and Boston 1975; articles—"Professional Photography in Sweden: Lennart Nilsson" in *Infinity* (New York), January 1971; "Venture to the Interior: The Photographs of Lennart Nilsson" in *The Observer Magazine* (London), 26 May 1974.

Photography has always been used as a means of scientific investigation. To record the infinitely small world of microbes, as the Italian Negri was already doing in the 19th century; to make visual evidence of the development of a pathology available; to keep a visual comparison ready for use on film—these are among the many tasks of photography as applied to medicine. Many medical laboratories and hospitals have their own photographic teams, responsible for documentation and research. It is an interesting field and attracts many photographers. Lennart Nilsson is perhaps the most famous of those who have devoted themselves to specialization in this field.

Nilsson has been working for years in close contact with medical teams, not only in his own country, Sweden, but all over the world. His work has also become known to the general public through a number of medical, biological and popular educational publications which have made use of it. He is always in search of new techniques to enable him to photograph things that were formerly impossible. His curiosity, coupled with a thorough knowledge not only of photography but also of biology, has enabled him to achieve some outstanding results over the years. His greatest success, which earned him fame even outside the restricted circle of experts in his field, came when he succeeded in perfecting special lenses to film inside the human body.

His technique is not entirely new, as less well-informed publicists often claim for it; it is an improved application of photography to endoscopic techniques. It was already possible before Nilsson's work to explore the inside of the human body visually by means of special probes. In recent years, too, this technology has been greatly improved by using special fibres in the construction of endoscopes. The virtue of Nilsson's work was that it effected a coherent combination of the techniques of photography and endoscopy. In this field he sets an example of all that a professional who devotes himself to scientific photography should be, as knowledgeable in photography and optics as in biology. Without such knowledge, in fact, no one can have a complete view of the phenomena they are called on to record.

In the 1960's, after many attempts to improve the existing apparatus, Nilsson, in collaboration with the photographic industry, succeeded in perfecting special lenses for photographing inside the human body. This enabled him to photograph inside the veins and to produce pictures—so he claims—of a live foetus in the mother's womb. To take the photographs of the foetus which aroused such a great sensation, Nilsson used an ultra-wide-angle lens mounted on top of an endoscope, with a tiny lamp on the end of it for the necessary lighting. The lens had an angle of view of 110°. An eminent Swedish gynaecologist said of these pictures that "...it is like seeing the face of the moon for the first time."

But the photographs that Nilsson claims to have taken "live" have been widely publicized since then together with others which are clearly of foetuses preserved in formalin. His book *The Everday Miracle: A Child Is Born*, published in 1965, is a clear example of this. The splendid photographs reveal a great photographic skill and a profound scientific knowledge. Unfortunately, they are all superficially passed off as pictures taken "live," playing on the average reader's ignorance of both photographic and medical techniques. As a result Nilsson's name has been somewhat besmirched in scientific circles. The value of his work, however, lies not in these exploits, genuine or not, but in the care with which he makes scientific records of the facts of medicine and biology by means of the photographic medium.

—Edo Prando

NILSSON, Pål-Nils.

Swedish. Born in Rome, 7 July 1929. Educated in Stockholm; self-taught in photography. Divorced; children: Mats-Nils and Paula. Freelance photographer, working for Svenska Riksbyggen, *Svenska Turistföreningens Årsbok*, Stockholm, since 1955; also filmmaker, mainly for Swedish television, Stockholm. Member, Tio Fotografer group, Stockholm, since 1958. Address: c/o Tio Fotografer, Drottninggatan 88c, 11136 Stockholm, Sweden.

Individual Exhibitions:

1956 Värmlands Museum, Karlstad, Sweden
1957 *Life in Sweden Today*, Addo. X Gallery, New York
1959 *New York*, Artek Gallery, Stockholm
1963 Museum Fodor, Amsterdam (with Albert Renger-Patzsch and Gabriel Cuallado)
1970 *Samit*, Swedish Institute, Stockholm (travelled to Belgrade, Paris, New York, Helsinki, etc., 1970-75)
1980 *Color Prints*, Lilla Galleriet, Viken, Sweden

Selected Group Exhibitions:

1954 *5 Photographers*, Moderna Musset, Stockholm
1955 *The Family of Man*, Museum of Modern Art, New York (and world tour)
1958 *Fotokonst '58*, Lunds Konsthall, Sweden
1960 *Tio Fotografer på Svensk Form*, Moderna Musset, Stockholm
1962 *Svenskarna sedda av 11 Fotografer*, Moderna Musset, Stockholm
1971 *Contemporary Photographs from Sweden: An Exhibition of the Work of the Tio Photographers*, Library of Congress, Washington, D.C.
1975 *The Land: 20th Century Landscape Photographs Selected by Bill Brandt*, Victoria and Albert Museum (travelled to the National Gallery, Edinburgh; Ulster Museum, Belfast; and National Museum of Wales, Cardiff, 1976)

Collections:

Fotografiska Museet, Moderna Museet, Stockholm; Valokuvamuseon, Helsinki; Norsk Fotohistorisk Forening, Oslo; Bibliothèque Nationale, Paris; Victoria and Albert Museum, London; Museum of Modern Art, New York; Library of Congress, Washington, D.C.

Publications:

By NILSSON: books—photographer, illustrator

Pål-Nils Nilsson

and designer of *Svenska Turistföreningens Årsbok* annual, Stockholm, since 1956; *Landskap*, Stockholm 1956; *Natur*, with text by Bo Rosen, Stockholm 1956; *Duov'dagat ja Bangot*, with text by Israel Ruong, Stockholm 1967; *Hantverkets 60-tal*, Stockholm 1968; *Jojk*, Stockholm 1969; *Dakkan*, Stockholm 1971; *En Bok om Barbro Nilsson*, Stockholm 1977; films—30 documentary films for Swedish Radio-TV.

On NILSSON: books—*Svenskarna sedda av 11 Fotografer*, exhibition catalogue, by K.G. Pontus Hulten and Stig Claeson, Stockholm 1962; *Photography Annual 1971*, New York 1970; *Contemporary Photographs from Sweden: An Exhibition of the Work of the Tio Photographers*, exhibition catalogue, Washington, D.C. 1971; *The Land: 20th Century Landscape Photographs Selected by Bill Brandt*, exhibition catalogue, edited by Mark Haworth-Booth, London 1975; *Geschichte der Fotografie im 20. Jahrhundert/Photography in the 20th Century* by Petr Tausk, Cologne 1977, London 1980.

For 25 years Pål-Nils Nilsson has, on behalf of the Swedish Tourist Board, made voyages of discovery around Sweden with his camera. Each year he has made an intensive study of one specific area or landscape, and for many years his pictures have dominated the Board's illustrated publications.

Nilsson has depicted Swedish cultural history and Swedish nature with insight and objectivity, and thereby splendidly followed the tradition laid down by his prominent predecessors, for example C.G. Rosenberg and Gösta Lundquist. But under Nilsson's leadership, the Tourist Board's traditional nature-romanticism and highly nuanced, lyrical pictures—their mainstay in the 1930's and 40's— have given way to a taut idiomatic expression and a journalistic realism. For example, Nilsson has portrayed the changed cultural landscape and the disturbance to the environment that follows in the wake of industrialization.

The 1960's were a productive decade for Nilsson. In addition to his work for the Tourist Board he published reportage and portraiture in magazines such as *Vi* and *Vecko-Journalen*, and he also made a

name for himself as an able fashion and advertising photographer. In all of these genres, he combined sober form with a kind of journalistic know-how and technical perfection.

Like many other Swedish photographers, Nilsson began to work with film in the mid-1960's. In the next decade or so he made more than 30 documentary films for Swedish Television. His personal engagement in social questions became more and more obvious during this period, and the effectiveness of his films can be judged by their impact. For example, his film series about stateless gypsies, who had been forced to leave Sweden for a difficult existence in a Parisian suburban slum, provoked such response that they were granted permission to return.

For a long time Nilsson has also been concerned with the Samian's difficulties as a minority in the Swedish welfare state. In films, books, exhibitions and press photographs he has illustrated the social injustices, the economic conditions, of their daily lives, at the same time that he has revealed the uniqueness of their traditional crafts. A film which exposed the state's land policy in the Samian reindeer domains led (among other results) to an official complaint against the activities of Swedish provincial governments.

In other films Nilsson has dealt with the living conditions of the Swedish coastal population, of middle-eastern immigrants, and Finnish gypsies. In this work he has collaborated with the Swedish television journalist Brita Reuterswärd.

In all of these films Nilsson has used the picture as a weapon in social debate, to inform and to educate. The medium has had to be subordinate to the message. He has treated different subjects with insight and understanding. If one looks at both intent and result, Nilsson must undoubtedly be placed among Europe's outstanding post-war documentary filmmakers and photographers.

—Rune Hassner

NIXON, Nicholas.

American. Born in Detroit, Michigan, in 1947. Studied American literature at the University of Michigan, Ann Arbor, 1965-69, B.A. 1969; art, at the University of New Mexico, Albuquerque, 1973-74, M.F.A. 1974. Married Bebe Brown in 1971. VISTA Volunteer, St. Louis, 1969-70; architectural photographer, Detroit, 1970-71; high school photography teacher, Minneapolis, 1971-73. Independent photographer, Cambridge, Massachusetts, since 1974. Associate Professor, Massachusetts College of Art, Boston, since 1975. Recipient: National Endowment for the Arts Photography Fellowship, 1976, 1979; Guggenheim Photography Fellowship, 1977. Agents: Light Gallery, 724 Fifth Avenue, New York, New York 10019; Fraenkel Gallery, 55 Grant Avenue, San Francisco, California 94106; and Galerie Rudolf Kicken, Albertusstrasse 47-49, 5000 Cologne, 1, West Germany. Lives in Cambridge, Massachusetts. Address: c/o Massachusetts College of Art, Boston, Massachusetts 02215, U.S.A.

Individual Exhibitions:

1976 Museum of Modern Art, New York
1977 Worcester Art Museum, Massachusetts (with Stephen Shore)
 Vision Gallery, Boston
1978 Light Gallery, New York
 Color Photographs, Cronin Gallery, Houston (with William Eggleston)
 Massachusetts Institute of Technology, Cambridge (with Linda Connor)
1979 Light Gallery, New York
 Vision Gallery, Boston
1980 Light Gallery, New York
 Fraenkel Gallery, San Francisco
1981 Light Gallery, New York
 Vision Gallery, Boston
1982 Fraenkel Gallery, San Francisco
 Light Gallery, New York

Selected Group Exhibitions:

1975 *New Topographics: Photographs of a Man-Altered Landscape*, International Museum of Photography, George Eastman House, Rochester, New York (travelled to the Otis Art Institute, Los Angeles, and Princeton University Art Museum, New Jersey)
1976 *Recent Acquisitions*, Museum of Modern Art, New York
1977 *10 Photographes Américains Contemporains*, Galerie Zabriskie, Paris
 Contemporary American Photographic Works, Museum of Fine Arts, Houston
1978 *Mirrors and Windows: American Photography since 1960*, Museum of Modern Art, New York (toured the United States, 1978-80)
1979 *Fleeting Gestures: Dance Photographs*, International Center of Photography, New York (travelled to *Venezia '79*, and to The Photographers' Gallery, London)
 American Images: New Work by 20 Contemporary Photographers, Corcoran Gallery, Washington, D.C. (travelled to the International Center of Photography, New York; Museum of Fine Arts, Houston; Minneapolis Institute of Arts; Indianapolis Institute of Arts, 1980; and American Academy, Rome, 1981)
1980 *American Children*, Museum of Modern Art, New York
 Recent American Photography, Art Institute of Chicago

Collections:

Museum of Modern Art, New York; Metropolitan

Nicholas Nixon: *View of Brookline High School Athletic Field*, Massachusetts, 1975 Courtesy Art Institute of Chicago

Museum of Art, New York; Joseph Seagram and Sons Inc. Collection, New York; International Museum of Photography, George Eastman House, Rochester, New York; Museum of Fine Arts, Boston; Fogg Art Museum, Harvard University, Cambridge, Massachusetts; Worcester Art Museum, Massachusetts; Art Institute of Chicago; Minneapolis Institute of Arts; Museum of Fine Arts, Houston.

Publications:

On NIXON: books—*New Topographics: Photographs of a Man-Altered Landscape*, exhibition catalogue, with text by William Jenkins, Rochester, New York 1975; *Contemporary American Photographic Works*, exhibition catalogue, by Lewis Baltz, Houston 1977; *Mirrors and Windows: American Photography since 1960* by John Szarkowski, New York 1978; *American Images: New Work by 20 Contemporary Photographers*, edited by Renato Danese, New York 1979; *American Children*, edited by Susan Kismaric, New York 1980; articles— "Topographical Error" by Charles Desmarais in *Afterimage* (Rochester, New York), November 1975; "Route 66 Revisited: The New Landscape Photography" by Carter Ratcliff in *Art in America* (New York), January 1976; "New York: Nicholas Nixon, Museum of Modern Art" by Leo Rubinfien in *Artforum* (New York), December 1976; "A Fascination with Man-Made Settings" in *Photography Year 1977*, by the Time-Life editors, New York 1977; "Nixon at Vision" by Arno Minkkinen in *Views* (Boston), no. 2, 1979; "Currents: American Photography Today: Nicholas Nixon" by Andy Grundberg and Julia Scully in *Modern Photography* (New York), May 1979; review by Kelly Wise in *Artforum* (New York), April/May 1981.

The facts of Nicholas Nixon's early biography have formed his developing aesthetic in complex ways. The fact that his earliest photographs were 35mm. snapshots "in the tradition of Cartier-Bresson," for instance, merely seems to be an ironic contradiction of the large format which is Nixon's hallmark. The ease and mobility with which Nixon uses large-format photography, while retaining the scrupulous detail possible with the 8 x 10" camera, has challenged its potential and opened the format to the possibility of accident and chance. Nixon has created a unique amalgam by reconciling the spontaneity of Cartier-Bresson with the measure of Walker Evans, another early favorite.

Seemingly insignificant facts of Nixon's career also hold meaning. Nixon worked briefly as an architectural photographer, which undoubtedly contributed not only to the choice of cityscape in his 1974-76 views of Boston but also to his architectonic use of space and precision of detail. The fact that he volunteered for VISTA signalled the concern and empathy for people which would surface in his portraiture. Nixon's work is, above all, intensely American in both its subject and its ruthless honesty of approach. This too has roots in his past, for he discovered photography while studying American literature and was initially attracted to the vigorous and forthright images of Walker Evans, which told the Whitmanesque saga of the American land and its people.

Honesty is the key to Nixon's work: taken to its extreme, it becomes almost a disinterested neutrality and anonymity of style which is particularly unsettling in photographs of people. Concurrent with his cityscapes, Nixon began a series of family snapshots which combine the artlessness of family snapshots with a highly developed technical sophistication. Nixon's first portrait subject was his wife Bebe; gradually he included other relatives in increasingly complex combinations. The portraits of Bebe and her three sisters—three of which were included in the Museum of Modern Art's *Mirrors and Windows* exhibition of 1978 and are thus among his best-known works—are unsettling, even

cutting. We are not used to portraits treated so frankly or women looking so proud and fierce and beautiful. Like all good photography, this portraiture shakes one to the core.

It is difficult not to say that Nixon's work has matured, for it has and continues to become increasingly complex and integrated. He has changed his pictorial structure in the last few years by moving closer to his subject, which decreases depth recession and allows the subjects to dominate the space. On a purely formal level, there is a new complexity in the way Nixon uses the spaces between his subjects, their overlap, and the forms they create on the picture surface.

These pictures *do* work on an emotional level as well, though not one usually associated with portraiture. They are infused with an intense calm, created in part by the fact that the subjects never make eye contact with either the viewer or each other. Nixon has created an entirely new emotional premise for portraiture, thereby expanding the very idea of what constitutes this mode of picture-taking. That these elements have begun to coalesce in Nixon's work is undeniable; where it will lead, and what form it will take in his increasingly assured and important production, is uncertain.

—Nancy Hall-Duncan

NOSKOWIAK, Sonya.
American. Born in Leipzig, Germany, 25 November 1900; emigrated to the United States, 1915: naturalized, 1922. Educated in Chile and California; studied photography with Edward Weston, San Francisco, 1929-34. Worked as a receptionist in the Johan Hagemeyer Photo Studio, Los Angeles, 1929; Darkroom Assistant to Edward Weston, San Francisco, 1929-34; Founder Member, with Willard Van Dyke, Imogen Cunningham, and Edward Weston, Group f.64, San Francisco, 1932; independent photographer, with own portrait and architectural photography studio, and working for Sunset Magazine, various architects and interior designers, San Francisco, 1935 until her death, 1975. *Died* (in Greenbrae, California), *28 April 1975.*

Individual Exhibitions:

1935 *Portraits by Sonya Noskowiak and Sibyl Arikeeff*, Denny-Watrous Gallery, Carmel, California
1952 Raymond and Raymond, San Francisco
1963 *Photographs of Forms and Places by Sonya Noskowiak*, Stanford Research Institute, California
1978 Center for Creative Photography, University of Arizona, Tucson (retrospective)
1979 *WPA Photographs by Sonya Noskowiak*, San Francisco Museum of Modern Art

Selected Group Exhibitions:

1932 *Group f.64*, M.H. de Young Memorial Museum, San Francisco
1933 *Group f.64*, Ansel Adams Gallery, San Francisco
1939 *Annual Exhibition*, Society of Women Artists, San Francisco (and 1940)
1941 *First Annual Salon: Photography West of the Rockies*, San Francisco Museum of Art
1943 *Photographs from the Federal Art Project*, San Francisco Museum of Art
1977 *Photographs: Sheldon Memorial Art Gallery Collection*, University of Nebraska, Lincoln
1978 *Group f.64*, University of Missouri, St. Louis

Collections:

University of Minnesota, Minneapolis; University of Nebraska, Lincoln; Center for Creative Photography, University of Arizona, Tucson; University of California, Berkeley; San Francisco Museum of Modern Art; San Francisco Public Library.

Sonya Noskowiak: *Untitled*, 1930

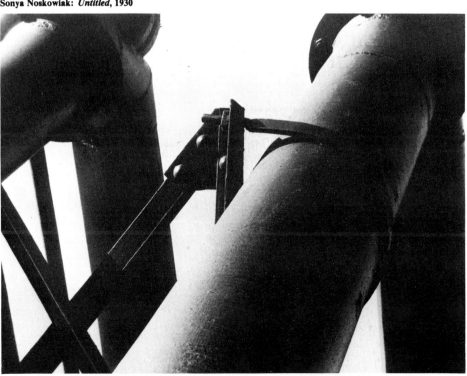

Publications:

On NOSKOWIAK: books—*Photographs: Sheldon Memorial Art Gallery Collection, University of Nebraska*, with an introduction by Norman A. Geske, Lincoln, Nebraska 1977; *Group f.64*, exhibition catalogue, with texts by Jean S. Tucker and Willard Van Dyke, St. Louis 1978; *Center for Creative Photography No. 9: Sonya Noskowiak*, with texts by Marnie Gillett and William Johnson, Tucson, Arizona 1979.

A charter member of the influential West Coast group of photographers, Group f.64, the German-American Sonya Noskowiak was an active participant in the struggle to define and practice a progressive, "straight" photography in an era still dominated by the conservative outlook of the pictorial esthetic.

Beginning her career as darkroom assistant and student to Edward Weston in 1929, Noskowiak learned Weston's painstaking technical procedures and shared his determination to achieve previsualized prints that could stand uncropped and unenlarged. In the course of her career, Noskowiak developed her vision and her craftsmanship to the point that the master said of her prints: "Any of these I would sign as my own."

In the first "Group f.64" show at the M.H. de Young Memorial Museum in 1932, Noskowiak exhibited photographs of natural objects—rocks, leaves and sand. The young photographers who formed the group intended its name to signify their preference for small lens apertures that would achieve sharply detailed images. Diverse in subject and style as the group proved to be, each member nevertheless subscribed to Weston's dictum, recorded in his *Daybook*, that "the camera must be used for recording life, for rendering the very substance and quintessence of the thing itself...."

Turning from natural subjects as her career progressed, Noskowiak developed the industrial landscape as her particular forte in the early 1930's. In these photographs the surface textures of massive girders, pipes and struts are rendered in tones that range from deep blacks to startlingly pure whites. Although sensitive and sensuous, such full-toned printing of mundane and inexpressive subject matter makes Noskowiak's work occasionally seem something of a tour de force.

As the decade continued, however, Noskowiak turned from this estheticized industrialism, which drew as much on constructivist and German avant-garde photography as it did on Weston's work, toward a somewhat less formalist consideration of architectural subjects. Her later photographs present identifiable architectural details or whole buildings—rather than the anonymous steel of the earlier work—in settings that give a more human sense of the urban social life of the time.

Noskowiak established her own studio in San Francisco in 1935; her commercial work included fashion, portraiture, and architectural views. As a portraitist, she photographed such artists and performers as Jean Charlot, John Steinbeck, and Martha Graham, and throughout her career she continued her landscape and architectural studies in the San Francisco Bay area.

—Maren Stange

Gabriele and Helmut Nothhelfer: *Girl with a Cigarette at a Springtime Festival*, 1975

NOTHHELFER, Gabriele and Helmut.

German. Gabriele Nothhelfer: born Gabriele Zimmermann in Berlin, 5 March 1945. Helmut Nothhelfer: born in Bonn, 3 June 1945. Married in 1973. Both studied photography at the Folkwangschule, Essen, 1969-70. Have worked jointly as freelance photographers, in Berlin and Bonn, since 1973. Held joint Mastership in Photography, Publicity Institute, Free University of Berlin, 1978. Agents: Galerie Wilde, Auf dem Berlich 6, 5000 Cologne 1; Galerie Breiting, Sächsische Strasse 1, 1000 Berlin 15; and Sander Gallery, 2604 Connecticut Avenue N.W., Washington, D.C. 20008, U.S.A. Address: Weimarerstrasse 32, 1000 Berlin 12, Germany.

Individual Exhibitions:

1976 Galerie Wilde, Cologne
1977 Galerie Nagel, Berlin

 Galerie Agathe Gaillard, Paris
1978 Sander Gallery, Washington, D.C.
1979 Galerie t'Venster, Rotterdam
 Galerie Breiting, Berlin
 Galerie Wilde, Cologne
1980 Folkwang Museum, Essen

Selected Group Exhibitions:

1976 *Porträts und Situationen*, Haus am Waldsee, Berlin (travelled to Leverkusen and Stuttgart)
 Berlin Now, Denise René Gallery Downtown, New York
1977 *Documenta 6*, Kassel, West Germany
1978 *Berlin: A Critical View*, Institute of Contemporary Arts, London
1979 *Photographie als Kunst 1879-1979*, Tiroler Landesmuseum, Innsbruck, Austria (travelled to the Neue Galerie am Wolfgang

Gurlitt Museum, Linz, Austria; Neue Galerie am Landesmuseum Joanneum, Graz, Austria; and Museum des 20. Jahrhunderts, Vienna)

1981 *New German Photography*, The Photographers' Gallery, London

Collections:

Folkwang Museum, Essen; Bibliothèque Nationale, Paris; Stedlijk Museum, Amsterdam; Museum of Modern Art, New York.

Publications:

By the NOTHHELFERS: books—*Wirklichkeitsvermittlung am Beispiel der Farm Security Administration*, Berlin 1978; *Bildinterpretationen zu Fotografien von Weegee*, Berlin 1978; *Friedrich Seidenstücker*, Berlin 1980.

On the NOTHHELFERS: books—*Geschichte der Photographie im 20. Jahrhundert/Photography in the 20th Century* by Petr Tausk, Cologne 1977, London 1980; *Photographie als Kunst 1879-1979/Kunst als Photographie 1949-1979*, exhibition catalogue, 2 volumes, by Peter Weiermair, Innsbruck 1979; *Gabriele und Helmut Nothhelfer*, exhibition catalogue (Folkwang Museum exhibition), by Michael Zimmermann, Berlin 1980; articles—"100 Jahre Photographie" in *Kunstforum* (Mainz), no. 18, 1976; "Gabriele and Helmut Nothhelfer" in *Creative Camera* (London), no. 2, 1977; "People on Sunday" by Arnd Schirmer in *Der Tagesspiegel* (Berlin), 28 April 1977; "The Joyless" by Hervé Guibert in *Le Monde* (Paris), 20 October 1977; "Pictures of a Crumbling Society" by Michel Nuridsany in *Le Figaro* (Paris), 24 October 1977; "People in Germany Today" by Thomas Hesterberg in *Kölner Stadtanzeiger* (Cologne), 27 June 1979.

Our photographs were taken on the occasions of festive events. People are shown detached from their workaday life, and they are not captured in snapshot-manner, not caught in the midst of an action, but observed at a moment of pause, of standstill, even of meditation. Often their expressions somewhat contrast with the surrounding festive atmosphere, almost showing melancholy. Maybe the meagreness of everyday life, the insufficient conditions of working and living, show through at these festivities and in that way become apparent.

It is difficult to divide the human being into work and leisure time beings. Signs of unsatisfying work and life situations are evident even on so-called special occasions. Isolation and the unfulfilled longing to please, the vain attempt to preserve a semblance of dignity, and petrified family structures are expressed in features, gestures and dress. Our mutual view of society provides the basis for our teamwork and is evident in the common character of the individual photographs. We photograph together, decide which negatives to print, and determine which croppings have to be made.

—Gabriele and Helmut Nothhelfer

If one designates "people in everyday life" as the theme of Gabriele and Helmut Nothhelfer's photographic work, then one must also qualify that statement by saying that their work is not concerned with a representation of everyday work life. Rather, what is meant, is that they depict people in commonplace situations, such as in a garden cafe, during an intermission at the theatre, at an industrial exhibition, or at a national festival. In the Nothhelfers' own words: "Our pictures show people, not in the midst of carrying out an action, but usually in a moment of pause, of inactivity, or of reflection. Often, the expressions of these figures contrast with the festive atmosphere

which surrounds them. A certain melancholia results from this."

This moment of detachment or of isolation is therefore emphasized, so that the different situations are perceived as being indifferent to one another. Thus, photographs are created which have the effect of being objective and obtrusive; often, at first glance, they even appear to be casual because there is no "composition" in the sense of a calculated viewpoint, of an "interesting" detail, or of a perspective rich in effect. The photos are, in a word, straightforward and unpretentious. Yet, the choice of subject—which becomes evident on closer examination—is just as precisely as consistently chosen. Everything which is unessential is left aside, and when details appear in the photos—for example, a photo gadget bag or an empty cola can from which a straw protrudes—they are there, not by chance, but are important in a dramaturgical way which becomes immediately evident.

The silent language of the objects corresponds to the facial expressions of the individuals and their mien. Their gaze is often empty, their eyes without focus or interest. This, in combination with the details, produces an atmospherically intense effect which stands in productive opposition to the apparent reality of the representation. The result of this is the above mentioned melancholia, the tone of which almost reduces these images to metaphors of general situations. Patterns of behavior and the conditions of the waiting, the state of loss and emptiness, and the state of being isolated in confusion become, then, thematically realized in a penetrating and meaningful manner.

—Rolf Wedewer

NYKVIST, Ralph.
Swedish. Born in Landskrona, 16 December 1944. Educated in Landskrona, until 1960; self-taught in photography. Served in the Swedish Army, 1963.

Ralph Nykvist: *Heidelberg*, 1978

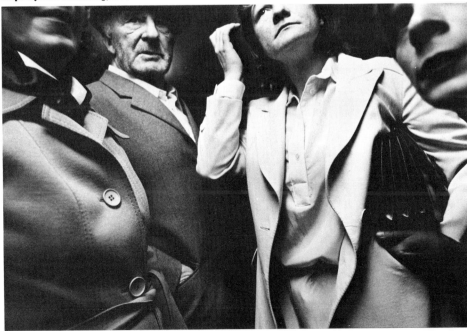

Has lived with Anne-Louise Kemdal, since 1979; daughter: Lisa. Worked as postman, for Swedish Post Office, Landskrona, 1960; Reproduction Photographer, Kliche and Reklam Company, Landskrona, 1960-68; Press Photographer, with Eko-Foto agency, Landskrona, 1968-72, and with Studio Hilding, Landskrona, 1972-80. Freelance photographer, Helsingborg, since 1980. Also freelance writer, contributing regularly to *Aktuell Fotografi*, Helsingborg, since 1978. Member, MIRA photographers agency, Stockholm, since 1980. Recipient: *Populär Fotografi* Award, Helsingborg, 1971; Press Photographers Club Award, Stockholm, 1972; Gullers' Grant, Swedish Museum of Photography, 1973; Photography Award, City of Landskrona, 1973; Photography Grant, Swedish Arts Council 1973, 1976; Swedish Authors Foundation Grants, 1978, 1979, 1980-85; *Foto* magazine Award, 1981. Address: Karl X Gustafsgatan 32, S-252 39 Helsingborg, Sweden.

Individual Exhibitions:

1970 *Report from Viarp*, City Theatre, Malmo, Sweden
1971 *In Sweden*, Landskrona Museum, Sweden
1972 *Paris, Easter 1972*, Gallery Athéneum, Lund, Sweden
1974 *Portrait of Painters*, Landskrona Bank Office, Sweden
 In Sweden, Fotografiska Museet, Moderna Museet, Stockholm
 Moscow, Modernage Gallery, New York
1976 *Moscow*, Kursverksamheten, Lund, Sweden
1977 Vehicule Art, Montreal, Quebec
1978 *Ralph Nykvist/Anders Petersen*, Fotogalleriet, Oslo
1981 Fotograficentrum, Örebro, Sweden
 Gallery 1 + 1, Helsingborg, Sweden
 Canon Photo Gallery, Amsterdam

Selected Group Exhibitions:

1977 *The Swedish Exhibition*, at *Rencontres Internationales de la Photographie*, Arles, France
1981 *Contemporary European Photography*, Museum of Modern Art, Tokyo (toured Japan)

Collections:

Moderna Museet, Stockholm; Landskrona Museum, Sweden; Fotogalleriet, Oslo; Canon Photo Gallery, Amsterdam; Museum of Modern Art, Tokyo.

Publications:

By NYKVIST: book—*I Sverige (In Sweden)*, Helsingborg, Sweden 1977.

On NYKVIST: articles—"The Street" by Allan Porter in *Camera* (Lucerne), March 1969; "Bilder från Gatan" by Jan Olsheden in *Populär Fotografi* (Helsingborg, Sweden), June 1969; "Ralph Nykvists Svenska Bilder" by Jan Olsheden in *Aktuell Fotografi* (Helsingborg, Sweden), July/August 1973; "Gullersstipendiat" by Rune Hassner in *FMV-Bulletinen* (Stockholm), February 1974; "Så tar Ralph Nykvist Sina Porträtt" by Rune Jonsson in *Aktuell Fotografi* (Helsingborg, Sweden), October 1975; "Visst tar Jag Färgbilder" by Jan Olsheden in *Aktuell Fotografi* (Helsingborg, Sweden), April 1979; "Stora Fotografipriset" by Peder Edstrom in *Foto* (Stockholm), January 1981.

It's not easy to write a statement about my own photography, but let me quote from my introduction to my book *I Sverige (In Sweden)*: "For me, photography is a way of telling about my own environment and myself, i.e. how I experience the people and places I come in contact with."

—Ralph Nykvist

Ralph Nykvist has mastered not only photography but also the written word. By means of the latter he has presented a large number of young photographers (often French) to readers of Swedish photographic magazines. He has also written fierce contributions to current debates, taking both his contemporaries and younger people to task. One of his arguments has been that in the 1970's Swedish documentary photography had run into a blind alley. Its aims, which often were the portrayal of negative aspects of the welfare state, certainly has his sympathy, but he finds the pictorial language inadequate: mere reproduction, marked by melancholy realism, work in which imagination and humor seem to have been banned.

Nykvist's own photography is comparatively "Un-Swedish." His pictures are often reminiscent of Cartier-Bresson, Robert Frank and Gerry Winogrand. Nykvist is the quick-thinking street photographer waiting for the right moment, the moment when his subject, thanks to the right choice of light and angle, becomes suitable for photography. Form and content must combine to make the moderately interested observer susceptible to the picture's message. Nykvist also attempts the synthesis of an event, so as to illustrate it in a minimum number of pictures. He has said in an interview: "The number of pictures can never be a replacement for sensitivity, which is necessary to reach another human being. To communicate feeling by means of pictures, one must respect and exploit the medium."

Nykvist has spent his working life in his native southern Sweden. He began his career as a reproduction photographer and came into daily contact with press photos. In 1968 he began to work as a press photographer himself at an agency that supplied pictures to a number of local newspapers. Here he saw—as have many of his colleagues—how ambitiously composed portraits of local politicians and athletes were cut down to the scale of passport photos by sloppy editors. The fact that the carefully chosen background functioned in both form and content was simply not realized by those responsible for the photo's reproduction. As long as mouth, nose and eyes were there, it passed. Nykvist feels that there has been some improvement during the 1970's. This may be due to the fact that photographers have had more say than used to be the case. And national newspapers have become more picture-conscious: this has clearly also made some impression on the editors of local papers.

In 1976 Nykvist published a book of black-and-white photographs called *I Sverige (In Sweden)*, reflecting his travels and walks with the camera from 1964 to 1976. He succeeded in capturing, among other things, the bleakness of small industrial communities and the suburbs of large cities. But it was no depiction of Hell. He looked at his fellow human beings with a touch of humor and with tenderness.

With the help of various grants, among them a five-year working grant from the Swedish Authors Fund, Nykvist has now been able to take leave of professional photography and to concentrate on his own projects.

—Rune Jonsson

ODDNER, Georg.
Swedish. Born in Stockholm, 17 October 1923. Educated at Wasa Real School, Stockholm, 1933-39; studied at the Art and Design School, Stockholm, 1940; student-assistant to the photographer Richard Avedon, New York, 1950. Served in the Royal Svea Life Guards, Swedish Army, 1944-45. Married Ewy Malmstrom in 1955; children: Christina, Lisa, Karin, and Frans. Worked as a jazz musician, Stockholm and throughout Scandinavia, 1946-49. Freelance photographer, Malmo and Stockholm, since 1951: established studio, Malmo, 1952; Member, Tio Fotografer group, Stockholm, since 1958. Feature film photographer, Copenhagen, 1963-65. Documentary film producer since 1965, and scriptwriter and director since 1971, Swedish Television, Stockholm and Malmo. Recipient: Å & Å Publishing House Illustration Prize, Stockholm 1955; Photography Prize, *Biennale*, Venice, 1957; Illustration Prize, *Weekly Vi*, Stockholm, 1957; *Svenska Dagbladets* Prize, Stockholm, 1958; Graphic Art Prize, Royal Library of Stockholm, 1961; Malmo Culture Prize, 1971; Swedish State Artists Scholarship, 1972. Address: Herrestadsgatan 1A, 217 49 Malmo, Sweden.

Individual Exhibitions:

1957 *Photographic Journey*, Malmo Art Museum (travelled to the Centre Gallery, Copenhagen, 1957, Norrkoping Museum, Sweden, Kalmar Museum, Sweden, and Göteborg Art Museum, Sweden, 1959, and Jonkoping Museum, Sweden, 1960)
1969 *The Eternal Soldier*, Trelleborg Museum, Sweden (travelled to the Fotografiska Museets Vanner, Stockholm, 1970)
1975 *Photographs*, Konstframjandet, Malmo

Selected Group Exhibitions:

1951 *Young Photographers of Sweden*, Galerie Kodak, Paris
1954 *Black and White*, National Museum, Stockholm
1957 *Biennale*, Venice
1958 *Photographic Art Tio*, Konsthall, Lund, Sweden
1962 *Weltausstellung der Photographie*, travelling exhibition
1967 *International Photography Exhibition*, at Expo '67, Montreal
1971 *Tio: Contemporary Swedish Photographs*, Library of Congress, Washington, D.C.

Collections:

Fotografiska Museet, Moderna Museet, Stockholm; Malmo Museum; Oslo Photographic Collection; Helsinki Photographic Collection; Bibliothèque Nationale, Paris; Library of Congress, Washington, D.C.

Publications:

By ODDNER: books—*Good Morning, South America*, with text by P. Persson, Stockholm 1956; *Till Spanien/To Spain*, with text by Klaus Rifbjerg, Copenhagen 1971; articles—"While the World Becomes Cooler" in *Femina* (Helsingborg, Sweden), April 1975; "Windows" in *Femina* (Helsingborg, Sweden), May 1975; "It's Fun to Play War" in *Expressen* (Stockholm), 15 May 1975; "Malmo New Art Hall" in *Svensk Fotografisk Tidskrift* (Stockholm), September 1975; "Dreamers on a Visit" in *Blixeniana* (Copenhagen), 1981; "Spots of Life" in *Artes* (Stockholm), 1981.

On ODDNER: books—*Creative Photography* by Helmut Gernsheim, London and Boston 1962, 1975; *A Concise History of Photography* by Helmut and Alison Gernsheim, London and New York 1965, 1971; articles—"A Master Shows His Work" by Karl Sandels in *Svensk Fotografisk Tidskrift* (Stockholm), April 1957; "Georg Oddner" by Romeo Martinez in *Camera* (Lucerne), July 1957; "Georg Oddner" by Helmut Gernsheim in *Photography* (London), July 1958; "Faces and Places" by Klaus Rifbjerg in *Vindrosen* (Copenhagen), May 1962; "Georg Oddner" in *Infinity* (New York), September 1968; "Georg Oddner" by Rune Jonsson in *Popular Fotografi* (Helsingborg, Sweden), June 1970; "Till Spanien" by Jan Olsheden in *Aktuell Fotografi* (Helsingborg, Sweden), May 1972; "Master in Picture" by Ture Burglund in *Arbetet* (Malmo, Sweden), May 1980.

Some thoughts about photography:
The interesting thing about photographing—to

Georg Oddner: *Man with Instrument*, 1958

depict exteriority—is in trying to catch that which doesn't meet the eye.

A photograph becomes an image when, at every glance, it yields something new. So, the picture cannot be wholly caught by our thoughts, because it is continuously transformed.

The unique power of the picture is that it arrests time and lives in spite of its unalterable form.

But that is also its weakness: the picture is quickly sensed—as is reality—but it demands time to be read. The more time, the more words it suggests, since the feelings react more directly than the intellect.

More simply, one can say that the main difference between words and pictures is that words depict thoughts and indicate exteriority, whereas pictures depict the exteriority and indicate thoughts.

—Georg Oddner

Photographers are commonly divided into two categories—those who make pictures in their heads and those who find their pictures—i.e., those who direct and those who observe and record. Portrait and fashion photographers belong to the former category; documentary and reportage photographers to the latter. "Cross-overs" are usually a disaster: most people have probably seen how mediocre the result can be when a studio photographer is made to go out and report a sports event or when the photojournalist attempts fashion photography. But occasionally a photographer excels in both categories: he can construct a picture in a studio and he is also a fast-reacting photographer of the instant. Georg Oddner is such a photographer. Not surprisingly, he has expressed his admiration of, for example, the fashion, film and documentary photographer William Klein.

In the 1950's Swedes who took an interest in such matters knew Oddner as an enviable fashion photographer, who supplied the weeklies with excellent pictures of beautiful girls, often in bathing suits. It probably came as a surprise to many people, therefore, when in his first one-man show, in Malmo in 1957, he exhibited reportage, portraits, and nature studies. Many of these photos were highly realistic, others were dreamingly poetic, and all were a far cry from the paradisical world of the glamorous advertisement. But the effective ability to perceive form and light featured in both Oddner's commercial pictures and in his more personal exhibition material.

Many of the pictures he exhibited in 1957 had been taken on journeys he took to produce advertising pictures for airlines. Alongside the commercial photography he had also continually worked at his more private pictures, closer to everyday life. He said, in 1959: "I believe in the truth of the photograph. I cannot forget that it always has something to do with reality. But it must, at the same time, be a kind of adaptation of reality, which is ambiguous and meaningful on many levels. A motif which is unambiguous and tritely obvious does not interest me."

During the 1960's Oddner was hired by several newpapers to produce extensive reportage from Japan, the U.S.S.R., Vietnam, among other places. It turned out that he possessed a highly professional ability as a photojournalist. But, like many of his colleagues, he increasingly moved to motion pictures—first as a film photographer, later as a director and scriptwriter. Then, in the early 1970's, rather unexpectedly, he produced a book of pictures from Spain—black-and-white pictures with the unmistakable Oddner character—grainy and a little unsharp, but intimate and alive. A combination of playfulness and tautness.

In this book he maintains that, in the twilight of his life, he hopes to devote himself to landscape photography, with tripod and large format camera. A slow and meditative occupation. If one remembers that in the 1940's Oddner was one of Sweden's best jazz drummers—then the contrasts in his various expressive needs emerge even more vividly.

—Rune Jonsson

OHARA, Ken.

Japanese. Born in Tokyo, 13 August 1942. Educated at Aoyama-Gakuin, Tokyo, 1956-61; studied photography and art at Nihon University, Tokyo, 1961-62, and the Art Students League, New York, 1963-65. Married Cora Lee MacEvoy in 1974. Photographic Assistant, studios of Richard Avedon and Hiro, New York, 1966-70. Freelance photographer, New York, since 1970. Technical Director, Menken and Seltzer, New York, since 1978. Recipient: Guggenheim Fellowship in Photography, 1974. Address: 335 Greenwich Street, New York, New York 10013, U.S.A.

Individual Exhibitions:

1970 *One*, Sony Building Gallery, Tokyo
1971 *Three Six Five*, Pentax Gallery, Tokyo
1979 *Contact*, Nikon Gallery, Tokyo

Selected Group Exhibitions:

1974 *The New Japanese Photography*, Museum of Modern Art, New York (toured the United States)

Collections:

Museum of Modern Art, New York.

Ken Ohara: *U.S.A.* from the book *One*, 1970

Publications:

By OHARA: book—*One*, Tokyo 1970; articles—"Ken Ohara" in *Komura's Eye* (Tokyo), no. 10, 1969; "Ken Ohara" in *Komura's Eye* (Tokyo), no. 12, 1970; "Camera Eyes 20's" in *Camera Mainichi* (Tokyo), January 1970; "International Film Directors" in *Harper's Bazaar* (New York), May 1971; "Album '72" in *Camera Mainichi* (Tokyo), January 1972.

On OHARA: books—*U.S. Camera Annual*, New York 1971; *The City-American Experience* by Peter C. Bunnell, New York 1971; *New Japanese Photography*, exhibition catalogue, by John Szarkowski and Shoji Yamagishi, New York 1974; *Human Behavior: Individual* by the Time-Life editors, New York 1974; articles—"Photography" by Ichiro Haryu in *The Photo Image* (Tokyo), Summer 1970; "Latent Image" by A.D. Coleman in the *Village Voice* (New York), September 1970; "Hot Foto Book" by Jo Boon in *Vooruit* (Erembodegem, Belgium), November 1971; "Isolation of Selftimer" by Tetsu Shimizu in *Geijutsu Seikatsu* (Tokyo), February 1972; "Photography" by A.D. Coleman in the *New York Times*, 7 April 1974; "Spot" by Akira Matsumoto in *Camera Mainichi* (Tokyo), April 1979; "Photo Review" by Kengo Mori in *Asahi Camera* (Tokyo), May 1979; "Scope/Photo Exhibition Review" by Kohshi Kurihara in *Nippon Camera* (Tokyo), May 1979.

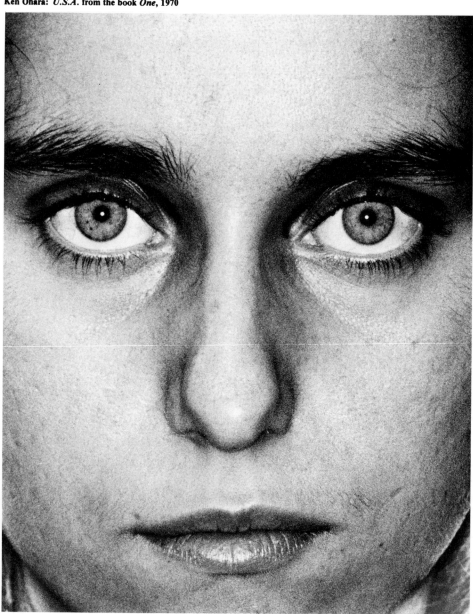

I am a photographer who has serious doubts about the treatment and direction of contemporary photography. I am searching for the basic concept of this medium called photography. I am trying to remove the externals of my subjects and expose their essential nature. I try not to photograph what "we" *think* it should be but what "it" *is*.

From 1974 to 1977 I sent a loaded, automatic camera to an unknown person whom I asked to expose film as he or she liked. This person chose the next participant who, in turn, chose another. This procedure was repeated one hundred times, producing one hundred contact sheets. These contacts represent one photograph. This photograph is my work. In this way my camera portrayed not the decisive moment taken from the "we" viewpoint, rather the "I" or private world from which the one behind the camera is never separated. There was no "we"—there existed only the situation.

—Ken Ohara

In his *One*, Ken Ohara captured in close-up the faces of people of numerous races and ages that he had encountered on the streets of New York. His photographs go beyond recording faces as just "objects" to capture the spirit and feelings that lurk beneath each mask.

What we discover there are expressions of energy and vitality that transcend mere emotions.

—Norihiko Matsumoto

OORTHUYS, Cas(parus Bernardus).

Dutch. Born in Leiden, 1 November 1908. Studied architeucture at the School vor Bouwkunde, Versierende en Kunstambachten, Amsterdam, 1926-27; also studied architecture in Haarlem and at the Akademie voor Beeldende Kunsten, The Hague; learned photographic technique form the fimmaker Joris Ivens, Amsterdam, in the early 1930's. Worked as an assistant in the photo studio of Cock de Graaff, Amsterdam, 1933; established studio with Jo Voskuil, Amsterdam, 1934; advertising photographer, under occasional pseudonym OV 20, Amsterdam, 1934-35; photo-reporter, working for *Het Vrije Volk*, *Wij*, etc. Amsterdam, 1935-41; freelance war-reporter, also active in documenting conditions in Holland and in producting false identity papers for the Dutch Underground, 1941-45; documentary and industrial photographer, working with Contact Photobooks, Nederlandse Spoorwegen, Hoogovens, Ten Cate, Puttershoek, Deirgeneeskunde, etc., Amsterdam, 1945 until his death, 1975. *Died* (in Amsterdam) *22 July 1975*.

Individual Exhibitions:

1969 *Mensen*, Stedelijk Museum, Amsterdam (toured the Netherlands)
1970 Hoogovens, Ijmuiden, Netherlands
1971 Stedelijk Museum, Amsterdam
 't Meyhuis, Helmond, Netherlands
1974 Galerie Fiolet, Amsterdam

Selected Group Exhibitions:

1937 *Foto '37*, Stedelijk Museum, Amsterdam
1945 *Ondergedonken Camera*, Atelier Meijboom, Amsterdam
1953 *European Photography*, Museum of Modern Art, New York
1954 *Subjektive Fotografie 2*, Saarbrucken
1957 *Biennale di Fotografia*, Venice
1961 *Dag Amsterdam*, Stedelijk Museum, Amsterdam
1970 *Kontrasten*, Haags Gemeentemuseum, The Hague
1975 *700 Jaar Amsterdam*, Van Gogh Museum, Amsterdam
1978 *Fotografie in Nederland 1940-75*, Stedelijk Museum, Amsterdam
1979 *Fotografie in Nederland 1920-40*, Haags Gemeentemuseum, The Hague

Collections:

Archief Oorthus, Amstel en Prinsengracht, Amsterdam; Stedelijk Museum, Amsterdam; Prentenkabinett, Rijksuniversiteit, Leiden; Haags Gemeentemuseum, The Hague.

Publications:

By OORTHUYS: books—*Agriculture in the Netherlands*, with text by D.J. Maltha, Amsterdam 1948; *Amsterdam: Its Beauty and Character*, with Emmy Andriesse, Amsterdam 1949; *De Vlaamse Steden*, with Emmy Andriesse, text by Lode Baekelmans and others, Amsterdam and Antwerp 1950; *Het Water*, with text by E. Zandstra, Amsterdam and Antwerp 1950; *De Steden*, with text by J.T.P. Bijhouwer and others, Amsterdam and Antwerp 1950; *Het Vlaamse Landschap*, with text by Bert Decorte and others, Amsterdam and Antwerp 1951; *This Is Paris from Dawn till Night*, with text by Jan Brusse, Amsterdam and Oxford 1952; *This Is London from Dawn till Night*, with text by Neville Brayburne, Amsterdam and Oxford 1953; *This Is Holland*, with text by C.J. Kelk, Amsterdam and Oxford 1953, 1964; *This Is Amsterdam from Dawn till Night*, with text by H.G. Hoekstra, Amsterdam and Oxford 1954; *This Is Florence*, with text by B. Premsela, Amsterdam and Oxford 1954; *The French Riviera from Marseilles to Menton*, with text by Jan Brusse, Amsterdam and Oxford 1955; *This Is Belgium*, with text by Karel J.B. Jonckheere, Amsterdam and Oxford 1955; *This Is Rome*, with text by R. Patris, Amsterdam and Oxford 1956, 1965; *This Is the Heart of Spain*, with text by Bert Schierbeek, Amsterdam and Oxford 1956; *This Is Austria*, with text by E. Zandstra, Amsterdam and Oxford 1956; *This Is Brussels and the World Exhibition*, with text by Delepinne, Amsterdam and Oxford 1958; *This Is Yugoslavia*, with text by A. den Doolaard, Amsterdam and Oxford 1958; *This Is Greece*, with text by A. den Doolaard, Amsterdam and Oxford 1958, 1960; *This Venice*, with text by A. den Doolaard, Amsterdam and Oxford 1958; *This Is the Italian Riviera*, with text by M. Ferro, Amsterdam and Oxford 1958; *Rotterdam: Dynamicsche Stad*, Amsterdam 1959; *This Is Switzerland*, with text by E. Straub, Amsterdam and Oxford 1960; *This Is Brittany*, with text by Pierre Cressard, Amsterdam and Oxford 1961; *This Is Alsace*, with text by Paul Ahnne, Amsterdam and Oxford 1962; *This Is Oxford and Cambridge*, with text by Roger Penrose, Oxford 1962; *This is Provence*, with text by Maurice Pezet, Amsterdam and Oxford 1962; *Term in Oxford*, with an introduction by Ian Bullock, Oxford 1963; *This Is Naples, Capri, Pompeii, Paestum*, with text by Wim Alings, Amsterdam and Oxford 1964; *This Is Majorca, The Balearic Islands, Minorca, Ibiza, Formentera*, with text by Jean A. Schaelkamp, Amsterdam and Oxford 1964; *Taal en Teken*, with text by Bert Schierbeek, Amsterdam 1965; *Nederland tussen verleden en toekomst*, with text by Albert Alberts, Amsterdam and Antwerp 1966; *This Is Como and the Italian Lakes*, with text by Wim Alings, Amsterdam and Oxford 1966; *Arnhem*, with an introduction by K. Schaap, Amsterdam 1968; *Mensen/People*, with text by Wim Alings and others, Amsterdam 1969; *1944-45 Het Laaste Jaar*, Amsterdam 1970; *Klederdrachten*, with Constance Nieuwhoff, Amsterdam 1976; article—"Cas Oorthuys: Interview" in *Wereldkroniek* (Amsterdam), 27 December 1969.

On OORTHUYS: books—*Holland and the Canadians* by Norman Phillips and J. Nikerk, Amsterdam 1946; *Amsterdam tijdens de hongerwinter* by Max Nord, Amsterdam 1947; *2nd World Exhibition of Photography*, exhibition catalogue, by Karl Pawek, Hamburg 1968; *Kontrasten*, exhibition catalogue, The Hague 1970; *Fotografie in Nederland 1940-1975*, exhibition catalogue, edited by Els Barents, The Hague and Amsterdam 1978; *Fotografie in Nederland 1920-1940*, exhibition catalogue, by Flip Bool and Kees Broos, The Hague 1979; article—"Cas Oorthuys" in *Groene Amsterdam* (Amsterdam), 30 July 1975.

One could describe Cas Oorthuys as a concerned photographer. It was his involvement with social causes that was responsible for his becoming a photographer in the first place. He was an out-of-work architect in the crisis period of the early 1930's, and he became involved with the Communist Party and the Association of Labor Photographers: in this environment he received his first lessons in photography from the filmmaker Joris Ivens. His first pictures were published in the left-wing magazine *Afwerfront*; they show a handcuffed negro, the children of an out-of-work seaman, and they demonstrate that his work was already that of reportage—down-to-earth, taken on the spot, without intentional "artistry."

In the work that followed, people were to remain his main theme. He felt that he wanted to photograph people throughout the world as they really were, not sensationally but sincerely portrayed in all situations. And, indeed, his subjects are always shown naturally, unposed, without artifice. His photos are like a momentary flash of vision, and they emphasize movement and action. Their strength is in his ability to choose the right moment at which to shoot: he captures life at a certain moment which is almost symbolic: the "capturing" seems to have been possible only at that moment, only rapidly, before it vanished. And the emotion of a single person, even if that emotion is a general one, becomes in his picture universal. Oorthuys' photo of a woman looking at nothing, blankly, while filling her mouth with a crust of bread conveys "starving" as well as his photograph of a wall on which in white paint the word "hunger" is written—a cyclist passes by, in the instant, apparently looking for food. These are only two examples of the impressive series of war pictures which Oorthuys produced in 1944 while he was a member of the "Underground Cameramen" in Amsterdam, often hiding his camera under his coat or in a bag, secretly taking his pictures. Apart from their photographic value, these photos provide an irreplaceable historical documentary of the time; they were collected by Oorthuys in his book *1944-45 Het Laaste Jaar*.

In his more commercial work—the commissions, the seemingly endless series of books produced after the war—we discover the same kind of intensity. There is, for example, his book *Mensen/People*, published on the occasion of his one-man exhibition at the Stedelijk Museum in 1969. The book is divided into 15 sections, for such subjects as death, birth, youth, hands, observation, discussions, laughter, etc. He himself wrote about the book: "It is a compilation of my work over the last 20 years, a kind of confession if you like, which I have gathered together from my previously unpublished photographs. They are all in black and white, because they were, and are, the colors of my generation."

What he neglected to say, but which we can see for ourselves in his archives in Amsterdam, is that in 40 years of work, Oorthuys revealed all aspects of human life.

—A. de Jonge-Vermeulen

ORKIN, Ruth.

American. Born in Boston, Massachusetts, 3 September 1921; grew up in Los Angeles. Educated at Beverly Hills and Eagle Rock High Schools, Los Angeles, 1935-39; Los Angeles City College, 1940; self-taught in photography. Served as a Private in the Women's Army Auxiliary Corps, 1943. Married the photographer Morris Engel, in 1952; children: Andy and Mary. Worked as a messenger at MGM Film Studios, Los Angeles, 1943-44. Freelance photographer since 1945; also, filmmaker, with Morris Engel, 1952-55. Freelance photojournalist, in New York, working for *Life, Esquire, Cosmopolitan, Ms., This Week, Collier's, Ladies' Home Journal*, etc. 1947-54. Instructor, School of Visual Arts, New York, 1976-78, and International Center of Photography, New York, 1979. Recipient: Silver Lion of San Marco, *Venice Film Festival*, 1953; Ten Best Women Photographers Award, New York, 1959; Manhattan Cultural Award for Photography, 1980. Address: 65 Central Park West, New York, New York 10023, U.S.A.

Individual Exhibitions:

1974 Nikon House, New York (retrospective)
1977 Witkin Gallery, New York (retrospective)
Enjay Gallery, Boston
1978 Milwaukee Center of Photography
Kiva Gallery, Boston
New York-New York, G. Ray Hawkins Gallery, Los Angeles (with Berenice Abbott and Lou Stoumen)
1979 *Window Photographs*, International Center of Photography, New York
University of Akron, Ohio
Rizzoli Gallery, New York (retrospective)
Afterimage Gallery, Dallas (retrospective)
Ruth Orkin: Exhibition of 100 Photographs, Rizzoli Gallery, Chicago (retrospective)
1980 Atlanta Gallery of Photography
1981 *A Photo Journal*, Witkin Gallery, New York
A Photo Journal, International Center of Photography, New York

Selected Group Exhibitions:

1950 *Young Photographers*, Museum of Modern Art, New York
1955 *The Family of Man*, Museum of Modern Art, New York (and world tour)
1964 *The World and Its People*, at the *World's Fair*, New York
1965 *Photography in the Fine Arts*, Metropolitan Museum of Art, New York
1978 *Photographic Crossroads: The Photo League*, National Gallery of Canada, Ottawa (travelled to the International Center of Photography, New York; Museum of Fine Arts, Houston; and Minneapolis Institute of Arts)
1981 *Manhattan Observed*, New York Historical Society
Art of the Olmsted Landscape, Metropolitan Museum of Art, New York

Collections:

Metropolitan Museum of Art, New York; Museum of Modern Art, New York; International Center of Photography, New York.

Publications:

By ORKIN: books—*Legacy of Love*, illustrations of poems by Ginsberg, New York 1971; *A World Through My Window: Photographs by Ruth Orkin*, New York 1978; *A Photo Journal: Ruth Orkin*, New York 1981; articles—"My Mother the Painter" in the *New York* magazine in the *New York Herald Tribune*, 29 December 1963; interview in *Photographers on Photography* by Jerry La Plante, New York 1979; films—*The Little Fugitive*, with Morris Engel and Ray Ashley, 1953; *Lovers and Lollipops*, with Morris Engel, 1955.

On ORKIN: book—*The Family of Man* (includes Orkin sequence), edited by Edward Steichen, New York 1955; *The Photograph Collector's Guide* by Lee. D. Witkin and Barbara London, Boston and London 1979; articles—"The Incredible Ruth Orkin" by Peter Martin in *Photography Workshop* (New York), Winter 1953; "Ruth Orkin's New York" in *Horizon* (New York), March 1959; "Frontier Woman" by Sarah Webb Barrell in *Camera 35* (New York), May 1975; "Ruth Orkin: Gravure Portfolio" by Nancy Stevens in *Popular Photography* (New York), June 1977; "We Are Not a Muse" by Burt Prelutsky in the *Los Angeles Times*, 28 August 1977; "Invisible Women" by Cecile Starr in *Sight and Sound* (London), Autumn 1980.

Taking pictures is my way of asking people to "look at this—look at that." If my photographs make the viewer feel what I did when I first took them—"isn't this funny/terrible/moving/beautiful?"—then I've accomplished my purpose.

—Ruth Orkin

Ruth Orkin has been an original and awarded (an Oscar nomination in the 50's for *The Little Fugitive*) film maker and a distinguished, successful photojournalist. *Life* and *Look*, et al, in their heydays sent her far away, hither and yon, to bring back a bounty of powerful pictures. But probably her finest, most deeply personal work has been accomplished in her role as New York City voyeur. Her documentation over a long period of years of what she has seen from her Westside window overlooking Central Park has resulted in an extraordinary series of images.

This loving spying has caught seasons and weather, parades and games, concerts and cars, joggers and cyclists, kites and fireworks. Like some apartment-house deity she has observed unobserved, from high up (but not too high), the personal and public activities below her. Included in her sometimes sharp, sometimes impressionistic record are the times of day, times of night, sunrise, sunset, all vividly recognized and composed, and with maximum usage of the drama of nature within towers: the city and park as a tireless, changing stage set.

—Ralph Pomeroy

ORTIZ-ECHAGÜE, José.

Spanish. Born in Guadalajara, 21 August 1886. Educated in Logrono, Rioja, until 1894; studied at Academy of Military Engineering, Guadalajara, 1903-09; self-taught in photography. Served in Aerial Regiment (balloon service), Spanish Army, in Spain, North Africa and Morocco, 1909-12; Pilot-Officer, Spanish Air Force, 1913-14; Commander, Air Maintenance Corps, Cuatros Vientos, Spain, 1915-17. Independent photographer, in Spain, 1900-80; also worked as an engineer for the City Planning Department, Buenos Aires, Argentina, 1912, Metal Industry Factories, France, 1914, and the Escoriaza Company, Zaragoza, Spain, 1916; Founder-Director, Electro-Mechanical Company, La Plata, Madrid, 1917-23; Founder-Director, then Chairman, Construcciones Aeronauticas S.A. (CASA), in Getafe and Cadiz, later in Seville and Madrid, 1923-70; Chairman and Manager, Sociedad Española de Automoviles de Turismo (SEAT), Barcelona, 1950-70. Recipient: First Prize, National Competition of Circulo de Bellas Artes, 1915; First Prize, Frederick and Nelson Competition, Washington, D.C., 1924; Silver Medal, *California Pacific International Exposition*, 1935; L. Misonne International Prize, Charleroi, Belgium, 1948; First Prize, *South African Salon of Photography*, Johannesburg, 1958; Medalla de Oro del Trabajo, Madrid, 1958; Gold Medal, Direccion General de Bellas Artes, Madrid, 1962; Gold Medal, Real Sociedad Fotografica de Madrid, 1975. Honorary Fellow, Royal Photographic Society, London, Photographic Society of America, and Hispanic Society of America; Honorary Life Member, Johannesburg Photographic Society; Honorary Member, New Pictorialist Society, U.S.A. *Died* (in Madrid) *7 September 1980*.

Ruth Orkin: *Israeli Teenager*, 1951

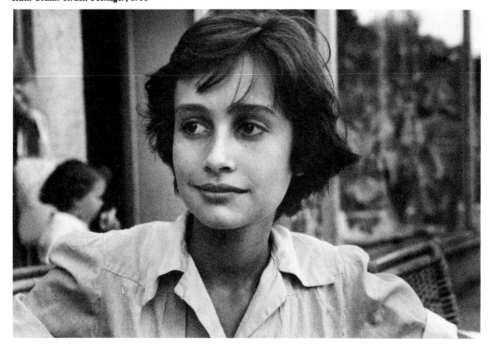

To refer to José Ortiz-Echagüe is to refer to the internationally best-known Spanish photographer of all time. As a man, he was spiritually aligned with the so-called "Generation of '98" (in 1898 Spain lost its last colonies overseas, and this critical historic moment utterly plunged a group of Castillian intellectuals into the most profound patriotic pessimism). In photography, Ortiz-Echagüe represents what Ignacio de Zuloaga represents in painting: an idealized vision of the Iberian people and their landscape, folklore, religion, etc. The actual country and its people are so sublimated to this vision that the photographer loses all connection with documented reality and in effect creates a fiction—or, perhaps better put, though paradoxically: he creates a remembrance of Spain's mythic past, in which traditions never evolve and everything breathes nobility and solemnity. Yet, despite the evidence of his photographs, Ortiz-Echagüe considered himself a documentalist.

Given the nature of those photographs, it is not difficult to understand the great esteem in which they were held by the Franco regime. For my part, if I had to choose his masterwork from among his very extensive production, I should select "Siroco en el Sahara" (1964), just precisely because, in this picture, his distance from his theme permits him to treat it with more spontaneity than is characteristic of his more celebrated pictures—many of which seem staged—and that spontaneity translated itself, thanks to his uncommon talent, into a very impressive image, clearly detached from the subjects with which he is usually associated.

Although, in fact, in his native country, Ortiz-Echagüe is now the target of polemics that have more to do with ideological than aesthetic questions (if one may separate the two), even his detractors must, I think, recognize the merit of his perseverance in the service of his vision, his great gifts for graphic creation for images, and the mastery with which he used the *"fresson"* method, which he himself modified and called *"al carbón."*

Despite the fact that he insisted that he was not a "pictorialist," it is possible and apt to place Ortiz-Echagüe with the second surge of European pictorialism and with the generation that comprised Pla Janini, Claudi Carbonell, Marqués de Sta. María del Villar, Conde de la Ventosa, etc.—that is, with those photographers who did not attempt to form an avant-garde or to be innovators, but who tried to shape and convey their environment as *they* honestly saw and felt it. It was a generation still interested in romantic values and in classic canons. Gerardo Vielba, who is his best biographer and critic, has said of him: Ortiz-Echagüe had "a fine sensibility, in general baroque, but modified at times by classicism, accented at others with a clear romanticism: what makes his representation so encompassing is the passionate way in which he dominates and, if need be, forces the theme, disclosing it as from within a fantastic aura." There can be no better description of the man or of his photographic style.

—Joan Fontcuberta

ORTIZ MONASTERIO, Pablo.

Mexican. Born in Mexico City, 2 June 1952. Educated at Instituto Patria, Mexico City, 1958-70; studied economics at the Universidad Nacional Autonoma, Mexico City, 1970-73; and photography at Ealing Technical College, London, 1974-75, and London College of Printing, 1975-76. Photographer, Rhigetti Audio-Visual Company, Mexico City, 1972-74. Photographer and Designer, Troje Taller, Mexico City, since 1978; Chief Editor, Archivio Etnografico Audiovisual, Mexico City, since 1979. Instructor in Photography, Universidad Autonoma Metropolitana, Mexico City, since 1977. Recipient: Prize, *Primer Bienal de Fotografia*, Mexico City, 1980. Address: Magnolia 38, San Angel Inn, Mexico 20, D.F., Mexico.

Pablo Ortiz Monasterio: *The Wind*, from the series *Les Pueblos del Viento* (original in sepia tint), 1980

1981 *Salon de Invitados*, at the *Coloquio Latino-americano de Fotografia*, Museo Palacio de Bellas Artes, Mexico City

Collections:

Instituto Nacional de Bellas Artes, Mexico City; Consejo Mexicano de Fotografia, Mexico City; Casa de las Americas, Havana; Bibliothèque Nationale, Paris.

Publications:

By ORTIZ MONASTERIO: books—*El Mundo Interior*, Mexico City 1979; *El Desnudo Fotografico*, Mexico City 1980; *La Casa en la Tierra*, editor, Mexico City 1980; *Los Pueblos del Viento*, with text by Jose Manuel Pintado, Mexico City 1981; *Los Que Viven en la Arena*, editor with Graciela Iturbide, Mexico City 1981; articles—"Pablo Monasterio" in *British Journal of Photography* (London), July 1975; "Pablo Monasterio: Portfolio" in *British Journal of Photography* (London), July 1976; "El Mimo" in *Revista de Bellas Artes* (Mexico City), July 1976; "Pablo Monasterio" in *Creative Camera* (London), November 1976; "Pablo Ortiz Monasterio" in *British Journal of Photography Annual*, London 1977; "Pablo Ortiz Monasterio" in *Anuario Fotozoom*, Mexico City 1977; "El Cardenal" in *Foto Zoom* (Mexico City), July 1980; "Pablo Ortiz Monasterio" in *Picture Paper* (Santa Fe, New Mexico), no. 5, 1979; "Pablo Ortiz Monasterio" in *Picture Paper* (Santa Fe, New Mexico), no. 9, 1980; "Pablo Ortiz Monasterio" in *Picture Paper* (Santa Fe, New Mexico), no. 10, 1980.

On ORTIZ MONASTERIO: books—*Bienal de Fotografia,* exhibition catalogue, by the Instituto Nacional de Bellas Artes, Mexico City 1980; *7 Portafolios Mexicanos*, edited by Universidad Nacional Autonoma de Mexico, Mexico City 1980; articles—"Pablo Monasterio" in *Nueva Lente* (Madrid), September 1976; "Predomino de lo Formal" by Chely Zarate in *Semana de Bellas Artes* (Mexico City), March 1980; "Mexican Photography" in *Camera 35* (New York), February 1981.

I am interested in photography as a form of expression, more precisely as a language with specific characteristics.

Over the years I have been learning and studying the elements one works with in a visual language. These include the technical crafts of photography, such as printing, exposure, etc., as well as the formal elements like composition, light, etc., and of course the meanings that the images convey.

All these elements are techniques that you can learn through observation, investigation and practice.

What remains as the more important question is what to say with the photographic language. The development of technical skills is only important as a tool.

My personal preoccupation is to use this tool (photography) to talk about aspects of our political reality, using different elements to convey meaning with depth, strength and beauty.

—Pablo Ortiz Monasterio

The artistic path of Pablo Ortiz Monasterio has been characterized by his search for self-expression and by his rigorous self-criticism. From 1968 until now, he has passed through a variety of different stages in his development.

He began with the intention of justifying the subject as he photographed art and artists. Then he began to hunt for the photogenic in everyday reality and to investigate the effect of bursting the grain of the film during developing. At times he playfully introduced color with a brush in order to emphasize a detail in the print. At some later stage he encountered Gibson's work and learned to liberate the shutter of his camera, using it as an instrument to tell a story. He tried to create a narrative sequence about a Greek village through several of its most typical characters. When in Portugal, he narrated the various activities of the inhabitants. In these works there was one recurrent element: his subjects were always placed with their backs to a wall (perhaps an unconscious symbol of captivity). Later, he appears to have been seduced by a surrealistic urge. He produced mysterious images of a certain intentional ambiguity in which dimensions, textures, proportions, and positions in space and time are deceptive. These trends in his work—the narrative and the mysterious—became one in the next stage of his work, a series of images about the life of a surgeon of the 16th century, Gaspar Talliacotti.

From then on, Ortiz Monasterio has worked simultaneously in two modes. One involves the development of elements as worked by Hausmann and Heartfield: building, through a single image, a specific political meaning for multiple reproduction. These compact images have a keen semantical accent, and they are distributed outside the usual realm of artistic photography.

The other mode are testimonies (through a sequence of 30 to 50 photographs each) of indigenous Mexican cultures, the Huaves and the Tarahumaras, on the verge of extinction. In these works Ortiz Monasterio has been a follower of Joseph Koudelka in his particular way of constructing photographic discourse around specific subject matter, particularly the way of life and behavior of little-known social groups.

The photograph produced here is from this second line of development. His main resource in these works (apart from his sensibility and obvious technical mastery) is a humble attitude, the result of his inability to directly communicate with these people. This difficulty forces him to recognize that he can capture only a few glimpses of the Indians' historic and cultural complexity. He works, as it were, as through the keyhole of a huge rusty door stuck between the western and indigenous cultures. His attitude is completely genuine, and his outlook is one of wonder, admiration and respect. He does not convey the "superiority" of the "civilized" white man who looks down on peoples of lesser economic development, nor does he give way to the temptation of the picturesque.

The mystery that he sought in his early photographs now comes naturally. It is the mystery that Pablo Ortiz Monasterio conveys in his lyrical and eloquent testimony to a dying culture. His is an aesthetic, political and human commitment.

—Katya Mandoki

OSTROVSKY, (Itzhak) Tzachi.

Israeli. Born in Tel Aviv, 7 July 1945. Educated at Shalva High School, Tel Aviv, graduated 1963. Served as a Photographer/Correspondent in the Israeli Army, 1963-66. Divorced. Staff Photographer, United Press International, in Israel, 1966; Senior Photographer, *Ha'aretz* weekly magazine, Tel Aviv, 1966-70. Freelance photographer since 1970: established Studio 500C, Tel Aviv, 1968, and worked with Studio Marco Glaviano, Milan, 1970. Address: 14 Ussishkin Street, Tel Aviv, Israel.

Selected Group Exhibitions:

1966 *Capa/Chim Memorial Fund Competition*, Journalists House, Tel Aviv

1967 *The Six-Day War*, Tel Aviv Museum
1969 *Israel: The Reality*, Jewish Museum, New York
1973 *World Press Photo*, Amsterdam (and 1976, 1977)
1974 *One World for All*, at *Photokina '74*, Cologne (travelled to Unesco, Paris, 1975)
1976 *Jerusalem: Types and Sights*, Jerusalem Museum
 J.A. Kamminer Memorial Fund Exhibition, Journalists House, Tel Aviv
1978 *Work and Leisure*, at *Photokina '78*, Cologne
1980 *Israel '80*, Municipal Library, Tel Aviv

Collections:

Tel Aviv Museum; Jerusalem Museum; World Press Photo Foundation, Amsterdam; Bibliothèque Nationale, Paris.

Publications:

By OSTROVSKY: books—*Israel: The Reality*, with others, edited by Cornell Capa, New York 1969; *Endless War*, with others, Haifa 1970; *Israeli Seaman*, with others, edited by J. Bar Joseph, Haifa 1971; *Sinai Desert*, with others, edited by A. Alon, Haifa 1972; *Bat Chen*, with others, edited by T. Cohen, Haifa 1972; *Israel: Years of Crisis, Years of Hope*, with others, edited by R. Prister, New York 1973; *Israel: 25th Year*, with others, edited by David Pedhetzur, Tel Aviv 1973; *Jerusalem*, with others, edited by E. Kore'n and R. Hecht, Haifa 1974; *Things I Wanted to Tell You*, with poems by Amos Ettinger, Tel Aviv 1981; *Shay Doesn't Hear*, with text by Murit Israeli, Tel Aviv 1981.

"Here," said the slim, intense man almost hidden behind an aureole of curly hair, curly beard, as he pulled five or six photographs from the pile we had just looked through—"if you want to know who I am, look at these. I don't know how to separate Tzachi Ostrovsky the individual from Tzachi Ostrovsky the photographer."

I asked about the particular photograph he had chosen for this book. "It represents my deep love of the desert, of solitude and open space. I'm always looking for simplicity, in my life and in my work. The sinai is the most beautiful piece of earth I've ever had the chance to see. It's glorious and sacred. The power of nature is incredibly strong there, and I'm fascinated at how human beings adjust.

"I took this picture at a beach south of Nueba. It's inhabited by hippies and wild dogs. The freaks usually don't let photographers in because most of them are only looking for sensationalism, sex, nudity. So I buried my cameras in the sand and just lived with them for two weeks. Then I dug out the cameras, shot for three days and left.

"To me, this picture is relaxation, harmony, quiet. The four animals are so similar, lying in the sand at the end of a hot afternoon when the overpowering sun has finally set. They're trying not to move, to reduce the dehydration. Man, dogs, they're all just lying there, feeling the heat coming from Mother Earth. In the desert you can learn true humility.

"Look, this may sound naive or silly, but I believe the human being is good, even if he is inevitably corrupted by society. I am always seeking for the good and trying to express it, though sometimes it's necessary to show the opposite in order to do that. What I want is to present something that is maybe worth other people's striving for."

—Bonnie Boxer

OUTERBRIDGE, Paul (Everard), Jr.

American. Born in New York City, 15 August 1896. Educated at elementary school in New York, 1902-06; Hill School, Pottstown, Pennsylvania, 1906-10; Cutler School, New York, 1910-14; studied anatomy and aesthetics at the Art Students League, New York, 1915-17; studied photography at the Clarence White School at Columbia University, New York, 1921-22; also studied with the sculptor Alexander Archipenko, New York, 1923-24. Served in the British Royal Flying Corps and the United States Army, 1917-18. Married Paula Smith in 1921 (divorced, 1928); married Lois Weir in 1945. Worked with Rollo Peters on stage designs, and for a brokerage firm, New York, 1916, and as a painter and designer, in New York and Bermuda, 1916-21; freelance advertising photographer, working for *Vogue, Vanity Fair, Harper's Bazaar*, etc., New York, 1922-25; freelanced, mainly for *Vogue*, associating with Man Ray, George Hoyningen-Huene, Berenice Abbott, Edward Steichen, Paris, 1925-28; established own studio, Paris, 1927-28; assistant film director, Berlin, and with E.A. Dupont, London, 1928-29; freelance commercial color photographer, working for *House Beautiful, McCall's, Mademoiselle, Harper's Bazaar, Vogue*, etc., and establishing own studio, Monsey, New York, 1929-43; freelance portrait and magazine photographer, Hollywood and Laguna Beach, California, 1943 until his death, 1958. Instructor, Clarence White School of Photography, Columbia University, New York, 1922-23; Co-Director, with Lois Outerbridge, Lois-Paul Originals, women's fashions, Hollywood, 1945-58; Contributor, *U.S. Camera*, New York, 1954-58. Recipient: Photography Medal, *11th Annual Exhibition of Advertising Photography*, New York, 1932. Honorary Member, Royal Photographic Society, London, 1925. Agent: G. Ray Hawkins Gallery,

7224 Melrose Avenue , Los Angeles, California 90046, U.S.A. *Died* (in Laguna Beach, California) *17 October 1958.*

Individual Exhibitions:

1924 Art Center, New York
1959 Smithsonian Institution, Washington, D.C.
1977 G. Ray Hawkins Gallery, Los Angeles
 Corcoran Gallery, Washington, D.C.
1978 Kiva Gallery, Boston
1979 G. Ray Hawkins Gallery, Los Angeles
1980 Robert Miller Gallery, New York
1981 G. Ray Hawkins Gallery, Los Angeles
 Laguna Beach Museum of Art, California
1982 *Paul Outerbridge: A Singular Aesthetic: Photographs and Drawings*, San Francisco Museum of Modern Art (toured the United States, 1982-84)

Selected Group Exhibitions:

1928 *Independent Salon of Photography*, Galerie de l'Escalier, Paris
1929 *Film und Foto*, Deutscher Werkbund, Stuttgart
1932 *11th Annual Exhibition of Advertising Photography*, Art Center, New York
1937 *History of Photography 1839-1937*, Museum of Modern Art, New York
1940 *A Pageant of Photography*, Palace of Fine Arts, San Francisco
1976 *Photographs from the Julien Levy Collection, Starting with Atget*, Art Institute of Chicago
1978 *Photos from the Sam Wagstaff Collection*,

Corcoran Gallery of Art, Washington D.C. (toured the United States and Canada)
1979 *Photography Rediscovered: American Photographs 1900-1930*, Whitney Museum, New York (travelled to the Art Institute of Chicago)
 Film und Foto der 20er Jahre, Württembergische Kunstverein, Stuttgart (toured Europe)
1981 *The Nude in Photography*, San Francisco Museum of Modern Art

Collections:

Metropolitan Museum of Art, New York; Museum of Modern Art, New York; International Museum of Photography, George Eastman House, Rochester, New York; Library of Congress, Washington, D.C.; Smithsonian Institution, Washington, D.C.; Art Institute of Chicago; Center for Creative Photography, University of Arizona, Tucson; Laguna Beach Museum of Art, California; San Francisco Museum of Modern Art; Australian National Gallery, Canberra.

Publications:

By OUTERBRIDGE: book—*Photographing in Color*, New York 1950; articles—statement and photos in *International Studio* (New York), April 1924; "Photos von Outerbridge" in *Die Dame* (Berlin), July 1928; "What Is Feminine Beauty?" in *Physical Culture*, January 1932; "American Aces: Paul Outerbridge Jr." in *U.S. Camera* (New York), February 1939; "Photographing in Color" in *U.S. Camera* (New York), May 1940; "Patternists and

Tzachi Ostrovsky: *Sasha and Dogs*, Nueba, 1976

Paul Outerbridge: *Legs in Stockings with Flowers*, c. 1928

Light Butchers" in *American Photography* (New York), August 1952.

On OUTERBRIDGE: books—*Foto-Auge/Photo-Oeil/Photo-Eye* by Franz Roh and Jan Tschichold, Stuttgart 1929; *Photography 1839-1937*, exhibition catalogue, with text by Beaumont Newhall, New York 1937; *A Pageant of Photography*, exhibition catalogue, San Francisco 1940; *Looking at Photographs: 100 Pictures from the Collection of the Museum of Modern Art* by John Szarkowski, New York 1973; *Outerbridge*, exhibition catalogue, by Graham Howe, Los Angeles 1976; *Photographs from the Julien Levy Collection, Starting with Atget*, exhibition catalogue, by David Travis, Chicago 1976; *Fotografie der 30er Jahre: Eine Anthologie*, edited by Hans-Jürgen Syberberg, Munich 1977; *A Book of Photographs from the Collection of Sam Wagstaff*, designed by Arne Lewis, New York 1978; *Photographen der 20er Jahre* by Karl Steinorth, Munich 1979; *Film und Foto der 20er Jahre*, exhibition catalogue, by Ute Eskildsen and Jan Christopher Horak, Stuttgart 1979; *Photography Rediscovered: American Photographs 1900-1930*, exhibition catalogue, by David Travis, New York 1979; *Paul Outerbridge Jr.: Photographs*, edited by Graham Howe, New York, London and Munich 1980; *Paul Outerbridge: A Singular Aesthetic* by Elaine Dines and Graham Howe, Santa Barbara, California 1981; articles—"From Cubism to Fetishism" by Graham Howe in *Artforum* (New York), Summer 1971; "Paul Outerbridge Jr." by Graham Howe in *Exposure* (New York), December 1976; "A Cubist Photographer" by Hilton Kramer in the *New York Times*, 21 October 1979; "The Triumph of the Spleen" by Ben Lifson in the *Village Voice* (New York), 5 November 1979; "Paul Outerbridge at Robert Miller" by Thomas Lawson in *Art in America* (New York), February 1980; "Paul Outerbridge" by Vicki Goldberg in *American Photographer* (New York), March 1980; "The Gentleman Photographer" by Owen Edwards in *Horizon* (New York), June 1980; "Paul Outerbridge Jr.: Photographs" by Graham Howe in *Printletter* (Zurich), May/June 1980; "Outerbridge: Commitment to Excellence" by Ted Hedgpeth in *Artweek* (Oakland, California), 6 February 1982.

The elegantly intellectual cubist abstractions of Paul Outerbridge, justly respected and widely published, orchestrated a successful career which would later decline while he pursued artistic and personal obsessions. His uncommon treatment of commonplace objects and his later virtuosic color works were well published, exhibited and collected by major museums. Outerbridge's conceptual approach to photographing objects—seeing them as plastic manifestations of light and dark, planes and diagonals, shapes and masses that create simultaneous tension and balance—kept his photographs uncompromised by the commercial illustrative and advertising market to which he sold much of his work.

After his early years studying life drawing and anatomy at the Art Students League in New York, he began to photograph late in 1921 at the age of 25. He enrolled at the Clarence White School of Photography and quickly demonstrated his technical proficiency. Outerbridge was, however, strongly influenced by his teacher, Max Weber, whose radical and avant-garde ideas about art and photography spirited Outerbridge to embrace photography as the new art. "To appreciate photography," Outerbridge said, "one must disassociate it from other forms of art expression. Instead of holding a preconceived idea of art, founded upon painting, it must be considered as a distinct medium of expression—a medium capable of doing certain things which can be accomplished in no other way."

With his conviction that both art and commerce could be combined to their mutual benefit, Outerbridge began to publish his photographs in magazines such as *Harper's Bazaar*, *Vanity Fair*, and

Vogue. His photographs were applauded for their innovative abstraction of the subject as a plastic idea. Outerbridge saw his earliest commercial assignment, creating the "Ide Collar" photograph in 1922, as an opportunity to redefine a "product shot" in his own visual language. By using this perfectly adaptable subject matter for an abstraction, Outerbridge at once described and transcended the object's function. The collar's crisp, broad sweep almost hovers above the player's chess board, and the alternating pattern of black-and-white squares is broken and offset by the starched circular form. When it was published in the July 1922 issue of *Vanity Fair* magazine, the photograph was seen by Marcel Duchamp in Paris. Seduced by the ad's abstraction, by its simplicity and directness, and by its sympathy for the "ready-made" object as art form, Duchamp took the page from the journal and immediately fixed it to his studio wall.

With an early commercial success in New York, Outerbridge hoped to repeat his achievement in Paris. Early in 1925 he was befriended by Man Ray, who in turn introduced Outerbridge to his Parisian colleagues, Duchamp, Picabia, Braque, Stravinsky and Picasso among others. During this creatively active time Outerbridge worked briefly for Paris *Vogue* and later freelanced. Photographs characteristic of this period are small platinum prints of elegantly arranged still-lifes showing cosmetic cases, jewelry, perfume bottles, and man's accessories, and pictures of exotically dressed mannequins. After working at film making in Berlin and London, Outerbridge returned to America in 1929 on the eve of the Great Depression.

He moved 25 miles up river from Manhattan to a country house at Monsey, where work on a greater challenge began: the perfection of color photography. With his typically superior technical ability and patience he achieved excellence in the tri-color carbro process, a long and tedious method of making a single color print. To this day the tricolor carbro print remains a superior process to all other color photographs not only in terms of brilliance and sharpness of image, but also in its great permanence. The rich optical effect of his carbro prints combines the same lush color gradations as his black-and-white studies utilize in their tonal ranges. The 1937 "Kandinsky" photograph almost exclusively uses solid structural objects: the Cinzano bottle, the exactingness of an accordian-folding-rule, a glossy red ball, a black developing timer, and the structural clarity of the table and wall impeccably positioned create a tough progression of mass through a space. The fluid sweep of the yellow paper upon which all objects are positioned passes its subtle reflection upon, and chromatically connects with, all these otherwise discrete and isolated objects.

Eighteenth century French painting appears to be a direct axial source in the genesis of Outerbridge's more erotic nudes, particularly his odalisques. Both Outerbridge and the French painters present the female nude with a balance of classical, naive shamelessness and worldly sensuality, for the delight of an aristocratic audience—an audience which, in Outerbridge's case, was a projected fantasy for himself. Outerbridge was mainly concerned with making images, shocking in their suggestiveness, about subjects which were "naughty" or taboo. Naked ladies wearing top hats that one might assume belonged to their male companions, satin sheets indicative of luxurious decadence, exotic hosiery and gloves, and various kinds of masks and rubber bathing caps were his favorite props for the ritualized performance of sexual masquerade. Outerbridge's "Girl with Fan," 1937, shows a partially undressed woman wearing a green velvet dress with the shoulder straps down at her elbows. To cover her breasts, she holds a fan, the motif of which echoes the shape of the bustline. Depicted on the fan is the scene of a naked child lying face down by a bush, with a black and white hen pecking at a snail crossing the child's buttocks. The woman's eyes are averted, and her pose is one of relaxed participation in an erotic

ritual. Outerbridge's virtuosic construction of the color and textural elements provides an intelligent backdrop for our unanswered questions about his intent, both in this picture and in his entire, brilliant artistic output.

In 1943 Outerbridge left New York for Hollywood, but did not break into the film industry as he had hoped to. Supporting himself in various ways such as running a portrait studio and writing for photographic and travel magazines, Outerbridge was underemployed considering his vast ability and experience. He died of cancer in 1958. Outerbridge's legacy, while not more than about 600 different images, stands with the best of 20th century art.

—Graham Howe

OWENS, Bill.

American. Born in San Jose, California, 25 September 1938. Educated at San Juan High School, Citrus Heights, California, 1953-57; Chico State College, California, 1957-63, B.A. 1963. Served in the Peace Corps, 1964-66. Married Janet Owens in 1963; sons: Andrew and Erik. Photographer for the *Livermore Independent*, California, 1968-78. Freelance photographer and publisher, Livermore, since 1978. Recipient: National Endowment for the Arts Grant, 1974, 1977, 1978, 1979; Guggenheim Fellowship in Photography, 1976. Agent: Rick Koopman, Box 65, Denver, Colorado 80306. Address: Box 687, Livermore, California 94550, U.S.A.

Individual Exhibitions:

1973 Oakland Art Museum, California
1974 Focus Gallery, San Francisco
1977 John Berggruen Gallery, San Francisco
 Drew University, Madison, New Jersey
1978 La Photo Galeria, Madrid
1979 Hippolyte Gallery, Helsinki

Selected Group Exhibitions:

1978 *Mirrors and Windows: American Photography since 1960*, Museum of Modern Art, New York (toured the United States, 1978-80)
 Tusen och En Bild/1001 Pictures, Moderna Museet, Stockholm

Collections:

Museum of Modern Art, New York; Oakland Art Museum, California; Bibliothèque Nationale, Paris.

Publications:

By OWENS: books—*Suburbia*, San Francisco 1973; *Our Kind of People: American Groups and Rituals*, San Francisco 1975; *Working: I Do It for the Money*, New York 1977; *Documentary Photography: A Personal View*, Danbury, New Hampshire 1978; *Publish Your Photo Book*, Livermore, California 1979.

On OWENS: books—*Mirrors and Windows: American Photography since 1960* by John Szarkowski, New York 1978; *Tusen och En Bild*, exhibition catalogue, by Ake Sidwell, Sune Jonsson and Ulf Hard

Bill Owens: *Most People Have the Wrong Attitude about Sex*, from *Suburbia*, 1972

af Segerstad, Stockholm 1978; article—"Bill Owens" in *Camera* (Lucerne), March 1974.

The heart of photography is the documentary image, as it is a record of people, places and events. The challenge to the documentary photographer is the highest, as the photograph must be technically perfect and show how people live. The documentary photograph contains the symbols of our society and tells us about ourselves. This type of photography, if properly done, will stand the test of time.

—Bill Owens

Bill Owens is a lively, fortyish, California ex-news photographer who is today, as a widening of his career, turning to self-publishing and helping others to do the same. His trade-marks are a fast flow of words and ideas, a fine eye for the folkways of middle-class Americans, and the drive and enthusiasm of a revivalist preacher. His first book, *Suburbia*, sold more than 20,000 copies in 1973, something of a phenomenon at the time, and established Owens as a sort of Weegee of the middle class. *Suburbia* and its descendants, *Our Kind of People* and *Working: I Do It for the Money*, proved to be a kind of photographic litmus paper, testing the acidity of the viewer's attitude toward middle-class America. Some loved the books, some hated them for what each saw in the same groups of photographs of middle-class life.

Bill Owens's newpaper assignments led him into the lodge halls, senior citizens' meetings, business-group lunches, political meetings, school activities, church organizations and tract homes of Californians, in search of news pictures. His sensibility as a photographer led him to shoot his own pictures of these people—his peers—after he had finished his assignments for the newspaper. The people in Owen's photographs take themselves quite seriously for the most part, despite some of their activities in the pictures. And, for the most part, Owens is content not to quarrel with them, visually at least. His images are sharp, clean, well-lit; his subjects are engaged in everything from backyard barbecues to posing in beauty contests.

But, as a working photojournalist, Bill Owens has learned the value of words as corollaries to images. So, he shrewdly includes words, usually those of one or more of the subjects in his pictures, along with the images he presents. In this way, he stays neutral, non-judgemental of his subjects (except in choosing the words he quotes, of course). This neutrality forces the viewer to his own conclusions about what he is seeing and learning about the people in an Owens picture. Whether he loves them or scorns them depends, then, on the viewer's own background, ideas and ideals. In effect, Owens is merely reporting and not editorializing, he claims.

Here's an example of the Owens technique from *Our Kind of People* (subtitle: *American Groups and Rituals*). The photograph shows a line of U.S. beauty contest entrants in clinging, one-piece bathing suits on stage, backs to their audience and the viewer. The photograph is a straight record shot, non-committal. The accompanying text, presumably the words of one of the contestants, says, "A lot of people say we're chunks of meat, like cattle, but we're not. We're all individuals with dreams and aspirations like everybody else. Being a beauty contestant has taught me about myself, other people, poise and public speaking. If I had to do it over again, I would."

Is the photographer sympathetic or unsympathetic to his subject? Whichever you think, can you be sure from what you've seen and read? Or is the decision up to you? Owens's wit and insight have caused him to realize that the most effective editorializing forces the viewer to make his own decisions about the subject.

—Kenneth Poli

PABEL, Hilmar.

German. Born in Rawitsch, Schlesien, 17 September 1910. Studied photography at the Agfa-Fotoschule, Berlin, Dip.Photog. 1929; also studied German culture, philosophy, and journalism, under Emil Dovifat, University of Berlin, 1930-35. Served in the German Army during World War II (prisoner of war, 1945). Freelance photographer, then war correspondent for *Neuen Illustrierten Zeitung*, Berlin, 1935-40; photographer, documenting war-displaced children, for the Bavarian Red Cross and Rowohlt-Verlag publishers, Berlin and throughout Europe, 1945-47; Contract Photographer, *Quick* magazine, Munich, working in Indonesia, Japan, China, Formosa, Africa, Russia and the United States, 1948-60; Staff Photographer, *Stern* magazine, Hamburg, 1961-70. Freelance photographer, West Berlin, since 1970. Member, Gesellschaft Deutsche Lichbildner, 1952-53, and since 1957. Recipient: Culture Prize, Deutsche Gesellschaft für Photographie, 1961; World Press Photo Prize, The Hague, 1968; Die Goldene Blende Prize, *Bild der Zeit* magazine, 1972; Photojournalism Prize, Federal Republic of Germany, 1976. Address: Post Frasdorf, 8201 Umratschausen, West Germany.

Individual Exhibitions:

1958 *Ich Fotografiere Menschen*, Staatlichen Landesbildstelle, Hamburg (toured West Germany)
1978 Stadtmuseum, Munich
1979 Galerie Nagel, West Berlin
1980 Museum Folkwang, Essen
 Karstadt, Hamburg

Selected Group Exhibitions:

1968 *2nd World Exhibition of Photography*, Pressehaus Stern, Hamburg (and world tour)
1977 *Documenta 6*, Museum Fridericianum, Kassel, West Germany
1979 *Photographie als Kunst 1879-1979*, Tiroler Landesmuseum Ferdinandeum, Innsbruck, Austria (travelled to the Neue Galerie am Wolfgang Gurlitt Museum, Linz, Austria; Neue Galerie am Landesmuseum Joanneum, Graz, Austria; and Museum des 20. Jahrhunderts, Vienna)
1979 *Deutsche Fotografie nach 1945*, Kasseler Kunstverein, Kassel, West Germany

Collections:

Museum Folkwang, Essen; Gesellschaft Deutsche Lichbildner, Cologne; Pressehaus Stern, Hamburg; Stadtmsueum, Munich.

Publications:

By PABEL: books—*Jahre unsereslebens*, Hamburg 1954; *Antlitz des Ostens*, Hamburg 1960; *Der Neben Dir*, Munich 1961.

On PABEL: books— *Ich Fotografiere Menschen*, exhibition catalogue, Hamburg 1958; *2nd World Exhibition of Photography*, exhibition catalogue, edited by Karl Pawek, Hamburg 1968; *Documenta 6/Band 2*, exhibition catalogue, by Klaus Honnef and Evelyn Weiss, Kassel and Cologne 1977; *Geschichte der Fotografie im 20. Jahrhundert/Photography in the 20th Century* by Petr Tausk, Cologne 1977, London 1980; *Photographie als Kunst 1879-*

Hilmar Pabel: *Ballet Girls*, Moscow, 1964 Courtesy Galerie Wilde, Cologne

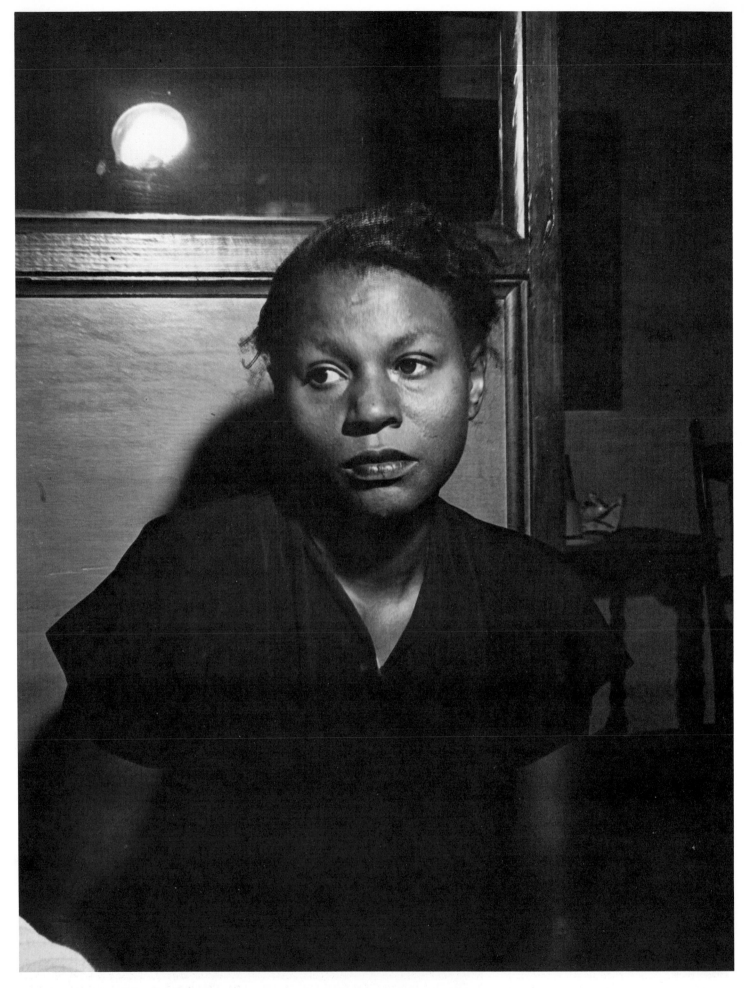

Marion Palfi: *Wife of a Lynch Victim*, **Irwinton, Georgia, 1949** Courtesy Palfi Collection, Menninger Foundation, Topeka, Kansas

1979/*Kunst als Photographie 1949-1979*, exhibition catalogue, 2 vols., by Peter Weiermair, Innsbruck, Austria 1979; *Deutsche Fotografie nach 1945* by Floris Neusüss, Wolfgang Kemp and Petra Benteler, Kassel, West Germany 1979; *Fotografie 1919-1979, Made in Germany: Die GDL-Fotografen*, edited by Fritz Kempe, Bernd Lohse and others, Frankfurt 1979.

"I came to photojournalism because I am passionately interested in life and in people all around the globe. I would like to participate in their destiny and contribute to an understanding among them. I would like to help to prevent misfortune by reporting on the tragedy of war and the catastrophes that afflict innocent people." With this simple, short and very honorable statement, photo-reporter Hilmar Pabel describes the philosophy of his life's work with the camera. He has always been a reporter, and there has always been a war to which he has been assigned by some board of editors but on which he has also wished to report. Yet, nothing lies further from his thoughts than to make war heroic; on the contrary, he follows particular destinies, showing individual suffering in the midst of mass murder.

Pabel was already at work for illustrated magazines before the Second World War; then he became a war correspondent; and after the war he undertook a commission—not very tempting from the standpoint of photography but humanly very rewarding: in the confusion of the post-war period 2000 children in orphanages had to be photographed in the effort to find possibly surviving relatives. After that assignment, he moved on to further journalistic work for the illustrated press, travels throughout the world, a volume of Far East photos, and finally the Vietnam War. It was there in 1968 that Pabel photographed his famous "Die Kleine Orchidee" (The Little Orchid)—the death of a war wounded Vietnamese child whom an American doctor was not able to rescue. In the same year he covered the Russian invasion of Czechoslovakia, and for his photographs Pabel received First Prize in the World Press Photo Competition.

Pabel works unobtrusively, sympathetically, never seeking out the sensational. He has the eye, and the reactions, of the classical reporter. He works for himself and for his fellow creatures and not, in the end, for any picture press. When in 1980 he set out on a second journey to the border camps of Cambodian refugees in Thailand, he had previously collected through contributions a large sum of money for private relief measures.

In spite of the large number of his publications at home and abroad, and in spite of numerous prizes and honors, Hilmar Pabel has not yet been given the international recognition that he deserves—but that may well be due to his personal modesty, not to the quality of his photography.

—Hans Christian Adam

PALFI, Marion (Hermine Serita).
American. Born, of Hungarian parents, in Berlin, Germany, 21 October 1907; emigrated to the United States, 1940: naturalized, 1944. Educated in Berlin until 1932; also trained as a dancer, in Berlin, 1930-34; self-taught in photography. Married Martin Magner in 1954. Worked as a model and film actress, Berlin, 1932-34; photographic apprentice in a commercial portrait studio, Berlin, 1934-35; freelance industrial and magazine photographer, Berlin,

and in Turkey, Lebanon, Syria and Iraq, 1935-36; freelance portrait photographer, establishing own studio, Amsterdam, 1936-40; worked as a photofinisher, Pavelle Laboratories, Los Angeles, 1940-44; freelance professional social documentary photographer, Los Angeles, working for *Ebony* magazine, New York Children's Committee, New York Advisory Committee for the Aged, etc., 1945 until her death, 1978. Instructor in Photographic Social Research, Inner City Institute, Los Angeles, 1971-78. Recipient: Council Against Intolerance in America Award, 1945; Ministry of Education Award, Haiti, 1945; Rosenwald Fellowship, 1946; Children's Bureau Award, Federal Security Administration, Washington, D.C., 1950; Government of the Netherlands Award, 1953; New York Mayor's Advisory Committee for the Aged Award, 1956; Taconia Foundation Award, 1963; Guggenheim Fellowship, 1967; National Endowment for the Arts Photography Fellowship, 1974. Agent: Witkin Gallery, 41 East 57th Street, New York, New York 10022. *Died* (in Los Angeles), *4 November 1978.*

Individual Exhibitions:

1945 *Great American Artists*, Norlyst Gallery, New York
 Museum of Port-au-Prince, Haiti
1949 *Children in America*, New York Public Library (toured the United States, 1949-52)
1953 *Photography: Its Artistic and Social Value*, Curacao, Dutch West Indies (travelled to Aruba)
1961 New School for Social Research, New York
1966 California Art Institute, Los Angeles
1968 *I Too Am America*, Inner City Cultural Center, Los Angeles
1970 El Camino College, Torrance, California
1973 *Invisible in America*, Witkin Gallery, New York
 Invisible in America, University of Kansas, Lawrence (travelled to the Pasadena Art Museum, California, and Friends of Photography, Carmel, California, 1974)
1974 *The Language of Light*, University of Kansas, Lawrence
 Public Landscapes, Museum of Modern Art, New York
1978 Women's Building, Los Angeles

Selected Group Exhibitions:

1974 *Femmes Photographes*, Bibliothèque Nationale du Quebec, Montreal
1975 *Women of Photography*, San Francisco Museum of Art (toured the United States, 1975-77)
 There Is No Female Camera, Neikrug Gallery, New York
 6th Anniversary Show, Witkin Gallery, New York
1976 *Women Look at Women*, Library of Congress, Washington, D.C. (toured the United States)
 Photographic Definitions, Los Angeles Institute of Contemporary Art
1979 *Fotografie in Nederland 1920-40*, Haags Gemeentemuseum, The Hague
 10th Anniversary Show, Witkin Gallery, New York

Collections:

Palfi Archive, Center for Creative Photography, University of Arizona, Tucson; University of Kansas, Lawrence; Museum of Modern Art, New York; New York Public Library; University of Colorado, Boulder; San Francisco Museum of Modern Art; Museum of Port-au-Prince, Haiti.

Publications:

By PALFI: books—*Suffer Little Children*, New York 1952; *Invisible in America*, with text by James Enyeart, and a foreword by Lee D. Witkin, Lawrence, Kansas 1973; *Marion Palfi: Language of Light*, Lawrence, Kansas 1974; *Silver See*, portfolio of 21 photos, with others, with an introduction by Victor Landweber, Los Angeles 1977; article—"You Have Never Been Old" in *Transactions* (New York), March 1959.

On PALFI: books—*Women of Photography: An Historical Survey*, edited by Margery Mann and Ann Noggle, San Francisco 1975; *Art: Anonymous Was a Woman!*, Valencia, California 1975; *Photographic Definitions*, exhibition catalogue, Los Angeles 1976; *A Ten Year Salute* by Lee D. Witkin, with a foreword by Carol Brown, Danbury, New Hampshire 1979; *Fotografie in Nederland 1920-40*, exhibition catalogue, by Kees Broos and Flip Bool, The Hague 1979; *The Photograph Collector's Guide* by Lee D. Witkin and Barbara London, Boston and London 1979; articles—in *Minicam Photography* (New York), July/August 1949; "Marion Palfi: Image of Social Change" by Jaki Beshears in *Artweek* (Oakland, California), 13 April 1974.

Marion Palfi practiced a form of advocacy photojournalism in which her own words and images, combined with textual material from other sources, were merged organically into extended statements on social, economic and political issues. She rejected the label of "documentarian," terming herself a "social research photographer"; her purpose was to provide that information and understanding necessary as the basis for change.

Unlike many of her contemporaries who worked in the documentary mode, Palfi never abandoned responsibility for the relationship between her imagery and its essential accompanying text, maintaining a commitment to exercising editorial control over the context of presentation of her work. In this she most resembled W. Eugene Smith, who also insisted on editorial autonomy of the photojournalist as one who bears witness, in the words of Oliver Wendell Holmes, to "the actions and passions of [her] time."

As a result of her refusal to relinquish control over her work, few of Palfi's extended essays have been published to date. Most of her "social researches" she funded herself; support also came from foundations, social work agencies, and other such organization—the Rosenwald Foundation, the Council Against Intolerance in America, the Children's Bureau of the Federal Security Administration, the New York Children's Committee, the New York Mayor's Advisory Committee for the Aged and the Guggenheim Foundation among them. Through their sponsorship her works were presented in the forms of reports and exhibitions, serving very practical functions despite their lack of acceptance in the world of commercial publishing. According to James Enyeart, who assembled the major retrospective and monograph on her work, *Invisible in America*, her essays were "twice used by Congress for the enactment of laws that have affected the poor and those subjected to discrimination."

Known to and ardently supported by such diverse figures as Eleanor Roosevelt, Langston Hughes, Edward Steichen and John Collier, Sr., Palfi addressed many of the major issues of her era. Racial discrimination was the subject of *There Is No More Time* and *That May Affect Their Hearts and Minds*; the dispossession of the American Indian was the theme of *My Children, First I Liked the Whites, I Gave Them Fruit...*, which concerns the Hopi, Navajo and Papago tribes; *You Have Never Been Old* examines the plight of the aged in the United States; and *Suffer Little Children*—the only one of her essays to achieve publication in full during her lifetime—is a painful scrutiny of the children of

poverty in America.

Despite its general exclusion from the gallery-museum circuit until late in her life, and notwithstanding its commercially "unpublishable" status, Palfi's work was unquestionably successful on its own terms. Coherent, purposeful and pointed, it provided effective ammunition in the ongoing struggle against social injustice on many fronts; its maker was able to direct its usage and to witness its consequences in her time.

—A.D. Coleman

PAOLINI, Améris M(anzini).

Brazilian. Born Améris Manzini in São Paulo, 22 December 1945. Educated at Ginasio Cristo Rei, São Paulo, 1955-60; did secretarial studies at Mackenzie Institute, São Paulo, 1960-63; studied Italian at the Italian-Brazilian Institute, São Paulo, 1964-67; studied photography, under Uli Bruhn, Institute of Arts and Decoration (IADE), São Paulo, 1970, and under Claudio Kubrusly, Cristiano Mascaro and Maureen Bissiliat, at the Enfoco School of Photography, São Paulo, 1970-72; studied English, University of New York, 1971; advanced photographic technique, Camera Nikon School, São Paulo, 1972-73; Technical Photography Course, Lasar Segal Museum, São Paulo, 1974. Married Ivo Paolini in 1968; children: Roberta, Fabio and Sandra. Worked as secretary, Swift of Brazil, S.A., São Paulo, 1965; Pfizer Corporation, São Paulo-Guarulhos, 1966-67; Texaco Brazil, S.A., São Paulo, 1967-68; Du Pont of Brazil, São Paulo, 1968. Freelance photographer, São Pualo, working for *Fotoptica, Iris* and *Photocamera* magazines, since 1976, and *Psicologia Agual*, since 1979. Lectured in photography, Zoom School, São Paulo, 1979-80. Member, Association of Graphic and Photographic Artists (AGRAF), São Paulo; Union of Photographers of São Paulo. Agent: Galeria Augosto Augusta, Rua Augusta 2161, São Paulo, Brazil. Address: Rua Banibas 1050, 05460 Vila Madalena, São Paulo, Brazil.

Individual Exhibitions:

1975 *Slaughterhouses of Campos do Jordão*, Museu de Arte de São Paulo
1979 *Landscapes and Abstracts*, Galeria Fotografia, São Paulo-Campinas
1980 *Brick Makers*, Faculdade de Artes e Comunicões, São Paulo

Selected Group Exhibitions:

1975 *Ação Valeparaiba '75*, travelling exhibition, (toured Paraiba Valley)
Greater São Paulo, Museu de Arte de São Paulo
1976 *Bienal Nacional '76*, São Paulo
1978 *Hecho en Latinoamerica*, Museo de Arte Moderna, Mexico City (travelled to *Venezia '79*)
International Exhibition of Photography of Santo André, ABC, São Paulo
Pró. Mulher, Fundação Getúlio Vargas, São Paulo
1979 *Post Card Editions*, Galeria Augosto Augusta, São Paulo
Freetime, Fundação Nacional de Arte (FUNARTE), Rio de Janeiro
1980 *1. Trienal de Fotografia*, Museu de Arte Moderna de São Paulo
1981 *Astrazione e Realtà*, Galleria Flaviana, Locarno, Switzerland

Collections:

Museu de Arte de São Paulo; Museu de Arte de Porto Alegre, Rio Grande do Sul, Brazil.

Publications:

By PAOLINI: books—*Hecho en Latinoamerica*, editor, Mexico City 1978; *Memoria e Sociedade*, with others, edited by T.A. Querioz, São Paulo 1979; article—"Depoimento" in *Iris* (São Paulo), April 1976.

On PAOLINI: books—*Grande São Paulo/Greater São Paulo*, exhibition catalogue, by Roberto Freire and Claudia Andujar, São Paulo 1976; *Trienal de Fotografia*, exhibition catalogue, by Moracy de Oliveira, São Paulo 1980; articles—"Améris Paolini" by Micheline Lagnado in *Fotoptica* (São Paulo), no. 74, 1976; "Améris Paolini" by Paulo R. Leandro in *Fotoptica* (São Paulo), no 75, 1976; "Depoimentos de 7 Fotografos" by Antonio H. Marques in *Iris* (São Paulo), April 1976; "Destruction at Campos de Jordão" by José Nogueira in *Iris* (São Paulo), November/December 1977; "Elderly People" by José Nogueira in *Iris* (São Paulo), March 1979; "Fotografico da Scoprire" by Giuliana Scimé in *Progresso Fotografico* (Milan), July/August 1979; "Cartão Postal Entre Nessa" by Alberto Neute in *Akopol* (São Paulo), January/February 1980; "Fotografia" by Mauro R. Barros in *Visão* (São Paulo), 23 June 1980; "Realidade para o Espectador Construir" by Stefania Bril in *Oestado de São Paulo*, 13 July 1980.

To me, a photograph is essentially a "moment" without past or future. I consider my photographic work as a collection of "moments." There are some examples in which I attempt to display my profes-

Améris M. Paolini: *Urban Detail*, São Paulo, 1975

sional concern with human activities and the presence of human beings (craftsmen at work, for instance)—"portraits" which are always trying to capture the most but never pretending to capture everything. Indeed, as complex as reality is, to capture everything in a single photographic image is impossible. An image is partial and subjective. The photographer is part of the photo; he interferes with reality. I attach most importance to sequences of photographs which reveal more interesting visual elements than a single photograph could suggest on its own.

—Améris M. Paolini

In an immense country of violent contrasts of attraction and repulsion, reality is reflected, multiplied and distorted as in a game with mirrors, and the true cannot be distinguished from the false, the imaginary, the exotic, the magical. Brazil is such a country. The Grand Hotel at Bahia, with its impressive size and luxury, is, in the eyes of the tourist, superimposed over cardboard huts, cancelling them out: the bright-colored postcard is ready made. Then there is the Rio Carnival, a powerful soporific for natives and foreigners alike. In such surroundings, there seem to be two traditional ways for the photographer to proceed—either to take on the gaudy surface of a world that is indeed full of visual excitement or enter fully into an alternative world of social, economic and political problems. The choice would seem to be between beautiful photography that is devoid of message and the somewhat bleak testimony of exposure. It is the accomplishment of Améris Paolini to have combined these two opposing attitudes, and to have done so with great originality within an unmistakable visual language all her own.

Aware of and sensitive to the real life around her, Paolini uses photography as an instrument of information, as a link between outer and inner life. The external facts—the actual conditions around her—stimulate a kind of social enquiry that she resolves by a subtle symbolism. The symbol is the expression of the emotional impact, of the personal reaction in the face of reality; and because it is a symbol, it is charged with universal meanings.

In fact, in all the thematic series that Paolini has completed so far—"Slaughterhouses of Campos do Jordão," "Old People's Shelters," "Brick Makers," etc.—the chosen subject becomes a symbol of her disquiet, the grief she feels about a human condition the wretchedness of which is almost beyond endurance. Even in those series in which there are no human figures—"Abstract Views of the Center of Sao Paulo"—there is always a disturbing element (the crooked hook, for instance) that breaks the broad serenity of the picture.

Quite uninfluenced by press photography, Paolini does not simply take pictures of people, events and objects as they appear to the eye of the beholder, but uses them to put over a profound message. Starting from the premise that reality is ambivalent and so impossible to record in a photo, she gets round the obstacle by drawing our attention to the concrete world—the subject represented—and playing with it so skilfully as to communicate her own vision, her own interpretation of the hidden reality.

Her pictures, then, can be read on two different levels: the first, the one we recognize immediately, has to do with our awareness of the objective world; the second is the message to be obtained from the visual representation. In this way photography, having once penetrated the surface of the concrete world and having resisted the temptation to be led astray to other goals, becomes a means of communi-

cating ideas and sentiments.

The sepia coloring that Paolini prefers to the more classical black-and-white smooths the tonal contrasts and gives her pictures a magic touch of unreality. This too, this sepia color, itself becomes a symbolic key, perhaps the first key, to the interpretation of the message.

—Giuliana Scimé

PAPAGEORGE, Tod.

American. Born in Portsmouth, New Hampshire, 1 August 1940. Educated at Portsmouth High School, 1954-58; University of New Hampshire, Durham, 1958-62, B.A. in English literature 1962. Married Pauline Whitcomb in 1962 (divorced, 1972). Photographer since 1962; lived and worked in San Francisco and Boston, 1962-64; travelled and photographed in Spain and France, 1965; worked as a photographer's assistant, New York, 1966-68. Freelance photographer, New York, since 1968. Visiting Instructor in Photography, Parsons School of Design, New York, 1969-72; Visiting Instructor in Photography, Pratt Institute of Art and Cooper Union School of Art, New York, 1971-74; Adjunct Lecturer in Photography, Queens College, New

Tod Papageorge: *New York Pier, July 5, 1976*

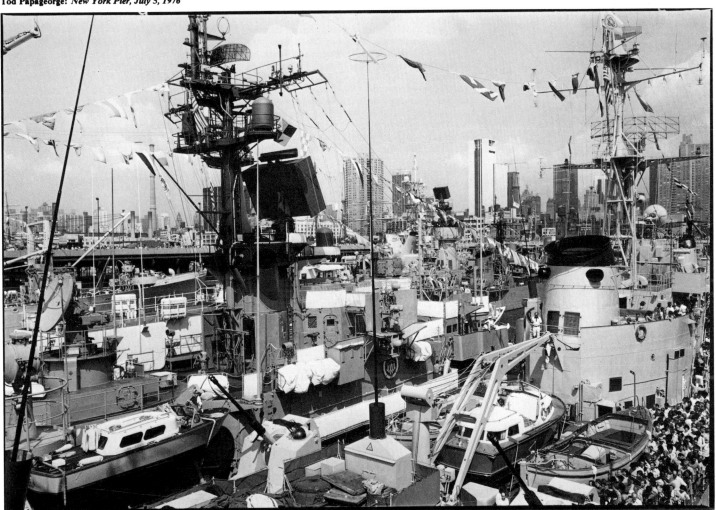

York, 1972-74; Lecturer on Photography, Massachusetts Insitute of Technology, Cambridge, 1974-75; Lecturer on Visual Studies, Harvard University, Cambridge, Massachusetts, 1975-76. Walker Evans Visiting Professor of Photography, 1978-79, and since 1979 Professor of Photography, Yale University, New Haven, Connecticut. Recipient: Guggenheim Fellowship for Photography, 1970, 1977; Fellowship-Grant in Photography, National Endowment for the Arts, 1973, 1976. Agents: Daniel Wolf Gallery, 30 West 57th Street, New York, New York 10019; and Galerie Zabriskie, 29 rue Aubry-le-Boucher, 75004 Paris, France. Address: 50 White Street, New York, New York 10013, U.S.A.

Individual Exhibitions:

1973 Light Gallery, New York
1976 University of Colorado, Boulder
1977 Cronin Gallery, Houston
Marin College, Kentfield, California
1978 Art Institute of Chicago
1979 Light Gallery, New York
1980 Stills Photography Group, Edinburgh
Galerie Zabriskie, Paris
1981 Galerie Lange-Irschl, Munich
Daniel Wolf Gallery, New York
Sheldon Memorial Art Gallery, University of Nebraska, Lincoln
Akron Art Museum, Ohio

Selected Group Exhibitions:

1971 *Recent Acquisitions*, Museum of Modern Art, New York
1975 *14 American Photographers*, Baltimore Museum of Art
1976 *100 Master Photographs from the Collection of the Museum of Modern Art*, Museum of Modern Art, New York
Recent American Photography, at the *Edinburgh Festival*
1977 *10 Photographes Americains Contemporains*, Galerie Zabriskie, Paris
1978 *Mirrors and Windows: American Photography since 1960*, Museum of Modern Art, New York (toured the United States, 1978-80)
1979 *American Photography in the 70's*, Art Institute of Chicago
1980 *American Images*, Corcoran Gallery of Art, Washington, D.C.
1981 *Robert Frank Forward*, Fraenkel Gallery, San Francisco

Collections:

Museum of Modern Art, New York; Seagrams Collection, New York; Museum of Fine Arts, Boston; Yale University Art Gallery, New Haven, Connecticut; Princeton University, Princeton, New Jersey; Akron Art Musuem, Ohio; Exchange National Bank, Chicago; Art Institute of Chicago; Museum of Fine Arts, Houston; Bibliotheque Nationale, Paris.

Publications:

By PAPAGEORGE: books—*Public Relations: The Photographs of Garry Winogrand*, editor and wrote introduction, New York 1977; *Walter Evans and Robert Frank: An Essay on Influence*, New Haven, Connecticut 1981; articles—"On Snapshots" in *Aperture* (Millerton, New York), vol. 19, no. 1, 1974; "Winogrand's Theater of Quick Takes" in the *New York Times Sunday Magazine*, 15 October 1977; "Aesthetics or Truth" in *Photo Communique* (Toronto), vol. 1, no. 6, 1980; "From Walker Evans to Robert Frank" in *Artforum* (New York), April 1981.

On PAPAGEORGE: books—*The Snaphot*, edited by Jonathan Green, Millerton, New York 1975; *14 American Photographers*, exhibition catalogue, edited by Renato Danese, Baltimore 1975; *Courthouse*, edited by Richard Pare, New York 1978; *American Images: New Work by 20 American Photographers*, edited by Renato Danese, New York 1979; articles—"Photographic Tapestry" by David Elliott in the *Chicago Daily News*, 9 February 1978; "Love-Hate Relations" by Leo Rubinfien in *Artforum* (New York), Summer 1978; "Tod Papageorge" by Rosalind Krauss in *Zabriskie Gallery Newsletter* (Paris), Spring/Summer 1980; "Papageorge's Natural Pauses" by Ben Lifson in the *Village Voice* (New York), 13 May 1981; in *Aperture* (Millerton, New York), no. 85, 1981.

As long as photographs are confused with their subjects, we are going to run in circles when we discuss them. This is not to suggest that photographers do not use the camera's mimetic gifts to seduce us: that is where photography—and the photographer's fascination with the medium—begins. Neither could I say that there are not serious photographers, perhaps most of them, who believe that their pictures are true and faithful recordings of the world—or at least believe it at home, away from the frustrating problems of making pictures that seem clear and intentional. Nor will it do to ignore the truth that, unlike other pictures, photographs describe things that once actually stood or moved in front of a machine, and therefore seem to be memories as much as they are pictures. None of this, however, negates the fact that photographs *are* pictures, that they describe prejudices, that they are signs, half-truths, and fictions that rise from moments and know only the surface of things.

This, of course, is a simple point: that the truth photographs contain is at best an adjusted truth, a mediated truth, a collaboration between the photographer, his subject and, finally, photography itself. To extend this, however, I would suggest that this collaboration is much like the one that the poet finds himself working with as he attempts to define his experience with language. In fact, I think about photography as a kind of language, one that claims and yet transforms what it describes in much the same way that the words of a language both name and recreate its subjects. As W.H. Auden put it: "It is both the glory and the shame of poetry that its medium is not its private language, that a poet cannot invent his words"—something that can as truthfully be said about the photographer and his relation to the importunate need of his medium to embrace our common world.

—Tod Papageorge

The rather grand dimensions of Tod Papageorge's success in the 1970's are implicit in critics' praise for him: "gorgeous", "pristine," "perfection...cold and glittering" critics call his clear, sunny images. Nothing if not self-consciously photographic, and a master teacher and critic of his medium, Papageorge goes beyond formalist experimentation and takes the risk of engagement with the natural and social worlds, with families, beauty, love, and lust as he find them in his leafy parks, motel pools, beaches and celebrations.

Papageorge's American quotidian associates him with the camera work descended from (in Papageorge's words) Walker Evans' "magisterial and emblematically just" images of America in the 1930's and Robert Frank's claim not only to this lineage but also to a special understanding of it: in his careful, image-by-image comparison of iconography in *Walker Evans and Robert Frank: An Essay on Influence*, Papageorge serves photography in a special way, a way that perhaps only a photographer can, by articulating for the medium the kind of tradition that a practitioner feels it deserves. Frank

was not, Papageorge asserts, a "Rimbaud of photography, an anarchic poet who...suddenly appeared, flared and then was lost to sight." Rather, his work had precedence in his "knowledge and love" of Evans' work—just as, Papageorge's argument of course implies, the new work of Winogrand, Friedlander, Papageorge and their students can and must be enhanced by appreciation of their own precedents.

Despite his appreciation, however, Papageorge's projects seem to stop short of the ambitions he attributes to his mentors. There is in Papageorge's work nothing recalling the fierce silence that concentrates in the very buildings of Evans' empty southern towns, nor do we recognize allusion to Frank's angry, opaque blur. Perhaps lacking as yet faith in his powers to express strong feelings, Papageorge deals for now in the minor emotions.

Yet, if Papageorge eschews the great, general, inevitably ambiguous and not entirely expressible themes that seem to describe or symbolize a whole country, a whole culture, it is his special gift to present what critic Ben Lifson calls the dream of "nature stilled." Papageorge's truthful photographs remind us by their photographic consciousness and the pleasures they offer that no matter how like nature they seem, such photographs are lovely fictions, never to fulfill the promise of quotidian beauty that they ironically extend.

—Maren Stange

PARKER, Olivia.

American. Born Olivia Hood in Boston, Massachusetts, 10 June 1941. Educated at Winsor School, Boston, 1951-59; studied art history at Wellesley College, Massachusetts, 1959-63, B.A. 1963; mainly self-taught in photography. Married John O. Parker in 1964; children; John and Helen. Freelance photographer, Massachusetts, since 1971. Recipient: Artists Foundation Fellowship, 1978. Agent: Vision Gallery, Boston. Lives in Massachusetts. Address: c/o Vision Gallery, 216 Newbury Street, Boston, Massachusetts 02116, U.S.A.

Individual Exhibitions:

1973 Harvard Business School, Cambridge, Massachusetts
1976 Vision Gallery, Boston
Nesto Gallery, Milton, Massachusetts
1977 Vision Gallery, Boston
F22 Gallery, Santa Fe, New Mexico
1978 Light Work, Syracuse, New York
Archetype, New Haven, Connecticut
1979 Yuen Lui Gallery, Seattle
Focus Gallery, San Francisco
Friends of Photography, Carmel, California
University of Vermont, Burlington
The Photography Place, Philadelphia
Portland Museum Art School, Oregon
Vision Gallery, Boston
1980 Portland School of Art, Maine
Marcuse Pfeifer Gallery, New York
Rhode Island School of Design, Providence
Bennington College, Vermont
Halsted Gallery, Birmingham, Michigan
Boston Atheneum
Work Gallery, Zurich
Wesleyan University, Middletown, Connecticut
1981 International Museum of Photography,

George Eastman House, Rochester, New York
Friends of Photography, Carmel, California
Orange Coast College, Costa Mesa, California
Clarence Kennedy Gallery, Cambridge, Massachusetts (with William Wegman and Willard Van Dyke)
Visions Gallery, London
Camera Obscura, Stockholm
1982 Susan Spiritus Gallery, Newport Beach, California

Selected Group Exhibitions:

1978 *14 New England Photographers*, Museum of Fine Arts, Boston
Loans to the Collection, Art Institute of Chicago
One of a Kind: Polaroid Color, Corcoran Gallery, Washington, D.C. (toured the United States)
1979 *20 x 24 Light*, Light Gallery, New York
1980 *Nouvelle Nature Morte*, Galerie Viviane Esders, Paris
Farbwerke, Kunsthaus, Zurich
Zeitgenossische Amerikanische Farbphotographie, Galerie Kicken, Cologne
Recent Polaroid Photography, Brown University, Providence, Rhode Island
By Arrangement, Center for Contemporary Photography, Chicago

Collections:

Museum of Modern Art, New York; Metropolitan Museum of Art, New York; Museum of Fine Arts, Boston; Addison Gallery of American Art, Andover, Massachusetts; Smith College, Northampton, Massachusetts; Polaroid Corporation, Cambridge, Massachusetts; Wellesley College, Massachusetts; Art Institute of Chicago; Phoenix College, Arizona; Portland Art Museum, Oregon.

Publications:

By PARKER: book—*Signs of Life*, Boston 1978; articles—"Split-Toning" in *Darkroom Dynamics*, edited by Jim Stone, New York and London 1979; "Olivia Parker: Interview," with Eelco Wolf, in *Photo Show* (Los Angeles), September 1980; "New England Landscapes" in *Printletter* (Zurich), January/February 1981.

On PARKER: book—*One of a Kind: Polaroid Color*, edited by Belinda Rathbone, Boston 1979; articles—"Olivia Parker" by Jacqueline Brody in *Print Collector's Newsletter* (New York), November/December 1977; "The Clear Yankee Eye" by Owen Edwards in *Saturday Review* (New York), March 1979; "Signs of (Still) Life" by Vicki Goldberg in *American Photographer* (New York), May 1979; "Olivia Parker" by Owen Edwards in *American Photographer* (New York), February 1980; "Photography" by Hilton Kramer in the *New York Times*, 29 February 1980; "Shaping Color to Sensibility" by David Featherstone in *Modern Photography* (New York), March 1980.

Children often collect crystals, bones, stamps, birds' nests and bubble gum cards. Are they attempting to emulate the random display of the bower bird, or are they drawn to these singular objects because they have lives of their own, because they offer new realms to the limited horizon of a young person? My feathers, bones, minerals, old books and more became personal artifacts, the sundry ephemera that expanded my world. As a child I did not intellectualize upon my collecting. Even now, it is not systematic; it is intuitive, a part of me.

The objects I like, whether alive or dead, are signs of life. *Memento mori* on a tombstone says remember death, but it also reminds me that someone once lived. A row of pea-pods, alike in structure but alive in their variation, fascinates me. A row of plastic flowers identical in their structure but dead in their sameness would hold little appeal—unless they had been chewed by my dog, varied, altered by living energy.

The expression of the classical ideals of form is dead matter for me. But even mortuary examples can come alive through time and human transformations. When drawn by an 18th century engraver, a Roman statue of the most formal demean can turn peculiar, perhaps even humorous, and far livelier than the original. I may change it again by expanding its space with mica, by changing its form with fruit; you will see it as something further transformed.

The protean quality of time and light, the way we perceive the continual flux of reality is close to life itself in its constant permutation. Objects which are, or have been, living things, things at the edges of change, interest me: the pregnant bulb, Indian pipes materializing from rot, a rose fully formed, but at the edge of decay. The living world seems to consist of fine balances and thin edges: small variations within fragile structure, delicate membranes, narrow temperature and pressure tolerances. I like the implications of visual edges: the swollen limits of a ripe pear touching a hard line of light, downy feathers confined by a metal grid, a mirror scattering its surfaces into nothing, or the thin shell of a bright face, its edges already deteriorating into darkness.

Many of my photographs are still lifes—*natures mortes*, an art form of death, of transformation, and of life. The paintings of Juan Sanchez Cotan (Spanish, 1561-1627), inhabited by powerful vegetables in geometric spaces, were important to my understanding of what still life can become. Even more the traditional Dutch, Flemish, and Spanish 17th century still lifes with their torn petals, their sumptuous but imperfect fruit, their improbable and exquisite insects, have the vitality implicit in both growth and decay. At present, photographic still life seems to me an open arena precisely because of those instrinsic qualities of the medium that distinguish it from painting. My own exploration is just beginning. I intend it to continue.

I have said what interests me. I cannot explain the photographs.

—Olivia Parker

Photography, as all of the myriad things we experience during our lives, must be seen in the context of all that has occurred before and all that is yet to come. Olivia Parker is captivated by time and its ceaseless cyclic journeys between life and death and regeneration.

Parker has incorporated in her still-life photographs some of the best artistic traditions. Like the 17th-century Dutch and Flemish painters, whose soft reflective lighting and static arrangements of time-pieces, bottles, and commonplace objects of the day gave still-life painting prestige, Parker has adapted similar aesthetic technique in a number of her 8 x 10 and 20 x 24 Polaroid photographs. Parker's photographs, comprised of objects that are antique, perhaps old photographs against peeling backgrounds, are then combined with the riotous color of flowers picked at that moment or fruit ripest before rotting. In addition, her choice of daylight and tungsten lights allows Parker to conjure up a world remote from our own experiences, the very essence of which nostalgia is born.

Just as 19th photographer Charles Aubry looked to 18th-century painter Jean Baptiste Chardin for imspiration on the transitoriness of life in the pictured world versus the real world, so has Olivia Parker benefited from both these artists. Chardin, a Frenchman and possibly one of the finest 18th-century painters, is renown for his unsurpassed ability to evoke textures in paintings of vegetables,

fruits, and game. His use of muted tone, delicate touch, and compositional skill can be seen as an influence in Parker's early work that appeared in the monograph *Signs of Life*. Taken with a view camera, the photographs of subjects ranging from ballet slippers to feathers and parts of radiators to collage combinations that result in whimsically dancing pea-pods on a part of a line drawing of a classical column, combine that personal sensitivity and placement. The crowning touch, however, comes from her contact printing on silver-chloride paper, leaving the opaque richness of the negative carrier as her framework, and then selenium toning the photograph for anywhere from four to twelve minutes. This process, which she calls "split-toning," produces the most sensual tonalities in the beige-gray-platinum gradations of the light areas and a rich brown-gray in the dark areas. Her choice of subject matter in these photographs seems at once to be intensely personal poetry, images evocative of interior dreams and reverently preserved delicate objects.

Charles Aubry, himself successful for his arrangement of elements in such a way as to make details stand out by placing them in direct contrast to one another, can be seen as another predecessor and influence of Parker's in the still-life aesthetic tradition. Her choice of objects in each of her photographs can be seen by the observer at first as disparate, often contradictory and sometimes ironic juxtapositions. And yet, one or more elements can jolt the memory of the past, whether it be historical or personal, and the viewer is enamored with the richness of the metaphor presented.

The surrealism in a number of her photographs and the compartmentalized construction remind one of Joseph Cornell's boxes. Similar in the sense that his work was about a France he never visited, so too are Parker's images which include old, torn, and discarded photographs about a history that now exists only in nostalgic form. And just as the surrealist painters in Paris made the aesthetic pilgrimages to the flea markets of that city seeking beauty in ugliness and the cast-off pieces and discarded items of those times looking for collages in three dimensions, so has Parker sought to include in her photographs objects from attics and junk shops, gardens and greenhouses.

Parker's choice of the instant 8 x 10 or 20 x 24 Polaroid process for image-making fosters her visionary private concerns and forces a certain hermeticism. The givens of the system: virtual grainlessness, rich color, shallow depth of field, the scale factor, and the control of the studio setting are all beneficial and imperative for Parker's photographs.

Parker's chance associations in her photographs create ordered structures just as our minds suggest or more strongly demand. And just as Emily Dickinson, the New England poet, wrote of the themes of nature, love, death, and immortality, perhaps Olivia Parker's own New England roots and her training as a painter allow her to juxtapose the abstract with the concrete and the eternal with the impermanent.

—Monica Cipnic

See Color Plates

589

PARKINSON, Norman.

British. Born Ronald William Parkinson Smith in Roehampton, London, 21 April 1913. Educated at Westminster School, London, 1927-31; apprentice to the court photographers Speaight and Sons Ltd., Bond Street, London, 1931-33. Married the actress and model Wenda Rogerson in 1945; son: Simon. Opened own studio with Norman Kibblewhite, Dover Street, London, 1934; worked for the British edition of *Harper's Bazaar* and for *The Bystander*, 1935-40; did series of photographic essays for the British Armed Services recruitment drive, 1937-39, and reconaissance photography over France for the Royal Air Force, 1940-45; a portrait and fashion photographer for *Vogue*, 1945-60; first advertising work, 1952; Associate Contributing Editor of *Queen*, 1960-64; moved to Tobago, 1963; currently, freelance photographer for *Vogue, Life, Elle, Town and Country*, etc. Also farmed in Gloucestershire, Worcestershire and Oxfordshire, 1937-60, and in Tobago, since 1964. Honorary Fellow, Royal Photographic Society, 1968; Fellow, International Institute of Photography, 1975. C.B.E. (Commander, Order of the British Empire), 1981. Address: Galera Point, Post Box 242, Scarborough, Tobago, West Indies.

Individual Exhibitions:

1935 Parkinson Studio, Dover Street, London
1960 Jaeger Showrooms, London
1978 The Photographers' Gallery, London
1981 *50 Years of Fashion and Portraits*, National Portrait Gallery, London (retrospective)

Selected Group Exhibitions:

1937 *Exposition Internationale*, Paris
1957 *Biennale di Fotografia*, Venice
1972 *The Mask of Beauty*, National Portrait Gallery, London
1975 *Fashion 1900-1939*, Victoria and Albert Museum, London (toured the U.K.)
1977 *Happy and Glorious: 6 Reigns of Royal Photography*, National Portrait Gallery, London
1980 *The Queen Mother: A Celebration*, National Portrait Gallery, London
Modern British Photography 1919-39, Museum of Modern Art, Oxford (toured the U.K.)

Collections:

National Portrait Gallery, London; Victoria and Albert Museum, London.

Publications:

By PARKINSON: book—*Sisters under the Skin*, with texts by several authors, London 1978; articles—"Vogue's Eye View of a Forthcoming Marriate: Photographs by Norman Parkinson," interview with Polly Devlin, in *Vogue* (London), November 1973; interview with Roger Clark, in *British Journal of Photography Annual*, London 1982.

On PARKINSON: books—*The Art and Technique of Color Photography: A Treasury of Color Photographs by the Staff Photographers of Vogue, House and Garden, and Glamour* by Alexander Liberman, with an introduction by A.B. Louchheim, New York 1951; *Fashion 1900-1939*, exhibition catalogue, by Valerie Lloyd and others, London 1975; *The Magic Image* by Cecil Beaton and Gail Buckland, London and Boston 1975; *The History of Fashion Photography* by Nancy Hall-Duncan, New York and Paris 1979; *Modern British Photography 1919-39*, exhibition catalogue, by David Mellor, London 1980; *50 Years of Portraits and Fashion: Photographs by*

Norman Parkinson: *Golfing at Le Touquet*, 1939 Courtesy National Portrait Gallery, London

Norman Parkinson, exhibition catalogue, London 1981.

I suppose I have had some success—people seem to enjoy my snaps and I enjoy taking them.

I know very little about the *technique* of photography—all that is for the expensive amateurs—but I require the camera to be my servant. I master it; it does not intimidate me.

Have always been aware that the camera is almost as dangerous as a gun. You can do almost as much damage with it. You can make people happy with your camera or downright miserable. If you have the responsibility of using your lens to record people for history, do it well. Everybody can look a little handsome, a touch beautiful—record them that way. Don't mount them and destroy them and make them look hideous for the sole purpose of inflating your own photographic ego. No, don't do that.

Hide inside your photographs; enjoy them—make them enjoyable—make your snaps full of happiness and sunshine and joy and desirability—it is not easy but try.

—Norman Parkinson

Norman Parkinson, an "incurable romantic", is unequivocal in his belief that photography is not art. He advises: "make your [portrait] snaps full of happiness and sunshine and joy and desirability". While this many suggest a limited understanding of the possibilities of his "craft," his talent is anything but limited; for several decades Parkinson has been one of Britain's foremost portrait and fashion photographers.

Not surprisingly, elegant models, the famous and the glamorous, are the regular subjects of Parkinson's lens. Nevertheless, some of his work in the 1930's, most notably his poignant study of Welsh mining families during the Depression, and his photographs for *The Bystander*, demonstrate a keen eye for reportage.

The pre-war trend to outdoor settings for fashion photography had not resulted, at least in Britain, in a "natural" look. If anything, the static models posed at chic society haunts accentuated artificiality. Parkinson wanted something livelier, and following the footsteps of his innovative European counterparts, he tried to capture action and spontaneity. By the end of the 1930's he had become a master at suggesting movement in a still photo-

graph. His fashion work of this time marks a turning point in the genre (see the accompanying photo, "Golfing at Le Touquet").

Parkinson's fashion photographs of his wife Wenda Rogerson typify his early post-war work. The model, smiling and demure, poised in unpretentious settings, became a new image, one with which British followers of fashion could readily identify. The new elegance seemed credible and accessible, a breath of fresh air after the remote, often elitist images of pre-war *haute couture*. The 1951 picture of his wife in cashmere twinset and pearls seated next to a cowman in a village pub seems for a moment gimmicky; but the juxtaposition works: Parkinson's odd couple catch your eye, then hold you with their sober, unifying gaze. The surreal quality of much of his fashion work of this period gradually gave way to a more vivacious, energetic style. The fun and the frolic are attention-getters; the star, almost always, is the clothes.

Norman Parkinson achieves some striking effects in his photographs of the famous. Early in his career as a fashionable London photographer he turned out the usual flattering studio plates that the debutantes of the day required. But when circumstances permitted, he experimented with unusual compositions created by dramatic lighting arrangements.

One of Parkinson's most memorable works is his 1951 portrait of Algernon Blackwood, the ghost story writer. Blackwood, seated on a balcony high above Hyde Park, London, eerily props up his wrinkled head with his outstretched hands. His hooded, gelatinous eyes stare skyward from dark sockets; below the modern, mundane world—the gray traffic—slips by.

Th 1952 close-up of Montgomery Clift is particularly telling: the handsome forehead is puckered and careworn; the eyes pensive, puzzled; and there's something indulgent about the mouth. Mercifully, Parkinson does not heed his own advice. The Clift picture, like many others, is hardly full of "happiness and sunshine," although Parkinson's portraits are always elegant and attractive, and never overearnest. He does not try to capture especially "meaningful" expression; he is more interested in the composition, the shape of the head and the hands, and the texture of skin and material.

As early as the 30's, Parkinson demonstrated a major talent for color photography and he is still renowned in the field. Using very few colors—some of his pictures are virtually monochromatic—he achieves some stunning, often highly romantic effects.

Parkinson's vitality, his self-deprecating humor, his delight in beauty but not in prettiness, and above all, his originality, are communicated through his work. Parkinson calls himself a craftsman; many would call him a consummate artist.

—Roland Turner

PARKS, Gordon (Alexander Buchanan).
American. Born in Fort Scott, Kansas, 30 November 1912. Educated at public schools in St. Paul, Minnesota, 1918-28; self-taught in photography. Served as a photographer with the Office of War Information, 1943-45. Twice married and divorced; children: Gordon, Toni, David and Leslie. Worked as a busboy, piano-player, lumberback, dining-car waiter and professional basketball player, St. Paul, 1928-37; freelance fashion photographer, Minneapolis, 1937-42; Staff Photographer, under Roy E. Stryker,

Farm Security Administration, Washington, D.C. and throughout the United States, 1942-43; photographer and documentary filmmaker, under Stryker, Standard Oil Company of New Jersey, thoughout the United States and in Saudi Arabia, 1945-48; Staff Photographer, *Life* magazine, New York, 1948-61; independent photographer, film writer and director, 1962-71; Editorial Director, *Essence* magazine, New York, 1970-73. Recipient: Julius Rosenwald Fellowship in Photography, 1942; National Council for Christians and Jews Award, 1964; School of Journalism Prize, Syracuse University, New York, 1963; Philadelphia Museum of Art Award, 1964; Art Directors Club of New York Award, 1964, 1968; Frederic W. Brehm Award, 1962; Carr Van Anda Journalism Award, Ohio University, 1970; Springarn Award, National Association for the Advancement of Colored People, 1972. D.F.A.: Maryland Institute of Fine Arts, Baltimore, 1968; D.H.: Boston University, 1969; D.Litt.: University of Connecticut, Storrs, 1969; Kansas State University, Manhattan, 1970; H.H.D.: St. Olaf College, Northfield, Minnesota, 1973. Address: 860 United Nations Plaza, New York, New York 10017, U.S.A.

Individual Exhibitions:

1953 Art Institute of Chicago
1960 Limelight Gallery, New York
1966 Time-Life Gallery, New York
1979 *Eye Music*, Alex Rosenberg Gallery, New York
1981 Alex Rosenberg Gallery, New York

Selected Group Exhibitions:

1951 *Memorable Life Photographs*, Museum of Modern Art, New York
1967 *Photography in the 20th Century*, National Gallery of Canada, Ottawa (toured Canada and the United States, 1967-73)
1973 *The Concerned Photographer 2*, Israel Museum, Jerusalem (toured Europe)
1977 *Documenta 6*, Museum Fridericianum, Kassel, West Germany
1979 *Images de L'Amerique en Crise*, Centre Georges Pompidou, Paris

Collections:

Museum of Modern Art, New York; International Center of Photography, New York; International Museum of Photography, George Eastman House, Rochester, New York; Library of Congress, Washington, D.C.; Art Institute of Chicago.

Publications:

By PARKS: books—*The Learning Tree*, novel, New York 1963, London 1964; *A Choice of Weapons*, New York 1966; *A Poet and His Camera*, New York and London 1968; *Whispers of Intimate Things*, New York 1971; *Born Black*, New York 1971; *In Love*, New York 1971; *Moments Without Proper Names*, London 1975; *Shannon*, novel, Boston 1981; music—*Piano Concerto*, 1953; *3 Piano Sonatas*, 1956, 1958, 1960; *Tree Symphony*, 1967; films—*Flavio*, 1962; *The Learning Tree*, 1969; *Shaft*, 1972; *Shaft's Big Score*, 1972; *The Super Cops*, 1974; *Leadbelly*, 1976.

On PARKS: books—*Memorable Life Photographs*, with text by Edward Steichen, New York 1951; *Life Photographers: Their Careers and Favorite Pictures*, edited by Stanley Rayfield, New York 1957; *Photography in the 20th Century* by Nathan Lyons, New York 1967; *Social Documentary Photography in the U.S.A.* by Robert J. Doherty, New York 1974;

The Magic Image by Cecil Beaton and Gail Buckland, London and Boston 1975; *Documenta 6/Band 2*, exhibition catalogue, by Klauf Honnef and Evelyn Weiss, Kassel and Cologne 1977; *Geschichte der Fotografie im 20. Jahrhundert/Photography in the 20th Century* by Petr Tausk, Cologne 1977, London 1980; articles—"The Concerned Photographer" by Cornell Capa in *Zoom* (Paris), no. 16, 1973; "Le Dossier de la Misere" in *Photo* (Paris), February 1980.

A writer and musician, Gordon Parks became interested in photography at an early age, when he was 15. As he points out, his passion for photography slowly became an absorbing one. Seven years after he won the first Julius Rosenwald Fellowship Award in photography in 1942, he was appointed a staff photographer for *Life* magazine. During his years with *Life* (1948-1961), Parks produced remarkable photo-essays on a wide range of events and topics: Harlem street gangs, Winston Churchill, Paris fashions, the civil-rights movement, and South America. His photo-journalism generates power and concern by the very directness and honesty of his art. His work with the Farm Security Administration and the Standard Oil Company of New Jersey also demonstrates his passion for the medium and the dedication with which he uses the camera. A picture of Place de la Concorde seething with automobiles shows the same clarity and force one finds in the picture of a Brazilian slum-child or the Harlem street gangs or the stern face of an old French woman.

For decades Parks' work has been essentially documentary. But his flair for catching the most dramatic and vivid events and faces, and a deep involvement in what he is doing, make these newspictures something significant and unforgettable. His Malcolm X photographs, portraits of Muhammad Ali and Ethel Shariff, and the Fontenelle group of images all bear testimony to Parks' talent as a special kind of photo-journalist. Although the "narrativeness" of his photography has power and directness, it seems to lack the kind of quality one finds in Cartier-Bresson, Brassaï, Dorothea Lange, or Russell Lee. At times he appears to be somewhat distant. However, there is a touch of the poetic in his art, especially the color-photography, particularly in his books combining poetry and photography, *A Whisper of Intimate Things* and *The Poet and His Camera*. He, undoubtedly, is a competent photographer in color, but the black-and-white photos convey Parks' strength more distinctly. One has the definite impression that he is stronger and better in recording human expressions and gestures as well as events and scenes than in conveying nature. The sort of power his photography reflects is that of a man of urbanity and concern rather than that of the "committed" photographer. Even though he is an Afro American, he is not polemical when he records the people and events of his own background. The Duke Ellington photographs display strong emotion because of his relationship with and admiration for the musician.

Despite his early rejection by many important periodicals in America because of the color of his skin, Gordon Parks has continued to devote his time and energy to photography with unusual commitment. His competence in other expressive forms—music, writing, film—has in no way interfered with his talents as a photographer. The poet, musician, and writer are well fused in the photographer, and he remains a inspiration to both white and black aspirants in photography.

—Deba P. Patnaik

PARR, Martin.

British . Born in Epsom, Surrey, 23 May 1952. Studied photography at Manchester Polytechnic, 1970-73. Photojournalist, Manchester Council for Community Relations, 1973-74. Freelance photographer, for magazines, dance and theatre companies, since 1974: established Albert Street Workshop, with Jenny Beavan, Ray Elliott, and Kate Mellor, Hebden Bridge, West Yorkshire, 1974; moved to Ireland, 1980. Part-time Instructor in Photography, Oldham College of Art, 1974-75, and Manchester Polytechnic, 1978. Member, Visual Arts and Photography Panels, Yorkshire Arts Association, since 1979. Recipient: Arts Council of Great Britain Photography Grant, 1975, 1976, 1979; Yorkshire Arts Association Photography Grant, 1978. Agents: The Photographers' Gallery, 8 Great Newport Street, London WC2; Neikrug Galleries, 224 East 68th Street, New York, New York 10021, U.S.A. Address: Drumanone, Cloonloogh, Boyle, County Roscommon, Ireland.

Individual Exhibitions:

1972 *Butlins by the Sea*, Impressions Gallery, York (with Daniel Meadows; toured the U.K.)
1974 *Home Sweet Home*, Impressions Gallery, York (toured the U.K.)
1975 *The Chimney Pot Show*, Northwest Arts Gallery, Manchester (toured the U.K.)
1976 *Beauty Spots*, Impressions Gallery, York (toured the U.K.)
 3 North West Photographers, Whitworth Art Gallery, Manchester (with Daniel Meadows and Dave Chadwick; toured the U.K.)
1977 The Photographers' Gallery, London
1978 Fotomania, Barcelona
 This Is Your Life, Hebden Bridge Information Centre, Yorkshire
1979 *The Brighouse Commission*, Smith Art Gallery, Brighouse, Yorkshire
 Photogallery, St. Leonard's-on-Sea, Sussex
1980 Canon Photo Gallery, Amsterdam
1981 Gallery of Photography, Dublin
 Abandoned Morris Minors of the West of Ireland, at the *Galway Arts Festival*, Ireland
 The Non-Conformists, Half Moon Gallery, London (toured the U.K.)

Selected Group Exhibitions:

1974 *10 from Co-optic*, Jordan Gallery, London
1978 *YAA Award Winners Show*, Impressions Gallery, York
 Personal Views 1860-1977, British Council, London (toured Europe)
 Art for Society, Whitechapel Art Gallery, London
 Albert Street Workshop, Northern College of Music, Manchester
1979 *3 Perspectives on Photography*, Hayward Gallery, London
1980 *4 Photographers*, at *Salford '80*, England

Collections:

Arts Council of Great Britain, London; Victoria and Albert Museum, London; Hebden Bridge Public Library, Yorkshire; Calderdale Museum, Halifax, Yorkshire; Castle Museum, York; Bibliothèque Nationale, Paris; Sam Wagstaff Collection, New York; Philadelphia Museum of Art.

Publications:

By PARR: articles—"Photographs by Martin Parr" in *Creative Camera* (London), June 1974; "Martin Parr" in *Creative Camera Collection 5*, London 1978; "Martin Parr: Portfolio" in *Popular Photography Annual 1980*, New York, 1979.

On PARR: book—*3 Perspectives on Photography*, exhibition catalogue, London 1979; articles—"The Slanted Mirror: The Photos of Martin Parr" by Stewart Scotney in *Art and Artists* (London), September 1974; "On View" by Ainslie Ellis in *British Journal of Photography* (London), 6 September 1974; "The Face in the Picture" by Paul Barker in *New Society* (London), 5 January 1978; "Martin Parr" in *Creative Camera* (London), May/June 1980.

The best way to describe my work is subjective documentary.

—Martin Parr

It was primarily French photography in the 1930's which made clear the distinctions between photojournalism and the snapshot, and French photographers (or, oddly, refugees from Eastern Europe living and working in France) who defined the snapshot aesthetic. André Kertész, Henri Cartier-Bresson, Brassaï, Izis and others all worked according to the precept that the world of men might be better understood at those moments when nothing seemed to be "happening," rather than the moments when prime ministers were assassinated or bombs exploded. Bresson became the acknowledged master of the snapshot aesthetic, partly because he verbally defined it in the 1950's, but also partly because his photographs were so consistently informed by the purest of its tenets.

However, art rarely respects national borders, and when it trespasses, it usually finds itself transformed by the special sensibilities of the country it invades. Translated from the French into the English, what the snapshot lost in understated elegance, it gained in biting humour. English photographers have consistently concerned themselves with the foibles of their fellow British, and while the work of Martin Parr finds its roots in Bresson's "decisive moment," it is touched by an overt surrealism and a dry wit that rarely crept into Bresson's images.

The people in Parr's photographs seem continually to be searching for something, although they may have momentarily forgotten exactly what. Whatever it is, it is usually outside the frame. No matter: Parr's concern is for the fragment of the search itself, for what the search moves us to do, not the object apparently being sought. The world is powerfully ordered in Parr's photographs, despite their essential snapshot character; but, it is an orderly world inhabited by disorderly people, who may at any moment stumble over the object of their search. If they did, one suspects they would excuse themselves and move on, cursing their luck under their breath like polite misanthropes. Possibly this is the reason so many of the people in Parr's photographs seem to be leaning at such precarious angles, as if trying to wave to friends while balancing on the head of a pin. It is this exactness of composition, plus the apparent lunacy of the human activities in his symmetrical landscapes, that give Parr's images both their surreal flavour and their humour—like an Evelyn Waugh novel. Or, maybe, a Spike Milligan theatre piece.

Generally, Parr's work comes out of that modern tradition of British snapshot photography which began after the Second World War and which has nearly always sought to explore the uniqueness of the British sensibility, through its structured cultural emphases and its often "strange" (to outsiders) traditional social activities. In Parr, these activities are more generalized, less specifically traditional than in the work of some of his contemporaries, but the moments when the shutter release has been pressed are thus necessarily all the more specifically meaningful. In face of the precisely momentary, all activities are equal and lose their specificity. In Parr's best photographs, the moment itself takes on a nearly physical presence in the image, and mystery might best be measured in hundredths of seconds. The humour is icing on the cake.

—Derek Bennett

Martin Parr: *Grouse-Shooting Lunch Hut, Hebden Bridge,* 1977

Irving Penn: *Colette,* **1951**

PENN, Irving.

American. Born in Plainfield, New Jersey, 16 June 1917. Studied design, under Alexey Brodovitch, Philadelphia Museum School of Industrial Art, 1934-38. Served as an ambulance officer in the American Field Service, with the British Army in Italy and India, 1944-45. Married the fashion model Lisa Fonssagrives in 1950; son: Tom. Worked as a graphic artist in New York, 1938-41; spent a year painting in Mexico, 1942; designer and photographer for *Vogue* magazine, New York, 1943-44. Photographer, working with Alexander Liberman, for Condé Nast Publications, New York, publishers of *Vogue*, etc., since 1946; also, freelance advertising photographer, New York, since 1952. Agent: Marlborough Gallery, 40 West 57th Street, New York, New York 10019. Address: Irving Penn Studios, Post Office Box 934, F.D.R. Station, New York, New York 10150, U.S.A.

Individual Exhibitions:

1961 *Photographs by Irving Penn*, Museum of Modern Art of New York travelling exhibition (toured the United States)
1963 Smithsonian Institution, Washington, D.C.
1975 *I Platini di Irving Penn: 25 Anni di Fotografia*, Galleria Civica d'Arte Moderna, Turin
 Recent Works, Museum of Modern Art, New York
1977 *Street Material*, Metropolitan Museum of Art, New York
 Photographs in Platinum Metals—Images 1947-1975, Marlborough Gallery, New York
1980 *Earthly Bodies*, Marlborough Gallery, New York
1981 *60 Photos*, Marlborough Fine Art, London

Selected Group Exhibitions:

1955 *The Family of Man*, Museum of Modern Art, New York (and world tour)
1967 *Photography in the 20th Century*, National Gallery of Canada, Ottawa (toured Canada and the United States, 1967-73)
1975 *Photography Within the Humanities*, Jewett Arts Center, Wellesley College, Massachusetts
1976 *Masters of the Camera*, American Federation of the Arts travelling exhibition
1977 *Fashion Photography*, International Museum of Photography, George Eastman House, Rochester, New York (travelled to the Brooklyn Museum, New York; San Francisco Museum of Modern Art; Cincinnati Art Institute, Ohio; and Museum of Fine Arts, St. Petersburg, Florida)
1978 *Tusen och En Bild/1001 Pictures*, Moderna Museet, Stockholm
1979 *Photographie als Kunst 1879-1979*, Tiroler Landesmuseum, Innsbruck, Austria (travelled to the Neue Galerie am Wolfgang Gurlitt Museum, Linz, Austria; Neue Galerie am Landesmuseum Joanneum, Graz, Austria; and Museum des 20. Jahrhunderts, Vienna)
1980 *Photography of the 50's*, Center for Creative Photography, University of Arizona, Tucson

Collections:

Metropolitan Museum of Art, New York; Museum of Modern Art, New York; International Museum of Photography, George Eastman House, Rochester, New York; Smithsonian Institution, Washington, D.C., Art Institute of Chicago; Galleria Civica d'Arte Moderna, Turin; Moderna Museet, Stockholm.

Publications:

By PENN: books—*Moments Preserved: 8 Essays in Photographs and Words*, with an introduction by Alexander Liberman, New York 1960; *Worlds in a Small Room*, New York 1974; *Inventive Paris Clothes 1909-1939: A Photographic Essay by Irving Penn*, with text by Diana Vreeland, New York 1977; *Flowers*, New York 1980.

On PENN: books—*The Photographer's Eye* by John Szarkowski, New York 1966; *The Studio* by the Time-Life editors, New York 1972; *Looking at Photographs* by John Szarkowski, New York 1973; *The Magic Image* by Cecil Beaton and Gail Buckland, London and Boston 1975; *Irving Penn: Recent Works*, exhibition catalogue, with an introduction by John Szarkowski, New York 1975; *Irving Penn: Street Material*, exhibition catalogue, with an introduction by Henry Geldzahler, New York 1977; *The History of Fashion Photography* by Nancy Hall-Duncan, New York 1979; *Irving Penn: Earthly Bodies*, exhibition catalogue, with an introduction by Rosalind E. Krauss, New York 1980; *Color* by the Time-Life editors, revised edition, New York 1981; articles—special issue of *Camera* (Lucerne), edited by R.E. Martinez, November 1960; "Great Photographers of the World: Irving Penn" by Tom Hopkinson in the *Telegraph Magazine* (London), 17 April 1970; "Certainties and Possibilities" by Janet Malcolm in *The New Yorker*, 4 August 1975; "Irving Penn: New Platinum Photographs" by Thomas B. Hess in *Vogue* (New York), August 1975; "Visual Recycling: Irving Penn's 'Street Material' " by A.D. Coleman in the *Village Voice* (New York), 30 May 1977, reprinted in Coleman's *Light Readings: A Photography Critic's Writings 1968-78*, New York 1979; "Perspectives of Penn" by Owen Edwards in the *New York Times Magazine*, 4 September 1977; "Penn's Earthly Goddesses" by Douglas Davis in *Newsweek* (New York), 22 September 1980; "The Nude According to Penn" by Owen Edwards in *American Photographer* (New York), September 1980.

The common denominator of Irving Penn's photographic work is formal intelligence. Penn has no rival in terms of formal complexity, the rich beauty of constructed shape, elegance of silhouette, and abstract interplay of line and volume. The appearance of simplicity Penn achieves through straightforward poses and natural lighting is a simplicity underpinned by a complex of visual decisions rarely equalled in the medium of photography.

One aspect of Penn's genius for form is the sureness with which he uses the means available to black-and-white photography—pure blacks, stark white, and the subtleties of gray. His oppositions of blacks and whites are sumptuous; grays are used for their subtle colorations. This interest in achieving a full range of blacks and grays explains Penn's choice of rare and difficult techniques that can achieve these ends. These include the platinum process and the complex bleaching technique by which he produces his female nudes. The platinum process, widely used around the turn of the century, is a painstaking process which requires great skill. Because of the nature of the expensive platinum salts that permeate the paper, the platinum process can easily disintegrate into fuzzyness, but well handled, as in Penn's work, it can yield a soft modulation as well as density and luminosity. "A beautiful print," Penn has insisted, "is a thing in itself, not just a halfway house on the way to the page."

Penn is always true to his subject, whether he is shooting fashion or flowers, a famous face or a cigarette butt. An object seen by Penn is unlike any other, presented in a very serene, restful moment. It is his attempt to find truth in a universalized time, the moment he terms "beatitude." Penn sees exactingly and abstractly: he senses the curve and intersection of each line, the weight and implication of

each form. The more one looks, the more one realizes that Penn's subjects are not simply seen.

Penn's portraiture combines the simplicity and directness of the 19th century portrait with a modern formal sophistication. In many cases his considerations are those of the portrait photographer of a century ago, favoring a simple studio set-up with natural light from a northern exposure. He has even constructed a portable studio in the tradition of 19th century itinerant photographers in order that he may produce authentic portraits in rural areas of the Cameroons, Peru, and other locales where no studio facilities are available.

The portraits that Penn produces in these places have a straightforward honesty, sharing an anthropological quality as well as a visual resemblance to the work of the German photographer, August Sander. In addition to the single and double portraits that so resemble Sander, Penn excels at the large group portrait: he achieves an ease which transcends the complexity of posing and technical problems inherent in this type of sitting.

The fact that Penn is one of this century's leading fashion photographers has been important to his development and style. Working with designers such as the legendary Alexey Brodovitch of *Harper's Bazaar* and Alexander Liberman, the long-time art director and current creative director of *Vogue*, has undoubtedly influenced Penn's sense of visual design. Working within the commercial requirements of fashion may have contributed to the clarity of Penn's style as well as its inbred elegance, tasteful and controlled.

As Rosalind Krauss has pointed out in *Earthly Bodies*, in an appreciation of Penn's female nudes, there are aspects of Penn's production that "has for him the quality of a covert operation, a kind of privately launched and personally experienced kamikaze attack on his own public identity as a photographer of fashion." Among these more personal and private productions are the female nudes, which are experiments in the formal possibilities and monumental densities possible in nude photography, and the platinum prints of cigarette butts, which question the meaning of subject matter *vis-a-vis* style. What Krauss overlooks, however, is that these partake rather than reject the values of monumentality, formal innovation and quiet truth that Penn has contributed to fashion. Public or private, Penn's work remains dedicated to questions of style and formal discovery as well as realism and depiction. As such, his work is one of the most important productions of our time.

—Nancy Hall-Duncan

PERESS, Gilles.

French. Born in Paris, 29 December 1946. Educated at the University of Vincennes, 1968-70. Freelance photographer, Paris and New York, since 1971; joined Magnum Photos, 1974. Artist-in-Residence, Apeiron Workshop, 1977. Recipient: Art Directors Club of New York Award, 1977; National Endowment for the Arts grant, 1978; Overseas Press Club Award, 1981. Address: c/o Magnum Photos, 2 rue Christine, 75006 Paris, France; or, 251 Park Avenue South, New York, New York 10010, U.S.A.

Selected Group Exhibitions:

1976 *Other Eyes*, Arts Council of Great Britain travelling exhibition (toured the U.K.)

Collections:

Bibliothèque Nationale, Paris; Arts Council of Great Britain, London; Museum of Modern Art, New York.

Publications:

On PERESS: articles—"Pay Guests: Photos, Gilles Peress" by P. Pringle in the *Sunday Times Magazine* (London), 26 May 1974; "Fern der Heimat: Turkische Fremdarbeiter in Deutschland—aufnahmen von Gilles Peress" in *Du* (Zurich), August 1974; "Still Life with Destruction: Photos by Gilles Peress" by L. Garner in the *Sunday Times Magazine* (London), 8 December 1974.

I started shooting in France in 1970, when there were still neither grants nor a photography school. First I worked as an assistant in a fashion studio, a job which consisted of setting the cameras and painting the floor, and then as a wedding photographer. I shot my first story about a coal mine strike in 1960: the men occupied the pit, with food lowered down to them, for months before they capitulated. Ten years later the unemployment was so high that the young men of that town spent their days blind drunk on Pernod.

I started working with Magnum in 1971 and became a member in 1974. I covered the deaths and burials of famous statesmen: DeGaulle, Franco, Coco Chanel. I arrived in Portugal 3 hours after the revolution, trailed behind Popes like an acolyte, went to S and M conventions, mercenary conventions, and Republican conventions. I saw my pictures cropped and people air-brushed away by art directors.

Meanwhile, I have tried to use the magazine world as a vehicle to approach the world and myself in a more sustained way. In 1973 I spent several months documenting immigrant workers in Europe, a story that was published as a portfolio in *Du*, the London *Sunday Times* and other periodicals. In 1970, 1971, 1972, 1973, 1974 and 1979, I found ways to convince editors to send me to Northern Ireland: the material that I gathered has appeared as a portfolio in the *Sunday Times*, the *New York Magazine* and *Photo*, and will soon be published as a book.

When I came to America in 1975, I started shooting projects related to the "outsider" element in American society: unemployment in Detroit in 1975 for the London *Sunday Times*, 42nd Street in 1976 for PBS and in 1980 for a Ford Foundation project. I began to shoot, for myself, the way that people drop out of society: the dumping of mental patients on the street, the welfare hotels on the Bowery.

In 1976, while covering the elections for PBS, I became fascinated by the political process and the road to the election. I cornered Carter, watched Wallace, checked Jackson and chewed gum with Ford. I followed many of them, attended conventions and witnessed a million handshakes.

In 1977, I was given an artist-in-residence fellowship at Apeiron, which enabled me to print the work I had done in the U.S. since 1975. In 1977-78 I supported myself with *GEO* stories in Central and South American. That paid for my first darkroom and enabled me to spend six months in the winter of 1978-79 re-editing my work of the last 8 years and trying to make sense of a career that seemed like a chaotic compromise between necessity and intention.

In 1979, I applied for and received a $3,000 grant from the NEA. Watching in frustration the television coverage of the hostage crisis, I realized that for the first time in my life I was free, entirely free, to shoot whatever, whichever way I wanted. A day later, I went to Iran, not knowing what I could do, knowing only that I wanted to be there, to see it with my own eyes, without responsibility or commitment (either political, visual or conceptual) to anyone. Although for many years I tried to escape the preconceived vision of the world that magazine work imposes on you, for the first time I recognized that I didn't have to, as we say in journalism, cover myself. I went to Iran for 5 weeks, travelled about the country (I did not have to wait in front of the embassy), returned to New York, edited, printed and attempted to make sense of what I had experienced. I published the Iran material as a 74-picture, 10-page layout in *Afterimage*. The *New York Times* decided to run it as well, as a visual portfolio without text, and I now plan to publish it in book form.

As soon as I came out of the darkroom, I began to shoot the 1980 elections. Apart from the conventions, I have not had either the time or the money to print the bulk of this work. Though I have not yet found a way to make sense of it, this process—at once both absurd and one of the most deadly serious things I have witnessed—continues to intrigue me.

Now more than ever it is essential for me to try to shoot the intersection between the internal and external world, to understand that the closest point to objectivity is the acceptance of subjectivity, to walk the thin line between dreams and events.

—Gilles Peress

As a young photojournalist and member of Magnum, Gilles Peress would seem at first glance to

Gilles Peress: *Republican Convention*, 1976

represent the continuity of the tradition of concerned photography, a tradition firmly established in the 1930's and exemplified by Magnum's founders—Robert Capa, David Seymour, and Henri Cartier-Bresson. Certainly the subject of Peress' major photoreportages (for example, Bloody Sunday and its aftermath in Northern Ireland, "New Slaves of Europe: Turkish Workers in Germany," Iran after the Revolution) are precisely those subjects that an "engaged" photographer would be expected to document. A further list of his subjects would include various strikes, demonstrations, political coverage in Europe and the U.S., and a continuing attention to the lives of the poor, the oppressed, the human casualties of the industrialized West. But close examination of the photographs themselves reveals a dissonance between the nominal subject matter, including its implicit political/social concerns, and an increasing abstraction and formalization of the images.

Careful scrutiny of the photographs comprising the reportages on Iran or Northern Ireland, divorced from either accompanying text or captions, elicits little hard information or any political sense of the issues or events they are purportedly documenting. To a certain extent this is a problem implicit in the nature of photographic documentation *per se*: news and documentary photographs are never meant to stand alone; substance, context, and explanation must always be supplied by text. That having been said, one may also assert that there are varying degrees of communicativeness a photograph may possess. While certain events—a rocket launch, an image of combat, a volcano eruption—may require minimal text in order to be instantly legible as pictorial witnesses, most events in the world can never be made comprehensible through images alone. A situation such as obtains in Northern Ireland makes no sense without the knowledge of its history and a political framework that is not presentable in image form. Peress in Belfast or Londonderry can only show effects, not causes. But within that *a priori* limitation, Peress' particular excellence is his ability to evoke atmosphere—the random violence, the rage, and progressive brutalization of occupied and occupier alike.

The evolution of Peress' photography becomes clear when one compares the Northern Ireland reportage with the one of post-revolutionary Iran. The direction is towards a cryptic, more personal signature style. Excepting certain images of the armed populace, the executed SAVAK officers, and

some harrowing photos of their armless and otherwise maimed victims, these photographs can in no way be described as a purely reportorial documentation. In formal terms, they display greater innovation, and are characterized by a nightmare anomic vision, but can only with some difficulty be placed within the category of traditional photojournalism.

This evolution in Peress' work from the relatively straightforward photographs of ten years ago to the more subjective and personal production of the past few years is paradigmatic. For many young photojournalists, it is Cartier-Bresson rather than Robert Capa who is the model, because in Bresson's work subject matter has always been presented in terms of identifiable style. As photographic prestige attaches more and more to art photography—self-referential, personal, and highly formalist—serious photojournalists are caught in a critical bind. If they define their work as the bearing of pictorial witness, they may render themselves invisible; but if they impose a signature style, the events they record may become invisible, the photograph's style and subjectivity having replaced the subject. In certain cases, one can have it both ways: Peress' photographs of French peasants at harvest time are classically composed pastoral celebrations of a vanishing life and culture. The congruence of subject matter and style of depiction is satisfying and appropriate. Judging from his more recent work, it seems reasonable to conclude that the future evolution and direction of Peress' work will be determined by his ability to balance the imperatives of style with those of documentation.

—Abigail Solomon-Godeau

PERKIS, Philip.

American. Born in Boston, Massachusetts, 12 November 1935. Studied at the San Francisco Art Institute, B.F.A. 1962. Served in the United States Air Force, 1954-58. Married Roselaine Perkis in 1960. Photographer since 1962. Teacher at Phillips Academy, Andover, Massachusetts, 1964-65; New York Institute of Technology, 1967-68; San Francisco Art Institute, Summers 1968, 1969, 1970; City College of New York, 1971; and New York University Film School, 1971-72. Assistant Professor since 1969, and Chairman of the Photography Department since 1975, Pratt Institute, Brooklyn, New York. Recipient: New York State Council on the Arts grants, 1971, 1976; National Endowment for the Arts grant, 1978. Address: 171 Steuben Street, Brooklyn, New York 11205, U.S.A.

Individual Exhibitions:

1971 San Francisco Art Institute
1972 Addison Gallery of American Art, Andover, Massachusetts
1976 Nexus Gallery, Atlanta
1977 Portland Art Institute, Maine
1981 *Photografía Actual en Neuva York*, Guadalajara, Mexico

Selected Group Exhibitions:

1967 *12 Photographers of the American Social Landscape*, Brandeis University, Waltham, Massachusetts
1970 *Be-Ing Without Clothes*, Hayden Gallery, Massachusetts Institute of Technology, Cambridge
1973 *Landscape/Cityscape*, Metropolitan Museum, New York
1978 *Photo Landscapes*, International Museum of Photography, George Eastman House, Rochester, New York
1980 *Photography: Recent Directions*, DeCordova Museum, Lincoln, Massachusetts

Collections:

Metropolitan Museum of Art, New York; Sam Wagstaff Collection, New York; International Museum of Photography, George Eastman House, Rochester, New York; Addison Gallery of American Art, Andover, Massachusetts.

Publications:

By PERKIS: books—*Faces*, with others, New York 1977; *The Warwick Mountain Series*, Atlanta 1979.

All photographers use light in the formation of their images. For many, light is the technical requirement necessary only to document the objects, place or people. Philip Perkis' photographs are about that special quality of light as it is reflected at that one instant of his shutter click. It glows in his images of trees and shadows, discovers people in their backyards and fills with movement and energy the streets of Tel Aviv. His matt surface images evoke a response similar to opening and looking at daguerreotypes. One discovers a person or an event in an extraordinary intimacy; the light radiates from the plate. His images are illuminated silver worlds which transmit a sensibility tuned to those rare times when the thing photographed and the light which discovers it for the film are in unusual harmony.

Perkis is very much a formalist and has highly developed strategies of controlled picture structure and subdued, modulated mid-tone prints. His subject interests are landscape and street photography which cross influence giving a snapshot feeling to carefully planned images of trees, rocks and rural areas and an archetonic quality of structure and space to people moving and interacting in the street. In his photographs there is always a sense of all the elements having been taken into consideration, examined, solved but not put forth as the most important aspect of his vision. Perkis is interested in giving the viewer a common pebble which one holds,

Philip Perkis: *Untitled*, 1978

almost discards, then discovers to possess an intricate structure and a surface which seems to emit light. Perkis is unusual among contemporary photographers because he shows us what he sees before he shows us what he thinks.

—James L. Sheldon

PETERHANS, Walter.

American. Born in Frankfurt, Germany, 12 June 1897; emigrated to the United States, 1938, and subsequently naturalized. Educated at the Stadtische Oberrealschule, Dresden-Johannstadt, until 1916; studied at the Technische Hochschule, Munich, 1920-21; studied mathematics, philosophy and art history at the University of Göttingen, 1921-23, and color photography and photoengraving at the Staatliche Akademie für Graphische Künste und Buchgewerbe, Leipzig, 1925-26; attained master's degree in photography, Weimar, 1926. Served in the German Army, 1916-19. Freelance photographer, establishing own industrial and portrait studio, Berlin, 1927-29; Head of the Photography Department, Staatliches Bauhaus, Dessau, 1929-32, and at Mies van der Rohe's private (Bauhaus) Institute, Berlin, 1932-33; Instructor in Photography, Reimann-Häring School, Berlin, 1934-35; freelance industrial and commercial photographer, Berlin, 1935-38 (relinquished photography, 1938); Professor of Visual Training, Analysis and History of Art, Illinois Institute of Technology, Chicago, 1938 until his death, 1960. Research Associate in Philosophy and Instructor in Photography, University of Chicago, 1945-57; Guest Lecturer, Hochschule für Gestaltung, Ulm, West Germany, 1953; Guest Professor, Hochschule für Bildende Künste, Hamburg, 1959-60. *Died* (in Stetten, Baden-Württemberg, West Germany) *12 April 1960.*

Individual Exhibitions:

1967 *Elementarunterricht und Photographische Arbeiten*, Bauhaus-Archiv, Ernst-Ludwig-Haus, Darmstadt
1977 Sander Gallery, Washington, D.C.

Selected Group Exhibitions:

1928 *Neue Wege der Photographie*, Kunstverein, Jena, Germany
 Pressa-Ausstellung, Cologne
1929 *Film und Foto*, Deutscher Werkbund, Stuttgart
1932 *Modern European Photography*, Julien Levy Gallery, New York
 Exposition Internationale de la Photographie, Palais des Beaux-Arts, Brussels (travelled to Lakenhal, Leiden; and Kunstzaal van Hasselt, Rotterdam)
1936 *Deutsche Textil-Ausstellung*, Berlin
1968 *50 Jahre Bauhaus*, Württembergische Kunstverein, Stuttgart (toured Europe and the United States)
1978 *Neue Sachlichkeit and German Realism of the 20's*, Hayward Gallery, London
1980 *Avant-Garde Photography in Germany 1919-1939*, San Francisco Museum of Modern Art (toured the United States, 1980-82)
1981 *Germany: The New Vision*, Fraenkel Gallery, San Francisco

Collections:

Bauhaus Archiv, Darmstadt; Museum Folkwang, Essen; Illinois Institute of Technology, Chicago; San Francisco Museum of Modern Art.

Publications:

By PETERHANS: books—*Die Sammlung Ida Bienert*, with Will Grohmann, Potsdam, Germany 1933; *Das Entwickeln Entscheidet/The Development Decides*, Halle, Germany, Boston and London 1937; *Was, Wann, Wie Vergrossern/What, When, How to Enlarge*, Halle, Germany, Boston and London 1937, new edition Halle 1950; *Richtig Kopieren/Copying Correctly*, Halle, Germany, Boston and London 1937; *Walter Peterhans*, portfolio of 10 photos, Washington, D.C. 1977; articles—"Zum gegenwartigen Stand der Fotografie" in *Red* (Prague), vol. 5, 1930; "Visual Training" in *Dimension* (Ann Arbor, Michigan), 1955; "Fragment über Aesthetik" in *Ratio* (Frankfurt), vol. 2, 1960, and as "Fragment on Aesthetics" in *Ratio* (Oxford), vol. 3, no. 2, 1961.

On PETERHANS: books—*Das Bauhaus 1919-1933: Weimar, Dessau, Berlin* by Hans M. Wingler, Cologne 1962; *Walter Peterhans: Elementarunterricht und Photographische Arbeiten*, exhibition catalogue, with text by Miles van der Rohe, Darmstadt 1967; *50 Jahre Bauhaus*, exhibition catalogue, edited by Wulf Herzogenrath, Stuttgart, London and Cambridge, Massachusetts 1968; *Into the 30's* by K.J. Sembach, London 1972; *Geschichte der Fotografie im 20. Jahrhundert/Photography in the 20th Century* by Petr Tausk, Cologne 1977, London 1980; *Das Experimentelle Photo in Deutschland* by Emilio Bertonati, Munich 1978; *Neue Sachlichkeit and German Realism of the 20's*, exhibition catalogue, by Wieland Schmied, Ute Eskildsen and others, London 1978; *Germany: The New Photography 1927-33*, edited by David Mellor, London 1978; *Film und Foto der 20er Jahre*, exhibition catalogue, by Ute Eskildsen and Jan Christopher Horak, Stuttgart 1979; *Photographen der 20er Jahre* by Karl Steinorth, Munich 1979; *Fotografie 1919-1979, Made In Germany: Die GDL-Fotografen*, edited by Fritz Kempe, Bernd Lohse and others, Frankfurt 1979; *Avant-Garde Photography in Germany 1919-1939*, exhibition catalogue, by Van Deren Coke, Ute Eskildsen and Bernd Lohse, San Francisco 1980; article—"Fotografie am Bauhaus" in *Fotografie* (Leipzig), November 1979.

Like most advocates of the "New Photography" in the 1920's in Weimar Germany, Walter Peterhans was not a trained photographer. He studied mathematics, philosophy and art history before deciding to go to Leipzig to enroll in the State Academy for Graphic Arts and Book Publishing. In the mid-1920's, during a period of relative economic stabilization, Peterhans maintained a photographic studio in Berlin. He earned his living by taking on assignments from industry and by giving private photography lessons. When he was appointed to the Bauhaus-Dessau in 1929, he turned his studio over to his students, Grete Stern and Ellen Rosenberg-Auerbach.

Walter Peterhans organized a photography class at the Bauhaus, which remained under his tutelage until the Bauhaus was forced to close in 1933. Previous to 1929, a number of Bauhaus students had already experimented with photography, especially in the context of their preliminary studies, when they were not required to utilize a specific medium. Yet until Peterhans entered the Bauhaus-Dessau, photography was not offered as a separate course of study.

Peterhans later taught at the Reimann-Häring School in Berlin, completed his master's examination in 1936, and continued to work as a self-employed photographer. Based on a recommenda-

tion by Mies van der Rohe, Peterhans was appointed to the faculty of the Illinois Institute of Technology in Chicago in 1938. There he taught visual training, art history and criticism until 1960. In 1953 the Ulm School of Design offered him a position as a guest lecturer, and asked him to organize their basic workshop. Until his death in 1960, Peterhans presented numerous guest lectures in various American cities and at the School of Fine Arts in Hamburg.

Whether persons, landscapes or objects, Walter Peterhans perceived the existing world as a still-life. He searched out and collected objects in order to compose a photographic image. The prerequisite for his work was his need to remove objects from their natural or everyday surroundings and then to place them within the newly created context of his image. As a result of lengthy observations of the "studio-motif," often intensifying the effect by directing light and shadows through glass plates, he created images that were comparable to montages. Montages, because they united objects which we would not ordinarily associate with each other in our everyday perception of reality. Peterhans attempted to call into question traditional meanings by photographing familiar objects from new perspectives and in unusual combinations.

The literal meaning thus competes with the formal design of the motif of his photographs. When haircombs are combined with balls and decorative fabrics to construct a graphic structure, for example, their descriptive aspect is not simultaneously nullified. There develops out of this tension in his photographs a poetic expression, which often produces a surreal effect. The original meaning of individual objects abides, even though they are combined with other objects through Peterhans' photographic design to achieve a new unity.

Peterhans applies a similar method in his portrait photography. The human form does not enter into a state of eternal motionlessness through the act of photographing, but rather has already been directed into such a state by the photographer creating a situation, which emphasizes this aspect: for example, he covers a girl's face with her own hair, in order to design a surface contrast to other materials.

Peterhans' handling of fragments of reality isn't provocative, but rather endeavors to harmonize. This is confirmed by his rejection of photo-optical experiments, like those conducted by László Moholy-Nagy. In contrast to the images of "new realism" photographers of his day, he was not interested primarily in the working out of formal principles in his photographs; instead they simultaneously express the various possible associative meanings of the motif's individual elements.

His essays on photography confirm that Peterhans' photographic work struggles to attain an exact cognizance of the medium's techniques and limitations. He is not only concerned with the precision of his presentation, but also with its transference to a nuanced grey-scale: "Forming an object by considering the aspect of photographic selection from single facts, we are able to abandon the manual pursuit of a purely photographic, previously completed process. The object itself defines the image, while chiarscuro, spatial relationships, and depth of field are precise techniques which tangibly approach the object."

Peterhans valued the process of selection as a belatedly discovered, specific capability of photography, which presupposed an in-depth knowledge of technique and its limitations. The work done before the actual act of photographing was for him the determining factor, while the technical process only served to "verify our conception."

In this context Peterhans rejected academicism as well as dilettantism, the latter being, according to Peterhans, the result of the mass acceptance of photography.

In 1930 he formulated his idea of an enrichment of visual media through photography as "an intensification of the image character," noting that this could only occur by recognizing the inherent laws of

photography. His optimistic evaluation of technique thus places Peterhans with that group of photo-designers of the 1930's who euphorically emphasized and employed photography as the most modern method of image making.

Walter Peterhans no longer photographed after he immigrated to the United States in 1938.

—Ute Eskildsen

PETERSEN, Anders.

Swedish. Born in Stockholm, in 1944. Studied at Christer Stromholm's Photography School, Stockholm, 1966-68; Swedish Filmschool (Dramatiska Institute), Stockholm, 1973-74. Independent photographer, Stockholm. Member, SAFTRA photographers' group. Instructor, Christer Stromholm's Photography School, 1969-71. Recipient: Kodak Fotobuchpreis, 1979. Address: Gotgatan 29, 11621 Stockholm, Sweden.

Individual Exhibitions:

1969	*Biennal de Paris*, Musée d'Art Moderne, Paris
1970	*Reeperbahn*, Galleri Karlsson, Stockholm (travelled to the Kunstforeningen, Oslo, 1971)
1973	*Hamburg*, Half Moon Gallery, London
1976	*Circus*, House of Culture, Stockholm
1977	*Cafe Lehmitz*, Musée Réattu, Arles, France
1978	*Bistro d'Hambourg*, FNAC Gallery, Paris
1979	*Anders Petersen Photographiet*, Badischer Kunstverein, Karlsruhe
	Neighbours, City Museum, Stockholm
1980	*Cafe Lehmitz*, Hippolyte Gallery, Helsinki
	Ralph Nykvist/Anders Petersen, Fotogalleriet, Oslo

Selected Group Exhibitions:

1967	*Young Photographers*, Moderna Museet, Stockholm
1969	*City in Return*, City Museum, Stockholm
1977	*SAFTRA*, at *Rencontres Internationales de la Photographie*, Arles, France

Collections:

Fotografiska Museet, Moderna Museet, Stockholm; Bibliothèque Nationale, Paris.

Publications:

By PETERSEN: books—*Grona Lund*, with text by Jan Stolpe, Helsingborg, Sweden 1973; *A Day at the Circus*, with Stefan Lindberg and Mona Larsson, Lund, Sweden 1976; *Cafe Lehmitz*, with text by Roger Anderson, Munich 1978, as *Bistro d'Hambourg*, Paris 1979.

On PETERSEN: article—"Anders Petersen" by Peder Alton in *Fotograficentrums Bildtidning* (Stockholm), May 1980.

When I'm out taking pictures and meeting people, it is always more important for me to establish a direct

dialogue than to be a photographer.

—Anders Petersen

Anders Petersen has often been described as a portrayer of "the damned". He has, for example, taken his motifs from a Hamburg bar (mostly frequented by elderly prostitutes and homosexuals), from a prison, and from a shopping centre where gangs of youths gather to seek warmth and fellowship. And even when he has depicted more usual and more accessible subjects, such an amusement park or a circus, he is not primarily attracted by the excitement and the festive atmosphere. Generally he keeps to the periphery: he points his camera towards the visitors to the amusement park, who are vacantly seeking a refuge from the drabness and loneliness of everyday life; in the circus he is as interested in the work behind the scenes and life in the caravans as in the circus itself.

Photographers have often been attracted by these subjects, but most have approached the motifs as prying outsiders. They have peeped in stealthily with a tele-objective and have all the time been prepared for a quick retreat. Obtaining a picture of a whore or a drunk bar-guest has become an end in itself. For Petersen the importance lies in the contact with his subject. He has to identify himself with the people he portrays, has to gain their confidence, has to like them. He has to achieve an emotional contact—he says that he "photographs with his belly."

Petersen has often talked of the photographer's responsibility and of the importance of believing in one's work; of explaining properly the purpose of the photo to those whom it affects; of showing them the pictures later and discussing the results, being able to argue for one's pictorial description; but, at the same time, being receptive to the arguments of the subjects. And obviously the photographer must take his share of the responsibility for how the pictures are distributed, in what context they are published, how the captions are written.

Not surprisingly, Petersen often mentions Bruce Davidson as an example. His depiction of gangs of youths in Brooklyn and his documentation of life on East 100th Street show what a receptive photographer can achieve, when he has gained the confidence of people within their surroundings.

"You must have a directness and self-confidence in your way of being with other people in order to make reality visible. With a little luck it then becomes possible to clarify something for others though your pictures" Petersen has said in an interview. He has evolved this working methodology since he documented life in the "Lehmitz" bar in Hamburg in the late 1960's. It took him two years to carry out this project, but it must also be pointed out that many of the people he portrayed there he had known seven years previously. For in the early 60's he had lived in Hamburg (without a camera) to improve his languages.

Anders Petersen has not used the camera as a shield between himself and reality. Photography becomes an integral part of the relationship. His pictures do not function as closed windows, through which we steal a glimpse. They are open, as are the people we meet in his pictorial world.

—Rune Jonsson

PETRUSOV, Georgii (Georgievich).

Russian. Born in Rostov-on-Don, in 1903. Educated at primary and secondary schools in Rostov until 1920; self-taught in photography. Married V.S. Petrusova. Worked for the Rostov Industrial Bank, 1920-24. Press photographer, Moscow, 1924 until his death, 1971: worked for the journals *Metallist* and *Robochii-Khimik*, 1924-25, and for *Pravda*, 1926-28; Chief Photographer, Magnitogorsk Foundries, 1928-30; photographer for *SSSR Na Stroike* (*USSR in Construction*), 1930-41; War Correspondent, for the Soviet Information Bureau and for the newspaper *Izvestiia*, 1941-45; Photo-Correspondent, APN/Agency Novosti, 1957-71; also worked for *Soviet Life*. Recipient: First Prize, *Moscow Masters of Photo-Art*, 1935; Gold Medal, *International Photo Exhibition*, Cairo, 1947; Gold Medal, *50 Years of Soviet Power*, Moscow, 1967; Posthumous Prize of Honor, *All-Union Photo-Exhibition Devoted to the 60th Anniversary of the Great October*, Moscow, 1977. Died (in Moscow) in 1971.

Selected Group Exhibitions:

1935	*All-Union Exhibition of Soviet Photo-Art*, Moscow
	Moscow Masters of Photo-Art, Moscow
1941	*International Salon of Photography*, Boston
1947	*International Photo Exhibition*, Cairo
1948	*The Great Fatherland War*, Moscow
1963	*Annual Associated Novosti Press Exhibition*, Moscow (and 1964, 1965)
1967	*50 Years of Soviet Power*, Moscow
1972	*Photographes de l'URSS: Le Pays, Les Hommes*, Galeries Nationale du Grand Palais, Paris
1975	*30 Years of the Great Victory*, Moscow
1977	*All-Union Photo-Exhibition Devoted to the 60th Anniversary of the Great October*, Moscow
1980	*Soviet Photography Between the Wars 1917-1941*, Dumuměni House of Art, Brno, Czechoslovakia

Collections:

Novosti Press Agency, Moscow; Daniela Mrázková/Vladimír Remeš Collection, Prague.

Publications:

On PETRUSOV: books—*Photographes de l'URSS: Le Pays, Les Hommes*, exhibition catalogue, Paris 1972; *Georgii Petrusov* by Anri Vartanov, Moscow 1979; *Die Sowjetunion Zwischen den Kriegen 1917-1941* by Daniela Mrázková and Vladimír Remeš, Oldenburg, West Germany 1981; *Sowjetische Fotografen 1917-1940*, edited by S. Morosov and others, Leipzig 1981; articles—"The Eighth Wonder of the World" by Daniela Mrázková in *Revue Fotografie* (Prague), no. 11, 1977; "Soviet Photography Between the World Wars 1917-1941" by Daniela Mrázková and Vladimír Remeš in *Camera* (Lucerne), June 1981.

Georgii Petrusov was one of the pioneer press-photographers of Soviet Russia during the 1930's and 1940's. His favorite subjects were industrial construction and military action, and a number of his photographs on these themes such as "The Dam of the Dnepr Hydroelectric Scheme" (1934) and "The Signing of the Peace Treaty with Germany" (1945) have been reproduced many times. Petrusov even lived for two years at Magnitogorsk (1928-30), producing a remarkable visual commentary on the construction of this ambitious industrial complex.

Although he started his photographic career in the 1920's and, after his arrival in Moscow in 1924,

Georgii Petrusov: *A Moment in the Working Day*, Magnitogorsk, 1928

was much influenced by the experimental artists and photographers of the time, especially by Rodchenko, Petrusov was always more interested in "content" than in "form." True, he investigated various viewpoints, angles and compositional methods, particularly the diagonal shot, but his photographs move us by their human, emotional force rather than by their formal innovations. This is very evident from his photographs concerned with World War II, such as "The Refugee" (1943) and "The Return" (1945).

As a press-photographer, Petrusov worked for many newspapers and magazines, including *Rabochii-khimik* [Worker-Chemist], *Metallist* [Metalworker], *Izvestiia* and, most importantly, the propaganda monthly *USSR in Construction*. Along with other important artists such as El Lissitzky, Rodchenko and Varvara Stepanova, Petrusov contributed many photographs to the special issues of *USSR in Construction* during the 1930's. His scenes from the Red Army, Magnitogorsk, the Moscow metro, Ukrainian collective farms, etc. that appeared in this magazine are especially worthy of note as documents of the time. During his travels for this and other magazines, Petrusov made the acquaintance of many famous people, especially writers and artists: his photographs of Isaak Babel (1933), Alexandr Dovzhenko (1929), Mikhail Sholokhov (1938),

Konstantin Simonov (1942), Alexei Tolstoi (1940), Ilia Ehrenburg (1944) and Sergei Yutkevich (1966) are vivid psychological portrayals. Petrusov was also active as a trick photographer and a satirist, particularly in the 1930's, and his photo-caricatures of Rodchenko (1936), and the photographers Max Alpert (1937) and Abram Shterenberg (1937) bring to mind the Dada methods of John Heartfield and Raoul Hausmann. Before his retirement, Petrusov worked for the propaganda journal *Soviet Life* (produced for US consumption) and achieved a new success as a theater photographer (particularly of the ballet).

—John E. Bowlt

PFAHL, John.

American. Born in New York City, 17 February 1939. Educated at Butler High School, Butler, New Jersey, 1953-57; Syracuse University, New York, 1957-61, B.F.A. in graphic design 1961, M.A. in color photography 1968. Served in the United States Army, Fort Belvoir, Virginia, 1961-63. Married Bonnie Gordon in 1965. Associate Professor, School of Photographic Arts and Science, Rochester Institute of Technology, Rochester, New York, since 1968. Recipient: Creative Artists Public Service Grant, 1975, 1979; National Endowment for the Arts Photography Fellowship, 1977. Agent: Robert Freidus Gallery, New York. Lives in Buffalo, New York. Address: c/o Robert Freidus Gallery, 158 Lafayette Street, New York, New York 10013, U.S.A.

Individual Exhibitions:

1970 University of New Hampshire, Durham
1973 East Tennessee State University, Johnson City
1976 Deja Vue Gallery, Toronto
 Visual Studies Workshop, Rochester, New York
1978 *Altered Landscapes*, Robert Freidus Gallery, New York
1979 Princeton University, New Jersey
 Thomas Segal Gallery, Boston
 Canon Photo Gallery, Geneva
 Robert Freidus Gallery, New York
 Danforth Museum, Framingham, Massachusetts
 University of Massachusetts, Amherst
 Divola/Henkle/Parker/Pfahl, Visual Studies Workshop, Rochester, New York (toured the United States)
1980 Jeb Gallery, Providence, Rhode Island
 Bell Gallery, Brown University, Providence, Rhode Island
 Kathleen Ewing Gallery, Washington, D.C.
 Visual Studies Workshop, Rochester, New York
 Picture Windows, Robert Freidus Gallery, New York

Selected Group Exhibitions:

1979 *Color: A Spectrum of Recent Photography*, Milwaukee Art Center
 The American Still Life 1879-1979, Addison Gallery, Andover, Massachusetts
 Attitudes: Photography in the 1970's, Santa Barbara Museum of Art, California
 American Photography in the 70's, Art Institute of Chicago
 Fabricated to Be Photographed, San Francisco Museum of Modern Art
 Polaroid 20 x 24, Light Gallery, New York
1980 *Polacolor*, Philadelphia Academy of Art
 Aspects of the 70's, De Cordova Museum, Lincoln, Massachusetts
 Zeitgenossische Amerikanische Farbphotographie, Galerie Rudolf Kicken, Cologne

Collections:

International Museum of Photography, George Eastman House, Rochester, New York; Albright-Knox Art Gallery, Buffalo, New York; Smith College, Northampton, Massachusetts; Princeton University, New Jersey; Minneapolis Institute of Art; Denver Art Museum; Contemporary Art Museum, Houston; University of New Mexico, Albuquerque; San Francisco Museum of Modern Art; Australian National Gallery, Canberra.

Publications:

By PFAHL: book—*Altered Landscapes*, Carmel,

California 1981; article—"Interview with John Pfahl," with Stuart Rome, in *Northlight* (Tempe, Arizona), April 1981.

On PFAHL: articles—"Photography" by Ben Lifson in the *Village Voice* (New York), March 1978; "John Pfahl's Picturesque Paradoxes" by Anthony Bannon in *Afterimage* (Rochester, New York), February 1979; "John Pfahl: Bagles and Rocks" in *Photography Year 1979* by the Time-Life editors, New York 1979.

Casual viewers of my "altered landscape" photographs are often misled into believing that there are dotted lines, arrows or other marks drawn on the prints. Closer observation reveals that the markings are actually type, string or foil introduced into the scene in front of the camera *before* the moment of exposure. The illusion created is somewhat related to the anamorphic impulses in painting and drawing that made their first appearances in the early Renaissance.

In this case, however, the illusions are a purely photographic phenomenon and can only be realized by a camera situated at one crucial point in space. A 4 x 5 inch view camera on a tripod was used at selected locations. Simple drawings were traced on the ground-glass and duplicated by placing artificial elements into the scene itself. This procedure involved hours of painstaking trial-and-error adjustments, occasionally with the aid of assistants, and periodically monitored by Polaroid exposures. The "decisive moment" generally turned out to be from two to eight hours long. After the exposures were made, all traces of the activity were removed and the landscape returned to its original inchoate state.

Large format color photography was chosen as the medium because of its great verisimilitude. Perceptual clues denoting depth and distance can be presented with great clarity. Color also permits the introduction of an unabashedly sensuous quality which serves to flesh out the bare conceptual basis for the work.

Locations for the photographs were chosen for their "picturesque" qualities, their formal structure, and their referential possibilities. The added elements suggest numerous markmaking devices associated with photographs, maps, plans, and diagrams. On different occasions, they may pointedly repeat a strong formal element in the landscape, they may fill in information or utilize information suggested by the scene, or they may be only arbitrarily related to the scene but refer instead to the process of making a photograph.

—John Pfahl

John Pfahl is best known for his series of *Altered Landscapes* (ca. 1974-77) in which he plays whimsical and often astonishing tricks with our perception. Pfahl, however, has used a number of other approaches to picture-making, including making photographs into sculpture and using materials such as sugar and latex to print photographs; in 1978 Pfahl was the first artist invited to use the Polaroid Corporation's 20 x 24 camera. Although Pfahl goes to great lengths to achieve technically perfect prints, he is constrained in no other way by "photographic purity." His open attitude has allowed him throughout his career to escape the conventions of photographic rendering but, in so doing, to comment upon them.

In *Altered Landscapes*, Pfahl uses a number of methods to enhance his lush views/scenes; with string, yarn, foil, tape, rods, and a variety of other props including bagels, lace, oranges, and a pie pan, Pfahl echoes the forms in the landscape, or uses them as the basis for other forms, or simply applies his own, often arbitrary, system of marks. In the present-day abundance of contemporary photographs that have been drawn on or marked, it is often difficult to remember that Pfahl's designs are part of the picture, rather than applied to the surface. His scenes take hours to set up, require complex figuring to achieve the perfect perspective and illusion he is after, and, unlike other photographs, his compositions "exist" from only one, very precise viewpoint.

Pfahl's imposed designs serve as a system of ordering information that both parallels and contrasts the pictorial system of camera-made imagery. Using the tricks of perspective, Pfahl underscores the nature of photographic illusion and sets up a dialectic between real and abstract, between three-dimensional space and the flat plane of the photograph, and also between photographic clichés and the constant search for novelty, as in his desert scene "Moonrise over Pie Pan." And just as the camera is both personal and mechanistic, Pfahl's unabashed romanticism is belied by the scientific precision of his diagrams.

Pfahl notes that his work represents an exaggeration of the concern, automatic in photography, with how space translates from three dimensions to two. Furthermore, he remarks that most contemporary photographers are concerned primarily with the photographic process itself rather than, simply, with subject matter. Yet, while the world is overphotographed, photographers are finding increasing sustenance in what Pfahl describes as specific detail. Recent advances in color technology, including the 20 x 24 Polaroid camera, have renewed photographers' interest in the idea of inventory, and the idea of setting up solely for the purpose of inventory, as Van Deren Coke's exhibit *Fabricated to Be Photographed* (1979) pointed out. "One of the most beautiful applications of photography," says Pfahl, "is the combination of specific detail with a sense of abstraction." The wit and lushness, the sheer visual appeal of his photographs aside, Pfahl offers in, say, the comparison of a wave breaking on the shore with a strip of lace, a fresh perception, both literally and figuratively, of some of photograph's most favorite, and overworked, motifs.

A more recent series of photographs, "Picture Windows," continues to explore the nature of perception using views of backyards, parking lots, mountains, and the variety of scenes for which picture windows were invented. Pfahl reveals that after years of laborious set-ups, the picture windows provide him an exhilarating freedom to accept what is there. The bright rectangles of windows seem to float in the dark interiors, like pictures within a picture, offering an endless series of connections between the camera, the frame, and the world.

Pfahl's greatest contribution lies in his unique ability to combine the conceptual with the pictorial and, perhaps, to pay homage to 19th century ways of viewing the world using modern ideas about perception and the ambiguous line between reality and abstraction.

—Dana Asbury

John Pfahl: *Australian Pines, Fort Desoto, Florida,* 1977

PLA JANINI, Joaquim.

Spanish. Born in Tarragona, 23 March 1879. Studied medicine, Universidad Pontificia de Santo Tomas, Manila, Philippines, 1897-1903, M.D. 1903; self-taught in photography. Married Concepció Guarro in 1906; children: Camila, Joaquim, Maria Lluisa and Concepció. Amateur photographer, from 1893; practiced medicine in Barcelona until 1931; full-time amateur photographer, Barcelona, 1931-70. Founder-Member, with Claudi Carbonell, Francesc de P. Ponti, Antoni Campana and others, 1923, and President, 1923-33, Agrupación Fotográfica de Catalunya, Barcelona. *Died* (in Barcelona) *11 February 1970.*

Individual Exhibitions:

1929 Agrupación Fotográfica de Catalunya, Barcelona
1935 Centro Excusionista de Catalunya, Barcelona
 Agrupación Fotográfica de Igualadam Igualada, Spain

1939 Sala Busquets, Barcelona
1944 Diputación Provincial de Tarragona, Spain
1945 Agrupación Fotográfica de Terrassa, Spain
1979 Galeria Fotomania, Barcelona
 Galeria 491, Barcelona
1980 Fundació Joan Miro, Barcelona

Selected Group Exhibitions:

1929 *Agrupación Fotográfica de Catalunya*, at
 the *International Exposition*, Barcelona.

Publications:

On PLA JANINI: articles—"El Dr. Joaquim Pla Janini, Figura Representativa de la Fotografia Catalana" by Claudi Carbonell in *Art de la Llum* (Barcelona), October 1934; "Pla Janini" by Aquiles Pujol in *Arte Fotografico* (Madrid), October 1963; "L'obra Retrobada del Dr. Pla Janini" by Joan Fontcuberta in *A VUI* (Barcelona), March 1979; "El Dr. Pla Janini" by Maria Teresa Blanch in *Arte Fotografico* (Madrid), July 1980; "Pla Janini 1879-1979" by Joan Fontcuberta in *Camera* (Lucerne), December 1980.

The name of Joaquim Pla Janini is associated in Spain with Catalan avant-garde photography of the 1920's and 30's. He is notable both as a photographer and as a driving force in photography during that period, for his enthusiastic promotion of collective initiatives, such as the founding of the Agrupación Fotográfica de Catalunya (Catalan Photographic Association) in 1923 and his contributions to the magazine *Art de la Llum* during the 1930's. He is pre-eminently the pioneer of photographic culture in Spain in the years before the Second World War.

Pla Janini belongs to the last generation of photographers who prepared their emulsions and instruments with their own hands, the generation who were, in a sense, made redundant by the new era of industrialized products. A technician of the "old ways," Pla Janini thrived on the pleasures of photographic alchemy, manual retouching, pigmentation changes. His use of bromide suspension achieved considerable quality and perfection, and his skills in this particular area gained international recognition. He was one of the very few photographers able to use the technique successfully.

The recession that began with the Spanish Civil War caused him to abandon any further public activity. He closed himself away in his garden-terrace above a street in the gothic quarter of Barcelona and thereafter, until a few years before his death in 1970, dedicated himself to his own photographic experiments.

He considered photography too elevated and humanistic an activity for him to deal with on a mundane or commercial level. A "noble pastime," he used to say, but one to which he dedicated so much energy, sensitivity and understanding that he eventually achieved standards of remarkable professionalism. His purist conception of the medium is one of the reasons that, even today, a good number of his negatives remain unpublished.

The photographs that we do know are typical of the "pictorialist" mode that was dominant during his time. His orthodoxy in dealing with photographic concepts and the singular heterodoxy of his treatment reveal him to be an academic with reforming ambitions—as someone has said, "the last romantic photographer of Barcelona."

His Mediterranean landscapes (Costa Brava, Ibiza) and his exuberant woods (Camprodon), with their softness and feeling of timelessness, strongly reveal a mysterious, enigmatic force, typical of the exquisite idealization that was Pla Janini's way of observing Mother Nature. He dealt with special artistic problems—particularly in some still-lifes—in an almost Constructivist manner and arranged his subjects in a highly personal way, sometimes creating allegorical representations. Among these there is a series of theatrical phantasmagories on death known as "Las Parcas" (1922), which are of great dramatic and poetic force in a style that, later, another photographer, Christian Staub, was also to use in his work.

—M. Teresa Blanch

PLOSSU, Bernard.

French (American resident). Born in Dalat, South Vietnam, 26 February 1945. Educated in Paris: self-taught in photography. Married to Kathy Yount; son: Shane. Photographer, Paris, Mexico, and now Santa Fe, New Mexico, since 1977. Address: Post Office Box 5451, Santa Fe, New Mexico 87502, U.S.A.

Individual Exhibitions:

1973 Centre Culturel Americain, Paris
 Galerie Multitude, Paris
 Creative Camera Gallery, London
1974 Galeria Spectrum, Barcelona
 Galeria Il Diaframma, Milan
 Friends of Photography, Carmel, California
1975 University of Essen
1976 Galerie Nicephore, Bollwiller, France
 La Photogalerie, Paris
 El Fotocentro, Madrid
 *3 Jeunes Photographes: Bruno, Kalvar,
 Plossu*, the Centre Georges Pompidou,
 Paris (toured France, Spain, Czechoslovakia and Poland)
1977 La Remise du Parc, Paris
 Galerie Aspects, Brussels
 Galerie 31, Vevey, Switzerland
1978 Le Chateau d'Eau, Toulouse

1979 Galerie Contrejour, Paris
 Phot'Oeil Galerie II, Paris
 Maggie Kress Gallery, Taos, New Mexico
 Hill's Gallery, Santa Fe, New Mexico
 Fifth Avenue Gallery, Scottsdale, Arizona
 French Cultural Center, New York
1980 Work Gallery, Zurich
 Stephen White Gallery, Los Angeles
 FIAC Fair, Paris
 Galerie Perspective, Paris
 Church Street Gallery, Melbourne
 Galeria Arpa, Bordeaux
 Santa Fe Gallery, New Mexico
 Galeria Fotomania, Barcelona
1981 Eaton/Scheon Gallery, San Francisco
 Musée Nicéphore Niepce, Chalon-sur-Saône,
 France (with Djan Seylan)

Selected Group Exhibitions:

1972 *Photokina '72*, Cologne
1975 *4 Photographes*, Bibliothèque Nationale, Paris
 (with Bruno, Descamps, and Kuligowski)
1977 *Sequences*, Stedelijk Museum, Amsterdam
1979 *Venezia '79*
1980 *French Photographers*, University of Oklahoma, Norman
 Accrochage, Musée Cantini, Marseilles

Collections:

Bibliothèque Nationale, Paris; Centre Beaubourg, Paris; Musée Cantini, Marseilles; Musée Réattu, Arles, France; Musées Royaux des Beaux-Arts, Brussels; Stedelijk Museum, Amsterdam; International Museum of Photography, George Eastman House, Rochester, New York; Center for Creative Photography, University of Arizona, Tucson; Australian National Gallery, Canberra.

Publications:

By PLOSSU: books—*Surbanalism*, with text by S. Leone, Paris 1972; *Creatis No. 2: Bernard Plossu*, with text by J.C. de Feugas, Paris 1977; *Mexique 65-66*, portfolio, Paris 1978; *Le Voyage Mexicain*, with text by Denis Roche, Paris 1979; *Nueva Lente*

Bernard Plossu: *Agades, Niger*, 1975

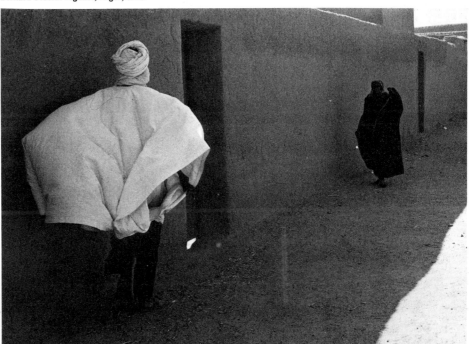

601

Monograph: Bernard Plossu, edited by C. Serrano and P.P. Minquez, Madrid 1979; *Egypte*, with text by Carole Naggar, Paris 1979.

On PLOSSU: books—*Photokina*, exhibition catalogue, Cologne 1972; *Bernard Plossu*, exhibition catalogue, Paris, 1976; *Paris* 1976; *Histoire de la Photographie Francaise* by Claude Nori, Paris 1978; *Venezia '79: La Fotografia*, edited by Daniela Palazzoli, Vittorio Sgarbi and Italo Zannier, Venice and New York 1979; articles—in *Photo* (Paris), October 1972; *Creative Camera* (London), April 1973; "Realisme: Bernard Plossu" in *Le Nouveau Photocinema* (Paris), September 1973; by Allan Porter in *Camera* (Lucerne), July 1974; by Joan Murray in *Artweek* (Oakland, California), August 1974; in *Progresso Fotografico* (Milan), January 1977; in *Creative Camera* (London), February 1979; by B. Clark in *Rocky Mountain Review* (Denver), October 1979; in *American Photographer* (New York), April 1980; M. Johnson in *Artweek* (Oakland, California), June 1980.

Photography is the discipline of evidence in a thousandth of a second delirium.

—Bernard Plossu

Time is the water of the river of life; photographs are the small pebbles that are thrown in...to kill time.

Like certain rhythms and refrains of the Beatles, the photographs of Bernard Plossu are the reflecting mirrors of that curious and mobile generation that went to look for its version of truth in the four corners of the globe, mixing different cultures along the way. The wandering so dear to a Kerouac, the fascination with the Orient, the call of the road—all involve a rupture with the ambient milieu, with habitual space, in exchange for a new world, one which, for the photographer, incites and provokes new pictures.

The photograph has always been linked to travel, for photography wants to speak, above all, about displacement, about "going there," so that others can imagine and devise things that they have not seen. Bernard Plossu travels, as it were, between Paul Strand and Edouard Boubat, but he is different from them in that he is more interested to prove by experience the emotions of displacement than merely to record them. True, the influences may be Robert Frank, or the Beat Generation, or the Hippy phenomena, but such comparisons are useful only to a point. For Plossu demands the importance of the "I"; that which happens in his pictures is, above all, a moment of his own life, a personal vibration, a state of his soul, an autobiographical sign. The act of photography is a totally personal experience; it is, each time, the Great Awakening similar to such spiritual experiences as "satori" or "nirvana" but it is, above all, the unique chance to be fully in life, in *his* life. That which Plossu shows us, that which he distills and attempts to transcribe, is the breath of life in the moment of epiphany, the sublime instant: deserts, rain, long roads, tender looks, the transparency of the sun, bustling streets, winking eyes, works of art, a happy tree, a sudden silence, a gust of wind, the smile of a woman early in the morning....

The autobiographical character of Plossu's photographs marks a salutary rupture with the French tradition of photojournalism and the aristocratic stance of Cartier-Bresson in which an abyss separates the photographer from the photograph. In his recent book, *Le Voyage Mexicain*, it is a matter, above all, of connivance, of complicity, of an intimacy between a young man who hardly knows how to use the Rétina Kodak that was lent to him and the people he encounters on his way to the great "hallucinatory" experience of Mexico. "We are in the picture instead of looking at it." The characters that parade through the pages of the book tell us their

own history; but, even more, they tell us of one that they cherish with the photographer—like the superb young girl with brown skin and a dress lightly turned up: she exudes love. As Kerouac said in his preface to Frank's *Americans*: "We would love to have her phone number."

This sensation of freedom, this emotional relationship, is the result of Plossu's great technical refinement—as if his camera had actually extended the body, making itself a crystallizer of the senses: "I use only the 50mm lens because its normal vision allows me to be self-effacing, and, in so doing, to avoid exercises in style, so that the subject speaks more strongly, by itself, for itself."

After the publication in 1972 of his first book, *Surbanalism*, which was misunderstood at the time, and after numerous trips to Asia and Africa, and after publication of his last two books, *Egypte* and *Le Voyage Mexicain*, Plossu has now settled in Santa Fe, New Mexico. This mythical place for photography (Beaumont Newhall, Paul Caponigro, Eliot Porter, Walter Chappell and others live there), this dry city in the middle of the desert, seems, for the moment, to suit his Mediterranean hedonism. Sensuality inheres in the burning rocks, in the caress of the wind, in the pulsations of the earth, in the soft cushiony folds of a Cadillac.

—Claude Nori

PLOWDEN, David.

American. Born in Boston, Massachusetts, 9 October 1932. Educated at the Collegiate School, New York, 1940-45, Choate School, Wallingford, Connecticut, 1945-46, Trinity School, New York, 1947-48, and Putney School, Vermont, 1948-51; studied economics, Yale University, New Haven, Connecticut, 1951-55, B.A. 1955; studied photography, under Minor White and Nathan Lyons, Rochester, New York, 1959, 1960. Married Pleasance Coggeshall in 1962 (divorced, 1976); married Sandra Schoellkopf in 1977; children: John, Daniel, Philip. Assistant Train Master, Great Northern Railway, Wilmar, Minnesota, 1955-56; Travel Clerk, American Express Company, New York, 1957; Travel Agent, Nametra Inc., New York, 1958-59. Photographer since 1959: Photographic Assistant, O. Winston Link Studio, New York, 1959, George Meluso Studio, New York, 1960-62; freelance photographer, on assignments from various institutions and for *Architectural Forum, American Heritage, Fortune, Horizon, Life, Newsweek*, etc., in New York, 1962-78, and in Chicago, since 1978. Associate Professor, College of Architecture, Planning and Design, Institute of Design, Illinois Institute of Technology, Chicago, since 1978. Recipient: Guggenheim Fellowship, 1968; Benjamin Baroness Award, 1971; Wilson Hicks Award, University of Miami, 1977; Horn Book Award, 1979; Award of Excellence, American Institute of Graphic Arts, 1979. Agents: Witkin Gallery, 41 East 57th Street, New York, New York 10022; Curtis Brown Ltd., 575 Madison Avenue, New York, New York 10022; Gilbert Gallery, 218 East Ontario Street, Chicago, Illinois 60611. Address: 797 Walden Road, Winnetka, Illinois 60093, U.S.A.

Individual Exhibitions:

1962 New York Public Library, Hudson Park Branch
Steam Engines, Suffolk Museum, Stonybrook, Long Island, New York

David Plowden: *Blast Furnaces, Jones and Laughlin Steel Mill, East Chicago*, 1981

1965 *The Route of Lincoln's Funeral Train*, Columbia University, New York
1971 *The Hand of Man on America*, Smithsonian Institution, Washington, D.C. (toured the United States)
1972 *The Great Plains*, Neikrug Gallery, New York
1976 *American Vernacular*, International Center of Photography, New York
Railroad Men, Smithsonian Institution, Washington, D.C.
Bridges, Smithsonian Institution, Washington, D.C.
Bryant Library, Roslyn, Long Island, New York
1977 Port Washington Library, New York
1979 Cincinnati Art Academy
Witkin Gallery, New York (retrospective)
Evanston Art Center, Illinois
Santa Fe Gallery of Photography, New Mexico
1980 The Gilbert Gallery, Chicago
1981 *Steel*, Smithsonian Institution, Washington, D.C.
The Gilbert Gallery, Chicago

Selected Group Exhibitions:

1967 *Photography in the Fine Arts*, Metropolitan Museum of Art, New York
1976 *The Face of Industry*, Kodak Gallery, New York
The River, Walker Art Center, Minneapolis
1977 *The Great West: Real/Ideal*, University of Colorado, Boulder (subsequently Smithsonian Institution travelling exhibition)
1978 *By the Side of the Road*, Currier Gallery of Art, Manchester, New Hampshire
1979 *Industrial Sights*, Whitney Museum, New York
1980 *Photographers of the Institute of Design*, The Gilbert Gallery, Chicago

Collections:

Library of Congress, Washington, D.C.; Smithsonian Institution, Washington, D.C.; Art Institute of Chicago; Center for Creative Photography, University of Arizona, Tucson.

Publications:

By PLOWDEN: books—*Farewell to Steam*, Brattleboro, Vermont 1966; *Lincoln and His America*, New York 1970; *Nantucket*, with text by Patricia Coffin, New York 1970; *The Hand of Man on America*, Washington, D.C. 1971; *Floor of the Sky: The Great Plains*, New York 1972; *Cape May to Montauk*, with text by Nelson P. Falorp, New York 1973; *Bridges: The Spans of North America*, New York 1974; *Commonplace*, New York 1974; *Desert and Plain; The Mountains and the River*, with text by Berton Roneché, New York 1975; *Tugboat*, New York 1976; *The Iron Road*, with text by Richard Snow, New York 1978; *Wayne County: The Aesthetic Heritage of a Rural Area*, with text by Stephen Jacobs, New York 1979; *Steel*, New York 1981; *David Plowden: Photographs*, New York 1982; *Heartland: The Middle West*, New York 1983; articles—"Farewell to the Ferry" in *American Heritage* (New York), April 1964; "A Whistle Goodbye" in *American Heritage* (New York), December 1966; "A Workshop for Bridge-Builders" in *Fortune* (New York), August 1967; "Tugboats" in *Fortune* (New York), April 1968; "The Hand of Man on America" in *The Smithsonian* (Washington, D.C.), January 1971; "The Island That Is" in *Audubon* (New York), March 1971; "A Sweep of Bridges" in *American Heritage* (New York), December 1973; "American

Vernacular" in *American Heritage* (New York), August 1974; "The End of Innocence" in *Journal of Current Social Issues* (New York), Fall 1976.

On PLOWDEN: articles—"The Hand of Man in America" by Rene Bruns in *Popular Photography* (New York), June 1971; "Passing Fancies" by Kenneth Poli in *Popular Photography* (New York), June 1973; "View of America" in *Time* (New York), 19 November 1973; "David Plowden" in *Photography Annual*, New York 1976; "David Plowden" by Richard F. Snow in *Modern Photography* (New York), January 1977; "Main Street U.S.A." by Owen Edwards in *American Photographer* (New York), July 1980.

In approaching the work of David Plowden one is struck, most of all, by a sense of balance. There is balance between words and pictures as well as a formal sense of balance within the photographs themselves. Plowden's work has appeared in many magazines, but he is best known for his work with books and it is in the books that his sense of balance best appears. In the book format his words and pictures can work toward a unified whole.

David Plowden's books are always about something other than photography itself. As Plowden puts it, "Photography has never interested me as much as the things I photographed." Make no mistake, Plowden is a very fine photographer, but his camera has generally been used in the service of a specific idea or a personal interest. His basic motivation is documentary.

In his first book, *Farewell to Steam*, Plowden was clearly reaching out to delineate an era (the era of steam locomotion on the railways) that was quickly slipping away. In *The Hand of Man on America* he was protesting the idiotic waste and pollution which has accompanied what we still insist on calling "progress." His major book, *Bridges: The Spans of North America* reflects Plowden's fascination with bridges as one of man's major technical works and also his sensitivity to the idea of the bridge as symbol of man's striving. That book not only contains some of Plowden's finest large-format black and white photographs but also a detailed historical analysis of trends in American bridgebuilding which has earned it a respected place in technical libraries all over the country. Other books by Plowden are celebrations of certain aspects of American life which he finds particularly attractive. *Floor of the Sky*, for example, celebrates the Great Plains, while his recent book, *Commonplace*, celebrates the life and architecture of small town America.

David Plowden was born in Boston in 1932 and spent his growth years "knocking about the East Coast." He graduated from Yale with every intention of entering a career in business. Already drawn to trains, he took a job with the Great Northern Railway because, "I wanted to be a railroad mogul." By the mid 1950's, however, it was clear that neither the American railway system nor David Plowden was likely to make a great success in the near future. Plowden was drawn more and more to photography and writing.

In 1959 and 1960 he studied with Minor White in Rochester, New York. It was a good experience and important for his visual development, but Plowden found the atmosphere of "art for art's sake" that White engendered somewhat limiting. "I was always the maverick there," he recalls. By the early 1960's he was in New York doing assignments for *Fortune* and working closely with Walker Evans who was then on the staff of that magazine. In this far more congenial atmosphere, Plowden found his stride. *Farewell to Steam* appeared in 1966 and his work has appeared at regular intervals ever since.

Since 1978 he has taught in Chicago at the Institute of Design where he finds the combination of teaching and publishing books particularly satisfying.

—F. Jack Hurley

PORTER, Eliot (Furness).

American. Born in Winnetka, Illinois, 6 December 1901. Educated at New Trier High School, Kenilworth, Illinois, 1916-18; Morristown School, New Jersey, 1918-20; Harvard University, School of Engineering, Cambridge, Massachusetts, 1920-24; B.S. 1924; Harvard Medical School, 1924-29, M.D. 1929; self-taught in photography. Married Marian Brown in 1927 (divorced, 1934); children: Eliot and Charles; married Aline Kilham in 1936; children: Jonathan and Patrick. Instructor in Biochemistry and Bacteriology, Harvard University and Radcliffe College, Cambridge, 1929-39. Took first photos, Great Spruce Head Island, Maine, 1913; began serious work as a photographer, 1930; took first bird photographs, 1937; and has concentrated on photography as a career since 1939: freelance photographer, Cambridge, 1939-42; war work on radar development, Radiation Laboratory, Massachusetts Institute of Technology, Cambridge, 1942-44; freelance landscape and wildlife photographer, Winnetka, 1944-46, and in Santa Fe, New Mexico, since 1946. Member, Board of Directors, Sierra Club, San Francisco, 1962-68. Recipient: Guggenheim Fellowship, 1941, 1946; Silver Plaque: Wildlife Photography Award, *Country Life International Exhibition*, London, 1950; Conservation Award, United States Department of the Interior, 1967; Maine Commission on Arts and Humanities Award, 1968; Distinguished Son of Maine Award, 1969; Newhouse Citation, Syracuse University, New York, 1973. D.F.A.: Colby College, Waterville, Maine, 1969; LL.D.: University of Albuquerque, New Mexico, 1974; D.Sc.: Dickinson College, Pennsylvania, 1979. Associate Fellow, Morse College, Yale University, New Haven, Connecticut, 1967. Fellow, American Academy of Arts and Sciences, 1971. Agent: Daniel Wolf Gallery, 30 West 57th Street, New York, New York 10019. Address: Route 4, Box 33, Santa Fe, New Mexico 87501, U.S.A.

Individual Exhibitions:

1936 Delphic Studios, New York
1939 An American Place, New York
Georgia Lingafelt Bookshop, Chicago
1940 Museum of Art, Santa Fe, New Mexico
1942 Katherine Kuh Gallery, Chicago
Bronx Zoological Society, New York
1943 *Birds in Color*, Museum of Modern Art, New York
Academy of Natural Sciences, Chicago
1952 Museum of Modern Art, New York
1953 Art Institute of Chicago
1955 Limelight Gallery, New York
1957 *Madonnas and Marketplaces*, Limelight Gallery, New York (with Ellen Auerbach)
1958 Fine Arts Museum of New Mexico, Santa Fe (with Laura Gilpin)
1959 Nelson Gallery, Kansas City, Missouri
1960 *Seasons*, International Museum of Photography, George Eastman House, Rochester, New York (retrospective)
San Francisco Museum of Modern Art
Baltimore Museum of Art
Museum of Science, Boston
Smithsonian Institution, Washington, D.C.
1962 De Cordova Museum, Lincoln, Massachusetts
Fine Arts Museum of New Mexico, Santa Fe (with Laura Gilpin and Todd Webb)
1963 Art Institute of Chicago
1970 Museum of Fine Arts, St. Petersburg, Florida
1971 Princeton University, New Jersey
1973 Amon Carter Museum, Fort Worth, Texas
University of New Mexico, Albuquerque (retrospective)
1974 Roswell Museum and Art Center, New Mexico
Witte Memorial Museum, San Antonio, Texas

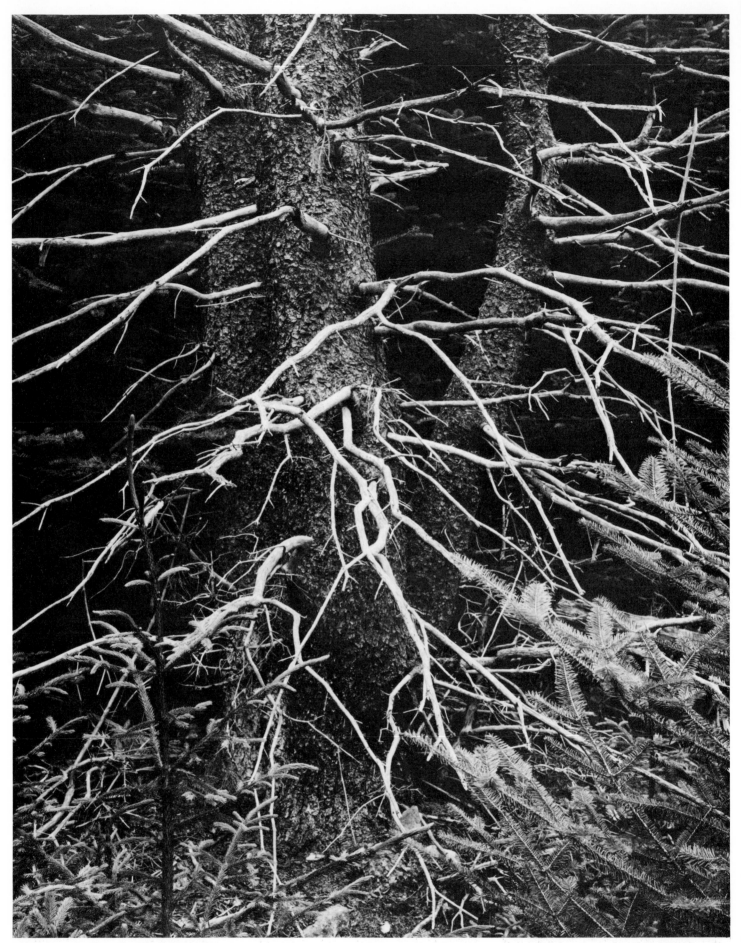

Eliot Porter: *Great Spruce Head Island, Maine,* **1965**

1975 Pensacola Center, Florida
1977 *Eliot Porter/Laura Eilpin/William Clift*, Horwitch Gallery, Santa Fe, New Mexico Smithsonian Institution, Washington, D.C. (with Daniel Lang)
1979 *Intimate Landscapes*, Metropolitan Museum of Art, New York
1981 *Ansel Adams/Eliot Porter/William Clift*, Cronin Gallery, Houston

Selected Group Exhibitions:

1940 *International Salon of Photography*, American Museum of Natural History, New York
1941 *Image of Freedom*, Museum of Modern Art, New York
1950 *Country Life International Exhibition*, London
1966 *American Photography: The 60's*, University of Nebraska, Lincoln
1967 *Photography U.S.A.*, De Cordova Museum, Lincoln, Massachusetts
1976 *Aspects of American Photography*, University of Missouri, St. Louis
1977 *The Great West: Real/Ideal*, University of Colorado, Boulder (subsequently Smithsonian Institution travelling exhibition; toured the United States)
Photographs: Sheldon Memorial Art Gallery Collection, University of Nebraska, Lincoln
1978 *Mirrors and Windows: American Photography since 1960*, Museum of Modern Art, New York (toured the United States, 1978-80)

Collections:

Museum of Modern Art, New York; Metropolitan Museum of Art, New York; International Museum of Photography, George Eastman House, Rochester, New York; Library of Congress, Washington, D.C.; Art Institute of Chicago; University of Nebraska, Lincoln; University of New Mexico, Albuquerque; Santa Fe Museum of Art, New Mexico; Center for Creative Photography, University of Arizona, Tucson.

Publications:

By PORTER: books—*American Birds*, with text by Amedon and Murphy, New York 1953; *In Wilderness Is the Preservation of the World*, with text by Henry David Thoreau, and an introduction by Joseph Wood Krutch, San Francisco 1962; *The Place No One Knew: Glen Canyon on the Colorado*, edited by David Bower, San Francisco 1963; *Summer Island: Penobscot Country*, edited by David Brower, San Fransisco 1966; *Forever Wild: The Adirondacks*, with text by William Chapman White, New York 1966; *Baja California: The Geography of Hope*, with text by Joseph Wood Krutch, San Francisco 1967; *Galapagos: The Flow of Wildness*, 2 volumes, with text by Kenneth Brower and Porter, San Francisco 1968; *Down the Colorado: Diary of the First Trip Through the Grand Canyon, 1869*, with text by John Wesley Powell, New York 1969; *Appalachian Wilderness: The Great Smoky Mountains*, with text by Edward Abbey and Harry M. Caudill, New York 1970; *The Tree Where Man Was Born: An African Experience*, with text by Peter Matthiessen, New York 1972; *Birds of North America: A Personal Selection*, New York 1972; *Portraits from Nature*, portfolio, with an introduction by Beaumont Newhall, New York 1973; *Moments of Discovery: Adventures with American Birds*, with text by Michael Harwood, New York 1977; *Antarctica*, New York and London 1978; *Seal Song*, with

text by Brian Davies, New York and London 1979; *The Greek World*, with text by Peter Levi, New York 1980; article—"Eliot Porter," interview, in *Dialogue with Photography*, edited by Paul Hill and Thomas Cooper, London 1979.

On PORTER: books—*Photography in America*, edited by Robert Doty, with an introduction by Minor White, New York 1974; *The Magic Image: The Genius of Photography from 1839 to the Present Day* by Cecil Beaton and Gail Buckland, Boston and London 1975; *The Great West: Real/Ideal*, edited by Sandy Hume, Gary Metz and others, Boulder, Colorado 1977; *Photographs: Sheldon Memorial Art Gallery Collecton, University of Nebraska*, exhibition catalogue, with an introduction by Norman A. Geske, Lincoln, Nebraska 1977; *Mirrors and Windows: American Photography since 1960* by John Szarkowski, New York 1978; *The Collection of Alfred Stieglitz* by Weston J. Naef, New York 1978; *The Photograph Collector's Guide* by Lee D. Witkin and Barbara London, Boston 1979; *Eliot Porter: Intimate Landscapes*, exhibition catalogue, with text by Weston Naef, New York 1979; articles—"A Collection of Photographs" in *Aperture* (Millerton, New York), Fall 1969; "Eliot Porter" in *Modern Photography Annual*, New York 1972; "Eliot Porter Retrospective" by R. Mautner in *Artweek* (Oakland, California), 25 May 1974; "Living Masters of Photography: Beaton, Karsh, Porter, Duncan" in *Camera* (Lucerne), June 1974.

When color film became available in the 1940's, it was not highly regarded by those photographers who practiced photography as an art. They disparaged color photography as too literal a medium for personal interpretation, which only black-and-white photography permitted. In color photography one was simply copying nature, whereas in black-and-white the hews of the subject could be rendered in almost any desired tone of gray, thus allowing a wide range of interpretation.

As my color photography shifted from the portrayal of birds for proper identification to other nature subjects, I began to realize that their appeal depended very largely on the subtleties of color lost when the subject was rendered in black-and-white; and when I began to make color prints it became apparent that almost infinite possibilities, contrary to the assertions of the disparagers of color, were available for interpretation and individual expression. Why, I wondered, was the remarkable attribute of color vision, not shared by all vertebrates, treated with such disdain by photographers, alone in all the fields of art? Perhaps it is because they feel least secure in their chosen medium and are, by raising restrictive barriers, immuring themselves against invidious comparisons.

Color photography has today become much more generally accepted as a legitimate art, but it has not yet entirely freed itself from an inferiority complex as the self-conscious and self-justifying workshops in color photography indicate. Color perception, color appreciation, color theory, color dynamics, color as medium, color in the natural scene, are taught as though color in photography were a different phenomenon from color in painting.

To say that because a photograph is in color it is less creative than one in black-and-white is to manifest a poverty of perception no less egregious than to condemn photography as a whole because it is the product of an optical instrument. I suspect that if color photography had been invented before black-and-white, the situation would be reversed.

—Eliot Porter

At a time in American history when the very government agencies charged with the well-being of the country's mountains and forests seem almost inimical to them, the photographs of Eliot Porter seem increasingly valuable. Not for their worth to

investor/collectors, but for their timeless and enduring sympathy for the landscape and myriad organisms and creatures not only possible but also worthwhile.

In a society increasingly technical, impersonal and divorced from the realities of working one-to-one with nature to survive each day, Eliot Porter works to keep alive, to share and to kindle in others his own respect and love for the natural world. He knows that man and his surroundings are interdependent, that if man subjugates and steals indiscriminately from nature, he will die along with his victim. From this knowledge and from a love of the positive beauties of the natural world comes the strength of Eliot Porter's photography.

Porter's strength as a photographer of birds and the landscape derives at least in part from his wholeness as a photographer. His physician's skills (he was a doctor before becoming a full-time photographer at age 37) of patience and thoroughness have been put to good work in waiting out the precise moment in the actions of a bird, the exact nuance of light or bloom or foliage in the making of a landscape photograph.

He taught himself mastery of die-transfer color printing—currently one of the most stable methods of making color images—and for many years made his own prints by this demanding process. Although best known for his work in color, Porter also works powerfully in black-and-white. His book *Summer Island*, a loving biography of a Maine island where he summered as a child, is chiefly photographed in black-and white, the color exploding like a delicate display of fireworks late in the book, adding its own unique statement to what had gone before.

To his love for and mastery of his medium, both color and black-and-white, Porter adds his lifelong love of and familiarity with nature and wild things. This blend of craft, concern and love has produced a life-work that assures Porter a high place among the outstanding nature photographers of the century.

A Porter photograph of a landscape (or detail of one) is, first of all, a contemplation. Typically, it is quiet. But it is the quiet of one who has shrugged off his backpack at trailside to rest a moment. The resulting quiet is not an exhausted but a studious one. The observer, we feel as we ourselves study the image, had looked hard at all within his field of view. He has seen the subtle shadings of different greens in trees and moss and grasses. He has noticed every ripple and reflection nuance on the surface of the quiet pool of water, the position of each leaf that floats on its surface.

And from this raw material he has extracted something that is at once universal and yet highly personal. By the use of his tool the view camera (in most, although not all cases), its lens and shutter, he has controlled his medium to express the mood of flowing water, the saturation of color reflected from leaves, the tone of the sky and other subtleties. He has adroitly edited nature to make it speak even more eloquently. The camera is more perceptive of detail even than the eye. Through the photographer's response to the scene and his capturing of it by the way he uses his medium, the viewer is almost literally given more than meets the eye.

For the most part, what is lacking in a Porter nature photograph is the obviously spectacular. Rather, what sustains and informs is a sense of revelation—the unveiling of what would otherwise perhaps go unseen, or at least unrealized.

In the photography of nature, subject matter that is the very essence of reality, Eliot Porter is able to exercise a vision and an artistry that make his photographs the mark at which his contemporaries must continually aim.

—Kenneth Poli

See Color Plates

POST WOLCOTT, Marion.

American. Born Marion Post in Montclair, New Jersey, 7 June 1910. Educated at the Edgewood School, Greenwich, Connecticut, 1925-27; New School for Social Research, New York, 1928-29; New York University, 1929-30; University of Vienna, 1930-32, B.A. 1932; also studied at informal photo workshops, under Ralph Steiner, New York, 1935, 1936. Married Leon O. Wolcott in 1941; children: John and Gail (stepchildren), Linda, and Michael. Freelance photographer, working for *Life, Fortune*, etc., New York, 1936-37; Staff Photographer, *Philadelphia Evening Bulletin*, 1937-38; Principal Photographer, Farm Security Administration (FSA), under Roy E. Stryker, Washington, D.C. and through the U.S.A., 1938-41; gradually relinquished photography to bring up family, San Francisco, 1942-74. Freelance photographer, San Francisco, since 1974. Agents: Witkin Gallery, 41 East 57th Street, New York, New York 10022; Focus Gallery, 2146 Union Street, San Francisco, California 94123; and Simon Lowinsky Gallery, 228 Grant Avenue, San Francisco, California 94108. Address: 2265 Broadway, San Francisco, California 94115, U.S.A.

Individual Exhibitions:

1976 *FSA and Contemporary Color Work*, Hartnell Gallery, Salinas, California
1976 *FSA Work of Russell Lee, Marion Post Wolcott and Walker Evans*, Copenhagen
1977 *Contemporary Color, Isla Vista*, Santa Barbara Museum of Art, California
1978 *FSA Photographs*, Berkeley Museum of Art, California
 FSA and New Color Work, Everson Museum of Art, Syracuse, New York (retrospective)
1979 *Contemporary Color and Black and White Photographs*, Focus Gallery, San Francisco
 FSA and Contemporary Photographs, Witkin Gallery, New York
 FSA and Contemporary Color Work, Equivalents Gallery, Seattle
 FSA and Contemporary Photos, Amarillo Art Center, Texas (with Russell Lee)
1980 *American Photography and Social Conscience*, Axiom Gallery, Richmond, Victoria, Australia (with Lewis Hine and Weegee)

Images of America: Photography from the FSA, Sonoma State University Art Gallery, California

Selected Group Exhibitions:

1955 *FSA Anniversary Show*, Brooklyn Museum, New York
1962 *The Bitter Years, FSA Photographs 1935-41*, Museum of Modern Art, New York
1968 *Just Before the War*, Newport Harbor Art Museum, California
1977 *A Vision Shared: The FSA*, Witkin Gallery, New York
 Women Look at Women, Library of Congress, Washington, D.C. (toured the United States)
 The FSA: People and Places of America, Santa Barbara Museum of Art, California
1979 *Images de l'Amerique en Crise: Photos de la FSA*, Centre Georges Pompidou, Paris
1980 *Annual Exhibition*, Friends of Photography, Carmel, California

Collections:

Metropolitan Museum of Art, New York; Museum of Modern Art, New York; International Center of Photography, New York; International Museum of Photography, George Eastman House, Rochester, New York; Library of Congress, Washington, D.C.; Smithsonian Institution, Washington, D.C.; Art Institute of Chicago; San Francisco Museum of Modern Art; National Gallery of Canada, Ottawa; National Gallery of Victoria, Melbourne.

Publications:

By POST WOLCOTT: books—*Washington*, with text by Edwin Rosskam, New York 1939; *Hometown*, with text by Sherwood Anderson, New York 1940; *Vermont: The Green Mountain State*, Burlington, Vermont 1941; *12 Million Black Voices: A Folk History of the Negro in the United States*, with text by Richard Wright and Edwin Rosskam, New York 1941; *Fair Is Our Land*, edited by Samuel Chamberlain, New York 1942.

On POST WOLCOTT: books—*The Bitter Years 1935-41* by Edward Steichen, New York 1962; *The History of Photography* by Beaumont Newhall, New York 1964; *Just Before the War: Urban America as Seen by the Photographers of the FSA*, edited by Thomas H. Garver, New York 1968; *Portrait of a Decade: Roy Stryker and the Development of Documentary Photography in the Thirties* by F. Jack Hurley, Baton Rouge, Louisiana 1972, New York 1977; *In This Proud Land* by Roy E. Stryker and Nancy Wood, Greenwich, Connecticut 1973; *The Years of Bitterness and Pride: FSA Photographs 1935-43*, compiled by Jerry Kearns and Leroy Bellamy, text by Hiak Akmajian, New York 1975; *A Vision Shared: A Classic Portrait of America and Its People 1935-43*, edited by Hank O'Neal, New York and London 1976; *Amerika Fotografie 1920-1940* by Erika Billeter, Berne 1979; *The Photograph Collector's Guide* by Lee D. Witkin and Barbara London, Boston and London 1979; articles—"Photographs of the Depression Era" by Robert Doherty in *Camera* (Lucerne), October 1962; "Marion Post Wolcott: FSA Photographs" by James Elliot and Marta Westover in *University Art Museum Bulletin* (Berkeley, California), April 1978; "Marion Post Wolcott's Spectrum of the Depression" by Hal Fischer in *Artweek* (Oakland, California), 27 May 1978; "From the FSA to Today" by Martha Chahroudi in *Afterimage* (Rochester, New York), November 1978; "Not a Vintage Show—Post Wolcott" by Ben Lifson in the *Village Voice* (New York), July 1979; "Marion Post Wolcott" by Joan Murray in *American Photographer* (New York), March 1980; "Photojournalism as Art" by Tony Perry in *The Age* (Melbourne), August 1980.

As an FSA documentary photographer I was committed to change the attitudes of people by familiarizing them with the plight of the underprivileged, especially in rural America. I wanted to show the extent of the gap between the wealthy and the poor; and, despite their marginal and destitute existence, to depict their dignity and courage. To create a general awakening and concern for their appalling conditions, I tried to contrast them with the wealthy and with the complacent tourists in Florida and with the fertility and abundant resources and beauty of our land. These, with the photographs of the positive side of the FSA remedial programs of our government, helped in placing exhibits and winning support for further appropriations from Congress. By informing the American public, the FSA photographs shocked and aroused public opinion to back New Deal policies and projects. They played a part in the social revolution of the 30's. Also, as an ongoing project, whenever possible, I documented, from an historical and sociological viewpoint, small town and rural life in America, especially winter in New England.

 Since my final months with the FSA, when I and several others did a little color photography, I've had a long-standing interest in color.

 In the early 1970's, following the Vietnam War and the students' burning of the Bank of America and other protests in Isla Vista, California, there was a period of intense re-evaluation—especially by youth—of predominant socio-political values. I tried to capture the essence of this new spirit and of changing life-styles, as well as their impact on cultural patterns and mores. I photographed, mostly in color, evidence expressed in their folk art, wall paintings and graffiti, banners, political signs, street fairs, ecology movements and recycling programs and efforts, free medical clinics and health care, etc.

 This led to other photography of the California scene, and of some tourists in Hawaii—essentially still documentary in feeling and intent.

 I welcome the "new frontier," the new wider vision, the experimentation in contemporary photography, so long as it has integrity and is artistically honest.

 —Marion Post Wolcott

Marion Post Wolcott: *Log Cabin, Rural Kentucky*, 1940

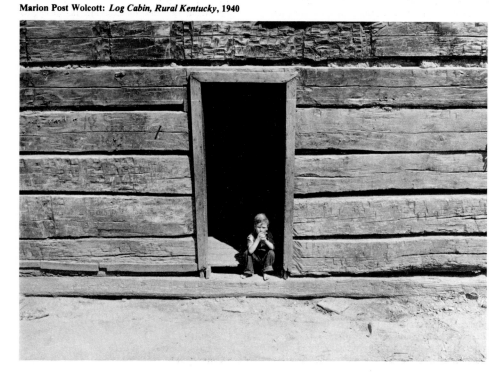

Although she has recently begun taking and exhibiting photographs again, Marion Post Wolcott's place in the medium's history rests securely upon the few years she spent in Roy Stryker's Farm Security Administration photography unit. When that project ended, Mrs. Wolcott left photography, having chosen to devote more time to raising her family. Yet, in a mere half-decade, first at the Philadelphia *Evening Bulletin* and after 1938 with the FSA, Marion Post Wolcott created a remarkable and diverse body of work, including some of the most powerful images in the vast FSA collection.

"The fact that I was a late-comer to the FSA photo documentary group," she wrote some years ago, "influenced much the selection of material, the areas, and the assignments given me by Roy (Stryker).... I picked up loose ends, filled in holes in areas closer to home base—an example being a series of pictures of mine on New England winter and very early spring, or of a remote back country area in Kentucky: going to school; burying their dead; delivering mail; bringing groceries up the creek bed, barefoot or on horseback; how people spent their leisure, their recreation and games."

As with many catalogs, the detail obscures the accomplishments. In the course of picking up "loose ends," Mrs. Wolcott created beautiful landscapes, particularly in New England and along northern Virginia's Shenandoah Valley. She retraced some of the coal mining regions photographed very early in the project by Ben Shahn, thus providing valuable comparative material. Perhaps most important, she provided an exceedingly rare glimpse of America's upper-middle and wealthy classes at play during the late Depression years.

The FSA file is, apart from Mrs. Wolcott's photographs, silent about those at the upper end of the income scale. She was very much aware of the lacuna: "There was virtually nothing in the files on...the elite, on the east or west coasts, or elsewhere. I thought these (pictures) could provide dramatic contrast, help tell our story."

Having been sent, in 1939, to document the life of migrant farm workers in Florida's Lake Okeechobee region, she also spent time in Miami and other areas, photographing wealthy hotel guests, visitors to the Hialeah Racetrack and others in that group for whom the Great Depression was merely an inconvenience. The Miami pictures are among Mrs. Wolcott's best. A particular favorite of mine is a Miami Beach photograph of a tropical-suited, panama-hatted gentleman exiting one of those Rococo Revival facades through a multi-storied arch. Another preserves the blasé expression of a wealthy Miami Beach couple showing off their private bar.

I do not mean to imply that these photographs were intended as satire. They scrupulously document what exists; the existence satirizes itself. The photographs were, therefore, a perfectly reasonable addition to the FSA files; it is simply unfortunate that they stand there so much apart. Unfortunate, too, as an indication of what photography lost during Marion Post Wolcott's long sabbatical from the profession.

—Stu Cohen

PRAZUCH, Wieslaw.

Polish. Born in 1925. Studied at the Academy of Political Sciences, Warsaw. Photojournalist for *Swiat* weekly, Warsaw, 1952-69; President, Union of Polish Art Photographers, 1973-76. Since 1976,

Chief Editor, *Fotografia* quarterly, Warsaw. Address: c/o Fotografia, Sniadec Kich 10, 00656 Warsaw, Poland.

Selected Group Exhibitions:

1975 *The Land: 20th Century Landscape Photographs Selected by Bill Brandt*, Victoria and Albert Museum, London (travelled to the National Gallery, Edinburgh; Ulster Museum, Belfast; and National Museum of Wales, Cardiff, 1976)

1979 *Fotografia Polska 1839-1979*, International Center of Photography, New York (travelled to the Museum of Contemporary Art, Chicago; Zacheta Gallery, Warsaw; Museum of Fine Arts, Lodz, Poland; and the Whitechapel Gallery, London, 1979-80)

Publications:

On PRAZUCH: books—*Fotografia Warsawska* by

Waclaw Zdzarski, Warsaw, 1974; *The Land: 20th Century Landscape Photographs Selected by Bill Brandt*, exhibition catalogue, by Mark Haworth-Booth, London 1975: article—"Wieslaw Prazuch" by Juliusz Garztecki in *Fotografia* (Warsaw), no. 4, 1968.

The first years after the Second World War brought to Poland a gradual return to normal, accompanied by great social changes and the gradual reconstruction of the country. Of all the various artistic media, this process found its fullest expression in camera-reportage. In 1951 the first issue of a new illustrated weekly periodical entitled *Swiat* (*World*) was published. It very quickly developed its own characteristic style in the presentation of human interest features. The style—not so much sensational as reflective, often lyrical—showed a true picture of the people, their everyday life, their worries and their hopes. One of the *Swiat* photographers was Wieslaw Prazuch.

Prazuch worked for *Swiat* throughout its existence, and his photographs excellently represent the characteristic style of the periodical. However, this

Wieslaw Prazuch: *United Polish Workers' Party Congress*, 1959

kind of photo-reportage was initiated in Poland not by Prazuch but by his editorial colleague, Wieslaw Slawny. The photographs of Slawny created a definitive new style in Polish photography, and the essence of this style is easily apparent if one compares Slawny's photographs with those of Polish photographers of the preceding, inter-war generation, which were commercial, smooth, elegant, picturing an affluent society (balls, hunts, social events) and essentially addressed only to that society. Nothing—or almost nothing—of that theme found its way into Slawny's photographs, for the simple reason that the country was in ruins, the people were poor, and the socio-political situation was now radically different. Slawny returned to Poland from Paris where he had witnessed the birth of Magnum and had learned first-hand from such illustrated weekly periodicals as *Paris-Match* and *Life* and from the photography of Henri Cartier-Bresson. The new ideas—and the new photographic equipment that Slawny brought with him—caught the imagination of his younger co-workers at *Swiat*, including Prazuch.

A vital role was played in this new Polish photography by the reality of the country's situation. The post-war years in Poland were a period of mass migration of the population, rapid industrialization, and reconstruction. Photographic themes were literally everywhere at hand—on the streets of Warsaw, on large building sites, at political meetings, even deep within the country in the changes in provincial life. But this new photography was not merely a straight-forward record, an ordinary communication of events or activities, but photography with an explicit ethical stance, rich in emotional and often poetic content. It realized the ideas of Edward Steichen, that the "mission of photography is to help a man in understanding other men and also in understanding himself."

The photographic output of the *Swiat* photojournalists created a great and unique document of an epoch, a record of the post-war history of Poland, her people, traditions and culture.

—Ryszard Bobrowski

PRIMOLI, Count Giuseppe.

Born in 1851. Educated in Paris, 1860-68 (lived in Paris until 1870); self-taught in photography. First photographs, with brother Luigi Primoli, 1880; thereafter freelance landscape and portrait photographer, associating with Theophile Gautier, Alexandre Dumas and Guy de Maupassant in France, and Duse, D'Annunzio and Serao in Italy. Estate: Fondazione Primoli, v. Zananobelli 1, Rome. *Died* (in Rome) *in 1927.*

Individual Exhibitions:

1979 *Venezia '79*

Selected Group Exhibitions:

1977 *Documenta 6*, Kassel, West Germany
1979 *Photographie als Kunst 1879-1979*, Tiroler Landesmuseum Ferdinandeum, Innsbruck, Austria (travelled to the Neue Galerie am Wolfgang Gurlitt Museum, Linz, Austria; Neue Galerie am Landesmuseum Joanneum, Graz, Austria; and Museum des 20. Jahrhunderts, Vienna)

Collections:

Fondazione Primoli, Rome; Museo Napoleonico, Rome.

Publications:

On PRIMOLI: books—*Gegé e Lulu Primoli Fotografi di Roma, Strenna dei Romanisti: Natale di Roma 1856* by S. Negro, Rome 1956; *Pages Inédites Recueillies: Présentées et Annotées par Marcello Spaziani* by J.-N. Primoli, Rome 1959; *Con Gegé Primoli nella Roma Byzantia*, letters, by AA. VV., Rome 1962; *Un Fotografo Fin de Siècle: Il Conte Primoli* by Lamberto Vitali, Turin 1968; *Documenta 6: Band 2*, exhibition catalogue, by Klaus Honnef and Evelyn Weiss, Cologne 1977; *Photographie als Kunst 1879-1979; Kunst als Photographie 1949-1979*, exhibition catalogue, 2 vols., by Peter Weiermair, Innsbruck, Austria 1979; *Il Conte Giuseppe Primoli* by Daniela Palazzoli, Milan 1979; articles—"Die Welt des Grafen Primoli" by Lamberto Vitali in *Du* (Zurich), December 1970; "Count Primoli" by Daniela Palazzoli in *Venezia '79: La Photografia*, exhibition catalogue, by Daniela Palazzoli, Vittorio Sgarbi and Italo Zannier, Milan and New York 1979.

Count Giuseppe Primoli was a precursor of modern photojournalism at the turn of the century, both in the field of the snapshot and in that of the picture story. The availability of industrially-prepared plates and relatively small cameras encouraged him and his brother Luigi to take up photography as amateurs. A noble *flâneur*, accepted in the most fashionable salons thanks to his direct descent from Napoleon, a friend of writers and artists like Théophile Gautier, Guy de Maupassant, Dumas *fils*, Daudet, Verga, D'Annunzio and Degas—into these exclusive circles he introduced his camera. An acute observer, objective and quick, he liked to capture the likeness of some of the most notable persons of his time when they were not expecting it, catching them unawares in spontaneous and often revealing attitudes. The painter Degas, elegantly dressed, coming out of a *pissoir*; the writer Maupassant rowing a boat during an outing with Colette Dumas; King Umberto greeting acquaintances at the races; Pope Pius IX caught leaning wearily on his walking-stick during a stroll—these are the kind of pictures that reveal his talent as a "snapshot" artist, his work the forerunner of the "candid camera." He recorded historic events and fashionable occasions of his time for a decade or more—between about 1885 and 1900—with an enthusiasm that led him to acquire more than 10,000 plates, which are now preserved in the Primoli Foundation in Rome, where they are kept together with photographs by his brother Luigi, who was also a keen amateur photographer for a time. The collection contains records of such events as the visit of Kaiser Wilhelm II of Germany to Rome: the Kaiser strutting impressively while King Umberto—popularly nicknamed the "little king" on account of his short stature—regards him with pride, inevitably looking up to him. There too is the wedding of Princess Elena of Montenegro and Victor Emanuel of Naples: bride and bridegroom splendidly dressed and surrounded by the nobility and the clergy, while guests and onlookers press in on all sides. In his scenes of foxhunting, his military pictures and the pictures he took at racecourses, he enjoyed depicting the finest racehorses, hunters and hounds, but he was also always ready to take a snap of, say, a group of ladies, their elegant silhouettes crowned by trim bonnets—little scenes, always marvellously well composed. The immediacy of the expressions of people taken unawares is backed by the most carefully planned composition: doors, hedges, hurdles, rails are arranged to make a frame for the figures.

Sometimes the Count liked to take posed portraits or to construct scenes of historical subjects such as were made in Victorian England. Members of the nobility, or actresses like Eleonora Duse and Sarah Bernhardt, are presented with great psychological skill—Duse modest, reflective, simply dressed; Bernhardt, the *femme fatale*, languidly wrapped in a fox-fur stole. Primoli also had an active social conscience which came to the fore in his street scenes. Rome, with its glaring contrasts, is one of his favorite subjects, but other cities too—Milan, Florence, Venice—are portrayed from original, revealing viewpoints. The celebrated monuments are made a background for beggars, hawkers, poor women with babies in their arms, even peasants squatting among the archaeological ruins.

A special feature of his collection is the *cartoni*—318 of them altogether. In them the Count put together photographs connected with some particular event or a particular theme—about 15 or 20 for each. There are dedicated for example to children: rich, smart, overdressed children contrasted with poor kids snapped in the street. Or to cities: Rome, once again, presenting the dramatic contrasts between the world of the aristocracy and that of the streets. Others deal with special events, like the visit of Buffalo Bill's Circus to Rome in March 1890 and its performances in the Roman countryside. The Count presents the different aspects of the event one after another—Buffalo Bill and Annie Oakley doing their turns, the Red Indians in support, but also the public crowding in to see—without glossing over the least detail (even the sale of tickets and the price of them advertised on a poster). For this occasion the Count himself pitched his tent nearby with a whole battery of cameras, which he got his servants to keep reloading and passing to him so that he could take the interesting scenes without interruption. In the same way he photographed the May Day demonstration, Labor Day, in 1891, depicting dramatically not only the platform with the speakers and banners and the crowds, but also the foot soldiers and cavalry hemming in the demonstrators. This is real photo-history, obtained not merely by recording the different phases of an event in their order but also by observing them from different points of view, including that of the public, which for the first time is itself seen as one of the protagonists.

—Daniela Palazzoli

PRINCE Doug(las Donald).

American. Born in Des Moines, Iowa, 2 January 1943. Educated at Johnston Consolidated High School, Johnston Station, Iowa, 1948-61; studied fine arts, 1961-65, and photography, under John Schulze and Ralph Koppel, 1966-68, University of Iowa, Iowa City, B.A. 1965, M.A. 1968. Married Rebecca S. New in 1977; children: Brice, Brian (from former marriage) and Case. Assistant Art Instructor, University of Iowa, Iowa City 1966-68; Assistant Professor of Art, University of Florida, Gainesville, 1968-76; Assistant Professor of Photography, Rhode Island School of Design, Providence, 1976-79. Freelance photographer since 1979. Lived and worked in Italy, 1980-81. Recipient: Prix de la Ville d'Avignon, France, 1972; National Endowment for the Arts Photography Fellowship, 1977, 1979. Agent: Witkin Gallery, 41 East 57th Street, New York, New York 10022. Address: 173 Cypress Street, Providence, Rhode Island 02906, U.S.A.

Individual Exhibitions:

1967 Des Moines Art Center, Iowa

Selected Group Exhibitions:

Collections:

Museum of Modern Art, New York; International Museum of Photography, George Eastman House, Rochester, New York; Rhode Island School of Design, Providence; Addison Gallery, Andover, Massachusetts; Worcester Art Museum, Massachusetts; Princeton Art Museum, New Jersey; Philadelphia Museum of Art; Exchange National Bank, Chicago; Museum of Fine Arts, St. Petersburg, Florida; University of New Mexico, Albuquerque.

Publications:

By PRINCE: book—*Photo Sculpture: Doug Prince*, New York 1979; article—"Portfolio: Doug Prince" in *Popular Photography Annual*, New York 1980.

On PRINCE: books—*Darkroom II*, edited by Jain Kelly, New York 1978; *Mirrors and Windows: American Photography since 1960* by John Szarkowski, New York 1978; *A Ten Year Salute* by Lee D. Witkin, New York 1979; *The Photograph Collector's Guide* by Lee D. Witkin and Barbara London, Boston 1979; articles—"Photography and Prints" by Peter C. Bunnell in *Art in America* (New York), September/October 1969; "Message into Medium" by Carol Stevens in *Print* (New York), May/June 1970; "Photography into Sculpture" by Peter C. Bunnell in *Artscanada* (Toronto), June 1970; "A Young Illusionist" by Gene Thornton in the *New York Times*, 14 September 1975; "From Fine Art to Plain Junk" by Gene Thornton in the *New York Times*, 14 November 1971; "Lights On and Chin Up" by A.D. Coleman in the *Village Voice* (New York), 18 November 1971; "Photography into Sculpture" in *Artweek* (Oakland, California), 18 December 1971; "Doug Prince, Light Gallery" by William Dyckes in *Artsmagazine* (New York), March 1973; "Shows We've Seen" by Harvey V. Fondiller in *Popular Photography* (New York), May 1980.

Photography is part of a continuous tradition of image-making in the arts. My work in photography has evolved to share concerns with three areas in this tradition: painting, printmaking and sculpture. In particular, I am attracted to the additive image-making characteristic in these disciplines, which allows the synthesis of elements at a conceptual as well as a process level. For me, this synthesis takes place in a manner closely related to dreams, where events and objects are re-ordered to offer new meanings and appreciations. It is this discovery of successful relationships which is my primary objective in both my black-and-white prints and photo sculptures.

—Doug Prince

Doug Prince belongs to a generation that has sought to expand the boundaries of the photographic medium through both conceptual and iconographic means. Inspired by 19th century ambrotypes, Victorian Easter eggs with peepholes, and miniature dioramas (all of which are small, hand-held objects which invite viewer participation), Prince began experimenting with 3-dimensional imagery while still in graduate school. He developed the idea of using photographic images on transparencies, placing one behind the other, and containing the images within the closed environment of a small plexiglas box. His further explorations into illusionistic fantasy continued at the University of Florida where he served as Assistant Professor of Photography. Additional influences can be traced to symbolist and surrealist painters, and to the photographer Jerry N. Uelsmann, a colleague at the University of Florida. A major group show, *Photography into Sculpture*, curated by Peter Bunnell, was mounted at the Museum of Modern Art in New York in 1970, and Prince's work in that show shared with others an exploitation of the technology of plastics and a concern with the photograph as a tactile object. His work was included in numerous other group shows in the early 70's focusing on transparent images, "Small Environments" or "Extraordinary Realities."

Prince's concern has been with examining the graphic qualities inherent in the materials as a means of translating light and space relationships into topographic images. He builds up new tonal relationships not possible with images printed on paper and viewed with refracted light. He has consistently explored the qualities of graphic arts film with its properties of high contrast and potential for

Doug Prince: *Brian, Snake and Mountain*, 1979

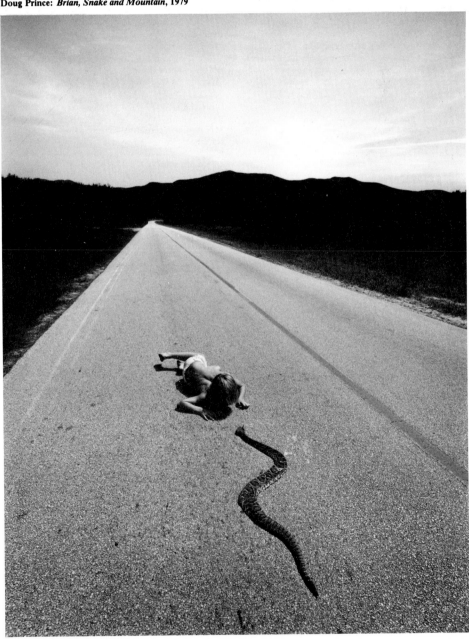

solarization of the image.

A number of diverse elements coalesce in Prince's work to make it dynamic and vital. The inherent veracity of the photographic image lends authenticity to the subject represented, and an intruiging tension results from the play between illusion and reality. The fusion and juxtaposition of diverse and unrelated images brings about a new illusionistic reality, creating Prince's own personal symbology. The fabrication of a photographic fantasy—in his words, "through the synthesis of unconnected images into new spatial and psychological relationships"—has been an on-going concern with him in both his photographic prints and in his boxes. His search for new personal symbols is both intuitive and empirical, and has become the crux of his image-making. Prince associates this "restructuring of reality" with dream imagery where "elements converge in new relationships to offer fresh insights and create personal symbols which further our understanding of ourselves and our environment." He works with restructuring the elements of light, time and space and explores the natural order of things (birth, death, evolution and entrophy). The content of his boxes "range from realistic environments, composed of objects in logical spaces, to the more problematic and surreal juxtaposition of elements akin to surrealistic imagery." His primary thematic concerns are the "sensory exploration of the environment by his two sons, the containment and vulnerability of domestic animals in the landscape, and evidence of humanity on the natural environment." Prince's union of structural and stylistic concerns, firmly entrenched in a photographic vision, make his work an important contribution to the language of photography.

—Jean Caslin

PROSEK, Josef.

Czechoslovak. Born in Mšeno, Czechoslovakia, 19 October 1923. Educated at public school in Prague, 1929-39; studied photography at the State Graphic School, Prague, 1945-49. Married Irena Wenigová in 1959; daughter: Magdalena. Editor, *Květy* magazine, Prague, 1950-55. Freelance photographer,

Prague, since 1956. Member, Mánes art group, Prague, 1948-53, and Radar art group, Prague, 1960-70. Member, Union of Czech Fine Artists, 1949. Address: Na dědince 13, CS-180 00 Prague 8, Czechoslovakia.

Individual Exhibitions:

1962 Václav Spála Gallery, Prague (retrospective)
1963 The House of Art, Brno, Czechoslovakia
1967 *Paris*, Gallery of Czech Writers, Prague

Selected Group Exhibitions:

1965 *Mánes Art Group*, Mánes Gallery, Prague
1961 *Artists Group "Radar"*, Gallery of Czech Writers, Prague
1964 *Artists Group "Radar"*, Mánes Gallery, Prague
1966 *Czechoslovak Photography*, Museum of Art, Belgrade
1969 *Cycles and Series*, Gallery of the City of Prague
1970 *100 Graphics and 100 Photos*, Museo Universitario, Mexico City
1973 *Lyrismo di Fotografia Cecoslovacci*, at SICOF, Milan (travelled to the Fotokabinett Jaromir Funke, Brno, Czechoslovakia, and the Städtische Museum, Freiburg, West Germany)
1977 *Members' Exhibition*, Mánes Gallery, Prague
1979 *Czechoslowakisches Photographie 1918-1978*, Fotoforum, Kassel, West Germany

Collections:

Museum of Decorative Arts, Prague; Bibliothèque Nationale, Paris.

Publications:

By PROSEK: books—illustrations for numerous Czech publications, including *Konrád: Na černé hodince*, Prague 1953; *The Work of M. Braun in Kuks*, Prague 1956; *Soujourn in Prague*, Prague 1958; *J. Wilgus: Sculptor*, Ostrava, Czechoslovakia 1965; *M. Braun: Sculptor*, Prague 1965; *Czechoslovakia*, Prague 1966; *Paris in Paris*, Prague 1967; *Akty a akty*, Bratislava 1967; *Kuks*, Prague 1970; *Radar: Anatomy of a Group*, Prague 1971; *South Bohemia*, Prague 1980; *Ceske Středohoří*, Prague 1980.

On PROSEK: books—*Josef Prošek* by Jan Rezáč, Prague 1962; *Czechoslovak Photography* by Karel Dvořák, Prague 1973; *Geschichte der Photographie im 20. Jahrhundert/History of Photography in the 20th Century* by Petr Tausk, Cologne 1977, London 1980; article—"Josef Prošek" by Petr Tausk in *Revue Fotografie* (Prague), no. 3, 1980.

I started my creative life in an avant-garde of all kinds of young artists. At that time we were fascinated by surrealism. Although my present stand, the result of successive evolution, is very far from that point of view, I have never forgotten that beginning. For similar reasons, I must confess, photography is for me a young, charming frivolous girl who is climbing Kilimanjaro.

—Josef Prošek

The mature work of Josef Prošek obviously developed from his original contacts with the artistic avant-garde of his youth. Surrealism, for example, caused him to esteem the poetic possibilities of the *objet trouvé*. The depiction of the surprising poetry discovered in the real world (without any intervention in arrangement from the photographer) was also consistent with the then current trend of coming "closer" to reality. And his use of lighting confirmed that approach: the play of beams and shadows was suppressed; his preference was for a diffuse light coming from above, which allowed the photographed subjects to be represented by themselves without deflecting the viewer's attention from their essential nature to any extraordinary inventive solutions devised by the photographer.

At the beginning of his career, Prošek also devoted much of his time to photographing sculptures. His sense for their forms and volumes seems to have created a kind of mental perspective that has informed his other pictures. Prosek is very adept at interpreting a simple chair in a park or a single house as if they, too, are statues. And in his later work this approach is amalgamated with the old (if slight) heritage of surrealism. An old car covered by an awning may be perceived as both a surrealist *objet trouvé* and as sculpture.

Prošek's work has always involved an effort to achieve, to come closer to, a sober depicting of reality, a quest that led him, finally, at the beginning of the 1970's, to colour photography. Given the nature of his interest, he does not as a rule strive for a likeable colour effect likely to please a wide audience; rather, Prošek sees in the enriching of an image by colour a more precise rendering of reality than was possible in a black-and-white image. The colour he allows himself is one that will enhance that direct contact with the world that has always been his goal as a photographer.

—Petr Tausk

Josef Prošek: *Courtyard in Prague*, 1966

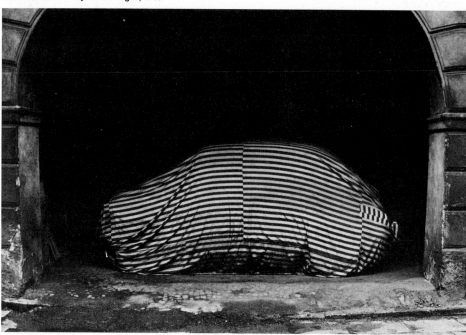

PURCELL, Rosamond Wolff.

American. Born Rosamond Wolff in Boston, Massachusetts, 28 June 1942. Educated at Buckingham High School, Cambridge, Massachusetts, 1953-60; Boston University, 1960-64, B.A. in French literature 1964; studied photography with Kipton Kumler,

Lexington, Massachusetts, 1973, and photo-darkroom technique with John Weiss, Arlington, Massachusetts, 1975. Married Dennis William Purcell in 1969; sons: Andrew and John Henry. Administrative assistant in a primary school, 1966; Instructor in French, Palfrey Street School, Watertown, Massachusetts, 1967-69. Freelance photographer, Medford, Massachusetts, since 1969. Agents: The Photographers' Gallery, 8 Great Newport, Street, London WC2, England; Marcuse Pfeifer Gallery, 825 Madison Avenue, New York, New York 10021. Address: 121 Allston Street, Medford, Massachusetts 02155, U.S.A.

Individual Exhibitions:

1972 Creative Photo Gallery, Massachusetts Institute of Technology, Cambridge
1973 Polaroid Gallery, Cambridge, Massachusetts
1974 Zone 4, Watertown, Massachusetts
1975 University of Iowa, Iowa City
 Enjay Gallery, Boston
1976 Madison Art Center, Wisconsin
 Archetype Gallery, New Haven, Connecticut
1977 Roswell Museum, New Mexico
 Galleria Il Diaframma, Milan
 The Photographers' Gallery, London
 Galerie Fiolet, Amsterdam
 Delaware Art Museum, Wilmington
1978 A Photography Place, Stafford, Pennsylvania
 Santa Fe Gallery of Photography, New Mexico
1979 Wah Lui Gallery, Seattle
 Images Gallery, New Orleans
 Archetype Gallery, New Haven, Connecticut
 After the Fact, Clarence Kennedy Gallery, Cambridge, Massachusetts
1980 Marcuse Pfeifer Gallery, New York
 Boston Atheneum
 The Billiard Room, Cambridge, Massachusetts

Selected Group Exhibitions:

1978 *Fantastic Photography in the U.S.A.*, Canon Photo Gallery, Amsterdam (toured Europe and the United States, 1978-80)
 One of a Kind: Polaroid Color, Corcoran Gallery, Washington, D.C. (toured the United States)

Collections:

Metropolitan Museum of Art, New York; Museum of Fine Arts, Boston; Polaroid Corporation, Cambridge, Massachusetts; Delaware Museum of Art, Wilmington; New Orleans Museum of Art; Madison Art Center, Wisconsin; University of Iowa, Iowa City; Victoria and Albert Museum, London.

Publications:

By PURCELL: books—*A Matter of Time*, with afterword by Dennis W. Purcell, Boston 1975; *Half-Life*, Boston 1980; articles—"Attracted by Structures and Transformations" in *Print Letter* (Zurich), July/August 1978; article in *Darkroom Dynamics*, edited by Jim Stone, Boston 1979.

On PURCELL: articles—"Rosamond Wolff Purcell" in *Popular Photography Annual*, edited by Jim Hughes, New York 1977; "Rosamond Wolff Purcell" in *Creative Camera Year Book*, edited by Colin Osman and Peter Turner, London 1978; "Rosamond Wolff Purcell" in *Popular Photography Annual*, edited by Jim Hughes, New York 1979; "Purcell's Haunting Visions" by Owen Edwards in *Saturday Review* (New York), November 1980.

One day a friend cut the edges off a Polaroid snapshot of converging boulders to show me that angles of rocks pointing inward was all that mattered; the rest should be thrown away. I had always thought that photography consisted of stepping off a tour bus to record the facade of the castle. I didn't know that recording a scene might require having an idea. I began to use a camera. At the time I was writing short stories. Friends were polite about the writing, but enthusiastic about the photographs. Now, aside from absorption with my family, I practice photography in one way or another almost every waking hour.

I do not keep track of what is being *said* about photographic styles, but I already know too much to work in a naive fashion. Although the technical training I received has proved invaluable to me, I am glad that I never spent much time in formal study of the medium. I would remember what had been said rather than how to see. Finding the thin edge again and again on one's own—that is what is hard to do. This is the only reason I can find for pursuing photography. I will learn what I can of various processes in order to continue.

Some of my photographs are one-of-a-kind Polaroid prints. Others are printed from Polaroid negatives or from 2¼ roll film. When using instant materials, I work from print to print rather than more sublimally with negatives which cannot be examined as the photographic event proceeds. My eyes and emotions select; the camera and prints tell me how much of an illusion will be possible. Although the images occasionally run ahead of consciously applied intelligence, the process is not mysterious. Each print presents itself as an established fact which I must accept, reject, or modify. The method does not allow for wishful thinking. When I go to the darkroom, I almost always know which proof print sent me, and what I want from it.

Probably because of my fondness for instant materials, I have never practiced a long-winded printing technique. I have not yet experimented with some of the time-honored methods (making one's own paper, emulsion, matching each image to its appropriate materials, large format contact printing, etc.). This has, upon a few occasions, seemed a handicap in more esoteric circles.

Prints meant to convey ideas should have a transparent quality. They should be free of technical flaws so as not to excite criticism, and they should support, rather than create, possible "meanings" for an image. Technique more loving than content never fails to impress me. It appeals directly. But the visual part of the photograph is just the beginning for me; its potential for creating various levels of meaning is far more significant.

In school I used flash cards to memorize Latin vocabulary. There were three categories of cards: words in which the English revealed itself in Latin; words which after mechanical perseverance could be memorized; and words which unfailingly came apart in my mind between one language and the other, like a piece of fraying rope—words which not only did not reveal their English equivalent, but which seemed to possess a range of seemingly unconnected meanings.

I have a photo of a woman lying in a shaft of light. A writer, having seen it on exhibit, wrote of "an unconscious astronaut hurtling through space." I offered it for exhibition because I liked the way the model had been forced into a narrow band of light but was not confined by it. The model, herself, said, "I look dead." I do not believe that interpretation has anything to do with my conscious intentions. Perhaps the photo is only the front of the flash card, its appearance standing for clusters of thoughts, which if written, would appear on the back.

At our house, among other treasures, we have a 10-foot long plaster mermaid, a year-old egg yolk which looks like amber glass, and a 60-year old piece of bread from a French prison. I often place fragments of paper or glass in available light in the hope that they will transcend recognizability and change into "something rich and strange." I am endlessly greedy for the sight of transformation of objects from one state to another. But I have rarely successfully recorded such a transformation directly.

My great-aunt wore a fox-headed stole and someone else has a hat made from a whole bird. In the zoological museum there is a hippopotamus with a pink plaster throat, a book eaten by worms. I look forward to seeing frescoes from Pompeii, and to buying fish for dinner just to see what might be in the ice-packed case...the mundane, the decadent, and the instructive presentations fascinate me equally. But the actual surfaces (with the possible exception of the wormy book) function only as allusions. Usually the memory of an atmosphere will contribute to

Rosamond Wolff Purcell

the photographs I actually take. I have had a great many visual experiences and made relatively few photographs.

I used to take bus trips to different parts of the United States. I travelled alone, to record conversations and to take Polaroid pictures (never of castles). West of Boston the country opens wide, and the hypnotic motion of the bus always released my thoughts from their usual tracks. I never remembered the route, perhaps because extraordinary sights occur regardless of geography and rarely in the same place twice. I have written many records, but the photographs occurred, for the most part, later, at home, inspired by the memory of being adrift.

I heard that a group of photographers crossed the U.S.A. on their own bus, stopping each time one of them "saw" a picture. I have often wondered how many photos came home and how many mirages.

There are as many clichés as there always were. In fact, there are *only* clichés. But photographers are travelling in herds these days, and the likelihood of throwing one's own light on commonly used subjects may seem harder, especially when it appears that the less effective version by the better-known artist receives all the acclaim. It may seem safer to decide to be strongly influenced by someone else's work. It may seem a good idea to subscribe to a popular way of seeing. I don't think so. I think today's school of thought is tomorrow's dead duck.

Periodically I come to believe in groups of my own photographs. They work together as clearly as trains of thought. At such moments I am tempted to refer to them as a "body of work," and the notion that I may be doing the "right thing" by photography produces euphoria that may last for days or even weeks.

But, in the end, it doesn't work. As soon as the dimensions of new work become clear to me, it does not seem important. Individual images recede. Exhibiting photographs has always seemed a rather dreamlike exercise to me—I feel both pride and sense of loss, because, of course, the work already seems vaguely suspect. Hopefully, by the time the photographs are on the wall, I will have managed to move along.

* * *

I wrote the above a few years ago, and some of the thoughts may now seem dated. The basic message is still, I suppose, that the equilibrium between knowing what has been (and is being done) and maintaining a private world is the best method I have devised for proceeding with my own work. I am working currently on *minding my own business*.
—Rosamond Wolff Purcell

Imagination is a word too loosely hung around artists' necks. To commend a photographer for his or her imagination is usually to say very little. Yet, "imagination," raw and infectious, is exactly what makes Rosamond Wolff Purcell's photographs stand out.

Purcell's photographs imagine a story more complicated than a single photograph can fully explain. Her new book *Half-Life* contains images that intimate bizarre family relationships, or a conspiracy of stuffed animals. The photographs imagine the worlds beyond the one we can directly touch. They imagine death and they explore life that has preceded our own.

The most interesting quality of Purcell's work is the way it proposes illogical or impossible scenarios without lapsing into the surreal. Her photographs gather elements from life which, in combination, speak directly about that life. The interest is not to create wild juxtapositions or to unravel the unconscious, but instead to allow artifacts to comment on the real world.

Purcell's best photographs are a recent untitled portfolio of color prints that utilize manipulated antique portraits. The composite pictures unveil hidden passions and suggest man's primitive nature. Purcell combines the stark and rigid expressions of 19th century portraits with pictures of stuffed animals, other portraits, or with hazy colors. In "Fuegia" and "The Climber" (from the book *Half-Life*), pictures of monkeys combine with portraits of 19th century ladies. These pictures allude to our animal origins which the ladies with their starched dresses and lace would like to deny. In "The Other Woman" a rigid and puritanical-looking man is montaged with the picture of a beautiful woman whose hair is haloed by butterfly wings. Purcell's title suggests an intriguing scenario of illicit love. The man's stern face is his public denial of wrong-doing.

Purcell's photographs work largely because they demand an active participation from the viewer. These strange stories are not fully explained. Purcell supplies the characters, specifies a setting, and then suggests a vague story. The confronting compositions demand an explanation that is not adequately provided. In this way, Purcell's fertile imagination entices the viewer to finish the story with his or her own imagination.
—Ken Winokur

RAGAZZINI, (Vinc)Enzo.

Italian. Born in Rome, 8 December 1934. Educated at the Liceo Classico, Rome, 1950-53; studied architecture at the University of Rome, 1953-55; self-taught in photography. Served in the Italian Army, in the tank battalion, Lecce, Caserta and Verona, 1955-56. Married Simonetta Piccone Stella in 1959 (separated, 1963); son: Giuseppe. Freelance photographer and photojournalist, Rome, 1958-66, London, 1966-76, and Rome, since 1976. Also a filmmaker, since 1972. Instructor in Photography, Hornsey College of Art, London, 1969-71. Address: Via Gradisca 13, 00198 Rome, Italy.

Individual Exhibitions:

1965 *Graphics and Photographs*, Libreria Eniaudi, Rome
1969 *Spectrum: The Diversity of Photography*, Institute of Contemporary Arts, London
 Museum of Modern Art, Oxford
1971 DM Gallery, London
1975 Galleria Il Diaframma, Milan (retrospective)
1976 Galleria Mara Chiareti, Rome
1981 Galleria Gregoriana, Rome
 Galleria Marconi, Milan

Selected Group Exhibitions:

1963 *Triennale*, Milan
 Biennale, Musée d'Art Moderne, Paris
1967 *Britain Today*, British Pavilion, at *Expo '67*, Montreal
1972 *Biennale*, Venice
1973 *Photography into Art*, Camden Arts Centre, London

Collections:

Mara Chiaretti Gallery, Rome; The Photographers' Gallery, London; Museum of Modern Art, Oxford; Museum of Modern Art, New York.

Publications:

By RAGAZZINI: books—*Conversazione in Sicilia*, with text by Elio Vittorini, Milan 1973; *Arno*, with text by Mario Tobino, Milan 1974; *Photographs of Bomarzo*, London 1980; *Tropici: Prima del Motore*, text also by Ragazzini, Milan 1981; films—*Una Macchia Rosa*, with Enzo Muzii, 1969; *Pensare Brazil*, with Enzo Muzii, 1971.

On RAGAZZINI: book—*Photography into Art*, exhibition catalogue, by Colin Osman, Ainslie Ellis and Margaret Harker, London 1973; articles—"Spectrum Photographics: Some of the Work of Enzo Ragazzini Shown at the ICA" in *British Journal of Photography* (London), 25 April 1969; "IBM United Kindgom Ltd.: Anatomy of a Computer" by H. Ochi in *Idea* (Tokyo), September 1970; "Enzo Ragazzini: l'Antifotografo" by Enzo Muzii in *Skema* (Bologna), December 1974.

Until a few years ago I spent part of my life in photographic research and experiments, and I found no great difference between subjects recorded in the dark-room, with or without lenses, and those taken on film with a camera. In the first case the light, the only active agent (projecting for instance abstract forms on to a sensitive emulsion in movement), left marks and shapes that depended on the speed and intensity with which it fell on the gelatine; in the second case it was still the light, reflected from a face, a landscape, an object, that left other marks and other messages on the film contained in some kind of photographic machine.

I was fascinated by the power of the photographic medium because it could range from the infinitely large to the infinitely small, taking in the scale of human activities; I was convinced, ingenuously perhaps, that this expressive medium was more just scientifically on account of the ingenious combination of optics and chemistry on which it was based, and for that reason it seemed to me that it ought to be preserved from the evils that afflicted painting.

As time passed my convictions became less "scientific": my love for the abstract has considerably cooled off and the dimension of human activities has

Enzo Ragazzini: *London*, 1973

now got the upper hand with me.

Nowadays I often find it hard to explain to myself why I like one photo better than another, why certain "artificial" photos are so much more beautiful than some "real" ones. Now I like to photograph human beings and everything on which they have left their mark.

Love for the abstract has been changed into love for perspective, for lights, for composition, for the materials, for focussing and finally for printing. With these means it is possible, barring complications, to control the creative process, which, as Roland Barthes says paradoxically, tends not to explain reality but rather to make it inexplicable, through that very mystery that surrounds everything created when it has life of its own.

—Enzo Ragazzini

Enzo Ragazzini is one of those photographers who are hardly known to the general public, particularly in their native country—in his case Italy—because of their style. Not that that style is ugly; on the contrary, it is too beautiful. To ingratiate oneself into those circles in which photographic criticism is practised, particularly in Italy, it is necessary to find oneself a sponsor, someone who writes for a newspaper or magazine or teaches in some university or institute. Ragazzini is above such little power games. Consequently, he is almost unknown, never mentioned in histories of Italian photography, even the most recent ones which claim to be comprehensively well informed. And among those who talk about recent Italian photography, very few know about him. Luckily for Ragazzini, his ability and his professionalism are well known to many art editors, editors of periodicals and others professionally concerned with photography on a day to day basis.

His work—always precise and always of a high standard—ranges from reportage to advertising campaigns. Whether he is photographing a truck for a calendar or doing a feature on the condition of the street-level dwellings of Naples, Ragazzini approaches his subject directly. He deals with each situation in the best way. For, say, the truck for the calendar, he relies on his expert knowledge of photographic technique; for Naples, he relies on his gifts as a human being. He succeeds in coming to some understanding, some comprehension, of even the most difficult subjects. This is, I think, a basic requirement for good work. He is not one of those reporters who "steal" their pictures: he prefers not to take a photograph at all rather than treat his subject improperly.

Ragazzini's reportage recalls the great documentary tradition of the best-known Italian reporters of the postwar period—to photograph an event is to take part in it, to make the viewer take part in it. To produce a clear photograph that everyone can understand, he prefers a documentary exactness to the allusiveness of some modern reportage. His photographic travels are always around the things and persons depicted; they are never excuses for narcissistic withdrawal over purely personal problems.

This love of his for precision through a simple—but not necessarily simplistic—visual communication is also the basis of his success as an advertising photographer. He always exploits the elements of photography to the best effect, for a clarity of information rather than allusion.

—Edo Prando

Claude Raimond-Dityvon: St. Emilion-Gironde, 1973

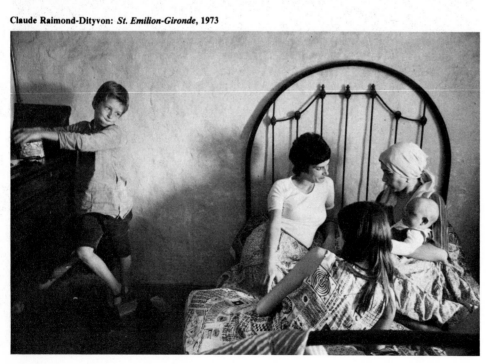

RAIMOND-DITYVON, Claude.

French. Born in La Rochelle, 12 March 1937. Educated at technical school in La Rochelle; self-taught in photography. Married Christiane Le Rumeur in 1966; son: Thomas. Photographer since 1968. Founder Member, Viva photo agency, Paris, 1972-79; Co-Director of Viva, since 1981. Recipient: Prix Niepce, 1970; Fondation Nationale de la Photographie Award, 1976; City of Paris Award, 1978. Address: 24 Avenue Edison, 75013 Paris, France.

Individual Exhibitions:

1970 Maison de Jeunes du 5ème, Paris (retrospective)
 Visage de la Ville, Maison de la Culture, Chalon-sur-Saône, France
1972 Musée d'Art Moderne (ARC), Paris (retrospective)
1974 Photogalerie, Paris (retrospective)
1975 Regard sur un Exil, Maison de la Culture, Bobigny, St. Denis, France

1977 L'Homme et le Travail, Maison de la Culture, La Rochelle, France
 Presence, Maison de la Culture, La Rochelle, France
1978 Territoire d'Enfance, Maison de la Culture, La Rochelle, France
 La Marée Noire, Maison de la Culture, Rennes, France
 Un Jour comme les Autres, Hôpital Universitaire, Limoges, France
 Dityvon, Bibliothèque Nationale, Paris (retrospective)
1979 Presence, Musée du Mans, Le Mans, France
 Maison des Jeunes, Angers, France (retrospective)
 Musée du Châtellerault, France (retrospective)
1980 Portrait d'une Ville, Maison des Jeunes, Châtellerault, France
 Centre Cultural, Rabat, Morocco (retrospective)
 Maison des Jeunes, Nanterre, France (retrospective)
1981 Centre Formation Technologique, Gobelin, Paris
 Les Heros du Moment, Espace Canon, Paris

Selected Group Exhibitions:

1973 Viva: Familles en France, Galleria Il Diaframma, Milan (travelled to the French Consulate, New York; The Photographers' Gallery, London; International Cultureel Centrum, Antwerp; and Optica Gallery, Montreal)
1976 Les Français en Vacances, Musée du Lyon
1977 Six Photographes en Quête de Banlieu, Centre Georges Pompidou, Paris
 Photos from Viva, Side Gallery, Newcastle upon Tyne
1979 Paris 1979: Les Parisiens, Salon de la Photo, Paris

Collections:

Bibliothèque Nationale, Paris.

Publications:

By RAIMOND-DITYVON: books—Visages de la Cité, edited by H. Calba, Paris 1972; Etrepilly-Glasherz, with text by Hans J. Scheurer, Cologne 1975; La Marée Noire, Paris 1978; Gens de La Rochelle, Paris 1979; films—Est-ce ainsi que les Hommes Vivent, 1976; Un Jour comme les Autres, 1977.

On RAIMOND-DITYVON: books—Dityvon, exhibition catalogue, Paris 1978; Un Jour comme les Autres, exhibition catalogue, Limoges, France 1978; Paris 1979, exhibition catalogue, by Christian Caujolle, Paris 1979; articles—"Claude Raimond-Dityvon" by Robert Salbitani in Progresso Fotografico (Milan), February 1974; "Le Régard Politique de Dityvon" by André Laude in Quotidien de Paris, October 1974; "Photographe du Non-Evenement" by Yves Bourde in Le Monde (Paris), 16 October 1974; "Etrepilly" by Christian de Bartillat in Nouveau Photo-Cinema (Paris), October 1974; "Régard sur un Exil" by Jean-Marie Dunoyer in Le Monde (Paris), 22 June 1975; "Raimond-Dityvon" in Zoom (Paris), March 1976; "Claude Raimond-Dityvon" in Creative Camera (London), July 1977; "Un Photographe en Limousin" by Liliane Boyer in Nouveau Photo-Cinema (Paris), February 1978; "Le Monteur d'Ours" by Christian de Bartillat in Zoom (Paris), March 1978; "May 1968" in Photo (Paris), May 1978; "Une Emotion Minimale" by Hervé Guibert in Le Monde (Paris), 18 October 1978; "Dityvon" by André Laude in Nouvelles Litteraires (Paris),

October 1978; "Hommes au Travail" in *Grand Angle* (Lyons), October 1978; "Dityvon" by Ghislaine de la Villeguerin in *Photo-Reporter* (Paris), July/August 1979.

I want to assume entirely my function as a professional photographer, yet at the same time I wish to be someone who walks around, a man among men.

To go beyond the created photo that is an end in itself, I want, with the help of photographic art, to convey the ideology of an economic and political system.

Initially, at the beginning of my career, I wished to do what one could call social reporting. Now, I want to express the inexpressible, to convey that incommunicability that restrains the individual, to go beyond the anecdotal for a deeper truth—the importance of the unsaid, of atmosphere, of the impalpable.

—Claude Raimond-Dityvon

Claude Raimond-Dityvon did not come to photography until 1967 when he was already 30. One of the paradoxes of the man (and not the least of them) is that he is a reporter who does not like photojournalism; he thinks that the press photographer has a tendency to produce stereotype or shock photos of superficially treated subjects. Yet Raimond-Dityvon was one of the instigators of the revival of the profession of the photo-reporter: he is one of the founders of the now famous Viva agency in Paris.

The paradox is explainable. The goal of his work is a new kind of photojournalism, and that goal is two-fold. The photograph must involve a "responsible" look at reality; it should not be the means to a "scoop," but rather, an effort to go to the depths of everyday existence, to show the ways in which the ordinary contains the marvellous. He attempts, therefore, a sociological approach to reality without forfeiting its poetry. Also, he does not forget that photography is itself a creator, that it brings about a certain point of view, that, as a consequence, one must not forget the formal exigencies of craft. And, in the manner of Goya, he believes that the horror, whatever it may be, cannot be disassociated from the beauty. His work is rather like the performance of a tightrope walker: it involves rapt attention to a particular activity, yet that activity is also the means of expression of being.

Raimond-Dityvon's work comprises a variety of in-depth reportages: miners; fishermen; May 1968; families in France; a chronicle of a village in the Paris region; the black tide of 1978; La Rochelle.... This poet of the banal and the ordinary has also produced films, audiovisual montage and animation—to all of which he brings the same deep commitment. To help others to see, to teach them to discover their surroundings with new eyes, to teach them to discover their own personal sensibility—these are all parts of the task of the photographer as Raimond-Dityvon conceives it.

Space and time meet in his photos to create slices of everyday life of rare density. There are always many things happening in his photos; they succeed in being a concentrate. The scenes unfold on several planes, and space achieves a depth rarely attained in photography. The photo ceases to be a flat surface of two dimensions and includes a third dimension— an essential dimension, but one that it is very difficult to create—call it the complexity of life. Each picture encloses confrontations, a game of glances. Lines of force are therefore created which translate themselves as broken lines that intersect at the interior of the field, creating there a mysterious but compelling dynamic. The exchanges, the fleeting glances, create a passage to the interior of the picture, evoking the space of non-communication. This space is not particularly dramatic, and it is not agonizing; simply, each person is about his own business. A part of life has been photographed, the most banal, that of the everyday, made up of affections and oversights, desires and unexpressed dreams: it is

life at the limits of consciousness that this master of photographic art succeeds in rendering perceptible to us.

—Ginette Bléry

RAJZÍK, Jaroslav.
Czechoslovak. Born in Hradec Králové, Bohemia, 3 May 1940. Studied film and television at the Academy of Arts, Prague, 1959-64, 1974-77, Dip.Film 1964, Dip.Photog. 1977. Married the painter Renata Rozsívalová in 1969; daughter: Denisa. Photographer since 1970. Assistant Professor, 1966-80, and since 1980 Associate Professor, Film and Television Faculty, Academy of Arts (FAMU), Prague. Member, Union of Czechoslovak Creative Artists, 1970. Address: Kyselova 1186, 18200 Prague 8, Czechoslovakia.

Individual Exhibitions:

1965 Gallery of Artist, Hradec Králové, Czechoslovakia
1971 Gallery of Artists, Hradec Králové, Czechoslovakia (retrospective)
1972 Gallery of Young Artists, Prague
1976 Gallery of Creative Arts, Hodonin Czechoslovakia (retrospective)
1977 North-Czech Museum, Liberec, Czechoslovakia

Selected Group Exhibitions:

1971 *Czechoslovak Photography*, Moravian Gallery, Brno, Czechoslovakia

Jaroslav Rajzík: *Windows I*, 1979

1973 *Czechoslovak Photography 1971-72*, Moravian Gallery, Brno, Czechoslovakia
Lyrismo di Fotografia Cecoslovacci, at *SICOF*, Milan (travelled to the Fotokabinett Jaromir Funke, Brno, Czechoslovakia, and the Städtisches Museum, Freiburg, West German)

1977 *Contemporary Art Photography*, Fragner's Gallery, Prague
Tschechoslowakische Photographie 1918-78, Fotoform, Kassel, West Germany

1980 *Exhibition of Photographs for Sale*, Centrum Gallery, Prague

Collections:

Museum of Art, Prague; Moravian Gallery, Brno, Czechoslovakia.

Publications:

On RAJZÍK: books—*Geschichte der Photographie im 20. Jahrhundert/Photography in the 20th Century* by Petr Tausk, Cologne 1977, London 1980; *Black and White Creative Photography* by Petr Tausk, Martin, Czechoslovakia 1980; articles—"Jaroslav Rajzík in *European Photography* (Göttingen), no. 3, 1980; "Exhibition of Photographs" by Vladimír Birgus in *Revue Fotografie* (Prague), no. 3, 1980.

The theme of my work is the discovery of thoughts and forms in the reality of the material world. Nature is full of perfect forms and thoughts: they are merely hidden in cyphers, needing to be emancipated or freed from the tangled chaos of the world.

For me, the key to this cypher is composition and light. My principal and continuing series of works are entitled: *Philosophy of a Landscape, Studies of Light*, and *Arches and Labyrinths*.

—Jaroslav Rajzík

Jaroslav Rajzík is both a photographer and a teacher of photography, and his academic background has influenced his own work as a photographer; he has meditated often on the nature of photography.

Rakzík was originally trained in secondary school as a chemist, and that heritage is evident in his work, in his interest in "explaining" facts in an exact way. As a scientist he understands the decisive role of light in the photographic depiction; as a photographer, he respects light for its creative possibilities. Because he esteems the "elements" of his medium, he has regarded research into the various kinds and uses of light as appropriate to his work as a photographer. Rajzík has carried on and continued the Czechoslovak tradition instigated by Jaromir Funke in the late 1920's of experiments with light and shadow resembling photograms but achieved by pure photography.

Rajzík began his researches by subjugating the objects that he photographed to the extent that they completely lost their identities: the subject of his creative experiments was, in effect, the path of beams of light within the observed space under conditions that he had carefully prepared in accordance with his own principles of composition. The simple patterns created in this way were very close to the geometrical abstractions successfully achieved by some painters. However, these experiments with composition were not solely the product of intellectual speculation about visually active forms; they involve, too, creative games, as well as a vision of subconscious forces at work in the artist. And, it's probably also true that some admirable results happened by trial and error—changing the paths of light beams, evaluating whether or not the resultant formations were suitable for the image.

Rajzík creates what might be called "chamber cycles" in small formats, which emphasize fine composition. As a person he tends to be shy, and his work, too, seems modest and in its nobility of forms easily vulnerable.

Apart from his exercises in light-composition, Rajzík is also keenly interested in small objects as subjects, objects that he photographs from a short distance in order to show vividly those features that to most people usually remain unnoticed.

—Petr Tausk

RAKAUSKAS, Romualdas.

Lithuanian. Born in Akmeneje, in September 1941. Educated at schools in Akmeneje, 1948-58; studied journalism at Vilnius University, Lithuania, 1958-63. Served in the Soviet Army, 1963-65. Photo-Correspondent for *Nemunas* magazine, Kaunas, Lithuania, since 1966. Member, Lithuanian Society for Art Photography. Address: Centralnyj bulvar 12-36, Kaunas, Lithuanian S.S.R., U.S.S.R.

Individual Exhibitions:

1977 *My Country*, Vilnius

Selected Group Exhibitions:

1975 *Lithuanian Photography*, House of Art, Brno, Czechoslovakia

Romualdas Rakauskas: *The Flowering*, 1977

1978 *Contemporary Soviet Photography*, Komorna Galeria, Bratislava, Czechoslovakia

Has also participated in the group exhibitions of the Lithuanian Society for Art Photography, since 1965.

Collections:

Lithuanian Society for Art Photography, Vilnius; Bibliothèque Nationale, Paris; Daniela Mrázková Collection, Prague.

Publications:

By RAKAUSKAS: book—*Masu Kaunas* (Our Kaunas), Kaunas, Lithuania 1974.

On RAKAUSKAS: books—*Lietuvos Fotografija*, Vaga, Lithuania 1967, Vilnius, Lithuania 1969; *Soviet Photo*, by the editors of Sovetskoe Foto, annually, 1970-75; article—"Romualdas Rakauskas" by Daniela Mrázková in *Ceskoslovenská Fotografie* (Prague), no. 11, 1978.

From about the mid-1960's Romualdas Rakauskas has been one of the leading representatives of Lithuanian photography, which at that time attracted attention for its impressive lyrical qualities and its sincere interest in the well-being of man. With his colleagues at the Lithuanian Society for Art Photography, Rakauskas produced optimistic photographs, attempted to create symbols of feeling of a healthy enjoyment of life. His aim, too, was an artistically modified picture based on reportage. A mother dancing with her children on the wide stretches of a summer meadow; tiny figures of children running across the countryside; a couple of lovers on a path covered with fallen leaves—human beings were

shown mostly in motion and dealt with as part of the countryside. These photos are always full of a sparkling purity of emotion and produce an unusually cheerful effect. This effect was partly the result of the way in which Rakauskas dealt with the texture of the countryside and objects, brightly lit by the Lithuanian low spring sun, accentuating even microscopically tiny particles.

Over the past few years, however the lyricism and cheerfulness have been receding in Rakauskas' pictures; the running figures, the ostensible joy, have been disappearing, and he has turned to a more sober but more significantly documentary approach, to the very essence of the people and the countryside, to meditation. This transformation does not come about by chance; it has to do with a change of interest in all of Lithuanian photography from "depiction" to "meditation," from an outward view to philosophical reflection.

Now, too, Rakauskas selects beautiful and pleasing subjects, including some that are, in fact, actually a kind of sweet pseudo-art; he is still known as a romantic who works to evoke a mood. However he brilliantly counterbalances the precisely measured dosage of banality by putting stronger emphasis on the texture of the surface, from which the principal motif stands out, and also by a contrast of romantic and documentary elements. Since 1976, he has been working on a long-term cycle, "Time of the Flower," in which a whitish pointillism of blooms and leaves artistically transforms the picture, giving it a purely photographic structure. Against the background of the white sea of flowers, living subjects are dealt with—an old married couple sitting at a table which has been laid for dining; an orderly line of country children; a boy gently holding a white rabbit in his hand; a family group on a Sunday outing—all in stationary peace in accordance with premeditated arrangement. The confrontation of the romantic motif of flowers and the documentary style employed in the arrangement of subjects evokes excitement and even irritation at the disharmony and unusual approach. The lesson to be drawn from the aesthetic purpose of the photographer is linked with the documentary approach.

The result, however, perfectly expresses the sensibility of contemporary man, his longing for feeling and dream that all the time comes up against reality. It contains the artist's constant reminiscences of his childhood, when life had a clear purpose in the direct merging of man and nature, which in turn suggest criteria essential to living in the world today. The dramatic conflict about truth and the purpose of life in Rakauskas' photographs constitutes a captivating emotion of rediscovering basic values.

Rakauskas is an artist who manages to speak about the basic things in life lightly, joyfully, emotionally and without pathos. The slightly grotesque touches of his latest work introduce a new quality of expression and thought to his photographs.

—Daniela Mrázková

RAY-JONES, Tony.

British. Born Holroyd Anthony Ray-Jones in Wokey, Wells, Somerset, 7 June 1941. Educated at Christ's Hospital School, 1951-57; studied commercial design and photography at the London College of Printing, 1957-61, and design at Yale University, New Haven, Connecticut, 1961-62, 1963-64, M.F.A. 1964. Married Anna Ray-Jones. Worked with Alexey Brodovitch and Richard Avedon at the Bro-

dovitch Design Laboratory, New York, 1962-63; Associate Art Director, with Brodovitch, *Sky* magazine, New York, 1964; freelance photographer, New York and San Francisco, 1965, London, 1966-72. Visiting Lecturer in Photography, San Francisco Art Institute, 1971-72. Estate: Anna Ray-Jones, 85 Eighth Avenue, Apartment 6D, New York 10011, U.S.A. *Died* (in London) *13 March 1972.*

Individual Exhibitions:

1969 *The English Seen*, Institute of Contemporary Arts, London (travelled to Paris and San Francisco)
1970 Galerie Rencontre, Paris
1972 Pasadena Art Museum, California
 San Francisco Museum of Art
1973 Fotogalerie Wilde, Cologne
 Visual Studies Workshop, Rochester, New York (toured the United States)
1974 *The English Seen*, Theatre Royal, York, England (toured the U.K. and New Zealand)
1975 Foto, New York
1976 Northlight Gallery, Arizona State University, Tempe
1979 Galerie Fiolet, Amsterdam
 Focus Gallery, San Francisco (with Keith Collie)
1981 Contrasts/Visions Gallery, London (with George Rodger)

Selected Group Exhibitions:

1969 *4 Photographers in Contrast*, Institute of Contemporary Arts, London
 Vision and Expression, International Museum of Photography, George Eastman House, Rochester, New York (toured the United States, 1969-71)
1972 *Personal Views 1850-1970*, British Council, London (toured Europe)
 ICA Photographic Workshop, Royal Photographic Society, London
1977 *Documenta 6*, Museum Fridericianum, Kassel, West Germany
 Concerning Photography, The Photographers' Gallery, London (travelled to the Spectro Workshop, Newcastle upon Tyne)

Collections:

Arts Council of Great Britain, London; Victoria and Albert Museum, London; Royal Photographic Society, Bath, England; Bibliotheque Nationale, Paris; Museum of Modern Art, New York; International Museum of Photography, George Eastman House, Rochester, New York; Visual Studies Workshop, Rochester, New York; San Francisco Museum of Modern Art.

Publications:

By RAY-JONES: book—*A Day Off: An English Journal*, with an introduction by Ainslie Ellis, London 1974, as *A Day Off*, Boston 1977; articles—"Tony Ray-Jones" in *Creative Camera* (London), October 1968; "A Gallery of Gurus" in *Horizon* (New York), Spring 1972.

On RAY-JONES: books—*Vision and Expression* by Nathan Lyons, New York 1969; *Personal Views 1850-1970*, exhibition catalogue, with an introduction by Bill Jay, London 1972; *Tony Ray-Jones: The English Seen*, exhibition brochure, with text by Peter Turner, London 1974; *The Magic Image* by Cecil Beaton and Gail Buckland, London and Boston 1975; *Concerning Photography*, exhibition cata-

logue, by Jonathan Bayer and others, London 1977; *Documenta 6/Band 2*, exhibition catalogue, by Klaus Honnef and Evelyn Weiss, Kassel and Cologne 1977; *Geschichte der Fotografie im 20. Jahrhundert/Photography in the 20th Century* by Petr Tausk, Cologne 1977, London 1980; articles—"One Part of the Spectrum: The English Seen—A Long Glance at the Work of Tony Ray-Jones at the ICA Exhibition" by Ainslie Ellis in the *British Journal of Photography* (London), 28 March 1969; "ICA Festival of Photography" in *Creative Camera* (London), April 1969; "Photographs by Tony Ray-Jones" in *Album* (London), April 1970; "Tony Ray-Jones: New Orleans Portraits" in *Creative Camera* (London), January 1971; "Obituary: Tony Ray-Jones" in the *British Journal of Photography* (London), 24 March 1972; "Tony Ray-Jones" in *Creative Camera* (London), June 1972; "Tony Ray-Jones: English at Play?" by Margery Mann in *Camera 35* (New York), July/August 1972; "Tony Ray-Jones: A Brief Biography" by Ainslie Ellis in the *British Journal of Photography Annual*, London 1973; "Tony Ray-Jones: The English Seen" by Peter Turner in *Afterimage* (Rochester, New York), October 1974; "Tony Ray-Jones" in *Creative Camera* (London), October 1974; "Ray-Jones' Great Day Off" by Owen Edwards in the *Village Voice* (New York), 14 November 1977.

Tony Ray-Jones died, from a rare form of leukaemia, in 1972. Only 30 years of age, Ray-Jones had already made a significant mark upon contemporary photography, at a time of life in which many careers are barely underway. Thus, his death was a particular loss because, having already accomplished so much, even more significant future contributions were not unexpected.

His best photographs, indeed most of his photographs, might be characterized, somewhat paradoxically, as impeccably conceived and composed snapshots (in the sense that any photograph taken at a "decisive moment" is a snapshot in the true sense of the phrase). They are marked, too, by their grace, wit, and gentle humanitarianism. Although utilizing a medium which Susan Sontag, and others, have rightfully characterized as "predatory," Ray-Jones insisted, as do Robert Doisneau and a bare handful of photographers, that people seen in odd situations and awkward poses must be treated with kindness. A Ray-Jones photograph may poke fun, but it does so gently; it never condescends to or brutalizes its subjects.

Tony Ray-Jones was, his family and friends report, a great lover of the cinema. The particular films they cite among his favorites are instructive in relation to his own works. Jean Vigo's *L'Atalante*, a gentle evocation of the human condition was a particular favorite; so, too, were the works of Buster Keaton, Chaplin, and the Marx Brothers. Elements of these films (and others)—Vigo's simple humanity, the surrealism of Keaton, and the controlled chaos of Groucho, Chico and Harpo—all found their way into Ray-Jones' vision.

Tony Ray-Jones's photographic craftsmanship, particularly the superb composition with which he built his images, was moulded and reinforced in his work as a designer, most specifically in his association with master-designer Alexey Brodovitch.

A photograph such as "Ramsgate, 1968" is both remarkable and typical of Ray-Jones' skills and achievement. One of a long series of English seaside pictures (included in the masterful posthumous anthology, *A Day Off*), "Ramsgate" is a skillful blend of order and tension. On a complex field of architectural and other man-made elements, adults, children and dogs stand, sit, walk, climb, and otherwise cavort. Despite the potential chaos, the geometry of Ray-Jones' composition provides a powerful bond to hold it all together.

"My aim," he wrote in a 1968 number of *Creative Camera*, "is to communicate something of the spirit and mentality of the English, their habits and their

617

way of life, the ironies that exist in the way they do things, partly through tradition and partly through the nature of their environment and mentality. I have tried to present some of these daily anachronisms in an honest and descriptive manner, the visual aspect being directed by the content."

Those words might easily have served as caption for a photograph such as "Glyndebourne, 1967." It is a summer day. A couple, perhaps in late middle-age, sits in two folding chairs, each person absorbed in individual activity. On the folding stack table between the chairs stands a bottle of wine, plates and utensils. A picnic hamper leans against one leg of the woman's chair. This typical picnic, however, is being held in a field full of cows and sheep. Several cows wander, in fact, quite close to the couple and pay them as little heed as the humans pay them.

Again and again, however, it is the ability to create order from many diverse visual elements which marks Tony Ray-Jones' best photographs.

Within the compass of *A Day Off*, for example, one may find such masterpieces as "Beachy Head, 1967," "Brighton, 1967," and "Scarborough, 1967." In the first of these—a personal favorite—a dozen individuals (or anatomical parts of individuals) are seen crowded on the deck of a small boat. Except for the young couple (the central element in the composition) locked in embrace, no one figure pays more than cursory attention to any other (although Ray-Jones seems to have attracted some notice). Yet, despite the obvious crowding imposed by the deck's dimensions, Ray-Jones' composition demands that each individual be accorded a bit of undivided attention once the whole is perceived. Again, it is the geometry of the image which both holds it together and assures that the viewer will miss nothing.

"I'm not an artist," Tony Ray-Jones once said. "I don't like the snob connotation of the word. I'm not especially sensitive and I wouldn't tolerate the stigma. I would like to be a journalist like George

Orwell or as Hogarth was in his medium." In general, people are not reliable critics of their own achievements. "Artist" and "journalist" are not mutually exclusive terms. Both terms may be comfortably applied to Orwell, to Hogarth, or, in truth, to Tony Ray-Jones, himself. The only evidence needed is in the pictures he left behind.

—Stu Cohen

RAYMOND, Lilo.

American. Born in Frankfurt, Germany, 23 June 1922; emigrated to the United States, 1939: subsequently naturalized. Studied photography, under David Vestal, New York, 1961-63. Married Henry A. Schubart in 1943; Herbert D. Raymond in 1954. Worked at various odd jobs, as milliner, waitress, tennis coach, etc., as a waitress in Helen Gee's Limelight Gallery, and as an assistant to the photographer Charles Pratt, in New York, 1940-64. Freelance photographer, New York, since 1964. Instructor in Photography, School of Visual Arts, New York, since 1978. Visiting Instructor in Photography, International Center of Photography, New York, 1980. Agent: Marcuse Pfeifer Gallery, 825 Madison Avenue, New York, New York 10021. Address: 212 East 14th Street, New York, New York 10003, U.S.A.

Individual Exhibitions:

1971 Floating Foundation of Photography, New York
1976 Schoelkopf Gallery, New York
Enjay Gallery, Boston
1977 Galerie Zabriskie, Paris
Marcuse Pfeifer Gallery, New York
Catskill Center of Photography, Woodstock, New York (travelled to the Port Washington Library, New York; and Wisconsin Art Center, Madison)
1978 831 Gallery, Birmingham, Michigan
Fredericksburg Gallery of Modern Art, Virginia
Quidacqua Ltd., Washington, D.C.
Gilbert Gallery, Chicago
Christian Vogt/Lilo Raymond, Focus Gallery, San Francisco
Camera Obscura, Stockholm
1979 Equivalents, Seattle
University of Texas, Dallas
Jeb Gallery, Providence, Rhode Island
Art Ringger/Lilo Raymond, Nikon Gallery, Zurich
Stephen White Gallery, Los Angeles
Kamp Gallery, St. Louis
1980 Kamp Gallery, St. Louis
Drew University, Madison, New Jersey
Marcuse Pfeifer Gallery, New York

Selected Group Exhibitions:

1971 *Festival of Women*, University of Toronto
1972 *Festival d'Avignon*, France
1974 *Women Look at Women*, Floating Foundation of Photography, New York
1976 *The Still Life in Photography*, Helios Gallery, New York
1977 *Photographs: Sheldon Memorial Art Gallery Collection*, University of Nebraska, Lincoln

Lilo Raymond: *Pitcher*, New York, 1980

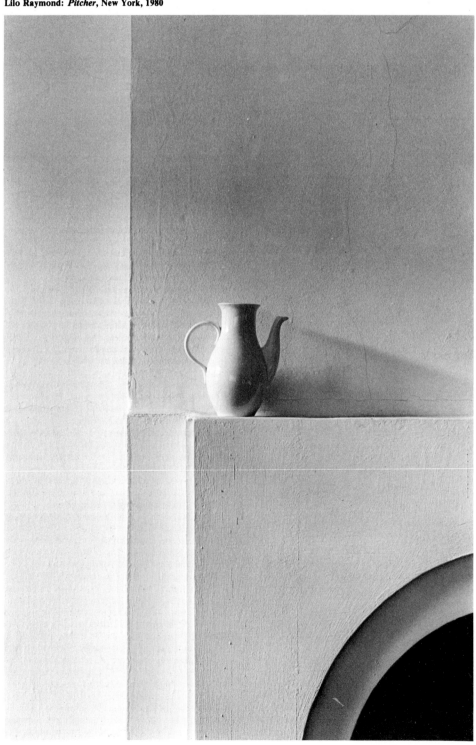

Collections:

Museum of Modern Art, New York; Metropolitan Museum of Art, New York; New Orleans Museum of Art; St. Louis Museum of Art; University of Nebraska, Lincoln; Bibliothèque Nationale, Paris.

Publications:

By RAYMOND: book—*Lilo Raymond*, portfolio, New York 1976.

On RAYMOND: books—*The Craft of Photography* by David Vestal, New York 1975; *The Magic Image* by Cecil Beaton and Gail Buckland, London and Boston 1975; articles—"Lilo Raymond" in *Popular Photography Annual*, New York 1964, 1967, 1968, 1971; "Lilo Raymond" in *U.S. Camera Annual*, New York 1964, 1967, 1970, 1971; "Lilo Raymond: Portfolio" in *35mm Photography* (New York), Winter 1975; review by Hilton Kramer in the *New York Times*, 15 April 1977; "Acrobatics vs. Pastoral Poetry" by Gene Thornton in the *New York Times*, 24 April 1977; "Poems of Order and Intimacy" by Alexandrea Anderson in the *Village Voice* (New York), 9 May 1977; "Lilo Raymond: Gravure Portfolio" by Alicia Wille in *Popular Photography* (New York), July 1977; "Photography: Focusing on the Posed and the Unposed" by Alfred Frankenstein in the *San Francisco Chronicle*, 4 November 1978; "Lilo Raymond: Photographs" by Ted D'Arms in *The Weekly* (Seattle), 21-27 February 1979.

My subjects are human in scale, the quieter evidences of people. These are objects people make or put someplace. God makes apples and vegetables, which I love, but I know that I like them because they have something to do with people.

Days with incredible light are like a gift. On a day when the light is right I will photograph God knows what. I prefer inanimate objects, because I can look at what the light is doing, and I am not confused by human beings who move or talk to me.

When you print a photograph you want to get back what you saw. You didn't see it in that glaring light. Film is so contrasty, whereas your eye isn't. That's how my addiction to various forms of backlight and sidelight started. And my photographic experiments led me also to a real awareness of the differences in effects between strong back- or sidelight and a milder variety. The latter often occurred when the sun was covered by a light layer of clouds. Then the lighting was still directional, but softer and more subtle rather than harsh.

Later on came an even more intense involvement with light as I started exploring the delight of tone in photographing *things* in my world. The interesting thing about such non-people pictures is that light tends to be an even more important force in the creation of strong images. Take my backlighted shot of a melon on a windowsill. Then consider the importance of that backlight, and how different the effect would have been with even lighting, or with the main light source to one side or somewhere in front.

That melon picture is part of a series on windows, shot from inside and out, that I am still involved with. At this writing, however, the aspect that intrigues me especially is how light from the sun strikes one or more panes of glass to create a dramatic glare.

The longer I work for this kind of delight of tone, the easier I find it is to pre-visualize the effect I want on the print and get it. When I'm kidding around with students, I sometimes say fliply that after a while you begin to see pictures you can print. But, to put this more seriously, there tends eventually to be a closer rapport between your seeing before shooting and the possibilities on the final print. This is because you have learned the limitations of film and paper and have taken them into account ahead of

time. And, as a general rule, experienced photographers do this almost automatically.

Good techniques are, of course, essential. Most of the time it pays to use a good lens shade with backlight and sidelight, and to shoot a lot of film of the same subject.

There is so much gross and technical ability necessary initially in the other art forms that are not necessary in photography. I could teach anyone in a few hours how to take a picture, develop it, contact it, and print it—but that is only the beginning. From my experience, photography gets hard after the first five years. Five years are joy, and then it really begins to be hell. When you know more, you begin to demand more of yourself. You take the same picture, and perhaps the ratio of better pictures you take is higher than it was when you started, but what can and must improve is technique.

—Lilo Raymond

Lilo Raymond's photographs convey an insistent stillness. They are exquisitely controlled pictures whose quiet surfaces belie a tension that strains almost to bursting. It is this tension that keeps them from being merely romantic and makes the images transcend their apparent simplicity. Her concern with order, with a simplified and ordered universe, comes from her past and is the motivation in her art. She photographs with intimacy everyday objects usually in an ordinary room illuminated by extraordinary light. "The way I remember incidents or what people have said, is by the setting and the room and the light." Her formalism appeals to painters and in fact she admits to being much more influenced by them than by photographers.

Her still life pictures bring to mind paintings by Cezanne or Braque. The objects she chooses are almost always found the way she photographs them. She relishes the search rather than the manufacture of her images. She is searching for a moment from her childhood when all was well in the world and light streamed in at the window. This was a time before the light exploded and security was torn to pieces by war.

Lilo Raymond is a survivor. She was born in Germany in 1922 to a father who was Nazi and fought with Rommel and a mother who was Jewish. In 1939 her mother gathered up her two daughters and brought them to America where she supported them by working as a professional tennis player. Raymond did many different things before she found herself in photography. She taught tennis for a time, was an artist's model for Hans Hofmann among others, and was also a waitress in Helen Gee's Limelight Cafe. Finally in her late thirties she turned her full attention to the art in which she is now recognized.

She uses the simplest tools and materials: a 35mm Nikon camera, even though most of her work is still life, and ordinary Polycontrast paper. She gets the most out of her materials, and although her prints vary somewhat according to her mood ("I'm not an automaton"), it is feeling she wants to convey rather than mechanical perfectionism. Light becomes the subject in those images that Hilton Kramer calls her "white pictures," and her subtle printing conveys this appropriately. Because so many of her pictures are painterly, she uses the texture and grain of the prints to advantage.

Since her first major exhibition at The Marcuse Pfeifer Gallery in New York in 1977, Lilo Raymond's photographs have been shown all over the United States and in several European countries. Her work has received critical acclaim everywhere it has been shown.

—John Esten

RENGER-PATZSCH, Albert.

German. Born in Würzburg, 22 June 1897. Educated at the Classical Grammar School, Sondeshausen, and the Kreuzschule, Dresden, until 1916; studied chemistry at the Technische Hochschule, Dresden, 1919-21; self-taught in photography. Served in the German Army, 1916-18. Married Agnes von Braunschweig in 1923; children: Sabine and Ernst. Head of the Photography Department, with Ernst Fuhrmann, Folkwang Archive, Hagen, 1921-24, and Head of the Visual Propaganda Department, Central Office for Home Affairs, Berlin, 1923; worked as a book-keeper and salesman, etc., in Kronstadt/Siebenburgen, 1924. Freelance documentary and press photographer, Bad Harzburg, Germany, 1925-28, and Essen, 1928-33; concentrated on his own photography, Essen, 1933-45, and Wamel bei Soest, Germany, 1945 until his death, 1966. Instructor, and Head of the Department of Pictorial Photography, Folkwangschule, Essen, 1933-34. Member, Gesellschaft Deutsche Lichtbildner (GDL), 1964-66. Recipient: David Octavius Hill Medal, Gesellschaft Deutsche Lichtbildner, 1957; Culture Prize, Deutsche Gesellschaft für Photographie (DGPh), 1960; Gold Medal, Photographische Gesellschaft, Vienna, 1961; State Prize for Skilled Crafts, Nordrhein-Westfalia, 1965. *Died* (in Wamel bei Soest) *27 September 1966*.

Individual Exhibitions:

1925 Renger-Patzsch Studio, Bad Harzburg, Germany
 Folkwang Archives, Hagen, Germany
1927 Museum im Behnhaus, Lubeck
1928 Galerie Neue Kunst, Dresden
 Galerie Günther Franke, Munich
 Graphisches Kabinett Kunde, Hamburg
 Gewerbemuseum, Wintherthur, Switzerland
 Städtisches Museum, Zwickau, Germany
 Kunsthaus Schaller, Stuttgart
 Museum im Behnhaus, Lubeck
 Kunstgewerbemuseum, Zurich
 Anhaltischer Kunstverein, Anhal, Germany
 Kunstgewerbemuseum, Cologne
 Landesmuseum, Oldenburg, Germany
1929 Städtisches Museum, Chemnitz
 Städtisches Museum, Zwickau, Germany
 Landesmuseum, Darmstadt
 Galerie Mittentzwey, Berlin
1930 Société Française de Photographie, Paris
 Graphisches Kabinett, Bremen
1960 *Photokina*, Cologne
1965 Lotte Jacobi Gallery, Hillsboro, New Hampshire
1966 *Der Fotograf der Dinge*, Ruhrland-und Heimat-Museum, Essen
1967 Sauerland Museum, Arnsberg, West Germany
1971 Friends of Photography, Carmel, California
1974 Galerie Wilde, Cologne
1975 University of Maryland Library, Baltimore
1977 *Fotografien 1925-1960*, Rheinisches Landesmuseum, Bonn, (retrospective)
 Städtische Galerie Haus Seel, Siegen, West Germany
 Galerie Taube, Berlin
1978 Galerie Breiting, Berlin
 Sander Gallery, Washington, D.C.
 Rotterdam Arts Foundation
1979 Bahnhof Rolandseck, Bonn
 100 Photos 1928, Centre Beaubourg, Paris; (travelled to the Kunsthalle, Bielefeld; and the Neue Sammlung, Munich)
1980 Galerie Zabriskie, Paris
 Prakapas Gallery, New York
 Sonnabend Gallery, New York
 Bäume, Galerie Wilde, Cologne
1981 *Gestein*, Galerie Wilde, Cologne

Selected Group Exhibitions:

1928 *Neue Wege der Photographie*, Kunstverein,

Albert Renger-Patzsch: *Winderhitzer Hochofenwerk Herrenwyk*, near Lubeck, 1927 Courtesy Galerie Wilde, Cologne

Jena, Germany
1929 *Film und Foto*, Deutscher Werkbund, Stuttgart
1932 *Exposition Internationale de la Photographie*, Palais des Beaux-Arts, Brussels (travelled to Lakenhal, Leiden, and the Kunstzaal Van Hasselt, Rotterdam
1959 *Hundert Jahre Photographie 1839-1939*, Museum Folkwang, Essen (travelled to Cologne and Frankfurt)
1978 *Neue Sachlichkeit and German Realism of the 20's*, Hayward Gallery, London
 Paris-Berlin 1900-1933, Centre Georges Pompidou, Paris
1979 *Deutsche Fotografie nach 1945*, Kunstverein, Kassel, West Germany (toured West Germany)
 Photographie als Kunst 1879-1979, Tiroler Landesmuseum Ferdinandeum, Innsbruck, Austria (travelled to the Neue Galerie am Wolfgang Gurlitt Museum, Linz, Austria; Neue Galerie am Landesmuseum Joanneum, Graz, Austria; and the Museum des 20. Jahrhunderts, Vienna)
1980 *Avant-Garde Photography in Germany 1919-39*, San Francisco Museum of Modern Art (toured the United States)
1981 *Germany: The New Vision*, Fraenkel Gallery, San Francisco

Collections:

Albert Renger-Patzsch Archiv, Galerie Wilde, Cologne; Museum Ludwig, Cologne; Bibliothèque Nationale, Paris; Royal Photographic Society, London; Museum of Modern Art, New York; International Museum of Photography, George Eastman House, Rochester, New York; Art Institute of Chicago; Gernsheim Collection, University of Texas at Austin; University of New Mexico, Albuquerque; San Francisco Museum of Modern Art.

Publications:

By RENGER-PATZSCH: books—*Das Chorgestühl von Kappenberg*, Berlin 1925; *Das Geschicht einer Landschaft, Die Halligen*, with a foreword by Johann Johannsen, Berlin 1927; *Lübeck*, with text by Carl Georg Heise, Berlin 1928; *Die Welt Ist Schön*, with text by Carl Georg Heise, Munich 1928; *Wegweisung der Technik*, with text by Rudolf Schwarz, Berlin and Potsdam 1928; *Dresden*, with others, Dresden 1929; *Norddeutsche Backsteindome*, with text by Werner Burmeister, Berlin 1929; *Spaziergang durch eine Badewannenfabrik*, Schwarzenberg, Germany 1929; *Das Münster in Essen*, with text by Kurt Wilhelm Kästner, Essen 1929; *Eisen und Stahl*, with a foreword by Albert Vogler, Berlin 1930; *Hamburg: Photographische Aufnahmen*, with text by Fritz Schuhmacher, Hamburg 1930; *Leistungen Deutsche Technik*, with others, with text by Albert Lange, Leipzig 1935; *Sylt-Bild einer Insel*, Munich 1936; *Kupferhammer Grunthal*, with text by Ernst van Leer, Grunthal, Germany 1937; *Deutsche Wasserburgen*, with a foreword by Wilhelm Pinder, Königstein and Leipzig 1940; *Das Silberne Erzgebirge*, with a foreword by Fr. E. Krauss, Schwarzenberg, Germany 1940; *Land am Oberrhein*, 1944; *Beständige Welt*, with text by Helene Henze, Munster 1947; *Paderborn*, with text by Reinhold Schneider, Paderborn, Germany 1949, 1971; *Soest*, with text by Adolf Clarenbach, Soest, Germany 1950; *Rund um den Mohnesse*, with text by Helense Henze, Soest, Germany 1952; *Munster*, Soest, Germany 1951; *Schloss Kappenberg*, with text by Erich Botzenhart, Soest, Germany 1953; *Lob des Rheingaus*, with a foreword by Ludwig Curtius, Ingelheim Rhein, Germany 1953; *Höxter und Corvey*, with text by Ludwig Rohling, Soest, Germany 1954; *Dresden wie es war und wurde*, with others, with text by Friedrich Schnack, Munich 1956; *Soest*, with text by Hubertus Schwartz, Soest, Germany 1957; *Bilder aus der Landschaft Zwischen Ruhr und Mohne*, with text by Helene Henze, Belecke, Germany 1957; *Schrift 6: Versuch einer Einordnung der Fotografie*, Essen 1958; *Bauten Zwischen Ruhr und Mohne*, with an introduction by Hugo Kukelhaus, Belecke, Germany 1959; *Oberrhein*, with a text by Michael Meier, Munich 1959; *Hohenstaufenburgeren in Süditalien*, with a text by Hanno Hahn, Ingelheim am Rhein, Germany and Munich 1961; *Bäume*, with text by Ernst Junger and Wolfgang Haber, Ingelheim am Rhein, Germany 1962; *Werkstatt Porträt 10: Der Fotograf Albert Renger-Patzsch*, Dortmund 1962; *Soest: Alte Stadt in Unserer Zeit*, with text by Hubertus Schwartz, Soest, Germany 1963; *Im Wald*, with text by Wolfgang Haber, Wamel-Möhnesee, Germany 1965; *Werkstattforum 1: Vom Sinn de Fotografie und Verantwortlichkeit des Fotografen*, Arnsburg and Dortmund 1965; *Gestein*, with text by Max Richter and Ernst Junger, Ingelheim am Rhein, Germany 1966; articles—"Das Photographieren von Bluten" in *Kamera-Almanach*, Berlin 1924; "Ziele" in *Das Deutsche Lichtbild* annual, Berlin 1927; "Hochkonjunkture" in *Bauhaus-Buch 4*, Dessau, Germany 1929; "An Essay Toward the Classification of Photography" in *Untitled 12: Friends of Photography*, Carmel, California 1977.

On RENGER-PATZSCH: books—*Hundert Jahre Photographie 1839-1939 aus der Sammlung Gernsheim*, exhibition catalogue, by Helmut and Alison Gernsheim, Essen 1959; *A Concise History of Photography* by Helmut and Alison Gernsheim, London and New York 1965; *Albert Renger-Patzsch: Der Fotograf der Dinge*, exhibition catalogue, by Fritz Kempe, Essen 1966; *Photography in the 20th Century* by Nathan Lyons, New York 1967; *Documenta 6/Band 2*, exhibition catalogue, edited by Klaus Honnef and Evelyn Weiss, Kassel and Cologne 1977; *Geschichte der Fotografie im 20. Jahrhundert/Photography in the 20th Century* by Petr Tausk, Cologne 1977, London 1980; *Industrielandschaft, Industrie Architektur, Industrieprodukt: Fotografien 1925-1960 von Albert Renger-Patzsch*, exhibition catalogue, edited by Klauf Honnef, Bonn 1977; *Germany: The New Photography 1927-33*, edited by David Mellor, London 1978; *Neue Sachlichkeit and German Realism of the 20's*, exhibition catalogue, by Wieland Schmied, Ute Eskildsen and others, London 1978; *Paris-Berlin 1900-1933*, exhibition catalogue, by Herbert Molderings, Gunter Metken and Others, Paris 1978; *Albert Renger-Patzsch: 100 Photos, 1928*, exhibition catalogue, with texts by Carl Georg Heise and Fritz Kempe, Boston, Cologne and Paris 1979; *Fotografie 1919-1979, Made in Germany: Die GDL-Fotografen*, edited by Fritz Kempe, Bernd Lohse, and others, Frankfurt 1979; *Photographen der 20er Jahre* by Karl Steinorth, Munich 1979; *Film und Foto der 20er Jahre*, exhibition catalogue, by Ute Eskildsen and Jan Christopher Horak, Stuttgart 1979; *Photographie als Kunst 1879-1979/Kunst als Photographile 1949-1979*, exhibition catalogue, 2 vols., by Peter Weiermair, Innsbruck, Austria 1979; *Avant-Garde Photography in Germany 1919-1939*, exhibition catalogue, by Van Deren Coke, Ute Eskildsen and Bernd Lohse, San Francisco 1980; articles—"Die Welt ist Schon" by Thomas Mann in *Berliner Illustrierte Zeitung*, 23 December 1928; "Film und Foto: Ausstellung des Deutschen Werkbundes" by Karl Sommer in *Essener Allgemeine Zeitung*, 26 May 1929; "Exhibition in Stuttgart, June 1929, and Its Effects" by Andor Kraszna-Krausz in *Close-Up* (London), February 1930; "Albert Renger-Patzsch" by Beaumont Newhall in *Image* (Rochester, New York), September 1959; "Deutschland 1920-1933" by Allan Porter and Bernd Lohse in *Camera* (Lucerne), April 1967; entire issue of *Untitled 12: Friends of Photography* (Carmel, California), 1977; "Albert Renger-Patzsch" in *Camera* (Lucerne), August 1978; "The Escape from the Painterly Look" by Gene Thornton in the *New York Times*, 17 February 1980; "Albert Renger-Patzsch" in the *Zabriskie Photography Newsletter* (Paris), Autumn 1980.

In 1928 the Kurt Wolff Verlag of Munich published an extraordinary photo-book which, in retrospect, can be seen to mark the end of a brief, yet vital period in the history of European photography, a book that was to achieve both wide acclaim and a lasting place in the history of photography-as-art. This period, whose beginnings can only be loosely located around 1923, saw the growth and assimilation of *Die Neue Sachlichkeit* or The New Objectivity—a many-faceted trend that encompassed the divergent activities of such photographers as Karl Blossfeldt, August Sander, Helmar Lerski and László Moholy-Nagy. The book was *Die Welt Ist Schön* (The World Is Beautiful) by Albert Renger-Patzsch, arguably the most successful and influential German photographer of his day.

Renger was introduced to photography at an early age by his father who was an enthusiastic amateur; indeed, the work of Stieglitz, Steichen, Clarence H. White and Gertrude Käsebier was well known to him at the age of 14. But the imagery which was to carry the *Renger-Foto* credit into fame in the 1920's was radically different from that of the hierarchy of art-photographers that dominated the early years of the century. Young photographers like Renger-Patzsch were foremost in initiating a complete renovation of the terms and practice of art-photography, a transformation that depended largely upon an engagement of those areas of picture-making which had previously been regarded beneath the dignity of a "serious" artist—the associated realms of book illustration and commercial advertising.

The first book wholly credited to Renger-Patzsch is, at first glance, innocuous in the extreme; a small volume of pictures of mostly 12th century religious woodcarvings entitled *Dan Chorgestühl von Kappenberg* (The Choirstalls at Kappenberg), published in 1925. Yet it is an early indicator of the kind of techniques which he was in the process of bringing to advertising. His subjects are rendered in terse close-up and lit by harsh artificial lighting which emphasizes their surfaces and contours, while their edges are thrown into relief by darkened and unfocussed backgrounds. Here it was not so much a matter of new subject-matter—illustrated texts on religious architecture had been stock-in-trade productions since at least the turn of the century—but of a rather novel mode of representation through full-page glossy pictures of objects isolated from their surroundings and rigidly framed, as if to invite microscopic examination. Such techniques were also used by Renger in his close-up images of plants, and they marked a complete *volte-face* from the typically soft, sepia-inked gravures which evoked a more melancholy and atmospheric quality more reminiscent of orthodox European Pictorialism.

Unlike most representatives of *Die Neue Sachlichkeit*, Renger-Patzsch was active in a variety of pursuits—photographing plant forms for the numerous illustrated popular publications, art and ethnographic objects, cityscapes and industrial hardware for topographical texts and advertising materials. But the artistic and economic climate of the Weimar Republic enabled him to make serious inroads into the conventional wisdom of art-photography. During the 1920's the commodity character of photography underwent an elemental transformation, and the aesthetic renovation of the medium by the photographers of The New Objectivity was largely a function of this gradual process, rather than an autonomous artistic development. Accordingly, these photographers emerged from the applied arts or avant-garde tendencies and posed themselves in direct and often violent opposition to the tenets of the German Pictorialists.

Throughout Europe and the United States art-

photography had been defined largely in terms of a disinterested and strictly non-utilitarian practice sustained by a complex system of legitimization that sought to promote the medium's entry into the domain of high art. Yet the proposal that certain photographs be considered art objects was of course insufficient in itself: photography had to be *seen* to be able to distinguish such products from those designed to conform to less lofty ideals. In practical terms, therefore, this distinction was frequently reproduced by way of strenuous efforts to overcome clarity of rendition and tonal breadth by means of soft-focus lenses and "artistic" printing techniques—the products of which tended to approximate conservative notions of what "art" looked like.

Such was the predominant German art-photographic practice encountered by Renger-Patzsch in the 20's. Yet he saw immediately that the only way forward from the impasse of Pictorialism was for the medium to separate itself off completely from those arts which it had been seen to emulate. Photography was to generate its own terms of reference based on axiomatic differences between it and other media, to be evaluated precisely in terms of its technical specificity—its ability to suggest the illusion of tactile and spatial reality—and on how well the photographer had characterized the material before his camera.

Such techniques were ideally suited to the needs of advertising and commerce, and some of Renger's most famous work was originally so conceived. The concentration upon formal and structural qualities that had been noted in his first book was subsequently applied to still-life studies of materials and manufactured goods for those rapidly expanding advertising outlets that were not slow in recognizing the precision, flexibility, economy and psychological impact of this highly stylized approach. It was not so much that his photographs were highly charged with information about the products in question, but rather that they presented, in an almost abstract and diagrammatic form, the most mundane subjects in an attractive, striking manner.

Renger's theoretical assertions about photography were also highly congruent with those of the New Architects who stressed truth to their materials and the creation of buildings whose aesthetic was to be derived from their efficiency and articulation of basic geometrical forms; and he produced numerous pictures of their work, emphasizing the uncompromising hard-edged contours of steel bridges, prefabricated factories and the repetitive Philibean solids of apartment blocks.

A similar stress upon astringent form was evident in the avowedly populist *Die Welt Ist Schön*, which drew together 100 images testifying to the photographer's versatility. Plant forms, animals, ancient and modern architecture, industrial structures, landscapes and commercial products all figured in the Renger-Patzschian itemization of the world—a plethora of subjects that most editors would be hard-pressed to reconcile. Yet the binding thread of the book—those constraints and supports which permit the emergence of some meanings, while discouraging others—is yet a further extension of Renger's formalism. Plant forms and commercial products were equated through their elegant formal simplicity, and the historical antagonisms of Gothic and Modernist architecture, over which there were violent debates, were similarly dissolved into congruent arrangements of shapes. Here was a technique which sought the equation of *all* subjects through the common denominator of formal resemblance, so that, for all the emphasis upon precision, detail and truth to visual reality, one was left with nothing more than attractive and enigmatic "pattern pictures" whose informational value was extremely limited. As if echoing the intangible presences of a Moholy-Nagy photogram, his pictures demonstrate such a semantic poverty that the viewer is inevitably lead from a depleted pictorial space to an image surface where the eye is invited to settle upon a complex array of interpenetrating or repetitive lines.

In mitigation, it must be said that there is some evidence to suggest that Renger had neither control over, nor liking, for the book; indeed, it was his only major art-photographic text. Yet the tendency implicit in the photographic technique which he employed with such virtuosity carried implications that were well noted in their time. As Carl Linfert remarked in 1931: "How seldom photographs tell us anything about the objects they show! But what is transmitted as a message to the eye stares at us like a fetish—especially since Renger-Patzsch, photographs have become thus frightening.... The urge to look, to record all that one sees is so feverish that, while we grasp at everything, we end up with nothing.... The thing itself, however concisely and exactly the camera perceives it, has less to say to us than ever."

—Brian Stokoe

REQUILLART, Bruno.

French. Born in Marcq en Baroeul, 30 December 1947. Educated at the Pension Saint Joseph, Arras, France, 1957-62; Ecole Superieure de Publicité, Tournai, Belgium, 1962-69. Began photographing in 1968; full-time freelance photographer, Paris, since 1973. Recipient: Prix des Communautées Européennes, *Photokina*, Cologne, 1968; Grand Prix, *Festival d'Arles*, 1976; Fellowship, Fondation Nationale de la Photographie, Lyons, 1980. Agent: Zabriskie Gallery, 29 West 57th Street, New York, New York 10019, and 29 rue Aubry le Boucher, 75004 Paris. Address: 16 rue Bezout, 75014 Paris, France.

Individual Exhibitions:

1970 Auditorium Mail, Brussels
1975 Galleria Il Diaframma, Milan
1976 13 x 15 Gallery, St. Louis
 Photographs by Linda Benedict-Jones and Bruno, Photographic Gallery, University

Bruno Requillart: *Versailles*, 1977

of Southampton
 3 Jeunes Photographes: Bruno, Kalvar, Plossu, Centre Georges Pompidou, Paris (toured France, Spain, Czechoslovakia and Poland)
1977 Galerie Fiolet, Amsterdam
1978 Centre Georges Pompidou, Paris
 Galerie Zabriskie, Paris
1979 Zabriskie Gallery, New York

Selected Group Exhibitions:

1968 *Photokina '68*, Cologne
1973 *Séquences et Conséquences*, Musée d'Art Moderne de la Ville, Paris
1975 *4 Photographes*, Bibliothèque Nationale, Paris (with Descamps, Plossu, and Kuligowski)
1976 *Rencontres Internationales de la Photographie*, Arles, France
1977 *French Photographers*, San Francisco Art Institute (also shown at Camerawork Gallery, San Francisco)
1978 *Jeunes Photographes Français*, University of Kreuzberg, Berlin
1979 *Photos de Famille*, at the *Festival d'Avignon*, France
1980 *Triennale Internationale de Photographie*, Charleroi, Belgium
1981 *Des Photographies dans le Paysage*, Galerie de France, Paris
 La Photographie Française après la 2e Guerre, Zabriskie Gallery, Paris and New York

Collections:

Bibliothèque Nationale, Paris; Musée d'Art Moderne, Paris; Centre Georges Pompidou, Paris; Musée Réattu, Arles, France; Musée Cantini, Marseilles; Fondation Nationale de la Photographie, Lyons; Polaroid Collection, Amsterdam, Stedelijk Museum, Amsterdam; Southampton University, Hampshire, England.

Publications:

On REQUILLART: books—*3 Jeune Photographes*, exhibition catalogue, by Pierre de Fenoel, Paris 1976; *Photographie Actuelle en France*, edited by Carole Naggar, Jean-Claude Lemagny and others,

Paris 1976; *Jeune Photographes Francais*, exhibition catalogue, by M. Schmidt, Berlin 1978; *Histoire de la Photographie Francaise* by Claude Nori, Paris 1979; *Triennale Internationale de Photographie*, exhibition catalogue, by Jean-Claude Lemagny, Charleroi, Belgium 1980; articles—"Bruno: From February to April" in *Creative Camera* (London), January 1975; "Bruno" in *Nueva Lente* (Barcelona), May 1976; "Bruno: La Photographie n'a pas de Sens" by Arnaud Claass in *Zoom* (Paris), November/December 1976; "Bruno" in *Creative Camera Yearbook 1978*, edited by Colin Osman and Peter Turner, London 1978; "Versailles" by Michel Nuridsany in *Light Vision* (Melbourne), November 1978; film—*Droit de Cité: Bruno Requillart*, television film, by Jean Brard, 1976.

Having approached photography from the bias of "reportage," I gradually realized that, in each instance, the photographs I obtained had little relation to the event I had photographed. That which now interests me is not to "cover" an event but to invent images in which I can recognize and rediscover myself.

More than the represented subject, it is the way in which we perceive space that seems to interest me: the way in which space is restored to us, the confrontation and ambiguity of planes, the way in which meaning is provoked by the relations of component parts—a kind of distortion of reality. Yet, paradoxically, the more we deviate from reality, the closer we are to it, for photography is always documentary.

While at the same time trying to develop these ideas, I'm also trying to integrate elements of my daily life into my work. More and more, I have come to feel that my photographs are becoming too formal, aesthetic and detached. In short, there is a repetition, and I am restricting myself within a style that is too rational. I am also very attracted to amateur photography, family photo albums and "snapshots." This kind of photography interests me more than most of the work done by professionals. I would like to combine these two kinds of photography in the same work.

My subject is Paris, since that is where I live. Everyday Paris, but also historic and touristic Paris. Likewise, my life, the places that I frequent, friends, people on the street, the anodyne events of every day. Parts of daily life are too often forgotten, yet they are closer to our own reality than other, more spectacular events, in front of which, for the most part, we are only spectators.

My work now compromises both exterior life— the same approach that I have adopted previously (in black and white)—and interior life, in the form of souvenir photographs (in color). The final, complete work will consist of large panels with several related images, which, through their own contradictions, their essential differences, the interaction of their identities, will, to my mind, provide a truer glimpse of reality.

—Bruno Requillart

By his own admission, Bruno Requillart was initially attracted to reportage, then quickly realized that the photos he obtained were inadequate representations of the events he thought he had photographed. He realized, too, that he was not interested in "covering" events, that his real interest was in inventing images. He was one of the first young French photographers to break away from reportage in order to search for a more personal, more immediate reality.

Bruno, as he is familiarly called, is an exacting and concerned photographer. So much so that he was even questioned whether he was right to choose photography as a means of expression. "Whether we like it or not," he says, "photography is always documentary. Yet, when I invent images, I do so by distorting reality." Bruno has not exhibited or published any new images for two years; he has allowed his negatives and contact plates to accumulate, and he has printed nothing.

Since 1968 Bruno has been adept at imposing an original vision in immediately recognizable images that have earned him great respect in international photographic circles. Despite that success, he chose to stand back, to regard his own work objectively. He came to feel that that which produced such strength in his images was a danger to him; he wanted to find a more spontaneous and less reflective method, to rediscover the freer vision of the amateur. The man who has always photographed motionless objects began to take pictures through the windscreen of a moving car. None of this new work has been seen.

Bruno assures us, however, that his new pictures, despite a different approach, will show the same formal characteristics. Preoccupied above all with space and sensations in space, he has gone in a direction diametrically opposed to reportage. He has chosen not the platitudes of graphic composition, but is striving for a unifying atmosphere. He balances values and sensations. He works with a rather strong grain in order to unify space and suppress detail. Photography for him is still a distortion of reality and a search for balance within this distortion. He looks for movement in immobility, that is, the translation of subjective variations in space.

—Jean-François Chevrier

RESNICK, Marcia.
American. Born in Brooklyn, New York, in 1950. Studied at the Cooper Union School of Art, New York, B.F.A. 1972, and California Institute of Arts, Valencia, 1972-73, M.F.A. 1973. Freelance photographer, California and New York, since 1973. Instructor in Photography, International Center of Photography, New York, 1977. Recipient: National Endowment for the Arts grant, 1975, 1978. Address: 530 Canal Street, New York, New York 10013, U.S.A.

Individual Exhibitions:

1977 Lightworks Gallery, New York
1978 Chicago Center for Contemporary Photography (with Larry Williams)

Selected Group Exhibitions:

1977 *Outside the City Limits*, Trope Intermedia Gallery, Spark Hill, New York
The Extended Frame, Visual Studies Workshop, Rochester, New York
1978 *Punk Art*, Washington Project for the Arts, Washington, D.C.
Book Art, Art Institute of Chicago
1979 *Kunst als Photographie 1879-1979*, Tiroler Landesmuseum Ferdinandeum, Innsbruck, Austria (travelled to the Neue Galerie am Wolfgang Gurlitt Museum, Linz, Austria; Neue Galerie am Landesmuseum Joanneum, Graz, Austria; Museum des 20. Jahrhunderts, Vienna)
1981 *Photos der 70er Jahre*, Galerie Wilde, Cologne

Collections:

Museum of Modern Art, New York; International Museum of Photography, George Eastman House, Rochester, New York; Visual Studies Workshop, Rochester, New York; Chicago Center for Contemporary Photography.

Publications:

By RESNICK: books—*See*, New York 1975; *Tahitian Eve*, New York 1975; *Landscape*, New York 1975; *Landscape-Loftscape*, New York 1977; *Re-Visions*, New York 1977, Toronto 1978; article—"Marcia Resnick: An Interview, " with Alex Sweetman, in *Exposure* (New York), Summer 1978.

On RESNICK: books—*Women on Women*, with an introduction by Katharine Holabird, New York 1978; *Photographie als Kunst 1879-1979/Kunst als Photographie 1949-1979*, exhibition catalogue, 2 vols., by Peter Weiermair, Innsbruck, Austria 1979; articles—"Marcia Resnick: Pop-Up People" in *Photography Year 1974*, by the Time-Life editors,

Marcia Resnick: *She Would Demurely Sip Cherry Kool-Aid from a Wine Glass and Puff on Bubble-Gum Cigarettes*
Courtesy the Friends of Photography, Carmel, California

New York 1974; "The Layered Eye: Painted Photographs by Marcia Resnick" in *Camera 35* (New York), July 1974.

The general terms used to describe photographers don't work very well with Marcia Resnick. Resnick is a photojournalist and a narrative photographer. she works with sequenced photographs, incorporates text with images, and attempts to document a community. But, Marcia Resnick is better described with terms from outside photography. She is a punk, a bit of a voyeur and, most simply, an artist.

Her work consciously crosses borders. Her serious art photographs are most easily seen in mass circulation newspapers and magazines. Her favorite medium is the artist's book, and her favorite trick (and perhaps the most heretical thing she does) is to be funny.

Resnick sees herself as an iconoclast. Consciously rebelling against the domination of the single image, her first works were three conceptually oriented books: *See, Tahitian Eve*, and *Landscape*. These books used repeating compositions in which only a few elements changed. *See*, for instance, has 35 photographs of people with their backs to the camera, surveying the landscape. The book is a somewhat precious attempt to examine the act of seeing.

Resnick explains that she was frustrated by the limited audience for this type of artist's book, and by the "incestuousness" of the art photography community in general. Her next project, a more elaborate book entitled *Re-visions*, effectively added an amusing narrative to make the book more accessible.

Re-visions, an extended self-portrait, is a story of the photographer as an adolescent, anxiously discovering her own sexuality and abandoning her innocent pleasures. Resnick uses a young girl as a model throughout the book, posing her in obviously staged scenes, with appropriate props. Each picture is faced with a single sentence text. A picture of the girl lying on the floor with her dress flying up to cover her face is accompanied by the text: "When her mother first noticed a red stain on her panties and roared, 'You're a woman now,' she promptly fainted." Unlike so many ponderous and formal exercises relating sequences of images, *Re-visions* is a funny and entirely delightful book. Functioning

much like a short novel, the book perceptively explores archetypical adolescent anxieties in a manner that is engrossing and remarkably easy to read.

When she had finished *Re-visions*, Resnick began working on her current project, *Bad Boys: Punks, Poets, and Politicians*. Resnick describes this project as the "great love work of men" which she undertook because "it was the subject I understood least." *Bad Boys* is a series of informal portraits of "men who look like men, men who look like women, and women who look like men." Many of the "boys" are prominent figures in the New York underground art/music scene: Brian Eno, Diego Cortez, Andy Warhol and others.

Individual photographs from the upcoming *Bad Boys* book have been widely published in magazines and newspapers, a perfect medium for the gossipy tone of the project. Taken as a whole (at least as much as is currently completed) *Bad Boys* is an intelligent document of several cultures who consider themselves outside the system. Resnick, the iconoclast, has found the perfect subject for her talents.

—Ken Winokur

REUSENS, Robert.

Belgian. Born in Antwerp, 29 December 1909. Educated at the College of the Holy Trinity, Louvain, 1921-28; self-taught in photography. Married Angela Anneessens in 1928; children: Rudolf, Jacky and Luc. Worked as Anglo-French Correspondent for Lloyds in Antwerp, 1928-30. Freelance portrait, fashion and theatre photographer, Antwerp, 1930 until his death, 1981: official photographer to theatres Royal Netherlands Schouwburg, Royal Flemish Opera and Netherlands Room-Stage, from 1947. Founder-Director, Department of Photography, St. Lucas Academy, Brussels 1964-68 and Department of Photography, Royal Academy, Antwerp, 1968-70. *Died* (in Duffel, Belgium) *9 September 1981.*

Selected Group Exhibitions:

1980 *De Fotografie in Belgie 1940-1980*, Het Sterckshof Museum, Deurne-Antwerp

Collections:

Het Sterckshof Museum, Deurne-Antwerp

Publications:

On REUSENS: book—*De Fotografie in Belgie 1940-1980*, exhibition catalogue, by Roger Coenen and Karel van Deuren, Antwerp 1980.

My thoughts and beliefs concerning photography are exactly the same as you can find in *On Photography* by Susan Sontag:

"Painting and photography are not potentially competitive systems for producing and reproducing images which simply had to arrive at a proper division of territory to be reconciled. Photography is an enterprise of another order. Photography, though not an art form in itself, has the peculiar capacity to turn its subjects into works of art. Superseding the issue of whether photography is or is not an art, is the fact that photography heralds (and creates) new ambitions for the arts."

—Robert Reusens

Robert Reusens was a professional photographer who had successfully exhibited as early as 1938. He was notable for his portrait, fashion and stage photography, and he served as official photographer to various Antwerp theatres.

His work is suffused with his great erudition; he had a special interest in history, literature, film and the stage. He was an intellectual photographer, and the quality of his work is derived more from his personality than from any artistic signature. He produced "classic" photographs, which excel not so much through their originality as through stylistic means, which are counter-balanced with great precision against the motif.

Theatrical photography was his speciality—and here, as in all this work, one notes his profound psychological insight. That he had it in no small measure is also apparent in his numerous portraits, above all those of theatre people.

In 1967 he made a brilliant diasonorama, *Espana*, at a time when this genre was not yet quite so vulgarized: it is a captivating attempt to create a new genre between photography and film, of which the main characteristic was the analysis of movement or, if you will, an analysis of time.

Robert Reusens was a photographer who could have achieved more in a wider cultural sphere than the one in which he lived and worked.

—Karel van Deuren

Robert Reusens: *Othello* (original in color), 1977

REXROTH, Nancy (Louise).
American. Born in Washington, D.C., 27 June 1946. Educated at Wakefield High School, Arlington, Virginia, 1960-64; Marietta College, Ohio, 1964-65; studied English, American University, Washington, D.C., 1965-69, B.F.A. 1969; studied photography, Ohio University, Athens, 1969-71, M.F.A. 1971. Freelance photographer. Instructor, Ohio University, Lancaster, 1975-76; Assistant Professor, Antioch College, Yellow Springs, Ohio, 1977-79. Assistant Professor, Wright State University, Dayton, Ohio, since 1979. Agents: Light Gallery, 724 Fifth Avenue, New York, New York 10019; Kathleen Ewing Gallery, 3020 K Street N.W., Washington, D.C. 20007; Grapestake Gallery, 2876 California Street, San Francisco, California 94115; Silver Image Gallery, 92 South Washington Street, Seattle, Washington 98104. Address: 421 North Stafford Street, Yellow Springs, Ohio 45387, U.S.A.

Individual Exhibitions:

1971 Putnam Street Gallery, Athens, Ohio
1973 Corcoran Gallery of Art, Washington, D.C.
1974 Jefferson Place Gallery, Washington, D.C.
1975 Light Gallery, New York
Antioch College, Yellow Springs, Ohio
1977 Light Gallery, New York
1978 Silver Image Gallery, Columbus, Ohio
Grapestake Gallery, San Francisco
1979 Catskill Center for Photography, Woodstock, New York
Northern Kentucky University, Highland Heights
1980 Light Gallery, New York
1981 Camerawork, San Francisco

Selected Group Exhibitions:

1973 *New Images: 1939-1973*, Smithsonian Institution, Washington, D.C.
1976 *The Snapshot...Then and Now*, Focus Gallery, San Francisco
Contemporary Photography, Halsted 831 Gallery, Birmingham, Michigan
1979 *Fleeting Gestures: Dance Photographs*, International Center of Photography, New York (travelled to The Photographers' Gallery, London, and to *Venezia '79*)
Attitudes: Photography in the 1970's, Santa Barbara Museum of Art, California
1980 *The Contemporary Platinotype*, Rochester Institute of Technology, New York
The Diana Show, Friends of Photography Gallery, Carmel, California

Collections:

Museum of Modern Art, New York; University of Massachusetts, Amherst; Smithsonian Institution, Washington, D.C.; Library of Congress, Washington, D.C.; Corcoran Gallery of Art, Washington, D.C.; Center for Creative Photography, University of Arizona, Tucson; Santa Barbara Museum of Art, California; Washington State Art Consortium, Seattle; Bibliothèque Nationale, Paris.

Publications:

By REXROTH: books—*Iowa*, with an introduction by Mark Power, New York 1976; *The Platinotype 1977*, pamphlet, New York 1977.

On REXROTH: books—*The Snapshot*, edited by Jonathan Green, Rochester, New York 1975; *Photography* by Phil Davis, Dubuque, Iowa 1975; *The Criticism of Photography* by Hugh Davies, Amherst, Massachusetts 1978; *130 Years of Ohio Photography* by Budd Bishop, Columbus, Ohio 1978;

Diana and Nikon by Janet Malcolm, Boston 1979; *Attitudes: Photography in the 1970's*, exhibition catalogue, by Fred R. Parker, Santa Barbara, California 1979; *The Platinum Print* by John Hafey and Tom Shillea, with an introduction by Marianne Fulton Margolis, Rochester, New York 1979; *The Diana Show*, exhibition catalogue, by David Featherstone, Carmel, California 1980; *Presences: The Figure and Man-Made Environments* by Bruce Sheftel, New York 1980; article—"The Intimate Visions of Nancy Rexroth and JoAnn Frank" by A.D. Coleman in *Camera 35* (New York), April 1978.

My first body of work eventually became a book called *Iowa*. It had to do with dreams and memories of the Mid-west. I used an 89-cent plastic camera called the "Diana." The book was rank with a feeling of deeply slanting nostalgia and melancholia; every image was out of focus. I still have trouble with people looking at the photographs and thinking I don't yet know how to use a camera. For me, *Iowa* had mostly to do with the growing up of a young girl. But few people understand this aspect of the work.

Somewhere along the way, I also produced a pamphlet which gave instructions for making platinum prints. It was called *The Platinotype 1977*. Both *Iowa* and *The Platinotype 1977* had lavender covers.

For the last year and a half I have been involved in doing the SX-70 Transfer. This is a process in which the emulsion of the SX-70 Polaroid image is transferred out of its pack and onto a sheet of paper. The image has an organic, painterly look about it that is very unlike any other photographic process. The look and feel of the resulting image is highly seductive, and the process itself becomes as important as the image. It is almost as though an image had somehow been imprinted on human flesh.

Nancy Rexroth: *Waving House*, Vanceburg, Kentucky

Some of the images are what I call "Embedded Transfers," in which I have lifted up the emulsion and laid objects underneath, such as a moth or even cigarette butts. In this way, I am creating three-dimensional images which are almost no longer photographs. Unfortunately, the new Zero Development SX-70 won't transfer as the old film did. I have a quantity of this older film, but it is running out.

I have eleven projects using the SX-70 going all at once, with certainly more to follow. I want to get away from the more romantic and beautiful images of outdoor Ohio landscapes. So lately I have been photographing bits and pieces of cut paper which I lay around the house, or maybe sometimes throw around the yard and allow the shadows to become as important as the cuts and folds. The Still Life is becoming one of my big interests. It allows me the mobility of photographing in any sort of lighting condition, and at any time of day. This means I am less tied to subject matter. I often use theatrical gels to alter the color balance of the film.

I find my interest in the Still Life to be similar to that of many other photographers. Photographers now are successfully struggling to gain control over their subject matter and lighting conditions. When I first started photographing, people tended to make images which were "found objects." Subject matter was inviolate and untouchable, and was recorded "as it existed" by the photographer. I believed that this was the way things should be. But lately I find myself doing very arranged and set-up photographs. Now suddenly I need a STUDIO, of all things.... Krim's idea of the "Fiction" approach to photography has now seeped into our everyday way of photographing.

I now find myself doing a new series of Still Lifes called *Still Life Disasters*, in which the still life has run back into itself. The cherries and the hammers, the push-pins and the tape in so many of the Still

Lifes I have seen are all descending into madness. What will happen in the future of the Still Life?
—Nancy Rexroth

It has been said, often enough and in various ways, that the power of the camera resides in its ability perfectly to delineate visual reality. The "problem" with such statements is that the history of photography has given us too many powerful images which do nothing of the sort. Some photographs make no attempt whatsoever to limn the lines of real objects. Their purpose has little to do with imparting information or describing something. In these photographs, we are not being asked to measure the dimensions of reality, but to enter into a conspiracy, a willing suspension of visual disbelief, and to give up our normal preferences for visual clarity. Various techniques, from very simple to extremely complex, are used to create these images. We often think of them as "mysterious" in some way or another, but only because we have been taught to hold 20/20 vision as superior to any other kind of vision.

The power of art to provoke a conscious recognition of particular feeling or understanding in a viewer resides at least partly in how effectively the artist has used the tools at his disposal. When the tools are simple, basic, or even primitive, the artist's task is all the greater. Obviously, photography requires tools of a very modern nature, and the effectiveness of a photograph cannot wholly be separated from the appropriateness of the techniques used to make it. However, given the particular photograph, the techniques themselves are totally unimportant.

At the beginning of her career, Nancy Rexroth worked with a cheap plastic camera called the "Diana." It was made in Hong Kong, cost a couple of dollars, and is now no longer available. With this camera, Ms. Rexroth made an extensive series of photographs based on two assumptions: a) that a photograph of one specific place could actually be "about" another quite different place, and b) that it was possible consciously to infuse a photograph with a manifest sense of nostalgia. The Diana camera was a tool whose simplicity and primitiveness worked towards destroying most of those elements in a photographic image that we normally think of as "photographic." Its plastic lens vignetted the picture edge, softened focus and contrast, and forced us to imagine in the image about as much detail as was actually given to us. In her book *Iowa*—many of whose images were made in Ohio— Ms. Rexroth wrote that her Diana photographs often appear to her "like something you might faintly see in the background of a photograph." The suggestion in this is that the prominent elements of a family snapshot, when seen many years after its making, have no greater importance for us than the partly hidden, out-of-focus details in the background. Anyone who has looked at old snapshots of his family or himself knows this to be true.

A sense of place is at the core of childhood, which is why a smell, a certain kind of light, the corner of a building—or almost anything—can create a strong feeling of nostalgia in us many years after we have left a place. Ms. Rexroth's "Iowa" photographs evoke those same feelings. Oddly enough, with the super cameras available to us today, we have in a sense forgotten how to see simply, and have consequently become more interested in what a photograph expresses about the medium of photography than in what it expresses about the world. Ms. Rexroth's "simple" photographs tell us a personal "document" need not document anything that is visibly recognizable, and that, occasionally, photography can express visually what the emotions can only hint at.
—Derek Bennett

RIBOUD, Marc.

French. Born in Lyons, 24 June 1923. Educated at secondary schools in Lyons; studied engineering at the Ecole Centrale, Lyons, 1945-48, Dip. Ing. 1948; self-taught in photography. Served with the French Resistance and the Free French Army, 1943-45: Croix de Guerre, 1945. Married the artist Barbara Chase (i.e., Barbara Chase-Riboud) in 1961; children: David and Alexis; married the writer Catherine Chaine in 1982. Worked as an industrial engineer, in Lyons, 1948-52. Freelance photographer and photojournalist, Paris, since 1953. Member, Magnum Photos Inc., Paris and New York, 1953-79: Vice-President, Paris, 1958-75; President, Paris and New York, 1975-76; Chairman of the Board, Paris and New York, 1976-77. Recipient: Overseas Press Club Award, New York, 1967, 1970. Agent: Galerie Agathe Gaillard, 3 rue du Pont-Louis-Philippe, 75004 Paris. Address: 3 rue Auguste-Comte, 75006 Paris, France.

Individual Exhibitions:

1963 Art Institute of Chicago
1966 *The Three Banners of China*, Asia House, New York (travelled to the Institute of Contemporary Arts, London, and Galerie Delpire, Paris, 1967)
1974 *Jean-Philippe Charbonnier/Marc Riboud: Reporters-Photographes*, French Institute, Stockholm
1975 International Center of Photography, New York (retrospective; travelled to *Rencontres Internationales de la Photographie*, Arles, France, 1976; The Photographers' Gallery, London, and Galerie Chateau d'Eau, Toulouse, 1977; the Galerie Agathe Gaillard, Paris, 1978)
1981 *China*, The Photographers Gallery, New York (travelled to Galerie Delpire, Paris, The Photographers' Gallery, London, and FNAC Galerie, Lyons)

Selected Group Exhibitions:

1972 *Behind the Great Wall*, Metropolitan Museum of Art, New York
1973 *The Concerned Photographer II*, Israel Museum, Jerusalem (toured Europe)
 Israel 25th Anniversary Exhibition, Jerusalem
1974 *Celebrations*, Hayden Gallery, Massachusetts Institute of Technology, Cambridge
1977 *Concerning Photography*, The Photographers' Gallery, London (travelled to the Spectro Workshop, Newcastle upon Tyne)
1981 *French Photographers*, Zabriskie Gallery, New York

Collections:

Bibliothèque Nationale, Paris; Victoria and Albert Museum, London; Museum of Modern Art, New York; Metropolitan Museum of Art, New York; Art Institute of Chicago.

Publications:

By RIBOUD: books—*Women of Japan*, with text by Christine Arnothy, Amsterdam and London 1959; *Les 3 Bannieres de la Chine/The Three Banners of China*, Paris, London and New York 1966; *The Face of North Vietnam*, New York 1970; *Bangkok*, with text by William Warren, New York, London, Tokyo and Hong Kong 1972; *Instantanés de Voyages Chine*, Paris 1980, as *Visions of China*, New York, 1981.

On RIBOUD: books—*The Concerned Photographer II*, edited by Cornell Capa, New York and London 1972; *Behind the Great Wall of China*, edited by Cornell Capa, with an introduction by Weston J. Naef, New York 1972; *Jean-Philippe Charbonnier/Marc Riboud: Reporters-Photographes*, exhibition catalogue, Stockholm 1974; *The Magic Image* by Cecil Beaton and Gail Buckland, London and Boston 1975; *Celebrations*, edited by Minor White, Cambridge, Massachusetts and Millerton, New York 1974; *Concerning Photography*, exhibition catalogue, by Jonathan Bayer and others, London 1977; *Geschichte der Fotografie im 20. Jahrhundert/Photography in the 20th Century* by Petr Tausk, Cologne 1977, London 1980; *Voyons Voir: 8 Photographes*, edited by Pierre Borhan, Paris 1980; articles—"A Collection of Photographs" in *Aperture* (Rochester, New York), Fall 1969; "Marc Riboud" in *Photography Annual*, New York 1970; "Marc Roboud: Gesichter aus Nord-Vietnam" in *Du* (Zurich), June 1970; "Les Nouveaux Chinois" in *Photo* (Paris), December 1971; "Marc Riboud" in *Modern Photography Annual*, New York 1972; "Power to All Our Friends: Photographs by Marc Riboud, with text by David Caute, in the *Sunday Times Magazine* (London), 10 March 1974; "Marc Riboud: Les Nouveaux Chinois" in *Photo* (Paris), October 1980.

Marc Riboud makes stunningly beautiful pictures— of land, harbors, cities—that are given an urgency because of the people he sees making these worlds come to life. Riboud saturates a picture. Many of his pictures are filled with five or six areas of activity, the viewer's eye pulled, pushed and drawn in as many directions. In one picture he took of a harbor in China in 1965, the viewer's eye slips over the bend of a man's body as the man hauls a boat to shore from the sea, but does so as if it were caressing, not just seeing, the man. But the scene is more complex. For the viewer's eye suddenly skips over to the woman next to the man. Every part of her body, from an outstretched hand to her foot straining from the haul, writhes as if it were crying out in a bloodless shriek. Meanwhile, the visual organization takes the viewer's eye in a contrary direction, against the lyrical swell and into details—like that tiny outstretched hand—that work against the smooth caresses of a lyrical flow. Riboud gives us visually and emotionally complex pictures, many filled with both smoothly lyrical and explosively furious components. He points to the complex and varying ways that a world takes shape, while his pictures tell us the world comes to life—with all of its beauty, hope and despair—because of the design and shape people give it. His passion for people dominates.

It is possible to analyze Riboud's photographs on formalist principles alone. His use of color in a color photograph is magnificent, both in its expression of contrasting hues and in its expression of the range of tones in any one color. Similarly, his black-and-white photographs, as in a terraced hillside (in China, as many of his best photos are), carry that same infinite expression of tones. His compositions are often filled with soaring shapes and minute sensibilities—as in a picture of a group in a rice paddy; while his use of a sharply isolated figure or an angularly paced object—like a hoe—often darts into a lyrical space to challenge a picture's dominant order only to spur the viewers's eye into new circles, new points of interest, new tonalities and new figures not seen on the first go-around. His control of light and shapes within a given space are of the first order.

But it is the excitement he generates by making those principles work that makes these pictures so powerful—and what those principles reveal that makes his pictures so exciting. Worlds come to life because his pictures are packed with people walking, thinking and doing. They have the lilt of a man walking, the querulousness of a woman lifting her

Marc Riboud: *Peking*, 1965

eyebrow, and the passion and fury of young people gathered in a city square. He turns color, form and shape into their servants.

Color, for instance, is conceived as a shape, but a shape that allows the viewer to see the people who have created the picture's momentum. In a photograph of a demonstration in China we see a band of red sweep across the top half of the picture. Irregularly toned—as if it were a banner waving in the wind—it receives, in effect, the jagged edge of the people below who are marching. More than just seeing color as a shape, he sees it mobilized by the people who have mobilized the picture. Sometimes he runs through every tone of blue, green, grey, mauve and brown—in one picture—as in a terraced hillside that lets the hill gracefully unfold behind the foreground figures, making the viewer marvel at such minute gradations of tone. A farmer and his bull—those foreground figures—contain most of those tones, but in the process of registering them more boldly, though solemnly, Riboud heightens the hillside's majesty, the foreground figures themselves heighten the hill's infinite capacities.

It's that capacity to run formal and substantive matter into each other so intricately that one speaks with the voice of the other that mark Riboud's pictures. Add to that his utter and complete control of form and color, and we are given a rare insight into the way people mirror and shape their worlds.

His black-and-white photographs often play on the same control of an expression of an infinite range of tonalities—did we ever know that grey could have so many tones...or that it could be so sensual? In a photograph he took in Peking in 1965, looking out of a shop window (the accompanying photo), he organizes the picture plane into six different units, each a complete entity—in tones of grey—at the same time it is joined to the others. Each person in the picture is looking, walking, bending, standing in a distinct fashion, different from the others, while the viewer is treated to a multiplicity of life and forms.

For, finally, Riboud's photographs let us see the many faces, configurations, shades, intensities, hues and desires that are human. Ushering us into magnificently conceived worlds of colors, shapes and movements, Riboud penetrates a static world to let us see the many, minute sensibilities that people develop; and the way that multiplicity—both formal and substantive—develop a power to reveal what we have never before seen.

—Judith Mara Gutman

RICCIARDI, Mirella.

Kenyan. Born Mirella Rocco in Kenya in 1933. Educated in Kenyan schools; studied photography as an assistant to photographer Harry Meerson, Paris, 1953-55. Married Lorenzo Ricciardi; has 2 daughters. Freelance photographer, Kenya and London, since 1955. Address: 25 Holmead Road, London SW6, England.

Individual Exhibitions:

1971 Time-Life Building, London
1972 Snack Gallery, Paris
 Nikon Gallery, New York
1973 Tryon Gallery, London

Selected Group Exhibitions:

1972 *Photokina '72*, Cologne

Publications:

By RICCIARDI: books—*Vanishing Africa*, New York and London 1971, 1974; *The Voyage of the Mir-El-Lah*, with text by Lorenzo Ricciardi, London 1980.

On RICCIARDI: articles—"Women Photographed by Women" in *Photokina '72: Bilder und Texte*, exhibition catalogue, by L. Fritz Gruber, Cologne 1972; "Les Perles Noires de Mirella Ricciardi" in *Photo* (Paris), January 1972; "Mirella Ricciardi: Fashion Photographs" in the *Daily Telegraph Magazine* (London), 23 August 1974.

Photography is a democratic art, and most practitioners have fairly ordinary backgrounds. Mirella Ricciardi's is, in contrast, extremely exotic. Her grandfather founded the Panama Canal. Her mother was a pupil of Rodin. She was born and brought up in Kenya, near Lake Naivasha, because this was where her father crashed his plane. She grew up as Miss Rocco, not Ricciardi, and learned her "trade" in Paris, working as an assistant to the French photographer Harry Meerson, before returning to Africa.

Meanwhile Lorenzo Ricciardi was travelling round the world making films (he'd been an assistant to Fellini and played the part of Christ in the film *Ben Hur*) and was in Kenya to film the flamingoes of Lake Nakuru. In a nightclub he saw a set of prints hung up over the bar: Mirella's pictures. He phoned her, met, wooed and married her, and they had two daughters.

The pictures were of Maasai and Samburu warriors, and they not only impressed Lorenzo, they also impressed a publisher, who coughed up a cheque. Mirella left the children with her parents, bought a Toyota land-cruiser, and set off with her sister and Kimuyu (her safari boy) to photograph the "vanishing tribes" of Kenya.

The resulting book, *Vanishing Africa*, was published in 1971 and reprinted in 1972, 1973, 1977 and 1978, as well as being revised in 1974. The pictures were exhibited in London, Paris and New York. Mirella Ricciardi became, on the publication of the book, a star almost overnight. She was young, beautiful (she still is), had enjoyed an exotic upbringing, and produced a book full of stylish, graceful and striking photographs. It all combined to make her, in a way, irresistible. However, it hardly equipped her for the often dull and repetitive work of being a commercial photographer in London for such publishers as Condé Nast.

The next major production was her husband's. He fulfilled a dream of sailing a dhow from the Arabian Gulf down the coast of East Africa—like some modern Sinbad. He called the boat Mir-El-Lah (after her, but making it sound Arabic), and she photographed the voyage for the resulting book, with somewhat uneven results.

Recently she has divided her time between London and Los Angeles, photographing colour stories, fashion and beauty for magazines such as *Brides*, *Beauty* and *Vogue*, photographing Pavarotti for *Life* magazine, and shooting for movies like *Green Ice*. She can throw herself into such jobs with the kind of intensity that only her kind of larger-than-life character can sustain. But do the jobs reciprocate?

None of them can substitute for the Edenic Kenya of her childhood before the Second World War. That Africa of noble warriors and shy but beautiful young girls full of natural grace was the Africa she embraced—made love to—through her camera and, like her childhood, it has vanished. However, some unpublished colour photographs of great delicacy, taken through the mists of dawn from a native boat on an isolated South American lake, suggest that a primitive, elemental setting could again provide the natural resonance in response to her artless photography that would raise it once again to the heights reached in *Vanishing Africa*.

—Jack Schofield

RICE, Leland.

American. Born in Los Angeles, California, in 1940. Studied at Arizona State University, Tempe, 1960-64, B.S. 1964; Chouinard Art Institute, Los Angeles, 1965; San Francisco State College, 1966-68, M.A. 1968; also attended photography workshops under Oliver Gagliani, Ruth Bernhard, and Paul Caponigro. Independent photographer, San Francisco, then Los Angeles, since 1968. Founder Member, with Judy Dater, Jack Welpott and others, Visual Dialogue Foundation, San Francisco, 1968-73. Assistant Professor, California College of Arts and Crafts, Oakland, 1969-72; Lecturer in Art, University of California at Los Angeles, 1972; Co-ordinator and Instructor, U.C.L.A. Extension, 1973-76; Lecturer in Art and Curator of the Photography Gallery, Pomona College, Claremont, California, 1973-79. Professor of Photography, University of Southern California, Los Angeles, since 1980. Trustee, Los Angeles Institute of Contemporary Art; Trustee, Friends of Photography, Carmel, California; Member of the Council, Center for Southern California Studies in the Visual Arts, Los Angeles. Recipient: National Endowment for the Arts grant, 1978; Guggenheim Photography Fellowship, 1979. Address: Box 4100, Inglewood, California 90309, U.S.A.

Individual Exhibitions:

1973 Witkin Gallery, New York
1976 Visual Studies Workshop, Rochester, New York
 Tyler School of Art, Philadelphia
 Jack Glenn Gallery, Newport Beach, California
1977 Diane Brown Gallery, Washington, D.C.
 Witkin Gallery, New York
 The Photographic Work of Leland Rice, Hirshhorn Museum, Washington, D.C.
 Orange Coast College, Costa Mesa, California
1978 University of Southern California, Los Angeles
1979 Diane Brown Gallery, Washington, D.C.
 Rosamund Felsen Gallery, Washington, D.C.
 University of Rhode Island, Kingston
1980 Grapestake Gallery, San Francisco

Selected Group Exhibitions:

1966 *Urban Reality*, SPUR, San Francisco
1968 *Young Photographers*, University of New Mexico, Albuquerque
1969 *Vision and Expression*, International Museum of Photography, George Eastman House, Rochester, New York
1970 *California Photographers 1970*, University of California at Davis (travelled to the Oakland Museum, California; Pasadena Art Museum, California)
 4 San Francisco Photographers, Witkin Gallery, New York
1976 *Exposing Photographic Definitions*, Los Angeles Institute of Contemporary Art
1977 *Photography into Painting*, Silver Image Gallery, Seattle
1978 *The Photograph as Artifice*, California State University at Fullerton
1980 *Spectrum: New Directions in Color Photography*, University of Hawaii, Honolulu
1981 *Californian Colour*, The Photographers' Gallery, London

Collections:

Museum of Modern Art, New York; Metropolitan Museum of Art, New York; International Museum of Photography, George Eastman House, Roches-

ter, New York; Fogg Art Museum, Harvard University, Cambridge, Massachusetts; Art Institute of Chicago; Center for Creative Photography, University of Arizona, Tucson; Los Angeles Institute of Contemporary Art; San Francisco Museum of Modern Art; National Gallery of Canada, Ottawa; Bibliothèque Nationale, Paris.

Publications:

By RICE: book—*The Photographs of Moholy-Nagy from the William Larson Collection*, exhibition catalogue, with David W. Steadman, Claremont, California 1975.

On RICE: books—*Young Photographers*, exhibition catalogue, by Van Deren Coke, Albuquerque, New Mexico 1968; *Vision and Expression* by Nathan Lyons, New York 1969; *California Photographers 1970*, exhibition catalogue, by Fred R. Parker, Davis, California 1970; *Photography in America*, edited by Robert Doty, with an introduction by Minor White, New York 1974; *Photographers' Choice*, edited by Kelly Wise, Danbury, New Hampshire 1975; *The Photographic Work of Leland Rice*, exhibition catalogue, with text by Charles W. Millard, Washington, D.C. 1977; *Mirrors and Windows: American Photography since 1960* by John Szarkowski, New York 1978; *The Photograph Collector's Guide* by Lee D. Witkin and Barbara London, Boston and London 1979; *Spectrum: New Directions in Color Photography*, exhibition catalogue, by Donna Nakao, Honolulu 1980; *Californian Colour*, exhibition catalogue, by Sue Davies, Avery Danziger and James Hugunin, London 1981; articles—"Kasten and Rice" by M.T. Wortz in *Artweek* (Oakland, California), 23 March 1974; "Enigmatic Portraits of Places" in *Photography Year 1978*, by the Time-Life editors, New York 1978.

In writing of Leland Rice's work, Charles Millard has said that it brings together "what seem to be the most disparate strands of contemporary photography into successful—and increasingly abstract—images." Millard is referring to the unlikely reconciliation of strains of abstraction, surrealism and pictorialism with the large-camera format and zone-system pre-visualization favored by the "straight" photography approach.

Rice's photographs, even when they are most minimal in terms of subject, exhibit a surreal inflection. The evocative quality of the commonplace rather than the manipulated interests Rice and is always created from photographic means—the way space can be used or the camera angled—rather than by oddities of subject matter, as in the work of Diane Arbus. In the early 1970's Rice created distortions through unexpected camera angles and spatial disjunctures by juxtaposing large areas of extreme value contrast.

Rice has also re-translated means derived from orthodox surrealism into ends that are purely photographic. Concurrent with a series of "overripe" and "decadent" portraits taken in extravagantly patterned and object-filled settings, Rice produced a series of "portraits" of unoccupied chairs. The use of furniture to evoke the human presence and animate space, seen commonly in surrealist painting such as that of Rene Magritte, created a haunting and eerie result. A series which Rice termed "Wall Sites"—interiors "inhabited" by various objects individually or in groups—depended on the same effect. In 1976 the sites gave way to bare interiors or fragments of interiors which often included nearly abstract patches of plaster.

A second concern of Rice's work is the continuing development of his formal means. In reference to this, Millard has written of Rice that "one is struck by how rapidly he has moved toward broader effects of tone and scale and how painterly his work is, without in any way becoming unphotographic." Rice's photography has become increasingly abstract and minimal, stripped progressively of its apparent subject matter but increased dramatically in visual strength. Experimentation with color, which Rice began in 1977, is the most recent development increasing the range of his formalist concerns.

—Nancy Hall-Duncan

Leland Rice: Image from the Visual Dialogue Foundation Founders Portfolio, 1970 Courtesy Art Institute of Chicago

RIEBESEHL, Heinrich.

German. Born in Lathen, 9 January 1938. Studied photography under Otto Steinert at the Folkwangschule, Essen, 1963-65, Dip.Design 1972. Married Gisela Remane in 1964; daughter: Catharina. Worked as an assistant at the Galerie Clarissa, Hannover, 1966; Reporter, *Hannoversche Presse*, 1967-68. Freelance photographer, Hannover, since 1968. Dozent, Fachhochschule, Hannover, since 1968; Co-Director, Galerie Spectrum im Kunstmuseum, Hannover, since 1971. Member, Gesellschaft Deutsche Lichtbildner (GDL), since 1970. Recipient: Bernhard-Sprengel Prize, Hannover, 1981. Agents: Galerie Kicken, Albertusstrasse 47-49, D-5 Cologne 1, Germany; and Sander Gallery, 2600 Connecticut Avenue N.W., Washington, D.C. 20008, U.S.A. Address: Am Kanonenwall 1, D-3000 Hannover 1, West Germany.

Individual Exhibitions:

1966 *Lokomotiven*, Galerie am Berg, Stuttgart (travelled to Galerie Clarissa, Hannover, Staatliche Landesbildstelle, Hamburg, and Galerie Form, Zurich, 1967)

1970 *Menschen im Fahrstuhl*, Kunstverein, Hannover (travelled to Galleria dell'Immagine, Bergamó, Italy, Staatliche Landesbildstelle, Hamburg, and Pressehaus, Hannover, 1971)

1975 *Situationen und Objekte*, Galerie im Steintor-Verlag, Burgdorf, Germany (travelled to Kunstverein, Unna, Germany, 1976, and Werkstatt für Photographie, Berlin, 1977)

1977 *Contemporary Photographs*, Sander Gallery, Washington, D.C.

1979 *Die Norddeutsche Agrarlandschaft*, Sander Gallery, Washington, D.C.

1980 *Agrarlandschaften*, Galerie Kicken, Cologne
 Norddeutsche Agrarlandschaften, Kunsthalle, Bremen

Selected Group Exhibitions:

1970 *Sei Fotografi della GDR*, Palazzo dell'Arte, Milan

1973 *Points de Vue sur le Portrait*, Société de Photographie, Paris

1975 *Photographie 1929-1975*, Kunstverein, Stuttgart

1976 *Photographie Hier und Heute*, Kunstverein, Hamburg
 Documents of the 19th and 20th Centuries, travelling exhibition (*Camera* magazine)

Collections:

Museum für Kunst und Gewerbe, Hamburg; Museum Folkwang, Essen; Musée d'Art et d'Histoire, Switzerland; Bibliothéque Nationale, Paris; Stedelijk Museum, Amsterdam; Philadelphia Museum of Art; Library of Congress, Washington, D.C.; Boston Museum of Fine Arts; New Orleans Museum of Art.

Publications:

By RIEBESEHL: books—*Photographierte Erinnerung*, Hannover 1975; *Situationen und Objekte*, with text by Jörg Krichbaum, Riesweiler, Germany 1978; *Agrarlandschaften*, with an introduction by Peter Sager, Bremen 1979.

On RIEBESEHL: book—*Menschen im Fahrstuhl*, exhibition catalogue, by Manfred de la Motte, Hannover 1970; articles—"Das Leben im Lift" by Ursula Bode in *Hannover Allgemeine*, February 1970; "Menschen im Fahrstuhl" by Rainer Fabian in *Die Welt* (Hamburg), April 1971; "Fotografie Heinrich Riebesehl" by Jiri Machu in *Ceskoslovenska Fotografie* (Prague), March 1973; "Master of the Leica: Heinrich Riebesehl" by Fritz Kempe in *Leica Fotografie* (Frankfurt), April 1973; "Situationen und Objekte" by Winfried Wiegand in *Frankfurter Allgemeine*, July 1979; "Die Unwirtlichkeit der Landschaft" by Manfred Schuchmann in *Frankfurter Rundschau*, December 1979.

I'm interested in photography because I'm interested in the different realities of things and situations, and photography can be a very authentic and spontaneous medium to make a document about my sense of the environment.

—Heinrich Riebesehl

Heinrich Riebesehl is one of the few young German photographers who is known internationally from exhibitions and publications. Born in 1938 in Lathen, he has lived in Hannover since 1958. The spareness and sobriety of the north German landscape and its inhabitants may have made an early contribution to his particular vision, and so, perhaps, did Hannover's distinctive artistic tradition: Hannover was one of the centers, with Berlin and Cologne, of the *Neue Sachlichkeit*, the "New Objectivity." But the most decisive influence on Riebesehl's development was his study with Otto Steinert at the Folkwangschule in Essen. What Riebesehl learned from the master of "Subjective Photography," already a legend in his own lifetime, apart obviously from technical perfection, was above all an emphasis on the artistic quality of photography, individual composition of the picture, and the necessity to make a decision to view an object in one way and no other. Added to this influence and already apparent in his early work—"Lokomotiven" of 1963, for example—was Riebesehl's preference for the series, a system of photographic art beyond the individual picture.

These characteristics are particularly clear in the series "Menschen in Fahrstuhl" of 1969: everyday faces, variations on a commonplace situation, gain an existential quality of expression. No less documentary in method, but more subjective in outcome, is the series "Selbstdarstellungen" of 1972, portraits

without the portraitist—people of various professions and ages take photographs of themselves using a lengthened cable release, as unaffected or peculiar as they wish.

Riebesehl published *Situationen und Objekte* in 1978, black-and-white photographs notable for their peculiar atmosphere of suspense and for their paradoxically unspectacular tension. In certain constallations of light and shade—which are as much accidental as calculated—people and things gain a new and disturbing reality. The ambivalence of the situations, the anonymity of the people, and the strangeness of familiar objects, are all increased by heavy cutting, overlapping, and a very fast, almost snap-shot-like, technique. It is photography as fiction of another reality: it casts doubt on what and how we see. Counter movements, mysterious meetings: in *Situationen und Objekte* Riebesehl shows a predilection for people who are cut from the edge of the picture, whose faces are in shade or who turn their backs on us. And at the provisional end of the series, there are pictures totally without people, landscapes with only traces of their inhabitants.

The characteristic perspective of most of the photographs in *Situationen und Objekte* has to do with Riebesehl's attitude, the striking anti-classical concept of the "wrong moment." He says: "The short time before or after the 'right moment' can be just as powerful in its statement. In fact, it is often more powerful; Before and After come from a period of activity, they allow the imagination to consider what could happen or has already happened."

Riebesehl's next book, *Agrarlandschaften*, published in 1979, is based on a series of more than 1,000 photographs of land, farm-houses, fields, machines and feed-silos in North Germany, nature under the aspect of its produce, documented in sober, normal, everyday light. The typology of landscape is apparent, the structure of things. Riebesehl's photographic land survey, with its precision and method, follows in the tradition of August Sander, Albert Renger-Patzsch, and Bernd and Hilla Becher. But here the magical surreal aspect of reality is also visible.

With his particular kind of subjective documentary photography Riebesehl belongs to a group of young German photographers—Wilhelm Schürmann, Michael Schmidt, Martin Manz, among others—who have devoted themselves to a new kind of "New Objectivity." Neither photo-journalists nor art photographers, they favor a neutral, diffuse light, take eye-level photographs (preferably in black-and-white), mistrust the "beautiful" picture, and set against the Kodachrome of the illustrated magazine a deliberately reserved, spare aesthetic. They renounce sensational motives and spectacular composition; they emphasize the normal, almost the banal. Heinrich Riebesehl is one of the purists of this new aesthetic.

—Peter Sager

RIEFENSTAHL, Leni.
German. Born Berta Helene Amalia Riefenstahl in Berlin, 22 August 1902. Educated at the Realgymnasium, Berlin, 1912-18; studied art at the Kunstakademie, Berlin, 1918-19; classical ballet, under Eduardova, Berlin, and modern dance, under Mary Wigman, Dresden, 1919-23. Married Peter Jakob in 1944 (divorced, 1946). Worked as a dancer in Germany and throughout Europe, 1923-26; film actress, appearing in *Der Heilige Berg*, 1926, *Der Grosse Sprung*, 1927, *Die Weisse Hölle von Piz Palü*, 1929, *Stürme über dem Montblanc*, 1930, *Der Weisse Rausch*, 1931, and *SOS Eisberg*, 1932. Film Producer, Leni Riefenstahl Produktion, Berlin, subsequently Munich, since 1931; has also worked in still photography, Munich, since 1962. Recipient: Gold Medal for Film, *Biennale*, Venice, 1932, 1936, 1938; Grand Prix, *Exposition Internationale*, Paris 1937; Gold Medal, Arts Directors Club of Germany, 1975; Order of Distinction, Republic of the Sudan, 1976. Address: Leni Riefenstahl—Produktion, Tengstrasse 20, 8000 Munich 40, West Germany.

Individual Exhibitions:

Selected Group Exhibitions:

Heinrich Riebesehl: *Schillerslage*, from *Agrarlandschaften*, 1979

Publications:

By RIEFENSTAHL: books—*Kampf in Schnee und Eis*, Leipzig 1933; *Hinter den Kulissen des Reichsparteitag-films*, Munich 1935; *Schönheit im Olympischen Kampf*, Berlin 1937; *Die Nuba*, Munich 1973, as *The Last of the Nuba*, New York 1974; *Die Nuba von Kau/People of Kau*, Munich and New York 1976; *Korallengarten/Coral Gardens*, Munich, Paris, London and New York 1978; articles—"Das Fest der Messer und der Liebe" in *Stern* (Hamburg), 7 October 1975; "Mein Wildes Leben" in *Quick* (Munich), August 1977; "Leni Riefenstahl: Weltkarriere als Taucherin" in *Submarine* (Munich), September 1978; "Der Trieb, Schön zu Sein" in *Quick* (Munich), 5 October 1978; films—*Das Blaue Licht*, 1932; *Triumph des Willens*, 1934; *Olympia*, 1938; *Tiefland*, 1954.

On RIEFENSTAHL: articles—"Leni et le Loup" by Carl Dreyer in *Cahiers du Cinema* (Paris), September 1965; "Comeback for Leni Riefenstahl" in *Film Comment* (New York), Winter 1965; "Leni Riefenstahl" by H. Weigel in *Filmkritik* (Munich),

Leni Riefenstahl: *Self-Portrait*, 1941

August 1972; "Leni" by A. Mannheim in *Modern Photography* (New York), February 1974.

Leni Riefenstahl's photographs remind one of movies, as they very well might. Having spent the better part of her life as a film-maker, it's no accident that Riefenstahl's pictures pick up some of a film's sensibilities. But they do so in a curious, and, in some sense, rather sophisticated way. For, instead of relying on the look of movies—as one might expect a camera to do—they catch the feel of movies. They allow viewers to think that as they look at the still picture, they are seeing a movie. Small and large objects, for instance, are thrown into the same scene without any attention to a "true" scale, and, actually, are rather outlandishly scaled. It's as if Riefenstahl were saying that the camera is about to change everything you see, that the imbalance in seeing a small object up front and an overpowering object in the distance is temporary. The scene is in transition. It's about to change. It suggests a vitality. Riefenstahl achieves the same effect with her lens, many of her people unpredictably out of focus in places where we have come to expect them to be in focus

(i.e. in the center of a crowd). Once again, the imbalance is temporary, as if the scene and people we are looking at are on their way towards being changed.

When she uses large grainy imagery, however, we're stymied. We can't make an adjustment and, furthermore, feel a discomfort that makes us question the work's premises. For we have come to understand grainy imagery as a device for heightening and intensifying physical reality. Grainy imagery does not do that in Riefenstahl's pictures. The figures, at first, look sculpted and we stop to take them in and absorb them. But we can't. Although the figures look like people to begin with, they aren't. Abstracted from humanity, they stand as forms, as shapes, as constructs that occupy a time and place—as if they were molded out of clay and made to stand in a particular way. They lack any sense of internal movement—they don't look as if they can breathe. A scene looks like a staged representation of reality, much like the ape-like figures in the film *2001*—no sense of a pulse ticking away.

This non-human thrust appears throughout her work. In one photograph, the shapes (resembling people) echo the shapes of rocks and look as inanimate. In another, silhouetted against the sky, the shapes look mindless. In another, where people are tattooed, the tattoos take over the faces so completely, the photograph becomes one overwhelming design, the people from whom that design originated reduced to raw material for the design.

Only when Riefenstahl broadens her focus to a whole village scene does one pick up a voluptuous swell of life, as, for instance, in a photograph of a village where her camera has swept across a landscape. And only then does the viewer, once again, pick up the vitality that movies—as a process and medium—can impart.

—Judith Mara Gutman

ROBINSON, David.
American. Born in 1936. Educated at Dartmouth College, Hanover, New Hampshire, B.A. 1959; did graduate work in African studies, University College of Ghana, Accra, 1960-61, and Boston University, 1961-62, M.A. 1962, and in education, Harvard University, Cambridge, Massachusetts (Member, Editorial Board, *Harvard Educational Review*, 1968-69), ED.M. 1967, ED.D. 1976; studied photography at workshops in Carmel, California, 1977, and in Arles, France, 1978. Freelance photographer, Boston, since 1970. Teacher of social studies in Western Nigeria; Assistant Professor of Communications, Fitchburg State College, Massachusetts, 1977-78; Instructor, Boston University School of Education, 1980-82. Recipient: National Endowment for the Humanities Fellowship, 1981. Address: 159 West Canton Street, Boston, Massachusetts 02118, U.S.A.

Individual Exhibitions:

1971 Boston Film Center
 Brockton Art Center, Massachusetts
1972 Galleria Pictogramma, Rome
1973 Dartmouth College, Hanover, New Hampshire
 Galleria Il Diaframma, Milan
1975 Tyler School of Art, Rome
1976 Cameraworks, Los Angeles
 International Center of Photography, New York

1977 Popular Photography Gallery, New York
Kiva Gallery, Boston
Dorry Gates Gallery, Kansas City, Missouri
1978 Weston Gallery, Carmel, California
Brentano's, Boston
1979 Canon Photo Gallery, Geneva
Logia Gallery, Palm Beach, Florida
Gallery of Photographic Arts, Cleveland
Boris Gallery of Photography, Boston
1980 Jeb Gallery, Providence, Rhode Island

Collections:

AT & T Company, New York; Chase Manhattan Bank, New York; Metropolitan Life Insurance Company, New York; IBM Corporation, White Plains, New York; Polaroid Collection, Cambridge, Massachusetts; Museum of Fine Arts, Boston; Gernsheim Collection, University of Texas at Austin; Bibliothèque Nationale, Paris.

Publications:

By ROBINSON: books—illustrations for *Beard's Roman Women* by Anthony Burgess, New York 1976; *Reflections*, New York and London 1978; articles—"Italian Reflections" in *Camera 35* (New York), October 1977; "Perspectives on the Art of Commercial Photography" in *The Boston Monthly*, October 1979; "Roman Holiday" in *The Boston Globe*, 13 April 1980; "Choices We Make" in *Views* (Boston), Fall 1980; "Eve Arnold's China" and "Never-Fail Image" in *Views* (Boston), Winter 1980; "Maestro Bob Tow of Matrix" in *Views* (Boston), Spring 1981.

On ROBINSON: articles—in *Fotografia Italiana* (Milan), March 1973; *Nuova Fotografia* (Naples), February 1974; *Popular Photography* (New York), March 1977; *British Journal of Photography* (London), 15 September 1978; *Popular Photography* (New York), August 1979; *Rhode Island Review* (Providence), December 1980.

David Robinson's photographic career began in Africa where he was a student at the University of Ghana and later a social studies teacher in Western Nigeria. His initial efforts documented the people and their environs and included some memorable close-ups of children's faces. After settling in Boston on his return to the U.S., Robinson met an Italian painter who encouraged him to see his subjects in more abstract terms. The result was the creation of a series of high contrast prints of a woman performing yoga, in which the volumes of the body were flattened and its contours merged with shadows to produce rhythmic shapes which were like graphic counterparts to the flow of energy during exercise.

His fascination with the fluidity of motion and unusual configurations culminated in a series of color photographs taken over a three-year period in Italy, entitled *Reflections*. The image was now multiplied rather than reduced, and the layers of association and allusion in the photographs proportionately increased. Robinson's expressive range also broadened with his introduction of color, as the hues varied from the subdued range of reflections in glass to the brilliant contrast of bright boats in the water. His first "Reflection" picture, "Piazza Navonna Cobblestones," was shot straight down into a puddle, with a short depth of field, so that the cobblestones provided a blurred border for the mottled image of the reflected church and female pedestrian. Because the picture is mounted upside down, with the church upright, it is not immediately apparent that we are looking at a reflection; instead, one has the sensation of looking at the church *through* the pavement, as if from another world. Our normal, linear, frontal vision is fragmented and one can look both forward and backward, both at and through things simultaneously. The resulting layered images accurately convey the situation of the sensitive tourist, whose past experiences become modified by unfamiliar environments. The juxtapositions of these gravity-free vignettes, transparent or opaque, focused or unfocused, lend the poetry to these works. Robinson thus builds on Atget, Brassaï, Kertész, and others who have exploited the capacity of reflections to dissociate us from our habits of seeing. Robinson's vision is rarely ironic; his figures, enveloped in golden atmosphere and surrounded by magnificent architecture and statuary, inhabit an environment of fleeting daydreams. None of the images were double exposed or printed, and the achievement of the series, and of the resulting book, is largely dependent on the fact that the images were the result of intense looking rather than darkroom manipulation. In the end, Robinson's approach parallels that of turn-of-the-century pictorial photography. "Red Boat, Burano" is a modern counterpart to Alvin Langdon Coburn's "White Bridge, Venice" of 1907, in which the graphic qualities of reflections in water yield a poetic mood, the result of the contemplation of beauty.

Robinson has produced several mini-series since *Reflections* was published in 1978, one on perception and another on advertising imagery. The latter consisted of 20 x 24" Polaroid close-ups of advertising images in the *New York Times Sunday Magazine*, photographed so that both sides of the page appeared at once. The double images explicitly call attention to the superficiality of the subjects but do not yield the kind of humorous or biting juxtapositions one might expect. His best work still results from travel. Using a long lens on a recent trip to Mexico, Robinson has telescoped space so that a courtyard with palm trees, "Mexican Palms," looks like a silk-screen print. He has also created an article on Mexican street photographers for Polaroid and has been exploring computer-aided photography.

—Pamela Allara

See Color Plates

RODCHENKO, Alexandr (Mikhailovich).

Russian. Born in St. Petersburg, 23 November 1891. Studied drawing and painting, under Nikolai Feshin and Georgii Medvedev, Kazan Art School, 1907-14; School of Fine Arts, St. Petersburg, 1910-14; Stroganov Institute, Moscow, 1914-15; mainly self-taught in photography. Married the painter Varvara Stepanova in 1911; daughter Varvara Alexandra. Independent painter and designer, associating with Cubo-Futurists, Moscow, 1915-21; renounced painting to concentrate on design and photography, Moscow, 1921-28; professional magazine photographer and photo-reporter, working for *Lef, Novyj Lef, Ogonjok, Radioslushatel, Prozhektor, Krasnoye Studenchestvo, Dayosh, Za Ruebzhom, Smena, Borba Klassov*, etc., Moscow, 1923-32, and phototheme contributor, *SSSR na Stroike* (*Soviet Union in Construction*), Moscow, 1933-41; resumed work as independent painter of abstract-expressionist works, Moscow, 1935-42; worked principally as exhibition designer, Moscow, 1942 until his death, 1956. Secretary, Leftist Federation of Artists, Moscow, 1917; Co-Director with Olga Rozanova, Industrial Art Faculty, IZO School, Moscow, 1919-22; Director, and Head of Purchasing Committee, Museum of Artistic Culture, Moscow, 1919-20; Member, with Vladimir Krinsky, Aleksandr Shevchenko and others, Zhivskulptarch (painting-sculpture-architecture group), Moscow, 1919-20; Member, Inhuk, Moscow, 1920; collaborator, with filmmaker Dziga Vertov, 1922, and with filmmaker B. Barnet, 1927; Member, *October Group*, Moscow, 1928-31; Chief Artistic Consultant, Dom Technika Exhibition, Moscow, 1944-45. Lecturer, Proletcult School, Moscow, 1918-26; Professor of Metalwork, Vkhutemas School, Moscow, 1920-30. *Died* (in Moscow) *3 December 1956*.

Individual Exhibitions:

1918 *5 Years of Art*, Leftist Federation Club, Moscow
1957 *Retrospective Alexandr Rodchenko*, House of Journalists, Moscow
1961 *70th Anniversary Exhibition*, House of Writers, Moscow
1962 House of Writers, Leningrad, U.S.S.R.
Memorial Exhibition, Sate Literary Museum, Moscow
1968 House of Journalists, Moscow
1970 Kostroma, U.S.S.R.
1971 *Alexandr Rodchenko: Photographs*, Museum of Modern Art, New York
1977 *A. Rodchenko: Photographe*, Musée d'Art Moderne de la Ville, Paris
Galleria Il Diaframma, Milan (toured Europe)
1978 *Rodtschenko: Fotografien 1920-1938*, Galerie Gmurzynska, Cologne (travelled to the Museum Ludwig, Cologne; Bauhaus Archiv, West Berlin; Kunsthaus, Zurich, and Staatliche Kunsthalle, Baden-Baden, West Germany)
1979 Museum of Modern Art, Oxford (travelled to Stedelijk Van Abbemuseum, Eindhoven, Netherlands; and Musée d'Art Contemporain, Montreal)

Selected Group Exhibitions:

1927 *Friends of Soviet Cinema and Photography*, Moscow
1928 *10 Years of Soviet Photo-Art*, Moscow (travelled to Leningrad)
1929 *Chicago International Photographic Exhibition*
Film und Foto, Deutscher Werkbund, Stuttgart
1931 *2nd Exhibition of the Photo Department of the October Artists Union*, Moscow
1964 *125 Years of Photography*, Film Artists Centre, Moscow
1969 *Die Fotomontage*, Kunstverein, Ingolstadt, West Germany
1977 *Künstlerphotographien im XX. Jahrhundert*, Kestner-Gesellschaft, Hannover
1978 *Photos from the Sam Wagstaff Collection*, Corcoran Gallery, Washington, D.C. (toured the United States and Canada
1979 *Paris-Moscou 1900-1930*, Centre Georges Pompidou, Paris

Collections:

George Costakis Collection, Moscow; Galerie Gmurzynska, Cologne; Museum of Modern Art, New York.

Publications:

By RODCHENKO: book—*A.M. Rodchenko: Stati, Wospominanija, Autobiografitscheski Sapiski, Pisma*, Moscow 1978; books illustrated—*Pro Eto* by Vladimir Mayakovsky, Moscow 1923, Ann Arbor, Michigan 1973; *An Sergei Jessenin* by Vladimir Mayakovsky, Moscow 1926; *Razgovon c Finispektorom o Poesii / Gespräch mit einem Finanzinspektor über Poesie* by Vladimir Mayakovsky, Moscow

Alexandr Rodchenko: *Photomontage for Mayakovski's Poem "Pro Eto,"* 1923

1926; *Samozveri/Roboter-Tiere*, with Varvara Stepanova, text by S. Tretyakov, Moscow 1926, as *Samozveri/Selbstgemachte Tiere*, Cologne 1980; *Rabota s Mayakovskym*, Moscow 1940; *O Vladmimme Tatline*, Moscow 1940; *Khorosho*, with Varvara Stepanova, text by Vladimir Mayakovsky, Moscow 1956; *Liniya*, 1973; articles—"Sistema Rodchenko" in *X Gosudarstvennaya Vystavka Bespredmetnoe Tvorchestvo i Suprematizm*, exhibition catalogue, Moscow 1919; "Protiv Summirovannogo Portreta za Momentalnyi Snimok" in *Novyj Lef* (Moscow), no. 4, 1928; "Artists and Critics" in *Sovetskoye Foto* (Moscow), no. 9, 1935; "Vladimir Tatlin" in *Opus International* (Paris), no. 4, 1967; "Black and White" in *Sovetskoye Foto* (Moscow), no. 12, 1971; "La Ligne" in *Art Press* (Paris), November/December 1973; "My Work with Mayakovsky" in *V. Mire Knig* (Moscow), no. 6, 1973; "Beseda c A.M. Rodchenko," interview, in *Sovetskoye Kino* (Moscow), no. 5/6, 1977.

On RODCHENKO: books—*Russkaya Chudoshestvennaya Fotografia* by S. Morosov, Moscow 1955; *The Great Experiment: Russian Art 1863-1922* by Camilla Gray, London 1962, Cologne 1963; *Alexander Rodchenko* by L. Linhart, Prague 1964; *A. Rodchenko* by L. Volkov-Lannit, Moscow 1968; *Die Fotomontage: Geschichte und Wesen einer Kunstform*, exhibition catalogue, by Richard Hiepe, Ingolstadt, West Germany 1969; *New Graphic Design in Revolutionary Russia* by Szymon Bojko, London 1971, Munich 1975; *Alexander Rodchenko* by German Karginov, Budapest 1975, Warsaw 1981; *Sowjetische Fotografie 1928-1932* by R. Sartori and H. Rogge, Munich 1975; *Russian Art of the Avant-Garde: Theory and Criticism 1902-1934*, edited by J.E. Bowlt, New York 1976; *Malewitsch: Mondrian und Ihre Kreise*, exhibition catalogue, by Christoph Brockhaus and Manfred Fath, Cologne 1976; *Photomontage* by Dawn Ades, London 1976; *Künstlerphotographièn im XX. Jahrhundert*, exhibition catalogue, edited by Carl-Albrecht Haenlein, Hannover 1977; *Geschichte der Fotografie im 20. Jahrhundert/Photography in the 20th Century* by Petr Tausk, Cologne 1977, London 1980; *Paris-Berlin 1900-1933*, exhibition catalogue, by H. Molderings, W. Spies, G. Metken and others, Paris 1978; *Rodtschenko: Fotografien 1920-1938*, edited by Evelyn Weiss, with texts by John E. Bowlt, Szymon Bojko, Hubertus Gassner, Ursula Czartorska and Donald Karshan, Cologne 1978; *A Book of Photographs from the Collection of Sam Wagstfff*, designed by Arne Lewis, New York 1978; *Alexander Rodchenko*, exhibition catalogue, by David Elliott, Oxford, 1979; *Paris-Moscou 1900-1930*, exhibition catalogue, by Pontus Hulten, Jean Miller, Alexander Khaltourine and others, Paris 1979; *Sowjetische Fotografen 1917-1940* by S. Morosov, A. Vartanov, G. Chulakov, O. Suslova and L. Uchtomskaya, Leipzig and West Berlin 1980; *Rodchenko and the Arts of Revolutionary Russia* by David Elliott, New York 1980; articles—"A. Rodchenko: A Constructivist Designer" by Camilla Gray in *Typographica* (London), June 1965; "Alexander Rodchenko: Chudoshnik-Fotograph" by V. Schlovski in *Prometei* (Moscow), no. 1, 1966; "A Rodchenko" by L. Volkov-Lannit in *Iskusstvo Kino* (Moscow), no. 12, 1967; "Collages et Photomontages Oubliés de A. Rodchenko" by Szymon Bojko in *Opus International* (Paris), April 1969; "A. Rodchenko: Fotografo d'Avanguardia" by Lubomir Linhart in *Popular Photography Italiana* (Milan), June 1971; "Notizen zur Marxistischen Geschichtsschreibung der Fotografie" by Richard Hiepe in *Tendenzen* (Munich), vol. 13, no. 86, 1972-73, vol. 14, no. 87, 1973, and vol. 14, no. 88, 1973; "Alexander Rodchenko: Photomontages" in *Creative Camera* (London), May 1973; "Il Tiempo di Rodchenko" by Schwarz, Fontana and Ricci in *Fotografia Italiana* (Milan), June 1976; "Rodchenko and Chaikov" by John E. Bowlt in *Art and Artists* (London), October 1976; "A. Rodchenko" by Varvara Rodchenko in *Revue Fotografie* (Moscow), no. 1, 1977; "A.M. Rodchenko, a Moskva Prvni

Petiletky" by Varvara Rodchenko in *Revue Fotografie* (Prague), vo. 1, 1977; "Back to the Material: Rodchenko's Photographic Ideology" by Andrei B. Nakov in *Artforum* (New York), October 1977; "A Revolutionary from Bolshevik Russia" in *Photography Year 1980*, by the Time-Life editors, New York 1980; "Soviet Photography Between the World Wars 1917-1941" by Daniela Mrázková and Vladimír Remeš in *Camera* (Lucerne), June 1981.

Alexandr Rodchenko began his artistic career as a painter and made himself known while still in school as a representative of the visual arts vanguard. During the period of social and cultural flux which occurred during and following the revolutions of 1917 in Russia, Rodchenko took an active part in the new ideological and artistic developments. He creatively devised Soviet photomontage, but, while he produced photomontages prior to that time, he did not himself use the camera until 1924. He made use of the camera, photoreportage and photomontage as the means of generating a new vision for a new reality. Daniela Mrázková and Vladimír Remeš, in their article "Soviet Photography Between the World Wars 1917-1941" (*Camera*, June 1981), provide an account of Rodchenko's role in the Soviet post-revolutionary world of art and phogography:

"In the 20's and early 30's, Soviet photography gradually developed into two basic and powerful currents: experimental-artistic and reportage. The former was strongly influenced by the Russian artistic vanguard, represented in the context of creative art principally by Kazimir Malevich and Vladimir Tatlin; in its ideology and internal contradictions, this trend was closely allied to the artistic aims of the Bauhaus. In photography, it aimed at achieving new approaches to reality from both without and within. Although it expressed the ideals of the revolution, it did so by means which were far ahead of the understanding of the time. The second current, reportage, was more suited to the practical needs of the time, but its intentions were basically the same: it also aimed at reacting to the new era in a new way. Naturally, with the gradual advance of technology and the possibility of printing newpapers and journals, the reportage became indispensable and finally decisive for the further development of Soviet photography.

"The most outstanding exponent of the experimental-artistic trend was, for many years, Alexandr Rodchenko. His significance for photography may be compared to that for literature of Vladimir Mayakovsky [whose work, e.g., *Pro Eto* (1923), Rodchenko illustrated with photomontages], a dazzling figure at the time. Like the latter, Rodchenko, too, was imitated, rejected, celebrated and persecuted all at the same time. But whether he was acknowledged or not, he always had to be respected; he was the leading spirit of the ideas of the time, of all creative endeavours, the pioneer of all new processes which he expressed in his work and by which he influenced others. Originally a painter, he supported the art concept of Vladimir Tatlin who, unlike Kazimir Malevich, held that the main criterion to be applied to art was its usefulness. Rodchenko was, however, strongly influenced by Malevich as regards the dynamism of his composition and, like most of his contemporary avant-garde fellow artists, he thought seriously about the purpose of art and emphasized its social function and practical application in various spheres of life.

"Rodchenko became an adherent of photography through experimental typographic journal layouts and during his work in publicity, where he met Mayakovsky. His friendship with El Lissitzky and their collaboration in educational work at the Moscow School of Applied Art, Vchutemas, acquainted him with contemporary trends in the photography of Western Europe—with the work of László Moholy-Nagy, Albert Renger-Patzsch, Man Ray and others to whom he is often compared and even accused of having imitated. What Rodchenko really

did was to absorb these influences and transform them into his own, entirely individual expression. He presented ordinary, well-known phenomena and things from new and unaccustomed angles, in detail, from above or below, or distorted in the diagonal. All this was done with the aim of expressing, in his own individual way, the purpose of the new age and its internal ideological dynamics, and to enrich the viewer's perception. After the dissolution of *Lef* in 1928, he joined the photography section of the October Group, which continued to follow the expressive trends which corresponded to his views. The activities of this group were, however, criticized from the outset because of thier allegedly nonpolitical views and an outlook directed towards Western aesthetics and formalism. In 1931, Rodchenko was actually expelled from the group for 'propagating a taste alien to the proletariat.'

"Like the majority of those who shared his ideological views, Rodchenko left for the great building sites of the first economic Five-Year-Plans after the dissolution of the October Group to photograph the prevailing 'revolutionary optimism.' Here, too, he continued to function as an innovator, always seeking a new 'reportage' language of photography. 'It is our duty to experiment,' he wrote in 1928. 'To photograph facts or to describe them, that is nothing new; however, the photograph may be replaced by a picture and the described fact by a novel.... There is nothing new in having begun to photograph workers' leaders in the same way as generals under the old regime.... In all circles, there are people who know what to photograph, but there are only a few who know how to photograph.... In short, we must see; we seek and we find new aesthetics, pathos and enthusiasm for the photographic expression of our new socialist reality....' "

—Michael Held

RODGER, George.
British. Born in Hale, Cheshire, 19 March 1908. Educated at St. Bees College, Cumbria, 1921-25. Served in the British Merchant Navy, 1926-29, and as a *Life* magazine War Correspondent, 1939-45: "assimilated" Captain; 18 campaign medals. Married Cicely Joane Hussey-Freke in 1942 (died, 1949); married Lois Witherspoon in 1952; children: Jennifer, Jonathan, and Peter. Worked as a machinist, wool-sorter, steel-rigger, fruit farmer, etc., in Boston and Geneva, New York, 1929-36; worked for the B.B.C., 1936-38; freelance photographer with the Black Star photo agency, London, 1938-39; Photographer and War Correspondent, through Europe, North Africa, the Middle East and Burma, 1939-45, and Staff Photographer, 1945-47, *Life* magazine, New York. Founder Member, with Robert Capa, Henri Cartier-Bresson, and David Seymour ("Chim"), Magnum Photos co-operative agency, Paris and New York, since 1947. Recipient: Arts Council Bursary, 1975, 1977. Agents: Magnum Photos, 2 rue Christine, 75006 Paris, and 251 Park Avenue South, New York, New York 10010; and The Photographers' Gallery, 8 Great Newport Street, London WC2. Address: Waterside House, Smarden, Kent TN27 8QB, England.

Individual Exhibitions:

1974 The Photographers' Gallery, London (toured the U.K.)

George Rodger: *The Courting Dance of the Wachimbiri in the Rain Forests of Kigezi,* Uganda/Congo, 1948

1976 Canterbury Library, Kent (toured Southeast England)
1978 University of South Africa, Cape Town
1979 *Masai Moran*, The Photographers' Gallery, London (toured the U.K.)
Masai Moran, FNAC Galleries, Paris (toured France)
1981 Contrasts Gallery, London

Selected Group Exhibitions:

1955 *The Family of Man*, Museum of Modern Art, New York (and world tour)
1960 *The World as Seen by Magnum*, Takashimaya Department Store, Tokyo (and world tour)
1969 *Fotomundi*, Eindhoven, Netherlands
1972 *Personal Views 1850-1970*, British Council, London (toured Europe)
1975 *The Real Thing: An Anthology of British Photographs 1840-1950*, Hayward Gallery, London (toured the U.K.)
1976 *British Photographers*, at *Rencontres Internationales de la Photographie*, Arles, France
1979 *Life: The First Decade 1936-1945*, Grey Art Gallery, New York University
1980 *Magnum Photos*, Galerie Le Cloître, St. Ursanne, Switzerland

Collections:

Victoria and Albert Museum, London; Arts Council of Great Britain, London; Rijksmuseum, Amsterdam; University of South Africa, Cape Town; Australian National Museum, Sydney.

Publications:

By RODGER: books—*Red Moon Rising*, London 1943; *Desert Journey*, London 1944; *Far on the Ringing Plains*, New York 1944; *Le Village des Noubas*, Paris 1955; *This England*, with others, Washington, D.C. 1966; *The World of the Horse*, with text by Judith Campbell, London 1975; articles—"Television History" in *Photo World* (London), March 1939; "Belsen" in *Time* (New York), 30 April 1945; "Africa's Most Dangerous Shooting" in *Argosy* (New York), August 1953; "Sand in Your Eyes" in *National Geographic Magazine* (Washington, D.C.), May 1958; "Elephants Have Right of Way" in *National Geographic Magazine* (Washington, D.C.), September 1960; "Beginnings of Magnum: Random Thoughts by a Founding Father" in *Creative Camera* (London), March 1969; "A Letter to My Son" in *Album* (London), no. 8, 1970; "Souvenirs en vrac d'un membre fondateur de Magnum" in *Reporter* (Paris), no. 10, 1973; interview in *Dialogue with Photography* by Paul Hill and Thomas Cooper, London and New York 1979.

On RODGER: books—*The History of Photography* by Helmut and Alison Gernsheim, London and New York 1955, 1969; *Personal Views*, exhibition catalogue, London 1972; *The World of Time Inc.*, edited by Robert Elson, New York 1973; *George Rodger* by Inge Bondi, London 1974; *The Real Thing: An Anthology of British Photographs 1840-1950*, exhibition catalogue, by Ian Jeffrey and David Mellor, London 1975; *Life Goes to War*, edited by David Scherman, New York 1977; *The Camera at War* by Jorge Lewinski, London 1978; articles—"George Rodger, the World's Most Travelled Photographer" in *Creative Camera* (London), February 1968; "L'Afrique Secrete de George Rodger" in *Photo* (Paris), May 1971; "George Rodger" in *Photographic Journal* (London), September 1974; "George Rodger, Photographer for *Life*" in *Orbit* (Eastbourne, Sussex), May 1975; "George Rodger" in *The Guardian* (London), 2 May 1975; "Photog-

raphy" by Richard Ehrlich in *Art and Artists* (London), March 1979; "George Rodger" by Tom Hopkinson in *You and Your Camera* (London), no. 10, 1979; "Masai Moran" by Carole Naggar in *Le Matin* (Paris), 1 February 1980.

From an early age I had an instinctive urge to document all I saw, all that I lived, and, at first, photography—as such or as an art—interested me not at all. It was only a means of expression to supplement my writing. In the beginning my typewriter was as much a part of my recording apparatus as my camera.

This meant that in those early years I had no contact with my contemporaries in the photographic field, nor even knowledge of their work. So I was influenced by no one, and there were no short cuts for me. I was self-taught, the hard way, by trial and error.

Probably this was the embryo stage of a natural "photo-journalist," though I didn't know it and, anyway, the word hadn't been coined yet.

During World War II, as war correspondent for *Life*, I reached my heyday as a photojournalist looking at tradedy, horror, disaster and sometimes glory through the viewfinder—as though my camera were a window on the world, and, instinctively, I founded my own photo philosophy.

Although I wrote detailed captions to my pictures for *Life* and sent lead-in text pieces with each package, I realized at last that the force of what I had to say lay in my pictures. They took on a new measure, and, to maintain their strength, I knew they had to be meticulously factual, honest and true—no staged effects, no Western Desert mock-ups, no falsity.

And I follow this principle still. It can probably be summed up in one word: "integrity."

I may juggle the composition, as the strength of a picture is in the composition. Or I may play with the light. But I never interfere with the subject. The subject has to fall into place on its own and, if I don't like it, I don't have to print it.

I am saddened sometimes to see among the young photographers of today so much desperate striving for effect, for distortion, for so much gimmickry, and for kudos.

—George Rodger

The theme of George Rodger's work since the end of World War II has been a noble one—the unity of man with the whole natural world. In many distant places, but above all in Africa, he has made an unforgettable record of the lives, customs and ceremonies of primitive peoples in their own surroundings, following a pattern of existence which has lasted unchanged over the centuries, sometimes indeed over thousands of years. "At school I was a dreamer. I dreamed of faraway places and never really studied. By the time I was 19 I had worked my way as a seaman twice around the world, and established an inability to keep still for long."

Basic to his photographic achievement is Rodger's capacity, not so much for "getting on with" people in remote parts, of whose language he can at best know only a few words, as for allowing himself to be quietly absorbed into their way of life, so that he becomes in spirit the tribesmen or villagers whose manner of life he is recording. Chiefly, he says, "this is a matter of the respect and liking you feel for them, and which somehow they understand and feel towards you in return."

The impulse that launched Rodger off into this special aspect of photography derived from his experiences in World War II. During those five years he crossed the Sahara from the Cameroons and on into Syria; made his way to Burma for the Japanese invasion; covered the North African campaign and the landings in Sicily and Italy; on to the D-Day assault, followed by the drive across France and Germany—to the ultimate horror of being present when the Belsen concentration camp was opened

up. *Life* magazine, for which he was then working, made an 8-page story on George Rodger's travels as a war photographer, and so fearful were many of the scenes he photographed that he resolved to have nothing more to do with the coverage of war and violence.

As one of the four "founding fathers" of the Magnum agency in 1947, he chose Africa as his quarter of the globe, with magical effect on his work, as Inge Bondi, who was his colleague at Magnum has described: "To inaccessible valleys, across roadless deserts and bushland, Rodger moved cautiously, observing and absorbing the customs and courtesies of tribal men. Accepting and adopting the local expressions of friendship and hospitality, however strange, opened up to him the wonders of varying village customs, which he has recorded with an accuracy and simplicity unrivalled in photography."

The word "simplicity" is all-important. Many photographers, as is well known, make efforts to establish a personal style which can be recognized as a hallmark on their pictures. But the only style that George Rodger cares about is truth—to catch, with simplicity and naturalness, that aspect of reality which is presented to him through the viewfinder. His pictures are always boldly composed; often, since he operates so much in bright sunshine, strongly lit; and, because his theme is people at home in their own environment, taken from a sufficient distance to allow their setting to appear, so drawing the viewer in to become part of the whole scene.

Operating so much on his own, far away from offices and colleagues, George Rodger took to being his own writer, first in the form of notes for captions, plus a careful diary of events and facts which a journalist later could write up. But after a while he took to writing, and sometimes cabling, his own stories. In addition, despite all the stress and hazard of the war period, he managed to write two books, the first on his experiences in the desert, the second on Burma and the Japanese invasion. Besides being his own writer, he is also his own darkroom worker, and has often spent the whole night printing up his pictures.

Only a year or two ago—at the age of 70, though looking 20 years younger—Rodger went back to East Africa, to Kenya, where he used his unique powers of making contact and gaining acceptance to photograph a secret circumcision ceremony among the Masai warrior tribe. The fifty or so pictures made early one morning in the course of a few hours created an unforgettable impression when exhibited in London and elsewhere. Speaking of them, he said: "That was the first story I've felt really happy about since I was living among the Nubas in the Upper Nile thirty years ago.... I was much more at home with them than in any city in the world."

—Tom Hopkinson

ROGOVIN, Milton.

American. Born in New York City, 20 December 1909. Educated at Stuyvesant High School, New York, 1923-27; Columbia University, New York, 1927-31, B.S. in optics and optometry 1931; State University of New York at Buffalo, 1970-72, M.A. in American studies 1971. Served in the United States Army, 1942-45: Technical Sergeant. Married Anne Setters in 1942; children: Ellen, Mark, and Paula. Self-employed optometrist, Buffalo, New York, 1931-77. Took first photographs, 1942; professional photographer since 1958. Address: 90 Chatham Avenue, Buffalo, New York 14216, U.S.A.

Individual Exhibitions:

1965 Pennsylvania State University, State College
1970 State University of New York at Buffalo
1971 International Museum of Photography, George Eastman House, Rochester, New York
1972 State University of New York at Buffalo
1975 Albright-Knox Art Gallery, Buffalo, New York
1976 International Center of Photography, New York
1977 St. Lawrence University, Canton, New York
Nina Freudenheim Gallery, Buffalo, New York
Finnish Photographic Museum, Helsinki
1978 The Photographers' Gallery, London
Fotografi Centrum, Stockholm

Panselinos Gallery, Thessaloniki
1979 State College of New York at Buffalo
1982 Studio 666, Paris (with Susan Muhlhausen and Mary Peck)

Selected Group Exhibitions:

1970 *Be-Ing Without Clothes*, Hayden Gallery, Massachusetts Institute of Technology, Cambridge (toured the United States)
1972 *Octave of Prayer*, Hayden Gallery, Massachusetts Institute of Technology, Cambridge
Images of Concern, Neikrug Galleries, New York
1977 *Foto International*, Pori, Finland
1978 *Tusen och En Bild/1001 Pictures*, Moderna Museet, Stockholm
1979 *Western New York Invitional Exhibition*, Albright-Knox Art Gallery, Buffalo, New York
1980 *Bifoto*, Berlin
1981 *Western New York Invitational Exhibition*, Albright-Knox Art Gallery, Buffalo, New York

Collections:

Metropolitan Museum of Art, New York; Museum of Modern Art, New York; International Museum of Photography, George Eastman House, Rochester, New York; Albright-Knox Art Gallery, Buffalo, New York; Rhode Island School of Design, Providence; Yale University, New Haven, Connecticut; Philadelphia Museum of Art; Library of Congress, Washington, D.C.; Bibliothèque Nationale, Paris; Moderna Museet, Stockholm.

Publications:

By ROGOVIN: books—*Learning by Doing*, with text by Anne Rogovin, New York 1977; *Let Me Do It!*, with text by Anne Rogovin, New York 1979; article—"Store-Front Churches," photoessay—with text by W.E. DuBois, in *Aperture* (Millerton, New York), no. 2, 1961.

On ROGOVIN: books—*Milton Rogovin*, exhibition catalogue, with an introduction by James Wood, Buffalo, New York 1975; *Milton Rogovin*, exhibition catalogue, Stockholm, 1978; articles—in *Aperture* (Milerton, New York), no. 4, 1975; "Endpaper" in the *New York Times*, November 1975; "Milton Rogovin's Latin America" by David Strack in the *Courier Express* (Buffalo, New York), 5 June 1977; "Milton Rogovin" by Ian Jeffrey in *London Magazine*, July 1978.

In 1927, when I enrolled at Columbia University—it was a period of mounting prosperity. A popular slogan at that time was, "A chicken in every pot, two cars in every garage."

When I graduated in 1931 the country was in the midst of a serious depression. This catastrophe had a profound effect on my thinking, on my relationship to other people—especially the poor, "the forgotten ones."

At the age of thirty-two I received my first camera. It was a fine little instrument, a Zeiss Super Ikonta "A." A friend gave me a few lessons in the use of the camera, also in developing and printing. But, for a long time, my photographic work was limited to family pictures, to my wife and three children, and to occasional shots on trips or in the neighboring areas of Buffalo, New York.

It wasn't until 1958 that my deep concern for the problems of the Black People of my community influenced me to begin some serious photographic work. For three years I devoted all my spare time to photographing some poor Black people in their store-front churches. With the encouragement of Minor White, editor of *Aperture*, I completed a photo essay, "Store-Front Churches, Buffalo," which appeared in *Aperture* in 1961 together with an introduction by the distinguished Black scholar, Dr. W.E. DuBois.

My photographic work was of necessity limited to evenings, weekends or vacation periods. But as an optometrist, I had some patients who introduced me to families in the Black community. Through these contacts, as well as through the numerous people I had met in the store-front churches, I began a new series dealing with the Black people in and around their homes. Taking advantage of our summer vacations my wife and I began work in 1962 on a new photo series dealing with the miners and their families in the "hollows" of West Virginia and eastern Kentucky. As our contacts and knowledge of the area expanded, so did the scope and depth of our project. The work in Appalachia was completed after nine summers.

Like my previous series, the choice was consistent with my interest in working among the poor, "the forgotten ones." The German artist Kaethe Kollwitz has expressed eloquently her thoughts as to choice of subject matter. I quote her at length since my feelings are consistent with hers:

> My real motive for choosing my subjects almost exclusively from the life of the workers was that only such subjects gave me in a simple and unqualified way what I felt to be

Milton Rogovin: From the series *Lower West Side*, 1975

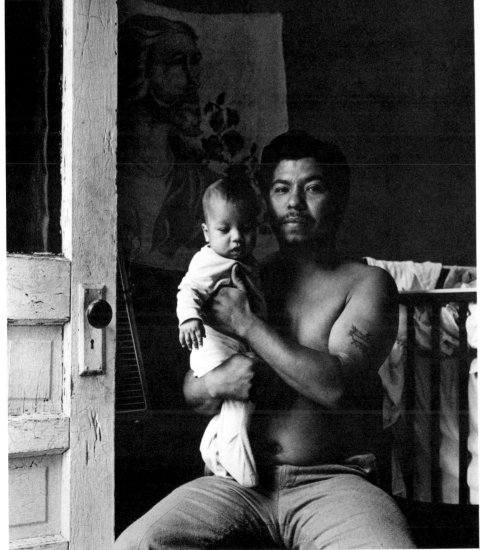

beautiful. For me the Koenigsberg long-shoremen had beauty; the Polish jimkes on their grain ships had beauty; the broad freedom of movement in the gestures of the common people had beauty. Middle-class people held no appeal for me at all. Bourgeois life as a whole seemed to me pedantic. The proletariat, on the other hand, had a grandness of manner, a breadth to their lives. Much later on, when I became acquainted with the difficulties and tragedies underlying proletarian life, when I met the women who came to my husband for help and so, incidentally, came to me, I was gripped by the full force of the proletarian's fate. Unsolved problems such as prostitution and unemployment grieved and tormented me, and contributed to my feeling that I must keep on with my studies of the lower classes. And portraying them again and again opened a safety-valve for me; it made life bearable.

From my office window I can look down on the area of my latest photo-series. When the sun is "just right," the City Hall casts its shadow on the tip of the area I have selected, a neighborhood in transition.

My close proximity to the area, plus the many contacts among the Blacks and Indians, plus professional dealings for many years with the Italians in the area, plus a working knowledge of Spanish, plus—above all—relating to the various groupings there—what more could anyone want! Never before have I or my wife been so enthusiastic while doing a photo series.

The area selected is about six blocks square. Looking at the photographs, it is apparent that we are dealing with an area that has been lived in for many shifts of populations. The Irish had been there, then Germans, followed by the Italians.

And now the more affluent Italians had moved away and in their place came Puerto Ricans, Indians, Black and poor white transients. With some variations, this pattern is repeating itself in hundreds of cities throughout the country. The poor, "the forgotten ones," are now in areas abandoned by the more affluent ones rushing to the suburbs.

The question may be raised as to why it is necessary to do such a photo series since others like Jacob Riis, Lewis Hine and, most recently, Bruce Davidson have done work in such areas.

There is too much at stake to abandon these people. Silence will not solve their problems. Time and again I think of the little twelve year old singing her favorite song to me, "La Lotteria." She looks to the grand prize to solve the family problems. Yes, many people think this is the way out—but there must be other more constructive ways.

And so I too—in my personal way—will repeat the story of these "forgotten ones." A quote from *The Making of an American* by Jacob Riis seems appropriate:

It takes a lot of telling to make a city know when it is doing wrong. However, that was what I was there for. When it didn't seem to help, I would go and look at a stonecutter hammering away at his rock perhaps a hunded times without as much as a crack showing in it. Yet at the hundred and first blow it would split in two, and I knew it was not that blow that did it, but all that had gone before.

—Milton Rogovin

Milton Rogovin's photography represents the blending of several important elements. Rogovin has strong and important statements to convey about his subjects which are designed to evoke an emotional reaction on the part of the viewer. It is difficult for the viewer to remain neutral, and more often than not, the viewer empathizes with the subject. Rogovin never compromises the dignity of his subjects, which are drawn from the minority elements of

the Buffalo, New York area. Blacks, American Indians, Italians, Puerto Ricans, Arabs and women are his subjects. To his subject matter, Rogovin brings exceptional vision, skill and craftsmanship as a photographer. He has combined the soul of Lewis Hine with the craftsmanship of Ansel Adams.

In the contemporary idiom, Rogovin is a "bleeding heart liberal," and while he may deny a cause, his photography has been of the downtrodden for most of his adult life and the haunting images he has produced speak loudly of his cause. Each picture cries out, I AM! It is not clear why Lewis Hine photographed Ellis Island early in this century. He was compelled by some force to call attention to the esential character of the people who were to become America. Similarly, Rogovin seems drawn to his subjects with a compassion and understanding that is impossible to ignore. Once encountered, his statements are hard to forget.

The response to Rogovin's pictures on public view is an intriguing phenomenon. At an opening of an exhibition of his work at the famed Albright-Knox Gallery in Buffalo several years ago, the attendance broke all records in many years. The professional world is equally responsive. Rogovin's work has been widely published and exhibited throughout the world. The noted photographer Arthur Rothstein has acclaimed his pictures as "the pure form of documentary photography—he is a superb photographer in the tradition of Lewis Hine, as yet unrecognized." Weston Naef, Curator of Photography at the Metropolitan Museum of Art in New York, has said that Rogovin is the best documentary photographer working in America today.

Hine in his later years devoted most of his work to trying to portray the nobility of work and workers. In recent years, Rogovin has taken us into modern day factories to show us not only the nobility of the worker as Hine somewhat naively did, but also to show us the effect of the work upon the individual. Rogovin then follows the worker into his or her home to reveal the full person.

Rogovin's photographs in the hands of a skillful propagandist could move the world to compassion for those in need.

—Robert J. Doherty

ROITER, Fulvio.

Italian. Born in Meolo, Venice, 1 November 1926. Studied chemistry at the Istituto Pacinotti, Venice, 1946-49; self-taught in photography. Married Louise Seuntjens in 1938; daughters: Evelyn and Jessica. Member, La Gondola group of photographers, Venice, since 1949. Freelance photographer, in Venice, working for *Rivista Pirelli, Du, Réalités, Camera, Schöner Wohnen*, etc., since 1953. Recipient: Prix Nadar, Paris, 1956; Best Photobook Prize, Arles, France, 1979. Address: Lungomare Marconi 28, Venezia-Lido, Italy.

Individual Exhibitions:

1970 Fondazione Querini Stamalia, Venice
1973 Musée des Beaux-Arts, Brussels
 Musée des Beaux-Arts, Anvers, Belgium
1979 Galerie L'Oeil, Paris
 Trent'anni di un Fotografo, Galleria Ravagnan, Palazzo delle Prigioni, Venice

Selected Group Exhibitions:

1955 *Subjektive Fotografie*, Saarbrucken, West Germany
1980 *Trent'anni di Fotografia a Venezia 1948-78*, Palazzo Fortuny, Venice

Publications:

By ROITER: books—*Venise à Fleur d'Eau*, Lausanne 1954; *Ombrie, Terre de St. François*, Lausanne 1955; *Andalousie*, with texts by Garcia Lorca, Machado, Jimenez and Unamuno, Lausanne 1957; *Bruges*, with poems by Maurice Careme, Brussels 1960; *Naquane*, Lausanne 1966; *Liban: Lumière des Siècles*, with text by Max-Pol Fouchet, Lausanne 1967; *Mexico*, Zurich 1968; *Brasil*, Zurich 1970; *Turquie*, Zurich 1971; *Algarve*, Lausanne 1971; *Espagne*, Zurich 1972; *Tunisie*, Zurich 1973; *Venice*, Zurich 1973; *Essere Venezia*, Udine 1977; *Laguna*, Udine 1978; *Mexico*, Zurich 1979; *Fulvio Roiter*, Milan 1980; *Verona*, Udine 1980; *Carnevale a Venezia*, Padua 1981; *Firenze e Toscana*, Udine 1981.

On ROITER: books—*Nuova Fotografia Italiana* by Guiseppe Turroni, Milan 1959; *Trent'anni di Fotografia a Venezia: Il Circolo La Gondola 1948-1978* by Italo Zannier, Venice 1980.

Since 1954 my photographic activity has essentially revolved round the production of books of photographs. It has always fascinated me to describe a country or a city by means of pictures. I did not move on to this as my main activity after a long apprenticeship as a newsman (as happens to many photographers), but suddenly, when as long ago as 1953 I decided to go off to Sicily on a bicycle.

It is a hard discipline, because each book is a form of harsh training. The publishers want all they can get with a minimum of outlay, on the grounds of cost, so I am forced to undertake a continual simplifying exercise.

And then the quality of the reproduction: many of these books (for example *Ombre et Terre de St. François*—which won the Prix Nadar in 1956—and *Algarve, Liban, Brasil, Turquie*) were printed in "heliogravure" in the great printing works of Heliogravure S.A. in Lausanne and are incomparable examples of quality both in black-and-white and in colour. *Andalousie*, for example, contains some colour pages in heliogravure that look as if they had been printed yesterday—yet they date from 1957!

But the most curious phenomen of the past few years has been the success of the book *Essere Venezia*, an all-colour volume that has sold, in only three years, 150,000 copies in four versions, Italian, French, German and English.

—Fulvio Roiter

It is hard not to recognize one of Fulvio Roiter's photographs at first sight; the presence—excessive, as some think—of his hand "adjustment" of the subject (in accordance with classical rules for the expression of forms and lines) is unmistakable. Roiter is without doubt one of the greatest international masters of illustrative photography. Apart from some work (as it were in anticipation) for magazines around the world, all of his vast reportage has been published in books. His pictures are destined to stand the test of time; they hardly ever include any trace of the ephemeral, but depict worlds that are almost timeless, "as they must have been before they were contaminated by the presence of man."

Folon has written of him that "for Roiter the 20th century does not exist"; it does not exist as events in the past or in the present, nor as a series of problems. Roiter is not interested in the news of the day, still less in recording great deeds. What Roiter depicts is

Fulvio Roiter: *Umbria,* 1954

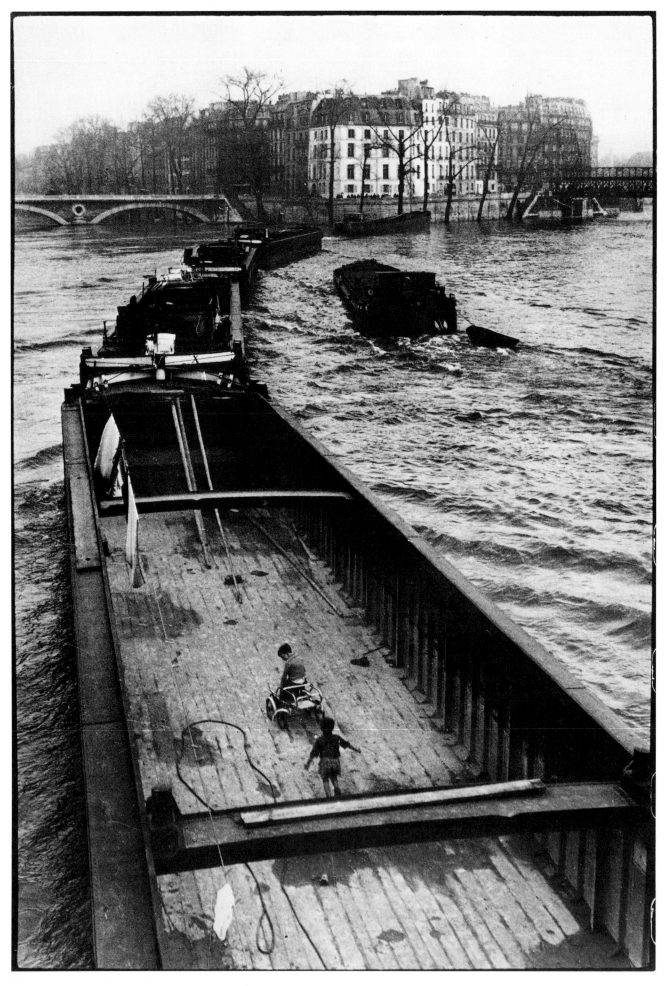

Willy Ronis: *La peniche aux Enfants,* 1959

sensations, emotions, impressions, in every country in the world from his native Venice or the Umbria of St. Francis to Brazil, Africa, Turkey, Spain.... The great merit of his photography lies in the value given to things that commonly go unobserved because we look at them in such a trivial way. Roiter tackles this by seeking to show the environment in which a people has developed, probing into basic features, almost into their archetypal structure. For this purpose he rarely needs human figures in his pictures; when they do appear they are often reduced to mere figures in the composition, hardly recognizable as individuals and virtually never as problems.

The great strength of Fulvio Roiter's language, its remarkable impressiveness, comes from the photographer's continual intervention in the composition, the arrangement, to obtain strict geometrical clarity and to emphasize the right features in the composition—problems that Roiter long worked on in black and white, a very complex discipline, to enable him finally to express himself in colour. Roiter's is a photography of colours, sumptuous, luxuriant and of great evocative power, which appeals to viewers all over the world for its spectacular quality, the dreams it creates, the atmosphere, the wide visions of timeless worlds. An optimistic photography too, if we wish, inseparable from the personality of the photographer, who loves people and is for ever in search of motifs of hope among them.

—Attilio Colombo

RONIS, Willy.

French. Born in Paris, 14 August 1910. Educated at the Lycée Rollin, now the Lycée Decour, Paris, 1909-27, Lycée Luis le Grand, Paris, 1928. Served as a meteorologist in the French Air Force, at Châteaurous, 1931, and at Châteaudun and Bergerac, 1939-40. Married the painter Marie-Anne Lansiaux in 1946. Freelance photographer, Paris, since 1936. Instructor, Lycée Louis Lumière, Paris, 1968, Lycée Estienne, Paris, 1968-70, Ecole des Beaux-Arts, Avignon, 1971-76, Faculty of Letters of the University of Aix en Provence, 1972-76, and at the University of Provence St. Charles, Marseilles, 1978-81. Recipient: Kodak National Prize, 1947; Gold Medal, Biennale, Venice, 1957; National Grand Prize of Arts and Letters for Photography, 1979. Honorary President, Association Nationale des Reporters Photographes Illustrateurs (ANRPI), 1975; Honoured Photographer, Rencontres Internationales de la Photographie, Arles, France, 1980. Agence Rapho, 8 rue d'Alger, 75001 Paris. Address: 8 rue Ledru-Rollin, 84800 L'Isle sur la Sorgue, France.

Individual Exhibitions:

1936 Neige dans les Vosges, Gare de l'Est, Paris
1937 Paris la Nuit, Gare de l'Est, Paris
1967 La Republique Democratique Allemande, toured France
 Mon Paris, toured the world
 La Provence des Montagnes, toured the world
 L'Alsace, toured the world
1979 Sur Paris, Centre Socio-Culturel, Lannion, France
1980 Willy Ronis: Photographies 1945-1979, at Rencontres Internationales de la Photographie, Arles, France
 Photographic Center of Athens

Sur le Fil du Hasard, FNAC Gallery, Montparnasse, Paris
1981 Fotogalerie Pennings, Eindhoven, Netherlands
 Le Château d'Eau, Toulouse
 Musèe d'Orange, France

Selected Group Exhibitions:

1935 La Photo qui Accuse, Maison de la Culture, Paris
 Salon International, Pavillon de Marsan, Paris
1938 Photos de Neige, Grand Atelier, Paris
1947 Groupe des XV, Paris (and annually until 1961)
1951 5 French Photographers: Brassaï/Cartier-Bresson/Doisneau/Izis/Ronis, Museum of Modern Art, New York
1955 The Family of Man, Museum of Modern Art, New York (and world tour)
1965 6 Photographes de Paris, Musée des Arts Décoratifs, Paris
 Photographie Française, French Embassy, Moscow
1978 Photographies de la Region Provence-Alpes Maritimes, Ecole d'Art, Luminy, Marseilles (toured France)

Collections:

Bibliothèque Nationale, Paris; Musée Réattu, Arles, France; Musée de Toulon; Musée d'Orange, France; Museum of Modern Art, New York.

Publications:

By RONIS: books—Photo-Reportage et Chasse aux Images, Paris 1951, as Il Manuale del Perfetto Fotoreporter, Rome 1953; Belleville-Mévilmontant, with text by Pierre MacOrlan, Paris 1954; Sur le Fil du Hasard, Paris 1980; articles—"Le Reporter et ses Batailles" in Photo-Cinema (Paris), March 1948; "L'Eclair Enchaine" in Photo-Service (Antwerp), January/February 1950; "Reverie d'un Chaseur d'Images" in Photo-Cinéma (Paris), August 1951; "Ne Tirez Pas sur le Photographe" in Photorama (Antwerp), May/June 1952; "Vieilles Pierres..." in Photo-Cinema (Paris), September 1952; "Comment J'ai Fait Cette Photo" in Photo Cinéma (Paris), November 1952; "Vision Naturelle et Vision Photographique" in Camera (Lucerne), December/January 1954/55; "A Batons Rompus" in Camera (Lucerne), September 1955; "Le Photographe devant la Réalité" in Photorama (Antwerp), July 1955; "A Propos de Photo Industrielle" in Photorama (Antwerp), January 1958; "Une Vieille Maison" in Photorama (Antwerp), October 1958; "Oeil, Objectif, Vision Globale" in Photographie Nouvelle (Paris), November 1967; "Willy Ronis," interview, with Jean-Claude Gautrand, in Le Photographe (Paris), November 1975.

On RONIS: books—U.S. Camera Album, edited by Tom Mahoney, New York 1953; Moderni Francousta Fotografie by J.A. Klein, Prague 1966; La Photographie Française by Claude Nori, Paris 1978, as French Photography, London 1979; articles—"Our Guest of Honour: Willy Ronis" in Photography (London), March 1952; "Willy Ronis" in Modern Photography (New York), April 1952; "Willy Ronis" in Photography (London), November 1955; "De Parijse Fotograaf Willy Ronis over" in Foto (Amersfoort, Netherlands), February 1962; "Il Reportage Umanistico" in Progresso Fotografico (Milan), July/August 1977; "Willy Ronis" in Il Fotografo (Milan), November 1979; "Willy Ronis" in Photo-Journal (Paris), February 1980; "L'Année Willy Ronis" in Le Photographe (Paris), February 1980; "Willy Ronis" in Photo (Paris), November 1980; "Willy Ronis" in Photo Cinéma (Paris), January 1981.

One of the best introductions to an understanding of my work (it is easy to read and comprehend) is contained in my book Photo-Reportage et Chasse aux Images. Edward Steichen produced a long extract when he presented my portfolio in U.S. Camera in 1953. I have not changed my ideas since those distant days. I worked until 1954 with a 6 x 6 Rolleiflex, then move, for 99% of my work, to small format, and I now maintain, without reservation, that I have always taken very nearly the same photographs with the same look.

As well, an interview with Jean-Claude Gautrand in Le Photographe of November 1975 and the article in Photo-Journal of February 1980 complete the picture better than I know how to do.

I will not hazard a judgment on contemporary photography. It is multi-form and a great deal of it is incomprehensible or of very little interest to me.

My latest book—published by Contrejour in 1980—begins with a long text which will, I hope, completely clarify my ideas. Here is that preface:

Level with the Daisies

When I go out with my camera I do not go in search of the Holy Grail. I do not feel invested with any message for anyone, nor do I perceive any transcendental vibration. I put in order and combine information, which my head and heart, in their fashion, immediately modify. To do this, I have no need to lift my eyes to the heavens for some sign, nor do I feel the emergence of any kind of spiritual approach; my eyes are occupied by scanning my surroundings as well as by the image captured by the viewfinder. This is already a great deal of effort; my attention cannot go further.

My photographs are not a vengeance on death, and I do not suffer from any existential anguish. I don't even know where I am going, except to be in front of—more or less by chance—things or people who please, interest, disturb or offend me. It is afterwards that I try to reflect, when I have my images in front of me. The limits of my intelligence are such that I do not dwell on this work; others, if they want to, will do that better than I can.

At the point I have reached I have acquired no certainty and no anxiety about having none. Nature has given me, purely by chance, a kind of sensitivity that has given me a fair amount of torment but also immense joy. Thank you! I have ploughed my furrow with my instinct, my ordinary decency, singing my song under my breath. I have often had a lot of pleasure and that compensates for the rest that happily is easily forgotten.

Have I found myself. I am not conscious of ever having lost myself, but I know no more about that than did the little boy in the sailor suit, who in 1913 wheeled his hoop in Condorcet Street (Paris 9), who has retained all his artlessness and hopes to preserve it to the end of the run.

—Willy Ronis

The photographs of Willy Ronis cannot be separated from Willy Ronis the man. Ronis is bursting with life, avid for knowledge, a man with a sharp eye, a modest man. His photographs are full, completely, of humanity. Not one of his pictures is without one or more people—men, women, children.

Ronis's real subject is human relationships, relationships experienced in real life as well as those he devises within the rectangular shape of his pictures, relationships between people as well as between people and the field in which they picnic, the walls of the town in which they live, the machines of the factory in which they work.

Ronis's world is not one of contorted faces or violence; it is a harmonious world. This isn't a weakness in his work; it involves a choice. This man wants

to have faith in man. The harmony within the pictures is the photographic equivalent of tenderness.

In 1951 Edward Steichen presented an exhibition, *5 French Photographers*, at the Museum of Modern Art in New York. The photographers were Brassaï, Doisneau, Izis and Ronis. A real family. Certainly they are not the only photographers who can be claimed to represent France; just the same, they are the most intensely French, the most completely Parisien, of photographers. And, they remain to this day among the most representative of French photography of the 1950's.

Indeed, for Ronis, the essential, the significant, is never far away; it is where people are—at a dance, at a fair, in a café. "Adventure is not measured by kilometers," he has said. "The strongest feelings of the exotic are not to be found in the bistros of Soho or Prague or Rostock, but in those of Paris among the belote players of the Café-Guinette in the rue des Cascades."

There is music in his photographs—not always accordions, sometimes a little jazz, a strain of violins. There is something that, like music, and better than words, conveys a particular idea, speaks to us of the human soul.

For Stravinsky, music was "the creation of a harmony between man and time." Are Willy Ronis's photographs also a creation of harmony between man and his spatial environment? In fact, he himself

says that "to transform chaos into harmony is the constant quest of the seeker of images." A faith that he immediately qualifies by stressing that "the beautiful picture is a geometry modulated by the heart."

—Guy Mandery

ROSENBLUM, Walter.

American. Born in New York City, 1 October 1919. Educated at Seward Park High School, New York, 1932-36; City College of New York, 1936-38; studied photography, under Paul Strand and Lewis Hine, at the Photo League, New York, 1937-40. Served as a photographer in the United States Army Signal Corps, in Europe, 1943-45; most decorated photographer in the Army: Silver Star; Bronze Star; Purple Heart; Presidential Unit Citation; 5 Battle Stars. Married Naomi Baker in 1949; daughters: Nina and Lisa. Photographer since 1937. Member of the Photo League, New York, 1938-52: Editor of *Photo Notes*, 1939-41; Chairman of the Exhibition Committee, 1941-42; Executive Secretary, 1945-46; Vice-President, 1946-47; and President, 1947-52. Worked as an assistant to the photographer Eliot Elisofon, New York, 1939-40; freelance photographer, working for *Survey Graphic*, *Mademoiselle*, Federation for the Support of Jewish Philanthropies, etc., New York, 1941-42; Staff Photographer, United States Department of Agriculture, Washington, D.C., 1940-41, and Agricultural Adjustment Administration, throughout the United States, 1942-43; Staff Photographer, Unitarian Service Committee, France and Texas, 1946-47. Joined the photography faculty, Brooklyn College, New York, 1947: Professor of Photography since 1971. Member of the faculty, Yale Summer School of Music and Art, Norfolk, Connecticut, 1952-77; Professor of Photography, Cooper Union, New York, 1956-65. Founder Member, Society for Photographic Education, 1962. Co-Curator, with Naomi Rosenblum, *Lewis Hine Retrospective*, Brooklyn Museum, 1977. Recipient: National Endowment for the Arts Fellowship, 1977; New York State Council for the Arts Fellowship, 1978; Institute for Art and Urban Resources Fellowship, 1978; Guggenheim Fellowship, 1979. Address: 21-36 33rd Road, Long Island City, New York 11106, U.S.A.

Walter Rosenblum: *Spanish Refugee Children, Mining Camp, Toulouse*, 1946

Individual Exhibitions:

1944 American Red Cross, London
1949 Brooklyn Museum, New York
1950 University of Minnesota, Minneapolis
1955 International Museum of Photography, George Eastman House, Rochester, New York
2 Photographers: Alfred Eisenstaedt and Walter Rosenblum, Philadelphia College of Art
1957 Whitman Hall, Brooklyn College, New York (retrospective)
Cooper Union Museum, New York (retrospective)
3 Photographers: Harry Callahan, Walter Rosenblum, Minor White, White Museum of Art, Cornell University, Ithaca, New York
1964 *Photographs of Haiti*, International Museum of Photography, George Eastman House, Rochester, New York (travelled to the Germantown Arts Association, Philadelphia
1969 Carr House Gallery, Rhode Island School of Design, Providence (retrospective)
1973 *Haitian Photographs*, Centrum Gallery, Hampshire College, Amherst, Massachusetts
1975 *Walter Rosenblum: Retrospective Exhibition*, Fogg Art Museum, Harvard University, Cambridge, Massachusetts
1976 Milwaukee Center for Photography (retrospective)
Photopia Gallery, Philadelphia (retrospective)
1978 Witkin Gallery, New York (retrospective)
1979 *People of the South Bronx*, Lincoln Hospital, New York (travelled to the Parsons School of Design, New York, 1980)

Selected Group Exhibitions:

1943 *New Photographers I*, Museum of Modern Art, New York
1959 *Photographs by Professors*, Limelight Gallery, New York
1962 *5 Photographers*, A Photographer's Place, Philadelphia
1965 *10 American Photographers*, University of Wisconsin at Milwaukee

1966 *21 Photographers*, New Hope Historical Society, Pennsylvania
1967 *Photography in the 20th Century*, National Gallery of Canada, Ottawa (toured Canada and the United States, 1967-73)
1968 *13 Photographers*, Pratt Institute, Brooklyn, New York
1972 *Masters of Photography*, Vogel Galleries, Layton School of Art, Milwaukee

Collections:

Museum of Modern Art, New York; Brooklyn Museum, New York; Queens Museum, New York; International Museum of Photography, George Eastman House, Rochester, New York; Yale University, New Haven, Connecticut; Detroit Institute of Art; National Gallery of Canada, Ottawa; Bibliothèque Nationale, Paris.

Publications:

By ROSENBLUM: books—*Paul Strand: A Retrospective Monograph*, with others, Millerton, New York 1971; *America and Lewis Hine*, with Naomi Rosenblum and Alan Trachtenberg, Millerton, New York 1977; *Photographs by Earl Dotter*, portfolio introduction, New York 1979; articles—"The Quiet One" in *Photo Notes* (New York), Fall 1941; "Image of Freedom" in *Camera Craft* (San Francisco), February 1942; "What Is Modern Photography?" in *American Photography* (New York), March 1951; "Five Weeks with a Camera" in *American Photography* (New York), January 1953; "Teaching Photography" in *Aperture* (Millerton, New York), no. 3, 1956; "Photographic Style" in *Contemporary Photographer* (New York), July 1963; "Educating the Young Photographer" in *Infinity* (New York), April 1970; "Edouard Boubat" in *35mm Photography* (New York), July 1975; "Robert Doisneau" in *35mm Photography* (New York), January 1977.

On ROSENBLUM: books—*Walter Rosenblum*, exhibition catalogue, by Paul Strand, Brooklyn, New York 1949; *Walter Rosenblum: Retrospective Exhibition*, exhibition catalogue, by Milton Brown, Cambridge, Massachusetts 1975; *Walter Rosenblum: People of the South Bronx*, exhibition catalogue, by Martica Sawin, New York 1980; articles—"Walter Rosenblum" by Jerome Liebling in *American Photography* (New York), May 1951; "Photography in the Classic Tradition" by Minor White in *Image* (Rochester, New York), December 1955; "The Art of Teaching" by Van Deren Coke in *College Art Journal* (New York), July 1960; "Famous Teachers" by Barbara Ullman in *Camera 35* (New York), July 1965; "Photography on the Mind" by Jack Somers in *New York Magazine*, 28 May 1973; "Between Teacher and Student" by Jacob Deschin in *35mm Photography* (New York), Summer 1974; "Documentary Style" by Stephen Perloff in *Philadelphia Review*, January 1976; "Rare Dancer" by Louis Stettner in *Camera 35* (New York), January 1976.

I have always felt that the photographer should remain mute about his own work, since he has chosen the photograph as his means of communication. But I have been invited to make a statement for this book—so I offer the following:
When successful, my photographs convey to others my most profound feelings about the world, in images that are without cant or hypocrisy. There is no conscious imitation of others or attempt to adhere to passing styles. My goal is to be sensitive to the reality I perceive and to be responsible to those people and places I choose to photograph. To celebrate, through my work, the potential, the richness and the mystery of life.

—Walter Rosenblum

Walter Rosenblum is most widely known for his relationship with the Photo League, but his career has included, besides his work at the League, a multiplicity of impressive accomplishments in photography. There is his extensive and important work as a photographer, his career as a teacher, his friendship with Paul Strand, and his work as archivist of the Lewis Hine Collection and as spirited critic, writer, and organizer for the continuing tradition of documentary photography.

Walter Rosenblum was born in New York City in 1919 on the Lower East Side. His family had come to the United States as immigrants via Ellis Island and could have been photographed by Lewis Hine. He grew up as a child of the streets, his life filled with immigrant poverty and idealism, searching for the American Dream of the "better world." In the late 1930's Rosenblum enrolled in photography classes at the Photo League, a loose organization that provided a center for photographic activity related to the documentary tradition of Lewis Hine and the F.S.A. As a precocious teenager, Rosenblum met many photographers, including Lewis Hine, and began to produce photographs as part of the Photo League's series of documentary projects. His work was quickly recognized for its penetrating insight and formal control, and he was soon successfully free-lancing, eventually assisting Eliot Elisofon, the *Life* photographer. Rosenblum was a combat photographer during World War II, and upon his discharge from the U.S. Army in 1945 he returned to New York City and again became active in the Photo League. This flourishing period for the League (1946-50) would see it become an important influence in establishing patterns of classes, projects, lectures, exhibitions, and publications that have become the commonplace activity of all present-day academic and museum photographic programs.

Art and photography training in academic institutions in the late 1940's had not as yet begun in the United States. There was a photography program in California with Minor White, Chicago with Moholy-Nagy, Clarence White in Ohio, and Walter Rosenblum at Brooklyn College in New York. He started teaching at Brooklyn College in 1946 when he was 27 years old, succeeding Berenice Abbott, and he has been teaching there until the present. His work as a teacher both at Brooklyn College and at the Yale Summer School in Norfolk, Connecticut has had significant influence on many students who in turn have become photographers, critics and teachers of reputation.

With the black-listing of the Photo League and its eventual demise in the early 1950's, the need to preserve the Lewis Hine Collection became a major problem. Hine had given most of his collection to the League, and for years volunteers had been slowly cataloging the material and printing a series of small portfolios. Various institutions were offered the collection but were not interested in receiving the work. With much difficulty, Walter and Naomi Rosenblum housed the collection and cared for it until George Eastman House, where it now resides, finally accepted the bulk of the collection. In the late 1970's the Rosenblums undertook a major exhibition of the work of Hine that was exhibited widely in the United States and finally in Canada. In conjunction with the exhibit, Alan Trachtenberg and the Rosenblums produced the definitive book on Hine, published by Aperture.

As a young man in his twenties, Rosenblum met Paul Strand, then in his fifties. Their close relationship was continuous until Strand's death in 1975 and strongly influenced Rosenblum's idea concerning style and direction in the use of documentary photography. Rosenblum's photography is an act of engagement and participation with the subjects of his work. From his early years, working on Photo League projects, the idea of the multi-faceted extended interaction of photographer and place has been the direction of his work. He strongly feels that photography demands social commitment and social responsibility.

Rosenblum continues to photograph actively and was recently the recipient of a Guggenheim Fellowship which permitted him to work for a year on the very important "People of the South Bronx" project. These photographs exemplify all of his working principles of extended personal involvement in issues of deep social concern. They reveal an aesthetic control that derives from the force and tension of the subject, and provides clarity, insight and compassion.

—Jerome Liebling

RÖSSLER, Jaroslav.

Czechoslovak. Born in Smilov, 25 May 1902. Educated at elementary school, Havlickuv Brod, 1909-17; student-apprentice in the studio of the photographer František Drtikol, Prague, 1917-21. Married Gertruda Fischerova in 1926 (died, 1976); daughter: Silvia Vítová. Photographer in Studio Drtikol, Prague, 1921-26, and Studio Manuel Freres, Paris, 1926-27; Photographer, *Pestrý týden* weekly review, Prague, 1927-28; Photographer, Studio Lorelle, Paris, 1928-32, Studio Piaz, Paris, 1932-34, and Studio Lucien Lorelle, Paris, 1934-35; maintained own studio, Prague, 1935-51; Photographer, Studio Fotografia, Prague, 1951-64. Address: Koněvova 181, CS-130 00 Prague 3, Czechoslovakia.

Individual Exhibitions:

1968 Malá Galerie, Prague
1975 Fotokabinett Jaromir Funke, Brno, Czechoslovakia

Selected Group Exhibitions:

1923 *Foto-Salon*, rue de Clichy, Paris
1926 *Devětsil Group*, Rudolfinum, Prague
1966 *Surrealism and Photography*, Fotokabinett Jaromir Funke, Brno, Czechoslovakia
1974 *Personalities of Czech Photography*, Municipal Gallery, Roudnice, Czechoslovakia (travelled to the Museum of Decorative Arts, Prague)
1979 *Tschechoslowakische Photographie 1918-1978*, Fotoforum Kassel, West Germany
 Photographie als Kunst 1879-1979, Tiroler Landesmuseum, Innsbruck, Austria (travelled to the Neue Galerie am Wolfgang Gurlitt Museum, Linz, Austria; Neue Galerie am Landesmuseum Joanneum, Graz, Austria; and Museum des 20. Jahrhunderts, Vienna)
1981 *Germany: The New Vision*, Fraenkel Gallery, San Francisco

Collections:

Museum of Decorative Arts, Prague; Moravian Gallery, Brno, Czechoslovakia; Polaroid Collection, Amsterdam; Bibliothèque Nationale, Paris; Museum of Fine Arts, Houston.

Publications:

On RÖSSLER: books—*Stavba a báseň/Construction and Poem* by Karel Teige, Prague 1927; *Tsche-*

choslowakische Fotografie 1918-1978 by Karel Teige, Prague 1947; *Die Geschichte der Fotografie im 20. Jahrhundert/Photography in the 20th Century* by etr Tausk, Cologne 1977, London 1980; *Photographie als Kunst 1879-1979/Kunst als Photographie 1949-1979*, Pexhibition catalogue in 2 volumes, by Peter Weiermair, Innsbruck 1979; articles—"Jaroslav Rössler" by Karel Dvořák in *Revue Fotografie* (Prague), no. 1, 1961; "Jaroslav Rössler" by Anna Fárová in *Revue Fotografie* (Prague), no. 2, 1971; "Jaroslav Rössler" by Antonín Dufek in *Ceskoslovenská Fotografie* (Prague), November 1978; "Jaroslav Rössler" by Petr Tausk in *Revue Fotografie* (Prague), no. 2, 1979.

Jaroslav Rössler started his career as an apprentice in the Prague studio of František Drtikol during the First World War. Although he admired his master, he very soon began looking for his own way. Instead of building artificial scenes into which the model was framed, Rössler used the effects of light and shadow when creating portraits, making them images of self-expression. The most important part of his work, however, was done outside the studio. He tried to discover interesting forms in the immediate vicinity. Very often he concentrated on details in order to create a balance in composition, for which he always had an intuitive sense.

In the mid-1920's Rössler went to Paris. Although his reason for going there was to enlarge his photographic experience by working in some of the city's well-known studios, he also enjoyed Paris itself very much: he found the atmosphere exciting, and it provided the inspiration for many photographs. The driving force of his enthusiasm seems to have been a sensitivity of vision that found stimulation quite universally in the reality of Paris, and his photos of that time are of a great variety of subjects. For instance, besides the views of the details of construction of the Eiffel Tower and the roofs of Paris, there are also photos of the audience at a racetrack, conveyed with Rössler's marvellous facility for depicting the fleeting situation.

Rössler's work of that time even attempted to enrich the conception of certain images by blurring the contours of moving objects—for instance, a car moving down a boulevard. He also experimented with depicting light beams coming through a simple lens, in order to discover, during the creative games, different forms and shapes.

In 1935 Rössler returned home to Prague and set up his own small studio for portrait photography. The problems connected with the business were such that he did not resume his own work until the beginning of the 1950's. This gap of some 15 years is a real one; it has tended to isolate his "first creative period" in Paris from his subsequent work: the photos of the late 1920's and early 1930's now seem a "closed" work with characteristic signs. And, indeed, since 1951 Rossler has created images quite different from those of the earlier period. He seems to have lost interest in depicting the real world through direct contact, and has preferred instead to experiment with the technical tools and resources of photography.

Rössler started this "new" period by using a prism placed before the frontal lens, enabling him to repeat his subject in a mirror-reverse position. He also worked on the various possibilities of photomontage, sometimes applying the Sabattier effect. And a large part of his present work concerns colour images, abstract compositions achieved by mounting three toned extracts based on a black-and-white photograph.

—Petr Tausk

ROTHSTEIN, Arthur.

American. Born in New York City, 17 July 1915. Educated at Stuyvesant High School, New York, 1929-32; studied under Roy Stryker, at Columbia University, New York, 1932-35, B.A. 1935. Served as a photo officer, in the United States Army Signal Corps, in India, Burma and China, 1943-46. Married Grace Goodman in 1947; children: Robert, Ann, Eve, and Daniel. Photographer, under Roy Stryker, Farm Security Administration, Washington, D.C. and throughout the United States, 1935-40; Photographer, *Look* magazine, New York, 1940-41; Picture Editor, Office of War Information (OWI), New York, 1941-43; Director of Photography, *Look* magazine, New York, 1946-71; Editor, *Infinity* magazine, New York, 1971-72. Since 1972, Director of Photography, *Parade* magazine, New York. Visual Aids Consultant, United States Environmental Protection Agency, and American Iron and Steel Institute, Washington, D.C., 1971-72. Instructor, Graduate School of Journalism, Columbia University, New York, 1961-70. Founder-Member, American Society of Magazine Photographers, 1941 (Vice-President, 1947); President, Photographic Administrators, New York, 1961-63. Recipient: First Prize for Color Photography, 1955, and Sprague Award, 1967, National Press Photographers Association; Newhouse Citation, Syracuse University, New York, 1963; Award of Distinction, New York Art Directors Club, 1963; Distinguished Service Award, United States Department of Defense, 1965; Photographic Scientists and Engineers Citation, 1966; International Award, Photographic Society of America, 1968. Fellow, Royal Photographic Society, London, 1968; Fellow, Photographic Historical Society of New York, 1979. Agent: Witkin Gallery, 41 East 57th Street, New York, New York 10022. Address: 122 Sutton Manor, New Rochelle, New York 10805, U.S.A.

Individual Exhibitions:

1956 International Museum of Photography, George Eastman House, Rochester, New York

Jaroslav Rössler: *Lucarne*, 1923

1960 Biblioteca Communale, Milan
1963 Smithsonian Institution, Washington, D.C.
1964 *World's Fair*, New York
1966 *Photokina*, Cologne
1967 Kodak Exhibition Center, New York
1972 Michigan State University, East Lansing
1973 University of Massachusetts, Boston
1974 United States Information Service, Washington, D.C. (and world tour)
1975 Washington Photo Gallery, Washington, D.C.
1976 *My Land, My People*, International Museum of Photography, George Eastman House, Rochester, New York
1977 Brigham Young University, Salt Lake City, Utah
1978 Prakapas Gallery, New York
1979 Western Heritage Museum, Omaha, Nebraska
Empire State Plaza, Albany, New York
Fine Arts Museum of the South, Mobile, Alabama
1980 Rizzoli Gallery, New York
Rizzoli Gallery, Chicago
Tulsa University, Oklahoma
Sun-Times Gallery, Chicago
Art Institute, Fort Lauderdale, Florida
Goddard Art Center, Daytona Beach, Florida
1981 *International Photographic Exposition*, Seattle
Douglas Elliott Gallery, San Francisco
Catskill Center for Photography, Woodstock, New York

Selected Group Exhibitions:

1938 *1st International Photographic Exposition*, Grand Central Palace, New York
1940 *Exposition Internationale d'Art Moderne*, Paris
1949 *Exact Instant*, Museum of Modern Art, New York
1959 *Hundert Jahre Photographie 1839-1939*, Museum Folkwang, Essen (travelled to Cologne and Frankfurt)
1962 *The Bitter Years: FSA Photographs 1935-41*, Museum of Modern Art, New York

(toured the United States)
1971 *The Artist as Adversary*, Museum of Modern Art, New York
1973 *The Compassionate Camera: Dustbowl Pictures*, Victoria and Albert Museum, London (toured the U.K.)
1977 *New Deal Art*, Delaware Art Museum, Wilmington
Documenta 6, Kassel, West Germany
1978 *Photographic Crossroads: The Photo League*, National Gallery of Canada, Ottawa (travelled to the International Center of Photography, New York; Museum of Fine Arts, Houston; and Minneapolis Institute of Arts)

Collections:

Rothstein Collection, Library of Congress, Washington, D.C.; Smithsonian Institution, Washington, D.C.; Museum of Modern Art, New York; International Museum of Photography, George Eastman House, Rochester, New York; Royal Photographic Society, London.

Publications:

By ROTHSTEIN: books—*Photojournalism*, New York 1956, 1965, 1974, 1979; *Creative Color Photography*, New York 1963; *Just Before the War*, with Roy Stryker and John Vachon, Philadelphia 1965; *Look at Us*, with text by William Saroyan, New York 1967, 1970; *Color Photography Now*, New York 1970; *The Depression Years*, New York and London 1978; *Words and Pictures*, New York 1979; *The American West in the Thirties*, New York and London 1981; articles—"Photojournalism and Ecology" in *Infinity* (New York), August 1970; "Arthur Rothstein: An Interview," with Bill Ganzel, in *Exposure* (New York), Fall 1978.

On ROTHSTEIN: books—*Hundert Jahre Photographie 1839-1939*, exhibition catalogue, by Helmut and Alison Gernsheim, Essen 1959; *The Bitter Years* by Edward Steichen and Grace Mayer, New York

1962; *Portrait of a Decade* by Jack Hurley, Baton Rouge, Louisiana 1969; *In This Proud Land* by Roy Stryker and Nancy Wood, New York 1973; *Social Documentary Photography in the U.S.A.* by Robert Doherty, New York 1974; *The Magic Image* by Cecil Beaton and Gail Buckland, London and Boston 1975; *A Vision Shared: A Classic Portrait of America and Its People 1935-1943*, edited by Hank O'Neal, New York and London 1976; *Documenta 6*, exhibition catalogue, by Klaus Honnef and Evelyn Weiss, Kassel, West Germany 1977; *Great News Photos* by John Faber, New York 1978; article—in the *Journal of the Smithsonian Institution* (Washington, D.C.), no. 1, 1977.

As a photojournalist for more than forty years, I have had the opportunity to photograph the people and places of this varied and vibrant world.

I have used the visual image to present facts, to register ideas and emotions, for the camera captures the decisive moment and records events with greater accuracy than does the human eye.

My photography is based on the concept of knowing the subject and telling the story as graphically as I can. I use design and composition to enhance the effect and make the message clear. I prefer to portray people with dignity and sympathy and to capture expressions with the greatest meaning. Sometimes I will select a revealing detail or fragment of the whole scene in order to make a more effective statement. My photographs are primarily designed to serve a useful purpose in communication, yet many of them have been considered works of art.

Because powerful images are fixed in the mind more readily than words, the photographer needs no interpreter. A photograph means the same thing all over the world and no translator is required. Photography is truly a universal language, transcending all boundaries of race, politics and nationality.

The photographer who uses this universal language has a great social responsibility. Accepting this challenge, I have probed the problems of our times and used my camera to communicate ideas, facts and emotions.

That is why I am pleased to have my photographs published in *Parade*. Their unique editorial blend of words and pictures permits me to inform, enlighten, persuade and convince a large audience.

For those who see my photographs, I hope that these images will be a remembrance of the past, a record of accomplishment, and an affirmation of faith in humanity.

—Arthur Rothstein

Arthur Rothstein has been at the very center of photo-journalism for nearly 50 years. He started running in the 1930's and will still be running in the 1990's and beyond. There is virtually nothing in the world of photography—no stylistic mode, technique or aspect of the craft of photography—that Rothstein has not attempted and mastered. In terms of early 20th century philosophical thought, Rothstein can be classified as a John Dewey "experimentalist." Rothstein still greets the world with all the awe and enthusiasm of a young child entering Times Square for the first time.

Rothstein began his photographic career while still a student at Columbia University assisting his teacher, Roy Stryker, in preparing teaching tools. Stryker believed photographs could add more reality to his economics classes. When Stryker left Columbia to form the Historical Section of the Resettlement Administration (later the Farm Security Administration: RA/FSA), Arthur Rothstein was one of the first photographers he hired to document the work of this agency in meeting the problems of drought, a declining farm market, depression and the mechanization of farming. Anyone who remembers the 1930's depression also remembers the dustbowl. The symbol of the dustbowl is Rothstein's photograph (accompanying this entry) of two

Arthur Rothstein: *Dust Storm, Cimarron County, Oklahoma*, 1936

children and a man caught in a dust storm in Cimarron, Oklahoma in 1936. It is a powerful and gripping, unforgettable image of this dismal period in American history.

An actual count of Rothstein's work at RA/FSA has never been made, but it is certain that he was one of the most prolific photographers of the group. He was sensitive yet aggressive, and while he was sympathetic to and understanding of the plight of his subjects, he maintained the essential detachment that allowed him to remain objective in his work. A study of Rothstein's work will quickly show that he learned many lessons from others in the field and utilized what he learned to perfect his craft. In his work, one occasionally encounters a Walker Evans by Arthur Rothstein, but there is usually a new wrinkle in the Rothstein: an element of whimsy or humor appears in the Evans-like picture. Sometimes Rothstein's zeal for the perfect picture caused panic. Rothstein photographed a parched skull on the mudflats of South Dakota in the spring of the 1936 national election year. Rothstein was not pleased with the position of the skull, so he moved it to get better shadows. A Dakota newspaper editor found the same skull in two different pictures and called foul. This issue reverberated in the American press throughout the summer and fall, being silenced only by the re-election of Roosevelt.

Rothstein left RA/FSA in spring 1940 to work for *Look* magazine. Two years later he returned briefly to government service with the New York office of the Office of War Information prior to entering military service during World War II as a photographer in the China-Burma-India theatre. Upon discharge from the service, Rothstein worked for the United Nations photographing in China. Rothstein rejoined the staff at *Look* and remained with the magazine until its demise. For most of his career at *Look* Rothstein was director of photography. Under his direction, some very outstanding photography, covering a much broader range and scope than *Life*, was undertaken. *Life* was much more narrowly photo-journalistic in its coverage. *Look* covered everything from fashion to furniture and architecture to cooking trends, and the level of the photo essays brought the reader a wider variety of picture experiences. Many of these were brilliant examples of the use of the camera, reflecting Rothstein's skill in assigning photographers.

In his search for new and novel, Rothstein spent much effort in reviving, perfecting and publishing the mass use of the 19th century parallax stereogram, a three-dimensional picture which appeared in the pages of *Look*. It was a bright, but short lived, experiment.

Rothstein is a teacher too. And, in his desire to share his experience with others, he has published widely and for many years at Florida and later at the University of Maryland, where he organized highly successful symposia in photojournalism. These symposia brought the student together with the stars of the field in a vital and fruitful forum.

As a photo-journalist, one senses Rothstein's awe, enthusiasm, sometimes wit and, always, his high level of craftsmanship.

—Robert J. Doherty

RUBENSTEIN, Meridel.

American. Born in Detroit, Michigan, 26 March 1948. Educated at Mumford High School, Detroit; Cambridge School, Weston, Massachusetts, 1961-65; Sarah Lawrence College, Bronxville, New York, 1965-70, B.A. 1970; studied photography, under Minor White, Massachusetts Institute of Technology, Cambridge, 1972-73, and under Beaumont Newhall and Van Deren Coke, University of New Mexico, Albuquerque, 1973-77, M.A. 1974, M.F.A. 1977. Worked as a holographer, PTR Optics Company, Waltham, Massachusetts, 1972-73. Professional photographer since 1973. Instructor in Photography, University of New Mexico, 1976, 1977-78, and College of Santa Fe, New Mexico, 1976-80; Visiting Lecturer, University of Colorado, Boulder, 1980-81. Contributor to *Afterimage*, Rochester, New York, since 1977. Recipient: New Mexico Bicentennial Grant, 1975-77; National Endowment for the Arts Exhibition Grant, 1975, and Photo Survey Grant, 1978; Ferguson Grant, Friends of Photography, Carmel, California, 1977. Address: c/o West, Route 2, Box 305A, Santa Fe, New Mexico 87501, U.S.A.

Individual Exhibitions:

1975 *Meridel Rubenstein/Baldwin Lee*, Creative Photo Laboratory, Massachusetts Institute of Technology, Cambridge
1977 *La Gente de la Luz*, Museum of Fine Arts, Santa Fe, New Mexico (toured the western United States)
1978 *A Personal Landscape*, Hill's Gallery, Santa Fe, New Mexico
1979 *La Gente de la Luz*, Museum für Kunst and Gewerbe, Hamburg
51 Portraits of Craftspeople, Museum of Albuquerque, New Mexico
From a Personal Landscape, Brattleboro Museum and Art Center, Vermont
1980 *The Lowriders*, Museum of Fine Arts, Santa Fe, New Mexico
1981 *Meridel Rubenstein/Joan Myers*, Galerie Arpa, Bordeaux (travelled to Galerie Montesquieu, Agens, France)
Orange Coast Community College Gallery, Costa Mesa, California
Neikrug Gallery, New York
Yuen Lui Gallery, Seattle
Galerie Ufficio dell'Arte/Créatis, Paris
Port Washington Library, New York
Eclipse Gallery, Boulder, Colorado
Colorado Mountain College, Breckenridge, Colorado

Selected Group Exhibitions:

1974 *Photography Unlimited*, Fogg Art Museum, Harvard University, Cambridge, Massachusetts
1977 *The Great West: Real/Ideal*, University of Colorado, Boulder (subsequently Smithsonian Institution travelling exhibition; toured the United States)
1979 *History of Photography in New Mexico*, University of New Mexico, Albuquerque
Attitudes: Photography in the 1970's, Santa Barbara Museum of Art, California
Four Photographers, Vision Gallery, Boston
1980 *The Portrait Extended*, Museum of Contemporary Art, Chicago
Woman/Image/Nature, Tyler School of Art, Philadelphia
1981 *10 Photographes de Santa Fe, Nouveau Mexique*, Centre Culturel Americain, Paris (travelled to *Rencontres Internationales de la Photographie*, Arles, France)

Collections:

Denver Museum of Art; University of Colorado, Boulder; Minneapolis Institute of Arts; Museum of New Mexico, Santa Fe; University of New Mexico, Albuquerque; Museum für Kunst und Gewerbe, Hamburg.

Publications:

By RUBENSTEIN: thesis—*The Circles and the Symmetry: The Mutual Influences of Georgia O'Keeffe and Alfred Stieglitz*, thesis, University of New Mexico, Albuquerque 1977; books—*One Space: Three Visions*, edited by Dextra Frankel, Albuquerque, New Mexico 1979; *The Lowriders*, portfolio, Santa Fe, New Mexico 1980; articles—"Holography as Art," "Ellen Landweber" and "Eileen Cowin" in *Light and Substance*, exhibition catalogue, Albuquerque, New Mexico 1973; "Photography in New Mexico" in *Afterimage* (Rochester, New York), January 1977; "The Great West: Real/Ideal" in *Afterimage* (Rochester, New York), January 1978; statement in *Friends of Photography Newsletter* (Carmel, California), April 1978; "Alternative Images" in *Afterimage* (Rochester, New York), September 1979.

On RUBENSTEIN: books—*La Gente de la Luz*, exhibition catalogue, with texts by Beaumont Newhall, Van Deren Coke and John Nichols, Santa Fe, New Mexico 1977; *The New Mexico Portfolio*, Santa Fe, New Mexico 1977; *The Great West: Real/Ideal*, exhibition catalogue, by Gary Metz, Ellen Manchester, and Sandy Hume, Boulder, Colorado 1977; *Five Photographers*, exhibition catalogue, by Katherine Chafee, Denver 1977; *Attitudes: Photography in the 70's*, exhibition catalogue, by Fred Parker, Santa Barbara, California 1979; *Photography in New Mexico* by Van Deren Coke, Albuquerque, New Mexico 1979; *The Portrait Extended*, exhibition catalogue, by Charles Desmarais, Chicago 1980; *Photography for Collectors: The West* by James Alinder and others, Carmel, California 1908; articles—"Meridel Rubenstein: Portfolio" in *Untitled* (Carmel, California), Spring 1978; "Report from Santa Fe" by Marcy Dickman in *American Photographer* (New York), November 1979; "Report from New Mexico" by Joan Simon in *Art in America* (New York), June 1980; "Photography in the West" in *Rocky Mountain Magazine* (Denver), July 1980; "Places in the Sun" in *Rocky Mountain Magazine* (Denver), September 1980; "The Lowriders" in *Native Arts* (Santa Fe, New Mexico), October 1980; "The Lowriders" in *Santa Fe Reporter* (New Mexico), October 1980; "Meridel Rubenstein: The Lowriders" in *Artspace* (Albuquerque, New Mexico), Spring 1981.

My main focus in the past seven years has been to make images about people in New Mexico and, more generally, in the West that combine elements of environment and culture, as well as references to family ties, and to the effect of time and change on individual histories. I hesitate to call these extended portraits collages. Many photographers are arranging and fabricating things in the studio in order to make collaged images that attest to the fragmented or overloaded quality of our times. The fragments I gather about people's lives have to do with recreating the whole I instinctively feel to be there. With portraiture, the layers need to be peeled away at first, in order to get to a subject's story. I try to involve myself deeply in this activity, and selectively to add back some of the layers visually. I've attempted this by making images from single and multiple negatives, and in black-and-white, palladium, and color. I use a 4 x 5 and 5 x 7 view camera.

Initially, I worked in a very straight way, trying to

cram as much as possible into a single environmental portrait. My first work in New Mexico involved a Bicentennial project to document the people of the state. Right away I found that the portraits only told half the story, since the people are inseparable from the overpowering and spacious landscape. After some experimenting, I found I could combine portrait and landscape through the blending of negatives and get a third image altogether. Once I saw that I could add one element, I realized I could add many. The next group of pictures involved adding borders of words, objects, fragments, or even children's drawings around a central portrait. These pictures are of people I know well and who are related. I became more concerned with relations past and present and in structuring the images in a totemic way. My own family in the east has been uprooted and divided. I'm fascinated with connections among people and how one yields to or extricates oneself from their familial web. I'm interested in how an image can be structured to convey the multiplicity of our lives.

Recently I completed a grant to document an Hispanic subculture, *The Lowriders*, in color. These young people elaborately print and decorate their cars, inside and out, and lower them close to the ground. They parade through the main streets of northern New Mexico towns at speeds so slow that people either love or hate them. They are the modern sons and daughters of the traditional Hispanic craftsperson. I've learned how family, religion, and the Anglo-American world have affected the lives of these people, and how such a seemingly materialistic obsession as lowriding can mirror a subculture's psychic development. The cars and their nightly processions have ancient religious as well as sexual overtones. While the Lowrider portraits are single images in color of person, car and environment together, an "extended portrait" was created by an exhibition featuring the photographs and cars together on Santa Fe's main plaza, sponsored by the Museum of Fine Art. This event merged elements of art and life, allowing two different cultures to interact through two different art forms. The event allowed me to elaborate upon my idea of the extended portrait without having to put everything into the photographs themselves. A video was also produced to document the event, so it will be able to accompany the photographs wherever they are exhibited. A Lowrider portfolio was produced that mirrors the feeling of the cars. The case is covered with red velvet, lined in silver, and tied with satin dice on silk strings. This project was important for me to learn that I don't have to put all of my ideas into one image, but instead can creat a totality from varied kinds of parts.

Some of my newest images don't have people in them. They are about putting things together, natural and human. Some are people-less portraits; others are about objects and spaces that move me. I'm learning that the best landscapes can resonate a human presence and that the most interesting portraits can yield new maps and terrain.

—Meridel Rubenstein

The diverse cultural heritages and magnificent expansive landscape of New Mexico are ongoing photographic concerns for Meridel Rubenstein. Few places in America can offer such an exotic and exciting visual array of people: Hispanic, Indian, and Anglo. And to compliment them, the ever-changing dramatic landscape of the South West. It's a magical, enchanted and often difficult land, one in which Ms. Rubenstein, an easterner, seems eminently at home.

She can be defined as a portrait photographer, but her portraits encompass more then just a likeness of her subject. They are environmental portraits in the largest sense, utilizing the person's own home, the land on which he or she lives, personal possessions, and sometimes handwriting. These are complex images. They are layered and textured by the various printing combinations that she employs. Unsatisfied with simply photographing a person in a particular place, she combines a portrait of her subject in one situation with part of a negative taken in another. Sometimes other objects are placed directly on the printing paper—a bit of lace, ribbon, or dried corn, for example. This combining of elements results in a multi-dimensional portrait.

The most recent works of Meridel Rubenstein may seem startling if one is familiar with her earlier work. They are straight-forward, large format color portraits of Lowriders in New Mexico posed with their cars. These pictures have a documentary quality but go beyond the ordinary document. The rich color of the New Mexico landscape coupled with the bright and garish colors of the Lowrider cars does give a vivid description of this small but highly visible group of Mexican Americans.

The project culminated in an exhibition in the downtown plaza in central Santa Fe. Portraits of the Lowriders were displayed along with the Lowriders and their cars. This type of presentation transformed what could have been a gallery showing into an event. Viewers were free to examine the photographs, wander about the cars, and talk to the Lowriders.

—Judy Dater

Meridel Rubenstein: *Wedding Picture*, New Mexico, 1979

Eva Rubinstein: *Nick*, 1980

RUBINSTEIN, Eva.

American. Born, of Polish parents, in Buenos Aires, Argentina, 18 August 1933; lived in Paris, 1933-39; emigrated to the United States, 1940: naturalized, 1946. Educated at Westlake School for Girls, graduated 1950; attended Scripps College, Claremont, California, 1950-51; studied acting at the University of California at Los Angeles, 1952-53; also attended photo workshops, under Lisette Model, Jim Hughes, Ken Heyman and Diane Arbus, New York, 1968-71. Married the Rev. William S. Coffin, Jr., in 1956 (divorced, 1968); children: Amy; Alexander; David. Performed as a dancer and actress, in New York and Europe, 1953-56 (in *Diary of Anne Frank*, New York, 1955-56). Freelance editorial, documentary and portrait photographer, New York, since 1968. Instructor in Photography, School of Visual Arts, New York, Spring 1972, and Manhattanville College, New York, 1974; Guest Teacher, 1977-81, and Member of the Faculty since 1980, New School for Social Research, New York. Agents: Lee Gross Associates, 366 Madison Avenue, New York, New York 10017; Neikrug Photographica, 224 East 68th Street, New York, New York 10021. Address: 145 West 27th Street, New York, New York 10001, U.S.A.

Individual Exhibitions:

1970 Focus Gallery, San Francisco
1971 Ogilvy-Mather Agency, New York
1972 Underground Gallery, New York
1973 Dayton Art Institute, Ohio
Archetype Gallery, New Haven, Connecticut
1974 Neikrug Galleries, New York
1975 Canon Photo Gallery, Amsterdam
Festival of Arles, France
Garrett Theological Seminary, Evanston, Illinois
La Photogalerie, Paris
Friends of Photography, Carmel, California
1976 Madison Art Center, Wisconsin
Galerie 5.6, Ghent
The Portfolio Gallery, Boston
Gallery of Photography, Washington, D.C.
The Infinite Eye, Milwaukee
Willette Gallery, Fort Lauderdale, Florida
1977 Drew University, Madison, New Jersey
Galerie Trockenpresse, West Berlin
Frumkin Gallery, Chicago
1978 University of Vermont, Burlington
Imagination, Seattle, Washington
Port Washington Public Library, New York
1979 Galleria Sinisca, Rome
Atlanta Gallery of Photography, Georgia
Neikrug Galleries, New York
Woodman Gallery, Morristown, New Jersey
1980 Soho Gallery, New York
John Young Museum of Science and Astronomy, Orlando, Florida
Film in the Cities, St. Paul, Minnesota
1981 Neikrug Galleries, New York

Selected Group Exhibitions:

1972 *Images of Concern*, Delgado Museum, New Orleans
Venus '71, Kracow, Poland
1973 *SICOF*, Milan
1974 *Photography U.S.A.*, U.S.I.A., Washington, D.C. (toured the United States and Europe, 1974-77)
Femmes Photographes, OVO Photo, Montreal
1975 *Breadth of Vision*, Fashion Institute of Technology, New York
1977 *Creative Photography of the 20th Century*, Centre Georges Pompidou, Paris
Women Photograph Men, International Center of Photography, New York
1978 *Tusen och En Bild/1001 Pictures*, Moderna

Museet, Stockholm
1979 *Venezia '79*

Collections:

Metropolitan Museum of Art, New York; International Center of Photography, New York; Library of Congress, Washington, D.C; Bibliothèque Nationale, Paris; Musée Réattu, Arles, France; Museum Het Sterckshof, Deurne-Antwerp; Israel Museum, Jerusalem.

Publications:

By RUBINSTEIN: books—*Eva Rubinstein*, with a preface by Sean Kernan, New York 1974; *Eva Rubinstein: Portfolio 1*, 12 photos, with an introduction by John Vachon, New York 1975; *Eva Rubinstein Portfolio*, slides/cassettes, Garfield, New Jersey 1976; *Explore and Express*, slides/cassettes, Minneapolis 1980; *Eva Rubinstein: Portfolio 2*, with an introduction by André Kertész, New York 1981; article—"Notes from Two Irelands" in *Camera 35* (New York), November 1972.

On RUBINSTEIN: books—*Leica Manual*, edited by Douglas O. Morgan, New York 1973; *Women Photograph Men*, edited by Danielle B. Hayes, introduction by Molly Haskell, New York 1977; *10 Photographers*, with text by Michael Edelson, New York 1978; *Tusen och En Bild*, exhibition catalogue, by Ake Sidwall, Sune Jonsson and Ulf Hard af Segerstad, Stockholm 1978; *Venezia '79: La Fotografia*, edited by Daniela Palazzoli, Vittorio Sgarbi and Italo Zannier, Milan and New York 1979; *Photographers on Photography*, edited by Jerry C. LaPlante, New York 1979; *The Photograph Collector's Guide* by Lee D. Witkin and Barbara London, Boston and London 1979; *The Male Nude in Photography*, edited by Lawrence Barns, Waitsfield, Vermont 1980; articles—"How Do You Photograph Chance" in *Camera 35* (New York), October 1971; "Meaningful Portraiture" by Ralph Hattersley in *Popular Photography* (New York), December 1971; "Eva Rubinstein" in *Camera* (Lucerne), January 1973; "Eva Rubinstein" by Jim Hughes in *Popular Photography* (New York), September 1975; "Eva Rubinstein" by Attilio Colombo in *Progresso Fotografico* (Milan), April 1977; "What Price Fame" by Alice Williams in *35mm Photography* (New York), Winter 1978.

I have always felt the need to leave footprints...perhaps because those of my family have been so blurred or simply swept away during the recent past. I am a keeper and a gatherer...my room, house, apartment has always looked like the home of the Queen of the Pack-Rats. Obsessed by the ephemeral quality of everything in my life (I even wrote really terrible poetry about it at 14...stuff about looking back where I'd walked along the beach and seeing that the tide had washed away my footprints!), I've always lived rather too intensely in the moment, but longed for something like roots, permanence...perhaps making photographs is for me a way of satisfying my need both for an "outward and visible sign," something solid which will not "melt, thaw, and resolve itself into a dew," and a way to hold on to the momentary, the fleeting, the emotionally charged or serene...and the need to have something to share with others, without benefit of translator, choreographer, script, or director.

Photography became for me a way of hanging on to the moments of my life when I was moved by anything from a wonderful or startling face or person, to the quality of light in an empty place, a conflict between people or forms of a nude body. The camera is for me both a means of reaching people, and, when I need it, a sort of refuge.

I am glad and grateful when someone likes, understands, is amused or moved by a photograph I have made, because each time I feel a little root go down into some sort of common ground, which makes me feel more as though I were a card-carrying member of the human race and less like a figment of my own imagination.

—Eva Rubinstein

When Eva Rubinstein came to photography in 1967, she entered and carved a spot in a tradition that was largely dying out. The failing picture magazines left a void in the market for talented photo-journalists, and serious photographers had to find other outlets for their expression. Eva Rubinstein managed to continue in the shrinking, ever more competitive field of the humanist documentarian while supporting her travels with magazine assignments.

Her monograph (1974) presented a selection of her personal photographs at the time when her work was not only gaining her assignments but also artistic recognition in the gallery world. The book opens with her portraits of children whose friendly and concentrated cooperation she has elicited with unusual skill. Suffused with the overcast light of northern Europe, these portraits are unmistakably localized yet timeless in their removal from mundane detail. Two small Spanish girls, well-behaved and carefully posed in their straw hats and pleated dresses, belong to the 19th century daguerreotype studio as much as to their town of Marbella in 1973. The grace and sensitivity Rubinstein brings to her subjects enables her to transcend the time-locked specificity of most photographs (especially journalistic illustration) and achieve that rare condition where the literal becomes universal. Rubinstein's photographs of adults similarly remain undated in terms of time or place; yet, the open, forthright faces and the few carefully chosen details satisfy our curiosity as to who they are and how they live. Rubinstein's eye is compassionate and never intrusive; it is simple human dignity which she spots and records with apparent ease.

Her photographs of interiors capture the same warmth of human presence even while the compositions are stark and austere. The light functions in these pictures as the principal character, a palpable presence as tangible as the familiar faces of her portraits. Many of these pictures are nearly empty, yet loaded with significance; they are, as one reviewer noted, repositories of archetypal memory. Light and fabric, light and wallpaper, light and peeling paint, or, even more simply, light on the empty spaces of waiting rooms and stages—these are images which recall the sounds and bustle of activity in the same way poetry can. Rubinstein uses visual elements as precisely and economically as a poet uses the well-chosen word; the response she triggers is lyrical and this side of sentimental.

Eva Rubinstein belongs to a tradition uncommon for contemporary photographers; her work is classicist. She seeks and arranges an orderly world; the studied formality of her compositions places her as a direct descendant of photography's grandest tradition, from Paul Strand to Henri Cartier-Bresson. In a world glutted with photographs, Eva Rubinstein's are enduring by virtue of her humanism and compassion and the trueness of her ability to translate that quality onto film.

—Dana Asbury

RUSCHA, Edward (Joseph).
American. Born in Omaha, Nebraska, 16 December 1937. Educated at Classen High School, Oklahoma City, 1954-56; Chouinard Art Institute, Los Angeles, under Richard Rubin, 1956-60. Served in the United States Navy, Los Angeles, 1956-64. Married Danica Knego in 1967 (separated, 1972); son: Edward Joseph V. Independent painter, photographer and book creator, since 1960. Lecturer in Painting, University of California at Los Angeles, 1969-70. Recipient: National Council on the Arts Award, 1967, 1978; Guggenheim Foundation Fellowship, 1971; Skowhegan Medal in Graphics, Maine, 1974. Agent: Leo Castelli Gallery, 420 West Broadway, New York, New York 10012. Address: 1024-3/4 North Western Avenue, Los Angeles, California 90029, U.S.A.

Individual Exhibitions (photography):

1970 Galerie Heiner Friedrich, Munich (books)
Nigel Greenwood Gallery, London (books)
1973 *Projection*, Galerie Ursula Wevers, Cologne (books)
1974 Francoise Lambert Gallery, Milan (film *Premium* and books)
1975 University of Arizona, Tempe (books)
Leo Castelli Gallery (Rizzoli Screening Room), New York (film *Miracle*)
Fox Venice Theatre, Venice, California (films *Premium* and *Miracle*)
Arts Council of Great Britain, London (prints and books; toured Britain)
1976 Stedelijk Museum, Amsterdam
1977 University of Calgary Art Gallery, Alberta (prints and books)
David Hockney: Photographic Pictures; *Edward Ruscha: Photographic books*, Nova Gallery, Vancouver, British Columbia

1978 Galerie Rudiger Schottle, Munich (books)
1982 *The Works of Edward Ruscha*, San Francisco Museum of Modern Art (toured the United States, 1982-83)

Selected Group Exhibitions (photography):

1969 *Series Photographs*, School of Visual Arts, New York
1970 *Artists and Photographs*, Multiples, New York
1975 *60's and 70': Trends of 6 California Artists*, Ruth S. Schaffner Gallery, Los Angeles
1976 *The Artist and the Photograph*, Israel Museum, Jerusalem
1977 *Some Color Photographs*, Castelli Graphics, New York
Bookworks, The Museum of Modern Art, New York
Photonotations II, Rosa Esman Gallery, New York
The Extended Frame, Visual Studies Workshop, Rochester, New York
1978 *Mirrors and Windows: American Photography since 1960*, The Museum of Modern Art, New York (toured the United States, 1978-80)
1980 *Aspects of the 70's: Recent Directions in Photography*, De Cordova Museum, Lincoln, Massachusetts

Collections:

Whitney Museum of American Art, New York; Hirshhorn Museum and Sculpture Garden, Washington, D.C.; Art Institute of Chicago; Minneapolis Institute of Arts; Art Museum of South Texas, Corpus Christi; The Fort Worth Art Museum, Texas;

Los Angeles County Art Museum; Norton Simon Museum of Art, Pasadena, California; Stedelijk Museum, Amsterdam; Auckland City Art Gallery, New Zealand.

Publications:

By RUSCHA: books—*26 Gasoline Stations*, 1962; *Various Small Fires*, 1964; *Some Los Angeles Apartments*, 1965; *The Sunset Strip*, 1966; *34 Parking Lots*, 1967; *Royal Road Test*, 1967; *Business Cards*, with Billy Al Bengston, 1967; *Nine Swimming Pools*, 1967; *Crackers*, 1968; *Real Estate Opportunities*, 1969; *A Few Palm Trees*, 1970; *Records*, 1971; *Colored People*, 1971; *Hard Light*, with Lawrence Weiner, 1972—all published in Hollywood, California; articles—"They Shoot Corners, Don't They?" in *Esquire* (New York), January 1977; "Ed Ruscha on V-Various S-Subjects" in *Stuff Magazine* (Los Angeles), no. 24, 1980, films—*Premium*, 1974; *Miracle*, 1975.

On RUSCHA: books—*Mirrors and Windows: American Photography since 1960*, exhibition catalogue, by John Szarkowski, New York 1978; *Photography als Kunst 1879-1979/Kunst als Photographie 1949-1979*, exhibition catalogue, 2 vols., by Peter Weiermair, Innsbruck, Austria 1979; *Guacamole Airlines*, edited by Hugh Levin, New York 1980; articles—"The Magic of Raw Life: New Photography" by Douglas Davis in *Newsweek* (New York), 3 April 1972; "Photography: 'My Books End Up in the Trash'" by A.D. Coleman in *New York Times*, 27 August 1972; "Photography: 'I'm Not Really a Photographer'" by A.D. Coleman in *New York Times*, 10 September 1972, reprinted in *Light Readings: A Photography Critic's Writings 1968-1978* by A.D. Coleman, New York 1979.

Edward Ruscha: *Lookheed Air Terminal, Burbank*, from *34 Parking Lots*, 1967

My work in photography has been mostly limited to a series of books and two 16 mm films. First of all, with any medium I choose using a camera, it is no miracle for me to actually do the shutter snapping. Photography for me is not an end in itself, but a means to an end. My books are books first and not pages of paper housing a collection of photographs. The films are films first and not exercises in cinematography—they are stories told in such a way as to make the camera as non-existent as possible.

I do not make photographic prints and for this reason may be disqualified as being a photographer. The camera has to be the workhorse of another medium, not an end in itself.

—Edward Ruscha

Well-known as a pop/conceptual artist through his paintings and prints, Ed Ruscha has also strongly affected the world of photography with his ingenious series of books. Mimicking the way in which Americans use their cameras, these collections of snapshot-like pictures question the medium's artistic potential and raise broader issues about our society's strange affair with photography.

Ruscha's books are so simple they become profound. Similar to Andy Warhol's Brillo Boxes, his *26 Gasoline Stations* shocked viewers with its conscious lack of artistic content and its refusal to make any judgments about its subject matter. The book is no more than the title implies: it contains 26 straightforward pictures of gasoline stations. That brand of Pop irony can be found in many of his other books as well. *Nine Swimming Pools*, *34 Parking Lots*, and *A Few Palm Trees* are purposely so uninspiring that they raise the question of why someone went to the trouble to publish them. Copying the look of a real estate brochure, *Real Estate Opportunities* shows a series of unappealing vacant lots in the L.A. area in order to make a viewer consider the activity of business from a fresh perspective. *Some Los Angeles Apartments* works sim-

ilarly. It presents examples of the worst L.A. architecture in a way that neither romanticizes nor condemns, thus allowing the viewer to reach his or her own conclusions.

In terms of its effect on photography, the most significant book has been *Sunset Strip*, which contains a picture of each building joined together in accordian fashion so it can be folded out and displayed as a continuous strip 27 feet long. This piece pokes fun at the documentary impulse of the snapshot takers as well as the art photographers, because the desire to capture every important person, place, event, or feeling on film creates just such a surrogate reality. By actually completing such a silly project, Ruscha proves that the result of these desires is inevitably an illusion of the real experience.

Since Ruscha does not consider himself a photographer, he holds no commitment to the history or the traditions of the medium, and he openly questions its use as a purely artistic endeavor. When questioned by Howerdena Pindell in the *Print Collectors Newsletter*, he said,

> I have special reservations about the limits of the photograph, and I couldn't cross it into any other medium.... The photographs are very simple things. They really don't mean that much to me. It's the making of the entire book that's important—the collecting of all those things.... I would never frame one of my photographs and put it in an art exhibit. The book is the look, not the photograph.

The irony of this stance, of course, is that as he denies photography's artistic potential, he uses it to make his own artistic statements. So again, he leaves the photographers and viewers on their own to ponder what it all might mean.

—Ted Hedgpeth

RUSSO, Marialba.

Italian. Born in Giugliano, Naples, 14 August 1947. Studied at the Accademia di Belle Arti, Naples, 1968-72. Freelance photographer, Naples, since 1968. Professor of Photography and Ethnography, University of Salerno, 1972-73. Professor, Liceo Artistico, Naples, since 1973; Professor of Photography, Department of Visual Communication Sciences, Universita Popolare, Naples, since 1975. Address: Via Monte di Dio 74, Naples, Italy.

Individual Exhibitions:

1972 *La Festa Popolare*, University of Bologna
1973 *Modonna dell'Arco*, Museo Nazionale delle Arti e Tradizioni, Rome

Selected Group Exhibitions:

1970 *Incontri di Sorrento*, Sorrento, Italy
1971 *Fotografia e Informazione Visiva*, Atelier 70, Naples
1972 *Naples and Its Region*, Italian Tourist Office, Boston
1977 *Carnevale*, at SICOF '77, Milan
1979 *Fotografia come Bene Culturale*, Commune di Modena, Italy (travelled to Venice and Florence)
 Gli Eredi della Terra, Unicef, Milan
 Ritratto di Mio Padre e Mia Madre, at SICOF '79, Milan
 Venezia '79
1980 *L'Abete e il Faggio*, Museo Nazionale Arte Moderna, Rome

Collections:

Museo Nazionale delle Arti e Tradizioni Popolari, Rome; Museo Nazionale d'Arte Moderna, Rome; Centro Studi e Archivio della Comunicazione, University of Parma.

Publications:

By RUSSO: books—*Immagini della Madonna dell' Arco*, with an introduction by A. Rossi and R. De Simone, Rome 1974; *Al Ristorante il 29 Settembre 1974*, Naples 1976; *Carnevale si Chiamava Vincenzo*, with an introduction by A. Rossi and R. De Simone, Rome 1977; *Giornale Spray*, with an introduction by Daniela Palazzoli, Naples 1977; *Gli Eretici dell' Assunta*, with an introduction by J. Recupero, Rome 1978; articles—"Dove Rinasce il Folk" in *Radiocorriere TV* (Turin), 9 October 1975; "Il Mondo delle Favole" in *Fotografia Italiana* (Milan), September 1976; "I Nuovi Graffiti" in *Paese Sera* (Naples), September 1977; "Carnevale" in *Paese Sera* (Rome), December 1977; "Libri di B. Alario" in *Nuova Fotografia* (Naples), January 1979; "Carnevale come Evasione" in *Vogue Italia* (Milan), February 1980; "Di Giovedi Rinasce..." in *Europeo* (Rome), February 1980; "Vedi Napoli e le sue Mostre" in *L'Uomo Vogue* (Milan), May 1980.

On RUSSO: books—*Violence and Aggression*, by the Time-Life editors, New York 1976; *Catalogo Bolaffi della Fotografia n.2*, Turin 1977; *L'Opera dei Pupi*, Palermo 1977; *SICOF '77*, exhibition catalogue, by Lanfranco Colombo, Milan 1977; *Gli Eredi della Terra*, exhibition catalogue, Milan 1979; *SICOF '79*, exhibition catalogue, by Lanfranco Colombo, Milan 1979; *Venezia '79: La Fotografia*, edited by Daniela Palazzoli, Vittorio Sgarbi and Italo Zannier, Milan and New York 1979; *Enciclopedia per Fotografare*, Milan 1980; *Arte e Critica 80*, Rome 1980; articles—"Riscoperta del Carne-

Marialba Russo: *Il Passaggio*, 1979

vale" by R. Lejdi in *Europeo* (Milan), March 1976; "Tre Modi di Intendere la Fotografia" by Edo Prando in *Fotografia Italiana* (Milan), May 1976; "Tra Pittura e Fotografia" by Lea Vergine in *Fotografia Italiana* (Milan), October 1977; "I Nuovi Fotografi" by Daniela Palazzoli in *Europeo* (Rome), June 1979; "L'Arte Impura" by M. Luisa Agnese in *Panorama* (Milan), June 1979; "Marialba Russo" by Attilio Colombo in *Progresso Fotografico* (Milan), October 1979.

I scarcely transcribe the shadows, more or less clear, of the different experiences of the eye.

They do not want only to be the evidence of my experiences; these images would like to remain at the same level of liveliness, of ambiguity, as the figures and events that provoked them.

This desire does not come from love of the phenomena, but from fear that institutions of the eye could always capture in the secure net of their rules those rituals and those cultures that they do not yet grasp.

Meanwhile, the camera has captured them, enlightening the scene in which some rituals unfold in dim light their figures of origin, of diversity and of survival.

I will then stop my eye on the image of the rules so that like a negative on a positive it will make more uncertain the signs of the positive.

—Marialba Russo

Marialba Russo was born, and lives, in the south of Italy. Her field of vision is wholly comprised within the borders (historical and psychological, perhaps, rather than geographical) of southern Italy, where she has been investigating religious festivals and archaic rites, and peasant customs and way of life, for more than a decade. She is specially interested in an anthropological situation that escapes any hasty recording, that goes beyond the mere recording of phenomena to become a synthesis of a people's complex spirit.

What interests Russo is not simply folklore, but the phychology of the depths, the motivations, that lie behind the archaic carnivals of the Compania, the religious ceremonies in the sanctuaries in the little villages of the Apennines—in short, the spirit of a civilization. For this purpose her photography must be more than pure documentation; she herself often uses the term "registration" to describe her work. In addition to collaboration with university institutions, "registration" involves the need to read, when considering a particular event, all the layers of cultural background that have kept it alive.

Russo's expressive instrumentation is individual and extremely effective. Her style of photography avoids the forms of classical documentary (expressive cutting, correct angulation, modulation of tones, clarity of detail and so on), choosing rather the methods of sequence and especially movement, with the pictures taken from an angle that allows her to "enter" into the actual event. Her pictures seem to be shots in a film taken with the camera shoulder high; but it is quite wrong to think that she regrets being unable to use the ciné-camera. What seems at first to be a limitation in still photography, the difficulty of reproducing movement, becomes the real virtue, the significance of her photographs. What takes place before her lens is not crystallized, simply because a ritual is unfolding whose profound comprehension sometimes escapes the photographer; it is a succession of vital moments in which the action evokes a mystery, the vitality adds up to ambiguity.

In rejecting formal perfection in her photographs, Marialba Russo defines the limitation of her research and at the same time declares her refusal to capture within the safe nets of photographic records, with their visual rules, those rituals and cultures that still escape understanding and rationalization. Russo's photographs, nearly always in series, upset people who are accustomed to rational certainties. They are, after all, transfigurations born of the encounter between there author's powerful sensibility and the very roots of her culture, endlessly probed but never adequately clarified.

—Attilio Colombo

SALOMON, Erich.

German. Born in Berlin, 28 April 1886. Studied zoology, then civil engineering, in Berlin, 1906-09; studied law at the University of Munich and in Berlin, 1909-18, LL.D. (Rostock) 1913; self-taught in photography. Served in the German Army, 1914-18: prisoner-of-war, in France, 1915-18. Married Maggy Schuler in 1912; sons: Otto (Peter Hunter) and Dirk. Worked as a bank clerk and as a stock exchange assistant, Berlin, 1920-21; Partner, Duysen Piano Factory, Berlin, 1921-22; proprietor, car and motorcycle agency, Berlin, 1923-25; Publicity Manager, Ullstein Verlag publishers, Berlin, 1926-28; took first photographs, 1927; freelance photojournalist, based in Berlin, working mainly for Ullstein Verlag, and for *Berliner Illustrirte Zeitung, Münchner Illustrierte Press, The Graphic* (London), *L'Illustration* (Paris), *Fortune* (New York), etc., 1928-32, and in the Hague, working for *De Telegraaf, Het Leven, Wereld Kroniek, Daily Telegraph* (London), *Life* (New York), 1932-43; as Jew, imprisoned at Scheveningen, then deported to Theresienstadt in Czechoslovakia, then to Auschwitz in Poland, 1943, where he died. Erich Salomon Prize for Photojournalism established by Deutsch Gesellschaft für Photographie, 1971. *Died* (in Auschwitz, with wife and son Dirk; approximate date established by Red Cross) *7 July 1944.*

Individual Exhibitions:

1935 Royal Photographic Society, London
1937 Ilford Galleries, London
1956 *Photokina*, Cologne
 Town Hall, Berlin-Schöneberg
1957 Museum für Kunst und Gewerbe, Hamburg
 Royal Photographic Society, London
 Prentenkabinet der Rijksuniversiteit, Leiden
 Landesgewerbemuseum, Stuttgart
1958 International Museum of Photography, George Eastman House, Rochester, New York
 Time/Life Building, New York
 Library of Congress, Washington, D.C. (toured the United States)
1959 University of Miami
1964 Kiekeboe Club, Amsterdam
1971 Deutsche Gesellschaft für Photographie, Cologne
 Sander/Salomon: Zwei Pioniere der Fotografie, Urania, West Berlin (travelled to London, Prague, Milan, Geneva and Trieste)
1973 Kunstgewerbemuseum, Zurich
1974 Fotografiska Museet, Moderna Museet, Stockholm
1976 La Photo Galerie, Paris
 Wittrock Gallery, Dusseldorf
1977 Kunsthaus, Zurich (travelled to Bonn and Tübingen)
1978 Landesbildstelle, Berlin (show of Ilford Gallery prints of 1937; travelled to *Photokina*)
1981 Stedelijk Museum, Amsterdam (travelled to the Rheinisches Landesmuseum, Bonn)

Selected Group Exhibitions:

1937 *Foto '37*, Stedelijk Museum, Amsterdam
1963 *Great Photographers of This Century*, at *Photokina*, Cologne
1965 *Un Siècle de Photographie*, Musée des Arts Décoratifs, Paris
1967 *Photography in the 20th Century*, National Gallery of Canada, Ottawa (toured Canada and the United States, 1967-73)
1969 *Het Portret*, Stadsmuseum, The Hague
1972 *Photographen 1900-1970*, Kölnischer Kunstverein, Cologne
1978 *Neue Sachlichkeit and German Realism of the 20's*, Hayward Gallery, London
1979 *Life: The First Decade*, Grey Art Gallery, New York University
 Fotografie in Nederland 1920-40, Haags Gemeentemuseum, The Hague
1980 *Avant-Garde Photography in Germany 1919-39*, San Francisco Museum of Modern Art (toured the United States)

Collections:

Berlinische Galerie, Berlin (archives: negatives and prints); Royal Photographic Society, Bath, England; Fotografiska Museet, Moderna Museet, Stockholm; Prentenkabinet, Leiden, Netherlands; Magnum Photos, New York; Museum of Modern Art, New York; International Museum of Photography, George Eastman House, Rochester, New York; Smithsonian Institution, Washington, D.C.; Gernsheim Collection, University of Texas at Austin.

Publications:

By SALOMON: books—*Berühmte Zeitgenossen in Unbewachten Augenblicken* (Famous Contemporaries in Unguarded Moments), Stuttgart 1931, Munich 1978; *Erich Salomon: Porträt einer Epoche/Erich Salomon: Portrait of an Age*, edited by Han de Vries and Peter Hunter, Frankfurt, Berlin and Amsterdam 1963, New York and London 1966; *Erich Salomon*, with an introduction by Peter Hunter, Millerton, New York 1978; article—"The Photographer as Reporter," interview with Hans Sahl, in *Gebrauchsgraphik* (Berlin), July 1931.

On SALOMON: books—*Words and Pictures: An Introduction to Photo-Journalism* by Wilson Hicks, New York 1952; *The History of Photography* by Helmut and Alison Gernsheim, London and New York 1955, 1969; *Available Light* by Jacqueline Judge, New York 1955; *Masters of Photography* by Beaumont and Nancy Newhall, New York 1958, 1969; *The Picture History of Photography* by Peter Pollack, New York 1958, 1969; *Creative Photography: Aesthetic Trends 1839-1960* by Helmut Gernsheim, London 1962; *The History of Photography 1839-1965* by Beaumont Newhall, New York 1965; *Un Siècle de Photographie de Niepce à May Ray*, exhibition catalogue by Laurent Roosens and

others, Paris 1965; *Photography in the 20th Century* by Nathan Lyons, New York 1967; *Erich Salomon*, exhibition catalogue, by Rune Hassner, Stockholm 1974 (includes extensive bibliography); *Die Unbestechliche Kamera des Dr. Erich Salomon* by Gabriele Forberg, Dusseldorf 1976; *Geschichte der Fotografie im 20. Jahrhunderts/Photography in the 20th Century* by Petr Tausk, Cologne 1977, London 1980; *Bilder för Miljoner* by Rune Hassner, Stockholm 1977; *Neue Sachlichkeit and German Realism of the 20's*, exhibition catalogue, by Wieland Schmied, Ute Eskildsen and others, London 1978; *Germany: The New Photography 1927-33*, edited by David Mellor, London 1978; *Fotografie in Nederland 1920-40*, exhibition catalogue, by Klip Bool and Kees Broos, The Hague 1979; *Life: The First Decade 1936-1945* by Robert Littman, Ralph Graves and Doris C. O'Neil, New York 1979, London 1980; *Avant-Garde Photography in Germany 1919-39*, exhibition catalogue, by Van Deren Coke, Ute Eskildsen and Bernd Lohse, San Francisco 1980; *Erich Salomon* by Romeo Marinez (in series "Maestri della Fotografia"), Milan 1980; *Erich Salomon 1886-1944: Aus dem Leben eines Photographen* by Els Barents, Munich 1981; articles—"Salomon" by Peter Hunter in *Photography* (London), January 1957; "Dr. Erich Salomon: Father of Modern Photojournalism" by Peter Hunter in *Camera 35* (New York), no. 4, 1958; "Dr. Erich Salomon 1886-1944: Historian with a Camera" by Helmut Gernsheim in *Creative Camera* (London), January 1972; "Salomon à créé le Reportage Indiscret" in *Photo* (Paris), April 1972; "Erich Salomon" in *NRC-Handelsblad* (Rotterdam), 8 September 1978.

Erich Salomon is the father of candid photography. The compact Ermanox camera with a very fast f2.0 lens was introduced in Germany in the 1920's: even on the relatively insensitive glass plates used in this camera, it was possible to take interior pictures in available light at shutter speeds of 1/2 to 1/25 of a second; and the man who made the most telling and imaginative use of this new camera—essentially and indispensably linked to the type of work he did and to the style of photography he developed—was Dr. Erich Salomon.

The son of a wealthy Berlin family, Salomon found his fortunes drastically diminished in the period of inflation that followed World War I, and after a series of jobs in the early 1920's he became a publicity manager for Ullstein Verlag, at that time the largest publishing house in the world. His career as a photojournalist began in 1927 when he was given the chance to take photographs for one of Ullstein's publications, *Berliner Illustrirte Zeitung*, the Berlin periodical which used the greatest number of photographs. He decided to take up photoreportage to cover the diplomatic and political scene of a highly interesting and turbulent era.

With his easy and cultured manner, a gift for persuasive conversation in seven languages, and the insight gained from his university training, Salomon had great success in capturing with his camera politicians and celebrities talking together in unguarded

653

Erich Salomon: *Second Hague Conference on German War Debts (after dinner at the Anjema Restaurant), The Hague, January 1930*

moments. He regarded himself as a kind of historian documenting high-level political and cultural events, and was often invited to photograph official functions—and when he wasn't, was ingenious at finding some way to record the occasion. Often, it was necessary to steady his small camera on a tripod behind a convenient curtain or beside a sofa, but so accustomed to posed portraits by press photographers with large camera apparatus and flash powder were the statesmen that they ignored the well-dressed Salomon as he unobtrusively took their pictures. His candid photographs of the famous as well as of ordinary people—a sensation when first published in *Berliner Illustrirte*—gave readers a feeling of being present at international conferences, court actions and other rarely photographed events. The term "candid camera" was coined by the London *Graphic* to describe his innovative work. He became so well known that in 1930 Aristide Briand, prime minister of France, jokingly advised the participants at a conference to await Salomon's arrival before convening: unless photographed by Salomon, the meeting might not be considered important.

Salomon's quick response, academic knowledge about the people he photographed and his willingness to wait for a revealing moment to click his shutter helped in a major way to create the new profession of photojournalism. He was, like Felix H. Man and Tim Gidal, one of the many German photographers who took up the camera as a means of livelihood during the bleak days of the 1920's when academically trained men were unable to find jobs in their chosen fields. Because of their fresh approach, a new style of photography began to appear in extensively illustrated topical periodicals in Munich and Cologne as well as in Berlin.

In the 1930's Salomon and his family left Germany for Holland, where he continued to work for Dutch newpapers and magazines. During the war they were arrested and deported to Auschwitz, where he, his wife and a son died.

—Colin Naylor

SAMARAS, Lucas.

American. Born in Kastoria, Macedonia, Greece, 14 September 1936; emigrated to the United States, 1948: naturalized, 1955. Educated at Memorial High School, West New York, New Jersey, 1951-55; studied, under Allan Kaprow, at Rutgers University, New Brunswick, New Jersey, 1955-59, B.A. 1959; Columbia University, New York (Woodrow Wilson Fellow), 1959-62. Artist and photographer, New York, since 1964: first "autopolaroid" photographs, 1970; first "photo-transformations," 1973. Visiting Instructor in Sculpture, Yale University, New Haven, Connecticut, 1969; Instructor, Brooklyn College, New York, 1971-72. Agent: Pace Gallery, 32 East 57th Street, New York, New York 10022. Address: 52 West 71st Street, New York, New York 10023, U.S.A.

Individual Exhibitions:

1955 Rutgers University, New Brunswick, New Jersey (and 1958)
1959 Reuben Gallery, New York
1961 *Dinners, Liquid Aluminum, Pastels and Plasters*, Green Gallery, New York
1962 *Pastels*, Sun Gallery, Provincetown, Massachusetts

1964 *Boxes, Constructions*, Dwan Gallery, Los Angeles
 Bedroom, Boxes, Plastics, Green Gallery, New York
1966 *Samaras: Mirror Room: Selected Works 1960-66*, Pace Gallery, New York
1968 *Transformations, Mirror Stairs, Paintings and Drawings*, Pace Gallery, New York
1969 *Book*, Museum of Modern Art, New York
 Mirror Room 3, Boxes and Drawings, Galerie der Spiegel, Cologne
1970 *Chair Transformations*, Pace Gallery, New York
 Mirror Room 3, Kunstverein, Hannover
1971 *Stiff Boxes and Autopolaroids*, Pace Gallery, New York
 Acrylics, Pastels, Inks, Phyllis Kind Gallery, Chicago
 Lucas Samaras' Boxes, Museum of Contemporary Art, Chicago
1972 *Chicken Wire Boxes*, Pace Gallery, New York
 Whitney Museum, New York (retrospective)
1974 *Photo-Transformations*, Pace Gallery, New York
1975 *Pastels*, Museum of Modern Art, New York
 Makler Gallery, Philadelphia
 Samaras and Some Others, Pace Gallery, New York
 Photo-Transformations, California State University at Long Beach
1976 University of North Dakota Art Gallery, Grand Forks
 Wright State University Art Gallery, Dayton, Ohio
 Institute of Contemporary Art, Boston
 Seattle Art Museum
 A.C.A. Gallery, Alberta College of Art, Calgary
 Phantasmata, Pace Gallery, New York
 Margo Leavin Gallery, Los Angeles
1977 *Photo-Transformations*, Galerie Zabriskie, Paris
 Photo-Transformations, Walker Art Center, Minneapolis
1978 *Reconstructions*, Pace Gallery, New York
 Mayor Gallery, London
 Reconstructions and Photo-Transformations, Akron Art Institute, Ohio
1979 Richard Gray Gallery, Chicago
1980 *Reconstructions*, Pace Gallery, New York
 Reconstructions, Photo-Transformations and Word Drawings, Pace Gallery, Columbus, Ohio
 Polaroid Photographs, Pace Gallery, New York
1982 *Pastels*, Lowe Art Museum, University of Miami

Selected Group Exhibitions:

1961 *The Art of Assemblage*, Museum of Modern Art, New York
1968 *The Obsessive Image*, Institute of Contemporary Arts, London
1974 *Photography in America*, Whitney Museum, New York
1977 *Documenta 6*, Kassel, West Germany
1978 *Mirrors and Windows: American Photography since 1960*, Museum of Modern Art, New York (toured the United States, 1978-80)
1979 *One of a Kind: Polaroid Color*, Corcoran Gallery, Washington, D.C. (toured the United States)
1980 *La Photo Polaroid*, Musée d'Art Moderne, Paris

Collections:

Metropolitan Museum of Art, New York; Museum of Modern Art, New York; Whitney Museum of American Art, New York; Guggenheim Museum, New York; Albright-Knox Art Gallery, Buffalo, New York; Larry Aldrich Museum, Ridgefield, Connecticut; Wadsworth Atheneum, Hartford, Connecticut; Art Institute of Chicago; Walker Art Center, Minneapolis; Los Angeles County Museum of Art.

Publications:

By SAMARAS: books—*Samaras Album, Autobiography, Autointerview, Autopolaroids*, New York 1971; *Lucas Samaras: Photo-Transformations*, with text by Arnold B. Glimcher, New York 1975; *Lucas Samaras*, with text by Kim Levin, New York 1975; articles—"An Exploratory Dissection of Seeing" in *Artforum* (New York), December 1967; "Greece 1967; A Reconstituted Diary" in *Artforum* (New York), October 1968; "Autopolaroids and Autointerview" in *Art in America* (New York), November/ December 1970; "The Art of Portraiture, in the Words of Four New York Artists" in the *New York Times*, 31 October 1976; film—*Self*, 1969.

On SAMARAS: books—*Samaras: Selected Works 1960-66*, exhibition catalogue, with text by Lawrence Alloway, New York 1966; *Chair Transformations*, exhibition catalogue, New York 1970; *Samaras: Selected Works 1960-1969*, exhibition catalogue, with text by Joan Siegfried and Lawrence Alloway, Chicago 1971; *Lucas Samaras' Boxes*, exhibition catalogue, with text by Joan Siegfried, Chicago 1971; *American Art in the 20th Century* by Sam Hunter, New York 1973; *Photography in America*, edited by Robert Doty, with an introduction by Minor White, New York and London 1974; *Mirrors and Windows: American Photography since 1960* by John Szarkowski, New York 1978; articles—"Samaras' Autopolaroids" by Bruce Kurtz in *Artsmagazine* (New York), December 1971; "Violated Instants: Lucas Samaras and Les Krims" by A.D. Coleman in *Camera 35* (New York), July 1976; "Lucas Samaras" by Shoji Yamagishi in *Camera Mainichi* (Tokyo), July 1977; "Lucas Samaras: The Self as Icon and Cultural Development" by Barbara Rose in *Artsmagazine* (New York), March 1978; "Modernism Turned Inside Out: Lucas Samaras' Reconstructions" by Carter Ratcliff in *Artsmagazine* (New York), November 1979; "Singular Developments: Polaroid's Paean to Color" by Allen Robertson in *TWA Ambassador* (St. Paul, Minnesota), December 1979.

The art of protean Lucas Samaras is singularly an extended metaphor—of his own self. Voraciously, passionately, and obsessively, he has explored various media to fabricate art-objects which constantly push the limits and possibilities of the particular art-form to stunning realizations. He is both original and fascinating, particularly with regard to the medium of photography.

Samaras' involvement with photography can be traced to the early use of self-portraits taken by others and used in his "Boxes." In Spring 1969 he made the film *Self*—his own self-image, alternating, duplicating, transforming. "I am," he says, "my own investigation territory;" the statement unquestionably applies to Samaras' entire artistic and creative endeavour. Most blatantly he has performed—"basically I'm a performer"—in this regard in his photography from "Autopolaroids," begun in December 1969, and continuing through "Photo-Transformations," started in 1973. Repeating themselves, photographic images continually acquire different transformations and symbolisms through new materials and contexts. An enormous lens-reflected face held in his own hand in a photograph of 1968 reappears in "Photo-Transformations" as a distorted snarling figure holding a sharp-focussed image in a shaving mirror. This again appears in 1974 in another form and context—under a conical lens on

a chiffon cloth between a fork and spoon. The yarn "Box 36" with a photo-lined lid and acrylic fingers emerging from a jewelled quicksand field anticipates the image of his mouth transformed into an incinerator consuming the fingers from the edges of his lips.

As one examines Samaras' photography several features emerge: the kind of camera used (Polaroid), the technique employed, the materials and contexts, the main subject (his own self), and the particular use of the medium. He first used Polaroid 360; since 1973 he has used SX-70. It could be suggested that he deliberately exploits the amateurish associations and the temporal immediacy of the Polaroid to tease us to look at the medium from a more philosophical and untraditional viewpoint. Unlike a roll of film with its flat, transparent continuous surface, each shot of Polaroid produces a box of a separate and distinct image. At the same time, his "Autopolaroids" and "Photo-Transformations," consisting of series of self-images, each constitute a single iconic enigma. In other words, what he tried to do with his earlier "assemblage" techniques to fuse the difference between the idea/concept and the mode/result of expression has come to fruition in a medium that offers the promise of such a possibility. The double and multiple images are created by manipulating (tricking) the electric eye of the camera for approximately 20 seconds to manage the number of exposures. Electronic strobe is used with red mylar, green mylar, and broken coloured glasses, effecting a surrealistic cartoon-world imagery—a kind of painting with coloured lights. By uplighting his pictures he reverses the expected order of highlights and shadows; frequently his images are photographed from below, magnifying the image. All this is not a matter of technical innovation; rather, it is a way of revolutionizing and transforming the system of communication for complex patterns of attitude, thought,

and response. The "Autopolaroids" and "Photo-Transformations" become objects and the system—the process in its entirety; photographic medium is appropriated as an authentic, personalized way of seeing and communicating the reality/realities. The camera as well as the images serve as mirrors—mirrors which Samaras uses often in his sculptural art.

The decor of his images is the very environment, which is only an extension of himself, be it pieces of furniture, silverware, or broken glass. The central and primary subject is Samaras himself—his body: legs, hands, fingers, genitals, buttocks, etc; Samaras spitting out silverware; Samaras kissing, embracing himself; Samaras making love to himself; Samaras as embryo, as a female, as a transvestite, a hermaphrodite, etc. etc. The monstrous exaggerations and distortions—faces becoming phalluses, faces with two mouths and four eyes, and his body turned into weird abstract shapes—expose him so totally and obsessively that the impact on the viewer is one of occultic reflection. Comic and grotesque, erotic and pornographic, realistic and surrealistic, these images at once evoke contrary and contradicting emotions and thinking. They embody a process of "transformation"—simultaneously divine and diabolic—a theatre of the absurd and the real, which constantly threatens and challenges our normal conceptual and perceptual categories. Samaras creates a tableaux which in exposing him exposes the viewer. The mirror in revealing him reflects us in the caves of our mind and soul. Thus, Samaras' photography transforms itself to an artifice, a ritual, a process of *catharsis*, a mirror, and a theatre of silence with primodial sounds and intimations.

—Deba P. Patnaik

Lucas Samaras: *Photo-Transformation*, 1976 Courtesy Pace Gallery, New York

SANDELS, Karl.

Swedish. Born in Stockholm, 5 November 1906; son of the photographer Knut Hjalmar Sandels. Educated at Södra Latin High School, Stockholm. Married Astrid Stilling in 1930; children: Curt, Björn and Rolf. Freelance news photographer, Stockholm, 1923-26; Photographer, *Stockholms Dagblad* newspaper (merged with *Stockholmstidningen*, from 1932), 1926-33; Founder and Director, Sandels Illustrationsbyrå picture agency, Stockholm, 1934-48; ceased active work as a photographer, 1942; served as Secretary and Executive Director, Svenska Fotografernas Förbund (Swedish Photographers Association), Stockholm, Editor of *Svensk Fotografisk Tidskrift* magazine, Stockholm, and Course Leader and Craft Instructor, Swedish Government Institute for Handicrafts, Stockholm, all 1942-60; Founder and Chief Editor, *Fotonyheterna* journal for professional photographers, Stockholm, 1961-80 (now edited by Björn Sandels). Founder Member, Press Photographers Club, Stockholm, 1930 and Bildleverantörernas Förening (Picture Suppliers Association), Stockholm, 1932; Member, Swedish Photographers Association, 1934. Recipient: Florman Medal, Stockholm, 1945; Royal Gold Medal, Swedish Government Institute for Handicrafts, 1960; Prisma Award, National Association of Swedish Photography, 1974. Address: Narvavägen 20, 11523 Stockholm, Sweden.

Individual Exhibitions:

1977 *Fotografer: Curt Götlin, Anna Riwkin, Karl Sandels*, Moderna Museet, Stockholm

Selected Group Exhibitions:

1934 *Internationell Fotografiutställning*, Liljevalchs Konsthall, Stockholm
Annual Press Photographers Club Exhibition, Ekströms Konstsalong, Stockholm
1939 *Det Nya Ögat: Fotografien 100 År*, Liljevalchs Konsthall, Stockholm
Den Store Nordiske Fotografiudstilling: Fotografien i 100 År, Charlottenborg, Copenhagen
1942 *Ögonblicket Räddat åt Framtiden*, Esseltehallen, Stockholm
1955 *The Family of Man*, Museum of Modern Art, New York (and world tour)

Collections:

Moderna Museet, Stockholm.

Publications:

By SANDELS: books—illustrations for *Löpande band* by Waldemar Hammenhög, Stockholm 1939; *Fotografens värld: en vägledning i fotografyrket*, Stockholm 1958; *Sjuttiofem år i fotografins tjänst*, Stockholm 1959; *Edvard Welinder: en minneskrift*, editor, Stockholm 1959; articles—"Bildreportage" in *Foto* (Stockholm), no. 4, 1939; numerous articles and editorials in *Svensk Fotografiska Tidskrift* (Stockholm), 1942-60; "Det fotografiska bildreportaget genom tiderna" in *Fotografisk Årsbok*, Stockholm 1950; "Sweden" in *Focal Encyclopaedia of Photography*, London 1956, 1970; numerous articles and editorials in *Fotonyheterna* (Stockholm), 1961-80; "Att samla fotografisk litteratur" in *Fotografisk Årsbok*, Stockholm 1963; "För 40 år sedan" in *Fotografica '67*, Stockholm 1967; "Att göra fototidningar: Fotonyheterna—tidningen för proffsfoto" in *Fotografisk Årsbok*, Stockholm 1968.

On SANDELS: book—*Fotografer: Curt Götlin, Anna Riwkin, Karl Sandels*, exhibition catalogue, by Åke Sidwall, Pär Frank, Leif Wigh, Carl-Adam

Nycop and Ulla Bergman, Stockholm 1977; article—"Karl Sandels 50 år" by Edvard Welinder in *Svensk Fotografisk Tidskrift* (Stockholm), no. 10, 1956.

When Sandels Illustrationsbyrå eventually got going in 1934, we took lots of sports pictures. We were known for making good prints, and it was said that on Sunday evenings newspaper editors would wait until our pictures arrived. The whole secret of the thing was our negatives. We used a very fine Ilford paper. We knew precisely what could be achieved with it. It was a matter of developing the negative to suit that paper. That was the whole secret. During my Association time, I saw so many bad negatives in portrait photographers' studios that it scared me to death. They were over-exposed. So, the photographers were forced to seek out a suitable paper. Well, that was all wrong, of course. They already had the paper. It was the negative they should have been working on.

I left the profession of photographer simply because it was clear to me that I could accomplish a bit more in the field of photography by first becoming Secretary and then Executive Director of the Association. It was a larger task. Whether it was the correct decision is debatable, I suppose. But I definitely believe it was correct—and, well, I guess I was tired of taking pictures, too. I'd been at it for so long, and who says that just because a person happens to be a photographer, he's got to keep doing the same thing all his life?

I started working for the Association in 1942. At first, it was mainly a half-time job (I still had my firm). Quite early on, I became interested in photographers' purely professional concerns: their being able to receive reasonable payments for their work. In the Association paper I wrote a column for many years—"Just Among Us Photographers." And for a couple of years, I also wrote about various colleagues. The work became more and more a full-time thing, and so it was pretty natural that I relinquished my firm in 1948.

I started the journal *Fotonyheterna* in 1961, and it's been a tremendous success. It's entirely professional-oriented and available only by subscription, and our subscription list includes the entire industry. My book, *Fotografens värld*, I wrote as a kind of guide, a general treatment of the profession of photographer. It was the first book of its kind.

—Karl Sandels

Karl Sandel's grandfather, uncle and father were all photographers. His grandfather taught himself the profession in the 1870's, and by the beginning of this century the family ran one of Stockholm's most popular portrait studios. It would therefore seem inevitable that Karl Sandels would also become a photographer. But he found portrait photography in a studio of only moderate interest and chose to become a clerk, who in his spare time took unpretentious snapshots with a simple amateur camera. It was due to sports that he became a professional photographer at all. He was interested in all kinds of sports, was himself an active sportsman, and he often had his camera with him and photographed his friends. In 1924 he managed to sell a picture of a victorious relay team to a morning paper in Stockholm. The fee of 6 kr. was then a large sum to a 17 year old, and he decided to augment his clerk's income with fees for pictures.

There were at that time about ten daily papers in Stockholm, but only four employed permanent photographers. So the field was open for free-lance photographers, and Karl Sandels specialized in sports and feature photos. By 1926 he had become so well known in the newspaper world that he was offered permanent employment at *Stockholms Dagblad*.

Sandels became one of the pioneers of photography in natural light. His great idol was a photographer at the English newspaper *Graphic* and naturally also Erich Salomon, who, with his Ermanox camera, attended political conferences in Europe. By buying *Das Deutsche Lichtbild* each year, as well as regularly reading the *British Journal of Photography*, *Berliner Illustrirte* and the *Daily Mirror*, Sandels kept himself well informed about international photography and the developments in press photography.

Like other successful press photographers, Sandels had the ability to sense the climax of an event before it occurred. In the decisive moment he had his finger on the release, and many of his sports pictures from the 1930's stand up well in comparison to the work of today's photographers. And it must not be forgotten, that he worked with a large and clumsy camera, and was only able to produce one exposure per event.

Karl Sandels thought, quite early on, that photographers lacked a fighting spirit in professional matters, and he was therefore among the founder members of the Press Photographers Club in 1930. Between 1942 and 1960 he was also Secretary and Executive Director of the Swedish Photographers Association, which before his time had been dominated by portrait photographers and had looked down on press and advertising photographers.

His many administrative concerns resulted in a less active career as a photographer. In 1934 he had started a picture agency, Sandels Illustrationsbyrå, but in 1948 he sold it in order to give his time completely to the Association. At the same time he worked as a highly respected teacher and lecturer all over Sweden.

In 1961 he started his own photographic magazine, *Fotonyheterna*, which is primarily for professional photographers and photographic retailers. Since the end of the 1970's his son Björn has been its Editor-in-Chief. Karl Sandels, the sports photo specialist, the press photo pioneer and the trades association man, now writes only an occasional editorial.

—Rune Jonsson

SANDER, August.

German. Born in Herdorf am Sieg, 17 November 1876. Educated at primary and secondary schools in Herdorf, 1882-89; studied at the Academy of Painting, Dresden, 1901-02; self-taught in photography. Served in the German Army, at Trier, 1896-98, and as a reserve officer, 1914-18. Married Anna Seitenmacher in 1902 (died, 1957); children: Erich (died, 1944), Gunther, and Sigrid. Apprentice miner, 1889-92, then coal-miner, 1893-96, San Fernando Mines, Herdorf; part-time photographic assistant, Jung Studio, Trier, 1898-99; freelance journeyman photographer, working in several studios, in Berlin, Magdeburg, Halle, Leipzig and Dresden, 1899-1900; assistant photographer, Greif Studio, Linz, Austria, 1901-02; partner, with Franz Stukenberg, Studio Sander and Stukenberg (took over old Greif Studio), Linz, 1902-04; Director, August Sander Studio for the Pictorial Arts of Photography and Painting, Linz, 1904-09; Manager, Blumberg and Hermann photo studio, Cologne, 1910; Director, Studio August Sander, Cologne-Lindenthal, 1910-44, in Kuchhausen, Westerwald, near Cologne, 1944-64 (worked on "Man of the 20th Century" project, 1910-34, 1939-51, and on landscape photography, 1934-39). Recipient: State Medal for Art, Linz, 1903; Gold Medal, *Arts and Crafts Exhibition*, Wels, Austria, 1904; Stifter Prize, Leipzig, 1904; Gold Medal and Cross of Honor, *International Exposition*, Paris, 1904; State Silver Medal, *Arts and Crafts Exhibition*, Linz, Austria, 1909; Honorary Membership, 1958, and Cultural Award, 1961, Deutsche Gesellschaft für Photographie (DGPh). Honorary Citizen of Herdorf, 1958. Federal Order of Merit, West Germany, 1961. *Died* (in Cologne) *20 April 1964*.

Individual Exhibitions:

1906 Landhaus-Pavillon, Linz, Austria
1927 Kölnischer Kunstverein, Cologne
1951 *Photokina*, Cologne
1958 Herdorf Gallery, West Germany
1959 *August Sander: Figures of His Time*, Deutsche Gesellschaft für Photographie, Cologne
1961 Freie University, West Berlin
1969 Museum of Modern Art, New York
1974 *Konfrontatie 2*, Van Abbemuseum, Eindhoven, Netherlands (with Willem Diepraam)
1975 Robert Schoelkopf Gallery, New York
 Gemalte Fotografie: Rheinlandschaften der 20er Jahre, Rheinisches Landesmuseum,

Karl Sandels: *Downpour*, Stockholm, 1930

Bonn (with F.M. Janssen and Theo Campion)
1976 Halsted 831 Gallery, Birmingham, Michigan
Art Institute of Chicago
Sander Gallery, Washington, D.C.
Thackrey and Robertson, San Francisco
California State University at Long Beach
1977 Goethe Institut, Turin
1979 Chateau d'Eau, Toulouse
1980 Galerie ARPA, Bordeaux
Museum Folkwang, Essen
August Sander: Photographs of an Epoch 1904-59, Philadelphia Museum of Art (toured the United States)
Miller Gallery, New York
1981 Fotogalleriet, Oslo
Portraits and Landscapes, Cultural Center, Chicago
Palais des Beaux-Arts, Charleroi, Belgium

Selected Group Exhibitions:

1955 *The Family of Man*, Museum of Modern Art, New York (and world tour)
1956 *Alvarez Bravo/Walker Evans/August Sander/Paul Strand*, Museum of Modern Art, New York
1977 *Neue Sachlichkeit and Realismus*, Museum des 20. Jahrhunderts, Vienna
Photographie: Zwischen Daguerreotypie und Kunstphotographie, Museum für Kunst und Gewerbe, Hamburg
1978 *Paris-Berlin 1900-1933*, Centre Georges Pompidou, Paris
Neue Sachlichkeit and German Realism of the 20's, Hayward Gallery, London
1980 *Old and Modern Masters of Photography*, Victoria and Albert Museum, London (toured Britain)
Avant-Garde Photography in Germany 1919-39, San Francisco Museum of Modern Art (toured the United States, 1980-82)
The Magical Eye: Definitions of Photography, National Gallery of Canada, Ottawa (toured Canada)
1981 *Germany: The New Vision*, Fraenkel Gallery, San Francisco

Collections:

Kölnischer Museum, Cologne; Museum of Arts and Crafts, West Berlin; Victoria and Albert Museum, London; Royal Photographic Society, Bath, England; Museum of Modern Art, New York; International Museum of Photography, George Eastman House, Rochester, New York; Art Institute of Chicago; New Orleans Museum of Art; University of New Mexico, Albuquerque; National Gallery of Canada, Ottawa.

Much of Sander's work was lost in the wartime bombing of his Cologne studio, 1944, and in a studio fire that destroyed 40,000 negatives, 1946.

Publications:

By SANDER: books—*Unsere Heimat Hannover*, Monchengladbach, Germany 1924; *Antlitz der Zeit (Faces of Our Time)*, with text by Alfred Döblin, Munich and Berlin 1929, Munich 1976; *Deutschenspiegel: Menschen des 20. Jahrhunderts*, with an introduction by Heinrich Lützeler, Munich 1929, Gutersloh 1962; *Bergisches Land: Deutsches Land, Deutsches Volk*, Dusseldorf 1933; *Die Eifel: Deutsches Land, Deutsches Menschen*, Dusseldorf 1933; *Das Siebenbirge: Deutsches Land, Deutsches Volk*, Rothenfeld, Germany 1934; *Die Mosel: Deutsches Land, Deutsches Volk*, Rothenfelde, Germany 1934; *Die Saar: Deutsches Land, Deutsches Volk*, with text by Joseph Witsch, Rothenfelde, Germany 1934;

Menschen ohne maske, with text by Gunther Sander, and a foreword by Golo Mann, Lucerne and Frankfurt 1971, as *Men Without Masks: Faces of Germany 1910-1938*, Greenwich, Connecticut 1972, as *August Sander: Photographer Extraordinary*, London 1973; *Rheinlandschaften*, with text by Wolfgang Kemp, Munich 1975; *Menschen des 20. Jahrhunderts: Portraitphotographien 1892-1952*, edited by Gunther Sander, with text by Ulrich Keller, Munich 1980; *August Sander: Photographs of an Epoch*, with text by Robert Kramer, with a preface by Beaumont Newhall, New York 1980; articles—"Haubergswirtschaft im Siegerland" in *Stadt-Anzeiger für Köln und Umgebung* (Cologne), 23 April 1933; "Wildegemuse" in *Velhagen und Klasings Monatshefte* (Berlin), June 1937; "Photography as a Universal Language" in the *Massachusetts Review* (Amherst), Winter 1978.

On SANDER: books—*Foto-Auge* by Franz Roh and Jan Tschichold, Tubingen 1929, 1973; *Grosse Photographen unserer Jahrhunderts*, edited by L. Fritz Gruber, Dusseldorf and Vienna 1964; *Un Siècle de Photographie de Niepce à Man Ray*, exhibition catalogue, by Laurent Roosens and others, Paris 1965; *Die Neue Sachlichkeit in Deutschland* by Emilio Bertonati, Munich 1974; *Gemalte Fotografie: Rheinlandschaften der 20er Jahre von F.M. Janssen, August Sander, Theo Campion*, exhibition catalogue, by Joachim Heusinger von Waldegg, Bonn and Cologne 1975; *The Magic Image* by Cecil Beaton and Gail Buckland, London and Boston 1975; *Geschichte der Fotografie im 20. Jahrhundert/Photography in the 20th Century* by Petr Tausk, Cologne 1977, London 1980; *Photographs: Sheldon Memorial Art Gallery Collection, University of Nebraska*, with an introduction by Norman A. Geske, Lincoln, Nebraska 1977; *Neue Sachlichkeit und Realismus*, exhibition catalogue, by Robert Schmitt, Vienna 1977; *Fotografische Kunstlerbildnisse*, exhibition catalogue, by Dieter Rönte, Evelyn Weiss and Jeane von Oppenheim, Cologne 1977; *August Sander* (Aperture monograph), with text by John von Hartz, Millerton, New York, Paris and London 1977; *Tusen och En Bild*, exhibition catalogue, by Ake Sidwall, Sune Jonsson and Ulf Hard af Segerstad, Stockholm 1978; *A Book of Photographs from the Collection of Sam Wagstaff*, designed by Arne Lewis, New York 1978; *Neue Sachlichkeit and German Realism of the 20's*, exhibition catalogue, by Wieland Schmied, Ute Eskildsen and others, London 1978; *Germany: The New Photography 1927-33*, edited by David Mellor, London 1978; *Paris-Berlin 1900-1933*, exhibition catalogue, by H. Molderings, W. Spies, G. Metken and others, Paris 1978; *Photographie als Kunst 1879-1979/Kunst als Photographie 1949-1979*, exhibition catalogue, 2 vols., by Peter Weiermair, Innsbruck, Austria 1979; *The Photograph Collector's Guide* by Lee D. Witkin and Barbara London, Boston and London 1979; *Avant-Garde Photography in Germany 1919-1939*, exhibition catalogue, by Van Deren Coke, Ute Eskildsen and Bernd Lohse, San Francisco 1980; *Old and Modern Masters of Photography*, exhibition catalogue, by Mark Haworth-Booth, London 1980; articles—"August Sander Portraits" by John Szarkowski in *Infinity* (New York), June 1963; "August Sander: Men of the 20th Century" in *Creative Camera* (London), November 1969; "August Sander" in *Camera* (Lucerne), June 1971; "Men Without Masks" in the *Sunday Times Magazine* (London), 3 June 1973; "The Uncanny Portrait: Sander, Arbus, Samaras" by Max Kozloff in *Artforum* (New York), June 1973; "A Great Portraitist Feared by the Nazis" by Gene Thornton in the *New York Times*, 28 September 1975; "August Sander and the Cologne Progressive" by Richard Pommer in *Art in America* (New York), January/February 1976; "He Changed the Face of Photography" by Owen Edwards in the *New York Times Magazine*, 2 March 1980; "Sander's Faces of a Nation" by Douglas Davis in *Newsweek* (New York), 24 March 1980;

"Humanism's Gone Mad Again" by Ben Lifson in the *Village Voice* (New York), 14 April 1980.

During the second decade of this century the German portraitist August Sander conceived an idea for a mammoth photographic document. The title was to be "Man of the 20th Century," implying universal scope; however, for whatever reason, Sander chose to work within the familiar milieu of his homeland. Beginning by meticulously categorizing the "archetypes" he intended to include in his final document, and selecting from his existing portraits those that he felt fit the scheme, he labored on the project until the mid 1950's (although he was most productive before World War II). In spite of its geographical limitations, the extensiveness of the document that exists (more than 540 portraits) as well as the precise description and compelling aura of the individual photographs mark it as one of the major studies in photographic history.

Sander's genius rests on his ability to indicate his subject's place in society at the same time that he conveys a strong sense of the sitter's individuality. He achieved these dual goals through several strategems. To ground his individually commanding likenesses in their societal roles or archetypes, Sander made extensive use of environment in his portraits. Many of his sittings took place in the subjects' homes or places of business. In one such photograph, for example, a baker is seen in his kitchen, mixing bowl and spoon in hand, with cast iron stove and flour-strewn floor included to further identify his trade and his everyday surroundings.

Similarly, Sander included details of clothing to indicate societal status and role. The mannish shirt, tie and pegged trousers of an artist's wife (and the cigarette clenched in her teeth) suggest the existence of a rebellious and independent bohemia; a stout wine merchant's well-cut suit, expensive watch chain and the stiff, lacy white dresses of his wife and daughter speak of mercantile pride and conventionality.

The full impact of Sander's talent for individualization becomes clear after viewing many images across a cross section of his subjects. Their faces reveal the essential differences between men who make their livings with their hands and those who deal in money; between those who accept the mores of their society and those who rebel; between artist and business man.

Adding dimension to these character-revealing expressions are the subject's gestures, for which the photographer had a keen sense. There are repeated examples of his sure instinct for the particular movement or posture that can pinpoint personality. Two cases in point: a politician appears as a stalwart crusader holding an umbrella upright against his shoulder like a ceremonial sword; in another portrait, the hands of the Cologne public prosecutor hint at this impatience as they lie in a V-shape in his lap, his fingertips lightly pressing against each other (the impression of impatience is re-inforced by his nervous eyes).

His success in achieving character-revealing results was no doubt enormously facilitated by Sander's familiarity with his subjects' world view. The range of sitters from whom he was able to elicit telling expressions—from brick-layer to baron, from SS guard to peasant bride—suggests that while he might have been part of the society, he also had the distance (whether self-imposed or intuitive) to put its members in artistic perspective.

Beyond their functions as revealing portraits of specific individuals and as delineations of societal types, Sander's photographs are effective on yet another level. He recorded the players who were to become the center of this century's most important drama to date. In his portraits of bourgeois families, revolutionaries, Nazis, politicians, tradesmen, industrialists and the unemployed, we can read the conflicting forces that ultimately led to the Third Reich. These pictures are pieces which, when viewed

August Sander: *Peasant Girls*, **Westerwald, 1928** Courtesy Art Institute of Chicago

in their entirety, form an invaluable historical mosaic. There is a little evidence, however, that the photographer saw himself as an historian. The existence of historical currents in his work is partially a function of hindsight and partially a by-product of his attempt to reveal archetypes.

August Sander's work is documentary in the best sense, in that he sought to record the fullness of 20th century life around him. Notably, he photographed mainly what was familiar to him, whereas other documentary photographers who were more or less contemporaries, such as Edward Curtis, Lewis Hine and Paul Strand, traveled to find their subject matter and viewed their subjects from the position of outsiders.

The mission that Sander set for himself was grandiose and probably beyond the reach of any one artist. At no point, however, did he allow that mission to overshadow his subject matter. While he conceived of a massive collection of archetypical portraits, he intended to show his world as it existed. If it was a relatively narrow world, it was a highly complicated and telling one. Sander's document gains its power from the fact that he allowed the complexity of that society to show in the work; he made no attempt to oversimplify what his camera saw or to subjectify his own vision.

In assessing his work within the context of other major documentaries, past and present, it seems likely that the fewer stylistic effects a photographer enjoys and the more concerned he is with honest description, the more meaning his work has for the future. In Sander's direct and precise delineations, beyond the styles of dress and appearance that indicate their time and place, lie timeless, universal human qualities. Moreover, the richness of man's societal fabric is reflected in the work. In this age of depersonalization and mass production, Sander's document reminds us of the enduring value of the individual.

—Julia Scully

SAUDEK, Jan.

Czechoslovak. Born in Prague, 13 May 1935. Educated at Gymnasium School, Prague; studied at the School for Industrial Photography, Prague, 1950-52. Served as a Corporal in the Czech Army: Exemplary Soldier's Medal. Married Marie Saudek in 1958 (divorced, 1972); children: Samuel, David, Marie, Karolina, and Tom. Worked at various jobs on farms and in factories, Czechoslavakia, 1952-80. Freelance photographer, Prague, since the early 1950's. Address: c/o (agent) Jacques Baruch Gallery, 900 North Michigan Avenue, Suite 605, Chicago, Illinois 60611, U.S.A.

Individual Exhibitions:

1963	Divadlo Na Zábradlí, Prague
1969	University of Indiana, Bloominton
1971	Fotochema, Prague
	Dum Pánu z Kunštátu, Brno, Czechoslovakia
1972	Galerie Výtv. Umění, Olomouc, Czechoslovakia
1973	Shado' Gallery, Portland, Oregon (and 1974, 1975)
1975	Studentské Koleje, Brno, Czechoslovakia
1976	Art Institute of Chicago
	Peter M. David Gallery, Minneapolis
	Jacques Baruch Gallery, Chicago

1977	National Gallery of Victoria, Melbourne
	Rencontres Internationales de la Photographie, Arles, France
	Australian Centre for Photography, Sydney
	La Photogalerie, Paris
	Church Street Photo Centre, Melbourne
1978	Photo Art Gallery, Basle
	Photogallery, Wroclaw, Poland
	Kresge Art Center, Michigan State University, East Lansing
	Galleria Il Diaframma, Milan
	Galerie im Riek, Essen
1979	*The World of Jan Saudek*, Jacques Baruch Gallery, Chicago
	G. Ray Hawkins Gallery, Los Angeles
	Galerie Fiolet, Amsterdam
	Galerij Paule Pia, Antwerp
	Pratt Manhattan Center Gallery, New York
1980	*New Colour Work*, Church Street Photo Centre, Melbourne
	Camden Arts Centre, London
	FNAC, Paris
	Equivalents Gallery, Seattle
	Photokina, Cologne
1981	Marcuse Pfeifer Gallery, New York
	Images Gallery, Sun Valley, Idaho
	Kamp Gallery, St. Louis
	Keystone Gallery, Santa Barbara, California
	Jacques Baruch Gallery, Chicago

Selected Group Exhibitions:

1977	*X-Rated*, Neikrug Gallery, New York
	Women, Jacques Baruch Gallery, Chicago
1978	*Faces of My Land*, Jacques Baruch Gallery, Chicago
	Collector's Choice, Cincinnati Art Museum, Ohio
	Photographic Collecting, Past and Present, in the United States, Canada, and Europe, International Museum of Photography, George Eastman House, Rochester, New York
1980	*Fine Art Photography*, Assocation of International Photography Art Dealers, New York

Collections:

Bibliothèque Nationale, Paris; Musée Nicéphore Niepce, Chalon-sur-Saône, France; National Gallery of Victoria, Melbourne; Sam Wagstaff Collection, New York; International Museum of Photography, George Eastman House, Rochester, New York; Museum of Fine Arts, Boston; Library of Congress, Washington, D.C.; Cincinnati Art Museum, Ohio; Kresge Art Center, Michigan State University, East Lansing; Art Institute of Chicago.

Publications:

On SAUDEK: book—*The World of Jan Saudek*, exhibition catalogue, with an introduction by David Travis, Chicago 1979; articles—"Photo's Suggestions Tantalize" by Don Morrison in the *Minneapolis Star*, 27 February 1976; article by Alan Artner in the *Chicago Tribune*, 9 May 1976; "Allegories of Jan Saudek" by Edward M. Uzemack in *Midwest Art* (Milwaukee), Summer 1976; "Photokina '76" by Pavel Vacha in *Revue Fotografie* (Prague), no. 1, 1977; "Akt & Erotik" by Anna Farova in *Fotografie* (Göttingen), no. 4, 1977; "Jan Saudek" by Gisele Freund in *Zoom* (Paris), October 1977; "Jan Saudek: I'm Led by Instinct" by Derek Bennett in *Printletter* (Zurich), March/April 1978; "Saudek's Eye Snaps World of Truth" by Alan Artner in the *Chicago Tribune*, 23 February 1979; "Pictures to Evoke Emotional Response" by Harold Haydon in the *Chicago Sun-Times*, 20 April 1979; "De Praga a Chicago" in *Bolaffiarte* (Turin), June 1979; "Jan

Saudek" by David Fahey in *Picture Magazine* (Los Angeles), June/July 1979; "Portfolio Jan Saudek: Le Grand Photographe Tcheque" by Pierre Borham in *Photo-Cinéma* (Paris), January 1980; "The Trend Is a Backward Look" by Gene Thornton in the *New York Times*, 24 August 1980.

After I was born, they made photographs of me—later, I've tried to make photographs of all the other people.

In 1952 I got a "baby brownie" Kodak camera—all you can do is turn the knob to roll the film and push the other button, which was nice and I did—until 1963 when a friend lent me a copy of Steichen's *Family of Man* catalogue. I was personally moved, even shocked: I cried. I said to myself: that's photography.

I immediately wanted to do such a book—with all the photographs made by me! I did not know that those pictures were selected from millions of pix made by hundreds of photographers—I simply intended to make a portrait of "man of my time"—but I soon discovered what a ridiculous goal it was (well, to be honest, I would probably still be happy to do it today).

I worked as a stoker, then as a farm worker.

Steichen's book had to be returned to the friend. In 1963 another friend, a writer, asked me to do an exhibition in a popular Prague theatre. Today, I would hardly have the courage to exhibit those photographs: they were horrible.

I was invited, much later, in 1969, to the United States. There was an exhibition at the State University of Indiana in Bloomington. I met some photography people there (in the U.S.A.)—especially the Chicago Art Institute's Hugh Edwards, who encouraged me to continue in what I was doing.

The trip to the States was good for me.

But since I could no longer travel, I was restricted to my own country, and I soon learned that people are pretty much the same everywhere. In Paris, a woman told me that I should not look at pictures by other photographers, and that I should stay at home, that it would be advantageous for my work: it hasn't been terribly difficult for me to follow her advice.

In my photographs or paintings I show only the people.

I found out early that it is impossible for me to make a photograph of a woman (or anyone) with whom I have no relationship (should we call it "love"?); that's why I've made a lot of pictures of my children, of women around me, of friends.

In all my pictures I'm led by instinct. I don't much trust intellectualism anyway.

People come and leave again—I want to take pix of them once and for all, as long as they are here as I know them. Not many people here seem to understand what I'm doing. Our art unions and groups ignore me completely.

And more: there seems to be no progress in my work—pix I took 30 years ago look exactly the same as those I do today: kind of timeless, universal photographs, without any nationality, photographs which could be created anywhere in the world.

Years passed—today I know that a single photograph, or even one photographer's lifetime's work, cannot be the apotheosis of a human being. At best, it can become a small stone in the wall of an immense temple through which a man can praise his world.

—Jan Saudek

Jan Saudek lives in Czechoslovakia. He does not earn his living as a photographer, but has for many years followed other employment. The particular social conditions of his country hardly permit due recognition of his "spare time" accomplishment, yet Czechoslovakia also profits from the growing international reputation which he has won for his unique photography.

SAVAGE, Naomi.
American. Born Naomi Siegler in Princeton, New Jersey, 25 June 1927. Studied photography, under Berenice Abbott, New School for Social Research, New York, 1943; studied at Bennington College, Vermont, 1944-47; student-apprentice to her uncle, the photographer Man Ray, Los Angeles, 1948-49. Married architect/sculptor David C. Savage in 1950; children: Michael and Lourie. Freelance photographer since 1950. Agent: Witkin Gallery, 41 East 57th Street, New York, New York 10022. Address: 41 Drakes Corner Road, Princeton, New Jersey 08540, U.S.A.

Individual Exhibitions:

1968 *Three Women Photographers*, Moore College of Art, Philadelphia, (with Marie Cosindas and Barbara Crane)
1969 *Spectrum 2*, Witkin Gallery, New York (with Barbara Morgan and Nancy Sirkis)
 2 Generations of Photographs: Man Ray and Naomi Savage, New Jersey State Museum, Trenton
1974 Ulster County Community College, New York
 School of the Art Institute of Chicago
1975 Center for Photographic Studies, University of Louisville, Kentucky
1976 *Photographic Works*, Princeton Gallery of Fine Arts, New Jersey
 CameraWorks Gallery, Los Angeles
1977 Madison Art Center, Wisconsin
 Artemesia Gallery, Chicago
 Witkin Gallery, New York (with Evelyn Hofer)

Selected Group Exhibitions:

1953 *Always the Young Stranger*, Museum of Modern Art, New York
1959 *Photography at Mid-Century*, International Museum of Photography, George Eastman House, Rochester, New York (toured the United States)
1962 *Photography U.S.A.*, De Cordova Museum, Lincoln, Massachusetts
1966 *Photographs for Collectors*, Museum of Modern Art, New York
1970 *Photography: Current Report II*, Museum of Modern Art, New York
1972 *New Photography U.S.A.*, Museum of Modern Art, New York
1975 *Women of Photography*, San Francisco Museum of Art (toured the United States, 1975-77)
1977 *Subjective Photography*, Kimmel/Cohn Gallery, New York
1978 *Mirrors and Windows: American Photography since 1960*, Museum of Modern Art, New York (toured the United States, 1978-80)
1980 *Exercises in Connoisseirship*, Museum of Fine Arts, Houston

Collections:

Museum of Modern Art, New York; Ulster County Community College, New York; Princeton University, New Jersey; Youth Tennis Foundation, Princeton, New Jersey; New Jersey State Museum, Trenton; Fogg Art Museum, Harvard University, Cambridge, Massachusetts; University of Illinois, Urbana; Madison Art Center, Wisconsin; University of Kansas, Lawrence; University of Texas at Austin; Museum of Fine Arts, Houston.

Publications:

By SAVAGE: book—*Man Ray from 8 Sides*, port-

folios, Princeton, New Jersey 1976; article—"Images of Man Ray" in *Print Collector's Newsletter* (New York), November/December 1974.

On SAVAGE: books—*Two Generations of Photographs: Man Ray and Naomi Savage*, exhibition catalogue, by Peggy Lewis, Trenton, New Jersey 1969; *New Photography U.S.A.*, exhibition catalogue, by John Szarkowski, New York 1972; *Looking at Photographs* by John Szarkowski, New York 1973; *Women See Women*, New York 1976; *The Photography Catalog*, edited by Norman Snyder, New York 1976; *Innovative Printmaking* by T.R. Newman, New York 1977; *Mirrors and Windows: American Photography since 1960*, exhibition catalogue, by John Szarkowski, New York 1978; articles—"Naomi Savage" in *Album* (London), October 1970; "Variations" in *Print* (New York), January/February 1971.

I like to present my view of the world with humor, beauty, and unique variations. Combining old and new techniques, I have explored many methods in an attempt to extend the range of photographic experience and interpretation.

—Naomi Savage

On first encounter with the work in photography for which Naomi Savage is known internationally, the new viewer's reaction is very likely to be, "It's *different* from anything I've seen before!" Indeed, such reaction may continue even after having seen more of her work. It is different because it *begins* with a photograph and ends with a print from an etched metal plate; many things happen between the beginning and ending.

Naomi Savage's interest in art commenced with classes in high school. This interest was encouraged when in 1943, at 16 years of age, she studied photography with Berenice Abbott at the New School for Social Research in New York City. Her background was enriched with studies at Bennington College (Vermont) in art, photography and music during 1944-1947. The year following, she worked in Hollywood with Man Ray, her uncle, during which time she was encouraged and influenced by the spirit and methods of this innovative artist. Artistic development for Savage continued in a variety of ways. Beginning in 1948, over a period of 10 years she made 35 photographic portraits of composers for music publications. This work demanded particular attention to composition, lighting of the subject and exposing the negative at the proper instant to express personality. As a free lance photographer she executed assignments for companies marketing pharmaceuticals, greeting cards, beauty products and record albums, all of which required resourcefulness and creative discipline.

Subsequent to her marriage to David Savage, an architect and sculptor, she lived in Paris for many years of work and study. In her photography, Naomi Savage concentrated on the environment with particular attention to trees and statues. However, she continued studio work, and being abroad did not prevent her from exhibiting in the United States or her work from appearing in publications there.

Subjects for Savage's photographs include portraits, human figures, landscapes, sculpture, toys and kitchen utensils. She is not dependent upon new or recent work to start a project, often finding subjects and inspiration in her photographs on hand. Subject matter is important to every artist, and for Savage it is the starting point from which adventures with technique begin.

The techniques and methods of working devised by Savage created a new art form. The techniques, both old (etching) and new (photography), utilize the modern photo-etching process. Basically, her method is: from photograph to photo-etching on a metal plate to a pulled print of it; but there are

variations—often many of them. For example, one project passed through sixteen stages, including re-photographing, new etchings and tonings. Each stage is studied and considered to be visually interesting. The etched plates may be coated with acrylic paint or silver plated, oxydized (for patina) and clear lacquered (to prevent further oxydization). Before printing, the etched plates may be inked, as is traditional, or they may not be inked. In the latter case, an impression from the plate is made into the paper, using more pressure and padding, producing a bas-relief or inkless intaglio print. The etched plates, with their reversed images plated or painted, are exhibited with their prints and the photographs used in a project to make a complete statement about the subject.

Two Generations of Photographers was the title of an exhibition of the works of Naomi Savage and Man Ray at the New Jersey State Museum, Trenton, in 1969. In this exhibition Savage's range of interest in media and techniques may be noted: photo-collage, negative/positive combination, photo-engraving, intaglio print, rayograph (photogram), solarization, color toner, negatives on silver and gold foil, multi-layered negatives and double exposure.

Seldom does an artist have the opportunity to do significant work in monumental dimensions. For Naomi Savage this opportunity was realized when she was commissioned, in 1971, to create the mural for the Lyndon Baines Johnson Library at the University of Texas in Austin. The subjects were of Mr. Johnson's political life and portraits of him and the four immediately preceding Presidents of the United States. Mr. Johnson selected the news-photographs which Savage used for enlargement and creative treatment with various techniques. The medium is five deeply etched panels of magnesium, each measuring 8 by 10 feet; the mural is 8 by 50 feet.

—Robert W. Cooke

SAWATARI, Hajime.

Japanese. Born in Tokyo, 1 January 1940. Studied photography at Nihon University Faculty of Art, Tokyo, graduated 1963. Married Hiroko Arahari in 1968; daughter: Machi. Staff Photographer, Nihon Design Center, Tokyo, 1963-66. Freelance photographer, Tokyo, since 1966: maintained studio in Roppongi, Tokyo, 1969-80, and in Minami Aoyama, Tokyo, since 1980. Recipient: Annual Prize, Photography Society of Japan, 1973; Kodan-Sha Best Photographer of the Year Award, Tokyo, 1979. Address: Pearl Mansion No. 503, 2-13-11 Minami Aoyama, Minato-ku, Tokyo, Japan.

Individual Exhibitions:

1973　*Nadia*, Wako Gallery, Tokyo
　　　Alice, Seibu Department Store, Tokyo (travelled to the Canon Gallery, Amsterdam, 1976)
1975　*Portraits*, Ao Gallery, Tokyo
　　　Seiji Ozawa, Parco Department Store, Tokyo
1977　*Angels in the Finder*, Ao Gallery, Tokyo
　　　Momoe Yamaguchi, Ao Gallery, Tokyo (with Kishin Shinoyama)

Selected Group Exhibitions:

1974　*Fifteen Contemporary Photographers*, National Museum of Modern Art, Tokyo
1978　*Photokina*, Cologne

Publications:

By SAWATARI: books—*Nadia*, with text by Shoji Yamagishi, Tokyo 1973; *Alice*, Tokyo 1973; *Seiji Ozawa*, Tokyo 1975; *Angels in the Finder*, Tokyo 1977; *Alice from the Sea*, Tokyo 1979.

On SAWATARI: book—*100 Photographers* by Takaki Hayashi, Tokyo 1973; articles—by Kan Sano in *Commercial Photo* (Tokyo), May 1971; by Kishin Shinoyama in *Commercial Photo* (Tokyo), Autumn 1972; by Ben Watanabe in *Asahi Camera* (Tokyo), May 1973; by Koji Taki in *Asahi Camera* (Tokyo), April 1977; by Shiroyasu Suzuki in *Asahi Camera* (Tokyo), March 1980.

Already well-known for his commercial photography, Hajime Sawatari made his debut as an art photographer with the exhibition and book *Nadia* in 1973.

Sawatari's sensitivity enabled him to create a dreamy world of adolescent sensuality.

—Norihiko Matsumoto

SCHAD, Christian.

German. Born in Miesbach, Upper Bavaria, 21 August 1894. Educated in Munich, Germany, until 1913; studied painting, under Heinrich von Zügel, Akademie der Bildenden Künste, Munich 1913-14. Served briefly in German Army, Munich, 1915. Married Marcella Arcangeli in 1923 (separated, 1927); son: Nikolaus; married Bettina Mittelstädt in

Christian Schad: *Untitled Schadograph*, 1918

1947. Independent painter, working for Walter Serner's *Sirius* magazine, Zurich, 1915-16, and with other Dadaist artists and writers Hans Arp, Hugo Ball, Emmy Hennings, Tristan Tzara, etc., in Geneva, 1916-20; experimentation with photographic processes, first "Schadograph" photograms, Geneva, 1918; independent painter, associating with Jules Evola, Enrico Prampolini and the Casa d'Arte Bragaglia avant-garde artists group, in Rome, 1920, travelling with Walter Serner throughout Italy; in Naples and Rome, 1920-25; in Vienna, 1925-27; in Berlin, establishing own studio, 1927-43 (destroyed, 1943): worked at various professions including picture-restorer, theatre critic, teacher, etc., and as manager of a brewery office, 1935-42; has lived and worked in or near Aschaffenburg, Germany, since 1943: has concentrated on painting, since 1951, and on new "Schadographs," since 1960. Recipient: Cross of Merit First Class, Republic of West Germany, 1979; Honorary Professor Award, Bürgermeister of West Berlin, 1980. Agent: Kunstkabinett G.A. Richter, Königstrasse 33, Haus Englisch, 7000 Stuttgart 1. Address: An der Dornhecke 1, 8751 Bessenbach-Keilberg, West Germany. *Died 25 February 1982.*

Individual Exhibitions:

1964 *Präsentation zum 70. Geburtstag*, Galerie Dorothea Loehr and Hessischer Rundfunk, Frankfurt
1969 *Bilder und Graphik nach 1945*, Neue Münchner Galerie, Munich
1970 *Schad/Dada*, Galleria Schwarz, Milan
1971 Städisches Museum, Trier, West Germany (retrospective)
 Galerie Loehr, Frankfurt (with Boris Keint)
1972 Palazzo Reale, Milan (retrospective)
1973 Galleria Stivani, Bologna
 Galleria Fant Cagni, Brescia, Italy
 Schadographien, Galleria del Levante, Munich
1974 Galerie G.A. Richter, Stuttgart
1975 *Schadographien 1918-1975*, Von der Heydt-Museum, Wuppertal, West Germany
1976 *Christian Schad*, Kunstkabinett G.A. Richter display, *Art 7*, Basle
 Christian Schad, Kunstkabinett G.A. Richter display, at the *Internationaler Kunstmarkt*, Dusseldorf
 Galerie Hilger, Vienna
 Galerie Piro, Frankfurt
1977 *Schadographien*, Kunstkabinett G.A. Richter display, at *Art 8*, Basle
 Kunstkabinett G.A. Richter, Stuttgart (2 exhibitions)
 Galerie Karin Brass, Aschaffenburg, West Germany
1978 *Das Graphische Werk und Schadographien*, Museum des 20. Jahrhunderts, Vienna (travelled to Kulturhaus der Stadt Graz, Austria)
 40 Schadographien von Christian Schad, Stadtmuseum Linz/Donau, Austria
 Goethe Institut, Munich (and world tour)
1979 Museum Stadt Miesbach, West Germany
 Vom Expressionismus bis zum Magischen Realismus, Kunstkabinett G.A. Richter, Stuttgart
1980 *Schadographien*, Galerie Beck, Augsburg, West Germany
 Staatliche Kunsthalle, West Berlin (retrospective)

Selected Group Exhibitions:

1936 *Fantastic Art, Dada and Surrealism*, Museum of Modern Art, New York
1951 *Abstraction in Photography*, Museum of Modern Art, New York
1958 *Dada: Dokumente einer Bewegung*, Kunstverein, Düsseldorf
 Dada, Stedelijk Museum, Amsterdam
1966 *Dada, 1916-66*, Kunsthaus, Zurich (travelled to Musée d'Art Moderne, Paris)
1968 *Dada, Surrealism and Their Heritage*, Museum of Modern Art, New York (toured the United States)
1970 *Photo Eye of the 20's*, Museum of Modern Art, New York (toured the United States)
1977 *Tendenzen der 20er Jahre*, Europäische Kunstausstelluug, West Berlin
 Malerei und Photographie im Dialog, Kunsthaus, Zurich
1978 *Dada and Surrealism Reviewed*, Hayward Gallery, London

Collections:

Württembergische Staatsgalerie, Stuttgart; Museum Ludwig, Cologne; Kunsthalle, Basle; Kunsthaus, Zurich; Museum of Modern Art, New York; Gernsheim Collection, University of Texas at Austin.

Publications:

By SCHAD: books—*Christian Schad: 10 Woodcut*

663

Prints, portfolio, Zurich 1915; *Christian Schad: Hommage à Dada 1916-1976*, portfolio of 10 schadographs, Stuttgart 1976; *Christian Schad: Gaspard de la nuit oder Die Hochzeit der Romantik mit dem Geist Dadas*, portfolio of 20 schadographs, Stuttgart 1978; *Gauguins und Seidenstrümpfe*, Stuttgart 1981; articles—"Köpfe" in *Sirius* (Zurich), December 1915; "Graphik" in *Sirius* (Zurich), January 1916; "Mein Legensweg" in *Christian Schad*, exhibition catalogue, Vienna 1927; "Grünewald-Kopie in der Stiftskirche zu Aschaffenburg" in *Maltechnik* (Munich), vol. 2, 1961; "Zürich/Genf: Dada" in *Imprimatur III*, Frankfurt 1962; "Appunti Autobiografici" in *Schad/Dada*, exhibition catalogue, edited by Arturo Schwartz, Milan 1970; "Relative Realitäten: Erinnerungen um Walter Serner" in *Die Tigerin* by Walter Serner, Munich 1971; "Dada, Surrealism et Autre Chose" in *Gradiva* (Brussels), May 1971; "Arte 80 intervista Christian Schad" in *Arte 80* (Rome), Autumn 1973.

On SCHAD: books—*Der Maler Christian Schad* by Max Osborn, Berlin 1927; *Fantastic Art, Dada and Surrealism* by Alfred H. Barr Jr., New York 1936, 1937; *Photography: A Short Critical History* by Beaumont Newhall, New York 1938; *Histoire de la Photographie* by Raymond Lecuyer, Paris 1945; *The History of Photography* by Beaumont Newhall, New York 1949, 1964; *Dada: Monographie einer Bewegung* by Willy Verkauf, Teufen, Switzerland 1957, New York and London 1973; *Creative Photography* by Helmut Gernsheim, London 1962; *The Painter and the Photograph* by Van Deren Coke, Albuquerque, New Mexico 1964, 1972; *Dada à Paris* by Michel Sanouillet, Paris 1965; *A Concise History of Photography* by Helmut and Alison Gernsheim, London 1965; *Le Futurisme et le Dadaisme* by José Pierre, Lausanne 1966; *Kunst und Photographie* by Otto Stelzer, Munich 1966; *Art and Photography* by Aaron Scharf, London 1968; *Die Collage* by Herta Wescher, Cologne 1968; *Designing with Light on Paper and Film* by Robert W. Cooke, Worcester, Massachusetts 1969; *Pioneers of Modern Typography* by Herbert Spencer, New York 1969; *The Picture History of Photography* by Peter Pollack, New York 1970; *Christian Schad*, exhibition catalogue, by Giovanni Testori, Milan 1970; *Photography Without a Camera* by Patra Holter, New York 1972; *Schadographien*, exhibition catalogue, by Daniela Palazzoli, Munich 1973; *Photographie als Künstlerisches Experiment* by Willy Rotzler, Lucerne and Frankfurt 1974; *Schadographien 1918-75*, exhibition catalogue, with text by Kah Jagals, Wuppertal, West Germany 1975; *Photomontage* by Dawn Ades, London 1976; *Dictionnaire du Dadaisme 1916-1922* by Georges Hugnet, Paris 1976; *Almanacco Dada*, edited by Arturo Schwarz, Milan 1976; *Geschichte der Fotografie im 20. Jahrhundert/Photography in the 20th Century* by Petr Tausk, Cologne 1977, London 1980; *Malerei und Photographie im Dialog*, exhibition catalogue, by Erika Billeter, Berne 1977; *Das Experimentelle Photo in Deutschland 1918-1940* by Emilio Bertonati, Munich 1978; *Dada und Surrealism Reviewed*, exhibition catalogue, by Dawn Ades, London 1978; *40 Schadographien von Christian Schad*, exhibition catalogue, with text by Arnulf Rohsmann, Linz, Austria 1978; *Photographie als Kunst 1879-1979/Kunst als Photographie 1949-1979*, exhibition catalogue, 2 vols., by Peter Weiermair, Innsbruck, Austria 1979; *Christian Schad: Gaspard de la Nuit*, exhibition catalogue, with text by Kurt Leonhard, Stuttgart 1979; *Avant-Garde Photography in Germany 1919-1939*, exhibition catalogue, by Van Deren Coke, Ute Eskildsen and Bernd Lohse, San Francisco 1980; *Das imaginäre Photo-Museum*, by Renate und L. Fritz Gruber, Cologne 1981; *Monographie Christian Schad*, edited by G.A. Richter, Stuttgart 1981; articles—"Salon Wolfsberg: Christian Schad" by Hans Trog in *Neue Zürcher Zeitung*, 10 October 1915; "Christian Schad" by R.R. Milrad in *Prager Tagblatt*, 22 December 1915; "Developpement de l'Art Dadaiste" by Alexandre Partens in *Le Mondain* (Geneva), 14 February 1920; "Christian Schad" by Max Roden in *Volkszeitung* (Vienna), 25 January 1927; "Christian Schad im Frankfurter Kunstverein" by Godo Remszhardt in *Frankfurter Rundschau*, 20 July 1956; "Christian Schad" by Gottfried Sello in *Die Zeit* (Hamburg), 6 November 1964; "Christian Schad" and "Neue Sachlichkeit" by Blida Heynold-von Graefe in *Weltkunst* (Munich), 15 December 1972; "Les Grands Maitres de l'Art Photographique: Christian Schad" by Jean-Claude Gautrand in *Point de Vue* (Paris), 1 March 1974; "Renaissance of the Schadograph" by Inge Bondi in *Printletter* (Zurich), March/April 1976; "Medium Foto" by Günther Wirth in *Das Kunstwerk* (Stuttgart), July 1976; "Metamorphosis of the Schadograph" by Inge Bondi in *Printletter* (Zurich), May 1979; "Christian Schad" by Irmelin Lebeer in *Cahiers du Musée National d'Art Moderne* (Paris), July 1979; "Revelations of the Weimar Era" by Hilton Kramer in the *New York Times*, 5 October 1980; "The Twenties' Bleak New World" by Robert Hughes in *Time* (New York), 10 November 1980.

*

Schadographie occupies a special place in my complete work, next to painting and the graphic arts. As far as I am concerned, it lies very close to graphic art, although it is classed with the art of photography—a medium which I have never used as an artistic means of expression. A photogram is created—if one disregards the use of the light sensitive surface of the photographic paper as the image carrier—in a multi-layered technique which has a far greater similarity to the creation of a graphic print. It approximates the process of aquatint drypoint rather than the very different processes involved in the creation of a photograph.

My first photograms, made in 1918 during my Dada period in Geneva, were something entirely new. My friend Walter Serner was the first to recognize this, and Tristan Tzara gave it the name "Schadographie."

As I began anew to make Schadographs in 1960, the daylight paper which I had used in 1918 was no longer available. It had allowed me to view the slow process of development, and I could intervene by directing or altering the process. Since then I have been forced to work in the darkroom with artificial light, "blind" so to speak, relying entirely on my imagination and conception of what effect I want to achieve. But, I am also open-minded as concerns the chance occurrences which this procedure allows. There can always result from these—controlled—chance occurrences new and unforeseen possibilities for further experimentation.

The first of the Schadographs made since 1960 were still closely related to my attempts from 1918 on, but the mere play with surface and form no longer satisfied me completely. As I came across the work of the French poet Aloysius Bertrand—who died in Paris in 1841 at the age of 34—I became fascinated with the spiritual kinship between his prose-poems in *Gaspard de la Nuit* and the new dimension of my Schadographs: in the one as in the other, a fantastic world is created in which the present seems timeless, as if one were fetched by means of a sudden light for an instant and sharply yanked from the darkness of night during which the past and future remain forever hidden.

The absolute sense of the present in Bertrand's prose-poems—without past or future—occupied me again and again in the 15 years which followed and most of the Schadographs which have originated within this time span carry either directly or indirectly the mark of *Gaspard de la Nuit*.

—Christian Schad

*

Christian Schad was an artist molded in the environment of the historic avant-garde, and, from the 20's on, one of the most representative painters of the New Objectivity and German Realism. His contribution to photography took shape within the realm of the Dadaist movement, with the invention of a kind of picture which the Dada theorist and poet Tristan Tzara christened "Schadograph" after its creator's name.

Schad has told us that, upon finding himself in Geneva in 1918, he began to be fascinated by materials and objects that he came across in the streets, in shop windows, even in dustbins. With the aim of discovering new aspects and relationships in these, the typical products and sub-products found in every town, he began to put them together and arrange them over a photosensitive glass or paper surface and then to expose these kinds of collages to the light, sometimes with appropriate filters. That was how he obtained his Schodographs, or photograms, without the use of a camera. The technique (which goes back to the very beginning of photography—Talbot's "talbotypes" were, of course, obtained by placing objects directly on photosensitive paper) was developed both by Schad and by other artists of the modern movement like Man Ray with his "Rayographs" and Moholy-Nagy with his "Photograms." The first Schadographs—one of which, "Arp and Val Serner in the Royal Crocodarium in London," was published in the seventh and last number of the review *Dada*, issued in Paris in 1920—deliberately avoided any association with geometric forms and all identification with recognizable figures and objects; the outlines were shifted and cut about, recalling Arp's work with the blot technique in the same period. Only later, when he resumed this technique in the 60's, was Schad to depict materials like pieces of string and paper, bits of writing, miscellaneous objects, netting and lace, making more open use of their physical and semantic characteristics—the transparency of the nets and lace, the recognizability of fragments of writing and pictures, the outlines and shapes of identifiable objects.

Schadographs, like the other manifestations of Dada, must be judged in the same spiritual sphere and philosophy which gave rise to them. Launched in 1916/17 by a group of intellectuals and artists who had taken refuge in Switzerland to escape from the war, Dadaism went further than the production of new works of art aimed at confounding the bourgeois fashion of conceiving art as a separate form of existence. According to Dadaist criticism, the bourgeois mentality conceived art as an ideal work in which the beauty and the values, made impossible in everyday life by the very social system that the bourgeoisie followed and defended, could actually be sought. In unmasking the hypocrisy and idealism implicit in traditional art, some artists developed new techniques and new creative strategies. Notable among these was the collage, a new way of looking at objects by placing the objects themselves directly on the pictures instead of painting them; another was the use of photography as a technique of creative manipulation, which, in turn, changed the collage into the transcription of light.

—Daniela Palazzoli

Xanti Schawinsky: *Structural Transformation*, 1944

Selected Group Exhibitions:

1941 *Bauhaus 1919-1938*, Museum of Modern Art, New York
1957 *Bienal de São Paulo*, Brazil
1968 *Bauhaus 50 Years/50 Jahre Bauhaus*, Württembergischer Kunstverein, Stuttgart (and world tour)
1978 *Das Experimentelle Photo in Deutschland 1918-1940*, Galleria del Levante, Munich
1980 *Photographia: La Linea Sottile*, Galleria Flaviana, Locarno, Switzerland

Collections:

Galleria Flaviana, Locarno, Switzerland; Museum of Modern Art, New York.

Publications:

By SCHAWINSKY: articles—"Development of Forms in Advertising" in *Industrial Arts* (London), 1936; "Play, Life, Illusion" in *Spectacles d'Aujourd-'hui*, Paris and Milan 1954; "Vom Bauhaus-Happening zum Spectrodrama" in *Das Kunstwerk* (Baden-Baden, West Germany), January 1966; "Bauhaus Metamorphosis" in *Bauhaus and Bauhaus People*, edited by Eckhard Neumann, New York 1970; "From the Bauhaus to Black Mountain" in *Drama Review* (New York), Summer 1971.

On SCHAWINSKY: books—*Bauhaus 1919-1928* by Herbert Bayer, Walter and Ise Gropius, New York 1938; *Xanti Schawinsky*, exhibition catalogue, by Hans Maria Wingler, Darmstadt 1961; *Das Bauhaus* by Hans Maria Wingler, Bramsche, West Germany 1968; *Xanti Schawinsky*, exhibition catalogue, by Francesco Solmi, Bologna 1975; *Photomontage* by Dawn Ades, London 1976; *Das Experimentelle Photo in Deutschland 1918-1940* by Emilio Bertonati, Munich 1978; article—"Xanti Schawinsky" by Hans Maria Wingler in *Aujourd'hui* (Paris), May 1963.

SCHAWINSKY, Xanti (Alexander Schawinsky).
American. Born in Basle, Switzerland, 25 March 1904; emigrated to the United States, 1936: naturalized, 1939. Studied painting, drawing and architecture in Basle and Zurich, 1915-22; architecture and graphic design, University of Cologne, and Akademie der Künste, Berlin, 1922-23. Married Irene von Debschitz in 1936; son: Benjamin; later married Gisela Hatzky; son: Daniel. Member of theatre group, Staatliches Bauhaus, Dessau, Germany, 1925-29; worked as designer for Town Council of Magdeburg, Germany, 1929-31; Designer, Olivetti Company, Cuneo, Italy, 1933-36; Instructor in Art, Black Mountain College, Beria, North Carolina, 1936-38, and City College of New York and New York University, 1943-54; freelance artist and photographer, New York City and Oggebbio, Italy, 1954 until his death, 1979. Recipient: Labor Ministry Prize, Bau-Ausstellung, Berlin, 1931; Langley Fellowship, Chicago, 1943; William and Noma Copley Foundation Prize, Paris, 1960. Agent: Galleria Flaviana, via Varenna 45, 6600 Locarno, Switzerland. *Died* (in New York) *11 September 1979.*

Individual Exhibitions:

1926 Bauhaus Kunsthalle, Dessau, Germany
1936 Black Mountain College, Beria, North Carolina
1942 A-D Gallery, New York
 Institute of Design, Chicago
 Harvard University, Cambridge, Massachusetts
1953 Hugo Gallery, New York
1954 Berkshire Museum, Pittsfield, Massachusetts
 Symington Gallery, Boston
 Raymond Galleries, Beverly Hills, California
1955 Moskin Gallery, New York
 Todes Gallery, New York
1956 Galeria Don Hatch, Caracas, Venezuela
1957 Saginaw Museum, Michigan
 Sandoz Gallery, Dallas (and Boston)
 Bennington College, Vermont
1958 Herman Miller Gallery, New York
 Bodley Gallery, New York
 Wittenborn Gallery, New York
 Highgate Gallery, Montclair, New Jersey
1961 Iolas Gallery, New York
 Messelhaus, Darmstadt
 Landesmuseum, Wiesbaden
 Galerie Suzanne Bollag, Zurich
1962 Galerie Interiors, Frankfurt
 Galerie Münsterberg, Basle
 Museum of Science and Industry, Chicago
1964 Galleria La Colonna, Florence
 Haus der Guten Form, Stuttgart
 Distelheim Galleries, Chicago
1966 Galerie Münsterberg, Basle
1968 Ireland House, New York
 Galerie Herman Miller, Basle
1969 Galleria Blu, Milan
1971 Galleria Corsini, Intra, Italy
1973 Galerie Suzanne Bollag, Zurich
 Galleria Spazzapan, Stresa, Italy
 Herbert Benevy Gallery, New York
1974 Galerie Münsterberg, Basle
 Galleria Spazzapan, Stresa, Italy
1975 Galleria d'Arte Moderna, Bologna
1978 Galleria del Levante, Munich
1979 Galleria Flaviana, Locarno, Switzerland
1980 Centre Georges Pompidou, Paris (retrospective)
1981 Galleria Flaviana, Locarno, Switzerland

A strange art, photography. It continues to provide an endless stream of new discoveries to delight and excite us. It is not only the chance finds in attics or the critical salvaging of obscure provincial photographers that produces these discoveries; they may involve even very well known contemporary artists whose photography has been obscured for many years by their accomplishments in other fields. This has been the case with Xanti Schawinsky, who has long been recognized as an important painter, scenic artist, book designer, and innovator at the Bauhaus. Yet Schawinsky's photographic work is the synthesis of his artistic evolution. It is the root and matrix of the thematics that were developed later in his other expressive creations: they are based on photography and combine the sum of all his experience and emotions.

An authentic and genuine exponent of the historic avant-garde, Schawinsky was aware of the enormous potential of photography and of the pliability of the medium; he used it with no prejudices or preconceived ideas. In fact, he used photography in a variety of different ways: as studies and inspiration for painting; for graphic elements in his advertising layout; for shots of theatrical action and for scene design; as an analysis of visual perception; and as an independent art form. And he invents a new technique for each of his requirements: the photogram, multiple exposures, photo-montage, superimposition, simple black-and-white, and elaborate optical deceptions created in the darkroom. But, within this multiplicity of photographic experimentation, there is a common link: photography is not a medium to reproduce some version of "reality"; it is a stimulus to the faculties of perception.

The picture suggests incomplete and indefinite forms that stimulate visual and emotional elaborations in the beholder. Between the creator and the beholder the work takes over the function of language in a silent conversation in which grammar and syntax are replaced by intuition. Schawinsky calls into question the validity of the picture as a straightforward medium of communication; rather, it should put questions, to which we reply with other questions, as in a chain of infinite correspondences. Schawinsky's position is of course revolutionary, particularly when one considers that his theories date from the 1930's, the golden age of "new realism," the age of Strand, Weston, Renger-Patzsch, the f.64 group and the F.S.A. Compared with his colleagues at the Bauhaus, too—with Moholy-Nagy, Bayer, Citroen—who either investigated the photographic medium to learn what its limits were or used it as a means for the transmission of quite definite concepts, Schawinsky's position is clearly very advanced.

Schawinsky regards the picture as suggestion—like a *Commedia dell'Arte* play in which the actors, following only a rudimentary script, improvise what inevitably becomes a different play each night. We are the actors, interpreting the work (the photograph) however we wish; we can turn it into anything our passing emotions, our feelings, our culture, dictate. In other words, Schawinsky asserts the importance of interpretive freedom: the artist does not presume; he does not provide concepts and elements that can be interpreted in only one way; he puts forward dialectically open propositions. The picture is alive, and is transformed by anyone who looks at it, who is forced to set in motion all of his various mental, emotional and perceptive processes. To stimulate those processes Schawinsky conceives and creates an "open" picture, in which the actual form he has chosen is of only marginal significance: it is simply a pretext for the creation of other forms, illusory and allusive. And it is with the medium of photography—with its countless possibilities for intervention in the process of producing the picture—that he succeeds in obtaining the perfect synthesis of theory and visual result.

Schawinsky introduced a typographical net under the enlarger, between negative and paper, separating the object from the reality—a face, a landscape, another photograph and so on—in bands of tone that obliterate the conventional meanings. Two levels of interpretation are thus created—the object/

pretext, still recognizable; the proposed picture—which have ambiguous effects on optical perception.

His experimentation is also of importance as research into the role of the picture in contemporary society, in which we receive a constant visual bombardment by the mass communication media (press, cinema and television), advertisements and posters. Because we cannot both simultaneously and completely take in all this information, we tend to take it in as mere optical illusion which can be swallowed whole. The final picture etched on our subconscious is created by free association and completely subjective assimilation. In this sense, therefore, Schawinsky must be considered a pioneer of the thematics of optical art and of that art of the cinema which were to be developed some decades later.

—Giuliana Scimé

SCHMIDT, Michael.

German. Born in Berlin, 6 October 1945. Educated at the Hauptschule, Berlin, 1951-60; self-taught in photography: passed external examination as graduate photo-designer at Fachhochschule, Dortmund, 1980. Married Angelika Miersch in 1968 (divorced, 1974); daughter: Olivia. Freelance photographer, Berlin, since 1960. Instructor in Photography, Volkhochschule, Berlin-Kreuzberg, since 1969 (Promoter and Leader, Werkstatt für Fotografie, Volkhochschule Kreuzberg, 1976-77). Instructor, Pädagogische Hochschule, Berlin, 1976-78, and Universität FB 4, Essen, 1979-80. Member, Deutsche Gesellschaft für Photographie (DGPh), and Gesellschaft Deutsche Lichtbildner (GDL). Agent: Galerie Rudolf Springer, Fasanenstrasse 13, 1000 Berlin 12, and Galerie Rudolf Kicken, Albertusstrasse 47-49, 5000 Cologne 1. Address: Wartenburgstrasse 16a, 1000 Berlin 61, West Germany.

Individual Exhibitions:

1973 *Michael Schmidt: Berlin-Kreuzberg*, Berlin Museum, West Berlin
1975 *Michael Schmidt: Photographien*, Galerie Springer, West Berlin
1977 *Michael Schmidt: Stilleben und Lifefotografie*, Landesbildstelle, Hamburg
1978 *Michael Schmidt: Berlin-Wedding*, Kunstamt Wedding, West Berlin
1979 *Michael Schmidt: Fotografien 1965-67*, Galerie Springer, West Berlin
1981 *Larry Fink/Andreas Müller-Pohle/Michael Schmidt*, Kunstmuseum, Dusseldorf

Selected Group Exhibitions:

1978 *Aspekte Deutscher Landschaftsfotografie*, Stadtmuseum München, Munich
1979 *In Deutschland*, Rheinisches Landesmuseum, Bonn
 Photographie 1839-1979, Galerie Rudolf Kicken, Cologne
1980 *Michael Schmidt und Schüler*, Werkstatt für Fotografie der VHS Kreuzberg, West Berlin
 Absage an das Einzelbild, Museum Folkwang, Essen

Collections:

Berlinische Galerie, West Berlin; Stadtmuseum München, Munich; Musée d'Art et d'Histoire, Fribourg, Switzerland; Bibliothèque Nationale, Paris.

Publications:

By SCHMIDT: books—*Berlin-Kreuzberg*, West Berlin 1973; *Michael Schmidt Photographien*, West Berlin 1975; *Berlin: Stadtlandschaft und Menschen*, with text by Heinz Ohff, West Berlin 1978; *Berlin-Wedding*, with text by Heinz Ohff, West Berlin 1978; articles—"Gedanken zu meiner Arbeitweise" and "Aufgabe und Ziele der Werkstatt für Photographie der Volkshochschule Kreuzberg" in *Camera* (Lucerne), March 1979; article in *Thomas Leuner: Notizen aus einer Stadt*, exhibition catalogue, West Berlin 1980.

On SCHMIDT: exhibition catalogues—*In Deutschland*, with text by Klaus Honnef, Bonn 1979; *Michael Schmidt und Schüler*, West Berlin 1980.

Photography helps me to portray the outward appearance of my surroundings as I see and experience them.

Everything that I photograph I render in its natural form. In this way it is possible to imagine the picture beyond the cropping. That which is not seen because of the cropping is for me of no less significance: I like to establish associations across boundaries.

—Michael Schmidt

Michael Schmidt is an unusual phenomenon among German photographers of the 1970's. After studying painting, he became a city official, but the constraints connected with that kind of work were contrary to his lively nature. In 1965 he began to take photographs with a miniature camera; by 1969, self-taught, he had become a lecturer in photography at the Volkhochschule in Berlin-Kreuzberg; in 1970 he organized a photography seminar which by 1976-77 had developed into a photography workshop. The enthusiastic teacher (he freed himself from his municipal job in 1973) attracted many students, amateurs of all ages who wanted to learn how to take photographs. Schmidt taught them with the aim that they should, in their pictures, record reality

Michael Schmidt: From the series *Berlin im Wiederaufbau nach 1945*, **1980**

as precisely as possible and so come to an understanding of it; at the same time, he hoped that with and through photography his students would discover something to which they could respond. A very human attitude.

His books of photographs provide a guide to his own development. *Berlin-Kreuzberg* presents, side by side with photographs of streets and houses, many photographs of people. It is a forceful and thrilling small format photography concentrating more on subject than on faultless reproduction. The social tendency is obvious, and a certain ruggedness of style is evidence of the photographer's temperament.

Substantial variations are discernible in *Berlin: Stadtlandschaft und Menschen*. The pictures of the Berlin city landscape are separated from those of people, and the pictures of people have lost their anecdotal quality. The "shots" show people going for a walk or standing around, and what appears accidental has a strong touch of reality; as well, the observer has a lot to look at in the pictures. This is also true of the city landscapes. Instead of "interesting" or picturesque detail, there are now views where many details are to be seen, which the eye is asked to discover. Neither focus nor lighting are accentuated.

These photos suggest a style that comes to maturity in *Berlin-Wedding*. Trees and concrete, wire netting and wooden huts, decay and modernity are all equally valid. In these photos the sun never shines: they are taken in refracted daylight in soft tones of grey with full focus by means of a 9 x 12 cm camera. Even though he could be said to be taking "notes," Schmidt sets a high value on technical precision. Here, too, people are found in a separate section. Schmidt documents, in a deliberate confrontation of people and camera, how people appear in their offices or workshops or at home. His people offer themselves in icy seriousness. They appear sterile, and their rooms, in general, are no less sterile. It is a terrifying analysis of modern uniformity.

One can only speculate on Michael Schmidt's future development, but it is certain that the social and critical aspects of his work will continue to take precedence over aesthetics.

—Fritz Kempe

SCHUH, Gotthard.
Swiss. Born, of Swiss parents, in Berlin-Schöneberg, Germany, 22 December 1897; returned to Switzerland, 1900. Educated at the Kantonschule, Arrau; studied painting at the Kunstgewerbeschule, Basle, 1916; self-taught in photography. Served in the Swiss Army, as an ordinary soldier and officer, patrolling the Swiss border, 1917-18. Married March Zürcher in 1927; son: Kaspar; married Annamarie Custer in 1944; daughters: Claudia and Sibylle. Independent painter in Basle, then Geneva, 1919, Munich, 1921-26, and Zurich, 1927, associating with the Rot-Blau group in Basle; began photographing, 1928; relinquished painting, 1931, and with encouragement of Arnold Kübler became professional freelance photographer, based in Zurich, working mainly for *Zürcher Illustrierte* but also for *Vu, Paris-Match, Berliner Illustrirte Zeitung, Life*, etc., 1931-41; Photographer, Picture Editor and Layout Artist, *Neue Zürcher Zeitung*, 1941 until his retirement, 1960. Recipient: Gold Medal, *Biennale di Fotografia*, Venice, 1957. Estate: Annamarie Schuh, Weinmanngasse 62, 8700 Küsnacht, Zurich, Switzerland. *Died* (in Küsnacht) *29 December 1969.*

Individual Exhibitions:

1955 Club Bel Etage, Zurich
1967 *Frühe Photographien 1929-39*, Helmhaus, Zurich (travelled to the Kunsthaus, Arrau, Switzerland, 1967; IBM Gallery, New York, 1968; Ministère de la Culture, Brussels, Musée Communale, Mons, Belgium, and Musée Communale, Verviers, Belgium, 1970; and Sigristenkeller, Bülach, Switzerland, 1971)
1976 Marlborough Gallery, New York (with Robert Frank)
1982 Stiftung für Photographie, Kunsthaus, Zurich

Selected Group Exhibitions:

1951 *Kollegium Schweizerischer Photographen*, Helmhaus, Zurich (with Werner Bischof, Walter Läubli, Paul Senn, and Jakob Tuggener)
1954 *Great Photographs*, Limelight Gallery, New York
1955 *Photographie als Ausdruck*, Helmhaus, Zurich
 The Family of Man, Museum of Modern Art, New York (and world tour)
1957 *Biennale di Fotografia*, Venice
1968 *Mostra di Fotografia*, Palazzo della Regione, Bergamo, Italy
1974 *Photographie in der Schweiz von 1840 bis Heute*, Kunsthaus, Zurich (toured Europe and the United States)
1978 *Images des Hommes*, Studio du Passage, Brussels (toured Europe)

Collections:

Kunsthaus, Zurich; Bibliothèque Nationale, Paris; Ministère de la Culture, Brussels.

Publications:

By SCHUH: books—*Zürich*, with text by Gotthard Jedlicka, Zurich 1935; *Insel der Götter*, with text by

Schuh, Zurich 1941, as *Eilanden der Goden*, Amsterdam 1941, new edition Zurich 1954, as *Iles des Dieux*, Lausanne 1954, as *Gudarnas Öar*, Uppsala, Sweden 1956; *50 Photographien*, with a foreword by Edwin Arnet, Basle 1942; *Italien*, with texts selected by Annamarie and Gotthard Schuh, Zurich 1953; *Begegungen*, with a foreword by Elisabeth Brock, Zurich 1956, as *Instants Volés, Instants Donnés*, with text by Max-Pol Fouchet, foreword by Elisabeth Brock, Lausanne 1956; *Tessin*, with an introduction by Titus Burckhardt, Zurich 1961; *Tiermütter im Zoo*, with text by Heini Hediger, Zurich 1961; *Tage in Venedig*, with text by Hanno Helbling, Zurich 1967; *Frühe Photographien 1929-1939*, with texts by Manuel Gasser and Schuh, Zurich 1967; articles—"Der Kampf mit der Dunkelheit mit Bildern von einer Südseereise" in *Camera* (Lucerne), March 1947; "Johann Adam Gabler 1833-1888," with Hans Kasser, in *Camera* (Lucerne), June 1947; "Brief an Robert Frank von Gotthard Schuh" in *Camera* (Lucerne), August 1957.

On SCHUH: books: *Photography of the World*, Tokyo 1957; *Photography Year Book*, edited by Norman Hall and Basil Burton, London 1958; *Schweizer Kunstler—Fotografie*, Zurich 1964; *Photographie in der Schweiz von 1840 bis Heute*, exhibition catalogue, by Hugo Loetscher, Walter Binder and Rosellina Burri-Bischof, Zurich 1974; articles— "Gotthard Schuh" by Elizabeth Brock-Sulzer in *Camera* (Lucerne), February 1958; "Gotthard Schuh, Venedig" by Hanno Helbling in *Du* (Zurich), February 1965; "Gotthard Schuh: Der Unwiederbringliche Augenblick" by Max A. Wyss in *Camera* (Lucerne), March 1968; "Gotthard Schuh: Zeuge und Kritiker Seiner Zeit" by Hans-Joachim Backhaus in *Fotografie* (Leipzig), July 1969; "3 Swiss Photographers: Jakob Tuggener, Gotthard Schuh, Rene Burri" in *Creative Camera* (London), December 1977.

It sometimes requires the official aura of an exhibition to draw the attention of a wider public to the significance of a photographer and his work. This function was performed by the exhibition, organized in 1967 by the City of Zurich and its Arts and Crafts Museum, entitled *Gotthard Schuh: Frühe Photographien 1929-39*. It initiated our critical

Gotthard Schuh: *Heilsarmee*, Zurich, 1933

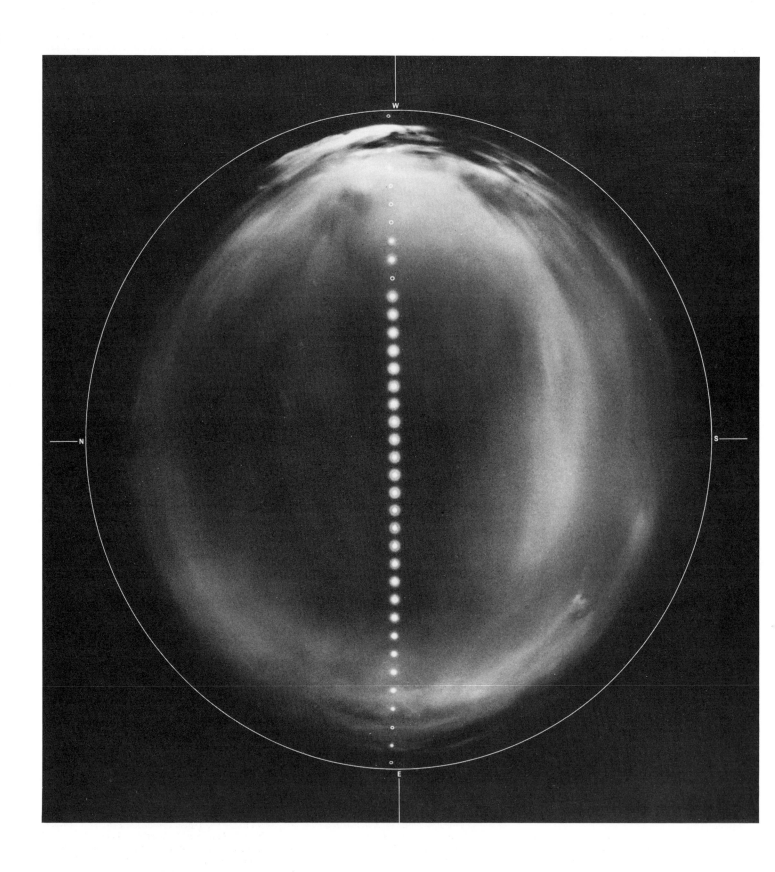

Emil Schulthess: *Course of the Sun at the Equator, Uganda, 6 a.m. to 6 p.m., 25 March 1956*

appraisal and recognition of the then 70-year-old Gotthard Schuh.

Schuh, who returned to Zurich in 1926 after travel in Italy and residence in Basle, Geneva and Munich, belonged for some time to the Rot-Blau group of artists in Basle (together with the painters Albert Müller, Coghuf, Hans Stocker among others). When Schuh once said he had been a somewhat questionable painter, it may be taken to be self-criticism; more important is the fact that he gave up painting as a form of expression in 1931 and took the step from amateur to professional photography. In photography he had discovered a medium with which to freeze the "irretrievable instant" in human affairs and make expression possible in all human circumstances and situations. In other words, he professed to realism in documentary form. In this connection he may also be considered a trend-setter in modern photographic reporting and one of its masters.

This acceptance of reality as a pictorial subject worthy of reproduction (subject in the traditional sense of a set task) might have burdened any photographer other than Schuh with purely technical recording problems. To him it must have seemed virtually obvious that this reality could only be achieved in the fast miniature camera "with a standard lens system of standard focal length" (in contrast to the rather manipulative photography of many so-called creative photographers). He trod the new path of reality in portrayal in the same year (1931) as Cartier-Bresson and Capa. Thus it is right that, historically at least, he should be mentioned with them in the same breath both in respect of significance, influence and creative achievement. This "dedication" is not an empty word: the first "sight" of a situation was so valuable to Schuh that he would brook no "arrangement" of it.

That his pictures, despite their realistic content, are not everyday in type, is due to two qualities in Schuh determined by his character and temperament. He possessed the eye to recognize the most pregnant moment of a facial expression or situation, and taste in the sense of artistic selection and pictorial composition. There is nothing to fault in the original designs of his well-considered formats and compositions. Here, maybe, lies the secret of the "completeness" of his pictures based on a subtle relationship between the main theme, the environmental atmosphere, or in an abrupt bordering which thrusts the picture content, as it were, out of a sequence of happenings.

Schuh was an inveterate globetrotter and discoverer. His picture book on Italy conveys seemingly untypical items which in the final analysis could not be more Italian. This is also valid for his *Tessin*, which he sees through different eyes because he stripped it of false pathos—and this applies in particular to *Insel der Götter*, in which he shows us a hitherto unrevealed world and the beauty of a different species of humanity, and thus, quite *en passant*, creates a rare document into the bargain.

Before the war Schuh was one of those picture reporters who could be relied on in Paris, Berlin, London and later in the U.S.A. to produce informative and artistic material. It seems almost tragic that nowadays these photographs are looked upon as part and parcel of the modern picture journalist's stock in trade. Pictures which, in their time, ranked as veritable *trouvailles*, as valid documents or irretrievable photographic instants—all of them still retain their validity, their freshness and impressiveness—because, like genuine lyric, they contain substance.

The exhibition in Zurich was, in its kind, an almost painfully felt retrospect—painful, because Schuh was then ill and had to content himself with this modest look backward, and probably also because of the recognition that there was nothing to add, that with this "legacy" he had taken his leave— at least of a certain public. How rich are the gifts that he did lavish on us will be appreciated only when more people have had the opportunity to know the full range of his creative work—an achievement of

unswerving, masterly endeavour.

—Allan Porter

SCHULTHESS, Emil.

Swiss. Born in Zurich, 29 October 1913. Educated at public primary school, Zurich, 1919-25; and public secondary school, Zurich 1925-28; student/apprentice in graphics, under Alex Walter Diggelmann, Zurich, 1928-32; studied photography, under Hans Finsler, *q.v.*, Kunstgewerbeschule, Zurich, 1932; art, Académie de la Grande Chaumière, Paris, 1932. Served in the Swiss Army, 1940-66. Married Bruna Castellini in 1937; children: Alfred and Elisabeth. Worked as freelance graphic artist, Zurich, 1932-36; Graphic Designer, Conzett and Huber publishers, Zurich, 1937-41, and Art Director, Picture Editor and Photographer, *Du* magazine (Conzett and Huber), Zurich, 1941-57. Freelance photographer, art director and writer, working mainly for Artemis publishers, Zurich, since 1957. Recipient: U.S Camera Award, 1959, 1967; Annual Award, American Society of Magazine Photographers, 1958; Prix Nadar, France, 1960; Culture Prize, Deutsche Gesellschaft für Photographie (DHPh), 1964; Goldene Blende Award, *Bild der Zeit*, Stuttgart, 1972. Address: Langacher 5, 8127 Forch/Zurich, Switzerland.

Individual Exhibitions:

1958 *Africa*, American Museum of Natural History, New York
1961 *Antarctica: The White Continent*, Jelmoli Department Store, Zurich (toured Europe, the United States, Latin America and India)
1963 *Africa-Antarctica-The Amazon*, IBM Gallery, New York
1965 *Africa-Antarctica-The Amazon*, Smithsonian Institution, Washington, D.C.
 Afrika-Amerika-Antarktis, Amerika-Haus, Hamburg
1966 *China*, Galerie Form, Zurich
 China: Mensch und Natur im Reich der Mitte, Galerie 38, Rapperswil, Switzerland

1972 *Unspoiled Nature*, U.S. Kodak travelling exhibition (toured Europe, South America, and the Far East, 1972-74)
 Unberührte Natur, Swiss Kodak travelling exhibition (toured Switzerland and France, 1972-75)

Selected Group Exhibitions:

1961 *Photography in the Fine Arts*, Metropolitan Museum of Art, New York
1974 *Photographie in der Schweiz von 1840 bis Heute*, Kunsthaus, Zurich (toured Europe and the United States)
1981 *Stiftung für die Photographie*, Kunsthaus, Zurich

Collections:

Kunsthaus, Zurich; Metropolitan Museum of Art, New York; Smithsonian Institution, Washington, D.C.

Publications:

By SCHULTHESS: books—*U.S.A.*, with texts by Emil Birrer, Doris Flach, Golo Mann, Fred M. Packard, Schulthess and others, Zurich 1955; *Africa I: From Mediterranean Sea to the Equator*, with texts by Otto Lehmann, Fritz Morgenthaler, and Schulthess, Zurich 1958; *Africa II: From the Equator to the Cape of Good Hope*, with texts by Otto Lehmann, Heini Hediger, Schulthess and others, Zurich 1959; *Africa*, with text by Emil Egli, London and New York 1959, revised edition, Zurich, Munich, London and New York 1969; *Antarctica*, with texts by Raymond Priestley, George J. Dufek, Henry Dater and Schulthess, Zurich, Munich, London and New York 1960; *The Amazon*, with text by Emil Egli and Schulthess, Zurich, Munich, London and New York 1962; *China*, with texts by Hans Keller, Emil Egli, Edgar Snow, Harry Hamm and Schulthess, Zurich, Munich, London and New York 1966; *Soviet Union*, with text by Klaus Mehnert and Schulthess, Zurich and Munich 1971, with text by Harrison Salisbury, London and New York 1971; *Midnight Sun*, Zurich 1973; *Matterhorn*, Zurich 1974; *Zurich*, Zurich 1975; *Lucerne*, Lucerne 1978; *New York*, Lucerne 1978; *Swiss Panorama*, Zurich 1982.

On SCHULTHESS: articles—"Emil Schulthess" by Philippe Halsman in *Infinity* (New York), June 1958; "Africa" in *Camera 35* (New York), February 1959; "Amazon by Emil Shulthess" by Arthur Goldsmith in *Infinity* (New York), May 1963; "Emil Schulthess und Seine Fotos" by L. Fritz Gruber in *Foto-Magazin* (Munich), March 1965; "Lynkeus mit der Kamera" by Helmuth de Hass in *Die Welt* (Hamburg), March 1965; "Chronicler of Continents" in *Modern Photography* (New York), April 1969; "Das Pedantische Objektiv" by Volkmar E. Strauss in *Bild der Zeit* (Hamburg), November 1971; "Des Affiches pour Rever" by L. Antonietti in *Typographische Monatsblätter* (St. Gallen, Switzerland), November 1972; "Emil Schulthess" in *Photography as a Tool*, by Time-Life editors, Amsterdam 1972.

As one of six children of a gardener for the city of Zurich, before affluence came to Switzerland, Emil Schulthess learned early how to make the best of things. In those days it was not taken for granted that a child would be given the opportunity to learn a trade. Schulthess considers himself lucky to have been allowed to take up an apprenticeship as a graphic designer.

He had been working for 12 years with Conzett and Huber as layout man and production supervisor for Arnold Kübler, then editor-in-chief of *Du*, when it was decided to dedicate an issue to the sun. Fired up by discussions with the editorial staff, Schulthess sketched in an 8-page layout the sine curve of the midnight sun. With an astronomer friend he checked out calculations for the 24 positions of the sun during 24 hours. The house technician built him a moving contraption to block out the sun's centre, so that its light would not eclipse the color in his photographs. He did not know what the landscape would look like in North-Norway, but set off for the Polar Circle to find on an island a spot where an extended water horizon would allow him to show the sun's full sine curve, with its low point just above it. Rarely does the sun remain uncovered by clouds for 24 hours, but this time it smiled throughout. Back in Zurich, Schulthess cropped his 24 photographs and fitted them together into a new historic layout that won awards and is constantly being republished in schoolbooks and atlases.

This panoramic view of the sun was the beginning of Schulthess' photographic life. In the 30 odd years since, he has published books on his travels across the United States and America, Antarctica, the Amazon, China and Russia. His photographs, almost always in color, are sensitive to man, beast, city and

landscape. The primitive stimulates his visual nerve, as does danger and the grandeur of those manifestations of nature that man cannot conquer. Schulthess believes in following with dogged determination his own path and in finding along it solutions for photographing in a new vision what is close to his heart. Always, after he has conceived a plan, he prepares its execution down to the last detail. He designs his own books and supervises their printing. Since 1957, when he began to freelance, he has financed on his own all his complex projects. Schulthess is a man who along the road of life knows how to make friends, to whom he remains loyal, friends with whom he cooperates and who add expertise to his soundly executed work.

One of his unique contributions is his photography of the sun and its paths. During a 10-month trip he photographed a circular eclipse in Africa and tracked the vertical ascent of the sun at the Equinox on the Equator. Ingeniously he solved his predilection for showing the sun's progress in one image. For the eclipse he stripped together five diagonally cropped photographs, with the desert horizon providing a unified base. For the path of the sun at the Equator, he used a self-built fish-eye-lens camera, which shows the whole firmament, and exposed the position of the sun every 20 minutes for 12 hours—from East to the West—on the same sheet of film.

Schulthess had now followed the sun from the polar circle to the Equator. The International Geophysical Year of 1958 presented an opportunity for the fulfilment of a long-held dream: to continue his researches in Antarctica. He was able to join the U.S. Navy's Research Mission "Operation Deep Freeze IV". In the below-freezing cold, with his broken English, Schulthess was nevertheless in his element. Not only was he able to track in one horizontal color picture the midnight sun over the Ross Sea, but also he added to his researches a series of fish-eye studies showing the sun's path during 18 hours as a perfect circle over the Pole.

Antarctica is an apex of what Emil Schulthess wants to achieve in his work. As opportunities to photograph in that uninhabited land are virtually non-existent, his work provides unique information of an unexplored, important part of the world, a part where the mysterious laws of nature assert themselves with beauty and virulence. In acknowledgement of his work there, the U.S. Board of Geographic Names has called the geographical point 84°47'S Latitude, 115°00'W Longitude "Schulthess-Buttress."

After twenty years of photographing powerful and primitive nations, 57-year-old Emil Schulthess found himself working at home on a mountain tip. Swissair had asked him to provide a souvenir for the Osaka *World's Fair*. He conceived the idea of a panoramic view from the highest point in Switzerland, the "Top of Switzerland." Although the 360° view taken at 4,634m. from the tiny peak, big enough only to hold the tripod of his camera with its 3 rotating Japanese lenses, became a best seller, thereafter Emil Schulthess forsook mountain tops and took to the air, always working in panoramic views, which have been published as posters. The challenges of overcoming helicopter vibration, so that levelling remains perfect, proved staggering. Years passed in designing and perfecting specially built camera equipment. Visualizing and finding points in the air that can be composed into vistas both exciting to look at and informative, requires incredible imagination, precision and skill. Working it all out in advance with a map, Schulthess now knows exactly from what angle to approach, say, the Matterhorn, to show it at its most beautiful, while making sure that none of the other most important mountains will be hidden in his circular composition. Schulthess is now preparing a book of this work.

From 1949 on, Emil Schulthess has been on a fertile voyage of photographic imagery and popular scientific knowledge, as orderly and mysterious as

the path of the sun. It has involved a progression from a 360° view in 24 negatives, taken from one place on the earth, to 360° views in 1 negative taken from the air. His purpose has been to provide new visual information, serving the mind as well as the eye.

—Inge Bondi

SCHÜRMANN, Wilhelm.

German. Born in Dortmund, Westphalia, 12 August 1946. Educated at the Staatliches Humanistisches Gymnasium, Bochum, West Germany, 1957-66; studied chemistry, Rheinisch Westfälische Technische Hochschule, Aachen, West Germany, 1966-71; self-taught in photography. Married Gabriele Füchtenschneider in 1972. Freelance photographer, since 1970. Staff photographer, *Neue Rheinische Zeitung*, Aachen, 1970-73; Director, with Rolf Kicken, Galerie Schürmann and Kicken, Aachen,

Wilhelm Schürmann: *Storch*, 1980

1973-78. Instructor, 1972-75, and since 1979 Dozent for Photography, Department of Design, Volkshochschule, Aachen. Recipient: Förderpreis (Advancement Prize), City of Aachen, 1978. Agent: Sander Gallery, 2600 Connecticut Avenue N.W., Washington, D.C. 20008, U.S.A. Address: Haus-Heyden-Strasse 195, 5120 Herzogenrath-Kohlscheid, West Germany.

Individual Exhibitions:

1975 Galerie im Riek, Essen
1976 Neue Galerie, Sammlung Ludwig, Aachen West Germany
1977 Galerie Spectrum, Hannover
1978 Sander Gallery, Washington, D.C.
 Galerie Agathe Gaillard, Paris
1979 Galerie Lange-Irschl, Munich
 Galerie Nagel, West Berlin
 Forum Stadtpark, Graz, Austria
 Regionalmuseum, Xanten, West Germany
1980 Galerie Primavere, Verviers, Belgium
 Sander Gallery, Washington, D.C.
1981 *Meine Strasse*, Folkwang Museum, Essen
 The Photographic Gallery, Cardiff (retrospective)
 Galerie Küpfer, Nidau, Switzerland
 3 Europeans: Michel Szulc Krzyzanowski,

Wilhelm Schürmann, Aleksandras Macijauskas, San Francisco Museum of Modern Art

Selected Group Exhibitions:

1976 *Photography as Art/Art as Photography*, Maison Européene de la Photographie, Chalon-sur-Saône, France (and world tour)
1977 *Über Fotografie*, Westfälischer Landesmuseum, Munster, West Germany
1979 *In Deutschland*, Rheinisches Landesmuseum, Bonn
Deutsche Fotografie nach 1945, Fotoforum, Kassel, West Germany (toured West Germany)
Schlaglichter, Rheinisches Landesmuseum, Bonn
1980 *Colour Works*, Kunsthaus, Zurich
Arbeitsgemeinschaft Öffentlicher Fotografie Sammlung en (AOFS), Museum Folkwang, Essen (toured Europe)
1981 *New German Photography*, The Photographers' Gallery, London (toured the U.K., 1981-82)
8 x 10, Susan Spiritus Gallery, Newport Beach, California

Collections:

Die Neue Sammlung, Munich; Stadtmuseum, Munich; Berlinische Galerie, Berlin; Rheinisches Landesmuseum, Bonn; Regionalmuseum, Xanten, West Germany; Bibliothèque Nationale, Paris; Sammlung Preus, Horton, Norway; International Museum of Photography, George Eastman House, Rochester, New York; New Orleans Museum of Art; San Francisco Museum of Modern Art.

Publications:

By SCHÜRMANN: books—*Josef Sudek*, co-editor, with Petr Task and others, Aachen 1976; *In Deutschland*, co-editor, with Klaus Honnef and others, Bonn 1979; *Kunstforum: Dokumentarfotografie, Band 41*, co-editor, with Walter Grasskamp, Mainz 1980; articles—"Mich interessiert die Fassade der Dinge," interview, with Jörg Krichbaum, in *Fotografie* (Göttingen), no. 6, 1978; "Visuelles Geschwätz" in *Photo* (Munich), January 1980.

On SCHÜRMANN: book—*Wilhelm Schürmann* by Klaus Honnef, Cologne 1979; articles—"Orientation: Wilhelm Schürmann" by Allan Porter in *Camera* (Lucerne), August 1974; "Photographs by Wilhelm Schürmann" by Peter Turner in *Creative Camera* (London), April 1976; "Wilhelm Schürmann" by Giuseppe Turroni in *Fotografia Italiana* (Milan), July 1976; "150 Jahre Fotografie" by Dieter Bechtloff in *Kunstforum* (Mainz), vol. 18, no. 4, 1976; "Wilhelm Schürmann" by Ignacio Barcelo in *Arte Fotografico* (Madrid), June 1977; "Some Notes on Wilhelm Schürmann's Photographs" by Jörg Krichbaum in *Camera* (Lucerne), April 1978; "Wilhelm Schürmann" by Maurice Coriat in *Zoom* (Paris), July 1978; "Wilhelm Schürmann" by Colin Osman in *Creative Camera* (London), September 1978; "Wilhelm Schürmann" by Dieter Bechtloff in *Kunstforum* (Mainz), vol. 41, no. 5, 1980.

My primary interest is the representation of my immediate environment—the street on which I grew up, the city in which I live, Aachen, the Belgian-Dutch border, the Rhineland. I am, however, also interested in urban photos of places unknown to me or known only by way of the media, because of the wide ranging interraction which can occur between reality and its photographic representation whereby recognition takes place at two different levels of experience. This is one way of gaining a clearer perception of reality.

I photograph objects just as they appear to me. They should simply be there in the photograph—the radiance should emanate from the object itself.

In order to intensify the physical presence of the object, I use an 8 x 10" camera for my interior still-lifes so that I need to make only contact prints. With these still-lifes, I am interested not only in a documentary record of a particular thing, but also in its formal elements which have much to do with the sculpture-like radiance of objects—how they lie, what they touch, whether they are suspended or flat, oblique or straight, what their material properties are like, e.g., how soft or hard, dull or glistening, etc.

Since I am constantly seeing I also photograph constantly, almost daily. I am happy that I have reached the point at which I can observe or contemplate something with fascination without having to think above all else that I should take a photograph.
—Wilhelm Schürmann

A particular attitude manifests itself in the pictures of Wilhelm Schürmann, which, characteristically, always deviate from traditional photography of whatever variety. Schürmann is one of that generation of photographers who made a lasting impression in the 1960's and 70's, whose influence on contemporary photography has been marked in both Europe and America. It is true that they still remain absolutely within the historical tradition of photography, but they are uninterested in that tradition on academic grounds; they consider it chiefly as the basis for material, for subject matter, and as the basis of accepted photographic practice. In general, the relation to reality of these leading documentary—in the wider sense—photographers is reflective and critical, insofar as they integrate as a determining factor in their photographic work the pictorial reality that photography has created in the course of its development.

Even if Wilhelm Schürmann's work cannot be identified directly with these meta-photographic endeavors, with that photographic attitude that every photographic portrayal of reality is, in effect, already "adjusted" by the medium of photography, nevertheless his photography does occur in that extensive range between documentary and the autonomous picture, and from a similar point of view. Stimulated on the one hand by such contrasting photographers as Werner Mantz, Josef Sudek and Robert Frank, and on the other by the attitude of avant-garde contemporary artists, Schürmann represents the position of, as it were, the modern author-photographer.

This is particularly clear if one examines his photographic methods more closely. Schürmann's photos have nothing to do with painfully staged pictorial architectures or with mere snapshots of various aspects of reality. They arise, rather, from a firmly defined artistic concept and are the products of selection—"products of articulated chance," as he says. The photographer knows in advance precisely what he wants; he does not fix on what reality accidently offers him. He waits for the "planned" moment which the occasion presents, to effect that photograph that corresponds to his creative idea. The actual photographic process is confined to seeing (registering), seizing, artistically composing, and clicking the shutter, a chain of events whose sequence is realized in fractions of seconds.

Schürmann brings reality to life with quite definite ideas, selects from the continuum only that which corresponds with those ideas, and takes into account no photographic subjects beyond his artistic concept, however attractive and pictorially worthy they may be. Yet, however apt this description may be of another kind of photographer, Schürmann does differ from the commercial photographer in his relation to reality. For the commercial photographer, the criteria of selection are based on the nature and type of problems of the commission to which he owes his initiative; he is subject to criteria prescribed not by him but by external factors. Schürmann, in contrast, proceeds exclusively according to principles and ideas that he has developed himself.

Accordingly, it is primarily the total photographic work, not the individual picture, that offers complete information about his artistic intentions and his vision of reality. Schürmann's favorite photographic motifs universally reflect a single theme, namely the symptoms and causes of human alienation in the civilization of the technical-electronic era. His photographs do not, however, cultivate a pessimistic view of the world; instead, they show a preference for the individual, mainly unavailing, touchingly helpless and therefore ridiculous struggles of man to free himself from the levelling forces of our civilization. His particular vision frequently lends to his photographs an undercurrent of absurdity in which are disclosed both the banality of ordinary daily life and the advanced spiritual disablement of late bourgeois society at the end of the modern era.

Schürmann's photographic grasp of reality achieves surprising and informative insights into its inner condition precisely because of its normality, its universal familiarity, and its intimacy. His photographs discover hidden connections behind the external appearance of reality, liberate them, and lift them into consciousness.

—Klauf Honnef

SECCHIAROLI, Tazio.
Italian. Born in Rome, 26 November 1925. Studied, to the 3rd grade, at Commerciale School, Rome, 1941; self-taught in photography, Married Rosanna Secchiaroli in 1948 (divorced, 1977); children: David and Lucy. Photojournalist, for evening newpapers in Rome, associated with the Porry Pastorel Agency, Rome, since 1952; Founder-Director, with Sergio Spinelli, Roma Press Photos agency, since 1955. Photographer/Reporter of filmmaking, Rome, particularly of the films of Federico Fellini, since 1959. Address: Via dei Platani 129, 00172 Rome, Italy.

Selected Group Exhibitions:

1979 *Venezia '79*

Publications:

On SECCHIAROLI: book—*70 Anni di Fotografia in Italia* by Italo Zannier, Modena, Italy 1978; articles—"Paparazzi on the Prowl" in *Time* (New York), 14 April 1961; "Tazio Secchiaroli" in *Progresso Fotografico* (Milan), November 1977; "Contemporary Italian Photography" by Italo Zannier in *Venezia '79*, Milan and New York 1979.

It doesn't often happen that a photographer becomes so famous that his name appears in all the newspapers. It happened to Tazio Secchiaroli. His name actually became the symbol of a whole generation of photographers—not his real name, of course, but his *nom de guerre*: who hasn't heard of Paparazzo?

Paparazzo, alias Tazio Secchiaroli, the assault photographer, the human photographic machine-gun, the bounty killer of Rome's Via Veneto in the 1950's, immortalized by Federico Fellini in his film *La Dolce Vita*. Events in Rome in those days—when Rome was the international capital of the cinema, of the nobility, of the jet-set—had in Tazio Secchiaroli their own quite uninhibited chronicler, and Fellini's film was based on the milieu that Secchiaroli had documented: film stars of both sexes bringing actions against each other, illicit love affairs, colossal orgies, *Arabian Nights* feasts in papal Rome.

Tazio Secchiaroli's basic achievement is to have created, quite deliberately, a style of news photography that in turn became the basis of a world wide school: he made "assault photography" an essential chapter in photographic history. The scoop is now obtained not only from long ambushes, pursuits and disguises but also from situations actually "provoked" by photographers who have thus become personalities in their own right. Their pictures, filling the columns of the yellow press and scandal weeklies all over the world, have the distinctive mark of the flash, used to make a subject stand out in the style of the best of Weegee.

But it would be wrong to think of Tazio Secchiaroli as being important only in those days when he was Paparazzo as deified by Fellini. Secchiaroli's great capacity for synthesis, his nose for news, his expressive devices, gradually refined over the years—they have enabled him to continue his work on a new scale, no less characteristic and still typically Roman. Still working in the film world, Secchiaroli has shown us since 1960 the same personalities as before, with the same artful style and the same debunking irony. But celebrities who once chased him in the Via Veneto now shake hands with him at cocktail parties or invite him to record their work on the film set. His notable capacity for figuration and his highly trained eye, which can sum up a whole story in a single picture, have enabled Secchiaroli to move on from press photography to a more profound and truthful study of the film personalities (Fellini, Sophia Loren, Marcello Mastroianni and many other actors and producers) whose activities he has long reported so acutely.

—Attilio Colombo

Tazio Secchiaroli: *Brigitte Bardot after Shooting the Film "Il Disprezzo,"* Rome, 1964

SELMA, Georgij. *See* **ZELMA, Georgij.**

SEMAK, Michael.
Canadian. Born in Welland, Ontario, 9 January 1934. Educated at Bloor, Oakwood and Parkdale high schools, Toronto, 1948-53; studied architectural technology, Ryerson Institute of Technology, now Ryerson Polytechnical Institute, Toronto, 1954-58, Dip.Arch. 1958; mainly self-taught in photography. Married Annette Antoniuk in 1960; children: James and Arlene. Freelance photographer, working for *Transaction, Reader's Digest, Time, National Geographic, Cosmopolitan*, Foster Advertising Agency, Alcan, Polaroid Corporation, etc., Toronto, since 1963. Part-time Lecturer, 1971-72, Sessional Lecturer, 1972-73, Lecturer, 1973-74, Assistant Professor, 1974-75, and since 1976 Associate Professor, Department of Visual Arts, York University, Toronto. Chairman of Interarts, Canada-USSR Association, 1974-76; Member of Nominations Committee and Executive Council, Royal Canadian Academy of Art, 1974-78. Recipient: Canada Council grants, 1967, 1969, 1971, 1973, 1974, 1979; Gold Medal, 1969, and grants, 1971, 1975, National Film Board of Canada; Award of Excellence, American Communication Arts, 1969; *Pravda* Award of Excellence, Moscow, 1970, 1971; International Fund for Concerned Photography Award, 1971, 1972; Ontario Countil for the Arts grant, 1972; Award of Excellence, Fédération Internationale d'Art Photographique (FIAP), 1972; York University grants, Toronto, 1973, 1974, 1975, 1977, 1978, 1979, 1981; USSR-Canada Society grant, to Moscow, 1975. Member, Royal Canadian Academy. Address: 1796 Spruce Hill Road, Pickering, Ontario L1V 1S4, Canada.

Individual Exhibitions:

1963 Gladstone Public Library, Toronto
1965 Toronto City Hall
1969 *Image 4: Ghana*, National Film Board of Canada, Ottawa (toured Canada, 1969-79, Ghana, 1970, and the U.S.S.R., 1980-81)
1971 Image Gallery, New York
1972 Image Gallery, New York

York University Art Gallery, Toronto
Ryerson Polytechnical Institute, Toronto
1973 Galleria Il Diaframma, Milan
Gallery Oseredok, Winnipeg, Manitoba
1975 The Shado Gallery, Oregon City, Oregon
1976 Galleria Il Diaframma, Milan
3 Photographers, Deja Vu Gallery, Toronto
(with Barbara Astman and Jerry Uels-
mann)
The Dark Room Gallery, Chicago
1977 Enjay Gallery, Boston
1978 University of Calgary Art Gallery, Alberta
1979 Secession Gallery of Photography, Victoria,
British Columbia
1980 Resolution Gallery of Photography,
Toronto

Selected Group Exhibitions:

1965 *Canadian National Exhibition*, Toronto
1966 *World Press Photos*, Moscow
1967 *Bytown International*, Ottawa
People Tree, at *Expo '67*, Montreal
1969 *Vision and Expression*, International Museum
of Photography, George Eastman House,
Rochester, New York (toured the United
States, 1969-71)
1970 *ASMP 25th Anniversary Show*, New York
Cultural Center
Expo '70, Osaka, Japan
1974 *6th Bifota Exhibition*, East Berlin
1976 *Calgary Stampede Exhibition*, Flare Square,
Calgary, Alberta
1980 *Words and Images*, National Film Board of
Canada, Ottawa

Collections:

National Film Board of Canada, Ottawa; National
Gallery of Canada, Ottawa; Public Archives of
Canada, Ottawa; Department of External Affairs,
Ottawa; York University, Toronto; Museum of
Modern Art, New York; International Museum of
Photography, George Eastman House, Rochester,
New York; Bibliothèque Nationale, Paris; Musée
Nicéphore Niépce, Chalon-sur-Saône, France;
Ukraina Society, Kiev.

Publications:

By SEMAK: books—*Image 4*, with text by Lorraine
Monk, Ottawa 1969; *Michael Semak: Monograph*,
Toronto 1974; articles—"Statement" in *Impressions*
(Toronto), Fall 1974; "Exposure Exhibition" in
Afterimage (Rochester), July/August 1976; "Semak/
USSR" in *Camera* (Lucerne), July 1978.

On SEMAK: book—*Vision and Expression: An
International Survey of Contemporary Photography*
by Nathan Lyons, New York 1969; articles—"Masters
of the Leica: Michael Semak" by Heinrich Stöckler
in *Leica Fotografie* (Frankfurt), February 1969;
"Brooklyn/Semak" by Allan Porter in *Camera* (Lu-
cerne), November 1970; "A Photographer Involved
with Life's Human Drama" by Michael Edelson in
Popular Photography (New York), November 1970;
"Each Photo Should Tell a Story" by Don Long in
Canadian Photo Annual 1975/76, Toronto 1975;
"Street Scenes of Russia" by Ed Spiteri in *Photo
Life* (Toronto), February 1978.

I wish to advocate socio-economic change in our
society, using photography as part of my arsenal for
that political end. Since photography alone cannot
fully explain man and his society, why not change
the uniform or role of photographic images, using
them in another way? The intention is to increase
our awareness of our relationships with others, vic-
tims and the victimizers. Coupling words, words

directed at us from the mass media, with my images
can provide more effective shells for the task ahead.

The system looks upon all of us as just one deep
pocket, always ready to buy the dreams and goods it
tirelessly dangles and spews out at us day in and day
out. Mediocrity seems to be the norm—seeping into
every keyhole of our mind. Words are hurled at us
from everywhere—what do they really mean? When
we unwrap the words we often end up with corpses
called empty words. I see many contradictions
around us, social realities which I believe rob us of
our self-esteem and individuality. Must we continu-
ally accept and succumb to the never-ending hot
baths for the mind society offers us? I wish my
photography and words to disturb the complacent
and the sleeper. I offer you cold showers for the
mind.

—Michael Semak

If in the Canadian context of more than twenty

Michael Semak: *My Crucifix*, Toronto, 1976

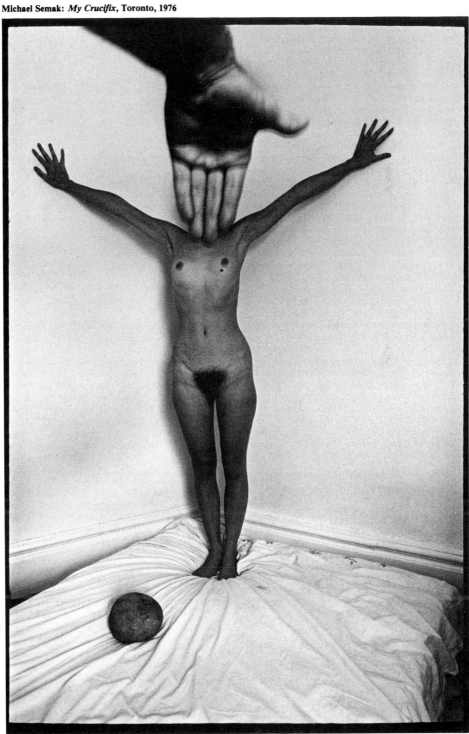

years ago, the choice of photography as a career can
be seen as an ordinary (or even practical) decision,
then Michael Semak's professional beginnings can
be deemed conventional. He worked on assignment
for *National Geographic*, the National Film Board
of Canada and Time-Life Books, travelling a great
deal, training his camera on things primitive and
non-North American as craved by a North Ameri-
can public. On completion of an eight week stint in
Ghana, which yielded an exhibition and a book,
Semak stated: "When I see, feel and photograph, I
am interested in and want to stress the common
denominator of people, the similarities of people
rather than the petty differences." *Ghana* had poeti-
cally described a proud and dignified people of
preoccupations so basic to survival, simplicity and
ease that Semak's common denominator seemed to
be a state of grace. His subsequent journeys through
asylums, slaughterhouses and the streets gave evi-
dence of a new conclusion: that we are guided not by

gentleness but by a paucity of human contact and compassion. Semak began to see it in all of us and to place it accusingly before the viewer in metaphoric images. Documents of faith gave way to despair.

Semak made the accompanying photograph late in 1976. Three elements are set in a corner, on a field of white of which one angle is a bed. Semak's compositional tools are not uncommon in photography: the nude, the gesturing hand, the stone. As well, these groupings have been made before: the nude and the smooth stone; the element of self-portrait which is the hand inserted in the landscape—the photographer's presence intruding on his subject. As structured in this photograph, they are both traditional and revolutionary and they introduce the troubling paradox of Semak's work.

The image is contained by a black line that both vaunts it as untampered with (as an event that actually took place—Semak in the room with the model and the stone) and stresses its photographic (therefore fictional) nature. There is a human presence here, two in fact, but the image while stemming from this human pairing does not suggest a portrait or divulge an introductory or concluding narrative. They are here gathered to be photographed.

The nude, whose outstretched arms are not welcoming but are pinned back in Christian archetype, is a woman in a man's pose. She stands on a rumpled bed. The stone is smooth, round and beautiful, yet it threatens the nude like an unexploded grenade. The bed becomes a battleground. The hand brutally thrust into the image and into the head of the figure conceals the identity of the woman. It is a man's hand, the photographer's left hand. This might be an act of chivalry or the theft of individuality.

If we look through the eyes of the awakening Adam, rising to God's touch through Michelangelo's conception, we look down the barrel of a left arm whose downturned hand closely resembles Semak's here. Cradled in God's arms, the unspoiled, still unambitious Eve is about to be delivered to her partner in the Garden. In Semak's renewal of this image, the apple of Knowledge is revealed for its sterility. The woman stands condemned and crucified. She is beautiful, faceless and tainted with original sin.

Whose conventions are these that Michael Semak both adopts and challenges? This work and Semak's more recent work wherein he captions his own classic imagery with consumer slogans, sexist labels, political and religious propaganda, are so entrenched in irony that the viewer may be left confused and disaffected. The same measure of faith that we once brought to his utopian exotica must now be applied against this reprehensible typecasting.

Semak uses models and slogans that we have come to find distasteful and turns them against liberal complacency. His work is difficult. Most of us would prefer to turn our backs on such usage and find a new vocabulary for our angers and our perceptions of inequity.

—Martha Langford

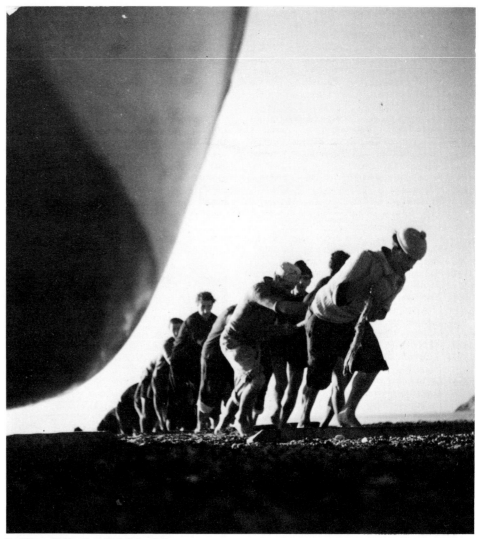

Paul Senn: *Fishing Boat*, Noli, Italy, 1948

SENN, Paul.

Swiss. Born in Rothrist, 14 August 1901. Educated at primary and secondary schools in Berne until 1916; apprentice graphic designer, Berne, 1917-21. Served in the Swiss Army, as war correspondent/ photographer, 1940-45; also, Photo-Reporter for the Swiss Red Cross in Spain and South of France during the Spanish Civil War, 1937, and in Germany, Sweden and Finland, 1945. Freelance graphic designer, working in France, Spain, England, and Germany, 1922-23; Staff Graphic Artist, *Basler Nachrichten*, Basle, 1924-30; established own graphics and publicity studio, Berne, 1930: increasingly worked as a photojournalist, under influence of Arnold Kübler, editor of *Zürcher Illustrierte*, and thereafter worked for *Du, Schweizer Illustrierte, Life, Paris-Match*, etc., until his death, 1953. Member, Swiss Society of Painters and Architects, 1952. Estate: Ida Marti, Lerchenweg 29, 3012 Berne, Switzerland. *Died* (in Berne) *25 April 1953*.

Individual Exhibitions:

1973 Kunstgewerbeschule, Berne
1977 Simon Gfaller Stiftung, Heimisbach, Switzerland
1981 Kunsthaus, Zurich

Selected Group Exhibitions:

1948 *Collegium of Swiss Photographers*, Kunsthalle, Berne
1951 *Collegium of Swiss Photographers*, Helmhaus, Zurich

1952 *Weltausstellung der Photographie*, Lucerne
1974 *Photographes Suisses depuis 1840 à Nos Jours*, Kunsthaus, Zurich

Collections:

Senn Archive, Kunstmuseum, Berne.

Publications:

By SENN: books—*Pablo Casals*, Zurich 1941; *Bauer und Arbeiter*, with an introduction by Arnold Kübler, Zurich 1943; *Der Oberemmenthal*, Berne 1946; *Der Mutz und Sein Graben*, Berne 1953; *Bern, Bildnis einer Stadt*, with others, Berne 1953.

On SENN: books—*Photographes Suisses depuis 1840 à Nos Jours*, exhibition catalogue, by Manuel Gasser, Hugo Loetscher, Rosellina Burri-Bischof, and Walter Binder, Zurich 1974; *Paul Senn, Photoreporter: Photographs from the Years 1930-1953*, with text by Guido Magnaguagno, Berne 1981.

Paul Senn's people are troubled; rarely do they smile. They are the hard-pressed, the down-trodden. His photographs are his response to bad times at home; to the Spanish Civil War; to need in countries destroyed by World War II; to America; to minorities.

It was his gift of making you feel that you were there, in the midst of things, that caught the attention of Arnold Kübler, then building a team for what became Switzerland's first modern picture magazine. He persuaded Senn, a graphic designer,

to become a free-lance "photo-reporter."

Looking at Paul Senn's early work, before the economic crisis hit home hard in Switzerland, one suspects that he originally had no intention of taking on the woes of his time, for his work shows a lyrical and humorous strain. But as conditions hardened, he began to concentrate on those in distress: the ordinary men and women who toil on the land, in the factories, at home on piece work; the unemployed; the aged; the mentally sick. He was, as his fiancée, Ida Marti, wrote, always ready to help with his pictures. During the war, his photographs and the people in them take on a new sense of hope and purposefulness.

From 1939 to 1945, Senn was attached to the equivalent of the Ministry of Information (the Geistige Landesverteidigung). Yet he was not ashamed to show men being mobilised, pensive, as human beings, nor did he feel it demeaned them when he showed soldiers bespattered with mud, and he chafed when the censor disagreed.

In the late 1940's and early 50's, before his early unexpected death, Senn seems to have once again, as early on in his career, tended to take photographs for the pure joy of it, nor does all of his work contain a social message. He had always photographed his city, Berne, and his friends, artists. From 1931 on he worked on a book on Pablo Casals.

Senn had wanted to become a painter. Though he became a "photo-reporter," he has a style very much his own, spontaneous, disciplined to eliminate detail, concentrated on the essential. His photography is a milestone in the history of his medium and in that of his people. However, until his files have been examined from the point of view of photography and history, we can only intuit his contribution.

—Inge Bondi

SEYMOUR, David. *See* **CHIM.**

SHAHN, Ben.
American. Born in Kovno (Kaunas), Lithuania, 12 September 1898; emigrated to the United States, 1906, and subsequently naturalized. Studied lithography as apprentice, Heisenberg's Lithography Shop, New York, 1913-17; painting, Art Students' League, New York, 1916; New York University, 1919; biology, City College of New York, 1919-22; painting, National Academy of Design, New York, 1917-22; biology, Marine Biological Laboratory, Woods Hole, Massachusetts, 1920, 1921, 1922; painting, Académie de la Grande Chaumière, Paris, 1925; fresco painting, under Jean Charlot, Art Students' League, New York, 1940; mainly self-taught in photography, but influenced initially by Walker Evans. Married Tilly Goldstein in 1922 (separated, 1932); children: Judith and Ezra; married the artist and journalist Bernarda Bryson in 1935; children: Susanna, Jonathan and Abigail. Independent paint-

er, New York, from 1925, photographer from 1928; photographer, under Roy E. Stryker, Farm Security Administration (FSA), Washington, D.C., 1935-38; independent painter, designer and occasional photographer, New York 1939-69; also worked as commercial artist and illustrator, New York, 1944-62. Visiting Instructor and Lecturer in Art, University of Colorado, 1950; Brooklyn Museum Arts School, 1951; Black Mountain College, North Carolina, 1951; Harvard University, Cambridge, Massachusetts, 1956. Recipient: J. Pennell Memorial Medal, Pennsylvania Academy of Fine Arts, 1939; Art Directors Club Medal, New York 1949; Gold Medal, Philadelphia Watercolor Society, 1952; A. McFadden Eyre Medal, Pennsylvania Academy of Fine Arts, 1952; Gold Medal, American Institute of Graphic Arts, 1958; Society of Illustrators Medal, 1960. D.F.A.: Princeton University, New Jersey, 1962; Pratt Institute, New York, 1966; Harvard University, 1967; D.H.L.: Hebrew Union College, Cincinnati, Ohio, 1964; LL.D.: Rutgers University, New Brunswick, New Jersey, 1964. Member, National Institute of Arts and Letters, 1956, and American Academy of Arts and Sciences, 1959. *Died* (in New York) *14 March 1969.*

Individual Exhibitions:

1930	Downtown Gallery, New York
1932	Harvard Society of Contemporary Art, Cambridge, Massachusetts
	Downtown Gallery, New York
1933	Downtown Gallery, New York
1940	Julien Levy Gallery, New York
1944	Downtown Gallery, New York
1945	Art Institute of Chicago
1947	Arts Council Gallery, London (toured Britain)
	Museum of Modern Art, New York (retrospective)
1949	Downtown Gallery, New York
1950	Albright-Knox Art Gallery, Buffalo, New York
	Frank Perls Gallery, New York
	Phillips Memorial Gallery, Washington, D.C.
1951	Arts Club, Chicago (with Willem de Kooning and Jackson Pollock)
	Downtown Gallery, New York
	Boris Mirsky Gallery, Boston
1952	Santa Barbara Museum of Art, California (with Lee Gatch and Karl Knaths; travelled to Los Angeles County Museum of Art)
1953	Minneapolis Institute of Arts
1954	Art Institute of Chicago
	Ben Shahn/Willem de Kooning, U.S. Pavilion, *Biennale di Venezia*
	Detroit Institute of Arts (with Charles Sheeler and Joe Jones)
	Allyn Art Gallery, Southern Illinois University, Carbondale
1955	Downtown Gallery, New York (retrospective)
	Galleria La Tartaruga, Rome
1957	Fogg Art Museum, Harvard University, Cambridge, Massachusetts
	Institute of Contemporary Art, Boston
	American Institute of Graphic Arts, New York
1959	Downtown Gallery, New York (2 shows)
	Katonah Gallery, New York
	Galleria dell'Obelisco, Rome
	Leicester Galleries, London
1960	University of Louisville, Kentucky
	University of Utah, Salt Lake City
	Galleria dell'Obelisco, Rome
	Jewish Community Center, Milwaukee (with Jack Levine and Abraham Rattner)
1961	Stedelijk Museum, Amsterdam (retrospective; toured Europe)
	Downtown Gallery, New York

	New Haven Jewish Community Center, Connecticut
1962	Staatliche Kunsthalle, Baden-Baden, West Germany (toured Europe and Israel)
	Armand Gallery, Sarasota, Florida
1963	Dartmouth College, Hanover, New Hampshire
1964	Leicester Galleries, London
1966	St. Paul Art Center, Minnesota
	Randolph-Macon Women's College, Ashland, Virginia
	Galleria Ciranna, Milan
1967	Philadelphia Museum of Art
	Santa Barbara Museum of Art, California (toured the United States)
1968	Orland Gallery, Encino, California
	Kennedy Galleries, New York
	Museum of African Art, Washington, D.C.
1969	Museum of Modern Art, New York
	New Jersey State Museum, Trenton
	Fogg Art Museum, Harvard University, Cambridge, Massachusetts
	Ankrum Gallery, Los Angeles
	Kennedy Galleries, New York
1970	Nantenshi Gallery, Tokyo
	National Museum of Modern Art, Tokyo (toured Japan)
	Kennedy Galleries, New York
1971	Gallery Ann, Houston
1972	Joseph Devernay-Berhen and Company, New York
	Kennedy Galleries, New York
1973	Joseph Devernay-Esther Begell, Washington, D.C.
1974	Joseph Devernay Schlos Remseck, Basle
1975	Allentown Art Museum, Pennsylvania
	Galerie Schloss Remseck, Stuttgart
1976	Joseph Deverany-Esther Begell, Washington, D.C.
	Jewish Museum, New York
	University of Maine at Portland-Gorham
1977	Lowe Art Museum, Syracuse University, New York
	Prakapas Gallery, New York
	University of Georgia, Athens (retrospective)
	Maurice Spertus Museum of Judaica, Chicago (retrospective)
	University of Texas at Austin (retrospective)
	Cincinnati Art Museum, Ohio (retrospective)
	Amon Carter Museum, Fort Worth, Texas (retrospective)
1978	Centre Culturel Américain, Paris (toured France)
1979	Nandin Galleries, New York

Selected Group Exhibitions:

1936	*Photographs*, W.P.A. Federal Art Project Gallery, New York
1964	*The Painter and the Photograph: From Delacroix to Warhol*, University of New Mexico, Albuquerque
1974	*Photography in America*, Whitney Museum, New York
1976	*A Vision Shared: FSA Photographs*, Witkin Gallery, New York
1977	*Documenta 6*, Museum Fridericianum, Kassel, West Germany
	Concerning Photography, The Photographers' Gallery, London (travelled to Spectro Workshop, Newcastle upon Tyne)
1979	*Amerika Fotografie 1920-1940*, Kunsthaus, Zurich
	Images de l'Amérique en Crise: Photos de la FSA, Centre Georges Pompidou, Paris
	Photographie als Kunst 1879-1979, Tiroler Landesmuseum Ferdinandeum, Innsbruck, Austria (travelled to Neue Galerie am Wolfgang Gurlitt Museum, Linz, Austria; Neue Galerie am Landesmuseum Joan-

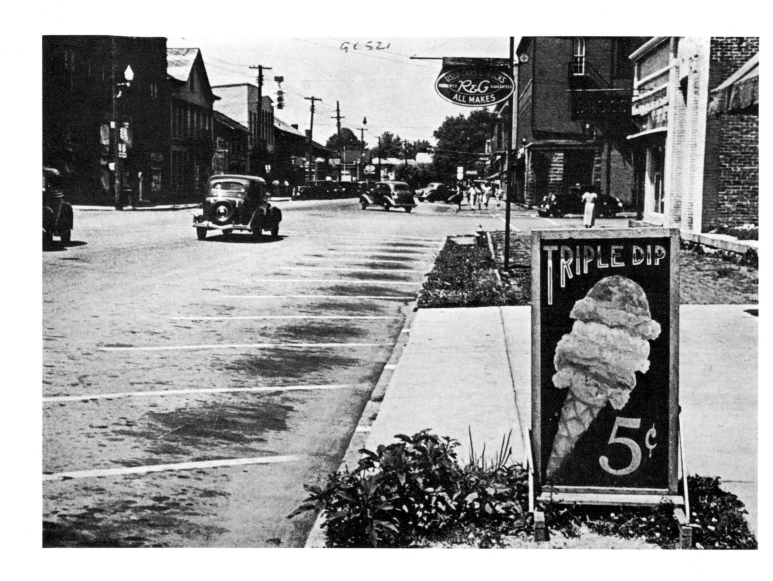

Ben Shahn: *Main Street*, **late 1930's** Courtesy Library of Congress/Victoria and Albert Museum, London

neum, Graz, Austria; and Museum des 20. Jahrhunderts, Vienna)

1980 *Les Années Ameres de l'Amérique en Crise*, Galerie Municipale du Chateau d'Eau, Toulouse

Collections:

Fogg Art Museum, Harvard University, Cambridge, Massachusetts (3,000 photos); Carpenter Center, Harvard University, Cambridge, Massachusetts; Rhode Island School of Design, Providence; International Museum of Photography, George Eastman House, Rochester, New York; Library of Congress, Washington, D.C.; University of Minnesota, Minneapolis; University of Louisville, Kentucky; San Francisco Museum of Modern Art.

Publications:

By SHAHN: books—*Partridge in a Pear Tree*, New York 1947; *The Alphabet of Creation*, New York 1954; *The Biography of a Painting*, Cambridge, Massachusetts 1956; *The Shape of Content*, Cambridge, Massachusetts 1957; *Love and Joy about Letters*, New York 1963; *Maximus of Tyre*, New York 1964; *Inside Krasilevka*, with Sholom Aleichem, New York 1965; *Kuboyama and the Saga of the Lucky Dragon*, with text by Richard Hudson, New York 1965; *The Cherry Tree Legend*, New York 1967; *Ben Shahn, Photographer: An Album from the Thirties*, with an introduction by Margaret R. Weiss, New York 1973; *The Complete Graphic Works of Ben Shahn*, edited by Kenneth W. Prescott, New York 1973; books illustrated—*The Sorrows of Priapus*, New York 1957; *Ounce, Dice, Thrice*, 1958; *Love Sonnets*, New York 1963; *Ecclesiastes or the Preacher*, New York 1964; articles— "Ben Shahn: An Interview," with John D. Morse, in *Magazine of Art* (New York), April 1944; "Photos for Art" in *U.S. Camera* (New York), May 1946; "An Artist's Credo" in *College Art Journal* (Mensaha, New York), Autumn 1949; "The Future of the Creative Arts: A Symposium" in *University of Buffalo Bulletin* (Buffalo, New York), February 1952; "What Is Realism in Art?" in *Look* (New York), January 1953; "How an Artist Looks at Aesthetics" in *Journal of Aesthetics and Art Criticism* (Philadelphia), September 1954; "Shahn in Amsterdam" in *Art in America* (New York), no. 3, 1961; "Shahn on Shahn" in the *New York Times*, 4 July 1965; "Imagination and Intention" in *Review of Existential Psychology and Psychiatry* (New York), Winter 1967; "For the Sake of a Single Verse" in *Notebooks of Malte Laurids Bridgge*, edited by Rainer Maria Rilke, New York 1968.

On SHAHN: books—*Ben Shahn* by James Thrall Soby, New York 1947; *Portrait of the Artist as an American: Ben Shahn: A Biography with Pictures* by Selden Rodman, New York 1951; *Ben Shahn: His Graphic Art* by James Thrall Soby, New York 1957; *The Bitter Years*, edited by Edward Steichen, New York 1962; *Ben Shahn: Paintings* by James Thrall Soby, New York 1963; *The Painter and the Photograph: From Delacroix to Warhol* by Van Deren Coke, Albuquerque, New Mexico 1964, 1972; *Ben Shahn: The Passion of Sacco-Vanzetti* by Martin Busch, Syracuse, New York 1968; *In This Proud Land* by Roy E. Stryker and Nancy Wood, New York 1973; *Photography in America*, edited by Robert Doty, with an introduction by Minor White, New York and London 1974; *Social Documentary Photography in the U.S.A.* by Robert J. Doherty, New York 1974; *Ben Shahn* by Bernarda Bryson Shahn, New York 1975; *The Photographic Eye of Ben Shahn*, edited by David Pratt, Cambridge, Massachusetts 1975; *The Years of Bitterness and Pride: FSA Photographs 1935-43*, compiled by Jerry Kearns and Leroy Bellamy, edited by Hiak Akmakjian, New York 1975; *Ben Shahn*, exhibition catalogue, by Kenneth W. Prescott, New York 1976; *A Vision Shared: A Classic Portrait of America and Its People 1935-1943*, edited by Hank O'Neal, New York and London 1976; *Concerning Photography*, exhibition catalogue, by Jonathan Bayer and others, London 1977; *Geschichte der Fotografie im 20. Jahrhundert/Photography in the 20th Century* by Petr Tausk, Cologne 1977, London 1980; *Documenta 6/Band 2*, exhibition catalogue, edited by Klaus Honnef and Evelyn Weiss, Cologne and Kassel 1977; *Amerika Fotografie 1920-1940* by Erika Billeter, Berne 1979; *Photographie als Kunst 1879-1979/Kunst als Photographie 1949-1979*, exhibition catalogue, 2 vols., by Peter Weiermair, Innsbruck, Austria 1979; *Les Années Ameres de l'Amérique en Crise 1935-1942*, exhibition catalogue, by Jean Dieuzaide, Toulouse 1980; articles—"Ben Shahn Shines On" by Grace Glueck in the *New York Times*, 13 October 1968; "Ben Shahn as Photographer" in *Harvard Bulletin* (Cambridge, Massachusetts), 27 October 1969; "Publicizing Social Causes on Canvas" by Hilton Kramer in the *New York Times*, 7 November 1976; "Art: Photo Roots of Shahn's Paintings" by Vivian Raynor in the *New York Times*, 21 October 1977; films—*A Profile of Ben Shahn*, WNBC television film, 1965; *This Is Ben Shahn*, CBS television film, 1965.

Ben Shahn's connection with photography can be seen both in his actual photographic activity and in his versatile and protean work in painting, drawing and murals. He emigrated to the United States at the age of eight and grew up in the crowded squalor of Brooklyn apartment houses, soon developing a strong social conscience which led to his becoming one of the most striking interpreters of American social realism. He learned photography from Walker Evans, with whom he shared a studio in New York in 1929. His first photographic interest was in the documentary field, when in order to paint a series in tempera, "The Passion of Sacco and Vanzetti" (1930), he made use of the photographs published in the papers of the two anarchists under trial. Other paintings that originated in photographic documentation or are in some way related to it are "Tom's Mother, Tom, Tom's Wife," of 1932, and "The Photographer's Shop Window" of 1940. The first of these is also a picture dealing with political martyrdom and social injustice; it makes great use of photographs taken by other press photographers of Tom Mooney, at first accused of and sentenced for sabotaging a parade in San Francisco, then later pardoned. The use of documentary photographs enabled Shahn to avoid sentimentalism and idealization and to give his records a sense of objectivity by the care he took with realistic details. "The Photographer's Shop Window" reveals a more sophisticated and reflective approach in his relationship with photography, which is manifested as an independent language with its own way of interpreting reality. Shahn, in painting the "15 photographs in one picture" which appear in this painting, consciously contrasts the appearance of "painted photographs" with his own way of "painting with the use of photography."

This picture was in fact painted after Ben Shahn had himself been able to practise photography intensively as one of the photographers engaged by Roy Stryker for the Farm Security Administration's photography project. This project, which the Roosevelt administration commissioned to enable the U.S. government to learn about, and to ameliorate, the conditions of life and work of the agricultural population of the South and Midwest, impoverished by competition by big industrial estates and by the disastrous effects of a four-year-long drought, included among its photographers not only Ben Shahn but also Walker Evans, Dorothea Lange, Arthur Rothstein, Margaret Bourke-White, John Vachon, Russell Lee and others. The artistic and intellectual level of the photographers engaged in the operation and the freedom given them by their having no fixed deadlines and no need to cultivate sensationalism for the benefit of the public, as can happen in press photography, made possible the collection of one of the most vast and significant social documentaries ever produced.

Ben Shahn worked for the FSA from 1935 to 1938 and contributed more than 6,000 photographs. This "one-third of a nation ill-housed, ill-clad, ill-nourished"—in President Roosevelt's works—finds in Shahn a compassionate and sympathetic champion. Here in these photographs are the Arkansas cottonpickers with their long, white sacks dangling from their shoulders; the coal-miners in Pennsylvania and Virginia with their blackened faces; the unskilled workers of Louisiana, whole families with drawn faces and twisted limbs on the march in convoy in search of work on the roads of Arkansas; the little rural railway stations with the rails vanishing in the distance and the yards and platforms dotted with piles of useless abandoned materials in which children search for playthings; the numerous, haggard-faced families, their pictures taken against their wooden houses; the Sunday afternoons with men sitting idly and miserably on the sidewalks of Ohio and Tennessee. But however wretched their living conditions, however sad their faces, these people retain a dignity, a sense of their own personality. Shahn's lens sees not crowds but persons, human beings in conditions of hardship. Ben Shahn often used to take his photographs with a Leica fitted with a right-angled viewfinder, but he never used this device, which allowed him to take pictures without the subjects being aware of it, to get sensational effects. His object was moral; he wanted to safeguard the spontaneity of the gestures and attitudes, not to get away with sensational pictures. While the composition, the harmonious relationship between figures and background, are grasped with a great graphic feeling, he deliberately avoided other sophisticated devices such as filters or opaque finishes. He was concerned to record, and to pass on, through the truth of the detail, a profound sense of a hard existence, a clenched-teeth struggle to survive.

Some of his snapshots were later made the subject of drawings and paintings. On other occasions— once earlier, when in order to prepare a project for a mural for Rikers Island penitentiary in 1934-35 he took photographs in New York's Lower East Side and in some of the State prisons, and once later, when he went to Asia in 1959—he took up the camera, but never with the same "interest in photographing people." It is chiefly in his years with the FSA that he feels that impassioned sharing in the human social drama of the people, when, in his own words, "we just took pictures that cried out to be taken."

—Daniela Palazzoli

SHAIKHET, Arkadii (Samoilovich).
Russian. Born in Nikolayev, Ukraine, in 1898. Educated at elementary school, Nikolayev, 1904-10; self-taught in photography, from 1922. Served in the Red Army, 1918-21, and as war correspondent/photographer, mainly for *Frontovaya Illustraziya* magazine, 1941-45. Married; son: Anatoly. Apprentice fitter, Marti factory, Nikolayev, 1910-14; worked as shipyard fitter, Nikolayev, 1914-18; photo-retoucher for a portrait photographer, Moscow, 1922-24; photojournalist, Moscow, mainly for *Ogonjok, Rabotchnaya Gazeta, SSSR na Stroike, Nashi Dostizheniya, Unsere Erregenschaften,* etc., from 1924. Recipient: Order of the USSR, 2nd Class, 1945; Order of the Red Banner, USSR, 1945. *Died* (in Moscow) *in 1959.*

Selected Group Exhibitions:

1929 *Film und Foto*, Deutscher Werkbund, Stuttgart
1931 *24 Hours in the Life of the Filippov Family*, Vienna and other European cities (with Alpert and Tulesa)
1975 *Soviet War Reportage 1914-1945*, House of Soviet Science and Culture, Prague
1977 *The Russian War 1941-1945*, International Center of Photography, New York
1978 *Soviet War Photography 1941-1945*, Side Gallery, Newcastle upon Tyne, England
1979 *Paris-Moscou 1900-1930*, Centre Georges Pompidou, Paris
 Film und Foto der 20er Jahre, Wüttembergische Kunstverein, Stuttgart (travelled to Museum Folkwang, Essen; Werkbundarchiv, West Berlin; Kunsthaus, Zurich; Kunstverein, Hamburg; and Museum des 20. Jahrhunderts, Vienna)
1980 *Soviet Photography Between the World Wars 1917-1941*, Brno, Czechoslovakia

Collections:

Shaikhet Family Collection, Moscow; Museum Folkwang, Essen; Daniela Mrázková and Vladimír Remeš Collection, Prague.

Publications:

By SHAIKHET: photo-essay—"A Day in the Life

Arkadii Shaikhet: *Ilyitsch's Lightbulb*, **Kolomenskaje Village, 1928**

of the Filippov Family," with Max Alpert and Salomon Tulesa, in *AIZ/Arbeiter Illustrierte Zeitung* (Berlin), 1931.

On SHAIKHET: books—*Arkadii Shaikhet* by A. Aleksandrov and Anatoly Shaikhet, Moscow 1973; *Liberation*, edited by Mikhail Trakhman, Boris Polevoi and Konstantin Simonov, Moscow 1974; *Fotografivalu Valku*, edited by Daniela Mrázková and Vladimír Remeš, Prague 1975, as *The Russian War*, with an introduction by Harrison Salisbury, New York 1977, with an introduction by A.J.P. Taylor, London, 1978, as *Von Moskau nach Berlin*, with an introduction by Heinrich Böll, Oldenburg, West Germany 1979; *An Introduction to Press Photography* by Petr Tausk, Prague 1976; *Geschichte der Fotografie im 20. Jahrhundert/Photography in the 20 Century* by Petr Tausk, Cologne 1977, London 1980; *Photographen der 20er Jahre* by Karl Steinorth, Munich 1979; *Film und Foto der 20er Jahre*, exhibition catalogue, by Ute Eskildsen and Jan Christopher Horak, Stuttgart 1979; *Sowjetische Fotografen 1917-1940* by S. Morosov, A. Vartanov, G. Chulakov, O. Suslova and L. Uchtomskaya, Leipzig and West Berlin 1980; *Die Sowjetunion zwischen den Kriegen 1917-1941*, edited by Daniela Mrázková and Vladimír Remeš, Oldenburg, West Germany 1981; articles—"Arkadii Shaikhet" in *Revue Fotografie* (Prague), September 1974; "Arkadii Shaikhet" in *Fotografie* (Leipzig), April 1976; "Photographie Creative" by Romeo Martinez and A.N. Lavrentiev in *Paris-Moscou 1900-1930*, exhibition catalogue, Paris 1979; "Soviet Photography Between the World Wars 1917-1941" by Daniela Mrázková and Vladimír Remeš in *Camera* (Lucerne), June 1981.

Originally a fitter at a shipyard, Arkadii Shaikhet went on to become a famous photojournalist. He started in photography as a retoucher, working in the darkroom of a privately owned Moscow studio; five years later he made a name for himself at a jubilee exhibition in Moscow and soon after in London. In his youth he experienced that time when the life of a man can change in a single day.

The photographs of the then unknown Shaikhet first appeared in the Soviet picture magazine *Ogonyok* in 1924. From then on his name was linked

with the development of Soviet photojournalism and indeed with the development of the Soviet Union and its people. Not only were industrial complexes springing up at that time in remote virgin lands, and irrigation canals crossing barren deserts, but also the formerly illiterate *mouzhik* was becoming a modern man. Press photographers were there to show how old peasant Russia was bidding farewell to the past in order to create a new life, and Shaikhet was the best among them.

In Soviet photography of the 1920's we find works that experiment with ways of expressing the new reality; at the same time, modern social reportage was being born. Both these currents informed the new programme of photographic communication: the urgent content expressing the turbulent dynamics of the time; the photograph itself achieving excitement because of the personal involvement of the photographer. But Shikhet was not an experimenter; he was a narrator. True to the traditional Russian inclination to the epic, he recorded ordinary everyday reality day by day, month by month. He photographed the little waifs, the neglected children who during the years of the Civil War roamed the streets of the cities like savages; the lines of country people who in rags and with bundles on their backs, made their way from all parts of the country to the factories in Moscow to help restore damaged industry; the first column of Soviet cars on their way from Nizhni Novgorod to the capital city; and the first encounter of an old peasant couple with the electric light bulb. None of these snapshots depicts an extremely dramatic situation—just ordinary events that might happen in the Russia of that time on any day.

In contrast to his contemporaries, Shaikhet was not fascinated by the constructions of gigantic buildings or by the unknown scope of technology. He was attracted by what the man in the street experienced, by his feelings and impressions. He did not "arrange" or embellish anything. He did not seem particularly concerned about the aesthetic aspect of his photographs. However, he anxiously guarded their documentary verisimilitude and truthfulness. *Ogonyok, Proletarskoye Foto, USSR na Stroike, Nashi Dostizheniya*—they were the media of the great era of development of Soviet photojournalism, and they were where Shaikhet's photos were published. And to this list should be added *Arbeiter Illustrierte Zeitung* in Berlin which in 1931 published one of the first Soviet picture-stories—"Twenty-Four Hours in the Life of the Filippov Family." In this story Shaikhet along with Max Alpert and Salomon Tulesa depicted the daily life of members of the family of a Moscow engineering worker. The collection of 78 photographs chosen from this work was exhibited that year in Vienna and later also in Berlin and Prague, propagating the new way of life in the Soviet Union. A social testimony—the main aim of all of Shaikhet's endeavors.

At the outbreak of the Second World War, Shaikhet was 33 years old. It seemed unlikely that he could still spring surprises. And yet he was to achieve the second climax of his artistic career. Just as in the 1920's and 30's, he was not attacted by the dramatic, not by the superficial glory of victory or the courage of heroes. He entered the photographic history of the war simply and modestly, depicting moments of an ordinary war-day in the life of anonymous people. There are no great gestures; instead, he gives us a soldier's emotional embrace of his mother and wife; freezing men building a pontoon bridge, the waters of the Odra up to the belts of their uniforms; German prisoners of war painfully moving through snow and fog; and the torso of a silenced tank jutting up to the skies after the battle at Kursk.

Arkadii Shaikhet died in 1959. His work—which numbers thousands of photographs—is scattered among many different journals, magazines and newspapers published from the early 1930's until the time of his death. It is an oeuvre that has laid the foundation of Soviet photojournalism.

—Daniela Mrázková

Charles Sheeler: *Industry* **(2nd panel of triptych), 1932** Courtesy Art Institute of Chicago

SHEELER, Charles.

American. Born in Philadelphia, Pennsylvania, 16 July 1883. Studied at School of Industrial Art, Philadelphia, 1900-03; painting, under William Merritt Chase, Pennsylvania Academy of Fine Arts, Philadelphia, 1903-06; mainly self-taught in photography. Married Katharine Schaffer in 1923 (died, 1933); Musya Sokolova in 1942. Independent painter, associating with painter and photographer Morton L. Schamberg, Philadelphia, 1906-18; freelance architectural photographer, with Morton L. Schamber, Philadelphia, 1912-18; collaborated with Paul Strand on the film *Manhatta*, 1920-21; independent painter and photographer, working for Marius de Zayas's Modern Gallery, New York, 1920-23; freelance photographer, working mainly for the Condé Nast Publications *Vogue* and *Vanity Fair*, New York, 1923-32, and for the Ford Motor Company, River Rouge, Michigan, 1927-28; independent painter and photographer, South Salem, New York, 1927-32, and Ridgefield, Connecticut, 1932-41; worked in Williamsburg, Virginia, 1935; Staff Photographer, Metropolitan Museum of Art, New York, 1942-45; independent painter, 1945-59, and photographer, 1950-59, Irvington-on-Hudson, New York. Artist-in-Residence, Phillips Academy, Andover, Massachusetts, 1946, and Currier Gallery of Art, Manchester, New Hampshire, 1948. Recipient: First and Fourth Prizes, *13th Annual John Wanamaker Photo Exhibition*, Philadelphia, 1918; Norman Wait Harris Medal, Art Institute of Chicago, 1945; Alumni Award, Pennsylvania Academy of Fine Arts, 1957; Hallmark International Competition Prize, New York, 1958; Merit Medal, American Academy of Arts and Letters, New York, 1962. Life Fellow, International Institute of Arts and Letters. *Died* (in Dobbs Ferry, New York) 7 May 1965.

Individual Exhibitions:

1908 McClees Gallery, Philadelphia
1917 *Doylestown House Photos*, Modern Gallery, New York (with Morton L. Schamberg and Paul Strand)
1920 De Zayas's Gallery, New York
1921 *New York the Magnificent*, Capital Theatre, New York (Sheeler/Strand film showing)
1922 Daniel Gallery, New York
1924 Whitney Studio, New York
1926 J.B. Neumann Print Room, New York (with Louis Lozowick)
 Art Center, New York
1931 Downtown Gallery, New York
1932 Arts Club, Chicago
1934 Fogg Art Museum, Harvard University, Cambridge, Massachusetts (with Charles Burchfield and Edward Hopper)
1935 Society of Arts and Crafts, Detroit (with Charles Burchfield)
1939 *Charles Sheeler: Paintings, Drawings, Photographs*, Museum of Modern Art, New York (retrospective)
1940 Downtown Gallery, New York
1944 Dayton Art Institute, Ohio
1946 Downtown Gallery, New York
 Phillips Academy, Andover, Massachusetts
1948 Currier Gallery of Art, Manchester, New Hampshire
1949 Downtown Gallery, New York
1951 Downtown Gallery, New York
1952 Walker Art Center, Minneapolis
1954 *Charles Sheeler: A Retrospective Exhibition*, University of California at Los Angeles (toured the United States)
1956 Downtown Gallery, New York
1958 Downtown Gallery, New York
1959 *Charles Sheeler: A Retrospective Exhibition from the William H. Lane Foundation*, The New Gallery, Charles Hayden Memorial Library, Massachusetts Institute of Technology, Cambridge
1961 Allentown Art Museum, Pennsylvania (retrospective)

1963 *The Quest of Charles Sheeler*, University of Iowa, Iowa City (retrospective)
1965 Downtown Gallery, New York
1966 Downtown Gallery, New York
1967 *Charles Sheeler: A Retrospective Exhibition*, Cedar Rapids Art Center, Iowa
1968 Smithsonian Institution, Washington, D.C. (retrospective organized by the National College of Fine Arts)
1974 *Charles Sheeler: Works on Paper*, Pennsylvania State University, University Park
1978 *The Rouge: The Image of Industry in the Art of Charles Sheeler and Diego Rivera*, Detroit Institute of Arts
1980 Whitney Museum, New York

Selected Group Exhibitions:

1917 *Exhibition of Photographs*, Modern Gallery, New York
1918 *13 Annual Exhibition of Photographs*, John Wanamaker and Company, Philadelphia
1929 *Film und Foto*, Deutscher Werkbund, Stuttgart
1931 *American Photography*, Julien Levy Gallery, New York
1932 *Murals by American Painters and Photographers*, Museum of Modern Art, New York
1964 *The Painter and the Photograph: From Delacroix to Warhol*, University of New Mexico, Albuquerque
1976 *Photographs from the Julien Levy Collection, Starting with Atget*, Art Institute of Chicago
1977 *Photographs: Sheldon Memorial Art Gallery Collection*, University of Nebraska, Lincoln
1979 *Photographie als Kunst 1879-1979*, Tiroler Landesmuseum Ferdinandeum, Innsbruck, Austria (travelled to Neue Galerie am Wolfgang Gurlitt Museum, Linz, Austria; Neue Galerie am Landesmuseum Joanneum, Graz, Austria; and Museum des 20. Jahrhunderts, Vienna)
 Photography Rediscovered: American Photographs 1900-1930, Whitney Museum, New York (travelled to Art Institute of Chicago)

Collections:

Museum of Modern Art, New York; Metropolitan Museum of Art, New York; Whitney Museum of American Art, New York; International Museum of Photography, George Eastman House, Rochester, New York; William H. Lane Foundation, Leominster, Massachusetts; Princeton University, New Jersey; Library of Congress, Washington, D.C.; Art Institute of Chicago; University of Nebraska, Lincoln; University of New Mexico, Albuquerque.

Publications:

By SHEELER: books—*Egyptian Statues*, New York 1945; *The Great King, King of Assyria*, New York 1946; article—"Charles Sheeler Talks with Martin Friedman" in *Archives of American Art Journal* (Washington, D.C.), vol. 16, no. 4, 1976; film—*Manhatta (New York the Magnificent)*, with Paul Strand, 1921.

On SHEELER: books—*Charles Sheeler: Artist in the American Tradition* by Constance Rourke, New York 1938; *Charles Sheeler: Paintings, Drawings, Photographs*, exhibition catalogue, with an introduction by William Carlos Williams, New York 1939; *Charles Sheeler: A Retrospective Exhibition*, catalogue, by Bartlett H. Hayes and Frederick S.

Wright, with a foreword by William Carlos Williams, Los Angeles 1954; *The Quest of Charles Sheeler*, exhibition catalogue, by Lillian Dochterman, Iowa City 1963; *The Painter and the Photograph: From Delacroix to Warhol* by Van Deren Coke, Albuquerque, New Mexico 1964, 1972; *Charles Sheeler: A Retrospective Exhibition*, catalogue, by Donn L. Young, Cedar Rapids, Iowa 1967; *Photography in the Twentieth Century* by Nathan Lyons, New York 1967; *Charles Sheeler* by Martin Friedman, Bartlett Hayes and Charles Millard, Washington, D.C. 1968; *Photography in America*, edited by Robert Doty, with an introduction by Minor White, New York and London 1974; *Charles Sheeler: Paintings, Drawings, Photographs* by Martin Friedman, New York 1975; *Fashion 1900-1939*, exhibition catalogue, by Valerie Lloyd and others, London 1975; *The Magic Image* by Cecil Beaton and Gail Buckland, Boston and London 1975; *Photographs from the Julien Levy Collection, Starting with Atget*, exhibition catalogue, by David Travis, Chicago 1976; *Fotografie der 30er Jahre: Eine Anthologie*, edited by Hans-Jürgen Syberberg, Munich 1977; *Photographs: Sheldon Memorial Art Gallery Collection, University of Nebraska*, with an introduction by Norman A. Geske, Lincoln 1977; *Documenta 6/ Band 2*, exhibition catalogue, edited by Klaus Honnef and Evelyn Weiss, Kassel and Cologne 1977; *The Collection of Alfred Stieglitz* by Weston J. Naef, New York 1978; *The Rouge: The Image of Industry in the Art of Charles Sheeler and Diego Rivera*, exhibition catalogue, Detroit 1978; *Life: The First Decade 1936-1945* by Robert Littman, Ralph Graves and Doris O'Neill, New York 1979, London 1980; *Photographen der 20er Jahre* by Karl Steinorth, Munich 1979; *Photographie als Kunst 1879-1979/Kunst als Photographie 1949-1979*, exhibition catalogue, 2 vols., by Peter Weiermair, Innsbruck, Austria 1979; *The History of Fashion Photography* by Nancy Hall-Duncan, New York 1979; *The Vogue Book of Fashion Photography* by Polly Devlin, with an introduction by Alexander Liberman, New York and London 1979; *Amerika Fotografie 1920-1940* by Erika Billeter, Berne 1979; *Charles Sheeler*, exhibition catalogue, by Patterson Sims, New York 1980; articles—"Commentaire" by Brice Parain in *Bifur* (Paris), no. 4, 1929; "Charles Sheeler, The Mythos" in *Transition* (Paris), no. 18, 1929; "Charles Sheeler: A Subtle and Complex Beauty Revealed in the Ford Plant by This Remarkable Camera Study" in *USA* (New York), vol. 1, no. 1, 1930; "Charles Sheeler: Four Photographs—Ford Plant" in *Hound and Horn* (New York), vol. 3, no. 3, 1930; "More Power for the Rouge Plant" in supplement to *Ford News* (Detroit), vol. 11, no. 11, 1931; "Ford Plant Photos of Charles Sheeler" by Samuel M. Kootz in *Creative Art* (New York), April 1931; "Portrayal by Photograph" in *Ford News* (Detroit), vol. 14, no. 6, 1934; "Sheeler at Seventy-Five" by George M. Craven in *College Art Journal* (New York), Winter 1959; "Charles Sheeler, American Photographer" by Charles W. Millard III in *Contemporary Photographer* (Culpeper, Virginia), vol. 6, no. 1, 1967; "When the City Sits for the Camera" by Hilton Kramer in *New York Times*, 6 January 1978; "Sheeler and Strand's 'Manhatta': A Neglected Masterpiece" by Scott Hammen in *Afterimage* (Rochester, New York), January 1979.

Charles Sheeler, acknowledged as a painter of exceptional ability, also has been called America's foremost industrial photographer. Early in his career, when he realized that the camera might be used as creatively as the brush, he questioned: "How long before photography shall be accorded an importance not less worthy than painting or music?" Because of his conviction that painting, with its synthesized image of nature seen inwardly, did not conflict with the camera's fixed point of view of the world outside the artist, he began to exhibit paintings and photographs together during the 1920's.

Sheeler's earliest camera images were architectural commissions undertaken in 1912 as a means of

livelihood. In 1915, a weekend house on the outskirts of Philadelphia, which he shared with the painter Morton Schamberg, provided inspiration for his initial creative work in the medium. Objectivity, sharp definition and rational orientation with regard to the horizon, which had been basic to his commissioned architectural work, remained the essential elements of his creative style as well.

In addition to striking clarity, Sheeler's early photographs reveal a keen interest in geometric form, textural definition and subtle tonal gradations. With few exceptions his preference for a classically oriented view of unambiguous reality remained a touchstone of his style. He usually found the straight silver print sufficient for his purpose, although at times he cropped the final image. One instance of his use of photomontage was in a triptych based on industrial themes that he submitted in 1932 to the photographic mural exhibition at the Museum of Modern Art.

Between 1915 and 1922, Sheeler's attitude toward the creative potential of photography was influenced significantly by Alfred Stieglitz and Paul Strand. His move to New York City in 1919 presented him with an opportunity to photograph skyscrapers in lower Manhattan, which he did while working with Strand on *Manhatta*, a short film based in part on Walt Whitman's poem. Evidence of his ability to organize and simplify complex structural formations can be seen in "Downtown Offices," and in the painting "Church Street El," based on a still from the movie.

Following several years of activity as a photographer for *Vogue/Vanity Fair* and for a prestigious Philadelphia advertising firm, Sheeler was commissioned in 1927 to make photographs of the Ford Motor Company's new installation at River Rouge, Michigan. It was for this project that he was acclaimed as the nation's pre-eminent photographer of industrial themes. In their satisfying integration of volume and pattern, the River Rouge images vividly project a sense of rationality and accomplishment, echoing the photographer's conviction that industrialism constituted the contemporary American religion.

Throughout his early years, Sheeler frequently used his photographs as a basis for graphic work and paintings, but after 1932 he began to regard the camera image more as a tool than as an independent creative pursuit. Nevertheless, the 75 photographic images in his retrospective exhibition of 1939 at the Museum of Modern Art comprised the largest single group. His work in all media should be considered as a totality in which graphic and photographic ideas, reinforcing and influencing each other, have contributed to the clarity and precision of his view of reality.

—Naomi Rosenblum

SHEMTOV, Igael.
Israeli. Born in Nahariya, 29 September 1952. Educated at Joint School of the Zvulon District, 1968-71; studied advertising and industrial photography, Neri Bloomfield Community College, Haifa, 1975-78, diploma in photography, 1978; creative photography, Bezalel Academy of Arts and Design, Jerusalem, 1977-79; State Art Teachers Training College, Ramat Hasharon, 1978-81. Freelance photographer, Tel Aviv, since 1978. Instructor in Photography, Bezalel Academy, Jerusalem, since 1979.

Instructor in Photography, State Art Teachers Training College, Ramat Hasharon, 1981. Recipient: Halperin Photography Award, 1978, and Agfa Award, 1979, Bezalel Academy, Jerusalem; America Israel Culture Foundation grant, 1979, 1980; Israeli Culture and Art Committee grant, 1979; Enrique Kavlin Photography Grant, Israel Museum, Jerusalem, 1981. Address: 32 Merkaz Baalei Melakha, Tel Aviv 63 824, Israel.

Individual Exhibitions:

1979 *Tel Aviv*, Yarkon Park Art Pavillion, Tel Aviv

Selected Group Exhibitions:

1978 *Photographic Exercises*, White Gallery, Tel Aviv
1979 *Israeli Photography: Acquisitions*, Tel Aviv Museum, Israel
1980 *Photographs*, Artists Pavilion, Tel Aviv

Collections:

Tel Aviv Museum; Israel Museum, Jerusalem.

Publications:

By SHEMTOV: articles—"Igael Shemtov: Portfolio" in *Hatzeelum* (Tel Aviv), October 1978; "Igael Shemtov," interview with Avi Holtzman, in *Hatzeelum* (Tel Aviv), September 1980; "Portfolio Igael Shemtov" in *Proza* (Tel Aviv), February 1981.

On SHEMTOV: articles—"Art in the Park" by Gil Goldfine in *Jerusalem Post*, 3 August 1979; "Above Reality" by Nissim Mevorah in *Haaretz* (Tel Aviv), 17 August 1979.

I use photography as a means of self-expression as one could use other options such as painting, sculpture, etc. Photography, directly connected to one's awareness of his surroundings, is—of all the visual forms of expression—probably the most confined by one's reality. The distinction between a common photograph and one which relates personal expression as an art form is sometimes very difficult to discern.

Igael Shemtov: *Untitled*, 1980

This difficulty is related to the commonness of the photograph and the credibility of any photograph as being able to impress or convince us of the reality of the situation taken from life. It is within these narrow limits that creative photography functions. One must express oneself, the values of one's aesthetics and personality, without compromise, while functioning within restrictions imposed by the medium. In photographing, I plan and stage situations; in the final imagery I carefully edit sequences and group photographs.

This control and final context of the work is my visual statement.

—Igael Shemtov

Igael Shemtov claims that he became a photographer because he didn't think he could succeed as a painter, not being a good enough draftsman. "But it doesn't really matter," he says, "because I don't think photography is a medium by itself. All the plastic, visual arts are one medium. If you want to talk about a different medium, then you mean music or poetry or theatre. Photography is a way to do art." In fact, now that he is teaching photography at two schools, including Israel's most prestigious art academy, the Bezalel Art Institute, where he became an instructor immediately upon graduation, he has also returned to art school as a student. "I'm going to continue photographing, but I don't want to stay in the ghetto of photography. It's a mistake too many photographers make. Photography is a part, and I want to learn about the whole."

Shemtov is currently working on four photographic projects. Two of them, one in black-and-white and one in color, are documentary—"it's photography's truest and most important vocation"—and two are personal expression. But he is quick to point out, "I'm not a social artist with something to say. I want to express myself, and that's more important to me than communication. It's easy to do a good photograph, even boring. I want to be surprised. It's what I ask of other people's work and what I want from my own. I like it when I do things I haven't seen before. I want always to advance, and I need theory to do that. I have to think about the issues all the time in order to grow. Personal expression without concept behind it doesn't give me enough. But don't ask me to explain a photograph. I used to be able to, but I can't anymore, and I don't want to."

Shemtov's views are like his photographs. Both reveal that he offers his strong visual talent to the service of paradox and challenge, for they are the wellsprings of his energy and development and the

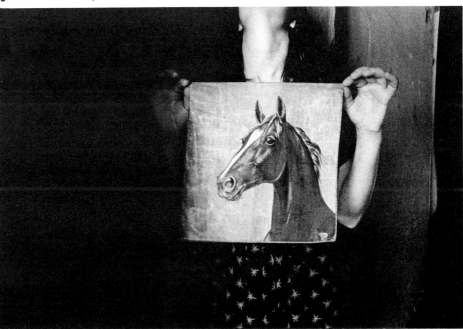

true object of his devotion. His photographs are essentially questions he is asking about physical reality. In all his photographic modalities, from documentary to blatant *mise-en-scene*, he is a mystic to whom the world is less important than what it may reveal.

—Bonnie Boxer

SHINOYAMA, Kishin.

Japanese. Born in Tokyo, 3 December 1930. Studied photography at Nihon University, Tokyo, 1961-63. Married Akemi Shinoyama in 1979; child: Naonori. Photographer, Light Publicity Company, Tokyo, 1961-68. Freelance photographer, Tokyo, since 1968. Recipient: New Photographer Prize, Japan Photo Critics Association, 1966; Photographer of the Year Award, Japan Photographic Society, 1970; New Talent Award, Japan Art Academy and Ministry of Education, Tokyo, 1973; Annual Prize, Kodansha Publishing Company, Tokyo, 1973. Address: 6-3-6 Roppongi, Minato-ku, Tokyo 106, Japan.

Individual Exhibitions:

1968 *The Birth*, Ginza Salon, Tokyo
1970 *Nudes*, Ginza Matsuzakaya Department Store, Tokyo
1972 *Kabuki Theater: Tamasaburo*, Daimaru Department Store, Tokyo
1973 *Iramours 106*, Daimaru Department Store, Tokyo
1976 *House*, Odakyu Department Store, Tokyo (travelled to the *Biennale*, Venice, and the Galerie Municipale du Chateau d'Eau, Toulouse, France)
 Arabia, Mitsukoshi Department Store, Tokyo
1977 *The Universe of Tamasaburo*, Seibu Department Store, Tokyo
 Momoe Yamaguchi, Ao Gallery, Tokyo (with Hajime Sawatori)
1979 *Dai Geki-Sha*, Seibu Department Store, Tokyo
1980 *Momoe Yamaguchi, The Actress*, Seibu Department Store, Tokyo
1981 *Silk Road: China*, Seibu Department Store, Tokyo

Selected Group Exhibitions:

1970 *Photokina*, Cologne
1975 *Rencontres Internationales de la Photographie*, Arles, France
1977 *Neue Fotografie aus Japan*, Kulturhaus, Graz, Austria (travelled to the Museum des 20. Jahrhunderts, Vienna)
1979 *Japanese Photography Today and Its Origin*, Galleria d'Arte Moderna, Bologna (travelled to the Palazzo Reale, Milan; Palais des Beaux-Arts Brussels; and Institute of Contemporary Arts, London)
 Japan: A Self-Portrait, International Center of Photography, New York

Collections:

Museum of Modern Art, New York.

Kishin Shinoyama: *Tattoo*, 1971

Publications:

By SHINOYAMA: books—*Kishin Shinoyama and 28 Girls*, Tokyo 1968; *Nudes*, Tokyo 1970; *The World of Kishin Shinoyama*, Tokyo 1970; *Olele Olala (Carnival of Brazil)*, Tokyo 1971; *Kabuki Oyama (Male Actress) Tamasaburo*, Tokyo 1972; *Hi, Marie*, Tokyo 1972; *Iramours 106*, Tokyo 1973; *A Fine Day*, Tokyo 1975; *Meaning of the House*, Tokyo 1975; *Paris*, Tokyo 1977; *Tamasaburo*, Tokyo 1978; *135 Girl Friends*, Tokyo 1979; *Venice*, Tokyo 1980; *Momoe Yamaguchi*, Tokyo 1980; *Silk Road*, Tokyo 1981.

On SHINOYAMA: books—*4 Meister der Erotischen Fotografie* by Alain Robbe-Grillet and Yukio Mishima and others, Munich 1970; *Neue Fotografie aus Japan*, exhibition catalogue, by Otto Breicha, Ben Watanabe and John Szarkowski, Graz and Vienna 1977; *Japan: A Self-Portrait*, exhibition catalogue, by Shoji Yamagishi, Cornell Capa and Taeko Tomioka, New York 1979; *Japanese Photography Today and Its Origin* by Attilio Colombo and Isabella Doniselli, Bologna 1979; articles—"Kishin Shinoyama" in *Camera* (Lucerne), April 1969; "Madchen: 3 Meister der Erotischen Fotografie" in *Film und Foto Prisma* (Munich), September 1970; "Kishin Shinoyama: Women as Design" in *Modern Photography Annual*, New York 1971; "4 Masters of Erotic Photography" by G.S. Whittet in *Art and Artists* (London), August 1971; "Shinoyama" in *Photo* (Paris), January 1972; "Kishin Shinoyama" in *Asahi Camera* (Tokyo), May 1972; "Un Couple et l'Enchanteur Shinoyama" in *Photo* (Paris), May 1972; "Kishin Shinoyama: Maria's Seven Days in Molokai" in *Asahi Camera* (Tokyo), October 1972;

"A Dazzling Slide Show" in *Photography Year 1976*, by the Time-Life editors, New York 1976.

Naturally, a photographer cannot see the world after his death or before his birth. Therefore, I want to gaze at the period in which I live, and to record it.

—Kishin Shinoyama

The popular success of Kishin Shinoyama in Japan goes beyond recognition as a photographer of diverse talent to that of celebrity. Shinoyama is both the exponent and product of a photographic market that has exploded on the wave of the flamboyant commercialism of Japanese economic prosperity. He is a household name; his face frequents the T.V. commercial or the illuminated billboard. His reputation has been sustained by a prolific output of work as well as by his enormous variety of style and subject.

He came from a background in advertising. His first work was published in *Camera Mainichi* in 1966, including the series "Dancer." In the same year he was awarded the New Photographer Prize by the Photo Critics Association for the "Sisters of Vajra." His first exhibition, *The Birth*, was held in the Nikon Salon in 1968. By 1970 his reputation as a photographer of nudes was established with an exhibition in the Ginza and the publication of his first two books by Mainichi. His early work also included a series on tattoos, executed in the style of Ukiyo-e prints. As opposed to the commercial style of much of his nude work, such as the "Twin" series, the tattoo studies are evidence of a curious exploration of the strange survival of an Edo aesthetic. The photographs are intimate and uncontrived portraits of a Tokyo subculture.

In September 1970 Shinoyama photographed Yukio Mishima only two months before the writer's suicide. The series was to be called "Death of a Man" and was intended for publication in a magazine called *Blood and Roses*. Shinoyama did not release the series, though several of the pictures later appeared in the *Sunday Times Magazine* in London. The series constituted a morbid theatre under the direction of the writer. Shinoyama unknowingly staged a dress-rehearsal for the writer's death, including the famous portrait of Mishima enacting the martyrdom of Saint Sebastian after Guido Reni. Two years later Shinoyama exhibited and published another theatrical series of studies of the Kabuki actor Tamasaburo.

Shinoyama has travelled widely, publishing work from the Middle East, Brazil, Paris and Australia, where he worked for Qantas. His most outstanding achievement is the large and ambitious series on the Japanese house, exhibited in Tokyo and at the Venice *Biennale* in 1976. Here he used large format colour to produce studies of the Japanese domestic environment in total contrast to normal architectural photography. While exploring the spaces of Japanese interiors, he has included all the details of daily life and juxtaposed traditional arrangements with the mundane utensils of modern Japan. He has not photographed houses as models of design, but as revealing statements of their inhabitants.

Kishin Shinoyama's output is both enormous and unpredictable.

—Mark Holborn

See Color Plates

SHIRAKAWA, Yoshikazu.

Japanese. Born in Kawanoe City, Ehime Prefecture, 28 January 1935. Educated at Kawanoe High School, 1950-53; studied photography at Nihon University College of Art, Tokyo, 1955-57. Married Kazuko Miyamoto in 1964; daughter: Eri. Literature and Arts Program Producer, Nippon Broadcasting System, Tokyo, 1957-58; Chief Cameraman, Fuji Telecasting Company, Tokyo, 1958-60. Freelance photographer, Tokyo, since 1960. Lecturer, Nihon Photography School, Tokyo, 1960, and Japan Photographic Academy, Tokyo, 1967; Chief Instructor and Chairman of the Board of Directors, Kanto Photo Technique Academy, Tokyo, 1974. Recipient: Japanese Ministry of Health and Welfare Award, 6 times, 1956-61; Special Prize, National Park Photo Contest, Tokyo, 1960; First Prize, *Nika Exhibition*, Tokyo, 1968; Annual Award, Japan Professional Photographers Society, 1970; Art Prize, Mainichi Newspapers, Tokyo, 1972; Ministry of Education Award, 22nd Fine Art Grand Prix, 1972; Photographer of the Year Award, American Society of Magazine Photographers, 1981. Agent: The Image Bank, Orion Service and Trading Co. Inc., 55-1 Kanda-Jimbocho, Chiyoda-ku, Tokyo 101. Address: 2-12-15 Takanawa, Minato-tu, Tokyo 108, Japan.

Individual Exhibitions:

1957 *Landscapes*, Konishiroku Gallery, Tokyo

1969 *Mountains*, Tokyu Department Store, Tokyo
1970 Nikon Salon, Tokyo (commemorating Japan Professional Photographers Society Annual Award)
1971 *The Seat of the Gods*, Odakyu Department Store, Tokyo (toured Japan)
1975 *Eternal America*, Odakyu Department Store, Tokyo (toured Japan and the United States)
1979 *The Land of the Bible*, Odakyu Department Store, Tokyo (toured Japan)
1981 *The World of Yoshikazu Shirakawa*, Nikon House, New York (toured Japan)

Selected Group Exhibitions:

1968 *Nika Exhibition*, Tokyo
1975 *The Land: 20th Century Landscape Photographs Selected by Bill Brandt*, Victoria and Albert Museum, London (travelled to the National Gallery, Edinburgh; Ulster Museum, Belfast; and National Museum of Wales, Cardiff, 1976)
1979 *Japanese Photography Today and Its Origin*, Galleria d'Arte Moderna, Bologna, Italy (travelled to the Palazzo Reale, Milan; Palais des Beaux-Arts, Brussels; and the Institute of Contemporary Arts, London)

Collections:

Victoria and Albert Museum, London; Museo de Arte Moderno, Mexico City.

Publications:

By SHIRAKAWA: technical books—*Cameras and How to Use Them*, Tokyo 1956; *Exposure and Its Determination*, Tokyo 1957; books of photographs—*White Mountains*, Tokyo 1960; *The Alps*, with text by Jeen Kruuse and Max A. Wyss, Tokyo 1969, Lucerne, Frankfurt and London 1973; *Mountains*, Tokyo 1971; *The Himalayas*, with text by Arnold Toynbee and others, Tokyo 1971, New York 1973; *The Seat of the Gods*, Tokyo 1971; *Mountain Photography*, Tokyo 1973; *Eternal America*, with text by Fred M. Paccard, Tokyo 1975, New York 1976; *The Land of the New Testament*, with text by Asajiro Satowaki, Tokyo 1979; *The Life of Jesus Christ*, Tokyo 1980; *The Land of the Old Testament*, with text by Virgil Gheorghui, Tokyo 1980.

On SHIRAKAWA: books—*The Land: 20th Century Landscape Photographs Selected by Bill Brandt*, exhibition catalogue, edited by Mark Haworth-Booth, London 1975; *Japanese Photography Today and Its Origin*, exhibition catalogue, by Attilio Colombo and Isabella Doniselli, Bologna, Italy 1979; articles—"Yoshikazu Shirakawa: Himalayas" in *Camera* (Lucerne), July 1972; "Alps" in *The Observer Magazine* (London), 18 November 1973; "Himalayas" by Edward Hoagland in the *New York Times*, 2 December 1973; "The Majesty of 'House of Snow'" by Edmund Fuller in the *Wall Street Journal* (New York), 5 December 1973; "The Himalayas" in the *Washington Post*, 9 December 1973; "From Snow Peaks" in *Time* (New York), 17 December 1973; "Himalayas" in *Newsweek* (New York), 17 December 1973; "Yoshikazu Shirakawa" in *Camera Mainichi* (Tokyo), February 1974; "Shirakawa Reaches the Peak" by R. Bradbury in the *Los Angeles Times*, 8 December 1974.

22 years ago, in 1959, I took a leave of absence from the television station where I was working to make my first trip around the world. During the trip I stopped in Switzerland and saw the Matterhorn. It changed my life. On the surface of the lake, like a mirror, there was a red symmetrical reflection of the mountain at sunrise, and the sky was a beautiful golden color. It was like an image of the Buddhist world of "higan." After I returned to Japan, I immediately left the TV station and returned to the Alps. Since then, I have photographed the Alps on and off for 8 years.

I was in a different world when I saw the sunrise over the Monch and Wetterhorn; the sunset over the Mont Blanc mountains and the scenery surrounding them were so beautiful that I felt faint, I was so moved. Each day I became more deeply moved. What impressed me was the beauty and the greatness of the earth on which we live. I dreamed of showing that emotion to all the people in the world through my photography. It was the start of the series "Rediscovery of the Earth."

Then, in 1967, I began to photograph the Himalayas from Bhutan in the East to Afghanistan in the West. I spent 4 years travelling almost 3,000 kilometers along these gigantic mountains across 7 countries. There were 14 mountain peaks of 8,000m (24,000 feet), more than 300 peaks of 7,000m (21,000 feet), and there were so many 6,000m mountains (18,000 feet) that it was impossible to count the exact number of them. A huge chain of mountains, completely separated from the world of men. During my travels, sometimes I became sick from the high altitude and lost consciousness. Other times, I was locked in the snow. For a week I was without food and almost died of hunger. But I made up my mind to escape from death. I walked and walked for two days and nights in the deep, threatening snow. It was not a few times that I thought I was going to die. I experienced the knowledge that one's life is very small within the vastness of the universe. It was in the Himalayas that I realized I believed in God.

I started shooting in America in 1971. I wanted to photograph the world of God there. I wanted to photograph God's world in places where people lived, not separated from the world of man. I thought of doing that because I wondered what our ancestors saw when they first started living on this planet Earth. I believe that they did not see the desert of Death Valley, the Grand Canyon or Mt. McKinley only as material. I believe that they saw Nature and the universe behind Nature; I believe they saw the existence of the great spirit and they respected it. When they felt reverence for that spirit, then they were not apes but men. And it made them develop spiritually. That realization of the great spirit in the universe was the one and only absolute reason for mankind to have become what we are now. Therefore, I excluded from my pictures of the American landscape all men and man-made objects such as roads, dams, homes, etc., in order to pursue the nature that our ancestors (apes) had when they started living here 1,800,000 years ago. It was my effort to find some way to recover the essence of our humanity.

Some may say that people of our age have already lost these pure feelings towards Nature and the universe. However, as far as we are human beings, it exists in the depths of our hearts. If not, and if men are mere physical beings, then words like "dignity" and "rights" have no meaning. And, when I came to feel that way, there was only one straight way to go further—the Bible.

In 1977 I started working toward visualizing the words of God. I spent three years visiting 251 holy places in 14 countries to put into images the important sayings of the Old and New Testament, including my own favorite chapter and verse. In the Old Testament, Genesis starts with the following: "In the Beginning, God created heaven and earth. And the earth was without form and void, and darkness was upon the face of the deep. And the spirit of God moved upon the face of the waters." My book also starts with a picture that says the same words. However, I had days of anxiety because the actual Holy Land is a wilderness of scattered pebbles. It was far from photogenic, yet I had to take pictures that

expressed images at the time of the Bible; otherwise, my photography would have lost its meaning. (Photographing the Alps and the Himalayas was less difficult in this respect, as I tried to photograph them just as they are.)

In the case of Jerusalem, for example, pictures of a beautiful Jerusalem would not be enough; they would also have to depict a Jerusalem of blood and war, because after the death of Christ, that city was invaded and destroyed by enemies more than 10 times. Another example: in order to recapture the natural calamities that occurred on the death of Christ, as recorded in the Bible, I climbed to the top of Mount Olive about 50 times to photograph lightning striking the land.

Have there been other times when people talked about the necessity of recovering human nature as we do today? Do we talk about it more now because we have lost the holy spirit? Destruction of spiritual values is surely one of today's greatest problems. If my photography has helped make people think of these spiritual values and has caused even one person to reflect on God as a result of seeing my pictures of the world of the Bible, then my efforts were not meaningless. "To recover human nature by rediscovering the earth"—that is my ideology, and that is the foundation of my photography. The important thing for mankind now is not progress in science but the recovery of humanity—the renaissance of the human spirit. It is my task to think about what human beings are, what it means to live, and to share those thoughts with others.

—Yoshikazu Shirakawa

Yoshikazu Shirakawa injects an intense personality into his portrayal of the severe and stern side of nature. He bases his work on two themes: the rediscovery of the earth and the rejuvenation of humanism.

Shirakawa's works precisely record nature's grandeur and its torturous side in a noble yet mystical approach. He attempts to capture the most minute details, beyond the usual range of human vision.

—Norihiko Matsumoto

See Color Plates

SHISHKIN, Arkadii (Vasilyevich).

Russian. Born in Kukarka, Vyatka, now Kirov, 6 February 1899. Educated at primary school in Kukarka, 1906-10; studied with the portrait photographer Nikolai Richter, Kazan, 1910-11. Served as a volunteer with the Red Army, 1918-22, as a war correspondent and ordinary soldier, 1941-43, and as a photographer for the political department of the 174th Riflemen's Division of the Red Army, 1943-45. Worked as an apprentice photo-printer, Petrograd, 1912-13; photo-printer, Petrograd, 1913-16; independent photographer, establishing own photo studio, Ekaterinburg, now Sverdlovsk, 1917-18; freelance magazine photographer, working for the local press, Vyatka, 1923-25; Photo-Reporter, *Krestianskaia Gazeta* (*Peasant Newspaper*), Moscow, 1925-39; Picture Editor, *Krestianka* (*Peasant Woman*) magazine, Moscow, from 1945. Recipient: Second Prize, *Color Photography* exhibition, Moscow, 1954; First Prize, *The 7th Five Year Plan in Action* exhibition, Moscow, 1960; First Prize, *International Competition for a Socialist Photo-Art* exhibition, East Berlin, 1964; Silver Medal, *50 Years of the Great October* exhibition, Moscow, 1967. Address: c/o Novosti Press Agency, 2 Pushkin Place, Moscow, U.S.S.R.

Individual Exhibitions:

1963 *Arkadii Shishkin 1923-1963*, Moscow (retrospective)
1964 *40 Creative Years*, Minsk
1967 *50 Years of the Soviet Countryside*, Kirov
1969 *Jubilee Exhibition: 70th Birthday*, Moscow
 A Photo-Chronicle of the Soviet Countryside, Tambov
1971 *Photo-Work by S.A. Lobovikov and A. Shishkin*, Moscow

Selected Group Exhibitions:

1935 *Works by Moscow Photo-Masters*, Moscow
1937 *All-Union Exhibition of Photo-Art*, Moscow
1954 *Color Photography*, Moscow
1956 *Works by Moscow Photo-Reporters*, Moscow
1958 *Soviet Photography after 40 Years*, Manezhnaya Gallery, Moscow
1960 *The 7th Five Year Plan in Action*, Moscow
 International Photo-Exhibition, Toronto (toured Europe and travelled to Hong Kong)
1964 *International Competition for a Socialist Photo-Art*, East Berlin
1967 *50 Years of the Great October*, Moscow
1977 *Interpressphoto*, Moscow

Collections:

Novosti Press Agency, Moscow.

Publications:

On SHISHKIN: books—*Arkadiis Shishkin* by Anatolii Fomin, Moscow 1979; *Sowetische Fotografen 1917-1940*, edited by S. Morosov, A. Vartanov, G. Chulakov, O. Suslova and L. Uchtomskaya, Leipzig and Berlin 1980; *Die Sojetunion Zwischen den Kriegen 1917-1941*, edited by Daniela Mrázková and Vladimír Remeš, Oldenburg, West Germany 1981.

Arkadii Shishkin is one of the Soviet Union's outstanding documentary photographers of agricultural life, and his career encompasses the entire history of the Soviet countryside. Of particular interest are

Arkadii Shiskin: *The First Woman Tractor Driver*, 1930

Shishkin's records of the various stages of Soviet farming—the introduction of American and then Soviet tractors in the 1920's-30's, the decision "to join or not to join" the state and collective farms as the collectivization program began in 1929, the role of the new Soviet woman on the farm, the development of huge state farms such as "Giant," and the exploits of the various shock-workers who, allegedly, have made records in production and yield. Born in a small village, Shishkin—like his fellow countrymen, the painters Ivan Shishkin (no relation) and Apollinarii and Viktor Vasnetsov—knew the countryside from his earliest childhood, and his photographs betray a deep, psychological understanding of the peasant, the village, the land, the animals.

Although Shishkin did not experiment with the formal devices of the camera, except for a few diagonal compositions and ground level perspectives in the 1920's (e.g., "Collective Sowing in the Crimea," 1933 and "The 'Rusko' Commune," 1931), his photographs are exciting, vivid and appealing. Shishkin was interested in documenting Soviet life. Indeed, the public for whom he created his photographs— the peasants—especially in the 1920s and 1930s— demanded images that were simple, readable and "relevant," and Shishkin did not disappoint them. That is why Shishkin scored an immediate and lasting success as a press photographer for the popular *Krestianskaia gazeta* [Peasant Newspaper], which he joined in 1925, and for other journals such as *Krestiana* [Peasant Woman]. His individual photographs such as "The First Woman Tractor Drivers" (accompanying photo) and his photographic series such as "Collective Farm Workers—Heroes of the Soviet Union" are clear demonstrations of his commitment.

Shishkin enlisted as a common soldier in 1941, and he stayed at the front until the end of the War. In 1943 he was appointed photographer for the Political Section of the Staff of the 174th Riflemen's Division. But, unfortunately, Shishkin's war photographs were practically all destroyed during action and only a handful survive (e.g., "Victory Has Come!" 1945).

—John E. Bowlt

SHORE, Stephen.

American. Born in New York City, 8 October 1947. Mainly self-taught in photography, but studied under Minor White, Hotchkiss Workshop, 1970. Married Ginger Cramer in 1980. Photographer since 1953. Recipient: National Endowment for the Arts Grant, 1974, 1979; Guggenheim Fellowship, 1975; Special Fellowship, American Academy, Rome, 1980. Agent: Light Gallery, 724 Fifth Avenue, New York, New York 10019. Address: 5075 Jackson Creek Road, Bozeman, Montana 59715, U.S.A.

Individual Exhibitions:

1971 Metropolitan Museum of Art, New York
1972 Light Gallery, New York
 Thomas Gibson Fine Arts, London
1973 Light Gallery, New York
1975 Light Gallery, New York
 Phoenix Gallery, San Francisco
 Galerie Schürmann und Kicken, Aachen, West Germany
1976 Museum of Modern Art, New York
 Aaron Siskind/Harry Callahan/Stephen

Shore, Silver Image Gallery, Tacoma, Washington
 National Collection of Fine Arts, Washington, D.C.
1977 Delahunty Gallery, Dallas
 Worcester Art Museum, Massachusetts (with Nicholas Nixon)
 Galerie Schürmann und Kicken, Aachen, West Germany
 Kunsthalle, Dusseldorf
 Light Gallery, New York
1978 Galerie Gundlach, Hamburg
 Light Gallery, New York
 University of Akron, Ohio
 Galerie Gillespie-De Laage, Paris
 Photogalerie Lange-Irschl, Munich
 Robert Miller Gallery, New York
 Vision Gallery, Boston
1979 La Photogaleria, Madrid
 Ewing Gallery, Washington, D.C.
 Susan Spiritus Gallery, Newport Beach, California
1980 Light Gallery, New York
 Light Gallery, Los Angeles
 Werkstatt für Photographie, West Berlin
 Catskill Center for Photography, Woodstock, New York
 Eloquent Light Gallery, Rochester, Michigan
1982 *Photographs 1974-1981*, Fraenkel Gallery, San Francisco

Selected Group Exhibitions:

1973 *Landscape/Cityscape*, Metropolitan Museum of Art, New York
1974 *Art Now '74*, Kennedy Center for the Performing Arts, Washington, D.C.
1975 *New Topographics*, International Museum of Photography, George Eastman House, Rochester, New York (travelled to the Otis Art Institute, Los Angeles, and the Princeton University Art Museum, New Jersey, 1976)
1976 *100 Master Photographs from MOMA*, Baltimore Museum of Art (toured the United States)

Stephen Shore: *Presidio, Texas* (original in color), 1975

1977 *Documenta 6*, Kassel, West Germany
 Court House: A Photographic Document, Art Institute of Chicago (toured the United States, 1978-79)
1978 *Mirrors and Windows: American Photography since 1960*, Museum of Modern Art, New York (toured the United States, 1978-80)
1979 *American Photography in the 70's*, Art Institute of Chicago
 American Images: New Work by 20 Contemporary Photographers, Corcoran Gallery, Washington, D.C. (travelled to the International Center of Photography, New York, and Museum of Fine Arts, Houston)
1980 *Color Works*, Kunsthaus, Zurich

Collections:

Metropolitan Museum of Art, New York; Museum of Modern Art, New York; International Museum of Photography, George Eastman House, Rochester, New York; Museum of Fine Arts, Boston; Library of Congress, Washington, D.C.; Art Institute of Chicago; Center for Creative Photography, University of Arizona, Tucson; Stedelijk Museum, Amsterdam; Neue Sammlung, Munich; Australian National Gallery, Canberra.

Publications:

By SHORE: books—*Andy Warhol*, Boston and Stockholm 1968; *The City*, New York 1971; *12 Photographs*, portfolio, New York 1976; articles— "Stephen Shore" in *Camera* (Lucerne), January 1976; article in *Quest/77* (New York), May 1977.

On SHORE: books—*Photography Year 1977* by the Time-Life editors, New York 1977; *Mirrors and Windows: American Photography since 1960*, exhibition catalogue, by John Szarkowski, New York 1978; *Court House: A Photographic Document*, edited by Richard Pare, New York 1978; *American Images* by Renato Danese, New York 1979; articles—"Photography: The Coming of Age of Color"

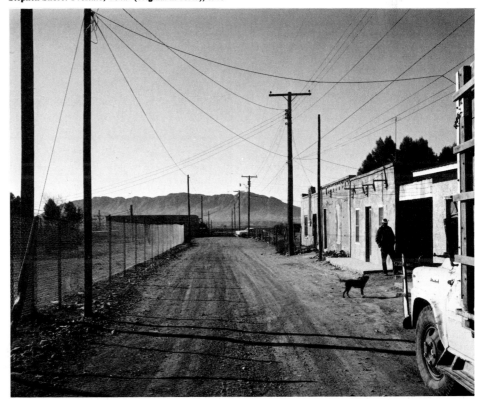

by Max Kozloff in *Artforum* (New York), January 1975; "Route 66 Revisitied" by Carter Ratcliff in *Art in America* (New York), January 1976; "New Frontiers in Color" by Douglas Davis in *Newsweek* (New York), 19 April 1976; "Color Photography" by Carol Squires in *Artforum* (New York), November 1978; "The Framing of Stephen Shore" by Tony Hiss in *American Photographer* (New York), February 1979.

Stephen Shore's photographs are often described in terms of what they do not contain. In his travels through small-town America, he presents a cross-sectional view of the country that is mutely straightforward. As much an anthropologist as an artist, Shore seems to eschew the quirks of individual identity that, in the past, have attracted the photographer's attention. In his empty, nearly desolate scenes, we find no trace of an obvious esthetic, sociological, or psychological theme. What attitude we can detect is one of ambivalence. Shore has been criticized for the banality of his subject matter and his detachment from and seeming boredom with it, but such a criticism does not account for the refinement and beauty of the prints themselves.

Szarkowski noted in his introduction to *William Eggleston's Guide* that "today's most radical and suggestive color photography derives much of its vigor from commonplace models." In Shore's photographs, the reverse may be true; that the commonplace derives its vigor from the clear, elegant color Shore achieves. In any case, the color sets Shore apart from his contemporaries loosely grouped together by the show and catalogue *New Topographics*, which included, among others, Joe Deal, Lewis Baltz, Henry Wessel, and Robert Adams. Similarities in the group have been noted in the tension between the photographers' sophisticated picture-making skills and the urban wasteland to which they apply them. Shore's approach differs, however, in his careful avoidance of any trace of social commentary.

This difference between the quality of vision and the banality of subject matter has inspired a comparison between Shore's photographs and Photo-Realist painting, but there is, it seems to me, a crucial difference between the Photo-Realists' uninflected painting of shiny, reflective, often dazzling modern urban surfaces, such as chrome, steel, and glass, and Shore's tasteful treatment of the mundane. Furthermore, whereas both use the vocabulary of the American vernacular, the Photo-Realists's use derives from Pop art and from reproduced, commercial imagery—that is, photographs. Shore's use of vernacular imagery owes a debt to Walker Evans.

Like Evans, Shore searches for the flattest possible statement; his reticence results in an austere casualness and a deadpan beauty. Like Evans, he photographs the structures and artifacts of middle class America in a clear, direct light, but his interest is evidently not in the implied humanism of the scenes, but simply in how they look. Garry Winogrand's famous dictum—"I photograph in order to see what something will look like on film"—is more plausible when applied to Shore's photographs. His use of color and the 8 x 10 camera does seem to bring to the most inert scene a measure of dignity and an artistic authority. Shore's presence behind the camera is both powerful and entirely unobtrusive.

—Dana Asbury

SIEFF, Jeanloup.

French. Born in Paris, 30 November 1933. Educated at the Lycée Chaptal, Paris, 1945-52; Lycée Decours, Paris, 1953; studied photography at the Vaugirard Photographic School, Paris, 1953, and at the Photography School, Vevey, Switzerland, 1954. Served in the Colonial Artillery of the French Army, in Paris, 1958. Married Barbara Williams in 1979; daughter: Sonia. Professional photographer, Paris, since 1954: Fashion Photographer, *Elle* magazine, Paris, 1955-58; photographer with Magnum Photos co-operative photo agency, Paris, 1959-60; freelance photographer, working with *Harper's Bazaar*, *Esquire*, *Vogue*, etc., Paris and New York, since 1961; established permanent studio in the rue Ampere, Paris, 1967. Recipient: Prix Niépce, 1959; Silver Medal, Art Directors Club, London, 1967; Gold Medal, Museum Espiritu Santo, Brazil, 1968; Gold Medal, *Zadar Exhibition*, Yugoslavia, 1969; Gold Medal, Museum of Modern Art, Skopje, Yugoslavia, 1971; Silver Medal, *Advertising Film Festival*, Cannes, 1975. Agents: Galerie Agathe Gaillard, 3 rue Pont Louis-Philippe, 75004 Paris, France; Galerie Fiolet, Herrengracht 86, Amsterdam, Netherlands; and The Photographers' Gallery, 8 Great Newport Street, London WC2, England. Address: 87 rue Ampere, 75017 Paris, France.

Individual Exhibitions:

1967 Kodak Gallery, London
1969 Galerie La Demeure, Paris (retrospective)
1970 Maison de la Culture, Amiens (toured France)
1971 Underground Gallery, New York (retrospective)

 Modern Art Academy, Ghent (retrospective)

Jeanloup Sieff: *Nude in an Empty Room*, 1980

1972 *Sad Landscapes and Lazy Nudes*, Nikon Gallery, Paris
1973 Philosophers' Gallery, Geneva (retrospective)
 Nikon Gallery, Tokyo (retrospective)
1974 Centre Culturel, Toulousse
 Spectrum Gallery, Barcelona
1975 Canon Photo Gallery, Amsterdam
 Silver Image Gallery, Tacoma, Washington
 20 Years, Oh Nicéphore!, FNAC Galerie, Paris
1976 Pentax Gallery, Tokyo (retrospective)
 Aspects Galerie, Brussels (retrospective)
 Galerie Jean Dieuzaide, Toulouse (retrospective)
 Portraits of 43 Ladies, Galerie Agathe Gaillard, Paris
 Foster White Gallery, Seattle (retrospective)
1977 Galerie Paula Pia, Antwerp (retrospective)
1978 *Death Valley*, Galerie La Hune, Paris (travelled to the Portfolio Gallery, Lausanne; Galerie Voir, Toulouse; and Sunprint Gallery, Madison, Wisconsin)
1979 Galerie Fiolet, Amsterdam
1981 *Jean-Pierre Sudre/Jeanloup Sieff*, Musée d'Orange, France
 Galerie Suzanne Kupfer, Nidau-Bienne, Switzerland

Selected Group Exhibitions:

1966 *Fashion Photography*, at *Photokina*, Cologne
1971 *Salon National de la Photographie*, Paris
1972 *Salon International*, Warsaw
 French Photography, Moscow
1973 *Confrontation 1973*, University of Dijon, France
1975 *Photo Festival*, Harze, Belgium
1977 *Fashion Photography*, International Museum of Photography, Rochester, New York (travelled to Brooklyn Museum, New York; San Francisco Museum of Modern Art, California; Cincinnati Art Institute, Ohio; Museum of Fine Arts, St. Petersburg, Florida)
1979 *French Fashion Photography*, Galerie Zabriskie, Paris
1980 *French Photographers*, University of Oklahoma, Norman

Collections:

Bibliothèque Nationale, Paris; Musée Réattu, Arles, France; Musée de Toulon.

Publications:

By SIEFF: books—*La Danse*, Lausanne 1961; *Jeanloup Sieff*, portfolio, Ghent 1971; *La Photo*, with Chenz, Paris 1976; *Erotic Photography*, London 1977; *Death Valley*, Paris 1978; *Best Nudes*, Tokyo 1980; article—"A Bâtons Rompus" in *Zoom* (Paris), December 1979.

On SIEFF: books—*The Magic Image* by Cecil Beaton and Gail Buckland, London and Boston 1975; *The History of Fashion Photography* by Nancy Hall-Duncan, New York 1979. *Clefs et Serrures* by Michel Tournier, Paris 1979; articles—"Young Photographers" by Romeo Martinez in *Camera* (Lucerne), June 1958; "Jeanloup Sieff: Death Valley Days" in *American Photographer* (New York), September 1979; "Jeanloup Sieff: Fashion" by Gabriel Bauret in *Zoom* (Paris), 1980.

Today I am 46 and my daughter is two months old. This is probably not a world-shaking occasion, but these little events fill the passing days and, like photographs, serve as reminders. They are like so many small whitestones helping us, according to our mood, rediscover feelings and forgotten faces.

I have been taking photographs for more than 30 years, but I have the curious feeling that I have only just finished an introductory apprenticeship which allows me now, at last, to get on with more serious matters—as if the past, and its thousands of images, have been only a sort of prelude.

For years I have been thinking about a "summing-up" book, one that will perhaps free me from the past. I have gone over and over its title—*Portraits of Seated Ladies, of Sad Landscapes and Indolently Weary Nudes, with Certain Selected Moments and Accompanied by Texts Having No Connection with the Images*, and as this will displease a lot of people I shall certainly keep it as it is. I have even signed a contract with an editor, but months and years have gone by and it is still not finished, hardly begun; perhaps I shall never do it. So when I was offered these pages in *Zoom* I said to myself that it would be a good opportunity to dive in and try, with a selection of a dozen or so images, to produce a kind of sketch of what the book might be.

But to choose 15 photographs out of 200 is a difficult and dangerous task. Why choose one image rather than another? Because of its plastic quality? Because of the memory that it evokes? Because one was happy on the day one made it, or in love with the person it portrays? I really don't know.

So the choice, like all choices, was laborious. All photography is a moment, of oneself and of others, of things and of the world; it is, at one and the same time, the eternalizing of an emotion and its erosion, a perfume that fades or, on the contrary, is strengthened by passing time.

Everyone imbues an image with his own substance—yet, one can share nothing, or very little, of one's deepest feelings. If one thinks otherwise, that is only a misunderstanding, like love, which sometimes lasts a long time and is called happiness. So why show one's work, publish, write books? Perhaps for the same reason that one, sometimes, spontaneously talks to a stranger: it is sometimes thanks to someone else that one comes to an understanding of oneself.

Taking photographs is a strange occupation: daring to want to stop time, to capture for oneself moments in life and things past, an absurd revenge on death to try to preserve, so that they outlive us, a loved face or a pleasant landscape.

The other evening there was a program on television dedicated to Gérard Philipe. His daughter, who had not known him, tried to discover him through his films, old photographs, and the memories of those who had worked with him. All the old actors and wrinkled directors were consoling her for a sadness she did not feel by telling her how marvellous it was that her father had died young, a man who had personified youth itself. As if it were not possible to be and to have been, and as if death were the greatest gift to over-provocative youth. A touching if necessary naiveté to think of life as fixed forever by a photographic representation. One perceives only the appearance; there remains only a beautiful butterfly pinned forever in its case—but where is its flight and the summer scents that enveloped it?

A photograph is only a clue. As Marcel Duchamp said, The spectator is the co-author of every work through the experience he brings with him from his own life. My photographs hardly belong to me any more; they live their own lives, good or bad they have grown up, so perhaps if I put them in this book I shall free myself of them altogether! My daughter Sonia will also leave me when she grows up, but I hope that we shall stay friends.

Robert Doisneau came a little while ago to give me his new book. Two splendid gifts, his book and his visit. He didn't know that it was my birthday, but he must have suspected something. No sooner had he arrived than he was already gone, shy, smiling, not wanting to disturb. I spent two hours reading and keeping company with him through his book.

Thanks to him I am in a good mood; thanks to him I again want to do something. It is impossible to talk about Robert Doisneau: words are clumsy compared to his light-heartedness; jokes are boorish faced with his humour; and, as for his talent, it is so conspicuous that I dare hardly write the word and I can already see his eyes creasing with laughter!

Trois secondes d'éternité is the title of his book, and whoever doesn't possess it will no longer deserve to be greeted!

—Jeanloup Sieff (from *Zoom*, December 1979)

Jeanloup Sieff is two persons at once: he conceals (quite well) the flame of an inner life rich in emotion and sensuous response behind a screen of measured coldness or surrealist humor. His pictures are like himself: they seem to confess only with regret the feelings from which they were born: a nude model appears from behind, transfixed or simulating an escape; the savage magnitude of Death Valley is demythologized by a foreground where we see a stupid bit of technology, the dashboard of the car of the travelling photographer; the poetry of an almost pictorial composition is denied by a falsely fortuitous presence—a cat passing by, for example; or, the potential lyricism of a shot is undercut by the strict documentary style of the print. Moreover, the man abounds in ambiguities. He is a lover of photography who in his youth slept with his camera, who now (unsuccessfully) discredits himself and his work by announcing that it is merely "the means to make a living"; he is a pretend-prude who says he refuses others the right to share or understand the fervor of his heart as he creates this or that picture. Yet Sieff is in fact a truly gifted photographer, gifted in portraiture, fashion, nudes, advertisements, landscapes, even the cinema. The charm—of the man, of his work—is in the ambiguities. He seems fragile; in fact, he is strong. He seems sociable, yet is fiercely independent.

Once, while taking his "entrance exam" at Magnum, he had to present his works to a man he revered, Henri Cartier-Bresson. Cartier-Bresson conspicuously examined the photos upside-down, conveying thereby that their content was of little importance to him: he wanted to see if the lines of force withstood such a test. Sieff was on the verge of rage. This reaction pleased the master, who had, of course, with this method, simultaneously evaluated both the work and the character of the candidate. It should be added, incidently, that, even upside-down, Sieff's photographs did "withstand."

Today, they withstand even better, for Sieff is an excellent technician, and over the last 20 years he has explored and mastered all the techniques of shooting: large format, medium format, 35mm format, black-and-white, color, long and particularly short focus distances (a mode he has used, without abusing it, since 1959). The formal quality is a hallmark of all of his work.

But why does that work so deeply move us? Because of the absence of that very armor that Sieff would like to construct to protect himself. Because of that which he allows to escape from himself into his work—inspiration, memories, impressions, loves, imtimate mysteries. He must be aware of this "presence," for he once said: "Primitive people hid from the camera, to avoid the theft of their souls. But they are mistaken; it is, rather, the soul of the photographer that is captured by the photograph." It is from just that perception that we understand our own response: to like the photographs of Jeanloup Sieff is to like him.

—Roger Therond

SIEGEL, Arthur (Sidney).
American. Born in Detroit, Michigan, 2 August 1913. Educated in Detroit public schools; studied sociology, University of Michigan, Ann Arbor, 1931-33, and, Wayne State University, Detroit, 1934-35; studied photography, under László Moholy-Nagy, *q.v.*, New Bauhaus School, now Institute of Design, Illinois Institute of Technology, Chicago, 1937-38. Served as photographer, under Roy E. Stryker, Office of War Information, Washington, D.C., 1942-43, and in the United States Air Corps Aerial Photography Department and Office of Assistant Chief, Air Staff Intelligence, Chanute Field, Rantoul, Illinois, 1944-46. Married Barbara Upshaw in 1946 (divorced, 1954); married Irene Yarovich in 1954; children: Julie; Adam; Ezra. First photographs, Detroit, 1927; first experimental abstract photographs, Chicago, 1937. Freelance magazine and industrial photographer, working for *New York Times, Wide World, Time, Life, Fortune, Sports Illustrated*, and for Farm Security Administration, and Associated Press Photo Bureau, based in Detroit, 1935-42, Chicago, 1946-68; gradually abandoned professional photography to concentrate on teaching, from 1968. Instructor, Department of Visual Education, Wayne State University, Detroit, 1934-37; Organizer and Head of Photography Department, 1946-49, Professor of Photography, 1949-54, 1965-78, and Chairman of the Department, 1971-78, Institute of Design, Chicago. Recipient: American Institute of Architects Award, 1979. Agent: Adam Siegel, 1200 West Webster, Chicago, Illinois 60614. *Died* (in Chicago) *1 February 1978.*

Individual Exhibitions:

1949 Wayne State University, Detroit
1954 Art Institute of Chicago
1955 International Museum of Photography, George Eastman House, Rochester, New York
1957 *Abstract Photography*, American Federation of Arts, New York (with Harry Callahan and Aaron Siskind; toured the United States)
1967 *Light and Color Photography*, Art Institute of Chicago
 2 Illinois Photographers, Hyde Park Art Center, Chicago (with Aaron Siskind)
1975 *Aaron Siskind and Arthur Siegel*, Oakton Community College, Morton Grove, Illinois
1981 *Arthur Siegel: A Life in Photography 1913-1978*, Chicago Historical Society

Selected Group Exhibitions:

1950 *Six States of Photography*, Milwaukee Art Institute, Wisconsin
1967 *Photography in the 20th Century*, National Gallery of Canada, Ottawa (toured Canada and the United States, 1967-73)
1974 *Photography in America*, Whitney Museum, New York
1975 *Color Photography: Inventors and Innovators 1850-1975*, Yale University Art Gallery, New Haven, Connecticut
1977 *New Acquisitions*, Art Institute of Chicago
 The Photographer and the City, Museum of Contemporary Art, Chicago
1980 *The New Vision*, Public Library Cultural Center, Chicago
 Photographers at the Institute of Design, Gilbert Gallery, Chicago

Collections:

Museum of Modern Art, New York; Metropolitan Museum of Art, New York; International Museum of Photography, George Eastman House, Rochester, New York; Museum of Fine Arts, Boston; Library of Congress, Washington, D.C.; Art Institute of Chicago; Exchange National Bank, Chicago; University of Chicago; Pasadena Art Museum, California.

Publications:

By SIEGEL: book—*Chicago's Famous Buildings*, editor and photographer, Chicago 1965, 1979; articles—"Creative Color Photography" in *Modern Photography* (New York), vol. 16, nos. 1/2/3, 1952; in *Life* (New York), 11 November 1957; "Photography Is" in *Aperture* (Rochester, New York), vol. 9, no. 2, 1961; "Anonymous Art and Choice: The Photographer's World" in *Aperture* (Rochester, New York), vol. 11, no. 2, 1964; "Fifty Years of Documentary" in *Photographers on Photography*, edited by Nathan Lyons, New York 1966.

On SIEGEL: books—*Photography in the Twentieth Century* by Nathan Lyons, New York 1967; *Photography in America*, edited by Robert Doty, with an introduction by Minor White, New York and London 1974; *The Photography Catalogue*, edited by Norman Snyder, New York 1976; *The Photographer and the City*, exhibition catalogue, by Gail Buckland, Chicago 1977; articles—"Experiment in Color" in *American Annual of Photography*, New York 1952; "A Collection of Photographs" in *Aperture* (Rochester, New York), Fall 1969; "Arthur Siegel" in *Camera* (Lucerne), February 1978; "Arthur Siegel: A Short Critical Biography" by John Grimes in *Exposure* (New York), Summer 1979; "Arthur Siegel: A Life in Photography, 1913-1978" by Larry A. Viskochil in *Chicago History*, Summer 1981.

Arthur Siegel's half-century involvement in photography took him into almost every branch of the profession. While he began his career as a photojournalist and commercial photographer, it was as a teacher and experimenter with creative uses of 35mm color and the photogram that brought him the most recognition. The complex images that he produced throughout his career were influenced heavily by his relationship with László Moholy-Nagy and with the New Bauhaus and Institute of Design schools that Moholy had founded in Chicago. Siegel had come from Detroit in 1937 to be one of Moholy's first students of photography. The year he spent at the New Bauhaus proved to be one of the pivotal experiences in his life.

Returning to Detroit the next year, Siegel applied what he had learned when he resumed his commercial work specializing in documentary photography.

Arthur Siegel: *The Right of Assembly*, Detroit, 1941

His "The Right of Assembly," which he made in 1941 while documenting a meeting of auto workers during a Chrysler strike, was certainly his most published image. During the early 1940's Siegel worked briefly for Roy Stryker as a freelance toward the end of the FSA survey and for the Office of War Information documenting industry's contributions to the war effort. This work, and later work that he did independently for a number of industrial clients, shows the influences of his contacts with Moholy and his own development based upon his experimental studies and his knowledge of the history of the medium.

After the war, in which he had served as a photographer at an Air Corps base in Rantoul, Illinois, Siegel returned to Chicago to teach at the Institute of Design. The photography program that he developed over the years, along with Harry Callahan and, later, Aaron Siskind, the two other famous teachers in the ID photographic trinity, still has a far reaching effect on photographic education nationwide.

Siegel spent much of the 1950's and 1960's away from teaching earning a living as a freelance for Time, Life, Fortune and other publications and doing advertising and annual report photography. His versatility, and his belief that his commercial work was as important as his personal work, made him a highly sought-after and successful professional. He also gained much public recognition for his architectural photography for, and his editorship of, Chicago's Famous Buildings, published by the University of Chicago in 1965. Most of the negatives and prints from Siegel's long career as a commercial photographer are now located at the Chicago Historical Society.

Siegel was a pioneer in the creative use of 35mm color in both his commercial and personal work. One color series of dye transfer prints made in the early 1950's called "In Search of Myself" was important both for its autobiographical implications and for its innovative use of strong colors and motion in complex organization. These elements were Siegel's subject matter as much as the neon signs, window displays, reflections, automobiles, and pedestrian traffic on Chicago's State Street. These images, like his earlier photograms and combination prints and his later "lucidagrams" and SX 70 prints, all include the same design elements he used throughout his career. These include the inevitable circles, layers, modified patterns of light and shadow and other inventions, adaptions, and adoptions that formed his own brand of Moholy's "new vision."

Siegel returned to full time teaching in 1967 and became head of the ID photography program again in 1971. Until the end of his life in 1978 he devoted his energies to teaching, inspiring a generation of photographers and future teachers to carry the ID's methods and messages around the world. In the end he rightly considered this contribution to be his greatest achievement.

—Larry A. Viskochil

SILK, George.
American. Born in Levin, New Zealand, 17 November 1916; emigrated to the United States after World War II, and subsequently naturalized. Educated in schools in New Zealand. Served as an official photographer with infantry forces, Australian Army, in the Middle East, 1940-42, and in New Guinea, 1942-43. Married Margery G. Schieber in 1947; children: Stuart, Georgiana and Shelley.

Worked as a "cowpuncher" and as an assistant in a photographic store, New Zealand, 1932-39; Staff Photographer, Life magazine, in Europe, 1943-45, in the Pacific, 1945, in China, 1946, and in New York City, 1947-73. Freelance photographer, New York, since 1973. Recipient: Photographer of the Year Award, Encyclopaedia Britannica, 1960; Gold Medal, Art Directors Club of New York, 1961; Memorial Award, American Society of Magazine Photographers, 1962. Address: Owenoke Park, Westport, Connecticut 06880, U.S.A.

Selected Group Exhibitions:

1951 Memorable Life Photographs, Museum of Modern Art, New York
1968 Man in Sport, Baltimore Museum of Art
1979 Life: The First Decade 1936-1945, Grey Art Gallery, New York University

Collections:

Time-Life Library, New York.

Publications:

By SILK: books—Memorable Life Photographs, with text by Edward Steichen, New York 1951; Life Photographers: Their Careers and Favorite Pictures, edited by Stanley Rayfield, New York 1957; Man in Sport, exhibition catalogue, by Roger Riger, Baltimore 1968; The Best of Life, edited by David E. Scherman, New York 1973; The Magic Image by Cecil Beaton and Gail Buckland, London and Boston 1975; Life: The First Decade 1936-1945 by Robert Littman, Ralph Graves and Doris C. O'Neill, New York 1979, London 1980; articles— "Color Essay of the Year: Skier's World of George Silk" by Arthur Goldsmith (includes interview) in Photography Annual 1959, New York 1958; "George Silk" in Modern Photography Annual, New York 1972.

Although known as an outstanding sports photographer, George Silk claims that he is more appropriately referred to as "an outdoor photographer." He prefers outdoor to stadium sports and is particularly gratified when a story takes him to a new location.

Born in New Zealand, Silk has led an adventurous life. During World War II he joined the Australian Army as a combat photographer, traveling to Greece, Crete and the Middle East before returning with the Australians to New Guinea. He was with the Army on the 700-mile walk and climb over the Kokoda Trail.

Silk's combat experience recommended him to Life Photography Editor Wilson Hicks, who hired him in 1943 to cover the Allied forces in Italy and Germany. Twice invalided back to the United States, he nevertheless returned each time to cover the front.

The courage and stamina evident in Silk's early years has stood him in good stead throughout his career. In 1952, on assignment for Life, Silk was the only photographer on an Air Force expedition to set up a weather station 100 miles from the North Pole. He worked in -60 degree cold, the shutters of his twelve cameras freezing one by one.

But Silk has also been a photographic innovator. In the 1950's he and Life colleague Mark Kauffman began experiments to devise more sensitive and flexible equipment for recording sports action. Silk worked with a prototype motor-driven sequence camera, the Foton, and he developed his own version of the "slit" camera. Used to record photo-finishes at racetracks, this kind of camera transports film past a stationary shutter, rather than exposing film by the normal method of opening and shutting the shutter while the film remains stationary.

An interesting 1960 Life essay, "The Spirit and Frenzy of Olympian Efforts," contrasts Silk's evocative distorted "slit" camera images with his conventionally-made photographs, Silk's expressive distortions convey the tension and grace, as well as the record-breaking facts, of world-class sports.

—Maren Stange

SINGH, Raghubir.
Indian. Born in Jaipur, 22 October 1942. Educated at St. Xavier School, Jaipur; studied arts at the Hindu College, New Delhi; self-taught in photography. Married Anne de Henning in 1972. Worked as a photo-journalist in India until 1976. Independent photographer, New Delhi, Hong Kong, and Paris since 1976. Agent: Holly Solomon Editions, 24 West 57th Street, New York, New York 10019, U.S.A. Address: 11 rue de Siam, 75016 Paris, France.

Individual Exhibitions:

1981 India, Holly Solomon Editions, New York (retrospective)
1982 Images de l'Inde, Galerie Nouvel Observateur/Delpire, Paris (retrospective)

Selected Group Exhibitions:

1981 Lichtbildnisse, Rheinisches Landesmuseum, Bonn, West Germany

Publications:

By SINGH: books—Ganga: Sacred River of India, Hong Kong 1974; Calcutta, Hong Kong 1975; Rajasthan: India's Enchanted Land, with an introduction by Satyajit Ray, London and New York 1981; Kumbh Mela, Paris 1981.

On SINGH: article—"Raghubir Singh: The Reality of Color" by William Gedney in Modern Photography (New York), October 1976.

My interest has always been to photograph in colour the life and people of India, my homeland. For this purpose, I repeatedly visit the subcontinent.

—Raghubir Singh

Raghubir Singh's Ganga is easily the most famous book by an Indian photographer. No river in the world, not even the Nile, has been the object of such veneration as the Ganges (to call it by its Anglicised name), and Singh, after six years of photographing, has brought out the deep emotions the river evokes, as well as its beauty and grandeur as it makes its way from the high Himalayas to the Bay of Bengal. "The river of India," Nehru called it, "whose story is the story of India's civilisation and culture." Ganga is one of the most perceptive pictorial statements on Indian life, beliefs and customs. Besides seeing this panorama through the camera lens, Singh has felt it as with a pilgrim's heart. The result is a sacrament and a celebration.

Some of Singh's photographs in Ganga (as elsewhere) can be faulted for being conventional, for it is

hard to avoid stereotypes about India. But he manages to invest almost all of his pictures with unusual detail and an element of contemplation which, combined with picturesqueness and vividness of colour, give them distinction and staying power. Among the more memorable pictures in *Ganga* are those showing sadhus above a waterfall at Gangotri, village women huddled in the rain on a bank of the river, a herd of elephants being given a wash, and pilgrim boats where the river meets the sea.

Singh maintains the same mood in *Kumbh Mela*, an exploration of the mammouth fair which is held once in 12 years at the confluence of Ganga and Jamuna. Very different in texture is *Calcutta*, in which he deals with urban realities at their most acute. Many adjectives—all uncomplimentary—have been used to describe the city of Calcutta, but Singh shows its grace as well as its garbage. The faces in the endless crowds reveal not only intensity, anger and despair but also acceptance and hope. *Calcutta* is a tribute to life battling against squalor and death, to the interplay between song and harshness.

In *Rajasthan* Singh has given himself over to nostalgia. Documenting the region of his birth, he relives his childhood dreams and memories. The pictures are declarations of his love for palaces and peacocks, for humble village homes with mud walls and decorated doorways, and for the very dust that hangs in the summer air. One of the finest pictures in the book is a scene around a village well, with camels and oxen and women in garments of postbox red. The composition is reminiscent of mediaeval miniatures. In his introduction to the book, Satyajit Ray has rightly extolled Singh for the searching curiosity and craftsmanship which his photographs reveal.

Singh worked in earlier years for newspapers in India, but he now lives in Paris. His work is published in many leading pictorial journals, whose editors demand pictures that conform to their own preconceptions. But Singh superimposes his own vision, achieving an unusual amalgam of objectivity and attachment. Above all, he is a master of colour and subtlety, most at home in mellowness.

—H.Y. Sharada Prasad

SINSABAUGH, Art(hur Reeder).

American. Born in Irvington, New Jersey, 31 October 1924. Studied photography under László Moholy-Nagy, Harry Callahan and Aaron Siskind, at the Institute of Design, Illinois Institute of Technology, Chicago, 1945-49, 1964-67, B.A. 1949, M.A. 1967. Served as a sergeant-photographer in the United States Army Air Force, in the Far East, 1943-45. Married twice; daughter: Elizabeth. Independent photographer, Chicago, then Urbana, Illinois, since 1945. Instructor in Photography, Institute of Design, Chicago, 1951-59. Associate Professor, then Professor of Art, University of Illinois, Urbana, since 1959 (formerly, Head of the Photography/Cinematography Department; also, Associate Member, University of Illinois Center for Advanced Studies, 1972-73). Founder Member, Society for Photographic Education. Recipient: New Talent Award, *Art in America*, New York, 1962; Society of Typographic Arts Award, 1964, 1965, 1966; Art Directors Club of Indiana Award, 1964; Art Directors Club of Los Angeles Award, 1964; Illinois Arts Council Award, 1966; Graham Foundation Award, 1966; Guggenheim Fellowship, 1969; National Endowment for the Arts Photography Fellowship, 1976. Agent: Daniel Wolf Inc., 30 West 57th Street, New York, New York 10019. Address: Box 322, Champaign, Illinois 61820, U.S.A.

Individual Exhibitions:

1959 St. Mary's College, Notre Dame, Indiana
1963 Art Institute of Chicago
1965 Gallery 500D, Chicago (with Harold Walter)
1970 Underground Gallery, New York
 Carl Siembab Gallery, Boston
1973 Williams College Museum of Art, Williamstown, Massachusetts
1978 Museum of Modern Art, New York
1980 Daniel Wolf Gallery, New York

Selected Group Exhibitions:

1963 *The Photographer and the American Landscape*, Museum of Modern Art, New York
1966 *American Photography: The 60's*, University of Nebraska, Lincoln
1967 *Photography in the 20th Century*, National Gallery of Canada, Ottawa (toured Canada and the United States, 1967-73)
1968 *Photography U.S.A.*, De Cordova Museum, Lincoln, Massachusetts
1971 *New Photography U.S.A.*, Museum of Modern Art, New York (toured the United States and Canada)
1977 *Concerning Photography*, The Photographers' Gallery, London (travelled to the Spectro Workshop, Newcastle upon Tyne)
 The Photographer and the City, Museum of Contemporary Art, Chicago
1978 *Mirrors and Windows: American Photography since 1960*, Museum of Modern Art, New York (toured the United States, 1978-80)
 70's Wide-View, Northwestern University, Evanston, Illinois
 Photos from the Sam Wagstaff Collection, Corcoran Gallery, Washington, D.C. (toured the United States, Canada, and Europe)

Collections:

Art Sinsabaugh Archive, University of Indiana, Bloomington; Museum of Modern Art, New York; International Museum of Photography, George Eastman House, Rochester, New York; Rhode Island School of Design, Providence; Williams College, Williamstown, Massachusetts; Smithsonian Institution, Washington, D.C.; Art Institute of Chicago; Exchange National Bank, Chicago; University of Nebraska, Lincoln; University of California at Los Angeles.

Publications:

By SINSABAUGH: book—*6 Mid-American Chants/11 Midwest Landscapes*, with Sherwood Anderson, Highlands, North Carolina 1964; articles—"Midwest Landscapes: Low, Wide and Handsome" in *International Harvester World* (Chicago), no. 10, 1963; "Chicago: City of Endless Horizons" in the *Sunday American Magazine* (Chicago), 3 July 1966; "Prairie Landscapes: Rural and Urban" in *Design and Environment* (New York), Fall 1970.

On SINSABAUGH: books—*The Photographer and the American Landscape*, exhibition catalogue, by John Szarkowski, New York 1963; *American Photography: The 60's*, exhibition catalogue, Lincoln, Nebraska 1966; *Photography in the 20th Century* by Nathan Lyons, New York 1967; *New Photography U.S.A.*, exhibition catalogue, by John Szarkowski, New York 1971; *Concerning Photography*, exhibition catalogue, edited by Jonathan Bayer and others, London 1977; *The Photographer and the City*, exhibition catalogue, by Gail Buckland, Chicago 1977; *Photographs: Sheldon Memorial Art Gallery Collection, University of Nebraska*, with an introduction by Norman A. Geske, Lincoln, Nebraska 1977; *70's Wide-View*, exhibition catalogue, by Elaine A. King, Evanston, Illinois 1978; *A Book of Photographs from the Collection of Sam Wagstaff*, designed by Arne Lewis, New York 1978; articles—"A Collection of Photographs" in *Aperture* (Rochester, New York), Fall 1969; "Art Sinsabaugh" in *Camera* (Lucerne), June 1972; "Found Horizon" by Greg Daugherty in *Professional Photographer* (Chicago), November 1978; "Art Sinsabaugh's Landscapes" by Gene Thornton in *Camera* (Lucerne), April 1979.

Arthur Reeder Sinsabaugh is a garrulous, hair-trigger Dutchman who loves nothing better than sitting in a cafe, having coffee and talking to absolutely anyone and everyone in sight. Oddly, when it comes to providing information about his life and his important career in photography, he clams up in the manner of Uncle Remus's Tar-Baby. (One is reminded of another sociable man, Erik Satie. After his death, they looked under the bed and found a twenty-year collection of mail he had received. It was all unopened.)

First, then, I quote from a note by Hugh Edwards, former Curator of Photography at the Art Institute of Chicago, provided for *Six Mid-American Chants*, by Sherwood Anderson, a Jargon Society publication of 1964 which contained 11 midwest photographs by Art Sinsabaugh: "Although, from now on, Art Sinsabaugh may be identified with the Midwestern environment, he did not come to Illinois until the 1940's. He was born in Irvington, New Jersey in 1924, and like so many photographers began taking pictures with the famous Brownie. During high school he worked first in a photography studio and later as a Junior Photographer for the War Department, commuting to New York City to attend a photography trade school. In 1943 he was drafted and served for three years in the Army Air Force in the United States and Asia. After his return he came to Chicago to the Institute of Design and was a graduate in 1949. He taught there from 1951 until 1959 when he went to the University of Illinois in Urbana as Professor of Art and where he is now organizing a photography program. His work has been published in England and America and exhibited by the Museum of Modern Art and the American Federation of Arts. In 1963 a one-man show was held at the Art Institute of Chicago and had much success." To up-date that account very briefly, Sinsabaugh remains at the University of Illinois but has resigned as head of department. His health has been indifferent for some years and his energies for new work sadly curtailed. A Sinsabaugh Archive has been established at Indiana University, Bloomington. Besides Hugh Edwards, his closest colleagues over the years include Arthur Siegel, Harry Callahan, Aaron Siskind, Henry Holmes Smith, and John Szarkowski.

One summer at Champaign-Urbana, Art Sinsabaugh found the "banquet" camera with which he has made his primary reputation. It enabled him to photograph the Illinois and Indiana landscape with sheet film 12 x 20 inches in size. As Hugh Edwards says: "One wonders how our horizontal landscape could ever have been represented before, except in these low, wide rectangles suggesting an infinity on either side of our vision as well as one before us in depth." Some have joked that the Sinsabaugh format is like viewing the world through a Venetian blind. But, he has other cameras and uses them all in masterly style. His clusters of farm buildings and telephone poles on the dark soil of Champaign County are as refined as the intelligence that Basho brought to bear in his haiku visions. Basho would have loved lugging a banquet camera along the narrow back roads of 17th century Japan.

—Jonathan Williams

SISKIND, Aaron.
American. Born in New York City, 4 December 1903. Educated at DeWitt Clinton High School, New York; City College of New York, B.S.S. in literature 1926; self-taught in photography. Married Sidonie Glaller in 1929. Instructor in English, various public schools, New York, 1926-49. Took first photos, Bermuda, 1930; professional freelance photographer since 1932. Member of the Film and Photo League, New York, 1932-35, 1936-41. Part-time Instructor in Photography, Trenton College, New Jersey, 1950; Instructor in Photography, with Harry Callahan, Black Mountain College, Beria, North Carolina, 1951; Professor of Photography, 1951-71, and Head of the Department of Photography, Institute of Design, 1961-71, Illinois Institute of Technology, Chicago. Adjunct Professor, Rhode Island School of Design, Providence, 1971; Visiting Lecturer, Harvard University, Cambridge, Massachusetts, 1973. Co-Editor, *Choice* poetry and photography magazine, Chicago, 1961-70. Founder Member, Society for Photographic Education, 1963; Trustee, Gallery of Contemporary Art, Chicago, 1964. Recipient: Guggenheim Fellowship, 1966; Distinguished Career in Photography Award, Friends of Photography, Carmel, California, 1981. Agent: Light Gallery, 724 Fifth Avenue, New York, New York 10019. Address: 15 Elmway, Providence, Rhode Island 02903, U.S.A.

Individual Exhibitions:

1941 *Tabernacle City*, Photo League, New York (travelled to Dukes County Historical Society, Edgartown, Massachusetts)
1947 *30 Recent Photographs*, Egan Gallery, New York
 California Palace of the Legion of Honor, San Francisco
1948 Santa Barbara Museum of Art, California
 Old Houses of Bucks County, Delaware Gallery, New Hope, Pennsylvania
 Black Mountain College, Beria, North Carolina
 Egan Gallery, New York
 Queens College Library, Flushing, New York
1949 Egan Gallery, New York
 Institute of Design, Illinois Institute of Technology, Chicago
1951 *New Photographs*, Egan Gallery, New York
1952 *Photographs*, Seven Stairs Gallery, Chicago
 Portland Museum of Art, Oregon
1954 *Recent Photographs by Aaron Siskind*, Egan Gallery, New York
 Menemsha Gallery, Martha's Vineyard, Massachusetts
 International Museum of Photography, George Eastman House, Rochester, New York
1955 Northwestern University, Evanston, Illinois
 Denver Art Museum
 Santa Barbara Museum of Art, California
 Art Institute of Chicago
1956 Cincinnati Art Museum, Ohio
 Photographs by Aaron Siskind, Evanston Township High School, Illinois
1957 *Harry Callahan/Aaron Siskind: Photographes Americains*, Centre Culturel Americain, Paris (travelled to Algiers and London)
1958 Alfred University, New York
 San Francisco State College
1959 *Photographs*, Martha Jackson Gallery, New York
 Carl Siembab Gallery, Boston
 Holland-Goldowsky Gallery, Chicago
1960 *Aaron Siskind/Harry Callahan*, The Cliff Dwellers, Chicago
1961 *3 Photographers*, Kalamazoo Institute of Arts, Michigan (with Wynn Bullock and David Vestal)

1962 John Gibson Gallery, Chicago
 Hanamura's, Detroit (with Toshiko Takaezu)
1963 International Museum of Photography, George Eastman House, Rochester, New York
1964 *Photographs 1954-1961*, Art Institute of Chicago
 Michigan State University, East Lansing
1965 *Photographs*, Pomona College Gallery, Claremont, California
 Aaron Siskind, Photographer, International Museum of Photography, George Eastman House, Rochester, New York (toured the United States and Canada)
 Twenty-Five Photographs, Reed College Photography Association, Portland, Oregon
 Siskind Recently, Museum of Modern Art, New York
1966 Kendall College, Evanston, Illinois
1967 *2 Illinois Photographers*, Hyde Park Art Center, Chicago (with Arthur Siegel)
1968 *Recent Photographs*, Carl Siembab Gallery, Boston
 Friends of Photography, Carmel, California
 Aaron Siskind, Photographer, Paul Arts Center, University of New Hampshire, Durham
1969 *An Exhibition of Photographs*, University of Louisville, Kentucky
1970 *Photography by Aaron Siskind*, Portland University, Oregon
 The Work of Aaron Siskind, Huntington College, Indiana
1971 *Photographs*, Milwaukee Art Center, Wisconsin
 Phoenix Evening College, Arizona
1972 *Aaron Siskind, Photographer*, Art Museum of the Rhode Island School of Design, Providence
1973 *Photographs 1935-1970*, Fogg Art Museum, Harvard University, Cambridge, Massachusetts
 Homage to Franz Kline: Photographs by Aaron Siskind, Bell Gallery, Brown University, Providence, Rhode Island
 Friends of Photography, Carmel, California
 3 Photographers, University of Colorado, Boulder (with Wynn Bullock and Edmund Teske)
1974 *Photographs by Aaron Siskind*, Washington Gallery of Photography, Washington, D.C.
 Light Gallery, New York
1975 *Aaron Siskind and Arthur Siegel*, Oakton Community College, Morton Grove, Illinois
 Art Institute of Chicago
 Photographs of Aaron Siskind in Homage to Franz Kline, Smart Gallery, University of Chicago
1976 *Aaron Siskind/Harry Callahan/Stephen Shore*, Silver Image Gallery, Tacoma, Washington
 Cronin Gallery, Houston
 Vision Gallery, Boston
1978 *Photographs by Aaron Siskind*, Worcester Art Museum, Massachusetts
 Recent Work, Bard College, Annandale-on-Hudson, New York
 Photographs 1976-77, Light Gallery, New York
1979 *Aaron Siskind: Retrospective Exhibition*, Chrysler Museum, Norfolk, Virginia
 Secuencia Fotogaleria, Lima, Peru
 Photographs 1932-1978, Museum of Modern Art, Oxford
1981 *Aaron Siskind: Harlem Project*, Chicago Center for Contemporary Photography

Selected Group Exhibitions:

1940 *Harlem Document*, New School for Social Research, New York
1941 *Image of Freedom*, Museum of Modern Art, New York
1947 *The Artist, Nature and Society*, St. Paul Gallery, Minnesota
1951 *Abstraction in Photography*, Museum of Modern Art, New York
1953 *Contemporary American Photography*, Museum of Modern Art, New York
1957 *Abstract Photography*, American Federation of Arts, New York (toured the United States)
1959 *Photography at Mid-Century*, International Museum of Photography, George Eastman House, Rochester, New York (toured the United States)
1962 *Photography U.S.A.*, De Cordova Museum, Lincoln, Massachusetts
1973 *The Photographer as Poet*, Arts Club, Chicago
1977 *Masters of the Camera*, International Center of Photography, George Eastman House, Rochester, New York
1978 *Amerikanische Landschaftsphotographie*, Neue Sammlung, Munich
1980 *The Magical Eye*, National Gallery of Canada, Ottawa

Collections:

Center for Creative Photography, University of Arizona, Tucson (Siskind Archive); Museum of Modern Art, New York; International Center of Photography, George Eastman House, Rochester, New York; Carpenter Center and Fogg Art Museum, Harvard University, Cambridge, Massachusetts; Art Institute of Chicago; Minneapolis Institute of Art; Museum of Fine Arts, Houston; National Gallery of Canada, Ottawa; Bibliothèque Nationale, Paris.

Publications:

By SISKIND: books—*Aaron Siskind: Photographs*, with an introduction by Harold Rosenberg, New York 1959; *Spring of the Thief*, poems by John Logan, New York 1963; *Terrors and Pleasures of Levitation*, portfolio, New York 1972; *Bucks County: Photographs of Early Architecture*, with text by William Morgan, New York 1974; *Places: Aaron Siskind Photographs*, with an introduction by Thomas B. Hess, New York 1976; *75th Anniversary Portfolio*, New York 1979; articles—"The Drama of Objects" in *Minicam Photography* (New York), June 1945; "When I Make a Photograph" in *American Photography* (New York), March 1951; "Local Color: Book Review" in *ASMP News* (New York), April/May 1951; "Book Review: The Decisive Moment" in *Saturday Review* (New York), 20 December 1952; "This Is My Best" in *Art Photography* (New York), June 1954; "The Essential Photographic Act" in *Art News* (New York), December 1955; "Learning Photography at the Institute of Design," with Harry Callahan, in *Aperture* (Millerton, New York), no. 4, 1956; "Credo 1950" and "Notes on the Photographic Art" in *Spectrum* (Providence, Rhode Island), May 1956; "Where I Find My Pictures" in *Modern Photography* (New York), February 1958; "Education at the Institute of Design," with Harry Callahan, in *Infinity* (New York), February 1960; "A Conversation Between Diana Johnson and Aaron Siskind" in *Spaces*, exhibition catalogue, Providence, Rhode Island, 1978.

On SISKIND: books—*Tabernacle City*, exhibition leaflet, by Henry Beetle Hough and Alex R. Stavenitz, New York 1941; *Aaron Siskind*, exhibition catalogue, by Hilda Loveman Wilson, New York 1948; *New Photographs*, exhibition catalogue, with an essay by Elaine de Kooning, New York 1951; *Aaron Siskind, Photographer*, exhibition catalogue,

Aaron Siskind: *Chicago*, **1949**

edited and introduced by Nathan Lyons, with essays by Henry Holmes Smith and Thomas B. Hess, Rochester, New York 1965; *Photographers on Photography*, edited by Nathan Lyons, New York 1966; *The Photographer's Eye* by John Szarkowski, New York 1966; *Photography in America*, edited by Robert Doty, with an introduction by Minor White, New York and London 1974; *Photographs by Aaron Siskind in Homage to Franz Kline*, exhibition catalogue, with text by Carl Chiarenza, Chicago 1975; *Aaron Siskind and His Critics 1946-66* by Carl Chiarenza, entire issue of *Center for Creative Photography* (Tucson, Arizona), no. 7/8, September 1978; *Aaron Siskind: Retrospective Exhibition*, exhibition catalogue, with text by Eric Zafran, Norfolk, Virginia 1979; *Aaron Siskind: Photographs 1932-1978*, exhibition catalogue, with text by Peter Turner and others, Oxford 1979.

When I make a photograph I want it to be an altogether new object, complete and self-contained, whose basic condition is order—unlike the world of events and actions whose permanent condition is change and disorder.

The business of making a photograph may be said in simple terms to consist of three elements: the objective world (whose permanent condition is change and disorder), the sheet of paper on which the picture will be realized, and the experience which brings them together. First, and emphatically, I accept the flat plane of the picture surface as the primary frame of reference of the picture. The experience itself may be described as one of total absorption in the object. But the object serves only a personal need and the requirements of the picture. Thus, rocks are sculptured forms; a section of common decorative iron-work, springing rhythmic shapes; fragments of paper sticking to a wall, a conversation piece. And these forms, totems, masks, figures, shapes, images must finally take their place in the tonal field of the picture and strictly conform to their space environment. The object has entered the picture, in a sense; it has been photographed directly. But it is often unrecognizable; for it has been removed from its usual context, disassociated from its customary neighbors and forced into new relationships.

What is the subject matter of this apparently very personal world? It has been suggested that these shapes and images are underworld characters, the inhabitants of that vast common realm of memories that have gone down below the level of conscious control. It may be they are. The degree of emotional involvement and the amount of free association with the material being photographed would point in that direction. However, I must stress that my own interest is immediate and in the picture. What I am conscious of and what I feel is the picture I am making, the relation of that picture to others I have made and, more generally, its relation to others I have experienced.

—Aaron Siskind

It is more than likely that, when the history of 20th century photography is written, Aaron Siskind will emerge as one of its most significant figures. Of particular note will be the judgement that Siskind forced photographers to confront the physical reality of their product—the photographic print within the boundaries, and on the surface, of a flat sheet of paper. "Siskind," wrote critic Henry Holmes Smith some years ago, "addressed himself to the central problems traditional photography still left unresolved," and provided "the missing answers for which photographers, many of them without realizing it, had been waiting."

Not that the photographer, still active in his mid-70's, would claim so exalted a position for himself. "I'm thinking I'm a little out of fashion right now," Siskind told me, all evidence to the contrary, in 1977, "maybe my pictures are pictures for old men; something to contemplate."

That characteristic self-effacement does not, however, extend to an under-estimation of purpose. "I've tried to get photographers (through both personal example and years of teaching) to accept the space that they're given to work with as a kind of realism. You're given a flat piece of paper; that's what you work with. Accept it, deal with it, and *be conscious* of it, instead of always having illusionary space or just not even thinking about it—just letting the damn image kind of bounce on it."

That realization was the result of Siskind's personal odyssey through photography. The gift of a $12 camera at age 28, his subsequent membership and leading role in the Film and Photo League of Depression-era New York, were but the first steps. Founder and active participant of the League's documentary unit, Siskind worked in a traditional documentary style during these years, and the resulting photographs contain both charm and power. Little of this work has been published; at least one volume is now planned for publication.

During summers on Martha's Vineyard off the Massachusetts coast, however, the elements of Siskind's mature vision were coalescing. Photographing a documentary about the Island's religious community, *Tabernacle City*, he found himself drawn to the formal architectural properties rather than traditional documentary subjects. This emphasis continued in his Bucks County, Pennsylvania photographs. The complete break with the past would come a few years later. Again, Martha's Vineyard would provide both setting and stimulus.

Returning to the island frequently during the early 1940's, Siskind began working with natural objects, composing on a flat plane with geometric organization. By eliminating the deep focus that other photographers cherished, he found the objects in his images taking on added significance. The "breakthrough" for Siskind occurred on a day in 1944, not on the island, but in the coastal community of Gloucester, Massachusetts.

Photographing an old glove against wood, Siskind "realized that I had to take that picture looking straight down...wiping out all perspective." He did so, with memorable results ("The Glove," 1944). "Then I realized just how powerful an object it was," he continued, at more than three decade's remove from the event, "I made an object which confronts you, not an object that you're just looking at—it's parallel to you." The object (and this remains true of Siskind's most recent photographs as well) had become both more and less important, both superreal and abstract, simultaneously. The photograph had become the object.

With this personal style of gesture and nuance, this new form of visual calligraphy, Siskind went on to create a remarkable body of work which orders the conflicts and tensions inherent in the subject matter. The imposed order, however, is always a fragile one, all too ready to break down at the edges.

If such characteristics are reminiscent of abstract expressionism, it should not be surprising. For many years, the world of painting showed far more understanding of and receptivity to Siskind's work than did his fellow photographers (indeed, the strict documentarians of the League greeted *Tabernacle City* with cries of "sellout!"). Siskind's photographs were, after all, *about* photography, in the same sense that Jackson Pollock's paintings were about his medium. Aaron Siskind's first major exhibit, in 1947, was at New York's Egan Gallery, a home for the most contemporary painting. His first book, with an introduction by respected art critic Harold Rosenberg, was published only because Franz Kline and other friends from the world of painting provided financial support for the project.

Photographers may have lagged behind, but they caught up in time. As Henry Holmes Smith suggested, other photographers finally perceived in Siskind's work, new possibilities, new answers for unavoidable (if persistently unasked) questions. Through all of this, Siskind continued doing what it gave him pleasure to do: making photographs and teaching young photographers.

Cryptic though some of his images may be at first glance (see, for example, the bits and pieces of wall graffiti from which many Siskind pictures are composed), their internal logic is overwhelming. It is necessary only to suspend the belief that there exists a world on the other side of the photographic image. Siskind's photographs are not windows looking out upon another reality; rather, each is a singular object, flat, irrevocably bounded by its borders—a self-contained reality.

"You know," Aaron Siskind mused in 1977, "for the first time in my life, I'm really free. I'm 73 now and I've made it. It should have happened when I was 71 and could really appreciate it."

—Stu Cohen

SJÖSTEDT, Ulf.

Swedish. Born in Karlstad, 7 April 1935. Educated at schools in Kristinehamn and Borlänge, Sweden, 1948-57; studied graphics and photography at the School of Arts and Handicrafts (Konstindustriskolan), Göteborg, 1959-62; also studied at the Institute of Higher Marketing Education, Göteborg, 1971-73, Dip. 1973. Served in the Swedish Army Infantry, in Falun and Stockholm, 1957-59: Captain, 1969. Married Brita Kåräng in 1970; daughter: Katarina. Photographer since 1950. Studio Manager, Tre Tryckare publishing company, Göteborg, 1962-64; Editor, *Nordisk Tidskrift för Fotografi* magazine, Göteborg, 1964-66. Editor-in-Chief, *Hasselblad Magazine*, Göteborg, 1967-75, and since 1969 Advertising Manager, Victor Hasselblad AB photo equipment company, Göteborg. Photography Correspondent, *Göteborgs Tidningen*, since 1971. Secretary, National Association of Swedish Photography, 1964-65; Chairman, Photographic Society of Göteborg, 1967-70. Recipient: Municipal Culture Award, Göteborg, 1967; Welinder Award, Swedish Photographers Association, 1967; Swedish Authors Fund Award, 1972, 1976, 1979. Address: Valnötsgatan 6, S-42174 V. Frölunda, Sweden.

Individual Exhibitions:

1966 *Swedish Artisans*, Historical Museum, Göteborg
1975 *Pictures*, Pentax Gallery, London
1976 *Photographs 1961-1975*, Fotografiska Museet, Stockholm (travelled to the Värmlands Museum, Karlstad, Sweden, and the Museet-Kulturhuset, Borås, Sweden)
 Portfolios, Galleri Nordenskiold, Göteborg
1978 *Pictures*, Pentax Gallery, Amsterdam

Selected Group Exhibitions:

1958 *How We Live*, at *Photokina*, Cologne
1961 *Two Generations*, Art Museum, Göteborg (toured Sweden)
1967 *Silver-Textil-Keramik-Foto*, Konsthall, Skovde, Sweden
 Young Photographers, Moderna Museet, Stockholm
1968 *Young Form—Once Again*, Rhösska Museum, Göteborg
1976 *Fantastic Photography in Europe*, Fondacion Joan Miro, Barcelona (toured Europe)

1977 *From Today Painting Is Dead*, Maneten, Göteborg
The Children of This World, Unicef/*Stern* travelling exhibition
1978 *A Thousand and One Pictures*, Moderna Museet, Stockholm
1979 *The History of Photography*, Art Museum, Göteborg

Collections:

Fotografiska Museet, Moderna Museet, Stockholm; Värmlands Museum, Karlstad, Sweden; Borås Museum, Sweden; Pentax Gallery, London; Pentax Gallery, Amsterdam.

Publications:

By SJÖSTEDT: books—*Min Bilderbok*, Göteborg 1961; *Modern Reklam*, with text by Lars Foxe, Göteborg 1967; *En Bok om Några Vänner*, Göteborg 1971; *Katarina: Stina och Sommaren*, Göteborg 1976; *Sjön Suger*, with text by Bengt Petersen, Göteborg 1976; *Mina Mest Subjektiva Bilder*, Alingsas, Sweden 1979; *Den Fotografiska Bilden*, Halmstad, Sweden 1979; *Barn på Bild*, Halmstad, Sweden 1981; *Foto på Resaw*, Halmstad, Sweden 1981; articles—"2 Generations" in *Nordisk Tidskrift för Fotografi* (Göteborg), no. 7/8, 1961; "The Problems of the Countryside Photographer" in *Foto* (Stockholm), no. 5, 1963; "My Best Pictures" in *Foto* (Stockholm), no. 12, 1965; "Schwedische Fotografie" in *Leica Fotografie* (Frankfurt), no. 6, 1967; article in *Amateur Photographer* (London), January 1976; "Foto di Gruppo" in *Nuova Fotografia* (Naples), January 1978; "Motion" in *Petersen's Photographic Magazine* (Los Angeles), May 1978;

"Ma...cos'e una buona fotografia" in *Nuova Fotografia* (Naples), July 1978; "Wellenspiele" in *Photo Revue* (Munich), no. 12, 1978; also numerous other articles in *Nordisk Tidskrift för Fotografi* (Göteborg), 1964-66, *Hasselblad Magazine* (Göteborg), 1965-80, *Fotonyheterna* (Stockholm), 1966-74, and *Photolife* (Toronto), 1978-79.

On SJÖSTEDT: articles—"Ulf Sjöstedt, Realist" by Bengt Gustafson in *Foto* (Stockholm), no. 8, 1962; "Der Weitwinkel" by Evald Karlsten in *Camera* (Lucerne), February 1968; "Vidvinkel, det dramat. obj." by Helge Jacobsen in *Foto og Smallfilm* (Copenhagen), no. 4, 1969; "The Egg Comes First" by Jane Dreyfuss in *Modern Photography* (New York), January 1970; "Ulf Sjöstedt: Egg Pictures" in *Creative Camera* (London), no. 5, 1971; "Ulf Sjöstedt" by Jean Tagret in *Phototribune* (Antwerp), no. 6, 1971; "Matador der Kamera" by Joachim Giebelhause in *Color Foto* (Munich), no. 7, 1972; "Ulf Sjöstedt, Tecnica del Sandwich" in *Nuova Fotografia* (Naples), no. 4, 1973; "Ulf Sjöstedt" by Knut Försund in *Fotografi* (Råholt, Norway), December 1975; "Ulf Sjöstedt" in *Flash* (Barcelona), January 1976; "Ulf Sjöstedt" by Evald Karlsten in *Svensk Fotografisk Tidskrift* (Stockholm), no. 1, 1976; "Ulf Sjöstedt Frammenti..." by Manlio Cammarata in *Nuova Fotografia* (Naples), February 1976; "Forum Junger Fotografen" by Evald Karlsten in *Foto Magazin* (Munich), no. 6, 1976; "Han vandrar not strommen" by Lars Fahlén in *Foto* (Stockholm), August 1976; "Fotografen en hun werk" in *Foto* (Amersfoort, Holland), March 1977; "Portfolio, Ulf Sjöstedt" by Jean-Pierre Vorlet in *Schweizerische Photorundschau* (Visp, Switzerland), March 1978; "Ulf Sjöstedt" in *Le Nouveau Grand Angle* (Paris), May 1978; "Ulf Sjöstedt" by Per Lindström in *Aktuell Fotografi* (Helsingborg, Sweden), April 1979.

Photography is a young medium—only about 150 years old—and therefore just in the beginning of its development. No doubt the main purpose of this medium has hitherto been and probably is still to give a realistic description of the world in which we are living—to tell people of today and tomorrow about justice and injustice....

Most of my pictures are documentary, but, as photography can be used in many different ways, I am more interested in creative photography, in what Professor Otto Steinert called "subjective photography." Painters, draughtsmen and graphic artists can use their media in order to capture a man's mood or his experience, and so can the photographer. It is true that photography has not yet produced a Leonardo, a Rembrandt or a Picasso, but be sure there will be one, someday.

Like the brush, the camera is just a tool, and the quality of all the equipment—camera, film, developer, enlarger, etc. must be of a sort that gives you the exact result of the vision you had at the moment of shooting. Technique and composition are interesting only as means to reach the goal: the contents of the picture; but, on the other hand, should you fail to master skills and technique, that failure will inevitably show up.

International photography is in rapid progress, but whether it is going straight ahead or sideways is not possible to say. I am afraid that in many countries—for instance, Sweden—it is moving sideways.

The great number of photo-galleries that have opened during the last ten years all over the world will, I hope, increase the quality of creative—or, if you will, subjective—photography in every country.

It is sad and almost ridiculous that photography must be hung in fine art galleries within glass and gold frames in order to be taken seriously as a medium for expressing feelings and moods. The picture-book is the best means of presenting photographic pictures—if the printing is of a high quality. You can, in peace and quiet at home, in the most comfortable armchair, take part in and study pictures produced through a medium which is suited more than any other for printing. For me, text and picture are one. The support that the two media can give each other is, I think, often needed. It is very seldom that a picture can manage alone. That generalization also applies to "subjective" pictures. Yet, there are pictures that can stand alone. I don't mean that the text should be "directions"; rather, it should be a guide for the imagination. To read pictures is not easy. Too many of us are picture-illiterates.

One photographer has said that you do not take more than 200-250 good pictures during a lifetime. I believe him. I am not sure that I will reach that number myself. I have not taken more than 50 good pictures. Hardly that.

There is no doubt that I am influenced by the international style of taking pictures. Each month I go through more than a hundred of the world's photo magazines, and I keep in touch with many of the world's leading photographers and photo writers. But I am also influenced by my Swedish friends working with painting, drawing and graphic art, and by their way of making pictures.

In my opinion photography is not more remarkable than painting. Everyone can take photographic pictures as well as draw funny drawings—each one according to their own conditions. Every pictorial medium has its own distinctive character. As I've said, photography is a young medium with enormous possibilities for development. Now is the time for those of us with a camera in hand to take advantage of those possibilities.

—Ulf Sjöstedt

Ulf Sjöstedt has sometimes been called "Sweden's best-known amateur photographer." It is an honorable title, and no doubt there's some truth in it. In spite of a very prolific photographic activity, Sjöstedt has succeeded in preserving the amateur's curiosity and delight in experiment. This is reflected in

Ulf Sjöstedt: *Birch I*, 1978

his picture-world. Nor has he ever been a professional photographer in the accepted sense of the term. He has never derived the main part of his income from selling pictures or from undertaking photographic commissions.

On the other hand, Sjöstedt has been involved with photos for the whole of his working life. After his studies at the School of Arts and Handicrafts in Göteborg, he was engaged as the head of a drawing office for a publishing company; between 1964 and 1966 he was the editor of the Göteborg photo-club's journal; and since 1967 he has been employed by Hasselblad in Göteborg: he was the editor of their journal from 1967 to 1974. In his daily work he has thus had a great deal of opportunity to come into contact with pictures and to reach people interested in pictures. Partly through his articles, partly through his own pictures. In addition, he has written and illustrated several books, and he is also a very popular lecturer in the photo-clubs. Photography has, in effect, become a full-time occupation for Sjöstedt. But he still modestly calls himself an amateur.

Thanks to that amateur status, Sjöstedt's picture-world has remained a private one. Much of what he does can be classified as family and holiday photos. But the technical and artistic quality of his work is certainly higher than what one normally associates with those kinds of pictures.

Names that he normally mentions with great respect are those of the Russian constructivists Rodchenko and Kandinsky. Sjöstedt attempts to adapt their composition theories of diagonals and points to a world of "subjects," and the results emerge sometimes as Scandinavian-romantic, sometimes as surrealistic.

Although many of his best-known pictures were taken in the 1970's, they are reminiscent of the 50's. The conscious idiomatic expression combined with a deep seriousness in many of his pictures reflect the epoch of "Subjective Photography"—and Otto Steinert is, not surprisingly, another pictorial theoretician to whom Sjöstedt refers.

In recent years he has worked on two large projects—birches and the sea. He sees the birchtree as a symbol of Sweden. In the 1930's and 40's it was almost a symbol of Swedish amateur photography as well, but at that time it was more the natural/lyrical and romantic aspects of the tree that were stressed in exhibition photos. Sjöstedt hopes in his series to combine romanticism and mysticism with a taut and decorative idiomatic expression.

The sea is limitless, and, as a resident of the West Coast, he comes into daily contact with it. It is a challenge to extract something new from that which is so well known. Sjöstedt likes such challenges.

—Rune Jonsson

SKOFF, Gail.

American. Born in Los Angeles, California, 27 September 1949. Educated at Hamilton High School, Los Angeles, 1964-67; University of California, Berkeley, 1967-69; Boston Museum School, 1969-71; San Francisco Art Institute, 1971-72, B.F.A. 1972, M.F.A. 1979; also studied at University of California Extension, San Francisco, 1972-73. Freelance photographer, Berkeley, since 1973. Instructor in Photography, University of California Extension, Berkeley, since 1976; Instructor since 1976, and Darkroom Supervisor and Photo Curator since

1977, A.S.U.C. Studio, University of California, Berkeley. Lecturer, College of Visual Design, Department of Architecture, University of California, Berkeley, Summer 1980. Recipient: National Endowment for the Arts Photography Fellowship, 1976. Agent: Simon Lowinsky Gallery, 228 Grant Avenue, San Francisco, California 94108. Address: 1718 Jaynes Street, Berkeley, California 94703, U.S.A.

Individual Exhibitions:

1973 University of California Extension, San Francisco
1974 *Introductions 74*, Phoenix Gallery, San Francisco
1977 Centre Culturel Americain, Paris
 Images of Bali, Simon Lowinsky Gallery, San Francisco
1979 Washington State University, Pullman
1980 Simon Lowinsky Gallery, San Francisco
1981 Simon Lowinsky Gallery, Los Angeles
1982 Equivalents Gallery, Seattle

Selected Group Exhibitions:

1975 *Hand-Colored Photographs*, Ohio Silver Gallery, Los Angeles
 Exchange DFW/SFO, Fort Worth Museum of Art, Texas (travelled to the San Francisco Museum of Modern Art)
1976 *The Photographers' Choice* (toured the United States, 1976-79)
1977 *Radical Photography and Bay Area Innovators*, Sacred Heart Schools Gallery, Menlo Park, California
1978 *Threads of Tradition*, University of California Art Museum and Lowie Museum, Berkeley
1979 *Attitudes: Photography in the 1970's*, Santa Barbara Museum of Art, California
1980 *SECA Photography Invitational*, San Francisco Museum of Modern Art
1981 *Four California Views*, Oakland Art Museum, California
 American Photographers and the National Parks, Oakland Museum, California (toured the United States, 1981-83)

Collections:

Smith College Art Gallery, Northampton, Massa-

Gail Skoff: *Lizard Mound*, **1980**

chusetts; Center for Creative Photography, University of Arizona, Tucson; Oakland Art Museum, California; Bibliothèque Nationale, Paris.

Publications:

On SKOFF: books—*Celebrations* by Minor White, New York 1974; *The Photographer's Choice*, edited by Kelly Wise, Danbury, New Hampshire 1976; *Alternative Photographic Processes* by Kent Wade, New York 1978; *The New Landscape*, edited by Friends of Photography, Carmel, California 1981; articles—"The Young Romantics" by Douglas Davis in *Newsweek* (New York), March 1979; "Northern California Photography" by Hal Fischer in *Picture Magazine* (Los Angeles), no. 11, 1979; "Reviews" by Hal Fischer in *Artforum* (New York), May 1980; "Contemporary Hand Colored Photography" in *Picture Magazine* (Los Angeles), no. 17, 1981.

My interest in the magical transformation of reality through hand coloring photographs has remained consistent over time although my subject matter has changed considerably. I try to create photographs where time and space are suspended, and a new world emerges separate from my everyday life.

My involvement with these ideas began in earlier hand-colored work, where I photographed costumed models in environments that had an illusion of timelessness. Subsequently, I photographed people in foreign places and exotic cultures, where contemporary life as I know it was non-existent. Every clue to date was removed from the photographs.

My recent work with the landscape seems to transcend the specificity of time and human presence even more dramatically. I am fascinated with photographing uninhabited spaces: oceans, deserts, prairies and unique natural land formations. Sometimes, when clouds appear in the sky, or in the light of dawn or dusk, the landscape takes on an unworldly glow. To reproduce the visual reality of these places at such moments is not enough. I use the processes of toning and hand-coloring to transform the black-and-white image by selectively emphasizing certain of its elements. When everything comes together in the finished piece, the feeling of being in these places is recreated.

—Gail Skoff

Gail Skoff's consuming passion is the land. Not any land, but the great, sprawling, uncultivated earth of

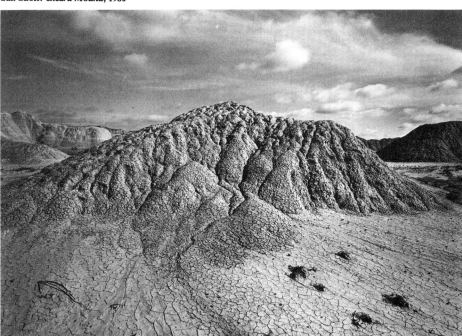

western America. Her safaries into this environment have become a personal odyssey, "the great adventure." Few women in the history of photography have dealt with the landscape as a major concern. Skoff is one of a growing number of women venturing back to this rediscovered frontier. Wanderlust is nothing new to her. She has traveled widely, and some of her best early work was done in France and Bali. But there is a freshness and mature assurance in the more recent American landscapes, an insight and understanding of the nature of the territory.

Gail's automobile excurions resemble the stagecoach journey that Mark Twain writes about in *Innocents Abroad*. He describes the vastness of the western American landscape in the early 1900's which today remains much the same. "....The first 700 miles a level continent, its grassy carpet greener and softer and smoother than any sea and figured with designs fitted to its magnitude—the shadow of the clouds..... Then 1300 miles of desert solitudes; of limitless panoramas of bewildering perspective; of mimic cities, of pinnacled cathedrals, of massive fortresses, counterfeited in the eternal rocks and splendid with the crimson and gold of the setting sun; of dizzy altitudes among fog-wreathed peaks and never-melting snows, where thunders and lightnings and tempests warred magnificently at our feet and the storm clouds above swung their shredded banners in our very faces!"

Skoff's images embody this landscape. The way in which she hand colors heightens and enriches the dramatic effects of light, space, and earth surface. Her hand coloring techniques were used in her earlier work, but have been refined and polished in her more recent work. She uses combinations of paints and dyes, rubbing, blending, masking, drawing and painting on the original black-and-white image. This produces sometimes subtle, sometimes striking, always exquisite results.

—Judy Dater

Neal Slavin: *Group Portrait: Wrestling Inc.* (original in color), 1974

SLAVIN, Neal.

American. Born in Brooklyn, New York, 19 August 1941. Educated at the Music and Art High School, New York, 1955-59; studied painting, graphic design and photography, Cooper Union, New York, 1959-63, B.F.A. 1963; Renaissance painting and sculpture, Lincoln College, Oxford University, England, 1961. Served in the United States Army Reserve, 1963-64. Freelance photographer and graphic artist, working for *New York Times, Sunday Times* (London), *Stern, Fortune, Esquire, Newsweek*, etc., since 1963; established studio, New York, 1975. Instructor in Photography, Manhattanville College, Purchase, New York, 1970-74; Queen's College, New York, 1972; Cooper Union, New York, 1972-74; and School of Visual Arts, New York, 1973. Recipient: Fulbright Photography Fellowship, 1968; National Endowment for the Arts Grant, 1972, 1976; Creative Artists Public Service Award, 1977. Agent: Barbara Von Schreiber, 315 Central Park West, New York, New York 10025. Address: 62 Greene Street, New York, New York 10012, U.S.A.

Individual Exhibitions:

1967	The Underground Gallery, New York
1968	National Museum of Ancient Art, Lisbon
1970	Museu Machado de Castro, Coimbra, Portugal
1971	The Underground Gallery, New York
	Royal Ontario Museum, Toronto
1972	Focus Gallery, San Francisco
	831 Gallery, Birmingham, Michigan
1976	Silver Image Gallery, Tacoma, Washington
	University of Maryland, Baltimore
	Oakland Museum, California
	Matrix, Wadsworth Atheneum, Hartford, Connecticut
	Center for Creative Photography, University of Arizona, Tucson
	Light Gallery, New York (2 exhibitions)
1978	Galerie Spectrum, Hannover
	Galerie Gothaer, Cologne
1979	Shadai Gallery, Tokyo
	Milwaukee Arts Center, Wisconsin
1980	Akron Art Institute, Ohio

Selected Group Exhibitions:

1971	*The Concerned Photographer*, Riverside Museum, New York
1975	*National Photography Invitational*, Virginia Commonwealth University, Richmond
1976	*Rooms*, Museum of Modern Art, New York
	Photokina 76, Cologne
1977	*Documenta 6*, Kassel, West Germany
1978	*Tusen och en bild*, Moderna Museet, Stockholm
1979	*Venezia '79: La Fotografia*
	Photographie als Kunst 1879-1979, Tiroler Landesmuseum Ferdinandeum, Innsbruck, Austria (travelled to Neue Galerie am Wolfgang Gurlitt Museum, Linz; Neue Galerie am Landesmuseum Joanneum, Graz; Museum des 20. Jahrhunderts, Vienna)
1980	*Aspects of the 70's*, DeCordova Museum, Lincoln, Massachusetts
1981	*Aspects of American Photography*, Galerie Spectrum, Hannover

Collections:

Metropolitan Museum of Art, New York; Museum of Modern Art, New York; New York Public Library; International Museum of Photography, George Eastman House, Rochester, New York; University of Maryland, Baltimore; Akron Art Institute, Ohio; Exchange National Bank, Chicago; Center for Creative Photography, University of Arizona, Tucson; University of California at Los Angeles; Moderna Museet, Stockholm.

Publications:

By SLAVIN: books—*Portugal*, with an afterword by Mary McCarthy, New York 1971; *When Two or More Are Gathered Together*, New York 1976; *Johnny's Egg*, with text by Earlene Long, illustrations by Charles Mikolaycak, Redding, Massachusetts 1980.

On SLAVIN: books—*Photographs: Sheldon Memorial Art Gallery Collection, University of Nebraska*, with an introduction by Norman A. Geske, Lincoln 1977; *Geschichte der Fotografie im 20. Jahrhundert/Photography in the 20th Century* by Petr Tausk, Cologne 1977, London 1980; *Documenta 6, Band 2*, exhibition catalogue, by Klaus Honnef and Evelyn Weiss, Kassel, 1977; *Tusen och en bild*, exhibition catalogue, by Ake Sidwall, Sune Jonsson and Ulf Hard af Segerstad, Stockholm 1978; *Dumont Foto 1*, edited by Hugo Schöttle, Cologne 1978; *Darkroom 2*, edited by Jain Kelly, New York 1978; *Faces* by Ben Maddow, Boston 1979; *Photographie als Kunst 1879-1979/Kunst als Photographie 1949-79*, exhibition catalogue, 2 vols., by Peter Weiermair, Innsbruck 1979; *The Photograph Collector's Guide* by Lee D. Witkin and Barbara London, Boston and London 1979; articles—"New American Imagery: Neal Slavin" in *Camera* (Lucerne), May 1974; "The Coming to Age of Color" by Max Kozloff in *Artforum* (New York), January 1975; "America '76," special issue of *Du* (Zurich), January 1976; "When Two or More Are Gathered Together" by Sheila Turner Seed in *Popular Photography* (New York), February 1976; "New Frontiers in Color" by Douglas Davis in *Newsweek* (New York), 19 April 1976; "Looking at Groups, Defining America" by Joan Murray in *Artweek* (Oakland, California), 9 October 1976.

There are the emotions and there is the intellect—somewhere in the middle there is photography. That is how I begin and end my photography.

—Neal Slavin

Neal Slavin is one of the most versatile and intelligent commercial photographers in America. Known as an imaginative problem-solver, he works with equal ease on location or in his Manhattan studio, producing images which appear regularly on book jackets and magazine covers, in essay form in such diverse publications as *New York* and *Geo*, and elsewhere.

Alongside his commercial work, Slavin periodically undertakes self-assigned projects of a professional nature, which generally resolve themselves in book form. To date, these extended works have shared a common sociological thrust, but have made radically divergent demands on Slavin's capabilities as an image-maker.

The first of these essays, *Portugal*, is a somber meditation on a repressed culture in the grip of a political dictatorship. For this study, Slavin chose to utilize the 35mm. camera and black-and-white film; this enabled him to work in an unobtrusive, fluid, intuitive and responsive manner under virtually any lighting conditions. The resulting sequence of images, a revealing and highly personal interpretation of his subject, showed Slavin to be adept at the small-camera documentary mode as defined by Cartier-Bresson and redefined by Robert Frank. Carefully structured for all their informality, and printed with an awareness of the emotional resonance of darkness, this set of pointed glimpses of Portuguese life cumulatively made a clear statement about the effect of political oppression on those who live under it.

Slavin's next project was conceived on a much larger scale, and involved a considerably different set of craft imperatives. Published as *When Two or More Are Gathered Together*, it is a lengthy suite of posed formal color portraits of American social and professional groups.

Slavin's particular concern in this work was to find and make evident those means by which the members of a group define themselves, in sociologist Erving Goffman's term, as "a *with*"—that is, the ways in which they signal their shared identity. Because clothing and such appurtenances of decor as banners are among those signals, Slavin chose to work in color, which enabled him to render full information on the groups' self-presentation to the camera. The ritualistic aspect of that conscious transaction between photographer and subjects virtually mandated the use of large-format cameras and (in most cases) controlled lighting. The ensuing large negatives provided greater detail—and thus more information—about the groups' dress, body language, hierarchical positioning and other matters.

Thus Slavin's adroit handling of a dramatically different photographic approach—different in its relation to subject matter and different in its materials and techniques—gave evidence of a remarkable adaptability, indicative of the photographer's capacity to conceptualize his projects carefully and bring to them a level of craft which permits the use of whatever tools, materials and techniques are appropriate to the work at hand. Slavin's is a clear case of the benefits which the rigorous demands of professional work bestow on the creative photographer.

—A.D. Coleman

SMITH, Edwin.

British. Born in Camden Town, London, 15 May 1912. Educated at Great College Street Elementary School, London, 1917-24; trained as a bricklayer, carpenter and decorator, 1924-28, then studied architecture 1928-30, at the Northern Polytechnic, Holloway, London; studied at the Architectural Association School, London (Royal Institute of British Architects Scholarship), 1930-33; self-taught in photography. Worked as a camouflage artist, 1940-42. Married Rosemary Austell in 1935 (divorced, 1943); married the writer Olive Cook in 1954: son: Martin. Assistant Architect, Office of Marshall Sisson, London, 1933; freelance book photographer, from 1934: concentrated on architectural and landscape photography, after 1945; also, painter, designer and graphic artist. Estate: c/o Olive Smith, The Coach House, Windmill Hill, Saffron Walden, Essex CB10 1RR. Agent: House Gallery, 62 Regent's Park Road, London NW1, England. *Died* (in Saffron Walden) *29 December 1971.*

Individual Exhibitions:

1970 *Photographs by Edwin Smith*, at the Cambridge Festival
1973 *Edwin Smith: Photographs*, at the Aldeburgh Festival, Suffolk
1974 *Aspects of the Art of Edwin Smith*, The Minories, Colchester, Essex (included paintings)
 Records and Revelation, Joshua Taylor Gallery, Cambridge (included paintings)
1975 *Observer with a Lens*, Fermoy Art Gallery, King's Lynn, Norfolk
1976 The Playhouse, Harlow, Essex
 Edwin Smith: Photographs, Paintings and Drawings, House Gallery, London
1977 *First and Last Interests*, House Gallery, London
 Royal Institute of British Architects, London
1978 University of Manchester
 A Camera Views the 16th Century House, House Gallery, London
1979 *Aspects of Englishness*, House Gallery, London
1980 House Gallery, London

Selected Group Exhibitions:

1977 *The Age of Elizabeth*, British Council, London
1979 *Aspects of British Documentary Photography: The 30's*, Midland Group Gallery, Nottingham
1980 *Modern British Photography 1919-39*, Museum of Modern Art, Oxford (toured the U.K.)

Collections:

Victoria and Albert Museum, London (permanent archives); London Museum (200 photographs of London).

Publications:

By SMITH: books—*Photo Tips on Cats and Dogs*, London 1938; *Better Snapshots*, London 1939; *All about the Light*, London 1940; *All about Winter Photography*, London 1940; *All the Photo Tricks*, London 1940, 1973; *English Parish Churches*, with text by Graham Hutton, London 1952; *English Cottages and Farmhouses*, with text by Olive Cook, London 1954; *Scotland*, with text by George Fraser, London 1955; *England*, with text by Geoffrey Grigson, London 1957; *The British Museum*, with text by Geoffrey Grigson, London 1957; *English Abbeys and Priories*, with text by Olive Cook, London 1960; *Pompeii: The Glory and the Grief*, with text by Marcel Brion, London 1960; *Great Houses of Europe*, edited by Sacheverell Sitwell, London and New York 1961; *Venice*, with text by Marcel Brion, London 1962; *Great Gardens*, edited by Peter Coats, London 1963; *Great Palaces*, London 1964; *The English Garden*, with text by Edward Hyams, London 1964; *British Churches*, with text by Olive Cook, London 1964; *Athens*, with text by Angelo Procopiou, London 1964; *Prospect of Cambridge*, with text by Olive Cook, London 1965; *The Wonders of Italy*, with text by Olive Cook, London 1965; *The Age of Charlemagne*, with text by Donald Bullough, London 1965, 1973; *The Making of Classical Edinburgh*, with text by A.J. Youngson, Edinburgh 1966; *Ireland*, with text by Michel MacLiammor and Olive Cook, London 1966; *Great Interiors*, edited by Ian Grant, London 1967; *The Age of Plantagenet and Valois*, with text by Kenneth Fowler, London 1967; *Scotland*, with text by Eric Linklater and Olive Cook, London 1968; *The English House Through Seven Centuries*, with text by Olive Cook, London 1968; *The Graphic Reproduction and Photography of Works of Art*, with John Lewis Cowell, London 1969; *English Cottage Gardens*, with text by Edward Hyams, London 1970; *England*, with text by Angus Wilson and Olive Cook, London 1971; *Rome*, with text by Stewart Perowne, London 1971; *London*, with text by David Piper, London 1971; *Hatfield House*, with text by David Cecil, London and Boston 1973; *Inverary and the Dukes of Argyll*, with text by Ian Lindsay, London 1973; *The Countryside of Britain*, London 1977; articles—numerous photos/articles in the annual *Saturday Book*, London 1943-72.

On SMITH: books—*Photographs by Edwin Smith*, exhibition catalogue, with introduction by Norman Scarfe, Aldeburgh, Suffolk 1973; *Aspects of the Art of Edwin Smith*, exhibition catalogue, with a preface by Michael Chase, texts by several authors, Colchester, Essex 1974; *The Magic Image* by Cecil Beaton and Gail Buckland, London and Boston 1975; *Modern British Photography 1919-1939*, exhibition catalogue, by David Mellor, London 1980; articles—"Obituary: Mr. Edwin Smith, Painter and Photographer" in *The Times* (London), 4 January 1972; "Photographer by Chance: Valediction to Edwin Smith" by Olive Cook in *The Saturday Book*, London 1972; "Edwin Smith" in *Creative Camera* (London), July 1973; "Photographs by Edwin Smith" in *British Journal of Photography* (London), 3 December 1976; "Edwin Smith 1912-1971" by Olive Cook in *Creative Camera Yearbook 1978*, London 1978; "Edwin Smith" in *Creative Camera* (London), May/June 1980.

Edwin Smith has been one of those curious cases where the actual work has been widely published and disseminated, to such a degree that it may be said that for a very substantial number of people their ideas of England, both her landscape and her architecture, Ireland, Venice and Athens, have been subtly influenced by the highly persuasive powerfully incisive eye he brought to bear on well-used, long lived-in landscape and buildings. Yet his name has not been one to conjure with outside professional circles, and only recently has he come again to be recognised as one of the most outstanding photographers of the sense of place—the genius loci—in his time.

He painted or drew nearly every day of his adult life, but was delighted at the details that the eye could not see, or glossed over, which were often revealed to him by the camera. He started in 1933 with a Box Brownie, then went on to a quarter plate camera, and then an old fashioned Ruby (1904) with its body of mahogany and brass. He was indefatigible in waiting for the right moment, or, rather, the right natural light by which to photograph. He was especially gifted in allowing the natural light to pick

out the forms of stone, to describe the three dimensionality of his subject matter in ways both sensitive and sophisticated, which is one of the reasons his architectural photographs, both exteriors and interiors, are so memorably successful. He did not indulge in melodrama—or even drama. He did not impose on the subject, but rather allowed the subject its own expressive space.

Some 8000 negatives by Smith are destined for the Victoria and Albert Museum. Smith, it is recorded, thought of his photographs as factual records, but in fact sequences of his work, categorised by subject matter, make highly sensitive visual essays and meditations on, for instance, the 16th century in terms of architecture, landscape and artifacts in Britain, France, Italy and Denmark; the circus; the fairground; village, town and city life; gardens; great houses, all over Europe; ecclesiastical architecture from the village church to the great cathedral. Books of his work number 34, including several written by himself about the subject of taking photographs, including one titled *All the Photo Tricks*. Yet "tricks" is the exact opposite of the impression given by Smith's photographs, which are honest, humane, thoughtful, persuasive for the best of reasons: this is how it really was.

Trained as an architect, and continually practicing as painter and draughtsman, Smith had an eye that was incisive: what underpins his photographs is the steadiness of his eye and hand, so that he could take interior photographs with a small hand-held camera holding it for long enough exposures to exploit natural light. His ability to find the essential detail or vantage point, or point of view, the essential anchorage or punctuation for the photograph or series of photographs of particular places or casual events was a gift disciplined by continual practice. Here was no imposed definition. The strength of Edwin Smith's photographs is located in his sensitive, intelligent and robust ability to find and describe through photographs the characteristics, the feeling, the atmosphere, of what he was observing, without tricksy, arty, contrived or bombastic effects. So successful is he, so classic many of his publications, that it is his view of many parts of Europe that has informed countless readers and viewers.

As he said himself, "The man who lives in his eyes is continually confronted with scenes and spectacles that compel his attention or admiration and demand an adequate reaction. To pass on without pause is impossible and to continue after merely mental applause is unsatisfying: some real tribute must be paid." Smith was a city child, born and brought up in Camden Town, London, and he was discovered to be short-sighted when about 10: first his apprenticeship in the building trades, then architectural training, and finally his daily devotion to the fine arts are all contributory aspects to the power he found through photography to express the intensity of his acute gaze on the world he found on his travels, and all around him. As his widow, the writer Olive Cook, has recorded, Edwin Smith "lived by looking." He said himself, "I have come to worship with the eyes." Yet his photographs are the least solemn of things: rather they are positive evocations of a multitude of delights.

—Marina Vaizey

SMITH, Henry Holmes.

American. Born in Bloomington, Illinois, 23 October 1909. Educated at primary and secondary schools in Bloomington; studied at the State Normal College, Bloomington, 1927-29, 1930-31; School of the Art Institute of Chicago, 1929-30; Ohio State University, Columbus, 1932-33, B.S. 1933. Served in the United States Army, in Hawaii, the Gilbert Islands and Iwo Jima, 1942-45. Married Wanda Lee Phares in 1947; sons: Christopher and Theodore. Independent photographer, Chicago, 1934-46, Bloomington, Indiana, 1946-77, and Tucson, Arizona, since 1977; has worked on color synthesis photography since 1947. Instructor of Photography, with Gyorgy Kepes and László Moholy-Nagy, New Bauhaus School, Chicago, 1937-38; Instructor of Photography, 1947-65, and Professor, 1965-77, Indiana University, Bloomington. Visiting Professor, Maryland Institute College of Art, Baltimore, 1967. Associate Editor, *Minicam Photography*, Chicago, and *College Art Journal*, Bloomington, 1955-64. Founder Member, 1963, Vice-Chairman, 1963-67, and Member of the Board of Directors, Society for Photographic Education. Recipient: Herman Frederick Lieber Distinguished Teaching Award, Indiana University, 1968. D.F.A.: Maryland Institute College of Art, 1968. Address: c/o Center for Creative Photography, University of Arizona, 843 East University Boulevard, Tucson, Arizona 85719, U.S.A.

Selected Group Exhibitions:

1951 *Abstract Photography*, Museum of Modern Art, New York
1959 *Photographer's Choice*, Indiana University, Bloomington
 Photography at Mid-Century, International Museum of Photography, George Eastman House, Rochester, New York (toured the United States)
1960 *Sense of Abstraction*, Museum of Modern Art, New York
1961 *6 Photographers 1961*, University of Illinois, Urbana
 20th Century American Art, Kalamazoo Art Center, Michigan
1967 *Photography in the 20th Century*, National Gallery of Canada, Ottawa (toured Canada and United States, 1967-73)
1973 *Midwest Invitational*, Walker Art Center, Minneapolis, Minnesota
1980 *Photography of the 50's*, Center for Creative Photography, University of Arizona, Tucson
 Cliché-Verre, Detroit Institute of Arts

Individual Exhibitions:

1946 Illinois Wesleyan University, Bloomington
1947 Indiana University, Bloomington
1956 University of North Dakota, Grand Forks
1958 State University of New York at New Paltz
1959 Indiana Art Directors Association, Indianapolis
1960 Akron Art Institute, Ohio
1962 Institute of Design, Illinois Institute of Technology, Chicago
1964 San Francisco State University
1971 Skidmore College, Saratoga Springs, New York
 Polaroid Corporation, Cambridge, Massachusetts
1972 Phos/Graphos Gallery, San Francisco
 Center for Photographic Studies, Louisville, Kentucky
1973 *Henry Holmes Smith's Art: 50 Years in Retrospect*, Indiana University, Bloomington
1974 Friends of Photography, Carmel, California
 J.B. Speed Museum, Louisville, Kentucky (with Ralph Eugene Meatyard)
1975 Addison Gallery, Andover, Massachusetts

Collections:

Indiana University, Bloomington (Henry Holmes Smith Archive); Museum of Modern Art, New York; International Museum of Photography, George Eastman House, Rochester, New York; Library of Congress, Washington, D.C.; New Orleans Museum of Art; Museum of Fine Arts, St. Petersburg, Florida; Center for Creative Photography, University of Arizona, Tucson; University Art Museum, University of New Mexico, Albuquerque; Oakland Art Museum, California; San Francisco Museum of Modern Art.

Publications:

By SMITH: book—*Henry Holmes Smith: Selected Critical Writings*, edited by Terence R. Pitts, Tucson, Arizona 1977; articles—"Photographs and Public" in *Aperture* (Rochester, New York), 1953; "Frederick Sommer: Collages and Found Objects" in *Aperture* (Rochester, New York), 1956; "The First Indiana University Workshop" in *Aperture* (Rochester, New York), vol. 5, no. 1, 1957; "The Education of Picture-Minded Photographers" in *Aperture* (Rochester, New York), 1957; "Two for the Photojournalist" in *Aperture* (Rochester, New York), vol. 8, no. 4, 1960; "Museum Taste and the Taste of Our Time" in *Aperture* (Rochester, New York), 1962; "The Photographs of Van Deren Coke" in *Photography* (London), 1963; "The Photography of Jerry N. Uelsmann" in *Contemporary Photographer* (Culpeper, Virginia), vol. 5, no. 1, 1964; "New Figures in a Classic Tradition" in *Aaron Siskind, Photographer*, edited by Nathan Lyons, New York 1965; "Photography in Our Time" in *Photographers on Photography*, edited by Nathan Lyons, New York 1966; "An Access of American Sensibility: The Photographs of Clarence John Laughlin" in *Exposure* (Chicago), November 1973; "Critical Difficulties: Some Problems with Passing Judgement and Taking Issues" in *Afterimage* (Rochester, New York), Summer 1978; "Henry Holmes Smith," interview, in *Dialogue with Photography*, edited by Paul Hill and Thomas Cooper, London 1979.

On SMITH: books—*Photographer's Choice*, exhibition catalogue, Bloomington, Indiana 1959; *Invitational Teaching Conference at the George Eastman House*, Rochester, New York 1962; *Photography in the 20th Century* by Nathan Lyons, New York 1967; *Henry Holmes Smith's Art: 50 Years in Retrospect*, exhibition catalogue, Bloomington, Indiana 1973; *Photographs: Sheldon Memorial Art Gallery Collection, University of Nebraska*, with an introduction by Norman A. Geske, Lincoln, Nebraska 1977; articles—"Photography: Henry Holmes Smith" by Joan Murray in *Artweek* (Oakland, California), 23 September 1972; "Henry Holmes Smith: Speaking with a Genuine Voice" by Betty Hahn in *Image* (Rochester, New York), December 1973; "Teacher's Legacy: My Teacher, Myself" by Mark Johnstone in *Artweek* (Oakland, California), 3 November 1979; "Cliché-Verre: Investigating the Interstices" by Ed Hill in *Afterimage* (Rochester, New York), Summer 1981.

Henry Holmes Smith, innovative photographer, writer and renowned teacher—whose students include Jerry Uelsmann, Robert Fichter, Betty Hahn and Jack Welpott—began taking simple photographs with a box camera in 1923. During his early years of development he was influenced by the photographs of Edward Weston (particularly the "Pepper"), Francis Bruguière and Edward Steichen. When Moholy-Nagy's *The New Vision* appeared, it was a key book for him, as he says in an interview with Paul Hill and Thomas Cooper: "There was nothing like it. The book had proposals for life, and it had proposals for ways of artistic behavior. It introduced me to certain possibilities, and I promptly

Edwin Smith: *Fairground Entertainers*, Hampstead, 1938

went to work; on my own I tried to practice some of these things—doing them ineptly, but doing them."

Thus, by the time he met Moholy-Nagy in 1937 in Chicago, he was already experimenting with his ideas and was involved with experimental color. Moholy-Nagy had written in the catalogue for his first photographic exhibition that "the concretization of light phenomena is peculiar to the photographic process and to no other technical invention. The photogram is a realization of spatial tension in black-white-gray. Through the elimination of pigment and texture it has a dematerialized effect. It is a writing with light, self-expressive through the contrasting relationship of the deepest black and lightest white with a transitional modulation of the finest grays. Although it is without representational content the photogram is capable of evoking an immediate optical experience, based on our psychobiological visual organization." As Betty Hahn has pointed out, in quoting the above, "Smith understood and shared Moholy's insight into this method of image making. Moreover, he was able to connect his own understanding of photograms to color when he made color separation negatives and dye transfer prints." Moholy-Nagy, impressed by Smith's ideas and his work in color experimentation, invited him to teach at the New Bauhaus in Chicago. Unfortunately, the institute did not survive long, and it was not until after World War II that Smith could return to his experimentation.

In 1946, he bought an enlarger and began to experiment with ideas he had proposed to Moholy-Nagy ten years earlier—ideas which were designed to release color photography from the burden of the camera. In 1947, on his way to Indiana University, where he was to teach until 1977, Smith planned a course of study on the light principles of refraction and reflection. This led to a body of work—refraction prints—which Betty Hahn has called his "particular gift and extraordinary contribution to the visual archive of photography." Smith describes the process by which he makes these prints in the interview with Hill and Cooper: "...the basic way that you do it is to have a fairly clean piece of glass; then you pour a not-too-heavy gesture of syrup on the glass, and then you either print it, or throw some water on it and print it. Some distance from the glass there will be a light source which gives a very clean kind of light that casts crisp shadows. The glass may be three or four inches or more from the paper, and the light is in such a position that the shadows and the refracting elements from the syrup and water will print on the paper. Then you turn the light on and give it an exposure that is appropriate in length, and you develop it just like a piece of normal photographic paper. Now you've got your key element in the process, and from that point on, you can do anything you want with it. You can leave it alone, you can copy it on a negative, you can make a positive from it, you can print it on a matrix film with different degrees of density, and you can dye them, then transfer them in any combination you care to in multiple printing." He stated once that "in my work I would like to praise heroes and enable some persons to remember the firm link between past and future that acts of the imagination provide us," and, indeed, such mythological figures as the Phoenix or Castor and Pollux are to be found among his images.

Speaking of his images in general, Mark Johnstone has the following to say: "His images have consistently involved elements that deal directly with the interplay of light and relational aspects of color.... The images suggest the space and flow of light, and function as both reproductive and poetic devices. Like parables, their careful construction can reveal many meanings. They offer an appreciation of light and color with a rare contemplative beauty, should we as spectators choose to become participants, and not just look at them but *see* them."

—Michael Held

SMITH, Keith.

American. Born in Tipton, Indiana, 20 May 1938. Educated at Mansfield Senior High School, Mansfield, Ohio; School of the Art Institute of Chicago, 1963-67, B.A.E. 1967; studied photography at the Illinois Institute of Technology, Chicago, 1968, M.S.Photog. 1968. Instructor, University of California at Los Angeles, 1970; Assistant Professor, School of the Art Institute of Chicago, 1971-74; Co-ordinator of Printmaking, Visual Studies Workshop, Rochester, New York, 1975-80. Recipient: Guggenheim Fellowship, 1973, 1980; National Endowment for the Arts Award, 1978. Address: 22 Cayuga Street, Rochester, New York 14620, U.S.A.

Individual Exhibitions:

1968 Art Institute of Chicago
1970 International Museum of Photography, George Eastman House, Rochester, New York
 Visual Studies Workshop, Rochester, New York
1971 Light Gallery, New York
1973 Galleria Civica d'Arte Moderna, Turin
1974 University of Illinois, Urbana
 Light Gallery, New York
 Sonia Sheridan and Keith Smith, Museum of Modern Art, New York

Keith Smith: *Philip Lange*, 1980

1975 *Irene Siegel and Keith Smith*, Barat College, Lake Forest, Illinois
1976 Visual Studies Workshop, Rochester, New York
 Lichtropfen, Aachen, West Germany
 Light Gallery, New York
1977 Vision Gallery, Boston
1978 Stuart Wilber Inc., Chicago
 Chicago Center for Contemporary Photography
1979 Stuart Wilber Inc., Chicago
1980 Stuart Wilber Inc., Chicago

Selected Group Exhibitions:

1976 *Photographie: Rochester*, Centre Culturel Americain, Paris
1978 *Fantastic Photography in the U.S.A.*, Canon Photo Gallery, Amsterdam (toured Europe and the United States, 1978-80)
 Mirrors and Windows: American Photography since 1960, Museum of Modern Art, New York (toured the United States, 1978-80)
1979 *Attitudes: Photography of the 1970's*, Santa Barbara Museum of Art, California
 American Photography of the 70's, Art Institute of Chicago
1980 *Cliché Verre: 1939 to the Present*, Detroit

Institute of Arts
Hand-Colored Photographs, Philadelphia
College of Art

Collections:

Museum of Modern Art, New York; International Museum of Photography, George Eastman House, Rochester, New York; Fogg Art Museum, Harvard University, Cambridge, Massachusetts; Art Institute of Chicago; Arnold H. Crane Collection, Chicago; Center for Creative Photography, University of Arizona, Tucson; National Gallery of Canada, Ottawa; Galleria Civica d'Arte Moderna, Turin; Museum of Geelong, Victoria, Australia.

Publications:

By SMITH: book—*When I Was Two*, Rochester, New York 1977; article—interview in *Photography Between Covers* by Thomas Dugan, Rochester, New York 1979.

Throughout my life I have spent a great deal of time examining the properties of line, tone, texture, color, space, suggestion of 3-dimensional space on 2-dimensional surfaces, repetition, symbolism, motif, transitions from picture to picture in diptychs, polyptics, in groups, series, sequences, as books. I am concerned about mood, movement, and a sense of time. These involvements have been expressed through photography, drawing, collage, non-silver and photo-related printmaking on paper and various surfaces, but just as importantly in day-to-day activities of sex, cooking, home, controlled, non-drug hallucination and dreams.

This discipline is basic, but just as important as hunches, accidents, intuition, and allowing the work to speak freely.

Process is never an end for me, merely the means of expression. I am not in love with photography.

I spend a large portion of my time making pictures, underpinned by exercises and a constant vigil of learning to see clearly and freshly and the courage to throw away old ways of seeing.

I exercise how to concentrate, how to evolve my imagination to help me more vividly image the page with energy, boldness, sincerity and openness.

—Keith Smith

Keith Smith lives in a simple late-Victorian row house in Rochester, New York. The interior woodwork he has decorated as richly and exuberantly as did that sport of an architect, Billy Burges. Window frames and door frames are like clusters of different-colored marble. The Outside World requires him now and then to walk over to the Visual Studies Workshop, where he is a legendary teacher of printmaking, unstinting with the students who want to work. And then it is straight back to the house, where he works day and night and twice on Sunday on his images. Lithography, etching, engraving, screen-printing, photography—the mix is incredible and it is constantly being extended. In Chicago at the Art Institute Keith Smith studied with Aatis Lillstrom. He remains collaborator, friend and critic, one of the few people Keith Smith sees. Another is Fritz Klemperer (nephew of Otto), a former student, who photographs in Cleveland. The friends are a tiny set; the house is peopled with thousands of visual companions.

Keith Smith makes the kind of prints that would make Jesse Helms grow four tits if he ever happened to encounter one in the wild. Which is a down-home way of saying that perhaps Keith Smith is not a photographer for all five seasons or for all tastes. He is a very important gay artist and it seems fair

enough to dwell on this fact at a time when the Oral Majority is busy trying to consign all us Country Genitalists to the fiery furnace. Accordingly, he runs the risk of not being taken "seriously" by a commodity society full of prudes, prunes, and drones. Keith Smith is the shyest and quietest of men. Very small and wistful, off a farm in Indiana. His imagination is wholly *cathectic* (look it up, damn it...). His working life is devoted to the making of images of erotical boys. I do not think it impious to say that he is as devoted to his singular task as a good Trappist is devoted to his. Mr. Smith celebrates spirit *and* flesh. The images are companionable, in a world that too seldom is.

I grew up with friends who were enthralled arse-over-tit with the obsessions of Petty and Vargas in the old *Esquire*. There wasn't much skin for those whose tastes were otherwise constituted, though now one knows that George Platt Lynes and Paul Cadmus and Tchelitchew were busy delineating a male sensuality for east-coast, ivy-league sophisticates. Today, the artist who calls himself Tom of Finland fills magazines with those grotesquely endowed macho gods who "turn him on." World Without End.... The writer Stephen King knows that, like himself, most of us were frightened of Daddy and of going into the Dark Cellar. He gives us a book a year and can't ever hope to spend all the money that piles in. But, few of us have obsessions that pay off. Trappists aren't abundant. They're not making money. Neither is Keith Smith.

Is the audience for this work "restricted"? I doubt it. People's sexual fantasies are more various than we know. And society has seen to it—up til now—that most quote homosexuals unquote were married, just like whitefolks. Aaron Siskind, for example, admires what Keith Smith makes. With so many sultry Shulamite damsels on his mind, can there be many less likely readers of *Blue Boy* in the nation? I suggest that *anyone* may look at Keith Smith's prints, precisely because they are full of aesthetic delight and the quality of one man's longing. Let Old Jesse get uptight. Jesse aint read the *Greek Anthology*, where some wise ancient has told us: "Women for use; boys for pleasure; goats for delight..." Somebody else will give you the ladies and the capricorns. Take what you're offered—and be polite!

—Jonathan Williams

SMITH, W(illiam) Eugene.

American. Born in Wichita, Kansas, 30 December 1918. Educated at Catholic parochial school, Wichita, 1924-30; Catholic High School, Wichita, 1930-35; studied photography, University of Notre Dame, Indiana, 1936-37. Married Carmen Martinez in 1940 (divorced); children: Juanita, Marissa, Shana, Patrick, and Kevin; married Aileen Mioko in 1970. First photographs, under advice from news photographer Frank Noel, Wichita, 1933-35; part-time press photographer, contributing to *Wichita Eagle* and *Wichita Beacon* newspapers, Wichita, 1935-36; staff photographer, *Newsweek* magazine, New York, 1937-38; freelance photographer, with Black Star Agency, contributing to *Life, Colliers, American Magazine, Harper's Bazaar* and the *New York Times*, New York, 1938-39; Staff Photographer, *Life* magazine, New York, 1939-41, as war correspondent, 1944-45, and 1947-54; Staff Photographer/War Correspondent, Ziff-Davis Publishing Company, in the Pacific, 1942-44; Member, Mag-

num Photos co-operative agency, working on a Pittsburgh photographic survey, and contributing to *Life, Pageant, Sports Illustrated*, etc., New York and Pittsburgh, 1955-58; freelance photographer, working for Hitachi Company, *Life* magazine, etc., New York and Japan, 1959-77; Special Medical Reportage Editor, *Visual Medicine* magazine, New York, 1966-69. Photography Instructor, New School for Social Research, New York, 1958; private classes in photojournalism, New York, 1960; School of Visual Arts, New York, 1969; University of Arizona, Tucson, 1978. Recipient: Guggenheim Fellowship, 1956, 1957, 1968; Honor Award, American Society of Magazine Photographers, 1959; Award Plaque for Photojournalism, and Clifford Edom Founders Award, University of Miami, 1959; National Endowment for the Arts Award, 1971. *Died* (in Tucson, Arizona) *15 October 1978*.

Individual Exhibitions:

1944 Museum of Modern Art, New York
1948 Museum of New Mexico, Santa Fe
1957 *10 Buildings in America's Future*, National Gallery of Art, Washington, D.C.
 Limelight Gallery, New York
1960 University of Oregon, Eugene
1969 Rochester Institute of Technology, New York
1970 International Museum of Photography, George Eastman House, Rochester, New York (toured the United States and Europe)
1971 *Let Truth Be the Prejudice*, Jewish Museum, New York (retrospective)
 Witkin Gallery, New York
1974 City Auditorium, Minamata, Japan
1975 International Center of Photography, New York
 University of Oregon, Eugene
1976 Witkin Gallery, New York
1977 State University, Wichita, Kansas
1978 Center for Creative Photography, University of Arizona, Tucson (memorial exhibition)
1979 Hippolyte Gallery, Helsinki
 Kunsthaus, Zurich
 West Virginia University, Morgantown
1980 Douglas Kenyon Gallery, Chicago
 Early Work, Center for Creative Photography, University of Arizona, Tucson
1981 Photograph, New York (retrospective)
 Eclipse Photographics, Boulder, Colorado
 Clarence Kennedy Gallery, Cambridge, Massachusetts

Selected Group Exhibitions:

1951 *Memorable Life Photographs*, Museum of Modern Art, New York
1954 *Great Photographs*, Limelight Gallery, New York
1955 *The Family of Man*, Museum of Modern Art, New York (and world tour)
1967 *Photography in the 20th Century*, National Gallery of Canada, Ottawa (toured Canada and the United States, 1967-73)
1970 *The Concerned Photographer 2*, Israel Museum, Jerusalem (toured Europe)
1974 *Photography in America*, Whitney Museum, New York
1979 *Life: The First Decade 1936-1945*, Grey Art Gallery, New York University
 Photographie als Kunst 1879-1979, Tiroler Landesmuseum Ferdinandeum, Innsbruck, Austria (travelled to Neue Galerie am Wolfgang Gurlitt Museum, Linz, Austria; Neue Galerie am Landesmuseum Joanneum, Graz, Austria; and Museum des 20. Jahrhunderts, Vienna)
1980 *Old and Modern Masters of Photography*, Victoria and Albert Museum, London (toured Britain)

Photography of the 50's, International Center of Photography, New York (travelled to the Center for Creative Photography, University of Arizona, Tucson; Minneapolis Institute of Art; California State University at Long Beach; and Delaware Art Museum, Wilmington)

Collections:

W. Eugene Smith Archive, Center for Creative Photography, University of Arizona, Tucson; Life Magazine Picture Collection, New York; Museum of Modern Art, New York; International Center of Photography, New York; International Museum of Photography, George Eastman House, Rochester, New York; Boston Museum of Fine Arts; Carpenter Center, Harvard University, Cambridge, Massachusetts; Dayton Art Institute, Ohio; Art Institute of Chicago; University of Colorado, Boulder.

Publications:

By SMITH: books—*Eugene Smith Photography*, Minneapolis 1954; *Hitachi Reminder*, Tokyo 1961; *Japan: A Chapter of Image*, with Carole Thomas, text by Smith under pseudonym Walter Trego, Tokyo 1963; *Pittsburgh: The Story of an American City*, edited by Stefan Lorant, New York 1964; *Hospital for Special Surgery*, with Carole Thomas, New York 1966; *W. Eugene Smith: His Photographs and Notes*, with text by Peter C. Bunnell and Lincoln Kirstein, New York 1969; *Minamata: Life—Sacred and Profane*, portfolio of 12 photos, with Aileen M. Smith, text by Michiko Ishimura, Tokyo 1973; *Minamata*, with Aileen M. Smith, New York 1975; *Ten Photographs*, portfolio, Roslyn Heights, New York 1977; *W. Eugene Smith: Early Work*, with text by William S. Johnson, Tucson, Arizona 1980; *W. Eugene Smith: Master of the Photographic Essay*, with text by William S. Johnson, Millerton, New York 1981; articles—"Photographic Journalism" in *Photo Notes* (New York), June 1948; "Photography Today" in *Photography Annual 1954*, New York 1953; "The Walk to Paradise Garden" in *Croton-Harmon News* (Croton, New York), 31 March 1955; "W. Eugene Smith Talks about Lighting" in *Popular Photography* (New York), November 1956; "Pittsburgh," with an introduction by H.M. Kinzer, in *Modern Photography Annual 1959*, New York 1958; "One Whom I Admire, Dorothea Lange (1895-1965)" in *Popular Photography* (New York), February 1966; "Minamata, Japan: Life, Sacred and Profane," with Aileen M. Smith, in *Camera 35* (New York), April 1974.

On SMITH: books—*Memorable Life Photographs*, with text by Edward Steichen, New York 1951; *Photography in the 20th Century* by Nathan Lyons, New York 1967; *The Concerned Photographer 2*, edited by Cornell Capa, New York and London 1972; *Photography in America*, edited by Robert Doty, with an introduction by Minor White, New York 1974; *Masters of the Camera* by Gene Thornton, New York 1976; *Photographs: Sheldon Memorial Art Gallery Collection, University of Nebraska*, with an introduction by Norman A. Geske, Lincoln 1977; *Darkroom*, edited by Eleanor Lewis, New York 1977; *Photography Within the Humanities*, edited by Eugenia Parry Janis and Wendy MacNeil, Danbury, New Hampshire 1977; *Geschichte der Fotografie im 20. Jahrhundert/Photography in the 20th Century* by Petr Tausk, Cologne 1977, London 1980; *Light Readings: A Photography Critics Writings 1968-1978* by A.D. Coleman, New York 1979; *Dialogue with Photography*, edited by Paul Hill and Thomas Cooper, London 1979; *Venezia '79: La Fotografia*, edited by Daniela Palazzoli, Vittorio Sgarbi and Italo Zannier, Milan and New York 1979; *Life: The First Decade 1936-1945* by Robert Littman, Ralph Graves and Doris C. O'Neill, New York 1979, London 1980; *Photographie als Kunst 1879-1979/Kunst als Photographie 1949-1979*, exhibition catalogue, 2 vols., by Peter Weiermair, Innsbruck, Austria 1979; *Old and Modern Masters of Photography*, exhibition catalogue, by Mark Haworth-Booth, London 1980; *Photography of the 50's: An American Perspective* by Helen Gee, Tucson, Arizona 1980; articles—"Wonderful Smith" by Tom Maloney and others in *U.S. Camera* (New York), August 1945; "Gene Smith Meeting" by Jo Chaslin and others in *Photo Notes* (New York), November 1947; "W. Eugene Smith's Spain" by Jacquelyn Judge in *Modern Photography* (New York), December 1951; "W. Eugene Smith" by Fritz Neugass in *Camera* (Lucerne), June/July 1952; "W. Eugene Smith Teaches Photographic Responsibility" by Bill Pierce in *Popular Photography* (New York), November 1961; "Gene Smith in Japan" in *Popular Photography* (New York), November 1962; "W. Eugene Smith" by H.M. Kinzer in *Popular Photography* (New York), February 1965; "A Great Unknown Photographer—W. Eugene Smith" by David Vestal in *Popular Photography* (New York), December 1966; "Why Does W. Eugene Smith Write on Walls?" by John Durniak in *Photography Annual 1971*, New York 1970; "W. Eugene Smith: Let Truth Be the Prejudice" by R. Porter in *Infinity* (New York), May 1971; "Notes on Walker Evans and W. Eugene Smith" by Van Deren Coke in *Art International* (Lugano, Switzerland), June 1971; "W. Eugene Smith: Minamata" in *Asahi Camera* (Tokyo), May 1973; "Eugene Smith: Les Morts Vivants de Minamata" in *Photo* (Paris), November 1973; "Rebel with a Camera" by Jim Hughes in *Quest/77* (New York), March/April 1977.

"Humanity," the late Eugene Smith liked to tell his students, "is worth more than a picture of humanity that serves no purpose other than exploitation." A fit epitaph, those words, for a premier master of photojournalism, an area of the medium in which exploitation of one's subjects is a line all too easily transgressed.

Yet, during much of his productive life, Smith clung passionately to his chosen side of that line; it was a basic belief underlying his work (both the successes and the arguable failures). Basic, too, and problematic from time to time, was an equally passionate belief in the integrity of his photographs, in the individual statements in which form, tone, and humanity coalesced with such grace and power.

Smith's early photographs, those of his apprenticeship years in the late 1930's and early 40's are mere footnotes, the traces of his evolution into a mature artist (although, characteristically, he included a roomful of these early efforts in his massive 1971 New York Jewish Museum retrospective). That maturity, both photographic and, perhaps, moral, was moulded in the cauldron of World War II. Until suffering near-critical wounds on Okinawa in 1945, Smith produced image after image in what he hoped might be "an indictment of war."

Two years later, barely recovered from those wounds (physical disaster, including a near blinding while photographing *Minamata*, stalked Smith throughout his life, culminating in the fall from which he died), fearing an inability to again hold a camera, Smith created his most famous single image, "The Walk to Paradise Garden." A sentimental, heavily romantic evocation of the journey from paradise lost to paradise regained, it became the most memorable feature of Steichen's *Family of Man* exhibit.

Fears assuaged, from 1947 to 1954, Smith worked with *Life* magazine and, in so doing, changed our perceptions of the photo-essay. If some, such as "Country Doctor", simper rather too much, others (i.e. "Spanish Village" and "Nurse Midwife") are exemplars of how the form might best be used. The 1951 essay, "Spanish Village," is perhaps the most striking example of a photo-essay in which the traditional subordination of pictures to words is essentially reversed. Without *Life*'s captions, Smith's pictures retain their communicative power; without the pictures, the words die.

Smith's relationship with *Life*, tenuous at best, was severed more than once. Two years after the last major photo-essay, Smith took advantage of a Guggenheim Fellowship (the first of three) to further one of his most ambitious endeavours: a massive photographic study of Pittsburgh, one of America's industrial capitals.

The results of those Pittsburgh years have been published only in fits and starts. The big book that Smith envisioned, *Pittsburgh: A Labyrinthian Walk*, never came to fruition. In the bowels of the U.S. Library of Congress, however, may be found three thick binders containing a complete record, in contact sheets, of Smith's Pittsburgh labors. Their publication, if permissible, would be of singular value.

Perhaps his most famous major project, *Minamata*, completed in the early 70's, is a lineal descendent of the wartime photographs. This, too, was an indictment, not of the abstraction of war, but of the harsh reality of individuals and institutions which foul the environment and, in the process of profit maximization, wreak unbelievable human suffering. Its value to the people of Minamata, its importance in stimulating the environmental movement, are among Smith's greatest legacies to the humanity from which he drew his subjects.

There is a photographic legacy, as well. The exacting standards he set for himself and the degree to which those standards were, time and again, met, are both inspiration and challenge to his survivors.

Smith's prints are marked by their subtle tonal changes, brilliant highlights (sometimes achieved with local application of bleaching agents), and full, rich-toned blacks. His attention to lighting is revealed most fully in the death bed scene from the Spanish village series. Relying upon strategically positioned candles to augment the light, Smith created a tone poem about life and death, a poem in which each human face speaks its stanza. From the same series, Smith's portrait of three young members of the *Guardia Civil*, demonstrates his mastery of individual light in even its harshest form.

As printmaker, as well as photographer, Smith was exceptional. There is a richness and lustre to even the greatest enlargements, a smoothness of grain (achieved by printing through silk and other diffusers) and a subtle tonality.

In his own work, and by his example, W. Eugene Smith helped transform photojournalism at mid-century. Though the great picture magazines that nourished the form have gone, an army of street photographers, documentarians and photojournalists remains. Whether consciously or not (although consciously in many cases), they are the heirs to Smith's legacies. Both in aesthetic and moral terms, his standards remain the best guideposts for those who follow.

—Stu Cohen

Bykert Gallery, New York
1972 Center for Inter-American Relations, New
York
Bykert Gallery, New York
1973 *Camera Works by Michael Snow*, University
of Manitoba, Winnipeg
1974 *Projected Images*, Walker Art Center,
Minneapolis
Isaacs Gallery, Toronto
1976 Museum of Modern Art, New York
1977 *7 Films et Plus Tard*, Centre Georges Pompidou, Paris (toured France, 1977-79)
1978 *Michael Snow*, Centre Georges Pompidou,
Paris (travelled to the Kunstmuseum, Lucerne; Rheinisches Landesmuseum, Bonn;
Städtische Galerie im Lenbachhaus, Munich; Musée des Beaux-Arts, Montreal;
and the Vancouver Art Gallery, 1978-80)
1979 Isaacs Gallery, Toronto

Individual Film Screenings: Filmmakers Cinematique, New York, 1967, 1968, 1969; Gallery of Modern Art, New York, 1969; Whitney Museum, New York, 1969; Museum of Modern Art, New York, 1969, 1970; Edinburgh Film Festival, 1969, 1975; The Jewish Film Museum, New York, 1970; Pesaro Film Festival, Italy, 1973; *Rameau's Nephew*, world premiere, National Gallery, Ottawa, 1974; Cinematique Quebecoise, Montreal, retrospective, 1975; Museum of Modern Art, New York, retrospective, 1976; Anthology of Film Archives, New York, 1975, 1976.

Selected Group Exhibitions:

1968 *Tokyo Film Art Festival*
1969 *Anti-Illusion: Procedures and Materials*,
Whitney Museum, New York
Information, Museum of Modern Art, New
York
1970 *Festival International du Film*, Cannes
1971 *Prospect '71*, Kunsthalle, Dusseldorf
1973 *Options and Alternatives*, Yale University,
New Haven, Connecticut
1977 *Documenta 6*, Kassel, West Germany
Another Dimension, National Gallery of
Canada, Ottawa (toured Canada, 1977-
78)

Collections:

National Gallery of Canada, Ottawa; Canada Council Art Bank, Ottawa; Art Gallery of Ontario, Toronto; Montreal Museum of Fine Arts; Winnipeg Art Gallery; Museum of Modern Art, New York; Philadelphia Museum of Art; Milwaukee Art Center, Wisconsin.

Publications:

By SNOW: books—*Place of Meeting*, with text by Ray Souster, Toronto 1962; *Michael Snow: A Survey*, with text by P. Adams Sitney, Toronto 1970; *Cover to Cover*, Halifax, Nova Scotia 1975; *High School*, Toronto 1980; article—"Passage" in *Artforum* (New York), September 1971; films—*A to Z*, 1956; *New York Eye and Ear Control (A Walking Woman Work)*, 1964; *Short Shave*, 1965; *Wavelength*, 1967; *Standard Time*, 1967; *Back and Forth*, 1969; *One Second in Montreal*, 1969; *Dripping Water*, 1969; *Side Seat Paintings Slides Sound Films*, 1970; *La Region Centrale*, 1970-71; *Table Top Dolly*, 1972; *Rameau's Nephew by Diderot (Thanks to Dennis Young) by Wilma Schoen*, 1974; *Presents*, 1980; sound recordings—*The Artists Jazz Band*, 1974; *CCMC*, 5 vols., 1974-80; *Michael Snow: Music for Whistling, Piano, Microphone, and Tape Recorder*, 1975; *The Artists Jazz Band: Live at the Edge*, 1977.

On SNOW: books—*Expanded Cinema* by Gene Youngblood, New York 1970; *Negative Space* by Manny Farber, New York 1971; *Experimental Cinema* by David Curtis, London 1971; *Visionary Film* by P. Adams Sitney, New York 1974; *Une Histoire du Cinema* by Peter Kubelka and others, Paris 1976; *Documenta 6/Band 2*, exhibition catalogue, by Klaus Honnef and Evelyn Weiss, Cologne 1977; *Michael Snow*, exhibition catalogue, Lucerne 1979; *Snow Seen* by Regina Cornwell, Toronto 1980; articles—"Wavelength" by Bob Lamberton in *Film Culture* (New York), Autumn 1967; "Conversations with Michael Snow" by Jonas Mekas and P. Adams Sitney in *Film Culture* (New York), Autumn 1967; "Critique: Glass and Snow" by Richard Foreman in *Art and Artists* (London), February 1970; "Towards Snow" by Annette Michelson in *Artforum* (New York), June 1971; "Michael Snow on 'La Region Centrale'" by Charlotte Townsend in *Film Culture* (New York), Spring 1971; "Michael Snow Framed" by Simon Field in *Art and Artists* (London), November 1972; "The Other Tradition" by Barbara Rose in *New York*, 11 December 1972; "Doubled Visions" by Amy Taubin in *October* (New York), Fall 1977.

My work relates more to the tradition of painting and sculpture than it does to that of printmaking/ "fine" photography. Yet I concentrate on the aesthetic/philosophical potential of processes or effects which are particular to photography. In several works I have created both the subject and its representation.

—Michael Snow

In 1961 Michael Snow began his "Walking Woman" series. This 'cut-out' figure functioned as a device in repeated explorations of framing, serialization, spatial and illusionary relationships expressed in a variety of media, forms and environments. Snow's earliest photographic piece, "Four to Five" (1962), consists of a montage of the "Walking Woman" placed in the surroundings of various public places. Twelve rectangular photographs are arranged in a grid formation of 3 horizontal lines; on the 4th (bottom) line the two central photographs are placed as verticals, flanked on each side with a horizontal photograph. In this very simple but remarkable piece, the photographs mirror real events, transferring particular realities into a photographic process. The situating of process and reorganization within its own constructed space conditions the work, no longer as a record, but as a response to the making of a record that reveals its own representation of a new "reality"—the final photographic object.

Very few of Snow's photographic works are "reproducible". They are frequently structured pieces constituted of, or including, photographic prints, in black/white or colour; 35mm slides; Polaroids; and photo-offset printing in conjunction with other materials and objects. All of the elements are in specific placement in relationship to one another. Of his piece "Tap" (1969), Snow says, "I wanted to make a composition which was dispersed, in which the elements would be come upon in different ways and which would consist of (1) a sound, (2) an image, (3) a text, (4) an object, (5) a line, which would be identified but the parts of which would be of interest in themselves if the connections between them were not seen (but better if seen)." The photographic pieces often occupy space for the eye and the mind to synthesize memory and visual elements

Michael Snow: *Field/Champ*, 1973-74

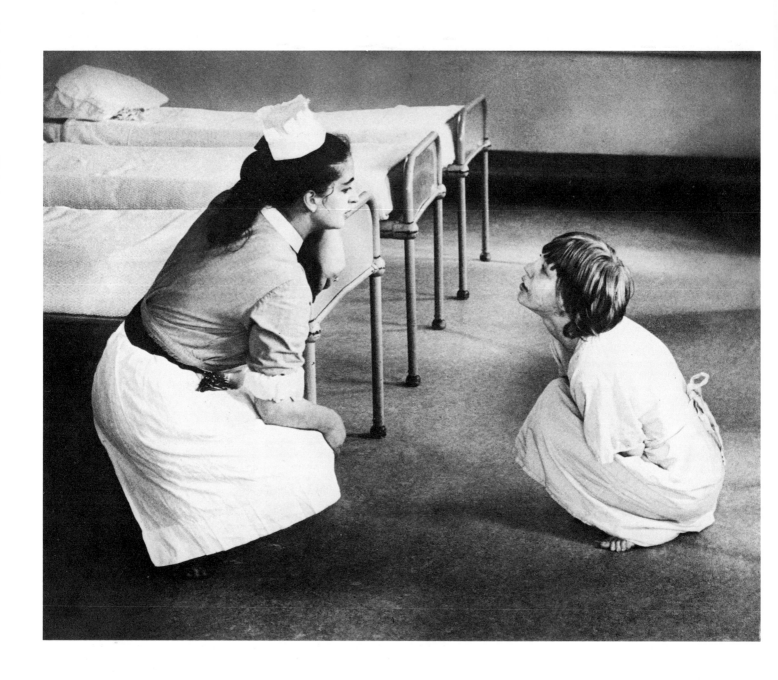

Snowdon: *Nursing the Mentally Ill,* **1968**

which cancel or annul and present themselves again, or repeat to establish a logic in perception of the sum-total.

Snow is best known for his highly acclaimed filmwork. His photographic pieces share many of the generative elements of investigation seen in the films, and, like his films, reverberate with masterly intellectual control. How the camera functions and the process of photography as an image making instrument; the relationship of the image to light, sequence, series, and self-reference; the relativity of sight, sound, and memory; the intensity of focusing and the transformation of representation—all are central concerns. In Snow's *Venice Biennial* catalogue (1970), Brydon Smith states that for Snow, "the content of his art follows from the process of its realization. It is realism of process." While this reference is to the piece "Authorization" (1969), the same basic tenets are characteristic of many of Snow's later photographic pieces in colour. Underlying references exist to his earlier period of painting: control of subject and relationship to final form, size, scale, and abstraction. Camera images are frequently used to aid representation and reorganization of surface, at the same time the pieces project recurring gestures of parody, punning, and wit.

Snow's overall creativity, evident throughout his paintings, sculpture, film, photography, and in his music, are specific visualizations and concepts constituting highly intelligent investigations that have generated into an authoratively analytical body of work.

—Maia-Mari Sutnik

SNOWDON, (1st Earl of, 1961).

British. Born Antony Charles Robert Armstrong-Jones in London, 7 March 1930. Educated at Sandroyd Preparatory School, Surrey, 1938-42; Eton School, Buckinghamshire, 1943-48; studied architecture at Jesus College, Cambridge, 1949-50. Married H.R.H. Princess Margaret in 1960 (divorced, 1978); children: David Albert Charles, Viscount Linley, Lady Sarah Frances Elizabeth; married Lucy Lindsay-Hogg in 1978; daughter: Lady Frances. Partner, Owen Lloyd Car Hire Ltd., London, 1950; Photographic Assistant to Baron (Nahum), London, 1950-51. Freelance photographer, working for *Sketch*, *Tatler*, *Country Life*, *Picture Post*, *Vogue*, *Queen*, *Harper's Bazaar*, *Sunday Times*, etc., London, since 1951: maintained photographic studio, Pimlico Road, London, 1953-60. Artistic Adviser, *Sunday Times* newspaper and publications, London, since 1962; Consultative Adviser, Design Council, and Editorial Adviser, *Design* magazine, London, since 1962. Designed the Snowdon Aviary, London Zoo, 1965, and Electric Chair (Chairmobile) for the disabled, 1972. Has also produced television films since 1968. Constable of Caernarvon Castle, 1963. President: Contemporary Art Society for Wales; Civic Trust for Wales; Welsh Theatre Company; and Greater London Arts Association; Patron: National Youth Theatre, London; Metropolitan Union of YMCA's; British Water Ski Federation; Welsh National Rowing Club; Physically Handicapped and Able Bodied; and Circle of Guide Dog Owners. Recipient: 2 Emmy Awards, for film, Hollywood, 1968; *Prague Film Festival* Award, 1968; *Barcelona Film Festival* Award, 1968; Diploma, *Venice Film Festival*, 1968; Certificate of Merit, Art Directors Club of New York, 1969; Certificate of

Merit, 1970, and Award of Excellence, 1973, Society of Publication Designers; Society of Film and Television Arts Award, 1971; Hugo Award, *Chicago Film Festival*, 1971; Wilson Hicks Certificate of Merit for Photocommunications, 1971; Design and Art Directors Award, London, 1978; Hood Award, Royal Photographic Society, 1979. Fellow, Society of Industrial Artists and Designers, Royal Photographic Society, Royal Society of Arts, and Manchester College of Art and Design; Royal Designer for Industry, 1978. G.C.V.O. (Knight Grand Cross, Royal Victorian Order), 1969. Address: 22 Launceston Place, London W8 5RL, England.

Individual Exhibitions:

1958 *Photocall*, London
1972 *Assignments*, at *Photokina '72*, Cologne (travelled to London, 1973; Brussels, 1974; Los Angeles, St. Louis, Kansas City, New York, and Tokyo, 1975; Sydney, Melbourne and Copenhagen, 1976; Paris and Amsterdam, 1977)

Selected Group Exhibitions:

1981 *One in Ten*, The Photographers' Gallery, London
Points of View, Kodak Gallery, London

Collections:

National Portrait Gallery, London.

Publications:

By SNOWDON: books—*Malta*, with text by Sacheverell Sitwell, London 1958; *London*, London 1958; *Private View*, with text by John Russell and Bryan Robertson, London 1965; *Assignments*, Cologne and London 1972; *A View of Venice*, London 1972; *Inchcape Review*, London 1977; *Pride of the Shires*, with text by John Oaksey, London 1979; *Personal View*, London 1979; articles—interview in *Photo* (Paris), December 1972; interview in *Interviews with Master Photographers* by James Danziger and Barnaby Conrad III, New York and London 1977; television films—*Don't Count the Candles*, 1968; *Love of a Kind*, 1969; *Born to Be Small*, 1971; *Happy Being Happy*, 1973; *Mary Kingsley*, 1975; *Burke and Wills*, 1975; *Peter, Tina and Steve*, 1977.

On SNOWDON: books—*Lord Snowdon* by Helen Cathcart, London 1968; *The Magic Image* by Cecil Beaton and Gail Buckland, London and Boston 1975; articles—"Lord Snowdon's Workroom" in *Vogue* (London), 15 April 1971; "Great Photographers of the World: Snowdon" in *Réalités* (Paris), September 1971; "Lord Snowdon" in *Photography Yearbook 1972*, edited by John Sanders, London 1971; "Photographs: Snowdon" in *U.S. Camera Annual*, New York 1972; "Snowdon: Assignments" in *Du* (Zurich), September 1972; "Profil de Snowdon" by M. Naumann in *Zeit Magazin* (Hamburg), 20 October 1972; "Snowdon, Photographer" by G. Hughes in *Amateur Photographer* (London), 7 March 1973; "A View of Venice: Photographs by Snowdon" in the *Sunday Times Magazine* (London), 29 April 1973; "Great Portraits: Snowdon" in *Amateur Photographer* (London), 29 August 1973.

Snowdon is an all-round man of the arts, interested in every aspect of design and expert in a number of them. In architecture; in designing for industry; in settings for ballet and the theatre; in the layout of magazines and newspapers; and in the direction and production of television films, he has achieved enough success to have launched a number of careers.

As a still photographer he combines a sharp perceptive eye with great technical ingenuity. Already as a schoolboy he had constructed his own enlarger out of soup cans and astonished his friends with trick photography, including one of matches falling out of a box, made by gluing them together. Later, requiring an area where his subjects could "walk about and not look lit", in a studio which had no window, he designed a light box. Standing six feet high and holding some sixty 100-watt bulbs, it could be folded to fit into the back of his Morris Minor.

Snowdon's early work was distinguished from that of other talented beginners by irreverence and humour. Fully confident in himself and his own methods, he shattered the conventions of fashion magazines by posing his models in ludicrous or catastrophic situations, slipping on a banana skin or overwhelmed by junked automobiles in a car dump. Sent to cover social events, he concentrated on their ludicrous aspect, disregarding whatever was impressive or imposing.

About his own photography too he has always shown a refreshing lack of vanity. Just the opposite of those photographers who seek to stamp their own "personality" on everything they do, he approaches each new task with an open mind and a readiness to improvise. He will work on the negative, crop his prints to any extent, even attack the surface with a razor blade if that is going to give him the effect he wants.

But at times Snowdon's ingenuity is his enemy. His portraits of celebrities, taken at leisure, too often turn out gimmicky—interpretations of a public personality through setting and contrivance, rather than allowing the subject's true character to appear. His pictures of actors or opera singers on the other hand, taken during stage productions which leave little opportunity for cleverness, are full of tension and vitality.

As a photojournalist he has always been ready to go anywhere and cover any assignment he finds interesting. He likes working to a deadline, which imposes a discipline he appears to want: "If I'm given a completely free hand I either turn the job down or quickly become uninterested". On his foreign assignments in particular, he has worked a good deal in colour. His colour pictures reveal his acute sense for tone and pattern, but appear to owe much to his knowledge of the various schools of painting.

During the last ten years a new and welcome note, a warmth of human feeling, has come into his work. When he started photographing stories for the *Sunday Times* magazine on the old, disabled, or on handicapped children, he showed only one concern—to convey what he saw in the most sympathetic manner. Gimmickry went out; simplicity and directness took over. "I thought if these things were recorded...then perhaps people would think more deeply about what it meant and about what might be done". It is this attitude also which has produced his affecting documentary films for television.

Hitherto Snowdon's main concentration has always been on still photography, but it seems far from certain that this will always captivate so versatile a mind and far-ranging an interest.

—Tom Hopkinson

SOMMER, Frederick.

American. Born Fritz Sommer in Angri, Italy, 7 September 1905; grew up in Brazil; emigrated to the United States, 1931: naturalized, 1939. Educated in German schools, Rio de Janeiro and Sao Paulo, 1911-16; Benedictine Gymnasium, Rio de Janeiro, 1916-21; studied landscape architecture at Cornell University, Ithaca, New York, 1926-27, M. Landscape Arch. 1927; self-taught in photography but influenced by Alfred Stieglitz and Edward Weston. Married Frances Watson in 1928. Worked as a landscape architect and city planner, with his father Carlos Sommer, Rio de Janeiro, 1927-30; independent painter and occasional photographer, Arizona, 1931-35. Independent photographer, Prescott, Arizona, since 1935. Founder-Instructor, with Lucy Marlow, Studio of Art School, Tucson, 1931-35; Lecturer in Photography, Institute of Design, Illinois Institute of Technology, Chicago, 1957-58, 1963; Co-ordinator of Fine Arts, Prescott College, 1966-71. Recipient: Gold Medal, Pan American Congress of Architects, Rio de Janeiro, 1930; Guggenheim Photography Fellowship, 1974. Agent: Light Gallery, New York. Address: c/o Light Gallery, 724 Fifth Avenue, New York, New York 10019, U.S.A.

Individual Exhibitions:

1934 Increase Robinson Gallery, Chicago (paintings)
1941 Howard Putzel Gallery, Hollywood, California
1946 Santa Barbara Museum of Art, California
1949 Egan Gallery, New York
1957 Institute of Design, Illinois Institute of Technology, Chicago
1959 Wittenborn Gallery, New York
1963 Art Institute of Chicago
1965 Washington Gallery of Modern Art, Washington, D.C. (travelled to the Pasadena Art Museum, California)
1967 Museum of Northern Arizona, Flagstaff
 San Fernando State College, Northridge, California (with Wynn Bullock and Edmund Teske)
1968 Philadelphia College of Art
1972 Light Gallery, New York
1973 Center for Contemporary Photography, Chicago
1977 Light Gallery, New York (with Michael Bishop and Carl Toth)
 Arizona Bank Galleria, Phoenix (with Ansel Adams)
1979 Princeton Art Museum, New Jersey
 Light Gallery, New York
1980 *Frederick Sommer at 75*, California State University at Long Beach (retrospective; toured the United States, 1980-81, and travelled to London, 1981)
 Venus, Jupiter and Mars: The Photographs of Frederick Sommer, Delaware Art Museum, Newark
1981 Serpentine Gallery, London

Selected Group Exhibitions:

1949 *Realism in Photography*, Museum of Modern Art, New York
1950 *Photography at Mid-Century*, International Museum of Photography, George Eastman House, Rochester, New York
1951 *Abstraction in Photography*, Museum of Modern Art, New York
1953 *Contemporary Photography: Japan and America*, National Museum of Modern Art, Tokyo
1956 *Contemporary American Photography*, Musée d'Art Moderne, Paris
1965 *Photography in America 1850-1965*, Yale University, New Haven, Connecticut

1967 *Photography in the 20th Century*, National Gallery of Canada, Ottawa (toured Canada and the United States, 1967-73)
1969 *Human Concern/Personal Torment*, Whitney Museum, New York (travelled to the University of California, Berkeley)
1979 *Photographic Surrealism*, New Gallery of Contemporary Art, Cleveland (travelled to the Dayton Art Institute, Ohio, and the Brooklyn Museum, New York)
1980 *Photography of the 50's*, International Center of Photography, New York (travelled to the University of Arizona, Tucson; Minneapolis Institute of Art; California State University at Long Beach; and the Delaware Art Museum, Wilmington)

Collections:

Museum of Modern Art, New York; International Museum of Photography, George Eastman House, Rochester, New York; Princeton University, New Jersey; Fogg Art Museum, Harvard University, Cambridge, Massachusetts; Art Institute of Chicago; University of Illinois, Urbana; Dayton Art Institute, Ohio; University of New Mexico, Albuquerque; Center for Creative Photography, University of Arizona, Tucson; Norton Simon Museum of Art, Pasadena, California.

Publications:

By SOMMER: book—*The Poetic Logic of Art and Aesthetics*, with Stephen Aldrich, Prescott, Arizona 1972.

On SOMMER: books—*Aperture 10:4: Frederick Sommer*, edited by Minor White, Rochester, New York 1962; *The Painter and the Photograph: From Delacroix to Warhol* by Van Deren Coke, Albuquerque, New Mexico 1964, 1972; *Frederick Sommer*, exhibition catalogue, with text by Gerald Nordland, Washington, D.C. 1965; *Photography in the 20th Century* by Nathan Lyons, New York 1967; *Frederick Sommer: An Exhibition of Photographs*, exhibition catalogue, by Gerald Nordland, Philadelphia 1968; *Light and Lens: Methods of Photography*, edited by Donald L. Werner and Dennis Longwell, New York 1973; *Photography in America*, edited by Robert Doty, with an introduction by Minor White, New York and London 1974; *The Magic Image* by Cecil Beaton and Gail Buckland, London and Boston 1975; *Photographic Process as Medium*, exhibition catalogue, with text by Rosanne T. Livingston, New Brunswick, New Jersey 1975; *Dada and Surrealism Reviewed*, exhibition catalogue, by Dawn Ades, London 1978; *Amerikanische Landschaftsphotographie 1860-1978*, exhibition catalogue, with an introduction by Klaus-Jürgen Sembach, Munich 1978; *Photographic Surrealism*, exhibition catalogue, by Nancy Hall-Duncan, Cleveland 1979; *Photography of the 50's: An American Perspective* by Helen Gee, Tucson, Arizona 1980; *Frederick Sommer at 75*, edited by Constance W. Glenn and Jane K. Bledsoe, Long Beach, California 1980; *Venus, Jupiter and Mars: The Photographs of Frederick Sommer*, exhibition catalogue, edited by John Weiss, Newark, Delaware 1980; articles—"Three Phantasists: Laughlin, Sommer, Bullock" by Jonathan Williams in *Aperture* (Rochester, New York), 9:3, 1961; "Frederick Sommer: 1939-1962 Photographs" by David Heath in *Contemporary Photographer* (Culpeper, Virginia), Summer 1963; "Frederick Sommer" in *Aperture* (Rochester, New York), 16:2, 1971; "Frederick Sommer" by J. Kelly in *Art in America* (New York), January/February 1973; "New York Letter: Frederick Sommer" by S. Schwartz in *Art International* (Lugano), January 1973; "Frederick Sommer" in *Exposure* (New York), February 1977.

The ostensible subject matter of Frederick Sommer's photographs includes portraits, peeling walls, landscapes, found objects and sculpture. Formally, he favors flat, two dimensional planes, often layered and always punctuated by precise details. His compositions, though often frontal and emblematic, more often than not use a sense of "field," a textured, middle grey background which extends beyond the edge of the frame. Beyond this, his images suggest the dissolution of matter: precise surfaces are shown wearing away to reveal layers beneath. As such, they may be read as metaphors for the process of time, or even, in a more extended sense, as the process of analysis (psychological) or the search for inner truth. Many of the images evoke horror, but usually the physical precision of the surfaces is such that they seem "beautiful" at the same time, and thus hang, dialectically poised, between these two extremes.

The 1948 portrait of the child "Livia" exhibits all these qualities. Although the child is beautiful, her pose, her stare, her juxtaposition against a peeling weathered wall, evoke a state of uneasiness in the viewer. The photograph is framed horizontally. The child is posed emblematically dead center, cut off just below the waist, her hands crossed, almost as if in death. Her white summer pinafore seems almost ceremonial, and accents the whites of her eyes, focused on the viewer in a disconcerting stare. The peeling wall behind her forms a flat two-dimensional surface, but also suggests layering and dissolution. The age of the child contrasts with the old, weathered wall. An interesting counterpart to "Livia" is "Medallion," done in the same year, in which a doll's head is substituted for the child, intensifying the sense of death and decay. The other qualities remain: the wall, middle grey and precisely textured, the flat space, the sense of "field" and past time.

A prototype for the "field" of the flat, peeling, middle grey wall (or other texture) may be found in the "Arizona Landscapes" done in the early 1940's. Shot from above with nothing to suggest scale, these panoramas of rocks, cacti and spare tufts of vegetation become almost abstract. The sense of three-dimensionality is modified onto a single plane; they are precisely textured and middle grey.

Found objects, especially those which are man-made, become part of many of Sommer's images, especially dolls, skeletons, old posters, (glass, pipes, machine parts, particularly those which might suggest body parts). Sommer arranges these artifacts against the ever present grey background. In "Valise d'Adam", a doll becomes, through positioning, a phallus, and a machine part becomes an animal head. What appear to be the arms and legs of a mannikin of small carved sculpture complete the totem-like figure. The amalgam of human, child, toy and animal references becomes a mythological "personage" which is both whimsical and terrifying at the same time. By using "real" objects, and rearranging them, Sommer creates an alchemical world which is always changing before our eyes.

The most horrifying of Sommer's images involve real objects—often decayed beyond recognition. He seems fascinated by the process of probing, of peeling away, and uses the camera like a surgeon's scalpel. In many of these images Sommer faces death and the ravages of physical matter with a cool stare. Most viewers will flinch from the extraordinary clarity of this vision. In "Detail," an amputated, partially dissected leg is examined, in excrutiating detail, classically centered against a black background. In "Coyotes," the dessicated carcasses of four of those animals are arranged against dry, cracked soil. The details are spellbinding: the grace of the skeletal forms, the juxtaposition of slender limbs, the terrible fangs, the clinging tufts of hair. In "Artificial Leg" (1944), the primitive leather and straps of the prosthetic device merge with a shadowed version of the "grey field". The decaying "boot" of the leg begins to merge with this background, flattening out, becoming a plane itself. The terrifying 1939 "Chicken" is a sickening, yet ulti-

Frederick Sommer: *Paracelsus* **(paint on cellophane), 1959** Courtesy Serpentine Gallery, London

mately fascinating image of a glistening, unborn chicken embryo. Sommer spares us nothing: the pale wash of blood adds a delicate tonality to the stark white background.

In a gentler, more romantic mode, Sommer's photographs of old posters, usually containing human figures, repeat the theme of dissolution. In "Venus, Jupiter and Mars" (1949), two men and a woman sit at a tea table in what appears to be an advertising poster for some unidentified product. They form a classic triangle as they gaze longingly into each other's eyes. The poster is ripped, and peels away to reveal the wall beneath. At the same time the peeling process partially obliterates the features of the three figures. The image suggests the transience of human passion and beauty.

This theme takes another form in the out-of-focus images of statues done in the 1960's. In "Capitoline Museum," a classical, draped nude statue appears to dance because of the slight movement of Sommer's camera at the moment of exposure. It is another way of giving the appearance of transparency and evanescence to something that is solid and man-made (a marble statue).

Sommer's images range from the delicate and ephemeral to the terrible and traumatic. He turns his lens unequivocally on death and decay; indeed, his great theme is that of the impermanence of matter, especially artifacts. He leaves us precise records of the dissolution of the physical world, the work of time, and the gradual progress of death.

—Carole Harmel

SONNEMAN, Eve.

American. Born in Chicago, Illinois, 14 January 1950. Educated at South Shore High School, Chicago, 1959-63; University of Illinois, Urbana, 1963-67, B.F.A. 1967; University of New Mexico, Albuquerque, 1967-69, M.A. 1969. Freelance photographer, with studio in New York City, since 1969. Lecturer, Cooper Union, New York, 1970-71, 1975-78; Visiting Artist, Rice University, Houston, 1971-72; Lecturer, City University of New York, 1972-75, and School of Visual Arts, New York, 1975-81. Recipient: Boskop Foundation Grant, New York, 1969; National Endowment for the Arts Award, 1972, 1978; Institute for Art and Urban Resources Grant, New York, 1977; Polaroid Corporation Grant for work in Polavision, 1978. Agents: Castelli Graphics, 4 East 77th Street, New York, New York 10021; Rudiger Schottle, Martiusstrasse 7, 8 Munich 40, West Germany; Texas Gallery, 2439 Bissonet, Houston, Texas; and Galerie Farideh Cadot, 11 rue du Jura, 75013 Paris, France. Address: 98 Bowery, New York, New York 10013, U.S.A.

Individual Exhibitions:

1970 *A Survey*, Cooper Union, New York (travelled to the Media Center, Rice University, Houston, 1971)
1972 Art Museum of South Texas, Corpus Christi
1973 Whitney Museum Art Resources Center, New York
1974 *Coney Island Series*, The Texas Gallery, Houston
 College of St. Catherine Museum, St. Paul, Minnesota
1975 *Subway Series*, The Texas Gallery, Houston
1976 Bard College, Annandale-on-Hudson, New York
 Observations: 1/4 Mile in the Sky, Castelli Gallery, New York
1977 *New Work*, Artemisia Gallery, Chicago
 New Work, Galerie Farideh Cadot, Paris
 New Work, The Texas Gallery, Houston
 New Work, Diane Brown Gallery, Washington, D.C.
 A Survey, College of Wooster, Ohio
1978 *New Work*, Castelli Gallery, New York
1979 *Color Work*, Thomas Segal Gallery, Boston
 3 Americans, Moderna Museet, Stockholm (with Lewis Baltz and Mark Cohen; travelled to the Alborg Kunstmuseum, Denmark; Kunstpavillionen, Esbjerg, Denmark; Tranegarden, Gentofte, Copenhagen; and Henie-Onstad Museum, Oslo, 1980)
 Color Work, Rudiger Schottle Gallery, Munich
1980 *Color Work*, La Nouveau Musée, Lyons
 5 Year Color Show, Contemporary Arts Center, New Orleans (travelled to the Contemporary Arts Center, Cincinnati, Ohio)
 Work from 1968-1978, Minneapolis Institute of Arts
 New Work and Polaroids, Galerie Farideh Cadot, Paris
 The Texas Gallery, Houston
 Polaroid Work, Young Hoffman Gallery, Chicago
 New Work, Francoise Lambert Gallery, Milan
 New Work: New York, Castelli Gallery, New York
1981 *Future Memories*, Cirrus Gallery, Los Angeles
 Work from 1968-1978, Tucson Museum of Art, Arizona

Selected Group Exhibitions:

1969 *Recent Acquisitions*, Museum of Modern Art, New York
1977 *Bookworks*, Museum of Modern Art, New York
 Documenta 6, Kassel, West Germany
 Biennale, Paris
1978 *Mirrors and Windows: American Photography since 1960*, Museum of Modern Art, New York (toured the United States, 1978-80)
1979 *Artemisia*, Galerie Yvon Lambert, Paris

 Attitudes: American Photography in the 1970's, Santa Barbara Musuem of Art, California
1980 *One of a Kind*, Corcoran Gallery of Art, Washington, D.C.
 Polaroids, Centre Beaubourg, Paris
 Biennale, Venice

Collections:

Museum of Modern Art, New York; Metropolitan Museum of Art, New York; Princeton University, New Jersey; Art Institute of Chicago; Museum of Fine Arts, Houston; de Menil Foundation, Houston; Centre Georges Pompidou, Paris; Bibliothéque Nationale, Paris; Rheinisches Landesmuseum, Bonn; National Gallery of Australia, Canberra.

Publications:

By SONNEMAN: book—*Real Time*, New York 1976.

On SONNEMAN: books—*Mirrors and Windows: American Photography since 1960*, exhibition catalogue, by John Szarkowski, New York 1978; *One of a Kind: Recent Polaroid Color Photography* by Belinda Rathbone, Boston 1979; *Diana and Her Nikon: Essays on the Aesthetic of Photography* by Janet Malcolm, Boston 1980; articles—"Eva Sonneman at Castelli" by Bruce Kurtz in *Art in America* (New York), January 1977; "Alternatives from New York" in *Flash Art* (Milan), February/April 1977; "A View from Kassel" by David Shapiro in *Artforum* (New York), September 1977; "Eve Sonneman" by Jonathan Crary in *Arts* (New York), November 1978; "Photography: Two Roads" by Janet Malcolm in *The New Yorker*, December 1978; "Eve Sonneman's Progressions in Time" by Tiffany Bell in *Artforum* (New York), October 1979; "Eblouissante Eve Sonneman" in *Le Figaro* (Paris), 23 January 1980.

My work as an artist includes photography. A photograph is a magical moment crossing time and open to the world.

—Eve Sonneman

Since 1968 Eve Sonneman has been making photographs in Europe and America. Her work characteristically contains pairs or quartets of images having some formal or thematic relationship to one another. In the earliest of these series, black and white quartets made in and around New York between 1968-1974, Sonneman began to explore subtle shifts in visual perspective and chronology and the effects of such manipulation on the viewer. At the conclusion of this period, the quartets were further complicated by the juxtaposition of pairs of color and black-and-white photographs within the same work. In the "Coney Island" photographs, made at this time, tightly framed variations on beach and street scenes, located within a quadruple image, give these vernacular subjects an analytical weight generally reserved for more heroic material.

Sonneman's investigations of formal mannerism in relation to subject and locale continued through 1976 in "Observations; 1/4 Mile in the Sky" (the title of her one-woman show containing a series of diptychs made at the World Trade Center observation deck during the Bicentennial celebration) as well as in the second group of photographs made in Europe during 1980.

In May 1980 Sonneman showed a group of paired photographs made in Europe and America over a period of two years; they demonstrate that photography need not be either a cold document of reality or a poetic evocation of the world processed through

Eve Sonneman: *Seafood Window, Mexico* (original in color), 1980

the photographer's manipulative intelligence. Each Sonneman diptych insists on vernacular situations which are simultaneously mysterious. The viewer's participation, apparent in the impulse to reconcile or paraphrase the joining of visually related information, is thus strongly encouraged by the formal strategy of this work. Through this strategy, Sonneman presents documents in which reality is not distilled or manipulated into a single privileged view, but is a progression excerpted from life. Her multiple images underscore the temporal process and activity of vision as it continues to select, revise, and edit what is ultimately taken to be real.

A number of pieces in this exhibition seemed at first to fall within the traditional category of the *nature morte*, but Sonneman's views of elaborately contrived displays (whether of magazines, seed packets, or chemical glassware in a shop window) are more accurately the means by which she denies that it is the photographer who composes. In point of fact, she records the works of those who invent and contrive such arrangements as part of their daily lives. Similarly, her views of the landscape (a gas station over which the rising moon intrudes, the progression of a plane as it dusts crops, or a frieze of chalk drawings in an urban gutter) maintain that reality, as seen and defined in these photographs, is a series of provisional, interchangeable, material situations in which viewers actively consider and synthesize what Sonneman has merely seen first.

Sonneman's work in 1981 has begun to emphasize the effect of scale rather than counterpoint in the impact of her work. In addition to her new diptychs, she is also preparing to show 20 x 24 inch Cibachrome single images in her one-woman exhibition at Castelli Photographs during the Winter of 1981-82.

—David Corey

SOUGEZ, Emmanuel.

French. Born in Bordeaux, 16 July 1889. Studied painting at the School of Fine Arts, Bordeaux, 1904-11; studied with various photographers, in Germany and Switzerland, 1911-14. Served in the French Army, 1915-18. Independent photographer from 1911: travelled in Europe, 1911-14; settled in Paris, working for various decorators, 1918-26; Director of Picture Services, *L'Illustration* magazine, from 1926; Editor, *Collection d'Arts et Metiers* annuals, Paris, 1930-39. Founder Member, Le Rectangle (renamed Groupe Les XV, from 1946), Paris, 1935. *Died* (in Paris) *in 1972.*

Individual Exhibitions:

1937 Galerie au Chasseur d'Images, Paris

Selected Group Exhibitions:

1932 *Exposition Internationale de la Photographie*, Palais des Beaux-Arts, Brussels (travelled to Lakenhal, Leiden, and Kunstzaal Van Hasselt, Rotterdam)
Modern European Photography, Julien Levy Gallery, New York
1976 *Photographs from the Julien Levy Collection, Starting with Atget*, Art Institute of Chicago
1979 *Paris-Moscou 1900-1930*, Centre Georges Pompidou, Paris

La Photographie Francaise 1925-1940, Galerie Zabriskie, Paris (travelled to the Zabriskie Gallery, New York)

Collections:

Bibliothèque Nationale, Paris (archives); Musée Francaise de la Photographie, Bièvres, France; Art Institute of Chicago.

Publications:

By SOUGEZ: books—*Régarde!*, Paris 1931; *La Sculpture au Musée du Louvre*, Paris 1936-58; *Histoire de la Photographie*, with Raymond Lecuyer, Paris 1945; *Arts de L'Afrique Noir*, Paris 1947; *Arts de l'Oceanie*, Paris 1948; *Art de l'Amerique*, Paris 1948; *La Sculpture Contemporaine Francaise et Etrangère*, Paris 1961; *La Photographie: Son Histoire, Son Univers*, Paris 1968-69.

On SOUGEZ: books—*The Magic Image* by Cecil Beaton and Gail Buckland, London and Boston 1975; *Photographs from the Julien Levy Collection, Starting with Atget*, exhibition catalogue, by David Travis, Chicago 1976; *Fotografie der 30er Jahre: Eine Anthologie*, edited by Hans-Jürgen Syberberg, Munich 1977; *Quinze Critiques/Quinze Photographes*, Paris 1981; articles—"Emmanuel Sougez" by Roger Doloy in *Arte Fotografico* (Madrid), September 1970; "Emmanuel Sougez 1889-1972" by Pierre Jahan in *Le Nouveau Photocinéma* (Paris), March 1973; "Photographie Francaise 1840-1940" in *Camera* (Lucerne), February 1974.

Editor, animator, critic, historian, compositor, art fanatic and photographer—all of these in one man, Emmanuel Sougez, a man who in all likelihood has done more than anyone else for photography in France, and done it with the greatest subtlety and intelligence.

It would be unfair to distinguish Sougez the editor and theorist from Sougez the animator and artist. Because he understood perfectly the problem of printing still photographs and publishing them, because he also understood what was at stake in the controversy over the relationship between painting and photography and understood that his own work had more in common with music and sculpture than with painting, he made "l'image argentique" dominate his creative life.

Thus his still-lifes—precise and sumptuous, graphic, and constructed amazingly enough out of materials which are often overworked and contradictory and used over and over again—are models of their kind. The same is true of his photographs of sculpture.

To "write with light," while knowing that he creates only by means of lines and deep blacks and whites which struggle with the greys, bringing out the abstract character of a photograph while playing with its representational content, and still finding time to help with the preparation of the best history of photography written in France and bringing together virtually an entire school of photography: given all these achievements how can we fail to call Sougez the creator—in that hackneyed phrase—of a complete *oeuvre*?

—Christian Caujolle

SPENDER, Humphrey.

British. Born in London, 19 April 1910. Educated at Greshams School, Holt, Norfolk, 1923-27; studied at University of Freiburg im Breisgau, Germany, 1927-28; and at the Architectural Association School, London, 1929-34, AA Dip. 1933; also studied anthropology, under Raymond Firth, London School of Economics, 1938; mainly self-taught in photography, but learned techniques with brother Michael, London, 1920-24. Trained in Royal Army Service Corps (Tanks), Salisbury Plain, Wiltshire, 1941, then served as War Office Official Photographer and subsequently transferred as Photo-Interpreter, Theatre Intelligence Service, London and Medenham, Buckinghamshire, 1942-46: Captain. Married the architect Margaret Low in 1937 (died, 1945); son: David; married Pauline Wynne; son: Quentin. Worked as a portrait and commercial photographer, establishing studio with Bill Edmiston, London, 1934-39; Staff Photographer, as "Lensman," *Daily Mirror* newspaper, London, 1936-38, and *Picture Post* magazine, London, 1938-41 and 1946-49; also photographer on Tom Harrisson's Mass Observation project, London and Blackpool, 1937-39, and for the Ministry of Information, London, 1941; gradually abandoned photography to concentrate on painting and textile design, from 1949 (individual exhibitions at Redfern Gallery, London, 1943, 1945, 1947, 1949, 1951, 1963; Leicester Galleries, London, 1953, 1958; and New Art Centre, London, 1975). Tutor in Textile Design, Royal College of Art, London, 1953-75; Visiting Lecturer, West Surrey College of Art and Design, Farnham, Camberwell School of Art, London, and Hornsey College of Art, London, 1960-75. Recipient: Design Award, Council of Industrial Design, London, 1951, 1953, 1955, 1961. Associate, Royal Institute of British Architects (ARIBA), London, 1934-70; Fellow, Society of Industrial Arts and Designers (FSIAD), 1960-75. Honorary Fellow, Royal College of Art, London, 1975. Agent: Jan Siegieda, 33 Nook Close, Temple Park, Shepshed, Leicestershire LE12 9DZ. Address: The Studio, Ulting, near Maldon, Essex CM9 6QX, England.

Individual Exhibitions:

1977 *Worktown 1937-38*, Gardner Art Centre, University of Sussex, Brighton
1978 *Mass Observation Photographs*, Brewery Arts Centre, Kendal, Cumbria
1979 *Mass Observation*, Impressions Gallery, York
1981 *Photographs of the 30's*, Prakapas Gallery, New York
Arnolfini Gallery, Bristol (retrospective)

Selected Group Exhibitions:

1975 *The Real Thing: An Anthology of British Photographs 1840-1950*, Hayward Gallery, London (toured the U.K.)
1976 *Young Writers of the 30's*, National Portrait Gallery, London
1979 *The 30's: British Art and Design Before the War*, Hayward Gallery, London
1980 *Portraying People*, Sandford Gallery, London
Modern British Photography 1919-39, Museum of Modern Art, Oxford (toured the U.K.)
1981 *The British Worker*, Mappin Art Gallery, Sheffield (toured the U.K.)

Collections:

Victoria and Albert Museum, London; National Portrait Gallery, London; Museum of London; Arts Council of Great Britain, London; Mass Observation Archive, University of Sussex, Brighton.

Publications:

By SPENDER: book—*Worktown People*, with transcriptions of taped interviews, Bristol 1981.

On SPENDER: books—*Mass Observation* by Tom Harrisson and Charles Madge, London 1937; *Mass Observation: The First Year's Work*, edited by Tom Harrisson, London 1938; *Britain by Mass Observation*, edited by Tom Harrisson, London 1939; *Britain Revisited*, with text by Tom Harrisson, London 1961; *Britain in the 30's*, with text by Tom Harrisson, London 1975; *The Real Thing: An Anthology of British Photographs 1840-1950*, exhibition catalogue, by Ian Jeffrey and David Mellor, London 1975; *Humphrey Spender: Worktown: Photographs of Bolton and Blackpool Taken for Mass Observation 1937-38*, exhibition catalogue, with text by Ian Jeffrey, David Mellor and Derek Smith, Brighton 1977; *Thirties: British Art and Design Before the War*, exhibition catalogue, by Ian Jeffrey, William Feaver, Brian Lacey and others, London 1979; *Modern British Photography 1919-1939*, exhibition catalogue, by David Mellor, London 1980; articles—"Humphrey Spender: MO Photographer," interview, by Tom Picton and Derek Smith in *Camerawork* (London), September 1978; "The Quiet Observer" by Stephen McClarence in *Photographers* (York), August/October 1979; "Humphrey Spender" in *Creative Camera* (London), May/June 1980; "The British Worker: Photographs of Working Life 1839-1939" by Colin Osman in *Creative Camera* (London), May/June 1981.

Looking through all my past work as photographer, I come increasingly to the conclusion that the most valid and proper use of a camera is as a means of recording aspects of human behaviour; as time passes, social-documentary photographs gain in interest, whereas the "beautiful" photograph (and I have taken many such) progressively loses interest, becomes boring.

Endless discussions go on about "Photography as Art," and I find these rather tedious, just as tedious as the type of photograph which manipulates photographic techniques to produce highly personal and individual statements deriving from the elements of contemporary painting, surrealism, abstract expressionism, etc. Occasionally, such manipulations produce seductively ravishing results if handled by a truly creative thinker, but too often the potential of the modern camera's superb technology seems not to have been exploited.

As disclosed by publications like Camera Workshop's journal *Camerawork*, there are many highly skilled young documentary photographers around, superbly exploiting the true potential of their cameras; but there are many distressing aspects of the contemporary photographic scene: e.g., 50 photographers stand in a regimented row to shoot the same subject (such as our future queen), each exposing ten frames—what an absurd waste; or, the tourist, victim of the sharp dealer's sales talk, loaded with a pack of expensive equipment which he doesn't understand (how many such photographers know how to use the depth-of-focus scale?); and the escalating inflated prices imposed by wheeler-dealers in the auction/collector/dealer world.

Finally, I become more and more aware of the power of the photographic image, and thus more and more aware of the responsibility of the individual photographer. The poet Wystan Auden is quoted as saying "the camera always lies: it just ain't art." That is a somewhat sensational exaggeration, but it is an alarming thought that in the wrong hands (those of Goebbels, for instance) the camera can be a bomb.

—Humphrey Spender

Humphrey Spender played an extremely important part in the development of British documentary photography during the 1930's and 40's.

Like a number of other English writers and artists of the time, he became interested in the social, political and artistic life of Germany and spent some time in that country during the 1920's. As a student of architecture in Freiburg he was exposed to the New Objectivity movement in art and photography and also the major German photo documentary magazines, notably the *Berliner Illustrierte Zeitung* and the *Arbeiter-Illustrierte-Zeitung*. One of his brothers, Michael, worked for the Leitz company which manufactured the Leica camera, so that Spender was also introduced to an improved technical means through which documentary photography might be extended. On his return to England Spender became an exemplar of and apologist for the new German styles of photography. He was, in addition to working as a press photographer for the *Daily Mirror*, to become a significant member of two important institutions of the time—Mass Observation and the illustrated magazine *Picture Post*.

Founded in 1937, Mass Observation brought together poets, painters, social scientists and documentary film makers who (aided by scores of volunteers) aimed to observe and record the pattern of ordinary life in Britain. Its purpose was to bridge the gulf between ruler and ruled, to establish a new basis for social democracy based on an educated, informed and participating public. Spender became the official (and unpaid) photographer for Mass Observation, which although it wanted to record the minutia of daily life, was unable to use many photographs in its published reports, or indeed to employ any other photographer, because of its lack of finance.

Spender worked in the manner of Erich Salomon, using a concealed camera in order to produce photographs in conditions of secrecy. His subjects, however, were not kings, politicians and leaders, but ordinary people usually photographed in public places—in streets, pubs, buses and cafes. Spender was instrumental in helping to establish this mode of documentary photography in Britain. Although captured with a hidden camera, his photographs are rarely badly composed, and it is clear that he used his interest in painting and architecture to good purpose so as not to sacrifice the formal characteristics of his photographs. Unsentimental and undramatic, they have a fine quality of suspended time in which the transposition from the mundane to the extra-ordinary is made through the representation itself.

When he was sacked from the *Daily Mirror* for refusing to work on an assignment which he found offensive, Spender joined *Picture Post*, the most interesting and successful of British illustrated magazines. From the late 30's and throughout the years of war he continued to work for the magazine but abandoned photography after the war in order to devote more time to painting and textile design.

—Derrick Price

SPLÍCHAL, Jan.

Czechoslovak. Born in Sloupnice, 17 December 1929. Studied at the School of Decorative Arts, Jablonec nad Nisou, 1945-49; Academy of Fine Arts, Prague, 1949-50. Married Libuše Struplová in 1953; children: Daniel and Věra. Graphic artist for Polygrafia, Prague, and freelance photographer, Prague, since 1950. Associate Member, Union of Czechoslovak Artists, 1964: Member since 1977. Address: Ladova Street 7, CS-12800 Prague 2—Nové Město, Czechoslovakia.

Individual Exhibitions:

1964 Club of the Arts, Cheb, Czechoslovakia
1967 Gallery Dromedaris, Enkhuizen, Netherlands
1968 Bunker Ulmenwall, Bielefeld, West Germany
 Gallery of the Castle, Duchcov, Czechoslovakia
1969 Gallery Dromedaris, Enkhuizen, Netherlands
 University of Purmerend, Netherlands
 Municipal Gallery, Wieringerwerg, Netherlands
1970 Gallery Fronta, Prague
1975 Municipal Gallery, Hodonín, Czechoslovakia
1979 Zentrum ZIF, Bielefeld, West Germany
1980 Jaromir Funke Studio, Brno, Czechoslovakia

Selected Group Exhibitions:

1958 *Creative Photography*, House of Exhibition Services, Prague
1965 *Fotosalon*, Municipal Gallery, Prague
 Czechoslovak Photography, Palac Kultury i Nauky, Warsaw
1966 *Surrealism and Photography*, Museum Folkwang, Essen
 20 Years of Czech Photography, Moravian Gallery, Brno, Czechoslovakia
1973 *Proměna Artists Group*, Capek's Gallery, Prague
 Lyrismo di Fotografia Cecoslovacci, at *SICOF*, Milan (travelled to the Fotokabinett Jaromir Funke, Brno, Czechoslovakia, and the Städisches Museum, Freiburg, West Germany)
1977 *Contemporary Photography*, Fragner's Gallery, Prague
1979 *Tschechoslowakische Photographie 1918-1978*, Fotoforum, Kassel, West Germany

Collections:

Moravian Gallery, Brno, Czechoslovakia; Municipal Gallery, Hodonín, Czechoslovakia; Town Hall, Bielefeld, West Germany.

Publications:

By SPLÍCHAL: books—*The Sculptor František Bílek*, with an introduction by Marcela Mrázová, Prague 1966; *Jan Splíchal: Photographs*, with an introduction by Petr Tausk, Prague 1971; article—"On Photomontage," with Karel Dvořák, in *Fotografie '73*, Prague 1973.

On SPLÍCHAL: books—*Encyclopedia of Practical Photography* by Petr Tausk and others, Prague 1972; *100 Temi di Fotografia* by Petr Tausk and H. Hofstätter, Milan 1977; *Geschichte der Photographie im 20. Jahrhundert/History of Photography in the 20th Century* by Petr Tausk, Cologne 1977, London 1980; articles—"On the Photographs of Jan Splíchal" by Petr Tausk in *Fotografia* (Bratislava), no. 1, 1969; "Photomontages of Jan Splíchal" by Karel Dvořák in *Ceskoslovenska Fotografie*

Humphrey Spender: *Covent Garden*, London, 1936

(Prague), no. 9, 1972; "From the Works of Art of Jan Splíchal" in *Ceskoslovenska Fotografie* (Prague), no. 10, 1976.

In my work I prefer the photomontage. Photomontage means for me multiplied expression of a creative character that can depict events and visions that could not be mediated by means of pure photography.
—Jan Splíchal

Jan Splíchal's most significant works, and that which best conveys his artistic and philosophical orientation are his photomontages. In his first attempts at this form he endeavored to connect images of various subjects, the surface structures of which differed considerably. His experiments in the laboratory enabled him to unite elements from various negatives into a new and fully autonomous image during enlarging. Although there was always obviously a certain idea at the beginning of the creative process, Splíchal did his main creative work in the darkroom, playing a game inspired by impulses from the subconscious as to choice of proper picture-elements and their placement in the montage.

After having mastered the "grammar" of the right combination of various images from a few negatives into one resulting enlargement, Splíchal was free to move away from the technical, formal side of the process and devote himself to expressing more complex ideas. A large cycle was inspired by his effort to create portraits of painters and sculptors in confrontation with their works: his goal was to show a unity of artist and art.

Splíchal lives in Prague, and the atmosphere of the city has challenged him for many years; he has searched for elements that could be the symbols of his vision of the city. Toward the end of the 1960's he found one solution in connecting images of various towers without regard to their particular location. A newer series of montages was of cathedrals. It was close to the previous cycle in its intellectual impetus: Splíchal admired both the architectonic forms and the significance of all these buildings in the shape of the present town.

His philosophic approach to the world is perhaps best conveyed in his cycle of landscapes, in which the organic and inorganic fuse with each other. Petrification projected onto a meadow reveals in a vortex a kind of hope for further development of the live. The problems of the environment, the ecology, have

influenced numerous contemporary artists; Splíchal is no exception. He has not expressed his views in images of regions devastated by industry but in images that manifest his sincere trust in the creative forces of nature. In the cycle "Landscapes," he offers a kind of cautious optimism.
—Petr Tausk

Jan Splíchal: Photomontage from the cycle *Landscapes*, 1975

SPURIS, Egons.

Latvian. Born in Riga, 5 October 1931. Studied radio-engineering at the Riga Polytechnical Institute, 1956-62, Dip.Eng. 1962. Married Lia Kimene in 1953; son: Egils. Worked as a locksmith, laboratory assistant, radio technician and engineer-designer in the VEF electro-technical factory, Riga, 1947-62; Design Leader, Rigas Radioizotopu Aparatu Buves Zinatniski Petnieciskais Institut, Riga, 1960-72; Chief Designer of Projects, 1972-76, and Chief Artist/Photographer, 1976-78, Specialais Maksli-Nieciskas Konstru Esanas un Technologisko Projektu Biro JS, Riga. Lecturer in Radio Engineering, Riga Polytechnical Institute, 1962-64. Member since 1968, Honorary Member since 1977, and Art Director since 1975, People's Photo Studio, Riga. Recipient: Gold Medal, *Premio Michelangelo*, Petrasanta, Italy, 1970; Prix de la Ville de Monaco, 1970; Grand Prize, *Dzintarzeme* (Amber Land), Siauliai, Lithuania, 1970, Riga, 1979; Gold Medal, Norwegian Photo Federation, 1971; Gold Medal, Photographic Society of America, 1971; Charles Kingsley Memorial Award, Toronto, 1971; Medal, *12 Top Photographers*, Ghent, 1971; Artist Award (AFIAP), Fédération Internationale de l'Art Photographique, 1975; Grand Prize, *Latvia '75*, Riga, 1975, and *Latvia '77*, Riga, 1977. Honorary Artist, Art-Photo Society of Ceylon (ANPAS); Honorary Member, Natron, Maglay, Yugoslavia. Address: Box 55, 226009 Riga, Latvia, U.S.S.R.

Individual Exhibitions (all retrospectives):

1973 City Museum, Tallinn, Estonia
1974 People's Photo Studio Exhibition Gallery, Riga, Latvia
City Museum, Valmiera, Latvia
City Museum, Cesis, Latvia
Town Museum, Dikli, Latvia
1975 Museum of Photography, Lithuanian Society of Art Photographers, Vilnius
1976 U.S.S.R. Palace of Culture, Prague
1978 U.S.S.R. Palace of Culture, Helsinki
1979 *Gunar Binde/Egons Spuris/Peeter Tooming*, Dum Panu z Kunstatu, Brno, Czechoslovakia (travelled to the Museum of Olomouc, Czechoslovakia, 1979, and Kiek in de Kök, Tallinn, Estonia, 1980)

Selected Group Exhibitions:

1968 *4th Exhibition of Latvian Photographers*, Kaunas, Lithuania
1969 *Vision and Expression*, International Museum of Photography, George Eastman House, Rochester, New York (toured the United States and Canada, 1969-71)
1971 *12 Top Photographers*, Ghent

Collections:

Museum of Photography, Siauliai, Lithuania; Bib-

liothèque Nationale, Paris; International Museum of Photography, George Eastman House, Rochester, New York.

Publications:

By SPURIS: books—*The Woman I Left*, Riga 1971; *Sacred Is Your Land* (Armenian poetry), Riga 1971; *Dance Around a Steam Engine*, with text by Mats Traat, Riga 1972; *Empress Ficke*, text by Ivanov, Riga 1972; article—"Photography in Design" in *Maksla* (Riga), October 1973.

On SPURIS: books—*Vision and Expression*, edited by Nathan Lyons, New York 1969; *Dumont Foto 1*, edited by Hugo Schöttle, Cologne; *Dumont Foto 2*, edited by Hugo Schöttle, Cologne 1980; *The History of Latvian Art Photography* by Peteris Zeile, Riga 1981; *Masters of Latvian Art Photography* by Atis Skalbergs, Riga 1981; articles—"Concerning the Photos of Egons Spuris" by J. Janackova in *Revue Fotografie* (Prague), November 1970; "Searching for an Individual Means of Expression" by Mihail Leontjev in *Sovetskoye Foto* (Moscow), February 1974; "Searching for the Essence of Creativity" by S. Daugovish in *Maksla* (Riga), October 1974; "Erst Kommt Mir die Idee" in *Sputnik* (Moscow), May 1976; "A Poet of Versatile Form" by Daniela Mrázková in *Revue Fotografie* (Prague), May 1978; "Searcher after the Simplest Truth" by P.K. Jaskari in *Kamera Lehti* (Helsinki), June 1978; "The Tracks of Time" by Vjaceslav Jegorov in *Sovetskoye Foto* (Moscow), April 1979.

I am interested in photography only as an art. Though I pay attention to technical means and devices, they serve *only* to enrich my photographic vocabulary. To my mind, the task and duty of an artist is not to multiply already extant beauty (nice landscapes, outstanding people, celebrities, beautiful girls, interesting events, etc.). I gain satisfaction by creating an effective picture, creating values from a material which plays a tiny role in our lives, and which has no (apparent) value of its own.

I try to avoid the so-called literary movement in my work—i.e., the outer and visual dynamism. Usually there is no action is my photographs. Compositions are mainly stable, even static. I try to see and reflect the character (not characteristic) of things or environment, the fascinating mood, inner dynamism or stillness.

I have been much engaged in photomontage (especially in 1969-71). I have acquired different special techniques in colour photography, too, and this knowledge serves me in my professional work. Since 1976, I have stopped using these particular technical means when creating works for myself or for exhibitions, as their use seems an easy way to success. That is why I create my works only in black-and-white, and though the technique is rather simple (I use masking, bleaching, etc., to get the necessary intensity and correspondence of tones), it often takes me several days to create a copy of my work (a good print).

Overcoming these difficulties is not an aim in itself; it is the test of my abilities—who am I?
—Egons Spuris

Egons Spuris started photographing as an amateur, and even today his attitude is basically that of an amateur. To Spuris photography has never been his means of earning a living but just a hobby, a fulfillment of a life's ambition, a love to which he completely devoted himself. It seems almost as if he were deliberately cultivating such an attitude, for it allows him to photograph only when he wishes to: he does not have to accept commissions, and he does not have to give way to the views of others.

Spuris' work is essentially modern, for with precise urgency it expresses the way of life of contemporary man. It does not reproduce reality as such; it does not aim at conveying illusions but at communicating sentiments about reality. Moreover, the work is based on Latvian national feelings. The span of themes and expressions in his work ranges from an inner experience of the landscape to the intimate style of portraits to still-lifes of urban nooks. The most striking feature of his style is the sharp contrast between black and white and the very high standard in presenting shape. He fondles, kneads and models the shapes of things and phenomena by the angle of the shot, with the help of views from below or above, and he communicates their internal sense mainly with the help of light. This method gives rise to expressive dramatic pictures in which the main motif emerges like a sudden spectre against the dark background, and also to an impressive optical magic that conveys the world of dreams, myths and fairytales. A strong sensibility, a perfect comprehension of the rhythmic arrangement of space, a deep admiration for ordinary things, a creative knowledge and an intellectual background—all these things have contributed towards making Egons Spuris one of the most striking personalities not only of Latvian but also of "Soviet Baltic photography"—the term now applied to the work of Latvian, Lithuanian and Estonian photographers.

Egons Spuris: Image from the series *The Proletarian Districts of Riga of the 19th Century*, **1975**

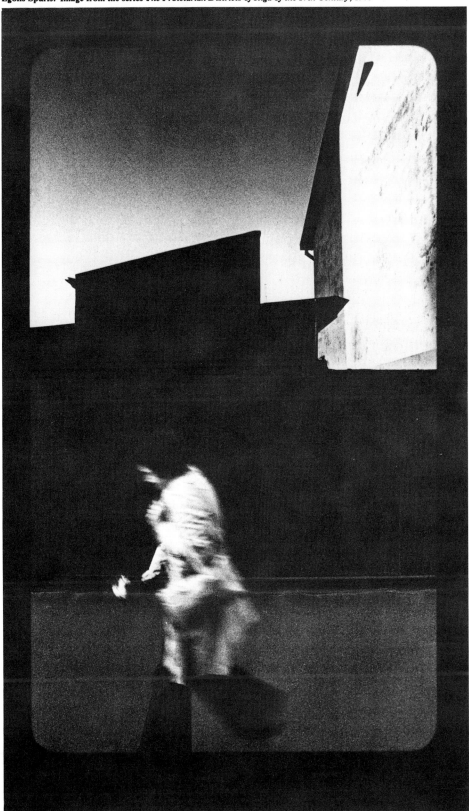

The roots of Spuris' work are closely linked with the rugged, melancholy seaside of the Baltic. This accounts also for the gentle nostalgia of his landscapes, in which the vast, almost deserted, stretches of the seacoast are usually photographed with a wide-angle lens. The rough structure of the windswept sand, rocks, coarse tufts of grass, and the dark surface of the sea, with the silhouette of a boat, a boulder or a fish on the foreground: these are Spuris' symbols of the land in which he lives. From this impetus, too, springs his meditative portraits in which the knowledgeable eyes of contemporary man usually gaze straight into the lens.

From about the mid-1970's the poetical quality of Spuris' prints, closely linked with domestic cultural traditions, suddenly became more sober, civil and matter-of-fact. Spuris withdrew from the natural themes of seaside landscapes and portraits to concentrate on problems of urban civilization. He became interested in architectural structures, both modern and historical, and in the urban environment—the geometry of roofs, paved streets, the surfaces of walls. He traces the sharply contrasting relationship between the products of technical progress and traditional life: the modern car or prefabricated house are alien in the environment of the streets and yards of ancient Riga and yet symbolize change in ways of living. Spuris, given his intellectual concerns, is still not merely interested in the bare system of form and structural agglomeration of urban shapes; rather, his interest is in an objective testimony of the process of civilization. Spuris' vision has suddenly become more cosmopolitan. His photographs are now psychological pictures of the world of modern man.

—Daniela Mrázková

Pavel Stecha: Image from the series _Traffic_, 1978

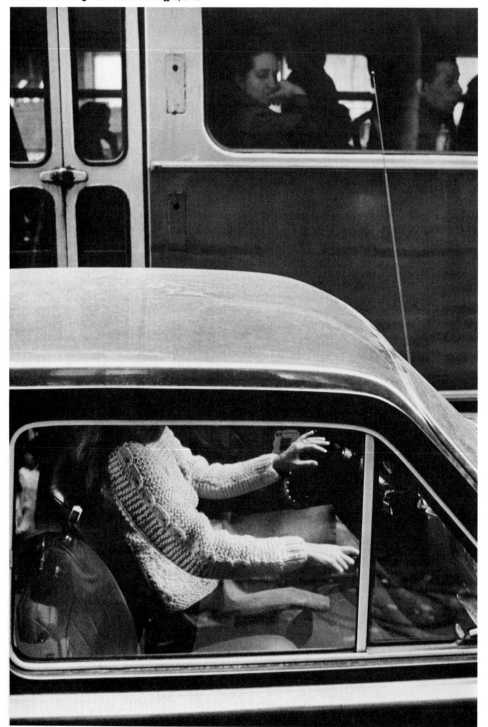

STECHA, Pavel.

Czechoslovak. Born in Prague, 20 December 1944. Educated at secondary school in Prague, 1959-63; studied photography at FAMU (Arts Academy), under Anna Fárová and Ján Smok, Prague, 1967-71. Served in the Czech Army, 1963-65. Married Alice Bubníková in 1969; daughter: Martina. Photographer, Prague, since 1971. Assistant Lecturer, 1975-78, and since 1978 Senior Lecturer in Documentary Photography, FAMU, Prague. Recipient: Youth Photography International Prize, _Photokina_, Cologne, 1968. Address: Navrátilova 2, 11000 Prague 1, Czechoslovakia.

Individual Exhibitions:

1978 _Weekend Houses_, Cinoherní Klub Theatre, Prague
1980 _Traffic_, Cinoherní Klub Theatre, Prague

Selected Group Exhibitions:

1968 _Youth Photography Exhibition_, at _Photokina_, Cologne
1971 _The Rest Home at St. Thomas_, Roudnice Art Gallery, Czechoslovakia (travelled to the Fotokabinett Jaromir Funke, Brno, Czechoslovakia, 1972)

Collections:

Museum of Decorative Arts, Prague.

Publications:

By STECHA: article—"Documentary Photography at FAMU" in _Revue Fotografie_ (Prague), January 1978.

On STECHA: articles—"Photography and Sociology" by J. Andel in _Ceskoslovenska Fotografie_ (Prague), July 1974; "Stecha's Tábor" by A. Dufek in _Ceskoslovenska Fotografie_ (Prague), June 1975; "Prague: At the Heart of Europe" by Daniela Mrázková in _Ovo Magazine_ (Montreal), no. 30/31, 1979; "At the Foyer Theatre Cinoherní Klub" by Anna Fárová in _Camera_ (Lucerne), July 1980.

I suppose that the most important thing about photography is the possibility of stopping time—Cartier-Bresson's "decisive moment."

I believe in the power and narrative potential of thematic photography, as opposed to the single, all-encompassing picture.

—Pavel Stecha

Among the middle generation of photographers in Czechoslovakia, Pavel Stecha is known for his attempts to solve, or at least creatively explore, complex sociological questions by means of images.

Stecha's main interest has been man living in the town. In collaboration with social scientists, he examined the environment close to old houses destined for demolition in the near future. In an attempt at a complete characterization, his images involve both typical exteriors and views into average flats. As well, he created a gallery of portraits of the inhabitants—useful documentation of the kinds of people living in such an environment. But this is not to suggest that his work is either indiscriminate or inartistic. With great care and comprehension Stecha has applied the principle of _pars pro toto_: he has chosen the precisely right details to depict the whole, and his photos are fresh reminders of the most important conclusions reached in the study. Quite often, too, he has been very skilful in choosing the typical situation, the characteristic event that reveals the style of living within the environment.

At the other extreme, but with the same intention, and with equal success, Stecha has also photographed the environments of new dwellings and their inhabitants. The mere comparison of the two series is illuminating, and new facts emerge from each viewing of these complex cycles.

Because of the greater distance of modern districts from the center of the city, Stecha has also been interested in all kinds of municipal transportation. This interest has provided the occasion for more dynamic images. Again, his interest is sociological, and his touch exact: he carefully selects the key situation, that which informs, say, not only about the density of traffic but also about the groups of people using cars, buses and the subway.

In another series, Stecha follows the urban dweller to his week-end cottage in the country. He confronts town-man in his log-cabin. These photos have both documentary strength and creative charm: the approach might be described as a modern variation on the heritage of August Sander.

These various and unusual cycles were in excess of what was required by the institutions that commissioned the work; they paid for only a simple documentary visual supplement to the scientists' text. But, because of his part-time employment as a lecturer in the Department of Creative Photography in the Film and TV Faculty in Prague, Stecha had the means to go much further. And, thanks to his great enthusiasm for his projects, he has been able to create works that are important not only as sociology but also as photography.

—Petr Tausk

STEELE-PERKINS, Chris(topher).

British. Born in Rangoon, Burma, 28 July 1947. Educated at Christ's Hospital School, Sussex, 1959-65; studied psychology at the University of Newcastle upon Tyne, 1967-70, B.Sc. 1970. Freelance photographer, London, since 1970. Member, Exit group of photographers, London, since 1975; Associate, Viva photo agency, Paris, 1976-78; Nominee, Magnum photo agency, Paris and New York, since 1979. Lecturer in Photography, Polytechnic of Central London, 1976-77. Member, Photography Committee, Arts Council of Great Britain, 1976-79. Recipient: Gulbenkian Foundation Grant, 1975. Address: 5 Homer House, Rushcroft Road, London SW2, England.

Individual Exhibitions:

1977 *Film Ends*, The Photographers' Gallery, London (with Mark Edwards; travelled to the International Center of Photography, New York)
 Prakapas Gallery, New York
1980 *The Teds*, Side Gallery, Newcastle upon Tyne (travelled to the National Theatre, London)

Selected Group Exhibitions:

1974 *The Face of Bengal*, Half Moon Gallery, London
 The Inquisitive Eye, Institute of Contemporary Arts, London
1975 *Young British Photographers*, The Photographers' Gallery, London (toured Europe, the United States, and Canada)

Collections:

Victoria and Albert Museum, London; Bibliothèque Nationale, Paris.

Publications:

By STEELE-PERKINS: books—*The Teds*, London 1979; *About 70 Photographs*, editor, London 1981.

On STEELE-PERKINS: book—*Young British Photographers*, exhibition catalogue, London 1975.

I work as a "reportage" photographer, as photography provides a unique vehicle for earning a living and examining the human condition. As many other photographers have stated—photography is a way of life.

I would hope not just to *take* photographs, but also to give something back.

—Chris Steele-Perkins

Chris Steele-Perkins obviously esteems photography for its ability to communicate in easily understood images and, simultaneously, for its ability to provoke emotional responses.

He strives for the expressive image, and his chief interest is what could be called the "live" photograph. He has based a large part of his work on the right evaluation of situations discovered by him in daily life, photos that suggest a non-intervention from the photographer. This kind of approach is apparent not only in his reportage but also in his portraits within environments typical of his subject.

He has a profound knowledge of the narrative

Chris Steele-Perkins: *Teddy-Boys at Southend*, **England, 1978**

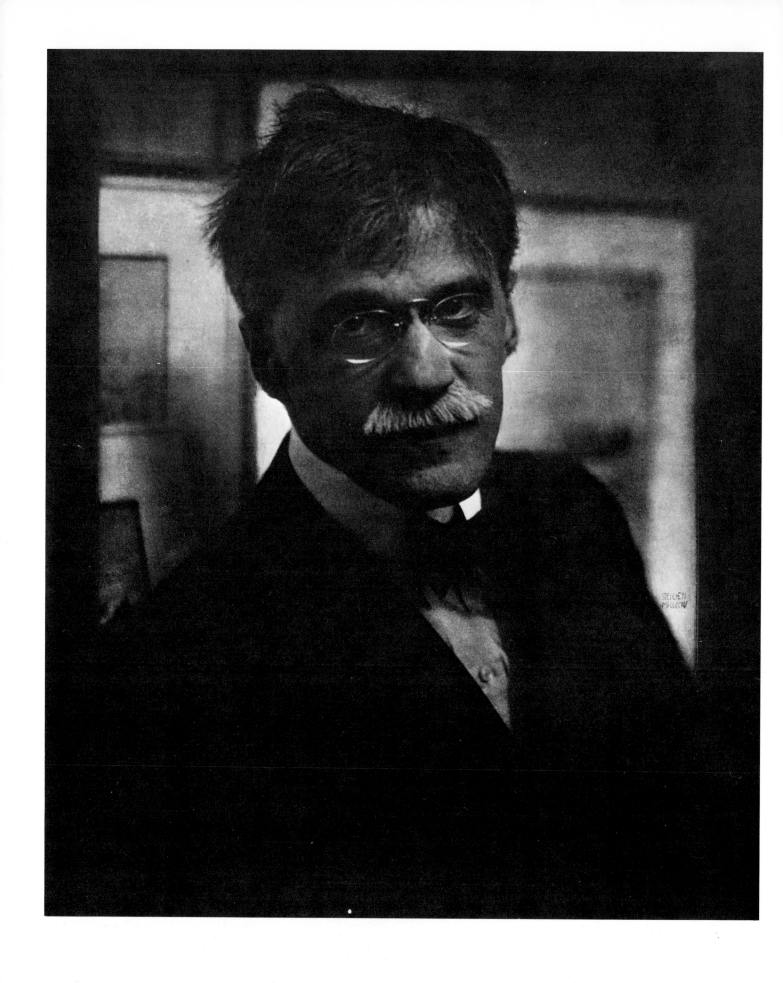

Edward Steichen: *Portrait of Alfred Stieglitz,* **1915** Courtesy Art Institute of Chicago

718

qualities of the image, so much so that he has been able to use photography as a means of providing sociological information—for instance, his large cycle *The Teds*. In this series he works in the genre of the journalistic portrait: many of the photos are of Teds' faces. Other photos in the series are "live," depicting typical situations from their lives, their amusements. The series as a whole, which has been published, is modern reportage at its best.

His comprehension of the significance of the eloquent situation might be called the driving force for a great part of his work. Simultaneously, Steele-Perkins seems to be aware that the capturing of important "events" can also be the result of luck and chance. Probably these points-of-view are what have led him to an interest in what might be called *objet trouvé* appropriately modified by the demands of reportage.

A special and very unusual kind of demonstration of the eloquent event discovered by chance is his work in the exhibition *Film Ends*. The ends of film are often automatically exposed by the photographer, and within these chance shots there might be, now and then, some interesting images. Having made this discovery with Mark Edwards, the two of them searched through about 5,000 "film ends" and chose 40 of the best for the exhibition. The creative act, obviously, was not in the careless exposing of film ends, but in discovering what a treasure of chance events of significance might be hidden in such photos. In its own way the cycle was very near in spirit to Conceptual Art.

—Petr Tausk

STEICHEN, Edward (Jean).

American. Born Eduard Steichen in Luxembourg, 27 March 1879; emigrated to the United States, 1881: naturalized, 1900; adopted father's name "Jean-Pierre," c. 1900; changed spelling "Eduard" to "Edward," c. 1918. Educated in Hancock, Michigan, and Milwaukee, Wisconsin, until 1894; studied art, under Richard Lorenz and Robert Schade, Milwaukee Art Students League, 1894-98; Académie Julian, Paris, 1900 (several weeks); sojourned in Europe, 1900-02, 1906-14; self-taught in photography, from 1895. Served as commander of photographic division, United States Army Expeditionary Forces, 1917-1919: Lieutenant Colonel; Director of Naval Photographic Institute, United States Navy, 1945-46: Captain. Married Clara E. Smith in 1903 (divorced, 1923); daughters: Mary and Kate; married Dana Desboro Glover in 1923 (died, 1957); married Joanna Taub in 1960. Worked as lithography apprentice, American Fine Art Company, Milwaukee, 1894-98; independent painter and photographer, Paris and New York, 1900-22; abandoned painting in favour of photography, New York, c. 1922; advertising, fashion and commercial portrait photographer, New York, 1923-37; Chief Photographer for the Condé Nast publications *Vogue* and *Vanity Fair*, and worked for J. Walter Thompson agency; abandoned own photography, New York, 1947, except for "The Little Tree" project, from 1955; Director, Department of Photography, Museum of Modern Art, New York, 1947-62. Founder-President, Milwaukee Art Students League, 1895-97; Founder-Member, Photo-Secession, New York, 1902: established, with Alfred Stieglitz, "291" Fifth Avenue photographic studio, New York, 1902-06, and Little Galleries of the Photo-Secession, New York, from 1905. Also active as horticulturist, Voulangis, France, and Connecticut,

from 1908. Recipient: First Prize, Eastman Kodak Competition, New York, 1903; Silver Medal for Advertising Photography, New York, 1937; United States Distinguished Service Medal, 1945; Art Directors Club Medal, New York, 1945; *U.S. Camera* Achievement Award, New York, 1949; Fine Arts Medal, American Institute of Architects, 1950; Front Page Award, Newspaper Guild, New York, 1955; Cultural Achievement Prize, Deutsche Gesellschaft für Photographie (DGPh), 1960; United States Silver Progress Medal, 1960; Progress Medal, Royal Photographic Society, London, 1961; *Art in America* Prize, New York, 1961; Special Award, Photographic Society of Japan, 1961; Honor Award, American Society of Magazine Photographers, 1962; Presidential Medal of Freedom, United States, 1963. Honorary M.A.: Wesleyan University, Middletown, Connecticut, 1942; D.F.A.: University of Wisconsin, Milwaukee, 1957; University of Hartford, Connecticut, 1960. Member, London Linked Ring, 1901; Honorary Fellow, Royal Photographic Society, London, 1931; Honorary Fellow, Photographic Society of America, 1945. Chevalier, Légion d'Honneur, France, 1919; Commander of the Order of Merit, Grand Duchy of Luxembourg, 1966. *Died* (in West Redding, Connecticut) *25 March 1973.*

Individual Exhibitions:

1900	Mrs. Arthur Robinson's Home, Milwaukee
1902	Maison des Artistes, Paris
1906	Photo-Secession Galleries, New York
1908	Photo-Secession Galleries, New York
1909	Photo-Secession Galleries, New York
1910	Montross Gallery, New York
	Photo-Secession Galleries, New York
1915	M. Knoedler and Company, New York
1938	Museum of Modern Art, New York
	Baltimore Museum of Art (retrospective)
1950	American Institute of Architects, Washington, D.C. (retrospective)
1961	Museum of Modern Art, New York (retrospective)
1965	Bibliothèque Nationale, Paris (retrospective)
1976	Allan Frumkin Gallery, Chicago
1978	*Steichen: The Master Prints 1895-1914: The Symbolist Period*, Museum of Modern Art, New York
1979	*A Centennial Tribute*, International Museum of Photography, George Eastman House, Rochester, New York

Selected Group Exhibitions:

1899	*2nd Philadelphia Photography Salon*
1900	*New School of American Photography*, Dudley Gallery, London (travelled to Photo Club, Paris)
1902	*American Pictorial Photography*, National Arts Club, New York
1904	*A Collection of American Pictorial Photographs*, Corcoran Art Gallery, Washington, D.C. (travelled to Carnegie Institute, Pittsburgh, Pennsylvania)
1905	*Opening Exhibition*, Photo-Secession Galleries, New York
1932	*Murals by American Painters and Photographers*, Museum of Modern Art, New York
1955	*The Family of Man*, Museum of Modern Art, New York (and world tour)*
1970	*Photo-Eye of the 20's*, Museum of Modern Art, New York (toured the United States)
1974	*Photography in America*, Whitney Museum, New York
1978	*The Collection of Alfred Stieglitz: Fifty Pioneers of Modern Photography*, Metropolitan Museum of Art, New York

*Steichen organized *The Family of Man* and over 45 other shows at the Museum of Modern Art.

Collections:

Edward Steichen Archive, Museum of Modern Art, New York; Metropolitan Museum of Art, New York; International Museum of Photography, George Eastman House, Rochester, New York; Fogg Art Museum, Harvard University, Cambridge, Massachusetts; Library of Congress, Washington, D.C.; Art Institute of Chicago; New Orleans Museum of Art; Center for Creative Photography, University of Arizona, Tucson; National Gallery of Canada, Ottawa; Royal Photographic Society, London.

Publications:

By STEICHEN: books—*The Steichen Book*, special number of *Camera Work*, New York 1906; *Steichen the Photographer*, with text by Carl Sandburg, New York 1929; *The First Picture Book: Everyday Things for Babies*, with Mary Steichen Martin, New York 1930; *The Second Picture Book*, with Mary Steichen Martin, New York 1939; *Walden, or Life in the Woods*, with text by Henry David Thoreau, Boston 1936; *U.S. Navy War Photographs: Pearl Harbor to Tokyo*, editor, New York 1946; *The Blue Ghost*, New York 1947; *The Family of Man*, with a foreword by Carl Sandburg, New York 1955; *Steichen the Photographer*, New York 1961; *The Bitter Years: F.S.A. Photographs*, New York 1962; *A Life in Photography*, New York 1963; *Sandburg: Photographer's View*, edited and with an introduction by Carl Sandburg, New York 1966; *Edward Steichen*, with text by Ruth Kelton, Rochester, New York 1978; *Steichen: The Master Prints, 1895-1914: The Symbolist Period*, with text by Dennis Longwell, New York and London 1978; *Edward Steichen*, with text by Tom Maloney, New York 1981; articles— "British Photography from an American Point of View" in *Amateur Photographer* (London), 2 November 1900; "The American School" in *The Photogram* (London), January 1901; "Ye Fakers" in *Camera Work* (New York), January 1903; "Painting and Photography" in *Camera Work* (New York), July 1908; "What Is 291?" in *Camera Work* (New York), July 1914; "American Aerial Photography at the Front" in *The Camera* (New York), July 1919; "The Fighting Photo-Secession" in *Vogue* (New York), 15 June 1941; "The New Selective Lens" in *Art News* (New York), September 1950; "The Living Joy of Pictures" in *Holiday* (New York), March 1956; "Photography: Witness and Recorder of Humanity" in *Wisconsin Magazine of History* (Milwaukee), Spring 1958; "My Life in Photography" in *Saturday Review* (New York), 28 March 1959; "My Half-Century of Delphinium Breeding" in *The Delphinium Society's Yearbook*, London 1959; "Steichen and the Bunch at 291," interview, with A.D. Coleman in *Photograph* (New York), vol. 1, no. 2, 1976.

On STEICHEN: books—*Photography as a Fine Art: The Achievements and Possibilities of Photographic Art in America* by Charles H. Caffin, New York 1901, 1971; *Wisdom: Conversations with the Elder Wise Men of Our Day*, edited by James Nelson, New York 1958; *Photo-Secession: Photography as a Fine Art* by Robert Doty, Rochester, New York 1960; *The Painter and the Photograph: From Delacroix to Warhol* by Van Deren Coke, Albuquerque, New Mexico 1964, 1972; *Photographers on Photography*, edited by Nathan Lyons, New York 1966; *Photography in the 20th Century* by Nathan Lyons, New York 1967; *Camera Work: A Critical Anthology*, edited by Jonathan Green, New York 1973; *Photography in America*, edited by Robert Doty, with an introduction by Minor White, New York and London 1974; *Fashion 1900-1939*, exhibition catalogue, by Valerie Lloyd and others, London 1975; *The Land: 20th Century Landscape Photographs Selected by Bill Brandt*, exhibition catalogue, edited by Mark Haworth-Booth, London 1975; *American Fashion*, edited by Sarah Tomerlin Lee, New York 1975, London 1976; *L'Arte nella*

Società: Fotografia, Cinema, Videotape by Daniela Palazzoli, and others, Milan 1976; *Fotografische Künstlerbildnisse*, exhibition catalogue, by Dieter Rönte, Evelyn Weiss and Jeanne von Oppenheim, Cologne 1977; *Paris-New York*, exhibition catalogue, by D. Abadie, A. Pacquement, H. Seckel, and others, Paris 1977; *Geschichte der Fotografie im 20. Jahrhundert / Photography in the 20th Century* by Petr Tausk, Cologne 1977, London 1980; *The Collection of Alfred Stieglitz* by Weston J. Naef, New York 1978; *The Linked Ring* by Margaret Harker, London 1979; *Amerika Fotografie 1920-1940* by Erika Billeter, Berne 1979; *Photographie als Kunst 1879-1979 / Kunst als Photographie 1949-1979*, exhibition catalogue, 2 vols., by Peter Weiermair, Innsbruck, Austria 1979; *Photographen der 20er Jahre* by Karl Steinorth, Munich 1979; *Film und Foto der 20er Jahre*, exhibition catalogue, by Ute Eskildsen and Jan-Christopher Horak, Stuttgart 1979.

Edward Steichen is and will remain one of the greatest photographers in the history of photography. This claim is substantiated by his photographs and by the record of his career in photography.

The traits of character which equipped him so well to realize such a remarkable achievement were his insatiable curiosity (he was not satisfied until he had discovered the "why", "how" and "wherefore" of everything which interested him); his capacity for the acquisition of knowledge; his aesthetic sensitivity and appreciation of harmony in all things; his patience and perseverance in mastering skills; his fastidiousness in attention to detail; and above all his love of life—fellow human beings as well as nature in all its forms. These attributes must have influenced his decision to make photography the medium through which to express his ideas about life, and they are reflected in one form or another in his subject selection and treatment. They contributed in no small way to his outstanding success as a professional photographer between 1923 and 1937.

Steichen's early training as an artist and his aesthetic sensibility induced him to use photography as an interpretative medium rather than for factual recording purposes. Between 1896 and c.1918 he practised both painting and photography as well as other graphic media, but after the end of World War I decided to concentrate on photography and spent a year in experimenting with the effects of light on form and textures. This preparation was invaluable to him in his professional career in respect of subject interpretation and communication of the creations of the fashion designers and others whose work he was to photograph for publication in *Vogue* and *Vanity Fair* magazines during the next two decades.

One of the most striking features of Steichen's photographs are their apparent simplicity in contrast to so many photographs of the present day which are highly detailed and complex in structure. Steichen reduced detail to a minimum to avoid packing his pictures with unnecessary and distracting information. This is particularly characteristic of his early works, many of which reveal the influence of the painter Whistler. Rather than dwell on the physical representation of a subject he preferred to express his idea of the subject, abstracting the characteristic mood of the sitter or the spirit of the place being photographed. For example, his black and white photograph of "The Photographer's Best Model—George Bernard Shaw," 1907, tells us more about the mischievous, high spirited Shaw than is conveyed in the standard texts without having to observe what suit, collar and tie he happened to be wearing that day.

Twilight fascinated Steichen: "What a beautiful hour of the day is that of twilight when things disappear and seem to melt into each other, when a great beautiful feeling of peace overshadows all. Why not, if we feel like this, have this feeling reflect itself in our work? Many of the negatives have been made in this hour, many early in the morning or on dark grey

days." "...At this time of day spirit seems to disengage itself from matter and to envelop it with a mystery of soul-suggestion." The majority of Steichen's photographs, 1897-c.1912, contain those qualities which he felt were essential to the interpretation of the spiritual rather than the physical presence and are redolent of the mysteries of the twilight hour (the lower end of the tone scale is dominant; tonal values have only barely discernible differences; forms, shapes and outlines are softened and diffused and blend into their immediate surroundings.) "Woods, Twilight," 1898, and "The Pool. Evening. Milwaukee," 1899, strike a chord in all nature lovers who have experienced the bewitching hour when Nature seems to hold her breath and is silent. These photographs have a greater sense of reality than the sharply defined photographs which attempt to record similar scenes. Other, later, Steichen photographs, strongly evocative and defiant of the materialistic world are "Nocturne, Orangerie Staircase, Versailles," c.1910, in which the distant palace is bathed in light and the staircase, barely discernible, is in deep shadow which occupies two thirds of the picture space; "The Big White Cloud, 1903, in which the same proportions of light to dark tones apply and which is an impressively dramatic photograph; "The Flat Iron," 1905, of which there are at least three versions of this angular New York building; and the series of photographs of Rodin's "Balzac Statue at Meudon," 1908. Rodin commissioned Steichen to take the photographs of his statue, which inspired the photographer with such enthusiasm that he wrote to Stieglitz about the two whole nights he spent photographing the statue by moonlight. The results are most impressive.

Steichen demonstrated his outstanding ability in the portrayal of people before World War I, during his years resident in Paris. Through knowledge of and understanding of his sitters he emphasised their characteristics rather than appearances, and by skillfull tonal control reduced inessentials but retained form, frequently by suggestion rather than definition. These include: "Maurice Maeterlinck," 1901, "J. Pierpont Morgan," 1903, "Clarence White," 1903, "Eleonora Duse," 1903. Most are in the same low key which characterises his landscapes of the same period.

Steichen's skill as a master craftsman was demonstrated during this early stage of his career. The print, at this time, was considered a vitally important stage of image production. Steichen experimented with various forms of printing including platinum, carbon, cyanotype, gum bichromate, multiple gum by which a single print in a range of colours could be produced, and a combination of two or more of these processes in the one image such as gum platinum. "Moonrise, Mamaroneck," 1906, was made from three printings: grey platinum, cyanotype (blue print), and a green pigmented gum. Steichen experimented with colour photography, using the Autochrome process, in 1906-7.

Symbolist imagery is evident in the work of members of the Linked Ring and the Photo-Secession; Steichen was a member of both so it is not surprising that references of a Symbolist nature are to be found in his commercial and advertising photography as well as his pictorial work. "The Black Vase," 1901, "The Mirror," 1902, "The Little Round Mirror," 1903, "The Brass Bowl, 1904, "The Cat," 1902, the nude studies of this period and especially the studies of Rodin and his sculpture are striking examples. "Heavy Roses, Voulangis," 1914, is surely one of the most nostalgic photographs in the history of photography, taken on the eve of Steichen's departure from France as the German forces swept in.

Steichen's transitional period, 1914-1922, shows the rejection of pictorialism and the enthusiasm for New Realism with subjects rendered in sharp focus throughout and often featured in "close-up," such as "The Lotus," in 1915, superb in formalistic design, and the photographs of Isadora Duncan and her team of dancers photographed by Steichen in Athens

in 1921. Symbolist nuances creep in as in "Isadora Duncan at the Portal of the Parthenon," a magnificent portrayal of the fragility and strength of the human race; and "Wind Fire—Therese Duncan", a magical photograph of a dancer, her clothes blown by the wind as though they are alight. A similar interpretation is to be found in Steichen's photograph of Lillian Gish as "Ophelia," 1936, for *Vanity Fair*, an extraordinary portrayal of the actress in the mad scene preceding death.

Steichen's work for Condé Nast (*Vogue* and *Vanity Fair* publications) in the 1920's and 30's, reached a high peak of achievement. In the fashion photographs he took for *Vogue* he ensured that the girls who modelled the garments imparted a sense of reality so that women readers could imagine themselves wearing the clothes featured. They were elegantly posed and chic but human. Of the many celebrities he photographed for *Vanity Fair* Steichen succeeded in getting behind the mask to portray the real men and women inside. The sensitive photograph of "Greta Garbo" 1928, is particularly fine in this respect. Steichen's sure feel for design is apparent in all his work—it is the most consistent ingredient. His public relations photographs are especially impressive. "Strange Interlude, Ah Wilderness" 1933, and "Carl Sandburg-Poet," 1936, are all composites (combined images from two or more negatives) and Symbolist in interpretation. One of his most impressive photographs for Condé Nast was "The Matriarch", 1935, used in connection with publicity for Jewish Relief.

Steichen's work did not end with his retirement from Condé Nast in 1937. He played a prominent role as head of Naval Film Services in World War II and was appointed Director of Photography at the Museum of Modern Art in 1945. His crowning achievement was the planning, preparation and staging of *The Family of Man* exhibition which toured the world in the 1950's.

—Margaret Harker

STEINER, Ralph.
American. Born in Cleveland, Ohio, 8 February 1899. Educated at Dartmouth College, Hanover, New Hampshire; Clarence H. White School of Photography, New York, 1921-22. Served in the United States Army, 1942-45. Married (3rd marriage) Caroline Neilson in 1960; daughter: Antonia. Freelance photographer, working originally as an advertising/public relations photographer, New York, 1922-69, in Thetford Hill, Vermont, since 1970. Picture Editor, *PM* newspaper, Long Island, New York, in the 1940's. Also, a filmmaker: worked as an assistant to Clarence Brown, MGM Films, Hollywood, 1949, and as a Producer, RKO Films, Hollywood. Artist-in-Residence, Dartmouth College. Recipient: Film Grant, Elmhurst Foundation; First Prize for Film, *Photoplay* magazine, New York; Guggenheim Fellowship, 1974; Honorary Master of Photography Award, Milwaukee Center of Photography, 1981. Address: Box 75, Thetford Hill, Vermont 05074, U.S.A.

Individual Exhibitions:

1931 *Photographs by 3 Americans*, John Becker Gallery, New York (with Walker Evans and Margaret Bourke-White)
1949 Museum of Modern Art, New York
1974 Witkin Gallery, New York
1981 Milwaukee Art Center (with Walker Evans) Northlight Gallery, Tempe, Arizona (with Wright Morris) Prakapas Gallery, New York

Selected Group Exhibitions:

1929 *Film und Foto*, Deutscher Werkbund, Stuttgart
1931 *American Photography*, Julien Levy Gallery, New York
1932 *New York by New Yorkers*, Julien Levy Gallery, New York
1971 *International Westdeutscher Kurzfilmtage*, Oberhausen, West Germany
1974 *Photography in America*, Whitney Museum, New York
1976 *Photographs from the Julien Levy Collection, Starting with Atget*, Art Institute of Chicago
1979 *Film und Foto der 20er Jahre*, Württembergische Kunstverein, Stuttgart (travelled to the Museum Folkwang, Essen; Werkbundarchiv, Berlin; Kunsthaus, Zurich; Kunstverein, Hamburg; and Museum des 20. Jahrhunderts, Vienna)
 Photography Rediscovered: American Photographs 1900-1030, Whitney Museum, New York (travelled to the Art Institute of Chicago)

Collections:

Metropolitan Museum of Art, New York; Museum of Modern Art, New York; Princeton Art Museum, New Jersey; Art Institute of Chicago.

Publications:

By STEINER: books—*Dartmouth*, New York 1922; *A Point of View*, with an introduction by Willard Van Dyke, Middletown, Connecticut 1978; films—*H²O*, 1929; *The Plow That Broke the Plains*, with Paul Strand, directed by Pare Lorentz, 1936; *People of the Cumberlands*, with Sidney Meyers and Eugene Hill, 1937; *The City*, with Willard Van Dyke, 1939.

On STEINER: books—*Der Bitterne Jahre: Der Soziale Amerikanische Dokumentar Film der Dreissiger Jahre*, edited by Will Wehling, Oberhausen, West Germany 1971; *The Photographer's Eye* by John Szarkowski, New York 1966; *Looking at Photographs* by John Szarkowski, New York 1973; *Photography in America*, edited by Robert Doty, with an introduction by Minor White, New York and London 1974; *The Julien Levy Collection*, edited by Lee D. Witkin, New York 1977; *Ralph Steiner* by Joel Zuker, New York 1979; *Photographen der 20er Jahre* by Karl Steinorth, Munich 1979; *Film und Foto der 20er Jahre*, exhibition catalogue, by Ute Eskildsen and Jan Christopher Horak, Stuttgart 1979; *Photography Rediscovered: American Photographs 1900-1930*, exhibition catalogue, by David Travis, New York 1979.

One of the best things I ever read by a man about his own work was in a small book by a number of modern English painters. On the left of every two facing pages was a reproduction of one man's painting and on the right was his statement of what he was doing in paint. Almost every statement but one was either incomprehensible or ridiculous or unrelated to the reproduced painting. Only one painter made sense to me with his declaration: "If I could tell you what I was doing in my painting, I'd be a writer, not a painter." Good man, that!

Before I'd try to explain what I think I do with a camera, I'd want to engage myself as my own psychiatrist at fifty dollars an hour for a full year or more. That would be costly and, more than likely, unprofitable.

The best things I can say about what I feel about photography (mine or anyone else's) are contained in one misquote and three quotations. Here goes:

Ralph Steiner: *New York*, 1965

By Descartes: "I photograph: therefore, I am." That's a misquote.

By the painter Edward Hopper: "The work's the man; you can't get something out of nothing." Quote number one.

By Chinese philosopher Lao Tse (that was not his name: it means old boy; he was called that because he was born with white hair): "On him who would glitter the sun never shines." The "glitter" has to do with success, fame, praise, ambition, status, profit—all highly American photographically unproductive purposes. And "if that be treason, make the best of it." Quote number two.

Quote number three: "The way to do is to be." If that should be so simple as to be difficult, then perhaps my view of it, applied to photographers, may help. I think that the "way to do" photography "is to be" simply, naturally, effortlessly, tooth-and-nail-y, modestly, arrogantly your own man. Nothing else works. All you have to do is to "know thyself." As a friend of mine said: "Of course, Know Thyself—by Thursday."

—Ralph Steiner

Ralph Steiner's earliest photography, done in his teens, was conventional of its time: romantic and slightly fuzzy. (I have watched him happily tear up prints from that time.) Then in 1921 and '22 he studied at the Clarence White school and was infected with Clarence White's mania for formalized, rule-dominated design, which cropped up in Steiner's work for some years. This sounds worse than it is: his visual sensitivity took much of that curse off his pictures made in the 1920's, and many

were excellent. Some were still romantic and soft, while others had a sharper edge of satire or observation. Most of the time, he responded appropriately to what he saw, and made appropriate prints—mainly by feel.

Steiner is far more articulate than most photographers and has more critical perspective on his own work. The quotations that follow are condensed from his book, *A Point of View* (Wesleyan University Press, 1978). It is well worth reading and contains many of his photographs. Here's part of what he says about his work done in the 1920s:

> I did not think about what a photographer was supposed to be or do, so this kept me from thinking I had to be an artist. I not only didn't think about the style of my photography; I couldn't have said what my attitude was toward the stuff of the world. So I simply photographed what I liked or what amused me. What resulted did show some point of view, though 50 years later it does seem thinly humorous and hardly robust. But I unconsciously located material and an attitude which suited me as a 20-year-old. I think I was fortunate to turn to the slightly humorous; it at least kept me in general from trying to be a painterly artist or from trying to make earth-shaking statements.

In 1927 he met Paul Strand and was more than impressed by Strand's technical mastery. Strand's dead-serious attitude was also noted, but luckily did not rub off on Steiner. He writes:

> The evening I spent looking at Paul Strand's photographs for the first time made me know I could not call myself a photographer. I had never before seen the tones and textures of the world so real and so rich on a piece of photographic paper. I knew just about enough to know that Strand had no technical secrets—no special developers and no magic—and that it was the ABC's of photography that I had to learn in order to make prints which were not the result of chance and would not be a disgrace to me. I bought an 8 x 10 camera, took off for a summer at Yaddo, and spent 12 hours a day learning to make negatives which would not fight me in the attempt to make the print I wanted.

> But the whole summer was not spent doing technical exercises; when I saw things that amused me I would stop to photograph them. It may be these things that Walker Evans referred to when he said I'd influenced him. He also photographed visual amusements. It is a grim world and can do with a bit of entertainment.

A long period of professional photography and movie-making followed; Steiner's advertising photographs came from a time that depressed him, and they are mostly proficient but impersonal except for the occasional job that allowed a visual joke. For relief, he took personal pictures.

Since the 1960's most of his photography and films have been personal. This later work is marked by a more lyrical sense of light and of place than his early pictures. It is shot more freely—design is used, but no longer as a duty—and it is printed with a more tender and exact regard for the precise quality and feeling of the experience that led to the picture. His craftsmanship is better and less noticeable than before, more integrated with his vision. When you look at a Steiner photograph from the 1970's you do not feel impressed by technique. The feeling of the picture takes over entirely.

—David Vestal

STEINERT, Otto.

German. Born in Saarbrücken, 12 July 1915. Educated at the Volksschule, Saarbrücken, 1921-25; Reformrealgymnasium, Saarbrücken, 1925-34; studied medicine at the universities of Munich, Marburg, Rostock, and Heidelberg, and at Charite Surgical Clinic, Berlin, 1934-39, Dip.Med. 1939; self-taught in photography. Served as a health officer in the German Army, 1939-45. Married Marlis Dalmer in 1943; son: Stefan. Assistant medical practitioner, Clinic of the University of Kiel, 1945-47, and Clinic of the University of the Saarland, Homburg, 1947. Independent portrait photographer, Saarbrücken, from 1947. Head of the Foundation Course in Photography, Staatliche Schule für Kunst und Handwerk, Saarbrucken, 1948-51; Director, 1952-78, and Professor, 1954-78, Photographic Department, Staatliche Werkkunstschule, Saarbrücken; also, Professor and Director of Photography, Folkwangschule, now the Universität/Gesamthochschule, and Founder-Curator of the Photography Collection, Museum Folkwang, Essen, 1959-78 (organized and designed numerous exhibitions on the history of photography). Founder Member, with Peter Keetman, Toni Schneiders, Ludwig Windstosser, and Siegfried Lauterwasser, "Fotoform" group of "subjective" photographers, Saarbrücken, 1949-55. Member, 1951, and Life Member, 1954, Deutsche Gesellschaft für Photographie (DGPh); Member, 1951, President of the Jury, 1958-65, 1969, and President, 1963-74, Gesellschaft Deutscher Lichtbildner (GDL). Recipient: Davanne Medal, Société Francaise de la Photographie, 1965; Kulturpreis, Deutsche Gesellschaft für Photographie, 1962; David Octavius Hill Medal, Gesellschaft Deutscher Lichtbildner, 1965; Bundesverdientskreuz, Government of West Germany, 1974. Honorary Member, Société Francaise de la Photographie, 1949. *Died* (in Essen-Werden, West Germany) 3 March 1978.

Individual Exhibitions:

1948 Europa-Haus, Saarbrücken (with Boris Kleint and Theo Siegle)
1959 Stedelijk van Abbe Museum, Eindhoven, Netherlands (travelled ton the Stedelijk Museum, Amsterdam)
1960 Galerie du Studio 28, Paris
1964 Expositiecentrum Huidevettershuis, Bruges, Belgium
1975 University of Essen
1976 *Otto Steinert: Der Initiator einer Fotografischen Bewegung*, Museum Folkwang, Essen (travelled to the Moderna Museet, Stockholm, and the Münchner Museum, Munich)
1981 Museum Folkwang, Essen

Selected Group Exhibitions:

1949 *French-German Exhibition*, Neustadt, West Germany
 Winter Salon of Photography, Milan
1950 *Photo-Kino Ausstellung (Photokina)*, Cologne (and 1952)
1951 *Subjektive Fotografie*, Staatliche Schule für Kunst und Handwerk, Saarbrücken, (organized by Steinert)
1954 *Subjektive Fotografie 2*, Staatliche Werkkunstschule, and Schule für Kunst und Handwerk, Saarbrücken (organized by Steinert)
1958 *Subjektive Fotografie 3* and *Das Selbstportrait des Fotografen*, at *Photokina '58*, Cologne
1967 *Photography in the 20th Century*, National Gallery of Canada, Ottawa (toured Canada and the United States, 1967-73)
1977 *Concerning Photography*, The Photographers' Gallery, London (travelled to Spectro Workshop, Newcastle upon Tyne)

1978 *Tusen och En Bild/1001 Pictures*, Moderna Museet, Stockholm
1979 *Deutsche Fotografie nach 1945*, Kunstverein, Kassel, West Germany (toured West Germany)

Steinert also organized and participated in photopedagogical series, *Otto Steinert und Schüler*, at various museums throughout Europe, 1949-73.

Collections:

Staatliche Werkkunstschule, Saarbrücken, West Germany; Deutsche Gesellschaft für Photographie, Cologne; Museum Ludwig, Cologne; Museum Folkwang, Essen; Museum für Kunst und Gewerbe, Hamburg; Bibliothèque Nationale, Paris; Museum of Modern Art, New York; International Museum of Photography, George Eastman House, Rochester, New York.

Publications:

By STEINERT: books (author)—*Subjektive Fotografie*, with Franz Roh and J.A. Schmoll, Bonn 1952; *Akt International*, Munich 1954; *Subjektive Fotografie 2*, with J.A. Schmoll, Munich 1955; *Selbstportraits*, with text by Albrecht Fabri, Gütersloh, West Germany 1961; *Bildnisse Hugo Erfurth*, with an introduction by J.A. Schmoll, Gütersloh, West Germany 1961; *Ereignisse in Stahl*, edited with Helmut Oldenhausen, with an introduction by Helmuth de Haas, Düsseldorf 1965; *Otto Steinert: Teaching Methods*, Essen 1965; *Begegnung mit dem Ruhrgebiet*, with text by Jürgen Lodemann, Düsseldorf and Vienna 1967; *Gesicht der Deutschen Industrie*, with Albert Oeckl, Düsseldorf and Vienna 1968; books, catalogues and brochures (designer)—*Deutsches Studentenwerk 1921-1961: Festschrift zum Vierzigjährigen Bestehen*, Bonn 1961; *Bühnen der Stadt Essen: Spielzeit 1962/1963*, Essen 1962; *Jean-Louis Barrault in Essen*, Essen 1962; *Humboldt-Schule Essen 1864-1964: Festschrift zum Hundertjährigen Bestehen*, Essen 1964; *Bretter, Die die Welt Bedeuten: Bühnen der Stadt Essen: Spielzeit 1965/66*, Essen 1965; *Im Reiche der Chemie: Bilder aus der Vergangenheit und Gegenwart: Badische Anilin- und Sodafabrik AG, Ludwigshafen am Rhein*, Düsseldorf and Vienna 1965; *100 Jahre Nordstern Versicherungen 1866-1966*, Düsseldorf and Vienna 1966; *Die Feuer Verlöschen Nie: August Thussen-Hütte 1890-1926* by Wilhelm Treue, Düsseldorf and Vienna 1966; *Düsseldorf-Ja, Das Ist Unsere Stadt* by Friedrich Tamms, Düsseldorf and Vienna 1966; *Museum Folkwang Essen: Das Museumsgebäude*, Essen 1966; *Musik Theater Tanz*, Essen 1966; *Die Orgel der Kreuzeskirche in Essen*, Essen 1968; *Humboldt-Schule Essen 1908-1968: Schüler-Turn- und Sportverein Humboldt: Festschrift zum Sechzigjährigen Bestehen*, Essen 1968; *Gesellschaft Deutscher Lichtbildner 1919-1969: Eine Dokumentation zum Fünfzigjährigen Bestehen der GDL*, Cologne 1969; *Mensch und Welt: Fotografien von Fee Schlapper*, with text by Leopold Zahn, Essen 1969; articles—"De Inzending Fotoform" in *Focus* (Amsterdam), no. 20, 1950; "Le Groupe Fotoform" in *Photo Cinema* (Paris), March 1952; "Subjektive Fotografie" in *Leica Fotografie* (Frankfurt), no. 4, 1955; "Subjektive Fotografie III," with Otto Toussaint, in *Camera* (Lucerne), March 1959; "Sur les Possibilités de Création en Photographie" in *L'Arc Revue Trimestrielle* (Aix-en-Provence), no. 21, 1963; "Strukturwandel im Beruf des Fotografen" in *Das Deutsche Lichtbild*, Stuttgart 1971.

On STEINERT: books—*Photography in the Twentieth Century* by Nathan Lyons, New York 1967; *The Magic Image* by Cecil Beaton and Gail Buckland, London and Boston 1975; *Otto Steinert: Der Initiator einer Fotografischen Bewegung*, exhibi-

tion catalogue, with text by Fritz Kempe, Essen 1976; *Concerning Photography*, exhibition catalogue, by Jonathan Bayer and others, London 1977; *Geschichte der Fotografie im 20. Jahrhundert / Photography in the 20th Century* by Petr Tausk, Cologne 1977, London 1980; *Tusen och En Bild*, exhibition catalogue, by Ake Sidwall, Sune Jonsson and Ulf Hard af Segerstad, Stockholm 1978; *Deutsche Fotografie nach 1945 / German Photography after 1945* by Floris Neusüss, Wolfgang Kemp and Petra Benteler, Kassel, West Germany 1979; *Fotografie 1919-1979, Made in Germany: Die GDL Fotografen*, edited by Fritz Kempe, Bernd Lohse and others, Frankfurt 1979; catalogues of the *Otto Steinert und Schüler* series—*Otto Steinert und Schüler: Fotografie als Bildgestaltung*, with text by Robert d'Hooghe, Kiel 1957; *Otto Steinert und Schuler: Fotografie als Bildgestaltung*, with text by Max Burchartz, Frankfurt 1958; *Otto Steinert en Leerlingen*, Eindhoven, Netherlands 1959; *Otto Steinert und Schüler*, with texts by Karl Pawek and L. Fritz Gruber, Frankfurt 1962; *Otto Steinert und Schüler*, with text by Fritz Kempe, Essen 1965; *Otto Steinert und Schüler: Fotografie als Bildgestaltung*, with text by Eo Plunien, Essen 1967; *Otto Steiner a Zachi*, with text by Petr Tausk, Brno, Czechoslovakia, 1967; *Points de Vue sur le Portrait—Quatre Photograpes et Leur Maître*, Paris 1973; articles—"Subjektive Fotografie" by Robert d'Hooghe in *Leica Fotografie* (Frankfurt), no. 5, 1951; "Subjektive Fotografie" by Franz Roh in *Camera* (Lucerne), October 1951; "Über einen Photographe, Dr. Otto Stinert, Saarbrücken" in *Fortschritt und Leistung* (Leverkusen, West Germany), no. 3, 1952; "Hommage au Docteur Steinert" by Daniel Masclet in *Ciné / Photo Magazin* (Paris), September 1956; "Subjective Photography and All That" by T.J. Williams in *The Photographic Journal* (London), 1960; "Otto Steinert" by Italo Zannier in *Ferrania* (Milan), no. 8, 1960; "Der Grosse Subjektive" by Fritz Kempe in *MFM Moderne Fototechnik* (Ludwigsburg, West Germany), no. 7, 1975; "Subjective Photography 4" by Allan Porter and Heinrich Freytag in *Camera* (Lucerne), no. 7, 1975.

The first *Photokina* in 1950 was something of a stock-taking of German postwar photography; as well, it introduced a group of young photographers known as "Fotoform." This group had been founded by a doctor of medicine, Otto Steinert, who had given up his medical career two years before to become the director of the photography class at the Staatliche Schule für Kunst und Handwerk in Saarbrücken. And it was not only Fotoform that came into the limelight, but also the Saarbrucken photography class and its director.

The concept of "subjektive fotografie" is a creation of the group, specifically of Otto Steinert, and by it Steinert meant "humanized and individualized photography; it simplifies the handling of the camera in such a way as to capture from the individual object a picture compounding to its nature." The meetings for photographers organized by Dr. Steinert, and the lectures and subsequent discussions in which the students of photography took part, became famous. In 1951 Steinert designed the exhibition *Subjektive Fotografie* in Saarbrucken; it was the first important German—and internationally oriented—exhibition of modern photography, and he defined the concept in the exhibition catalogue as follows: "Subjective photography is to be understood as a framework concept which embraces all areas of personal photographic creation from the abstract photogram to the psychologically profound and visually composed reportage. All efforts in this direction are, consciously or unconsciously, an integral part of the so-called 'new photography' of the 1920's."

Thus a wide territory was marked out, and it is characteristic of the spirit of the exhibition that it included a section devoted to the work of Moholy-Nagy, Man Ray and Herbert Bayer in honor of these great pioneers. The other works in the exhibition—approximately 700 of them—were divided into two groups, one of which represented the aspirations of "subjektive fotografie" and the other the national artists' groups and individual artists. The group "Fotoform" presented a section complete in itself. Otto Steinert ended his foreword to the catalogue with the following words: "Photography, up till now the medium with the widest efficacy, is called upon to make a decisive contribution to the formation of the visual consciousness of our time. As the most readily understandable and most easily handled visual technique available, it is particularly suited to the promotion of understanding between the nations. In awareness of this responsibility, the Saarbrücken exhibition *Subjektive Fotografie* is designed to provide a contribution to the creative development of the international language of pictures."

The book *Subjektive Fotografie*, which appeared in 1952, summarized the points raised by the exhibition and defended the new attitude to the medium while at the same time recognizing its limits. Thus Franz Roh wrote: "What an abundance of possibilities lie in subjective photography! That which can be termed photographic surrealism is regarded by the realists among photographers as "extra-photographic territory." But everything that results from the specific processes—movement of the camera, light-sensitive film material, prints on paper, developing processes, etc.—may be regarded as photographic, as long as no other graphic processes or retouching are employed."

Steinert also drew a line between subjective photography and the "new objectivity": "With the definition of 'subjective photography' we also wish to stress that it emphasizes something specifically individual within the photographic process. The revolutionary photography of new objectivity, apart from its discovery of an original way of seeing, opened varied technical possibilities, demanded recognition for all photographic experiments, and acknowledged the fascination of the specifically technical."

Three years later Steinert held another exhibition, *Subjektive Fotografie 2*, which covered a somewhat wider area. Steinert published a short summary on the development of photography since 1900 in the catalogue and gave his reasons for staging another exhibition: "After a period of three years, in an era of approaching harmony and reassurance, no revolutionary events can be expected in the visual arts. *Subjektive Fotografie 2* is intended to draw attention to the evolutionary tendencies of modern creative photography while retaining its previous program. The new aspects become evident not only through new comprehension of the motive and new techniques, but also in the form of a conscious synthesis towards the photographic black-and-white picture." Steinert's introduction to volume II of *Subjektive Fotografie* takes the form of a systematic treatment of the creative possibilities of photography, which is a classic of its kind and which is as topical today as when it was written. This volume ends with a contribution by J.A. Schmoll, who writes: "There are two kinds of photography: that based on the old faith in objectivity which produces insignificant snapshots and successful reportages and object photographs, and that which is dedicated to visual form and the personal expressive value of the creation. In the narrow area of experimental and creative—i.e., subjective—photography, the actual intellectual and artistic process takes place—the process that can teach us about the tendencies and trends in not only photographic evolution, but also optical development in general."

Subjektive Fotografie 3, the last exhibition on this theme, followed in 1958. In fact, Steinert had his doubts about the wisdom of staging this third exhibition, since it appeared that the concept of "subjective photography" had been widely misinterpreted and misunderstood, and had in some cases led to uncontrolled experimentation and even to charlatanism. The only document about his third exhibition in existence is the March 1969 issue of *Camera*, which includes a conversation between Otto Toussaint and Steinert. Toussaint maintained: "The whole world is engaged in the subjective, and 'structuritis' has virtually broken out. Photographers solarize, produce negative prints, and explode in black and white. No one, on the other hand, is interested in the visual idea, since "photographing subjectively" has become a recipe." In his answer Steinert makes the point that is was not he who started the avalanche, since he wanted only to document the creative tendencies in photography at the middle of the century.

In the meantime Steinert had been appointed professor and director of the Werkkunstschule in Saarbrücken, and in 1959 he became Professor and Director of the Department of Photography at the Folkwangschule in Essen. In addition to his teaching work, Steinert was constantly occupied with the organization of exhibitions at the Museum Folkwang, which is attached to the school, on the general theme of events in the history of photography.

Steinert's own portraits of Nobel Prize winners and famous scientists are well known, and he published an almost countless number of articles in photographic magazines and in daily newspapers.

The fame of the *Subjektive Fotografie* exhibitions, the numerous subsequent exhibitions that he staged and the catalogues he wrote for them, and his critical and historical writings on photography have perhaps obscured Steinert's achievements as a teacher—a field in which he is perhaps less well-known to the general public, but in which he enjoys a high reputation in professional circles. There can hardly be another teacher who has trained so many young people in photography. This is largely due to the fact that he made his name quickly in the medium and lost no time in doing away with out-dated rules in order to devote himself to trends which were undermined in 1933 and which he tried to revive in his exhibitions of the early 50's. Thus it was that anyone who aspired to become a "modern photographer" did all in his power to become a student of Steinert—a fact which becomes abundantly clear in conversations with his previous pupils. On the other hand, it is clear that his reputation made it possible for Steinert to refuse all but really talented students.

His teaching methods were clear and uncompromising; he demanded much of his pupils, his criticism was strict, and not everyone was able to keep up with the pace. But his ability to inspire was apparently inexhaustible, and his wide experience as a journalist and designer of exhibitions was invaluable. Perhaps the best description of his methods is that which he provided: "Training in photography is training in craftsmanship, technique and creation; its aim is the picture. Neither words nor the equipment with which it is involved are the essence of training in photography; the teacher and his work are the model for his pupils. If this model is missing, the whole relationship between teacher and pupil becomes questionable."

—Allan Porter

STERENBERG, Abram.

Russian. Birn in Zhitomir, Russia, in 1894. Educated at the Jewish School, Zhitomir 1901-09. Served in Tsarist Army, 1915-17, in photographic department, Red Army, 1919-22, and as a war photographer, Red Army, 1941-45. Married: had no children. Apprentice in photo-order studio, Zhitomir, 1911-15; Photographer, studio of Boris Kapustianski, Taschkent, 1917-19, Sojuzfoto picture agency, Moscow, 1926-41, and Novosti Press Agency, Moscow, 1945 until his death, 1978. Agent: Novosti Press Agency, 2 Pushkin Place, Moscow. *Died* (in Moscow) *6 December 1978.*

Selected Group Exhibitions:

1924 *Annual Exhibition*, Russian Photographic Society, Moscow
1928 *Soviet Photography After 10 Years*, Moscow
1933 *Social Photography*, Metro, Prague
1936 *International Exhibition of Photography*, Mánes Gallery, Prague
1938 *International Photo Exhibition*, Royal Photographic Society, London
1958 *Soviet Photography After 40 Years*, Manezhnaya Gallery, Moscow
1980 *Soviet Photography Between The World Wars 1917-1941*, Dumumení House of Art, Brno, Czechoslovakia

Collections:

Novosti Press Agency, Moscow; Lubomír Linhart, Prague; Daniela Mrázková/ Vladimír Remeš Collection, Prague.

Abram Sterenberg: *The Poet Vladimir Mayakovski,* **1919**

Publications:

By STERENBERG: article—"Terrible Assignment" in *Sovetskoye Foto* (Moscow), January 1934.

On STERENBERG: books—*Soviet Art Photography* by Sergej Morozov, Moscow 1958; *Die Sowjetunion zwischen den Kriegen 1917-1941* by Daniela Mrázková and Vladimír Remeš, Oldenburg 1981; article—"Portraits by Abram Sterenberg" by Lubomír Linhart in *Revue Fotografie* (Prague), March 1977.

In contrast to the majority of outstanding figures of Soviet photography engaged in documentary, reportage or artistic experiments in the period between the two world wars, Abram Sterenberg focused throughout his life on three genres: portrait, still life and landscape. It was expecially portraiture that made him famous. He devoted himself to it from the beginning—while working on photoagency assignments and during his work in the photo department of the Red Army, which he joined after the Revolution—until his death in the 1970's. The only time when he did not engage in portraiture was during the second half of the 1930's, a time when the portrait as well as still life and landscape photography were declared "useless rubbish." For a time, like his friends of the progressive Oktyabr group—Alexander Rodchenko, Eleazar Langman, Boris Ignatovich and others—he engaged in reportage photography, believing that it alone could express the greatness of the time. He tried to depict the social, political and economic changes taking place in the country.

Sterenberg produced a number of outstanding portraits of both well-known and unknown personalities. Characteristic of these portraits is the heightened detail of the head or face. He made artistic use of light (usually side-lighting, but sometimes front lighting) and emphasized the structure and texture of the surface, thereby highlighting the character and expressing the individual qualities of the subject; he would emphasize essential factors and eliminate all that was unnecessary or distracted from his subject. He deliberately eliminated light from the background causing the face to stand out dramatically against a black background. While, for example, the photograph of the poet Vladimir Mayakovski (1919) still has a ring of light around the face and the photo of the violinist (1925) makes use of lighting effects which bring out not only the line but the surface of the hand and the instrument, the portrait of the photographer and painter Yuri Yeremin (1935) focuses solely on the demonically lit face of the artist, and the portrait "Mother" (1926) focuses on the shape and expression of the wrinkled face which stands out plastically against the dark background. We find a similar effect in the portraits of Henri Barbusse (1934) and Rabindranáth Thákur (1929) in which only the illuminated faces fill the entire area of the picture.

Sterenberg, however, also makes use of other elements to bring out the characteristic features: the movement of the head in the photograph of the Georgian ballet dancer Maka Macharadze (1969), the traditional collar used with fine irony in the portrait of the British actor, producer and theatre theoretician Edward Gordon Craig (end of the 1930's) and the delicate conventionality of the direct look at the face of the film genius Sergej Eisenstein (1940).

Sterenberg's portraits are as much studies of the mind as of the physiognomy of the subject. Each photograph by the artist was created as a unique work, an original worked out in detail and destined for exhibition rather than reproduction. He therefore recognized only those copies made by the artist himself, where an important role is played by the selection of the paper and chemicals or by cropping. Sterenberg was therefore unique in Soviet photography between the two world wars as well as in the postwar period, when stress was laid on multiplication and on the massive propaganda effect of photography.

—Daniela Mrázková

STERN, Bert.

American. Born in Brooklyn, New York, 3 October 1929. Educated at Brooklyn High School, 1942-46; self-taught in photography. Served as a movie cameraman in the United States Army, in Japan, 1951-53. Married the dancer Allegra Kent in 1959; children: Trista, Susannah, Amanda and Bret. Worked as a mailroom clerk, etc., at *Look* magazine, New York, 1946-48; assistant to art director Hershel Bramson, *Flair* magazine, New York, 1948-51; freelance advertising photographer, initially with Hershel Bramson, working for Pepsi-Cola, Revlon, Smirnoff Vodka, American Cyanamid, U.S. Steel, I.B.M., etc., New York, 1953-71 (established Bert Stern Inc. photographic studio, New York, 1959); freelance magazine photographer, working for *Look, Life, Holiday, Vogue, Glamour, Esquire*, etc., New York, from 1960; relinquished photography in the mid-1970's; now living in Europe.

Individual Exhibitions:

1958 Limelight Gallery, New York

Selected Group Exhibitions:

1971 *Photo-Graphics*, International Museum of Photography, George Eastman House, Rochester, New York
1977 *The History of Fashion Photography*, International Museum of Photography, George Eastman House, Rochester, New York (travelled to the Brooklyn Museum, New York; San Francisco Museum of Modern Art; Cincinnati Art Institute, Ohio; and Museum of Fine Arts, St. Petersburg, Florida)

Collections:

Museum of Modern Art, New York; Fashion Institute of Technology, New York; International Museum of Photography, George Eastman House, Rochester, New York.

Publications:

By STERN: books—*Marilyn Monroe*, portfolio of silkscreen prints, New York 1967; *Marcel Duchamp: Electronic Prints*, portfolio, New York 1968; film—*Jazz on a Summer's Day*, 1968.

On STERN: books—*Polaroid Portfolio No. 1*, edited by John Walbarst, New York 1959; *Photo/ Graphics*, exhibition catalogue, with text by Van Deren Coke, Rochester, New York 1971; *The Vogue Book of Fashion Photography* by Polly Devlin, with an introduction by Alexander Liberman, London 1979; *The History of Fashion Photography* by Nancy Hall-Duncan, New York 1979.

It is hardly possible to confine Bert Stern to a specific section of photography. Basically a commercial photographer, Stern belongs to that elite class of photographers for whom the expression of beauty pervades everything they choose to touch. Essentially a dreamer, Stern has that rare gift of making his dreams come true in his photographs and, at the same time, of being a huge commercial success. In achieving this he has been helped by an unusual sense of understanding of both his subject and the purpose of the picture as well as by an unusual ability to translate ideas into images. He has also been helped by a relentless urge to achieve perfection, irrespective of the time factor or possible inconveniences involved.

In 1955 he went to Egypt to photograph a glass of martini in front of the pyramid of Gizeh. It was for one of his numerous Smirnoff ads. The picture became legend, his own legend.

During the twenty odd years of Stern's fame, from approximately the mid-1950's to the mid-70's, he was a pioneer in his field. He liberated commercial photography from unwanted clutter and lifelessness. He religiously followed the famous motto: less is more. With tremendous insight, patience and respect for a model's needs, he obtained the desired results, the visions he wanted to convey. He worked with Dian Parkinson for nearly two years before obtaining the symbolic expressions he knew he could extrapolate from her: the image he carried with himself of the American Dream Girl.

Lighting was Stern's main tool. Combined with his own spontaneous reactions, his ingenuity, the choice of camera and film, there was nothing which did not become unforgettable: the photographs of Audrey Hepburn, of Marilyn Monroe, the wonderful series of "Romantic Little Girls," the picture of "What to give to a woman who has everything," the symbolic image of "Lolita" wearing heart-shaped sunglasses. His constant urge to create led to experiments with printing processes, silk-screening, videotaping and photo-collage.

Bert Stern has been true to his beliefs and to his dreams. He has been an innovator and a leader.
—Ruth Spencer

STETTNER, Louis.

American. Born in Brooklyn, New York, 7 November 1922. Educated at Abraham Lincoln High School, New York, 1938-39; studied engineering at Princeton University, New Jersey, 1940-42; studied at the Institut des Hautes Etudes Cinematographiques, Paris, 1952-56, B.A. in photography and cinematography 1956. Served in the United States Army, 1942-45. Married and divorced 3 times; has 2 children. Freelance photographer, New York, since 1949, working as contract and freelance photographer for *Time, Fortune, Du, Paris-Match, Réalités, National Geographic* etc., and advertising photographer for various American and European agencies; Photojournalist for *M.D. Magazine*, New York, 1965-70. Adjunct Lecturer in Photography, Brooklyn College, Queensborough College, and Cooper Union, all New York, 1972-73; Professor of Art, C.W. Post Center, Long Island University, New York, 1973-79; Visiting Lecturer, International Center of Photography, New York, and Bennington College, Vermont, 1976. Recipient: Creative Photography Fellowship, Yaddo, Saratoga Springs, New York, 1956, 1957; Creative Artists Public Service Grant, New York, 1973; National Endowment for the Arts Photography Fellowship, 1974; First Prize, Pravda International Photography Contest, 1975. Address: Stettner Studio, 172 West 79th Street, New York, New York, 10024, U.S.A.

Individual Exhibitions:

1954 Limelight Gallery, New York
1958 E. Leitz Gallery, New York
1959 Moderna Museet, Stockholm
1964 Village Camera Club, New York
1971 International Museum of Photography, George Eastman House, Rochester, New York
1973 Witkin Gallery, New York
1974 Neikrug Gallery, New York
1975 Gallery 1199, New York
1979 Yellowstone Art Center, Billings, Montana
1980 Milwaukee Center for Photography (retrospective; with Brad Temkin)
1981 *40 Photographs*, travelling exhibition (toured France, 1981-83)

Selected Group Exhibitions:

1953 *Subjektive Fotografie*, Saarbrucken
1967 *The Camera as Witness*, at *Expo '67*, Montreal

Louis Stettner: *Aubervilliers, France*, 1950

Alfred Stieglitz: *Spring Showers,* **New York, 1902**
From a *Camera Work* gravure; print by David Vestal

Collections:

Museum of Modern Art, New York; International Museum of Photography, George Eastman House, Rochester, New York; Hopkins Center, Dartmouth College, Hanover, New Hampshire; Victoria and Albert Museum, London; Bibliothèque Nationale, Paris.

Publications:

By STETTNER: books—*Paris Street Stories*, with an introduction by Brassaï, Paris 1949; *35mm Photography*, New York 1956; *History of the Nude in American Photography*, New York 1966; *Workers: 24 Photographs*, with an introduction by Jacob Deschin, New York 1974; *Women: Portfolio*, New York 1976; *Weegee the Famous*, editor, New York 1978; *Sur le Tas*, with an introduction by Cavanna, Paris 1979.

On STETTNER: articles—"Un Artiste Americain et son Conception de l'Art" by Paul Montel in *Photo Cinema* (Paris), no. 12, 1948; "Collaboration" by Jacob Deschin in the *New York Times*, 13 October 1964; "Framing the Photos" by James Auer in the *Milwaukee Journal*, 2 March 1980.

Photography has always been to me a passionate way of interpreting the world around me. Human beings (whether they are in the photograph or not) have always been the central theme of my work.

—Louis Stettner

Louis Stettner's photographs have spoken for more than three decades in a quiet but firm and confident voice in behalf of the essential goodness of mankind. In an era of self-expressive, self-involved and, alas, self-indulgent photography, Stettner's camera chooses to reveal his fellows' rather than his own preoccupations. And at a time when assaults upon the image with brush, pigment pointed stick and razor blade are counted "creative," Louis Stettner has held to straight photography. Rather, he creates by his insight and choice of moment and lighting.

As a writer and teacher as well as a photographer, Stettner has always championed humanism as photography's most important goal. Since photography, more than any other medium, excels at presenting outer reality—the world and its people—as opposed to the photographer's inner reality, he has chosen to do with it what it does most strongly. But, of course, he is no mere recorder of the passing scene.

From the first, Stettner's photographs have had a pared-down simplicity in composition, a strong feeling for light and a directness that communicates swiftly, like a poster. Affection for mankind flows through a Stettner photo—sentiment but not sentimentality, however. And his eye is quick to find the memorable segments of an otherwise unmemorable scene. One such that comes to mind shows a small girl in the dimness of a large city railroad terminal. Oblivious to scurrying figures in the background, she is stepping from one to another of a series of bright circles of light, circles which are out-of-focus images of the sun framed by pinholes in the ceiling far above. In a frilly, uncomfortably dressed-up outfit, the little girl is nevertheless acting her age. She is enjoying striding from spot to spot, stepping only into the circles of light. Although her back is to us, we know her. We know that she is still mistress of childhood's ability to make its own world, to extract magic from the mundane. And we know it because Louis Stettner knows it and also recognizes how to show us what he knows.

His feeling for people also comes through in two portfolios which he has published: *Women* and *Workers*. The titles, like the photographs, are direct. Stettner's women are real women. there is no idealized beauty among them. They are on picket lines.

Age and trouble and poverty have marked some of them. They are the women we pass on the street on our way to work and in the check-out lines in the supermarket. And, although life has marked each, each has a kind of beauty because Stettner has seen it, captured it and pointed it out to us.

His workers are also seen and photographed with the sympathy for humankind that pervades Stettner photographs. Frequently he relates the worker to his work, combining in one image a portrait and a strong, spare, dramatic composition that presents us at once with an individual and a symbol.

Louis Stettner has an abiding faith in Man. It showed in his early work; it shows in his most recent. He is an unquenchable humanist, preserving the strengths of his medium—immediacy, detail and the ability to seize the moment—in an era of photographic self-indulgence and navel contemplation.

—Kenneth Poli

STIEGLITZ, Alfred.

American. Born in Hoboken, New Jersey, 1 January 1864. Educated at the Charlier Institute, New York, 1871-77; New York Public School, 1877-79; College of the City of New York, 1879-81; Realgymnasium, Karlsruhe, Germany, 1881-82; studied mechanical engineering, then photography, under H.W. Vogel, at the Berlin Polytechnic and the University of Berlin, 1882-90. Married Emmeline Obermeyer in 1893 (divorced); daughter: Katherine; married the painter Georgia O'Keeffe in 1924. First photographs, Berlin, 1883; independent photographer, contributing to various photographic magazines, Berlin, 1885-86; worked in the photo-engraving business, New York, 1890-95; independent photographer, New York, 1892 until he stopped photographing, 1937. Editor, *American Amateur Photographer*, New York, 1893-96; Founder-editor, *Camera Notes*, New York, 1897-1902, and *Camera Work*, New York, 1903-17; Founder-Leader, Photo-Secession group of pictorial photographers, New York, 1902: Founder-Director, with Edward Steichen, Little Galleries of the Photo-Secession (later titled "291"), New York, 1905-17, and Editor of the *291 Magazine*, 1915-16; Editor, *MSS Magazine*, New York, 1922-23; Director, Intimate Gallery, New York, 1925-29, and An American Place gallery, New York, 1929-46. Recipient: First Prize, Amateur Photographer Competition, London, 1887; Progress Medal, Royal Photographic Society, London, 1924. Member, New York Society of Amateur Photographers, 1891; Honorary Member, Linked Ring Fellowship of Photographers, London, 1893; Vice-President, New York Camera Club, 1896-1908; Honorary Member, Royal Photographic Society, London, 1905; Honorary Vice-President, *International Exhibition of Modern Art* (Armory Show), New York, 1913. *Died* (in New York) *13 July 1946.*

Individual Exhibitions:

1899 Camera Club, New York (retrospective)
1913 291 Gallery, New York
1921 Daniel Gallery, New York
 Anderson Gallery, New York
1923 Daniel Gallery, New York
 Anderson Gallery, New York
1924 Daniel Gallery, New York
 Anderson Gallery, New York
1929 Metropolitan Museum of Art, New York

1932 An American Place, New York
1934 An American Place, New York
 Metropolitan Museum of Art, New York
1935 Cleveland Museum of Art
1944 *Alfred Stieglitz: 291 and After*, Philadelphia Museum of Art
1949 *The Alfred Stieglitz Collection*, Fisk University, Nashville, Tennessee
1955 *Stieglitz and O'Keeffe: Portraits of Each Other*, Limelight Gallery, New York
1958 National Gallery of Art, Washington, D.C.
 The Stieglitz Circle, Pomona College, Claremont, California
1965 Museum of Fine Arts, Boston
1971 *Alfred Stieglitz: The Camera Work Years*, Art Institute of Chicago
1972 *The Stieglitz Circle*, Vassar College, Poughkeepsie, New York
1976 *The 291 Years: 1912-17: Walkowitz and Stieglitz*, Zabriskie Gallery, New York
1977 Metropolitan Museum of Art, New York
 Galerie Zabriskie, Paris
1978 *Stieglitz and the Photo-Secession*, New Jersey State Museum, Trenton
 Georgia O'Keeffe by Alfred Stieglitz, Metropolitan Museum of Art, New York
1979 Museum of Fine Arts, Boston
 Metropolitan Museum of Art, New York

Selected Group Exhibitions:

1902 *Photo Secession*, National Arts Club, New York
1959 *Hundert Jahre Photographie 1839-1939*, Museum Folkwang, Essen (travelled to Cologne and Frankfurt)
 Photo-Secession, International Museum of Photography, George Eastman House, Rochester, New York
1960 *The Sense of Abstraction*, Museum of Modern Art, New York
1963 *The Photographer and the American Landscape*, Museum of Modern Art, New York
1965 *Un Siècle de Photographie*, Musée des Arts Décoratifs, Paris
1967 *Photography in the 20th Century*, National Gallery of Canada, Ottawa (toured Canada and the United States, 1967-73)
1974 *Photography in America*, Whitney Museum, New York
1979 *Photography Rediscovered: American Photographs 1900-1930*, Whitney Museum, New York (travelled to the Art Institute of Chicago)
1980 *Old and Modern Masters of Photography*, Victoria and Albert Museum, London (toured the U.K.)

Collections:

National Gallery of Art, Washington, D.C. (master set of all images in Stieglitz's personal collection); Library of Congress, Washington, D.C.; Metropolitan Museum of Art, New York; Museum of Modern Art, New York; International Museum of Photography, George Eastman House, Rochester, New York; Alfred Stieglitz Archive, Yale University, New Haven, Connecticut; Museum of Fine Arts, Boston; Stieglitz Collection, Philadelphia Museum of Art; Art Institute of Chicago; San Francisco Museum of Modern Art.

Publications:

By STIEGLITZ: books—*Picturesque Bits of New York and Other Studies*, portfolio of 12 gravures, with text by Walter Woodbury, New York 1898; *American Pictorial Photography, Series I*, portfolio of 18 photos, New York 1899; *The Camera Club*, exhibition catalogue, New York 1899; *American*

Pictorial Photography, Series II, portfolio of 18 photos, New York 1901; *America and Alfred Stieglitz: A Collective Portrait,* edited by Waldo Frank and others, New York 1934, 1977; *History of an American: Alfred Stieglitz: 291 and After,* Philadelphia 1944; *Stieglitz Memorial Portfolio 1864-1946,* edited by Dorothy Norman, New York 1947; *Georgia O'Keeffe: A Portrait by Alfred Stieglitz,* edited by Weston Naef, text by Georgia O'Keeffe, New York 1979; articles—"A Plea for a Photographic Art Exhibition" in *American Annual of Photography,* New York 1895; "A Natural Background for Out-of-Door Portraiture" and "Night Photography with the Introduction of Light" in *American Annual of Photography,* New York 1898; "The Progress of Pictorial Photography in the United States" in *American Annual of Photography,* New York 1899; "Pictorial Photography" in *Scribner's Magazine* (New York), November 1899; "Modern Pictorial Photography" in *Century Magazine* (New York), October 1902; "The Photo-Secession": Its Objects" in *Camera Craft* (New York), August 1903; "The Photo-Secession" in *American Annual of Photography,* New York 1904; "The Fiasco at St. Louis" in *Photographer* (New York), August 1904; "Simplicity in Composition" in *The Modern Way of Picture Making,* Rochester, New York 1905; "The Hand Camera: Its Present Importance," "How I Came to Photography Clouds" and "Alfred Stieglitz: Four Happenings" in *Photographers on Photography,* edited by Nathan Lyons, New York 1966; also numerous essays in *The American Amateur Photographer* (New York), July 1893-January 1896; *Camera Notes* (New York), July 1897-April 1901, July 1901-July 1902; *The Photo-Secession* (New York), no. 1, 1902-no. 7, 1909; *Camera Work* (New York), January 1903-June 1917; *291* (New York), March 1915-February 1916 (see: *Camera Work: A Critical Anthology,* edited by Jonathan Green, New York 1973).

On STIEGLITZ: books—*Catalogue of the Alfred Stieglitz Collection for Fisk University,* Nashville, Tennessee 1949; *Exhibition of Photographs by Alfred Stieglitz,* exhibition catalogue, by Doris Bry, Washington, D.C. 1958; *Alfred Stieglitz: Introduction to an American Seer* by Dorothy Norman, New York 1960; *Photo-Secession: Photography as a Fine Art* by Robert Doty, Rochester, New York 1960; *Alfred Stieglitz, Photographer* by Doris Bry, Boston 1965; *Alfred Stieglitz Talking: 1925-31,* by Herbert Jacob Seligmann, New Haven, Connecticut 1966; *The Hieroglyphics of a New Speech: Cubism, Stieglitz, and the Early Poetry of William Carlos Williams,* by Bram Dijkstra, Princeton, New Jersey 1969; *Alfred Stieglitz: An American Seer* by Dorothy Norman, New York 1973; *Photography in America,* edited by Robert Doty, with an introduction by Minor White, New York 1974; *Alfred Stieglitz* (Aperture monograph), with an introduction by Dorothy Norman, Millerton, New York 1976; *Masters of the Camera: Stieglitz, Steichen and Their Successors* by Gene Thornton, New York 1976; *Alfred Stieglitz and the American Avant-Garde* by William Innes Homer, Boston 1977; *Stieglitz and the Photo-Secession: Pictorialism to Modernism 1902-1917,* exhibition catalogue by Helen Gee, Trenton, New Jersey 1978; *The Collection of Alfred Stieglitz: 50 Pioneers of Modern Photography* by Weston J. Naef, New York 1978; *Amerika Fotografie 1920-1940* by Erika Billeter, Berne 1979; *Photography Rediscovered: American Photographs 1900-1930,* exhibition catalogue, by David Travis, New York 1979; *Old and Modern Masters of Photography,* exhibition catalogue, by Mark Haworth-Booth, London 1980.

Alfred Stieglitz was a gifted and autocratic person who built so strong a cult around himself that 35 years after his death it is still hard to see him in proportion. The present generation of the cult venerates him ignorantly; its opponents hate him as

ignorantly. In him there were both good and evil. He generated strong, lasting feelings.

The family he came from was prosperous, cultured and comfortable. Their background was German, Jewish without religion, and they lived in Hoboken, New Jersey. Their son was accustomed to having his own way. Naturally young Alfred went to Germany to study. He began to take photographs in Berlin in 1883. One of his very first photographs shows several photographic portraits of himself arranged on a drawing board. He studied the chemistry and the practice of photography with Dr. Hermann Wilhelm Vogel, who invented orthochromatic film, at the Berlin Polytechnic. From Vogel's course, Stieglitz learned that for him the technical part of photography was boring and incomprehensible, while the picture-making side became his passion. He began to experiment intensively, taking pleasure in achieving things he'd been told were impossible. His approach was impulsive and intuitive rather than methodical.

Here we see lifelong traits emerging. He was unself-consciously self-centered, intense, full of energy and challenge. He did things his own way or not at all—especially if opposed. He despised method. And he talked a lot, especially about himself. (That's our source for all this.)

Stieglitz traveled around Europe photographing in the 1880's and 90's. His early European photographs are conventional, done in the spirit of 19th-century academic painting. Clichés abound. Some of this work is nevertheless beautiful, but it is weak and impersonal compared to what he did soon afterward in New York City, where he felt less at home. There is some overlap: European work done after the first strong New York pictures reverts to the empty pictorialism of his first work in Europe.

Returning to New York in the early 1890's, he was set up by his father in the photoengraving business, together with two school friends. Photoengraving didn't interest him, so instead of working at it, he photographed around New York City in the 1890's and early 1900's. This was a good decision.

For me these early New York pictures are Stieglitz's most consistently beautiful and moving work. For a good example, see his 1902 "Spring Showers": rainy weather, a little city tree, and a street-sweeper at the place where Broadway crosses Fifth Avenue. This is a tender and exquisite picture.

He was a wonderful portrait photographer. His portraits at once show the subject as he or she is—a good likeness, physically and psychologically—and are satisfying as pictures. Bringing these two qualities together is rare: Stieglitz does it consistently. And these portraits are full of life. See his 1915 portrait of Marsden Hartley and his 1922 one of John Marin. There are many more.

Already a ringleader in camera clubs and photo exhibitions and magazines, Stieglitz became preoccupied with "fighting for photography"—for its recognition as art—at the expense of doing his own work. He continued to photograph, but Stieglitz the entrepreneur began to outweigh Stieglitz the photographer. In 1902 he started a loose organinzation of art-oriented photographers which he named the Photo Secession (in honor of a mildly radical mid-European art movement, the Secession).

The exhibitions he put on started with photography but were dominated increasingly by modern French painting and sculpture—Cézanne, Rodin, Matisse, Picasso, and so on—for which Stieglitz became one of the first American spokesmen. The paintings were chosen and sent to Stieglitz by a young American painter and photographer in Paris, Edward Steichen. The Little Gallery of the Photo Secession lost its name and became known by the number of its address on Fifth Avenue: 291.

Having found financial backing, Stieglitz began to edit and publish a little art magazine, *Camera Work,* which regularly presented photographs as well as paintings: excellent reproductions of work by Stieglitz, the Photo Secessionists and others. In retrospect, many of the pictures hold up well, and

most of the articles by critics of the time do not. *Camera Work* itself has become the focus of a cult, and is the forerunner of today's *Aperture.*

For the rest of his life, Stieglitz functioned mainly as an eccentric entrepreneur of the arts. Supported by a group of wealthy sponsors, and by some of the artists whom he had helped, he was an art dealer, in that he sold pictures. But he took no commissions on sales: all money went to the artists. Business was beneath him.

Though he affected to disdain it, Stieglitz was a master of publicity. Early in his career he developed uncanny skill at what Ralph Steiner calls "post-transcendentalization": the ability to weave a verbal web of enchantment around any mediocre picture he had made until everyone within range of his voice really believed the thing was a masterpiece charged with incredibly deep meaning.

A good example is his vastly overrated 1907 picture, "The Steerage." Others, and there are many, include the famous "Equivalents," of which some are fine photographs and most are merely dull. But according to Stieglitz—and to disagree is heresy—they are all great masterworks. Loudly and constantly, Stieglitz blew his own horn: he also claimed to be modest.

To see any photograph by Stieglitz clearly and truly, it must be looked at entirely apart from anything he said about it—preferably with no words by anyone. Too often the verbal fog obscures the picture's real qualities, good as well as bad. For instance, one of his early New York pictures, "The Terminal" of 1893, is made to seem ridiculous by Stieglitz's overblown account of its symbolic profundities. But seen by itself without the sales talk, it's a beautiful photograph.

Between bouts of playing god to his disciples, Stieglitz went on taking pictures, many of them beautiful, until 1937. His last known photograph, of a little tree in a meadow at Lake George, is one of the best.

To sum up Stieglitz: He was a non-stop garrulous bore, a cruel, arrogant, domineering egomaniac, and a vicious prima donna. His photographs are often dull, overrated, and derivative (thus some of his "Equivalents" borrow obviously from the paintings of Georgia O'Keeffe, his wife.)

And he was patient, generous, self-denying, a man of integrity; understanding, wise, and supportive. A saintly person. His photographs are strikingly original, full of depth and feeling, and have a rare beauty. They are among the finest ever made.

There are excellent arguments for both versions. Take your choice or accept both as true. In another hundred years we may come to understand Stieglitz.

No matter what, he and his work matter.

—David Vestal

STOCK, Dennis.

American. Born in New York City in 1928. Educated in New York City schools; photographic apprentice to Gjon Mili, New York, 1947-51. Freelance photographer, New York, since 1951. Founder-Director and Film Producer/Director, Visual Objectives Inc., New York. Member, Magnum Photos co-operative agency, New York. Recipient: First Prize, *Life* photo competition, New York, 1959. Address: Long Ridge Road, Pound Ridge, New York, U.S.A.

Individual Exhibitions:

1963 Art Institute of Chicago
1966 Form Gallery, Zurich
1967 *The Sun*, International Museum of Photography, George Eastman House, Rochester, New York (toured the United States)
1970 M.H. de Young Memorial Museum, San Francisco

Selected Group Exhibitions:

1960 *Magnum Photographers*, Takashimaya Department Store, Tokyo (and (world tour)
1967 *Photography in the 20th Century*, National Gallery of Canada, Ottawa (toured Canada and the United States, 1967-73)
1974 *Photography in America*, Whitney Museum, New York
 Celebrations, Hayden Gallery, Massachusetts Institute of Technology, Cambridge

Collections:

Art Institute of Chicago; International Museum of Photography, George Eastman House, Rochester, New York.

Publications:

By STOCK: books—*Portrait of a Young Man, James Dean*, Tokyo 1956; *Jazz Street*, with text by Nat Hentoff, New York and London 1960; *The Happy Year*, New York 1963; *California Trip*, New York 1970; *The Alternative*, with text by William Hedgepeth, New York and London 1970; *Gelebte Zukunft Franz von Assisi*, Lucerne 1970, London 1972; *National Park Centennial Portfolio*, New York 1972; *Estuary: The Edge of Life*, New York 1972; *The Circle of Seasons*, with text by Josephine W. Johnson, New York and London 1974; *James Dean Revisited*, New York and London 1978; article—"Dennis Stock," interview, with Pucci Meyer, in *Zoom* (Paris), January/February 1972; films—*Efforts to Provoke*; *Quest*; *British Youth*; *One Little Indian*.

On STOCK: books—*Photography in the 20th Century* by Nathan Lyons, New York 1967; *America in Crisis: Photographs for Magnum*, edited by Charles Harbutt and Lee Jones, with an essay by Mitchel Levitas, New York 1969; *Photography in America*, edited by Robert Doty, with an introduction by Minor White, New York and London 1974; articles—"Dennis Stock" in *Modern Photography Annual*, New York 1973; "Dennis Stock" by Jim Hughes in *Popular Photography* (New York), March 1978; "7 Maitres du Paysage" in *Photocinema* (Paris), May 1980.

Dennis Stock seems impeccably contemporary in his perceptions, whether they be of splendid nature or "peccable" humanity. He has managed to evoke jazz without the assistance of sound—its places, its atmosphere, its times, its makers. He catches the life of hotels and suitcases, backstage relaxation, the gestures of performance, the cherished children, the companions, the pets. He has shot memorable portraits of such jazz greats as Satchmo, Billie Holiday, Sidney Bechet, Gene Krupa, Duke Ellington.

Stock can also capture the intimacy of nature—trees in bud, a bug on a blossom—along with its expansive fields and canyons, the look of animals, the flight of gulls. He responds both sympathetically and critically to California which, of course, means cars; surfers; animate as well as inanimate eccentricities—freaky people; freaky architecture; once-upon-a-time hippies; the difficult world of Watts; cops; the large spaces beside the sea, along the mountains and deserts; a plane casting its shadow on a beach. His photographs of James Dean have entered the pantheon of 20th century icons.

Stock's choice of subject, his attitude of observance, the "color" of his interests, reveal him as truly of his time, not in the sense of being "with it," which has to do with the ephemeral and fashion, but in the sense of attunement to the temper of American modern experience.

—Ralph Pomeroy

Dennis Stock: *James Dean: Jimmy Visiting a Cemetery,* **1956** Courtesy Art Institute of Chicago

STRAND, Paul.

American. Born in New York City, 16 October 1890. Educated, under Lewis Hine and Charles H. Caffin, Ethical Culture School, New York, 1904-09. Served as an x-ray technician in the United States Army Medical Corps, at Hospital 29, Fort Snelling, Minnesota, 1918-19. Married Rebecca Salsbury in 1922 (separated, 1934); Virginia Stevens in 1936 (separated, c. 1949); and Hazel Kingsbury in 1951. Worked in his father's enamel-ware business, New York, 1910-11; freelance commercial portrait photographer, New York, 1912-22; freelance commercial filmmaker, using the Akeley motion picture camera, New York, 1923-29, also still photographer in New York, 1922-25, in Georgetown and other parts of Maine, 1925, 1927, 1928, in New Mexico and Colorado, 1926, 1930, 1931, 1932, and 1936, and in Gaspe, Canada, 1929; concentrated mainly on filmmaking, in New York and Mexico City, 1931-45 (Chief of Photography and Cinematography, Department of Fine Arts, Secretariat of Education, Mexico City, working on the film Redes, 1932-34; freelance in New York, 1934-37, 1942-45; President, Frontier Films, documentary film co-operative, New York, 1937-42); independent still photographer, New York, 1945-50, and Orgeval, France, 1951 until his death, 1976. Member, Camera Club of New York, 1909-22; Guest Lecturer, Clarence White School of Photography, Columbia University, New York, 1923; Adviser, Group Theatre, New York, 1932; Chairman, Committee of Photography, Independent Voters Committee of Arts and Sciences for Roosevelt, New York, 1943. Recipient: First Prize, 12th and 15th annual John Wanamaker Photo Exhibition, Philadelphia, 1917, 1920; David Octavius Hill Medal, Geselschaft Deutscher Lichtbildner, Mannheim, 1967. Honorary Member, American Society of Magazine Photographers, 1963; Fellow, American Academy of Arts and Sciences, 1973. Agent: The Paul Strand Foundation, Millerton, New York. Died (in Orgeval, France) 31 March 1976.

Individual Exhibitions:

1916 291 Gallery, New York
1917 Doylestown House Photos, Modern Gallery, New York (with Charles Sheeler and Morton L. Schamberg)
1921 New York the Magnificent, Capitol Theatre, New York (Sheeler/Strand film showing)
1929 New Photographs, Intimate Gallery, New York
1932 An American Place, New York (with Rebecca Strand)
1933 Sala de Arte, Mexico City
1945 Photographs 1915-1945, Museum of Modern Art, New York (retrospective)
1967 Worcester Art Museum, Massachusetts
1969 Kreis Museum, Haus der Heimat, Freital, East Germany
 Museum of Fine Arts, St. Petersburg, Florida
 Musée des Beaux-Arts, Brussels (toured Belgium and the Netherlands)
1970 Swedish Photographers Association, Stockholm
 Swedish Film Archives, Stockholm (film showings)
1971 Photographs 1915-1968, Philadelphia Museum of Art (retrospective; toured the United States, 1971-73)
1972 Light Gallery, New York
1973 Metropolitan Museum of Art, New York (retrospective)
1976 Light Gallery, New York
 Paul Strand: A Retrospective Exhibition of His Photographs 1915-1968, National Portrait Gallery, London
1977 Sessanti Anni di Fotografia, University of Pisa, Italy
 Centre Georges Pompidou, Paris
1978 The Hebridean Photographs, Scottish Photography Group, Edinburgh (travelled to

Aberdeen, Oxford, and Glasgow)
1979 Kunsthaus, Zurich
1981 Vintage Photographs 1915-74, Fraenkel Gallery, San Francisco
 Photographs 1910-1974, Hirschl and Adler Gallery, New York
 Mexican Portfolio, Musée de la Photographie, Charleroi, Belgium

Selected Group Exhibitions:

1915 Pictorial Photography, The Print Gallery, New York
1925 7 Americans, Anderson Galleries, New York
1954 Great Photographs, Limelight Gallery, New York
1959 Hundert Jahre Photographie 1839-1939, Museum Folkwang, Essen (travelled to Cologne and Frankfurt)
1963 The Photographer and the American Landscape, Museum of Modern Art, New York
1974 Photography in America, Whitney Museum, New York
1977 Paris-New York, Centre Georges Pompidou, Paris
1979 Photography Rediscovered: American Photographs 1900-1930, Whitney Museum, New York (travelled to the Art Institute of Chicago)
1980 Photography of the 50's, International Center of Photography, New York (travelled to the Center for Creative Photography, University of Arizona, Tucson; Minneapolis Institute of Art; California State University at Long Beach; and Delaware Art Museum, Wilmington)
1981 Cubism and American Photography 1910-1930, Sterling and Francine Clark Institute, Williamstown, Massachusetts (toured the United States)

Collections:

Paul Strand Archive, Center for Creati... raphy, University of Arizona, Tucson; ... tan Museum of Art, New York; Museum ... Art, New York; International Museum ... raphy, George Eastman House, Roch... York; Museum of Fine Arts, Boston; P... Museum of Art; Yale University, New H... necticut; San Francisco Museum of M... National Gallery of Canada, Ottawa; B... Nationale, Paris.

Publications:

By STRAND: books—Paul Strand, ... Elizabeth McCausland, Springfield, M... 1933; Photographs of Mexico, with ... Hurwitz, New York 1940, as The Mex... lio, with a preface by David Alfaro Si... York 1967; Time in New England, ... Nancy Newhall, New York 1950; ... Profil, with text by Claude Roy, Laus... Paese, with text by Cesare Zavattini, T... a'Mhurain, Outer Hebrides, with ... Davidson, London and Dresden 19... 1968; Living Egypt, with text by Ja... London, Dresden and New York 196... A Retrospective Monograph, in 2 ... Years 1915-1946 and The Years 195... ton, New York 1971, 1972; Ghana: ... trait, with text by Basil Davidson, N... don and Paris 1976; Paul Strand: ... Photographs, with text by Calvin T... ton, New York and London 1976; O... portfolio, edited by Michael Hof... France 1976; The Garden, portf... Michael Hoffman, Orgeval, France ... "Photography" in Seven Arts (Ne...

1917; "The Independents in Theory and Practice" in The Freeman (New York), 6 April 1921; "Photography and the New God" in Broom (New York), November 1922; "The Art Motive in Photography" in the British Journal of Photography (London), 5 October 1923; "An American Exodus by Dorothea Lange and Paul S. Taylor" in Photo Notes (New York), March/April 1940; "Photography to Me" in Minicam Photography (New York), May 1945; "Alfred Stieglitz 1864-1946" in New Masses (New York), 6 August 1946; "Stieglitz: An Appraisal" in Popular Photography (New York), July 1947; "From a Student's Notebook" in Popular Photography (New York), December 1947; "Address by Paul Strand" in Photo Notes (New York), January 1948; "Paul Strand Writes a Letter to a Young Photographer" and "A Platform for Artists" in Photo Notes (New York), Fall 1948; "Realism: A Personal View" in Sight and Sound (London), January 1950; "Painting and Photography" in Photographic Journal (London), July 1963; "Manuel Alvarez Bravo" in Aperture (Rochester, New York), vol. 9, no. 4, 1968: films—Manhatta (New York the Magnificent), with Charles Sheeler, 1921; Redes (The Wave), 1933; The Plow That Broke the Plains, with Ralph Steiner and Leo T. Hurwitz, directed by Pare Lorentz, 1936; The Heart of Spain, with Leo T. Hurwitz and Herbert Kline, 1937; Native Land, with Leo T. Hurwitz, 1942; China Strikes Back, as adviser, 1937; The People of Cumberland, as adviser, with Leo T. Hurwitz, 1938.

On STRAND: books—Paul Strand: New Photographs, exhibition pamphlet, with text by Gaston Lachaise, New York 1929; Paul Strand: Photographs 1915-1945, exhibition catalogue, with text by Nancy Newhall, New York 1945; Paul Strand by Frantisek Vrba, Prague 1961; The Photographer and the American Landscape...

Paul Strand: *Rebecca with Post*, 1931 Courtesy Art Institute of Chicago

Daily Compass (New York), 31 December 1950; "Paul Strand" by Walter Rosenblum in *American Annual of Photography*, New York 1952; "Paul Strand" by Nancy Newhall in *Modern Photography* (New York), vol. 17, no. 9, 1953; "Paul Strand, Travelling Photographer" by Beaumont Newhall in *Art in America* (New York), Winter 1962; "Two by Strand: When the People Draw a Curtain" by Margery Mann in *Popular Photography* (New York), December 1969; "Paul Strand: Close-Up on the Long View" by Margaret Weiss in the *Saturday Review* (New York), 18 December 1971; "Meditations Around Paul Strand" by Hollis Frampton in *Artforum* (New York), February 1972; "Paul Strand: An Eye for the Truth" by Jacob Deschin in *Popular Photography* (New York), April 1972; "L'Oeuvre de Paul Strand" in *Le Nouveau Photocinema* (Paris), October 1972; "Paul Strand: A Limited Veracity" by Ted Hedgpeth in *Artweek* (Oakland, California), 10 October 1981.

Paul Strand's debut in photography coincided with America's awakening to modernism in the visual arts. His vision was formed by two seemingly disparate influences which he fused into a compelling modern expression. As a student of Lewis Hine at the Ethical Culture School, Strand was heir to the humanistic social and scientific outlook of the Progressive Era, while his aesthetic ideas evolved from long and close contact with the modern artists associated with Alfred Stieglitz.

Following his initial exposure to photography in Hine's class in 1908, Strand set out to master the complicated print processes associated with pictorial photography by joining the Camera Club of New York. Despite his acknowledged technical accomplishment, however, it was not until 1915 that his work began to embody concepts of abstraction of which he had become aware at the *Armory Show* of 1913 and at Stieglitz's 291 gallery. The power of Strand's new imagery, which was concerned mainly with urban themes, was acknowledged by Stieglitz who exhibited the photographs in 1916 and devoted the two final issues of *Camera Work* to what he termed the "only original vision" in American photography.

Like others of his time, Strand's rejection of soft-focus pictorialism was further stimulated by his experiences with straight photography. One result of his activity as an Army medical photographer was a lifelong preference for the sharp, pre-visualized, large format image. Another was a deepening respect for objective reality coupled with a conviction that both the arts and the sciences had as their goal the understanding of truth. As he experimented with these concepts, his themes expanded beyond urban architecture to include machinery and organic formations; in the late 1920's he became interested in the landscape and in the early 30's turned to the human figure in an environment.

Throughout the 20's Strand maintained close contact with Stieglitz in a mutually supportive relationship. However, as Stieglitz became more concerned with finding visual equivalents for his innermost feelings, Strand continued to explore the world of objects and experiences in order to recreate structure, growth and relationships. Eventually, the strain engendered by basic philosophical and personal differences ended the close friendship between the two photographers.

In 1932, impelled by a growing conviction about the importance of social and economic forces in society, Strand turned to the motion picture as a medium for a more politicized statement. Previously, in 1920, he and painter photographer Charles Sheeler had collaborated on a short expressive film based in part on Walt Whitman's poem, *Mannahatta*. Shortly afterwards, Strand embarked on a career as an Akeley cameraman, filming for newsreels, shorts and feature films. Consequently, the decision to devote himself entirely to film also can be seen as a logical outcome of twelve years of cinema experience. Strand made few still photographs between 1932 and 1945, other than a group of images of Mexican peasants. Taken with a prism lens, as his earlier street portraits in New York had been, they were issued in gravure reproduction as the *Photographs of Mexico* in 1940.

Strand's concept of the documentary film differed from the traditional view in that he considered the aesthetic or formal aspects integral to the meaning of the work. Because he believed that the director would be unable to control these elements in the filming of actual events as they occurred, *Redes*, his first documentary for the Secretariat of Education of Mexico, was a dramatization of the distressing conditions of existence in a small fishing village near Vera Cruz.

Following a trip to the Soviet Union to seek work with Eisenstein in 1935, and filming for Pare Lorentz on *The Plough That Broke the Plains*, Strand returned to New York to become President of Frontier Films, formed to produce documentaries on issues of significance. *Native Land*, the last and most completely realized of the company's productions, was a restaged and reenacted drama based on actual incidents and testimony amassed by a congressional committee investigating anti-union practices.

After 1943, financial problems made continued work in cinema impossible but film form left an imprint on Strand's subsequent still photography. In order to present a sequenced relationship of image and work, which he considered the essence of a realist commitment in photography, he turned to the photographic book. *Time in New England*, created with Nancy Newhall, sought to make a fervent yet coherent statement regarding the evolution of American ideals through an integration of text and image. The disappointing quality of reproduction convinced Strand of the necessity in future projects for greater control over platemaking, graphic design and printing.

After 1950, Strand photographed in Europe and Africa, seeking to develop an idea that had preoccupied him since the early 1920's. Derived from the then popular poem, *Spoon River Anthology* by Edgar Lee Masters, its objective was to suggest through word and image the extent and complexity of physical and emotional reality among people of differing cultures. To this end, he worked with Claude Roy on *La France de Profil* and with Cesare Zavattini on *Un Paese*, hoping to evoke the distinctive substance and tempo of life characteristic of each locality.

Strand considered the medium of photography to be the most modern means of making an expressive visual statement about enduring values and relationships. An undiminished respect for craft and technical excellence informed his observations as he attempted to create a synthesis involving observable reality and his own perceptions of its emotional and intellectual significances. Despite slight shifts in emphasis throughout a long career, his images affirm his conviction that man, nature and artifact are part of an infinitely complex and continually absorbing material reality, which, as photographer, he aspired to make understandable and compelling.

—Naomi Rosenblum

STRELOW, Liselotte.

German. Born in Redel bei Polzin, Lower Pomerania, 11 September 1908. Educated at the Volksschule, Neustettin, 1915-17, and a private lyceum, Neustettin, 1917-20; later studied agriculture; studied photography, Lette-Verein, Berlin, 1930-32. Worked in the photo studio of Sys Byk, Berlin, 1932-33; Staff Photographer, Kodak AG, Berlin, 1933-38; freelance portrait and magazine photographer, working for *Frankfurter Allgemeine Zeitung, Rheinisches Post, Die Welt, Der Spiegel, Die Zeit, Theater der Zeit*, etc., and establishing own studio, in Berlin, 1938-43, in Neustettin, 1943-44, in Detmold, 1945-50, in Dusseldorf, 1950-66, in West Berlin, 1966-68, in Munich, 1969-76, and in Hamburg, 1977-81. Staff Theatre Photographer, under Gustaf Grundgens, Schauspielhaus, Dusseldorf, 1947-54; Official Photographer, *Richard Wagner Festival*, Bayreuth, 1952-61; Chief Photographer, City Theatres, Cologne, 1959-62. Member, Gesellschaft Deutsche Lichtbildner, 1959-61 and 1979-81. Recipient: Silver Medal, *World Photo Exhibition*, Rochester, New York, 1935; Handwerkskammer Prize, Berlin-Brandenburg, 1938; International Art Photo Diploma, Salzburg, 1950; Plaque, *Photokina*, Cologne, 1951, 1952; City of Hamburg Prize, 1951; Diploma, *Camera* magazine, Lucerne, 1951; Diploma, *World Exhibition of Photography*, Lucerne, 1952; Gold Chain, Centralverbandes des Deutschen Photographenhandwerke, 1952; Gold Medal, *Biennale di Fotografia*, Venice, 1957; Honor Award, *World's Fair*, Brussels, 1958; Adolf-Grimme Prize, with S. Mohrhof, WDR Broadcasting, Cologne, 1966; David Octavius Hill Prize, Gesellschaft Deutsche Lichtbildner, 1969; Culture Prize, with R. Clausen and R. Relang, Deutsche Gesellschaft für Photographie, 1976. *Died* (in Hamburg) *30 September 1981.*

Individual Exhibitions:

1949 Galerie Mutter Ey, Dusseldorf
1952 Galerie de Parnass, Wuppertal
1958 German Pavilion, *World's Fair*, Brussels
1961 Deutsche Gesellschaft für Photographie, Cologne
1962 Kunstverein, Dusseldorf
1973 Münchner Stadtmuseum, Munich
1977 Galerie Kuhling, Hamburg
 Galerie Nagel, West Berlin
 Liselotte Strelow: Porträts 1933-1972, Rheinisches Landesmuseum, Bonn

Selected Group Exhibitions:

1935 *World Photo Exhibition*, International Museum of Photography, George Eastman House, Rochester, New York
1950 *Photo-Kino Ausstellung* (*Photokina*), Cologne
1951 *Subjektive Fotografie*, Saarbrucken
1952 *World Exhibition of Photography*, Lucerne
1957 *Biennale di Fotografia*, Venice
1963 *World Press Photos*, The Hague
1969 *50 Jahre GDL*, Museum für Kunst und Gewerbe, Hamburg
1970 *Fotografinnen*, Museum Folkwang, Essen
1977 *Documenta 6*, Museum Fridericianum, Kassel, West Germany
1979 *Deutsche Fotografie nach 1945*, Kasseler Kunstverein, Kassel, West Germany (toured West Germany)

Collections:

Rheinisches Landesmuseum, Bonn; Museum Folkwang, Essen; International Museum of Photography, George Eastman House, Rochester, New York.

Publications:

By STRELOW: books—*Gustaf Grundgens*, with text by Werner Vielhaber, Bad Honnef, West Germany 1953; *Das Manipulierte Menschenbildnis*, Dusseldorf and Vienna 1961, as *Photogenic Portrait Management*, London 1966; articles—"Das Geschicht einer Landschaft" in *Photo-Graphik* (Berlin), no. 10, 1936; "Lichtbildner unserer Zeit" in *Suddeutscher Zeitung* (Munich), 2 April 1952; "Fotoschau Vorbildich Aufgebaut" in *Die Welt* (Berlin), 21 June 1952; "Eine Ketzerin an ein Dunkelkammergenie" in *Foto Magazin* (Munich), March 1953; "Ensusste Kinderbilder" in *Frankfurter Illustrierte*, 4 April 1953; "Hof-Fahig" in *Die Welt* (Berlin), 9 March 1960.

On STRELOW: books—*Liselotte Strelow: Porträts 1933-1972*, exhibition catalogue, with text by Klaus Honnef, Bonn 1977; *Geschichte der Fotografie im 20. Jahrhundert/Photography in the 20th Century* by Petr Tausk, Cologne 1977, London 1980; *Fotografie 1919-1979, Made in Germany: Die GDL-Fotografen*, edited by Fritz Kempe, Bernd Lohse and others, Frankfurt 1979; *Deutsche Fotografie nach 1945* by Floris Neusüss, Wolfgang Kemp and Petra Benteler, Kassel, West Germany 1979; articles—"Liselotte Strelow" by Hanns Riss in *Camera* (Lucerne), January 1959; "Die Augenblich is ihr Fetisch" by Fritz Kempe in *Die Welt* (Berlin), vol. 5, no. 1, 1966; "Photographic Portraiture" by Jacob Deschin in the *New York Times*, 3 March 1968; "Photographinnen" by Peter Sager in *Die Zeit* (Hamburg), 16 September 1976.

The ascent and decline of the portrait in art are closely connected with the development of bourgeois society. In the individual likeness of his own person the self-confident bourgeois showed his sovereign attitude towards his environment. Photography brought a final flowering of the classical portrait, to a certain extent its apotheosis and perfection. The portrait in the post-bourgeois age of post-modernism signifies something other than it did in the vast stretch of "modern times" from the Renaissance to the mid 20th century. The self-assured, composed personality, perennial subject of the artistic portrait, has given way to the vast faceless masses of industrial civilization: individual behavior, and appearance, adapt to prevailing conditions. Only recently does there appear to be a change in direction, yet, admittedly, one cannot yet foresee which course it will take.

Liselotte Strelow is one of the last great practitioners of portrait photography in the classical sense. Yet even her portraits reveal a radical change, even if that change is not apparent at first sight. For with vast psychological powers of intuition, she is ingenious in her understanding of how to work to the individual core of her "model," to release the contemporary individual from his cocoon. Strelow's portraits, unpretentious in formal arrangement, free from any distracting accessories (so that they dispense with an external aid to characterization) and free furthermore from any conspicuous striving after "reality," trace out the personality structure of the people portrayed as well as their physiognomy. Strelow tries to make visible the human psyche, human experience and human fate. She rarely takes the whole human body into the pictures; she restricts herself throughout to the head, though now and then some motif may be reiterated by the hands. In contrast to the older August Sander, Liselotte Strelow defines people not primarily as social types, but as autonomous, independent subjects.

Her photographic portraits still suggest something of the humanism of Renaissance portraits: to paraphrase Walter Benjamin, they make us ask after those who have passed safely and irrevocably from sight, regardless of whether or not they were prominent in politics, trade and industry, or culture. Precisely this factor lends even those images that people

take of themselves in photo-booths—which can't properly be called "portraits"—a painful and almost desperate dimension. And this—forgivable?—self-assertion of the human individual from within the levelling clutch of the social workforce, paradigmatically evidenced by the omnipresence of those clichés of reality that the technical and electronic photographic media spew forth daily—this is Liselotte Strelow's particular theme, the basis of her artistic vision. Her photographic work lays stress on the active portrait, on the likeness, which resists the levelling out tendencies of the medium, may gain ascendency—though that goal is frequently met only with the vehement support and deliberate and circumspect direction of the photographer.

—Klaus Honnef

STRYKER, Roy (Emerson).

American. Born in Great Bend, Kansas, 5 November 1893. Educated at Montrose High School, Colorado; studied metallurgy at the Colorado School of Mines, Golden, 1912-13, 1920-21; and economics, under Rexford Guy Tugwell, Columbia University, New York, 1921-24, B.A. 1924, M.A. 1926. Served as an infantryman in the United States Army, in France, 1916-18. Married Alice Frazier in 1921; daughter: Phyllis. Worked as a cowhand on his brother's cattle ranch, Uncompaghre Valley, near Montrose, Colorado, 1913-16; Assistant, Union Settlement House, New York, 1921-22; Assistant Professor, under Rexford Guy Tugwell, Columbia University, New York, 1924-34; Assistant, under Rexford Guy Tugwell, Agricultural Adjustment Administration, Washington, D.C., 1934; Director, Historical Section, Resettlement Administration, later the Farm Security Administration (FSA), Washington, D.C., 1935-43 (as part of the Office of War Information, from 1942); Director, Industrial Photo Library Project, Standard Oil Company of New Jersey (and Editor of the company's *Photo Memo*, 14 issues), New York, 1943-50; Visiting Instructor and Lecturer, University of Missouri Photography Workshops, Columbia, 1948; Director, Pittsburgh Project, later Pittsburgh Photo Library, 1950-52; Director, Photographic File and Library, Jones and Laughlin Steel Company, Pittsburgh (also Editor of the company's *Steel Pix*, 6 issues), 1954-57; retired to concentrate on cataloguing his photo collection, Montrose, Colorado, 1962-68; moved to Grand Junction, Colorado, in 1968. *Died* (in Grand Junction) *27 December 1975*.

Exhibitions (of FSA and other Stryker-directed projects):

1938 *International Photographic Exposition*, Grand Central Palace, New York
 Farm Security Administration Photos, Photo League, New York
1940 *Farm Security Administration Photos*, Photo League, New York
1955 *FSA Anniversary Show*, Brooklyn Museum, New York
1961 *USA-FSA*, University of Louisville, Kentucky (toured the United States)
1962 *The Bitter Years: FSA Photographs 1935-41*, Museum of Modern Art, New York (toured the United States)
1968 *Just Before the War*, Newport Harbor Art Museum, Newport Beach, California

1975 *As It Was: FSA Photographs*, University of Maine, Orono
1976 *A Vision Shared: FSA Photographers*, Witkin Gallery, New York
1978 *Roy Stryker: Humane Propagandist*, University of Louisville, Kentucky (toured the United States)
 FSA Photographs, Palo Alto Cultural Center, California
1979 *Images de l'Amerique en Crise: Photos de la FSA*, Centre Georges Pompidou, Paris
1980 *Amerika: Traum und Depression 1920-1940*, Kunstverein, Hamburg (toured West Germany)
 Images of America: Photography from the FSA, Sonoma State University, California
 Ohio: A Photographic Portrait: FSA Photos, Akron Art Institute, Ohio
 Les Années de l'Amerique en Crise, Galerie Municipale du Château d'Eau, Toulouse

Collections:

Roy Stryker Collection, University of Louisville, Kentucky (Stryker's own collection of photos); FSA Archive, Library of Congress, Washington, D.C. (about 272,000 negatives, 150,000 prints, 640 color transparencies); Archives of American Art, Detroit (Stryker correspondence, taped interviews); New York Public Library (reference set of FSA prints); Museum of Modern Art, New York; Harvard University, Cambridge, Massachusetts; National Archives Records Service, Washington, D.C.; University of Chicago; University of Indiana, Bloomington; New Orleans Museum of Art.

Publications:

By STRYKER: books—*American Economic Life*, with Thomas Munro and Rexford Guy Tugwell, with photos by Lewis W. Hine and others, New York 1925; *Just Before the War: Urban America from 1935 to 1941 as Seen by the Photographers of the Farm Security Administration*, with Arthur Rothstein and John Vachon, edited by Thomas Garver, Boston and New York 1968; *In This Proud Land: America 1935-1943 as Seen in the FSA Photographs*, with Nancy Wood, New York 1973, London 1974.

On STRYKER: books—*The Bitter Years: 1935-1941: Rural America as Seen by the Photographers of the Farm Security Administration*, edited by Edward Steichen, New York 1962; *Poverty and Politics: The Rise and Fall of the FSA* by Sidney Baldwin, Chapel Hill, North Carolina 1968; *Portrait of a Decade: Roy Stryker and the Development of Documentary Photography in the Thirties* by F. Jack Hurley, Baton Rouge 1972, New York 1977; *Documentary Expression and Thirties America* by William Stott, New York 1973; *The Years of Bitterness and Pride: FSA Photographs 1935-1943*, compiled by Jerry Kearns and Leroy Bellamy, edited by Hiak Akmakjian, New York 1975; *A Vision Shared: A Classic Portrait of America and Its People 1935-1943*, edited by Hank O'Neal, New York and London 1976; *Roy Stryker: Humane Propagandist* by James C. Anderson, with an introduction by Calvin Kytle, Louisville, Kentucky 1977; *The Photograph Collector's Guide* by Lee D. Witkin and Barbara London, Boston and London 1979; *Amerika: Traum und Depression 1920-1940*, exhibition catalogue, by Hubertus Gassner, Hamburg 1980; *Ohio: A Photographic Portrait: Farm Security Administration Photographs*, exhibition catalogue, Kent, Ohio 1980; *Les Années Ameres de l'Amerique en Crise 1935-1942*, exhibition catalogue, by Jean Dieuzaide, Toulouse 1980; articles—"Pictures from the FSA" in *U.S. Camera Annual 1938*, New York 1937; "The FSA Photographers" by Edward Steichen in *U.S.*

Camera Annual 1939, New York 1938; "Roy Stryker: Photographic Historian" by Edward Stanley in *Popular Photography* (New York), July 1941; "The Man Behind the Man Behind the Lens: Roy Stryker" by Jhan and June Robbins in *Minicam Photography* (New York), November 1947; "The Lean Thirties" in *Harvester World* (Chicago), February/March 1960; "Focus on Stryker" by John Durniak in *Popular Photography* (New York), September 1962; "USA-FSA" by Robert J. Doherty in *Camera* (Lucerne), October 1962; "The Camera as Sociological Weapon" in *U.S. Camera* (New York), May 1966; "Obituary: Roy Stryker 1893-1975" in *Afterimage* (Rochester, New York), November 1975; "Roy Stryker 1893-1975" in *Photography Year 1976* by Time-Life editors, New York 1976; "Le Dossier de la Misere" in *Photo* (Paris), February 1980.

Roy Emerson Stryker directed three major projects in photography which have become landmarks by which all others are measured. These projects have had profound effect upon documentary photography and photojournalism in America.

Stryker's first major undertaking was as director of the Historical Section of the Resettlement Administration (later the Farm Security Administration; RA/FSA). The Resettlement Administration was founded by Rexford Guy Tugwell, then Assistant Secretary of Agriculture and one of Roosevelt's "Brain Trust." Tugwell was also Stryker's former teacher, fellow author of an economics textbook and his boss at Columbia University where they both taught economics. When World War II resolved many of the Great Depression issues and public awareness and concern focused on the war effort, the RA/FSA project changed orientation toward war mobilization propaganda, and Stryker's operation became the photographic section of the Office of War Information (OWI).

Stryker remained with the OWI for a brief period, leaving it in 1942 to direct a major documentary project for the Standard Oil Company of New Jersey (SONJ). The premise of this project was that "there is a drop of oil in the life of everyone." The actual reason behind the program was that SONJ had received bad press during the summer of 1942 when the company was accused of collaborating with the enemy by restricting the making of synthetic rubber. SONJ was cleared of these charges, but, according to a Roper survey, the public still regarded them as an unsavory monopoly. To counter this, SONJ sought to portray themselves as friends, neighbors and as a positive force in society. Stryker was a major part of this campaign.

The SONJ project lasted about ten years at which time Stryker left New York for Pittsburgh where he undertook his last significant work. While working on the Pittsburgh Photo Library, which was a history of Pittsburgh both past and continuing, Stryker was hired by Jones and Laughlin Steel Company to improve their image to the public.

Stryker was not a photographer. During his work on these three projects, Stryker directed a group of outstanding photographers, most of whom are represented in this volume. Dorothea Lange, Russell Lee, Arthur Rothstein, John Collier, Jr., Walker Evans, Ben Shahn, Esther Bubley, John Vachon, Gordon Parks and Ed Rosskam are but a few of this distinguished group. Many continued their relationship with Stryker from one project to another and each project added new names such as Clyde Hare or Arthur Siegel.

The RA/FSA project is probably the largest undertaking in the history of photography. A group of photographers worked under government sponsorship to document the nation in the throes of the Great Depression. It was a self-examination attempting to portray the plight of the people who were destitute by reason of drought, poor farming techniques, exhausted farm land, a declining international farm market and an unprecedented depression. With the hope of arousing empathy for the depressed third of the nation, Roosevelt hoped to enlist the aid of the public in support of his New Deal programs. Stryker, in pursuit of this objective, sent his photographers into every corner of the country to document "life as it was." The goal was obviously propagandistic. The noted author Glenway Wescott stated, "...for me this is better propaganda than it would be if it were not aesthetically enjoyable. It is because I enjoy looking that I go on looking until the pity and the shame are impressed upon me unforgettably."

Whether the RA/FSA project was successful or not will never be known because the advent of the war deprived us of knowing if the Roosevelt plans would have worked. One thing that is certain is the vast influence the RA/FSA had on art, literature and journalism. Stryker's work spawned many books, among them Archibald MacLeish's *Land of the Free* and Walker Evans' and James Agee's *Let Us Now Praise Famous Men*. Walker Evans was the first photographer ever to have a one-man exhibition at New York's Museum of Modern Art, and a major exhibition at the Grand Central Palace in New York in 1938 evoked much comment from the art world. Many of the RA/FSA photographers later went on to become star performers in the picture press for magazines such as *Life* and *Look*.

The transition Stryker made from government to private industry was an immense one for him. While he devoted his efforts to the Roosevelt cause, he had a cause of his own which was grander in scope than most realize. John Collier, Jr. summed up this cause eloquently: "Stryker was first and last a social geographer and historian. He seized the FSA opportunity to look at the American earth, its rivers, valleys, plains, deserts and vast western mountains.... Stryker wanted to assemble a model and each incoming picture was another unit in the puzzle that when assembled was the most sweeping record ever made of the American earth and culture."

With the coming of the war and the end of the RA/FSA, SONJ offered Stryker an opportunity to continue toward his grander goal and still fulfill the commitment of documenting oil. Stryker had to make some personal compromises with his conscience in going to SONJ. He was the son of a Populist who taught him there were two great evils in the world: Standard Oil and Wall Street. The challenge and opportunity to work for his higher goal were too great to stand in the way of those teachings, and he joined SONJ in 1943 and began to amass an incredible statement about America, the world and oil.

Two important aspects of Stryker's accomplishments are frequently overlooked. The first is that he found a way to get the work of his band of photographers before the public eye in an unprecedented way. The second is that he found, developed, taught and placed in the field a number of young photographers who have distinguished themselves at the forefront of photography in the third quarter of the 20th century. No other figure in photography has had such influence.

Exactly how Stryker found the channel between the making of pictures to the Sunday morning breakfast table newspaper is still not entirely clear. His accomplishments with the FSA were slightly different from these with SONJ: there he found a way to get the SONJ pictures into virtually every illustrated textbook in America from the mid 1940's into the 70's. While not a photographer, Stryker was indeed a Dean of Photographers.

—Robert J. Doherty

SUDA, Issei.

Japanese. Born in Kanda, Chiyoda-ko, Tokyo, 24 April 1940. Educated at Toyko University, Department of Economics, Tokyo, 1960-61; studied at the Tokyo College of Photography, 1961-62. Married Sachiko Nakagawa in 1969. Worked as a freelance photographer for various magazines, Tokyo, 1962-67; Photographer, Tenjo Sajiki Play Laboratory, Tokyo, 1967-70. Freelance photographer, contributing to *Asahi Camera, Camera Mainichi, Nippon Camera, Camerart*, etc., Tokyo, since 1971. Tutor, Tokyo College of Photography, Yokohama, since 1979. Recipient: New Photographer of the Year Award, Japan Photographic Society, 1976. Address: 25 Tomiyama-cho, Kanda, Chiyoda-ku, Tokyo 101, Japan.

Individual Exhibitions:

1977　*Fushi Kaden*, Nikon Salon, Tokyo
1978　*A Photographic Exhibition of Issei Suda*, CAMP Gallery, Tokyo
　　　Anonymous Men and Women: Tokyo 1976-78, Nikon Salon, Tokyo
1979　*Issei Suda: Views of Shinano*, Minolta Photo Space, Tokyo
　　　Original Prints of Issei Suda, Tsukaido Gallery, Fukuoka, Japan
1981　*My Tokyo*, at *SICOF*, Milan

Selected Group Exhibitions:

1977　*Neue Fotografie aus Japan*, Kulturhaus, Graz, Austria (toured Europe, 1977-79)
1978　*Photokina '78*, Cologne
1979　*Japanese Photography Today and Its Origin*, Galleria d'Arte Moderna, Bologna (travelled to the Palazzo Reale, Milan; Palais des Beaux-Arts, Brussels; and the Institute of Contemporary Arts, London)
　　　Five Photographers, Santa Fe Gallery of Photography, New Mexico
　　　Japan: A Self-Portrait, International Center of Photography, New York (travelled to *Venezia '79*)

Collections:

Tokyo College of Arts and Crafts; Museum für Kunst und Gewerbe, Hamburg.

Publications:

By SUDA: books—*Fushi Kaden*, edited by Tatsuo Shirai, Tokyo 1978; *My Tokyo*, edited by Yusaku Kamekura, Tokyo 1979.

On SUDA: books—*The Era of Photography* by Taeko Tomioka, Tokyo 1979; *Japanese Photography Today and Its Origin* by Attilio Colombo and Isabella Doniselli, Bologna 1979; articles—"Fushi Kaden: A Season of Festivals" by Masao Tanaka in *Photo Art* (Tokyo), April 1976; "Issei Suda: Profile" by Masao Tanaka in *Camera Mainichi* (Tokyo), July 1976; "Fushi Kaden" by Taeko Tomioka in *Camera Mainichi* (Tokyo), June 1977; "A Theatre of Images" by Koji Taki in *Asahi Camera* (Tokyo), November 1977; "Trusting a Thought to an Image" by Masao Tanaka in *Camera Mainichi* (Tokyo), March 1979; "New Photo Theory" by Shiroyasu Suzuki in *Asahi Camera* (Tokyo), February 1980.

The act of taking a picture is just one of the many manifestations of being alive.

My confrontations with life are like a pendulum—to be touched, not to be touched, to be betrayed, not to be betrayed, the progress of which seems to me to constitute my photography.

Issei Suda: From *Fushi Kaden*, 1976

My sense of sight usually takes precedence over my sense of touch; it is, at any rate, difficult to know all of one's senses. However, in everyday occurrences, that to which I respond, I often feel a kind of strangeness about me or feel attracted to some object. In trying to take pictures as within the perspective and response to such feelings, I verify myself and try to practice according to a certain model of Japanese action and spirit.

—Issei Suda

After graduation, Issei Suda found work as a stage photographer, supplying background photographs for the productions of poet/playwright Shuji Teryama's theatrical troupe, which was known as "Tenjo-Sajiki." His photographs did not, however, appear in published form until 1971 when they were shown in the contribution section of *Camera Mainichi* called "Album." After that, series of his photographs appeared independently in *Camera Mainichi* under the title *Fushi Kaden*. But it was not until he produced the photographs using mirrors that Suda established his own style. Thereafter, each time that his photographs appeared in *Camera Mainichi*, recognition of them grew, and in 1976 he won the "New Photographer of the Year Award" of the Photographic Society of Japan. Now, Suda's works are highly valued in the world of Japanese photography for their artistic merit and uniqueness.

Fushi Kaden has been translated as "Transmission of the Flower of Art." The term was originally the title of a 15th century literary work by Zeami on the classical Japanese theatre of the *Noh*. Zeami, an accomplished actor himself, wrote the work to preserve the teachings of his father, Kanami, the most highly revered actor, composer, instructor and playwright of the time. In addition to his father's teachings, the work also includes Zeami's own

interpretations of the Noh, as well as his theories on acting, production, play composition, practice and other techniques. Although it was written mainly as a guide for transmission of the oral teachings of the Kanze school of the Noh, the work has also come to be widely read today as a philosophical classic on artistic technique and human nature. In the original *Fushi Kaden*, Zeami described the ultimate accomplishment which the actor must strive for in Noh as a "flower" which, in effect, refers to the attainment of total beauty in the actor's level of performance.

The main reason why *Fushi Kaden* was borrowed as the title for Suda's best-known work is that Suda himself is an avid reader of Zeami's original *Fushi Kaden*. The Noh and photography are, of course, different modes of expression. Yet, Suda has found much to learn about art in the teachings of Zeami that he feels may also be applied to photography. Suda undoubtedly feels this way because he himself is an exceptionally accomplished photographer in quest of the "flower" that Zeami spoke of in the world of the Noh.

—Akira Hasegawa

SUDEK, Josef.

Czechoslovakian. Born in Kolin-on-the-Elbe, Bohemia (Czechoslovakia), 17 March 1896. Educated at Kolin, until 1911; apprentice book-binder, Prague, 1911-13; studied photography, under Karel Novak, State School of Graphic Arts, Prague, 1922-24. Served in the Czech Army, in Italy, 1915-20 (wounded and hospitalized, 1917-20). Independent photographer, Prague, 1920-76; Official City Photographer, Prague, 1928; worked as commercial advertising and portrait photographer, working with Druzstevni Prace publishing company, Prague, 1928-36; Co-Editor and Illustrator, *Panorama* magazine, and later, *Zijene* magazine, 1928-36. Member, Amateur Photographers Club, Prague, 1920-24; Founder-Member, with Jaromir Funke, and others, Czech Photographic Society, Prague, 1924. Recipient: Artists of Merit Award, Czech Government, 1961; Order of Work, Czech Government, 1966. *Died* (in Prague) *15 September 1976.*

Individual Exhibitions:

1933 Krasna Jizba, Prague
1958 Alsova sin Umelecke besedy, Prague
1961 Slezske Museum, Opava, Czechoslovakia
 Frenstat Pod Radhostem, Prague
1964 Regional Gallery, Olomouc, Czechoslovakia
1966 Severoceske Museum, Liberec, Czechoslovakia
1971 Moravska Gallery, Brno, Czechoslovakia
 Bullaty-Lomeo Studio, New York
1972 Neikrug Gallery, New York
1974 International Museum of Photography, George Eastman House, Rochester, New York
 Light Gallery, New York
 Corcoran Gallery, Washington, D.C.
1976 Moravska Gallery, Brno, Czechoslovakia
 Roudnice, Czechoslovakia (retrospective)
 Museum of Decorative Arts, Prague (retrospective; toured Europe and the United States)
 The Photographers' Gallery, London
 Impressions Gallery, York, England
1977 International Center of Photography, New York
 Light Gallery, New York
 International Museum of Photography, George Eastman House, Rochester, New York (retrospective)
1978 Moderna Museet, Stockholm
 Allan Frumkin Gallery, Chicago
1981 Daytona Beach Community College, Florida
 Prakapas Gallery, New York
 Stephen White Gallery, Los Angeles
1982 Jacques Baruch Gallery, Chicago

Selected Group Exhibitions:

1960 *Sudek in the Arts*, Mlada Fronta, Prague (homage by painters and graphic artists)
1967 *Czech Photography Between 2 World Wars*, Prague
1968 *5 Photographers*, University of Nebraska, Lincoln
1972 *Octave of Prayer*, Massachusetts Institute of Technology, Cambridge
1977 *Concerning Photography*, The Photographers' Gallery, London (travelled to Spectro Workshop, Newcastle upon Tyne)
 Photographs: Sheldon Memorial Art Gallery Collection, University of Nebraska, Lincoln
 Documenta 6, Museum Fridericianum, Kassel, West Germany
1978 *Tusen och En Bild/1001 Pictures*, Moderna Museet, Stockholm
1979 *Photographie als Kunst 1879-1979*, Tiroler Landesmuseum Ferdinandeum, Innsbruck,

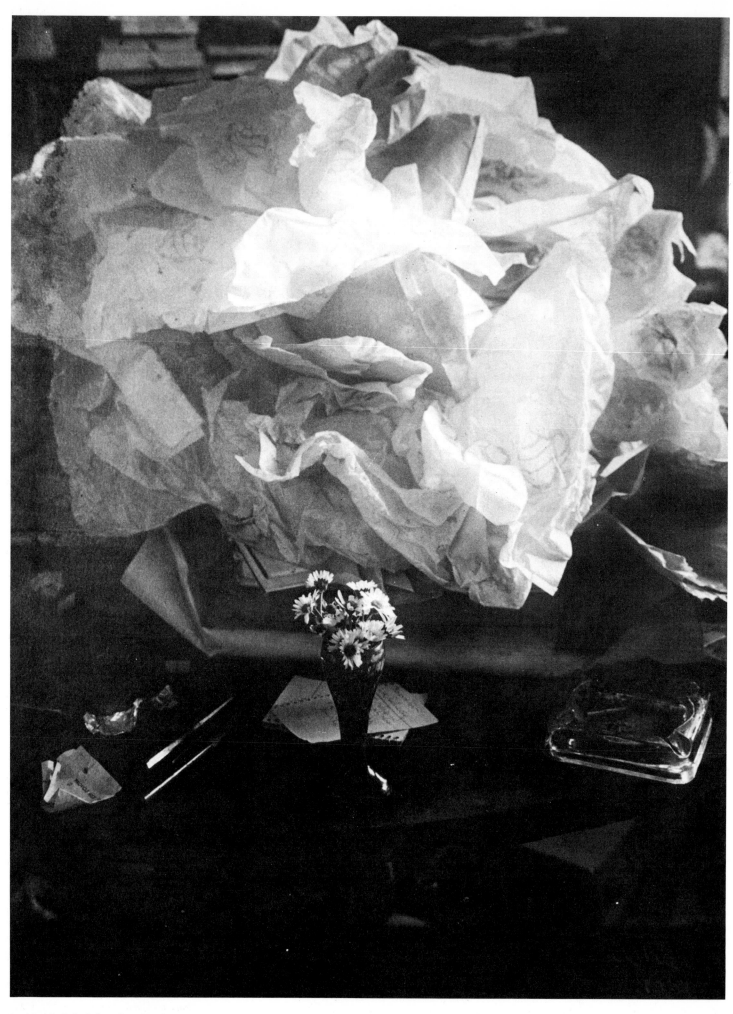

Josef Sudek: *Labyrinth on the Table,* 1967

Austria (travelled to Neue Galerie am Wolfgang Gurlitt Museum, Linz, Austria; Neue Galerie am Landesmuseum Joanneum, Graz, Austria; and Museum des 20. Jahrhunderts, Vienna)
1981 *Landschaften*, PPS-Galerie, Hamburg

Collections:

Museum of Decorative Arts, Prague; Moravska Gallery, Brno, Czechoslovakia; Jaromir Funke Fotokabinett, Brno, Czechoslovakia; Hodoniner Gallery, Czechoslovakia; Royal Photographic Society, London; International Museum of Photography, George Eastman House, Rochester, New York; University of Nebraska, Lincoln; University of New Mexico, Albuquerque; San Francisco Museum of Modern Art.

Publications:

By SUDEK: books—*Svaty Vit* (*Saint Vitus*), portfolio of 15 photos, with an introduction by J. Durich, Prague 1928; *Prazsky Hrad* (Prague Castle), with text by Rudolf Roucek, Prague 1947; *Baroque Prague*, with text by Arne Novak, Prague 1947; *Magic in Stone*, with text by Martin S. Briggs, London 1947; *Praha: Josef Sudek*, with text by Vitezslav Nezval, Prague 1948; *Nas Hrad (Our Castle)*, with text by A. Wenig and J.R. Vilimek, Prague 1948; *Josef Sudek: Fotografie*, with an introduction by Lubomir Linhart, Prague 1956; *Lapidarium Narodniho Muzea* (*Lapidarium of the National Museum*), with text by V. Denkstein, Z. Drobna and J. Kybalova, Prague 1958; *Praha Panoramaticka* (*Prague Panoramas*), with poems by Jaroslav Seifert, Prague 1959; *Karluv Most* (*Charles Bridge*), with text by Emanuel Poche and Jaroslav Seifert, Prague 1961; *Josef Sudek Profily*, set of 12 postcards, with text by Jan Rezac, Prague 1962; *Sudek: 96 Photographs*, with an introduction by Jan Rezac, Prague 1964; *Mostecko-Humboldtka*, set of 11 postcards, Prague 1969; *Wychowanie Muzyczne* (*A Musical Education*), with text by Alojz Suchanek, Prague 1970; *Janacek-Hukvaldy*, with an introduction by Jaroslav Seda, Prague 1971; *Josef Sudek: Portfolio*, 13 photos, with an introduction by Petr Tausk, Prague 1976; *Sudek*, with text by Sonya Bullaty, introduction by Anna Farova, New York 1978.

On SUDEK: books—*Prazske Palace* (*Prague Palaces*), by Alois Kubicek, Prague 1946; *Light and Shadow*, Prague 1959; *Prazske Ateliery* (*Prague Studios*), Prague 1961; *Five Photographers*, exhibition catalogue, Lincoln, Nebraska 1968; *Great Photographers* by Time-Life editors, New York 1971; *Octave of Prayer*, exhibition catalogue, by Minor White, Cambridge, Massachusetts 1972; *The Magic Image* by Cecil Beaton and Gail Buckland, London and Boston 1975; *Sudek*, exhibition catalogue, with text by Anna Farova, Prague 1976; *Josef Sudek*, exhibition catalogue, with text by Antonin Dufek, Brno, Czechoslovakia 1976; *Josef Sudek*, exhibition catalogue, with text by Petr Tausk and Werner Lippert, Aachen, West Germany 1976; *Photographs: The Sheldon Memorial Art Gallery Collection, University of Nebraska*, with an introduction by Norman A. Geske, Lincoln, Nebraska 1977; *Concerning Photography*, exhibition catalogue, edited by Jonathan Bayer and others, London 1977; *Documenta 6/Band 2*, exhibition catalogue, edited by Klaus Honnef and Evelyn Weiss, Kassel and Cologne 1977; *Geschichte der Fotografie im 20. Jahrhundert/Photography in the 20th Century* by Petr Tausk, Cologne 1977, London 1980; *The Photograph Collector's Guide* by Lee D. Witkin and Barbara London, Boston and London 1979; articles—"Josef Sudek" by Vaclav Sivko in *Zpravodaj* (Prague), Fall/Winter 1956; "Josef Sudek: 60 Years" by V. Jiru in *Vytvarna Prace* (Prague), no. 5, 1956; "An Artist-Photographer" in *Fotografie* (Prague), no. 4, 1961; "Josef Sudek: 70 Years" in *Ceskoslovenska Fotografie* (Prague), no. 2, 1966; "Sudek" by Allan Porter in *Camera* (Lucerne), no. 3, 1966; "Josef Sudek" in *Camera* (Lucerne), no. 4, 1967; "Gallery: Josef Sudek: Poet of Prague" in *Life* (New York), 29 May 1970; "Josef Sudek" in *Fotografia Italiana* (Milan), July 1974; "Josef Sudek: The Birthplace of Janacek" in Creative Camera (London), October 1975; "Josef Sudek: A Monograph" by Allan Porter and Anna Farova in *Camera* (Lucerne), no. 4, 1976; "Josef Sudek: The Czech Romantic" by Charles Sawyer in *Modern Photography* (New York), September 1976; "Josef Sudek: A Tribute" by Ruth Spencer in *British Journal of Photography* (London), 3 December 1976; "Josef Sudek: Poet of Prague" in *Photography Year 1977* by Time-Life editors, Alexandria, Virginia 1977; "Backyard Romantic" by Ilka Normile in *Afterimage* (Rochester, New York), May/June 1977; "Josef Sudek's Poetic Reveries" by Gene Thornton in *New York Times*, 19 July 1977; "Josef Sudek: Photographs" by Carter Ratcliff in *Print Collector's Newsletter* (New York), September/October 1977; "Sudek: A Monk of Photography" by Vicki Goldberg in *American Photographer* (New York), 3 March 1979; "Josef Sudek" in *Creative Camera* (London), April 1980.

Even though belated, the recent international recognition of Josef Sudek in western Europe and America has added an artist of consummate quality to the pantheon of photography's pioneer masters. Among them, all born before the turn of the century, he is most like Eugène Atget in the simplicity of his vision and the unity of his life's work. Like Atget he was always and exclusively concerned with the imagery of his immediate experience, the streets and buildings of Prague, the objects in his studio and garden, the landscapes of his native Bohema. In the prints of Atget, however, the object, be it buildings, streets, trees or human beings, is seen objectively: the artist's response is held delicately within the bounds of an affectionate familiarity. In Sudek the quality of the response is of a different kind. It is warm with the subjective emotion of a true romantic. The subject is imbued with a sense of wonder. In a sense the subject is not the object itself but the light and atmosphere in which it exists. Atget the realist, Sudek the romantic is perhaps too simple a formulation, but there is no doubt of the difference between them. In the miraculous seizure of time which is the essence of their photography, Sudek is the enchanted one.

The numerous prints taken within the darkened interior of his studio, the still-lifes of eggs and bread, plates of fruit, glasses of water, are impeccable in form and dense with sensory associations. They remind one of the miraculous still-lifes of Chardin. It is, however, in the equally marvelous views through a window clouded with condensation or rain, that Sudek's definitive imagery may be found. These windows are more than windows. They act as filters for the artist's imagination. From within the security of self, through a fluctuating veil of moisture and light, he sees his world in terms of uncertainty, mystery and flux. In a larger sense, Sudek's camera almost always provides a transition from one reality to another. His landscapes have the hushed and waiting atmosphere of dawn or dusk. His deserted garden with its spectral white chairs arranged in the accidental patterns of contemplation or conversation, waits for the entry of an animating presence. It is in these prints that Sudek declares himself most noticeably as poet and magician. The light of burning kerosene lamps penetrates the tangled vegetation of the garden. A man's hat lies on the ground among stones and pebbles placed with a knowing but undeclared purpose. Sudek's most personal device is his use of glass eyes, often inserted into still life arrangements to invest them with a spiritual presence. In one of his best known prints such an eye is lodged in the gnarled trunk of a dead tree thus creating a fantastic creature to engage in a demonic conversation with the artist himself who sits with his back to the viewer, but with his spectacles reversed on the back of his head.

In these instances there is something of the exquisite horror of the surreal, but this same peculiarity of mood may be seen as present in varying degrees in most of Sudek's work. Throughout the range of his work; in the hundreds of views of Prague seen in all seasons and times of day and night; in the veritable archive of trees, forests, groves, storm-struck survivers (again reminding us of Atget); in the almost terrifying views of Prague's Jewish cemetery, known as Mala Strana; even in his few portraits and nudes of magisterial quality, there is an extraordinary sensibility at work, performing magic of a kind that is rare, not merely in photography, but in art.

—Norman A. Geske

SUDRE, Jean-Pierre.
French. Born in Paris, 27 September 1921. Educated at the Lycée Montaigne, and the Lycée Saint Louis, Paris, 1931-38; Ecole Nationale de Cinématographie, Paris, 1941-43; Institut des Hautes Etudes Cinématographiques (IDHEC), Nice and Paris, 1943-45. Married Claudine Richard in 1947; children: Dominique and Fanny. Independent photographer, since 1946. Instructor, Ecole des Arts Appliqués de la Ville de Paris, 1957-58, and Ecole Supérieure Nationale d'Architecture et des Arts Visuels (La Cambre), Brussels, 1965-70; Founder-Director, Photography Department, Ecole Supérieure des Arts Graphiques, Paris, 1968-72; Founder, Photography Department, Galerie La Demeure, Paris, 1968; Founder-Instructor, Stage Expérimental Photographique (research centre for experimental photography), with Claudine Sudre, Paris, 1968-73, and in Lacoste, Vaucluse, France, 1974-81; Founder, History of Photography Course, Université Saint Charles, Marseilles, 1976-77, and at Ecole des Beaux-Arts de Luminy, Marseilles, 1977-81. Member, Board of Directors, Société Française de Photographie, 1968-72, and Fondation Nationale de la Photographie and Comité Pédagogique, Paris, 1979. Member, Board of Directors, *Rencontres Internationales de Photographie*, Arles, France, since 1978. Awards: Gold Lion Medal, *Biennale di Venezia*, 1957; Prix de l'Association des Critiques d'Art, Brussels, 1963; Davanne Medal, Société Francaise de Photographie, 1970. Chevalier de l'ordre des Arts et des Lettres, 1981. Address: "Le Mourre du Bès," 84710 Lacoste, France.

Individual Exhibitions:

1952 *Sous-Bois*, Galerie La Demeure, Paris
1955 *Végétal et Natures Mortes*, Musée National, Amiens, France
1956 *Natures Mortes*, Galerie Morian, Courtrai, Belgium
1957 *Végétal et Natures Mortes*, Société Française de Photographie, Paris
1961 *Matériographies*, Galerie Veranneman, Courtrai, Belgium
1962 *Aventure de Matière*, Galerie Montaigne, Paris (with Denis Brihat)
Matériographies, Palais des Beaux-Arts, Brussels

1963 *Matériographies*, Galerie Huidevettershuis, Bruges, Belgium
1964 *Matériographies*, Galerie La Demeure, Paris
1965 *Grands Panneaux et Tryptiques*, Institut Français, Cologne (toured Germany)
1966 *Grands Panneaux et Tryptiques*, Galerie Les Contards, Lacoste, France
1967 *Denis Brihat / Pierre Cordier / Jean-Pierre Sudre*, Galerie Artek, Helsinki
1968 *Végétal et Minéral*, Centre Culturel, Toulouse, France
1969 *Végétal et Minéral*, Galerie Les Contards, Lacoste, France
Apocalypse, Galerie La Demeure, Paris
1971 *Murals*, Arras Gallery, New York
1972 *Paysages Matériographiques*, Galerie Les Contards, Lacoste, France
Paysages Matériographiques, Galerie Die Brücke, Vienna
1975 *Paysages Matériographiques*, Galerie Fiolet, Amsterdam
Galerie Municipales du Château d'Eau, Toulouse, France (retrospective)
1976 Musée Nicéphore Niepce, Chalon-sur-Saône, France (retrospective)
Matériographies et Natures Mortes, Atelier Galerie, Aix-en-Provence, France
1978 *Natures Mortes*, Marcuse Pfeifer Gallery, New York
Musée de Besançon, France (retrospective)
1980 Galerie Les Métiers, Biot, Alpes-Maritimes, France (retrospective)
Galerie Philippe Médard, Avignon, France (retrospective)
Work Gallery, Zurich (retrospective)
1981 *Natures Mortes*, French Institute, New York
Galerie Portefolio, Lausanne, Switzerland (retrospective)
Jean-Pierre Sudre / Henri Cartier Bresson, Stephen Wirtz Gallery, San Francisco
Jean-Pierre Sudre / Jeanloup Sieff, Musée d'Orange, France
Natures Mortes, Galerie Photogramme, Quebec
Galerie Reflex, Brussels (retrospective)
Galerie Le Grand Cachot de Vent, Neuchâtel, Switzerland (retrospective)
Musée Ancien de Grignan, France (retrospective)

Selected Group Exhibitions:

1957 *Biennale di Venezia*

Jean-Pierre Sudre: From *Paysage Matériographique*, 1975

1960 *Salon Comparaisons*, Musée d'Art Moderne, Paris (and to 1966)
1968 *L'Oeil Objectif*, Musée Cantini, Marseilles (with Denis Brihat, Lucien Clergue, and Robert Doisneau)
1972 *La Photographie Française*, National Museum, Moscow
1973 *Photography as Art*, Scottish Arts Council Gallery, Edinburgh
1980 *Photographie: La Linea Sottile*, Galleria Flaviana, Locarno, Switzerland

Collections:

Bibliothèque Nationale, Paris; Musée Nicéphore Niepce, Chalon-sur-Saône, France; Musée Cantini, Marseilles, France; Museum of Modern Art, New York; Gernsheim Collection, University of Texas at Austin; Center for Creative Photography, University of Arizona, Tucson.

Publications:

By SUDRE: books—*Bruges: Au Berçeau de la Peinture Flamande*, with text by F. Cali, Paris 1963; *Diamantine*, Paris 1964; *Pralinne*, Paris 1967; *Argentine*, Paris 1968; *Apocalypse*, exhibition catalogue, Paris 1970; *Paysages Matériographiques*, portfolio, Paris 1975; *Nus*, portfolio, Paris 1978.

On SUDRE: books—*Dictionnaire Pittoresque de la France*, Paris 1955; *Aventure de Matière*, exhibition catalogue, Paris 1962; *L'Oeil Objectif*, exhibition catalogue, Marseilles 1968; *Histoire de la Photographie* by J. Keim, Paris 1970; *Photography into Art*, exhibition catalogue, by Pat Gilmour, Edinburgh 1973; *Jean-Pierre Sudre*, exhibition catalogue, by Jean Dieuzaide, Toulouse 1975; *The Magic Image* by Cecil Beaton and Gail Buckland, London and Boston 1975; *Jean-Pierre Sudre*, exhibition catalogue, by Paul Jay, Chalon-sur-Saône, France 1976; *Geschichte der Fotografie im 20. Jahrhundert / Photography in the 20th Century* by Petr Tausk, Cologne 1977, London 1980; *Photographia: La Linea Sottile*, exhibition catalogue, by Rinaldo Bianda and Giuliana Scimé, Locarno, Switzerland 1980; articles—"Jean-Pierre Sudre" in *Camera* (Lucerne), August 1956; "Jean-Pierre Sudre" in *Terre d'Images* (Paris), no. 3, 1964; "Jean-Pierre Sudre" by Romeo E. Martinez in *Camera* (Lucerne), November 1966; "Jean-Pierre Sudre" in *Techniques Graphiques* (Paris), July/August 1966; "Jean-Pierre

Sudre" by Michel Kempf in *Photo Revue* (Paris), December 1976; "Jean-Pierre Sudre" by Guy Mandery in *Le Photographe* (Paris), no. 4, 1977; "Jean-Pierre Sudre" in *Photo Jeunesse* (Paris), February 1979; television film—*Chambre Noire* by Michel Tournier, 1967.

Start with a general view of the forest.
Approach a tree.
Analyze its branches,
count its leaves,
scrutinize its bark,
slip into its trunk
and wander
the enchanted paths of its veins.
Then plunge
into the darkness of its roots
and glide softly while
travelling to the centre of matter;
this, photographically,
is the fantastic journey
that I have taken for fifteen years.
Will I ever discover
the palace of Diamantine, Queen of the night,
whose thousand crystallized towers
scintillate obliquely
when the hidden suns
are gradually dispersed?

—Jean-Pierre Sudre

The photography of Jean-Pierre Sudre is a search. Having begun during the 1950's by questioning ordinary everyday objects and plant life, he has gone on to push his investigations to the limit, to the very substance of photography.

"Without wishing to forget the great charm of the vegetable kingdom, the world of crystallographic silence brings to this age, the era of the atom, a pleasure and an inexhaustible source of inspiration. To prepare a crystallization for the purpose of making pictures that seem vital is to go back to the art of still-life where objects are arranged with precision" (Preface to *Apocalypse*, 1970).

This original attitude to photography requires special means of investigation. The main photographic tool used by Sudre, other than large format plates, is an unequalled photochemical knowledge. Together with his wife Claudine, Sudre works as a researcher in photographic art, producing everything himself, sometimes even down to the light sensitive surfaces. In his laboratory pictures develop in his manipulation of flasks containing rare substances.

Naturally, Sudre's work is not entirely to be perceived as chemistry. The objects and plants of his early work and his more recent nudes frame a long series of "matériographies," which are sometimes suggestive of the countryside and sometimes of anthropomorphic details—but that is not the point. What matters are the prints, the photographic object itself. And Sudre's prints are among the most exquisite that one is privileged to see.

A leading spirit of the French school of pure photography, Sudre has pursued the artistic adventure to its ultimate consequences, even to the point of making it into a kind of ritual practice somewhere between alchemy and the martial arts. In all ways, a noble exercise.

His artistic work cannot be disassociated from his decisive role in France as a teacher at the highest level. He was also, during the 1950's and 60's, one of a handful of French photographers who fought for the recognition in their country of photography as an art in itself.

Jean-Pierre Sudre is, in other words, one of the most completely original figures in the international gallery of photographers.

—Guy Mandery

SUSCHITZKY, Wolf(gang).

British. Born in Vienna, Austria, 29 August 1912; emigrated to Britain, 1935: naturalized, 1947. Studied photography, Graphische Lehr- und Versuchsanstalt, Vienna, 1930-33. Married Puck Voute in 1934 (divorced, 1936); Ilon Donat (divorced); Beatrice Cunningham; children: Peter, Misha and Julia. Freelance photographer since 1933: established studio with Puck Voute, Amsterdam, 1934-36; freelance photographer, working for *Illustrated Animal and Zoo Magazine* and *Geographical Magazine*, London, 1936-42; film cameraman, with Paul Rotha, London, 1937, 1942-44, and for Data Film Unit, 1944-53. Associate, Royal Photographic Society, London. Address: Flat 11, Douglas House, 6 Maida Avenue, London W2 1TG, England.

Individual Exhibitions:

c.1940 *Animal Pictures*, Ilford Galleries, London

Selected Group Exhibitions:

1959 *Hundert Jahre Photographie 1839-1939*, Museum Folkwang, Essen, West Germany (travelled to Cologne and Frankfurt)
1979 *Fotografie in Nederland 1920-1940*, Haags Gemeentemuseum, The Hague
The 30's: British Art and Design Before the War, Hayward Gallery, London

Collections:

Archives of the City of Amsterdam; Haags Gemeentemuseum, The Hague; Gernsheim Collection, University of Texas, Austin.

Publications:

By SUSCHITZKY: books—*Photographing Children*, London and Glasgow 1940, 1948; *Photographing Animals*, London and New York 1941; *An Animal Tour*, with text by Cecilia Davies, London and Glasgow 1944; *That Baby*, with text by L. Frank, London and Glasgow 1946; *Open Air ABC in Colour Photography*, London and Glasgow 1947; *Faithfully Ours: Cats and Dogs Photographed by Wolf Suschitzky*, with text by Cecil Smyth, Norwich 1950; *The Flying Poodle*, with text by Roland Collins, London 1951; *Baby Animals*, with others, London and Glasgow 1952; *All About Taking Baby and Your Camera*, London and New York 1952, 1958; *Kingdom of the Beasts*, with text by Julian Huxley, London 1956; *Animal Babies*, London 1957; *Island Zoo*, with text by Gerald M. Durrell, London 1961; *Brendan of Ireland*, with text by Bryan MacMahon, London 1961, 1965; article—in *Photography* (London), June 1954; films (as cameraman/director of photography)—*Power for the Highlands*, 1943; *Children of the City*, 1944; *The Bridge*, 1945; *Adventure in Sardinia*, 1950; *No Resting Place*, 1950; *The Oracle*, 1952; *The Bespoke Overcoat*, 1955; *Small World of Sammy Lee*, 1962; *Lunch Hour*, 1962; *Ulysses*, 1966; *Ring of Bright Water*, 1968; *Entertaining Mr. Sloane*, 1969; *Get Carter*, 1970; *Living Free*, 1971; *Something to Hide*, 1971; *Theatre of Blood*, 1972; *Moments*, 1973; documentaries—*Cradle of Genius*, 1959; *From Stone into Steel*, 1959; *Trinidad and Tobago*, 1964; *The River Must Live*, 1965; *Design for Today*, 1965; *The Tortoise and the Hare*, 1965; *Carbon*, 1967; *Poussin*, 1967; *Claude Lorraine*, 1969; has also worked on numerous television commercial films and series for British television, including: *Sailor of Fortune*, 1956; *Charlie Chan*, 1957; *Worzel Gummidge*, 1979, 1980, 1981; *Staying On*, 1980.

On SUSCHITZKY: books—*The Man Behind the Camera* by Helmut Gernsheim, London 1948, New York 1979; *Great Photographs 1: Suschitzky*, edited by Norman Hall and Basil Burton, London 1954; *Hundert Jahre Photographie 1839-1939 aus der Sammlung Gernsheim, London* by Helmut and Alison Gernsheim, Essen 1959; *Fotografie in Nederland 1920-1940*, exhibition catalogue, by Flip Bool and Kees Broos, The Hague 1979; *Thirties: British Art and Design Before the War*, exhibition catalogue, by Ian Jeffrey, William Feaver, Brian Lacey and others, London 1979; articles—"Wolf Suschitzky" in *U.S. Camera Annual*, New York 1962 and 1972.

I prefer straightforward, honest photography—the selective eye waiting for the right moment. A photograph should make some statement, and it should be aesthetically pleasing. I'm afraid that I'm old-fashioned enough not to like the modern trend of obscure pictures, taken without knowledge of the photographer's craft.

My main work, in the last thirty years or more, has been cinematography. I grew up in documentary films, and I was cameraman on a good number of features, like: *Ulysses* (1966), *Ring of Bright Water* (1968), *Entertaining Mr. Sloane* (1969), *Get Carter* (1970), *Living Free* (1971), and *Something to Hide* (1971).

I have worked on films for television and countless commercials. Last year I worked on *Staying On* and *Worzel Gummidge*.

While I still take photographs, it is rarely as a professional photographer—more for pleasure and interest.

—Wolf Suschitzky

Wolf Suschitzky came to Britain from Vienna before the war. He had gone first to Holland for a brief spell, but in England he settled down and soon began to work as a documentary film cameraman, and it is for that work that he is probably best known today. All the while, however, he has taken stills for himself and for magazines, and he was often published in photography magazines in the 1950's. His range is wide, from reportage to portraits, and there are, in his work, many marvellous photographs of animals and birds.

Early on he made a series of pictures of the Charing Cross Road, which show not only the place, its bookshops and the cross-section of activities to be found there, but also record the various people and itinerant tradesmen as well as buildings that have now sadly disappeared. The area fascinated him; so did the East End, which he also photographed extensively, producing a marvellous series of people both in portraits and groups. Children play in streets that now have been blocked with cars, if not pulled down altogether, and throughout these photos there

Wolf Suschitzky: *Burma*, 1957

is sentiment without sentimentality—a rare quality in pictures of an intrinsically emotive place and time.

Nowadays, his documentary filming takes him to many parts of the world, and it is interesting to compare pictures taken in Thailand before the war with those taken just a short while ago: so much has not changed, and Suschitzky's trained eye and sympathetic vision can produce images that do actually evoke a place and make one long to see it for oneself—without their ever being "picaresque" or creating the impression that it is simply a tourist's view. The work seems real, it is interesting, it is evocative without being either despairing or seedy—or romantic, as the geographical magazines can make of places. It is this realism that is the most enduring and stimulating thing about these photographs. There is a consistency between the early and later work that is reassuring, and though the portraits now may be of more famous people, they are still done with respect but not adulation of the subject and with a certain sense of humour. This humour is probably most apparent in some of the animal pictures, also done with respect—the owl is indeed most frightening—and there is no overt attempt to anthropomorphize creatures out of their own characters.

His film work has long since widened from the purely documentary and now covers many subjects; lately, for instance, he has filmed *Staying On* with Celia Johnson and Trevor Howard and a series based on the famous children's book *Worzel Gummidge* for television. It is to be hoped, however, that more of Wolf Suschitzky's still photographs will be seen again soon, either in book or exhibition form—preferably both.

—Sue Davies

SUTKUS, Antanas (Motiejaus).

Lithuanian. Born in Kluoniskiai, Kaunas, 27 June 1939. Studied journalism at Vilnius State University, Lithuania. Married Mardjosaite Aukse in 1964; children: Simas, Giedre and Indre. Worked at the Eserelis Peat-Works, Lithuania, 1956-58. Full-time photographer since 1958: Reporter-Cameraman, *Literatura ir Menas* (*Literature and Art*) weekly magazine, Vilnius, 1960-62; Photo-Reporter, *Tarybine Moteris* (*Soviet Woman*) magazine, Vilnius, 1962-69; independent photographer, with studio in Vilnius, since 1969. President of the Organizing Committee, 1969-74, Vice-President of the Praesidium, 1974-80, and since 1980 President of the Praesidium, Photography Art Society of Lithuania, Vilnius. Recipient: Michelangelo Gold Medal, Italy, 1970; First Prize, *Fotoforum*, Ruzomberok, Czechoslovakia, 1970; Grand Prize, *Golden Eye '73* exhibition, Novy Sad, Yugoslavia, 1973; Grand Prize, *Man and His World* exhibition, Katowice, Poland, 1973; Artist Award, 1976, and Gold Medal, 1979, Fédération de l'Art Photographique (FIAP); Macumba Cross, Ndola, Zambia, 1980; Merited Worker in Culture Award, Supreme Soviet of the Lithuanian S.S.R., 1980. Agent: Photography Art Society of the Lithuanian S.S.R., Pionieriu Street 8, 232600 Vilnius. Address (studio): Mickeviciaus Street 14, Apt. 7, 232600 Vilnius, Lithuania S.S.R., U.S.S.R.

Individual Exhibitions:

1969 Bratislava, Czechoslovakia
1970 Novi Sad, Yugoslavia
1975 Sofia, Bulgaria (toured Bulgaria)
1976 Photography Salon, Vilnius, Lithuania
 Photography Gallery, Kaunas, Lithuania

1978 Rostock, East Germany
 Helsinki, Finland (travelled to Pori, Finland)
 Photography Gallery, Kaunas, Lithuania
1979 United Nations Building, New York
 Art History Research Institute, Moscow
 Photographs by Antanas Sutkus and Aleksandras Macijauskas, Prakapas Gallery, New York
1980 Joensuu, Finland
 Gothenburg, Sweden

Selected Group Exhibitions:

1964 *4 Photographers*, Vilnius, Lithuania
1969 *9 Lithuanian Photographers*, Union of Journalists, Moscow
1970 *Fotoforum*, Ruzomberok, Czechoslovakia
1973 *Golden Eye '73*, Novy Sad, Yugoslavia
 Man and His World, Katowice, Poland
1976 *Lithuanian Art Photography*, Leningrad (travelled to Sverdlovsk, U.S.S.R.)
1978 *Lithuanian Art Photography*, Moscow
1979 *Lithuanian Photographers*, Amsterdam (travelled to Paris, 1979, and London, 1980)
1980 *Man and Earth* open-air exhibition, Plateliai, Lithuania

Collections:

Photography Museum, Siauliai, Lithuania; Bibliothèque Nationale, Paris; Musée Francais de la Photographie, Bièvres, Paris; Valokuvamuseon, Helsinki.

Antanas Sutkus: *Jean-Paul Sartre*

Publications:

By SUTKUS: books—*Everyday Vilnius*, with text by Romualdas Rakauskas, Vilnius, Lithuania 1968; *Souvenirs of Native Meadows*, Vilnius 1969; *This Country Is Called Lithuania*, with text by Romualdas Rakauskas, Vilnius 1970; *Lazdynai*, Vilnius 1975; *Fragments of Old Vilnius*, Vilnius 1975; *Colors of the Native Land*, Vilnius 1976; *Soviet Lithuania*, with texts by several authors, Vilnius 1976; *Lithuania from a Bird's-Eye View*, Vilnius 1981.

On SUTKUS: articles—in *Sovetskoye Foto* (Moscow), no. 10, 1979; *Valokuva* (Helsinki), no. 3, 1979.

Let's leave technology and professional culture aside. They are an alphabet that is a must to each professional photographer.

Photography must be needed by people. The main direction of my effort in photography is rehabilitation of old topics. I try to find generosity, kindness, love and dreams in people. I look for thoughtfulness and heartiness. My aim, like that of a number of other Soviet photographers, is to take part in painting a big canvas on contemporary spiritual life, and my main purpose is to make an attempt at drawing a psychological portrait of contemporary man. I work mostly on portraits. I contribute regularly to my series *People of Lithuania*, commenced in 1976.

Generations succeed one another, and man's perception of the world also changes. I try to express, by means of photographic language, things and notions that are irrevocably leaving our times. I feel it is my responsibility, because future generations will judge our way of life, our culture and our inner world on the basis of photographs.

The part played by photography in the contemporary world is unusually great. Often it is by means of photography that we try to overcome alienation, to come to better mutual understanding. Although it is the youngest branch of art, photography has a considerable informational significance. That significance is so great that often it's hard to tell the difference between informative and art photography. Sometimes a trend emerges, determined by the historial period, in which there is a transition of informative photography into art photography.

I believe in photography that not only informs about main world events, serves scientific purposes, decorates public buildings and private apartments, advertises goods, etc., but also influences our feelings and thoughts by its beauty, emotive qualities, inner power and broadness of generalization. I am most of all interested in art photography. In general, I think more theoretical work is needed in the subject to prevent any merely good photography from being automatically classified as art. Such cases, by the way, are quite frequent in the various international salons, where enthusiastic jury panels lavishly decorate any picture, whatever its quality, with medals or citations. And, once determined, standards in photography travel quickly from continent to continent. Yet, in my view, this fashion of standards is a hindrance to the development of genuine photographic art, and salon photography often retards the progress of thought and resource in the field.

When a predestination of value exists, and when that value was determined in the first place by fashion, then there will inevitably be a devaluation of significant topics and of photography itself. Sometimes the criteria for assessing photography remind one of those for sports.

Like any other branch of art, photography requires sacrifice, the artist's entire lifetime. Names and personalities—similar to those in painting, literature, music or cinematography—are needed in photography. Their emergence would certainly reinforce the position of photography as art.

Photography must be loyal to its times; it must help to solve contemporary problems. It must be an efficient champion of peace, friendship among nations, and ideas of internationalism and their dissemination. It must struggle for social progress and humanism, for the clean and bright face of the Earth, man's planet. Nevertheless, in my opinion, art photography should not serve only a particular brief moment, or—what's even worse—surrender to expediency. It should never be used to stress violence or sex or be guilty of pure advertising and formal experiment as a means of shocking the world. Art photography ought to be involved with accumulating stable artistic values. Modern photographic artists must be able to differentiate between the essential and the accidental. They must be particularly sensitive to human truth, the truth of life. Finally, photographers must choose the important moments of our restless planet's life, and consider, too, the view of coming generations.

—Antanas Sutkus

Antanas Sutkus is a photographer whose main subject is man in all his situations and moods. Like a first-rate photojournalist, Sutkus "fixes" everyday life. Recognizing the power of photography for just that kind of "fixing," he primarily applies that particular feature in his work. Only the camera is able to preserve our contemporaries and we ourselves as we really exist—and to capture one moment of our lives is still to generalize. Sutkus doesn't indulge in tricks; deformations caused by the wide-angle lens are not conspicuous; his photos of our environment are normal, ordinary and familiar, though, as photography, still very stylish. Because of his profound photographic culture and his mastery of the medium, Sutkus can photograph well in every situation—from the planned sculptural form to the sudden snapshot.

A large series, "People of Lithuania," is a good example of his strenuous efforts over a long period of time to depict the people of his native country for posterity. These photos are often produced in what seems to be the mode of the photojournalist, but in fact Sutkus is adept at asking his model to stand, sit or act, and in a certain place—to behave in a way that is, in his view, most characteristic. As a result of his technique, Sutkus has created many memorable photos of artists, composers, cultural figures, artists, and ordinary country people. Sutkus loves the countryside, as is revealed by close-up photos that range from ploughing the fields to the folds in the faces of old people. Most of all, his mastery is revealed in those photos taken during trips across Lithuania or trips as a tourist where there was no time for long preparation and planning and where he had to react quickly and resolutely. In such a situation only a real professional can remain himself—and with Sutkus, that means capturing something essential in a rapidly changing situation. His series about Bulgaria and her people is a good example of his skill.

During the last 10 years Sutkus has been an officer—he is now the President—of the Photography Art Society of Lithuania. He has had to deal continuously with problems connected with the whole of Lithuanian photographic life, and the greatness of the task has left him little time for his own creative work. Nevertheless, exhibitions by the President have taken place in several foreign countries, and he has been involved in producing several photography books. During recent years he has published and has now collected a great series of aero-photos, taken from a helicopter, of the rivers and lakes, forests and fields, villages and towns of Lithuania. These photos reveal that Sutkus, whatever his other responsibilities, continues with what has become his life's work—photographing Lithuania. Because of his accomplishments, Sutkus has been honored with the title of Merited Worker in Culture of the Lithuanian S.S.R.

—Peeter Tooming

SYKES, Homer.

Canadian. Born in Vancouver, 11 January 1949. Educated at Sidcot School, Somerset, England, 1960-68; studied at the London College of Printing, 1969-71. Married Juliet Watson in 1974; children: Theo and Jacob. Freelance photographer, London, since 1971. Address: 19 Kenilworth Avenue, London SW19, England.

Individual Exhibitions:

1977 *Traditional British Calendar Customs*, Arnolfini Gallery, Bristol (toured the U.K.)

Selected Group Exhibitions:

1970 *Personal Views 1850-1970*, British Council, London (toured Europe)
1972 *Young British Photographers*, Museum of Modern Art, Oxford
1976 *Rencontres Internationales de la Photographie*, Arles, France
1978 *Reportage Fotografen*, Museum des 20. Jahrhunderts, Vienna (travelled to Forum Stadtpark, Graz, Austria)

Collections:

Arts Council of Great Britain, London.

Publications:

By SYKES: books—*Facts about a Pop Group*, with text by Dave Gelly, London 1976; *Once a Year: Some Traditional Country Customs*, London 1977.

On SYKES: books—*Creative Camera International Yearbook*, edited by Colin Osman and Peter Turner, London 1975; *British Image 1*, London 1975; articles—"Homer Sykes" by Peter Turner in *Creative Camera* (London), December 1971; "Pictures of America" by David Litchfield in *The Image* (London), no. 3, 1972; "Photographs by Homer Sykes" by Peter Turner in *Creative Camera* (London), March 1974; "Homer Sykes: Special Occasions" in *London Magazine*, April 1977; "Une Fois l'An, Quelques Coutumes Britanniques" in *Zoom* (Paris), December 1977; "Our Violent Society" by George Hughes in *Amateur Photographer* (London), May 1978; "Homer Sykes: Law and Order" in *London Magazine*, August 1978; "Fotograficke Svedectvi Homera Sykese" in *Revue Fotografie* (Prague), no. 2, 1979.

I'm a working magazine/news photographer. I enjoy going places, meeting people, but above all watching them. It seems a good way to make a living.

—Homer Sykes

Homer Syke's best known and most widely regarded work is his series "Traditional British Calendar Customs." These are events and happenings that take place regularly each year in different parts of the country, some of them dating from pre-Christian times but most often revived or started by the Victorians. Sykes has been working on the series since 1972, and in 1977 he published *Once a Year: Some Traditional Country Customs*. Obviously, such events will change or even die out as time passes, and Sykes continues to explore them whenever possible, making special forays to remote villages and towns whenever he hears of a new find—a kind of photographic archaeology.

His photography is direct—in the documentary tradition. He shows what is there as well as the background to the event. His skill has enabled him

741

to gain many editorial assignments (they are his main area of work), and he has worked through the now defunct French agency Viva and has lately photographed for *GEO* and other European magazines.

Like many young photographers in Britain, Sykes has received his share of bursaries, has taken part in various collective exhibitions, has even had a one-man show, but he is now at that stage in his career when he must build on his reputation for good, well-considered work and his ability to respond to an assignment, deliver on time, with that extra dimension of originality in his work that yet remains within the bounds of the editor's intention. Sykes has risen very well to that challenge; he is very busy—no mean feat these days—and still finds time to take his own pictures and pursue the eccentric streak in the British character that so obviously intrigues him.

The original project was not only interesting but also great training. The events were not repeatable: whatever the weather or conditions, there was only one time and place where they could be found in any one year, and his ability to record them in even the most adverse circumstances has undoubtedly proved useful in his current work.

—Sue Davies

SZABO, Steve.

American. Born in Berwick, Pennsylvania, 17 July 1940. Studied at Pennsylvania State University, University Park, 1958-62; Art Center School of Design, Philadelpia, 1964-66. Served in the United States Army, 1963: Private. Staff Photographer, *Virgin Island Times* newspaper, U.S. Virgin Islands, 1963-64; and *The Washington Post* newspaper, Washington, D.C., 1966-71. Freelance photographer, Washington, D.C., since 1971. Instructor in photography, Corcoran School of Art, Washington, D.C., since 1979. Recipient: World Press Photography Award, The Hague, 1968; White House News Photographer Award, Washington, D.C., 1968, 1969, 1970, 1971. Agent: Kathleen Ewing Gallery, 3020 K Street N.W., Washington, D.C. 20007. Address: 3615 Ordway Street N.W., Washington, D.C. 20016, U.S.A.

Individual Exhibitions:

1973 Phillips Collection, Washington, D.C.
1976 Afterimage Gallery, Dallas
 University of Kansas, Lawrence
1977 Gallery of Photographic Art, North Olmsted, Ohio
 Springfield Art Museum, Missouri
 Fisher Gallery, Nantucket, Massachusetts
 Silver Fantasy Gallery, Camden, Maine
 Hunter Museum of Art, Chattanooga, Tennessee
 International Center of Photography, New York
 Fine Arts Museum of the South, Mobile, Alabama
 Academy of the Arts, Easton, Maryland
 Baltimore Museum of Art

1978 Focus Gallery, San Francisco
 Kathleen Ewing Gallery, Washington, D.C.
1979 Madison Art Center, Wisconsin
1980 *3 Washington Photographers*, Kathleen Ewing Gallery, Washington, D.C.
1981 Atelier Galerie, Aix-en-Provence, France
 Steve Szabo: Urban Landscapes, at *Rencontres Internationales de la Photographie*, Arles, France
 Contrasts Gallery, London (with Mark Power)

Selected Group Exhibitions:

1972 *Washington Photographers*, University of Maryland, College Park
1979 *The Contemporary Platinotype*, Rochester Institute of Technology, New York
 Auto as Icon, International Museum of Photography, George Eastman House, Rochester, New York
1980 *Non-Silver and Hand-Made Photographs*, Kathleen Ewing Gallery, Washington, D.C.
1981 *Portrait d'Arbes*, Centre Culturel de Boulogne, Paris, France

Collections:

Museum of Modern Art, New York; International Center of Photography, New York; International Museum of Photography, George Eastman House, Rochester, New York; Library of Congress, Washington, D.C.; Corcoran Gallery of Art, Washington, D.C.; Exchange National Bank, Chicago; Sheldon Memorial Art Gallery, University of

Homer Sykes: *The Electric-Diskon*, London, 1980

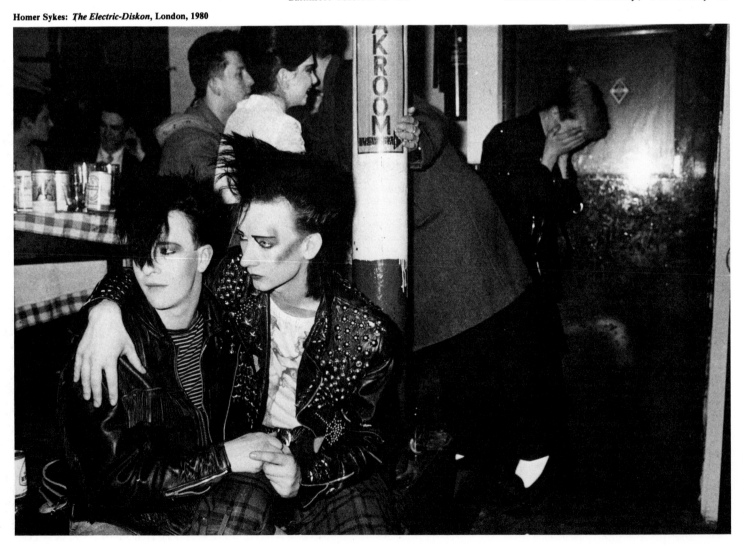

Nebraska, Lincoln; Fine Arts Museum of the South, Mobile, Alabama; High Museum, Atlanta, Georgia; Bibliothèque Nationale, Paris.

Publications:

By SZABO: books—*Where We Live: Photographs of Housing in America Today*, Washington, D.C. 1973; *The Eastern Shore*, Danbury, New Hampshire 1976; article—"Steve Szabo: An Interview" by Melissa Shook in *Photograph* (New York), April 1978.

On SZABO: book—*The Platinum Print* by John Hafey and Tom Shillea, with an introduction by Marianne Fulton Margolis, Rochester, New York 1979; articles—"Taking Pictures" by Tom Zito in *Washington Post* (Washington, D.C.), April 1973; "Dialogue...Document the Past" in *Camera* (Lucerne), May 1976; "Photo Giant and Ascendant" by H. Cullinan in *Plain Dealer* (Cleveland), August 1977; "Photography Books" by Andy Grundberg in *Art in America* (New York), November 1977; "The Eastern Shore" in *Photo Revue* (Paris), November 1978; "Three Washington Photographers" in *American Photographer* (New York), November 1980; "Art Portfolio" by C. Wittenberg in the *Washington Revue* (Washington, D.C.), July 1980.

Steve Szabo started his career as a newspaper photographer in the fast moving, electric Washington scene. Considering that background, his current photography is all the more remarkable. Szabo is the master of the romantic landscape. His photographs are quiet, contemplative, classically composed, and very reminiscent of the work of some late 19th century English and American landscape photographers.

The principal subject of Szabo's work is Maryland and especially the world of the watermen along Chesapeake Bay. Szabo does not photograph the people directly nor does he photograph any contemporary 20th century scenes. Instead, he captures old skipjack sailboats laying on the mudbanks and in salt marshes, empty houses hidden in among burgeoning foliage, abandoned cars settling back into the earth, and silent rocking chairs. Szabo's world is arcadian and pastoral.

The absence of people is deliberate. This region was once a land of small salt water farms and crab and oyster fishermen. The small farms were uneconomical, and the oyster beds gave out. The artifacts of this culture are returning to nature. They have the same fascination for Szabo that crumbling abbeys had for 18th and 19th century Englishmen. In Szabo's photos we always expect nymphs and shepherds to gambol from off camera across the scene. The works of man are dead but haunted with rich memories. Nature is alive and filled with a presence encroaching on the mouldering remnants of man's past.

Most of Szabo's current work is printed on platinum paper. Many contemporary photographers have experimented with platinum paper, but few have mastered it. Szabo is perhaps the best of all. The difficulties are formidable: since platinum paper is no longer commercially available, the photographer must make his own. Since the only practical way to use it is by contact printing, the photographer must use a large format camera. Szabo uses 4 x 5 and 8 x 10 view cameras. Since platinum paper requires a very contrasty negative, the photographer must expose and develop with platinum especially in mind.

Even more difficult for most photographers is using platinum paper in a way that justifies its nuisance and expense. Platinum paper has a very low range of brillancy but a very long and subtle range of tones. The blackest black is a deep brown. The whitest white is a pale gold. But within those limits it beautifully delineates the slightest variation in tone.

Szabo makes excellent use of this tonal richness, and the warm golden tone of the paper is especially suitable to his arcadian vision. The pale gold highlights evoke the warm hazy skies of Chesapeake Bay. The soft brown shadows arouse a remembrance of things past.

Steve Szabo is a regional photographer who has made a universal statement that transcends geography to depict a dream of a pastoral golden age common to all men.

—Mike Rowell

SZCZUKA, Mieczyslaw.

Polish. Born in Warsaw, 19 October 1898. Educated at Chrzanowski Gymnasium, Warsaw, 1910-15; studied at the Academy of Fine Arts, Warsaw, 1915-18. First photomontages, Warsaw, 1924; Founder/Editor, *Blok* constructivist magazine, Warsaw, 1924-26; Editor-in-Chief, *Dzwignia* monthly, in Warsaw, 1927. *Died* (in the Tatra Mountains) *13 August 1927*.

Individual Exhibitions:

1920 Polski Klub Artystyczny "Polonia," Warsaw
1921 Polski Klub Artystyczny "Polonia," Warsaw
1923 Galeria Zacheta, Warsaw
Szczuka/Zarnower, Galerie Der Sturm, Berlin

Selected Group Exhibitions:

1923 *Wystawa Nowej Sztuki*, Vilnius, Lithuania
1924 *Blok*, Laurin i Clement, Warsaw

Steve Szabo: *House and Pond* from *The Eastern Shore*, 1976

1926 *Pierwsza Miedzynarodowa Wystawa Nowej Architektury*, Galeria Zacheta, Warsaw
1927 *New Architecture Exhibition*, Moscow
1979 *Fotografia Polska 1839-1979*, International Center of Photography, New York (travelled to Museum of Contemporary Art, Chicago; Galeria Zacheta, Warsaw; Whitechapel Art Gallery, London; and Museum of Fine Arts, Lodz, Poland)
1981 *Photographie Polonaise 1900-1981*, Centre Georges Pompidou, Paris

Collections:

Museum of Fine Arts, Lodz, Poland.

Publications:

By SZCZUKA: books—*Ziemia na Lewo*, with text by Bruno Jasinski and Anatol Stern, Warsaw 1924; *Dymy nad Niastem*, with text by Wladyslaw Broniewski, Warsaw 1926; *Europa*, with text by Anatol Stern, Warsaw 1929; articles—"Fotomontaz" in *Blok* (Warsaw), no. 2, 1924; "Czego dice Blok" in *Reflektor* (Lublin), no. 2, 1925; "Co to jest Koustroktywizm" in *Blok* (Warsaw), no. 6/7, 1925; "Fotomontaz" in *Blok* (Warsaw), no. 9, 1925; "Pozgonne suprematyzmu" in *Dzwignia* (Warsaw), no. 2/3, 1927; "Sztuka i Rzeczywistosc" in *Dzwignia* (Warsaw), no. 5, 1927.

On SZCZUKA: book—*Mieczyslaw Szczuka*, with text by Anatol Stern and Mieczyslaw Berman, Warsaw 1965; articles—"Mieczyslaw Szczuka," series of articles edited by Teresa Zarnower in *Dzwignia* (Warsaw), no. 5, 1927; "Mieczyslaw Szczuka" by H. Walden in *Der Sturm* (Berlin), no. 1, 1928/29; "Europe" by Mieczyslaw Walis in *Robotnik* (Warsaw), January 1930; "Mieczyslaw Szczuka" by A. Stawar in *Szkice Literackie*, Warsaw 1957; "Geneza program Teoretycsny Grupy Blok 1924-26" by A. Turowski in *Historia Sztuki* (Warsaw), vol. 4, 1966.

The artist has begun to think. He has clearly realized the meaninglessness of his previous

social position. The artist is breaking away from the framework of present political systems, and yearns for a practical aim, the practical application of his work. He does not want to remain an empty ornament of society; he wants to participate in the organization of life.

—M. Szczuka

Mieczyslaw Szczuka, the co-founder of the periodical *Blok*, the most important avant-garde organ of the Polish constructivists, was the first Polish artist who seriously worked in photomontage. From childhood he lived in artistic circles, and at first found himself under the strong influence of expressive art and even mysticism. Later, he became interested in those aspects of the fine arts which contained expressionist elements, for example, Dadaism, with its contrasting, often literary associations, and Futurism, which he saw as representing the dynamics of contemporary life.

These elements of expressionism and futurism were the basis of his manifesto of photomontage:

Photomontage is poeto-art; photomontage evokes an image of interleaved events taking place in the world; photomontage is objectivism of form; cinema is a multitude of events taking place in time; photomontage is a simultaneous multiplicity of events; photomontage is the fusion of two and three dimensions; photomontage broadens the scope of possible techniques, enables the use of events which are inaccessible to the human eye and which can be recorded on a sensitive negative film; photomontage is the modern "epos."

His articulation of photomontage and his terms "poeto-art" and "modern epos" all indicate the literary or at least anecdotal character of Szczuka's first photomontages, such as "Ziema na Lewo" and "Karmel Pasza" (1924). However, his concept of a mutual interrelationship of many different phenomena happening at different places—the "simultaneous multiplicity of events"—is a direct analogy to futuristic Simultanism.

But in Szczuka's manifesto there is something more. He does not talk only about artistic problems. In the 1920's, poetry, art and literature were often considered inseparable. What linked the artists of Polish Constructivism, Futurism and the contemporary avant-garde was a fight for the freedom of artistic consciousness, in other words, the problem of liberated imagination. Szczuka wrote that "...art should not be the expression of an artist's individual

intentions but an *oeuvre* of mass effort," and he propagated such ideas as the "...inseparability of artistic and social problems." His views illustrated two fundamental truths of Constructivism: on the one hand, a belief in the social and utilitarian character of art, which was the result of the strong radical or even left-wing sympathies of many members of the avant-garde; on the other hand, an emphasis on the objective and mechanical character of art. "Constructivism," wrote Szczuka, "does not aim to create a style, but addresses the question of construction" and is "not a particular fragment of art but art as a whole...."

The ideas of Dadaism and Futurism, the Constructivist thesis, and, in particular, his belief in the necessity of replacing hand-made individual elements with objective mechanical ones (like film or photography) brought Szczuka to photomontage. His work, which remained mainly in the form of projects, illustrations for periodicals, and posters, emphasized his left-wing involvement and placed it on the fringe of political journalism. Its other characteristics were a poetic dynamism and the desire to achieve objective form.

In all his work, particularly the illustrations to Anatol Stern's poem *Europe*, Szczuka juxtaposed abstract, geometric forms with natural photographs, often with very simple lettering. The lines and colors provide a dramatic counterpart to the contrasting scenes.

The great merit of Szczuka's work is that it united the aesthetics of art and photography with his theories about the social role of art.

—Ryszard Bobrowski

Mieczyslaw Szczuka: *Smoke over the City*, 1926

SZÉKESSY, Karin.
German. Born in Essen, 17 April 1939. Educated at a school in Hertfordshire, England; studied, under Hans Schreiner, at the Institut für Photojournalismus, Munich. Married the painter Paul Wunderlich in 1972; children: Oliver, Natascha and Laura. Photojournalist, *Kristall* magazine, Hamburg, 1963-66; Instructor in Photography, Art Academy, Hamburg, 1967-70. Freelance photographer, Hamburg, since 1970: established studio, 1974. Member, Gesellschaft Deutsche Lichtbildner (GDL), 1970-77, and since 1979. Recipient: Special Price, *Triennale of Photography*, Fribourg, Switzerland, 1977; Kodak Prize, 1978, 1979. Agents: PPS Photo Gallery, 1 Feldstrasse, 2000 Hamburg 4; Witkin Gallery, 41 East 57th Street, New York, New York 10022; and Redfern Gallery, 20 Cork Street, London W1, England. Address: Haynstrasse 2, 2000 Hamburg 20, West Germany.

Individual Exhibitions:

Selected Group Exhibitions:

Collections:

Staedel Museum, Frankfurt; Stadtmuseum, Munich; Kunsthalle, Kiel, West Germany; Museum Folkwang, Essen; Bibliothèque Nationale, Paris; Musée des Beaux-Arts, Brussels; University of California at Berkeley.

Publications:

By SZÉKESSY: books—*Les Filles dans l'Atelier*, Paris 1969; *Correspondenzen/Transpositions*, with Paul Wunderlich, Stuttgart and Zurich 1976, London 1980; *Pariser Zeichen*, introduced by Max Bense and Marie Cardinal, Stuttgart 1977; *Best Nudes*, with Irèna Ionesco, Tokyo 1979.

On SZÉKESSY: books—*The Painter and the Photograph: From Delacroix to Warhol* by Van Deren Coke, Albuquerque, New Mexico 1964, 1972; *Karin Székessy*, exhibition catalogue, by Fritz Kempe, Hamburg 1975; *Women on Women*, introduced by Katharine Holabird, London 1978; *Deutsche Fotografie nach 1945/German Photography After 1945* by Floris Neusüss, Wolfgang Kemp and Petra Benteler, Kassel, West Germany 1979; article—"Karin Székessy" in *Zoom* (Paris), June 1981.

I leave it to others to speak or write. My small statement on my life—or, life in general—well, I try to do it with the lenses of my camera.
—Karin Székessy

A blonde from Essen who married Paul Wunderlich (the German artist whose visuals of fantasist contortions once brought him into trouble with the police, a brush with authority that failed to hinder his inclusion in the top ranks of his country's art hierarchy), Karin Székessy has discovered a way of coping with a family, acting as purveyor of inspirations that have sparked off some of her husband's finest works, besides gaining for herself a position amongst the world's foremost investigatory photographers.

Her purposeful and exploratory control of nude photography, either of a solitary figure, a couple, or a throng, has frequently helped the composition of Wunderlich's extraordinary paintings and, on more than one occasion, man and wife have combined, he to prompt her with the strangeness of his imagination, she to carry out with personal contributions her own considerable craft as photographer.

Double images, focus manoeuvrability, introduction of fantasist and surrealist elements, together with point-of-impact figuration and an understanding she shares with her husband of the shock-sensation of realist/figurative contortion, all reflect her powers as a camera artist.

The nude brunette, her arms languidly resting on the back of an easy chair, curves her haunches langourously towards camera, one leg extended over the chair's arm while, beside a massive Fernando Botero picture of a woman, a mysterious naked male stands tautly half hidden by the plump upholstery. This is nude photography beguiling for its composition and, because of its story-line, redolent with carnal quietus, magnetic and daunting.

But parallel with this eye-catching experimentation Székessy is also a straight verité-realist, capable of effecting the transition few can attain that transforms a "photo" into a meaningful and enduring "portrait" (creating records, psychologically sound, of such artists as Hans Bellmer, Richard Lindner, her husband Wunderlich of course, Hundertwasser, Jan Voss, Bernhardt Schültze, Jens Lausen and Johannes Grützke—pictures in which the subjects do not so much pose as comfortably fall into a personality attitude). She also has the Cartier-Bresson knack of replacing "reportage" with absolute moments of life—such as her "Woman with a Gold Tooth," "Lolitas 1964," "Alcohol" and "Morning at the Mainline Rail Terminus."

The vital and principal *rôle* that Karin Székessy has come to play in the development of modern photography lies in her rejuvenation of the "Lichtdruck," the Heliograph. In a determined effort to shrug off the familiar routines of photo-production, she made her way to a little workshop in Lübeck (which specialized in printing heliographic postcards) some two years after she had met her husband and he asked her if he could use one of her photographs as a "silent model." At Lübeck in 1967 she was able to do her printing only once—shortly before the workshop closed down—but the little studio taught her the heliograph techniques that have been the hallmark of so much of her work since then.

Of course the nudes (very successfully) invaded the sphere of what this half-forgotten but now-revived photographic system had to offer: one result, a collaboration with her husband, was the book *Correspondenzen* in 1976.

The special value of the heliographs is that in their final states (and they can end up in a series of different colour combinations), they have the finish of a "work of art" rather than that of a photograph. Even to the print connoisseur they possess the character of a mezzotint or a lithograph, or a mixture of both. (Photographer and printer work in close contact right the way through to production of the final state.)

Karin Székessy: *Feet*, 1975

However, it is in a recent venture, a haunting selection of heliographs of Paris for the volume *Pariser Zeichen*, which she calls "natures mortes," that Karin Székessy has one of her greatest triumphs. Direct pictures of a shuttered house in the rue Montbrun an SNCF metal safe, the red-and-white notice on a red garage door advising constant use and forbidding parking, a grotesque double-snake doorknocker, a *trompe-l'oeil* perspective of marble tiling in different shades of blue—these images are simultaneously touching and magnificent.

—Sheldon Williams

SZILASI, Gabor.

Canadian. Born in Budapest, Hungary, 3 February 1928; emigrated to Canada, 1957: naturalized, 1964. Educated at Evangélikus Gimnázium, Budapest, until 1944; studied medicine, University of Budapest, 1945-47; photography, School of Modern Photography, Montreal, 1959-61; Thomas More Institute, Montreal, 1967. Married Doreen Lindsay in 1962; daughter: Andrea. Worked at various jobs in Budapest, 1949-57; Cartographer, Ministère des Terres et Fôrets, Quebec, 1957-59; Photographer, Office du Film du Québec, Montreal, 1959-71. Instructor in Photography, Collège du Vieux Montréal, 1971-79. Professor of Photography, Concordia University, Montreal, since 1979. Recipient: Canada Council Grant, 1970, 1973, 1976-77; Fellowship, Ministère des Affaires Culturelles du Québec, Montreal, 1979. Address: 483 Grosvenor Avenue, Montreal, Quebec H3Y 2S5, Canada.

Individual Exhibitions:

1967 Loyola Bonsecours Centre, Montreal
1970 *Charlevoix*, Studio 23, Montreal (travelled to Baldwin Street Gallery, Toronto, and Institute of Design, Illinois Institute of Technology, Chicago, 1971; National Film Board of Canada, Ottawa, 1972; and Gallery of Photography, Vancouver, 1973)
1974 *La Beauce*, McCord Museum, Montreal
1977 *Images du Québec*, National Film Board of Canada, Ottawa
1978 Yajima/Galerie, Montreal
1980 Musée d'Art Contemporain, Montreal
The Photographers Gallery, Saskatoon, Saskatchewan
Toronto Photographers Co-op at Harbour-front Gallery
Images du Québec, Memorial University, St. John's, Newfoundland
1981 *Portraits/Interiors*, Art Gallery of Cobourg, Ontario
Maritime Photographic Workshops, Fredericton, New Brunswick

Selected Group Exhibitions:

1967 *Montréal Insolite*, Bibliothèque National du Québec, Montreal
1973 *Le Groupe d'Action Photographique*, Musée d'Art Contemporain, Montreal
1978 *Tusen och En Bild/1001 Pictures*, Moderna Museet, Stockholm
Rencontres Internationales de la Photographie, Arles, France
1979 *Canadian Perspectives*, Ryerson Polytechnical Institute, Toronto

Gabor Szilasi: *Mme. Louise Pedneault et Mlle. Laura Harvey*, Ile-aux-Coudres, Quebec, 1970

1980 *Aspects de la Photographie Québecoise Contemporaine*, Musée d'Art Contemporain, Montreal
Photographies en Couleur, Yajima/Galerie, Montreal
Environments, National Film Board of Canada, Ottawa
1981 *Points of View: Architectural Photographs*, Musée des Beaux-Arts, Montreal

Collections:

Mount Allison University, Sackville, New Brunswick; McCord Museum, Montreal; Musée d'Art Contemporain, Montreal; Musée des Beaux-Arts de Montreal; The Art Bank, Canada Council, Ottawa; Public Archives of Canada, Ottawa; National Film Board of Canada, Ottawa; National Gallery of Canada, Ottawa; Edmonton Art Gallery, Alberta.

Publications:

By SZILASI: article—"You Only Have to Look and See..." in *Foto-Canada* (Montreal), October/November 1967.

On SZILASI: articles—"Gabor Szilasi Photographs Charlevoix Country" by Geoffrey James in *Vie des Arts* (Montreal), no. 62, 1971; "Gabor Szilasi" in *Camera* (Lucerne), August 1973; "Gabor Szilasi: Portraits de Beauce" in *Ovo* (Montreal), May 1974; "Responding to Photographs: A Canadian Portfolio" in *Artscanada* (Toronto), December 1974; "Gabor Szilasi: Photographies Récentes" by Sandra Marchand in *Atelier* (Montreal), December 1979-March 1980; "L'Objectif Humain de Gabor Szilasi" in *Vie des Arts* (Montreal), no. 100, 1980; "Exhibitions: Gabor Szilasi" by Louise Abbott in *Artscanada* (Toronto), December 1980; "The Physiognomy of Building/Photography and Architecture" by Peter Wollheim in *Vanguard* (Vancouver), May 1981; "Petrobucks and Prairie Oysters" by Peter Wollheim in *Vanguard* (Vancouver), Summer 1981.

My three main interests in photography are people, interiors and architecture. The latter two are closely related to the first in that they are made by man to

serve as space in which to live and work. For me to find the subject interesting to photograph, there has to be some trace of men present.

When I came to Quebec in 1957, I used a 35mm camera exclusively, working in a journalistic tradition. In the late sixties, I started using a 4" by 5" view camera and for nearly ten years visited the people of rural Quebec, documenting their lives, the interiors and the architecture.

I was much influenced by Paul Strand's *Tir a' Mhurain*, a book of photographs with text on the outer Hebrides. His carefully composed, clear, simple images impressed me for their honesty and straightforwardness in depicting the land and its people. I regard colour in a photograph as interesting if it surprises me. I find that in most cases the abstraction of black and white conveys aspects of the subject that are far more important than colour. In interiors, however, the colour provides an additional set of information that is absent in black and white. It may indicate individual tastes, cultural traits or social position. Colour composition has no interest for me. When photographing an interior

with, for example, a great deal of orange in the lower left, if I were concerned with pictorial matters I would put, let's say, a complementary blue in the upper right. But I am not interested in formal colour composition. I respect the individual taste of someone who has spent a great deal of time arranging his or her room. I simply set up the camera and let the colours speak for themselves.

I feel that it is important for a photographer to maintain a freshness of vision through which other people may discover the world and gain awareness of the environment they live in.

—Gabor Szilasi

Gabor Szilasi is committed to making people aware of their environment. Relationships are his subject, either through portraits or through photographs of interiors—settings which, for Szilasi, mirror the soul. His vision is simple and straightforward. Curiosity has in his case become art.

"Portraits/Interiors" is Szilasi's major statement on the theme which preoccupies him. Begun in 1977, the series elaborately contrasts and juxtaposes black-and-white Roleiflex portraits of people who interest him with interiors shot in colour using a 4 x 5 view camera. The paired pictures complement each other—the portraits are flat; the interiors have great depth. The portraits require the viewer's concentration but reveal the psychological aspect of the subject. The furnished spaces add an unexpected dimension—not only the surface of the subject's life, but also their individual tastes, cultural traits, and social position.

For Szilasi, certain furnished rooms reveal the folk artist in Everyman. Over the last ten years, he has documented life in rural Quebec. In his work in this area, he has used the scale of his sitter in his composition to define the physical space of the room. Even in empty rooms, the human presence is evident. His most recent work—urban views of Montreal taken with an 8 x 20 camera—reveals the city as a setting for the individual, an outdoor echo of the subject he has always loved.

—Joan Murray

T

TABARD, Maurice.

French. Born in Lyons, 12 July 1897. Studied violin, Lyons, 1903-13; studied fabric design in father's silk manufacturing plant, Lyons, until 1918; studied photogrphy, under Emil Brunel, New York Institute of Photography, 1918; studied portraiture, under the painter Carlos Baca-Flor, in New York, 1927, in Paris, 1928. Worked as silk fabric designer, Lyons, 1914-18; delivery boy for Shoe Craft Company, New York 1918-20; Assistant Photographer, Bachrach Studio (New York), working in Baltimore, Cincinnati and Washington, D.C., 1922-28; freelance magazine, fashion, advertising and portrait photographer, working for *Jardin des Modes, Vu, Bifur, Art et Decoration, Arts et Metiers. Graphiques*, etc., Paris, 1928-38; organized photo studio for advertising, Deberny-Peignot publishers, Paris, 1930-31; darkroom man for Pathó Films, Paris, 1932; still photographer and motion picture photographer for Gaumont Films, Paris, 1936; filmed news-*cum*-propaganda films for the French Government, 1936; freelance photographer in south of France, 1939-45; Staff Photographer, *Harper's Bazaar*, under editor Carmel Snow, travelling to England and Scotland, 1946-48, in America, under Alexey Brodovitch, 1948-50; worked for Paul Linwood Gittings Studio, New York, 1948-49, 1968; freelance photographer, working for *Femina, Elle, Album du Figaro, Silhouette, Marie-Claire, Paris-Match*, etc., 1948-65 (returning to Paris, 1950); Instructor of Photography, Winona School for Professional Photographers, Indiana, 1950; gradually gave up photography and retired, living in Paris, 1965-80, in south of France, since 1980.

Individual Exhibitions:

1933 Galerie de la Pléiade, Paris
1948 Professional Photographers Association of America, Chicago
1976 Marlborough Gallery, New York
1977 Sander Gallery, Washington, D.C.
1978 Salon International de la Photographie, Porte Versailles, Paris
1979 Institut Français, Cologne
1981 Sander Gallery, Washington, D.C.

Selected Group Exhibitions:

1929 *Film und Foto*, Deutscher Werkbund, Stuttgart
1931 *Annual Exhibition of Photographs*, Galerie de la Pléiade, Paris (and annually until 1934)
1932 *Surrealisme*, Julien Levy Gallery, New York
Modern European Photography, Julien Levy Gallery, New York
1976 *Photographs from the Julien Levy Collection, Starting with Atget*, Art Institute of Chicago
1978 *Paris-Berlin 1900-1933*, Centre Georges Pompidou, Paris

1979 *Film und Foto der 20er Jahre*, Württembergische Kunstverein, Stuttgart (travelled to the Museum Folkwang, Essen; Werkbundarchiv, West Berlin; Kunsthaus, Zurich;

Maurice Tabard: *Advertisement for Lingerie,* **Paris, 1928** Courtesy Galerie Wilde, Cologne

Kunstverein, Hamburg; and Museum des 20. Jahrhunderts, Vienna)

La Photographie Française 1925-40, Galerie Zabriskie, Paris (travelled to the Zabriskie Gallery, New York)

Paris-Moscou 1900-1930, Centre Georges Pompidou, Paris

Photographic Surrealism, New Gallery of Contemporary Art, Cleveland (travelled to the Dayton Art Institute, Ohio, and the Brooklyn Museum, New York)

Collections:

Condé Nast Publications, Paris; Bibliothèque Nationale, Paris; Museum Folkwang, Essen; Fashion Institute of Technolgoy, New York; International Museum of Photography, George Eastman House, Rochester, New York; Art Institute of Chicago; St. Louis Art Institute, New Orleans Museum of Art; San Francisco Museum of Modern Art.

Publications:

By TABARD: article—"Notes on Solarization" in *Arts et Metiers Graphiques* (Paris), 1933.

On TABARD: books—*Photographs from the Julien Levy Collection, Starting with Atget*, exhibition catalogue, by David Travis, Chicago 1976; *Fotografie der 30er Jahre: Eine Anthologie* by Hans Jürgen Syberberg, Munich 1977; *Paris-Berlin 1900-1933*, exhibition catalogue, by H. Molderings, W. Spies, G. Metken and others, Paris 1978; *Paris-Moscou 1900-1930*, exhibition catalogue, by Romeo Martinez, A.N. Lavrentiev and others, Paris 1979; *Photographen der 20er Jahre* by Karl Steinorth, Munich 1979; *Film und Foto der 20er Jahre*, exhibition catalogue, by Ute Eskildsen and Jan Christopher Horak, Stuttgart 1979; *The History of Fashion Photography* by Nancy Hall-Duncan, New York and Paris 1979; *Photographic Surrealism*, exhibition catalogue, by Nancy Hall-Duncan, Cleveland 1979; articles—"Maurice Tabard" in *L'Art Vivant* (Paris), January 1930; "Focus Your Brain First: The Story of Maurice Tabard of Paris" by Paul Linwood Gittings in *PSA Journal* (New York), vol. 14, 1948; "Tabard" in *Modern Photography* (New York), January 1950; "Tabard" in *Photo* (Paris), June 1976; "Camera Eye" by Allan Porter and "The International Werkbund Exhibition Film und Foto Stuttgart 1929" by Karl Steinorth in *Camera* (Lucerne), October 1979.

A warm, friendly man with merry, sparkling eyes opened the iron door to a darkly situated room facing the street in a quiet and elegant residential district of the 16th quarter of Paris. We found ourselves in a makeshift workroom, not particularly comfortable—actually rather damp and repelling—which was, nevertheless, the latest refuge of the photographer Maurice Tabard. He appeared to be pleased that I was repaying his 1974 visit to me, and he was happy to be able to show me a portfolio of photographs spanning his long career in photography.

I had many questions about that highly celebrated "golden age" of the 1920's and 30's. At that time Tabard had been acquainted with almost all of his colleagues—those who in the meantime have taken their places in the history of photography and whose works have been extensively exhibited and published. (To date, Tabard has had no book published on or about his work. On the one hand he regrets this, but on the other excuses it on the basis of his restlessness and the new interests that he is constantly pursuing.) Tabard maintained close contact with very few of his colleagues; most of the time they met one another at exhibition openings at the Galerie de la Pléiade, Galerie de la Plume d'Or or the Galerie d'Art Contemporain, where almost eve-

ryone who worked for the important magazines of the era had several pictures. Everything that was exhibited and offered for sale in a gallery was signed by its creator—in Paris it would have been unthinkable to do otherwise. Yet very few photographs were sold: photography had not yet found recognition as an art form. To live in Paris then was expensive, as it is at any time, and one had to earn money somehow. Tabard worked for various advertising studios and magazines. Of particular interst to him were unique lines of automobiles, and he succeeded in producing impressive photographs by using exaggerated perspectives—that is, when he was given complete freedom to do as he wished.

Towards the end of the 20's Tabard experimented with double exposure: usually he used two negatives which he continued to slide around against one another until the arrangement of the individual parts confirmed his mental image of what the whole picture should be. He produced not only highly interesting portrait and life studies, but also pictures of objects which could be classified as within the realm of Surrealism. Tabard had a fine sense for nuance in his compositions, in the various superimposed layers. The attraction of these works lies particularly in the possibility of multiple meanings and symbolic relationships between persons and situations. Alienation of reality by means of printing various negatives one on top of the other to photomontage or to the photogram was only a small step. Even if some of his photographs produce the effect of montage because of their geometric abstraction, the few preserved photomontages are more expressive and more advanced in their symbolic functioning than similar works of the time. Indeed, Tabard succeeded in expanding the boundaries of the photographic medium through the diversity of his experimentation. He constantly astonished visitors to the numerous exhibitions of the time with his newest work.

Unfortunately, most of his work, including his entire negative archive, was lost during the war, and Tabard has hardly been given the place in the history of photography which he has earned. Until now, one has looked in vain for his name in the well-known works on the history of photography.

—Jürgen Wilde

TAHARA, Keiichi.
Japanese. Born in Kyoto, Japan, 21 August 1951. Educated at high school, Osaka, Japan, 1968-70; self-taught in photography, but influenced by his grandfather, the photographer Yoshitaro Miyagawa. Lighting designer and photographer, Red Buddha theatrical group, throughout Europe, 1971-72. Freelance photographer, Paris, since 1972. Recipient: Young Photographer Prize, *Rencontres Internationales de la Photographie*, Arles, France, 1977; Kodak Prize, France, 1978. Agents: UNAC, 112-1-1-20 Azabudai Minato-ku, Tokyo, Japan; Marcuse Pfeifer Gallery, 825 Madison Avenue, New York, New York 10022, U.S.A. Address: 21 avenue Alphand, 94160 St. Mandé, France.

Individual Exhibitions:

1975 *Environment*, Canon Photo Gallery, Amsterdam (travelled to Galleria Il Diaframma, Milan, and La Photogalerie, Paris, 1975; and Galleria Nadar, Pisa, Italy, 1976)

1978 *Window*, UNAC, Tokyo (travelled to Iida Gallery Annexe, Tokyo, and Bibliothèque Nationale, Paris, 1978; Galerie Pennings, Eindhoven, Netherlands, 1979; and Marcuse Pfeifer Gallery, New York, 1980)

Selected Group Exhibitions:

1974 *Sur la Ville*, Bibliothèque Nationale, Paris
Festival of Royan, France

1977 *Tendences Actuelles de la Photographie en France*, Musée d'Art Moderne de la Ville (ARC 2), Paris
The Naked Environment, Salzburg College, Austria (toured Italy)

1979 *Les 3 Lauréats du Prix Kodak*, Centre Kodak, Paris
Japanese Photography Today and Its Origin, Galleria d'Arte Moderna, Bologna (travelled to the Palazzo Reale, Milan; Palais des Beaux-Arts, Brussels, and the Institute of Contemporary Arts, London)

1980 *7 European Photographers*, University of Oklahoma, Norman
Transparency, Galerie Viviane Esders-Rudzinoff, Paris

1981 *Des Photographies dans le Paysage*, Galerie de France, Paris

Keiichi Tahara: Image from the series *La Fenêtre*, 1978

Collections:

Bibliothèque Nationale, Paris; Musée Réattu, Arles, France; Asahi Pentax Gallery, Tokyo; Nikon Salon, Tokyo; University of Oklahoma, Norman.

Publications:

By TAHARA: articles—"Windows" in *Clef* (Paris), no. 2, 1978; "Keiichi Tahara," with Jean-Claude Lemagny, in *Asahi Camera* (Tokyo), August 1978.

On TAHARA: articles—"Keiichi Tahara: Environment" in *Nouveau Photocinema* (Paris), no. 29, 1974; "Keiichi Tahara" by Roberto Salbitani in *Progresso Fotografico* (Milan), no. 82, 1975; "Keiichi Tahara" by Julia Scully in *Modern Photography* (New York), March 1976; "Keiichi Tahara: Environment" in *Creative Camera* (London), no. 152, 1977; "Discoveries: Keiichi Tahara" in *Time-Life Photography Year*, New York 1978; "Keiichi Tahara: Fenêtre" in *Zoom* (Paris), no. 53, 1978; "Keiichi Tahara: Window" by Seigo Matsuoka in *Camera Mainichi* (Tokyo), April and June 1978; "Keiichi Tahara: Environment" in *Yu* (Tokyo), no. 1002, 1978; "Keiichi Tahara: Window" by Naomi Yanagimoto in *Bijutsu Techo* (Tokyo), August 1978; "Keiichi Tahara" in *Pentax Photography* (Paris), March 1979; "Keiichi Tahara: Window" in *L'Album Photographie I*, Paris 1979; "K. Tahara: Windows" by Emès Manuel de Matos in *Alternes* (Paris), no. 1, 1980; "Keiichi Tahara" by Julia Scully in *Modern Photography* (New York), July 1980.

When I arrived in Europe, I noticed a great strength in the energy of light which I had never previously experienced. This archetypal image is, in fact, caused by the harsh and cavernous blackish blue sky, pierced by the light which illuminates buildings aligned like walls under this sky as well as by the charm of the very sharp contrast between light and shade. The violence of the light, particularly at sunset, was so keen that I had the illusion that the molecules of light possessed a formidable destructive power attacking all existing forms and colours and reducing the world to black and white.

Filip Tas: From the series *Heros Place*, 1976

Perhaps because my astonishment was so great and because I was continually conscious of it at the back of my mind, all landscapes in the light began gradually to transform themselves into a reality that one could call a "scene": buildings outlined in the erosion of light, the chiaroscuro seemed to exude from these walls.... The walls and the stone streets were absorbed with the energy of the light as if they obtained life from it—they themselves exhaled light, creating shadows, detaching themselves and developing a great and ponderous existence swarming with life.

How useful were the windows of my apartment to observe this meeting with the light! From dawn to sunset one could watch as much as one wanted to.

By watching continually, I realised a very interesting thing: that which I see is sometimes the air between me and the window, sometimes the powder glued to the windowpane, sometimes the window-frame, sometimes the landscape in the distance, sometimes the air between the window and the landscape, or even sometimes the light itself that dominates all these things. That said, my gaze moves all the time in search of what is called "distance," and the visual field grows or diminishes, even if one is not conscious of it. Momentarily, space and things present are no longer within the framework of the "object" and dissolve into thoughts and sensibilities evoked by the vision. Consequently, places particular to me, one can probably say to my existence, have very often become ambiguous....

For the past seven years, I have performed this daily action of looking through the window at landscapes, and I leave the window of my apartment with photographs in order to confirm the places that I could have.

—Keiichi Tahara

Keiichi Tahara, who is from Kyota, went to France in 1971 as director of lighting and imagery for the theatre company "Red Buddha" led by Tsutomu Yamashita. He remained in Paris to pursue photography, as in a relatively short time his work has been shown at the Bibliothèque Nationale and Musée d'Art Moderne in Paris as well as in Amsterdam, Pisa and Tokyo.

His series entitled "Mado/Fenêtre/Window," in two parts, has received wide critical acclaim. Tahara photographed images seen through the window of the attic where he has resided during his Paris years. He has captured the beauty of shadows and shades in a manner reminiscent of ink painting.

—Norihiko Matsumoto

TAS, Filip (Josef).
Belgian. Born in London, England, 11 March 1918. Educated at primary school in Mortsel, Antwerp, 1924-32; Academy of Fine Arts, Antwerp, 1935-39; studied chemistry at the School of Industry, Antwerp, 1939-46, Dip.Chim. 1946. Married in 1945 (divorced, 1965); children: Joris, Els, Hilde, and Bruno. Worked as a chemist for Gevaert Photo Products, Mortsel, 1937-44. Freelance photographer, Antwerp, since 1945. Founder-Member, G 58-Hessenhuis photography group, Antwerp, 1958. Film director for Flemish Television, Antwerp, since 1960. Photography Editor, *De Standaard* newspaper, Brussels, since 1965. Professor of Photography, National Higher Institute for Architecture and Town Planning (NHIBS), Antwerp, since 1968. Recipient: Gold Medal for Photography, San Sebastian, Spain, 1948; First Prize for Photography, Province of Antwerp, 1951, and Province of Limburg, Belgium, 1952; Gold Workshop Prize, Belgian Government, 1977. Agent: Galerij Paule Pia, Kammenstraat 57, 2000 Antwerp. Address: Kleine Beerstraat 42, 2000 Antwerp, Belgium.

Individual Exhibitions:

1957 Gallery Ulysses, Antwerp
1959 G 58-Hessenhuis, Antwerp
1960 Celbeton, Dendermonde, Belgium
Discotheque, Antwerp
Deutscher Bücherbund, Bonn
Galleria del Disegno, Milan
Gallery Het Venster, Rotterdam
1961 Hessenhuis, Antwerp
1962 Gallery Het Venster, Rotterdam
1968 Patati, Vlassenbroek, Belgium
1971 Celbeton, Dendermonde, Belgium
1975 *Dreams*, Galerij Paule Pia, Antwerp
1976 *Bad Weather*, Arenberg, Antwerp
Heros Place, at the *Biennale*, Venice
1979 *Statues of Brussels*, Palais des Beaux-Arts, Brussels

Selected Group Exhibitions:

1958 *Group G 58*, Middelheim, Antwerp
1959 *Foto '59*, G 58-Hessenhuis, Antwerp
1960 *7 Artisti del G 58*, Galleria Bruno Danese, Milan
Group G 58, Hessenhuis, Antwerp
1963 *Zeigt Europäische Avantgarde*, Galerie d, Frankfurt
1976 *Funfzehn Photographen aus Flandern*, Künstlerhaus, Vienna (travelled to the Palais des Beaux-Arts, Brussels)
1977 *Photography in Flandern*, Centrum voor Kunst en Kultuur, Ghent
1980 *Photography in Belgium 1940-1980*, Het Sterckshof Museum, Deurne-Antwerp

Collections:

Het Sterckshof Museum, Deurne-Antwerp; Museum

of Photography, Brussels; Ministry of Culture, Brussels; Museum of Fine Arts, Bruges; Provincial Museum, Limburg, Belgium.

Publications:

By TAS: books—*Antwerp: City on the River*, Tielt, Belgium 1965; *De Keygnaert: A Residence in the Polder*, Tielt, Belgium 1975; *The Catholic University of Louvain-Kortrijk*, Tielt, Belgium 1975; *South America: People and Tribes*, Amsterdam 1977; *Filip Tas: Portfolio*, Antwerp 1980; articles—"Haiti" in *Avenue* (Amsterdam), November 1972; "Bolivia" in *Libelle-Rosita* (Antwerp), October 1973; "Bolivia" in *Avenue* (Amsterdam), December 1974; "Bolivia" in *Avenue* (Amsterdam), February 1976; "Mexico" in *Avenue* (Amsterdam), January 1977.

On TAS: articles—"The Photography of Filip Tas" by Eduard Braun in *Flemish Pockets*, Hasselt, Belgium 1964; "Photographs by Tas" by Karel van Deuren in *Fototribune* (Antwerp), no. 2, 1965; "Tas and Statues of Brussels" by Xavier Rombouts in *Foto* (Amersfoort, Netherlands), March 1980; "Portfolio—Tas" by Karel van Deuren in *Foto* (Amersfoort, Netherlands), April 1980; "Filip J. Tas" in *Foto-Magazine* (Brussels), April 1980; "Tas: Un Promeneur Visionaire" by Guy Vaes in *Special* (Brussels), September 1980.

A few short contemplations on photography as a means towards the liberation of mankind:

In the evolution of human emancipation photography has a very important role to play. Above all that which separates races and nations it has become a universal language understandable to every human being.

Photography takes a very important part in our era of images and visualization, which have—as everyone knows—a strong unifying influence on mankind. Prejudices, ignorance and fixed ideas are gradually cleared away through information (provided it is not abused, used to achieve contrary goals).

More, important, however, is the liberating effect that photography can have on individuals: particularly those who, through lack of certain skills (in sketching, painting, etc.), feel their creative urges limited or even thwarted in other media—for them, photography permits a form of visual artistic expression. In this way, the so-called "non-artistic" contribute to the cultural development of mankind.

—Filip Tas

Filip Tas is one of the most noteworthy figures of contemporary photography. He has produced an extensive, varied and prestigious body of work over the past 35 years.

Tas sees photography as a discipline that belongs to the plastic arts, a point of view that is certainly discernible from his work. In the 1950's his first exhibition was devoted entirely to geometric/abstract photographic prints that were made directly under the enlarger as monotypes without camera. Since then his purely artistic work has evolved under the influence, on the one hand, of the subjective photography of Otto Steinert (more through Steinert's ideas and concepts than through his actual work) and, on the other hand, the photo-montage of the Bauhaus. These influences are especially apparent in those of his works that seem like quick sketches of a personal response.

Tas is a photographer of incomparable technical prowess, which he employs to formulate his wonder at the bizarre world in which we live. His work has the deepest roots in reality, yet it is also a photography of poetic, impressionist reportage, endowed with a touch of the surrealist—as, for example, in his montage series *Heros Places*. His work is the reflection of an attitude of constant surprise at what he

sees around him, a continual exploration of the instrument of the photograph, with which, in his work, the organic is fused with art.

—Karel van Deuren

TESKE, Edmund.

American. Born in Chicago, Illinois, 7 March 1911. Educated in Chicago public schools, 1916-28; self-taught in photography. Photographer since 1928: also worked in the family business, Chicago, 1928-33, and as a designer, actor, make-up artist, and photographer, Theatre Department, Hull House, Chicago, 1933-34; Assistant Photographer, A. George Muller's Photography Inc., commercial photo studios, Chicago, 1934-36; established photo workshop, as an honorary Taliesin Fellow, Frank Lloyd Wright's Taliesin, Spring Green, Wisconsin, 1936-37; Instructor, New Bauhaus Institute of Design, under László Moholy-Nagy, Chicago, 1937-38; assistant, Katharine Kuh Gallery, Chicago, 1937-38; Instructor, Federal Arts Project, Chicago, 1939-40; assistant to the photographer Berenice Abbott, New York, 1940-41; worked for the United States Engineers, at Rock Island Arsenal, Illinois, 1941-43; settled in Los Angeles, 1943; worked in the photographic department, Paramount Pictures, Hollywood, 1944; assistant to Aline Barnsdall, Los Angeles, 1945-46; actor in the film *Lust for Life*, 1956; Instructor, Chouinard Art Institute, Los Angeles, 1962-64; Visiting Professor, under Robert Heinecken, University of California at Los Angeles, 1965-70; Visiting Instructor, Immaculate Heart College, Los Angeles, 1974; Visiting Professor, California State University at Los Angeles, 1979. Recipient: Certificate of Recognition, Photographic Society of America, 1969. Address: 1652 North Harvard Boulevard, Los Angeles, California 90027, U.S.A.

Individual Exhibitions:

1950 Third Street Gallery, Los Angeles
1954 Cafe Galeria, Laurel Canyon, Los Angeles
1961 Pasadena Art Museum, California
 Santa Barbara Museum of Art, California
1963 San Francisco Museum of Art
 Ceejee Gallery, Los Angeles
1965 Palos Verdes Community Association, California
1968 Camera Work Gallery, Costa Mesa, California
 3 Photographers, San Fernando State College, California (with Wynn Bullock and Frederick Sommer)
1970 Art Institute of Chicago
 Sheldon Memorial Art Gallery, University of Nebraska, Lincoln
1971 International Museum of Photography, George Eastman House, Rochester, New York
 Witkin Gallery, New York
 Mammoth Gallery, Mammoth Lake, California
1972 Ohio Silver Gallery, Los Angeles
1973 *3 Photographers*, University of Colorado, Boulder (with Wynn Bullock and Aaron Siskind)
 University of Southern California, Los Angeles
1974 Focus Gallery, San Francisco
 Light Impressions Gallery, Manhattan

 Beach, California
 Shado' Gallery, Oregon City, Oregon
 Municipal Art Gallery, Barnsdall Park, Los Angeles
1975 Friends of Photography, Carmel, California
 Revision Gallery, Santa Monica, California
1976 Susan Spiritus Gallery, Newport Beach, California
1977 Visual Studies Workshop, Rochester, New York

Selected Group Exhibitions:

1963 *6 Photographers*, University of Illinois, Urbana
1960 *Sense of Abstraction*, Museum of Modern Art, New York
1962 *Contemporary Photographs*, University of California at Los Angeles
1964 *Purchase Award Photos from Krannert*, University of Illinois, Urbana (toured the United States)
1970 *Continuum*, Downey Museum of Art, Los Angeles
1973 *Light and Substance*, University of New Mexico, Albuquerque
1974 *Through One's Eyes*, Muckenthaler Cultural Center, Fullerton, California
 Photography 1974, Los Angeles County Museum of Art
1979 *A Survey of the Nude in Photography*, Witkin Gallery, New York
 10 Year Salute 1969-1979, Witkin Gallery, New York

Collections:

Museum of Modern Art, New York; International Museum of Photography, George Eastman House, Rochester, New York; Art Institute of Chicago; Krannert Art Museum, University of Illinois, Urbana; New Orleans Museum of Art; University of Nebraska, Lincoln; Center for Creative Photography, University of Arizona, Tucson; University of New Mexico, Albuquerque; San Francisco Museum of Art, Norton Simon Museum of Art, Pasadena, California.

Publications:

By TESKE: book—*Untitled 22: Images from Within—The Photographs of Edmund Teske*, with an introduction by Aron Goldberg, Carmel, California 1980.

On TESKE: books—*Edmund Teske*, exhibition catalogue, with text by Gerald Nordlund, Los Angeles 1974; *Photographs: Sheldon Memorial Art Gallery Collection, University of Nebraska*, with an introduction by Norman A. Geske, Lincoln, Nebraska 1977; articles—"Neglected Photographer" by Gerald Nordland in the *Los Angeles Mirror*, 21 August 1961; "Teske—Realist of Reverie" by Rosalind G. Wholden in the *Beverly Hills Times* (Los Angeles), 18 January 1963; "Edmund Teske" by Rosalind G. Wholden in *Artforum* (New York), February 1964; "The Work of Edmund Teske" by Aron Goldberg in the *Los Angeles Free Press*, 2 September 1966; "Little Seen, Less Said" by A.D. Coleman in the *Village Voice* (New York), 1 April 1971; "Edmund Teske" by Leland Rice in *Artweek* (Oakland, California), 27 October 1973; "Edmund Teske" by Lois R. Fishman in *Artweek* (Oakland, California), 27 April 1974.

Photography!
Summation of the life experience
Exquisite focal point of all being
Aromatic distillation
Inmost

Edmund Teske: *Davenport, Iowa: Composite with Shirley Berman and Male Nude,* Los Angeles, 1977

And ultimate
Light.

From out of Darkness
Ascending, once again,
God alone.

Photography?
Realization,
Identity,
My religion of
Organic infoldment.

Spaciously
In the lap of
Mother alone
Full blown as a rose
Organic unfoldment.

—Edmund Teske

Suffused with a lyric mysticism, the photography of Edmund Teske is directed toward a spiritual investigation of the photographer's own psyche.

Dream, memory, sexuality and nature are among the primary components of Teske's introspective vision. Concerned as much with the printmaker's craft as with camera vision, Teske makes virtuosic use of photomontage, solarization and split-toning (or, in his term, "duo-toning") to create one-of-a-kind prints whose unique subtleties render them iconic. Within the context of Teske's work as a whole, they take on the role of religious objects, embodying the emotional and psychological nuances of the photographer's relationships to other people, to himself and his past, and to the natural and spiritual worlds.

These images are then organized into extended sequences and suites which are the photographer's preferred means of presentation. This makes possible the reiteration of central motifs, the presentation of variations on themes, and even the recurrence of specific image components—since, like many photographers who work with photomontage, Teske utilizes a file of negatives from which his final images are built, and a particular key negative may be printed into numerous different image structures.

Such reiteration gives a cyclical, time-suspended ambience to Teske's oeuvre, and creates a coherence and continuity within it. Thus images from diverse areas and periods of Teske's life co-exist, combine and recombine in an ongoing exploration of personal experience.

The homoerotic has been a central issue in Teske's life and work, and his courageous insistence on manifesting it in his imagery dates back at least to the 1950s. Since at that time this aspect of self and sexuality was considered unacceptable, the professional repercussions of Teske's "coming out" were considerable, and its impact on his career severe. Now that this taboo has been lifted somewhat, Teske can be seen as a pioneer in that regard, to whom such photographers as Duane Michals, Arthur Tress and Robert Mapplethorpe are indebted directly.

Teske's willingness to address the intimate issues of autobiography in a frankly romantic and emotional fashion, and his embrace of photographic techniques (such as solarization) which the medium's dominant historians—Beaumont Newhall among them—have labelled "aberrations," have been inspirational to a younger generation of photographers seeking to claim as their birthright the full scope of the medium's possibilities. Through his role as a teacher, Teske has since the 1960's promulgated an approach to photography which encourages an openness to chance, experimentation, and the resonance of personal history. His advocacy of this position has been as influential as his imagery has been exemplary of its potential.

—A.D. Coleman

TICE, George A(ndrew).

American. Born in Newark, New Jersey, 13 October 1938. Studied commercial photography at Newark Vocational and Technical High School, 1955. Served as a photographer's mate in the United States Navy, in Memphis, Tennessee, and on the *U.S.S. Wasp*, 1956-59. Married Joanna Blaylock in 1958 (divorced, 1960); Marie Tremmel in 1960 (divorced, 1976); children: Christopher, Loretta, Lisa, Lynn and Jennifer. Worked as a home portrait photographer, Americana Portraits Inc., West Orange, New Jersey, 1960-69. Freelance photographer, since 1969. Instructor in Photography, New School for Social Research, New York, since 1970. Recipient: Grand Prix, *Festival d'Arles*, 1973; National Endowment for the Arts Photography Fellowship, 1973; Guggenheim Fellowship, 1973. Agent: Witkin Gallery, 41 East 57th Street, New York, New York 10022. Address: 323 Gill Lane, No. 9B, Iselin, New Jersey 08830, U.S.A.

Individual Exhibitions:

1965 Underground Gallery, New York
1966 Gallery 216, New York
1970 *The Amish Portfolio*, E. Weyhe Gallery, New York
 831 Gallery, Birmingham, Michigan
 Fields of Peace, Witkin Gallery, New York
1971 *Paterson*, New Jersey Historical Museum, Newark
1972 *Paterson, New Jersey*, Metropolitan Museum of Art, New York
1973 *Seacoast Maine*, Witkin Gallery, New York
 The Photography Place, Berwyn, Pennsylvania
1974 Silver Image Gallery, Tacoma, Washington
 Festival d'Arles, France
1975 Rutgers University, New Brunswick, New Jersey
 Witkin Gallery, New York
1976 New Jersey State Museum, Trenton
 Afterimage Gallery, Dallas
 Susan Spiritus Gallery, Newport Beach, California
 Pedro Meyer and George Tice, Enjay Gallery, Boston

1977 Milwaukee Center for Photography
 Werkstatt für Photographie der VHS Kreuzberg, Berlin
 Artie Van Blarcum, Witkin Gallery, New York
1978 Cronin Gallery, Houston
 Atlanta Gallery of Photography
 Columbia Gallery, Missouri
1979 *Liberty Park*, Museum of Modern Art, New York
 Maitland Art Center, Florida
 North Carolina State University, Raleigh
 Jeb Gallery, Providence, Rhode Island
 The Photography Place, Philadelphia
1980 Robeson Center Gallery, Newark, New Jersey
 Metropolitan Museum, Miami Beach
 Gallery Exposures, Coral Gables, Florida
1981 Hills Gallery, Denver, Colorado
 The Photographs of George Tice 1953-1981, Witkin Gallery, New York
1982 Images Gallery, Cincinnati, Ohio

Selected Group Exhibitions:

1971 *Obsolete Processes/Contemporary Practitioners*, Art Institute of Chicago
1973 *Landscape/Cityscape*, Metropolitan Museum of Art, New York
1974 *Photography in America*, Whitney Museum, New York
1976 *Aspects of American Photography*, University of Missouri at St. Louis
1977 *Concerning Photography*, The Photographers' Gallery, London (travelled to the Spectro Workshop, Newcastle upon Tyne)
1978 *Mirrors and Windows: American Photography since 1960*, Museum of Modern Art, New York (toured the United States, 1978-80)
1979 *Photographs*, National Arts Club, New York
1980 *1st International Photographic Arts Exhibition*, at *Salford '80*, England
 Platinum, Musuem of Fine Arts, Springfield, Massachusetts

George A. Tice: *Charlie and Violet on Their Houseboat*, Jersey City, 1979

6 Photographers, Newark Musuem, New Jersey

Collections:

Metropolitan Museum of Art, New York; Museum of Modern Art, New York; New Jersey State Museum, Trenton; Library of Congress, Washington, D.C.; Art Institute of Chicago; Minneapolis Institute of Arts; University of Kansas, Lawrence; Amon Carter Museum Fort Worth, Texas; Victoria and Albert Museum, London; Bibliothèque Nationale, Paris.

Publications:

By TICE: books—*Fields of Peace: A Pennsylvania German Album*, with text by Millen Brand, New York 1970; *Goodbye, River, Goodbye*, with poems by George Mendoza, New York 1971; *Paterson*, New Brunswick, New Jersey 1972; *Seacoast Maine: People and Places*, with text by Martin Dibner, New York 1973; *George A. Tice: Photographs 1953-73*, with an introduction by Lee Witkin, New Brunswick, New Jersey 1975 (includes bibliography); *Urban Landscapes: A New Jersey Portrait*, New Brunswick, New Jersey 1975; *Artie Van Blarcum: An Extended Portrait*, Danbury, New Hampshire 1977; articles—"The Lost Art of Platinum" in *Album* (London), no. 11, 1970; "George Tice," interview, with J. Novak, in *Camera 35* (New York), February 1978; interview in *Photography Between Covers* by Thomas Dugan, Rochester, New York 1979; "Conversation with George Tice," with W. Abranowicz, in *Photography Forum* (Santa Barbara, California), May/June 1980.

On TICE: books—*The Print* by Time-Life editors, New York 1970; *Photography Year 1973* by Time-Life editors, New York 1972; *Photography in America*, edited by Robert Doty, with an introduction by Minor White, New York and London 1974; *Darkroom* by Eleanore Lewis, Rochester, New York 1977; *Concerning Photography*, exhibition catalogue, by Sue Davies and others, London 1977; *Mirrors and Windows: American Photography since 1960*, exhibition catalogue, by John Szarkowski, New York 1978; *The Darkroom Handbook* by Curtin, DeMaio and London, Marblehead, Massachusetts 1979; *The Photograph Collector's Guide* by Lee D. Witkin and Barbara London, Boston 1979; *A Ten Year Salute*, edited by Lee D. Witkin, Danbury, New Hampshire 1979; *The Platinum Print* by J. Hafey and T. Shillea, Rochester, New York 1980; articles—"Fields of Peace" by P. Killer in *Du* (Zurich), December 1971; "Book Review: Paterson" by S. Schwartz in *Art International* (Lugano), November 1972; "George Tice: Craft and Vision" by Julia Scully in *Modern Photography* (New York), February 1975; "Book Review: Urban Landscapes" by Peggy Sealfon in *Camera 35* (New York), November 1976; "Recent Books—Urban Landscapes" by Gerry Badger in *British Journal of Photography* (London), 25 March 1977; "The Native Eye" by N. Sullivan in *New Jersey Monthly* (Princeton), January 1980; "Magic and the Fine Print" by R. Hilliard in *Darkroom/Photography* (San Francisco), July/August 1980.

Photography is whatever you want it to be.
—George A. Tice

Any consideration of George A. Tice's photographs must include the word "unusual"—with the caution not to use the word too often. His formal education ended abruptly in vocational high school which had fostered his interest in photography, begun at the age of 14 in a local camera club. A short time as darkroom assistant for a commercial photographer was followed by enlistment at 17 years of age in the United States Navy as Photographer's Mate. When Tice returned home to New Jersey, he joined the Vailsburg Camera Club in Newark and became active in competitions and judgings that helped develop his aesthetic attitudes. For several years following, he made his livelihood as a photographer of infants in New Jersey and California. However, during the time Tice was in the Navy he had photographed an explosion aboard the *U.S.S. Wasp*; in 1959 this photograph came to the attention of Edward Steichen, then director of the photography department at the Museum of Modern Art in New York, who acquired a print for the museum's collection. This event marked the first national recognition for Tice's work and the beginning of his relationship with Steichen, for whom he became protégé and printmaker. Tice's determination for personal growth is high-lighted in his self-assignment to perform the major experiments and discoveries in the history of photography. His many and diverse experiences, beginning early in life, have served to broaden his vision, provide a continuum for building technical competencies and shape professional opportunities. Lee Witkin, a long-time friend who represents Tice in New York, refers to him as having taught himself everything, gaining a firm place in his art which contains spare romanticism in seeking perfection and beauty.

Tice's essential interest in places is illustrated in his study of Paterson (N.J.), which was published in a book with the same name. Using an 8" x 10" format camera, he recorded parts of this city in his straight-forward manner, providing icons of the urban condition of many cities. Without nostalgia for Paterson's more fortunate historic past, he did not overlook its spectacular falls (the Passaic River), trees and bluffs. Almost as a footnote, he photographed, with a hand-held 35mm camera, local people on downtown streets. This book is another of Tice's self-assignments and illustrates his complete dedication to a project, sensitiveness to a subject and thoroughness of effort; a commercial assignment of this type might have been completed in one week or so. His vision grew as he developed insights about the city as it was revisited and photographed over several years.

A review of Tice's work to date reveals that most subjects have been places, rather than people. However, his "places" emit emotional content that includes feelings of human presence—that someone may have just left or is about to appear. There is also a sense of intrigue suggested by the tonal ranges (often low key) and the placement of light in the negative and/or induced in the darkroom. Color is not essential in Tice's photographs, partly because of the choice of subject matter—but more important is the aura which takes its place. He does not use color materials because of their general impermanence; he believes that black-and-white photography is immortality.

Characteristic of artists and typical of Tice's work is that, with time, it becomes more difficult to generalize about him. This condition results from new interests which produce change and inconsistencies in the choice of subject matter and how it is interpreted. His photographs in *Fields of Peace* are revealing and straight reporting of both the Pennsylvania German people and their farmlands. Another departure from "places" is Tice's photo-essay *Artie Van Blarcum*, which has the subtitle, "An Extended Portrait." And that it is: a selection of photographs about one person by the photographer, who is again on self-assignment, over a long period of time. Here the emphasis is upon one subject: a person. That person was the focus of Tice's attention, and, as with *Paterson*, time let him reflect and review what he had done and needed to do in presenting his subject while still in the process of doing it. With Tice's informal photographs of a factory worker, Artie, and written comments, intimacy and identification merge to reveal "....there's a little bit of Artie in all of us."

George A. Tice's mastery of photographic techniques can be accounted for by his interest and diligence in the study of equipment, materials and processes plus the practice of what he has learned. The unusual range of subjects he selects for painstaking portrayal naturally follows his inclination, in his mid-forties, not to develop a personal style: an artist can have many visions.

—Robert W. Cooke

TOMATSU, Shomei.

Japanese. Born in Nagoya-shi, 15 January 1930. Educated at Science and Engineering High School, Nagoya, 1942-46; studied economics at Aichi University, 1954; self-taught in photography. Married Matsuko Inoue in 1960 (divorced, 1975); son: Izumi. Photographer since 1951. Founder, with Eikoh Hosoe and others, Vivo group of photographers, Tokyo, 1959. Director, Japan Professional Photographers Society, since 1959. Professor, Tokyo University of Art and Design, since 1966. Recipient: Most Promising Photographer Award, Japan Photo Critics Association, 1958; Photographer of the Year Award, Japan Photo Critics Association, 1961; Photographic Society of Japan Award, 1975; *Mainichi* Art Award, 1976; Art Encouragement Award, Ministry of Education, 1976. Address: Yoyogi Grand Cop. 703 4-22-7 Yoyogi, Shibuya-ku, Tokyo, Japan.

Individual Exhibitions:

1959 *The Japanese*, Fuji Photo Salon, Tokyo
1962 *11:02 Nagasaki*, Fuji Photo Salon, Tokyo
1964 *Kingdom of Mud*, Fuji Photo Salon, Tokyo
1981 *The World of Shomei Tomatsu*, Special Gallery, Yatsusiro, Japan (toured Japan, 1981-84)

Selected Group Exhibitions:

1957 *The Eyes of 10 People*, Konishiroku Photo Gallery, Tokyo
1960 *Modern Photography*, National Museum of Modern Art, Tokyo (and 1963)
1968 *Triennale*, Milan
1974 *New Japanese Photography*, Museum of Modern Art, New York (toured the United States)
1975 *Modern Photography of Japan*, Seibu Art Museum, Tokyo
1977 *Neue Fotografie aus Japan*, Kulturhaus, Graz, Austria (travelled to the Museum des 20. Jahrhunderts, Vienna)
1978 *Vivo*, Santa Barbara Museum of Art, California
 Reportage Fotografen, Forum Stadtpark, Graz, Austria
1979 *Japan: A Self-Portrait*, International Center of Photography, New York (travelled to *Venezia '79*)

Collections:

Museum of Modern Art, New York

Publications:

By TOMATSU: books—*11:02 Nagasaki*, with text

by Motoi Tamaki, Tokyo 1966; *Nihon*, with Taroh Yamamoto and Takahiko Okada, Tokyo 1967; *Salaam Aleikoum*, Tokyo 1968; *Okinawa, Okinawa, Okinawa*, Tokyo 1969; *Oh! Shinjuku*, Tokyo 1969; *The Asahi Camera Class of Photography*, with others, Tokyo 1970; *A History of Japanese Photography*, editor, with others, Tokyo 1971; *Après-Guerre*, with text by Akiyuki Nosaka, Tokyo 1971; *Modern Art: The Expanding World of Design*, with others, Tokyo 1972; *I Am a King*, Tokyo 1972; *The Pencil of the Sun: Okinawa and South-East Asia*, Tokyo 1975; *Akemodoro No Hana*, Tokyo 1976; *Kingdom of Mud*, with text by Koh-ichi Tanigawa, Tokyo 1978; *A Brilliant Wind*, with text by Kineo Kuwabara, Kenichi Tanigawa and others, Tokyo 1979; articles—"Ideas of an Image Explorer" in *Photo Contest* (Tokyo), February 1965; "In Search of Punctual Coordinates 'P'" in *Camera Mainichi* (Tokyo), December 1966; "Can Imagery Be on Its Own?" in *Asahi Camera* (Tokyo), April 1967; "Mother Nature of Japan" in *Camera Mainichi* (Tokyo), July 1967; "A Stake on 'Seeing' " in *Yomiuri* (Tokyo), 24 April 1969; "Kitch" in *Shashin Eizo* (Tokyo), Spring 1972; "A Photographic Ego Identity" in *Camera Mainichi* (Tokyo), Autumn 1973; "An Interview: Kishin Shinoyama Speaks Up" in *Asahi Camera* (Tokyo), June 1975; "Primer on Photography" in *Riyubou* (Tokyo), April 1977; "Keep Taking Pictures" in *Chunichi* (Tokyo), 6 April 1979; "Okinawa Diary" in *Nihon Camera* (Tokyo), Summer 1979; "The Photographer as Story Teller" in *Asahi Camera* (Tokyo), March 1980.

On TOMATSU: books—*Imagery and Languages* by Kougin Kondoh, Tokyo 1965; *The Photographer's Quest in a Shutter Chance* by Shinichi Tsuda, Tokyo 1968; *Dual Notions: Photographers at Work* by Hiroshi Osada, Tokyo 1969; *Demolition and Eruption* by Nagisa Ohshima, Tokyo 1970; *A Study of the Best Modern Photographs* by Nobuya Yoshimura, Tokyo 1970; *Act and Art* by Taeko Tomioka, Tokyo 1970; *100 Photographers: Profiles and Photographs* by Daido Moriyama, Tokyo 1973; *Camera Eye* by Kohen Sigemori, Tokyo 1974; *Modern Photographs and Photographers* by Tsutomu Watanabe, Tokyo 1975; *Photographic Age* by Taeko Tomioka, Tokyo 1980; articles—"Shomei Tomatsu" by Koubou Abe in *New Current of Art* (Tokyo), June 1960; "Shomei Tomatsu" by Tatsuo Fukushima in *Notebook of Art* (Tokyo), February 1961; "An Essay on Shomei Tomatsu" by Gohzoh Yoshimasu in *Camera Mainichi* (Tokyo), March 1963; "On Shomei Tomatsu" by Kohgi Taki in *The Camera Age* (Tokyo), July 1966; "New Trends in Documentary" by Toshio Matsumoto and others in *The Camera Age* (Tokyo), October 1966; "Image: Its Prime Point" by Kougi Taki in *Design Critique* (Tokyo), February 1967; "On Shomei Tomatsu" by Shiroyasu Suzuki in *Photographic Images* (Tokyo), February 1969; "I Saw a Land in Its Nakedness Right in Front of My Eyes" by Gohzo Yoshimasu in *Camera Mainichi* (Tokyo), April 1975; "Shomei Tomatsu" by Tatsuo Fukushima and Daido Moriyama, special number of *Photo Art* (Tokyo), 1976.

Photography is life itself. What I feel influences my photographs; and my taking photographs affects my life. I exist within this reciprocity.

—Shomei Tomatsu

Shomei Tomatsu's photography is a most explicit demonstration of the predominant social forces of post-war Japan. Emerging from photojournalism, Tomatsu developed a form of documentary reportage that aims beyond illustration to personal polemic. He records an environment of abrasive contrasts, where he contains chaos and decay in formal abstractions and where human scar tissue can be photographed with graphic detail. His work developed with the post-war economic recovery and exposed the conflicts obscured by the rapidly expanding economy and by the Occupation. His subjective documentary is an assertion of a national identity; it exposes the conflict of a country caught between a native and an alien culture.

In 1959 Tomatsu formed the Vivo group with Hosoe, Ikko and others, which marked the beginning of a new Japanese photography. In 1961 he worked with the leading Japanese photographer Ken Domon on the Hiroshima-Nagasaki document. His own book, *11:02 Nagasaki*, which was published in 1966, refers to the time of the atomic explosion. He confronted the victims directly and formally, exposing suppurating sores, mutilated flesh and the contours of ravaged human features. His technique went far beyond clinical, medical evidence. In his photograph of the melted beer bottle he transformed glass into contorted flesh—like an image from a slaughterhouse. The following year his great series *Nihon* was published. It was revolutionary in that it dismissed the image of Japan as a source of traditional aesthetic order. He photographed the mud of riverbeds, the melted asphalt of a Tokyo street, and the aftermath of a typhoon in Nagoya, where human debris and objects had been scattered by the violence of the storm. It was a volatile landscape, not the Japan of harmonious order. His portraits from the same series include the mask-like faces of the Tokyo sandwich men, poor shopkeepers, or the psychic medium in a trance. Tomatsu was focussing on the exploited or those displaced to the outer periphery of society. In 1969 a political and cultural crisis exploded on the streets of Tokyo, which Tomatsu recorded in his series *Oh! Shinjuku*. He juxtaposed imagery of riots with the overt sexuality of that area of the city.

Since the late 1960's Tomatsu has concentrated on the conflicts surrounding the American bases in Japan and Okinawa. In Okinawa itself he has found the roots of a society with which he can identify at the same time as he has come to see the mainland of Japan as an increasingly contaminated culture. His sympathies are evident in his recent book *The Pencil of the Sun: Okinawa and South-East Asia*.

Tomatsu has been of seminal importance in the development of Japanese photography, and a great influence on the new generation of photographers, notably Moriyama and Tsuchida.

—Mark Holborn

Shomei Tomatsu: *Kitchen*, 1959

TOOMING, Peeter.

Estonian. Born in Rakvere, Estonia, 1 June 1939. Educated at secondary school, Rakvere, 1953-57; studied journalism at the State University of Tartu, Estonia, 1968-74. Married Sirje Ong in 1963; daughter: Lee. Photographer since 1961. Lighting Director, 1961-63, Cameraman, 1963-72, and since 1972 Producer and Director of Photography, Tallinnfilm film studios, Tallinn, Estonia. Recipient: Best Director of Photography, *Film Festival of Tallinn*, 1980. Address: Harju 1-7, 200 001 Tallinn, Estonia, U.S.S.R.

Individual Exhibitions:

1967 *Selected Photos*, University of Kaunas, Lithuania
1972 *A Summer's Story*, Kiek in de Kök, Tallinn, Estonia
 Selected Photos, Fotograficka Galerie, Dečin, Czechoslovakia
1976 *Selected Photos*, Kiek in de Kök, Tallinn, Estonia (travelled to the Museum of Rakvere, Estonia; Museum of Võru, Estonia; and the House of Culture, Haapsalu, Estonia)
 3 Photographers, Kiek in de Kök, Tallinn, Estonia (with A. Dobrovolsici and P. Kraas)
1977 *Selected Photos*, Focus Gallery, Ljubljana,

Yugoslavia (travelled to the Dolenjska Galereja, Novo Mesto, Yugoslavia)
One Day's Story, Kiek in de Kök, Tallinn, Estonia
1978 *Selected Photos*, KTF Photo Gallery, Cracow, Poland (travelled to the Panther Passage, Linz, Austria)
1979 *Returning Home*, Kiek in de Kök, Tallinn, Estonia
Selected Photos, Photography Museum, Siauliai, Lithuania (travelled to the Municipal Museum, Riga, Latvia; Municipal Museum, Steyr, Austria; and the Gallery of Modern Art, Warsaw)
Selected Photos, Photography Gallery, Prjbor, Czechoslovakia
Gunar Binde/Egons Spuris/Peeter Tooming, Dum Panu z Kunstatu, Brno, Czechoslovakia (travelled to the Museum of Olomouc, Czechoslovakia, 1979, and Kiek in de Kök, Tallinn, Estonia, 1980)
1980 *Every Coming Consists of the Leaving*, Kiek in de Kök, Tallinn, Estonia (travelled to the House of Culture, Kaapsalu, Estonia)
Selected Photos, Urania-Schaufenstergalerie, Vienna
Selected Photos, Photo Gallery, Kaunas, Lithuania

Selected Group Exhibitions:

1966 *Stodom: Maal; Graafika; Foto*, Academy of Sciences, Tallinn, Estonia
1979 *Fotoimpressionen*, Künstlerhaus, Vienna

Collections:

Municipal Museum, Tallinn, Estonia; Photography Museum, Siauliai, Lithuania; Musée Francais de la Photographie, Bièvres, France; Australian Photography Society.

Publications:

By TOOMING: books—*25 Fotot*, Tallinn, Estonia 1975; *Rakvere*, Tallinn, Estonia 1976; *Fotolood*,

Peeter Tooming: *Bog*, 1970

Tallinn, Estonia 1970; articles—numerous in Estonian periodicals, and "Aadu Treufeldt, Estonian Photographer" in *History of Photography* (University Park, Pennsylvania), January 1978; "Ein Fotomuseum in Tallinn" in *Fotografie* (Leipzig), May 1980; films—*Moments*, 1976; *Fotorondo*, 1978.

On TOOMING: articles—"The Ideas of Peeter Tooming" by A.G. in *Fotografie* (Prague), no., 4, 1969; "A Baltic Pictorialist" by F.T. Merkler in *New Pictorialist* (Spartanburg), no. 2, 1977; "Wplywologia stosowana" by Juliusz Garztecki in *Perspektywy* (Warsaw), no. 11, 1979; "Estonian Photographer Peeter Tooming: We Must Love Our Roots" by Mary Ann Lynch in *Combinations* (New York), no. 5, 1980.

Taking photos in actually opening one's soul to the whole world. With a glance one can say with certainty who the author is—a realist or romanticist, a sensitive person or an indifferent one. We see here very different works; some of them affect us like the work of a news reporter, whereas others seem to be deliberately staged; we become aware of a searching for new decorative elements, or of attempts to penetrate to the inner world of men.

A photographer has the right to make use of the most diverse means for expressing his thoughts and feelings. An artistic photo is not only the recording of a fact but also one of the forms of expression of an artist. A photo ought not to be dull, but it should enrich our emotional world and help us to understand life. And that is a noble aim to strive for.

—Peeter Tooming

Peeter Tooming's introduction to photography was connected with the creative activity of the 1960's, which in the Soviet Union was particularly marked in the Baltic Republics—Lithuania, Latvia and Estonia. This activity was based on the historic artistic culture of the region and its folk art tradition. It enhanced the revival of creative photography with striking national elements. Peeter Tooming is an outstanding figure in this significant cultural transformation in one of these republics, Estonia.

As cameraman of the film studio Tallinnfilm and an active member of the photographic group known as Stodom, he devoted himself mainly to artistically felt and deliberately composed photography. At the same time Tooming was also working as a journalist and photographer for the daily press. These were the bases of his further development, which logically went from emotional symbolism to a kind of vital authenticity. However, even now he has not entirely renounced poetic arrangements, special lighting, a certain stress (which, incidentally, form part of the arsenal of all of Baltic photography), and a certain aesthetic quality regarding man's relationship with nature which retains all the features of the former natural symbiosis.

These characteristics inform his latest works, particularly the series known as "Returning Home." But though these photographs are no less attractive then his previous work, they are much less "constructed." They are also much less dependent on tradition, a tradition that at one time had to be promoted in photography (as in the other arts) if continuity was to be maintained after the forceful interruption of the country's political development. That is why Tooming, like so many other photographers of the Baltic Republics, experimented so extensively with photographic techniques, investigating the qualities of light on shapes, so important for expressing the specific atmosphere of the Baltic region and, following the example of representatives of the post-revolutionary artistic avant-garde, he also took up collage. Even in the combination of such incongruous elements as the juxtaposition of a coloured surface with newspaper cuttings, it was possible to find a unique expression, a novel idea.

The versatility with which Tooming approached photography and which he has cultivated for decades is still with him. It allows him to make use of the experiences he has gained in a variety of ways. He is one of few photographers in the U.S.S.R. who is aware of and exploits the many uses of photography—in communications, books, exhibitions, and in films. For example, in his composition "Fotorondo," he makes use of the pleasant custom of Baltic artists to stage exhibitions of photos in the open air: he arranged such a display in a village street and, like the Polish "expansive photographers," at the same time he took pictures of the photos and the immediate reaction of onlookers. Also, Tooming does not hesitate to use conceptual methods, the purpose of which he describes as "training expression". He collects and saves unique photographs, and he is preparing a *History of Estonian Photography*. But, above all, he is a passionalte lover of photography, through the modern practice of which he opens up a window to his native land.

—Vladimír Remeš

TOROSIAN, Michael.
Canadian. Born in Fort Erie, Ontario, 31 October 1952. Educated at Ridgeway-Crystal Beach High School, Ridgeway, Ontario, 1966-70; studied photography at the Ryerson Polytechnical Institute, Toronto, 1970-73, Diploma in Photography, 1973. Independent photographer, Toronto, since 1973. Also, cinematographer, and proprietor of Lumiere Press, Toronto. Recipient: Ontario Arts Council Grant, 1973, 1975, 1976; Canada Council Grant, 1973, 1974, 1979. Address: 465 St. Clarens Avenue, Toronto, Ontario M6H 3W4, Canada.

Individual Exhibitions:

1974 *A Manual Alphabet*, National Film Board

Gallery, Ottawa
A Manual Alphabet, Robert McLaughlin Gallery, Oshawa, Ontario
1975 *Nocturne*, Cafe La Barge Gallery, Toronto
Nocturne, National Film Board Gallery, Ottawa
1976 Photo Arts Gallery, Ryerson Polytechnic Institute, Toronto
Conestoga College, Kitchener, Ontario
Photography Gallery, Bowmanville, Ontario
1977 Owen Sound Public Library, Ontario
Photo Arts Gallery, Ryerson Polytechnic Institute, Toronto
Kelowna Art Gallery, British Columbia
Penticton Arts Centre, British Columbia
Seaway Valley Libraries, Cornwall, Ontario
1978 Vanier College, Montreal
Greater Victoria Public Library, British Columbia
Atikoken Centennial Museum, Ontario
1979 Vanier College, Montreal
National Film Board Gallery, Ottawa
Conestoga College, Kitchener, Ontario
Sanctuary, University of Oregon, Eugene
1981 Burton Gallery of Photography, Toronto

Selected Group Exhibitions:

1975 *Exposure*, Art Gallery of Ontario, Toronto (toured Canada)
1978 *Canadians*, Mount St. Vincent University, Halifax, Nova Scotia (toured Canada, and travelled to London)

Collections:

National Film Board of Canada, Ottawa; Ryerson Polytechnic Institute, Toronto.

Publications:

By TOROSIAN: books—*Michael Torosian: Portfolio 1976*, portfolio of 10 photos, Toronto 1976; *Signature 3: Michael Torosian: Nocturne*, Ottawa 1977; *Lunarglyphics*, Toronto 1981; articles—"Collecting Photographs" in *Financial Post Magazine* (Toronto), February 1979; "Newsbreak: The Controversy Continues" in *Photo Communique* (Toronto), September 1979; "Memento Mori" in *Photo Communique* (Toronto), November 1979; "Think-

ing of Hippolyte" in *Photo Communique* (Toronto), May 1980; "Sanctuary" in *Descant* (Toronto), no. 24, 1980; "The Fifties Focus" in *Toronto Life*, June 1981.

On TOROSIAN: book—*Exposure*, exhibition catalogue, Toronto 1975.

Michael Torosian's first works in photography were largely concerned with the evidence and insight into human nature afforded by detail. "A Manual Alphabet," a work first exhibited in 1974, gathered together photographs of hands. It was described at the time and in a gallery setting dominated by colour landscapes of Canada as "a real documentation of unposed gesture," a statement which stresses informational qualities ascribed by the viewer from the clues of age, the tension in the hand or the dress of the wrist.

It was clear from the next major series that what Torosian was after was something far less concrete, as elusive perhaps as a line of light along a torso and something that separated flesh and shadow by as little as a tone. He followed "A Manual Alphabet" with "Nocturne," the title of which, describing "a dreamy or pensive piece of music," set the mood for small, dark, black-and-white Polaroid images of female bodies and faces. Torosian experimented with exposure and development of these images, extending the chemical action for as long as 30 minutes to alter the surface and depth of the shadows. His model, sometimes partially draped or enclosed in a black leotard, was deliberately posed and shaped before textured or neutral backgrounds. Torosian strove for and found a richness in the unplumbed depths of Polaroid, making works pleasing for their sensuality and preciousness.

Back on the street and drawing from the moodiness of "Nocturne" and the intuitive characterizations of his first works, Torosian began making expressionist portraits. These were not decisive moments but sections of them, shards of the interaction that had characterized the photography of human contact since the inception of the unseen 35 mm camera. Torosian collected incidents of recessed sensibility. He found a population of sleep-walkers deep in thought or listening to their inner voices. These are people that we do not see but who are always quietly in the background. The photographs of "Sanctuary" are again details. What is shocking, even saddening, is that his subjects are whole human beings, coexisting but mutely, in ordinary lives.

The work that Michael Torosian has chosen for this publication is his newest, a series in progress. He has returned to the studio, to the model and to control. The photograph he has selected again eliminates parts of the body, but this time the mask is not obscurity but an artifact that we must identify and contend with as an element of the portrait. This woman is conventionally groomed, conventionally posed yet comically masked and marred by the overlaying on her chest of textures of crumbling stone. Others in the series disguise the model in different ways: sunglasses, primitive masks, veils slit to reveal a Revlon eye. One model is simply made to bare her teeth and make a gargoyle of herself.

In his theatre/studio, Torosian is using the nude as a starting point for a series of tableaus. His current format and content are without softness and without compromise. They glare and they challenge.
—Martha Langford

Michael Torosian: *Untitled*, 1979

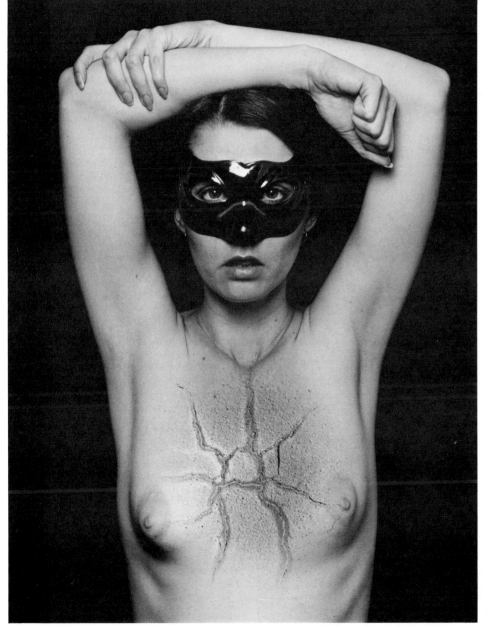

TRAGER, Philip.

American. Born in Bridgeport, Connecticut, 27 February 1935. Educated at Wesleyan University, Middletown, Connecticut, 1952-56, B.A. 1956; studied law, Columbia University School of Law, 1956-60, J.D. 1960; self-taught in photography. Married Ina Shulkin in 1957; children: Julie and Michael. Attorney, with Bernard H. Trager, Trager and Trager counsellors-at-law, Fairfield, Connecticut, since 1960. Independent photographer, Fairfield, Connecticut, since 1966. Recipient: Book of the Year Award, American Institute of Graphic Arts, 1977; 25 Best Books Award, Association of American University Presses, 1977; Recommended Book of the Year Citation, *New York Times* Annual Review of Books, 1977, 1980; Distinguished Alumnus Award, Wesleyan University, 1981; Lay Person Award, Connecticut Society of Architects, 1981. Witkin Gallery, 41 East 57th Street, New York, New York 10022. Address: 20 Rolling Ridge Road, Fairfield, Connecticut 06430, U.S.A.

Individual Exhibitions:

1970	Underground Gallery, New York
	Davison Art Center, Wesleyan University, Middletown, Connecticut
1972	831 Gallery, Birmingham, Michigan
	Witkin Gallery, New York
1974	*Philip Trager and Ron Stark*, San Francisco Museum of Art

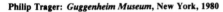

Philip Trager: *Guggenheim Museum,* **New York, 1980**

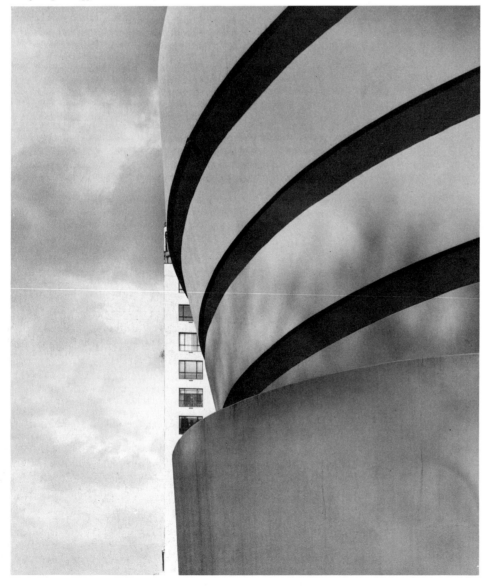

	Davison Art Center, Wesleyan University, Middletown, Connecticut
1975	Photopia Gallery, Philadelphia
	Washington Gallery of Photography, Washington, D.C.
1977	Baltimore Museum of Art
	Focus Gallery, San Francisco
	University of Connecticut, Storrs
	Witkin Gallery, New York
1978	Photographics Workshop, New Haven, Connecticut
	Friends of Photography, Carmel, California
	Milwaukee Center for the Arts
1979	Camera Work Gallery, New York
	Boston Center for the Arts
1980	Witkin Gallery, New York
	Museum of the City of New York
1981	Photo Gallery International, Tokyo
	Ufficio dell'Arte, Paris
	Centre International de Fotografia, Barcelona
	Davison Art Center, Wesleyan University, Middletown, Connecticut

Selected Group Exhibitions:

1971	*Members Exhibition*, Friends of Photography, Carmel, California
1972	*Photo-Vision '72*, Boston Center for the Arts
1973	Christmas Exhibition, Witkin Gallery, New York
1975	*Photo-Vision 75*, Boston Center for the Arts
1979	*Attitudes: Photography in the 1970's*, Santa Barbara Museum of Art, California
	10th Anniversary Exhibition, Witkin Gallery, New York ('*A Ten-Year Salute*')
	Photographers Look at Buildings, Yale University Art Gallery, New Haven, Connecticut
1980	*The Photographer and the Frame*, Wesleyan University, Middletown, Connecticut
1981	*New Acquisitions*, Corcoran Gallery of Art, Washington, D.C.
	Manhattan Observed: 14 Photographers Look at New York 1972-1981, New York Historical Society

Collections:

Museum of Modern Art, New York; Metropolitan Museum of Art, New York; Museum of the City of New York; Wesleyan University, Middletown, Connecticut; Yale University Gallery of Art, New Haven, Connecticut; William Benton Museum of Art, University of Connecticut, Storrs; Smith College Museum of Art, Northampton, Massachusetts; Corcoran Gallery of Art, Washington, D.C.; Baltimore Museum of Art, Maryland; Bibliothèque Nationale, Paris.

Publications:

By TRAGER: books—*Echoes of Silence*, Danbury, Connecticut 1972; *Photographs of Architecture*, with an introduction by Samuel M. Green, Middletown, Connecticut 1977; *Philip Trager: New York*, with an introduction by Louis Auchincloss, Middletown, Connecticut 1980; article—"Following the Beat of an Inner Drummer," interview, with Peggy Sealborn, in *Print Letter* (Zurich), May/June 1978.

On TRAGER: books—*Philip Trager and Ron Stark*, exhibition catalogue, by John Humphrey, San Francisco 1974; *A Ten-Year Salute* by Lee D. Witkin, New York 1979; *The Photograph Collector's Guide* by Lee D. Witkin and Barbara London, Boston and London 1979; articles—"The Pursuit of Excellence" in *The Art of Photography* by Time-Life editors, New York 1971; "Trager and Stark" by Joan Murray in *Artweek* (Oakland), California, 2 February 1974; "Philip Trager" in *Creative Camera* (London), September 1975; "Ageless Architecture" by David L. Shirey in the *New York Times*, 10 April 1977; "Philip Trager" by Don Owens in *Photoshow* (Los Angeles), no. 2, 1980; "A Gossamer Gotham" by Owen Edwards in *American Photographer* (New York), September 1980; "Our Town" by Richard Shepherd in the *New York Times*, November 1980; "Cityscapes" by Carol Halebian in *Camera 35* (New York), November 1980; "Philip Trager: New York" by Marco Misani in *Print Letter* (Zurich), November/December 1980; "City Shapes" by Louis Auchincloss in *Camera Arts* (New York), November/December 1980; "Philip Trager at Witkin" by Lynn Enton in *Art in America* (New York), February 1981; "Philip Trager: New York" by Hilton Kramer in the *New York Times*, 27 March 1981.

Very generally, the photography of architecture falls into three categories: the commercial, most often commissioned by architects or builders; the documentary, a systematic depiction of the architecture of particular places or styles; and the aesthetic, the photography of buildings which, quite simply, appeal to the artistic sensibilities of the particular photographer. The first is characterized by stylistic judgements mortgaged to "standards" well known to any junior assistant photographer at any commercial studio anywhere. The second is characterized by its blind adherence to the assumption that all buildings are inherently interesting (and by its occasionally

conclusive capacity to bore). And the last is characterized by its innate belief in the "music" of architecture, in the *idea* of architecture.

Philip Trager has concerned himself with walking a thin line between the latter two categories. In Trager's work, it is at times a very thin line, though his images clearly manifest the differentiation between photographs of architecture and photographs whose visible and nominal subject is a building. Recent documentary photographs of architecture are less interested in the buildings themselves than in how they are representative of something else—culture, social class, style, whatever. Trager's, though, are invariably interesting buildings in themselves, existing within their own framework. His judgements are always aesthetic and architectural, never social.

Even so, there are some anomalies in his two large series to date, the first published as *Photographs of Architecture* in 1977, the second as *Philip Trager: New York* in 1980. In the former, even those buildings which are photographed straight on, from the front, are decidedly three-dimensional. They have substance, "body;" there is no question of their reality as buildings. In the latter, we are confronted with a curious insubstantiality; even though most of the New York photographs are taken from oblique angles, creating perspective, the buildings are façades, strangely delicate. In the Manhattan photographs, Trager has succeeded (magically?) in depicting a nearly Augustinian essence of "city," while simultaneously denying it any "body." It is a depiction of city that is as close to the Gothic as one is likely to come—a city seen as sculptured, hewn from a single huge stone, rather than built. It is a city in Trager's eyes in which one form is irrevocably connected to every other form, as a single chaotic whole hovering in the chancel of an immense cathedral. Trager's Manhattan floats. And its absence of people ("empty" is neither objectively sad nor negative) makes it nearly mythic, a city of the departed gods. It is in this that Trager's photographs document something more truly "architectural" than the mere form or function of a building: the essential nature of architecture as an intellection of the most primitive and sophisticated sort.

—Derek Bennett

TRAKHMAN, Mikhail (Anatol'evich).

Russian. Born in Moscow in March 1918. Educated at a grammar school in Moscow until 1933. Married Lalya Trakhmanova; son: Igor. Cameraman in a documentary film studio, Moscow, 1934-39; Photo-Reporter, Sovinformburo/Soviet Information Bureau, Moscow, 1939-41; War Photo-Correspondent, with the Red Army, for TASS, 1941-42, and for Sovinformburo, 1942-45; activities unknown, 1945-58; Chief Photo-Correspondent, *Literaturnaja Gaseta*, Moscow, 1958 until his death, 1976. Also, creator and editor of books for Planeta, Moscow. *Died* (in Moscow) *in 1976.*

Selected Group Exhibitions:

1972 *Photographes de l'URSS: Le Pays, Les Hommes*, Galerie Nationale du Grand Palais, Paris
1975 *Soviet War Reportage 1941-45*, House of Soviet Science and Culture, Prague
1977 *The Russian War*, International Center of Photography, New York

1978 *Russian War Photography*, Side Gallery, Newcastle upon Tyne, England

Collections:

Novosti Press Agency, Moscow; National Film and Photo Archives, Moscow; Daniela Mrázková/Vladimír Remeš Collection, Prague.

Publications:

By TRAKHMAN: books—*Zarevo*, with photographs by Trakhman and others, poems, and text by Andrei Voznyesensky, Moscow 1970; *Osvobozhdenye (Liberation)*, editor, with text by Boris Polevoy and Konstantin Simonov, Moscow 1974; *Das der Mensche ein Mensch Sei*, Berlin 1975; *Srdcem přítete* (on Prague and Moscow), Prague 1975.

On TRAKHMAN: books—*Fotografovali Válku*, by Daniela Mrázková and Vladimír Remeš, Prague 1975, as *The Russian War 1941-45*, with an introduction by Harrison Salisbury, New York 1977, as *The Russian War 1941-45*, with text by A.J.P. Taylor, London 1978; *Von Moskau nach Berlin*, edited by Daniela Mrázková and Vladimír Remeš, with an introduction by Heinrich Böll, Oldenburg, West Germany 1979; articles—"Sovětská válecná fotoreportáz 1941-45" by Daniela Mrázková and Vladimír Remeš in *Revue Fotografie* (Prague), March 1975; "A Cry of Anguish from Wartime Russia" in *Photography Year*, by the Time-Life editors, New York 1976; "Il Soldato Fotografo" in *Fotografia Italiana* (Milan), April 1976.

If he could have remained a war correspondent, Mikhail Trakhman would have become a great star in his field. For, in his war photographs, he knew perfectly how to combine the images of war and its impact on the broad masses of the population with an ideological and symbolic significance. But the young Trakhman had had enough of war: he had had such a dose of it that he virtually refused the opportunity to photograph war after the victory in Europe and in the Far East, where he was one of very few Soviet photo-reporters. As a photographer in uniform, he had had to obey military commands, and his refusal to obey orders considerably complicated his start in post-war life. But even without these personal complications, Trakhman would have found it difficult to find a photographic program in keeping with his former personal, partial, sensitive and pensive vision of the war holocaust that had played havoc with the lives of millions of people, uprooted from their environment and forced to fight for their mere existence.

Before the war Trakhman had worked as a documentary film cameraman. This experience is obvious in his photographs: his approach to reality and his spontaneity imprint his photographs with a special quality; they are often composed like shots in a film. Trakhman photographs in great detail—the whole, or half, at the same time—confronting the action on the first and second plane. Not infrequently he also links several dominant features of the action in mutual significance, the combination of which leads to an almost complete testimony. Such a richly articulated presentation does not so much create an epic as a photo full of internal significance from which it is actually possible to obtain a number of equally valuable prints by cropping.

And each photograph does not seem a complete, smooth action, but the record of an event that will continue: the dynamics and depth in space of his prints indicate what has preceded the recorded action and how it is going to develop further.

The photos of the war events, devoted to the lives of guerrilla fighters, men, women and children behind the enemy lines, were taken when Trakhman, as special correspondent for Sovinformburo,

was travelling throughout the Soviet Union, and in most cases they were not meant for publication. And yet they are his masterpieces, though, unlike most other Soviet war photographers, he does not deliberately look for the drama of war in battle but in a quiet social analysis of the everyday events. This work is supremely dramatic and effective, above all in its unique emotional and ideological quality, which is in sharp contrast to Trakhman's post-war work, which is completely "adjusted" to the official canon.

In the 1960's and especially in the 70's, when circumstances made it possible, Trakhman became the author and editor of a number of photographic books and publications that made full use of photography. Here, in this work, his effort during the war came into its own, though he did search the archives for the work of other photographers. Of his picture books on a war theme, the most significant is *Zarevo*, which he edited with the poet Andrei Voznyesensky. It contains his own as well as other war photos, together with Soviet war- and post-war poems. Trakhman was also the co-instigator of several volumes on the war for Planeta, Moscow, in which, however, the photographs play only a minor role, being used purely as illustration, to the detriment of the books.

It's fair to say that in the U.S.S.R. Mikhail Trakhman is one of the pioneers in the creation of books endeavoring to speak in the language of photography. He continued to photograph tirelessly until his death, and his books were published not only in the U.S.S.R. but also in Czechoslovakia, Poland and the G.D.R. However, Trakhman's importance as an artist lies entirely in that short period of his war photographs. Neither before nor after did he succeed in again producing outstanding photographs; mostly, they were average. The war was his legacy, which he used successfully throughout his career.

—Vladimír Remeš

TRAUB, Charles (Henry).

American. Born in Louisville, Kentucky, 6 April 1945. Educated at Louisville High School, 1960-63; University of Illinois, Champaign, 1963-67, B.A. in literature 1967; University of Louisville, 1967-69; studied photography, under Aaron Siskind and Arthur Siegel, at the Institute of Design, Illinois Institute of Technology, Chicago, 1969-71, M.S. 1971. Served in the United States Army, 1969. Married Mary Cadden in 1969; son: Aaron. Photographer, Chicago and New York, since 1971. Instructor in Photography, 1971-75, Chairman of the Photography Department, 1975-78, and Founder and Chairman, Center for Contemporary Photography, 1975-78, Columbia College, Chicago; Director of the Light Gallery, New York, 1978-80. Visiting Lecturer, International Center of Photography, New York, since 1978. Address: 39 East 10th Street, New York, New York 10003, U.S.A.

Individual Exhibitions:

1971 Center for Photographic Studies, Louisville, Kentucky
1972 Dayton Art Institute, Ohio
Cincinnati Art Institute, Ohio

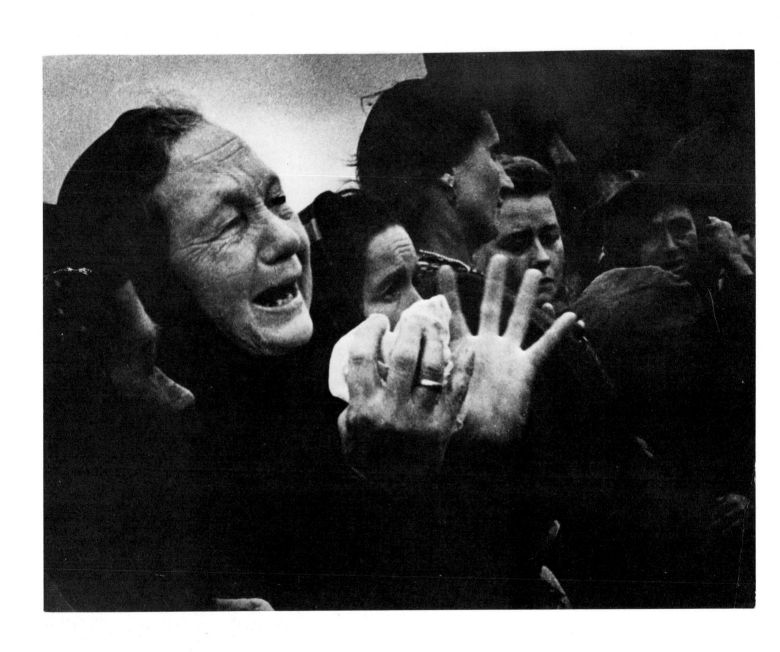

Mikhail Trakhman: *Grief, Evacuation*, **1941**

760

Selected Group Exhibitions:

Collections:

Museum of Modern Art, New York; International Center of Photography, New York; International Museum of Photography, George Eastman House, Rochester, New York; Visual Studies Workshop, Rochester, New York; Art Institute of Chicago; Center for Contemporary Photography, Chicago; Speed Museum, Louisville, Kentucky.

Publications:

By TRAUB: book—*Charles Traub: Beach*, New York 1978; articles—"Charles Traub: Cajun Photographs" in *Southern Voices* (Atlanta), June 1974; "Charles Traub: Photographs" in *Creative Camera* (London), December 1978; "Portfolio: Charles H. Traub" in *Modern Photography* (New York), November 1979.

On TRAUB: books—*Photographing Children* by the Time-Life editors, New York 1971; *The Photographer and the City*, exhibition catalogue, by Gail Buckland, Chicago 1977.

As a photographer I am concerned with the welfare and growth of the medium of contemporary photography in all its parts. I attend to the business of photography management and the administration of affairs of teaching with the same vigor and creative energy that I apply to my own photographic endeavors. This is done out of deep-felt obligation to the community of photographers and well being of the state of the art. For many years the best endeavors in the medium's promotion were made by photographers themselves; I would hope to be able to contribute to this tradition. Our history is still not yet properly written, our critical literature is too little and our audience is still yet to be properly informed. To these ends I feel we should all contribute.

As an artist it is my intention to simply express those needs and urges which come to me out of a process of working in the medium—something I have done for approximately 12 years. In photographic work one idea is generated by another, one picture begets another, and so on, until a body of work is achieved. Out of that body a great amount of selection must be done, and from that selection comes a core idea which is then build upon anew. The total experience of work should be a synergistic one, something bigger than the sum of its parts.

So far in my career as a photographer I have done what I feel are five significant bodies of work. I am currently engaged in working with color and the idea of random descriptive portraiture. I attempt to extend the nature and the history of portraiture itself, as I feel that this is a proper challenge for all photographers in their work.

My current works are confrontational, spontaneous portraits, all with the agreement and participation of their subjects. They are about gestures, body language, sensuality and, indeed, the idea of confrontation itself. People are what they seem; their gestures and responses are in accordance with their personalities. If one knows how to look, one can read much from a picture about an individual. I also look for relationships between one person and another. I am curious at the repetition of types or the repetition of particular personal styles.

Photography is the most exciting act I can engage in. I am totally out of myself while I am photographing. There are powers and controls gained through the act of photography which are truly exceptional. To recognize those feelings is a great release and is, of itself, enough reason to pursue making pictures.

—Charles Traub

The photographs of Charles Traub challenge the underlying concerns of photography's portraiture and documentary traditions. Although there are people in most of them, his photographs do not exude the standard humanist attitude we have come to expect from such pictures. What was partisan sympathy on the part of the traditional photographer has, in Traub, become cool objectivity: he is not so much interested in who the people are as he is in what they look like.

The influence of Traub's study at the Illinois Institute of Technology with Aaron Siskind can be seen in the strong design qualities present in all his images. Odd perspectives and points of view dominate photographs that often flirt with pure formalism before giving in to their subject matter. The black vignette in the beach pictures functions primarily as a graphic device, giving the series a strong sense of continuity, but then it adds meaning as it begins to look more and more like a TV screen in the act of monitoring real life. A fascination with the body's form, shape, and gesture as it translates into two-dimensional pictures creates sometimes unpleasant close-ups of male and female bodies engaged in leisurely activities. Made with a wide angle lens at very close range, Traub's pictures are aggressively voyeuristic, and they reveal the slightly perverse

Charles Traub: *Palm Beach* (original in color), 1979

sexuality prevalent in beach scenes.

Traub's color photographs are even more challenging than his black-and-white ones. What he calls "confrontational, spontaneous portraits" are very straightforward pictures of people on public pathways taken at close range in daylight using strong flash. Unlike traditional portraits, which are meant to reveal some inner quality of the subject, these portraits characterize people by their appearance. Their focus on posture, hair style, hand gesture, facial expression, and clothing seems to be an attempt to redefine the message of photographs. The underlying statement in these—and many other images by Traub—is that since the camera reveals nothing, it is best used to record outward appearance.

—Ted Hedgpeth

TRESS, Arthur.

American. Born in Brooklyn, New York, 24 November 1940. Educated at Abraham Lincoln School, Coney Island, New York, 1954-58; studied painting and art history, under Heinrich Bluecher, Bard College, Annandale-on-Hudson, New York, 1958-62, B.F.A. 1962; travelled and studied the arts in Japan, Mexico, and Europe, 1962-66. Photographer, Stockholm Ethnographical Museum, 1966-68. Freelance photographer, New York, since 1968. Visiting Instructor, New School for Social Research, New

Arthur Tress: *The Actor*, 1973

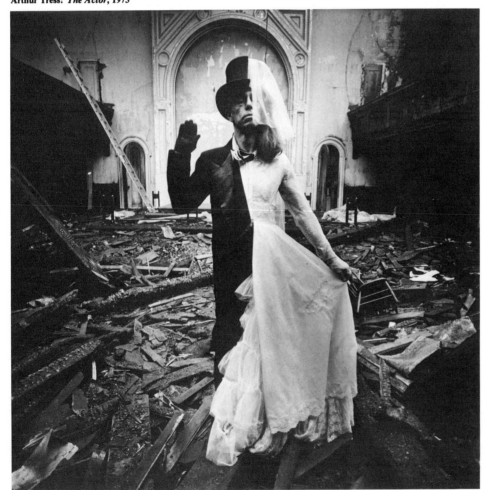

York, 1976. Recipient: New York State Council on the Arts Grant, 1971, 1976; National Endowment for the Arts Grant, 1972; Reva and David Logan Foundation Grant, 1974. Address: 2 Riverside Drive, New York, New York 10023, U.S.A.

Individual Exhibitions:

1968 *Appalachia: People and Places*, Sierra Club Gallery, New York (travelled to the Smithsonian Institution, Washington, D.C., 1969)
1970 *Open Space in the Inner City*, Sierra Club Gallery, New York
1972 *The Dream Collector*, Raffi Photo Gallery, New York (travelled to the Focus Gallery, San Francisco, 1973; Galleria Il Diaframma, Milan, *Rencontres Internationales de la Photographie*, Arles, France, and Canon Gallery, Amsterdam, 1974; and Galerij Paule Pia, Antwerp, 1976)
1973 *Vision Seekers*, SoHo Gallery, New York
1975 *Shadow*, Neikrug Gallery, New York (travelled to La Photogalerie, Paris, Gallery of Photography, Washington, D.C., and Shadow Gallery, Portland, Oregon, 1975)
1976 Canon Photo Gallery, Geneva
1977 Galerie Trockenpresse, Berlin
 Foto Gallery, New York
1978 Friends of Photography, Carmel, California
 Galerie Die Brücke, Vienna
1979 Robert Samuel Gallery, New York
 Galerie Agathe Gaillard, Paris
 Canon Photo Gallery, Geneva
1980 G. Ray Hawkins Gallery, Los Angeles
 Arthur Tress: A Twelve Year Survey, Robert Samuel Gallery, New York
1981 Galerie Agathe Gaillard, Paris

Selected Group Exhibitions:

1969 *Vision and Expression*, International Museum of Photography, George Eastman House, Rochester, New York (toured the United States, 1969-71)
1978 *Self-Portrait*, Friends of Photography, Carmel, California
1979 *Attitudes: Photography in the 1970's*, Santa Barbara Museum of Art, California
 Photographic Surrealism, New Gallery of Contemporary Art, Cleveland (travelled to the Brooklyn Museum, New York)
1981 *The Nude*, Massachusetts Institute of Technology, Cambridge

Collections:

Museum of Modern Art, New York; Metropolitan Museum of Art, New York; International Museum of Photography, George Eastman House, Rochester, New York; Center for Contemporary Photography, Chicago; Bibliothèque Nationale, Paris; Centre Pompidou, Paris; Stedelijk Museum, Amsterdam.

Publications:

By TRESS: books—*Songs of the Blue Ridge Mountains*, New York 1968; *Open Space in the Inner City*, New York 1970; *The Dream Collector*, with text by John Minahan, Richmond, Virginia 1972, New York 1973; *Shadow: A Novel in Photographs*, New York 1975; *The Theatre of the Mind*, with an introduction by A.D. Coleman, New York 1976; *Tress: Facing Up*, with an introduction by Yves Navarre, Geneva and New York 1980; *Reves*, with an introduction by Michele Tournier, Brussels 1980; *Tress II: Nature Morte*, with an introduction by Michele Tournier, Geneva and New York 1981.

On TRESS: books—*Vision and Expression* by Nathan Lyons, New York 1969; *The Best of Life*, New York 1973; *Terrorist Chic* by Michael Selzer, New York 1979; *Clefs et Serrures* by Michel Tournier, Paris 1979; articles—"Arthur Tress" in *Photography Annual*, New York 1970; "Arthur Tress: Open Spaces in the Inner City" in *Creative Camera* (London), December 1970; "Portfolio: Arthur Tress" in *Photography Annual 1972*, New York 1971; "Arthur Tress" in *Modern Photography Annual*, New York 1973; "Arthur Tress" in *Photo* (Paris), December 1973; "Arthur Tress" in *Photographing Children*, by the Time-Life editors, Amsterdam 1973; "Insolite Tress" by Michel Tournier in *L'Oeil* (Paris), October 1974; interview in *Photo Revue* (Paris), July 1975; "Shadow," interview with Sheila Turner, in *Popular Photography* (New York), August 1976; "Further Adventures of Arthur Tress," interview with Marcia Caro, in *35mm Photography* (New York), Summer 1978.

A photographer could be considered a kind of magician—a being possessed of very special powers that enable him to control mysterious forces and energies outside himself. The photographer's intensely heightened sense perception, product of the brutal discipline of constantly seeing at 1/250th of a second, unevenly evolves his visual facilities to an almost superhuman degree. With these highly-developed instincts, he seems to be able to almost anticipate the activities of his subjects and sometimes actually appears to cause their occurrence by some mental will power of his own that projects outward, making reality conform to his mentally-conceived image of it that he records on film. Often his best photographs are taken in a trance-like state, where there is an almost unspoken mystical communication between his subject and himself, and action is directed through non-verbal gesture and

psychic transference. As a trained observer, he can foretell the potential movements of his subjects and perhaps even by mental intimidation and expansion actually cause them to happen. The photographer participates in an almost ritual dance with the world, whereupon his own intense response to its rhythms corresponds to his being able to predict its following certain predetermined patterns.

The photographic image itself has great magical possibilities. Like the ceremonial mask, the ritual incantation, the protective amulet, or magical mandala, the photograph has the potency of releasing in the viewer preconditioned reactions that cause him to physically change or be mentally transformed. In fact, because of our intense belief in the factual literalness of the photograph, it can provoke even stronger reactions than other graphic media. A photograph can more often "grab our guts" or arouse our sexual desires than other art forms because of its purported realness, but it can also more subtly stimulate unconscious responses that we are hardly aware of. The grotesque or frightening image may stir forgotten animal instincts of primordial helplessness and fear, reaching back to the basic insecurity of early man and our own personal childhoods. Images of great peace and harmony have the curative possibility of restoring tranquility and balance to a disturbed soul or agitated body. The photographic image which hints to the essential mystery of growing things and the unknown qualities of life itself can make the viewer aware of higher states of nature to which we are faintly sensitive. The magical photograph is simply one that attempts by its mere assertive presence to go beyond the immediate context of the recorded experience into realms of the undefinable. The photographer as magician is just someone who is more acutely aware of the subliminal "vibrations" of the everyday world which can call forth hidden emotions or states of feeling that are usually tightly wrapped up in our unconscious selves. He is, himself, totally "opened" to the multiplicities of association that are submerged behind the appearances of the objective world. He uses the repressed mythology of dreams and the archetypal designs of geometry to magically conjure up deep and irrational reactions from the viewer.

Perhaps why so much of today's photography doesn't "grab us" or mean anything to our personal lives is that it fails to touch upon the hidden life of the imagination and fantasy which is hungry for stimulation. The documentary photographer supplies us with facts or drowns in humanity, while the pictorialist, avant-garde or conservative, pleases us with mere aesthetically correct compositions—but where are the photographs *we can pray to, that will make us well again, or scare the hell out of us?* Most of mankind's art for the past 5,000 years was created for just those purposes. It seems absurd to stop now.

—Arthur Tress

An essentially theatrical attitude has been a hallmark of Arthur Tress' imagery since his public debut as a photographer.

The first themes he addressed were nominally topical ones: pollution, ecology, and the claustrophobia of life in urban sinks. One of Tress' primary concerns has always been the various ways in which the world (the physical world, in this case) impinges upon the individual's sense of freedom and psychic territory. Tress photographed his understandings of the causes and effects of these problems—and their possible solutions—in several fashions. Though sometimes his observations were presented in conventional photographic terms, as often as not he found ways and means (through the use of volunteer actors, props and other devices) to dramatize those conditions and situations which he found to be most significant.

This penchant for photographic *tableaux vivants* became even more pronounced in his next extended work, a suite of photographs depicting the fantasies and dreams of children. Almost without exception,

these were carefully staged productions of specific scenarios which had been recounted by children to the photographer. Tress scouted appropriate locations, provided the necessary props and costumes, and photographed the children acting out their own inner visions. The photograph became the proscenium arch; the viewer became the audience.

This series was followed, several years later, by a "novel in photographs" whose protagonist was Tress himself, portrayed through his own shadow in an extended sequence of ingenious and intelligent images, all set up and acted out. *Shadow* is an ambitious experiment in photographic storytelling, reminiscent on several levels of the wordless woodblock-print novels of Lynd Ward and Franz Masereel. Like many of those books, this one is also an account of a picaresque spiritual voyage; in Tress' work the adventurer travels through time and space in a symbolic, allegorical and (one presumes) autobiographical narrative.

His next book, *The Theater of the Mind*, was a collection of tableaux and portraits in which adults as well as children revealed intimate aspects of self and acted out fantasies, both the photographer's and their own. In the past few years, Tress has explored at length in books and exhibitions the homosexual subculture and the realm of homoerotic fantasy.

The evolution of Tress' imagery, then, has been towards an increasingly directorial approach and increasingly personal themes. If *The Dream Collector* is (albeit by proxy) an expression of the photographer's own childhood traumas, and *Shadow* the tale of his coming of age, then the work of the past few years has been about Tress in the here and now, a catalogue of his own ongoing concerns and obsessions.

It is not coincidental that the photographer's background includes the study of film directing and Kabuki theater; the impact of these disciplines on his work is apparent. Similarly it is appropriate that his interests include psychology, ethnography, eastern philosophy, magic and the supernatural; his imagery is consistently attuned to the manifestations of power in personal and cultural mythology, and the harmonies and discords between the two.

—A.D. Coleman

TSUCHIDA, Hiromi.

Japanese. Born in Fukui Prefecture, 20 December 1939. Educated at Fukui University, 1959-63, B.S. in dyeing chemistry 1963; studied photography, under Koen Shigemori, at the Tokyo College of Photography, 1965-68. Worked as a researcher, 1963-68, and Publicity Manager, 1968-71, Pola Cosmetics Company, Yokohama and Tokyo. Freelance photographer, Yokohama, since 1971. Instructor, Tokyo College of Photography, since 1972. Awards: Newcomer's Prize, Camera Jidai, 1967; Grand Prize, *Taiyo Magazine*, 1971; Nobuo Ina Award, 1978. Address: 8-18-405 Sakonyama Danchi, Asahi-ku, Yokohama 241, Japan.

Individual Exhibitions:

1962 *Ku*, Bon Gallery, Fukui, Japan
1964 *Black Rhapsody*, Shizuoka Industrial Hall, Shizuoka, Japan
1971 *Self-Autism Space*, Nikon Salon, Tokyo (travelled to Nikon Salon, Osaka)
1977 *Gods of the Earth*, Doi Gallery, Fukuoka, Japan (toured Japan; travelled to the Canon Photo Gallery, Amsterdam, 1978)
1978 *Hiroshima: 1945-1978*, Nikon Salon, Tokyo (travelled to Nikon Salon, Osaka)
 The Crowd, Minoruta Gallery, Tokyo
1979 *Hiroshima Monument*, Nikon Salon, Tokyo (travelled to Nikon Salon, Osaka)
 Shoal, Eye-heart Gallery, Tokyo
1980 *Tokyo Dolls*, Minoruta Gallery, Tokyo

Selected Group Exhibitions:

1974 *New Japanese Photography*, Museum of Modern Art, New York (toured the United States)
1977 *Neue Fotografie aus Japan*, Kulturhaus, Graz, Austria (toured Europe, 1977-79)
1979 *Japan: A Self Portrait*, International Center of Photography, New York (travelled to *Venezia '79*)
 Japanese Photography Today and Its Origin, Galleria d'Arte Moderna, Bologna (travelled to the Palazzo Reale, Milan; Palais des Beaux-Arts, Brussels; and the Institute of Contemporary Arts, London)

Hiromi Tsuchida: *Zokushin*, 1972

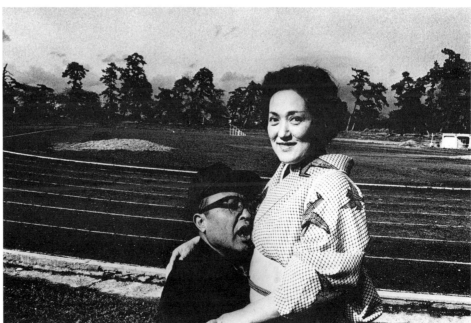

Collections:

Tokyo Sogo Institute of Photography, Yokohama; Japan Professional Photography Society, Tokyo; Museum of Modern Art, New York.

Publications:

By TSUCHIDA: books—*Zokushin: Gods of the Earth*, with an introduction by Goichi Matsunaga, Yokohama 1976; *Hiroshima: 1945-1978*, edited by Tatsuo Shirai, Tokyo 1979; *Tokyo Dolls*, Tokyo 1981.

On TSUCHIDA: articles—"The Visible and the Invisible" by Kohi Taki in *Asahi Camera* (Tokyo), September 1977; "The Other Face" by Koji Taki in *Asahi Camera* (Tokyo), January 1978; "Freedom from the Gods of the Earth" by Kazuo Nishii in *Camera Mainichi* (Tokyo), May 1978; "Encounter with the Children of Hiroshima" by Satoshi Hidaka in *Camera Mainichi* (Tokyo), January 1979; "Crossing of the Consciousness of Self" by Shiroyasu Suzuki in *Asahi Camera* (Tokyo), April 1980.

Before my interest in photography comes my concern with the mentality of the Japanese people. This is why, for the last ten years, I have toured the country (in particular, the rural areas) and documented people as they participate in festivals and ritual ceremonies. I have tried to record the basic elements of Japanese culture as it manifests itself in such extraordinary time-space situations as festivals.

You could say that my photographs constitute a type of visual "Japanology." The reason I have focussed upon folk culture in particular is that it most clearly expressed itself in visual terms. Another motive lies in the fact that I myself am a product of that culture. My work has become a confirmation of my own identity. The results of this effort have been brought together in my book of photographs, *Zokushin*. At present, I have changed the setting of my work from the country to a metropolis (Tokyo) and am pursuing the theme of people as they appear in groups, swarms, and shoals.

Since 1975 I have been documenting the subject of "Hiroshima." In photographing the present-day scenery of the city and the remaining "hibakusha" (victims of the A-bomb) as they live today, I have tried to become conscious of the way a tragedy of the past survives and changes in nature with time. The great changes that have occurred in Japanese culture thirty-five years after the year may be enacted on the stage of "Hiroshima." This subject also provides me with a framework in which to contemplate the Japanese mentality as well as to ponder the tragic nature of a nuclear explosion in this present day. My documentation of "Hiroshima" has continued along the following themes: 1) 1975-78—Hibakusha: interviews and photographs; II) 1978-79—Hiroshima landscape: relics of the blast (buildings, trees, etc.) standing within a 3 km. radius of the bomb site; III) 1980—Documents and exhibits inside the Hiroshima Peace Memorial Museum; and IV) At present—Investigating other photographic possibilities.

As for the future, I myself am not sure in which direction my camera will turn; but basically the crux of my photography will continue to be an investigation into Japanese culture and the Japanese people.

—Hiromi Tsuchida

In the early 1970's the young photographer Hiromi Tsuchida travelled throughout the remoter areas of Japan, from Aomori and Hokkaido in the north to southern Kyushu. He was ostensibly recording festivals and pilgrimages. Under the guidance of Shoji Yamagishi, Tsuchida returned from his travels with an extraordinary body of work, which was published in 1976 as *Zokushin: Gods of the Earth*.

"I suppose what I was trying to do was to find myself again as a Japanese," said Tsuchida. This assertion of a Japanese identity was a preoccupation he shared with many of his contemporaries. After the prosperity of the 1960's, a cultural crisis was evident at the start of the new decade. The distinguished novelists Mishima and Kawabata both committed suicide. The photographers Hosoe and Tomatsu, who had surfaced with Vivo in the early 1960's, had overthrown the first phase of post-war realism. They now directed their work into areas that strongly emphasized the exploration of Japanese tradition as well as the cultural conflicts that resulted from western influence. Tsuchida was to emerge with a new generation, including Shinoyama and Moriyama, all of whom were exploring the roots of their native culture.

In *Zokushin* the pre-war notion of the purity of the Yamato race—as Matsunaga puts it in his preface, "that pitiful fabrication of the ruling powers linking the myth of the descent from the Gods with reality"—is dismissed. The Gods of the Earth are the people of Japan, balanced between the profane—the sake and sex—and the spiritual devotion of the pilgrimage. Tsuchida found his subjects either in the outer, wilder regions of Japan or else on the outer periphery of society. The Shinto devotions of the festivals are coupled with the assertion of the communal spirit celebrated through dance and drink, not through the traditional concept of holiness or abstinence. Against such a background the characters in *Zokushin* are often anachronistic. In the mist on Mount Fuji a pilgrim in white robes peers through his dark glasses as if on the edge of the 20th century. Following the backroads of Japan, Tsuchida found the actors, the bar girls, the transvestites, the widow on the beach and the wedding couple on the outskirts of town; they all appear as displaced people. Like Robert Frank's American journey Tsuchida's *Zokushin* moves across an often desolate landscape with an abrasive technique that challenges many previous concepts of photographic order.

Between 1976 and 1978 Tsuchida worked on a portrait project called "Children of Hiroshima." The series was based on a text of interviews with child victims of the atomic explosion, which had been published in 1951. He integrated his portraits taken 30 years after the explosion with the original interviews. The series is a sign of the spirit of recovery. Many of the portraits have an intimate, domestic calm; they are, however, violently juxtaposed

with the revelations of the text. The trauma of 1945 remains a deep scar across modern Japan, which Tsuchida has exposed with understatement as he strips back the veneer of Japanese post-war prosperity.

—Mark Holborn

TUCKER, Nicolas.

British. Born in Topsham, Devon, 6 June 1948. Educated at Hardye's School, Dorchester. Freelance photographer, London, since 1970. Agent: Contrasts Gallery, 19 Dover Street, London W1. Address: 24 Hasker Street, London SW3 2LG, England.

Selected Group Exhibitions:

1977 *Open Photography*, Midland Group Gallery, Nottingham
1978 *Objects*, Victoria and Albert Museum, London

Collections:

Victoria and Albert Museum, London; Bibliothèque Nationale, Paris; Museum of Modern Art, New York.

Publications:

By TUCKER: article—"Circus Days and Nights" in *Photographic Journal* (London), December 1975.

On TUCKER: article—"Fotografie di Nicolas Tucker" in *Photo 13* (Milan), September 1974.

Nicolas Tucker: *Rats from Les Halles*, Paris, 1980

It was about twelve years ago, working for Lester Bookbinder in his oversized Joseph Cornell construction of giant shaving brushes, flying yellow canaries and spinning barber's pole, his studio, that I saw my first Bill Brandt print. A beautiful little 10 x 8 print of a girl's profile in an Eaton Square room. This photograph was of immense importance. I realized that there was a whole world of photography that I was unaware of, that a photograph can transcend its subject-matter and exert a mysterious power.

About the same time I became aware of other photographers: Edward Weston, Harry Callahan, Garry Winogrand, Manuel Alvarez Bravo, Minor White, Lee Friedlander, Eugene Smith, Aaron Siskind and others who took photographs that were revelatory.

The most successful of my photographs, then as now, seem to be an almost intuitive response. It took a very long time to relax rigid control of composition and to watch the viewfinder without preconceived ideas of the result, but with an open and alert mind. I am sure the subliminal mind plays a major role in the result.

Light, of course, is essential: the image is made up of blocks of light and shade; and the darkroom is extremely important. I usually have to waste a lot of paper and alter a lot of tones to get a good print.

The photographs I like most are rarely very simple, often impossible to analyze logically, but have qualities and resonances that go beyond representation, an iconic quality.

I think that there are various analogies with music in photography. Give several photographers the same theme and their development will be different. The "theme" could be nude or landscape, but the treatment should be individual. Yet photography tends to stagnate into cliché. Music has moved from Bach to Berg and Bartok, Beethoven to Tippett and Britten, each searching for their conception of beauty. Any composer now who composed in the style of Brahms would be considered a fool, yet many photographers seem to work in the belief that they are Edward Weston or Paul Strand. Since *Perspective of Nudes* (Brandt) in the mid-1950's there has been no quantum leap, few major figures of our generation—and little oxygen for them to survive on even if there were.

—Nicolas Tucker

The accompanying photograph by Nicolas Tucker taken in Paris in 1980 shows a shop window of traps, on which are hung a neat row of dead rats. From this photo one might assume that his wry humour was born from old-fashioned surrealism. In fact it comes from a very different tradition. The sparse, tightly controlled rhythm of Tucker's work is derived from a strong sense of musical equivalence. It is predictable that he should be greatly drawn to the work of Callahan, whose friend the painter Hugo Weber spoke of a "rhythmic, energetic working method" leading to "painting as a dynamic form of meditation." The ambition of Tucker's photographs is in a lineage of photographers who were capable of transforming photography to the meditation Weber describes, and that aspiration is evident in the best of his work.

Much of Tucker's work centred around key portraits of his acknowledged masters. Notable were the portraits of Manuel Alvarez Bravo and Bill Brandt. He placed Bravo beneath dark, threatening branches like the sombre, morbid shadows of Bravo's own Mexican pictures. His portrait of Brandt is one of smiling geniality, not the austere, elusive master. Amongst his other fine portraits are those of Aaron Siskind, Sir Michael Tippett and Muhammed Ali.

In 1977 John Szarkowski included some of Tucker's nudes in his exhibition for the Midland Group selected with the painter R.B. Kitaj. His nudes are examples of an intricate sensuality. Like Brandt, he is the explorer of shadow. In his outstanding Spanish nudes, the dark lines of the body are splashed in light as if through a moresque lattice. His bodies suggest intimacy, not plastic form. His recent work has included studies of dancers. He is using the dancer as model in order to look past the attractions of a finely tuned body to reassert his sense of rhythm.

From the portrait to the nude, he is aware of the endless physical possibilities and, like the portraits of Giacometti and the pastel nudes of Kitaj he so admires, his pictures imply a continual unresolved state of work in progress—a movement towards an understanding of the body. Tucker is dealing with traditional problems of form, but he aims at areas of intuition beyond constructed response.

—Mark Holborn

Jakob Tuggener: *My First Ball*, 1934

TUGGENER, Jakob.

Swiss. Born in Zurich, 7 February 1904. Educated at Sekundärschule, Zurich, 1916-19; studied drawing, Reimann Kunstschule für Gestaltung, Berlin, 1930-31; self-taught in photography. Served in the Swiss Army, 1931-32. Married 3 times; 2 sons (1 deceased). Apprentice draughtsman, 1919-23, then machine draughtsman, 1923-30, Maag Zahnräder AG, Zurich; freelance industrial photographer, working for Maschinenfabrik Oerlikon, Steckborn Kunstseide, Jakon Rieter und Co., Sprecher and Schuh, etc., Zurich, 1932-51 (established own photo studio, Zurich, 1935). Freelance magazine and advertising photographer, Zurich, working for *Du* and other magazines, since 1951. Also, independent documentary and fantasy filmmaker, and painter, Zurich, 1937-70. Recipient: Gold Medal, *Biennale di Fotografia*, Venice, 1957; City of Zurich Cultural Achievement Award, 1981. Address: Titlistrasse 52, 8032 Zurich, Switzerland.

Individual Exhibitions:

1969 *Ballnächte*, Neue Sammlung, Munich

1974 *Photographien 1930 bis Heute*, Helmhaus, Zurich
1978 *Fotografien 1930 bis Heute*, Museum der Stadt Solothurn, Switzerland
1980 Work Gallery, Zurich
1981 Kunsthaus, Zurich
Galerie zur Stockeregg, Zurich

Selected Group Exhibitions:

1951 *Collegium of Swiss Photographers*, Helmhaus, Zurich (and annually, to 1954)
1954 *Great Photographs*, Limelight Gallery, New York
1955 *The Family of Man*, Museum of Modern Art, New York (and world tour)
1957 *Biennale di Fotografia*, Venice
1963 *Die Grossen Fotografen unseres Jahrhunderts*, Cologne
1964 *Lausanne Exposition*, Pavilion of Woods and Wine, Lausanne, Switzerland
1981 *Photographs from European Collections*, Kunsthaus, Zurich (toured Europe)

Collections:

Stiftung für die Photographie, Kunsthaus, Zurich; Museum der Stadt Solothurn, Switzerland.

Publications:

By TUGGENER: books—*Fabrik: Ein Bild Epos der Technik*, Zurich 1943; *Zürcher Oberland*, with text by Emil Egli, Zurich 1956; *Forum Alpinum*, Lausanne, Switzerland, 1965; films (all 16mm, black/white, silent)—*Flugmeeting (Dubendorf)*, 1937; *Zürich Stadt und Land*, 1937-40; *Die Maschinenzeit*, 1938-70. *Abbruch der Tonhalle*, 1938; *Rosmarie*, 1942; *Die Schiffmaschine*, 1943; *Wir Fordern*, 1943; *Die Seemühle*, 1944; *Der Weg aus Eden*, 1946; *Dazio Grande*, 1947; *Uerikon-Bauma Bahn*, 1948; *Die Strassenbahnen im Kt. Zug*, 1952; *Hyronimus*, 1953; *Illusion*, 1954; *Die Muse*, 1957; *Das Grab des Kelten* (unfinished), 1959; *Palace Hotel, St. Moritz*, 1960; *Dornröschen*, 1961; *Wien, Nur Du Allein*, 1960-62; *Mortimer*, 1962; *Die Versuchung des Hl. Antonius*, 1963; *Die Hölzfäller*, 1963; *Ciel Naïf*, 1967; *Roberto Niederer, der Glasbläser*, 1970.

On TUGGENER: books—*Schweizer Künstler: Fotografie*, Zurich 1963; *Jakob Tuggener: Fotografien 1930 bis Heute*, exhibition catalogue, by André Kamber and Kurt Ulrich, Solothurn, Switzerland 1978; articles—by Hans Kasser in *Camera* (Lucerne), October 1949; in *Schweizer Journal* (Zurich), no. 1/2, 1952; in *Du* (Zurich), May 1954; by Arnold Kubler in *Du* (Zurich), January 1957; "Jakob Tuggener" by Norman Hall in *Photography* (London), September 1962; "Palace Hotel" by Manuel Gasser in *Du* (Zurich), February 1968; by Oswald Ruppen in *Schweizerische Photorundschau* (Visp), no. 24, 1974; "Tuggener Stimme aus der Stille" in *Schweizerische Photorundschau* (Visp), December 1978; film—*Zum Beispiel Tuggener* by Dieter Bachmann, 1974.

Only the greatest among photographic story tellers have in their single pictures an easily recognizable handwriting. This is true of Jakob Tuggener, astute and gentle observer of humanity at work and at play. Tuggener is a warm and perceptive person who delights in what he sees, reports on it with empathy and feeling, totally non-judgmental in his attitude toward rich and poor, reacting with fresh imagery to whatever is real. His response is immediate, his personality effacing, resulting in photographs that are intimate and true.

Tuggener's main subject is Switzerland, its nooks and crannies, its private places, where only God has had time to look. In the past 50 years he has woven a unique tapestry. It has been his custom to work for himself for decades on themes that please him and to assemble photographs from these into albums. He considers his oeuvre not single photographs, but the 70 or so bound books, which he has composed of photos in a visual rhythm, mounted and bound. The books contain up to 108 photographs. His main themes are Industry (13 for industry itself, 10 on technology), Ballnights (8), and Farmers (9). Many more are devoted to various parts of Switzerland, his travels and European capital cities.

His imagery is not influenced by any photographer. Perhaps it was stimulated by the many silent films he has made and by his painting, for he is a master at varying range and scene of a chosen subject, and his composition was from the beginning unfailingly right. Between his early and late pictures there is no difference in concept, feeling, composition or quality. Perhaps, he volunteers, the early themes are more monumental.

Social criticism has been ascribed to him, but his intention is purely photogenic: sot and dirt, pomp and glitter he likes because they make pictures. "My domain," he says, "is the soul; my photography, the shortest route to the heart."

Stimulus comes to Tuggener from the past. As others transform reality into a private vision, Tuggener draws on his strong sense of identity with his great Swiss ancestors. To their noble deeds as advisors and captains of French King's bodyguards, to their mercy shown in battle centuries ago, he ascribes the equanimity with which he photographs all.

It was an army encounter that turned the amateur from an unemployed draughtsman into a professional photographer with unheard of freedom, working for the house organ of one of Switzerland's greatest machine builders. Tuggener's specialty developed into self-designed anniversity books for Swiss companies. His oeuvre thus includes a unique coverage of Swiss industry, by now, because of automation, archeology.

At 77 Tuggener is still in love with seeing. When the light is right, his heart overflows into poignant photographs, which endear themselves with the simplicity and rightness of their conception. From the minutiae of every day life, familiar objects and places, he distills poetry.

—Inge Bondi

TURBEVILLE, Deborah.

American. Born in Medford, Massachusetts, 6 July 1937. Educated at Brimmer and May Preparatory School, Boston, 1949-54; studied photography in seminars with Richard Avedon and Marvin Israel, New York, Design Assistant to Claire McCardell, New York, 1956-58; Editorial Assistant, *Ladies' Home Journal*, New York, 1960-62; Fashion Editor, *Harper's Bazaar*, New York, 1962-65; Associate Fashion Editor, *Mademoiselle*, New York, 1967-71. Freelance fashion photographer, working for *Vogue*, *Marie-Claire*, *Nova*, etc., Paris and New York, since 1972. Agent: Sonnabend Gallery, 420 West Broadway, New York, New York 10012. Address: c/o Janice Goodman, Attorney-at-Law, 36 West 44th Street, New York, New York 10036, U.S.A.

Individual Exhibitions:

1976 Cameraworks, Beverly Hills, California
Camera Gallery, Sydney
1977 Sonnabend Gallery, New York (retrospective)
Kölnischer Kunstverein, Cologne
1978 Newport Museum, Rhode Island
Weston Art Gallery, Massachusetts
Wallflower, Sonnabend Gallery, New York
1980 *Collages*, Paul Cava Gallery, Philadelphia (travelled to the Stephen Wirtz Gallery, San Francisco)
1981 *John Baldessari/Deborah Turbeville*, Sonnabend Gallery, New York

Selected Group Exhibitions:

1975 *Fashion Photography: 6 Decades*, Emily Lowe Gallery, Hofstra University, Hempstead, New York (toured the United States)
Fashion and Fantasy, Rizzoli Gallery, New York
1977 *Fashion Photography*, International Museum of Photography, George Eastman House, Rochester, New York (travelled to the Brooklyn Museum, New York; San Francisco Museum of Modern Art, California; Cincinnati Art Institute, Ohio; Museum of Fine Arts, St. Petersburg, Florida)
1980 *Surrealism in Photography*, Cleveland Art Museum (travelled to the Brooklyn Museum, New York)

Collections:

Paul Walter Collection, New York; Sam Wagstaff Collection, New York; Bruno Bischoffberger, Zurich.

Publications:

By TURBEVILLE: books—*Maquillage*, New York 1975; *Wallflower*, edited by Marvin Israel and Kate Morgan, New York and London 1978; *Unseen Versailles: Photographs by Deborah Turbeville*, with text by Louis Auchincloss, New York 1981.

On TURBEVILLE: books—*Time-Life Photography Year*, New York 1976; *Women on Women*, edited by Katharine Holabird, London 1978; *The History of Fashion Photography* by Nancy Hall-Duncan, New York 1979; articles—"Deborah Turbeville" in *Zoom* (Paris), June/July 1976; "Deborah Turbeville" by Allan Porter in *Camera* (Lucerne), 1976; "Deborah Turbeville" by Andrea Skinner in the *New York Times*, January 1977; "Deborah Turbeville" by Gene Thornton in the *New York Times*, May 1977; "Deborah Turbeville" in *Zoom* (Paris), March 1978; "Deborah Turbeville: Wallflower" in *The Guardian* (London), May 1979; "Wallflower" by Carter Ratcliff in *Art in America* (New York), June 1979; "Deborah Turbeville: Wallflower" in *Zoom* (Paris), July 1979.

Deborah Turbeville: *L'heure entre Chien et Loup*, Montova, Italy, 1977

In 1972 I moved away from New York to live in Paris and while packing and sorting I came across a piece of paper on which I had written several years ago. It went like this: "Through a series of vignettes in stills, I wish to use the medium of photography to explain a group of rather eccentric people...sometimes one or two, sometimes many...placed in settings that help describe them. These people perform like a repertory company, often reappearing in different roles."

My pictures walk a tightrope. They never know. At 41 I am one of the very few "enfants terribles" still claiming to take fashion photographs. I am not a fashion photographer; I am not a photojournalist; I am not a portraitist.

The photographs are like the women you see in them: a little out of balance with their surroundings, waiting anxiously for the right person to find them, and thinking perhaps they are not of their times. They move forward clutching their past around them, as if the ground of the present may fall away. Their exteriors endless...airless. The very print quality reflects something in the women that is hesitant, a little faded and scratched. Or that, having emerged into a light too harsh, stand frozen in space—overexposed.

It is interesting to me that the definition of the rather old-fashioned word "wall-flower" is: a pale yellow or brownish-red flower that clings, wild, to the sides of walls—and someone who chooses not to, or is not chosen to, dance: a spectator.

—Deborah Turbeville

Former fashion editor Deborah Turbeville breaks all the traditional fashion photography rules when she takes her pictures. She neither portrays the aloof statuesque woman featured by high fashion magazines nor the vapid and featureless girl-next-door featured by magazines for the middle class; her models are interesting women—haunted, desperate, and beautiful. You want to know them. Though elusive and lonely, they are real flesh and blood, not two-dimensional objects. Their expressions are brooding and anxious. The deep set eyes do not sparkle and contain no flirtatious come-on or put-down. It is the whole woman who dominates the scene; her clothes are part of her. The traditional tendency of fashion photography, to reduce women to erotic objects, is missing. Turbeville likes women, and she does not fear them.

A photographer of proven courage, Turbeville produces prints that are grainy and often scratched. Her photographs contrast sharply with the perfect creamy prints of fashion, the kind produced by large cameras and complicated studio lighting. You are aware of the air that surrounds her models. Outdoors, they peer at us through mist and fog; inside, they wander through empty spaces in light filtered by dirty and cracked windows. Her color pictures are full of odd muted tones.

Turbeville chooses her locations with care and originality. Abandoned mansions, greenhouses lying in ruins, deserted public bathhouses, empty corridors, and jumbled warehouses replace the seamless backdrops and the elegantly furnished society manors that we are accustomed to. Her settings seem more appropriate to a mystery play than to the selling of clothes. The mood is one of menace and uncertainty. The sense of theatre prevails—something is about to happen in this soft focus dream world.

Are clothes the meaning of these pictures? Turbeville appears to be more interested in the making of interesting and eye-stopping pictures. It is often difficult to get a clear idea of the details of the garments being worn. Yet, the magazine reader's eye is caught, the women are real and appealing, and the reader can identify with them. Perhaps these haunting pictures do sell clothes.

If Turbeville's view of fashion is about its time, then women live in a world of malaise, of uncertainty, angst, boredom, loneliness, and terror. They are victims. Turbeville's evocative photographs reflect the women in them and are a strong criticism of our culture. Her care in choice of model, location, staging, camera, lens, and printing all contribute to her view of the anxious isolation of even the most beautiful of women placed in a disquieting time.

—Barbara Norfleet

UEDA, Shoji.

Japanese. Born in Sakaiminato, Tottori Prefecture, 27 March 1913. Educated at Yonago Public High School, Tottori Prefecture, 1924-30; studied, under Toyo Kikuchi, at the Oriental School of Photography, Tokyo, 1930-31. Married Norie Shiraishi in 1932; children: Hiroshi, Kazuko, Mitsuru, and Touru. Photographer since 1933, with studio in Sakaiminato; Member, Chugoku Photographers' Club, Okayama, 1934-37, Ginryusha Photographers' Club, Tokyo, 1948, and Nika Photographers Club, Tokyo, 1955. Professor of Photography, Kyushyu Sangyo University, Fukuoka Prefecture, since 1975. Recipient: Photography Prize, Nika Exhibition, Tokyo, 1955. Agent: Zeit-Photo, Yagicho Bld. 5F 1-4, Muromachi, Nihonbashi, Chuo-ku, Tokyo. Address: 82 Suehiromachi, Sakaiminato-shi, Tottori-ken, Japan.

Individual Exhibitions:

1953 Shoji Ueda/ Youichi Midorikawa, Muramatsu Gallery, Tokyo
1971 Children the Year Round, Asahi Pentax Gallery, Tokyo
1972 Sketch Album in Europe, AO Gallery, Tokyo
1975 Shoji Ueda's World, Nikon Salon, Tokyo (travelled to the Nikon Salon, Osaka)
1979 Shoji Ueda, Asahi Pentax Gallery, Tokyo
 Matsue, Olympus Photo Plaza, Tokyo
1980 Izumo, Minolta Photo Space, Tokyo
 Europe, Asahi Pentax Gallery, Tokyo
 Shoji Ueda, Nikon Salon, Tokyo

Selected Group Exhibitions:

1948 Ginryu-sha Exhibition, Matsuya Department Store, Tokyo
1949 Ginryu-sha Exhibition, Matsuya Department Store, Tokyo
1960 Japanese Photography, Museum of Modern Art, New York
1970 Six Photographers, Fuji Photo Salon, Tokyo
1979 Photo Festival, Bologna
 Japan: A Self-Portrait, International Center of Photography, New York (travelled to Venezia '79)

Collections:

Museum of Modern Art, New York; Bibliothèque Nationale, Paris.

Publications:

By UEDA: books—Izumo Myths, with Masaaki Ueda, Tokyo 1965; Oki, with Tatsuya Naramoto, Tokyo 1967; Children the Year Round, Tokyo 1971;

The Legend of Izumo, Tokyo 1974; Sketch Album in Europe, Tokyo 1974; Sand Dunes, Tokyo 1978; Izumo Fudoki, Tokyo 1979.

On UEDA: book—Japanese Photography by Shoji Yamagishi, Tokyo 1979; articles—"The World of Shoji Ueda" in Photo Art Annual, Tokyo 1974; "Shoji Ueda: Cute Stories" in Camera Mainichi (Tokyo), January 1974.

Photography has been placed in a lower position and evaluated less in Japan than the other arts—for instance, painting. Although there may be many reasons for this attitude and neglect, the main ones seem to be that there prevailed a wrong way of thinking in the past, when the majority of people had a biased view that recognized photography in graphic journalism but not in other fields, and that Japanese graphic journalism itself did not show any particularly positive attitude in communicating with foreign countries.

Recently, however, these tendencies have been gradually rectified by progressive photographers and journalists. Evidence of this change is that a movement to found a photography museum in Japan has become one of the dominant concerns of the Japan Professional Photographers Society.

It is, indeed, encouraging and delightful that we are moving into a new age, leaving behind the old narrow and regional way of thinking, exchanging communication broadly with photographers and photographic circles throughout the world.

My photographs in graphic journalism are, of course, an important part of my work. But I also

regard the original prints made for exhibitions and my other works as important as well.

Needless to say, we must evaluate and respect the masterpieces of the past. But it is also the duty of present-day photographers to direct our work as from the realization that our significance lies in how well we produce photographs appropriate to the new age.

—Shoji Ueda

The most appropriate description of Shoji Ueda must be "poet of images." There is an authentic poesie in his photographs.

Ueda was born in 1913 in Sakaiminato City in Tottori Prefecture. From childhood he took a delight in photography, and he went on to set up his own photographic studio in Sakaiminato. He worked continually on his most personal of prints, which came to be published widely. His prime subjects have been landscapes and people, rendered in the particular local colors of the Sanin District. The unique Ueda-style is an amalgam of a strong compositional sense and a feeling of spaciousness; another factor is an almost childlike simplicity. Ueda himself has said that he was influenced by the paintings of Rousseau, and this influence would seem to be borne out by his series Sand Dunes.

Recently Udea has expanded his range from the limited imagery of Sanin; he has now gone so far as to include western and even Chinese elements. Nevertheless, whatever the subject-matter, the Ueda-style is still there, ready to surprise the observer. On the evidence of these latest works, his vision as a photographer is still both strong and original.

Shoji Ueda: Son and Fox-Mask, 1948

Ueda has matured; he has been a practicing photographer for a long time; and he is now treated as a senior member of the Japanese photographic fraternity—and yet neither his sensitivity nor his freshness has left him. Rather, he seems to be getting younger by the day, possibly because his enthusiasm and curiosity are still those of a young boy. Whatever the reasons, Ueda still shows an interest in anything new—not just new techniques of developing and printing but new clothes, new ideas, new products; at present he is growing an orchard and breeding Afghan hounds.

In his own profession he is currently fascinated by soft focus color prints taken through a customized lens fitted to a single lens reflex Pentax. These most recent photographs are soon to be published.

From the beginning of his career, Ueda has regarded photography as an art, and it is perhaps owing to that attitude that his own work has always set a standard for excellence. Almost by himself, Shoji Ueda pioneered serious photography in Japan, and he is still at the forefront of that photography today.

—Takao Kajiwara

UELSMANN, Jerry N(orman).

American. Born in Detroit, Michigan, 11 June 1934. Educated at Cooley High School, Detroit, 1948-52; studied photography, under Ralph Hattersley and Minor White, at Rochester Institute of Technology, Rochester, New York, 1953-57, B.F.A. 1957; audio visual communication, 1957-58, and photography, under Henry Holmes Smith, 1958-60, at Indiana University Graduate School, Bloomington, M.S. 1958, M.F.A. 1960. Married Marilynn Kamischke in 1957 (divorced, 1974); married Diane Farris in 1975; son: Andrew. Photographer since 1953. Interim Instructor in Photography, 1960-62, Instructor, 1962-64, Assistant Professor, 1964-66, Associate Professor, 1966-69, Professor, 1969-74, and since 1974 Graduate Research Professor, University of Florida, Gainesville. Visiting Professor, Nihon University College of Art, Tokyo, October 1979. Founder Member, 1962, and Member of the Board of Directors, 1966, Society for Photographic Education. Advisory Trustee, Friends of Photography, Carmel, California, since 1975. Recipient: Guggenheim Fellowship, 1967; Faculty Development Grant, 1971, and Teacher/Scholar of the Year Award, 1975, University of Florida; National Endowment for the Arts Fellowship, 1972; City of Arles Medal, France, 1973; Bronze Medal, *International Exhibition of Photography*, Zagreb, 1979. Fellow, Royal Photographic Society, London, 1973. Agent: Witkin Gallery, 41 East 57th Street, New York, New York 10022. Address: 5701 South West 17th Drive, Gainesville, Florida 32608, U.S.A.

Individual Exhibitions:

1960 Indiana University, Bloomington
1961 University of Florida, Gainesville
 San Francisco State College
 Illinois Institute of Technology, Chicago
1962 School of the Art Institute of Chicago
 Indiana University, Bloomington
1963 Kalamazoo Art Institute, Michigan
 Jacksonville Art Museum, Florida
 3 Photographers, International Museum of

Photography, George Eastman House, Rochester, New York
 University of Florida, Gainesville
1964 Arizona State University, Tempe
 Heliography Gallery, New York (with Wynn Bullock)
1965 University of South Florida, Tampa
1966 Pratt Institute, Brooklyn, New York
 Lowe Art Gallery, University of Miami
1967 University of New Hampshire, Durham
 Museum of Modern Art, New York (toured the United States)
1968 Ringling Museum of Art, Sarasota, Florida (toured the United States)
 Refocus, University of Iowa, Iowa City
 Long Island University, Brooklyn, New York
 University of Oregon Art Museum, Eugene
 Creative Photography Gallery, Massachusetts Institute of Technology, Cambridge
 Phoenix College, Arizona
 Minneapolis Institute of Arts
 Ayer Gallery, Philadelphia
 Container Corporation of America, Chicago
1969 University of South Florida, Tampa
 Friends of Photography, Carmel, California
 Recent Photographs, Carl Siembab Gallery, Boston
 Camera Work Gallery, Costa Mesa, California
1970 Philadelphia Museum of Art (retrospective; toured the United States)
 International Museum of Photography, George Eastman House, Rochester, New York (toured the United States)
1971 College of Idaho, Caldwell
 Southern Illinois University, Carbondale
 Boise State College, Idaho
1972 Witkin Gallery, New York
 Stetson University, DeLand, Florida
 Barry College, Mt. Barry, Georgia (with Todd Walker and Doug Prince)
 Art Institute of Chicago
 Vanderbilt University, Nashville, Tennessee
1973 Western Carolina University, Cullowhee
 Camera Work Gallery, Portland, Oregon
 University of Northern Iowa, Cedar Falls
 SoHo Photo, New York
1974 The Photographic Place, Berwyn, Ilinois
 Middle Tennessee State University, Murfreesboro
 Eastern Washington State College, Cheney
 Art Academy of Cincinnati, Ohio
 Centre Culturel Americain, Paris (toured France)
1975 Rochester Institute of Technology, Rochester, New York
 Washington Gallery of Photography, Washington, D.C.
 Jack Glenn Gallery, Newport Beach, California
 Witkin Gallery, New York
1976 Deja Vue Gallery, Toronto (with Barbara Astman and Michael Semak)
 Center for Creative Photography, University of Arizona, Tucson
 J. Hunt Gallery, Minneapolis
 Texas Center for Photographic Studies, Dallas
 University of Texas, Dallas
1977 *Jerry N. Uelsmann Retrospective*, San Francisco Museum of Modern Art
 Grapestake Gallery, San Francisco
 Susan Spiritus Gallery, Newport Beach, California
 Pennsylvania State University, University Park
 Recent Work, Witkin Gallery, New York
1978 Worcester Art Museum, Massachusetts
 Cronin Gallery, Houston
 Museum of Fine Arts, Santa Fe, New Mexico
 Galerie Fiolet, Amsterdam (in conjunction with Canon Gallery)
 Nova Gallery, Vancouver
 Photographers Gallery, South Yarra, Vic-

toria, Australia
1979 The Photography Place, Phildelphia
 Atlanta Gallery of Photography
 Thomas Center, Gainesville, Florida
 Silver Image Gallery, Ohio State University, Columbus
 Nihon University Gallery, Tokyo
 Deja Vue Gallery, Toronto
 Photo Gallery International, Tokyo
1980 *Photographs from 1975-79*, Center for Contemporary Photography, Chicago
 Read Centre, Indiana University, Bloomington
 Witkin Gallery, New York
1981 Gilbert Gallery, Chicago (with Diane Farris)
 Eclipse Photographics, Boulder, Colorado
1982 Images Gallery, Cincinnati, Ohio

Selected Group Exhibitions:

1959 *Photography at Mid-Century*, International Museum of Photography, George Eastman House, Rochester, New York (toured the United States)
1967 *Photography in the 20th Century*, National Gallery of Canada, Ottawa (toured Canada and the United States, 1967-73)
1969 *The Photograph as Object 1843-1969*, National Gallery of Canada, Ottawa (toured Canada)
1970 *Into the 70's*, Akron Art Institute, Ohio
1972 *4 Directions in Modern Photography: Paul Caponigro, John T. Hill, Jerry N. Uelsmann, Bruce Davidson*, Yale University Art Gallery, New Haven, Connecticut
1974 *Photography in America*, Whitney Museum, New York
1975 *The Land: 20th Century Landscape Photographs Selected by Bill Brandt*, Victoria and Albert Museum, London (travelled to the National Gallery, Edinburgh; Ulster Museum, Belfast; and National Museum of Wales, Cardiff, 1976)
1978 *Mirrors and Windows: American Photography since 1960*, Museum of Modern Art, New York (toured the United States, 1978-80)
1979 *Venezia '79*
1981 *American Photographers of the National Parks*, Corcoran Gallery, Washington, D.C. (toured the United States, 1981-83)

Collections:

Museum of Modern Art, New York; International Museum of Photography, George Eastman House, Rochester, New York; Philadelphia Museum of Art; Art Institute of Chicago; Center for Creative Photography, University of Arizona, Tucson; San Francisco Museum of Modern Art; National Gallery of Canada, Ottawa; Victoria and Albert Museum, London; Bibliothèque Nationale, Paris; Moderna Museet, Stockholm.

Publications:

By UELSMANN: books—*8 Photographs: Jerry Uelsmann*, with text by William E. Parker, New York 1970; *Jerry N. Uelsmann*, with an introduction by Peter C. Bunnell, fables by Russell Edson, Millerton, New York 1970, 1973; *Jerry N. Uelsmann*, portfolio, New York 1972; *Jerry Uelsmann: Silver Meditations*, with an introduction by Peter C. Bunnell, Dobbs Ferry, New York 1975; articles—"Interrelationship of Image and Technique" in *Invitational Teaching Conference at the George Eastman House*, edited by Nathan Lyons, Rochester, New York 1963; "Post-Visualization" in *Florida Quarterly* (Gainesville), Summer 1967, reprinted in *Creative Camera* (London), June 1969, and included in

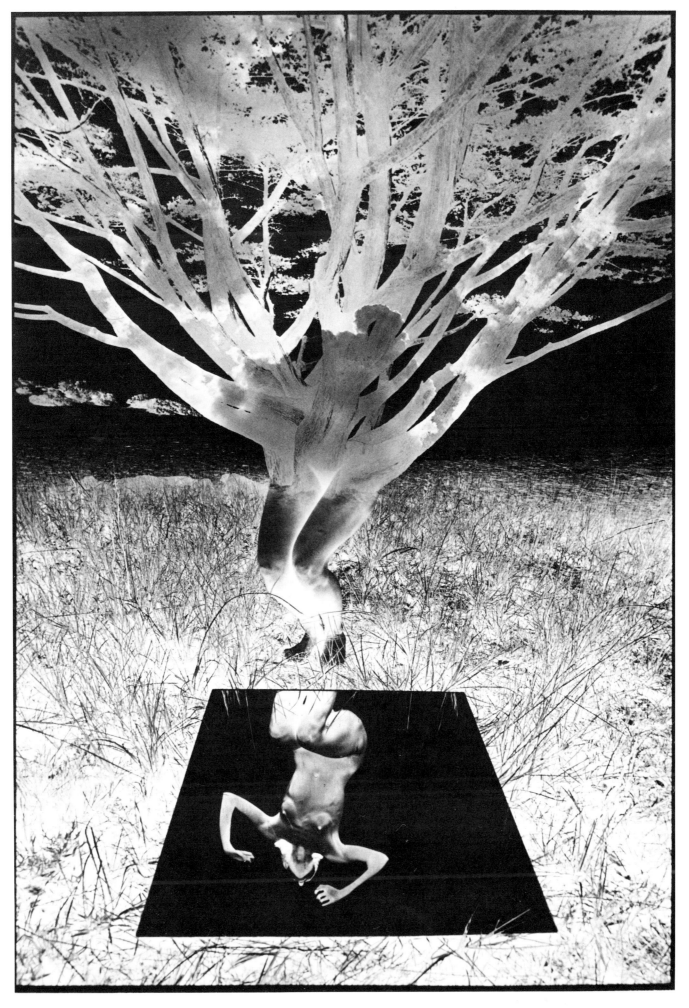

Jerry N. Uelsmann: *Untitled*, 1976

The Camera Viewed: Writings on 20th Century Photography, edited by Peninah R. Petruck, New York 1979; "Wynn Bullock: Tracing the Roots of Man in Nature" in *Modern Photography* (New York), May 1970; statement in *Into the 70's*, exhibition catalogue, Akron, Ohio 1970; article in *Infinity* (New York), September 1970; article in *Color*, by the Time-Life editors, New York 1970; "Some Humanistic Considerations of Photography" in *The Photographic Journal* (London), March 1971; comments in *Modern Photography* (New York), July 1973; "How Jerry Uelsmann Creates His Multiple Images" in *Popular Photography* (New York), January 1977, reprinted as "Multiple Images" in *Darkroom*, edited by Eleanor Lewis, New York 1977; statement in *American Photographer* (New York), November 1979.

On UELSMANN: books—*The Persistence of Vision* by Nathan Lyons, New York 1967; *Jerry N. Uelsmann*, illustrated checklist, by John Szarkowski, New York 1967; *The Criticism of Photography as Art: The Photographs of Jerry Uelsmann* by John Ward, Gainesville, Florida 1970; *Photography in America*, edited by Robert Doty, with an introduction by Minor White, New York and London 1974; *The Land: 20th Century Landscape Photographs Selected by Bill Brandt*, exhibition catalogue, edited by Mark Haworth Booth, London 1975; *Masters of the Camera* by Gene Thornton, New York 1977; *Geschichte der Fotografie im 20. Jahrhundert/Photography in the 20th Century* by Petr Tausk, Cologne 1977, London 1980; *Mirrors and Windows: American Photography since 1960* by John Szarkowski, New York 1978; *Light Readings: A Photography Critic's Writings 1968-1978* by A.D. Coleman, New York 1979; *The Photograph Collector's Guide* by Lee D. Witkin and Barbara London, Boston and London 1979; *Jerry N. Uelsmann: Photographs from 1975-79*, exhibition catalogue, with an introduction by Steven Klindt and an essay by Jim Enyeart, Chicago 1980; articles—"Jerry Uelsmann" in *Infinity* (New York), May 1962; "The Photographs of Jerry N. Uelsmann" in *Contemporary Photographer* (Culpeper, Virginia), no. 1, 1964; "Color, Candids, Novelty" by Jacob Deschin in the *New York Times*, 22 November 1964; "Jerry N. Uelsmann: Involved with the Celebration of Life" by H.M. Kinzer in *Popular Photography* (New York), November 1965; "Notes on Uelsmann's Invented World" by William E. Parker in *Infinity* (New York), February 1967; "Uelsmann's Unitary Reality" by William E. Parker in *Aperture* (Rochester, New York), no. 3, 1967; "Sense and Perception" by Margaret Harker in *The Photographic Journal* (London), May 1968; "Jerry N. Uelsmann: New Symbols" in *Modern Photography Annual*, New York 1971; "Jerry Uelsmann" in *Infinity* (New York), May 1972; "An Album of Cryptic Impressions" in *Photography Year 1976*, by the Time-Life editors, New York 1976; "The Inclusion of Medieval and Victorian Art in Jerry Uelsmann's Photographs: A Reading of Associations" by Susan Dodge Peters in *Image* (Rochester, New York), March 1979; "Tarnished Meditations: Some Thoughts on Jerry Uelsmann's Photographs" by James Hugunin in *Afterimage* (Rochester, New York), May 1979; "Jerry Uelsmann's Recent Work" in *Afterimage* (Rochester, New York), April 1980.

Images of astounding variety, mystery and enigma characterize the photographs of Jerry Uelsmann. His ability to produce works of great interest in regularity is the hallmark of his style. In the past, when the energy of viewers and critics alike has lagged in the face of the enormity of his body of work, attempts to pigeonhole or categorize his photographs as Surrealist, Jungian, Neo-romantic, or literary has taken precedence over more detailed analysis of its content.

Uelsmann's photography is singularly none of these, yet encompasses all of them and more. As a body, his photographs defy any categorization

which is all inclusive, just as each individual photograph defies exact referential interpretation. What most often appears as surreal in his work is the dominance of absurd or unbelievable juxtaposition of subject matter. However, actual stream of consciousness method is rarely employed. One can perceive through a large cross-section of his photographs several repeated choices of juxtaposed subject matter which contradict the surrealist dictum of automatism. Further, Uelsmann makes the inappropriate appear appropriate and the unbelievable, believable—qualities rarely found in Surrealism.

Because his images are generally mysterious, there is a temptation to find intellectual security in sweeping generalizations like Surrealism. While Uelsmann may be predisposed to contain Surrealist tendencies like free-association, he nevertheless makes aesthetic judgements of what will and will not work together in creating an image. It is this process which places his work in a contemporary realm and accounts for the repetition of certain visual associations in his imagery. The visual associations I refer to are based on recurrent use of subject motif and iconographic devices. Among the motifs he consistently uses are hands, eyes, the nude, objects of antiquity, the mirror, water, rocks. The iconographic devices include floating objects, metamorphosis and positive/negative combinations.

The primary method by which Uelsmann arrives at his imagery, what he calls "in process discovery," is in essence a gestalt position in which creativity is viewed in terms of one's ability to associate dissimilar elements in meaningful ways and in terms of restructuring the entire stimulus field. To disassociate known subject relationships (reality) and associate them in new but perhaps mysterious ways is the modus operandi of "in process discovery." To this point Uelsmann has said:

> It seems to me that life abounds with mystery, that it is central to life, that when you are truly alive there are many kinds of questions...and it is the challenge of these questions that makes life interesting.

> It is important that we maintain a continual open dialogue with our materials and process; that we are constantly questioning and in turn being questioned.... In terms of my own development I have found the recognition of questions more provocative than the provision of answers. Often, confident that we have the right answers, we fail to ask enough questions, and then our seeming confidence fogs our vision, and the inconceivable remains truly unconceived.

It has never been easy and remains difficult to tell exacting what is going on in Uelsmann's imagery (even for him), except in his overtly humorous and portrait works. These two manifestations of his photographs have generally been straightforward and without allegory, myth or mystery.

Whereas Uelsmann's photographs up to 1975 may have been interpreted from various personal biases relating to psychological theories, it should not be ignored that they were also more simply symbolic. Uelsmann himself often pointed to that symbolism by his use of titles to reinforce the symbol, as in "Massacre of the Innocents" or "Apocalypse." In his work since 1975 the use of titles has become less frequent and less meaningful. Although some aspects of symbolism may remain in even the most recent work, it is no longer pervasive or obvious. As early as 1971 Uelsmann made it clear that his use of symbol existed, but with qualifications. "I think of many of my photographs as being obviously symbolic, but not symbolically obvious." His twisting of words is no less enigmatic than his mixture of humor and symbol. He claims to believe in angels and adores strawberries because they do not hide their seeds.

On rare occasions Uelsmann has expressed his

own interpretation or intention in the use of symbolism in his work—as in the "Massacre of the Innocents" of 1971:

> Being basically from the Midwest I developed certain prejudices toward the South. I moved there and I found myself in the position of being very upset by certain attitudes of Southerners, particularly relative to racial concerns, and at the same time there was a gentleness among the people, there was a pace that I found very human and very appealing. I think "Massacre of the Innocents" deals with the South that is very much going through a painful transition. It was also done at the same time that three civil rights workers were killed in Mississippi.

In this image, as in all of Uelsmann's imagery, the use of symbol is not specific and certainly not brutal. He did not document the fact or event in media-style violence. Rather, he attempted to represent in a larger context the pertinent human condition.

If pictorialism dressed up as classicism in the first part of this century in order to make eroticism acceptable, then Uelsmann may be seen as making the symbol pictorial in order to provoke simultaneously the intellect and emotions. In this sense, his photographs would not differ so greatly from Robert Heinecken's earlier sensitized canvas renderings of our socio-sexual environment. For that matter, it would place him squarely in the center of contemporary photography, the concern of which seems to be devoted to beautiful objects whether drawn from banal subjects or hand treated intellectualizations. The primary difference would be that Uelsmann has chosen not to disregard emotion as a part of his aesthetic goal:

> By our cameras we are introduced to an endless array of trees, clouds, rocks, objects, people, feelings, experiences, and so on. We wander through this varied landscape as contemporary archeologists, anthropologists, poets and explorers essentially serarching in our own internally directed way. Each click of the shutter becomes an emotional investment, and a part of the world becomes our visual possession.

As an alternative to psychologizing about Uelsmann's imagery, I would like to suggest viewing his recent work in terms of mythology. When Uelsmann states that we are as contemporary archeologists, anthropologists, poets and explorers in a search for internally directed meaning of our environment, there is a correlation to spontaneous myth-making, the creation of symbolic stories to represent the inexpressible verbalizations of our visions and emotions. What is drawn from our psychic sources finds difficulty existing elsewhere, and for Uelsmann, as for the ancient Greeks, myth can represent what cannot really exist. Uelsmann's controlled choices in organizing his subject combinations, and the rhythmic repetition thereof, make me less satisfied with the possibility of aleatory or dream consciousness in his work than the more structured elements of mythology.

Uelsmann is careful in the making of his photographs not to invoke the purely personal vernacular of Surrealism. His final choice of subjects and their combinations reflect instead associative forms in super-realistic terms, which may in turn and in part be archetypal. In fact, mythological subject divisions of Uelsmann's work would often be analogous to or incorporate traditional archetypes: cosmogony, hero, earth woman, mother goddess, flood, death, apocalypse, paradise and morphology. In most cases the archetype would simply serve as a symbol within the visual myth.

The mythology I suggest does not relate to any extant narratives, classical or primitive, but would be individual to each photograph and contemporary

Doris Ulmann: Sitter Unknown, either North Carolina or Kentucky, c. 1934 Courtesy University of Oregon Library, Eugene

to its creation. Uelsmann's mythology could then represent a kind of story-telling about a personal journey between visual discovery and visual creation. Within its sphere emotions would be set free, humor and seriousness would be inseparable, and enigma would be god-head of associative form. To use Uelsmann's words: "If one accepts the fact that you can impose yourself on subject matter, then perhaps you can literally create subject matter."

The scenario for each myth introduced in each of Uelsmann's photographs is contained completely therein. There is no beginning and no end as in verbalized or written myths. Rather, these are visual mythologies which contain elements of unlived, but psychically recognizable, experiences.

Uelsmann's faith in "in-process discovery" and his evolution from simple symbol to myth invokes the spirit of a Latin phrase painted by Giorgio de Chirico on his self-portrait in 1908. *Et quid amabo misi quod aenigma est*—And what am I to love, if not the enigma?

—James Enyeart

ULMANN, Doris.

American. Born in New York City, 29 May 1882. Educated at New York public schools until 1900; studied teacher training, under Lewis W. Hine, at the Ethical Culture School, New York, 1900-03; studied psychology and law at Columbia University, New York, and photography, under Clarence H. White, at the Clarence White School of Photography at Columbia. Married Charles H. Jaeger c. 1915 (divorced, c. 1925). Professional photographer, New York, 1918-34, particularly noted for her photographic projects in the Appalachians. Member, Pictorial Photographers of America, 1915-26. Ulmann Foundation established on her death, 1934: archives now housed in the Special Collections Department, University of Oregon Library, Eugene. *Died* (in New York City) *28 August 1934.*

Individual Exhibitions:

1929 Delphic Studios, New York
1933 Delphic Studios, New York
 Southern Mountain Workers Conference, Brasstown, North Carolina
1934 Berea College, Kentucky
1974 Witkin Gallery, New York

 University of Oregon Museum of Art, Eugene
1976 Western Carolina University, Cullowhee, North Carolina (retrospective)
 G. Ray Hawkins Gallery, Los Angeles
1977 Marcus Pfeifer Gallery, New York (retrospective)

Selected Group Exhibitions:

1955 *The Family of Man*, Museum of Modern Art, New York (and world tour)
1975 *Women of Photography*, San Francisco Museum of Art (toured the United States, 1975-77)
1977 *Photographs: Sheldon Memorial Art Gallery Collection*, University of Nebraska, Lincoln
1978 *Photos from the Sam Wagstaff Collection*, Corcoran Gallery, Washington, D.C. (toured the United States and Canada)
1979 *Photography Rediscovered: American Photographs 1900-1930*, Whitney Museum, New York (travelled to the Art Institute of Chicago)
 10th Anniversary Show, Witkin Gallery, New York
 Fleeting Gestures: Dance Photographs, International Center of Photography, New York (travelled to *Venezia '79*, and to The Photographers' Gallery, London)
 Amerika Fotografie 1920-40, Kunsthaus, Zurich

Collections:

Ulmann Archives, University of Oregon, Eugene (10,000 proof prints; 2,700 glass negatives; 150 original prints); Berea College, Kentucky; International Museum of Photography, George Eastman House, Rochester, New York; Philadelphia Museum of Art; Library of Congress, Washington, D.C.; Detroit Institute of Arts; Art Institute of Chicago; New Orleans Museum of Art; University of Nebraska, Lincoln; University of New Mexico, Albuquerque.

Publications:

By ULMANN: books—*24 Portraits of the Faculty of Physicians and Surgeons of Columbia University* (as Doris Jaeger), with a foreword by Samuel W. Lambert, New York 1918; *A Book of Portraits of the Medical Faculty of Johns Hopkins University*, Baltimore 1922; *A Portrait Gallery of American Editors*, with text by Louis Evan Shipman, New York 1925; *Roll, Jordan, Roll*, with text by Julia Peterkin and Robert Ballou, New York 1933; *Handicrafts of the Southern Highlands*, with text by Allen Hendershott Eaton, New York 1937; *The Appalachian Photographs of Doris Ulmann*, with text by John Jacob Niles and Jonathan Williams, Penland, North Carolina 1971; *The Darkness and the Light: Photographs of Doris Ulmann*, with text by Robert Coles and William Clift, Millerton, New York 1974; *Doris Ulmann*, exhibition catalogue, Cullowhee, North Carolina 1976.

On ULMANN: books—*The Magic Image* by Cecil Beaton and Gail Buckland, London and Boston 1975; *Women of Photography: An Historical Survey* by Margery Mann and Ann Noggle, San Francisco 1975; *Photographs: Sheldon Memorial Art Gallery Collection, University of Nebraska*, with an introduction by Norman A. Geske, Lincoln 1977; *A Book of Photographs from the Collection of Sam Wagstaff*, designed by Arne Lewis, New York 1978; *Amerika Fotografie 1920-1940* by Erika Billeter, Berne 1979; *A Ten Year Salute* by Lee D. Witkin, with a foreword by Carol Brown, Danbury, New

Hampshire 1979; *Photography Rediscovered: American Photographs 1900-1930*, exhibition catalogue, by David Travis, New York 1979; *The Photograph Collector's Guide* by Lee D. Witkin and Barbara London, Boston and London 1979; articles—"Doris Ulmann, Photographer-in-Waiting" by Warren Dale in *Bookman* (New York), October 1930; special issue of *Call Number* (Eugene, Oregon), Spring 1958; "The Appalachian Photographs of Doris Ulmann" by Gene Thornton in *Aperture* (Rochester, New York), vol. 16, no. 2, 1971; "Ulmann Forces a New Look at Pictorialism" by Gene Thornton in the *New York Times*, 12 January 1975.

Doris Ulmann's photographs reflect her position on the cusp of two trends of early 20th century photography in the United States. Her career was influenced by the philosophical changes that took place both in photography and in American culture as a whole during the 1920's and 1930's. Ulmann studied photography with Clarence H. White, Sr., and her early work falls clearly within the pictorialist tradition. She was active in White's organization, the Pictorial Photographers of America. Her husband, Dr. Charles Jaeger, at one time served as President for the group, and both Jaeger and Ulmann (she signed her prints "Doris U. Jaeger" prior to their divorce) had photographs included in the annual publication of the Pictorial Photographers of America.

Many of Ulmann's early photographs were made on photographic excursions with her husband and other photographers to places such as Gloucester Bay, Massachusetts, where the boats in the harbor and the waterfront buildings offered many picture-making opportunities. She quickly developed an interest in portraiture, however, and began to photograph people in her New York living room. Many of her initial subjects were part of the New York medical community—her husband was an orthopedic surgeon—while others were well-known theatrical or literary figures she sought out on their visits to the city. Suffering the fate of many portraits of the famous, a great number of these first portraits fail to portray more than the visage of a well-known person. Ulmann continued to make portraits of the well-known throughout her career, but it was not until she began to travel away from the city to photograph unknown people in rural areas that her portraits took on a poignant intensity.

It is these portraits, made first in the Amish, Mennonite and Shaker communities of New York and, after 1927, when she began to travel with the singer and traditional song-collector John Jacob Niles, in the mountain areas of Kentucky, Tennessee and North Carolina, for which Ulmann is best known. To these should be added the series of photographs she made during the winter of 1929 of black people living along the South Carolina coast. This latter group, while more distant than her work in Appalachia, explores the life of the sitters more directly than through portraiture alone. A group of these images were published in the 1933 Julia Peterkin book, *Roll, Jordan, Roll*.

Doris Ulmann was caught between two distant photographic concerns in the 1930's, and it is this apparent contradiction that gives her work its unique character. On one hand, she steadfastly held to many of the tenets of the Pictorialist tradition and maintained a traditional feeling for what a photograph should look like. She insisted on using a view camera taking 6½" x 8½" glass plates that was equipped with a soft-focus lens. She used neither a shutter nor a light meter, although both were readily available. Her prints, either in platinum or silver, retained the warm-toned and soft quality she had initially learned as a student of Clarence White.

In contrast to this approach, Ulmann also had a strong desire for her work to be of social value. She cannot, however, be called a documentary photographer of the same school as the Farm Securities Administration photographers who began their work during the early 1930's. Ulmann had no desire to change the world with her photographs, only to document what existed, to record the variety of people she found in the rural areas of the east. These were people she, like many others during the period, feared would disappear as the effects of urbanization spread outward from the cities. She sought not to show the poverty of those she photographed, but to portray the character of individuals—her interest was in the older generation rather than in children and young people—who had been touched by their difficult life in the rural east.

It should be noted that when Ulmann died in the late summer of 1934 she had been travelling and photographing in the Appalachians for nearly five months. She left some 3,000 negatives from that year and from the previous summer's trip undeveloped. The Doris Ulmann Foundation, which was established by her will, arranged to have these negatives developed and printed. Proof prints were made of the approximately 10,000 images she had made during her career; the proofs were bound in albums. Many of the Doris Ulmann photographs extant were not made by her but are quality prints made after her death by the Foundation. Identification of these prints is easily made. Negative numbers were added to the margin of the glass-plate negatives during the proofing process. The Foundation prints were sandwiched in a window mat without being trimmed so that, even though the overmat is firmly attached to the backing, the negative number can be seen by lifting up the edge of the mat at the upper right corner of the image. These prints were also signed using a stamp of a high-quality facsimile of her signature.

—David Featherstone

UMBO.

German. Born Otto Umbehr in Dusseldorf, 18 January 1902; adopted the name "Umbo" in 1924. Educated in Saarland, Stuttgart, Duisberg and Dusseldorf, 1908-16; studied art, under Johannes Itten, Walter Gropius, Wassily Kandinsky, Paul Klee, etc., at the Staatliches Bauhaus, Weimar, Germany, 1921-23; self-taught in photography. Served as a driver in the German Army, 1943-45. Married Irmgard Hirz in 1943 (divorced, 1950); daughter: Phyllis. Worked as coal-miner, Essen, 1920; as potter with Kuno Jaschinsky, Goslar, Germany, 1920; as actor in Maria Heide's mystery performance group, in several German towns, 1921; in workshops of Muck Lamberty, Naumberg, Germany, 1921; with Friedel Dicker and Franz Singer in Arts and Crafts Workshops for Theater Berthold Viertel, Berlin, 1923-24. Worked as film editor and cameraman with Kurt Bernhardt and Walter Ruttmann; also, film-poster designer, glass- and alabaster-worker, clown, photomontagist, etc., Berlin, 1924-26; freelance photographer, establishing own studio, Berlin, 1926-45; studio photographer and photojournalist, under Simon Guttmann, Dephot (Deutscher Photodienst) co-operative photo agency, Berlin, 1928-33; Staff Photographer, Ullstein Verlag publishers, Berlin, 1938-43; freelance press photographer, working for *Quick, Der Spiegel, Picture Post*, etc., Hannover, 1945 until his death in 1980: House Photographer, Kestner-Gesellschaft, Hanover, 1948-72. Instructor in Photography, Landesversehrtenberufsschule, Bad Pyrmont, West Germany, 1957-74; Werkkunstschule, Hannover, and Werkkunstschule,

Hildesheim, West Germany, 1965-74. Member, Gesellschaft Deutsche Lichtbildner (GDL), 1977-80. Agent: Rudolf Kicken, Albertusstrasse 47-49, 5000 Cologne 1, West Germany. *Died* (in Hannover), *13 May 1980*.

Individual Exhibitions:

1927 Kneipe (pub) "Die Lunte," Berlin
1928 Kabarett "Im Toppkeller," Berlin
1979 *Umbo: Photographien 1925-1933*, Galerie Spectrum in Kunstmuseum, Hannover (retrospective)
 Galerie Rudolf Kicken, Cologne (with Paul Citroen)
1981 Centre Georges Pompidou, Paris (with Herbert Bayer)

Selected Group Exhibitions:

1929 *Film und Foto*, Deutscher Werkbund, Stuttgart
1978 *Das Experimentelle Photo in Deutschland 1918-1940*, Galleria del Levante, Munich
 Neue Sachlichkeit and German Realism of the 20's, Hayward Gallery, London
1979 *Dada-Fotografie und Fotocollage*, Kestner-Gesellschaft, Hannover
 Film und Foto der 20er Jahre, Württembergische Kunstverein, Stuttgart (travelled to Museum Folkwang, Essen; Werkbundarchiv, West Berlin; Kunsthaus, Zurich; Kunstverein, Hamburg; and Museum des 20. Jahrhunderts, Vienna)
 Photographie als Kunst 1879-1979/Kunst als Photographie 1949-1979, Tiroler Landesmuseum Ferdinandeum, Innsbruck, Austria (travelled to Neue Galerie am Wolfgang Gurlitt Museum, Linz; Austria; Neue Galerie am Landesmuseum Joanneum, Graz, Austria; and Museum des 20. Jahrhunderts, Vienna)
 Photographic Surrealism, New Gallery of Contemporary Art, Cleveland (travelled to Dayton Art Institute, Ohio; and Brooklyn Musuem, New York)
1980 *Avant-Garde Photography in Germany 1919-1939*, San Francisco Museum of Modern Art (toured the United States, 1981-82)
 Experimental Photography, Stills Gallery, Edinburgh (toured the U.K.)
1981 *Germany: The New Vision*, Fraenkel Gallery, San Francisco

Collections:

Kunstbibliothek der Staatlichen Museen, West Berlin; Ullstein-Archiv, West Berlin; Kestner-Gesellschaft, Hannover; Art Institute of Chicago.

Publications:

By UMBO: article—"Knieschuss Ohne: Nur Drei Haare Fehlten" in *Spiegel-Almanach* (Hannover), 25 October 1950.

On UMBO: books—*Es Kommt der Neue Fotograf!* by Werner Graeff, Berlin 1929; *Foto-Auge: 76 Fotos der Zeit* by Franz Roh and Jan Tschichold, Stuttgart 1929; *Die Fotomontage und Wesen einer Kunstform*, exhibition catalogue, by Richard Hiepe, Ingolstadt 1969; *Deutschland: Beginn des Modernen Photojournalismus* by Tim N. Gidal, Lucerne 1972; *Fotografie der 30er Jahre: Eine Anthologie*, edited by Hans-Jürgen Syberberg, Munich 1977; *Geschichte der Fotografie im 20. Jahrhundert/Photography in the 20th Century* by Petr Tausk, Cologne 1977, London 1980; *Das Experimentelle Photo in Deutsch-*

land 1918-1940 by Emilio Bertonati, Munich and Milan 1978; *Germany: The New Photography 1927-33*, edited by David Mellor, London 1978; *Tusen och En Bild*, exhibition catalogue, by Åke Sidwall, Sune Jonsson and Ulf Hard af Segerstad, Stockholm 1978; *Fotografie 1919-1979, Made in Germany: Die GDL-Fotografen*, edited by Fritz Kempe, Bernd Lohse and others, Frankfurt 1979; *Photographie als Kunst 1879-1979 / Kunst als Photographie 1949-1979*, exhibition catalogue, 2 vols., by Peter Weiermair, Innsbruck, Austria 1979; *Film und Foto der 20er Jahre*, exhibition catalogue, by Ute Esildsen and Jan Christopher Horak, Stuttgart 1979; *Photographen der 20er Jahre* by Karl Steinorth, Munich 1979; *Photographic Surrealism*, exhibition catalogue, by Nancy Hall-Duncan, Cleveland 1979; *Dada Photomontagen*, exhibition catalogue, by Carl-Albrecht Haenlein and others, Hannover 1979; *Umbo: Photographien 1925-1933*, exhibition catalogue, by Georg Reinhardt, Hannover 1979; *Experimental Photography*, exhibition catalogue, by Dawn Ades, London 1980; *Avant-Garde Photography in Germany 1919-1939*, exhibition catalogue, by Van Deren Coke, Ute Eskildsen and Bernd Lohse, San Francisco 1980; articles—"Exhibition in Stuttgart, June 1929, and Its Effects" by Andor Kraszna-Krausz in *Close-up* (London), 29 December 1929; "Bildjournalismus: Die Legendaren Zwanziger Jahre" by Bernd Lohse in *Camera* (Lucerne), April 1967; "Umbo" by Karl Steinorth in *Color Foto* (Munich), November 1975; "Der Dopplelte Umbo: 75. Geburtstag des Fotografen Otto Umbehr" by Dirk Tils in *Hannover'sche Allgemeine Zeitung*, 18 January 1977; "Otto Umbehr—Genannt Umbo" by Georg Reinhardt in *Professional Camera* (Munich), February 1979; "Umbo: Fotos 1927" in *Zweitschrift* (Hamburg), no. 4/5, 1979; "Umbo (Otto Umbehr): Mit der Kamea Durchs Leben" by Georg Reinhardt in *Neues Rheinland* (Cologne), vol. 22, no. 8, 1979; "Umbo Ist Tot" by Dagmar Figl in *Foto-Scene* (Mainaschaff, West Germany), June 1980.

Otto Umbehr, or Umbo, was a versatile and innovative photographer, specializing in photoreportage; he belonged to that group of German photoreporters which includes other pioneers of modern photojournalism such as Erich Salomon and Felix Man. Yet he was far more than a documentary photoreporter—his interest in experimentation and his artistic sense create aspects in common with the Surrealists; his interest in collage and photomontage, his experimentation with camera angle and perspective, and his use of the negative print and prints from X-ray film provoke comparisons with such people as Christian Schad and Franz Roh.

In 1925, Umbo met Paul Citroen with whom he became lifelong friends. Citroen built him his first darkroom, and Umbo began to make images using a 13 x 18 cm field camera which his father had used to take family photographs. This led to his becoming a freelance portrait photographer for several years: his photos of the actress Rut Landshoff brought him sufficient recognition and customers from the circle of the Berlin salons that he was able to open up his own studio and photo laboratory in Berlin-Charlottenburg.

His interest in photojournalism did not really begin until 1928 when he met Simon Guttmann who was then Director of Dephot, the German photoreportage cooperative news agency. Umbo worked for Dephot (with such other notable figures as Fritz Goro, Andreas Feininger and Felix Man) until its demise as an indirect result of the Hitler regime in 1933. His versatility as a photographer, combining current avant-garde trends of the artistic and experimental with solid documentary reportage and portraiture, caused him to be a great asset to Guttmann. After the Dephot had ended, Umbo continued as a freelance photographer, doing local reportage, advertising photographs, and overseas assignments which carried him to North Africa and Italy.

Umbo's Berlin studio, complete with negatives and photographs, was destroyed in 1945, and he moved to Hannover, freelancing for various periodicals, and eventually becoming the house photographer for the Kestner-Gesellschaft in Hannover. While he enjoyed the experimental and artistic aspects of photography, Umbo was first and foremost a documentary reportage photographer.

Although he did not study photography at the Bauhaus—no formal course in it was offered there—Umbo's photographic career was certainly influenced by his years spent there. His experimental work in several areas of photography, e.g., political and social photomontage and collage, produced notable results as did his multiple exposures of subjects in different positions (e.g., his "Simultanporträt" of Rut Landshoff, as well as many of his other female portraits). A further unique aspect of many of these photos is that he either used X-ray film (which did not produce half-tones) or printed a negative image.

In 1935 Umbo began a series—"Die Wolkenkamera sieht sich auf der Erde um"—using a fisheye camera with an angle of 180°. The camera itself was originally designed for meteorological studies because it was capable of showing the whole sky with cloud formations in one image. By experimenting with picture angle and distorted perspective in this and another series entitled "Die unheimliche Strasse," he was able to produce unusual effects with his photos. There is a surrealistic, abstract, almost "Dali-esque" quality to these and other photos of the same period. In the former series, this is created by unusual camera angle (above or below the line of sight) as well as by the distorted perspective caused by the 180° lens; in the latter, it is produced again by distorted perspective, but this time caused by the angle of light in many cases, producing shadows which are greatly elongated. The result is that the subjects appear dwarfed, causing the observer to concentrate on the 2-dimensional shadows rather than on the subjects—the effect of this is to make the subjects (i.e., shadows) appear to blend right into the street.

As Georg Reinhardt points out, Umbo's photos, like Salvatore Dali's paintings, combine real elements with fantastic abstractions. His more conventional portraits and photoreportages also contain

Umbo: *Mannequin: Legs and Slippers*, **1928** Courtesy Art Institute of Chicago

elements of the artist and experimenter at work. The photos come to life because he attempted to capture the spontaneous as well as the feverish qualities of life which are reflected in his choice of theme and location for photographing: persistent restlessness or excitement and sensation-filled atmosphere (although this is not to say that he doesn't take photographs where the opposite sense of total peace and calm prevails), dance, cabaret, masses coming together for some social ritual, scenes of misfortune, and—certainly not to be forgotten—his fascination for scenes at the circus, particularly the trapeze artists.

—Michael Held

URBAN, João Aristeu.

Brazilian. Born in Curitiba, 21 April 1943. Educated at Grupo Escolar Professor Cleto, Curitiba, 1950-54; Colégio Santa Maria, Curitiba, 1954-56; Colégio Estaduel do Parana, 1956-63. Married Adelaide Fortes in 1969 (divorced, 1980); children: Dora and Vladimir. Worked as a store clerk for the family business Urban Ltd., Curitiba, 1957-59; bank teller in Bamerindus, Curitiba, 1959-67; maintained own studio, Photon Photos Ltd., Curitiba, 1967-69. Since 1969, photographer for Phototecnica, Curitiba. Recipient: Prize, *Bienal de Sao Paulo*, 1977; Banco do Brasil Prize, 1978. Address: Rua Brigadeiro Franco 549, 80.000 Curitiba, Brazil.

Individual Exhibitions:

1978　*Boias-Frias, Vista Parcial*, Federation of Rural Workers (FETAEP), Curitiba, Brazil (travelled to Fernando Moreira Gallery, Curitiba; Faculty of Agronomy, University of Parana, Brazil; Pontificia Universidade, Parana, and *Bienal de Sao Paulo*, 1979; and Pontificia Universidade, Sao Paulo, 1980)

1980　*Os Polacos*, Pope John Park II Park, Curitiba, Brazil

Selected Group Exhibitions:

1976　*Photojournalism Exhibition*, Cultural Foundation, Curitiba, Brazil (and 1977, 1978, 1981)
1977　*Bienal de São Paulo*
1978　*Latin American Exhibition*, Museo de Arte Moderno, Mexico City
1979　*Our People*, Fundáción Nacional de Bellas Artes, Rio de Janeiro
　　　Venezia '79
　　　O Espaco Habitado, Brazilian Institute of Architecture, Brasilia
　　　Biennial of Ecologic Photography, Porto Alegre, Brazil (and 1981)
1980　*Triennial of Photography*, Museu de Arte Moderno, São Paulo
1981　*SICOF '81*, Milan

Collections:

Fundáción Nacional de Bellas Artes, Rio de Janeiro; Casa Romario Martins, Curitiba, Brazil.

Publications:

By URBAN: books—*Hecho en Latino-America*, with others, edited by Consejo Mexicano de Fotografia, Mexico City 1978; *O Espaco Habitado*, with others, edited by the Institute de Arquitetos do Brasil, Brasilia 1979; *Our People*, with others, Rio de Janeiro 1979; *The Child in Latin America*, with others, edited by Unicef, Santiago, Chile 1980; articles—series of articles in *Grafia, O Jornal da Foto* (Curitiba, Brazil), 1978-79.

On URBAN: book—*Venezia '79: La Fotografia*, edited by Daniela Palazzoli, Vittorio Sgarbi and Italo Zannier, Milan and New York 1979.

My relation to photography is to produce it so that it can be both documentary, in the long term, and informative in the short term. Although I can't always obtain such a result (still less with just one shot), that is the aim which I pursue.

João Aristeu Urban: *Boias Frias at Bandeirantes City*, **1978**

I place myself among the photographers who see photography as a result of a co-production between the photographer and reality—that is, as co-author of the photograph with the subject.

I am looking for a balance, with either a single or several photographs, between an absolute record which would bring about a kind of naturalism and a photography of an excessive discursive kind, which may distort reality. Of course, sometimes the photographs are rather descriptive, and in other cases they clearly avoid description in favour of a personal and often subjective opinion. Generally, I try to avoid extremes of either kind, so that the viewer can have his own opinion, and even discuss the photographer's commentary.

I see exhibitions at galleries and other cultural centres as a necessity for the photographer to keep the public and colleagues well in touch with his work, so that there is an exchange of information, and so that the work may be criticized and thereby developed and improved.

However, I think there are other larger and more particular media that will expose the photographer's work. There is a public in schools, trade unions, factories, in large commercial areas and even on the streets which the photographer must find and to which he must exhibit his work.

—João Aristeu Urban

In recent years the photography of social documentary has been more and more a cold and calculated reportage, with pictures that, though they depict obvious facts, have more in them of demagogy than of human fellowship. João Aristeu Urban is an exception. He has not only recorded facts, events and conditions; he has also been able to represent that mass of feelings—hopes and sorrows—that are the inward nature of man.

The "boias frias"—the itinerant agricultural laborers—who seek work day after day on the enormous estates of Parana number at least 800,000; they constitute a social factor of great importance to the Brazilian economy. Exploited, regarded as no more than hired hands, they, each day, contribute to the foundation of the entire country's prosperity. In four successive journeys between 1977 and 1979, Urban investigated the day-to-day existence of the boias frias. And if his original intention was born of a profound desire to "expose," his record, in fact, has been transformed into a portrait of a community. This transformation is the result of Urban's attitude, to use the camera as an instrument—as a language, rather—of communication between men, as a medium for the exchange of sentiments.

The invisible curtain that the cold glass eye of the lens erects between the subject and the photographer has been obliterated. The people in his pictures do not feel or see any such impediment, because Urban, modestly and with warmth, has got close to them and discovered their lives. They do not feel their intimacy to have been violated, and they feel no shame for the state of poverty in which they live: they are neither judged nor patronized. The photographer has established a relationship of understanding. The black box of his camera disappears; the scenes of life in their simple spontaneity are sensitively recorded.

Yet Urban remains faithful to reality; there is no sentimentalized exaggeration or ideological orchestration; he achieves an harmonious synthesis of emotion and truth. It's often said that truth in photography is wholly subjective, but the truth of Urban's pictures avoids excessive subjectivity and succeeds in being an objective record and an expressive portrait.

And, in fact, he does not start from any preconceived idea which he is obliged to follow or demonstrate. His is a sort of "candid camera" operation, in which, however, he still follows the thread of his story. As in every good novel, the characters, the background, the everyday objects, the way of life are all described exactly, incisively, in such a way as to

furnish the reader/beholder with the material he needs to understand.

Urban's visual story is a great epic poem of our anti-heroic times: instead of wondrous deeds, he describes the heroism of daily survival.

—Giuliana Scimé

UZZLE, Burk.

American. Born in Raleigh, North Carolina, 4 August 1938. Educated at Dunn High School, North Carolina; self-taught in photography. Divorced; children: Tad and Andy. Staff Photographer, *News and Observer* newspaper, Raleigh, 1955-56; Contract Photographer, Black Star news agency, New York, working in Atlanta, Houston and Chicago, 1957-62. Contract Photographer, *Life* magazine, Chicago and New York, since 1962. Member, Magnum Photos co-operative agency, New York, since 1967 (President, 1979-80). Recipient: Page One Award, Newspaper Guild of New York, 1970; National Endowment for the Arts Photography Fellowship, 1975. Agent: Magnum Photos, New York and Paris. Address: c/o Magnum Photos, 251 Park Avenue South, New York, New York 10010, U.S.A.

Individual Exhibitions:

1970 *Typically American*, International Center of Photography, New York
1973 Witkin Gallery, New York
 University of Massachusetts, Boston
1974 Dayton Art Institute, Ohio
 831 Gallery, Birmingham, Michigan
1977 Aperion Workshops, Millerton, New York (toured the United States)
 Center for Contemporary Photography, Chicago
 Hayden Gallery, Massachusetts Institute of Technology (with Mary Ellen Mark)
1979 Witkin Gallery, New York
 Galerie Fiolet, Amsterdam
 Galerie Agathe Gaillard, Paris
 Art Institute of Chicago
1980 *News form Cambodia*, International Center of Photography, New York

Selected Group Exhibitions:

1968 *Photography '68*, International Museum of Photography, George Eastman House, Rochester, New York
1969 *Spectrum One*, Witkin Gallery, New York
 Recent Acquisitions, Museum of Modern Art, New York
1971 *Contemporary Photographers*, Fogg Art Museum, Harvard University, Cambridge, Massachusetts
1974 *100 Years of American Photography*, La Maison de Port Deauville, France
1975 *The Impact of Design*, Nikon House, New York
1976 *Festival d'Automne*, Musée Galliera, Paris
1978 *Contemporary Photographers*, Stedelijk Museum, Amsterdam
1979 *Contemporary Photographers*, Santa Barbara Museum of Art, California

Collections:

International Center of Photography, New York; Metropolitan Museum of Art, New York; Museum of Modern Art, New York; International Museum of Photography, George Eastman House, Rochester, New York; Fogg Art Museum, Harvard University, Cambridge, Massachusetts; Smithsonian Institution, Washington, D.C.; Art Institute of Chicago; Santa Barbara Museum of Art, California; Bibliothèque Nationale, Paris; Stedelijk Museum, Amsterdam.

Publications:

By UZZLE: book—*Burk Uzzle: Landscapes*, with an introduction by Ronald Bailey, New York 1973; article—"New York" in *Du* (Zurich), September 1977.

On UZZLE: books—*America in Crisis: Photographs for Magnum*, edited by Charles Harbutt and Lee Jones, New York 1969; *Album Photographique 1*, Paris 1979; *The Photograph Collector's Guide* by Lee D. Witkin and Barbara London, Boston and London 1979; articles—"Burk Uzzle" in *Camera* (Lucerne), October 1970; "Burk Uzzle" in *Photo* (Paris), May 1971; "Burk Uzzle" in *35mm Photography* (New York), Spring 1973; "Burk Uzzle" in *Camera* (Lucerne), November 1973; "Transposing the Ordinary" by Julia Scully in *Modern Photography* (New York), March 1974; "Burk Uzzle: Marines" in *Reporter Objectif* (Paris), November 1974; "Burk Uzzle" in *Zoom* (Paris), April 1976; "Burk Uzzle" in *Photo* (Paris), October 1976; "Burk Uzzle: The Hustle Comes of Age" by James Baker Hall in *Aperture* (Millerton, New York), no. 77, 1976; "Burk Uzzle" in *Photo* (Paris), April 1978; "Burk Uzzle" in *Zoom* (Paris), December 1978; "Burk Uzzle" by Ronald Bailey in *American Photographer* (New York), March 1980.

I give to photography as photography gives to me; and one turns into the other, as myself and my medium form the ground from which the harvest comes.

Life has been a rich diet of trial and error and knowledge through experimentation. I know what I can do because that's what's left that feels natural.

Photography is robust, vital, and demands honesty. Too many tools can be divisive, obscuring primary relationships between photographer and subject.

Dogma is the declaration of shallowness, while discipline—if used instead of worshipped—is liberating.

The imperatives of a visual medium have everything to do with the dynamics of graphics and composition and are among a photographer's strongest tools. Others are instinct, intelligence, humor and energy.

The work of a complex photographer using simple equipment compares favorably to the work of a simple photographer using complex equipment. We give our mechanical medium its life by the contribution of our humanity, while responding to the essence of ourselves and the properties of our materials.

America is my home; it's what formed me, and it's those values I take every place I go. Many countries and many people have offered later layers of experience that later become pictures.

My work is a collage of sometimes contradictory, sometimes harmonious, parts in search of meaning, order and beauty.

I love humor, beauty, silliness, and the greatness of meaningful commitment. My life is a swirl of parts that are both accidental/circumstantial and personally controlled. I use them all; I put them together. They are me, they are my pictures. My work is my visible love.

—Burk Uzzle

If Eugène Atget was the gentle poser of surreal questions, Burk Uzzle delivers the Surrealist answer: yes, the photographed world is full of marvels; yes, its beauty is convulsive; and yes, both its humour and its chance are entirely objective!

The photographs are technically immaculate, direct views of ordinary events in the familiar world. Like a good philosopher, Burk Uzzle tends to select trivial examples so that the form of his argument shall not be confused by the importance of the content.

Extraordinarily enough, the elegance and simplicity which dominate a first sight of the photographs, are not the signposts to understanding which might be anticipated. For, as the pictures are studied, the certainties of the finely matched optics and materials lead only to ambiguities of reading. The very objectivity of Burk Uzzle's description of the people and the people inflatables, milling around the outside of a public lavatory, paradoxically obscures the differences between them; and however much it ought to undercut the resemblances, the fact that the inflatables are together, about ten feet above their breathing counterparts does nothing to weaken the association. Truly, his photography is as humorous, chancy and convulsive as it is objective.

Perhaps, though, the concept of humour does not fit snugly enough across the range of images to leave the term unchallenged as a description. For many of Burk Uzzle's ambiguities of space and identity leave one, either at first recognition or as an aftertaste, with that sense of having entered his dream on the point of balance at which things will either continue as a pleasant adventure, or shift through territories of unspecific menace, into the horrors of nightmare.

It is wit that forms the truest quality of these photographs. Sometimes warm, sometimes very chill indeed, and occasionaly all things mixed; it is born out of the precise enunciation of uncertainty and incongruity, an apparently nonchalant proof of André Breton's contention that "it is only at the approach of the fantastic, at a point where human reason loses its control, that the most profound emotion of the individual has the fullest opportunity to express itself."

For Burk Uzzle to have achieved thus, in straight photography, without contrived whimsy or melodrama, is no mean feat.

—Philip Stokes

Burk Uzzle: *Miss Main Street*, 1979

VACHON, John.
American. Born in St. Paul, Minnesota, 19 May 1914. Educated at St. Thomas College, St. Paul, 1930-34, B.A. 1934; self-taught in photography. Served in the United States Army, 1943-45. Married Penny Vachon (died); children: Brian, Ann and Gail; married Françoise Fourestier; children: Christine and Michael. Assistant messenger, 1936-37, junior file clerk and unofficial photographer, 1937-40, and junior photographer, 1940-42, under Roy E. Stryker, Farm Security Administration (FSA), Washington, D.C.; photographer, under Roy E. Stryker, Office of War Information, Washington, D.C., 1942-43; photographer, under Roy E. Stryker, Standard Oil Company of New Jersey, 1943, and for the *Jersey Standard*, in New Jersey and in Venezuela, 1945-47; staff photographer, *Life*, magazine, New York, 1947-48; *Look* magazine, New York, 1948-71; freelance photographer, New York 1971-75. Visiting Lecturer in Photography, Minneapolis Art Institute, 1975. Recipient: Guggenheim Fellowship, 1973. *Died* (in New York) *20 April 1975.*

Individual Exhibitions:

1972 Imageworks, Cambridge, Massachusetts (retrospective)

Selected Group Exhibitions:

1942 *Road to Victory*, Museum of Modern Art, New York
1955 *FSA Anniversary Show*, Brooklyn Museum, New York
1962 *The Bitter Years: FSA Photographs*, Museum of Modern Art, New York (toured the United States)
1967 *Photography in the 20th Century*, National Gallery of Canada, Ottawa (toured Canada and the United States, 1967-73)
1968 *Just Before the War*, Newport Harbor Art Museum, Newport Beach, California (travelled to Library of Congress, Washington, D.C.)
1976 *A Vision Shared: FSA Photographers*, Witkin Gallery, New York
1979 *Images de l'Amérique en Crise*, Centre Georges Pompidou, Paris
Amerika Fotografie 1920-1940, Kunsthaus, Zurich
1980 *Les Années Ameres de l'Amérique en Crise 1935-1942*, Galerie Municipale du Chateau d'Eau, Toulouse

Collections:

New York Public Library; Museum of Modern Art, New York; International Museum of Photography, George Eastman House, Rochester, New York; Library of Congress, Washington, D.C.; Minneapolis Art Institute.

Publications:

By VACHON: books—*Just Before the War: Urban America from 1935 to 1941 as Seen by the Photographers of the Farm Security Administration*, with Arthur Rothstein and Roy Stryker, with an introduction by Thomas Garver, Boston 1968; *John Vachon Memorial Portfolio*, New York 1977; articles—"John Vachon: A Realist in Magazine Photography," interview, with Edna Bennett, in *U.S. Camera* (New York), December 1960; "Tribute to a Man, an Era, an Art" in *Harper's Bazaar* (New York), September 1973.

On VACHON: books—*The Bitter Years*, edited by Edward Steichen, New York 1962; *Photography in the 20th Century* by Nathan Lyons, New York 1967; *The Years of Bitterness and Pride: FSA Photographs 1935-1943*, compiled by Jerry Kearns and Leroy Bellamy, edited by Hiak Akmakjian, New York 1975; *A Vision Shared: A Classic Portrait of America and Its People 1935-1943*, edited by Hank O'Neal, New York and London 1976; *Amerika Fotografie 1920-1940* by Erika Billeter, Berne 1979; *Les Années Ameres de l'Amérique en Crise 1935-1942*, exhibition catalogue, by Jean Dieuzaide, Toulouse 1980; articles—"John Vachon; Profile of a Magazine Photographer" by Sean Kernan in *Camera* 35 (New York), December 1971; "John Vachon 1914-1975" in *Photography Year 1976* by the Time-Life editors, New York 1976; "John Vachon" by Brian Vachon in *American Photographer* (New York), October 1979; "Le Dossier de la Misère" in *Photo* (Paris), February 1980.

"Strange things happen to me when I look at these pictures again," said John Vachon while considering some of the work that resulted from his participation in the Farm Security Administration's Historical Section.

Vachon was among Roy Stryker's "second generation" of photographers and, quite remarkably, it was his first experience with a camera. He had been hired, in 1936, by the FSA as a messenger, which translated into writing captions on, mounting, and filing the photographs turned in by Evans, Lange, Shahn, Mydans, Lee, and the other photographers hired and nourished by Stryker.

Bored, as Vachon later recounted the story, he began looking at and being captivated by the photographs he had been rather cavalierly handling. "About that time, Roy Stryker decided he would like to mold a photographer in his own image. He put a camera in my hand, breathed upon me, and told me to see what I could do (but only on weekends, of course)."

John Vachon: *Tia Juana Oil Field*, **Western Venezuela, 1944** Courtesy Art Institute of Chicago

In the beginning, Vachon spent a great deal of time scouring the world for the real-life analogs to Walker Evans' photographs. In a strange way, he admitted later, the pictures were defining the world and the master's style defining the disciple's. The mold was broken in 1941, however, when Vachon (now officially classified as a photographer) was sent by Stryker to the West (an area never visited by Evans).

It was in the West, midst the loneliness of the Great Plains, dotted with small towns, that Vachon's style developed. He produced stark, beautiful images of the plains; evocative, often gentle pictures in the small towns and cities; and, in the closest that any FSA photographer ever came to pure abstraction, a remarkable series of grain-elevator-and-railroad-car photographs. Among the best known, and most typical, pictures from this period is one of a farmer and his dog riding after cattle across a storm-swept landscape. Its simple, yet powerfully dynamic composition exemplifies the degree to which Vachon had developed his own style.

In later years, Vachon would be a mainstay of *Look* magazine's photo staff (whose director was another FSA alumnus, Arthur Rothstein). However, with one exception, Vachon's best work remained his FSA work. He felt this, too, in the years before his death (several other FSA colleagues have expressed similar feelings about their careers).

The exception, and I saw these pictures only once, in Vachon's apartment, are photographs made in Europe after the Second World War for the United Nations Relief and Rehabilitation Agency (UNRRA). They are gritty documents of anger and humanitarian concern and, as with much of Vachon's *oeuvre*, richly deserve publication.

—Stu Cohen

van der ELSKEN, Ed(ward).

Dutch. Born in Amsterdam, 10 March 1925. Educated at schools in Amsterdam; studied photography at a professional school in The Hague. Married several times; has several children. Freelance photographer, in Amsterdam, 1947-50, Paris, 1950-55, and in Edam, Netherlands, since 1955; also free-lance filmmaker, Edam, since 1959. Address: Zeevngszeedijk 4, 113 5 PZ Edam, Netherlands.

Individual Exhibitions:

1955 Art Institute of Chicago
1956 Steendrukkery de Jong, Hilversum, Netherlands
 Galerie 't Venster, Rotterdam
1959 Stedelijk Museum, Schiedam, Netherlands
 Zonnehof, Amersfoort, Netherlands
 Museum voor Stad, Groningen, Netherlands
1966 Stedelijk Museum, Amsterdam
1977 Stedelijk Museum, Amsterdam

Selected Group Exhibitions:

1954 *Subjektive Fotographie 2*, Saarbrücken
1955 *The Family of Man*, Museum of Modern Art, New York (and world tour)
1967 *Expo '67* Montreal
1973 *5 Masters of European Photography*, The Photographers' Gallery, London
1977 *Fotos voor de Stad*, Historisch Museum, Amsterdam

Collections:

Stedelijk Museum, Amsterdam; Bibliothèque Nationale, Paris; Museum of Modern Art, New York; Art Institute of Chicago.

Publications:

By van der ELSKEN: books—*Love on the Left Bank*, Amsterdam, London, New York and Paris 1954; *Nederlands Danstheater*, Amsterdam 1958; *Jazz*, Amsterdam 1959; *Bagara, Central Africa*, Amsterdam and Paris 1959; *Sweet Life*, Amsterdam, New York and London 1963; *Eye Love You*, Amsterdam 1977; *Life of a Swan Family*, Amsterdam 1977; *Hallo!*, Amsterdam 1978; *Amsterdam: Old Photographs*, Amsterdam 1980; *Paris: Old Photographs*, Amsterdam 1981.

On van der ELSKEN: book—*Fotografie in Nederland 1940-1975*, edited by Els Barents, The Hague 1978.

Ed van der Elsken: *Durban, South Africa* from *Sweet Life*, 1960

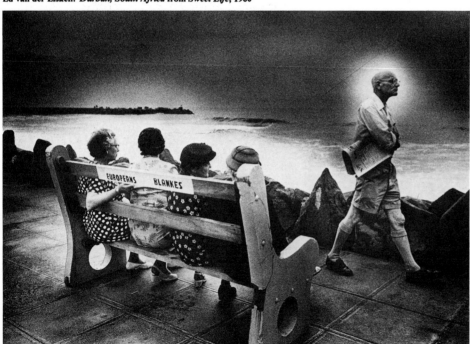

I have been a freelance roving photographer since 1947. I have lived most of my life in Holland except for four years in Paris (1950-55). With Amsterdam as a home base and, later, the small Dutch town of Edam as home, I travel a lot.

In 1959 I started filming as well, mainly for television. In filming, part of my activity is designing and developing new cameras and other equipment which make spontaneous, lightweight reportage—like filming—easier. My pride is that I was working professionally with my own self-blimped 16mm sync camera before the famous Eclair NPR camera came onto the market. For six years now I have worked with "professional super 8, direct sound." And, of course, I work with low budget video. I am also making slides with sync things.

I think it characteristic that I make personal things with low budget techniques, which makes me as independent as possible of the money people.

—Ed van der Elsken

In the 1950's Ed van der Elsken became known for his pictures of the Paris district of St. Germain. This series of romantic, sensitive photographs impressed Edward Steichen when he was looking for material for the exhibition *Family of Man* in 1955. American critics praised van der Elsken's work for his sharp eye, for the dramatic situations in the lives of the bohemians in the Paris of Sartre and Sagan, and for the strong personal impact of the images. The pictures were taken with extremely sensitive materials, without flash, and van der Elsken's way of developing them augmented the dramatic effect. He had already shown the series at various international exhibitions before he published it in book form in 1954, a self-invented love story expressed in photographs and a short text, *Love on the Left Bank*—and in so doing he invented a new kind of photographic book: fiction in documentary photography.

After *Love on the West Bank* van der Elsken was established as a photographer, and he went on to photograph—only people—all over the world. He sometimes emphasizes the sensational: he has tried to convey the boredom and depression that exists in life in the cities. His intention is to show how other people feel and what they do, and that intention comes over in the photographs. He says that his photographs are a product of days of "wandering around." "In Hong Kong I wandered every day for six weeks through the streets. I did not create or invent anything: I hoped that I would suddenly see something fantastic happen and that I would have my camera with me." Because of this method, his pictures seldom possess well-balanced composition. They also lack a social or political message. He captures everyday emotions. And he knows how to capture the most typical features in every city and country—later, he selects for a book. For most of his career he has worked outside the Netherlands, in Europe and beyond.

His books reflect his life-style and working methods: *Bagara*, a report about the people and their way of life in Equatorial Africa; *Jazz*, in which jazz musicians, with their shining instruments and emotional facial expressions, are dramatically captured in light and dark effects; *Sweet Life*, the result of a 14-month tour around the world. Van der Elsken has always opposed the usual practice in publishing, that for commissions photographers must make concessions. He is rigorous in his own demands. All the photographs in his books are his own choice, and the layout of each book has been worked out in close collaboration with the graphic designer.

In the 1960's van der Elsken also began to film, choosing the same subject-matter as for his photographs. In recent years he has remained in Edam, a small town near Amsterdam, concentrating on photographing and filming the nature surrounding him.

—A. de Jonge-Vermeulen

James Van Der Zee: *Mother and Sons*, **New York, 1924** Courtesy Galerie Wilde, Cologne

VAN DER ZEE, James (Augustus).
American. Born in Lenox, Massachusetts, 29 June
1886. Educated in Lenox public schools; self-taught
in photography. Married Kate Brown in 1906
(divorced, 1914); children: Rachel (died, 1923) and
Emile (died, 1911); married Gaynella Van Der Zee
in 1923. Worked as busboy, waiter, elevator man,
etc., New York, 1906-07; dining-room waiter, etc.,
Hotel Chamberlain, Old Point Comfort, Virginia,
1907-09; worked as waiter, and musician, with
Fletcher Henderson Band and John Wanamaker
Orchestra, New York, 1909-15; darkroom assistant
and photographer, Gertz's Department Store,
Newark, New Jersey, 1915-16; opened own photo-
graphic studio (Guarantee Photos, and later, GGG
Photo Studio), New York, 1916-68; ceased profes-
sional photography, New York, 1969; resumed pho-
tography, New York, 1980. Recipient: American
Society of Magazine Photographers Award, 1969;
Life Fellowship, Metropolitan Museum of Art, New
York, 1970. James Van Der Zee Institute estab-
lished by Reginald McGhee and Charles Innis, now
under care of Metropolitan Museum of Art, New
York, 1969. Address: c/o James Van Der Zee Insti-
tute, 103 East 125th Street, New York, New York
10035, U.S.A.

Individual Exhibitions:

1970 Lenox Library, Massachusetts
1971 Studio Museum, Harlem, New York
1974 Lunn Gallery/Graphics International, Wash-
 ington, D.C.
1979 *The Legacy of James Van Der Zee: A Por-
 trait of Black Americans*, Alternative
 Center for International Arts, New York
 Delaware Art Museum, Wilmington

Selected Group Exhibitions:

1969 *Harlem on My Mind: Cultural Capital of
 Black Ameria 1900-1968*, Metropolitan
 Museum of Art, New York
1979 *The Black Photographer*, San Francisco
 Museum of Modern Art
 Fleeting Gestures: Dance Photographs,
 International Center of Photography, New
 York (travelled to The Photographers'
 Gallery, London)

Collections:

Metropolitan Museum of Art, New York; Balti-
more Museum of Art, Maryland; Library of Con-
gress, Washington, D.C.; University of Michigan,
Ann Arbor; Cleveland Museum of Art; Minneapo-
lis Institute of Arts; University of Nebraska, Lin-
coln; Museum of Fine Arts, Houston; Center for
Creative Photography, University of Arizona, Tuc-
son; University of California at Los Angeles.

Publications:

By VAN DER ZEE: books—*The World of James
Van Der Zee: A Visual Record of Black Americans*,
with an introduction by Reginald McGhee, New
York 1969; *James Van Der Zee*, edited by Liliane De
Cock and Reginald McGhee, with an introduction
by Reginia A. Perry, New York 1973; *James Van
Der Zee: 18 Photographs*, portfolio, with an intro-
duction by Reginia A. Perry, Washington, D.C. and
New York 1974; *The Harlem Book of the Dead*,
with poetry by Owen Dodson and text by Camille
Billops, Dobbs Ferry, New York 1978.

On VAN DER ZEE: books—*Harlem on My Mind:
Cultural Capital of Black America 1900-1968*, exhi-
bition catalogue, edited by Allon Schoener, New
York 1969; *Photographs: Sheldon Memorial Art

Gallery Collection, University of Nebraska, with an
introduction by Norman A. Geske, Lincoln 1977;
*The Legacy of James Van Der Zee: A Portrait of
Black Americans*, exhibition catalogue, with a pre-
face by Gino Rodriguez, foreword by Robert W.
Brown, New York 1977; *The Photograph Collec-
tor's Guide* by Lee D. Witkin and Barbara London,
Boston and London 1979; article—"Harlem's 'Pic-
ture-Taking Man'" by Val Wilmer in *The Observer
Magazine* (London), 21 September 1980; film—
"James Van Der Zee" in *Black Journal*, educational
TV series, New York 1972.

"The message of Van Der Zee's photography is a
universal one," wrote Prof. Reginia A. Perry some
years ago. "To the Black viewer, the revealing
glimpses of people and activities in America's most
unique Black community are bound to instill an
element of pride and self-respect. To the non-Black
viewer, Van Der Zee's photographs represent Black
Americans in all their grace and dignity—an impres-
sive point of view which should help dispel existing
misconceptions. Above all, Van Der Zee was a pho-
tographer of people, and his works are both raceless
and timeless."

James Van Der Zee has lived and photographed
in Harlem for decades. Equally important, however,
is that he lived and worked in Harlem during that
community's remarkable decade of cultural flower-
ing, the "Harlem Renaissance" from approximately
1919-1929. This was the period of Marcus Garvey's
back-to-Africa movement (for which Van Der Zee
served as official photographer), of Countee Cullen's
poetry, of James P. Johnson's piano, and Duke
Ellington's orchestra. It is unclear whether every
celebrity of the period passed before Van Der Zee's
lens, or merely "almost" every celebrity.

Harlem's political, religious and cultural figures,
therefore, comprise a large block of Van Der Zee's
carefully preserved archive. So, too, do the groups
around which much of everyday life was organized,
the fraternal lodges, and sports and social clubs. As
with the community itself, celebrations are promi-
nent. Van Der Zee photographed weddings, dinners,
and (especially in the years of the great influenza
pandemic) many funerals. Perhaps above all, he
photographed individuals, especially women, and
families.

Although many of Van Der Zee's photographs
were made "on location," he was a studio photog-
rapher in the truest sense. Much of his vision, indeed
much of his time, was devoted to posing his subjects,
to providing the right backgrounds, to structuring
the moment. His portraits are deeply psychological,
providing rich insights into sitter and photographer
alike.

Among other qualities, Van Der Zee's pictures
reveal his romanticism and unashamed sentimental-
ity. Asked to photograph the funeral of Blanche
Powell (sister of Adam Clayton Powell, Jr.), he
deemed the picture incomplete until he had double-
printed the image of Blanche, herself, towering
above the choir. Such combination printing and the
deft use of the air brush were hallmarks of Van Der
Zee's technique.

But if such manipulated compositions project a
"period piece" aura, many of Van Der Zee's
"straighter" efforts are as contemporary now as
when they were made. Indeed, the straight portrait
of Blanche Powell, from which the overprint was
made, is a lovely image of a charming young
woman.

However, Van Der Zee's photographs inhabit two
realms of importance. They are a record of the life's
work of one of America's first great Black photog-
raphers. At the same time, they are an historical
archive, a picture of Harlem in an era in which that
name conjured visions of jazz, art, and literature,
not grinding poverty and occasional rebellion.

—Stu Cohen

VAN DYKE, Willard (Ames).
American. Born in Denver, Colorado, 5 December
1906. Self-taught in photography, but influenced by
Edward Weston, Ansel Adams, and Ralph Steiner.
Married Mary Gray Barnett in 1938 (divorced,
1950); children: Alison and Peter; married Margaret
Barbara Murray Milikin in 1950; children: Murray
and Cornelius. Independent social documentary
photographer since 1930, and filmmaker since 1935
(in San Francisco, 1930-45; New York, 1945-81;
settled in Santa Fe, New Mexico, 1981): Founder
Member, with Edward Weston, Ansel Adams, Sonya
Noskowiak and Imogen Cunningham, Group f/64,
San Francisco, 1932; photographer for the Public
Works Administration Art Project, San Francisco,
1934, and for *Harper's Bazaar*, New York, 1935;
Technical Director, Film Section, Office of War
Information, Washington, D.C., 1940-45; Producer,
Affiliated Film Producers, New York, 1946-58;
President, Van Dyke Productions Inc., New York,
since 1958; Director, Film Department, Museum of
Modern Art, New York, 1965-72. Professor of Film,
1972-77, and Professor Emeritus since 1977, State
University of New York at Purchase. Member of the
Visiting Committee, Rhode Island School of Design,
Providence, since 1969, Carpenter Center, Harvard
University, Cambridge, Massachusetts, since 1980,
and School of the Museum of Fine Arts, Boston,
since 1981. President, New York Film Council,
1947, Screen Directors International Guild, New
York, 1960-62, and International Film Seminars,
New York, 1965-72. Recipient: First Prize, *Camera
Craft*, 1927; Silver Cup, George Eastman House,
Rochester, New York, 1978. Address: 408 Don
Miguel, Santa Fe, New Mexico 87501, U.S.A.

Individual Exhibitions:

1932 M.H. de Young Memorial Museum, San
 Francisco
1933 San Diego Museum of Art, California
1969 Hetzel Center, Pennsylvania State Univer-
 sity, University Park
1971 Hungarian National Gallery, Budapest
1977 *Photographs 1930-37*, Witkin Gallery, New
 York
 Wirtz Gallery, San Francisco
 Archetype Gallery, New Haven, Connecticut
 Neuberger Museum, Purchase, New York
1978 International Museum of Photography,
 George Eastman House, Rochester, New
 York
 Carpenter Center, Harvard University, Cam-
 bridge, Massachusetts
 Stephen White Gallery, Los Angeles
1980 Milwaukee Center for Photography
 Film in the Cities Gallery, St. Paul,
 Minnesota
 Clarence Kennedy Gallery, Cambridge, Mas-
 sachusetts (with William Wegman and Oli-
 via Parker)
1981 Douglas Kenyon Gallery, Chicago (with
 Mark Godfrey)
 Museum of Modern Art, New York (testi-
 monial screening of films)
 Whitney Museum, New York (retrospective
 screening of films)

Selected Group Exhibitions:

1932 *Group f/64*, M.H. de Young Memorial Mu-
 seum, San Francisco
1933 *Group f/64*, Ansel Adams Gallery, San
 Francisco
1978 *Group f/64*, University of Missouri, St.
 Louis
1979 *Life: The First Decade 1936-45*, Grey Art
 Gallery, New York University
 One of a Kind, Museum of Fine Arts,
 Houston (toured the United States)

Collections:

Museum of Modern Art, New York; Neuberger Museum, Purchase, New York; Polaroid Corporation, Cambridge, Massachusetts; Detroit Institute of Fine Arts; Art Museum of St. Louis; Museum of Fine Arts, Houston; Center for Creative Photography, University of Arizona, Tucson; San Diego Museum of Art, California; Oakland Museum, California; San Francisco Museum of Modern Art.

Publications:

By VAN DYKE: books—*Group f/64*, with Jean S. Tucker, St. Louis 1978; introduction to *A Point of View* by Ralph Steiner, Middletown, Connecticut 1978; films—*The River*, as cameraman, with Stacey Woodward and Floyd Crosby, directed by Pare Lorentz, 1937; *The City*, with Ralph Steiner, 1939; *Valley Town*, 1940; *The Children Must Learn*, 1940; *Sarah Lawrence*, 1940; *To Hear Your Banjo Play*, 1941; *Tall Tales*, 1941; *The Bridge*, 1942; *Oswego*, 1943; *Steeltown*, 1943; *Pacific Northwest*, 1944; *San Francisco*, (official film on founding of the United Nations), 1945; *Journey into Medicine*, 1946; *The Photographer*, 1947; *This Charming Couple*, 1949; *Mount Vernon*, 1949; *Years of Change*, 1950; *New York University*, 1952; *Working and Playing to Health*, 1953; *There Is a Season*, 1954; *Recollections of Boyhood*, 1954; *Cabos Blancos*, with Angel Rivera, 1954; *Excursion House*, 1954; *Life of the Molds*, 1957; *Skyscraper*, with Shirley Clarke, 1958; *Tiger Hunt in Assam*, 1958; *Mountains of the Moon*, 1958; *Land of White Alice*, 1959; *The Procession*, 1959; *Ireland: The Tear and the Smile*, 1960; *Sweden*, 1960; *So That Men Are Free*, 1962; *Harvest*, 1962; *Depressed Area*, 1963; *Rice*, with Wheaton Galentine, 1964; *Frontiers of News*, 1964; *Pop Buell: Hoosier Farmer in Laos*, 1965; *Taming the Mekong*, 1965; *The Farmer: Feast or Famine*, with Roger Barlow, 1965; *Frontline Camera 1935-1965*, 1965; *Shape of Films to Come*, 1968.

On VAN DYKE: books—*One of a Kind: Recent Polaroid Color Photography*, with a preface by Belinda Rathbone, introduction by Eugenia Parry Janis, Boston 1979; *Life: The First Decade 1936-1945* by Robert Littman, Ralph Graves and Doris C. O'Neill, New York 1979, London 1980; *Film on the Left* by William Alexander, Princeton, New Jersey 1981; article—"Willard Van Dyke" by Helen Morse in *Image* (Rochester, New York), June 1978.

I believe that photography is the most important way of seeing the meaning of society, and its most potent form is documentary photography.
—Willard Van Dyke

Willard Van Dyke began young and was good from the beginning. He even had the friendship of such colleagues as Edward Weston, Imogen Cunningham and Ansel Adams, all of whom joined him for a time in a loosely formed working group called "f/64" that he founded with them in San Francisco in 1932. Sharp focus and depth of field were the main things they were all after, a kind of "straight" photography devoid of the influence of traditional painting all too prevalent in photography at that time. They were aided in their efforts by the clarity of California light, pollution-free in the 1930's.

Van Dyke has also been an active filmmaker, and has made numerous films, including such distinguished works as *The Bridge*, *The Skyscraper*, and one on Weston, *The Photographer*. Van Dyke's still photographs deal with a wide range of subject matter. He has photographed sand dunes and dried bones; store fronts; poor people and poor streets; a boxer wrapping his hands—all curve of trouser folds and fingers; a fence post with abstracting arabesques of barbed wire. Ironically, although his esthetic abjured that of painting, Van Dyke's cool compositions of ship funnels link him to such modern painters as the Precisionists Sheeler and Demuth. In contrast, his portraits are full of warmth and knowledge—a thoughtful Ansel Adams musing over a tea cup, a smiling, extravert William Saroyan. Among his most powerful pictures are those revealing an unblinking look at victims of the Depression—despairing people and abandoned buildings—in which depths of meaning find an equivalent to depth of technique.
—Ralph Pomeroy

Willard Van Dyke: *Untitled*, c. 1930

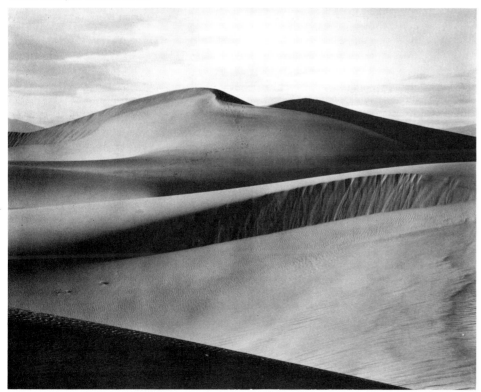

VAN VECHTEN, Carl.

American. Born in Cedar Rapids, Iowa, 17 June 1880. Educated at the University of Chicago, 1899-1903, Ph.B. 1903; mainly self-taught in photography. Married Anna Elizabeth Snyder in 1907 (divorced, 1912); married the actress Fania Marinoff in 1914 (died, 1971). Assistant Music Critic, 1906-07, 1910-13, and Paris Correspondent, 1908-09, *New York Times*; Drama Critic, *New York Press*, 1913-14; Editor, *Trend Magazine*, New York, 1914; freelance writer and novelist, New York, 1915-64; also, independent portrait photographer, New York, from 1932. Literary Executor to Gertrude Stein, 1946-58; Trustee, W.C. Handy Foundation for the Blind, New York, 1952. Founder: James Weldon Johnson Memorial Collection of Negro Arts and Letters, Yale University, New Haven, Connecticut, 1941 (Honorary Curator, 1946); Carl Van Vechten Collection, New York Public Library, 1941; George Gershwin Memorial Collection of Music and Musical Literature, Fisk University, Nashville, Tennessee, 1944; Rose McClendon Memorial Collection of Photos of Celebrated Negroes by Carl Van Vechten, Howard University, Washington, D.C., 1946; Azalia E. Hackley Memorial Collection of Photos of Celebrated Negroes, Detroit Public Library, 1946; Jerome Bowers Peterson Memorial Collection of Photos of Celebrated Negroes, University of New Mexico, Albuquerque, established at Wadleigh High School, New York, 1946, transferred to the University of New Mexico, 1956; Anna Marble Pollock Memorial Library of Books about Cats, Yale University, 1947; Florine Stettheimer Memorial Collection of Books on Fine Arts, Fisk University, 1949. Recipient: Yale University Gold Medal, 1955. D.Litt.: Fisk University, 1955. Member, National Institute of Arts and Letters, 1961. *Died* (in New York) *21 December 1964.*

Individual Exhibitions:

1942 *The Theatre Through the Camera of Carl Van Vechten*, Museum of the City of New York
1945 *American Negro Exhibit*, Syracuse University, New York
1949 *Personalities of Our Time*, Roger Kent, Rockefeller Plaza, New York
1951 Philadelphia Museum of Art (with Adrian Siegel and Harry Wright)
1955 Yale University Library, New Haven
1961 Coe College, Cedar Rapids, Iowa
1965 *Memorial Exhibition*, San Francisco Public Library
1967 American Academy of Arts and Letters Museum, New York
1968 Arts Center, Oneonta, New York
 The Lens of Carl Van Vechten, Hammond Museum, North Salem, New York
1977 Hannibal Goodwin College, Lancaster, Pennsylvania
1980 Millersville State College, Lancaster, Pennsylvania
 Yale University Library, New Haven, Connecticut
 Kirkwood Community College, Cedar Rapids, Iowa
1981 *Vintage Photographs: Carl Van Vechten*, 12 Duke Street Gallery, St. James's, London

Selected Group Exhibitions:

1933 *Bergdorf Goodman Exhibition of New York Beauty*, New York
1934 *First Leica Exhibition*, New York (and 2nd and 3rd exhibitions, 1935, 1936)

Collections:

Museum of Modern Art, New York; Carl Van

Vechten Collection, New York Public Library; Hammond Museum, North Salem, New York; Yale University, New Haven, Connecticut; Philadelphia Museum of Art; Howard University, Washington, D.C.; Detroit Public Library; Fisk University, Nashville, Tennessee; Arts Center, Cedar Rapids, Iowa; University of New Mexico, Albuquerque.

Publications:

By VAN VECHTEN: books—*Music after the Great War*, New York 1915; *Music and Bad Manners*, New York 1916; *Interpreters and Interpretations*, New York 1917; *The Merry-Go-Round*, New York 1918; *The Music of Spain*, New York 1918, London 1920; *In the Garret*, New York 1919; *Interpreters*, New York 1920; *The Tiger in the House*, New York 1920, London 1921; *Lords of the Housetops*, New York 1921; *Peter Whiffle: His Life and Works*, New York 1922, London 1923; *The Blind Bow-Boy*, New York and London 1923; *The Tattooed Countess*, New York 1924, London 1926; *Red*, New York 1925; *Firecrackers*, New York 1925, London 1927; *Excavations*, New York 1926; *Nigger Heaven*, New York and London 1926; *Spider Boy*, New York and London 1928; *Feathers*, New York 1930; *Parties*, New York and London 1930; *Sacred and Profane Memories*, New York and London 1932; *Fragments from an Unwritten Autobiography*, New Haven, Connecticut 1955; *The Dance Writings of Carl Van Vechten*, edited by Paul Padgette, New York 1975; *Portraits: The Photography of Carl Van Vechten*, Indianapolis 1978; *"Keep a-Inchin' Along": Selected Writings of Carl Van Vechten about Black Arts and Letters*, Westport, Connecticut 1979; *Ex Libris*, San Francisco 1980; *The Dance Photography of Carl Van Vechten*, New York 1981; books edited—*My Musical Life* by Nikolai Rimsky-Korsakoff, New York 1923, London 1924; *Selected Writings of Gertrude Stein*, New York 1946; *Last Operas and Plays by Gertrude Stein*, New York 1949; Yale Edition, *Unpublished Work of Gertrude Stein*, 8 volumes, 1951-58; other—introductions and contributions to more than 50 books, including *Prancing Nigger* by Ronald Firbank, New York 1924; *The Weary Blues* by Langston Hughes, New York 1926; *Autobiography of an Ex-Coloured Man* by James Weldon Johnson, New York 1927; *Three Lives* by Gertrude Stein, New York 1933; *Nijinsky*, New York 1946; *Isadora Duncan*, New York 1947; *Pavlova*, New York 1947; *The Gershwin Years* by Edward Jablonski, New York 1958; *Giselle and I* by Alicia Markova, London 1960; *Between Friends* by James Branch Cabell, New York 1962; *Florine Stettheimer* by Parker Tyler, New York 1963; articles—more than 1,200 periodical and newspaper articles and reviews, 1903-64.

On VAN VECHTEN: books—*A Bibliography of Carl Van Vechten* by Scott Cunningham, Philadelphia 1924; *Carl Van Vechten: A Bibliography* by Klaus Jonas, New York 1955; *Carl Van Vechten and the Twenties* by Edward Lueders, Albuquerque, New Mexico 1955; *Carl Van Vechten* by Edward Lueders, New York 1965; *Carl Van Vechten and the Irreverent Decades* by Bruce Kellner, Norman, Oklahoma 1968; *A Bibliography of the Work of Carl Van Vechten* by Bruce Kellner, Westport, Connecticut 1980; *Vintage Photographs*, exhibition catalogue, with text by Bruce Kellner, London 1981; articles—"The Van Vechten Vogue" by Hugh M. Gloster in *Phylon* (Atlanta), no. 6, 1945; "The Van Vechten Revolution" by George Schuyler in *Phylon* (Atlanta), no. 11, 1950; "Carl Van Vechten Is Dead at 84" in the *New York Times*, 22 December 1964; "The Connoisseur" in *Newsweek* (New York), 4 January 1965; "Carl Van Vechten 1880-1964" by Lincoln Kirstein in the *Yale University Library Gazette* (New Haven, Connecticut), April 1965; "Carl Van Vechten's Centenary" by Anna Kisselgoff in the *New York Times*, 11 January 1981; "Delayed Exposure" by Graham Snow in the *Sunday Times*

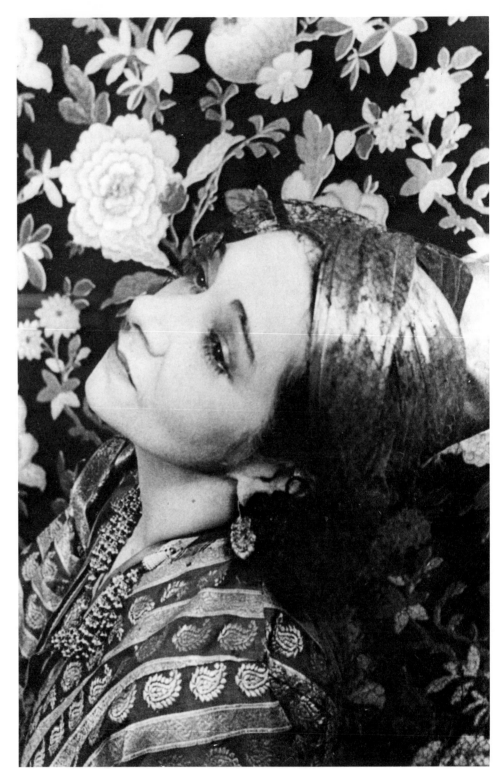

Carl Van Vechten: *Fania Marinoff,* **1939** Courtesy Van Vechten Estate

Magazine (London), 15 March 1981; "Past Performance Photographed" by Patrick Kinmouth in *Vogue* (London), March 1981; "Carl Van Vechten" by Bruce Kellner in *American Writers, Supplement II*, New York 1981.

After two decades as musical and literary critic, and another decade as a popular novelist, Carl Van Vechten turned to photography in 1932. His major interest was portraiture, and documenting celebrated personalities connected with the arts became his passion. From his own literary connections, he had many subjects to call upon, and his wife, the actress Fania Marinoff, knew many others connected with the theater. Two early interests—ballet and black artists and writers—gave him his most

abiding subjects, however, and these taken in connection with the best of his work, provide a valuable record of the first half of the century.

Unlike most photographers, Van Vechten made finished prints of nearly every picture he took. In recalling the Karsh portrait of Albert Einstein, for example, or the Muray portrait of D.H. Lawrence, or the Genthe portrait of Isadora Duncan, or indeed the Hoyningen-Huene portrait of Van Vechten himself, one usually sees only a single photograph in each case. Contrarily, there are at least a dozen Van Vechten portraits of the blues singer Bessie Smith, most of which have been widely reproduced, and there are nearly 100 of Gertrude Stein. This inevitably leads to a good deal of unevenness among his photographs, although he was inconsistent in his own judgment of them, claiming "I always throw

out anything that isn't perfection." Van Vechten's photography was a hobby, a labor of love; he gave the prints away to subjects, to friends; he never accepted commissions; he never sold his photographs; when they made money, through an occasional permission fee for reproduction, he donated it to the James Weldon Johnson Memorial Collection of Negro Arts and Letters, which he founded at Yale University.

During the 1930's, Van Vechten's work was characterized by a dramatic chiaroscuro, moving Henry McBride to call him "the Bronzino of this camera period." After the mid-1940's, Van Vechten's photographs took on a documentary quality, often badly lighted, with oddly placed shadows. As he neither cropped nor retouched his work, it is sometimes disappointing and even amateurish.

At their best, however, his photographs are memorable. F. Scott Fitzgerald, tentative and uncertain in front of the Algonquin Hotel; Thomas Mann, aloof and sartorial outside his publisher's office; and the black heavyweight champion, Joe Louis, between bouts at his training camp, are all happy accidents. Anna May Wong, in a feathered cloche against several Chinese embroidered pillows; Eugene O'Neill, half his brooding face in darkness, the other half in strong relief; Truman Capote, cockeyed before a jumble of marionettes; Isak Dinesen, fragile as spun glass, in pale fox furs and chiffon; an enraptured Mahalia Jackson singing in one photograph and praying in another, are all masterful studio portraits. Van Vechten's documentation of Judith Anderson and Ethel Waters in their various theatrical roles is of some historical value, as are his catalogs of Alicia Markova, Hugh Laing, and Nora Kaye in their various ballets; and in their kodachrome versions they are especially beautiful. Nearly all of Van Vechten's photographs are marked by backgrounds rich in texture and suggestive of their subjects, sometimes deliberately playing patterns against each other.

In later years, Van Vechten's hobby served to supplement and enhance the various collections of books and manuscripts he established in libraries: black arts and letters at Yale University; music and musical literature at Fisk University; theater and dance at the New York Public Library, the Museum of Modern Art, and the Museum of the City of New York; the largest collection, at the Philadelphia Museum of Art, contains more than 12,000 prints. Once Van Vechten observed: "My photographs are intended primarily as documents, but I believe that is no reason they should not be beautiful."

—Bruce Kellner

VERONESI, Luigi (Mario).
Italian. Born in Milan, 28 May 1908. Studied painting under the painter Carmello Violante and the critic Rafaello Giolli, Milan, 1924-29; studied painting and experimental photography with Fernand Léger, Paris, 1932-35, but essentially self-taught in photography, from 1925. Served in the Italian Resistance, 1940-45. Married Ginetta Nicora in 1945; son: Silvio. Independent graphic artist, associating with Léger and Georges Vantongerloo, Milan and Paris, from 1928; first abstract photographs, 1930, photographic stage designs, 1934. Member, Campo Grafico artists group, Milan, 1933-36; Abstraction-Création artists group, Milan and Paris, 1934-36; and Gruppo Milione artists group, Milan, 1935-40; Founder Member, with Giuseppe Cavalli, Mario Finazzi, Ferruccio Leiss and Federico Vender, La Bussola group of photographers, Milan, 1947-56; Member, Gruppo MAC artists group, Milan, 1948-57. Recipient: First Prize for Color, *International Film Festival*, Knokke-le-Zoute, Belgium, 1949; Prix St. Gobain, Milan, 1966; Grand Prix, *Quadriennale d'Arte di Torino*, 1968. Agent: Galleria Milano, Via Manin 13, Milan. Address: Via Bellotti 2, 20129 Milan, Italy.

Individual Exhibitions:

1932 Galleria il Milione, Milan
1934 Galleria il Milione, Milan
1939 Galerie Equipe, Paris
 Galleria Schettini, Milan
1956 *Oeuvres Recentes*, Galerie de l'Institut, Paris
1957 Galleria Apollinaire, Milan
1958 Galleria del Grattacielo, Milan
1960 *Silografie e Litografie*, Galleria Salto, Milan
1962 Galleria delle Cre, Milan
 Galleria Ciranna, Milan
1963 Galleria Ciranna, Milan
1965 Galleria Lorenzelli, Milan
 Galleria Marciso, Turin
 Galleria del Corco, Padua
1966 Galleria La Polena, Genoa
 Galleria San Petronio, Bologna
1967 Galleria Milano, Milan
 Galleria Pegaso, Milan
1968 Galleria il Grattacielo, Legnano, Italy
 Galleria Vismara, Milan
 Galleria La Colonna, Como
 Galleria il Bilico, Rome
 Galleria Martano, Turin
 Centro Rosmini, Trento, Italy
1970 Musée Municipal, St. Paul de Vence, France
 Galleria Peccolo, Livorno
 Galleria La Chioccola, Padua
 Galleria Ghelfi, Vicenza, Italy
1972 Studio Marconi, Milan
 Galleria Milano, Milan
 Galleria Martano, Turin
 Galleria La Polena, Genoa
 Galleria Pourquoi-pas, Genoa
 Galleria Eunomia, Milan
 Galleria dei Mille, Bergamo, Italy
1974 Galleria Pictogramma, Rome
 Städtisches Museum, Leverkusen, West Germany
 Museo del Teatro della Scala, Milan
 Galleria Milano, Milan
 Galerie Friedrich, Munich
 Galerie Liatowitsch, Basle
1975 Galleria Milano, Milan
 Galleria Martano, Turin
 Salone della Pilotta, Parma (retrospective)
 Studio Marconi, Milan
1978 Galleria Civica, Palazzo dei Diamanti, Ferrara, Italy (retrospective)
1981 Galleria Flaviana, Locarno, Switzerland
 Galleria Radice, Lissone, Italy
 Galleria Toninelli, Rome

Selected Group Exhibitions:

1934 *Mostra Internazionale di Scenografia*, Circolo Nuova Vita, Milan
1944 *Konkrete Kunst*, Kunsthalle, Basle
1947 *Arte Astratta e Concreta*, Palazzo Reale, Milan
1954 *Biennale*, Venice
1955 *Bienal de Sao Paulo*, Brazil
1964 *44 Protagonisi della Visualita Struttura*, Galleria Lorenzelli, Milan
1971 *Konkrete Kunst*, Kunstverein, Hamburg
1973 *Medium Fotografie*, Städtische Museum, Leverkusen, West Germany
1979 *Photographie als Kunst 1879-1979*, Tiroler Landesmuseum Ferdinandeum, Innsbruck, Austria (travelled to the Neue Galerie am Wolfgang Gurlitt Museum, Linz, Austria; Neue Galerie am Landesmuseum Joanneum, Graz. Austria; Museum des 20. Jahrhunderts, Vienna)
1980 *Photographia: La Linea Sottile*, Galleria Flaviana, Locarno, Switzerland

Collections:

Museo della Fotografia, Università di Parma; Galleria Civica d'Arte Moderna, Turin; Galleria Civica d'Arte Moderna, Ancona; Gallerià Civica, Palazzo dei Diamanti, Ferrara; Galleria Civica, Avezzano; Calcografia Nazionale, Rome; Musée de Saint Paul de Vence, France.

Publications:

By VERONESI: books:—*Quaderno di Geometria*, with text by Leonardo Sinisgalli, Milan 1936; *14 Variazione di un Tema Pittorico 1936: 14 Variazioni di un Tema Musicale*, with text by Riccardo Malipiero, Milan 1939; *Del Film Astratto*, Milan 1948; *Voyelles*, with text by Arthur Rimbaud, Milan 1959; *15 Disegni di Veronesi*, with text by Osvaldo Patani, Milan 1961; *Le Stelle sono i Fiori della Notte*, with text by Osvaldo Patani, Milan 1963; *Veronesi*, with text by Osvaldo Patani, Milan 1965; *Veronesi: La Ragioni Astratta*, edited by Paolo Fossati, Turin 1972; films—*Caratteri*, 1939; *Viso e Colore*, 1939-40; *Film No. 4*, 1940; *Film No. 5*, 1940; *Film No. 6*, 1941; *Film No. 9*, 1951; *Film No. 13*, 1980-81.

On VERONESI: books—*Luigi Veronesi: Oeuvres Recentes*, exhibition catalogue, with text by Alain Dalembert, Paris 1956; *Pittura Italiana del Dopoguerra* by Tristan Sauvage, Milan 1957; *Arte Italiana dal Futurismo ad Oggi* by Guido Ballo, Rome 1958; *Nuova Fotografia Italiana* by Giuseppe Turroni, Milan 1959; *Luigi Veronesi: Silografie e Lithografie*, exhibition catalogue, with text by Giulia Veronesi, Milan 1960; *Disegno Moderno in Italia* by Osvaldo Patani, Milan 1960; *Veronesi*, exhibition catalogue, with text by Osvaldo Patani, Milan 1962; *Strutture di Visione*, exhibition catalogue, Rome 1964; *Nuovi Materiali, Nuove Techniche*, Caorle, Italy 1969; *Aspetti del Primo Astrattismo Italiano 1930-1940*, exhibition catalogue, by Luciano Caramel, Monza, Italy 1969; *L'Immagine Sospesa: Pittura e Scultura Astratti in Italia 1934-1940* by Paolo Fossati, Turin 1971; *The Non-Objective World 1939-1955*, exhibition catalogue, edited by George Rickey, London 1972; *Medium Fotografie*, exhibition catalogue, by Rolf Wedewer and L. Romain, Leverkusen, West Germany 1973; *Luigi Veronesi*, exhibition catalogue, with texts by Guido Ballo, Paolo Fossati and others, Parma 1975; *Photographie als Kunst 1879-1979/Kunst als Photographie 1949-1979*, exhibition catalogue, 2 vols., by Peter Weiermair, Innsbruck, Austria 1979; *Photographia: La Linea Sottile*, exhibition catalogue, by Rinald Bianda and Giuliana Scimé, Locarno, Switzerland 1980; *Luigi Veronesi* by Glauco Viazzi, Rome 1980; articles—"Come la Musica puo Diventare Colore" by S. Danese in *Bolaffiarte* (Turin), March 1972; "Sette Schede di Carico" in *Arte Milano* (Milan), May 1972; "Italia" in *NAC* (Milan), May 1972; "Veronesi e Bonfanti" by F. Vincitorio in *NAC* (Milan), November 1972; "Parma: Luigi Veronesi" by Daniela Palazzoli in *Bolaffiarte* (Turin), Summer 1975.

I am a painter; for 50 years I have been painting

Luigi Veronesi: *Fotogramma #6,* **1937**

non-representational pictures and for the same time I have also been seeking to express myself in another medium: photography.

The technique of the "photogram"—the picture obtained without using a camera, only with light on the sensitive material—is the one that interests me most and that answers best to what I am aiming for.

The picture that I obtain is never a likeness; to describe or portray an object, I transform the image of the object into a pure design of light and shade.

The "photogram" really originated the first time a ray of light fell on some object and made a shadow.

In the majority of cases the photogram forms part of that "metaphysical" or "abstract" orientation that has influenced and conditioned so much of all modern art. In the photogram objects rediscover their primordial expression; we can see them beyond their actual shape, in pictures that are not apparent to us and yet are true, and that change instantaneously at the movement of the least glimmer of light.

—Luigi Veronesi

Born in 1908, Luigi Veronesi studied art in Milan while still a boy under the guidance of the painter Violante and the avant-garde critic Rafaello Giolli, who were at that time at the center of a circle of many of those intellectuals, architects and painters who were later to set the tone of anti-Fascist Italian art. It was not until 1932, however, after long experience in many artistic genres—painting, photography, film, illustration—that Veronesi mounted an exhibition of his work at the Galleria il Milione in Milan.

He then began to travel. He was particularly attracted by Paris, by the sparkling cultural climate stimulated in those years by the protagonists of the historic avant-garde. The avant-garde immediately became the arena of Veronesi's work, animated as he was by a never-satisfied curiosity about research in all the visual arts—a contrast to that academicism in Italy which was chained to the myth, the mythomania, of the Fascist regime.

The friends he made during his stay in Paris were members of the "Abstraction, Création, Art Non-Figuratif" group of 1934, among whom George Vantongerloo was particularly close to him; at the same time he came in contact with other members of the avant-garde, such as László Moholy-Nagy, Max Bill, and Joseph Albers; while in Italy he consorted with Lucio Fontana, Atanasio Soldati, Rene Radice, Mauro Reggiani and Fausto Melotti, men who, at that period, as Giulio Carlo Argan has written, "launched in a disciplined way, with no sensational polemics, a purely formal, non-figurative research."

Veronesi had begun to interest himself in photography as early as 1925, encouraged by his father, who was himself an amateur photographer; but his studies were immediately directed towards a picture freed from the theories of naturalism, seeking a self-sufficient experimentation with new expressive techniques such as the photogram and investigating the language of photography not as a means of "documentary reproduction" but as a creative instrument. In this, Moholy-Nagy was his most authentic master: his work, as Paolo Fosseti has written, "not only became a reference point always to be kept in view but, by setting Veronesi outside every Italian context, made him a very special case in events in Italy."

Photography, painting, cinema, illustration—Veronesi used all these techniques in a search for new figurative solutions, which in this artist tend to be essentials, cleansed of every traditional semantic superstructure. In the Italian cultural climate of those years, when "19th centuryism" and, in photography, "pictorialism" were dominant, Veronesi's actions were inevitably provocative—but they seemed less so because of his association with various rationalist authors, who together with certain other photographers (Scopinich, Lattuada, Comencini) and some book-creators (Steiner, Boggeri, Grignani), were building a new cultural foundation

which, in the case of photography, was to be given voice by the magazine *Domus* in its yearbook *Fotografia* of 1943, still an invaluable source of information about historic events in Italian photography.

In 1937, besides producing abstract photograms, Veronesi employed solarization techniques (the Sabbatier effect), which Man Ray had already experimented with in the 1920's but the effects obtained by the Italian photographer were less dramatic than Ray's, often decorative, sometimes making use of advertising layouts, with which he was concerned at the time. Photography also had its part in the many stage sets that Veronesi designed in those years for leading theatres, including La Fenice in Venice and La Scale in Milan. In 1941 his remarkable sets for Malipiero's *Balletto* appeared, which included the projection of an abstract film. For a long time Veronesi concentrated on experimental films, and in 1949 he won the prize for the "best utilization of color" at the *International Film Festival* at Knokke-le-Zoute.

In Luigi Veronesi's research, writes Giuliana Ferrari, "the *experimental* aspect is stressed in an examination of the artistic operation, which he tends to organize as a methodology of vision...": Veronesi's creativity, which is both fresh and tireless, is not an end in itself but has as its goal the establishment of a new semantic parameter, of a hitherto unknown lexical element to be added to his stimulating, hypothetical grammar of seeing. It is a "grammar" that he has constructed not only through the alchemy of the laboratory but also by means of a direct reading of elementary objects such as rocks or the bark of trees, bringing to light hidden forms in them quite foreign to their surroundings, so as to suggest a different reading of reality, always to the limits of abstraction, in a visual space which in Veronesi's pictures appears fantastic.

With macrophotography and microphotography (the latter a technique that he has been using for a long time), Veronesi has tried to retrace the affinities and formal analogies of the "very small" and the microscopic, putting forward a visual "continuum," as it were an idea of the *infinite*, which would be symbolized in the inexhaustibility of forms that the picture can include, different only because of their conventional dimensions, but confirmed by the photographic relief. It is as if Veronesi found his natural "landscape" in the microscope, as if he found himself very much at ease in this dimension, where the optical instrument or polarized light revealed to him an inexhaustible universe of forms, surprisingly similar to those of his photograms, executed directly on sensitized photographic paper in the darkroom.

Luigi Veronesi—who is best known as a painter—has since his early youth sought out in photography and films the languages that are perhaps most congenial to him, but he has had a great struggle to get these "machine-made" pictures appreciated on the same level as painting and drawing in the Italian cultural environment, where these techniques have always been looked at askance, as if their use involved a sort of secondary "minor art." Veronesi's activity has thus been a kind of witness to his faith in the photographic medium. With his friends, he has been involved in a long battle—in promoting photography, collaborating in the organization of photographic exhibitions, and in the publication of books and articles on photography. In 1947, with Giuseppe Cavalli, Mario Finazzi, Ferruccio Leiss and Federico Vender, he founded the Bussola Group, which had a notable influence on post-war Italian photography in the period when the foundations of a culture which had been the victim of Fascism, which now sought to be integrated with art throughout the Western world, making up for lost time, were being rebuilt.

Veronesi, then, has been among the very few artists in Italy in a position to suggest a line of research in the field of photography, with his work influenced by the experiments of the avant-garde outside Italy, of which he has been a member since the start of the 1930's. His contribution has been

fundamental to the development of Italian photography, its purging of provincialism, and Veronesi has certainly worked as few others have, as Wladimiro Settimelli writes, to "chuck out photography of Fascist stamp"—which in Italy has long been taken to mean the representational.

—Italo Zannier

VESTAL. David.

American. Born in Menlo Park, California, 21 March 1924. Educated at University High School, Urbana, Illinois, 1938-41; studied painting at the Art Institute of Chicago, 1941-44; photography, privately, with Sid Grossman, New York, intermittently 1947-55. Married Ann Treer in 1961; daughter: Anne Doherty. Photographer since 1947. Assistant to Ralph Steiner, New York, 1955-57; freelance magazine photographer, New York, 1957-63. Private teacher in photography since 1956. Dean, New York Institute of Photography, 1965-66; Instructor in Photography, School of Visual Arts, New York, 1967-72; Visiting Artist in Photography, Art Institute of Chicago, 1972-73; Visiting Lecturer in Photography, University of New Mexico, Albuquerque, 1974; Instructor in Photography, College of Santa Fe, New Mexico, 1975-77. Freelance writer on photography since 1961. Associate Editor, 1967-69, and since 1975 Contributing Editor, *Popular Photography* magazine, New York; Associate Editor, *Travel and Camera* and *Camera 35* magazines, New York, 1969-71. Recipient: Guggenheim Fellowship in Photography, 1966, 1973. Agent: Marcuse Pfeifer Gallery, 825 Madison Avenue, New York, New York 10021. Address: Post Office Box 309, Bethlehem, Connecticut 06751, U.S.A.

Individual Exhibitions:

1954 Limelight Gallery, New York
1955 A Photographer's Gallery, New York
1959 Smithsonian Institution, Washington, D.C.
Image Gallery, New York
1961 Limelight Gallery, New York
3 Photographers, Kalamazoo Institute of Arts, Michigan (with Wynn Bullock and Aaron Siskind)
1963 University of Maine, Orono
1967 Temple University, Philadelphia
1971 Witkin Gallery, New York
1975 East Street Gallery, Grinnell, Iowa
1979 MFA Gallery, Rochester Institute of Technology, Rochester, New York

Selected Group Exhibitions:

1967 *Photography U.S.A. '67*, De Cordova Museum, Lincoln, Massachusetts
1969 *Vision and Expression*, International Museum of Photography, George Eastman House, Rochester, New York (toured the United States, 1969-71)
1978 *Photographic Crossroads: The Photo League*, National Gallery of Canada, Ottawa (travelled to the International Center of Photography, New York; Museum of Fine Arts, Houston; and Minneapolis Institute of Arts)
1979 *The Great West: Real/Ideal*, University of

Colorado, Boulder (subsequently Smithsonian Institution travelling exhibition; toured the United States)

Collections:

Museum of Modern Art, New York; International Museum of Photography, George Eastman House, Rochester, New York; Art Institute of Chicago; High Museum of Art, Atlanta; Museum of Fine Art, St. Petersburg, Florida; Museum of New Mexico, Santa Fe; University of New Mexico Art Museum, Albuquerque.

Publications:

By VESTAL: books—*U.S. Camera Annual 1971*, editor, New York 1970; *Leica Manual*, editor, with others, New York 1972; *The Craft of Photography*, New York 1975; articles—numerous, mainly in *Popular Photography* (New York), *Camera 35* (New York), and *Infinity* (New York), since 1962.

On VESTAL: book—*Vision and Expression*, edited by Nathan Lyons, New York 1969; articles—"David Vestal" in *Photography Annual*, New York 1962; "David Vestal" in *Photography Annual*, New York 1976.

I try to evoke feeling both by form and by information given in the pictures. The mode is conventional "straight" photography in black and white.

Subjects are whatever I feel like photographing: places and conditions more often than people and events, but nothing is ruled out.

I try for accuracy, without understatement or melodrama; the result is often mistaken for understatement. I'm after depth and am indifferent to impact.

I work mostly in single pictures as they present themselves; not projects. I don't plan work, but improvise it. No rules or systems.

I do not work on assignment: to quote Berenice Abbott's quotation from Atget, "People don't know what to photograph." I recognize mine when I see it, not before.

The criteria are feeling and clarity.

—David Vestal

David Vestal is perhaps best known to American photographers as a writer whose wise and often iconoclastic views have appeared in many photographic magazines. In fact, however, he is an accomplished and award winning photographer who also writes and teaches.

After a short period at the Art Institute of Chicago, where he studied painting, Vestal moved to New York in 1946. There he "discovered photography," becoming an active member of the Photo League and a student of Sid Grossman. From 1955 to 1957 he worked as assistant to Ralph Steiner while also starting to develop his own career. His quiet, introspective photographs have appeared in most of the major magazines in the United States and his pictures are in the permanent collections of the George Eastman House and the Museum of Modern Art.

Vestal has held two prestigeous Guggenheim Awards, the first in 1966 and the second in 1973-74. These have allowed him to travel in the southwestern United States seeking "the places that people ignore."

In the late 1950's Vestal began to teach private seminars in photography to small groups of serious students. This, and more institutional teaching, has continued. From 1967 to 1972 he taught at the School of Visual Arts in New York. In 1972-73 he taught at the Art Institute, "which was fun, because I had dropped out of there years ago."

Vestal began to write free lance articles for *Popular Photography* in 1963, becoming a member of the staff in 1967. He is now contributing editor of the magazine. He has also written for *Travel and Camera* and *Camera 35*. His book, *The Craft of Photography*, is a lucid discussion of straight black-and-white still photography. He is currently writing a book on fine printing techniques.

—F. Jack Hurley

David Vestal: *Portrait of Minor White*, Arlington, Massachusetts, 1970

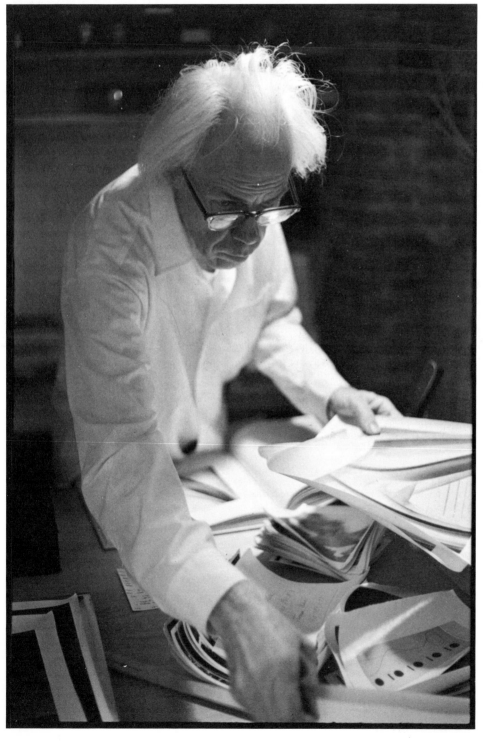

VISHNIAC, Roman.
American. Born in Pavlovsk, Russia, now U.S.S.R., 19 August 1897; emigrated to the United States, 1940: naturalized, 1946. Studied zoology and medicine at Shanyavsky University, Moscow, 1914-20, Ph.D. 1920; also studied oriental art at the University of Berlin in the 1920's; self-taught in photography. Served in the Tsarist, Kerensky and Soviet Armies, Russia, 1914-17. Married; has 1 son and 1 daughter. Lived in Berlin, 1920-30: worked at various odd jobs and as a medical/scientific researcher, 1920-35; freelance photographer, documenting Jewish life and problems in Germany and Eastern Europe, 1935-39; moved to France, 1939: imprisoned as stateless person at Du Richard, Annot, France, 1940. Freelance portrait and medical microphotographer, New York, since 1940. Chevron Professor of Creativity, Pratt Institute, New York; Visiting Professor of Art, Rhode Island

Roman Vishniac: *Vitamin C: Ascorbic Acid* Courtesy The Photographers' Gallery, London

School of Design, Providence. Recipient: Honor Award, American Society of Magazine Photographers, 1956. Address: 219 West 81st Street, New York, New York 10024, U.S.A.

Individual Exhibitions:

1939 Musée du Louvre, Paris
1941 Teachers College, New York
1962 *Through the Looking-Glass*, IBM Gallery, New York
1963 *3 Photographers in Color*, Museum of Modern Art, New York (with Helen Levitt and William Garnett)
1971 *The Concerns of Roman Vishniac*, Jewish Museum, New York
1973 The Photographers' Gallery, London
1977 *Jewish Ghettos of Eastern Europe 1936-39*, Witkin Gallery, New York
1979 Photopia Gallery, Philadelphia

Selected Group Exhibitions:

1960 *The Sense of Abstraction*, Museum of Modern Art, New York
1973 *The Concerned Photographer II*, Israel Museum, Jerusalem (toured Europe)
1979 *10th Anniversary Show*, Witkin Gallery, New York
 Life: The First Decade 1936-45, Grey Art Gallery, New York University

Collections:

Museum of Modern Art, New York; Jewish Museum, New York; Library of Congress, Washington, D.C.; Smithsonian Institution, Washington, D.C.

Publications:

By VISHNIAC: books—*Polish Jews: A Pictorial Record*, with text by Abraham Joshua Heschel, New York 1942, 1965, as *Les Juifs de Passe*, Paris 1979; *A Day of Pleasure*, with text by Isaac Bashevis Singer, New York 1969; *Building Blocks of Life*, New York 1971; *Roman Vishniac*, with text by Eugene Kinkead, New York 1974; *Roman Vishniac: The Vanished World of the Shtetl*, portfolio of 12 photos, New York 1978, as *The Life That Disappeared*, New York 1980; *Roman Vishniac: Einstein*, portfolio of 7 photos, New York 1980.

On VISHNIAC: books—*Polaroid Portfolio No. 1*, edited by John Wlbarst, New York 1959; *The Concerned Photographer II*, edited by Cornell Capa, New York 1972; *The Magic Image* by Cecil Beaton and Gail Buckland, London and Boston 1975; *A Ten Year Salute* by Lee D. Witkin, foreword by Carol Brown, Danbury, New Hampshire 1979; *Life: The First Decade 1936-1945* by Robert Littman, Ralph Graves and Doris C. O'Neill, New York 1979, London 1980; *The Photograph Collector's Guide* by Lee D. Witkin and Barbara London, Boston and London 1979; articles—"The Concerns of Roman Vishniac" by M. Edelson in *Infinity* (New York), October 1971; "The Magnification of Roman Vishniac" by M. Edelson in *Camera 35* (New York), October 1974; "The Concerned Photographer" by Cornell Capa in *Zoom* (Paris), no. 16, 1973; "Roman Vishniac" by Inge Bondi in *Die Weltwoche* (Zurich), 20 September 1978; "The Photomicrographic World of Roman Vishniac" by Francene Sabin in *Omni* (New York), October 1978; "Roman Vishniac" by Erla Zwingle in *American Photographer* (New York), July 1981.

Personal experience, culture, family and ethnic traditions, even a particular mother tongue—all of these factors constitute the connecting tissue of the personality of an individual. In the artist in particular these "biographical" characteristics have a deep influence on the individual's chosen mode of expression. And certain choices, apparently casual, can lead to the discovery of working tools, life-long passions. In photography there seems to be almost an infinity of examples—from Lartigue to Bill Brandt to Aaron Siskind, all of whom became photographers because they found themselves with a camera in their hands by chance, and chance resolved an inward questioning. And so it was with Roman Vishniac, who was given a camera and a microscope when he was only six; he was already intensely curious about nature.

That trivial episode—long ago in 1904—was the first step to a destiny: science and photography have been interwoven throughout the whole of Vishniac's life. He is one of the great humanists of our time, a man in the tradition of the Italian Renaissance, when the figure of the scientist-artist was the key to the thought of the epoch that opened the door to the modern world. Science and art, then, were not in conflict—and neither are they in conflict for Vishniac: a simultaneity of expression of pure reason and abstraction is a reflection of the sublime expression of nature itself. A rare exponent of the new humanism, Vishniac has replaced empirical research with the modern tools of technology and the brush with the camera. Vishniac has a particular love for natural history, from the microscopic world of the life of insects to the world of the life of man. Patience, scrupulous reasoning, strict documentation, organized reasearch—he applies all of these gifts to the magic instrument of photography which he uses for the recording of truth.

Internationally recognized for this work, for his outstanding research and photographic records, Vishniac entered the world of creative photography with a remarkable historical account of the Jewish communities of Eastern Europe, communities that were later completely wiped out by the methodical barbarity of the Nazis. In fact, this step involved no break in Vishniac's photographic methods: his scientific records and his human records spring from the same philosophy of life, a regard for every organism as an essential and irreplaceable part of the harmony of the universe. There is nothing casual about Vishniac. In four years, starting in 1936, he made a series of journeys to the eastern European ghettos, journeys that covered 5,000 miles, to record a world that he knew would disappear: "And I thought maybe years and years after the killing, maybe the Jews will be interested to hear of the life that disappeared, of the life that is no more, and I went from country to country, from town to village.... It was a terrible task; I was many times in prison, but I returned again and again because I wanted to save the faces." He thus preserved the memory of what could no longer exist. Urged on by a conscious foresight based on a knowledge and analysis of past history, he responded to an inward necessity in himself which, as an individual belonging to an ethnic group, he transformed into the necessity of an entire community.

What is so extraordinary about Vishniac's account (apart from its enormous historical value) is the way in which he has made visual records as if in a sketchbook, a series of minute observations of customs that enables him to reconstruct the everyday history of a people. Accustomed to move about in the world of nature as if he were invisible, so as to leave its life undisturbed, he now moved unseen among people recording their attitudes, expressions, movements. In order not to interfere with their everyday activities he kept his camera concealed, operating it with his delicate hands by loving instinct. He became an integrated member of the community. His pictures record life as it was and, even though 40 years have passed, have the life and spontaneous freshness of pictures made today. Vishniac's transcends the limitations he imposed on himself: we are no longer looking at a historical record—"The life that disappeared; the vanished world of the Shtetl"—but at memory, which art can make eternal.

Every picture has a quality so tangible that we can feel the piercing cold in our bones and ourselves experience the worry that wrinkles the face of a woman, the disappointment of an unhappy little girl, the thoughtful wisdom of a studious old man, the shy smile of a youth setting out on a life that will never be—the fear, the desperation of not understanding the reason for the cruelty. And over it all, the song of prayer.... The testament of Vishniac is the visual counterpart of the tradition of mystically inspired Jewish culture, a historical cycle that ends in tragedy. The tales of Sholem Aleichem, the stories of Isaac Bashevis Singer, the philosophy and teaching of Hassidism collected by Martin Buber: these tell of men and places, of conditions and customs, of beliefs and sentiments—a whole world wiped out that can never be rebuilt. Vishniac grasps this world in its last moments, photographs it, fixes it forever. It is a heritage for everyone in the world who, through his work, may know that which they were never able to see.

Vishniac's words, "Nature, God, or whatever you want to call the creator of the universe comes through the microscope clearly and strongly. Everything made by human hands looks terrible under magnification—crude, rough and unsymmetrical. But in nature every bit of life is lovely"—these words reveal the man to us, Vishniac the scientist and artist, and the profound value of his work.

—Giuliana Scimé

VOGT, Christian.

Swiss. Born in Basle, 12 April 1946. Studied photography at the Gewerbeschule, Basle. Worked as an assistant to the photographer Will McBride, Munich. Established own studio, Basle, 1970. Recipient: *Photokina* Award, Cologne, 1972; Swiss National Scholarship, 1974, 1975; Grand Prix, *Triennale of Photography*, Fribourg, Switzerland, 1975; Art Award, Lyons, France, 1976; Canada Council Grant, 1977; Art Directors Club Award, Germany, 1978. Address: Augustinergasse 3, 4051 Basle, Switzerland.

Individual Exhibitions:

1972 Galerie Hilt, Basle
1973 Galeria Il Diaframma, Milan
1974 Canon Gallery, Amsterdam
 Galleria Il Diaframma, Milan
 Galleria Documenta, Turin
 Galleria Schillerhof, Graz, Austria
1975 The Photographers' Gallery, London
 Galerie Christine, Paris
 Galerie Rivolta, Lausanne
1976 Kunsthaus, Zurich
 Galerie in der Altstadt, Zug, Switzerland
 Galerie im Forum Stadtpark, Graz, Austria
 Photoselection, Dusseldorf
 Hotel de Ville, Lausanne
1977 Galerie Jean Dieuzaide, Toulouse, France
 Canon Galerie, Geneva
 Yajima Galerie, Montreal
 Salzburg College, Austria
 Art 77, Basle
 Focus Gallery, Ljubljana, Yugoslavia
1978 Galerie Handschin, Basle
 International Center of Photography, New York

Christian Vogt: *Barbara and Rike* from the *Box Series*, 1978-81

Focus Gallery, San Francisco
Trudelhaus, Baden, Switzerland
1979 University of North Dakota, Grand Forks
Galerie Trockenpresse, West Berlin
Tel Aviv Museum
1980 Galerie Photo Art, Basle
Jacques Baruch Gallery, Chicago
Boris Gallery, Boston
Rencontres Internationales de la Photographie, Arles, France
Nikon Galerie, Zurich
1981 Galerie Watari, Tokyo
Preus Fotomuseum, Horten, Norway
Blixt Gallery, Ann Arbor, Michigan
Galerij Paule Pia, Antwerp
Netzhaut Photogalerie, Frankfurt

Selected Group Exhibitions:

1972 *Photokina '72*, Cologne

1975 *Art as Photography / Photography as Art*, Musée Nicéphore Niepce, Chalon-sur-Saône, France
Triennale Internationale de Photographie Fribourg, Switzerland
1977 *Festival Internationale d'Art*, Royan, France
SICOF '77, Milan
Sequential '77, Harkness House, New York
1979 *Venezia '79*
Photographie als Kunst 1879-1979, Tiroler Landesmuseum Ferdinandeum, Innsbruck, Austria (travelled to the Neue Galerie am Wolfgang Gurlitt Museum, Linz, Austria; Neue Galerie am Landesmuseum Joanneum, Graz, Austria; and Museum des 20. Jahrhunderts, Vienna)
1980 *Photographia: La Linea Sottile*, Galleria Flaviana, Locarno, Switzerland
Fashion Photos, Hastings Gallery, New York

Collections:

Stiftung für Photographie, Kunsthaus, Zurich; Hoffmann Stiftung, Gegenwartsmuseum, Basle; Die Neue Sammlung, Munich; Bibliothèque Nationale, Paris; Moderna Museet, Stockholm; Preus Fotomuseum, Horten, Norway; Tel Aviv Museum; Sam Wagstaff Collection, New York.

Publications:

By VOGT: books—*Christian Vogt: Photographs*, with text by Sue Davies, Fritz Gruber and Allan Porter, Geneva 1980; *Christian Vogt*, portfolio, Chicago 1981; *Box Book*, Geneva 1982.

On VOGT: books—*Photokina '72: Bilder und Texte*, edited by L. Fritz Gruber, Cologne 1972; *Women by 10*, Chicago 1973; *Four Masters of Erotic Photography*, London 1972; *SX 70 Art*, edited by Ralph Gibson, New York 1979; *Photographie als Kunst 1879-1979/Kunst als Photographie 1949-1979*, exhibition catalogue, 2 volumes, by Peter Weiermair, Innsbruck 1979; *Dumont Foto II*, edited by Hugo Schottle, Cologne 1980; *Photographia: La Linea Sottile*, exhibition catalogue, by Giuliana Scimé and Rinaldo Bianda, Locarno, Switzerland 1980; articles—"Vogt" in *Camera* (Lucerne), August 1970; "Sequence" and "Sequence, part 2" in *Camera* (Lucerne), February 1971 and October 1972; "Christian Vogt: Zwischen Hirsingue und Werentzhouse" in *Du* (Zurich), April 1971; "Christian Vogt: Dreams and Reality" in *Photography Year*, by the Time-Life editors, New York 1973; "Christian Vogt" in *Camera* (Lucerne), March 1973; "Basler Zuhause: 19 Aufnahmen von Christian Vogt" in *Du* (Zurich), February 1974; "Christian Vogt" in *British Journal of Photography* (London), 25 October 1974; "Christian Vogt: Wohnungsportraets" in *Werk* (Zurich), December 1974; "Bilder aus dem Jura," special issue of *Du* (Zurich), no. 7, 1981.

I think that there is almost nothing that I identify with. I sometimes feel as if something good happens through me, and this I enjoy. I just play and work: I learn to understand only through doing.
—Christian Vogt

Christian Vogt has combined an intellectual and technical approach in his photography to produce "made" rather than "taken" photographs. Working from an early age in the medium of advertising, he has been aware of the value of subliminal ideas concealed beneath a beautiful surface image. Surrealism has always intrigued photographers and on the face of it appears sometimes an easy option and over-exploited by the advertising fraternity. Because Vogt has always been interested in exploring the evocation of associations in his own work and in pushing the possibilities to the limits of photography, making use of the qualities of reality which the medium carries with it, he has been able to continue his own work while utilising some of the simpler ideas for his clients. The "frame" series explored not only the limitations of the rectangular frame, an old problem for both painters and photographers, but by the addition of the nude or scantily dressed figure, also discussed the role of women as caged objects. In the same way the "red" series not only used the great swathes of colour in a dramatic way but also as a series held some of the ritualistic associations of this colour with the female cycle.

Now that his work is selling well, Vogt is able to try to explore more complex ideas. He appears to believe in the collective unconscious and in his search to visualise ideas that are common to us all, the early work is being overtaken by less easily assimilable images. Since his technique is prodigious and the perfectionism of his finished image is important to him, the problem arises that the viewer can be

791

seduced by the surface quality of a print and thus prevented from seeing or absorbing the more complicated message it may contain. To help avoid this, he has created pictures recently that are less obviously beautiful and require more effort on the part of the viewer.

The problem remains as to whether in fact photography as a medium can cope with the poetry of ideas as well as the prose ones for which it is justly famous. It will be interesting to see how Christian Vogt progresses in his attempts to push these boundaries further forward and whether he will be able to stay within the limits of pure photography or will feel, like Duane Michals, the need to add words to the medium.

—Sue Davies

von GAGERN, Verena.

German. Born Verena Merkl in Bonn, 1 December 1946. Educated at Humanistisches Gymnasium, Cologne, 1956-65; studied architecture at the Technical University, Aachen, 1966-70, and architecture and planning at Pennsylvania State University, University Park, 1970-72, M.A.Arch. 1972. Married Michael von Gagern in 1968; children: Franziska and Moritz. Freelance photographer, Munich, since 1972. Teaching Assistant, Pennsylvania State University, 1972-72; Instructor, Salzburg College of Photography, Austria, 1975-79. Recipient: Young Photographer's Prize, *Rencontres Internationales de la Photographie*, Arles, France, 1975. Address: Genterstrasse 13, 8 Munich 40, West Germany.

Individual Exhibitions:

1975 Galleria Il Diaframma, Milan
 Galerij Paule Pia, Antwerp
 Galerie Fiolet, Amsterdam
1976 Salzburg College Gallery, Austria
1977 Galleria Nadar, Pisa, Italy
 Salzburg College Gallery, Austria
1978 *Öffentliche Bilder von Privatem und Private Bilder von Öffentlichem*, Work Gallery, Zurich
1979 *Kamera Fotografie: Raoul Haussmann und Verena von Gagern*, Neue Sammlung, Munich
1980 *Zufälle in Erinnerung*, Photogalerie Lange-Irschl, Munich

Selected Group Exhibitions:

1976 *8 German Photographers*, at *Photokina 76*, Cologne
1978 *4 Femmes Photographes*, Centre Culturel, Bordeaux
 Exhibition de la Collection, Musée Réattu, Arles, France
1979 *Incontri di Fotografia*, Prato, Italy
1980 *Vorstellung und Wirlichkeit: 7 Aspekte Subjektiver Fotografie*, Städtisches Museum, Leverkusen, West Germany
 Neue Wege in der Fotografie, Kunstmuseum, Leverkusen, West Germany
 Triennale de la Photographie, Charleroi, Belgium

Collections:

Neue Sammlung, Munich; Kunstgewerbemuseum, Hamburg; Musée Réattu, Arles, France.

Publications:

By von GAGERN: articles—"Verena von Gagern: Notes" in *Le Nouveau Photocinéma* (Paris), October 1975; "Notes on My Work" in *Photorevue* (Paris), 1975; "Notes" in *Popular Photography* (New York), Obtober 1976; "Verena von Gagern" in *Camera* (Lucerne), October 1977; "The Camera as a Notebook" in *Photo* (Munich), May 1978; "Against German Photographic Ideologies" in *Fotografie* (Göttingen), October 1978; "To Photograph Is the Decision to Remember," with Ralph Gibson and André Gelpke, in *Fotosymposium Dusseldorf: Reader I*, Munich 1980.

On von GAGERN: books—*Photokina '76*, exhibition catalogue, with an introduction by Fritz Gruber, Cologne 1976; *Kamera Fotografie: Raoul Haussmann und Verena von Gagern*, exhibition leaflet, Munich 1979; *Vorstellung und Wirlichkeit*, exhibition catalogue, by Dieter Wellershof and Rolf Wedewer, Cologne 1980; *Triennale Internationale de la Photographie*, exhibition catalogue, Charleroi, Belgium 1980.

The points of departure for my photographs have been actual private realities at home, in cities, on trains. The printed images, however, show memories of unknown images behind these actual highlighted moments.

The language of photography to me is most interesting in its relationship to time, the doorway between language and reality. In photographs I rediscover a hidden knowledge of the stored traces of past images, both individual and collective, which we call memory. In a single photograph—executed at the peak of presence—I read about a part of reality of which I know only traces, signs and codes within one chosen frame of beautiful memory.

—Verena von Gagern

Stylistically, the photographs of Verena von Gagern are difficult to characterize. They portray "subjective" moments captured autonomously, so that the subject as a dramatic motif is less important than the mysterious articulation of light, shadow, surfaces and space. These are followed by narrative moments in which everything is comparatively clear. The subject is suspended—in most instances between representation and associative freedom—so that it becomes ambiguous and evocative.

Verena von Gagern herself speaks of "romantic documentation" and in this context means photography as the "documentation of suggested images, formed recollections, products of visual perception, which is also a type of experience—an experience in which a single visual phenomenon unites with a particular thought.... Images feed memories and hopes and become the occasion for reflections and their control." A good illustration of this point is one of her best-known photographs, "Untersberg" (1976).

It is evident throughout von Gagern's work that her photographs are caught in a characteristic flux between direct likeness and creative freedom which will support different kinds of interpretation and emphasis. We can see this, for example, in a photograph in which we have the rear view of a girl wearing pig-tails who is looking from the foreground into a room with an interior staircase and a wall lined with books. Two girls are standing in the middle ground, facing the viewer but not looking at him. Obviously one of the girls is looking to the right of the girl in the foreground, but the latter is clearly looking in a different direction. What the first girl is looking at lies completely outside the range of the photograph itself. The occasion for this assemblage of figures is not apparent, nor can it be deduced from the photograph. Because of this, the viewer has a certain space which he is free to fill with his own recollections and associations. Yet no matter how he fills that space, his interpretation will not contradict what is in the photograph itself.

Verena von Gagern realizes this "romantic" dimension of things stylistically, by reflections and displaced perspectives. By means of her art she produces in her photographs a precarious tension between the determinate and the ambiguous which the viewer is unable to resolve. Opposed to the realized artistic fact is always something casual and fortuitous which is nevertheless completely convincing. (Take for example the position of the ravens, in one photograph, in relation to the white-aproned figure of a waiter, or another photograph in which a dog is sitting on the floor so that patches of sunlight and shadow give us a distorted perspective of its two pairs of legs.) In theme and intention, then, Verena von Gagern achieves a persuasive stylistic synthesis.

—Rolf Wedewer

WAHLBERG, Arne.

Swedish. Born in Orebro, near Stockholm, Sweden, 4 November 1905. Educated in local schools, 1911-20; self-taught in photography. Married Margareta Lindeborg in 1938. Worked as assistant to commercial photographer Anders Karnell, Gothenburg, 1927-28, and to Herman Sylwander, Atelier Jaeger, Stockholm, 1928-29; freelance portrait, advertising and industrial photographer, establishing own studio, in Stockholm, 1929-59, in Blekinge, Sweden, 1959-73; retired, living in Asarum, Sweden, since 1973. Address: Asarum, Sweden.

Selected Group Exhibitions:

1928 *Andra Internationella Fotografiska Salongen*, Stockholm
1930 *2. Internationale Fotografiutstalling*, Trondheim, Norway
1944 *Moderna Svensk Fotokonst*, National-museum, Stockholm
1946 *Internationella Fotografiutstallning*, Abo, Finland
1950 *Internationale Tentoonstelling: Vak Fotografie 1950*, Van Abbemuseum, Eindhoven, Netherlands
1952 *5th Annual Masters Exhibition*, Photographers Association of America, Chicago
1967 *Vi i Bild*, Stadsmuseum, Stockholm
1977 *Fotografer: Heilborn, Järlås, Sundgren, Wahlberg*, Moderna Museet, Stockholm
1978 *Tusen och En Bild/1001 Pictures*, Moderna Museet, Stockholm
1979 *Svenskt Landskap*, Moderna Museet, Stockholm

Collections:

Nationalmuseum, Stockholm; Moderna Museet, Stockholm.

Publications:

By WAHLBERG: articles—"Nagot om bildmassighet" in *Nordisk Tidskrift för Fotografi* (Eneby-berg, Sweden), no. 3, 1931; "Materialatergivning vid foremalsfotografering" in *Nordisk Tidskrift för Fotografi* (Enebyberg, Sweden), no. 3, 1938; "Den 'Konstnarliga' fotografiska bilden" in *Nordisk Tidskrift för Fotografi* (Enebyberg), no. 3, 1940; "Brollopsfotografering" in *Svensk Fotografisk Tidskrift* (Stockholm), no., 10, 1943; "Forernalet och Kameran" in *Fotografisk Arsbok*, Stockholm 1950; "Fototryck pa tyg," "Principerna för Formgivning med Ijus," and "Kommersiell fotografering" in *Fotografisk Handbok*, vol. 12, Stockholm 1958.

On WAHLBERG: books—*Fotografer: Emil Heilborn, Sven Järlås, Gunnar Sundgren, Arne Wahlberg*, exhibition catalogue, by Ulla Bergman and Ake Sidwall, Stockholm 1977; *Tusen och En bild*, exhibition catalogue, by Ake Sidwall, Sune Jonsson and Ulf Hard af Segerstad, Stockholm 1978; articles—"Arne Wahlberg: amatören som blev yrkesfotograf" by K.O. Sjostrom in *Nordisk Tidskrift för Fotografi* (Enebyberg, Sweden), no. 1, 1945; "De gamla som unga: Arne Wahlberg" in *Foto* (Stockholm) no. 6, 1953.

At the beginning of this century the international photographic exhibitions were dominated by picutes produced as bromoil prints, gum prints, carbon prints etc. The 1920's saw an avant-garde emerge in reaction, with its roots in Germany: people were now photographed from below; factories were, more often than not, placed diagonally across the picture; and there was a return to photographic clarity and distinctness. Photographers such as Hans Finsler and Renger-Patzsch made razor-sharp pictures of plant fragments and architectural detail—the term "new objectivity" was coined.

Sweden, however, was somewhat isolated culturally, and here "pictorial" photography continued to be dominant for a little longer. The advertising and portrait photographer Arne Wahlberg was one of the first to take up the new ideas from Germany. He had been there on a study tour in 1931 and had made valuable contacts with, among others, the great portrait photographer Hugo Erfurth and the versatile Franz Fiedler. At this time Wahlberg was still making lyrical bromoil pictures, but very soon his trade mark became photographic sharpness and compositional purity. In addition to his German contacts he had also come across the American f/64 group. He was an early subscriber to American photographic magazines, and Edward Weston became another source of inspiration, as did the painter Paul Klee. Wahlberg was always very open to different artistic modes of expression and for this reason he became a highly regarded photographer in the fields of modern architecture, interior design and Swedish craft and design. Few were as adept as he in letting the material and the subject speak for themselves, and soon he became something of a specialist in metal and glass.

His lighting was often exquisitely simple—mostly just a window and some reflecting screens. "It is better to move the subject to the light, than the light to the subject" was one of his basic rules. But when the darkness of the northern winter descended on Stockholm he did, of course, have to resort to artificial light. With the camera stopped down to 32 or 45 he then often worked with flexible lighting. He "painted" with the lamp over the subject, with the shutter left open, in order to avoid hard shadows. And he was also a master of complicated interior photography, for example of mines and large industrial spaces.

During the years many pupils and colleagues worked with him in his studio and later came to establish themselves as prominent advertising and architectural photographers. Arne Wahlberg was an excellent teacher, and he was also much in demand as a lecturer and teacher at courses all over Sweden.

At the end of the 1950's he moved to southern Sweden, to finish his work in milder climes, and he still lives there in retirement while this is written—still with a lively interest in art and culture and with the Continent within easy reach.

—Rune Jonsson

WAKABAYASHI, Yasuhiro. *See* HIRO.

WALKER, (Harold) Todd.

American. Born in Salt Lake City, Utah, 25 September 1917. Educated at Hoover High School, Glendale, California, 1930-34; Glendale Junior College, 1939-40; Art Center School, Los Angeles, under Edward Kaminski, 1939-41. Served as an Air Cadet, then as a Flying Instructor, United States Army Air Corps, 1943-45: 2nd Lieutenant. Married Betty Mae McNutt in 1944; children: Kathleen and Melanie. Worked in the Scienic Department of RKO Film Studios, Hollywood, 1934-42. Photographer, Tradefilms Inc., Hollywood, 1941-43; freelance advertising, industrial and magazine photographer, in Los Angeles, 1946-51, and Beverly Hills, California, 1951-70. Since 1970, independent photographer, in Gainesville, Florida, 1970-77, and in Tucson, Arizona, since 1977. Instructor in Photography, Art Center College of Design, Los Angeles, 1966-70, and University of California Extension, Los Angeles, 1969-70; Associate Professor of Art, California State University at Northridge, 1970; Associate Professor of Art, Printmaking and Photography, University of Florida, Gainesville, 1970-77. Since 1977, Professor of Art at the University of Arizona, Tucson. Recipient: National Foundation for the Arts Grant, 1971; Florida Council on the Arts Fellowship, 1976. Address: 2890 North Orlando Avenue, Tucson, Arizona 85712, U.S.A.

Individual Exhibitions:

1963 *Resemblances of Reality*, California Museum of Science and Industry, Los Angeles
1965 *3 Photographers*, at the *World's Fair*, New York
1969 International Museum of Photography, George Eastman House, Rochester, New York (with Oliver Gagliani)
Camera Work Gallery, Costa Mesa, California
1970 Focus Gallery, San Francisco
Utah State University, Logan
Friends of Photography Gallery, Carmel, California
Phoenix Gallery, Arizona
1971 Bathhouse Gallery, Milwaukee, Wisconsin
Chicago Center for Contemporary Photography
University of Nevada Art Gallery, Reno
1972 Rhode Island School of Design, Providence
3 Photographers, Berry College, Mt. Berry, Georgia (with Jerry Uelsmann and Doug Prince)
University of Rhode Island, Kingston
University of Iowa, Iowa City
Silver Image Gallery, Ohio State University, Columbus
Light Gallery, New York
1973 Clemson University, South Carolina
University of Northern Iowa, Cedar Falls
Visual Studies Workshop, Rochester, New York (toured the United States)
Uelsmann/Prince/Walker, University of Alabama (with Jerry Uelsmann and Doug Prince)
3 Photo-Printmakers, Western Illinois University, Macomb
3 Photographers, Pennsylvania State University, University Park (with Jerry Uelsmann and Doug Prince)
1974 University of Notre Dame Art Gallery, Indiana
1975 University of Oregon, Eugene
University of Florida, Gainesville (retrospective)
Camerawork Gallery, Fairfax, California
Madison Art Center, Wisconsin
Utah State University, Logan
Center for Photographic Studies, Dallas
1976 Center for Photographic Studies, University of Louisville, Kentucky
Light Work Gallery, Syracuse, New York
Nexus Gallery, Atlanta
Silver Image Gallery, Tacoma, Washington
1977 Deja Vue Galleries, Toronto
Visual Studies Workshop, Rochester, New York
Center for Creative Photography, University of Arizona, Tucson
1978 Northern Kentucky State College, Highland Heights
Florida Technological University, Orlando
Daytona Beach Community College, Florida
Fichter/Walker/Wood, Light Factory, Charlotte, North Carolina (with Robert Fichter and John Wood)
1979 Orange Coast College, Fullerton, California
One Thing Just Sort of Led to Another, University of Arizona Art Museum, Tucson
Photographs by Steve Cromwell and Todd Walker, Colorado College, Leadville
1980 Daytona Beach Community College, Florida
1981 Chicago Center for Contemporary Photography

Selected Group Exhibitions:

1963 *Biennale*, Venice

1968 *Contemporary Photographers*, University of California at Los Angeles
1971 *Photo/Graphics*, International Museum of Photography, George Eastman House, Rochester, New York (travelled to the University of New Mexico, Albuerque)
1973 *Light and Lens*, Hudson River Museum, Yonkers, New York
1974 *Photography in America*, Whitney Museum, New York
1976 *Premeditated Fantasy*, University of Colorado, Boulder
1978 *Tusen och En Bild/1001 Pictures*, Moderna Museet, Stockholm
Mirrors and Windows: American Photography since 1960, Museum of Modern Art, New York (toured the United States, 1978-80)
1979 *Attitudes: Photography in the 1970's*, Santa Barbara Museum of Art, California
1980 *Photography: Recent Directions*, De Cordova Museum, Lincoln, Massachusetts

Todd Walker: *Untitled*, 1970

Collections:

Museum of Modern Art, New York; International Museum of Photography, George Eastman House, Rochester, New York; Fogg Art Museum, Harvard University, Cambridge, Massachusetts; Philadelphia Museum of Art; Museum of Fine Arts, St. Petersburg, Florida; Minneapolis Institute of Arts; Center for Creative Photography, University of Arizona, Tucson; University of California at Los Angeles; Norton Simon Museum of Art, Pasadena, California; Bibliothèque Nationale, Paris.

Publications:

By WALKER: books published by Walker from the Thumbprint Press, Los Angeles—*8 Shakespeare Sonnets/8 Todd Walker Photographs*, 1965; *John Donne*, 1966; *The Story of an Abandoned Shack in the Desert*, 1966; *An Abandoned Shack*, portfolio, 1967; *How Would It Feel to Be Able to Dance Like*

This, 1967; *John Donne*, portfolio, 1968; *Melancholy*, 1968; *Portfolio III*, 1974; *27 Photographs*, 1975; *"For Nothing Changes*," 1976; *The Edge of the Shadow*, 1977; *A Few Notes*, 1977; *Three Soliloquies*, 1977; *See*, 1978; articles—"Photo Fun Indoors—with a Pound of Salt" in *U.S. Camera* (New York), June 1949; "Patterns from Your Negatives" in *Popular Photography* (New York), September 1952; "Trends for Photographers," in 2 parts, in *The Rangefinder* (Los Angeles), August and September 1960; "Todd Walker, " interview, with Charles Kelly, in *Afterimage* (Rochester, New York), March 1974.

On WALKER: books—*Photography in America*, edited by Robert Doty, with an introduction by Minor White, New York and London 1974; *The Photographers' Choice*, edited by Kelly Wise, Danbury, New Hampshire 1975; *Mirrors and Windows: American Photography since 1960* by John Szarkowski, New York 1978; *Tusen och En bild*, exhibition catalogue, by Ake Sidwall, Sune Jonsson and Ulf Hard af Segerstad, Stockholm 1978; *One Thing Just Sort of Led to Another*, exhibition catalogue, with texts by William S. Johnson and Susan E. Cohen, Tucson, Arizona 1979; *The Photograph Collector's Guide* by Lee D. Witkin and Barbara London, Boston 1979; *Photography for Collectors: Volume 1, The West*, San Francisco 1979; articles— "Advertising's Natural Look" in *Infinity* (New York), October 1959; "We Look at Todd Walker" in *PSA Journal* (Chicago), January 1964; "The Restless Eye of Todd Walker" in *U.S. Camera* (New York), April 1964; "Todd Walker" by Leland Rice in *Artweek* (Oakland, California), 3 April 1971; "Todd Walker" in *Camera* (Lucerne), December 1971/January 1972; "Todd Walker" in *Creative Camera* (London), May 1973; "Retrospective: Photographer Walker's Personal Vision" in *Gainesville Sun* (Florida), 6 April 1975; "Beyond the Negative" by Ed Scully in *Modern Photography* (New York), November 1975; "Walker Pictures Life in His Art" in *Gainesville Sun* (Florida), 27 December 1976; "Two from Todd," book review, by Michael Lonier, in *Exposure* (New York), May 1977; "Nudes" in *American Photographer* (New York), December 1978.

I am a photographer, firmly grounded in the California tradition of photography. That is where I learned photography and worked for many years. The function of working with a camera is to produce not merely an image, as it is now called, but a picture. A dictionary tells me what I mean by those words—*image*: the optical counterpart of an object produced by a lens; *picture*: the representation of something in visible or symbolic form.

For me, the image from the camera needs to be transformed into a picture. That transformation is an important part of my work. In addition to being involved with the image while using the camera, I must then concentrate on that image, with my reaction to the illusions that I have about my enironment, and form a concrete picture that attempts to describe and delineate my illusion. *Representation*: to present again.

When, from among the many incomplete or inadequate pictures that I have done, one seems to support the illusion that I had while using the camera, or now may have, this becomes the particular one from which I evolve my representation of that illusion. *Representation*: to present again.

In the "purist" tradition of photography, this representation of the picture had certain restrictions, and the direct print from the negative was among them. Although I have come from that tradition, I have not gone far. The alteration of my images has to do with light, chemistry, and pigments other than silver. Yet my concern is strongly with the ability of the photographic process to reveal subtle differences in tone, the way that light is reflected and absorbed, and the marvellous extension of vision that results.

I came to photography with the desire to conquer this machine, the camera, and make it my slave. Instead, I have now a respect for it and for other machines as expanders of my awareness. The printing press, the process camera, photomechanical methods are now part of my photography and are teaching me what else is latent in the negative that comes from the camera.

Through all of this I am trying to make pictures, to re-present something in visible and/or symbolic form.

—Todd Walker

From childhood on, Todd Walker has been interested in photography. He has also been fascinated by machines and by the way things work, understanding them after the briefest examination—a talent that has had a great impact on his development as a photographer. He worked for a time as a painter's apprentice at RKO studios in Hollywood where he observed the creative power of light; he then attended the Art Center School in Los Angeles part-time in order to learn commercial photographic skills. Never content, but always patient, Walker went on to master the skills of each type of photography he encountered. He came from the California School of "straight" photography and found a creative outlet in the boom of commercial photography in Southern California in the 1950's, becoming a much admired and sought-after commercial photographer as a result of his knowledge of how to capture reality in an appealing and eye-catching manner. He also studied and experimented with the "Dorothea Lange" or documentary school of photography as well as the editorial school, although his participation in these areas was minimal.

While he was at the Art Center School, Walker took a course from Eddie Kaminski which introduced him to cubism and surrealism. By the early 1950's he had achieved sufficient success to allow himself to return to those things which were of private interest to him. According to Susan Cohen, "Todd's primary drive [is] to match in visual form his personal response to the phenomenal world, to confirm what he calls his 'illusion of reality.' " After a reassessment of his work and goals, Walker gave up the security and prosperity of the commercial world of photography in the late 60's to pursue his own artistic interests, which attests to his strong commitment to his art and to his belief in the "individual."

His break with traditional "straight" photography and his skill and ingenuity in using such techniques as the Sabbatier line, solarization, posterization, the offset lithographic press or the collotype allow him to play with space, line, motion, alterations in color, repetition, use of blur, etc. By way of experimentation and by mastering such various and diverse techniques, Walker has successfully revitalized the clichéd tropes of the nude and the landscape. In his work with the female nude, for example, he does not dwell on the sexually provocative or the voyeuristic aspect, but rather often creates a soft intimacy with the subjects by placing them in "caves" or "artificial structures" (in addition to the natural environment) to explore how "people relate to themselves rather than there being an outside reference to something else." It should be noted, perhaps, that his use of diverse techniques is not to correct a "failed" image, but to enhance a perfectly good image and give it a new significance.

Walker's photographers are constantly becoming more and more complex—perhaps this is because it is not easy to successfully "match in visual form [one's increasingly complex] personal response to the phenomenal world." Regardless, Walker's photography is exciting and invigorating—whether he is photographing machines, still-lifes, people, leaves or nudes—because he is never afraid to continue experimenting and attempting to redefine the boundaries of modern photography. He has been able to move away from the purely objective to surrealism

as an alternative approach to the medium, yet without losing an important link with reality. As William Johnson has noted, "Todd has always been attracted to surrealism, or rather to a certain aspect of the surrealist message—that there is more to the world than what is physically there; that there can be a world of cause and consequence not structured by normal expectations; that the world can have a sense of poetry, of elusiveness, of mystery that can never be quite categorized or defined.... This sense of the power of mystery is conveyed in his 'salt table' photographs in the late 1940's and again in the best of the solarized prints of the later 1960's . Gradually, however, Todd has been able to strip away the forms of surrealism to achieve the substance of its idea. He no longer has to make images that look surreal; now he has reached the point where he can embody the sense of mystery within the most quotidian images." Ultimately, then, as is often the case, it is not the specific subject matter which is so important, but the overall coherent effect which the artist has achieved.

—Michael Held

WALSH, John.

Australian. Born in Melbourne, 16 January 1945. Educated in Melbourne schools. Mathematics and science teacher, Melbourne high schools, 1965-67. Freelance photographer since 1967, in Melbourne, Sydney, and, since 1971, in England. Taught at the National Art School, Sydney; served as Company Photographer for the Australian Opera. Address: c/o Derek Bayes, Aspect Picture Library, 73 Kingsmead Park, Surrey KR4 8UW, England.

Individual Exhibitions:

1970 Holsworth Gallery, Sydney
 Brummels Gallery, Melbourne

John Walsh likes to move among people as unobtrusively as possible. For a man with a camera this is, fairly obviously, not easy. People react in all manner of unpredictable ways when confronted with a stranger pointing a camera at them. Walsh goes out of his way to avoid creating tensions and emotional difficulties when he is mingling with the madding crowd. For him the Eastern ideal of "making of oneself a vacuum into which others can freely move" is the key to success in his role as photographer. He feels that the photographer is something of a trespasser, a potential invader of other people's privacy.

If his subjects object to his presence in any way, Walsh is prepared to cease work and move on. His hypersensitivity to others is reflected in much of his work, such as his first one-man exhibition at Sydney's Holdsworth Galleries in 1970. The theme was an in-depth and very personal response to the Australian urban life style as observed over a six year period, mostly in Sydney, Brisbane and Melbourne (where Walsh was born and spent most of his earlier life).

Walsh is in some respects a fairly typical product of the university campuses of the 1960's. He is primarily concerned with the impact of industrialisation on urban man and the questionable values of an establishment dominated by a lust for money and power.

Walsh's photographic essay entitled "The Myth of Equality" exposed the daunting problems faced

by low-income groups in attempting to provide their children with a reasonable education. No doubt Walsh's experiences as a mathematics and science teacher in Melbourne high schools (1965-1967) made him only too aware of the seriousness and complexity of this little discussed subject.

Industrial consumerism and its effects on society resulted in an approach to photography akin to that of social documentation.

When Walsh first departed from Australia in 1971 he went to England where he has spent most of his time since. He did return to Australia in 1973 for a time but not before visiting some of the heavily industrial areas in England, where he talked to workers and their families. His photographs of this period reflect the influence of Bill Brandt's observations of the working classes in the 1930's, depicting the effects of rapid social change.

In 1973 the *British Journal of Photography* published a portfolio of Walsh's photos of industrial Britain. The best of this work juxtaposed figures and faces with industrial environments in a most telling and sympathetic manner.

John Walsh's role as a photographer is very much that of social reformer.

—Arthur McIntyre

WARHOL, Andy.

American. Born in McKeesport, Pennsylvania, 6 August 1928. Studied at Carnegie Institute of Technology, Pittsburgh, 1945-49, B.F.A. 1949. Worked as illustrator for *Glamour Magazine*, New York, 1949-50, and as a commercial artist, New York, 1950-57. Independent artist, New York, since 1957: concentrated on making paintings derived from strip comics and advertisements, 1960-61; first silk-screen paintings, 1962; first films, mainly with Paul Morrissey, 1963. Editor, *Inter/View* magazine, New York. Recipient: Art Directors Club of New York Medal for shoe advertisements, 1957; 6th Film Culture Award, New York, 1964; *Los Angeles Film Festival* Award, 1964. Agent: Leo Castelli Gallery, New York. Address c/o Leo Castelli Gallery, 4 East 77th Street, New York, New York 10021, U.S.A.

Individual Exhibitions:

1952	Hugo Gallery, New York
1956	Bodley Gallery, New York (and 1957, 1958, 1959)
1962	Ferus Gallery, Los Angeles
	Stable Gallery, New York
1963	Ferus Gallery, New York
1964	Leo Castelli Gallery
	Stable Gallery, New York
	Galerie Sonnabend, Paris
1965	Leo Castelli Gallery, New York
	Galerie Sonnabend, Paris
	Galerie Rubbers, Buenos Aires
	Galerie M.E. Thelen, Essen
	Gian Enzo Sperone Arte Moderna, Milan
	Institute of Contemporary Art, Philadelphia
	Galerie Buren, Stockholm
	Jerrold Morris International Gellery, Toronto
	Gian Enzo Sperone Arte Moderna, Turin
1966	Galerie M.E. Thelen, Essen
	Gian Enzo Sperone Arte Moderna, Milan
	Institute of Contemporary Art, Boston
	Contemporary Arts Center, Cincinnati, Ohio

	Galerie Hans Neuendorf, Hamburg
	Ferus Gallery, Los Angeles
	Le Castelli Gallery, New York
1967	Galerie Rudolf Zwirner, Cologne
	Galerie Sonnabend, Paris
1968	Galerie Rudolf Zwirner, Cologne
	Stedelijk Museum, Amsterdam
	Galerie der Spiegel, Cologne
	Rowan Gallery, London
	Galerie Heiner Friedrich, Munich
	Kunstnernes, Oslo
	Moderna Museet, Stockholm
1969	Neue Nationalgalerie der Staatlichen Museen Preussischer Kulturbesitz, West Berlin
	Irvin Blum Gallery, Los Angeles
	Leo Castelli Gallery, New York
1970	Galerie Folker Skulima, West Berlin
	Museum of Contemporary Art, Chicago
	Stedelijk van Abbemuseum, Eindhoven, Netherlands
	Musée d'Art Moderne de la Ville, Paris
	Pasadena Museum of Art, California (toured the United States and Europe)
1971	Galerie Bruno Bischofberger, Zurich
	Gotham Book Mart Gallery, New York
	Institute of Contemporary Arts, London
	Musée d'Art Moderne, Paris
1972	Castelli Downtown Gallery, New York
	Multiples Gallery, New York
1973	Margo Leavin Gallery, Los Angeles
1974	Mayor Gallery, London
	Musée Galliera, Paris
1975	Baltimore Museum of Art
1976	Württembergischer Kunstverein, Stuttgart (travelled to Kunsthalle, Dusseldorf)
1980	*Andy Warhol: Photos*, Lisson Gallery, London
1981	*Portrait Screenprints 1965-1980*, Gloucestershire College of Arts and Technology, Cheltenham, England

Selected Group Exhibitions:

1964	*The Painter and the Photograph: From Delacroix to Warhol*, University of New Mexico, Albuquerque
1966	*11 Pop Artists: The New Image*, Galerie M.E. Thelen, Essen
1967	*The 60's*, Whitney Museum, New York
1968	*Documenta 4*, Kassel, West Germany
1971	*Photo/Graphics*, International Museum of Photography, George Eastman House, Rochester, New York
1975	*Photographic Process as Medium*, Rutgers University, New Brunswick, New Jersey
1977	*Paris-New York*, Centre Georges Pompidou, Paris
1978	*Mirrors and Windows: American Photography since 1960*, Museum of Modern Art, New York (toured the United States, 1978-80)
1980	*La Photo Polaroid*, Musée d'Art Moderne, Paris
	Instantanés, Centre Georges Pompidou, Paris

Collections:

Museum of Modern Art, New York; Whitney Museum, New York; Corcoran Gallery of Art, Washington, D.C.; Walker Art Center, Minneapolis; County Museum of Art, Los Angeles; Norton Simon Museum of Art, Pasadena, California; Art Gallery of Ontario, Toronto; Tate Gallery, London; Moderna Museet, Stockholm.

Publications:

By WARHOL: books—*Andy Warhol's Index Book*,

New York 1967; *A: A Novel*, New York 1968; *Andy Warhol: Transcript of David Bailey's ATV Documentary*, London 1972; *A to B and Back Again*, London and New York 1975; *Ladies and Gentlemen*, Milan 1975; *Andy Warhol: Photographs*, portfolio of 12 photos, New York and Zurich 1980; articles—"My Favorite Superstar: Notes on My Epic, *Chelsea Girls*," interview, with Gerard Malanga in *Arts* (New York), February 1967; "Andy Warhol Tapes Roman Polanski" in *Inter/View* (New York), November 1973; "Andy Warhol: Interview" in *Photo* (Paris), May 1979; "Warhol: Mon Carnet Mondain" in *Photo* (Paris), March 1980; films—*Kiss*, 1973; *Tarzan and Jane Regained Sort Of*, 1963; *Dance Movie*, also known as *Roller Skate*, 1963; *Haircut*, 1963; *Eat*, 1964; *Blow Job*, 1963/64; *Batman Dracula*, 1964; *Empire*, 1964; *Henry Geldzahler*, 1964; *Soap Opera*, also known as *The Lester Persky*, 1964; *Couch*, 1964; *Shoulder*, 1964; *Mario Banana*, 1964; *Harlot*, 1964; *13 Most Beautiful Women*, 1964/65; *13 Most Beautiful Boys*, 1964/65; *50 Fantastics and 50 Personalities*, 1964/66; *Ivy and John*, 1965; *Suicide*, 1965; *Screen Test 1*, 1965; *Screen Test 2*, 1965; *The Life of Juanita Castro*, 1965; *Drunk*, 1965; *Horse*, 1965; *Poor Little Rich Girl*, 1965; *Vinyl*, 1965; *Bitch*, 1965; *Restaurant*, 1965; *Kitchen*, 1965; *Prison*, 1965; *Face*, 1965; *Afternoon*, 1965; *Beauty 2*, 1965; *Space*, 1965; *Outer and Inner Space*, 1965; *My Hustler*, 1965; *Camp*, 1965; *Paul Swan*, 1965; *Hedy*, also known as *Hedy the Shoplifter* and *The 14 Year Old Girl*, 1965; *The Closet*, 1965; *More Milk, Evette*, also known as *Lana Turner*, 1965; *Lupe*, 1965; *Bufferin*, also known as *Gerard Malanga Reads Poetry*, 1966; *Eating Too Fast*, 1966; *The Velvet Underground*, 1966; *Chelsea Girls*, 1966; **** also known as *Four Stars*, 1966/67; *International Velvet*, segment of ****, 1967; *Alan and Dickin*, segment of ****, 1967; *Imitation of Christ*, segment of ****, 1967; *Gerard Has His Hair Removed with Nair*, segment of ****, 1967; *Alan and Apple*, segment of ****, 1967; *Bike Boy*, 1967; *Nude Restaurant*, 1967; *Lonesome Cowboys*, 1967; *Blue Movie*, 1969; *Schrafft's Commercial*, 1969.

On WARHOL: books—*The Painter and the Photograph: From Delacroix to Warhol* by Van Deren Coke, Albuquerque, New Mexico. 1964, 1972; *Andy Warhol*, John Coplans, Pasadena, California 1970; *Andy Warhol* by Rainer Crone, London 1970; *The Autobiography and Sex Life of Andy Warhol* by John Wilcock, New York 1971; *Andy Warhol: Films and Paintings* by Peter Gidal, New York 1971; *Photo/Graphics*, exhibition catalogue, with text by Van Deren Coke, Rochester, New York 1971; *Photographic Process as Medium*, exhibition catalogue, with text by Rosanne T. Livingston, New Brunswick, New Jersey 1975; *L'Arte nella Società: Fotografia, Cinema, Videotape* by Daniela Palazzoli and others, Milan 1976; *Mirrors and Windows: American Photography since 1960* by John Szarkowski, New York 1978; *SX-70 Art*, edited by Ralph Gibson, New York 1979; *Instantanés*, exhibition catalogue, by Michel Nuridsany, Paris 1980.

The photographic image is central to the art of Andy Warhol: without it his imagery, his intent and his result would differ entirely. Much of Warhol's impact as an image-maker depends on his use of the dream figures, horrific events, and the products of the advertising world. Furthermore, he presents these subjects in the way most 20th-century consumers understand—through the advertisement, the media image and the photograph. All photography has the uncanny ability to appear as an unmediated record of objects and events: we take it to be real. Warhol plays upon this quality. His art seems not to represent interpreted objects (as paintings and drawings do) but objects merely one step away from reality, seen through the lens. Pop art deals with images that already exist as signs, such as comics or brand goods; Warhol's art deals with the power of

images and how we perceive the sign-system of photographic images which is this century's most powerful and ubiquitous formal language.

Both Warhol's imagery and his art form are derived from popular culture. His subjects are well-known: Brillo boxes, Campbell soup cans, Coca-Cola bottles, Marilyn, Liz, Elvis, the Mona Lisa. His mass-media sources are meant to question the elitist, purist attitude toward art: his subjects show Warhol's willingness to treat our whole culture as if it were art. He thus questions not only the meaning of "taste" but also the value of "art." The banality of his artistic subject, his choice of the garish hues of a cheap color reproduction, and his choice of the cheapest reproductive process, the silkscreen, all speak of Warhol's opposition to the idea of artistic purity.

The silkscreen process—which is the simplest and technically most straightforward as well as the cheapest printing process—offered Warhol results which look not like "art" but like common reproduction. The artist reputedly once said that he "thought somebody should be able to do all his paintings for him." This desire for the "artist" to be minimized is possible with silkscreen: Warhol's artistic imput consists merely of sending a selected image, which has been ripped from a newspaper or magazine, to commercial silkscreenmakers with his size and color specifications. Ultimately, he is implying that an "artist" is not needed to make anti-art.

However, the mechanical anonymity of Warhol's art is, to some extent, a sham. Even in the most repetitive of Warhol's images—row upon row of Campbell soup cans or bland repeats of Liz Taylor—there are numerous variations made in the print according to the amount of ink and the amount of pressure applied in its making.

Both this technique and Warhol's subject are aimed to hit the "center of a communal nerve": his images are instantly recognizable to everyone. Many are images which under normal circumstances elicit violent emotional response: they are figures who are idolized and lusted after or the horrifying symbols of instant death and violent destruction. His people no less than his objects are icons and totems of contemporary life. They are media presentations—people we know and sometimes feel we know intimately, only through photography.

Warhol's art forces us to rethink the meaning of photographic images and the uses of photography as a form-language in our society. By serializing his images—stacking row upon boring row—he shows us the emotional and intellectual impact caused by repetition of even the most shocking and startling images. He makes us look again at both the content of our world and the content of our art by presenting the "contentless" image. Warhol presents his viewer with only the "thingness" of a thing (just a soup can) rather than any implicit or explicit content. He shows how images *can* and have been stripped of content in our daily lives.

—Nancy Hall-Duncan

WASSERMAN, Cary.

American. Born in Los Angeles, California, 27 November 1939. Educated at Los Angeles High School, 1954-57; University of California at Los Angeles, 1957-63, B.A. in English literature 1961, M.A. 1963; studied literature, 1963-66, art history, education, and contemporary music, 1966-69, and photography, under Henry Holmes Smith, 1967-70,

Indiana University, Bloomington. Freelance photographer, with studio in Cambridge, Massachusetts, since 1970. Instructor, Indiana University, Indianapolis, 1966-70; Art Institute of Boston, 1971-74; Phillips Academy, Andover, Massachusetts, 1973; Northfield-Mt. Hermon School, Northfield, Massachusetts, 1976; University of Maine, Portland-Gorham, 1976-77; University of Lowell, Massachusetts, 1977-79; Phillips Academy, 1979; and Martha's Vineyard School of Photography, Massachusetts, 1980. Columnist ("Photoart"), *Boston Globe*, 1970-73. Recipient: Polaroid Corporation Grant, 1974; Cambridge Arts Council Open Competition Prize, 1975. Address: 6 Porter Road, Cambridge, Massachusetts 02140, U.S.A.

Individual Exhibitions:

1970 *Urban Color Photographs*, Arthur D. Little Corporation, Cambridge, Massachusetts
 Mexican Photographs, Polaroid Gallery, Cambridge, Massachusetts
1971 *Recent Photographs*, Art Institute of Boston
1972 *Photographs 1969-71*, Addison Gallery of American Art, Andover, Massachusetts
~1974 *Photographs*, Belknap College, Center Harbor, New Hampshire
 Recent Photographs, Mather House, Harvard University, Cambridge, Massachusetts
 Rural Values, Enjay Gallery, Boston
 Charlestown: In Progress, Charlestown YWCA, Massachusetts
 Photographs 1970-74, Portland Museum of Art, Maine
1975 *Changes: Boston Area Architecture*, Harvard School of Design, Cambridge, Massachusetts
1976 *Cambridge Memories*, City Hall, Cambridge, Massachusetts
 Cyanotypes (*In Memory of Minor White*), Newton Free Library, Massachusetts
1978 *Color Photography*, Williams College, Williamstown, Massachusetts (retrospective)
 Color Photographs 1971-74, Portland School of Art, Maine
1979 *SX-70 Photographs*, Pine Manor College, Chestnut Hill, Massachusetts

Kwik-Prints, North Cambridge Library, Massachusetts
1980 *SX-70 Photographs*, Next Move Theatre, Boston

Selected Group Exhibitions:

1972 *Points of View*, Institute of Contemporary Art, Boston
 The New England Experience, De Cordova Museum, Lincoln, Massachusetts
1974 *Private Realities*, Museum of Fine Arts, Boston
1975 *Color Photography Now*, Wellesley College Museum of Art, Massachusetts
1976 *The Photographers' Choice*, Witkin Gallery, New York (toured the United States, 1976-79)
 New Blues (Cyanotypes), Arizona State University, Tempe
1977 *Color Photography*, Photoworks, Richmond, Virginia
1978 *Artists' Books*, Boston Visual Arts Union Gallery
1980 *Urban/Suburban Color Photographs*, Addison Gallery of American Art, Andover, Massachusetts
 Aspects of the 70's: Recent Directions in Photography, De Cordova Museum, Lincoln, Massachusetts

Collections:

Museum of Fine Arts, Boston; Polaroid Collection, Cambridge, Massachusetts; Smith College Museum of Arts, Northampton, Massachusetts; Wellesley College Museum of Art, Massachusetts; Portland Museum of Art, Maine.

Publications:

By WASSERMAN: articles—"SX-70 Manipulation" in *Petersen's Photographic Magazine* (Los Angeles), December 1976; "Ben Shahn, Photographer" in *Maine Sunday Telegram* (Portland), November 1977; Photographs of Architecture" in *New Age*

Cary Wasserman: *God's Eye Maker* from the series *City of Gold* (original in color), 1974

Journal (Boston), April 1978; "Bruguière" in *New Age Journal* (Boston), June 1978; "Edward Weston Nudes" in *Boston Visual Artists Union Newsletter*, no. 10, 1978; "Steichen: Master Prints" in *New Age Journal* (Boston), December 1978; "Minor White: Rites and Passages" in *Parabola* (New York), Winter 1979; "Duane Michals" in *New Age Journal* (Boston), April 1979; "Man Ray" in *New Age Journal* (Boston), May 1979; "Expressive Toning" in *Darkroom Techniques* (Chicago), Winter 1980.

On WASSERMAN: books—*Points of View*, exhibition catalogue, edited by Susan Channing and John Snyder, Boston 1972; *Private Realities* by Clifford S. Ackley, Boston 1974; *The Photographers' Choice*, edited by Kelly Wise, Danbury, New Hampshire 1975; *New Blues*, exhibition catalogue, edited by Che Du Puich, Tempe, Arizona 1976; *Creative Camera International Yearbook 1977*, edited by Peter Turner, London 1976; *The Color Photographs of Cary Wasserman* by Susan Dodge Peters, articles—"Cary Wasserman: Active Experimenter" by Jonathan Goell in the *Boston Globe*, 7 November 1971; "Wasserman's View" by Jonathan Goell in the *Boston Globe*, 18 January 1974; "Rural Values" by Vladimir Gulevich in *Popular Photography* (New York), July 1974; "Private Realities: Recent American Photography" by Vladimir Gulevich in *Popular Photography* (New York), August 1974; "'Color Photography Now' Belongs to the Experimentalists" by David Akiba in the *Boston Globe*, 12 October 1975; "A Decade of Dramatic Progress" by Jessica Bethoney in the *Boston Globe*, 31 July 1980.

My concerns involve expressively documenting aspects of time and facets of space that describe a felt reality.

Photography enables me to set my perceptions, memories, feelings, aspirations and ideals into an accessible, communicable form.

I assume that art emerges from the interaction of freedom of expression and aesthetic choice. Photography offers a broad range of materials and traditions, of camera formats, light sensitized materials, and diverse subject matter, each choice having its own implications.

I work with conventional camera optics and formats from 35mm to 12 x 20 contact negatives; perceptually natural curvilinear lenses; conceptual materials such as stereo (3-D cameras and prints); with assemblage sculpture; and with the sequential time delineation of movie film. I am interested in capturing a feeling of life in my work and describing our psychic environment.

I have been most deeply influenced by the ideas of Moholy-Nagy, Hans Richter and Wassily Kandinsky; by the work of Atget and Cartier-Bresson in their manner of describing the real; in the ability to transform the ordinary by the work of Edward Weston; and of the potential of color by theories from various cultures, by the work of Henry Holmes Smith, and by my own predisposition.

—Cary Wasserman

Speaking of black-and-white photography during a recent conversation, but in terms equally applicable to his color work, Cary Wasserman said: "There must be an awareness of all the possibilities of experimentation for black-and-white—including transformation to color. Sometimes a black-and-white negative goes beyond the possibilities in silver."

"Experimentation" is the key word in, and the key to, both the work and the photographic lineage of this artist. Wasserman readily admits to the influences of Henry Holmes Smith, Atget and Cartier-Bresson, among other 20th century masters; as well, there is a more antique influence at play (and "play" is a most appropriate characterization). Like Bayard, Fox-Talbot, and countless others, both named and anonymous, Cary Wasserman is chiefly concerned with understanding the technology at his disposal,

utilizing it, and pushing it ever further in the service of creating an evolving imagery.

Thus, a given lens-made or chemically-created image may exist in a stream of technical incarnations over time. A carefully crafted "straight" black-and-white photograph of Ranchos de Taos Church (also the subject of one of Paul Strand's most beautiful pictures) will later be toned in yellow or otherwise altered, with each alteration producing a new experience for photographer and viewer alike.

This fascination with photographic experimentation has yielded a rich and diverse body of work since the late 1960's (when Wasserman studied with the abstract-color master Henry Holmes Smith in Indiana). Of particular note, both because of their photographic and pure color qualities, is a series of gum bichromate prints from 1974. Of this antique technology, Wasserman says: "It's such a magical process; the point was to create color which looks natural, even if manipulated."

A more recent endeavor, although one that is coming to an end because of changes in available Polaroid materials, consists of several groups of SX-70 prints, each of which has been manipulated, by pressing with an awl, before the surface hardened. Whether built upon constructed elements (i.e., "Death and the Maiden," 1976) or natural, environmental ones (i.e., "Ciudad de Los Angeles," 1978), these delicate images evoke the colors and imagery of Hundertwasser without abandoning a strong loyalty to the medium from which they spring.

Most recently, Wasserman has been experimenting with stereographic pairs of SX-70 images; it is very much a work in progress but one with interesting possibilities.

I have dwelt upon Wasserman's color work because it is the area of his greatest contribution. However, this thoroughgoing belief in experimentation and the sense of joy and playfulness that mark his work are valuable lessons no matter what the tonal range in which one works.

—Stu Cohen

WEBB, Todd.

American. Born Charles Clayton Webb in Detroit, Michigan, 15 September 1905. Educated at Newmarket High School, Ontario, 1920-24; University of Toronto, 1924-25; studied photography, under Ansel Adams, photography workshop, Detroit, 1940. Served as a photographers mate first class, United States Navy, in the South Pacific, 1942-45. Married Lucille Minqueau in 1949. Freelance photographer since 1946: worked with Roy Stryker, Standard Oil Company, New York, 1947-49; in Paris and throughout Europe, 1949-54; and for the United Nations, New York, 1955-69. Recipient: Guggenheim Fellowship in Photography, 1955, 1956; National Endowment for the Arts Photography Fellowship, 1979. Agent: Rinhart Gallery, Upper Grey, Colebrook, Conn. 06021. Address: 120 North Street, Bath, Maine 04530, U.S.A.

Individual Exhibitions:

1946 *I See a City*, Museum of the City of New York

1947 Delgado Museum, New Orleans
Louisiana State University, Baton Rouge

1950 *Paris Architecture*, Architectural Center, Wuppertal, Germany (travelled to the Münchner Stadtmuseum, Munich)

1951 *Photographs of Paris*, United States Embassy, Paris

1954 *80 Photographs by Todd Webb*, International Museum of Photography, George Eastman House, Rochester, New York

1956 *90 Photographs by Todd Webb*, Art Institute of Chicago

1962 Kalamazoo Art Institute, Michigan
University of Indiana, Bloomington
Fine Arts Museum of New Mexico, Santa Fe (with Laura Gilpin and Eliot Porter)

1965 *Todd Webb: Photographs*, Amon Carter Museum, Fort Worth, Texas (travelled to Texas A and M College, College Station, Texas, 1966)

1966 *19th Century Texas Homes*, Amon Carter Museum, Fort Worth, Texas (travelled to the Museum of the Southwest, Midland, Texas, 1967)

Todd Webb: *Amish Farmers at a Horse Auction*, New Holland, Pennsylvania, 1955

1967 *Todd Webb Photographs*, University of Southwestern Louisiana, Lafayette
1968 *U.S.A. Arts*, Maison de la Tour, St. Restitut, France
1971 *Todd Webb Photographs*, New Mexico Museum, Santa Fe
1974 *19th Century Texas Public Buildings*, Amon Carter Museum, Fort Worth, Texas
1977 *Todd Webb Photographs*, Rinhart Gallery, New York (retrospective)
Photographs by Todd Webb, Westbrook College, Portland, Maine
1979 Prakapas Gallery, New York
1980 University of Southern Maine, Gorham

Selected Group Exhibitions:

1948 *In and Out of Focus*, Museum of Modern Art, New York
50 Photographs by 50 Photographers, Museum of Modern Art, New York
1953 *Diogenes with a Camera*, Museum of Modern Art, New York
1955 *The Family of Man*, Museum of Modern Art, New York (and world tour)
1958 *United States Photographic Exhibition*, at the *World's Fair*, Brussels
1962 *Les Grandes Photographes de Notres Temps*, Hotel de Ville, Versailles
Ideas and Images, American Federation of Arts, New York (and world tour)
1967 *Photography in the 20th Century*, National Gallery of Canada, Ottawa (toured Canada and the United States, 1967-73)
1968 *Harlem on My Mind*, Metropolitan Museum of Art, New York

Collections:

Museum of Modern Art, New York; New York Public Library; Worcester Museum of Art, Massachusetts; Art Institute of Chicago; Amon Carter Museum, Fort Worth, Texas; New Mexico Museum, Santa Fe; Bibliothèque Nationale, Paris.

Publications:

By WEBB: books—*Gold Strikes and Ghost Towns*, New York 1961; *The Gold Rush Trail and the Road to Oregon*, New York 1961; *Todd Webb: Photographs*, Fort Worth, Texas 1965, 1979; *19th Century Texas Homes*, Austin, Texas 1966; *19th Century Texas Public Buildings*, Austin, Texas 1974.

On WEBB: books—*The History of Photography* by Beaumont Newhall, New York 1964; *Photography in the 20th Century* by Nathan Lyons, New York 1967; *Harlem on My Mind*, exhibition catalogue, New York 1968; *The Picture History of Photography* by Peter Pollack, New York 1969; article—"The Photography of Todd Webb" by Betty Bryce in *El Palacio* (Santa Fe, New Mexico), March 1971.

In my opinion, photography is:
Photography means many different things to different people and has many aspects and uses. It can be a means of communication, illustration, education, expression, conservation and more. It can be simple, complex, thoughtful, trite, realistic, abstract, humorous or sad.
The craft of photography is not difficult to learn but it is vitally important. It takes a well-exposed and properly-developed negative to make a fine print. Weston Meter instructions carefully read and followed give the same results with roll film as the complicated zone system that has confused and frustrated so many neophytes. I think the tendency now is to put the instructions into words that are vague and sometimes incomprehensible. Technical aspects

of photography can be talked to death and often are. Photography is not a bag of tricks. It does help if you have someone capable of showing you what a good print and good negative look like.
A photograph can often be used to illustrate a statement. But a photograph can be a statement without any explanatory treatise. Creative photography does not have anything to do with location, projects or causes as such—yet it can involve any one of them. It is a need to express something within the photographer. A creative photograph is one seen *through* the photographer. The reason for making the photograph is often unexplainable.
My personal photography seems to have more to do with what man does to nature than with nature itself. I do have a sense of history, and I am concerned about the disappearance of relics. I think that over the past forty years I have photographed unconsciously many objects and aspects of living that have already disappeared.

—Todd Webb

The three predominating elements in the photography of Todd Webb are humanity, sense of time and place, and humor. Todd Webb was drawn into photography in the first place by the lure of far-off people and places. His first inspiration came not from photographers but from globe trotting writers such as Richard Halliburton and Lowell Thomas. He soon discovered that photography could open up a new way of viewing the world and that even his home town of Detroit could be seen in a new fashion.
From the first Todd Webb did most of his work with large format view cameras. As a result people actually appear in only about 30% of his photographs from the late 1930's, the 1940's and early 1950's. When someone criticized Todd's photos for this, his friend Alfred Stieglitz defended him by saying that no one put more "people" into his photographs than Todd Webb. Even in the emptiest of scenes, we have the feeling that someone has just left and will step back into view any second. For example, in a view of a Parisian side alley that Todd Webb did in the mid-1970's, a baby carriage sits prominently in the scene, and we have the impression that a mother will emerge from a door to collect it momentarily.
Todd Webb first came to national attention for his photographs of New York in the 1940's. He photographed the bustling crowds of people, the exuberant marketplaces, and most of all the elevated railway system that shuttled people roof-high through the metropolis. All of this he staged against a backdrop of towering skyscrapers, teeming tenements and soaring bridges. He created a portrait of a dynamic city filled with power and creative energies that was uniquely New York in the late 1940's.
In the early 1950's he photographed in Paris in a very different style. The photos are mellow and quiet and less staccato than the New York prints. He portrayed an aging Paris that was gentle and tolerant to artists, lovers and those seeking a quiet existence. In 1954, he photographed Ibiza in the Balearic isles. For a change he abandoned his 5 x 7 and 8 x 10 view cameras in favor of a little Leica 35mm. The resulting photographs of stately women in black shawls parading past dazzling white facades bleached by the Mediterranean sun are very striking. It is like intruding upon a mystic ritual that has continued unchanged since the beginning of time.
Todd Webb has photographed in England, Ireland, Spain, Portugal, Southern France, North Africa, Mexico, New Guinea, the Amish country of Pennsylvania, the American Southwest, and many other places. To each he has brought his special artistry, the ability to capture the essence of time and place while at the same time defining a little further what it is to be human.
There are many recurring subjects in Todd Webb's photography: cars, doorways, bridges and most importantly signs. In his work these things always

represent themselves. Whereas many modern photographers depict signs or portions of signs as symbols fractured of their original meanings, in Todd Webb's pictures a sign always stands for itself and means exactly what it says. The insight, humor, or pathos comes from the situation itself.
Despite Todd Webb's retiring nature and the limited access the public has had to his work, his reputation as an artist is steadily rising because of his universal appeal and unique vision.

—Mike Rowell

WEEGEE.
American. Born Usher (later, "Arthur") H. Fellig, in Zloczew, Poland, 12 June 1899; emigrated to the United States, 1910: subsequently naturalized; adopted the name "Weegee" (from "Ouija" board), c. 1938. Educated at public schools, New York City, 1910-13; self-taught in photography. Married Wilma Wilcox in 1956. Worked as dishwasher, tin-type operator, assistant to commercial photographer, and freelance street photographer, New York, 1914-24; photographic darkroom assistant and unofficial news photographer, Acme New Pictures, later United Press International, New York, 1924-35; also worked as violinist in silent film theatres, New York, 1924-28; freelance news photographer based at Manhattan Police Headquarters, working for *Herald Tribune*, *World-Telegram*, *Daily News*, *Post*, *Journal-American* and *Sun* newpapers, and for syndicates Associated Press Photos, World Wide Photos, in New York, 1936-45, 1952-58; contract photographer, *PM* newspaper, New York, 1940-45; freelance news photographer and lecturer, in Europe, 1958-68. Worked as film consultant and actor, Hollywood, California, 1947-52, 1958. Agent: Marcuse Pfeifer Gallery, 825 Madison Avenue, New York, New York 10025, U.S.A. *Died* (in New York) *26 December 1968.*

Individual Exhibitions:

1944 Photo League, New York
1959 Moscow (travelled throughout U.S.S.R. as part of lecture tour)
1962 *Weegee*, at *Photokina '62*, Cologne
1977 *Weegee the Famous*, International Center of Photography, New York
1979 Nikon Fotogalerie, Zurich (with Christian Moser)
1980 Side Gallery, Newcastle upon Tyne, England
1981 *Weegee the Famous*, Port Washington Public Library, New York

Selected Group Exhibitions:

1962 *Photo Group Exhibition*, Ligoa Duncan Art Centre, Paris
1967 *Photography in the 20th Century*, National Gallery of Canada, Ottawa (toured Canada and the United States, 1967-73)
1970 *Into the 70's: 16 Artists/Photographers*, Akron Art Institute, Ohio
1974 *News Photography*, Museum of Modern Art, New York
Photography in America, Whitney Museum, New York

Weegee: *Woman Being Pulled Away from Dying Man by Policemen,* **New York** Courtesy Art Institute of Chicago

1977 *Documenta 6*, Museum Fridericianum, Kassel, West Germany
1978 *Tusen och En Bild/1001 Pictures*, Moderna Museet, Stockholm
1979 *Photographie als Kunst 1879-1979*, Tiroler Landesmuseum Ferdinandeum, Innsbruck, Austria (travelled to Neue Galerie am Wolfgang Gurlitt Museum, Linz, Austria; Neue Galerie am Landesmuseum Joanneum, Graz, Austria; and Museum des 20. Jahrhunderts, Vienna)
Amerika Fotografie 1920-1940, Kunsthaus, Zurich
1980 *Southern California Photography 1900-1965*, Los Angeles County Museum of Art

Collections:

Center for Creative Photography, University of Arizona, Tucson (142 Prints); Museum of Modern Art, New York; Metropolitan Museum of Art, New York; International Center of Photography, New York; International Museum of Photography, George Eastman House, Rochester, New York; Bibliothèque Nationale, Paris.

Publications:

By WEEGEE: books—*Naked City*, New York 1945, 1975; *Weegee's People*, New York 1946, 1975; *Naked Hollywood*, with Mel Harris, New York 1953, 1975; *Weegee's Secrets of Shooting with Photo Flash*, with Mel Harris, New York 1953; *Weegee's Creative Camera*, with Roy Ald, Garden City, New York 1959; *Weegee's Creative Photography*, with Gerry Speck, London 1964; *Weegee by Weegee: An Autobiography*, New York 1961, 1975; *Weegee*, with text by Lou Stettner, New York 1977; *Weegee (Arthur Fellig)*, with text by Allene Talmey and Marvin Israel, New York and London 1978; *Weegee: Violenti e Violentati*, edited by John Coplans, Milan and Munich 1978; articles—"Punch in Pictures" in *U.S. Camera* (New York), March 1943; "Weegee," interview, in *U.S. Camera* (New York), February 1947; "Camera Caricatures" in *Express* (New York), 5 October 1964; films—*Weegee's New York*, 1948; *Cocktail Party*, 1950; *The Idiot Box*, 1965.

On WEEGEE: books—*Photography in the 20th Century* by Nathan Lyons, New York 1967; *Photography in America*, edited by Robert Doty, with an introduction by Minor White, New York 1974; *L'Arte nella Società: Fotografia, Cinema, Videotape* by Daniela Palazzoli and others, Milan 1976; *Documenta 6/Band 2*, exhibition catalogue, edited by Klaus Honnef and Evelyn Weiss, Kassel, West Germany and Cologne 1977; *Weegee the Famous*, exhibition catalogue, with text by John Coplans and Cornell Capa, New York 1977; *Geschichte der Fotografie im 20. Jahrhundert/Photography in the 20th Century* by Petr Tausk, Cologne 1977, London 1980; *Tusen och En Bild*, exhibition catalogue, by Ake Sidwall, Sune Jonsson an Ulf Hard af Segerstad, Stockholm 1978; *Photographie als Kunst 1879-1979/Kunst als Photographie 1949-1979*, exhibition catalogue, 2 vols., by Peter Weiermair, Innsbruck, Austria 1979; *The Photograph Collector's Guide* by Lee D. Witkin and Barbara London, Boston and London 1979; *Amerika Fotografie 1920-1940* by Erika Billeter, Berne 1979; articles—"Weegee gives Journalism a Shot for Creative Photography" by Paul Strand in *PM* (New York), 22 July 1945; "Uncouth Genius" by Lou Stettner in *British Journal of Photography* (London), December 1960; "Weegee the Photographer Dies" by Harold Blumenfeld in *New York Times*, 27 December 1968; "Weegee Obituary" by Charles Reynolds in *Infinity* (New York), January 1969; "Weegee: A Lens on Life 1899-1968" by Harvey Fondiller and David Vestal

in *Popular Photography* (New York), April 1969; "Weegee" in *Creative Camera* (London), July 1969; "Weegee the Famous: Photo-Caricatures" in *Creative Camera* (London), August 1969; "Naked Weegee" by Gretchen Berg in *Photograph* (New York), Summer 1976; "Night Light: Brassaï and Weegee" by Colin Westerbeck in *Artforum* (New York), December 1976; "He Was There" by Anna Quindlen in *New York Times Magazine*, 11 September 1977; "Weegee the Famous" by John Coplans in *Art in America* (New York), September/October 1977; "Chi e: Weegee" by Wladimiro Settimelli in *Fotografare* (Rome), December 1979; "Violent Visions from the Past" in *Sunday Times Magazine* (London), 15 June 1980; films—*Weegee in Hollywood* by Erven Jourdan and Esther McCoy, 1950; *The Naked Eye* by Lou Stoumen, 1957.

Weegee was a crime news photographer, and it was the passionate determination, the almost violent satisfaction, with which he depicted the dark, demoniacal side of the great city of New York in the 1930's and 40's that made him the most famous of all photographers of street scenes. "Weegee the famous" was what he actually christened himself after he changed his real Polish immigrant's name from Arthur Fellig to Weegee. His life was shaped by his profession; after leaving the Acme Agency in 1935 he took a room near the Manhattan Police Headquarters and installed a radio that picked up the emergency signals of the police and the firemen. He slept next to it, fully dressed, so as to be sure of being the first on the scene. Motor accidents, murders, arrests—Weegee claimed to have photographed more than 5,000 crimes in 10 years—were represented by him in a crude, direct manner. His style, adapted to suit the requirements of the newspapers he sold his pictures to, was direct and expressive, almost expressionist. The scene, taken as it actually happened in a way that stressed its dramatic character—a woman in tears comforting her husband as he is arrested, a man with a swollen face trying to escape as he is photographed for the police files, a poor man left face down on the sidewalk, with a pistol lying on the ground in the foreground, a youth who has just been arrested for strangling a girl, photographed through the bars—is placed in the centre of the picture. It is often taken with a flash, which highlights the faces with unexpected bright light and deep shadow so that they slowly dissolve into a dark background. This concentration of attention, which wipes out everything outside the central focus of the picture and the circle of light made by the flash, was perfectly adapted to the coarse-grained half-tone printing in the big-circulation dailies. But Weegee also valued his aesthetic effect; he liked the crude contrast of whites and blacks, the flattening of space produced by what he called his "Rembrandt lighting," the short focal length used for close shots. And certainly this expressionist, breathless style was very well suited to the subjects he concentrated on.

In his photogrpahs Weegee is looking for the sensationalism that will sell the picture, but sometimes his representation of the Naked City, the damned, violent metropolis, is tinged with other sentiments: not only horror—cynic that he was, it seemed that no cruelty could shock him—but also compassion and sarcasm. The compassion is mostly kept for women and children, the frail and most frequent victims of a city that does not protect them—the two poor women with faces petrified in an infinite despair, still lit by the flames of the fire that has killed their families, the slum children sleeping nine in a bed, the Harlem children who lift up to the flash faces on which the black of the skin is mixed with the grimy traces of their tears, and also the circus children, sad with the sadness of clowns under the stereotyped smile of their painted make-up. The sarcasm is mostly reserved for the rich—the old lady in evening dress, tipsy at the opera; the famous picture "The Critic" in which two women

covered in diamonds walk smugly beside a poor defeated woman. However, Weegee, though many people have learned from him how to represent the ugliness hidden behind the papier mâché façade of life in the big city, is no Lewis Hine, deliberately seeking ways of showing up the wretchedness with a view to social reform. His desire to "show how, in a city of ten and a half million inhabitants, people live together in a state of complete solitude" does not aim to change the situation but springs from an instinct and a character fed by the same sentiments that he shares with the unfortunates he depicts in his photographs.

When, in the 50's, Weegee concentrated on creative photography—pictures produced by a variety of optical games which change the realistic photograph: distortions, mirror technique, kaleidoscopic effects—he revealed the same talent for sarcasm and irony, even if it was less violent and aggressive. The most effective of these pictures are in fact his "photo-caricatures" of film stars and politicians. Marilyn Monroe with her mouth stretched out in a grotesque kiss, Elizabeth Taylor with exaggeratedly elongated eyelashes, Hedda Hopper with the face concentrated on the gossip columnist's mouth. And Charles de Gaulle, too, all nose and ears, Dwight D. Eisenhower with a smile stretching from ear to ear, Khrushchev like a Roman emperor as seen by Walt Disney. And of course Weegee caricatures himself too, exaggerating his protruding eyes and distorting his own face crowned by the eternal cigar.

—Daniela Palazzoli

WEGMAN, William.

American. Born in Holyoke, Massachusetts, 12 February 1942. Educated at Massachusetts College of Art, Boston, B.F.A. 1965; University of Illinois, Urbana, 1965-67, M.F.A. 1967. Married to Gayle Wegman; son: Man Ray. Artist and freelance photographer, California and New York. Instructor, University of Wisconsin at Wausau, 1967, and at Waukesha, 1968-69; Assistant Professor, University of Wisconsin, Madison, 1969-70; Lecturer, 1970-71, and Visiting Artist, 1978, California State University at Long Beach. Recipient: Guggenheim Fellowship, 1975; National Endowment for the Arts Grant, 1975-77; Creative Artists Public Service Grant, 1979. Agent: Holly Solomon Gallery, New York. Address: c/o Holly Solomon Gallery, 392 West Broadway, New York, New York 10012, U.S.A.

Individual Exhibitions:

1971 Galerie Sonnabend, Paris
Pomona College, California
1972 Sonnabend Gallery, New York
Galerie Ernst, Hannover
Situation, London
Galerie Konrad Fischer, Dusseldorf
Courtney Sale Gallery, Dallas
1973 Galerie Sonnabend, Paris
Texas Gallery, Houston
Los Angeles County Museum of Art
Francoise Lambert and Claire Copley Gallery, Los Angeles
1974 Modern Art Agency, Naples
Galerie D, Brussels
Galleria Toselli, Milan
112 Greene Street Gallery, New York
Texas Gallery, Houston

1975 Mayor Gallery, London
 Galleria Alessandra Castelli, Milan
 Galerie Konrad Fischer, Dusseldorf
1976 The Kitchen, New York
1977 Sonnabend Gallery, New York
 Bruno Soletti Gallery, Milan
1978 Rosamund Felsen Gallery, Los Angeles
 Robert Cumming/William Wegman, California Intitute of Technology, Pasadena
1979 Holly Solomon Gallery, New York
 Arnolfini Gallery, Bristol
 Galerie Konrad Fischer, Dusseldorf
 Otis Art Institute, Los Angeles
 William Wegman: Retrospective, Fine Arts Galleries, University of Wisconsin at Milwaukee
1980 *William Wegman: Selected Works 1970-1979*, University of Colorado Art Galleries, Boulder (travelled to the Aspen Center for Visual Arts, Colorado)
1981 Clarence Kennedy Gallery, Cambridge, Massachusetts (with Willard Van Dyke & Olivia Parker)
1982 Dart Gallery, Chicago

Selected Group Exhibitions:

1969 *Place and Process*, Edmonton Art Gallery, Alberta
 When Attitudes Become Form, Kunsthalle, Berne (toured Europe)
1971 *Prospect 71*, Dusseldorf
1973 *Whitney Annual*, Whitney Museum, New York
1977 *Photography as an Art Form*, Ringley Museum of Art, Sarasota, Florida
1978 *23 Photographers*, Walker Art Gallery, Liverpool
1979 *The Altered Photograph*, Project Studio 1, Long Island City, Queens, New York
 20 x 24, Light Gallery, New York
 Attitudes: Photography in the 1970's, Santa Barbara Museum of Art, California
1980 *The Photograph Transformed*, Touchstone Gallery, New York

Collections:

Whitney Museum of American Art, New York; Museum of Modern Art, New York; Ed Ruscha Collection, Los Angeles.

Publications:

By WEGMAN: articles—"Shocked and Outraged" in *Avalanche* (New York), Winter 1971.

On WEGMAN: articles—"Photography" by Ben Lifson in the *Village Voice* (New York), 9 April 1978; "Everything You Wanted to Know about William Wegman but Didn't Dare Ask" by Stuart Morgan in *Arnolfini Review* (Bristol), May/June 1979; "William Wegman" by Ian Walker in *Art Monthly* (London), no. 27, 1979; "William Wegman: Altered Photographs" in *Domus* (Milan), July 1979.

William Wegman belongs deliberately to that large area between strictly defined photography and strictly defined art that has been so consciously fertilized and exploited as a major result of the intentions behind minimal and conceptual art. The whole idea of posing for photographs and arranging effects, so contrary to the concepts of documentary photography, harks back neatly and poignantly to the tenets of "art" photography current in the 19th century. We might almost consider that that desirable goal of having one's cake—and eating it, too—has come near realization.

Wegman began as a painter; his dog, who has featured in many a photographic sequence, was appropriately named Man Ray. Wegman has moved easily among a variety of techniques and media: he has used video extensively as well as photography and drawing. There are hints of the story-board, surreal autobiographical content, and sardonic use of the artifacts of consumer culture, as well as a subliminal take-off of the culture-vulture aspects of American culture.

Thus his imagery, often hilarious, sardonic and ironical, can be rather emotional too, and intricately baroque. The deliberate set-ups that he creates to photograph can be elaborate put-downs, a visual commentary on Madison Avenue culture laced with West Coast exuberance.

What makes Wegman so unusual is that without being punky or funky, he is funny, amusing, wry. There is surprisingly little humour in "art" or in "photography." Wegman will, say, produce something like "Family Combinations," in which eyes, hair, nose, mouth are matched in various combinations—harking back to Victorian face games—which is both telling and hilarious. His work is domestic, sometimes fetchingly silly and absurd: in "Untied On Tied Off" one hairy leg wears an untied boot, the other has tied to it a boot. In an image called "The Morphy Richards Problem" (shades of sociological pomposity) an electric radiator of that make keels over. In "Before Learning to Write with His Own Sweater He Learned to Write with His Hand," we see just that: a sheet of paper, bearing upon it one besweatered arm through which a pen is writing, and one hand, not writing.

It is absurd, arresting, a freshly surreal look at reality, in intimate mode.

—Marina Vaizey

WEINER, Dan.

American. Born in New York City, 12 October 1919. Educated at public schools in New York, 1930-37; studied painting at the Art Students League, New York, 1937-38, and Pratt Institute, Brooklyn, New York, 1939-40; self-taught in photography. Served as photographer and instructor, United States Army Air Force, 1942-46. Married the photographer Sandra Smith in 1942; daughter: Dore. Worked as assistant to commercial photographer Valentino Sarra, New York, 1940-42; freelance advertising photographer, establishing own studio, New York, 1946-49; freelance photojournalist, working for *Collier's, Fortune, Harper's Bazaar, New York Times,* etc., New York, and in South Africa, Russia, and

William Wegman: *Double Profile,* **1980** Courtesy Holly Solomon Gallery, New York

Europe, 1949 until his death, 1959. Member, Photo League, New York, 1940-51. Estate: Sandra Weirer, 30 West 60th Street, New York, New York 10023, U.S.A. *Died* (in plane crash, Versailles, Kentucky) *26 January 1959.*

Individual Exhibitions:

1953　Camera Club, New York (toured the United States)
1954　International Museum of Photography, George Eastman House, Rochester, New York
1955　*Photographs of Italy*, Limelight Gallery, New York
1956　*Photographs of South Africa*, Limelight Gallery, New York
1959　*Russia and Eastern Europe*, Limelight Gallery, New York
1980　Prakapas Gallery, New York (retrospective)

Selected Group Exhibitions:

1967　*The Concerned Photographer*, Riverside Museum, New York (and world tour)
1968　*The Concerned Photographer 2*, Matsuya Department Store, Tokyo (toured Japan)
1969　*The Concerned Photographer 3*, Smithsonian Institution, Washington, D.C. (and world tour)
1979　*Fleeting Gestures: Dance Photographs*, International Center of Photography, New York (travelled to *Venezia '79*, and The Photographers' Gallery, London)
1980　*Photography of the 50's*, International Center of Photography, New York (travelled to the Center for Creative Photography, University of Arizona, Tucson; Minneapolis Institute of Arts; California State University at Long Beach; and Delaware Art Museum, Wilmington)

Collections:

International Center of Photography, New York; Museum of Modern Art, New York; International Museum of Photography, George Eastman House, Rochester, New York.

Publications:

By WEINER: books—*South Africa in Transition*, with text by Alan Paton, New York 1956.

On WEINER: books—*The Concerned Photographer*, edited by Cornell Capa, New York 1968; *Dan Weiner 1919-1959*, edited by Cornell Capa and Sandra Weiner, New York 1974; *Photography of the 50's* by Helen Gee, Tucson, Arizona 1980; articles— "Portfolio: Dan Weiner" in *Leica Magazin* (Wuerzbach, Germany), 1953; "Dan Weiner" in *Photography* (London), June 1953; "Dan Weiner" in *Infinity* (New York), May 1959; "In Memoriam: Dan Weiner" in *Camera 35* (New York), 1959; "Dan Weiner" in *Popular Photography Annual*, New York 1960; "Dan Weiner" in *Infinity* (New York), October 1967; "The Concerned Photographer," special issue of *Contemporary Photographer* (Culpeper, Virginia), vol. 6, no. 2, 1968; "Dan Weiner" in *Camera* (Lucerne), May 1969.

A native of New York, Dan Weiner was 15 years old when he received his first camera—a 9 x 12 cm Voigtlander—as a birthday present from an uncle. At that age, in 1934, he had no thoughts of becoming any kind of photographer at all: he wanted to be a painter.

On finishing school, Weiner left home and enrolled at the Art Students League—much against the wishes of his father, who didn't consider being an artist a "real" job. To further his career in painting, he then went on to the Pratt Institute in Brooklyn. He soon found himself short of money, so he began using his earlier experience with a camera to do portrait photographs as a sideline, a way to earn money for art supplies. It was during this period that he joined the Photo League, where he came under the influence of social documentary photographers: the work of Jacob Riis and Lewis Hine and especially the Farm Security Administration pictures of Dorothea Lange, Walker Evans and Ben Shahn. Their documentation of the lives of migrant families struck a powerful chord in Weiner, whose parents had immigrated to America from Russia and Rumania.

He decided to turn to photography as a profession. His first job was an assistant in the studio of commercial photographer Valentino Sarra, where he spent two years learning darkroom skills. After America entered the Second World War, Weiner served in the Air Force as a photographer and instructor, frequently using for his own photography a secondhand 35mm Contax purchased from a serviceman. When the war was over he opened his own commercial studio in New York, where he was soon principally occupied with routine advertising work, such as photographing women's hats for sale catalogues. Weiner felt unfulfilled, making somewhat "artificial" pictures for marketing purposes only, and longed to create something more relevant and intelligible to people. He later wrote: "Photography today should speak with urgency, should be free from contrivance, so that it must never be suspect; it combines those elements of spontaneity that say: this is happening, this is real."

In 1949 he gave up his studio and thereafter devoted himself full-time to photojournalism. His photographer-wife Sandra recalls that Weiner converted half of their apartment's main room into a darkroom-cum-studio. His work began to appear in leading American magazines such as *Collier's*, *Fortune* and *Harper's Bazaar*. When *Collier's* teamed him with South African writer Alan Paton for two articles on the Negro in America, the two men got on so well that they decided to do a book together. The result was *South Africa in Transition*, published in 1956.

Weiner loved to photograph wherever people were, especially in cities. Landscapes didn't interest him—unless there were people as the "real" subject of the picture. He travelled in Europe photographing people on the streets; he produced some of the first major stories on the rising militancy of the civil rights movement in Alabama; he became involved with interpreters, drivers, guides, factory owners and engineers on an assignment for *Fortune* in Russia and Eastern Europe. And he developed and established a strong reputation for sensitivity and social awareness. He was on assignment when he was killed in a plane crash in Kentucky in January of 1959.

At Cornell Capa's *Concerned Photographer* exhibition in 1967, in which a "monograph" type of presentation was employed, the public saw the first retrospective of Dan Weiner's work: the photographer could express his opinions through his own language, manifested in a personal photographic statement. Weiner was revealed as a man whose vision had been fired with passion, concern and reverence for all living things. For those 10 years prior to his death he had used his camera as a tool of social conscience.

—Colin Naylor

WELPOTT, Jack.

American, Born in Kansas City, Kansas, 27 April 1923. Educated at primary and secondary schools, Bloomington, Indiana; studied photography under Henry Holmes Smith, painting under Leon Golub and Harry Engle, and design under George Rickey, University of Indiana, Bloomington, 1946-59, B.S. 1949, M.S. in Visual Communication 1955, M.F.A. 1959. Served in the 13th Intelligence Unit, United States Air Force, 1943-46; Staff Sergeant, 3 combat stars. Married Doris Jean Franklin in 1949 (divorced, 1968); children: Jan Marie and Matthew David; married the photographer Judy Dater, *q.v.*, in 1971 (divorced, 1977). Production Supervisor, Audio-Visual Center, Indiana University, Bloomington, 1949-59. Independent photographer since 1959. Assistant Professor of Photography, 1959-60, Associate Professor, 1961-70, and Professor since 1971, San Francisco State University. Lecturer, University of California Extension, San Francisco, 1966-

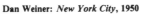
Dan Weiner: *New York City*, 1950

69. Member, Board of Trustees, Friends of Photography, Carmel, California, and Society for Photographic Education, since 1963. Recipient: Medal of Arles, France, 1973; National Endowment for the Arts Grant, 1979. Agent: Witkin Gallery, 41 East 57th Street, New York, New York 10022. Address: 28½ Precita Avenue, San Francisco, California 94110, U.S.A.

Individual Exhibitions:

1961 Kalamazoo Institute of Art, Michigan
1962 University of California at Davis
1963 Florida State Museum, Tallahassee
 University of Florida, Gainesville
1966 International Museum of Photography, George Eastman House, Rochester, New York
1969 Phoenix College, Arizona
1970 Friends of Photography, Carmel, California
1972 Art Institute of Chicago
1973 Wall Street Gallery, Spokane, Washington
 Ohio Silver Gallery, Los Angeles (with Judy Dater)
 Sisters: A Photographic Exhibition, Focus Gallery, San Francisco (with Judy Dater)
 Ms.: Portraits of Women, International Museum of Photography, George Eastman House, Rochester, New York (with Judy Dater)
1974 Gallery 113, Santa Cruz, California
 Witkin Gallery, New York (with Judy Dater)
1975 Washington Gallery of Photography, Washington, D.C. (with Judy Dater)
 Shadai Gallery of Photography, Tokyo (with Judy Dater)
 International Center for Photography, New York (with Judy Dater)
 Jack Welpott: The Artist as Teacher/The Teacher as Artist: Photographs 1950-1975, San Francisco Museum of Art (retrospective; travelled to Indiana University Art Museum, Bloomington and University of Southern California at Los Angeles, 1977)
 University of Colorado, Boulder (with Nathan Lyons
1976 Musée Réattu, Arles, France (with Judy Dater)
1977 Silver Image Gallery, Seattle
1978 Ohio State University, Columbus
1979 Center for Creative Photography, University of Arizona, Tucson
1980 Colorado Mountain College, Leadville
 Equivalents Gallery, Seattle
1981 Jehu Gallery, San Francisco
 Bard College, Annandale-on-Hudson, New York
 O.W. Gallery, Dallas, Texas
 Jeb Gallery, Providence, Rhode Island

Selected Group Exhibitions:

1966 *Contemporary Photography since 1950*, International Museum of Photography, George Eastman House, Rochester, New York (toured the United States)
1967 *Photography in the 20th Century*, National Gallery of Canada, Ottawa (toured Canada and the United States, 1967-73)
 Photography in the Fine Arts, Metropolitan Museum of Art, New York (and 1968)
1969 *Recent Acquisitions*, Pasadena Art Museum, California
1970 *California Photographers 1970*, University of California at Davis (travelled to the Oakland Museum, California; and Pasadena Art Museum, California
1974 *Photography in America*, Whitney Museum, New York
1977 *Photographs: Sheldon Memorial Art Gallery Collection*, University of Nebraska, Lincoln
 Concerning Photography, The Photographers' Gallery, London (travelled to Spectro Workshop, Newcastle upon Tyne, England)
 The Great West: Real/Ideal, University of Colorado, Boulder (subsequently Smithsonian Institution travelling exhibition; toured the United States)
1979 *Teacher's Legacy: My Teacher, Myself*, Susan Spiritus Gallery, Newport Beach, California (homage to Henry Holmes Smith)

Collections:

Museum of Modern Art, New York; Whitney Museum, New York; International Museum of Photography, George Eastman House, Rochester, New York; Art Institute of Chicago; Center for Creative Photography, University of Arizona, Tucson; University of New Mexico, Albuquerque; Norton Simon Art Museum, Pasadena, California; Oakland Art Museum, California; San Francisco Museum of Modern Art; Bibliothèque Nationale, Paris.

Publications:

By WELPOTT: books—*Women and Other Visions: Photographs by Judy Dater and Jack Welpott*, with an introduction by Henry Holmes Smith, New York 1975; articles—"Genre Photography: Jack Welpott" in *Camera* (Lucerne), May 1975; "Judy Dater and Jack Welpott," interview with Gilles Walinski, in *Zoom* (Paris), November/December 1979.

On WELPOTT: books—*Photography in the 20th Century* by Nathan Lyons, New York 1967; *California Photographers 1970*, exhibition catalogue, by Fred R. Parker , Davis, California 1970; *The Print*, by the Time-Life editors, Amsterdam 1972; *Photography in America*, edited by Robert Doty, introduction by Minor White, New York 1974; *The Photographers' Choice*, edited by Kelly Wise, Danbury, New Hampshire 1975; *The Artist as Teacher/The Teacher as Artist: Photographs 1950-1975*, exhibition catalogue, with text by Henry Holmes Smith and Rodney C. Stuart, San Francisco 1975; *Photographs: Sheldon Memorial Art Gallery Collection*, University of Nebraska, with an introduction by Norman A. Geske, Lincoln 1977; *The Great West: Real/Ideal*, edited by Sandy Hume and others, Boulder, Colorado 1977; *Concerning Photography* by Jonathan Bayer and others, London 1977; *The Photography Collector's Guide* by Lee D. Witkin and Barbara London, Boston and London 1979.

Part of the fascination that photography holds is its ability to unlock secrets kept even from ourselves. Like dreams, the photograph can uncork a heady bouquet of recognition which can escape into the cognitive world. Sometimes the aroma is sharp, sometimes dry. This "shock of recognition" can be, at times, unsettling. It can also be sublime.

—Jack Welpott

Jack Welpott is a part of the recent, post-World War II, generation of photographers that has been able to "study" photography formally at the University level. He attended Indiana University as a student of Henry Holmes Smith and soon became acquainted with other influential photographers—Aaron Siskind, Minor White, Roy Stryker, Harry Callahan, Jerry Uelsmann, etc. He himself has since become a respected photographer and teacher whose main photographic themes are "the psychological landscape" and the "attempt to define changing reality in terms of human psychology."

For a period of time in the 1970's, Welpott and his former wife, Judy Dater, worked together, often photographing women, sometimes even photographing the same subjects to bring out the subtle differences in interaction between the subject and the male photographer and the subject and the female photographer. As Welpott says in the introduction to *Women and Other Visions*, "Portrait photography is an experience between two human beings, an experience shared with the viewer through the resulting photograph. If the moment was charged with feeling, the image can be personal and revealing." The people whom they photographed were people who "we found fascinating and who, in some manner, expressed something about the 'feminine

Jack Welpott: *The Ramparts, San Francisco Financial District*, 1981

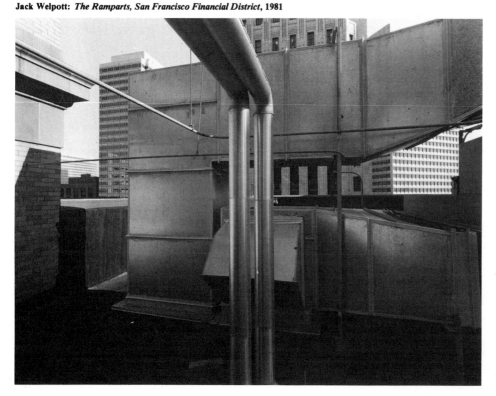

mystique.' Most were strangers to us. We discovered them in cafes, banks, shops, and on the streets—anywhere we happened to be. We usually spent several hours photographing them in their own environment. In every case, the few hours spent with these people were intense and, at times, progressed to extended friendships."

Mark Johnstone in *The Print* provides a mild criticism of Welpott's work, describing his imagery as "quiet in a nice Midwestern way. As reflections of a moment, rather than staggering revelations of a time, the works exist as meditations. But the meditative 'softness' comes across as content without substance—neither a pictorial quality that might enhance the image nor a classic composition that mirrors more than the subject matter depicted. Instead, a consideration of his photographs implies that his way of working is one that has been passed over not only by the 70's but by the 60's as well.... Welpott's imagery lacks the verve which might otherwise transform it into an active living vision."

Several years later, Henry Homes Smith, writing in the catalogue for *The Artist as Teacher/The Teacher as Artist* exhibition, took a more favorable view of Welpott's development and work: "He offers us today a child's eye view of the world, seen as through the mind of a kindly, sophisticated, secure adult. Welpott has ripened as have the times as well. The increasing frequency of pictures reminding us of the pleasures of mind and body were long foretold in earlier work. Those of us who know the earlier pictures may feel the chagrin that accompanies belated recognition of overlooked earlier truths. This passage back to joy, rewarding both artist and a sympathetic audience, lies through thorn bush and dark groves during a time of troubles. Our arrival is all the better for it.... Culturally commonplace, culturally over-saturated visual matter was reached

and passed through quite early in his career. These include the security of simple geometric picture structure, the appeal of made-up good looks, the unmeant poses of fashion models and the insecure stance of hometown beauty. Beyond these come the pressure generated by the intense feeling of being alone, the need to achieve one's greatest potential, contemplation of certain dark mysteries that generate fear and awe and probably most important of all the longings that males tend to believe are theirs exclusively. We can see from [his] pictures the trail of a journey far from finished, toward uneasy insights about how men and women fare together and the place of nature in our...environment."

—Michael Held

WESSEL, Henry, Jr.

American. Born in Teaneck, New Jersey, 28 July 1942. Educated at Northern Valley Regional High School, Demarest, New Jersey, 1956-60; studied psychology, Pennsylvania State University, University Park, 1960-66, B.A. 1966; photography, State University of New York at Buffalo/Visual Studies Workshop, Rochester, New York, 1969-72, M.F.A.

1972. Instructor in Photography, San Francisco Art Institute, since 1973. Recipient: Guggenheim Fellowship, 1971, 1978; National Endowment for the Arts Grant, 1975, 1977, 1978. Agent: Fraenkel Gallery, 58 Grant Street, San Francisco, California 94108. Address: Box 475 Point Richmond, California 94807, U.S.A.

Individual Exhibitions:

1973 Museum of Modern Art, New York
1974 Pennsylvania State University, University Park
1976 Grossmont College, El Cajon, California
1977 Visual Studies Workshop, Rochester, New York
1981 Charles Cowles Gallery, New York
 Fraenkel Gallery, San Francisco

Selected Group Exhibitions:

1969 *Vision and Expression*, International Museum of Photography, George Eastman House, Rochester, New York (toured the United States)
1970 *Contemporary Photographers V*, International Museum of Photography, George Eastman House, Rochester, New York (toured the United States)
1975 *New Topographics: Photographs of a Man-altered Landscape*, International Museum of Photography, George Eastman House, Rochester, New York (toured the United States)
1978 *Mirrors and Windows: American Photography since 1960*, Museum of Modern

Henry Wessel, Jr.: *San Francisco*, 1976

Art, New York (toured the United States, 1978-80)

1981 *Robert Frank Forward*, Fraenkel Gallery, San Francisco

Collections:

Museum of Modern Art, New York; Seagram Collection, New York; International Museum of Photography, George Eastman House, Rochester, New York; Visual Studies Workshop, Rochester, New York; University of Maine, Gorham; Philadelphia Museum of Art; University of Nebraska, Lincoln; Norton Simon Art Museum, Pasadena, California; National Gallery of Canada, Ottawa; American Arts Documentation Center, Exeter, England.

Publications:

On WESSEL: books—*Vision and Expression* by Nathan Lyons, New York 1969; *New Topographics: Photographs of a Man-altered Landscape*, exhibition catalogue, with text by William Jenkins, Rochester, New York 1975; *Henry Wessel, Jr.*, exhibition catalogue, with an introduction by Ben Lifson, El Cajon, California 1976; *Photographs: Sheldon Memorial Art Gallery Collection, University of Nebraska*, with an introduction by Norman A. Geske, Lincoln, 1977; *Mirrors and Windows: American Photography since 1960* by John Szarkowski, New York 1978; articles—"New American Imagery: Henry Wessel, Jr." in *Camera* (Lucerne), May 1974.

The imagery of Henry Wessel, Jr. is part of a split in the tradition of documentary photography. Unlike earlier members of this tradition such as Walker Evans or Robert Frank, Wessel is not trying to reveal that which is particularly American, he is not trying to persuade his viewers to recognize the wrongs of our society. His is a more detached point of view, a more dispassionate tone. His images carry a new attitude toward the significance of the photographic message. In this contemporary branch of photography the photographer is no longer expected to concentrate on the beauty, the drama, or the tragedy of life; here the photographer is free to explore unnoticed aspects of modern life.

When photographing, Wessel is attracted to ordinary, almost mundane, subjects he encounters in his daily life. His photographs are full of telephone poles, chain link fences, TV antennas, tract houses, patios, and parking lots. When people are included in his photographs, they are never aware of the photographer's presence; they are immersed in routine activities such as walking, sunbathing or talking on the phone. Although the photographs are titled with the name of a city, state, and the date, they have very little to do with specific places or times. The tree in a picture titled "Tempe, Arizona, 1974" or the house in "Albany, California, 1972" could be found anywhere. In these photographs, then, the subject matter is less important than the way in which it is presented.

The formal arrangement and printing of Wessel's pictures are understated. An overall grayness, created by a preponderance of midtones, gives way to a subtle interplay of rich tones throughout each print where silvery gray poles and surfaces of sand and sidewalk suddenly command attention. Similarly, what appear to be random compositions eventually reveal a highly organized structure. Palm trees, poles, and wires are used to fracture the picture plane as well as to join diverse elements together. Shadows, from both seen and unseen objects, take on a life of their own as they appear in the most unexpected places and shapes. After some exploration, one can see that these photographs are full of surprising visual intricacies.

In the end, the world of Hank Wessel's photographs is far from mundane. Unlike many artists

who are disturbed by "normal life," Wessel finds sustenance in it. His pictures remind us that forlorn banality is part of life, and with their quiet sense of acceptance and their unique sense of humor, they allow us to ponder those oddly common moments and places we can so easily forget.

—Ted Hedgpeth

WESTON, Brett.
American. Born in Los Angeles, California, in 1911; son of photographer Edward Weston, *q.v.* Educated in California schools; studied photography with his father. Established studio with Edward Weston, San Francisco, 1929; later moved to Carmel, California; freelance photographer, working for film studios and aeroplane factories, California, 1941-43, in New York, 1943-45; worked with Edward Weston on Edward's photographic portfolios, Carmel, California, 1948-58. Recipient: Guggenheim Fellowship, 1946. Address: Post Office Box 694, Carmel Valley, California 93924, U.S.A.

Individual Exhibitions:

1927 Los Angeles Museum (with Edward Weston)
1930 Jake Zeitlin Gallery, Los Angeles
1932 M.H. de Young Memorial Museum, San Francisco
1935 Julien Levy Gallery, New York
1966 Amon Carter Museum of Western Art, Fort Worth, Texas
Museo de Arte Moderno, Mexico City (with Edward Weston)
1971 Witkin Gallery, New York
Carl Siembab Gallery, Boston (with Edward Weston)
1975 Thackrey and Robertson, San Francisco
1976 G. Ray Hawkins Gallery, Los Angeles
1977 Cronin Gallery, Houston
Modesto Junior College, California (with Edward Weston and Paul Strand)
1979 Fifth Avenue Gallery of Photography, Scottsdale, Arizona
1981 Hills Gallery, Denver (retrospective)

Brett Weston: *Sutton Place*, New York, 1945 Courtesy Art Institute of Chicago

Selected Group Exhibitions:

1929 *Film und Foto*, Deutscher Werkbund, Stuttgart
1963 *The Photographer and the American Landscape*, Museum of Modern Art, New York
1967 *Photography in the 20th Century*, National Gallery of Canada, Ottawa (toured Canada and the United States, 1967-73)
1974 *Photography in America*, Whitney Museum, New York
1975 *The Land: 20th Century Landscape Photographs Selected by Bill Brandt*, Victoria and Albert Museum, London (travelled to Edinburgh, Belfast and Glasgow)
1979 *Photography Rediscovered: American Photographs 1900-1930*, Whitney Museum, New York (travelled to Art Institute of Chicago)
10th Anniversary Show, Witkin Gallery, New York
1980 *Photography of the 50's*, International Center of Photography, New York (travelled to University of Arizona, Tucson; Minneapolis Institute of Arts, Minnesota; California State University at Long Beach; and Delaware Art Museum, Wilmington)

Collections:

Museum of Modern Art, New York; International Museum of Photography, George Eastman House, Rochester, New York; Carpenter Center and Fogg Art Museum, Harvard University, Cambridge, Massachusetts; Library of Congress, Washington, D.C.; Art Institute of Chicago; New Orleans Museum of Art; Amon Carter Museum of Western Art, Fort Worth, Texas; University of New Mexico, Albuquerque; Norton Simon Museum of Art, Pasadena, California; Oakland Art Museum, California.

Publications:

By WESTON: books—*San Francisco*, portfolio of 12 prints, Carmel, California 1938; *White Sands*, portfolio of 10 prints, Carmel, California 1949; *New York*, portfolio of 12 prints, with a foreword by Beaumont Newhall, Carmel, California 1951; *Brett Weston Photographs*, with text by Merle Armitage, New York 1956; *10 Photographs*, portfolio, Carmel, California 1958; *Aperture Monograph: Brett Weston*, New York 1960; *Baja California*, portfolio of 15 prints, Carmel, California 1967; *Japan*, portfolio of 15 prints, Carmel, California 1970; *Europe*, portfolio of 12 prints, Carmel, California 1973; *Brett Weston: Voyage of the Eye*, with text by Beaumont Newhall, New York 1975; *Oregon*, portfolio of 15 prints, Carmel, California 1975; *Portraits of My Father*, portfolio of 10 prints, with an introduction by Ansel Adams, 1976; *20 Photographs*, 1970-1977, portfolio, with a foreword by Rosario Mazzeo, Carmel, California 1977.

On WESTON: books—*Edward Weston—Brett Weston*, exhibition catalogue, Los Angeles 1927; *The Photographer and the American Landscape*, exhibition catalogue, by John Szarkowski, New York 1963; *Fotografias de Edward Weston/Brett Weston*, exhibition catalogue, with an introuction by Carmen Barreda, texts by Eleanor Green and Nancy Newhall, Mexico City 1966; *Photography in the Twentieth Century* by Nathan Lyons, New York 1967; *A Collection of Photographs* by Beaumont and Nancy Newhall, Millerton, New York 1969; *Photography in America*, edited by Robert Doty, with an introduction by Minor White, New York and London 1974; *The Land: 20th Century Landscape Photographs Selected by Bill Brandt*, exhibition catalogue, edited by Mark Haworth-Booth, London 1975; *The Magic Image* by Cecil Beaton

and Gail Buckland, London and Boston 1975; *Interviews with Master Photographers* by James Danziger and Barnaby Conrad III, New York and London 1977; *Photographs: Sheldon Memorial Art Gallery Collection, University of Nebraska*, with an introduction by Norman A. Geske, Lincoln 1977; *Geschichte der Fotografie im 20. Jahrhundert/Photography in the 20th Century* by Peter Tausk, Cologne 1977, London 1980; *Photography Rediscovered: American Photographs 1900-1930* by David Travis, New York 1979; *A Ten Year Salute* by Lee D. Witkin, with a foreword by Carol Brown, Danbury, New Hampshire 1979; *Dialogue with Photography* by Paul Hill and Thomas Cooper, London 1979; *The Photograph Collector's Guide* by Lee D. Witkin and Barbara London, Boston and London 1979; *Landscape: Theory*, edited by Carole di Grappa, New York 1980; articles—"Brett Weston: Japan 1970 and Other New Pictures" in *Creative Camera* (London), February 1970; "Brett Weston" in *Camera* (Lucerne), June 1973; "Brett Weston and Edward Weston: An Essay in Photographic Style" by Roger Aikin in *Art Journal* (New York), Summer 1973; "Group f/64" in *Camera* (Lucerne), February 1973; "New York, Established Style" by D. Turner in *Artweek* (Oakland, California), 23 February 1974; "Profile: Brett Weston" by Joan Murray in *American Photographer* (New York), April 1980.

If abstract expressionism has a master in modern photography, Brett Weston would be a logical choice for the title. Unfortunately, the terms that we use to define artistic styles are never precise. Some would even argue that a photograph by its very nature cannot be abstract. And yet, Brett Weston's work has a consistent, dark and penetrating quality that is derived from the fact that like an expressionist, or a Japanese landscape painter, Brett is relatively unconcerned with simply recording the surface phenomena of nature. In fact it's not unusual to find yourself thoroughly perplexed as to the subject matter of one of his photographs, while fully appreciating it nevertheless. In many of Brett Weston's photographs, highlights, shadows, and reflections are simply points of departure, abstracted in order to better express his deep and essentiallly emotional reactions to nature. Normal shades of gray give way to dramatic contrast; glimmers of light become startling brilliance. Brett Weston's skill as a printer is such that he manages to exploit every nuance of richness and texture that the medium has to offer. His photographs are not simply black and white, they are brooding darkness and polished silver, a beautiful combination of formal elegance and masculine intensity.

Brett Weston has a gift for using his art to transform details of the natural world into personal statements. His father, the great photographer Edward Weston, also photographed nature, but Brett has developed a style that is distinctly his own. While Edward's work embodies the sensuality, the order and the harmony of nature, Brett's photographs seem to penetrate to a more primal source. In some of his work one feels as if all traces of the soft, surface elements of nature have been removed in order to reveal the solid and poetic beauty beneath. His little known sculptures in wood also have this quality. They are stylized, simplified natural forms that, like the work of Constantin Brancusi, transform the complex structures of nature into symbols of unity and grace. And in fact, it is perhaps the persistent search for a stable and elegant truth that motivates Brett Weston's creative life. This motivation is expressed by his remarkable prolific output. He photographs and prints constantly, travelling and enjoying his time and friends with the robust enthusiasm of a man wholly committed to life and art.

The sheer visual impact of Brett Weston's photographs is obvious, but it's also important to note the quality of awe that pervades his work. Brett doesn't attempt to dominate nature with his perceptions, but rather to discover the infinite variety of form

and meaning that the natural world reveals to an artist with vision. Aesthetic discovery in nature requires sensitivity, perseverance, and a profound respect for art and its ability to inspire and delight. Brett Weston has these qualities, and it is for this reason that his work is so important.

—Chris Johnson

WESTON, Cole

American. Born in Los Angeles, California, 30 January 1919; fourth son of the photographer Edward Weston, *q.v.* Educated at University High School, Los Angeles, graduated 1937; studied theatre arts at the Cornish School, Seattle, 1937-40; studied photography with his father. Served as a photographer, in the United States Navy, in Norman, Oklahoma, 1943-45. Married Dorothy Hermann in 1940 (divorced); Helen Prosser in 1951 (divorced); children: Ivor, Kim, Cara and Rhys; married Margaret Woodward in 1963; son: Matthew. Worked for Lockhead Aircraft Corporation, 1940-43; photographer with *Life* magazine, Los Angeles, 1945-46; photographic studio assistant to his father Edward Weston, Carmel, California, 1946-58 (executor of his father's estate, including printing from original negatives, from 1958). Independent photographer, concentrating on color landscape photography, Carmel, California, since 1958. Independent Progressive Party candidate for United States Congress, 1948; started Weston Trout Farm, Garrapata Canyon, Monterey County, 1949; Stage Director, Forest Theatre, Carmel, 1951; started Old Mill Stream Trout Farm, at Knott's Berry Farm, Buena Park, California, 1959; Cultural Director, Sunset Center, Carmel, 1966-69; Founder, with Kim Weston, Three Generation Gallery, Carmel, 1981. Address: Box 22155, Carmel, California 93922, U.S.A.

Individual Exhibitions:

1971 Focus Gallery, San Francisco (with Edward Weston)
1973 Focus Gallery, San Francisco
1974 Afterimage Gallery, Dallas
1975 Halsted 831 Gallery, Birmingham, Michigan
1976 Witkin Gallery, New York
1977 Halsted 831 Gallery, Birmingham, Michigan
1978 Leiserowitz Gallery, Des Moines, Iowa
1979 Deja Vue Gallery, Toronto
1981 Susan Spiritus Gallery, Newport Beach, California

Collections:

Museum of Modern Art, New York; International Museum of Photography, George Eastman House, Rochester, New York; Fogg Art Museum, Harvard University, Cambridge, Massachusetts; Philadelphia Museum of Art; Los Angeles Museum of Art.

Publications:

By WESTON: book—*Cole Weston: 18 Photographs*, with a foreword by Ben Maddow and an introduction by Charlis Wilson, Salt Lake City, Utah 1981;

Edward Weston: *Church Door*, Hornitos, California, 1940 Courtesy Art Institute of Chicago

articles—"Edward Weston: Dedicated to Simplicity" in *Modern Photography* (New York), May 1969; "Printing Dad's Negatives" in *Popular Photography* (New York), October 1978.

On WESTON: book—*Darkroom 2*, edited by Jain Kelly, New York 1978.

The work of Cole Weston has long been overshadowed by the more famous photos of his father, Edward Weston, and his older brother, Brett Weston. Many observers feel that this is only a temporary situation, and that Cole Weston's beautiful sensuous color work will find a place of its own in the world's great photography.

Part of Cole Weston's obscurity is due to his quieter nature, which pales beside that of the more flamboyant Edward and Brett. Part is due to a certain self-abnegation. But most comes from the fact that Cole's work is so closely derived from that of his father that it seems to be just a logical continuation of the father's style.

Until World War II Cole worked by his father's side and under his father's close direction. During the conflict Cole served as a Navy photographer, and afterwards went out on his own as a photojournalist. But the ailing and elderly Edward Weston called Cole back to his side. Edward could no longer print his great black-and-white work himself, so he instructed Cole in the precise techniques for printing his negatives. From that time until today, Cole has provided prints from the Edward Weston negatives. He has become so well known for this work that many are susprised to discover that Cole is a photographer in his own right.

Late in his career, Edward Weston began photographing a little in color. Cole was with him, and took to the new materials immediately. Cole Weston, one of the master black-and-white printers of our day, has done the bulk of all his own photography in color.

Cole Weston's color photographs were amazingly beautiful yet restrained right from the beginning. In those early days of color, most photographers were anxious to make their prints "colorful:" they drowned every scene in a sea of blazing oranges, vibrant yellows and searing reds. Cole was the first to realize that color could be subtle, delicate, and gentle. He photographed much of what his father had photographed, including Point Lobos and the Big Sur country, but he captured it in color with soft browns, pale blues, and quiet greens.

The bulk of Cole Weston's color has been done with large format cameras, and is very much in the f/64 school tradition with its love of the perfectly sharp ground glass image. Cole has continued this emphasis with precise and exquisite dye transfer printing.

At a time when many young photographers are turning to large format color photography, Cole Weston is beginning to be seen as the real pioneer of color photography as an art form.

—Mike Rowell

See Color Plates

WESTON, Edward (Henry).
American. Born in Highland Park, Illinois, 24 March 1886. Educated at Oakland Grammar School, Illinois, until 1903; mainly self-taught in photography, from 1902, but attended Illinois College of Photography, Chicago. Served as air-raid plane spotter, Carmel, California, 1941-44. Married Flora May Chandler in 1909 (divorced); sons: Chandler, Brett, *q.v.*, Neil and Cole, *q.v.*; married Charis Wilson in 1938. Worked as assistant railroad surveyor, Los Angeles and Nevada, 1906; house-to-house postcard photographer, Los Angeles, 1907-08; photo-printer, for commercial portraitists, Los Angeles, 1909-11; independent photographer, establishing own studio, Tropico, now Glendale, California, 1911-22, with Tina Modotti and Chandler Weston, in Tacubaya and Mexico City, 1923-25, 1926, with Johan Hagemeyer, in San Francisco, 1925, with Brett Weston, in San Francisco, 1927, with Brett Weston, in Carmel, California, 1929-34, with Brett Weston, in Santa Monica, California, 1935-37, and at Wildcat Hill, Carmel, California, 1938-58. Photographer, WPA Federal Arts Project, New Mexico and Monterey, California, 1933. Member, London Salon of Photography, 1917; Organizer, American Section, *Film und Foto* exhibition, Stuttgart, 1929; Founder Member, with Ansel Adams, Imogen Cunningham, Sonya Noskowiak, and Willard Van Dyke, Group f/64, San Francisco, 1932-34. Recipient: Guggenheim Fellowship (first awarded to a photographer), 1937. Honorary Fellow, American Photographic Society, 1951. Estate: Cole Weston, Wildcat Hill, Route 1, Box 233, Carmel, California 93921, U.S.A. *Died* (in Carmel) *1 June 1958.*

Individual Exhibitions:

1919 Shaku-Do-Sha, Los Angeles
1921 California Camera Club, San Francisco
1922 Academia de Bellas Artes, Mexico City
1923 Aztec Land Gallery, Mexico City
1924 Aztec Land Gallery, Mexico City (with Tina Modotti)
1925 Museo del Estado, Guadalajara, Mexico (with Tina Modotti)
1926 Sal de Arte, Mexico City (with Tina Modotti)
1927 Los Angeles Museum (with Brett Weston)
1930 Delphic Studios, New York
1931 Denny Watrous Gallery, Carmel, California
 M.H. de Young Memorial Museum, San Francisco
1932 Delphic Studios, New York
1933 Dayton Art Institute, Ohio
1937 Nierendorf Gallery, New York
1946 Museum of Modern Art, New York (retrospective)
1950 Musée d'Art Moderne, Paris (retrospective)
1951 *Edward Weston: 50 Photos*, American Society of Photographers, New York
1956 Smithsonian Institution, Washington, D.C.
1960 Limelight Gallery, New York
 Art Institute of Chicago
1962 Staatliche Landesbildstelle, Hamburg
1963 Carl Siembab Gallery, Boston
1965 *The Heritage of Edward Weston*, University of Oregon, Eugene
1966 International Museum of Photography, George Eastman House, Rochester, New York
 Washington Gallery of Modern Art, Washington, D.C. (travelled to the University of Texas at Austin, and the University of Oregon, Eugene)
 Museo de Arte Moderno, Mexico City (with Brett Weston)
1968 Carl Siembab Gallery, Boston
1969 Witkin Gallery, New York
1970 Metropolitan Museum of Art, New York
1971 Carl Siembab Gallery, Boston (with Brett Weston)
 International Museum of Photography, George Eastman House, Rochester, New York
 Edward Weston: Nudes and Vegetables,

 Witkin Gallery, New York
 Eikon Gallery, Monterey, California
 Focus Gallery, San Francisco (with Cole Weston)
1972 Metropolitan Museum of Art, New York
 Friends of Photography, Carmel, California (toured the United States)
1973 University of Nebraska, Lincoln
1975 Museum of Modern Art, New York (retrospective)
 Witkin Gallery, New York (retrospective)
 G. Ray Hawkins Gallery, Los Angeles
1976 David Mirvish Gallery, Toronto
 Stedelijk Museum, Amsterdam
 Photopia, Philadelphia
 Paul Caponigro/Edward Weston/Derek Bennett, Silver Image Gallery, Tacoma, Washington
1977 Port Washington Public Library, New York
 Hayward Gallery, London
 Ex Libris, New York (with Tina Modotti)
 Kiva Gallery, Boston
 Helios Gallery, New York
 Witkin Gallery, New York
 Modesto Junior College, California (with Brett Weston and Paul Strand)
1978 *Edward Weston's Gifts to His Sister*, Dayton Art Institute, Ohio (travelled to International Center of Photography, New York)
1980 Deja Vue Gallery, Toronto
 Galeria Spectrum/Canon, Zaragoza, Spain
1981 *50 Nudi 1920-1945*, Palazzo Fortuny, Venice
 The Last Edward Weston Show, Witkin Gallery, New York
 Photo Gallery International, Tokyo

Selected Group Exhibitions:

1929 *Film und Foto*, Deutscher Werkbund, Stuttgart
1933 *Group f/64*, Ansel Adams Gallery, San Francisco
1963 *The Photographer and the American Landscape*, Museum of Modern Art, New York
1967 *Photography in the 20th Century*, National Gallery of Canada, Ottawa (toured Canada and the United States, 1967-73)
1975 *The Land: 20th Century Landscape Photographs Selected by Bill Brandt*, Victoria and Albert Museum, London (travelled to The National Gallery, Edinburgh; Ulster Museum, Belfast; and National Museum of Wales, Cardiff, 1976)
1978 *Amerikanische Landschaftsphotographie 1860-1978*, Neue Sammlung, Munich
1979 *Photography Rediscovered: American Photography 1900-1930*, Whitney Museum, New York (travelled to Art Institute of Chicago)
1980 *Old and Modern Masters of Photography*, Victoria and Albert Museum, London (toured Britain)
 Southern California Photography 1900-1965, Los Angeles County Museum of Art
1981 *The Nude in Photography*, San Francisco Museum of Modern Art

Collections:

Museum of Modern Art, New York; International Museum of Photography, George Eastman House, Rochester, New York; Art Institute of Chicago; Krannert Art Museum, University of Illinois, Urbana; Amon Carter Museum of Western Art, Fort Worth, Texas; New Orleans Museum of Art; University of New Mexico, Albuquerque; Oakland Art Museum, California; Museo de Arte Moderno, Mexico City; Royal Photographic Society, London.

Publications:

By WESTON: books—*Idols Behind Altars*, with

Tina Modotti, with text by Anita Brenner, New York 1929; *The Art of Edward Weston*, edited by Merle Armitage, New York 1932; *Seeing California with Edward Weston*, Los Angeles 1939; *California and the West*, with text by Charis Wilson, New York 1940, Millerton, New York 1978; *Walt Whitman: Leaves of Grass*, New York 1942, with an introduction by Richard Ehrlich, New York 1972; *The Photographs of Edward Weston*, text by Nancy Newhall, New York 1946; *Edward Weston: 50 Photographs*, edited by Merle Armitage, New York 1947; *The Cats of Wildcat Hill*, with Charis Wilson Weston, New York 1947; *Edward Weston: My Camera on Point Lobos*, edited by Ansel Adams, Yosemite, California and Boston 1950, New York 1968; *Edward Weston: 50th Anniversary Portfolio 1902-1952*, Carmel, California 1952; *Studies of the Human Form by Two Masters: Edward Weston and John Rawlings*, New York 1957; *The Daybooks of Edward Weston: Vol. 1—Mexico*, with an introduction by Beaumont Newhall, and a foreword by Nancy Newhall, Rochester, New York 1961; *The Daybooks of Edward Weston: Vol. 2—California 1927-34*, with an introduction by Nancy Newhall, New York and Rochester, New York 1966, both vols. reprinted, Millerton, New York 1971; *Accent on Life*, with text by Merle Armitage, Ames, Iowa 1965; *The Flame of Recognition*, edited by Nancy Newhall, Millerton, New York 1965, expanded edition 1971; *Edward Weston*, portfolio of 10 photos, with an introduction by Wynn Bullock, foreword by Cole Weston, New York and Carmel, California 1971; *8 Photographs: Edward Weston*, portfolio, with text by Peter C. Bunnell, New York 1971; *Untitled No. 1: Edward Weston*, with text by Dody Warren, Carmel, California 1972; *Edward Weston: Desnudos*, portfolio of 11 photos, with foreword by Charis Wilson, Carmel, California 1972; *Edward Weston: Fifty Years*, with text by Ben Maddow, Millerton, New York 1973, Boston 1978; *Weston to Hagemeyer: New York Notes—Center for Creative Photography no. 3*, Tucson, Arizona 1976; *Six Nudes of Neil*, 1925, portfolio, with an introduction by Neil Weston, New York 1977; *Edward Weston: Nudes*, with text by Charis Wilson, Millerton, New York 1977; *Edward Weston: Photographs and Papers*, compiled by Terence R. Pitts, Sandra Schwartz and Marnie Gillett, Tucson, Arizona 1980.

On WESTON: books—*Principles of Pictorial Photography* by John Wallace Gillies, New York 1923, 1973; *Edward Weston: Exposición de Sus Fotografías*, exhibition catalogue, Mexico City 1924; *Edward Weston—Brett Weston*, exhibition catalogue, Los Angeles 1927; *Exhibition of Edward Weston Photographs*, catalogue, with an introduction by Laurence Bass-Becking, New York 1930; *Edward Weston, Photographer*, exhibition catalogue, Carmel, California 1931; *Modern Photography*, with an introduction by E.O. Hoppé, New York 1933; *Making a Photograph* by Ansel Adams, London and New York 1935, 1938, 1948; *Art from the Mayans to Disney* by Jean Charlot, London and New York 1939; *A Pageant of Photography*, edited by T.C. Maloney and others, San Francisco 1940; *Photography Year Book 1955*, edited by Norman Hall and Basil Burton, London 1955; *Masters of Photography* by Beaumont and Nancy Newhall, New York 1958; *The Picture History of Photography* by Peter Pollack, New York 1958, 1969; *This Is the American Earth* by Ansel Adams and Nancy Newhall, New York 1960; *The Photographer and the American Landscape*, exhibition catalogue, by John Szarkowski, New York 1963; *The History of the Nude in Photography* by Peter Lacey, New York 1964; *A Concise History of Photography* by Helmut and Alison Gernsheim, London and New York 1965, 1971; *The Heritage of Edward Weston*, exhibition catalogue, with an introduction by Wallace Baldinger, Eugene, Oregon 1965; *Edward Weston*, exhibition catalogue, with text by Eleanor Green, Washington, D.C. 1966; *Fotografias de Edward Weston/Brett Weston*, exhibition catalogue, with an introduction by Carmen Barreda, texts by Eleanor Green and Nancy Newhall, Mexico City 1966; *Photographers on Photography*, edited by Nathan Lyons, New York 1967; *Photography in America*, edited by Robert Doty, with an introduction by Minor White, New York and London 1974; *The Land: Twentieth Century Landscape Photographs Selected by Bill Brandt*, exhibition catalogue, edited by Mark Haworth-Booth, London 1975; *The Magic Image* by Cecil Beaton and Gail Buckland, London and Boston 1975; *Photographs: Sheldon Memorial Art Gallery Collection, University of Nebraska*, with an introduction by Norman A. Geske, Lincoln, Nebraska 1977; *Geschichte der Fotografie im 20. Jahrhundert/Photography in the 20th Century* by Petr Tausk, Cologne 1977, London 1980; *Amerikanische Landschaftsphotographie 1860-1978*, exhibition catalogue, with an introduction by Klaus-Jürgen Sembach, Munich 1978; *Edward Weston's Gifts to His Sister*, exhibition catalogue, edited by Kathy Kelsey Foley, Dayton, Ohio 1978; *Life: The First Decade 1936-1945* by Robert Littman, Ralph Graves and Doris C. O'Neill, New York 1979, London 1980; *Photography Rediscovered: American Photographs 1900-1930* by David Travis, New York 1979; *Amerika Fotografie 1920-1940* by Erika Billeter, Berne 1979; *The Photograph Collector's Guide* by Lee D. Witkin and Barbara London, Boston and London 1979; articles—"The Man Who Made Tropico Famous: A Little Journey to the Home of a Noted Photographer" in *Lensology and Shutterisms* (Rochester, New York), May/June 1916; "Una Transcendental Labor Fotografica" by David Alfaro Siqueiros in *El Informador* (Guadalajara, Mexico), 4 September 1925; "Edward Weston and Tina Modotti" by Diego Rivera in *Mexican Folkways* (Mexico City), April 1926; "Weston in Retrospect" by Pauline Schindler in *The Daily Carmelite* (California), 29 July 1931; "Fotografias de Edward Weston" in *Contemporaneos* (Mexico City), September/October 1931; "Edward Weston Special Number" with texts by Johan Hagemeyer, Una Jeffere, Lincoln Steffens and others in *The Carmel Cymbal* (California), 17 April 1935; "Weston's Westerns" in *Life* (New York), 27 December 1937; "Edward Weston" by Jean Charlot in *California Arts and Architecture* (Los Angeles), April 1940; "Edward Weston: Photographer" by Ralph Samuels in *Universal Photo Almanac*, New York 1951; "Edward Weston and the Nude" by Nancy Newhall in *Modern Photography* (New York), June 1952; "Special Weston Issue," edited by Lew Parella, of *Camera* (Lucerne), April 1958; "Edward Weston: Tools and Techniques of the Greatest Craftsman" by Arthur Kramer in *U.S. Camera* (New York), December 1962; "Edward Weston: Dedicated to Simplicity" by Cole Weston in *Modern Photography* (New York), May 1969; "Gallery: Edward Weston's Graceful Images of Nature" in *Life* (New York), 24 September 1971; "Edward Weston's Privy and the Mexican Revolution" by Hilton Kramer in *New York Times*, 7 May 1972; "The Weston World" by Margaret R. Weiss in *Saturday Review* (New York), 22 February 1975; "Edward Weston: A Chronological Bibliography" by Bernard Freemesser in *Exposure* (New York), February 1977; "Nudes: Edward Weston—She Stoops, He Conquers" in *American Photographer* (New York), February 1980; films—*The Photographer* by Willard Van Dyke, 1948; *The Naked Eye* by Louis Clyde Stoumen, 1957; *The Daybooks of Edward Weston*, KQED television film, by Robert Katz, 1965.

My first encounter with the photographs of Edward Weston at an exhibition some years ago remains one of the most important experiences of my life. The pictures struck me with the force of revelation: it seemed that until that moment I had never understood the true potential of photography. It was immediately clear that, in the richness of their tones, the subtle balances of light and shade, the monumental boldness of the forms, these photographs were more sensuously beautiful than any that I had ever seen. I had not even dreamt that it was possible to make photographs that were so visually perfect, photographs whose every detail seemed to be controlled and willed, in which the chaos of the world's innumerable incidents was resolved into such perfect harmony. And what sharpness, what precision of detail! These pictures seemed to be immaculately-constructed art-works and, at the same time, windows on the world of observable reality, transmitting both meaning and appearance with total truth and an hallucinatory degree of clarity. Surely, I felt, this is the work of a great master, whose importance stretches far beyond the usual limitations of photography.

Weston's photographs have prompted many reactions similar to mine in the years since the early 1920's, when he discarded the soft-focus pictorialism of his—often very beautiful—early pictures in favour of the hard-edged brilliance that characterized his mature style. The body of his most important work, from the photographs of the Armco Steelworks of 1922, which heralded the flowering of genius, to the final negative on Point Lobos in 1948, is so rich and complex that it would be difficult here even to outline the main achievements. Through all the variety of this work, however, Weston maintained a constancy of principle. Series as different in their expression as the Mexican portraits of the mid-1920's; the close-ups of shells and vegetables; the nudes; the Oceano dunes of 1936; and the late, dark meditations on the forces of life and death expressed in the rocks and trees of Point Lobos, are united by a similarity of overall approach.

Although the works themselves are more intuitively than intellectually organized, Weston was fully conscious of his aims. Key passages of the surviving *Daybooks* (in which, for 15 years, Weston recorded his activities and perceptions) clearly define the underlying intentions. Thus he wrote: "To see the Thing itself is essential: the quintessence revealed the fog of impressionism—the casual noting of a superficial phase, or transitory mood." This then: to photograph a rock, to have it look like a rock, but be more than a rock. I want the greater mystery of things revealed more clearly than the eyes see, at least more than the layman, the casual observer, notes." And again: "Through photography I would present the significance of facts so they are transformed from things seen to things known. Wisdom controlling the means—the camera—makes manifest this knowledge, this revelation, in form communicable to the spectator."

Weston pursued his creative ambition with ruthless tenacity and perfectionism, to which he added the special gift of an eye uniquely responsive to the sculptural rhythms of the forms that it observed. Working slowly and patiently, with large-format equipment, he eschewed the excitement of the fleeting moment in favour of a pursuit of the timeless and essential truths he perceived beneath the surface of appearances. For the most part, Weston selected his subjects from the surroundings of his daily life, working only with things or people that moved him powerfully and directly. Many of his subjects could, to another man, have seemed uninspiringly ordinary—a green pepper, a lavatory bowl, the trunk of a palm tree, a woman's back. His practise, in fact, was diametrically opposed to that of photographers who rely upon startling subject-matter, instants of explosive action, or bizarre happenings to give their work its interest. Paradoxically, though, Weston was able to discover a significance and grandeur in the most commonplace objects that went far beyond the merely dramatic. The originality of his expression, the enduring freshness and power of his images, derives ultimately from his success in perceiving the formal and metaphysical unities underlying everyday things.

By unifying a concern for objective reality, subjective response, and aesthetic control, Weston has come to exemplify one of the major approaches to photography, and has remained a powerful influ-

ence on subsequent generations despite the changes in photographic theory and practice that have occurred since his death. The power of his influence can be seen not only in the work of his admirers, but also in the strength of reaction of those more politically and socially-motivated photographers who have rejected Weston's procedures as self-indulgent, narcissistic and unacceptable by reason of their elevation of individual feeling above social action. On a general and theoretical level, these criticisms have a measure of validity; but in practice, Weston's own work demonstrates triumphantly that the absolute pursuit of artistic truth remains a liberating and radical undertaking, whatever the path it takes.

—Tom Evans

WHITE, Minor (Martin).

American. Born in Minneapolis, Minnesota, 9 July 1908. Educated at public schools in Minneapolis, 1913-28; studied botany, University of Minnesota, Minneapolis, 1928-31, 1932-33, B.S. 1933; art history and aesthetics, Columbia University, New York, 1945-46; mainly self-taught in photography, from 1916, influenced by Beaumont and Nancy Newhall, New York 1945-46. Served as infantryman, United States Army, in the Philippines, 1942-45: Bronze Star. Worked as a waiter and barman, University Club, University of Minnesota, 1933-37; hotel night clerk and assistant in photographic studio, Portland, Oregon, 1937-38; instructor in photography, YMCA, Portland, 1938; secretarial assistant, People's Power League, Portland, 1938; photographer, Works Progress Administration (WPA), Portland, 1938-39; Instructor in Photography, then Director, La Grande Art Center, Oregon, 1940-41; Photographer, Museum of Modern Art, New York, 1945; Instructor in Photography, California School of Fine Arts, now San Francisco Art Institute, 1946-52; Founder-Editor with Dorothea Lange, Ansel Adams, Barbara Morgan, Beaumont and Nancy Newhall and others, and Production Manager, *Aperture* magazine, San Francisco and New York 1952-75; Exhibitions Organizer, 1953-57, and Editor, *Image* magazine, George Eastman House, Rochester, New York, 1953-57; Instructor in Photography and Photojournalism, Rochester Institute of Technology, New York, 1955-64; Editor, *Sensorium* magazine, Cambridge, Massachusetts, 1965 (not published); Visiting Professor, Department of Architecture, Massachusetts Institute of Technology, Cambridge, 1965-76. Member, Oregon Camera Club, Portland, 1938; Photo League, New York, 1947; Founder Member, Society for Photographic Education, 1962. Recipient: Guggenheim Fellowship, 1970. Died (in Boston) 24 June 1976.

Individual Exhibitions:

1939 *Portland Iron Front Buildings*, W.P.A. Exhibition, Portland, Oregon (toured the United States)
 Portland Waterfront, W.P.A. Exhibition, Portland, Oregon (toured the United States)
1942 *Grande Ronde Valley Photographs*, Port-

land Art Museum, Oregon
 Two Portland Houses, Portland Art Museum, Oregon
 First Sequence, YMCA, Portland, Oregon
1948 *Song Without Words*, San Francisco Museum of Art (toured the United States)
1949 The Record Shop, San Francisco
1950 *Intimations of Disaster*, Photo League, New York
 Two Portland Houses, Portland Art Museum, Oregon
 Mendocino, San Francisco Museum of Art
1952 *Fourth Sequence*, Raymond and Raymond Gallery, San Francisco
 Fifth Sequence, Sequence 6, Intimations of Disaster, San Francisco Museum of Art
1954 *Sequence 7, Sequence 8*, International Museum of Photography, George Eastman House, Rochester, New York
 Sequence 7, 8, 9, Limelight Gallery, New York
 Sequence 8, Santa Barbara Museum of Art, California
1955 *These Images*, International Museum of Photography, George Eastman House, Rochester, New York
 The Photographers Gallery, San Francisco
 Sequence 11, Village Camera Club, New York
1957 Limelight Gallery, New York
 3 Photographers: Harry Callahan, Walter Rosenblum, Minor White, White Museum of Art, Cornell University, Ithaca, New York
 Sequence 10/Rural Cathedrals, Sequence 12/Doors, San Francisco Museum of Art (with Dorothy Norman)
1959 Gateway Gallery, San Francisco
 Sequence 13/Return to the Bud, International Museum of Photography, George Eastman House, Rochester, New York
 Sequence 13/Return to the Bud, Henry Ford Museum, Dearborn, Michigan
 Fourth Sequence, Sequence 12/Doors, Song Without Words, Image Study, Boston University
 Sequence 15A, Limelight Gallery, New York (with Paul Caponigro)
 Sequence 13/Return to the Bud, Oregon Centennial Celebration, Portland
1960 *Sequence 13/Return to the Bud*, Art Institute of Chicago
 Sequence 15A, Smithsonian Institution, Washington, D.C.
 University of Buffalo, New York
1961 *Song Without Words*, Carl Siembab Gallery, Boston
1962 *Sequence 15A*, Pennsylvania State University, University Park
1964 *Sequence 17/Out of Love for You I Will Try to Give You Back to Yourself*, Humboldt State College, Arcata, California
 Sequence 17, Ellsworth Museum, St. Lawrence University, Canton, New York
 Underground Gallery, New York
1965 Gallery 216, New York
 Everything Gets in the Way, Reed College, Portland, Oregon
 Sequence 17, Massachusetts Institute of Technology, Cambridge
1966 *Everything Gets in the Way*, Lotte Jacobi Gallery, Hillsboro, Massachusetts
1967 *It's All in the Mind*, Carl Siembab Gallery, Boston
1968 *Sequence 16/Sound of One Hand Clapping*, Ringling Museum, Sarasota, Florida
1970 Philadelphia Museum of Art (retrospective)
1973 *The Photograph as Object, Metaphor and Document of Concept: Robert Heinecken, Minor White and Robert Cumming*, California State University at Long Beach
1975 U.S.I.A. Gallery, Paris (toured Europe)
1980 Visions Gallery, London

Selected Group Exhibitions:

1959 *Photography at Mid-Century*, International Museum of Photography, George Eastman House, Rochester, New York (toured the United States)
1962 *Photography USA*, DeCordova Museum, Lincoln, Massachusetts
1964 *The Photographer's Eye*, Museum of Modern Art, New York
1967 *Photography in the 20th Century*, National Gallery of Canada, Ottawa (toured Canada and the United States, 1967-73)
1968 *Light⁷*, Massachusetts Institute of Technology, Cambridge
1974 *Photography in America*, Whitney Museum, New York
1975 *The Land: 20th Century Landscape Photographs Selected by Bill Brandt*, Victoria and Albert Museum, London (travelled to Edinburgh, Belfast and Cardiff)
1978 *Amerikanische Landschaftsphotographie*, Neue Sammlung, Munich
1979 *Photographie als Kunst 1879-1979*, Tiroler Landesmuseum Ferdinandeum, Innsbruck, Austria (travelled to Neue Gallery am Wolfgang Gurlitt Museum, Linz, Austria; Neue Galerie am Landesmuseum Joanneum, Graz, Austria; and Museum des 20. Jahrhunderts, Vienna)
1980 *Photography of the Fifties*, International Center of Photography, New York (travelled to Center for Contemporary Photography, University of Arizona, Tucson; Minneapolis Institute of Arts,; California State University at Long Beach; and Delaware Art Museum, Wilmington)

Collections:

Minor White Archive, Princeton University Art Museum, New Jersey; International Museum of Photography, George Eastman House, Rochester, New York; Carpenter Center, and Fogg Art Museum, Harvard University, Cambridge, Massachusetts; Library of Congress, Washington, D.C.; Kalamazoo Institute of Arts, Michigan; Art Institute of Chicago; University of Louisville, Kentucky; New Orleans Museum of Art; University of New Mexico, Albuquerque; Oakland Art Museum, California.

Publications:

By WHITE: books—*Sequence 6*, portfolio of 14 photos, San Francisco 1951; *Exposure with the Zone System*, New York 1956, as *Zone System Manual*, New York 1961, 1965, 1968; *Photographers on Photography*, with others, edited by Nathan Lyons, New York 1966; *Light⁷*, editor, New York and Cambridge, Massachusetts 1968; *Mirrors, Messages, Manifestations*, New York 1969; *Be-Ing Without Clothes*, exhibition catalogue, New York and Cambridge, Massachusetts 1970; *Octave of Prayer*, New York and Cambridge, Massachusetts 1972; *Celebrations*, with Jonathan Green, preface by Gyorgy Kepes, New York and Cambridge, Massachusetts 1974; *Jupiter Portfolio*, 12 photos, with text by Peter Rasun Gould, New York 1975; *The New Zone System Manual*, with Richard Zakia and Peter Lorenz, New York 1976; *Minor White: Rites and Passages*, with an introduction by James Baker Hall, New York 1978; articles—"When Is Photography Creative?" in *American Photography* (New York), January 1943; "Photography Is an Art" in *Design* (Minneapolis), December 1947; "What Is Photography?" in *Photo Notes* (New York), Spring 1948; "How to Find Your Own Approach to Photography" in *American Photography* (New York), July 1951; "Analysis of Five Prints" in *Universal Photo Almanac*, New York 1951; "The Camera Mind and Eye" in *Magazine of Art* (New York), January 1952;

"How Creative Is Color Photography?" in *Popular Photography Color Annual*, New York 1957; "On the Strength of a Mirage" in *Art in America* (New York), Spring 1958; "The Craftsmanship of Feeling" in *Infinity* (New York), February 1960; "Call for Critics" in *Infinity* (New York), November 1960; "Photography: An Undefinition" in *Popular Photography* (New York), April 1962; "Pictorial Photography" in *The Encyclopaedia of Photography*, New York 1964; "Extended Perception Through Photography" in *Ways of Growth*, edited by Herbert Otto and John Mann, New York 1968; introduction to *Photography in America*, edited by Robert Doty, New York 1974; interview in *Interviews with Master Photographers*, edited by James Danziger and Barnaby Conrad III, London and New York 1977; interview in *Dialogue with Photography*, edited by Paul Hill and Thomas Joshua Cooper, London 1979; numerous writings in *Image* (New York), 1956-57, and *Aperture*, 1952-75.

On WHITE: books—*Photography in the 20th Century* by Nathan Lyons, New York 1967; *Photography in America*, edited by Robert Doty, New York 1974; *The Magic Image* by Cecil Beaton and Gail Buckland, London and Boston 1975; *The Land: 20th Century Landscape Photographs Selected by Bill Brandt*, exhibition catalogue, edited by Mark Haworth-Booth, London 1975; *Geschichte der Fotografie im 20. Jahrhundert / Photography in the 20th Century* by Petr Tausk, Cologne 1977, London 1980; *Photographs: Sheldon Memorial Art Gallery Collection, University of Nebraska*, with an introduction by Norman A. Geske, Lincoln 1977; *Amerikanische Landschaftsphotographie 1860-1978*, exhibition catalogue, with an introduction by Klaus-Jürgen Sembach, Munich 1978; *Photographie als Kunst 1879-1979 / Kunst als Photographie 1949-1979*, exhibition catalogue, 2 vols., by Peter Weiermair, Innsbruck, Austria 1979; *The Photograph Collector's Guide* by Lee D. Witkin and Barbara London, Boston and London 1979; *Light Readings: A Photography Critic's Writings 1968-1978* by A.D. Coleman, New York 1979; *Photography of the Fifties: An American Perspective* by Helen Gee, Tucson, Arizona 1980; articles—"Minor White" in *Camera* (Lucerne), August 1959; "Minor White" by Allan Porter in *Camera* (Lucerne), January 1972; "From Minor White: A Choice Collection" by Gene Thornton in the *New York Times*, 14 October 1973; "Minor White Gathers Final M.I.T. Show" by Hilton Kramer in the *New York Times*, 1 March 1974; "On the Invention of Photographic Meaning" by Allan Sekula in *Artforum* (New York), January 1975; "Minor White (1908-1976): Significance of Formal Quality in His Photographs" by Janet E. Buerger in *Image* (Rochester, New York), vol. 19, no. 3, 1976; "Remembering Cunningham and White" by Hilton Kramer in the *New York Times*, 1 August 1976; "Minor White 1908-1976" by David Vestal in *Popular Photography* (New York), October 1976; "Minor White—Mystic and Mentor" in *Photography Year 1977*, by the Time-Life editors, New York 1977; "Minor White" in *Progresso Fotografico* (Milan), November 1977; "The Quest for Angelic Vision: The Photographs of Minor White" by David Bartlett in *Camera Lucida* (Milwaukee), Winter 1980.

A bright, energetic tactician, one versed in the politics of art and the museum and publishing worlds, a teacher with provocative classroom strategies, and a photographer of richly metaphoric images, Minor White was fully conscious of the uniqueness and privacy of his vision and of the roles he maintained as the passing years thinned his hair to diaphanous, white strings: arbiter of photographic tastes, lecturer, director of vigorous workshops, entrepreneur, and editor of quoted and problematical books (*Be-Ing Without Clothes* and *Octave of Prayer*).

He brought to his students at Massachusetts Institute of Technology, where he taught from the mid-60s almost up until his death, a vast experience and knowledge. The standards that he created and upheld for others were standards that he also observed for himself. As with the format and design of *Mirrors, Messages, Manifestations*, the extensive *Aperture* monograph of his work published in 1969—the spatter of quotes and poetry, the orchestration of rhythms and enlightening juxtapositions—he was an imaginative and fastidious editor.

For White, a photograph was not simply food for senseless consumption. Its offering of nourishment was more delicate and substantive. Its craft, its shapes, and composition, often predicated by the subject, its unarticulated and subliminal facets of being—some of these, at times most of these, could be deciphered, in fact *read*, or determined by the exercise of an engaged and watchful intellect. A photograph could also act as a metaphorical mirror, reflecting for the viewer as well as for the photographer and critic, *feeling-states* and resonances that defy facile descriptions.

Through his editorship of *Aperture*, an influential journal of photography begun in 1952, his curatorial judgements, his own experimentation and creativity, his generous and astute critiques of the work of his colleagues and students, White insisted that if a photograph were worth viewing, it required bold and probing viewing. In White's teaching, scrutiny of a photograph was soulful endeavor; joyful and intense, an often solemn activity that could alter and enlarge one's critical perception, one's creative energies and productivity, and occasionally even one's attitude toward life. Such scrutiny required dedication, integrity, patience, a burgeoning sensibility, and a game covenant with the unknown. As his students were shown, a photograph could be appraised in countless ways—first, for its craft, its elements of composition, its format and print qualities, its freshness of conception; then later for its deeper apprehensions and acknowledgements.

In a public sense, White came to think of photographs principally as either objects to be exhibited in galleries and museums or presented in compelling arrangements in magazines and books. In a private and pedagogic sense, there was an alternative use of photography, that being the opportunity of exploring the interiority of oneself or of studying the exploration and achievement of another human being, at least through the visual manifestation of that exploration and achievement.

During the last phase of his life, this alternative use of photography absorbed more and more of his creative energy and thought. It is what he labored with in his myriad workshops by employing at times provocative silences and cryptically abrasive comments. His students suffered his preoccupations and unsparing aspirations; they were urged to disengage themselves from preconceptions, inhibitions, defense mechanisms, and the telltale smudges of ego. Dance, mime, classical music, readings from esoteric masters, the *I Ching*—all were used to promote self-discovery and to provide a new context for perception.

"I have been defining *creative* ever since I came to M.I.T.," he observed late in his life, "as anything which brings us into contact with our Creator, either inwardly or outwardly." The source for White's spirituality and some of his workshop techniques came from a Russian, George Ivanovich Gurdjieff (1870s-1949). Gurdjieff proposed energizing the three centers of being: intellectual, emotional, and instinctual. After fifty, White adopted Gurdjieff's discipline and philosophy, and they provided lasting sustenance for his intense and hungry spirit.

A poet himself, White thought of poetry as one kind of expression, a harvesting of knowledge within oneself—and of photography as another, as symbolized by one of his supreme images, "The Sandblaster," in which a man is pictured at work, excavating, with only his helmet and shoulders visible. White admitted special fondness for this image; it was a remembrance of himself, digging away at life.

White's early work shot in Portland, Oregon and along the California coast is direct and earthbound—images of rock formations at Point Lobos and of sea flung like wet snow and of streets and buildings that glisten like freshly painted brick and steel. Almost all of his work after 1945, though, yearns in one way or another for the spiritual. The best seem to gain a purchase on mystery and spirit without deserting the mundane. In "Two Barns and Shadow," for instance, the shadow of a telephone pole falls obliquely across a field and points up toward two barns, whose visual arrangement seems something more than ordinary. The image possesses immediate visual coherence, as most of White's images do, and then there is the recognition of another mode. The shadow reads as a black cross and the two barns suggest two sides, one darker and one lighter, of spiritual or psychic being. That image like so many created by White—"Ritual Branch," "Birdlime and Surf," "Long Cloud," "Christmas Ornament," and "Rings and Roses"—abides first in the subtle articulation of light and form.

The non-narrative photographic sequence is White's conceiving. In White's hands a sequence often enacted a dialogue between two people or manifested changing moods and complex feeling-states. For thirty odd years he worked with sequences. Some preserved their original shapes over the years, while others were altered again and again—as often by the inclusion of a new image as by an internal adjustment in sequential order. The individual images were not conceived as from a schedule or filmmaker's script, but first as separate children with equal love and pampering. Scattered about his floor or laid out along the tiers of his wall rack, there were profound differences among them in pitch, density, and velocity. These differences became some of the hidden strings of formal arrangement that ordered images in his sequences.

In his mature sequential work, White achieved a context both indecipherable and as tactile as the rock and snow and frosted glass appropriated as canvas. The context was often highly personal—"Sequence 4" and "Sequence 17", for instance—disclosures of sexuality and states of mind whose lives depend upon revelation but not upon precise identification. "Sound of One Hand Clapping," no doubt his finest sequence, originated from meditations on a Zen koan. Composed of ten images, most of which were frost configurations on the windows of his flat in Rochester, New York, the sequence is a visual equivalent of sound. Covertly hinged together, the images pass from an initial closed and ineffable form to an open showering form. Forces as commanding as hands guide the viewer through the sequence. It is as if the individual images are forms in their secret effulgence, awaiting scrutiny and meditation. Circles, hands, eyes, heads, stars, icicles, scallops of frost, snowbursts—these forms rise and subside, take body and resonance in subtle recurrence. The images seem at first simple and inert, but upon closer scrutiny they break into untutored vitality. They gambol, and chatter, igniting the imagination, exploding into objects of new being.

The bedrock of White's work is self. After 1964, he steadfastly embraced the personal and esoteric. All of his interests and inclinations urged him in that direction: his sexuality; poetry; pedagogy; Stieglitz's equivalence concept, which for him became dogma; oriental ritual, diet, and thought; Gurdjieff work; and the developing concept of non-narrative sequence. Like most of his sequences, "Sound of One Hand Clapping" evades literary reduction and interpretation. Through its sound, the liveliness of its forms, the rhythmical and poetic nature of its arrangement, it provokes the viewer in ways that a single image could not. It passes from a static and enigmatic form, one that affronts almost with its amplitude, through various stages of lyrical calm, unrest, joyful disturbance, bold peace, to the lovely and, perhaps for White, redemptive release of the final image. "Frost Wave," in scale both microcosmic and macrocosmic, communicates as eternally

Minor White: *Grand Tetons, Wyoming,* **1959** Courtesy Art Institute of Chicago

alive.

White may best be remembered for the intensity of his commitment to photography and for the boldness of his vision. With his teaching and his own creative photography, he asserted the significance of the human and the personal. A number of his images and sequences are among the treasures of 20th century photography.

—Kelly Wise

WINDSTOSSER, Ludwig.

German. Born in Munich, 19 January 1921. Educated at the Realgymnasium, Berlin; studied mechanics at the Robert Bosch GmbH company, Stuttgart, and technical draughtsmanship at the Esslingen Engineering School; studied photography, under Adolf Lazi, in Stuttgart, 1946-47. Served as a Senior Lance Corporal in the German Army, at the Russian Front, 1942-45. Married Ingrid Windstosser in 1951; son: Peter. Freelance photographer, working for the Ruhr coal and steel industry companies, AEG and Zeiss, etc., Stuttgart, since 1948; has concentrated on his own colour photography since 1964. Founder Member, with Otto Steinert, Toni Schneiders, Peter Keetman and others, Fotoform, 1949; Director, Arbeitskreis Bild im Centralverband Deutscher Fotografen (ABCV), since 1964; Member of the Praesidium, Europhot, since 1973. Member, Deutsche Gesellschaft für Photographie (DGPh), and Gesellschaft Deutsche Lichtbildner (GDL). Recipient: Gold Medal, ABCV, 1970; Bundesverdienstkreuz, Federal Republic of Germany, 1981. Agent: Galerie Rudolf Kicken, Albertusstrasse 47-49, Cologne. Address: Neue Weinsteige 80, 7000 Stuttgart 1, West Germany.

Individual Exhibitions:

1978 Industrie, Bahnhof, Bad Godesburg, Bonn (and at the Wirtschaftsministerium, Bonn)

Selected Group Exhibitions:

1947 Stuttgarter Photographischen Gesellschaft, Stuttgart
1949 Photographische Kunst 1949, Neustadt an der Haardt, West Germany
1950 Fotoform, at Photo-Kino Ausstellung, Cologne
1963 Europhot, Lucerne
1964 Photo '64, Stuttgart
1967 Commercial Photography, Stuttgart
1979 Deutsche Fotografie nach 1945, Kasseler Kunstverein, Kassel, West Germany
1980 Fotoform, Galerie Kicken, Cologne

Collections:

Folkwang Museum, Essen.

Publications:

By WINDSTOSSER: books—Württemberg, 1950; Stuttgart Jahrbuch, annually, Stuttgart 1952-81; Kloster Maulbronn, 1954; Konzerthaus Stuttgarter Liederhalle, Stuttgart 1956; Ludwigsburg, 1957; Marbach am Neckar, 1959; Stuttgart, Stuttgart 1960, 1963, 1968, 1975; Ulm, 1966; Berlin, 1972; Bruchsal, 1975; Heilbronn, 1975; Martin Knoller: Abteikirche Neresheim, 1976; Das Land der Staufer, Stuttgart 1976; Stuttgart für Kinder, 1978; Göppingen, 1979; Baden-Wüttemberg im Wandel der Geschichte, 1979; Leonberg, 1980; also numerous booklets and brochures for industrial companies.

On WINDSTOSSER: books—Fotografie 1919-1979, Made in Germany: Die GDL-Fotografen, edited by Fritz Kempe, Bernd Lohse and others, Frankfurt 1979; Deutsche Fotografie nach 1945/German Photography After 1945 by Floris Neusüss, Wolfgang

Ludwig Windstosser: *Chargen-Plan*

Kemp and Petra Benteler, Kassel, West Germany 1979.

Ludwig Windstosser was born in Munich in 1921, the son of a salesman in industry, but he grew up in Stuttgart—and he still lives and works there today. It is not by chance that I mention this fact first, for if Windstosser is mentioned in German specialist circles, the whole group knows immediately: ah yes, the well-known industrial photographer!

Baden-Württemberg, with its capital Stuttgart, is truly the professionally industrious region in today's German Federal Republic; it has a high reputation for precision and specialized industry, for a spirit of inventiveness and diligence. With this background and with just such a spirit, Windstosser, who himself began his professional life as an apprentice mechanic with Bosch and then went on to complete engineering school, has developed a highly successful career. For many years Windstosser has enjoyed the role of a kind of "elder Statesman" among those photographers who take photographs for industry—whether for advertising, business reports, public relations, etc. Windstosser is approached whenever photographs are required that are more than just precise documentation or sober reproductions.

During the last decade Windstosser has also succeeded brilliantly in overcoming a difficult transition period. In earlier times the major and obvious attraction of taking photographs in large factories was the contribution to pictorial form of the glowing, steam-hissing, smoking chimney; today, where it still exists, it is as antiquated as the hissing and smoking steam train. In its place reigns, with great coolness, the computer and micro-processor-controlled productions processes, encapsulated machine units, coils and cooling towers. Windstosser's particular professional strength today lies in his ability to obtain pictorially suitable depictions from this new and photographically difficult world.

Given these accomplishments, it is easy to overlook the "other Windstosser." The Swabians are not only diligent workers and precise technicians, but also secret romantics. So it is no wonder that Windstosser, after his return home from the Second World War and his photographic apprentice with Adolf Lazi, had his first great photographic experience (the remembrance of which still moves him today) when he discovered the gothic architectural jewel of the Maulbronn Monastery. He published a book on it in 1954.

And in these early days it was decisive for Windstosser that he belonged to the "Fotoform" group, a community of young photographer friends founded in 1949 which made a stir at the time because it embodied a fresh start in German photography—in a conscious re-connection with the "New Photography" of the 1920's. There was too, the discovery of form in nature and technology in the manner of the Neue Sachlichkeit (the New Objectivity) of Renger-Patzsch, a re-awakening of the desire for experiment in the tradition of Moholy-Nagy. Finally, there was the sphere of the group's intellectual leader, Otto Steinert.

Windstosser devoted himself at that time primarily to the pictorial depiction of nature and of historic architecture. And he is still dedicated to such subjects today, alongside and in between his work for industry. Possibly it is also his recreation from his industrial work. Whatever the reasons, we have the results, a large number of photographic volumes—charming landscapes, urban scenes, evocations of city and countryside, culminating in a mammoth work of great cultural aspiration, *Baden-Wüttemberg im Wandel der Geschichte*.

—Bernd Lohse

WINNINGHAM, Geoff(rey L.).

American. Born in Jackson, Tennessee, 4 March 1943. Studied English at Rice University, Houston, 1961-65; photography, at Illinois Institute of Technology, Chicago, 1965-68, M.S. 1968. Married Judy Gordon in 1973; children: Elizabeth, Alyson, Charles, and Michael. Freelance photographer, working for *Esquire, Atlantic Monthly, Life, Time, Newsweek, Photo*, etc., Houston, since 1968. Instructor, New Trier Township High School, Winnetka, Illinois, 1966-68, and University of St. Thomas, Houston, 1968-69. Member of the faculty, Rice University, Houston, since 1969; currently, Professor of Art and Master of Wiess College. Recipient: Public Broadcasting Corporation grant, 1971; Guggenheim Fellowship, 1972, 1978; Documentary Prize, *U.S. Film Festival*, 1973; Public Grant, 1974, and Photography Fellowship, 1975, 1977, National Endowment for the Arts; American Society of Art Directors Award, 1975. Agent: Harris Gallery, 1100 Bissonnet, Houston, Texas 77004. Address: Post Office Box 2011, Houston, Texas 77001, U.S.A.

Individual Exhibitions:

1968 Rice University, Houston
1972 Rhode Island School of Design, Providence
 Institute of Design, Chicago
 Art Institute of Chicago
1973 Pan Opticon Gallery, Boston
1974 Museum of Fine Arts, Houston
1975 Witkin Gallery, New York
 Madison Art Center, Wisconsin
1976 Halsted 831 Gallery, Birmingham, Michigan
 Afterimage Gallery, Dallas
1977 Cronin Gallery, Houston

Geoff Winningham: *Little Richard*, 1971

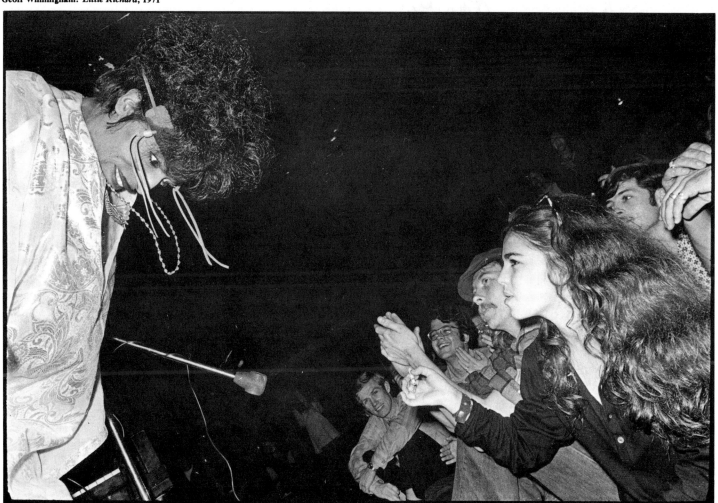

Southwestern College Gallery, La Jolla, California
1979 Cronin Gallery, Houston
1980 Wah Lui Gallery, Seattle
Harris Gallery, Houston
Allen Street Gallery, Dallas
1981 First Federal Savings and Loan Association, Little Rock, Arkansas (permanent exhibition of 124 photographs of the vernacular architecture of Arkansas)

Selected Group Exhibitions:

1969 *Vision and Expression*, International Museum of Photography, George Eastman House, Rochester, New York (toured the United States, 1969-71)
1971 *Photography Invitational '71*, Arkansas Arts Center, Little Rock
1975 *On Time*, Museum of Modern Art, New York
1976 *Light Is the Theme*, Kimbell Art Museum, Fort Worth, Texas
Masters of the Camera, American Federation of Arts travelling exhibition
1977 *Contemporary American Photographic Works*, Museum of Fine Arts, Houston (travelled to the Museum of Contemporary Art, Chicago; La Jolla Museum of Contemporary Art, California; and Newport Harbor Art Museum, Newport Beach, California)
The Great West: Real/Ideal, University of Colorado, Boulder (subsequently Smithsonian Institution travelling exhibition: toured the United States)
4 American Photographers, Whitney Museum, New York
1978 *Mirrors and Windows: American Photography since 1960*, Museum of Modern Art, New York (toured the United States, 1978-80)
1981 *Southern Eye, Southern Mind*, Memphis Academy of Art, Tennessee

Collections:

Museum of Modern Art, New York; Seagrams Foundation, New York; International Museum of Photography, George Eastman House, Rochester, New York; Museum of Fine Arts, Boston; Carpenter Center, Harvard University, Cambridge, Massachusetts; Princeton University Art Museum, New Jersey; Museum of Fine Arts, Houston; Rice University, Houston; San Antonio Museum, Texas; Dallas Museum of Fine Arts.

Publications:

By WINNINGHAM: books—*Friday Night in the Coliseum*, Houston 1977; *Going Texan: The Days of the Houston Livestock Show and Rodeo*, with text by William C. Martin, Houston 1972; *A Texas Dozen: 15 Photographs by Geoff Winningham*, portfolio, with an introduction by Robert Adams, Houston 1976; *Houston Ballet*, with others, Houston 1977, 1978; *Rites of Fall*, with text by Al Reinert, Austin, Texas 1979; films—*Friday Night in the Coliseum*, 1972; *The Pleasures of This Stately Dome*, 1975.

On WINNINGHAM: *Vision and Expression* by Nathan Lyons, New York 1969; *Geoff Winningham: Photographs*, exhibition catalogue, with an interview by E.A. Carmean Jr., Houston 1974; *Contemporary American Photographic Works*, edited by Lewis Baltz, Houston 1977; *The Great West: Real/Ideal*, edited by Sandy Hume and others, Boulder, Colorado 1977; *Faces: A History of the Portrait in Photography*, edited by Ben Maddow, New York

1977; *Mirrors and Windows: American Photography since 1960* by John Szarkowski, New York 1978; *Light Readings: A Photography Critic's Writings 1968-1978* by A.D. Coleman, New York 1979; *The Photograph Collector's Guide* by Lee D. Witkin and Barbara London, Boston and London 1979; article—"Deep in the Heart of Texas" in *Camera* (Lucerne), August 1977.

Geoff Winningham's photographs set before us the improbable customs, costumes, characters, and architecture of the state of Texas. In Winningham's images, Texas is a mixture of outsized myth and scarcely more credible reality. His Texans are exuberant, unrestrained; they are also poignant and sometimes heart-breaking. Winningham has a fine ironic eye for details of dress and nuances of situation, but his curiosity is too wide-ranging and systematic to settle for a superficial recording of isolated, extravagant gestures. It's his willingness to enter deeply and fully into Texas culture—to suspend his disbelief, and ours—that makes his photographs so valuable.

Winningham is perhaps best known for two books which examine the Texan predilection for hard-hitting sport. *Friday Night at the Coliseum* devotes equal attention to big-time wrestling and its fervent fans. *Rites of Fall* takes a vivid look inside the world of Texas high-school football.

The wrestling arena provides Winningham with the chance to observe the exaggerated tumult of the contest and the wildly uninhibited response of its audience. Although he shows us the broad, often ludicrous strokes with which the action is staged, Winningham still makes us share the exhilaration of the elaborately choreographed—but by no means predictable—antics in the ring. The photographs are set off by long statements from the wrestlers themselves, who become no longer one-dimensional heroes or villains but flesh-and-blood people with whom we begin to feel strong ties.

Winningham's photographs of Texas high-school football and the elaborate social ritual which has grown up around it provide the occasion for pictures crowded with incident and emotion. His use of electronic flash helps transfer the raw, unbridled energy of the young players to the photographs themselves. Caught in stylized postures of victory or defeat, the young men and women in these pictures unexpectedly convince us that their emotion is the genuine article. Winningham's photographs are as high-spirited and full of surprises as the game he portrays.

—Christopher Phillips

WINOGRAND, Garry.

American. Born in New York City in 1928. Studied painting at City College of New York, 1947-48; Columbia University, New York, 1948-51; studied photography, under Alexey Brodovitch, New School for Social Research, New York, 1951. Served in the United States Air Force, 1945-47. Married the dancer Adrienne Lubow in 1952 (divorced). Freelance photographer (initially a commercial photographer, working with the Pix agency, then Brackman Associates), New York and Los Angeles, since 1952. Teacher since 1969: taught at the School of the Art Institute of Chicago; Instructor of Photography, University of Texas at Austin, 1973. Recipient: Guggenheim Fellowship, 1964, 1969; New York Council on the Arts Award, 1971; National Endowment for the Arts grant, 1975. Agent: Light Gallery, New York. Address: c/o Light Gallery, 724 Fifth Avenue, New York, New York 10019, U.S.A.

Individual Exhibitions:

1960 Image Gallery, New York
1963 Museum of Modern Art, New York
1967 *New Documents*, Museum of Modern Art, New York (with Diane Arbus and Lee Friedlander; toured the United States, 1967-75)
1969 *The Animals*, Museum of Modern Art, New York
1975 Light Gallery, New York
1976 Light Gallery, New York
Cronin Gallery, Houston
1977 *Public Relations*, Museum of Modern Art, New York
1979 Orange Coast Gallery, Costa Mesa, California

Selected Group Exhibitions:

1955 *The Family of Man*, Museum of Modern Art, New York (and world tour)
1959 *Photographer's Choice*, Workshop Gallery, New York
1963 *Photography '63*, International Museum of Photography, George Eastman House, Rochester, New York
1966 *Contemporary Photography since 1950*, International Museum of Photography, George Eastman House, Rochester, New York
Towards a Social Landscape, International Museum of Photography, George Eastman House, Rochester, New York
1967 *Photography in the 20th Century*, National Gallery of Canada, Ottawa (toured Canada and the United States, 1967-73)
1968 *5 Photographers*, Sheldon Memorial Art Gallery, University of Nebraska, Lincoln
1979 *Fleeting Gestures: Dance Photographs*, International Museum of Photography, George Eastman House, Rochester, New York (travelled to The Photographers' Gallery, London)
Photographie als Kunst 1879-1979, Tiroler Landesmuseum Ferdinandeum, Innsbruck, Austria (travelled to Neue Galerie am Wolfgang Gurlitt Museum, Linz, Austria; Neue Galerie am Landesmuseum Joanneum, Graz, Austria; and Museum des 20. Jahrhunderts, Vienna)
1980 *Old and Modern Masters of Photography*, Victoria and Albert Museum, London (toured Britain)

Collections:

Museum of Modern Art, New York; International Museum of Photography, George Eastman House, Rochester, New York; Baltimore Museum of Art;

Garry Winogrand: *Hard Hat Rally*, New York, 1969

Library of Congress, Washington, D.C.; University of Michigan, Ann Arbor; Museum of Fine Arts, Houston; University of Nebraska, Lincoln; Center for Creative Photography, University of Arizona, Tucson; University of California at Los Angeles; National Gallery of Canada, Ottawa.

Publications:

By WINOGRAND: books—*The Animals*, with text by John Szarkowski, New York 1969; *A Photographer Looks at Evans*, exhibition catalogue, Austin, Texas 1974; *Women Are Beautiful*, with text by Helen Gary Bishop, New York 1975; *Public Relations*, with texts by Tod Papageorge and John Szarkowski, New York 1977; *Stock Photographs: Fort Worth Fat Stock Show and Rodeo*, with an introduction by Ron Tyler, Austin, Texas 1980; articles—"Monkeys Make the Problem More Difficult: A Collected Interview with Garry Winogrand" in *Image* (Rochester, New York), July 1972; "An Interview with Garry Winogrand," with Charles Hagen, in *Afterimage* (Rochester, New York), December 1977.

On WINOGRAND: books—*Photography in the 20th Century* by Nathan Lyons, New York 1967; *5 Photographers*, exhibition catalogue, Lincoln, Nebraska 1968; *New Photography USA*, exhibition catalogue, by John Szarkowski, Arturo Quintavalle and Massimo Mussini, Parma, Italy 1971; *Documentary Photography*, by The Time-Life editors, New York 1973; *New Images in Photography: Object and Illusion*, exhibition catalogue, Miami 1974; *The Magic Image* by Cecil Beaton and Gail Buckland, London and Boston 1975; *Peculiar to Photography*, exhibition catalogue, by Van Deren Coke, Albuquerque, New Mexico; *Aspects of American Photography, 1976*, exhibition catalogue, St. Louis 1976; *Concerning Photography*, exhibition catalogue, by Jonathan Bayer, Peter Turner, Ian Jeffrey and Ainslie Ellis, London 1977; *Photographs: Sheldon Memorial Art Gallery Collection, University of Nebraska*, with an introduction by Norman A. Geske, Lincoln, Nebraska 1977; *Mirrors and Windows: American Photography since 1960* by John Szarkowski, New York 1978; *Photographie als Kunst 1879-1979/Kunst als Photographie 1949-1979*, exhibition catalogue, 2 vols., by Peter Weiermair, Innsbruck, Austria 1979; *The Photograph Collector's Guide* by Lee D. Witkin and Barbara London, Boston and London 1979; *Old and Modern Masters of Photography*, exhibition catalogue, with an introduction by Mark Haworth-Booth, London 1980; articles—"Garry Winogrand" by Arthur Goldsmith in *Photography* (New York), October 1954; "Garry Winogrand" by Mary Orovan in *U.S. Camera* (New York), February 1966; "Photographs by Garry Winogrand" in *Creative Camera* (London), August 1969; "The Animal Kingdom: Myth and Reality" in *Print* (New York), March/April 1970; "Winogrand's Women" by Dan Meinwald in *Afterimage* (Rochester, New York), January 1976.

Born in New York City in 1928, Gary Winogrand is one of the post World War II photographers who metamorphosized classic 35-mm available-light photojournalism into a powerful instrument for expressing personal vision. A prolific and energetic worker, Winogrand has an approach to the medium that is direct, sometimes brutally so, and visceral. Although he avoids self-explanations, he has said that his purpose in photographing is to see what things look like when photographed. What he often achieves are anti-haikus, spontaneous but intensely concentrated images that reflect the angst and absurdities of contemporary urban life.

Winogrand began photographing in 1948, after graduating from high school and serving 18 months in the Army Air Force. With help from the G.I. Bill, he first began to study painting at the City College of New York, then transferred to Columbia where a school camera club offered darkroom facilities. Soon he was passionately involved in photography and abandoned painting.

In 1952 he became associated with Pix, a photographic agency in Manhattan, and one of a number of aspiring young photojournalists who worked exclusively with 35-mm cameras and only whatever light existed at the scene. In 1954 he left Pix for another agency, Brackman Associates, and his photographs and picture stories began to appear in a number of national magazines including *Collier's* and *Pageant*. Significant photographic influences on him during this period were the Alexey Brodovitch class and the publication of Robert Frank's *Americans*.

The market for photography changed towards the decade's end, as *Collier's* folded in 1957 with other picture-oriented magazines to follow, and Winogrand turned more and more to advertising work. Then, in 1960, his personal life and career underwent a crisis, triggered by the breakup of his marriage. Turning to his personal photography as a means of escape and psychological support, "I began to live within the photographic process," he said. Photographing in the streets of New York, he began to use a wide-angle lens and a freer concept of framing his images, sometimes deliberately tilting the camera to destroy the conventional rectangularity of the composition.

By 1964 he was beginning to master his new style. Photographing in New York zoos and the Coney Island Aquarium, he produced the images for his remarkable first book, *The Animals*, published in 1969. Seemingly casual as snapshots, the photographs precisely frame and capture telling moments, creating a gallery of the grotesque, comic and disturbing, in which the accustomed relationship between human and animal, the uncaged and the caged, is shattered.

Continuing to forge his reputation as a street photographer par excellence, Winogrand received a Guggenheim Fellowship in 1964, and began to teach photography in 1969, finally deciding to give up his commercial work. A second Guggenheim enabled him to complete the photographs for *Public Relations*, ostensibly a visual study of the "effect of the media on events" but more importantly a further development of his personal style and vision. The book's publication, along with a major exhibition at the Museum of Modern Art in 1977, firmly established Winogrand's reputation in the by now rapidly growing photography establishment of museums, critics, galleries, and collectors.

Moving West, Winogrand spent a year as teacher-in-residence at the photography department of the Art Institute of Chicago, then made Los Angeles his home base while he continued to travel extensively, photographing and becoming a leading figure of the photographic lecture/workshop circuit. His energy, tough-minded unpretentiousness about his own photography and that of others, and the originality of his talent attracted many students. Always a prolific worker (with by now an accumulated store of thousands of unprinted negatives) he published *Women Are Beautiful* (a macho look at contemporary sex mores which brought down the wrath of some women's libbers) and *Stock Photographs*, a characteristically Winograndian look at the American institution of the rodeo.

His photographs began to sell well to collectors, and to his own suprise he found he could make a satisfactory living from this source alone. At the moment he is planning to return to New York and has purchased large-format view camera equipment, restless to discover how differently the world may look to him when photographed by such a distinctively different tool than the 35-mm camera he has used all his life.

—Arthur Goldsmith

WINQUIST, Rolf.

Swedish. Born in Gothenburg, 3 October 1910. Studied photography, under David Sorbon, at the Slöjdföreningens Skola, Gothenburg. Married Raina Winquist. Assistant, Åke Lange Studio, Stockholm, 1939; Chief Photographer, Ateljé Uggla, Stockholm, 1939 until his death, 1968. Recipient: Annual Photo Prize, *Svenska Dagbladet*, Stockholm, 1950. Fellow, Royal Photographic Society, London, 1947. Member, London Salon of Photography, Cercle Royal d'Etudes Photographiques et Scientifiques, Paris, and Gesellschaft Deutsche Lichtbildner. *Died* (in Stockholm) *18 September 1968.*

Individual Exhibitions:

1942 *Ateljé Uggla*, Expohallen, Stockholm
1970 *Rolf Winquist*, Liljevalchs Konsthall, Stockholm (retrospective)

Selected Group Exhibitions:

1944 *Fotografi*, Nationalmuseum, Stockholm
1949 *Stockholms Kameraklubb*, De Unga, Stockholm
1954 *Fotografi*, Nationalmuseum, Stockholm
1955 *Fotografi '55*, Göteborgs Konsthall, Gothenburg, Sweden
1958 *Fotokonst 1958*, Lunds Konsthall, Lund, Sweden
1960 *Två Generationer*, Göteborgs Konsthall, Gothenburg, Sweden
1962 *Svenskarna Sedda av 11 Fotografer*, Moderna Museet, Stockholm
1963 *Grosse Photographen dieses Jahrhunderts*, at *Photokina '63*, Cologne

Collections:

Moderna Museet, Stockholm; Royal Photographic Society, London; Bibliothèque Nationale, Paris; Museum of Modern Art, New York; Library of Congress, Washington, D.C.

Publications:

By WINQUIST: articles—"Modern Svensk Fotokonst" in *Svensk Fotografisk Tidskrift* (Stockholm), December 1944; "Bildmässig fotografi" in *Svensk Fotografisk Tidskrift* (Stockholm), January 1947; "Photogramme" in *Camera* (Lucerne), March 1953; "Photograms" in *Photography* (London), January 1957; "Engelska bilder" in *Nordisk Tidskrift för Fotografi* (Gothenburg, Sweden), November 1959.

On WINQUIST: books—*Svenskarna sedda av 11 fotografer*, exhibition catalogue, by K. G. Pontus Hulten and Stig Claeson, Stockholm 1962; *Geschichte der Fotografie im 20. Jahrhundert/Photography in the 20th Century* by Petr Tausk, Cologne 1977, London 1980; *Fotografie 1919-1979, Made in Germany: Die GDL-Fotografen*, edited by Fritz Kempe, Bernd Lohse and others, Frankfurt 1979; articles—"Rolf Winquist, Meister des Nordens" by Evald Karlsten in *Foto-Prisma* (Dusseldorf), no. 6, 1958; "Women by Winquist" in *Photography Annual*, New York 1961; "Rolf Winquist" by Jan-Olle Lindell in *Populär Fotografi* (Helsingborg, Sweden), November 1963; "25 Års Artisteri" by Ulf Hård af Segerstad in *Foto* (Stockholm), no. 11, 1963; "Winquist" by Kurt Bergengren in *Aftonbladet* (Stockholm), 21 September 1968; "Rolf Winquist in Memoriam" by Ulf Hård af Segerstad in *Svensk Dagbladet* (Stockholm), 24 September 1968; "Rolf Winquist—en av fotokonstens sista Stormästare" by Rune Hassner in *Populär Fotografi* (Helsingborg, Sweden), September 1969; "Rolf Winquist" in *Popular Photography Italiana* (Milan), July/August 1970; film—*Ansikten och fragment av blommor* by Rune Hassner, 1970.

Rolf Winquist: *Dream Nude,* 1946

and self-absorption.

One could say that an epoch in Swedish photography finished with Winquist at this time, and another began. In both he took a leading role.

The studio photographs were only a part of Winquist's extensive production. During weekends and annual holidays, released from customer's demands and from pressing work schedules, he worked intensively with his Leica as an ordinary "amateur photographer." From trips to Copenhagen, the island of Bornholm, London and the English Channel coast, he brought back carefully selected "slices of life," instant shots of people and places. During the 1960's he made a series of lively portraits of children, distinguished by a keen feeling for the individual and the personal. At the same time, he created an entire series of close-up studies of plant segments, which he described as "transferring the pattern of nature to graphic design." Here he used the Sabattier effect, and sometimes the final print was obtained after 8-10 successive stages of printing with paper negatives and positives.

After 1966 Winquist worked increasingly on colour studies of plants and flowers, rocks and the sea. In the summer of 1968, during the last months of his life, he created a compact series of still-lifes—close-ups of the flowers in his garden. The matter-of-fact realism and the sharp colours in these pictures are, despite the difference in subject matter, reminiscent of the last photo sequences made by another famous European studio photographer—Madame d'Ora's striking documentary studies of Parisian abattoirs. Though taciturn and withdrawn, Winquist had a rare talent for teaching. Over the years he became a mentor for, and shared his knowledge with, a number of young assistants. They are today active as prominent professionals in different fields of photography in Sweden.

The many-sided camera artist Winquist left an impressive body of work: about 700 prints are today in the collection of the Museum of Photography in Stockholm.

—Rune Hassner

After having completed his education as a photographer and having spent some years roaming the oceans as a cruise photographer, Rolf Winquist was engaged in 1939 as Chief Photographer at the newly established Ateljé Uggla in Stockholm. He worked there until his death in 1968, and during those three decades he made portraits of the famous of his day as well as of ordinary Swedes. Under Winquist's artistic direction, Uggla soon became one of the foremost studios in Sweden. His ability to capture expressions and moods, and his outstanding technical mastery, transformed routine studio photos into works of remarkably high quality. He also spent periods of intensive work in fashion and advertising photography, and made a name for himself as one of he country's leading photographers in those fields is well.

Winquist's early portraits of men were clearly influenced by the prominent English portrait photographers and also by German photographers, for instance Perscheid and Erfurth. His many sensual studies of women were, however, closer to the "vanity fair" of American fashion journals and glamorous Hollywood star portraits.

Winquist mastered to perfection various complicated printing techniques that were popular during the period of "art photography" at the turn of the century. He explored the possibilities of carbon printing and the Person method, and he experimented with his own variations. During the 1940's he worked mostly with Rodenstock Imagon lenses, which, combined with his masterful lighting technique and his meticulous darkroom work, yielded results that bore an unmistakably personal stamp.

During the Second World War and the following decade, Winquist became known all over the world. His pictures were shown in all the important international salons and exhibitions and shown in a variety of photographic annuals. He came high on the list in Frank Fraprie's *Who's Who in Pictorial Photography* and was elected to a number of exclusive photographers' associations abroad, including the London Salon of Photography.

During the 1950's, however, Winquist abandoned the sober salon pictorialism that had made him famous. He ceased exhibiting annually at the London Salon and attempted a more journalistic realism. For his studio work a Leica now increasingly replaced the heavy 5 x 7 camera. His portraits of men from this period are brutally lit, minutely distinct and un-retouched; they remind one of Fritz Kempe's "Hamburg Suite." His earlier dreamy studies of women were replaced by a series of cooler observations, which sometimes openly reflect vanity

WISE, Kelly.

American. Born in New Castle, Indiana, 1 December 1932. Educated at New Castle High School, 1948-51; Purdue University, West Lafayette, Indiana, 1951-55, B.S. in creative writing 1955; Columbia University, New York, 1957-59, M.A. in contemporary literature 1959. Served in the United States Navy, in the South Pacific, 1955-57: Lieutenant Junior Grade. Married Sybil Zulalian in 1959; children: Jocelyn, Adam and Lydia. Photographer since 1968. Instructor of English and Cinematography, Mount Hermon School, Massachusetts, 1960-66. Instructor of English and Chairman of the English Department, Phillips Academy, Andover, Massachusetts, since 1966. Agents: Vision Gallery, 216 Newbury Street, Boston, Massachusetts 02116; and Witkin Gallery, 41 East 57th Street, New York, New York 10022. Address: 22 School Street, Andover, Massachusetts 01810, U.S.A.

Individual Exhibitions:

1973 Hewitt Gallery, University of New Hampshire, Durham
1974 Southern Illinois University, Carbondale
Washington Gallery of Photography, Washington, D.C.

WISE

Portland Museum of Art, Maine
1975 Silver Image Gallery, Ohio State University, Columbus
Addison Gallery, Andover, Massachusetts
1977 Shado Gallery, Eugene, Oregon
Canon Photo Gallery, Amsterdam
1978 Andover Gallery of Art, Massachusetts
University of Massachusetts, Amherst
1979 University of Dayton, Ohio
Portland School of Art, Maine
Neikrug Gallery, New York
1980 Sheldon Memorial Art Gallery, University of Nebraska, Lincoln
Yuen Lui Gallery, Seattle
Middle Tennessee State University, Murfreesboro
1981 Jeb Gallery, Providence, Rhode Island
Rose Art Museum, Brandeis University, Waltham, Massachusetts
Blixt Gallery, Ann Arbor, Michigan

Selected Group Exhibitions:

1972 *Points of View*, Institute of Contemporary Art, Boston
Octave of Prayer, Hayden Gallery, Massachusetts Institute of Technology, Cambridge
1974 *Private Realities*, Museum of Fine Arts, Boston
1977 *Warm Truths and Cool Deceits*, Sidney Janus Gallery, New York (toured the United States)

Collections:

International Museum of Photography, George Eastman House, Rochester, New York; Yale University, New Haven, Connecticut; Museum of Fine Arts, Boston; Polaroid Corporation, Cambridge, Massachusetts; Fogg Art Museum, Harvard University, Cambridge, Massachusetts; Addison Gallery of American Art, Andover, Massachusetts; Library of Congress, Washington, D.C.; Sheldon Memorial Art Gallery, University of Nebraska, Lincoln; Museum of Fine Arts, Houston; Bibliothèque Nationale, Paris.

Publications:

By WISE: books—*The Photographers' Choice*, editor, Danbury, New Hampshire 1975; *Still Points*, with a foreword by Duane Michals, Danbury, New Hampshire 1977; *Lotte Jacobi*, editor, Danbury, New Hampshire 1979; *Midwest Photo '80*, exhibition catalogue, Elkhart, Indiana 1980; *Appraisals*, editor, Danbury, New Hampshire 1981; *Portrait: Theory*, editor, New York 1981; articles—"The Addison Gallery and Photography" in *Views* (Boston), Fall 1979; "Frederick Sommer" in *Creative Arts* (New York), no. 2, 1980; "Nude: Theory" in *Print Collector's Newsletter* (New York), March 1980; "A Ten Year Salute" in *Camera* (Lucerne), Summer 1980; "Diana and Nikon" and "Steve Grohe: An Interview" in *Views* (Boston), Summer 1980; "Carl Zohn: An Interview" in *Views* (Boston), Fall 1980; "Manuel Alvarez Bravo and Alen MacWeeney" in *Art New England* (Boston), October 1980; "Sand Creatures" in *Views* (Boston), Winter 1980; "1980: A Vintage Year for Photography Books" in *Art New England* (Boston), December 1980; "Nick Nixon" in *Artforum* (New York), April 1981.

On WISE: books—*Private Realities*, edited by Clifford S. Ackley, New York 1974; *Photography and Fascination* by Max Kozloff, Danburg, New Hampshire 1979; articles—"Points of View" by Michael Bry in *Popular Photography* (New York), February 1972; "Private Realities" by Deac Rossell in the

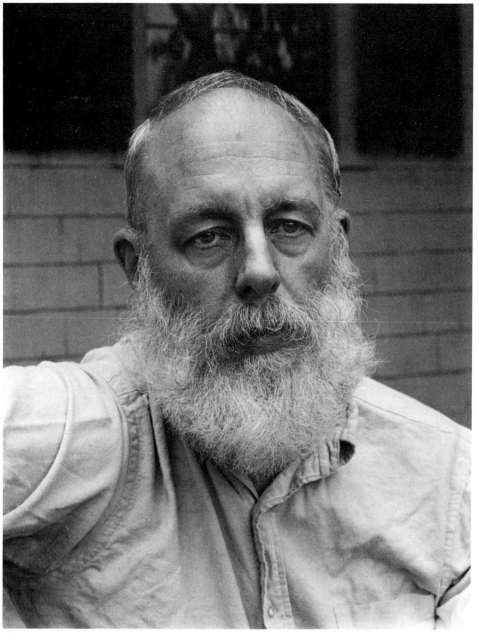

Kelly Wise: *Edward Gorey*, 1980

Boston Sunday Globe, 31 March 1974; "Eye Is a Camera" by Douglas Davis in *Newsweek* (New York), 29 April 1974; "Private Realities" by Vladimir Gulevich in *Popular Photography* (New York), August 1974; "The Photographers' Choice" by Michael Edelson in *35mm Annual*, New York 1977; "Introductions to New Artists" by Alfred Frankenstein in the *San Francisco Chronicle*, 14 July 1977; "Kelly Wise" by Nancy Dickinson in *Art New England* (Boston), February 1981.

Photography came late to me, at 36. I am thankful, deeply so, that the muse came at all. With harlequin eyes, she lured me into interior spaces, places I had visited, if at all, with only the safety and distance of the intellect.

Perhaps because I love books and am an English teacher, there is a recurrent literary integer in my work. The funny, the absurd, the terrifying, the sensuous, the tender—all merge. My early work was in black and white, private metaphoric imagery of my family and friends. In 1976 I got into color by using the SX-70 camera. Objects and peopleless spaces—in large and small format color—have become a fascination. Lately, I have been making

black and white and color portraits of artists, writers of all types, editors, and publishers.

—Kelly Wise

Out of the first century of photographic development, with its contests between classic and romantic, emotion and objectivity, pictorialism and science, has come an international practice which includes them all. Not only is it possible to find distinguised exponents of all the possibilities of photographic vision; it is also frequently possible to find a significant degree of variation within the work of individual artists and, even more interestingly, within the compass of a single print. It is certainly a characterizing mark of this moment in photographic history that a significant number of photographers can and do work with notable fluency in what might well be described as a repertory of styles.

Kelly Wise is one of these multilingual artists. He was first known as a "straight" photographer, catching his subjects in normal contexts but with the second sight enhancements of light and space seen subjectively. Objects seen through a window seem to share the space of other objects in the foreground. A wall and a closed door are invaded and made animate by a floating oval of light emanating from an

820

Witkacy: *Self-Portrait*, c. 1912

unseen source. In such imagery, to seem is to be. Cognitive magic has taken place, and the observer has, firmly in his optical grasp, an enlargement of his visual experience, creativity shared with the artist. Subsequently, or perhaps independently, Wise became involved, along with many others among his contemporaries, with the exploration of color, not the color of verisimilitude but color peculiar to the widening range of films and processes. With this involvement his subjects become more exclusive, single objects seen against the simplest of backgrounds, fragments or details of forms, seen without an informational context, the abstracted minutiae of experience. Again, however, the transmitted intelligences that form in and of themselves are rich with implication and act as sensors for an enormous range of experience.

Wise has most recently undertaken that most demanding of photographic problems, the portrait, in a series devoted to living artists and literati. The precedents are formidable: Abbott, Stieglitz, Freund, Avedon and, even more so, the non-celebrity portraits of Sander and Arbus. Again, however, Wise's distinctive point of view established the integrity of his likenesses. Characteristically, they are not "up tight" in their projection of either personality or celebrity. The familiarity of the photographer with his subject is visible in the easy, relaxed naturalism of the image. It is portraiture taken, as it were, from inside the relationship, without pretense and as natural as a look exchanged.

—Norman A. Geske

WITKACY (Stanislaw Ignacy Witkiewicz).
Polish. Born in Warsaw, 24 February 1885. Educated at home by his father, a painter and art critic; studied at the Academy of Fine Arts, Cracow, 1904-1910. Served in the Russian Army, at St. Petersburg, 1914-18. Married Jadwiga Unrug in 1923. Worked as an independent writer, painter and photographer, from c.1900 until his death, 1939: established portrait studio, Zakopane, Poland, 1925-39. Stage Manager, Teatr Formistyczyn, Zakopane, 1925; Art Director, Teatr Niezalczny, Zakopane, 1937-39. *Died* (in Jeziory) *18 September 1939*.

Individual Exhibitions:

1974 Museum Folkwang, Essen
1979 Museum of Fine Arts, Lodz, Poland
 Museum Narodowe, Wroclaw, Poland
 Galeria Krytykow, Warsaw
1980 Museum of Fine Arts, Lodz, Poland
 Museum Narodowe, Cracow, Poland

Selected Group Exhibitions:

1979 *L'Avanguardia Polacca 1918-1978*, Rome
 Fotografia Polska 1839-1979, International Center of Photography, New York (travelled to the Museum of Contemporary Art, Chicago; Galeria Zacheta, Warsaw; Museum of Fine Arts, Lodz, Poland; and the Whitechapel Art Gallery, London)
1981 *Photographie Polonaise 1900-1981*, Centre Georges Pompidou, Paris

Collections:

Ewa Franczak and Stefen Okolowicz Collection, Warsaw; Tatras Museum, Zakopane, Poland; Museum of Fine Arts, Lodz, Poland.

Publications:

By WITKACY: books—*Nowe Formy w Malarstwie i Wunikajace Stad Nieporozumienie*, Warsaw 1919; *Szkice Estetyczne*, Cracow 1922; *Pojecia i Twierdzenia*, Warsaw 1935; also, more than 30 plays for the theatre and numerous novels; articles—regular columns on art criticism in *Przeglad Wieczorny* (Warsaw), 1925-30.

On WITKACY: books—*Studia o Stanislawie Witkiewicz*, Wroclaw, Poland 1972; *Stanislaw Ignacy Witkiewicz*, exhibition catalogue, Essen 1974; *Stanislaw Ignacy Witkiewicz, Bez Kompromisu* by Janusz Degler, Warsaw 1976; *Stanislaw Ignacy Witkiewicz, Pojecia i Twierdzenia* by Bohdan Michalski, Warsaw 1977; articles—"Witkacy Zwierciadle Fotografii" by Urszula Czartoryska in *Fotografia* (Warsaw), no. 5, 1972; "Stanislaw Ignacy Witkiewicz: La Conscienza dell'Immagine, Immagine della Conscienza" by Grzegorz Musial in *L'Avanguardia Polacca 1918-1978*, exhibition catalogue, Rome 1979; "Stanislaw Ignacy Witkiewicz" by Grzegorz Musial in *Fotografia* (Warsaw), no. 3, 1979. "O Fotografiach Witkacego" by Urszula Czartoryska in *Odra* (Wroclaw), no. 3, 1980; "Tworczosc Fotograficzna Stanislaw Ignacy Witkacego" by Grzegorz Musial in *Stanislaw Ignacy Witkiewicz*, exhibition catalogue, Lodz 1980.

Stanislaw Ignacy Witkiewicz—Witkacy—a well-known writer, philosopher, painter, and playwright of the European avant garde theatre, also made a serious contribution to photography.

Witkacy developed an early passion for photography during childhood, when, encouraged by his father, he started to photograph the Tatra mountain landscape. These photographs, which were taken as

souvenirs during mountain walks and were later used as the basis for paintings, reveal a deep sense of aesthetic sensitivity, a feeling for composition and form, and an understanding of the documentary character of photography (all his negatives were carefully described, with subject, aperture, exposure time, etc.) His interest in documentary photography is also obvious in a subsequent passion, a series of photographs of railway locomotives taken around the year 1900. Later, in the maturity of his creative life, he discarded these earlier, perhaps inferior, uses of photography and thereafter devoted himself entirely to the study of portraiture. In fact, the portrait and portraiture—as an investigation of human nature—were constant themes of Witkacy's art whatever the medium used.

This way of expressing and communicating his thoughts, of defining reality, of studying people, particularly himself, was closest to his heart; it was almost innate. He never paid much attention to photography as such. "To my mind," he wrote, "making a good, psychologically natural portrait, and devoting oneself to photography, is not a crime, just so long as one does not make oneself believe and persuade the general public that this is the highest art, art with a capital A...." Yet, despite that point of view, he brought many innovations to photography.

From 1905 Witkacy took photographs that obviously gave him a great deal of pleasure—photographs of his father, his girlfriends, and the artistic Bohemians of Zakopane. At first, these photographs were beautiful, classically composed portraits, then only half-lit faces, eventually fragments of faces, lips, eyes, nose, eyebrows—nothing more. Witkacy created these photographs with the help of a specially adapted camera, the lens of which was elongated by a section of rainwater pipe. Within this narrow area of view, and with this complete concentration on the essentials of human expression—a smile, the expression of an eye—Witkacy attempted to capture what was most important to man, the truth of his inner being.

Later, in the 1920's and 30's Witkacy abandoned this kind of photography. The watershed seems to have been his "Quintuple Auto Portrait," made in Russia in the years 1915-17. With this photograph Witkacy moved to period of creating repetitions, different photos and presentations of the same theme. The subject of these photographs, his main theme and model, was Witkacy himself. The "decomposition" of that subject, its various personifications and mystifications, became his main interest. It is symptomatic that Witkacy was not actually the author of these photographs (the author was his friend Josef Glogowski); Witkacy arranged and directed them. In these photographs we see Witkacy as a priest, as an artist, as a humorous wag, then in a thoughtful mood; then he appears as a prisoner, as a member of High Society, as a judge, etc. The same Witkacy but always different—because of situation or because of dress but, mainly, because of facial expression.

What is important in all of this clownery is the question of "essential existence," the essential of each personality. "Only the camera," Witkacy wrote, "gives a picture that is able to unearth from the depth of our subconscious the need to replace a subject with something more than just a mere copy—with a new object, free from time's limitations and conditions."

In these numerous character studies of the original and its transformation in deformations, dissociations and caricatures, Witkacy not only experienced his own identity—or, rather, his own identities as they appeared to him—but he also challenged the belief in the objectivity of photography: each of his images was true, but each was also false. In effect, Witkacy announced the *analytic* function of photography. It is remarkable that he could so well translate theory into a visual language, a language of form, shadows and lines.

—Ryszard Bobrowski

WOLS.

German. Born Alfred Otto Wolfgang Schulze, in Berlin, 27 May 1913; adopted pseudonym "Wols," Paris, 1937. Studied violin, under Jan Dahrnen, Stadtsoper, Dresden, 1920-22; educated at Gymnasium, Dresden, 1922-30; studied ethnology, Afrika-Institut, Frankfurt, 1932; studied briefly at Mies van der Rohe's (Bauhaus) Institute, Berlin, 1932; mainly self-taught in photography. Married Gréty Baron in 1940. Assistant in photo studio of Genga Jonas, Dresden, 1931; worked in a Mercedes auto repair shop, Dresden, 1931; portrait photographer and painter, Paris, 1933, in Barcelona, 1933, in Majorca, 1934-35, in Ibiza, 1933-34; independent photographer, Paris, 1936-39; Official Photographer, *Pavillon d' Elégance*, at the *Exposition Internationale*, Paris, 1937; abandoned photography on outbreak of World War II, Paris, 1939; interned as enemy alien in concentration camps, Montargis, Neuilly, Nimes and Aix, France, 1939-40; worked mainly as illustrator and painter, in Cassis, and Dieulefit, France, 1940-45, in Paris, 1945-48, and in Champigny-sur-Marne, France, 1948-51. *Died* (in Champigny-sur-Marne), *1 September 1951.*

Individual Exhibitions:

1936	Librairie des Pléïades, Paris
1937	"A Small Gallery," Paris
1942	Betty Parsons Gallery, New York
1945	Galerie René Drouin, Paris
1947	Galerie René Drouin, Paris
1949	Galleria del Milione, Milan
	Galerie des Pas Perdus, Paris
1951	Iolas-Hugo Gallery, New York
1952	Galerie Nina Dausset, Paris
	Iolas-Hugo Gallery, New York
1954	Gutekunst and Klipstein, Berne
1955	Galerie Edouard Loeb, Paris
	Galerie der Spiegel, Cologne
	Galerie Folklore, Lyons (with Artaud and Picq)
1956	Galerie Morbach, Berne (with Fautrier)
	Kunstkabinett Otto Stang, Munich
	Kunstverein, Mannheim
1957	Galerie Daniel Cordier, Paris
	Institute of Contemporary Arts, London
	Galerie Springer, West Berlin
	Galerie Sandner, Hamburg
	Studio Franco Garelli, Turin
1958	Galerie Nächst St. Stephan, Vienna
	Galerie Claude Bernard, Paris
1959	Galerie Europe, Brussels
	Borgenicht Gallery, New York
	Hanover Gallery, London
	Galerie Schmela, Dusseldorf
	Galerie Charles Lienhard, Zurich
	Galerie Europe, Paris
1960	Svensk-Franska Konstgalleriet, Stockholm
	Galleria Blu, Milan
	Gimpel Fils, London
1961	Städtische Kunstgalerie, Bochum, West Germany (travelled to Karlsruhe and Wiesbaden)
	Kunstverein, Freiburg, West Germany
	Wols: Peintures et Gouaches 1932-1942, Galerie Europe, Paris
	Galerie Bornier, Lausanne, Switzerland
	Libreria Einaudi, Rome
1962	Galerie Daniel Cordier, Paris (travelled to Michael Warren Gallery, New York)
	Galerie Schmela, Dusseldorf
	Galerie Raymond Cazeneuve, Paris
	Galerie Saggarah, Gstaad, Switzerland
	Galerie Gunther Franke, Munich
	Galerie Dorothea Loehr, Frankfurt (with Camille Bryen)
1963	Galerie Michel Couturier, Paris
	Galerie Europe, Paris
1964	Galerie Cogeime, Brussels
	Salle Apollinee, La Fenice, Venice
	Galerie Michel Couturier, Paris
1965	Svensk-Franska Konstgalleriet, Stockholm
	Galerie Artek, Helsinki
	Galerie Alexandre Iolas, Paris
	Galerie Michel Couturier, Paris
	Kunstverein, Frankfurt
1966	Stedelijk Museum, Amsterdam
1972	Galerie Kornfeld, Zurich
1973	Nationalgalerie, West Berlin (travelled to Musée d'Art Moderne de la Ville, Paris)
1978	*Wols als Photograph*, Von der Heydt Museum, Wuppertal, West Germany (travelled to Krefelder Kunstverein, West Germany)
1979	Centre Georges Pompidou, Paris

Selected Group Exhibitions:

1937	*Expostion Internationale*, Paris
1947	*Salon des Réalités Nouvelles*, Paris
1951	*Vehemences Confrontées*, Galerie Nina Dausset, Paris
1958	*Biennale*, Venice
1959	*Documenta 2*, Museum Fridericianum, Kassel, West Germany
1965	*From Toulouse-Latrec to Wols*, Kunstverein, Tübingen, West Germany
1977	*Künstlerphotographien im XX. Jahrhundert*, Kestner-Gesellschaft, Hannover
	Paris-New York, Centre Georges Pompidou, Paris
1978	*Das Experimentelle Photo in Deutschland 1918-1940*, Galleria del Levante, Munich
1979	*Photographic Surrealislm*, New Gallery of Contemporary Art, Cleveland, Ohio (travelled to Dayton Art Institute, Ohio; and the Brooklyn Museum, New York)

Collections:

Kestner-Gesellschaft, Hannover; Kunsthalle, Hamburg; Wallraf-Richartz Museum, Cologne; Landesmuseum für Kunst und Kulturgeschichte, Munster, West Germany; Saarland Museum, Saarbrücken, West Germany; Staatliche Kunstsammlungen, Kassel, West Germany; Staatsgalerie, Munich; Bayerische Staatgemälde, Munich; Kunsthaus, Zurich; Musée National d'Art Moderne, Paris.

Publications:

By WOLS: books—*Wols, Saggio Introduttorivo*, edited by Gillo Dorfles, Milan 1958; *Wols en Personne: Aquarelles et Dessins*, with texts by Werner Haftmann, Jean-Paul Sartre and Henri-Pierre Roche, Paris and Cologne 1963, as *Wols: Aphorisms and Pictures*, Gillingham, Kent 1971; *Wols: Photographien*, with text by Laszlo Glozer, Munich 1979.

On WOLS: books—*Wols*, exhibition catalogue, with text by Camille Bryen and others, Paris 1945; *Wols: Peintures et Gouaches 1932-1942*, exhibition catalogue, with text by Werner Haftmann, Paris 1961. *Schri, Kunst Schri, Ein Almanach Älter und Neuer Kunst* by Heinz Troekes and others, Hannover 1977; *Paris-New York*, exhibition catalogue, by D. Abadie, A Pacquement, H. Seckel and others, Paris 1977; *Circus Wols: The Life and Work of Wolfgang Schulze*, edited by Peter Inch, with articles by Inch and others, Lancaster, England 1977; *Das Experiementelle Photo in Deutschland 1918-1940* by Emilio Bertonati, Munich 1978; *Wols als Photograph*, exhibition catalogue, with text by Kah Jagals, Wupptertal, West Germany 1978; *Photographic Surrealism*, exhibition catalogue, by Nancy Hall-Duncan, Cleveland, Ohio 1979; articles—"Wols" by Pierre Restany in *Cimaise* (Paris), October/November 1958; "Souvenirs de Wols" by Marcel Lecomte, and "Das Graphische Werk von Wols" by Will Grohmann in *Quadrum* (Brussels), 1959; "Wols à Batons Rompus" by Ione Robinson in

L'Oeil (Paris), December 1959; "Wols" by Michel Ragon in Jardin des Arts (Paris), May 1963; "The Destruction of Wols" by Peter Inch in Art and Artists (London), December 1971; "Vingt Ans Après: Restany Revoit Wols" in Domus (Milan), April 1974; "Wols" by Werner Haftmann in Art Press (Paris), December 1974/January 1975.

Wols grew up in Dresden, the son of a prominent Saxony jurist. As a result of family trips, he very early developed an interest in botany and geography which had a permanent influence on his work. He was also a precocious musician: he had mastered the violin and had been offered the first chair in a symphony orchestra before he was out of school. But he did not pursue music as a career; he could not tolerate the regimen necessary for success. Perhaps it was the strict, formal life style of his cultured bourgeois family which—while it had the advantage of providing him with opportunities for learning about the arts—accounted for his reaction against the "formal" in life and for his attraction to the simple and spontaneous, to his own eventual bohemian life style.

Wols left school in 1930. He worked first at the photographic studio of Genga Jonas, where Hugo Erfurt saw his photographic work and thought it showed great promise. Thereafter, Wols worked as a mechanic in a Mercedes repair garage, then studied "primitive" cultures at the Afrika-Institut of Leo Frobenius in Frankfurt. Largely as a result of his interest in photography, Wols spent a brief period in 1932 at the Bauhaus in Berlin where he met—and was encouraged by—Moholy-Nagy. His photographs during this period were largely experimental. The Bauhaus influence is evident in some of his images, but, for the most part, he created montages or experimented with the effects of light on negative—i.e., photograms which are reminiscent of the work done by Moholy-Nagy, Man Ray or Schad.

In 1933, encouraged by Moholy, Wols went to Paris not only as a reaction against the Nazi regime, but also as a reaction against his own rigid environment. There he met Léger and Giacometti, was profundly influenced by the Dadaists and Surrealists, and became friends with J.-P. Sartre and Simone de Beauvoir.

A refugee from Germany for refusing military service, he travelled to Barcelona, Majorca and finally to Ibiza in the Mediterranean. He continued to develop as a photographer working as a portraitist to support himself. The fertile atmosphere of Ibiza had a distinct effect on his artistic personality and work, bringing out an emphasis in his fascination with nature. He began also at this time to paint; he worked mainly in watercolor and created "dream landscapes" which show the influence of Parisian surrealism. Although he continued to photograph, painting rapidly became his primary artistic outlet.

In 1937, however, Wols again turned seriously to photography and became the official photographer for the Pavillon d'Elégance at the Paris World's Fair, where his photographs were well received. Wols never considered himself a photographer, however; photography was merely one of his many interests and served in his overall development as an artist. As Peter Inch points out, his photographs during this period appear to be anticipations of his later painting: "They have a similar organic-tragic quality. Here are forms such as a flayed rabbit, an open kidney, some lizards, onions and garlic suggestive of intestines. Various dislocated human subjects also appear, travestied mannequins, mutilated people, an old cripple waiting by an imposing gateway, a corpse amongst the rubble with its arms sticking out." This, his main and final period of photographic activity, lasted until 1939 when he was interned in various French prisons. Thereafter, until his death in 1951, Wols devoted himself primarily to painting.

Although he has never achieved much acclaim in Britain or America, Wols achieved great critical interest in the late 50's on the Continent where his work has been variously called art informel, lyrical abstraction or tachisme. His artistic predecessors were mostly literary—Novalis, Georg Büchner, Baudelaire, Poe, Rimbaud, etc. As Dore Ashton has pointed out, he was an existential artist, rejecting the formal French painting tradition of the 19th century—he was a peintre maudit as well as an ideologist, who, like the Surrelaists, strove to desanctify Art in order to make way for art. His fascination with nature had a great effect on his work, and his intense love of living things became an irresistable urge for unification, just as his work evolved from a narrative poetic vision into direct involvement with the cosmos, the ultimate search for le Tout. As Claire van Damme says, "His pictures are one thing and many things: images and liberations; reactions to the violence of their time; the goal of a person running away; answer to the whys and wherefores of existence; a surrender to the innate; the redeclaration of childhood's wilfulness; self-expression turning to autodestruction...."

Wols was non-objective in the truest sense, going beyond the Surrealists to the extent of using automatic writing in his paintings as a means to finding le Tout, of discovering the cosmic rhythm which pervades all life—that vast network of hidden relationships. Yet at the same time, as Roger Cardinal notes, his strategy "was not that his pictures should be stripped of all relevance with reality."

—Michael Held

WORTH, Don.

American. Born in Hayes Center, Nebraska, 2 June 1924. Educated at Chariton High School, Iowa; University of Arizona, Tucson, 1945-46; studied piano at the Juilliard School of Music, New York, 1946-47, and Manhattan School of Music, 1947-51, B.Mus. 1949, M.Mus. 1951; studied photography with Ansel Adams, San Francisco, 1956-60. Instructor in Music, Hartnett Studios, New York, 1947-52, and Manhattan School of Music, 1949-51; Engineering Surveyor, Southern Pacific Railroad, Tucson, 1952-56; Instructor in Music, Mills College, Oakland, California, 1955; Assistant to Ansel Adams, San Francisco, 1956-60. Professor of Art, San Francisco State University, since 1960. Recipient:

Don Worth: Tropical Leaves: Hoffmannia Refulgens, 1975

Guggenheim Fellowship, 1974; National Endowment for the Arts Photography Fellowship, 1979. Agents: Witkin Gallery, 41 East 57th Street, New York, New York 10019; Weston Gallery, 6th and Dolores, Carmel, California 93921; and G. Ray Hawkins Gallery, 9002 Melrose Avenue, Los Angeles, California 90069. Address: 38 Morning Sun Avenue, Mill Valley, California 94941, U.S.A.

Individual Exhibitions:

1957 International Museum of Photography, George Eastman House, Rochester, New York
 Nexus Gallery, Boston
1958 California Academy of Science, San Francisco
1959 San Francisco Museum of Art
1963 Carl Siembab Gallery, Boston
 Arizona State University, Tempe
1965 Washington State University, Pullman
1966 San Francisco State University
1967 Santa Barbara Museum of Art, California
 M.H. de Young Museum, San Francisco
 Pasadena Museum of Art, California
 University of California at Davis
1968 Lawson Galleries, San Francisco
1969 Phoenix College, Arizona
1970 Hancock College, Santa Maria, California
 Halsted 831 Gallery, Birmingham, Michigan
 Ohio State University, Columbus
1973 Strybing Arboretum, San Francisco
 San Francisco Museum of Art (retrospective)
 Addison Gallery, Andover, Massachusetts (retrospective)
 University of Nebraska, Lincoln (retrospective)
 Evergreen College, Olympia, Washington
1974 Witkin Gallery, New York (retrospective)
 Spectrum Gallery, Tucson, Arizona
1976 Camerawork Gallery, San Francisco
 Mills College Art Gallery, Oakland, California
 Falkirk Gallery, San Rafael, California
1977 Ohio State University, Columbus
 Plants, Friends of Photography, Carmel, California
1978 Focus Gallery, San Francisco
1979 Afterimage Gallery, Dallas
1980 Photography Southwest Gallery, Scottsdale, Arizona
 Blixt Gallery, Ann Arbor, Michigan
 Vision Gallery, Boston
 Photo Graphics Workshop, New Canaan, Connecticut
1981 Northern Arizona University, Flagstaff
 Photo Gallery International, Tokyo
1982 *Landscapes*, Douglas Elliott Gallery, San Francisco

Selected Group Exhibitions:

1959 *Photography at Mid-Century*, International Museum of Photography, George Eastman House, Rochester, New York (toured the United States)
1961 *7 Contemporary Photographers*, International Museum of Photography, George Eastman House, Rochester, New York
1962 *Photography U.S.A.*, De Cordova Museum, Lincoln, Massachusetts
1963 *Photography in the Fine Arts*, Metropolitan Museum of Art, New York (and 1967)
 Photography '63, International Museum of Photography, George Eastman House, Rochester, New York
1966 *American Photography: The 60's*, Sheldon Memorial Art Gallery, University of Nebraska, Lincoln
1968 *Light*[7], Massachusetts Institute of Technology, Cambridge
1970 *Be-Ing Without Clothes*, Massachusetts Institute of Technology, Cambridge (toured the United States)
1974 *Photography in America*, Whitney Museum, New York
1981 *American Photographers and the National Parks*, Corcoran Gallery, Washington, D.C. (toured the United States, 1981-83)

Collections:

Museum of Modern Art, New York; Guggenheim Foundation, New York; International Museum of Photography, George Eastman House, Rochester, New York; Addison Gallery, Phillips Academy, Andover, Massachusetts; Massachusetts Institute of Technology, Cambridge; Art Institute of Chicago; Center for Creative Photography, University of Arizona, Tucson; San Francisco Museum of Modern Art; Bibliothèque Nationale, Paris; National Gallery of Australia, Canberra.

Publications:

On WORTH: books—*Photography in the 20th Century* by Nathan Lyons, New York 1967; *Light*[7], edited by Minor White, Rochester, New York 1968; *California Photographers 1970*, exhibition catalogue, by Fred R. Parker, Davis, California 1970; *Don Worth: Photographs*, exhibition catalogue, San Francisco 1973; *Photography in America*, edited by Robert Doty, with an introduction by Minor White, New York and London 1974; *Don Worth: Plants*, exhibition catalogue, Carmel, California 1977; *A Ten Year Salute* by Lee D. Witkin, foreword by Carol Brown, Danbury, New Hampshire 1979; articles—"Don Worth" in *Aperture* (Rochester, New York), 9:3, 1961; "Gallery: Don Worth" in *Life* (New York), 7 May 1971.

A well-known younger photographer who once was speaking to a prestigious group of people was asked to make a statement regarding the purpose of his work. In reply he said, "I take photographs in order to see what something looks like when I take a photograph of it." His answer must have seemed shocking, in this situation where a "profound" reply was expected.

Photography is used for many obvious reasons, both superficial and "profound." We use the camera to preserve a moment, a place or an event; we use it to convey our feelings and our experiences to other people; it is used to stop the flow of time and thereby make ourselves seem god-like. We also use the camera to explore our psyche and the psyches of others; we many times use it to create an escape route to a never-never land. And some photographers use the camera to express deep affection for the subject (animate or inanimate). This affection may become so intense that we might even think of the camera as a unique instrument used for "making love."

But apart from all these reasons, most of which could provide inexhaustible material for psychological treatises, lies the simply trait of curiosity: what will this subject look like when it is reduced to black, white, shades of gray and also confined to a small, two-dimensional piece of paper?

But, finally, thinking of one more aspect, there are some of us who take photographs that may please the eye on an abstract level. Relating this idea to music, we should remember that a Beethoven piano sonata or a Bach fugue, which greatly intrigues the mind with its complex and mathematical ordering of melodies, harmonies, meters and rhythms, was written basically to appeal to the ear. Perhaps the ideal approach to photography implies involvement, to some degree, with all of these seemingly disparate reasons for using the camera.

—Don Worth

The direct vision and impeccable technique of Don Worth's photographs have led to his being associated with the "West Coast" tradition in photography, yet the variety of his photographic interests has always been much broader than the conservative stance that the west coast label has come to imply. He is motivated to make photographs that please the eye, but he is not restrained by a limiting concept of what might constitute that pleasure.

Initially trained as a musician, Worth spent 16 years studying music, performing and composing. In photography he found an expressive medium that provided a creative experience less transitory than that of music. The photographer's ability to have a lasting record of his creativity had appeal for him. Undoubtedly his association with Ansel Adams, also a musician, for whom he worked as an assistant during the late 1950's, helped him make the transition from one creative field to another.

Worth is perhaps best known for his extensive series of photographs of plants. These range from close-up studies of the structure of an individual plant to images of entire forested hillsides. It is an indication of Worth's broad interest in photography that these plant photographs were made using color as well as black-and-white material. He is deeply involved with plants as both a botanist and a gardener; this intensity and understanding of growing things are fully conveyed in his plant photographs.

Worth's photographs are unified through two formal characteristics. Most apparent is his attraction to soft, overall light. The majority of his exposures have been made on overcast or even fog-enshrouded days with no direct sunlight. Rather than reflecting light, the subjects of his photographs appear to be glowing, often a source of light itself. The second unifying aspect of his work is seen in his tendency to compose his subjects as a part of a larger whole. What is beyond the borders of the frame is almost always implied by the arrangement of objects within the image; the photograph is constructed as a part of a larger reality. This is particularly true in the plant photographs, where there is rarely a distinct center of interest. The eye is left free to search and discover the particular attribute of a plant or a group of plants.

The same characteristics are evident in Worth's other images. He has traveled throughout the world and has photographed many kinds of subjects in addition to plants. Over a number of years he has made a group of self-portraits, many of which portray him nude as a partially blurred form moving through an otherwise still environment. He has used other models in similar contexts, and has photographed buildings and other structures as well. In recent years both his plant photographs and his images made in urban areas have assumed an interest in the commonplace or mundane, expressed through a more environmental point of view that maintains the soft light and the feeling for objects beyond the edges of the frame, but places less importance on the specific objects depicted.

The motion found in his self-portraits reappears in a group of color photographs made during the late 1960's. In these, Worth made three successive exposures on color film using three different colored filters. Still objects are portrayed in their natural colors, while moving elements such as streams, clouds or waves take on an almost pointillist coloration.

From very early in his career Worth considered working in color to be a integral part of his photographic activities. Throughout the late 1950's and 1960's, and into the 1970's, he regularly made color prints as well as black-and-white, not viewing the two as separate activities as many photographers today have come to do. This color work was done at a time when color was not accepted as relevant to fine-art photography by most museums, galleries and dealers, or even by other photographers. As color was "discovered" by photographers during the late 1970's, Worth's interest in working in that medium became distilled. In recent years he has returned to photographing solely in black-and-white.

—David Featherstone

ZELMA, Georgij (Anatolyevich).

Russian. Born in Uzbekistan, Tashkent, July 1906. Educated at primary and secondary schools, Tashkent, until 1921; studied photography in school photo-club, Moscow, 1921-22; studied camerawork at Proletkino film studio, Moscow, 1922-23; apprentice at Russfoto agency, Moscow, 1923-24. Served as war correspondent/photographer, with Red Army, and for *Isvestiya* newspaper, Stalingrad, Odessa and at the front, 1941-45. Married Zina in 1934; son: Timur. Photographer, Russfoto agency, Moscow and Tashkent, 1924-47; with Soyuzfoto agency, freelancing for *SSSR na Stroike, Krasnaya Svezda, Izvestiya,* etc., 1929-36; also worked as filmmaker/cameraman, with Roman Kamen, Soyuzfoto agency, Moscow, 1930-36; staff publicity photographer and photojournalist, *Izvestiya* newspaper, 1936-45; photographer, *Ogonjak,* 1946-62, Novosti Press Agency (APN), Moscow, since 1962. Address: Olenij val 20, kv. 54, 107 014 Moscow, U.S.S.R.

Individual Exhibitions:

1966 Retrospective Exhibition, Moscow
1973 *Stalingrad,* Moscow
1975 Retrospective Exhibition, Mali (travelled to Nigeria and Nepal)

Selected Group Exhibitions:

1975 *Soviet War Reportage 1941-1945,* House of Soviet Science and Culture, Prague
1977 *The Russian War 1941-1945,* International Center of Photography, New York
1978 *Soviet War Photography 1941-1945,* Side Gallery, Newcastle upon Tyne, England
1980 *Soviet Photography between the World Wars,* House of Art, Brno, Czechoslovakia

Collections:

Novosti Press Agency, Moscow; Daniela Mrázková and Vladimír Remeš Collection, Prague.

Publications:

By ZELMA: books—*Stalingrad: July 1942-February 1943,* with text by Konstantin Simonov, Moscow 1966; *Living Legend,* Moscow 1967.

On ZELMA: books—*Fotografivalu Valku,* edited by Daniela Mrázková and Vladimír Remeš, Prague 1975, as *The Russian War,* with an introduction by Harrison Salisbury, New York 1977, with an introduction by A.J.P. Taylor, London 1978, as *Von Moskau nach Berlin,* with an introduction by Heinrich Böll, Oldenburg, West Germany 1979; *Geschichte der Fotografie im 20. Jahrhundert/Photography in the 20th Century* by Petr Tausk, Cologne 1977, London 1980; *Georgij Zelma: Izbrannye Fo-*

tografie (Selected Photos), with text by Boris Vilenkin, Moscow 1978; *Sowjetische Fotografen 1917-1940* by S. Morosov, A. Vartanov, G. Chudakov, O. Suslova and L. Uchtomskaya, Leipzig and West Berlin 1980; *Die Sowjetunion zwischen den Kriegen 1917-1941,* edited by Daniela Mrázková and Vladimír Remeš, Oldenburg, West Germany 1981; articles—"Soviet War Reportage" by Daniela Mrázková and Vladimír Remeš in *Revue Fotografie* (Prague), March 1975; "A Cry of Anguish from Wartime Russia" in *Photography Year 1976,* by the Time-Life editors, New York 1976; "Il Soldato Fotografo" in *Fotografia Italiana* (Milan), April 1976; "The Eighth Miracle of the World" by Daniela Mrázková in *Revue Fotografie* (Prague), September 1977; "Classic Images of the Russian Front" in the *Sunday Times* (London), April 1978; "Soviet Photography Between the World Wars 1917-1941" by Daniela Mrázková and Vladimír Remeš in *Camera* (Lucerne), June 1981.

Georgij Zelma is one of the pioneers of Soviet documentary photography. Starting in the first half of the 1920's he became involved in depicting the profound changes taking place in his country, particularly in the non-Russian areas of the Soviet state. His basic qualifications as a reporter (which enabled him to become a correspondent for Central Asia for the Russfoto Agency) were: a thorough knowledge of the problems of Soviet Central Asia with its countless nationalities; understanding of the mentality and way of life of its people, many of whom were still living in medieval conditions, with all the social, economic and political implications of that situation; and a knowledge of their language (Zelma himself comes from Uzbekistan). The young photographer did not just record the outward transformations taking place in those distant parts of the country in the period between the October Revolution and the beginning of the Second World War; he also penetrated to the depth of meaning of those changes

Georgij Zelma: Wedding in Uzbekistan, 1925

to provide a social analysis. He conveyed, particularly, a general theme of the time, the gradual liberation of women, who for thousands of years had lived in bondage in a traditional inequality with men, for on the fate of that tradition depended the further fate of the revolutionary process in the country. He devoted himself also to other no less important subjects: the fight against illiteracy; the first introduction of technology into the region; the dependence of the progressive development of the country on the construction of an irrigation system that might force the ever-moving sands of the desert to give way at last to vegetation.

Zelma mastered the contrasts inherent in the coming into being of a new way of life—for example, in the accompanying photo, which is of one of the first civil weddings in Uzbekistan: the bride's face and all her charms are still carefully covered by the traditional parandzha veil, yet the couple is being married by an Uzbekistan woman, and there is the picture of Lenin on the wall looking down at the whole scene. Another photograph based on contrast is that of an Uzbekistan sportsman who has taken off the top of his national costume to do exercises on a bar

made of rough-hewn tree trunks. There is fine irony, too, in the picture of a man looking surprised and almost full of adoration, holding the earphone of a crystal radio-set to his ear; the caption reads, "Moscow Calling." Zelma's pictures of Central Asia are valuable historical documents, photographically valid, which are being appreciated only now: after the topical aspects serving propaganda purposes have receded into the past, they are now being evaluated for what they are, a profoundly erudite social study.

In the 1930's Zelma continued to deal with the problems of Central Asia—in fact, he has continued to do so throughout his life—but simultaneously he also devoted himself to depicting the great building projects of the first economic Five-Year Plan. Acquainted with the formal approaches of Soviet experimental photography of those years, and like Rodchenko and his friends who held similar views, Zelma composes his pictures into diagonals, uses steep angles when viewing the object from below or above, uses expressive large details—but his approach is cooler. This work does not have the extremely strong personal involvement of his photographs of

Central Asia. It was not until the Second World War that Zelma again produced photographs based on deep personal experience: he created a unique testimony of the Battle of Stalingrad and life in that besieged city. The documentary photographer proved to be an alert reporter, active and ready to fight, who took risks to be with the soldiers in the front line as to be able to capture the most critical moments of the historic battle.

Georgij Zelma has untiringly devoted his long life to the work of the committed social reporter, but it is because of his documentation of Central Asia of the 1920's and 30's and his reportage of the war that he stands out as a remarkable personality in the world of photography.

—Daniela Mrázková

Piet Zwart: *Gliederschlauch*, 1932 Courtesy Galerie Wilde, Cologne

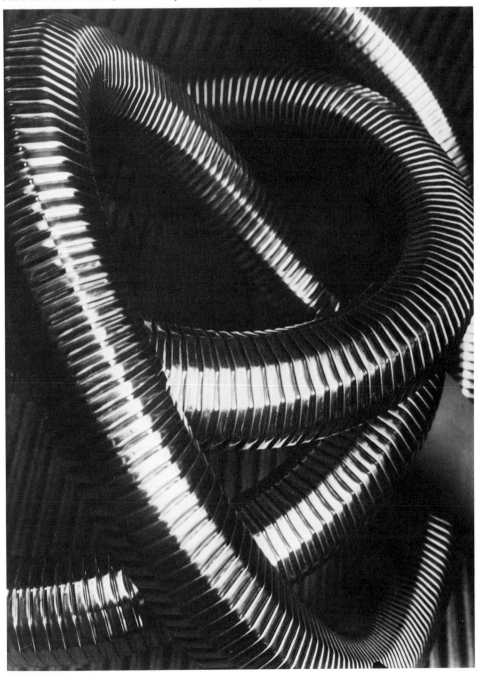

ZWART, Piet.

Dutch. Born in Zaandijk, 28 May 1885. Studied at the Rijksschool voor Kunstnijverheid, Amsterdam, 1902-07; Technische Hogeschool, Delft, 1913-14; mainly self-taught in photography and photomontage, from 1924. Served in the Dutch Army, at Den Helder, 1908. Furniture and interior designer, from 1911, and graphic and industrial designer, architect and photographer, from 1919; Assistant Architect, office of Jan Wils, Voorburg, 1919-21, and office of H.P. Berlage, The Hague, 1921-27; freelance graphic designer, concentrating on photography, and working for Posts and Telecommunications, Schevingen Radio, Nederlandse Kabelfabriek (NFK), Bruynzeel Company, etc., in Delft, The Hague, and Rotterdam, 1928-39, and from 1945. Instructor in Drawing and Art History, Industrie-en Huishoudschool voor Meisjes, Leeuwarden, 1909-19; Instructor in Design and Ornament, Academie van Beeldende Kunsten en Technische Wetenschappen, Rotterdam, 1919-33. Visiting Instructor, Technische Hochschule, Delft, 1929, and Bauhaus School, Berlin, 1931. Architect Correspondent, *Het Vaderland* magazine, 1925-28; Organizer, Dutch Section, *Film und Foto* exhibition, Stuttgart, 1929. Recipient: Quellinus Prize for Typography, 1959; David Roell Prize, 1964. Honorary Royal Designer for Industry, London, 1966. *Died* (in Leidschendam, Netherlands) *24 September 1977*.

Individual Exhibitions:

1933 Drukkerij Trio, The Hague
1968 *Piet Zwart en PTT*, Haags Gemeentemuseum, The Hague
1973 Haags Gemeentemuseum, The Hague (travelled to Dortmund and Zurich, 1974)

Selected Group Exhibitions:

1929 *Film und Foto*, Deutscher Werkbund, Stuttgart
1930 *Das Lichtbild*, Munich (travelled to Essen)
1931 *Fotomontage*, Kunstgewerbemuseum, Berlin
 Foreign Photography, New York Cultural Center
 Moderne Fotos en Drukwerken, Genootschap voor de Kunst, Utrecht

1932 *Exposition Internationale de la Photographie*, Palais des Beaux-Arts, Brussels (travelled to Lakenhal, Leiden, and the Kunstzaal van Hasselt, Rotterdam

1933 *Nieuwe Richtingen in de Fotografie*, I.O.O.F. Building, Amsterdam

1979 *Fotografie in Nederland 1920-40*, Haags Gemeentemuseum, The Hague

Film und Foto der 20er Jahre, Württembergische Kunstverein, Stuttgart (travelled to the Museum Folkwang, Essen; Werkbundarchiv, Berlin; Kunsthaus, Zurich; Kunstverein, Hamburg; and Museum des 20. Jahrhunderts, Vienna)

Dada Photomontagen, Kestner-Gesellschaft, Hannover

Collections:

Piet Zwart Archive, Prentenkabinet, Leiden University; Haags Gemeentemuseum, The Hague; Stedelijk Museum, Amsterdam; Museum Folkwang, Essen; Kestner-Gesellschaft, Hannover.

Publications:

By ZWART: books—*Filmreclame*, Rotterdam 1933; *Piet Zwart*, with text by F. Muller and P.F. Althaus, Teufen, Switzerland 1966; *Piet Zwart: 12 Phographien*, portfolio, with an introduction by Kees Broos, Cologne 1974; photomontages and designs for—*De Absolute Film* by Ter Braaks, Rotterdam 1931; *De Techniek van de Kunstfilm* by Mannus Franken and Joris Ivens, Rotterdam 1931; *Wij Slaven Van Suriname* by Anton de Kok, Rotterdam 1934; and other books in the series *Monografien over Filmkunst* for W.L. and J. Brusse publishing company, Rotterdam, 1931-34; article—"Gemeinigde Fotografie" in *Foto '48*, exhibition catalogue, Amsterdam 1948.

On ZWART: books—*Foto-Auge: 76 Fotos der Zeit* by Franz Roh and Jan Tschichold, Stuttgart 1929; *Gefesselter Blick*, exhibition catalogue, by Hugo and Bodo Rasch, Stuttgart 1930; *Fotomontage*, exhibition catalogue, Berlin 1931; *Piet Zwart*, exhibition catalogue, with text by Kees Broos, The Hague 1973; *Photomontage* by Dawn Ades, London 1976; *Tendenzen der Zwanziger Jahre*, exhibition catalogue, by D. Honisch, U. Prince, E. Roters and W. Schmied, Berlin 1977; *Fotografie in Nederland 1920-1940*, exhibition catalogue, by Flip Bool and Kees Broos, The Hague 1979; *Photographen der 20er Jahre* by Karl Steinorth, Munich 1979; *Film und Foto der 20er Jahre*, exhibition catalogue, by Ute Eskildsen and Jan Christopher Horak, Stuttgart 1979; *Dada Photomontagen*, exhibition catalogue, by Carl-Albrecht Haenlein and others, Hannover 1979.

At the beginning of the 1920's Piet Zwart, together with Paul Schuitema, gave a great forward impetus to Dutch photography. In 1923, when "pictorial" art photography still flourished in the Netherlands, Zwart, already an architect and interior and graphic designer by profession, met El Lissitzky who taught him the principles of the photogram and of photofixing. A few years later Zwart used a photogram for an advertisement booklet for a cable factory in Delft. In 1928, in a catalogue for the same company, he purposely chose photography as the means of illustration: he had realized that what he really wanted to do was to produce thoughtful, exact, extremely sharp commercial photographs, in line with the "New Objectivity" and in accordance with Moholy-Nagy's views about the integration of image and text. In effect, from 1923, he taught himself photography: all the optical, technical and chemical problems he encountered he solved by consulting German technical literature. Together with Schuitema and G. Kiljan, he tried out all the various photographic possibilities: light-shadow effects, reflections, movements, etc.

In 1929 Zwart, Schuitema and Kiljan took part in the important exhibition, *Film und Foto*, in Stuttgart. Zwart was responsible for the Dutch submissions. Works by such participants as the American Edward Weston, the German Walter Peterhans and the Russian Rodchenko overwhelmingly impressed Zwart—for their technique, expression, composition: confronted with such artistry, he felt keenly how much the Netherlands was behind, and what little photographic education there was in his own country. The experience stimulated his own work. So did his stay as guest lecturer in photography at the Bauhaus in 1931. In the years that followed he tried inexhaustibly to bring Dutch photography up to an international standard. Describing his work, he said: "We used the camera only as a means of expression and as a visual medium that offers possibilities found in no other artistic technique, possibilities that the eye can not catch in their totality. We tried to establish a characteristic vision of photography."

Zwart created an extensive archive of technical photographs from his commercial commissions and of his own personal work. His own work very often involves reproductions of structures of great clarity of line—tree-bark, cobwebs, ice formed in a ditch, waterdrops on a branch, a misted window. They are dynamic because of a diagonal line, an unusual angle, or unexpected composition.

In the many articles that he wrote Zwart also stressed the importance of photography in social and scientific life.

His work paved the way for a new generation of photographers—Emmy Andriesse, Eva Besnyö, Cas Oorthuys, and Carel Blazer—none of whom did any commercial photography, but all of whom used and built on his principles in their documentation of people.

—A. de Jonge-Vermeulen

NOTES ON ADVISERS AND CONTRIBUTORS

ADAM, Hans Christian. Essayist. Freelance picture researcher and photo-historian, Göttingen. Co-Editor, *Fotografie*, Göttingen, 1976-78. Contributor to *European Photography, Printletter*, etc. **Essays:** Bennett; Häusser; Pabel; Saudek.

ALINDER, James. Entrant and essayist. See his own entry. **Essays:** Bernhard; Cumming; Morris.

ALLARA, Pamela. Essayist. Assistant Professor, Fine Arts Department, Tufts University, Medford, Massachusetts, since 1978 (Lecturer, 1973-77). Boston Correspondent, *ARTnews*, New York, since 1977. **Essays:** Dahl-Wolfe; Robinson.

ALLEN, Karyn. Essayist. Curator of Art, Nickle Arts Museum, University of Calgary, Alberta, since 1981. Cultural Affairs Officer, Government of Ontario, Toronto, 1973-74; Special Projects Officer, Art Gallery of Ontario, Toronto, 1974-77; Curator-in-Charge, 10th International Sculpture Conference, Toronto, 1977-78; Associate Curator, Contemporary Art, Winnipeg Art Gallery, 1978-81. Author of *Colour Xerography*, 1976; *The Winnipeg Perspective*, 1979; *The R.C.A. Exhibition*, 1980; *The Winnipeg Perspective*, 1980; *David Craven/Harold Klunder*, 1980; *Michael Hayden: Lumetric Sculpture Installation*, 1981; and *The Winnipeg Perspective*, 1981; editor of *Artists with Their Work*, 1977. **Essays:** Astman; Lake.

ASBURY, Dana. Essayist. Writer and photographer, Albuquerque, New Mexico. Teacher of Photography, University of New Mexico, Albuquerque, 1978-80. Contributor to *Artweek, Afterimage, Artspace, Progresso Fotografico*, etc. **Essays:** Barrow; Burchard; Callis; Fichter; Hahn; Josephson; Pfahl; Rubinstein; Shore.

BALDWIN, Roger. Essayist. Instructor in Photography and Photographic History since 1979, and Director of Co-operative Education, Arts, since 1981, University of Bridgeport, Connecticut; Instructor of Photography, Fairfield University, Connecticut, since 1979. Editor of the exhibition catalogue *First They Wrought: New England's Teaching Photographers*, 1981; and author of *Jack Sal: Mark Making*, 1981, and *Discovering Photographic History*, with Mark Roskill (forthcoming). **Essay:** Gibson.

BALTZ, Lewis. Entrant and essayist. See his own entry. **Essays:** Davies; Gossage.

BARROW, Thomas F. Entrant and essayist. See his own entry. **Essay:** Mertin.

BENNETT, Derek. Entrant and essayist. See his own entry. **Essays:** Parr; Rexroth; Trager.

BILLETER, Erika. Essayist. Director, Kunsthaus, Lausanne, Switzerland, since 1981. Chief Curator, Museum Bellerive, Zurich, 1968-75; Deputy Direc-tor of the Kunsthaus, Zurich, 1975-80. Author of *Malerei und Photographie im Dailog von 1840 bis Heute*, 1977, and *Amerika Fotografie 1920-40*, 1979. **Essay:** Mathys.

BISCHOFF, Ulrich. Essayist. Curator of the Kunsthalle, Kiel. **Essay:** Kiffl.

BLANCH, M. Teresa. Essayist. Art Critic, *AVUI* newspaper, Barcelona, since 1975. Editor-in-Chief, *Batik* magazine, Barcelona, 1976-80; Barcelona Correspondent for *Arteguia* magazine, Madrid, 1977-79; Director, Art Section, *Mundo* magazine, Barcelona, 1978. Author of *Human and Pictorial Meaning in the Landscapes of Hernandez Pijuan*, 1979. **Essays:** Herraez Gomez; Pla Janini.

BLANCO, Lázaro. Entrant and essayist. See his own entry. **Essays:** Corrales; Kolko; Neyra.

BLÉRY, Ginette. Essayist. Freelance photography critic, Paris, since 1977, contributing to *Le Photographe, Photo*, and *Photo-Revue*. Formerly worked in public relations for Kodak. Author of *Photography*, with Jean Prinet, 1978, and *Pictures for Children*, 1978. **Essays:** John Batho; Dieuzaide; Masclet; Moon; Raimond-Dityvon.

BOBROWSKI, Ryszard. Adviser and essayist. Art and photography critic, Warsaw. Formerly, Deputy Editor-in-Chief, *Fotografia* quarterly, Warsaw. Curator of numerous exhibitions, including, recently, *Fotografia Polska 1839-1979*, shown in New York, Chicago, Warsaw, Lodz, and London, 1979-80; and *Photographie Polonaise 1900-1981*, Paris 1981. **Essays:** Bulhak; Dlubak; Dorys; Hartwig; Lewczyński; Lokajski; Prazuch; Szczuka; Witkacy.

BONDI, Inge. Essayist. Freelance critic, historian, teacher and curator of photography, and film consultant on films dealing with photography, since 1968; Consulting Editor, *Printletter*, Zurich, since 1975; Contributor to *Die Weltwoche*, Zurich, since 1976. Associated with Magnum Photos Inc., New York, 1950-70 (one of 2 non-photographer shareholders in the cooperative; Secretary-Treasurer of the Corporation; Director for Special Projects); taught 20th Century History of Photography, Fairleigh Dickinson University, Rutherford, New Jersey, 1971-72. **Essays:** Bosshard; Finsler; Groebli; Haas; Lichtsteiner; Moholy; Schulthess; Senn; Tuggener.

BORKLUND, Elmer. Essayist. Professor of English, Pennsylvania State University, University Park (member of the faculty since 1962). Author of *Contemporary Literary Critics*, 1977, 1982, and editor of *Great Thinkers of the 20th Century*, 1983. **Essays:** Bischof; Freund; Gidal; Kühn; Lynes; Man Ray.

BOWLT, John E. Essayist. Professor, Slavic Department, University of Texas at Austin, since 1971; also, Director of the Institute of Modern Russian Culture at Blue Lagoon, Texas. Books include: *Russian Formalism*, editor, with Stephen Benn, 1973; *The Russian Avant-Garde: Theory and Criticism 1902-34*, editor and translator, 1976; *Russian Art 1870-1970*, 1976; *Benedikt Livshits: "The One and a Half-Eyed Archer,"* translator and commentator, 1977; *The Silver Age: Russian art of the Early 20th Century*, 1979; *The Life of Vasilii Kandinsky in Russian Art*, with Rose-Carol Washington, 1980. **Essays:** Petrusov; Shishkin.

BOXER, Bonnie. Essayist. Freelance writer and critic, Tel Aviv. Foreign Rights Editor, Zmora, Bitan, Modan Publishers Ltd., Tel Aviv, since 1980. Director of Sales, Production and Distribution, *American Showcase*, New York, 1977-78; American Editor, *Zoom*, Paris, 1979. **Essays:** Bar-Am; Braun; Ganor; Ostrovsky; Shemtov.

BROWN, Theodore M. Essayist. Professor of the History of Art, Cornell University, Ithaca, New York, since 1967. Assistant and Associate Professor of the History of Art, University of Louisville, Kentucky, 1958-61. Author of *The Work of G. Rietveld, Architect*, 1958; *Introduction to Louisville Architecture*, 1960; *Old Louisville*, 1961; *Margaret Bourke-White, Photojournalist*, 1972. **Essay:** Bourke-White.

BRY, Doris. Essayist. Writer, consultant and art dealer; Publisher of Atlantis Editions, New York, since 1967. Assisted Georgia O'Keeffe with disposition of Alfred Stieglitz estate, as well as related matters in the arts, 1946-54; freelance writer and editor, 1954-57; Assistant to the Vice-President, Fund for the Advancement of Education, and Administrative Assistant, Ford Foundation, New York, 1957-61; Writer and Researcher, Time Inc. books, 1961-65; representative for the sale of O'Keeffe paintings, 1965-77; Guest Curator, Whitney Museum's Georgia O'Keeffe retrospective, New York, 1969-71. Author of the catalogues, *Alfred Stieglitz: Photographer*, 1958 and 1965; editor of *Georgia O'Keeffe: Drawings*, 1968, and of *Some Memories of Drawings* by O'Keeffe, 1974; author of the book *Georgia O'Keeffe*, with Lloyd Goodrich, 1970. **Essay:** Clift.

CAPA, Cornell. Adviser and entrant. See his own entry.

CARROLL, Alison. Essayist. Curator of Prints, Drawings and Photographs, Art Gallery of South Australia, Adelaide. **Essay:** Douglas.

CASLIN, Jean. Essayist. Assistant Director, Photographic Resource Center, Boston, since 1979. Lecturer in the History of Photography, Clark University, Worcester, Massachusetts, 1980, and University of Massachusetts Harbor Campus, Boston, 1981. Contributor to *Afterimage, Views*, and *Sojourner* magazines. **Essay:** Prince.

CAUJOLLE, Christian. Essayist. Photography Critic since 1978, and Picture Editor since 1981, *Liberation*, Paris. Author of the exhibition catalogues, *Les Petits Enfants de Robert Doisneau*, 1980; *Le Jeune Photographie Suisse*, 1981; and author of the books, *Album Photographique No. 1*, with Pierre de Fenoyl, Paris 1980; *Jenny de Vasson: Une Femme Photographe au Debut au Siècle*, 1982; *Jacques-Henri Lartigue*, 1982; *Manual Alvarez Bravo*, 1982. **Essays:** Claude Batho; Brihat; Charbonnier; Drahos; Faucon; Hamilton; Lennard; Nash; Sougez.

CHEVRIER, Jean-François. Essayist. Freelance photography critic, Paris. **Essays:** Baltauss; Gloaguen; Hers; Requillart.

CIPNIC, Monica R. Essayist. Picture Editor, *Popular Photography* magazine, *Camera Arts* magazine and *Photography Annual* (on staff of *Popular Photography* since 1973); also, Director, Popular Photography Photo Gallery, New York, since 1976. **Essays:** Hosoe; Parker.

COHEN, Stu. Essayist. Photography Critic, *Boston Phoenix*, since 1973; also, Public Affairs Writer, Office of Health Policy Information, Harvard School of Public Health, Boston, since 1979. Photography Editor, *Boston Review of the Arts*, 1971-72; Instructor in the History of Photography, Art Institute of Boston, 1976-78. **Essays:** Alvarez Bravo; William Klein; Post Wolcott; Ray-Jones; Siskind; W. Eugene Smith; Vachon; Van Der Zee; Wasserman.

COLEMAN, A.D. Essayist. Contributing Editor, *Camera 35*, New York, since 1976. Vice-President, Photography Media Institute Inc., since 1977; Instructor, Department of Undergraduate Film and TV, New York University, since 1978; Member, Board of Directors, Photographic Resource Center, since 1979. Photographic Critic, *Village Voice*, New York, 1968-73; Photography Critic, *New York Times*, 1970-74; Founding Editor, *Views: A New England Journal of Photography*, 1979-80. Author of *The Grotesque in Photography: A Critical Survey*, 1977; *Light Readings: A Photography Critic's Writings 1968-1978*, 1979; *Lee/Model/Parks/Samaras/Turner: Five Interviews Before the Fact*, 1979; and *The Photography A-V Program Directory*, with Patricia Grantz and Douglas Sheer, 1980. **Essays:** Aigner; Hyde; Kirstel; Palfi; Slavin; Teske; Tress.

COLOMBO, Attilio. Essayist. Editor of *Progresso Fotografico*, Milan. **Essays:** Berengo-Gardin; Leonardo; Lotti; Merisio; Mulas; Roiter; Russo.

COOKE, Robert W. Essayist. Art Professor Emeritus, The William Paterson College of New Jersey in Wayne, since 1977 (Professor of Art, 1958-77; Chairman of the Department, 1958-68). Contributor of the monthly feature "Photography" in *School Arts* magazine, 1973-76. Author of *Designing with Light on Paper and Film*, 1969. **Essays:** Savage; Tice.

COREY, David. Essayist. Lecturer in Humanities, Brooklyn College, City University of New York, since 1967. Member of the faculty, Lehigh University, Bethlehem, Pennsylvania, 1966-67. Author of *Fearful Symmetries*, 1979. **Essay:** Sonneman.

DATER, Judy. Entrant and essayist. See her own entry. **Essays:** Ansel Adams; Rubenstein; Skoff.

DAVIES, Sue. Essayist. Founder Director, The Photographers' Gallery, London, since 1971. **Essays:** Badger; David Bailey; Benton-Harris; Campbell; Chambi; Cranham; Freedman; Killip; Luskačová; Suschitzky; Sykes; Vogt.

de JONGE-VERMEULEN, A. Essayist. Researcher, Print Collection, University of Leiden. **Essays:** Andriesse; Berssenbrugge; Blazer; Citroen; Den Hollander; Aart Klein; Oorthuys; van der Elsken; Zwart.

DOHERTY, Robert J. Essayist. Director, Salt Lake City Art Center, Utah, since 1981; also, Publisher, International Archives of Photography. Director, Allen R. Hite Art Institute, University of Louisville; Founder, University of Louisville Photography Archives, 1962. Director, George Eastman House, Rochester, New York, 1972-79. Picture Editor of *Portrait of a Decade* by F. Jack Hurley, 1972; author of *Sozialdocumentarishe Photographie in den USA*, 1973, and *The Complete Photographic Work of Jacob A. Riis*, 1981. **Essays:** Lange; Rogovin; Rothstein; Stryker.

ENYEART, James L. Adviser and essayist. Director, Center for Creative Photography, University of Arizona, Tucson, and Editor of the *CCP Journal*, since 1978. Charter Director, Albrecht Gallery of Art, St. Joseph, Missouri, 1967-68; Curator of Photography, University of Kansas Museum of Art, 1968-76, also Lecturer, 1968-69, Assistant Professor, 1969-75, and Associate Professor, Department of Art History, University of Kansas; Executive Director, Friends of Photography, Carmel, California, 1976-77. Author *Francis Bruguière*, 1977, and of numerous exhibition catalogues, including *Karsh*, 1970, *Kansas Landscape*, 1971, *Invisible in America*, 1973, *Language of Light*, 1974, *No Mountains in the Way*, 1975, etc. **Essays:** Bruguière; Uelsmann.

ESKILDSEN, Ute. Essayist. Curator of Photography, Museum Folkwang, Essen, since 1978. Co-Editor/Author of *Film und Foto der Zwanziger Jahre*, 1978, and of the exhibition catalogues, *Neue Sachlichkeit and German Realism of the 20's*, 1978, *Heinrich Kühn 1866-1944*, 1978, and *Absage an das Einzelbild*, 1980. **Essay:** Peterhans.

ESTEN, John. Essayist. Art Director of Bonwit Teller, New York. An Art Director, *Harper's Bazaar*, 1971-78; Art Director, *L'Officiel U.S.A.* magazine, 1979. Editor and designer of *Style in Motion: Photographs by Martin Munkacsi*, with Nancy White. **Essays:** Brodovitch; Hoyningen-Huene; Munkacsi; Raymond.

EVANS, Tom. Essayist. Painter and photographer, London. Visiting Lecturer, London College of Printing, since 1972. Photography Correspondent, *Art and Artists*, London, 1979-80. Contributor to *Camerawork* and *Art Monthly*. Author of *Shunga: The Art of Love in Japan*, with Mary Anne Evans, 1975; *Guitars: From the Renaissance to Rock*, 1977. **Essays:** Bellocq; Blakemore; Jumonji; Edward Weston.

FEATHERSTONE, David. Essayist. Executive Associate, The Friends of Photography, Carmel, California, since 1977. Curator, Historical Photography Collection, University of Oregon Library, Eugene, 1974-77, and Co-Director, Image Point Gallery, Eugene, 1975-76. Author of *Vilem Kriz: Photographs*, 1979; *The Diana Show: Pictures Through a Plastic Lens*, 1980; and *Postures: The Studio Photographs of Marsha Burns*, 1982. **Essays:** Garnett; Ulmann; Worth.

FONTCUBERTA, Joan. Entrant and essayist. See his own entry. **Essays:** Catany; de Nooijer; Descamps; Gelpke; Ghirri; Lenart; Meyer; Navarro; Ortiz-Echagüe.

FREEMAN, Tina. Essayist. Curator of Photography, New Orleans Museum of Art. **Essay:** Oscar Bailey.

FULTON, Marianne. Essayist. Assistant Curator, Photographic Collection, George Eastman House, Rochester, New York, since 1978 (researcher at Eastman House, 1976-78): has curated numerous exhibitions at Eastman House, including *Symbolism in Photography 1890-1920*, 1978; *Steichen: A Centennial Tribute*, 1979; and *Barbara Morgan: Photomontage*, 1979. Editor of, and wrote introduction to, *Camera Work: A Pictorial Guide*, 1978; also wrote introductions to *Muray's Celebrity Portraits of the 20's and 30's*, 1978; *The Platinum Print*, 1979; and *Barbara Morgan: Photomontage*, 1980. **Essays:** Coburn; Gowin; Harold Jones.

GASSAN, Arnold. Essayist. Author of *A Chronology of Photography*, 1972. **Essays:** Chappell; Heinecken; Labrot.

GERNSHEIM, Helmut. Adviser, entrant and essayist. See his own entry. **Essays:** Berko; Fieger; Gianella; Henle.

GESKE, Norman A. Essayist. Director, Sheldon Memorial Art Gallery, University of Nebraska at Lincoln, since 1953 (Assistant Director, 1950-53, and Acting Director, 1953-56, University of Nebraska Art Galleries, Lincoln). Director, Hennepin County Historical Society, Minneapolis, 1940-41; Curator, Walker Art Center, Minneapolis, 1947-50. **Essays:** Alinder; DeCarava; Gilpin; Sudek; Wise.

GIDLEY, G.M. Essayist. Senior Lecturer in American Literature, and Head of American and Commonwealth Arts, University of Exeter, Devon, since 1978 (Lecturer in American Literature, 1971-78). Author of *Catalogue of American Paintings in British Public Collections*, 1974; *With One Sky Above Us: Life on an Indian Reservation at the Turn of the Century*, with photographs by Dr. E.H. Latham, 1979; *Kopet: A Documentary Narrative of Chief Joseph's Last Year*, 1981; and editor of *The Vanishing Race: Selections from Edward S. Curtis' "The North American Indian,"* 1976. **Essays:** Collier; Genthe.

GOLDBERG, Vicki. Essayist. Editor of *Photography in Print: Writings from 1816 to the Present*, 1981. **Essays:** Erwitt; Michals.

GOLDSMITH, Arthur. Essayist. Editorial Director, *Popular Photography, Camera Arts*, and *Photography Annual*, New York. Executive Editor, *Popular Photography*, 1953-60; Picture Editor, *This Week*, 1960-62; President and Director, Famous Photographers School, 1962-72. Author of *The Eye of Eisenstaedt*, 1969, and *How to Take Better Pictures, The Photography Game, The Nude in Photography*, and *The Camera and Its Images*. **Essays:** Halsman; Newman; Winogrand.

GORMAN, Bradford G. Essayist. Assistant to the Director, Art Gallery of Hamilton, Ontario, since 1981. Coordinator, Canadian Images: A National Conference on Photography and Filmmaking in Canada, at Trent University, Peterborough, Ontario, 1977-79; Director and Curator of Contemporary Photography, Canadian Centre of Photography, Toronto, 1980-81. **Essay:** Horeis.

GRCEVIĆ, Nada. Essayist. Freelance art and photography critic and historian, Yugoslavia, since 1960. Member of the Advisory Board, *History of Photography*, since 1977. Collaborator, Yugoslav Lexicographic Institution, 1964, Arts and Crafts Museum, 1965, and of the Zagreb Center for Photography, Film and Television, 1977. Author of *Nineteenth Century Photography in Croatia*, 1980. **Essays:** Dabac; Djordjević; Grčević.

GUTMAN, Judith Mara. Essayist. Guest Curator, International Center of Photography, New York, since 1980. Co-Producer, Art Director and Scriptwriter, Current Affairs Films, Wilton, Connecticut, 1973-78; Adviser, Oxford University Press, New York, 1975-76; Director of the research project, "The Photograph as a Cultural Artifact: India 1850-1920," 1976-80. Author of *The Colonial Venture*, 1966; *Lewis W. Hine and the American Social Conscience*, 1967; *The Making of American Society*, with Edwin Rozwenc, 1972-73; *Lewis Hine: Two Perspectives*, 1974; *Is America Used Up?*, 1973; *Buying*, 1975; and *Through Indian Eyes*, 1982. **Essays:** Cornell Capa; Hine; Kepes; Mehta; Riboud; Riefenstahl.

HALL-DUNCAN, Nancy. Essayist. Assistant Curator, International Museum of Photography, George Eastman House, Rochester, New York, 1975-76; Guest Curator, *Photographic Surrealism*, New Gallery of Contemporary Art, Cleveland, and national tour, 1979-80. Author of *The History of Fashion Photography*, 1979, and of the exhibition catalogue for *Photographic Surrealism*, 1979. **Essays:** Avedon; Brandt; Edgerton; Groover; Hiro; Mark; Nixon; Penn; Rice; Warhol.

HARKER, Margaret. Essayist. Professor and Pro-Rector, Polytechnic of Central London. Author of *The Linked Ring: The Secession in Photography 1892-1910*, 1979. **Essays:** Demachy; Hosking; Keighley; Steichen.

HARMEL, Carole. Essayist. Assistant Professor of Humanities, Harry S. Truman College, Chicago, since 1972. Chicago Correspondent, *Afterimage*, Rochester, New York, since 1979. **Essays:** Jachna; Mapplethorpe; Sommer.

HARRIS, David. Essayist. Assistant Archivist, Art Gallery of Ontario, Toronto, 1975-78. **Essay:** Mitchell.

HASEGAWA, Akira. Essayist. Freelance photographic critic, Tokyo. **Essay:** Suda.

HASSNER, Rune. Adviser, entrant and essayist. See his own entry. **Essays:** Johnson; Pål-Nils Nilsson; Winquist.

HATTERSLEY, Ralph. Essayist. Contributing Editor, *Popular Photography* magazine, New York, since 1970. Associate Professor, Rochester Institute of Technology, New York, 1948-61. Author of *Discover Your Self Through Photography*, *Photographic Printing*, *Photographic Lighting*, *Beginner's Guide to Photography*, *Beginner's Guide to Darkroom Techniques*, *Beginner's Guide to Photographing People*, *Beginner's Guide to Color Photography*, and *Beginner's Guide to Color Printing*; and *Andreas Feininger*, 1973. **Essay:** Feininger.

HAWORTH-BOOTH, Mark. Adviser and essayist. Assistant Keeper of Photographs, Department of Prints and Drawings and Photographs, Victoria and Albert Museum, London, since 1977 (Assistant Keeper of Circulation, 1970-1977). Editor of *The Land: 20th Century Landscape Photographs Selected by Bill Brandt*, 1975; and author of *E. McKnight Kauffer*, 1979. **Essay:** Raymond Moore.

HEDGPETH, Ted. Essayist. Contributing Editor, *Artweek*, Oakland, California; Contributing Writer, *Artbeat*, San Francisco, *Photoshow*, Los Angeles, and *San Francisco Review of Books*. Member of the Board of Directors, Camerawork Gallery, San Francisco. Co-Editor of *Latent Image: A Quarterly of Fine Art Photography*, 1977-79. **Essays:** Coke; Dater; Dutton; Fitch; Golden; Heyman; Lyon; Lyons; MacGregor; Minick; Misrach; Nettles; Ruscha; Traub; Wessel.

HEIFERMAN, Marvin. Essayist. Publisher and dealer, New York. Assistant Director, Light Gallery, New York, 1972-74; Director of Photography, Castelli Gallery, New York, 1975-82. **Essays:** Robert Adams; Baltz; Namuth.

HELD, Michael. Associate editor and essayist. Editor of *Contemporary Designers*, 1983. **Essays:** Meyerowitz; Rodchenko; Henry Holmes Smith; Umbo; Walker; Welpott; Wols.

HENISCH, H.K. Essayist. Professor of the History of Photography, Pennsylvania State University, University Park, since 1974, and Fellow of the Institute for the Arts and Humanistic Studies, Pennsylvania State University, since 1978 (Professor of Physics, 1963). Editor of the international research quarterly *History of Photography*, since 1977. Author of *Chipmunk Portrait*, with B.A. Henisch, 1970; and *Crystal Growth in Gels*, 1970. **Essay:** Kriz.

HOLBORN, Mark. Adviser and essayist. Freelance writer and critic, London (specialist in Japan). Contributor to the *British Journal of Photography*, *Camerawork*, *London Magazine*, and *Aperture*. Author of *The Ocean in the Sand*, 1978. **Essays:** Domon; Fukase; McCullin; Moriyama; Narahara; Shinoyama; Tomatsu; Tsuchida; Tucker.

HONNEF, Klaus. Essayist. Director of the Rheinisches Landesmuseum, Bonn. **Essays:** Becher; Mantz; Neusüss; Newton; Schürmann; Strelow.

HOPKINSON, (Sir) Tom. Adviser and essayist. President of The Photographers' Gallery, London. Assistant Editor, *Weekly Illustrated*, London, 1934-38; Assistant Editor, 1938-40, and Editor, 1940-50, *Picture Post*, London; also Editor of *Lilliput*, London, 1941-46; Editor, *Drum* magazine, Johannesburg, 1958-61; Director for Africa, International Press Institute, 1962-66; Senior Fellow in Press Studies, University of Sussex, 1967-69; Visiting Professor in Journalism, University of Minnesota, Minneapolis, 1968-69; Chairman, British National Press Awards, 1968-77; Director, Centre for Journalism Studies, University College, Cardiff, 1970-75. Author of novels, collections of short stories and various non-fiction works, and of *Bert Hardy, Photojournalist*, 1975, and *Treasures of the Royal Photographic Society*, 1980; editor of *Picture Post 1938-50*, 1970, 1979. **Essays:** Berry; Burrows; Hardy; Henderson; Hurn; Hutton; Jarché; Magubane; Man; Rodger; Snowdon.

HOWE, Graham. Entrant and essayist. See his own entry. **Essay:** Outerbridge.

HURLEY, F. Jack. Essayist. Professor of History, Memphis State University (member of the faculty since 1966). Author of *Portrait of a Decade: Roy Stryker and the Development of Documentary Photography in the Thirties*, 1971; and *Russell Lee, Photographer*, 1978; editor of *Industry and the Photographic Image*, 1980; and *Southern Eye, Southern Mind: A Photographic Inquiry*, 1981. **Essays:** Plowden; Vestal.

JOHNSON, Chris. Essayist. Instructor in Photography since 1977, and Chairman of the Department since 1981, California College of Arts and Crafts, Oakland. Assistant Instructor, Ansel Adams Yosemite Workshops, 1973-74; Curator and Adviser to the Imogen Cunningham Trust, 1975-79. **Essays:** Bullock; Brett Weston.

JOHNSON, William. Essayist. Freelance curator, teacher and author. Public Services Librarian for the Fine Arts Library, 1967-76, and Lecturer in the History of Photography, 1970-76, Harvard University, Cambridge, Massachusetts; Instructor in the History of Photography, Tufts University for the

School of the Museum of Fine Arts, Boston, 1975-76; Instructor in the History of Photography, Visual Studies Workshop, Rochester, New York, 1976-78; Curator, W. Eugene Smith Archive, Center for Creative Photography, University of Arizona, Tucson, 1978-81. Author of *W. Eugene Smith: Early Work 1937-51*, 1980; *W. Eugene Smith: A Chronological Bibliography 1934-1980*, 2 volumes, 1980-81; *W. Eugene Smith: Master of the Photographic Essay*, 1981; and of the exhibition catalogue, *The Photographs of Todd Walker*, 1980; editor of *An Index to Articles on Photography 1977* and *1978*, 1978, 1980. **Essay:** Heath.

JONSSON, Rune. Essayist. Teacher at the Konstfackskolan, Stockholm, since 1969; also, Lecturer at Uppsala University, Sweden, since 1975. Freelance writer for various Swedish photography magazines, since 1960. Author of *Vi börjar fotografera*, 1961; *Fotografera i svartvitt*, 1964; *Bilder av nuet*, 1966; *Hans Hammarskiöld*, 1979; *Hammarby*, pictures by Curt Larsson, 1980; and *Fotografi*, with Werner Noll and Jan Olsheden, 1980; editor of *Fotografisk Årsbok*, 1967, 1968, 1969, 1970. **Essays:** Baum; Hammarskiöld; Hassner; Jonsson; Nykvist; Oddner; Petersen; Sandels; Sjöstedt; Wahlberg.

KAJIWARA, Takao. Adviser and essayist. Editor-in-Chief, *Nippon Camera*, Tokyo, since 1975. Freelance photographer, Tokyo, 1955-75; Professor, Tokyo Photo College, 1959-70. Editor of *Brilliant Scenes by Shoji Ueda*, 1981. **Essays:** Fujii; Hamaya; Ishimoto; Kimura; Midorikawa; Naitoh; Ueda.

KELLNER, Bruce. Essayist. Professor of English, Millersville State College, since 1969. Author of *Carl Van Vechten and the Irreverent Decades*, 1968; and *A Bibliography of the Work of Carl Van Vechten*, 1980; editor of *Keep A-Inchin' Along*, 1979. **Essays:** Muray; Van Vechten.

KEMPE, Fritz. Entrant and essayist. See his own entry. **Essay:** Schmidt.

KNIGHT, Hardwicke. Essayist. Freelance photographer and writer, Dunedin, New Zealand. Director of Medical Photography, Enfield Group Hospitals, England, 1948-57; and University of Otago Medical School and Dunedin Hospital, New Zealand, 1957-77. President, Otago Anthropological Society, 1960; Photographer and Surveyor, National Science Foundation Pitcairn Island Expedition, 1963-64; President, New Zealand Institute of Medical Photographers; President, Dunedin Film Society; Vice-President, New Zealand Archives and Records Association, 1978-80. Author of *Photography in New Zealand: A Social and Technical Study*, 1971; *Dunedin Then*, 1974; *Matanaka*, with Dr. Coutts, 1975; *History of the Broad Bay School*, 1977; *Princes Street by Gaslight*, 1976; *Otago Peninsula: A Local History*, 1978, 1979; *Cutten*, with Dr. Greif, 1979; *Burton Brothers, Photographers*, 1980; *Brief Biographies of Dunedin Photographers*, 2 vols., 1979-80. **Essay:** Brake.

KUWABARA, Kineo. Entrant and essayist. See his own entry. **Essays:** Kurata; Morinaga.

LANGFORD, Martha. Essayist. Executive Producer, Still Photography Division, National Film Board of Canada, Ottawa, since 1981 (Exhibition Producer, 1977-80; Senior Producer, 1980-81). Editor of the exhibition catalogue, *Separate from the World*, 1979; and author of the catalogues, *Atlantic Parallels*, 1980; and *Paradise/Le Paradis*, 1980. **Essays:** Semak; Torosian.

LE GUAY, Laurence. Adviser and essayist. Freelance photographer and writer, Sydney, since 1938.

Editor of *Contemporary Photography* (first independent photographic journal in Australia), 1946-49. Author/photographer of *Sydney Harbour*, 1960; *Sailing Free Around the World*, 1976; and *Shadows in a Landscape*, 1980; editor of *A Portfolio of Australian Photography*, 1950; *Australian Photography*, 1975; and *Australian Photography: A Contemporary View*, 1980. **Essays:** Cazneaux; David Moore.

LEMAGNY, Jean-Claude. Adviser. Curator of Photography, Bibliothèque Nationale, Paris.

LEWINSKI, Jorge. Essayist. Freelance photographer, London, since 1967. Senior Lecturer in Photography, London College of Printing, since 1968. Managing Director, P.D. Constable Ltd., London, 1950-67. Author and author/photographer of *Byron's Greece*, with text by Elizabeth Longford, 1975; *Colour in Focus*, with Bob Clarke, 1976; *Photography Dictionary*, 1977; *The Camera at War*, 1978; *A Writer's Britain*, with text by Margaret Drabble, 1979; *James Joyce's Odyssey*, with text by Frank Delaney, 1981. **Essays:** Griffin; Horvat.

LIEBLING, Jerome. Entrant and essayist. See his own entry. **Essays:** Hallman; Rosenblum.

LOHSE, Bernd. Essayist. Photographic critic and historian, Leverkusen, West Germany. Picture Editor, Verlag Scherl, Berlin, 1932-34; freelance photographer, 1934-42, 1951-53; Editor, *Foto-Spiegel*, 1947-49, and *Photo-Magazin*, 1949-50; Book Editor, Umschau Verlag, Frankfurt, 1955-65; Editor, *Photoblätter*, 1965-75; now retired. Author of *Cameras from Germany*, 1950; *Australien und Südsee heute*, 1953; *Kanada: Land der Zakunft?*, 1954; and *Hugo Erfurth, Photograph der Goldenen 20er Jahre*, 1977; and editor of numerous books, including *Monumente des Abendlandes*, 9 vols., 1958-65. **Essays:** Baumann; Erfurth; Heinemann; Hubmann; Windstosser.

MANDERY, Guy. Essayist. Journalist in Paris. Writer for the magazine *Le Photographe*, Paris, 1975-80; Paris Correspondent for *Il Diaframma*, Milan, 1978-81. Contributor to numerous French photo magazines. **Essays:** Boucher; Ronis; Sudre.

MANDOKI, Katya. Essayist. Professor at the Universidad Autonoma Metropolitana, Mexico City, since 1979; Art Critic for *Uno Mas Uno* daily newspaper, Mexico City, since 1979; also, Correspondent in Mexico for *American Photographer*. **Essays:** Bostelmann; Iturbide; Ortiz Monasterio.

MARGOLIN, Victor. Essayist. Visiting Lecturer, School of Art and Design, University of Illinois, Champaign-Urbana. Advisory Editor, *Contemporary Designers*, 1983. Author of *The American Poster Renaissance*, and co-author of *The Promise and the Product: 200 Years of American Advertising Posters*; editor of *Propaganda, The Art of Persuasion—World War II*. **Essay:** Moholy-Nagy.

MARKHAM, Jacqueline. Essayist. Independent artist, Los Angeles, since 1969; freelance writer for art and photography publications, since 1978; exhibitions designer and photographer, Aesthetech Corporation, Paso Robles, California, since 1980. Author of *Two Views of Manzanar: Ansel Adams and Toyo Miyatake*, 1978; and *The Graham Nash Collection*, 1978; co-author of *Paul Outerbridge: Photographs*, 1980. **Essays:** Howe; Mudford.

MATSUMOTO, Norihiko. Essayist. Freelance photographer, critic and editor, Tokyo. Editor of the *History of Japanese Photography 1940-1945* and *1946-56*. **Essays:** Ichimura; Kawada; Kuwabara; Nakamura; Ohara; Sawatari; Shirikawa; Tahara.

McINTYRE, Arthur. Essayist. Artist and freelance writer, Sydney. Lecturer at N.I.D.A., University of New South Wales, since 1979; Sydney Art Critic for *The Age*, Melbourne, since 1980. Sydney Art Critic for *The Australian*, 1977-78. Co-Author of *The Visual Arts*, 1980. **Essays:** Ellis; Walsh.

MESSER, William. Essayist. Director of The Photographic Gallery, Cardiff. **Essay:** Claass.

MEYER, Pedro. Adviser and entrant. See his own entry.

MINKKINEN, Arno Rafael. Entrant and essayist. See his own entry. **Essays:** Baltermans; Bloch; Callahan; DeCock; Frank; Gohlke; Krause; Lounema.

MIRALLES, Francesc. Essayist. Freelance photographic critic, Barcelona. **Essay:** Freixa.

MISANI, Marco. Essayist. Editor and Publisher of *Printletter*, Zurich, since 1976. **Essays:** Kumler; Leverant; Müller-Pohle.

MITCHELL, Margaretta K. Essayist. Freelance photographer, writer, teacher and photo historian. Guest Curator of the exhibition *Recollections: 10 Women of Photography*, International Center of Photography, New York, and national tour, 1979-82. Author of *Gift of Place*, 1969; *To a Cabin*, with Dorothea Lange, 1973; introduction to *After Ninety* by Imogen Cunningham, 1977; and *Reflections: 10 Women of Photography*, 1979. **Essays:** Abbe; Abbott; Corpron; Frissell; Jacobi.

MOORE, David. Entrant and essayist. See his own entry. **Essay:** Dupain.

MOZLEY, Anita V. Essayist. Curator of Photography, Stanford University Museum of Art, California. **Essays:** Connor; Cunningham; Deal; Pirkle Jones; Leonard.

MRÁZKOVÁ, Daniela. Essayist. Editor, Czechoslovaktelevision, Prague, since 1979. Assistant Editor, 1966-71, and Editor-in-Chief, *Revue Fotografie*, Prague. Author, with Vladimír Remeš, of *They Photographed the War: Soviet War Photography 1941-45*, 1975; *The Russian War*, 1977; *The Russian War 1941-45*, 1978; *Von Moskau nach Berlin*, 1979; *Irena Blüh*, 1980; *Die Sowjetunion Zwischen den Kriegen 1917-1941*, 1981; *Tschechoslowakische Fotografen 1900-1939*, 1981; *Josef Sudek*, 1981. **Essays:** Binde; Garanin; Gnevashev; Koposov; Mikhailovsky; Rakauskas; Spuris; Sterenberg; Zelma.

MÜLLER-POHLE, Andreas. Entrant and essayist. See his own entry. **Essay:** Fontcuberta.

MURRAY, Joan. Essayist. Director, The Robert McLaughlin Gallery, Oshawa, Ontario, since 1974. Research Curator, 1969, Curator of Canadian Art, 1970-73, and Acting Chief Curator, 1973, Art Gallery of Ontario, Toronto. Art Editor, *The Canadian Forum*, 1970-74. Author of *The Art of Tom Thomson*, 1971; *Impressionism in Canada 1895-1935*, 1973; *Dennis Burton Retrospective*, 1977; *Louis de Niverville Retrospective*, 1978; *Gordon Rayner Retrospective*, 1979; *Painters Eleven in Retrospect*, 1979; *Ivan Eyre Exposition*, 1980. **Essays:** Bourdeau; Lynne Cohen; Gagnon; Livick; Maggs; Szilasi.

NAEF, Weston J. Adviser. Curator of Photography, Metropolitan Museum of Art, New York. Author of *Era of Exploration: The Rise of Landscape Photography in the American West 1869-1885*, with James N. Wood, 1975; and *The Collection of Alfred Stieglitz: 50 Pioneers of Modern Photography*, 1978.

NAYLOR, Colin. Associate Editor and essayist. Editor of *Contemporary Artists*, 1977; Associate Editor of *Contemporary Architects*, 1980, and of *Contemporary Designers*, 1983. Formerly Editor, *Art and Artists*, London. **Essays:** Burri; Dekkers; Dibbets; Drtikol; Kessel; Salomon; Weiner.

NEWHALL, Beaumont. Adviser. Visiting Professor of Art, University of New Mexico, Albuquerque, since 1971. Curator of Photography, The Museum of Modern Art, New York, 1940-45; Curator, 1948-58, Director, 1958-71, and since 1971 Director Emeritus, International Museum of Photography, George Eastman House, Rochester, New York. Author of *The History of Photography*, 1949, 5th edition 1982; *Masters of Photography*, with Nancy Newhall, 1958; *The Daguerreotype in America*, 1961, 3rd edition 1976; *Latent Image*, 1967; *Airborne Camera*, 1969; *William H. Jackson*, with Diana Edkins, 1974; and *Frederick H. Evans*, 2nd edition 1975; and editor of *Photography: Essays and Images: Illustrated Readings in the History of Photography*, 1980.

NORFLEET, Barbara. Essayist. Lecturer in Visual and Environmental Studies since 1970, and Curator of Photography at the Carpenter Center for the Visual Arts since 1972, Harvard University, Cambridge, Massachusetts; also a photographer (individual exhibition at Carl Siembab Gallery, Boston, 1980). Author of *The Champion Pig*, 1979, and *Wedding*, 1979. **Essays:** Cosindas; Eggleston; Koudelka; Turbeville.

NORI, Claude. Essayist. Correspondent in Paris for *Progresso Fotografico*, Milan, since 1971. Founder, Contrejour (journal, publishing house and gallery), Paris, 1974. Organized the exhibitions *Photographie Actuelle en France and La Photographie Française des Origines à Nos Jours*, 1978. Author of *Les Masques Humains*, 1970; *Lunettes*, 1973; *Histoire de la Photographie Francaise*, 1975; *Je Vous Aime*, 1978; and *Une Fille Instantanée*, 1981. **Essays:** Boubat; Franck; Gautrand; Plossu.

NURIDSANY, Michel. Essayist. Photography critic, Paris. Author of the exhibition catalogue *Instantanés*, 1980. **Essays:** Boltanski; Brassaï; Henri.

ORIVE, Maria Cristina. Essayist. Founder and Director, with Sara Facio and Alicia D'Amico, Editorial La Azotea, Buenos Aires, since 1973; Correspondent of the Gamma Press Agency in Argentina, since 1974; Founding Member, Latin American Photographic Council, since 1978; Founding Member, Argentinian Photographic Council, since 1979. Editor-in-Chief, Art Section, *El Imparcial*, Guatemala, 1954-57; Latin-American Desk, French Radio-Television, Paris, 1961-69; Correspondent in Latin America for ASA Press, Paris, 1971-72, and for SIPA Press, Paris, 1972-74. Author, with Sara Facio, of *Actos de Fe en Guatemala*, with text by Miguel Angel Asturias, 1980. **Essay:** Eleta.

PALAZZOLI, Daniela. Adviser and essayist. Professor of Theory and Method of Mass Media, Academy of Brera, Milan. Editor in charge of the Photographic Book Section, Electa Editrice, Milan. Curator/organizer of numerous exhibitions, including *The Fight for the Image*, 1973, *Fantastic Photography in Europe*, 1976, etc. Author of *Fotografia, Cinema, Videotape: L'Uso Artistico dei Nuovi Media*, 1977, and *Giuseppe Primoli*, 1979; editor of *Combattimento per un'Immagine: Fotografi e Pit-*

tori, 1973; *Venezia '79: La Fotografia*, with others, 1979; and *La Fotografia Italiana dell'800*, 1979. **Essays:** Primoli; Schad; Shahn; Weegee.

PATNIK, Deba P. Essayist. Director of the Third World House and Professor of English, Oberlin College, Ohio, since 1980. Professor of Religious Studies, University of North Carolina, 1975-76; Special Consultant, George Eastman House, Rochester, New York, 1975-79; Writer-in-Residence, Le Moyne College, Syracuse, New York, 1976-77; Professor of English, Briarcliff College, 1979-80. Author of *Geography of Holiness: Thomas Merton's Photography*, 1980, and editor of *Concelebration: Poetic Tribute to Thomas Merton*, 1980. **Essays:** Bedi; Caponigro; Metzker; Morgan; Parks; Samaras.

PFEIFER, Marcuse. Essayist. Owner of the Marcuse Pfeifer Gallery, New York, since 1976. Assistant to the Director, New School Art Center, New School for Social Research, New York, 1966-69; Director, Photography Section, Robert Schoelkopf Gallery, New York, 1970-76. Editor of the catalogue *The Male Nude: A Survey in Photography*, 1978; author of the introduction to the book *The Male Nude in Photography*, 1980. **Essay:** Hujar.

PHILLIPS, Christopher. Essayist. Freelance writer. Contributor to *American Photographer* and *Exposure*. Curatorial Assistant, Department of 20th Century Photography, International Museum of Photography, George Eastman House, Rochester, New York, 1979-80. Author of *Steichen at War: Naval Aviation in the Pacific*, 1981. **Essays:** Bayer; Blumenfeld; Bruehl; Horst; Keppler; Matter; Winningham.

POLI, Kenneth. Essayist. Editor of *Popular Photography*, New York, since 1970 (Senior Editor, 1968-70). Freelance magazine photographer, 1949-51; Editor, *Leica Photography* magazine (U.S.A.), 1954-65. **Essays:** Mark Cohen; Davidson; Eisenstaedt; Mili; Owens; Porter; Stettner.

POMEROY, Ralph. Essayist. Poet, painter, critic and curator, New York. Associate Director of the Forum Gallery, New York, since 1979. Director, Anna Leonowens Gallery, Halifax, Nova Scotia, 1968-69; Staff Critic, *ARTnews*, New York, 1963-68; Contributing Editor, *Art and Artists*, London, 1966-71; San Francisco Correspondent, *Art and Artists*, 1973. Author of (poetry) *Book of Poems*, 1948, *Stills and Motives*, 1961, *The Canaries as They Are*, 1965, and *In the Financial District*, 1968, and (other) *Stamos*, 1974, *The Ice Cream Connection*, 1975, and *First Things First*, 1977. **Essays:** Beny; Brown; Duncan; Elisofon; Liberman; Morath; Orkin; Stock; Van Dyke.

PORTER, Allan. Essayist. Editor of *Camera*, Lucerne. **Essays:** Model; Schuh; Steinert.

PRANDO, Edo. Essayist. Journalist in Turin, specializing in photography. Editor of the fortnightly *Fotogiornale*. Freelance photographer, 1969-73; Member, Editorial Staff, Teletorino TV, 1973-75; Editor, *Fotografia Italiana*, Milan, 1976-79. Author of *Guida alle Grotte d'Italia*, 1973; *Fotografia Speleologica e Archeologica*, 1977; *La Famiglia Barolo*, 1978; *Valtellina*, 1978. **Essays:** Almasy; Clergue; Freed; Gagliani; Lennart Nilsson; Ragazzini.

PRASAD, H.Y. Sharada. Essayist. Information Adviser to the Prime Minister of India, 1968-78, and since 1980. Contributor on Indian events to the *Britannica Yearbook*, since 1963. News Editor, *The Indian Express*, Bombay, 1948-55; Chief Editor, *Yojana*, 1959-66; Deputy Information Adviser to the Prime Minister, 1966-68; Director, Indian Institute of Mass Communication, 1978-80. Editorial Consultant to the *Nehru Exhibition*, 1964-65, the Indian Pavilion at *Expo '67*, Montreal, and the *Gandhi Centenary Exhibition*, 1969. **Essays:** Nag-

arajan; Singh.

PRICE, Derrick. Essayist. Principal Lecturer in Media Studies, Bristol Polytechnic, England. Member of the Centre for Contemporary Cultural Studies, University of Birmingham. **Essays:** Delano; Hausmann; Heartfield; Lee; Mydans; Spender.

PUTNAM, Sarah. Essayist. Freelance photographer, Boston, since 1978; Photo Editor for *Sojourner* since 1980. Exhibition Editor, *Views: The New England Journal of Photography*, 1980-81. **Essays:** Beaton; Karsh; Mayes.

REMES, Vladimír. Essayist. Chief Dramatist, Play Section, Czechoslovak Radio, Prague, since 1972. Member of the Cultural Section, Czechoslovak Radio, 1960-68; film critic for various magazines in Czechoslovakia and writer for Czechoslovak films, 1968-72. Writer on photography, and collaborator with Daniela Mrázková on *Revue Fotografie*, Prague, since 1971. Author, with Mrázková, of *They Photographed the War: Soviet War Photography 1941-45*, 1975; *The Russian War*, 1977; *The Russian War 1941-45*, 1978; *Von Moskau nach Berlin*, 1979; *Irena Blüh*, 1980; *Die Sowjetunion Zwischen den Kriegen 1917-1941*, 1981; *Tschechoslowakische Fotografen 1900-1939*, 1981; *Josef Sudek*, 1981. **Essays:** Abramochkin; Gnisyuk; Makarov; Malyshev; Tooming; Trakhman.

ROMER, Grant B. Essayist. Freelance photographer, lecturer and writer. Assistant Director of Exhibitions, 1976-77, Intern Coordinator, 1978, and Conservator, 1979, International Museum of Photography, George Eastman House, Rochester, New York. **Essay:** D'Alessandro.

ROSENBLUM, Naomi. Essayist. Adjunct Professor of Art History, Parsons School of Design, New York, since 1976. Formerly Adjunct Associate Professor of Art History, Brooklyn College. Co-Curator of the *Lewis Hine Retrospective*, Brooklyn Museum, 1977, Venice Biennale, 1979, and China, 1980. Author of *America and Lewis Hine*, with Walter Rosenblum and Alan Trachtenberg, 1977; and *American Art*, with Milton Brown, Sam Hunter, John Jacobus, and David Sokol, 1979. **Essays:** Arbus; Doisneau; Levitt; Liebling; Sheeler; Strand.

ROWELL, Mike. Essayist. Freelance photojournalist, since 1970; Photography Critic, *Maine Sunday Telegram*, since 1973. Automotive Editor, Chilton Book Company, 1970; Editor, *Maine Racing Annual*, 1974-79; Editor, *Super Stock and Drag Illustrated*, 1979-80. Editor of books on auto repair; author of the forthcoming *Auto Racing Photography*. **Essays:** Szabo; Webb; Cole Weston.

SAGER, Peter. Essayist. Journalist: member of staff of the weekly *Die Zeit*, Hamburg, since 1975. Broadcaster in Cologne, 1970-75. Author of *Neue Formen des Realismus*, 1973; *Sud-England*, 1977; *Heinrich Riebesehls Agrarlandschaften*, 1979; and *Schottland*, 1980. **Essays:** Hajek-Halke; List; Riebesehl.

SANDERS, Catharine. Essayist. Associate, The Photographers' Gallery, London. **Essay:** Edwards.

SCHARF, Aaron. Adviser and essayist. Professor of the History of Art, The Open University (U.K.), 1969-82. Member, Arts Council of Great Britain Photography Sub-Committee, 1972-78. Author of *Creative Photography*, 1965; *Art and Photography*, 1966; and *Pioneers of Photography*, 1975. **Essays:** Cooper, Cordier.

SCHOFIELD, Jack. Essayist. UK Editor of *Zoom*, Paris, since 1978; Editor of *Omni: The Book of the Future* weekly magazine, London, since 1981. Editor of *Photo Technique* monthly magazine, London, 1973-78, and *You and Your Camera* weekly magazine, London, 1979-80. Consultant Editor of *The Darkroom Book*, 1981, and *Nude and Glamour Photography*, 1982. **Essays:** Arnold; Benedict-Jones; Cagnoni; Claridge; Davis; Gatewood; Gerster; Harbutt; Jones-Griffiths; Kane; McBride; Meiselas; Ricciardi.

SCIMÉ, Giuliana. Essayist. Freelance photography critic, Milan. Regular contributor to *Printletter*, *Foto*, *Fotozoom*, and *European Photography*. Author of the exhibition catalogues, *10 Fotografos Italianos*, 1979, *The Thin Line*, 1980, *The Line in Movement*, 1980, and *Women*, 1981, and of *Giuseppe Arcimboldi, Fantasia e Capriccio*, 1974, *Espressività e Razionalità*, 1975, and *Concettualismo come Ribellione*, 1976. **Essays:** Blanco; D'Amico; Facio; Figueroa Flores; Laizerovitz; Mahr; Paolini; Fontana; Schawinsky; Urban; Vishniac.

SCULLY, Julia. Essayist. Editor, *Modern Photography*, New York, since 1966. Editor, *Camera 35*, New York, 1961-66. Author and editor of *Disfarmer: The Heber Spring Portraits 1939-1946*, 1976; and editor of *The Family of Women*, 1979. **Essays:** Disfarmer; Sander.

SHELDON, James L. Freelance photographer and filmmaker. Curator of Photography, Addison Gallery of American Art, Phillips Academy, Andover, Massachusetts, since 1977. Author of the exhibition catalogues, *Beaumont Newhall: Photographer*, 1980; *Aspects of the 70's*, 1980; and *Looking at America*, 1981. **Essays:** Blumberg; Margolis; Perkis.

SOLOMON-GODEAU, Abigail. Essayist. Freelance photography critic, Paris and New York, since 1978; contributor to various photographic journals. Formerly a photo editor. **Essays:** Baldessari; Burgin; Clark; Friedman; Peress.

SPENCER, Ruth. Essayist. Photo-historian; picture researcher, Time Inc. Picture Collection, New York. Regular contributor to the *British Journal of Photography*, London. **Essays:** Goro; Stern.

SPIELMANN, Heinz. Essayist. Chief Curator for Modern Art, Museum für Kunst und Gewerbe, Hamburg. Author of *Oskar Kokoscha: Das Schriftliche Werk*, 4 volumes, 1972-76; *Spektrum der Kunst*, 1974, 1982; *Epochen, Künstler, Meisterwerke*, 13 volumes, 1975-77. **Essays:** Kempe; Lebeck.

STANGE, Maren. Essayist. Freelance photographic critic and lecturer. Regular contributor to the *New Boston Review*. Fellow, Smithsonian Institution/George Mason University, Washington, D.C., since 1982. **Essays:** Beard; Bishop; Blondeau; Dominis; Fink; Glinn; Hartmann; Joel; McCombe; Noskowiak; Papageorge; Silk.

STOKES, Philip. Essayist. Photographer and photographic critic. Coordinator of Theoretical Studies, Photography Course, Trent Polytechnic, Nottingham, England. **Essays:** Auerbach; Godwin; Hedges; Hill; Hilliard; Ionesco; Larson; Magritte; Mayne; Uzzle.

STOKOE, Brian. Essayist. Freelance photographic critic and historian. Founder Member, Photographic Archive and Research Collective, Midland Group Gallery, Nottingham, England. **Essays:** Hoppé; Renger-Patzsch.

STOTT, William. Essayist. Professor of American Studies and English, University of Texas at Austin, since 1971. Foreign Service Officer, United

States Information Agency, 1964-68. Author of *Documentary Expression and 30's America*, 1973; co-author of *On Broadway: Performance Photographs by Fred Fehl*, 1978. **Essay:** Evans.

SUTNIK, Maia-Mari. Essayist. Photographic Co-ordinator, Art Gallery of Ontario, Toronto, since 1973. Audio-Visual Librarian, 1969-73. Author of the exhibition catalogues, *Eisenstein Drawings from Theatre to Film*, 1974, and *E. Haanel Cassidy: Photographs 1933-1945*, 1981. **Essays:** Lambeth; Snow.

TAUSK, Petr. Essayist. Photographer, critic and lecturer, Prague. Senior Scientific Researcher, Central Institute of Scientific, Technical and Economic Information, Prague, since 1968; Visiting Lecturer, Department of Creative Photography, Film and TV Faculty, Prague, since 1967. Author of *Photography with Interchangeable Lenses*, with B. Biskup, 1960; *Encyclopedia of Practical Photography*, with others, 1972; *Fundamentals of Creative Colour Photography*, 1973; *Introduction to Press Photography*, 1976; *Die Geschichte der Fotografie im 20. Jahrhundert/Photography in the 20th Century*, 1977; *100 Temi di Fotografia*, with H. Hofstätter, 1977; *Black and White Creative Photography*, 1981. **Essays:** Alpert; Chochola; Dias; Ehm; Funke; Gernsheim; Giacomelli; Haskins; Helmer-Petersen; Hopkins; Ignatovich; Jodas; Kalláy; Kuščynskyj; Mante; Martinček; Prošek; Rajzík; Rössler; Smoková-Váchová; Splíchal; Stecha; Steele-Perkins.

THEROND, Roger. Essayist. Photography critic, *Le Monde*, Paris. **Essays:** Cartier-Bresson; Depardon; Izis; Lartigue; Sieff.

TOOMING, Peeter. Entrant and essayist. See his own entry. **Essays:** Butyrin; Kalvelis; Macijauskas; Sutkus.

TUCKER, Anne W. Essayist. Photographic historian, critic and lecturer. Curator of Photography, Museum of Fine Arts, Houston, since 1976. Research Assistant, International Museum of Photography, George Eastman House, Rochester, New York, 1968-70; Photography Consultant, Creative Artists Public Service Program, New York, 1971-72; Director, Photography Lecture Series, Cooper Union Forum, New York, 1972-75. Author of *Rare Books and Photographs: Catalogue 1*, with Lee Witkin, 1973, and *The Target Collection of American Photography*, exhibition catalogue, with William C. Agee, 1977; editor of *The Woman's Eye*, 1973; *The Anthony G. Cronin Memorial Collection*, 1979; *Suzanne Bloom and Ed Hill* (manual), 1980; and *Target II: 5 American Photographers*, 1981. **Essay:** Leipzig.

TURNER, Roland. Essayist. Freelance writer, critic and editor, New York. Formerly, Editor, St. James Press, London, and Director of the Reference Books Department, St. Martin's Press, New York. Author/editor of *The Grants Register* and *The Annual Obituary*. **Essay:** Parkinson.

VAIZEY, Marina (Lady Vaizey). Essayist. Art Critic, *The Sunday Times*, London, since 1974. Art Critic, *The Financial Times*, London, 1970-74. Member of the Arts Panel, 1973-78, Member, 1976-78, and Chairman of Arts Films, 1976-78, Arts Council of Great Britain. Author of *100 Masterpieces of Art*, 1979; *Andrew Wyeth*, 1980; and *The Artist as Photographer*, 1982. **Essays:** Chim; Fulton; Glass; McBean; McCormick; Edwin Smith; Wegman.

VAN DEUREN, Karel. Essayist. Corresponding Editor for Belgium, *Foto*, Hilversum, Netherlands,

since 1977; also, Member of the Working Party on Photo and Film, Museum of Photography of the Province of Antwerp, since 1974; Editor of *Vlaanderen* arts review, since 1977; Editor of *Photohistorica*, bibliographical review of the European Society for the History of Photography, since 1978. Editor and Press Officer for Agfa-Gevaert, Morstel, Belgium, 1954-81, and editor of the Gevaert publication *Photorama*, 1954-58; also, Editor of *Photo-Tribune*, Duerne, Belgium, 1959-64. Author of *Dit Vlaanderen heb ik Hartelijk Lief*, 1974; *Liefde Gaf u Duizend Namen*, 1976; *De Reizigers Worden Verzocht van in te Stappen*, 1980; and of the catalogue *Belgian Photography 1940-80*, 1980. **Essays:** Ausloos; Dries; Reusens; Tas.

VESTAL, David. Entrant and essayist. See his own entry. **Essays:** Atget; Grossman; Kertész; Modotti; Steiner; Stieglitz.

VISKOCHIL, Larry A. Essayist. Curator, Graphics Collection, Chicago Historical Society, since 1977 (Head of Library Reference and Reader Services, 1967-77). Chairman, Picture Division, Special Library Association, 1981-82. **Essay:** Siegel.

WEDEWER, Rolf. Essayist. Curator, Museum Leverkusen, West Germany. **Essays:** Jansen; Nothhelfer; von Gagern.

WEISS, Evelyn. Essayist. Photographic critic and historian. Curator of Photography, Museum Ludwig, Cologne. **Essay:** Chargesheimer.

WIGH, Leif. Essayist. Assistant Curator, Fotografiska Museet: Swedish Museum of Photography, Stockholm, since 1977. Part-time writer for the magazines *Fotonyheterna* and *Aktuell Fotografi*, since 1976. Freelance photographer, 1963-77; Teacher, School of Photography, Stockholm, 1965-69; Photographer/Information Officer, Swedish National Theatre Centre and the Cullberg Ballet, 1972-77. Has collaborated with curator Åke Sidwall on numerous exhibition catalogues at the Fotografiska Museet, since 1974; author of *Fotograferna och det svenska landskapet*, 1981. **Essays:** Goodwin; Malmberg.

WILDE, Jürgen. Essayist. Photographic critic, historian and archivist. Director of the Galerie Wilde, Cologne. **Essays:** Blossfeldt; Krull; Lotar; Tabard.

WILLIAMS, Jonathan. Essayist. Poet, publisher, and writer on photography. Director of a writers' press, The Jargon Society, Highlands, North Carolina, since 1951. Contributing Editor of *Aperture*, Millerton, New York. Author of numerous volumes of verse, and of books, *The Appalachian Photographs of Doris Ulmann*, 1971; *Clarence John Laughlin: The Personal Eye*, 1973; *The Family Album of Lucybelle Crater*, 1974; *Hot What? Collages, Texts, Photographs*, 1975; *"I Shall Save One Land Unvisited": 11 Southern Photographers*, 1978; and *Portrait Photographers*, 1979. **Essays:** Joyce; Kalisher; Laughlin; Meatyard; Sinsabaugh; Keith Smith.

WILLIAMS, Sheldon. Essayist. Cultural Adviser to RONA, London. Secretary to the Société Européenne de la Culture, 1965-73; Editor of *Art Illustrated*, 1968-70. Sometime Arts Correspondent with *Contemporary Review*, *Pall Mall Gazette*, *Apollo*, *Arts Voices*, *Questions d'Art*, *Artis*, etc. Author of *Situation Humaine*, 1967; *Verlon*, 1968; *A Background to Sfumato*, 1969; *Voodoo and the Art of Haiti*, 1971; *20th Century British Naive and Primitive Artists*, with Eric Lister, 1975; editor of *RONABOOK*, 1978, and *A Quiet Thunder*, 1978. **Essays:** Bellmer; Székessy.

WINAND, Anna. Essayist. Executive Assistant, International Center of Photography, New York, since 1975. Counselor/Photographer, The Voice of the Children, Brooklyn, 1968-72; Teacher/Photographer, Alternative High School Program, Harlem, New York, 1969-73. Editor of *Whispers from a Continent* by Wilfred Cartey, 1968; researcher and editorial coordinator for the exhibition catalogues, *Andreas Feininger*, 1976; *Halsman*, 1979; *Japan: A Self-Portrait*, 1979; and *Lucien Aigner*, 1979. **Essay:** Robert Capa.

WINOKUR, Ken. Essayist. Freelance writer and photographer, Boston. Managing Editor/Feature Editor of *Views: The Journal of Photography in New England*, Boston, 1979-81; Photo Critic for *The Real Paper*, 1980-81. **Essays:** Krims; Manos; Purcell; Resnick.

WISE, Kelly. Entrant and essayist. See his own entry. **Essays:** Friedlander; Minkkinen; White.

ZANNIER, Italo. Essayist. Professor of Communications at the Faculty of Architecture, Venice, since 1971, and Professor of Photography at the University of Bologna, since 1974. Professional photographer, specializing in architectural photography, 1952-76; taught photography at the Corso Superiore di Disegno Industriale, Venice, 1960-70. Has published numerous volumes of photographs; also, author of *Breve Storia della Fotografia*, 1962, 1974; *Fotografia dell'Architettura*, 1969; *Conoscere la Fotografia*, 1978; *70 Anni di Fotografia in Italia*, 1978; *Fotografia in Friuli*, 1979; *Ferruccio Leiss, Fotografo a Venezia*, 1979; and *I Manuali del Fotografo: Lo Sport*, with M. Cappon, 1980. **Essays:** Carmi; Cavalli; Del Tin; Gioli; Grignani; Veronesi.

ZIWES, Colette. Essayist. Freelance writer and critic, Paris. **Essay:** Darche.

Verena von Gagern: *Untitled*, 1980

Tall Contemporary photographers / editors,
TR George Walsh, Colin Naylor, Michael
139 Held. -- New York : St. Martin's
C66 Press, [1982]
 x, 837 p. : ill. ; 33 cm.

 ISBN 0-312-16791-1

1. Photographers--Biography. 2. Photography,
Artistic. I. Walsh, George. II. Held,
Michael. III. Naylor, Colin.

MUNION ME 830305 830228 CStoC
D000016 KW /EW A* 83-B1591
 82-3337